D1312583

BIBLIOGRAPHY ON PORTRAITURE

Selected Writings on Portraiture
as an Art Form and as Documentation

Volume II: Classified Arrangement and Index to Topics

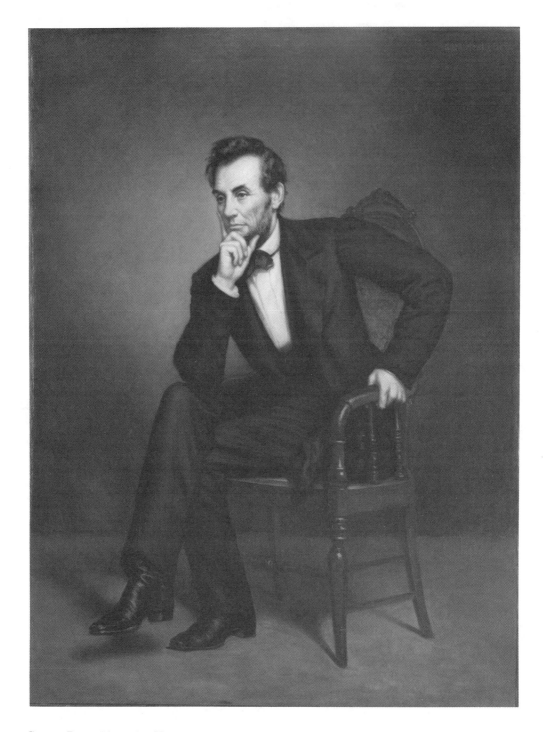

George Peter Alexander Healy, *Abraham Lincoln* (1887), oil on canvas, 188 x 137.1 cm. National Portrait Gallery, Smithsonian Institution. Transfer from the National Gallery of Art. Gift of Andrew W. Mellon, 1942.

BIBLIOGRAPHY ON PORTRAITURE

Selected Writings on Portraiture
as an Art Form and as Documentation

Compiled by Irene Heppner

Volume II: Classified Arrangement and Index to Topics

G.K. Hall & Co.
Boston, Massachusetts

ISBN 0-8161-0481-6

Contents

Abbreviations

Acad.Inscr.Paris Mon et Mem.	*Academie des inscriptions et belles lettres. Paris. Commission de la fondation Piot . . . Monuments et memoires*
Act Arch.	*Acta Archaeologica, Kopenhagen*
Am or Amer.	American
Am Coll.	*American collector*
Am de l'art	*L'Amour de l'art*
A.Soc.Archeol.Brux	*Annales de la Societe royale d'archeologie, Bruxelles*
Ann'l	Annual
Ant.collector	*Antique Collector*
Arch.	Archives or Archivo or Archivio
Artbibl.modern	*ARTbibliographies MODERN*
At. Pontif.Accad,rom.Archeol.R.C	*Atti della Pontificia Accademia romana di archeologia, Rendiconti,Roma*
attr.	attributed
B.	Bulletin
Bibl.	Bibliothek
Brit.	British
Brit.J.Aesth.	*British Journal of Aesthetics*
Brookl.m.Q.	*Brooklyn Museum Quarterly*
Burl Mag	*Burlington Magazine*
c. or ca.	circa
C.Belgique	*Cahier de Belgique*
C.R.Acad.Inscrip.	*Compte-rendus de l'academie des Inscriptions et Belles-Lettres, Paris*
Cat.	Catalogue

Ch.	Chapter
Col.	Colonial
Coll.	Collection
Coll.Art J.	*College Art Journal*
Comp.	Compiled
Conn.Hist.Soc.B.	*Connecticut Historical Society, Bulletin*
Cum Mag Subj.ind.	*Cumulative Subject index*
Deutsch Archäol.Inst.Mitt.Röm.Abt.	*Deutsches archäologisches Institut.Mitteilungen. Romische Abteilung*
Dig.	Digest
Diss.	Dissertation
Div.	Division
Dpt.	Department
drags. or drgs.	drawings
Dt.Kst.u.Dek	*Deutsche Kunst und Dekoration*
ed.	edition (edited)
Enc.	Encyclopedia
Eng.	England
Eng.Ill.Mag.	*English Illustrated Magazine*
engr.	engraving
fg.	figure
fl.	flourished
FOGG	*Catalogue of the Harvard University Fine Arts Library, The Fogg Art Museum*
fr.	from
Gaz Beaux-Arts	*Gazette des Beaux-Arts*
Graph.Künste	*Die Graphischen Künste*
Hist. (hist.)	History (historical)
Ill.Hist J	*Illinois Historical Journal*

illus.	illustrated
incl.	includes
Ind.	Index
Indic.suisse	*Indicateur d'antiquities suisse*
Inst.	Institute, (Institution)
J.	Journal
J.Interdisc.Hist.	*Journal of Interdisciplinary History*
Jb.	Jahrbuch
jhrh.	Jahrhundert
K.u.K	*Kunst und Künstler*
L.A.	Los Angeles
L.C.	Library of Congress
Loma	*Literature in modern art*
M.Comm.Monum.Hist.Pas-de-Calais	*Mémoires de la commission départementale des monuments historiques des Pas-de-Calais, Arras, France*
Mag.	Magazine
Md.	Maryland
MET	*Library Catalog of the Metropolitan Museum of Art, New York*
Mitt.	Mitteilungen
MOMA	*Catalog of the Library of the Museum of Modern Art, New York (City)*
Mon.	Monograph (Monografia)
Münch Jahr Bild Kunst	*Münchner Jahrbuch der bildenden Kunst*
Mus. or mus.	Museum
NCFA	National Collection of Fine Arts (after 1980 called National Museum of American Art)

NGA	National Gallery of Art, Washington, D.C.
N.J.	New Jersey
NMAA	National Museum of American Art (before 1980 called National Collection of Fine Arts)
NPG	National Portrait Gallery
N.Y.P.L.	*Dictionary Catalog of the Art and Architecture Division (New York Public Library)*
Nat. or Nat'l	National
Nouv. Rev.Française	Nouvelle Revue Française
Numism.Chron.	*Numismatic Chronicle*
Nuremberg.Germ.nat.mus..	Nuremberg.Germanisches National-museum
part col.	partly colored
Penn.	Pennsylvania
Phila.	Philadelphia
Pl.	Plate
portr.	portrait
Proc.Am Ant Soc	*Proceedings of American Antiquarian Society*
pseud.	pseudonym
pt.	part
ptg.	painting
publ.	published (publisher)
Q.	Quarterly
R.	Revue (Review)
Ref.	Reference
Rep.	*Repertoire d'art et d'archéologie*
Repro.	Reproduction
Rev.	Review (Rivista)

Roy.	Royal
Sculpt Rev	*Sculpture Review*
ser.	serie (series)
Slg.	Sammlung
Soc.	Society
Subj.	Subject
t.-p-	title page
Th.	Thesis
Uni. or (Univ.)	University
V & A	*National Art Library Catalogue Victoria & Albert Museum, London, England*
VF	Vertical files
W.C.	Water color
Yale Ctr.	Yale Center for British Art

Guide to the Classified Arrangement

I. General

I.A. Reference

 I.A.1. Bibliographies on Portraiture

I.B. General Treatises

 I.B.1. Collections and Exhibitions
 a. Public, A-Z by institution
 b. Private, A-Z, by name of collector
 c. Dealers' Catalogs, A-Z, by dealer or gallery name
 d. Auction Catalogs, A-Z, by auction house
 I.B.2. Individual Artists
 I.B.3. Journals, Yearbooks
 a. Festschriften and Other Miscellaneous Collections of Essays
 I.B.4. Portrait-Making as an Occupation
 I.B.5. Juvenile Works on Portraits (all media)

I.C. Special Periods and Styles – Chronological

 I.C.1. Antiquity
 I.C.2. Early Christian Coptic Byzantine
 I.C.3. c. 5th c.-14th c.
 I.C.4. 14th c.-17th c.
 I.C.5. 18th c.
 I.C.6. 19th c.
 I.C.7. 20th c.
 I.C.9. Influences Comparisons Contrasts

I.D. Special Countries, A-Z, subdivided – chronological and regional
("European art" listed under "E")

I.E. Special Subjects, A-Z, including works on painting as well as general
works. For works primarily of photographic interest, see II.E.4. For other
special media, see Special Subjects under Drawing, Sculpture, Prints, etc.

 Allegory and Religion (including mythology, symbolism)
 Anatomy
 Ancestral (only when specifically discussed)
 Artists, Physically Handicapped
 Caricature (paintings, or when several media are discussed)
 Children

Costume
Curiosities
Death
Donor Portraits
Equestrian
Ethnic Groups, A-Z (e.g. Jews, Negroes, etc.)
Eyeglasses in Art
Family
Folk Art
Funerary Memorials (other than sculpture)
Groups
Hairdressing
Individual Sitters, A-Z (other than photography)
Lighting in Portraiture
Men
Mummies
Object Portraits (abstract compositions, chiefly 20th c.)
Old Age
Origami
Postage Stamps
Professions, A-Z
Self-Portraits (for individual artists, see artist; see also Special
 Media – Special Subjects)
Skulls
State Portraits, see Professions – Statesmen
Women
Youth

I.F. Special Pose or Length

 I.F.1. General
 I.F.2. Frontal
 I.F.3. 3/4 View
 I.F.4. Profile
 a. General
 b. Silhouette
 I.F.5. Length
 a. Bust, see also II.C.5. – Busts
 b. Waist, Half Length (including kit-kat size)
 c. 3/4 (knees included.)
 d. Full Standing
 e. Full Seated

I.G. Connoisseurship and Examination

 I.G.1. General
 I.G.2. Forgeries
 I.G.3. Mutilation (vandalism)
 I.G.4. Conservation (X-ray, etc.)

I.H. Intellectual Concepts

 I.H.1. General (including the uses of portraits, portraits as historical document)
 I.H.2. Aesthetics
 I.H.3. Philosophy
 I.H.4. Psychology
 a. General (including Pathology and Physiognomy)
 b. Intentions of Sitter and/or Artist
 c. Formal versus Informal Portraits
 I.H.5. "Disguised" Portaits: "Assistenzia"
 I.H.6. Portraits within Other Portraits

I.J. Theses and Dissertations

II. Special Media

II.A. Painting

 II.A.1. General
 II.A.2. Chronological
 II.A.3. By Country, A-Z, subdivided – chronological and regional
 II.A.4. Primitive Painting (including all folk painting; subdivided by country only), see also I.F. Folk Art
 II.A.5. Specific Media, A-Z (if not specifically listed below, paintings are in oil or tempera)
 Acrylic
 Enamel
 Encaustic
 Gouache
 Hair
 Pastel
 Water-Color
 II.A.6. Special Forms, A-Z
 Glass (e.g. Hinterglasmalerei, gilded glasses; engraved gold on glass, see II.B.3.f)
 Manuscripts
 Miniatures

Wax
Wood
II.C.5. Special Forms and Subjects, A-Z
 Busts
 Cameos and Intaglios (including glass cameos)
 Caricature (e.g. Messerschmidt, Daumier)
 Children
 Coins and Medals
 Equestrian
 Funerary
 Groups
 Masks (including life- and death-masks)
 Relief
 Self-Portraits
 Standing Figures

II.D. Decorative Arts, A-Z

 Ceramics (portraits on ceramics)
 Fabrics
 Needlework (including stump work)
 Tapestry
 Wood (e.g. carving, intarsia)

II.E. Photography

 II.E.1. General
 Collections
 a. Public, A-Z, by institution
 b. Private, A-Z, by name of collector
 c. Dealers, A-Z, Catalogs and Collections
 II.E.2. Chronological
 II.E.3. By Country, A-Z, subdivided – chronological and regional
 II.E.4. Special Forms and Subjects (used only for works exclusively – or
 primarily – of photographic interest; otherwise see I.E.)
 Allegory and Religion
 Anatomy
 Ancestral
 Caricature
 Cartes de Visite
 Children
 Costume
 Curiosities
 Death
 Donor Portraits
 Equestrian

Classified Arrangement

I. General

I. GENERAL

N
7593
C57
NFG

I.A Cirker, Blanche, ed.

Cirker, Hayward.
Dictionary of American portraits. 4045 pictures of important Americans from earliest times to the beginning of the twentieth century. Edited by Hayward and Blanche Cirker and the staff of Dover Publications. New York, Dover Publications ₍1967₎

xiv, 756 p. (chiefly ports.) 34 cm. (Dover pictorial archive series)

Bibliography: p. 713–715.

1. Portraits, American. 2. U. S.—Biog.—Portraits. I. Cirker, Blanche, joint ed. II. Dover Publications, inc., New York. III. Title. IV. Title: American portraits. (Series)

N7593.C53 704.9′42′0973 66–30514

Library of Congress ₆₁

I.A. REFERENCE

751.2261 I.A
.C61

Clarke, Harold George
The story of old English glass pictures, 1690–1810,...London,Courier press.1928.
107 p. illus.(part col.)

Alphabetical catalogue of glass pictures: p.89–97
Alphabetical catalogue of engravers:p.98–104

LC ND1590.C5

I.A Reference Items of general nature, not pertaining to a special collection or institution. Items of a universal character.

N
7616
C64
NCFA

I.A

Clouzot, Henri, 1865–1941
...Dictionnaire des miniaturistes sur émail... ₍Paris,A.Morancé,c.1924₎
241 p. illus. (Archives de l'amateur)

Bibliography

Covers the period 1630–c.1860

LC N7616.C5 Th.B.-Petitot Lit.

N
7620
A51
NPG Ref.

I.A

...A.L.A. portrait index;index to portraits contained in printed books and periodicals... Washington,Govt.print.off.,1906

1600 p.

LC N7620.A2

NK
928
C75
1968
NCFA

I.A

The Connoisseur
The Connoisseur's complete period guides to the houses,decoration,furnishing and chattels of the classic periods;edited by Ralph Edwards and L.G.G.Ramsey. London,The Connoisseur,1968
1536 p. illus.

Bibliography

LC NK928.C63

I.A

Avesac-Lavigne, Charles
L'histoire moderne par la gravure;ou,Catalogue raisonné des portraits historiques avec renseignements iconographiques...Paris,E.Leroux, 1878
238 p.

LC NE220.A8 Fogg,v.11,p.320

I.A

Darmon, J.E.
Dictionnaire des peintres miniaturistes sur vélin,parchemin,ivoire et écaille..Paris.Morancé ₍1927₎
121 p. illus. (Aide mémoire de l'amateur et du professionel)
FOGG Fogg edition .1927.
FA3930
62

LC ND1330.D3 Amsterdam,Rijksmuseum cat. 25939A52,deel 1 NCFA p.128 ed..1930?.

N
7598
D5
1979X
NPG
Ref.
v.1-2

I.A

Dictionary of British portraiture;ed.by Richard
 Ormond and Malcolm Rogers.N.Y.,Oxford Uni.
 Press,c.1979-
 v

 1.Davies, Adriana.The middle ages to the
early Georgians.Historical fgs.born before 1700
2.Kilmurray, Elaine.Later Georgians and early
Victorians.Historical fgs.born betw.1700 and
1800

N
31
E56
NCFA

I.A

Encyclopedia of World Art
 Portraiture

In:v.11:469-515 illus.Pls.209-30 London,
McGraw-Hill,1966

 Contents:Concepts of portraiture(cols.469-71)
...Primitive Peoples(cols.471-2);The ancient
World(cols.472-83);The European West(cols.483-
501);The Orient(cols.501-10);Bibl.(cols.510-5)

LC N31.E4833

I.A

Diepenbroick-Grüter, Hans Dietrich von, firm
 Allgemeiner porträt-katalog;verzeichnis
einer sammlung von 30000porträts des 16.bis 19.
jahrhunderts in holzschnitt,kupferstich,schab-
kunst und lithographie,mit biographischen notizen.
Hamburg,...1931

 902 p. issued in 5 parts.

 Index of professions & subjects(aSchlagwort")
list of places & countries.Index of hidden names

LC NE220.D5

I.A

Errera, Isabelle, d.1929
 ...Répertoire abrégé d'iconographie.I-II.
Wetteren,Imprimerie J.de Meester et fils,1929-
 v.

 Bibliography

LC N7525.F7 Fogg,v.11,p.322

N
7624
H24
NPG

I.A

Diepenbroick-Grüter, Hans Dietrich von, firm
 Porträtsammlung. Tecklenburg in Westfalen,
1954-

 Cat.with price-list of portrait prints,
grouped mainly by regions in Germany.Published
in sections(1)Niedersachsen,1954,(2)Schöne,sel-
tene und interessante porträts,1955,(3)Westfa-
len nebst Lippe,1956,(4)Nordrhein...1956,(5)
Rheinland-Pfalz,1956,(6)Hessen,1956,(7)Grosse,
dekorative porträts.grouped by profession,1958,
(8)Schleswig-Holstein Hamburg,Lübeck,Bremen,
(9)Württemberg, nebst Hohenzollern

704.942 I.A.
F499

Fink, Frances Sharf.
 Heads across the sea;an album of 18th c.
English literary portraits in America. Char-
lottesville,bibliographical Society of the
University of Virginia;Distributed by the Uni-
versity of Virginia Press,1959
 251 p. illus.

 Bibliography

LC N7598.F5

NE
250
D79
1860a
NPG
Ref.

I.A

Drugulin, Wilhelm Eduard. 1822-1879
 Allgemeiner porträt-katalog...verzeichnis
einer gewählten sammlung von 24000 porträts be-
rühmter personen aller länder und zeiten(mit
biographischen und chalkographischen notizen)...
Leipzig,Kunst-comptoir,1860

 2 v.in one

LC NE250.D65 Chamberlin,M.W.Guide to art
 ref.books #101

I.A

Forrer, Leonard
 Biographical dictionary of medallists;coin,
gem,and seal engravers...500B.C.-1900.London,
Spink & son,1902-30
 8 v. illus.

 Bibliography,v.1

LC CJ5535.F7 Lederer.Portrs.in wax
 In:Conn.705/C75,v.94,p.105

N
31
E56
NCFA

I.A

Encyclopedia of World Art
 Hellenistic Art:Portraiture

In:v.7:363-4 illus. London,McGraw-Hill,1963

LC N31.E4833

ND
1337
G7F74d
NPG

I.A

Foskett, Daphne
 A dictionary of British miniature painters.
London,Faber & Faber.1972.
 2 v. illus(part col.)

ND
1337
O7F74m
1987
NPG
Ref.

I.A

Foskett, Daphne, 1911-
 Miniatures:dictionary and guide.Printed in
England by the Antique Collectors' Club Ltd.,
1987
 702 p. illus(part col.)

 Index
 Bibliography,p.683-5

 Incl.:Fakes,Forgeries & Facts,Ch.XII

I.A

Heinzel, Erwin
 Lexikon historischer ereignisse und personen
in kunst,literatur und musik.Wien,Hollinek,1956.
 782 p. illus.

 Bibliography
 Lists portraits in all media

 Also cited:"Lexikon historischer personen
und ereignisse in literatur,kunst und musik"

LC D9.H48

ND
1336
F75
1968
NPG

I.A

Foster, Joshua James, 1847-1923
 A dictionary of painters of miniatures
(1525-1850), with some account of exhibitions,
collections, sales, etc. ... Edited by Ethel M.
Foster. New York,B.Franklin,.1968.

 330 p.

LC N7616.F72 1968

I.A

Jackson, Mrs.F.Nevill, 1861-
 Silhouette;notes and dictionary,...
New York,C.Scribner's sons,1938
 154 p. illus.(part col.)

NC
910
J26
1938ax
CHM
LC NC910.J26

757.7
.F75

I.A 1

Foster, Joshua James, 1847-1923
 Miniature painters, British and foreign,with
some account of those who practised in America in
the 18th c...., New York,E.P.Dutton & co.;London,
Dickinsons,1903

 2 v. 123 pl.(part col)

 Missal ptgs.,Early portr.ptrs.,Hans Holbein,
Hilliard. The Olivers & Hoskins. S.Cooper. Enam-
els. Petitot. From death of Cooper onwards. Cos-
way,Robertson,W.C.Ross,R.Thorburn. List of portr.
min.,exh.at Burlington fine arts club,1889
 see next card

N
7620
L477
REF.

I.A

Lee, Cuthbert, 1891-
 Portrait register..Asheville,N.C.,Biltmore
Press.1968-
 v. illus.

 v.1 lists 8000 portrs.by ca.1200 ptrs.,from
ca.15th-20th c.;individual owners in 41 states
of U.S.
 Intro.:Uses of portrs. Photographs of portrs.
Portrs.as examples of the art of ptg.,etc.
 Contents:Gen'l ref.sect.:Places,events,ob-
jects incl,facts,circumstances,referring...to
portrs.concerned-
LC N7620.L4 Fogg,v.11,p.323 see next card

I.A

Guiffrey, Jules Marie Joseph, 1840-1918
 Table des portraits,peints,sculptés,dessinés
ou gravés,exposés aux Salons du 18e siècle.
Paris,1889
 47 p.

 Reprinted from the Revue de l'art français
Jan-Feb,'1889

LC Rev.de l'art fr.
see
Archives de l'art français C.Wildenstein In:Gas Beaux
N6841.A9 Arts 61:9 & 15
Reprint in MB PPPM NN CtY

I.A

Lemberger, Ernst, 1866-
 Beiträge sur geschichte der miniaturmalerei.
Ein handbuch für sammler,museen...Anhang:Künst-
ler-register,orts-verzeichnis,monogramm-liste...
Berlin,Druck von G.Bernstein,1907
 200 p.

 "Als manuscript gedruckt"
 "Moderne literatur"

LC ND1337.A2L4 Schidlof 757.7/.S33

I.A

Heinzel, Erwin
 Lexikon der kulturgeschichte in literatur,
kunst und musik mit bibliographie und ikonogra-
phie.Wien,Hollinek,1962.
 494 p. illus.

 Continuation,resp. supplement to "Lexikon
historischer ereignisse und personen in kunst
literatur und musik.,1956.

 Lists portraits in all media

LC CT143.H4 Fogg,v.11,p.323

I.A

Lemberger, Ernst, 1866-
 Meisterminiaturen aus fünf jahrhunderten...
Anhang:Künstler-lexikon der miniaturmalerei mit
den biographischen daten von mehr als 6000 mini-
aturisten.Stuttgart,Deutsche verlags-anstalt,
1911
 111 p. illus.(in col.)

LC N7616.L4

Z5948
M6L5X
NMAA
I.A

Lister, Raymond
 A title-list of books on miniature painting,
compiled for the use of artists,collectors,and
Connoisseurs .Cockertons,Linton,Cambridge,1952.
 18 p.

 Contents:General & introductory handbooks,p.5;
Enamels-Histories & monographs,p.5-6;Illumin.mi-
niatures-Hist.&monogr.,p.6-10;Portr.min.-Hist.&
monogr.,p.10-12;...Oriental min.,p.12-13;Treatises
on technique,p.13-14;Dictionarie of artists;cats.
p.14-18.Miscellaneous ,p.18

LC
Z5948.M6L5

:PG
xerox copy
in VF
Por-
trai-
ture
I.A

Rath, Erich von, 1881-
 Porträtwerke

In:Lexikon des gesamten Buchwesens,Bd.III,1937
p.38-41
 "Porträtwerke"as discussed here, is essentially
the same concept as Rave's discussion of "Bild-
nisvitenbücher"
 Rath describes biographies of men & women of the
past with added portrs.or vice versa portrs.with
short biogr.notes.From 15th c.(see Ochsenbrunner,
1494)to 17th c. Rave.Jb.d.Berl.Mus. I 1959
LC Z118.L67 LC N3.J16 fol. p.141 footn.
 Paolo Giovio & d.Bildnisvi-
 tenbücher d.Humanismus

I.A

Maillinger, Joseph
 Bilder-Chronik der kgl.Haupt-und Residenz-
stadt München.Verzeichniss einer Sammlung von...
graphischen künste.n...vom 15.-19.Jhrh.München,
Montmorillon,1876
 3v. in 1

 Every chapter has a list of portrs.of reign-
ing nobility & other personalities with artists'
names
 Index of sitters and artists

NN MiU(DD901.M95M2)

I.A

Rovinskii, Dmitrii Aleksandrovich, 1824-1895
 Detailed dictionary of Russian engraved
portraits.With 700 phototyped portraits.St.Pe-
tersburg,1886-89
 4 v. illus.
 v.4 is appendix,conclusion and alphabetic
index

 In Russian.Title transliterated:Podrobnyǐ
slovar' russkikh gravirovannikh portretov.

LC NE290.R62 Th.-B.Faithorne.Lit.
 v.11,p.206,d

fN
7620
N53
NPG Ref.
I.A

New York Academy of Medicine. Library.
 Portrait catalog. Boston,G.K.Hall,1960
 5 v.(4564 p.)

---- --------. Supplement...
 1965-
 v. fN.7620.N53 Suppl.
 NPG Ref.
 Lib. has suppl.1-2

LC R153.5.N4

N
7593.1
S19
NPG Ref.
NPG
I.A

Samuel, Bunford, 1857-
 Index to American portraits (which were
published 1732-1852. Philadelphia, 1901;
 47-70, 228-247, 384-399 p. 26 cm.
 Caption title.
 Extracted from the Pennsylvania magazine
of history and biography, April, July, and
October of vol. 25, 1901.

 1. Portraits, American - Indexes.
 I. Title.

N
6536
N53
NCFA
NPG
I.A

New York Historical Society
 Dictionary of artists in America,1564-1860,
by George C.Groce and David H.Wallace.New Haven,
Yale University Press,1957
 759 p.

 Bibliography

 "A comprehens.accurate biograph.dict.of over
10000 artists,act.in America prior to 1860.Entries
cite sources - see over
LC N6536.N4 Whitehill.The Arts in ear-
 ly Amer.Hist.Z5935.W59
 Bibl.,p.84

I.A

Sauerhering, Friedrich, 1865-
 Bildnisse von meisterhand

In:his.Vademecum für künstler & kunstfreunde.
2.aufl.Stuttgart,P.Neff,1904.3v.
 v.3

 Ein systematisch geordnetes verzeichnis.

LC ND45.S3 Amsterdam Rijksmus. cat.
 Z5939A52,deel 1,p.131

NK
9580
P94X
NPG
I.A

Pyke, E.J.
 A biographical dictionary of wax modellers.
London:Oxford University Press/Clarendon Press
.1973.
 216 p. illus

 Review by H.L.Blackmore In:Connoisseur
185:14-6 Apr.,'74

 ...contains "good technical introduction...
bibliography..."

757.7
.S33
I.A

Schidlof, Leo
 Die bildnisminiatur in Frankreich im 17.,18.
und 19.Jahrhundert. Als anhang:Allgemeines lexi-
kon der miniaturisten aller länder. Wien und Leip-
zig,Ed.Beyers nachfolger,g.m.b.h.,1911

 391 p. illus(part.col.)

:7616.S4

I.A

Schmitt, Otto, 1890-1951 ed.
 Reallexikon zur deutschen kunstgeschichte.
Stuttgart, J.B.Metzler,1937-<58.
 4 v. illus.
 Bibliographies
 v.1-2(only)ed.by Otto Schmitt

 Survey of Renaissance portr.-sculpture:
<a>Gerstenberg,K. Bildhauerbildnis,in v.2
Rave,P.C. Bildnis, in v.2,cols639ff;<c>Keller,
H. Büste,in v.3,cols.255ff;<d>Keller,H. Denkmal.
in v.3,cols.1257ff Irving Lavin in Art Q v.33
LC N561.S45 autumn 1970,p.215,footnote
LC Nc561.R4 1.
LC N 6961.R42

I.A

Solly, Edward, 1619-1886
 Indexes of portraits in the "European
Magazine","London Magazine," and "Register of
the Times".London,1879
 23 p.

FOGG
FA980.4

 Fogg,v.11,p.325

I.A

Seidlitz, Woldemar von, 1850-1922
 Allgemeines historisches porträtwerk.Eine
sammlung von 600 porträts der berühmtesten per-
sonen aller völker & stände seit 1300...-ca.1840.
München,Verlagsanstalt für kunst & wissenschaft,
vormals, F.Bruckmann,1884-90
 6 v. illus.
 Contents.-.ser.I-II.Fürsten & päpste(100 portr)
<ser.III-IV.Staatsmänner & feldherrn(100 portr.)-
<ser.V-VII.Dichter & schriftsteller(151 portr.)-
<VIII-IX.Künstler & musiker(100 portr.)-<ser.X-XI.
Gelehrte & männer der kirche(100 portr.)-<ser.XII.
Berühmte frauen.Ver... ...editions(50 portr.)
LC N7575.S5 Av...nat.deel l,p.131
 N7939.S2 MCFA

I.A

Someren, Jan Frederik van, 1852-1930
 Beschrijvende catalogus van gegraveerde
portretten van Nederlanders...vervolg op Fred.
Mullers catalogus van 7000 portretten van N....
Amsterdam,F.Muller & cie,1888-91

 3 v.

LC NE285.S7 Chamberlin.Guide to art
 reference books #105

N
7575
S62 I.A
1967
NPG Singer, Hans Wolfgang, 1867-
 Allgemeiner bildniskatalog...Leipzig,K.W.
 Hiersemann,1930-36. Nachdruck. Nendeln,Kraus Re-
 print,ltd.,1967

 14 v.

 Graphic portraits of 20 German public coll.

NE
505
A51 I.A
1964
Ref. Stauffer, David McNeely, 1845-1913
 American engravers upon copper and steel.
 N.Y.,Burt Franklin,1964.
 3 v. (Burt Franklin:Bibliography and Refe
 rence Series,54)

 v.1 & 2, 1st ed.1907;v.3 by Mantle Fielding.
 1st ed.1917
 Contents:1.-Biogr.sketches illus.;2.-Check-
 list of the work of earlier engravers;3.-Biogr.
 sketches & check-list of engravings
 NPG A 19th c.gall.of disti
 guished Americans.Bibl.

N
7575
S62n I.A
1967
NPG Singer, Hans Wolfgang, 1867-
 Neuer bildniskatalog...Leipzig,K.W.Hierse-
 mann,1937-38. Nachdruck. Nendeln,Kraus Reprint,
 ltd.,1967

 5 v.

 " "...lists the ptd. & sculpted portrs. from
 everywhere."

LC N7575.S56

I.A

Steinberg, Sigfrid Heinrich, 1899-
 Bibliographie zur geschichte des deutschen
porträts. Hamburg,Dieponbroick-Grüter & Schulz,
1934
 166 p. (Historische Bildkunde,Heft 1)

LC Z5948.P8S8 Encyclop.of World Art
 N31E56 Ref.Bibl.on portr.

I.A

Smith, John Chaloner, 1827-95
 British mezzotint portraits;being a des-
criptive catalogue...from the introduction of
the art to the early part of the present century.
Arranged according to the engravers;...biographi-
cal notes...London,H.Sotheran & co.,etc.1883

 4 v.in 5 illus.

 Bibliography

LC NE265.S6 Chamberlin,M.W. Guide to
 art reference books #1572

I.A

Stockholm,Nationalmuseum,svenska porträttarkivet.
 Index över svenska porträtt,1500-1850 i
svenska porträttarkivets smalingar.<Stockholm,
Nordisk rotogravyr,1935-43>

Met
115.01 3 v. illus
st6 v.1:A-K, v.2:L-Z, v.3:royal portrs:medieval,
 Gustav I to Karl XII; v.1 & 2 mostly ptgs,
 v.3:seals,murals,tombstones,wood,coins,medallions,
 MSS.,etc.

LC N7610.S9S8 Rep.,1936*347

ND
1337
U5W41 I.A
1537
NCFA Wehle, Harry Brandeis, 1887-
NPG American miniatures,1730-1850;one hundred
2 cops. and seventy-three portraits ...& a biographical
 dictionary of the artists by Theodore Bolton.
 Garden City publishing company,inc.,c1937.
 127 p. illus.(part col.)

 Bibliography

LC ND1337.U5W4 1937

I.A.1 BIBLIOGRAPHIES ON PORTRAITURE

I.A

Weigel, Rudolph, 1804-1867
 Eine grosse sammlung von künstler-portraits
in werken & in einzelnen blättern von frühester
zeit bis zur gegenwart.Leipzig,R.Weigel.1857?.
 (his Kunstcatalog,v.4,pt.2)

 In all:...3832 portrs.of artists

LC Z5939.W41 v.4pt.2

qZ
5961
U5A77X I.A.1
NCFA Arts in America,a bibliography.Bernard Karpel,
Ref. ed. Washington,Publ.for the Archives of
 American Art by the Smithsonian Inst.Press,
 1979
 4 v.

 v.4 index incl.portrs.,portraitists,portrai-
 ture,photography-portrs.,photo.-portraiture,
 photo.-portraitists,sculpture-portrs.,por-
 traitists

I.A

Wilckens, Hans Jürgen von
 Porträtbilder in den leichenpredigten des
17.-18.jahrhunderts...Hildesheim,A.Lax,1967
 91 p. illus.

 Alphabetical cat.of 1476 portrs.in prints
which accompanied printed funeral sermons.En-
tries incl.name of artist and location of prints
in 8 German collections of funeral sermons.

LC N7620.W5 Fogg,v.11,p.319

I.A.1

Björkbom, Carl and Boo von Malmborg
 Svensk porträttlitteratur;bibliografisk för-
teckning....Gävle,1941.
 171 p. (Svensk porträttarkivets publika-
tioner,3)

LB Z5305.S9B55 Besterman World bibl.of
 bibliographiesZ1002B56v.3
 p.4971

705
G28
NCFA I.A
v.61
 Wildenstein, Georges, 1892-1963
 Table alphabétique des portraits peints,
 sculptés,dessinés et gravés,exposés à Paris au
 salon entre 1800 et 1826

 In:Gaz Beaux Arts
 61:9-60 Jan,'63 illus.

 Table is preceded by an article pointing out
 the changes in taste in portraiture.Works f'ly
 attr.to David are by artists then well known:
 Lefèvre,Romany,Ansiaux,etc.Miniat.drags.by Mon-
 saldy after exhibited portrs.were used for
 attributions Fogg,v.11,p.326

I.A.1

Destailleur, Hippolyte, 1822-1893
 Cat.de livres rares et précieux,compos.la
bibl.de m.H.Destailleur.Paris,D.Morgand,1891
 Auctioned by M.Delestre.Paris,Rue Drouot,27
Apr.13-24,1891

 Incl.V:Rapports avec les personnes,p.110-153
(entries no.435-614):a.-Recueils de portrs.de
personnages divers(divided by nationality of ar-
tists).b.-Portrs.des papes,cardinaux,personnages
religieux.c.-Portrs.des Empereurs Romains,Capi-
taines,Jurisconsultes,Ambassadeurs.

LC Z5939.D42 Rath.Porträtwerke.Bibl.:
 ich coll.of "Porträtwerken"

I.A.1. BIBLIOGRAPHIES ON PORTRAITURE

ND
61
806? I.A.1
NPGX
 The Genius of British painting.Editor David
 Piper.London,Weidenfeld & Nicolson,c.1975
 152 p. illus(part col.)

 Bibliography

 Incl.Index
 Partial contents:Ch.2:Tudor & Early Stuart
 pt..ly D.Piper,p.62-110;Ch.3:Ptg.under the
 Stuarts,by C.Millar,p.111-144;Ch.4:The 18th c.,
 by Mary Webster,p.145-197

 Archer.India & Brit.Portr...
 N1327.I44A72X NPG Bibl.
 p.483

Z
5947
A31.66
1974
NCFA

I.A.1

Levis, Howard Coppuck
 A descriptive bibliography of the most im-
portant books in the English language relating
to the art & history of engraving and the col-
lection of prints.With supplement and index.
ₑFolkestone,Kent,Eng.ₑDawsons of Pall Mall.1974ₑ
 141 p. illus.

 First published 1912 and 1913
 Numerous references to portrs.,e.g."Books
about portrs."p.190-240;"Private colls."p.214-
27;"Sale catalogues"p.228-53

I.B

Ambrose, Charles E.
 Problems in portraiture

 Master's Th.-Univ.of Alabama,1950

 Lindsay,K.C.,Harpur Ind.of
 master's theses in art...
 Z5931.L74 1955 NCFA Ref.
 p.84,no.1547

Z5948
M615 X
NMAA

I.A.1

Lister, Raymond
 A title-list of books on miniature painting,
compiled for the use of artists,collectors,and
Connoisseurs ₑCockertons,linton,Cambridge,1952.
 18 p.

 Contents:General & introductory handbooks,.
Enamels-Histories & monographs,ₚ.4-6;Illumin.mi-
niatures-hist.&monogr.,p.6-10;portr.in hist.
monogr.,p.10-12;...Oriental min.,p.12-13;Treatise
on technique,p.13-14;Dictionarie of artists;cats.
p.14-18.Miscellaneous,p.18

LC
Z5948.M615

I.B

Bähr, Hans Walter
 Adel des mannes;malerei,dichtung,plastik...
ₑ1950.Tübingen,Katzmann Verlag
 92 p. illus. (Die Schöne Kunst,Bd.1)

LC N7626.B3 Fogg,v.11,p.320

I.A.1

Mitchell, James Tyndale, 1834-1915
 ...The valuable collection of books on en-
graved portraits owned by the Hon.Js.T.Mitchell
...Also an unique coll.of caricatures by Cruik-
shank,Gillray,Heath,Seymour...and others.To be
sold...Jan.4,1909...and...Jan.5,1909...Cata-
logued & ₑsales.conducted by Stan.V.Henkels.At
the book auction rooms of Sam.T.Freeman & co...
Philadelphia.ₑ....Press of M.H.Power,1908?ₑ
 91 p.
 Cat.no.944,pt.VIII
 715 items Levis.Descr.bibl...Z5947
 ₑ31.66 1974 NCFA p.250;
LC NE240.M54 "A valuable bibliography of engraved portraiture"

I.B

Bender, Paul
 Wirklichkeit und wahrheit im porträt

In:Kunst
72:45-53 1938 illus.

 Comparison of portr.in ptg.,sculpture & pho-
tographs.
 Incl:Delacroix,Corinth,Sintenis,Cézanne,
Renoir,etc.

LC N3.K5 Rep.,1938#568

I.B. GENERAL TREATISES

I.B

Berühmte köpfe;3200 männer und frauen im bild.
 Hrsg.von der Bertelsmann Lexicon-Redaktion
ₑ1.Aufl.Gütersloh.C.Bertelsmann.1959ₑ
 413 p. illus.

LC N7575.B47 Fogg,v.11,p.320

I.B GENERAL TREATISES or more than one medium, or coun-
try or period. History. Theory
(For history see also I.D.)

705
B97
NCFA
v.69

I.B

Bodkin, Thomas, 1887-
 Some problems of national portraiture

In:Burl.Mag.
69:246-51 illus. Dec.,1936

 Official Nat'l portr.coll originated in Eng-
land,1856. Policy of administration of a NPG.
Intentions of sitter,artist etc.Important factors
such as age,health,circumstances. Scientific needs
of historians & biographers better served by pho-
tographs & sound-film Encyclop.of World Art
 N31E56Ref. bibl.on portr.

Xerox copy I.B
NPG
VF
 Boston. Museum of Fine Arts
 Portraits through fortyfive centuries.exhib..
 Feb.19-April 6,1941
 41 p.

 Introd.by G.H.Edgell,Dir.(MFA)4 p.

 Exh.drawn from MFA collections of sculpture,
paintings,gems,coins,prints,drgs.,silhouettes,
daguerreotype,Egyptian,Far &Near East,etc.
 Short biographical notes

 LC N7575B7

I.B

 Busch, Frieda
 Bases of portrait painting

 Master's Th.-Columbus,O.,1938

 Lindsay,K.C.,Harpur Ind.of
 master's theses in art...
 Z5931.L74 1955 NCFA Ref.
 p.35,no.616

N
7580
B82 I.B
NPG
 Breckenridge, James Douglas, 1926-
 Likeness;a conceptual history of ancient
portraiture,...Evanston,Ill,Northwestern Universi-
ty Press,1968,c.1969.
 293 p. illus.

 Bibliographical notes

 LC N7580.B7

N
7575
P97 I.B
NPG
 Buschor, Ernst, 1886-
 Das Porträt; Bildniswege und Bildnisstufen in
fünf Jahrtausenden. München,R.Piper,1960,

 222p. illus(142)

 General history of portr.from the beg.of
Egyptian art to the present

 Review by Lücken,Gottfried von
 In:Deutsche Literaturz. v.84,col.628-30
LC Based on author's Bildnisstufen(1947)
cN7575.B.
 Rep.1963:911review by Lük-
 ken,Gottfried von

705
C69 I.B
NPAA
v.46 Brilliant, Richard
 Editor's statement:Portraits:The limitations
of likeness

 In:Art J.
 46,no.3:171-? Fall,'87

Xerox copy I.B
in VF
Por- Carlyle, Thomas, 1795-1881
trai- Project of a national exhibition of Scottish
ture portraits .a letter.to David Laing...c1854.

 In his Critical and miscellaneous essays, col-
lected and republished...in 7 volumes. N.Y.,
Scribner,Welford,and Co.,1872. v.7,pp.129-37

 Letter first printed in Proceedings of the
Society of Antiquaries of Scotland,v.1,pt.3,
Edinburgh,1855

 LC PR4425.A2 1872

 I.B

 Brilliant, Richard
 On portraits

 In:Z.f.Ästhetik & allgem.kunstwiss.
 16(1):11-26 1971

 LC N3.Z45

ND
1300
C7X I.B
NPG
 Collier, John, 1850-1934
 The art of portrait painting...London,N.Y.,
Cassell & Co.,Ltd.,1905
 108 p. illus(part col.)

 The substance of an article on.portr.ptg.
in its historical aspects,which appeared
In:19th century,v.39:762-78,May,1896,reproduced
in the historical section of this work

 LC ND1300.C7 DNB 1931-1940,p.187

N
8217
H5B87 I.B
NPG
 Brophy, John, 1899-1965
 The face in Western art.London,Harrap,1963.
 184 p.,104 p.of illus.

 Shows how faces have been depicted by dif-
ferent artists at different times & in diffe-
rent countries & the techniques used from
ca.1450 to the present

 LC N8217.H5B7

 I.B

 Collingwood, Robin George, 1889-1943
 The principles of art.N.Y.,Oxford Uni.press,
1958
 347 p. (A galaxy book,G.B.11)

 Discussion of portraiture p.44ff.

 LC N70.C62 1958 Breckenridge.Portraiture and
 the cult of the skulls
 In:Gaz Beaux Arts63:288 '64

I.B

Cust, Lionel Henry, 1859-1929
 Portraits as historical documents

In:Saint George
8 20pp. 1905

LC HN381.S2 V.& A-Cust in v.2,p.743

N
7575
F68 I.B
NPO
 Foote, Henry Wilder, 1875-
 False faces;a study of the use and misuse
 of portraits as historical documents..Boston,
 Massachusetts Historical Society,1943.
 18 p.

 Reprint fr.the Proceedings of the Mass.
 Historical Society,v.67

NE
218 I.B
S84
NPO
 Edinburgh. Scottish national portrait gallery
 A face for any occasion.Some aspects of
 portrait engraving;by Sara Stevenson..Glasgow,
 for H.M.Stationery off.by Bell & Bain,ltd.,
 1976.
 127 p. illus.

 Based on an exh.,summer,1974,which demon-
 strated how various factors influenced the way
 in which both portr.ptrs.& engravers have shown
 their sitters

 continued on next card

I.B

 Fowler, Frank, 1852-1910
 Portraits as decoration

 In:Century Mag.
 46:765-8 Dec.,'09 illus.

LC AP2.C4 Index
 DLC NN etc.

I.B

 Eitelberger von Edelberg, Rudolf von,1817-1885
 Das Porträt in..his.Gesammelte kunsthistori-
 sche schriften,III.Bd.Wien,Wm.BraumUller,1884,
 p.189-220(Lecture given March 7,1860)

 Portrait and Ideal.Defines as source of a
 true portr.the capacity of the artist not to imi-
 tate nature but to apprehend and interpret it.De-
 pendence of good portraiture on a wholesome so-
 ciety.The significance of the portr.in its entire-
 ty & its connection with the overall development
 of art.
LC N27.E5 Goldscheider 757.G52
 Waetzoldt ND1300.W12

AP
1
342 I.B
NCFA
v.35 Fowler, Frank, 1852-1910
 Some notes on portraiture and the recent
 portrait exhibition

 In:Scribner's Mag.
 35:381-4 Mar,1904

 Exhibition of 1903 FOR COMPLETE ENTRY
 SEE MAIN CARD

 Poole's index AI 3.P82 NCF
 v.6,p.510

I.B

 Eller, Povl
 Historisk ikonografi.København,1964
 76 p. (Dansk historisk faellesfore-
 nings Haandbøger)

 Bibliographical references

LC N7575.E45

I.B

 Francastel, Galienne
 Le portrait;50 siècles d'humanisme en
 peinture;par.... & Pierre Francastel..Paris.
 Hachette.1969.
 207 p. illus.

LC N7575.F7

I.B

 Enzinck, Willem
 Het onvergetelijk gelaat.Den Haag,Servire
 .1962.
 51 p. illus.

FOGG Title transl.:The unforgettable face
980.32

 Fogg,v.11,p.318

I.B

 Galerie choisie des hommes et des femmes cé-
 lèbres de tous les temps et de toutes les
 nations,etc.Amsterdam,1823-22
 5 v. illus.

Brit mus. The 5th v. bears the date 1822
10601.aa.9

I.B

Gantner, Joseph, 1896-
Schicksale des menschenbildes von der roma-
nischen stilisierung zur modernen abstraktion.
Bern,Francke,1958.
203 p. illus.

LC ND1303.G2 Fogg,v.11,p.322

I.B

Grassi, Luigi
Lineamenti per una storia del concetto di
ritratto

In:Arte antica e moderna
4:477-94 1961

How art of portr.has been considered in dif-
ferent epochs,fr.renaissance to abstract art
(Rep.1961*877)

LC N5320.A74 Encycl.of World Art.Portr.
bibl.N31:56Ref.

I.B

George, Waldemar
Essai sur le portrait, suivi de quelques con-
sidérations sur l'art romain tardif et sur l'art
de ce temps

In:C.Belgique
:100-10 1931 illus.

The author thinks, that the individual has
lost his rights in our standardized world.With
their refinding the portr.could be reborn. It was
born in Roman times,has lived in begin.of Renaiss.
& had died again with Rodin.

LC DH Rep.,1931*7
682 C13 (?)

I.B

Guérin, Joseph
L'art du portrait

In:R.hist.litt.Languedoc
:314-24 1947

Elements of the value of ptd. or sculpted
portraits

LC PQ2.R5 Rep.,1945-47*851

mfm I.B
12m:3
NCFA
George, Waldemar
Masks or faces

In:Apollo
13:271-81 My,1931(pt.1) illus.

Sculptors of Roman Empire,ptgs. by LaTour,
Degas,Delacroix,Bermann,Modigliani,Manet,Derain,
Matisse,Rouault,Soutine

LC N1.A255 Rep.,1931*8

I.B

Gwynne-Jones, Allan, 1892-
Portrait painters;European portraits to the
end of the 19th c. & English 20th c. portraits.
London,Phoenix House,1950.
39 p. 163 illus.

An anthology of portr.ptgs.from Greco-Roman
coffin-lids to end of 19th c. Also 20th c. Engl.
portrs. The critic'l appreciation of a practising
artist.

LC N7575.G9 R.L.Douglas in Conn.v.126
v.162,footnote

I.B

Gill, P.R.B.
Critical analysis of the relationship of
the portrait background to the portrait

Master's Th.-Pittsburgh,Pa.,Univ.,1951

Lindsay,K.C.,Harpur Ind.of
master's theses in art...
Z5931.L74 1955 NCFA Ref.
p.94,no.1728

I.B

Hake, Henry Mendelssohn, 1892-
The study of historical portraits

In:Archaeol.J.
98:99-104 1941

Historical portrs. since end of 18th c.

LC DA20.R86 Rep.,1942-44*679

I.B

Gombrich, Ernst Hans Josef, 1909-
Portrait painting and portrait photography
28 p.

In:Paul Wengraf,ed.Apropos portrait ptg.London,
1945 (Apropos;a series of art
books)

C N7445.A7 OCIMA Gombrich.Mask & face.In:Art
percept'n & reality
471/G64X NCFA p.2 footnote

I.B

Hamburg. B.A.T-Haus
Köpfe, 111 gesichter des menschen in male-
rei und skulptur,auf münsen,schmuck und gerät
aus drei jahrtausenden und allen kulturkreisen.
B.A.T-Haus,Hamburg 36,Esplanade 39,1973
:16,12 p.. illus.

Cat.for the 50th B.A.T.(Cigaretten-Fabriken
G.m.b.H.)exhibition,Aug.30-Oct.13,1973

Individual portrs.,physiognomy,idols,masks,
etc.

I.B

Hart, Charles Henry, 1847-1918
 Hints on portraits and how to catalogue them.
...Philadelphia,Press of J.B.Lippincott company,
1898
 32 p.

LC ND1311.H3 Fogg,v.11,p.322

I.B

Hollanda, Francisco de, 1517-1584
 De la pintura antigua por Francisco de Ho-
landa(1548);versión castellana de Manuel Denis
(1563).Madrid.J.Ratés,impresor,1921
 297 p.

 "Del sacar por el natural"p.:249.-283
 'Earliest work devoted exclusively to por-
traiture,embraces theoretical & practical as-
pect of the subject."-Bury

LC ND70.H65 Bury.Use of candle-light.
 In:Burl.Mag.119:434 June;77

I.B

Hartlaub, Gustav Friedrich, 1884-
 Zauber des spiegels.Geschichte und bedeu-
tung des spiegels in der kunst.München,R.Piper,
:1951:
FOGG 231 p. illus(part col.)
FA312.34
 Bibl.references.179.-213

 The use of the mirror in self-portraits,p.
181,f.

 Holsten.N7618.H75 NPG
 Bibl.p.119

qN
7575
H918 I.B
NPG The Human face
 :1st ed.;Greenwich,Conn.,N.Y.,Graphic Soc.
 :1968:
 64 p. illus(part col.) (Man through his
 art v.6)

 Bibliographies

 Endorsed by the World Confederation of Or-
 ganisations of Teaching Professions

LC N7575.H77 Art Books 1950-79 Z5937
 A775 NCFA Ref. p.897

I.B

Havelaar, Just, 1880-1930
 Het portret door de eeuwen. 2.druk. Arnhem,
Van Loghum Slaterus,1932
 292 p. illus.(p.151.-.284.plates)

LC N7575.H3 1932 Fogg,v.11,p.323

I.B

Jakovsky, Anatole
 Du portrait

In:Arts de France
:15-28 no.1,1945 illus.

 The rudiments of portraiture,its development
& its historical role in regard to society
 Incl.:Funerary monument fr.Palmyra. Fouquet,
Largillière,Fragonard,Prud'hon,David,Ingres,Cour-
bet,Delacroix,Corot,Cézanne,Gauguin

LC N2.A88 Rep.,1945-47#852

Xerox I.B
copy NPG

Heinsel, Erwin
 Porträt und selbstporträt

In.his.Lexikon der kulturgeschichte in literatur
kunst und musik...:XVII-XXII

 Bibliography

 Development of portraiture

LC CT143.H4

I.B

Kainz, Luise C., 1902-
 Portraits and personalities,an intro.to the
world's great art.by.L.C.Kainz.and.Olive L.Riley
N.Y.,Abrams:1967 or 68:
 127 p. illus(part col.)

 From ancient Egypt to Marisol.organised by
period

LC ND1302.K3 Art Books 1950-79 Z5937
 A775 NCFA Ref. p.894

ND
1329.8
H54 I.B
1981K
NPG Hilliard, Nicholas, ca.1547-1619
 A treatise concerning the arts of limning
 together with a more compendious discourse
 concerning ye art of limning.sic.by Edw.Norgate
 with a parallel modernized text edited by
 R.K.R.Thornton and T.G.S.Cain.Ashington,Mid
 Northumberland Arts Group in ass.with Carcanet
 New Press,1981
 139 p. illus(part col.)

 Bibliography p.137-9

I.B

Keary, Charles Francis
 Modern portrait painting

In:Edin R
195:237-55 Jan.,1902

 Bibliography

 (Published anonymously)

LC AP4.E3 19th c.Readers' Guide to
 Periodical Literature
 1890-1899,p.1468

ND
1302
K56 I.B
NPG
 Kinstler, Everett Raymond, 1926-
 Painting portraits. New York,Watson-Guptill
publ.,1971

 170 p. illus.

 Chapters incl:Material & tools;setting up the
studio;your attitude toward the portr.;preparing
the composition;getting a likeness;...demonstra-
tions;etc.

LC 76-159563

705
S94 I.B
v.163
NCFA
 Levy, Mervyn
 Public image or private face ? The dilemma
of a portrait painter

 In:Studio
163:64-7 illus. 1962

 Effigy rather than portr. The power of the
portraitist to convey a sense of the sitter's
psychological & emotive identity languishes on
account of the sitter's vanity.

 Encyclop.of World Art
 Portrs.bibl.N31E56 Ref.

705
A63 I.B
NCFA
v.46
 Knox, James
 The art in portraits....

 In:Antique Collector
46:33 Oct.,'75 illus(part col.)p.32-6

 FOR COMPLETE ENTRY
 SEE MAIN CARD

 I.B

 Lomazzo, Giovanni Paolo, b.1538
 Trattato dell'arte della pittvra,scoltvra
ed architettvra.Milan,1584
 700 p.

 Richard Haydocke publ.a translation,which
he called'A Tracte,containing the artes of cu-
rious paintinge,carvinge and buildinge...Ox-
ford,...1598 LC ND1130.L685 Rosenwald Coll.

LC N7420.L6 1584 Norman.Nicholas Hilliard's
 treatise...in:Walpole Soc.
 AP1.W225 v.1:1:

 I.B

 Laskin, Myron, 1930-
 The concept of portraiture in the Middle
Ages from the Early Christian through the High
Gothic..Cambridge,Mass..,1952
FOGG
985 96 p. illus.
L34
 Thesis,April,1952

 Fogg,v.11,p.323

 I.B

 MacColl, Dugald Sutherland, 1859-1948
 Mr.W.B.Richmond on portrait painting

 In:Spectator
66:594-5 Apr.25,1891

LC AP4.S7 (19th c.)Readers' Guide to
 Periodicals,AI3B39,Ref.v.2,
 p.715

AP
1
B599 I.B
NPG
v.6
 Le Guin, Charles A.
 The language of portraiture

 In:Biography
6:333-9 Fall,1983

 Examines the goals & possibilities of artists
in portraits and of authors in biography.Diffe-
rences & common problems in realizing their aims

 I.B

 Mann, Harrington, 1864-
 The technique of portrait painting;...guide
to handling,composition & lighting of portraits
in oils,w.comp.survey of the methods of port.
painters of to-day & the past. Philadelphia,J.B.
Lippincott.1933.

 144 p. illus.

 Review in Apollo,19:46,Jan,1934

LC ND1300.M3

AP
1
A784E9 I.B
NMAA
v.1
 Leslie, Seaver
 Notes on portraiture

 In:Art Express
1,no.2:24-6 Sept.,Oct.,'81 illus(part col.)

 Discussions incl.History of portr.Two kinds
of portr.:exact resemblance and aesthetic quali-
ties.
 Repro incl.:Stamp with Whistler's mother.
Stuart:Washington.Roman head.Picasso:Gertrude
Stein.Gorky:Artist & mother.Warhol:Marilyn Mon-
roe.Photos by Leslie,Mapplethorpe.Peggy
Wall:Digitized computer portrait.

 I.B

 Keller, Peter
 La cappella Brancacci;problemi ritrattistic
ed iconografici

 In:Acropoli
4:186-227,273-312 1960/61 illus(part col.)

FOGG
FA1.194F
1960-61
&
1.#18

 Prinz.Slg.d.selbstbildnis
 ..N7618P95,bd.1 NPG.p.147.

I.B.

Merriman, Mrs.Helen(Bigelow), 1844-1933
 Concerning portraits and portraiture...read
before the Worcester art soc.,Feb.17,1891
.Worcester,Press of C.Hamilton,c.1891.
 36 p.

LC ND1300.M6

750
.N83 I.B

Norgate, Edward, d.1650
 Miniatura;or, The art of limning;...Oxford,
Clarendon press, 1919
 Ed.& introd.by Martin Hardie
 111 p.

 The treatise dates from 1648-50 and is in
the Bodleian Library,Oxford(MS.Tanner 326)

 Reviewed in Burl.Mag.v.37:207-8 Oct.,1920

LC ND1330.N7 Warburg j.v.6,1943,p.89
 Footnote

N
7575
N66 I.B
MCFA
Milwaukee. Art Center
 The Inner circle;.exh..Sept.16 through Oct.23,
1966..Milwaukee,Printed by Arrow Press,1966.
 unpaged illus.

 Introduction by Tracy Atkinson

 Portraits of intimate friends of artists, their
families & of other artists.

LC N5020.M53

AP
1
W225 I.B
v.1
MCFA
Norman, Philip ed.
 Nicholas Hilliard's treatise concerning
'The Arts of Limning'with introduction and
notes by Philip Norman,L.L.D.

 In:Walpole Soc.
 1:1.-54 1911-12 illus.

N
910
O 7A554 National Gallery of Canada
1987X European and American painting,sculpture and
MMAA decorative arts;general editors Myron Laskkn,jr.,
Michael Pantazzi.Ottawa,Nat'l Gall.of Canada,
National Museums of Canada,1987-
 v.1 in 2 illus.
 v.1,pt.1 1300-1800;text
 v.1,pt.2 Plates

 Index p.340-42 lists the portraits

I.B

Norton, Richard, 1872-1918
 The art of portraiture

In.his.Bernini and other studies in the history
of art...New York,The Macmillan company;London,
Macmillan and company,1914

 pp.57-92 illus.

LC N7445.N85 Fogg,v.11,p.324

I.B

Nebesky, Váslav, 1889-
 Die krise des porträts

In:Kunstblatt
 :53ff. 1928

(N3.K55)
DLC NN MiU TxU OC1MA Die 20er jahre im portr.
 MnU N6868.5.E9Z97 NPO,p.138

I.B

Osborn, Max, 1870-1946
 Porträtmalerei

 In:.his?.Moderne essays. Berlin,1906

 ND
 Waetzoldt 1300
 W12

I.B

Norgate, Edward, d.1650
 An exact and compendious discours concern-
ing the art of Miniatura or Limning....1621-
1626.

 The treatise is in the Brit.Mus.(MS.Harl.
6000)

 Norgate.Miniatura.750.N83
 p.XII ff
 Walpole Soc.AP1W225,v.3,
 p.83

I.B

Peacham, Henry,1576?-1643?
 The art of drawing with the pen,and limning
in water colours. London, 1606

 Footnote in:Pope-Hennessy
 Warburg Journal5-6,1942-3
 p.89

N
40.1
P352 I.B
Alp Peale, Rembrandt, 1778-1860 comp.
R B Portfolio of an artist...Philadelphia,H.Per-
NCFA kins,Boston,Perkins & Marvin, 1839
 263 p.

 ,an antholcfy of writings which interested
 Rembrandt Peale

 Writings on portraits see over

LC PR1109.P43

I.B
Roland, Browse and Delbanco, London
 Portraiture:the dying art.Ja.1958
 19 p. illus.

 Text.-49 works

V & A

MOMA, p.434, v.11
in MOMA Library Gallery
Box

I.B
Plinius Secundus, Caius, 23-79
 The natural history of Pliny...London.& N.1
G.Bell & sons,1890-
 v. (Half-title:Bohn's classical library)

 'Our understanding of the character and
function of portraiture in the Roman Republic..
is based on...passages in the 'Natural History'
of Pliny the elder.'-Breckenridge

LC QH41.P738

Breckenridge.Origins of Rom
Republ.portr.In:Temporini.
,Aufstieg u.niedergang...
LC DG209.T36,Bd.1,T.4,p.827

N
7621.2
C5L84r I.B
1980 Royal Society of London
NPG Royal Society cat.of portraits;by Norman H.
 Robinson;with biographical notes by Eric G.
 Forbes.London,The ^oyal Society,1980
 343 p. illus(part col.)

 Index of artists

I.B
Polybius, 205?-?125 B.C.
 The Histories of Polybius...London and N.Y.
MacMillan and co.,1889
 2 v.

 'Our understanding of the character and
function of portraiture in the Roman Republic
is based on passages in the "Histories"of Poly-
bius...".-Breckenridge

LC D58.P7

Breckenridge.Origins of Ro
Republ.portr.In:Temporini.
,Aufstieg u.niedergang...
LC DG209.T36,Bd.1,T.4,p.827

ND
1301
S15 I.B
NCFA Saisselin, Rémy Gilbert, 1925-
I.B Style, truth, and the portrait. ,Cleveland, Cleveland
 Museum of Art; distributed by H. N. Abrams ,New York,
 1963,

 215 p. 91 ports. (part col.) 27 cm.

 Serves as a catalogue of the exhibition, Style, truth, and the por-
 trait, held at Cleveland from Oct. 1 to Nov. 10, 1963, and as a study
 of the golden ages of portraiture.

 1. Portraits—Exhibitions. 2. Portrait painting—Hist. s. Cleve-
 land Museum of Art. II. Title.

ND1301.S24 707.8 63—19063

Library of Congress ,64c2,
 ///.C.

708.1
M66 I.B
NCFA Portraits of women and children

 In:B.Minneapolis Inst.Arts
 30:1-7 Jan,1941 illus.

 General thoughts on portraiture

 Incl:Clouet,Mierevelt,Slaughter,Hannemann,
 Ramsay,Theus,Courbet

 Rep.,1945-47*863

I.B
Schlosser, Julius, ritter von, 1866-1938
 Gespräch von der bildniskunst.1906

 In:his.Präludien.Berlin,J.Bard.1927,
 408 p. illus.

: N27.S35

Gombrich.Mask & face.In:
rt percept'n & reality
,N71/C64 X NCFA p.2.footnote

I.B
Roh, Frans, 1890-1965
 Das bildnis bei Kokoschka und die heutige
problematik des porträts

In:Kunst
53:130-3 1954-1955 illus.

LC N3.K5

Die 20er jahre im portr.
N6868.5.E9Z97 NPG,p.138
also:Rep.1955 #9229

Xerox copy I.B
NPG
in VF Steegmann, John, 1899-1966
Portrai- What is a good portrait
ture
 In:Lambert,R.S.,ed.Art in England,Harmondsworth,
 Mdx.Penguin books ltd.1938 150 p.(incl.illus.)
 (Pelican books) First published(Pelican books)'38
 pp.28-32
 "...the good portr...carries with it the con-
 viction of being a good likeness...anything be-
 yond this depends on ,the ptr.'s ability to se-
 parate the significant fr.the irrelevant..see
 over...
 N.Y.,:CMA.20th c.portrs.by
LC N6761.L35 M.Wheeler N7592.6N53NPG
 Bibl.

N
6505
T38X
NCFA

I.B

Taylor, Joshua Charles, 1917-
 How do you know it's a portrait ?

In.his.To see is to think:Looking at American
Art,Wash.,D.C.,Smithsonian Institution Press,
1975
 pp.11-23 illus.

 Describes the difference of ptg. an indivi-
dual face & a stylized rhythm creating a harmo-
nious interplay of lines & movement in an imagi-
nary face.
 "A portr.is a kind of evaluation.It re-
veals not just the likeness of an individual

I.B

A very proper treatise,wherein is briefly sett
 forthe the arte of limming...London,Im-
 printed by R.Tottill,1573
 12 1.

 Running title:The arte of limming

LC ND3305.V4 1573 Rosenwald Coll. Hilliard.Treatise...
 ND1329.8.H54 1981X
 p.139

I.B

Thevet, André, 1502-1590
 Les vrais povrtraits et vies des hommes
illvstres,grecz,latins,et payens recveilliz de
levr tableavx,liures,medalles antiques et modernes,
par André Thevet Angovmoysin...Paris,Par la ve-
sue I.Kervert et Guillaume Chaudiere,1584
 2 v.in 1

 2d ed.appeared under title:Histoire des plus
illustres et savants hommes de leurs siècles,
Paris,1670-71
 Review by Adhémar,Jean. In:R.archéol.
LC no. see card for Adhémar, Jean

ND
1300
W12
NCFA

I.B

Waetzoldt, Wilhelm
 Die kunst des portrXts.Leipzig,F.Hirt
& Sohn,1908
 451 p. illus.

 "Dieses Buch möchte als ein Beitrag sur
Xsthetik der Malerei betrachtet werden."

 Bibliography

LC ND1300.W3

I.B

Tiffin, Walter, F.
 Gossip about portraits,including engraved
portraits....London,J.R.Smith,1867
 223 p. illus.

LC N7575.T6 Yale ctr.f.Brit.art Ref.
 N7575.T5 1867

q N
7575
W34
1983X
NPG

I.B

Walker, John, 1906-
 Portraits:5000 years.N.Y.,Harry N.Abrams,
inc.c1983.
 288 p. illus(part col.)

 Bibliography p.271-5

 Incl.:Index

LC N7575.W34 198C.

I.B

Tocqué, Louis, 1696-1772
 Le discours de Tocqué sur le genre du por-
trait;avant-propos et notes par le comte
Arnauld Doria...Paris,J.Schemit,1930
 47 p. illus.

 Edited fr. original MS, with title:Reflexions
sur la peinture et particulièrement sur le genre
du portrait

LC ND1300.T6 Amsterdam Rijksmus.Cat.
 Z5939A52deel 1 NCFA,p.125

q ND
1300
W37
1979X
NPG

I.B.

Warner, Malcom, 1953-
 Portrait painting.1st American ed. N.Y.,
Mayflower Books,c.1979
 80 p. illus(col.)

 Bibliography
 14th-20th c.

 For source see main card
LC ND1300.W37 1979

I.B

Tschudi, Hugo von, 1851-1911 ed.
 Das portrXt. Berlin,J.Bard & B.Cassirer,
1906-07
 4 pts. illus.(part col.)

N&T
155.3
T78
3pts.
in 1 v.
 Contents.-1.Gurlitt,Cornelius.D.englische por-
trXt im 18.jahrh:Gainsborough,Romney,Raeburn.-
2-C,C. D.engl.portr...:Reynolds,Hoppner,Lawrence.-
3.Bie,Oscar.D.bürgerliche portr.des 19.jahrh.in
Deutschland:Chodowiecki,Graft,Krüger,Runge,Oldnach-
4.Schaeffer,Emil:D.portr.der italienischen hochre-
naissance

 Amsterdam.Rijksmus.Kunsth.
 bibl.Cat.Z5939.A52deel 1
 NCFA p.125

ND
465
W32
1962
NCFA

I.B

Waterhouse, Ellis Kirkham, 1905-
 Painting in britain,1530-1790,2nd ed.,Har-
mondsworth,Middlesex.Penguin Book.1962.
 274 p. illus. (The Pelican hist.of art,
 Z1)

 Bibliography

705
M18
NPG

I.B

Watkins, Charles Law
 Pictures of people

In:Mag Art
26:498,501-2,508-9 Nov.,'32 illus.

 Defines "Portrait"as reasonable physical
likeness of a human being.Many excellent works
wrongly labeled portr.In order to be more than
a craft it needs line,space,light,color & emo-
tional & expressive design related to the cha-
racter portrayed. see over
 N.Y.,FOMA.20th c.portrs.by
 F.Wheeler.N7592.6N53NPG
 Bibl.

I.B.1

American Art Association, New York
 Catalogue of the loan exhibition of portraits
...beginning Nov.18th,:1903.New York,J.J.Little
& Co.,1903
 37 &

MM Ide.Portrs.of John Jay
 B.J42I1 & CT275.J42I1NPG
 Bibl.

705
C69
NPAA
v.46

I.B

Woods-Marsden, Joanna
 "Ritratto al Naturale":Questions of realism
and idealism in early Renaissance portraits

In:Art J.
46,no.3:209-16 Fall,1987 illus.

 The"true likeness"had to be presented under
idealized guise. Comparison of portrs.in ptg.,
relief,medals. Discussion of use of portrs,p.213

I.B.1

Caffin, Charles Henry, 1854-1918
 Some American portrait painters

In:Critic
44:31-48 Jan.,1904 illus.

 Portr.exh."Treasures of art worth millions"
Repro.incl.:Sargent;JJ.Shannon,Beaux,Amanda
Brewster Sewell,F.Duveneck,Rbt.Henri,F.D.Millet,
J.W.Alexander,Alden Weir,Wilton Lockwood,DeFo-
rest Brush,Louis Loeb.
LC AP2.092 Poole's index AI.3.P82 NCFA
D.C. P.L. Lit.mf. v.6,p.510

I.B

Zahar, Marcel
 Le portrait

In:L'arche
:112-20 no.20,1946

 The different tendencies in the different
countries, from the Middle ages to our times

LC AP20.A67 Rep.,1945-47*853

AP
1
S42
NCFA
v.35

I.B.1

Fowler, Frank, 1852-1910
 Some notes on portraiture and the recent
portrait exhibition

In:Scribner's Mag.
35:381-4 Mar,1904

 Exhibition of 1903

 FOR COMPLETE ENTRY
 SEE MAIN CARD
 Poole's index AI 3.P82 NCF
 v.6,p.510

I.B.1. COLLECTIONS & EXHIBITIONS

I.B.1.a. PUBLIC, A-Z by institution

I.B.1 COLLNS.& EXHIBS.
 Exhibitions of portraits if nothing else is known

 COLLECTIONS
(Author of book/article is disregarded)

N
6510
C71
NCFA
I.B.1.a - ABBY ALDRICH ROCKEFELLER FOLK ART COLL.
.WILLIAMSBURG, VA.
Colonial Williamsburg, inc.
 The Abby Aldrich Rockefeller folk art coll:
a descriptive cat.by Nina Fletcher Little
.1st ed.Williamsburg,Va.,Publ.by.Colonial
Williamsburg;distributed by Little,Brown,
Boston,1957.
 402 p. illus.(col.)

 Bibliography
 Incl.:Portrs.in oil and W.C.

 List of artists

LC N6510.C66

ND
230
N7A32
NPG
I.B.1.a - ALBANY INSTITUTE OF HISTORY AND ART
Albany Institute of History and Art
 Hudson Valley painting,1700-1750,in the Al-
bany Inst.of Hist.and Art.Albany,1959.
 48 p. illus. (Cogswell Fund series,pu-
lication no.1)

 Bibliography

 Incl.Vanderlyn,Watson,Wollaton,Pierpont
Limner,Schuyler Painter,Gansevoort Limner,
Aetatis Suae ptgs.,etc.

LC ND230.N4A4

N
7593
A23
1981X
NMAA
c.1
c.2 Ref.
I.B.1.a - ABBY ALDRICH ROCKEFELLER FOLK ART
.CENTER
Abby Aldrich Rockefeller Folk Art Center
 American folk portraits;paintings and
drawings from the Abby Aldrich Rockefeller
Folk Art Center.1st ed. Boston,N.Y.Graphic
Society,c.1981
 295 p. illus(part col.) (The Center's
series 1)

 Incl:Bibliographical references & index

705
17875
NCFA
v.25
I.B.1.a - ALBANY INSTITUTE OF HISTORY AND ART
MacFarlane, Janet R.
 The Wendell family portraits

In: Art Q
25:385-88 Winter,'62 illus.p.384,369-92

 Incl.:Checklist of Wendell portrs.before
1740

 Black.In:Am Art J AP1.A51
 A64 NMAA v.12:5 footnote 2

705
A56
NCFA
v.89
I.B.1.a - ABBY ALDRICH ROCKEFELLER FOLK ART COL
Etchison, Bruce
 The Olen-Sanders portraits of Scotia,N.Y.

In:Antiques
89:245-6 Feb.,'66 illus(part col.)

 Abby Aldrich Rockefeller
 Folk Art Ctr.N7593.A23
 Am.folk portrs.Bibl.p.293

I.B.1.a - AMERICAN ANTIQUARIAN SOCIETY, WORCES-
.TER, MASS.
American Antiquarian Society,Worcester,Mass.
 ...Checklist of the portraits in the American
antiquarian society,by Waldo Lincoln...Worces-
ter,Mass., The Society,1924
 14 p.

 Reprinted from the Council report,Oct.1923

LC N7593.A3

NX
807
F64x
NCFA
I.B.1.a - ABBY ALDRICH ROCKEFELLER FOLK ART COL-
LECTION,WILLIAMSBURG, VA.
Folk art in America, a living tradition
 Selections from the Abby Aldrich Rockefeller
Folk Art collection,Williamsburg,Va. Atlanta,
The High Museum of Art,1974
 96 p. illus(part col.)
 Exh.held at the High Mus.of Art,Atlanta,etc.
 Exhibition cat.
 pp.19-33:Portraits

 Exhib.traveled Sept.'74-Nov.'75

 Bibliography

LC NX807.F64

N
7593
A512
NPG
I.B.1.a - AMERICAN ANTIQUARIAN SOCIETY,WORCESTER
American Antiquarian Society,Worcester,Mass.,
Library
 Checklist of the portraits in the library
of the American antiquarian society;by Frede-
rick L.Weis.Worcester,Mass.,published by the
society,1947
 76 p. illus.

 Reprinted fr. the Proceedings of the Amer.
Antiqu.Soc.for April 1946
 Alphabetical list of artists.
 Incl.:Washington,Franklin;marble busts.Co-
lumbus;oil,mosaic John Adams;gold on glass
 see over

AP
1
A83
NCFA
I.B.1.a - ACHENBACH FOUNDATION FOR GRAPHIC ARTS,
.SAN FRANCISCO
Stofflet-Santiago, Mary
 Artists' portraits and self-portraits

In:Artweek
7,pt.3:3-4 Jan.17,1976 illus.

 Pertains to exh. at Achenbach Foundation
for Graphic Arts,San Francisco,comprising
prints fr.their coll. & a private coll.

 FOR COMPLETE ENTRY
 SEE MAIN CARD

705
A56
NCFA
v.96
I.B.1.a - AMERICAN ANTIQUARIAN SOCIETY,WORCESTER,
MASS.
Dresser, Louisa
 Portraits owned by the American Antiqua-
rian Society

In:Antiques
96:717-26 Nov.,'69 illus(part col.)

 Repro.incl.Ths.Smith,Pelham,Copley,Chandler
Gullager,M'Kay(Mrs.Rush holding miniature),Ma-
ther Brown,Greenwood,A.Fisher,S.Goodridge,E.
Goodridge

705
A784
NCFA
v.51

I.B.1.a - AMERICAN JEWISH HISTORICAL SOCIETY

Gardner, Albert Ten Eyck
An old New York family

In:Art in Am
51 no.3:58-61 June,'63 illus.

Six portrs.of the Franks family,f'ly in
the Cpt.N.Taylor Phillips coll,now in the coll.
of the Am.Jew.Hist.Soc.,attr.by Waldron Phoe-
nix Belknap,jr.to Gerardus Duyckinck I ?;by
Virgil Barker to the Duyckinck Limner;by Flex-
ner "in the de Peyster Manner".They derive fr.
engravings by ⌒ Godfrey Kneller.
see-over

N
40.1
W49B4
NPG

I.B.1.a - AMHERST COLLEGE. MEAD ART BUILDING

Morgan, Charles Hill, 1902-
Benjamin West:his times and his influence...
Springfield,Mass.,Art in America,1950

Calls attention to West's role in the deve-
lopment of English & Amer.ptg.Exh.shows a fine
group of ptgs.of these two schools, now in Am-
herst's coll. ...

⌒ FOR COMPLETE ENTRY
SEE MAIN CARD

N
7593
A75
NPG

I.B.1.a - AMERICAN JEWISH HISTORICAL SOCIETY,
⌐WALTHAM, MASS.

American Jewish Historical Society
Paintings,daguerreotypes,artifacts;comp.
and ed.by Carlo M.Lamagna & Judith E. Endel-
man.Waltham,Mass.,Amer.Jew.Soc.,1974
48 p. illus.

I.B.1.a - AMHERST COLLEGE. MEAD ART BUILDING

Trapp, Frank ⌐Anderson⌐
British portrait paintings,in Amherst Col-
lege,Mead Art Bldg.,Amherst,Mass.;in⌐,Mead Art
Mus.Monographs,v.6 & 7,Winter,'85-'86
p.1-15 illus.

VF
Amherst,
Mass.
Amherst
College

Incl.:Amherst Family portrs. See also:
Amherst College,Mead art bldg.:The Amherst
family portraits.Exh.Oct.23-Nov.12,'67

N
7621
P5A52
NCFA

I.B.1.a -

American Philosophical Society, Philadelphia
A catalogue of portraits and other works
of art in the possession of the American Philo-
sophical Society.Philadelphia,...,1961
173 p. illus(part col) (Memoirs of the
American Philosophical Society,v.54)

LC Q11.P612 v.54

VF
Amherst,
Mass.
Amherst
College

I.B.1.a - AMHERST COLLEGE. MEAD ART BUILDING

Robinson, Duncan
George Pearce:a new masterpiece;in,Mead Art
Mus.Monographs,v.6 & 7,Winter.'85-'86
p.16-9 illus.

705
A56
NCFA
v.104

I.B.1.a - AMERICAN PHILOSOPHICAL SOCIETY, PHILA-
⌐DELPHIA

Bell, Whitfield Jenks,jr.
Painted portraits and busts in the American
Philosophical Society

In:Antiques
104:878,882-3,886-7,890-1 Nov.,'73 illus(part
⌐col.

Repro.incl.:Busts of Jefferson by Houdon,Ritten-
house by Ceracchi,J.Q.Adams by Cardelli,etc.
Ptgs.of Franklin by Ch.W.Peale,Rittenhouse by
Ch.W.Peale,Deborah Franklin aatr.to B.Wilson,etc.
Self-portr.of Su⌐ ⌐ly

NB
450
M4
1983X
NMAA

I.B.1.a - AMHERST COLLEGE,MEAD ART BUILDING

Trapp, Frank ⌐Anderson⌐ ed.
Masterworks of European sculpture⌐in Am-
herst College,Mead Art Bldg.,Amherst,Mass.⌐
⌐in⌐Mead Art Mus.Monographs,v.4,Summer,1983
30.p. illus.

Incl.:"Imported icons of the Early Repub-
lic",p.13,14;"Two portrs.by ⌐odin",p.19-21;
"Three French monuments",incl."Head of Beet-
hoven"by Bourdelle,1861-1929

VF
Amherst,
Mass.
Amherst
College

I.B.1.a - AMHERST COLLEGE,MEAD ART BUILDING

Amherst college. Mead art building
The Amherst family portraits.Feb.Oct.23-
Nov.12, 1967
21 p. illus.

Mead Art Mus.Monographs
v.6-7
p.1

I.B.1.a - AMSTERDAM. RIJKS-MUSEUM

Amsterdam. Rijks-Museum
Kinderen in de Nederlandse schilderkunst,
1480-1700.Children,with English text.Amsterdam,
Rijksmuseum,1962
40 p. illus. (Its Facetten der verza-
meling,2.serie,no.2)

In Dutch and English

Text by B.Haak

ICA PPPM
LC ND1329.3.C45A57 1962X--⌐ ⌐(Chm)

VF I.B.1.a - AMSTERDAM. RIJKSMUSEUM. PRENTENKABINET.

Amsterdam. Rijksmuseum. Prentenkabinet
Getekende kunstenaarsportretten....1975
(Rijksprentenkabinet no.XI)

FOR CO........
SEE MAIN CARD

NC
860
P23
NPG

I.B.1.a - AZAY-LE-RIDEAU, FRANCE. CHÂTEAU D'
(MUS.DE LA RENAISSANCE)
Bouchot, Henri François Xavier Marie, 1849-1906
Les portraits aux crayons de 16e et 17es.
conservés à la bibl.Nat.(1525-1646). Paris,
H.Oudinet Cie,1884
412 p. illus.

Incl.:Listes de crayons ou peintures conservés
dans des coll.publ.ou privées.Étrangères.A la
Bibl.nat.:France:Bibl.d'Arras-Bibl.desArts-et-Mé-
tiers-Coll.de l'.Courajod-Ancien Cabinet Fontette-
Mus.du Louvre(dessins et peinture)-Portrs.peints
du Mus.de Versailles
LC N7621.P3

M
516
B5453
1971X
NMAA

I.B.1.a - ANGLO-AMERICAN ART MUSEUM, BATON ROUGE

Anglo-American Art Museum
Cat.paintings,prints,drawings.Baton Rouge.
Louisiana State University.1971.
39.p. illus.

Arranged alphabetically by artists'names

I.B.1.a - AZAY-LE-RIDEAU,FRANCE. MUS.DE LA
RENAISSANCE SEE
I.B.1.a - AZAY-LE-RIDEAU,FRANCE. CHÂTEAU D'

NC
860
P23
NPG

I.B.1.a - ARRAS,FRANCE. BIBLIOTHÈQUE MUNICIPALE

Bouchot, Henri François Xavier Marie, 1849-1906
Les portraits aux crayons de 16e et 17es.
conservés à la Bibl.Nat.(1525-1646). Paris,
H.Oudinet Cie,1884
412 p. illus.

Incl.:Listes de crayons ou peintures conservés
dans des coll.publ.ou privées.Étrangères.A la
Bibl.nat.:France:Bibl.d'Arras-Bibl.desArts-et-Mé-
tiers-Coll.de l'.Courajod-Ancien Cabinet Fontette-
Mus.du Louvre(dessins et peinture)-Portrs.peints
du Mus.de Versailles
LC N7621.P3

I.B.1.a - BATH,HOLBURNE OF MENSTRIE MUSEUM
see
I.B.1.a - HOLBURNE ART MUSEUM, BATH, ENGLAND

I.B.1.a - ASHMOLEAN MUSEUM, OXFORD
see
I.B.1.a - OXFORD. UNIVERSITY. ASHMOLEAN MUSEUM

I.B.1.a - BATON ROUGE, LA., ANGLO-AMERICAN
ART MUSEUM SEE
I.B.1.a - ANGLO-AMERICAN ART MUSEUM, BATON ROUGE

I.B.1.a - AUXERRE, MUSÉE LEBLANC-DUVERNOY

Musée Leblanc-Duvernoy, Auxerre
Portraits du Musée d'Auxerre:Musée Leblanc-
Duvernoy,1er juin-31 oct.1984.Auxerre,le Musée
1984.
52 p. illus(part col.)

Essay by Micheline Durand

LC N7621.2.F8A89 1984 Additional short-listed
titles of worldwide art
cat.Bull.

N
1090
A612
NPG

I.B.1.a - BENINGBROUGH HALL

London. National Portrait Gallery
National Portrait Gallery at Beningbrough
Hall.London,National Portrait Gallery,1979
32 p. illus(part col.)

Incl.List of sitters

I.B.l.a - BERKELEY.ROBERT H.LOWIE MUS.OF
 see ₑANTHROPOLOGY
I.B.l.a - CALIFORNIA - UNIVERSITY - ROBERT H.
 LOWIE MUS.OF ANTHROPOLOGY - BERKELEY

I.B.l.a - BERLIN. STAATLICHE MUSEEN

Blümel, Carl, 1893-
 Römische bildnisse. Berlin,Verlag für kunst-
wissenschaft,1933
 57 p. illus.

 (Berlin,Staatl.Mus. Kat.der sammlung antiker
skulpturen)

LC £733B625r

I.B.l.a - BERLIN. GEMÄLEGALERIE
 see
I.B.l.a - BERLIN. STAATLICHE MUSEEN. GEMÄLDE
 ₑGALERIE

I.B.l.a - BERLIN. STAATLICHE MUSEEN. GEMÄLDE
ND1337 ₑGALERIE
A2B515
NPG Berlin. Staatliche museen. Gemäldegalerie
 Miniaturen.1970
 56 p. illus(some col.) (Kleine Schrif-
ten,ne.13)

 Incl.:Chodowiecki.Self-portrait while draw-
ing with wife(who holds a min.portr.of Luise
Erman). Hockins.Oliver Cresswell. Parent.Napo-
leon

I.B.l.a

Berlin. K.Museen. Sammlung von bildwerken & ab-
güssen des christlichen zeitalters.
 Italienische portraitskulpturen des 15.jahr-
hunderts in den königlichen museen su Berlin,
hrsg. von Wilhelm Bode.Berlin,Druck der Reichs-
druckerei,1883.
 53 p. illus.

 Heliographien etc.& radierungen von Ludwig
Otto

LC NB615.B4 Amsterdam,Rijksmus.,cat.
 Z5939J52,deel 1,p.607

I.B.l.a - BERN. HISTORISCHES MUSEUM

Trenschel, Hans Peter
 Die bildnisse im Bernischen historischen
Museum.Zuwachs der jahre 1955-1966

In:Jb.Bern.Hist.Mus.
45-46:73-183 1965-66 illus.

 Descriptive cat.of recent acquisitions(por-
traits of Berne)

LC DQ401.B41 Rep.1969 #190

I.B.l.a - BERLIN. NATIONAL-GALERIE

Berlin. National-Galerie
 ...Führer durch die bildnis-sammlung,bearbei-
tet von Hans Mackowsky..Berlin,H.S.Hermann,
G.m.b.H.,1929
 215 p. illus.

MM

PHOT COPY I.B.l.a - BERNE, BERNISCHES HISTORISCHES MUS.
in VF Panofsky, Erwin, 1892-
Por- Facies illa Rogeri maximi pictoris
trai-
ture In:Late classical & medieval studies in honor of
 A.M.Friend,Jr.Edited by Kurt Weitzmann...Prince-
 ton,N.J...1955 pp.392-400 illus.

 One of the figs.in "Miracle of the Tongue"in
R.v.d.Weyden's tapestries "Examples of Justice"in
Bern considered to be self-portr.(Testimony of
Cardinal Nic.Cusanus)
LC N5975.W4. Encyclop.of World Art
 bibl.Portrs. N31E56 Ref.

qND40.1 I.B.l.a - BERLIN. NATIONAL-GALERIE
H519hxM2
NPG Berlin. National-Galerie
 Preussische bildnisse des 19.jahrhunderts.
 Zeichnungen von Wilhelm Hensel.Ausstellung Na-
 tionalgalerie Berlin...21.Aug.-18.Okt.,1981.
 Berlin,1981.
 167 p. illus.
 Personenregister p.161-7
 Einführung zu Wilhelm Hensel & Kat.by
 Cécile Lowenthal-Hensel
 Die bildnissammlung Wilhelm Hensels in der
 Nationalgalerie by Lucius Grisebach

 Exh.also at Nuremberg.Germ.Nat'l Mus.
 30.Okt.1981-3.Jan.1982, etc.

I.B.l.a - BERNE, BERNISCHES HISTORISCHES MUSEUM

Kauffmann, Hans
 Ein selbstporträt Rogers van der Weyden
auf den Berner Trajansteppichen

In:Rep.Kunstwiss.
MET 39:15-30 illus. 1916
100.53
R29
P v.39

LC N3R4 Panofsky.Facies illa Ro-
 geri..:"finest contribu-
 tion to our literature"

I.B.1.a - BLACKHEATH, RANGER'S HOUSE see
I.B.1.a - RANGER'S HOUSE, BLACKHEATH

705
C75
NCFA
v.109

I.B.1.a - BOSTON. MUSEUM OF FINE ARTS

Comstock, Helen
 Drawings by J.S.Copley in the Karolik col-
lection

In:Connoisseur
109:150-5 June,'42 illus.

 Drawings now in Boston. Mus.of Fine Arts

FOR COMPLETE ENTRY
SEE MAIN CARD

NC
860
P23
NPG

I.B.1.a - BLOIS,FRANCE. MUSÉE

Bouchot, Henri François Xavier Marie, 1849-1906
 Les portraits aux crayons de 16e et 17e s.
conservés à la Bibl.Nat.(1525-1646). Paris,
H.Oudinet Cie,1884
 412 p. illus.

 Incl.:Listes de crayons ou peintures conservés
dans des coll.publ.ou privées.Étrangères.A la
Bibl.nat.:France:Bibl.d'Arras-Bibl.desArts-et-Mé-
tiers-Coll.de ?.Courajod-Ancien Cabinet Fontette-
Mus.du Louvre(dessins et peinture)-Portrs.peints
du Mus.de Versailles
LC N7621.P3

705
A56
NCFA
v.110

I.B.1.a - BOSTON. MUSEUM OF FINE ARTS

Luckey, Laura C.
 Family portraits in the MFA, Boston

Antiques
 American painting ,special issue.
 110:965-1070, Nov.,1976 illus(part col.)
 Chiefly 18th-19th century
 Partial contents:...Luckey,L.C.,Family por-
traits in the MFA,Boston,p.1006-11;...

I.B.1.a - BODLEIAN LIBRARY. OXFORD
see
I.B.1.a - OXFORD.UNIVERSITY. BODLEIAN LIBRARY

I.B.1.a -

Boston. Museum of fine arts
 Greek and Roman portraits,470 BC - AD 500;
written and prepared by Cornelius Vermeule, 1959
 80 p. with 75 illus. (Picture book)

 Bibliography

 Boston,MFA Bull.705.1B762
 v.57-60,p.114
MH CU MiU NIC etc. Richter,G. Portrs. of the
 Greeks N7586R53,v.3,p.304

I.B.1.a - BOSTON ATHENAEUM

Frazee, John
 The autobiography of John Frazee(1790-1852),
first American sculptor in marble

In:Am.Coll.
16:12-4 Nov.,'46 illus.

 '...portr.-busts which brought nat'l fame
to...his work.'
 Most of the portr.-busts in Boston, Athe-
naeum

LC NK1125.A15

705
A784
NCFA
v.30

I.B.1.a - BOSTON. MUSEUM OF FINE ARTS

Cunningham, C,harles, C,rehore,
 The Karolik collection-some notes on Copley

In:Art In Amer
30:26,29,30,33-5 Jan,,'42 illus.

 Discussion incl.C.'s "borrowing"of composi-
tion,pose,costume from British portrs.

 Fairbrother in:Arts Mag.
 705.A7834 NCFA 55:129

705
A56
NCFA
v.103

I.B.1.a - BOSTON ATHENAEUM

Whitehill, Walter Muir, 1905-
 Portrait busts in the Library of the Boston
Athenaeum

In:Antiques
103:1141-56 June,'73 illus(part col.)

 Walker,Wm.In:
 Arts in America,v.1,F1424d
 qZ5961.U5A774 NCFA Ref.

Xerox copy I.B.1a
NPG
VF

Boston. Museum of Fine Arts
 Portraits through fortyfive centuries.exhib..
Feb.19-April 6,1941
 41 p.

Introd.by G.H.Edgell,Dir.(MFA)4 p.

 Exh.drawn from MFA collections of sculpture,
paintings,gems,coins,prints,drgs.,silhouettes,
daguerreotype,Egyptian,Far &Near East,etc.
 Short biographical notes

LC N7575B7

NE
230
B7B675
1979X
NPG
2 c.

I.B.1.a - BOSTON. MUSEUM OF FINE ARTS

Boston. Museum of Fine Arts
Printed portraits...Boston,Mus.of Fine Arts,
c.1979

FOR COMPLETE ENTRY
SEE MAIN CARD

705
G28
2.pér.
1884
NCFA

I.B.1.a - BRESLAU.SCHLESISCHES MUSEUM FUR KUNST-
GEWERBE UND ALTERTUMER
Courajod,Louis Charles Jean, 1841-1896
La collection de médaillons de cire du Mus.
des antiquités silésiennes à Breslau

In:Gaz.Beaux-Arts
2nd per.,29:236-41 1884 illus.

FOR COMPLETE ENTRY
SEE MAIN CARD

705
I61
NCFA
v.77

I.B. 1.a - BOWDOIN COLLEGE. MUSEUM OF FINE ARTS

Robie, Virginia
An American old master-Feke.Colonial ar-
tist's portraits of the Bowdoins are prized
possessions of the college of that name

In:Studio
77:430-33 Aug.,'23 illus.

Moos.Art of Rbt.Feke N:C.)
F21248 1970a NMAA Publ.
p. CXXV

NC
860
P23
NPG

I.B.1.a - BRESLAU. SCHLESISCHES MUS.F.KUNSTGEWER-
BE UND ALTERTUMER
Bouchot, Henri François Xavier Marie, 1849-1906
Les portraits aux crayons de 16e et 17e s.
conservés à la Bibl.Nat.(1525-1646). Paris,
H.Oudinet Cie,1884
412 p. illus.

Incl.:Listes de crayons ou peintures conservés
dans des coll.publ.ou privées.Étrangères.À la
Bibl.nat.:France:Bibl.d'Arras-Bibl.desArts-et-Mé-
tiers-Coll.de F.Courajod-Ancien Cabinet Montette-
Mus.du Louvre(dessins et peinture)-Portrs.peints
du Mus.de Versailles
LC N7621.P3

N
7593.1
B78
NPG

I.B.1.a

Bowdoin College. Museum of Fine Arts
Colonial and Federal portraits at Bowdoin
College ;by.Marvin S.Sadik,director.Brunswick,
Me.,1966
222 p. illus(part col.)

Bibliography

LC N7634.B6

F
24
A34
1987X
NPA 4

--- I.B.1.a - BRICK STORE MUSEUM, KENNEBUNK,ME.

Agreeable situations:society,commerce and art
in southern Maine,1780-1830;ed.by Laura
Fecych Sprague;essays by Joyce Butler...
,et al.,Kennebunk,Me.:Brick Store Mus.
Boston:Distributed by Northeastern Univ.
Press,1987
289 p. illus(part col.)
Incl.Brewster,jr.,deaf artist,p.88,122,254
Cat.of selected objects from the Brick
Store Mus.et al
Index
Bibliography

705
A56
NCFA
v.104

I.B.1.a - BOWDOIN COLLEGE. MUSEUM OF FINE ARTS

Moos, R.Peter
Colonial and 19th c.American paintings at
the Bowdoin College Museum of Art

In:Antiques
104:854-5, 859,862,865 Nov.,1973 illus(part
col.)
Repro.incl.:Copley,Stuart,Feke,R.Peale,
Smibert,Sully,Eakins,Healy,etc. Portrs.of Jef-
ferson,etc.

I.B.1.a - BRITISH MUSEUM

Vertue, George, 1684-1756
Alphabetical list of portraits mentioned
in the collections of George Vertue,preceded
by a brief description of the contents of the
several volumes,about 1752.Autograph.29 folios.
...Contains index,made by Vertue,of portraits
with references to the volumes in which they
are noted.

MS owned by the British mus.(MS.Add.23097)

Walpole Soc.AP1.W2?5 NCFA
v.3,p.131 & 139

I.B.1.a - BRESLAU. MUSEUM SCHLESISCHER ALTER-
TUMER
see
I.B.1.a - BRESLAU. SCHLESISCHES MUSEUM FUR KUNST-
GEWERBE UND ALTERTUMER

I.B.1.a - BRITISH MUSEUM

Norgate, Edward, d.1650
An exact and compendious discours concern-
ing the art of Miniatura or Limning....1621-
1626,

The treatise is in the Brit.Mus.(MS.Harl.
6000)

Norgate.Miniatura.750.N83
p.XII ff
Walpole Soc.AP1W2?5,v.3,
p.83

I.B.1.a - BRITISH MUSEUM. DEPT.OF COINS AND ME-
ₐDALS
British Museum. Dept.of Coins and Medals
 Coins of the Roman Empire in the British
Museum.London,Printed by order of the Trustees
1923-
 v. illus.

 v.1 by Harold Mattingly

 Bibliography

LC CJ969.A4

I.B.1.a - BRITISH MUSEUM. DEPT.OF GREEK AND
 ROMAN ANTIQUITIES
British museum. Dept.of Greek and Roman anti-
 quities
 Greek and Roman portrait-sculpture...London,
 Brit.mus....,1976

LC NB1296.3.B72 1976 FOR COMPLETE ENTRY
 SEE MAIN CARD

I.B.1.a - BRITISH MUSEUM. DEPT.OF COINS AND ME-
 ₐDALS
British Museum. Dept.of Coins and Medals
 Coins of the Roman republic in the British
Museum,by H.A.Grueber...London,Printed by order
of the Trustees,1910
 3 v. illus.

LC CJ909.B7 Hiesinger.Portr.in the Rom.
 Rep.Bibl.In:Temporini.Auf-
 stieg u.niederg....LC DG209
 T36.Bd.1.T.4.p.821

NE
265
L8A5 British museum. Dept.of prints and drawings
NPG Catalogue of engraved British portraits pre-
 served in the Department of prints and drawings
 in the British museum, by Freeman O'Donoghue...
 London,Printed by order of the Trustees,1908-25

 6 v.

 incl.bibliographies

 v.5(Groups):...and Harry M.Hake
 v.6(Suppl't & indexes):by Harry M.Hake
LC NE265.L8A5 1908

I.B.1.a

I.B.1.a - BRITISH MUSEUM. DEPT.OF COINS & MEDALS
Hill, George Francis, 1867-
 A corpus of Italian medals of the Renaissance
before Cellini. London,British museum...,1930

 2 v. illus.(202 pl.)

 Bibliography

LC NK6352.H45 Lipman.The Florentine pro-
 file portr...

NC
772
B86 British museum. Dept.of prints and drawings
NPG Portrait drawings 15-20 centuries.cat.of.
 an exh.held...Aug.2-Dec.31,1974.London,British
 Museum,1974. 112 p. illus.
 Intro.by J.A.Gere

 Index of artist;index of sitters

 pp.c-23:15-16th c.;24-35:17th c.;36-63:ar-
 tists(many self-portraits);64-71:caricatures;
 72-75:actors,singers,etc.;76-108:16-20th c.Engl.
LC NC772.B74 1974

I.B.1.a -

I.B.1.a

British Museum. Dept.of Egyptian and Assyrian
 antiquities
 Portrait painting from Roman Egypt, by A.F.
Shore. London...,1962
 48 p. illus.

CLU FTaSU

I.B.1.a - BRUSSELS - BIBLIOTHÈQUE ROYALE
see ₐALBERT 1er
I.B.1.a - BRUSSELS - BIBLIOTHÈQUE ROYALE DE BEL-
 ₐGIQUE

I.B.1.a

British museum. Dept.of Greek and Roman anti-
 quities
 Greek and Roman portrait-sculpture, by
R.P.Hinks, London,Brit.mus.,1935

 35 p. illus.

LC NB164.B7

I.B.1.a - BRUSSELS - BIBLIOTHÈQUE ROYALE DE BEL-
 ₐGIQUE
Les Mémoiriaux d'Antoine de Succa;exposition or-
 ganisée à la Bibliothèque royale Albert 1er
 ...1977

LC ND655.P664 t.7 FOR COMPLETE ENTRY
 SEE MAIN CARD

23

705
A6
NCFA
v.57

I.B.1.a - BUCKINGHAM PALACE

Hughes, George Bernard, 1896-
Crystallo Ceramie.Illustrated examples at
Buckingham Palace

In:Apollo
57:183-5 June,'53 illus.

Repro.incl.:Cameos of Queen Victoria.King
Geo.III,by Apsley Pellatt.Princess Charlotte.
King Geo.IV,by Apsley Pellatt.Fred.,Duke of
York,King Geo.IV by Apsley Pellatt.

Technique of Sulphide cameos embedded
in glass

I.B.1.a - BUTLER ART INSTITUTE,YOUNGSTOWN,O.

Butler, Joseph Green
Autographed portraits, collection of Jos.G.
Butler,jr.,the Butler art institute,Youngstown,
Ohio, with biographies. Youngstown,O.,The Butler
art institute,1927.
470 p. illus.

LC N176.B98

I.B.1.a - BUDAPEST. MUSEUM OF FINE ARTS
see
I.B.1.a - BUDAPEST. SZÉPMŰVÉSZETI MŰZEUM

I.B.1.a - CAEN, FRANCE. MUSÉE DES BEAUX-ARTS

Caen, France. Musée des beaux-arts
Le Portrait peint dans les collections du
Musée des beaux-arts,Hôtel d'Escoville,30 juin-
10 oct.,1968.Caen,Mus.des beaux-arts,1968
21 p. illus.

LC ND1301.C3

N.Y.(City).P.L.Art & architec
Div. Bibliogr.guide to art
& architectur; Z5939.A791
1979 v.2,p.233

I.B.1.a - BUDAPEST. SZÉPMŰVÉSZETI MŰZEUM

Budapest. Szépművészeti Múzeum.
Italian Renaissance portraits.Mus.of Fine
Arts,Budapest;by Klára Garas.2nd enl.ed. Buda-
pest,Corvina Press,c.1965,1974 printing.
26 p. col.illus.(48 l.of plates)

CtY Rép.1975 #13508(:98 p.)

q NB
1296
R75
NPG

I.B.1.a - CALIFORNIA - UNIVERSITY - ROBERT H.
LOWIE MUS.OF ANTHROPOLOGY -BERKELEY
Roman portraits;aspects of self and society,
1st c.B.C.-3rd c.A.D.;a loan exh.:Los An-
geles,Calif.?,Regents of the Univ.of Cal.,
Loyola Marymount Univ.,and the J.Paul
Getty Mus.,1980.
108 p. illus.
Bibliography
Exh.schedule:Mary Porter Sesnon art
Gall.,College V,Univ.of Calif.,Santa Cruz,
Calif.Feb.20-Apr.9,1980;Art Gall.Loyola
Marymount Univ.,L.A.,Cal.,Oct.14-Nov.10,
1980

Worldwide art cat.B.,705.
W927 NB1A v.17,no.3,1981
p.61

I.B.1.a - BULGARSKA AKADEMIIA NA NAUKITE, SOFIA
Institut za izobrazitelni izkustva
Mikhalcheva, Irina
Portretut v bulgarskata shivopis.Sofia,
Izdatelstvo na Bulgarskata akademiia na naukite,
1968-
v. illus(part col.)

FCGO
FA
.202
.800.1

Added t.p. in French:Le portrait dans la
peinture bulgare
French & Russian summaries
Contents.-1. 1878-1918

Bibliography v.1,p.164-5
FCGO,v.11,p.319

705
C75
v.139
NCFA
also
N
7621
G6X
NPG
1955

I.B.1.a - Cambridge. University

Goodison, J.W.
Cambridge portraits,I:16th & 17th c.

In:Connoisseur
139:213-18 illus. June,1957

1st article in a series of 4
400 years of Cambridge portraiture
Pictorial & historical treatment of more im-
portant portrs.in the Univ. of Cambridge. Repro:
Henry VII, VIII,James I,Elizabeth I,Charles I,etc.
Encyclop.of World Art Portrai
ture,N31E56,v.11 Ref.

NK
4335
B93
NrU

I.B.1.a - BUTEN MUSEUM OF WEDGWOOD, MERION, PA.

Buten, David and Patricia Pelehach
Wedgwood and America.Wedgwood bas-relief
ware.Merion,Pa.,The Buten Mus.of Wedgwood,1977

705
C75
v.140
NCFA

I.B.1.a - Cambridge. University

Goodison, J.W.
Cambridge portraits,II:later 17 & early
18th c.

In:Connoisseur
140:231-6 illus. Jan.,1958

2nd article in a series of 4

Repro:Ptgs.by Lely,Kneller,Rigaud

Encyclop.of World Art
Portr .bibl.N31E56 Ref.
v.11

705
C75
v.143
NMAA

I.B.1.a - CAMBRIDGE. UNIVERSITY

Goodison, J.W.
Cambridge portraits,III:later 18th and early
19th c.

In:Connoisseur
143:84-90 illus. Apr.,1959

3rd article in a series of 4
Repro.:Ptgs.by Reynolds,Benj.Wilson,Gainsborough,Matt.Wm.Peters,G.Stuart,Henry Walton,Romney,
John Opie,John Hoppner,Lawrence,Js.Lonsdale

Encyclop.of World Art
Portr.bibl. N31E56 Ref.
v.11

I.B.1.a -

Cambridge. University. Magdalene college.
Pepysian library.
A catalogue of the engraved portraits in
the library of Samuel Pepys...compiled by John
Charrington...Cambridge.Eng..The university
press,1936
203 p. illus.

Bibliography

LC NE240.P4 Fogg,v.11,p.321

705
C75
v.144
NCFA

I.B.1.a - Cambridge. University

Goodison, J.W.
Cambridge portraits,IV:later 19 & 20th c.

In:Connoisseur
144:8-13 illus. Sept.,1959

4th article in a series of 4
Repro:Wm.Wordsworth,Alfr.Tennyson,Chs.Rbt.
Darwin,Thom.Hardy. Ptgs.by Sargent,Orpen,John,etc.

Encyclop.of World Art
Portr .bibl. N31E56 Ref.
v.11

I.B.1.a - CAMBRIDGE. UNIVERSITY. TRINITY COLLEGE

Esdaile, Katharine A.
Roubiliac's work at Trinity College,Cambridge.Cambridge,Univ.press,1924
42 p. illus.

Repro.incl.:Statue of Isaac Newton ;10 bust:
of the greatest personages connected with the
College during 17 & 18th c.

LC NB553.R75E7

N
7598
C23X
NPG

I.B.1.a - CAMBRIDGE. UNIVERSITY. FITZWILLIAM MUS

Cambridge portraits from Lely to Hockney..Cat.
of an exhibition.Cambridge University Press
for the Fitzwilliam Museum,1978
52 p.text 94 illus. (Fitzwilliam Museum
catalogues)

Index of artists
Index of sitters,all are members of the University
Preface by Michael Jaffé

Incl.:Ptgs.,miniatures,silhouettes,drags.,
medals,busts

I.B.1.a - CANTERBURY CATHEDRAL DEANERY

Strong, Roy C., 1935-
Portraits of the Deans of Canterbury in the
Deanery

In:Canterbury Cathedral chronicle
65:102-11 1970

LC BX5195.C3A12 Ingamells.Engl.Episcopal
portrait N7598.?I44,p.84

I.B.1.a - CAMBRIDGE. UNIVERSITY. FITZWILLIAM..
see also
I.B.1.a - FITZWILLIAM MUSEUM

I.B.1.a - CAPE TOWN.SOUTH AFRICAN NAT'L GALL.
see
I.B.1.a - SOUTH AFRICAN NATIONAL GALLERY..CAPE
.TOWN

I.B.1.a - CAMBRIDGE. UNIVERSITY. KING'S COLLEGE

Cambridge. University. King's College
Cat.of the plate,portraits and other
pictures at King's College,Cambridge.Cambridge
.Eng..Univ.Press,1933
93 p.

MET
146.5
314

MM CtY Winterthur Mus.Library
Z881.W78 NCFA v.6,p.227

I.B.1.a - CAPODIMONTE. MUSEO E GALLERIE NAZ.
see
I.B.1.a - NAPLES. MUSEO E GALLERIE NAZIONALI DI
CAPODIMONTE

I.B.1.a - CARLETON COLLEGE, NORTHFIELD,MINN.

Hamhourg,Maria Morris
Photographers and authors.A coll.of portraits of 20th c.writers;from the Carleton College collection.Northfield,Minn.,Carleton College,c.1984
15 p. 43 plates

LC TR681.F3H35

ND
1314.4
T8
NPG
1985

I.B.1.a - CASTLE OF FYVIE(Aberdeenshire)

Edinburgh. Scottish national portrait gallery
Treasures of Fyvie,exh.)4 July-29 Sept.
1985.Publ.by the Trustees of the National
Galleries of Scotland.1985.
79 p. illus(part col.)

Exh.organized by Js.Holloway
Alexander Forbes-Leith was the founder
of the Fyvie Castle collection

VINC=Norfolk Chrysler
Mus.Libr.

ND
1311.9
C47C3
1984X
NPG

I.B.1.a - CAROLINA ART ASSOCIATION, CHARLESTON,
S.C.
Carolina art association, Charleston, S.C.
The miniature portrait collection of the
Carolina art association;by Martha R.Severens;
ed.by Chs.L.Wyrick,jr. Charleston,S.C.,Gibbes
Art Gallery,1984
189 p. illus(part col.)

Incl.:Index
Bibliography

Js.Peale painting a miniature by Chs.W.
Peale,p.XV

LC ND1311.9.C47C3 1984

705
G28
NCFA
v.77

I.B.1.a - CHANTILLY. MUSÉE CONDÉ

Broglie, Raoul de
Les Clouet de Chantilly;Catalogue illustré
(coll.de Catherine de Médicis)

In:Gaz Beaux Arts
77:257-336 May,1971 illus.

Bibliogr.footnotes

Cat.classified according to costume
Alphabetical list of sitters
Adhémar.Gaz Beaux Arts
Sept.&Déc,1973

N
529
C27A67X
NPG

I.B.1.a - CAROLINA ART ASSOCIATION, CHARLESTON,
S.C.
Carolina art association, Charleston, S.C.
Selections from the collection.Charleston,
S.C.,Carolina Art Ass.,1977
127 p. illus.

Bibliography

I.B.1.a -

Chantilly. Musée Condé
Chantilly;crayons français du 16e siècle.
Catalogue précédé d'une introduction par
Étienne Moreau-Nélaton.Paris,Librairie centrale
des beaux-arts Émile Lévy,éd.,1910
282 p. illus.

PET
102.71
C36

NNC NcD PPULC OClMA PU PPPM Broglie.In:Gaz
Beaux Arts,77:269

I.B.1.a - CASSEL
see
I.B.1.a KASSEL

N
40.1
C28x08
NPG
R.B.

I.B.1.a - CHANTILLY. MUSÉE CONDÉ

Gruyer, François Anatole, 1825-
Chantilly;les portraits de Carmontelle...
Paris,Plon-Nourrit et cie,1902
388 p. illus.

Incl.:Contents. List of sitters

LC N7604.C2 Winterthur Mus.Libr. fZ811
.W78 v.9,p.226

NC
860
P23
NPG

I.B.1.a - CASTLE HOWARD, ENGLAND

Bouchot, Henri François Xavier Marie, 1849-1906
Les portraits aux crayons de 16e et 17e s.
conservés à la Bibl.Nat.(1525-1646). Paris,
H.Oudinet Cie,1884
412 p. illus.

Incl.:Listes de crayons ou peintures conservés
dans des coll.publ.ou privées.Étrangères.À la
Bibl.nat.:France:Bibl.d'Arras-Bibl.desArts-et-Mé-
tiers-Coll.de l'.Courajod-Ancien Cabinet Fontette-
Mus.du Louvre(dessins et peinture)-Portrs.peints
du Mus.de Versailles

LC N7621.P3

I.B.1.a - CHANTILLY. MUSÉE CONDÉ

Aubert, Marcel et Malo, Henri
La collection de Poncins-Biencourt au Musée
Condé de Chantilly

In:Monum.Piot
42:1-24 1947 illus.

Incl.:Corneille de Lyon,Clouet,Pourbus,v.Dyck or
Rubens,Decourt,Le Mannier,Duval,etc.
15th to 17th c.portrs.Incl.:Duc d'Alençon,Henry II
Maximilian of Austria,Cath.de Médicis,Charles IX,
Mary Tudor,Mary of Burgundy
Rep.,1945-47*1880

I.B.l.a - CHANTILLY. MUSÉE CONDÉ

Moreau-Nélaton, Étienne, 1859-1927
Le portrait à la cour des Valois. Crayons
français du 16me siècle,conservés au Musée Condé
à Chantilly:introduction & notices...Paris,Librai-
rie centrale des beaux-arts.1908.
5 v. illus.

v.2-5:portraits in portfolios

LC N7604.C5 Amsterdam,Rijksmus.cat.
 Z5939A52,deel 1,p.501

I.B.l.a - CHÂTEAU DE BEAUREGARD near Blois
see
I.B.l.a - BLOIS,FRANCE(near).CHÂTEAU DE BEAURE-
 GARD

N
579
C3A3X
NPG

I.B.l.a - CHARLESTON, S.C. CITY HALL

Charleston, S.C. City Council
Catalogue of painting and sculpture in the
Council Chamber,City Hall,Charleston,S.C.;by
Anna Wells Rutledge.Charleston.The City council,
ca.1943
30 p. illus(part col.)

LC N529.C3A3

I.B.l.a - CHÂTEAU DE COPPET on L.Geneva
see
I.B.l.a - COPPET on L.Geneva,CHÂTEAU

705
A56
NCFA
v.98

I.B.l.a - CHARLESTON, S.C. CITY HALL

Rutledge, Anna Wells
Paintings in the Council Chamber of Charles-
ton's City Hall

In:Antiques
98:794-99 Nove.,'70 illus.

FOR COMPLETE ENTRY
SEE MAIN CARD

705
A56
NCFA
v.104

I.B.l.a - CHICAGO. ART INSTITUTE

Hanks, David A.
American paintings at the Art Institute
of Chicago.Part I:The 18th century

In:Antiques
104:408 Sept.,1973. illus(part col.)

Illustrations p.408-17 incl.:Smibert,Wol-
laston,Copley,Hesselius,Chs.W.Peale,Earl,Phil-
lips,Sully,Stuart

ND
1311.2
P6Lx
NPG

I.B.l.a - CHARLESTON, S.C. CITY HALL
Rutledge, Anna Wells
Ptgs.in the Council Chamber of Charles-
ton's City Hall
Miles, Ellen Gross comp.
Portrait painting in America.The nineteenth
century.N.Y....,1977 (card 2)

Partial contents:A.W.Rutledge,Ptgs.in the
Council Chamber of Charleston's City Hall,p.25-
30;...

N
7621
C4A7
NPG

I.B.l.a - CHICAGO. ART INSTITUTE

Chicago. Art Institute
European portraits,1600-1900 in the Art In-
stitute of Chicago.Exh. .Chicago,Art Inst.,1978,

FOR COMPLETE ENTRY
SEE MAIN CARD

I.B.l.a - CHARLESTON, S.C. - GIBBES MEMO-
see .RIAL ART GALLERY
I.B.l.a - GIBBES ART GALLERY

708
M18
NCFA

I.B.l.a - CHICAGO, ART INSTITUTE

Fischkin, Rose Mary
Portraits of artists

In:Mag of Art
16:528-32 Oct.,'25 illus.

Refers to portrs. in a special gall.in
Chicago's Art Institute

Repr.:Monet by A.André,Renoir by A.André,
Self-portr.by L.Simon,Manet by Fantin-Latour
 N.Y.,MOMA.20th c.portrs.
 by M.Wheeler N7592.6N53
 NPG Bibl.

I.B.1.a - CHICAGO HISTORICAL SOCIETY

Chicago Historical Society
American primitive paintings,19th century;
The Chicago Historical Society's collection.
₍Chicago₎1950
24 p. illus.

NMWL-W NNC DLC etc. Flint Inst.of Arts.Am.naive
LC ND210.C45 ptgs. ND210.5.P7F5 1981X
 NMAA Bibl.p.91

I.B.1.a - CLUNY, MUSÉE DE
see
I.B.1.a - PARIS. MUSÉE DE CLUNY

705 I.B.1.a - CHICAGO HISTORICAL SOCIETY
A56
NCFA Chicago Historical Society
v.58 Primitives on view in Chicago

 In:Antiques
 58:392-3 Nov.,'50 illus.

 Exh.Nov.,1950-Feb.,1951

 Repre.incl.:Frymeier,Krans,Rester,Ambroise
 Andrews

HD I.B.1.a - COLBY COLLEGE, WATERVILLE,ME.
210
C67X Colby College, Waterville,Me.
NCFA A group of paintings from the American
 heritage collection of Edith Kemper Jetté and
 Ellerton Marcel Jetté.Waterville,Colby College
 Press,1956
 94 p. illus.

 Mainly reproductions of ptgs.,silhouettes,
 etc. 19th c.

 Dewhurst.Artists in aprons
 Bibl.p.186

qND I.B.1.a - CHRYSLER MUSEUM AT NORFOLK
207.5
P7Ch9 Chrysler Museum at Norfolk
1975X 48 masterpieces from the Collection of
NCFA Edgar William & Bernice Chrysler Garbisch.
 Norfolk,Va.,Chrysler Museum at Norfolk₍1975₎
 68 p. illus.

 American naive ptg.of the 18th and 19th c.

 Preface by Dennis R.Anderson

 Rila III/1 1977 #3517

MK I.B.1.a - COLONIAL WILLIAMSBURG
805
C719 Colonial Williamsburg, inc.
NCFA A cat.of the American folk art coll. of Co-
 lonial Williamsburg;collected and presented by
 Mrs.John D.Rockefeller,jr. Comp.by Edith Gregor
 Halpert with a foreword by James L.Cogar.
 Williamsburg,Va.,₍c.1947₎
 49 p. illus.

 Repro.incl.:Portr.of Washington,ca.1785

 Cat.lists portrs.in oil,pastel and W.C.

 Flint Inst.of arts.Am.naive
 ptgs. ND210.5.P7F5 1981X
 NMAA Bibl.p.91

AP I.B.1.a - CHRYSLER MUSEUM AT NORFOLK
1
C565 Chrysler Museum at Norfolk
 Naive gift grows to unprecedented eighty
 paintings;by DRA₍Dennis R.Anderson₎

 In:Chrysler Mus.Norfolk.Bull.
 5,no.4:2-4 Apr.,'76 illus.

 Incl.:Ammi Phillips,Wm.Jennys,Erastus Salis-
 bury Field
 Gift of Edr.Wm.& Bernice Chrysler Garbisch

 Rila IV/1 1978 #3927

I.B.1.a - COMO. MUSEO DEI RITRATTI
see
I.B.1.b - GIOVIO, PAOLO, 1483-1552

ND I.B.1.a
1337
C63 Cleveland Museum of Art
NCFA Portrait miniatures;the Edw.B.Greene coll.
NPG ₍Cleveland₎1951
 38 p. illus.(part col.)

 Cat.by Louise H.Burchfield
 "Portr.miniatures,origin and technique"by L.H.
 Burchfield. "Portr.miniatures,their history"by
 Harry B.Wehle

 LC N7616.C49

705 I.B.1.a - CONNECTICUT HISTORICAL SOCIETY, HART-
A56 ₍FORD
NCFA Oliver, Andrew, 1906-
v.104 Connecticut portraits at the Connecticut
 Historical Society

 In:Antiques
 104:418 Sept.,1973 illus(part col.)

 Illustrations p.419-35 incl.:Durand,Earl,
 Steward,Jennys,Morse,Moulthrop,etc.

AP
1
C76
NPG
I.B.1.a - CONNECTICUT HISTORICAL SOCIETY, HART-FORD

Dunbar, Philip H.
Portrait miniatures on ivory,1750-1850;from the coll.of the Connecticut historical society

In:Conn.Hist.Soc.B.
29:97-144 Oct.,'64 illus.

Incl.Checklist
Pertains to an exh.at the Conn.Hist.Soc.

Incl.Hair painting

Winterthur Mus.Libr.f2881
W78 NCFA v.6,p.217

AP
1
C76
NPG
v.37
I.B.1.a - CONNECTICUT HISTORICAL SOCIETY, HART-FORD

Keihn., P.hyllis.
The Reuben Humphrey portraits.by P.K..

In:Conn.Hist.Soc.B.
37:42-50 Apr.,'72 illus.

Portrs.attr.to Richard Brunton

Report on restoration:examination,treatment

Winterthur Mus.Libr.
f2881 W78 NCFA v.6,p.230

40.1
x52R6
NCFA
I.B.1.a - COPENHAGEN. NATIONALMUSEET

Birket-Smith, Kaj, 1893-
Charles B.King's indianerportraetter i Nationalmuseet. København,Bianco Lunos Bogtrykkeri A/S, 1947
39 p. illus(part col.)

Avers.Ann.Rep...S.I.,1953
bibl.,p.473

I.B.1.a

Copenhagen. Ny Carlsberg glyptotek
Les portraits grecs par Vagn Poulsen.
Copenhagen,1954
86 p. illus. (Its publication,no.5)

Bibliographical references

LC N7585.C6
Breckenridge.Likeness...
N7580.B82 NPG bibl.notes

I.B.1.a

Copenhagen. Ny Carlsberg glyptotek
Les portraits romains;par Vagn Poulsen.
Copenhagen, 1962
illus. (Its publications no.7)

Bibliogr.references
Catalogue v.1 p.39.-148
Contents:-1.République et dynastie Julienne

LC NB115.C6
Enc.of World Art v.11
P.511 Portraiture,bibl.
N31856 Ref.

N
40.1
J934x
P8
NPG
I.B.1.a - COPENHAGEN. STATENS MUSEUM FOR KUNST
KOBBERSTIKSAMLINGEN

Poulsen, Ellen
Tegninger af Jens Juel;illustreret katalog.
København,Statens Mus.for kunst,1975
284.p. illus.

Bibliography

705
C28
v-33
1905
NCFA
I.B.1.a - COPPET on L.Geneva,CHÂTEAU

Rod, Édouard
Les souvenirs du château de Coppet

In:Gaz Beaux-Arts
33:305-25 1905 illus.
421-34 1905 illus.

Repro.incl.:Statue of Mr.Necker by Tieck.
Mr.& Mrs.Necker by Duplessis;Germaine Necker attr.to Carmontelle;Mme de Staël by Gérard;
Mme de Staël by Vigée-Lebrun;Mrs.Necker & daughter Germaine by Massot;Auguste de Staël by Girodet

708.1
C86
NCFA
v.6
I.B.1.a - CORCORAN GALLERY OF ART, WASHINGTON,
D.C.

Breckenridge, James Douglas, 1926-
Portraits of Americans.On American portraiture

In:Corcoran G.A.Bull
c:.1-14, Feb.,'53 chiefly illus.

Winterthur Mus.Libr. f2881
W78 NCFA v.6,p.222

I.B.1.a - CYRENE.CYRENAICAN PROVINCIAL MUSEUM

Rosenbaum, Elisabeth
A cat. of Cyrenaican portrait sculpture.
London,Publ.for the Brit.Acad.by Oxford Univ.
Press,1960
140 p. illus.

Bibliography p.29-.31.

LC NB118.C9R6
Gesichter.NB1296.3.G38
1983 NPG p.316
.also:Kraus.D.röm.weltreich.N5760.K92Bibl.p.315

I.B.1.a - DARMSTADT. HESSISCHES LANDESMUSEUM

Darmstadt. Hessisches Landesmuseum
Repräsentation und selbstverständnis:Bildnisse vom 16.-20.jahrh.:Gemälde aus eigenem bestand;ausstellung 8.3-195,1974.Katalogtexte,
Rainer Schoch,Hans M.Schmidt.1974?.
23 leaves

LC ND1301.5.G3D372 1974

N
7623
H15D22
NPG

I.B.1.a - DARTMOUTH COLLEGE. HOPKINS CENTER

Dartmouth College. Hopkins Center
 Portraits at Dartmouth;.cat..by Arthur R.
Blumenthal..Exh..10 March to 16 April 1978.
Hanover,N.H.,Dartmouth College,1978
 137 p. illus.(col.cover illus.)

 Bibliography

 Development of portraiture fr.16th c.to ear
ly 20th c. shown by works of Dartmouth College
collection.
 Appendices are—checklists of portrs.in all
media which are not in this exhibition.

VF
Stock,D.
xerox
copy

NCA
Uni.Md
N 1.A1P3

I.B.1.a - DRESDEN.INSTITUTE AND MUSEUM FOR THE
 HISTORY OF THE CITY OF DRESDEN

Siegel, Linda
 The portraits of Dora Stock in Dresden

 In:Pantheon
41:15-21 Ja/Mr.,'83 illus(part col.)

705
A784
NCFA
v.17

I.B.1.a - DETROIT. INSTITUTE OF ARTS

Burroughs, Clyde Huntley, 1882-
 Early American portraits at Detroit Insti-
tute of Arts

 In:Art in Amer.
17:258-74 Oct., '29 illus.

 "...The portr.is art's lucid interpreter of
ea.period..."

 Repr.:Blackburn,Badger,Woolaston,Trumbull,
Neagle,Harding,Sully
 Cumulated Mag.subj.index
 A1/3/C76 Ref. v.2,p.443

NB
27
I 6D81
1975
NCFA

I.B.1.a - DUBLIN.NATIONAL GALLERY OF IRELAND

Dublin. National Gallery of Ireland
 Cat.of the sculptures.Comp.by Michael Wynne.
Foreword by James White.Dublin,The Gallery,1975
 54 p.

 Summary cat.of the sculptures in the gal-
lery,most of them portraits of distinguished
persons of Ireland

 Rila II/2 1976 #6930

708.1
D47
v.23-27
1943-48

I.B.1.a - DETROIT. INSTITUTE OF ARTS

Richardson, E.P.
 Madame Henriette de France as a vestal virgin
by Jean-Marc Nattier

 In:B.Detroit Inst.Arts
23:2-3 Oct,1943 illus.
 see also article by E.P.Richardson
 In:Art Q
6,no.4:238-56 Autumn,1943 illus.

 Rep.,1945-47#7741

705
A7875
1943

ND
544G56
1984X
NMAA

I.B.1.a - DUBLIN. NATIONAL GALLERY OF IRELAND

Dublin. National Gallery of Ireland
 Fifty French paintings.described.by Honor
Quinlan.Dublin,Nat'l Gall. of Ireland,c.1984
 50 p. illus(col.)

 Indexes
 Incl.:Portrs. by Largillière,J.M.Nattier,
M.N.de la Tour,Perroneau,A.S.Belle,Roslin,
Baron Gérard,Morisot,Kees van Dongen

708.1
D47
NMAA
v.57

I.B.1.a - DETROIT. INSTITUTE OF ARTS

Raetjer, Katharine
 A portrait by Holbein the younger

 In:Detroit inst Bull
57,no.1:25-9 1979 Illus(part col.)

 The new acquisition by the Detroit Inst.of
Arts compared with H.'s other portrs. It came
from the coll.of Earl of Lonsdale

ND
482
N37
1983X
NMAA

I.B.1.a - DUBLIN. NATIONAL GALLERY OF IRELAND

Dublin. National Gallery of Ireland
 Fifty Irish painters.by.Michael Wynne.The
National Gall.of Ireland,1983
 52 p. illus(col.)

 Incl.:Index

 Incl.portr.ptrs.:p.1-12,22,24,37,42,43,45

929.2
Pc52D48

I.B.1.a -

Detroit. Institute of Arts.
 Portraits of eight generations of the Pitts
family,from the 17th to the 20th century.
.Detroit.1959.
 59 p. illus.
 Exhibition Oct.6-Nov.8,1959
 "Catalogue by Elizabeth H.Payne."

 "Ancestral portrs.of the Pitts family,which
included Bowdoins,Mountforts,and Warners of Mass.
& New Hampshire in the 18th c.painted by Bad-
 ger
LC N7621.D4 Whitehill.The arts in ear-
 y Amer.Hist.Z5935.W59
 Bibl.,p.98

N
7600
N27
NPG

I.B.1.a - DUBLIN. NATIONAL GALLERY OF IRELAND

Dublin. National Gallery of Ireland
 Fifty Irish portraits;by Ann Stewart.
Dublin,Nat'l Gall.of Ireland,1984
 50 p. illus(col.)

 Index

I.B.1.a -

Dublin. National Library of Ireland.
...Catalogue of engraved Irish portraits,mainly in the Joly collection,and of original drawings.By Rosalind M.Elmes...Dublin,The Stationery off.,1937.
279 p.

Bibliography

LC NE265.D8 Yale ctr.f.Brit.art Ref.
 NE265.D8

I.B.1.a - DYCKMAN, STATES, GARRISON-ON-HUDSON, NY

AP
1
A51A62
NYAA
v.2

Black, Mary Childs, 1922-
 Tracking down John Watson:The Henderson portraits at Boscobel

In:Am Art & Antiques
2,no.5:78-85 Sept.-Oct.,'79 illus(part sel.)

 John Watson's portrs.,previously attr.to the
Van Rensselaer Limner
 Repro.incl.:The Js.Henderson portrs.at Boscobel, the States Dyckman house at Garrison-on-
Hudson,N.Y. Black.In:Am Art J. AP1.A51
 A64,v.12:6,footnote

I.B.1.a - DULWICH COLLEGE,LONDON - DULWICH GALL.

Dulwich college,London
 Cat.of the manuscripts and muniments of
Alleyn's college of God's gift at Dulwich...
London,Pub....by Longmans,Green & co.,1881-1903

LC Z6621.D88l FOR COMPLETE ENTRY
 SEE MAIN CARD

I.B.1.a - EDINBURGH - NATIONAL LIBRARY OF SCOT-
 LAND

mfm
124n13
NCFA

Murdoch, William Garden Blaikie, 1880-1934
 A bequest of Stuart engravings to the National Library of Scotland

In:Apollo
13:167-73 Mar,'31 illus.

 400 items relating to the dynasty

I.B.1.a - DULWICH COLLEGE,LONDON - DULWICH GALL.

Dulwich college,London - DULWICH GALLERY
 Cat.of the pictures in the gallery of Alleyn's college of God's gift at Dulwich...London
printed by Darling & son,ltd.,1914

LC N1270.A3 1914 FOR COMPLETE ENTRY
 SEE MAIN CARD

I.B.1.a - EDINBURGH. SCOTTISH NATIONAL PORTRAIT
 GALLERY

N
1285
A63X
NPG

Edinburgh. Scottish national portrait gallery
 Concise catalogue.Comp.by Duncan Thomson
and Sheila Bruce Lockhart.Edinburgh,The Trustees of the National Galleries of Scotland,1977
187 p.

 Cat.of subjects
 Index of artists

I.B.1.a - DULWICH COLLEGE,LONDON - DULWICH GALL.

Dulwich college,London - Dulwich Gallery
 The Dulwich picture gallery.A descriptive
cat...London,Philip Wilson Publishers Ltd.,1980

FOR COMPLETE ENTRY
SEE MAIN CARD

 Cat.Sotheby Parke Bernet
 Publications 1979-80 p.16

I.B.1.a - EDINBURGH. SCOTTISH NATIONAL PORTRAIT
 GALLERY

NE
218
S84
NPG

Edinburgh. Scottish national portrait gallery
 A face for any occasion. Some aspects of
portrai engraving;by Sara Stevenson...1976

 Based on an exh.,summer,1974...
 Most works belong to Scottisch nat'l portr.
 gallery

I.B.1.a - DULWICH COLLEGE,LONDON - DULWICH GALL.

705
C75
NCFA
v.90

Roe, F.Gordon
 London's forgotten gallery

In:Connoisseur

 Incl.:Portrs. in Dulwich College,London -
Dulwich Gallery

FOR COMPLETE ENTRY
SEE MAIN CARD

I.B.1.a - EDINBURGH. SCOTTISH NATIONAL PORTRAIT
 GALLERY

CT
817.5
S26
1985X
NPG

Edinburgh. Scottish national portrait gallery
 Great Scots.Publ.by the Trustees of the
National Galleries of Scotland,n.d.,

 73 p. illus(col.)

 Comp. by James Holloway
 Index of sitters
 Index of artists

N
7621.2
67B22
1951
NPG

I.B.1.a -

Edinburgh. Scottish national portrait gallery
 Illustrated catalogue. Edinburgh,H.M.Sta-
tionery Off.,1951
 159 p. illus.

 "This cat...supersedes the cat.(last ed.1909)
LC N1285.A6 1909

Fog.,v.11,p.321 (ed.1909)

705
B97
NCFA
v.114

I.B.1.a - EDINBURGH. SCOTTISH NATIONAL PORTRAIT
 GALLERY

Evans, Dorinda
 Twenty-six drawings attributed to Mather
Brown

In:Burl Mag
114:534-41 Aug.,'72 illus.

 The drags.are in Edinburgh. Scottish N.P.G.

Moon.Engl.portr.drags...
NC860.N66X NPG p.XIII
footnote 19

757
.E23
1928

I.B.1.a - EDINBURGH. SCOTTISH NATIONAL PORTRAIT
 GALLERY
Edinburgh. Scottish national portrait gallery
 ...Illustrated list with 97 illustrations and
index of artists.Edinburgh,Printed under autho-
rity of H.M.Stationery off.,1928
 36 p. illus.

N
7621.2
C7E23
NPG

I.B.1.a

Edinburgh. University.
 The University portraits;compiled by
D.Talbot Rice...Edinburgh,Published for the Uni-
versity Court by the University Press,1957
 239 p. illus(part col.)

LC N7621.E3

QN
1285
S63
1985
NPG

I.B.1.a - EDINBURGH. SCOTTISH NATIONAL POR-
 TRAIT GALLERY
Edinburgh. Scottish national portrait gallery
 A portrait gallery for Scotland.The foun-
dation,architecture and mural decoration of
the Scottish National portrait gallery,1882-
1906,by Helen Smailes.Publ.by the trustees of
the National Galleries of Scotland,1985
 78 p. illus.(part col.)

 Incl.:A pantheon in stone:sculpture as
architectural decoration,p.37-44

757
.E59

I.B.1.a - ENOCH PRATT FREE LIBRARY, BALTIMORE

Enoch Pratt free library, Baltimore
 The Lords Baltimore;contemporary portraits
of the founder and the five proprietaries of
Maryland,...Baltimore,The Enoch Pratt free libra-
ry,1942.
 13 p. illus.

 Text by James Foster and Beta K.Manakee

N
7599
E23
NPG

I.B.1.a -

Edinburgh. Scottish national portrait gallery
 The royal house of Stewart.Portraits...Notes
by R.E.Hutchison,keeper,Edinburgh,1958
 62 p. illus.

LC DA758.3S8E3

I.B.1.a - Essen. Folkwangschule für Gestaltung

Erfurth, Hugo, 1974-1948
 Bildnisse....1961.

 ...aus der fotografischen sammlung der Folk-
wangschule für Gestaltung...Essen

LC TR680.F7

757
.E26

I.B.1.a

Edinburgh. Scottish national portrait gallery
 Scottish history told by portraits,a popular
guide to the Scottish national portrait gallery,
Edinburgh...Edinburgh,printed under the autho-
rity of H.M.Stationery off.,1934
 23 p. illus.
 2d ed.
 Signed:James L.Caw

N
7621
E78

I.B.1.a -

Essex Institute, Salem,Mass.
 Catalogue of portraits in the Essex Insti-
tute...covering three centuries...Salem,Mass.,
The Essex Institute,1936
 306 p. illus.
 Intro.by Henry Wilder Foote

N
7621
E78
suppl.

--- --- Additions to the Catalogue...
 received since 1936. Comp.by Russell Leigh
Jackson..Salem,Mass.,1950.
 82 p. illus.
 Repr.fr.Essex Inst.hist.coll.,vols.85,Oct.,
1949 and 86,Jan.and Apr.,1950
LC F72.E7E825 Hist.Rec.survey,Mass.
 N7593.1H67 v.2,Bibl.p.510

I.B.1.a - ETON COLLEGE(PROVOST'S LODGE)

Cust, Lionel Henry, 1859-1929
 Eton college portraits...London,Spottiswoode
& co.,1910
 81 p. illus.

 Incl:Ramsay,Nath.Dance,Reynolds,Romney,
Hoppner,Beechey,Opie,Northcote,Lawrence,Carpenter
Phillips,etc.

LC N598.C8

David Piper:Eton leaving portr
in:burl.Mag.v.93:201:
"Standard work"

ND
1314.4
E96
NPG

I.B.1.a - ETON COLLEGE(PROVOST'S LODGE)

Eton college
 Exhibition of the Eton leaving portraits.
The Tate gallery, London, Apr.-May,1951
 28 p. illus.

FOGG
4103
L84

Review by David Piper,In:Burl.Mag.
93:201-2 June,1951 illus. Repro:Fabre,Reynolds
Romney,Carpenter

NE NN

HD
210.5
P775
1981X
NMAA
2 c.

I.B.1.a - FLINT INSTITUTE OF ARTS

Flint Institute of Arts
 American naive painting:the Edgar William
and Pernice Chrysler Carbisch collection:Flint
Inst.of Arts,Dec.6,1981-Jan.24,1982.cat.by.
Alain G.Joyaux..Flint,Mich..The Institute,
c.1981
 55 p. illus.

 Bibliography

 Intro.by Richard J.Wattenmaker

Worldwide Art Cat.Bull.
19:no.1:64 705.W972 NMAA

I.B.1.a - FLORENCE. GALLERIA DEGLI UFFIZI

Viallet, Bice
 Gli autoritratti femminili della R.Galleria
degli Uffizi in Firenze.Florence,1923
 137 p. illus.

MET
276
V65

Enc.of World Art
N31E56Ref.v.11col.512
bibl on portr.

qN
1615.5
E85P14
1988
NMAA

I.B.1.a - FLORENCE.GALLERIA DEGLI UFFIZI

New York. National academy of design
 Painters by painters.N.Y.,Nat'l academy of
design.1988.
 108 p. illus(part col.)

 Cat.of an exh.held at the Nat'l acad.of des.
May12-July 31,1988 & Mus of fine arts,Houston,
Aug.13-Oct.23,1988
 Bibliography
 List of portrs.of artists in the Uffizi
 Index to artists and plates
 Essays:The history of a collection by Cate-
rina Caneva,p.8-2 Studio portrs.by Antonio
Natali,p.28-34.Po within portr.:Cover & no.17

:7618
P95
NPG

I.B.1.a - FLORENCE .GALLERIA DEGLI UFFIZI

Prinz, Wolfram
 Die Sammlung der selbstbildnisse in den
Uffizien;hrsg.v.U.Middeldorf & U.Procacci.
Red.v.W.Prinz.Berlin, Mann verl.,1971-
 3 v. illus. (Ital.Forsch.,Folge 3,Bd.5)

 Contents:1.-Geschichte der sammlung;2-Die
selbstbildnisse der ital.künstler;3.-Die selbst-
bildnisse der nicht ital.künstler
 v.1:Incl.Hist.develpom't of portrs.fr.repre-
senting famous fgs.of the past to actual portrs.

VF:
Florence
Gall.
degli
Uffizi

I.B.1.a - FLORENCE. GALLERIA DEGLI UFFIZI

Buerkel, Ludwig von
 Die selbstbildnisse von malern in den Uffi-
zien

In:Ueber Land & Meer
94,no.46:1065-7 Apr.-Oct.,1905 illus.

LC AP30.U2

FOR COMPLETE ENTRY
SEE MAIN CARD

I.B.1.a - FLORENCE. GALLERIA DEGLI UFFIZI

Moücke, Francisco
 Serie di ritratti degli eccellenti pittori
dipinti di propria mano,che esistono nell'Imperial
Galleria di Firense...Firense,Stamperia Moückiana,
1752-1762
 4 v. illus. (Museum florentinum...7-10)

LC N2571.G6 vol.7-10

Amsterdam,Rijksmus.,cat.
Z5939A52,deel 3,p.626

I.B.1.a - FLORENCE. PALAZZO PITTI

Saletti, Cesare
 I ritratti antoniniani di Palazzo Pitti...
1 ed. Firenze,La nueva Italia,1974
 69 p. illus. (Pubbl,Facoltà di lettere
e filosofia dell' Università di Pavia,17)

 Bibl.references
 Index

LC NB165.A57824

Gesichter.NB1296.3.G38
1983 NPG p.316

I.B.1.a - FLORENCE, UFFIZI GALLERY
 see
 FLORENCE. GALLERIA DEGLI UFFIZI

I.B.l.a - Fogg Art Museum
see
Harvard university William Hayes Fogg art mus.

I.B.l.a - GENEVA. MUSÉE D'ART ET D'HISTOIRE

Geneva. Musée d'Art et d'Histoire
Le Monde des Césars,portraits romains.présentés par.Jiři Frel,Jacques Chamay,Jean-Louis Maier..Le musée.c.1982
323 p. illus.
Bibliography
Index
Summary in English
Exposition organisée au Mus.d'art et d'histoire de Genève,28 oct.1982-30 jan.1983

1ère ptie,Portrs.romains du Mus.J.Paul Getty, à Malibu,Calif.-2e ptie,Portrs.romains du mus.d'art et d'h st.de Genève
LC NB1296.3M66 1982

I.B.l.a - FREEMASONS' HALL. LONDON
see
I.B.l.a - LONDON. UNITED GRAND LODGE OF ENGLAND.
LIBRARY & MUSEUM. FREEMASONS' HALL

I.B.l.a - GENEVA. MUSÉE D'ART ET D'HISTOIRE

Schneeberger, Pierre Francis
Les peintres sur émail genevois au 17e et au 18e siècle.Genève,Mus.d art et d'histoire, 1958

MET
195.4
Sch5

MiDA

FOR COMPLETE ENTRY
SEE MAIN CARD

ND
1321
E44K
NPG

I.B.l.a - GAMMEL KJØGEGAARD

Eller, Povl
Portraetsamlingen pa Gammelkjøgegaard..Hillerød,Det nationalhistoriske Museum.pa Frederiksborg,1970
91 p. illus.

A typical mannerhouse collection:Portrs. from 1576-1863

LC ND1321.E44

I.B.l.a - GENEVA. MUSÉE D'ART ET D'HISTOIRE

Geneva. Musée d'Art et d'Histoire
Les portraits romains du Musée d'Art et d'Histoire.by.Isabelle Rilliet-Maillard. Genève,Mus.d'Art et d'Histoire,1978
79 p. illus.

Met
617.9
G28M97

Gesichter.NB1296.3.G38
1983 NPG p.116

ND
1314
G24
NCFA
(p.257-
319 mis-
sing)

I.B.l.a -

Garrick Club, London
Catalogue of pictures in the Garrick Club. .London,1936?.
310 p. illus.

The club's coll.now comprises some 400 ptgs. & an approx.equal number of drags.which are with a few exceptions portrs.of members of the theatrical profession,usually in character

Compiled by C.K.Adams
Bibliography
LC N759803

I.B.l.a - GETTY MUSEUM
see
I.B.l.a - J.PAUL GETTY MUSEUM

N
7592
G24
NPG

I.B.l.a - GARRICK CLUB, LONDON

Garrick Club, London
Cat.of the pictures and miniatures in the possession of the Garrick Club.Rev.ed.London, Eyre and Spottiswoode,1909
125 p.

Incl.:Index of sitters

705
A56
NCFA
v.98

I.B.l.a - GIBBES ART GALLERY

Bilodeau, Francis W.
American art at the Gibbes Art Gallery Charleston

In:Antiques
98:782-6 Nov.,'70 illus.

FOR COMPLETE ENTRY
SEE MAIN CARD

I.B.1.a - GOSUDARSTVENNYY ERMITAZH see
I.B.1.a - LENINGRAD. ERMITAZH

I.B.1.a - GRIPSHOLM SLOTT. STATENS PORTRÄTTSAML'G

Sinclair, O.A.
 Gripsholm:Sweden national portrait gallery

In:Chambers's Journal
20:423-5 7th ser.Jun.,'30

DLC

Cumulated Mag.subj.index
A1/3/C76 Ref. v.2p.444

I.B.1.a -

Greenwich, Eng. National Maritime Museum
 Portraits at the National Maritime Museum,
selected by E.H.H.Archibald.London,H.M.Stationer
Off.,1954-55
 2 v.

 Contents:-Series I. 1570-1748. -Series II.
1748-1944

LC N7598.G63

Fogg,v.11,p.331

I.B.1.a

Gripsholm slott. Statens porträttsamling
 Katalog över Statens porträttsamling på
Gripsholm...Stockholm,1951-
 2 v. illus.

 Compiled by Boo von Malmborg

 Contents.-1.Porträtt före 1809.-2.Porträtt
after 1809

LC N1935.G7A55

I.B.1.a - GREENWICH, ENG. ROYAL NAVAL MUSEUM

Greenwich royal hospital, Greenwich,Eng.
 ...Descriptive catalogue of the portraits
of naval commanders...Exhibited in the Painted
hall of Greenwich hospital,and the Royal naval
museum, Greenwich.London,Printed for H.M.Sta-
tionery off.,by Eyre and Spottiswoode,ltd.,1912
 106 p.

LC DA89.G2G7 1912

Fogg,v.11,p.322

NPG
Ref.
Coll. I.B.1.a - GRIPSHOLM SLOTT. STATENS PORTRÄTTSAML'G

 Johnsson, Ulf G.
 Masterpieces from Gripsholm Castle:The Swe-
dish National Portrait Collection.Cat. of an exh.
at the National Portrait Gallery,Washington,D.C.,
Apr.13-July 10,1988.Stockholm,The National Swe-
dish Art Museums,1988
 134 p. illus(part col.)

 Incl.:Index:Artists and sitters
 Foreword by Alan Fern
 Intro.by Per Pjurström & Ulf G.Johnsson

I.B.1.a - GREENWICH ROYAL HOSPITAL,GREENWICH,ENG.

Greenwich royal hospital, Greenwich,Eng.
 ...Descriptive catalogue of the portraits
of naval commanders...Exhibited in the Painted
hall of Greenwich hospital,and the Royal naval
museum, Greenwich.London,Printed for H.M.Sta-
tionery off.,by Eyre and Spottiswoode,ltd.,1912
 106 p.

LC DA89.G2G7 1912 Fogg,v.11,p.322

I.B.1.a - HAGERSTOWN,MD WASHINGTON COUNTY
see ,MUSEUM OF FINE ARTS
I.B.1.a - WASHINGTON COUNTY MUSEUM OF FINE ARTS.
 HAGERSTOWN,MD.

I.B.1.a - GREIZ, STAATLICHE BUCHER-UND KUPFER-
 STICHSAMMLUNG
Hornbogen, Alfred
 Englische porträts des 18.jahrh.;schabkunst-
blätter aus der staatlichen bücher-und kupfer-
stichsammlung Greiz.Berlin,Henschelverlag,1959
 42 p. illus. (Museumsschriften,Bd.1)

 Bibliography

LC NE1815.H6 Fogg v.11,p.332

I.B.1.a - HAGUE. GEMEENTEMUSEUM, MUSIC DEPT.

Hague. Gemeentemuseum
 Portraits of composers and musicians on
prints and drawings.Collection Music Dpt.Haags
Gemeentemus..Zug,Switzerland,Inter Documenta-
tion Co.,1977.

N.Y.P.L. *XML-1269 microfiche **FOR COMPLETE ENTRY
 SEE MAIN CARD**

I.B.1.a - HAMBURG (GENERAL)

Hamburg. B.A.T-Haus
Köpfe, 111 gesichter des menschen in male-
rei und skulptur,auf münsen,schmuck und gerät
aus drei jahrtausenden und allen kulturkreisen.
B.A.T-Haus,Hamburg 36,Esplanade 39,1973
.16,12 p., illus.

Cat.for the 50th B.A.T.(Cigaretten-Fabriken
G.m.b.H.)exhibition,Aug.30-Oct.13,1973

Individual portrs.,physiognomy,idols,masks,
etc.
see next card

757.0838 I.B.1.a -
.H33
Harvard university.
Harvard portraits;a catalogue of portrait
paintings at Harvard university,comp.by Laura
M.Huntsinger under the direction of Edward Waldo
Forbes.Edited by Alan Burroughs.Cambridge,Mass.,
Harvard university press,1936
158 p. illus.

Arranged alphabetically according to the
names of the sitters.Index of artists.

LC N7621.H32 Hist.rec.survey,Mass.v.2
 N7593.1H67 p.511

I.B.1.a - HARDWICK HALL, DERBYSHIRE

National Trust for Places of Historic Interest
or Natural Beauty
Hardwick Hall,Derbyshire;biographical notes
on the portraits at Hardwick,National Trust,
.London,The Trust,1977
19 p.

LC ND1314.N37 1977

I.B.1.a - HARVARD UNIVERSITY

Brown, William Garrott, 1868-1913
. ...A list of portraits in the various build-
ings of Harvard university...Cambridge,Library
of Harvard university,1898
52 p. (Harvard university.Library
Bibliographical contributions,no.53)

LC Z1000.H33 Fogg,v.11,p.327

AP I.B.1.a - HARTFORD MUSEUM
1
C76 Joseph Steward and the Hartford museum
NPG
v.18 In:Conn.Hist.Soc.B.
 18:1-16 Jan.-Apr.,'54 illus.

Pertains to exh. of Steward's portraits.
Biographical treatment of this Conn.portraitist
and museum owner

Arts in America qZ5961
USA 77X NCFA Ref. H492

N I.B.1.a - HARVARD UNIVERSITY. LIBRARY. THEATRE
7621 COLL.
H33 Harvard University. Library. Theatre coll.
NPC Cat.of dramatic portraits in the theatre
 coll.of the Harvard college library.Cambridge,
 Mass.Harvard univ.press,1930-34
 4 v.
 Compiled by Lillian Arvilla Hall
 "A descriptive index to the engraved dra-
 matic portrs.in the theatre coll....arranged
 alphabetically according to names."-Pref.

Woon.Engl.portr.drags.&min.
NC860.N66X NPG Bibl. p.145

ND I.B.1.a - HARVARD, MASS. FRUITLANDS MUSEUMS
1311.5
S43 Sears, Clara Endicott, 1863-
NPG Some American primitives;a study of New
 England faces and folk portraits...Boston,
 Houghton Mifflin company,1941
 291 p. illus.

Bibliography Mus.
These portrs.are in Harvard,Mass.Fruitlands
Incl.references to the Fall River-Sturbridge
school of ptg.,see p.42-6 and illustrs.p.20-1,
23-6

LC ND1311.S4

ND I.B.1.a - HARVARD UNIVERSITY WILLIAM HAYES FOGG
1311.1 .ART MUSEUM
A512 Vogel, Anne H.
1983 American Colonial portraits from the Fogg
NPG Art Museum and Harvard University.Cat.of exh.
 at Milwaukee Art Museum.Milwaukee Art Mus.,
2 c. June 30,1983
 .14.p. illus(col.cover)

Bibliography

ND I.B.1.a - HARVARD UNIVERSITY
1311.1
A512 Vogel, Anne H.
1983 American Colonial portraits from the Fogg
NPG Art Museum and Harvard University.Cat.of exh.
 at Milwaukee Art Museum.Milwaukee Art Mus.,
2 c. June 30,1983
 .14.p. illus(col.cover)

Bibliography

I.B.1.a - HARVARD UNIVERSITY. WILLIAM HAYES
 .FOGG ART MUS.

Harvard university. William Hayes Fogg art mus
Exhibition:Washington,Lafayette,Franklin;
portraits,books,manuscipts,prints...for the
most part from the university.Cambridge,Fogg
mus.of art,Harvard univ.,1944
53 p. illus.

Feb.22-May 28,1944
Preface ...edited...Morgan and Mary Wads-
worth

LC N5020.C234

I.B.1.a - HARVARD UNIVERSITY WILLIAM HAYES FOGG
ART MUSEUM

Hanfmann, George Maxim Anossov, 1911-
Observations on Roman portraiture. Bruxelles,
Latomus,Revue d'études latines,1953
50 p. illus. (Collection Latomus,v.11)

Bibliogr.footnotes

Descriptive essay on Roman portrait sculpture
based on three examples acquired by the Fogg
Art mus.

LC N°[illegible]

N
1935
H5A52X
NPG

I.B.1.a -

Hillerød, Denmark. Nationalhistoriske museum
paa Frederiksborg slot.
Hilledur fra Frederiksborg.Pictures from
Frederiksborg.Billedudvalg og tekster:Jørgen
Paulsen,H.D.Schepelern og Povl Eller..Hille-
rød,1961.
162 p. illus(part col.)

p.39-162 mainly repro of portrs.

LC N1935.H5A52

VF
Calif.
San
Marino

I.B.1.a - HENRY E.HUNTINGTON LIBRARY and ART G.

Henry E.Huntington Library and Art Gallery,
San Marino,Calif. The Virginia Steele
Scott Gallery
A gift to the Huntington Art Gallery.Pasa-
dena,The Castle Press,1984
24 p. illus(col.)

Incl.:Checklist of ptgs.& W.C.,June,1984
(incl.American portrs.,18-20th c.)

AP
1
C27
NMAA

I.B.1.a - HILLERØD, DENMARK. NATIONALHISTO-
RISKE MUSEUM PAA FREDERIKSBORG SLOT

Frederiksborgmuseet
Engelske Christian IV-portrætter.I anled-
ning af en gave.Af museumsinspektør Steffen
Heiberg

In:Carlsbergfondet,Frederiksborgmuseet,Ny Carls-
bergfondet.Arsskrift 1986,p.92-8 illus(part
col.)

ND
207
H46
1986X
NMAA

I.B.1.a - HENRY FRANCIS DU PONT WINTERTHUR MUS.

Richardson, Edgar P.reston,1902-1985.
American paintings and related pictures
in the Henry Francis du Pont Winterthur Mus.
Charlottesville,Univ.Press of Va.,1986
157 p. illus(col.)

Bibliography:p.153-7

Partial contents:Ch.1:The Family Connec-
tion;-Ch.2:The Am.School to 1776.-Ch.3:The Am.
School from 1776
Repro.incl.:Washington Family by Edw.Savage,
Washington by Trumbull,Kemmelmeyer,Stuart,

I.B.1.a - HILLERØD, DENMARK. NATIONALHISTORIS-
KE MUSEUM PAA FREDERIKSBORG SLOT

Hillerød,Denmark. Nationalhistoriske museum
paa Frederiksborg slot
The Museum of National History at Frede-
riksborg Castle,official guide.Hillerød,1961
86 p. illus.

LC N1935.H5A6

705
A56
NCFA
v.100

I.B.1.a - HENRY FRANCIS DU PONT WINTERTHUR MUS.

Sweeney, John A.H.
Paintings in the Winterthur collection

In:Antiques
100:758-67 Nov.,'71 illus(part col.)

Repr.incl.:Portrs.by Henry Benbridge,1775-6,
R.Peale,1813,Willem Verelst,1734-6,Benj.West,
1782-4,Ch.W.Peale,1771,Feke,1746,Wm.Williams,
1775.TheWashington family by Edw.Savage,1789-90,
Washington by G.Stuart,1755-6

AP
1
C27
NMAA

I.B.1.a - HILLERØD, DENMARK. NATIONALHISTORIS-
KE MUSEUM PAA FREDERIKSBORG SLOT

Frederiksborgmuseet
Det nationalistorisk Museum paa Frederiks-
borg.Beretning of året 1984-85.by Mogens Wahl,
Kristof Glamann,Olaf Olsen,Povl Eller

In:Carlsbergfondet,Frederiksborgmuseet,Ny Carls
bergfondet.Arsskrift 1986,p.81-91 illus(part
col.)
Report of purchases & gifts.
Repro.incl.:Drags.:Frederik VI by Christof-
fer Vilhelm Eckersberg.Frederik IX & other
portrs.by Johannes Ejnor Glob.Ptgs.by Victor
Isbrand,etc.

705
A56
NCFA
v.107

I.B.1.a - HENRY FRANCIS DU PONT WINTERTHUR MUS.

Schmiegel, Karol A.
Pastel portraits in the Winterthur museum

In:Antiques
107:323-31 Feb.,'75 illus(part col.)

Rila II/2 1976 #7092

708.8
H65

I.B.1.a -

Hillerød, Denmark. Nationalhistoriske museum
paa Frederiksborg slot.
Det nationalhistoriske museum paa Frederiks-
borg...Billedhefte:interiører og portraetter
fra samlingen. 3rd ed.,1943
160 p. illus.

P.39-159 repro. of portrs.

I.B.1.a-

Hillerød, Denmark. Nationalhistoriske museum
paa Frederiksborg slot.
Det Nationalhistoriske museum paa Frederiks-
borg,1928-1953...Katalog over et udvalg af dets
erhvervelser.Udg.af Museets bestyrelse i anled-
ning af 75 aars jubilaeet,1953.København,1954,
355 p. illus.

Minnesota Univ.Library for IC
NN

I.B.1.a - INDEPENDENCE NATIONAL HISTORICAL
.PARK
VF
Pa.
Philadel- Philadelphia.Independence National Historical
phia Checklist of portraits in the .Park
collection of Independence National Park,Phi-
ladelphia.1962?.
.23.1.

NJP

AP I.B.1.a - HOLBURNE ART MUSEUM. BATH, ENGLAND
1
A64 Foskett, Daphne
NCPA Miniaturists silhouettists in Bath
v.92

In:Apollo
98:385-9 Nov.'73 illus.

Repro.incl.:Chs.Jagger,Abr.of Jos.Daniel,
Charlotte Jones,Sampson Towgood Roch(e),Chs.
Ford,Ozias Humphry,Ths.Redmond,Chs.Foot Taylor,
Nathaniel Hone,T.Hamlet,Jac.Spornberg,Elliott
Rosenberg

F I.B.1.a - INDEPENDENCE NATIONAL HISTORICAL PARK
158.65
I 3T78 Milley, John C.
NPG Portraiture:Commemorative and symbolic

In:Treasures of Independence:Independence Natio-
nalHistorical Park & its collections,p.151-70 &
notes p.179-80 illus(part col.)

Bibl.:Painted & Printed material,p.185-7

Incl.Chs.Willson & Rembrandt Peale's "museum
portrs.":bust portrs.;and commissions of private
nature Miles.In:Am Art J,15:64
footnote 4

VF I.B.1.a - HOUSTON, TEX. MUSEUM OF FINE ARTS
Houston
Mus.Fine Houston, Tex. Museum of fine arts
Arts The Sonia and Kaye Marvins portrait coll.
.Cat.of exh.Apr.10-June 22,1986.Houston,Mus.
of fine arts,1986
24 p. illus.

Coll.of famous subjects & famous photogra-
phers given to the mus.by the Marvins family.
Incl.:Duke & Duchess of Windsor by Avedon;
Casals by Yousuf Karsh;Victor Hugo by Bertall;
Horst's self-portr.with Gertr.Stein;Albert
Schweitzer by Smith,etc.
Incl.:Article by A.W.Tucker.Checklist
by M.Olvey

I.B.1.a - INDIA OFFICE LIBRARY AND RECORDS

Rohatgi, Pauline
India Office Library and Records.Portraits
in the India Office Library and Records...
London,British Library,c.1983
414 p. illus.(1 col.)

Bibliography p.407-14
Index

LC CT1504.5.I53 1983 Books in print.Subject
guide 1985-86,v.3,p.4865

I.B.1.a -

Huntington Galleries
The Bagby collection:Portraits in the grand
manner of the Huntington Galleries.Huntington,
W.Va..The Galleries,1962?.
.24.p. illus.

CtY Yale ctr.f.Brit.art Ref.
ND1311.H85

ND I.B.1.a - INDIANAPOLIS. STATE HOUSE
1311.8
I6P42 Peat, Wilbur David, 1898-
1978X Portraits and painters of the governors of
NPG Indiana,1800-1978...Indiana Histo.Soc.,1978

FOR COMPLETE ENTRY
SEE MAIN CARD

I.B.1.a - ILLINOIS UNIVERSITY-KRANNERT ART
see .MUS.
I.B.1.a - KRANNERT ART MUSEUM

I.B.1.a - IOWA

Des Moines Art Center
19th century American portraits from Iowa
collections.Exh.14 Sept.-17 Oct.'76..Cat..by
Js.T.Demetrion
4 p. illus.

Incl.portrs.from G.Stuart to M.Cassatt

34 works shown

RILA IV/X 1978 #2122

I.B.1.a

Iowa. Historical,Memorial & Art Department
 Historical portrait collection in Iowa his-
torical department

In:Annals of Iowa
9:535-8 Jul.-Oct.,'10

Cumulated Mag.subj.index
A1/3/C76 Ref. v.2,p.444

I.B.1.a - J.PAUL GETTY MUSEUM

Thompson, David L.
 Mummy portraits in the J.Paul Getty mu-
seum.2nd ed.,Malibu,Calif.,The Museum,c.1982
 70 p. illus(part col.)

 Rev.ed.of:The artists of the mummy portrs.
 c.1976 with new material added
 Cat.p.31-63
 Index

LC ND1327.E3T48 1982

CJ
161
P65J46C
NPG

I.B.1.a - J.PAUL GETTY MUSEUM

Jentoft-Nilsen, Marit, 1938-
 Ancient portraiture;the sculptor's art in
coins and marble.A loan exh.on display at the
Virginia Museum,Apr.29 to July 20,1980...
Richmond,Virginia Museum,c.1980
 64 p. illus.

 Most items from the coll.of Jeffrey H.
Miller and the Getty Museum
 Excellent introd.to the numismatic portrai-
ture in relation to work in marble.
Discussion of the develop't of portrs.by the
Romans Worldwide Art cat.R. v.17
 no5.W527 NPAA p.60

q NB
1296
R75
NPG

I.B.1.a - J.PAUL GETTY MUSEUM

Roman portraits;aspects of self and society,
 1st c.P.C.-3rd c.A.D.;a loan exh..Los An-
geles,Calif.?,Regents of the Univ.of Cal.,
Loyola Marymount Univ.,and the J.Paul
Getty Mus.c.1980.
 108 p. illus.
 Bibliography
 Exh.schedule:Mary Porter Sesnon art
Gall.,College V,Univ.of Calif.,Santa Cruz,
Calif.Feb.20-Apr.9,1980;Art Gall.Loyola
Marymount Univ.,L.A.,Cal.,Oct.14-Nov.10,
1980 cont'd next ed.(& over)
 Worldwide art cat.R./705.
 W527 NBAA v.17,no.3,1981
 p.61

I.B.1.a - J.PAUL GETTY MUSEUM

California State University, Northridge.
 Fine Arts Gallery
 Greek and Roman portraits from the J.Paul
Getty Museum.cat.of the exh..Oct.16-Nov.11,
1973.Northridge,Calif.,1973?,
 32 p. illus.
 Incl.Bibliography

 Introd. by Jiří Frel

LM CMoS Roman portrs.Aspects of
 self...qNB1296.R75 NPG NPAA
 p.107

NB
1296.3
F73C
NPG

I.B.1.a - J.PAUL GETTY MUSEUM

J.Paul Getty Museum
 Roman portraits in the Getty mus.Cat.pre-
pared for the special loan exh."Caesars and Ci-
tizens"Philbrook Art Center,Tulsa,Okla.,Apr.26-
July 12,1981...by Jiří Frel in collaboration
with S.K.Morgan.Philbrook Art Ctr.& The J.Paul
Getty Mus.,1981
 137 p. illus.

 Statues,busts,heads,funerary reliefs,sarco-
phagi

I.B.1.a - J.PAUL GETTY MUSEUM

J.Paul Getty Museum
 Greek portraits in the J.Paul Getty museum
.cat.by.Jiří Frel.Malibu,Calif.,The Museum,
c.1981
 121 p. illus.

 Cat.p.38-118

 Index

LC NB1296.3.J18 1981 Books in Print.Subject
 Guide,1985-6,v.3,p.4864

I.B.1.a - JEFFERSON MEDICAL COLLEGE, PHILADEL-
 PHIA

Frankenberger, Charles, 1884-
 The collection of portraits belonging to
the college

In:The Jeffersonian
17,no.1321-10 Nov.,'15

 Jefferson Medical College,Philadelphia

DNLM(W1JE1H9) Gerdts.Art of healing
 N8223.G36 NPG p.114,note38

I.B.1.a - J.PAUL GETTY MUSEUM

Geneva. Musée d'Art et d'Histoire
 Le Monde des Césars,portraits romains.pré-
sentés par.Jiří Frel,Jacques Chamay,Jean-Louis
Maier..Le musée.c.1982
 323 p. illus.
 Bibliography
 Index
Summary in English
Exposition organisée au Mus.d'art et d'his-
toire de Genève,28 oct.1982-30 jan.1983

 1ère ptie,Portrs.romains du Mus.J.Paul Getty,
à Malibu,Calif. 2e ptie,Portrs.romains du
mus.d'art et d st.de Genève
LC NB1296.3M66 1982

I.B.1.a - JENA. UNIVERSITÄT

Kusch, D
 Die Rektoren-und professorenbildnisse des
16.Jhr.in der Friedrich-Schiller-universität,
Jena.

In:Jena.Universität.Wissenschaftliche Zeitschr.
 Gesellschafts-und Sprachwissenschaftl.Reihe
7:9-33 1957/58

LC AS182.J5 Wolstenholme.N7598.W86 NPG

I.B.1.a - JOHNS HOPKINS UNIVERSITY. John WORK
 ⸱GARRETT LIBRARY

Johns Hopkins University. John Work Garrett
 ⸱Library
 Medals relating to medicine...in the numis-
matic coll.of the Johns Hopkins Univ.,a cat.by
Sarah Elizabeth Freeman.Baltimore,Evergreen
House ⸱Foundation,1964
 430 p. illus. (Evergreen House Founda-
tion.Publication no.2)

 Bibliography

LC CJ5793.M⸱J6 Wolstenholme.The Royal Col-
 lege of Physicians of London

705
A56
NMAA
v.122

I.B.1.a - KINGSTON, N.Y., SENATE HOUSE STATE
 ⸱HISTORIC SITE
Jones, Leigh Rehner & Shirley A.Mearns
 Seven portraits attributed to Ammi Phillips

In:Antiques
122:548-51 Sept.,'82 illus.

 Article has been adapted fr.the cat.to"Ammi
Phillips and Company,popular taste.in face ptg.'
an exh. on view at the Senate House State Histo-
rie Site,Kingston,N.Y.
 Repro.incl.:Engr.after a photograph by Mat-
hew B.Brady

N
7592
K16
NCFA

I.B.1.a
Kansas. University. Museum of Art.
 Images:23 interpretations;an exhibition of
portrait and figure painting....Lawrence,1964
 56 p. illus. (University of Kansas.Misc.
publications of the Museum of Art,no.54)

 '"Image" points to universal qualities as well
as those unique to a single being'

LC N7592.K3

705
B97
v.18

I.B.1.a - KNOWSLEY(LANCASHIRE). LIBRARY
Dimier, Louis,1865-1943
 French portrait-drawings at Knowsley

In:Burl.Mag.
18:162-8 Dec.,1910

 A 'Court Album', copies of drawings which al-
so served enamelers; list of sitters & name of
artist of original drg.;Facsimile of handwritten
descriptions

ND
1316.3
L38X
NPG

I.B.1.a -
Karlsruhe. Staatliche Kunsthalle
 Französische bildnisse des 17.und 18.jahr-
hunderts,von Jan Lauts. Karlsruhe,1971
 75 p. illus(part col.) (Bildhefte der
Staatlichen Kunsthalle,Karlsruhe,nr.8)

 Contents.-1.Phil.de Champagne.-2.H.Rigaud.-
3.N.de Lar_illière.-4.J.-B.Perronneau.-5.P.P.
Prud'hon

LC ND1316.3L38

AP
1
K86
NCFA

I.B.1.a - KRANNERT ART MUSEUM
Risatti, Howard
 A French court portrait

In:Krannert Art Mus.B.
II,no.1:12-27 1976 illus(part col.)

 Chaps.:Portr.tradition.Rebirth of Humanism.
Ital.influence in France.The Clouets.Other por-
traitists.Court portr.style.François Clouet._
A lady of the court.Portr.drag.colls.Conclusion

705
G28
NCFA
v.97

I.B.1.a - KASSEL. STAATLICHE KUNSTSAMMLUNG
 SCHLOSS WILHELMSHOHE
Schenk su Schweinsberg, Eberhard, 1893-
 Un album de "Lagneau"provenant de Thouars?

In:Gas Beaux-Arts
97:189-200 May-June,'81 illus.

N
1455
A55
1983
NMAA

I.B.1.a - LADY LEVER ART GALLERY, PORT SUN-
 ⸱LIGHT
Lady Lever art gallery, Port Sunlight
 Cat.of foreign paintings,drawings,minia-
tures,tapestries,post-classical sculpture and
prints.Merseyside County Council,1983
 322 p. illus.

 Incl.Ch.Miniatures,p.57-87

 Ch.Sculpture incl.:Deathmasks of Napoleon
by Antommarchi and Burton;Bust of Napoleon
by Chaudet;wax profile of Napoleon by Cinga-
nelli;Equestrian statuetteof Napoleaon by Du-
bray

I.B.1.a - KENNEBUNK,ME.,BRICK STORE MUS.
 see
I.B.1.a - BRICK STORE MUSEUM, KENNEBUNK,ME.

ND
1311
L16
NPG

I.B.1.a
Lafayette College, Easton,Pa.
 The Kirby collection of historical paintings
located at Lafayette College,....Easton,1963.
 54 p. illus(part col.)

 "The philosophy behind this collection,by
Allan P.Kirby":p.9-10

 Bronze busts of four "Pioneers of the Indepen-
dence"after Houdon...

I.B.1.a - LEIDEN
see
I.B.1.a - LEYDEN

I.B.1.a - LENINGRAD.GOSUDARSTVENNYI RUSSKII
MUZEI

Leningrad. Gosudarstvennyi russkii muzei
Portretnaia miniatiura:iz sobraniia
Gosudarstvennogo Russkogo muzeia,18-nachalo
20 veka=Portrait miniatures from the coll.of
the Russian museum,18-early 20th c.:Al'bom/
avtory vstup.stat'i i kataloga K.V.Mikhailova
i G.V.Smirnov,.2-ed.Leningrad,Khudozhnik
RSFSR,1979
 451 p. illus(col.)

 Summary in English;legends in Russian and
 English
LC ND1335.R91464 1979 Books in print.Subject
 guide,1985-86,v.3,p.4865

I.B.1.a - LEIPZIG. UNIVERSITÄT

Janda-Bux, A
 Die Entstehung der bildnissammlung an der
universität Leipzig und ihre bedeutung für die
geschichte des gelehrten-porträts.

In:Leipzig.Universität.Wissenschaftliche Zeit-
 schrift.Gesellschafts und Sprachwissenschaftl.
 Reihe.Leipzig.
4:143-68 1954-55

LC AS182.L18 Welstenhelms.N7598.W86 v.2
 NPG p.22

I.B.1.a - LENINGRAD. HERMITAGE
see
I.B.1.a - LENINGRAD. ERMITAZH

I.B.1.a - LENINGRAD. ERMITAZH

Vrangel',Nikolai Nikolaevich,baron, 1882-1915
 Les chefs-d'oeuvre de la galerie de tableaux
de l'Ermitage impérial à St.-Pétersbourg...texte
par le baron Nicolas Wrangell.Londres,N.Y.,etc.,
F.Hanfstaengl,1909.
 32 p. 239 pl.(inclportrs)

N3350.V7
LC

ND
1311.5 I.B.1.a - LEXINGTON HISTORICAL SOCIETY, LEXING-
L48 TON, MASS.
1977X Lexington Historical Society, Lexington, Mass.
NPG Lexington portraits;a cat.of American por-
 traits at the Lexington Historical Society,
 1734-1884:by Dean T.Lahikainen.Lexington,Mass.,
 ...1977
 72 p. illus(part col.)

 Bibl.references

NC I.B.1.a - LENINGRAD. ERMITAZH
860
P23 Bouchot, Henri François Xavier Marie, 1849-1906
NPG Les portraits aux crayons de 16e et 17es.
 conservés à la Bibl.Nat.(1525-1646). Paris,
 H.Oudin,t Cie,1884
 412 p. illus.

 Incl.:Listes de crayons ou peintures conservés
 dans des coll.publ.ou privées.étrangères.A la
 Bibl.nat.:France:Bibl.d'Arras-Bibl.desArts-et-Mé-
 tiers-Coll.de F.Courajod-Ancien Cabinet Fontette-
 Mus.du Louvre(dessins et peinture)-Portrs.peints
 du Mus.de Versailles
LC N7621.P3

I.B.1.a - LEYDEN. RIJKSUNIVERSITEIT.BIBLIOTHEEK

Eckart, Rudolf E.O.
 Portraits in Leiden University Library

In:Quaerendo
5:52-65 1975

LC Z1007.Q13 WelstenhelmsN7098.W86 v.2
 NPG p.22

ND
1335 I.B.1.a - LENINGRAD. ERMITAZH
R9146
NPG Leningrad. Ermitazh
 Western European miniatures,16-19th centu-
 ries.Cat.of.an.exh.from the coll.of the State
 Hermitage,Leningrad,1982/.The museum,,1982
 47 p. illus.

 Gosudarstvennyi Ermitazh
 Zapadnoeuropeiskaia miniatiura 16-19 vekov

 In Russian

I.B.1.a - LIBRARY OF CONGRESS
see
I.B.1.a - U.S. LIBRARY OF CONGRESS

705
A56
NCFA
v.112

I.B.1.a - LITCHFIELD HISTORICAL SOCIETY

Ballard, Lockett Ford jr.
 Paintings of Ralph Earl at the Litchfield
Historical Society

In:Antiques
112:959-63 Nov.,'77 illus(col.)

I.B.1.a -

London. Guildhall library
 A cat.of engraved portraits...exhibited
at the opening of the new library and mus.of
the Corp.of London,Nov.,1872.Ed.by W.H.Overall
...London.Printed by Blades,East and Blades,
1872
 .6th. p.

LC N1033.A75 Yale ctr.f.Brit.art Ref.
 N1033+A53

I.B.1.a - LONDON COLLECTIONS

Society for Theatre Research.London Group.Cat.
of theatrical portraits in London public
collections.Comp.by the London Group of the
Society for Theatre Research,Mavis Bimson
and others.Edited,with an intro.by J.F.
Kerslake.London,Society for Theatre Re-
search,1961
 62 p.

LC PN2205.865 Noon.Engl.portr.drwgs.&min
 NC860.N66X NPG Bibl. p.146

I.B.1.a - LONDON, JEWISH MUSEUM

Rubens, Alfred, 1903-
 Anglo-Jewish portraits;a biographical cata-
logue of engraved Anglo-Jewish & colonial por-
traits from the earliest times to the accession
of Queen Victoria,by...with a foreword by
H.M.Hake. London,The Jewish museum,1935
 191 p. illus.

 Bibliography

LC DS135.E6A17 Waterhouse.Ptg.in Britain
 1530-1790 ND465.W32 1962
 NCFA bibl.

I.B.1.a - LONDON. CRYSTAL PALACE

Phillips, Samuel, 1814-1854
 The portrait gallery of the Crystal Palace.
London,Crystal Palace Library,etc.,1854
 238 p. (Crystal palace company,Syden-
ham..Official handbook..The palace and park...2)

LC AM101.C85 no.2 Fogg,v.11,p.325

1
A64
NMAA
v.114

I.B.1.a - LONDON. MANDER & MITCHENSON THEATRE
 .COLL.
Ashton, Geoffrey
 Paintings in the Mander and Mitchenson
theatre collection

In:Apollo
114:88-92 Aug.,'81 illus.

 Repro.:Wm.Hamilton,Mather Brown,Geo.Clint,
Rbt.Wm.Buss

I.B.1.a - LONDON. FREEMASONS'HALL MUSEUM
see
I.B.1.a - LONDON. UNITED GRAND LODGE OF ENGLAND.
 LIBRARY & MUSEUM. FREEMASONS' HALL

I.B.1.a - LONDON. MIDDLE TEMPLE
see
I.B.1.a - MIDDLE TEMPLE, LONDON

I.B.1.a - LONDON. GRAND LODGE MUSEUM. FREE-
 MASONS' HALL see
I.B.1.a - LONDON. UNITED GRAND LODGE OF ENGLAND.
 LIBRARY & MUSEUM. FREEMASONS' HALL

I.B.1.a - LONDON. NATIONAL GALLERY

Smith, Alistair
 Renaissance portraits.London,National Galle-
ry,1973
 48 p. illus. (Themes and painters in
the National Gallery,no.5)

LC ND1309.2S64

N
7621.2
C5L84
NCFA
NPG

I.B.1.a

London. National Portrait Gallery.
British historical portraits;a selection from the National Portrait Gallery,with biographical notes. Cambridge,Published for the National Portrait Gallery at the University Press, 1957
265 p. illus.

LC N1090.A575

N
7598
L58
1970X
NPG
Ref.

I.B.1.a -

London. National Portrait Gallery
Concise catalogue,1856-1969;edited and arranged by Maureen Hill.London,...1970
v, 346 p.

Arranged in alphabetical order by sitters. Appendix:Groups and collections. Appendix:Unknown sitters(by century). Index of artists

QN
7598
K43X
v.1 & 2
NPG Ref.

I.B.1.a - LONDON. NATIONAL PORTRAIT GALLERY

Kerslake, John comp.
Catalogue of early Georgian portraits.
London,H.M.Stationery Office,1977
2 v. illus(part col.)

Portrs.of celebrities fl.during reign of George I & George II in the NPG,London

LC N7598.K43

London,NPG.Concise cat.
/598.L58 1970 NPG Ref.
p.V

N
7598
L58
1977
NPG
Ref.

I.B.1.a - LONDON. NATIONAL PORTRAIT GALLERY

London. National Portrait Gallery
Concise catalogue,1970-76...London,The Gallery,1977

FOR COMPLETE ENTRY
SEE MAIN CARD

N
7621.2
C5L84c
1963
NPG

I.B.1.a

London. National portrait gallery
Catalogue of 17th c.portraits in the National Portrait Gallery,1625-1714. Cambridge,Univ.press, 1963
409 p. illus.

Compiled by David Piper

Bibliogr. references

LC N1090.A598

Encyclop.of World Arts,bibl.
Portrs.N31E56 Ref.

C75
NCFA
v.85

I.B.1.a - LONDON. NATIONAL PORTRAIT GALLERY

Kelly, Francis Michael, 1879-
Costume at the National portrait gallery .London.

In:Connoisseur
85:214-21 Ap.,'30 illus.

Examples from 16-18th c.

Repro.:Dan.Mytens,Luke Sullivan,Gottfried Kneller,Largillière

Cumulated Mag.subj.index
A1/3/C76 Ref.,v.2,p.443

757
.L82
1932

I.B.1.a

London. National portrait gallery
Catalogue of the National portrait gallery, 1932. Oxford,Printed for the Trustees at the University press.1932.

391 p. illus.

Foreword signed:H.M.Hake

LC N1090.A6 1932

757
.B54

I.B.1.a - London. National Portrait gallery

Bertram, Anthony, 1897-
English portraiture in the National portrait gallery,...London,John Lane.1924.
154.p. illus.

LC ND1314.B4

N
1090
A55
NPG
Ref.

I.B.1.a - LONDON. NATIONAL PORTRAIT GALLERY

London. National Portrait Gallery
Complete illustrated cat.1856-1979;comp.by K.K.Yung.Ed.by Mary Pettman.London,NPG,1981
749 p. illus.

Index of artists,engravers and photographers

Repro.of all ptgs.,drags.,miniatures,sculptures,photographs

N
40.1
W34L8
NPG

I.B.1.a -

London. National Portrait Gallery
G.F.Watts,the hall of fame:Portraits of his famous contemporaries.London,H.M.'s Stationery, 1975
24 p. illus.

List of portrs.by G.F.Watts in the National Portrait Gallery,London,in alphabetical order by sitters.
In the intro.,some of W.'s portrs.are compared with Renaissance masters.

LC ND1329.W37L66

N
40.1
C18L8
NPG

I.B.1.a - LONDON. NATIONAL PORTRAIT GALLERY

Cameron, Julia Margaret(Pattle),1815-1879
 The Herschel album;an album of photograph
presented to Sir John Herschel...London,Natio
nal Portrait Gallery,c.1975
 [32]p. chiefly illus.

LC TR681.P3C355

DA
758.3
S867x
NCFA

I.B.1.a - LONDON. NATIONAL PORTRAIT GALLERY

London. National Portrait Gallery
 The house of Stuart,by David Cransby.London,H.M.stationery off.,1968

 20 p. illus(part col.) (Its Kings and
Queens series;1603-1714)

MET
276.5
L84

N
7621.2
C5L84h
1888
NPG

I.B.1.a

London. National portrait gallery
 Historical and descriptive catalogue of the
pictures,busts, etc. in the Nat'l portr.gall.,on
loan at the Bethnal Green museum.By George Scharf..
A new and enl.ed. Including every portrait up to
the present date.London,Printed for H.M.Station-
ery off.,by Eyre and Spottiswoode,1888
 608 p.

LC N1090.A6 1888

Amsterdam,Rijksmus.cat.,
Z5939A52,deel 1,p.151

N
7598
S92
NPG

I.B.1.a - LONDON. NATIONAL PORTRAIT GALLERY

London. National Portrait Gallery
 The house of Tudor;by Roy C.Strong.London,
H.M.stationery office,1967
 20 p. illus(part col.) (Its Kings and
Queens series;1485-1603)

LC DA317.1.S7

N
7621.2
C5L84h
1903
NPG

I.B.1.a - LONDON. NATIONAL PORTRAIT GALLERY

London. National Portrait Gallery.
 Historical and descriptive cat.of the pic-
tures,busts,etc.in the Nat'l Portr.Gall....
12th ed.London,Printed for H.M.Stationery off.,
by Darling & son,ltd.,1903
 621 p. illus.

 Supplement.April,1906; 39 p. bound with
main work.

DA
28.1
O 7x
NPG
2 c.

I.B.1.a - LONDON. NATIONAL PORTRAIT GALLERY

London. National Portrait Gallery
 The house of Windsor;by Richard Ormond.
London,H.M.stationery office,1967
 [20]p. illus(part col.) (Its Kings and
Queens series;1838-1966)

Winterthur Mus.Library
Z881.W78 NCFA v.6,p.228

N
7621.2
C5L84h
1907
NPG

I.B.1.a

London. National portrait gallery
 Historical and descriptive catalogue of the
pictures,busts &c. in the National portrait gal-
lery....13th ed. London,Printed for H.M.Station-
ery off.,by Darling & son,ltd.,1907
 562 p.

 Introduction by Lionel Cust

LC N1090.A6

N
40.1
D636L8
NPG

I.B.1.a -

London. National Portrait Gallery
 Lewis Carroll at Christ Church;edited by Co-
lin Ford; introduction by Morton N.Cohen.
[London]...1974
 32 p. [chiefly]illus.

 Photographic album;28 portrs.by Lewis
Carroll together with 'Hiawatha's photograph-
ing';a parody of Longfellow's 'The Song of
Hiawatha'.

LC PR4612.L8 1974

DA
480
K4x
NPG

I.B.1.a - LONDON. NATIONAL PORTRAIT GALLERY

London. National Portrait Gallery
 The house of Hanover;by J.Kerslake and
Louise Hamilton.London,H.M.stationery office,
1968
 [20]p. illus(part col.) (Its Kings and
Queens series;1714-1837)

Winterthur Mus.Library
Z881.W78 NCFA v.6,p.228

I.B.1.a - LONDON. NATIONAL PORTRAIT GALLERY

Harding, George.Perfect,died 1853.
 Lists of portraits,pictures in various man-
sions of the United Kingdom,MS at NPG.London.
before 1854

 Derived from Warner's and Neale's lists

Ranger's House.qND1301.5
G71667 1977X NPG Literatur

I.B.1.a - LONDON. NATIONAL PORTRAIT GALLERY

The masque of beauty....London,1969?.

MET
196.6L84 Cat.of portraits of famous women in the NPG,
N2422 London

CU

705
C75
NCFA Kerslake, John
v.161 1965 - a vintage year for the National Por-
 trait Gallery

In:Conn.
161:159-63 Mar.,'66 illus(part col.)

 Repro.:Ths.More by Holbein,Charles I by
 Honthorst,Js.Boswell by Reynolds,Self portr.by
 Gainsborough,M.A.Clarke,bust by Gahagan,Warren
 Hastings by Reynolds

 Rep. 1966 #921

N
7621.2
05L84n I.B.1.a -
1960 London. National Portrait Gallery
NPG National Portrait Gallery catalogue 1856-
 1947 with a supplement 1948-1959
 320 p. 57 p. illus.

 Bibliographical note;index of artists

 Yale ctr.f.Brit.art Ref.

I.B.1.a - LONDON. NATIONAL PORTRAIT GALLERY

Firth, Charles Harding, 1857-1936
 The portraits of historians in the National
 portrait gallery...

In:Royal historical society,London.Transactions.
London,1923. 4th ser.
6:93-125

Newberry libr.for Cumulated Mag.subj.index
LC.DA20.R9,v.6. A1/3/C76 Ref. v.2,p.444

757
.L84 I.B.1.a

 London. National portrait gallery
 The National portrait gallery,ed.by Lionel
 Cust...London,New York.etc.. Cassell and company,
 ltd.,1901-02
 2 v. illus.

LC N1090.A7

757
L89
NCFA London. National portrait gallery
 The portraits of members of the Kit Cat club,
 painted...1700-1720,by Sir Godfrey Kneller for
 Jacob Tonson...Presented to the nation in 1945...
 London,c1945.
FOGG 19 p. illus.
56
L84p 1945
MET
196.6L84
N2492

qN
1090
A633X London. National Portrait Gallery
NPG National Portrait Gallery in colour;ed.by
 Richard Ormond.Intro.by John Hayes.Lodon,Studio
 Vista,1979

 FOR COMPLETE ENTRY
 SEE MAIN CARD

N
40.1
T75XL8 I.B.1.a -
NPG London. National portrait gallery
 The Townshend album/Eileen Harris;.for the.
 National portrait gallery.London,H.M.S.O.,1974
 26 p. illus.

 Bibliography

LC NC1479.T66L66 1974

VF in: I.B.1.a - LONDON. NATIONAL PORTRAIT GALLERY
London
NPG Gibson, Robin
 The National Portrait Gallery's set of Kings
 and Queens at Montacute House

In:Nat'l Trust Year Book
1:81-87 1975-76 illus.

LC NX28.G72N3716 1975-76 FOR COMPLETE ENTRY
 SEE MAIN CARD

I.B.1.a - LONDON. NATIONAL PORTRAIT GALLERY

London. National Portrait Gallery
Treasures in the National Portrait Gallery..
1977
 c68.p.of portrs.

LC ND1301.5.G71L44 1977 FOR COMPLETE ENTRY
 SEE MAIN CARD

N
7598
S92t
NPG

I.B.1.a - LONDON. NATIONAL PORTRAIT GALLERY

Strong, Roy C.
 Tudor & Jacobean portraits,...London,
H.M.S.O.,1969
 2 v. illus(part col.)

 Bibliography

 Portrs.of all major historical fgs.of Tudor
& Jacobean period,including all portrs.in the
National Portrait Gallery,London.to the year 1625

LC N7598.S7

N
1165
R6A6x
NPG

I.B.1.a -

London. Royal College of Surgeons of England
 A cat.of the portraits...drawings and sculp
ture in the Royal College of Surgeons of Eng-
land,by William LeFanu,librarian.Edinburgh,
E.& S.Livingstone,1960.i.e.1959.
 118 p. illus(part.col.)

 Bibliography

 Pt.2 incl.Racial types,anomalies

LC N1165.R6A6 Yale ctr.f.Brit.art Ref.
 N1165.R6A56

AP
1
M98

I.B.1.a - LONDON. NATIONAL PORTRAIT GALLERY

Adams, Charles Kingsley, 1899-
 The Washington and London Portrait Galle-
ries:a comparison

In:Museums J.
68,no.4:160-1 March,'69

 History and principles of these museums.

 Rep. 1969 #161

I.B.1.a - LONDON. UNITED GRAND LODGE OF ENGLAND.
 LIBRARY & MUSEUM. FREEMASON'S HALL
Freemasons. England. United grand lodge.
 Library and museum
 Cat.of portraits and prints at Freemason's
hall in the possession of the United grand
lodge of England,comp.and arranged by Major Sir
Algernon Tudor-Craig...1938.London,The United
grand lodge of England.1938.
 119 p. illus(1 col.)

LC N1165.F7A53 Winterthur Mus.Library
 Z881.W78 NCFA v.6,p.227

I.B.1.a - LONDON. NATIONAL PORTRAIT GALLERY &
 BENNINGBROUGH HALL see
I.B.1.a - BENINGBROUGH HALL

I.B.1.a - LONDON. WALLACE COLLECTION
 see
I.B.1.a - WALLACE COLLECTION, LONDON

I.B.1.a - LONDON.ROYAL COLLEGE OF PHYSICIANS
 see
I.B.1.a - ROYAL COLLEGE OF PHYSICIANS OF LONDON

708.1
L86
NCFA

I.B.1.a - LOS ANGELES CO.,CALIF. MUS.OF ART,
 LOS ANGELES

Feinblatt, Ebria
 Baroque portraits

In:L.A.Mus.of Art Bull.
1,nos.3-4:18-24 Spring,'48 illus.

 Repro:Busts by Angelo del Rossi,Jean-Jacque
Caffieri,Bernini; Painting by Bernini

 Portr.bust.Renaiss.to En-
 lightenment.NB1309.P6x NPG
 Bibl.

I.B.1.a -

London. Royal College of Surgeons of England
 Catalogue of portraits and busts in the
Royal College of Surgeons of England,with short
biographical notes.Revised to January,1930
.London,Printed by Taylor and Francis,1930.
 95 p. illus.

 Prepared by Fred.C.Hallett

 Bibliography

MN CU-M MiDW-M DNLM
PPA CtY Yale ctr.f.Brit.art Ref.
 N1165.R6A55

N
7593.8
L8L68
1979X
NPG

I.B.1.a - LOUISIANA STATE MUSEUM, NEW ORLEANS

Louisiana State Museum, New Orleans
 The Louisiana Portrait Gallery;by John
Burton Harter and Mary Louise Tucker.New Orleans,
Louisiana State Mus.,c.1979-
 v. 1 illus(part col.)

 Bibliography v.1,p.126-30
 Incl.index
 Contents.-v.1.from c.1775.to 1870

I.B.1.a - LOUISIANA STATE UNIVERSITY.ANGLO-
AMERICAN ART MUSEUM see
I.B.1.a - ANGLO-AMERICAN ART MUSEUM, BATON ROUGE

I.B.1.a - MADRID.MUSEO OF LA REAL ACADEMIA DE
BELLAS ARTES OF SAN FRANCISCO
Herrero, José J.
 Retratos del Museo de la Real Academia de
San Francisco.Madrid,Impr.Aldecoa,1930
 41 p. illus.
 At head of title:Junta de Iconografía Na-
cional
"Estudio preliminar por José J.Herrero":p.5.-28

LC N7621.2.S6 NNU-W NJP Mengs.N40.1.M541M9.Bibl.
 p.191

I.B.1.a - LOWIE MUS.OF ANTHROPOLOGY,BERKE-
see LEY
I.B.1.a - CALIFORNIA- UNIVERSITY - ROBERT H.
LOWIE MUS.OF ANTHROPOLOGY - BERKELEY

I.B.1.a - MADRID. MUSEO NACIONAL DE PINTURA Y
ESCULTURA
Madrid. Museo Nacional de Pintura y Escultura
 Retratos de hombres célebres del Museo del
Prado.Madrid,Fernando Fé,1929.
 44 p. (44 pl. (Los grandes maestros de
la pintura en España,7)

MET
156.1
M26
P991

I.B.1.a - LUXEMBURG(CITY). MUSÉE D'HISTOIRE

Luxemburg(City). Musée d'histoire
 La sculpture médiévale figurée...Luxemburg,
Mus. d'histoire et d'art.1977.

FOR COMPLETE ENTRY
SEE MAIN CARD

LC NB1297.L89 1977

I.B.1.a - MADRID. MUSEO NACIONAL DE PINTURA Y
ESCULTURA
Madrid. Museo Nacional de Pintura y Escultura
 Retratos de mujeres célebres del Museo del
Prado.60 repro.de los mejores cuadros.Madrid,
Fernando Fé.1929.
 44 p. 60 pl. (Los grandes maestros de la
pintura en España,8)

NJP

I.B.1.a -
Madrid, Biblioteca Nacional
 Iconografía britana;catálogo de los retra-
tos grabados de personajes ingleses...por Elena
Páez Ríos...Madrid,1948
 839 p. illus.

 Bibliography

LC NE55.M3A45 Fogg,v.11,p.332

I.B.1.a - MADRID. MUSEO NACIONAL DE PINTURA Y
ESCULTURA
Allende-Salazar, Juan
 ...Retratos del Museo del Prado,identifica-
ción y rectificaciones,por J.Allende-Salazar y
F.J.Sánchez-Cantón.Madrid,Impr.de J.Cosano,1919
 303 p. illus.

 At head of title:Junta de iconografía na-
cional,memoria premiada en el concurso de 1914

LC N7592.A4 Fogg,v.11,p.320

I.B.1.a - MADRID. MUSEO ARQUEOLÓGICO NACIONAL

García y Bellido, Antonio, 1903-
 Retratos romanos del Museo Arqueológico
Nacional de Madrid.Madrid,1950
 34 p. illus.

 Bibliography

LC N7588.G37. CU NNC Kraus.Das römische welt-
 reich N5760.K92 Bibl. p.315

I.B.1.a - MADRID. PRADO
see
I.B.1.a - MADRID. MUSEO NACIONAL DE PINTURA Y
ESCULTURA

P
24
A34
1987X
NPA*

I.B.1.a - MAINE HISTORICAL SOCIETY, PORTLAND,ME.

Agreeable situations:society,commerce and art
in southern Maine,1780-1830;ed.by Laura
Focych Sprague;essays by Joyce Butler...
.et al..Kennebunk,Me.Brick Store Mus.
Boston:Distributed by Northeastern Univ.
Press,1987
 209 p. illus(part col.)
 Incl.Brewster,jr.,deaf artist,p.88,122,254
 Cat.of selected objects from the Brick
Store Mus.et al
 Index
 Bibliography

N
40.1
P35M3
NCFA

I.B.1.a - MARYLAND HISTORICAL SOCIETY

Maryland Historical Society
 Four generations of commissions:The Peale
coll.of the Maryland Historical Society.Exh.
3 Mar-29 June 1975.By Eugenia Calvert Holland
et al..Baltimore,Md.,Maryland Hist.Soc.,1975
 187 p. illus.

 126 works shown
 Bibliography
 Incl.:ptgs.,drags,,miniatures...,silhouettes
by 11 Peale artists

 Hila Z5937.R105 NCFA
 II/1 1976 *1978

I.B.1.a - MAINZ, MITTELRHEINISCHES LANDESMUS.
 see
I.B.1.a - MITTELRHEINISCHES LANDESMUSEUM, MAINZ

757.7
R98

I.B.1.a -

Maryland Historical Society
 Handlist of miniatures in the coll...by
Anna Wells Rutledge.Balto.,Md.,1945
 18 p. illus (Repr.fr.Md.Hist.Mag.
AP1 v.40,no.2,June,1945,pp.119-36)
M39
NPG

 Sellers.Archives of Amer.
 art:Mezzotint prototypes...
 In:Art Q 20,no.4,p.468

I.B.1.a - MALIBU, CALIF., GETTY MUSEUM
 see
I.B.1.a - J.PAUL GETTY MUSEUM

AP1
M39
NPG

I.B.1.a -

Maryland Historical Society
 Portraits in varied media in the coll...
by Anna Wells Rutledge

 In:Md.Hist.Mag.
 41,no.4:282-326 Dec,'46

 Sellers.Archives of Amer.
 art:Mezzotint prototypes..
 In:Art Q 20,no.4,p.468

I.B.1.a - MARIEFRED. THE SWEDISH NAT'L PORTR.
 see
 GALL.
I.B.1.a - GRIPSHOLM SLOTT. STATENS PORTRÄTTSAMLING

N7621
M39p
NPG

I.B.1.a -

Maryland Historical Society
 Portraits painted before 1900 in the coll...
by Anna Wells Rutledge.1946.
 39 p. illus. (Repr.fr.Md.Hist.Mag.
 v.41,1,March,1946)
N7621- ----Oil portraits in the coll...;a supplement to
M39 the cat.of portraits,published in 1946;incl.all
NPG those acquired to Nov.,'55
 26 p. (Repr.fr.Md.Hist.Mag.
 v.50,no.4,Dec.,'55

 Sellers.Archives of Amer.
 art:Mezzotint prototypes..
 In:Art Q 20,no.4,p.468

705
B97
NCFA
v.6

I.B.1.a - MARSEILLE. MUSÉE DES BEAUX-ARTS

Auquier, Philippe, 1863-1908
 An 18th century painter:Françoise Duparc

 In:Burl Mag
 6:477-8 Mar.,'05 illus.

 Repro.4 portrs.in Marseille.Mus.des Beaux-
Arts

CT
217.5
M37
1988X
NPG

I.B.1.a - MASSACHUSETTS HISTORICAL SOCIETY,BOSTON

Massachusetts Historical Society, Boston
 Portraits in the Mass.Hist.Soc. An ilustr.
cat...by Andrew Oliver,Ann Millspaugh Huff,
Edw.W.Hanson.Boston,The Society,1988
 163 p. illus(part col.)

 Index
 Bibliography

I.B.1.a -

Massachusetts Historical Society, Boston.
Portraits of men, 1670-1936. Boston,1955
.32.p. illus. (A Massachusetts Histori-
cal Society picture book)

FCGG
4253
M41
1955

MiD Vi MH M41
IHi etc. Foll.,v.11.,p.328

708.1 I.B.1.a - MINNEAPOLIS. INSTITUTE OF ARTS
M66.
NCFA Portraits of women and children

In:B.Minneapolis Inst.Arts
30:1-7 Jan,1941 illus.

General thoughts on portraiture

Incl:Clouet,Mierevelt,Slaughter,Hannemann,
Ramsay,Theus,Courbet

Rep.,1945-47#863

N
7634 I.B.1.a
M41
NPG Massachusetts Historical Society, Boston
Portraits of women, 1700-1825. Boston,1954
unpaged illus. (A Massachusetts Histori-
cal Society picture book)

LC N7634.M3

AP
1
G25 McCoskey Goering, Karen
NPG A Legacy from the Wyman museum:The Society's
v.2 coll.of St.Louis mayors' portraits

In:Gateway Heritage
2:32-41 Spring,'82 illus(col.)

Exhibited at City Hall.Owned by Missouri
Historical Society

I.B.1.a - MISSOURI HISTORICAL SOCIETY, ST.LOUIS

I.B.1.a - MEAD ART GALLERY
see
I.B.1.a - AMHERST COLLEGE. MEAD ART BUILDING

I.B.1.a - MITTELRHEINISCHES LANDESMUSEUM, MAINZ

Suhr, Norbert
Philipp Veit portraits aus dem Mittelrheini-
schen Landesmuseum,Mainz und aus privatbesitz.
Kat.-bearbeitung von N.Suhr.Mainz,Mittelrheini-
sches Landesmuseum,1977
199 p. illus(part col.)

Bibliography

City

(In Rila,1979 N.Y.(city)P.L.Art & architect.
#8128):123 p Div.Biol.guide to art & archit
Z5939.A791 1980 NCFA Ref.
p.284:(NYPL 3-MCK+V42 80-
737): 119 p.

I.B.1.a - MELBOURNE. NATIONAL GALLERY OF
see .VICTORIA
I.B.1.a - VICTORIA, AUSTRALIA. NATIONAL GALLE-
.RY, MELBOURNE

AP
1
A64 Lisconbe, R.W.
MCFA Three centuries of British portrait paint-
ing

In:Apollo
103:406-11 May,'76 illus.

This issue pertains to the Montreal MFA

Repro.:Hilliard,Watts,Hogarth,Reynolds,High-
more,Romney,Gainsborough,Lawrence,Raeburn

I.B.1.a - MONTREAL. MUSEUM OF FINE ARTS

I.B.1.a - MIDDLE TEMPLE, LONDON

Middle Temple, London
Cat.of paintings and engravings in the pos-
session of the Hon.Soc.of the Middle Temple,
prepared by Master Bruce Williamson.London,
The Society,1931
62 p. illus.

LC N7598.M53 1931

I.B.1.a - MUNICH - BAYERISCHE STAATSBIBLIOTHEK

Stollreither, Eugen
Bildnisse des 9.-18.jahrhunderts. München,1928

Contents:Part I.9-14.jahrh.(Miniaturen aus
FCGG handschriften der kgl.Hof-& Staatsbibl.in
FA München,9)
1120.
229(9)F

Enc.of World Art
N31K56Ref.bibl.on portr.
col.512

I.B.1.a - MUNICH. BAYERISCHES NATIONAL-
MUSEUM

Munich. Bayerisches Nationalmuseum
 Katalog der miniaturbilder im Bayer.Nat.
mus..von.Hans Buchheit.1911
 141 p. illus. (Its Katalogs,12.Bd.)

FOGG
57
M96b
v.12

ViU Winter.Holbein's minist...
 .n:Burl.Mag.83:256 ff

I.B.1.a - NAPLES. MUSEO E GALLERIE NAZIONALI DI
CAPODIMONTE

Molajoli, Bruno, 1905-
 Ritratti a Capodimonte..Torino.ERI,Edi-
sioni RAI-Radiotelevisione italiana.1959.
 104 p. illus(color)

In Italian and French

LC N2727.M6 Fogg,v.11,p.324

I.B.1.a - MUSEO PROFANO LATERANENSE see
I.B.1.a - VATICAN. MUSEO VATICANO. MUSEO PROFANO
LATERANENSE

I.B.1.a - NATIONAL COLLECTION OF FINE ARTS
 see
I.B.1.a - SMITHSONIAN INSTITUTION - NCFA

ND
921
M8
1983X
NMAA

I.B.1.a - MUZEUL BRUKENTHAL

Muzeul Brukenthal
 Catalog patrimonial de pictură românească
Maria Olimpia Tudoran.Sibiu.Muzeul Brukenthal
Sibiu.Galeria de Artă.1983?-
 v. 1 illus(part col.)

 Bibliography:v.1,p.7.

I.B.1.a - National Gallery of Art, Washington,D.C.

 For publications before 1937,
 see
 Smithsonian Institution. National Collection of
 Fine Arts

 For publications after 1937,
 see
 U.S. National Gallery of Art

I.B.1.a - MUZEUL BRUKENTHAL SIBIU

Bertalan, Karin
 Catalogui expozitici comemorative Arthur
Coulin.Muzeul Brukenthal,Sibiu,1969

 Muzeul Brukenthal Sibiu
 Cat.Patrimonial ND921.M8
 1983X NMAA Bibl.p.7.

705
028
NCFA
v.28

I.B.1.a - NATIONAL GALLERY OF ART, WASHINGTON,D.C

Cook, Walter W.S.
 Spanish paintings in the National Gallery
of Art.II.Portraits by Goya

In:Gas.Beaux-Arts
28:151-62 Sept.,'45 illus.

I.B.1.a - MUZEUL BRUKENTHAL SIBIU

Bertalan, Karin
 Catalogui expozitici comemorative Carl
Dörschlag.Sibiu

 Muzeul Brukenthal Sibiu.
 Cat.Patrimonial ND921.M8
 1983X NMAA Bibl.p.7.

N
910
O 7A554
1987X
NMAA

I.B.1.a - NATIONAL GALLERY OF CANADA

National Gallery of Canada
 European and American painting,sculpture and
decorative arts;general editors Myron Laskkn,jr.,
Michel Pantazzi.Ottawa,Nat'l Gall.of Canada,
National Museums of Canada,1987-
 v.1 in 2 illus.
 v.1,pt.1 1300-1800;text
 v.1,pt.2 Plates

 Index p.340-42 lists the portraits

I.B.1.a - NATIONAL GALLERY OF CANADA

AP
1
A64
NMAA
v.127

Ditner, David C.
 Nineteenth-century English portrait sculpture.Marble busts in the Nat'l Gall.of Canada.

In:Apollo
127:334-8 May,'88 illus.

 pro.incl.:Mollekens,Chantrey

I.B.1.a - NATIONAL MUSEUM OF AMERICAN ART

ND
1337
U5N3
1984X
NMAA

National Museum of American Art
 Portrait miniatures in the National Mus.
of American Art.by.Robin Bolton-Smith.Chicago,
Univ.of Chicago Press,1984
 80 p. illus(part col.) (Chicago visual
library text-fiche series,no.46

 Microfiches in pocket;illus.on fiche
 Index

 Books in print.Subject
 Guide,1985-86 v.3,p.4864

I.B.1.a - NATIONAL GALLERY OF CANADA

fN
40.1
H6393
P2
NPG

The painter as photographer;David Octavius Hill,
 Auguste Salzmann,Charles Nègre.Works from
 the National Gallery of Canada at the Van-
 couver Art Gallery,Dec.9,1978 to Jan.14,'79
 ...Vancouver,B.C.,Vancouver Art Gallery.1978

 FOR COMPLETE ENTRY
 SEE MAIN CARD

 I.B.1.a - NATIONAL PORTRAIT GALLERY; GREAT
 see BRITAIN
I.B.1.a - LONDON. NATIONAL PORTRAIT GALLERY

 I.B.1.a - NATIONAL GALLERY OF IRELAND
 see
I.B.1.a - DUBLIN. NATIONAL GALLERY OF IRELAND

NPG I.B.1.a -

National Portrait Gallery, Washington, D.C.
 Checklist of the permanent collection/Na-
tional Portrait Gallery,Smithsonian Institution
Washington:Smithsonian Institution Press...,
1975
 72 p.

 Includes index

LC N857e.A55 1975

 I.B.1.a - NATIONAL GALLERY OF VICTORIA
 see
I.B.1.a - VICTORIA, AUSTRALIA. NATIONAL GALLE-
 RY, MELBOURNE

757 I.B.1.a - "NATIONAL PORTRAIT GALLERY,WASHINGTON
.N27 D.C."
National art committee
 Exhibition of war portraits;signing of the
Peace treaty,1919,and portrs.of distinguished
leaders of America and of the allied nations,
painted by eminent American artists for presenta-
tion to the National portrait gallery....New York,
1921.
 64.p. illus.

 Circulated by The American Federation of Arts
Cat.compiled by Florence N.Levy
On cover:National gall.of art under direction
of the Smithsonian Inst.,Wash.,D.C.,May5-22,1921
 Review by Leila Mechlin see over
LC D507.N3

 I.B.1.a - NATIONAL MUSEUM OF AMERICAN ART (U.S.)

For publications before 1980 see

I.B.1.a - SMITHSONIAN INSTITUTION. NATIONAL
 COLLECTION OF FINE ARTS

TR I.B.1.a - NATIONAL PORTRAIT GALLERY, WASHINGTON,
680 D.C.
P47X
NPG Pfister, Harold Francis
 Facing the light;historic American portrait
daguerreotypes;an exh.at the National Portrait
Gallery,Sept.22,1978-Jan.15,1979....Smithsonian
Inst.Press,City of Washington,1978
 178 p. illus.

 Foreword by Marvin Sadik
Curatorial preface by Wm.F.Stapp
Bibliography

N
7593
C49X
NPG

I.B.1.a - NATIONAL PORTRAIT GALLERY, WASHINGTON,
D.C.

Christman, Margaret C.S.
Fifty American faces from the collection
of the National Portrait Gallery,Washington,
D.C.,Smithsonian Inst.Press for NPG,1978
256 p. illus(part col.)

Foreword by Marvin Sadik

Bibliographies
Index of artists

LC N7593.C49

NPG
N857.8
A66
1978X

I.B.1.a - NATIONAL PORTRAIT GALLERY, WASHINGTON,
D.C.

National Portrait Gallery, Washington, D.C.
National Portrait Gallery Smithsonian In-
stitution permanent collection,illustrated check-
list...1978

2nd edition

FOR COMPLETE ENTRY
SEE MAIN CARD

N
7593
N23
1979X
NPG

I.B.1.a - NATIONAL PORTRAIT GALLERY, WASHINGTON,
D.C.

National Portrait Gallery, Washington, D.C.
A gallery of presidents;by Marc Pachter.
Washington,D.C.Smiths.Inst.Press for NPG,1979
95 p. illus.

Foreword by Marvin Sadik

LC N7593.N23 1979

NPG
Ref.
coll.

I.B.1.a -

National Portrait Gallery, Washington, D.C.
Nucleus for a national collection...comp.
by Robert S.Stewart,Washington,D.C.,Smithsonian
Institution,1966
unpaged illus(part col.) (Smithsonian
publication 4653)
Cat.of exh.,Sep.15-Nov.14,1965 in the Arts
& Industries Bldg.

Index of artists

LC N7593.N213

705
A56
NCFA
v.108

I.B.1.a - NATIONAL PORTRAIT GALLERY, WASHINGTON,
D.C.

Jones, Karen M.
" Museum accessions

In:Antiques
108:78-79 July,'75 illus.

Acquisitions made by the NPG in the past
two years
Repro.incl.:John Jay by G.Stuart and J.
Trumbull;P.Revere,Th.Jefferson by Févret de
Saint-Mémin;John Marshall by Wm.Hubard;Washing-
ton,Martha Washington by Rembrandt Peale

VF
Wash.,D.C.
S.I.NPG

I-B.1.a - NATIONAL PORTRAIT GALLERY, WASHING-
TON; D.C.

Dickson, Paul
Putting a face on America.The National
Portrait Gallery

In:Town & Country
:180-1,277,218 Nov.,1974 1 illus.

AP
1
A51
NPG
v.19
no.5

I.B.1.a NATIONAL PORTRAIT GALLERY, WASHINGTON,
D.C.

Ketchum, Richard M., 1922-
National portrait gallery

In:Am.Heritage
19,no.5:5-17 Aug.,'68 illus(part col.)

NPG
Ref.
coll.

I.B.1.a -

National Portrait Gallery, Washington, D.C.
Recent acquisitions...comp.by Robert S.
Stewart.Washington,D.C.Smithsonian Institution,
1966
unpaged illus. (Smithsonian publ.4885)

Cat of exh.Oct.4-Nov.28,1966 in the Arts
& Industries Bldg.

List of artists

LC N7593.N22

AP
1
M98

I.B.1.a - NATIONAL PORTRAIT GALLERY, WASHINGTON,
D.C.

Nagel, Charles
The National Portrait Gallery of the Smith-
sonian Institution,Washington

In:Museums J.
68,no.4:156-9 March,'69 illus.

Repro.:NPG,ext.;Delian Gall.;Display hall
of patent models(now library);Portrs.:John Bar-
tram by Wollaston;J.Ward Howe by J.Elliott

705
M18
NCFA
v.12

I.B.1.a "NATIONAL PORTRAIT GALLERY,WASHINGTON,
D.C."

Mechlin, Leila, 1874-
War portraits by eminent artists

In:Mag Art
12:76-88 Mar,'21 illus.

Travel exhib.starting in the Met,N.Y.,Jan17-
Feb.14,'21 of portrs.to be presented to the NGA,
thus initiating in Wash.a "National Portr.Gall."

"Portr.is conceded to be the highest form of
art. ...man is to man invariably the most engag-
ing of exhibits." Cumulated Mag.subj.index
A1/3/C76 Ref. v.2,p.445

AP
1
N98

I.B.1.a - NATIONAL PORTRAIT GALLERY, WASHINGTON,
D.C.
Adams, Charles Kingsley, 1899-
The Washington and London Portrait Galle-
ries:a comparison

In:Museums J.
68,no.4:160-1 March,'69

History and principles of these museums.

Rep. 1969 #161

705
A56
NCFA
v.110

I.B.1.a - NEW ENGLAND HISTORIC GENEALOGICAL SOC.
Bell, James B. & Fleming, C.Dunn
Paintings at the New England Hist.Genealo
gical Society
Antiques
American painting special issue,
110:965-1070, Nov.,1976 illus(part col.)
Chiefly 18th-19th century
Partial contents:...Js.B.Bell & C.Dunn Fle-
ming,Ptgs.at the New England Hist.Genealogical
Soc.,p.986-931...

N
7593.8
K4W61
NPG

I.B.1.a - NAT'L SOC.OF THE COLONIAL DAMES OF
AMERICA. KENTUCKY
Whitley, Edna Talbott, 1891-
Kentucky ante-bellum portraiture;illus.by
photos from the coll. of the "at'l Soc. of the
Colonial Dames of America in the Commonwealth
of Kentucky. <Paris?Ky.,1956>
848 p. illus.

Bibliography

LC N7593.W45

AP
1
H63
NPG

I.B.1.a - NEW HAMPSHIRE HISTORICAL SOCIETY

Purvis, Doris F.
The Joseph Blackburn portraits of Lieute-
nant-Governor John Wentworth and Governor
Benning Wentworth

In:Hist New Hampshire
24,no.3:34-9 Fall,'69 illus.

Full standing patgs.from 1760 in the
New Hampshire Historical Society

AP
1
H62
NCFA
v.26-27

I.B.1.a - NATIONAL TRUST FOR HISTORIC PRESERVA-
TION
Landau, Ellen G.
Study in National Trust Portraits

In:Historic Preservation
27,no.2:30-7 Apr.-June,'75 illus(part col.)

Repro.incl.:Washington's Family by Savage
Development of Amer.portraiture:Simple, aus-
tere in the 17th c.;idealized,elegant early
18th c.;neo-classical style,revelation of the
inner life,early 19th c.;return to exactitude
to rival with photography in the 1840's-50's;

Rila III/2 1977 #5606

AP
1
N534
NPG

I.B.1.a - NEW JERSEY HISTORICAL SOCIETY

Bolton, Theodore, 1889-
John Watson of Perth Amboy,artist

In:Proc.N.J.Hist.Soc.
72:233-47 Oct.,'54

Quotes Wm.Dunlap's Biogr.of J.W.in Hist.of the
Rise & progress of the arts of design in the
U.S.,v.1
Refers to Benson J.Lossing's artiles in The
Amer.Hist.Record,Aug.& Oct.,1872;lists Los-
sing's "Enumeration"of portr.drags.by J.W.

ND
1301
A7X
NPG

I.B.1.a - NATIONAL TRUST (GREAT BRITAIN)

Arts Council of Great Britain
Portrait groups from National Trust col-
lections.exhibition,London,1960.
22 p. illus.

Incl.:Index of houses,Index of artists

Exhs.:Eastbourne,Towner Art Gall.Nov.5-22;&
Luton,Art Gall.,Wardown Park,Dec.3 -Dec.24;60;
Coventry,Herbert Art Gallery,Dec.31-Jan.21,'61;
Wakefield,City Art Gallery,Jan.28-Feb.18,'61;
Cardiff,Nat.Mus.of Wales,Feb.25-Mar.18,'61

MH DLC

NC
880
N53
NPG

I.B.1.a - NEW JERSEY HISTORICAL SOCIETY

New Jersey Historical Society
Painted in crayon:Pastel portraits from the
collection.By S.Gail Fuller.An exh.at the New
Jersey Historical Society,12 May-27 Nov.1982.
Newark,N.J.,The Society,1980.
<16.p. illus(part col.)

Reprinted from New Jersey History

757.7
L95

I.B.1.a - <Netherlands,Queen of>

Lugt, Frits
Le portrait-miniature, illustré par la col-
lection de S.M.la reine des Pays-bas...
Amsterdam,P.N.van Kampen & fils,1917
108 p. incl illus.(part col.)

AP
1
N534
NPG

I.B.1.a -

New Jersey Historical Society
Portraits in possession of the New Jersey
Historical Society;by Maud E.Johnson

In:Proc.N.J.Hist.Soc.
n.s.10,no.2:129-67 Apr.,'25

List of sitters.Photographs,prints,paintgs.

Cum.Mag.Subj.Ind.1907-49
AI/3/C76/NPG.Ref.v.2,p.444

AP
1
W78
v.7
NCPA

I.B.1.a – NEW JERSEY. STATE MUSEUM, TRENTON

Mitchell, James
Ott & Brewer:Etruria in America

In:Winterthur Portfolio
7:217-28 illus.

Etruria Pottery,Trenton,N.J.,1863-1893,
established by Bloor,Ott & Booth,later C.R.
Burroughs & John Hart Brewer became partners

Repr.incl.:Busts of U.S.Grant,Lincoln,all
Parian porcelain:Washington,bisque metallic
green porcelain Pitcher with head of Wa-
shington.Ivory porcelain. All in N.J.State m

N
7593
N5
1974X
NPO
Ref.

I.B.1.a – NEW YORK HISTORICAL SOCIETY

New York Historical Society
Cat.of American portraits in the New York
Historical Society.New Haven;publ.for the N.Y.
Hist.Soc.by Yale Uni.Press,1974
2 v. illus.(2 col.)

Bibliography
Incl.:Index of artists

2420 portrs.by or of Americans:ptgs.,mini-
atures,silhouettes,marble,plaster etc.,arranged
alphabetically by sitter.

ND
1337
O7N48
1978X
NCFA

I.B.1.a – NEW ORLEANS MUSEUM OF ART

New Orleans Museum of Art
English and continental portrait miniatures;
the Latter-Schlesinger collection...1978

FOR COMPLETE ENTRY
SEE MAIN CARD

I.B.1.a

New York historical society
Catalogue of American portraits in the New York
historical society:oil portraits,miniatures,
sculptures. New York city,the New York histori-
cal society,1941
374 p. illus.

LC N7593.N37

705
A56
NCFA
v.110

I.B.1.a – NEW YORK. CITY HALL
Holzer, Edith & Harold
Portraits in City Hall,New York
Antiques
American painting .special issue. (card 2)
...Nov.,1976...

Partial contents cont'd:E.& H.Holzer,Portrs.
in City Hall,N.Y. p.1030-39...

759.1
.M84

I.B.1.a – NEW YORK HISTORICAL SOCIETY

Morgan, John Hill, 1870-
Early American painters;illustrated by
examples in the collection of the New York histo-
rical society,...New York,The N.Y.histor.society,
1921
136 p. illus. (The Schr. Divine Jones fund
series of histories and memoirs,IV)

Bibliography

LC ND205.M6

161
NCFA
V.77

I.B.1.a – NEW YORK HISTORICAL SOCIETY

McCormick, William B.
A "backwater" of American art. New York
hist.soc.'s coll.of 374 portraits,an almost
unknown treasure

In:Studio
77:110-16 May,'23 illus.

Repro.incl.:Rembrandt Peale,Cha.Willson
Peale,Benj.West,Sam.F.B.Morse,Vanderlyn,Trum-
bull,Durand,Wm.C.Stone,A.B.Healy

705
A5
NCFA
v.16

I.B.1.a – NEW YORK HISTORICAL SOCIETY

Scoon, Carolyn
A fine collection of historical textiles

In:Am Coll
16:12-15 Sept.,'47 illus.

Repro.incl.:Kerchief printed with equestrian
fig.of Wm.Henry Harrison,c.1840;Lincoln kerchief,
c.1864;silk kerchief broadside with portr.of
Washington,Jefferson & Adams,French,c.1820;printed
yard-goods fabric with G.Stuart's portr.of Wa-
shington,early Federal period

AP
1
N547
NCFA
v.42

I.B.1.a – NEW YORK HISTORICAL SOCIETY

Vail,Robert William Glenroie, 1890-1966
The case of the Stuyvesant portraits

In:N.Y. Hist.Soc.Q.
42:171-204 Apr.,'58 illus.

Incl.:Checklist of the Stuyvesant portraits

AP
1
N547
NCFA
v.35

I.B.1.a – NEW YORK HISTORICAL SOCIETY

Phillips, John Marshall
Portraits in the Prentis collection

In:N.Y. Hist.Soc.Q
35:157-64 Apr.,'51 illus.

'Portrs.representative of New England and
the South'

N
613
A5
NCFA

I.B.1.a - NEW YORK HISTORICAL SOCIETY

New York Historical Society
 The Waldron Phoenix Belknap,jr.collection of
portraits and silver,with a note on the discove-
ries of Waldron Phoenix Belknap,jr.concerning the
influence of the English mezzotint on colonial
painting....Cambridge,Harvard University Press,
1955.
 177 p. illus.

 Catalogue of the coll.which was bequeathed to
the N.Y.Historical Soc. in 1949

LC N613.A65

708.1
N52
NS v.7

I.B.1.a - NEW YORK. METROPOLITAN MUSEUM OF ART

Simpson, William K.
 A 4th dynasty portrait head

In:B-Metrop.Mus.Art
7(NS):286-92 May 1949 illus.

 Individual character of heads at Giseh,4th
dyn.derived fr.3rd dyn;use of plaster to model
limestone surface. Influence on realistic sculpt.
of 5th dyn. In Old Kingdom also use of masks for
mummies. Comparison with bronze heads of Ile-Ife
in Nigeria
 Rep.,1948-49#3265

TR
646
U6N484X
NPG

I.B.1.a - NEW YORK. METROPOLITAN MUSEUM OF ART

New York. Metropolitan museum of art
 The collection of Alfred Stieglitz...N.Y.,
Viking Press,1978.

FOR COMPLETE ENTRY
SEE MAIN CARD

708.1
N52
NCFA
v.35-36

I.B.1.a - NEW YORK. METROPOLITAN MUSEUM OF ART

Remington, Preston
 Miniature portraits in wax:a recent gift

In:Bull.of Met mus.
35:54-6 Mar,1940 illus.

 Incl:Samuel Percy, Joachim Smith(?)

708.1
N52
NMAA
v.43

I.B.1.a - NEW YORK. METROPOLITAN MUSEUM OF ART

Bauman, Guy
 Early Flemish portraits,1425-1525

In:Met Mus Bul
43,no.4:1-65 "pring,'86 illus(part col.)

 Repro.incl.:Donor portraits
Discusses the attitudes of early Flemish
artists and their patrons toward portraiture.
Investigates the uses of the genre at the time

I.B.1.a - NEW YORK. METROPOLITAN MUSEUM OF ART

Roman portraits in New York

In:Archaeology
1:104-14 1948 illus.

 Busts in Metrop.Mus.of Art

LC GN700.A725 Rep.,1948-49#5036

N
7593
N53
NPG

I.B.1.a

New York. Metropolitan museum of art
 ...Eminent Americans;a picture book. New
York,The Museum press,1939
 (Its Picture books)

LC N7593.N43

I.B.1.a - NEW YORK. METROPOLITAN MUSEUM OF ART

Standen, Edith Appleton
 Self-portraits. New York,Distributors Book-
of-the-Month Club,Inc.,c.1954
 ,28,p.- col.illus. (The Metropolitan
Museum of Art Miniatures,Album MS)

FOGG
4353
S78
 Fogg,v.11,p.325

705
A7832
NCFA

I.B.1.a - NEW YORK. METROPOLITAN MUSEUM OF ART

Breck, Joseph, 1885-1933
 The Ficoroni medallion and some other
gilded glasses in the Metropolitan Museum of Art

In:Art Bull
9:3 53-6 June,'27 illus.

 Incl.forgeries

 Swindler.Ancient painting
 759.93.S97;p.461
 Bibl.,

731
.N19

I.B.1.a -

New York. Metropolitan museum of art
 ...A special exhibition of heads in sculpture
from the museum collection.N.Y.,Jan.16 through
March 3,1940...1940.
 ,5,p. illus.(chiefly)
 Illus.arr.in pairs for comparison:similari-
ties in different cultures.
 Review by J.Goldsmith Phillips In:Met Mus B
35:2-4 Jan.,'40 illus.

 Review initialed J.W.L. In:Art N
38,no.16:16,17
LC NB1300.N, Portr.bust.NB1X 9.P6x NPG
 Bibl.

N
7592
Q24
NPG

I.B.1.a — NEW YORK. METROPOLITAN MUSEUM OF ART
 Crosby Brown collection
New York. Metropolitan museum of art. Crosby
Brown collection
 ...Cat.of the Crosby Brown coll.of musicians'
portraits...N.Y.,The Metrop.mus.of art,1904
 131 p. (The Metropolitan mus.of art.Hand-
book no.13,IV)
 Cat.by Clara Buffum

 Incl.:Classified,geographical and alphabe-
tical indexes
 NPG copy bound with Garrick club,London.Cat.
of the pictures...London,1909
LC ML390.M5 copy 2:N611.B7

I.B.1.a — NEW YORK. PUBLIC LIBRARY. EMMET COLL.

Emmet, Thomas Addis, 1828-1919
 American portraits collected by Thomas
Addis Emmet.A-Z.N.Y.,1896
 9 v.

N.Y. P.L.
AOW

 Rosenthal,Albert...List of
 portrs.N40.1.R734yR8 NPG
 p.6

I.B.1.a —

New York. Museum of modern art
 Family portraits from the museum collection.
₅N.Y.,The Museum,1964₃
 2 p.

 Checklist of temporary exh.May 27,1964-Feb.7
1965
 Ptgs. & sculpt.by Beckmann,Guglielmi,Hark-
avy,Lindner,Marisol,Moore,Quirt,Ruiz,Shahn,
Spencer,Stettheimer,Tanguy,Vuillard

 MOMA,v.11,p.435
 MOMA FMA733 and Archive
 FMA 733

I.B.1.a — NEW YORK. PUBLIC LIBRARY. EMMET COLL.

Emmet, Thomas Addis, 1828-1919
 Foreign portraits,collected by Thomas Addis
Emmet.N.Y.,1896
 11 vols.

N.Y. P.L.
 ACK
 ACK 3 vols.
 x 6 vols.
 ACK
 xx 2 vols.

I.B.1.a —

New York. Museum of modern art
 Portraits from the museum collections...
N.Y.,The Museum,1960
 7 p. mimeographed

 Checklist of the exhibit,May 4-June 26

 MOMA, p.435 v.11
 MOMA:1 xML7 1960,also:
 FMA 664 and Archive
 664

705
A56
NCFA
v.114

I.B.1.a — NEW YORK STATE HISTORICAL ASSOCIATION

Cilella, Salvatore G.,jr.
 Seven paintings by Samuel F.B.Morse

In:Antiques
114:150-2 July,1978 illus.

 Six are portrs.,ptd.betw.1823 & 29,now at
N.Y.State Historial Association in Coopers-
town

qN7618
N27
NPG

I.B.1.a — NEW YORK. NATIONAL ACADEMY OF DES.

New York. National academy of design (U.S.)
 Artists by themselves;artists' portraits
from the Nat'l academy of design.N.Y.,¹he
Academy;Seattle.Univ.of Wash.Press.distribu-
tor,c.1983
 175 p. illus(part col.)
 Bibliographical references
 Index
 Cat.of an exh.held at the Nat'l academy
of design Nov.3,1983-Jan1,1984,The NPG,Wash.,
D.C. Feb.10-Mar 25,1984 & 5 other mus.in 1984
and 1985. Introd.by Michael Quick
 Inventory of portrs.of artists & archi-
tects in the coll. of the Nat'l acad.of des.
p.161-73

705
A784
NCFA
v.38

I.B.1.a — N.Y.STATE HISTORICAL ASS'N.(MUS.& ART
 GALLERY, COOPERSTOWN, N.Y.)
Millard, Everett Lee
 The Browere life masks

In:Art in Am.
38:69,71,74,76,78,80 Apr.,'50 illus.

 Busts in N.Y.State hist.assoc'n's "Hall of
Life Masks"in Fanimore hse.,Cooperstown,N.Y.

 This article is drawn fr.Millard's ms of a
life of J.H.I.Browere
 Arts in America qZ5961.U5
 A77X NCFA Ref. I72

N
11
N27C9
NCFA

I.B.1.a — NEW YORK. NATIONAL ACADEMY OF DESIGN

Cummings, Thomas Seir, 1804-1894
 Historic annals of the National academy
of design,New York drawing association,etc.,
with occasional dottings by the way-side,from
1825 to the present time...Philadelphia,
G.W.Childs,1865
 364 p.

 "Ranks next to Dunlap's 'History' in impor-
tance as source for info. concerning early
American artists."(Wehle.American min.,1730-1850,
bibl. ND1337U5W41NCFA)

LC N11.N25 1865a

705
A56
NCFA
v.110

I.B.1.a — N.Y.STATE HISTORICAL ASS'N(MUS. & ART
 GALLERY, COOPERSTOWN,N.Y.)
Demer, John H.
 The portrait busts of John H.I.Browere

In:Antiques
110:111-7 July,'76 illus.

 "B.spent more than $12000.-attempt'g.with-
out success to establish a Nat'lCall.of Busts
and Statues."-Demer

 Incl.H.Clay;Thos.Jefferson,Js.Madison;Dolley
Madison;J.Adams;Lafayette;M.van Buren;J.Q.Adams.
 Checklist of B.'s sculptures

705
A784
NCFA
v.38

I.B.1.a - N.Y.STATE HISTORICAL ASS'N.(MUS.& ART
 GALLERY, COOPERSTOWN, N.Y.)
MacFarlane, Janet R.
 Portraits

In:Art in Am.
38:90 Apr.,'50 illus.

 Ptgs.in N.Y.State histor.assoc'n's Feni-
more House,Cooperstown,N.Y.

 Repro.with captions incl.:B.West,G.Stuart,
S.F.B.Morse,E.Ames,R.Earl,Js.Peale

AP -
1
M971
NCFA

I.P.1.a - NEWARK MUSEUM

Bishop, Edith
 Newark portraits by Rembrandt Peale and
Oliver Tarball Edly

In:The Museum
n.s.1,no.4:1-21 Oct.,'49 illus.

 Notes and Bibliography

 Penn.Hist.Soc. Rembrandt
 Peale...Bibl.p.117

I.B.1.a -

New York university. Gallery of living art
 Gallery of living art,A.E.Gallatin col-
lection,N.Y.University....N.Y.O.Grady press,
1936.
 .39.p. illus.

 Portrs.of Braque,Léger,Matisse,Picasso,
Mondrian,Miró;photographs by A.E.Gallatin

LC N620.N4A3 MOMA,v.11,p.438

ND
210
N86
1566
NMAA

I.B.1.a - NORTH CAROLINA. MUSEUM OF ART, RALEIGH

North Carolina. Museum of Art, Raleigh
 American paintings to 1900.2nd ed..Raleigh,
N.C.:North Carolina Mus.of Art,1966
 117 p. chiefly illus(part col.)

 Cat.of ptgs.,v.1
 Incl.:Portrs.by 'W.M'.Chase,J.S.Copley,Wm.
Dunlap,' .Duveneck,R.L.W.Earl,J.A.Elder,Wm.H.Fair-
fax,J.Hesselius,J.W.Jarvis,J.Marling,Washington
by R.Peale,J.S.sargent,G.Stuart,Ths.Sully,A.U.
Wertmuller

CJ
5807
M53
NPG

I.B.1.a

New York University. Hall of Fame
 America's most distinguished series of medals
honoring our nation's immortals..New York,1966.
 1 v. illus.

I.B.1.a - NORWICH CASTLE MUSEUM, NORWICH,ENG.

Norwich Castle Museum, Norwich,Eng.
 ...Cat.of the pictures,drawings,etchings...in
the picture gallery of the Norwich Castle mus.
4th ed. Norwich,"Norwich mercury"co.,ltd.,prin-
ters,1909

MET
108.?
N83M97

LC N1443.A6 1909 FOR COMPLETE ENTRY
 SEE MAIN CARD

NB
25
N53
1962
NPG
2 c.

I.B.1.a - NEW YORK UNIVERSITY. HALL OF FAME

New York University. Hall of Fame
 The Hall of Fame for Great Americans...
.N.Y.:N.Y.Uni.Press,1962

 FOR COMPLETE ENTRY
 SEE MAIN CARD

I.B.1.a - NORWICH,ENG., ST.ANDREW'S HALL

Norwich,Eng., St.Andrew's Hall
 A cat. of the portraits...in St.Andrew's
Hall and other buildings.Norwich,1905

MET
196.6
N83Sa?

 FOR COMPLETE ENTRY
 SEE MAIN CARD

I.B.1.a - NEW YORK university. Museum of living
see art
I.B.1.a - New YORK UNIVERSITY. GALLERY OF LIVING
 ART

I.B.1.a -

Notre Dame,.Ind. University. Art Gallery
 Sobriety and elegance in the Baroque:an exh
of portraits from the University of Notre Dame
Coll.presented by the Renaissance Soc.at the
University of Chicago,Goodspeed Hall,Apr.5-
May 10,1961.s.1.,s.n.,1961?.
 .48.p. illus.

 Incl.index

Cty FoU' Yale ctr.f.Brit.art Ref.
 ND1313.N68

I.B.1.a - OHIO STATE ARCHAEOLOGICAL AND HISTO-
RICAL MUSEUMS
Howard, Betty J.
A cat.of 19th c. portraits in the Ohio
state archeological and historical museums

Master's Th.-Columbus,O.S.Univ.,1948

Lindsay,K.C. Harpur Ind.of
master's theses in art...
1955 NCFA Ref. Z5931.L74
p.73 no.1330

750
.M83

I.B.1.a - OXFORD. UNIVERSITY. BODLEIAN LIBRARY

Norgate, Edward, d.1650
Miniatura;or, The art of limning;...Oxford,
Clarendon press, 1919
Ed.& introd.by Martin Hardie
111 p.
The treatise dates from 1648-50 and is in
the Bodleian Library,Oxford(MS.Tanner 326)

Reviewed in Burl.Mag.v.37:207-8 Oct.,1920

LC ND1330.N7

Warburg J.v.6,1943,p.89
footnote

F
24
A34
1987C
IMAA

I.B.1.a - OLD YORK HISTORIAL SOCIETY, YORK,ME.

Agreeable situations:society,commerce and art
in southern Maine,1780-1830;ed.by Laura
Fecych Sprague;essays by Joyce Butler...
et al..Kennebunk,Me.Brick Store Mus.
Boston:Distributed by Northeastern Univ.
Press,1987
205 p. illus(part col.)
Incl.Brewster,jr.,deaf artist,p.88,122,254
Cat.of selected objects from the Brick
Store Mus.et al
Index
Bibliography

ND
1301
G7
O 98
NPG

FOGG
59
O 98bp
no.6

I.B.1.a -

Oxford. University. Bodleian Library
Portraits of the 16th and early 17th cen-
turies,by J.N.L.Myres..Oxford,1952.
7 p. illus. (Bodleian picture book,no.6)

23 plates

Fogg,v.11,p.324

AP
1
W225
NCFA
v.14

I.B.1.a - OXFORD COLLECTIONS

Bell, Charles Francis, 1871- and Rachel Poole
English 17th-century portrait drawings in
Oxford collections.Pt.II:Miniature portraiture
in black lead and Indian ink

In:Walpole Soc.
14:43-80 1925-26 illus.
In:Walpole Soc.
5:1-18 1915-17 General account of the collec-
tions
LC N12.W3

FOR COMPLETE ENTRY
SEE MAIN CARD

I.B.1.a - PADUA. Museo MANTOVA
see
I.B.1.b - MANTOVA BENEVIDES, MARCO,conte,1489-1582,
Padua

750
375
NCFA
v.56

I.B.1.a - OXFORD. UNIVERSITY. ASHMOLEAN MUSEUM

Williamson, George Charles, 1858-1942
The Bentinck-Hawkins coll.of enamels at
the Ashmolean museum,Oxford

In:Connoisseur
56:34,36-7 Jan.,'20 illus.

Repro.:H.Bone,the younger,Birch,Craft,Hone,
Spicer,Zincke,H.Bone,the elder,Hatfield,Spencer

NC
860
P23
NPG

I.B.1.a - PARIS. BIBLIOTHÈQUE DU CONSERVATOIRE
DES ARTS ET MÉTIERS
Bouchot, Henri François Xavier Marie, 1849-1906
Les portraits aux crayons de 16e et 17es.
conservés à la Bibl.Nat.(1525-1646). Paris,
H.Oudinot Cie,1884
412 p. illus.

Incl.:Listes de crayons ou peintures conservés
dans des coll.publ.ou privées.Étrangères.A la
Bibl.nat.:France:Bibl.d'Arras-Bibl.desArts-et-Mé-
tiers-Coll.de).Courajod-Ancien Cabinet Fontette-
Mus.du Louvre(dessins et peinture)-Portrs.peints
du Mus.de Versailles
LC N7621.P3

I.B.1.a - OXFORD. UNIVERSITY. BODLEIAN LIBRARY
Sutherland, Alexander Hendras
Catalogue of the Sutherland collection.of
portraits,views,and miscellaneous prints....Lon-
don,Payne & Foss,and P.& D.Colnaghi & co.,1837-
.38.
2 v.
Cat.of 1908: engravings & drgs....with the
text of Clarendon's History of the rebellion,
and Life,and Burnet's History of his own time.
The coll.completed by Mrs.Charlotte Hussey Suther-
land,who compiled the cat.& presented the extra
illustrated sets...to the Bodleian library
LC NE215.07S6

I.B.1.a - PARIS. BIBLIOTHÈQUE NATIONALE

Couderc, Camille, 1860-
Album de portraits d'après les collections
du département des manuscrits...Paris,Impr.
Berthaud frères.1910.
86 p. illus.

LC ND3399.A6C7

Amsterdam,Rijksmus.cat.
6939252,deel 1,p.133
2

I.B.1.a - PARIS. BIBLIOTHÈQUE NATIONALE

Paris. Bibliothèque Nationale. Département des estampes.
Cat.de la coll.des portraits français et étrangers conservée au Département des estampes de la Bibliothèque nationale...Paris,G.Rapilly, 1896-1912(1919)
.7.vols.

Commencé par Georges Duplessis,continué par Georges Riat,.P.A.Lemoisne,Jean Laran.

Amsterdam,Rijksmus.cat.
25939A52,deel 1,p.133

LC NE230.P2A6

705
C70
C.pér.
1884
NCFA

I.B.1.a - PARIS. MUSÉE DE CLUNY

Courajod, Louis Charles Jean, 1841-1896
La collection de médaillons de cire du Mus. des antiquités silésiennes à Breslau

In:Gaz.Beaux-Arts
2nd pér.,29:236-41 1884 illus.

.16th c. wax medallions

Incl.list of medallions at the mus.de Cluny

Farrer.In:Conn.23:126 foot-
note 705.C75 NCFA
v.42,no.71,
also Phila.Mus.B.V705.1.P31 NCFA p.63

NC
860
P23
NPG

I.B.1.a - PARIS. BIBLIOTHÈQUE NATIONALE

Bouchot, Henri François Xavier Marie, 1849-1906
Les portraits aux crayons de 16e et 17e s. conservés à la Bibl.Nat.(1525-1646). Paris, H.Oudinet Cie,1884
illus.

LC N7621.P3

I.B.1.a - PARIS. MUSÉE NATIONAL DU LOUVRE

Vitry, Paul, 1872-
Les accroissements des musées.(Musée du Louvre).Quelques bustes du 18e siècle récem-ment entrés au Musée

In:Les Arts
10,no.117:1-6 Sept.,'11 illus.

Repro.:(of)-Nicolas Coypel by J.-B.Lemoyne. Antoine Coypel by Coysevox. Mme.Favart by De-fernex.

TC N2.AR5

Portr.bust.Ren.to Enlighten-
ment.NB1309P6x NPG

ND
1316.2
D97
NPG

I.B.1.a - PARIS. BIBLIOTHÈQUE NATIONALE

Tillet, Jean du, sieur de la Bussière,d.1570
...Portraits des rois de France du Recueil de Jean du Tillet.Reproduction réduite des 32 miniatures du manuscrit français 2848 de la Bibliothèque nationale. Paris,Impr.Berthaud frères, .1908.
12 p. illus.

Edited by Henri Omont

LC N7004.T5

Amsterdam,Rijksmus.cat.
25939A52,deel 1, p.145

I.B.1.a - PARIS. MUSÉE NATIONAL DU LOUVRE

Paris. Musée national du Louvre
Cat.de la donation Félix Doistau...Paris, 1922

MFT
196.5
P21
1958

FOR COMPLETE ENTRY
SEE MAIN CARD

I.B.1.a - PARIS. BIBLIOTHÈQUE NATIONALE

Laborde, Léon Emmanuel Simon Joseph de, 1807-
La Renaissance des Arts à la cour .1869 de France (card 2)

FOGG
FA
723.3

études sur le seizième siècle, tom.1.with .additions.Peinture.Paris,Potier,1850-55
2 v.(1088 p.)
No more published
Incl.list of portrs. now in the Biblio-thèque nationale & an essay on Jean Fouquet & his pupils.-Bouchot.Portrs.aux crayons,p.12

N
2030
A56
1979
v.2
NMAA

I.B.1.a - PARIS. MUSÉE NATIONAL DU LOUVRE

Paris. Musée national du Louvre
Cat.sommaire illustré des peintures du Mus.du Louvre.Paris.Editions de la Réunion des musées nationaux
v.2 illus.

v.2:Italie,Espagne,Allemagne,Grande-Bre-tagne et divers

Coordination par Arnauld Bréjon de Laver-ñée et Dominique Thiébaut
For list of portrs.see:Index iconogra-phique,p.400-40?

NC
772
A23
NPG

I.B.1.a - PARIS. BIBLIOTHÈQUE NATIONALE.DÉPARTE-
MENT DES ESTAMPES

Adhémar, Jean
Les portraits dessinés du 16e siècle au ca-binet des estampes:.by:J.Adhémar et Christine Moulin.Paris,Gaz.des beaux-arts,1973
104 p. illus.

Extrait de la Gaz.des beaux-arts,Paris,sept. et décembre,1973
Repros.of almost all drags.with name of sit-ters,date,biographical note,artist,info.given by other catalogers(Bouchot,Dimier,etc.)
Alphabetical index of sitters
Alphabetical index of artists by Bou-chot & Dimier

N
7616
P23
NCFA

I.B.1.a - PARIS. MUSÉE NATIONAL DU LOUVRE

Paris. Musée national du Louvre.Cabinet des dessins
Donation de D.David-Weill au Musée du Louvre.Miniatures et émaux..Exposition.Oct.'56-Janvier 1957.Paris,Editions des Musées natio-naux.1956.
186 p. illus.
Miniatures p.3-90; Enamels p.93-170
Cat.by Maurice Sérullas
Bibliography
Index of artists and of sitters
Repro.incl.:(A)Miniaturists:Hall,Dumont,

I.B.1.a - PARIS. MUSÉE NATIONAL DU LOUVRE

Horsin-Déon, Léon
 Essai sur les portraitistes français de la renaissance,contenant un inventaire raisonné de tous les portraits du 16e siècle des musées de Versailles et du Louvre.Paris,Impr.Ve P.Larousse et cie.,1888
 212 p.

MET
186
H78
FOGG
Deposit libr.

Amsterdam,Rijksmus.cat.
Z5939A52,deel 1,p.489

I.B.1.a - PARIS. MUSÉE NATIONAL DU LOUVRE

Charbonneaux, Jean, 1895-
 Portraits ptolémaïques au Musée du Louvre

In:Acad Inscr Paris Mon et Mém
47:99-129 1953 illus.

 Style & chronology of 7 portrs.of Kings & Queens are identifiable by means of monetary effigies.Works of the 3rd c.,they still have the grand pathos & the idealizing traits of the 4th c (Ptolomy I,II,III,IV,Arsinoë II,III,Berenice II)

LC ND3.A25 fol.

Richter,G. Portrs. of the Greeks N7586R53,v.3,p.295
Rep.1953*3438

705
G28
NCFA
v.29

I.B.1.a - PARIS. MUSÉE NATIONALE DU LOUVRE

Chennevières, Henry de
 François Dumont.Miniaturiste de la reine Marie Antoinette

In:Gaz Beaux Arts 3rd ser.
29:177-92 1903 illus.

 Portr.within portrait p.187

Draper,Js.D.:Grétry Encore
In:Met.Mus.J. 9:235 note 6

I.B.1.a - PARIS.MUSÉE NATIONAL DU LOUVRE.DPT. DES OBJETS D'ART DU MOYEN-AGE,DE LA RENAISSANCE.
Paris. Musée national du Louvre.Dpt.des objets d'art du moyen-âge,de la renaissance et des temps modernes.
 Notice des émaux exposés dans les galeries du Musée du Louvre,par M.de Laborde...Paris, Vinchon,imprimeur des musées nationaux,1852-53
 2 v.

NN
Part 1:Histoire et descrip tion,1852.348 p. illus.
LC NK4999.P3M85

Heath.Miniatures.ND1330.H43
NCFA Bibl. p.XXXVII

I.B.1.a - PARIS. MUSÉE NATIONAL DU LOUVRE

Coche de la Ferté, Etienne
 La peinture des portraits romano-égyptiens au Musée du Louvre

In:Soc.fr.Egyptol.
no.13:69-78 Jun,1953 illus.

 Problems of technique & chronology.Portrs. of end 3rd c. (Rep.1953*3460)

ULS:"DLC"

Richter,G. Portrs of the Greeks N7586R53,c.3,p.295

I.B.1.a - PARIS. MUS.NAT.DU LOUVRE.DPT.DES PEINTURES,DES DESSINS ET DE LA CHALCOGRAPHIE
Paris. Musée national du Louvre. Dpt.des peintures,des dessins et de la chalcographie
 Les émaux de Petitot du Musée impérial du Louvre;portraits de personnages historiques et de femmes célèbres du siècle de Louis XIV, gravés au burin par M.L.Ceroni.Paris,Blaisot, 1862-64
 2 v. illus.

 1st part:Jean Petitot(1607-1691)by Henri Bordier,31 p.,illus.
 Petitot was assisted in his miniature ptg. by his brother-in-law,Jacques Bordier

NN CtY NB MdBWA,etc.

NC
860
P23
NPG

I.B.1.a - PARIS. MUSÉE NATIONAL DU LOUVRE

Bouchot, Henri François Xavier Marie, 1849-1906
 Les portraits aux crayons de 16e et 17es. conservés à la Bibl.Nat.(1525-1646). Paris, H.Oudin&Cie,1884
 412 p. illus.

 Incl.:Listes de crayons ou peintures conservés dans des coll.publ.ou privées.Étrangères.A la Bibl.nat.:France:Bibl.d'Arras-Bibl.desArts-et-Mé- tiers-Coll.de M.Courajod-Ancien Cabinet Fontette- Mus.du Louvre(dessins et peinture)-Portrs.peints du Mus.de Versailles

LC N7621.P3

I.B.1.a - PARIS. PALAIS-ROYAL

Vulson de la Colombière, Marc, d.1658
 Les hommes illustres et grands capitaines françois qui sont peints dans la Galerie du Pa- lais Royal...avec leurs portraits...dessignes & graves par les sieurs Heince & Bignon..Paris, Estienne Loyson,1650
 .66.p. illus.

 Publ.previously in 1650 with title:Les por- traits des hommes illustres françois...400 p.
LC has 1668 ed.:DC36.V8

CSt

Winterthur Mus.Libr.fZ861
.W78 NCFA v.9,p.226

I.B.1.a

Paris. Musée national du Louvre
 Portraits français 14e,15e et 16e siècles, par Hélène Adhémar. Paris,F.Hazan.1950,
 .26.p. illus.(col.) (Bibl.aldine des arts,14

LC ND1316.P37

Encyclop.of World Art
Portrs.bibl.w31L56 Ref.

757
P35

I.B.1.a -

Peabody museum of Salem, Salem,Mass.
 Portraits of shipmasters and merchants in the Peabody museum of Salem,with an introduction by Walter Muir Whitehill.Salem,Peabody museum, 1939
 185 p. illus.

LC N7593.P4

Whitehill.The Arts in ear- ly Amer.Hist.Z5935.W59
Bibl.,p.101

I.B.1.a -

Peabody museum of Salem, Salem,Mass.
 A special exhibition of the Saltonstall
family portraits,Nov.15-Dec.31,1962.Salem,Mass.,
1962.
 12 p. illus.

 Cat.compiled by Carl Crossman

 "...16 family portrs.recently given to the
Peabody mus....by Senator Leverett Saltonstall,
dating from the middle of the 17th c."(Whitehill)

MB CtY Whitehill.The arts in ear-
 ly Amer.Hist.Z5935.W59
 Bibl.,p.59

N
40.1
S93P4
NPG

I.B.1.a - PENNSYLVANIA ACADEMY OF THE FINE ARTS,
 PHILADELPHIA
 Pennsylvania Academy of the Fine Arts, Philadel-
 phia
 Portraits by Gilbert Stuart,1755-1828...
 Philadelphia.1963.

LC ND1329.S7P4

I.B.1.a - PENNSYLVANIA ACADEMY OF THE FINE ARTS,
 PHILADELPHIA

Cary, Elisabeth Luther, 1867-1936
 The gallery of national portraiture in the
Pennsylvania academy of fine arts

MET In:The Scrip
100.51 2:363-6 1907 illus.
Scr.7
1906-07

LC N1.S4

N
683
A5
1942
NCFA
NPG

I.B.1.a -

Pennsylvania. Historical society
 Catalogue,descriptive and critical of the
paintings and miniatures in the Historical so-
ciety of Pennsylvania,by William Sawitzky.Phila-
delphia,The Historical society of Pennsylvania,
1942
 285 p. illus.

LC N683.A5 1942 Whitehill.The Arts in ear-
 ly Amer.Hist.Z5935.W59 NPG
 Bibl.,p.101

I.B.1.a - PENNSYLVANIA ACADEMY OF THE FINE ARTS,
 PHILADELPHIA
Historical records survey. Pennsylvania.
 Inventory of American portraiture in the
permanent collection of the Penn.academy of
the fine arts.Comp.by.U.S.Work projects ad-
ministration,1942
 2 v. (Survey of American portraiture
Arch. in Pennsylvania)
Am.Art
mfm Typescript
P51/676-
p 2/14 Alphabetical by subject

 Archives of American Art
 Portraits

705
A56
NCFA
v.102

I.B.1.a - PENNSYLVANIA. HISTORICAL SOCIETY

Wainwright, Nicholas B.
 Early American paintings at the Historical
Society of Pennsylvania

In:Antiques
102:831-9 Nov.'72 illus(part col.)
 Repro.incl.:Gust.Hesselius,John Meng,Rbt.
Feke,Ths.Spence Duché;Benj.Franklin by Chs.Wm.
Peale;Geo.Washington by Rembrandt Peale;Rbt.
Edge Pine,John Wollaston,Ben.West,Jac.Eichholtz,
Js.Peale,J.S.Copley;Geo.Washington by J.Wright.

ND
205
C57m
NCFA

I.B.1.a - PENNSYLVANIA ACADEMY OF THE FINE ARTS,
 PHILADELPHIA
Cincinnati. Art Museum
 Masterpieces of American painting from the
Pennsylvania academy of the fine arts,Philadel-
phia...Cincinnati Art Museum,c.1974.

 FOR COMPLETE ENTRY
 SEE MAIN CARD

N
683
A5
1974X
NPG
Ref.

I.B.1.a - PENNSYLVANIA. HISTORICAL SOCIETY

Pennsylvania. Historical society
 Paintings and miniatures at the Historical
society of Pennsylvania.Rev.ed.comp.by Nicholas
B.Wainwright.Philadelphia,1974
 334 p. illus(part col.)

 Publ.in 1942 under title:Cat.,descriptive
and critical of the ptgs.& miniatures...
 1942:615 items by 166 artists.1974:791 items
by 201 artists.
 Portrs.arranged alphabetically by sitters.
 Index of artists.
 rts in Am.qZ5961.U5A77X
 CFA Ref. I 257

N
675
H49
NCFA

I.B.1.a - PENNSYLVANIA ACADEMY OF THE FINE ARTS,
 PHILADELPHIA
Henderson, Helen Weston, 1874-
 The Pennsylvania academy of the fine arts
and other collections of Philadelphia...Boston,
L.C.Page & co.,1911
 383 p. illus. (The art gall.of America se-
 ries)
 Bibliography

 Ch.I.Historical sketch of the academy.-
Ch.III.Benj.West & Wash.Allston.-Ch.IV.Mathew
Pratt & the Peales.-V.Gilbert Stuart.-Ch.VI.A
group of early portr.ptrs.-VII.The portr.gall.
completed.
LC N675.H5
 Weddell...p.436

N
675
H49
NCFA

I.B.1.a - PENNSYLVANIA. HISTORICAL SOCIETY

Henderson, Helen Weston, 1874-
 The Pennsylvania academy of the fine arts
and other collections of Philadelphia...Boston,
L.C.Page & co.,1911
 383 p. illus. (The art gall.of America se-
 ries)
 Bibliography

 Ch.I.Historical sketch of the academy.-
Ch.III.Benj.West & Wash.Allston.-Ch.IV.Mathew
Pratt & the Peales.-V.Gilbert Stuart.-Ch.VI.A
group of early po .ptrs.-VII.The portr.gall
completed.
LC N675.H5
 Weddell...p.436

757
.P41

I.B.1.a - PENNSYLVANIA. UNIVERSITY

Pennsylvania. University
 Portraits in the University of Pennsylvania;
edited by Agnes Addison. Philadelphia,University
of Pennsylvania press,1940
 67 p. illus.

LC N7593.P45 Fogg,v.11, p.328

J
585
.5
NCFA

I.B.1.a -

Philadelphia Museum of Art
 A.E.Gallatin collection,"Museum of living
art".Philadelphia.1954.
 153 p. illus(part col.)

 Previous eds.iss.by N.Y.university.Gall.of
Living Art,A.E.Gallatin collection.

 Incl.photos by A.E.Gallatin of Arp,1934;
Braque,1931;Léger,1931;Matisse,1932;Miró,1936;
Mondrian,1934;Picasso,1933..This is a different
set than in previous eds.,Life,May 2,'38,Bri-
tannica Book..39 o.147-53

N
7621
P513ec
1855
NPG

I.B.1.a - PHILADELPHIA. INDEPENDENCE HALL

Philadelphia. Independence hall
 Catalogue of the national portraits in Inde-
pendence hall,comprising many of the signers of
the Declaration of Independence and other dis-
tinguished persons...Philadelphia,John Coates,
1855
 24 p.

798.1
P52
NCFA
v.44

I.B.1.a - PHILADELPHIA MUSEUM OF ART

Zigrosser, Carl.
 Franklin portraits. The Rockefeller collection

In:The Philadelphia Mus.Bull.
44:18-31 no.220,1948 illus.

 Show,built around a coll.of 151 portrs.given
to the Mus..F.'s wide-spread reputation is shown
graphically through portrs.from 9 different coun-
tries. Repro.:ptgs.by Peale,West,miniature by Du-
plessis,stipple engr.by Darcis,line-engrs.by Saint
Aubin after Cochin,Masquelier after Moreau-le-
Jeune,color aquatint by Alix,etc.
 Rep.,1948-49*1146

N
7621
P54
NCFA
NPG

I.B.1.a

Philadelphia. Independence hall
 Catalogue of the portraits and other works
of art,Independence hall,Philadelphia,....Phila-
delphia,Press of Geo.H.Buchanan company,c.1915.
 187 p. illus.

 "The James Sharpless coll.of portrs.in pastel"
p.:175.-186

LC F158.8.I3P55

708.1
P31
NCFA

I.B.1.a - PHILADELPHIA MUSEUM OF ART

Prentice, Joan
 Wax miniatures

In:Phila Mus.B.
42,no.213:50-62 March,'47 illus.

FOR COMPLETE ENTRY
SEE MAIN CARD

I.B.1.a - PHILADELPHIA. INDEPENDENCE NATIO-
 NAL HISTORICAL PARK
 see
I.B.1.a - INDEPENDENCE NATIONAL HISTORICAL PARK

F
68
P63
1955

I.B.1.a - Pilgrim Society, Plymouth Mass.

Pilgrim Society, Plymouth, Mass.
 A catalogue of the collections of the
Pilgrim Society in Pilgrim Hall, Plymouth,
Massachusetts: comp. and arr. by Rose T.
Briggs. [Revised 1955] Plymouth [1955]
 61 p. illus., port. 23 cm.

 1. Pilgrim Fathers. 2. Portraits, Ameri-
can - Catalogs. I. Briggs, Rose T., comp.

I.B.1.a - PHILADELPHIA MUSEUM
 see
I.B.1.b - PEALE'S MUSEUM, PHILADELPHIA

I.B.1.a - PHILADELPHIA,ROSENBACH MUSEUM & LIBRA-
 RY
 see
I.B.1.a - ROSENBACH MUSEUM & LIBRARY,PHILADEL-
 .PHIA

I.B.1.a - PORT SUNLIGHT, ENG. LADY LEVER
see
 &ART GALLERY
I.B.1.a - LADY LEVER ART GALLERY, PORT SUN-
 &LIGHT

B
.W31
K84

I.B.1.a - PRINCETON UNIVERSITY

Morgan, John Hill, 1870-
 Two early portraits of George Washington,
painted by Charles Willson Peale...Princeton,
N.J.&Univ.Press&1927
 29 p. illus.

 "The Wilson-Munn portrait",1779 and
"The Princeton portrait",1784,both at Princeton
university

LC ND237.P27M6

Weddell.A mem'l vol.of Va.
hist.portraiture.757.9.W38
NCFA Bibl. p.437

I.B.1.a - PORTLAND,ME.,MAINE HISTORICAL SOC.
see
I.B.1.a - MAINE HISTORICAL SOCIETY, PORTLAND,M.

AP
1
NCFA
v.101

I.B.1.a - RANGER'S HOUSE, BLACKHEATH

Jacob, John
 Ranger's House,Blackheath,a new gallery of
English portraits

In:Apollo
101:14-8 Jan.,'75 illus(1 col.)

 Discusses the Suffolk coll.of Tudor,Stuart
and later portrs.Gift to the Greater London
Council;displayed at Ranger's House,Blackheath.
 Coll.contains group of full-length portrs.
by Wm.Larkin
 Rila II/1 1976&3481

I.B.1.a - PORTRÄTARCHIV DIEPENBROICK

Der Herrscher:graphische bildnisse des 16-19.
 Jahrhunderts aus den porträtarchiv Diepen-
 broick....s.l.:Landschaftsverband Westfa-
 len Lippe&1977&

LC NE219.2.03M833

**FOR COMPLETE ENTRY
SEE MAIN CARD**

qND
1301.5
G7L667
1975X
NPG

I.B.1.a - RANGER'S HOUSE, BLACKHEATH

Ranger's House.
 The Suffolk collection;cat.of paintings
&...compiled by John Jacob and Jacob Simon;
photographs by Robert Evans..London,Greater
London Council&1975&
 &86&p. illus.

 Bibliography

I.B.1.a - PORTRÄTARCHIV DIEPENBROICK

Westfälisches Landesmuseum für Kunst und Kul-
 turgeschichte, Münster
 Porträt 2:Der Arzt:graphische bildnisse
des 16.-20.Jahrhunderts aus dem Porträtarchiv
Diepenbroick.Ausstellung.17.12.1978-18.2.1979.
Westfälisches Landesmuseum für Kunst und Kul-
turgeschichte Münster,Landschaftsverband West-
falen-Lippe;8.3.1979-22.4.1979.Historische
Museen,Kölnisches Stadtmuseum,Köln,29.4.1979-
27.5.1979 Ritterhaus-Museum,Offenburg..Münster
Landschaftsverband Westfalen-Lippe,1978&
 310 p. illus.
 Ausstl.und Kat.:Peter Berghaus et al
NCFA

N
7592
G24
NPG

I.B.1.a - REDWOOD LIBRARY AND ATHENAEUM, NEW-
 &PORT,R.I
Redwood Library and Athenaeum, Newport,R.I.
 Cat.of pictures,statuary etc.,belonging to
The Redwood Library,Sept.1,1885.&Newport,R.I.&
1885?
 16 p.

 268 items:ptgs.,photographs,engravings,etc.
?1? of the ptgs.given by Chs.B.King,incl.self-
portr.Most of the ptgs.are by Chs.B.King.
38 sculptures
 NPG copy bound with Garrick Club,London.
Cat.of the pictures...London,1909

757.3
.E28

I.B.1.a - PRINCETON UNIVERSITY

Egbert, Donald Drew, 1902-
 Princeton portraits...with the assistance of
Diane Martindell Lee. Princeton, Princeton Univ.
Press,1947

 360 p. illus.

 Portrs. owned by Princeton University

LC N7593.E36

Q17.37
P3
NCFA
sale no.
3056

I.B.1.a - REDWOOD LIBRARY AND ATHENAEUM, NEWPORT,
 R.I.
King, Charles Bird, 1785-1862
 The important collection of 21 portraits of
North American Indians by Chs.B.King,property
of the Redwood Library and Athenaeum,Newport,
R.I. Auction May 21&1970&Parke-Bernet Galleries,
New York,1970
 49 p. illus(part col.)

 Intro.by Marc Rosen

 Bibliography

 Toce,v.11.,p.327

705
A56
NCFA
v.100

I.B.1.a - RHODE ISLAND HISTORICAL SOCIETY

Goodyear, Frank Henry, 1944- .
 The Painting collection of the Rhode Island
Historical Society

In:Antiques
100:749-57 Nov.,'71 illus(part col.)

 Central portr.gall. added in 1891
 Cat.of portrs. & landscapes,1895
 'Life-like portrs...may serve the cause of
history better than elaborate essays.'-Amos
Perry,keeper to the Society.

I.B.1.a - ROBERT H.LOWIE MUS.OF ANTHROPOLO-
see .OY
I.B.1.a - CALIFORNIA - UNIVERSITY - ROBERT H.
 LOWIE MUS.OF ANTHROPOLOGY - BERKELEY

705
A56
NCFA
v.110

I.B.1.a - RHODE ISLAND SCHOOL OF DESIGN,PROVI-
 DENCE. MUS.OF ART
 Mandel, Patricia C.F.
 Amer.paintings at the Mus.of Art,Rh.Isl.
 school of design,Providence,
Antiques
American painting ,special issue,
110:965-1050, Nov.,1976 illus(part col.)
Chiefly 18th-19th century
Partial contents:P.C.F.Mandel,Amer.ptgs.at
the Mus.of Art,Rh.Isl.sch.of des. p.965-751...

I.B.1.a -

Rome. Museo nazionale romano
 I ritratti..Catalogo di,Bianca Maria
Felletti Maj.Roma.Libreria dello Stato,1953

LC NB87.R6A35 Richter,G. Portrs. of the
 Greeks N7586R53,v,3,p.296

NPG

I.B.1.a-RHODE ISLAND SCHOOL OF DESIGN,PROVIDENCE
 MUS.OF ART.
 Loring, William C.
 Portrait painters of Colonial days

In:Antiquarian
11:52-3,96 Dec.,'28 illus.

 The article deals only with Ralph Earl's
portrs. in Rh.Isl.School of Design,Providence,
Mus.of Art

 Arts in America qZ5961 USA
 77X NCFA Ref. H317

I.B.1.a

Rome. Palazzo Venezia
 Il ritratto francese da Clouet a Degas.cat.
di mostra 1962;premessa e introd. di Germain
bazin..Roma,1962
MET 120 p. illus.
sup2
195.37 cat.;annotations by O.Dutilh & P.Rosenberg
F66

R.x.o Encyclop.of World Art
 Portrs.bibl.N31E56 Ref.

708.1
R176
NCFA
v.16

I.B.1.a-RHODE ISLAND SCHOOL OF DESIGN,PROVIDENCE
 ,MUS.OF ART
Two needlework pictures in the museum,by M.A.B..

In:R I Sch Des Bull
16:16-8 Apr.,'28 illus.

 Repro.incl.:Charles I & Henrietta Maria.
Stumpwork,17th c.

 Description of stumpwork,p.15-6

I.B.1.a - ROME. PROTOMOTECA CAPITOLINA

Rome. Protoroteca Capitolina
 La Protomoteca Capitolina.A cura di V.Mar-
tinelli e C.Pietrangeli.Rome,1955 (Cataloghi
dei musei comunali di Roma,ser.II,5)
FOGG
62
R76pro
1955
FA62.10

MET
138.7
M36
(LC 708.5.R76 Mp) TxDaM FOR COMPLETE ENTRY
MH-FA CU NJP SEE MAIN CARD

I.B.1.a - RIJKSUNIVERSITEIT TE LEIDEN.BIBLIO-
see .THEEK
I.B.1.a - LEYDEN. RIJKSUNIVERSITEIT.BIBLIOTHEEK

I.B.1.a - ROSENBACH MUSEUM &LIBRARY,PHILADELPHIA

Spanish Institute,Inc.,N.Y.
 The Spanish golden age in miniature.Portraits
from the Rosenbach Museum & Library.Cat.of exh..
March 25-Apr.23,'88.New York,The Institute,1988
(see main card)

MdBMA MB(NB1337.S636 1988)

VF
Rotterdam

I.B.1.a - ROTTERDAM, MUSEUM BOYMANS-VAN BEUNIN-
␣GEN

Rotterdam. Museum Boymans-van Beuningen
Dubbelportret.Exh.4 oct.1980-4 Jan.1981

Double portraits:1.Jean Bapt.de Champaigne
by Nicolas de Platte-Montagne and Nicolas de
Platte-Montagne by Jean Bapt.de Champaigne
2.Hans Mardersteig & Carl Georg Heise by Oskar
Kokoschka

705
C75
NCFA
v.84

I.B.1.a - ROYAL COLLEGE OF PHYSICIANS OF LON-
DON

Thompson, C.J.S.
 Historical portraits at the Royal College of
physicians

In:Connoisseur
84:3-11,94-101 Jul.,Aug.'29 illus.

 Repro.:v.Dyck,Calcar,J.Mich.Wright,Allan Ram-
say,Godfr.Kneller,Mary Reale,Chs.Jervas,bust,by
L.F.Roubillac. J.Closterman,Ths.Lawrence,Gainsbo-
rough,Henry Monro,Mary Black,J.Zoffany
 Cumulated Mag.subj.index
 A1/3/C76 Ref. v.2,p.444

I.B.1.a - ROTTERDAM. MUSEUM BOYMANS-VAN BEUNIN-
GEN. PRENTENKABINET
Rotterdam. Museum Boymans-Van Beuningen, Pren-
tenkabinet
 Denkers,dichters en mannen van de wetenschap:
15-17eneeuw;tentoonstelling(Thinkers,poets &
scientists:15-17th c.;exh.)...Rotterdam,Mus.Boy-
mans-Van Beuningen,1974,

LC N2505.A29 nr.56 FOR COMPLETE ENTRY
 SEE MAIN CARD

N
7598
W86
NPG

I.B.1.a - ROYAL COLLEGE OF PHYSICIANS OF LONDON

Wolstenholme, Gordon E.W., ed.
 The Royal College of Physicians of London:
portraits.London,J.& A.Churchill,1964-77
 2 v. illus.
 v.2 publ.by Elsevier/Excerpta Medica,North
Holland,Amsterdam,and American Elsevier,N.Y.

 Bibliographies
 Index to artists
 Contents:v.1.The portrs.descr.by D.Piper.
v.2Cat.by W.Wolstenholme & J.F.Kerslake,with es-
says by R.E.O.Ekkart & D.Piper
 The portrs.are in alphabetical order by sit-
ter
LC N489.A146

I.B.1.a -

Royal College of Physicians of London
 Catalogue of engraved portraits in the
Royal College of Physicians of London,by A.H.
Driver.London,1952
 219 p.

FOGG
4353
L84p

 Fogg,v.11,p.324

N
7621.2
C5L84r
1980
NPG

I.B.1.a - ROYAL SOCIETY OF LONDON

Royal Society of London
 Royal Society cat.of portraits,by Norman H.
Robinson;with biographical notes by Eric G.
Forbes.London,The Royal Society,1980
 343 p. illus(part col.)

 Index of artists

I.B.1.a - ROYAL COLLEGE OF PHYSICIANS OF LONDON

Royal College of Physicians of London
 A cat. of the engraved portraits of British
medical men, compiled by Herbert Breun;by Arnold
Chaplin and W.J.Bishop.1930.
 Unpublished typescript

 London.Royal Coll.of Sur-
 geons of Engl.N1165.R6A6x
 NPG. Books quoted,p.IX

I.B.1.a - SAN FRANCISCO. ACHENBACH FOUNDA-
SEE ␣TION FOR GRAPHIC ARTS
I.B.1.a - ACHENBACH FOUNDATION FOR GRAPHIC ARTS,
 ␣SAN FRANCISCO

I.B.1.a -

Royal College of Physicians of London
 A descriptive catalogue of the portraits,
busts,silver...in the Royal College of Physi-
cians of London..London,Harrison,Printers,1926
 76 p.

 Arnold Chaplin,the Harveian Librarian...is
responsible for the work in its present form

LC N489.A1R6M 1926 Yale ctr.f.Brit.art Ref.
CU-M GrBVaU CtY ND165.R5A55
MdBA

N
7605
S34
NPG

I.B.1.a

Schleswig-Holsteinisches Landesmuseum, Schleswig
 Schleswig-Holsteinische porträts. Neuerwer-
bungen für die porträtsammlung...seit 1964. Aus-
stellung vom 31.1. - 7.3.1971..Schleswig,1971.

 53 p. illus.

 Introduction by Ernst Schlee
 Selection & cat.by Paul Zubek
 Catalogue, illus. accompanied by short bio-
graphy of sitters & artists.

I.B.1.a - SCHENECTADY,N.Y.,UNION COLLEGE
see
I.B.1.a - UNION COLLEGE, SCHENECTADY, N.Y.

757
.M27

I.B.1.a - SMITHSONIAN INSTITUTION - NCFA

National art committee
 Exhibition of war portraits;signing of the
Peace treaty,1919,and portrs.of distinguished
leaders of America and of the allied nations,
painted by eminent American artists for presenta-
tion to the National portrait gallery....New York,
1921.
 ₆64₇p. illus.

 Circulated by The American Federation of Arts
Cat.compiled by Florence N.Levy
On cover:National gall.of art under direction
of the Smithsonian....,Wash.,D.C.,May5-22,1921
 Review by Leila Mechlin

LC D507.N3

N
7621.2
A9V66
NPG

I.B.1.a - SCHLOSS AMBRAS(NEAR INNSBRUCK)

Heinz, Günther
 Porträtgalerie zur geschichte Osterreichs
von 1400 bis 1800.Kat.der gemäldegalerie.Bear-
beiter des kat.G.Heinz und Karl Schütz.Wien,
Kunsthist.Mus.,1976
 316 p. illus(part col.) (Führer durch
das Kunsthist.Mus.,no.22)

 1976:This "Porträt Galerie"is temporarily
exhibited in Schloss Ambras,near Innsbruck

 List of sitters.p.301-6;List of artists,
p.307-16;Genealo- gical tables,p.317ff.

705
C75
NCFA
v.191

I.B.1.a - SMITHSONIAN INSTITUTION - NCFA

Butler, Joseph T.
 Rare portraits acquired by the National
Collection of fine Arts

In:Conn.
191:140-1 Feb.,'76 illus.

 2 portrs.by Ralph Earl,f'ly Joseph Alsop
coll.Sitters:Hannah Gilbert Wright,and Mary
Wright Alsop,both ptd.1792

I.B.1.a - SCHWEIZERISCHES LANDESMUSEUM
see
I.B.1.a - ZÜRICH. SCHWEIZERISCHES LANDESMUSEUM

705
A56
NMAA
v.126

I.B.1.a - SMITHSONIAN INSTITUTION - NCFA

Platt, Frederick, 1946-
 The war portraits

In:Antiques
126:142-53 July,'84 illus(part col.)

 '...American finest portr.ptrs.were...to re-
cord 22 Allied leaders...These ptgs....were to
form the basis of a Nat'l Portr.Gallery...'

 Repro.incl.:Admiral Beatty,Cardinal Mer-
cier,Clemencau ⊢ Cecilia Beaux

I.B.1.a - SEVILLE. MUSEO ARQUEOLÓGICO PROVIN-
CIAL

García y Bellido, Antonio, 1903-
 Catálogo de los retratos romanos.del Museo
Arqueológico Provincial.Sevilla..Madrid,1951
 25 p. illus.

N.Y.P.L.
3-MAR
p.v.1322 Bibliogr.footnotes

I.B.1.a - SMITHSONIAN INSTITUTION. NATIONAL
COLLECTION OF FINE ARTS

For publications after 1980 see

I.B.1.a - NATIONAL MUSEUM OF AMERICAN ART (U.S.

I.B.1.a - SIBIU, MUZEUL BRUKENTHAL
see
I.B.1.a - MUZEUL BRUKENTHAL

I.B.1.a - Smithsonian Institution. National Gallery of
₆Ar
For publications before 1937,
see
Smithsonian Institution. National Collection of
Fine Arts

For publications after 1937,
see
U.S. National Gallery of Art

66

I.B.1.a - SMITHSONIAN INSTITUTION. NATIONAL
PORTRAIT GALLERY
see
I.B.1.a - NATIONAL PORTRAIT GALLERY, WASH., D.C.

NE
240
K64S72X
NPG

I.B.1.a -

Stanford University. Libraries. Division of
Special Collections
Portraits: a cat.of the engravings,etchings,
mezzotints,and lithographs presented to the
Stanford Univ.Library by Dr.and Mrs.Leon Kolb.
Comp.by Susan V.Lenkey..Stanford,Calif..Stan-
ford University,1972
373 p. 1 illus.

Listed by sitters,indexed by social and
historical positions of the subjects; painters
with their sitters; engravers; techniques

LC NE240.K64S72

AP
1
S72
NPG
v.13

I.B.1.a - SOC.FOR THE PRESERVATION OF N.ENGL.
Bolton, Ethel(Stanwood), 1873-1954 «ANTIQUITIES
Two notable wax portraits

In:Old Time N.Engl.
13:3,6,8,10,13 July,'22 illus.

Two acquisitions by the Soc.for the Preser-
vation of N.Engl.Antiquities

Repro.:Rauschner;Washington,by Patience
Wright;Geo.M.Miller;Ball-Hughes

LC F 1.S68

I.B.1.a - STOCKHOLM, NATIONALMUSEUM

Stockholm,Nationalmuseum,svenska porträttarkivet.
Index över svenska porträtt,1500-1850 i
svenska porträttarkivets smalingar..Stockholm.
Nordisk rotogravyr.1935-43.

Met
115.01
st6

3 v. illus
v.1:A-K, v.2:L-Z, v.3:royal portrs:medieval,
Gustav I to Karl XII; v.1 & 2 mostly ptgs,
v.3:seals,murals,tombstones,wood,coins,medallions,
MSS.,etc.

LC N7610.S9S8 Rep.,1936#347

ND
1320
I115
NPG

I.B.1.a - SOLIGALICH REGIONAL MUSEUM
Ilmshchikov, Savelii Vasil'evich
Kostromskie portrety(Kostroma portraits)-
18-19th centuries;new discoveries.Cat.of an
exhibition of portraits from the Soligalich
Regional Museum of the Kostroma Oblast...exhi-
bited at the State Russian Museum in Leningrad.
Leningrad,1974
4 p.(text) 31 illus.(col.cover)

In Russian

757.7
.S86

I.B.1.a - STOCKHOLM, NATIONALMUSEUM

Stockholm. Nationalmuseum
Nationalmusei miniatyrsamling,den Wican-
derska samlingen och museets övriga miniatyrer.
Stockholm,«P.A.Norstedt & söner.1929
100 p. illus.

"Inledning"signed:Axel Sjöblom

LC ND1335.S8

I.B.1.a - SOUTH AFRICAN NATIONAL GALLERY, CAPE
«TOWN

South African National Gallery, Cape Town
Portraits from the permanent collection,cat.
of special exh.at the occasion of Cape Town's
2nd festival,April 1977
49 numbers

Intro.by L.McClelland incl.a brief consider-
ation of the history of portr.painting

English and Afrikaans

OCDMA

I.B.1.a - STOCKHOLM, NATIONALMUSEUM

Stockholm - Nationalmuseum - Glass
Nationalmusei småskriften 11
Hernmarck, Carl
Graverade glas i Nationalmusei samlingar.
Stockholm.«National museum.,1946

Met
142.6
H43

19 p. illus.

Bibliography

German & Scandinavian engraved glasses from
17th c. to present. Incl:portrs.:Charles VI, Gus-
tavus Adolphus,Fre—derick William I,Francis I,
etc. Rep.,1945-47#721

I.B.1.a - STAFFORD HOUSE

Lenoir, Alexandre, 1761-1839
The Lenoir collection of original French
portraits at Stafford House.Auto-lithographed by
Lord Ronald Gower.London,Maclure & Macdonald...
1874

illus.

From Francis I till Marie-Antoinette

LC N7604.L36 Amsterdam,Rijksmus.,cat.
Rare book coll. Z5939A52,deel 1, p.146

I.B.1.a - STONY BROOK,N.Y.,SUFFOLK MUSEUM
see
I.B.1.a - SUFFOLK MUSEUM, STONY BROOK, N.Y.

Bibliography on Portraiture —Classified Arrangement

759.1
K72s
and
ND
1311
K5X
NPG

I.B.1.a - STRATFORD HALL, WESTMORELAND CO., VA.

Knoedler,H.,& company, New York
Stratford;the Lees of Virginia and their
contemporaries...April 29 through May 18,1946.
New York,Knoedler galleries.1946.
47 p. illus.

List of officials of the Rbt.E.Lee Memorial
Foundqtion inserted at end.

LC ND1311.K5

I.B.1.a - THESSALONIKI. ARCHAEOLOGICAL MUSEUM

Andronicon, Manolis
Portrait de l'ère républicaine du Musée de
Thessalonique

In:Acad Inscr Paris Mon et Mém
51:37 ff. 1957

LC N13.A25 fol. Richter,G.Portrs.of the
Greeks,v.3,p.293 N7566.53

705
A56
NCFA
v.116

I.B.1.a - STURBRIDGE,MASS., OLD STURBRIDGE VIL-
.LAGE
Curtis, John Obed
Portraits at Old Sturbridge Village

In:Antiques
116:880-9 Oct.,'79 illus(col.)

FOR COMPLETE ENTRY
SEE MAIN CARD

AP
1
A51S2
NCFA

I.B.1.a - THOMAS GILCREASE INSTITUTE OF AMERI-
CAN HISTORY AND ART, TULSA,OKLA.
Viola, Herman J.
Portraits,presents,and peace medals:Thomas
L.McKenney and the Indian visitors to Washing-
ton

In:Am.Scene
11,no.2 June,1970 illus(part col.)

Incl.documentation of portrs.by Chs.Bird
King in the Ths.Gilcrease Inst.of Am.Hist.& Art,
Tulsa,Okla.

Viola.Ind.legacy...N40.1
K52V7 Bibl.

N
40.1
M923S9
NPAA

I.B.1.a - SUFFOLK MUSEUM, STONY BROOK, N.Y.

Suffolk Museum, Stony Brook, N.Y.
The Mount brothers.Suffolk Mus.& Carriage
House,1967
49 p. illus.

Henry Smith Mount,Shepard Alonzo Mount,
William Sidney Mount

Shepard Alonzo Mount & Wm.Sidney Mount
ptd. genre,landscapes,etc. and portraits.

Text& cat.by Jane des Grange

AP
I
T683
NCFA
v.11

I.B.1.a - TORONTO. ROYAL ONTARIO MUSEUM

Hickl-Szabo, Heribert, 1920-
Portrait miniatures.Amassing a collection

In:Rotunda
11,no.1:12-7 Spring,'78 illus(part col.)

Six miniatures, acquired by the Royal
Ontario Museum,Toronto

I.B.1.a - SWEDISH NAT'L PORTRAIT GALLERY
see
I.B.1.a - GRIPSHOLM SLOTT. STATENS PORTRÄTTSAML'G

ND
1335.C2
T677
1981X
NPG

I.B.1.a - TORONTO. ROYAL ONTARIO MUSEUM

Hickl-Szabo, Heribert, 1920-
Portrait miniatures in the Royal Ontario
Museum....1981.
60 p. chiefly illus(part col.)

16-19th c.,arr.chronologically

VF

I.B.1.a - SYRACUSE UNIVERSITY. JOE AND EMILY
LOWE ART CENTER
Artist portraits and self portraits, selections
from the Syracuse University Art collection
Exh.in the Joe and Emily Lowe Art gallery,
Oct.1-22,1978
8 p. cover illus.

Checklist of prints,drags.,ptgs.,sculptures

I.B.1.a - TÜBINGEN. UNIVERSITÄT

Scholl, Reinhold
Die bildnissammlung der Universität Tübin-
gen,1477-1927.Stuttgart,Müller,1927
63 p. illus. (Verein für Württembergi-
sche Familienkunde,Schriften,v.?)

VET
276.?
Sch62

Bibliography

MH Ekkart in:Wolstenholme,
1977 p.22

68

ND
1311.2
F29
NFC

I.B.1.a - UNION COLLEGE, SCHENECTADY, N.Y.

Feigenbaum, Rita
 American portraits,1800-1850;a cat. of early
portraits in the collections of Union College.
Schenectady,N.Y.,Union College Pres,1972
 155 p. illus(part col.)

 originally presented as the author's thesis
(M.A.)Union College,1966-67
 Bibliography p.143-50
 Index

LC ND13311.2F4 1972 Art Books 1950-79 Z5937
 .A775 NCFA Ref. p.897

AP1
A784
A4
NCFA
v.5

I.B.1.a - U.S. - LIBRARY OF CONGRESS

Wright, Helen
 Some rare old portraits

In:Art & Archaeol
5:275-84 May,'17 illus.

 Pertains to coll.at U.S.Library of Congress
of ca.500 engr.portrs.of noted men,fr.3rd-18th c.

 Repro.:Drevet after Bossuet;Bracquemond after
Holbein;Steinla after Raphael;Forster after Dürer;
Benj.Smith after Hogarth;Masson after Mignard;
Goya after Velasquez Cumulated Mag.subj.index
 a1/3/C76 Ref. v.2,p.444

709.75
W4F2
NGA

I.B.1.a - U.S. - CAPITOL

Fairman, Charles Edwin, 1854-
 ...Art and artists of the Capitol of the U.S.
of America....1927
 526 p. illus(incl.portrs.)

LC N853.F4 Weddell.A men'l vol.of Va.
 hist.portraiture.757.9.W38
 NCFA Bibl. p.434

NE
53
W3U554
NCFA

I.B.1.a - U.S. LIBRARY OF CONGRESS. PRINTS &
 PHOTOGRAPHS DIV.

U.S. Library of Congress. Prints and photo-
 graphs division.
 ...Catalog of the Gardiner Greene Hubbard
collection of engravings...compiled by Arthur
Jeffrey Parsons...Washington,Govt.print.off.,
1905
 517 p. illus.

 Contents.:...Catal.of engravers...Portrait
index...

LC NE53.U5H8 1905 Levis.Descr.bibl.Z5947A3
 166 1974 p.221

ND
1311
U52
1900

I.B.1.a - U.S. DEPARTMENT OF STATE

U.S. Department of State
 Descriptive catalogue of the collection of
portraits in the Department of state.Washing-
ton,Govt.print.off.,1900
 13 p.

LC N7593.A2 1900

ND
1311.2
P61x
NPG

I.B.1.a - UNITED STATES MILITARY ACADEMY, WEST
 Steadman, William F. POINT
 The Sully portraits at West Point
Miles, Ellen Gross corp.
 Portrait painting in America.The nineteenth
century.N.Y....,1977 (card 2)

 Partial contents:...Wm.E.Steadman.The Sully
portrs.at West Point,p.62-5;...

qE
209
U54
1975X
NMAA

I.P.1.a - U.S. LIBRARY OF CONGRESS

U.S. Library of Congress
 The American Revolution in drawing and
prints,a checklist of 1765-1790 graphics in
the L.C. Corp. by Donald H.Cresswell,with a
foreword by Sinclair H.Hitchings.Washington,
1975
 455 p. illus.

 Bibliography p.414-22

VF
Evanston
Illinois

I.B.1.a - U.S. NATIONAL GALLERY OF ART

Evanston,Ill., Terra Museum of American Art
 American naive painting from the National
Gallery of Art.Cat.by Ronald McKnight Melvin.
Foreword by John Wilmerding.Exh.Dec.19,1981-
March 4,1982
 32 p. illus(part col.)

 Bibliography

 (Paintings from the Garbisch collection)

AP
1
W78
v.6
NCFA

I.B.1.a - U.S. LIBRARY OF CONGRESS

Kaplan, Milton, 1918-
 Heads of States

In:Winterthur Portf.
6:135-150 illus.

 Altered plates

 Repro.All of prints in the LC

705
A784
NCFA
v.42

I.B.1.a - U.S. NATIONAL GALLERY OF ART

American primitive painting.An anthology of
 the,coll.of Edg.Wm.& Pernice Chrysler
Garbisch

In:Art in Am
42:95-170 May,'54 illus.

 Incl.:Foreword by Edg.Wm.& Bernice Chrys-
ler Garbisch,refers to the fact that their
coll.is going to the National Gallery of Art,
p.95;Ptgs.for the people by Alice Winchester,
p.96;Portr.gall.of provincial America by Frank
O.Spinney,p.98 Illus.p.97,99-105
154-6

ND
207
U56
pt.1-2
NCFA
NPG

I.B.1.a - U.S. NATIONAL GALLERY OF ART

U.S. National Gallery of Art
American primitive paintings from the coll
of Edgar William and Bernice Chrysler CARBISCH
pt.I and II.Washington,NGA 1954 and 1957
2 v.in 1 illus.

Pt.I:Exh.of the gift of 300 ptgs.& 200 mi-
niatures
Pt.II:Exh.of a selection of the Carbisch
collection

Flint Inst.of Arts.ND210.4
P7F5 1981X MIAA bibl.p.91

N
40.1
C36D6
NCFA

I.B.1.a - U.S. NATIONAL MUSEUM. CATLIN COLL.

Donaldson, Thomas Corwin, 1843-1898
The George Catlin Indian gallery in the
U.S.National museum(Smithsonian inst.)with me-
moirs and statistics...Washington, D.C.,1887
939 p. illus.

Bibliography by George Catlin

From the Smithsonian report for 1885

LC E77.C45

Viola.The Indian legacy...
N40.1/K52V7 NPG Bibl.

Portrs.
Italian

I.B.1.a - U.S. National gallery of art

Monsen, Christine
A comparative study of 16th c.Italian
male portraits in the National Gallery with
a brief discussion of General Portraiture.
Typewritten MS.,1984
12 p. illus.

Bibliography

I.B.1.a - U.S. - WAR DEPT. INDIAN GALLERY
see
I.B.1.a - WASHINGTON, D.C. .INDIAN GALLERY IN
THE DEPARTMENT OF WAR.

705
A7832
NCFA
v.34

I.B.1.a - U.S. NATIONAL GALLERY OF ART

Seymour, Charles, 1912-
A group of royal portrait-busts from the
reign of Louis XIV.in the National gallery,Kress
collection.

In:Art Bull.
34:285-96 Dec,1952 illus.

Systematic evaluation of stylistic diversity
of official sculpture in France,ca.1700
Repro:Coysevox,Prou,Girardon,etc.

Enc.of World Art,v.11
N31E56 Ref.,col.513
bibl.on portr.

I.B.1.a - VATICAN. MUSEO VATICANO. MUSEO PRO-
FANO LATERANENSE

Giuliano, Antonio
Catalogo dei ritratti romani del museo pro
fano lateranense,con prefazione di Filippo Mag,
Città del Vaticano.Tipografia poliglotta vatica
na,1957
103 p. illus. (Monumenti vaticani di
archeologia e d'arte. 10)

Bibliography

NNC CU DDO MdBWA etc.
Hiesinger.Portr.in the Rom
Rep.Bibl.In:Temporini.Auf
stieg u.niederg. LC D02
T36,Bd.1,T4,p.824

705
C75
NCFA

I.B.1.a - U.S. NATIONAL GALLERY OF ART

Comstock, Helen
Quattrocento portrait sculpture in the
National Gallery,Washington

In:Conn.
122:45-9 Sept.,'48 illus.

Busts by Mino da Fiesole, Verrochio, Deside
rio da Settignano, Laurana, Ant.Pollaiuolo;
Busts by Lombard School

Portr.bust.Renaiss.to En-
lightenment.NB1309.P6x NPG
Bibl.

I.B.1.a -

Vatico. Museo archeologico
I ritratti..Di Gustavo Traversari.Roma,Ist.
poll.rafico dello Stato.Libreria,1968
125 p. illus. (Cataloghi dei musei e gal-
lerie d'italia)

Bibliography

LC N7585.V4

Fogg,v.11,p.330

759.1
.C37M4

I.B.1.a - U.S. NATIONAL MUSEUM. CATLIN COLL.

Matthews, Washington, 1843-1905
The Catlin collection of Indian paintings.

In:U.S. National museum. Annual report. 1890.
Washington,1891 p.593-610 illus. Reprint,
1892.
Reprint of a lecture delivered in...the Na
tional museum,Saturday,April 13,1889

LC Q11.U5 1890

I.B.1.a - VERSAILLES

Hitchcock, Agnes
Interesting portraits at Versailles

In:Fine Arts J
31:405-21 Aug,'14 illus.

LC N1.F5

Cumulated Mag.subj.index
A1/3/C76 Ref. v.2,p.444

I.B.1.a - VERSAILLES. MUSÉE NATIONAL

Horsin-Déon, Léon
 Essai sur les portraitistes français de la
renaissance,contenant un inventaire raisonné de
tous les portraits du 16e siècle des musées de
Versailles et du Louvre.Paris,Impr.Ve P.Larousse
et cie.,1888
MFT 212 p.
186
H78
FOGG
Deposit libr.

Amsterdam,Rijksmus.cat.
Z5939A52,deel 1,p.489

705 I.B.1.a - VICTORIA & ALBERT MUSEUM,SOUTH KENSINGTON
B97
NCFA Millar, Oliver, 1923-
v.94 The Brunswick Art Treasures at the Victoria
 & Albert museum:The Pictures

In:Burl Mag.
94:267-8 Sep,1952 illus.

 Repro:Honthorst, Cotes, Zoffany, Ramsay

Enc.Of World Art,v.11
N31E56 Ref.col.513
bibl.en portr.

ND I.B.1.a - VERSAILLES. MUSÉE NATIONAL
1316.3
G67 Gordon, Alden R.
1983X Masterpieces from Versailles.Three centuries
NPG of French portraiture.Cat.of E:h.at the Nat'l
2 c. Portrait Gall.,Washington,D.C.,Nov.11,1983 to
 Jan.8,1984.Washington,D.C.,Publ.for the NPG by
 Smithsonian Inst.Press,1983
 127 p. illus(part col.)

 Incl.:Index:Artists and sitters
 Bibliography
 Foreword by Alan Fern
 Preface by Pierre Lemoine

NB I.B.1.a - VICTORIA & ALBERT MUSEUM, SOUTH KEN-
1305 SINGTON
G7W45x Whinney, Margaret Dickens
NPG English sculpture 1720-1830...London,H.M.
 Stationery Off.,1971
 160 p. illus. (Victoria & Albert Museum
 Museum monograph,no.17)

 Bibliographical references

Yale ctr.f.Brit.art Ref.

705 I.B.1.a - VERSAILLES. MUSÉE NATIONAL
C28
v.23 Bouchot, Henri François Xavier Marie, 1849-1906
 Les nouvelles salles de portraits au musée
 de Versailles

In:Gaz Beaux Arts
23:365-82 May,1900 illus.

 Main interests in portra of important
 French people of the 15th & 16th c.
 Incl.Spanish,Flemish & Dutch portrs of the
 17th c.

AP I.B.1.a - VICTORIA AND ALBERT MUSEUM, SOUTH KEN-
1 SINGTON
W225 Kitson, Sydney Decimus, 1871-
NCFA Notes on a collection of portrait drawings
v.21 formed by Dawson Turner

In:Walpole Soc.
21:67.-104 illus. 1932-1933

 "In 1927 2 v.of portr.drawgs.were sold at
 Sotheby's & bought by the V.& A.mus. ..."

 Repro.incl.J.P.Davis,Cotman,Chantrey,Varley
 etc.
LC N12.W3,v.21 Fogg,v.11,p.323

I.B.1.a -

Versailles. Musée national
 Portraits

In:Versailles. Musée national
 Notice historique des peintures et des
 sculptures du Palais de Versailles.Paris,Impr.
 de L.Thomassin et cie.,1838
 766 p.

 3.ptie.-Portraits

LC N2180.A6 Fogg,v.11,p.326

705 I.B.1.a - VICTORIA AND ALBERT MUSEUM, SOUTH KEN-
.C75 SINGTON
NCFA Long, Basil Somerset, 1881-
v.92 On identifying miniatures

In:Connoisseur
92:298-307 Nov,'33 illus.

 Critical methods of identifying English mini-
 atures,chiefly of the 18th c.

 Repro.:I.Oliver,N.Hilliard,Chr.Richter,S.T.
 Roche,G.Engleheart,J.Smart,Jer.Meyer,A.Plimer,
 J.Barry,R.Cosway,R.Crosse,N.Plimer,Wm.Wood, etc.
 Almost all in Vic- toria and Albert mus.,S.
 Kensington

NC I.B.1.A - VERSAILLES. MUSÉE NATIONAL
860
P23 Bouchot, Henri François Xavier Marie, 1849-1906
NPG Les portraits aux crayons de 16e et 17e s.
 conservés à la Bibl.Nat.(1525-1646). Paris,
 H.Oudinet Cie,1884
 412 p. illus.

 Incl.:Listes de crayons ou peintures conservés
 dans des coll.publ.ou privées.Étrangères.A la
 Bibl.nat.France:Bibl.d'Arras-Bibl.desArts-et-Mé-
 tiers-Coll.de }.Courajod-Ancien Cabinet Fontette-
 Mus.du Louvre(dessins et peinture)-Portrs.peints
 du Mus.de Versailles
LC N7621.P3

708.2 I.B.1.a - VICTORIA AND ALBERT MUSEUM, SOUTH
V62 KENSINGTON
 Victoria and Albert museum,South Kensington
 ...a picture book of portrait busts.London,
 Publ.under the authority of the Board of Edu-
 cation.1927.
 4 p. 20 pl. (Its Picture book,no.23)

708.2
V622
.12,
NCFA

I.B.l.a -

Victoria and Albert Museum, South Kensington
 Portrait drawings.London,H.M.Stationery
Off.,1948,1963 printing
 [32]p. chiefly illus. (Small picture
book,12)

Yale ctr.f.Brit.art Ref.

I.B.l.a

Victoria and Albert Museum, South Kensington.
 National art library.
 A catalogue of engraved national portraits
in the National Art Library, with a prefatory
note by Julian Marshall. London,1895
 523 p.

MET
276.5
V66

Amsterdam,Rijksmus.cat.
Z5939A52,deel 1,p.151

708.2
V622
.11,
NCFA

I.B.l.a - VICTORIA AND ALBERT MUSEUM, SOUTH KEN-
 [SINGTON

Victoria and Albert museum, South Kensington
...Portrait miniatures.London.1948.

MiD OC1MA have 1959 reprint

FOR COMPLETE ENTRY
SEE MAIN CARD

qN
6756
C593
NMAA
2 c.

I.B.l.a - VICTORIA, AUSTRALIA. NATIONAL GALLE-
 [RY, MELBOURNE
Clark, Jane, 1955-
 The great eighteenth century exhibition in
the National Gallery of Victoria.[Melbourne,
Nat'l Gall.of Victoria,1983.
 179 p. illus.(part col.)

 Ch."The proper study of mankind is man",
some 18th c.people,pp.137-61
 Additional portrs.p.115,118,(Luigi Boccheri-
ni)p.123. Busts p.106. Miniatures p.48-9.
Groups p.18,p.22-3,p.28,30,110,122
 Portraits within portraits p.27,54

I.B.l.a - VICTORIA AND ALBERT MUSEUM, SOUTH
 [KENSINGTON
Reynolds, Graham, 1914-
 Samuel Cooper's pocket-book...London,Victo-
ria and Albert Museum,1975
 21 p. illus. (Victoria and Albert Mus.
brochure 8)

 Bibl.references

LC ND1337.G8C667

AP
1
V65
NCFA

I.B.l.a - VICTORIA,AUSTRALIA. NATIONAL GALLERY,
 [MELBOURNE
Burke, Joseph T., 1913-
 Romney's Leigh family(1768):A link between
the conversation piece and the Neo-Classical
portrait group

IN:Ann'l B.of NGA of Victoria
2:5-14 1960 illus.

I.B.l.a - VICTORIA AND ALBERT MUSEUM, SOUTH KEN-
 SINGTON Dept.of paintings
Victoria and Albert museum, South Kensington
 Dept.of paintings
 Paintings,water-colours and miniatures/C.M.
Kauffmann.London,H.M.Stationery Off.,1978
 24 p. illus. (V.&A.Mus.departmental
guides)

N.Y.(city)P.L.Art & archi-
tecture Div.Bibl.guide to
art & architecture 25976.
.A78I 1949 NCFA Ref. p.359

LC N1150.A85

I.B.l.a - VIENNA. KUNSTHISTORISCHES MUSEUM

Dimier, Louis, 1865-1943
 Die französischen bildnisse in der porträt-
sammlung des Erzherzogs Ferdinand von Tirol.
 Portraits.

MET
100.53
J191
Q
v.25

In:Jahrbuch der kunsthistor.Sammlungen des aller-
höchsten Kaiserhauses
25:219-25 Wien 1904 illus.

ND MB NN
LC N3.J4

L
40.1
M956xR7
NCFA

I.B.l.a - VICTORIA AND ALBERT MUSEUM, SOUTH KEN-
 SINGTON Dept.of prints and drawings
Mulready, William, 1786-1863
 Drawings by William Mulready.:Cat.of draw-
ings in the Victoria and Albert Museum.by.Anne
Rorimer.London,Victoria and Albert Museum,1972
 173 p. illus.

 Incl.bibliography

 Ch.VI.Portraits and heads,p.108-20

Noon.Engl.portr.drags.&min.
NC860.N66X NPG Bibl. p.147

N
7621.2
A9V66
NPG

I.B.l.a - VIENNA. KUNSTHISTORISCHES MUSEUM

Heinz, Günther
 Porträtgalerie zur geschichte Österreichs
von 1400 bis 1800.Kat.der gemäldegalerie.Bear-
beiter des kat.G.Heinz und Karl Schütz.Wien,
Kunsthist.Mus.,1976
 316 p. illus(part col.) (Führer durch
das Kunsthist.Mus.,no.22)

 1976:This "Porträt Galerie"is temporarily
exhibited in Schloss Ambras,near Innsbruck

 List of sitters,p.301-6;List of artists,
p.307-16;Genealo- gical tables,p.317ff.

I.B.1.a - VIENNA. KUNSTHISTORISCHES MUSEUM

Kenner, Dr.Fr.
 Die porträtsammlung des Erzherzogs Ferdinand
von Tirol

In:Jb.d.kunsthist.sammlungen des Österr.kaiserh.
Bd.XIV:37-186:Geschichtey der Slg:D.Bildnisse d.
Erzhauses Habsburg(1893);Bd.XV:147-259:D.deut-
schen Pildnisse.Wundermenschen(1894);Bd.XVII:101-
274:Ital.Bildn.(1896);Bd.XVIII:135-261:D.Medici.
Neapel,Celebritäten(1897);Bd.XIX:6-146:Spanien,
Portugal,Frankr.Engl.Schottld. Der Orient(1898)

LC N3.J4 Rave,P.O. Paolo Giovio u.
 s.bildnisvitenbücher...
 Jb.d.Berl.Mus. I 1959:144
 footnote LC N3.J16 fol.

I.B.1.a -

Vienna. Nationalbibliothek
 Die vertreter des schöngeistigen schrifttums
mit literarhistorikern und philologen in der
porträtsammlung der Österreichischen National-
bibliothek;ein nachweisbehelf(ohne einzelanführ-
ung der vorhandenen bildnisse).Wien,G.Prachner,
1963
 364 p. (Museion:Veröffentlichungen der
Österr.Nat'l bibl. 3.Reihe.Veröffentlichungen
der porträtsammlung,Bd.1)

DLC Fogg,v.11,p.326

I.B.1.a

Vienna. Kunsthistorisches Museum
 Die porträtsammlung des Erzherzogs Ferdinand
von Tirol;vorwort von A.Loehr. Wien,Verlag der
Kunsthistorischen sammlungen,1932. S.
MET 92 p. (Führer durch die Kunsthisto-
276 rischen sammlungen in Wien,v.17)
V67
FoGG
66 Compiled by Gerhart B.Ladner
V66mg
1932
V&A under Ladner

I.B.1.a - VIENNA. NATIONALBIBLIOTHEK.BILDARCHIV

Pauer, Hans
 Das Bildarchiv der Österreichischen Nati-
onalbibliothek,ein institut zur öffentlichen
pflege der dokumentarphotographie.Geschichte
und programm.Wien,Gallus-Verlag,c.1947.
 130 p. illus.

 Repro.incl.:Photo of Leon Gambetta;Johann
Strauss with Johannes Brahms
 Appendix p.117 lists :Reproduktionsplatten
aus abteilungen der Österr.Nat'lbibl.500001-
600000 Porträtsammlung(Graphik und foto)
LC Z794.V66P3

I.B.1.a - VIENNA. KUNSTHISTORISCHES MUSEUM

Keil, Luis
 Os retratos de personagens portuguesas da
colecçao do arquiduque Ferdinando do Tirol

In:b.Acad.nac.belas artes
15:18-22 1946 illus.

Portuguese personalities in the miniature coll.
of archduke Ferdinand of Tyrol,brought together
from 1563 on

LC N16.A6613 Rep.,1948-49*1027

I.B.1.a - VIENNA. NATIONALBIBLIOTHEK.PORTRAIT-
 SAMMLUNG
Beetz, Wilhelm, 1892-
 ...Die Porträtsammlung der Nationalbiblio-
thek in ihrer entwicklung...Graz.Verlag der
Deutschen vereins-dr.a.g.,1935
 60 p. illus.

 Bibliography

LC N1700.B4 VF Vienna.W.G.Wieser.Ein
 Institut für Bilddokumen-
 tation...footnote 1

I.B.1.a - VIENNA. KUNSTHISTORISCHES MUSEUM -
 MÜNZEN-MEDAILLEN-SAMMLUNG
Domanig, Karl, 1851-1913 ed.
 Porträtmedaillen des erzhauses Österreich
von Kaiser Friedrich III.bis Kaiser Franz II.,aus
der medaillensammlung des allerhöchsten kaiser-
hauses. Wien,Gilhofer & Ranschburg,1896
MET 40 p. illus. (Kunsthistorische sammlungen
140.92 des allerhöchsten kaiserhauses)
D71
Q

MH MBuG CaOTP TU MiBJ Amsterdam,Rijksmus.,cat.
 Z5939.A52,deal 2,p.683

AP I.B.1.a - VIRGINIA HISTORICAL SOCIETY,RICHMOND
1
V81 Virginia Historical Society, Richmond
NPG Cat.of portraits in the coll.of the Virgi-
v.35 nia Historical Society.With a tentative plan
 for their Arrangement in Virginia House

 In:Va.Mag.Hist.Biogr.
 35:57-69 Jan.,'27

 Winterthur Mus.Libr.
 fZ881.W78 v.6 NCFA,p.225

I.B.1.a - VIENNA. NATIONALBIBLIOTHEK

Gesellschaft der bilder-und miniaturfreunde,
 Vienna
 Das gemalte kleinporträt.I.Das kleinporträt
in den handschriften der Nationalbibliothek...
Wien,Selbstverlag,1931

LC Jdc45.931G. FOR COMPLETE ENTRY
 CtY SEE MAIN CARD

q F I.B.1.a - VIRGINIA HISTORICAL SOCIETY, RICHMOND
225
V87 Virginia Historical Society, Richmond
1981X Portraits in the coll.of the Virginia His-
NPG torical Society.Cat. comp.by Virginius Cornick
 Hall,jr. Charlottesville,Univ.Press of Va.,1981
 283 p. illus(part col.)

 Index of artists & their subjects

 Oils,W.C.,pastels,drags.,silhouettes,cameos,
 reliefs,sculpture

757.0838 I.B.1.a
.V81
 Virginia historical society, Richmond
 Portraiture in the Virginia historical socie-
ty, with notes on the subjects and artists by
Alexander Wilbourne Weddell. Richmond,Virginia
historical society, 1945
 192 p. illus.

LC N716.V44A55

NT I.B.1.a - VIRGINIA. STATE LIBRARY, RICHMOND
7593.8
V8H92 Hummel, Ray Orvin
NPG Portraits and statuary of Virginians owned
by the Va.State Library,the Medical College of
Va.,the Va.Mus.of Fine Arts and other state
agencies;an illustr.cat.by R.O.Hummel and Ka-
therine M.Smith.Richmond,The Va.State Library,
1977
 160 p. illus. (Va.State Libr.publ.no.43)

 Bibliography
Incl.indexes
 Va.Hist.Soc.,Richmond
 Portrs...qF225.V87 1981X
 NPG p.XV

N I.B.1.a - VIRGINIA, MEDICAL COLLEGE, RICHMOND
7593.8
V8H92 Hummel, Ray Orvin
NPG Portraits and statuary of Virginians owned
by the Va.State Library,the Medical College of
Va.,the Va.Mus.of Fine Arts and other state
agencies;an illustr.cat.by R.O.Hummel and Ka-
therine M.Smith.Richmond,The Va.State Library,
1977
 160 p. illus. (Va.State Libr.publ.no.43)

 Bibliography
Incl.indexes
 Va.Hist.Soc.,Richmond
 Portrs...qF225.V87 1981X
 NPG p.XV

I.B.1.a-WALLACE COLLECTION, LONDON

Wallace Collection, London
 Miniatures and illuminations...Wallace coll.
1935

LC ND1335.L6 **FOR COMPLETE ENTRY
SEE MAIN CARD**

AP I.B.1.a - VIRGINIA MUSEUM OF FINE ARTS, RICH-
1 MOND
A79 Bunnell, Peter C.
NCFA Gertrude Käsebier
v.16
 In:Arts in Virg.
 16:2,4 Fall,'75 illus.

 'The Virg.mus.coll.of K.'s photographs re-
presents an excellent cross-section of her ex-
pression and style.'-Artbibl.

 Artbibl.modern,v.7,no.2
 1976 qZ5935.L105 NCFA #5342

I.B.1.a - WALLACE COLLECTION, LONDON

 Reynolds, Graham, 1914-
 Wallace collection:Cat.of miniatures.
London,Trustees of the Wallace Coll.,1980
 366 p. illus(part col.)

 Incl.:Indexes
 Bibliography

 Review by Murdoch in:Burl.Mag.v.124:450-1,
July,1982

LC ND1335.07L68 1980

N I.B.1.a - VIRGINIA MUSEUM OF FINE ARTS, RICHMOND
7593.8
V8H92 Hummel, Ray Orvin
NPG Portraits and statuary of Virginians owned
by the Va.State Library,the Medical College of
Va.,the Va.Mus.of Fine Arts and other state
agencies;an illustr.cat.by R.O.Hummel and Ka-
therine M.Smith.Richmond,The Va.State Library,
1977
 160 p. illus. (Va.State Libr.publ.no.43)

 Bibliography
Incl.indexes
 Va.Hist.Soc.,Richmond
 Portrs...qF225.V87 1981X
 NPG p.XV

708.1 I.B.1.a - WALTERS ART GALLERY, BALTIMORE
W243
NCFA Weinberger, Martin
 A french model of the fifteenth century

 In:J.Walters Art Gall.
 9:9-21 1946 illus.

 Incl:Jean II,Duke of Bourbon by school of
Jacques Morel;Jean,Duke of Berry by Jean de Cam-
brai,Philip the Bold by Sluter;tomb effigies of
Charles I,Duke of Bourbon & Agnes of Burgundy by
Jacques Morel & Louis II,Duke of Bourbon & Anne of
Auvergne;Thomas de Plaine by Le Moiturier

N I.B.1.a -
7621
V88 Virginia. State library, Richmond
1920 ...A list of the portraits and pieces of sta-
NPG tuary in the Va.state library...Richmond,
D.Bottom...,2nd ed.,1920
 29 p. illus. (In its Bull.,Richmond,
1920,v.13,nos.1,2)

 1st ed.was prepared by Earl Gregg Swem,Bull
v.6,no.2,Apr.2,1913(In NPG bound with Garrick
Club,London.Cat.of the pictures..London,1909call
no.N7592.G24 NPG)
LC Z881.V81B no1.13 no.1/2 Weddell.A mem'l vol.of Va.
F225.V83 1920 hist.portraiture.757.9.W3
 NCFA Bibl. p.439

708.1 I.B.1.a - WALTERS ART GALLERY, BALTIMORE
.W243
NCFA Segall, Berta
 Realistic portraiture in Greece and Egypt.
A portrait bust of Ptolemy I

 In:J.Walters Art Gall.
 9:53-67,106 1946 illus.

 Coins of Ptolemy I
 Ptolemy as Dionysos

ND
1337
U5W23
NCFA

I.B.1.a

Walters Art Gallery, Baltimore
 A selection of portrait miniatures. Balti-
more,1966.
 1 v.(unpaged) illus. (A Walters Art Gallery
picture book)

LC N7616.W3

CN4
1174
NCFA

I.B.1.a - WASHINGTON, D.C. ‹INDIAN GALL.IN THE
 DPT. OF WAR.

Hodge, Frederick Webb, 1864-
 The origin and destruction of a National
Indian Portrait Gallery

In:Holmes anniversary volume,Washington,1916
pp.187-93 illus.

 T.L.McKenney & L.Cass promoted a Nat'l Ind.
Portr.Gall.Ptgs.found their way finally to the
Smithsonian Inst.,where,in 1865 fire destroyed
most of them.Incl.were ptgs.by Chs.B.King,J.O.
Lewis,A.Ford,S.M.Charles,G.Cooke,Shaw

ND
1311.8
V8W31
NCFA

I.B.1.a - WASHINGTON & LEE UNIVERSITY, LEXING-
 ‹TON,Va.

Washington and Lee University, Lexington,Va.
 Washington-Custis-Lee family portraits from
the coll.of Washington & Lee univ.,Lexington,
Va.,circulated by the International Exhibitions
Foundation,1974-1976.Intro.by Alfred Franken-
stein.Washington,D.C.,International Exh.Found'n,
c.1974
 ‹10›p. illus(1col.)

 17 portrs.,representing 6 generations of
men & women in the Washington,Custis and Lee
families
 Rila I/1-? 1975 #1365

AP
1
S66
NPG
v.3

I.B.1.a - WASHINGTON, D.C. ‹INDIAN GALLERY IN
 THE DEPARTMENT OF WAR.

Viola, Herman J.
 Washington's first museum:The Indian office
collection of Ths.L.McKenney

In:Smiths.Jl.of Hist.
3,no.3:1-18 Fall 1968 illus.

 p.10-14:The gallery of 130 portrs.of In-
dian dignitaries by Athanasius Ford and Chs.
B.King,some after sketches by J.O.Lewis

 Viola.The Ind.legacy...Bibl
 N40.1K52V7 NPG

ND
1301
H3W37X
NPG

I.B.1.a - WASHINGTON COUNTY MUSEUM OF FINE ARTS.
 HAGERSTOWN, MD.
Washington County Museum of Fine Arts. Hagers-
town,Md.
 Portraits through the ages
 12 p. chiefly illus.

 Cat.of the exh.held Aug.11th-Sept.11,1963...

I.B.1.a - WASHINGTON, D.C. NATIONAL COLL.
 OF FINE ARTS
 see
I.B.1.a - SMITHSONIAN INSTITUTION.-(NATIONAL
 COLLECTION CF FINE ARTS) NCFA

I.B.1.a - WASHINGTON, D.C. ‹INDIAN GALLERY IN
 THE DEPARTMENT OF WAR.
King, Charles Bird, 1785-1862
 Cat.of 115 Indian portraits,representing
18 different tribes...Phila.,n.p.,1836
 24 p.

 The portrs.are copies by Inman,fr.the cele-
brated coll.in the War Dept.at Washington
 Also cited in Nat'l M. & T.'s exh.cat.
"Perfect likenesses" qNE263.N37 1977X NCFA,
p.10, p.4

Arch.
Am.Art
mfm
P24
181-193

 Arch.Am.Art mfm P24 181-
 193

I.B.1.a - WASHINGTON, D.C. NATIONAL GALLERY
 ‹OF ART
 see
I.B.1.a - U.S. NATIONAL GALLERY OF ART

E
77
M155
1848
RB
NPG

I.B.1.a - WASHINGTON, D.C. ‹INDIAN GALLERY IN
 THE DEPARTMENT OF WAR.
McKenney, Thomas Loraine, 1785-1859
 History of the Indian tribes of North Ame-
rica,with biogr.sketches...of the principal
chiefs.Embellished with 120 portraits,fr.the
Indian gall.in the Dept.of war,at Washington.
Philadelphia,J.T.Bowen,1848-50
 3 v. illus(col.) octavo
 First ed.1836-44 was folio size
 "An essay on the history of the North Ame-
rican Indians.By James Hall":v.3,p.149-387

 From ptgs.chiefly by Charles Bird King

LC E77.M1305 NMHT.Perfect likenesses
 p.3

I.B.1.a - WASHINGTON, D.C. NATIONAL POR-
 TRAIT GALLERY
 see
I.B.1.a - NATIONAL PORTRAIT GALLERY, WASHINGTON,
 D.C.

E
176.1
F52X
NPG

I.B.1.a - WASHINGTON, D.C. WHITE HOUSE

First Federal Savings and Loan Association of
Worcester.
A book of the Presidents;with portraits
from the White House Collection....1971....

LC E176.1F52

I.B.1.a - WILHELMSHÖHE, KASSEL
see
I.B.1.a KASSEL. STAATLICHE KUNSTSAMMLUNGEN,
SCHLOSS WILHELMSHÖHE

705
C75
NCFA
v.192

I.B.1.a - WASHINGTON, D.C. WHITE HOUSE

Sadik, Marvin S.
Paintings from the White House

In:Connoisseur
192:22-31 May,'76 illus(part col.)

Repro.incl.:John Tyler by Healy;Sharitar-
rish by Chs.Bird King;Taft by Zorn;Mrs.van
Buren by Inman;Audubon by Syme;Jefferson by
R.Peale;Ruth Harding by Eakins

Rila III/2 1977 #7310

757
.W7159

I.B.1.a -

William and Mary college, Williamsburg,Va.
Library
...Catalog of portraits in the library and
in other buildings of William and Mary college,
by E.G.Swem...Williamsburg,Va.,1936
62 p. illus. (Bull.of the College of
William and Mary,v.30,no.6)

Incl.photographs,landscapes,maps,indentures,
etc.

LC N7621.W55

I.B.1.a - WATERVILLE,ME., COLBY COLLEGE
see
I.B.1.a - COLBY COLLEGE, WATERVILLE,ME.

ND
1337
C7W719
NPG

I.B.1.a -

William Rockhill Nelson Gallery of Art and
Mary Atkins Museum of Fine Arts, Kansas City,
Mo.
The Starr Collection of miniatures in the
William Rockhill Nelson Gallery.With introd.by
Graham Reynolds.Kansas City,1971
84 p. illus(part col.)

...patterned after...Reynolds'.book Eng-
lish portrait miniatures

LC ND1337.C7W47 Yale ctr.f.Brit.art Ref.

q?
152.5
W44
1973x
NPG

I.B.1.a -

Wellcome Institute of the History of Medicine
Portraits of doctors & scientists in the
Wellcome Institute of the History of Medicine;
a cat.,by Renate Burgess,London,Wellcome Inst.
of the Hist.of Medicine,1973
459 p. illus. (Publications of the
Wellcome Inst.of the Hist.of Medicine.Mus.cat.)

Incl.index

Bibliography

Yale ctr.f.Brit.art Ref.

I.B.1.a - WINDSOR CASTLE

Agnew(Thos.) & Sons,ltd.,London
Cat.of engraved portraits from the royal
collection,Windsor Castle on exhibition...May &
June 1906.:London.n.d.
55 p.

MET
276.5
Ag6

I.B.1.a - West Point,N.Y. United States
Military Academy
see
I.B.1.a - UNITED STATES MILITARY ACADEMY, WEST
POINT

705
C75
NCFA
v.92

I.B.1.a - WINDSOR CASTLE

Cundall, Herbert Minton, 1848-1940
Drawings at Windsor Castle.III.Some portraits

In:Connoisseur
92:75-82 Aug,'33 illus.
Repro.:Sam.Cooper,Bartolozzi,Cipriani,
Hamilton,Conway,Edridge,Buck,Ross,Lely

741.91
.P23

I.B.1.a - WINDSOR CASTLE

Parker, Karl Theodore, 1895-
 The drawings of Hans Holbein in the col-
lection of His Majesty the King at Windsor
castle...London,The Phaidon press ltd.,1945.N.Y.
Oxford Univ.Pr.
 62 p. illus.

 Bibliographical footnotes

LC NC1055.H7P3

I.B.1.a - WINDSOR CASTLE

Cust, Lionel Henry, 1859-1929
 Windsor Castle.Portrait miniatures.Privately
printed 1910

V & A

Arts Counc.of Gr.Britain
Brit.portr.min.ND133707A79
Bibliography

I.B.1.a - WINDSOR CASTLE

Oppé, Adolf Paul, 1878-1957
 The drawings of Paul and Thomas Sandby in
the coll.of H.M.the king at Windsor Castle.Ox-
ford,Phaidon Press,1947
 85 p. illus(part col.)

 Cat.p.:19.-85

LC NC1115.S3 06 Noon.Engl.portr.drags.&min.
 NC860.N66X NPG Bibl.p.147

I.B.1.a - WINTERTHUR MUSEUM, WINTERTHUR,DEL.
see
I.B.1.a - HENRY FRANCIS DU PONT WINTERTHUR MUS.

I.B.1.a - WINDSOR CASTLE

Oppé, Adolf Paul, 1878-1957
 English drawings,Stuart and Georgian pe-
riods,in the coll.of H.M.the King at Windsor
Castle.London,Phaidon Press.1950.
 215 p. illus.

LC NC1025.06 Noon.Engl.portr.drags.&min.
 NC860.N66X NPG Bibl. p.147

765
A56
NCFA
v.110

I.B.1.a - WISCONSIN. STATE HISTORICAL SOCIETY
Jensen, James F.
 19th c.Amer.ptg.& sculpt.at the State
Historical Society of Wisconsin
Antiques
 American painting .special issue.
110:965-1070, Nov.,1976 illus(part col.)
 Chiefly 18th-19th century
 Partial contents:P.C.F.Mandel,Amer.ptgs.at
the Mus.of Art,Rh.Isl.sch.of des.,p.966-75;J.S.M.
Hall & C.Dunn Fleming,Ptgs.at the New England
Hist.Genealogical Soc.,p.986-91;N.F.Little,Ptg.
in New England provincial artists,1775-1800,
p.996-1008;J.C.Luckey,Family portrs.in the 19th
Boston,p.1008-11;J.F.Jensen,19th c.Amer.ptg.&
sculpt.at the State Hist.Soc.of Wisconsin
p.1012-19;

500
W83X
NPG
(v.)

I.B.1.a - WISCONSIN. STATE HISTORICAL SOCIETY
Wisconsin. State Historical Society
 Triennial cat.of the portrait gallery of
the State Historical Soc.of Wisconsin.Comp.by
Reuben G.Thwaites and Daniel S.Durrie.Madison,
Wis.,Democrat Printing Cy.,state printers,
1889-92
 v.1

 Index of sitters.Index of artists

 Sculpture,painting,prints,photographs

I.B.1.a - WINDSOR CASTLE

The Family of Sir Thomas More.Facsimiles of
 the drawings by Hans Holbein the younger
 in the Royal Library,Windsor Castle....
 1978

 Intro.by Jane Roberts

NPG VF Holbein,Hans,the
younger

AP
1
W892
NCFA

I.B.1.a - WORCESTER, MASS. ART MUSEUM

Reutlinger, Dagmar E.
 American folk art:two groups of family por-
traits by Ruth Henshaw Hascom and Erastus Salis-
bury Field

In:Worcester Art Mus.Bull.
5,no.3:1-12 May,'76 illus.

 "Hascom cut out paper silhouette portrs.&
embellished them with charming color & imagina-
tive collage."-Reutlinger in Rila

 Rila IV/1 1978 #4033

I.B.1.a - WINDSOR CASTLE

Sandby, William
 Thomas and Paul Sandby;Royal academicians;
some account of their lives and works...London,
Seeley & co.,ltd.,1892
 230 p. illus.

 Appendices(p.:204.-224):I.Works exh.by Th.
& P.Sandby.II.Lists of their drags.in the royal
coll.at Windsor.III.Works contained in public
galleries & institutions

LC N6797.S3S3 Noon.Engl.portr.drags.&min.
 NC860.N66X NPG Bibl. p.147

ND
205
A684
NCFA
book

I.B.1.a - WORCESTER, MASS. ART MUSEUM

Amon Carter Museum of Western Art, Fort Worth,
American art from the coll.of the
Worcester Art Mus..exh..April 27-June 24,1979;
with an intro.by Rich.Stuart Telts.Fort Worth,
Tex.,Amon Carter Mus.,1979
117 p. illus.

Incl. index

LC W01311.W6 1979

N.Y.(city)P.L.Art & archi-
tecture Div..Biliographic
guide to art & architecture
1980 Z5939.A78 NCFA Ref.p 292

LD
6320
H72
NPG

I.B.1.a - YALE UNIVERSITY

Holden, Reuben Andrus, 1918-
Profiles and portraits of Yale University
presidents,....Freeport,Me.,Bond Wheelwright Co.
1968,
184 p. illus. American university his-
tory series,

Bibliography

LC LD6320.H65

NC
860
N66X
NPG

I.B,1,a - YALE CENTER FOR BRITISH ART

Noon, Patrick J.
English portrait drawings and miniatures.
New Haven,Ct.,Yale Center for British Art,1979

FOR COMPLETE ENTRY
SEE

N
7621
Y18
NPG

I.B.1.a -

Yale University
Yale University portrait index,1701-1951.
New Haven,Yale University Press,1951
185 p. illus.

Subject entries followed by index of artists

LC N590.A62

Whitehill.The Art in early
Amer.Hist.Z5935.W59 NPG
p.102

AP
1
A64
NCFA
v.105

I.B.1.a - YALE CENTER FOR BRITISH ART

Waterhouse, Ellis Kirkham, 1905-
An impressive panorama of British portrai-
ture

In:Apollo
105:230-9,244-5,247,249,251 Apr.'77 illus.
(part col.)
Discusses some portrs. in the
Paul Mellon coll.at Yale Center for British Art
ranging from c.1550-c.1850

Rila IV/1 #1133
1978

ND
1311
Y18
NPG

I.B.1.a - YALE UNIVERSITY. ART GALLERY

Yale University. Art Gallery
Early American portrait painting;by A.E.C.,
New Haven,1944
12 p. 1 illus(Roger Sherman by Ralph Earl)

Bibliography

Incl.Description of "factory system",a work-
shop system by Godfrey Kneller

Reproduction of typescript

I.B.1.a -

Yale University
A catalogue,with descriptive notices,of the
portraits,busts,etc.belonging to Yale university.
1892...New Haven,Press of Tuttle,Morehouse &
Taylor,1892.
192 p.

Prefatory note signed:F.B.D..i.e.Franklin
Bowditch Dexter,
The appendix contains lists of the authentic
portrs.in the series of Revolutionary ptgs.by
Col.Trumbull...

LC LD6325 1892 & N590.A6 1892 Fogg,v.11,p.326

qNE
230
Y18
NPG

I.B.1.a -

Yale university. Art gallery
The Edward B.Greene collection of engraved
portraits and portrait drawings at Yale univer-
sity.A catalogue comp.by Alice Wolf,with a pre-
face by Theodore Sizer.New Haven,Yale university
press;London,H.Mildford,Oxford university press,
1942
141 p. illus.

Bibliography

Prints are alphabetically arranged according
to the sitters

LC NE230.Y3
Yale Univ.Libr.for LC
Fogg,v.11,p.326

I.B.1.a - YALE UNIVERSITY

Offner, Richard, 1889-
Italian primitives at Yale university,
comments & revisions. New Haven,Yale university
press,1927

48 p. illus.

LC ND615.O4

Lipman.The Florentine pro-
file portr...:"..formulate
difference betw.primitive
abstract viewpoint & modern
optical vision.."

BX
5197
I 53X
NPG

I.B.1.a - York, Eng. BISHOPTHORPE PALACE

Ingamells, John
Catalogue of portraits at Bishopthorpe
Palace. York,Borthwick Inst.of Hist.Research,
1972
77 p. illus.

Portrs. of archbishops of York and of Hano-
verians

Incl.Bibliographical references
Incl.:Kneller,Hudson,Reynolds,West,Owen,etc.

LC BX5197.I 53

I.B.1.a - YORK,ME.,OLD YORK HISTORICAL SOC.
see
I.B.1.a - OLD YORK HISTORICAL SOCIETY, YORK,ME.

I.B.1.b - ANDRADE, CYRIL, LONDON

Andrade, Cyril
 Old English pottery,Astbury,Whieldon,Ralph
Wood;Cyril Andrade collection..London,n.d.
 .11,p. illus.(32 phot.on 29 pl.)

MET
143.C2
An24

705
Z18
NMAA
v.38

I.B.1.a - ZÜRICH. SCHWEIZERISCHES LANDESMUSEUM

Schneider, Jenny
 Hut ab vor so viel kopfbedeckungen!200 jah-
re frauenhüte und -hauben in der Schweiz

In:Z.f.schw.ArchMol.Kunstgesch.
38:305-12 Dec.,'81 illus.

 Repro.:Portrs.fr.the Portr.coll.of the
Schweizerisches Landesmuseum

I.B.1.b - APPLETON, THOMAS GOLD, 1812-1884

Boston. Public Library
 The Tosti engravings.Portraits.

In:Full.
 22 p. 1871

 List of 676 portrs.Gift of Ths.G.Appleton,
1869.Formerly in the coll.of Cardinal Antonio
Tosti

LC NE57.B7T7 1871 Levi.Descript.bibliography
 Z5947.A3L66 1974 NCFA
 p.200

I.B.1.b. PRIVATE, A-Z, by name of collector

705
C75
v.67
NCFA

I.B.1.b - APPLEWHAITE-ABBOTT, MRS.

Way, Herbert W.L.
 Apsley Pellatt's glass cameos in the col-
lection of Mrs.Applewhaite-Abbott

In:Connoisseur
67:3-10 Sept.,1923 illus.

 Repro.incl.:cameo portrs.of Nelson,Welling-
ton,George IV,Rbt.Burns,Shakespeare,George III,
Queen Charlotte,etc.
 Apsley Pellatt,1791-1863,Brit.glass manufac
turer.His process Crystallo ceramie

705
C75
NCFA
v.191

I.B.1.b - ALSOP, JOSEPH WRIGHT, 1910-

Butler, Joseph T.
 Rare portraits acquired by the National
Collection of fine Arts

In:Conn.
191:140-1 Feb.,'76 illus.

 2 portrs.by Ralph Earl,f'ly Joseph Alsop
coll.Sitters:Hannah Gilbert Wright,and Mary
Wright Alsop,both ptd.1792

VF

I.B.1.b - ARTINIAN, ARTINE, 1907-

Bowdoin College. Museum of Fine Arts
 The French visage; a century and a half of
portraiture and caricature from the Artine
Artinian collection. Brunswick,Me.,1969
 20 p. illus.

 Also shown at Currier Gallery(N.H.),Gorham (Me.)
State college, and Hopkins Center Art Gall's at Dart
mouth...

705
P18
NCFA

I.B.1.b - AMORY, EDWARD LINZEE, -1911
 (son of Martha Babcock Amory)
Comstock, Helen
 Drawings by John Singleton Copley

In:Panorama
2:99-108 May,1947 illus.

 ...More than 50 drags.fr.the Edward Linzee
Amory coll.

FOR COMPLETE ENTRY
SEE MAIN CARD

I.B.1.b - ARTINIAN, ARTINE, 1907-

New York. State University College, New Paltz.
 Art Gallery
 From Victor Hugo to Jean Cocteau.Portraits
of 19th and 20th century.French writers from
the Artinian collection.Cat.by P.J.Bohan and
A.Artinian.A loan exh.,May 26-Aug.6,1965,the
Art Gall...New Paltz,1965.
 68 p. illus.

LC N7604.N45 Rep.1967 #1146

I.B.1.b - AUSTRIA - IMPERIAL COLLECTION
Domanig, Karl, 1851-1913 ed.
 Porträtmedaillen des erzhauses Österreich
von Kaiser Friedrich III.bis Kaiser Franz II.,aus
der medaillensammlung des allerhöchsten kaiser-
hauses. Wien,Gilhofer & Ranschburg,1896
MET 40 p. illus. (Kunsthistorische sammlungen
140.92 des allerhöchsten kaiserhauses)
D71
Q

MH NBuG CaOTP TU MdBJ Amsterdam,Rijksmus.,cat.
 25939A52,deel 2,p.683

AP
1
A784.J8 Armstrong, Walter, 1850-1918
NCFA Early Italian portraits

I.B.1.b - BEATTIE, W.,Esq.

In:Art J.
146-8 1901 illus.

 Repro.:Ghirlandaio,Ambrogio de Predis,
Lorenzo di Credi,all at that time from the coll.
W.Beattie,Esq.

 FOR COMPLETE ENTRY
 SEE MAIN CARD

705
C75 I.B.1.b - BACHE, JULES.
NCFA
v.113 English portraits in the Jules Bache collection

In:Connoisseur
113:51-5 Mar,1944 illus.

 Incl. van Dyck,Gainsborough,Reynolds,Romney,
Raeburn

705
S94
NCFA Wood, T.Martin
v.62 The Beauchamp miniatures at the Victoria
 and Albert museum

I.B.1.b - BEAUCHAMP

In:Studio Sept.,'17

 FOR COMPLETE ENTRY
 SEE MA... ..D

I.B.1.b - BAGBY, GEORGE L., 1880-1962

Huntington Galleries
 The Bagby collection:Portraits in the grand
manner of the Huntington Galleries.Huntington,
W.Va.,The Galleries,1962?,
,24,p. illus.

CtY Yale ctr.f.Brit.art Ref.
 ND1314.H85

ND
1314.6 I.B.1.b - BEAVERBROOK, WILLIAM MAXWELL AITKEN,
B38 ,BARON, 1879-1964
NPO Beaverbrook Art Gallery, Fredeicton, N.B.
 From Sickert to Dali;interntaional por-
 traits;an exh.,organized by the Beaverbrook Art
 Gallery,Fredericton,New Brunswick,summer 1976
 31 p. illus.

 Bibliography
 41 works shown
 Cat.by Ian G.Lumsden
 The portrs.are mainly from the coll.donated
 by Lord Beaverbrook and Sir James Dunn.
 Exh.in commemoration of the visit of Queen
 Elizabeth II;July 15th and 16th,1976

 Rila II/2 1976 #5750

AP
1
C284 Hovey, Walter Read, 1855-
NCFA American provincial painting
v.19-20

I.B.1.b - BALKEN, EDWARD DUFF, 1874-1960
 ,PITTSBURGH

In:Carn.Mag.
20:240-4 March,'47 illus.

 Ptgs.from the coll. of Edw.Duff Balken

I.B.1.b - BEDFORD, DUKE OF, WOBURN ABBEY

Bedford, Adeline Marie (Somers-Cocks)Russell,
 duchess of, 1852-1920
 Biographical catalogue of the pictures at
Woburn Abbey.Comp.by Adeline Marie Tavistock &
Ela M.S.Russell...London, E.Stock,1890-92
 2 v. illus.

LC N7622.B4 Yale ctr.f.Brit.art Ref.
 N7622.2.G7R87B43

I.B.1.b - BALKEN, EDWARD DUFF, 1874-1960
 ,PITTSBURGH
Pittsburgh, Carnegie Institute. Dept.of Fine
 Arts
 American provincial painting,1750-1877,
 from the coll.of Edward Duff Balken.Jan.9
 through Feb.23,1947,Dept.of Fine Arts,Carnegie
 Institute,Pittsburgh?1946 or 7,
 1 v.(unpaged) illus.

PHi Colonial Williamsbg.,inc.
 The Abby Aldrich Rockefel-
 ler folk art coll.N6510.C71
 NCFA Bibl.p.104

I.B.1.b - BEDFORD, DUKE OF, WOBURN ABBEY

Bone, Henry, 1755-1834
 A set.of miniature-portraits in enamel by
Henry Bone...In the coll. of the Duke of Bedford
at Woburn Abbey.London,1825
MET 63 p. illus.
155.4
B64

 Clouzot.Dict.miniaturistes
 N7616.C64 NCFA bibl.p.XVIII

NPG | I.B.1.b - BELASCO, DAVID, 1854-1931

Weil, Elsa Allen
Wax portraiture

In:Antiquarian
10:49-52 Mar.,'28 illus.

Repro.examples in the coll.of David Belasco.

**FOR COMPLETE ENTRY
SEE MAIN CARD**

705
C75
NCFA
v.83 | I.B.1.b - BERRY, GOMER,bart.

Rutter, Frank Vane Phipson, 1876-1937
Sir Gomer Berry's paintings at Chandos
House

In:Connoisseur
83:259-70 May,'29 illus(part col.)

Repro.incl.:Raeburn, Michael Dahl, Nathaniel
Dance, Simon Verelst, Nattier, Jos.Highmore,
Hogarth, Reynolds, Cotes, Zoffany

N
613
A5
NCFA | I.B.1.b - BELKNAP, WALDRON PHOENIX,1899-1949

New York Historical Society
The Waldron Phoenix Belknap,jr.collection of
portraits and silver,with a note on the discove-
ries of Waldron Phoenix Belknap,jr.concerning the
influence of the English mezzotint on colonial
painting....Cambridge,Harvard University Press,
1955.
177 p. illus.
Edited by John Marshall Phillips...
Catalogue of the coll.which was bequeathed to
the N.Y.Historical Soc. in 1949

LC N613.A65

N
7616
B55
NCFA | I.B.1.b - BERWICK Y DE ALBA

Berwick, Jacobo Maria del Pilar Carlos Manuel
Stuart Fitz-James, 1o.duque de, 1878-
Catalogo de las miniaturas y pequeños retra-
tos pertenecientes al Excmo.Sr.duque de Berwick
y de Alba, por D.Joaquín Esquerra del Bayo.
.Madrid,Imprenta de los Sucesores de Rivadeneyra
(s.a.).1924.
180 p. illus(part col.)

LC N7616.B4

I.B.1.b - BENTINCK L.HAWKINS,Rev.W.
see
I.B.1.b - HAWKINS, WILLIAM BENTINCK L.

I.B.1.b - BINDLEY, JAMES, 1737-1818

Sotheby, firm,auctioneers, LONDON
Cat.of a...coll.of engraved British por-
traits formed by the late proprietor for the
illustration of Granger's history of England;
many...originally in the Sykes,Bindley & Dela-
bère collections...by...Elstracks...Cecil...
Vaughan...Faithorne....London,1863.
19 p.
Sale cat.Jl.22,1863 & ff.day
.The proprietor was E.Rose TUNNO'-Lugt.In:
Marques de collections.N8380.L95,NCFA,p.158,no.
.902

Not.Vales ca C.F2881.N53 NCFA v.25.B.
.023315

I.B.1.b -

Béraldi, Henri, 1849-1931
Catalogue des très beaux portraits...compo-
sant la collection de Monsieur H.B...La vente
aura lieu à Paris,Galerie Georges Petit...
.Paris,G.Petit,1928.
2 v. illus.

v.2,sale held at Hôtel Drouot,1930

Contents.-Très beaux portrs. des 17e,18e,et
19e siècles.La vente,30 Nov.et 1er déc.,1928.-
v.2. ...du 16o au 19e s. La vente,7 et 8 Avr,'30

MdBA NNC CtY

I.B.1.b

Bindley, James, 1737-1818
A catalogue of the...coll.of British por-
traits...the property of...James Bindley...which
will be sold at auction by Mr.Sotheby.London,
Wright & Murphy,printers.1819.
3 v.in 1 illus.

At head of title:The Bindley Granger
Contents.-.pt.1.From the reign of Egbert to
the Revolution of 1688.-Pt.2.From the Revolution
of1688 to the present period.-Pt.3.Miscellaneous

CN MH PP PPULC DLC Fogg,v.11,p.333
MBAt

qND
1301.5
G71667
1975X
NPG | I.B.1.b - BIRKSHIRE, EARLS OF

Ranger's House.
The Suffolk collection;cat.of paintings
...compiled by John Jacob and Jacob Simon;
photographs by Robert Evans..London,Greater
London Council.1975.
.86.p. illus.

Bibliography

mfm
124hn13
NCFA | I.B.1.b - BLAIKIE, Dr. WALTER

Murdoch, William Garden Blaikie, 1880-1934
A bequest of Stuart engravings to the Na-
tional Library of Scotland

In:Apollo
13:167-73 Mar,'31 illus.

400 items relating to the dynasty

I.B.1.b -

Boissard, Jean Jacques; 1528-1602
 Bibliotheca chalçographica,hoc est virtute
et eruditione clarorum virorum imagines, collec-
tore Iano-Iacobo Boissardo,Vesunt.,sculptore
Theodoro de Pry,Ieod.,primum editae,et ab ipso-
rum obitu hactenus continuatae.Heidelbergae,im-
pensis Clementis Ammoni,1669
 5 v. illus.

LC NE218.B6 1669 Poll,v.11,p.321

I.B.1.b - BROWN,MARY ELIZABETH(ADAMS)(MRS.CROSBY
 BROWN)1842-1917
New York. Metropolitan museum of art. Crosby
 Brown collection
 ...Cat.of the Crosby Brown coll.of musicians'
portraits...N.Y.,The Metrop.mus.of art,1904
 131 p. (The Metropolitan mus.of art.Hand-
book no.13,IV)
 Cat.by Clara Buffum

 Incl.:Classified,geographical and alphabe-
tical indexes
 NPG copy bound with Garrick club,London.Cat.
of the pictures...London,1909
LC ML390.M5 copy 2:N611.B7

I.B.1.b - BOSCOBEL
see
I.B.1.1.a - DYCKMAN, STATES, Garrison-on-Hudson,
 N.Y.

I.B.1.b - BUCCLEUCH, DUKE OF

MacKay, Andrew
 The coll.of miniatures in the Montagu
House(The property of the Duke of Buccleuch and
Queensberry) London,1896

V.&A.

 Fitzwilliam Mus. Cat.of
 qrtr.miniatures...ND1337
 7M; 1985X NPG bibl.p.222

I.B.1.b - BOURGOING

Bourgoing, Jean de, 1877-
 ...Miniaturen von Heinrich Friedrich Füger
und anderen meistern aus der sammlung Bourgoing.
Vorwort von Dr.Leo Grünstein.Zürich,Amalthea-Ver-
lag.1925.
 83 p. illus(part col.)

 Bibliogr.references

LC N7616.B72 Bildnismin.& ihre meister
 757.B59,v.4,Bibl.

I.B.1.b - BUCCLEUCH, DUKE OF

Heath, Dudley
 Some ancestors of Alphonse XIII and other
miniatures in oil in the coll.of his Grace the
Duke of Buccleuch at Montagu House

In:Connoisseur
18:137-42 July,1907 illus(part col.)

 This coll.is a valuable moment of Spain's
power in the 16th c.-Compares Northern schools
with Southern & professional miniaturists with
ptrs.who ptd.miniatures as a diversion fr.lar-
ger work

I.B.1.b - BRADFORD, EARLS OF
see
I.B.1.b - NEWPORT, EARLS OF BRADFORD, WESTON

I.B.1.b - BUCCLEUCH, JOHN CHARLES MONTAGU-DOUG-
 LAS-SCOTT, 7th duke of, 1884-
Cundall, Herbert Minton, 1848-1940
 The Buccleuch miniatures

In:Connoisseur

 FOR COMPLETE ENTRY
 SEE MAIN CARD

I.B.1.b

The Brook, New York
 The collection of portraits of American
celebrities and other paintings belonging to
The Brook. A catalogue compiled by Diego Suarez,
together with a history of The Brook...New York,
George Grady Press,1962.
 105 p. illus(part col.)

I.B.1.b - BUCCLEUCH, JOHN CHARLES MONTAGU-DOUG-
 LAS-SCOTT, 7th duke of, 1884-
Wood, T.Martin
 The Buccleuch miniatures at the Victoria
and Albert museum

In:Studio Feb.,'17

 FOR COMPLETE ENTRY
 SEE MAIN CARD

ND
1337
G7X35
NCFA

I.B.1.b - BUCCLEUCH, JOHN CHARLES MONTAGU-DOUGLAS-
SCOTT, 7th duke of, 1884-
Kennedy, H A
Early English portrait miniatures in the
collection of the Duke of Buccleuch,ed.by Charles
Holme,...London,New York,etc.,"The Studio"ltd.,
1917
44 p. illus(part col.)

LC N7616.K4

E
89
C35
NPG

I.B.1.b - BUTLER,Jr.,JOSEPH GREEN, 1840-1927
,YOUNGSTOWN, OHIO
A catalogue of Indian portraits in the coll.
of Jos.G.Butler,jr.,on free exh.at the
Y.M.C.A.bldg,Youngstown,O.,,s.n.,s.l.,
ca.1907.(Youngstown,Ohio,Vindicator Press)
39 p. illus.

The greater part of the coll.is the work
of J.H.Sharp and E.A.Burbank.Other artists re-
presented are Frederick Remington,Bert Phillips
Deming and Candy
Smithsonian "National Museum"bought 11
Sharp ptgs.,Dec.1900

I.B.1.b - BUCKINGHAM, DUKES OF

The Stowe.Oranger and other engravings;cat.of
the remaining portion of the engr.British
portrs.,comprising those fr.the reign of
James II forming the illus.copy of the con-
tinuation of the Biographical hist.of Engl.
by the Rev.Mark Noble...engrs.of the English
school.Woollett,Strange,Hogarth...Sir Josh.
Reynolds...removed fr.Stowe house,Bucking-
hamshire...sold...by...S.Leigh Sotheby & Co
...21st Mar.1849 & 5 ff.days...London 1849,
62 p.

MET
21,
X9

Priced
(For more le ,ens of this cat. see over)
Met.Sales cat.,Z881.N53 NCFA v.25,p.023318

N
6507
H57X
NPG
NMAA

I.B.1.b - BYRD, HAROLD, DALLAS,TEXAS

Hirschl & Adler Galleries,inc.,N.Y.
American art from the Colonial and Federal
periods,,Cat.of an e h.,Jan.14-Feb.10,1982.In-
troduction by Stuart P.Feld.,The Gallery,
c.1982.
102 p. illus(part col.)

Index of artists

Incl.:McKenney & Hall coll of portrs.of
American Indians by Henry Inman,,now in Harold
Byrd coll,Dallas,Texas(1984).

I.B.1.b - BUHLER, ADOLPH, PARIS

Jean Millette

In:Collector
47,no.12:121-2 Oct.,'33

Adolph Buhler,Paris bought M.'s silhouettes
in 1890
Catalogue of American Portrait has xerox
copy of article.
The Nat'l Portr.Gallery's curatorial staff
regards ,M.'s,silhouettes as...colonial revival
"fakes".

DCL

M
1
J8643
NMAA
v.14

I.B.1.b - BYRD II, WILLIAM, 1674-1744

Meschutt, David
William Byrd and his portrait collection

In:J.early S.dec.arts
14,no.1:19-46 May,1988 illus.

Most portrs. in B.'s coll.have been attr.to Sir
Godfrey Kneller.Three(or more)attr.to Hans Hysing

This article..was presented in 1988 as...
completion of the Master's Degree...State Univ.
of N.Y.

I.B.1.b - BURLETT, E,de .

Muller, Frederik, 1817-1881
Beschrijvende catalogus van 7000 portretten
van Nederlanders,en van buitenlanders,tot Neder-
land in betrekking staande...Amsterdam,F.Muller,
1853
401 p.
Muller coll.in 1852
Part 1:Ruling fgs.& their families,in chro-
nological order.Pt.II.Exceptional individuals,
in alphabetical order,with biographical notes
& dates of the prints.
Hijbroek.Fred.Muller en
zijn prentenverzamelingen
LC ME285.M8 In:Bull.Rijksmus.29:26
note 12 708,949:,A523 NMAA

AP
1
K32
NCFA
v.9-10

I.B.1.b - CARROLL FAMILY, MARYLAND

Kennedy Galleries,inc., New York
Two hundred years of American portraits;a
selection of portraits from the early 18th to
the early 20th century.N.Y.1970.

In:The Kenn.Gall.Q.
9,no.4:229,232-92 May,'70 illus(part col.)
Portr.of Lincoln by unknown primitive p.268
Intro.by Rud.C.Wunderlich
Alphabetical index of artists
The portrs.date fr.ca.1714 to 1932
Notes of the Carroll Family Portraits
LC N8640.K4 Art Books 1950-79 Z5937
v.9no.4 A775 NCFA Ref. p.897

NCFA has I.B.1.b - BURLINGHAM, HIRAM

Burlingham, Hiram
American portraits,incl.Abraham Lincoln by
Lambdin,Thos.Jefferson by Bass Otis & works by
Peale,Copley,Mare,Vanderlyn,Audubon...minia-
tures,ship paintings...property of H.Burling-
ham...sale Jan.11,N.Y.,American Art Ass.,Ander-
son Galleries,1934
56 p. illus
Sale no.4076 priced.

MET
199.8
B22
1934

FMU MBAt IU PPULC Met.v.25,Sales cat.
Cty PPPM Z881.N53 NCFA p.,023319

I.B.1.b

Carson, Hampton Lawrence, 1852-1929
...The Hampton L.Carson collection of en-
graved portraits of American naval commanders &
early American explorers & navigators...Cat. comp.
& sale conducted by Stan.V.Henkels at the art auc-
tion rooms of Davis & Harvey....Philadelphia,1905,
80 p. illus.
Cat.no.906,pt.IV

To be sold Oct.31 & Nov.1,,1905.

LC NE260.C26 Amsterdam,Rijksmus.cat.
Z5939A52, deel 1, p.154

N
7628
W31C3
NPG

I.B.1.b

Carson, Hampton Lawrence, 1852-1929
...The Hampton L.Carson collection of en-
graved portraits of Gen.George Washington. Cat.
comp. & sale conducted by Stan.V.Henkels.At the
art auction rooms of Davis & Harvey...Phila.,Pa.,
...,Press of W.F.Fell co.,1904.
173 p. illus(part col.)
Cat.no.906,pt.I

Incl.St.Mémin personal coll.of proof mezzo-
tints...to be sold Jan.21 & 22, 1904

LC Z999.H505 no.906,pt.1 Amsterdam Rijksmus.cat.
c.2 E312.43.C32 Z5939A52, deel 1, p.154

I.B.1.b -

Castell-Rüdenhausen, Siegfried,Fürst zu, 1916-
Die porträts im Schloss Rüdenhausen.hrsg.
von.Max Domarus.Würzburg,Freunde Main-fränki-
scher Kunst und Geschichte;(Volkach vor Würz-
burg,Hart.in Kommission.),1966
164 p. illus(part col.) (Main-fränki-
sche Hefte,46)

Bibliography

LC N7622.C33 Fogg,v.11,p.325

I.B.1.b

Carson, Hampton Lawrence, 1852-1929
.. ...The Hampton L.Carson collection of en-
graved portraits of Jefferson,Franklin,and La-
fayette.Cat. comp. & sale conducted by Stan.V.
Henkels.At the art auction rooms of Davis &
Harvey...Phila.,Pa.......Press of W.F.Fell co.,
1904.
157 p. illus.
Cat.no.906,pt.II

To be sold Apr.20 & 21,.1904.

LC Z999.H505 no.906,pt.2 Amsterdam,Rijksmus.cat.
Z5939A52, deel 1, p.154

705
G28
NCFA
v.77

I.B.1.b - CATHERINE DE MÉDICIS, 1519-1589

Broglie, Raoul de
Les Clouet de Chantilly;Catalogue illustré
(coll.de Catherine de Médicis)

In:Gaz Beaux Arts
77:257-336 May,1971 illus.

Bibliogr.footnotes

Cat.classified according to costume
Alphabetical list of sitters

Adhémar.Gaz Beaux Arts
Sept.&Déc,1973

I.B.1.b

Carson, Hampton Lawrence, 1852-1929
...The Hampton L.Carson collection of en-
graved portraits of signers of the Declaration
of independence,presidents & members of the Con-
tinental congress,officers in the American revo-
lutionary war...Cat. comp. & sale conducted by
Stan.V.Henkels.At the art auction rooms of Davis
& Harvey...Phila.,Pa. ...1904.
93 p. illus.
Cat.no.906,pt.III

To be sold Dec.16 & 17, .1904

LC Z999.H505 no.906,pt.3 Amsterdam, Rijksmus.cat.
Z5939A52, deel 1, p.154

I.B.1.b - CATHERINE DE MÉDICIS, 1519-1589

'...ordered the creation of a portrait gallery
of famous women in 1552.'-Rave.Paolo Giovio
und die bildnisvitenbücher des humanismus
NE218.R25 NPG p.138

fN
40.1
F43D4
RB
NPG

I.B.1.b - CARSON, HAMPTON LAWRENCE, 1852-1929

Fevret de Saint-Mémin,Charles Balthazar Julien,
1770-1852
The St.-Mémin collection of portraits;...760
medallion portrs.,....of distinguished Americans,
photographed...from proof impressions of the ori-
ginal copperplates,engraved by M.de St.-Mémin,
from draws.taken from life by himself,...in the
U.S.from 1793 to 1814.To which are prefixed a me-
moir of M.de St.-Mémin.by Ph.Guignard...,compiled
...by the publisher E.Dexter,New York,...1862
104 p. illus.

LC N7593.F5 Morgan,J.H.,The work of M.
Fevret.Brooklyn mus.Q.,5:6
708.1.B87 NCFA

I.B.1.b - CAVENDISH, WILLIAM GEORGE SPENCER,
sixth DUKE OF DEVONSHIRE, 1790-1858
see
I.B.1.b - DEVONSHIRE, WILLIAM GEORGE SPENCER
CAVENDISH, sixth DUKE OF, 1790-1858

705
:75
NCFA
r.90

I.B.1.b - CARY-BARNARD, H.

Rayner, Stanford
Ancestors

In:Connoisseur
90:27-30 Jul.,'32 illus.

Repro.:Guttenbrun,Pickering,Cosway(all in
H.Cary-Barnard coll.)

"Portraiture...popular form of ptg. as well
as an illuminating manual of unwritten history"

Cumulated Mag.subj.index
Z1/3/C76 Ref. v.2,p.443

I.B.1.b - CHARLES I, 1600-1649

Hoff, Ursula
Charles I,patron of artists.London,Wm.Collin
1942
23 p. illus(part col.) (The colour art
books)
Study of origins of Engl.collecting.Engl's
court-mecca for foreign artists & dealers.Influ-
ence on Engl.taste by Inigo Jones & the Masque.
Rivalry betw.Arundel & Buckingham.-D.Sutton.Re-
view In:Burl Mag 83:259

LC N8366.C4H6 Fogg,v.11,p.331

705
C75
NCFA

I.B.1.b - CHRISTIE, .AJ. & FAMILY

Hickman, Peggy
 Some unknown silhouettes from the Christie collection

In:Connoisseur
180:20-9 May,'72 illus.

 List of most represented artists, 1770-1820

 Incl.silhouettes on porcelain;jewelry;with silhouettes;églomisé

AP
1
A area
v.12

I.B.1.b - CLARKE, THOMAS BENEDICT, 1848-1931

Salisbury, William
 The Clarke collection of paintings

In:Antiquarian
12:46-7,74 June,'29 illus.

 Three centuries of American portrs.(164 portraits by 77 artists)

 Repro.incl.:Chs.Bird King,Couturier,Gilbert Stuart,David Johnson,Duveneck

 Winterthur Mus.Libr. fZ881
 .W78 NCFA v.6,p.224

ND
1311
C449c
NPG

I.B.1.b - CLARENDON, EARL OF, FAMILY

Gibson, Robin
 Catalogue of portraits in the collection of the Earl of Clarendon.London,Paul Mellon Center for studies in British art,1977.
 147 p. &(146)illus.

 Index of artists

C17.37
.C59

I.B.1.b

Clarke, Thomas Benedict, 1848-
 De luxe illustrated catalogue of early American portraits collected by Mr.Thomas B.Clarke, New York city;to be sold.....Jan.7th,1919..New York.Lent & Graff co.,printers.1919
 .113.p. illus.

 The sale will be conducted by Mr.Thomas E. Kirby of the Americ.art association,managers

LC N7593.C6

I.B.1.b - CLARENDON, EDWARD HYDE, 1609-1674

Evelyn, John, 1620-1706
 .Description of Earl of Clarendon's portrait gallery and suggested additions.

In.his:Diary...ed.by William Bray,new ed.in 4
London,Bickers & son,1879
v.3,p.443-6

LC DA447.E9A25

 Proceedings of the Brit.Academy,1943.Hake,H.M.Engl.historic portr...p.144(Xerox in NPG)LC AS122.15,1943

705
S94
NCFA
v.86

I.B.1.b - CLARKE, THOMAS BENEDICT, 1848-1931

Carroll, Dana
 Early American portrait painting

In:Studio
86:64-71 Feb.'27 illus.

 Portrs.from 1641 to mid-19th c. in the Th.B.Clarke coll.
 Repro.:Wm.Read,Evert & Gerardus Duyckinck, Couturier,Pieter Vanderlyn,Smibert,Strycker

 Cumulated Mag.subj.index
 A1/3/C76 Ref. v.2,p.443

I.B.1.b - CLARENDON, Edw.HYDE, 1609-1674

Lewis, Lady Maria Theresa (Villiers)Lister,
 1803-65
 Lives of the friends and contemporaries of Lord Chancellor Clarendon, illustrative of portraits in his gallery. London,J.Murray,1852

 3 v. illus.
 "The Clarendon gallery":v.1,p.15-64
 "Descriptive catalogue of the collection of portraits at the Grove:v.3,p.239-435"

 Hake,H.M. In:Proceedings of the Brit.Acad.1943
LC DA400C 62 p.144:"Clarendon assembled the first NPG' in his own house)"

927
.C82

I.B.1.b - CLARKE, THOMAS BENEDICT, 1848-1931

Cortissoz, Royal, 1869-1948
 Early American portraiture

In.his.Personalities in art.N.Y.,London,Chs. Scribner's Sons,1925

 pp.321-33

 A retrospective survey of the Clarke coll. as it appeared by sections at the Union League Club...

NE
262
C59
NPG

I.B.1.b - CLARK, DR.CHARLES EDWARD

Clark, Charles Edward
 Catalogue of the Dr.Charles E.Clark collection of American portraiture,including...Washington portraits...To be sold by auction...Jan15,16 and 17,1901...C.F.Libbie & co.,auctioneers... Boston,Mass.Press of the Libbie show print,1901.
 136 p. illus.

LC NE260.C6 see,v.11,p.327

757.6
C61
NCFA

I.B.1.b - CLARKE , THOMAS BENEDICT

Clarke, Thomas Benedict, 1848-1931
 Portraits by early American artists of the 17th,18th and 19th centuries,collected by Th.B. Clarke....Philadelphia(?)c.1928.
 .68.p.

AP
1
A788
NCFA
v.13

I.B.1.b - CLARKE, THOMAS BENEDICT, 1848-1931

Barker, Virgil, 1890-
Portraiture in America before 1876

In:Arts
13:275-88 May,'28 illus.

Ths.B.Clarke coll.exh.in Philadelphia Mus.
of Art.164 portrs.almost all dating fr.before
1876

FOR COMPLETE ENTRY
SEE MAIN CARD

I.B.1.b -

Cope, Edwin R.
...The magnificent coll.of engraved por-
traits formed by...Edwin R.Cope...being the
most important coll..to be sold...at Thos.
Birch's sons...Cat.comp.& sale conducted by
Stan V.Henkels....Philadelphia,The Bicking
print,1896..1899.
Pt.I:148p.;1126 items,portraits,illus.
Pt.II:68p.;1247 items,portraits,illus.
Pt.III:144p.;814 items,miscellaneous,illus.
Pt.IV:144p.;586 items,balance of coll.with
suppl.contain'g illus.

LC has pt.?:NE240.C7

.evis.Descr.bibl.Z5947.A3
L66 1974 NCFA p.244

705
M18
NCFA
v.19

I.B.1.b - CLARKE, THOMAS BENEDICT, 1848-1931

Lee, Cuthbert, 1891-
The Thomas B. Clarke collection of early
American portraits

In:Mag Art
19:293-305 June,'28 illus.

In inaugural exh.of Philadelphia Mus. of Art

Incl.:earliest known portr.ptd.in this coun-
try:Rich.Bellingham by Wm.Read,1641
Repro.:see over Cumulated Mag.subj.index
A1/3/C76 Ref.,v.2,p.443

F
1219.3
M4M48X
NPG

I.B.1.b - CORDRY, DONALD & MRS.

Mexican masks..Essay by Donal Cordry.Fort Worth
Amon Carter Museum of Western Art,c.1973.
32 p. illus.

Cat.of an exh.from the collection of Mr.
and Mrs.Donald Cordry,presented at Witte Memo-
rial Museum,San Antonio,Jan.6-Mar.3,1974,and
other museums.

W
7592
H513
RB
NPG

I.B.1.b - CLAY, J.HENRY, PHILADELPHIA

Henkels, Stanislaus Vincent, 1854-1926
The rare and valuable coll.of portraits
and choice engravings gathered by J.Henry Clay
of Philadelphia embracing the most important
coll.of rare Washington portraits...also rare..
portraits,in line,mezzotint and stipple of emi-
nent Americans,artists,actors,authors,clergy-
men,lawyers,statesmen,etc...to be sold Fri.&
Sat.,Dec.3 & 4,1897,at the book & art auction
rooms of Davis & Harvey,Philadelphia
124 p. illus.

LC Z999 cat.no.799 priced
H505 no.799 Several hundreds portrs.of Washington,
p.77-102

NC
860
P23
NPG

I.B.1.b - COURAJOD, LOUIS CHARLES JEAN,1841-1896

Bouchot, Henri François Xavier Marie, 1849-1906
Les portraits aux crayons de 16e et 17es.
conservés à la Bibl.Nat.(1525-1646). Paris,
H.Oudinot Cie,1884
412 p. illus.

Incl.:Listes de crayons ou peintures conservés
dans des coll.publ.ou privées.étrangères.A la
Bibl.nat.:France:Bibl.d'Arras-Bibl.desArts-et-Mé-
tiers-Coll.de ?.Courajod-Ancien Cabinet Fontette-
Mus.du Louvre(dessins et peinture)-Portrs.peints
du Mus.de Versailles
LC N7621.P3

W
6527
C48
1984 X
NMAA

I.B.1.b - COGGINS, ROBERT P., Marietta,Georgia

Chambers, Bruce W.
Art and artists of the South:the Robert
P.Coggins coll.,essay and cat.entries by Bruce
W.Chambers,Columbia,S.C.:Univ.of South Caro-
lina Press,c.1984
149 p. illus(part col.)

Bibliography
Cat.of an exh.organized by the Columbia
Museum of Art
Incl.:Portraiture in the Antebellum South,
p.5-12;Twentieth century portraiture,p.117-126

I.B.1.b - COWPER, FRANCIS THS.DE GREY,7th EARL,
1834-1905

Boyle, Mary Louisa, 1810-1890
Biographical catalogue of the portraits at
Panshanger,the seat of Earl Cowper,K.G. London,
F.Stock,1885
506 p.

FOGG
FA985.1

MET
195.36
C83

Yale ctr.f.Brit.art Ref.
N7622.2.C7C68B68

I.B.1.b - COGNIET, LÉON, 1794-1880

Paris. Bibliothèque Nationale. Département
des estampes-Cogniet collection
Album of 220 drawings,collected by Léon
Cogniet,donated to the Dpt.by Pere au-Mélaton.
Unpublished

The album is almost entirely made up of
portraits,caricatures & studies of artists at
work,rest or play

For this album see:Stein,J.C.:The image of
the artist in France...around 1800. ND1316.S
819.1982a NPG p.247.

I.B.1.b - CUMBERLAND, DUKE OF
see
I.B.1.b - ERNST AUGUST,DUKE OF CUMBERLAND AND
BRUNSWICK-LÜNEBURG, 1845-1923

N
7592
H513
RB
NPG

I.B.1.b - CUSHING, HENRY S., PHILADELPHIA

Henkels, Stanislaus Vincent, 1854-1926
Rare books and engravings illustrative of
national and local history...belonging to the
estate Thos.Donaldson,deceased and Henry S.
Cushing,late of Philadelphia....to be sold
March 14 & 15,1902 at the book auction rooms of
Davis & Harvey,Philadelphia
illus.
Cat.no.877

Incl.:Portr.ptgs,busts,prints of George &
Martha Washington,all presidents

N
7616
P23
NCFA

I.B.1.b - DAVID-WEILL, DAVID, 1871-1952,Paris

Paris. Musée national du Louvre.Cabinet des
dessins
Donation de D.David-Weill au Musée du
Louvre.Miniatures et émaux..Exposition.Oct.'56-
janvier 1957.Paris.Editions des Musées natio-
naux.1956.
186 p. illus.
Miniatures p.3-90; Enamels p.93-170
Cat.by Maurice Sérullas
Bibliography
Index of artists and of sitters
Repro.incl.:(A)Miniaturists:Hall,Dumont,

(cont'd on next card)

N
7592
D24
NPG

I.B.1.b - DALY, AUGUSTIN, 1838-1899

Daly, Augustin, 1838-1899
The Augustin Daly collection of portraits
of eminent men and women of the stage.New York,
The Anderson Galleries,1912
30 p. illus.
NPG copy Bound with the Garrick Club,London.Catal.of
the pictures...London,1909

I.B.1.b DAVID-WEILL, DAVID, 1871-1952, Paris

MFT
106.4
D28

Paris. Musée de l'Orangerie
Donations de D.David-Weill aux musées fran-
çais....Paris,Editions des Musées nationaux,
1953

705
M19
NCFA
v.21
or 22

I.B.1.b - DANCE, REV.GEORGE, died 1898
Grandson of artist
Roberts, William, 1862-1940,
George Dance and his portraits recently
come to light

In:Mag Art
21:656-8 1898 illu.

...Over 200 portr.drags...the coll.of D.'s
grandson, the Rev.Geo.Dance sold...1898

**FOR COMPLETE ENTRY
SEE MAIN CARD**

705
A786
NCFA

I.B.1.b - DAVID-WEILL, 1871-1952, PARIS

Frankfurter, Alfred M.
Unique view of French sculpture,18th cen-
tury masterpieces:The David-Weill collection

In:Art N
38,no.29:6-8 Apr.20,'40 illus.

Pertains to exh.at Wildenstein & co.,inc.,
New York, Apr.10-May4,1940

Repro:Portr.-busts by Peru,Coysevox,Houdon
Lemoyne,Pajou,de Montigny.
Portr.bust.Renaiss.to En-
lightenment.NB1309.P6x NPG
P1b1.

I.B.1.b - DAVID-WEILL, DAVID, 1871-1952, Paris

David-Weill, David, 1871-1952
Collection David Weill...Paris,Brauns,1926-
1928

LC N5260.D25

**FOR COMPLETE ENTRY
SEE MAIN CARD**

705
A56
NCFA
v.23

I.B.1.b - DAVIES, SIR LEONARD TWISTON, 1894-

Long, Basil Somerset, 1881-1937
Costumed miniatures

In:Antiques
23:222-3 June,'33 illus.

Repro.:Miniature & a sequence of the same
miniature with talc(mica)disguises;from the
Leonard Twiston Davies coll.

I.B.1.b - DAVID-WEILL, DAVID, 1871-1952, Paris

David-Weill, David, 1871-1952
Miniatures and enamels from the D.David-
Weill collection.Paris,Les Beaux-Arts,édition
d'études et de documents,1957

Cat.of that part of the collection which
was sold to Messrs.Wildenstein

LC N7616.D33

**FOR COMPLETE ENTRY
SEE MAIN CARD**

705
C75
NCFA
v.61

I.B.1.b - DAVIS, DAVID, 1877-1930

Hodgson, Mrs.Willoughby
Old Wedgwood portrait medallions in the
coll.of Mr.David Davis,J.P.,L.C.C.

In:Connoisseur
61:201-9 Dec.,'21 illus.

Repro.incl.:Washington,Franklin,George I,
George III,George IV

I.B.1.b - DEBROU, P.

‹Debrou, P.›
Catalogue des portraits imprimés en noir et
en couleurs de la reine Marie-Antoinette et de
la famille royale...composant la collection de
m.P.D...vente le 8 mars,1907.Paris,Hôtel Drouot
47 p. illus.

PPPM NJP

I.B.1.b - DIDOT, AMBROISE FIRMIN, 1790-1876

Didot, Ambroise Firmin, 1790-1876
Les graveurs de portraits en France;catalogue
raisonné de la collection des portraits de l'é-
cole française appartenant à A.Firmin-Didot...
ouvrage posthume. Paris,1875-77

2 v.in one

LC NE270.D5 (reprint of 1970 — not listed in LC)

I.B.1.b - DELABÈRE

Sotheby, firm,auctioneers, LONDON
Cat.of a...coll.of engraved British por-
traits formed by the late proprietor for the
illustration of Granger's history of England;
many...originally in the Sykes,Bindley & Dela-
bère collections...by...Elstracks...Cecil...
Vaughan...Faithorne...London,1863.
19 p.
Sale cat.Jl.22,1863 & ff.day
‹The proprietor was E.Rose TUNNO!-Lugt.In:
Marques de collections.N8380.L95,NCFA,p.158,no.
‹902

MET
212
J
1853
60-61
63-64

For more loc~ations of this cat.see over
Met.sales ca t.fZ881.N53 NCFA v.25 ‹023315

NE
275
K83X
NPO

I.B.1.b - DÖRRIES, ADOLF

Künstler sehen sich selbst:Graphische selbst-
bildnisse unseres jahrhunderts,Privatsamm-
lung.Ausst.im Städtischen Mus.,Braunschweig,
vom 5.Dez.1976 bis 23 Jan.1977.1976
192 p. illus.(part col.)

Collection Adolf Dörries
Incl.index
Bibliography

Notizen über das Selbstbildnis by Heinrich
Mersmann,p.9-19

LC NE275.K83

I.B.1.b - DELABÈRE FAMILY

‹Delabère Family›
A cat.of a most singular,rare and valuable
collection of portraits....in a very celebrated
book that has been preserved 15 years in the
Delabère family...London,G.Smeeton,1811.
44 p.

152 items Priced Names of buyers

Auction sale,Christie,March 29,1811

(For more locations of this cat. see:Lugt
Rép.des cat.de ...ventes,1600-1825;017.L95
NCFA Ref.,no.7955

V & A

PU-R

I.B.1.b - DOISTAU, FÉLIX

Paris. Musée national du Louvre
Cat.de la donation Félix Doistau...Paris,
1922

MET
196.5
P21
1958

FOR COMPLETE ENTRY
SEE MAIN CARD

I.B.1.b - DEVONSHIRE, WILLIAM GEORGE SPENCER
CAVENDISH, sixth DUKE OF, 1790-1858
Thompson, Francis
A history of Chatsworth,being a supplement
of the sixth Duke of Devonshire's handbook.
London,Country Life;N.Y.,Scribner‹1949›
250 p. illus.

Bibliography

LC DA690.C46T5

N
7592
H513
RB
NPO

I.B.1.b - DONALDSON, THOMAS

Henkels, Stanislaus Vincent, 1854-1926
Rare books and engravings illustrative of
national and local history....belonging to the
estate Thos.Donaldson,deceased and Henry S.
Cushing,late of Philadelphia....to be sold
March 14 & 15,1902 at the book auction rooms of
Davis & Harvey,Philadelphia
illus.
Cat.no.877

Incl.:Portr.ptgs,busts,prints of George &
Martha Washington,all presidents
continued on next card

I.B.1.b - DICK, JACK R. & MRS.

Sotheby, firm,auctioneers, LONDON
Cat.of the Mr.& Mrs.Jack R.Dick coll.of
English sporting and conversation paintings:
part 1;...auction.s.l.:s.n.:c.1973(Ipswich,Eng.,
W.S.Cowell)
108 p. illus(part col.)
Price list encl.

LC ND1388.D7368

705
C28
v.20

I.B.1.b - DU PLESSIS-MORNAY,1549-1623, SAUMUR

Fillon, Benjamin, 1819-1881
La galerie de portraits de Du Plessis-Mornay
au Château de Saumur

In:Gaz.Beaux Arts
2pér.v.20:162-68 Aug.,1879
:212-28 Sep.,1879 illus.

Reprint issued(same title)Paris,Quentin,1879

Aug.article incl.list of sitters:Protestant
reformers,royalty,etc. Bouchot.Portrs.aux crayons
NC860.P23NPG,p.1,footn.1
MB(reprint ed.)

I.B.1.b - DUFF, EARL OF FIFE
see
I.B.1.b - DUKE OF FIFE

I.B.1.b-EDEN, SIR TIMOTHY CALVERT,8th bart.,
1893-

Eden, Sir Timothy Calvert,8th bart., 1893-
Catalogue of important English historical
and family portraits and pictures by the old
masters removed from Windlestone,co.Durham,incl.
the celebrated series of portraits of the Lords
Baltimore,proprietors of Maryland,the property
of Sir Timothy Calvert Eden,baronet of Maryland.
Which will be sold by auction,by Messrs.Sotheby
and co....the 26th of July,1933...London,Printed
by J.Davy & sons,ltd.,1933.
16 p. illus.
(Sotheby & Co.Sale cat.Jl.26,1933)
Priced

MET
119.6
0
1933³

MdBP

Met.Sales cat.fZ881.N53
NCFA p.023316

705
CYS
NCFA
v.10

I.B.1.b - DUKE OF FIFE

Clouston, Mrs.K.Warren
The Duke of Fife's collection at Duff House,
rev.& completed by Mrs.Crosby Smith,

In:Connoisseur
10:3-9 Sept.,'04. illus.
167-74 Oct., '04. "

Repro.incl.Jameson,Velasquez(attr.),C.Pope,
Reynolds,P.van Somer

'Almost every room in Duff House is a pic-
ture gallery'.There are portrs.fr.16th-19th c
including
Jackson,S.Theodote

I.B.1.b - EMDEN, HERMANN, HAMBURG.

Emden, Hermann
Sammlung Hermann Emden,Hamburg.Versteige-
rung.Rudolph Lepke's Kunst-Auctions-Haus,2...
3.Mai,1911.Berlin.1908-11.

MET
119.2
E83

.3.Teil.
4: Miniaturbildnisse, 18 & 19.Jahrhundert

I.B.1.b - DUKE OF PORTLAND

Goulding, Richard William, 1868-1929 and
C.K.Adams
Cat.of the pictures belonging to His Grace
the Duke of Portland,at Welbeck Abbey...comp.
by R.W.Goulding and revised...by C.K.Adams.
Cambridge,Eng.,The University Press,1936
495 p.

Consists mainly of portrs.

LC N7622.P6

I.B.1.b.- EMMET, THOMAS ADDIS, 1828-1919

Emmet, Thomas Addis, 1828-1919
American portraits collected by Thomas
Addis Emmet.A-Z.N.Y.,1896
9 v.

N.Y. P.L.
AON

Rosenthal,Albert...List of
portrs.N40.1.R734yR8 NPG
p.6

AP
1
W225
NCPA
v.4
1914/15

I.B.1.b - DUKE OF PORTLAND

Goulding, Richard William, 1868-1929
The Welbeck Abbey miniatures belonging to
His Grace the Duke of Portland;a catalogue rai-
sonné.Oxford,The University Press,1916.Reprinted
London,Wm.Dawson & sons,ltd.1969
224 p. illus. (Half-title:The fourth
annual vol.of the Walpole Society)

LC N12.W3

Cf.,v.11,p.331

I.B.1.b - EMMET, THOMAS ADDIS, 1828-1919

Emmet, Thomas Addis, 1828-1919
Foreign portraits,collected by Thomas Addis
Emmet.N.Y.,1896
11 vols.

N.Y. P.L.
ACK
ACK
x
ACK
xx

3 vols.
6 vols.
2 vols.

ND
1314.6
B38
NPG

I.B.1.b - DUNN, JAMES HAMET, SIR,BART.,1874-1956

Beaverbrook Art Gallery, Fredeicton, N.B.
From Sickert to Dali;interntaional por-
traits;an exh.,organized by the Beaverbrook Art
Gallery,Fredericton,New Brunswick,summer 1976
31 p. illus.

Bibliography
41 works shown
Cat.by Ian G.Lumsden
The portrs.are mainly from the coll.donated
by Lord Beaverbrook and Sir James Dunn.
Exh.in commemoration of the visit of Queen
Elizabeth II;July 15th and 16th,1976

Rila II/2 1976 #5750

I.B.1.b - ERNST AUGUST,DUKE OF CUMBERLAND AND
BRUNSWICK-LÜNEBURG, 1845-1923
Ernst August, duke of Cumberland and Brunswick-
Lüneburg, 1845-1923
Cat.of a coll of miniatures,the property of
His Royal Highness Prince Ernest Augustus Wil-
liam Adolphus George Frederick,.the.duke of Cum-
berland,duke of Brunswick-Lüneburg...London,
Priv.print,at the Chiswick press,1914

LC N7616.E68

FOR COMPLETE ENTRY
SEE MAIN CARD

I.B.1.b - ERNST LUDWIG,GRANDDUKE OF HESSE
see
I.B.1.b - HESSE, ERNST LUDWIG, GRANDDUKE OF,...

I.B.1.b - FERDINAND VON TIROL

Keil, Luis
 Os retratos de personagens portuguesas da
 colecçao do arquiduque Ferdinando do Tirol

In:b.Acad.nac.belas artes
15:18-22 1946 illus.

Portuguese personalities in the miniature coll.
of archduke Ferdinand of Tyrol,brought together
from 1563 on

LC N16.A6613 Rep.,1948-49#1027

705
A56
NCFA
v.108

I.B.1.b - FELDMAN, HOWARD A.

Feldman, Howard A.
 A collection of American folk painting

In:Antiques
108:764-71 Oct.,'75 illus(part col.)

 Mostly illustrations.Repro:Wm.Prior,Sturte-
vant Hamblen,Ammi Phillips,Jacob Maentel,J.Park
L.K.Rowe and anonymous works

 Rila III/1 1977 #3631

I.B.1.b - FIRMIN-DIDOT, AMBROISE
see
I.B.1.b - DIDOT, AMBROISE FIRMIN, 1790-1876

I.B.1.b - FERDINAND VON TIROL

Dimier, Louis, 1865-1943
 Die französischen bildnisse in der porträt-
sammlung des Erzhersogs Ferdinand von Tirol.
Portraits.

MET
100.53 In:.Jahrbuch der kunsthistor.Sammlungen des aller-
J191 höchsten Kaiserhauses
Q 25:219-25 Wien 1904 illus.
v.25

ND MB MM
LC N3.J4

I.B.1.b - FOL, WALTHER

Vollenweider, Marie Louise
 Les portraits romains sur les intailles et
et camées de la collection Fol.Genève,1960
.137.-152 p. illus.

 Reprinted from Genava,n.s.,v.8

InU

I.B.1.b - FERDINAND VON TIROL

Kenner, Dr.Fr.
 Die porträtsammlung des Erzherzogs Ferdinand
von Tirol

In:Jb.d.kunsthist.sammlungen des österr.kaiserh.
Bd.XIV:37-186:Geschichte/ der Slg:D.Bildnisse d.
Erzhauses Habsburg(1893);Bd.XV:147-259:D.deut-
schen Bildnisse,Wundermenschen(1894);Bd.XVII:101-
274:Ital.Bildn.(1896);Bd.XVIII:135-261:D.Medici.
Neapel,Celebritäten(1897);Bd.XIX:6-146:Spanien,
Portugal,Frankr.Engl.,Schottld. Der Orient(1898)

LC N3.J4 Rave,P.O. Paolo Giovio u.
 d.bildnisvitenbücher...
 Jb.d.Berl.Mus. I 1959:144
 footnote LC N3.J16 fol.

I.B.1.b - FONTETTE, FEVRET DE

Dimier, Louis, 1865-1943
 Histoire de la peinture de portrait en Franc
au 16e siècle. Paris et Bruxelles,G.van Oest
et Cie,1924-26

 3 v. illus.
 Bibliography v.3

 With catalogue of all existing works in this
genre, in drawgs.,oil ptgs.,miniatures,enamels,
tapestries & wax medallions

LC ND1316.D5

I.B.1.b - FERDINAND VON TIROL

Vienna. Kunsthistorisches Museum
 Die porträtsammlung des Erzherzogs Ferdinand
von Tirol;vorwort von A.Lochr. Wien,Verlag der
Kunsthistorischen sammlungen,1932. S.

MET 92 p. (Führer durch die Kunsthisto-
276 rischen sammlungen in Wien,v.17)
V67
FoOG
66 Compiled by Gerhart B.Ladner
V66mg
1932

V&J under Ladner

I.B.1.b - FONTETTE,(2) FEVRET DE

Dimier, Louis, 1865-1943
 Histoire
____Supplément;Douze crayons de François Quesnel,
provenant des collections Fontette.
Paris & Bruxelles,1927
 13 p. illus.

MET
186 Review by G.de Corles,In:Gaz Beaux Arts
D594 15:311-16 ser.5 1927 illus.
705
028
v.15 1927
NCFA

I.P.1.b - FONTETTE, FEVRET DE

Fontette, Fevret de
Liste générale et alphabétique des por-
traits gravés des françois et françoises illus-
tres jusqu'en 1775;publiée par Barbeau de la
Bruyère.Paris,1809

‹Suppl.by Lieutaud,1846.
cf.Lelong.v.IV

Listed in Universal Cat.of Zahn,Albert von,1836-1873
Books on Art.Suppl.p.224; Hist.Kunstslgn.In:Archiv f.
Fevret de Fontelle d.zeichnenden Künste.Univ.Ky
 Marg.I.King Libr.v.5,p.179

685
15 A5
NCFA

I.B.1.b - GALLATIN, ALBERT EUGENE, 1881-1912

Philadelphia Museum of Art
A.E.Gallatin collection."Museum of living
art".Philadelphia.1954.
153 p. illus(part col.)

Previous eds.iss.by N.Y.university.Gall.of
Living Art,A.E.Gallatin collection.

Incl.photos by A.E.Gallatin of Arp,1934;
Braque,1931;Léger,1931;Matisse,1932;Miró,1936;
Mondrian,1934;Picasso,1933..This is a different
set than in previous eds.,Life,May 2,'38,Bri-
tannica Book..39 ‹p.147-53

ND
1314.4
T78
NPG
1985

I.B.1.b - FORBES-LEITH,1847-1925

Edinburgh. Scottish national portrait gallery
Treasures of Fyvie.exh.‹4 July-29 Sept.
1985.Publ.by the Trustees of the National
Galleries of Scotland‹1985,
79 p. illus(part col.)

Exh.organized by Js.Hooloway

Alexander Forbes-Leith was the founder of the
Fyvie Castle collection

VINC=Norfolk Chrysler
Mus.Libr.

I.B.1.b - GALLATIN, ALBERT EUGENE, 1881-1912

New York university. Gallery of living art
Gallery of living art,A.E.Gallatin col-
lection,N.Y.University....N.Y.G.Grady press,
1936.
‹39›p. illus.

Portrs.of Braque,Léger,Matisse,Picasso,
Mondrian,Miró;photographs by A.E.Gallatin

LC N620.N4A3 MOMA,v.11,p.438

CS
71
F836
1968X
NPG

I.B.1.b - FRIEDMAN, LEE MAX

Franks, Abigail, 1696-1756
The Lee Max Frieman coll.of American
colonial correspondence:letters of the Franks
family,1733-1748.Ed.by Leo Hershkowitz and
Isidore S.Meyer.Waltham,Mass.,American Jewish
Histo.Doc.,1968
171 p. illus(1col.) (Studies in Ame-
rican Jewish Hist.,no.5)

Bibliography
Index

VV
Evanston
Illinois

I.B.1.b - GARBISCH, EDG.WM.& BERNICE CHRYSLER

Evanston,Ill., Torra Museum of American Art
American naive painting from the National
Gallery of Art.Cat.by Ronald McKnight Melvin.
Foreword by John Wilmerding.Exh.Dec.19,1981-
March 4,1982
32 p. illus(part col.)

Bibliography

(Paintings from the Garbisch collection)

qNC
1477
C4C53
NCFA

I.B.1.b - FURNESS, THOMAS FOSTER

Chicago. Art Institute
British caricatures of the 18th and early
19th century from the William McCallin McKee
collection held at the Art Institute of Chi-
cago in honor of the late Thomas Foster Furness
May 12-June 30,1977.Chicago,The Art Inst.,c1977
24 p. illus.

ND
207
A7X
NCFA

I.B.1.b - GARBISCH, EDG.WM.& BERNICE CHRYSLER

Arts Council of Great Britain
American naive painting of the 18th and 19
centuries from the coll. of Edgar William and
Bernice Chrysler Garbisch at the Royal Academy
of Arts,London,6 Sept.to 20 Oct.,‹1968›.London
Arts Council,1968
‹65›p. illus(part col.)

Intro.by Robert Melville

Flint Inst.of Arts.Am.naiv
ptg.=ND210.5.P7F5 1981X
NMAA Bibl.,p.92

LC Z2176.154

I.B.1.b - GAIGNIÈRES, FRANÇOIS ROGER DE, 1642-
‹1715

Lelong, Jacques, 1665-1721
Bibliothèque historique de la France...l'his-
toire de ce royaume...Nouv.éd. Paris,Impr.Heris-
sant,1768-78
5 v.

Tome 4 includes:"III.Table générale du re-
cueil de portraits,fait par les soins du m.de
Gaignières & maintenant dans la Bibliothèque du
roi." IV."Liste de portraits des François il-
lustres.".cf.Fontette, Fevret de.

Amsterdam,Rijksmus.cat.
25939A52,deel3,p.815

ND
207
P37
F 1969
NCFA

I.B.1.b - GARBISCH, EDG.WM.& BERNICE CHRYSLER

American naive painting of the 18th and 19th
centuries;111 masterpieces from the coll.
of Edgar William and Bernice Chrysler Gar-
bisch.Foreword by John Walker.Pref.by
Lloyd Goodrich.Introd.by Albert Ten Eyck
Gardner.‹New York,American Federation of
Arts,1969.
159 p. illus(part col.)
Cat.of an exh.being circulated through
the U.S.and Europe 1968-70 under the auspi-
ces of the American Federation of Arts

Flint Inst.of Arts.Am.naiv
ptr. ND210.5.P7F5 1981X
NMAA Bibl.p.92

ND
210.5
P7F5
1981X
NMAA
2 c.

I.B.1.b - GARBISCH, EDG.WM. AND BERNICE CHRYS-
.LER

Flint Institute of Arts
American naive painting at the Edgar William
and Bernice Chrysler Garbisch collection:Flint
Inst.of Arts,Dec.6,1981-Jan.24,1982,cat.by.
Alain G.Joyaux.,Flint,Mich.,The Institute,
c.1981
55 p. illus.

Bibliography

Intro.by Richard J.Wattenmaker

⌒ Worldwide Art Cat.Bull.
19:no.1:64 705.W972 NMAA

AP
1
G565

I.B.1.b - GARBISCH, EDG.WM. & BERNICE CHRYSLER

Chrysler Museum at Norfolk
Naive gift grows to unprecedented eighty
paintings;by DR.A.Dennis R.Anderson.

In:Chrysler Mus.Norfolk.Bull.
5,no.4:2-4 Apr.,'76 illus.

Incl.:Ammi Phillips,Wm.Jennys,Erastus Salis-
bury Field
Gift of Edg.Wm.& Bernice Chrysler Garbisch

⌒ Rila IV/1 1978 #3927

705
A784
NCFA
v.42

I.B.1.b - GARBISCH, EDG.WM.& BERNICE CHRYSLER

American primitive painting.,An anthology of
the.coll.of Edg.Wm.& Bernice Chrysler
Garbisch

In:Art in Am
42:95-170 May,'54 illus.

Incl.:Foreword by Edg.Wm.& Bernice Chrys-
ler Garbisch,refers to the fact that their
coll.is going to the National Gallery of Art,
p.95;Ptgs.for the people by Alice Winchester,
p.96;Portr.gall.of provincial America by Frank
O.Spinney,p.98, Illus.p.97,99-105
154-6

ND
207
G21
1962
NPG
NCFA

I.B.1.b - GARBISCH, EDG.WM.& BERNICE CHRYSLER

Garbisch, Edgar William
101 masterpieces of American primitive paint-
ing,from the coll.of Edg.Wm.& Bernice Chrysler
Garbisch.New ed.,N.Y.,American Federation of
Arts,1962.

⌒ FOR COMPLETE ENTRY
SEE MAIN CARD

ND
207
M56
pt.1-2
NCFA
NPG

I.B.1.b - GARBISCH, EDG.WM.& BERNICE CHRYSLER

U.S. National Gallery of Art
American primitive paintings from the col-
of Edgar William and Bernice Chrysler GARBISCH
pt.I and II,Washington,NGA,1954 and 1957
2 v.in 1 illus.

Pt.I:Exh.of the gift of 300 ptgs.& 200 mi-
niatures
Pt.II:Exh.of a selection of the Garbisch
collection

Flint Inst.of Arts.ND210.5
P7F5 1981X NMAA bibl.p.51

NK
5435
G3D78
1983X
NPG

I.B.1.b - GERMANY -(UNTERFRANKEN)LOWER FRANCO-
.NIA

Brückner, Wolfgang, 1930-
Hinterglasbilder aus unterfränkischen
sammlungen,zur sonderausstellung des Main-
fränkischen Museums,Würzburg(25.Feb.-1.Mai
1983).by.W.Brückner,Hanswernfried Muth,Hans-
Peter Trenschel.Würzburg,Freunde Mainfränki-
scher Kunst und Geschichte,1983
335 p. illus. (Mainfränkische Hefte,
Heft 79)
Index
Bibliography
Portraits 18th c. p.38-41,256-7

qND
207.5
P7Ch9
1975X
NCFA

I.B.1.b - GARBISCH, EDG.WM.& BERNICE CHRYSLER

Chrysler Museum at Norfolk
48 masterpieces from the Collection of
Edgar William & Bernice Chrysler Garbisch.
Norfolk, Va.,Chrysler Museum at Norfolk.1975.
48 p. illus.

American naive ptg.of the 18th and 19th c.

Preface by Dennis R.Anderson

⌒ Rila III/1 1977 #717

VF

I.B.1.b - GERRITSEN, HERMANUS PHILIPPUS,1850-
.1917

Amsterdam. Rijksmuseum. Prentenkabinet
Getekende kunstenaarsportretten...1975
(Rijksprentenkabinet no.XI)

FOR COMPLETE ENTRY
SEE MAIN CARD

I.B.1.b - (GENERAL)

Propert, John Lumsden
A history of miniature art.With notes on
collectors and collections...London & New York,
Macmillan & co.,1887
285 p. illus.

Bibliography

LC N7616.P8 757.7.B85. Brieger.Die Min
iatur Literatur

705
C75
NCFA
v.23

I.B.1.b - GEX, LADY DE

Carrer, Edmund, 1848-1935
Lady de Gex's collection of reliefs in co-
loured wax

In:Connoisseur
23:225-32 Apr.,'09 illus.

FOR COMPLETE ENTRY
SEE MAIN CARD

I.B.1.b - GIOVIO, PAOLO, 1483-1552

Kossmann, Ernst Ferdinand, 1861-
 Giovios porträtsammlung und Tobias Stimmer

In:Anzeiger für Schweiz.Alterumskunde
N.F.24:49-54 1922

LC DQ1.A72

Rave.Jb.d.Berl.Mus. I 1959
LC N3.J16 fol. p.150 footr.
Paolo Giovio & d.bildnisvi-
tenbücher d.Humanismus

NE
218
R25
NPG

I.B.1.b - GIOVIO, PAOLO, 1483-1552

Rave, Paul Ortwin, 1893-1962
 Paolo Giovio und die bildnisvitenbücher des
Humanismus

In:Jb.der Berliner Mus.
I 1959:119-54 illus.

 Der bildnissmaler und vitenschreiber Giovio.
Die ersten bücher mit bildnisreihen.Die "vera
effigies"und die frühen münsbildbücher.Die gros-
sen chroniken der jahrhundertmitte.Giovio,Vasari
(cont.on next cd.)

LC N3.J16

Prins.Slg.d.selbstbildn.
in d.Uffizien N7618/P95
Bd.1,p.146,note 42

I.B.1.b - GIOVIO, PAOLO, 1483-1552

Müntz, Eugène
 Le musée de portraits de Paul Jove;contribu-
tions pour servir à l'iconographie du moyen-âge
et de la renaissance. Paris,Imprimerie nationale,
1900
 95 p. illus.

 "Extrait des "Mémoires de l'académie des in-
scriptions et belles lettres". Tome 36,2e partie"

 "Lists 266 items"-Rave.P.O. Paolo Giovio & die
bildnisvitenbücher...In:Jb.d.Berl.Mus.,p.120, I 1959

LC N7592.M8 and
AS162 P315 V.36 pt.2

Amsterdam,Rijksmus.,cat.
Z5939A52,deel 1,p.136

I.B.1.b

Gower, Ronald Charles Sutherland, 1845-1916
 Iconographie de la reine Marie-Antoinette.
Catalogue descriptif et raisonné de la collec-
tion de portraits,...caricatures,etc.,formée par
R.Gower,précédé d'une lettre par m.G.Duplessis.
Paris,A.Quantin,1883
 250 p. illus(part col.)

LC DC137.1207

Amsterdam,Rijksmus.,cat.
Z5939A52,deel 1,p.146

I.B.1.b - GIOVIO, PAOLO, 1483-1552

Rave, Paul Ortwin, 1893-1962
 Das Museo Giovio zu Como

In:Rome(City)Bibliotheca Hertziana.Miscellanea
Bibliothecae Hertzianae:275-84 Wien,1960

DLC

Prins.Slg.d.selbstbildn.
N7618/P95Bd.1,p.146note33
NPG

I.B.1.b - GRAF, THEODOR

Graf, Theodor
 Cat.of the Theodor Graf coll.of unique an-
cient Greek portraits 2000 years old recently
discovered and now on view in Old Vienna,Mid-
way Plaisance at the World's Columbian exposi-
tion.Chicago?,1893.
 49 p.

 Cat.by F.H.Richter and F.von Ostini.
 The encaustic ptg.of the ancients,by Otto
Donner von Richter pp.45-49

F000
3718
375e

VFT
590.8
ZX
N.Y.P.L. MCD p.v.1

Winterthur Mus.Libr. fZ281
f78 NCFA v. .5.227

I.B.1.b - GIOVIO, PAOLO, 1483-1552

Rovelli, Luigi
 L'opera storica ed artistica di Paolo Giovio,
Comasco,Vescovo di Nocera.Il Museo di ritratti.
Como,1928
 126 p.

 Lists 366 items

 "Collection dispersed;only c.100 of the
portrs.at various locations,are now known"-Rave,
Paolo Giovio & d.bildnisvitenbücher...In:Jb.der
Berliner Mus.,p.121 I 1959
 Rave,P.O. Paolo Giovio & d.
 bildnisvitenbücher...In:
 Jb.d.Berl.Mus.I 1959,p.120
 footnote

I.B.1.b - GREAT BRITAIN - COUNTRY HOUSES

Poulsen, Frederik, 1876-
 Greek and Roman portraits in English coun-
try houses...transl.by the Rev.G.C.Richards.
Oxford,The Clarendon press,1923
 112 p. illus.

LC NB164.P6

I.B.1.b - GIOVIO, PAOLO, 1483-1552

Rovelli, Luigi
 Paolo Giovio nella storia e nell' arte,
1552-1952;breve monografia...del Museo dei
ritratti,ecc.,...nel 4.centenario della morte
del geniale fondatore del Museo dei ritratti...
Como,1952
 28 p. illus.

F000
221
G52r

Prins.Slg.d.selbstbildn.
in d.Uffizien N7618/P95
Bd.1,p.146,note 33

705
C75
NCFA
v.144

I.B.1.b - GREAT BRITAIN - ROYAL COLLECTION

Fleming, John
 Giuseppe Macpherson;a Florentine minia-
turist

In:Connoisseur
144:166-7 Dec.,'59 illus.

 Repro.incl.:Group from the 224 miniatures
in the Royal coll.at Windsor Castle...

FOR COMPLETE ENTRY
SEE MAIN CARD

I.B.1.b - GREAT BRITAIN - ROYAL COLLECTION

Chamberlaine, John, 1745-1812
 Imitations of original drawings by Hans
Holbein,in the collection of His Majesty,for the
portraits of illustrious persons of the court of
Henry VIII...London,Printed by W.Bulmer and co.,
1792
 142,p. illus.in color

 The plates are stipple engravings printed
in colors,all but four by F.Bartolozzi,three by
C.Metz,one by P.Knight

LC NC1655.H7 Fogg,v.11,p.321

705
C75
NCFA

I.B.1.b - GREAT BRITAIN - ROYAL COLLECTION

Jackson, Mrs.F.Neville,1861-
 Silhouette portraits in the Royal collections

In:Connoisseur
90:359-67 Dec,1932,II illus.
 217-28 Oct,1932,II illus(part col.)
 287-98 Nov,1932,II illus.

 All known techniques represented:freehand
scissor work,ptg.on underside of flat glass,ptg.
on convex glass,plaster ptg.,ptd card work,ivory
work in miniature for jewels,portrs.on porcelain
etc.

I.B.1.b - GREAT BRITAIN - ROYAL COLLECTION

George VI, King of Great Britain, 1895-1952
 The King's pictures;an illustrated souvenir
of the exhibition...at the Royal Academy of Arts,
London,1946-47. London,Royal Academy of Arts
1946.
 111 p. illus.

LC N5245.G4

N
5245
M64
NCFA

I.B.1.b - GREAT BRITAIN - ROYAL COLLECTION

Millar, Oliver, 1923-
 The Tudor,Stuart and early Georgian pictures
in the collection of Her Majesty the Queen.
London,Phaidon Press.1963.
 227 p. illus.(part col.)v.1:text,v.2:plates
 First part of a cat.raisonné of the royal
collection of pictures

 Bibliography

LC N5245.M62

I.B.1.b - GREAT BRITAIN - ROYAL COLLECTION

London. Royal academy of arts
 The King's pictures.at the Royal Academy ex-
hibition in Burlington House,Nov.,1946-March,1947
catalogue, London, 1946
 159 p.
see also: George VI,King of Great Britain,1895-
1952 The King's pictures;an illustrated
souvenir of the exhibition...

qN2
230
Y18
NPG

I.B.1.b - GREENE, EDWARD BELDEN, 1878-

Yale university. Art gallery
 The Edward B.Greene collection of engraved
portraits and portrait drawings at Yale univer-
sity.A catalogue comp.by Alice Wolf,with a pre-
face by Theodore Sizer.New Haven,Yale university
press;London,H.Mildford,Oxford university press,
1942
 141 p. illus.

 Bibliography

 Prints are alphabetically arranged according
LC NE230.Y3 to the sitters
Yale Univ.Libr.for LC Fogg,v.11,p.326

qND
466
M64
NCFA

I.B.1.b - GREAT BRITAIN - ROYAL COLLECTION

Millar, Oliver, 1923-
 The later Georgian pictures in the collec-
tion of Her Majesty the Queen..London,Phaidon,
1969.
 2 v. illus(part col.)

 Contents:1.Text.-2.Plates

 Third part of the new cat.raisonné of the
royal coll.of pictures

 Bibliography
LC ND466.M5 Fogg,v.11,p.332

ND
1337
N5C63
NCFA
NPG

I.B.1.b - GREENE, EDWARD BELDEN, 1878-

Cleveland Museum of Art
 Portrait miniatures;the Edw.B.Greene coll.
Cleveland,1951
 36 p. illus.(part col.)

 Cat.by Louise H.Burchfield
 "Portr.miniatures,origin and technique"by L.H.
Burchfield. "Portr.miniatures,their history"by
Harry B.Wehle

LC N7616.C49

q N
5247
W56M54
1977X
NPG

I.B.1.b - GREAT BRITAIN - ROYAL COLLECTION

Millar, Oliver, 1923-
 The Queen's pictures.1st American ed.
N.Y.,Macmillan,1977
 240 p. illus(part col.)

 Incl.bibliographical references and index

 Contents:The Tudors,The early Stuarts,
Charles I,The late Stuarts,The early Hanover-
ians,George III, George IV,Queen Victoria and
Prince Albert,Modern times

757
.B59

I.B.1.b - Grünstein, Leo

 Die Bildnisminiatur und ihre meister...

 v.1Saml.Ullmann,by L.Grünstein

ND
207
H18
NCFA

I.B.1.b

Halladay, J.Stuart.
American provincial paintings,1680-1860,from the collection of J.Stuart Halladay and Herrel George Thomas. April 17 to June 1, 1941,Department of fine arts,Carnegie institute..n.p...1941.
40 p. illus.

LC ND207.H33

I.B.1.b - HELMINGHAM HALL,STOWMARKET,SUFFOLK
see
I.B.1.b - TOLLEMACHE,JOHN EDW.HAMILTON TOLLEMA-
CHE,baron,1910-

705
C75
v.94

I.B.1.b - HAMILL,MRS.ALFRED E.,LAKE FOREST,ILL.

Lederer, P.hilipp, 1872-
Portraits in wax.The collection of Mrs. A.E.Hamill

In:Conn.
94:101-5 Aug.,'34 illus.

History of wax-modelling,which reached its zenith in the 16th c.in Italy,16-17th c.in France,18th c.in Britain.Repro.:Low-relief full face & profile.Artists:Caspar Hardy,Curtius,Chs Claude Dubut,Sam.Percy

I.B.1.b - HESSE, ERNST LUDWIG,grand duke of,
.1868-1937
Hesse, Ernst Ludwig,grand duke of, 1868-1937
Die miniaturen-sammlung...des Grossherzogs Ernst Ludwig von Hessen und bei Rhein...München. Kurt Wolff.1917.

MET
155.4
H46
Q

**FOR COMPLETE ENTRY
SEE MAIN CARD**

705
C75
NCFA
v.26

I.B.1.b - HARCOURT, LEWIS, LONDON, 1863-1922

Bate, Percy H.,1868-1913
Mr.Lewis Harcourt's collection of waxes

In:Connoisseur
26:135-42 Mar.,'10 illus.

**FOR COMPLETE ENTRY
SEE MAIN CARD**

I.B.1.b - HINCHINGBROOKE
see
I.B.1.b - MONTAGU, JOHN WM.,7th EARL OF SAND-
WICH,1811-1884, HINCHINGBROOKE

705
075
NCFA
v.56

I.... , WILLIAM BENTINCK 2.

Williamson, George Charles, 1858-1942.
The Bentinck-Hawkins coll.of enamels at the Ashmolean museum,Oxford

In:Connoisseur
56:34,36-7 Jan.,'20 illus.

Repro.incl.:H.Bone,the younger,Birch,Craft,Hone, Spicer,Zincke,H.Bone,the elder,Hatfield,Spencer

A64
NCFA
v.98

I.B.1.b - HOLBURNE, THS.WM., 1793-1874

Foskett, Daphne
Miniaturists silhouettists in Bath

In:Apollo
98:15-9 Nov.'73 illus.

Repro.incl.:Chs.Jagger,Abr.of Jos.Daniel, Charlotte Jones,Sampson Towgood Roch(e),Chs. Ford,Czias Humphry,Ths.Redmond,Chs.Foot Taylor, Nathaniel Hone,T.Hamlet,Jac.Spornberg,Elliott Rosenberg

ND
1333
P6C28
NCFA

I.B.1.b - HECKETT, Eric H.

Pittsburgh. Carnegie Institute. Dept.of
Fine Arts
Four centuries of portrait miniatures;from the Heckett collection,Heckmere Highlands, Valencia,Pennsylvania..Pittsburgh,1954
.39.p. illus.

Cat.of an exh.,compiled by Herbert Weiss-
berger
Bibliography
Notes incl.etymology of "miniature";tech-
niques;uses.

LC ND1333.P55

I.B.1.b - HOTHFIELD, LORD

Williamson George Charles, 1858-1942 comp.
Catalogue of a collection of miniatures Belonging to the Lord Hothfield.London,privately printed at the Chiswick Press,1916

MET
195.4
M678

no.6 of 60 copies printed

**FOR COMPLETE ENTRY
SEE MAIN CARD**

I.B.1.b - HOWARD, ,DUKE OF NORFOLK
　　　　　see
　　NORFOLK, DUKE OF

I.B.1.b - HUTTEN-CZAPSKI, EMERYK, hrabia, 1828-
　　　　　　　　　　　　　　　　　　　　　　-1896

Hutten-Czapski, Emeryk, hrabia, 1828-1896
　　Spis rycin przekstawiajacych portrety prze-
ważnie polskich osobistości w zbiorze Emeryka
hrabiego Hutten-Czapskiego w Krakowie.Z rekopisu
Emeryka Hutten-Czupskiego.wyd.F.Kopera.Kraków,
₂Nakk.Emerykowej Hutten-Czapskiej₂1901
FOGG　382 p.
AM340.7　List of graphic works representing portrs.of
mostly Polish personalities in the coll.of Count
Emeryk Hutten-Czapski in Krakau.From manuscript
...publ.F.Koper.Krakau.commissioned by Mrs.
Emeryk Hutten-Czapska₂1901

　　　　　　　　　　　　Fogg,v.11,p.323

I.B.1.b HOWARD CASTLE, YORKSHIRE

Gower, Ronald Charles Sutherland, 1845-1916
　　Three hundred French portraits representing
personages of the courts of Francis I,Henry II &
Francis II by Clouet.Auto-lithographed from the
originals at Castle Howard,Yorkshire.London,
S.Low,Marston & Searle,Paris,Hachette & cie.,
1875
　　2 v.　illus.

LC N7604.C6　　　　Amsterdam,Rijksmus.cat.
　　　　　　　　　Z5939A52,deel 1, p.509

NB
1310
H98　　I.B.1.b - HUTTON, LAURENCE
NPG
　　Hutton, Laurence,1843-1904
　　　Portraits in plaster,from the collection of
Laurence Hutton. New York,Harper & brothers,1894
　　271 p.　illus.

　　Masks;portraits

LC NB1310.H9

ME
53
W3U554　I.B.1.b - HUBBARD, GARDINER GREENE, 1822-1897
NCFA
U.S. Library of Congress.　Prints and photo-
graphs division.
　...Catalog of the Gardiner Greene Hubbard
collection of engravings...compiled by Arthur
Jeffrey Parsons...Washington,Govt.print off.,
1905
　　517 p.　illus.

　　Contents.:...Catal.of engravers...Portrait
index...

LC ME53.U5H8　1905　　Levis.Descr.bibl.Z5947A3
　　　　　　　　　　　　L66 1974　p.221

I.B.1.b - HYDE, EDWARD,1st EARL OF CLARENDON
　　　　　see
　　CLARENDON, Edw.HYDE, 1609-1674

N
40.1
I278　　I.B.1.b - HUDSON, THOMAS, 1701-1779
I S
NPC　Iveagh Bequest, Hampstead,Eng.
　　　Thomas Hudson,1701-1778;portrait painter
and collector;a bicentenary exh.;held.6 July
to 30 Sept.,1979.at.Iveagh Bequest.London,
Greater London Council,1979
　　₁88₂p.　illus.

　　　Exh.selected and intro.written by Ellen G.
Miles
　　　Cat.nos.1-66;Hudsons' work;nos.67-78;Hudson'
collection

705
B97　　I.B.1.b - IMSTENRAEDT, FRANZ VON
NCFA
　　Kurz, Otto
　　　Holbein and others in a 17th c. collection

　In:Burl.Mag.
83:279-82　Nov.1943　illus.

　　17th c. collection of Frans von Imstenraedt,
included Holbein;3 portrs. and Thomas More with
his family, and 2 portr. drawgs.　Large part of
coll. burnt in 1752,15items remained in Kremsier
palace,Moravia, rest is missing.

I.B.1.b - HUGHES, TALBOT, 1869-1942

Spanish Institute,Inc.,N.Y.
　　The Spanish golden age in miniature.Portraits
from the Rosenbach Museum & Library.Cat.of exh.;
March 25-Apr.23,'88.New York,The Institute,1988
　　62 p.　illus(part col.)
　　Bibliography

　　Incl.the miniatures of the Talbot Hughes
coll.
　　Exh.also in Philadelphia,Rosenbach Mus.&
Library,June 7-July 31,'88

MdBMA　MB(ND1337.S7S636　1988)

I.B.1.b - IOWA　see also
I.B.1.b - U.S. - IOWA

705
A56
NCFA
v.26

I.B.1.b - JACKSON, Mrs.F.NEVILL, 1861-

Jackson, Mrs.F.Nevill, 1861-
 Profiles on porcelain

In:Antiques
26:217-9 Dec.,'34 illus.

 Silhouettes on porcelain,most items in Mrs.
Jackson's collection

I.B.1.b - JOLY,.JOHN, 1857-1933, DUBLIN.

Dublin. National Library of Ireland.
 ...Catalogue of engraved Irish portraits,main-
ly in the Joly collection,and of original draw-
ings.By Rosalind M.Elmes...Dublin,The Station-
ry off.,1937.
 279 p.

 Bibliography

LC NE265.D8 Yale ctr.f.Brit.art Ref.
 NE265.D8

I.B.1.b - JAFFÉ, ALBERT, HAMBURG

Jaffé, Albert
 Cat.of the important coll.of miniatures and
paintings of Mr.Albert Jaffé,Hamburg,which will
be sold by auction by Messrs.J.M.Heberle(H.Lem-
pertz'sons)Cologne...March 27th to April 1st,
1905...The direction of the auction will have
Mr.Henry Lempertz...Cologne,M.D.Schauberg,1905
 59 p.

LC N5265.J3

N
7592
H513
RB
NPG

I.B.1.b - JONES, COL.CHARLES COLCOCK

Henkels, Stanislaus Vincent, 1854-1926
 Cat.of the valuable autographic coll. and en-
graved portraits...gathered by...Col.Chs.Colcock
Jones...to be sold Tue.,Wed.,Thurs.,April 24,25,
26,1894.Cat.comp.and sale conducted by Stan.V.
Henkels,at the book auction rooms of Thos.Birch's
Sons,Philadelphia
 148 p. illus.
 cat.no.720
 16 engravings of Washington
 Contains autographic sets of the signers of
the Declaration of Independence,Rulers & Govs.

I.B.1.b - JAFFÉ, ALBERT, HAMBURG

Jaffé, Albert
 Kat.der...miniaturen-sammlung des herrn
Albert Jaffé in Hamburg...Versteigerung zu
Köln a.Rh.den 27.-30.März 1905 bei J.M.Heberle
(H.Lempertz'söhne)...Der amtierende notar:Theo-
tor Lempertz...Leiter der versteigerung dr.phil
Heinrich G.Lempertz...Köln,Druck von M.D.Schau-
berg,1905
 89 p. illus(1 col.)

LC N7616.13

I.B.1.b - JOSEPH, EDWARD

Joseph, Edward
 Cat.of a coll.of miniatures by Richard
Cosway,and contemporary miniaturists...in the
possession of E.Joseph..London?,1883

LC ND1337.08C75 **FOR COMPLETE ENTRY
 SEE MAIN CARD**

MET
255.4
J18

I.B.1.b - JAFFÉ, ALBERT, HAMBURG

Jaffé, Albert
 Sammlung A.Jaffé...Miniaturbildnisse des
17.bis 19.jahrhunderts...versteigerung...den
23.-24.Okt.1912...Rudolph Lepke's kunst-auk-
tions-haus..Berlin,1912.
 F. pt.2 36 pl.

I.B.1.b - JOVE, PAUL
 see
 GIOVIO, PAOLO, 1483-1552

ND
210
C67X
NCFA

I.B.1.b - JETTÉ, EDITH KEMPER & ELLERTON MARCEL

Colby College, Waterville,Me.
 A group of paintings from the American
heritage collection of Edith Kemper Jetté and
Ellerton Marcel Jetté.Waterville,Colby College
Press,1956
 94 p. illus.

 Mainly reproductions of ptgs.,silhouettes,
etc. 19th c.

 Dewhurst.Artists in aprons.
 Bibl.p.186

I.B.1.b - KAAN, KLAAS, HAARLEM

Muller, Frederik, 1817-1881
 Beschrijvende catalogus van 7000 portretten
van Nederlanders,en van buitenlanders,tot Neder-
land in betrekking staande...Amsterdam,F.Muller,
1853
 401 p.
 Muller coll.in 1852
 Part I:Ruling fgs.& their families,in chro-
nological order.Pt.II.Exceptional individuals,
in alphabetical order,with biographical notes
& dates of the prints.
 Rijsbroek.Fred.Muller en
LC NE265.M8 zijn prentenversamelingen
 In:Bull.Rijksmus.29:26
 note 12 708.949z.A523 NMAA

```
"
6507        I.B.1.b - KAROLIK, M.& M.
M98
1950         Boston. Museum of Fine Arts
NMAA           Eighteenth-century of American arts,the
             M.& M.Karolik coll.of paintings,drawings,en-
             gravings,furniture...gathered to illustrate
             the achievements of American artists and
             craftsmen of the period from 1720 to 1820 by
             Edwin J.Hipkiss.With notes on drawings and
             prints by Henry P.Rossiter,and comments on
             the coll.by Maxim Karolik.Cambridge,Mass.Publ.
             for the MFA,Boston,Harvard Univ.Press,1950
                366 p.   illus.
                Bibliography       Worldwide Art Book Biblio-
                                   graphy Z5931.W92 NMAA 2,
             see-over-             no.2-4 1967-71,v.111,no.1
                                   p.10
```

```
AP
1           I.B.1.b - KEPPEL
A784
J8          Williamson, George Charles, 1858-1942
NCFA          Four miniatures of the Keppel family

            In:Art J.
            73(?):222-4   July,'11   illus.

                            FOR COMPLETE ENTRY
                            SEE MAIN CARD
```

```
705         I.B.1.b - KAROLIK, M.and M.
A784
NCFA        Cunningham, C.harles. C.rehore.
v.30          The Karolik collection-"ome notes on Copley

            In:Art In Amer
            30:26,29,,30,33-5   Jan.,'42   illus.

               Discussion incl.C.'s "borrowing"of composi-
            tion,pose,costume from British portrs.

                            Fairbrother in:Arts Mag.
                            705.A7834 NCFA 55:129
```

```
705         I.B.1.b - KERN, SYBIL B. & ARTHUR B.
A56
NMAA        Oak, Jacquelyn
v.122         American folk portraits in the coll.of Sybil
            B.& Arthur B.Kern

            In:Antiques
            122:564-70   Sept.,'82   illus(mostly col.)

               Repro.incl.:J.Dalee, J.Maentel, Z.Belknap,
            B.Greenleaf, R.Whittier Shute, R.B.Smith, M.W.Hop-
            kins, S.Peck, E.S.Field, R.H.Bascom, J.S.Ellsworth,
            J.A.Davis, J.W.Stock, M.Williams, R.Porter,
```

```
"D
210         I.B.1.b - KAROLIK, M.& M.
B74ls
NMAA        Boston. Museum of Fine Arts
              M. & M.Karolik coll.of American paintings,
            1815-1865.Boston,Mus.of Fine Arts,c.1976
              60 p.   chiefly illus(part col.)

                            Colonial Williamsby.,inc.
                            The Abby Aldrich Rockefel-
                            ler folk art coll.N6510.C7
                            NCFA Bibl. p.394a
```

```
            I.B.1.b - KISTERS, KREUZLINGEN,SWITZERLAND

            Kaplan, Paul H.D.
              Titian's Laura Dianti and the origins of the
            black page in portraiture

NOA         In:Antichità viva
N 1         21,no.1:11-18   1982
A3          21,no.4:10-18   1982   illus.
v.21
               The black page has in instances functioned
            as an identifying attribute,alluding to the inter
            ests of the sitter or given a hint of the sit-
            ter's nationality.
               Repro.incl.:
```

```
N
6510        I.B.1.b - KAROLIK, M.And M.
B74
NCFA        Boston. Museum of Fine Arts
c.1Ref.       M. & M.Karolik coll.of American Water co-
c.2NCFA     lors & drawings,1800-1875.Boston,1962?
              2 v.   illus(part col.)

            v.2,p.96-136:Portraits

            Exh.held...Oct.18,1962-Jan.6,1963
            Incl.bibliographies
```

```
NE
240         I.B.1.b - KOLB, DR.LEON, 1890-
K64S72X
NPG         Stanford University. Libraries. Division of
               Special Collections
               Portraits:a cat.of the engravings,etchings,
            mezzotints,and lithographs presented to the
            Stanford Univ.Library by Dr.and Mrs.Leon Kolb.
            Comp.by Susan V.Lenkey..Stanford,Calif..Stan-
            ford University,1972
               373 p. 1 illus.

               Listed by sitters,indexed by social and
            historical positions of the subjects; painters
            with their sitters: engravers; techniques

LC NE240.K64S72
```

```
705         I.B.1.b - KAROLIK, MAXIM, 1893-1963
C75
NCFA        Comstock, Helen
v.109         Drawings by J.S.Copley in the Karolik col-
            lection

            In:Connoisseur
            109:150-5   June,'42   illus.

                            FOR COMPLETE ENTRY
                            SEE MAIN CARD
```

```
            I.B.1.b - KRITTER, ULRICH VON

            Westfälisches Landesmuseum für Kunst und Kul-
            turgeschichte,Münster
              In caricature:Militaire in Frankreich
            11.Kp-19.Kp aus der sammlung von Kritter.Aus-
            stellung,16.März-10.Mai 1980.Kunstsammlung
            der Universität Göttingen,26.Okt.-7.Dez.1980,
            Gutenberg Mus.Mainz,26.Apr.-7.Juni 1981..Kat..
            hrsg.von Gerd Unverfehrt.Göttingen:Kunstge-
            schichtliches seminar der Universität,c.1980
              300 p.   illus.
              Bibliography

LC DC266.5.C37              Worldwide Art Cat.b. 705.
                           W27 NCFA v.18,no.1,p.23
```

ND
1311.2
P61x
NPG

I.B.1.b - KUNTZ, FELIX H.
 Toledano, Roulhac B. & W.Jos.Fulton
 Portr.ptg.in colonial & ante-bellum New
Orleans
Miles, Ellen Cross comp.
 Portrait painting in American.The nineteenth
century.N.Y....,1977 (card 2)

 Partial contents:...R.B.Toledano & W.J.Ful-
ton,Portr.ptg.in colonial & ante-bellum New Or-
leans,p.31-8;...

VF in:
London
NPG

I.B.1.b - LEEDS, DUKES OF. Hornby Castle,Bedale,
 .Yorks.
Gibson, Robin
 The National Portrait Gallery's set of Kings
and Queens at Montacute House

In:Nat'l Trust Year Book
1:81-87 1975-76 illus.

 Examines...the set,f'ly at Hornby Castle,Be-
dale,Yorks,in the coll.of the Dukes of Leeds,
now...NPG

LC NX28.G72N3716 1975-76 FOR COMPLETE ENTRY
 SEE MAIN CARD

I.B.1.b - LAMBERTS, GERRITT, 1776-1850 AMSTERDAM
Müller, Frederik, 1817-1881
 Beschrijvende catalogus van 7000 portretten
van Nederlanders,en van buitenlanders,tot Neder-
land in betrekking staande...Amsterdam,F.Müller,
1853
 401 p.
 Müller coll.in 1852
 Part 1:Ruling fgs.& their families,in chro-
nological order.Pt.II.Exceptional individuals,
in alphabetical order,with biographical notes
& dates of the prints.
 Hijbroex.Fred.Müller en
LC NE285.M8 sijn prentenverzamelingen
 In:Bull.Rijksmus.29:26
 note 12 708.949z.A523 NMAA

760.5
.P94

I.B.1.b - LELY, PETER, 1618-1680

The complete etched portrait work of Anthony
van Dyck,from the collections of Sir Peter
Lely and Prosper Henry Lankrink.N.Y.,M.
Knoedler & co.,inc.,1934
 ,44,p. illus. (The print collec-
tor's bulletin,v.3,no.3)

 Coll.Lely sold Apr.11-18,1688 under the
direction of Sonnius,Lankrink & Thompson,
London.-Coll.Lankrink sold May8,1693 & Feb.
22,1694,"At the Golden Triangle,in Long
Acre,London
 Mostly portrs.of Flemish painters

N05
C75
NCFA
v.48

I.B.1.b - LANE, JOHN, 1854-1925

Baker, Charles Henry Collins, 1880-
 Notes on some portraits in Mr.John Lane's
collection

In:Connoisseur
48:127-36 Jul.'17 illus.

 Collection of 100 portrs.by obscure British
painters

 Repro.:John Betts,Ths.Lawranson,Ths.Hudson,
Isaac Whood,Jos.Highmore,Js.Worsdale,Benj.Wilson
 Cumulated Mag.subj.index
 A1/3/C76 Ref. v.2,p.444

I.B.1.b

Lenoir, Alexandre, 1761-1839
 The Lenoir collection of original French
portraits at Stafford House.Auto-lithographed by
Lord Ronald Gower.London,Maclure & Macdonald...
1874

 illus.

 From Francis I to Marie-Antoinette

LC N7604.L36 Amsterdam,Rijksmus.,cat.
Rare book coll. 25939A52,deel 1, p.146

760.5
.P94

I.B.1.b - LANKRINK, PROSPER HENRY, 1628-1692

The complete etched portrait work of Anthony
van Dyck,from the collections of Sir Peter
Lely and Prosper Henry Lankrink.N.Y.,M.
Knoedler & co.,inc.,1934
 ,44,p. illus. (The print collec-
tor's bulletin,v.3,no.3)

 Coll.Lely sold Apr.11-18,1688 under the
direction of Sonnius,Lankrink & Thompson,
London.-Coll.Lankrink sold May8,1693 & Feb.
22,1694,"At the Golden Triangle,in Long
Acre,London
 Mostly portrs.of Flemish painters

705
C75
NCFA
v.43

I.B.1.b - LEON, GEORGE

Baker, Charles Henry Collins, 1880
 Some pictures in Mr.George Leon's collection.

In:Connoisseur
43:2-11 Sep,1915 illus(part col.)

 Chief interest of collection:Portraits of 17th
& early 18th c.

 Incl:Edwards:Sir Edward Walpole; Miereveld,
Soest, Greenhill, etc.

ND
1337
G7N48
1978X
NCFA

I.B.1.b - LATTER-SCHLESINGER (Harry & Anna Lat-
 ter)
New Orleans Museum of Art
 English and continental portrait miniatures;
the Latter-Schlesinger collection...1978

LC ND1337.G7N48 1978 FOR COMPLETE ENTRY
 SEE MAIN CARD

N
1455
A55
1983
NMAA

I.B.1.b - LEVERHULME,1st VISCOUNT(WM.HESKETH
 LEVER), 1851-1925
Lady Lever art gallery, Port Sunlight
 Cat.of foreign paintings,drawings,minia-
tures,tapestries,post-classical sculpture and
prints.Merseyside County Council,1983
 322 p. illus.

 Incl.Ch.Miniatures,p.57-87

 Ch.Sculpture incl.:Deathmasks of Napoleon
by Antommarchi and Burton;Bust of Napoleon
by Chaudet;wax profile of Napoleon by Cinga-
nelli;Equestrian statuetteof Napoleon by Du-
bray

705
A56
NCFA
v.20

I.B.1.b - LEVY, DAVID J., DETROIT, MICH.

Levy, David J.
Italian wax miniaturists

In:Antiques
20:354-7 Dec.,'31 illus.

**FOR COMPLETE ENTRY
SEE MAIN CARD**

AP
1
164
NCFA
v.104

I.B.1.b - LUGT, FRITS

Reynolds, Graham, 1914-
Portrait miniatures from Holbein to Augustin
in the Lugt collection.

In:Apollo
104:274-81 Oct.,1976 illus(part col.)

N
7593
L4X
NPG

I.B.1.b - LEWIS, JOHN FREDERICK, PHILADELPHIA,
1860-1932

Lewis, John Frederick, 1860-1932
Coll.of John Frederick Lewis:American por-
traits,presented to the Pennsylvania academy of
fine arts and other institutions.Phila.The Penn-
sylvania academy of fine arts.1934
112 p. illus.

Exh.of American portrs:Coll.J.F.Lewis,Apr.15-
May 6,1934.Cat.& foreword by Mantle Fielding
'Incl.portrs.of Washington by Rembrandt Peale,
Rbt.Street,K.H.Schmolze,John Trumbull.Washington
family by Edw.Savage,Martha W. by J.Wollaston.'-
Art Digest 8:18, May 1,'34
ICN7593.L4

705
B97
NCFA
v.99

I.B.1.b - LUMLEY, BARON JOHN, 1534?-1609

Piper, David
The 1590 Lumley inventory:Hilliard,Segar
and the Earl of Essex-I & II

In:Burl.Mag.
99:224-31 July,'57 illus.
:299-303 Sept.,'57 illus.

I:Incl.:List of 22 portrs.bearing Lumley
labels.

Strong.The Engl.Icon ND1314
S924 NPG p.45 note 3

I.B.1.b - LIVERPOOL, C.G.S.Foljambe,4th Earl of
1846-1907
Liverpool, Cecil George Savile Foljambe,4th
Earl of, 1846-1907
Cat.of portraits,miniatures,etc.in the pos-
session of Cecil George Savile,4th Earl of Li-
verpool,Lord Steward,etc. Hull Browns'Savile
Yale Ctr. Press,1905
f.Brit.Art 167 p. illus.
Ref. N For private circulation only
7622.2 Incl.index
.C71S8

I.B.1.b - LUMLEY FAMILY

Milner, Edith
Records of the Lumleys of Lumley Castle...
ed.by Edith Benham.London,G.Bells & sons,1904
380 p. illus.

'.Lumley's....the largest portr.coll.in
Elizabethan England...over 200 portrs.'.-Strong

LC DA28.35L8M6

Strong.The Engl.Icon ND131
S924 NPG p.45 note 3

I.B.1.b - LONGLEAT, (WILTS)
see
I.B.1.b - THYNNE, MARQUISES OF BATH, LONGLEAT,
(WILTS)

705
A64
NCFA
v.73

I.B.1.b - MACDONALD, ALEXANDER, 1836-1884,Aberdeen

Carter, Charles
A gallery of artists' portraits. A yardstick
of taste

In:Apollo
73:3-7 Jan,1961 illus.

Repro:Drgs.by Sambourne:Royal Academy banquet,1881,
Royal Academicians,1884. Self-portrs.by Frith,
Sargent,Tenniel. Sir John Everett Millais

Enc.of World Art,v.11,
col.514.N31E56 Ref.
bibl.on portr.

I.B.1.b - LOWER SAXONY COLLECTIONS

Kestner-Gesellschaft
Katalog nr.64
Bildnisminiaturen aus Niedersächsischem pri-
vatbesitz.Hannover,1918
v. illus.

Katalog:Prior to 1955/56 issued without:title
and numbering..Title and number found in Bruijn
Kops.

LC N5070.H3K4

Bruijn Kops.In B.Rijksmus.
36,p.179,note 45

I.B.1.b - MCFADDEN, JOHN H., PHILADELPHIA

Pittsburgh. Carnegie Institute. Dept.of
Fine Arts
Cat.of an exh.of early English portraits
and landscapes lent by Mr.John H.McFadden,April
26 through June 15,1917.Pittsburgh,Carnegie inst.
dept.of fine arts,1917,
24,p. illus.

LC ND464.P5

**FOR COMPLETE ENTRY
SEE MAIN CARD**

705
C75
NCFA
v.52

I.B.1.b - MCFADDEN, JOHN H., PHILADELPHIA

Roberts, William, 1862-1940
The John H.H.McFadden collection.I.-Portrait

In:Conn.
52:125-30,134,137 Nov.,'18 illus.

18th & 19th c. paintings
Repro.incl.:Hogarth,Reynolds,Gainsborough,
Romney,Raeburn,Harlow,Hoppner,J.W.Gardon,etc.

Cum.Mag.subj.index A1/3/7
Ref. v.2,p.444

I.B.1.b - MANTOVA BENEVIDES, MARCO,conte,1489-158:
Padua

Mantova Benevides, Marco,conte, 1489-1582
Illvstrivm ivreconsvltorvm imagines...Ex mu-
saeo Marci Mantuae Benauidij patauini...Romae,
Ant.Lafrerij...1558

25 engraved portrs.of jurists by Niccolò
Nelli after portrs.in Mantova's "little" museum

HU-L MNUT MH
Rave.Jb.d.Berl.Mus. I 1959
LC N3.J16 fol.p.146
Paolo Giovio & d.Bildnisvitenbücher..

qNC
1477
C4C53
NCFA

I.B.1.b - MCKEE, WILLIAM MCCALLIN

Chicago. Art Institute
British caricatures of the 18th and early
19th century from the William McCallin McKee
collection held at the Art Institute of Chi-
cago in honor of the late Thomas Foster Furness
May 12-June 30,1977.Chicago,The Art Inst.,c1977
24 p. illus.

I.B.1.b -

Mariani, Angelo
Figures contemporaines,tirées de l'album
Mariani...Paris,E.Flammarion,1894-
11 v. illus.

v.2.— published by H.Floury

Each plate has engraved portr. ...

LC CT148.M3
Fogg,v.11,p.324

N
6507
H57K
NPG
NMAA

I.B.1.b - MCKENNEY,THS.L.& HALL,JS.

Hirschl & Adler Galleries,inc.,N.Y.
American art from the Colonial and Federal
periods.Cat.of an exh.,Jan.14-Feb.10,1982.In-
troduction by Stuart P.Feld..The Gallery,
c.1982.
102 p. illus(part col.)

Index of artists

Incl.:McKenney & Hall coll of portrs.of
American Indians by Henry Inman now in Harold
Byrd coll,Dallas,Texas(1984).

I.B.1.b - MAY, LEONARD MORGAN, LONDON,BLACK-
HEATH

May, Leonard Morgan
A master of silhouette.John Miers:portrait
artist,1757-1821.London,Martin Secker,1938.
107 p. illus.

Bibliography

LC NC910.M5M3

705
C75
NCFA
v.6 &
v.7

I.B.1.b-MANNERS

Manners, Lady, Victoria, 1876-1933
Notes on the pictures at Belvoir Castle

In:Connoisseur
Pt.I.6:67-71,74 June,1903 illus.
Pt.III.7:3,6,8,10,13 Sept.,1903 illus.

FOR COMPLETE ENTRY
SEE MAIN CARD

I.B.1.b - MAYO, LORD, PALMERSTOWN, IRELAND

Williamson, George Charles, 1858-1942
Miniatures belonging to the Earl of Mayo

In:Connoisseur
23:259-64 Apr,1909 illus.

On enamel:Chs.Boit,C.F.Zincke,Jos.Lee,P.G.
Bone,Wm.Essex,etc.On ivory:Henry Bone.Ink drg.
of Wordsworth by D.B.Murphy

Blanshard,F. The portrs.of
Wordsworth N7628W92B6

I.B.1.b - MANNING, AMBROSE SPENCER and JAMES,
ALBANY

Albany Institute of History and Art
Portrait index of Albany Inst.of Hist.&Art
"Mayors Collection","Ambrose Spencer Manning
Collection","James Manning Collection Albany
Portraits c.1897"
Unpublished (Typewritten)

Feigenbaum.Amer.portrs....
N311.2.F29 NPG Bibl.
.150

I.B.1.b.- MAZOCHIO, JACOPO, ROME,printer & coll.

Fulvio, Andrea, fl.1510-1543
Illvstrivm imagines...Romae,Jacopo Masochio,
1517
illus.

202 portrs.Woodcuts by Ugo da Carpi or work-
shop after antique medals of Mazochio's coll.
"One of the oldest publications...with portrs
-Prinz
"this work became the example for numerous
portr.works".-Rath Prinz.Slg.d.selbstbildn.in d.
Uffizien N7618/P95 Bd.1,p.146
LC N7585.F8 ote 43.Rave.In:Jb.d.Berl.m.
also in: 1959 LC N3.J16 fol.p.128
Rath.Portr.werke in Lex.d.ges.Buchwesens,III,p.39 NPGxerox

NC
860
N66X
NPG

I.B.1.b – MELLON, PAUL

Noon, Patrick J.
English portrait drawings and miniatures.
New Haven,Ct.,Yale Center for British Art,1979

(some drags.in the exh.lent by Mr.Paul Mel-
lon)

FOR COMPLETE ENTRY
SEE MAIN CARD

I.B.1.b – METTERNICH, PRINCESS MELANIE, d.1854
(3rd wife of Prince Cl.Loth.Wenzel Metternich)
Guglia, Eugen, 1857-1919
Die porträtsammlung der Fürstin Melanie
Metternich, verzeichnis der porträtminiaturen

In:Die graph.künste
40:71-112 1917 illus.

MET
100.53
G76
Q
v.39-40

LC N3.G7

Bildnismin.& ihre meister
757.B59,v.4,Bibl.

AP
1
A64
NCFA
v.105

I.B.1.b – MELLON, PAUL

Waterhouse, Ellis Kirkham, 1905-
An impressive panorama of British portrai-
ture

In:Apollo
105:236-9,244-5,247,249,251 Apr.'77 illus.
.(part col.)

Discusses some portrs. in the
Paul Mellon coll.at Yale Center for British Art
ranging from c.1550-c.1850

Rila IV/1 #1133
1978

I.B.1.b – MEYSSENS, Jan (portr.coll.of 1648/49)

Bie, Cornelis de, 1627-17 ?
Het gulden cabinet van de edele schilder-
const...2de ed..Antwerpen,1662.

MET
182
B471

'Contains the portr.coll.of Jan Meyssens of
1648/49'.-Goldschhider

UkOxU

Goldschhider.N40.065xNCFA
Bibl.p.59

ND
466
V81
NCFA

I.B.1.b – MELLON, PAUL

Virginia Museum of Fine Arts, Richmond.
Painting in England 1700-1850;collection
Mr.& Mrs.Paul Mellon..Cat.by Basil Taylor.
Richmond,1963
2 v. illus(part col.)

v.1:Intro.,cat.,small illus.-v.2:Repro.in
alphabetical order.

Exh.divided into 4 parts.2:Portrs.,conve-
tion pieces,scenes fr.contemp.life

LC ND466.V5 MOMA,v.11,p.432

NPG I.B.1.b – MILLER, C.V.

Weil, Elma Allee
Wax portraiture

In:Antiquarian
10:49-52 Mar.,'28 illus.

Repro.examples in the coll.of ... & C.V.
Miller

FOR COMPLETE ENTRY
SEE MAIN CARD

R
.17JM5

I.B.1.b –

Meserve, Frederick Hill, 1865-
The photographs of Abraham Lincoln,by Fre-
derick Hill Meserve and Carl Sandburg.N.Y.,Har-
court,Brace and company,1944; 1st ed.
30p. illus.

Contents.-The face of Lincoln,by Carl Sand-
burg.-Frederick Hill Meserve,by Carl Sandburg.-
The photographs of Abraham Lincoln,by F.H.
Meserve

LC E457.6.M569

CJ
161
P65JM6X
NPG

I.B.1.b – MILLER, JEFFREY H.

Centoft-Hilsen, Marit, 1938-
Ancient portraiture;the sculptor's art in
geius and marble.A loan exh.on display at the
Virginia Museum,Apr.29 to July 20,1980...
Richmond,Virginia Museum,c.1980
64 p. illus.

Most items from the coll.of Jeffrey H.
Miller and the Getty Museum
Excellent introd.to the numismatic portrai-
ture in relation to work in marble.
Discussion of the develorm't of portrs.by the
Romans
Worldwide Art cat.N. v.17
LC N527 WWAA p.60

I.B.1.b – MESERVE, FREDERICK HILL, 1865-1962

Meserve, Frederick Hill, 1865-1962
Portraits of the Civil War period,photo-
graphs for the most part from life negatives
by M.B.Brady,now in the possession of F.H.
Meserve..N.Y.Corlies,Macy & Co.,incorp...1903?.
36 p. illus.

LC N7624.M4

I.B.1.b

Mitchell, James Tyndale, 1834-1915
...Collection of engraved portraits of Wa-
shington belonging to Hon.James T.Mitchell...
Cat.comp. & sale conducted by Stan.V.Henkels at
the art auction rooms of Davis & Harvey,Phila.,Pa.
...,1906.
2 pts. illus.
Cat.no.944,pt.I-II

v1. ...to be sold Jan.18 & 19,1906.-v.2...to
be sold May 3, 1906

LC E312.43.M68

I.B.1.b

Mitchell, James Tyndale, 1834-1915
...The unequaled collection of engraved por-
traits belonging to Hon.T.Mitchell...embracing
statesmen of the colonial,revolutionary and pres-
ent time,incl.the extens.coll. of portrs. of Benj.
Franklin,Sam.Adams,John Hancock,Henry Laurens,
Henry Clay,and Daniel Webster,also chief and as-
sociate justices of the Supreme court of the U.S,
attorneys-general of the U.S.,judges,lawyers,etc.
To be sold...Dec.5 and 6,1907...Cat.comp.and sale
conducted by Stan.V.Henkels.At the book auction
rooms of Davis & Harvey...Phila,Pa..Phila.,1907.
 134 p. illus.
 Cat.no.944,pt.

LC E176.M68

.N21M68

Mitchell, James Tyndale, 1834-1915
...The unequalled collection of engraved
portraits of Napoleon Bonaparte and his family
and marshals,belonging to Hon.J.T.Mitchell...
portraits in mezzotinto,aquatint,line and stiple
...caricatures on Napoleon by Cruikshank,Gillray,
Rowlandson...to be sold...1908.Philadelphia,Pa.,
,Press of W.F.Fell,company,1908.
 100 p. illus.
 (Sold at book auction rooms of S.T.Freeman & co
 (Catalogue compiled...by Stan V.Henkels)
 Cat.no.944,pt.VII

LC DC203.M85

I.B.1.b

Mitchell, James Tyndale, 1834-1915
...The unequaled collection of engraved por-
traits belonging to Hon.T.Mitchell...embracing
the lord chancellors and chief justices of Great
Britain,éminent English lawyers,kings & queens of
Great Britain,English princes & princesses & mem-
bers of royal families,mostly engraved in mezzo-
tinto,to be sold...Feb.26...and...Feb.27,1908...
Cat.comp.& sale conducted by Stan.V.Henkels.At
the book auction rooms of Davis & Harvey,Phila.Pa
...Press of W.F.Fell co.,1908.
 93 p. illus.
 Cat.no.944,pt. VI

LC NE265M5

I.B.1.b

Mitchell, James Tyndale, 1834-1915
...The unequaled collection of engraved por-
traits of officers...of the war of the revolu-
tion,2nd war with Great Britain and the Mexican
war,belonging to Hon.James T.Mitchell...to be
sold Nov.30 and Dec.1,1906...Cat.comp.& sale con-
ducted by Stan.V.Henkels,at the book auction
rooms of Davis & Harvey...Phila.,Pa...M.H.Power
printer,1906.
 131 p. illus.
 Cat.no.944,pt.III

LC E181.M84

017.37 I.B.1.b
.M68

Mitchell, James Tyndale, 1834-1915
...The unequaled collection of engraved
portraits of beautiful women of Europe and Ame-
rica,and actors,actresses,vocalists,musicians,
and composers,belonging to Hon.James T.Mitchell...
to be sold,..Phila.,Pa.,.M.H.Power,printer,1910.
 144 p. illus(part col.)

 (Catalogue compiled...by Stan.V.Henkels)
 (Sold at book auction rooms of S.T.Freeman & co
 Cat.no.944,pt.X

LC NE240.M5

I.B.1.b

Mitchell, James Tyndale, 1834-1915
...The unequaled collection of engraved por-
traits of the English royalty & English officers
...,statesmen,artists,authors,poets,dramatists,
doctors,lawyers,etc.,from the earliest to the
present time.belonging to Hon.James T.Mitchell...
to be sold...May 2d & 3d,1911.Cat.comp.& sale con
ducted by Stan.V.Henkels,at the book auction
rooms of S.T.Freeman & co...Phila.,Pa...M.H.
Power,printer,1911.
 72 p. illus.
 Cat.no.944,pt.XII

LC NE240MM52

I.B.1.b -

Mitchell, James Tyndale, 1834-1915
...The unequalled coll.of engraved portraits
of eminent American and some noted foreign-
ers belonging to Hon.James T.Mitchell...a
large coll.of lithographs engraved by A.Newsam
an unique coll.of American revolutionary and
political caricatures and numerous portraits
for extra illustrating,to be sold...Oct.28,
1913.Phila.,Pa..Stan V.Henkels,1913.
 56 p. Plates
 Cat.Stan V.Henkels,no.944,pt.13

LC Z999.M505 no.944,pt.13 Rosenwald coll.

I.B.1.b

Mitchell, James Tyndale, 1834-1915
...The unequaled collection of engraved por-
traits of the Presidents of the United States,be-
longing to Hon.James T.Mitchell...to be sold...
May 16...&...May 17,1907...Cat.comp. and sale con-
ducted by Stan.V.Henkels at the book auction
rooms of Davis & Harvey...Phila.,Pa.M.H.
Power,printer,1907.
 123 p. illus.
 Cat.no.944,pt.IV

LC E176.1.M68

I.B.1.b

Mitchell, James Tyndale, 1834-1915
...The unequaled collection of engraved por-
traits of eminent foreigners,embracing kings,
eminent noblemen & statesmen,great naval command-
ers...explorers,...reformers...also a collection
of caricatures on Napoleon & a ...coll.of portrs.
engravings by the great masters of the last four
centuries in line,mezzotinto,stipple & etching..
to be sold...Oct.14,1912...and Oct.15,1912.Cat.
comp.& sale conducted by Stan.V.Henkels at the
book auction rooms of S.T.Freeman & co.,Phila.,Pa
.M.H.Power,printer,1912.
 111p. illus.
 Cat.no.944,pt. XII

LC NE240.M515

I.B.1.b-

Mitchell, James Tyndale, 1834-1915
...The valuable collection of books on en-
graved portraits owned by the Hon.Js.T.Mitchell
...Also an unique coll.of caricatures by Cruik-
shank,Gillray,Heath,Seymour...and others.To be
sold...Jan.4,1909...and...Jan.5,1909...Cata-
logued & .sales.conducted by Stan.V.Henkels.At
the book auction rooms of Sam.T.Freeman & co...
Philadelphia.....Press of M.H.Power,1904?.
 91 p.
 Cat.no.944,pt.VIII
 715 items
 Levis,Descr.bibl...Z5947
 #3166 1974 NCFA p.250;
LC NE240.M54 "A valuable bibliography of engraved portraiture"

I.B.1.b - MONTAGU, JOHN, 1M., 7th EARL OF SAND-
WICH, 1811-1884, HINCHINGBROOKE

Boyle, Mary Louisa, 1810-1890
 Biographical notice of the portraits at
Hinchingbrook...London,printed at the Victo-
ria Press(Office for the Employment of women)
1876
 275 p.

Yale Ctr.
f.Br.Art
N7622.2
O7935B68

ND
205
S37
1981X
NMAA

I.B.1.b - MORTON, PRESTON

Santa Barbara,Calif. Museum of art
 The Preston Morton collection of American
art;Katherine Harper Mead,editor.Santa Barbara,
Calif...Mus.of Art,c.1981
 272 p. illus(part col.)

 Bibliography p.267-72
 Incl.:Essays on:J.S.Copley,by M.W.Schantz;
Benj.West,by M.W.Schantz;Chr.Gullager,by E.G.
Miles;Js.Peale,by E.G.Miles;Ths.Sully,by E.G.
Miles;Geo.P.A.Healy,by E.G.Miles;Wm.M.Hunt,by
P.Bermingham;Ths.Eakins,by R.Bowman;Wm.M.Chase,
by G.M.Ackerman;R. Henri,by K.H.Mead

757.7
.M84

I.B.1.b - MORGAN, JOHN PIERPONT, 1837-1913

Morgan, John Pierpont, 1837-1913
 Catalogue of the collection of miniatures
the property of J.Pierpont Morgan;comp....by
G.C.Williamson...London,Priv.print.at the Chis-
wick press,1906-1908
 4 v. illus.

LC N7616.M8 Pittsburgh.Carn.Inst.Dpt.
 Fine Arts.Four c.of portr.
 min.ND1333P6C28 Bibl.

I.B.1.b - MULLER, FREDERIK, 1817-1881

Muller, Frederik, 1817-1881
 . Beschrijvende catalogus van 7000 portretten
van Nederlanders,en van buitenlanders,tot Neder-
land in betrekking staande...Amsterdam,F.Muller,
1853
 401 p.
 Muller coll.in 1852
 Part 1:Ruling fgs.& their families,in chro-
nological order.Pt.II.Exceptional individuals,
in alphabetical order,with biographical notes
& dates of the prints.
 Hijbroek.Fred.Muller en
 zijn prentenverzamelingen
LC NE285.M8 In:Bull.Rijksmus.29:26
 note 12 708.949z.A523 NMAA

757.7
C55
NCFA

I.B.1.b - MORGAN, JOHN PIERPONT, 1867-1943

Christie,Manson & Woods
 Cat.of the famous coll.of miniatures of the
Prit.and foreign schools,the property of J.Pier-
pont Morgan...to be sold at auction by Messrs.
Christie,Manson & Woods...June 24,1935 & three
following days...London,...1935
 272 p. illus(part col.)

 Based on descriptive & illus.cat.in 4 v.,
comp.by G.C.Williamson for the late J.Pierpont
Morgan, father of the present owner.
 16-19th c.miniatures of Royalties,statesmen,
ladies of the court,etc.

705
M18
NCFA
v.7

I.B.1.b - MUNN, CHARLES ALLEN, NEW YORK

Early American engraved portraits.An exh.at
 the N.Y.Public Library

In:Mag Art
7:452-7 Sept.,'16 illus.

 Exh.May-Oct.15,1916.First public exh.of
early Amer.engr.portrs.in N.Y. Incl.the first
engr.published in the U.S.:Ths.Emmes' Increase
Mather,1701;Washington as central fg.in a Toile
de Jouy(Printed fabric)which also shows medal-
lion portrs. of distinguished Americans

705
C75
NCFA
v.16

I.B.1.b - MORGAN, JOHN PIERMONT, 1837-1913

Roberts, William, 1862-1940
 Mr.J.Pierpont Morgan's pictures. The early
English school.I.II. III.

In:Connoisseur
16:134-43 Nov.,'06 illus(part col.)
16:66-74 Oct.,'06
17:71-1 Feb.,'07
 Incl.:Gainsborough:Duchess of Devonshire,
and others. Hoppner

705
A784
NCFA
v.31

I.B.1.b - MUÑOZ, FRANCISCO OROZCO, MEXICO CITY

Pach, Walter, 1883-1958
 A newly found American painter:Hermenegildo
Bustos

In:Art in Am
31:32-43 Jan.,'43 illus.

 Most of Bustos'work in Muñoz collection

I.B.1.b - MORGAN, JUNIUS S.

Ederheimer, Richard, firm,N.Y.
 Illus.cat.of portraits by the master engra-
vers of the 17th century...widely known as the
Junius S.Morgan collection....N.Y.,Amer.Art
association,1916.

LC(769.E22)M1U MH MA FOR COMPLETE ENTRY
 SEE MAIN CARD

705
A56
NCFA
v.19

I.B.1.b - MUNSON, EDGAR S.,MRS., MUNCY, PA.

Nolan, J.Bennett
 A long-lost Franklin.Some speculations con-
cerning the authorship of an unidentified wax
portrait

In:Antiques
19:184-7 March,'31 illus.

 Comparison with wax portrs.in various colls.
Munson,Nolan,Tuck

 FOR COMPLETE ENTRY
 SEE MAIN CARD

708.1
P31
NCFA

I.B.1.b - MUNSON, MRS.EDGAR S.,PHILADELPHIA

Prentice, Joan
 Wax miniatures

In:Phila.Mus.R.
42,no.213:50-62 March,'47 illus.

 The Mrs.Edgar S.Munson coll.,Phila. 222 items
given to the Phila.Mus.of Art in 1943 and 1944

FOR COMPLETE ENTRY
SEE MAIN CARD

I.B.1.b - NEWPORT, EARLS OF BRADFORD, WESTON

Doyle, Mary Louisa, 1810-1890
 Biographical catalogue of the portraits a
Weston,the seat of the Earl of Bradford...
London,E.Stock,1868
 266 p. illus.

12 no. DLC NcD

I.B.1.b - MURPHY, MRS.KATHARINE PRENTIS
 see
I.B.1.b - PRENTIS, WESTBROOK, CONN.

I.B.1.b - NICKOLLS, JOHN, 1710?-1745
 QUEENHITHE, TRINITY PARISH
Ames, Joseph, 1689-1759
 A catalogue of English heads:or,an account
of about 2000 prints...name,title or office of
the person...name of painter,graver,etc...
London,Printed by W.Faden for the editor,1748
 182 p.

 An index to the collection of 2000 prints,
bound in 10 v.,belonging to Mr.John Nickolls

LC NE265.A5 Fogg,v.11,p.320

I.B.1.b - MUSGRAVE, SIR WILLIAM, BART.,1735-1800

 Musgrave, Sir William, Bart., 1735-1800.
 A catalogue of a....collection of English
portraits consisting of the royal families...
lawyers...artists...from Egbert the Great to
the present time...works of Delaram...Hollar,
Loggan...with...remarks by an eminent collector
 Sir W.Musgrave....sold by....Mr.Richardson...?
Feb.3.1800.and the 17 ff.days...and Mar.3,and
the 12 ff.days...London 1800.
 323 p.

MET
212
F98

DLC

 Priced 3495 items Names of
buyers

Mec.Sales cat.[ZN81.N5] NCFA v.20

705
A56
NCFA
v.19

I.B.1.b - NOLAN, J.BENNETT

Nolan, J.Bennett
 A long-lost Franklin.Some speculations con-
cerning the authorship of an unidentified wax
portrait

In:Antiques
19:181-7 March,'31 illus.

 Comparison with wax portrs.in various colls.
Munson,Nolan,Tuck

FOR COMPLETE ENTRY
SEE MAIN CARD

I.B.1.b - NACHEMSOHN, JACOB

 Nachemsohn, Jacob
 Signed enamel miniatures of the 17th,18th &
19th centuries.London,J.Nachemsohn,1926.

 ...Jacob Nachemsohn,owner of the collection

N.Y.P.L.MDO Art div.254496B

CSmH FOR COMPLETE ENTRY
 SEE MAIN CARD

705
C75
NCFA
v.75

I.B.1.b - NORFOLK, DUKE OF

Manners, Lady Victoria, 1876-
 The later historical portraits in the col-
lection of the Duke of Norfolk,E.M.,at Arundel
Castle

In:Connoisseur
75:74-9 Jun,1926 illus.

 Incl:Bernard Howard,12th Duke of Norfolk,by
Gainsborough, Frances Howard,Duchess of Richmond
& Lennox, Mary Blount,Duchess of Norfolk by Ang.
Kauffmann, Charles Howard,10th D.o.N.,by Opie

705.
S94
NCFA

I.B.1.b - NADELMAN,Mr.& Mrs.ELIE,RIVERDALE-ON-
 HUDSON, N.Y.

Gould, Mr./ Mrs. C.Glen
 The Nadelman ship figureheads

In:Studio
94:51-3 Sept.,'29 illus.

N.Y.,MOMA 709.73.N5 NCFA
bibl.p.51

705
C75
NCFA
v.72

I.B.1.b - NORFOLK, DUKE OF

Manners, Lady Victoria, 1876-
 More historical portraits in the collection
of the Duke of Norfolk,E.M., at Arundel Castle

In:Connoisseur
72:67-73 Jun,1925 illus.

 Incl:v.Somer(or Daniel Mytens):portrs.of
Thom.Howard,Earl of Arundel,his wife), v.Dyck:
(Charles I.,Lord Maltravers,Earl of Arundel)

705
C75
NCFA
v.70

I.B.1.b - NORFOLK, DUKE OF

Manners, Lady Victoria, 1876-
Some historical portraits in the collection
of the Duke of Norfolk,K.M.,at Arundel Castle

In:Connoisseur
70:3-14 Sep,1924 illus.

Incl:Thomas Howard,2nd Duke of Norfolk, John
Howard,1st D.o.N., Thomas Howard,3rd D.o.N.after
Holbein, Henry Howard,Earl of Surrey by Stretes,
Henry Fitzalan,Earl of Arundel,attr.to Eworth,

AP
1
W225
NCFA
v.14

I.B.1.b - OXFORD COLLECTIONS

Bell, Charles Francis, 1871- and Rachel Poole
English 17th-century portrait drawings in
Oxford collections.Pt.II:Miniature portraiture
in black lead and Indian ink

In:Walpole Soc.
14:43-80 1925-26 illus.

Pt.I

In:Walpole Soc.
5:1-18 1915-17

LC N12.W3 General account of the collections

I.B.1.b - NORTHUMBERLAND, DUKES OF
see
I.B.1.b - PERCY FAMILIES, DUKES OF NORTHUMBER-
=LAND

I.B.1.b - PANSHANGER HALL
see
I.B.1.b - COWPER, FRANCIS THS.DE GREY,7th EARL,
1834-1905

ND 1
1311.2
A53
NPG

I.B.1.b - OBERLIN, OHIO

Ancestors:an exh.of 19th c.American portraits.
Oberlin,Ohio,Allen Memorial Art Museum,Ober-
lin College,c.1980

Exh.:May 14-Sept.7,1980.Cat.by Maria Gold-
berg and Polly Anderson
All items from Oberlin collections
List of sitters.Selection for the exh.was
made on the basis of the relationship of
the sitter to Oberlin or its citizens.

Incl.Ch.on children's portraits.

qN
7621.2
N4A52
NPG
2 c.

I.B.1.b - PAPENBROECK, GERHARD VAN, 1673-1743

Regteren Altena, I.Q.van, 1899-
De portret-galerij van de universiteit van
Amsterdam en haar stichter Gerard van Papen-
broeck,1673-1743...I.Q.van Regteren Altena en
P.J.J.van Thiel...met een voorwoord van H.
Engel.Amsterdam,Swets en Zeitlinger,1964
387 p. illus(1 col.)

Summary in English

705
28
.29
CFA

I.B.1.b - ORSINI, FULVIO, ROME 1529?-1600

Nolhac, Pierre de, 1859-1936
Une galerie de peinture au 16e siècle.Les col-
lections de Fulvio Orsini

In:Gaz Beaux Arts
2s29:427-36 1884

Incl.list of paintings,cartoons & drawings
(some portraits)
"Un véritable musée d'antiquité".-Nolhac

List is part of cat.of the whole collection

I.B.1.b - PEALE'S MUSEUM, PHILADELPHIA

Philadelphia museum
Historical cat.of the paintings in the Phi-
ladelphia museum consisting chiefly of portraits
of revolutionary patriots and other distin-
guished characters..Phil.,1813

LC N25.M7 no.8

705
C75
NCFA

I.B.1.b - OXENDEN

Manners, Lady Victoria, 1876-
The Oxenden collection.Pt.1,2,3

In:Connoisseur
40:3-12 Sep,1914 illus.
41:121-30 Mar.,1915 illus.(also opp.p.46)
43:200-08 Dec.,1915 illus.

Mainly Engl.portrs.of the 16-18th c.Espe-
cially interesting for the study of early Engl.
school of portraiture
Repro.incl.:Corn.Janssens.van Ceulen.,
Mytens,John Eykes,Fayram,Aikman,Beach..

I.B.1.b - PEALE'S MUSEUM, PHILADELPHIA

Peale, Charles Willson, 1741-1827
Peale's museum gallery of oil paintings...
cat.of the national portrait and historical gal-
lery...formerly belonging to Peale's museum,
Philadelphia, to be sold...6th Oct.,1854...at
Phila.,M.Thomas & sons,auctioneers...Phila.,
W.Y.Owen,printer,1854
16 p.
'A copy is in the library of the American
Philosophical Society,Philadelphia.'-Miley.
F158.65 I 3T78 NPG p.179,note 2

LC N5220.P35

Weddell.A men'l vol.of Va.
hist.portraiture.757.9.W38
NCFA Bibl. p.437

ND
230
P4D55
NCFA

I.B.1.b - PENNSYLVANIA COLLECTIONS

Dickson, Harold Edward, 1900-
Masterworks by Pennsylvania painters in
Pennsylvania cells.....exh.inaugurating the
opening of the Mus.of Art,The College of Arts &
Architecture,The Pennsylvania State University,
University Park,en Oct.8, 1972...til Nev.5,1972.
University Park,Pa..Museum of Art,Penn.State
University.1972.
.71.p. illus(sel.)

Incl.:Portrs.by Hesselius,West,Ch.W.Peale,
Rembrandt Peale,Sully,Eichholtz,Neagle,Eakin,
Cassatt,Cecilia ⌒ Beaux
⌒ts in Am.qZ5961.U5A77X
NCFA Ref. I324

I.B.1.b - PHILIP,LANDGRAVE OF HESSE, 1806-

Heintze, Helga von
Die antiken porträts in Schloss Fasanerie
bei Fulda...Mainz,von Zabern.1968,
121 p. illus.

Half-title:Deutsches archäologisches Inst.

From the coll.of Philip,Landgrave of Hesse

Bibliography

LC N7580.H4 Fogg,v.11,p.330

I.B.1.b - PEPYS, SAMUEL, 1633-1703

Cambridge. University. Magdalene college.
Pepysian library.
A catalogue of the engraved portraits in
the library of Samuel Pepys...compiled by John
Charrington...Cambridge.Eng.,The university
press,1936
203 p. illus.

Bibliography

LC NE240.P4 Fogg,v.11,p.321

705
A784
NCFA
v.51

I.B.1.b - PHILLIPS, CPT.N.TAYLOR

Gardner, Albert Ten Eyck
An old New York family

In:Art in Am
51 no.3:58-61 June,'63 illus.

Six portrs.of the Franks family,f'ly in
the Cpt.N.Taylor Phillips coll,now in the coll
of the Am.Jew.Hist.Doc.,attr.by Waldron Phoe-
nix Belknap,jr.to Gerardus Duyckinck I ?;by
Virgil Barker to the Duyckinck Limner;by Flex-
ner "in the de Peyster Manner".They derive fr.
engravings by ⌒ Godfrey Kneller.

705
C75
NCFA
v.73

I.B.1.b - PERCY FAMILIES, DUKES OF NORTHUMBER-
.LAND
Foster, Joshua James, 1847-1923
The Alnwick coll. of miniatures

In:Connoisseur
73:209-17 Dec.,'25 illus.

Alnwick Castle, home of the Percys,the dukes
of Northumberland

II.B.1.b - POLAND

Hutten-Czapski, Emeryk, hrabia, 1828-1896
Spis rycin przekstawiajacych portrety prze-
ważnie polskich osobistości w zbiorze Emeryka
hrabiego Hutten-Czapskiego w Krakowie.Z rekopisu
Emeryka Hutten-Czapskiego.wyd.F.Kopera,Kraków,
.Nakk.Emerykowej Hutten-Czapskiej.1901
382 p.
List of graphic works representing portrs.of
mostly Polish personalities in the coll.of Count
Emeryk Hutten-Czapski in Krakau.From manuscript
...publ.F.Koper,Krakau.commissioned by Mrs.
Emeryk Hutten-Czapska.1901

F000
AM340.7

Fogg,v.11,p.323

I.B.1.b - PERCY FAMILIES, DUKES OF NORTHUMBER-
.LAND
Foster, Joshua James, 1847-1923
A cat.of miniatures,the property of His
Grace the Duke of Northumberland.London,Priv.
printed,1921
72 p. illus.

V & A

Foskett.Dict.of Brit.min.
ptrs.ND1337.G7F74d NPO
Bibl.p.593

I.B.1.b - PONCINS-BIENCOURT

Aubert, Marcel et Malo, Henri
La collection de Poncins-Biencourt au Musée
Condé de Chantilly

In:Monum.Piot
42:1-24 1947 illus.

Incl.:Corneille de Lyon,Clouet,Pourbus,v.Dyck or
Rubens,Decourt,Le Mannier,Duval,etc.
15th to 17th c.portrs.Incl.:Duc d'Alençon,Henry II
Maximilian of Austria,Cath.de Médicis,Charles IX,
Mary Tudor,Mary of Burgundy
⌒ep.,1945-47*1880

I.B.1.b - PFUNGST, HENRY JOSEPH

Victoria and Albert museum, South Kensington
Dept.of paintings
Cat.of a collection of miniatures lent in
1914.15 by Henry J.Pfungst....Lodnon,1915

LC N7616.P5 FOR COMPLETE ENTRY
 SEE MAIN CARD

I.B.1.b - Portland,Wm.John Arthur Chs.James
Cavendish-Bentinck,6th duke of,1857-
see I.B.1.b - DUKE OF PORTLAND .1947

I.B.1.b-POULETT, GEORGE AMIAS FITZWARRINE, EARL
.POULETT, 1909-

Hardman, Sammy J.
Lord Poulett's paintings in Georgia...Deca-
tur,Ga., International Salon,c.1978

LC ND1301.1.6.P68H37

FOR COMPLETE ENTRY
SEE MAIN CARD

I.B.1.b -
Raphael, Herbert Henry, 1859-
Horace Walpole;a descriptive catalogue of
the artistic and literary illustrations col-
lected by Herbert H.Raphael,M.P.Trustee of the
Nat'l Portr.Gall...Bristol,Edw.Everard,1909
659 p. illus.

...a remarkable coll.of portrs.

Mezzotint portrs.are described according
Chaloner Smith.
Frontispiece portr.of Walpole

LC DA483.W2R2 ICU CSmH Lewis,Descr.Bibl.Z5947A3
OCTW NIC L66 1974 p.224
MH DeU

AP
1
N547
NCFA
v.35

I.B.1.b - PRENTIS, WESTBROOK, CONN.

Phillips, John Marshall
Portraits in the Prentis collection

In:N.Y.Hist.Soc.Q
35:157-64 Apr.,'51 illus.

'Portrs.representative of New England and
the South'

Winterthur Mus.Libr. fZ881
NCFA v....

705
C75
NCFA
v.34

I.B.1.b - REISS, FRITZ, London

Grundy, Cecil Reginald, 1870-
Mr.Fritz Reiss's mezzotint portraits. I.II.

In:Connoisseur
34:71-83 Oct.,'12 illus.
34:209-26 Dec.,'12 "
Coll.includes works fr. the time of Prince
Rupert to Samuel Cousins.
Article I treats mainly early mezzotints.
Repro.:Prince Rupert,John Smith,McArdell,
John Faber,Rich.Huston,etc.

I.B.1.b - PRICE, ROBERT KENRICK, AKELEY WOOD,
.BUCKINGHAM, ENGLAND
Price, Robert Kenrick
Astbury,Whieldon,and Ralph Wood figures,
and Toby jugs,coll.by Captain R.K.Price...with
an intro.by Frank Falkner...London,John Lane,
1922
140 p. illus(part col.)

'Largest coll.of tobies in the world.'-North-
end in:The joly old toby

LC NK4087.36P7

I.B.1.b - REULING, DR.GEORGE R.,BALTIMORE, 1839-
1915
Anderson Galleries, New York
A cat.of paintings of American celebrities..
of the Colonial and Revolutionary periods,and
of other...portraits...from a private collec-
tion...sale April,26,1905 by the Anderson auc-
tion company....N.Y.1905.
35 p. illus.

MET
199.8
Q511

No.383 30 items priced

Coll.:Reuling, Dr.George R.,Baltimore, 1839-
1915
Met.v.25,Sales cat. fZ881
N53 NCFA p.023314

I.B.1.b - PROPERT, JOHN LUMSDEN, 1834-1902
.Propert, John Lumsden, 1834-1902.
Cat.of miniatures,enamels,pastels,and
waxes,at 112 Gloucester place,Portman Square
.London,Printed by W.Clowes & sons,ltd.,189-?.

"Coll.of Dr.J.Lumsden Propert(ca.1890)"

CSmH MdBWA

I.B.1.b - ROGERS, J.HENRY, NEWCASTLE, DEL.

Henkels, firm auctioneers, Philadelphia
(1895.Stan.V.Henkels)
...Cat.of autograph letters,historical docu-
ments,and rare engraved portraits;being the
coll.of J.Henry Rogers,of Newcastle,Del.,and
of a Western gentleman...Also an extraordinary
coll.of rare and scarce engraved portraits.To
be sold...May 8th,9th and 10th,1895...Cat.comp.
and sale conducted by Stan.V.Henkels at the
book auction rooms of Thos.Birch's Sons..Phila-
delphia,The Bicking print,1895.
109 p. illus. Winterthur Mus.Libr.
LC Z42.R72 fZ881.W78 NCFA v.6,p.229
Z909.H505 no.738

I.B.1.b - PROPERT, JOHN LUMSDEN, 1834-1902

Fine Art Society, London
...Cat.of the historical coll.of miniatures
formed by Mr.J.Lumsden Propert and exh.at the
Fine Art Society's...May,1897.London,1897
40 p. (Exh.no.164)

MET
155.4
P942

CSmH Moon.Engl.portr.drags.&min.
NC860.N66X NPG Bibl. p.145

I.B.1.b - ROSE, E.(cited as TUNNO)
see
I.B.1.b - TUNNO, died 1863

I.B.1.b -

Rose, James Anderson, 1819-1890
 A collection of engraved portraits...
exhibited...at the opening of the new library
and mus.of the Corp.of London,Nov.,1872...intro-
duction by Gordon Goodwin.London,New York.etc..
M.Ward & co.,ltd.,1894
 366 p. illus.

LC N7592.R6 2 v. Fogg;v.11,p.325

705
C75
NCFA
v.6 &
v.7

I.B.1.b - RUTLAND, DUKE OF

Manners, Lady Victoria, 1876-1933
 Notes on the pictures at Belvoir Castle

In:Connoisseur
Pt.I.6:67-71,74 June,1903 illus.
Pt.III.7:3,6,8,10,13 Sept.,1903 illus.

FOR COMPLETE ENTRY
SEE MAIN CARD

I.B.1.b - ROSENBACH, Dr.A.S.W., 1876-1952

Spanish Institute,Inc.,N.Y.
 The Spanish golden age in miniature.Portraits
from the Rosenbach Museum & Library.Cat.of exh.,
March 25-Apr.23,'88.New York,The Institute,1988
 62 p. illus(part col.)
 Bibliography

 Incl.the miniatures of the Talbot Hughes
coll.
 Exh.also in Philadelphia,Rosenbach Mus.&
Library,June 7-July 31,'88
MdBMA MB(ND1337.S7S636 1988)

I.B.1.b - SACHSE, JOHANN DAVID WILHELM,1772-1860

Weigel, Rudolph, 1804-1867
 Catalog der von ...J.D.W.Sachse hinterlasse-
nen grossen sammlung von porträts. Leipzig,1861

FOGG
FA
980.5

I.B.1.b - ROSENBACH, PHILIP H., 1863-1953

Spanish Institute,Inc.,N.Y.
 The Spanish golden age in miniature.Portraits
from the Rosenbach Museum & Library.Cat.of exh.,
March 25-Apr.23,'88.New York,The Institute,1988
 62 p. illus(part col.)
 Bibliography

 Incl.the miniatures of the Talbot Hughes
coll.
 Exh.also in Philadelphia,Rosenbach Mus.&
Library,June 7-July 31,'88
MdBMA MB(ND1337.S7S636 1988)

qN
5247
S16A9
NCFA

I.B.1.b - SALISBURY, ROBERT ARTHUR JAMES CAS-
 COYNE-CECIL,5th MARQUIS OF, 1893-
Auerbach, Erna
 Paintings and sculpture at Hatfield House...
London,Constable,1971.

 Cat.of the private coll.in the possession of
Lord Salisbury

757
.R81H5

I.B.1.b

Rosenthal, Albert, 1863-
 The Albert Rosenthal collection of miniatures
and small oil portraits including a few from
other sources with a list of miniature painters
identified with America from the earliest periods,
catalogued by Stan V.Henkels. Philadelphia,1920
 31 p. illus.

 "A list of all the known miniaturists, living
and deceased,who have practised their art in this
country"

I.B.1.b - SALTING, GEORGE, 1835-1909, London

Moreau-Nélaton, Étienne, 1859-1927
 Le portrait en France à la cour des Valois.
Crayons français du 16me siècle conservés dans la
collection de M.G.Salting à Londres,introduction
& notices...Paris,Librairie centrale des beaux-
arts,1909.
 26 p. illus.

LC N7604.S3 Amsterdam,Rijksmus.cat.
 25939A52,deel 1, p.501

I.B.1.b - ROTHSCHILD, JAMES A. DE

Waterhouse, Ellis Kirkham, 1905-
 Paintings.Fribourg,Swits..Office du livre
London,National trust for places of historic
interest or natural beauty,1967
MKT 334 p. illus(part col.) (The James A.de
108.? Rothschild coll.at Waddesdon Manor,ed.by Anthony
Ay4W11 Blunt,1)
v.1

I.B.1.b - SANDWICH, JOHN WM.MONTAGU,7th EARL
 SEE
I.B.1.b - MONTAGU, JOHN WM.,7th EARL OF SAND-
 WICH,1811-1884, HINCHINGBROOKE

mim
12h n:3
NCFA

I.B.1.b - SASSOON, Sir PHILIP ALBERT GUSTAVE
 ᵣDAVID,3rd bart.,1888-1939
Jourdain, Margaret
 The Georgian art exh.at Sir Philip Sassoon's
house

In:Apollo
13:17h-6 Mar,'31 illus.

 Exh.in aid of the Royal Northern Hospital,
concentrated upon portrs.& portr.groups by Rey-
nolds,Gainsborough & Hoppner & incl.items of P.
Sassoon's own coll.
 In Purl Mag v.58 Repro.:Gainsborough;E.F.
Burney;Reynolds-ᵣSassoon coll.)

M
40.1
M9561h7
1978a
NMAA

I.B.1.b - SHEEPSHANKS, JOHN, 1787-1863

Heleniak, Kathryn Moore
 William Mulready,R.A.,1786-1863.British
landscape and genre artist.N.Y.Univ.1978
 5h6 p. illus.

 Bibliography
Thesis Ph.D.-N.Y.University,1978
Photocopy of typescript

 Ch.6 incl.:Portraiture,p.272-7
Portrs. in Sheepshanks & Swinburne colls.

I.B.1.b - SAUMUR, CHATEAU
 see
I.B.1.b - DU PLESSIS-MORNAY,1549-1623, SAUMUR

M
7592
H513
RB
NPG

I.B.1.b - SILLIMAN, BENJAMIN, NEW YORK

Henkels, Stanislaus Vincent, 1854-1926
 Cat.of the very important coll.of studies
and sketches,made by Col.John Trumbull...as
well as his important coll.of engravings and
portraits in mezzotint,line and stipple...to
be sold Thur,Dec.17,1896.Cat.comp.,and sale
conducted by Stan.V.Henkels at the art auction
rooms of Thos.Birch's Sons,Philadelphia
 39 p. illus.
 cat.no.770

 Sale by order of B.Silliman,who inherited
the effects of Col.John Trumbull

I.B.1.b - SCHLOSS FASANERIE (NEAR FULDA)

Heintse, Helga von
 Die antiken porträts in Schloss Fasanerie
bei Fulda...Mains,von Zabern,1968.
 121 p. illus.

 Half-title:Deutsches archäologisches Inst.

 From the coll.of Philip,Landgrave of Hesse

 Bibliography

LC N7580.H4 Fogg,v.11,p.330

I.B.1.b - SIMON, Dr.THEOBALD, BITBURG

Kunstverein Ulm
 Graphische selbstbildnisse aus der samm-
lung Dr.Theobald Simon,Bitburg.Ausst.:Kunst-
verein Ulm im Rathaus,7.Mai bis 4.Juni 1972
ᵣUlm,1972ᵣ
 ᵣ31ᵣp. illus.

 Essay by Wilhelm Weber

MH Netuschil.Künstler unter
 sich N7619.5.03K86 1983X
 NMAA p.136

I.B.1.b - SCHLOSS RUDENHAUSEN SEE
I.B.1.b - CASTELL-RUDENHAUSEN,SIEGFRIED,FURST ZU

NE
265
L42
NCFA

I.B.1.b - SLIGO, MARQUESS OF

Layard, George Somes, 1857-1925
 Catalogue raisonné of engraved British
portraits from altered plates, ...,arranged by
H.M.Latham,with an introduction by the Marquess
of Sligo. London,P.Allan & co.,ltd.,1927.
 133 p. illus.

 Marquess has c.60 sets in her collection

LC NE265.L3

705
A56
NCFA
v.112

I.B.1.b - SCOTT, STANLEY DEFOREST

Grote, Susy Wetsel
 Engravings of George Washington in the
Stanley deForest Scott collection

In:Antiques
112:128-33 July,'77 illus.

I.B.1.b -

Smith, Frank Bulkeley
 Illustrated cat. of the ...collection of
early American and British portraits...formed
by...F.B.Smith...sold....Apr.22nd and 23rd,1920,
...by the American Art Association...N.Y.,1920
 unpaged illus.

MET
199.8
Sol3 Priced

FOGG
S.C.
A512 Fogg,v.11,p.332

I.B.1.b - SMITH, JOHN CHALONER, 1827-1895

Smith, John Chaloner, 1827-1895
 Cat.of the coll.of mezzotint engravings
formed by J.C.Smith...sold...by Messrs.Sotheby,
Wilkinson & Hodge,1887/8
 2 pt.in 1 v.(1 illus.)

MET
212
C7
 Pt.1 March 21-30,1887. Pt.2 Apr.25-May 4,'8t
 Priced

 (Lugt nos.46377 &47324)

FU MiU-C PP ICN Ars Artis cat.41 Books on
CSmH NBuG prints,drags. no.681

705
C75
NCFA
v.64

I.B.1.b - SPENCER, EARL

Williamson, George Charles, 1858-1942
 Two important miniatures in the possession
of the Rt.Hon.the earl Spencer,K.G.

In:Connoisseur
64:40-5 Sep.,'22 illus.

I.B.1.b - SMITH, JOHN CHALONER, 1827-1895

Smith, John Chaloner, 1827-1895
 Twelve portraits of persons connected dur-
ing the last century with the States of America
(chiefly in their Colonial period)...from the
original mezzotint engravings in the coll.of
N.Y.P.L. J.Ch.Smith.London,H.Sotheran & co.,1884
3-AON 2 p. 12 portrs. (American series)
Avery coll.

705
C28
2.pér.
v.24
NCFA

I.B.1.b - SPITZER, FRÉDÉRIC, 1815-1890

Blondel, Spire, 1836-1900
 Collections de F.Spitzer.-Les cires

In:Gaz.Beaux-Arts
2nd per.,24:289-96 1881 illus.

FOR COMPLETE ENTRY
SEE MAIN CARD

NC
772
S78
NPG

I.B.1.b - SONNENBERG, BENJAMIN, 1901-

Stampfle, Felice
 Artists and writers;19th and 20th century
portrait drawings from the coll.of Benj.Sonnen-
berg.Cat. by Felice Stampfle and Cara Dufour.
With an introd.by Brendan Gill..Exh.held at
the Pierpont Morgan Library,N.Y.,May 13-July 30
1971..New York, 1971.
 52 p. illus.

 Bibliography

LC NC31.S688
 MOMA,p.434, v.11

708.9492
A523
NMAA
v.30

I.B.1.b - STARING VAND DE WILDENBORCH, ADOLPH,
 1890-1980

Bruijn Kops, C.J.de
 Keuze uit de aanwinsten.Portretminiaturen
uit de verzameling Mr.Adolph Staring

In:B.Rijksmus.
30,no.4:192-205 1982 illus.

 Summary in English,p.209

 Mainly Netherlandish miniatures,also 5 sil-
houettes on glass(3 verre églomisé)

 Bruijn Kops in B.Rijksmus.
 36:177,note 5

ND
1333
C4C2
NCFA

I.B.1.b - SOUTH CAROLINA

Carolina Art Association, Charleston, S.C.
 Exh.of miniatures owned in South Carolina
and miniatures of South Carolinians owned else-
where painted before the year 1860.Carolina Art
Association,Gibbes Memorial Art Gallery,Charles
town,South Carolina...1936
 .77.p.

 Preface signed:Robt.N.S.Whitelaw

 List of artists;list of sitters

 Rutledge.In:Am Coll 705.A5
 17:23

AP
I
T683
NCFA
v.6

I.B.1.b - STARR, JOHN W., 1925-

Hickl-Szabo, Heribert, 1920-
 Portraits in miniature

In:Rotunda
6,no.3:37-40 Summer,'73 illus(part col.)

 Pertains to exh.of the Starr coll.,Wm.Rock-
hill Nelson Gall.of Art,Kansas City,at the Ro-
yal Ontario Mus.,Toronto,Dec.8,1972-Jan.14,1973
 Article incl.ROM's own miniatures,among
others eye miniatures

 Hickl-Szabo.In:Rotunda,v.11
 no.1 API.T683 NCFA,p.12

757
.C28

I.B.1.b - SOUTH CAROLINA - CHARLESTON

Carolina art association, Charleston, S.C.
 Exh.of miniatures from Charleston and its
vicinity painted before the year 1860.Carolina
art association,Gibbes memorial art gallery,
Charleston,South Carolina,1935..Charleston,S.C.
Southern ptg.& pub.co.,1935.
 .75.p.

 Preface signed:Robt.N.S.Whitelaw

 List of artists;list of sitters

 Largest 18th c.group by Henry Benbridge
or his wife Rutledge.In:Am Coll 705.A5
 17:23

ND
1337
C7U.719
NPG

I.B.1.b - STARR, JOHN W., 1925-

William Rockhill Nelson Gallery of Art and
Mary Atkins Museum of Fine Arts, Kansas City,
Mo.
 The Starr Collection of miniatures in the
William Rockhill Nelson Gallery.With introd.by
Graham Reynolds.Kansas City,1971
 84 p. illus(part col.)

 ...patterned after....Reynolds',book Eng-
lish portrait miniatures

LC ND1337.C7U47
 Yale ctr.f.Brit.art Ref.

VF
Calif.
San
Marino

I.B.1.b - STEELE SCOTT, VIRGINIA, 1905-1974,
 ₍Pasadena
Henry E.Huntington Library and Art Gallery,
San Marino,Calif. The Virginia Steele
Scott Gallery
A gift to the Huntington Art Gallery.Pasa-
dena,The Castle Press,1984
 24 p. illus(col.)

 Incl.:Checklist of ptgs.& W.C.,June,1984
(incl.American portrs.,18-20th c.)

I.B.1.b - STRADA, JACOBUS DE, MANTUA, d.1588

Strada, Jacobus de,à Rosberg, d.1588
 Epitome dv thresor des antiquitez,c'est à
dire,pourtraits des vrayes medailles des empp.
tant d'Orient que d'Occident...Tr.par Iean Lou-
veau d'Orleans.Lyon,Par I.de Strada,et T.Cverin,
1553
 394 p. illus.
 For revision see Keller, Diethelm
 485 portr.woodcuts by B.Salomon after Strada
drags.,made from antique medals in Strada's coll.
Emperors fr.Caesar to Charles V
 Wave.Jb.d.Berl.Mus.I 1959
C CJ4975.S8 ₍LC NJ.J16 fol.p.131 Paolo
 Giovio & d.H₍ildnisvitenbücher...
 Rath.Porträtwerke,p.39

AP
1
C76
NPG
v.18

I.B.1.b - STEWARD, JOSEPH, 1753-1822

Joseph Steward and the Hartford museum

In:Conn.Hist.Soc.B.
18:1-16 Jan.-Apr.,'54 Illus.

 Pertains to exh. of Steward's portraits.
Biographical treatment of this Conn.portraitist
and museum owner

 Arts in America qZ5961
 USA77X NCFA Ref. H492

I.B.1.b - STRASSER, A., Vienna

Gesellschaft der bilder-und miniaturfreunde,
 ₍Vienna
 Das gemalte kleinporträt.I...II.Zwei Wiener
miniatursammlungen:A.Strasser...Wien,Selbstver-
lag,1931

₍LC Jdc45.9310₎ FOR COMPLETE ENTRY
 CtY SEE MAIN CARD

TR
646
U6N484X
NPG

I.B.1.b - STIEGLITZ, ALFRED, 1864-1946
New York. Metropolitan museum of art
 The collection of Alfred Stieglitz...N.Y.,
Viking Press,1978₎

 FOR COMPLETE ENTRY
 SEE MAIN CARD

AP
1
NCFA
v.101

I.B.1.b - SUFFOLK, EARLS OF

Jacob, John
 Ranger's House,Blackheath,a new gallery of
English portraits

In:Apollo
101:14-8 Jan.,'75 illus(1 col.)

 Discusses the Suffolk coll.of Tudor,Stuart
and later portrs.Gift to the Greater London
Council,displayed at Ranger's House,Blackheath.
 Coll.contains group of full-length portrs.
by Wm.Larkin
 Rila II/1 1976#3481

I.B.1.b - STIRLING-MAXWELL,SIR WILLIAM,bart.
 1818-1878
Stirling-Maxwell, Sir William,bart.,1818-1878.
 Examples of the engraved portraiture ₍ed.
of the 16th century.London,Privately printed,
1872
 120 l.(chiefly illus.)

LC NE218.S75 Rosenwald coll₎ Ars Artis cat.41 Books on
 Prints Drws. no.684

qND
1301.5
C71L667
1975X
NPG

I.B.1.b - SUFFOLK, EARLS OF

Ranger's House.
 The Suffolk collection;cat.of paintings
₍...compiled by John Jacob and Jacob Simon;
photographs by Robert Evans..London,Greater
London Council₎1975₎
 ₍86₎p. illus.

 Bibliography

I.B.1.b - STOWE HOUSE

The Stowe,Granger and other engravings;cat.of
 the remaining portion of the engr.British
 portrs.,comprising those fr.the reign of
 James II forming the illus.copy of the con-
 tinuation of the Biographical hist.of Engl.
 by the Rev.Mark Noble...engrs.of the English
MET school...Woollett,Strange,Hogarth...Sir Josh.
212 Reynolds...removed fr.Stowe house,Bucking-
K9 hamshire...sold...by...S.Leigh Sotheby & Co.
 ...21st Mar.1849 & 5 ff.days...London 1849.
 62 p.

 Priced

 Met.Sales cat.fZ881.N53 NCFA v.25,p.023318

I.B.1.b - SUTHERLAND

Sutherland, Alexander Hendras
 Catalogue of the Sutherland collection.of
portraits,views,and miscellaneous prints....Lon-
don,Payne & Foss,and P.& D.Colnaghi & co.,1837-
₍38₎
 2 v.
 Cat.of 1908₎ engravings & drgs....with the
text of Clarendon's History of the rebellion,
and Life,and Burnet's History of his own time.
The coll.completed by Mrs.Charlotte Hussey Suther-
land,who compiled the cat.& presented the extra.
illustrated sets...to the Bodleian library
LC NE215.G7S6

I.B.1.b - SWINBURNE, JOHN EDWARD, 1762-1860

40.1
M956W17
1978a
NMAA

Heleniak, Kathryn Moore
William Mulready,R.A.,1786-1863.British
landscape and genre artist.N.Y.Univ.1978
546 p. illus.

Bibliography
Thesis Ph.D.-N.Y.University,1978
Photocopy of typescript

Ch.6 incl.:Portraiture,p.272-7
Portrs. in Sheepshanks & Swinburne colls.

I.B.1.b - THEVET, ANDRÉ, 1502-1590

coll. Adhémar, Jean
André Thevet collectionneur de portraits.

In:R.archéol.
20:41-54 1942-43

Review of Thevet's :"Les vrais povtraits et vies
des hommes illvstres,grecs,latins...Paris,Par la
vesue I.Keruert et Ouill.Chaudiere,1584,2v. Each
portr.accompanied by short notes. Funeral ephigies
medallions,miniatures etc.

LC CC3.R4 Rep.,1942-44#685

NR
1296.1
G38
1983
NMAA

I.B.1.b - SWITZERLAND

Gesichter:griechische und römische bildnis..
aus Schweizer besitz.Ausst.in..Basel...hen
Hist.Mus.vom 6.Nov.1982 bis 6.Febr.1983.
Hrsg.von Hans Jucker und Dietrich Villers.
3.erneut verb.aufl.Bern,Archäologisches
seminar der Univ.Bern,1983,c.1982
316 p. illus.

I.B.1.b - THEVET, André, 1502-1590

Thevet, André, 1502-1590
Les vrais povtraits et vies des hommes
illvstres,grecz,latins,et payens recveillis de
levr tableavx,livres,medalles antiques et modernes
par André Thevet Angovmoysin...Paris,Par la ve-
sue I.Keruert et Guillaume Chaudiere,1584
2 v.in 1

2d ed.appeared under title:Histoire des plus
illustres et savants hommes de leurs siècles,
Paris,1670-71

LC no. Review by Adhémar,Jean In:R.archéol.
see card for Adhémar, Jean

I.B.1.b - SYKES,SIR MARK MASTERMAN, 1771-1823

Sotheby, firm,auctioneers, LONDON
Cat.of a...coll.of engraved British por-
traits formed by the late proprietor for the
illustration of Granger's history of England;
many...originally in the Sykes,Bindley & Dela-
bère collections...by...Elstracks...Cecil...
Vaughan...Faithorne....London,1863.
19 p.
Sale cat.Jl.22,1863 & ff.day
:The proprietor was E.Rose TUNNO:-Lugt.In:
Marques de collections.N8380.L95,NCFA,p.158,no.
.902

MET
212
D
1853
60-61
63-64

Met.Sales ca c.FZ881.N53 NCFA v.25
.023315

ND
207
H18
NCFA

I.B.1.b - THOMAS, HERREL GEORGE

Halladay, J.Stuart.
American provincial paintings,1680-1860,from
the collection of J.Stuart Halladay and Herrel
George Thomas. April 17 to June 1, 1941,Depart-
ment of fine arts,Carnegie institute..n.p...1941.
40 p. illus.

LC ND207.H33

I.B.1.b - SYKES, SIR MARK MASTERMAN, 1771-1823

Sykes, Sir Mark Masterman, 1771-1823
A cat.of the highly valuable collection of
prints,the property of Sir M.M.Sykes...sold by
Mr.Sotheby,March-Dec.,1824..London,J.Davy,prin-
ter.1824.
5 pt.in 1 v. illus.
Priced

MET
212
I4

Partial contents:Pt.1.-Series of Brit.portrs.,fr.
the heptarchy to the end of the reign of William
III.-Pt.4.Continuation of a series of Brit.portr.
fr.the commencem't of the reign of Queen Ann to
the present time

LC WE59.S82
Met.Sales cat.FZ881.N53 NCFA v.25,p.[23561]

705
B97
NMAA
v.128

I.B.1.b - THRALES' LIBRARY,STREATHAM PARK
(destroyed 1863)

Tscherny, Nadia
Reynolds's Streatham portraits and the art
of intimate biography

In:Burl Mag
v.128:4-11 Jan.'86 ill s.

Discussion of the natural association be-
tween portraiture and written biography
:The Streatham portrs.are...remarkable...
for their honesty in representing...physical
imperfection...'thus distinguished from the
iconic pictorial...records of Kneller's Kit-
Cat series.

VF
Collec-
tions

I.B.1.b - TANNENBAUM, MURIEL & HERBERT

The Norton Gallery and School of Art, West Palm
Beach, Fla.
The Tannenbaum collection of miniatures.
Exh.May 22-June 27,1982
32 p. illus.

Develpm't of the art of min.ptg.from the
18th to the early 20th c.
Intro.by Robin Bolton-Smith
Article:Private romances:The Tannenbaum coll.
& the art of the miniature,by Bruce Weber,p.7-10
List of artists

I.B.1.b - THYNNE, MARQUISES OF BATH, LONGLEAT,
(WILTS)

Boyle, Mary Louisa, 1810-1890
Biographical catalogue of the portraits at
Longleat,in the county of Wilts,the seat of the
Marquis of Bath. London,Elliott Stock,1881
369 p.

FOGG
FA3681.1

I.B.l.b -

Tiffin, Walter F.
Cat.of a coll.of English portraits in mes-
sotint(from the beginning of that style of en-
graving to the end of the 18th c.)...portion...
of a coll.of portrs.formed by Walter R.Tiffin...
Salisbury,Bennett brothers,printers,1883
136 p. illus.
Cat.of 1202 items
List of engravers
Frontispiece by Ludw.v.Siegen,earliest publ.
messotint

LC NE265.T5
Levis.Descr.bibl.Z5947.A3
L66 p.190 and p.202,127

N
7592
H513
RB
NPG

I.B.l.b - TRUMBULL, JOHN, 1756-1843

Henkels, Stanislaus Vincent, 1854-1926
Cat.of the very important coll.of studies
and sketches,made by Col.John Trumbull...as
well as his important coll.of engravings and
portraits in messotint,line and stipple...to
be sold Thur,Dec.17,1896.Cat.comp.,and sale
conducted by Stan.V.Henkels at the art auction
rooms of Thos.Birch's Sons,Philadelphia
39 p. illus.
cat.no.770

Sale by order of B.Silliman,who inherited
the effects of Col.John Trumbull

ND
210
T57
NPG

I.B.l.b - TILLOU, PETER H. & MRS.TILLOU

Tillou, Peter H.
Nineteenth-century folk painting:our spi-
rited national heritage.Works of art from the
coll.of Mr.and Mrs.Peter Tillou.Selection and
cat.by Peter H.Tillou.The Univ.of Conn.,The
William Benton Mus.of Art,1973.
209 p. illus(port col.)
Organised by Paul F.Rovetti
Bibliography
Incl.complete cat.of the Tillou coll.incl.
works not in the exhibition

Dewhurst.Artists in aprons
bibl.p.187

705
A56
NCFA
v.19

I.B.l.b - TUCK, EDWARD, PARIS

Nolan, J.Bennett
A long-lost Franklin.Some speculations con-
cerning the authorship of an unidentified wax
portrait.

In:Antiques
19:184,-7 March,'31 illus.

Comparison with wax portrs.in various colls.:
Munson,Nolan,Tuck

FOR COMPLETE ENTRY
SEE MAIN CARD

I.B.l.b - TOLLEMACHE,JOHN EDW.HAMILTON TOLLEMA-
CHE,baron,1910-

Tollemache, John Edw.Hamilton Tollemache,baron,
1910-
The collection of pictures in Helmingham
Hall,by Ellis Waterhouse..Ipswich?Eng..1958
.i.e.1959.
64 p. illus.

LC N5245.T58
Yale ctr.f.Brit.art Ref.
N5247.T65W38

705
A56
NCFA
v.22

I.B.l.b - TUCK, EDWARD, PARIS

Problems in waxes

In:Antiques
22:221-3 Dec.,'32 illus.

18th c. wax portrs.

"...a group of ... unpublished wax portrs.
from the coll.of Edw.Tuck.Paris."

FOR COMPLETE ENTRY
SEE MAIN CARD

I.B.l.b - TOSTI, CARDINAL ANTONIO, 1776-1866

Boston. Public Library
The Tosti engravings.Portraits.

In:Bull.
22 p. 1871

List of 676 portrs.Gift of Ths.G.Appleton,
1869.Formerly in the coll.of Cardinal Antonio
Tosti

LC NE57.B7T7 1871
Levi.Descript.bibliography
Z5947.A3L66 1974 NCFA
p.200

ET
B2
1
1853
C-61
53-64

I.B.l.b - TUNNO(E.Rose), died 1863

Sotheby, firm,auctioneers, LONDON
Cat.of a...coll.of engraved British por-
traits formed by the late proprietor for the
illustration of Granger's history of England;
many...originally in the Sykes,Bindley & Dela-
bère collections...by...Elstracks...Cecil...
Vaughan...Faithorne....London,1863.
19 p.
Sale cat.Jl.22,1863 & ff.day
{The proprietor was E.Rose TUNNO!-Lugt.In:
Marques de collections.N8380.L95,NCFA,p.158,no.
.902

Met.Sales ca...fZ8861.M53 NCFA v.25,p.
.023315

705
F19
v.6
1930
NCFA

I.B.l.b - TRIVULZIO, MILAN

Kiel, Hanna
Oberitalienische porträts der sammlung
Trivulzio

In:Pantheon
6:441-8 sup.78-9 Oct.,'30 illus(1 col.)

Repro.incl.Antonello da Messina,Bernardino
dei Conti,Zanetto Bugatti,Baldass d'Este(Baldas
sare Estense)Ambrogio de Predis?,Paolo Morando

AP
1
W225
NCFA
v.21

I.B.l.b - TURNER, DAWSON, 1775-1858

Kitson, Sydney Decimus, 1871-
Notes on a collection of portrait drawings
formed by Dawson Turner

In:Walpole Soc.
21:67,-104 illus. 1932-1933

"In 1927 2 v.of portr.drawgs.were sold at
Sotheby's & bought by the V.& A.mus. ..."

Repro.incl.J.P.Davis,Cotman,Chantrey,Varley
etc.

LC N12.WJ,v.21
Forr,v.11,p.323

I.B.1.b - ULLMANN, PROF.E., VIENNA

Gesellschaft der bilder-und miniaturfreunde,
Vienna
Das gemalte kleinportrMt.I....II.Zwei Wiener
miniatursammlungen:...& Prof.E.Ullmann.Wien,
Selbstverlag,1931

.LC Jdc45.931G.

CtY

FOR COMPLETE ENTRY
SEE MAIN CARD

I.B.1.b - VERSTOLK VAN SOELEN, GISBERT, baron,
GEAR .1776-1845
Muller, Frederik, 1817-1881
. Beschrijvende catalogus van 7000 portretten
van Nederlanders,en van buitenlanders,tot Neder-
land in betrekking staande...Amsterdam,F.Muller,
1853
401 p.
Muller coll.in 1852
Part 1:Ruling fgs.& their families,in chro-
nological order.Pt.II.Exceptional individuals,
in alphabetical order,with biographical notes
& dates of the prints.
Rijbroek.Fred.Muller en
zijn prentenverzamelingen
In:Bull.Rijksmus.29:26
LC NE205.M8 note 12 708.949x.A523 NMAA

I.B.1.b - U.S.

Du Bois, Guy Pène, 1884-
English portraits in American collections

In:Arts & Dec
4:180-3 Mar,'14 illus.

LC N1A85

Cumulated Mag.subj.index
Al/3/C76 Ref. v.2,p.444

I.B.1.b - VERTUE, GEORGE, 1684-1756

Vertue, George, 1684-1756
Alphabetical list of portraits mentioned
in the collections of George Vertue,preceded
by a brief description of the contents of the
several volumes,about 1752.Autograph.29 folios.
...Contains index,made by Vertue,of portraits
with references to the volumes in which they
are noted.

MS owned by the British mus.(MS.Add.23097)

Walpole Soc.AP1.W??5 NCFA
v.3,p.131 & 139

I.B.1.b - U.S. - IOWA

Des Moines Art Center
19th century American portraits from Iowa
collections.Exh.14 Sept.-17 Oct.'76..Cat..by
Js.T.Demetrion
4 p. illus.

Incl.portrs.from G.Stuart to M.Cassatt

34 works shown

RILA IV/I 1978 #2122

NO
.1333
V8V817
NPG

I.P.1.b - VIRGINIA

Virginia museum of fine arts, Richmond
An exh.of Virginia miniatures.Dec.3rd,1941-
Jan.5th,1942....Richmond,The Va.mus.of fine
arts,1941.
55 p. illus.

Miniatures ptd.prior to 1830

Index of sitters

Rutledge.In:Am Coll.705.A5
17:23

705
B97
NCFA
v.43

I.B.1.b - VAN GELDER, MICHEL, CHATEAU ZEEBRUGGE

Dussler, Luitpold, 1895-
Unpublished terra-cottas of the quattrocen-
to

In:Burl.Mag.
43:125-30 Sept.,'23 illus.

Busts in the coll.of Michel van Gelder,
Château Zeebrugge(near Brussels)

Portr.bust Renaiss.to En-
lightenment.NB1309.P6x NPG
Bibl.

I.B.1.b - VIRGINIA - ALBEMARLE CY.

National Society of the Colonial Dames of
America. Virginia. Blue Ridge Committee
An exh.of portraits owned in Albemarle Cy.,
Va.,painted before the year 1830.Presented...
April 8-30,1951,Mus.of Fine Arts,Bayley Memo-
rial Building,Uni.of Va.,Charlottesville,Va.,
1951.
10 p.

CAP has
NPG copy

For the benefit of Gunston Hall

.LC ND1301.M3 1951.
ViU

I.B.1.b - VASARI, GIORGIO, 1512-1574

Prinz, Wolfram
Vasari's sammlung von künstlerbildnissen

In:Florence,kunsthist.Inst.,Mitt.
12 suppl. 1966

On Vasari's woodcut portrs.,and their de-
pendence on self-portrs.

LC N14.F5515

Daugherty.Self-portrs.of
.P.Rubens mfal61 NPG
p.XIII footnote 10

N
40.1
C94783
NPG

I.B.1.b - WALKER, THOMAS BARLOW, 1840-

Cress, Henry H., 1837-1918
The T.B.Walker coll.of Indian portraits;125
reproductions of ptgs. by Henry H.Cross,of which
22 are in color.With historical commentary by
A.W.Schorger.Madison,State Historical Society
of Wisconsin,1948
164 p. illus(part col.)

Incl.Ch.:White men in the Indian Country...
p.140-64

I.B.1.b

Walpole, Horace, Earl of Orford, 1717-1797
The collection of rare prints & illustrated works,removed from Strawberry Hill...catalogue of the ...collection of engraved portraits of ... British characters that figure in ...history and biography from the time of Egbert the great,in the 8th c...to the termination of the 18th...as... collected by H.Walpole,...sold...13th...of June 1842....London 1842.
131 p.

MET
Print
Dept.

I.B.1.b -

Wellesley, Francis
A hand-list of the miniatures and portraits in plumbago or pencil belonging to Francis and Minnie Wellesley,with a foreword by Dr.C.C. Williamson.Oxford.H.Hart,printer.1914
85 p.

LC N7616.W43 Fogg,v.11,p.326

705
A56
NCFA
v.100

I.B.1.b - WASHINGTON, GEORGE, MOUNT VERNON

Floyd, William Barrow, 1934-
The portraits and paintings at Mount Vernon from 1754 to 1799. Part I and II

In:Antiques
100:768-74 Nov.,'71 illus(part col.)
:894-99 Dec.,'71 illus.

Repro.incl.:Lafayette,by Chs.W.Peale,1781; Lawrence Washington;Martha Washington,by Wollaston,1757;John and Martha Parke Custis,by Wollaston,1757;Col.Geo.Washington,by Chs.W.Peale,1772;

705
C75
NCFA
v.51
v.52
v.53

I.B.1.b - WELLESLEY, FRANCIS,Augustin,1865-

Williamson, George Charles, 1858-1942
Mr.Francis Wellesley's collection of miniatures and drawings

In:Connoisseur

FOR COMPLETE ENTRY
SEE MAIN CARD

I.B.1.b - WEILL, DAVID DAVID, 1871-1952
see
I.B.1.b - DAVID-WEILL, DAVID, 1871-1952, Paris

fNC
910
W45
NPG
Shelved
in NCFA
NPG
Librarian's
office

I.B.1.b -

Wellesley, Francis
One hundred silhouette portraits selected from the collection of Francis Wellesley, with a preface by Weymer Mills.Oxford,printed by H.Hart at the university press for F.Wellesley,1912
20 p. illus.

Contains list of silhouettists;list of sitters
Repro.of silh.painted on paper,glass,pasteboard,plaster,silk.Cut.Etched on metal
LC NC910.W4 Wellesley coll contains Lavater's own album

I.B.1.b - WELLESLEY, DUKES OF WELLINGTON
see
I.B.1.b - WELLINGTON, DUKES OF

MET
212
G
1866

I.B.1.b - WELLESLEY, REV.DR.HENRY, 1791-1866

Sotheby, firm,auctioneers, LONDON
The cat.of the memorable Cabinet of drawings...formed...by the late Rev.Dr.Wellesley, principal of New Inn Hall,Oxford.1866

FOR COMPLETE ENTRY
SEE MAIN CARD

I.B.1.b - WELLESLEY, FRANCIS,AUGUSTIN,, 1865-

Wellesley, Francis
Cat.of the ... coll.of plumbago,pen and ink and coloured pencil drawings and miniatures... sold by Sotheby,Wilinson & Hodge,June 28,1920 and 4 ff days..London.Riddle,Smith & Duffus.1920.

LC N5245.W45 NN NH NiU FOR COMPLETE ENTRY
SEE MAIN CARD

AP
1
A64
NCFA
v.102

I.B.1.b - WELLINGTON, DUKES OF

Ford, Brinsley
The pictures at Stratfield Saye

In:Apollo
102:19-29 July,'75 illus.

FOR COMPLETE ENTRY
SEE MAIN CARD

AP
1
A64
NCFA
v.102

I.B.1.b - WELLINGTON, DUKES OF

Archer, Mildred
 Wellington and South India:portraits by Thomas Hickey

In:Apollo
102:30-5 July,'75 illus.

 Portr.studies...at Stratfield Saye House,
Hampshire

**FOR COMPLETE ENTRY
SEE MAIN CARD**

705
C75
v.67
NCFA

I.B.1.b - WICANDER, HJALMAR

Foster, Joshua James, 1847-1923
 The Wicanders collection of miniatures

In:Connoisseur
67:13-8 Sept.,1923 illus.

 Coll.of 400-500 miniatures,mostly Swedish.
Also English,French,Italian,Austrian,Danish,
Russian pieces.
 Repro.incl.miniatures by P.A.Hall,Augustin
Ritt,R.Cosway,I.and P.Oliver,J.Petitot,Lafrensen the younger

I.B.1.b - WESTON
 see
I.B.1.b - NEWPORT, EARLS OF BRADFORD, WESTON

I.B.1.b - WILLIAM IV, THE WISE, 1532-1592

Schwindrazheim, Hildamarie
 Eine porträtsammlung Wilhelms IV von Hessen
und der "Güldene Saal"

In:Marburger Jahrb.
10:263-302 1937 illus.

 Bibliography

LC N9.M3 Eller.Kongel.portr.malere
 p.519

N
7628
W31W5
NCFA

I.B.1.b -

Whelen, Henry,jr.
 ...The important collection of engraved portraits of Washington belonging to the late Henry Whelen,jr., of Philadelphia...from whose collection the late Wm.S.Baker compiled his...book
..."Engraved portrs.of Washington"...also engraved portrs.of Franklin;to be sold...Apr.27,
1909...Cat.comp.and sale conducted by Stan V.
Henkels at...Samuel T.Freeman & co...Philadelphia.Phila.,Press of M.H.Power,1909.
 102 p. illus.

LC NE320.W2W5 Levis.Descr.bibl.Z5947A3
E312.43.W64 L66 1974 NCFA p.250
 incl.some prices.

ND
207
W66E
NPG

I.B.1.b - WILTSHIRE, WILLIAM E.III & Mrs.W.

Woodward, Richard P., 1950-
 American folk painting;selections from
the coll.of Mr.and Mrs.William E.Wiltshire III
an exh.organized by the Virginia Museum...Cat.
comp.by Richard P.Woodward.Richmond,The Museum
,1977.
 110 p. illus(col.)

 Introd.by Mary Black

 Exh.Nov.29,1977-Jan.8,1978

 Flint Inst.of Arts.Am.naive
 ptrs..ND210.5.P7F5 1981X
 NAA bibl.p.93

I.B.1.b - WICANDER, HJALMAR

Wicander, Hjalmar
 Hjalmar Wicanders miniatyrsamling;beskrivande katalog.Stockholm,1920-29
 2 v. 242 pl.(57 col.)

MET
195.4
W63
Q

 At head of title:Karl Asplund

ND
1301
M5M52X
NPG

I.B.1.b - WISCONSIN - MILWAUKEE

Milwaukee. Art Center
 Portraits from Milwaukee collections;an
exh.presented by the Milwaukee Art Center in
co-sponsorship with the National Society of
the Colonial Dames of America in the State of
Wisconsin.Sept.3 through Oct.10,1971.Milwaukee,
Arrow press,1971
 1 v.(unpaged) illus.

 Intro.by Tracy Atkinson

757.7
.S86

I.B.1.b - WICANDER, HJALMAR

Stockholm. Nationalmuseum
 Nationalmusei miniatyrsamling,den Wicanderska samlingen och museets övriga miniatyrer.
Stockholm.P.A.Norstedt & söner.1929
 100 p. illus.

 "Inledning"signed:Axel Sjöblom

LC ND1335.S8

I.B.1.b - WOODBURN, SAMUEL, 1785 or86-1853

Woodburn, Samuel, 1785 or86-1853
 Cat.of splendid and capital coll.of engraved British portraits...for sale...at
S.Woodburn's,no.112,St.Martin's Lanes,London.
London,1815(or1816)
 2 v.

 W.'s Gall.of rare portrs.(fr.original plates
& facsimiles)
 see Hind.Hist.of engr.& etching fr.the 15th
c.to the yr.1914 NE400.H66 1963 NCFA p.410

 Ars Artis cat.41 books on
 Prints Drngs. no.689

I.B.1.b - WOODBURN, SAMUEL, 1785 or86-1853

Woodburn, Samuel, 1785 or86-1853
　　Gallery of rare portraits,consisting of
200 original plates and facsimile copies of
rare and curious portraits,illustrative of
Britisih history.London,1816
Brit.　　2 v.
Mus.

　　　　　　Universal Cat.of Books on
　　　　　　Art Z5931.U58 1964,v.2,
　　　　　　p.2161
　　　　　/ & A v.10 Pre-1890,p.505
　　　　　fZ921.V64 NCFA

N　　I.B.1.c - BORG, JAMES M.W.,INC.,CHICAGO
7624
J29　Borg, James M.W.,Inc.,Chicago
NPG　　Gallery.Portraits of literary and histori-
cal figures.1962
　　　unpaged(121 nos.　illus.

　　Incl.:Caricatures;drawings,prints

I.B.1.b - WOODBURN, SAMUEL, 1785 or86-1853

Woodburn, Samuel, 1785 or 86-1853
　　Woodburn's Gallery of rare portraits;con-
sisting of original plates by Cecil,Dalarum,
Droeshout...illustrative of Granger's Biograph.
hist.of England,Clarendon's Hist.of the rebel-
lion,Burnet's Hist.of his own time,Pennant's
London,etc...containing 200 portrs.of persons
celebrated...London,G.Jones,1816
　　　2 v.　illus.

　　　For full subtitle see(LC)Z881A1U525　1942
　　v.165,p.418　NPG Ref.or Pre-1956,v.672,p.489

LC N7598.W6

I.B.1.c - CHARPENTIER, PARIS
　　see
I.B.1.c - GALERIE CHARPENTIER, PARIS

I.B.1.c.　DEALERS' CATALOGS, A-Z, by dealer or gallery
　　　　　　　name

N　　I.B.1.c - CHILDS GALLERY, BOSTON
7593
C53　Childs Gallery
NPC　　Portraits.Childs Gallery.Boston,The Gallery
.1979.
　　.33.leaves　illus.

　　Sales cat.

I.B.1.c　Dealers' catalogues of portraits for sale
　　　　　(N o t　for loan exhibitions)

ND　　I.B.1.c -
1311.1
B35
NPG has　Copley gallery, Boston
no.2-3　　...Little known American portrait painters,
no.　　Boston,Copley gallery,193-?
　　　v.　illus

FCOO　　.no.1:Blackburn,Earl,Oullager,Feke,Johnston,
46　　Badger,Savage,Woolaston.-no.2:Greenwood,Emmons,
H747c　Chandler,Blyth.no.3:Theus,King,Wright,Pine,Fur-
　　　nass,Ramage,Trott,Pratt,Metcalf. No.1,2,3 in
　　　OCIMA

　　　　　　　Text by F.W.Bayley
DSI
LC reports "no.1-5"19......　　　　Fogg,v.11,p.327
MWA NN PPULC

　　　I.B.1.c -

　　Agnew (Thos.) & Sons,ltd.,London
　　　　English life and landscape;an exh.of Eng-
lish pictures,1730-1870, 8th March-'th April,
1971.London,1971.
　　　32 p.　illus.

LC ND1314.4.A7
　　　　　　　　　　　Yale ctr.f.Brit.art　Ref.
　　　　　　　　　　　　ND1314.4.A35

　　I.B.1.c -

　　Daniell, Walter Vernon　comp.
　　　A catalogue of engraved portraits of cele-
brated personages,chiefly connected with the
history and literature of Great Britain...Lon-
don,W.V.Daniell,1900
　　　278 p.　illus.

LC NE265.D3
　　　　　　　　　　　Whitman's print coll.hdbk.
　　　　　　　　　　　1921. NE885W614　1912 NCFA
　　　　　　　　　　　Bibl.III

AP
1
A788
v.7

I.B.1.c - DUDENSINO GALLERIES

Goodrich, Lloyd, 1897-
Early American portraits;an exhibition at
Dudensing Galleries

In:The Arts
7:46-7 Jan.,'25 illus.

I.B.1.c

Evans, Edward, 1789-1835
Catalogue of a collection of engraved portraits
the largest ever submitted to the public;compris-
ing nearly 20000 portraits of persons connected
with the history & literature of this country,from
the earliest period to the present time...alpha-
betically arranged with the names of the painter
& engraver...Now on sale...London,E.Evans,etc.,
1836-53.

LC Rare Books dpt. Amsterdam,Rijksmus.cat.
 Z5939A52, deel 1,p.151

757.C942
.D98

I.B.1.c

Duveen brothers.
Catalogue of forty British portraits,with an
introduction by W.G.Constable;exhibited by
Duveen brothers at their galleries...New York...
Apr.9 to Apr.30,1940..New York,Publishers print-
ing company,c.1940.
24 p: illus.

LC N7598.D85

705
G28
v.15
1927
NCFA

I.B.1.c - GALERIE CHARPENTIER, PARIS

Ratouis de Limay, Paul
L'exposition de pastels français du 17e et
du 18e siècle

In:Gaz Beaux Arts
15:321-38 ser.5,1927 illus.
Exhibition at Hôtel Charpentier,1927
Incl:Nanteuil,Vaillant,Vivien,Coypel,La Tour,
Perronneau,Chardin,Boucher,Ducreux,Bose,Labille-
Guiard,V.Le Brun,M.S.Giroust Roslin,Valade,N.Loir,
S.B.Le Noir,Regnault,Sergent-Marceau,Prud'hon
Portr.of LaTour by Perronneau & by himself

I.B.1.c - EDERHEIMER, RICHARD, firm,N.Y.

Ederheimer, Richard, firm,N.Y.
Illus.cat.of portraits by the master engra-
vers of the 17th century...to be sold...Feb.18,
1916....N.Y.,Amer.Art association,1916.

LC(769.E22)MiU MH MA FOR COMPLETE ENTRY
 SEE MAIN CARD

I.B.1.c - GALERIE CHARPENTIER, PARIS

Florisone, Michel
Portraits français. Paris,Galerie Charpentier,
1946

181 p. illus.

LC ND553.M3F54 Rep.,1945-47*856

927
E33

I.B.1.c -

Ehrich galleries, New York
One hundred early American paintings.New
York,The Ehrich galleries,1918
176 p. illus.

Bibliography

"Book arranged by W.A.Bradley,Yale University
Press,New Haven"
Portraits of the 18th & 19th c.
List of ptrs.& their dates,in alphabetical
order
LC ND207.E5 Repr,v.11,p.327

NE
250
A63
NPG

I.B.1.c - GROSSE-WORTMANN, LAGE

Antiquariat Dieter Grosse-Wortmann
Alte porträt-graphik
141 p. illus.

cat.no.38

Arranged in alphabetical order by sitter

I.B.1.c - ELLIS,firm,booksellers, LONDON

Ellis,firm,booksellers, London
A cat.of engravings...London,18...

N.Y.P.L.
MDF77-737

 FOR COMPLETE ENTRY
 SEE MAIN CARD

I.B.1.c

Heitzmann, Johann
Portraits-Catalog. Verzeichnis aller por-
traits welche in Deutschland bis ende des jahres
1857 erschienen & noch vom verleger zu beziehen
sind.Mit einschluss einer grossen anzahl auslän-
discher portraits & mit angabe der verleger & la-
denpreise.München,Mey & Widmayer,1858
430 p.

MB MiU Cty IEN Amsterdam,Rijksmus.,cat.
 Z5939A52,deel 1,p.131

I.B.1.c - James M.W.Borg,Inc.
see
I.B.1.c - BORG, JAMES M.W.,INC.,CHICAGO

NE
250
052
NPG

I.B.1.c - OLSCHKI, FLORENCE

Olschki, Leo Samuel, 1861-1940,firm, Florence
Portraits of artistic and iconographical
interest.Firenze, Libreria antiquaria...,1961
521 nos. illus.

Contents:Some choice portrs.:Artists;Kings
& soldiers;Men of letters;Musicians;Physicians
& men of science;Statesmen & magistrates;Various;Some books with portraits

Cat.no.139

I.B.1.c - KNOEDLER, M. AND COMPANY, NEW YORK

British mezzotinto portraits of the 18th century.N.Y.,M.Knoedler & Co.,Inc.,1930.
61 p. illus. (The print collector's
bulletin,v.1,no.6.)

LC NE1.P67

757
.K73

I.B.1.c - PORTRAITS,INC., NEW YORK
Knoedler (M.) and company, inc.
...A loan exhibition of American portraits by
American painters,1730-1944;1730-1921 group at
Knoedler galleries...New York; 1921-1944 group at
Portraits,inc....New York.New York,The William
Bradford press,1944.
28,p. illus.

LC N7593.K58

760.5
.P94

I.B.1.c - KNOEDLER, M.& CO., NEW YORK

Fifty men and women.Engraved portraits of certain persons of importance of the 16-19th
centuries.N.Y.,M.Knoedler & co.,inc.,1930
57.p. illus. (The print collector's bulletin,v.1,no.3)

Repro.incl.Benjamin Franklin by Js.McArdell,
John Evelyn by Nanteuil,Amelia Elizabeth of
Hesse by Ludw.von Siegen(earliest mezzotint
known-1642)

NC
773
P85
NPG

I.B.1.c

Portraits, Inc., New York
Portrait drawings 1900-1966. Catalog of
exhibition.....New York,1966.
28,p. illus.

NPG
V F

I.B.1.c

London. Ferrers Gallery
Marcel Proust and his friends. Exhib.,1971

Princesse Marthe Bibesco by Boldini; Mme de
Noailles,Duchesse de Gramont,Count Rbt. de Montesquiou by Helleu;drgs. by Helleu

Repro:Bérand,Blanche,Boldini,Gervex,Orasi

N
7624
R26
NPG
2 cops.

I.B.1.c - RAYDON GALLERY, NEW YORK

Raydon Gallery, New York
Masters in portraiture.Cat.of exh. Spring,
1971
24 p. illus.

Mainly ptgs.,some busts

I.B.1.c -

Maggs Bros., London
Choice engravings of American historical
importance.(Portraits of famous American and
British officers,statesmen and others connected
with the War of Independence)Rare political
cartoons,emblems...Washington portraits.Selected from the Stock of Maggs Bros...London,
1909
23 p. illus.
no.249 237 items

CSmH

Levis.Descr.bibl.Z5947.43
66,p.212:"Particularly interesting list"

705
A786
NCFA
v.38
pt.2

I.B.1.c - SCHAEFFER GALLERIES, INC., NEW YORK

Goldwater, Robert John, 1907-
Artists painted by themselves.Self-portraits
from baroque to Impressionism

In:Art N
38,pt.2:7-12,23-4 Mar.,30,'40 illus(part col)

Pertains to exh.at Schaeffer gall,inc.,N.Y.,
Apr.2-30,1940
Artist vs.society.Description of changes in
attitude in the modes of portraiture.
Repr.incl.:P.Brill,Leyster,Rembrandt(1629)

NE
260
S64
NPG

I.B.1.c - SMITH,,George D., FIRM,BOOKSELLERS,N.Y.

Smith, George D., firm,booksellers,New York
Catalogue of American historical portraits
and engravings,including rare revolutionary
prints...N.Y.,Geo.D.Smith,between 1905 and 1917.
29 p illus.

I.B.1.c

Weigel, Rudolph, 1804-1867
Eine grosse sammlung von künstler-portraits
in werken & in einzelnen blättern von frühester
zeit bis zur gegenwart.Leipzig,R.Weigel.1857?.
(his Kunstcatalog,v.4,pt.2)

In all:...3832 portrs.of artists

LC Z5939.W41 v.4pt.2

I.B.1.c -

Smith, John Russell, 1810-1894
A catalogue of 10000 engraved portraits,
chiefly of personages connected with the his-
tory and literature of Great Britain on sale by
J.R.Smith,London,1875

FOGG
FA983.1.7

Fogg,v.11,p.325

I.B.1.d. AUCTION CATALOGS, A-Z, by auction house

I.B.1.c -

Smith, John Russell, 1810-1894
A catalogue of 20000 engraved portraits,
chiefly of personages connected with the his-
tory and literature of Great Britain,on sale...
by John Russell Smith...London,1883

LC NE265.S5 Fogg,v.11,p.325

NCFA has

I.B.1.d - AMERICAN ART ASSOCIATION, ANDERSON
GALLERIES, NEW YORK

Burlingham, Hiram
American portraits,incl.Abraham Lincoln by
Lambdin,Thos.Jefferson by Bass Otis & works by
Peale,Copley,Mare,Vanderlyn,Audubon...,minia-
tures,ship paintings...property of H.Burling-
ham...sale Jan.11,N.Y.,American Art Ass.,Ander-
son Galleries,1934
56 p. illus.
Sale no.4076 priced.

MET
499.8
B22
.934

FMU MBAt IU PPULC Met.v.25,Sales cat.
Cty PPPM Z881.N53 NCFA p..023319

I.B.1.c - VOLLARD, AMBROISE

Vollard, Ambroise
Mes Portraits

In:Arts et Métiers graph.
:38-44 no.64 1938 illus.

Incl:Renoir,Cézanne,Picasso,Bonnard,Rouault,.
Denis,Dufy

Met
268.54
Ar7

LC Z119.A84 Rep.,1938#646

I.B.1.d - AMERICAN ART ASSOCIATION, NEW YORK

Johnson, Eastman, 1824-1906
Cat.of finished pictures,studies and draw-
ings by the late Eastman Johnson,N.A.,to be sold
at unrestricted public sale...at the American
Art galleries...on,Feb.26 & 27,1907....The sale
will be conducted by Mr.Ths.E.Kirby of the Ame-
rican art assoc'n...N.Y.,Americ.art assoc'n
.Press of J.J.Little & co..1907
.98.p. illus.
'Shows...his unusual accomplishm't as por-
traitist & fig.ptr..&.illustrates his method of
work...'-J.Benj.Townsend
LC ND237.J7 Arts in Am qZ5961.U5A77X
NCFA Ref. I 1015

I.B.1.c

Weigel, Rudolph, 1804-1867
Catalog der von ...J.D.W.Sachse hinterlasse-
nen grossen sammlung von porträts. Leipzig,1861

FOGG
FA
980.5

017.37
.C59

I.B.1.d - AMERICAN ART ASSOCIATION, NEW YORK

Clarke, Thomas Benedict, 1848-
De luxe illustrated catalogue of early Ameri-
can portraits collected by Mr.Thomas B.Clarke,
New York city;to be sold......Jan.7th,1919..New
York.Lent & Graff co.,printers.1919
.113.p. illus.

The sale will be conducted by Mr.Thomas E.
Kirby of the Americ.art association,managers

LC N7593.C6

I.B.1.d - AMERICAN ART ASSOCIATION, NEW YORK

Smith, Frank Bulkeley
 Illustrated cat. of the ...collection of
early American and British portraits...formed
by...F.B.Smith...sold....Apr.22nd and 23rd,1920.
...by the American Art Association...N.Y.,1920
 unpaged illus.

MET
199.8
So13 Priced

FOGG
S.C.
A512 Fogg,v.11,p.332

I.B.1.d - AMERICAN ART GALLERIES
see
I.B.1.d - AMERICAN ART ASSOCIATION, NEW YORK

I.B.1.d - ANDERSON AUCTION COMPANY, NEW YORK

Anderson Galleries, New York
 A cat.of paintings of American celebrities..
of the Colonial and Revolutionary periods, and
of other...portraits...from a private collec-
tion...sale April.26,1905 by the Anderson auc-
tion company....N.Y.1905.
 35 p. illus.

MET
199.8
Q511

 Met.v.25,Sales cat. fZ881
 N53 NCFA p.023314

N
7592
O24
NPG

I.B.1.d - ANDERSON GALLERIES, NEW YORK

Daly, Augustin, 1838-1899
 The Augustin Daly collection of portraits
of eminent men and women of the stage.New York,
The Anderson Galleries,1912
 30 p. illus.
NPG copy bound with the Garrick Club,London,Catal.of
the pictures...London,1909

 .Daly.Auction Nov.27,1912.

 Met.v.25,Sales cat. fZ881
 N53 NCFA p.023315

I.B.1.d - BIRCH'S SONS, PHILADELPHIA

Henkels, firm auctioneers, Philadelphia
(1895.Stan.V.Henkels)
 ...Cat.of autograph letters,historical docu-
ments,and rare engraved portraits;being the
coll.of J.Henry Rogers, of Newcastle,Del.,and
of a Western gentleman...Also an extraordinary
coll.of rare and scarce engraved portraits.To
be sold...May 8th,9th and 10th,1895...Cat.comp.
and sale conducted by Stan.V.Henkels at the
book auction rooms of Thos.Birch's Sons..Phila-
delphia,The Bicking print,1895.
 109 p. illus. Winterthur Mus.Libr.
LC Z42.R72 Z881.W78 NCFA v.6,p.229
Z909.H505 no.738

I.B.1.d - BIRCH'S SONS, PHILADELPHIA

Henkels, firm,auctioneers, Philadelphia
 Cat.of rare & choice engravings;incl.an ex-
traordinary coll.of portraits of Washington &
other notable Americans & of European celebri-
ties,a coll.of Napoleoniana & misc.engravings
to be sold Nov.24 & 25,1896 at the rooms of
Thos.Birch's Sons,Phila.,Pa....1896
 52 p. illus.

 940 engravings,18 photographs (no.768)
 (For more locations of this cat.see:Lugt
Rép.des cat.de ventes,1861-1900;017.37.L95 NCFA
MH MdBP OCl NIC MiU p.615,no.5476d) Ref.

N
7592
H513
RB
NPG

I.B.1.d - BIRCH'S SONS, PHILADELPHIA

Henkels, Stanislaus Vincent, 1854-1926
 Cat.of the valuable autographic coll. and en-
graved portraits...gathered by...Col.Ths.Colcock
Jones...to be sold Tue.,Wed.,Thurs.,April 24,25,
26,1894.Cat.comp.,and sale conducted by Stan.V.
Henkels,at the book auction rooms of Thos.Birch's
Sons,Philadelphia
 148 p. illus.
 cat.no.720
 16 engravings of Washington
 Contains autographic sets of the signers of
the Declaration of Independence,Rulers & Govs.
 (cont'd on next card)

N
7592
H513
RB
NPG

I.B.1.d - BIRCH'S SONS, PHILADELPHIA

Henkels, Stanislaus Vincent, 1854-1926
 Cat.of the very important coll.of studies
and sketches,made by Col.John Trumbull...as
well as his important coll.of engravings and
portraits in mezzotint,line and stipple...to
be sold Thur,Dec.17,1896.Cat.comp.,and sale
conducted by Stan.V.Henkels at the art auction
rooms of Thos.Birch's Sons,Philadelphia
 39 p. illus.
 cat.no.770

 Sale by order of B.Silliman,who inherited
the effects of Col.John Trumbull

I.B.1.d - BIRCH'S SONS, PHILADELPHIA

Cope, Edwin R.
 ...The magnificent coll.of engraved por-
traits formed by...Edwin R.Cope...being the
most important coll..to be sold...at Thos.
Birch's sons...Cat.comp.& sale conducted by
Stan V.Henkels....Philadelphia,The Bicking
print,1896..1899.
 Pt.I:148p.;1126 items,portraits,illus.
 Pt.II:60p.;1247 items,portraits,illus.
 Pt.III:44p.;814 items,miscellaneous,illus.
 Pt.IV:44p.;586 items,balance of coll.with
 suppl.contain'g illus.
 continued on next card
LC has pt.2:NE240.C7 Levis.Descr.bibl.Z5947.A3
 L66 1974 NCFA p.244

757.7
C55
NCFA

I.B.1.d -

Christie,Manson & Woods
 Cat.of the famous coll.of miniatures of the
Brit.and foreign schools,the property of J.Pier-
pont Morgan...to be sold at auction by Messrs.
Christie,Manson & Woods...June 24,1935 & three
following days...London,...1935
 272 p. illus(part col.)

 Based on descriptive & illus.cat.in 4 v.,
comp.by G.C.Williamson for the late J.Pierpont
Morgan,father of the present owner.
 16-19th c.miniatures of Royalties,statesmen
ladies of the court,etc.

I.B.1.d - CHRISTIE, MANSON & WOODS, LTD., LONDON

‚Delabère Family‚
 A cat.of a most singular, rare and valuable
collection of portraits...in a very celebrated
book that has been preserved 15 years in the
Delabère family...‚London, G.Smeeton, 1811‚
 44 p.

 152 items Priced Names of buyers

 Auction sale, Christie, March 29, 1811

PU-R (For more locations of this cat. see: Lugt
 Rép.des cat.de x.x ventes, 1600-1825; 017,195
 NCFA Ref., no.7955 (5)

I.B.1.d - CHRISTIE, MANSON & WOODS, LTD., LONDON

Foster, Joshua James, 1847-1923
 A list, alphabetically arranged, of works of
English miniature painters of the 17th century,
...Supplementary to Samuel Cooper and the Eng-
lish miniature painters of the 17th century. Lon-
don, Dickinsons, 1914-16

 "A list of miniatures by the artists whose
works are described in this vol., sold at Messrs.
Christie's from 1858-1912 inclusive": p.159-‚182‚

LC ND1337.G7F6

NPG I.B.1.d - CHRISTIE, MANSON & WOODS, LTD., LONDON

Christie, Manson & Woods, ltd.
 Fine miniatures, gold boxes and Russian
works of art to be sold at Christie's Great
Rooms, 26 june 1980. London...1980

 Code name: Kingfisher

 FOR COMPLETE ENTRY
 SEE MAIN CARD

I.B.1.d - DAVIS & HARVEY, PHILADELPHIA

Mitchell, James Tyndale, 1834-1915
 ...Collection of engraved portraits of Wa-
shington belonging to Hon.James T.Mitchell...
Cat.comp. & sale conducted by Stan.V.Henkels at
the art auction rooms of Davis & Harvey, Phila., Pa.
s...,1906‚
 2 pts. illus.
 Cat.no.944, pt.I-II

 v1. ...to be sold Jan.18 & 19,1906.-v.2...to
be sold May 3, 1906

LC E312.43.M68

705 I.B.1.d - CHRISTIE, MANSON & WOODS, LTD., LONDON
M19
NCFA Roberts, W‚illiam, 1862-1940‚
v.22 George Dance and his portraits, recently
 come to light

 In: Mag Art
 22:656-8 1898 illus.

 Over 200 portr.drags.,53 of artists in Royal
 Academy, Authors, actors, medical men, etc. sold at
 Christie's, July 1,1898

 FOR COMPLETE ENTRY
 SEE MAIN CARD

VF I.B.1.d - DAVIS & HARVEY, PHILADELPHIA

Dunlap, William, 1766-1839
 Collection of ivory miniatures...cat.comp.
and sale conducted by Stan V.Henkels at the
book auction rooms of Davis & Harvey, Phila., Pa.
Mar.10,1905
 26 p. illus(1 col.)

 Cat.no.927

 Incl.: Scarce American portrs.: Americus Ves-
pucius, Washington & family, Franklin, Lincoln,
Wm.Penn... engravings, ptgs. by other artists.

B I.B.1.d - CHRISTIE, MANSON & WOODS, LTD., LONDON
.E58W7
 Williamson, George Charles, 1858-1942
 George Engleheart, 1750-1829...London, G.Bell
 & sons, 1902

 Appendices incl.:....List of min.recently
 sold at Christie's. (Nov.1893, Feb.1894, June, 1895,
 June, 1896, Feb.25, 1902, Feb. 1902, May 14, 1902)
 p.157-159

 FOR COMPLETE ENTRY
 SEE MAIN CARD

I.B.1.d - DAVIS & HARVEY, PHILADELPHIA

Carson, Hampton Lawrence, 1852-1929
 ...The Hampton L.Carson collection of en-
graved portraits of American naval commanders &
early American explorers & navigators...Cat. comp.
& sale conducted by Stan.V.Henkels at the art auc-
tion rooms of Davis & Harvey....Philadelphia,1905‚
 80 p. illus.
 Cat.no.906, pt.IV

 To be sold Oct.31 & Nov.1, ‚1905‚

LC NE260.C26 - Amsterdam, Rijksmus.cat.‚
 Z5939A52, deel 1, p.154

N40.1 I.B.1.d - CHRISTIE, MANSON & WOODS, LTD., LONDON
S638
F7 Foskett, Daphne
NCFA John Smart, the man and his miniatures. London
 Cory, Adams & Mackay. c.1964‚
 100 p. illus(part col.) (Collectors
 Guidebooks)
 Geneal.tables
 Bibliography
 List of sitters
 Christie's catalogues, Dec.17, 1936, Feb.15, 193
 Nov.26, 193
 List of engravings after John Smart & John
 Smart jr.
 Incl.1 chapter on John Smart, jr.
LC ND1337.08S63

N I.B.1.d - DAVIS & HARVEY, PHILADELPHIA
7628
W31C3 Carson, Hampton Lawrence, 1852-1929
NPG ...The Hampton L.Carson collection of en-
 graved portraits of Gen.George Washington. Cat.
 comp. & sale conducted by Stan.V.Henkels. At the
 art auction rooms of Davis & Harvey...Phila., Pa.,
 s...,Press of W.F.Fell co.,1904‚
 173 p. illus(part col.)
 Cat.no.906, pt.I

 Incl.St.Mémin personal coll.of proof messo-
 tints...to be sold Jan.21 & 22, 1904
LC Z999.H505 no.906, pt.1 Amsterdam Rijksmus.cat.
c.2 E312.43.C32 Z5939A52, deel 1, p.154

I.B.1.d - DAVIS & HARVEY, PHILADELPHIA

Carson, Hampton Lawrence, 1852-1929
.. ...The Hampton L.Carson collection of en-
graved portraits of Jefferson,Franklin,and La-
fayette.Cat. comp. & sale conducted by Stan.V.
Henkels.At the art auction rooms of Davis &
Harvey...Phila...Phila.......Press of W.F.Fell co.,
1904.
 157 p. illus.
 Cat.no.906,pt.II

 To be sold Apr.20 & 21, 1904.

LC Z999.H505 no.906,pt.2 Amsterdam,Rijksmus.cat.
 Z5939A52, deel 1, p.154

I.B.1.d - DAVIS & HARVEY, PHILADELPHIA

Carson, Hampton Lawrence, 1852-1929
 ...The Hampton L.Carson collection of en-
graved portraits of signers of the Declaration
of independence,presidents & members of the Con-
tinental congress,officers in the American revo-
lutionary war...Cat. comp. & sale conducted by
Stan.V.Henkels.At the art auction rooms of Davis
& Harvey...Phila.,Pa.1904.
 93 p. illus.
 Cat.no.906,pt.III

 To be sold Dec.16 & 17, 1904

LC Z9994H505 no.906,pt.3 Amsterdam, Rijksmus.cat.
 Z5939A52, deel 1, p.154

N
7592
H513
RB
NPG

I.B.1.d - DAVIS & HARVEY, PHILADELPHIA

Henkels, Stanislaus Vincent, 1854-1926
 The rare and valuable coll.of portraits
and choice engravings gathered by J.Henry Clay
of Philadelphia embracing the most important
coll.of rare Washington portraits...also rare...
portraits,in line,mezzotint and stipple of emi-
nent Americans,artists,actors,authors,clergy-
men,lawyers,statesmen,etc...to be sold Fri.&
Sat.,Dec.3 & 4,1897,at the book & art auction
rooms of Davis & Harvey,Philadelphia
 124 p. illus.

LC Z999 cat.no.799 priced
H505 no.799 Several hundreds portrs.of Washington,
 p.77-102

N
7592
H513
RB
NPG

I.B.1.d - DAVIS & HARVEY, PHILADELPHIA

Henkels, Stanislaus Vincent, 1854-1926
 Rare books and engravings illustrative of
national and local history...belonging to the
estate Thos.Donaldson,deceased and Henry S.
Cushing,late of Philadelphia....to be sold
March 14 & 15,1902 at the book auction rooms of
Davis & Harvey,Philadelphia
 illus.
 Cat.no.877

 Incl.:Portr.ptrs,busts,prints of George &
Martha Washington, all presidents

I.B.1.d - DAVIS & HARVEY, PHILADELPHIA

Mitchell, James Tyndale, 1834-1915
 ...The unequaled collection of engraved por-
traits belonging to Hon.T.Mitchell...embracing
statesmen of the colonial,revolutionary and pres-
ent time,incl.the extens.coll. of portrs. of Benj.
Franklin,Sam.Adams,John Hancock,Henry Laurens,
Henry Clay,and Daniel Webster,also chief and as-
sociate justices of the Supreme court of the U.S,
attorneys-general of the U.S.,judges,lawyers,etc.
To be sold...Dec.5 and 6,1907...Cat.comp.and sale
conducted by Stan.V.Henkels.At the book auction
rooms of Davis & Harvey...Phila,Pa...Phila.,1907.
 134 p. illus.
 Cat.no.944,pt.
LC E176M68

I.B.1.d - DAVIS & HARVEY, PHILADELPHIA

Mitchell, James Tyndale, 1834-1915
 ...The unequaled collection of engraved por-
traits belonging to Hon.T.Mitchell...embracing
the lord chancellors and chief justices of Great
Britain,eminent English lawyers,kings & queens of
Great Britain,English princes & princesses & mem-
bers of royal families,mostly engraved in mezzo-
tinto,to be sold...Feb.26...and...Feb.27,1908...
Cat.comp.& sale conducted by Stan.V.Henkels.At
the book auction rooms of Davis & Harvey,Phila.Pa.
....Press of W.F.Fell co.,1908.
 93 p. illus.
 Cat.no.944,pt. VI

LC NE265M5

I.B.1.d - DAVIS & HARVEY, PHILADELPHIA

Mitchell, James Tyndale, 1834-1915
 ...The unequaled collection of engraved por-
traits of officers...of the war of the revolu-
tion,2nd war with Great Britain and the Mexican
war,belonging to Hon.James T.Mitchell...to be
sold Nov.30 and Dec.1,1906...Cat.comp.& sale con-
ducted by Stan.V.Henkels,at the book auction
rooms of Davis & Harvey...Phila.,Pa...M.H.Power,
printer,1906.
 131 p. illus.
 Cat.no.944,pt.III

LC E181.M84

I.B.1.d - DAVIS & HARVEY, PHILADELPHIA

Mitchell, James Tyndale, 1834-1915
 ...The unequaled collection of engraved por-
traits of the Presidents of the United States,be-
longing to Hon.James T.Mitchell...to be sold...
May 16...&...May 17,1907...Cat.comp. and sale con-
ducted by Stan.V.Henkels at the book auction
rooms of Davis & Harvey...Phila.,Pa.,M.H.
Power,printer,1907.
 123 p. illus.
 Cat.no.944,pt.IV

LC E176.1.M68

I.B.1.d - DELESTRE, MAURICE, Paris

Destailleur, Hippolyte, 1822-1893
 Cat.de livres rares et précieux,compos.la
bibl.de m.H.Destailleur.Paris,D.Morgand,1891
 Auctioned by M.Delestre.Paris.Rue Drouot,27
Apr.13-24,1891

 Incl.V,Rapports avec les personnes,p.110-153
(entries no.435-614):a.-Recueils de portrs.de
personnages divers(divided by nationality of ar-
tists).b.-Portrs.des papes,cardinaux,personnages
religieux.c.-Portrs.des Empereurs Romains,Capi-
taines,Jurisconsultes,Ambassadeurs,

LC Z5939.D42 Ruth.Porträtwerke.Bibl.:
 such coll.of "Porträtwerken"

I.B.1.d - DROUOT, HOTEL, PARIS see
I.B.1.d - HOTEL DROUOT, PARIS

017.37
.M68

I.B.l.d - FREEMAN, SAMUEL T.& CO., PHILADELPHIA

Mitchell, James Tyndale, 1834-1915
...The unequaled collection of engraved
portraits of beautiful women of Europe and Ame-
rica,and actors,actresses,vocalists,musicians,
and composers,belonging to Hon.James T.Mitchell...
to be sold,,.Phila.,Pa.,M.H.Power,printer,1910.
144 p. illus(part col.)

(Catalogue compiled...by Stan.V.Henkels)
(Sold at book auction rooms of S.T.Freeman & c
Cat.no.944,pt.X

LC NE240.M5

N
7628
W31W5
NCFA

I.B.l.d - FREEMAN, SAMUEL T.& CO., PHILADELPHIA

Whelen, Henry,jr.
...The important collection of engraved por-
traits of Washington belonging to the late Hen-
ry Whelen,jr.,of Philadelphia...from whose co
lection the late Wm.S.Baker compiled his...boo
..."Engraved portrs.of Washington"...also en-
graved portrs.of Franklin;to be sold...Apr.27,
1909...Cat.comp.and sale conducted by Stan V.
Henkels at...Samuel T.Freeman & co...Philadel-
phia,Phila.,Press of M.H.Power,1909.
102 p. illus.

LC NE320.W215
E312.43.W64

Levis.Descr.bibl.Z5947A3
/66 1974 NCFA p.250
incl.some prices.

I.B.l.d - FREEMAN, SAMUEL T. & CO., PHILADELPHIA

Mitchell, James Tyndale, 1834-1915
...The unequaled collection of engraved por-
traits of eminent foreigners,embracing kings,
eminent noblemen & statesmen,great naval command-
ers...explorers,...reformers...;also a collection
of caricatures on Napoleon & a ...coll.of portrs.
engravings by the great masters of the last four
centuries in line,mezzotinto,stipple & etching..
to be sold...Oct.14,1912...and Oct.15,1912.Cat.
comp.& sale conducted by Stan.V.Henkels at the
book auction rooms of S.T.Freeman & co.,Phila.,Pa.
,M.H.Power,printer,1912.
111p. illus.
LC NE240.M515 Cat.no.944,pt. XII

I.B.l.d - GALERIE GEORGE PETIT, PARIS see
I.B.l.d - PARIS. GALERIE GEORGES PETIT

760
.N21M68

I.B.l.d - FREEMAN, SAMUEL T.& CO., PHILADELPHIA

Mitchell, James Tyndale, 1834-1915
...The unequalled collection of engraved
portraits of Napoleon Bonaparte and his family
and marshals,belonging to Hon.J.T.Mitchell...
portraits in mezzotinto,aquatint,line and stipple
...caricatures on Napoleon by Cruikshank,Gillray,
Rowlandson...to be sold...1908.Philadelphia,Pa.,
,Press of W.F.Fell,company,1908.
100 p. illus.

(Sold at book auction rooms of S.T.Freeman & c
(Catalogue compiled...by Stan V.Henkels)
Cat.no.944,pt.VII

LC DC203.8M5

I.B.l.d - HEBERLE, J.M.(H.LEMPERTZ' SÖHNE),Co-
 Jaffé, Albert LOGNE
 Cat.of the important coll.of miniatures and
paintings of Mr.Albert Jaffé,Hamburg,which will
be sold by auction by Messrs.J.M.Heberle(H.Lem-
pertz'sons)Cologne...March 27th to April 1st,
1905...The direction of the auction will have
Mr.Henry Lempertz...Cologne,M.D.Schauberg,1905
59 p.

LC N5265.J3

I.B.l.d - FREEMAN, SAMUEL T. & CO., PHILADELPHIA

Mitchell, James Tyndale, 1834-1915
...The unequaled collection of engraved por-
traits of the English royalty & English officers
...,statesmen,artists,authors,poets,dramatists,
doctors,lawyers,etc.,from the earliest to the
present time,belonging to Hon.James T.Mitchell...
to be sold...May 2d & 3d,1911.Cat.comp.& sale con-
ducted by Stan.V.Henkels,at the book auction
rooms of S.T.Freeman & co...Phila.,Pa.,...M.H.
Power,printer,1911.
72 p. illus.
Cat.no.944,pt.III

LC NE240M52

I.B.l.d - HEBERLE, J.M.(H.LEMPERTZ' SÖHNE)CO-
 Jaffé, Albert LOGNE
 Aat.der...miniaturen-sammlung des herrn
Albert Jaffé in Hamburg...Versteigerung zu
Köln a.Rh.den 27.-30.März 1905 bei J.M.Heberle
(H.Lempertz'söhne)...Der antierende notar:Theo-
tor Lempertz...Leiter der versteigerung dr.phil
Heinrich O.Lempertz...Köln,Druck von M.D.Schau-
berg,1905
89 p. illus(1 col.)

LC N7616.13

I.B.l.d - FREEMAN, SAMUEL T. & CO.,PHILADELPHIA

Mitchell, James Tyndale, 1834-1915
...The valuable collection of books on en-
graved portraits owned by the Hon.Js.T.Mitchell
...Also an unique coll.of caricatures by Cruik-
shank,Gillray,Hoath,Seymour...and others.To be
sold...Jan.4,1909...and...Jan.5,1909...Cata-
logued & sales conducted by Stan.V.Henkels.At
the book auction rooms of Sam.T.Freeman & co...
Philadelphia,...,Press of M.H.Power,1909.
91 p.
Cat.no.944,pt.VIII
715 items

LC NE240.M54

Levis.Descr.bibl...Z5947
,3L66 1974 NCFA p.250,
"A valuable bibliography of engraved portraiture"

I.B.l.d - HENKELS, firm,auctioneers, Philadelph.

Henkels, firm auctioneers, Philadelphia
(1895.Stan.V.Henkels)
...Cat.of autograph letters,historical docu-
ments,and rare engraved portraits;being the
coll.of J.Henry Rogers,of Newcastle,Del.,and
of a Western gentleman...Also an extraordinary
coll.of rare and scarce engraved portraits.To
be sold...May 8th,9th and 10th,1895...Cat.comp.
and sale conducted by Stan.V.Henkels at the
book auction rooms of Thos.Birch's Sons..Phila-
delphia,The Bicking print,1895.
109 p. illus.

LC Z42.R72
Z909.H505 no.738

Winterthur Mus.Libr.
Z881.W78 NCFA v.6,p.229

I.B.1.d - HENKELS, firm,auctioneers,Philadelphia

Henkels, Stanislaus Vincent, 1854-1926
Cat..of.oil portraits of Washington,
Lafayette,Lincoln...and other eminent Americans
...mezzotintos and stipples...original copper
plates...sold...Mar 27,1919....by.Stan.V.
Henkels...Philadelphia.1919.
26 p. illus.

263 items (no.1232)

MET
276
H38

Met.Sales cat. fZ881.N53
NCFA v.25,p.023316

I.B.1.d - LEPKE'S KUNST-AUKTIONS-HAUS, BERLIN

Jaffé, Albert
Sammlung A.Jaffé...Miniaturbildnisse des
17.bis 19.jahrhunderts...versteigerung...den
23.-24.Okt.1912...Rudolph Lepke's kunst-auk-
tions-haus..Berlin,1912.
F. pt.2 36 pl.

MET
295.4
J18

I.B.1.d - HENKELS, firm,auctioneers,Philadelphia

Henkels, firm,auctioneers, Philadelphia
Cat.of rare & choice engravings;incl.an ex-
traordinary coll.of portraits of Washington &
other notable Americans & of European celebri-
ties,a coll.of Napoleoniana & misc.engravings
to be sold Nov.24 & 25,1896 at the rooms of
Thos.Birch's Sons,Phila.,Pa....1896
52 p. illus.

940 engravings,18 photographs (no.768)
(For more locations of this cat.,see:Lugt
Rép.des cat.de ventes,1861-1900;017.37.L95 NCFA
MH MdBP OCl NIC MiU p.615,no.54768) Ref.

I.B.1.d - LEPKE'S KUNST-AUKTIONS-HAUS, BERLIN

Emden, Hermann
Sammlung Hermann Emden,Hamburg.Versteige-
rung.Rudolph Lepke's Kunst-Auctions-Haus,2...
3.Mai,1911.Berlin.1908-11.

MET
119.2
E83

.3.Teil.
4:Miniaturbildnisse,.18 & 19.jahrhundert

I.B.1.d - HOTEL DROUOT, PARIS

.Debrou, P..
Catalogue des portraits imprimés en noir et
en couleurs de la reine Marie-Antoinette et de
la famille royale...composant la collection de
m.P.D...vente le 8 mars,1907.Paris,Hôtel Drouot
47 p. illus.

PPPM NjP

NE
262
C59
NPG

I.B.1.d - LIBBIE, C.F.& CO., BOSTON

Clark, Charles Edward
Catalogue of the Dr.Charles E.Clark collec-
tion of American portraiture,including...Washing-
ton portraits...To be sold by auction...Jan15,16
and 17,1901...C.F.Libbie & co.,auctioneers...
Boston,Mass.Press of the Libbie show print,1901.
136 p. illus.

LC NE260.C6 Fogg,v.11,p.327

I.B.1.d - HÔTEL DROUOT, PARIS

Béraldi, Henri, 1849-1931
Catalogue des très beaux portraits...compo-
sant la collection de Monsieur H.B...La vente
aura lieu à Paris,Galerie Georges Petit...
.Paris,G.Petit,1920.
2 v. illus.

v.2,sale held at Hôtel Drouot,1930

Contents.-Très beaux portrs. des 17e,18e,et
19e siècles.La vente,30 Nov.et 1er déc.,1928.-
v.2. ...du 16e au 19e s. La vente,7 et 8 Avr,'30
MiDA NNC CtY

I.B.1.d -

Muller, Frederik & co., Amsterdam
Catalogue d'une collection remarquable de
portraits du 16e siècle...Amsterdam.1895.
113 p.

"catalogue à prix marqués"

FOGG
4353
M95

Fogg,v.11,p.324

I.B.1.d - LEMPERTZ,H.SÖHNE
see
I.B.1.d-HEBERLE, J.M.(H.LEMPERTZ'SÖHNE),COLOGNE

I.B.1.d -

Muller, Frederik & co., .Amsterdam.
Portraits de médecins,naturalistes,mathéma-
ticiens,astronomes,voyageurs,etc. Au vente...
.1880?.

FOGG
FA977.5

Fogg,v.11,p.324

I.B.1.d - PARIS. GALERIE GEORGES PETIT

Béraldi, Henri, 1849-1931
Catalogue des très beaux portraits...composant la collection de Monsieur H.B...La vente
aura lieu à Paris,Galerie Georges Petit...
₌Paris,G.Petit,1928₌
2 v. illus.

v.2,sale held at Hôtel Drouot,1930

Contents.-Très beaux portrs. des 17e,18e,et
19e siècles.La vente,30 Nov.et 1er déc.,1928.-
v.2. ...du 16e au 19e s. La vente,7 et 8 Avr,'30

M1DA NNC CtY

I.B.1.d - SOTHEBY, firm,auctioneers, LONDON

Archer, Mildred
Arthur William Devis:portrait painter in
India(1785-95)

In:Art at Auction
₌96-₌ 1971-2 ill'us.
Lived in Bengal,1785-95

Archer,India & Brit.portrai-
ture.ND1327.I44A72XNPO
Bibl.p.477

I.B.1.d - PARIS. HOTEL DROUOT see
I.B.1.d - HOTEL DROUOT, PARIS

I.B.1.d - SOTHEBY, firm,auctioneers, LONDON

Sotheby, firm,auctioneers, LONDON
Cat.of a...coll.of engraved British por-
traits formed by the late proprietor for the
illustration of Granger's history of England;
many...originally in the Sykes,Bindley & Dela-
bère collections...by...Elstracks...Cecil...
Vaughan...Faithorne....London,1863.
19 p.
Sale cat.J1.22,1863 & ff.day
₌The proprietor was E.Rose TUNNO'-Lugt.In:
Marques de collection.N8380.L95,NCFA,p.158,no.
.902

Met.sales ca ₌.f2881.N53 NCFA v.25,p.
₌023315

017.37
P3
NCFA
sale no.
3056

I.B.1.d - PARKE-BERNET GALLERIES,INC.,NEW YORK

King, Charles Bird, 1785-1862
The important collection of 21 portraits of
North American Indians by Chs.B.King,property
of the Redwood Library and Athenaeum,Newport,
R.I. Auction May 21,1970.Parke-Bernet Galleries,
New York,1970
49 p. illus(part col.)

Intro.by Marc Rosen

Bibliography

Fogg,v.11.,p.327

I.B.1.d - SOTHEBY, firm,auctioneers, LONDON

Sotheby, firm,auctioneers, LONDON
A catalogue of a most beautiful collection
of British portraits,from Edward the Third to
George the First...embracing the most rare and
esteemed works of Elstracke,Delaram,the Pass fa-
mily,Voerst,Vosterman,Blootelling,Loggan,White,
Valck,Smith,Williams,Becket,etc.and particular-
ly...Wm.Faithorne,incl.an unique impression of
Oliver Cromwell between Pillars.The Houbraken
heads...sold by Mr.Sotheby...on Wednesday,12th
day of Dec.,1827.London 1827
40 p.

CtY

I.B.1.d - PETIT, GEORGES, PARIS see
I.B.1.d - PARIS. GALERIE GEORGES PETIT

MET
119.6
O
1933

I.B.1.d - SOTHEBY, firm,auctioneers, LONDON

Eden, Sir Timothy Calvert,8th bart., 1893-
Catalogue of important English historical
and family portraits and pictures by the old
masters removed from Windlestone,co.Durham,incl.
the celebrated series of portraits of the Lords
Baltimore,proprietors of Maryland,the property
of Sir Timothy Calvert Eden,baronet of Maryland.
Which will be sold by auction,by Messrs.Sotheby
and co....the 26th of July,1933...London,Printed
by J.Davy & sons,ltd.,1933.
16 p. illus.
(Sotheby & Co.Sale cat.J1.26,1933)
Priced Met.Sales cat.f2881.N53
MdBP NCFA p.023316

I.B.1.d - RICHARDSON, LONDON

₌Musgrave, Sir William, Bart., 1735-1800₌
A catalogue of a....collection of English
portraits consisting of the royal families...
lawyers...artists...from Egbert the Great to
the present time...works of Delaram...Hollar,
Loggan...with...remarks by an eminent collector
₌Sir W.Musgrave....sold by....Mr.Richardson...?
Feb.3,1800,and the 17 ff.days...and Mar.3,and
the 12 ff.days...London 1800₌
323 p.

MET
212
F98

Priced 3495 items Names of
DLC buyers
(For more locations of this cat. see over)
Met.Sales cat.f2881.N53 NCFA v.26 p.023315

I.B.1.d - SOTHEBY, firm,auctioneers, LONDON

Bindley, James, 1737-1818
A catalogue of the...coll.of British por-
traits...the property of...James Bindley...which
will be sold at auction by Mr.Sotheby.London,
Wright & Murphy,printers,1819.
3 v.in 1 illus.

At head of title:The Bindley Granger
Contents.-₌pt.1₌From the reign of Egbert to
the Revolution of 1688.-Pt.2.From the Revolution
of1688 to the present period.-Pt.3.Miscellaneous

NN MH PP PPULC DLC
MBAt Fogg,v.11,p.333

I.B.1.d - SOTHEBY, firm auctioneers, LONDON

Smith, John Chaloner, 1827-1895
 Cat.of the coll.of mezzotint engravings
formed by J.C.Smith...sold...by Messrs.Sotheby,
Wilkinson & Hodge,1887/8
 2 pt.in 1 v.(1 illus.)

MET
212
C7

 Pt.1 March 21-30,1887. Pt.2 Apr.25-May 4,'88
 Priced

 (Lugt nos.46377 &47324)

FU MiU-C PP ICN Ars Artis cat.41 Books on
CSmH NRuO prints,drags. no.681

I.B.1.d - SOTHEBY, firm,auctioneers, LONDON

The Stowe,Grenger and other engravings;cat.of
 the remaining portion of the engr.British
 portrs.,comprising those fr.the reign of
 James II forming the illus.copy of the con-
 tinuation of the Biographical hist.of Engl.
 by the Rev.Mark Noble...engrs.of the English
 school.Woollett,Strange,Hogarth...Sir Josh.
 Reynolds...removed fr.Stowe house,Bucking-
 hamshire...sold...by...S.Leigh Sotheby & Co.
 ...21st Mar.1849 & 5 ff.days...London 1849.
 62 p.

MET
212
S9

 Priced

 Met.Sales cat.fZ881.N53 NCFA v.25,p.023318

I.B.1.d - SOTHEBY, firm,auctioneers, LONDON

Wellesley, Francis
 Cat.of the ... coll.of plumbago,pen and ink
and coloured pencil drawings and miniatures...
sold by Sotheby,Wilkinson & Hodge,June 28,1920
and 4 ff days..London.Riddle,Smith & Duffus.1920.

LC N5245.W45 NN MH MiU FOR COMPLETE ENTRY
 SEE MAIN CARD

I.B.1.d - THOMAS & SONS, PHILADELPHIA

Peale, Charles Willson, 1741-1827
 Peale's museum gallery of oil paintings...
cat.of the national portrait and historical gal-
lery...formerly belonging to Peale's museum,
Philadelphia, to be sold...6th Oct.,1854...at
Phila.,M.Thomas & sons,auctioneers...Phila.,
W.Y.Owen,printer,1854
 16 p.
' A copy is in the library of the American Philo-
sophical Society,Philadelphia'.-Milley.F158.65
I 3T78 NPG p.179,note 2

LC N5220.P35 Weddell.A mem'l vol.of Va.
 hist.portraiture.757.9.W38
 NCFA Bibl. p.437

I.B.1.d - SOTHEBY, firm,auctioneers, LONDON

Sykes, Sir Mark Masterman, 1771-1823
 A cat.of the highly valuable collection of
prints,the property of Sir M.M.Sykes...sold by
Mr.Sotheby,March-Dec.,1824..London.J.Davy,prin-
ter.1824.
 5 pt.in 1 v. illus.
 Priced

MET Pt.1
212 Partial contents.-Series of Brit.portrs.,fr
I4 the heptarchy to the end of the reign of William
 III.-Pt.4.Continuation of a series of Brit.portr
 fr.the commencem't of the reign of Queen Ann to
 the present time
LC NE59.S82
 Met.Sales cat.fZ881.N53 NCFA v.25.p.023561

I.B.2. INDIVIDUAL ARTISTS

I.B.1.d - SOTHEBY, firm,auctioneers, LONDON

Sotheby, firm,auctioneers, LONDON
 The cat.of the memorable Cabinet of drawings
...1866

 Sale:June25-July 10,1866

MET
212
G
1866

 FOR COMPLETE ENTRY
 SEE MAIN CARD

I.B.2 INDIVIDUAL ARTISTS
 working in all media, except photography
For photographers see
II.E.8

When appropriate both are used:
I.B.2 and II.E.8

I.B.1.d - SOTHEBY, firm,auctioneers, LONDON

Sotheby, firm,auctioneers, LONDON
 Cat.of the Mr.& Mrs.Jack R.Dick coll.of
English sporting and conversation paintings:
part 1;...auction.s.l.:s.n.:c.1973(Ipswich,Eng.,
W.S.Cowell)
 108 p. illus(part col.)
 Price list encl.

LC ND1388.D7S68

705
P19
NCFA

I.B.2 - ABT FAMILY, 15-16th c.

Baldass, Ludwig von, 1887-
 Studien zur Augsburger porträtmalerei des
16.Jhrh.

In:Pantheon
4:393-40, sup.70:Bildnisse der Künstlerfamilie
 1929 illus(1 col.) .Apt
6:395-402, sup.70-1:Bildnisse von Leonhard Beck
 1930 illus.
9:177-84, sup.41-3:Christoph Amberger als bild-
 1932 illus(1 col.) .nismaler
 Summary in English

I.B.2 - ADAMS, JOHN QUINCY, 1874-1933

Poch, Margarethe(Kalous)
John Quincy Adams:ein vergessener Wiener
maler(a forgotten Viennese painter)

In:Alte & Moderne Kunst
v.20,no.138:33-5 1975 illus.

Ptr.is great-grandson of Pres.J.Q.Adams

LC N3.A45 FOR COMPLETE ENTRY
 SEE MAIN CARD

I.B.2 - AGOTHA, IOAN, 19th c.

Drăgoi, Livia
Ioan Agotha,portretist din Transilvania

NCA In:Revista Muzeelor
M1.R523 3:65-6 1979 illus.

 Summary in French

LC AM69.R8R43 Muzeul Brukenthal Sibiu
 Cat.Patrimonial ND921.M8
 1983X IMAA Bibl.p.:7.

705 I.B.2 - ADAMS, WAYMAN, 1883-1959
K18
NCFA Henderson, Rose
v.21 Wayman Adams,portrait painter

 In:Mag Art
 21:640-8 Nov.,'30 illus.

705 I.B.2 - ALEXANDER, COSMO JOHN, c.1724-1772
A56.
NCFA Geddy, Pam McLellan
v.112 Cosmo Alexander's travels and patrons in
 America

 In:Antiques
 112:972-7 Nov.,'77 illus(part col.)

AP I.B.2 - AETATIS SUE LIMNER, fl.ca.1715-1725
1
A79 Black, Mary C.
NCFA The case reviewed. Fresh evidence suggests
v.10 a surprising authorship for a puzzling series
 of family portraits.

 In:Arts in Va.
 10,no.1:12,15,20 Fall,'69 illus.

 Some portraits attr.to a limner of the Up-
 per Hudson are now given to the Aetatis Sue Lim-
 ner of Tidewater,Va. Refers to Black's "The
 case of the red and green birds."

705 I.B.2 - ALEXANDER, COSMO JOHN, c.1724-1772
A7875
NCFA Goodfellow, Gavin L.M.
v.26 Cosmo Alexander in America

 In:Art Q.
 26:309-22 Autumn,'63 illus.

 Geddy.In:Antiques
 112:976,note 15

ND I.B.2 - AETATIS SUE LIMNER, fl.ca.1715-1725
207
W78 Black, Mary C.
1971 Pieter Vanderlyn and other limners of the
NPG Upper Hudson

 In:Winterthur Conf.on Mus.Oper'n and Conn'ship
 17th:217-49 1971 illus.

 Bibliography

I.B.2 - ALEXANDER, COSMO JOHN, c.1724-1772

Goodfellow, Gavin L.M.
 Cosmo Alexander:the art,life and times of
Cosmo Alexander(1724-1772).Portrait painter in
Scotland and America

 M.A.thesis,Oberlin,1961

 'This is at present the only monograph
About Alexander.'-Geddy(Nov.,'77)

 Geddy.In:Antiques 112:976
 note 4

I.B.2 - AETATIS SUE LIMNER see also
I.B.2 - PARTRIDGE, NEHEMIAH,the AETATIS SUE LIMNER,
 .1683-

I.B.2 - ALEXANDER, FRANCIS, 1800-1881

Pierce, Catherine W.
 Francis Alexander

In:Old Time N.Engl.
44:29-46 Oct.-Dec.,'53 illus.

 Incl.:List of A.'s portrs.with their loca-
tions

LC F 1.568 Arts in America qZ5961.U5
 A77X NCFA Ref. I 385

N
40.1
A363P6
NCFA

I.B.2 - ALEXANDER, JOHN WHITE, 1856-1915

Pittsburgh. Carnegie institute. Dept.of fine
 Cat.of paintings,John White Alexan- .arts
der memorial exh.,March 1916,Dept.of fine arts
Carnegie institute,Pittsburgh..Pittsburgh,Mur-
doch-Kerr press,c.1916.
 66 p illus.

 Bibliography

 Incl.Record of paintings by J.W.Alexander,
Portrs.before 1887-1913,p.37-55,...
 See also:Mag Art,v.7:345-73,Memorial numbe

LC ND237.A35P5

705
A56
NMAA
v.122

I.B.2 - AMES, ASA, 1824-1851

Ericson, Jack T.
 Asa Ames,sculptor

In:Antiques
122:522-9 Sept.'82 illus(part col.)

 Incl.:Phrenological head,Pl.VIII;Ears,eyes
& hair,fgs.8,8,10

M.Black.Phrenological asso-
ciations,p.50

N
40.1
AU4R5
NMAA
3 c.

I.B.2 - ALLSTON, WASHINGTON, 1779-1843

Richardson, Edgar Preston, 1902-1985
 Washington Allston,a study of the roman-
tic artist in America.Chicago,Univ.of Chicago
Press,1948.
 233 p. illus.

 Bibliography,p.220-8

 Cat.of the existing and recorded ptrs.of
W.A.cby...and Henry Wadsworth Longfellow
Dana,p.183-219

Mooz.The art of Rbt.Feke
N40.1.F312M8 1970a NMAA

40.1
A52P6
NPG

I.B.2 - AMES, EZRA, 1768-1836

Bolton, Theodore, 1889-
 Ezra Ames of Albany,portrait painter...
1768-1836,by Theodore Bolton and Irwin F.Cortel-
you;and a catalogue of his works...New York,
New-York Historical Society,1955
 398 p illus.

 Bibliography

LC ND237.A58B6

Whitehill.The Arts of ear-
ly Amer.Hist.Z5935W59 NPG
Bibl.,p.87

I.B.2 - AMANS, JACQUES GUILLAUME LUCIEN, 1801-
 .1888

Tucker, Mary Louise
 Jacques G.L.Amans,portrait painter in
Louisiana,1836-1856

 M.A.-Thesis,Tulane,Univ.,1970

Arts in Am.qZ5961.U5A77X
NCFA Ref. T 1247

705
B97
NCFA
v.99

I.B.2 - AMIGONI, JACOPO, 1675(or 1682)-1752

Woodward, John
 Amigoni as portrait painter in England

In:Burl Mag
99:20-3 Jan.'57 illus.

705
P19
NCFA

I.B.2 - AMBERGER, CHRISTOPH, ca.1500-ca.1562

Baldass, Ludwig von, 1887-
 Studien zur Augsburger porträtmalerei des
16.jhrh.

In:Pantheon
4:393-40,sup.70:Bildnisse der Künstlerfamilie
 1929 illus(1 col.) .Apt
6:395-402,sup.70-1:Bildnisse von Leonhard Beck
 1930 illus.
9:177-84,sup.41-3:Christoph Amberger als bild-
 1932 illus(1 col.) .nismaler
 Summary in English

I.B.2 - AMMAN, JOST, 1539-1591
.Bernard, George.
 Effigies regum Francorum omnivm,a Pharamvndo
ad Henricum vsqve tertium...Caelatoribvs,Virgili
Solis & Iusto Amman...Noribergae...1576
 64 1 62 ports.

 Engraved portrs.with a scene in woodcut in-
serted in frame

 Title:Chronica regum Francorum

LC DC37.B5 1576
Rosenwald coll.
 Rave.Jb.d.Berl.Mus. I 195
 LC N3.J16 fol. p.149-50
 Paolo Giovio & d.Bildnisvi-
tenbücher d.Humanismus

AP
1
C59
NMAA

I.B.2 - AMES, ASA, 1824-1851

Black, Mary.C.
 Phrenological associations.Footnotes to
the biography of two folk artists:J.Wh.Stock &
A.Ames.
In:Clarion
1982-84:44-52 Fall,'84 illus.

 'The photograph became..a guide,providing .ar
tists.with inspiration for portraits.'

I.B.2 - AMMON, KLEMENS, 17th c.

Boissard, Jean Jacques, 1528-1602
 Bibliotheca chalcographica,hoc est virtute
et eruditione clarorum virorum imagines, collec-
tore Iano-Iacobo Boissardo,Vesunt.,sculptore
Theodoro de Bry,leod.,primum editae,et ab ipso-
rum obitu hactenus continuatae.Heidelbergae,in-
pensis Clementis Ammoni,1669
 5 v. illus.

LC NE218.B6 1669
 Poll.,v.11.p.321

I.B.2 - ANARGYROS, SPERO DROSOS, 1915-

Anargyros, Spero Drosos, 1915-
 Electronic portrait sculpture

In:Southwest Art
5,pt.7:70-1 Jan.,'76 illus.

FOR COMPLETE ENTRY
SEE MAIN CARD

I.B.2 - ANDERSON, ALEXANDER, 1775-1870

Lossing, Benson John, 1813-1891
 A memorial of Alexander Anderson,M.D.,the
first engraver on wood in America.Read before
the N.Y.Hist.Soc.,Oct.5,1870. N.Y.,1872
 107 p. illus. (Amer.culture series,
74:5)

LC Microfilm 01291 reel74
no.5E

705
A49
NCFA
v.31

I.B.2 - ANARGYROS, SPERO DROSOS, 1915-

Whitaker, Frederic, 1891-
 The sculpture of Spero Anargyros

In:Am Artist
31:32-7,59,61-2 Feb.,'67 illus.

Z
1023
P95
1968
NCFA

I.B.2 - ANDERSON, ALEXANDER, 1775-1870

Princeton University. Library
 Alexander Anderson

In:Early American book illustrators and wood
engravers,1670-1870,
v.1:48-66 and v.2:28-40. List of books illus-
trated by Alexander Anderson

LC Z1023.P9 1968

I.B.2 - ANDERSON, ALEXANDER, 1775-1870

Burr, Frederic Martin
 Life and works of Alexander Anderson,M.D.,
the first American wood engraver...Three portrs.
of Dr.A.,and over 30 engravings by himself.
N.Y.,Burr brothers,1893
 210 p. illus.

 Appendix A. A brief sketch of Dr.A.'s life,
written by himself in 1848,p.77-90
 Appendix B. Extracts fr. the diary of A.
for 1795-1798,p.91-210
LC NE1215.A5B8

705
C75
NCFA

I.B.2 -ANDRÉ, JOHN (MAJOR), 1751-1780

Jackson, Mrs.F.Nevill, 1861-
 Major André-Silhouettist

In:Connoisseur
76:209-18 illus.

 Portrs. of Horatio Gates,Cathcart,Franklin,
Burgoyne,André,Washington. Collection Mr.Rbt.
Fredenberg, N.Y.

N
6505
D92
1965
NCFA

I.B.2 - ANDERSON, ALEXANDER, 1775-1870

Dunlap, William, 1766-1839
 Alexander Anderson

In his History of the Rise and Progress of the
Art of Design in the United States,v.2:134-7
biography of A.Anderson,"who introduced the art
wood engraving into our country..."

I.B.2 - ANGERS, DAVID D'
see
I.B.2 - DAVID D'ANGERS, PIERRE JEAN, 1788-1856

I.B.2 - ANDERSON, ALEXANDER, 1775-1870

Duyckinck, Evert Augustus, 1816-1878
 A brief catalogue of books illustrated with
engravings by Dr.Alexander Anderson.N.Y.,Thomp-
son & Moreau,1885.
 35 p. illus.

LC NE1215.A5D8

I.B.2 - ANGUISCIOLA, SOFONISBA
see
I.B.2 - ANGUISSOLA, SOFONISBA, c.1527-1625

705
397
NCFA
v.26

I.B.2 - ANGUISSOLA, SOFONISBA, c.1527-1625

Cook, H.
 More portraits by Sofonisba Anguissola

In:Burl Mag
26:228-36 March,'15 illus.

4 N
40.1
A673A6
NM1A

I.B.2 - ARCIMBOLDO, GIUSEPPE, 1527?-1593

The Arcimboldo effect.Transformation of the face
 from the 16th to the 20th century.Publ.in
 the U.S.by Abbeville Press,N.Y.,1987
 402 p. illus(part col.)

 Published on the occasion of the exh.in
 Venice,Palazzo Grassi,till May 31,1987.
 Artistic director & General Commissioner
Pontus Hulten.Ed.by Piero Falchetta

I.B.2 - ANGUISSOLA, SOFONISBA, c.1527-1625

Fournier-Sarlovèse, Joseph Raymond, 1836-1916
 Sofonisba Anguissola et ses soeurs, in.his.
Artistes oubliés.Paris,P.Ollendorff,1902
 illus.

LC N40.F73

qAP
1
P975
NMAA

I.B.2 - ARCIMBOLDO, GUISEPPE, 1527?-1593

Peyer, Andreas
 Venice.Palazzo Grassi.Arcimboldo

In:Burl Mag
129:343-4 May,'87 illus.

 Discusses the exh.'The Arcimboldo effect'and
diverse articles in the book:The Arcimboldo ef-
.fect,q:N4C.1.A673.A6 NM'AA

N
40.1
A61507
NMAA

I.B.2 - ANSHUTZ, THOMAS, 1851-1912

Anshutz, Thomas, 1851-1912
 Thomas Anshutz,1851-1912.cat.of an exh.
held at.the Graham Gallery,Feb.19-Mar.16,1968
N.Y.,Graham Gallery.1963?.
 .12.p. illus.

AP
1
W225
v.3
HCMA

I.B.2 - ASHFIELD, EDMUND, fl.1675, d.ca.1700

Baker, Charles Henry Collins, 1880-
 Notes on Edmund Ashfield

In:Walpole Soc.
2:63-7 1913-14 illus.

I.B.2 - ANTHING, JOHANN FRIEDRICH, 1753-1805

Anthing, Johann Friedrich, 1753-1805
 Collection de cent silhouettes des per-
sonnes illustres et célébrés.Desinées d'après
les originaux.Gotha,1791
 5 p. illus.(100 ports.)

 "Joh.Fr.Anthing;eine skizze von Carl Schüdde-
kopf,Weimar,1913.Gesellschaft der bibliophilen"
added at end.

LC NC910.A5 Cat.of B.Quaritch,ltd.Lon-
 don,1978;no.983,p.17,no.15.

I.B.2 - ASTBURY, JOHN, 1688?-1743

Andrade, Cyril
 Old English pottery,Astbury,Whieldon,Ralph
Wood;Cyril Andrade collection..London,n.d.
 .11.p. illus.(32 phot.on 29 pl.)

MET
143.02
An24

I.B.2 - 'APE'
 see
I.B.2 - PELLEGRINI, CARLO, 1839-1889

I.B.2 - ASTBURY, JOHN, 1688?-1743

Price, Robert Kenrick
 Astbury,Whieldon,and Ralph Wood figures,
and Toby jugs,coll.by Captain R.K.Price...with
an intro.by Frank Falkner...London,John Lane,
1922
 140 p. illus(part col.)

 'Largest coll.of tobies in the world.'-North-
end in:The joly old toby

LC NK4087.S6P7

705
A56
NCFA
v.67

I.B.2 - AUDUBON, JOHN JAMES, 1785-1851

McDermott, John Francis, 1902-
 Likeness by Audubon

In:Antiques
62:499-501 June,'55 illus.

N
40.1
.B1195xL8
NPG

I.B.2 - BACHARDY, DON, 1934-

Bachardy, Don, 1934-
 Don Bachardy,drawings.exh..Los Angeles,Mu-
nicipal Art Gallery.pref.1973.

FOR COMPLETE ENTRY
SEE MAIN CARD

qN
40.1
A913xA1
NPG

I.P.2 - AUERBACH-LEVY, WILLIAM, 1889-

Auerbach-Levy, William, 1889-
 Is that me? A book about caricature...
assisted by Florence Von Wien.N.Y..Watson-
Guptill Publ..1947.
 155 p. illus(part col.)

LC NC1320.A8

I.B.2 - BACHARDY, DON, 1934-

Bachardy, Don, 1934-
 70 x 1:drawings.Illuminati,1983
 80 p. illus.

CVala CStmo

Books in print.Subject
guide,1985-6,v.3,p.4864

ND
1337
F8M44
NPG

I.B.2 - AUGUSTIN, JEAN BAPTISTE JACQUES, 1759-
 .1832

Mauclair, Camille, 1872-
 ...les miniatures de l'empire et de la restaura-
tion, portraits de femmes. Paris,H.Piazza,1913
 137 p. illus(part col.)

 Cont.-Jean-Baptiste-Jacques Augustin et son
oeuvre.-La vie de Jean-Baptiste Isabey.-I.et ses
élèves.-Quelques figures de ce livre.-D'autres
portrs.de femme.-Miniatures et figures étran-
gères.

LC ND1337.F7M35

705
A56
NCFA
v.14

I.B.2 - BACHE, WILLIAM, 1771-1845

Carrick, Alice van Leer, 1875-
 The profiles of William Bache

In:Antiques
14:220-4 Sept.,'28 illus.

 Repro-:T.Nixon and Wm.Bache.Sitters incl.
celebrities of the time

705
G28
NCFA
v.32

I.B.2 - AVED, JACQUES-ANDRÉ-JOSEPH-CAMELOT, 1702-
 1766

Dorbec, Prosper, 1870-
 Le portraitiste Aved et Chardin portraitiste

In:Gaz Beaux Arts
3rd per.v.32:89-100 1904 illus.
 :215-24 " "
 :341-52 " "

 Repr.Engravings after the ptgs.
 Pt.1 & 2 on Aved,pt.3:Dorbec suggests attr.
to Aved of most of Chardin's portrs.(p.346ff)

 Dumont-Wilden.Le portr.en
 France ND1316D9,p.165

NO
1328
B35
NCFA

I.B.2 - BADGER, JOSEPH, 1708-1765

Bayley, Frank William, 1863-1932
 Five colonial artists of New England:Joseph
Badger,Joseph Blackburn,John Singleton Copley,
Robert Feke,John Smibert...Boston,Priv.print,1929
 448 p. illus.

 Bibliography

LC N6536.B3

ND
1300
A98
NPG

I.B.2 - AYMAR, GORDON CHRISTIAN, 1893-

Aymar, Gordon Christian, 1893-
 The art of portrait painting;portraits
through the centuries as seen through the eyes
of a practicing portrait painter...Philadelphia,
Chilton Book Co..1967.

 337 p. illus(part col.)

LC ND1300.A9

I.B.2 - BADGER, JOSEPH, 1708-1765

Nylander, Richard C.
 Joseph Badger,American portrait painter

 M.A.Thesis,State Univ.of N.Y.,college at
Oneonta,1972

 Arts in Am.qZ5961.U5A77
 NCFA Ref. Z 926

I.B.2 - BADGER, JOSEPH, 1708-1765

Park, Lawrence, 1873-1924
Joseph Badger (1708-1765) and a descriptive list of some of his works...Boston,The University press,1918
45 p. illus.

LC ND237.B2P3

705.A784 NCFA.Art in Amer.
v.17,p.260 footnote

AP
1
A51A62
NMAA

I.B.2 - BARNET, Will, 1911-

Barnett, Catherine
Striking poses.Will Barnet's sitters capture the painter who captured them

In:Art & Ant.
10:85-90 March,'87 illus(part col.)

AP
1
S72
NPG
v.13

I.B.2 - BADGER, JOSEPH, 1708-1765

Park, Lawrence, 1873-1924
Joseph Badger of Boston,and his portraits of children

In:Old Time N Engl
13:99-109 Jan,'23

Incl. check list

LC F1.868

Whitehill.The Arts of early Amer.Hist.Z5935.W59 NPG bibl.,p.87

N
40.1
B293
S6

I.B.2 - BARNEY, ALICE(PIKE), 1857?-1931

Barney, Alice(Pike), 1857? - 1931
Portraits in oil and pastel.Washington,National Collection of Fine Arts,Smithsonian Institution,1957
.2.p. illus(part col.) (Smithsonian publication 4291)

LC ND237.B265A5

Fogg,v.1..p.320

N
40.1
B162
P8
NMAA
also VF

I.B.2 - BALASSANIAN, SONIA

Balassanian, Sonia
Portraits by Sonia Balassanian.1st ed.
N.Y.,Balassanian,1983
.2., all illus.

N
40.1
B2935
P9
NMAA

I.B.2 - BARRY, JAMES, 1741-1806

Pressly, William L., 1944-
The life and art of James Barry.Publ.for the Paul Mellon Centre for Studies in British Art,by Yale Univ.Press,New Haven and London,1981
320 p. illus(part col.)

Incl.index
bibliography

Ch.III.:Portraits and Politics,p.67-81
Cat.nos.37-68 Portraits & self-portraits

LC N6797.B38P73 1981

AP
1
C59
NMAA

I.B.2 - BALIS, CALVIN, 1817-after 1856

Sutherland, Cynthia
The Elusive C.Balis

In:Clarion
1982-84:54-61 Fall,'84 illus.

Incl.:Checklist of known works of Calvin Balis

705
A56
NCFA
v.56

I.B.2 - BARTOLL, WILLIAM THOMPSON, 1817-1859

Dods, Agnes M.
A Marblehead painter

In:Antiques
56:372 Nov.,'49 illus.

Colonial Williamsburg,inc.
Abby Aldrich Rockefeller
Folk Art coll.N6510.C75
NCFA p.14

N
40.1
B248N2
NMAA

I.B.2 - BARKER, CLIVE, 1940-

Barker, Clive, 1940-
Clive Barker;exh.of drawings and sculpture, 24 July to 18 Oct.,1987.London, NPG,1987
32 p. illus(part col.)

Exh.organizers:Robin Gibson & Honor Clerk

I.B.2 - BARTOLOZZI, FRANCESCO, 1730?-1813?

Chamberlaine, John, 1745-1812
Imitations of original drawings by Hans Holbein,in the collection of His Majesty,for the portraits of illustrious persons of the court of Henry VIII...London,Printed by W.Bulmer and co., 1792
.142.p. illus.in color

The plates are stipple engravings printed in colors,all but four by F.Bartolozzi,three by C.Metz,one by C.Knight

LC NC1055.H7

Fogg,v.11,p.321

ND
236
L76
NPG

I.B.2 - BASCOM, RUTH HENSHAW MILES, 1772-1848

Lipman,Mrs.Jean Herzberg, 1909- comp.
 Primitive painters in America,1750-1950;an
anthology,by J.Lipman & A-Winchester.N.Y.,Dodd,
Mead.1950.
 182 p. illus(part col.)

 Contents.-2.N.F.Little, Primit.ptrs.of 18th
4.A.M.Dods, R.H.Bascom.-5.A.E.Bye, E.Hicks.-8.F.F.
Sherman, J.S.Ellsworth.-9.F.B.Robinson, E.S.Fiel
10.N.F.Little, W.M.Prior.-11.J.Lipman, D.Gold-
smith.-12.F.O.Spinney, J.H.Davis.-14.J.L.Clarke,
jr., J.W.Stock

I.B.2 - BAUGNIET, CHARLES, 1814-1886

Galerie de portraits d'artistes musiciens du
 royaume de Belgique,lithographiés d'après
 nature par Baugniet...Imprimé par Degobert
Bruxelles,V.Deprins.1842-43.
 .41.p. illus.

 Biographical sketches by F.J.Delhasse etc.

LC ML385.015

AP
1
W892
NCFA

I.B.2 - BASCOM, RUTH HENSHAW MILES, 1772-1848

Reutlinger, Dagmar E.
 American folk art:two groups of family por-
traits by Ruth Henshaw Bascom and Erastus Salis-
bury Field

In:Worcester Art Mus.Bull.
5,no.3:1-12 May,'76 illus.

 "Bascom cut out paper silhouette portrs.&
embellished them with charming color & imagina-
tive collage."-Reutlinger in Rila

 Rila IV/1 1978 #4033

I.B.2 - BAXTER, SARAH, née BUCK, 1770-c.1796

Norfolk and Norwich archaeological society,
 Norwich,Eng.
 Mrs.Sarah Baxter,née Buck(1770-?),Norfolk
portrait painter and miniaturist;by M.C.Evans.
Norfolk and Norwich archaeological Soc.,1972,
v.25:400-9

 For biography of Sarah Baxter see:Archer.
India & Brit.portraiture,1770-1825,p.400-2,
illustrated

LC DA670.N59N8? Archer.Ind.& Brit.portrait
 ure...ND1327.I 44A72X NPG
 Bibl.p.480

I.B.2 - BATONI, POMPEO GIROLAMO, 1708-1787

Russell, Francis, 1910-
 Portraits of classical informality.Batoni's
British sitters.II

In:Country Life
154,no.3964:1754-6 June 14,'73

LC S3.C9 Chicago.A.I. European ports.
 N7621.C447 NPG Bibl.p.181

I.B.2 - BAYER, HANS, 1932-

Das Porträt im phantastischen Realismus(.Aus-
 stellung,Bayer et al)...Wien,Hauska,1972

 Work by Hans Bayer and others

LC N6808.5.M3P67 FOR COMPLETE ENTRY
 SEE MAIN CARD

I.B.2 - BATONI, POMPEO GIROLAMO, 1708-1787

Russell, Francis, 1910-
 Portraits on the Grand Tour.Batoni's British
sitters.I

In:Country Life
154,no.3963:1608-10 June 7,'73

LC S3.C9 Chicao.A.I. European portrs.
 N7621.C4A7 NPG Bibl.p.181

705
C75
NCFA
v.51

I.B.2 - BEACH, THOMAS, 1738-1809

Finberg, Hilda F.élicité(Ehrmann).
 Thomas Beach,portrait painter

In:Connoisseur
51:139-48 July,'18 illus.

705
B97
NCFA
v.88

I.B.2 - BATONI, POMPEO, 1708-1787

Steegman, John, 1899-1966
 Some English portraits by Pompeo Batoni

In:Burl.Mag.
88:55-63 Mar.,'46 illus.

 Batoni,usually known as ptr.of allegories,
religious & history ptgs.,was one of a group
of Italian ptrs.who portrayed Englishmen in
Italy.List of 90 of these portrs.

 Poulsen,Ellen.Jens Juel.In:
 Conn.149,p.72

I.B.2 - BEALE, MARY, 1632-1697

Beale, Mary, 1632-1697
 "The excellent Mrs.Mary Beale";13 Oct.-
21 Dec.1975,Geffrye Museum,London;10 Jan.-21 Feb
1976,Towner Art Gall.,Eastbourne;cat.by Eliza-
beth Walsh & Rich.Jeffree...London,Inner London
Education Authority,1975
 72 p. illus(1 col.)

 Bibliography
 102 works shown,incl.5 self-portrs.
 Incl.works by Charles Beale,Sarah Curtis-
Hoadley,Nathaniel Thache,Thomas Flatman

LC ND1329.B36W4 Rila III/1 1977 #1085

I.B.2 - BEARD, WILLIAM HOLBROOK, 1825-1900

Viele, Chase
. Four artists of mid-19th century Buffalo
.Cooperstown?,N.Y.,196-.
49-73 p. illus.

Bibl.references

Reprinted fr.N.Y.history,43,no.1,Jan.1962

Survey of the life and work of Sellstedt,
Wilgus, Le Clear, Beard

Arts in Am q25961.U5A77X
NPA Ref. I 1072

N
40.1
B38P4
NPG
NCFA

I.B.2 - BEAUX, CECILIA, 1855-1942

Pennsylvania Academy of the Fine Arts, Phila-
delphia
The paintings and drawings of Cecilia Beaux.
Philadelphia,1955
119 p. illus.

"Contains cat.,listing ca.300 of Beaux's
works."-Hill
Intro.by Henry S.Drinker
Incl.:Lecture at Simmons College,May 14,
1907 by C.Beaux 'Portraiture',p.109-19
Wellesley Coll.Librr.for LC Hill.Cecilia Beaux...In:
Antiques 105:168,note 2
Jan.'74

705
A56
NMAA
v.126

I.B.2 - BEARDSLEY LIMNER

Heslip, Colleen Cowles and Kellogg, Helen
The Beardsley Limner identified as
Sarah Perkins

In:Antiques
126:548-65 Sept.,'84 illus(part col.)

I.B.2 - BEAUX, CECILIA, 1855-1942

Uithol, Ruthann
Cecilia Beaux

Masters Thesis-American Univ.,1985

Archives of American Art
Journal AP1.D39 NMAA v.24,
no.4,1984,p.25

N
40.1
B372S3
NPG

I.B.2 - BEARDSLEY LIMNER

Schloss, Christine Skeeles
The Beardsley Limner and some contemporaries:
post-revolutionary portraiture in New England,
1785-1805..Williamsburg,Va.,Colonial Williamsburg
Foundation,1972.
47 p. illus(part col.)

Exhib.cat.
Exhib.organized by Abby Aldrich Rockefeller
Folk Art coll.,Oct.'72-Dec.'72;traveled -Mar.'7
Incl.bibl.references

LC ND1329.B38S34 Folk Art in America NK807
F64xNCFA Bibl.

705
P19
NCFA

I.B.2 - BECK, LEONHARD, ca.1480-1542

Baldass, Ludwig von, 1887-
Studien zur Augsburger porträtmalerei des
16.jhrh.

In:Pantheon
4:393-40,sup.70:Bildnisse der Künstlerfamilie
1929 illus(1 col.) .Apt
6:395-402,sup.70-1:Bildnisse von Leonhard Beck
1930 illus.
9:177-84,sup.41-3:Christoph Amberger als bild-
1932 illus(1 col.) .nismaler
Summary in English

VF
Amherst,
Mass.
Amherst
College

I.B.2 - BEARE, GEORGE, fl.ca.1741-1749

Robinson, Duncan
George Beare:a new masterpiece.in.Mead Art
Mus.Monographs.v.6 & 7, Winter.'75-'76
p.16-9 illus.

I.B.2 - BEERBOHM, MAX, 1872-1956

Beerbohm, Max, 1872-1956
Caricatures of 25 gentlemen...London,
L.Smithers,1896
5 p. 25 pl.

LC NC1479.B432

705
C75
NCFA
v.195

I.B.2 - BEAUMONT, JOHN THOMAS BARBER, 1774-1841

Noakes, Aubrey
John Thomas Barber Beaumont miniaturist an
art tutor of Henry Alken

In:Connoisseur
195:189-90,194 July,'77 illus(part col.)

Barber Beaumont stopped painting 1806

I.B.2 - BEERBOHM, MAX, 1872-1956

Lynch, John Gilbert Bohun, 1884-1928
Max Beerbohm in perspective...N.Y.,Haskell
House Publishers,1974
185 p. illus.

Bibliography

Reprint of the 1922 ed.publ.by Knopf,N.Y.

LC PR6003.F4Z7 1974 Cumulative book index 1974
The World list by author...
Z1219.C97 NPG p.1296

I.B.2 - BEETHAM, ISABELLA, c.1753-1825
Beetham, Frederick
 Mrs.Beetham, silhouettist.c.1931

V.& A Typescript,86,p.41 Library V.& A.

 '...one of the finest of all profilists...
 ptd.profiles on glass & card...'-Hickman.W.Y.,
 Walker,1968,p.27

 For illus.see Hickman.Silhouettes.London,
 NPG,1972 nos.25- 89
 Piper.Shades.Bibl.p.63

I.B.2 -

Beham, Hans Sebald, 1500-1550
 Das Kunst vnd Lere-Büchlin...Malen und Reis-
 sen zu lernen...Franckfurt,bei Christian Egen-
 olff.1552.
 illus.

 Incl.schema of profiles

LC Typ 520/82.201 1582 MH Source:Gombrich,Art & Il
53 p. illus. sion N7006J,p.166-7
NC705.B4 Rare bk. 1594
55 p. illus. NN | ed.1557 55 p. illus.
 in IH

705 I.B.2 - BELKNAP, ZEDEKIAH, 1781-1858
A56 Mankin, Elizabeth R.
NCFA Zedekiah Belknap
v.110 Antiques
 American painting special issue. (card 2)
 ...Nov.,1976 ...

 Partial contents cont'd:E.& H.Holzer,Portr.
 in City Hall,N.Y.,p.1036-39;C.J.Weekley,Artist
 working in the South,1750-1820,p.1044-55;E.R.
 Mankin,Zedekiah Belknap,p.1056-70(incl.chronol
 list of portrs.by and attr.to Belknap

NPG I.B.2 - BELLOWS, GEORGE, 1882-1925
N
40.1 Christman, Margaret C.S.
B44C5 Portraits by George Bellows;cat.of an exh.
 at the National Portrait Gall.,Nov.4,1981
 through Jan.3,1982.Washington,D.C.,Smithsonian
 Inst.Press,1981
 56 p. illus(col.)

 Intro.by Marvin Sadik
 Bibliography

LC ND1329.B43A4 1981

757 I.B.2 - BENBRIDGE, HENRY, 1743-1812
.C28
 Carolina art association, Charleston, S.C.
 Exh.of miniatures from Charleston and its
 vicinity printed before the year 1860.Carolina
 art association,Gibbes memorial art gallery,
 Charleston,South Carolina,1935..Charleston,S.C
 Southern ptg.& pub.co.,1935.
 75 p.

 Preface signed:Robt.N.S.Whitelaw

 List of artists;list of sitters

 Largest 18th c.group by Henry Penbridge
 or his wife Rutledge.IntAm Coll 705.A5
 17:23

705 I.B.2 - BENBRIDGE, HENRY, 1743-1812
A784
NCFA Hart, Charles Henry, 1847-1918
v.6 The Gordon Family painted by Henry
 Penbridge

 In:Art in Am
 6:191-200 June,'18 illus.

 Rutledge.IntAm Coll 705.A5
 17:23

N I.B.2 - BENBRIDGE, HENRY, 1743-1812
40.1
B45N2 ..National Portrait Gallery, Washington, D.C.
NPG Henry Benbridge (1743-1812): American portrai
 painter. Edward G.Stewart,curator. Washington,
 published for the National Portrait Gallery by
 the Smithsonian Institution Press,1971
 93 p. illus.

 Catalog of an exhibition
 Bibliography

LC ND1329.B4583

705 I.B.2 - BENBRIDGE, HENRY, 1743-1812
A784
NCFA Roberts, William, 1862-1940
v.6 An early American artist:Henry Pembridge

 In:Art in Am
 6:96-101 Feb.,'18 illus.

 Roberts' spelling Pembridge, dates given
 according to Ch.H.Hart 1744-1820

 For source see main card

705 I.B.2 - BENBRIDGE, HENRY, 1743-1812
A5
NCFA Rutledge, Anna Wells
v.17 Henry Benbridge(1743-1812?);American por-
 trait painter

 In:Am.Coll.
 17:6-10,23 Oct.,'48 illus.
 :8-11,23 Nov.,'48 illus(miniatures)

 Tentative list of portrs.in oil
 " " miniatures,probably by
 Letitia Sage Benbridge

I.B.2 - BENBRIDGE, HENRY, 1743-1812

 Stewart, Robert G.
 An attractive situation:Henry Benbridge and
 James Earl in the South

 In:The Southern Q
 26,no.1:39-56 Fall,'87 illus.

 Bibliography

LC AS30.S658

AP
1
J8643
NCAA

I.B.2 - BENBRIDGE, HENRY, 1743-1812

Weekley, Carolyn J.
 Henry Benbridge:Portraits in small from
Norfolk

In:J.early So.dec.arts
4,no.2:50-64 Nov.'78 illus.

Stewart,Rbt.G. In:So.Q.
v.26,Fall,'87:56

I.B.2 - BENZIGER, AUGUST, 1867-1955

Benziger, August, 1867-1955 comp.
 Portraits of great men and women of our
time,with ...testimonials by the most prominent
art critics and leading men of intellect of
France,England,Switzerland and America.Grate-
fully dedicated to my patrons and friends as
a souvenir of my 25th anniversary as a portrait
painter..N.Y.,Wynkoop,Hallenbeck,Crawford cy.,
1917?.
 48 p. illus.

LC ND853.B4 N45 Archives of Am.Art
 N51 1056-1080

757
.C28

I.B.2 - BENBRIDGE, LETITIA SAGE, fl.-1780

Carolina art association, Charleston, S.C.
 Exh.of miniatures from Charleston and its
vicinity painted before the year 1860.Carolina
art association,Gibbes memorial art gallery,
Charleston,South Carolina,1935..Charleston,S.C
Southern ptg.& pub.co.,1935.
 .75.p.

Preface signed:Rbt.N.S.Whitelaw

List of artists;list of sitters

Largest 18th c.group by Henry Benbridge
or his wife Rutledge.In:Am Coll 705.A5
 17:23

NPG
Print
Dpt.

I.B.2 - BERCZY, WILLIAM, 1744-1813
 (younger brother of Bernh.Albr.Moll)

Andre, John
 William Berczy,co-founder of Toronto,a
sketch.Toronto,A Canada centennial project of
the Borough of York.1967.
 168 p. illus.

 William Berczy is a pseudonym for Johann
Albrecht Ulrich Moll.

 Repro.incl.:Self-portr.,drawing.Self-portr.
painting..Bernhard Moll?,pastel.Adm.Horatio Nel-
son,ptg. The Woolsey family,ptg. Joseph Brant,
ptg. and silhou- ettes by Bernh.Albr.Moll,
from 1783

Li
F10595.T
6Ppl.2

705
A5
NCFA
v.17

I.B.2 - BENBRIDGE, LETITIA SAGE, fl.-1780

Rutledge, Anna Wells
 Henry Benbridge(1743-1812?);American por-
trait painter

In:Am.Coll.
17:8-10,23 Oct.,'48 illus.
 :9-11,23 Nov.,'48 illus(miniatures)

 Tentative list of portrs.in oil
 " " " miniatures,probably by
Letitia Sage Benbridge

I.B.2 - BERLEWI, HENRYK, 1894 - 1967

Berlewi, Henryk
 Portraits et masques. Anvers,De Sikkel,.1937.
 illus.

 Preface de Jules Destrée

Rep.,1938,#570

VF

I.B.2 - BENDINER, ALFRED, 1899-1964

Philadelphia Museum of Art
 Dept.of prints and drawings
 Alfred Bendiner;lithographs,complete cata-
log..Exh..Jan.21-March 4,1965...Phila.,Mus.of
Art.1965?.
 1 v.(unpaged) illus.

NMAH:NE2415.P45A1

705
S94
NCFA
v.60

I.B.2 - BERTIERI, PILADE, 1874-

Baldry, Alfred Lys, 1858-1939
 The paintings of Pilade Bertieri

In:Studio

FOR COMPLETE ENTRY
SEE MAIN CARD

705
I 61
NCFA
v.35

I.B.2 - BENSON, FRANK WESTON, 1862-1951

Smith, Minna C.
 The work of Frank W.Benson

In:Studio
35:XCIX-CVI Oct.,'08 illus.

Olney,S.F.Two Amer.Impres-
sionists.N40.1.B47 O 5,
note 3

I.B.2 - BICKHAM, GEORGE,the elder, 1684?-1769

Portraits of the Hungarians,Pandours,or Croats,
Waradins of Sclavonians,and Ulans,etc. who
are in the service of their Majesties the
Queen of Hungary and the King of Prussia,
designed after the life,by persons of dis-
tinction...London,William Meyer,1742
 8 p. 6 plates

Winterthur In English and French
Mus.Libr. Plates engraved by Hulett and Bickham
SF301
B54*
 Winterthur,Mus.Libr.
 fZ881.W78 NCFA v.6,p.231

I.B.2 - BIGNON, FRANÇOIS, ca.1620-

Heince, Zacharie, 1611-1669
Les Portraicts av natvrel,avec...,nors et
qvalitez de messievrs les plenipotentiaires as-
serbles à Mvnster et Csnabvrg povr faire la
paix generale.Paris,Chez Henry Sara et Chez
Jean Paslé,et chez les auteurs:F.Bignon fecit
et excudit.1648.
19 p. illus.

Comprises 33 full page engr.portrs.by Fran-
cois Bignon after Heince & list of the plenipo-
tentiaries(more than 33)assembled to make the
Peace of Westphalia

NW

I.B.2 - BIGNON, FRANÇOIS, ca.1620-

Vulson de la Colombière, Marc, d.1658
Les hommes illustres et grands capitaines
françois qui sont peints dans la Galerie du Pa-
lais Royal...avec leurs portraits...desseignes
& graves par les sieurs Heince & Bignon..Paris,
Estienne Loyson,1650
.66.p. illus.

Publ.previously in 1650 with title:Les por-
traits des hommes illustres françois...400 p.
LC has 1668 ed.:DC36.V8

CSt
Winterthur Mus.Libr. fZ80
.W78 NCFA v.9,p.226

I.B.2 - BILLINGS, MOSES, 1809-1879

N
40.1
M057X2
NPM
Kully, Elizabeth K
Moses Billings:19th century portrait paint-
er...1979
69 p. illus.

Reproduction of typescript.
Incl.Cat.of artist's works
. Thesis Georgetown Univ.,Nov.5,1979
Bibliography

I.B.2 - BINGHAM, GEORGE CALEB, 1811-1879

qN
40.1
B56B6p
NMAA
Bloch, E.Maurice
The paintings of George Caleb Bingham.
A cat.raisonné.Columbia,Univ.of Missouri
Press,1986
296 p. illus(part col.)

Bibliography,p.275-87

LC ND237.B59A4 1986

I.B.2 - BIRCH, WILLIAM, 1755-1834

Ross, Marvin Chauncey, 1904-
William Birch,enamel miniaturist

In:Am.Coll.
5:16,20 July,'40 illus.

Brief biographical note

LC NK1125.A15
Art in Am.qZ5961 USA77X
NCFA Ref. H218

VF
xerox
copy
I.B.2 - BLACKBURN, JOSEPH, fl.1752-1778

Baker, Charles Henry Collins, 1880-
Notes on Joseph Blackburn and Nathaniel
Dance

In:Huntington Libr.Q
9:33-47 Nov.,'45 illus.

Incl.chronological list of Blackburn's por-
traits,p.40-2

LC Z733.S24Q

qND
1328
B35
NCFA
I.B.2 - BLACKBURN, JOSEPH, fl.1752-1778

Bayley, Frank William, 1863-1932
Five colonial artists of New England:Joseph
Badger,Joseph Blackburn,John Singleton Copley,
Robert Feke,John Smibert...Boston,Priv.print,1929
448 p. illus.

Bibliography

LC N6536.B3

NPG
I.B.2 - BLACKBURN, JOSEPH, fl.1752-1778

Bolton, Theodore, 1889- and H.L.Binsse
An American artist of formula:Joseph Black-
burn

In:Antiquarian
15:50-3,88,90,92 Nov.,'30 illus.

Incl.check list, arranged alphabetically
by sitter

Baker,C.H.C. Notes on J.
Blackburn,p.33 VF

705
775
NCFA
v.99
I.B.2 - BLACKBURN, JOSEPH, fl.1752-1778

Coburn, Frederick William, 1870-
Joseph Blackburn,a mysterious Anglo-Ameri-
can painter

In:Connoisseur
99:71-5 Feb.,'37 illus.

Facts concerning Blackburn,erroneously
called Jonathan B.Blackburn

N
40.1
B628M8
1937
NPG
I.B.2 - BLACKBURN, JOSEPH, fl.1752-1778

Morgan, John Hill, 1870-1945
...An extension of Lawrence Park's descriptive
list of the work of Joseph Blackburn,by John
Hill Morgan and Henry Wilder Foote...Worcester,
Mass.,The Society,1937
69 p. illus.

Reprinted fr.the Proceedings of the American
Antiquarian Society for April,1936

Detroit Public Library ... McGill.The Arts of ear-
...Hist.Z5935.M59 NPG

I.B.2 - BLACKBURN, JOSEPH, fl.1752-1778

0.1
P626P2
.923
NPO
Park, Lawrence, 1873-1924
...Joseph Blackburn,a colonial portrait
painter;with a descriptive list of his works...
Worcester,Mass.,The Society,1923
62 p. illus.

Reprinted from the Proceedings of the
American antiquarian society for October,1922

LC ND237.B595P3 Whitehill.The Arts of ear-
ly Amer.Hist.Z5935.W59 NPO
bibl.,p.88

I.B.2 - BLACKBURN, JOSEPH, fl.1752-1778

AP
1
H63
NPO
Purvis, Doris F.
The Joseph Blackburn portraits of Lieute-
nant-Governor John Wentworth and Governor
Benning Wentworth

In:Hist New Hampshire
24,no.3:34-9 Fall,'69 illus.

Full standing ptgs.from 1760 in the
New Hampshire Historical Society

I.B.2 - BLAKE, CATHERINE

QN
7628
B63C7
RB
NPO
The Complete portraiture of William and Cathe-
rine Blake;with an essay and an iconogra-
phy by Geoffrey Keynes..Clairvaux,France,
Trianon Press for the William Blake Trust,
1977
155 p. chiefly illus.

Limited first ed.of 562 copies

Incl.bibliographical references

I.B.2 - BLAKE, WILLIAM, 1757-1827

QN
7628
B63C7
RB
NPO
The Complete portraiture of William and Cathe-
rine Blake;with an essay and an iconogra-
phy by Geoffrey Keynes..Clairvaux,France,
Trianon Press for the William Blake Trust,
1977
155 p. chiefly illus.

Limited first ed.of 562 copies

Incl.bibliographical references

I.B.2 - BLANCHE, JACQUES-ÉMILE, 1861-1942

705
161
NCFA
v.20-21
Frantz, Henri
Jacques-Emile Blanche:Portrait painter

In:Intern.Studio
21:191-9 1904 illus.

I.B.2 - BLANCHE, JACQUES-ÉMILE, 1861-1942

George, Waldemar
Jacques-Emile Blanche, peintre de visage

In:Beaux-Arts
:1-2 May1931 illus.

LC N2.03 Rep.,1931*3504

I.B.2 - BLANCHE, JACQUES-ÉMILE, 1861-1942

Jacob, Max
A propos de Jacques-Emile Blanche

In:Formes
:85-6 1931 illus.

LC N1.F67 Rep.,1931*3503

I.B.2 - BLANCHE, JACQUES-ÉMILE, 1861-1942

Rothenstein, John
Jacques-Emile Blanche

In:Apollo
:201-5 1930(pt2) illus.

LC N1.A255 Rep.,1931*3505

I.B.2 - BLUNT, JOHN S., 1798-1835,the BORDEN
LIMNER

Bishop, Robert Charles
The Borden Limner and his contemporaries.
Ann Arbor,University of Michigan,1975
330 p. illus.

mfm 76-
9345
Diss.Uni.of Mich,1975(resulted in an exh.
at Ann Arbor,Mus.of Art,Nov.14,1976-Jan.16,'77)

In-depth study & survey of the Borden Lim-
ner & the attribution of his portrs.to John S.
Blunt
For cat. of exh.see QN.0.1.B72?B6 NPO. 90 p
illus(part col.) RILA III/1 1977 *2376
Diss.Abstr.,Apr.1976

I.B.2 - BLYTH, BENJAMIN, 1740-after 1787
1737(?)-1803(?)

705
A56
NCFA
v.69
Cole, Ruth Townsend
Limned by Blyth

In:Antiques
69:331-3 Apr.'56 illus.

I.B.2 - BLYTH, BENJAMIN, 1740-after 1787
1737(?)-1803(?)

Foote, Henry Wilder, 1875-
Benjamin Blyth,of Salem:eighteenth century
artist.Boston,1957
46 p. illus.

MET
Dpt.Am.
ptgs.& Incl.:Checklist of portrs.known in 1957
sculpt. Publ.in Mass.Hist.Soc.Proceedings,71:64-107
192B623 Oct.53-May '57
F73

Little.In:Essex Inst.Hist.
coll.AP1.E78.v.108:49 foot-
note 1

AP
1
E78 I.B.2 - BLYTH, BENJAMIN, 1740-after 1787
NPG 1737(?)-1803(?)
v.108 Little, Nina Fletcher, 1903-
The Blyths of Salem:Benjamin,Limner in cra-
yons and oil,and Samuel,Painter and cabinetmaker

In:Essex inst.hist.coll.
108:49-57 Jan.,'72 illus.

Payson.Mus.colls.of the
Essex Inst.N6505,P34X NPG
p.65,note 34

I.B.2 - BLYTHE, DAVID GILMOUR, 1815-1865

N
40.1
B67C4d Chambers, Bruce William,1941-
1974a David Gilmour Blythe(1815-1865):an artist
NMAA at urbanization's edge.Philadelphia,s.n.,1974
437 l. illus.

Index
Photocopy.Ann Arbor,Mich.
Ph.D.Thesis,Univ.of Pa.,1974
Bibliography,p.XVII-XXXIII
Checklist of ptgs.,drawings,sculpture

N
40.1
B67M6 Miller, Dorothy, 1915-
NPG The life and work of David G.Blythe.Pitts-
NCFA burgh.Univ.of Pittsburgh Press.1950.
142 p. illus.

Bibliography

Incl.:List of B.'s ptgs.

Index
Repro.incl.:Wood sculpt.of Lafayette.
LC ND237.B72M5 Lincoln writ'g emancipat'n Pro-
clamation

I.B.2 - BLYTHE, DAVID GILMOUR, 1815-1865
AP
1
C284 Paintings by David G.Blythe
NCFA
In:Carnegie M
6:229-32 Jan.,'33 illus.

N
40.1 I.B.2 - BOEHM, JOSEPH EDGAR, SIR, 1834-1890
B6766
S8 Stocker, Mark, 1556-
N(VA) Royalist and realist.The life and work of
Sir Joseph Edgar Boehm.N.Y.,Garland,1988
447 p. illus.

Ph.D.thesis,Univ.of Hull,1986
Bibliography:p.386-95

Ch.2:Portraiture,Ch.4:Portrait statues
Cat.of works,p.396-422
Excerpts of Boehm's lectures:"Portraiture in
sculpture",p.423-31
(

I.B.2 - BOILLY, LOUIS LÉOPOLD, 1761-1845

Mabille de Poncheville, André, 1886-
...Boilly.Paris,Plon.1931. (Les Maîtres
de l'art)
137 p. illus.

Bibliography

"Cat. sommaire des principles oeuvres de
Boilly"p.163-172

LC ND553.B57M2 Réau.L'iconogr.de Houdon
v.9:157,note 3 Gas Beaux Arts ser.6 1933

I.B.2 - BOILLY, LOUIS LÉOPOLD, 1761-1845

Marmottan, Paul, 1856-1932
Le peintre Louis Boilly(1761-1845):ouvrage
orné de 72 planches et figures.Paris,H,Gateau,
1513
256 p. illus.

LC ND553.B57M3 Réau.L'iconogr.de Houdon
Gas Beaux Arts ser.6 1933
v.9:157 note 3

N
40.1 I.B.2 - BOLDINI, GIOVANNI, 1842-1931
P692R4
NPG Reynolds, Gary A.
Giovanni Boldini and society portraiture,
1880-1920..Cat.of an exh.held at:Grey Art
Gallery and Study Center,N.Y.Univ.,Nov.13-
Dec22,1984.N.Y.,The Gallery,1984
64 p. illus(part col.)

Bibliography

N
40.1 I.B.2 - BOLDINI, GIOVANNI, 1842-1931
B692
W8 Wildenstein & company,inc., New York
NMAA Paintings by Boldini,1845-1931.Loan exh.
March 20 to April 8,1933
34 items illus.

Exh.for the benefit for The Child Welfare
Committee,Social Service Bellevue Hospital

I.B.2 - BONE, HENRY, 1756-1834

Bone, Henry, 1755-1834
A cat.of miniature-portraits in enamel by
Henry Bone...In the coll.of the Duke of Bedford
at Woburn Abbey.London,1825
63 p. illus.

MET
155.4
B64

Clouzot.Dict.miniaturistes
N7616.C64 NCFA Bibl.p.XVIII

I.B.2 - BORDEN LIMNER see
I.B.2 - BLUNT, JOHN S., 1798-1835,the BORDEN
.LIMNER

I.B.2 - BONE, HENRY, 1755-1834

Bone, Henry, 1755-1834
Cat.of portraits of illustrious characters
in the reign of Elisabeth...painted in enamel
by Henry Bone,R.A. London,G.Smeeton,1813
7 p.

MB

I.B.2 - BORDER LIMNER
see
I.B.2 - PHILLIPS, AMMI, 1788-1865

I.B.2 - BOLT, CHARLES, 1662?-1727

Nisser, Wilhelm, 1897-
Michael Dahl and the contemporary Swedish
school of painting in England...Uppsala,Alm-
qvist & Wiksells,...1927
159 p. illus.

Inaug.-diss.-Upsala
Literature & sources of info.

Contents.-Michael Dahl.-Hans Hysing.-Charl
Bolt.-Christian Richter

LC ND793.D3N5 Yale ctr.f.Brit.art Ref.
ND786+N57

I.B.2 - BORDIER, JACQUES, 1616-1684

Stroehlin, Ernest, 1844-
Jean Petitot et Jacques Bordier,deux artistes
huguenots du 17? siècle.Genève,Kündig,1905
284 p. illus.

I.B.2 - BONNEVILLE, FRANÇOIS, fl.1790

Bonneville, François, fl.1790
Portraits des personnages célèbres de la
Révolution avec tableau historique et notices
par P.Quénard,l'un des représentants de la com-
mune de Paris,en 1793 et 1790.Paris,Chez l'auteu
1796-1802
4 v. illus.

Partly the only authentic portr.of celebri-
ties of this epoch
Repre.incl.Fouquier-Tinville,Carrier,Char-
lotte Corday,Bonaparte,Kleber,Marceau,etc.
LC DC145.Q42 Lewine.Bibl.of 18th c.art &
illus.books.Z1023.L67 1969v

I.B.2 - BORGLUM, GUTZON, 1867-1941

4
40.1
P72S95
1985A

Shaff, Howard
Six wars at a time:the life and times of
Gutzon Borglum;sculptor of Mount Rushmore,by
H.Shaff and Audrey Karl Shaff;...1st ed..
Sioux Falls,S.D.,Ctr.for Western Studies,Au-
gustana College,Darien,Conn.Permelia Pub.,
1985
379 p. illus.
Bibliography p.350-68
Mainly biography;incl.list of Gutzon
Borglum's works,p.369-71

I.B.2 - BORCHT, PIERRE VAN DER, 1545-1608

Sambucus, Johannes, 1531-1584
Icones veterum aliqvot,ac recentivm medicorvm,
philosophorvmqve elogiolis svis editae...Nage-
drukt in fac-simile volgens de uitgave van Plantin
van 1574,met eeno inleiding door...Max Rooses...
Antwerpen,Nederlandsche boekhandel etc.1901
7p,69:1,incl.illus. (Maatschappij der Antwerpsche
bibliophilen,no.21)
Preface in Dutch and French
"La manière des gravures indique...que Pierre
v.d.Borcht les executa à l'eau-forte..."

LC N7627.S2 Amsterdam,Rijksmus.,cat.
Z5939A52,deel 1,p.138

I.B.2 - BORSELAER, PIETER SEE
I.B.2 - BORSSELER, PIETER, fl.1665-84

705
C75
NCFA
v.64

I.B.2 - BORSSELER, PIETER, fl.1665-84

Baker, Charles Henry Collins, 1880-1959
 Pieter Borsseler, a forgotten 17th century
master

In:Connoisseur
64:5-6,9,12,15 Sept.,'22 illus(part col.)

705
A5
NCFA
v.17

I.B.2 - ROUNETHEAU, HENRY BRINTNAL, 1797-1877

Rutledge, Anna Wells
 Henry Rounetheau(1797-1877)Charleston,S.C.
miniaturist

In:Am Coll
17,no.6:12-15,23 July,'48 illus.

 Incl.:List of R.'s miniatures & oil ptgs.

 Incl.:List of works of Mrs.Rounetheau which
incl.Geo.Washington,oil

LC NK1125.A15 Carolina Art ass..Charles-
 on,S.C.Miniature portr.col.
 ibl.p.179

I.B.2 - BOSCH, HIERONYMUS, d.1516

Fraenger, Wilhelm, 1890-1964
 "Die Selbstbildnisse Boschs".In.his.Hiero-
nymus Bosch.Dresden,VEB Verlag der Kunst,1975
pp.490-92

 An analysis of several self-portrs.in Bosch'
ptgs.,a.o.in the Arras Codex & Lampsonius' Ef-
figies of 1572

LC ND653.B65F719 1975 Gibson,W.S.Hieronymus Bosch
 8109.678.G5 1983 p.135
 LC2

705
A5
NCFA
v.17

I.B.2 - ROUNETHEAU, JULIA CLARKSON DUPRÉ

Rutledge, Anna Wells
 Henry Rounetheau(1797-1877)Charleston,S.C.
miniaturist

In:Am Coll
17,no.6:12-15,23 July,'48 illus.

 Incl.:List of R.'s miniatures & oil ptgs.

 Incl.:List of works of Mrs.Rounetheau which
incl.Geo.Washington,oil

LC NK1125.A15 Carolina Art ass..Charles-
 on,S.C.Miniature portr.col.
 ibl.p.179

AP
1
N56
1967
NCFA

I.B.2 - BOUCHÉ, RENEÉ ROBERT, 1905-1963

Barr, Alfred H.amilton,jr.,1902-1981
 Painting and sculpture acquisitions,1960

In:Mus.Mod.Art Bul.
28,no.2:3-5 illus.p.6-34

 Repro.incl.:Bouché's portr.of Braque,p.25

I.B.2 - BOYDELL, JOHN, 1719-1804

Boydell, John, 1719-1804
 Boydell's heads of illustrious and cele-
brated persons generally connected with the
history of Great Britain in the reigns of
James I,Charles I,Charles II and James II;with
biographical memoirs by J.Watkins.London,1811

Listed in Universal Cat.of
Books on Art,p.155

705
A783L
NCFA
v.35

I.B.2 - BOUCHÉ, RENE ROBERT, 1905-1963

New York. Museum of the city of New York
 René Bouché,exh.Nov.2,1960-Feb.5,1961

In:Arts Mag
35:51 Dec.,'60 1 illus.

 Exh.also at Iolas Gall.Oct.9-Nov.7,'59
see Art Mag.34:59 and Art N 58:19,D,'59

N40.1
B79B3
1973
NCFA

I.B.2 - BRACKMAN, ROBERT, 1898-

Bates, Kenneth, 1895-
 Brackman,his art and teaching.Rev.enl.ed..
Madison,Conn..Madison Art Gall.Pub.Co.,...,1973.
 84 p. illus(part col.)

 A discussion of this conservative portrait-
ist,incl.his working methods

 Bibliography

 Arts in Am q25961.U5A77X
 NCFA Ref. J 496

AP
1
W78
v.9
1974

I.B.2 - BOUDON, DAVID, b.1748,fl.still 1816

Richards, Nancy E.
 A most perfect resemblance at moderate
prices

In:Winterthur Portfolio
9:77-101 1974 illus.

 An article on David Boudon,who worked mos
ly in silverpoint and W.C.on ivory

 Checklist of 51 portrs. 24 reproduced

705
A56
NCFA
v.90

I.B.2 - BRADLEY, JOHN, fl.1832-1847

Black, Mary Childs & Stuart P.Feld
 Drawn by I.Bradley from Great Britton

In:Antiques
90:502-08 Oct.,'66 illus.

 "Interim study of the work of John Bradley..

 Incl.:Checklist of the works of J.B.

 Phillips,Ammi:portr.ptr.
 N40.1P558H7 NCFA Bibl.

705
A784
v.33

I.B.2 - BRADLEY, JOHN, fl.1832-1847

Lipman, Mrs.Jean Herzberg, 1909-
 I.J.H.Bradley

In:Art in Am
33:154-66 Jul.,'45 illus.

 List of portrs.signed by & attr.to I.J.H.
Bradley
 "Not a single attribution can be accepted."-
M.C.Black & S.P.Feld in "Drawn by I.Bradley...
In:Antiques,90:502 Oct.'66
 Black.Drawn by I.Bradley
 Antiques,90:502 Oct.'66

AP
1
C76
NPG
v.25

I.B.2 - BREWSTER, JOHN,Jr., 1766-1854

Little, Nina Fletcher, 1903-
 John Brewster,Jr.,1766-1854...

In:Conn.Hist.Soc.Bull.
25:97-111 Oct.,'60 42 illus.
 Cat.
 and...Supplementary list of paintings not in
exh.

 **FOR COMPLETE ENTRY
 SEE MAIN CARD**

705
B97
NCFA
v.83

I.B.2 - BREDA, CARL FREDRIK VON, 1759-1818

Asplund, Karl, 1890-
 Carl Fredrik von Breda

In:Burl Mag
83:296-301 Dec.,'43 illus.

 Repr.incl.:Self-portr.with sketched portr.
on easel

AP
1
V81
NPG
v.60

I.B.2 - BRIDGES,CHARLES, 1670-1747

Foote, Henry Wilder, 1875-
 Charles Bridges:"Sergeant-Painter of Virgi-
nia",1735-40

In:Va.Mag.Hist.& Biogr.
60:1-55 Jan.,'52 illus.

 Incl.:Descriptive cat.of portrs.

Bibliography

I.B.2 - BREDA, CARL FREDRIK VON, 1759-1818

Hultmark, Emil, 1872-1943
 Carl Fredrik von Breda,sein leben und sein
schaffen.Stockholm,Centraltryckeriet,1915
 234 p. illus.

LC ND793.B8H8 Asplund,C.F.von Breda,in:
 Burl.Mag.83:299

N
40.1
B847H7
NPG

I.B.2 - BRIDGES, CHARLES, 1670-1747

Hood, Graham, 1936-
 Charles Bridges and William Dering.Two Vir-
ginia painters,1735-1750.Williamsburg,Va.,The
Colonial Williamsburg Foundation,1978,
 135 p. illus(part col.)

LC ND1329.B75H66

705
B97
NCFA

I.B.2 - BREDA, CARL-FREDRIK VON, 1759-1818

Steegmann, John
 Portraits of Reynolds

In:Burl.Mag.
88:33-4 Feb,1942 illus.

 Incl:Selfportrs.ptgs.1773,1780;drg.1740
ptg. of Reynolds by C.F.von Breda(Swed.ptr.1759-
1818, was in London 1787-96),1791, etc.

 Rep.,1942-44#780

AP
1
A79
NCFA
v.9

I.B.2 - BRIDGES, CHARLES, 1670-1747

Thorne, Thomas, 1905-
 Charles Bridges,limner

In:Arts in Va.
9:22-31 Winter,'69 illus.

 'An English painter,working in Va.,reveals
some of the fashionable methods of making portrs
in the 18th c.'

 Winterthur Mus.Libr.
 Z881.W78 NCFA v.6,p.225

F
24
A34
1987A
NMAA

I.B.2 - BREWSTER, JOHN,JR.,1766-1854

Agreeable situations:society,commerce and art
in southern Maine,1780-1830;ed.by Laura
Fecych Sprague;essays by Joyce Butler...
et al.Kennebunk,Me.Brick Store Mus.
Boston:Distributed by Northeastern Univ.
Press,1987
 285 p. illus(part col.)
 Incl.Brewster,jr.,deaf artist,p.88,122,254
 Cat.of selected objects from the Brick
Store Mus.et al
 Index
 Bibliography

N
40.1
B8537
S5
NPG

I.B.2 - BRILLIANT, FREDDA, 1915-

Brilliant, Fredda
 Biographies in bronze...1st ed. N.Y.,Chapels-
ky,c.1986
 159 p. illus.

Originally published by Vikas,1986

AP
1
C76
NPG
v.38

I.B.2 - BROADBENT, Dr.SAMUEL, 1759-1828

Warren, William Lamson
Doctor Samuel Broadbent(1759-1828).Itiner-
ant Limner

In:Conn.Hist.Soc.B.
38:97-112 Oct.,'73 illus.p.117-28 & cover

Checklist of portrs.in exh.,p.113-6
16th annual art show at the Society

Abby Aldrich Rockefeller
folk Art Ctr.Am.folk portrs
N7593.A23 NMAA Bibl.p.295

N
40.1
B878B4
NCFA

I.B.2 - BROWERE, JOHN HENRI ISAAC, 1792-1834

Bennett, James O'Donnell, 1870-
The mask of fame;the heritage of historical
life masks made by John Browere,1825 to 1833
.by...and Everett L.Millard..Highland Park,Ill..
The Elm press.c.1938.
29 p. illus.

LC NB237.B7R4

VF
Brockhurst

I.B.2 - BROCKHURST, GERALD LESLIE, 1890-1978

Albrecht Art Museum, St.Joseph,Mo.
Gerald L.Brockhurst.Master of the etched
portrait..Exh.,3 Sept.-10 Nov.,1985
unpaged illus.

Incl.:Pamphlet:'Adolescence'by G.L.Brock-
hurst, the five states and drawing

705
A56
NCFA
v.110

I.B.2 - BROWERE, JOHN HENRI ISAAC, 1792-1834

Demer, John H.
The portrait busts of John H.I.Browere

In:Antiques
110:111-7 July,'76 illus.

"B.spent more than $12000.-attempt'g.with-
out success to establish a Nat'lCall.of Busts
and Statues."-Demer

Incl.H.Clay;Thos.Jefferson,Jn.Madison;Dolley
Madison;J.Adams;Lafayette;M.van Buren;J.Q.Adams.
Checklist of B.'s sculptures

40.1
P9557y
F6
NMAA

I.B.2 - BROCKHURST, GERALD LESLIE, 1890-1978

Fletcher, William Dolan
Complex simplicity;Gerald Leslie Brock-
hurst and his graphic work.New Haven,Conn..
The sign of the arrow,1984.
95 p. illus.
Index
Cat.raisonné 1934-1947

NB
1310
H32
NPG

I.B.2 - BROWERE, JOHN HENRI ISAAC, 1792-1834

Hart, Charles Henry, 1847-1918
Browere's life masks of great Americans, ...
.New York.Printed at the De Vinne press for
Doubleday and McClure company,1899
123 p. illus.

LC NB1310.H3

N
40.1
B87507
NCFA
2 c.

I.B.2 - BROOKS, ROMAINE, 1874-1970

Brooks, Romaine
Portraits,tableaux,dessins..Introd.de Elisa-
beth Gramont.Paris,1952.
52 p. illus.

LC ND237.B87207

705
A784
NCFA
v.38

I.B.2 - BROWERE, JOHN HENRI ISAAC, 1792-1834

Millard, Everett Lee
The Browere life masks

In:Art in Am.
38:69,71,74,76,78,80 Apr.,'50 illus.

Busts in N.Y.State hist.assoc'n's "Hall of
Life Masks"in Fenimore hse.,Cooperstown,N.Y.

This article is drawn fr.Millard's ms of a
life of J.H.I.Browere

Arts in America q25961.U5
A77X NCFA Ref. I72

791
A87
NB
237
B7F6X
NPG

I.B.2 -

Browere, John Henri Isaac, 1792-1834
Life masks of noted Americans of 1825...
exhib.,Feb.12-24,1940 under the sponsorship of
the New York state historical association,Coo-
perstown,New York.N.Y.,M.Knoedler and cy..1940.
6 p. illus.

Foreword signed:Dixon Ryan Fox

LC NB237.B7F6 Kimball.Life portrs.of Jef-
ferson.N7628.J45Kh,p.532
NPG NCFA

705
A56
NCFA
v.100

I.B.2 - BROWN, HENRY JAMES, 1811-1854

Watson, Lucille McWane
Virginia planter-painter Henry James Brown

In:Antiques
100:591-5 Oct.,'71 illus.

N
40.1
B8785
E9
NPG
NMAA

I.B.2 - BROWN, MATHER, 1761-1831

Evans, Dorinda
 Mather Brown,early American artist in Eng-
land.A Barra Foundation/Kress Foundation Book.
Middletown,Conn.,Wesleyan Univ.Press,1982
 297 p. illus(part col.)

 Bibliography

 Incl.:Cat.raisonné,incl.drsgs. & prints

 Revised & expanded from the Ph.D.disserta-
tion Courtauld Inst.of Art.Univ.of London,1972

NP
Brush,G.
de Forest

I.B.2 - BRUSH, GEORGE DE FOREST, 1855-1941

Grand central art galleries, New York
 Retrospective exh.of paintings by George
de Forest Brush;Jan.7-18,1930
 16 p. illus.

 Mother & child, Family groups, etc.

705
.B97
NCFA
v.114

I.B.2 - BROWN, MATHER, 1761-1831

Evans, Dorinda
 Twenty-six drawings attributed to Mather
Brown

In:Burl Mag
114:534-41 Aug.,'72 illus.

 The drgs.are in Edinburgh. Scottish N.P.G.

 Noon.Engl.portr.drags...
 NC860.N66X NPG p.XIII
 footnote 19

I.B.2 - BRY, THEODOR DE, 1528-1598

Boissard, Jean Jacques, 1528-1602
 Bibliotheca chalcographica,hoc est virtute
et eruditione clarorum virorum imagines, collec-
tore Iano-Iacobo Boissardo,Vesunt.,sculptore
Theodoro de Bry,Leod.,primum editae,et ab ipso-
rum obitu hactenus continuatae.Heidelbergae,im-
pensis Clementis Ammoni,1669
 5 v. illus.

LC NE218.B6 1669 Foce,v.11,p.321

I.B.2 - BROWNE, MARGARET FITZHUGH, 1884-1972

Browne, Margaret Fitzhugh, 1884-1972
 Portrait painting...with foreword by Royal
Cortissos.N.Y.,I.Pitman & sons,1933
 101 p. illus(part col.)

 Repro.incl.:Velasquez,Raeburn,Bronzino,Orpen
Sargent,Ingres,F.Hals,L.Seyffert,M.F.Browne,etc.
 Incl.Ch.on Portr.ptg.as a profession

 Miss B.,a noted portraitist,gives an account
of her methods. Rev.in Art Dig.7:21,Jl.'33 &
Conn.92:46 Jl.'33
LC ND1300.B7 Art Books 1876-1949.Z5937
 A775 NCFA Ref. p.455

I.B.2 - BRY, THEODOR DE, 1528-1598

Hulsius, Levinus, d.1606
 XII Primorvm Caesarvm et LXIIII ipsorvm
vxorvm...ex antiquis numismatibus...collextae.
Sumptibus Pauli Brachfeldij,Francoforti ad Moe-
num,1597
 198 p. illus.

 Engr.after Vico by Theodor de Bry

 Vico's Le imagini of 1548 & 1557 combined

NN ICN CtY Lenox coll. Rath,in:Lex.d.ges.buchwe-
 sens,Bd.III,p.39
 LC Z118.L67(NPG xerox cop

AP
1
W225
NCFA
v.44

I.B.2 - BROWNE, MARIA, 1786-1828

Ormond, Richard
 Chinnery and his pupil,Mrs.Browne

In:Walpole Soc.
44:123-214 1972-1974 illus.

 '...the letters are very largely concerned
with the practice of miniature ptg...'p.126

 Hutcheon.Chinnery...N40.1
 C53H9 NCFA Bibl.p.173

705
C75
NCFA
v.50

I.B.2 - BUCK, ADAM, 1759-1833(or'34)

Malet, Harold
 Adam Buck

In:Connoisseur
50:135-40 Mar.,'18 illus.

 List of Buck's works,exhibited at Royal Aca-
demy and British Institution,betw.1795 & 1833

AP
1
C76
NPG
v.37

I.B.2 - BRUNTON, RICHARD, ?-1832

Kihn,,Phyllis,
 The Reuben Humphrey portraits,by P.K.,

In:Conn.Hist.Soc.B.
37:42-50 Apr.,'72 illus.

 Portrs.attr.to Richard Brunton

 Report on restoration:examination,treatment

 Winterthur Mus.Libr.
 [...] NCFA v.,p.230

705
A56
NCFA
v.86

I.B.2 - BUNDY, HORACE, 1814-1883

Shepard, Hortense O.
 Pilgrim's progress:Horace Bundy and his
paintings

In:Antiques
86:445-9 Oct.,'64 illus.

 Burdick.Aaron Dean Flet-
 cher..Antiques 115:193
 705.A56 NCFA

I.B.2 - BURBANK, ELBRIDGE AGER, 1858-1949

Browne, Charles Francis, 1859-
Elbridge Ayer Burbank, a painter of Indian portraits. Chicago. The Arts & crafts company, n.d. p.16-35 illus.(part col.)

From "Brush and pencil,v.III,no.1,Oct.1898"

NH-P

E
89
C35
NPG

I.B.2 - BURBANK, ELBRIDGE AGER, 1858-1949

A catalogue of Indian portraits in the coll. of Jos.G.Butler,jr..on free exh.at the Y.M.C.A.bldg,Youngstown,O.,:s.n.,s.l., ca.1907.(Youngstown,Ohio,Vindicator Press) 39 p. illus.

The greater part of the coll.is the work of J.H.Sharp and E.A.Burbank.Other artists represented are Frederick Remington,Bert Phillips Deming and Gandy
Smithsonian "National Museum"bought 11 Sharp ptgs.,Dec.1900

N
40.1
J86F6
NPG
NCFA

I.B.2 - BUSH, JOSEPH H., 1794-1865

Floyd, William Barrow, 1934-
Jouett-Bush-Frazer:early Kentucky artists. Lexington,Ken..pribately printed,1968 204 p. illus.

Bibliography

LC ND236.F5

NPG A 19th c.gall.of distinguished Americans.Bibl.

705
A784
NCFA
v.31

I.B.2 - BUSTOS, HERMENEGILDO, 1832-1907

Pach, Walter, 1883-1958
A newly found American painter:Hermenegildo Bustos

In:Art in Am
31:32-43 Jan.,'43 illus.

Most of Bustos'work in Muñoz collection

I.B.2 - CAMERON, JAMES, 1817-1882

705
A56
NCFA
v.100

Bishop, Budd H.arris,,1936- ,
 Three Tennessee painters:Samuel M.Shaver,
Washington B.Cooper, and James Cameron

In:Antiques
100:432-7 Sept.,'71 illus.

I.B.2 - CARRIERA, ROSALBA, 1675-1757

700.549?
A523
NMAA
v.36

Bruijn Kops, C.J.de
 Een portretminiatuur deer Rosalba Carriera.
(1675-1757)en de oorsprong van haar schilder-
kunst op ivoor

In:B.Rijksmus.
36,no.3:181-210 1988 illus.(1 eel.en eever)

 Summary in English,p.268-71

I.B.2 - CAMPANA, IGNACE JEAN VICTOR, died 1786

Jeannereat, Carlo
 Vittoriano Campana,pittore di gabinetto di
Maria-Antonietta

In:Società piemontese di archaeologia e belle
art,Turin.Bolletino,1923

LC DC610.S55

Paris.Mus.nat.du Louvre.
Cab.d.dessins.Donation de
D.David-Weill.N7616.P23
NCFA p. XI

I.B.2 - CARRIERA,ROSALBA, 1675-1757

Jeannerat, Carlo
 Les origines du portrait'à miniature'sur
ivoire.J.B.Massé et Rosalba Carriera

In:B.art fr.
57:80-8 1931

LC N6811.A92

Bruijn Kops In:B.Rijksmus.
36:206,note 13

I.B.2 - CARMONTELLE, LOUIS CARROGIS, 1717-1806

N
40.1
C28x08
NPG
R.B.

Gruyer, François Anatole, 1825-
 Chantilly:les portraits de Carmontelle...
Paris,Plon-Nourrit et cie,1902
 388 p. illus.

 Incl.:Contents. List of sitters

LC N7604.C2

Winterthur Mus.Libr. fZ811
J78 v.9,p.226

I.B.2 - CARRIERA, ROSALBA, 1675-1757

Malamani, Vittorio, 1860-1934
 Rosalba Carriera.Bergamo,Istituto italiano
d'arti grafiche,1910
 120 p. illus. (Collezione di monografie
illustrate:Pittori,scultori,architetti,8)

 'Carriera introduced pastel to the world'.-
Adair
 'Best book on Carriera'.-Adair

.ND623.C43.M3.
NWU ICU NRU CtY NjP

Adair.18th c.pastel portrs.
qNC885.A32 1971X Bibl.
p.203

I.B.2 - CARPI, UGO DA, fl.-1525

N
7585
F97
1972
NPG

Fulvio, Andrea, fl.1510-1543
 Illustrium imagines.Portland,Ore.,Collegium
Graphicum,1972.
 CXX illus. (The printed sources of Wes-
tern art,no.9)

 Reprint of Rome,1517 ed.

 'The fine medallions are supposed to be by
Ugo da Carpi!'

I.B.2 - CASSATT, MARY, 1855-1926

Ségard, Achille, 1872-
 Un peintre des enfants et des mères,Mary
Cassatt...Paris,P.Ollendorff,1913
 207 p. illus.

 Documents et bibliographie p.199-201

LC ND237.C3S4

sham.The History of Ameri-
can ptg.ND205.I79 1933 NPG

I.B.2 - CARPI, UGO DA, fl.-1525

Fulvio, Andrea, fl.1510-1543
 Illvstrivm imagines...Romae,Jacopo Mazochio,
1517
 illus.

 202 portrs.Woodcuts by Ugo da Carpi or work-
shop after antique medals of Mazochio's coll.
 "One of the oldest publications...with portrs
-Prinz
 "this work became the example for numerous
portr.works".-Rath Prinz.Slg.d.selbstbildn.in d.
 Uffizien N7618/P95 Bd.1,p.146
LC N7585.F8 ote 43.Rave.In:Jb.d.Berl.m.
also in: 1959 LC N3.J16 fol.p.128
Rath.Portr.werke in Lex.d.ges.buchwesens,III,p.39 NPGxerox

I.B.2 - CATLIN, GEORGE, 1796-1872

N
40.1
C36
Alep
1979
NMAA

Catlin, George, 1796-1872
 Episodes from life among the Indians,and
last rambles.With 163 scenes and portrs.by
the artist.Ed.and with an intro.by Marvin C.
Ross.Norman,Univ.of Oklahoma Press,1979
 354 p. illus. (The Civilization of
the American Indian series,55.)
 Bibliography

Worldwide Art Book Biblio-
graphy Z5931.W92 NMAA 2,
no.2-4 1967-71,v.IIIno.1
p.12

N
40.1
C36D6
NCFA
I.B.2 - CATLIN, GEORGE, 1796-1872

Donaldson, Thomas Corwin, 1843-1898
The George Catlin Indian gallery in the
U.S.National museum(Smithsonian inst.)with me-
moirs and statistics...Washington,D.C.,1887
939 p. illus.

Bibliography by George Catlin

From the Smithsonian report for 1885

LC E77.C45 Viola.The Indian legacy...
 N40.1/K52V7 NPG Bibl.

I.B.2 - CECILL, THOMAS, fl.1625-1640

Woodburn, Samuel, 1785 or 86-1853
Woodburn's Gallery of rare portraits;con-
sisting of original plates by Cecil,Dalaram,
Droeshout...illustrative of Granger's Biograph.
hist.of England,Clarendon's Hist.of the rebel-
lion,Burnet's Hist.of his own time,Pennant's
London,etc...containing 200 portrs.of persons
celebrated...London,G.Jones,1816
^ v. illus.

For full subtitle see(LC,Z8614U525 194?
v.165,p.418 NPG Ref.

LC N7598.W6

B
C36H1
NCFA
I.B.2 - CATLIN, GEORGE, 1796-1872

Haberly, Loyd, 1896-
Pursuit of the horizon,a life of George
Catlin,painter and recorder of the American
Indian.N.Y.,Macmillan Co.,1948
239 p. illus.

Ch.VIII & Ch.XXVI pertain to C.'s portrs.
of the American Indians

LC ND237.C35H3

705
A7875
NCFA
v.26
I.B.2 - CERACCHI, GIUSEPPE, c.1751-1802

Desportes, Ulysse
Giuseppe Ceracchi in America and his busts
of George Washington

In:Art Q.
26:140-78 Summer,'63 illus.

'Over two dozen life portrait busts of Ame-
rica's founding fathers were left in Florence
by their author Giuseppe Ceracchi...'

759.1
.C37M4
I.B.2 - CATLIN, GEORGE, 1796-1872

Matthews, Washington, 1843-1905
The Catlin collection of Indian paintings

In:U.S. National museum. Annual report. 1890.
Washington,1891 p.593-610 illus. Reprint,
1892.
Reprint of a lecture delivered in...the Na
tional museum,Saturday,April 13,1889

LC Q11.U5 1890

I.B.2 - CERONI, LUIGI, 19th c.

Paris. Musée national du Louvre. Dpt.des
peintures,des dessins et de la chalcographie
Les émaux de Petitot du Musée impérial du
Louvre;portraits de personnages historiques
et de femmes célèbres du siècle de Louis XIV,
gravés au burin par M.L.Ceroni.Paris,Blaisot,
1862-64
2 v. illus.

1st part:Jean Petitot(1607-1691)by Henri
Bordier,31 p.,illus.
Petitot was assisted in his miniature ptg.
by his brother- in-law,Jacques Bordier
NN CtY MB MdBWA,etc.

705
.A56
v.54
I.B.2 - CATLIN, GEORGE, 1796-1872

Thomas, W.Stephen
George Catlin,portrait painter

In:Antiques
54:96-7 Aug.,'48 illus.

Discusses C.'s portrs.of Americans,1821-30,
before he portrayed North American Indians
Repro.:Miniature on ivory of C.'s wife;
min.of Gov.DeWitt Clinton,1824(here reproduced
as an engraving);self-portr.,1824

FOGG
F8
3892
271
2
I.B.2 - CERUTI, GIACOMO, fl.1750

Mallè, Luigi
Giacomo Ceruti e la ritrattistica del suo
tempo nell' Italia Settentrionale a cura di L.
Mallè e Giovanni Testori.Mostra.Torino,Galleria
Civica d'arte moderna,febbraio-marzo,1967.Tori-
no,Galleria civica d'arte moderna,1966.
169 p. illus(part col.)

Bibliography

Fogg,v.11,p.320

qN
40.1
C36T8
NCFA
Ref.
2 copies
I.B.2 - CATLIN, GEORGE, 1796-1872

Truettner, William H.
The natural man observed:a study of Catlin's
Indian gallery...1st ed. Washington,Smithsonian
Inst.Press,1979.
323 p. illus(part col.)

Bibliography
Incl.indexes

Incl.a descriptive cat.of the Indian gall.
Portrs.p.142-232,p.293-99

qN
40.1
C42xA5
NCFA
I.B.2 - CÉZANNE, PAUL, 1839-1906

Andersen, Wayne V
Cézanne's portrait drawings by Wayne An-
dersen.Cambridge,MIT Press,1970.
247 p. illus.

Bibliography

Incl.Chronology for the portr.drags.
Cat.raisonné
Self-portrs.,Mme Cézanne,Cézanne's father,
mother,friends,etc.
LC NC1135.C45A7
 NCFA, p.43, v.11

AP
1
S776
NPG
v.4

I.B.2 - CÉZANNE, PAUL, 1839-1906

Geist, Sidney
 Reflections on the mirror in Cézanne

In:Source
4,nos.2/3 Winter/Spring '85 illus.

 Discusses the mirror image in self-portr.

QN
40.1
C457V3
NPG

I.B.2 - CHANDOR, DOUGLAS GRANVILLE, 1897-

Vaughan, Malcolm
 Chandor's portraits...with a foreword by
Deems Taylor...N.Y.,Brentano's,1942.
 92 p. illus(part col.)

AP
1
A784.J8
NCFA

I.B.2 - CHALON, ALFRED EDWARD, 1780(or 1781)-
 c1860

Leslie, R.A. and Eaton, Fred.A.
 Alfred Edward Chalon,R.A.in .their.The
Royal Academy in the present century

In:Art J.
66-7 1899 illus.

 'Portrait-painter in water colours to her
Majesty'...-Dafforne,Js.in:Art J. 1862:10

AP
1
A4
R.AA
v.127

I.B.2 - CHANTREY, FRANCIS, 1781-1842

Ditner, David C.
 Nineteenth-century English portrait sculp-
ture.Marble busts in the Nat'l Gall.of Canada.

In:Apollo
127:334-8 May,'88 illus.

 Repro.incl.:Nollekens,Chantrey

705
B97
NCFA
v.82

I.B.2 - CHAMPAIGNE, PHILLIPPE DE, 1602-1674

Blunt, Anthony, 1907-
 Philippe de Champaigne's portraits of the
Echevins of Paris

In:Burl Mag
82:83-7 Apr.,'43 illus.

 Rosenfeld.Largillière
 Bibl.p.400

705
A56
NCFA
v.73

I.B.2 - CHAPMAN, JOHN GADSBY, 1808-1889

Chamberlain, Georgia S.,mm,1910-1961.
 John Gadsby Chapman:a reappraisal

In:Antiques
73:566-9 June,'58 illus.
 Repro.incl.:Self-portr.;David Crockett;
Horatio Greenough;Alexander Anderson

 '..his:psychological insight & competent ptg
make Ch.one of the most interesting,if not one
of the best of the artists...in the U.S...1830's
and 40's.'
 Robert Hull Fleming Mus.
parlor.Bibl.p.39 Univ.of Vt. Faces in the

705
A56
NCFA
v.102

I.B.2 - CHANDLER, JOSEPH GOODHUE, 1813-1884

Keefe, John Webster
 Joseph Goodhue Chandler(1813-1884)itinerant
painter of the Connecticut River valley

In:Antiques
102:849-54 Nov.,'72 illus(1 col.)

I.B.2 - CHAPPEL, ALONZO, 1828-1887

Duyckinck, Evert Augustus, 1816-1878
 Lives and portraits of the presidents of the
United States,from Washington to Arthur.The bio-
graphies by Evert A.Duyckinck...the portraits
by Alonzo Chappel...New York, Henry J.Johnson
.c.1881.
 280 p. illus.

LC E176.1.D9

705
A784
NCFA

I.B.2 - CHANDLER, WINTHROP, 1747-1790

Little, Nina Fletcher, 1903-
 Winthrop Chandler

In:Art in Am
35:75-168 Apr,'47 illus.

 Foreword by Jean Lipman
 Catalogue of ptgs.attr.to W.Chandler

 Bibliography

757
.C46
NGA

I.B.2 - CHAPPEL, ALONZO, 1828-1887

Duyckinck, Evert Augustus, 1816-1878
 National portrait gallery of eminent Ameri-
cans,incl.orators,statesmen,naval & military he-
roes,jurists,authors,etc.,from original full
length ptgs.by Alonzo Chappel...New York,Johnson,
Fry & Co.,.1862.
 2 v. illus.

LC E176.D98 Cirker.Dict.of Am.portrs.
 N7593/C57/NPG Bibl. p.714
 Ref.

Bibliography on Portraiture —Classified Arrangement

705
G28
NCFA
v.32

I.B.2 - CHARDIN, JEAN-BAPTISTE SIMÉON, 1699-1779

Dorbec, Prosper, 1870-
 Le portraitiste Aved et Chardin portraitiste

In:Gaz Beaux Arts
3rd per.v.32:89-100 1504 illus.
 :215-24 " "
 :341-52 " "

 Repr.Engravings after the ptgs.
 Pt.1 & 2 on Aved,pt.3:Dorbec suggests attr.
to Aved of most of Chardin's portrs.(p.346ff)

 Dumont-Wilden.Le portr.en
 France ND1316D89,p.165

705
I 61
NCFA
v.39

I.B.2 - CHASE, WILLIAM MERRITT, 1849-1916

Downes, William Howe, 1654-1941
 William Merritt Chase,a typical American ar
tist

In:Studio
39:XXIX-XXXVI Dec.,1909 illus.

 Framing the board.ND1311.9
 PSF813 NPG p.8

I.B.2 - CHARDON, Mme.C.DEBILLEMONT
 see
I.B.2 - DEBILLEMONT-CHARDON, Mme.GABRIELLE, 1865
 -1957

N
40.1
C48R7
1975
NCFA

I.B.2 - CHASE, WILLIAM MERRITT, 1849-1916

Roof, Katharine Metcalf
 The life and art of William Merritt Chase,
by Katharine.i.e.Katharine.Metcalf Roof.N.Y.,
Hacker Art Books,1975
 352 p. illus.

 Reprint of the 1917 ed.publ.by Scribner,N.Y.

 Incl.Index

 Bassham.The theatrical
 photographs...N.40.1.S245
 B3 NPG Bibl.p.122

VF

I.B.2 - CHASE, JOSEPH CUMMINGS, 1878-1965

Chase, Joseph Cummings, 1878-1965
 A portrait painter speaks and other articles

In:Sat.Eve.Post
159:14-5,177-8 June 18,'27 'A portr.ptr.speaks'
200:20-1,141-2 Aug.13,'27 'The adventure of
 being painted'
200:16-7,81-2 Aug.27,'27 'Famous sitters'
200:16-7 Oct.15,'27 'What is this art
 game?'
200:37,157-8,160 Apr.28,'28 'Ptg.the A.E.F.on the
 Gallop'
A.E.F.=Amer.Expeditionary Forces|all illustrated

705
M18
NCFA
v.21

I.B.2 - CHILD, THOMAS, c.1655-1706

Coburn, Frederick William, 1870-
 Thomas Child,limner

In:Mag Art
21:326-8 June,'30 illus(Gov.Sir Wm.Phips)

B
C48A7

I.B.2 - CHASE, WILLIAM MERRITT, 1849-1916

Art Association of Indianapolis,Indiana. John
Herron Art Institute
 Chase centennial exh.,commemorating the
birth of William Merritt Chase,Nov.1,1849. Nov.1
to Dec.11,1949.Indianapolis,1949,
 83 p. illus.

 Introd.by Wilbur D.Peat

 Incl.:Check list of known work by William
M.Chase.Chapters on portraits.

LC ND237.C48A72

I.B.2 - CHINNERY, GEORGE, 1774-1852

Arts Council of Great Britain. Scottish Commit-
 tee
 George Chinnery,1774-1852...London,1957.

N.Y.P.L. MAR p.v.1451
M1DA FOR COMPLETE ENTRY
 SEE)

N
40.1
C48A3
NPG
2 c.

I.B.2 - CHASE, WILLIAM MERRITT, 1849-1916

Chase, William Merritt, 1849-1916
 William Merritt Chase:portraits.Akron Art
Museum.Akron,Ohio,The Museum,c.1982
 48 p. illus(part col.)

 Cat. of an exh. held June 5-Aug.29,1982,by
Carolyn Kinder Carr

 Bibliography

705
A7875
NCFA
v.16

I.B.2 - CHINNERY, GEORGE, 1774-1852

Gardner, Albert Ten Eyck
 Cantonese Chinnerys:Portraits of Hou-qua
and other China Trade paintings

In:Art Q
16:305-24 Winter,1953 illus.

 Peabody Mus.of Salem,Mass.
 o.Chinnery...N40.1.C53P3
 FA Bibl.p.XII

151

N
40.1
C53116
NPG

I.B.2 - CHINNERY, GEORGE, 1774-1852

Hill, Henry D., 1899-
George Chinnery,1774-1852,artist of the
China coast,by Henry & Sidney Berry-Hill,with
foreword by Alice Winchester.Leigh-on-Sea,F.
Lewis,1963.
63 p. illus.

Bibliography

Archer.India & Brit.por-
traiture.ND1327.I44A72X NPG
Bibl.p.477

705
C75
NCFA
v.54

I.B.2 - CHINNERY, GEORGE, 1774-1852

Sée, Robert René Meyer
Gouaches by George Chinnery

In:Connoisseur
54:141-51 July,'19 illus(part col.)

N
40.1
C53H9
NCFA

I.B.2 - CHINNERY, GEORGE, 1774-1852

Hutcheon, Robin
Chinnery, the man and the legend....Hong-
kong.South China Morning Post,1975
180 p. illus(part col.)

Incl.chapter on Lamqua(real name Kwan Kiu-
chin)

I.B.2 - CHINNERY, GEORGE, 1774-1852

Tate Gallery, London
Loan exh.of works by George Chinnery,R.H.A.
1774-1852. 1932

MET
107.2
T12
Pamphlet
Box no.3d

V & A

Peabody Mus.of Salem,Mass.
Geo.Chinnery...N40.1C53P3
NCFA Bibl. p.XVII

705
I61
NCFA
v.72

I.B.2 - CHINNERY, GEORGE, 1774-1852

Orange, James
The life and work of George Chinnery in
China

In:Studio
72:81-92 Nov.,'20 illus(part col.)

FOR COMPLETE ENTRY
SEE MAIN CARD

I.B.2 - CHODOWIECKI, DANIEL NIKOLAUS, 1726-1801

Selbstbildnisse 1752-1962 von Chodowiecki bis
zur gegenwart.Ausst.des Kupferstichkabi-
netts der Staatl.Museen zu Berlin,Okt.-
Des.1962..Kat.hrsg.von den Staatl.Mus.zu
Berlin,c.1962.
55 p. illus.

Bibliography

Intro.by Werner Timm

CLU CSfST

Netuschil.Künstler unter
sich...N7619.5.G3X86 1983X
NMAA.Literatur p.136

AP
1
W225
NCFA
v.44

I.B.2 - CHINNERY, GEORGE, 1774-1852

Ormond, Richard
Chinnery and his pupil,Mrs.Browne

In:Walpole Soc.
44:123-214 1972-1974 illus.

'...the letters are very largely concerned
with the practice of miniature ptg...'p.126

Hutcheon.Chinnery...N40.1
C53H9 NCFA Bibl.p.173

I.B.2 - CHRÉTIEN, GILLES LOUIS, 1754-1811

Hennequin, René
Avant les photographies;les portraits au
physionotrace,gravés de 1788 à 1830.Cat.nomina-
tif,biographique et critique illustré des deux
premières séries de ses portraits comprenant les
1800 estampes cotées de "1"à"R27".Troyes,J.L.
Paton,1932
345 p. illus.
Contents.-La société parisienne à la veille
de la Révolution;portrs.dess.par Quenedey et gra-
vés par Chrétien,1788-1789.-Au temps de la Révo-
lution ...portrs.dess et gravés par Quenedey,
1789-1796
LC NE270 .H4

705
C75
NCFA
v.167

I.B.2 - CHINNERY, GEORGE, 1774-1852

Ormond, Richard
George Chinnery's image of himself

In:Connoisseur
167:89-93 Feb.,'68 illus.
 160-4 Mar.,'68 illus.

FOR COMPLETE ENTRY
SEE MAIN CARD

705
C75
NCFA
v.74

I.B.2 - CHRÉTIEN, GILLES LOUIS, 1754-1811

Martin, Mary
The Physionotrace in France and America

In:Connoisseur
74:144-52 Mar,'26 illus.

Repro. incl.:apparatus for making physiono-
trace from a drawing

G.L.Chrétien invented the physionotrace,1786
F.Quenedey-assistant of Chrétien
Physionotrace portrs.most valuable historical
records

VF
Christy

I.B.2 - CHRISTY, MARGARET ARLINGTON(MARNA PRIOR)

Christy, Margaret Arlington(Marna Prior)
Quest for centenarians.Publ.by Christy,
Norwalk,Ohio,1982
128 p. illus.

Dayton,O. Dayton &
Montgomery P.L.

Plain Dealer(Cleveland,O.)
Dec.4,'83,p﹖,31,35

N
40.1
C628
W18
NCFA

I.B.2 - CLOSE, CHUCK, 1940-

Close, Chuck, 1940-
Close portraits.Walker Art Center,Minnea-
polis,exh..edited.by Lisa Lyons and Martin
Friedman.Minneapolis, The Center,c.1980.
80 p. illus(part col.)

Checklist inserted
Bibliography

LC N6537.C54A4

Worldwide Art Cat.Bul.
705.W527 HMAA v.17no.2 1981
p.53

I.B.2 - CLAYPOOLE, JAMES, 1720-1796

Sellers, Charles Coleman, 1903 -
James Claypoole:* Founder of the art of
painting in Pennsylvania

In:Penn.History
17:106-9 'pr.,'50

LC F146.P597

Hart,Pat.Wright.In:Conn.
19:18 footnote:Js.Claypool
"face painter"

705
A7834
NCFA
v.52

I.B.2 - CLOSE, CHUCK, 1940-

Levin, Kim
Chuck Close:decoding the image

In:Arts
52:146-9 June,1978 illus(part col.)

AP
1
S72
NPG

I.B.2 - CLEMENT, AUGUSTINE, ca.1600-ca.1671

Gold, Sidney M.
A study in early Boston portrait attribu-
tion. Augustine Clement,painter-stainer of
Reading,Berkshire,and Massachusetts Bay
In:Old Time NE
58,no.3:61-78 Winter,'68 illus.

Green,S.M. Engl.origins of
N.E.ptg.In:Winterthur Conf.
ND207/W78/1971,p.60

I.B.2 - CLOSTERMAN, JOHANN BAPTIST, 1660-1711

Rogers, Malcolm
John Closterman:master of the English
Baroque,1660-1711.cat.of the exh.at NPG,London
July 24 to Oct.4,1981..London,Nat'l Portrait
Gallery,c.1981
20 p. illus.

N.Y.P.L.
3-MCV
C645
82-783

AP
1
S72
NPG

I.B.2 - CLEMENT, SAMUEL, 1635-1678

Gold, Sidney M.
A study in early Boston portrait attribu-
tion. Augustine Clement,painter-stainer of
Reading,Berkshire,and Massachusetts Bay
In:Old Time NE
58,no.3:61-78 Winter,'68 illus.

Green,S.M. Engl.origins of
N.E.ptg.In:Winterthur Conf.
ND207/W78/1971,p.60

I.B.2 - CLOUET, JEAN & FRANÇOIS

Adler, Irene
Die Clouet. Versuch einer Stilkritik

In:Jahr.Kunsthist.Samm.Wien
N.F.3:201-46 1929 illus.

16th c. portr. in France

Catalogue of drgs.,ptgs.,and miniatures by
Jean Clouet and François Clouet

LC N3.J4?

Rep.,1929=1711

I.B.2 - CLORIVIÈRE
see
I.B.2 - PICOT DE LIMOELAN DE CLORIVIÈRE,
JOSEPH-PIERRE, 1768-1826

I.B.2 - CLOUET, JEAN & FRANÇOIS

Bouchot, Henri François Xavier Marie, 1849-1906
Les Clouet et Corneille de Lyon,d'après des
documents inédits...Paris,Librairie de l'Art,
c1892,
62 p. illus. (Les artistes célèbres,v.44)

Bibliography

Contains repro.fr.miniatures,drags,etc.

LC ND553.C7B7

Heath.Miniatures.ND1330H43
CFA Publ.p.XXXV

705
G28
NCFA
v.77

I.B.2 - CLOUET, JEAN & FRANÇOIS

Broglie, Raoul de
 Les Clouet de Chantilly;Catalogue illustré
(coll.de Catherine de Médicis)

In:Gaz Beaux Arts
77:257-336 May,1971 illus.

 Bibliogr.footnotes

 Cat.classified according to costume
 Alphabetical list of sitters
 Adhémar.Gaz Beaux Arts
 Sept.&Déc,1973

I.B.2 - CLOUET, JEAN & FRANÇOIS

Paris, Bibliothèque Nationale
 Les Clouet et la cour des rois de France,
de François I er à Henri IV.Paris,1970
96 p. illus.

 Les notices...rédigées par M.Jean Adhémar

LC DC36.6P35

I.B.2 - CLOUET, JEAN & FRANÇOIS

Gower, Ronald Charles Sutherland, 1845-1916
 Three hundred French portraits representing
personages of the courts of Francis I,Henry II &
Franais II by Clouet.Auto-lithographed from the
originals at Castle Howard,Yorkshire.London,
S.Low,Marston & Searle,Paris,Hachette & cie.,
1875
 2 v. illus.

LC N7604.C6 Amsterdam,Rijksmus.cat.
 Z5939A52,deel 1, p.509

759.4
W67

I.B.2 - CLOUET, JEAN & FRANÇOIS

Wilenski, Reginald Howard, 1887-
 French Renaissance portraits

In:his.French painting.Boston,Hale,Cushman &
Flint,inc.,1931.

 pp.32-4 illus(part col.)
 The portrait albums.The Clouets and Cor-
nelle de Lyons

LC ND541.W5

I.B.2 - CLOUET, JEAN & FRANÇOIS

Laborde, Léon Emmanuel Simon Joseph de, 1807-
 La Renaissance des Arts à la cour .1869
de France.Paris,1850
 152 p.

 "Les trois Clouet.s.,p.1-152

 'Tries to substantiate the tradit'l hist.of
French portraiture,incl.the role .of.the Clouet
-Risatti

FOGG
728
L11(?)

 Risatti.A French court ptr.
 AP 1 K86.v-II,no.1,'76
 Footnote 15

I.B.2 - CLOVIO, GIORGIO GIULIO, 1498-1578

Bradley, John William, 1830-1916
 The life and work of Giorgio Giulio Clovio,
miniaturist,with notices of his contemporaries..
London, B.Quaritch,1891
 400 p. illus.

 A list of C.'s work by Vasari,p.343-9;of
works attr. to C.,p.350-9;Engravings on copper
fr.pictures by C.,p.359-68

 '...excellent portrs.of his patrons...ear-
liest examples of real portr.miniatures in Ita-
lian illumination ..a skilled portr.ptr.'-
LC ND1137.I7C6 Heath,p.49 ath.Miniatures.
 NCFA Bibl.p.xxv

I.B.2 - CLOUET, JEAN & FRANÇOIS

Mandach, L.de
 Les Clouet et quelques portraits de Huguenots
refugiés en Suisse

In:Pro Arte
:129-34 1947 illus.

 Jacqueline de Rohan,Marquise de Rothelin,
M.de Luxembourg-Martigues,Françoise d'Orléans,
Princesse de Condé,Louise de Coligny

LC N8.P75 Rep.,1945-47=1050

I.B.2 - COCK, HIERONYMUS, 1510?-1570

Lampsonius, Dominique, 1532-1599
 Pictorvm Aliqvot celebrivm Germaniae Inferi-
oris Effigies...Anverpiae,Apud Viduam Hieronymus
Cock,1572

 23 full-page portrs.of artists north of Alps
Engravings by J.Wierix,C.Cort & probably H.Cock

 Facsimile ed.,Liége,J.Puraye,1956

 "Important source for Carel van Manders
Schilderboek"-Rave
 Rave.Jb.d.Berl.Mus. I 1959
NN LC N3.J16 fol. p.148
 Paolo Giovio & d.Bildnisvi
 tenbücher d.Humanismus

I.B.2 - CLOUET, JEAN & FRANÇOIS

Moreau-Nélaton, Étienne,1859-1927
 Les Clouet et leurs émules. Paris,H.Laurens,
1924

 3 v. illus.

 Bibliography in v.1

 Paintings and drawings

LC ND553.C7M6

705
A5
NCFA
v.15

I.B.2 - COFFEE, WILLIAM JOHN, c.1774-1846

Groce, George Cuthbert, 1859-
 William John Coffee,long-lost sculptor

In:Am Coll
15:14-5,19,20 May,'46 illus.

 Repro.incl.:Terra-cotta bust,1824;Dr.Hugh
Williamson,plaster,before 1816;"So far as is
known,this is the earliest extant bust of an
American sculptured...in the U.S.";Pierre van
Cortlandt
 Coffee made bust of Ths.Jefferson,his
daughter & grand- daughter

I.B.2 - COFFEE, WILLIAM JOHN, c.1774-1846

AP
1
J8643
NYAA Rauschenberg, Bradford L.
v.4 William John Coffee, sculptor-painter: His Sou-
 thern experience

 In: J.Early So.dec.arts
 4,no.2:26-48 Nov.,'78 illus.

705
A7875
v.18 I.B.2 - COOPER, J.OHN, c.1695-c.1754

 Groce, George Cuthbert, 1899-
 Who was J.ohn?..Cooper(b.ca.1695-living
 1754?)

 In: Art Q
 18:73-82 Spring '55 illus.

 References
 Checklist (oil ptgs.by or ascribed to J.
 Cooper)

705
G28
NCFA I.B.2 - COFFEE, WILLIAM JOHN, c.1774-1846
v.28
 Rutledge, Anna Wells
 William John Coffee as a portrait sculptor

 In: Gaz.Beaux-Arts
 28:297-312 Nov.,'45 illus.

 Repro.incl.Bust of Jefferson

 I.B.2 - COOPER, ROBERT, fl.1800-1836

 Cooper, Robert, fl.1800-1836
 Fifty wonderful portraits.Engraved by R.
 Cooper and R.Page,from authentic originals.
 London,J.Robins & co.,1824
Winterthur
NE330 8 p. plates
.77

.H NW Winterthur Mus.Libr.
 Z881.W78 NCFA v.1 p.225

 I.B.2 - COGNIET, LÉON, 1794-1880

 Paris. Bibliothèque Nationale. Département
 des estampes-Cogniet collection
 Album of 220 drawings,collected by Léon
 Cogniet,donated to the dpt.byMoreau-Mélaton.
 Unpublished

 The album is almost entirely made up of
 portraits,caricatures & studies of artists at
 work,rest or play

 For this album see:Stein,J.C.:The image of
 the artist in France...Around 1800. ND1316.S
 819.1982a NPG p.224f.

qN
40.1
C769F7s I.B.2 - COOPER, SAMUEL, 1609-1672
NPG
 Foskett, Daphne
 Samuel Cooper and his contemporaries.Lon-
 don,H.M.Stationery Off....1974
 140 p. illus(part col.)
 Cat.of exh.held at the NPG,London,15 March
 30 May,1974
 Incl.List of sitters;biogr.sketch by D.F.
 S.C.:an Engl.baroque'man for his century',by
 J.Douglas Stewart;C.'s ptg.technique by V.J.
 Murrell;Fashion, by Diana de Marly
 For list of chapters see over

 Yale ctr.f.Brit.art Ref.

.5
A784
NCFA I.B.2 - COLE, JOSEPH GREENLEAF, 1806-1858
v.38
 Frankenstein, Alfred Victor, 1906 and Arthur K.
also: D.Healy
N40.1 Two journeyman painters
M39F8
NPG In: Art in Am.
NCFA 38:7-63 Feb.,'50 illus.

 Benjamin Franklin Mason,Vermonter,p.7-43
 Abraham G.D.Tuthill,p.47-63

 Bibliography
 Chronological list of known portrs.
 J.G.Cole,teach er of Mason,see p.10-11,13

 I.B.2 - COOPER, SAMUEL, 1609-1672

 Foster, Joshua James, 1847-1923
 Samuel Cooper and the English miniature pain-
 ters of the 17th c. London,Dickinsons,1914-16

 .96.p. illus.
 .v.2.alphabetical list of works of English
 min.ptrs.of 17th c. 181 p.

 Illustrated by over 200 examples from the
 most celebrated collections.

 LC ND1337.G7F5

705
A56
NCFA I.B.2 - COOKE(COOK), GEORGE, 1793-1849
v.102
 Banks, William Nathaniel
 George Cooke,painter of the American scene

 In: Antiques
 102:448-54 Sept.,'72 illus(part col.)

 Portraiture was always the mainstay of C.
 Repro.incl.:Mrs.Rbt.Donaldson,Mrs.Mann S.
 Valentine & children,Henry Clay,Mrs.Daniel
 Pratt,daughter & nurse,Kish-ke-kosh/A Fox Brave

 Arts in America qZ5961.U5
 A77X NCFA Ref. I625

705
B97
NCFA I.B.2 - COOPER, SAMUEL, 1609-1672
v.9
 Holmes, Richard R.
 The English miniature painters illustrated
 by works in the Royal & other collections. Ar-
 ticle V & VI. Samuel Cooper,Pt.I,Pt.II

 In: Burl Mag
 9:254,296-303 Aug,'06 illus.
 9:366-75 Sep,'06 illus.

705
C75
NCFA
v.147

I.B.2 - COOPER, SAMUEL, 1609-1672

Reynolds, Graham, 1914-
Samuel Cooper: some hallmarks of his ability

In:Connoisseur
147:17-21 March, '61 illus.

Murdoch.Engl.miniatures.
ND1202.67E5X NMAA Abbreviations.

705
C75
NCFA
v.109

I.B.2 - COPLEY, JOHN SINGLETON, 1737-1815

Comstock, Helen
Drawings by J.S.Copley in the Karolik collection

In:Connoisseur
109:150-5 June,'42 illus.

FOR COMPLETE ENTRY
SEE MAIN CARD

I.B.2 - COOPER, SAMUEL, 1609-1672

Reynolds, Graham, 1914-
Samuel Cooper's pocket-book...London,Victoria and Albert Museum,1975
21 p. illus. (Victoria and Albert Mus. brochure 8)

Bibl.references

LC ND1337.G8C667

705
P18
NCFA

I.B.2 - COPLEY, JOHN SINGLETON, 1737-1815

Comstock, Helen
Drawings by John Singleton Copley

In:Panorama
2:99-108 May,1947 illus.

Exh.at N.Y.,Harry Shaw Newman Gall.,May,'47

FOR COMPLETE ENTRY
SEE MAIN CARD

705
A56
NCFA
v.100

I.B.2 - COOPER, WASHINGTON BOGART, 1802-1889

Bishop, Budd H.,arris,,c1936- .
Three Tennessee painters:Samuel M.Shaver, Washington B.Cooper, and James Cameron

In:Antiques
100:432-7 Sept.,'71 illus.

N
40.1
C78H6
NPG
2 c.

I.B.2 - COPLEY, JOHN SINGLETON, 1737-1815

Copley, John Singleton,1737-1815
American portraits by John Singleton Copley; an exh.organized for the benefit of the Skowhegan School of Painting & Sculpture,Dec-3,1975-Jan.3,1976.N.Y.,Hirschl & Adler Galleries,1975
c57,p illus(part col.)

Intro.by Stuart P.Feld

QND
1328
B35
NCFA

I.B.2 - COPLEY, JOHN SINGLETON, 1737-1815

Bayley, Frank William, 1863-1932
Five colonial artists of New England:Joseph Badger,Joseph Blackburn,John Singleton Copley, Robert Feke,John Smibert...Boston,Priv.print,1929
448 p. illus.

Bibliography

LC N6536.B3

705
A784
NCFA
v.30

I.B.2 - COPLEY, JOHN SINGLETON, 1737-1815

Cunningham, C.harles. C.rehore.
The Karolik collection-some notes on Copley

In:Art In Amer
30:26,29,30,33-5 Jan.,'42 illus.

Discussion incl.C.'s "borrowing"of composition,pose,costume from British portrs.

Fairbrother in:Arts Mag.
705.A7834 NCFA 55:129

40.1
C78B3
PG

I.B.2 - COPLEY, JOHN SINGLETON, 1737-1815

Bayley, Frank William, 1863-1932
The life and works of John Singleton Copley, founded on the work of Augustus Thorndike Perkins...Boston,The Taylor press,1915
285 p. illus.

LC ND237.C7B3

Whitehill.The Arts of early Amer.Hist.Z5935.W59 NPG Bibl.,p.88

705
A7834
NMAA
v.55

I.B.2 - COPLEY, JOHN SINGLETON, 1737-1815

Fairbrother, Trevor J.
John Singleton Copley's use of British mezzotints for his American portraits:A reappraisal prompted by new discoveries

In:Arts Mag
55:122-30 March,'81 illus.

I.B.2 - COPLEY, JOHN SINGLETON, 1737-1815

.C78F6

Flexner, James Thomas, 1908-
 John Singleton Copley. Boston, Houghton
Mifflin Co., 1948
139 p. illus.

 Revised & enlarged version of the biography
of Copley originally published...as part of
the author's....America's old masters.

 Bibliography

LC ND237.C7F6 Whitehill. The Arts of ear-
 ly Amer.Hist.Z5935.W59 NPG
 Bibl.,p.88

I.B.2 - COPLEY, JOHN SINGLETON, 1737-1815

Schwartz, Marvin David, 1926-
 The meaning of portraits:John Singleton
Copley's American portraits and 18th century
Art theory.1954
69 p. illus.

 Master's Th.-Univ.Del.,1954

 Winterthur Mus.Libr.f2881
 W78 NCF v.9,p.226

AP
1
P45
v.1
NPG

I.B.2 - COPLEY, JOHN SINGLETON, 1737-1815

Harris, Neil
 The persistence of portraiture

In:Perspectives in Am.Hist.
1:380-9 1967

 Review of The Landscapes of Fred.Edwin Church
by David C.Huntington. The Life and works of
Thomas Cole,by Louis Legrand Noble. John Singleton
Copley,by Jules David Prown

N40.1
C78P9
NPG

7C5
A7P4
NCFA
v.23

I.B.2 - COPLEY, JOHN SINGLETON, 1737-1815

Sherman, Frederic Fairchild, 1874-1940
 Recently recovered miniatures by John
Singleton Copley

In:Art in Am
23:34-8 Dec.,'34 illus.

 C.'s miniatures date from 1755-1790

N
40.1
C78P2
NCFA
NPG

I.B.2 - COPLEY, JOHN SINGLETON, 1737-1815

Parker, Barbara Neville
 John Singleton Copley;American portraits in
oil,pastel,and miniature,with biographical
sketches by Barbara Neville Parker and Anne
Bolling Wheeler.Boston,Mass.,Museum of fine
arts,1938
 284 p. illus.

LC ND237.C7P3 Whitehill.The Arts of ear-
 ly Amer.Hist.Z5935.W59 NPG
 Bibl.,p.89

N
40.1
C78U5
NCFA
NPG

I.B.2 - COPLEY, JOHN SINGLETON, 1737-1815

U.S. National Gallery of Art
 John Singleton Copley,1738-1815;....exh....
Washington,1965.

LC ND237.C7U5 FOR COMPLETE ENTRY
 SEE MAIN CARD

N
40.1
C78P4
NPG

I.B.2 - COPLEY, JOHN SINGLETON, 1737-1815

Perkins, Augustus Thorndike, 1827-1891
 A sketch of the life and a list of some
of the works of John Singleton Copley.Boston,
J.R.Osgood,1873
 144 p.

 Supplement, 15 p. at end

LC ND237.C7P4 Whitehill.The Arts of ear-
 ly Amer.Hist.Z5935.W59 NPG
 Bibl.,p.89

N
40.1
C813P3
NCFA

I.B.2 - CORNÈ, MICHELE FELICE, 1752-1845

Cornè, Michele Felice, 1752-1845
 Michele Felice Cornè,1752-1845,versatile
Neapolitan painter of Salem,Boston,and Newport.
Introd.by Nina Fletcher Little.Salem,Mass.,
Peabody Mus.of Salem,1972
 44 p. illus(part col.)

 Cat.of summer exh.,1972,Peabody Mus.of Salem

 Ch.'Portraits'p.21-33

LC ND623.C6977P42 Simmons.Jac.Frymire N40.1
 .F95S5 NPG Notes,p.54

N
40.1
C78P9
NPG
Ref

I.B.2 - COPLEY, JOHN SINGLETON, 1737-1815

Prown, Jules David
 John Singleton Copley.Cambridge,Mass...
Harvard Uni.Press,1966
 2 v. illus. (The Ailsa Mellon Bruce
studies in American Art,1)

 v.1:In America,1738-1774.-v.2:In England,
1774-1815

 Bibliography

 NPG A 19th c.gall of distin
 guished Americans. Bibl.
LC ND237.C7P7

I.B.2 - CORNÈ, MICHEL FELICE, 1752-1845

Merney, Helen
 An Italian painter comes to Rhode Island

In:Rh.Isl.Hist.
1:65-71 July,'42

 Article on M.F.Cornè

LC F76.R472

I.B.2 - CORNEILLE DE LYON, died ca.1574

Beuchot, Henri François Xavier Marie, 1845-1906
Les Clouet et Corneille de Lyon,d'après des documents inédits...Paris,Librairie de l'Art, ₁892.
62 p. illus. (Les artistes célèbres,v.44)

Bibliography

Contains repro.fr.miniatures,dr₁gs,etc.

LC ND553.C7B7

Heath.Miniatures.ND1330H43
CFA Bibl.p.XXLV

ND
1311.?
P61x
NPG

I.B.2 - CORWINE, AARON HOUGHTON, 1802-1830
Dwight, Edward H.
Aaron Houghton Corwine:Cincinnati artist
Miles, Ellen Gross comp.
Portrait painting in America.The nineteenth century.N.Y....,1977 (card 2)

Partial contents:...E.H.Dwight,Aaron Houghton Corwine:Cincinnati artist,p.59-61;...

I.B.2 - CORNEILLE DE LYON, died ca.1574

Epitomes des roys de France en latin & en francoys auec leur vrayes figures...Lvgdvni.-Lyo. Balthasar Arnoullet,1546
159 p. illus.
2nd issue.lst issue entitled:Epitome gestorv: lVIII.regvm Franciae,1546

58 portrs,attr. to Corneille de Lyon,from leg.king Pharamond to Francis I

LC Typ 515
46.366 MH Rave.Jb.d.Berl.Mus.I 1959
LC N3.J16 fol. p.138
Paolo Giovio & d.Bildnisvitenbücher....

B
.C84W7

I.B.2 - COSWAY, Mrs.MARIA LOUISA CATHERINE CECI- LIA CHADFIELD, 1759-1838

Williamson, George Charles, 1858-1942
Richard Cosway and his wife...London,G.Bell & sons,1897

LC ND1337.C8C8 FOR COMPLETE ENTRY SEE MAIN CARD

759.4
W67

I.B.2 - CORNEILLE DE LYON, died ca.1574

Wilenski, Reginald Howard, 1887-
French Renaissance portraits

In₌his₌French painting.Boston,Hale,Cushman & Flint,inc.₌1931₌

pp.32-4 illus(part col.)
The portrait albums.The Clouets and Corneille de Lyons

LC ND541.W5

I.B.2 - COSWAY, RICHARD, 1740-1821

Joseph, Edward
Cat.of a coll.of miniatures by Richard Cosway....₌London?₌1883

LC ND1337.C8C75 FOR COMPLETE ENTRY SEE MAIN CARD

I.B.2 - CORNER, JOHN, fl.1788-1825

Corner, John,fl.1788-1825
Portraits of celebrated painters,with medallions from their best performances,engraved by J.Corner,with authentic memoirs from established authorities.London,Longman,Hurst,etc.,1825
₌52₌p. illus.

Published also anonymously,under title: Portrs.& lives of eminent artists...London, ₌182-?₌
Contents:v.Dyck-Poussin-Both-Castelfranco-
Lanfranco-Snyders-Titian-Domenichino-da Cortona-

LC ND85.C75 ARS ARTIS cat.41 Books on Prints & drags. no.667

B
.C84W7

I.B.2 - COSWAY, RICHARD, 1740-1821

Williamson, George Charles, 1859-1942
Richard Cosway...London,G.Bell & sons,1897

LC ND1337.C8C8 FOR COMPLETE ENTRY SEE MAIN CARD

I.B.2 - CORT, CORNELIS, 1533-1578

Lampsonius, Dominique, 1532-1599
Pictorvm Aliqvot celebrivm Germaniae Inferioris Effigies...Anverpiae,Apud Viduam Hieronymu: Cock,1572

23 full-page portrs.of artists north of Alps Engravings by J.Wierix,C.Cort & probably H.Cock

Facsimile ed.,Liége,J.Puraye,1956

"Important source for Carel van Manders Schilderboek"-Rave

NN Rave.Jb.d.Berl.Mus. I 1959
LC N3.J16 fol. p.148
Paolo Giovio & d.Bildnisvi
tenbücher d.Humanismus

705
A784
NCFA
v.20

I.B.2 - COTES, FRANCIS, 1726-1770

Heil, Walter, 1890-
Portraits by Francis Cotes

In:Art in Am.
20:2-12 Dec.,'31 illus.

Johnson,E.M. Francis Cotes
qN40.1.C84J6 NPG Bibl.

QN
40.1
C84J6
NPG
I.B.2 - COTES, FRANCIS, 1726-1770

Johnson, Edward Mead
Francis Cotes...complete ed..with critical
essay and catalogue.Oxford,Phaidon,1976
178 p. illus(part col.)

Originally presented as the author's thesis,
Stanford

Bibliography

LC:
ND1329.C68J64

N
40.1
C847C8
NMAA
I.B.2 - COUPER, WILLIAM, 1853-1942

Couper, Greta Elena
An American sculptor on the grand tour:the
life and works of William Couper(1853-1942).
Los Angeles,TreCavalli Press,c.1988
147 p. illus.

Index
Ch.on portraiture,p.80-4

Medallions,busts,statues,reliefs

LC NB237.C64C68 1988

705
A56
NCFA
v.19
I.B.2 - COTES, FRANCIS, 1726-1770

Keyes, Homer Eaton, 1875-
The rising of Francis Cotes

In:Antiques
19:217-20 Mar.,'31 illus.

Johnson, E.M. Francis
Cotes.qN40.1.C84J6 NPG Bibl

N
40.1
C85L5
NCFA
I.B.2 - COURBET, GUSTAVE, 1819-1877

Lemoyne de Forges, Marie Thérèse
Autoportraits de Courbet.Cat.rédigé par
Marie-Thérèse de Forges.Etude au Laboratoire de
recherche des musées de France par Suzy Del-
bourgo et Lola Faillant.Paris,Editions des Mu-
sées nationaux,1973
59 p. illus. (Dossiers du Departement d
des peintures,6)
Bibliography

Holsten N7618.H75 NPG
Bibl.p.119

705
C75
NCFA
v.88
I.B.2 - COTES, Francis, 1726-1770

Winter, Carl, 1906-1966
Francis Cotes

In:Connoisseur
88:170-7 Sept.,'31 illus.
244-52 Oct.,'31 illus.

Johnson,E.M. Francis Cotes
qN40.1.C84J6 NPG Bibl.

I.B.2 - COUSIN,JEAN, THE YOUNGER, c.1522-c.1594

Cousin, Jean, the younger, c.1522-c.1594
Livre de Pourtraicture....Paris.,1560

Woodcuts by author

Oxford
Uni.Bod- Later eds.called:La vraye Science de la
leian Pourtraicture
libr.

LC has several later eds. Rave.Jb.d.Berl.Mus.I 1959
 LC N3.J16 fol. p.141
 Paolo Giovio & d.Bildnisvitenbüche...

I.B.2 - COULIN, ARTHUR, 1869-1912

Fertalan, Karin
Catalogul expozitiei commemorative Arthur
Coulin.Museul Brukenthal,Sibiu,1969

Museul Brukenthal Sibiu
Cat.Patrimonial ND921.M8
1983X NMAA Bibl.p-e7,

I.B.2 - COUSIN, JEAN, THE YOUNGER, c.1522-c.1594

Les effigies des Roys de France,tant antiques
que modernes...Paris.François Des Prez,1565?

62 woodcuts by Jean Cousin,the younger,all
waist-length

NN Rave.Jb.d.Berl.Mus.I 1959
 LC N3.J16 fol. p.141
 Paolo Giovio & d.Bildnisvitenbücher..

I.B.2 - COULIN, ARTHUR, 1869-1912

Krasser, Harald
Arthur Coulin.Bucaresti,editura Meridiane,
1970
39 p. illus(part col.)

Also in German

Museul Brukenthal Sibiu
Cat.patrimonial ND921.M8
1983X NMAA Bibl.p..7.

I.B.2 - COUSIN, JEAN, THE YOUNGER, c.1522-c.1594

Espinosa de los Monteros, Thomas de
Heroicos hechos y vidas de varones yllustres
asy Griegos,como Romanos...Paris,Por Françisco
de Prado,1576
52 f. portrs.

52 heroes since Theseus,probably by Jean
Cousin,the younger

NN NNH Rave.Jb.d.Berl.Mus. I 1959
 LC N3.J16 fol. p.141
 Paolo Giovio & d.Bildnisvitenbücher..

I.B.2 - COUSINS, SAMUEL, 1801-1887

Whitman, Alfred, 1860-1910
...Samuel Cousins...London,G.Bell & sons,1908
143 p. illus. (Nineteenth century rez-
sotinters)

Incl.Cat.of portrs.-Appendix...Cat.of the
plates after Sir Joshua Reynolds...

LC NE642.C8W6
 Levis.Descr.bibl.Z5947.A?
 L66 1974 NCFA p.132

40.1
C872?.B
NPG

I.P.2 - COX, GARDNER, 1906-1988

Loss, Bernice
 Lawyers painted by Gardner Cox.Cambridge,
Mass.,Harvard Law Library,1984
 43 p. illus.

705
A786
NCFA
v.24

I.B.2 - COVARRUBIAS, MIGUEL, 1904-1957

Caricatures by Covarrubias:exh.at Dudensing
 Galleries,N.Y.:"The Prince of Wales and
 other famous Americans"

In:Art N
24,no.9:3 Dec.5,'25

 Exh.incl.caricatures of Pres.Coolidge,Otto
Kahn,Mary Pickford,Rud.Valentino,Heywood Broun,
Alfred Stieglitz,Theod.Dreiser,I.Stravinsky

(see also Parnassus,v.2:17,Ap.'30)
(Biography in Am.Artist,v.12:21-4,Jan,'48)

705
C75
NCFA
v.64

I.B.2 - CRANKE, JAMES, the elder, 1707-1780

Dibdin, Edward Rimbault, 1853-1941
 James Cranke,the elder:A forgotten Lancas-
ter painter

In:Conn.
64:199-208 Dec,'22 illus.

 Incl.:Preliminary list of Cranke's portrs.

NPG
1984
Ref.

I.B.2 - COVARRUBIAS, MIGUEL, 1904-1957

Cox, Beverly J.
 Miguel Covarrubias caricatures,by,B.J.Cox
and Denna Jones Anderson.Cat. of an exh.,held
at the NPG,Washington,D.C.,Nov.16,1984 to Jan.
13,1985.Publ.for the NPG by the Smiths.Inst.
Press,1985
 163 p. illus(part col.)
 Incl.:Index

bibliography
Foreword by Alan Fern.Incl.essays by ?1
Hirschfeld & by Bernard C.Reilly,jr.

LC NC1460.C68A4 1984

MET
171.1C86
M85

I.B.2 - CREMER, FRITZ, 1906-

Moscow. Gosudarstvennyĭ muzeĭ izobrazitel'nykh
 iskusstv.
 Fritz Cremer;catalogue of sculpture und
graphic art.1965
 .24.p. illus.

 Cat.in Russian

N
40.1
C867K6a
1971a
NPAA

I.B.2 - COVERT, JOHN, 1882-1960

Klein, Michael ,Eugene,,1940-
 The art of John Covert...N.Y.s.n.,1971,
c.1974
 346 p. illus.

Bibliography,p.222-228

Thesis Ph.D.-Columbia Univ.,1971
Photocopy of typescript

I.B.2 - CREMER, FRITZ, 1906-

Prague. Národní galerie
 Fritz Cremer,projekty,studie,výsledky,
dub.-kvet.,Cat.by Christine Hoffmeister.1978
 56 p. illus.

 Bibliography,p.34-54

LC N6888.C74A4

N
40.1
C868C16
NPAA

I.B.2 - COWIE, JAMES, 1886-1956

Cowie, James, 1886-1956
 James Cowie,by,Richard Calvocoressi.Edin-
burgh,Scottish National Gallery of Modern Art,
1979
 64 p. illus. (National Galleries of
Scotland,Scottish ptg.1)

N
40.1
C932T2
NCFA

I.B.2 - CRISTALL, JOSHUA, 1768-1847

Taylor, Basil
 Joshua Cristall,1768-1847,cat.of an.exh.,
Feb.-Apr.,1975...London,Victoria and Albert Mus.
1975
 126 p. illus(part col.)

 Bibliography

 Ch.on portrs.,p.120-2(cat.nos.286-9)

 Noon.Engl.portr.drags.&min.
 NC860.N66X NPG Bibl.p.148

I.B.2 - CRITZ, JOHN DE see
I.B.2 - DE CRITZ, JOHN I, ca.1555-ca.1641

705
B97
NCFA
v.121

I.B.2 - CROSS, PETER, ca.1645-1724

Edmond, Mary
 Peter Cross limner, died 1724

In:Burl Mag
121:585-6 Sep.'79

 Bibliography

 E.establishes that there was no 'Lawrence
Cross.e., English miniaturist, but only 'Peter'

I.B.2 - CROQUIS, ALFRED
 see
I.B.2 - MACLISE, DANIEL, 1806-1870

705
B97
NCFA
v.120

I.B.2 - CROSS, PETER, ca.1645-1724

Murdoch, John, 1945-
 Hoskins' and Crosses:Work in progress

In:Burl Mag
120:284-90 May,'78 illus.

 Info.on miniatures with monograms of John
Hoskin & PC & LC of Peter & Lawrence Cross.e...
Proposes the Hoskins oeuvre should be devided
betw.the elder John H.& the younger & contribu-
tions fr.studio works & all works with PC or LC
marks should be classified together.
 Bruijn Kops.In:B.Rijksmus.
 301:196,note 3

M
40.1
C94783
NPG

I.B.2 - CROSS, HENRY H., 1837-1918

Cross, Henry H., 1837-1918
 The T.B.Walker coll.of Indian portraits:125
reproductions of ptgs. by Henry H.Cross,of which
22 are in color.with historical commentary by
A.W.Schorger.Madison,State Historical Society
of Wisconsin,1948
 164 p. illus(part col.)

 Incl.Ch.:White men in the Indian Country...
p.140-64

AP
1
W225
NCFA
v.17

I.B.2 - CROSSE, RICHARD, 1742-1810

Long, Basil Somerset, 1881-1937
 Richard Crosse,miniaturist and portrait-
painter

In:Walpole Soc.
17:61-94 1928-1929 illus.

 Dict.of Brit.ptrs.by Fos-
 kett.ND1337.07*74 NCFA
 Bibl.p.594

705
B97
NCFA
v.120

I.B.2 - CROSS, LAWRENCE, c.1650-1724

Murdoch, John, 1910-
 Department of prints,drawing and photo-
graphs,and paintings:Old problems and new ac-
quisitions.A. Hoskins' and Crosses:Work in pro-
gress

In:Burl Mag.
120:284-90 May,'78 illus.

 This article is part of special issue on the
Vict.& Albert Museum
 New info.on miniature portrs.with the IH
monogram of John Hoskins

FOR COMPLETE ENTRY
SEE MAIN CARD 2

qN
40.1
C953xW2
1978
NPG

I.B.2 - CRUIKSHANK, GEORGE, 1792-1878

Wardroper, John
 The caricatures of George Cruikshank.text
by.John Wardroper.Boston,D.R.Godine,1978
 144 p. illus(part col.)

 Bibliography

 Cumulative book index
 Z1219.C97 NPG 1979.p.609

705
B97
NCFA
v.120

I.B.2 - CROSS, LAWRENCE, c.1650_1724

Murdoch, John, 1945-
 Hoskins' and Crosses:Work in progress

In:Burl Mag
120:284-90 May,'78 illus.

 Info.on miniatures with monograms of John
Hoskin & PC & LC of Peter & Lawrence Cross.e...
Proposes the Hoskins oeuvre should be devided
betw.the elder John H.& the younger & contribu-
tions fr.studio works & all works with PC or LC
marks should be classified together.
 Bruijn Kops.In:B.Rijksmus.
 301:196,note 3

705
B97
NCFA
v.105

I.B.2 - CUSTODIS, HIERONIMO, fl.1589-1593

Strong, Roy C.
 Elizabethan painting:An approach through
inscriptions - II:Hieronimo Custodis

In:Burl Mag
105:103-8 Mar.,'63 illus.

 Incl.list of sitters

N
40.1
D127D9
NPG

I.B.2 - DACOTY, PIERRE EDOUARD, 1775-1871

Du Pasquier, Jacqueline
 Dacoty,1775-1871,peintre de la société
Bordelaise,1973.
 26 p. illus.

 Extrait de la Revue historique de Bordeaux
et du département de la Gironde,tome 22,nou-
velle série,1973

 Portr.with'n portr.,p.19 & p.21

705
M19
NCFA
v.22

I.B.2 - DANCE, GEORGE, 1740-1825

Roberts, W. illiam, 1862-1940,
 George Dance and his portraits,recently
come to light

In:Mag Art
22:656-8 1898 illus

**FOR COMPLETE ENTRY
SEE MAIN CARD**

I.B.2 - DAHL, MICHAEL, 1659?-1743

Nisser, Wilhelm, 1897-
 Michael Dahl and the contemporary Swedish
school of painting in England...Uppsala,Alm-
qvist & Wiksells,...1927
 159 p. illus.

 Inaug.-diss.-Upsala
 Literature & sources of info.

 Contents.-Michael Dahl.-Hans Hysing.-Charl
Bolt.-Christian Richter

LC ND793.D3N5 Yale ctr.f.Brit.art Ref.
 ND786+N57

705
C75
NCFA
v.93

I.B.2 - DANCE, NATHANIEL (SIR DANCE-HOLLAND),
 1735-1811

Armstrong, Scobell J.W.
 A new light on Nathaniel Dance, R.A.

In:Conn.
93:145-52 Mar,'34 illus(part col.)

 Baker,C.H.C. Notes on Jos.
 Blackburn & Nath.Dance
 VF xerox copy p.45

AP
1
A83
NCFA

I.B.2 - DALKEY, FRED

Ball, F.
 Dalkey on Dalkey

In:Artweek
7,pt.9:4 Feb.28,'76 illus.

**FOR COMPLETE ENTRY
SEE MAIN CARD**

VF
xerox
copy

I.B.2 - DANCE, NATHANIEL (SIR DANCE-HOLLAND),
 1735-1778

Baker, Charles Henry Collins, 1880-
 Notes on Joseph Blackburn and Nathaniel
Dance

In:Huntington Libr.Q
9:33-47 Nov.,'45 illus.

 Incl.chronological list of Blackburn's por-
traits,p.40-2

LC Z733.S24Q

I.B.2 - DANCE, GEORGE, 1740-1825

Dance, George, 1740(or 41)-1825
 A coll.of portraits sketched from life
since the year 1793 by George Dance...
London,Longman(etc.)1808-14

LC N7598.D3 **FOR COMPLETE ENTRY
 SEE MAIN CARD**

N
40.1
D166
NPG

I.B.2 - DANCE, NATHANIEL(SIR DANCE-HOLLAND),
Dance, Nathaniel, 1735-1811 1735-1811
 Nathaniel Dance,1735-1811.exh.Greater Lon-
don Council, the Iveagh Bequest,Kenwood...25 June
to 4 Sept.1977.London,Greater London Council,
1977
 64.p. illus.

 Cat.by David Goodreau

 Incl.drags.by George Dance, the younger

N
40.1
D166
NPG

I.B.2 - DANCE, GEORGE, 1741-1825
Dance, Nathaniel, 1735-1811
 Nathaniel Dance,1735-1811.exh.Greater Lon-
don Council, the Iveagh Bequest,Kenwood...25 June
to 4 Sept.1977.London,Greater London Council,
1977
 64.p. illus.

 Cat.by David Goodreau

 Incl.drags.by George Dance,the younger

705
C75
NCFA

I.B.2 - DANCE, NATHANIEL (SIR DANCE-HOLLAND),
 1735-1811

Manners, Lady Victoria, 1876-
 Nathaniel Dance,R.A.(Sir Nathaniel Dance-
Holland,Bart.)

In:Conn.
64:77-87 Oct,'22 illus(part col.)
65:23-33 Jan.,'23 illus.
67:143-53 Nov,'23 illus(part col.)

 (Titles:in v.65:Fresh light on N...D...;
in v.67:Last words on N...D...)

 Baker,C.H.C. Notes on Jos.
 Blackburn & Nath.Dance
 VF xerox copy p.45

ND
465
W33
1962
NCFA

I.B.2 - DANDRIDGE, BARTHOLOMEW, b.1691,fl.-1751

Waterhouse, Ellis Kirkham, 1905-
Bartholomew Dandridge;in his.Painting in Britain,1530 to 1790.2nd ed. Baltimore,Penguin books
275 p. illus.

p.127 plate 110

I.B.2 - DAVID, JACQUES LOUIS, 1748-1825

109 x .Hundertneunmal.Napoleon.Miniaturen nach
J.L.David(Ausstellung)21.jan.-18.febr.1973
(Katalog von Klaus Hoffmann)Göttingen,Städtisches Mus.(1973)
16 p. illus.

LC ND1335.G3.G633

I.B.2 - D'ANGERS, DAVID
see
I.B.2 - DAVID D'ANGERS, PIERRE JEAN, 1788-1856

ND
1316
S819
1982a
NPG

I.B.2 - DAVID, JACQUES LOUIS, 1718-1825

Stein, Joanne Crown, 1940-
The image of the artist in France;Artists'
portraits and self-portraits around 1800
c.1982 238 p.
Thesis Ph.-D.-UCLA 1982
Bibliography
Photocopy of typescript
List of illus.p.V-XVI.A copy with plates
& 3 supplemental catalogues is on file at the
UCLA library

Ch.III:David's self-portrs....

I.B.2 - DANIELL, WILLIAM, 1769-1837

Dance, George, 1740(or 41)-1825
A coll.of portraits sketched from life
since the year 1793 by George Dance...and engraved in imitation of the original drags.by
William Daniell...London,Longman(etc.)1808-14

LC N7598.D3

**FOR COMPLETE ENTRY
SEE MAIN CARD**

I.B.2 - DAVID D'ANGERS, PIERRE JEAN, 1788-1856

David d'Angers, Pierre Jean, 1788-1856
Les médaillons de David d'Angers,réunis et
publiés par son fils.Paris,Lahure,1867
11 p. illus.

Preface signed Edmond About

Incl.:portrait of Houdon

ICN KU

Réau.L'iconogr.de Houdon
Gas Beaux Arts ser.6 1933
v.9:170.note 1

I.B.2 - DANLOUX, HENRI PIERRE, 1753-1809

Portalis, Roger,baron, 1841-1912 ed.
Henry Pierre Danloux...Paris,Pour la Soc.
des bibliophiles français,E.Rahir,1910

LC ND553.D22A3

**FOR COMPLETE ENTRY
SEE MAIN CARD**

I.B.2 - DAVID D'ANGERS, 1788-1856

Jouin, Henri Auguste, 1841-1913
David d'Angers,sa vie,son oeuvre,ses écrits
et ses contemporains...Paris,E.Plon et cie.,
1878
2 v. illus.
Bibliography v.2,523-8

v.1:Vie du maître,ses contemporains.-v.2:
Écrits du maître.Son oeuvre sculpté

LC NB553.D3J8

708.1
B762
NCFA
v.61

I.B.2 - DARBY, HENRY F., 1829-1897

Maytham, Thomas N.
Two faces of New England portrait painting.
Erastus Field and Henry Darby

In:Boston Mus Bul
61:31-43 1963 illus.

Article incl.comparison of a family group by
Field with on e by Darby,both in M.F.A.,M.& M.
Karolik coll.

**FOR COMPLETE ENTRY
SEE MAIN CARD**

N
40.1
D243P2
NCFA

I.B.2 - DAVID D'ANGERS, PIERRE JEAN, 1788-1856

Paris. Musée de la monnaie
David d'Angers,1788-1856.Hôtel de la monnaie,Paris,juin-sept.,1966.Cat.par François
Bergot.Préfaces par Pierre Dehaye et Pierre
Pradel.Paris,Hôtel de la monnaie,1966
151 p. illus.

Bibliography
Repro.incl.:Ptgs.miniatures,daguerreotype,
caricatures,drags.,prints by D.'s contemporaries.Bronze statuettes,busts,medallions by
David d'Angers of poets,military,clergy,statesmen,artists
List of sitters

N
40.1
D243S3
NPG

I.B.2 - DAVID D'ANGERS, PIERRE-JEAN, 1788-1856

Schazmann, Paul-Emile, 1902-
David d'Angers,profils de l'Europe.Genève,
Ed.de Bonvent,c1973.
136 p. illus.

Bibliography

705
A56
NCFA
v.104

I.B.2 - DAVIS, J.A., fl.ca.1837-ca.1854

Savage, Norbert H., and Gail Savage
J.A.Davis

In:Antiques
104:872-5 Nov.,'73 illus.

Abby Aldrich Rockefeller
Folk Art Ctr.Am.Folk portrs.
N7593.A23 Bibl.-p.294

N
40.1
D247A1
NPG

I.B.2 - DAVIDSON, JO, 1883-1952

Davidson, Jo, 1883-1952
Between sittings,an informal autobiography.
N.Y.,Dial Press, 1951
369 p. illus.

LC NB237.D3A2

N
40.1
E91C5
NCFA

I.B.2 - DAVIS, JOS. H., fl.1832-1837

Chicago. Art Institute
Three New England watercolor painters.Cat.
by Gail and Norbert H.Savage and Esther Sparks.
Chicago,A.I.,1974
72 p. illus(part col.)

78 works shown;W.C.portrs. by Jos.H.Davis,
J.Evans,J.A.Davis.The cat.documents all the
known ptgs.by the three.
Rev.In:Art Gallery,v.18:54-6 Jan.'75 illus.,
by Esther Sparks
Exh.at Chicago A.I. Nov.16-Dec.22,1974;Art
Mus.St.Louis,Jan. 17-March 2,1975
LC ND181.S28
(Savage,Gail) Rila I/1-2 1975 #2940/41

739
U58

I.B.2 - DAVIDSON, JO, 1883-1952

U.S. National gallery of art
Presidents of the South American republics.
Bronzes by Jo Davidson.Washington, D.C.,Natio-
nal gallery of art, 1942
c27,p. illus.

ND
236
L76
NPG

I.B.2 - DAVIS, JOSEPH H., fl.1832-1837

Lipman, Mrs.Jean Herzberg, 1909- comp.
Primitive painters in America....1950. (card 2

Contents-cont.-17.M.E.Jacobson, O.Krans

List of primitive painters

12.F.O.Spinney, J.H.Davis

LC ND236.L76

I.B.2 - D'AVIGNON, FRANÇOIS, c.1814-

Lester, Charles Edwards, 1815-1890, ed.
The gallery of illustrious Americans,con-
taining the portraits...of 24 of the most emi-
nent citizens of the American republic,since
the death of Washington.From daguerreotypes by
Brady...by d'Avignon.N.Y.,M.B.Brady,F.d'Avig-
non,C.E.Lester,1850
3 p. illus.

,Only 12 lithographs were completed.NPG Print
Dpt. Brady,M.B.The Gallery of illustrious Ameri-
NPG cans,12 biographies.
Print Dpt.
LC E302.5.L47 Rare book

705
A56
NCFA
v.44

I.B.2 - DAVIS, JOS.H., fl.1832-1837

Spinney, Frank O.
Joseph H.Davis:New Hampshire artist of the
1830's

In:Antiques
44:177-80 Oct.,'43 illus.

List of 20 ptgs.attr.to Jos.H.Davis

Abby Aldrich Rockefeller
Folk Art Ctr.Am.Folk por-
traits.N7593.A23 Bibl.p.294

N
40.1
E91C5
NCFA

I.B.2 - DAVIS, J.A.

Chicago. Art Institute
Three New England watercolor painters.Cat.
by Gail and Norbert H.Savage and Esther Sparks.
Chicago,A.I.,1974
72 p. illus(part col.)

78 works shown;W.C.portrs. by Jos.H.Davis,
J.Evans,J.A.Davis.The cat.documents all the
known ptgs.by the three.
Rev.In:Art Gallery,v.18:54-6 Jan.'75 illus.,
by Esther Sparks
Exh.at Chicago A.I. Nov.16-Dec.22,1974;Art
Mus.St.Louis,Jan. 17-March 2,1975;
LC ND181.S28 Rila I/1-2 1975 #2940/41
(Savage,Gail)

I.B.2 - DEBILLEMONT-CHARDON,Mme.GABRIELLE; 1865-
1957

Debillemont-Chardon, Mme.Gabrielle, 1865-1957
La miniature sur ivoire;essai historique et
traité pratique...Paris,H.Laurens.1909.

FOOG
4490
D28

LC(W7775.22) ICN McU NIC MB FOR COMPLETE ENTRY
SEE MAIN CARD

705
I61
NCFA
v.39

I.B.2 - DEBILLEMONT-CHARDON, Mme.GABRIELLE,1865-
.1957

Usanne,.Louis,Octave, 1852-1931
Mme.Debillemont-Chardon's miniatures

In:Studio
39:210-6 Jan.,1910 illus(part col.)

FOR COMPLETE ENTRY
SEE MAIN CARD

I.B.2 - DEGAS, HILAIRE GERMAIN EDGAR, 1834-1917

Blanche, Jacques Emile, 1861-1942
Faces:portraits by Degas

In:Formes
12:21-3 Feb.,'31 illus.

Commentary on the nature of 19th & 20th c.
portraiture

LC N1.F67

N.Y.,MOMA.20th c.portrs.
by M.Wheeler N7592.6N53
Bibl. NPO

I.B.2 - DE CLORIVIÈRE
see
I.B.2 - PICOT DE LIMOELAN DE CLORIVIÈRE,
JOSEPH-PIERRE, 1768-1826

N
40.1
D31R6
NCFA

I.B.2 - DEGAS, HILAIRE GERMAIN EDGAR, 1834-1917

Boggs, Jean Sutherland
Portraits by Degas.Berkeley,Univ.of Calif.
Press,1962
142 p. illus(part col.) (Calif.studies
in the history of art,2)

Bibl.refer.and Bibliography

Incl.Biographical dictionary of sitters

LC ND553.D3B6

MOMA, p.432, v.11

I.B.2 - DE CRITZ, JOHN I, ca.1555-ca.1641

Piper, David
Some portraits by Marcus Gheeraerts II and
John de Crits reconsidered

In:Huguenot Soc.of London,Proc.
20,no.2:210-29

LC BX9450.H7

Strong,R.C.,Elizab.ptg....
In:Burl Mag 105:149,Apr.'c

AP
1
N547
NCFA
v.41

I.B.2 - DELANOY, ABRAHAM, 1742-1795

Sawitzky, Susan
Abraham Delanoy in New Haven

In:N.Y.Hist Soc Q
41:193-206 Apr.,'57 illus.

FOR COMPLETE ENTRY
SEE MAIN CARD

AP
1
W225
NCFA
v.2

I.B.2 - DE CRITZ, EMMANUEL, c.1605-1665

Poole,Rachael Emily(Malleson)"Mrs.R.L.Poole"
An outline of the history of the De Crits
family of painters

In:Walpole Soc.
2:46-68 1912-13 illus.

Repro.Portrs.by Emanuel de Crits

see also:757.0 98 NCFA:Oxford hist.soc.
Cat.of portrs...v.1

I.B.2 - DELARAM, FRANCIS, c.1590-1627

Woodburn, Samuel, 1785 or 86-1853
Woodburn's Gallery of rare portraits;con-
sisting of original plates by Cecil,Dalaram,
Droeshout...illustrative of Granger's Biograph.
hist.of England,Clarendon's Hist.of the rebel-
lion,Burnet's Hist.of his own time,Pennant's
London,etc...containing 200 portrs.of persons
celebrated...London,G.Jones,1816
2 v. illus.

For full subtitle see(LC)Z881A1U525 1942
v.165,p.418 NPO Ref.

LC N7598.W6

AP
1
W225
NCFA
v.2

I.B.2 - DE CRITZ FAMILY

Poole,Rachael Emily(Malleson)"Mrs.R.L.Poole"
An outline of the history of the De Crits
family of painters

In:Walpole Soc.
2:46-68 1912-13 illus.

Repro.Portrs.by Emanuel de Crits

see also:757.0 98 NCFA:Oxford hist.soc.
Cat.of portrs...v.1

I.B.2 - DELFF, WILLEM JACOBSZOON, 1580-1638

Franken, Daniel, 1838-1898
L'oeuvre de Willem Jacobszoon Delff.Amster-
dam,C.M.van Gogh,1872
87 p. illus.

MET
183D37
F85

N.Y.P.L.
MDO
(Delff)

MH PPAPA PP CUI

Mallett.In:Conn.v.57,p.213
Aug.,'20

705
C75
NCFA
v.57

I.B.2 - DELFF, WILLEM JACOBSZOON, 1580-1638

Mallett, John
 The portraits in line of Willem Jacobszoon
Delff

In:Connoisseur
57:213-4,218,222 Aug.,'20 illus.(also Pls.
 «p.229
 p.209)

708.9492
A523
NMAA
v.36

I.B.2 - DENNER, BALTHASAR, 1685-1749

Bruijn Kops, C.J.de
 Twee Amsterdamse portretminiaturen van Bal-
thasar Denner(1685-1749)

In:B.Rijksmus.
36,no.3:163-80 1988 illus.(2 col.on cover)

 Summary in English,p.266-8

AP
1
P89
NCFA
v.3

I.B.2 - DELFF, WILLEM JACOBSZOON, 1580-1638

Metcalfe, Louis R.
 ...Willem Jacobsz.Delff(1580-1638)and his
father-in-law

In:Print Coll Q
3:117-53 Apr.,'13 illus.

 Delff engraved many portr.ptgs.by Mierevelt,
his father-in-law

 Thomas.Drwgs.& pastels of
 Nanteuil in Pr.coll.Q.
 4:332

I.B.2 - DENNER, BALTHASAR, 1685-1749

Niemeijer, J.W.
 Denner en van der Smissen,twee Hanse-Schil-
ders án Holland

In:Ned.kunsthist.jaarb.
21:199-224 1970

LC N5.N4 Bruijn Kops.In:B.Rijksmus.
 v.36:177,note 11

I.B.2 - DE LIMOELAN
 see
I.B.2 - PICOT DE LIMOELAN DE CLORIVIÈRE,
 Joseph-Pierre, 1768-1826

N
6505
B62
NCFA

I.b.2 - DE PEYSTER LIMNER,fl.c.1715-c.1743

Black, Mary C.
 What is American in American art.An exh...
for the benefit of the Mus.of Amer.Folk Art
«Feb.9-March 6,1971.Intro.by Lloyd Goodrich,
cat.by Mary Black.N.Y.,M.Knoedler.1971.
 80 p. illus(part col.)

Exh.in memory of Jos.B.Martinson

 Index of artists

 'Folk art contained the essence of native
flavor
 —Artain America H61c

I.B.2 - DELVAUX, LAURENT, 1696-1778

Willame, Georges, 1863-1917
 Laurent Delvaux 1696-1778...Bruxelles,
G.van Oest & Cie.,1914
 97 p. illus.

N.Y.P.L. Bibliography p.40-9
NCO Preface signed Jules Destrée
(Delvaux)

CGIMA DLC-P4 NRC Whinney.Sculpture in Bri-
NJP MH MnU tain...NB464.W57 NCFA
 p.283

N
40.1
B847H7
NPG

I.B.2 - DERING, WILLIAM, fl.18th c.

Hood, Graham, 1936-
 Charles Bridges and William Dering.Two Vir-
ginia painters,1735-1750.Williamsburg,Va.,The
Colonial Williamsburg Foundation,1978
 125 p. illus(part col.)

LC ND228.H75H66

705
C75
NCFA
v.82

I.B.2 - DEMPSEY, JOHN(JACK), fl.?1832-?1844

Jackson, Mrs.F.Nevill, 1861-
 Jack Dempsey,silhouettist

In:Connoisseur
82:154-61 Nov.'28 illus.

 Colored silhouette work

AP
1
V81
NPG
v.60

I.B.2 - DERING, WILLIAM, fl.18th c.

Pleasants, Jacob Hall, 1873-1957
 William Dering,a mid-eighteenth century
Williamsburg portrait painter

In:Va.Mag.Hist.& Biogr.
60:56-63 Jan.,'52 illus.

I.B.2 - DERING, WILLIAM, fl.18th c..

AP
1
J8643
NCFA
v.1

Weekley, Carolyn J.
Further notes on William Dering,Colonial
Virginia portrait painter

In:J.early S.dec.arts
1:21-8 May,'75 illus.

Abby Aldrich Rockefeller
Folk Art Ctr.Am.folk portrs.
N7593.A23 NMAA Bibl.p.295

I.B.2 - DEVIS, ARTHUR, 1712-1787

Harris Museum and Art Gallery, Preston,Eng.
Polite society,portraits of the English
country gentleman and his family by Arthur
Devis.Cat.of the exh.Oct.1st - Nov.12th,1983.
NPG,London Nov.25th,1983-Jan.29th,1984,organ.
by the Harris Mus.and Art Gall.,Preston...with
financial assist.fr.the Arts Council of Great
Britain.Preston.the Gallery.1983
122 p. illus(part col.)

Portrait within portrait p.92
Intro.by John Hayes,p.9-16.Cat.essay'Arthur
Devis:His life & art'by Stephen V.Sartin,
p.19-35

I.B.2 - DESFONTAINES
see
I.B.2 - SWEBACH, JACQUES FRANÇOIS JOSEPH,called
FONTAINE & DESFONTAINES, 1769-1823

AP
1
S76
1971-72
NCFA

I.B.2 - DEVIS, ARTHUR WILLIAM, 1762-1822

Archer, Mildred
Arthur William Devis:portrait painter in
India(1785-95)

In:Art at Auction
:80-3 1971-2 illus.

Lived in Bengal,1785-95

Archer.India & Brit.portrai-
ture.ND1327.I44A72XNPG
bibl.p.477

I.B.2 - DESROCHERS, ÉTIENNE JEHANDIER, 1668-1741

Desrochers, Étienne Jehandier
Recueil de portraits des personnes qui se
sont distinguées,tant dans les armes que dans
les belles-lettres et les arts.Corre aussi la
famille Royale de France et autres cours étran-
gères..Paris,1700-1730,or 1735?.
4 v. illus.

Prit.
Mus.
554.d.1,2
(2 v.)

Engraved portrs.most of them by Desrochers

Lewine.Bibl.of 18th c.art
illus.books.Z1023.L67 1969
NCFA p.164

AP
1
W202
v.25
NCFA

I.B.2 - DEVIS FAMILY, 18th c.

Pavière, Sydney Herbert, 1891-
Biographical notes on the Devis family of
painters

In:Walpole Soc.
25:115-66 1936-1937 illus.

Pavière.Devis family
N40.1.D495P3 NPG Bibl.p.14

I.B.2 - DEUTSCH, HANS RUDOLF MANUEL, 1525-1571

Strada, Jacobus de, à Rosberg, d.1588
Imperatorum romanorum...verissimae imagines.
ex antiquis numismatis...Zürich,Andreas Gesner,
1559
illus.
118 woodcuts by Rudolph Wyssenbach after
drags.by Hans Rudolf Manuel Deutsch

V & A

Rave.Jb.d.berl.Mus.I 1959
LC N3.J16 fol. p.132
Paolo Gio Gio & d.Bildnisvitenbücher.

N
40.1
D495P3
NPG

I.B.2 - DEVIS FAMILY, 18th c.

Pavière, Sydney Herbert, 1891-
The Devis family of painters...Leigh-on-Sea,
F.Lewis,1950.
148 p. illus(part col.)

Bibliography

Cat.of known and unknown works.Index of
owners of Arthur and Arthur William's ptgs.
'...Arthur,Devis remained faithful to his
one love-the conversation piece...'.p.32
Portrs.within portrs.Pl.24

LC ND497.D4 P3

Archer.Arth.Wm.Devis.In:Art
at Auction.AP1.S76,1971-2
p.80,note 1

N
40.1
D497D6
NCFA

I.B.2 - DEVIS, ARTHUR, 1712-1787

D'Oench, Ellen G.
The conversation piece:Arthur Devis and his
contemporaries.New Haven,Yale Center for Bri-
tish Art,1980
99 p. illus(part col.)

Publ.on the occasion of an exh.at the Yale
Ctr.for Brit.Art,New Haven,Conn.,Oct.1 to Nov.
30,1980
Bibliography

Harris Mus. Preston.
p.38

I.B.2 - DEVOL(DAVOL,DEVOLL)ARUBA(RUBY)BROWNELL
see
I.B.2 - FINCH, RUBY DEVOL, 1804-1866

I.B.2 - DE WILDE, GEORGE JAMES, 1804-1871

Mayes, Ian
 Samuel De Wilde,c.1751-1832;theatre in Geor-
gian Regency London.George James De Wilde,1804-
1871;the life and times of Victorian Northampton
an exh.at Northampton Central Art Gallery,4 Sept-
2 Oct.,1971.Northampton,1971
 ,367,p. illus.

NJP

Noon.Engl.portr.drags.&min
NC860.N66X NPG Bibl. p.146

705
C75
NCFA
v.14

I.B.2 - DIGHTON, RICHARD, 1795-1840

Calthrop, Dion Clayton
 Robert and Richard Dighton,Portrait etchers

In:Connoisseur
14:231-6 Apr.,1906 illus.

FOR COMPLETE ENTRY
SEE MAIN CARD

I.B.2 - DE WILDE, SAMUEL, c.1751-1832

Mayes, Ian
 Samuel De Wilde,c.1751-1832;theatre in Geor-
gian Regency London.George James De Wilde,1804-
1871;the life and times of Victorian Northampton
an exh.at Northampton Central Art Gallery,4 Sept-
2 Oct.,1971.Northampton,1971
 ,367,p. illus.

NJP

Noon.Engl.portr.drags.&min
NC860.N66X NPG Bibl. p.146

705
C75
NCFA
v.14

I.B.2 - DIGHTON, ROBERT, 1752-1814

Calthrop, Dion Clayton
 Robert and Richard Dighton.Portrait etchers

In:Connoisseur
14:231-6 Apr.,1906 illus.

FOR COMPLETE ENTRY
SEE MAIN CARD

705
A56
NMAA
v.124

I.B.2 - DICKINSON, ANSON, 1779-1852

Dearborn, Mona Leithiser
 Anson Dickinson,painter of miniatures

In:Antiques
124:1004-09 Nov.,'83 illus(part col.)

Repro.incl.:Gilbert Stuart

I.B.2 - DIX, OTTO, 1891-1969

Schmidt, Diether
 Otto Dix im selbstbildnis...2.ergänste aufl.
Berlin,Henschelverlag,1981
 320 p. illus(part sel.)

 Bibliography

LC N6888.D5A4 1981b

Billeter.Selbstportraits
N7618.B95 p.26,note 4

N
40.1
D547D2
NPG

I.B.2 - DICKINSON, ANSON, 1779-1852

Dearborn, Mona Leithiser
 Anson Dickinson,the celebrated miniature
painter,1799-1852.Hartford,Ct.,The Connecticut
historical society,1983
 187 p. illus(part col.)

 Incl.:List of sitters
 Bibliography
 Index

 Cat.publ.in conjunction with the exh.,start-
ing in Hartford,Conn Hist.soc.June 15,1983
 93 of D.'s ork give a chronological
sampling

I.B.2 - DIX, OTTO, 1891-

Schubert, Dietrich
 Die Elternbildnisse von O.Dix

In:Städel-Jahrbuch N.F.
4:271 ff. 1973

7000
A19.38

Die 20er jahre im porträt
N6868.5.E9Z97 NPG p.139

R
.D54K4

I.B.2 - DICKINSON, ANSON, 1779-1852

Kidder, Mary Helen, ed.
 List of miniatures painted by Anson
Dickinson,1803-1851...Hartford,1937
 75 p. illus.

LC ND1337.U6D5

Whitehill.The Arts of ear-
y Amer.Hist.Z5935.W59 NPG
Bibl.,p.89

705
B97
NCFA
v.20

I.B.2 - DIXON, NICHOLAS, fl.1665-1708

Goulding, Richard William, 1868-1929
 Nicholas Dixon, the limner

In:Burl Mag
20:24-5 Oct.,'11

VF I.B.2 - DOBELL, BYRON MAXWELL, 1927-

Dobell, Byron,Maxwell, 1927-
 They had faces in those days

In:Newsweek
95,no.22:17 June 2, 1980 illus(selfportr.)

LC AP2.N6772
LC Microfiche FOR COMPLETE ENTRY
 SEE MAIN CARD

I.B.2 - DORSCHLAG, CARL, 1832-1917

Bartalan, Karin
 Catalagui expozitici comemorative Carl
Dürschlag.Sibiu

 Museul Brukenthal Sibiu
 Cat.Patrimonial ND921.M8
 1983X NMAA Bibl.c7.

705 I.B.2 - DOBELL, WILLIAM, 1899-
S94
NCFA Portrait or caricature?

In:Studio
129:168 May,1945 illus.

 "...the portr..is.concerned with the inner
spirit of the sitter,where a caricature...with
superficial outward appearances."

 Repro:Portr.of Joshua Smith by William Dobell

NC I.B.2 - DOMANSKI, A.
772.D66
NPC Domanski, A.
 Faces 1973.Santa Barbara,Calif.,Intelman
 books,1974
 116 p. (mostly illus.) (Intelman Library
 no.5)

 Drawings made from public television appear-
 ances
 Alphabetical list of sitters

705 I.B.2 - DOBSON, WILLIAM, 1610-1646
B97
NCFA Millar, Oliver, 1923-
v.90 A subject picture by William Dobson

In:Burl Mag
90:97-9 Apr,1948 illus.

 Portrs. by Engl.portr.ptrs.of 17th c. in sub-
ject pictures:Dubson's Woman taken in adultery
with portr.of Cowley, Decollation of St.John:
Saint portr.of Prince Rupert, Allegory of French
religious wars:The Four Kings of France:Francis II
Charles IX,Henry III & Henry IV(Newbottle Manor)
 Rep.,1948-49*8374

B I.B.2 - DOWNMAN, JOHN, 1750-1824
.D75W7
 Williamson, George Charles, 1858-1942
 ...John Downman...with a cat.of his drawings.
 London,Otto,ltd.,1907

LC ND497.D6W5 FOR COMPLETE ENTRY
 SEE MAIN CARD

N I.B.2 - DOBSON, WILLIAM, 1610-1646
40.1
D6285 Rogers, Malcolm
R7 William Dobson,1611-46.cat.of an exh.at
NPG NPG,London,Oct.21,1983 to Jan.8,1984.Publ.by
 the Gallery,1983.
 92 p. illus(part col.)

 Bibl.references
 Index

I.B.2 - DROESHOUT, MARTIN THE YOUNGER,c.1601-
 .after 1650

Woodburn, Samuel, 1785 or 86-1853
 Woodburn's Gallery of rare portraits;con-
sisting of original plates by Cecil,Dalaram,
Droeshout...illustrative of Granger's Biograph.
hist.of England,Clarendon's Hist.of the rebel-
lion,burnet's Hist.of his own time,Pennant's
London,etc...containing 200 portrs.of persons
celebrated...London,G.Jones,1816
 2 v. illus.

 For full subtitle see(LC)Z881A1U525 1942
v.165,p.418 NPG Ref.

LC N7598.W6

I.B.2 - DOBSON, WILLIAM, 1610-1648
Spencer, B.M.
 William Dobson

 Th.for the degree MA.Uni.of London,1937

 Rogers,Malcolm.Wm.Dobson
 p.20,note?
 N40.1.D6285R7 NPG

I.B.2 - DROUAIS, FRANÇOIS-HUBERT, 1727-1775
705
d28 Gabillot, C.
NCFA Les trois Drouais
v.34
v.35 In:Gaz Beaux-Arts
 34(3ième ser):177-94,288-98(Hubert D.)
 384-400(François-Hubert D.) 1905
 35(3ième ser):155-74,246-54(François-Hubert D.)
 1906
 illus.

 (Germain-Jean Drouais was no portraitist)

I.B.2 - DROUAIS, FRANÇOIS-HUBERT, 1727-1775

705
028
NCFA
v.51

Wildenstein, Georges, 1892-1963
A propos des portraits peints par François-
Hubert Drouais

In:Gas Beaux-Arts
51(6th ser):97-104 Feb.,'58 illus.

Incl.:List of the works and the prices which
are owed to the estate of F.-H.Drouais

I.B.2 - DURER, ALBRECHT, 1471-1528

705
A784
NCFA

Kuspit, Donald B.
Dürer and the Lutheran image

In:Art in Am
63:56-61 Jan.-Feb.,'75 illus(part col.)

Cultural & stylistic reasons for the impact
of Dürer's late portrs.,1524,1526

I.B.2 - DROUAIS, HUBERT, 1699-1767

705
028
NCFA
v.34
v.35

Gabillot, C.
Les trois Drouais

In:Gas Beaux-Arts
34(3ième ser):177-94, 288-98(Hubert D.) 1905
 384-400(François-Hubert D.)
35(3ième ser):155-74, 246-54(François-Hubert D.)
 1906
 illus.

(Germain-Jean Drouais was no portraitist)

I.B.2 - DURER, ALBRECHT, 1471-1528

Och(g)enkowski, Henryk August
Die selbstbildnisse von A.Dürer. Strasbourg,
1910
 66p.

Inaug.diss.Heidelberg

Bibliography

LC 759.3D93Yo Goldscheider 757.052
IU CtY PU MH 500 self-portrs.

705
A7832
NCFA

I.B.2 - DURER, ALBRECHT, 1471-1528

Bainton, Roland,H.
Dürer and Luther as the man of sorrows

In:Art Bul.
29:269-72 1947 illus.

The religious atmosphere of the 16th c.
allowed to portray in the image of Christ.
Dürer's self-portrs. and engravings of 1521 &
1545

Rep.,1945-47#906

705
A784
NCFA
v.20

I.B.2 - DUMMER, JEREMIAH, 1645-1718

Coburn, Frederick W.illiam,,1870-
 Jeremiah Dummer,gold-and silversmith and
limner

In:Art in Am
20:72-82,85 Feb.,'32 illus.

'Probably the 1st American born artist-
painter'

Craven.Colonial Am.portr.
N7593.1.C73 1986X NPG
Bibl.p.440

I.B.2 - DURER, ALBRECHT, 1471-1528

De Ortigao Burnay, Luis
As relacoes de Alberto Dürer com os Portgue-
ses da Feitoria de Anvers

In:B.Acad.nac.belas Artes
15:23-32 1946 illus

Publication of fragments of Dürer's travel
journal in the Netherlands,1520-21, where he
speaks of relations he established with Portu-
guese in Antwerp. Pencil drgs. of Lucas van Ley-
den,Erasmus,Patinir and portr. of Dürer by
Portuguese ptr.Th. Vencidor,engr.by Stock,1629
LC N16.A6613 Rep.1948-49#6682

705
A784
NCFA
v.18

I.B.2 - DUMMER, JEREMIAH, 1645-1718

Coburn, Frederick W.illiam,,1870-
 Jeremiah Dummer's portraits of John Coney,
siversmith,and Mary Atwater Coney,his wife

In:Art in Am
18:244-51 Aug.,'30 illus.

Craven.Colonial Am.portr.
N7593.1.C73 1986X NPG
Bibl.p.440

I.B.2 - DURER, ALBRECHT, 1471-1528

Friedländer, Max J.,1867-1958
 Dürer als bildnismaler

In:Museum
1:

LC for Museum Waetzoldt ND1300.W12
N7511.M7

705
028
NCFA
v.29

I.B.2 - DUMONT, FRANÇOIs, 1751-1831

Chennevières, Henry de
 François Dumont.Miniaturiste de la reine
Marie Antoinette

In:Gas Beaux Arts 3rd ser.
29:177-92 1903 illus.

Portr.within portrait p.187

Draper,Js.D.:Grétry Encore
In:Met.Mus.J. 9:235 note 6

705
A784
NCFA
v.39

I.B.2 - DUNCANSON, ROBERT S., 1821-1872

Porter, James Amos, 1905-
Robert S.Duncanson,mid-Western romantic-
realist

In:Art in Am
39:98-154 Oct.,'51 illus.

The entire issue is devoted to a study of D.
D.is one of the earliest American Negro ar-
tists.
Ch."Years of transition:The portraits,p.121-
127
Incl.check lis()D.'s ptgs.(13 portrs.)
Bibliography
Arts in Am. I 664

I.B.2 - DUPLESSIS, JOSEPH SIFFRED, 1725-1802

Belleudy, Jules, 1885-
J.S.Duplessis,peintre du roi,1725-1802.
Chartres,Imprimerie Durand,1913 (Académie de
Vaucluse)
N.Y.P.L. 359 p. illus.
Art Dpt.
MCO
D93.Mi Incl.cat.of D.'s work.

Bibliography

I.B.2 - DUNKARTON, ROBERT, 1744-betw.1811/17

Earlom, Richard, 1743-1822, engr.
Portraits of characters illustrious in Brit-
ish history, from the beginning of the reign of
Henry the eighth to the end of the reign of James
the second. Engraved in mezzotinto. Richard
Earlom & Charles Turner. From original pictures,
miniatures, etc. London,S.Woodburn,(1815?)

illus.(100 portrs.)

Each portr.accompanied by brief biogr.sketch
Besides Earlom & Turner,plates by Rbt.Dunkarton
LC N7598.E3

CJ
5805
F16
NPG

I.B.2 - DUPRÉ, AUGUSTIN, 1748-1833

Failor, Kenneth M.
Medals of the United States;by K.M.Failor
and Eleonora Hayden.Washington;For sale by the
Supt.of Docs.,U.S.Govt.Print Off.,1969.
274 p. illus.

First printed Aug.,1969,revised 1972
Incl.history of the U.S.presidential medals
series,by Francis Paul Prucha,S.J.,p.285-8.
The medallic sketches of Augustin Dupré in
American collections,by Carl Zigrosser,p.289-
304
LC CJ5805.F3

VF

I.B.2 - DUNLAP, WILLIAM, 1766-1839

Dunlap, William, 1766-1839
Collection of ivory miniatures...cat.comp.
and sale conducted by Stan V.Henkels at the
book auction rooms of Davis & Harvey,Phila.,Pa.,
Mar.10,1905
26 p. illus(1 col.)

Cat.no.927

Incl.:Scarce American portrs.:Americus Ves-
pucius,Washington & family,Franklin,Lincoln,
Wm.Penn... engravings,ptgs. by other artists.

AP
1
A51A64
NCFA
v.3

I.B.2 - DURAND, ASHER BROWN, 1796-1886

Craven, Wayne
Asher B.Durand's career as an engraver

In:Am Art J
3:39-57 Spring,'71 illus.

Jaffe,I.B. John Trumbull..
N40.1.T86J2 NPG Bibl.p.334

I.B.2 - DUNLAP, WILLIAM, 1766-1839

Elam, Charles H.
The portraits of William Dunlap(1766-1839)
and a cat.of his works

Master's Th.-N.Y.Univ.,1952

Lindsay,K.C.Harpur Ind.of
master's theses in art,..
1955 Z5931.L74 1955 NCFA
Ref. p.102 no.1895

N
40.1
D942D9
NCFA

I.B.2 - DURAND, ASHER BROWN, 1796-1886

Durand, John, 1822-1908
The life and times of A.B.Durand.N.Y.,
C.Scribner's sons,1894
232 p. illus.

Appendix III incl.list of engraved portrs.

LC ND237.D8D8 Craven,W. Asher B.Durand's
in:Am Art J v.3:39 footnot
1

705
B97
NCFA
v.6

I.B.2 - DUPARC, FRANÇOISE, ca.1705-1778

Auquier, Philippe, 1863-1908
An 18th century painter:Françoise Duparc

In:Burl Mag
6:477-8 Mar.,'05 illus.

FOR COMPLETE ENTRY
SEE MAIN CARD

705
A784
NCFA
v.18

I.B.2 - DURAND, ASHER BROWN, 1796-1886

Sherman, Frederic Fairchild, 1874-1940
Nathaniel Jocelyn,engraver and portrait
painter

In:Art in Am.
18:251-2,57-8 Aug.,1930 illus.

Incl.list of portrs. by J.

705
A56
NCFA
v.24

I.B.2 - DU SIMITIÈRE, PIERRE EUGÈNE,ca.1736-1784

Donnell, Edna.Bowden, 1891- .
 Portraits of eminent Americans after draw-
ings by Du Simitière

In:Antiques
24:17-21 July,1933 illus.

 Repro.incl:Washington on ceramics;enamel
cloak hooks;printed cotton with portr.medal-
lions derived fr. engravings after Du Simitière
 Incl.list of Prévost's,Reading's & B.B.
Ellis' engravings.

N
40.1
D985T5
NMAA

I.B.2 - DUYCKINCK FAMILY

Whitney Museum of American Art, New York
 Three American families.A tradition of ar-
tistic pursuit.Exh.at Philip Morris,Sept.8-
Oct.26,1983
 unpaged illus.

 Ptgs.by the families of Duyckinck,Peale,
and Weir
 31 works shown

I.B.2 - DU SIMITIÈRE, PIERRE EUGÈNE,ca.1736-1784

 Du Simitière, Pierre Eugène,ca.1738-1784
 Heads of illustrious Americans.London,
R.Wilkinson,1783.

 Engraved by B.B.Ellis.'From these engrav-
ings the Engl.industry spread the portrs. or
printed textiles,enamel & decorative earthen-
ware.'-Donnell

MiU-C NjP

705
B97
NCFA
v.106

I.B.2 - DYCE, WILLIAM, 1806-1864

Roberts, Keith, 1937-
 Centenary exh.devoted to...Wm.Dyce.in,
Current and forthcoming exhibitions

In:Burl Mag
106:527 Nov.'64 illus.

 Exh.at Agnew(Thos.)& Sons,ltd.,London

 Repro.incl.:Gen.Sir Calbraith Lowry Cole,
c.1834-5
 '...ptd.in 7 yrs.more than 100 portrs.,esp.
children portrs...'-Th.B.

I.B.2 - DU SIMITIÈRE, PIERRE EUGÈNE,ca.1736-1784

Du Simitière, Pierre Eugène,ca.1736-1784
 Portraits of the generals,ministers,magis-
trates,members of Congress,and others,who have
rendered themselves illustrious in the revolu-
tion of the United States of North America.
Drawn from the life by M.Du Simitier...and en-
graved by the most eminent artists in London.
London,R.Wilkinson and W.Debrett,1782
 2 p. 12 portrs.

 Incl.:Washington, John Jay
 'Set was signed P.E.E.'-Donnell

LC E206.D97

760.5
.P94

I.B.2 - DYCK, ANTHONY, 1599-1641

The complete etched portrait work of Anthony
van Dyck,from the collections of Sir Peter
Lely and Prosper Henry Lankrink.N.Y.,M.
Knoedler & co.,inc.,1934
 [44]p. illus. (The print collec-
tor's bulletin,v.3,no.3)

 Coll.Lely sold Apr.11-18,1688 under the
direction of Sonnius,Lankrink & Thompson,
London.-Coll.Lankrink sold May8,1693 & Feb.
22,1694,"At the Golden Triangle,in Long
Acre,London
 Mostly [] portrs.of Flemish painters

I.B.2 - DU SIMITIÈRE, PIERRE EUGÈNE,ca.1736-1784

Du Simitière, Pierre Eugène, ca.1736-1784
 Thirteen portraits of American legislators,
patriots,and soldiers,who distinguished them-
selves in rendering their country independent;
...drawn from the life by Du Simitière...and en-
graved by Mr.B.Reading.London,J.Richardson
,1783.
 13 plates

 Incl.:Washington, John Jay

MB NjP MH CtY MiU-C Winterthur Mus.Libr. Z881
PPi. .W78 NCFA v.5,p.226

I.B.2 - DYCK, ANTHONIE VAN, 1599-1641

Dyck, Anthonie van, 1599-1641
 Le cabinet des plus beaux portraits de plu-
sieurs princes et princesses,des hommes il-
lustres,fameux peintres,sculpteurs,architectes,
amateurs de la peinture & autres,faits par le
fameux faict graver à ses propres despens par
les meileurs graveurs de son temps.Antwerp,
Henry & Corneille Verdussen,173-?,
 [4]p. 125 plates

NcD Winterthur Mus.Libr. fZ881
 .W78 NCFA v.9,p.225

XP
1
A51A64
NMAA
v.12

I.B.2 - DUYCKINCK, GERARDUS I, 1695-1746?

Black, Mary C.
 Contributions toward a history of early
,18th c. New York portraiture:The identification
of the Aetatis Suae and Wendell Limners

In:Am Art J
12:4-31 Autumn,'80 illus.

 Black identifies Nehemiah Partridge as the
Aetatis Sue limner and John Heaten as the ptr.
of Abraham Wendell and his brothers as well as
of a dozen or more N.Y. area portrs. ascr.un-
til now to the Wendell limner.
 Miles.

I.B.2 - DYCK, ANTHONIE VAN, 1599-1641

Dyck, Anthonie van, 1599-1641
 Icones principvm virorvm dictorvm pictorvm...
Antverpiae,G.Hendricx,1646,
 1p.l. 109 port

 Best engravers of the period collaborated

LC ND673.D9A3 Rath.Porträtwerke p.40

I.B.2 - DYCK, ANTHONIE VAN, 1599-1641

»Hind, Arthur Mayger«,1880-1957
 Van Dyck and portrait engraving and etch-
ing in the 17th c. N.Y.,Frederick A.Stokes co.
»1911«
 15 p. illus. (Half-title:Great engrav-
ers,ed.by Arthur M.Hind)

 Bibliography,p.11-12

 65 illus.

LC NE440.H6 Levis.Descr.bibl.Z5947,A3
 66 1974 NCFA p.265

N
40.1
E11H4 I.B.2 - EAKINS, THOMAS, 1844-1916
NPG
 Eakins, Thomas, 1844-1916
 The photographs of Thomas Eakins,by Gor-
don Hendricks.N.Y.,Grossman Publishers,1972
 214 p. illus.

 Bibliographical references

 H.'s essay is grouped,incl.The artist &
his family.-The artist's wife and her family.-
The artist & Walt Whitman.-The artist in pho-
tographs by others.

LC TR647.E2H47 1972 Arts in America.qZ5961.U5
 A77X NCFA Ref. I700

705
C75
NCFA I.B.2 - DYCK, ANTHONY VAN, 1599-1641
v.194
 Mannings,David Michael
 Reynolds' portraits of the Stanley Family

 In:Connoisseur
 194:85-9 Feb.,'77 illus(1 col.)

 4 Kit-cat portrs.,based on v.Dyck & with
motifs derived fr.Brit.16-17th c. portraiture

 Rila III/2 1977 #4984

705
A7834
NCFA I.B.2 - EAKINS, THOMAS, 1844-1916
v.53
 Cerdts, William H.
 Thomas Eakins and the Episcopal portrait:
Archbishop William Henry Elder

 In:Arts Mag.
 53,no.9:154-7 May'79 illus(part col.)

757
R31 I.B.2 - DYCK, ANTHONY, 1599-1641
 Reder, Jacob
 The portraits of the Brignole-Sale family in
the Palazzo Rosso in Genoa by Sir Anthony van
Dyck,in commemoration of the 300th Anniversary of
the death of Sir A.van Dyck,Dec.9,1641. Samuel
Hofmann from Zurich,pupil of Rubens;a first pre-
face to a rediscovered European art....New York,
Printed by Art press,c1941.
 133 p. illus.

LC ND853.H64R4

S
784
PFA I.B.2 - EAKINS, THOMAS, 1844-1916
53
 Goodrich, Lloyd, 1897-
 "...About a man who did not care to be
written about":Portraits in friendship of
Thomas Eakins

 In:Arts Mag.
 53,no.9:96-8 May,'79 illus.

705
A7834
NCFA I.B.2 - EAKINS, THOMAS, 1844-1916
v.53
 Arts Magazine
 Special issue:Thomas Eakins
 53,no.9:96-159, May,1979 illus(part col.)

 Partial contents:L.Goodrich:Abt.a man who
did not care to be written about:Portrs in
friendship of Th.Eakins,p.96-8;E.H.Turner:Th.E.:
The Earles'Gall.exh.of 1896,p.100-7;J.Wilmerding:
Th.E.'s late portrs.,p:108-12;F.C.Parry,III:The
Th.E.portr.of Sue & Harry,or,when did the art-
ist change his mind?,p.146-53;W.H.Cerdts:Th.E.
& the Episcopal portr.Archbishop Wm.H.Elder,p.
154-7
 »Articles analyzed«

ND
1300
L8 I.B.2 - EAKINS, THOMAS, 1844-1916
1985X
NPG Lubin, David M.
 Act of portrayal:Eakins,Sargent,James.
New Haven,Yale Univ.Press,c.1985
 208 p. illus. (Yale publications in
the history of art,32)
 Index
 Bibliography,p.177-83
 Examination of three major works of por-
traiture,two ptgs.& one novel,from the 1880s.
L.probes the contradiction each artist sensed
betw. masculine power & feminine passivity.

LC ND1300.L8 1985 Books in print.Subject
 guide 1985-6 v.3,p.4864

708.1
.C13 I.B.2 - EAKINS, THOMAS, 1844-1916

 Cahill, Holger, 1893-1960 ed.
 Portrait painters,fashionable and unfa-
shionable-Eakins,Sargent,in,his,Art in America
in modern times....c.1934»

 p.21-4 illus.

 Influence of European methods

 Arts in America qZ5961.U5A
 77x NCFA Ref. I 31

705
A7834
NCFA I.B.2 - EAKINS, THOMAS, 1844-1916
v.53
 Parry, Ellwood C.
 The Thomas Eakins portrait of Sue and Harry
or,when did the artist change his mind?

 In:Arts Mag.
 53,no.9:146-53 May'79 illus(part col.)

705
A7834
NCFA
v.53

I.B.2 - EAKINS, THOMAS, 1844-1916

Turner, Evan H.
 Thomas Eakins:The Earles'Galleries exh.of 1896

In:Arts Mag.
53,no.9:100-7 May,'79 illus.

 Portrs.became the dominant element of his work

I.B.2 - EARL, JAMES, 1761-1796(Brother of Ralph)

Stewart, Robert G.
 An attractive situation:Henry Benbridge and James Earl in the South

In:The Southern Q
26,no.1:39-56 Fall,'87 illus.

 Bibliography

LC AS30.8658

705
A7834
NCFA
v.53

I.B.2 - EAKINS, THOMAS, 1844-1916

Wilmerding, John
 Thomas Eakins'late portraits

In:Arts Mag.
53,no.9:108-12 May,'79 illus.

AP
1
A51A64
NMAA
v.20

I.B.2 - EARL, JAMES, 1761-1796.
 (Brother of Ralph)

Stewart, Robert G.
 James Earl:American painter of Loyalists and his career in England

In:Am Art J
20,no.4:35-58 1988 illus.

I.B.2 - EARL FAMILY

Earle, Pliny, 1809-1892
 The Earle family;Ralph Earle and his descendants.Worcester,Mass.,Press of C.Hamilton,1888
 492 p. illus.

 Supplement.by Amos Earle Voorhies.Grants Pass, Or.,1932. 12 p.

LC CS71.E13 1888
LC CS71.E13 1888 suppl.

705
A56
NCFA
v.112

I.B.2 - EARL, RALPH, 1751-1801

Ballard, Lockett Ford jr.
 Paintings of Ralph Earl at the Litchfield Historical Society

In:Antiques
112:959-63 Nov.,'77 illus(col.)

I.B.2 - EARL, JAMES, 1761-1796(brother of Ralph)

Connecticut university,Storrs - Museum of art
 The American Earls:Ralph Earl,James Earl, R.E.W.Earl.exh..Oct.14-Nov.12,1972.Storrs,Conn. .e.1972.

MET
192Ea7
076
 59 p. illus.

 Harold Spencer, coordinator

705
075
NCFA
v.191

I.B.2 - EARL, RALPH, 1751-1801

Butler, Joseph T.
 Rare portraits acquired by the National Collection of fine arts

In:Conn.
191:140-1 Feb.,'76 illus.

 2 portrs.by Ralph Earl,f'ly Joseph Alsop coll.Sitters:Hannah Gilbert Wright,and Mary Wright Alsop,both ptd.1792

705
A784
NCFA
v.23

I.B.2 - EARL, JAMES, 1761-1796
 (Brother of Ralph)
Sherman, Frederic Fairchild, 1874-1940
 James Earl,a forgotten American portrait painter

In:Art in Am
23:143-53 Oct.,'35 illus.

Arts in America qZ5961 USA
77X NCFA Ref. H307

757
C75

I.B.2 - EARL, RALPH, 1751-1801

Connecticut. Tercentenary commission
 ...Connecticut portraits by Ralph Earl, 1751-1801. Aug.1-Oct.15.1935..Gall.of fine arts, Yale university.New Haven,Yale uni.press,1935.
 30 p. illus

 Biogr.sketch of artist signed:William Sawitzky

LC ND237.E18C6

I.B.2 - EARL, RALPH, 1751-1801

Connecticut university,Storrs - Museum of art
The American Earls:Ralph Earl,James Earl,
R.E.W.Earl.exh..Oct.14-Nov.12,1972.Storrs,Conn.
.c.1972.
MET
192Ea7 59 p. illus.
C76

Harold Spencer, coordinator

N I.B.2 - EARL, RALPH, 1751-1801
40.1
F12W6 Whitney Museum of American Art, New York
NPG Ralph Earl,1751-1801;catalogue by William
Sawitzky.Whitney Museum of American Art,New
York,Oct.16-Nov.21,1945.Worcester Art Museum,
Worcester,Mass.,Dec.13,1945-Jan.13,1946.New
York,1945.
 .30.p. illus.

Harvard Univ.Library for Whitehill.The Arts of ear-
LC ly Amer.Hist.Z5935.W59 NPG
 Bibl.,p.90

N I.B.2 - EARL, Ralph, 1751-1801
40.1
E1206 Goodrich, Laurence B.
NPG Ralph Earl,recorder for an era....Albany.
State University of N.Y.,1967.
 96 p. illus(part col.)

 Bibl.ref.incl.in "Notes"

 '.Earl.is among the most brilliant & histo-
rically important artists of the land'.-Goodric

LC ND237.E1806 Arts in Amer. qZ5961 USA 77
 NCFA Ref. H308

I.B.2 - EARL, RALPH ELEASER WHITESIDE, c.1785-
 (son of Ralph) .c1838

Connecticut university,Storrs - Museum of art
The American Earls:Ralph Earl,James Earl,
R.E.W.Earl.exh..Oct.14-Nov.12,1972.Storrs,Conn.
.c.1972.
MET
192Ea7 59 p. illus.
C76

Harold Spencer,coordinator

705 I.B.2 - EARL, RALPH, 1751-1801
A56
NCFA Goodrich, Laurence B.
v.78 Ralph Earl's debt to Gainsborough and other
English portraitists

In:Antiques
78:464-5 Nov.,'60 illus.

Arts in America qZ5961 USA
77X NCFA Ref. H311

705 I.B.2 - EARL, RALPH ELEASER WHITESIDE, c.1785-
A56 (son of Ralph) .c1838
NCFA Macbeth, Jerome R.
v.100 Portraits by Ralph E.W.Earl

In:Antiques
100:390-3 Sept.,'71 illus(part col.)

 Incl.:Several portrs.of Andrew Jackson

NPG I.B.2 - EARL, RALPH, 1751-1801

Loring, William C.
 Portrait painters of Colonial days

In:Antiquarian
11:52-3,96 Dec.,'28 illus.

 The article deals only with Ralph Earl...

 FOR COMPLETE ENTRY
 SEE MAIN CARD

I.B.2 - EARLOM, RICHARD , 1743-1822

Earlom, Richard, 1743-1822, engr.
 Portraits of characters illustrious in Brit-
ish history, from the beginning of the reign of
Henry the eighth to the end of the reign of James
the second. Engraved in mezzotinto. Richard
Earlom & Charles Turner. From original pictures,
miniatures, etc. London,S.Woodburn,.1815?.

 illus.(100 portrs.)

 Each portr.accompanied by brief biogr.sketch
Besides Earlom & Turner,plates by Rbt.Dunkarton
LC N7598.E3

705 I.B.2 - EARL , RALPH, 1751-1801
C75
NCFA Two unpublished portraits by Ralph Earl
v.90
In:Connoisseur
90:281-2 Oct.,'32 illus.

 Sitters:Colonel William Taylor & Mrs.Wm.
Taylor(Abigail Storr) with a child(Daniel board-
man). All painted 1790. Repro.:Col.Wm.Taylor

 Cumulated Mag.subj.index
 A1/3/C76 Ref. v.2,p.443

N I.B.2 - ECKERSBERG, CHRISTOFFER WILHELM, 1783-
40.1 .c1853
E187 Aarhus, Denmark. Kunstmuseum
A114 C.W.Eckersberg.exh..Sept.3-Oct.9,1983.Aar-
NMAA hus Kunstmuseum,1983.
 127 p. illus(part col.)

 Incl.:article :Eckersberg portraettist,by
Henrik Bramsen,p.25-30

 Bibliography

AP -
1
M971
NCFA

I.B.2 - EDDY, OLIVER TARBELL, 1799-1868

Bishop, Edith
Newark portraits by Rembrandt Peale and
Oliver Tarbell Eddy

In:The Museum
n.s.1,no.4:1-21 Oct.,'49 illus.

Notes and Bibliography

Penn.Hist.Soc. Rembrandt
Peale...Bibl.p.117

B
.E21N5

I.B.2 - EDDY, OLIVER TARBELL, 1799-1868

Newark Museum Association,Newark,N.J.
Oliver Tarbell Eddy,1799-1868;a cat.of his
works comp.by Edith Bishop in connection with
an exh.shown at the Newark Museum,March 28-
May 7,1950,and the Baltimore Museum of Art,
May 28-June 25,1950.Newark,1950.
68p. illus.

"References"

ND237.E39N4

I.B.2 - EDELINCK, GÉRARD, 1640-1707 ---

Perrault, Charles, 1628-1703
Les Hommes illustres qui ont paru en France
pendant ce siècle;avec leurs portraits au natu-
rel.Paris,A.Desallier,1696-1700
2v.in 1 illus.

Portrs.engr.by Gérard Edelinck,Jacques Lubin
& others

C CT1011.P4 1696

I.B.2 - Edouart, Augustin, 1789-1861

Edouart, Augustin Amant Constance Fidèle, 1789-
Catalogue of 5200 named and dated .1861
English silhouette portraits....London,Walbrook,
1911.

N.Y.P.L. *ZM-41 Film repro.

FOR COMPLETE ENTRY
SEE MAIN CARD

741.7
E24c
NCFA

I.B.2 - ÉDOUART, AUGUSTIN, 1789-1861

Edouart, Augustin Amant Constance Fidèle, 1789-
Catalogue of 3800 named and dated .1861
American silhouette portraits.Discovered by
F.Nevill Jackson....London,1911?.
31 p. illus.

ondon,H.R. Shades of my
forefathers 241.7/L847
Bibliography

741.7
E24
and
N
7592
G24
NPG

I.B.2 - ÉDOUART, AUGUSTIN, 1789-1861

Edouart, Augustin Amant Constance Fidèle, 1789-
...The collection of American silhouette.1861
portraits cut by August Edouart....with an
introduction by Arthur S.Vernay....New York,
Arthur S.Vernay,1913.
183 p.

On Exhibition at no.12 East 45th St.,N.Y.,
Oct.27th-Nov.,15th,1913...

"A notable coll.of portrs.taken between
1839-1849"

London,H.R. Shades of my
forefathers 741.7/L847
Bibliography

I.B.2 - ÉDOUART, AUGUSTIN, 1789-1861

Edouart, Augustin,1789-1861 (Silhouettist)
Treatise on silhouette likenesses.London
1835,Longman and company.etc.,

Met has
book in
Miss Martin
coll.

122 p. illus.

Chapter on hair pictures

LC NC910.E3

708.1 N52 NCFA Bull.Met.
v.35-6 p.54

N
40.1
F245
J2
NPG
RB

I.B.2 - EDOUART, AUGUSTIN, 1789-1861

Jackson, Mrs.F.Nevill,1861-
Ancestors in silhouette, cut by August
Edouart;illustrative notes and biographical
sketches...London,John Lane;New York John Lane
co.,1921

239 p. illus.

List of English silhouette portraits as
transcribed by Edouart. Edouart's list of portrs.
of Charles X and members of his court..taken at
Holyrood palace,1831. Complete list of 3600 portrs
of Americ. citizens taken betw.1839-49

LC NC910.J17

705
C75
NCFA
v.90

I.B.2 - ÉDOUART, AUGUSTIN, 1789-1861

Jackson, Mrs.F.Nevill, 1861-
The shadows of Scott

In:Connoisseur
90:167-71 Sept.,'32 illus.

Repro.incl.:Silhouettes by Edouart

Quimby,Nellie Earles.Beauty
in black & white.Oregon
State Libr.,Salem 741.10/16
Bibl.p.46

qNC
910.5
E3 O44X
NPG

I.B.2 - ÉDOUART, AUGUSTIN, 1789-1861

Oliver, Andrew, 1906-
Auguste Edouart's silhouettes of eminent
Americans,1839-1844.Publ.for the NPG,Smiths.
Institution by Uni.Press of Virg.,Charlottes-
ville,1977
.553.p. illus.

Appendix:"Cat.of 3800 named & dated Ameri-
can silhouette portra by August Edouart"by
F.Jackson.Mrs.F.Nevill.
Intro.by A.Hyatt Mayor

LC NC910.5.E3 O44

705
C75
NCFA
v.90

I.B.2 - EDOUART, AUGUSTIN, 1789-1861

Ritchan
 Hair portraiture

In:Connoisseur
90:392-3 Dec,1932 illus.(dogs)

Augustin Edouart, silhouettist, artist in hair
work:portrs.,etc. & bas-relief

AP
1
P41
NPG
v.28

I.B.2 - EDWIN, DAVID, 1776-1841

Fielding, Mantle, 1865-1941
 Engraved works by David Edwin (not men-
tioned in Mr.Hildeburn's list)

In:Penn Mag of Hist & Biogr.
28:420-27 1904
 List of portrs.p.420-4

I.B.2 - EDOUART, AUGUSTIN, 1789-1861

Tuer, Andrew White, 1838-1900.
 The Art of silhouetting

In:Engl.Ill.Mag.
7:747 1890 illus.

 Mainly abt. Edouart.Illus.all from Edouart's
treatise of 1835

LC AP4.E5 Négros.Profile art.741.7
 49, p.93

AP
1
P41
NPG
v.18

I.B.2 - EDWIN, DAVID, 1776-1841

Hildeburn, Charles R.
 A contribution to a cat.of the engraved
works of David Edwin

In:Penn Mag of Hist & Biogr
18:97-118,223-38 1894

AP
1
P892
NCFA
v.2

I.B.2 - EDWIN, DAVID, 1776-1841

Fielding, Mantle, 1865-1941
 American naval portraits engraved by David
Edwin after Gilbert Stuart and others

In:Print Connoisseur Dec.,'21
2:123-30 illus.p.122,125,127,129,131-7

LC NE1.P75 Arts in Amer.v.2 K668
 q Z5961.U5A77X NCFA Ref.

I.B.2 - EGON, NICHOLAS

Some beautiful women of to-day.Drawn by Nicho-
las Egon.London,Putnam,1952.
 10 p. illus.(48 portrs.)

 Introd.by Maurice Collis

 'The psychology of these faces is quite
unlike that in any other epoch.'-Collis

MoK ILfC etc. Book review.Studio,July,'5
 v.146:32
 " " Apollo,Feb.'53
 v.57:64

Mfm
41
NCFA

I.B.2 - EDWIN, DAVID, 1776-1841

Fielding, Mantle, 1865-1941
 Cat.of the engraved work of David Edwin...
Philadelphia,Priv.print.,1905
 61 p.

LC NE539.E2F4 Winterthur Mus.Libr.
 Z881.W78 NCFA v.6,p.229

I.B.2 - EHRENSTRAHL, DAVID KLÖCKER, 1629-1698

Hahr, August, 1868-
 Day,Klöcker Ehrenstrahl...Stockholm...1905

LC 709.485.Eh85h FOR COMPLETE ENTRY
MnU PPPM SEE MAIN CARD

AP
1
P41
NPG
v.29

I.B.2 - EDWIN, DAVID, 1776-1841

Fielding, Mantle, 1865-1941
 David Edwin,engraver

In:Penn Mag of Hist & Biogr.
29:79-88,320-25 1905

 List of portrs.,not in Hildeburn's list,
p.321-2

 "E...the 1st good engraver of portrs....in Ame-
rica."

N
40.1
E34B3
NCFA

I.B.2 - EICHHOLTZ, JACOB, 1776-1842

Beal, Rebecca J
 Jacob Eichholtz,1776-1842;portrait painter
of Pennsylvania...Phila.,Hist.Soc.of Pennsyl-
vania,1969
 401 p. illus(part col.)

 Bibliography

 "...Catalogue...to serve as a record and a
source for study..."

LC ND237.E44B4 Fogg,v.11,p.326

N
40.1
E34H5
NPG

I.B.2 - EICHHOLTZ, JACOB, 1776-1842

Hensel, William Uhler, 1851-1915
Jacob Eichholtz,painter...an address de-
livered at the opening of an expo.of"the evolu-
tion of portraiture in Lancaster,Penn."...Lan-
caster,Pa.,Nov.22,1912...Lancaster,Pa.,Press of
the Brecht printing co.,1912,
39 p. illus.
Expo.under ausp.of Lanc.Cy.hist.soc.& Iris
Revised cat.of Eichholtz's works ,clu,.

Papers read before the Lancaster Cy.hist.
soc. v.16,no.10 Dec.6,1912 suppl't
Weddell.A mem'l vol.of Va.
hist.portraiture.757.9.W38
NCFA Bibl. p.436

ND
205
I79
1933
NPG

I.B.2 - ELLIOTT, CHARLES LORING, 1812-1868

Isham, Samuel, 1855-1914
Elliott, in his,The history of American
painting, Ch.XV,p.272-7.N.Y.,MacMillan co.
,c.1933,

1 repro.p.273
see also p.282,529

LC ND205.I7 1936

I.B.2 - EICHHOLTZ, JACOB, 1776-1842

Milley, John
Jacob Eichholtz,1776-1842,Pennsylvania por-
traitist

M.A.thesis Univ.of Delaware,1960

Arts in Am.q25961.U5A77X
FCA Ref. T855

705
A56
NCFA
v.24

I.B.2 - ELLIS, R.B., 18th c.

Donnell, Edna,Bowden, 1891- .
Portraits of eminent Americans after draw-
ings by Du Simitière

In:Antiques
24:17-21 July,1933 illus.

Repro.incl:Washington on ceramics;enamel
cloak hooks;printed cotton with portr.medal-
lions derived fr. engravings after Du Simitière
Incl.list of Prévost's,Reading's & R.B.
Ellis' engravings.

N
40.1
E34P4
NPG

I.B.2 - EICHHOLTZ, JACOB, 1776-1842

Pennsylvania academy of the fine arts, Philadel-
Jacob Eichholtz,1776-1842, ,phia
Pennsylvania painter:A retrospective exh.Fore-
word by Wm.B.Stevens,jr.Intro.by Edg.Preston
Richardson.Phila.,c.1969,
18 p. illus(col.)

Exh.Nov.13-Dec.14,1969

Arts in Am. q25961.U5A77X
FCA Ref. I 738

I.B.2 - ELLIS, R.B. - 18th c.

,Du Simitière, Pierre Eugène,ca.1738-1784
Heads of illustrious Americans,London,
R.Wilkinson,1783,

Engraved by R.B.Ellis.'From these engrav-
ings the Engl.industry spread the portrs. on
printed textiles,enamel & decorative earthen-
ware.'-Donnell

MET-C NjP

I.B.2 - ELDH, CARL JOHAN, 1873-1954

Asplund, Karl, 1890-
Carl Eldh.Stockholm,Horstedt,,1943,
271 p. illus.

Swedish sculptor, mainly portraits

LC NB793.E55A8 1943

I.B.2 - ELLIS, R.B. - 18th c.

Du Simitière,,Pierre Eugène,ca.1736-1784
Portraits of the generals,ministers,magis-
trates,members of Congress,and others,who have
rendered themselves illustrious in the revolu-
tion of the United States of North America.
Drawn from the life by M.Dusiritier...and en-
graved by the most eminent artists in London.
London,,.Wilkinson and ,.Debrett,1782
2 p. 12 portrs.

Incl.:Washington, John Jay
'Set was signed P.P.F.'-Donnell

LC E206.D97

759.1
C14
1907a
NCA

I.B.2 - ELLIOTT, CHARLES LORING, 1812-1868

Caffin, Charles Henry, 1854-1918
Elliott in his,The story of American paint-
ing...,p.93-4.N.Y.,Fred.A.Stokes co.,1907

1 repro.p.95

LC ND205.C2 1907a

ND
236
L76
NPG

I.B.2 - ELLSWORTH, JAMES SANFORD, 1802-1874

Lipman, Mrs.Jean Herzberg, 1909- comp.
Primitive painters in America....1950, (card 2

Contents-cont.-17.M.E.Jacobson, O.Krans

List of primitive painters

8.FF Sherman, J.S.Ellsworth

LC ND236.L76

705
A784
NCFA
v.41

I.B.2 - ELLSWORTH, JAMES SANFORD, 1802-1874

Mitchell, Lucy B., 1901-
James Sanford Ellsworth:American minia-
ture painter

In:Art in Am
41:151-84 Autumn,'53 illus.

Bibliography

Abby Aldrich Rockefeller
Folk Art Ctr.Am.Folk portr:
N7593.A23 Bibl.p.294

N
40.1
F554E5
NPC

I.B.2 - EMMET, ELLEN RAND, 1875-1941
Cousin of Rosina & Lydia
Hoppin, Martha J.
The Emmets:a family of women painters.Essay
& checklist by Martha J.Hoppin.Pittsfield,Mass.,
The Berkshire Mus.,1982
63 p. illus(part col.)

Exh.at Berkshire Museum,Pittsfield,Mass.,
Aug.6-Sept.26,1982.The Danforth Museum,Framing-
ham,Mass.,Oct.16-Dec.5,1982

Preface by Lydia Sherwood McClean

40.1
E476M6
NPG
2 cops.

I.B.2 - ELLSWORTH, JAMES SANFORD, 1802-1874
Mitchell, Lucy B., 1901-
The paintings of James Sanford Ellsworth,
itinerant folk artist,1802-1873;cat.of an exh.
presented by the Abby Aldrich Rockefeller Folk
Art Coll.,Williamsburg,Va.,Oct.13-Dec.1,1974...
Colonial Williamsburg Foundation,.1974.
103 p. illus(part col.)

Bibliography
Incl:Checklist:Oil ptgs. and W.C.miniature
See also other articles in Art in Am.v.41:
151-84(Autumn,'53) v.42:218-9(Oct.,'54)
LC ND1337.U6E495

N
40.1
F554E5
NPC

I.B.2 - EMMET, LYDIA FIELD, 1866-1952
Sister of Rosina
Hoppin, Martha J.
The Emmets:a family of women painters.Essay
& checklist by Martha J.Hoppin.Pittsfield,Mass.,
The Berkshire Mus.,1982
63 p. illus(part col.)

Exh.at Berkshire Museum,Pittsfield,Mass.,
Aug.6-Sept.26,1982.The Danforth Museum,Framing-
ham,Mass.,Oct.16-Dec.5,1982

Preface by Lydia Sherwood McClean

705
A56
NCFA
v.7

I.B.2 - ELLSWORTH, JAMES SANFORD, 1802-1874
Sherman, Frederic Fairchild, 1874-1940
A family painted in miniature

In:Antiques
7:18-19 Jan.,'25 illus.

Here attr.to Ellsworth

Mitchell.Js.S.Ellsworth
N40.1.E476M6 bibl. NPC
p.103

N
40.1
F554E5
NPC

I.B.2 - EMMET, ROSINA SHERWOOD, 1854-1948
Hoppin, Martha J.
The Emmets:a family of women painters.Essay
& checklist by Martha J.Hoppin.Pittsfield,Mass.,
The Berkshire Mus.,1982
63 p. illus(part col.)

Exh.at Berkshire Museum,Pittsfield,Mass.,
Aug.6-Sept.26,1982.The Danforth Museum,Framing-
ham,Mass.,Oct.16-Dec.5,1982

Preface by Lydia Sherwood McClean

705
A56
NCFA
v.21

I.B.2 - ELLSWORTH, JAMES SANFORD, 1802-1874
Snow, Julia D.Sophronia
King versus Ellsworth

In:Antiques
21:118-21 Mar.,'32 illus.

Repro.:incl.Daguerreotypes

.............of......,f'ly given to
.................Erastus King's
................evidence in support of her at-
tribution.

Sherman,F.F.,J.S.Ellsworth
In:Lipman,Prim.ptrs.in Amer.
ND236.L76,p.71

705
A56
NCFA
v.4

I.B.2 - EMMONS, ALEXANDER HAMILTON, 1816-fl.till
after 1848
Sherman, Frederic Fairchild, 1874-1940
Three New England miniatures

In:Antiques
4:275-6 Dec.,'23 illus.

Miniatures attr.to Alexander Hamilton Emmons

Repr.:Emmons,J.S.Ellsworth

Robinson.Amer.primit.ptg.
In:Antiques,19:33 705A56

I.B.2 - ELSTRACK, RENOLD, 1571-after 1625

Holland, Henry, 1583-1650?
Basiliωlogia, a booke of kings;notes on a
rare series of engraved English royal portraits
...By H.C.Levis. New York,The Grolier club,1913

'Engravings largely by Renold Elstrack'.-Gib-
son,R. The NPG's set of Kings & Queens...p.83

LC NE1685.B3L5 FOR COMPLETE ENTRY
SEE MAIN CARD

708.2
V63

I.B.2 - ENGLEHEART, GEORGE, 1750(or 1752)-1829

Victoria and Albert museum. South Kensington
Dept.of paintings
Exhibition of miniatures by George Engle-
heart,....May-June 1929.London,1929

MET
189En3
V66

LC(ND1337.G8E64)
CSmH OClMA PPPM
CtY FOR COMPLETE ENTRY
SEE MAIN CARD

B
.E58W7

I.B.2 - ENGLEHEART, GEORGE, 1750(or 1752)-1829

Williamson, George Charles, 1858-1942
George Engleheart,1750-1829...London,G.Bell
& sons,1902

LC ND1337.G8E6

FOR COMPLETE ENTRY
SEE MAIN CARD

N
40.1
E91C5
NCFA

I.B.2 - EVANS, J.

Chicago. Art Institute
Three New England watercolor painters.Cat.
by Gail and Norbert H.Savage and Esther Sparks.
Chicago,A.I.,1974
72 p. illus(part col.)

78 works shown;W.C.portrs. by Jos.H.Davis,
J.Evans,J.A.Davis.The cat.documents all the
known ptgs.by the three.
Rev.In:Art Gallery,v.18:54-6 Jan.'75 illus.,
by Esther Sparks
Exh.at Chicago A.I. Nov.16-Dec.22,1974;Art
Mus.St.Louis,Jan. 17-March 2,1975;

LC ND1810.S28
(Savage,Gail)

Rila I/I-2 1975 #2940/41

708.2
V63

I.B.2 - ENGLEHEART, JOHN COX DILLMAN, 1783-1862

Victoria and Albert museum, South Kensington
Dept.of paintings
Exhibition of miniatures by ...,J.C.D.Engle-
heart ... May-June,1929.London,1929

MET
189En3
V66

LC(ND1337.G8E64)
CSmH OC1MA PPPM CtY

FOR COMPLETE ENTRY
SEE MAIN CARD

I.B.2 - EVELYN , JOHN, 1620-1706

Evelyn, John, 1620-1706
Extracts from the diaries and correspond-
ence of John Evelyn and Samuel Pepys relating
to engraving,with notes by Howard C.Levis.
London,Ellis,1915
166 p. illus.

Contents...-Portraits of John & Mary Evely
and Samuel & Elizabeth Pepys. ...John Evelyn's
etchings
Bibliography

LC NE440.E8

B
.E58W7

I.B.2 - ENGLEHEART, JOHN COX DILLMAN, 1783-1862

Williamson, George Charles, 1858-1942
George Engleheart...London,G.Bell & sons,
1902

Appendices incl:...List of works by John
Cox Dillman Engleheart.List of min. by ...& by
J.C.D.Engleheart with names of their owners

LC ND1337.G8E6

FOR COMPLETE ENTRY
SEE MAIN CARD

7C5
B97
NCFA
v.93

I.B.2 - EWORTH, HANS, fl.in England after 1543

Auerbach, Erna
Holbein's followers in England

In:Burl Mag
93:44-6,49-51 Feb.,'51 illus.

Refers to exh.Works by Holbein & other mas-
ters of the 16th & 17th c.at London, Royal aca-
demy of arts,1950-51
see over
Repro.:Strates(dated ptgs.:1546,1550)Eworth
(1549,1550,1562,1566)Flicke(1547)
Strong.Engl.Icon.qND1314
S924 Bibl.:"Valuable espe-
cially for its material on Scrots"

927.3
E64

I.B.2 - EPSTEIN, JACOB, 1880-

Epstein, Jacob, 1880-
Portraits

In:his:Let there be sculpture...N.Y.,G.P.Put-
nam's sons.1940.
pp.58-91 illus.

p.58-62,90-1:E.describes his workmethod & his
thoughts abt. portraiture.-p.63-89:Individual
sitters.

LC NB497.E6A2

Vincent,C.In search of like-
ness...Met Mus Bul 24ns:252

AP
1
W225
NCFA
v.2

I.B.2 - EWORTH, HANS, fl.c.1547-c.1578

Cust, Lionel Henry, 1859-1929
The painter HE ('Hans Eworth')

In:Walpole Soc.
2:1-44 1913 illus.
3:113-14 1914 illus.
:114-17 " " (by Mary F.S.Hervey)
:118-19 " " (by Rich.W.Goulding)

Incl.List of portrs.by or attr.to Hans Eworth

Strong.Engl.Icon.qND1314
S924 Bibliography

759.972
M77

I.B.2 - ESTRADA, JOSÉ MARÍA,born in Guadalajara
fl.19th c.

Montenegro, Roberto, 1887-
...Pintura mexicana(1800-1860).Mexico,1934
19 p. illus(part col.)
Second edition

53 Repro.of portrs.,most of them by José
María Estrada

LC .N7596.M6.

NCMA p.432, v.11

N
40.1
E9515
NPG

I.B.2 - EWORTH , HANS, fl.1545-1574

Leicester, Eng. Museum and Art Gallery
Hans Eworth:a Tudor artist and his circle
.Prepared by Dr.Roy Strong....:1965.
26 p. illus.

Catalogue of an exhibition
Bibliography

Repr.incl.:Baroness Dacre with portr.of 1s
husband by Holbein?;Sir John Luttrell,with al-
legorical scene:Peace caresses Sir John's arm,
by School of Fontainebleau;Queen Elizabeth in

LC ND497.E914

cont'd on back of card
source:Yale ctr.f.Brit.art Ref.

705
B97
NCFA
v.93

I.B.2 - EWOUTSZ see EWORTH, HANS

Auerbach, Erna
 Holbein's followers in England

In:Burl Mag
93:44-6,49-51 Feb.,'51 illus.

 Refers to exh.Works by Holbein & other mas-
ters of the 16th & 17th c.at London, Royal aca-
demy of arts,1950-51
 see over
 Repro.:Stretes(dated ptgs.:1546,1550)Eworth
(1549,1550,1562,1566)Flicke(1547)
 Strong.Engl.Icon qND1314
 S92A Bibl.:"Valuable espe-
 cially for its material on Scrots"

N
40.1
.7A2
NMAA

I.B.2 - FAED FAMILY

McKerrow, Mary
 The Faeds.A biography.Edinburgh,Canongate,
1982
 158 p. illus.

 Bibliography

 Incl.:Cat.of major Faed works.List of pic-
tures in permanent collections

705
C28
1910
NCFA
v.3

I.B.2 - EYCK, VAN

Durrieu, Paul, 1855-1925
 Quelques portraits historiques du début du
15e siècle

In:Gaz Beaux Arts
3:461-9 Jun,1910 illus.

 Identifications of persons in the "Heures
de Turin"& on the wing of the Ghent altar by
van Eyck:Knights of Christ;in Berlin

 Fogg,v.11,p.321

N
40.1
F156F2
NPG

I.B.2 - FAGNANI, GUISEPPE, 1819-1873

Fagnani, Mrs.Emma Everett (Goodwin)
 The art life of a 19th century painter,
Joseph Fagnani,1819-1873...Priv.print.,Paris,
H.Clarke,1930
 123 p. illus.

 Preface signed:Charles Prospero Fagnani

 Incl.:Partial list of some 1432 portraits

705
C75
NCFA

I.B.2 - EYKES, JOHN, fl.mid 17th c.

Manners, Lady Victoria, 1876-
 The Oxenden collection.Pt.1,2,3

In:Connoisseur
40:3-12 Sep.,1914 illus.
41:121-30 Mar.,1915 illus.(also opp.p.46)
43:200-08 Dec.,1915 illus.

 Mainly Engl.portrs.of the 16-18th c.Espe-
cially interesting for the study of early Engl.
school of portraiture
 Repro.incl.:Corn.Janssens,van Ceulen,
Mytens,John Eykes,Payram,Aikman,Beach..

AP
1
W225
NCFA
v.14

I.B.2 - FAITHORNE, WILLIAM, ca.1616-1691

Bell, Charles Francis, 1871- and Rachel Poole
 English 17th-century portrait drawings in
Oxford collections.Pt.II:Miniature portraiture
in black lead and Indian ink

In:Walpole Soc.
14:43-80 1925-26 illus.

 Incl.chapter on Wm.Faithorne,p.45-55;David
Loggan,n.55-64;Rht.White,p.64-71;Portr.of Arch-
bishop Oliver Plunket,p.71-73;Ths.Forster,p.71-
80. Lists of dated,or named drags.& engrs.'ad
vivum'& signed e grs.not inscribed 'ad viv'

I.B.2 - FABER, JOHN, THE ELDER, 1650(or'60)-1721

Faber, John, the older, fl.1650(or'60)-1721
 Portraits of the founders of Colleges in
Oxford and Cambridge;in mezzotinto.London,
1712-14
 illus.
Brit.Mus.

 Lewine.Bibl.of 18th c.art &
 illus.books.Z1023.L67 1969
 NCFA p.175

I.B.2 - FAITHORNE, WILLIAM, 1616-1691

British museum. Dept.of prints and drawings
 Early engraving & engravers in England
(1545-1695)a critical and historical essay by
Sidney Colvin...London,Printed by order of the
Trustees,1905
 170 p. illus.

 Appendix I.List of engravers' works

 Incl.account of Faithorne's life

LC NE628.B8 Hind.Studies in English
 Engraving.In:Connoisseur
 92:92, 1933

I.B.2 - FABER, JOHN,the younger, c.1684-1756

Kneller, Godfrey & Faber, John
 The Kit-Cat Club done from the original
paintings of Sir Godfrey Kneller by Mr.Faber.
London,J.Tonson & J.Faber,1735
 p. illus.

LC ND497K47F3 Marlborough,London
 cat.,1972,no.17
 (offered for £350.00)

I.B.2 - FAITHORNE, WILLIAM, 1616-1691

Fagan, Louis Alexander, 1845-1903
 A descriptive catalogue of the engraved
works of William Faithorne...London,B.Quaritch,
1888
 104 p.

LC NE642.F2.F3 Hind.Studies in English En-
 graving.In:Connoisseur
 92:92,1933

I.B.2 - FAITHORNE, WILLIAM, 1616-1691

Grolier club, New York
 Cat.of an exh.of portraits engraved by
William Faithorne...Feb.16-Mar.4,N.Y.,De Vinne
press,1893
 38 p.

LC NE642.F207
 Levis, Descr.bibl.Z5947A3
 L66 1974 NCFA p.380

I.B.2 - FEKE, ROBERT, ca.1705-1750

705
A7832
NCFA
v.35

Belknap, Waldron.Phoenix,1899-1949
 Feke and Smibert:a note on two portraits

In:Art Bul
35:225-6 Sept.,'53 illus.

 B.suggests that Smibert and Feke ptd.Henry
Collins.Feke's portr. formerly called to re-
present Gershom Flagg III

705
C75
NCFA
v.92

I.B.2 - FAITHORNE, WILLIAM , 1616-1691

Hind, Arthur Mayger, 1880-1957
 Studies in English engraving. IV.William
Faithorne

In:Connoisseur
92:92-105 Aug, '33 illus.

705
A7832
NCFA
v.29

I.B.2 - FEKE, ROBERT, c.1705-1750

Belknap, Waldron Whoenix, 1899-1949
 The identity of Robert Feke

In:Art Bul
29:201-7 Sept.,'47

 Craven.Colonial Am.portrai
 ture N7593.1.C73 1986X NPO
 Bibl.p.138

I.B.2 - FANTIN-LATOUR, IGNACE HENRI JEAN
 THEODORE, 1836-1904
Jullien, Jean Lucien,Adolphe, 1845-
 Fantin-Latour;groupes et portraits d'ar-
tistes et d'hommes de lettres

MET
100.54
Ar72
1906

In:Les Arts
5,no.53:25-32 May,1906 illus.

LC N2.A85
 Chicago,A.I. European portrs.
 N7621.C4A7 NPG Bibl. p.177

AP
1
A625
NMAA

I.B.2 - FEKE, ROBERT, c.1705-1750

Bolton, Theodore, 1889- and H.L.Binsse
 Robert Feke,first painter to Colonial
aristocracy

In:Antiquarian
15:33-37,74,76,78 Oct.,1930 illus.

 Biography and checklist

 Flexner,Js.Ths. Rbt.Feke
 in:Art Bul,28:197 footnote
 2

705
A56
NCFA
v.111

I.B.2 - FARIS, WILLIAM, 1728-1804

Weekley, Carolyn J.
 Portrait painting in 18th c.Annapolis

In:Antiques
111:345-53 Feb.,'77 illus(part col.)

 Incl.:Engelhardt,Kühn,Hesselius,Wollaston,
Chs.W.Peale,Js.Peale,Faris

 RILA IV/I 1978 #1138

705
M18
NCFA
v.40

I.B.2 - FEKE, ROBERT, ca.1705-1750

Flexner, James Thomas, 1908-
 Aristocratic visions:The art of Robert
Feke

In:Mag. Art
40:3-7 Jan.,'47 illus.
 :35-6:Chronology of Feke's pictures,before
 1741-1750

 F.had been influenced by John Smibert before
developing his own style.

 Mooz.Art of Rbt.Feke N40.1
 F31?M8 1970a NMAA Bibl.
 p.XXXIII

qND
1328
B35
NCFA

I.B.2 - FEKE, ROBERT, c.1705-1750

Bayley, Frank William, 1863-1932
 Five colonial artists of New England:Joseph
Blackburn,John Singleton Copley,Robert Feke,John
Smibert...Boston,Priv.print.,1929
 448 p. illus.

 Bibliography

LC N6536.B3

705
A7832
NCFA
v.28

I.B.2 - FEKE, ROBERT, ca.1705-1750

Flexner, James Thomas, 1908-
 Robert Feke;active ca.1741-ca.1750

In:Art Bul.
28:197-202 Sept.,'46 illus.

 "...the object of this article..is..a new
chronology for his pictures..."

 Belknap.Amer.Colonial ptg.
 ND1311.1.B43 NCFA Bibl.
 p.359

B
.F31F6

I.B.2 - FEKE, ROBERT, c.1705-1750

Foote, Henry Wilder, 1875-
 Robert Feke, colonial portrait painter...
Cambridge, Mass., Harvard university press, 1930
 223 p. illus.

LC ND237.F35F6

Whitehill, The Arts of early Amer.Hist.Z5935.W59 NPG Bibl.,p.90

N
40.1
F312G6
NCFA

I.B.2 - FEKE, ROBERT, ca.1705-1750

Robert Feke. Whitney museum of American art, New York. Oct.48-30, 1946. Rochester art. gal. Huntington, Long Island, Nov.2-24, 1946. Mus. of fine arts, Boston, Nov.27-Dec.22, 1946. .New York? 1946.
 .36.p. illus.

Foreword by Henry Wilder Foote. Text sign. Lloyd Goodrich
Early works infl.by John Smibert.
See also H.W.Foote, Robert Feke as revealed in recent exh.of portrs. "In:Art in Am.v.35 56-70 Jan. 1947 illus.

I.B.2 - FEKE, ROBERT, ca.1705-1750

Foote, Henry Wilder, 1875-
 Robert Feke, portrait painter

In:R.Isl.History
6,no.2 April,'47 illus.

LC F76.R472

Mooz.Art of Rbt.Feke N40.1 F312M8 1970a NPAA Bibl. p.XXXIV

705
I61
NCFA
v.77

I.B.2 - FEKE, ROBERT, ca.1705-1750

Robie, Virginia
 An American old master-Feke.Colonial artist's portraits of the Boudoins are prized possessions of the college of that name

In:Studio
77:h30-33 Aug.,'23 illus.

Mooz.Art of Rbt.Feke N40.1 F312M8 1970a NPAA Bibl. p.XXXV

N
40.1
F312M8
1970a
NMAA

I.B.2 - FEKE, ROBERT, ca.1705-1750

Mooz, Ralph Peter, 1940-
 The Art of Robert Feke.Phila,Univ.of Penn. 1970
 334 p. illus.

Thesis Ph.D -UNIV.OF Penn.,1970
Bibliography,p.27-36
Checklist of portraits
Photocopy of typescript

N
40.1
F33yU5

I.B.2 - FENDERICH, CHARLES, fl.ca.1833-1887

U.S. Library of Congress. Prints and Photographs Division
 Charles Fenderich, lithographer of American statesmen: a cat.of his work, by Alice Lee Parker and Milton Kaplan.Washington,1959
 64 p. illus.

LC NE2415.F4U5

ND
207
W78
1971
NPG

I.B.2 - FEKE, ROBERT, c.1705-1750

Mooz, R.Peter
 Robert Feke:The Philadelphia story

In:Winterthur Conf.on Mus.Oper'n and Conn'ship
17th:181-216 1971 illus.

 Bibliographical notes

LC ND207.W5 1971

705
A784
NCFA
v.9

I.B.2 - FÉVRET DE SAINT-MÉMIN, 1770-1852

Bolton, Theodore, 1889-
 Saint-Mémin's crayon portraits

In:Art in Am
9:160-7 Jun,'21 illus.

 Incl.list of crayon drawings by St.-Mémin

I.B.2 - FEKE, ROBERT,c.1705-1750

Poland, William Carey, 1846-1929
 Robert Feke,the early Newport portrait painter and the beginnings of colonial painting;a paper read before the Rhode Island hist soc.,Apr.5,1904...Providence,1907
 26 p.

 "150 copies reprinted from the Proceeding of the Hist.Soc.,1904-05"

MdRP MiU MB RPD MH etc.
 Mooz.The Art of Rbt.Feke Bibl.p.XXXI

N
7628
W31C3
NPG

I.B.2 - FÉVRET DE SAINT-MÉMIN, 1770-1852

Carson, Hampton Lawrence, 1852-1929
 ...The Hampton L.Carson collection of engraved portrais of Gen.George Washington. Cat. comp. & sale conducted by Stan.V.Henkels.At the art auction rooms of Davis & Harvey...Phila.,Pa.,,Press of W.F.Fell co.,1904.
 173 p. illus(part col.)
 Cat.no.906,pt.I

 Incl.St.Mémin personal coll.of proof mezzotints...to be sold Jan.21 & 22, 1904
LC Z999.R505 no.906,pt.1 Amsterdam Rijksmus.cat.
c.2 E312.43.C32 Z5939A52, deel 1, p.154

I.B.2 - FÉVRET DE SAINT-MÉMIN, 1770-1852

Colquitt, Delores Boisfeuillet
 Distinguished Jews in St.Mémin miniatures

In:Daughters of the Amer.Rev.Mag.
59 Feb.,1925

LC E202.5.A12 London,H.R. Shades of my
 forefathers.741.7.L847 Bibl.

VF
St.Mémin
 I.B.2 - FÉVRET DE SAINT-MÉMIN, 1770-1852

Lockwood, Luke Vincent, 1872-
 The St.-Mémin Indian portraits

In:N.Y.Hist Soc Q.B.
12,no.1:3-26 Apr.'28 illus.

LC F116.N638 Dijon.Mus.municipal M40.1
 F43D5 NPG Bibl.p.25

VF
St.-Mémin
 I.B.2 - FÉVRET DE SAINT-MÉMIN, 1770-1852

Colquitt, Delores Boisfeuillet
 Pennsylvanians in St.-Mémin's miniatures

In:Daughters of the Amer.Rev.Mag.
60:217-25 Apr.,'26 illus.

LC E202.5.A12

705
C75
NCFA
v.75
 I.B.2 - FÉVRET DE SAINT-MÉMIN, 1770-1852

Martin, Mary
 The physionotrace in France and America:
Saint Mémin and others

In:Connoisseur
75:141-8 Jul,'26 illus.

M
40.1
F43C7
NPG
3 c.
 I.B.2 - FÉVRET DE SAINT-MÉMIN, CHARLES BALTHA-
 ZAR JULIEN, 1770-1852
Corcoran Gallery of Art, Washington, D.C.
 Cat.of engraved portraits by Favret de
Saint Memin,1770-1852,in the permanent coll. of
the Corcoran gallery of art,Washington,D.C.
«Washington,W.F.Roberts co.,19--»
 17 p.

LC NE650.F4C6

VF
St.-Mémin
 I.B.2 - FÉVRET DE SAINT-MÉMIN, 1770-1852

Maryland Historical Society
 St.Mémin in Maryland;loan exh.of portraits
of "Distinguished characters"in W.C.,crayon and
engraving.Baltimore,1951
 15 p. illus.

Exh.Feb.15-Apr.15,1951

Alphabetical list of sitters

 Dijon.Mus.municipal M40.1
 F43D5 NPG Bibl.p.26

fN
40.1
F43D4
RB
NPG
 I.B.2 - FÉVRET DE SAINT-MÉMIN, 1770-1852

Fevret de Saint-Mémin,Charles Balthazar Julien,
 1770-1852
 The St.-Mémin collection of portraits;...760
medallion portrs.,....of distinguished Americans,
photographed...from proof impressions of the ori-
ginal copperplates,engraved by M.de St.-Mémin,
from drags.taken from life by himself,...in the
U.S.from 1793 to 1814.To which are prefixed a me-
moir of M.de St.-Mémin.by Ph.Guignard...,compiled
...by the publisher E.Dexter.New York,...1862
 104 p. illus. see over
LC N7593.F5 Morgan,J.H.,The work of M.
 Fevret.Brooklyn mus.Q.,5:6
 708.1.B87 NCFA

AP
1
A51A64
N:AA
v.20
 I.B.2 - FÉVRET DE SAINT-MÉMIN, 1770-1852

Miles, Ellen G.ross.
 Saint-Mémin's portraits of American Indians,
1804-1807

In:Am Art J
20,no.4:2-33 1988 illus(1 col.)

I.B.2 - FÉVRET DE SAINT-MÉMIN, 1770-1852

Guignard, Philippe, 1820-1905
 Notice historique sur la vie et les travaux
de m.Fevret de Saint-Mémin...Dijon,Impr.Loireau-
Feuchot,1853
 22 p.
 Extrait des Mémoires de l'Académie des
sciences,arts et belles-lettres de Dijon
LC NE650.F4G9
 (In Académie des sciences,arts et belles-
lettres de Dijon.Mémoires. Dijon,1854,sér.2,t.2,
p.1-20)

LC DC611.B771.A3 Morgan,J.H. The work of
Wash.D.C, Corcoran Gall. m.Fevret de Saint-Mémin
 In:Brookl.m.Q.5,p.6 708.1
 B87

708.1
.B87
v.5
 I.B.2 - FÉVRET DE SAINT-MÉMIN, 1770-1852

Morgan, John Hill, 1870-
 The work of M. Fevret de Saint-Mémin

In:Brooklyn Mus. Q.
5:14-26 Jan,'18 illus.

 .«F.'s work portrays so many of those inti-
mately connected with...our government"
 Repro.:Alex.Smith of Baltimore,Theod.Gourdin,
Timothy Pickering,Judge John Sam.Sherburne

N
40.1
F43N8
NCFA
NPG

I.B.2 - FÉVRET DE SAINT-MÉMIN, 1770-1852

Norfleet, Fillmore
Saint-Mémin in Virginia:portraits and bio-
graphies...Richmond,Va.,The Dietz press,1942
235 p. illus.

Bibliography

Repro.of 56 crayon portrs.& 142 engravings

Valdenuit is mentioned p.14-16

LC N7593.N7

N
40.1
F43V1
NPG
2 cops

I.B.2 - FÉVRET DE SAINT-MÉMIN, 1770-1852

Valentine museum, Richmond,Va.
Exhibition of the works of Charles Baltha-
zar Julien Fevret de Saint-Mémin,a special loan
exhibition of crayons,engravings,copper plates,
w.c.,silhouettes.Valentine museum,Richmond,1941
68 p. illus.

Bibliography

Special emphasis on portrs. of Virginians

Exhib.,Apr.1-Nov 10,1941

LC N7593.F52V3 Fogg,v.11,p.329

757.7
.P72
NCFA

I.B.2 - FÉVRET DE SAINT-MÉMIN, 1770-1852

Pleasants, Jacob Hall, 1873-
Saint Mémin water color miniatures.
,Portland,Maine, Anthoensen Press,1947?.
29 p. illus.

"Reprinted from The Walpole Society Notebook,
1947,by The Anthoensen Press,Portland,Maine..."

Fogg,v.11,p.325

I.B.2 - FÉVRET DE SAINT-MÉMIN, 1770-1852

Weitenkampf, Frank, 1866-1962
Sketch of the life of Charles Balthazar
Julien Fevret de Saint-Mémin;issued to accom-
pany an exh.of his engraved portraits at the
Grolier club,March 5-25,1899
10 p.

LC NE650.F4W4 Levis.Descr.bibl.Z5947A3
 L66 1974 NCFA p.383

VF
St.-Mémin

I.B.2 - FÉVRET DE SAINT-MÉMIN, 1770-1852

Rice, Howard Crosby, 1904-
An Album of Saint Mémin portraits

In:Princeton Uni Lib Chron
13:23-31 Autumn, '51

Re:Valdenuit see p.24-5

LC Z733.P96C5

N
40.1
F44Jy
A5
NPG
RB

I.B.2 - FICQUET, ÉTIENNE, 1719-1794

Andrews, William Loring, 1837-1920
A trio of 18th century French engravers of
portraits in miniature.Ficquet,Savart,Grateloup..
N.Y.,Dodd,Mead & co.,1899
123 p. illus(1 col.)
Contents.-Intro.,giving a short account of
the various methods of engr.on metal.-A trio of
18th c.French engravers...-Extracts fr.La Calco-
grafia of Giuseppe Longhi.-List of portrs.engr.
by Étienne Ficquet,Pierre Savart,Jean Baptiste
de Grateloup

LC NE647.A5 evi.Descript.bibl.Z5947.A3
 L66 1974 NCFA p.205

VF
St.-Mémin

I.B.2 - FÉVRET DE SAINT-MÉMIN,1770-1852

Rice, Howard Crosby, 1904-
Saint-Mémin's portrait of Jefferson

In:Princeton Uni Lib Chron
20:182-92 Summer,'59 illus.

Bibliography on Saint-Mémin

Note on the physiognotrace

LC Z733.P96C5 Whitehill.The Arts in ear-
 ly Amer.Hist.Z5935.W59 NPG
 Bibl.,p.93

qN
40.1
F44BA2

I.B.2 - FIELD, ERASTUS SALISBURY, 1805-1900

Abby Aldrich Rockefeller Folk Art Collection,
Williamsburg,Va.
Erastus Salisbury Field,1805-1900...Williams-
burg,Va.,1963

705
M18
NCFA
v.11

I.B.2 - FÉVRET DE SAINT-MÉMIN, 1770-1852

Seaton-Schmidt, Anna
St.-Mémin and his portraits

In:Mag Art
11:438-41 Oct.,'20 illus.

A784
NCFA
v.32

I.B.2 - FIELD, ERASTUS SALISBURY, 1805-1900

Dods, Agnes M.
A check list of portraits and paintings by
Erastus Salisbury Field

In:Art in Am
32:32-40 Jan.,'44 illus.

"Used daguerreotypes as an aid in producing
good likenesses on canvas.'-Robinson

I.B.2 - FIELD, ERASTUS SALISBURY, 1805-1900

Dods, Agnes M.
Erastus Salisbury Field, a New England folk artist

In:Old Time N Engl
33:26-32 Oct., '42

LC F1.S68

705
C75
NCFA
v.88

I.B.2 - FIELD, H.W. (son or brother of John F.)

Jackson, Mrs.F.Nevill, 1861-
John Field,profilist

In:Connoisseur
88:316-321 Nov., '31 illus.

'...at the V.&A.Mus.is a double locket in which is on one side a signed profile by J.F. & on the other side a signed profile by H.W. Field'

Quimby,Nellie Earles.Beauty in black & white.Oregon State Libr.,Salem 741041b Bibl:n.46

AP
1
C76
NPG
v.28

I.B.2 - FIELD, ERASTUS SALISBURY, 1805-1900

French, Reginald F.
Erastus Salisbury Field,1805-1900

In:Conn.Hist.Soc.P.
28:97-130 Oct., '63 illus.(portrs.p.131-43)

Incl.:Checklist of ptgs.attr.to E.S.Field; Portrs.nos.1-240

FOR COMPLETE ENTRY
SEE MAIN CARD

705
C75
NCFA
v.88

I.B.2 - FIELD, JOHN, 1771-1841

Jackson, Mrs.F.Nevill, 1861-
John Field,profilist

In:Connoisseur
88:316-321 Nov., '31 illus.

'...at the V.&A.Mus.is a double locket in which is on one side a signed profile by J.F. & on the other side a signed profile by H.W. Field'

Quimby,Nellie Earles.Beauty in black & white.Oregon State Libr.,Salem 741041b Bibl.n.46

ND
236
L76
NPG

I.B.2 - FIELD, ERASTUS SALISBURY, 1805-1900

Lipman,Mrs.Jean Herzberg, 1909-
Primitive painters in America,1750-1950;an anthology...N.Y.,Dodd,Mead,1950.

Contents.-...9.F.B.Robinson,E.S.Field

see also:Robinson,F.B. Erastus Salibury Field in Art in Am. vol.30:244-53 Oct., '42,illus

N
40.1
F45A7
NPG

I.B.2 - FIELD, ROBERT, ca.1769-1819

Art Gallery of Nova Scotia
Robert Field..Cat.of exh..Oct.5-Nov.27,1978. The Gallery,1978
121 p. illus(part col.)

Article"Rbt.Field"by Sandra R.Paikowsky

List of works:oil,W.C.,prints

Repre.incl.:Jefferson,Washington,Martha Washington(all W.C.)

708.1
B762
NCFA
v.61

I.B.2 - FIELD, ERASTUS SALISBURY, 1805-1900

Maytham, Thomas N.
Two faces of New England portrait painting. Erastus Field and Henry Darby

In:Boston Mus Bul
61:31-43 1963 illus.

Article incl.comparison of a family group by Field with one by Darby...

FOR COMPLETE ENTRY
SEE MAIN CARD

705
C75
NCFA
v.76

I.B.2 - FIELD, ROBERT, died 1819

Grundy, Cecil Reginald, 1870-1944
Robert Field,an Anglo-American artist

In:Connoisseur
76:195-6,198 Dec., '26 illus.

AP
1
W892
NCFA

I.B.2 - FIELD, ERASTUS SALISBURY, 1805-1900

Reutlinger, Dagmar E.
American folk art:two groups of family portraits by Ruth Henshaw Bascom and Erastus Salisbury Field

In:Worcester Art Mus.Bull.
5,no.3:1-12 May, '76 illus.

"Bascom cut out paper silhouette portrs.& embellished them with charming color & imaginative collage."-Reutlinger in Rila

Rila IV/1 1978 #4033

N
40.1
F45P6
NPG

I.B.2 - FIELD, ROBERT, 1769?-1819

Piers, Harry, 1870-
Robert Field,portrait painter in oils, miniatures and watercolours and engraver... New York,F.F.Sherman,1927
202 p. illus.

Descriptive cat. of Field's works:p.117-96

LC ND497.F45P5

London,Hannah Ruth.Min.& silh. N7593.L84 Bibl.

705
A784
NCFA
v.20

I.B.2 - FIELD, ROBERT, 1769?-1819

Sherman, Frederic Fairchild, 1874-1940
Two newly discovered watercolor portraits
by Robert Field

In:Art in Am
20:84-6 Feb.,'32 illus.

Field,Robert N40.1.F45A7
p.123

N
40.1
F574K
A1
NCFA

I.B.2 - FLAGG, JAMES MONTGOMERY, 1877-1960

Flagg, James Montgomery, 1877-1960
Celebrities:a half-century of caricature and
portraiture,with comments by the artist.Watkins
Glen,N.Y.,Century House,1951
104 p. illus.

Alphabetical list of sitters

LC NC1429.F53 Art Books 1950-79 Z5937
A775 NCFA Ref. p.897

qAP
1
M225
NPG

I.B.2 - FINCH, RUBY DEVOL, 1804-1866

Walters, Donald R.
Out of anonymity:Ruby Devol Finch(1804-
1866)

In:Maine Ant.Dig.
6:10-40 June,'78 illus.

Discussion of all recorded works & details
of Finch'life.

Abby Aldrich Rockefeller
Folk Art Ctr.Am.Folk portr
N7593.A23 Bibl.p.294

N
40.1
F576P4
NPG

I.B.2 - FLAGG, JARED BRADLEY, 1820-1899

Perkins, Helen D.
An illustr.cat.of known portraits by Jared
B.Flagg,1820-1899.Comp.by H.D.Perkins.Hartford,
Conn.,Stowe-Day Foundation,1972,
64 p. illus.

A cat. of a Conn.artist.Publ.for an exh...
March 1-June 30,1972,held at Nook Farm Visitors'
Center,Hartford,Conn.
A Critique of Jared.B.Flagg's paintings by
Chs.B.Ferguson,p.8-9

LC ND1329.F55P46 Art Books 1950-79 Z5937
.775 NCFA Ref. p.897

N
40.1
F53J6
NCFA

I.B.2 - FISHER, ALVAN, 1792-1863

Johnson, Charlotte Buel
The life and works of Alvan Fisher.,New
York,1951,
213 p. illus.

Thesis(M.A.)-New York University,Institut
of Fine Arts.

Incl.a chapter on F.as portr. ptr.

705
A56
NCFA
v.115

I.B.2 - FLETCHER, AARON DEAN, 1817-1902

Burdick, Virginia ,Mason, & Nancy C.Muller
Aaron Dean Fletcher,portrait painter

In:Antiques
115:184-93 Jan.,'79 illus(part col.)

Abby Aldrich Rockefeller
Folk Art Ctr.N7593.A23
Am.folk portrs.Bibl.p.293

I.B.2 - FITCH, CAPTAIN BERIAH
see
I.B.2 - FITCH, CAPTAIN SIMON, 1758-1835

I.B.2 - FONTAINE
see
I.B.2 - SWEBACH, JACQUES FRANÇOIS JOSEPH,called
FONTAINE & DESFONTAINES, 1769-1823

AP
1
C76
NPG
v.26

I.B.2 - FITCH, CAPTAIN SIMON, 1758-1835

Warren, William Lamson
Captain Simon Fitch of Lebanon,1758-1835.
Portrait painter

In:Conn.Hist.Soc.B.
26:97-120 Oct.,'61 illus.

Discusses life and style of Fitch

FOR COMPLETE ENTRY
SEE MAIN CARD

AP
1
S66
NPG
v.3

I.B.2 - FORD, ATHANASIUS, fl.1826

Viola, Herman J.
Washington's first museum:The Indian office
collection of Ths.L.McKenney

In:Smiths.Jl.of Hist.
3,no.3:1-18 Fall 1968 illus.

p.10-14:The gallery of 130 portrs.of In-
dian dignitaries by Athanasius Ford and Chs.
B.King,some after sketches by J.O.Lewis

Viola.The Ind.legacy...Bibl

I.B.2 - FORSTER, JOHN WYCLIFFE LOWES, 1850-1938

Forster, John Wycliffe Lowes, 1850-1938
 The ideals and aims of the portrait painter

In:Dalhousie R
9:303-12 Oct,'29

LC AP5.D3

Cumulated Mag.subj.index
A1/3/C76 Ref. v.2,p.444

B
F84C2
NCFA

I.B.2 - FRASER, CHARLES, 1782-1860

Carolina art association, Charleston, S.C.
 A short sketch of Charles Fraser and a list
of miniatures and other works,exh.by the Caro-
lina art association,Gibbes art gallery,Charles-
ton,S.C.,Jan.29th-Feb.26th,1934.«n.p.,1934?»
 33 p.

 Incl.:List of located miniatures not on ex-
hibit & list of unlocated,damaged or destroyed
ones.

I.B.2 - FORSTER, JOHN WYCLIFFE LOWES, 1850-1938

Forster, John Wycliffe Lowes, 1850-1938
 Sight and insight...Toronto,Oxford uni.press,
1941
 176 p. illus.

FOOG
FA
4353.17

mfm
316117
NPG

I.B.2 - FRASER, CHARLES, 1782-1860

Fraser gallery, Charleston,S.C.
 Cat.of miniature portraits,landscapes,and
other pieces,executed by Chs.Fraser,esq.,and
exh.in "The Fraser gallery",February and March,
1857...Charleston,S.C.James & Williams,1857
 65 p.

 American culture series:Art & architecture
sect.3:Ptg.,drawg.,design,and sculpture

MH

Tolman.In:Antique,27:19
Jan.,'35

I.B.2 - FOUQUET, JEAN, 1420-betw.1477 and 1481

Laborde, Léon Emmanuel Simon Joseph de, 1807-
 La Renaissance des Arts à la cour «1869
de France (card 2)

FOOG
FA
723.3

 études sur le seizième siècle,tom.1.with
"additions".Peinture.Paris,Potier,1850-55
 2 v.(1088 p.)
 No more published
 Incl.list of portrs. now in the Biblio-
thèque nationale & an essay on Jean Fouquet & his
pupils.-Bouchot.Portrs.aux crayons,p.12

705
A784
NCFA
v.23

I.B.2 - FRASER, CHARLES, 1782-1860

Smith, Alice Ravenel Huger, 1876-
 Charles Fraser

In:Art in Am
23:22-34 Dec.'34 illus.

Carolina Art ass.,Charles-
ton,S.C.Miniature portr.co
Bibl.p.180

I.B.2 - FRANCESCHI,PIETRO DI BENEDETTO DEI
see
I.B.2 - PIERO DELLA FRANCESCA, 1416?-1492

N
40.1
F84S6
1967
NPG

I.B.2 - FRASER, CHARLES, 1782-1860

Smith, Alice Ravenel Huger, 1876-
 Charles Fraser,by A.R.Huger Smith and D.E.
Huger Smith.Charleston,S.C.,Garnier.1967.
 58 p. illus.

 Republication of 1924 ed.(N 40.1.F84xS6 NPG)

N
40.1
F84C4
NPG

I.B.2 - FRASER, CHARLES, 1782-1860

Carolina art association, Charleston,S.C.
 Charles Fraser of Charleston.Essays on the
man,his art and his times;comp.& ed.by Martha
R.Severens & Chs.L.Wyrick,jr. 1983
 168 p. illus(part col.)

 Gibbes art gallery

 Ch.III.:F.'s place in the evolution of mini-
ature portrs.by Robin Bolton-Smith,p.39-56.Ch.IV
The miniature by Paula Welshimer,p.57-74

N
40.1
F84xS6
NPG

I.B.2 - FRASER, CHARLES, 1782-1860

Smith, Alice Ravenel Hugar, 1876-
 Charles Fraser;by Alice R.H.Smith and D.E.
Hugar Smith.N.Y.,F.F.Sherman,1924
 58 p. illus.

 Incl.:Ch.'Review of F.'s work in miniature
painting'

LC ND1337.U6F7

Art Gall.of Nova Scotia.
Bt.Field
p.18

705
A784
NCFA
v.3

I.B.2 - FRASER, CHARLES, 1782-1860

Smith, Alice Ravenel Huger, 1876-
Charles Fraser, the friend and contemporary
of Malbone

In:Art in Am
3:174-83 June,'15 illus.

Carolina Art ass.,Charles-
ton,S.C.Miniature portr.col
Bibl. p.180

VF
Frazee

I.B.2 - FRAZEE, JOHN, 1790-1852

Maxfield, David M.
Historian traces obscure path of once-cel-
ebrated portrait sculptor

In:Research Reports
no.45:2,8 Spring,'85 illus.

Re-evaluation of John Frazee,the 1st Ameri-
can to fashion a portr.in marble.
'Frazee's work was good,better than anyone
ever realized.'-Fred Voss

705
M18
NCFA
v.27

I.B.2 - FRASER, CHARLES, 1782-1860

Smith, Alice Ravenel Huger, 1876-
The miniatures of Charles Fraser

In:Mag Art
27:198-202 Apr.,'34 illus.

Carolina Art ass.,Charles-
ton,S.C.Miniature portr.col
Bibl.,p.180

705
A56
NCFA
v.52

I.B.2 - FRAZER, OLIVER, 1808-1864

Bridwell, Margaret M.
Oliver Frazer,early Kentucky portrait
painter

In:Antiques
92:718-21 Nov.,'67 illus.

"...one of the most distinguished...early Ken-
tucky artists."-Bridwell

Arts in America qZ5961.U5
A77X NCFA Ref. I773

705
A56
NCFA
v.27

I.B.2 - FRASER, CHARLES, 1782-1860

Tolman, Ruel Pardee, 1878-
The technique of Charles Fraser,miniatu-
rist

In:Antiques
27:19-22(pt.1) Jan.,'35 illus.
110-62(pt.2) Feb.,'35 illus.

Careful analysis of the artist's stylistic
development

Carolina Art ass.Charleston,
S.C.Miniature portr.coll.
Bibl.,p.180

N
40.1
J86F6
NPG
NCFA

I.B.2 - FRAZER, OLIVER, 1808-1864

Floyd, William Barrow, 1934-
Jouett-Bush-Frazer:early Kentucky artists.
Lexington,Ken.:privately printed,1968
204 p. illus.

Bibliography

NPG A 19th c.gall.of distin-
guished Americans.Bibl.

LC ND236.F5

I.B.2 - FRAZEE, JOHN, 1790-1852

Caldwell, Henry Bryan
John Frazee,American sculptor

Master's thesis,N.Y.Uni.Graduate School,195?

ND
705
H86
1976x
NCFA

I.B.2 - FREAKE LIMNER, 17th c.

Huntington Galleries
American art:From the limners to the Eight.
[Exh.]Feb.1 through May 2,1976,Huntington Gal-
leries,Huntington,W.Va. Ashland Oil,1976
128 p. illus(part col.)

Bibliography

Ptgs.are fr.private & public colls.in East
Kentucky,South Ohio.& West Virginia.

Grouped:Portraiture,p.30-53;landsc.,Folk art
The West;The Eight

LC ND205M 86
1976

I.B.2 - FRAZEE, JOHN, 1790-1852

Frazee, John
The autobiography of John Frazee(1790-1852),
first American sculptor in marble

In:Am.Coll.
16:12-4 Nov.,'46 illus.

'...portr.-busts which brought nat'l fame
to...his work.'
Most of the portr.-busts in Boston, Athe-
naeum

LC NK1125.A15

I.B.2 - FREMY, JACQUES-NOEL-MARIE, 1782-1867

Frémy, Jacques-Noël-Marie, 1782-1867
Croquis de portraits des personnages remar-
quables dans tous les genres.Paris,1815-17
2 v.

Réau-L'iconogr.de Houdon
Gas Beaux Arts ser.6 1933
v.9:168,note 2

NN

705
C75
NCFA
v.43

I.B.2 - FRITH, F., fl.1830-40

₌Jackson,Mrs.F.Nevill,1861-
 ₌Silhouettes by F.Frith₌
 Notes₌by E.J.

In:Connoisseur
43:166-7 Nov.,1915 illus.

Roe.In:Conn.70:215-23,D'24

N
40.1
F9396x
V9
NMAA

I.B.2 - FRUHAUF, ALINE, 1907-1978

Fruhauf, Aline, 1907-1978
 Making faces.Memoirs of a caricaturist₌ed.
by Erwin Vollmer.Cabin John,Md./Washington,D.C.,
Seven Locks Press,c.1987
 254 p. illus.

Incl.:Index

N
40.1
F9171L5

I.B.2 - FRITSCH, WALDEMAR, 1909-

Fritsch, Waldemar, 1909-
 Das gesicht₌porträts und kompositorische
bildnisse.Einführung von Georg Lengl.Nürnberg,
H.Carl₌1969₌
 15 p. 65 plates(part col.)

 Repro.of F.'s sculptures are in 2 groups:
1st group:"ritratti";2nd group:"portraits".
Lengl differenciates betw."Ritratto":a reshaping
of the model given by nature and "Portrait",fr.
Latin-French protrahere-portraire:Draw forth,re
veal,"the idea-portrait".L.uses "face" to cover
both concepts.- ₌p.9

LC NB1301.F7 Verzeichnis lieferbarer Bü-
 cher 19/3/70 ...v.1.11..

I.B.2 - FRYMEIER, G.
see
I.B.2 - FRYMIRE, JACOB, betw.1765 and 1774-1822

N
40.1
S93M8
1969
NPG
2 c.

I.B.2 - FROTHINGHAM, JAMES, 1788-1864
see
Morgan, John Hill, 1870-1945
 Gilbert Stuart and his pupils...N.Y.,Kenne-
dy Galleries,Da Capo Press,1969
 p.52-54 2 illus.

N
40.1
F95285
NPG
2 c.

I.B.2 - FRYMIRE, JACOB(Frymeier, G.)ca.1765-1822

Simmons, Linda Crocker
 Jacob Frymire,American limner...Washington,
Corcoran Gall.of Art,c.1975
 56 p. illus(part col.)

 Based on M.A.Thesis at Uni.of Delaware,1975
 Incl.Ch.on 'Works by Chs.Peale Polk and
other contemporaries'
 Exh.at Corcoran Gall.,Oct.4-Nov.16,1975,
Kauffman Gall.,Shippensburg,Pa.,Winston-Salem,
N.C.,Mus.of Early South.Dec.Arts,Abby Aldrich
Rockefeller Folk Art Coll.,Williamsburg,Va.

708.1
B18
NCFA
v.8

I.B.2 - FRUHAUF, ALINE, 1907-

Caricaturist - Sophisticated and gay

In:Balto.M.A.News
8:6 Feb.,'46

 Short note on Aline Fruhauf.
 Exh.at Theatre gall.

I.B.2 - FUGER, FRIEDRICH HEINRICH, 1751-1818

Bourgoing, Jean de, 1877-
 ...Miniaturen von Heinrich Friedrich Füger
und anderen meistern aus der sammlung Bourgoing.
Vorwort von Dr.Leo Grünstein.Zürich,Amalthea-Ver-
lag₌1925₌
 83 p. illus(part col.)

 Bibliogr.references

LC N7616.B72 Bildnismin.& ihre meister
 757.B59,v.4,Bibl.

I.B.2 - FRY, ROGER ELIOT, 1866-1934

London. University. Courtauld Institute of Art
 Exhibition catalogues.₌3₌Portraits by
Roger Fry.Sept.18-Oct.14,1976

MET
107.2
L846

705
A784
NCFA
v.39

I.B.2 - FULLER, AUGUSTUS, 1812-1876

Robinson, Frederick Bruce, 1907-
 A primitive portraitist

In:Art in Am
39:50-52 Apr.,'51 illus.

Arts In Am.qZ5961.U5A77X
NCFA Ref. I 1895

N
40.1
F97M6
NCFA

I.B.2 - FULLER, GEORGE, 1822-1884

Millet, Josiah B., ed.
George Fuller:His life and works.Boston,
Houghton Mifflin & co.,1886
93 p. illus.

Incl.'Notes on very early employment of the
daguerreotype by an itinerant portr.ptr. & dis-
cusses economic motivations.'-Rudisill

LC ND237.F8M6 Rudisill.Mirror image
 TR365.R916 NCFA p.250

705
B97
NCFA

I.B.2 - GAINSBOROUGH, THOMAS, 1727-1788

Hayes, John T.
Some unknown early Gainsborough portraits

In:Burl Mag
107:62-74 Feb.,'65 illus.

Incl.:List of Suffolk period portrs. not in-
cluded in Ellis Waterhouse:Gainsborough,London
,1958.
Repro.incl.:Gainsborough,van Loo,Ramsay,
Hogarth,Perroneau,van Dyck,Reynolds

H
.F97F9
NCFA

I.B.2 - FULTON, ROBERT, 1765-1815

Fulton, Eleanore J
Robert Fulton as an artist,...Lancaster,Pa.
...1938
p.49-96 illus.

(Papers read before the Lancaster county
historical society,v.42,no.3)

I.B.2 - GAINSBOROUGH, THOMAS, 1727-1788

Iveagh Bequest, Hampstead,Eng.
Gainsborough and his musical friends;a ce-
lebration of the 250th anniversary of the ar-
tist's birth.Cat.of.exh.5 May-7 June,1977.
London,Greater London Council,1977,
36 p. illus.

Bibliography

Foreword by Ellis Hillman

Discusses...possible affinities betw.G.'s
art and music Rila IV/1 1978 #1400

AP
1
A51H7
NPG

I.B.2 - FULTON, ROBERT, 1765-1815

Philip, Cynthia Owen
Adventurer armed with fortitude

In:Am.Hist.Illus.
21,no.8:8-23 Dec.,'86 illus(part col.)

Incl.:'Robert Fulton...artist',p.10-12
Repro.incl.:Fulton by Benj.West;by Vander-
lyn;Miniatures by Fulton

I.B.2 - GAINSBOROUGH, THOMAS, 1727-1788

London. Queen's Gallery, Buckingham Palace
Gainsborough,Paul Sandby and miniature-
painters in the service of George III and his
family.cat.of an exhibition. ,London,1970
30 p. illus.

Bibl.references

LC ND1314.4.L6 Yale ctr.f.Brit.art Ref.

I.B.2 - FURCK, SEBASTIAN, 1589-1666

Boissard, Jean Jacques, 1528-1602
Bibliotheca chalcographica,hoc est virtute
et eruditione clarorum virorum imagines, collec-
tore Iano-Iacobo Boissardo,defunt.,sculptore
Theodoro de Bry,Leod.,primum editae,et ab ipso-
rum obitu hactenus continuatae.Heidelbergae,im-
pensis Clementis Ammoni,1669
5 v. illus.

LC NE218.B6 1669 For .v.11,p.321
 see next card

AP
1
A64
NCFA
v.98

I.B.2 - GAINSBOROUGH, THOMAS, 1727-1788

Waterhouse, Ellis Kirkham, 1905-
Bath and Gainsborough

In:Apollo
98:360-5 Nov.,'73 illus(part col.)

q N
40.1
C14xH4
NCFA

I.B.2 - GAINSBOROUGH, THOMAS, 1727-1788

Hayes, John T.
The drawings of Thomas Gainsborough...
New Haven,Yale Univ.Press,1971.c.1970.
2v. illus.
vol.I:Text; vol.II:Plates

"Publ.for the Paul Mellon Centre for Studies
in Brit.Art(London),ltd."
Bibliography p.327-33

Portr.drawings vl.I,p.109-29

 Noon.Engl.portr.drawgs&min.
 NC860.N66X NPG Bibl. p.146

I.B.2 - GALLE, PHILIPP, 1537-1612

Bataillon, Marcel
Philippe Galle et Arias Montano. Matériaux
pour l'iconographie des savants de la Renaissance

In:Bibl.Humanisme et Ren.
2:132-60 1942 illus.

Album engraved & edited by Galle,Antwerp,1572-87;
commentary by Arias;alphabetical list of 94 portrs

 Rep.,1942-44#686

I.B.2 - GALLE, PHILIPPE, 1537-1612

Galle, Philippe, 1537-1612
 ₌Imagines L.doctorum virorum...cum singulo-
rum elogijs. ₌Antverpiae,1587.2nd ed.

 50 engr.portrs.

 1st ed."Effigies virorum doctorum..."1572
with 44 engr.portrs.

LC TYP
530 MH Cty PU
72.419

Rave.Jb.d.Berl.Mus. I 1959
LC N3.J16 fol. p.148-9
Paolo Giovio & d.Bildnisvi-
tenbücher d.Kunstgesch.

705
C75
NCFA
v.59

I.B.2 - GARDNER, DANIEL, 1750-1805

Grundy, Cecil Reginald, 1870-1944
 Daniel Gardner

In:Connoisseur
59:83-8 Feb.,'21 illus.

VF
Galt

I.B.2 - GALT, ALEXANDER, 1827-1863

O'Neal, William P.ainter.
 Chiselled lyrics(Alexander Galt,jr.,sculp-
tor)

In:Arts in Va.
7,no.14-19 Fall,1966 illus.

Winterthur Mus.Libr.
Z881.W78 NCFA v.6,p.224

I.B.2 - GARDNER, DAN, 1750-1805

Kendal, Eng. Abbot Art Gallery
 Four Kendal portrait painters₌cat.of an
exh.held.16 June-29 July,1973...Kendal...,1973
 23 p. illus.

 Works by Christopher Steele,George Romney,
Daniel Gardner,Thomas Stewardson

Yale Ctr.
f.Brit.Art
Ref.ND
1314.4
.A22

ND
1311.9
S48C9s
NPG

I.B.2 - GANSEVOORT LIMNER

Curran, Ona
 Schenectady ancestral portraits early 18th
century

In:Schenectady Co.Hist.Soc.B.
10,no.1 Sept.'66

 Based on Curran's Master Thesis,N.Y.State
Univ.College,Oneonta,N.Y.
 Incl.:Van Epps Limner,Veeder Limner,Schuyler
Limner,Pierpont Limner,Gansevoort Limner.
 Hudson Valley Patroon Painters,except Pier-
NM pont Limner

Feigenbaum.Amer.portrs....
ND1311.2.F29 NPG Bibl.p.147

I.B.2 - GARDNER, DANIEL, 1750-1805

Williamson, George Charles, 1858-1942
 Daniel Gardner,painter in pastel and gou-
ache₌₌. London,N.Y.,John Lane company,1921
 190 p. illus(part col.)

LC ND497.G3W5

FOR COMPLETE ENTRY
SEE MAIN CARD

I.B.2 - GANSEVOORT LIMNER see also
I.B.2 - VANDERLYN, PIETER,the GANSEVOORT LIMNER,
 ca.1687-1778

I.B.2 - GAUNTT, JEFFERSON, fl.1826-1857

Gaines, Edith ed.
 Collector's notes

In:Antiques
89:238-9 Feb.,'66 illus.

 Incl.checklist of portrs.by Jefferson
Gauntt(fl.1826-1857)

N
40.1
C226C7
NPG

I.B.2 - GARDNER, DAN, 1750-1805

Greater London Council
 Daniel Gardner,1750-1805.London,1972
 1 v. (unpaged) illus.

 Cat.of an exh.held at Kenwood,The Iveagh
Bequest,from May 16th to June 26th,1972

 Text by Helen Kapp

I.B.2 - GAUTIER DAGOTY(d'Agoty), JEAN-BAPTISTE
 ANDRÉ, 1740-1780

Gautier d'Agoty, Jean Baptiste André, 1740-1786
 Galerie françoise,ou Portraits des hommes
et des femmes célèbres qui ont paru en France...
On y a joint un abrégé de leur vie...A Paris,
gravé par m.Gautier Dagoty le fils...1770
 11 pts.in 1 v. illus.

FOGG
Houghton Consists of pts.1 & 2₌...of a proposed coll.
Libr.

 Portrs.incl.:Louis XV,Louis IX,Phil.d'Orléan
Louis XIV,Louis XIII,Henri IV,Stan.Leszynski,etc

LC *fFC7.G2396
 770g MH Fogg,v.11,p.338

I.B.2 - GAUTIER-DAGOTY, PIERRE EDOUARD
see
I.B.2 - DAGOTY, PIERRE EDOUARD, 1775-1871

705
B97
NCFA
v.105

I.B.2 - GHEERAERTS, MARCUS, the younger, 1561-1635

Strong, Roy C.
Elizabethan painting:An approach through
inscriptions - III:Marcus Gheeraerts the younger

In:Burl Mag
105:149-57 Apr.'63 illus.

Incl.list of sitters

Gheeraerts'earlier oeuvre,1590-1600

"In his full length portrs.....he strikes a
new and exotic note"

I.B.2 - GÉRARD, JEAN IGNACE ISIDORE
see
I.B.2 - GRANDVILLE, JEAN IGNACE ISIDORE GÉRARD
,called,1803-1847

I.B.2 - GHISLANDI, FRA VITTORE, 1655-1743
(v)
Lazaref, Viktor Nikitich, 1896-
Portret v Evropeiskom iskousstve 17 veka
(The portrait in 17th c.European art).Moscou,
1937

95 p. illus.

Intelectual relation betw.West & East Europe.
French influence in the portraits of Ghislandi de
Bergamo

Gaz.Beaux Arts,v.20,1938
LC p.327 (Réau)

..'L
W225
NCFA
v.3

I.B.2 - GHEERAERTS, MARCUS, the younger, 1561-1635

Cust, Lionel Henry, 1859-1929
Marcus Gheeraerts

In:Walpole Soc.
3:9-45 1913-14 illus(72)

English school of patg.,1580-1620
List of,portraits by Gheeraerts & his imita-
tors:Groups;Queen Elizabeth;James I,Anne of Den-
mark & their family;Miscellaneous portrs.

I.B.2 - GIBSON, CHARLES DANA, 1867-1944

Gibson, Charles Dana, 1867-1944
Pictures of people,by Charles Dana Gibson.
N.Y.,R.H.Russell & Son,1896
1 l. 43pl.

NN OKac PP OCIW etc Books in print,Subject
Guide,1985-6,v.3,p.4864

705
B97
NCFA
v.105

I.B.2 - GHEERAERTS, MARCUS, the younger,1561-1635

Millar, Oliver, 1923-
Marcus Gheeraerts the younger,a sequel through
inscriptions

In:Burl Mag
105:533-41 Dec.,'63 illus.

Gheeraerts's later oeuvre from 1600-1629

Incl.list of sitters

Strong.The English Icon
qND1314S924,Bibl.

I.B.2 - GIETLEUGHEN, JOOS, 2nd half 16th c.

Goltzius, Hubert, 1526-1583
Les images presqve de tovs les emperevrs,
depvis C.Ivlivs Caesar ivsqves à Charles V et
Ferdinanws son frère,povrtraites av vif,prinses
des medailles anciennes...par Hvbert Gholtz...
1557. Livre I
,350,p. illus.
149 portrs.by Joos Gietleughen after drags.by
Goltzius(see over)
Italian edition:LC fJ 036.351:early ex.of chiaroscurc ptg
Latin edition:LC N7627.C6

NO CLU-C PPPM PU-Mu Amsterdam,Rijksmus.cat.
Z5939352,deel 1,p.134

I.B.2 - GHEERAERTS, MARCUS, the younger,1561-
1635
Piper, David
Some portraits by Marcus Gheeraerts II and
John de Critz reconsidered

In:Huguenot Soc.of London,Proc.
20,no.2:210-29

LC BX9450.H7 Strong,R.C.,Elizab.ptg....
In:Burl Mag 105:149,Apr.'c

705
A.9
NCFA
v.39

I.B.2 - GILL, ROBERT, 1924-1972

Holden, Donald
Robert Gill's imaginary portraits

In:Am.Artist
39:24-9,58 July'75 illus.

FOR COMPLETE ENTRY
SEE MAIN CARD

I.B.2 - GIORDANO, LUCA, 1632-1705

Bellori, Giovanni Pietro, 1615?-1696
 Le vite de' pittori,scultori,ed architetti
moderni,co' loro ritratti al naturale,...2 ed.
accresciute colla vita e ritratto del cavaliere
D.Luca Giordano...Roma,F.Ricciardo,e G.Buono,
1728
 394 p. illus.

 1st.ed.Roma,Per il succeso.el Mascardi,1672

LC N40.B44 1728 Daugherty.Self-portrs.of
 P.P.Rubens mfm161NPG,p.XIV
 footnote 12

N
40.1
G519y
S4
NPG

I.B.2 - GIRTIN, JAMES, c.1780-after 1820

Girtin, James, etcher, c.1780-after 1820
 Seventy-five portraits of celebrated
painters from authentic originals.Etched by
James Girtin.London,printed by J.M'Creery,1817
 .2.l. 75 plates

LC(J18.G445.817)
CtY NjP etc.

I.B.2 - GIRODET-DE-ROUSSY-TRIOSON,ANNE LOUIS
 see
I.B.2 - GIRODET-TRIOSON, ANNE LOUIS, 1767-1824

N40.1
G61E7
NPG

I.B.2 - GOGH, VINCENT VAN, 1853-1890

Erpel, Frits
 Van Gogh, the self-portraits-With a pref.by
H.Gerson...Greenwich,Conn.,New York Graphic
Society.1969.
 66 p. illus(part col.)

I.B.2 - GIRODET-TRIOSON, ANNE LOUIS, 1767-1824

Girodet-Trioson, 1767-1824
 Oeuvres posthumes de Girodet-Trioson...pré-
cédées d'une notice historique,et mises en ordre
par P.A.Coupin...Paris,J.Renouard,1829
 2 v. illus.

 v.1 incl."Liste des principaux ouvrages de G
...Portraits peintes.Portraits au crayon.Études
peintes(têtes,bustes,etc.)

LC ND553G6A3

705
A7834
NMAA

I.B.2 - GOGH, VINCENT VAN, 1853-1890

Koslow, Susan
 Two sources for Vincent van Gogh's"Portrait
of Armand Roulin":a character likeness and a
portrait schema

In:Arts Mag.
56,no.1:156-63 Sept.,1981 illus.

 Hans·Holbein the elder's portr.of a youth is
considered the inspiration of "character like-
ness".The "schema"seems to come from Charles
Bargue's "Cours de dessin"
 Portrs.within portrs.,fgs.4,5,6
 Brilliant In:Art J.v.46
 no.3:172,note 14

705
A7832
NCFA

I.B.2 - GIRODET-TRIOSON, ANNE LOUIS, 1767-1824

Levitine, George
 The influence of Lavater and Girodet's
"Expression des sentiments de l'âme"

In:Art B.
36:33-44 March,'54 illus.

 Cresswell.Printr of the
 Am.Revol. NE506.C92 1977A
 NMAA p.70,note 115

ND
236
L76
NPG

I.B.2 - GOLDSMITH, DEBORAH, 1808-1836

Lipman, Mrs.Jean Herzberg, 1909- comp.
 Primitive painters in America....1950. (card 2

 Contents-cont.-17.M.E.Jacobson, O.Krans

 List of primitive painters

 11.J.Lipman, D.Goldsmith

LC ND236.L76

I.B.2 - GIROUST, MARIE-SUZANNE(Mme.ROSLIN),1734-
 .1772
Fidière, Octave, 1855-
 Les femmes artistes à l'Académie royale de
peinture et de sculpture.Paris,Charavay frères,
1885
 55 p. illus.
 Seal of the Soc.de l'histoire de l'art fran-
çais on t.-p.

 Marie-Suzanne Giroust(Mme.Roslin),p.31 f.

LC N13.d4F5 Fidière.Gas.Beaux-Arts
 705 028 v-19,1898,p.104
 footnote

I.B.2 - GOLDSMITH, DEBORAH, 1808-1836

Shaffer, Sandra C.
 Deborah Goldsmith,1808-1836:a naive artist
in Upstate New York

 MA thesis,State Uni.of N.Y.,College at
Oneonta,1968

 Abby Aldrich Rockefeller
 Folk Art Ctr.Am.Folk portrs
 N7593.A23 Bibl. p.294

I.B.2 - GOLTZIUS, HUBERT, 1526-1583

Goltzius, Hubert, 1526-1583
 Les images presqve de tovs les emperevrs,
depvis C.Ivlivs Caesar ivsqves à Charles V et
Ferdinanvs son frère,povrtraites av vif,prinses
des medailles anciennes...par Hvbert Gholtz...
1557. Livre I
 ₓ350₋p. illus.
 149 portrs.by Joos Gietleughen after drags.by
Goltzius(see over)
Italian edition:LC fJ 036.351:early ex.of chiaroscuro prtg
Latin edition:LC N7627.G6

MG CLU-C PPPM PU-Ma Amsterdam,Rijksmus.cat.
 Z5939A52,deel 1,p.134

705
A784
NCFA
v.64

I.B.2 - GORKY, ARSHILE, 1904-1948

Herrera, Hayden
 Gorky's self-portraits:the artist by him-
self

In:Art in Am
64:56-64 Mar-Apr.,'76 illus(part col.)

FOR COMPLETE ENTRY
SEE MAIN CARD

VF
NPG

I.B.2 - GOLUB, LEON, 1922-

Leon Golub,portraits of power.Catalogue of ex-
hibition at the Picker Gallery,Charles A.
Dana Arts Center,Colgate University,Hamil-
ton,N.Y.,Nov.11-Dec.10,1978
 unpaged illus.

 Bibliography

 Preface by Edw.Bryant

705
B97
NCFA
v.90

I.B.2 - GOWER, GEORGE, died ca.1596

Goodison, Jack Weatherburn
 George Gower,Serjeant-painter to Queen
Elizabeth

In:Burl Mag.
90:261-4 Sep.,'48 illus.

705
AP1
A788
NCFA

I.B.2 - GOLUB, LEON, 1922-

Robins, Corinne
 Leon Golub:The Faces of power

In:Arts
51:110-11 Feb.,'77 illus.

Leon Golub,portrs.of power
VF NPG Bibliography

I.B.2 - GOWER,RONALD CHARLES SUTHERLAND,1845-1916

Gower, Ronald Charles Sutherland, 1845-1916
 Three hundred French portraits representing
personages of the courts of Francis I,Henry II &
Francis II by Clouet.Auto-lithographed from the
originals at Castle Howard,Yorkshire.London,
S.Low,Marston & Searle,Paris,Hachette & cie.,
1875
 2 v. illus.

LC N7604.C6 Amsterdam,Rijksmus.cat.
 Z5939A52,deel 1, p.509

AN
10.1
C636P6
NPG

I.B.2 - GOODELL, IRA CHAFFEE, 1800(or ca.1810)-
 ₓca.1875
Piwonka, Ruth
 A cat.and checklist of portraits done in
Columbia County and elsewhere by Ira C.Goodell
(1800-ca.1875).Kinderhook,N.Y.,The Columbia
County Hist.Soc.,1979.
 28 p. illus.

 Contributions by Cynthia Seibels

I.B.2 - GOWER, RONALD CHARLES SUTHERLAND,1845-1916

Lenoir, Alexandre, 1761-1839
 The Lenoir collection of original French
portraits at Stafford House.Auto-lithographed by
Lord Ronald Gower.London,Maclure & Macdonald...
1874

 illus.

 From Francis I till Marie-Antoinette

LC N7604.L36 Amsterdam,Rijksmus.,cat.
Rare book coll. Z5939A52,deel 1, p.146

705
A56
NCFA
v.51

I.B.2 - GOODRIDGE, SARAH, 1788-1853

Dods, Agnes M.
 Sarah Goodridge

In:Antiques
51:328-9 May,'47 illus.

 List of sitters & owners of G.'s miniatures

 Repro.incl.:David Webster,Gilbert Stuart

I.B.2 - GOYA Y LUCIENTES, FRANCISCO JOSE DE,
 ₓ1746-1828

Beruete y Moret, Aureliano de, 1876-1922
 Goya as portrait painter.2nd ed.₋London
₋etc.₋Constable & company,ltd.,1922
 216 p. illus.

 Bibliography,p.195-9
 List of portraits,p.₋201₋-6

 Translated from the Spanish

LC ND813.G7B6 1922 Minneapolis I.A.Bull.65
 708.1.M66 NMAA p.47,note 1

705
028
NCFA
v.28

I.B.2 - GOYA Y LUCIENTES, FRANCISCO JOSÉ DE,
c.1746-1828

Cook, Walter W.S.
Spanish paintings in the National Gallery
of Art.II.Portraits by Goya

In:Gaz.Beaux-Arts
28:151-62 Sept.,'45 illus.

u
40.1
F443y
A5
NFG
RB

I.B.2 - GRATELOUP, JEAN BAPTISTE DE, 1735-1817

Andrews, William Loring, 1837-1920
A trio of 18th century French engravers of
portraits in miniature.Ficquet,Savart,Grateloup..
N.Y..Dodd,Mead & co..1899
123 p. illus(1 col.)
Contents.-Intro.,giving a short account of
the various methods of engr.on metal.-A trio of
18th c.French engravers...-Extracts fr.La Calco-
grafia of Giuseppe Longhi.-List of portrs.engr.
by Étienne Ficquet,Pierre Savart,Jean Baptiste
de Grateloup

LC NE647.A5 avi.Descript.bibl.Z5947.A3
 L66 1974 NCFA p.205

I.B.2 - GRAFLY, CHARLES, 1862-1929

Pennsylvania academy of the fine arts, Phila-
delphia
Memorial exh.of work by Charles Grafly,
Jan.26-March 16,1930,Philadelphia.1930.
15 p. illus.

LC(NB237.G7P4) DSI MiD etc.

I.B.2 - GREEN, VALENTINE, 1739-1813

Whitman, Alfred, 1860-1910
...Valentine Green.London,A.H.Bullen,1902
204 p. illus. (British mezzotinters)

Cat.of 325 prints

Incl.Index "Portraits"

LC NE642.G8W6 Levis,Descr.bibl. #5947.A
 L66 1974 NCFA p.132

qN
40.1
G748D3
NMAA

I.B.2 - GRANDMAISON, NICHOLAS RAFFAEL DE,
1892-1978

Dempsey, Hugh Aylmer, 1929-
History in their blood:The Indian por-
traits of Nicholas de Grandmaison;intro.by
J.Russell Harper;foreword by Frederick J.
Dockstader.1st American ed.N.Y.,Hudson Hill
Press.Distr.by Viking Penguin,c.1982
124 p. illus(part col.)

Index

LC NC143.G68D46 1982 Books in print.Subject
 guide,1985-86,v.3,p.4864

F
24
A34
1587d
RB A4

I.B.2 - GREENLEAF, BENJAMIN, 1769-1821

Agreeable situations:society,commerce and art
in southern Maine,1780-1830;ed.by Laura
Fecych Sprague;essays by Joyce Butler...
et al..Kennebunk,Me.Brick Store Mus.
Boston:Distributed by Northeastern Univ.
Press,1987
289 p. illus(part col.)
Incl.Brewster,jr.,deaf artist,p.88,122,254
Cat.of selected objects from the Brick
Store Mus.et al
Index
Bibliography

I.B.2 - GRANDVILLE, JEAN IGNACE ISIDORE GÉRARD,
called,1803-1847

Nancy. Musée des beaux-arts
Grandville:caricatures et illustrations
.exposition.Mus.des beaux-arts,Nancy,du 4 juil-
let au 15 septembre 1975.Nancy,Mus.des beaux-
arts.1975.
110 p. illus.

LC NC1499.G66N36 1975 Worldwide art cat.B.
 705.W927 NCFA v.13,no.4
 p.24

705
A56
NCFA
v.52

I.B.2 - GREENLEAF, BENJAMIN, 1786-1864

Lipman, Mrs.Jean Herzberg, 1909-
Benjamin Greenleaf;New England limner

In:Antiques
52:155-7 Sept.,'47 illus.

Portraits on glass

List of Greenleaf's portraits

I.B.2 - GRANT, DUNCAN JAMES CORROWR, 1885-1928

Arts Council of Great Britain
Portraits by Duncan Grant;an Arts Council
exhibition..Cat.by Richard Shone.London,1969.
16.p. illus.

Exh. held at the Arts Council Gall.,Cambridge,
Nov.8-29;Laing Art Gall.,Newcastle on Tyne,Dec.6-
Jan.4;Univ.of Hull,Jan.10-Feb.1

InU

I.B.2 - GREENWOOD, ETHAN ALLEN, 1779-1856

Bumgardner, Georgia Brady
The early career of Ethan Allen Greenwood.
The Dublin Seminar for New England Folklife:
Annual Proceedings,1975,p.212-25.Published by
Boston University.

lor.Bibl.p.39 Robert Hull Fleming Museum
 Univ.of Vt.F.ces in the par-

N
40.1
G836B2
NPG

I.B.2 - GREENWOOD, ETHAN ALLEN, 1779-1856

Greenwood, Ethan Allen,1779-1856
A list of portraits painted by Ethan Allen
Greenwood. Worcester,Mass.,The Society,1947
27 p.

Reprinted from the Proceedings of the Ameri-
can Antiquarian Society of April 1946

Compiled by Marianne Bartholomew from the
painter's diary subsequently destroyed

I.B.2 - GRIMALDI, WILLIAM, 1751-1830

Grimaldi, Alexander Beaufort, 1839-
A cat.chronological and descriptive of
paintings,drawings,and engravings by and after
William Grimaldi,R.A. Paris,...London,Privately
printed,1873
60 p.

Br.Mus.
7857
f35(3)

pp

Noon.Engl.portr.drags.&min.
NC860.N66X NPG Bibl. p.145

I.B.2 - GREENWOOD, ETHAN ALLEN, 1775-1856

A list of portraits painted by Ethan Allen
Greenwood

In:Proc.of Amer.Antiqu.Soc.
56:129-53 April,'46

Lists over 800 works

LC E172.A35

Robert Hull Fleming Museum
Univ.of Vt. Faces in the
parlor Bibl.p.39

705
G28
NCFA
v.5

I.B.2 - GRIMOU, ALEXIS, 1678-1733

Gabillot, C.
Alexis Grimou,peintre français(1678-1733)

In:Gaz.Beaux-Arts
5(4ième ser):157-72;309-23;412-26 1911 illus.

G.p-311:'Grimou s'est laissé prendre à la
magie de Rembrandt....Ses.contemporains le sur-
nommèrent le Rembrandt français'.p.314:'...sa cô
leur s'est affinée sous l'influence de Rembrandt

B
.G78B9

I.B.2 - GREENWOOD, JOHN, 1727-1792

Burroughs, Alan, 1897-1965
John Greenwood in America,1745-1752.A mono-
graph and a check list...Andover,Mass.,Addison
gallery of American art,Phillips academy,1943
87 p. illus.

LC ND237.G63B9

Whitehill.The Arts of ear-
ly Amer.Hist.Z5935.W59 NPG
Bibl.,p.90

I.B.2 - GROS, ANTOINE JEAN, BARON, 1771-1835

Escholier, Raymond, 1882-
...Gros,ses amis et ses élèves:.70 repro-
ductions dont 2 en couleurs.Paris,Floury,1936
23 p. illus(part col.)

Petit palais,mai-Julliet,1936 .cat.no.26.

LC ND553.G85E8

Hubert.In:Gaz.Beaux-Arts
Jul/Aug.'86,v.108,p.29note2

N
40.1
G84.3M9
NCFA

I.B.2 - GREUZE, JEAN-BAPTISTE, 1725-1805

Munhall, Edgar
Jean-Baptiste Greuze,1725-1805,selection
and cat.by Edg.Munhall;ed.by Jos.Focarino.
Hartford,Wadsworth Atheneum,1976
.228.p. illus(part col.)
An exh.organ.by the Wadsworth Atheneum,
Hartford,1 Dec.1976-23 Jan.1977.Exh.also at
Calif.Pal.of the Legion of Honor,S.F.,5 March-
1 May 1977 and the Mus.des Beaux-Arts,Dijon,
4 June-31 July 1977.
Bibliographies
Repro.incl.:Portr.of Benj.Franklin('F.'s
finest portr.')
see over
Hubert.In:Gaz.Beaux-Arts
Jul/Aug.'86,v.108,p.29 note

I.B.2 - GROS, ANTOINE JEAN, BARON, 1771-1835

Tripier Le Franc J.
Histoire de la vie et de la mort du baron
Gros,le grandpeintre...illustrée...de six de
ses portraits retracés par l'héliogravure
d'Amand Durand...Paris,J.Martin.etc..1880
706 p. illus(part col.)

LC ND553.G85T7

Hubert.In:Gaz.Beaux-Arts
Jul./aug.'86,v.108,p.29
note 2

B
G83P6
NCFA

I.B.2 - GREUZE, JEAN BAPTISTE, 1725-1805

Pilon, Edmond .
Greuze,J.-B.peintre de la femme et la jeune
fille du 18esiècle. Paris,L'édition d'art,1912

I.B.2 - GROSSMANN, RUDOLF, 1882-1941

Grossmann, Rudolf, 1882-1941
Ausdrucksstudien bei den irren

In:Kunst u.K.
26:390-4 1928 illus.

Studies of physiognomy of insane people.
Prints and drags.by Rubens,Brueghel and by the
author.

LC N3.K8

Rep.,1928:56

I.B.2 - GROSSMANN, RUDOLF, 1882-1941

Grossmann, Rudolf, 1882-1941
Fünfzig köpfe der zeit.Berlin,R.Mosse,1926
206 p. illus.

1st-4th ed.
Text by R.Grossmann,Hans Barth,Paul Block,
Erich Dombrowski & others

LC N7592.07 1926

I.B.2 - GULDAGER, CHRISTIAN see
I.B.2 - GULLAGER, CHRISTIAN, 1759-1826

I.B.2 - GROSSMANN, RUDOLF, 1882-1941

Grossmann, Rudolf, 1882-1941
Das selbstporträt der modernen

In:Kunstblatt
13:371 f. 1929

LC N3.K55 Die 20er jahre im portr.
 N6868.5.E9297 NPG,p.139

I.B.2 - GULLAGER, CHRISTIAN, 1759-1826

Dresser, Louisa
Christian Gullager,an introduction to his
life and some representative examples of his
work

In:Art in Am
37:105-79 July,'49 illus.

Illus.incl.works exh. at Worcester Art Mus.
June 18-Sept.,1949,no.1-29

LC N1.A43 v.37

705
B97
NCFA
v.97

I.B.2 - GUELFI, GIOVANNI BATTISTA, 18th c.

Webb, M.I.
Giovanni Battista Guelfi:an Italian sculp-
tor working in England

In:Burl Mag
97:139-45 May,'55 illus.
 Aug.'55

 Whinney.Sculpt.in Britain..
 NB464.W57 NCFA Bibl.p.203

NPG
Ref.
coll.

I.B.2 - GULLAGER, CHRISTIAN, 1759-1826

National Portrait Gallery, Washington,D.C.
Christian Gullager,portrait painter to
Federal America;by Marvin Sadik.NPG,Smithsonian
Institution,Wash.,1976
108 p. illus.(1 col.on cover)

Exhib.July 8-Dec.18,1976

705
B97
NCFA
v.112

I.B.2 - GUIDI, DOMENICO, 1625-1701

Pershad, David L.
A series of papal busts by Domenico Guidi

In:Burl Mag
112:805-9 Dec.,'70 illus.

 Spike.Baroque portraiture
 in Italy.N7606.S75NPG
 Bibl.p.154

I.B.2 - HAIDT, JOHN VALENTINE, 1700-1780

Howland, Garth A.
John Valentine Haidt,a little known 18th c.
painter

In:Penn History
8:304-13 Oct,'41

LC F146.P597 Whitehill.The Arts of ear-
 ly Amer.Hist.Z5935.W59 NPG
 Bibl.,p.90

I.B.2 - GUILD, JAMES, 1797-1841

Guild, James
From Tunbridge,Vt.,to London,England:The
Journal of James Guild...from 1818-1824.Mont-
pelier,Vt.,1937.

In:Vt.Hist.
n.s.5:249-314 Sept.,'37

LC F46.V55 Winterthur Mus.Libr.fZ881
 W78 NCFA v.6,p.217

I.B.2 - HALL, PETER ADOLF, 1739-1793

Villot, Frédéric, 1809-1875
Hall célèbre miniaturiste...Paris,Librairie
française et étrangère,1867...

MET
180H14
V71

MH MdBWA MBRP MB ICU FOR COMPLETE ENTRY
 SEE MAIN CARD

705
A56
NCFA
v.53

I.B.2 - HAMBLEN, STURTEVANT J., fl.1837-1856

Little, Nina Fletcher, 1903-
William M.Prior,traveling artist and his
in-laws,the painting Hamblens

In:Antiques
53:44-8 Jan.,'48 illus.

Colonial Williamsburg,inc.
The Abby Aldrich Rockefelle
Folk Art coll.N6510.C71 NCF
Bibl.p.394

AP
1
W225
NCFA
v.2

I.B.2 - HAMILTON, HUGH DOUGLAS, c.1739-1808

Strickland, Walter George, 1850-1928
Hugh Douglas Hamilton,portrait painter

In:Walpole Soc.
2:99-110 1912-13 illus.

Incl.:List of sitters in alphabetical order,
with medium and owner
Strickland mentions H.'s daughter,Harriott,
portraitist who finished one of H.'s.portrs.

Noon.Engl.portr.drags.&min.
NC860.N66X NPG Bibl.p.148

705
A56
NCFA
v.53

I.B.2 - HAMBLIN see
I.B.2 - HAMBLEN STURTEVANT J.,fl.1837-1856

Little, Nina Fletcher, 1903-
William M.Prior,traveling artist and his
in-laws,the painting Hamblens

In:Antiques
53:44-8 Jan.,'48 illus.

Colonial Williamsburg,inc.
The Abby Aldrich Rockefelle
Folk Art coll.N6510.C71 NCF
Bibl.p.394

3
H21
H2

I.B.2 - HAMILTON, JOHN MCLURE, 1853-1936

Hamilton, John McLure, 1853-1936
Men I have painted...London,T.F.Unwin,ltd.
s1921,
263 p. illus.

Hamilton describes his meetings with nume-
rous statesmen & other celebrities who sat for
him

Foreword by Mrs.Drew

LC ND497.H32A1

College of physicians...
Arch.Am.Art mfm P86 v.12
References

705
B97
NCFA

I.B.2 - HAMILTON, GAVIN, 1723-1798

Ford, Brinsley
A portrait group by Gavin Hamilton...

In:Burl Mag
97:372-8 Dec.,'55 illus.

FOR COMPLETE ENTRY
SEE MAIN CARD

I.B.2 - HANDLY, AVERY, jr., 1913-1958

Baker, Gus
. Avery Handly memorial exh.of paintings.Cat.
comp.and annotated by Gus Baker.The Parthenon,
Nashville,May 8-29,1960.Nashville.Avery Handly
Mem'l.Exh.Comm.s1960
32 p. illus.

MiDA

AP
1
W225
NCFA
v.6

I.B.2 - HAMILTON, GAWEN, 1697-1737

Finberg, Hilda F.élicité(Ehrmann),
Gawen Hamilton an unknown Scottish portrait
painter

In:Walpole Soc.
6:51-8 1917-1918 illus.

VF
Harding

I.B.2 - HARDING, CHESTER, 1792-1866

Danforth Museum
Family connections.Portraits by Chester
Harding.exh..Jan.18-March 29,1981
17 p. illus.

.Cat.by Leah Lipton.

AP
1
W225
NCFA
v.2

I.B.2 - HAMILTON, HARRIOTT(Mrs.John Way), c.1769
-after 1828

Strickland, Walter George, 1850-1928
Hugh Douglas Hamilton,portrait painter

In:Walpole Soc.
2:99-110 1912-13 illus.

Incl.:List of sitters in alphabetical order,
with medium and owner
Strickland mentions H.'s daughter,Harriott,
portraitist who finished one of H.'s.portrs.

Noon.Engl.portr.drags.&min.
NC860.N66X NPG Bibl.p.148

N
40.1
H26W5
1929
NCFA

I.B.2 - HARDING, CHESTER, 1792-1866

Harding, Chester, 1792-1866
A sketch of Chester Harding,artist,drawn
by his own hand...New ed.Boston and N.Y.,Hough
ton Mifflin co.,1929
203 p. illus.
Ed.by Margaret E.White.
Repro.incl.:Daniel Boone,Js.Madison,Wash.
Allston,Chester Harding(self-portr.)John Mar-
shall,Daniel Webster,Henry Clay,etc.
New ed.with annotations by W.P.G.Harding

LC ND237.H3A3 1929

Weddell.A mem'l vol.of Va
hist.portraiture.757.9.W3
NCFA Bibl. p.435

N
40.1
H26L7
NPG
2 c.

I.B.2 - HARDING, CHESTER, 1792-1866

Harding, Chester.A truthful likeness:Chester
Harding and his portraits
 Cat.by Leah Lipton.Exh.held at the Nat'l
Portrait Gallery,Washington,D.C.,Apr.12-Sept.
1985 and at the J.B.Speed Art Mus.,Louisville,
Ky.,Sept.27-Dec.9,1985.Publ.by the NPG,Smiths.
Inst.,City of Washington,1985
 195 p. illus(part col.)
 Incl.:Index

 Foreword by Alan Fern
 Bibliography
 Checklist of ptgs.in alphabetical order
 by sitters:last
LC N01329.H36A4 1985

705
A56
NMAA
v.131

I.B.2 - HATHAWAY, RUFUS, 1770-1822

Valentine, Lancia & Nina Fletcher Little
 Rufus Hathaway,artist and physician

In:Antiques
131:628-41 March,'87 illus(part col.)

 Incl.:ptgs.come to light since 1953

I.B.2 - HARDING, GEORGE PERFECT, died 1853

Harding, George Perfect, died 1853
 Portraits of illustrious persons in English
history,drawn by G.P.Harding from original pic-
tures;with biographical and historical notices,
by Thomas Moule.London,Smith,1869
 32 p. illus.

MR NN

705
A7875
NCFA
v.14

I.B.2 - HAUER, JEAN-JACQUES, 1751-1829

Grigaut, Paul L.
 Three French works of American interest

In:Art Q
14:348-52 Winter, 1951 illus.

Refers to the exh."The French in America,1520-
1880"at Detroit. Institute of Arts. 1951
 Repre.:John Paul Jones,pastel drag.by Moreau
le Jeune. Lafayette & Mme.Roland by Jean-Jacques
Hauer. Mr.& Mrs.Kemper,drag.by Valdenuit

705
B97
NCFA
v.69

I.B.2 - HARLOW, GEORGE HENRY, 1787-1819

Holmes,(Sir)Charles John, 1868-1936
 The heirs of Lawrence, 1825-1835

In:BurlMag.
69:195-201 Nov.,'36 illus.

 Study of costume gives new attributions to
ptgs. which had been attributed to Harlow

 Repro.:Margaret Carpenter,Geo.Henry Harlow,
Henry Wyatt
 Stecmann,J.Burl.Mag.v.73
 pp.177-8,183 Oct.,'38

I.B.2 - HAUSMANN, ELIAS GOTTLOB, 1695-1774

Sigismund, Ernst
 Der Porträtmaler Elias Gottlob Hausmann
und seine zeit;die Bachbildnisse

In:Zs.f.Kunst
4:126-35 1950(2) illus.

LC N3.Z5 Bibl.zu kunst & kunstgesch
 Z5931.B58 1945-53 NCFA
 p.217 no.4335

ND
1302.H318
NPG

I.B.2 - HARRISON, CLAUDE, 1922-

Harrison, Claude, 1922-
 The portrait painter's handbook.London,
Studio Vista;N.Y.,Watson-Guptill Publ.,1976
 96 p. illus(part col.)

 Bibliography

 1st ed.1968

LC ND1302.H3 1968

AP
1
A64
NMAA
v.114

I.B.2 - HAYTLEY, EDWARD, fl.1740-1761

Devapriam, Emma
 Two conversation pieces by Edward Haytley

In:Apollo
114:85-7 Aug.,'81 illus(part col.)

705
A784
NCFA
v.41

I.B.2 - HATHAWAY, RUFUS, 1770-1822

Little, Nina Fletcher, 1903-
 Doctor Rufus Hathaway,physician and painter
of Duxbury,Mass.,1770-1822

In:Art in Am
41:95-139 Summer,'53 illus.

 Incl.:List of H.'s paintings

 see also:Art in Am. 42:223,Oct.,'54

 Arts in America qZ5961 USA
 77X NCFA Ref. H368

AP
1
W78
v.6
NCFA

I.B.2 - HAZLITT, JOHN, 1767-1837

Mayne, Ernest J.
 John Hazlitt,miniaturist and portrait pai-
ter in America.1783-1787

In:Winterthur Portfolio
6:33-40 illus.

920 I
HL34D37
NPG

I.B.2 - HEALY, GEORGE PETER ALEXANDER, 1813-1894

De Mare, Marie
G.P.A.Healy,American artist; an intimate
chronicle of the 19th century.N.Y.,David McKay
co.,Inc.,1954.
304 p. illus.

Foreword by Eleanor Roosevelt
Index

51 illus.provide a good sampling of H's
Portraits.

⌒rts in Am.qZ5961.U5A77X
.CFA Ref. I 872

N
6505
B62
NCFA

I.B.2 - HEATEN, JOHN, 18th c.,the WENDELL LIM-
.NER

Black, Mary C.
What is American in American art.An exh....
for the benefit of the Mus.of Amer.Folk Art
.Feb.9-March 6,1971.Intro.by Lloyd Goodrich,
cat.by Mary Black.N.Y.,M.Knoedler.1971.
80 p. illus(part col.)

Exh.in memory of Jos.B.Martinson

Index of artists

'Folk art contained the essence of native
flavor continued on next card
 ⌒
Art in America H61c

N
40.1
H4305
NPG

I.B.2 - HEALY, GEORGE PETER ALEXANDER,1813-1894

Glasgow, Vaughn L.
G.P.A.Healy:famous figures and Louisiana
patrons.,Exh..the Louisiana State Museum,Dec.
1976-May 1977.Cat.by Vaughn L.Glasgow and
Pamela A.Johnson..New Orleans,The Museum,c.1976
74 p. illus.(part col.)

32 works shown

Bibliography

LC ND1329.H4058 Rila IV/1 * ?914
 1978

705
C28
NCFA
v.29

I.B.2 - HÉBERT, ERNEST, 1817-1908

Cantinelli, Richard
Gustave Ricard

In:Gaz Beaux Arts
29:99-103 1903 illus.

Incl.:Ernest Hébert's homage to Gust.Ricard

N
40.1
H43V8
NCFA
NPG

I.B.2 - HEALY, GEORGE PETER ALEXANDER, 1813-1894

Virginia Museum of Fine Arts, Richmond
A souvenir of the exh.entitled Healy's sit-
ters;or,A portr.panorama of the Victorian Age,
being a comprehensive coll.of the likenesses of
some of the most important personages of Europe
& America,as portrayed by Geo.Peter Alex.Healy
betw.the years 1837 and 1899,suppl.with docu-
ments relating to the artist's life & furnish-
ings of the period,on view at the Va.M.f.A....
24 Jan.-5 March 1950..Richmond,1950.
94 p. illus.
Index see over
LC ND237.H4V5 ⌒Art Books 1950-79 25937
 A775 NCFA Ref. p.698

I.B.2 - HEINCE, ZACHARIE, 1611-1669

Heince, Zacharie, 1611-1669
Les Portraictz av natvrel,avec...,noms et
qvalitez de messievrs les plenipotentiaires as-
semblez à Mvnster et Csnabvrg povr faire la
paix generale.Paris,Chez Henry Sara et Chez
Jean Paslé,et chez les auteurs:F.Bignon fecit
et excudit.1648.
19 p. illus.

Comprises 33 full page engr.portrs.by Fran-
çois Bignon after Heince & list of the plenipo-
tentiaries(more than 33)assembled to make the
NN Peace of Westphal⌒ia

N
40.1
H4313
M6
NMAA

I.B.2 - HEALY, THOMAS CANTWELL, 1820-1889

Healy, Thomas Cantwell, 1820-1889
To live upon canvas,the portrait art of
Thomas Cantwell Healy..Exh..Mississippi Muse.of
Art,Apr.18-June 15,1980..Jackson,MS.,The Museum,
1980.
40 p. illus.

Bibliography
Index
Incl.:checklist of known works by Ths.C.
Healy

I.B.2 - HEINCE, ZACHARIE, 1611-1669

Vulson de la Colombière, Marc, d.1658
Les hommes illustres et grands capitaines
françois qui sont peints dans la Galerie du Pa-
lais Royal...avec leurs portraits...dessignez
& gravez par les sieurs Heince & Bignon..Paris,
Estienne Loyson,1650
.66.p. illus.

Publ.previously in 1650 with title:Les por-
traits des hommes illustres françois...400 p.
LC has 1668 ed.:DC36.V8
CSt Winterthur Mus.Libr. fZ861
 .W78 NCFA v.9,p.226

AP
1
A51A64
:MYA?
v.12

I.B.2 - HEATEN, JOHN, 18th c.,the WENDELL LIMNER

Black, Mary C.
Contributions toward a history of early
18th c. New York portraiture:The identification
of the Aetatis Suae and Wendell Limners

In:Am Art J
12:4-31 Autumn,'80 illus.

Black identifies Nehemiah Partridge as the
Aetatis Sue limner and John Heaten as the ptr.
of Abraham Wendell and his brothers as well as
of a dozen or more Alb⌒y area portrs. ascr.un-
til now to the Wen⌒dell limner.
 Am Ar⌒ 15:65 ⌒note 13
 Miles.Portrs.of the heroes.

I.B.2 - HEINSIUS, JOHANN ERNST, 1740-1812

Oulmont, Charles, 1883-
...J.E.Heinsius,1740-1812,peintre de mesdames
de France...Paris,Hachette et cie,1913
129 p. illus(part col.)

LC ND588.H4708 ⌒Reynolds.Portr.miniatures...
 N1Apollo,104:281

I.B.2 - HELLEU, PAUL CÉSAR FRANÇOIS, 1859-1927

Helleu, Paul César, 1859-1927
A gallery of portraits,reproduced from ori-
ginal etchings,with an intro. by Frederick Wed-
more.London,E.Arnold,1907
.3.p. 24 illus(part col.)

Portrs.of women

"Wedmore's intro....is important".-Levis

HM (N.Y.publ.NP) ILM LM lnU)
 Levis.Descr.bibl...Z5947.A3
 L66 1974 NCFA p.208

I.B.2 - HELM, F.

Boissard, Jean Jacques, 1528-1602
Bibliotheca chalcographica,hoc est virtute
et eruditione clarorum virorum imagines, collec-
tore Iano-Iacobo Boissard,Vesunt.,sculptore
Theodero de Bry,Leod.,primum editae,et ab ipso-
rum obitu hactenus continuatae.Heidelbergae,im-
pensis Clementis Ammoni,1669
5 v. illus.

LC NE218.B6 1669
 Toe.,v.11,p.321
 see next card

N
40.1
H514M2 I.B.2 - HENNING, JOHN, 1771-1851
NPG
Henning, John, 1771-1851
John Henning,1771-1851:"...a very ingenious
modeller..".text John Malden;photography Alexan-
der Wilson.Paisley,Renfrew District Council
Museum and Art Galleris Dept.,1977
.139.p. illus(1 col.)

LC NK9582.H46A4 1977

qN40.1
H5194xN2 I.B.2 - HENSEL, WILHELM, 1794-1861
NPG
Berlin. National-Galerie
Preussische bildnisse des 19.jahrhunderts.
Zeichnungen von Wilhelm Hensel.Ausstellung Na-
tionalgalerie Berlin...21.Aug.-18.Okt.,1981.
Berlin,1981.
167 p. illus.
Personenregister p.161-7
Einführung zu Wilhelm Hensel & Kat.by
Cécile Lowenthal-Hensel
Die bildnissammlung Wilhelm Hensels in der
Nationalgalerie by Lucius Grisebach

Exh.also at Nuremberg.Germ.Nat'l Mus.
30.Okt.1981-3.Jan.1982, etc.

AP
1
C57 I.B.2 - HERVIEU, AUGUSTE-JEAN-JACQUES, 1794-after
NPG 1858
v.47
Stewart, Robert G.
Auguste Hervieu,a portrait painter in Cin-
cinnati

In:Queen City Heritage
47:23-31 Spring,'89 illus(part col.)

Repro incl.:Andrew Jackson

I.B.2 - HESSELIUS, GUSTAVUS, 1682-1755

Fleischer, Roland E.
Gustavus Hesselius

Dr.diss. John Hopkins Univ.,1964

 diss.In:Am Art J AP1.A51A61
 AAA v.15:65 note 14

AP
1
A51 I.B.2 - HESSELIUS, GUSTAVUS, 1682-1755
A61
HMAA Fleischer, Roland Eduard, 1928- ,
v.19 Gustavus Hesselius and Penn family portraits;
a conflict between visual and documentary evi-
dence

In:Ar Art J.
19,no.3:4-18 1987 illus.

Repro.incl.:Two Delaware chiefs.

ND
207
W78 I.B.2 - HESSELIUS, GUSTAVUS, 1682-1755
1971
NPG Fleischer, Roland E.
Gustavus Hesselius:a study of his style

In:Winterthur Conf.on Mus.Oper'n and Conn'ship
17th:127-58 1971 illus.

Bibliographical notes

LC ND207.W5 1971

AP
1
H29 I.B.2 - HESSELIUS, GUSTAVUS, 1682-1755
NCFA
Hart, Charles Henry, 1847-1918
The earliest painter in America.Recently
discovered records of Gustavus Hesselius and
of our first public art commission

In:Harper's Mag.
96:566-70 Mar.,'98 illus.

 Fleischer.G.Hesselius...in
 Winterthur Conf...ND207.
 W78,p.158

705
A56 I.B.2 - HESSELIUS, GUSTAVUS, 1682-1755
NCFA
Keyes, Homer Eaton, 1875-
Doubts regarding Hesselius

In:Antiques
34:144-6 Sept.,'38 illus.

Refers to exh. of 16 ptgs.by H.at Phila.
Mus.of Art,June 29-July 17,1938

 Richardson,E.P. Gust.Hess-
 lius.In:Art Q,12:226
 705.A7875 NCFA

N
40.1
H5755
F5
NYAA

I.B.2 - HESSELIUS, GUSTAVUS, 1682-1755

New Jersey State Museum, Trenton
Gustavus Hesselius, free painter to the
Middle Colonies.cat. of the exh. by,Roland E.
Fleischer.Feb.13-Apr.24,1988.Trenton,New Jersey
State Mus.,1987
88 p. illus(1 col.)

Ch.:The Portraits,p.23-44,cat.nos.1-21
no.5 & 6 Indian chiefs

AP
1
W225
NCFA
v.34

I.B.2 - HEWETSON, CHRISTOPHER, c.1739-1798

Hodgkinson, Terence
Christopher Hewetson,an Irish sculptor in
Rome

In:Walpole Soc.
34:42-54 1952-1954 illus.

I.B.2 - HESSELIUS, GUSTAVUS, 1682-1755

Philadelphia Museum of Art
Gustavus Hesselius,1682-1755;an exh.held
at the Phila.Mus.of Art,under the auspices of
the Pennsylvania 300th anniversary commission.
.Phila.,1938
28 p. illus.

CHM ND237.H55P4X Mooz.The art of Wmt.Peke,
Mi0.1F312M8 1970a NNAA
Bibl.p.XXIX

AP
1
A64
NCFA
v.102

I.B.2 - HICKEY, THOMAS, 1741-1824

Archer, Mildred
Wellington and South India:portraits by
Thomas Hickey

In:Apollo
102:30-5 July,'75 illus.

FOR COMPLETE ENTRY
SEE MAIN CARD

705
A7875
NCFA

I.B.2 - HESSELIUS, GUSTAVUS, 1682-1755

Richardson, Edgar Preston, 1902-
Gustavus Hesselius

In:Art Q
12:220-6 Summer,1949 illus.

"H.painted the first interesting portrs. of
American Indians."-Richardson

Doud.John Hesselius,In:
Winterthur Portf.5,p.141

AP
1
A64
NCFA
mfm
124:n:1

I.B.2 - HICKEY, THOMAS, 1741-1824

Bodkin, Thomas, 1887-
Thomas Hickey

In:Apollo
3:96-102 Feb.,'26 illus.

FOR COMPLETE ENTRY
SEE MAIN CARD

AP
1
V81
NPG
v.75

I.B.2 - HESSELIUS, JOHN, 1728-1778
(Son of Gustavus)

Doud, Richard K.
The Fitzhugh portraits by John Hesselius

In:Va.Mag.Hist & biogr.
75:159-73 Apr.'67 illus.

Incl.:Cat.of signed Fitzhugh portraits

Based on Doud's Master's thesis,Univ.of De-
laware,1963:"John Hesselius:his life and work"

Miles.Amer.Col.portrs.
p.73,note 121

705
B97
NCFA
v.99

I.B.2 - HIGHMORE, JOSEPH, 1692-1780

Edwards, Ralph, 1894-
An attribution to Joseph Highmore

In:Burl.Mag.
99:234-7 July,'57 illus.

Some conversation pictures previously attr.
to Hogarth

FOR COMPLETE ENTRY
SEE MAIN CARD

AP
1
W78
1969
NCFA

I.B.2 - HESSELIUS, JOHN, 1728-1778

Doud, Richard K.
John Hesselius,Maryland limner

In:Winterthur Portfolio
5:129-53 1969 illus.

Incl.cat.of ptgs.in alphabetical order by
sitters

Based on Master's thesis,Univ.of Del.,1963

I.B.2 - HIGHMORE, JOSEPH, 1692-1780

Lewis, Alison Shepherd
Joseph Highmore,1692-1780(An 18th c.English
portrait painter)
959 p.

Ph.D.diss.-Harvard Univ.,1975

Incl.Cat.of His work

'H.'s contemporary reputation was high...His
best portrs. rank among the finest Engl.portrs.
of the early 18th c '

Miles.Portrs.of the heroes
of Louisbourg:P1A51A6, NYAA

705
C75
NCFA
v.189

I.B.2 - HIGHMORE, JOSEPH, 1692-1780

Mannings, David
 A well-mannered portrait by Highmore,dated 1747.

In:Connoisseur
189:116-9 June,'75 illus.

 Acceptable postures and attitudes prescribed in 'Rudiments of Genteel Behaviour' (1737);by Nivelon.His and others' writings on etiquette influenced 18th c. portraiture.

 Rila II/2 1976 #5004

N
40.1
H645H2
NMAA

I.B.2 - HILLIARD, NICHOLAS, ca.1547-1619

Edmond, Mary
 Hilliard and Oliver.The lives and works of two great miniaturists.London,Rbt.Hale,1983
 238 p. illus(part col.)

 Incl.:Index

 Bibliography p.217-222

 Review in:Burl Mag.v.125:698-9,Nov.'83)

ND
461
W218
1969
NPG
v.2

I.B.2 - HIGHMORE, JOSEPH, 1692-1780

Walpole, Horace,Earl of Orford, 1717-1797
 Highmore,Joseph,1692-1780,in:his.Anecdotes of painting in England.N.Y.,Arno Press,1969

 v.2:322-3

 Walpole refers to Gentleman's Mag.,April, 1766 for longer article on Highmore

I.B.2 - HILLIARD, NICHOLAS, c.1547-1619

Farquhar, Helen
 Nicholas Hilliard,"embosser of medals of gold"..London,1908
 33 p. illus.

 Reprinted from the Numismatic Chronicle, 4th ser.,vol.8

Numiem.Chron.
LC CJ7.N6

PP

705
A56
NCFA
v.95

I.B.2 - HILLER, JOSEPH,SR., 1748-1814

Shadwell, Wendy J.
 An attribution for His Excellency and Lady Washington

In:Antiques
95:240-1 Feb.,'69 illus.

 The mezzotints of Geo.Washington & Lady Washington, once attr.to Chs.Willson Peale, here attr.to Joseph Hiller,sr.

 Shadwell.Portr.engr.of Chs.
 .Peale.NE500.36X NCFA
 p.143,note 7 (In:18th c.
 prints in Col'l America)

ND
1329.8
H54
1981X
NPG

I.B.2 - HILLIARD, NICHOLAS, ca.1547-1619

Hilliard, Nicholas, ca.1547-1619
 A treatise concerning the arte of limning Together with a more commendious discourse concerning ye art of limning,sie,by Edw.Norgate with a parallel modernized text edited by R.K.R.Thornton and T.G.S.Cain.Ashington,Mid Northumberland Arts Group in ass.with Carcanet New Press,1981
 139 p. illus(part col.)

 Bibliography p.137-9

I.B.2 - HILLIARD, NICHOLAS, c.1547-1619

Auerbach, Erna
 Nicholas Hilliard. London,Routledge & Paul ,1961.
 352 p. illus(part col.)

 "Catalogue":p.287-335
FOGG Bibliography
FA4117.11.5

 Arts Council of Gr.Britain
 Brit.portr.min.ND133707A79
 Bibl.

705
P57
NCFA
v.8

I.B.2 - HILLIARD, NICHOLAS, c.1547-1619

Holmes, Richard R.
 The English miniature painters illustrated by works in the Royal & other collections.Article I & II. Nicholas Hilliard,Pt.I,Pt.II

In:Burl Mag
8:229-35 Jan,'06 illus.
8:316-25 Feb,'06 illus.

 Contains excerpts of Hilliard's 'Treatise on the Art of Limning'

I.B.2 - HILLIARD, NICHOLAS, ca.1547-1619

Brett, Edwina
 A kind of gentle painting,cat.of,an exh. of miniatures by the Elizabethan artists Nicholas Hilliard and Isaac Oliver,16 Aug.-14 Sept. 1975,the Scottish Arts Council Gallery...Edinburgh,Scottish Arts Council,1975
 40 p. illus(1 col.)

 Bibliography

 79 works shown

LC ND1337.07H54 Rila III/1 1977 #1294

705
C75
NCFA
v.112

I.B.2 - HILLIARD, NICHOLAS, c.1547-1619

Jones, E.Alfred
 Some notes on Nicholas Hilliard,Miniaturist and goldsmith,c.1547-1617

In:Connoisseur
112:3-6 Sept.'43 illus(part col.)

 Repro.incl.:Queen Elizabeth,the'Pelican portrait'.Second Great Seal of England.Miniatures: Self portr.Queen Elizabeth.A gentleman.Alice Brandon,wife of N.H. The Armada jewel

AP
1
W225
v.1
NCFA

I.B.2 - HILLIARD, NICHOLAS, ca.1547-1619

Norman, Philip ed.
Nicholas Hilliard's treatise concerning
'The Arte of Limning'with introduction and
notes by Philip Norman,L.L.D.

In:Walpole Soc.
1:1.-54 1911-12 illus.

705.
B97
NCFA
v.101

I.B.2 - HILLIARD, NICHOLAS, ca.1547-1619

Strong, Roy C.
Queen Elizabeth,the Earl of Essex and
Nicholas Hilliard

In:Burl Mag
101:145-9 Apr.,1959 illus.

Hilliard.Treatise...ND
329.8.H54 1981X NPG p.139

I.B.2 - HILLIARD, NICHOLAS, ca.1547-1619

Pope-Hennessy, John,1913-
A lecture on Nicholas Hilliard. London,Home
and Van Thal.1949.

29p. illus.

LC ND1337.G8H55

757
V65

I.B.2 - HILLIARD, NICHOLAS, ca.1547-1619

Victoria and Albert Museum,South Kensington.
Nicholas Hilliard and Isaac Oliver; an exhi-
bition to commemorate the 400th anniversary
of the birth of Nicholas Hilliard. Monograph
and catalogue by Graham Reynolds..1st ed.,
London...Ministry of Education,1947

46 p. illus.

Bibliography
For review of exhibition see Winter, Carl
Hilliard and Elizabethan miniatures.

LC N1150.A759

AP 1
L84
NCFA

I.B.2 - HILLIARD, NICHOLAS, ca.1547-1619

Pope-Hennessy, John,1913
Nicholas Hilliard and mannerist art theory

In:J.Warburg Inst.
6:89-100 1942-43

Short account of Hilliard's 'Arte of limning'
& its stylistic implications

Rep.,1942-44*7153

qN
40.1
H64.5V6
1971
NPG

I.B.2 - HILLIARD, NICHOLAS, ca.1547-1619

Victoria and Albert Museum, South Kensington.
Nicholas Hilliard and Isaac Oliver. 2nd ed.
London, Her Majesty's Stationery office,1971

115 p. illus.(part col.)

Biographical details; Characteristics & de-
velopment of style; Costume & accessories; Expla-
natory note; Catalogue. Description with each
illustr.
Bibliography
Monograph and catalogue by Graham Reynolds

LC ND1328.V53

AP
1
W225
NCFA
v.34

I.B.2 - HILLIARD, NICHOLAS, ca.1547-1619

Reynolds, Graham, 1914-
Portraits by Nicholas Hilliard and his as-
sistants of King James I and his family

In:Walpole Soc.
34:14-26 1952-53 illus.

705
M18
NCFA
v.7

I.B.2 - HILLS, LAURA COOMBS, 1859-1952

Mechlin,Leila, 1874-1949.
Laura Coombs Hills

In:Mag Art
7:458-61 Sept.,'16 illus.

In'Philadelphia notes'in Art Bul.705.A77,
6:309,Mar.16,'07:"...she has fairly won the right
to be considered by far the greatest of living
American miniaturists..."

I.B.2 - HILLIARD, NICHOLAS, ca.1547-1619

Strong, Roy C.
Nicholas Hilliard...London,Joseph,1975
48 p. illus(chiefly col.) (Folio minia-
tures)

Bibliography

LC ND1337.G8H57

Hilliard.Treatise...ND
ND1329.8.H54 1981X NPG
p.138

N
40.1
H66xA1
NPG

I.B.2 - HIRSCHFELD, ALBERT, 1903-

Hirschfeld, Albert, 1903-
The American theatre as seen by Hirschfeld.
N.Y.,G.Braziller,1961
unpaged (chiefly illus.)

LC NC1429.H527A48

qN
40.1
H66xAlw
NPG

I.B.2 - HIRSCHFELD, ALBERT, 1903-

Hirschfeld, Albert, 1903-
The world of Hirschfeld .by.Al Hirschfeld.
Introd.by Lloyd Goodrich.N.Y.,H.N.Abrams
.1970?.
233 p. illus(part col.)

LC NC1429.H527A57

I.B.2 - HOGARTH, WILLIAM, 1697-1764

Hogarth, William, 1697-1764
The drawings of William Hogarth,by A.P.Oppé
London,Phaidon Press,1948
65 p. illus.

Cat.p..?6.-65

. Bibliography

LC NC1115.H65 06

Moon.Engl.portr.drags.&min
NC860.N66X Bibl. p.147
NPG

I.B.2 - HODLER, FERDINAND, 1853-1918

Brüschweiler, Jura
Ferdinand Hodler:Selbstbildnisse als
selbstbiographie.Bern,Benteli Verlag,1979
188 p. illus(part col.) (Hodler Publi-
kation 2)
Bibliography
June 17-Sept.16,1979 was an exh.under the
same title at Basel.Offentl.Kunstslg.Cat.by
Franz Meyer

NCA
Nh4
H69B72

705
C69
NMAA
v.46

I.B.2 - HOGARTH, WILLIAM, 1697-1764

Wendorf, Richard
Hogarth's dilemma

In:Art J.
46,no.3:200-8 Fall,1987 illus.

W.discusses H.'s ambivalent commentary on
portraiture & examines his success in adapting
traditional forms & motifs.
Portraits within portraits,figs.1 & 8

757
R31

I.B.2 - HOFFMANN, SAMUEL, 1592? - 1641

Reder, Jacob
The portraits of the Brignole-Sale family in
the Palazzo Rosso in Genoa by Sir Anthony van
Dyck,in commemoration of the 300th Anniversary of
the death of Sir A.van Dyck,Dec.9,1641. Samuel
Hofmann from Zurich,pupil of Rubens;a first pre-
face to a rediscovered European art....New York,
Printed by Art press,c1941.
133 p. illus.

LC ND853.H64R4

ND
1311.2
P61x
NPG

I.B.2 - HOIT, ALBERT GALLATIN, 1809-1856
Heard, Patricia L.
Albert Gallatin Hoit(1809-1856)
Miles, Ellen Gross comp.
Portrait painting in America.The nineteenth
century.N.Y.....,1977 (card 3)

Partial contents cont'd:P.L.Heard,Albert
Gallatin Hoit(1809-56),p.73-8;...

705
B97
NCFA
v.91

I.B.2 - HOGARTH, WILLIAM, 1697-1764

Beckett, R.B.
Hogarth and Rembrandt

In:Burl.Mag.
91:198-201 Jul.1949 illus

Repro.of ptgs.by Hogarth which show strong
influence of Rembrandt

Rep.,1948-49*8388

708.1
D47
NMAA
v.57

I.B.2 - HOLBEIN, HANS, THE YOUNGER, 1497-1543

Baetjer, Katharine
A portrait by Holbein the younger

In:Detroit inst Bull
57,no.1:25-9 1979 Illus(part col.)

The new acquisition by the Detroit Inst.of
Arts compared with H.'s other portrs. It came
from the coll.of Earl of Lonsdale

705
B97
NCFA
v.99

I.B.2 - HOGARTH, WILLIAM, 1697-1764

Edwards, Ralph, 1894-
An attribution to Joseph Highmore

In:Burl.Mag.
99:234-7 July,'57 illus.

Some conversation pictures previously attr.
to Hogarth

Repro.:Family group,known as 'The Rich fa-
mily'and 'Pamela tells a nursery tale'

I.B.2 - HOLBEIN, 1497-1543

Chamberlaine, John, 1745-1812
Imitations of original drawings by Hans
Holbein,in the collection of His Majesty,for the
portraits of illustrious persons of the court of
Henry VIII...London,Printed by W.Bulmer and co.,
1792
142 p. illus.in color

The plates are stipple engravings printed
in colors,all but four by F.Bartolozzi,three by
C.Metz,one by J.Knight

om.,v.11,p.321

I.B.2 - HOLBEIN, HANS THE YOUNGER, 1497-1543

The Family of Sir Thomas More.Facsimiles of
the drawings by Hans Holbein the younger
in the Royal Library,Windsor Castle.N.Y.,
Johnson Reprint Corp.,1978
8p.&8 pl. col.

Intro.by Jane Roberts

NPG VF Holbein,Hans,the
younger

N
40.1
H74389
NMAA

I.B.2 - HOLBEIN, HANS THE YOUNGER, 1497-1543

Strong, Roy C.
Holbein and Henry VIII.London,Routledge
& K.Paul for the Paul Mellon Foundation for
British Art,1967
75 p. col.front;illus. (Studies in
British Art)

Bibl.references

LC ND588.H7S78

Schama,S.Domestication of
Majesty.In:J.Interdisc.Hist
AP1.J8654 NPG v.17,p.163
footnote 10

705
B97
NCFA

I.B.2 - HOLBEIN, 1497-1543

Kurz, Otto
Holbein and others in a 17th c. collection

In:Burl Mag.
83:279-82 Nov.1943 illus.

17th c. collection of Frans von Imstenraedt,
included Holbein:3 portrs. and Thomas More with
his family, and 2 portr. drawgs. Large part of
coll. burnt in 1752,15items remained in Kremsier
palace,Moravia, rest is missing.

705
B97
NCFA
v.83

I.B.2 - HOLBEIN, 1497-1543

Winter, Carl, 1906-1966
Holbein's miniatures

In:Burl Mag
83:266-9 Nov.,'43 illus.

'Holbein, the progenitor of the British
school of miniature-painters'

Reynolds.Portr.miniatures...
Apollo,v.104,:281
AP1.A54 NCFA

741.91
.P23

I.B.2 - HOLBEIN, HANS THE YOUNGER, 1497-1543

Parker, Karl Theodore, 1895-
The drawings of Hans Holbein in the col-
lection of His Majesty the King at Windsor
castle...London,The Phaidon press ltd.,1945.N.Y.
Oxford Univ.Pr.
62 p. illus.

Bibliographical footnotes

LC NC1055.H7P3

N
40.1
N741B2
NCFA

I.B.2 - HOLBEIN FAMILY

Basel. Öffentliche Kunstsammlung
Die Malerfamilie Holbein in Basel.Ausstel-
lung im Kunstmuseum Basel zur fünfhundertjahr-
feier der Universität Basel..4.Juni-25.Sept.
1960.Basel,1960.
352 p. illus.

Bibliography p.38-55

705
B97
NCFA
v.121

I.B.2 - HOLBEIN, HANS THE YOUNGER; 1497-1543

Rowlands, John
Holbein and the court of Henry VIII at the
Queen's Gall.,Buckingham Palace

In:Burl Mag
121:53-4 Jan.,'79 illus.

'This exh.is ..of the first importance...
central core portr.drags.by Holbein fr.Windsor
Castle.'-J.R.
R.discusses in this article mainly the ptgs.
& miniatures. The cat.by Susan Foister
has notes on cos- tumes worn by the sitters.

I.B.2 - HOLLANDA, FRANCISCO DE, 1517-1584

Hollanda, Francisco de, 1517-1584
De la pintura antigua por Francisco de Ho-
landa(1548);versión castellana de Manuel Denis
(1563).Madrid.J.Ratés,impresor,1921
297 p.

"Del sacar por el natural"p..249.-283
'Earliest work devoted exclusively to por-
traiture,embraces theoretical & practical as-
pect of the subject."-Bury

LC ND70.H65

Bury.Use of candle-light.
In:Burl.Mag.119:434 June;77

I.B.2 - HOLBEIN, 1497-1543

Schmidt, H.Alfred
Holbeins porträts

In:Museum
4:

"Museum"
LC N7511.M7

Waetzoldt ND1300.W12

I.B.2 - HOLMES, JAMES, 1777-1860

Story, Alfred Thomas, 1842-1934
James Holmes and John Varley.London,R.
Bentley,1894
303 p. illus.

CSt CaOTP NN MBAt PPL

Heleniak.N;0.1.H956H47
1978a NMAA Bibl.p.545

I.B.2 - HONDIUS HENDRIK, the elder, 1573-after
.1649

Hondius, Hendrik, the elder, 1573-after 1649
Pictorum aliquot celebrium praesipue Ger-
maniae Inferioris, effigies. Hague, Comitis ex off
Henrici Hondi. ca. 1610. *°

Brit.Mus.
555 d.22 3 pt.
565 g.8
565 f.4 Coll.of portrs.by Netherlandish artists.
e(2) Continuation of Cock's artist portrs., Pictorum
 aliquot celebrium...Antwerp, 1572

 see also: Szwykowski, I.v. Historische skizze...
 *°"Iconographically very important."-Th.-B.
 Hall.Portr.v.Nederl.Beeld.
 kunstenaars. N7620.H17 NPG
 p.XII

705 I.B.2 - HORNEBOUT, LUKAS, died c.1544
B97
NCFA Paget, Hugh
v.101 Gerard and Lucas Hornebolt in England

 In: Burl Mag
 101:396-402 Nov., '59 illus.

 FOR COMPLETE ENTRY
 SEE MAIN CARD

I.B.2 - HOPKINSON, CHARLES SYDNEY, 1869-1962

Shurcliff, Joan Hopkinson (Mrs.Wm.A.)
Portraits by Charles Hopkinson; an informal
catalog. Cambridge, Mass..s.n..c.1987
185 leaves illus.

MBAt

705 I.B.2 - HOSKINS, JOHN, -1664
B97
NCFA Holmes, Richard R.
v.9 The English miniature painters illustrated
 by works in the Royal & other collections. Ar-
 ticle IV. Peter Oliver & John Hoskins

 In: Burl Mag
 9:108-13 May, '06 illus.

 Repro.:P.Oliver:Eliz.of Bohemia, Arabella
 Stuart, Chs.I, Henr.Maria, Marquis Ouasto & his mis-
 tress after Titian, B.Jonson. Hoskins:Falkland,
 Mrs.Cromwell, Charles I

CT I.B.2 - HOPKINSON, FRANCIS, 1737-1791
275
H81H3 Hastings, George Everett
1968 The life and works of Francis Hopkinson.
NPG N.Y., Russell & Russell, 1968.
 516 p. illus.

 'A revision of a doctoral thesis written at
 Harvard Univ.in 1917-18'-Pref.

 Reprint of 1926 ed.

 Alberts.Penj.West N40.1.W49
 A3 NPG Bibl.p.491

705 I.B.2 - HOSKINS, JOHN, -1664
B97
NCFA Murdoch, John, 1545-
v.120 Hoskins' and Crosses: work in progress

 In: Burl Mag
 120:284-90 May, '78 illus.

 Info. on miniatures with monograms of John
 Hoskin & PC & LC of Peter & Lawrence Cross.e...
 Proposes the Hoskins oeuvre should be devided
 betw.the elder John H.& the younger & contribu-
 tions fr.studio works & all works with PC or LC
 marks should be classified together.
 Bruijn Kops.In:B.Rijksmus.
 30:196, note 3

I.B.2 - HORNEBOLT
see
I.B.2 - HORNEBOUT

705 I.B.2 - HOSKINS, JOHN, THE YOUNGER, ca.1630-
B97
NCFA Murdoch, John, 1545-
v.120 Hoskins' and Crosses: work in progress

 In: Burl Mag
 120:284-90 May, '78 illus.

 Info. on miniatures with monograms of John
 Hoskin & PC & LC of Peter & Lawrence Cross.e...
 Proposes the Hoskins oeuvre should be devided
 betw.the elder John H.& the younger & contribu-
 tions fr.studio works & all works with PC or LC
 marks should be classified together.
 Bruijn Kops.In:B.Rijksmus.
 30:196, note 3

705 I.B.2 - HORNEBOUT, GERARD, died c.1540
B97
NCFA Paget, Hugh
v.101 Gerard and Lucas Hornebolt in England

 In: Burl Mag
 101:396-402 Nov., '59 illus.

 FOR COMPLETE ENTRY
 SEE MAIN CARD

I.B.2 - HOUBRAKEN, ARNOLD, 1660-1719

Houbraken, Arnold, 1660-1719
Arnold Houbraken's Grosse schouburgh der nie-
derländischen maler und malerinnen. Übersetzt
und mit einleitung, anmerkungen und inhalts-ver-
zeichnissen versehen von dr.Alfred von Wurzbach.
1.band:Übersetzung des textes nebst drei inhalts-
verzeichnissen. Wien, W.Braumüller, 1880.

495 p. (Quellenschriften für kunstgeschichte
und kunsttechnik XIV)

Arnold H.'s drawings were engraved by son Ja-
LC ND652.H65 cobus(Thieme-Becker:Houbraken, Arnold)
 Thieme-Becker:Houbraken,
 Jacobus

I.B.2 - HOUBRAKEN, JACOBUS, 1698-1780

Houbraken, Arnold, 1660-1719
 Arnold Houbraken's Grosse schouburgh der nie-
derländischen maler und malerinnen. Übersetzt
und mit einleitung, anmerkungen und inhalts-ver-
zeichnissen versehen von Dr.Alfred von Wurzbach.
1.band:Übersetzung des textes nebst drei inhalts-
verzeichnissen. Wien,W.Braumüller,1880.

 495 p. (Quellenschriften für kunstgeschichte
und kunsttechnik XIV)

 Arnold H.'s drawings were engraved by son Ja-
LC ND652.H85 cobus (Thieme-Becker:Houbraken,Arnold)
 Thieme-Becker:Houbraken,
 Jacobus

705
.C75
NCFA
v.121

I.B.2 - HOUDON, JEAN ANTOINE 1741-1828

Réau, Louis, 1881-
 A great French sculptor of the 18th century:
Jean-Antoine Houdon

In:Connoisseur
121:74-7 Jun,1948 illus.

 Repro:Marble busts of Franklin,Mme Victoire,
etc. Houdon in Italy, France, Germany, U.S. &
England

 Rep.,1948-49=8006

TNE
266
G7H83
1813
NPG

I.B.2 - HOUBRAKEN, JACOBUS, 1698-1780

Houbraken, Jacobus, 1698-1780
 The heads of illustrious persons of Great
Britain, engraven by Mr.Houbraken and Mr.Vertue;
with their lives and characters by Thomas Birch.
New ed. London, Printed for W.Baynes by C.Wood,
1813

 216 p. illus.

 'Jacobus H. & G.Vertue engraved after Arnold
Houbraken's drawings.(Thieme-Becker: Houbraken,
LC DA28.H6 1813 [Arnold

705
G28
v.10
NCFA

I.B.2 - HOUDON, JEAN ANTOINE, 1741-1828

Réau, Louis, 1881-1961
 Houdon sous la révolution et l'Empire

In:Gas Beaux-Arts
10(5ième ser):59-86 Jul,Aug.,1924 illus.

Repro.incl.:Busts of Lafayette,Necker,Mirabeau,
Barnave,Dumouriez,Napoleon,Lalande,Collin d'Har-
leville,Sabine Houdon

I.B.2 - HOUDON, JEAN ANTOINE, 1741-1828

Giacometti, Georges, d.1932
 ...La vie et l'oeuvre du sculpteur J.-A.Houdon
Paris,A.Camoin,1929.
 2 v. illus.

Md.Univ. Preface by Camille Mauclair
Libr.
NB553
.H8G52
folio

H.E.Huntington Libr.
for LC NB553.H8G52
 NB553.H8G53

I.B.2 - HOUDON, JEAN ANTOINE, 1741-1828

Tschaegle, Robert
 Actualism in portrait sculpture:a problem
of style based on examination of the natural-
ism of French 18th c.portrait busts with empha-
sis on the style of Houdon

 Master's Th.-Chicago,Ill.,1937

 Lindsay,K.C.,Harpur Ind.of
 master's theses in art...
 Z5931.L74 1955 NCFA Ref.
 p.33,no.591

ND
1311
L16
NPG

I.B.2 - HOUDON, JEAN ANTOINE , 1741-1828

Lafayette College, Easton,Pa.
 The Kirby collection of historical paintings
located at Lafayette College,....Easton,1963.
 54 p. illus(part col.)

 "The philosophy behind this collection,by
Allan P.Kirby":p.9-10

 Bronze busts of four "Pioneers of the Indepen-
dence"after Houdon...

I.B.2 - HOUDON, JEAN ANTOINE, 1741-1828

Versailles. Bibliothèque municipale
 Centenaire de J.-A.Houdon,né à Versailles.
Préface de m.Paul Vitry.Avril-mai,1928..Ver-
sailles,1928.
 55 p. illus.

 Bibliography p.52-55

 see also:Réau,L.Les expos.du centenaire...
in:Gaz.Beaux-Arts,v.17:339-56,June,'28 illus.

NJP

735
H86P23
NCFA

I.B.2 - HOUDON, JEAN ANTOINE, 1741-1828

Paris. Galeries Buvelot
 Exposition du centenaire de Houdon,organi-
sée au bénéfice des ligues française et espag-
nole contre le cancer;préface de A.Camoin...
5 juin au...5 juillet,1928..Paris,1928.
 107 p. illus.

 see also:Réau,L.Les expos.du centenaire...
in:Gaz.Beaux-Arts,v.17:339-56,June,'28 illus.

705
A786
NCFA
v.46

I.B.2 - HUBARD, WILLIAM JAMES, 1807-1862

Jenkins, Marianna Duncan.
 Richmond discovers its own Romantic

In:Art M
46:29-31 Jan.,'48 illus.

 First modern view of Wm.Jas.Hubard,1807-62,
mysterious & eccentric Southern ptr.in his na-
tive Richmond's two-museum retrospective

 Quirby,"ollie Earles.Beauty
 in black & white.Oregon
 State Libr.,Salem 74.1Q.1b
 H101.p.46

705
A56
NCFA
v.15

I.B.2 - HUBARD, WILLIAM JAMES, 1807-1862

Swan, Mabel Munson
 Master Hubard,profilist and painter

In:Antiques
15:496-500 June,'29 illus.

 Repro.:Silhouettes & ptgs.
 Incl.:"Hubard's gall.of silhouettes:From his catalogue & memoirs published in N.Y.in 1825

 London,H.R.Shades of my
 forefathers.741.7.L847
 Bibliography

I.B.2 - HULETT, JAMES, died 1771

Portraits of the Hungarians,Pandours,or Croats,
 Maradins or Sclavonians,and Ulans,etc. who
 are in the service of their Majesties the
 Queen of Hungary and the King of Prussia,
 designed after the life,by persons of dis-
 tinction...London,William Meyer,1742
 8 p. 6 plates

Winterthur In English and French
Mus.Libr. Plates engraved by Hulett and Fickhar
SF301
B94*
 Winterthur Mus.Libr.
 fZ881.W79 NCFA v.6,p.231

705
A56
NCFA
v.20

I.B.2 - HUBARD, WILLIAM JAMES, 1807-1862

Swan, Mabel Munson
 A neglected aspect of Hubard

In:Antiques
20:222-3 Oct.,'31 illus.

 H.,known as silhouettist is shown here as painter & sculptor

N
40.1
H92W7
NCFA

I.B.2 - HUMPHRY, OZIAS, 1743-1810

Williamson, George Charles, 1858-
 Life and works of Ozias Humphry...London,
N.Y.,John Lane cy,1918
 329 p. illus(part col.)

 Bibliography

 "List of engravings after Ozias Humphry,
arranged under the names of the persons repre-
sented,together with sizes and descriptions"

LC ND497.H87W5 Foskett,D.John Smart...
 N40.1S638F7 Bibliography

N
40.1
H87V2
NCFA
NPG

I.B.2 - HUBARD, WILLIAM JAMES, 1807-1862

Valentine museum, Richmond,,Va.
 William James Hubard,1807-1862;a concurrent
survey and exhibition,January,1948.Richmond,
Valentine museum.and.the Virginia museum of
Fine Arts.1948.
 35 p. illus.

 Text by Helen Gardner McCormack

 Bibliography

LC ND237.H84V3

N
40.1
H935S5
NCFA

I.b.2 - HUNT, WILLIAM MORRIS, 1824-1879

Shannon, Martha A.S.
 Boston days of William Morris Hunt.Boston,
Marshall Jones Co.,1923
 165 p. illus.

LC ND237.H9S5 Robert Hull Fleming Museum
 Univ.of Vt. Faces in the
 parlor. Bibl.p.40

N
40.1
H878
I S
NPG

I.B.2 - HUDSON, THOMAS, 1701-1779

Iveagh Bequest, Hampstead,Eng.
 Thomas Hudson,1701-1778;portrait painter
and collector;a bicentenary exh.:held.6 July
to 30 Sept.,1979.at.Iveagh Bequest.London,
Greater London Council,1979
 88.p. illus.

 Exh.selected and intro.written by Ellen C.
Miles
 Cat.nos.1-66:Hudons' work;nos.67-78:Hudson's
collection

I.B.2 - HUNT, WILLIAM MORRIS, 1824-1879

Vose, Robert C.(Robert Churchill)1911-
 The Return of William Morris Hunt.Exh.cat.
.Exh.:Sept.30-Nov.26,1986.Boston,Mass.,Vose
Galleries of Boston,c.1986

LC N6537.H83A4 1986 Robert Hull Fleming Museum
parlor.Bibl.p.40 Univ.of Vt. Faces in the

qNA
247
NPG

I.B.2 - HUDSON, THOMAS, 1701-1779

Miles, Ellen
 Thomas Hudson(1701-1779)portraitist to the
British establishment..New Haven,Conn.:Yale Uni.
1976
 2 v. illus.

 Bibliography

 Thesis Yale

 Incl.:Cat.of Hudson's portraits

I.B.2 - HUNTINGTON, DANIEL, 1816-1906

.American Art Union, New York.
 Cat.of paintings by Daniel Huntington,N.A.,
exhibiting at the Art Union building,497 Broad-
way..New York,1850.
 40 p.

 "The exh.will continue open until 1st of
May."

DNCA Nat'l academy of design.
 Artists by themselves
 qN7618.N27 NPG.p.69.note 2

ND
1311.2
P61x
NPG

I.B.2 - HUNTINGTON, DANIEL, 1816-1906
Gilchrist, Agnes Eleanor(Addison), 1907-
Daniel Huntington,portrait painter over
seven decades
Miles, Ellen Gross comp.
Portrait painting in America.The nineteenth
century.N.Y....,1977 (card 3)

Partial contents cont'd:...A.Gilchrist,Dan.
Huntington,portr.ptr.over 7 decades,p.91-3;...

I.B.2 - INGRAM, WAYNE

Heckmann, M.
Changing the face of portraiture

In:Southwest Art
5,pt.11:44-9 May'76 illus.

Multi-image portrs.by Wayne Ingram...

LC N6525.S58

FOR COMPLETE ENTRY
SEE MAIN CARD

705
C75
NCFA
v.35

I.B.2 - HYSING, HANS, 1678-1752?
Hultmark, Emil, 1872-1943
An interesting portrait by the Swedish pain-
ter Hans Hysing

In:Connoisseur
35:103-5 Feb.,1913 1 illus.

H.mentions several Swedish portraitists:
Georg Schröder,Lorenz Pasch,Christian Richter,
Charles Boit,Frédéric Peterson,Charles Bancks,
Elias Martin,Carl Frederik van Breda

qN40.1
I55C7
NMAA

I.B.2 - INGRES, JEAN-AUGYSTE-DOMINIQUE, 1780-
1867
Condon, Patricia
Ingres,in pursuit of perfection;the art
of J.-A.-D.Ingres;the J.B.Speed Art Museum,
Louisville,Ky.,Dec.6,1983 to Jan.29,1984;
the Kimbell Art Museum, ort Worth,Tex.,Mar3-
May 6,1984;by P.Condon with Marjorie B.Cohn,
and Agnes Mongan,ed.by Debra Edelstein.
Bloomington,Ind.Indiana Univ.Press,1983
255 p. illus(part col.)
For portrs.see:Mongan,p.138-49 & cat.nos.57-78
Indexes
Bibliography
Based on diss. research by P.Condon for
Ph.D. at Brown Univ.,Providence,R.I.

AP
1
J8643
NMAA
v.14

I.B.2 - HYSING, HANS, 1678-1752?
Meschutt, David
William Byrd and his portrait collection

In:J.early S.dec.arts
14,no.1:19-46 May,1988 illus.

Most portrs. in B.'s coll.have been attr.to Sir
Godfrey Kneller.Three(or more)attr.to Hans Hysing

This article..was presented in 1988 as...
completion of the Master's Degree...State Univ.
of N.Y.

N
40.1
I 55xN2
NCFA

I.B.2 - INGRES, JEAN AUGUSTE DOMINIQUE,1780-1867
Naef, Hans, 1920-
Die bildniszeichnungen von J.-A.-D.Ingres.
Beiträge zu einer historisch-kritischen gesamt-
darstellung.Teildruck:Schweizer künstler in
bildnissen von Ingres.Zürich,Conzeit & Huber,
1962
101 p. illus.

Ph.D. Dissertation,Zürich,1962

I.B.2 - HYSING, HANS, 1678-1752?

Nisser, Wilhelm, 1897-
Michael Dahl and the contemporary Swedish
school of painting in England...Uppsala,Alm-
qvist & Wiksells,...1927
159 p. illus.

Inaug.-diss.-Upsala
Literature & sources of info.

Contents.-Michael Dahl.-Hans Hysing.-Charl
Bolt.-Christian Richter

LC ND793.D3N5 Yale ctr.f.Brit.art Ref.
ND786.N57

N
40.1
I55x
N2b
NMAA

I.B.2 - INGRES, JEAN AUGUSTE DOMINIQUE, 1780-
1867
Naef, Hans, 1920-
Die Bidlniszeichnungen von J.A.D.Ingres...
Bern,Benteli,cop.1977-cop.1980
5 vols. illus.

Incl.text in English,French,German or
Italian
Bibl.ref.
Index

N
40.1
I 44N5
NCFA

I.B.2 - INGALLS, WALTER, 1805-1874
New Hampshire Historical Society
Walter Ingalls,maker of likenesses;an exh.
at the New Hampshire Historical Society,Concord,
N.H.,Aug.26,1975 to Oct.10,1975.Concord,N.H.,
New Hampshire Hist.Soc.,c.1975

FOR COMPLETE ENTRY
SEE MAIN CARD

N
40.1
I55T7
NMAA

I.B.2 - INGRES, JEAN AUGUSTE DOMINIQUE, 1780-1867
Toussaint, Hélène
Les portraits d'Ingres,peintures des musées
nationaux.Paris,Ministère de la Culture.Editions
de la Réunion des musées nationaux,1985
141 p. illus(part col.) (Monographies
des musées de France)

Bibliography, p.136-9
Repro incl.:Napoleon,1806,Luigi Cherubini,
1841,1842,Lorenzo Bartolini,1820,Jean-Pierre Cor-
tot,1815,1818

AP1
A784
A4
NCFA
v.28

I.B.2 - INGRES, JEAN AUGUSTE DOMINIQUE, 1780-1867

Zabel, Morton Dauwen
The portrait methods of Ingres

In:Art & Archaeol
28:102-16 Oct,'29 illus.

I.perfected methods to describe wealth,social
rank,intellectual eminence of sitters, as well as
to build up compact,organized composition.He uses
robes,biographical details,costume,hairdress of-
ten as pattern & design & chromatic relationship,
later portrs. rely solely on character presenta-
tion & solidity of ⌒design
Co....ing.pub.,ind.A1/3/C76 Ref.
v.?,p.

I.B.2 - ISABEY, JEAN BAPTISTE, 1767-1855

Taigny, Edmond
Jean-Baptiste Isabey,sa vie et ses oeuvres..
Paris,E.Panckoucke et cie., 1859
55 p.

FOGG
FA
3943.2

LC no. DLC MB Heath.Miniatures.ND1330H43
⌒CFA Bibl. IL

705
A7875
NCFA
v.3

I.B.2 - INMAN, HENRY, 1801-1846

Bolton, Theodore, 1889-
Henry Inman,an account of his life and
work

In:Art Q
3:353-75,401-18 Autumn,'40 illus.

401-18 is a cat.of the ptgs.of H.I.;
Part I:Portrs.in oils;Part III:Miniatures and
portr.drags.

I.B.2 - ISENRING, JOHANN BAPTIST, 1796-1860

Stenger, Erich, 1878-
Der daguerreotypist J.B.Isenring;seine ver-
dienste um einführung und ausgestaltung der da-
guerreotypie 1839-1842.Berlin,Selbstverlag des
verfassers,1931
16 p. illus.

N.Y.P.L.

Kunstausstellung enthaltend eine sammlung
von lichtbildern meistens porträts nach dem le-
ben gefertigt im Mai,Juni,Juli 1840 von J.B.
Isenring,maler aus St.Gallen...
Bibliography ⌒

N
6507
H57X
NPG
NMAA

I.B.2 - INMAN, HENRY, 1801-1846

Hirschl & Adler Galleries,inc.,N.Y.
American art from the Colonial and Federal
periods.Cat.of an exh.,Jan.14-Feb.10,1982.In-
troduction by Stuart P.Feld..The Gallery,
c.1982.
102 p. illus(part col.)

Index of artists

Incl.:McKenney & Hall coll of portrs.of
American Indians by Henry Inman;now in Harold
Byrd coll,Dallas,Texas(1984).

705
M18
NPG

I.B.2 _ JACOB, DR.GERTRUD

Portraits of psychotics

In:Mag Art
30:485-9 Aug.,'37 illus.

Contents:1.Art & psychiatry by G.E.Benson.-
2.Psychological interpertation by Dr.E.Schachtel-
3.Biogr.note on the artist,Gertrud Jacob

Psychiatric thought fertilized 20th c."isms"

N.Y.,MOMA.20th c.portrs.by
M.Wheeler.N7592.6N53 NPG
⌒Bibl.

I.B.2 - INMAN, HENRY, 1801-1846

King, Charles Bird, 1785-1862
Cat.of 115 Indian portraits,representing
18 different tribes...Phila.,n.p.,1836
24 p.

The portrs.are copies by Inman,fr.the cele-
brated coll.in the War Dept.at Washington
Also cited in Nat'l M. & T.'s exh. cat.
"Perfect likenesses" qNE263.N37 1977X NCFA,
p.10, p.4

Arch.
Am.Art
mfm
P24
181-193

Arch.Am.Art mfm P24 181-
193

CJ
5805
L88
1967
NPG

I.B.2 - JACQUEMART, JULES FERDINAND, 1837-1880

Loubat, Joseph Florimond,duc de, 1831-1927
The medallic history of the U.S.of America,
1776-1876.With 170 etchings by Jules Jacquemart.
New Milford,Conn.,N.Flayderman;1967.

FOR COMPLETE ENTRY
SEE MAIN CARD

ND
1337
F8M44
NPG

I.B.2 - ISABEY, JEAN BAPTISTE, 1767-1855

Mauclair, Camille, 1872-
...Les miniatures de l'empire et de la restaura-
tion, portraits de femmes. Paris,H.Piazza,1913
137 p. illus(part col.)

Cont.-Jean-Baptiste-Jacques Augustin et son
oeuvre.-La vie de Jean-Baptiste Isabey.-I.et ses
élèves.-Quelques figures de ce livre.-D'autres
portrs.de femme.-Miniatures et figures étran-
gères.

LC ND1337.F7M35

I.B.2 - JÄGER, OTTO, 1900-

Freiberg,Ger. Stadt-und Bergbaumuseum
Otto Jäger bildnisse.Sonderausstellung
Febr.bis März 1948.Freiberg/Sa.,Sachsenverlag,
1948
;8;p. illus(part col.)

Cat.by Richard Hamann

PPPM

Bibl.zu kunst & kunstgesch.
Z5931.B58 1945-53 NCFA
p.229 no.4602

I.B.2 - JAHANDIER, ÉTIENNE
see
I.B.2 - DESROCHERS, ÉTIENNE JEHANDIER, 1668-1741

B
.J38D5

I.B.2 - JARVIS, JOHN WESLEY, 1780-1840

Dickson, Harold Edward, 1900-
John Wesley Jarvis, American painter, 1780-
1840;with a checklist of his works.New York,
Historical Society,1949
476 p. illus. (The New York Historical
Society.The John Divine Jones Fund series of
histories and memoirs,12)

Bibliography

LC ND237.J35D5

Whitehill.The Arts of ear-
ly Amer.Hist.Z5935.W59 NPG
Bibl.,p.91

N
40.1
J28
NCFA
2 c.

I.B.2 - JAMES, ALEXANDER, 1890-1946

Currier Gallery of Art, Manchester,N.H.
Memorial exh.:Alexander James,1890-1946.
Manchester,N.H.,The Currier Gall.of Art,July 15-
Sept.15,1947.Boston,Mass.,Mus.of Fine Arts,Oct.
15-Nov.16,1947,Wash.D.C.,The Corcoran Gall.of
Art,Dec.7-Jan.4,1948.Manchester,1947.
20 p. illus.

Cat.incl.notes on J.'s methods of working

LC ND237.J3C8

Arts in Am.qZ5961.U5A77X
NCFA Ref. J 631

I.B.2 - JEHANDIER, ÉTIENNE DESROCHERS
see
I.B.2 - DESROCHERS, ÉTIENNE JEHANDIER, 1668-1741

705
C75
NCFA
v.61

I.B.2 - JAMESONE, GEORGE, 1587?-1644

Shaw, Wm.A.
How did George Jamesone paint?

In:Connoisseur
61:127-34 Nov.,'21 illus(part col.)

705
A784
NCFA
v.34

I.B.2 - JENNYS, RICHARD, fl.1766-1799

Dods, Agnes M.
More about Jennys

In:Art in Am
34:114-6 Apr.,'46 illus.

Repre.:1 portr.by William Jennys,1portr.by
Richard Jennys

I.B.2 - JANSSENS, CORNELIS
see
I.B.2 - JONSON VAN CEULEN, CORNELIS I, 1593-1661

H
J5495

I.B.2 - JENNYS, RICHARD, fl.1766-1799

Sherman, Frederic Fairchild, 1874-1940
Richard Jennys, New England portrait painter.
Springfield, Mass.,The Pond-Ekberg comapny,1941
96 p. illus.

"Newly discovered portrs. & min. by Richard
Jennys, by Jean Lipman":p.71-76

705
A7875
NCFA

I.B.2 - JARVIS, JOHN WESLEY, 1780-1840

Bolton, Theodore(and Groce,George C.,jr.)
John Wesley Jarvis.An account of his life
and the first catalogue of his work.

In:Art Q
1:299-321 Autumn,1938 illus.

Incl.:Catalogue of portrs. by Jarvis

705
A784
NCFA
v.24

I.B.2 - JENNYS, RICHARD, fl.1766-1799

Sherman, Frederic Fairchild, 1874-1940
Seven hitherto unrecorded portraits by
Richard Jennys

In:Art in Amer.
24:32-6 Jan.,'36 illus.

Repro.:Children of Deming family,Dan.Math.
Brinsmade,Abigail Ferrand Brinsmade

AP1
C76
NPG
v.21-25

I.B.2 - JENNYS, RICHARD, fl.1766-1799

Warren, William Lamson
 A checklist of Jennys portraits

In:Conn.Hist.Soc.B.
21:33-64 Apr., '56 illus.

 Article p.34-41.Check list:Richard Jennys,
p.42-6,William Jennys,p.46-64

I.B.2 - JENNYS, WILLIAM, fl.1795-1807

Warren, William Lamson
 The Jennys portraits

In:Conn.Hist.Soc.B.
20:97-128 Oct., '55 illus.

 Cat.of exh.."Portraits by Richard & William
Jennys".Nov.'55-Jan., '56

LC F91.C67

I.B.2 - JENNYS, RICHARD, fl.1766-1799

Warren, William Lamson
 The Jennys portraits

In:Conn.Hist.Soc.B.
20:97-128 Oct., '55 illus.

 Cat.of exh.."Portraits by Richard & William
Jennys".Nov.'55-Jan., '56

LC F91.C67

706
NCFA
v.69

I.B.2 - JENNYS, WILLIAM, fl.1795-1807

Warren, William Lamson
 Portraits by William Jennys

In:Antiques
69:153 Feb., '56 illus.

 Pertains to exh."Portrs.by Richard & William
Jennys" at Connecticut historical society,Hart-
ford,Nov., '55-Jan., '56

 "...shows a mastery of paint application &
drg.with the brush,that one is almost tempted to
call him an Amer. Frans Hals."

705
A784
NCFA
v.34

I.B.2 - JENNYS, WILLIAM, fl.1795-1807

Dods, Agnes M.
 More about Jennys

In:Art in Am
34:114-6 Apr., '46 illus.

 Repre.:1 portr.by William Jennys,1portr.by
Richard Jennys

705
A784
NCFA
v.18

I.B.2 - JOCELYN, NATHANIEL, 1796-1881

Sherman, Frederic Fairchild, 1874-1940
 Asher B.Durand as a portrait painter

In:Art in Am.
18:309-10,15-6 Oct.,1930 illus.

 During 1833-1838 D.patd.portrs.

 Incl.list of portrs.by D. and list of
portrs.of D.

 Pfister.Facing the light
 TR680.P47X NPG p.366

705
A784
NCFA
v.33

I.B.2 - JENNYS, WILLIAM, fl.1795-1807

Dods, Agnes M.
 Newly discovered portraits by J.William
Jennys

In:Art in Am
33:4-12 Jan., '45 illus.

 Lists:Portrs.by J.W.Jennys;Unrecorded pertr.
by J.W.Jennys;Unrecorded portrs.atrr.to J.W.J...

N
40.1
J646H7
NPG

I.B.2 - JOHN, AUGUSTUS EDWIN, 1878-1961

Holroyd, Michael
 Augustus John;a biography.London,Heinemann
1974-c75.
 2 v. illus.

 Incl.bibl.references & index

LC ND1329.J631H64 705.B97,v.117:308
 Burl.Mag.,My, '75

AP1
C76
NPG
v.21-25

I.B.2 - JENNYS,WILLIAM, fl.1795-1807

Warren, William Lamson
 A checklist of Jennys portraits

In:Conn.Hist.Soc.B.
21:33-64 Apr., '56 illus.

 Article p.34-41.Check list:Richard Jennys,
p.42-6,William Jennys,p.46-64

N
40.1
J648E2
NCFA

I.B.2 - JOHN, AUGUSTUS EDWIN, 1878-1961

John, Augustus Edwin, 1878-1961
 The art of Augustus John,text by Malcolm
Easton and Michael Holroyd.Boston,Mass.,David
R.Godine,1975
 216 p. chiefly illus(part col.)

 Incl.Bibl.references

LC N6797.J65E27 1974 .London,Seckert & Warburg

705
897
NCFA
v.117

I.B.2 - JOHN, AUGUSTUS EDWIN, 1878-1961

Roberts, Keith, 1937-
 Augustus John

 «Ptgs.,drawgs.,and etchings by A.John,exn.
NPG,London,25th March-31st August,1975.

In:Burl.Mag.
117:312-15 May,'75 illus.

I.B.2 - JOHNSON, EASTMAN, 1824-1906

Johnson, Eastman, 1824-1906
 Cat.of finished pictures,studies and draw-
ings by the late Eastman Johnson,N.A.,to be sold
at unrestricted public sale...at the American
Art galleries...on.Feb.26 & 27,1907....The sale
will be conducted by Mr.Ths.E.Kirby of the Ame-
rican art assoc'n...N.Y.,Americ.art assoc'n
«Press of J.J.Little & co.»1907
 «98»p. illus.
 'Shows...his unusual accomplishm't as por-
traitist & fig.ptr.«&»illustrates his method of
work...'-J.Benj.Townsend
LC ND237.J7 ⌐Arts in Am qZ5961.U5A77X
 NCFA Ref. I 1015

N
40.1
J65L2
NMAA

I.B.2 - JOHN, GWEN, 1876-1939

Langdale, Cecily and David Fraser Jenkins
 Gwen John(1876-1939);an interior life.
Cat.of an exh.held at the Barbican Art Gall.,
London,12 sept.-3 nov.1985;the Manchester Ci-
ty Art Gall.28 nov.1985-26 jan.1986;Yale Cen-
ter for Brit.Art 26 feb-20 apr.1986.N.Y.,
Rizzoli,1986
 94 p. illus(part col.)

 Bibliography
 Index

LC ND497.J613A4 1986

N
40.1
J683W3
NMAA

I.B.2 - JOHNSON, JOSHUA, 1765-1830
 (or JOHNSTON)

Weekley, Carolyn J.
 Joshua Johnson:freeman and early American
portrait painter,«by»Carolyn J.Weekley,Stiles
Tuttle Colwill with Leroy Graham,Mary Ellen
Hayward.Williamsburg,Va.Abby Aldrich Rockefeller
Folk Art Center;Baltimore,Md.,Maryland Histori-
cal Society,1987
 173 p. illus.
 Bibliography

 Publ.on the occasion of an exh.,org.by the
Abby Aldrich Rockefeller Folk Art Ctr.of Col'l
Williamsburg & th Md.Hist.Soc.

N
40.1
J65L2g
NMAA

I.B.2 - JOHN, GWENDOLEN MARY (GWEN),, 1876-1939

Langdale, Cecily
 Owen John;with a cat.raisonné of the paint-
ings and a selection of the drawings.New Haven,
publ.for the Paul Mellon centre for studies in
Brit.Art by Yale Univ.Press,1987
 251 p. illus(part col.)

 Incl.:Indexes
 Bibliography,p.233-39

N
7628
N42M9
NCFA
NPG
(RB)

I.B.2 - JOHNSON, THOMAS, fl.1683

Murdock, Kenneth Ballard, 1895-
 The portraits of Increase Mather,with some
notes on Thomas Johnson,an English mezzotinter...
Cleveland,For private distribution by W.G.
Mather,1924
 70 p. illus(part col.)

LC F67.M478
N7628.M3M8 (copy 2) ⌐Whitehill.The Arts in ear-
 ly Amer.Hist.Z5935.W59 NPG
 Bibl.,p.98

I.B.2 - JOHNSON, CORNELIUS
 see
I.B.2 - JONSON VAN CEULEN, CORNELIS I, 1593-1661

705
A56
NCFA

I.B.2 - JOHNSTON, HENRIETTA, ? - 1728/29

Keyes, Homer Eaton, 1875-
 Coincidence and Henrietta Johnston

In:Antiques
16:490-4 Dec.,'29 illus(part col.)

 First portraitist in pastel in the U.S.

 Keyes searches for antecedents of H.J.

707
A786
NCFA
v.7

I.B.2 - JOHNSON, EASTMAN, 1824-1906

Eastman Johnson's Indians

In:(Am)Art N
7,no.10:3 Dec.15,1908 1 illus.

 (Clipping in NPG copy of:"A catalogue of
Indian portraits in the coll.of Joseph G.
Butler,jr....E89.G35) "

705
A56
NCFA
v.51

I.B.2 - JOHNSTON , HENRIETTA, ? - 1728/29

Rutledge, Anna Wells
 Who was Henrietta Johnston ?

In:Antiques
51:183-5 Mar.,'47 illus.

 1st woman artist in the U.S. Pioneer in the
art of pastel

VP
7
5648
NCFA

I.B.2 - JOHNSTON, HENRIETTA, ? - 1728/29

Troop, Miriam
 Two lady artists led the way for success and fame

In:Smithsonian
8,no.11:114-24 Feb.,'78 illus(part.col.)

 "Patience Lovell Wright,mother of all New
England,Henrietta Johnston first portraitist
,inspected in the New World."-M.Troop

 Patience Lovell Wright and her sister,Rachel
Wells had a waxworks in N.Y.City,Philadel-
phia & London

705
I61
NCFA

I.B.2 - JOHNSTON, HENRIETTA, ? - 1728/29

Willis, Eola
 The first woman painter in America

In:Studio
87:13-20,84 July,'27 illus.

 Incl.:List of pastel portrs.,by Henrietta
Johnston,ptd.in S.Carolina,1710-20

 Keyes.Coincidence and H.
 Johnston.In:Antiques,16

NCFA
uncat.

I.B.2 - JOHNSTON, HENRIETTA, ? - 1728/29

Willis, Eola
 Henrietta Johnston,South Carolina pastel-
list

In:The Antiquarian
11,no.2:46-7 Sep.,'28 illus.

 Several previously unknown portrs.by Ameri-
ca's 1st woman ptr.,H.J.,have been found re-
cently

B
.J72P724

I.B.2 - JOHNSTON, JOSHUA, fl.ca.1796-1824
 (or JOHNSON)
Pleasants, Jacob Hall, 1873-1957
 Joshua Johnston,the 1st American negro por-
trait painter...Baltimore,The Maryland histori-
cal society,1942
 29 p. illus.

 Incl.descriptive cat.of 21 portrs.
 Reprinted fr.The Md.hist.mag.v.37no.2,June,
1942

 Arts in Am.qZ5961.U5A77
 CFA Ref. H 390

I.B.2 - JOHNSTON, THOMAS & WILLIAM

Coburn, Frederick William, 1870-
 The Johnstons of Boston

In:Art in Am
21:29-36 Dec.,'32
 :132-8 Oct.,'33

IB N1.A63

 N.Y.Hist.Soc.Q,39:63 footn.
 2 1955
 974.06.N7v.39

974.06
N7
v.39

I.B.2 - JOHNSTON, WILLIAM, 1732-1772

Lyman, Lila Parrish
 William Johnston,1732-1772,a forgotten por-
trait painter of New England

In:N.Y.Hist Hist Soc Q
39:63-78 Jan.'55 illus.

 Beardsley Limner N40.1B372
 S3 NPG p.9,footnote 2

974.06
N7
v.39

I.B.2 - JOHNSTON, WILLIAM, 1732-1772

Sawitzky, Susan
 The portraits of William Johnston:A preli-
minary checklist

In:N.Y.Hist Soc Q
39:79-89 Jan.,'55 illus.

 Beardsley Limner N40.1.B37
 S3 NPG p.9 footnote 2

AP
1
C76
NPG

I.B.2 - JOHNSTON, William, 1732-1772

William Johnston:Portrait painter,1732-1772

In:Conn.Hist.Soc.Bull.
19:97 f. Oct.,'54 illus.

 List of ptgs.attr.to Johnston and exh.at
the society,Oct.18,54-Jan.15,'55

 Beardsley Limner N40.1B372
 S3 p.9 footnote2

I.B.2 - JONES, INIGO, 1573-1652

Veevers, E.E.
 The source of Inigo Jones' masquing designs

In:Warburg
22:373-4 1959 illus.

 (Repertoire d'art et d'arch.:Rapprochements
entre des dessins de I.J.et des oeuvres de J.
Callot,B.Küchler,J.J.Boissard,A.de Bruyn)

LC AS122.L8515 Enc.of World Art,v.11
 col.514.N31E56 Ref.
 bibl.on portr.

705
B97
NCFA
v.61

I.B.2 - JONSON VAN CEULEN, CORNELIS I, 1593-1661
 or1664
Edwards, Ralph, 1894-
 Oil miniatures by Cornelius Johnson

In:Burl.Mag.
61:131-2 Sept.,'32 illus.

 Noon.Engl.Portr.drngs.&min.
 NC860.N66X NPG bibl.p.145

AP
1
W225
NCFA

I.B.2 - JONSON VAN CEULEN, CORNELIS I, 1593-1661
 or 1664.

Finberg, Alexander Joseph, 1866-1939
 A chronological list of portraits by Cornelius Johnson or Jonson

In:Walpole Soc.
10:1-37(text) 1921-2 illus(80 Pl.)

Ranger's House.qND1301.5
C7L667 1975X NPG Lit.

927
.P94

I.B.2 - JOUETT, MATTHEW HARRIS, 1788-1827

Price, Samuel Woodson, 1828-
...The old masters of the Bluegrass;Jouett,
Bush,Grimes,Frazer,Morgan,Hart...Louisville,Ky.
J.P.Morton & co.,1902
 181 p. illus. (Filson club publ.,no.17)

Jouett,Matthew Harris,1788-1827;Bush,Jos.
Henry,1794?-1865;Grimes,John,1799-1837;Frazer,
Oliver,1808-1864;Morgan,Louis M.,1814-1852;
Hart,Joel Tanner,1810-1877.
Incl.cat.of Jouett's pictures & their owners

LC N6530.K4P8
P446.F48

Weddell.A mem'l vol.of Va.
hist.portraiture.757.9.W38
NCFA Ref. p.86

N
40.1
J86F6
NPG
NCFA

I.B.2 - JOUETT, MATTHEW HARRIS, 1788-1827

Floyd, William Barrow, 1934-
 Jouett-Bush-Frazer:early Kentucky artists.
Lexington,Ken.:privately printed,1968
 204 p. illus.

Bibliography

LC ND236.F5

NPG A 19th c.gall.of distin-
guished Americans.Bibl.

N
40.1
J86S7
NPG

I.B.2 - JOUETT,MATTHEW HARRIS, 1788-1827

Speed Art Museum, Louisville,Ky.
 Cat.of all known paintings by Matthew
Harris Jouett,by Mrs.William H.Martin.Louisville,1939
 65 p. Det.of self-portr.on cover
 Publ.by the mus.under its earlier name:
J.B.Speed Memorial Museum
 List of 529 portrs.& miniatures
 Arranged alphabetically as to sitters
 List of owners' names

LC ND237.J836

Arts in Am qZ5961.U5A77
NCFA Ref. I 1023

AP
1
H29
NCFA
v.1C1

I.B.2 - JOUETT, MATTHEW HARRIS, 1788-1827

Hart, Charles Henry, 1847-1918
 Jouett's Kentucky children

In:Harper's Mag
101:51-6 June,1900 illus.

Jonas. M.H.Jouett
B J86J76 NCFA p.101

N
40.1
J86T7
NPG

I.B.2 - JOUETT, MATTHEW HARRIS, 1788-1827

Transylvania University,Lexington,Kentucky
 Matthew Harris Jouett...Lexington,Ky.,Transylvania Printing Co.,1980

FOR COMPLETE ENTRY
SEE MAIN CARD

AP
1
H29
NCFA
v.98

I.B.2 - JOUETT, MATTHEW HARRIS, 1788-1827

Hart, Charles Henry, 1847-1918
 Kentucky's master-painter:Matthew Harris
Jouett,1788-1827

In:Harper's Mag
98:914-21 May,1899 illus.

Repro.incl.a pen drawing

Jonas.M.H.Jouett B J86J76
NCFA p.101

N
40.1
W334y
C6
NPG

I.B.2 - JUDKINS, ELIZABETH, fl.1772,1775

Goodwin, Gordon
 Thomas Watson,James Watson,Elizabeth
Judkins.London,A.H.Bullen,1904
 230 p. illus. (British mezzotinters,
ed.by Alfred Whitman)

 Contents:Thomas Watson,cat.of portrs.p.27.
48...James Watson,cat.of portrs.,p.81,-146...
Elizabeth Judkins,cat.of portrs.,p.229-30

LC NE642.W406

Levis.Descr.bibl.Z5947.A3
L66 1974 NCFA p.133

B
J86J76
NCFA

I.B.2 - JOUETT, MATTHEW HARRIS, 1788-1827

Jonas, Edward Asher, 1865-
 Matthew Harris Jouett,Kentucky portrait
painter(1787-1827)...Louisville,Ky.,The J.B.
Speed memorial museum,1938
 118 p. illus.

LC ND237.J8J6

Arts in Am.qZ5961.U5A77
CFA Ref. I 1022

705
C75
NCFA
v.149

I.B.2 - JUEL, JENS, 1745-1802

Poulsen, Ellen
 Jens Juel.Master portrait painter

In:Connoisseur
149:71-5 Feb.'62 illus(1 col.)

 1780 Juel was appointed court ptr.
 Created a portr.gallery of his contemporaries
 Incl.:Groups

Poulsen,Ellen.Tegninger af
Jens Juel...N40.1.J93jx NPG
Bibl.p.276

N
40.1
J934x
P8
NPG

I.B.2 - JUEL, JENS, 1745-1802

Poulsen, Ellen
Tegninger af Jens Juel;illustreret katalog.
København,Statens Mus.for kunst,1975
.284.p. illus.

Bibliography

UG
635
G7K45X
NPG

I.B.2 - KENNINGTON, ERIC HENRI, 1888-1960

Kennington, Eric Henri, 1888-1960
Drawing the R.A.F. A book of portraits in-
troduced by Sir Ronald Storrs.p.11-32..London,
Oxford university press,1942
143 p. illus(part col.)

MOMA,p.434, v.11

I.B.2 - JUST, OSKAR

Just, Oskar illus.
Nordisches blutserbe im süddeutschen
bauerntum mit...tafeln von Oskar Just und
Wolfgang Willrich.Geleitwort von R.Walther
Darré.München,F.Bruckmann.c.1938-39.
2 v. illus(part col.)

LC DD75.J8 MOMA, p.435, v.11

I.B.2 - KENT LIMNER
 see
I.B.2 - PHILLIPS, AMMI, 1788-1865

I.B.2 - KARP, LEON, 1903-1951

Philadelphia Museum of Art
Leon Karp;memorial exh.,May 3rd to June 1st,
1952.Philadelphia Mus.of Art,in collaboration
with the Pennsylvania Academy of Fine Arts.
.Philadelphia,1952.
24 p. illus(1 col.)

F000
4275
K19

LC(ND237.K3P5ART)

AP
1
W225
v.15
NCFA

I.B.2 - KETTLE, TILLY, 1735-1786

Milnor, James D.
Tilly Kettle, 1735-1786

In:Walpole Soc.
15:47-103 1926-27 illus.

Incl.Chronological list of K.'s paintings

N
40.1
K243y
E9
NCFA

I.B.2 - KAY, JOHN, 1742-1826

Evans, Hilary, 1929-
John Kay of Edinburgh,barber,miniaturist
and social commentator,1742-1826.by.Hilary and
Mary Evans.Aberdeen,Impulse Publ.,Ltd.,1973
53 p. illus(1 col.)

Bibliography and iconography

LC NE642.K39E92 1973 Yale ctr.f.Brit.art Ref.

705
I 61
NCFA
v.82

I.B.2 - KIHN, WILFRID LANGDON, 1898-1957

Comstock, Helen
Langdon Kihn,Indian painter

In:Studio
82:50-5 Oct.,'25 illus.

'...there is no one who has given us quite
the same kind of Indian portraiture as that of
Langdon Kihn...These pictures have unusual va-
lue as portraits...'
Repro.incl:Medicine man of Gitwinkool;Boy &
Eagle chief of Kitwanga;woman chief of Gitsegul-
ka,woman of Kulde tribe

N
40.1
K243y
A1
1877

I.B.2 - KAY, JOHN, 1742-1826

Kay, John, 1742-1826
A series of original portraits and cari-
cature etchings...New ed.Edinburgh,A.& C.Black,
1877
2 v. illus.

Incl.Index of sitters

LC N7599.K3 1877 Yale ctr.f.Brit.art Ref.
 NJ18.K24.A12 1877

F
24
A34
1987K
NMAA

I.B.2 - KING, CHARLES BIRD, 1785-1862

Agreeable situations:society,commerce and art
in southern Maine,1780-1830;ed.by Laura
Fecych Sprague;essays by Joyce Butler...
.et al..Kennebunk,Me.Brick Store Mus.
Boston:Distributed by Northeastern Univ.
Press,1987
285 p. illus(part col.)
Incl.Brewster,jr.,deaf artist,p.88,122,254
Cat.of selected objects from the Brick
Store Mus.et al
Index
Bibliography

40.1
K52P6
NCFA

I.B.2 - KING, CHARLES BIRD, 1785-1862

Birket-Smith, Kaj, 1893-
. Charles B.King's indianerportraetter i
Nationalmuseet. København,Bianco Lunos Bogtryk-
keri A/S, 194?
39 p. illus(part col.)

Ewers.Ann.Rep...S.I.,1953
Bibl.,p.473

q NE
263
N37
1977X
NCFA

I.B.2 - KING, CHARLES BIRD, 1785-1862

National Museum of History and Technology
Perfect likenesses.Portraits for history
of the Indian Tribes of North America
(1837-44)..Washington,Smithsonian Insti-
tution Press,1977.
27 p. Cover illus.(col.)

Catalog essays by Peter C.Marzio and Wm.
C.Sturtevant
Exhib.April-Sept.,1977
30 ptgs.and 160 lithographs;ptgs.chiefly by
Charles Bird King

LC NE263.N37 1977

NPG
shelved
in Li-
brarian's
Office

I.B.2 - KING, CHARLES BIRD, 1785-1862

Ewers, John Canfield
Charles Bird King, painter of Indian visi-
tors to the nation's capital

In:Ann.Rep.of the Board of Regents of the S.I.
463-73 1953 illus.

Incl.checklist of Indian portrs.attr.to King

Bibliography

Whitehill.The Arts of ear-
ly Amer.Hist.Z5935.W59 NPG
Bibl.,p.91

N
7592
G24
NPG

I.B.2 - KING, CHARLES BIRD, 1785-1862

Redwood Library and Athenaeum, Newport,R.I.
Cat.of pictures,statuary etc.,belonging to
The Redwood Library,Sept.1,1885..Newport,R.I.,
1885?
16 p.

268 items:ptgs.,photographs,engravings,etc.
212 of the ptgs.given by Chs.B.King,incl.self-
portr.Most of the ptgs:are by Chs.B.King.
38 sculptures
NPG copy bound with Garrick Club,London.
Cat.of the pictures...London,1909

I.B.2 - KING, CHARLES BIRD, 1785-1862

King, Charles Bird, 1785-1862
Cat.of 115 Indian portraits,representing
18 different tribes...Phila.,n.p.,1836
24 p.

The portrs.are copies by Inman,fr.the cele-
brated coll.in the War Dept.at Washington
Arch. Also cited in Nat'l M. & T.'s exh cat.
Am.Art "Perfect likenesses"qNE263.N37 1977X NCFA,
mfm p.10, p.4
P24
181-193

Arch.Am.Art mfm P24 181-
193

NPG
Ref.
coll.

N
40.1
K52C8
NCFA
2 cop.

I.B.2 - KING, CHARLES BIRD, 1785-1862

Smithsonian Institution. National Collection
of Fine Arts
The paintings of Charles Bird King(1785-
1862);.Cat.of an exh.,Nov.4,1977-Jan.22,1978,
by Andrew Joseph Cosentino.Washington,Publ.shed
for the National Coll.of Fine Arts by the Smith-
sonian Institution Press,1977
213 p. illus(part.col.)

Bibliography
Portrs.p.121-165. Indians p.165-186
Foreword by Joshua C.Taylor

LC ND237.K53C67

017.37
P3
NCFA
sale no.
3056

I.B.2 - KING, Charles Bird, 1785-1862

King, Charles Bird, 1785-1862
The important collection of 21 portraits of
North American Indians by Chs.B.King,property
of the Redwood Library and Athenaeum,Newport,
R.I. Auction May 21.1970,Parke-Bernet Galleries,
New York,1970
49 p. illus(part col.)

Intro.by Marc Rosen

Bibliography

Fogg,v.11.,p.327

I.B.2 - KING, CHARLES BIRD, 1785-1862

Viola, Herman J.
The Indian legacy of Charles Bird King.
1st ed.Washington:Smithsonian Institution Pre
c.1976
152 p. illus(part col.) (Smithsonian
Inst.Press publication;no.6256)

Bibliography

Incl.Cat.of War dept.Indian Gallery,p.143-5

LC ND237.K53V56

E
77
M155
1848
RB
NPG

I.B.2 - KING, CHARLES BIRD, 1785-1862

McKenney, Thomas Loraine, 1785-1859
History of the Indian tribes of North Ame-
rica,with biogr.sketches...of the principal
chiefs.Embellished with 120 portraits,fr.the
Indian gall.in the Dept.of war,at Washington.
Philadelphia,J.T.Bowen,1848-50
3 v. illus(col.) octavo
First ed.1836-44 was folio size
"An essay on the history of the North Ame-
rican Indians.By James Hall":v.3,p.149-387

From ptgs.chiefly by Charles Bird King

LC E77.M1305 NMHT.Perfect likenesses
p.3

AP
1
A51S2
NCFA

I.B.2 - KING, CHARLES BIRD, 1785-1862

Viola, Herman J.
. Portraits,presents,and peace medals:Thomas
L.McKenney and the Indian visitors to Washing-
ton

In:Am.Scene
11,no.2 June,1970 illus(part col.)

Incl.documentation of portrs.by Chs.Bird
King in the Ths.Gilcrease Inst.of Am.Hist.& Art
Tulsa,Okla.

Viola.Ind.legacy...N40.1
K52V7 Bibl.

AP
1
S66
NPG
v.3

I.B.2 - KING, CHARLES BIRD, 1785-1862

Viola, Herman J.
 Washington's first museum:The Indian office
collection of Ths.L.McKenney

In:Smiths.Jl.of Hist.
3,no.3:1-18 Fall 1968 illus.

 p.10-14:The gallery of 130 portrs.of In-
dian dignitaries by Athanasius Ford and Chs.
B.King,some after sketches by J.O.Lewis

 Viola.The Ind.legacy...Bibl
 N40.1K52V7 NPG

I.B.2 - KNELLER, GODFREY, 1646-1723

⌐Caulfield, James⌐ 1764-1826
 Memoirs of the celebrated persons composing
the Kit-Cat club;...illustr.with 48 portraits
from the original paintings by Sir Godfrey
Kneller...London,Jurst,Robinson,& co,1821
 261 p. illus.

LC DA687.K6C3

705
A56
NCFA
v.21

I.B.2 - KING, JOSIAH BROWN, 1831-1889

Snow, Julia D.Sophronia
 King versus Ellsworth

In:Antiques
21:118-21 Mar.,'32 illus.

 Repro.:incl.Daguerreotypes
 Snow identifies miniatures,f'ly given to
James Sanford Ellsworth as Josiah Brown King's
work.She presents evidence in support of her at-
tributions.
 Sherman,F.F.,J.S.Ellsworth
 In:Lipman,Prim.ptrs.in Amer
 ND236.L76,p.71

N
40.1
K682K4
NPG

I.B.2 - KNELLER, GODFREY, 1646-1723

Killanin, Miachael Morris, 1914-
 Sir Godfrey Kneller and his times,1646-1723,
being a review of English portraiture of the
period. London,New York,Batsford,1948.
 117 p. illus(part col.)

 Chronological cat.of some of G.Kneller's prin-
cipal works which can be attributed and dated
 Bibliography

ND497.K47K5

ND
1302
K56
NPG

I.B.2 - KINSTLER, EVERETT RAYMOND, 1926-

Kinstler, Everett Raymond, 1926-
 Painting portraits. New York,Watson-Guptill
publ.,1971

 170 p. illus.

 Chapters incl:Material & tools;setting up the
studio;your attitude toward the portr.;preparing
the composition;getting a likeness;...demonstra-
tions;etc.

LC 76-159563

I.B.2 - KNELLER, GODFREY, 1646-1723

Kneller, Godfrey & Faber, John
 The Kit-Cat Club done from the original
paintings of Sir Godfrey Kneller by Mr.Faber.
London,J.Tonson & J.Faber,1735
 p. illus.

LC ND497K47F3 Marlborough,London
 cat.1972,no.17
 (offered for £350.00)

I.B.2 - KLOCKER, DAVID, called EHRENSTRAHL
 see
I.B.2 - EHRENSTRAHL, DAVID KLOCKER, 1629-1698

757
L89
NCFA

I.B.2 - KNELLER, GODFREY, 1646-1723

London. National portrait gallery
 The portraits of members of the Kit Cat club,
painted...1700-1720,by Sir Godfrey Kneller for
Jacob Tonson...Presented to the nation in 1945...
London,⌐1945⌐

FOGG
56
L84p 1945
MET
196.6L84
N2492

 19 p. illus.

I.B.2 - KNELLER, GODFREY, 1646-1723

Baker, Charles Henry Collins, 1880-
 Lely and Kneller...London,P.Allan & co.
⌐1922⌐
 137 p. illus.

LC ND497.L65B3 Weddell.A mem'l vol.of Va.
 hist.portraiture 757.9.W3t
 NCFA Bibl.p.433

AP
1
J8643
NPAA
v.14

I.B.2 - KNELLER, GODFREY, 1646-1723

Meschutt, David
 William Byrd and his portrait collection

In:J.early S.dec.arts
14no.1:19-46 May,1988 illus.

 Most portrs. in B.'s coll.have been attr.to Sir
Godfrey Kneller.Three(or more)attr.to Hans Hysing

 This article..was presented in 1988 as...
completion of the Master's Degree...State Univ.
of N.Y.

705
B97
NCFA
v.76-77

I.B.2 - KNELLER, GODFREY, 1646-1723

Sewter, A.C.
 Kneller and the English Augustan portrait

In:Burl Mag
77:106-11 Oct,1940 illus.

 Kneller's severity,sombre colors,generally an_
gular drapery & 2 dimensional style of design is
in contrast to Lely's elegance & subtle romanti-
cism & Rigaud's flamboyant drapery & 3 dimensional
movements. Repro.see over
 Enc.of World Art
 ◯ N31E56Ref.v.11
 ◯ col.513 bibl.on portr.

ND
236
L76
NPG

I.B.2 - KRANS, OLAF, 1838-1916

Lipman, Mrs.Jean Herzberg, 1909- comp.
 Primitive painters in America....1950. (card 2

 Contents-cont.-17.M.E.Jacobson, O.Krans

 List of primitive painters

LC ND236.L76 ◯)

N
40.1
K682S8
NPG

I.B.2 - KNELLER, GODFREY, 1646-1723

Stewart, J.Douglas
 Sir Godfrey Kneller;cat.of an exh.at the
NPG,London,Nov.-Dec.,1971....London,Bell;Nat'l
Portrait Gallery,1971
 82 p. illus(part col.)

 Bibl.references
 Incl.:Lady Eliz.Cromwell as St.Cecilia
 Chapters incl.:Drawings;Ladies & children;
Lords & Gentry;Scholars & Poets;Army & Navy;
Parade portrait.Appendix:Kit-cat club portrs.

LC ND1329.K55S7 ◯

qN
40.1
K929
N2J
PMAA

I.B.2 - KRIMMEL, JOHN LEWIS, 1786-1821

Naeve, Milo M.
 John Lewis Krimmel:an artist in federal Ame-
rica...Newark:Univ.of Delaware;London:Associated
Univ.Presses,c.1987
 204 p. illus(part col.) (American arts
series)
 Index
 Bibliography,p.187-93

 ◯

qN40.1
K82yJ5
NPG

I.B.2 - KOKOSCHKA, OSKAR, 1886-1980

Kokoschka, Oskar, 1886-
 Jerusalem faces.Vaduz,Marlborough Graphics,
1974.
 ₂17₃p. illus.

 For the benefit of the Jerusalem Foundation

 Portr.-lithographs of Golda Meir,Dr.Agranat,
Benedictos I,Moshe Dayan,Sheikh Ansari,Teddy
Kollek,created in April 1973

InU ◯

N
40.1
K948P7
NCFA

I.B.2 - KUHN, JUSTUS ENGELHARDT, d.1717

Pleasants, Jacob Hall, 1873-
 Justus Engelhardt Kühn,an early 18th c.
Maryland portrait painter...

In:Proc.Am.Ant Soc,Worcester,Mass.
n.s.46:243-80 Oct.,'36 illus.

 Reprint 1937

Newberry libr. Dresser.Backgr.of Col.Amer
for LC portraiture ND1311.1.D77
) NPG p.20

I.B.2 - KOKOSCHKA, OSKAR, 1886-1980

Roh, Franz, 1890-1965
 Das bildnis bei Kokoschka und die heutige
problematik des porträts

In:Kunst
53:130-3 1954-1955 illus.

LC N3.K5 ◯Die 20er jahre im portr.
 ◯ N6868.5.E9Z97 NPG,p.138
 also:Rep.1955 #9229

I.B.2 - KUPECKY, JOHANN, 1667-1740

Dvořák, František
 Kupecký, der grosse porträtmaler des Barock...
Prag,Artia,₂1956₃
 48 p. illus(part col.)

LC ND538.K85D9 ◯

I.B.2 - KOKOSCHKA, OSKAR, 1886-1980

Kokoschka, Oskar, 1886-
 Oskar Kokoschka:Gemälde,aquarelle,aqua-
relle,zeichnungen,1907-1966.₂Ausstellung.Ba-
discher Kunstverein Karlsruhe,21.Aug.-20.Nov.,
1966.2nd ed.
 ₂246₃p. (incl.140)illus(part col.)

 Cat.ed.by Klaus Gallwitz.Essay by Benno
Reifenberg
 Bibliography

NBuU
 1st ed.MU IaU ◡ MOMA, p.435, v.11

N
40.1
K97
N9
NPG

I.B.2 - KUPECKY, JOHANN, 1667-1740

Nyári, Johann
 Der porträtmaler Johann Kupetzky.Sein leben
und seine werke.Wien...,A.Hartleben's Verlag,
1889
 124 p. illus.

 ◖

I.B.2 - KUPEZKY
see KUPECKY, Johann, 1667-1740
Dvořák, František
Kupecký, der grosse porträtmaler des Barock.
Prag,Artia,°1956.
48 p. illus(part col.)

LC ND538.K85D9

NC
772
A23
NPG

I.B.2 - LAGNEAU, fl.16-17th c.

Adhémar, Jean
Les portraits dessinés du 16° siècle au ca-
binet des estampes;°by°J.Adhémar et Christine
Moulin.Paris,Gas.des beaux-arts,1973
104 p. illus.

Extrait de la Gas.des beaux-arts,Paris,sept.
et décembre,1973
Repros.of almost all drags.with name of sit-
ters,date,biographical note,artist,info.given by
other catalogers(bouchot,Dimier,etc.)
Alphabetical index of sitters
Alphabetical index of artists by Bou-
chot & Dimier

I.B.2 - KWAN KIU-CHIN, 19th c.
see
I.B.2 - LAMQUA, 19th c.(real name Kwan Kiu-chin)

705
G28
NCFA
v.97

I.B.2 - LAGNEAU, fl.16-17th c.

Sehenk zu Schweinsberg, Eberhard, 1893-
Un album de "Lagneau"prevenant de Thouars?

In:Gas Beaux-Arts
97:189-200 May-June,'81 illus.

I.B.2 - LACHAISE, GASTON, 1882-1935

Goodall, Donald Bannard, 1912-
Gaston Lachaise,sculptor.1969
2 v.in 5 illus.

Ph.-D.thesis Harvard,1969

FOGG
Widener v.2-Plates

N
40.1
C53H9
NCFA

I.B.2 - LAMQUA, 19th c.(real name Kwan Kiu-chin)

Hutcheon, Robin
Chinnery, the man and the legend....Hong-
kong,South China Morning Post,1975
180 p. illus(part col.)

Incl.chapter on Lamqua(real name Kwan Kiu-
chin)

AP
1
A51
A72
NCFA
Ref.

I.B.2 - LACHAISE, GASTON, 1882-1935

Nordland, Gerald
Gaston Lachaise portrait sculpture

In:Am.Art Rev.
2:109-18 Mar-Apr.,1975 illus(part col.)

Essay fr.N.'s book Gaston Lachaise:the man
and his work,1974

Rila II/2 1976 *6430

I.B.2 - LANNEAU
see
I.B.2 - LAGNEAU, fl.16-17th c.

N
40.1
L13N8
NCFA

I.B.2 - LACHAISE, GASTON, 1882-1935

Nordland, Gerald
Gaston Lachaise:The man and his work.N.Y.,
George Braziller,1974
184 p. illus.

Incl.Ch.Portraits,p.82-105

Publ.on the occasion of an exh.held at
Herbert F.Johnson Mus.of Art,Cornell Univ.,
Fred.S.Wight Art Gall.,Univ.of Calif.at Los An-
geles,Mus.of Contemp.Art,Chicago,Walker Art Ctr.,
Minneapolis

705
G28
NCFA
v.17

I.B.2 - LARGILLIÈRE, NICOLAS DE, 1656-1746

Gronkowski, Camille
L'Exposition N.de Largillierre au Petit
Palais

In:Gas.Beaux-Arts
17:321-38 June,'28 illus.

In exh.:64 portrs.of men,51 of women,and
7 of children

AF
1
028
NMAA

I.B.2 - LARGILLIÈRE, NICOLAS DE, 1656-1746

Lastic, Georges de
Nicolas de Largillierre.Documents notariés inédits

In:Gas.Beaux-Arts
98:1-27 Jul-Aug.1981 illus.

N
40.1
L329R15
NCFA

I.B.2 - LAROON, MARCELLUS,the younger, 1679-1772

Raines, Robert
Marcellus Laroon.London,Routledge & K.Paul for Paul Mellon Foundation for British Art,1967
219 p. illus. (Studies in British art)

Bibliography

Chapter on portrs.:74-5; Conversation pieces 75-81

LC ND497.L28R4 Noon.Engl.portr.drags.&min
NC860.N66X NPG Bibl.P.147

102
028
NCFA
v.10

I.B.2 - LARGILLIÈRE, NICOLAS DE, 1656-1746

Mantz, Paul, 1821-1895
Largillière

In:Gas Beaux-Arts
10:89-105 Aug.,'93 illus.
:295-306 Oct.,'93 "

I.B.2 - LASALLE, PHILIPPE DE, 1723-1805

Borland,Mrs.Belle(McCullough)
Philippe de Lasalle,his contribution to the textile industry of Lyons...Chicago,Ill., The univ.of Chicago press.1936.
48 p. illus.

This essay is a rearrangement of the author's thesis
Repro.incl.:woven portrs.of Philippe de Lasalle,Catherine the Great
Re:Portrs.woven in silk see p.41-42,46

LC NK8949.R6 1936

N
40.1
L314R8
NPG

I.B.2 - LARGILLIÈRE, NICOLAS DE, 1656-1746

Rosenfeld, Myra Nan
Largillière and the 18th century portrait. Exh.Montreal Mus.of Fine Arts,Sept.19 to Nov.1 1981.Montreal,Quebec,The Museum,1982.
418 p. illus(part col.)

Foreword by Pierre Rosenberg
Contributions by Inna S.Nemilova,Hal N. Opperman,Ant.Schnapper

Bibliography p.400-10
Gordon.Masterpieces from
LC ND1329.L37A1 1982 Versailles.Notes p.34
no.2

757
L41

I.B.2 - LÁSZLÓ, FÜLÖP, 1869-

László, Fülöp, 1869-
...Painting a portrait....recorded by A.L.Baldry. London,The Studio,ltd.;N.Y.,The Studio publications,inc.,1937
79 p. illus.(part col.) ("How to do it" series.6.)

LC ND1300.L3

AP
1
NCFA
v.101

I.B.2 - LARKIN, WILLIAM, died 1619

Jacob, John
Ranger's House,Blackheath,a new gallery of English portraits

In:Apollo
101:14-8 Jan.,'75 illus(1 col.)

Discusses the Suffolk coll.of Tudor,Stuart and later portrs.Gift to the Greater London Council;displayed at Ranger's House,Blackheath.
Coll.contains group of full-length portrs. by Wm.Larkin
Rila II/1 1976#3481

I.B.2 - LA TOUR, MAURICE QUENTIN DE, 1704-1788
Besnard, Albert, 1849-1934
...La Tour;la vie et l'oeuvre de l'artiste,... cat.critique par Georges Wildenstein;l'oeuvre de l'artiste en 268 héliogravures.Paris,Les Beaux-arts,édition d'études et de documents.1928.
333 p. illus. (L'art français;collection dirigée par Georges Wildenstein)

Bibliography

Bury,A. Maurice-Quentin de
La Tour N40.1.L35xB9 NCFA
LC ND553.L3B4 Bibliography

AP
1
A64
NCFA
v.22

I.B.2 - LAROON, MARCELLUS,the younger, 1679-1772
 (or 1774)
Edwards, Ralph, 1894-
Conversation pictures of Marcellus Laroon (1679-1772)

In:Apollo
22:193-8 Oct.,'35 illus.

Source:
FOR COMPLETE ENTRY
SEE MAIN CARD

N
40.1
L35xB9
NCFA

I.B.2 - LA TOUR, MAURICE QUENTIN DE, 1704-1788
Bury, Adrien, 1891-
Maurice-Quentin de La Tour:the greatest pastel portraitist.London,Skilton,1971
201 p. illus(part col.)

Bibliography

Incl.:List of sitters

705
G28
NCFA
v.22

I.B.2 - LA TOUR, MAURICE QUENTIN DE, 1704-1788

Goncourt, Edmond Louis Antoine Huot de, 1822-
.1896
La Tour

In:Gaz.Beaux-Arts
22:127-53 Feb.,1867 illus.
350-71 Apr.,1867

Incl.:Lists year by year of portrs.La Tour
exhibited in the Salon;1737-1773

Goncourt, Jules Alfred Huot de, 1830-1870
.joint author
Tourneux.L'exp.des 100 pas-
tels.Caz.Beaux-Arts,v.n0:9

I.B.2 - LAWRENCE, Sir THOMAS, 1769-1830

Garlick, Kenneth, 1916-
Sir Thomas Lawrence....London,Routledge &
Paul,1954
92 p. illus (English master painters)

Cat.p.23-65
Bibliography

LC ND497.L403 Noon.Engl.portr.drags.&min.
C860.N66X NPG Bibl.p.145

I.B.2 - LA TOUR, MAURICE QUENTIN DE, 1704-1788

Desmaze, Charles Adrien, 1820-
Maurice-Quentin de La Tour,peintre du roi
Louis XV.Paris,Lévy,1854
78 p.

FOGG FA
3946.1.15

Bury,A. Maurice-Quentin de
La Tour N40.1.L35xB9 NCFA
Bibliography

N40.1
L427C6
NPG

I.B.2 - LAWSON, THOMAS BAYLEY, 1807-1888

Coburn, Frederick William, 1870-
Thomas Bayley Lawson;portrait painter of
Newburyport and Lowell.Salem,Mass.,Printed by
Newcomb & Gauss,1947.
59 p. illus.

"Reprinted fr.Essex inst.hist.colls.,v.83,
Oct.,'47"

Incl.Lawson Register

I.B.2 - LA TOUR, MAURICE QUENTIN DE, 1704-1788

Nolhac, Pierre de, 1859-1936
Vie et l'oeuvre de Maurice Quentin de La
Tour.Paris,H.Piazza,1930.
131 p. illus(col.)

LC ND553.L3N6

Bury,A. Maurice-Quentin de
La Tour N40.1.L35xB9 NCFA
Bibliography

I.B.2 - LAX, DAVID, 1910-

Lax, David, 1910-
Portraits.N.Y.,Associated American artists,
1950
Unpaged illus.

LC ND237.L35A45 Art Books 1950-79 A5937
A775 NCFA Ref. p.897

I.B.2 - LAVERY, SIR JOHN, 1856-1941

Sparrow, Walter Shaw, 1862-1940
John Lavery and his work...with a preface
by R.B.Cunninghame Graham.Boston,Mass.Lates
.1912?.
209 p. illus(part col.)
(For additional info.see Studio,Nov.'02,Dec.
1902. Art J.,1904,1908. Studio,Jan.,'09,July'11,
Art N.,Dec.5,'25. Studio,1932, Apollo,1925,'28,
1932)

(LC ND497.L38786)
LC ND497.L387 (London,1911)

I.B.2 - LE BOUCQ, JACQUES, 16th c.

Le Recueil d'Arras,conservé à la bibliothèque
de l'Abbaye de Saint-Vaast.Paris,A.Giraudon,
1906
20 p.

A'dam Photographies,par A.Giraudon,de 280 portrs.,
Kunst-h. représentant des personnages ayant vécu aux
Bibl. cours de Flandre et de Bourgogne pendant les
14e,15e et 16e s.From Arras Codex.
V & A 'The Arras Codex is now preserved in the Bibl.
(under Municipale d'Arras,Recueil de portrs.MS266'.-
Giraudon) W.Gibson Cat.der Kunsthist.Bibl.in
et Rijksmus.te A'dam Z5939
2 NCFA deel 1,p.132
(cont'd on next card)

AP
1
W225
NCFA
v.39

I.B.2 -,, 1769-1830

Garlick, Kenneth, 1916-
A cat.of the paintings,drawings and pastels
of Sir Thomas Lawrence

In:Walpole Soc.
39:13-336 1962-1964

Noon.Engl.portr.drags.&min.
NC860.N66X NPG Bibl. p.145

I.B.2 - LEBRUN, CHARLES, 1615-1690

LeBrun, Charles, 1619-1690
...La physionomie humaine comparée à la phy-
sionomie des animaux,d'après les dessins de
Charles LeBrun;cent trente reproduction...
FOGG 2nd éd.Paris,H.Laurens,1927
FA3946 25 p. illus.
.2.7

At head of title:Contribution à l'étude de
la caricature

See also:Resemblances.in:Art Express,1,no1:
54 Sept.Oct.,'81 AP 1 A78X9 NMAA

I.B.2 - LEBRUN, EUGÉNIE
see
I.B.2 - TRIPIER LEFRANC, EUGÉNIE, 1805-

705
G28
NCFA
v.9

I.B.2 - LEDRU, HILAIRE, 1769-1840

Saunier, Charles, 1865-
Les oubliés.Hilaire Ledru

In:Gaz Beaux Arts
9:45-68 Jan.,1913 illus.

List of ptgs.& drawgs.sent to the Salon,
1795-1824
"L.doit surtout ses succès aux portrs.au cra-
yon exécutés "au pointillé".-Rep.
"During the Directory the most sought after
portraitist."-Th.-B.

705
G28
NYAA
v.99

I.B.2 - LEBRUN, Mme.MARIE LOUISE ELISABETH
(VIGÉE), 1755-1842
Baillio, Joseph
Quelques peintures réattribuées à Vigée
Le Brun

In:Gaz Beaux-Arts
99:13-26 Jan.,'82 illus.

705
G28
NCFA
v.62

I.B.2 - LEFEBVRE, CLAUDE, 1632-1675

Claude Lefebvre restitué par l'estampe

In:Gaz.Beaux-Arts
62:305-13 Dec.'63 illus.

Self-portrait,fg.1

705
A56
NCFA
v.92

I.B.2 LEBRUN, Mme.Marie Louise Elisabeth(VIGÉE),
1755-1842
Bischoff, Ilse
Vigée-Lebrun and the women of the French
court

In:Antiques
92:706-12 Nov.,'67 illus.

"...V.-L.has her place among the masters of
portraiture,for she rendered an exact image of
her epoch..."t is the French woman V.-L.knew
how to paint best."-Pierre de Nolhac in Mme.V.L
peintre de Marie Antoinette.

I.B.2 - LEFEBVRE, CLAUDE, 1632-1675

Lhuillier, Theophile
Le peintre Claude Lefebvre de Fontainebleau
Paris,Plon,1892
29 p.

MH FA3946.26

I.B.2 - LE CLEAR, THOMAS, 1818-1882

Viele, Chase
Four artists of mid-19th century Buffalo
Cooperstown?,N.Y.,196-
49-78 p. illus.

Bibl.references

Reprinted fr.N.Y.history,43,no.1,Jan.1962

Survey of the life and work of Sellstedt,
Wilgus, Le Clear, Beard
Arts in Am q25961.U5A77X
FA Ref. I 1072

I.B.2 - LEFEBVRE, CLAUDE, 1632-1675

Thoison, E.
Claude Lefebvre

In:France-Instruction publique et des beaux-arts,
MET l in.de l'...Réunion d.Soc.des Beaux-Arts des dé-
100.64 partements à la Sorbonne...
F84 29:358-83 1905

705
G28
NCFA
v.3

I.B.2 - LEDRU, HILAIRE, 1769-1840

Hédouin, Pierre, 1789-1868
Hilaire Ledru;détails bigraphiques sur ce
dessinateur

In:Gaz Beaux Arts
3:230-6 Aug.,1859 illus.

Lists 4 ptgs. & 12 drawgs.

"During the Directory the most sought after
portraitist."-Th.-B.

I.B.2 - LEGRIP, FRÉDÉRIC, 1817-1871

Chennevières-Pointel, Charles Philippe,Marquis
de, 1820-1899
Portraits inédits français...lithographies
et gravures par F.Legrip.Paris.1853-69.

Brit. in progress
Mus.
1757.b 4 etchings & 26 lithographs

V & A

Bouchot.Portrs.aux crayons
NC860.P2J NPG p.77 footn.1

QN
40.1
152M3
NPG

I.B.2 - LEHMANN, RUDOLF, 1819-1905

Lehmann, Rudolf, 1819-1905
Men and women of the century,being a col-
lection of portraits and sketches...ed.with
introduction and short biogr.notes by H.C.
Marillier.London,G.Bell & sons,1896
78 p. illus.

Classified list:Church & State,Literature,
Science,Painting & Sculpture,Music

LC f704.94? L523m

N
40.1
L552D3
NMAA

I.B.2 - ~~LEMPICKA, TAMARA DE, 1898-1980~~

De Lempicka-Foxhall, Kizette,Baroness
Passion by design.The art and times of Tamara
de Lempicka.N.Y.,Abbeville Press,1987
191 p. illus(part col.)

I.B.2 - LELY, SIR PETER, 1618-1680

Baker, Charles Henry Collins, 1880-
Lely and Kneller...London,P.Allan & co.
c1922,
137 p. illus.

LC ND497.L65B3

Weddell.A mem'l vol.of Va.
hist.portraiture 757.9.W38
NCFA Bibl.p.433

705
G28
v.34
1905
NCFA

I.B.2 - LENBACH, FRANZ VON, 1836-1904

Marguillier, Auguste
Frans von Lenbach

In:Gas Beaux Arts
34(3e ser):259-310 Oct.,'05 illus.

Repro.incl.:Self-portr.with daughter;Glad-
stone & Döllinger;Edw.Emerson;Mommsen;Bismarck

757
.B16

I.B.2 - LELY, SIR PETER, 1618-1680

Baker, Charles Henry Collins, 1880-
Lely & the Stuart portrait painters;a study
of English portraiture before & after van Dyck:
with 240 reproductions after the original pic-
tures...London,P.L.Warner,publisher to the Medici
society,limited,1912

2 v. illus.(part.col.)

"Dated,but still an immensely valuable pio-
neer study".-R.Strong in The EnglIcon.Bibl.

LC ND1314.B25

706
B97
NCFA
v.115

I.B.2 - LEONARDO DA VINCI, 1452-1519

Clark, Kenneth McKenzie, 1903-
Mona Lisa

In:Burl Mag
115:144-50 Mar,'73 illus.

First in a series of lectures on portraiture,
held Jan.17,1973 at Victoria and Albert mus.

708.9493
B921
NMAA

I.B.2 - LELY, SIR PETER, 1618-1680

Benkö, Éva
The archetype of Netscher's "Portrait of
Mary II Stuart"in Brussels and its use

In:Mus.Royaux
des Beaux-Arts
de Belgique.B
30-33:123-34 1981-1984/1-3 illus.

The portr.by Constantin or Caspar Netscher
of Mary II Stuart could be copies after Sir
Peter Lely
Synopsis in Dutch and French

705
A784
NCFA
v.29

I.B.2 - LEONARDO DA VINCI, 1452-1519

Suida, Wilhelm Emil, 1877-1959
A Leonardo profile and dynamism in portrai-
ture

In:Art in Am
29:62-72 Apr.'41 illus.

Profile head,bust turned more or less toward
observer."Development of dynamic into the former
statical form of profile portraits"

Cumulated Mag.subj.index
A1/3/C76 Ref. v.2,p.444

N
40.1
L539
M6
NPG
2 c.

I.B.2 - LELY, SIR PETER, 1618-1680

Millar, Oliver, 1923-
Sir Peter Lely...exh....London,National Por-
trait Gallery,1978

**FOR COMPLETE ENTRY
SEE MAIN CARD**

I.B.2 -

Leoni, Ottavio, c.1578-1630
Ritratti di alcuni celebri pittori del seco-
lo 17.,disegnati ed intaliati in rame dal Cava-
liere Ottavio Leoni...si e' aggiunta la vita di
Carlo Maratti...Roma,Antonio de'Rossi,1731
272 p. illus.,12 engr.portr.

MET
175
L55

Met,v.19, p.17200

708.9492
A523
NMAA
v.26

I.B.2 - LE SAGE, PIERRE, 1755?-

Tiethoff-Splietheff, M.E.
De miniatuurschilder Pierre Le Sage en het
hof van Prins Willem V

In:B.Rijksmus.
36,no.3:216-24 illus.

Summary in English, p.272-3

I.B.2 - LEWIS, JAMES OTTO, 1799-1858

Lewis, James Otto, 1799-1858
The aboriginal port-folio;a collection of
portraits of the most celebrated chiefs of the
North American Indians.7? colored plates...
Philadelphia,J.O.Lewis,1835.-36.
pts. illus(col.)

"Issued monthly untill 10 nos.are completed"

LC E89.L66 Viola.Ind.legacy of Chs.
 Bird King N40.1K52V7 Bibl.

705
G28
NCFA
v.58

I.B.2 - LEU, THOMAS DE, c.1555-1612(or 1614)

Jouan, Andrée
Thomas de Leu et le portrait français de
la fin du 16e siècle

In:Gaz Beaux Arts
58:203-22 Oct,'61 illus.
Summary in English
Chronological arrangement of more than 200
portrs of de Leu's engravings.Info.on how portr.
engravers proceeded to work,on the selling of
their prints & their utility in the study of ptgs
of that period. Eller.Kongelige portr.male-
 p.154

AP
1
S66
NPG
v.3

I.B.2 - LEWIS, JAMES OTTO, 1799-1858

Viola, Herman J.
Washington's first museum:The Indian office
collection of Ths.L.McKenney

In:Smiths.Jl.of Hist.
3,no.3:1-18 Fall 1968 illus.

p.10-14:The gallery of 130 portrs.of In-
dian dignitaries by Athanasius Ford and Chs.
B.King,some after sketches by J.O.Lewis

Viola.The Ind.legacy...Bibl
N40.1K52V7 NPG

N
40.1
L6508
NCFA

I.B.2 - LEUTZE, EMANUEL, 1816-1868

Groseclose, Barbara S.
Emanuel Leutze,1816-1868;freedom is the on-
ly king...Washington;Publ.for the National Coll.
of Fine Arts by the Smiths.Inst.Press...1975
159 p. illus(part col.)

"Publ.in conjunction with an exh. at NCFA,
Smiths.Inst.,Jan16-March 14,1976

Bibliography

Portr.ptg.cat.nos.144-236;Miniatures nos.
237-40;Drags.& W.C. nos.241-74 incl.portrs

I.B.2 - LEYDEN, LUCAS VAN, 1494-1533

Cronycke van Hollandt,Zeelandt en Vrieslant be-
ghinnende vã Adams tiden tot die geboerte on
heren Jhū voertgaende tot de iare 1400...Leyden,
Jan Seuersz,1517

Brit Whole-length fgs.by Lucas van Leyden
Mus

 Rave.Jb.d.Berl.Mus.I 1959
 LC N3.J16 fol.p.127

MD
1311.2
P61x
NPG

I.B.2 - LEUTZE, EMANUEL, 1816-1868
Groseclose, Barbara S.
Emanuel Leutze;Portraitist
Miles, Ellen Gross comp.
Portrait painting in America.The nineteenth
century.N.Y....,1977 (card 3)

Partial contents cont'd:...B.S.Groseclose,
Eman.Leutze:Portraitist,p.79-84;...

I.B.2 - LICHTENSTEIN, ISAAC, 1888-

Lichtenstein, Isaac, 1888-
Portraits of myself..N.Y.,,Machmadim Art Edi-
tions,Inc.,1947
1 v.(6 portrs.)

LC (K759.13.L617p) NdW NB CCH

I.B.2 - LEVITSKII, DMITRII GRIGOR'EVICH,1734-1822

Gershenzon-Chegodaeva, Natalia Mikhailovna
Dmitrii Grigor'evich Levitskii. Moscow,Is-
kusstvo,1964
456 p. illus.

Bibliography

In Russian

LC ND699.L44G4

245
S28
NCFA
v.17

I.B.2 - LIEURE, JULES PIERRE fITLE, 1866-
Bouvy, Eugène, 1859-
Jules Lieure

In:Gaz.Beaux-Arts
17:119-25 Feb.,'28 illus.

Repro.incl.:Geo.Clemenceau

ND
207
W78
1971
NPG

I.B.2 - LIMNERS (various)

Black, Mary C.
 Pieter Vanderlyn and other limners of the
Upper Hudson

In:Winterthur Conf.on Mus.Oper'n and Conn'ship
17th:217-49 1971 illus.

 Bibliography

AP
1
O 28
NMAA

I.B.2 - LIOTARD, JEAN ETIENNE, 1702-1789

Roethlisberger, Marcel
 Des inédits de Liotard

In:L'oeil
no.395:50-55 June,'88 illus(part col.)

 I.B.2 - LIMOELAN
 see
I.B.2 - PICOT DE LIMOELAN DE CLORIVIÈRE,
 JOSEPH-PIERRE, 1768-1826

708.9492
A523
NMAA
v.36

I.B.2 - LIOTARD, JEAN ÉTIENNE, 1702-1789(or 1785)

Schaffers-Bodenhausen, Karen E.
 Een miniatuurportret van Willem IV,geschil-
derd door Jean-Etienne Liotard

In:B.Rijksmus.
36,no.3:211-15 1988 illus.(1 col.on cover)

 Summary in English,p.271-2

 I.B.2 - LINNELL, JOHN, 1792-1882

Story, Alfred T.homas,,1842-1934
 The life of John Linnell.London,R.Bentley
and sons,1892
 2 v. illus.

 List of pictures,engravings,etc.:v.2,p.:239-
284

LC ND497.L7S88

 I.B.2 - LIOTARD, JEAN ÉTIENNE, 1702-1789

Tras, Georges de, 1881-
 Liotard(1702-1789)par François Fosca.pseud..
Paris,A.Delpeuch,1928
F000 168 p. illus. (Les Petits maîtres fran-
3946 çais)
L76

 ivas.In:Burl Mag 68:117,
 ...ote 2

I.B.2 - LIOTARD, JEAN ÉTIENNE, 1702-1789

Humbert, Édouard, 1823-1899
 La vie et les oeuvres de Jean Étienne
Liotard(1702-1789)étude biographique et icono-
graphique par...Ed.Humbert et m.Alphonse Revill-
iod...et...J.W.R.Tilanus...Amsterdam,C.M.van
Gogh;,ets,etc.,1897
 220 p. illus.

 Traité des principes et des règles de la
peinture par m.J.E.Liotard...1781,p.:51.-100
 Principaux écrits sur J.E.Liotard,p.:218.

LC ND853.L5H8
 eath.Miniatures.ND1330H43
 NCFA bibl.p.XXXVII

AP
1
B975
NCFA
v.68

I.B.2 LIOTARD, JEAN ÉTIENNE, 1702-1789

Trivas,N.S.
 Liotard's portraits of Frederick Lewis,
Prince of Wales,and his family

In:Burl Mag
68:117-8 March,'36 illus.

 Schaffers-Bodenhausen.In:
 B.Rijksmus.v.36,no.3:215
 note 14

705
C75
NCFA
v.91

I.B.2 - LIOTARD, JEAN ÉTIENNE, 1702-1789

Manners, Lady Victoria, 1876-1933
 New light on Liotard

In:Connoisseur
91:294-303 May,'33 illus(part col.)

705
C75
NCFA
v.99

I.B.2 - LIOTARD, JEAN ÉTIENNE, 1702-1789

Trivas, N.S.
 London society portrayed by Liotard

In:Connoisseur
99:30-4 Jan.,'37 illus.

AP
1
W225
NCFA
v.14

I.B.2 - LOGGAN, DAVID, ca.1635-1692

Bell, Charles Francis, 1871- and Rachel Poole
English 17th-century portrait drawings in
Oxford collections.Pt.II:Miniature portraiture
in black lead and Indian ink

In:Walpole Soc.
14;41-80 1925-26 illus.

Incl.chapter on Mr.Faithorne,p.45-55;David
Loggan,p.55-69:31 t.White,p.69-71;Portr.of Arch-
bishop Oliver Plunket,p.71-73;Ths.Forster,p.73-
76. Lists of dated,or named drags.& engrs.'ad
vivum'& signed engrs.not inscribed 'ad vivum'

705
C75
NCFA
v.192

I.B.2 - LOTTO, LORENZO, 1480-1556

Hall, Mariette van
l'esser Marsilio and his bride

In:Connoisseur
192;292-7 Aug.,'76 illus(part col.)

Iconography of Lorenzo Lotto's ptg.
Discussion incl.:Symbols in bridal portrs.
Relation to tradition of double portraiture

Rila IV/I 1978 #1480

I.B.2 - LOMBART, PIERRE, 1612-1682

Layard, George Somes, 1857-1925
The headless horseman,Pierre Lombart's en-
graving,Charles or Cromwell?...with an intro.
by Campbell Dodgson...London,P.Allan & co.,1922
125 p. illus.

7 states of an engr.,3 with Cromwell's head,
1 with the head of Charles I,2 with the head of
Louis XIV,1 without head;after v.Dyck's eques-
trian portr.of Charles I.
cf.Connoisseur bookshelf in Conn.63;247,
Aug.,'22:'...L.contends that Lombart never in-
tended to produce a portr.of Charles I
LC NE650.L84L3

I.B.2 - LOUYS, JAN or JACOB, c.1595-

Soutman, Pieter Claesz, 1580-1657
Effigies imperatorum domus Austriacae,ducum
Burgundiae,regum principumque Europae,comitum Nas-
saviao...Harlemi.1644-1650,
4 pts. illus.

Compilation of portrs.1.16 emperors of the
house of Hapsburg.-2.Ferdinandus IIus et IIIus.-
3.Duces Burgundiae.-4.Comites Nassaviae
Engravings by P.v.Sompel,P.v.Soutman,J.Suyder-
hoof,J.Louys

Amsterdam,Rijksmus.,cat.
25939A52,deel 1,p.135

AP
1
A51A64
NMAA
v.18

I.B.2 - LONGACRE, JAMES BARTON, 1794-1869

Bumgardner, Georgia Brady
Political portraiture:Two prints of Andrew
Jackson

In:Am Art J
18,no.4:84-95 1986 illus.

Engr.by Ja.Barton Longacre in 1828.
'The motives behind its publications were politi-
cal'.-Lithograph by the Pendleton firm,1832,
'created in the context of political events'.

I.B.2 - LUBIN, JACQUES, a.1659-after 1703

Perrault, Charles, 1628-1703
Les Hommes illustres qui ont paru en France
pendant ce siècle;avec leurs portraits au natu-
rel.Paris,A.Dezallier,1696-1700
2v.in 1 illus.

Portrs.engr.by Gérard Edelinck,Jacques Lubin
& others

C CT1011.P4 1696

I.B.2 - LONGHI, ALESSANDRO, 1733 -1813

Longhi, Alessandro, 1733-1813
Compendio delle vite de' pittori veneziani
istorici più rinomati del presente secolo con
suoi ritratti tratti dal naturale delineati
ed incisi da Alessandro Longhi...Venèzia,Appres-
so l'autore,1762
53 l. illus.

NN IU MH

705
A7875
NCFA

I.B.2 - LUTTICHUYS, ISAAC, 1616-1673

Valentiner, Wilhelm Reinhold, 1880-1958
Isaac Luttichuys,a little known Dutch por-
trait painter

In:Art Q
1:151-2,155-8,161-2,167-8, Summer'38 illus.
171-4

List of Luttichuys' work.established by
scholarly research.

MET
200
L86

I.B.2 - LONGHI, GIUSEPPE, 1766-1831

Longhi, Giuseppe, 1766-1831
La calcografia propriamente detta;ossia
L'arte d'incidere in rame coll'acqua-forte,col
bulino e colla punta...Opera...da Guiseppe
Longhi...Volume I.Concernente la teorica dell'
arte.Milano,Stamperia reale,1830
436 p. illus.
Notizie biografiche di Giuseppe Longhi,
raccolte da Francesco Longhena,p.:387-431.
The chalcography or the art of engraving on
copper with aquaforte with burin or graver...
Biographical i .on G.L.collected by Fran-
cesco Longhena .:387-431
NN MH cct.

I.B.2 - MCARDELL, JAMES, ca.1728-1765

Goodwin, Gordon
...James McArdell...London,A.H.Bullen,1903
168 p. illus. (British mezzotinters,
ed.by Alfred Whitman)

Cat.of portrs.p.:17.-136

LC NE642.M206 Levis.Descr.bibl.A5947.A3
 L66 1974 NCFA p.133

N
40.1
M129283
NMAA

I.B.2 - McCLELLAN, CYRENIUS B., 1827-1883

Basso, Dave comp.
 The works of C.B.McClellan,19th century Neva-
da portrait and landscape artist.Bibliographical
catalog.Sparks,NV,Falcon Hill Press,1987
 35.p. illus.

757
.M16
(New ed.)

I.B.2 - MACLISE, DANIEL, 1806-1870

Maclise, Daniel, 1806-1870
 The Maclise portrait-gallery of "illustrious
literary characters...N.Y.,Scribner & Welford,
1883

**FOR COMPLETE ENTRY
SEE MAIN CARD**

705
S94
NCFA
v.61

I.B.2 - McEVOY, AMBROSE, 1878-1927

Wood, T.Martin
 The portrait paintings of Ambrose McEvoy

In:Studio

**FOR COMPLETE ENTRY
SEE MAIN CARD**

705
S94
NCFA
v.29

I.B.2 - MACMONNIES, FREDERICK WILLIAM, 1863-1937

Pettit, Edith
 Frederick MacMonnies, portrait painter

In:Studio
29:319-24 Oct,'06 illus.

 MacMonnies, the sculptor turns to portrait
painting

705
A784
NCFA
v.12

I.B.2 - McKILLOP, WILLIAM, -1937

Ely, Catherine Beach
 The portraits of William McKillop

In:Art in Am
12:189-196 June,1924 illus.

Rep.1924 #874

705
C75
NCFA
v.144

I.B.2 - MACPHERSON, GUISEPPE, 1726-?

Fleming, John
 Guiseppe Macpherson;a Florentine minia-
turist

In:Connoisseur
144:166-7 Dec.,'59 illus.

**FOR COMPLETE ENTRY
SEE MAIN CARD**

AP
1
N547
NCFA
v.35

I.B.2 - MCILWORTH, THOMAS, fl.1758-1769 or 1770

Sawitzky, Susan
 Thomas McIlworth,act.1758 to c.1769,identi-
fied by William Sawitzky and Katharine Hastings
as the painter of the Gerardus Stuyvesant group
of portraits.Rediscovered and assembled by Wil-
liam Sawitzky,1929-1944

In:N.Y. Hist.Soc.Q.
35:117-39 Apr.,'51 illus.

 Incl.:Checklist of the portrs.attr.by Wm.
Sawitzky to Ths.McIlworth.-Outline of McIlworth'
life from 1757- 1769

I.B.2 - MAGNUS, EDUARD, 1799-1872

Glaser, Ludwig
 Eduard Magnus. Ein beitrag zur berliner
bildnismalerei des 19.jahrhunderts. Berlin-
Grunewald,Arani Verlags Gmbh (1963)

 141 p. illus

 Bibliography

LC ND588.M147G55

N
40.1
M171 07
NPG

I.B.2 - MACLISE, DANIEL, 1806-1870

Maclise, Daniel, 1806-1870
 Daniel Maclise,1806-1870.cat.of an exhibi-
tion held at the.National Portrait Gallery,
London,3 March-16 April,1972.and the National
Gallery of Ireland,Dublin,5 May-18 June,1972.
London,Arts Council.1972.
 125 p. illus.

 Exh.organised & cat.comp.by Rich.Ormond &
John Turpin
 Incl.bibl.references

I.B.2 - MAIR, ALEXANDER, fl.1600/16

Bara, Aline et Crick,Lucien
 Un jeu de cartes en argent

In:B.Mus.Art Hist.Belgique
:98-105 1942 illus.

 Incl.:Maximilian of Austria,Mary of Burgundy,
Ferdinand V & Isabella,the Catholic,Henry II &
Catherine de Médicis,Sigismund III Vasa,Anne of
Poland. 7cards by Alexander Mair

LC N1835.A3 Rep.,1942-44#7579

705
628
NMAA
v.99

I.B.2 - MAISONCELLES, JEAN DE, died 1479?

Smith, Jeffrey Chipps
 Jean de Maisoncelles' portrait of Philippe
Le Bon for the Chartreuse de Champmol. A study
in Burgundian political symbolism

In:Gaz.Beaux-Arts
99:7-12 Jan.,'82 illus.

 '...it is a political image. Ph.is
dressed in his Toison d'or robe...He is crowned'

N
40.1
M265E4
NPG

I.B.2 - MANDER, KAREL VAN, c.1608/10-1670

Eller, Povl
 Kongelige portraetmalere i Danmark 1630-82.
En undersøgelse af kilderne til Karel van Manders
og Abraham Wuchters' verksomhed..Udg.af.Selskabet
til Udgivelse af danske Mindesmaerker.København,
Dansk Historisk Faellesforening,1971
 563 p. illus.

 Thesis-Copenhagen
 Summary in English
 Bibliography

LC ND1328.E43

VF
Malbone

I.B.2 - MALBONE, EDWARD GREENE, 1777-1807

Smithsonian Institution.National Collection of
 Fine Arts
 Catalogue of an exhibition of miniatures
and other works by Edward Greene Malbone,Feb.23-
April 21,1929.Washington,1929
 21 p. illus.

 Boston,Mus of F.A. New Eng.
 min.1750-1850 ND1337.U5B74
 Bibl.

I.B.2 - MARATTI, CARLO, 1625-1713

Leoni, Ottavio, c.1578-1630
 Ritratti di alcuni celebri pittori del seco-
lo 17.,disegnati ed intaliati in rame dal Cava-
liere Ottavio Leoni...si e' aggiunta la vita di
Carlo Maratti...Roma,Antonio de'Rossi,1731
 272 p. illus.,12 engr.portr.

MET
175
L55

 Met,v.19, p.17200

N
40.1
M24M76
c.NPG
c.2NMAA

I.B.2 - MALBONE, EDWARD GREENE, 1777-1807

Tolman, Ruel Pardee, 1878-
 The life and works of Edward Greene Malbone
1777-1807...New York,New-York Historical Socie-
ty,1958
 322 p. illus. (New York Historical Socie-
ty.The John Divine Jones Fund series of histo-
ries and memoirs,13)

 Bibliography
 Incl.:Checklist of misattributed miniatures.
Descriptive list of known works by Malbone
 Whitehill.The Arts of early
LC ND1337.U6M32 Amer.Hist.Z5935.W59 NPG
 Bibl.,p.92

AP
1
N859
NPG
v.44

I.B.2 - MARE, JOHN, 1739-1803

Smith, Helen Burr and Elisabeth V.Moore
 John Mare:A composite portrait

In:N.C.Hist Rev .
44:18-52 Jan.,'67 illus.

 The most complete account of Mare's life.
M.'s work listed p.33

 Arts in Amer.qZ5961 USA
 NCFA Ref. H407 (?)

I.B.2 - MALCOLM, JAMES PELLER, 1767-1815

Malcolm, James Peller, 1767-1815
 Historical sketch of the art of caricaturing
...London,...1813

 Illustrated by Malcolm's engravings

LC NC1325.M3 **FOR COMPLETE ENTRY**
 SEE MAIN CARD

I.B.2 - MARTIN, DAVID, 1737-1798

Brubaker, Albert Philson, 1852-1943
 The Martin portraits of Franklin

In:Penn.Mag.of Hist.& Biogr.
56:245-59 1932

 Description of portr.of Franklin by David
Martin between 1764 and 1766

LC F146.P65 Arts in America qZ5961 USA
 7X NCFA Ref. H667

I.B.2 - MALCOM
 see
I.B.2 - MALCOLM, JAMES PELLER, 1767-1815

I.B.2 - MARWAN, 1934-

Olbricht, K.-H.
 Analyse im selbstporträt oder künstlerische
metamorphose:zu den radierungen von Marwan

In:Kunst & d.schöne Heim
88,pt.5:281-8 May,'76 illus.

LC N3.K5 FOR COMPLETE ENTRY
 SEE MAIN CARD

705
A784
NCFA
v.38

also:
N40.1
M39F8
NPG
NCFA

I.B.2 - MASON, BENJAMIN FRANKLIN, 1804-1871

Frankenstein, Alfred Victor, 1906 and Arthur K.
D.Healy
 Two journeyman painters

In:Art in Am.
38:7-63 Feb.,'50 illus.

 Benjamin Franklin Mason,Vermonter,p.7-43
Abraham O.D.Tuthill,p.47-63

 Bibliography
 Chronological list of known portrs.
 J.G.Cole,teach⌒er of Mason,see p.10-11,13

I.B.2 - MENGS, ANTON RAPHAEL, 1728-1779

Copenhagen, Statens museum for kunst
 Kunstmuseets aarsskrift,1921-23:Meng's
fürstenbildnisse,by C.Axdrup,København,1924

 see also:Copenhagen,Statens mus.for kunst
 Registre til Kunstmuseets Aarsskrift I-XXX
 København,Gyldendalske boghandel-Nordisk for-
 lag,etc.,1945(Re:Indexes)
 144 p.
 CtY

LC N1915.A3

I.B.2 - MASSÉ,JEAN-BAPTISTE, 1687-1767

Jeannerat, Carlo
 Les origines du portrait'à miniature'sur
ivoire.J.B.Massé et Rosalba Carriera

In:B.art fr.
57:80-8 1931

LC N6811.A92 ⌐ruijn Kops In:B.Rijksmus.
 36:206,note 13

N
40.1
M541
19
M'AA

I.B.2 - MENGS, ANTON RAPHAEL, 1728-1779

Mengs, Anton Raphael, 1728-1779
 Antonio Rafael Mengs,1728-1779,exposición
Museo del Prado,junio-julio,1980,Madrid,Madrid,
el museo,1980?
 195 p. illus(part col.)

 Bibliography

 Ministerio de cultura.Dirección general del
Patrimonio artístico,Archivos y Museos

 No.1-68:Portraits

B
N41S4
NCFA

I.B.2 - MASQUERIER, JOHN JAMES, 1778-1855
See, Robert René Meyer
 Masquerier and his circle...With an intro.
and a chapter on the engravings after Masquerier
by C.Reginald Grundy.London,The Connoisseur,
1922
 270 p. illus(part col.)

 List of works by J.J.Masquerier
 List of engravings after Masquerier

LC ND497.M4S4 ⌒

I.B.2 - MENGS, ANTON RAPHAEL, 1728-1779

Mengs, Anton Raphael,1728-1779
 ...Antonio Rafael Mengs 1728-1779;noticia
de su vida y de sus obras con el catálogo de
la exposición celebrada en mayo de 1929.Madrid
,T.Marinas,1929
 68 p. illus.

LC ND588.M;A3

I.B.2 - MATISSE, HENRI, 1869-1954

Matisse, Henri, 1869-1954
 Portraits par Henri Matisse.Monte-Carlo,
André Sauret,1954
 151 p. illus(part col.)

 Also issued in English ed.by A.Skira,N.Y.

Harvard Univ.Libr.for
LC ND553.M37A44 MOMA, p.434,v.11

I.B.2 - MENGS, ANTON RAPHAEL, 1728-1779

Mengs, Anton Raphael, 1728-79
 The works of Anthony Raphael Mengs,first
painter to his Catholic Majesty Charles III,
trans.from the Italian;publ.by Chev.Don Joseph
Nicholas d'Azara.London,R.Faulder,etc.,1796
 2 v.

LC ND27.M62 1796 Penn.Ac.of the Fine Arts,
 Phila. J.F.Eichholtz
 ⌐J.1N34P4 NPG,p.5,footn.1

AP
1
A784
J8
NCFA

I.B.2 - MEE, Mrs.ANNE, née FOLDSONE, ca.1775-
 1851
Williamson, George Charles, 1858-1942
 Four miniatures of the Keppel family

In:Art J.
73(?):222-4 July,'11 illus.

 Repro....Miss Keppel by Anne Mee

 **FOR COMPLETE ENTRY
 SEE MAIN CARD**

I.B.2 - MESSERSCHMIDT, FRANZ XAVER, 1736-1784

Kris, Ernst, 1900-
 A psychotic sculptor of the 18th century

In:his,Psychoanalytic explorations in art.New
York,Schocken Books,1964,1952,

 pp.128-50 illus. Based on a paper read
to the Vienna Psychoanalytic Soc.,Nov,'32,publ.
in Imago,XIX,1933.Span.transl.in Revista de Psi-
coanalisis,III,1945/46

 Repro.:Busts by Messerschmidt

LC N70.K84 1964

N
40.1
M5975B5
NMAA

I.B.2 - MEYEROWITZ, WILLIAM, 1887-1981

Bernstein, Theresa
William Meyerowitz,the artist speaks...
Phila.:Art Alliance Press;N.Y.:Cornwall books,
c.1986
99 p. illus(part col.)

Index

LC N6537.M49M48 1986

CT
275
W31W2

I.B.2 - MIDDLETON (English officer)18th c.

Walter, James
Memorials of Washington and of Mary...,and
Martha...from letters and papers of Rbt.Cary
and Js.Sharples...portraits by Sharples.and.
Middleton.N.Y.,C.Scribner's sons,1887
362 p. illus.

NPG copy contains reprint of Boston Post,
Feb.,2,1887 & clippings,letters by Wash.,Bryant
Longfellow,Hawthorne,etc.,quoted by Walter de-
clared spurious'

Weddell.A mem'l vol.of Va.
hist.portraiture.757.9.W3c
NCFA Bibl. p.439

I.B.2 - MEYSSENS, JOANNES, 1612-1670

Meyssens, Joannes, 1612-1670
The true effigies of the most eminent paint-
ers,and other famous artists that have flour-
ished in Europe,together with an account of the
time when they lived,etc..,by S.Resta,engraven
on 125 copper plates by J.Meyssens.&others,
London,1694
20 p. 126 engr.pl.

V & A

Published originally by J.M.at Antwerp,1649

See also:The portrs.of the most eminent
painters...London,J.Duke,1739

AP
1
P89
NCFA
v.3

.I.B.2 - MIEREVELT, MICHIEL VAN, 1567-1641

Metcalfe, Louis R.
..Willem Jacobsz.Delff(1580-1638)and his
father-in-law

In:Print Coll Q
3:117-53 Apr.,'13 illus.

Delff engraved many portr.ptgs.by Mierevelt,
his father-in-law

Thomas.Drags.& pastels of
Nanteuil in Pr.coll.Q.
4:332

I.B.2 - MEYSSENS, JOANNES, 1612-1670

The portraits of the most eminent painters,and
other famous artists,that have flourished in
Europe.Curiously engraven on above 100
copper plates...From original paintings...
To which is now added,An historical and
chronological series of all the most eminent
painters for near 500 years.Chiefly collecte
from a manuscript of...Father Resta.London,
J.Duke,1739
18 p. illus.
An histor.& chronol.series...has special t.p
& separate paging

LC M40.P6 Published originally by Jean Meyssens at
Antwerp,1649

I.B.2 - MIERS, JOHN, 1757-1821

May, Leonard Morgan
A master of silhouette,John Miers;portrait
artist,1757-1821,...London,M.Secker,1938,
107 p. illus.

Bibliography

LC NC910.M5M3 Roe.Women in profile,p.27
 LC NC910.R63

I.B.2 - MICHELANGELO, 1475-1564

Baldass, Ludwig von, 1887-
Ein unbeachtetes bildnis de Michelangelo

In:Pantheon
28:281-2 1941 illus.

Tondo in Kunsthist.Mus.,Vienna, a replica of the
portr.of Michelangelo, made after 1538 in Rome

LC temporary
N3.P3 Rep.,1942-44*767

I.B.2 - "MILLETTE, JEAN",1750-1798
(Fictitious artist)

Jean Millette

In:Collector
47,no.12:121-2 Oct.,'33

Adolph Buhler,Paris bought M.'s silhouettes
in 1890
Catalogue of American Portrait has xerox
copy of article.
The Nat'l Portr.Gallery's curatorial staff
regards .M.'s.silhouettes as...colonial revival
"fakes".

DCL

I.B.2 - MICHELANGELO, 1475-1564

Heimeran, Ernst, 1902-1955
Michelangelo und das porträt.München,
F.Bruckmann,1925

LC N6923.B9H47 FOR COMPLETE ENTRY
 SEE MAIN CARD

705
C28
v.35
1906
NCFA

I.B.2 - MIRBEL, LIZINKA AIMÉE ... DE,née ROE,1796-1849

Jean, René, 1879-
Madame de Mirbel

In:Gaz Beaux-Arts
35(3ième ser):131-46 1906 illus.

N
40.1
M694E2
NPG

I.B.2 - MOFFAT, ALEXANDER

Edinburgh. Scottish national portrait gallery
A view of the portrait. Portraits by
Alexander Moffat 1968-1973. Intro.by R.E.
Hutchison..An exhibition 17 Aug.-16 Sept.,1973..
Edinburgh,...1973
33 p. illus.

Moffat's work "seems to illustrate the use of
the portr.as an art form in the true sense...Mof-
fat.achieves the basic ends of portraiture:a like-
ness & a personal interpretation of character..."
Dialogue betw.organisers of exh.&A.Moffat abt
M.'s intentions & () method

705
A7875
NCFA
v.14

I.B.2 - MOREAU, JEAN-MICHEL, called MOREAU LE
JEUNE, 1741-1814

Grigaut, Paul L.
Three French works of American interest

In:Art Q
14:348-52 Winter, 1951 illus.

Refers to the exh."The French in America,1520-
1880"at Detroit. Institute of Arts. 1951
Repre.:John Paul Jones,pastel drag.by Moreau
le Jeune. Lafayette & Mme.Roland by Jean-Jacques
Hauer. Mr.& Mrs.Kemper,drag.by Valdenuit

I.B.2 - MOLENAER, JAN MIENSE, c.1610-1668

Hinz, Berthold
Das Familienbildnis des J.M.Molenaer in
Haarlem.Aspekte zur ambivalenz der porträt-
funktion

In:Städel Jb.
4:207-16 1973 illus.

Change from functional to aesthetic value
during Renaissance.
The ambivalence of approach remains inhe-
rent in portrs. of burgeois subjects
LC N9.57
Rila I/1-2 1975 #2129

I.B.2 - MORIN, JEAN, c.1609-1666

Hornibrook, Murray and Ch.Petitjean
Cat.of the engraved portraits by Jean Mori:
...Cambridge.Eng.The University press,1945
55 p. illus.

LC NE650.M68H6

NPG
Print
Dpt.

I.B.2 - MOLL, BERNHARD ALBRECHT, 1743-ca.1787
(older brother of Johann Albrecht Ulrich)
Andre, John and Fraenckle, Herbert

Bernhard Albrecht Moll's European silhou-
ettes..Moll's American silhouettes:.In:The Ger-
man contribution to the building of the American
Studies in honor of Karl J.R.Arndt.ed.by Gerh.
K.Friesen & Walter Schatzberg.Publ.by Clark Uni-
versity Press.Hanover,N.H.,1977..Ch..6.The Ame-
rican expedition of Joseph II and Bernh.Moll's
silhouettes.
p.158-63 illus.

Silhouettes from 1783
Pamphlet in NPG Print Dpt.

AP
1
P89
NCFA
.v.2

I.B.2 - MORIN, JEAN, c.1609-1666

Metcalfe, Louis R.
Jean Morin, 1600-1666

In:Print Coll Q
2:1-30 Feb.,'12 illus.

Incl.:Description of development of en-
graved portrs.in France
'.Morin's.technique is chiefly etching com-
bined with burin work'-p.17

Metcalfe.Pr.coll.Q.3:119

I.B.2 - MOLL, JOHANN ALBRECHT ULRICH
see
I.B.2 - BERCZY, WILLIAM, 1744-1813

N
72
P74P78
v.2
NPAA

I.B.2 - MORISOT, BERTHE, 1841-1895

Genné, Beth
Two self-portraits by Berthe Morisot.in.
Psychoanalytic perspectives on art.The Analytic
Press,1987
p.133-170 illus.

705
G28
NCFA
v.61

I.B.2 - MONSALDY, ANTOINE MAXIME, 1768-1816

Wildenstein, Georges, 1892-1963
Table alphabétique des portraits peints,
sculptés,dessinés et gravés,exposés à Paris au
salon entre 1800 et 1826

In:Gaz Beaux Arts
61:9-60 Jan,'63 illus.

Table is preceded by an article pointing out
the changes in taste in portraiture.Works f'ly
attr.to David are by artists then well known:
Lefèvre,Romany,Ansiaux,etc.Miniat.drags.by Mon-
saldy after exhib ed portrs.were used for
attributions
Fogg,v.11,p.326

I.B.2 - MORO, ANTONIO, 1519-1576

Jay, Margrit A.
Antonio Moro:Royal court painter,1519-1576
134 p.

Ph.D.Dissertation,Texas Christian Univ.,
1975

Diss.Abstr.no.76-4717
Diss..Abstr.Z5055.U49D57NPG
v.36,no.9,p.5607-A,March'7c

I.B.2 - MORRET, JEAN BAPTISTE

Blin, Pierre
Portraits des grands hommes,femmes illus-
tres et sujets mémorables de France,gravés et
imprimés en couleurs...Paris,Chez Blin,impri-
meur en Taille-douce,1792.
Brit.
mus.
1260 c.
2 vols. 192 col.pl.in 3 v.
Originally publ.in 50 parts.
96 portrs.& 96 histor.scenes.Designed by
Sergent,Desfontaine,Naigeon,P.Barbier,Bénard,
F.Gérard,Deplessis-Berteaux & engraved by Ser-
gent,Mme.de Cernel,J.Morret,Ridé,L.Roger,
Le Coeur
NN
Source:Lewine,E. of art & illus.Books
A1023.L67 1969 NCFA p.505

I.B.2 - MORSE, SAMUEL FINLEY BREESE, 1791-1872

Morse, Samuel F.B. Educator and champion of the
arts in America.N.Y.,Nat'l Academy of De-
sign,1982
112 p. illus(part col.)

Incl.:Cat.of exh.,Sept.20-Nov.18,1982(Main-
ly drawings)at N.Y.Nat'l academy of design and
at Mount Holyoke College.Art Mus.,1983
Repre.incl.:Portr.of Benj.West,Wm.Cullen
Bryant
Incl.articles by Paul S.Staiti,Nicolai
Cikovsky
Bibl.referen des

N
40.1
M8714
M2
NMAA
I.B.2 - MORRIS, EDMUND MONTAGUE, 1871-1913

McGill, Jean S.,1920-
Edmund Morris,frontier artist.Toronto
and Charlottetown,Dundurn Press,1984
208 p. illus(part col.) (Dundurn live:

Index
Bibliography,p.197-201

LC ND249.M67M24 1984

N
40.1
M89N5
NCFA
2 c.
I.B.2 - MORSE, SAMUEL FINLEY BREESE, 1791-1872

New York. Metropolitan Museum of Art
Samuel F.B.Morse,American painter;a study
occasioned by an exh.of his paintings,Feb.16
through March 27,1932;by Harry B.Wehle.N.Y.,1932
49 p. illus.

Incl.:List of ptgs.:Portraits by sitter in
alphabetical order,p.31-44...

LC ND237.M75N4 1932

N
40.1
M8714
F5
NMAA
I.B.2 - MORRIS, EDMUND MONTAGUE, 1871-1913

Morris, Edmund, 1871-1913
The diaries of Edmund Montague Morris:
Western journeys 1907-1910;trancribed by
Mary Ritz-Gibbon.Toronto,Royal Ontario Mu-
seum,1985
179 p. illus(part col.)

Bibliography p.167-70
Index

KP
1
C76
NPG
I.B.2 - MOULTHROP, REUBEN, 1763-1814

Reuben Moulthrop, 1763-1814

In:Conn.Hist.Soc.Bull.
20,no.2:44-51 Apr.,1955 illus.

"...Moulthrop was best remembered,in his
life-time,as a maker of wax figures...None have
survived...Ptgs.are in Yale Uni; Conn.Hist.Soc.,
Hartford"

Beardley Limner N40.1B372
S3 NPG,p.16 footnote 14

705
A56
NCFA
v.114
I.B.2 - MORSE, SAMUEL FINLEY PREESE, 1791-1872

Cilella, Salvatore O.,jr.
Seven paintings by Samuel F.B.Morse

In:Antiques
114:150-2 July,1978 illus.

Six are portrs.,ptd.betw.1823 & 29,now at
N.Y.State Historial Association in Coopers-
town

705
A784
NCFA
v.44
I.B.2 - MOULTHROP, REUBEN, 1763-1814

Sawitsky, Susan
New light on the early work of Reuben
Moulthrop

In:Art in Am
44:8-11,55 Fall,'56 illus.

759.1
.C75
I.B.2 - MORSE, SAMUEL FINLEY BREESE, 1791-1872

Connecticut. Tercentenary commission
...Paintings by John Trumbull and Samuel Finley
Breese Morse,Gallery of fine arts,Yale universi-
ty,New Haven,Yale university press,1935.
24 p. illus.

Ids.Portrs.of John Jay
B.J421I & CT275.J421INPG
Bibl.

974.06
N7
v.39
I.B.2 - MOULTHROP, REUBEN, 1763-1814

Sawitzky, William, 1880-1947
Portraits by Reuben Moulthrop,a checklist...
Supplemented and edited by Susan Sawitzky.

In:N Y Hist Soc Q
39:385-404 Oct,'55 illus.

Whitehill,The Arts in ear-
ly Amer.Hist.E935.W59 NPG
Bibl.,p.92

AP
1
C76
NPG
v.21

I.B.2 - MOULTHROP, REUBEN, 1763-1814

Thomas, Ralph W.
 Reuben Moulthrop, 1763-1814

In:Conn.Hist.Soc.R.
21,no.4 Oct.,'56 illus.
p.97-100
 List of portrs.in exh.,p.101-3,illus.p.104-1?

Phillips,Ammi N40.1P558H7
Bibl.

I.B.2 - MUNCH, EDVARD, 1863-1944

Langaard, Johan Henrik, 1899-
 Edvard Munchs selvportretter.Samlet av Regn-
vald Vaering med en innledning av Johan H.Lang-
aard.Oslo,Cyldendal norsk forlag,1947
 161 p. illus.

MOMA
*
M86L2
A10754 Norwgian,French & English on versos facing
plates

olsten. N7618.H75 NPG
Bibl.p.119

N
40.1
M923S9
NMAA

I.B.2 - MOUNT, SHEPARD ALONZO, 1804-1868

Suffolk Museum, Stony Brock, N.Y.
 The Mount brothers.Suffolk Mus.& Carriage
House,1967
 49 p. illus.

 Henry Smith Mount,Shepard Alonse Mount,
William Sidney Mount

 Shepard Alonzo Mount & Wm.Sidney Mount
ptd. genre,landscapes,etc. and portraits.

 Text& cat.by Jane des Grange

705
M18
NCFA
v.9

I.B.2 - MUNDY, ETHEL FRANCES, 1876-1964

Bragdon, Claude
 Wax portraits by Ethel Frances Mundy

In:Mag Art
9:490-3 Oct.,'18 illus.

 "Mundy's best...work....is.Child portraiture"

Cumulated Mag.subj.index
A1/3/C76 Ref. v.2,p.445

N
40.1
M923S9
NMAA

I.B.2 - MOUNT, WILLIAM SIDNEY, 1807-1868

Suffolk Museum, Stony Brock, N.Y.
 The Mount brothers.Suffolk Mus.& Carriage
House,1967
 49 p. illus.

 Henry Smith Mount,Shepard Alonse Mount,
William Sidney Mount

 Shepard Alonzo Mount & Wm.Sidney Mount
ptd. genre,landscapes,etc. and portraits.

 Text& cat.by Jane des Grange

VF
Mundy

I.B.2 - MUNDY, ETHEL FRANCES, 1876-1964

Syracuse,N.Y. Museum of Fine Arts
 Wax miniatures,antique and modern,with re-
cent portraits by Ethel Mundy.Exh.May4-31,1944
 .6.p. cover illus.

 Repro.:Henry II of Valois,16th c.,Elisabeth,
Queen of England,by Ethel Mundy

 Foreword by Claude Bragdon

40.1
M956R47
1978a
NMAA

I.B.2 - MULREADY, WILLIAM, 1786-1863

Heleniak, Kathryn Moore
 William Mulready,R.A.,1786-1863.British
landscape and genre artist.N.Y.Univ.1978
 546 p. illus.

 Bibliography
 Thesis Ph.D.-N.Y.University,1978
 Photocopy of typescript

 Ch.6 incl.:Portraiture,p.272-7
 Portrs. in Sheepshanks & Swinburne colle.

705
B97
NCFA
v.91

I.B.2 - MYTENS, DANIEL, the elder, 1590-1648

Charles I

In:Burl.Mag.
91:p.3 Jan.1949

 Mytens, court painter, representative style,
most famous portr.ptr. until van Dyck

40.1
M956xR7
NCFA

I.B.2 - MULREADY, WILLIAM, 1786-1863

Mulready, William, 1786-1863
 Drawings by William Mulready..Cat.of draw-
ings in the Victoria and Albert Museum.by.Anne
Rorimer.London,Victoria and Albert Museum,1972
 173 p. illus.

 Incl.bibliography

 Ch.VI.Portraits and heads,p.108-20

Noon.Engl.portr.drogs.&min.
NC860.N66X NPG Bibl. p.147

I.B.2 - NADAR(pseud.)
 see
I.B.2 - TOURNACHON, FÉLIX, 1820-1910,called NADAR

I.B.2 - NANTEUIL, ROBERT, 1623-1678

Bouvy, Eugène, 1859-
...Nanteuil...Paris,Le Goupy,1924
8 p. illus. (Le portrait gravé et ses maîtres)

Aperçu bibliographique sur Nanteuil:p.193-196.

LC NE650.N4H6

I.B.2 - NANTEUIL, ROBERT, 1623-1678
1
P89
NMAA Metcalfe, Louis R.
v.1 Robert Nanteuil(1630-1678)

In:Print Coll.Q.
1,no.5:526-61 Dec.,'11 illus.

I.B.2 - NANTEUIL, ROBERT, 1623-1678

Ederheimer, Richard, firm,N.Y.
 Illus.cat.of an exh.of portraits by Robert
Nanteuil...Oct.4 to Oct.25,1913.N.Y.,R.Ederheimer,1913

MET
204.9
Ed2
no.5

MH NjP ICN CtY PPPM NIC **FOR COMPLETE ENTRY SEE MAIN CARD**

I.B.2 - NANTEUIL, ROBERT, 1623-1678

Petitjean, Charles and Ch.Wickert
 Cat.de l'oeuvre gravé de Robert Nanteuil.
Paris,L.Delteil et M.Le Garrec,1925
 411 p. illus.

 234 portrs.
 Bibliography

LC NE650.N4P4 Berlin.St.Mus.Kupferst.K.
 Ruhm des porträts VF NPG
 Bibl.

705
G28
NCFA Froarich, Yane
v.49 Robert Nanteuil dessinateur et pastelliste

In:Gaz Beaux Arts
49:209-17 Apr.,'57 illus.

English summary
...one of the great masters of French portraiture in the 17th c.& the precursor of the art of the pastellists of the 18th c.

 Moon.Engl.portr.drag...
 NC860.N66X NPG p.XI
 footnote 12

I.B.2 - NANTEUIL, ROBERT, 1623-1678

Robert-Dumesnil, Alexandre Pierre François,
 Nanteuil,Robert in ,his, ,1778-1864
Le peintre-graveur français ou cat.raisonné
des estampes gravées par les peintres et les
dessinateurs de l'école française;ouvrage faisant suite au Peintre-Graveur de M.Bartsch.
Paris,G.Warée,etc.,etc.,1835-71 (11 v.)

 v.4:Nanteuil, Robert(234 items)

LC NE149.R6 Metcalfe,L.R. In:Print Coll
 Q. 1,no.5:529
 AP1.P89 NNAA

I.B.2 - NANTEUIL, ROBERT, 1623?-1678

Grolier club, New york
 17th century line engraved portraits,an
exh....Nov.21-Dec.11,1935.Philadelphia,:Printe
and designed by H.Stern & co.,inc.,1935.
 11 p.

 "...centers around the work of Robert
Nanteuil."

N.Y.P.L.

AP
1
P89 Thomas, Thomas Head, 1881-
NCFA The drawings and pastels of Nanteuil
v.4
In:Print Coll Q
4:327-61 Dec.,'14 illus.

Repro incl.a pastel of Louis XIV

 Froarich.Rbt.Nanteuil in:
 Gaz Beaux Arts 49:209,footnote 1

I.B.2 - NANTEUIL, ROBERT, 1623-1678

Loriquet, Charles, 1818-1889
 Robert Nanteuil,sa vie et son oeuvre;discours du 17 jillet 1884,adresse à l'academie du Reims,dans la Séance publique,...2.ed.
Reims,F.Michaud,1886
 154 p.

FOOG
FA
5759
680
110
 Metcalfe.Rbt.Nanteuil in
 Print coll.Q AP1.P89 NNAA
 v.1,no.5,p.527/28

708.1 I.B.2 - NATTIER, JEAN-MARC, 1685-1766
D47
v.23-27 Richardson, E.P.
1943-48 Madame Henriette de France as a vestal virgin
by Jean-Marc Nattier

In:B.Detroit Inst.Arts
23:2-3 Oct,1943 illus.

see also article by E.P.Richardson
705 In:Art Q
A7875 6,no.4:238-56 Autumn,1943 illus.
1943
 dep.,1945-47*7741

705
B97
NCFA
v.91

I.B.2 - NAZARI FAMILY, 18th c.

Watson, F.J.B.
 The Nazari, a forgotten family of Venetian
portrait painters

In:Burl Mag.
91:75-9 mar 1949 illus.

 Bartolomeo and Nazario Nazari

Rep.,1948-49*8520

705
C69
NCFA

I.B.2 - NEEL, ALICE, 1900-

Hope, Henry R.
 Alice Neel:Portraits of an era

In:Coll.Art J.
38:273-81 Summer,'79 illus.

A784
NCFA
v.37

I.B.2 - NEAGLE, JOHN, 1796-1865

Lynch, Marguerite
 John Neagle's "Diary"

In:Art in Am
37:79-99 Jan.,'49 illus.

N
40.1
N363G3
NCFA

I.B.2 - NEEL, ALICE, 1900-

Neel, Alice, 1900-
 Alice Neel,the woman and her work,7 Sept.-
15 Oct.,1975.Athens,Georgia Museum of Art, Univ.
of Georgia,c.1975
 [160]p. illus.

 Bibliography
 Preface by Wm.D.Paul
 Essay:Alice Neel,Teller of Truth,by Cindy
 [Nemser

 Hope,H.R. Alice Neel
 In:Art J. 38:281

I.B.2 - NEAGLE, JOHN, 1796-1865

Patrick, Ransom R.
 The early life of John Neagle,Philadelphia
portrait painter
 222 p. illus.

 '...one of the most significant portr.ptrs.
in 19th c. American art!-Patrick

 Ph.D.Dissertation,Princeton Univ.,1959

 Art in AmqZ5961.USA77X
LC card no.Mic59-5210 NCFA Ref. T 958
 ss.Abstr.Z5055.U49D57NPG

N
40.1
N363H3
NPG

I.B.2 - NEEL, ALICE, 1900-

Neel, Alice, 1900-
 An exh.presented at the Art Gallery Loyola
Marymount Univ.,from March 29-May 7,1983,cat.
by Ann Sutherland Harris.,Los Angeles,Calif.,
The Gallery,1983.
 79 p. illus(part col.)

 Paintings 1933-1982

 Bibliography

705
A7832
NCFA
v.33

I.B.2 - NEAGLE, JOHN, 1796-1865

Patrick, Ransom R.
 John Neagle,portrait painter and Pat Lyon,
blacksmith

In:Art Bul
33:187-92 Sept.'51 illus.

708.9493
B921
NMAA

I.B.2 - NETSCHER, CASPAR, 1639-1684

Benkö, Eva
 The archetype of Netscher's "Portrait of
Mary II Stuart"in Brussels and its use

In:Mus.Royaux
 des Beaux-Arts
 de Belgique.B
30-33:123-34 1981-1984/1-3 illus.

 The portr.by Constantin or Caspar Netscher
of Mary II Stuart could be copies after Sir
Peter Lely
 Synopsis in Dutch and French

B
N33P4
NCFA

I.B.2 - NEAGLE, JOHN, 1796-1865

Pennsylvania academy of the fine arts, Philadel-
...Cat.of an exn.of portraits by [phia
John Neagle;final ed.Phila.,1925
 158 p. illus.

 Exh....Apr.12,1925-May 13,1925
 "John Neagle,artist(1796-1865)by Mantle
Fielding":p.5-15

LC ND237.N4P4 1925 Art Books 1876-1949. Z5937
 A775 NCFA Ref. p.496

708.9493
B921
NMAA

I.B.2 - NETSCHER, CONSTANTIN, 1668-1723

Benkö, Eva
 The archetype of Netscher's "Portrait of
Mary II Stuart"in Brussels and its use

In:Mus.Royaux
 des Beaux-Arts
 de Belgique.B
30-33:123-34 1981-1984/1-3 illus.

 The portr.by Constantin or Caspar Netscher
of Mary II Stuart could be copies after Sir
Peter Lely
 Synopsis in Dutch and French

I.B.2 - NEGUS, NATHAN, 1801-1825

705
A56
NCFA
v.58

Dods, Agnes M.
Nathan Negus

In:Antiques
58:194 Sept.,'50 illus.(self-portr.)

I.B.2 - NEWTON, GILBERT STUART, 1794-1835
see

N
40.1
S93M8
1969
NPG
2 c.

Morgan, John Hill, 1870-1945
Gilbert Stuart and his pupils...N.Y.,Kennedy Galleries,Da Capo Press,1969
p.42-5 1 illus.

I.B.2 - NELLI, NICCOLO, born c.1530

Mantova Benevides, Marco,conte, 1489-1582
Illvstrivm ivreconsvltorvm imagines...Ex musaeo Marci Mantuae Benavidij patavini...Romae,
Ant.Lafrerij...1558

25 engraved portrs.of jurists by Niccolò
Nelli after portrs.in Mantova's "little"museum

MiU-L MNUT MH Rave.Jb.d.Berl.Mus. I 1959
 LC N3.J16 fol.p.146
 Paolo Giovio & d.Bildnisvitenbücher..

I.B.2 - NOGUCHI, ISAMU, 1904-

705
A786
NCFA
v.45

Hess, Thomas B.
Isamu Noguchi

In:Art N
45:14-8,47-51 Sept.'46 illus.

Repro.incl.:Head of Gershwin

'Fashionable popular portraits...supported
N.until 1936'
Exhibited 15 busts at Marie Sterner's Gall.
'His portrs.were excellent likenesses & had
more than enough sculptural merits...'
(Exh.till Feb.14, 1930)

I.B.2 - NEWSAM, ALBERT, 1809-1864

VF
NEWSAM

Intramuralia

In:Huntington Library Quarterly
34,no.4:371 Aug.,'71 illus.

Repro.:Lithograph of Andrew Jackson(1834)by
Albert Newsam

I.B.2 - NOLLEKENS, JOSEPH, 1737-1823

AP
1
A64
HMAA
v.127

Bitner, David C.
Nineteenth-century English portrait sculpture:Marble busts in the Nat'l Gall.of Canada.

In:Apollo
127:334-8 May,'88 illus.

Repro.incl.:Nollekens,Chantrey

I.B.2 - NEWSAM, ALBERT, 1809-1864

Mitchell, James Tyndale, 1834-1915
The unequalled coll.of engraved portraits
of eminent American and some noted foreigners belonging to Hon.James T.Mitchell...a
large coll.of lithographs engraved by A.Newsam,
an unique coll.of American revolutionary and
political caricatures and numerous portraits
for extra illustrating,to be sold...Oct.28,
1913.Phila.,Pa.,Stan v.Henkels,1913.
56 p. Plates
Cat.Stan v.Henkels,no.1044,pt.13

LC Z999.H505 no.1044,pt.13 Rosenwald coll.

I.B.2 - NOLLEKENS, JOSEPH, 1737-1823

927
.S63

Smith, John Thomas, 1766-1833
Nollekens and his times and memoirs of contemporary artists fr...Roubiliac,Hogarth and
Reynolds to...Fuseli,Flaxman and Blake...ed.and
annotated by Wilfred Whitten with 85 illustr.
2 v. illus.,London,N.Y.,John Lane cy.,1920

1st ed. Colburn publ.,1828,2nd ed.1829

List of Nollekens' sitters in v.2,p.10ff.
Incl.a biography of J.T.Smith

LC NB497.N8S7 1917 Foskett.John Smart...Bibl.
 N40.1S638F7 NCFA

I.B.2 - NEWSAM, ALBERT, 1809-1864

Stauffer, David McNeely, 1845-1913
Lithographic portraits of Albert Newsam...
Philadelphia,1901
52 p.

Reprinted fr.the Penn.magazine of history
and biography,Oct.1900 and Jan.and Apr.,1901

LC NE2415.N5S7 College of Physicians...
 Arch.Am.Art mfm P86 v.12
 References

I.B.2 - NORGATE, EDWARD, died 1650?

Norgate, Edward, d.1650
An exact and compendious discours concerning the art of Miniatura or Limning...1621-
1626.

The treatise is in the Brit.Mus.(MS.Harl.
6000)

Norgate.Miniatura.750.N83
p.XII ff
Walpole Soc.AP1W225,v.3,
p.83

750
.N83

I.B.2 - NORCATE, EDWARD, died 1650?

Norgate, Edward, d.1650
 Miniatura;or, The art of limning;...Oxford,
Clarendon press, 1919
 Ed.& introd.by Martin Hardie
 111 p.

 The treatise dates from 1648-50 and is in
the Bodleian Library,Oxford(MS.Tanner 326)

 Reviewed in Burl.Mag.v.37:207-8 Oct.,1920

LC ND1330.N7 Warburg J.v.6,1943,p.89
 footnote

ND
2200
W3
1949X
NPG

I.B.2 - O'HARA, ELIOT, 1890-

Walker, Phoebe Flory, 1914-
 Watercolor portraiture,by Phoebe Flory
Walker with Dorothy Short and Eliot O'Hara.
N.Y.,G.P.Putnam's Sons.1949.
 143 p. illus(part col.)

 Incl.:A suggested reference list of books
for the painter of watercolor portraits,p.139-
143

705
A56
NCFA
v.112

I.B.2 - NORTH, NOAH, 1809-1880

Muller, Nancy C. & Jaquelyn Oak
 Noah North, 1809-1880

In:Antiques
112:939-45 Nov.,'77 illus(part col.)

I.B.2 - OLIVER, ISAAC, 1556?-1617

Brett, Edwina
 A kind of gentle painting.cat.of.an exh.
of miniatures by the Elizabethan artists Nicho-
las Hilliard and Isaac Oliver,16 Aug.-14 Sept.
1975,the Scottish Arts Council Gallery...Edin-
burgh,Scottish Arts Council,1975
 40 p. illus(1 col.)

 Bibliography

 79 works shown

LC ND1337.O7H54 Rila III/1 1977 #1294

I.B.2 - NORTHCOTE, JAMES, 1746-1831

Gwynn, Stephen Lucius, 1864-1950
 Memorials of an 18th c. painter(James North-
cote).London,T.F.Unwin,1898
 288 p. illus.

 List of Northcote's ptgs.p.265-88

LC ND497.N8308 Foskett.Dict.of Brit.min.
 ptrs.ND1337.F74dNPG v.1
 Bibl.p.594

N
40.1
H645:2
NMAA

I.B.2 - OLIVER, ISAAC, 1556?-1677

Edmond, Mary
 Hilliard and Oliver.The lives and works of
two great miniaturists.London,Rbt.Hale,1983
 238 p. illus(part col.)

 Incl.:Index

 Bibliography p.217-222

 Review in:Burl Mag.v.125:698-9,Nov.'83

705
B97
NCFA
v.9

I.B.2 - NORTHCOTE, JAMES, 1746-1831

Holmes,(Sir)Charles John, 1868-1936
 A portrait by Northcote

In:Burl Mag
9:217-8 July,'06 illus.

 Repro.:Ladies of the Bulwer family in the
possession of Messrs.Thos.Agnew & sons

N
40.1
O 48F5
1981
NPG

I.B.2 - OLIVER, ISAAC, ca.1556-1617

Finsten, Jill
 Isaac Oliver,art at the courts of Eliza-
beth I and James I. N.Y.,Garland Pub.1981
 2 v. illus. (Outstanding dissertation
in the fine arts)

 Originally presented as Ph.D.-Thesis,Har-
vard,1979

 Bibliography in v.1,p.220-9;
 Cat.raisonné in v.2
 Fitzwilliam Mus. Cat.of por-
 trait min. ND1337.O7F4 1985
 NPG Bibl.p.222

I.B.2 - ODIEUVRE, MICHEL, 1687-1756

Dreux du Radier, Jean François, 1714-1780
 L'Europe illustre,contenant l'histoire abré-
gée des souverains,des princes,des prélats,des
ministres,des grands capitaines,des magistrats,
des savans,des artistes,& des dames célèbres en
Europe;dans le 15e siècle compris,jusqu'à présent
...Ouvrage enrichi de portraits,gravés par les
soins du Sieur Odieuvre...Paris,Odieuvre.et.Le
Breton,1755-65
 6 v. illus.
 Planches par N.Dupuis,G.Duchange,J.G.Wille.
Pinssio,etc.
NN Amsterdam,Rijksmus.,cat.
 Z5939A52,deel 1,p.131

705
B97
NCFA
v.9

I.B.2 - OLIVER, ISAAC, 1556? - 1617

Holmes, Richard R.
 The English miniature painters illustrated
by works in the Royal & other collections.Ar-
ticle III. Isaac Oliver

In:Burl Mag
9:22-8 Apr,'06 illus.

 Repro.:Self portr.,Anne of Denmark,Henry,
Prince of Wales,Mary,Queen of Scots,Phil.Sidney,
Ths.Howard,Earl of Arundel

qN
40.1
H645V6
1971
NPG

I.B.2 - OLIVER, ISAAC, 1556? - 1617

Victoria and Albert Museum, South Kensington.
Nicholas Hilliard and Isaac Oliver. 2nd ed.
London, Her Majesty's Stationery office,1971

115 p. illus.(part col.)

Biographical details; Characteristics & development of style; Costume & accessories; Explanatory note; Catalogue. Description with each illustr.
Bibliography
Monograph and catalogue by Graham Reynolds

LC ND1328.V53

I.B.2 - ORR, JOHN WILLIAM, 1815-1887

Jones, Abner Dumont, 1807-1872
The American portrait gallery;containing correct portraits and brief notices of the principal actors in American history...From Christopher Columbus down to the present time. The portraits engraved on wood by J.W.Orr,from original drawings by S.Wallin...N.Y.,J.M. Emerson & co.,1855
768 p. illus.

LC E176.J68

757
V65

I.B.2 - OLIVER, ISAAC, 1556? -1617

Victoria and Albert Museum,South Kensington.
Nicholas Hilliard and Isaac Oliver; an exhibition to commemorate the 400th anniversary of the birth of Nicholas Hilliard. Monograph and catalogue by Graham Reynolds..1st ed.. London...Ministry of Education,1947

46 p. illus.

Bibliography
For review of exhibition see Winter, Carl
Hilliard and Elizabethan miniatures.

LC N1150.A759

N
40.1
C916S5
NMAA

I.B.2 - OSBORNE, WALTER FREDERICK, 1859-1903

Sheehy, Jeanne
Walter Osborne..Cat.of exh..The National Gallery of Ireland,1983
184 p. illus(part col.)

Bibliography
Index

Exh.held at The Nat'lGall.of Ireland 16 Nov. to 31 Dec.,1983.The Ulster Mus.,Belfast 20 Jan. to 29 Feb.,1984
Based on thesis.Trinity College.Dublin?.1974

705
B97
NCFA
v.9

I.B.2 - OLIVER, PETER, ca.1594-1648

Holmes, Richard R.
The English miniature painters illustrated by works in the Royal & other collections. Article IV. Peter Oliver & John Hoskins

In:Burl Mag
9:108-13 May,'06 illus.

Repro.:P.Oliver:Eliz.of Bohemia,Arabella Stuart,Chs.I,Henr.Maria,Marquis Guasto & his mistress after Titian,B.Jonson. Hoskins:Falkland, Mrs.Cromwell,Charles I

I.B.2 - OTIS, BASS, 1784-1861

Jackson, Joseph, 1867-
Bass Otis,America's first lithographer

In:Penn Mag of Hist & Biogr
37 1913

LC F146.P65

Penn.Hist.Soc. Rembrandt
Peale... Bibl.p.118

I.B.2 - OPIE, JOHN, 1761-1807

Rogers, John Jope, 1816-1880
Opie and his works,being a cat.of 760 pictures by John Opie...London,P.& D.Colnaghi & co....1878
247 p.

"Table of authorities consulted":p..X.-XII

LC ND497.06R7

Yale ctr.f.Brit.art Ref.
NJ18.Op6R64

N
40.1
O 88D3
NPG

I.B.2 - OTIS, BASS, 1784-1861

Otis, Bass, 1784-1861
Bass Otis,painter,portraitist and engraver. Intro.by Roland H.Woodward.Essays by Gainor R.Davis and Wayne Craven.Wilmington,The Historical Society of Delaware,1976
116 p. illus(part col.)

Cat.of an exh.held at the Hist.Soc.of Del. Oct.15-Dec.31,1976

Sitters incl.Dolly Madison,Lafayette, Jefferson,Js.Monroe. RILA III/2 1977 #6674

I.B.2 - OPPENHEIMER, MAX, 1885-1954

Oppenheimer, Max, 1885-1954
Menschen finden ihren maler.Text,bilder & graphiken von Mopp(Max Oppenheimer).Zürich, Oprecht,.1938.
63 p. illus.

Gemaltes und geschriebenes selbstporträt, p.60-3

LC L759.3.062m MOMA p.432, ~ 11

I.B.2 - PAGE, E. 19th c.

Cooper, Robert, fl.1800-1836
Fifty wonderful portraits.Engraved by R. Cooper and R.Page,from authentic originals. London,J.Robins & co.,1824
8 p. plates

Winterthur
RE330
C77

MH NN Winterthur Mus.Libr.
 Z881.W78 NCFA v.5,p.224

705
A7875

I.B.2 - PAGE, WILLIAM, 1811-1885

Taylor, Joshua Charles, 1917-
The fascinating Mrs.Page

In:Art Q
20,no.4:347-62 winter '57 illus.

Wm.Page's technique. Comparison with photography

I.B.2 - PAZZI, P.ANTONIO, 1706-after 1766

Marrini, Orazio, 1722-1790
Serie di vitratti di celebri pittori dipinti
di propria mano in seguito a quella gia'pubbli-
cata nel Museo fiorentino esistente appreso
l'abate Antonio Pazzi...Firenze,Stamperia
Moückiana,1765-1766
2 v. illus. (Museum florentinum...11-12)

LC N2571.06 vol.11-12 Amsterdam,Rijksmus.,cat.
 Z5939A52,deel 3,p.627

705
B97
NCFA
v.91

I.B.2 - PALMER, SIR JAMES, died 1657

Reynolds, Graham, 1887-
A newly identified miniaturist of the early
seventeenth century, probably Sir James Palmer

In:Burl Mag.
91:196-7 Jul,1949 illus.

Rep.,1948-49*8405

AP
1
W225
NCFA
v.9

I.B.2 - PEAKE, ROBERT I, died 1626?

Finberg, Alexander Joseph, 1866-1939
An authentic portrait by Robert Peake

In:Walpole Soc.
9:89-95 1920-21 illus.

Rep.:Charles I as Duke of York,1613

AP
1
A51A64
NCFA
v.12

I.B.2 - PARTRIDGE, NEHEMIAH,the AETATIS SUE LIM-
 NER,1683-

Black, Mary C.
Contributions toward a history of early
18th c. New York portraiture:The identification
of the Aetatis Suae and Wendell Limners

In:Am Art J
12:4-31 Autumn,'80 illus.

Black identifies Nehemiah Partridge as the
Aetatis Sue limner and John Heaten as the ptr.
of Abraham Wendell and his brothers as well as
of a dozen or more Albany area portrs. ascr.un-
til now to the Wen---dell limner.
An footnote 13
(Miles,Portrs.of the heroes)

705
B97
NCFA
v.105

I.B.2 - PEAKE, ROBERT, the elder, fl.1576-1626

Strong, Roy C.
Elizabethan painting:An approach through
inscriptions - I:Robert Peake the elder

In:Burl Mag
105:53-7 Fe.,'63 illus.

"...In 1598 P.could be regarded as one of
the most important ptrs...in England"
Serjeant ptr.from 1607 on

Incl.list of -ters

I.B.2 - PASSE, CRISPIJN VAN DE,the younger,
 ca.1593-1667

Passe,Crispijn van de,the younger,ca.1593-1667
Les vrais pourtraits de quelques unes des
plus grandes dames de la chrestiente,desguisées
en bergères...Ware afbeeldighe van eenige der
aldergrootste ende doorchluchtigste vrouwen van
heel christenrijck,vertoont in gedaente als her
derinnen...Amsterdam,Gedruckt by J.Ercersz voor
den autheur.1640
4 v. illus.

LC NE670.P2A3

ND
1311.1
B43
NPG
NCFA

I.B.2 - PEALE, CHARLES WILLSON, 1741-1827

Belknap, Waldron Phoenix, 1899-1949
American colonial painting...Cambridge,Mass.
Belknap press,Harvard Univ.,1959

Partial contents:Pt.II.Problems of identifi-
cation in 17th & 18th c.portraiture.Portrs.in
the Dutch background.Discussion of a group of
portrs.by Chs.W.Peale,p.37-58...

FOR COMPLETE ENTRY
SEE MAIN CARD

I.B.2 - PAYNE LIMNER, fl.1791

Lyon, Elizabeth Thompson
Payne Limner

Masters Thesis,Virginia Commonwealth Univ
Richmond.c1977.,1981

Woodward.American Folk ptg
ND207.W66X NPG p.14 & 22

AP
1
A(area)

I.B.2 - PEALE, CHARLES WILLSON, 1741-1827

Bolton, Theodore, 1889- and H.L.binsse
The Peale portraits of Washington

In:Antiquarian
16:24-7,58,60,62,64 Feb.,'31 illus(part col

Miniatures, physionotrace
Incl.cat.,comp.from ms.copy of C.W.Peale's
diary for the years 1775-1778 and part of 1788.
Description & notes on the life portrs.of W
by members of the Peale family
C.P.Polk copied many C.W.Peale portrs.of
 c1787

Arts in Am.qZ5561
USA77X NCFA Ref. H722

I.B.2 - PEALE, CHARLES WILLSON, 1741-1827

B
P35B85

Briggs, Berta N.
 Charles Willson Peale:Artist and patriot.
N.Y.,McGraw-Hill,1952.
 262 p. illus.

LC ND237.P27B7 Alberts.Benj.West N.O.1
 .W9A3 NPG Bibl.p.483

757
.P42

I.B.2 - PEALE, CHARLES WILLSON, 1741-1827

Pennsylvania academy of the fine arts, Philadel-
phia
 ...Catalogue of an exhibition of portraits by
Charles Willson Peale and James Peale and Rem-
brandt Peale.Final edition.Phila.,1923
 239 p. illus.

 Exhib.Apr.11-May 9, 1923

 Short biographies of printer and sitters

 Review In:Am Mag,14:301-3,307-10,June,'23,ill.
LC ND237.P27P4 Fogg,v.11,p.329

B
.W31
M84

I.B.2 - PEALE, CHARLES WILLSON, 1741-1827

Morgan, John Hill, 1870-
 Two early portraits of George Washington,
painted by Charles Willson Peale...Princeton,
N.J.,Univ.Press,1927
 29 p. illus.

 "The Wilson-Munn portrait",1779 and
"The Princeton portrait",1784,both at Princeton
university

LC ND237.P27M6 Weddell.A mem'l vol.of Va.
 hist.portraiture.757.9.W38
 NCFA Bibl. p.437

I.B.2 - PEALE, CHARLES WILLSON, 1741-1827

Philadelphia museum
 Historical cat.of the paintings in the Phi-
ladelphia museum consisting chiefly of portraits
...Phil.,1813

 Many of the portrs.are by Chs.W.Peale,who
formed the collection

LC N25.M7 no.8 **FOR COMPLETE ENTRY
 SEE MAIN CARD**

N
7628
W31X9
NPG

I.B.2 - PEALE, CHARLES WILLSON, 1741-1827

Munn, Charles Allen, 1859-1924
 Three types of Washington portraits:John
Trumbull,Charles Willson Peale,Gilbert Stuart..
N.Y.,Priv.print.The Gillis press.1908
 66p. illus.
 Munn aims to preserve in this book the his-
tory and the pedigree of three portrs.of Wash.,
which are beyond dispute.Authenticity of the
identity & genuineness rests partly on these
records. of the portrs.

LC E312.43.M96 Weddell.A mem'l vol.of Va.
 hist.portraiture.757.9.W38
 NCFA Bibl. p.437

AP
1
W78
NCFA

I.B.2 - PEALE, CHARLES WILLSON, 1741-1827

Richardson, Edgar Preston, 1902-
 Charles Willson Peale's engravings in the
year of national crisis,1787

In:Winterthur Portfolio
1:166-81 1964 illus.

 Repro.incl.:Mezzotints of Franklin,Lafa-
yette,Rev.Pilmore,Washington

NPG
Ref
1982

I.B.2 - PEALE, CHARLES WILLSON, 1741-1827

Peale, Charles Willson, 1741-1827
 Charles Willson Peale and his world.Cat.
of exh.at the National Portrait Gallery,Washing-
ton, D.C.,Oct.28,1982-Jan.2,1983 ,by E.P.Richard-
son,B.Hindle,L.B.Miller.N.Y.,Harry N.Abrams,Inc.,
1983
 272 p. illus(part col.)
 A Barra Foundation Book
 Incl.:Bibl.& index
 Foreword by Chs.Coleman Sellers
 Exh.at Amon Carter Mus.,Fort Worth,Texas,
Feb.11-Apr.3,1983.At N.Y.,Met.June 10-Sept.4,'83
LC ND237.P27A4

N
.O.1
P35S46
1969
NCFA

I.B.2 - PEALE, CHARLES WILLSON, 1741-1827

Sellers, Charles Coleman, 1903-
 Charles Willson Peale. New York,Scribner
.1969.

 510 p. illus.

 Bibl.references

LC ND237.P27S44 Whitehill.The Arts in early
 Amer.Hist.Z5935.W59 NPG
 Bibl.,p.92

I.B.2 - PEALE, CHARLES WILLSON, 1741-1827

Peale, Charles Willson, 1741-1827
 Peale's museum gallery of oil paintings...
cat.of the national portrait and historical gal
lery...formerly belonging to Peale's museum,
Philadelphia, to be sold...6th Oct.,1854...at
Phila.,M.Thomas & sons,auctioneers...Phila.,
W.Y.Owen,printer,1854
 16 p.
 'A copy is in the library of the American
Philosophical Society,Philadelphia.'-Milley.
F158.65 I 3T78 NPG p.179,note 2

LC N5220.P35 Weddell.A mem'l vol.of Va.
 hist.portraiture.757.9.W38
 NCFA Bibl. p.437

AP
1
A51A64
NCFA
v.2

I.B.2 - PEALE, CHARLES WILLSON, 1741-1827

Sellers, Charles Coleman, 1903-
 Charles Willson Peale as sculptor

In:Am Art J
2:5-12 Fall,'70 illus.

 P.'s influence on Wm.Rush.-Their mutual in-
terest in the allegorical fg. or emblem
 P.sculpture is now known only as it appears
in ptgs.& documentaties.

N
40.1
P35S4c
NCFA
NPG
I.B.2 - PEALE, CHARLES WILLSON, 1741-1827

Sellers, Charles Coleman, 1903-
Charles Willson Peale.Philadelphia,1939-47
2 v. illus.

v.1 published by Feather & Good,Hebron,Conn
v.2:Memoirs of the American Philsophical
Society,v.23,pt.2

Contents:v.1:The artist of the Revolution:
the early life(1741-1790).-v.2:Later life
(1790-1827

Abby Aldrich Rockefeller
Folk Art Ctr.Am.Folk portr:
N7593.A23 Bibl. p.294

705
A56
NCFA
v.22
I.B.2 - PEALE, JAMES, 1749-1831

Brockway, Jean Lambert
The miniatures of James Peale

In:Antiques
22:130-4 Oct.,'32 illus.

Incl.checklist of miniatures

708.1
N52
NCFA
I.B.2 - PEALE, CHARLES WILLSON, 1741-1827

Sellers, Charles Coleman, 1903-
Charles Willson Peale's portraits of
Washington

In:Met Mus Bul
9:147-55 Feb.,'51 illus.

P.ptd.7 life portrs.of W. & many replicas.
Portrs.of W.by the Peale family

Simmons.qN40.1.P74S5 NCFA
Bibl. p.20

757
.P42
I.B.2 - PEALE, JAMES, 1749-1831

Pennsylvania academy of the fine arts, Philadel-
phia
...Catalogue of an exhibition of portraits by
Charles Willson Peale and James Peale and Rem-
brandt Peale.Final edition.Phila.,1923
239 p. illus.

Exhib.Apr.11-May 9, 1923

Short biographies of painter and sitters

Review In:Am Mag,14:301-3,307-10,June,'23,ill.
LC ND237.P27P4 Fogg,v.11,p.329

qN
40.1
P35S4
NCFA Ref.
NPG
I.B.2 - PEALE, CHARLES WILLSON, 1741-1827

Sellers, Charles Coleman, 1903-
Portraits and miniatures by Charles Willson
Peale.Philadelphia,Amer.Phil.Soc.,1952
369 p. illus(part col.) (Transactions
of the American Philosophical Society,n.s.,v.42
pt.1)
Bibliography

qN
:0.1
P35S4
Suppl.
LCO11P6
----Charles Willson Peale with patron and popu-
lace;a suppl.to Portraits and miniatures...1969
146 p. illus. (Transactions of the Amer.
Philos.Soc.,n.s.,v.59,pt.3)
n.s.,v.42,pt.1 and n.s. . Whitehill.The Arts in ear-
v.59,pt.3 ly Am.Hist.Z5935.W59,p.92

I.B.2 - PEALE, JAMES, 1749-1831 (& Family)

Walker Galleries, New York
Paintings and water colors by James Peale
and his family 1749-1891,exh.,Feb.13-March 11,
1939,New York,1939,
11.p. 5 illus.

IU MH
Simmons qN40.1.P74S5 NCFA
Bibl. p.20

705
A56
NCFA
v.95
I.B.2 - PEALE, CHARLES WILLSON, 1741-1827

Shadwell, Wendy J.
An attribution for His Excellency and Lady
Washington

In:Antiques
95:240-1 Feb.,'69 illus.

The mezzotints of Geo.Washington & Lady
Washington, once attr.to Chas.Willson Peale,
here attr.to Joseph Hiller,sr.

Shadwell.Portr.engr.of Chs.
.Peale.NE500E36X NCFA
p.14,3,note 7 (In:18th c.
prints in Col'l America)

AP
1
M971
NCFA
I.B.2 - PEALE, REMBRANDT, 1778-1860

Bishop, Edith
Newark portraits by Rembrandt Peale and
Oliver Tarbell Eddy

In:The Museum
n.s.1,no.4:1-21 Oct.,'49 illus.

Notes and Bibliography

Penn.Hist.Soc. Rembrandt
Peale...Bibl.p.117

NE
506
E36X
NCFA
I.B.2 - PEALE, CHARLES WILLSON, 1741-1827

Shadwell, Wendy J.
The portrait engravings of Charles Willson
Peale

In:18th c.prints in Colonial America.Uni.Press
of Va.1979,p.123-44 illus.

List of the engravings & their location

Repro.incl.:Mezzotints of Geo.Washington,
Benj.Franklin,Lafayette,Rev.Jos.Filmore
Paper originally presented at symposium in
Williamsburg,Va. March,1974

I.B.2 - PEALE, REMBRANDT, 1778-1860

Fowble, Eleanor McSherry
Rembrandt Peale in Baltimore

Master's Thesis,Univ.of Delaware,Newark,
1965

Penn.Hist.Soc. Rembrandt
Peale...Bibl.p.118

I.B.2 - PEALE, REMBRANDT, 1778-1860

Hart, Charles Henry, 1847-1918
 Peale's original whole-length portrait of
Washington;a plea for exactness in historical
writings.
In:Am hist.ass. Annual report for the year 1896
Washington,1897
1:189-200

LC card div.E172.A60 1896, Weddell.A mem'l vol.of Va.
 v.1 hist.portraiture.757.9.W38
LC--separate E312.43.H33 NCFA Bibl. p.435

705
A56
NCFA
v.33

I.B.2 - PEALE, REMBRANDT, 1778-1860

Morgan, John Hill, 1870-1945
 Rembrandt Peale's life portrait of Washing-
ton

In:Antiques
33:70-2 Feb.,'38 illus.

 Penn.Hist.Soc. Rembrandt
 Peale...Bibl.,p.119

705
A784
1915
NCFA

I.B.2 - PEALE, REMBRANDT, 1778-1860

Hart, Charles Henry, 1847-1918
 Portrait of Jacques Louis David painted by
Rembrandt Peale

In:Art in Am
3:257-8 Aug.,'15 1 illus.

N
40.1
P352
A1p
R B
NCFA

I.B.2 - PEALE, REMBRANDT, 1778-1860 comp.

Peale, Rembrandt, 1778-1860 comp.
 Portfolio of an artist...Philadelphia,H.Per-
kins,Boston,Perkins & Marvin, 1839
 263 p.

 an anthology of writings which interested
Rembrandt Peale

 Writings on portraits see over

LC PR1109.P43

705
A784
1915
NCFA

I.B.2 - PEALE, REMBRANDT, 1778-1860

Hart, Charles Henry, 1847-1918
 Portrait of Jean-Antoine Houdon painted by
Rembrandt Peale

In:Art in Am
3:78-81 Feb.,'15 1 illus.

 Réau-L'iconogr.de Houdon
 Gas Beaux Arts ser.6 1933
 v.9:168,note 1

757
.P42

I.B.2 - PEALE, REMBRANDT, 1778-1860

Pennsylvania academy of the fine arts, Philadel-
phia
 ...Catalogue of an exhibition of portraits by
Charles Willson Peale and James Peale and Rem-
brandt Peale.Final edition.Phila.,1923
 239 p. illus.

 Exhib.Apr.11-May 9, 1923

 Short biographies of painter and sitters

 Review In:Am Mag,14:301-3,307-10,June,'23,ill.
LC ND237.P27P4 Fogg,v.11,p.329

705
A56
NCFA
v.97

I.B.2 - PEALE, REMBRANDT, 1778-1860

Mahey, John A.
 Lithographs by Rembrandt Peale

In:Antiques
97:236-42 Feb.,'70 illus.

 Repro.incl.:Washington,Lord byron

 Penn.Hist.Soc. Rembrandt
 Peale...Bibl.p.118

N
40.1
P352H5
NMAA

I.B.2 - PEALE, REMBRANDT, 1778-1860

Pennsylvania. Historical society
 Rembrandt Peale,1778-1860:a life in the
arts.Philadelphia,Hist.soc.of Penn.,1985
 121 p. illus.

 Incl.:Index
 Bibliography p.112-20

 Cat.for an exh.at the Hist.soc.of Penn.,
Feb.22,1985 to June 28,1985,organized by Carol
Eaton Hevner.With a biographical essay by
Lillian B.Miller

AP
1
A64
NCFA
v.1

I.B.2 - PEALE, REMBRANDT, 1778-1860

Mahey, John A.
 The studio of Rembrandt Peale

In:Am Art J
1:20-40 Fall,'69 illus.

 Incl.:List of ptgs.,drags.,prints,etc.com-
prising the contents of R.P.'s studio at the
time of his death.

 Penn.Hist.Soc. Rembrandt
 Peale...Bibl.,p.118

N
40.1
P354.R2
NCFA
npg

I.B.2 - PEALE, SARAH MIRIAM, 1800-1885

Baltimore. Municipal Museum
 Miss Sarah Miriam Peale,1800-1885;por-
traits and still life,by Wilbur H Hunter and
John Mahey.Exh.,Feb.5-March 26,1967,the Peale
Museum,Baltimore,Maryland.(Baltimore,1967.
 36 p. illus.

LC ND237.P32B3 Chico.2 Amer.firsts
 In:Md.Hist.Mag.71:349
 Fall,'76 AP1.M39 NPG

AP
1
M39
NPG

I.B.2 - PEALE, SARAH MIRIAM, 1800-1885

Chico, Beverly Berghaus
　　Two American firsts:Sarah Peale,portrait
painter,and John Neal,critic

In:Md.Hist.Mag.
71:349-59　Fall,'76　illus.

　　'Sarah Miriam Peale,first American profes-
sional woman portrait painter.'

　　　　　　Penn.Hist.Soc.,Rembrandt
　　　　　　Peale...Bibl.117

N
40.1
P35W3
NCFA
NPG

I.B.2 - PEALE FAMILY

Washington County Museum of Fine Arts. Hagers-
　town,Md.
　　The Peale heritage,1763-1963;an exh.Sept.15-
Oct.30,1963.Hagerstown,Md.,c.1963.
　　66 p.　illus.

　　Foreword & cat.compilation by Chs.Coleman
Sellers

　　　　　　Simmons qN40.1P748S5 NCFA
　　　　　　Bbl. p.20

N
40.1
P354K5
NMAA

I.B.2 - PEALE, SARAH MIRIAM, 1800-1885

King, Joan
　　Sarah M.Peale,America 's first woman artist.
Brookline Village,MA,Branden Publ.Co.,c.1987
　　296 p.　illus.

　　'This is a work of fiction...drawn from a stu-
dy of the...Peale family'-Introduction.

N
40.1
D985T5
NMAA

I.B.2 - PEALE FAMILY

Whitney Museum of American Art, New York
　　Three American families.A tradition of ar-
tistic pursuit.Exh.at Philip Morris,Sept.8-
Oct.26,1983
　　unpaged　illus.

　　Ptgs.by the families of Duyckinck,Peale,
and Weir
　　31 works shown

N
40.1
P35D4
NPG

I.B.2 - PEALE FAMILY

Detroit. Institute of Arts
　　The Peale family;three generations of Ame-
rican artists.,Exh.,organized by Chs.H.Elam.
,Detroit,Detroit Inst.of Arts,1967
　　150 p.　illus(part col.)

　　"Sponsored by Founders Soc.Detroit Inst.of
Arts & Munson-Williams-Proctor Inst.,Utica,N.Y."
　　Exh.in Detroit,Jan.18-Mar.5,1967 and in
Utica,Mar.28-May 7,1967
　　Cat.by Chs.H.Elam;articles by C.C.Sellers,
E.G.Paine,& E.H.Dwight　　cont'd on next card
　　Bibliography
　　Index of si:　　ers　　Simmons:Chs.P.Polk
　　　　　　qN40.1.P748S5 Bibl.p.20

705
A784
NCFA

I.B.2 - PEARLSTEIN, PHILIP, 1924-

Herrera, Hayden
　　Pearlstein:Portraits at face value.

In:Art in Am
63:46-7　Jan.-Feb.,'75　illus(part col.)

N
40.1
P35M3
NCFA

I.B.2 - PEALE FAMILY

Maryland Historical Society
　　Four generations of commissions:The Peale
coll.of the Maryland Historical Society.Exh.
3 Mar-29 June 1975.By Eugenia Calvert Holland
,et al.,Baltimore,Md.,Maryland Hist.Soc.,1975
　　187 p.　illus.

　　126 works shown
　　Bibliography
　　Incl.:ptgs.,drags.,miniatures...,silhouettes
by 11 Peale artists

　　　　　　Rila Z5937.R105 NCFA
　　　　　　II/1 1976 *1978

I.B.2 - PECCHIAI, PIO

I Ritratti dei benefattori dell'Ospedale Maggio-
re di Milano(secoli 15-20)illustrati da Pio
Pecchiai;con introduzione di Corrado Ricci.
Milano,Pizzi & Pizio,1927
　　24 p.　illus(part col.)

London,Wellcome Inst.

708.1
N52
NCFA

I.B.2 - PEALE FAMILY

Sellers, Charles Coleman, 1903-
　　Charles Willson Peale's portraits of
Washington

In:Met Mus Bul
9:147-55　Feb.,'51　illus.

　　P.ptd.7 life portrs.of W. & many replicas.
Portrs.of W.by the Peale family

　　　　　　Simmons.qN40.1.P748S5 NCFA
　　　　　　Bibl. p.20

705
A56
NCFA
v.108

I.B.2 - PECK, SHELDON, 1797-1868

Balazs, Marianne E
　　Sheldon Peck

In:Antiques
108:273-84　Aug.,'75　illus(part col.)

　　Sheldon Peck exh.at Whitney Mus.of American
Art,N.Y.,Aug.0-Oct.5,1975;Abby Aldrich Rocke-
feller Folk Art coll.,Williamsburg,Va.,Oct.12-
Dec.1,1975;etc.

　　　　　　Woodward,Amer.folk ptg.
　　　　　　ND207.W66X NPG p.14

AP
1
A51A64
NCFA
v.11

I.B.2 - PECKHAM, DEACON ROBERT, 1785-1677

Johnson, Dale T.
 Deacon Robert Peckham:"Delineator of the
'Human Face Divine' "

In:Am.Art J.
11:27-36 Jan.,'79 illus.

705
A6
NCFA
v.57

I.B.2 - PELLATT, APSLEY, 1791-1863

Hughes, George Bernard, 1896-
 Crystallo Ceramie.Illustrated examples at
Buckingham Palace

In:Apollo
57:183-5 June,'53 illus.

 Repro.incl.:Cameos of Queen Victoria.King
Geo.III,by Apsley Pellatt.Princess Charlotte.
King Geo.IV,by Apsley Pellatt.Fred.,Duke of
York,King Geo.IV by Apsley Pellatt.

 Technique of Sulphide cameos embedded
in glass

705
A56
NCFA
v.52

I.B.2 - PELHAM, PETER, 1697-1751

Allison, Anne
 Peter Pelham-engraver in mezzotinte

In:Antiques
52:441-3 Dec.,'47 illus.

705
C75
v.67
NCFA

I.B.2 - PELLATT, APSLEY, 1791-1863

Way, Herbert W.L.
 Apsley Pellatt's glass cameos in the col-
lection of Mrs.Applewhaite-Abbott

In:Connoisseur
67:3-10 Sept.,1923 illus.

 Repro.incl.:cameo portrs.of Nelson,Welling-
ton,George IV,Rbt.Burns,Shakespeare,George III,
Queen Charlotte,etc.
 Apsley Pellatt,1791-1863,Brit.glass manufac
turer.His process:Crystallo ceramie

AP
1
A625
NMAA
v.5-6

I.B.2 - PELHAM, PETER, 1697-1751

Thorpe, Russell Walton
 Peter Pelham,founder of the arts of paint-
ing and engraving in America

In:Antiquarian
5-6:22-5 Aug.,'25 illus.

 Incl.:list of P.'s American mezzotints

 '...the 1st American mezzotinto artist...
of exquisite quality...'

 Moor.Art of Rbt.Feke N.O.]
 P312Y8 197Ca NMAA Bibl.
 p.XXXV

AP
1
A64
NCFA
v.103

I.B.2 - PELLEGRINI, CARLO, 1839-1889

Harris, Eileen
 Carlos Pellegrini:Man and 'Ape'

In:Apollo
103:53-7 Jan.,1976 illus.

 'Ape' sobriquet under which Pellegrini was
known

 Ormond.Vanity Fair qN01L78
 V3&D75I,p.13,footnote 10

I.B.2 - PELHAM, PETER, 1697-1751

Whitmore, William Henry, 1836-1900
 Notes concerning Peter Pelham,the earliest
artist resident in New England and his succes-
sors prior to the Revolution.Cambridge,Press
of J.Wilson & son,1867
 31 p.

 Repr.with additions fr.the Proc.of the Mass
hist.soc,1866-67

LC N6515.W5 Dresser.Backgr.of Col.Amer.
 portraiture ND1311.1.D77
 NPG p.19

AP.
1
A51A64
NMAA
v.18

I.B.2 - PENDLETON,WILLIAM S., 1795-1879

Bumgardner, Georgia Brady
 Political portraiture:Two prints of Andrew
Jackson

In:Am Art J
18,no.4:84-95 1986 illus.

 Engr.by Js.Barton Longacre in 1828.
'The motives behind its' publications were politi
cal'.-Lithograph by the Pendleton firm,1832,
'created in the context of political events'.

705
C75
NCFA
v.62

I.B.2 - PELLATT, APSLEY, 1791-1863

Way, Herbert W.L.
 Apsley Pellatt's glass cameos

In:Connoisseur
62:78-82 Feb,1922 illus.

 Portraits:George IV,Louis XVIII,Prince Leopold
Princess Charlotte,Fred.William III,Shakespeare
 Apsley Pellatt,1791-1863,Brit.glass manufac-
turer.His process:Crystallo ceramie

705
A56
NMAA
v.120

I.B.2 - PENNIMAN, JOHN RITTO, 1782-1841

Andrews, Carol Damon
 John Ritto Penniman(1782-1841),an ingenious
New England artist

In:Antiques
120:147-70 July,'81 illus(part col.)

 Incl.list of Penniman's works

 '...his recently dicovered oil portrs.reveal
that he was a talented portraitist...'.-Andrews

705
A56
NMAA
v.126

I.B.2 - PERKINS, SARAH, 1771-1831

Heslip, Colleen Cowles and Kellogg, Helen
 The Beardsley Limner identified as
Sarah Perkins

In:Antiques
126:548-65 Sept.,'84 illus(part col.)

708.1
P31
NMAA
v.83

I.B.2 - PETITOT, JEAN, 1607-1691

Grace, Priscilla
 A celebrated miniature of the Comtesse
d'Olonne

In:Phila.Mus.Art B.
83,no.353:3-21 Fall,'86 illus(part col.)

 Comtesse d'Olonne,as Diana by Jean Petitot

 Incl.repr.of several miniatures by Petitot

I.B.2 - PERRÉAL, JEAN, c.1455-1530

Goldblatt, Maurice H.
 Jean Perréal. Thirty portraits identified

In:Connoisseur
123:3-9 & 94-8 1949 illus. .

 Ptgs.,drgs,miniatures
 Incl.:Louis XI,Charles VIII, Louis XII,
Francis I, Henry VII (Tudor),Mary Tudor,etc.

LC N1.C75 Rep.,1948-49#6964

I.B.2 - PETITOT, JEAN, 1607-1691

Paris. Musée national du Louvre. Dpt.des
 peintures, des dessins et de la chalcographie
 Les émaux de Petitot du Musée impérial du
Louvre;portraits de personnages historiques
et de femmes célèbres du siècle de Louis XIV,
gravés au burin par M.L.Ceroni.Paris,Blaisot,
1862-64
 2 v. illus.

 1st part:Jean Petitot(1607-1691)by Henri
Bordier,31 p.,illus.
 Petitot was assisted in his miniature ptg.
by his brother- in-law,Jacques Bordier
NN CtY MB MdBWA,etc.

I.B.2 - PERRONEAU, JEAN-BAPTISTE, 1715-1783

Vaillat, Léandre, 1878-
 J.-B.Perronneau,sa vie et son oeuvre;par
L.V.et Paul Ratouis de Limay.2.éd.rev.et augm.
Paris,G.van Oest,1923
 253 p. illus. (Bibliothèque de l'art
du 18e siècle)

LC(ND553.P43V3 1923) Smart.Life & art of A.Ram-
 say N40.1R17356 NCFA
 Bibl.p.204

I.B.2 - PETITOT, JEAN , 1607-1691

Stroehlin, Ernest, 1844-
 Jean Petitot et Jacques Bordier,deux artistes
huguenots du 17e siècle.Genève,Kündig,1905
 284 p. illus.

N
40.1
P475B6
NPG

I.B.2 - PETERSEN, CHRISTIAN, 1885-1961

Bliss, Patricia Lounsbury
 Christian Petersen remembered.1st ed.
Ames,Iowa State University Press,1986
 217 p. illus.

 Incl.Index
 Bibliography,p.208-11

 'Christian was a superb portraitist-probab-
ly one of the best in America.'-Charlotte
Petersen.
 Full-length sculpture,Busts,Reliefs,Medal-
lions,Plaques.

I.B.2 - PEVETZ, GEORG, 1893-

Pevetz, Georg, 1893-
 Das zeitgenössische selbst-portrüt

In:Kunstwanderer
Het :3-5 May,1933 illus.
100.53
K967 Incl:Rembrandt,Hen(bust),Harta,Pevetz

 Rep.,1933#149

705
G28
NCFA
v.22

I.B.2 - PETITOT, JEAN, 1607-1691

Bordier, Henri [Leonard,1817-1888]
 Les émaux de Petitot en Angleterre

In:Gaz Beaux Arts
22:168-79 1867 1 illus.

 Phila.M.of art Bul.83:19
 note 2

705
A784
v.48
NCFA

I.B.2 - PHILLIPS, AMMI, 1788-1865

Holdridge, Barbara and Larry
 Ammi Phillips

In:Art in Am
48,no.2:59-103 1960 illus.

 The Kent Limner identified as Ammi Phillips

 Holdridge.Ammi Phillips
 In:Antique,86:558

705
A56
NCFA
v.80

I.B.2 - PHILLIPS, AMMI, 1788-1865

Holdridge, Barbara and Larry
 Ammi Phillips, limner extraordinary

In:Antiques
80:558-62 Dec.,'61 illus(part col.)

 List of portrs.
 "The Border Limner & the Kent Limner...iden.
tified as,Ammi Phillips"

 Black.Drawn by I.Bradley..
)In:Antiques,90:502 1966

AP
1
C76
NPG
v.31

I.B.2 - PHILLIPS, AMMI, 1788-1865

Warren, William Lamson
 Ammi Phillips, a critique

In:Conn.Hist.Soc.B.
31,no.1:1-18 Jan.,'66 illus.

 Pertains to exh.at Conn.Hist.Soc.,1965
 Cat.in v.30,no.4,Oct.,'65

 Phillips,Ammi N40.1P558H7
)Bibl.

AP
1
C76
NPG

I.B.2 - PHILLIPS, AMMI, 1788-1865

Holdridge, Barbara and Larry
 Ammi Phillips, 1788-1865

In:Conn Hist Soc B.
30,no.4:97-105 Oct.,'65 illus.

 Bibliography
 Checklist of ptgs.,p.106-24
 Illus.frontisp.& verso,p.125-45

 Centennial exh.of ptgs.at the Conn Hist.Soc.
Nov.1,'65-Feb.1,'66)

AP
1
A784
J8
NCFA

I.B.2 - PHILLIPS, THOMAS, 1770-1845

Hodgson, John,F.van,
 The Royal Academy of the present century,
by J.E.Hodgson and Fred A.Eaton

In:Art J.
:243-7 1895 illus.

 Thomas Phillips,R.A.,p.245-6

705
A56
NMAA
v.122

I.B.2 - PHILLIPS, AMMI, 1788-1865

Jones, Leigh Rehner & Shirley A.Mearns
 Seven portraits attributed to Ammi Phillips

In:Antiques
122:548-51 Sept.,'82 illus.

 Article has been adapted fr.the cat.to"Ammi
Phillips and Company,popular taste.in face ptg.'
an exh. on view at the Senate House State Histo-
ric Site,Kingston,N.Y.
 Repro.incl.:Engr.after a photograph by Ma-
thew B.Brady

705
A7832
NCFA
v.57

I.B.2 - PICABIA, FRANCIS, 1879-1953

Homer, William Innes
 Picabia's 'Jeune fille américaine dans l'é-
tat de nudité'and her friends

In:Art Bull.
57:110-5 Mar.,'75 illus.

 Col.Uni.Dpt.Art Hist.,Mo-
 dern portrs.N7592.6.C72
 NPG, p.127

N
40.1
P558H7
NPG
NCFA

I.B 2 - PHILLIPS, AMMI, 1788-1865

Phillips, Ammi, 1788-1865
 Ammi Phillips:portrait painter,1788-1865.
Intro.by Mary Black.by Barbara C.& Lawrence
B.Holdridge.New York,C.N.Potter for the Mus.of
American Folk Art;distr.by Crown Publishers.1969
 56 p. illus(part col.)

 Exhib.at Mus.of Amer.Folk Art, New York,Oct.
14-Dec.1,1968 & at Albany Inst.of Hist.& Art,
Dec.9,1968-Jan.7,1969
 Bibliography

LC ND237.P47A6) Folk art in America NK80?
 F64x NCF/ Bibl.

705
G28
NCFA
v.35

I.B.2 - PICOT DE LIMOELAN OF CLORIVIÈRE,
 ,JOSEPH-PIERRE, 1768-1826

Rutledge, Anna Wells
 A French priest,painter and architect in
the United States:Joseph-Pierre Picot de
Limoëlan de Clorivière

In:Gaz Beaux Arts
33:159-76 March,'48 illus.

 Incl:List of Clorivière's miniatures
 Biography.Appendix refers to his miniatures

 Carolina Art ass.,Charles-
 ton,S.C.Miniature portr.co
 Bibl.p.179

N
40.1
P558P6
NPG

I.B.2 - PHILLIPS, AMMI, 1788-1865

Piwonka, Ruth and Roderic H.Blackburn
 Ammi Phillips in Columbia County.A cat.of an
exh.of portraits done in Columbia County by
Ammi Phillips(1788-1865).Kinderhook,N.Y.,The
Columbia County Hist.Soc.,1977.
 42 p. illus.

 Bibliography

 Exh.Aug.15-Sept.30,1975

N
40.1
F811.8
E 1930
NMAA

I.B.2 - PIERO DELLA FRANCESCA, 1416?-1492

Longhi, Roberto, 1890-
 Piero della Francesca...London,N.Y.,F.Warne
& Co.,ltd.,1930.
 176 p. illus.

 Bibliography,p.143-53
 see pp.100ff for a discussion of the profile
portraits in Italy in the 15th c.

 Lipman.The Florentine pro-
 file portr.In:Art Bul.18:
 63,footnote 13

ND
1311.9
S48C9s
NPG

I.B.2 - PIERPONT LIMNER, early 18th c.

Curran, Ona
 Schenectady ancestral portraits early 18th
century

In:Schenectady Co.Hist.Soc.B.
10,no.1 Sept.'66

 Based on Curran's Master Thesis,N.Y.State
Univ.College,Oneonta,N.Y.
 Incl.:Van Epps Limner,Veeder Limner,Schuyler
Limner,Pierpont Limner,Gansevoort Limner,
Hudson Valley Patroon Painters,except Pier-
pont Limner Feigenbaum.Amer.portrs...

NN ND1311.2.F29 NPG Bibl.p.142

705
A56
NMAA
v.120

I.B.2 - PINE, ROBERT EDGE, 1730?-1788

Stewart, Robert G.
 Robert Edge Pine in America,1784-1788

In:Antiques
120:1164-69(71) Nov.,'81 illus(col.)

AP
1
C76
NPG
v.21-25

I.B.2 - PIERPONT LIMNER, early 18th c.

Warren, William Lamson
 The Pierpont Limner and some of his con-
temporaries

In:Conn.Hist.Soc.B.
23:97-128 Oct.,'58 illus.

 Pertains to exh.,Fall;58 at the Conn.Hist.
Soc.. Catalogue p.113-9

 A critical study of a group of portrs.,
painted 1710-15 in New England

705
C75
NCFA
v.137

I.B.2 - PINTO BASTO,JOSÉ FERREIRA, 1774-1839

Pinto, Augusto Cardoso
 Portuguese glass cameos

In:Connoisseur
137:32-4 Mar,1956 illus.

 19th c.moulded cut glass with incrustations.
Also pressed glass plates with incrusted medals.
José F.Pinto Basto,1774-1839,founder of factory:
Fábrica Vista Alegre in 1824

NGA
N3540
A2 v.488

I.B.2 - PILO, CARL GUSTAF, 1711-1793

Stockholm. National Museum
 Carl Gustaf Pilo i Danmark.Utstallning i
Nationalmuseum,1985.inledning Bo G.Wennberg;
katalogtext Lars Rostrup Boyesen.Oversättning
och katalogredaktion Ulf G.Johnsson..Uddeval-
la,Risbergs Tryckeri.1985.
 94 p. illus(part col.) (Nationalmusei
utställningskatalog no.488)

AP
1
A64
NCFA
v.102

I.B.2 - PISTRUCCI, BENEDETTO, 1784-1855

Avery, Charles
 Neo-classical portraits by Pistrucci and
Rauch

In:Apollo
102:36-43 July,'75 illus.

FOR COMPLETE ENTRY
SEE MAIN CARD

I.B.2 - PINE, ROBERT EDGE, 1730?-1788
Philadelphia. Independence Hall
 Descriptive cat.of pictures painted by
Robert Edge Pine.Printed by Francis Bailey,1784
 6 p.

 List of 27 ptgs.

Library Company of Phila. Stewart.Rbt.Edge Pine...
 Cat.of exh.NPG Appendix,A1.
so note 7 in Antiques,120:

AP
1
N277
NCFA
v.24

I.B.2 - PLATT, ELEANOR, 1910-1974

Tarby-Derujinsky, Natalie
 Eleanor Platt...Portraits of fame and dis-
tinction

In:Nat.Sculp.R.
24:20-1,26-7 Spring,'75 illus.

NPG

I.B.2 - PINE, Robert Edge, 1730?-1788

Stewart, Robert G.
 Robert Edge Pine,a British portrait painter
in America,1784-1788.Cat.of an exh.at the Na-
tional Portrait Gallery.Washington,D.C.Nov.1,
1979-Jan.6,1980.Wash.,D.C.,publ.for NPG by
Smiths.Inst.Press,1979
 126 p. illus.

 Bibliography

 Foreword by Marvin Sadik

LC ND1329.P47A4 1979

I.B.2 - PLEYDENWURFF, WILHELM, died 1494

Schedel, Hartmann, 1440-1514
 Nuremberg chronicle.German.
 Das buch der Chroniken unnd geschichten mit
figuren und pildnissen von Anbeginn der Welt
biss auff onsere Zeyt.Cuts.Fol. 2nd ed.,Augsburg,
1496
 Innumerable stylized representations of...&
people by M.Wohlgemut & W.Pleydenwurff

WGA 1st ed. Nürnberg,1493 in Latin
FOGG
XPA5767
788.210
DWP-Facsimile ed.:1967.093 (3315 Prinz.Slg.d.selbst-
MET Print dpt " " " bildn.N7618/P95
279.1/Schl/ Bd.1,p.20

B
.P72W7

I.B.2 - PLIMER, ANDREW, 1763-1837

Williamson, George Charles, 1858-1942
Andrew and Nathaniel Plimer,miniature paint-
ers...London,G.Bell & sons,1903

LC ND1337.O8P5

FOR COMPLETE ENTRY
SEE MAIN CARD

AP
1
B19
NMAA

I.B.2 - POLK, CHARLES PEALE, 1767-1822

Johnston, William R.
Charles Peale Polk:a Baltimore portraitist

In:Balto.M.A.Annual III
3:33-37 1968 illus.

Simmons,L.C. Chs.Peale Polk
qN40.1.P74855 NCFA
.ibl.p.20

B
.P72W7

I.B.2 - PLIMER, NATHANIEL, 1757-1822?

Williamson, George Charles, 1858-1942
Andrew and Nathaniel Plimer,miniature paint-
ers...London,G.Bell & sons,1903

LC ND1337.O8P5

FOR COMPLETE ENTRY
SEE MAIN CARD

qN
40.1
P74855
NCFA

I.B.2 - POLK, CHARLES PEALE, 1767-1822

Simmons, Linda Crocker
Charles Peale Polk,1767-1822.A limner and
his likenesses...Washington,D.C.Corcoran Galle-
ry of Art,1981
92 p. illus(part col.)

Cat.of exh.at the Corcoran Gallery of Art,
July 18-Sept.6,1981,and at four other museums,
Sept.27,1981-Oct.15,1982

Incl.Bibl.references & index
Alphabetical list of sitters

N
40.1
P73x
W2
NPG

I.B.2 - PLUNKET, JEAN REASONER, 1923-

Plunket, Jean Reasoner, 1923-
Faces that won't sit still...Washington,D.C.
Acropolis books,1978

FOR COMPLETE ENTRY
SEE MAIN CARD

I.B.2 - POLLARD LIMNER

Comstock, Helen
Portraits of American craftsmen

In:Antiques
76:320-7 Oct.,'59 illus.

Incl.Chronological table of American artistic
works of artisans compared with those on the con-
tinent,from 1725-1825
Incl.:Pollard Limner,John Smibert,Nathaniel
Smibert,Copley,Chs.W.Peale,Ralph Earl,Sarah Good-
ridge,Mather Brown,G.Stuart,Benj.Blyth,Ths.Sully,
John Neagle,J.W.Jarvis,Ezra Ames
Rep.1959 #977

AP
1
J8643
NCFA
v.3

I.B.2 - POLK, CHARLES PEALE, 1767-1822

Batson, Whaley
Charles Peale Polk:gold profiles on glass

In:J.early S.dec.arts
3:51-7 Nov.,'77 illus.

Verre églomisé

Simmons.Chs.P.Polk N40.1
P74855 NCFA Bibl.p.20

705
.P784
NCFA

I.B.2 - PONTORMO, JACOPO, 1494-1557

Steinberg, Leo, 1920-
Pontormo's Alessandro de'Medici,or,I only
have eyes for you

In:Art in Am
63:62-5 Jan.-Feb.,'75 illus.

Hypothesis that Pontormo's portr.of the
duke,drawing a lady,was used as a gift of devo-
tion;in contrast to political representation
for propaganda purposes

AP
1
A(area)

I.B.2 - POLK, CHARLES PEALE, 1767-1822

Bolton, Theodore, 1889- and H.L.binsse
The Peale portraits of Washington

In:Antiquarian
16:24-7,58,60,62,64 Feb.,'31 illus(part col

Miniatures, physionotrace
Incl.cat.,comp.from rs.copy of C.W.Peale's
diary for the years 1775-1778 and part of 1788.
Description & notes on the life portrs.of W
by members of the Peale family
C.P.Polk copied many C.W.Peale portrs.of
«1767

Arts in Am.qZ5561
USA77X NCFA Ref. H7??

705
C75
NCFA
v.55

I.B.2 - POPE, ALEXANDER, 1763-1835

Séo, Robert René Meyer
Alexander Pope(1763-1835)

In:Connoisseur
55:131-38 Nov.,'15 illus(part col.)

AP
1
B87
NCFA
v.8

I.B.2 - POPE, ALEXANDER, 1849-1924

Hoopes, Donelson F.
 Alexander Pope, painter of "characteristic
pieces"

In:Brooklyn Mus Ann
8:129-46 1966-67 (illus.of still lifes only)

 '...prospered;also.as portr.ptr.'e.g.the
equestrian portr.of General Pershing.-Hoopes,
p.134 f
 'After 1912 P.was chiefly a portr.ptr.'-
Fielding.Dict.of Amer.ptrs.etc.

 Arts in Am.qZ5961.U5A77X
 NCFA Ref. I1210

705
M19
NCFA
In v.1897

I.B.2 - PRAGA, ALFRED, 1867-1949

Praga, Alfred, 1867-1949
 The renaissance of miniature painting

In:Mag Art
:87-9 Dec.,1896 illus.

I.B.2 - POPELIN-DUCARRE, CLAUDIUS MARCEL, 1825-
 -1892
Falize, Lucien, 1842-1897
 ...Claudius Popelin et la renaissance des
émaux peints.Paris,Gaz.des beaux-arts,1893
 104 p. illus.

 Originally published in Gaz Beaux Arts.See:
705.028 NCFA:v.9:418-35,Apr.,'93;v.9:502-48,
June,'93;v.10:60-76,July,'93,426-37,Nov.,'93,
478-89,Dec.,'93;v.11:130-48,Feb.,'94

MJP

705
A56
NCFA
v.102

I.B.2 - PRATT, HENRY CHEEVES, 1803-1880

Hodgson, Alice Doan
 Henry Cheever Pratt

In:Antiques
102:842-7 Nov.,72 illus(part col.)

 Arts in Am.qZ5961.U5A77X
 NCFA Ref. I 1214

I.B.2 - POSCH, LEONHARD, 1750-1831
Blank, M.
 Der medailleur Leonard Posch und seine
Goethebildnisse

In:Blätter f.Münzfreunde & -forschung,Lübeck
:213-7 1941

 Rep.,1945-47#8299

AP
1
N547
NCFA
v.42

I.B.2 - PRATT, MATTHEW, 1734-1805

Hamilton, Milton Wheaton, 1901-
 A new portrait of Sir William Johnson

In:N.Y. Hist.Soc.Q.
42:317-27 Oct.,'58 illus.

 Bibl.footnotes

705
B97
NCFA
v.89

I.B.2 - POUSSIN, NICOLAS, 1594-1665

Blunt, Anthony, 1907-
 Poussin Studies I. Self-Portraits

In:Burl Mag
89:219-22,225-6 Aug.,'47 illus.

 FOR COMPLETE ENTRY
 SEE MAIN CARD

N
40.1
P914S27
NPAA

I.B.2 - PRATT, MATTHEW, 1734-1805

Sawitzky, William, 1880-1947
 Matthew Pratt,1734-1805,a study of his work...
New York,The New York historical society in
cooperation with the Carnegie corporation of
New York,1942
 103 p. illus. (His Studies in early Ame-
rican portraiture. I)

LC ND237.P83S3

 Whitehill.The Arts in early
 Amer.Hist. Z5935.W59 NPG
 Bibl.,p.93

ND
1311.2
P61x
NPG

I.B.2 - POWERS, ASAHEL L., 1813-1843
 Little, Nina Fletcher, 1903-
 Asahel Powers,painter of Vermont faces
Miles, Ellen Cross comp.
 Portrait painting in America.The nineteenth
century.N.Y....,1977 (card 3)

 Partial contents cont'd:...N.F.Little,Asahel
Powers,ptr.of Vt.faces,p.140-7;...

I.B.2 - PRELLER, FRIEDRICH, 1804-1878

Rademacher, Frans
 Goethe's letztes bildnis. Krefeld,Scherpe
Verlag,1949

 52 p. illus.

 Drawing by Friedrich Preller

LC PT2143.P8R3

705
A56
NCFA
v.24

I.B.2 - PRÉVOST, BÉNOIT LOUIS, 1735-1804

Donnell, Edna Bowden, 1891-
 Portraits of eminent Americans after draw-
ings by Du Simitière

In:Antiques
24:17-21 July,1933 illus.

 Repro.incl:Washington on ceramics;enamel
cloak hooks;printed cotton with portr.medal-
lions derived fr. engravings after Du Simitière
 Incl.list of Prévost's,Reading's & P.P.
Ellis' engravings.

I.B.2 - PRIOR, MARNA
 see
I.B.2 - CHRISTY, MARGARET ARLINGTON (MARNA PRIOR

ND
236
L76
NPG

I.B.2 - PRIOR, WILLIAM MATTHEW, 1806-1873

Lipman, Mrs.Jean Herzberg, 1909- comp.
 Primitive painters in America...1950. (card

Contents-cont.-17.M.E.Jacobson, O.Krans

List of primitive painters
 10.N.F.Little, W.M.Prior

LC ND236.L76

705
A56
NCFA
v.53

I.B.2 - PRIOR, WILLIAM MATTHEW, 1806-1873

Little, Nina Fletcher, 1903-
 William M.Prior,traveling artist and his
in-laws,the painting Hamblens

In:Antiques
53:44-8 Jan.,'48 illus.

 Colonial Williamsburg,inc
 The Abby Aldrich Rockefell
 Folk Art coll.N6510.C71 NC
 Bibl.p.394

705
A56
NCFA
v.26

I.B.2 - PRIOR, WILLIAM MATTHEW, 1806-1873

Lyman, Grace Adams
 William M.Prior,The "Painting Garret"
artist

In:Antiques
26:180 Nov.,'34 illus.

 Portrs.on glass

 Abby Aldrich Rockefeller
 Folk Art Ctr.Am.folk portr
 N7593.A23 NMAA Bibl.p.294

I.B.2 - QUENEDEY, EDME, 1756-1830

Hennequin, René
 Avant les photographies;les portraits au
physionotrace,gravés de 1788 à 1830.Cat.nomina-
tif,biographique et critique illustré des deux
premières séries de ses portraits comprenant les
1800 estampes cotées de "1"à"R27".Troyes,J.L.
Paton,1932
 345 p. illus.
 Contents.-La société parisienne à la veille
de la Révolution;portrs.dess.par Quenedey et gra-
vés par Chrétien,1788-1789.-Au temps de la Révo-
lution ...portrs.dess.et gravés par Quenedey,
1789-1796
C NE270.H4

I.B.2 - QUENEDEY, EDME, 1756-1830

Hennequin, René, 1869-
 Un "photographe"de l'époque de la Révolution
et de l'Empire,Edme Quenedey des Riceys(Aube),
portraitiste au physionotrace.Troyes,J.L.Paton,
1926
 170 p. illus.

FOGG
FA
6553.7

 At head of title:Société académique d'agri-
culture,des sciences,arts et belles lettres du
dép.de l'Aube,Troyes Nov.12,1928

MM NJP

705
C75
NCFA
v.74

I.B.2 - QUENEDEY, EDMÉ, 1756-1830

Martin, Mary
 The Physionotrace in France and America

In:Connoisseur
74:144-52 Mar,'26 illus.

 Repro. incl.:Apparatus for making physiono-
trace from a drawing

 G.L.Chrétien invented the physionotrace,1786
 E.Quenedey-assistant of Chrétien
 Physionotrace portrs.most valuable historical
records

I.B.2 - QUESNEL, FRANÇOIS, 1543-1619

Dimier, Louis, 1865-1943
 Histoire de la peinture de portrait en France
au 16e siècle. Paris et Bruxelles,G.van Oest
et Cie,1924-26

 3 v. illus.
 Bibliography v.3

 With catalogue of all existing works in this
genre, in drawgs.,oil ptgs.,miniatures,enamels,
tapestries & wax medallions

LC ND1316.D5 see next card

I.B.2 - QUESNEL, FRANÇOIS, 1543-1619

Dimier, Louis, 1865-1943
 Histoire
 Supplément;Douze crayons de François Quesnel,
provenant des collections Fontette.
Paris & Bruxelles,1927
 13 p. illus.

MET
186
D594

Review by G.de Gerles,In:Gaz Beaux Arts
15:311-16 ser.5 1927 illus.

705
G28
NCFA

705
I61
NCFA
v.70

I.B 2 - QUISTGAARD, JOHAN WALDEMAR VON REHLING,
1877-1962

Nelson, W.H.de B.
The Hannevig Foundation

In:Studio
70:LXXX-LXXXIV Jun,'20 illus.

Christoffer Hannevig commissioned 25 portrs.
of eminent men, the collection to be donated to
Washington as the nucleus of"a NPG!" Chrm.of art-
ists' selection comm.was J.W.v.R.Quistgaard.
Repro.:Chs.Dana Gibson by Speicher,Chs.M.
Schwab Judge Albert H.Gary by Quistgaard,Sam.
Gompers by Seyffert Cum.Mag.subj.ind.A1/3/C76
Ref. v.2,p.444 See over

AP
1
W225
v.25

I.B.2 - RAMSAY, ALLAN,1713-1784

Caw, James Lewis, 1864-1950
Allan Ramsay,portrait painter.1713-1784

In:Walpole Soc.
25:33-81 1936-37 illus.

FOR COMPLETE ENTRY
SEE MAIN CARD

I.B.2 - RAINER, ARNULF, 1929-
Hartmann, Wolfgang
"Face farces" von Arnulf Rainer

In:Rainer, Arnulf, 1929-
Der grosse bogen.Cat.of the exh.Apr.30-June 15
1977 in Bern,Kunsthalle
p.17-27 illus.

A summary of the history of physiognomy.
Psychology of the expressionism.Influences of
psychical realism & Vienna actionists on Rainer
R.seen as one of the most influential artists o
the present.Photography used by painters.

MET
185RD4
Ar7

MiDA NNMM

I.B.1.2 - RAMSAY, ALLAN, 1713-1784
Edinburgh. National Gallery of Scotland
Allan Ramsay(1713-1784)his masters and
rivals.The Nat'l Gall.of Scotland and the Arts
Council,Scottish Committee.Exh.9 Aug.-15 Sept.,
1963
47 p. illus.

Intro.& cat.by C.Thompson
Ptgs.& drawings.Also works by Hysing,Soli-
mena,Hogarth,Hudson,Reynolds,Gainsborough,etc.
Indices of artists & sitters
See also article by D.Irwin"Edinburgh"in:
Burl Mag.105:465 Oct.'63:'Allan Ramsay...'

N
40.1
R16M8
NPG
2 c.

LC ND1337.U6R3

I.B.2 - RAMAGE, JOHN, d.1802

Morgan, John Hill, 1870-1945
A sketch of the life of John Ramage,Mini-
ture painter.N.Y.,The N.Y.Historical Society,
1930
55 p. illus.

Carolina art association..
Miniature portr.coll...
p.XVI footnote 5

I.B.2 - RAMSAY, ALLAN, 1713-1784

Iveagh Bequest(Kenwood)Hampstead,Eng.
Paintings and drawings by Allan Ramsay,1713-
1784,painter-in-ordinary to George III.intro.by
Alastair Smart.London,London County Council,
c.1958
32 p. illus.

Exhibition May to September 1958

LC ND497.R23A4 1958

N
40.1
R16S5
NPG

LC ND1337.U6R37

I.B.2 - RAMAGE, JOHN, d.1802

Sherman, Frederik Fairchild, 1874-1940
John Ramage;a biographical sketch and list
of his portrait miniatures...N.Y.,Priv.print,
1929
25 p. illus.

Incl.:3 portrs.of Washington

I.B.2 - RAMSAY, ALLAN, 1713-1784

London. Royal academy of arts
Paintings and drawings by Allan Ramsay,1713-
1784.exh.,Royal Academy Diploma Gallery,1964.
London,The Academy.c.1964
62 p. illus.
Indexes.
Bibliography

Cat.by Alastair Smart

Rev.by John Hayes in Burl Mag 106:190-3,Apr.
1964
LC ND497.R23A4 1964

I.B.2 - RAMBERG, JOHANN HEINRICH, 1763-1840
Forster-Hahn, Franziska
Johann Heinrich Ramberg als karikaturist
und satiriker.Hanover,1963
235 p. illus.

"Sonderdruck aus Hann.Geschichtsblättern,n.F.
Band 17(1963)"
Thesis Bonn

Bibliography:p.223-230

LC NC1509.R3F6 1963 Noon.Engl.portr.drogs & Min
Bibl. p.145

MET
172.M39Q
v.43

PP11I InU NNC

I.B.2 - RAMSAY, ALLAN, 1713-1784

Smart, Alastair, 1922-
Allan Ramsay,1713-1784.London,Knowledge pub.
c.1967.
8 p. 4 illus.,16 col.pl. (The Masters,43)

N
40.1
R173S6
NCFA

I.B.2 - RAMSAY, ALLAN, 1713-1784

Smart, Alastair, 1922-
. The life and art of Allan Ramsay..London.
Routledge & Paul.1952.
235 p. illus.

Bibliography p.195-206

Incl.Cat.of portraits in alphabetical order
Index of collections .

LC ND497.R23S85

Noon.Engl.portr.drags.&min.
NC860.N66X NPG Bibl.p.147

705
B97
NCFA
v.113

I.B.2 - RAPHAEL, 1483-1520

Oberhuter, Konrad
Raphael and the State portrait.-II:The por-
trait of Lorenzo de' Medici

In:Burl Mag
113:436,439-40, 443 Aug.,'71 illus(part col.

Problems of state portraiture
Re-attribution fr. Bronzino to Raphael
Portrs.of royalty in 3/4 length;origin in
France,spread to Lombardy
Sitter as representative of a specific group

705
A56
NCFA
v.100

I.B.2 - RANDOLPH, BENJAMIN, 1737?-1791

Smith, Robert C.
Finial busts on 18th century Philadelphia
furniture

In:Antiques
100:900-905 Dec.,'71 illus.

Repro.incl.:B.Franklin;John Locke;John Milton;
Washington
'...study of all this furniture...could well
reveal ..resemblances linking it with the shop
of Benjamin Randolph.
Saunders.Am.colonial portr
N7593.1.S28,p.74,note 152

I.B.2 - RAPHAEL , 1483-1520

Wölfflin, Heinrich, 1864-1945
Raffaels bildnisse

In:Museum
2:

LC for Museum:
N751.M7

Waetsoldt ND1300.W12

N
40.1
R15W8
1988a
NMAA

I.B.2 - RANSOM, CAROLINE LOUISE OWENS, 1826(1838?)
-1910

Woods, Marianne Berger
Shrouded in obscurity:The life and works of
Caroline L.Ransom(1826-1910.1988
217 leaves illus.

Bibliography:leaves 213-17
Thesis(M.A.)Case Western Reserve Univ.1988

AP
1
A64
NCFA
v.102

I.B.2 - RAUCH, CHRISTIAN DANIEL, 1777-1857

Avery, Charles
Neo-classical portraits by Pistrucci and
Rauch

In:Apollo
102:36-43 July,'75 illus.

FOR COMPLETE ENTRY
SEE MAIN CARD

AP
1
A64
NCFA
v.92

I.B.2 - RAPHAEL, 1483-1520

Gould, Cecil
The Raphael portrait of Julius II;problems
of versions and variants;and a goose that turned
into a swan

In:Apollo
92:187-9 Sep.,'70 illus(part col.)

Re-emergence of the original portr.of Julius
II

Oberhuber.Raphael...In:Burl
Mag.113:124,footnote 4

705
A56
NCFA
v.31

I.B.2 - RAUSCHNER, JOHANN CHRISTOPH, 1760-after
1810

Keyes, Homer Eaton, 1875-
More waxes by Rauschner

In:Antiques
31:186-7 Apr.,'37 illus.

FOR COMPLETE ENTRY
SEE MAIN CARD

705
B97
NCFA
v.113

I.B.2 - RAPHAEL, 1483-1520

Oberhuber, Konrad
Raphael and the State portrait.-I:The por-
trait of Julius II

In:Burl Mag
113:124,127-30 Mar.'71 illus.

Problems of the state portraiture.
One of the first informal portr.of the Ita-
lian Renaissance,going back to the change fr.for-
mal to informal in dedication pictures of Charle
V of France

Debs,b.From eternity to
here...In:Art in Am. 63:53c
& footnote 9

705
C75
NCFA
v.89

I.B.2 - READ, CATHERINE, 1723-1770

Manners, Lady Victoria, 1876-1933
Catherine Read and Royal patronage

In:Connoisseur
89:35-40 Jan.,'32 illus.

705
O75
NCFA
v.88
v.89

I.B.2 - READ, CATHERINE, 1723-1778

Manners, Lady Victoria, 1876-1933
 Catherine Read:The English Rosalba"

In:Connoisseur
88:37&86 Dec.,'31 illus.
89:171-8 March,'32 illus.

Archer.India & Brit.portr...
ND1327.I44A72X NPG Bibl.
p.483

ND
2200
R44 X
NPG

I.B.2 - REID, CHARLES, 1937-

Reid, Charles, 1937-
 Portrait painting in watercolor.N.Y.,Watson-
Guptil Publications,1973.
 156 p. illus(part col.P

Bibliography

Cumulative Book Index 1974
Z1219C97 1974 NPG p.1682

705
A786
NCFA
v.24

I.B.2 - READ, WILLIAM, 1607-1679

First of colonial portraits placed

In:Art News
24,no.10:2 Dec.12,'25

 William Read,1607-1679,the earliest portr.
ptr.in the English-American colonies

FOR COMPLETE ENTRY
SEE MAIN CARD

VF

I.B.2 - REISS, WINOLD, 1886-1953

Winold Reiss:Plains portraits
 =Cat.of.exh. at N.Y.,Kennedy Gall.,Inc.,
Oct.4-Oct.28,1972
 9 p. text 23 p. illus(part col.)

 Incl.:articles by John C.Ewers and by Rudolf
G.Wunderlich

 40 works shown

705
A56
NCFA
v.24

I.B.2 - READING, BURNET, fl.1780-1820

Donnell, Edna Bowden, 1891-
 Portraits of eminent Americans after draw-
ings by Du Simitière

In:Antiques
24:17-21 July,1933 illus.

 Repro.incl:Washington on ceramics;enamel
cloak hooks;printed cotton with portr.medal-
lions derived fr. engravings after Du Simitière
 Incl.list of Prévost's,Reading's & B.B.
Ellis' engravings.

I.B.2 - REMBRANDT HERMANSZOON VAN RIJN,1606-1669

Erpel, Frits
 Die Selbstbildnisse Rembrandts.Berlin,
Henschelverlag,1967
 233 p. illus.

C ND653.R4E7

Daughety.Self-portrs.of
P.Rubens.mfal61 NPG
Bibl.p.361

I.B.2 - READING, BURNET, fl.1780-1820
 (Th.-B. and LC:fl.1780-1822)

Du Simitière, Pierre Eugène, ca.1736-1784
 Thirteen portraits of American legislators,
patriots,and soldiers,who distinguished them-
selves in rendering their country independent;
...drawn from the life by Du Simitière...and en-
graved by Mr.B.Reading.London,W.Richardson
=1783=
 13 plates

 Incl.:Washington, John Jay

MB NjP MH CtY MiU-C Winterthur Mus.Libr. Z881
 PPL W78 NCFA v.6 p.22?

AP
1
A64
NCFA

I.B.2 - RENALDI, FRANCESCO, 1755- (fl.1777-98)

Archer, Mildred
 Renaldi and India.A romantic encounter

In:Apollo
104:98-105 Aug.,'76 illus.

Rila III/2 1977 #4983

I.B.2 - REASONER, JEAN
 see
I.B.2 - PLUNKET, JEAN REASONER, 1923-

I.B.2 - RENNELL, THOMAS
 see
I.B.2 - REYNELL, THOMAS, 1716-1788

I.B.2 - REVERDY, Georges, fl.1531-c.1570

Rouillé, Guillaume, 1518?-1589
...La première,-la seconde,partie du promptvaire des medalles des plus renommées personnes qui ont esté depuis le commencement du monde...
send with king Henry II.Lyon,G.Roville,1553
2v.in 1 illus.

Title:Promptvaire des medalles
For revision see Keller, Diethelm
Dedication v.2...signed:Charles Fontaine

Over 600 illus.by Georges Reverdy
LC SJ5569.R74
LC has also Italian ed.SJ556 .R7 For source see over

I.B.2 - REYNOLDS, Sir JOSHUA, 1723-1792

Graves, Algernon
- A history of the works of Sir Joshua Reynolds,P.R.A. by A.Graves and William Vine Cronin...London,Pub.by subscription for the proprietors by H.Graves & co.,ltd.,1899-1901
4 v. illus.

LC ND497.R4075 Noon.Engl.portr.drags.&min.
NC860.N66X NPG Bibl. p.145

I.B.2 - REVERE, PAUL, 1735-1818

Hart, Charles Henry, 1847-1918
Paul Revere's portrait of Washington
4 p.

Reprinted from the proc.of the Mass.hist.
soc,Dec.,1903.Boston,1903.

LC E312.43.H328 Weddell.A mem'l vol.of Va.
hist.portraiture.757.9.W3b
NCFA Bibl. p.435

705
C75
NCFA
v.194

I.B.2 - REYNOLDS, SIR JOSHUA, 1723-1792

Mannings, David Michael
Reynolds' portraits of the Stanley Family

In:Connoisseur
194:85-9 Feb.,'77 illus(1 col.)

4 Kit-cat portrs.,based on v.Dyck & with motifs derived fr.Brit.16-17th c. portraiture

Rila III/2 1977 #4984

W
40.1
H87P
I S
NPC

I.B.2 - REYNELL, THOMAS, 1716-1788

Iveagh Bequest, Hampstead,Eng.
Thomas Hudson,1701-1778;portrait painter and collector;a bicentenary exh..held.6 July to 30 Sept.,1979.at.Iveagh Bequest.London,Greater London Council,1979
.88.p. illus.

Exh.selected and intro.written by Ellen G.
Miles
Cat.nos.1-66:Hudsons' work;nos.67-78:Hudson's collection

705
B97
NCFA
v.117

I.B.2 - REYNOLDS, SIR JOSHUA, 1723-1792

Mannings, David
The sources and development of Reynolds's pre-Italian style

In:Burl.Mag.
117:212,15,16,19-22 Apr.,'75 illus.

Examines R.'s portrs.of the 1740's & seeks to define the chief phases of the artist's early development
Repr.incl.:Self-portrs.of Reynolds,Hogarth, Soldi
Rila II/1 1976 #1500

qN
40.1
R465yW6
NPG

I.B.2 - REYNOLDS, SAMUEL WILLIAM, 1773-1835

Whitman, Alfred, 1860-1910
...Samuel William Reynolds,...London,G.Bell & sons,1903.
167 p. illus. (Nineteenth century mezsotinters)

29 illustrations
Contents:...Cat.of portrs.p.21-94...
Samuel William Reynolds,jr.;cat.of portrs.p.1?
140...Appendix...Cat.of portrs.by S.Wm.Reynolson.after works by Joshua Reynolds,p.150-161

LC NE642.R5W6 Levis.Descr.bibl.Z5947.A3
L66 1974 NCFA p.132

N
40.1
R463H6
NPG

I.B.2 - REYNOLDS, SIR JOSHUA, 1723-1792

Reynolds, Sir Joshua, 1723-1792
Portraits;character sketches of Oliver Goldsmith,Samuel Johnson,and David Garrick,together with other manuscripts of Reynolds discovered among the Boswell paper...1st ed..N.Y.,McGraw-Hill.1952.
197 p. illus. (The Yale editions of the private papers of James Boswell)

References to sources,p.185-90

Winterthur Mus.Libr. fZ881
.W78 NCFA v.6,p.221

qN
40.1
R465yW6
NPG

I.B.2 - REYNOLDS, SAMUEL WILLIAM, JR., 1794-
1872

Whitman, Alfred, 1860-1910
...Samuel William Reynolds,...London,G.Bell & sons,1903.
167 p. illus. (Nineteenth century mezsotinters)

29 illustrations
Contents:...Cat.of portrs.p.21-94...
Samuel William Reynolds,jr.;cat.of portrs.p.1?
140...Appendix...Cat.of portrs.by S.Wm.Reynolson.after works by Joshua Reynolds,p.150-161

LC NE642.R5W6 Levis.Descr.bibl.Z5947.A3
L66 1974 NCFA p.132

N
40.1
R463R8
NMAA

I.B.2 - REYNOLDS, SIR JOSHUA, 1723-1792

Reynolds, Joshua,Sir,1723-1792
Reynolds,ed.by Nicholas Penny;with contributions by Diana Donald...et al.N.Y.,Abrams, 1986
408 p. illus(part col.)

Cat.of an exh.held by the Royal Academy of Arts,London
Bibliography,p.394-9
Index
Incl.article by.R.Rosenblum.Reynolds in an international milieu
LC ND497.R4A4 1986

705
B97
NCFA

I.B.2 - REYNOLDS, SIR JOSHUA , 1723-1792

Steegmann, John
 Portraits of Reynolds

In:Burl Mag.
88:33-4 Feb,1942 illus.

 Incl:Selfportrs. ptgs.1773,1780;drg.1740
ptg. of Reynolds by C.F.von Breda(Swed.ptr.1759-
1818, was in London 1787-96),1791, etc.

Rep.,1942-44*780

708.2
V63

I.B.2 - RICHMOND, THOMAS, 1771-1837

Victoria and Albert museum, South Kensington
 Dept.of paintings
 Exhibition of miniatures by ... and Thomas
Richmond.May-June 1929.London,1929

MET
189En3
V66

LC(ND1337.G8E64)
CSmH OC1MA PPPM CtY

FOR COMPLETE ENTRY
SEE MAIN CARD

705
B97
NMAA
v.128

I.B.2 - REYNOLDS, SIR JOSHUA, 1723-1792

Tscherny, Nadia
 Reynolds's Streatham portraits and the art
of intimate biography

In:Burl Mag
v.128:4-11 Jan.'86 ill s.

 Discussion of the natural association be-
tween portraiture and written biography
 'The Streatham portrs.are...remarkable...
for their honesty in representing...physical
imperfections...'thus distinguished from the
iconic pictorial records of Kneller's Kit-
Cat series.

I.B.2 - RICHMOND, WILLIAM BLAKE, 1842-1921

MacColl, Dugald Sutherland, 1859-1948
 Mr.W.B.Richmond on portrait painting

In:Spectator
66:594-5 Apr.25,1891

LC AP4.S7

(19th c.)Readers' Guide to
Periodicals,AI3B39,Ref.v.2,
p.715

I.B.2 - REYNOLDS, SIR JOSHUA, 1723-1792

Whitman, Alfred, 1860-1910
 ...Samuel Cousins...London,G.Bell & sons,190
 143 p. illus. (Nineteenth century mez-
sotinters)

 Incl.Cat.of portrs.-Appendix...Cat.of the
plates after Sir Joshua Reynolds...

LC NE642.C8W6

Levis.Descr.bibl.Z5947.A3
L66 1974 NCFA p.132

I.B.2 - RICHTER, CHRISTIAN, 1678-1732

Nisser, Wilhelm, 1897-
 Michael Dahl and the contemporary Swedish
school of painting in England...Uppsala,Alm-
qvist & Wiksells,...1927
 159 p. illus.

 Inaug.-diss.-Upsala
 Literature & sources of info.

 Contents.-Michael Dahl.-Hans Hysing.-Charl-
Bolt.-Christian Richter

LC ND793.D3N5

Yale ctr.f.Brit.art Ref.
ND7864N57

qN
40.1
R465yW6
NPG

I.B.2 - REYNOLDS, SIR JOSHUA, 1723-1792

Whitman, Alfred, 1860-1910
 ...Samuel William Reynolds,...London,G.Bell
& sons,1903.
 167 p. illus. (Nineteenth century mez-
sotinters)

 29 illustrations
 Contents:...Cat.of portrs.p.21-94...
Samuel William Reynolds,jr.;cat.of portrs.p.1
140...Appendix...Cat.of portrs.by S.Wm.Reynold
sen.after works by Joshua Reynolds,p.156-161

LC NE642.R5W6

Levis.Descr.bibl.Z5947.A3
L66 1974 NCFA p.132

I.B.2 - RIFFAUT, ADOLPHE PIERRE, 1821-1859

Niel, P.O.J.
 Portraits des personnages français les plus
illustres du 16e siècle,reproduits,en facsimilé,
sur les originaux dessinés aux crayons de cou-
leur par divers artistes contemporains;recueil
publié avec notices par P.O.J.Niel...Paris,
M.A.Lenoir,1848-56
 2 v. illus(col.)

 Contents.1.sér.Rois et reines de France.Mai-
tresses des rois de France.2.sér.Personnages di-
vers
 ...facsimile ar Riffaut.'-Bouchot,p.11

LC DC35.5.N67

Bouchot.Portrs.aux crayons,p.11

705
G28
NCFA
v.29

I.B.2 - RICARD, GUSTAVE, 1823-1873

Cantinelli, Richard
 Gustave Ricard

In:Gaz Beaux Arts
29:89-103 1903 illus.

 Incl.:Ernest Hébert's homage to Gust.Ricard

F
24
A34
1987c
N:A4

I.B.2 - ROBERTS, JOHN, 1769-1803

Agreeable situations:society,commerce and art
in southern Maine,1780-1830;ed.by Laura
Fecych Sprague;essays by Joyce Butler...
et als.Kennebunk,Me.Brick Store Mus.
Boston:Distributed by Northeastern Univ.
Press,1987
 289 p. illus(part col.)
 Incl.Brewster,jr.,deaf artist,p.88,122,254
 Cat.of selected objects from the Brick
Store Mus.et al
 Index
 Bibliography

I.B.2 - ROBERTSON, ANDREW, 1777-1845

Robertson, Emily ed.
...Letters and papers of Andrew Robertson,
miniature painter...also treatise on the art by
...Archibald Robertson.London,Eyre & Spettis-
woode.pref.1895.
285 p. illus.

2nd ed..pref.1897.contains 12 excellent
repros.of R.'s larger miniatures on ivory.
LC Mellen Reference NJ18.R546R63 1897

LC ND1337.08R7 Heath.Miniatures.ND1330.H43
 .CFA Bibl. p.XXXIX

AP
1
V65
NCFA

I.B.2 - ROMNEY, GEORGE, 1734-1802

Burke, Joseph T., 1913-
 Romney's Leigh family(1768):A link between
the conversation piece and the Neo-Classical
portrait group

In:Ann'l B.of NGA of Victoria
2:5-14 1960 illus.

I.B.2 - ROBERTSON, ARCHIBALD, 1765-1835

Robertson, Emily ed.
...Letters and papers of Andrew Robertson,
miniature painter...also treatise on the art by
...Archibald Robertson.London,Eyre & Spettis-
woode.pref.1895.
285 p. illus.

2nd ed..pref.1897.contains 12 excellent
repros.of R.'s larger miniatures on ivory.
LC Mellen Reference NJ18.R546R63 1897

LC ND1337.08R7 Heath.Miniatures.ND1330.H43
 .CFA Bibl. p.XXXIX

I.B.2 - ROMNEY, GEORGE, 1734-1802

Kendal, Eng. Abbot Art Gallery
 Four Kendal portrait painters.cat.of an
exh.held,16 June-29 July,1973...Kendal...,1973
 23 p. illus.

Works by Christopher Steele,George Romney,
Daniel Gardner,Thomas Stewardson

Yale Ctr.
f.Brit.Art
Ref.ND
1314.4
.A22

qN
40.1
R684M6
NPG
2 v.

I.B.2 - ROCKWELL, NORMAN, 1894-1978

Moffatt, Laurie Norton, 1956-
 Norman Rockwell,a definitive catalogue.
Stockbridge,Mass.,The Norman Rockwell Museum
1986
 2 v. chiefly illus(part col.)

Intro.by David H.Wood
Bibliography

v.2,Ch.5-Portraits,p.963-1045

LC ND237.R684 1986

B
.R76W2

I.B.2 - ROMNEY, GEORGE, 1734-1802

Ward, Thomas Humphry, 1845-1926
 Romney.A biographical and critical essay
with a cat.raisonné of his works;by Th.H.Ward
and W.Roberts.London,Manchester.etc..T.Agnew &
sons;N.Y.,C.Scribner's sons,1904
 2 v. illus.

LC ND497.R7W3 Moon.Engl.portr.drags.& mi
 .NC860.N66X NPG Bibl.p.148

705
A784
v.23

I.B.2 - ROGERS, NATHANIEL, 1788-1844

Nathaniel Rogers and his miniatures

In:Art in Am
23:158-9,161-2 Oct,'35 illus.

Incl.list of Rogers' miniatures

I.B.2 - ROSENTHAL, ALBERT, 1863-1939

Rosenthal, Albert, 1863-1939
 Albert Rosenthal,painter,lithographer,
etcher...Philadelphia,Priv.printed,1929
 21 p. illus.

Reprinted from the Print Connoisseur

LC NE1.P75 Winterthur Mus.Libr. fZ881
 I78 NCFA v.6,p.224

AP
1
1817
NMAA

I.B.2 - ROKOTOV, FJODOR or FEDOR, ca.1735-1808

Karev, A
 Portretnoe Masterstvo Rokotova(Portrait
workshop of Rokotov)

In:ИCKYCCTBO(ISKUSSTVO)
9:58-64 1986 illus(col.)

I.B.2 - ROSENTHAL, ALBERT, 1863-1939

Rosenthal, Albert, 1863-1939
 The chief justices of the supreme court of
Pennsylvania,reproductions of paintings by
Albert Rosenthal from life and authentic ori-
ginals.Phila.,Haeseler Photographic Studios,1907

Arch.
Am.Art
mfm
P29/32-60

Archives of American Art
"Portraits"

N
40.1
R734yR8
NPG

I.B.2 - ROSENTHAL, ALBERT, 1863-1939

Rosenthal, Albert, 1863-1939
List of portraits.Lithographs-etchings,
mezzotints by Max Rosenthal and Albert Rosen-
thal.Phila.,Privately printed,1923

This is a list of sitters whos autographs
had been collected by autograph-collectors.

I.B.2 - ROTHENSTEIN,(SIR)WILLIAM, 1872-1945

Pittsburgh. Carnegie Institute. Dept. of
Fine Arts
Exh.of portrait lithographs by William
Rothenstein.Dept.of Fine Arts,Carnegie Insti-
tute,Dec.4th through Dec.31st,1916.Pittsburgh,
1916.
3 l.

NN

N
40.1
R734yR8
NPG

I.B.2 - ROSENTHAL, MAX, 1833-1918

Rosenthal, Albert, 1863-1939
List of portraits.Lithographs-etchings,
mezzotints by Max Rosenthal and Albert Rosen-
thal.Phila.,Privately printed,1923

This is a list of sitters whos autographs
had been collected by autograph-collectors.

I.B.2 - ROTHENSTEIN,(SIR)WILLIAM, 1872-1945

Rothenstein, (Sir)William, 1872-1945
Contemporaries; portrait drawings by Sir
William Rothenstein, with appreciations by
various hands. London,Faber & Faber ltd.,1937.

112 p. illus.

Incl:Viscount Allenby,Austen Chamberlain,
Kipling,Macmillan,Maugham,Munthe,Aurel Stein,
Tagore,Tovey,Yeats

LC N7598.R49 Rep.,1938#572

705
G28
v.19
1898
NCFA

I.B.2 - ROSLIN, ALEXANDER, 1718-1793

Fidière, Octave, 1855-
Alexandre Roslin

In:Gas.Beaux-Arts
19:45-62 Jan.,1898 illus.
104-16 Feb.,1898 illus.
'il mérite une place honorable parmi les
maîtres secondaires de la fin du 18e sièle.'-
Fidière
'Roslin,the eminent ptr.in oils...a court
ptr.par excellence.'-J.J.Foster in "The Wican-
ders coll.of miniatures.In:Conn.,67:13,Sep.,'23

fN
40.1
R84R8
1927
NPG

I.B.2 - ROTHENSTEIN, (SIR)WILLIAM, 1872-1945

Rothenstein, (Sir)William, 1872-1945
The portrait drawings of William Rothen-
stein,1889-1925;an iconography...N.Y.,Viking
Press,1927
Incl.:Iconography of lithographs

FOR COMPLETE ENTRY
SEE MAIN CARD

ND
544
M383
NCFA

I.B 2 - ROSLIN, ALEXANDER, 1718-1793

Martin-Méry, Gilberte
La peinture française en Suède,hommage à
Alexandre Roslin et à Adolf-Ulrik Wertmüller,
Bordeaux,19 mai-15 sept.1967.,Musée de Bordeaux
Cat.par Gilberte Martin-Méry,avec le concours d
Gunnar W.Lundberg.Bordeaux,le Musée,1967
151 p. illus.

LC ND546.M34

I.B.2 - ROUBILIAC, LOUIS FRANÇOIS, 1695?-1762

Esdaile, Katharine A.
The life and works of Louis François Roubi-
liac...London,Oxford university press,H.Milford
1928
249 p. illus.

Bibliography

Bookreview by M.H.L.in Burl.Mag.55:100:'...
the illus...alone...form a strikingly comprehen-
sive "National portr.gall."...'

LC NB553.R75E65 Noon.Engl.portr.drags.&min.
 NC860N66X NPG bibl.p.145

I.B.2 - ROSLIN, Mme.MARIE-SUZANNE GIROUST
see
I.B.2 - GIROUST, MARIE-SUZANNE(Mme.ROSLIN),1734-
 -1772

705
B97
NCFA
v.42

I.B.2 - ROUBILIAC, LOUIS FRANÇOIS, 1695?-1762

Esdaile, Katharine A.
Roubiliac and Rysbrack

In:Burl Mag
42:157-9 Apr.'23 illus.

Attribution changes from Rysbrack to Roubi-
liac and conversely from Roubiliac to Rysbrack
Repro.incl.:Bust of Charles I by Roubiliac.
Shakespeare by Roubiliac.Sir Hans Sloane by
Rysbrack

I.B.2 - ROUBILIAC, LOUIS FRANÇOIS, 1695?-1762

Esdaile, Katharine A.
 Roubiliac's work at Trinity College, Cambridge. Cambridge, Univ. press, 1924
 42 p. illus.

 Repro. incl.: Statue of Isaac Newton ; 10 busts of the greatest personages connected with the College during 17 & 18th c.

LC NB553.R75E7

705
197B
R76

I.B.2 - RUBENS, PETER PAUL, 1577-1640

Glück, Gustav, 1871-
 Rubens as a portrait painter

In: Burl.Mag.
 76:173-4,.77-8,183 June,1940 illus.

Daugherty.Self-portrs.of
P.P.Rubens.mfm161 NPG,p.209
footn.55

N
40.1
R863
AD'AA

I.B.2 - ROUSSEAU, HENRI JULIEN FÉLIX, 1844-1910

Certigny, Henry, 1919-
 Le douanier Rousseau et Frumence Biche. Lausanne, la Bibliothèque des Arts, 1973.
 116 p. illus (col.cover)

 English and French
 Bibl.references

I.B.2 - RUBENS, PETER PAUL, 1577-1640

Huemer, Frances
 Portraits. Brussels, Arcade Press, N.Y., Phaidon, 1977
 v. illus. (Corpus Rubenianum Ludwig Burchard, pt.19)

LC ND673.R9C63 Pt.19
 ND1329.R8

**FOR COMPLETE ENTRY
SEE MAIN CARD**

I.B.2 - ROUSSEL, THÉODORE, 1847-1926

Rutter, Frank Vane Phipson, 1876-1937
 Théodore Roussel...with an introd. by C. Reginald Grundy. London, The Connoisseur, ltd., N.Y., The Connoisseur publications of America, ltd., 1926
 80 p. illus.

LC ND553.R73R8

I.B.2 - RUBENS, PETER PAUL, 1577-1640

Hymans, Henri Simon, 1836-1912
 Rubens d'après ses portraits

In: Bull.Rubens(Anvers)
 2:1-23 1885

LC (ND673.R9H92)
MiU NcU

Daugherty.Self-portrs.of
P.P.Rubens mfm161 NPG,p.26

mfm
161
NPG

I.B.2 - RUBENS, PETER PAUL, 1577-1640

Daugherty, Frances Perry, 1938-
 The self-portraits of Peter Paul Rubens; some problems in iconography...Chapel Hill, N.C., University of N.C., 1976
 2 v. illus.

 Thesis.-University of North Carolina at Chapel Hill. Typescript.

 Bibliography

I.B.2 - RUBENS, PETER PAUL, 1577-1640

Schöne, Wolfgang, 1910-
 Peter Paul Rubens; die Geissblattlaube. Doppelbildnis des künstlers mit Isabella Brant. Stuttgart, Reclam, 1956.
 32 p. illus. (Werkmonographien sur bildenden kunst, no.11)

 History of marriage portraiture fr. antiquity to the 17th c.

 Universal-bibliothek no.B9011

NIC MH

Daugherty.The self-portrs.
of P.P.Rubens.mfm161 NPG
p.158 footn.5

I.B.2 - RUBENS, PETER PAUL, 1577-1640

Evers, Hans Gerhard, 1900-
 Zu den selbstbildnissen und bildnissen von Rubens

In: Jrb.der preussischen kunstslgn.
 63:133ff. 1943

LC N3.J2

Daugherty.Self-portrs.of
P.P.Rubens.mfm161 NPG

705
028
v.35
1906
NCFA

I.B.2 - RUE, LIZINKA
 see
I.B.2 - MIRBEL

Jean, René, 1879-
 Madame de Mirbel

In: Gas Beaux-Arts
 35(3ième ser):131-46 1906 illus.

705
C75
NCFA
v.92

I.B.2 - RUPERT, PRINCE, 1619-1682

Hind, Arthur Mayger, 1880-1957
 Studies in English engraving. VI.Prince
Rupert and the beginnings of mezzotint

In:Connoisseur
92:382-91 Dec.,'33 illus.

 Incl.:Catalogue of mezzotints by and attri-
buted to Prince Rupert

I.B.2 - RUSSELL, JOHN, 1745-1806

Williamson, George Charles, 1858-1942
 John Russell...London,G.Bell & sons,1909

LC ND497.R9W7

FOR COMPLETE ENTRY
SEE MAIN CARD

N
NO.1
R95V3
NCFA
NPG

I.B.2 - RUSH, WILLIAM, 1756-1833

Marceau, Henri, 1896-
 William Rush,1756-1833;the first native
American sculptor....Cat.of an exh.held at the
Pennsylvania Museum of Art,Philadelphia,1937
85 p. illus.

 Complete list of R.'s works

LC NB237.R9M3

Gerdts.Art of healing
223.G36 NPG,p.112,note 6

705
M19
NCFA
v.15

I.B.2 - RUSSELL, JOHN, 1745-1806

Williamson, George Charles, 1858-1942
 John Russell,"the prince of crayon portrait-
painters"

In:Mag Art illus. 1892

 Mainly a biography of J.Russell

AP
1
A51A64
NCFA
v.2

I.B.2 - RUSH, WILLIAM, 1756-1833

Sellers, Charles Coleman, 1903-
 Charles Willson Peale as sculptor

In:Am Art J
2:5-12 Fall,'70 illus.

 P.'s influence on Wm.Rush.-Their mutual in-
terest in the allegorical fg. or emblem
 P.sculpture is now known only as it appears
in ptgs.& documentation.

705
B97
NCFA
v.42

I.B.2 - RYSBRACK, JOHN MICHAEL, 1694-1770

Esdaile, Katharine A.
 Roubiliac and Rysbrack

In:Burl Mag
42:157-9 Apr.'23 illus.

 Attribution changes from Rysbrack to Roubi-
liac and conversely from Roubiliac to Rysbrack
 Repro.incl.:Bust of Charles I by Roubiliac.
Shakespeare by Roubiliac.Sir Hans Sloane by
Rysbrack

705
C75
NCFA
v.57

I.B.2 - RUSSELL, JOHN, 1745-1806

Sée, Robert René Meyer
 How Russell executed his pastels

In:Connoisseur
57:161-2,164,166 Jly,'20 illus(part col.)

 '...pastel artist"par excellence".-Sée

I.B.2 - RYSBRACK, JOHN MICHAEL, 1694-1770

Webb, Marjorie Isabel
 Michael Rysbrack,sculptor.London,Country
Life,ltd.,1954.
 241 p. illus.

 Bibl.footnotes
 Cat. of ca. 350 recorded works

 Reviews:Burl.Mag.v.97:59,Feb.,'55
 Connoisseur v.134:210f.,Dec.'54

LC NB497.R9W4

Waterhouse.Three decades
N6766.W3X NCFA p.20,note
32

705
C75
NCFA
v.52

I.B.2 - RUSSELL, JOHN, 1745-1806

Sée, Robert René Meyer
 Portraits of children of the Russell family
by John Russell

In:Connoisseur
52:183-4,186,188,192 Dec.,'18 illus(part col.)

 'Prince of pastellists'.-Sée

N
40.1
S13D7
NPG

I.B.2 - SAINT-GAUDENS, AUGUSTUS, 1848-1907

Dryfhout, John, 1940-
 Augustus Saint-Gaudens:the portrait reliefs,
the National Portrait Gallery,the Smithsonian
Institution.New York,Grossman Publishers,1969.
 unpaged illus.

 Intro.by Marvin S.Sadik
 Cat.by John Dryfhout & Beverly Cox
 Bibliography
 Exh.Nov.13,1969-Jan.30,1970

LC NB237.S2D7

I.B.2 - SAINT-MÉMIN, CHARLES B.J.FÉVRET DE
see
FÉVRET DE SAINT-MÉMIN, CHARLES B.J.

I.B.2 - SANDBY, PAUL, 1725-1809

Oppé, Adolf Paul, 1878-1957
The drawings of Paul and Thomas Sandby in
the coll.of H.M.the king at Windsor Castle.Ox-
ford,Phaidon Press,1947
85 p. illus(part col.)

Cat.p.,19.-85

LC NC1115.S3 O6 Noon.Engl.portr.drags.&min.
 NC860.N66X NPG Bibl.p.147

q N46.1 I.B.2 - SALISBURY, FRANK O., 1874-1962
S167
W6
NMAA Wildenstein & company,inc.,New York
 Recent portraits of Frank O.Salisbury.Cat.
of exh.,Jan.4-18,1935.
.5 p., mainly illus.

 NMAA copy incl.typewritten story on the
work of Salisbury.
 Repro.incl.:King Geo.V,Calvin Coolidge,
Mussolini

I.B.2 - SANDBY, PAUL, 1725-1809

Sandby, William
 Thomas and Paul Sandby;Royal academicians;
some account of their lives and works...London,
Seeley & co.,ltd.,1892
 230 p. illus.

 Appendices(p.,204,-224):I.Works exh.by Th.
& P.Sandby.II.Lists of their drags.in the royal
coll.at Windsor.IIIWorks contained in public
galleries & institutions

LC N6797.S3S3 Noon.Engl.portr.drags.&min.
 NC860.N66X NPG Bibl. p.147

I.B.2 - SALOMON, BERNARD, 1506-1561

Strada, Jacobus de,à Rosberg, d.1588
 Epitome dv thresor des antiquitez,c'est à
dire,pourtraits des vrayes medailles des empp.
tant d'Orient que d'Occident...Tr.par Iean Lou-
veau d'Orleans.Lyon,Par I.de Strada,et T.Cverin,
1553
 394 p. illus.
 For revision see Keller, Diethelm
 485 portr.woodcuts by B.Salomon after Strada's
drags.,made from antique medals in Strada's coll.
 Emperors fr.Caesar to Charles V
 Wave.Jb.d.Berl.Mus.I 1959
LC CJ4975.S8 LC N3.J16 fol.p.131 Paolo
Giovio & d.P ildnisvitenbücher...
Rath.Porträtwerke,p.39

I.B.2 - SANDBY, THOMAS, 1721-1798

Oppé, Adolf Paul, 1878-1957
 The drawings of Paul and Thomas Sandby in
the coll.of H.M.the king at Windsor Castle.Ox-
ford,Phaidon Press,1947
 85 p. illus(part col.)

 Cat.p.,19.-85

LC NC1115.S3 O6 Noon.Engl.portr.drags.&min.
 NC860.N66X NPG Bibl.p.147

I.B.2 - SAMARAS, LUCAS, 1936-

NMAA
Ref.
1588 Samaras, Lucas, 1936-
 Lucas Samaras-objects and subjects,1969-1986.
Published in association with the Denver Art Mus.
...exh.,...May 7 - July 10,1988...and at other mu-
seums.N.Y.,Abbeville Press,1988
 231 p. illus(part col.)

 Bibliography
 For S.'s portrs. see articles by D.Kuspit,
p.34-5,and R.Smith,p.56,illus.pp.195-207
 Exh.at NMAA Aug.12-Oct.16,1988

I.B.2 - SANDBY,THOMAS, 1721-1798

Sandby, William
 Thomas and Paul Sandby;Royal academicians;
some account of their lives and works...London,
Seeley & co.,ltd.,1892
 230 p. illus.

 Appendices(p.,204,-224):I.Works exh.by Th.
& P.Sandby.II.Lists of their drags.in the royal
coll.at Windsor.IIIWorks contained in public
galleries & institutions

LC N6797.S3S3 Noon.Engl.portr.drags.&min.
 NC860.N66X NPG Bibl. p.147

I.B.2 - SANDBY, PAUL, 1725-1809

London. Queen's Gallery, buckingham Palace
 Gainsborough,Paul Sandby and miniature-
painters in the service of George III and his
family.cat.of an exhibition. London.1970
 30 p. illus.

 Bibl.references

LC ND1314.4.L6 Yale ctr.f.Brit.art Ref.

705 I.B.2 - SANGALLO, FRANCESCO DA, 1494-1576
.A7875
NCFA Middeldorf, Ulrich
 Portraits by Francesco da Sangallo

 In:Art Q
 1:109-38 Spring 1938 illus.

 Sangallo only important Florentine portrait
sculptor of the 16th c. From "classic" to realis-
tic. Reliefs,busts,tombs,crayon sketch. Woodcut
after lost relief,self-portr.in relief

705
A784
NCFA
v.17

I.B.2 - SARGENT, HENRY, 1770-1845

Addison, Julia de Wolf(Gibbs),1866-
Henry Sargent,a Boston painter

In:Art in Am
17:279-84 Oct.,'29 illus(no portrs.)

Article refers also to Sargent as portrait-
ist

Morgan.O.Stuart & his pupil
N40.1S93M8 1969 NPG p.72

I.B.2 - SARGENT, JOHN SINGER, 1856-1925

Sargent, John Singer, 1856-1925
Sargent portrait drawings...N.Y.,Dover,
1983
48 p. illus. (Dover Art Library)

42 works

LC NC139.S27A4 1983 Books in print,subject
guide 1985-86,v.3,p.4864

705
I61
NCFA
v.10

I.B.2 - SARGENT, JOHN SINGER, 1856-1925

Baldry, Alfred Lys, 1858-1939
The art of John Singer Sargent

In:Studio
10:3-21 Mar.,1900 illus.
107-19 Apr.,1900 illus.

Repro.of ptgs.& drags.

Art in Am.qZ5961.U5A77X
NCFA Ref. I 1289

I.B.2 - SARGENT, JOHN SINGER, 1856-1925

Slater, Frank
Adventuring into portrait painting

In:Artist
18:7-8 Sep.,'39 illus(part col.)

The mental outlook of the ptr.Incl.a compa-
rison of Sargent and Sickert

N.Y.,MOMA.20th c.portrs.by
M.Wheeler N7592.6N53 NPG
Bibl.
LC N1.A82

708.1
.C13
NCFA

I.B.2 - SARGENT, JOHN SINGER, 1856-1925

Cahill, Holger, 1893-1960 ed.
Portrait painters,fashionable and unfa-
shionable-Eakins,Sargent,in,his,Art in America
in modern times...c.1934

p.21-4 illus.

Influence of European methods

Arts in America qZ5961.U5A
77x NCFA Ref. I 31

705
A784
NCFA
v.40

I.B.2 - SAVAGE, EDWARD, 1761-1817

Dresser, Louisa
Edward Savage,1761-1817. Some representa-
tive examples of his work as a painter

In:Art in Am
40:157-212 autumn,'52 illus.

Article written in connection with exh.at
the Worcester Art Museum,Jan.4-March 8,1953

Repro.incl.:Hancock,Washington,Martha Wa-
shington,Washington Family
see also:v.42:217,Oct.,'54 -- Gerdts.Ptg.& sculpt.in N.J.
N6530.N5G36 NCFA bibl.p.255

708.9493
B921
NMAA
v.30-33

I.B.2 - SARGENT, JOHN SINGER, 1856-1925

Goley, Mary Anne
Sargent's "Dr.Pozzi at home",exhibited
in Brussels in 1884

In:Mus.Royaux
des Beaux-Arts
de Belgique.B.
30-33:143-150 1981-1984/1-3 illus.

Synopsis in Dutch and French

N
40.1
F44 3y
A5
NFG
RB

I.B.2 - SAVART, PIERRE,b.1737

Andrews, William Loring, 1837-1920
A trio of 18th century French engravers of
portraits in miniature.Ficquet,Savart,Grateloup..
N.Y.,Dodd,Mead & co.,1859
123 p. illus(1 col.)
Contents.-Intro.,giving a short account of
the various methods of engr.on metal.-A trio of
18th c.French engravers....-Extracts fr.La Calco-
grafia of Giuseppe Longhi.-List of portrs.engr.
by Étienne Ficquet,Pierre Savart,Jean Baptiste
de Grateloup

LC NE647.A5 Levi.Descript.bibl.Z5947.A3
L66 1974 NCFA p.205

ND
1300
L8
1985X

I.B.2 - SARGENT, JOHN SINGER, 1856-1925

Lubin, David M.
Act of portrayal:Eakins,Sargent,James.
New Haven,Yale Univ.Press,c.1985
208 p. illus. (Yale publications in
the history of art,32)
Index
Bibliography,p.177-83
Examination of three major works of por-
traiture,two ptgs.& one novel,from the 1880s.
L.probes the contradiction each artist sensed
betw.masculine power & feminine passivity.

LC ND1300.L8 1985 Books in print.Subject
guide 1985-6 v.3,p.4864

N
.S29H5

I.B.2 - SCARBOROUGH, WILLIAM HARRISON, 1812-1871

Hennig, Helen(Kohn)
William Harrison Scarborough,portraitist
and miniaturist ... Columbia,S.C.,The R.L.Bryan
company,1937
171 p. illus.

Bibliographical notes

LC ND237.S37H4

K
40.1
S365C7
NPG

I.B.2 - SCHIELE, EGON, 1890-1918

Comini, Alessandra
Egon Schiele's portraits...Berkeley.Uni.of
Calif.Press,c.1974
271 p. illus(part col.) (California stu
dies in the history of art;17)

Bibliography

«Based on Ph.D.Dissertation,Columbia U.,
1969»

LC ND1329.S34C65

Diss.Abstr.Z5055.U49D57NPG
v.35,no.7,p.4330-A;Jan'75
no.74-29,573

I.B.2 - SCROTS
see
I.B.2 - STRETES, GUILLIM

N
40.1
S365S2e
MMAA

I.B.2 - SCHIELE, EGON, 1890-1918

Sabarsky, Serge
Egon Schiele...Milano,Mazzotta,c.1984
194 p. illus(part col.)

Bibliography

Roma,Pinacoteca capitolina,Campidoglio,
21 giugno-5 agosto 1984.Venezia,Museo d'arte
moderna Ca'Pesaro,26 agosto-25 novembre 1984
P.1.

705
B97
NCFA
v.99

I.B.2 - SEGAR, WILLIAM and FRANCIS

Piper, David
The 1590 Lumley inventory:Hilliard,Segar
and the Earl of Essex-I & II

In:Burl.Mag.
99:224-31 July,'57 illus.
:299-303 Sept.,'57 illus.

I:Incl.:List of 22 portrs.bearing Lumley
labels.

Strong.The Engl.Icon ND13
S924 NPG p.45 note 3

I.B.2 - SCHNEIDER, HEINRICH JUSTIN, 1811-1884

Kohlrausch, Friedrich, 1780-1865
Bildnisse der deutschen könige & kaiser von
Karl dem Grossen bis Maximilian I...gezeichnet
von Heinrich Schneider...Hamburg,& Gotha,F.& A.
Perthes,1846
680 p. illus.

37 woodcuts by Herburger,Kreuser & Rahle
after H.Schneider

LC DD85.6.K7

Amsterdam,Rijksmus.cat.
Z5939A52,deel 1,p.147

705
B97
NCFA
v.91

I.B.2 - SEISENEGGER, JAKOB, 1505-1567

Auerbach, Erna
Notes on some Northern Mannerist Portraits

In:Burl Mag.
91:218-22 Aug.1949 illus.

The importance of Seisenegger.
Same formula in official portrs.in Austria,
Flanders & France. English version modified by
Holbein's influence
Repro.:Amberger,Seisenegger

705
B97
NCFA
v.15

I.B.2 - SCHNORR VON CAROLSFELD, LUDWIG F.,1788-1853

Baillie-Grohman, William A.
Some historical portraits of the Biedermaier
period of German art

In:Burl Mag
15:114,118-9 May,'09 illus.

Repro.:Archduke of Austria,Emperor Francis I
of Austria,drgs.by Louis Schnorr von Carolsfeld

Cumulated Mag.subj.index
A1/3/C76 Ref. v.2,p.444

I.B.2 - SELLSTEDT, LARS GUSTAF, 1819-1911

Sprague, Henry Ware
Lars Gustaf Sellstedt

In:Buffalo & Erie Cy.Hist.Soc. Publications
17:37-74 1913 illus.

LC F129.B8B88

Arts in Am.qZ5961.U5A77X
CFA Ref. I 1309

ND
1311.9
S48C9s
NPG

I.B.2 - SCHUYLER LIMNER

Curran, Ona
Schenectady ancestral portraits early 18th
century

In:Schenectady Co.Hist.Soc.B.
10,no.1 Sept.'66

Based on Curran's Master Thesis,N.Y.State
Univ.College,Oneonta,N.Y.
Incl.:Van Epps Limner,Veeder Limner,Schuyler
Limner,Pierpont Limner,Gansevoort Limner.
Hudson Valley Patroon Painters,except Pier-
pont Limner

MM

Feigenbaum.Amer.portrs....
ND1311.2.F29 NPG Bibl.p.147

I.B.2 - SELLSTEDT, LARS GUSTAF, 1819-1911

Viele, Chase
Four artists of mid-19th century Buffalo
«Cooperstown?,N.Y.,196-»
49-73 p. illus.

Bibl.references

Reprinted fr.N.Y.history,43,no.1,Jan.1962

Survey of the life and work of Sellstedt,
Wilgus, Le Clear, Peard

Arts in Am qZ5961.U5A77X
CFA Ref. I 1072

I.B.2 - SERGENT-MARCEAU, ANTOINE FRANÇOIS,1751-
.1847

Blin, Pierre
 Portraits des grands hommes,femmes illus-
tres et sujets mémorables de France,gravés et
imprimés en couleurs...Paris,Chez Blin,impri-
meur en Taille-douce,1792.

Brit. 2 vols. 192 col.pl.in 3 v.
mus. Originally publ.in 50 parts.
1260 c. 96 portrs.& 96 histor.scenes.Designed by
Sergent,Desfontaine,Naigeon,P.Barbier,Bénard,
F.Gérard,Deplessis-Berteaux & engraved by Ser-
gent,Mme.de Cernel,J.Morret,Ridé,L.Roger,
Le Coeur
NN Source:Lewine.Bibl. of art & illus.Books
A1023.L67 1969 NCFA p.505

E I.B.2 - SHARP, JOSEPH HENRY, 1859-1953
89
C35 A catalogue of Indian portraits in the coll.
NPG of Jos.G.Butler,jr..on free exh.at the
 Y.M.C.A.bldg,Youngstown,O..:s.n.,s.l.,
 ca.1907.(Youngstown,Ohio,Vindicator Press)
 39 p. illus.

 The greater part of the coll.is the work
of J.H.Sharp and E.A.Burbank.Other artists re-
presented are Frederick Remington,Bert Phillips
Deming and Candy
 Smithsonian "National Museum"bought 11
Sharp ptgs.,Dec.1900

AP I.B.2 - SETON, JOHN THOMAS, fl.1761-1806
1
A64 Maison, Karl Eric
NCFA John Thomas Seton
v.34
(765.A6) In:Apollo
 34:59,75 Sept.'41 illus.(p.59-60)

 Ircher.India & Brit.portr..
 ND1327.I44A72X NPG Bibl.
 p.483

N I.B.2 - SHARPLES, JAMES, 1750?-1811
7621
P54 Philadelphia. Independence hall
NCFA Catalogue of the portraits and other works
NPG of art,Independence hall,Philadelphia,...:Phila-
delphia,Press of Geo.H.Buchanan company,c.1915.
 187 p. illus.

 "The James Sharpless coll.of portrs.in pastel"
p.:175-186

LC F158.8.I3P55

705 I.B.2 - SEYFFERT, LEOPOLD, 1887-1956
M18
NCFA Eggers, George William, 1883-1958
v.20 Leopold Seyffert and his place in American
portraiture

In:Mag Art
20:64-73 Feb.'29 illus.

 Points out that in times of experimentation
portraiture needs a discipline which is not neces-
sary for landsc.-or still life ptg.Compares
S.'s work with contemporaries'.Evaluates S.'s
portrs. as to technique & contents
 Cumulated Mag.subj.index
 A1/3/C76 Ref. v.2,p.443

CT I.B.2 - SHARPLES, JAMES, 1750?-1811
275
W31W2 Walter, James
 Memorials of Washington and of Mary...,and
Martha...from letters and papers of Rbt.Cary
and Js.Sharples...portraits by Sharples.and.
Middleton.N.Y.,C.Scribner's sons,1887
 362 p. illus.

 NPG copy contains reprint of Boston Post,
Feb.,2,1887 & clippings,letters by Wash.,Bryant
Longfellow,Hawthorne,etc.,quoted by Walter de-
clared spurious'
 Weddell.A mem'l vol.of Va.
 hist.portraiture.757.9.W3:
 NCFA Bibl. p.439

I.B.2 - SHAHN, BEN, 1898-1969

Shahn, Ben, 1898-1969
 Concerning 'likeness'in portraiture

In:Nordenfalk, Carl Adam Johan, 1907-
Ben Shahn's portr.of Dag Hammarskjöld.Medde-
landen från Nationalmus.no.87.Stockholm.1962.

 States the Neo-Platonic idea"...the genius'
eyes can penetrate through the veil of mere ap-
pearances & reveal the truth."--Gombrich

LC N3540.A2
 Gombrich.Mask & face.In:
 Art percept'n & reality
 N71/C64 NCFA p.2.footnote

927.5 I.B.2 - SHARPLES FAMILY
.S44K74
 Knox, Katharine(McCook)
 The Sharples, their portraits of George
Washington & his contemporaries;a diary & an
account of the life & work of James Sharples &
his family in England and America...New Haven...
London,H.Milford...,1930
 133 p. illus.

LC ND497.S445K6

AP I.B.2 - SHANNON, JAMES JEBUSA, 1862-1923
1
A784J8 Rinder, Frank
NCFA J.J.Shannon,A.R.A.

In:Art J.
:141-5 1901 illus.

705 I.B.2 - SHARPLES FAMILY
A784
v.32 Sherman, Frederic Fairchild, 1874-1940
 The portraiture of the Sharples family

In:Art in Am
32:84-6 Apr.,'44 illus.

705
A56
NCFA
v.100

I.B.2 - SHAVER, SAMUEL M., c.1816-1878

Bishop, Budd H.,arris,,1936- ,
 Three Tennessee painters:Samuel M.Shaver,
Washington B.Cooper, and James Cameron

In:Antiques
.100:432-7 Sept.,'71 illus.

qAP
1
M225
NPG

I.B.2 - SHUTE, Dr.SAMUEL ADDISON, 1803 -1836

Savage,Norbert H.,Bert and Gail Savage
 Mrs.R.W.and S.A.Shute

In:Maine Ant.Dig.
6:1B-3B Aug.,'78 illus.

 Repro.p.3B:Portr.of a woman,c.1829'has
gilt paper appliques for jewelry which are
found on a number of Shute W.C.& perhaps
one oil'.
 'Collage technique,was used,to give three
dimensional effect,'-Walters & Weekley in:Abbey
Aldrich Rockefel' Art Ctr.Am.Folk portrs.p.3

705
A56
NCFA
v.84

I.B.2 - SHEFFIELD, ISAAC, 1798? -1845

Mayhew, Edgar deN.
 Isaac Sheffield,Connecticut Limner

In:Antiques
84:589-91 Nov.,'63 illus.

Am.Folk ptg.Selected fr.t]
coll.of Mr.&Mrs.Wm.E.Wilt-
shire III.ND207.W66X NPG
p.107

qAP
1
M225
NPG

I.B.2 - SHUTE, RUTH WHITTIER, 1803-1882

Savage,Norbert H.,Bert and Gail Savage
 Mrs.R.W.and S.A.Shute

In:Maine Ant.Dig.
6:1B-3B Aug.,'78 illus.

 Repro.p.3B:Portr.of a woman,c.1829'has
gilt paper appliques for jewelry which are
found on a number of Shute W.C.& perhaps
one oil'.
 'Collage technique,was used,to give three
dimensional effect,'-Walters & Weekley in:Abbey
Aldrich Rockefel' Art Ctr.Am.Folk portrs.p.3

I.B.2 - SHERRIFF, CHARLES
 see
I.B.2 - SHIRREFF, CHARLES, c.1750-

I.B.2 - SICARD, LOUIS MARIE, 1746-1825, called
 ,SICARDI

Belleudy, Jules, 1855-
 Louis Sicardi,miniaturiste,peintre du Cabi-
net du Roi.Extrait du Bulletin de la Société de
l'histoire et de l'art français.1932

LC N6811.A92

FOR COMPLETE ENTRY
SEE MAIN CARD

705
C75
NCFA
v.91

I.B.2 - SHIRREFF, CHARLES, c.1750-

Long, Basil Somerset, 1881-1937
 Charles Shirreff,the deaf-mute

In:Connoisseur
91:83-8 Feb.,'33 illus.

Archer.India & Brit.portrai-
ture...ND1327.I44A72X NPG
Bilb.p.482

I.B.2 - SICKERT, WALTER RICHARD, 1860-1942

Slater, Frank
 Adventuring into portrait painting

In:Artist
18:7-8 Sep.,'39 illus(part col.)

 The mental outlook of the ptr.Incl.a compa-
rison of Sargent and Sickert

LC N1.A82

N.Y.,MOMA.20th c.portrs.by
M.Wheeler N7592.6N53 NPG
Bibl.

ND
2200
W3
1949X
NPG

I.B.2 - SHORT, DOROTHY, 1920-

Walker, Phoebe Flory, 1914-
 Watercolor portraiture,by Phoebe Flory
Walker with Dorothy Short and Eliot O'Hara.
N.Y.,G.P.Putnam's Sons,1949.
 143 p. illus(part col.)

 Incl.:A suggested reference list of books
for the painter of watercolor portraits,p.139-
143

I.B.2 - SIEGEN, LUDWIG VON, 1609-1680

Laborde, Léon Emmanuel Simon Joseph de, 1807-186
 Histoire de la gravure en manière noire...
Paris,Impr.de J.Didot l'aîné,1839
 413 p. illus.

 Bibliography

 Genesis of the art.The work of Ludwig von
Siegen.Incl.descriptive catalogue of mezzotints
made before 1720 by Dutch,German,English,French,
Spanish & Russian engravers. List of early mezz.
printed in color.

LC NE1815.L2

Davenport.Mezzotints.NE1815
.D24 NPG:"The most important
book,on,mezzotints" p.46 & p.XVII

I.B.2 - SIMITIÈRE, PIERRE EUGENE DU
see
I.B.2 - DU SIMITIÈRE, PIERRE EUGENE, ca.1736-1784

N
40.1
S63847c
1972a
NMAA

I.B.2 - SLOAN, JOHN, 1871-1951

Holcomb III, Grant, 1942-
A cat.raisonné of the paintings of John
Sloan, 1900-1913.Univ.of Delaware, 1972
163 p. illus.

Bibliography

Thesis Ph.D.-Univ.of Delaware, 1972
Photocopy of typescript

705
C75
v.110
NCFA

I.B.2 - SIMON, ABRAHAM, 1617-1692

Rhode, Winslow
England's greatest medallists Abraham and
Thomas Simon

In:Connoisseur
110:34-8 Oct.,'42 illus.

N40.1
S638
F7
NCFA

I.B.2 - SMART, JOHN, 1741-1811

Foskett, Daphne
John Smart,the man and his miniatures.London
Cory,Adams & Mackay,c.1964.
100 p. illus(part col.) (Collectors
Guidebooks)
Geneal.tables
Bibliography
List of sitters
Christie's catalogues,Dec.17,1936,Feb.15,193
Nov.26,193
List of engravings after John Smart & John
Smart jr.
Incl.1 chapter)on John Smart,jr.
LC ND1337G8863

705
C75
v.110
NCFA

I.B.2 - SIMON, THOMAS, 1618-1665

Rhode, Winslow
England's greatest medallists Abraham and
Thomas Simon

In:Connoisseur
110:34-8 Oct.,'42 illus.

705
C75
NCFA
v.74

I.B.2 - SMART, JOHN, 1741-1811

Long, Basil Somerset, 1881-1937
John Smart, miniature painter

In:Connoisseur
74:196-200 Apr.,'26 illus.

I.B.2 - SIMON, THOMAS, 1618-1665

Vertue, George, 1684-1756
Medals and other works of Thomas Simon;
engraved and described by George Vertue
1753 (and 1780)

South Kensington 1780
Brit.mus. 1753, 1st ed. Universal cat. of books

N40.1
S638
F7
NCFA

I.B.2 - SMART, JOHN,JR., 1776-1809

Foskett, Daphne
John Smart,the man and his miniatures.London
Cory,Adams & Mackay,c.1964.
100 p. illus(part col.) (Collectors
Guidebooks)
Geneal.tables
Bibliography
List of sitters
Christie's catalogues,Dec.17,1936,Feb.15,193
Nov.26,193
List of engravings after John Smart & John
Smart jr.
Incl.1 chapter)on John Smart,jr.
LC ND1337G8863

I.B.2 - SITTOW
see
I.B.2 - ZITTOZ

ND
1328
B35
NCFA

I.B.2 - SMIBERT, JOHN, 1688-1751

Bayley, Frank William, 1863-1932
Five colonial artists of New England:Joseph
Badger,Joseph Blackburn,John Singleton Copley,
Robert Feke,John Smibert...Boston,Priv.print,1929
448 p. illus.

Bibliography

LC N6536.B3

705
A7832
NCFA
v.35

I.B.2 - SMIBERT, JOHN, 1688-1751

Belknap, W.aldron.Phoenix,1899-1949
 Feke and Smibert:a note on two portraits

In:Art Bul
35:225-6 Sept.,'53 illus.

 B.suggests that Smibert and Feke ptd.Henry
Collins.Feke's portr. formerly called to re-
present Gershom Flagg III

N
40.1
S6492
NPG

I.B.2 - SMIBERT, JOHN, 1688-1751

Saunders, Richard Henry
 John Smibert(1688-1751)Anglo-American por-
trait painter.1979
 2 v.in one illus.

 Ph.D.diss.-Yale Univ.,1979

 Bibliography 257-69

 Photocopy(Problems with illustrations)

 Miles.Portrs.of the heroes
 of Louisbourg AP1A51A64
 NPAA v.1:65 footnote

705
A784
NCFA
v.30

I.B.2 - SMIBERT, JOHN, 1688-1751

Burroughs, Alan, 1897-1965
 Notes on Smibert's development

In:Art in Am
30:109-21 Apr.,'42 illus.

 Incl.:Chronologically arranged list of S.'s
portrs.

N
40.1
S6459

I.B.2 - SMIBERT, JOHN, 1688-1751

Smibert, John, 1688-1751
 The notebook of John Smibert. With essays by
...,and Andrew Oliver, and with Notes relating to
Smibert's American portraits by Andrew Oliver.
Boston,Mass.Historical Society,1969
 131 p. illus.

 Bibliographical footnotes

LC ND237.S59A52

705
A784
NCFA
v.17

I.B.2 - SMIBERT, JOHN, 1688-1751

Coburn, Frederick William, 1870-
 John Smibert

In:Art in Am
17:175-87 June,'29 illus.

N
40.1
S64F6
NCFA
NPG

I.B.2 - SMIBERT, NATHANIEL, 1734 or 5-1756

Foote, Henry Wilder, 1875-
 John Smibert,painter;with a descriptive
catalogue of portraits,and notes on the work
of Nathaniel Smibert.Cambridge,Harvard Univer-
sity Press,1950
 292 p. illus.

 Bibliography

LC ND237.S59F6 Whitehill.The Arts in ear-
 ly Amer.Hist.Z5935.W59
 NPG bibl.,p.94

N
40.1
S64F6
NCFA
NPG

I.B.2 - SMIBERT, JOHN, 1688-1751

Foote, Henry Wilder, 1875-
 John Smibert,painter;with a descriptive
catalogue of portraits,and notes on the work
of Nathaniel Smibert.Cambridge,Harvard Univer-
sity Press,1950
 292 p. illus.

 Bibliography

LC ND237.S59F6 Whitehill.The Arts in ear-
 ly Amer.Hist.Z5935.W59
 NPG bibl.,p.94

I.B.2 - SMISSEN, DOMINICUS VAN DER, 1704-1760

Niemeijer, J.W.
 Denner en van der Smissen,twee Hanse-Schild
ders in Holland

In:Ned.kunsthist.jaarb.
21:159-224 1970

LC N5.N4 Bruijn Kops.In:B.Rijksmus.
 v.36:177,note 11

ND
207
W78
1971
NPG

I.B.2 - SMIBERT, JOHN, 1688-1751

Riley, Stephen T.
 John Smibert and the business of portrait
painting

In:Winterthur Conf.on Mus.Oper'n and Conn'ship
17th:159-80 1971 illus.

 Bibliographical notes

LC ND207.W5 1971

705
C75

I.B.2 - SMITH, JOHN, 1652-1742

Grundy, Cecil Reginald, 1870-
 Two mezzotints by John Smith

In:Conn
36:239,242-4 Aug.,1913 illus.

 ,Smith',work represents a portr.gall.of the
office holders of England of his time.-Th-B.,
v.31:172
 Illustrations in:Conn.39:267,Aug.,1514,
 91:37 ,Jan.,1933
 Apollo 10:302 1929

I.B.2 - SMITH, JOHN, 1652?-1742

Wessely, Joseph Eduard, 1826-1895
John Smith,verzeichnis seiner schabkunstblät-
ter.Hamburg,Haendcken & Lehmkuhl,1887
156 p. illus. (Kritische verzeichnisse
von werken hervorragender kupferstecher.v.3)

MET
201
K89
v.3
Print Dpt.

DLC CSt PP MN

I.B.2 - SOLIS, VIRGIL, 1514-1562
.Bernard, George.
Effigies regum Francorum omnivm,a Pharamvndo
ad Henricum vsqve tertium...Caelatoribvs,Virgili
Solis & Iusto Amman...Noribergae...1576
64 1 62 ports.

Engraved portrs.with a scene in woodcut in-
serted in frame

Title:Chronica regum Francorum

LC DC37.B5 1576
Rosenwald coll.
Rave.Jb.d.Berl.Mus. I 1959
LC N3.J16 fol. p.149-50
Paolo Giovio & d.Bildnis-
tenbücher d.Humanismus

705
C75
NCFA

I.B.2 - SMITH, JOHN RAPHAEL, 1752-1812

Edwards, Ralph, 1894-
Pastel portraits by J.R.Smith

In:Conn.
90:299-307 Nov.,'32 illus.
93:96,98-101 Feb.,'34 illus. (J.R.Smith & his
pupils)

Cumulated mag.subj.index
A1/3/C76 Ref.v.2,p.444

I.B.2 - SOLIS, VIRGILIUS, 1514-1562

Stumpf, Johannes, 1500-1576?
Keyser Heinrychs des vierdten...fünfftzig-
järige historia...in vier bücher geteilt...
Zürych,Christian Froschouer,1556
CXXIVII numb. illus.

Woodcut portrs.by H.Vogtherr,the elder,
V.Solis and others

LC DD143.S9
Rave.Jb.d.Berl.Mus I 1959
LC N3.J16 fol. p.134
Paolo Giovio & d.Bildnis-
vitenbücher d.Humanismus

N
40.1
S654yF8
1975
NPG

I.B.2 - SMITH, JOHN RAPHAEL, 1752-1812

Frankau, Julia(Davis), 1864-1916
John Raphael Smith,1752-1812;a cat.raison-
né:The life and works of an 18th c.English ar-
tist and engraver of mezzotints...Amsterdam,
G.W.Hissink,1975
259 p. illus. (Scripta artis
monographia,10)

Reprint of 1902 ed.
Index of titles.

Noon.Engl.Portr.drags.&
min. NC860.N66X NPG Bibl.
p.145

I.B.2 - SOMPEL, PIETER VAN, c.1600-after 1643

Soutman, Pieter Claesz, 1580-1657
Effigies imperatorum domus Austriacae,ducum
Burgundiae,regum principumque Europae,comitum Nas-
saviae...Harlemi.1644-1650.
.4 pts. illus.

Compilation of portrs.1.16 emperors of the
house of Hapsburg.-2.Ferdinandus IIus et IIIus.-
3.Duces Burgundiae.-4.Comites Nassaviae
Engravings by P.v.Sompel,P.v.Soutman,J.Suyder-
hoef,J.Louys

Amsterdam,Rijksmus.,cat.
Z5939.A52,deel 1,p.135

I.B.2 - SMITH, JOHN RAPHAEL, 1752-1812

Hind, Arthur Mayger, 1880-1957
John Raphael Smith and the great mezzotin-
ters of the time of Reynolds. N.Y.,Frederick
A.Stokes co.,1911.
15 p. illus. (Half-title:Great engrav-
ers:ed.by A.M.Hind)

Bibliography p.12

4 illus.

LC NE628.H6
Lewis.Descr.bibl.Z5947.A3
L66 1974 NCFA p.265

N
40.1
S71809
1981a
NY.AA

I.B.2 - SOUTINE, CHAIM, 1893-1943

Dunow, Esti
Chaim Soutine, 1893-1943...1981
2 v.in 1 323 p. illus.

Bibliography,p.305-321

Ch.V:Portraits,p.216-287

Thesis Ph.D.-N.Y.Univ.,1981
photocopy of typescript

705
C75
NCFA
v.85

I.B.2 - SMITH, JOHN RUBENS, 1775-1849

Smith, Edward S.
John Rubens Smith,an Anglo-American artist

In:Connoisseur
85:300-7 May,'30 illus.

Gerdts.Art of healing
N8223.G36 NPG,p.113,note113

N
40.1
S73H6
NY.AA

I.B.2 - SOYER, RAPHAEL, 1899-1987

Larner, Abram
Soyer since 1960;...Washington,D.C.Publ.for
the Hirshhorn Mus.and Sculpture Garden by Smiths.
Inst.Press,...1982
17 l. illus(mainly col.)

Cat. of exh.Aug.5-Oct.3,1982

AP1
C912
NCFA
v.7

I.B.2 - SPARRE, LOUIS, 1863- ,Swedish portr.p.

Sparre, Louis, 1863-
.Views on portraiture.

In:Creative Art
7:270-5 Oct.,'30 illus.

Cumulated Mag.subj.index
A1/3/C76 Ref. v.2,p.444

I.B.2 - STEPHAN, PIERRE, 2nd half 18th c.

Hurlbutt, Frank
Old Derby porcelain and its artist.workmen.
London,T.W.Laurie,ltd.,1925
312 p. illus.

Incl.:Ch.Modellers and figure-makers,p.25-52
"...He.Pierre Stephan...modelled most of the
statuettes of the national heroes..."
Pl.15:John Wilkes by Pierre Stephan;biscuit
figure
Bibliography

LC NK4399.D4H8 Groce.In:Am Coll v.15
705.A5 NCFA May,'46,p.19,
note 1

B
.S78B9

AP
1
S654
1924
pt.1
NCFA

I.B.2 - STANLEY, JOHN MIX, 1814-1872

Bushnell, David Ives, 1875-1941
John Mix Stanley,artist explorer...

In:Smithsonian institution.Ann.rep.,1924
p.507-12 illus.

LC Q11.866 1924 Kiniets.J.M.Stanley...
N40.1.S788K5 NCFA p.17

I.B.2 - STETTHEIMER, FLORINE, 1871-1944

Heins, Barbara
Florine Stettheimer and the avant-garde
American portrait

Ph.D.-thesis,Yale Univ.,1986

Archives of American Art
Journal,v.24 no.4,1984
AP1.D39 NMAA,p.28

N
40.1
S788K5
NCFA

I.B.2 - STANLEY, JOHN MIX, 1814-1872

Kiniets, William Vernon, 1907-
John Mix Stanley and his Indian paintings.
Ann Arbor,University of Michigan press,1942
40 p. illus(part col.)

Bibliography

The portrs.of North American Indians,p.13-

LC ND237.864K5 Viola.Indian legacy of
Ch.B.King N40.1.K52V7 NPG
Bibl.

AP
1
C76
NPG
v.16

I.B.2 - STEWARD, JOSEPH, 1753-1822

Joseph Steward and the Hartford museum

In:Conn.Hist.Soc.B.
18:1-16 Jan.-Apr.,'54 Illus.

Pertains to exh. of Steward's portraits.
Biographical treatment of this Conn.portraitist
and museum owner

Arts in America q25961
I5A77X NCFA Ref. H492

705
B97
NCFA
v.119

I.B.2 - STEELE, CHRISTOPHER, ca.1730-

Burkett, Mary E.
A third portrait by Christopher Steele

In:Burl Mag
119:347 May,'77 illus.

Addition:119:774 Nov.,'77 illus.

see also:Kendal,Eng. Abbot Art Gall. 'Four Ken-
dal portrait painters'

I.B.2 - STEWARDSON, THOMAS, 1781-1859

Kendal, Eng. Abbot Art Gallery
Four Kendal portrait painters.cat.of an
exh.held,16 June-29 July,1973...Kendal...,1973
23 p. illus.

Works by Christopher Steele,George Romney,
Daniel Gardner,Thomas Stewardson

Yale Ctr.
f.Brit.Art
Ref.ND
1314.4
.K22

I.B.2 - STEELE, CHRISTOPHER, ca.1730-

Kendal, Eng. Abbot Art Gallery
Four Kendal portrait painters.cat.of an
exh.held,16 June-29 July,1973...Kendal...,1973
23 p. illus.

Works by Christopher Steele,George Romney,
Daniel Gardner,Thomas Stewardson

Yale Ctr.
f.Brit.Art
Ref.ND
1314.4
.K22

I.B.2 - STIEGEL, HENRY WILLIAM, 1729-1785

In sect.
AP
1
A

Stow, Charles Messer, 1880-
A portrait in iron:Stiegel

In:Antiquarian
14:29-31 June,'30 illus.

N.Y.,MMA 709.73.N5
Bibl.p.52

I.B.2 - STIMMER, TOBIAS, 1539-1584

Giovio, Paolo, 1483-1552
..Elogia virorum bellica virtute illustrium...
.Basileae.Petri Pernae...1575
391 p. illus.

126 woodcuts after portrs.in Giovio's coll.
by Tobias Stimmer. 1 woodcut portr.of Giovio

LC CT93.G58 1575

Rave.Jb.d.Berl.Mus.I 1959
LC N3.J16 fol. p.150
Paolo Giovio & d.Bildnisvi-
tenbücher d.Humanismus

I.B.2 - STIMMER, TOBIAS, 1539-1584

Giovio, Paolo, 1483-1552
...Elogia virorum literis illustrium...Basileae
Petri Pernae...1577
231 p. illus.

60 woodcuts after portrs.in Giovio's coll.
by Tobias Stimmer,incl.1 of Giovio

LC CT95.G5

Rave.Jb.d.Berl.Mus. I 1959
LC N3.J16 fol. p.150
Paolo Giovio & d.Bildnisvi-
tenbücher d.Humanismus

I.B.2 - STIMMER, TOBIAS, 1539-1584

Kossmann, E.rnst.F.erdinand., 1861-
Giovios porträtsammlung und Tobias Stimmer

In:Anzeiger für Schweiz.Alterumskunde
N.F.24:49-54 1922

LC DQ1.A72

Rave.Jb.d.Berl.Mus. I 1959
LC N3.J16 fol. p.150 footr
Paolo Giovio & d.Bildnisvi-
tenbücher d.Humanismus

I.B.2 - STIMMER, TOBIAS, 1539-1584

Panvinio, Onofrio, 1529-1568
Accuratae effigies Pontificum Maximorum...
Argentorati,1573,2nd ed.(1st ed.1568)
Durch Verdolmetschung J.Fischaert,gen.Ment-
zer Teutsch beschriben,Strassburg,1573

V & A

Printer & publisher:Bernard Jobin.Woodcuts
by Tobias Stimmer:Half-fgs. of Urban VI to
Gregory XIII;after engravings in the 1st ed.
Fischart condemns onesidedness of Vasari.
Speaks for the 1st time in art-history of German
artists who are Rave.Jb.d.Berl.Mus. I 1959
still famous to- LC N3.J16 fol.p.146 & 149
day. Paolo Giovio & d.Bildnis-
 vitenbücher d.Humanismus

VF
Stock,D.
xerox
copy

I.B.2 - STOCK, DOROTHEA, 1760-1832

Siegel, Linda
The portraits of Dora Stock in Dresden

In:Pantheon

NCA
Uni.Md
N 1.A1P3

41:15-21 Ja/Mr.,'83 illus(part col.)

AP
1
C59
N'AA

I.B.2 - STOCK, JOSEPH WHITING, 1815-1855

Black, Mary.C.
Phrenological associations.Footnotes to
the biography of two folk artists.J.Wh.Stock &
A.Ames.
In:Clarion
1982-84:144-52 Fall,'84 illus.

'The photograph became..a guide,providing.ar-
tists.with inspiration for portraits.'

705
A56
NCFA
v.34

I.B.2 - STOCK, JOSEPH WHITING, 1815-1855

Clarke, John Lee,Jr.
Joseph Whiting Stock,American primitive
painter(1815-1855)

In:Antiques
34:83-4 Aug.,'38 illus.

Stock.Ptgs.& journal N.O.1
S853A1 NCFA Bibl.,p.167

ND
236
L76
NPG

I.B.2 - STOCK, JOSEPH WHITING, 1815-1855

Lipman, Mrs.Jean Herzberg, 1909- comp.
Primitive painters in America....1950. (card 2

Contents-cont.-17.M.E.Jacobson,O.Krans

List of primitive painters

14.J.L.Clarke,jr., J.W.Stock

LC ND236.L76

N
40.1
S853A1
NCFA

I.B.2 - STOCK, JOSEPH WHITING, 1815-1855

Stock, Joseph Whiting, 1815-1855
The paintings and the journal of Joseph
Whiting Stock;ed.by Juliette Tomlinson;with
checklist of his works comp.by Kate Steinway.
1st ed.Middletown,Conn.,Wesleyan Univ.Press,
c.1976
190 p. illus(part col.)

Bibliography
Index

LC ND1329.S69A25

705
A5
NCFA

I.B.2 - STREET, ROBERT, 1796-1865

Semon, Kurt M.
Who was Robert Street?

In:Am.Coll.
14:6-7,19 June,'45 illus.

705
B97
NCFA
v.93

I.B.2 - STRETES, GUILLIM, 16th c.

Auerbach, Erna
 Holbein's followers in England

In:Burl.Mag
93:44-6,49-51 Feb.,'51 illus.

 Refers to exh.Works by Holbein & other mas-
ters of the 16th & 17th c.at London, Royal aca-
demy of arts,1950-51
 see over
 Repro.:Stretes(dated ptgs.:1546,1550)Eworth
(1549,1550,1562,1566)Flicke(1547)
 Strong.Engl.Icon.qND1314
 S924 Bibl.:"Valuable espe-
cially for its material on Scrots"

705
S94
NCFA

I.B.2 - STUART, GILBERT, 1755-1828

Eisen, Gustav, 1847-1940
 Stuart's three Washingtons

In:Intern.Studio
76:86-94 Feb,1923 illus

N
7628
J45C18
1966
NPG

I.B.2 - STUART, GILBERT, 1755-1828

Campbell, Orland, 1890-
 The lost portraits of Thomas Jefferson
painted by Gilbert Stuart..Exhibition.Oct.1965,
Swirbul Library,Adelphi Uni.Rev.printing.Garden
City,N.Y.:Adelphi Uni.,1966
 29 p. illus.

 NPG A 19th c.gall.of disti-
 guished Americans.Bibl.

705
A786
NCFA
v.74

I.B.2 - STUART, GILBERT, 1755-1828

Esterow, Milton
 Who painted the George Washington portrait
in the White House?

In:Art News
74:24-8 Feb.,'75 illus(part col.)

 'White House "Lansdowne"portr.not by Stuart
..'.-M.S.Sadik

FOR COMPLETE ENTRY
SEE MAIN CARD

I.B.2 - STUART, GILBERT, 1755-1828
Cat.of an exh.of portraits,painted by the late
 Gilbert Stuart,Esq.....Boston,Eastburn,
printer,1828,
 8 p.

 'The exh.was held in 1828,in the gallery of
the Boston Athenaeum.'.-Jos.Sabin.Dict.of books
relating to America,v.24,p.188

 182 items

LC ND237.S8C3

N
7628
W31F4
NCFA
R.B.

I.B.2 - STUART, GILBERT, 1755-1828

Fielding, Mantle, 1865-1941
 Gilbert Stuart's portraits of George
Washington...Philadelphia,Printed for the
subscribers,1923
 264 p. illus.

 Incl.:Cat.of 124 portrs.of Washington by
Stuart and one chapter on likenesses of
Gilbert Stuart

LC E312.43.F54 and F541

AP
1
W78
NCFA
v.14

I.B.2 - STUART, GILBERT, 1755-1828

DeLorme, Eleanor Pearson
 Gilbert Stuart;portrait of an artist

In:Winterthur Port
14:339-60 Winter,'79 illus.

 Bibl.references

I.B.2 - STUART, GILBERT, 1755-1828

Fielding, Mantle, 1865-1941
 Paintings by Gilbert Stuart not mentioned
in Mason's Life of Stuart

In:Penn.Mag.of Hist.& Biogr.
38:311-34 1914

LC F146.P65

 Isham,S. Hist.of Amer.ptg.
 ND205.I79 1936 NCFA Bibl.
 p.599

AP
1
W78
NCFA
v.14

I.B.2 - STUART, GILBERT, 1755-1828

DeLorme, Eleanor Pearson
 The Swan Commissions.Four portraits by
Gilbert Stuart

In:Winterthur Port
14:361-95 Winter,'79 illus.

 Bibl.references

705
A784
NCFA

I.B.2 - STUART, GILBERT, 1755-1828

Flexner, James Thomas, 1908-
 Early American painting:Stuart's full-lengths
of Washington

In:Art in Amer.
35:329-33 Oct.1947 Illus.

 Realistic vs. representational approach

 Rep.,1945-47#7561

N
4C.1
S93F6
NCFA

I.B.2 - STUART, GILBERT, 1755-1828

Flexner, James Thomas, 1908-
 Gilbert Stuart;a great life in brief..1st ed.
New York,Knopf,1955
 197 p. (Great lives in brief;a new series
of biographies)

LC ND237.S8F5 Whitehill.The Arts in ear-
 ly Amer.Hist.Z5935.W59 NPG
 Bibl.,p.94

AP
1
A51
A64
NCFA
v.13

I.B.2 - STUART, GILBERT, 1755-1828

Meschutt, David
 Gilbert Stuart's portraits of Thomas
Jefferson

In:Am Art J
13:2-16 Winter,'81 ill.

 Bibl. footnotes

705
G28
NCFA
6 ser.
v.23

I.B.2 - STUART, GILBERT, 1755-1828

Kimball, Sidney Fiske, 1888-1955
 The Stuart portraits of Jefferson

In:Gas Beaux Arts
6 ser.23:329-44 June,'43 illus.

Incl.:Corrections of errors in L.Park's 'Gilbert
Stuart; 1926

N
40.1
S93M8
1969
NPG
2 c.

I.B.2 - STUART, GILBERT, 1755-1828

Morgan, John Hill, 1870-1945
 Gilbert Stuart and his pupils,...;together
with the complete notes on painting by Matthew
Harris Jouett from conversations with Gilbert
Stuart in 1816.N.Y.,Kennedy Galleries,Da Cape
Press,1969
 102 p. illus.

 Incl.:Information concerning Jane Stuart,
p.49-51 illus.

LC ND237.S8M6 Reprint of 1939

708.1
.W243
NCFA

I.B.2 - STUART, GILBERT, 1755-1828

King, Edward S.
 Stuart's last portrait of Washington, its
history and technique

In:J.Walters Art Gall.
9:81-96 1946 illus.

 Rep.,1945-47#7562

N
40.1
S93M9
NCFA
NPG

I.B.2 - STUART, GILBERT, 1775-1828

Mount, Charles Merrill
 Gilbert Stuart,a biography.New York,W.W.
Norton,1964,
 384 p. illus.

 "The works of Gilbert Stuart":p.,357-379

 Bibl.references

LC ND237.S8M65 Whitehill.The Arts in ear-
 ly Amer.Hist.Z5935.W59 NPG
 Bibl.,p.95

N
40.1
S93M16
NMAA

I.B.2 - STUART, GILBERT, 1755-1828

McLanathan, Richard B.K.
 Gilbert Stuart.N.Y.,H.W.Abrams,in associa-
tion with the NMAA,Smiths.Inst.,1986
 159 p. illus(part col.)

 The Library of American Art

 Index
 Bibliography

LC ND1329.S7M39 1986

N
7628
W31M9
NPG

I.B.2 - STUART, GILBERT, 1755-1828

Munn, Charles Allen, 1859-1924
 Three types of Washington portraits:John
Trumbull,Charles Willson Peale,Gilbert Stuart...
N.Y.,Priv.print.The Gillis press.1908
 66p. illus.
 Munn aims to preserve in this book the his-
tory and the pedigree of three portrs.of Wash.,
which are beyond dispute.Authenticity of the
identity & genuineness rests partly on these
records. of the portrs.

LC E312.43.M96 Weddell.A mem'l vol.of Va.
 hist.portaiture.757.9.W38
 NCFA Bibl. p.437

filed
with
N40.1
S93

I.B.2 - STUART, GILBERT, 1755-1828

Mason, George Champlin, 1820-1894
 The life and works of Gilbert Stuart,...
New York,C.Scribner's sons,1879
 286 p. illus.(reproduced on steel & by
photogravure)

LC ND237.S8M4

N
40.1
S93P2
NPG
NCFA

I.B.2 - STUART, GILBERT, 1755-1828

Park, Lawrence, 1873-1924
 Gilbert Stuart;an illustrated descriptive
list...,with an account of his life by John Hill
Morgan,and an appreciation by Royal Cortissoz...
New York,W.E.Rudge,1926
 4 v. illus.

 Work concluded...by Wm.Sawitzky,E.Hadley
Galbreath,John Hill Morgan and Theod.Bolton.
cf.v.1,p.4

 Contents.-v.1.L.Park.... see next card
LC ND237.S8P3 Whitehill.The Arts in ear-
 ly Amer.Hist.Z5935.W59 NPG
 Bibl.,p.55

N
40.1
S93P4
NPG

I.B.2 - STUART, GILBERT, 1755-1828

Pennsylvania Academy of the Fine Arts, Philadel-
 phia
 Portraits by Gilbert Stuart,1755-1828,Nov.7
through Dec.1st,1963.Philadelphia,c1963,

LC ND1329.S7P4

708.1
B685S97
NPG
Ref.

I.B.2 - STUART, GILBERT, 1755-1828

Swan, Mabel Munson
 The unfinished Washington portraits,in her,
Boston Athenaeum Gallery,1827-1873...1940
Ch.V,p.74-84 illus.

 Repro.:Gilbert Stuart's portraits of
Washington and of Martha Washington

Photo in
VF

I.B.2 - STUART, GILBERT, 1755-1828

Sawitzky, Wm.
 Lost portraits add to Stuart's fame

In:N.Y.Times Mag.
4:p.14-15, Aug.,12,1928

 Five hitherto unrecorded portrs. by Stuart
Portrs. of Wm.Bingham,Pres.of U.S.Senate,Miss
Montagu,Geo.Frederick,Earl of Westmeatn,Adam
Walker,author & inventor,Geo.Thomas John,Marquis
of Westmeath

LC AP2N6575,July-Dec,1928 Tarkington,Booth:Some
 old portrs. Bibliogr.

705
C75
NCFA
v.171

I.B.2 - STUART, GILBERT, 1755-1828

Truettner, William H.
 Portraits of Stephen Decatur by or after
Gilbert Stuart

In:Connoisseur
171:264-73 Aug.'69 illus.

 Exchanges attributions & dates proposed by
Chs.L.Lewis
 Repro.incl.:Ths.Sully,J.W.Jarvis,R.Peale,Js.
A.Simpson,Chs.Bird King,Js.H.Cafferty

705
A784
NCFA
v.21

I.B.2 - STUART, GILBERT, 1755-1828

Sawitzky, William, 1880-1947
 Some unrecorded portraits by Gilbert Stuart

In:Art in Am
21:15-27,38-48,81-93 Dec,'32-Jan,'33

 Whitehill.The Arts in ear-
 ly Amer.Hist.Z5935.W59 NPG
 Bibl.,p.95

N
40.1
S93U5
NPG

I.B.2 - STUART, GILBERT, 1755-1828

U.S. National Gallery of Art
 Gilbert Stuart,portraitist of the young
Republic,1755-1828..Exh.....Providence,Mus.of
Art Rhode Island School of Design 1967

LC ND237.G8A46 FOR COMPLETE ENTRY
 SEE MAIN CARD

AP
1
S42
NCFA
v.12

I.B.2 - STUART, GILBERT, 1755-1828

Stuart, Jane, 1812-1888
 The Stuart portraits of Washington

In:Scribner's Monthly
12:367-74 July,1876 illus.(1)

 The history of St.'s portrs.of W.& Mrs.
Washington after life & copies by Stuart of these,
St.'s 5 whole-lengths of W.& 20 others of dif-
ferent sizes.
 Incl.:St.'s list of gentlemen who are to
have copies of the portrs.of the Pres.of the US
 Morgan.G.Stuart & his pupil
 N40.1S93M8 NPG p.29 note 2

S92W6

I.B.2 - STUART, GILBERT, 1755-1828

Whitley, William Thomas
 Gilbert Stuart...Cambridge,Mass.,Harvard
university press,1932
 240 p. illus.

 Bibliography

LC ND237.S8W5 Whitehill.The Arts in ear-
 ly Amer.Hist.Z5935.W59 NPG
 Bibl.,p.95

708.1
B685S97
NPG
Ref.

I.B.2 - STUART, GILBERT, 1755-1828

Swan, Mabel Munson
 The Stuart benefit exh.,in her,Boston Athe-
naeum Gallery,1827-1873...1940
Ch.IV,p.62-73

 Refers to exh.Aug.4-Sept.1,1828,ca.250 por-
traits had been lent.
 Reproduced Gilbert Stuart by John Neagle
List of 216 sitters

N40.1
S93M8
1969
NPG

I.B.2 - STUART, JANE, 1812-1888

Morgan, JOHN HILL, 1870-
 Gilbert Stuart and his pupils...N.Y.,Kenne-
dy Gall.,Da Capo Press,1969

 Reprint of 1939 ed.

 Incl.:Information concerning Jane Stuart,
p.49-51 illus.

I.B.2 - STUART, JANE, 1812-1888
(daughter of Gilbert Stuart)

Powel, Mary E.
Miss Jane Stuart,1812-1888

In:Newport hist.soc.,Newport,R.I.
Bull.of the Newport hist.soc.
31:1-16 Jan.'20

LC F89.N5N615

Morgan.Gilb.Stuart & his
pupils N40.1.S93M8 1969
p.49 note 2

705
S94
NCFA
v.96

I.P.2 - SULLY, THOMAS, 1783-1872

Comstock, Helen
Jefferson in his old age

In:Studio
96:17-18 June,'30 illus(part col.)

Painting by Thomas Sully,1821

Kimball.Life portrs.of Jef-
ferson...N7628.J45K4,p.529

qN
40.1
S932T15
1985
NMAA

I.P.2 - STUBBS, George, 1724-1806

Tate Gallery, London
George Stubbs, 1724-1806.London Tate Gal-
lery Publications,c.1984.
248 p. illus(part col.)
"...for the exh.at the Tate Gall.17Oct.
1984-6 Jan.1985 and at the Yale Center for
Briti.Art 13 Feb.-7 Apr.1985"--t.p.verso
Selection of exhibited works by J.Egerton
'Most of us know St.as..ptr.of animals...
he was also an incisive portraitist...'.-
Harry J.Gray
'One of the chief aims of the exh.is to
show what a per ceptive observer of human

N
40.1
S95F2
NPG

I.B.2 - SULLY, THOMAS, 1783-1872

Fabian, Monroe H.
Mr.Sully,portrait painter.An exh.at the
National Portrait Gallery,June 3 to Sept.5,1983
86 p. illus(part col.)

Incl.Index of sitters
Bibliography

LC ND1329.S8L4 1983

I.B.2 - SUCCA, ANTOINE DE, died 1620

Les Mémoriaux d'Antoine de Succa...Bruxelles,
Bibliothèque Albert 1er,1977

LC ND655.P664 t.7

FOR COMPLETE ENTRY
SEE MAIN CARD

N
40.1
S95S8
1986a
NPG

I.B.2 - SULLY, THOMAS, 1783-1872

Greene, Margaret Harm
Dr.Edward Hudson and Maria Mackie Hudson:
Thomas Sully's portrait style,1810-1820. 1986
41 leaves illus.

Bibliography;Leaves 40-41
Photocopy
Masters essay-Univ.of Michigan,1986

N
40.1
S95B5
NPG

I.B.2 - SULLY, THOMAS, 1783-1872

Biddle, Edward
The life and works of Thomas Sully(1783-
1872)by Edward Biddle and Mantle Fielding...
Philadelphia,1921
411 p. illus.

"List of ptgs":p.83-325."Miniatures":p.327-
333."Subject ptgs.":p.335-392

LC ND237.S9B5

Whitehill.The Arts in ear-
ly Amer.Hist.Z5935.W59 NPG
Bibl.,p.95

I.P.2 - SULLY, THOMAS, 1783-1872

Hart, Charles Henry, 1847-1918
A register of portraits painted by Thomas
Sully,1801-1871. Philadelphia,1909
158 p. illus.

LC ND237.S9H3

I.B.2 - SULLY, THOMAS, 1783-1872

Budd, Henry, 1783-1872
Thomas Sully

In:Penn.mag.hist.& biogr.,Phila.
42:97-126 1918

A paper read before the Hist.soc.of Penn.,
Jan.14,1918

LC F146.P65
LC ---separate ND237.S9B7

Weddell.A mem'l vol.of Va.
hist.portraiture.757.9.W3c
NCFA Bibl.p.434

ND
1311.2
P61x
NPG

I.P.2 - SULLY, THOMAS, 1783-1872

London, Hannah Ruth, 1894-
Portraits of Rebecca Gratz by Ths.Sully
Miles, Ellen Cross corp.
Portrait painting in America.The nineteenth
century.N.Y.....,1977 (card 4)

Partial contents cont'd:...H.London,Portrs.
of Rebecca Gratz by Ths.Sully,p.162-4;...

B
S94P4

I.B.2 - SULLY, THOMAS, 1783-1872

Pennsylvania academy of the fine arts,Philadelphia
...Catalogue of the memorial exhibition of portraits by Thomas Sully.Philadelphia,1922
181 p. illus.

Exh.Apr.9-May 10,1922

"No such exh.of S.'s works...has been gathered before..."-Foreword

LC ND237.S9P4

Weddell.A mem'l vol.of Va.
hist.portraiture.757.9.W38
NCFA Bibl. p.438

I.B.2 - SUYDERHOEF, JONAS, c.1613-1686

Soutman, Pieter Claesz, 1580-1657
Effigies imperatorum domus Austriacae,ducum
Burgundiae,regum principumque Europae,comitum Nassaviae...Harlemi.1644-1650,
4 pts. illus.

Compilation of portrs.1.16 emperors of the
house of Hapsburg.-2.Ferdinandus IIus et IIIus.-
3.Duces Burgundiae.-4.Comites Nassaviae
Engravings by P.v.Sompel,C.C.Soutman,J.Suyderhoef,J.Louys

Amsterdam,Rijksmus.,cat.
Z5939A52,deel 1,p.135

ND
1311.2
P61x
NPG

I.B.2 - SULLY, THOMAS, 1783-1872
Steadman, William F.
The Sully portraits at West Point
Miles, Ellen Cross corp.
Portrait painting in America.The nineteenth
century.N.Y....,1977 (card 2)

Partial contents:...Wm.E.Steadman.The Sully
portrs.at West Point,p.62-5;...

705
A56
NMAA
v.120

I.B.2 - SWAIN, WILLIAM, 1803-1847

Agler, Raymond B.
William Swain,portrait painter

In:Antiques
120:124-33 July,'81 illus(part col.)

Repro incl.:Geo.Washington,1826(after
Stuart s Lansdowne portr.)

N
40.1
S95A1
NCFA

I.B.2 - SULLY, THOMAS,1783-1872

Sully, Thomas, 1783-1872
Hints to young painters;a historic treatise
on the color,expression,and painting techniques
of American artists of the Colonial and Federal
periods.Reprinted in new format from the original
ed.of 1873...N.Y.,Reinhold Pub.Corp.,1965
46 p. illus.

ND1262.S9 1965

I.B.2 - SWEBACH, JACQUES FRANÇOIS JOSEPH,called
FONTAINE & DESFONTAINE,1769-1823
Blin, Pierre
Portraits des grands hommes,femmes illustres et sujets mémorables de France,gravés et
imprimés en couleurs...Paris,Chez Blin,imprimeur en Taille-douce.1792,

Brit.
mus.
1260 c.

2 vols. 192 col.pl.in 3 v.
Originally publ.in 50 parts.
96 portrs.& 96 histor.scenes.Designed by
Sergent,Desfontaine,Naigeon,P.Barbier,Bénard,
F.Gérard,Deplessis-Berteaux & engraved by Sergent,Mme.de Cernel,J.Morret,Ridé,L.Roger,
Le Coeur

NN

Source:Lowine.Bibl. of art & illus.Books
A1023.L67 1969. NCFA p.565

N
40.1
S96H4
NPG

I.B.2 - SUTHERLAND, GRAHAM VIVIAN, 1903-

Hayes, John T.
Portraits by Graham Sutherland.London,National Portrait Gallery,1977
96 p. illus(part col.)

Exh.held at .London.National Portrait Gall.
24 June-16 Oct.,1977

Bibliography

LC ND1329.S87A4 1977

N
40.1
T118D3
NCFA
NPG

I.B.2 - TACK, AUGUSTUS VINCENT, 1870-1949

Deerfield Academy, Deerfield, Mass.
American Studies Group
Augustus Vincent Tack,1870-1949.Exh.organ.
by the American Studies Group.shown at.the Hilson Gall.,Deerfield Academy,Deerfield,Mass.,1968
.Deerfield,Mass.,1968.
63 p. illus.

*Special suppl.to the Deerfield J.,v.24,no.3

Arts in Am qZ5961.U5A77X
NCFA Ref. J 859

I.B.2 - SUTTERMANS, JUSTUS, 1597-1681

Bautier, Pierre
Juste Suttermans, peintre des Médicis...
Bruxelles.etc..G.van Oest & cie.,1912
139 p. illus. (coll.des grands artistes
des Pays-Bas)

"Distributions géographique de l'oeuvre
de Juste Suttermans",p..123.-30

Bibliography

LC ND673.S9B3

Enc.of World Art
N31E56Ref.v.11 col.512
Bibl.on portr.

AP
1
I261
NPG
v.78

I.B.2 - TAFT, LORADO, 1860-1936

Carvey, Timothy J.
Conferring status:Lorado Taft's portraits
of an artistic community

In:Ill.Hist.J.
78:162-78 Aut.,'85 illus.

705
I 61
NCFA
v.32

I.B.2 - TARBELL, EDMUND CHARLES, 1862-1938

Coburn, Frederick W.illiam.,1870-
Edmund C. Tarbell

In:Studio
32:75-87 Sept.'07 illus.

Nat'lAcad.of design.Ar-
tists by themselves
qN7618.N27 NPG p.127,note
b10

N
40.1
T2107
1974
NPG

I.B.2 - TASSIE, WILLIAM, 1735-1799

Gray, John Miller, 1850-1894
James and William Tassie...London,The Hol-
land Press,1974

FOR C0......... ENTRY
SEE MAIN CARD

705
B97
NCFA
v.14

I.B.2 - TARBELL, EDMUND CHARLES, 1862-1938

Cox, Kenyon
Art in America.The recent work of Edmund
C.Tarbell

In:Burl Mag
14:254-60 Jan.,'09 illus.

705
B97
NCFA
v.124

I.B.2 - TAYLOR, JOHN, died 1651

Edmond, Mary
The Chandos portrait:a suggested painter

In:Burl Mag
124:146-9 Mar,'82 illus.

Edmond suggests John Taylor as the painter
of the only supposed portr.of Shakespeare done
during his lifetime

Rila 1984/I #1991

N
40.1
T192P6
NMAA

I.B.2 - TARBELL, EDMUND CHARLES, 1862-1938

Pierce, Patricia Jobe
Edmund C.Tarbell and the Boston School of
painting,1889-1980...ed.by John Douglas Ingra-
ham.Hingham,Mass.,Pierce Galleries,c.1980
253 p. illus(part col.)

Index
Bibliography,p.236-45

Ch.7:Tarbell's portraiture,p.119-28
Ch.8 incl.:Photographs of E.C.Tarbell
paintings,p.141-49
Nat'l academy of design
Artists by themselves
qN7618.N27 NPG p.127,note99

N
T416

I.B.2 - THEUS, JEREMIAH, c.1719-1774

Middleton, Margaret Simons
Jeremiah Theus,colonial artist of Charles
Town.Columbia,University of South Carolina
Press,1953
218 p. illus.

"A contribution of the National Society of
the Colonial Dames of America in the State of
South Carolina."

LC ND237.T53M5

Whitehill.The Arts in ear-
...ner.Hist.Z5935.W59 NPG
v.1.,p.95

ND
205
H86
1976x
NCFA

I.B.2 - TARRYTOWN LIMNER, 18-19th c.

Huntington Galleries
American art:From the limners to the Eight.
.Exh.,Feb.1 through May 2,1976,Huntington Gal-
leries,Huntington,W.Va. Ashland Oil,1976
128 p. illus(part col.)

Bibliography

Ptgs.are fr.private & public colls.in East
Kentucky,South Ohio & West Virginia.

Grouped:Portraiture,p.30-53;landsc.,Folk art
LC ND205 86 The West;The Eight

1976

AP
1
N267
NMAA

I.B.2 - THIELCKE, HENRY DANIEL, c.1788/89-1874

Fox, Ross
Henry D.Thielcke:a recently found portrait
and some reflections on Thielcke's links with
the English school

In:Ann'l B NG of Canada
8:21-27 1984-85 illus.

Résumé in French

N
40.1
T2107
1974
NPG

I.B.2 - TASSIE, JAMES, 1735-1799

Gray, John Miller, 1850-1894
James and William Tassie...London,The Hol-
land Press,1974

FOR COMPLETE ENTRY
SEE MAIN CARD

I.B.2 - THOMAS, STEPHEN SEYMOUR, 1868-1956

Los Angeles Co.,Calif. Museum of Art,Los Angeles
"Portraiture,1891-1935"by S.Seymour Thomas,
exh...Jan.10 to Feb.10,1935,biographical
sketch of the artist.Los Angeles?,1935.
23 p. illus.

(LC ND237.T5L7)

N
40.1
T462Th
1981a
NPG

I.B.2 - THOMAS, STEPHEN SEYMOUR, 1868-1956

Thomas, Hazel T.
S.Seymour Thomas,portrait painter(1868-
1956).Unpublished manuscript,1981
81 p. illus.

Incl.:List of sitters in alphabetical order

Bibliography

I.B.2 - TINTORETTO, 1518-1594

Haack, H.
Tintoretto als portr*tmaler

In:Z bildende Kunst
1896

Z bildende Kunst
LC N3.Z5

Waetzoldt ND1300.W12

N
40.1
T469A1
NPG
rare book

I.B.2 - THOMPSON, CEPHAS, 1775-1856

Thompson, Cephas, 1775-1856
Cephas Thompson's memorandum of portraits.
Northampton,Mass.:c.1965:
:78:p.

Facsim.of the original MS which lists some
of the sitters whose portrs.the artist ptd.
during the 1st quarter of the 19th c.
Original MS now in coll.Boston,Athenaeum
(June,1979)

LC ND237.T552A35 Art Books 1950-79 Z5937
 A775 NCFA Ref. p.897

I.B.2 - TITIAN, 1477-1576

Gronau, Georg, 1868-
Tizian als bildnismaler

In:Museum
5:

LC for Museum:
N7511.M7

Waetzoldt ND1300.W12

N
40.1
T486M2
NMAA

I.B.2 - THORNYCROFT, William Hamo, 1850-1925

Manning, Elfrida
Marble and bronze:the art and life of
Hamo Thornycroft...introd.by Benedict Read.
London,Trefoil Books;Westfield,N.J.:Eastview
Editions,1982
216 p. illus.

Index
Bibliography
Cat.of works(incl.many portrs.)

I.B.2 - TIZIANO VECELLI, 1477-1576

Kaplan, Paul H.D.
Titian's Laura Dianti and the origins of the
black page in portraiture

NCA
N 1
A3
v.21

In:Antichità viva
21,no.1:11-18 1982
21,no.4:10-18 1982 illus.

The black page has in instances functioned
as an identifying attribute,alluding to the inter
ests of the sitter or given a hint of the sit-
ter's nationality.
Repro.incl.: (see author card)

705
A7832
NCFA
v.52

I.B.2 - THORVALDSEN, BERTEL, 1768-1844

Light, Fred
Review of Thorvaldsen's portraetbuster,by
Else Kai Sass. Copenhagen,G.E.C.Gad Forlag,
1963-65

In:Art Bul
52:334-6 Sep.1970

Compares 18th c. representative portrs. with
19th c. portrs. of individual characters

I.B.2 - TORY, GEOFFROY, c.1480-1533

Giovio, Paolo, 1483-1552
Vitae dvodecim Vicecomitvm Mediolani princi-
pvm.Lvtetiae,R.Stephani,1549
199 p. illus.

10 woodcuts after portrs. in Giovio's coll.
perhaps by Claude & Pierre Woeiriot.-Rave
Portrs.engr.on wood have the Lorraine cross
device of Geoffroy Tory.-LC
Portrs.of the Visconti family,Milan

LC DG657.7.G5 1549 Rave.Jb.d.Berl.Mus. I 1959
Rosenwald coll. LC N3.J16 fol. p.139-41
 Paolo Giovio & d.Bildnisvi-
 tenbücher d.Humanismus

qN
40.1
T487S2
NPG

I.B.2 - THORVALDSEN, BERTEL, 1768-1844

Sass, Else Kai, 1912-
Thorvaldsens portraetbuster. Copenhagen,
G.E.C.,Gads Forlag,1963-65

3 vol. illus.

Review in Art Bul by Fred Light
52:334-6 Sep.,1970
"Most important work on Th."
Two short essays & chronological cat.raisonné
in English

NB723.T5S26

I.B.2 - TOURNACHON, FÉLIX, 1820-1910,called NA-
 :DAR

Tournachon, Félix, 1820-1910
Panthéon Nadar.1° feuille.Paris,1854

Caricature portraits of contemporary French
celebrities

MB

Stelzer.Kunst & photogr.
LC N72.P5S8,p.34

705
C75
v.94

I.B.2 - TOWNSHEND, GEORGE, 1724-1807

Grundy, Cecil Reginald, 1870-
 An 18th century caricaturist George,1st
Marquess Townshend

In:Conn.
94:94-7 Aug.,'34 illus.

London.NPG.Townshend album
N40.1T75XL8 NPG Bibl.

705
B97
NCFA
v.113

I.B.2 - TROY, FRANÇOIS DE, 1645-1730

Cailleux, Jean ed.
 L'Art du dix-huitième siècle.Some family
and group portraits by François de Troy(1645-
1730)

In:Burl Mag
113,suppl.no.26:I-XVIII Apr.,'71 illus.

f.6:Mme.de Franqueville & her children
with black servant and portr.within portrait

Rosenfeld,M.N. L'Argillie

p.401,408

N
40.1
T75XL8
NPG

I.B.2 - TOWNSHEND, GEORGE, 1724-1807

London. National portrait gallery
 The Townshend album/Eileen Harris;.for the.
National portrait galley.London,H.M.S.O.,1974
26 p. illus.

Bibliography

LC NC1479.T66L66 1974

I.B.2 - TROY, FRANÇOIS DE, 1645-1730

Goulinat, Jean Gabriel
 François de Troy

In:L'Art et les artistes
10:149-52 Feb.,1923 illus.

FOGG
Fal.
185F

'Très célèbre au 18e s.le portraitiste a été
méconnu longtemps.'

LC N2A5

Rep.1925
#1734

CT
275
K151
F8
NPG
NCFA

I.B.2 - TRIPIER LEFRANC, EUGÉNIE, 1805-

Frankenstein, Alfred Victor, 1906-
 The royal visitors..Portland,Oregon Histo-
rical Society.c.1963.
 32 p. illus(part col.)

King Kamehameha II & Queen Kamamalu by
Eugénie Lebrun in the Iolani Palace,Honolulu

I.B.2 - TROY, FRANÇOIS DE, 1645-1730

see also
Gabillot,C. Alexis Grimou
In:Gas Beaux-Arts
5(4ième ser):309 f.

'François De Troy fut un des trois grands
portraitistes de cette époque...'

ND
1311.2
P61x
NPG

I.B.2 - TROTT, BENJAMIN, c.1770-1843
Brockway, Jean Lambert
 Unpublished miniatures by Benj.Trott
Miles, Ellen Gross comp.
 Portrait painting in America.The nineteenth
century.N.Y....,1977 (card 2)

Partial contents:...J.L.Brockway,Unpublished
miniatures by Benj.Trott,p.53-5;...

AP
1
A--area

I.B.2 - TRUMBULL, JOHN, 1756-1843
Bolton, Theodore, 1889- and H.L.Binsse
 Trumbull,"Historiographer"of the Revolution

In:Antiquarian
17:13-18,50,52,54,56,58 July,'31 illus(1 col)

Repro.incl.:Washington(drawing)

Incl.:1st check list of portrs.by John Trumbull

705
A784
NCFA
v.29

I.B.2 - TROTT, BENJAMIN, c.1770-1843

Sherman, Frederic Fairchild, 1874-1940
 Benjamin Trott,an early American minia-
turist

In:Art in Am
29:151-4 Jul,'41 illus.

List of 75 miniatures (most on ivory)

London,Hannah Ruth
Min.&silh. Bibl.
N7593.L84

759.1
.C75

I.B.2 - TRUMBULL, JOHN, 1756-1843

Connecticut. Tercentenary commission
 ...Paintings by John Trumbull and Samuel Finley
Breese Morse,Gallery of fine arts,Yale universi-
ty.New Haven,Yale university press,1935.
 24 p. illus.

Ids.Portrs.of John Jay
B.J42I1 & CT275.J42I1NPG
Bibl.

AP
1
A51A7
v.2
2nd div.
NCFA
R.R.

I.B.2 - TRUMBULL, JOHN, 1756-1843

Durand, John, 1822-1908
John Trumbull

In:Am.Art Rev.Benton, Estes & Lauriat,1881
2,2nd div.:181-91,221-30 illus.

Jaffe, I.B. John Trumbull..
N40.1.T86J2 NMAA Bibl.p.335

105
A7875
NCFA
v.1

I.B.2 - TRUMBULL, JOHN, 1756-1843

Richardson, Edgar Preston, 1902-
A portrait of John Trumbull,the poet

In:Art Q
1:213-24 Summer,'38 illus.

Incl.discussion of Flemish baroque influ-
ence on Trumbull.

N
7592
H513
RB
NPG

I.B.2 - TRUMBULL, JOHN, 1756-1843

Henkels, Stanislaus Vincent, 1854-1926
Cat.of the very important coll.of studies
and sketches,made by Col.John Trumbull...as
well as his important coll.of engravings and
portraits in mezzotint,line and stipple...to
be sold Thur,Dec.17,1896.Cat.comp.,and sale
conducted by Stan.V.Henkels at the art auction
rooms of Thos.Birch's Sons,Philadelphia
39 p. illus.
cat.no.770

Sale by order of B.Silliman,who inherited
the effects of Col.John Trumbull

705
A784
NCFA
v.19

I.B.2 - TRUMBULL, JOHN, 1756-1843

Sherman, Frederic Fairchild,1874-1940
John Trumbull's portrait miniatures on wood

In:Art in America
19:257-61 Oct,1931 illus.

Chronological list

Ptd.in oil. Comparison of W.C. on ivory &
oil on wood

N
40.1
T86J2
NPG

I.B.2 - TRUMBULL, JOHN, 1756-1843

Jaffe, Irma B.
John Trumbull,patriot-artist of the Ameri-
can Revolution.Boston,N.Y.,Graphic Society,
1975
346 p. illus(part col.)

Incl.:Index
Bibliography

Incl.:Cat.of illustrated works by Trumbull
Ch.1:Portrait(3 portrs.of Washington
Carolina Art ass.,Charles-
ton,S.C. Miniature portr.
coll.
Bibl.p.179

N
40.1
T86S6
1967
NPG

I.B.2 - TRUMBULL, JOHN, 1756-1843

Sizer, Theodore, 1892-1967
The works of Colonel John Trumbull,artist
of the American Revolution...Rev.ed.New Haven,
Yale University Press,1967
181 p. illus.(part col.)

Bibliographical references

Incl.list of over 750 portrs.

LC ND237.T8S5 1967

Whitehill.The Arts in ear-
ly Amer.Hist.Z5935.W59 NPG
Bibl.,p.96

N
40.1
T86M8
NCFA
NPG

I.B.2 - TRUMBULL, JOHN, 1756-1843

Morgan, John Hill, 1870-1945
Paintings by John Trumbull at Yale Univer-
sity.New Haven,Yale University Press,1926
90 p. illus.

LC ND237.T8M6

Ide.Portrs.of John Jay
B.J42I1 & CT275.J42I1NPG
Bibl.

N
40.1
T86A1
1953
NPG

I.B.2 - TRUMBULL, JOHN, 1756-1843

Trumbull, John, 1756-1843
The autobiography of Colonel John Trumbull.
ed.by Theodore Sizer.Containing a supplement
to the editor's,The works of Colonel John Trum-
bull.New Haven,Yale University Press,1953
404 p. illus.

Bibliographical footnotes

First publ.in 1841

LC ND237.T8A32

Whitehill.The Arts in ear-
ly Amer.Hist.Z5935.W59 NPG
Bibl.,p.96

N
7628
W31M9
NPG

I.B.2 - TRUMBULL, JOHN, 1756-1843

Munn, Charles Allen, 1859-1924
Three types of Washington portraits:John
Trumbull,Charles Willson Peale,Gilbert Stuart..
N.Y.,Priv.print.The Gillis press,1908
66p. illus.
Munn aims to preserve in this book the his-
tory and the pedigree of three portrs.of Wash.,
which are beyond dispute.Authenticity of the
identity & genuineness rests partly on these
records. of the portrs.

LC E312.43.M96

Weddell.A mem'l vol.of Va.
hist.portraiture.757.5.W38
NCFA Bibl. p.437

B
.T865
W4

I.B.2 - TRUMBULL, JOHN, 1756-1843

Weir, John Ferguson, 1841-1926
John Trumbull;...catalogue of his works,pre-
pared for the Committee on the bi-centennial ce-
lebration of the founding of Yale college...
New York,C.Scribner's sons,1901
79 p. illus.

LC ND237.T8W4

Ide.Portr.of John Jay
B.J42I1 & CT 275.J42I1NPG
Bibl.

N
40.1
T86Y18
1864
RB
NPG

I.B.2 - TRUMBULL, JOHN, 1756-1843

Yale University
Catalog of paintings by Colonel Trumbull
including 8 subjects of the American Revolu-
tion,with near 250 portrs.of persons distin-
guished in that important period...on exh.in the
picture gall.of Yale College...5th ed.1864(New
Haven,Conn.,E.Hayes)
35 p.

Archives of American Art
Portraits

I.B.2 - TURNER, CHARLES, 1773-1857

Whitman, Alfred, 1860-1910
The masters of mezzotint;the men and their
work...London,G.Pell & sons,1898
95 p. illus.

Bibliography

Appendix:Cat.of portrs...in mezzotint by
Charles Turner,1774-1857

LC NE1815.W5 Sellers.Archives of Amer.
art:Mezzotint prototypes...
In:Art Q 20no.4,p.467

I.B.2 - TRUMBULL, JOHN, 1756-1843

Yale University
A catalogue,with descriptive notices,of the
portraits,busts,etc.belonging to Yale university.
1892...New Haven:Press of Tuttle,Morehouse &
Taylor,1892.
192 p.

Prefatory note signed:F.B.D.:i.e.Franklin
Bowditch Dexter.
The appendix contains lists of the authentic
portrs.in the series of Revolutionary ptgs.by
Col.Trumbull...

LC LD6325 1892 & N590.A6 1892 Fogg,v.11,p.326

I.B.2 - TUSSAUD, MARIE(GRESHOLTZ), 1760-1850

Tussaud, John Theodore, 1850-1943
The romance of Madame Tussaud's by John The-
odore Tussaud;with an intro.by Hilaire Belloc...
New York,George H.Doran company(c.1920)
368 p. illus.

Rev.:Connoisseur,57:61-2,May,1920

LC DC146.T9T9

705
C75
NCFA
v.61

I.B.2 - TURMEAU, JOHN, 1777-1846

Dibdin, E.Rimbault, 1853-1941
John Turmeau,miniaturist

In:Connoisseur
61:20,23-4 Sept.,'21 illus.

FOR COMPLETE ENTRY
SEE MAIN CARD

705
A784
NCFA
v.38

also:
N40.1
M39F8
NPG
NCFA

I.B.2 - TUTHILL, ABRAHAM G.D., 1775 or 6-1843

Frankenstein, Alfred Victor, 1906 and Arthur K.
D.Healy
Two journeyman painters

In:Art in Am.
38:7-63 Feb.,'50 illus.

Benjamin Franklin Mason,Vermonter,p.7-43
Abraham G.D.Tuthill,p.47-63

Bibliography
Chronological list of known portrs.
J.G.Cole,teach er of Mason,see p.10-11,13

I.B.2 - TURNER, CHARLES, 1773-1857

Earlom, Richard, 1743-1822, engr.
Portraits of characters illustrious in Brit-
ish history, from the beginning of the reign of
Henry the eighth to the end of the reign of James
the second. Engraved in mezzotinto. Richard
Earlom & Charles Turner. From original pictures,
miniatures, etc. London,S.Woodburn,.1815?.

illus.(100 portrs.)

Each portr.accompanied by brief biogr.sketch
Besides Earlom & Turner,plates by Rbt.Dunkarton
LC N7598.E3

I.B.2 - TUTHILL, ABRAHAM, 1776-1843

Tuthill, Abraham, 1776-1843,portrait painter
in the young republic..Cat.of exh.at.Jef-
ferson County Hist.Soc. Intro.by David
Tatham.Watertown,N.Y.,The Society,1983
24 p. illus.

DeWint Books in print.Subject
guide,1985-'86,p.4864

I.B.2 - TURNER, CHARLES, 1774-1857

Whitman, Alfred, 1860-1910
...Charles Turner...London,G.Bells & sons,
1907
293 p. illus. (Nineteenth century mez
sotinters)

Incl.Cat.of portrs.,p..31.-220

LC NE642.T8W5 Levis.Descr.bibl.A5947.A3;
L66 1974 NCFA p.133

705
A7875
NCFA
v.14

I.B.2 - VALDENUIT, THOMAS BLUGET DE, 1763-1846

Grigaut, Paul L.
Three French works of American interest

In:Art Q
14:348-52 Winter, 1951 illus.

Refers to the exh."The French in America,1520-
1880"at Detroit. Institute of Arts. 1951
Repre.:John Paul Jones,pastel drag.by Moreau
le Jeune. Lafayette & Mme.Roland by Jean-Jaeques
Hauer. Mr.& Mrs.Kemper,drag.by Valdenuit

N
40.1
F43N8
NCFA
NPG

I.B.2 - VALDENUIT, THOMAS BLUGET DE, 1763-1846

Norfleet, Fillmore
Saint-Mémin in Virginia;portraits and bio-
graphies...Richmond,Va.,The Dietz press,1942
235 p. illus.

Bibliography

Repre.of 56 crayon portrs.& 142 engravings

Valdenuit is mentioned p.14-16

LC N7593.N7

705
A56
NCFA
v.96

I.B.2 - VANDERLYN, PIETER,the GANSEVOORT LIMNER,
ca.1687-1778

Black, Mary C.
The Gansevoort Limner

In:Antiques
96:738-44 Nov.,'69 illus.

VF
St.-Mémin

I.B.2 - VALDENUIT, THOMAS BLUGET DE, 1763-1846

Rice, Howard Crosby, 1904-
An Album of Saint Mémin portraits

In:Princeton Uni Lib Chron
13:23-31 Autumn, '51

Re:Valdenuit see p.24-5

LC Z733.P9605

ND
2C7
W78
1971
NPG

I.B.2 - VANDERLYN, PIETER,the GANSEVOORT LIMNER,
ca.1687-1778

Black, Mary C.
Pieter Vanderlyn and other limners of the
Upper Hudson

In:Winterthur Conf.on Mus.Op'n and Conn'ship
17th:217-49 1971 illus.

Bibliography

N5
C85
NCFA
v.141

I.B.2 - VANDERBANK, JOHN, 1694-1749

Hammelmann, Hanns A.
A draughtsman in Hogarth's shadow.The draw-
ings of John Vanderbank

In:Country Life
141:32-3 Jan.5,'67 illus.

N
6505
B62
NCFA

I.B.2 - VANDERLYN, PIETER, the GANSEVOORT LIMNER,
c.1687-1778

Black, Mary C.
What is American in American art.An exh....
for the benefit of the Mus.of Amer.Folk Art
.Feb.9-March 6,1971.Intro.by Lloyd Goodrich,
cat.by Mary Black.N.Y.,M.Knoedler.1971.
80 p. illus(part col.)

Exh.in memory of Jos.B.Martinson

Index of artists

'Folk art contained the essence of native
flavor continued on next card
Artsin America H61c

N5
99
NCFA

I.B.2 - VANDERLYN, JOHN, 1775-1852
(Grandson of Pieter Vanderlyn)

Averill, Louise Hunt, 1915-
John Vanderlyn,American painter(1775-1852)
.New Haven,Conn..Yale University,1949
389 leaves illus.

Incl.:Cat.raisonné
Bibliography:leaves 378-89

Thesis. Yale University

(Microfilm does not incl.illustrations)

705
A56
NCFA
v.75

I.B.2 - VANDERLYN, PIETER, the GANSEVOORT LIMNER
c.1687-1778

Flexner, James Thomas, 1908-
Pieter Vanderlyn come home

In:Antiques
75:546-9 June,'59 illus.

Incl.:List of portrs. attr. to Pieter Van-
derlyn by Flexner, p.580

Black.In:AmArt J AP1.A51
MAA v.12:6

N
40.1
V23L7
NPG

I.B.2 - VANDERLYN, JOHN, 1775-1852
(Grandson of Pieter Vanderlyn)

Vanderlyn, John, 1775-1852
The works of John Vanderlyn,from Tammany to
the Capitol,by Kenneth C.Lindsay..Binghamton,N.Y.
Univ.Art Gall.,State Univ.of N.Y.at Binghamton
.1970.
155 p. illus.

Cat.of a loan exh.held Oct.11-Nov.,1970

Bibliography

LC ND237.V15L5

I.B.2 - VANDERLYN, PIETER,the GANSEVOORT LIMNER,
c.1687-1778

Harris, Charles X.
Pieter Vanderlyn;portrait painter

In:N.Y.Hist.Soc.Q.
5:59-73 Oct.,'21

Attributes a variety of portrs.in the Dutch-
American tradition to other patrs.

LC F116.N638

Belknap.Amer.col.ptg.
ND1311.1.B43 NPG p.205

705
A56
NCFA
v.42

I.B.2 - VANDERLYN, PIETER, the GANSEVOORT LIMNER,
ca.1687-1778

Hastings, Mrs.Russel
 Pieter Vanderlyn.A Hudson River portrait
painter

In:Antiques
42:296-99 Dec.,'42 illus.

I.B.2 - VEIT, PHILIPP, 1793-1877

Spahn, Martin, 1875-
 Philipp Veit...Bielefeld & Leipzig,Velha-
gen & Klasing,1901
 101 p. illus. (Künstler Monographien 51

LC ND588.V4S7

ND
1311.9
S4809s
NPG

I.B.2 - VAN EPPS LIMNER

Curran, Ona
 Schenectady ancestral portraits early 18th
century

In:Schenectady Co.Hist.Soc.B.
10,no.1 Sept.'66
 Based on Curran's Master Thesis,N.Y.State
Univ.College,Oneonta,N.Y.
 Incl.:Van Epps Limner,Veeder Limner,Schuyler
Limner,Pierpont Limner,Gansevoort Limner.
 Hudson Valley Patroon Painters,except Pier-
pont Limner Feigenbaum.Amer.portrs...
MM ND1311.2.F29 NPG Bibl.p.117

I.B.2 - VEIT, PHILIPP, 1793-1877

Suhr, Norbert
 Philipp Veit portraits aus dem Mittelrheini-
schen Landesmuseum,Mainz und aus privatbesitz.
Kat.-bearbeitung von N.Suhr.Mainz,Mittelrheini-
sches Landesmuseum,1977
 199 p. illus(part col.)

 Bibliography

 N.Y.(city)P.L.Art & architect.
 Div.biol.guide to art & archit
CTY (In Rila,1979 25935.A791 1980 NCFA ref.
 #8128):123 p p.284:(NYPL 3-MCK+V42 80-
 737): 119 p.

I.B.2 - VAN RENSSELAER LIMNER
see
I.B.2 - WATSON, JOHN, 1685-1768

705
C75
v.90

I.B.2 - VELAZQUEZ, 1599-1660

Baker, Charles Henry Collins, 1880-
 Some Velazquez problems

In:Conn
90:147-9,154,159 Sep.,'32 illus(part col.)

 A study of execution of portrs.ascribed to
Velazquez in order to attribute them to the mas-
ter or to his school

 Cum.Mag.subj.ind.11/3/76
 Ref.v.2,p.444

I.B.2 - VASARI, GIORGIO, 1512-1574

Prinz, Wolfram
 Vasari's sammlung von künstlerbildnissen

In:Florence,kunsthist.Inst.,Mitt.
12 suppl. 1966

 On Vasari's woodcut portrs.,and their de-
pendence on self-portrs.

LC N14.F5515 Daugherty.Self-portrs.of
 PP.Rubens mfml61 NPG
 p.XIII footnote 10

AP
1
J8654
NPG
v.17

I.B.2 - VELÁZQUEZ, 1599-1660

Brown, Jonathan
 Enemies of flattery:Velásques' portraits
of Philip IV

In:J.Interdisc.Hist
17,no.1:137-54 Summer,'86 illus.

 Bibliographical references

ND
1311.9
S4809s
NPG

I.B.2 - VEEDER LIMNER

Curran, Ona
 Schenectady ancestral portraits early 18th
century

In:Schenectady Co.Hist.Soc.B.
10,no.1 Sept.'66
 Based on Curran's Master Thesis,N.Y.State
Univ.College,Oneonta,N.Y.
 Incl.:Van Epps Limner,Veeder Limner,Schuyler
Limner,Pierpont Limner,Gansevoort Limner.
 Hudson Valley Patroon Painters,except Pier-
pont Limner Feigenbaum.Amer.portrs...
MM ND1311.2.F29 NPG Bibl.p.117

I.B.2 - VELASQUEZ 1599-1660

Woermann, Karl, 1844-1933
 Velasquez;seine bildnisse

In:Museum
8:

"Museum" Waetzoldt ND1300W12
LC N7511.M7

TNE
266
G7H83
1813
NPG

I.B.2 - VERTUE, GEORGE, 1684-1756

Houbraken, Jacobus, 1698-1780
The heads of illustrious persons of Great
Britain, engraven by Mr.Houbraken and Mr.Vertue;
with their lives and characters by Thomas Birch.
New ed. London, Printed for W.Baynes by C.Wood,
1813

216 p. illus.

'Jacobus H. & G.Vertue engraved after Arnold
Houbraken's drawings.(Thieme-Becker: Houbraken,
[Arnold

LC DA28.H6 1813

I.B.2 - VERTUE, GEORGE, 1784-1756

Vertue, George, 1684-1756
Prints. King Charles I & the heads of the
noble earls,lords & others,who suffered for their
loyalty in the rebellion & civil-wars of England.
With their characters engraved under each print,
extracted from Lord Clarendon.Taken from original
pictures of the greatest masters.Many of them Sir
Anthony van Dyke's & all the heads accurately en-
graved by Mr.Geo.Vertue.London,C.Davis,1746

LC N7598.V4 Rosenwald coll.

I.B.2 - VERTUE, GEORGE, 1684-1756

Salmon, Thomas, 1679-1767
The chronological historian;containing...
all material...relating to the English affairs,
from the invasion of the Romans to the present
time...Illustrated with the effigies of all
our English monarchs,curiously engraven,by
Mr.Vertue.London,printed for W.Mears,1723
422 p. illus.

LC(9425172c)Rare book coll.
(DA34S1733 2nd ed.495 p.illus.
(DA34S2)3rd ed. 2 v. il. Brit.mus.Additions 1965
v.5,p.677,Z921.B862 NCFA Ref
Dept.of printed books

I.B.2 - VESTIER, ANTOINE, 1740-1824

Sueur, Jean Claude
Le portraitiste Antoine Vestier,1740-1824.
Neuilly-sur-Seine,1974

LC ND1329.V48S93

**FOR COMPLETE ENTRY
SEE MAIN CARD**

I.B.2 - VERTUE, GEORGE, 1684-1756

Vertue, George, 1684-1756
A description of nine historical prints, re-
presenting kings,queens,princes,etc.of the Tudor
family. Selected,drawn & engraved,from the origi-
nal paintings by George Vertue....London,Republish.
by the Society,1776

21 p. illus.

LC NE642.V4A3

I.B.2 - VICO, ENEA, 1523-1567

Vico, Enea, 1523-1567
Augustarum Imagines...Venetiis.Paul Manuce?,
1558
192 p. illus.

55 engravings of Roman empresses after medal

1st ed.1557

LC DC276.5.V5

Rave.Jb.d.Berl.Bus.I 1959
LC N3.J16 fol. p.145
Paolo Giovio & d.Bildnisvitenbücher

I.B.2 - VERTUE, GEORGE, 1684-1756

Vertue, George, 1684-1756
The heads of the kings of England;also 22
plates of the monuments of the kings of England.
London, 1736

Brit.mus. Universal cat.of books

I.B.2 - VICO, ENEA, 1523-1567

Zantani, Antonio
Le Imagini e le vite de gli imperatori trat1
dalle medaglie e dalle historie de gli antichi.
Florence,Enea Vico,1548

From Caesar to Domitian,engravings after
medals

Oxford
Uni.Bod- Vico,the publisher was an engraver
leian
libr. has latin ed.

Rave.Jb.d.Berl.Mus. I 1959
LC N3.J16 fol. p.141-2
Paolo Giovio & d.Bildnisvitenbücher.

I.B.2 - VERTUE, GEORGE 1684-1756

Vertue, George, 1684-1756
Medals and other works of Thomas Simon;
engraved and described by George Vertue
1753 (and 1780)

South Kensington 1780
Brit.mus. 1753, 1st ed.
Universal cat. of books

I.B.2 - VIGÉE-LEBRUN
see
I.B.2 - LEBRUN, Mme.MARIE LOUISE ELISABETH(VIGÉE)
1755-1842

705.44
A67
NCFA
v.1

I.B.2 - VIOLET, PIERRE-NOEL, 1749-1819

Bruel, François Louis, 1881-1912
Cat.de l'oeuvre point,dessiné et gravé de
Pierre-Noël Violet(1749-1819)

In:Arch.l'art fr.
nouv.pér.v.1:367-408 1907

Incl.:List of sitters and list of painters
and print-makers mentioned in cat. in alphabe-
tical order

705
028
NCFA
v.77

I.B.2 - VONNOH, ROBERT WILLIAM, 1858-1933

Vonnoh's half century

In:Studio
77:231-3 June'23 illus(1 col.)

705
028
NCFA
v.6

I.B.2 - VIOLET, PIERRE-NOEL, 1749-1819

Bruel, François Louis, 1881-1912
Un miniaturiste de l'émigration:Pierre-Noël
Violet(1749-1819)

In:Gaz Beaux Arts
ser.4,v.6:19-44 July,'11 illus.

ND
2200
W3
1949X
NPG

I.B.2 - WALKER, PHOEBE FLORY, 1914-

Walker, Phoebe Flory, 1914-
Watercolor portraiture,by Phoebe Flory
Walker with Dorothy Short and Eliot O'Hara.
N.Y.,G.P.Putnam's Sons,1949.
143 p. illus(part col.)

Incl.:A suggested reference list of books
for the painter of watercolor portraits,p.139-
143

I.B.2 - VISSCHER, CORNELIS, c.1619-1662

Smith, William
A catalogue of the works of Cornelius
Visscher...Bungay,J.Childs & son.printers.1864
73 p.
198 items

Reprinted fr.the Fine arts quarterly re-
view,for private circulation only

"...one of the most important portr.engra-
vers of his time..."-Th.B.

LC NE670.V5S5 Levis,Descr.bibl.Z5947.A3
 166 p.281

I.B.2 - WALKOWITZ, ABRAHAM, 1880-1965

Brooklyn Institute of Arts and Sciences. Museum
One hundred artists and Walkowitz.Feb.9-
Mar.26,1944.Brooklyn,1944.
28 p. illus.

"This is the presentation of an experiment:
100 artists and one subject...a unique opportu-
nity for study to layman...artist & psychologist
-Foreword
Portrs.of A.Walkowitz:89 ptgs.,11 pieces of
sculpture,caricatures & photographs & 2 self-
portrs.Portrs.range fr.conservative

LC ND1301.B7 MOMA p.433, v.11

I.B.2 - VOGTHERR, HEINRICH, THE ELDER, 1490-1556

Stumpf, Johannes, 1500-1576?
Keyser Heinrychs des vierdten...fünfftzig-
jährige historia...in vier bücher geteilt...
Zürych,Christian Froschouer,1556
CXXXVII numb. illus.

Woodcut portrs.by H.Vogtherr,the elder,
V.Solis and others

LC DD143.S9 Rave.Jb.d.Berl.Mus I 1959
 LC N3.J16 fol. p.134
 Paolo Giovio & d.Bildnis-
 vitenbücher d.Humanismus

VF

I.B.2 - WALKOWITZ, ABRAHAM, 1880-1965

Lichtenstein, Isaac, 188?-
Abraham Walkowitz.Machmadim Art Editions,
Inc.,1946
5 p.

I.B.2 - VONNOH, ROBERT WILLIAM, 1858-1933

Howard, Stanton W.
A portrait by R.W.Vonnoh

In:Harper's Mag
116:254 Jan.,1908 illus.

see also obituaries:Art Dig v.8,no.8:21
Art News v.32,no.14:10

D.C.P.L. Biogr.sketches Amer.ar-
 tists 927.M58 NCFA Ref.
 p.322

I.B.2 - WALKOWITZ, ABRAHAM, 1880-1965

Walkowitz, Abraham, 1880-1965
Faces from the ghetto,by Abraham Walkowitz
.N.Y.,Machmadim Art Editions,inc.,1946
40 p. illus.

"These prints are reproduced from originals
in the coll.of the Gall.of Jewish art,N.Y.city"

LC NC1075.W29

I.B.2 - WALKOWITZ, ABRAHAM, 1880-1965

Walkowitz, Abraham, 1880-1965
One hundred drawings by A.Walkowitz,intro-
ductions by Henry McBride ..et al..N.Y.,B.W.
Huebsch,inc.,1925
22 p. illus.

LC NC1075.W3

I.B.2 - WARE, THOMAS, 1803-1826 or 1827

Kern,Arthur B. & Sybil B.
Thomas Ware:Vermont portrait painter

In:Clarion
1982-84:36-45 Winter,'83/84 illus.

Incl.:Checklist

Robert Hull Fleming Museum
Univ.of Vt. Faces in the
Past:Bibl.p.39

I.B.2 - WALLIN, SAMUEL, fl.1838-1851

Jones, Abner Dumont, 1807-1872
The American portrait gallery;containing
correct portraits and brief notices of the
principal actors in American history...From
Christopher Columbus down to the present time.
The portraits engraved on wood by J.W.Orr,from
original drawings by S.Wallin...N.Y.,J.M.
Emerson & co.,1855
768 p. illus.

LC E176.J68

I.B.2 - WARHOL, ANDY, 1931-

Bourdon, David
Andy Warhol and the society icon

In:Art in Am
63:42-5 Jan.-Feb.,'75 illus(part col.)

I.B.2 - WARD, JAMES, 1769-1859

Frankau, Julia(Davis), 1864-1916
William Ward,A.R.A.,James Ward,R.A.,their
lives and works.London,N.Y.,Macmillan & co.,ltd
,1904
333 p. illus. and portfolio of 40 pl.
(part col.) (18th c.artists and engravers)

LC NE642.W3F7

Noon.Engl.portr.drags.&min
NC860.N66X NPG Bibl.p.145

I.B.2 - WARREN, LEONARD DEAKYNE, 1906-

Langsam, Walter Consuelo, 1906-
The world and Warren's cartoons...1st ed.
Hicksville,N.Y.,Exposition Press,c.1977
302 p. illus. (An Exposition-Banner
book)

Incl.history of caricature(later called
cartoon)p.11-17

LC D840.L28

Cumulative book index 197
Z1219.C97 NPG p.1364

I.B.2 - WARD, JAMES, 1769-1859

Grundy, Cecil Reginald, 1870-1944
James Ward, R.A.;his life and works,with
a cat.of his engravings and pictures...London,
Otto ltd.,1909
75 p. illus(part col.)

List of W's works incl.Portraits,no.661-715

LC ND497.W2507

I.B.2 - WATERS, SUSAN CATHERINE, 1823-1900

Heslip, Colleen Cowles
Mrs.Susan C.Waters,19th c. itinerant pain-
ter.exh..Oct.19-Nov.19,1979,Bedford Call.,Long-
wood Fine Arts Ctr.,Longwood College,Farmville
Va.;Jan.5-31,1980,Arnot Art Mus.,Elmira,N.Y...
Farmville,Va.,Longwood Fine Arts Ctr.,Longwood
college,1979
39 p. illus.

Bibliography

Worldwide Art Cat.Bul.
705.W927 NMAA v.17,1981
p.50

I.B.2 - WARD, WILLIAM, 1766-1826

Frankau, Julia(Davis), 1864-1916
William Ward,A.R.A.,James Ward,R.A.,their
lives and works.London,N.Y.,Macmillan & co.,ltd
1904
333 p. illus. and portfolio of 40 pl.
(part col.) (18th c.artists and engravers)

LC NE642.W3F7

Noon.Engl.portr.drags.&min
NC860.N66X NPG Bibl.p.145

I.B.2 - WATERS, SUSAN, 1823-1900

Heslip, Colleen
Susan Waters

Masters Thesis,Cooperstown Program,c.197

Woolward,American Folk P
ND207.W66X NPG p.14 & 82

N
40.1
W33P5
NCFA

I.B.2 - WATKINS, FRANKLIN CHENAULT, 1894-1972

Philadelphia Museum of Art
 Franklin Watkins, by Henry Clifford..Exh.
held at.Phila.Mus.of Art,Mar.6 to Apr.5,1964
.Philadelphia,1964.
 47 p. illus(part col.)

LC ND237.W354P5 Framing the board.ND1311.9
 SF813 NPG p.10

705
028
NCFA
v.4

I.B.2 - WATTEAU, ANTOINE, 1684-1721

Jamot, Paul, 1863-1939
 Watteau portraitiste.Remarques sur quel-
ques-unes des dernières oeuvres de Watteau

In:Gas Beaux-Arts
5e ser.v.4:257-78 Nov.,'21 illus.

 Pour le centenaire de Watteau

IN
40.1
W334y
06
NPG

I.B.2 - WATSON, JAMES, 1739?-1790

Goodwin, Gordon
 Thomas Watson,James Watson,Elizabeth
Judkins.London,A.H.Bullen,1904
 230 p. illus. (British mezzotinters,
ed.by Alfred Whitman)

 Contents:Thomas Watson,cat.of portrs.p..7,
48...James Watson,cat.of portrs.,p..81.-196...
Elizabeth Judkins,cat.of portrs.,p.225...

LC NE642.W406 Levis.Descr.bibl.Z5947.A3
 L66 1974 NCFA p.133

AP
1
A784A5
NCFA
v.10

I.B.2 - WATTS, GEORGE FREDERICK, 1817-1904

Bazarov, Konstantin
 G.F.Watts:portrait painter

In:Art & Artists
10:18-23 Oct.,'75 illus.

 FOR COMPLETE ENTRY
 SEE MAIN CARD

AP
1
A51A62
RMAA
v.2

I.B.2 - WATSON, JOHN, 1685-1768

Black, Mary Childs, 1922-
 Tracking down John Watson:The Henderson por-
traits at Boscobel

In:Am Art & Antiques
2,no.5:78-85 Sept.-Oct.,'79 illus(part col.)

 John Watson's portrs.,previously attr.to the
Van Rensselaer Limner
 Repro.incl.:The Js.Henderson portrs.at Bos-
cobel,the States Dyckman house at Garrison-on-
Hudson,N.Y. Black.In:Am Art J. AP1.A51
 A64,v.12:6,footnote 5

N
40.1
W34L8
NPG

I.B.2 - WATTS, GEORGE FREDERICK, 1817-1904

London. National Portrait Gallery
 G.F.Watts,the hall of fame:Portraits of his
famous contemporaries.London,H.M.'s Stationery,
1975
 24 p. illus.

 List of portrs.by G.F.Watts in the National
Portrait Gallery,London,in alphabetical order
by sitters.
 In the intro.some of W.'s portrs.are com-
pared with Renaissance masters.

LC ND1329.W37L66

AP
1
N534
NPG

I.B.2 - WATSON, JOHN, 1685-1768

Bolton, Theodore, 1889-
 John Watson of Perth Amboy,artist

In:Proc.N.J.Hist.Soc.
72:233-47 Oct.,'54

 Quotes Wm.Dunlap's Biogr.of J.W.in Hist.of the
Rise & progress of the arts of design in the
U.S.,v.1
 Refers to Benson J.Lossing's articles in The
Amer.Hist.Record,Aug.& Oct.,1872;lists Los-
sing's "Enumeration"of portr.drags.by J.W.

I.B.2 - WAY, MRS.JOHN
 see
I.B.2 - HAMILTON, HARRIOTT (Mrs.John Way),
 c.1769-after 1828

N
40.1
W334y
G6
NPG

I.B.2 - WATSON, THOMAS, 1743-1781

Goodwin, Gordon
 Thomas Watson,James Watson,Elizabeth
Judkins.London,A.H.Bullen,1904
 230 p. illus. (British mezzotinters,
ed.by Alfred Whitman)

 Contents:Thomas Watson,cat.of portrs.p.7,
48...James Watson,cat.of portrs.,p.81.-195...
Elizabeth Judkins,cat.of portrs.,p.225-30

LC NE642.W.G6 Levis.Descr.bibl.Z5947.A3
 L66 1974 NCFA p.133

NK
4210
W4N38
1976X
NPG

I.B.2 - WEDGWOOD FAMILY, 17-19th c.

National Portrait Gallery, Washington, D.C.
 Wedgwood portraits and the American Revolu-
tion..Washington:National Portrait Gallery,
Smithsonian Institution,1976
 134 p. illus.
 Cat.of an exhibition,July 13-Oct.31,1976

 Foreword by Marvin Sadik

 Intro.by Bruce Tattersall

 Bibliography
LC NK4210.W4N38 1976

NK
4335
R36w
NPG
2 cops.

I.B.2 - WEDGWOOD FAMILY, 17-19th c.

Reilly, ~~David~~ Robin
Wedgwood portrait medallions. A catalogue.
London,Barrie & Jenkins.1973?.
﹏48﹏p. illus(part col.)

Review by H.L.Blackmore In:Connoisseur
185:314-6 Apr,'74

Cat. of ca.100 medallions in Exhib.at
London,NPG,~~ca.1973~~ Oct.3,1973-Jan.5,1974

LC NK4210.W4R42

N
40.1
D985TS
NMAA

I.B.2 - WEIR FAMILY

Whitney Museum of American Art, New York
Three American families.A tradition of ar-
tistic pursuit.Exh.at Philip Morris.Sept.8-
Oct.26,1983
unpaged illus.

Ptgs.by the families of Duyckinck,Peale,
and Weir
31 works shown

I.B.2 - WEDGWOOD FAMILY, 17-19th c.

Reilly, ~~David~~ Robin and George Savage
Wedgwood.The Portrait medallions.London,
Barrie & Jenkins.1973?.
379 p. illus(part col.)

Review by H.L.Blackmore In:Connoisseur
185:314-6 Apr,'74 illus.

"Catalogue covering the whole subject of
Wedgwood relief portraiture,ancient & modern.."

LC NK4210.W4R43

I.B.2 - WENDELL LIMNER
see
I.B.2 - HEATEN, JOHN, 18th c., the WENDELL LIM-
﹏NER

705
C75
NCFA
v.98

I.B.2 - WEDGWOOD FAMILY, 17-19th c.

Thomas, John
Wedgwood ceramic portraits

In:Connoisseur
98:29-35 July,'36 illus(part col.)

Repro.incl.:Jos.Wedgwood by Hackwood;Wm.Her-
shel by John Flaxman;Queen Charlotte by Flaxman;
Adam Smith by Js.Tassie;Lord Nelson by Devaere;
Linnaeus by Flaxman;Josh.Reynolds by Flaxman;
Is.Newton by Flaxman

qN
40.1
W481A1
NPG

I.B.2 - WERBOFF, MICHAEL ALEXANDER, 1896-

Werboff, Michel, 1896-
Michel Werboff.N.Y.,1963?
43 p. illus(1 col.)

I.B.2 - WEIDITZ, HANS II, before 1500-fl.-1536

Huttich, Johann, 1480?-1544
Imperatorum et Caesarum vitae....Argentorati
Vuolphgangus Caephalaeus excussit.1534
2pts.in 1 v. illus.

(Argentoratum-Strassbourg,Caephalius-Koepfel
1st ed.1525)
Woodcuts after medals, most of them by Hans
Weiditz II
Contains portrs.of the Roman,Byz.& German
emperors to Charles V & archd.Ferdinand,etc.

LC DG203.H8 1534 Rave.Jb.d.Berl.Mus.I 1959
 LC N3.J16 fol.p.128/9
Paolo Giovio & d.Bildnisvitenbücher...

ND
544
M383
NCFA

I.B.2 - WERTMULLER, ADOLPH ULRIC, 1751-1811

Martin-Méry, Gilberte
La peinture française en Suède,hommage à
Alexandre Roslin et à Adolf-Ulrik Wertmüller,
Bordeaux,19 mai-15 sept.1967.﹏Musée de Bordeaux
Cat.par Gilberte Martin-Méry,avec le concours de
Gunnar W.Lundberg.Bordeaux,le Musée,1967
151 p. illus.

LC ND546.M34

AP
1
A51A64
NCFA

I.B.2 - WEIR, ROBERT WALTER, 1803-1889

Ahrens, Jacob Edward Kent, 1939-
The portraits by Robert W.Weir

In:Amer.Art J.
6:4-17 May,'74 illus.

Repr.incl.Self-portrait

See also:Ahrens,Robt.W.Weir.Ph.D.thesis
mfm Univ.of Delaware,1972 Ch.III.Portraits,p.36-65
103
NCFA
 Rila I/1-2 1975 #4549

I.B.2 - WERTMULLER, ADOLPH ULRIC, 1751-1811

Scott, Franklin Daniel, 1901- ed.and tr.
Wertmüller,artist and immigrant farmer.
Chicago,Swedish Pioneer Historical Soc.,1963
173 p. illus.

LC ND793.W4S3 Penn.Hist.Soc. Rembrandt
 Peale...Bibl.,p.119

N
40.1
W49A16
NMAA

I.B.2 - WEST, BENJAMIN, 1738-1820

Abrams, Ann Uhry
 The valiant hero,Benjamin West and grand-
style history painting.Washington,D.C.,Smith-
sonian Institution Press,c.1986
 254 p. illus(part col.) (New direction
in American Art,v.1)
 Incl.Index
 Bibliography,p.231-42
 Ch.1:A hero for his time incl.:Self-por-
traits,p.18-26
 fg.8:Self-portr.with portr.of his wife

AP
1
N547
NCFA
v.36

I.B.2 - WEST, BENJAMIN, 1738-1820

Flexner, James Thomas, 1908-
 Benjamin West's American Neo-Classicism,
with documents of Benjamin West and William
Williams

In:N.Y.Hist.Soc.Q.
36:5-41 Jan.,'52 illus.

 Mentions use of camera,p.11,12(15),for p
in general

 Alberts.Benj.West N40.1
 .W49A3 NPG Bibl.p.488

N
40.1
W49A5
NCFA
2 c.

I.B.2 - WEST, BENJAMIN, 1738-1820

Allentown,Pa. Art Museum
 The world of Benjamin West.exh.Mayl-July31,
1962.Cat.by Richard Hirsch.Allentown Art Mus.
1962
 96 p. 96 illus.

 Incl.:Index of artists

 Ch.1:Selected works of B.West.-Ch.2:Colo-
nial inspiration.-Ch.3:Roman inspiration.-
Ch.4:Personages of the Royal Academy.-Ch.5:
Some students of the master.
 Alberts.Benj.West N40.1.W49
 A3 NPG Bibl.p.491

I.B.2 - WEST, BENJAMIN, 1738-1820

Hart, Charles Henry, 1847-1918
 Benjamin West's family...Philadelphia,1908
 33 p. 2 portrs.

DLC PH1 PHC PPL MB Isham.Hist.of Amer.paint'g
 ND205I79 1933 Bibl.p.600

I.B.2 - WEST, BENJAMIN, 1738-1820

Carson, Hampton Laurence, 1852-1929
 The life and works of Benjamin West.An ad-
dress delivered before the Hist.soc.of Penn.,
Dec.12,1921.Philadelphia?1922?
 19 p. illus.

 Also in Penn.mag.of hist.& biogr.,Phila.
v.45,no.4,1921

LC ND237.W45C3
LC F146.P65---Penn.mag... Alberts.Benj.West.N40.1.W4
 A3 NPG Bibl.p.485

B
.W51J12
NCFA

I.B.2 - WEST, BENJAMIN, 1738-1820

Jackson, Henry Ezekiel, 1869-
 Benjamin West,his life and work...Phila-
delphia,The J.C.Winston co.,1900
 115 p. illus.

 Ch.VI.:West's portrait paintings,p.65-71

LC ND237.W45J3 Isham.Hist.of Amer.paint'g
 ND205I79 1933 Bibl.p.600

NPG

I.B.2 - WEST, BENJAMIN, 1738-1820

Evans, Dorinda
 Benjamin West and his American students.
.Publ.for.an exh.at the National Portrait Galle-
ry,Oct.16,1980 to Jan.4,1981 and at the Pennsyl-
vania Academy of the Fine Arts,Jan.30 to Apr.19
1981.Publ.for NPG by the Smiths.Inst.Press,City
of Washington,1980
 203 p. illus(part col.)

 Bibliography
 Incl.index

LC ND207.E94

N
40.1
W49B4
NPG

I.B.2 - WEST, BENJAMIN, 1738-1820

Morgan, Charles Hill, 1902-
 Benjamin West:his times and his influence,
...Springfield,Mass.,Art in America,1950

 FOR COMPLETE ENTRY
 SEE MAIN CARD

920I
W516E92
NCFA

I.B.2 - WEST, BENJAMIN, 1738-1820

Evans, Grose
 Benjamin West and the taste of his times.
Carbondale,Southern Illinois University Press,
1959
 144 p. illus(part col.)

 Bibliography

 Review by Rbt.Rosenblum in Art B.42:76-9
March,'60

LC ND237.W45E85 Whitehill.The Arts in ear-
 ly Amer.Hist.Z5935.W59 NPG
 Bibl.,p.96

N
40.1
W49P5
NPG

I.B.2 - WEST, BENJAMIN, 1738-1820

Philadelphia Museum of Art
 Benjamin West,1738-1820.Phila.,Pennsylva-
nia museum of art,1938
 58 p. illus.

 See also article by Richard Graham in:
Art News,v.36,Mar 19,'38,p.12-13.Cover illus.:
West painting his wife

LC ND237.W45P4

AP
1
P43
NPG

I.B.2 - WEST, BENJAMIN, 1738-1820

Sawitsky, William, 1880-1947
 The American work of Benjamin West

In:Penn.Mag.of Hist.& Biogr.
62:433-62 Oct.,'38 illus.

 Descriptive cat.of West's American ptgs.
 notes.,all but three are portrs.
 Repro.incl.also pencil studies for portrs.

also:
B.W5182
NCFA

Offprint from The Penn.Mag.of Hist.&Biogr.,
Oct.,1938

N
40.1
W517P4
NPG

I.B.2 - WEST, WILLIAM EDWARD, 1788-1857

Pennington, Estill Curtis
 William Edward West,1788-1857,Kentucky
painter;exh.at Nat'l Portrait Gall.,April 12-
June 16,1985;Lauren Rogers Mus.of Art,Laurel,
Miss.,July 7-Sept.11,1985;J.B.Speed Art Mus.,
Louisville,Ky.,Sept.27-Dec.9,1985.Washington,
D.C.,Smiths.Inst.,NPG,1985
 154 p. illus(part col.)

 Incl.:Index
 Foreword by Alan Fern

 Bibliography

qN
40.1
W49V9
NMAA

I.B.2 - WEST, BENJAMIN, 1738-1820

Von Erffa, Helmut
 The paintings of Benjamin West,by.Helmut
von Erffa and Allen Stanley.New Haven & London,
Yale Univ.Press,1986
 606 p. illus(part col.) (a Barra foun-
dation book)
 Index
 Portraits:p.450-576(incl.groups)
 Port.within portrait,p.453,501,567

LC 237.W45A4 1986

I.B.2 - WEYDEN, ROGER VAN DER, 1399?-1464

Kauffmann, Hans
 Ein selbstporträt Rogers van der Weyden
auf den Berner Trajansteppichen

MET
100.53
R29
P v.39

In:Rep.Kunstwiss.
39:15-30 illus. 1916

LC N3R4

 Panofsky.Facies illa Ro-
 geri..:"finest contribu-
 tion to our literature"

705
A784
NCFA
v.37

I.B.2 - WEST, GEORGE WILLIAM, 1770-1795

Pleasants, Jacob Hall, 1873-1957
 George William West.A Baltimore student
of Benjamin West

In:Art in Am
37:6-47 Jan.,'49 illus.

 Monograph on G.Wm.West
 List of West's portraits
 Article written in connection with
Exh.at Md.Hist.Soc.,Jan.,'49

Xerox copy I.B.2 - WEYDEN, ROGER VAN DER, 1399?-1464
NPG
in VF Panofsky, Erwin, 1892-
Por- Facies illa Rogeri maximi pictoris
trai-
ture In:Late classical & medieval studies in honor of
 A.M.Friend,jr.Edited by Kurt Weitsmann...Prince-
 ton,N.J...1955 pp.392-400 illus.

 One of the figs.in "Miracle of the Tongue"in
 R.v.d.Weyden's tapestries "Examples of Justice"in
 Bern considered to be self-portr.(Testimony of
 Cardinal Nic.Cusanus)
LC N5975.W4 Encyclop.of World Art
 bibl.Portrs. N31E56 Ref.

N
6505
D92
1834a
v.2pt.1
NCFA
Ref.

I.B.2 - WEST, WILLIAM EDWARD, 1788-1857

Dunlap, William, 1766-1839
 William E.West -1815;in.his.Hist.of the
rise and progress of the arts of design in the
United States.v.2,pt.1
 p.269-71 illus.

I.B.2 - WHIELDON, THOMAS, 1719-1795

Andrade, Cyril
 Old English pottery,Astbury,Whieldon,Ralph
Wood;Cyril Andrade collection..London,n.d.
 .11.p. illus.(32 phot.on 29 pl.)

MET
143.62
An24

705
A56
NMAA
v.124

I.B.2 - WEST, WILLIAM EDWARD, 1788-1857

Flanary, Sara E.
 William Edward West in New Orleans and
Mississippi

In:Antiques
124:1010-15 Nov.,'83 illus(part col.)

 Based on Master thesis "The Pre-European
career of Wm.Edw.West in New Orleans & Missis-
sippi.Richmond,Va.,Va.Commonwealth Univ.

I.B.2 - WHIELDON, THOMAS, 1719-1795

Price, Robert Kenrick
 Astbury,Whieldon,and Ralph Wood figures,
and Toby jugs,coll.by Captain R.K.Price...with
an intro.by Frank Falkner...London,John Lane,
1922
 140 p. illus(part col.)

 'Largest coll.of tobies in the world.'-North-
end in:The joly old toby

LC NK4087.S6P7

N
40.1
W57066
1973a
NMAA

I.B.2 - WHISTLER, JAMES ABBOTT McNEILL, 1834-1903

Corder, Judith Elaine, 1942-
James McNeill Whistler:a study of the oil paintings,1855-1869...Iowa City,1973
261 p. illus.

Bibliography

Thesis Ph.D.-Univ.of Iowa,1973
Photocopy of typescript

I.B.2 - WILGUS, WILLIAM JOHN, 1819-1853

Sellstedt, Lars Gustaf, 1819-1911
Life and works of William John Wilgus, artist,1819-1853,...Printed for private circulation.Buffalo,N.Y.,etc.,The Matthews-Northrup works.1912
32 p. illus.

Prepared at the request of the Historical Soc.of Buffalo,by L.G.Sellstedt,Jan.21,1864, revised by the author Jan.21,1910

LC ND237.W65S4
Isham.Hist.of Amer.paint'g
MD205I79 1933 Bibl.p.600

AP
1
W225
NCFA
v.14

I.B.2 - WHITE, ROBERT, 1645-1703

Bell, Charles Francis, 1871- and Rachel Poole
English 17th-century portrait drawings in Oxford collections.Pt.II:Miniature portraiture in black lead and Indian ink

In:Walpole Soc.
74:43-80 1925-26 illus.

Incl.chapter on Wm.Faithorne,p.49-55;David Logan,p.55-69;Rt.White,p.69-71;Portr.of Archbishop Oliver Plunket,p.71-73;Ths.Forster,p.73-
Lists of dated,or noted 'drags.& engrs.'ad vivum'4 signed engravers,not inscribed 'ad vivum'

I.B.2 - WHITING, FABIUS, 1792-1842
see

Morgan, John Hill, 1870-1945

N
40.1
S93M8
1969
NPG
2 c.

Gilbert Stuart and his pupils...N.Y.,Kennedy Galleries,Da Capo Press,1969
p.70-71 ("no portrait by Whiting has been located")

I.B.2 - WILGUS, WILLIAM JOHN, 1819-1853

Viele, Chase
Four artists of mid-19th century Buffalo
.Cooperstown?,N.Y.,196-
49-79 p. illus.

Bibl.references

Reprinted fr.N.Y.history,43,no.1,Jan.1962

Survey of the life and work of Sellstedt, Wilgus, Le Clear, Beard

Arts in Am qZ5961.U5A77X
NCFA Ref. I 1072

N
40.1
W629
C5
NMAA

I.B.2 - WILKIE, DAVID,SIR, 1785-1841

Sir David Wilkie of Scotland,1785-1841;exh., organ.by William J.Chiego;cat.by H.A.D.Miles and David Blaney Brown...Raleigh,North Carolina Mus.of Art,c.1987
378 p. illus(part col.)

Bibliography,p.371-78

Incl.article:W.as a portraitist:Observations on "A National misfortune"p.49-58

I.B.2 - WIERIX, JOHAN, c.1549-1615

Lampsonius, Dominique, 1532-1599
Pictorvm Aliqvot celebrivm Germaniae Inferioris Effigies...Anverpiae,Apud viduam Hieronymus Cock,1572

23 full-page portrs.of artists north of Alps
Engravings by J.Wierix,C.Cort & probably H.Cock

Facsimile ed.,Liége,J.Puraye,1956

"Important source for Carel van Manders Schilderboek"-Rave

NN
Rave.Jb.d.Berl.Mus. I 195?
LC N3.J16 fol. p.148
Paolo Giovio & d.Bildnisvitenbücher d.Humanismus

705
C75
NCFA
v.167

I.B.2 - WILKIN, FRANCIS WILLIAM, 1791-1842

Isham, Sir Gyles
Francis William Wilkin,c.1791-1842;an up-to-date identification of his work

In:Connoisseur
167:144-51 Mar.,'68 illus.

FOR COMPLETE ENTRY
SEE MAIN CARD

705
I 61
NCFA
v.77

I.B.2 - WILES, IRVING RAMSEY, 1861-1948

McCormick, Wm.B.
The portraits of Irving R.Wiles

In:Studio
77:256-62 June,'23 illus.

705
C75
NCFA

I.B.2 - WILKIN, FRANCIS WILLIAM, 1791-1842

Long, Basil Somerset, 1881-
F.W.Wilkin:a once fashionable portrait draughtsman

In:Connoisseur
81:40-1 May,1928 illus.

Blanshard,F.The portrs.of Wordsworth N7628W92B6

757.7
W72

I.B.2 - WILLIAMS, ALYN, 1865-1941

Williamson, George Charles, 1858-
An essay on portrait miniatures, with a brief note on the work of Alyn Williams...
London, Women's printing society, ltd., 19--.
.40.p. illus.

705
A56
NCFA
v.74

I.B.2 - WILLIAMS, MICAH, 1782-1837

Cortelyou, Irwin F.
Notes on Micah Williams, native of New Jersey

In: Antiques
74:540-1 Dec., '58. illus.

N
7616
W72
NPG

I.B.2 - WILLIAMS, ALYN, 1865-1941

Williamson, George Charles, 1858-1942?
How to identify portrait miniatures...with chapters on how to paint miniatures by Alyn Williams.London, G.Bell & sons, 1904
126 p. illus.

Bibliography

Partial contents: XI.Portrs.in enamel and plumbago; XIV.Collectors and collections.

Noon.Engl.portr.drags.& min-
C860.N66X NPG Bibl.p.148

AP
1
N547
NCFA
v.36

I.B.2 - WILLIAMS, WILLIAM, ca.1710-ca.1790

Flexner, James Thomas, 1908-
Benjamin West's American Neo-Classicism, with documents of Benjamin West and William Williams

In:N.Y.Hist.Soc.Q.
36:5-41 Jan., '52 illus.

Mentions use of camera, p.11,12(15), for p
in general

Alberts.Benj.West N40.1
.W49A3 NPG Bibl.p.488

705
A56
NCFA
v.66

I.B.2 - WILLIAMS, MICAH, 1782-1837

Cortelyou, Irwin F.
Collectors' Notes: Henry Conover: sitter not artist

In: Antiques
66:481 Dec., '54

. Pertains to C.'s Aug.article: "A mysterious pastellist identified".He suggests, that Micah Williams is the artist of the ptgs. from Monmouth Cy.& vicinity

705
M18
NCFA
v.37

I.B.2 - WILLIAMS, WILLIAM, ca.1710-ca.1790

Flexner, James Thomas, 1908-
The amazing William Williams:painter, author, teacher, musician, stage designer, castaway

In:Mag Art
37:242-6 Nov., '44 illus.
276-8

Incl.:Conversation pieces

705
A56
NCFA
v.78

I.B.2 - WILLIAMS, MICAH, 1782-1837

Cortelyou, Irwin F.
Micah Williams, pastellist

In:Antiques
78:459-61 Nov., '60 illus.

AP
1
N547
NCFA
v.25

I.B.2 - WILLIAMS, WILLIAM, ca.1710-ca.1790

Sawitzky, William, 1880-1947
Further light on the work of William Williams

In:N.Y.Hist.Soc.Q.B.
25:101-12 July, '41 illus.

705
A56
NCFA
v.66

I.B.2 - WILLIAMS, MICAH, 1782-1837

Cortelyou, Irwin F.
A mysterious pastellist identified

In:Antiques
66:122-4 Aug., '54 illus.

see also this.Henry Conover, sitter, not artist, p.481, Dec., '54 in Antiques, v.66

New Jersey Hist.Soc.NCRBO
N53 NPG note 6

705
A56
NCFA
v.31

I.B.2 - WILLIAMS, WILLIAM, ca.1710-ca.1790

Sawitzky, William, 1880-1947
William Williams, the first instructor of Benjamin West

In:Antiques
31:240-2 May, '37 illus.

Alberts.Benjamin West
N40.1.W49A3 NPG Bibl.p.501

I.B.2 - WILLRICH, WOLFGANG, 1897-1948

Just, Oskar illus.
 Nordisches blutserie im süddeutschen
bauerntum mit...tafeln von Oskar Just und
Wolfgang Willrich.Geleitwort von R.Walther
Darré.München,F.Bruckmann,c.1936-39.
 2 v. illus(part col.)

LC DD75.J8 MOMA, p.435, v.11

I.B.2 - WOHLGEMUT, MICHEL, 1434-1519

Schedel, Hartmann, 1440-1514
 .Nuremberg chronicle.German.
 Das buch der Chroniken unnd geschichten mit
figuren und bildnissen von Anbeginn der Welt
biss auff onsere Zeyt.Cuts.Fol. 2nd ed.,Augsburg,
1496
V&A Innumerable stylized representations of...&
people by M.Wohlgemut & W.Pleydenwurff

FOGG 1st ed. Nürnberg,1493 in Latin
KFA5767
788.210
DWP-Facsimile ed.,1967.093 ─ 5315 Prinz.Slg.d.selbst-
MET Print dpt " " " " bildn.N7618/P95 :
.79.1/Schl/ Bd.1,p.20

N
40.1
W75C7 I.B.2 - WILSON, RICHARD, 1713-1782
NCFA
 Constable, William George, 1887-
 Richard Wilson.London,Routledge & Kegan
 Paul,1953.

 FOR COMPLETE ENTRY
 SEE MAIN CARD

NPG I.B.2 - WOLLASTON, JOHN, c.1710-c.1767

 Bolton, Theodore, 1889- and H.L.Binsse
 Wollaston,an early American portrait manu-
 facturer

 In:Antiquarian
 16:30-3,50-2 June,'31 illus.

LC NK1125.A25 Kimball.Life portrs.of Jef-
 ferson...N7628.J45K4 NCFA
 NPG p.498

705
A786 I.B.2 - WINSTANLEY, WILLIAM, fl.1793-1806
NCFA
v.74 Esterow, Milton
 Who painted the George Washington portrait
 in the White House?

 In:Art News
 74:24-8 Feb.,'75 illus(part col.)

 "White House "Lansdowne"portr....attributed
 to William Winstanley".-M.S.Sadik

 FOR COMPLETE ENTRY
 SEE MAIN CARD

AP
1
A51A64 I.B.2 - WOLLASTON, JOHN, c.1710-c.1767
NCFA
v.7 Craven, Wayne
 John Wollaston:his career in England and
 New York City

 In:Am.Art J
 7:19-31 Nov.,'75 illus.

 FOR COMPLETE ENTRY
 SEE MAIN CARD

705
A63 I.B.2 - WINTERHALTER, FRANZ XAVER, 1805-1873
NMAA
v.58 Foister, Susan
 Winterhalter and his contemporaries

 In:Ant.Collector
 58,no.11:83- Nov.'87 illus(col)

 'The 19th c.Imperial court portrs.of F.X.
 Winterhalter were brilliantly successful & im-
 mensely popular.'-S.F.
 F.X.Winterhalter & the courts of Europe,
 1830-1870.Refers to exh. at NPG,London,Oct.30,
 1987-Jan.10,1988;Paris,Petit Palais,Feb.11-May 7,
 1988

705
A7875 I.B.2 - WOLLASTON, JOHN, c.1710-c.1767

 Croce, George Cuthbert, 1899-
 John Wollaston(fl.1736-1767):A cosmopolitan
 printer in the British colonies

 In:Art Q
 15,no.2:133-48 Summer,'52 illus.

I.B.2 - WOEIRIOT, CLAUDE & PIERRE
Giovio, Paolo, 1483-1552
 Vitae dvodecim Vicecomitvm Mediolani princi-
pvm.Lvtetiae,R.Stephani,1549
 199 p. illus.

 10 woodcuts after portrs. in Giovio's coll.
perhaps by Claude & Pierre Woeiriot.-Rave
 Portrs.engr.on wood have the Lorraine cross
device of Geoffroy Tory.-LC
 Portrs.of the Visconti family,Milan

LC DG657.7.G5 1549 Rave.Jb.d.Berl.Mus. I 1959
Rosenwald coll. LC N3.J16 fol. p.139-41
 Paolo Giovio & d.Bildnis-
 tenbücher d.Humanismus

N
40.1
W863W3 I.B.2 - WOLLASTON, JOHN, c.1710-c.1767(1710-1775?)
NPG
 Weekley, Carolyn Jeanette
 John Wollaston,portrait painter....Newark,
 Del.,Uni.of Delaware,1976

 FOR COMPLETE ENTRY
 SEE MAIN CARD

705
C75
NCFA

I.B.2 - WOOD, ENOCH, 1759-1840

Sarpisson, C.S.
John Wesley busts in Staffordshire pottery

In:Conn.
19:11-7 Sep.,'07 illus.

Busts by Enoch Wood

AP
1
A51A64
NCFA
v.7

I.B.2 - WOOLASTON, JOHN,SR., c.1672-c.1743

Craven, Wayne
John Wollaston:his career in England and
New York City

In:Am.Art J
7:19-31 Nov.,'75 illus.

FOR COMPLETE ENTRY
SEE MAIN CARD

705
A7875
NCFA
v.3

I.B.2 - WOOD, JOSEPH, ca.1778-1830

Groce, George Cuthbert, 1899-& J.T.Chase Willet
Joseph Wood;a brief account of his life and
the first cat.of his work

In:Art Q
3:148-61, 393-400 Spring,'40 illus.

Cat.lists 80 ptgs.and 4 engravings

Arts in Am qZ5961.U5A77X
NCFA Ref. K 1173

I.B.2 - WOOLNOTH, THOMAS, 1785-after 1836

Woolnoth, Thomas, 1785-after 1836
Facts and faces;being an enquiry into the
connection between linear and mental portrai-
ture,with a dissertation on personal and rela-
tive beauty.?nd ed. London, The author,1854
269 p. illus.

LC BF841.W93 V & A cat.

I.B.2 - WOOD, RALPH, 1715-1792

Andrade, Cyril
Old English pottery,Astbury,Whieldon,Ralph
Wood;Cyril Andrade collection..London,n.d.
.11.p. illus.(32 phot.on 29 pl.)

MET
143.C2
An24

I.B.2 - WOOLNOTH, THOMAS, 1785-after 1836

Woolnoth, Thomas, 1785-after 1836
A study of the human face.Wm.Tweedie,1865
260 p. illus.

V & A 26 steel engravings

Blackwell's of Oxford cat.
A1077 (1977),no.304
p.30

I.B.2 - WOOD, RALPH, 1715-1792

Price, Robert Kenrick
Astbury,Whieldon,and Ralph Wood figures,
and Toby jugs,coll.by Captain R.K.Price...with
an intro.by Frank Falkner...London,John Lane,
1922
140 p. illus(part col.)

'Largest coll.of tobies in the world.'-North-
end in:The joly old toby

LC NK4087.S6P7

AP
1
A784
J8
NCFA

I.B.2 - WRIGHT, JOHN, 1745-1820

Williamson, George Charles, 1858-1942
Four miniatures of the Keppel family

In:Art J.
73(?):222-4 July,'11 illus.

Repro.:...Lady Southampton by John Wright...

FOR COMPLETE ENTRY
SEE MAIN CARD

I.B.2 - WOOD, WILLIAM, c.1768-1803

Williamson, George Charles, 1858-1942
The miniature collector;a guide for the
amateur collector of portrait miniatures...
London,H.Henkins,1st.1921
308 p. illus.

Bibliography,p.263-74

Incl.:Complete list of all the persons who
sat for their portr.to William Wood(1768-1809):
p.275-94

LC N7616.W817 Fitzwilliam Mus. Cat.of
portr.min. ND1337C79i 1985x
NFG 1461.

N
40.1
W925.S8
:WAA
2 c.

I.B.2 - WRIGHT, JOHN MICHAEL, ca.1623-1700

Stevenson, Sara
John Michael Wright,the King's painter;by
S.Stevenson & Duncan Thomson.Edinburgh,National
Galleries of Scotland,1982
96 p. illus(part col.)

Cat.of an exh.held at Edinburgh, Scottish
National Portrait Gallery,16 July-19 Sept.,1982

Incl.:Wright's technique by John Dick,p.47-9

B
W93R4

I.B.2 - WRIGHT, JOSEPH, 1734-1797
Bemrose, William
The life and works of Joseph Wright,A.R.A.,
commonly called "Wright of Derby"...with a pre-
face by Cosmo Monkhouse.Illus.with two etchings
by Mr.F.Seymour Haden,and other plates and wood
cuts.London and Derby,Bemrose & sons,1885
128 p. illus

LC ND497.W8B4 Grundy In:Connoisseur
 86:347

705
C75
NCFA
v.94

I.B.2 - WRIGHT, JOSEPH, 1756-1793
Comstock, Helen
The Connoisseur in America

In:Connoisseur
94:125-9 Aug.,'34 illus.

Incl.note on .Joseph.Wright's Washington
portraits,pp.128-9.".Washington.is known to have
preferred.Wright's portrs..to all others."

 Thieme-Becker N10.T43,v.36
 p.283.Lit.on Jos.Wright

705
C75
NCFA

I.B.2 - WRIGHT, JOSEPH, 1734-1797
Grundy, Cecil Reginald, 1870-1944
Wright of Derby

In:Connoisseur
86:345-54 Dec.,'30 illus(part col.)
87:13-9 Jan.,'31 " " "

Repro.incl.some portrs.

N
6505
D92
1918
NCFA

I.B.2 - WRIGHT, JOSEPH, 1756-1793
Dunlap, William, 1766-1839
Joseph Wright

In .his.History of the Rise and Progress of the
Arts of Design in the United States,v.1 New ed.
...1918
 p.370-4 illus.

N6505 See also ed.1834,pp.254,312-15 illus.
D92
1834a
Ref.

705
B97
NCFA
v.121

I.B.2 - WRIGHT, JOSEPH, 1734-1797
Isepp, Rosa
Three portraits by Wright of Derby

In:Burl Mag
121:311-12 May,'79 illus.

N
40.1
W931F118
NPG

2 c.

I.B.2 - WRIGHT, JOSEPH, 1756-1793
Fabian, Monroe H.
Joseph Wright,American artist,1756-1793;
an exh.at the Nat'l Portrait Gallery,Feb.15-
June 9,1985.Publ.for the NPG by the Smiths.
Inst.Press,City of Washington,1985
 155 p. illus(part col.)

Foreword by Alan Fern
Incl.:Index
Bibliography,p.148-52

LC ND1329.W76A4 1985

AP
1
A64
NCFA
v.88

I.B.2 - WRIGHT, JOSEPH, 1734-1797
Nicolson, Benedict
Addenda to Wright of Derby

In:Apollo
88suppl.:1-4 Nov.,'68 illus.
(Paul Mellon Foundation for Brit.Art,notes on
British Art,12)

Repro.of portrs.which turned up since Nov.
1967
'It is always the portrs.-the most neglected
aspect of Wright's art-that yield the richest
treasures.'-B.N. Isepp.3 portrs.of Wright of
 Derby.In:Burl Mag 121:311
 note 2

N
40.1
W931H3
NPG
RB

I.B.2 - WRIGHT, JOSEPH, 1756-1793
Hart, Charles Henry, 1847-1918
Original portrait of Doctor Franklin,
painted by Joseph Wright,1782,belonging to the
Royal society,London.Portraits of Franklin attri-
buted to Duplessis in the Corcoran gall.of art,
Washington,D.C. and to Greuze in the P.L.,Boston,
Mass.shown to be by Joseph Wright...Philadelphia,
1908
 335 p. illus.

Reprint fr.Penn.Mag.of History & Biography,
July,1908

qN
40.1
W931N6
NCFA

I.B.2 - WRIGHT, JOSEPH, 1734-1797
Nicolson, Benedict
Joseph Wright of Derby:painter of light.
London,Paul Mellon Foundation for British Art;
Routledge and K.Paul;New York,Pantheon Books,
1968
 2 v. illus(part col.) (Studies in Bri-
tish art)

Bibliography:v.1,p.285.292
v.1 Text and catalogue.-v.2 Plates

LC 497.W8N5 Noon.Engl.portr.drags.Amin.
 NC860.N66X NPG Bibl. p.146

705
A56
NCFA

I.B.2 - WRIGHT, JOSEPH, 1756-1793
Kimball, Sidney Fiske, 1888-
Joseph Wright and his portraits of
Washington

In:Antiques
15:377-82 May,'29 illus.

Bibliographical footnotes

 Kimball.Life portrs.of Jef-
 ferson...N7628/J45/k4,p.49
 footnote

705
C75
NCFA
v.68

I.B.2 - WRIGHT, JOSEPH, 1756-1793

Mechlin, Leila, 1874-
 Early American portrait painters

In:Connoisseur
68:127-32 Mar.,'24 illus.
 Repro.:Franklin by Wright,Blackburn,Feke,C.W.
Peale,Rembrandt Peale,Neagle,Hamilton by Trumbull,
Waldo,Malbone,Harding,Copley,Stuart(p.135),West
(p.177)
 Emphasis on close association of American &
British schools

Cumulated Mag.subj.index
11/3/C76 Ref. v.2,p.443

705
A784
NCFA

I.B.2 - WRIGHT, PATIENCE LOVELL, 1725-1786

Lesley, Everett Parker
 Patience Lovell Wright,America's first
sculptor

In:Art in Am.
24:148-54,157 Oct.,'36 illus.

 Repro.:Franklin,Washington,Js.Johnson,Bi-
shop of Worcester,Lord Chatham

I.B.2 - WRIGHT, JOSEPH, 1756-1793

Morgan, John Hill, 1870-1945
 Joseph Wright

In:his.The life portraits of Washington and their
replicas...Mantle Fielding(joint author)...

 pp.69-75 illus.

LC N7628.W3M6

Groce-Wallace,N6536.N53
Ref.,p.705

I.B.2 - WRIGHT, PATIENCE LOVELL, 1725-1786

Munson, L.F.
 The celebrated Mrs.Wright,...

In:House Beautiful
62:392- Oct.,'27

LC NA7100.H65

FOR COMPLETE ENTRY
SEE MAIN CARD

708.1
C62
NCFA
v.7-8

I.B.2 - WRIGHT, JOSEPH, 1756-1793

Park, Lawrence,,1873-1924
 Joseph Wright's portrait of Washington

In:Cleveland Mus Bul
8:91-2 Jun-Jul,'21 illus.

N
40.1
W933S4
NPG

I.B.2 - WRIGHT, PATIENCE LOVELL, 1725-1786

Sellers, Charles Coleman, 1903-
 Patience Wright:American artist and spy in
George III's London.Middletown,Wesleyan Univ.
press,c.1976
 281 p. illus.

 Incl.Bibl.ref. & index
 Catalogue of works

 'P.W.brought wax sculpture in the round to
prominence as a portrait art in a way unknown
before or since'
Rila III/2 1977 #5132

I.B.2 - WRIGHT, JOSEPH, 1756-1793

Perrine, Howland Delano, 1853-
 The Wright family of Oysterbay,L.I....1423-
1923...New York,1923
 236 p. illus.

 pp.89-92:Joseph Wright

LC CS71.W95 1923

Groce & Wallace.N6536N53
Ref.,p.705

AP
1
S648
NCFA

I.B.2 - WRIGHT, PATIENCE LOVELL, 1725-1786

Troop, Miriam
 Two lady artists led the way for success
and fame

In:Smithsonian
8,no.11:114-21; Feb.,'78 illus(part.col.)

 "Patience Lovell Wright,Mother of all New
Realism.Henrietta Johnston first portraitist
...painted in the New World."-M.Troop

 Patience Lovell Wright and her sister,Rachel
Wells had a waxworks in N.Y.City,Philadel-
phia & London

705
C75
NCFA

I.B.2 - WRIGHT, PATIENCE LOVELL, 1725-1786

Hart, Charles Henry, 1847-1918
 Patience Wright,Modeller in wax

In:Conn.
19:18-22 Sep.,'07 illus.

 Repro.incl.:Washington,Earl of Chatham,
Franklin

N
40.1
M265E4
NPG

I.B.2 - WUCHTERS, ABRAHAM, c.1608/10-1682

Eller, Povl
 Kongelige portrætmalere i Danmark 1630-82.
En undersøgelse af kilderne til Karel van Manders
og Abraham Wuchters' værksorhed.Udg.af Selskabet
til Udgivelse af danske Mindesmærker.København,
Dansk Historisk Faellesforening,1971
 563 p. illus.

 Thesis-Copenhagen
 Summary in English
 Bibliography

LC ND1328.E43

I.B.2 - WYSSENBACH, RUDOLPH, fl.1545-1560

Strada, Jacobus de, à Rosberg, d.1588
 Imperatorum romanorum...verissimae imagines.
ex antiquis numismatis...Zürich,Andreas Gesner,
1559
 illus.
V & A 118 woodcuts by Rudolph Wyssenbach after
drags.by Hans Rudolf Manuel Deutsch

 Rave.Jb.d.Berl.Mus.I 1959
 LC N3.J16 fol. p.132
 Paolo Gio vio & d.Bildnisvitenbücher.

I.B.3 Journals;special issues on portraiture.

I.B.2 - ZEIMERT, CHRISTIAN, 1934-

Le portrait de profil et de farce.Musée de
 Chartres...1977

 At the head of title:Le Musée de Chartres et
Christian Zeimert présentent

LC ND1301.5.F8C486 FOR COMPLETE ENTRY
 SEE MAIN CARD

705
A56
NCFA
v.110 I.B.3 - ANTIQUES

 Antiques
 American painting ₍special issue₎
 110:965-1070, Nov.,1976 illus(part col.)
 Chiefly 18th-19th century
 Partial contents:P.C.F.Mandel, Amer.ptgs.at
 the Mus.of Art,Rh.Isl.sch.of des.,p.966-75;Js.B.
 Bell & C.Dunn Fleming,Ptgs.at the New England
 Hist.Genealogical Soc.,p.986-93;N.F.Little,Ptgs.
 by New England provincial artists,1775-1800,
 p.994-1005;L.C.Luckey,Family portrs.in the MFA,
 Boston,p.1006-11;Js.F.Jensen,19th c.Amer.ptg.&
 sculpt.at the State Hist.Soc.of Wisconsin
 p.1012-19;

705
BS7
NCFA
v.90 I.B.2 - ZITTOZ, MIGUEL, c.1469-1525

Weinberger, Martin
 Notes on Maître Michiel ₍Zittos,Miguel₎

In:Burl Mag.
90:247-54 Sep,1948 illus.

 Repro:Christian II of Denmark;Philibert of
Savoy by Jan Mostaert;Philip the Handsome of
Austria by Pieter de Jode,etc.

 Rep.,1948-49#6758

705
A784
NCFA
v.42 I.B.3 - ART IN AMERICA

 American primitive painting.₍An anthology of
 the₎coll.of Edg.Wm.& Bernice Chrysler
 Garbisch

 In:Art in Am
 42:95-170 May,'54 · illus.

 Incl.:Foreword by Edg.Wm.& Bernice Chrys-
 ler Garbisch,refers to the fact that their
 coll.is going to the National Gallery of Art,
 p.95;Ptgs.for the people by Alice Winchester,
 p.96;Portr.gall.of provincial America by Frank
 O.Spinney,p.98. Illus.p.97,99-105
 ₍154-6₎

B
Z85M2
NCFA I.B.2 - ZOFFANY, JOHANN, 1725-1810

Manners, Lady Victoria, 1876-1933
 John Zoffany,R.A.,his life and works,1735-
1810;by Lady V.Manners & Dr.G.C.Williamson.
London,John Lane,N.Y.,J.Lane Co.,1920
 331 p. illus(part col.)

 Bibliography

 List of engravings after Zoffany...p.257-65

 Archer:India & Brit.portr...
 ND1327.I44A72X NPG Bibl.
 p.483

705
A784
NCFA
v.40 I.B.3 - ART IN AMERICA

Dresser, Louisa
 Edward Savage,1761-1817. Some representa-
tive examples of his work as a painter

In:Art in Am
40:157-212 autumn,'52 illus.

 Article written in connection with exh.at
the Worcester Art Museum,Jan.4-March 8,1953

 Repro.incl.:Hancock,Washington,Martha Wa-
shington,Washington Family
see also:v.42:217,Oct.'54 Gerdts.Ptg.& sculpt.in N.J.
 N6530.N5G36 NCFA bibl.p.255

I.B.3. JOURNALS, YEARBOOKS

705
A784
NCFA
v.38 I.B.3 - ART IN AMERICA
 Frankenstein, Alfred Victor, 1906 and Arthur K.
 D.Healy
 Two journeyman painters
also:
N40.1 In:Art in Am.
M39F8 38:7-63 Feb.,'50 illus.
NPG
NCFA Benjamin Franklin Mason,Vermonter,p.7-43
 Abraham O.D.Tuthill,p.47-63

 Bibliography
 Chronological list of known portrs.
 J.G.Cole,teach er of Mason,see p.10-11,13

705
A784
NCFA

I.B.3 - ART IN AMERICA

Little, Nina Fletcher, 1903-
 Winthrop Chandler

In:Art in Am
35:75-168 Apr.,'47 illus.

 Foreword by Jean Lipman
 Catalogue of ptgs.attr.to W.Chandler

 Bibliography

705
C65
NFAA
v.46

I.B.3 - ART JOURNAL

Portraits:The limitations of likeness

In:Art J.
46,no.3:171-275 Fall'87 illus.

 Richard Brilliant arranged a symposium under
this title for the 1986 Annual Meeting of the
College Art Association of America in New York
 See articles by R.Prilliant,W.Steiner,B.M.
Stafford,H.Tscherny,R.Wendorf,J.Woods-Marsden,
D.Halle

705
A784
NCFA
v.41

I.B.3 - ART IN AMERICA

Mitchell, Lucy B., 1901-
 James Sanford Ellsworth:American minia-
ture painter

In:Art in Am
41:151-84 Autumn,'53 illus.

 Bibliography

 Abby Aldrich Rockefeller
 Folk Art Ctr.Am.Folk portr
 N7593.A23 Bibl.p.294

705
A7834
NCFA
v.53

I.B.3 - ARTS MAGAZINE

Arts Magazine
 Special issue:Thomas Eakins
 53,no.9:96-159, May,1979 illus(part col.)

 Partial contents:L.Goodrich:Abt.a man who
did not care to be written about:Portrs in
friendship of Th.Eakins,p.56-8;E.H.Turner:Th.E.:
The Marles'Gall.exh.of 1896,p.100-7;J.Wilmerding
Th.E.'s late portrs.,p:108-12;F.C.Parry,III:The
Th.L.portr.of Sue & Harry,or,when did the art-
ist change his mind?;p.146-53;W.H.Cerdts:Th.E.
& the Episcopal portr.Archbishop Wm.H.Elder,p.
154-7
Articles analyzed

705
A784
NCFA
v.37

I.B.3 - ART IN AMERICA

Pleasants, Jacob Hall, 1873-1957
 George William West.A Baltimore student
of Benjamin West

In:Art in Am
37:6-47 Jan.,'49 illus.

 Monograph on G.Wm.West
 List of West's portraits
 Article written in connection with
 Exh.at Md.Hist.Soc.,Jan.,'49

B
.D75W7

I.B.3 - CONNOISSEUR

Williamson, George Charles, 1858-1942
 ...John Downman...London,Otto ltd.,1907

 At head of title"CONNOISSEUR"extra no.(no.2)

LC ND497.D6W5

 FOR COMPLETE ENTRY
 SEE MAIN CARD

705
A784
NCFA
v.39

I.B.3 - ART IN AMERICA

Porter, James Amos, 1905-
 Robert S.Duncanson,mid-Western romantic-
realist

In:Art in Am
39:98-154 Oct.,'51 illus.

 The entire issue is devoted to a study of D.
D.is one of the earliest American Negro ar-
tists.
 Ch."Years of transition:The portraits,p.121-
127
 Incl.check lis D.'s ptgs.(13 portrs.)
 Bibliography

NC
772
A23
NPG

I.B.3 - GAZETTE DES BEAUX-ARTS
 v.82:121-98,Sept.'73;327-49,Dec.'73

Adhémar, Jean
 Les portraits dessinés du 16e siècle au ca-
binet des estampes;.by:J.Adhémar et Christine
Moulin.Paris,Gaz.des beaux-arts,1973
 104 p. illus.

 Extrait de la Gaz.des beaux-arts,Paris,sept.
et décembre,1973
 Repros.of almost all drags.with name of sit-
ters,date,biographical note,artist,info.given by
other catalogers(bouchot,Dimier,etc.)
 Alphabetical i x of sitters
 Alphabetical index of artists by Bou-
chot & Dimier cont'd on other side

705
A784
NCFA

I.B.3 - ART IN AMERICA

Art in America
 Portrait issue
 63:26-82, Jan-Feb.,1975 illus.

Articles analyzed

705
M18
NCFA

I.B.3 - MAGAZINE OF ART

Benson, E.M.
 Problems of portraiture

In:Mag.of Art
30,no.11,supplement:1-28 Nov.,1937 illus.

 1300 BC - 20th c.
Psychology or document. Sitter's point of view;
Artist's point of view; Concerning method & tech-
nique; Photography & film & their relation to the
plastic arts; Portraiture:its present and future
 Also published as a separate pamphlet

N
40.1
A363P6
NCFA

I.B.3 - MAGAZINE OF ART

Pittsburgh. Carnegie institute. Dept.of fine
Cat.of paintings,John White Alexan- arts
der the memorial exh.,March 1916,Dept.of fine arts
Carnegie institute,Pittsburgh..Pittsburgh,Mur-
doch-Kerr press,c.1916.
66 p illus.

Bibliography

Incl.Record of paintings by J.W.Alexander:
Portrs.before 1887-1913,p.37-55...
See also:Mag Art,v,7:345-73,Memorial number

LC ND237.A35P5

**I.B.3.a. FESTSCHRIFTEN & OTHER
MISCELLANEOUS COLLECTIONS OF
ESSAYS**

I.B.3 - OVO MAGAZINE

OVO Magazine
Portraits

In:OVO Mag.
13,no.50:1-48 1983 illus.

Md.U.Art Libr.
TR640.071 Folio

I.B.3.a Festschriften and other miscellaneous collections
of essays

VF
Amer.
Portr.
Soc.
Calif.
Hunting-
ton Har-
bour

I.B.3 - PROFILE

Doherty, M.Stephen
Artists by themselves

In:Profile
:3-5 1984 illus.

Article pertains to traveling exh.In NPG
Feb.10-March 25,1984;from Nat'l Academy of De-
sign,Nov.3,1983-Jan.1,1984

NPG
Print
Dpt.

I.B.3.a

Andre, John and Froeschle, Hartmut
Bernhard Albrecht Moll's European silhou-
ettes.&:Moll's American silhouettes;.in.The Ger-
man contribution to the building of the American
Studies in honor cf Karl J.R.Arndt;ed.by Gerh.
K.Friesen & Walter Schatsberg.Publ.by Clark Uni-
versity Press.Hanover,N.H.,1977..Ch..6.The Ame-
rican expedition cf Joseph II and Bernh.Moll's
silhouettes.
p.158-63 illus.

Silhouettes from 1783
Pamphlet in NPG Print Dpt.

VF

I.B.3 - SATURDAY EVENING POST

Chase, Joseph Cummings, 1878-1965
A portrait painter speaks and other articles

In:Sat.Eve.Post
159:14-5,177-8 June 18,'27 'A portr.ptr.speaks'
200:20-1,141-2 Aug.13,'27 'The adventure of
being painted'
200:16-7,81-2 Aug.27,'27 'Famous sitters'
200:16-7 Oct.15,'27 'What is this art
game?'
200:37,157-8,160 Apr.28,'28 'Ptg.the A.E.F.on the
Gallop'
A.E.F.=Amer.Expeditionar Forces|all illustrated

I.B.3.a

Brinckmann, Albert Erich, 1881-1958
Porträtdarstellungen als symbola des Euro-
päischen,in,Olsson,Martin,1866- ed. Studier
tillägnade Henrik Cornell pa sextioårsdagen...
Stockholm,Nordiska museet,Bokförmedlingen,1950
271 p. illus.

p.165-71

General survey of the successive tenden-
cies of portraiture in the different European
countries,fr.Carolingian times to the 19th c.

Rep.1950-51 #142

757.7
.W727

I.B.3 - THE STUDIO

Williamson, George Charles, 1858-1942
Portrait miniatures;...London,N.Y..etc..
'The Studio',ltd.,1910

On cover:Spring number of "The Studio",1910

LC N7616.W82 The Studio

FOR COMPLETE ENTRY
SEE MAIN CARD

I.B.3.a

Cust, Lionel Henry, 1859-1929
On portraits at the universities

In:Fasciculus Ioanni Willis Clark dicatus.
Cantabrigiae,typis academicis impressus,1909
p.423-37

LC LF108.C6 Ekkart.Coll.s of portrs.in
W.Europe,p.22

ND
2202
07F5X
NMAA

I.B.3.a

The English miniature;by John Murdoch....et al
New Haven,Yale University Press,1981
240 p. illus(part col.)

Incl.:bibliographical references and index

'.For.the most concise...surveys of the
development of miniature portrs. see...Murdoch
The English miniature.'-M.R.Severens

Carolina art association..
Miniature portr.coll...
p.XI footnote
by M.R.Severens

I.B.3.a

North Carolina. University. William Hayes
 Ackland Memorial Art Center
 Ancient portraits;a show of Greek,Etruscan
and Roman sculptured portraits in honor of the
70th birthday of T.R.S.Broughton....
 .Chapel Hill,N.C.,1970,

F000
FA4623.3 unpaged illus.

Bibliographies

Winkes.Physiognomonia.In:
Temporini.Aufstieg und nie-
dergang...LC DG209.T36,Bd.1
T4,p.908

I.B.3.a

Huemer. Frances
 Portraits.Brussels,Arcade Press,N.Y.,
Phaidon,1977
 v. illus. (Corpus Rubenianum Ludwig
Burchard,pt.19)

LC ND673.R9C63 Pt.19
NDl329.R8

**FOR COMPLETE ENTRY
SEE MAIN CARD**

Xerox copy I.B.3.a
NPO
in VF Panofsky
Por- Facies illa Rogeri maximi pictoris
trai-
ture In:Late classical & medieval studies in honor of
 A.M.Friend,jr....Princeton,N.J...1955 pp.392-400

LC N5975.W4

**FOR COMPLETE ENTRY
SEE MAIN CARD**

I.B.3.a

Karo, G.
 Etruskisch-römische Bildniskunst

In:Antike Plastik.Festschrift.Walther Amelung
zum 60.Geburtstag.Berlin,Leipzig,W.de Gruyter &
co.,1928
 p.100-105 .illus.?.

LC NB70.A5

Hiesinger.Portr.in the Rom
Rep.Bibl.In:Temporini.Auf-
stieg u.niederg....LC DG209
T36,Bd.1,T.4,p.822

I.B.3.a

Riegl, Alois, 1858-1905
 Zur spätrömischen porträtskulptur

In:Strena Helbigiana sexagenario obtulerunt
 amici a.d.4.non.febr.a.1898.Leipzig,Teub-
 ner,1900. p.250-

LC N5605.89

Kraus.Das römische welt-
reich.N5760.K92 Bibl.p.316

I.B.3.a ...

Keller, Harald, 1903-
 Entstehung und blütezeit des freundschafts-
bildes

 In:Essays in the history of art,presented
to Rudolf Wittkower...part 2.London,Phaidon,1967
pp.161-73 illus.
 Bibliography

LC N5303.E7

Praz.Conversation pieces
ND1304P92E1971,p.161,foot-
note 1

I.B.3.a

Rodenwaldt, Gerhart, 1886-1945
 Griechische porträts aus dem ausgang der
antike...Berlin,W.de Gruyter & Co.,1919
 30 p. illus. (Programm zum Winckelmanns-
feste der archäologischen gesellschaft zu Ber-
lin. 76)

Title from Univ.of Chicago
N5325.B37. v.76
LC .N5325.A8 no.76.

Kraus.Das römische welt-
reich.N5760.K92 Bibl.p.316

TR
15
053X
NCFA
p.110-4

I.B.3.a

Michaelson, Katherine
 The first photographic record of a scienti-
fic conference

In:One hundred years of photographic history;
essays in honor of Beaumont Newhall,p.110-4

**FOR COMPLETE ENTRY
SEE MAIN CARD**

I.B.3.a

Schweitzer, Bernhard, 1892-1966
 Bedeutung und geburt des porträts bei den
Griechen

MET In:Acta Congressus Madvigiani(Copenhagen,1954)
138.7 2:27-41 1958 illus.
In8

 The 1st manifestations of portrs.,the part
played by the heroes & the development of indi-
viduality.The most important period is the last
third of the 5th c.Repro.of sculpt.,vase-ptg.,me-
dallion fr.Abdera with portr.of Pythagoras
 Richter,G.Portrs.of the
LC PA23a1 I5 reeks N7586.R53,v.3,p.303
 .p.1958-3000

I.B.3.a

Schweitzer, Bernhard, 1892-1966
 Griechische portrktkunst.Probleme und for-
schungsstand

MET
138.7 In:Acta Congressus Madvigiani(Copenhagen,1954)
In8 1:7-26 1958

 Western portr.begun in Greece.Development
of the art of portr.in sculpture,ptg.,numisma-
tics.Faithfullness of representaion & the state
of research

LC PA23.A1 I5 Richter,G. Portrs.of the
 Greeks N7586R53,v.3,p.303
 Rep.1958#3599

I.B.1.a

Yates, F.A.
 The allegorical portraits of Sir John
Luttrell

In:Essays in the History of Art presented to
Rud.Wittkower...London,Phaidon, 1967

LC N5303.E7 Strong.Engl.icon qND1314
 .S924.bibl.:"Good ex.of com
plexities of meaning to be extracted fr.a Tudor portr.

NE
506
E36X I.B.3.a
NCFA
 Shadwell, Wendy J.
 The portrait engravings of Charles Willson
 Peale

 In:18th c.prints in Colonial America.Uni.Press
 of Va.1979,p.123-44 illus.

 List of the engravings & their location

 Repro.incl.:Mezzotints of Geo.Washington,
 Benj.Franklin,Lafayette,Rev.Jos.Pilmore
 Paper originally presented at symposium in
 Williamsburg,Va. March,1974

I.B.4. PORTRAIT-MAKING AS AN OCCUPATION

I.B.3.a

Stewart, J.Douglas
 English portraits of the 17th and 18th cen-
turies,papers read...Apr.14,'73 by J.D.Stewart
and:Herman W.Liebert.Los Angeles,Wm.Andrews
Clark Memorial Library,Univ.of Calif.,1974
 v. 95 p. illus. (Wm.Andr.Clark Mem'l
Library seminar papers)

 Bibliographical references

 Contents:Stewart,J.D.:Pin-ups or virtues?
The concept of the "beauties" in late Stuart
portraiture
LC ND1314.3.S73 Rila I/1-2 1975 #1456

I.B.4 Portrait-making as an occupation(e.g.artist's note-
 books,financial records,etc.)

I.B.3.a

Taylor, Joshua Charles, 1917-
 La fotografia e la macchia;in:his:Vedere
prima la credere;saggi sull'arte del primo otto-
cento...Parma,Università di Parma,Istituto di
storia dell'arte.1970.
 pp.73-94 illus. (Quaderni di storia
dell'arte 7)

WU

I.B.4

Browne, Margaret Fitzhugh, 1884-1972
 Portrait painting...with foreword by Royal
Cortissos.N.Y.,I.Pitman & sons,1933
 101 p. illus(part col.)

 Repro.incl.:Velasquez,Raeburn,Bronzino,Orpen
Sargent,Ingres,F.Hals,L.Seyffert,M.F.Browne,etc.
Incl.Ch.on Portr.ptg.as a profession

 Miss B.,a noted portraitist,gives an account
of her methods. Rev.in Art Dig.7:21,Jl.'33 &
Conn.92:46 Jl.'33
LC ND1300.B7 Art Books 1876-1949.25937
 A773 NCFA Ref. p..95

NK
805
W35 I.B.3.a
1983X
NMAA Washington Meeting on Folk Art (1983)
 Folk art and art worlds;essays drawn from
 the Washington meeting on Folk art,organ.by the
 Amer.Folklife Ctr.of the Library of Congress;
 ed.by John Michael Vlach and Simon J.Bronner.
 Ann Arbor,Mich.UMI Research Press,c.1986
 293 p. illus. (Amer.material culture and
 folklife)
 (Meeting held Dec.5-6,1983)
 Index
 Bibliographies
 Ch.4:Finished to the utmost nicety:Plain por-
 traits in America. 1760-1860;p.85-120

AP
1
A784 Pointon, Marcia
H6 Portrait-painting as a business enterprise
NMAA in London in the 1780s
v.7
 In:Art Hist
 7,no.2:187-205 June,'84

ND
207
W78
1971
NPG

I.B.4

Riley, Stephen T.
John Smibert and the business of portrait painting

In:Winterthur Conf.on Mus.Oper'n and Conn'ship 17th:159-80 1971 illus.

Bibliographical notes

LC ND207.W5 1971

I.C. SPECIAL PERIODS & STYLES - CHRONOLOGICAL

I.B.5. JUVENILE WORKS ON PORTRAITS (all media)

I.C.1. ANTIQUITY

I.B.5

Fisher, Leonard Everett
The limners;America's earliest portrait painters...N.Y.,F.Watts.1969.
47 p. illus. (Colonial Americans)

Discusses the motivations,materials,and techniques of the first "artists"in Colonial America. The sign painters & how their works contribute to a better understanding of early American history & society

LC ND1311.F5

Art Books 1950-79 Z5937
'775 NCFA Ref. p.896

I.C.1

Andronicos, Manolis
Portrait de l'ère républicaine au Musée de Thessalonique

In:Acad Inscr Paris Mon et Mém
51:37 ff. 1957

LC N13.A25 fol.

Richter,G.Portrs.of the Greeks,v.3,p.293 N7586R53

I.B.5

Kainz, Luise C., 1902-
Portraits and personalities,an intro.to the world's great art.by.L.C.Kainz.and.Olive L.Riley N.Y.,Abrams.1967 or 68.
127 p. illus(part col.)

From ancient Egypt to Marisol,organized by period

LC ND1302.K3

Art Books 1950-79 Z5937
'775 NCFA Ref. p.894

I.C.1

Bethe, Erich, 1863-1940
Ahnenbild und familiengeschichte bei Römern und Griechen.München,C.H.Beck'sche verlagsbuchhandlung,1935
121 p. illus.

Bibliography

NNC etc.

Hiesinger.Portr.in the Ror Rep.Bibl.In:Temporini.Auf. stieg u.niederg..LC DG209 T36.Bd.1.T.4.p.82s

I.B.5

Lerner, Sharon
Self-portrait in art.Lerner Publications, 1965 (Fine arts book)
64 p. illus.

Designed by Rbt.Clark Nelson.Minneapolis, Lerner Publ.Co..1965.

Juvenile work

LC N7575.L4

I.C.1

Bianchi Bandinelli, Ranuccio, 1900-
L'origine del ritratto in Grecia e in Roma. Roma,Edizioni "Ricerche".1960.
151 p. (Corsi universitari)

LC N7585.B5

Kraus.
Das.römische weltreich N5760.K92 Bibl.p.315

I.C.1

Bianchi Bandinelli, Ranuccio, 1900-
Ritratto

In:Enc.dell'arte antica classica e orientale
v.6:695 ff. 1965

LC N31.E48,v.6 Kraus.Das römische welt-
 reich N5760.K92 Bibl.p.315

I.C.1

Evans, Elizabeth Cornelia, 1905-
Physiognomics in the ancient world.Phila-
delphia,American Philosophical Society,1969
101 p. (Transactions of the Am.Phil.Soc.
nev ser.59,pt.5)

Bibliographical footnotes

"The best modern treatment of the literary
evidence,that there were practicing physiogno-
mists in Antiquity,".-Crawford
 Crawford.Physiognomy...
LC Q11.P6 n.s.v.59,pt.5 In:Am.Art J.,9:50,May '77

I.C.1

Boston. Museum of fine arts
Greek and Roman portraits,470 BC - AD 500;
written and prepared by Cornelius Vermeule. 1959
80 p. with 75 illus. (Picture book)

Bibliography

 Boston,MFA Bull.70S.1B762
 v.57-60,p.114
MH CU MiU NIC etc. Richter,G. Portrs. of the
 Greeks N7586R53,v.3,p.304

I.C.1

Förster, Richard, 1843-1922, ed.
Scriptores physiognomonici graeci et latini,
recensuit Richardus Foerster...Lipsiae,...B.G.
Teubneri,1893
2 v.

LC PA3403.P6 1893 Crawford.Physiognomy..in:
 Am.Art J.9:49-60,May'77,
 nomical theor. p.50 and Meller.Physiog
 N21.I 61,p.59,footnote1º

I.C.1

Breckenridge, James Douglas, 1926-
Origins of Roman Republican portraiture:Re-
lations with the Hellenistic world

VF In:Temporini,Hildegard.Aufstieg und niedergang
Portrs der römischen welt...Berlin,N.Y.,Walter de Gruy-
Roman ter,1973.Pt.I:Von den anfängen Roms bis zum aus-
gang der republik,v.4(in 2 parts, text & plates)
p.826-854(text),& p.173-187(plates)

Bibl.footnotes

DO209.T36 porini.Aufstieg & Nie-
1,T.4 also in: dergang...LC DO209.T36 LC

I.C.1

Fulvio, Andrea, fl.1510-1543
Illvstrivm imagines...Romae,Jacopo Mazochio,
1517
illus.

202 portrs.Woodcuts by Ugo da Carpi or work-
shop after antique medals of Mazochio's coll.
"One of the oldest publications...with portrs
-Prinz
"this work became the example for numerous
portr.works".-Rath Prinz.Slg.d.selbstbildn.in d.
 Uffizien N7618/P95 Bd.1,p.146
LC N7585.F8 ote 43.Rave.In:Jb.d.Berl.m.
also in: 1959 LC N3.J16 fol.p.128
Rath.Portr.werke in Lex.d.ges.Buchwesens,III,p.39 NPGxerox

I.C.1

Delbrück, Richard, 1975-
Antike Portraits. Bonn,A.Marcus & E.Weber
etc.,1912

120 p. illus.

"Litteratur"
Egyptian,Greco-Roman

LC N7580.D4

I.C.1

Hafner, German.
Römische und italische porträts des 4.jahr
v.Chr.

In:Deutsch.Archäol.Inst.Mitt.Röm.Abt.
77:46-71 1970

LC DE2.D42 Hiesinger.Portr.in the Rom
 Rep.Bibl.In:Temporini.Auf-
 stieg u.niederg...LC DG20
 T36,Bd.1,T.4,p.822

I.C.1

Dohrn, Tobias,1910- .
Zur geschichte des italisch-etruskischen por-
träts

In:Deutsch.Archäol.Inst.Mitt.Röm.Abt.
52:115-39 1937

LC DE2.D42 Hiesinger.Portr.in the Rom-
 Rep.Bibl.In:Temporini.Auf-
 stieg u.niederg...LC DG209
 T36,Bd.I,T.4,p.822

I.C.1

Keller, Harald, 1903-
Das Nachleben des antiken bildnisses von
der Karolingerzeit bis zur gegenwart.Freiburg,
Herder,1970.
237 p. illus. (Humanistisches Lesebuch)

Incl.bibl.references

LC N7575.K4

I.C.1

Leningrad. Gosudarstvennyi institut istorii
iskusstv
Antichnyi portret;sbornik statei.L.,Acade-
mia,1929
116 p. illus.

FOGG
615
156g
"Posviashchastsia Oskaru Ferdinandovichu
Val'dgaueru"
Translation:
Leningrad. State Institute of History of Art
Ancient portrait;collection of articles
"Dedicated to Oskar Ferdinandovich Val'dgaue
Fogg,v.11,p.330
R____ter,G. N7586R53,v.3,p.304

I.C.1

Ochsenbrunner, Thomas
Priscorum Heroum stemmata...Rome,Joh.
Besicken & Sygism.Mayr,1494
illus.

Brit
Mus.
9040d
72 woodcuts

Viten of the Roman history from Romulus to
Theodosius

Rave.Jb.d.Berl.Mus.I 1959
C N3.J16 fol.,p.125
Paolo Gi. io & d.Bildnisvitenbücher.

I.C.1

L'Orange, Hans Peter, 1903-
Apotheosis in ancient portraiture. Oslo,
H.Aschehoug,Cambridge,Mass.Harvard Univ.Press,
1947

156 p. illus.
(Instituttet for sammenlignende kulturforsknin
serie B-Skrifter 44)

Connection of portr.with dogma of divination
of sovereigns since Alexander,esp.in Egypt & Rome.
Hellenistic type continues in Rome until end of
antiquity,through Ottonian emperors & to
Frederick II
LC N7580.16

I.C.1

Parlasca, Klaus
Mumienporträts und verwandte denkmäler..Hrsg:
Deutsches arch.inst. Wiesbaden,Steiner,1966
294 p. illus(part col.)

Bibliography

LC DT62.M7P3

N
5610
L67X
NPG
I.C.1

L'Orange, Hans Peter, 1903-
Likeness and icon.Selected studies in clas
sical and early mediaeval art.Odense,Univ.Pres
1973
343 p. illus.

Articles in English,French,German & Italia
bibl.references

Partial contents:Pt.I:Portraits.10 article
p.1-102 incl.a.o.Zum frührömischen frauenpor-
trät,p.14-22;Der subtile stil.Eine Kunstströ-
mung aus der ze um 400 n.Chr.,p.54-71(per-
tains to coiffu.

I.C.1

Poulsen, Vagn, 1909-
Oldtids menneskerjblade af den antikke por-
traetkunsts historie.København,P.Haase,1959
136 p. illus. (Fra antikkens verden,3)

MET
519.7
P86
Bibliography

DLC-P4 NNMM Kraus.Das römische welt-
reich.N5760.K92 Bibl.p.315
315

I.C.1

L'Orange, Hans Peter, 1903
Studien zur geschichte des spätantiken por-
träts. Oslo,H.Aschehoug & Co.;Cambridge,Mass.,
Harvard univ.press...1933

157 p. illus.

(Instituttet for sammenlignende kulturfors-
kning. Serie B. Skrifter 22)

LC N7585.16

page of I.C.1 1
contents
in NPG Schefold, Karl, 1905-
(xerox) Die bildnisse der antiken dichter,redner und
QN7585 denker. Basel,Benno Schwabe,1943.
S317 NPG
Met 2 v. 228 p. illus.
577 Bibliography
Sch24 Review by Alfons Wotschitzky,In:Ans.f.Altertums-
wiss.,vl:23-4,1948.."important".Rep.1948-49*1012

J.Walters Art Gall.v.9
p.55 footnote "indispensable
Yale Univ.Libr.
Jb53*943S Rep.,1948-49*1012

I.C.1

Michalowski, Casimir (Kazimierz)
...Les portraits hellénistiques et romains.
Paris,E.de Boccara,1932
66 p. illus. (Ecole française d'Athènes
Exploration archéologique de Delos....fasc.XIII)

Bibl.footnotes

MiU MdBWA NN:MTR etc. Hiesinger.Portr.in the Rom
LC:DF261.f.D3E2 v.13(C1) Rep.Bibl.In:Temporini.Auf-
stieg u.niederg .LC DG20
136,Bd.1,T.4,p.824

I.C.1

Schütz, Roland
Das auge in der antiken kunst

In:Kunst,A.K.
77:80-2 1937 illus.

The eye in antique art & its association with
a head in the cathedral at Naumburg & a bust of
Goethe by Rauch

LC N3K5: Rep.,1937*383

I.C.1

Sittl, Karl, 1862-1899
 Die gebärden der Griechen und Römer.Leipzig
B.G.Teubner,1890
 386 p. illus.

LC DF78.S6 Winkes.Physiognomonia.In:
 Temporini.Aufstieg u.nieder
 gang...LC DG209.T36,Bd.1,T.
 p.925

I.C.1 - ETRURIA

Dohrn, Tobias,1910-
 Zur geschichte des italisch-etruskischen por
träts

In:Deutsch.ArchÄol.Inst.Mitt.Röm.Abt.
52:119-39 1937

LC DE2.D42 Hiesinger.Portr.in the Rom.
 Rep.Bibl.In:Temporini.Auf
 stieg u.niederg...LC DG209
 36,Bd.I,T.4,p.822

I.C.1

Snowden, Frank Martin,1911-
 Blacks in Antiquity:Ethiopians in the Greco
Roman experience.Cambridge,Mass.,Belknap Press
of Harvard University Press,1970
 364 p. illus.

LC DE71.86 Winkes.Physiognomonia.In:
 Temporini.Aufstieg u.nieder
 gang---LC DG209.T36,Bd.1,T.
 p.908

I.C.1 - GREECE

Bianchi Bandinelli, Ranuccio, 1900-
 Il problema del ritratto greco.....:Firenze,
Soc.editrice universitaria,1952.
 113 p.

 Bibliography

Cincinnati Uni.Libr.
N7586.B5

705
.V57
NCFA

I.C.1 - EGYPT

Boreux, Charles, 1874-
 A word on two Egyptian bas-reliefs of the
New Empire

In:Verve
2,nos.5/6:102 Jul.-Oct.,'39 illus(col.)

 In Egypt the shift from realistic likeness
to stylization corresponds to the evolution of
religious & funeral beliefs

 N.Y.,MOMA.20th c.portrs.
 byM.Wheeler.N7592.6N53
 Bibl.p.148:Verve

I.C.1 - GREECE

Dickins, Guy, 1881-1916
 Some Hellenistic portraits

In:J Hell Stud
34:299 ff. 1914

LC DF 10.J8 Richter,G.Portrs.of the
 Greeks N7586 R53,v.3,p.296

I.C.1 - EGYPT

Petrie, William Matthew Flinders, 1853-1942
 Roman portraits and Memphis

In :his. Memphis.London School of archaeology
in Egypt.etc..,1909-1915
 6 v. illus.

 v.:IV.,1911

LC DT57.E5 .v.IV. Zaloscer.Mummy portrs...
 In:Apollo,79,p.107 footnote

N
31
E56
NCFA

I.C.1 - GREECE

Encyclopedia of World Art
 Hellenistic Art:Portraiture

In:v.7:363-4 illus. London,McGraw-Hill,1963

LC N31.E4833

I.C.1 - EGYPT

Schaefer, Heinrich, 1868-
 Das altägyptische bildnis. Glückstadt.etc.,
J.J.Augustin.1936.

 46 p. illus.

LC PJ1025.L53 no.5 J.Walters Art Gall. v.9
 p.55 footnote

I.C.1 - GREECE

Förster, Richard, 1843-19??
 Die physiognomik der Griechen.Rede zur
feier des geburtstages des deutschen kaisers
Wilhelm I.,gehalten am 22 märz 1884.Kiel,
Schmidt & Klaunig,1884
 23 p.

 'Aristoteles-Physiognomica'-note on LC card

MH CtY PPAP ICU IU NjP LC Pre-'56,v.176,p.:78
DLC ICRL

I.C.1 - GREECE

Grünaisen, Wladimir de
...Le portrait;traditions hellénistiques et
influences orientales...Rome,W.Modes,1911
110 p. illus.

Études comparatives

Bibl.footnotes

LC N7580.G7 Fogg,v.11,p.322

I.C.1 - GREECE

Schweitzer, Bernhard, 1892-1966
 Bedeutung und geburt des porträts bei den
Griechen

In:Acta Congressus Madvigiani(Copenhagen,1954)
3:27-41 1958 illus.

 The 1st manifestations of portrs.,the part
played by the heroes & the development of indi-
viduality.The most important period is the last
third of the 5th c.Repro.of sculpt,vase-ptg.,me-
dallion fr.Abdera with portr.of Pythagoras
 Richter,G. Portrs.of the
 Greeks N7586R53,v.3,p.303
 Rep.1958#3600

I.C.1 - GREECE

Löwy, Emanuel, 1857-
 The rendering of nature in early Greek art.
Transl.fr.German by J.Fothergill. London,
Duckworth & co.,1907

 100 p. illus.

LC N5633.L7 Lipman.The Florentine pro
 file portrait...In:Art Bu
 18:60,footnote 11

I.C.1 - GREECE

Schweitzer, Bernhard, 1892-1966
 Griechische porträtkunst.Probleme und for-
schungsstand

In:Acta Congressus Madvigiani(Copenhagen,1954)
3:7-26 1958

 Western portr.begun in Greece.Development
of the art of portr.in sculpture,ptg.,numisma-
tics.Faithfullness of representaion & the state
of research
 Richter,G. Portrs.of the
 Greeks N7586R53,v.3,p.303
 Rep.1958#3599

I.C.1 - GREECE

Richter, Gisela Marie Augusta, 1882-
 Late hellenistique portraiture

In:Archaeology
16:25-8 Mar.,'63

LC GN700.A725 Breckenridge.Origins of Ro
 Republ.portr.In:Temporini.
 Aufstieg u.niedergang...
 LC DG209.T36,Bd.1,T.4,p.84

I.C.1 - GREECE

Schweitzer, Bernhard, 1892-1966
 Studien zur entstehung des porträts bei den
Griechen.Leipzig,S.Hirzel,1940
 67 p. illus. (Berichte über die Verhand-
lungen der Sächsischen Akademie der Wissenschaf-
ten...,Philologisch-historisch Klasse,91.Bd.,
1939,4.hft.)

FOGG
Widener

 Richter,G. Portrs.of the
 Greeks N7586R53,v.3,p.303
 Fogg,v.11,p.342

N
7586
R53 I.C.1 - GREECE
NPG Richter, Gisela Marie Augusta, 1882-
 The portraits of the Greeks...London,Phaidon
Press,1965.
 3 v. illus.

 Contents.-v.1.The early period.The 5th c.-
v.2.The 4th & 3rd c. The 3rd & 2nd c.-v.3.The Hel-
lenistic rulers. Greeks of the Roman period
 Bibliography

LC N7586.R5 Enc.of World Art v.11
 p.511 Portraiture,bibl.
 N31E56Ref.

I.C.1 - GREECE

Wace, Alan John Bayard, 1879-1957
 Hellenistic royal portraits

In:J Hell Stud
25:86-105 1905 illus.

LC DF10.J8 Richter,G. Portrs.of the
 Greeks N7586R53,v.3,p.304

I.C.1 - GREECE

Rodenwaldt, Gerhart, 1886-1945
 Griechische porträts aus dem ausgang der
antike...Berlin,W.de Gruyter & Co.,1919
 30 p. illus. (Programm zum Winckelmanns-
feste der archäologischen gesellschaft zu Ber-
lin. 76)

Title from Univ.of Chicago
5325.B37. v.76
LC :N5325.A8 no.76. Kraus.Das römische welt-
 reich.N5760.K92 Bibl.p.316

I.C.1 - (4th c.B.C.) GREECE

Winter, Frans, 1861-1930
 Griechische porträts des 4.jahrhunderts

In:Museum
3:

"Museum"
LC N7511.M7 Waetzold ND1300.W12

I.C.1 - ROME

Bianchi Bandinelli, Ranuccio, 1900-
 Sulla formazione del ritratto romano

In his Archeologia e cultura.Milano,R.Ricciardi,
1961
 v.5,p.172 ff.

 Reprint of article in Società,13:18- 1957

ICN
 Kraus.Das römische welt-
 reich N5760.K92 Bibl.p.315

I.C.1 - ROME

Frel, Jiří
 Reflexions sur le portrait à l'époque ro-
maine

In:Acta Univ.Carolinae.Philosophica et hist.
4: 1960 illus.

LC AS141.A52
Universita Karlova, Kraus.Das römische welt-
 Prague reich N5760.K92 Bibl. p.

I.C.1 - ROME

Blanckenhagen, Peter Heinrich von
 Das bild des menschen in der römischen kunst.
Marburg,1949/50
 115-134 p. illus.

LC Reprinted from Marburger Jahrbuch für Kunst-
N9M3 wissenschaft,15(1949/50)

LC Also Krefeld,Scherpe-Verlag,1948 26p. illus.
N7588.B64(C1)

 DDO NB Enc.of World Art v.11
 p.511 Portraiture,bibl.
 N31E56 Ref.

I.C.1 - ROME

Giuliano, Antonio
 Catalogo dei ritratti romani del museo
profano lateranense,con prefasione di Filippo
Magi.Città del Vaticano.Tipografia poliglotta vat
cana,1957
 103 p. illus. (Monumenti vaticani d
 archeologia e d'arte. 10)

 Bibliography

MNC CU DDO MdBWA Hiesinger.Portr.in the
 ..Rom.Rep.Bibl.In:Temporini.
 Aufstieg u.niederg. LC
 DG209T36,Bd.1,T4,p.824

I.C.1 - ROME

Brommer, Frank
 Zu den römischen ahnenbildern

In:Deutsch.Archäol.Inst.Mitt.Röm.Abt.
50/51:163- 1953/54

LC DE2.D42 Kraus.Das römische welt-
 reich N5760.K92 Bibl. p.315

I.C.1 - ROME

Heintze, Helga von
 Aspekte römischer porträtkunst

In:Gymnasium,Beihefte
4:149-62 1964

New Ser.Titles:"in LC" Hiesinger.Portraiture in
 the Roman Republic LC DG209
 .T36,1.Teil,Bd.4 bibl.n.825

I.C.1 - ROME

Charbonneaux, Jean, 1895-1969
 Portraits du temps des Antonins

In:Acad Inscr Paris Mon et Mém
49:67-82 1957 illus.

 Bibl.footnotes

 ...étude d'un groupe de portrs.à placer entre
150 et 170 et attribuables à deux artistes grecs
de l'entourage d'Hadrien et d'Hérode Atticus qui
ont eu une influence décisive sur l'évolution
du portr.romain Rep.1957#4199
LC N13.A25 fol.

I.C.1 - ROME

L'Orange, Hans Peter, 1903-
 Die bildnisse der Tetrarchen

In:Act Arch
2:29-52 1931

OC1.A2 Winkes.Physiognomonia.In:
 Temporini.Aufstieg u.nieder
 ng...LC DG209.T36.Bd.1,T4
 .905

I.C.1 - ROME

Dohrn, Tobias,1910-
 Zur geschichte des italisch-etruskischen por-
träts

In:Deutsch.Archäol.Inst.Mitt.Röm.Abt.
52:119-39 1937

C DE2.D42 Hiesinger.Portr.in the Rom.
 Rep.Bibl.In:Temporini.Auf-
 stieg u.niederg...LC DG209
 36,Bd.I,T.4,p.822

I.C.1 - ROME

Müller, Ernst, 1877-
 Caesarenporträts,von dr.med.Ernst Müller.
Bonn,A.Marcus & E.Weber,1914-27
 3 v. illus.

MET
617 Bibliography
M91
 Pt.3 has sub-title:Beiträge zur physiognom
iK& pathographie der römischen kaiserhäuser nach
 ihren münzen & andern antiken denkmälern.

 Incl.comparison of photographs of insane
people with Rom emperors.
LC no call number MH NN etc.

I.C.1 - ROME

Petrie, William Matthew Flinders, 1853-1942
Roman portraits and Memphis

In ₍his₎ Memphis.London School of archaeology
in Egypt₍etc₎.,1909-1915
6 v. illus.

v₍₎IV₍₎,1911

LC DT57.E5 ₍v.IV₎
Zaloscer.Mummy portrs...
₍n:Apollo,79,p.107 footnote

I.C.1 - ROME

Schweitzer, Bernhard, 1892-1966
Altrömische traditionselemente in der
bildniskunst des 3.jhs.n.Chr.

In₍his₎Zur kunst der antike.Ausgewählte schrif-
ten.Tübingen,1963,Bd.2,p.265-

LC N5.N4 1st publ.in Nederlands kunsthist.jaarbk.
v.5 5:173- 1954

LC N5610.S37 v.2
₍raus.Das römische welt-
reich.N5760.K92 Bibl.p.316

I.C.1 - ROME

Plinius Secundus, Caius, 23-79
The natural history of Pliny...London.& N.Y.
G.Bell & sons,1890-
v. (Half-title:Bohn's classical library)

'Our understanding of the character and
function of portraiture in the Roman Republic...
is based on...passages in the 'Natural History'
of Pliny the elder.'-Breckenridge

LC QH41.P738
Breckenridge.Origins of Rom.
Republ.portr.In:Temporini.
₍Aufstieg u.niedergang...
LC DG209.T36,Bd.1,T.4,p.827

I.C.1 - ROME

Schweitzer, Bernhard, 1892-1966
Das vorkaiserzeitliche römische porträt,
ursprünge,wesen,überlieferung

In:Forschungen und Fortschritte
19:109 ff. 1943

LC Q3.F6
Richter,G. Portrs.of the
Greeks N7586R53,v.3,p.303

I.C.1 - ROME

Polybius, 205?-?125 B.C.
The Histories of Polybius...London and N.Y.,
MacMillan and co.,1889
2 v.

'Our understanding of the character and
function of portraiture in the Roman Republic
is based on passages in the "Histories"of Poly-
bius...".-Breckenridge

LC D58.P7
Breckenridge.Origins of Rom
Republ.portr.In:Temporini.
₍Aufstieg u.niedergang...
LC DG209.T36,Bd.1,T.4,p.827

I.C.1 - ROME
Sydow, Wilhelm von
Zur kunstgeschichte des spätantiken por-
träts im 4.jhrh.A.D. Bonn,R.Habelt,1969
165 p. illus. (Antiquas,Reihe 3(Serie
in 4to):Abhandlungen zur Vor-& Frühgeschichte,
zur klassischen & provinzial-römischen Archäolo-
gie & zur Geschichte des Altertums,Bd.8)

Diss.Tübingen,1967

Bibliography

LC N7588.S95 1969
Verzeichnis lieferbarer Bü-
cher 1973/74 NPO v.1,
p.1898

I.C.1 - ROME

Richter, Gisela Marie Augusta, 1882-
Verism in Roman portraits.₍eadings in Art
History I,ed.H.Spencer.N.Y.,1969

Reprinted from Journal of Roman Studies
45,1955,pp.35-46

LC D011.J7
AP1.A51A64 HCFA,p.55
Crawford.Physiognomy...In
Am.Art J.,v.9,no.1,may,'77

I.C.1 - ROME

Vessberg, Olof, 1909-
Studien zur kunstgeschichte der römischen
republik.Lund,C.W.K.Gleerup,1941
304 p. illus. (Svenska institutet i Rom.
Skrifter 8)

MET Bibliography
617 ₍Based on₎Diss.-Uppsala₍1941₎
V63

LC D012.S8 v.8,etc.
Gasda.Etrusc.infl.in fune-
rary reliefs...In:Temporin₍
₍Aufstieg u.niedergang...
LC DG209.T36,Bd.1,T.₍ p.855

I.C.1 -₍ROME

Schmidt, Eduard, 1879-
Römerbildnisse vom ausgang der republik. Ber-
lin,W.de Gruyter,1944

63 p. illus.
(Winckelmannsprogr.d.archäologisch.Gesellschaft
zu Berlin,103)

Marius & Sulla; Corbulo; a sculptor from the
beginning of Augustan epoch

Repro.of sculpt.,coins & mosaics
LC N5325.A8Bd.103

I.C.1 - ROME

Winkes, Rolf
Physiognomonia:Problem der charakterinter-
pretation römischer porträts

VF In:Temporini,Hildegard. Aufstieg und niedergang
Portrs., der römischen welt...Berlin,N.Y.,Walter de Gruy-
Roman ter,1973.Pt.I:Von den anfängen Roms bis zum aus-
 gang der republik,v.4(in 2 parts,text & plates):
 p.899-926(text),& p.217-242(plates)

Bibliography
'The best summary on the problem of physiog-
nomy in Roman po₍ traiture...'.-Crawford In:
LC DG209.T36 Am.J.AP1.A51A64.v.9,no.1.49
₍d.1,T.4 May '77

I.C.1 - ROME

Winkes, Rudolf
 Clipeata imago.Studien zu einer römischen
bildnisform.Bonn,Habelt,1969
 265 p. illus. (Habelt's Dissertation-
drucke.Reihe klassische Archäologie,Heft 1)

 Originally presented as the author's thesis
Giessen
 Bibl. references
 Clipeata imago=shield portr.:Painted ances-
tor portrs.hung in Roman houses.None survived
LC NB1296.W56 1969 Winkes.Mummy portrs.In:
 Rh.Isl.Sch.of Des. B.59
 708.1R471,p.7

I.C.1 - ROME

Zadoks,Annie Nicolette (Josephus Jitta), 1904-
 Ancestral portraiture in Rome and the art of
the last century of the republic, Amsterdam,
N.v.Noord-Hollandsche uitgevers-mij.,1932

 119 p. illus.

Title fr.Univ.of Va.
Printed by LC

I.C.1 - ROME

Zinserling, Gerhard
 Altrömische traditionselemente in porträt-
kunst und historienmalerei der ersten hälfte des
3.jhs.unserer zeitrechnung

In:Klio
41:196-220 1963 illus.

 'Continuité des traditions dans le portrait
romain,de l'époque républicaine jusqu'à celle
de Gallienus.'-Rep.
LC D51.K6 Rep.1963 #4448 and
 Kraus.Das römische welt-
 reich.N5760.K92 Bibl.p.316

I.C.1 - ROME

Zinserling, Gerhard
 Die Stilentwicklung der stadtrömischen
porträtkunst vom ausgang des 2.jahrhunderts
n.Chr.bis zum beginn der spätantike.Jena,1950
 328 p.

 Phil.Diss.,Jena,1950
 Maschinenschr.

 Bibl.zu kunst & kunstgesch
 Z5931.B58 1945-53 NCFA
 p.90 no.1734

I.C.2. EARLY CHRISTIAN COPTIC BYZANTINE

I.C.2

Bolten, Johannes
 Die imago clipeata,ein beitrag zur portrait-
und typengeschichte...Paderborn,F.Schöningh,
1937
 131 p. (Added t.p.:Studien zur
geschichte und kultur des altertums,XXI.bd.1.hft.)

 Literaturangaben

LC N7832.B6 Fogg,v.11,p.321

I.C.2

Ehlich, Werner.
 Von hellenistischen mumienporträt zum
christlichen heiligenbild

In:Helikon
8:370-9 1968

NN 708.1.R471,p.7.Winkes.Mum-
 my portrs.In:Rh.Isl.Sch.of
 Des. B.59

I.C.2

Grimm, Günter.
 Thebanische Mumien porträts?

In:Arch.Anz.
86:246-52 1971

LC DE 1.A6 708.1.R471,p.7.Winkes.Mummy
 portrs.In:Rh.Isl.Sch.of
 Des.B. 59,Jan73

I.C.2

Pavlov, Vsevolod Vladimirovich
 Egipetskii portret I-IV vekov. Moskva,
Iskusstvo,1967
 86 p. illus(part col.) (Iz istorii
mirovogo iskusstva)

 English summary

 Bibliography

LC ND1327.E3P33 Fogg,v.11,p.319

708.1 I.C.2
R47b
NCFA Rowe, L.Earle
 Graeco-Egyptian portraits

 In:Rh.Isl.Sch.of Des. B.
 5,no.4:26-7 Oct.,'17 illus.

 708.1.R471,p.9
 Winkes.Mummy portrs.
 In:Rh.Isl.Sch.of Des. B.59

I.C.2

Thompson, David L.
Mummy portraits in the J.Paul Getty mu-
seum.2nd ed.,Malibu,Calif.,The Museum,c.1982
70 p. illus(part col.)

Rev.ed.of:The artists of the mummy portrs.
c.1976 with new material added.
Cat.p.31-63
Index

LC ND1327.E3T48 1982

I.C.2
see also
I.E - MUMMIES

59.938 I.C.2
W42

Weir, Irene, 1863-1944
Greco-Egyptian portraits

In:her.The Greek painters' art...Boston,N.Y.,etc
Ginn & co.,c.1905,,Ch.4,p.246-56

I.C.3. c.5th c. - 14th c.

708.1 I.C.2
W.71
NCFA

Winkes, Rudolf
Mummy portraits

In:Rh.Isl.Sch.of Des.B.
59,no.44:4-15 Jan.,'73 illus.

A.I.Nov.'73-Oct.'74,p.818

I.C.3 MEDIEVAL PRE-ROMANESQUE ROMANESQUE GOTHIC
MEROVINGIAN CAROLINGIAN OTTONIAN

AF I.C.2
1
A04
NCFA
v.79
Zaloscer, Hilde
Mummy-portrait:An interpretation

In:Apollo
79:101-7 Feb,'64 illus.
Bibliographical footnotes

The author considers stylistic reasons or
the prohibition in the decalogue of sculptured
representation of nature as possible causes for
the change.... see over
Praeger.Enc.of Art,v.2,
p.672 Fayum portrs. Bibl.

I.C.3 - 5-6th c.

Fuchs, Siegfried
Bildnisse und denkmäler aus der ostgotenzeit

In:Antike
19:109-53 1943 illus.

Incl.:Portrs.of Theodoric & his descendants
Theodat,Totila in mosaics,statues & ivory diptychs.
Incl.for comparison:Justinian,Theodora,Charle-
magne

LC DE1.A4 Rep.,1942-44*788

I.C.2

Zaloscer, Hilde
Vom mumienbildnis zur ikone.Wiesbaden,
O.Harrassowitz,1969
85 p. illus(part col.)

Bibliography

LC N8187.5.Z3

I.C.3 - MEDIEVAL

Blankenhagen, Peter Heinrich von
Das bild des menschen in der bildenden kunst

In:Marburg Jahrb.
15:115-34 1949-50 illus.

The manner in which Roman art represented
the human being played an intermediary role
between Greek and medieval art

LC N9.M3 Richter,G.Portrs. of the
GreeksN7586R53,v.3,p.294
sp.1950-1*7028

I.C.3- MEDIEVAL

Cornelius, Carl, 1668-
 Bildniskunst;2.teil, das mittelalter

Inaug.diss.,Freiburg,i.B.,1901

LC no call no. NC ICRL PU WU Waetzoldt ND1300.W12

I.C.3 - MEDIEVAL

Müntz, Eugène
 Le musée de portraits de Paul Jove;contribu-
tions pour servir à l'iconographie du moyen-âge
et de la renaissance. Paris,Imprimerie nationale,
1900
 95 p. illus.

 "Extrait des "Mémoires de l'académie des in-
scriptions et belles lettres". Tome 36,2ªpartie"

 "Lists 266 items"-Rave,P.O. Paolo Giovio & die
bildnisvitenbücher...In:Jb.d.Berl.Mus.,p.120

LC N7592.M8 and Amsterdam,Rijksmus.,cat.
AS162 P315 v.36 pt.2 Z5939A52,deel 1,p.136

I.C.3-- MEDIEVAL
Goetz, Walter Wilhelm, 1867- ed.
 Die entwicklung des menschlichen bildnisses.
Leipzig & Berlin,B.G.Teubner,1928-

Contents.-1.Schramm,P.E.D.deutschen Kaiser &
Könige in bildern ihrer zeit.1.Bis zur mitte des
12.jhrh(751-1152)2 v.1929.-2.Prochno,Joachim.Das
schreiber-& dedikationsbild in d.deutsch.buchma-
lerei,v.1,1929-3 Steinberg,S.H.,D,bildnisse geist-
licher & weltlicher fürsten & herren.1.Von d.mit-
te d 10.bis z.ende d.12.jhrh(950-1200),1931
LC N7575.E6 v. II,III

I.C.3 - MEDIEVAL

Rovelli, Luigi
 Paolo Giovio nella storia e nell' arte,
1552-1952;breve monografia....del Museo dei
ritratti,ecc.,....nel 4.centenario della morte
del geniale fondatore del Museo dei ritratti...
Como,1952
FOGG 28 p. illus.
221
052r

Prins.Slg.d.selbstbildn.
in d.Uffizien N7618/P95
Bd.1,p.146,note 33

I.C.3 - MEDIEVAL

Laskin, Myron, 1930-
 The concept of portraiture in the Middle
Ages from the Early Christian through the High
Gothic..Cambridge,Mass..,1952
FOGG 96 p. illus.
985
L34 Thesis,April,1952

Fogg,v.11,p.323

N
7592
T65X I.C.3 - MEDIEVAL
NPG Tomlinson, Amanda
 The mediaeval face.London,National Portrait
Gallery,1974.
 48 p. chiefly illus.

 A selection from the photographs included
in the exh. The mediaeval face...

FOR COMPLETE ENTRY
SEE MAIN CARD

I.C.3 - MEDIEVAL

L'Orange, Hans Peter, 1903-
 The antique origin of the medieval portrai-
ture

 Extract fr. Acta congressus madvigiani,pro-
ceedings of the 2nd internat'l congress of clas-
sical studies,v.3,p.53.-70 .Copenhagen,1957.
 .1954.*)
 Also in .his.Likeness & icon.Selected stu-
N dies in classical & early mediaeval art.Odense,
5610 Univ.Press,1973
L67X p.91-102 *)1954 in Bibl.of Likeness
NPG
DDO Icon,p.XIX

I.C.3 - MEDIEVAL(late)

Keller, H.
 Die entstehung des bildnisses am ende des
hochmittelalters

In:Röm Jahr Kunstges
3:227-356 1939

LC N6911.A1R6

N
5610
L67X I.C.3 - MEDIEVAL
NPG
 L'Orange, Hans Peter, 1903-
 Likeness and icon.Selected studies in clas-
sical and early mediaeval art.Odense,Univ.Pres,
1973
 343 p. illus.

 Articles in English,French,German & Italia
bibl.references

 Partial contents:Pt.I:Portraits.10 article
p.1-102 incl.a.o.Zum frührömischen frauenpor-
trät,p.14-22;Der subtile stil.Eine Kunstströ-
mung aus der ze um 400 n.Chr.,p.54-71(per-
tains to coiffu

I.C.4. 14th c. - 17th c.

I.C.4 RENAISSANCE MANNERISM BAROQUE

N
71
I 61
1961
NCFA

I.C.4 - RENAISSANCE

Meller, Peter
 Physiognomical theory in Renaissance heroic
portraits.

In:International Congr.of the Hist.of Art,20th
N.Y.,1961
v.II:Renaissance & Mannerism:53-69 illus.

 Article examines some heroic portrs.which
show the linkage with the characteristics of
animals,after a theory of antique & medieval
physiognomics.

Portr.bust.Renaiss.to En-
lightenment.NB1309.P6x NPG Bibl.

I.C.4 - RENAISSANCE

Bataillon, Marcel
 Philippe Galle et Arias Montano. Matériaux
pour l'iconographie des savants de la Renaissance

In:Bibl.Humanisme et Ren.
2:132-60 1942 illus.

Album engraved & edited by Galle,Antwerp,1572-87;
commentary by Arias;alphabetical list of 94 portrs

Rep.,1942-44#686

I.C.4 - RENAISSANCE

Müntz, Eugène
 Le musée de portraits de Paul Jove;contribu-
tions pour servir à l'iconographie du moyen-âge
et de la renaissance. Paris,Imprimerie nationale,
1900
 95 p. illus.

 "Extrait des "Mémoires de l'académie des in-
scriptions et belles lettres". Tome 36,2epartie"

 "Lists 266 items"-Rave,P.O. Paolo Giovio & die
bildnisvitenbücher...In:Jb.d.Berl.Mus.,p.120

LC N7592.M8 and Amsterdam,Rijksmus.,cat.
A5162 P315 v.36 pt.2 Z5939A52,deel 1,p.136

I.C.4 - RENAISSANCE

Chojecka, Ewa
 Theorie und praxis des porträts der Früh-
renaissance.Die 'Phisionomia' des Johann von
Glogau(1518)

In:Jena Uni.Wiss.Z.,gesellschafts-& sprachwis-
senschaftliche Reihe,
18:177-00 1969

LC AS182.J5

NE
218
R25
NPG

I.C.4 - RENAISSANCE

Rave, Paul Ortwin, 1893-1962
 Paolo Giovio und die Bildnisvitenbücher des
Humanismus

In:Jb.der Berliner Mus.
I 1959:119-54 illus.

 Der bildnissammler und vitenschreiber Giovio.
Die ersten bücher mit bildnisreihen.Die "vera
effigies"und die frühen münsbildbücher.Die gros-
sen chroniken der jahrhundertmitte.Giovio,Vasari

LC N3.J16 Prins.Slg.d.selbstbildn.
 in d.Uffisien N7618/P95
 Bd.1,p.146,note 42

'05
;784
CFA

I.C.4 - RENAISSANCE

Debs, Barbara K.
 From eternity to here:Uses of the Renais-
sance portrait

In:Art in Am
63:48-55 Jan.,-Feb.,'75 illus(part col.)

 Transformation of intention in portrs.fr.
medieval to early 15th c. donors to mid 15th c.
& later portrs."in context"& individual portrs.

I.C.4 - RENAISSANCE

Rovelli, Luigi
 Paolo Giovio nella storia e nell' arte,
1552-1952;breve monografia....del Museo dei
ritratti,ecc.,...nel 4.centenario della morte
del geniale fondatore del Museo dei ritratti...
Como,1952
 28 p. illus.

FOGG
221
G52r

 Prins.Slg.d.selbstbildn.
 in d.Uffisien N7618/P95
 Bd.1,p.146,note 33

705
A786
NCFA
v.45

I.C.4 - RENAISSANCE

Frankfurter, Alfred M.
 International portraits of baroque royalty

In:Art N
45:32-5- March,'46 illus.

 Discusses portrs.of Frenchmen painted by
Netherlanders;Englishmen by Dutchmen;Austrians
by Spaniards,etc.in the exh.at Duveen's:"15-18th
c.paintings"

I.C.4 - 15-16th c.

Bergström, Ingvar
 On religious symbols in European portraiture
of the 15th & 16th c.

In:Arch Filosofia
:335.43 1960 illus.

 Umanesimo e esoterismo (Atti del V convegno
internazionale di studi umanistici)Padua,1960

 Essay illustr. by works of Lippo Vanni,
Pleydenwurff,v.d.Weyden,Luini,Crivelli,Master of
Mary of Burgundy, eisenegger,v.Cleve,Beham
MH CtY ICU NjP CaQQLa Rep.1960#852

705
G23
NCFA

I.C.4 - 16th c.

Lebel, Gustave
British-French artistic relations in the 16th century

In:Gaz.Beaux Arts
33:267-80

Exchange of portrs.betw.court of France & that of England,chiefly on occasion of projects of princely marriages.Ptg.,drg.&engr.of Mary Tudor, miniature of Henry VIII. Incl:de Bie,J.& F.Clouet, Perréal,Belliart-Hilliart?(also Oeuillard)
Rep.,1948-49 * 6641

N
7623
H15D22
NPG

I.C.4 - 16-20th c.

Dartmouth College. Hopkins Center
Portraits at Dartmouth;cat..by Arthur R. Blumenthal..Exh..10 March to 16 April 1978. Hanover,N.H.,Dartmouth College,1978
137 p. illus.(col.cover illus.)

Bibliography

Development of portraiture fr.16th c.to early 20th c. shown by works of Dartmouth College collection.
Appendices are checklists of portrs.in all media which are not in this exhibition.

I.C.4 - 16th c.

Muller, Frederik & co., Amsterdam
Catalogue d'une collection remarquable de portraits du 16e siècle...Amsterdam.1895.
113 p.

"catalogue à prix marqués"

FOGG
4353
M95

Fogg,v.11,p.324

I.C.4 - 17th c.
(v)

Lasaref, Viktor Nikitich, 1896-
Portret v Evropeiskom iskousstve 17 veka (The portrait in 17th c.European art).Moscou, 1937

95 p. illus.

Intelectual relation betw.West & East Europe. French influence in the portraits of Ghislandi de Bergamo

LC

Gaz.Beaux Arts,v.20,1938
.327 (Réau)

ND
1301
G7
O 98
NPG

I.C.4 - 16-17th c.

Oxford. University. Bodleian Library
Portraits of the 16th and early 17th centuries,by J.N.L.Myres.Oxford.1952.
7 p. illus. (Bodleian picture book,no.6)

23 plates

FOGG
59
O 98bp
no.6

Fogg,v.11,p.324

I.C.4 - 17-18th c.

Heim Gallery
Faces and figures of the Baroque;cat.of the autumn exh.,Nov.9-Dec.24,1971.London ,1971.
26 p. illus. (Heim exh.cat.,no.14)

LC N8640.H4 no.14

Ars libri,ltd.Special Bull. no.48 17th c.art no.193 p.22

I.C.4 - 16-17th c.

For early collections of biographies with portraits
see also
II.B.3.f - BILDNISVITENBÜCHER

N
7606
S75
NPG

I.C.4 - 17-18th c.

Spike, John T.
Baroque portraiture in Italy.Works from North American collections.Cat.for an exh.at The John and Mable Ringling Mus.of Art,Dec.7, 1984-Feb.3,.985.Printed by Joe R.Klay & Sons, Inc..1985.
214 p. illus(part col.)

Bibliography
Ptgs.,medals,busts,drags.,prints.In alphabetical order by artist
Incl.:Introductory essays on 4 aspects of Baroque portrai ture
Portr.with? .portr.no.50.Black servant no.68

I.C.4 - 16-18th c.

Obshchestvo pooshchreniia khudozhnikov,Leningrad
Katalog istoricheskoi vystavki portretov lits 16-18 vv.,ustroennoi Obshchestvom pooshchreniia khudozhnikov.Sostavil P.N.Petrov.Izd.2., ispr.i dop. S.-Petersburg,Tip.A.Transhelia,1870
232 p.

Translation:
Society for the Encouragement of Artists,Leningrad
Cat.of the histor.exhib.of portrs.of persons fr.the 16 to 18th c.,arranged by the Society... compiled by P.N. Petrov.2nd ed....

FOGG
980
O14

Fogg,v.11,p.324

I.C.5. 18th c.

I.C.5 ROCOCO U.S. COLONIAL

I.C.6. 19th c.

qN
6756
C593
NMAA
2 c.

I.C.5 - 18th c.

Clark, Jane, 1955-
 The great eighteenth century exhibition in
the National Gallery of Victoria..Melbourne,
Nat'l Gall.of Victoria,1983.
 179 p. illus.(part col.)

 Ch."The proper study of mankind is man",
some 18th c.people,pp.137-61
 Additional portrs.p.115,118,(Luigi Boccheri-
ni)p.123. Busts p.106. Miniatures p.48-9.
Groups p.18,p.22-3,p.28,30,110,122

 Portraits within portraits p.27,54

I.C.6 Neo-CLASSICISM BIEDERMEIER VICTORIAN ART NOU-
 VEAU IMPRESSIONISM

NK
4210
W4N38
1976X
NPG

I.C.5 18th c.

National Portrait Gallery, Washington, D.C.
 Wedgwood portraits and the American Revolu-
tion..Washington,:National Portrait Gallery,
Smithsonian Institution,1976
 134 p. illus.
 Cat.of an exhibition,July 13-Oct.31,1976

 Foreword by Marvin Sadik

 Intro.by Bruce Tattersall

 Bibliography
LC NK4210.W4N38 1976

AP
1
C75
NMAA

I.C.6 - 19th c.

Bonafoux, Pascal
 (Portraits d'artistes)Regards croisés

In:Conn.Arts
no.419:28-34 Jan.,'87 illus(col.)

I.C.5 - 18-(early)19th c.

Lankheit, Klaus
 Das freundschaftsbild der Romantik.Heidel-
berg,C.Winter,1552.c.1951.
 200 p. illus. (Heidelberger kunstge-
schichtliche abhandlungen,N.F.Bd.1)

 Bibliographical notes

LC PN754.L3 Praz.Conversation pieces
 ND1304P92E1971,p.161,foot-
 note 1

qN
40.1
152M3
NPG

I.C.6 - 19th c.

Lehmann, Rudolf, 1819-1905
 Men and women of the century,being a col-
lection of portraits and sketches...ed.with
introduction and short biogr.notes by H.C.
Marillier.London,G.Bell & sons,1896
 78 p. illus.

 Classified list:Church & State,Literature...
Science,Painting & Sculpture,Music

LC £704.942 L523m

I.C.5-18th & 19th c.

Leisching, Julius, 1865-1933
 Das bildnis im 18.& 19. jahrhundert. Wien,
1906

 illus.

 Copy in kunsthist.bibliotheek in het Rijks-
museum te Amsterdam (cat.le deel,1934,p.126)

 ICU NNC CtY OC1 Waetzoldt ND 1300.W12

N
7592.5
166
1974X
NMAA

I.C.6 - 19th c.

London. National Portrait Gallery
 Early Victorian portraits...text by:
Richard Ormond.London:H.M.S.O.,1973.i.e.1974.
 2 v. illus(part col.)

 Bibliographical references
 Contents.-v.1:text;index of owners....in-
dex of artists;index of photographers.-v.2:
Plates...

LC N7592.166 1974

705
Q28
NCFA
v.28

I.C.6 - 19th c.

Lostalot, Alfred de
 Exposition de portraits du siècle,à l'école
des Beaux-Arts

In:Gaz.Beaux-Arts
28:81-91 July,1883 illus.

 Repro.incl.:Paul Delaroche,Louis David,
John S.Sargent
 400 items exhibited:Drgs,ptgs.,miniatures

· I.C.6 - 19th c.

Waldmann, Emil, 1880-1945
 Das bildnis im 19.Jahrhundert. Berlin,1921
Propyläen-Verlag

 299 p. illus(part col.)

 Causes of inferiority of 19th c.portrs. to
previous centuries:lack of tradition in the
epoch of the predominent middle-class;influence
of photography(in preface)
 Contents:D.erbe des 18.jahrh.& d.klassisisti-
scho repräsentation.D.bildnis d.romantik,(over)
ND 1309.W2
 Goldscheider. 757.G52

N
7592.5
M96
NPG
2 c.

I.C.6 - 19th c.

Munson-Williams-Proctor Institute,Utica,N.Y.
 Portraiture:the 19th and 20th centuries.
This exh....will be shown under the auspices
of the Museum Exhibition Association at the
Munson-Williams-Proctor Institute.March 31-
Apr.21,1957.,the Baltimore Mus.of Art,Dallas
Mus.of Fine Arts and Colorado Springs Fine Arts
Center.Utica,1957.
 36 p. illus.

 Ptgs.,nos.1-47;Prints & drgs.,nos.48-63;
Photographs,nos.64-82 Winterthur Mus.Libr. fZ881
 f78 NCFA v.6,p.218

I.C.7. 20th c.

I.C.6- 19th c.

Pecht,.August.Friedrich, 1814-1903
 Zur bildnismalerei der gegenwart

In:Kunst für alle
 1: .1885.

LC for Kunst für alle: Wastsoldt 1300.W12
N3.K4

I.C.7 "ISMS"
 Computer art

N
6510
P54
NMAA

I.C.6 - 19th c.

Pike, Martha V.
 A time to mourn,expressions of grief in
19th century America;by M.V.Pike and Janice
Gray Armstrong.Brooklyn,N.Y.:Museums at Stony
Brook,1980
 192 p. illus(part col.)

 Exh.held May 24-Nov.16,1980 at Museums at
Stony Brook,Stony Brook,N.Y.
 Incl.Posthumous mourning portraiture
Bibliography

 Incl.Index
LC N6510.P54 (also in MMT) Gerdts.Art of healing
 223.036,p.112,note 13 NPG

I.C.7 - 20th c.

Anargyros, Spero Drosos, 1915-
 Electronic portrait sculpture

In:Southwest Art
5,pt.7:70-1 Jan.,'76 illus.

 Describes the 'Pechman'system...:the use
of multiple cameras which programme a computer.
This then instructs implements which will pro-
duce an exact replica of the subject.This pro-
vides a sculptor with accurate material for ma-
king portr.busts.
LC N6525.S58 Artbibl.modern,v.7,no.2
 1976 qZ5935.L105 NCFA-65C4

N
40.1
H41V8
NCFA
NPG

I.C.6 - 19th c.

Virginia Museum of Fine Arts, Richmond
 A souvenir of the exh.entitled Healy's sit-
ters;or,A portr.panorama of the Victorian Age,
being a comprehensive coll.of the likenesses of
some of the most important personages of Europe
& America,as portrayes by Geo.Peter Alex.Healy
betw.the years 1837 and 1899,suppl.with docu-
ments relating to the artist's life & furnish-
ings of the period,on view at the Va.M.f.A....
24 Jan.-5 March 1950.=Richmond,1950=
 94 p. illus.
 Index

LC ND237.H4 V5 Art Books 1950-79 Z5937
 A775 NCFA Ref. p.898

N
40.1
H297.P6
NPG

I.C.7 - 20th c.

Barton, Ralph, 1891-1931
 The Jazz age,as seen through the eyes of
Ralph Barton,Miguel Covarrubias, and John Held,Jr
.Providence,1968.
 .59.p. illus.

 Cat.of exh.of the jazz age in caricature...
held at the Mus.of Art,R.Isl.School of Design,
Sept.25-Nov.10,1968,and at the Art Gall.,State
Univ.of N.Y.College at Potsdam,Nov.15-Dec.15,'68

 Repro.incl.:actors,authors,musicians,ptrs.,
LC politicians,journalists,etc...
NC1427.P74B3

705
A7834
v.19

I.C.7 - 20th c.

Breuning, Margaret
 The cerebral approach to portraiture

In:Art Digest
19:13 Apr.15,'45 illus.

 Exh.at Mortimer Brandt Gall."Portrs.of to-
day by painters of today"April,1945,emphasizes
the tendency to present emotional or cerebral
ideas suggested by the sitter or a reflection
of the artist's reaction to the sitter"

I.C.7 - 20th c.

Houchens, Douglas
 Contributions of expressionists painting
to the art of portraiture

 Master's Th.-Coll.of Wm.& Mary,Richmond,Va.,
1952

 Lindsay,K.C.,Harpur Ind.of
 master's theses in art...
 Z5931.L74 1955 NCFA Ref.
 p.103,no.1908

N
7592.6
C72
NPG

I.C.7 - 20th c.

Columbia University. Dept.of Art History and
 Archaeology
 Modern portraits.The self and others..N.Y.
Col.Univ.,1976
 201 p. illus(part col.)

 Exhibition organized by the Dept.of Art
Hist...at Wildenstein,N.Y.,Oct.20-Nov.28,1976
 Index of sitters
 Intro.by J.Kirk Varnedoe

 Reevaluation of portraiture,representation-
al & otherwise in modern art

AP
1
A784E9
NMAA
v.1

I.C.7 - 20th c.

Leslie, Seaver
 Notes on portraiture

In:Art Express
1,no.2:24-6 Sept.,Oct.,'81 illus(part col.)

 Discussions incl.History of portr.Two kinds
of portr.:exact resemblance and aesthetic quali-
ties.
 Repro incl.:Stamp with Whistler's mother.
Stuart:Washington.Roman head.Picasso:Gertrude
Stein.Gorky:Artist & mother.Warhol:Marilyn Mon-
roe.Photos by Leslie.Mapplethorpe.Peggy
Wollheim:Digitized computer portrait

I.C.7 - 20th c.

Darmstadt. Stadt
 Darmstädter gespräch.1950-1952.v.1,Das
menschenbild in unserer zeit.Darmstadt,Neue
Darmstädter Verlagsanstalt,1951.
 1 v.,247 p., illus.
 The proceedings in v.1 contain discussion
on the pros and cons of abstract art and incl.
a speech by Willi Baumeister.Each conference is
accomp.by an exh.,arr.by the "Neue Darmstädter
Sezession",July 15-Sept.3,1950
 Bibliography

LC N7443.D3 1950 MOMA,v.11,p.432

I.C.7 - 20th c.

London. Grosvenor Gallery
 Friends and famous people..Exh.July 30-
Aug.24,1968.

V & A Review by Js.Burr In:Apollo 88:139 Sg.'68
has illus.:"Documents of socio-political interest.
cat. Incl.:Blatas'bronzes;Gerald Scarfe,Sam Walch,
 Calabria,Ph.Sutton,Noakes,Narotzki,A.Hoffmeis-
 ter"
 Review by O.Blakeston In:Arts review
 20,no.15:487 Ag.3,'68 illus.

 MOMA, v.11,p.434

N
7592.6
G44
NPG

I.C.7 - 20th c.

Gibson, Robin
 20th century portraits;exh.at Carlton
House Terrace,9 June - 17 Sept.,1978.London,
National portrait gallery,1978
 80 p. illus(part col.)

 Lists of artists,sitters,lenders

I.C.7 - 20th c.

Munro, Eleanor C.
 Portraits in our time

In:Horizon
v.1,no.3:95-105 Jan.,'59 illus(part col.)

LC AP2.H788 MOMA p.432, v. II

I.C.7 - 20th c.

Hodurek, J.
 Die selbstbildnisse der nord- und mittel-
deutschen Expressionisten.

 Thesis München,1976

 Netuschil.N7619.503K86
 1963X NMAA p.136

N
7592.5
M96
NPG
2 c.

I.C.7 - 20th c.

Munson-Williams-Proctor Institute,Utica,N.Y.
 Portraiture:the 19th and 20th centuries.
This exh....will be shown under the auspices
of the Museum Exhibition Association at the
Munson-Williams-Proctor Institute.March 31-
Apr.21,1957.,the Baltimore Mus.of Art,Dallas
Mus.of Fine Arts and Colorado Springs Fine Arts
Center.Utica,1957.
 36 p. illus.

 Ptgs.,nos.1-47;Prints & drags.,nos.48-63;
Photographs,nos.64-82.Winterthur Mus.Libr. fZ881
 Z78 NCFA v.6,p.218

I.C.7 - 20th c.

New York. Museum of modern art
Family portraits from the museum collection.
⟨N.Y.,The Museum,1964⟩
2 p.

Checklist of temporary exh.May 27,1964-Feb.7
1965
Ptgs. & sculpt.by Beckmann,Guglielmi,Hark-
avy,Lindner,Marisol,Moore,Quirt,Ruiz,Shahn,
Spencer,Stettheimer,Tanguy,Vuillard

MOMA,v.11,p.435
MOMA MMA733 and Archive
MMA 733

qN
40.1
S81A1
NPO

I.C.7 - 20th c.

Steichen, Edward, 1879-
A life in photography.Publ.in collaboration
with the Mus.of Modern Art.Garden City,N.Y.,
Doubleday,1963
1 v.(unpaged) illus(part col.)

Ch.10:On portraits & portraiture.3 p.,44
portrait photographs of celebrities of the
20th c.

LC TR140.S68A25

N
7592.6
N53
NPG

I.C.7 - 20th c.

New York. Museum of modern art.
20th century portraits, by Monroe Wheeler. New York, The
Museum of modern art ⟨1942⟩
148 p. col. front., illus, col. plates. 26ᵐ.
Illustrations: p. 23-132.
Bibliography: p. 146-148.

1. Portraits—Exhibitions. 2. Wheeler, Monroe. 3. Title.
42-305
Library of Congress N7592.N4
⟨45x2⟩ 707.2

705
C69
NMAA
v.46

I.C.7 - 20th c.

Steiner, Wendy
Postmodernist portraits

In:Art J.
46,no.3:173-7 Fall,1987 illus.

Illus.incl.:Warhol,Rauschenberg,Close,
Hockney,Kolář
Discusses the 'odd migration of high-moder-
nist literary goals into post-modernist'portra.

I.C.7 - 20th c.

Paris. Musée Galliéra
Peintres témoins de leur temps.Cat.of 5th
annual exh.,entitled:"Réhabilitation du por-
trait;held July,1956.Preface de Jean Cassou

F000
3928
P23a
(15 v.)

Portrs.of eminent personalities by 100
painters & sculptors
For commentary see Studio,v.152:22-3 Jul,
1956

LC N5068.P33(Paris.Peintres témoins de leur temps)
MOMA,v.11,p.434

N
7575
T58
NPG

I.C.7 - 20th c.

Time, inc.
Famous likeness;an exh.co-ordinated by
Time,inc.,N.Y. and the Inst.of Contemp.Art,
Boston,in participation with the Columbus Gall.
of Fine Arts,Columbus,Ohio and the Milwaukee
Art center,Milwaukee,Wisc..March-Aug.,1961.
⟨Text:Francis Brennan..N.Y.,1961⟩
unpaged illus.
drws.
Portrs.(ptgs.& sculptures)of famous people
by great artists.

LC ND1301.T5 MOMA, p.435

705
A787
NCFA
v.36

I.C.7 - 20th c.

Porter, Fairfield
Speaking likeness

In:Art N Annual
36:40-51 Oct,'70 illus(part col.)
The issue is called "Narrative Art"

Under the title:"In its emphasis on parti-
cularity,on the individual sitter as well as of
the individual work,portraiture reveals the
weakness of modern dogma."

MOMA,v.11,p.431

I.C.7 - 20th c.

Uhde-Bernays, Hermann.Hans Friedrich,1873-1965
Die neu-zeitliche bildniskunst

In:Der Spiegel(Jahrbuch des Propyläen-Verlags)
1923

LC N3.S6 Die 20er Jahre im porträt
N6868.5.E9Z97 NPG p.138

I.C.7 - 20th c.

Das Porträt im phantastischen Realismus...
Wien,Hauska,1972

LC N6808.5.M3P67 FOR COMPLETE ENTRY
SEE MAIN CARD

768.1
N52
NCFA

I.C.7 - 20th c.

Vincent, Clare
In search of likeness:Some European portrait
sculpture

In:Met Mus Bul Apr.,'66 illus.
24 ns:245-60
Comparisons of sculpt.with ptg.& photo.of
same sitter.
Difference betw.Fr.& Germ.art,beg.20th c.

Repr.:Balzac by Rodin / Séguin;Mme X by Rodin
& photo;G.B.Shaw by Epstein,Rodin & Steichen pho-
to;

I.C.7 - 20th c.

Wentzel, Hans, 1913-
 Bildnisse der Brücke-Künstler von einander
Einführung von Hans Wentzel.Stuttgart,Reclam
,1961,
 32 p. illus (Werkmonographien zur
bildenden Kunst no.63)

 Reclams Universal-Bibliothek,Nr.B9063

LC N6848.W4 Metuschil.N7619.503K86
 1963X NMAA p.136

AP
1
A64
NCFA

I.C.9

Auerbach, Erna
 The development of particular groups of
German portrait painting.II.Plasticity and sym-
metry about 1530

In:Apollo
22:3,5,7,9 July,'35 illus.

 Repro.:Strigel,Unknown Swabian artist,Cra-
nach the elder,v.Heemskerck,Brosamer,Penes
 Desire to bring calmness and "monumentality
to the fig. Flemish influence is discussed.

ND
1301
N5W67
NPO

I.C 7 - 20th c.

Wildenstein & co.,inc., New York
 Great portraits,from impressionism to mo-
dernism;a loan exh....Mar.1-Mar.29,1938.N.Y.
city,Wildenstein & co.,inc.,1934,
 40 p. illus.

 Foreword by Frank Crowninshield:"...a wholly
new school of portraiture...new objectives,new
aesthetic relationships...betw.ptr.& sitter...
when...photography...had become universal,the
doom of the "likeness"school of portr.,
LC ND1301.W5 was definitely sealed."

I.C.9

Blankenhagen, Peter Heinrich von
 Das bild des menschen in der bildenden kunst

In:Marburg Jahrb.
15:115-34 1949-50 illus.

 The manner in which Roman art represented
the human being played an intermediary role
between Greek and medieval art

LC N9.M3 Richter,G.Portrs. of the
 GreeksN7586R53,v.3,p.294
 ,p.1950-1*7028

N
6868.5
E9297
NPO

I.C.7 - 20th c.

Die swansiger jahre im porträt:porträts in
 Deutschland 1918-1933:malerei,graphik,foto-
 grafie,plastik.,Rheinisches Landesmuseum
 Bonn,Ausst.10.9-24.10.1976.Kat.:Joachim
 Heusinger v.Waldegg unter mitarbeit von
 Brigitte Lohkamp and Adam C.Oellers.Köln,
 Rheinland-Verlag;Bonn,in kommission bei
 R.Habelt,c.1976
 277 p. illus(part col.) (Kunst und
 Altertum am Rhein,no.68)
 Bibliography
LC N2255.R5A5 no.68
,N6868.5.E9,

VF

I.C.9 - COMPARISONS

Dobell, Byron;Maxwell, 1927-
 They had faces in those days

In:Newsweek
95,no.22:17 June 2, 1980 illus(self-portr.)

 Discusses...also the difference betw.photo-
graphy and ptg.

LC AP2.N6772
LC Microfiche FOR COMPLETE ENTRY
 SEE MAIN CARD

I.C.9. INFLUENCES, COMPARISONS, CONTRASTS

AP
1
S4?
NCFA
v.35

I.C.9

Fowler, Frank, 1852-1910
 Some notes on portraiture and the recent
portrait exhibition

In:Scribner's Mag.
35:381-4 Mar,1904

 ...Compares Sargent's virtuosity & characte-
rization with works by Dagnan-Bouveret,Alfred
Collins etc..Discusses influence of Dutch,German
& Italian ptrs.on the English

 FOR COMPLETE ENTRY
 SEE MAIN CARD

I.C.9 INFLUENCES COMPARISONS CONTRASTS

I.C.9

Keller, Harald, 1903-
 Das Nachleben des antiken bildnisses vom
der Karolingerzeit bis sur gegenwart.Freiburg,
Herder,1970,
 237 p. illus. (Humanistisches Lesebuch)

 Incl.bibl.references

LC N7575.K4

I.C.9

(v)
Lazaref, Viktor Nikitich, 1896-
Portret v Evropeiskom iskousstve 17 veka
(The portrait in 17th c.European art).Moscou,
1937

95 p. illus.

Intelectual relation betw.West & East Europe.
French influence in the portraits of Ghislandi de
Bergamo

LC
Gaz.Beaux Arts,v.20,1938
p.327 (Réau)

I.C.9 - COMPARISONS

Comstock, Helen
Portraits of American craftsmen

In:Antiques
76:320-7 Oct.,'59 illus.

Incl.Chronological table of American artistic
works of artisans compared with those on the con-
tinent,from 1725-1825
Incl.:Pollard Limner,John Smibert,Nathaniel
Smibert,Copley,Chs.W.Peale,Ralph Earl,Sarah Good-
ridge,Mather Brown,G.Stuart,Benj.Blyth,Ths.Sully,
John Neagle,J.W.Jarvis,Ezra Ames

Rep.1959 #977

I.C.9

Quintilianus, Marcus Fabius, c.35-c.95 A.D.
The Institutio oratoria of Quintilian,
with an English translation by H.E.Butler...
London,W.Heinemann;N.Y.,G.P.Putnam's sons,
1921-??
4 v. (The Loeb classical library.Latin
authors.)
Bibliography
Resources of the discipline of physiogno-
mics
"...The most influential writing on the ap
plication of the principles of physiognomics,

LC PA6156.Q5 1921
PA6649.A2 1921

I.C.9 - COMPARISONS

Dayot, Armand Pierre Marie, 1856-1934 ed.
Cent portraits de femmes des écoles anglaise
et française.Paris,F.Petit,1910
165 p. illus. (Maîtres de 18e siècle)

Luxury ed.of cat.of exh.in Paris,Mus.du jeu
de paume,Spring,1910;intro.by A.Dayot & Claude
Phillips.Documentation by Léandre Vaillat & Ro-
bert Dell
Exhibited portrs.offer a study in differen-
ces of temperament & character betw.2 nations
(see L.C.ust.in:Burl Mag,v.17:52,55)

LC R757
fD27c OC MdBWA NN

708.1 I.C.9
N52
NS v.7 Simpson, William K.
A 4th dynasty portrait head

In:B-Metrop.Mus.Art
7(NS):286-92 May 1949 illus.

Individual character of heads at Giseh,4th
dyn.derived fr.3rd dyn;use of plaster to model
limestone surface. Influence on realistic sculpt.
of 5th dyn. In Old Kingdom also use of masks for
mummies. Comparison with bronze heads of Ile-Ife
in Nigeria

Rep.,1948-49*3265

I.C.9 - COMPARISONS

Gazda, Elaine K.
Etruscan influence in the funerary reliefs
of late Republican Rome:A study of Roman verna-
cular portraiture
Portrs.
VF Roman In:Temporini,Hildegard.Aufstieg und niedergang
der römischen welt...Berlin,N.Y.,Walter de Gruy
ter,1973.Pt.I:Von den anfängen Roms bis zum aus
gang der republik,v.4(in 2 parts,text & plates)
p.189-205(plates),& p.855-870(text)

Bibl.footnotes

LC DG209.T36 Temporini.Aufstieg und nie
Bd.1,T.4 dergang...LC DG209.T36

I.C.9 - COMPARISONS

Bender, Paul
Wirklichkeit und wahrheit im porträt

In:Kunst
72:45-53 1938 illus.

Comparison of portr.in ptg.,sculpture & pho-
tographs.
Incl:Delacroix,Corinth,Sintenis,Cézanne,
Renoir,etc.

LC N3.K5
Rep.,1938#568

ND
1311.1
D77
NPG I.C.9 - COMPARISONS

Dresser, Louisa
The background of colonial American por-
traiture:some pages from a European notebook

In:Proc.Am.Ant.Soc,Worcester,Mass.
76,pt.1:19-58 1966

Bibliographical footnotes

LC E172.A35 vol76,pt.1 Green,S.M.Engl.orig.of N.E.
Newberry Library ptg.In:Winterthur Conf....
 ND207/W78/1971,p.56

705
P19
NCFA I.C.9 - COMPARISONS
v.13 Christoffel, Ulrich, 1891-
Das deutsche bildnis der Dürerzeit

In:Pantheon
13:1-9 Jan,1934 illus(part col.)

Synopsis in English,pp.1-3:"The German portrai-
tist did not paint so much the portrait of the
sitter, but rather his psychical power"...

Repro:Kulmbach,Schäufelein,Holbein,Cranach,
Baldung,etc.
Enc.of World Art,v.11
N31E56 Ref.,col.513
bibl.on portr.

I.C.9 - COMPARISONS

Harrison, James
On the artistic element in French photo-
graphic portraiture compared with English

In:Brit.J.of photography
May 3, 1867

LC TR1.B8
McCauley.Likenesses qTR
575.M12 NPG notes p.23
no.89

705
A784
NCFA
v.33

I.C.9 - COMPARISONS

Kaldis, Laurie Eglington
 American and English portraiture:democracy
versus aristocracy

In:Art in Amer.
33:48-63 Apr.,'45 illus.

 Pertains to exh."Old & New England"in Rhode
Island school of des.For cat.see 757.6R47NCFA

 Repro.:Winthrop Chandler,Ralph Earl,Reynolds,
Gainsborough,Feke,Moulthrop,Gilb.Stuart
 Cumulated Mag.subj.index
 A1/3/C76 Ref. v.2,p.443

757.6
.R47
NCFA

I.C.9 - COMPARISONS

Rhode Island school of design,Providence. Mus.of
art
 The cat. of old & New England,an exh.of Amer.
ptg. of colonial & early Republican days together
with English ptg.of the same time...fr.Jan.19
through Feb.18,1945.Providence,Akerman-Standard
press,1945?.
 .75.p. illus.

 Review by E.P.Richardson:"Old & New England"
In:Art Q.,v.8:3-15, winter 1945 illus.

708.1
B762
NCFA
v.61

I.C.9 - COMPARISONS

Maytham, Thomas N.
 Two faces of New England portrait painting.
Erastus Field and Henry Darby

In:Boston Mus Bul
61:31-43 1963 illus.

 Article incl.comparison of a family group by
Field with one by Darby...

 FOR COMPLETE ENTRY
 SEE MAIN CARD

705
A7875

I.C.9 - COMPARISONS

Richardson, E.P.
 Old and new England

In:Art Q.
8:3-15 Winter 1945 illus.

 Illuminates certain traits in Amer.art by deli?
berate comparisons with their opposites in Eng-
lish art,17th to 19th c.,main emphasis 2nd half
18th c.
Pertains to Exhib. in Rhode Island school of de-
sign. For catalogue see 757.6/.R47/NCFA
 Rep.,1945-47*1055

Portrs.
Italian

I.C.9 - COMPARISONS

Monsen, Christine
 A comparative study of 16th c.Italian
male portraits in the National Gallery with
a brief discussion of General Portraiture.
Typewritten MS.,1984
 12 p. illus.

 Bibliography

705
A56
v.72

I.C.9 - COMPARISONS

Rutledge, Anna Wells
 Facts and fancy:Portraits from the Provin-
ces

In:Antiques
72:446-8 Nov.,'57 illus.

 "The American look...may be anything but
American.It may be found in the work of many
a European provincial painter."
 Repro.all of European paintings
 Dresser.Background of Col.
 Amer.portraiture ND1311.1
 /D77 NPG p.22 footnote

731
.N49

I.C.9 - COMPARISONS

New York. Metropolitan museum of art
 ...A special exhibition of heads in sculpture
from the museum collection.N.Y.,Jan.16 through
March 3,1940....1940.
 .54.p. illus.(chiefly)
 Illus.arr.in pairs for comparison:similari-
ties in different cultures.
 Review by J.Goldsmith Phillips In:Met Mus B
 ?:?-? Jan.,'40 illus.

 Review initialed J.W.L. In:Art N
38,no.16:10,17
LC NB1300.N4 .Portr.bust.NB1X 9.P6x NPG
 Bibl.

705
B97
NCFA

I.C.9 - COMPARISONS

Sakisian, A.
 Turkish miniatures.

In:Burl.Mag.
87:224-32 1945 illus.

 16th to 18th c.

 Incl:Portrs.of Mohammed II,II,Selim II;works
by Haidar,Wali Dschân(Persian),Kemâl(Persian).
Connection with Persian ptg;influence in 15 & 16th
c.by Italian ptg.
 Rep.,1945-47*10850

705
C91
NCFA
v.4

I.C.9 - COMPARISONS

Peale, Rembrandt, 1778-1860
 Portraiture

In:The Crayon
4:144-5 1857

 'Observations on the quality of photographic
portraiture compared with ptgs. Also reflects
attitudes on visual art relative to photogra-
phy'-Rudisill,Mirror image,p.251

 Sobieszek.Spirit of fact
LC N1.C9 .qn40.1.S71686 NPG p.162

705
B97
NCFA
v.76-77

I.C.9 - COMPARISONS

Sewter, A.C.
 Kneller and the English Augustan portrait

In:Burl Mag
77:106-11 Oct,1940 illus.

 Kneller's severity,sombre colors,generally an_
gular drapery & 2 dimensional style of design is
in contrast to Lely's elegance & subtle romanti-
cism & Rigaud's flamboyant drapery & 3 dimensional
movements. Repro.see over
 Enc.of World Art
 N31E56Ref.v.11
 col.513 bibl.on portr.

I.C.9 - COMPARISONS

Slater, Frank
 Adventuring into portrait painting

In:Artist
18:7-8 Sep.,'39 illus(part col.)

 The mental outlook of the ptr.Incl.a comparison of Sargent and Sickert

LC N1.A82
 N.Y.,MOMA.20th c.portrs.by
 M.Wheeler N7592.6N53 NPG
 Bibl.

705
C69
NMAA
v.46

I.C.9 - COMPARISONS

Woods-Marsden, Joanne
 "Ritratto al Naturale":Questions of realism and idealism in early Renaissance portraits

In:Art J.
46,no.3:209-16 Fall,1987 illus.

 The"true likeness"had to be presented under idealized guise. Comparison of portrs.in ptg., relief,medals. Discussion of use of portrs,p.213

705
A56
NCFA
v.21

I.C.9 - COMPARISONS

Snow, Julia D.Sophronia
 King versus Ellsworth

In:Antiques
21:118-21 Mar.,'32 illus.

Repro.:incl.Daguerreotypes
 Two identified miniatures,f'ly given to James Sanford Ellsworth as Josiah Brown King's ... presents evidence in support of her attributions.

 Sherman,F.F.,J.S.Ellsworth
 In:Lipman,Prim.ptrs.in Amer
 ND236.L76,p.71

759.1
B25
NCFA

I.C.9 - INFLUENCES

Barker, Virgil, 1890-
 Critical introduction to American painting.
N.Y.,Pub.by W.E.Rudge for the Whitney mus.of American art.1931.
 52 p.
 Incl.selective,chronological list of Americ. ptrs.,underdivided by styles,subject matter,form etc.
 Discusses national modifications of portraiture,p.5-24

 Lipman,J.Amer.primit.ptg.
LC ND205.B3 759.1.L76,Bibl.

705
B97
NMAA
v.128

I.C.9 - COMPARISONS

Tscherny, Nadia
 Reynolds's Streatham portraits and the art of intimate biography

In:Burl Mag
v.128:4-11 Jan.'86 ill s.

 Discussion of the natural association between portraiture and written biography
 'The Streatham portrs.are...remarkable... for their honesty in representing...physical imperfections...'thus distinguished from the iconic pictorial ... records of Kneller's Kit-Cat series.

I.C.9 - INFLUENCES

Bazin, Germain
 Le portrait sans âme

In:Art viv.
:254-5 1934 illus.

 A look upon influence of the English portr. on French ptg. in the 19th c. & especially since 1900. Incl.:Lawrence,Hogarth,Gainsborough, Reynolds

LC N2.A65
 Rep.,1934=57

708.1
N52
NCFA

I.C.9 - COMPARISONS

Vincent, Clare
 In search of likeness:Some European portrait sculpture

In:Met Mus Bul Apr.,'66 illus.
24 ns:245-60
 Comparisons of sculpt.with ptg.& photo.of same sitter.
 Difference betw.Fr.& Germ.art,beg.20th c.

 Repr.:Balzac by Rodin & Seguin;Mme X by Rodin & photo;G.B.Shaw by Epstein,Rodin & Steichen photo;

705
B97
NCFA
v.91

I.C.9 - INFLUENCES

Beckett, R.B.
 Hogarth and Rembrandt

In:Burl.Mag.
91:198-201 Jul.1949 illus

 Repro.of ptgs.by Hogarth which show strong influence of Rembrandt

 Rep.,1948-49=8388

705
C75
NCFA
v.79

I.C.9 - COMPARISONS

Volkov, Nicholas
 Russian portrait painting in the 18th c. Rokotov,Levitzky and Borovikovsky

In:Conn
79:69-77 Oct.,'27 illus.

 Comparison with English school

 Cum.Mag.subj.ind.A1/3/76 Re
 v.2,p.444

ND
1311.1
B43
NPG
NCFA

I.C.9 - INFLUENCES

Belknap, Waldron Phoenix, 1899-1949
 American colonial painting...Cambridge,Mass.
Belknap press,Harvard Univ.,1959

 Partial contents:...Pt.VI.Discovery of the English mezzotint as prototype of American portraiture...(see also:Sellers.In:Art Q.v.20:407-468,winter,'57)

 FOR COMPLETE ENTRY
 SEE MAIN CARD

ND
210
B62
E1960
NCFA

I.C.9 - INFLUENCES

Bizardel, Yvon
American painters in Paris...New York,Mac-
millan,1960
177 p. illus.

"...influence of Paris on...Amer.artists
(e.g.West,Copley,Trumbull,Mather Brown,Patience,
Jos.Wright,Peale,Vanderlyn,Fulton,etc.)....re-
lates these artists to the European scene & con-
temp.trends in ptg...."(Whitehill)

LC ND207.P57

Whitehill.The Arts in ear-
ly Amer.Hist.Z5935.W59
Bibl.,p.82

708.1
.C13
NCFA

I.C.9 - INFLUENCES

Cahill, Holger, 1893-1960 ed.
Portrait painters,fashionable and unfa-
shionable-Eakins,Sargent,in his Art in America
in modern times...c.1934.

p.21-4 illus.

Influence of European methods

Arts in America qZ5961.USA
77x NCFA Ref. I 31

AP
1
A79
NCFA
v.1-3

I.C.9 - INFLUENCES

Black, Mary C.
The case of the red and green birds.Thir-
teen persons,one of whom has never been identi
fied,pose a picture puzzle wherin a cardinal &
a parakeet are vital clues.

In:Arts in Va.
3,no.2:2-4,7-8 Winter,'63 illus.
Portrs.of members of two prominent fami-
lies by an unknown artist.Five facts suggest
a Va.provenance,inspired by Engl.mezzotints.
Black.The case reviewed.
In:Arts in Va.,v.10,no.1

I.C.9 - INFLUENCES

Campbell, Edith
A discussion of certain aspects of the in-
fluence of the Renaissance on Netherlandish
portrait painting in the 1st half of the 16th
century

Master's Th.-Northampton,Mass.,Smith Coll.,
1934

Lindsay,K.C.,Harpur Ind.of
master's theses in art...
Z5931.L74 1955 NCFA Ref.
p.24.no.411

I.C.9 - INFLUENCES

Breckenridge, James Douglas, 1926-
Origins of Roman Republican portraiture:Re-
lations with the Hellenistic world

VF
Portr.
Roman

In:Temporini,Hildegard.Aufstieg und niedergang
der römischen welt...Berlin,N.Y.,Walter de Gruy-
ter,1973.Pt.I:Von den anfängen Roms bis zum aus-
gang der republik,v.4(in 2 parts,text & plates):
p.826-854(text),& p.173-187(plates)

Bibl.footnotes

LC
DG209.T36
1,T.4

Temporini.Aufstieg & Nie-
dergang...LC DG209.T36

I.C.9 - INFLUENCES

Charbonneaux, Jean, 1895-1969
Portraits du temps des Antonins

In:Acad Inscr Paris Mon et Mém
49:67-82 1957 illus.

Bibl.footnotes

...étude d'un groupe de portrs.à placer entre
150 et 170 et attribuables à deux artistes grecs
de l'entourage d'Hadrien et d'Hérode Atticus qui
ont eu une influence décisive sur l'évolution
du portr.romain

N13.A25 fol.

N
7593
B88
NPG

I.C.9 - INFLUENCES

Brown University. Dept.of Art.
The classical spirit in American portrai-
ture;an exhibition.Providence,R.I.,1976
120 p. illus.

Held at the Bell Gallery,List Art Bldg.,
Feb.6-29,1976

Bibliography

706
A784
NCPA
v.49

I.C.9 - INFLUENCES

Coke, Van Deren, 1921-
Camera and canvas

In:Art in Am.
49,no.3:68-73 1961 illus.
Development of the influence of photogra-
phy on art as a profession.Quoted are the por-
traitists Ch.Harding,Rembrandt Peale,Ths.Sully,
Wm.Page,G.P.A.Healy and Whistler
Repres.th w ptgs.& the photographs used for
them

Rudisill.Mirror image
TR365.R916 NCFA,p.242

AP
1
V65
NCFA

I.C.9 - INFLUENCES

Burke, Joseph ?., 1913-
Romney's Leigh family(1768):A link between
the conversation piece and the Neo-Classical
portrait group

In:Ann'l B.of NGA of Victoria
2:5-14 1960 illus.

Vertue correctly identified the sources of
the Engl.conversation piece as informal group
portraiture in the Low Countries...and in France
Burke

I.C.9 - INFLUENCES

Golding, Torben Holck
Aspects of miniature painting, its origins
and development. Copenhagen,E.Munksgaard,1953

218 p. illus.

Bibliography

"Relates the Brit.school of miniaturists to
its European context".J.Mayne,Portr.min.In:Conn.
Compl.Per.Guides,p.734

LC ND1337.A2C6

Reynolds,Graham.N.Hilliard
Vict.& Alb.Mus. p.30
2nd edition

705
A56
NCFA

I.C.9 - INFLUENCES

Comstock, Helen
 Some Hudson valley portraits

In:Antiques
46:138-40 Sept.,'44 illus.

FOR COMPLETE ENTRY
SEE MAIN CARD

705
C28
NCFA
v.10

I.C.9 - INFLUENCES

Dorbec, Prosper, 1870-
 Les influences de la peinture anglaise sur
le portrait en France(1750-1850)

In:Gaz Beaux-Arts
10:85-102 1913 illus.

FOR COMPLETE ENTRY
SEE MAIN CARD

AP
1
A51A64
NCFA
v.6

I.C.9 - INFLUENCES

Crawford, John Stephens
 The classical orator in 19th century Ameri-
can sculpture

In:Am.Art J.
6:56-72 Nov.,'74 illus.

 Pt.3 examines the specific statues of Ame-
rican orators & their relationship to antique
prototypes,p.61-72

Am.Art J.,May'77,p.49

ND
1311.1
D77
NPG

I.C.9 - INFLUENCES

Dresser, Louisa
 The background of colonial American por-
traiture:some pages from a European notebook

In:Proc.Am.Ant.Soc,Worcester,Mass.
76,pt.1:19.-58 1966

 Bibliographical footnotes

LC E172.A35 vol.76,pt.1
Newberry Library

Green,S.M.Engl.orig.of N.E.
ptg.In:Winterthur Conf....
ND207/W78/1971,p.56

AP
1
A51A64
NCFA
v.9

I.C.9 - INFLUENCES

Crawford, John Stephens
 Physiognomy in classical and American por-
trait busts

In:Am.Art J.
9:49-60 May,'77 illus.
 Bibl.references
 "...Demonstrates 1.both classical & Ameri-
can civilizations subscribed to similar theo-
ries of physiognomics.2.The likeness of promi-
nent Americans wereconsciously altered stylist-
ically to make them closer to the portrs. of the
great personalities of Greece & Rome."

I.C.9 - INFLUENCES

Edinburgh. National Gallery of Scotland
 Allan Ramsay(1713-1784)his masters and
rivals.The Nat'l Gall.of Scotland and the Arts
Council,Scottish Committee.Exh,9 Aug.-15 Sept.,
1963
MET
189R14
Ar7
 47 p. illus.

 Intro.& cat.by C.Thompson
 Ptgs.& drawings.Also works by Rysing,Soli-
mena,Hogarth,Hudson,Reynolds,Gainsborough,etc.
 Indices of artists & sitters
 See also article by D.Irwin"Edinburgh"in:
Burl Mag.105:465 Oct.'63:'Allan Ramsay...'
M1DA NNMM

705
A784
NCFA
v.30

I.C.9 - INFLUENCES

Cunningham, Charles Crehore
 The Karolik collection-some notes on Copley

In:Art In Amer
30:26,29,30,33-5 Jan.,'42 illus.

 Discussion incl.C.'s "borrowing"of composi-
tion,pose,costume from British portrs.

 Fairbrother in:Arts Mag.
705.A7834 NCFA 55:129

NPG

I.C.9 - INFLUENCES

Evans, Dorinda
. Benjamin West and his American students.
.Publ.for.an exh.at the National Portrait Galle-
ry,Oct.16,1980 to Jan.4,1981 and at the Pennsyl-
vania Academy of the Fine Arts,Jan.30 to Apr.19
1981.Publ.for NPG by the Smiths.Inst.Press,City
of Washington,1980
 203 p. illus(part col.)

 Bibliography
 Incl.index

LC ND207.E94

I.C.9 - INFLUENCES

Dohrn, Tobias,1910- .
 Zur geschichte des italisch-etruskischen por-
träts

In:Deutsch.Archäol.Inst.Mitt.Röm.Abt.
52:119-39 1937

LC DE2.D42

Hiesinger.Portr.in the Rom.
Rep.Bibl.In:Temporini.Auf-
stieg u.niederg...LC DG209
T36,Bd.I,T.4,p.822

705
A7834
NMAA
v.55

I.C.9 - INFLUENCES

Fairbrother, Trevor J.
 John Singleton Copley's use of British
mezzotints for his American portraits:A reap-
praisal prompted by new discoveries

In:Arts Mag
55:122-30 March,'81 illus.

705
M18
NCFA
v.40

I.C.9 - INFLUENCES

Flexner, James Thomas, 1908-
Aristocratic visions;The art of Robert Feke

In:Mag.Art
40:3-7 Jan.,'47 illus.
:35-6:Chronology of Feke's pictures,before 1741-1750

F.had been influenced by John Smibert before developing his own style.

Mooz.Art of Rbt.Feke N:C.1
P31?18 1970 NPAA N161.
p.XXXVII

708.9493
B921
NMAA
v.30-33

I.C.9-INFLUENCES

Ooley, Mary Anne
Sargent's "Dr.Pozzi at home",exhibited in Brussels in 1884

In:Mus.Royaux
des Beaux-Arts
de Belgique.B.
30-33:143-150 1981-1984/1-3 illus.

Synopsis in Dutch and French

ND
1311.9
P5FR13
NPG
2 c.

I.C.9 - INFLUENCES

Framing the board;a look at corporate portrai-ture;an exh.organized and sponsored by the Mutual Assurance Corp.with the cooperation of Independence National History Park;Second Bank of the U.S.,Oct.27,1982-Jan.17, 1983.Phila.,Pa.,The Mutual Assurance Comp. 1982
16 p. illus.

Essay on the history & style of corporate commissioned portraits.Foreign influences.

705
A56
NCFA
v.78

I.C.9 - INFLUENCES

Goodrich, Laurence B.
Ralph Earl's debt to Gainsborough and other English portraitists

In:Antiques
78:464-5 Nov.,'60 illus.

Arts in America qZ5961 USA
77X NCFA Ref. H311

705
G28
NCFA
v.5

I.C.9 - INFLUENCES

Gabillot, C.
Alexis Grimou,peintre français(1678-1733)

In:Gas Beaux-Arts
5(4ième ser):157-72;309-23;412-26 1911 illus.

G.p-311:'Grimou s'est laissé prendre à la magie de Rembrandt....Ses.contemporains le sur-nommèrent le Rembrandt français'.p.314:'...sa co-leur s'est affinée sous l'influence de Rembrandt:

ND
207
W78
1971
NPG

I.C.9 - INFLUENCES

Green, Samuel M.
English origins of 17th c.painting in New England

In:Winterthur Conf.on Mus.Oper'n and Conn'ship
17th:15-69 1971 illus.

Bibliographical notes
Incl.:Chronological checklist of English antecedents to N.E.ptg.

LC ND207.W5 1971

705
A784
NCFA
v.51

I.C.9 - INFLUENCES

Gardner, Albert Ten Eyck
An old New York family

In:Art in Am
51 no.3:58-61 June,'63 illus.

Six portrs.of the Franks family,f'ly in the Cpt.N.Taylor Phillips coll,now in the coll. of the Am.Jew.Hist.Soc.,attr.by Waldron Phoe-nix Belknap,jr.to Gerardus Duyckinck I ?;by Virgil Barker to the Duyckinck Limner;by Flex-ner "in the de Peyster Manner".They derive fr. engravings by Godfrey Kneller.

N
40.1
S9508
1986a
NPG

I.C.9 - INFLUENCES

Greene, Margaret Harm
Dr.Edward Hudson and Maria Mackie Hudson: Thomas Sully's portrait style,1810-1820. 1986
41 leaves illus.

Bibliography;Leaves 40-41
Photocopy
Masters essay-Univ.of Michigan,1986

I.C.9 - INFLUENCES

Gazda, Elaine K.
Etruscan influence in the funerary reliefs of late Republican Rome:A study of Roman verna-cular portraiture

VF
Portrs,
Roman

In:Temporini,Hildegard.Aufstieg und niedergang der römischen welt...Berlin,N.Y.,Walter de Gruy-ter,1973.Pt.I:Von den anfängen Roms bis zum aus gang der republik,v.4(in 2 parts,text & plates) p.189-205(plates),& p.855-870(text)

Bibl.footnotes

LC DG209.T36
Bd.1,T.4

Temporini.Aufstieg und nie dergang...LC DG209.T36

I.C.9 - INFLUENCES

Grüneisen, Wladimir de
...Le portrait;traditions hellénistiques et influences orientales...Rome,W.Modes,1911
110 p. illus.

Études comparatives

Bibl.footnotes

LC N7580.G7 Fogg,v.11,p.322

I.C.9 - INFLUENCES

Hafner, German.
 Römische und italische porträts des 4.jahr
 v.Chr.

In:Deutsch.ArchÄol.Inst.Mitt.Röm.Abt.
77:46-71 1970

LC DE2.D42

Hiesinger.Portr.in the Rom
Rep.Bibl.In:Temporini.Auf-
stieg u.niederg....LC DG20
T36,Bd.1,T.4,p.822

705
B97
NCFA
v.18

I.C.9 - INFLUENCES

Hill, George Francis, 1867-1948
 Classical influence on the Italian medal

In:Burl.Mag.
18:259-68 Feb.,'10 illus.

Keller.Physiognomical the
ory...N21I61 1961 p.53
footnote

759.1
.H2

I.C.9 - INFLUENCES

Hagen, Oskar Frank Leonard, 1888-
 The birth of the American tradition in art..
New York,C.Sribner's sons;London,C.Sribner's
sons,1td.,1940
 159 p. illus.

 "The present vol.covers the history of ptg.
in America fr.ca.1670 to the revolution."(Pref.
 "An early attempt to define what is particular-
ly American in U.S.Colonial ptg.Emphasis on the
works of Smibert,Feke,Copley & West."-Keaveney.
Am.ptg.Z5949 A45K4xRef.

LC ND207.H3 cp.25

Whitehill.The Arts in ear-
ly American Hist.Z5935W59
Bibl.,p.84

I.C.9 - INFLUENCES

Karo, G.
 Etruskisch-römische bildniskunst

In:Antike Plastik.Festschrift.Walther Amelung
zum 60.Geburtstag.Berlin,Leipzig,W.de Gruyter &
co.,1928
 p.100-105 cillus.?c

LC NB70.A5

Hiesinger.Portr.in the Rom
Rep.Bibl.In:Temporini.Auf-
stieg u.niederg....LC DG20
T36,Bd.1,T.4,p.822

705
B97
NCFA

I.C.9 - INFLUENCES

Hayes, John T.
 Some unknown early Gainsborough portraits

In:Burl Mag
107:62-74 Feb.,'65 illus.

 Incl.:List of Suffolk period portrs. not in-
cluded in Ellis Waterhouse:Gainsborough,London
c1958.
 Repro.incl.:Gainsborough,van Loo,Ramsay,
Hogarth,Perroneau,van Dyck,Reynolds

I.C.9 - INFLUENCES

Kaschnitz-Weinberg, Guido von, 1890-1958
 Studien zur etruskischen und frührömischen
porträtkunst

In:Deutsch ArchÄol Inst Mitt Röm
41:133-211 1926 illus.

 Author studies the Etruscan portr & looks
for its survival in the Roman portr."Etruscan
cubism"resisted the Greek influences

LC DE2.D42

Richter,G. Portrs of the
Greeks N7586R53,v.3,p.298
Rep.1927#721

I.C.9 - INFLUENCES

Herbig, Reinhard, 1898-
 Die italische wurzel der römischen bildnis-
kunst

In:Das neue bild der antike,hrsg.H.Berve,Bd.2
p.85- 1942 illus. Bibl.footnotes

LC DE71.B45,Bd.2

Kraus.Das römische welt-
reich.N5760.K92 Bibl.p.316

705
A784
NMAA

I.C.9 - INFLUENCES

Koslow, Susan
 Two sources for Vincent van Gogh's"Portrait
of Armand Roulin":a character likeness and a
portrait schema

In:Arts Mag.
56,no.1:156-63 Sept.,1981 illus.

 Hans·Holbein the elder's portr.of a youth is
considered the inspiration of "character like-
ness".The "schema"seems to come from Charles
Bargue's "Cours de dessin"
 Portrs.within portrs.,figs.4,5,6
 Brilliant In:Art J.v.46
 no.3:172,note 14

705
A784
NCFA
v.64

I.C.9 - INFLUENCES

Herrera, Hayden
 Gorky's self-portraits:the artist by him-
self

In:Art in Am
65:56-64 Mar-Apr.,'76 illus(part col.)

 ...he evolved fr.skillful apprentice,who is
strongly influenced,particularly by Cézanne &
Picasso,to dedicated master

FOR COMPLETE ENTRY
SEE MAIN CARD

I.C.9 - INFLUENCES

Lang, J.T.
 Portrait painting including the historical
background of contemporary portrait painting

 Master's Th.-Columbus,O.S.Univ.,1930

Lindsay,K.C. Marpur Ind.of
master's theses in art...
1955 Z5931.L74 1955 NCFA
Ref.p.14 no.222

708.1
C62
NCFA

I.C.9 - INFLUENCES

Lee, Sherman E.
Varieties of portraiture in Chinese and
Japanese art

In:Cleve.Mus.of Art,B.
64,no.4:118-36 Apr.,'77 illus.

"True portrs."more common in Western art
than in that of the Far East.Western influence
started in the 17th c.,was particularly heavy
in the 19th c.- Scholarly attitudes,7en concepts
of transmittal and commemoration of the dead.

705
C75
NCFA
v.68

I.C.9 - INFLUENCES

Mechlin, Leila, 1874-
Early American portrait painters

In:Connoisseur
68:127-32 Mar., '24 illus.
Repro.:Franklin by Wright,Blackburn,Feke,C.W.
Peale,Rembrandt Peale,Neagle,Hamilton by Trumbull,
Waldo,Malbone,Harding,Copley,Stuart(p.135),West
(p.177)
Emphasis on close association of American &
British schools

Cumulated Mag.subj.index
A1/3/C76 Ref. v.2,p.443

705
A7832
NCFA

I.C.9 - INFLUENCES

Levitine, George
The influence of Lavater and Girodet's
"Expression des_sentiments de l'âme"

In:Art B.
36:33-44 March,'54 illus.

Cresswell.Prints of the
Am.Revol. NE506.C92 1977a
NMAA p.70,note 115

ND
1309.3
M648
1985
NMAA

I.C.9 - INFLUENCES

Miller, Lillian B.
The Puritan portrait:its function in Old
and New England.Offprint from her.Seventeenth
century New England.The Colonial Society of
Massachusetts,1985
p.153-84 illus.

Bibliographical references
English portrs.of the 16th & 17th c.are
prototypes for American portrs.of that period
in style and symbolism

I.C.9 - INFLUENCES

L'Orange, Hans Peter, 1903-
The antique origin of the medieval portrai-
ture

Extract fr. Acta congressus madvigiani,pro-
ceedings of the 2nd internat'l congress of clas-
sical studies,v.3,p.53-70 Copenhagen,1957,
1954,*)

N
5610
L67X
NPG
DDO

Also in :his.Likeness & icon.Selected stu-
dies in classical & early mediaeval art.Odense,
Univ.Press,1973
p.91-102

)1954 in Bibl.of Likeness
& Icon,p.XIX

N
40.1
W49B4
NPG

I.C.9 - INFLUENCES

Morgan, Charles Hill, 1902-
Benjamin West:his times and his influence,
...Springfield,Mass.,Art in America,1950

FOR COMPLETE ENTRY
SEE MAIN CARD

705
C75
NCFA
v.194

I.C.9 - INFLUENCES

Mannings David Michael
Reynolds' portraits of the Stanley Family

In:Connoisseur
194:85-9 Feb.,'77 illus(1 col.)

4 Kit-cat portrs.,based on v.Dyck & with
motifs derived fr.Brit.16-17th c. portraiture

Rila III/2 1977 #4984

N
40.1
S93M8
1969
NPG
2 c.

I.C.9 - INFLUENCES

Morgan, John Hill, 1870-1945
Gilbert Stuart and his pupils,...;together
with the complete notes on painting by Matthew
Harris Jouett from conversations with Gilbert
Stuart in 1816.N.Y.,Kennedy Galleries,Da Capo
Press,1969
102 p. illus.

Incl.:Information concerning Jane Stuart,
p.49-51 illus.
Incl.:List of Stuart's pupils
Reprint of 193 d.

LC ND237.S8M6

705
C75
NCFA
v.189

I.C.9 - INFLUENCES

Mannings, David
A well-mannered portrait by Highmore,dated
1747.

In:Connoisseur
189:116-9 June,'75 illus.

Acceptable postures and attitudes pre-
scribed in 'Rudiments of Genteel Behaviour'
(1737);by Nivelon.His and others' writings on
etiquette influenced 18th c. portraiture.

Rila II/2 1976 #5004

I.C.9 - INFLUENCES

Murell, Dorothy C.
The effects of foreign influences upon
American portrait painting

Master's Th.-Columbus,O.S.Univ.,1948

Lindsay,K.C. Harpur Ind.of
master's theses in art...
1955 Z5931.L74 1955 NCFA Ref
p.74 no.1344

N
6505
N48
NPG

I.C.9 - INFLUENCES

Neuhaus, Eugen, 1879-
 The history & ideals of American art...Stanford University,Calif.,Stanford university press;
London,H.Milford,Oxford university press,1931
 444 p. illus.

 Bibliography
 Author stresses Engl.influence which shaped
American art's course. Historical & esthetic
analysis. Survey of begin.& development of art
in the West & Pacific coast.

LC N605.N4

Whitehill.The Arts in early Amer.Hist.Z5935W59 NPG
Bibl.,p.85

ND
464R316
1981
NMAA

I.C.9 - INFLUENCES

Redgrave, Richard, 1804-1888
 A century of British painters;by R.Redgrave
and Samuel Redgrave.Ithaca,N.Y.,Cornell Uni.
Press,1981
 612 p. illus (Landmarks in Art History)

 Reprint of Phaidon ed.of 1947
 Bibliography,p.595-612
 Chapters on 18thc.and on 19th c.portraitists;17-19th c.miniatures;early Victorian portr.
ptrs. Influence of foreigners on English art.

N
613
A5
NCFA

I.C.9 - INFLUENCES

New York Historical Society
 The Waldron Phoenix Belknap,jr.collection of
portraits and silver,with a note on the discoveries of Waldron Phoenix Belknap,jr.concerning the
influence of the English mezzotint on colonial
painting....Cambridge,Harvard University Press,
1955.
 177 p. illus.

 Catalogue of the coll.which was bequeathed to
the N.Y.Historical Soc. in 1949

LC N613.A65

N
40.1
R463R8
NMAA

I.C.9 - INFLUENCES

Reynolds, Joshua,Sir,1723-1792
 Reynolds,ed.by Nicholas Penny;with contributions by Diana Donald....et al.N.Y.,Abrams,
1986
 408 p. illus(part col.)

 Cat.of an exh.held by the Royal Academy of
Arts,London
 Bibliography,p.394-9
 Index
 Incl.article by.R.Rosenblum.Reynolds in
an international milieu
LC ND497.R4A4 1986

fN
40.1
H6393
P2
NPG

I.C.9 - INFLUENCES

The painter as photographer;David Octavius Hill,
 ...c1978?;

 Hill was the direct heir to the tradition
of English portraiture through Raeburn

705
A7875
NCFA
v.1

I.C.9 - INFLUENCES

Richardson, Edgar Preston, 1902-
 A portrait of John Trumbull,the poet

 In:Art Q
 1:213-24 Summer,'38 illus.

 Incl.discussion of Flemish baroque influence on Trumbull.

N
40.1
T192P6
NMAA

I.C.9 - INFLUENCES

Pierce, Patricia Jobe
 Edmund C.Tarbell and the Boston School of
painting,1889-1980...ed.by John Douglas Ingraham.Hingham,Mass.,Pierce Galleries,c.1980
 253 p. illus(part col.)

 Index
 Bibliography,p.236-45

 Ch.7:Tarbell's portraiture,p.119-28
 Ch.8 incl.:Photographs of E.C.Tarbell
paintings,p.141-49
 Nat'l academy of design
 Artists by themselves
 qN7618.N27 NPG p.127,note 9

I.C.9 - INFLUENCES

Richardson, Emeline Hill
 The Etruscan origins of early Roman sculpture...Rome,American academy in Rome,1953
 p.77.-124 illus.

 This is v.21,1953 of the Memoirs of the
Academy in Rome

 Hiesinger.Portr.in the Rom.
 Republic.In:Temporini.Aufst.
 .niedergang...LC DG209.T36
OCLMA Bd.1,T4,p.823

AP 1
L84
NCFA

I.C.9 - INFLUENCES

Pope-Hennessy, John,1913-
 Nicholas Hilliard and mannerist art theory

 In:J.Warburg Inst.
 6:89-100 1942-43

 Short account of Hilliard's 'Arts of limning'
& its stylistic implications

 Rep.,1942-44*7153

705
B97
NCFA

I.C.9 - INFLUENCES

Sakisian, A.
 Turkish miniatures.

 In:Burl.Mag.
 87:224-32 1945 illus.

 16th to 18th c.

 Incl:Portrs.of Mohammed II,II,Selim II;works
by Haidar,Wali Dschan(Persian),Kemal(Persian).
Connection with Persian ptg;influence in 15 & 16th
c.by Italian ptg.
 Rep.,1945-47*10850

705
H19
NCFA
v.42

I.C.9 - INFLUENCES

Schwarz, Heinrich, 1894-
Art and photography:Forerunners and influences

In:Mag.Art
42:252-7 Nov.,'49 illus.

From Schmalcalder's profile machine of 1806
to the 2nd half of 19th c.,when portraiture was
taken over by photography to Cézanne,when photography was dethroned.
Coke.Ptr.& photograph...
qN72-P5C68 NCFA Preface

705
C69
NMAA
v.46

I.C.9 - INFLUENCES

Steiner, Wendy
Postmodernist portraits

In:Art J.
46,no.3:173-7 Fall,1987 illus.

Illus.incl.:Warhol,Rauschenberg,Close,
Hockney,Kolář
Discusses the 'odd migration of high-modernist literary goals into post-modernist'portrs.

705
A7875
v.20

I.C.9 - INFLUENCES

Sellers, Charles Coleman, 1903-
Archives of American art:Mezzotint prototypes of colonial portraiture:a survey based on
the research of Waldron Phoenix Belknap,jr.

In:Art Q
20,no.4:407-68 winter,'57 illus.
Bibliography

Grouped:Prtrs.of men;women;children.The
painters.
Incl.cat.:Colonial ptgs.side by side with
mezzotint prototyp all illustrated

I.C.9 - INFLUENCES

Stelzer, Otto
Kunst und photographie.Kontakte,einflüsse,
wirkungen.München,Piper(1966)
192 p. illus.

Bibliography

Photography fostered international art
styles by publishing ptgs. in magazines around
the world

LC N72.P588 Coke.Ptr.& photograph...
qN72.P5C68 Preface

AP
1
A51A64
NCFA
v.2

I.C.9 - INFLUENCES

Sellers, Charles Coleman, 1903-
Charles Willson Peale as sculptor

In:Am Art J
2:5-12 Fall,'70 illus.

P.'s influence on Wm.Rush.-Their mutual interest in the allegorical fg. or emblem
P.sculpture is now known only as it appears
in ptgs.& documentaties.

705
A7875
v.14
NCFA

I.C.9 - INFLUENCES

Sweet, Frederick A.
Mezzotint sources of American colonial
portraits

In:Art Q
14:148-57 illus. Summer,1951

Amer.portr.painters, espec.J.S.Copley, used
mezzotints & engravings, done after English portrs
to keep up with current trends

Encyclop.of World Art
Portrs.bibl. N31k56 Ref.

MD
1314
S46
1987X
NPG
Ref.

I.C.9 - INFLUENCES

Simon, Robin, 1947-
The portrait in Britain and America:with a
biographical dictionary of portrait painters
1680-1914.Boston,G.K.Hall & Co.,1987
255 p. illus(part col.)

Ch.2:Poses

bibliography,p.247-50

Robert Hull Fleming Museum
Univ.of Vt. Faces in the
parlor,p.6,note 13

I.C.9 - INFLUENCES

Taylor, Joshua Charles, 1917-
La fotografia e la macchia:in:his.Vedere
prima di credere;saggi sull'arte del primo otto-
cento...Parma,Università di Parma,Istituto di
storia dell'arte.1970.
pp.73-94 illus. (Quaderni di storia
dell'arte 7)

WU

I.C.9 - INFLUENCES

Staring, Adolph, 1890-
Fransche kunstenaars en hun Hollandsche
modellen,in de 18do en in den aanvang der 19de
eeuw.'s-Cravenhage,A.A.M.Stols,1947
120 p. illus.

LC N7604.88 FOGG,v.11,p.317,col.3

AP
1
A79
NCFA
v.9

I.C.9 - INFLUENCES

Thorne, Thomas, 1909-
Charles Bridges,limner

In:Arts in Va.
9:22-31 Winter,'69 illus.

'An English painter,working in Va.,reveals
some of the fashionable methods of making portrs
in the 18th c.'
Bridges was influenced by Lely and Kneller

Winterthur Mus Libr.
fZ881.W78 NCFA v.6,p.225

705
A7875
NCFA

I.C.9 - INFLUENCES

Valentiner, W.R.
 A portrait bust of King Alphonso I of Naples

In:Art Q
1:61-89 Spring 1938 illus.

 Foreign influence in Naples
Frescoes by da Besozzo, reliefs by Mino da
Fiesole, busts by Laurana,drgs.by Pisanello

I.D - AUSTRIA

Vienna. Verein der museumsfreunde
 Osterreichische porträtausstellung,1815-1915;
veranstaltet vom Verein...Okt.bis Des.1927.
Künstlerhaus. Catalogue by Wilhelm Beets,1927
 80 p. illus.

MET
276.2
V67

 Enc.of World Art
 N31E56Ref.v.11.col.512

I.C.9 - INFLUENCES

Veevers, E.E.
 The source of Inigo Jones' masquing designs

In:Warburg
22:373-4 1959 illus.

 (Repertoire d'art et d'arch.:Rapprochements
entre des dessins de I.J.et des oeuvres de J.
Callot,B.Küchler,J.J.Boissard,A.de Bruyn)

LC AS122.L8515 Enc.of World Art,v.11
 col.514.N31E56 Ref.
 bibl.on portr.

I.D - AUSTRIA - VIENNA - 19th c.

Leitich, Ann Tizia, 1896-
 Wiener Biedermeier.Kultur,kunst und leben
der alten kaiserstadt,vom Wiener kongress bis...
1848.Bielefeld and Leipzig,Velhagen & Klasing,
 c.1941:
 159 p. illus(part col.)

LC DB851.L4 Praz.Conversation pieces
 ND1304P92E1971,p.195,foot-
 note 17

I.C.9 - INFLUENCES

Vigneau, André, 1892-
 Une brève histoire de l'art de Niepce à
nos jours.Préf.de Jean Cassou.Paris,R.Laffont
 1963:
 190 p. illus(part col.)

 Various ways photography has interacted
with art

LC N6450.V45 Coke.Ptr.& photograph...
 qN72.P5C68 Preface

I.D - AUSTRIA - VIENNA - 20th c.

Hartmann, Wolfgang
 "Face farces" von Arnulf Rainer

In:Rainer, Arnulf, 1929-
Der grosse bogen.Cat.of the exh.Apr.30-June 15
1977 in Bern,Kunsthalle
 p.17-27 illus.

 ...ry of the history of physiognomy.
...ctory of the expressionism.Influences of
psychical realism & Vienna actionists on Raine
R.seen as one of the most influential artists o
the present.Pho...tography used by painters.

 I.D. SPECIAL COUNTRIES, A-Z, subdivided --
 chronological & regional ("European
 Art" listed under "E")

I.D BELGIUM
 before 1830 see NETHERLANDS

I.D SPECIAL COUNTRIES. No media or more than one medium,
 or specific country's approach to portraiture
 Historical interest (see also I.B.)

AP
1
T683
NCFA
v.11

I.D - CANADA - 18-19th c.

Allodi, Mary
 Canadian faces.Some early portraits

In:Rotunda
11,no.1:18-25 Spring,'78 illus(part col.)

 Pertains to exh.of portrs.of residents of
Canada,c.1780-1870,at the Royal Ontario Mus.,
Apr.7-Sep.10,1978
 Incl.some prices for portrs.,social stand-
ing of artists,the evolution of the portr.trade
in Canada

AP
1
A51A64
NMAA
v.15

I.D - CANADA - LOUISBOURG - 18th e.

Miles, Ellen G.
 Portraits of the heroes of Louisbourg,1745-
1751

In:AmArt J
15:48-66 Winter,'83 illus.

 Bibl.notes
 Repro.incl:John Smibert,Ths.Hudson,Rbt.
Feke;Messotints by Peter Pelham,John Faber and
Js.McArdell

N
7620
O28E4
NPG

I.D - DENMARK

Eller, Povl
 Adam Oehlenschläger portraetter.:Hillerød,
Nationalhistoriske museum paa Frederiksborg,
1958.
 142 p. illus.

 Incl.chronological cat.of portrs. of Oeh-
lenschläger:Ptgs,drags.,sculpture.-Silhouettes
Daguerreotypes.-Death-mask

LC PT8156.8.E4

GN4
H74
NCFA

I.D - CENTRAL AMERICA

Spinden, Herbert Joseph, 1879-
 Portraiture in Central American art

In:Holmes Anniversary volume,Washington,1916
pp.434-50 illus.

LC(card div.)GN4.H6 Fogg,v.11,p.325

N
7628
C88F4
NPG

I.D - DENMARK

Eller, Povl
 N.F.S.Grundtvig portraetter.Med en indled-
ning af Steen Johansen.Frederiksborg,National-
historiske museum,1962
 144 p. illus.

 Bibliographical references

LC PT8130.75E4

I.D - CHINA
Oriental Art only used by exception

N
1935
H5A52X
NPG

I.D - DENMARK

Hillerød, Denmark. Nationalhistoriske museum
 paa Frederiksborg slot.
 Billeder fra Frederiksborg.Pictures from
Frederiksborg.Billedudvalg og tekster:Jørgen
Paulsen,H.D.Schepelern og Povl Eller.:Hille-
rød,1961.
 162 p. illus(part col.)

 p.39-16? mainly repro of portrs.

LC N1935.H5A52

708.1
C62
NCFA

I.D - CHINA

Lee, Sherman E.
 Varieties of portraiture in Chinese and
Japanese art

In:Cleve.Mus.of Art,B.
64,no.4:118-36 Apr.,'77 illus.

 "True portrs."more common in Western art
than in that of the Far East.Western influence
started in the 17th c.,was particularly heavy
in the 19th c.- Scholarly attitudes,"en concept:
of transmittal and commemoration of the dead.

N
7610
D4N18
NPG

I.D - DENMARK

Hillerød,Denmark. Nationalhistoriske Museum
 paa Frederiksborg slot
 Det Kongelige Teaters Kunstnere Maleri og
Skuptur.Kat.ved Kirsten Nannestad.Clostrup,L.
Levison Junr,A/S,1984
 88 p. illus.
 Foreword by Povl Eller

 Portrs.Ptgs.,sculpt.,drags.arranged in al-
phabetical order by sitter,p.10-75
 Register of artists

I.D - CZECHOSLOVAKIA - BOHEMIA - 17th c.

Strettiová, Olga
 Baroque portraits...London,Spring Books,
c1957,
 1 v.(unpaged) illus(part col.)

 Bibliography

LC N7614C9S712 Fogg,v.11,p.330

I.D - DENMARK

Hillerød,Denmark. Nationalhistoriske museum
 paa Frederiksborg slot
 The Museum of National History at Frede-
riksborg Castle,official guide.Hillerød,1961
 86 p. illus.

LC N1935.H5A6

708.8
H65
I.D - DENMARK

Hillerød, Denmark. Nationalhistoriske museum
 paa Frederiksborg slot.
 Det Nationalhistoriske museum paa Frederiks-
borg...Billedhefte:interiører og portraetter
fra samlingen. 3rd ed.,1943
 160 p. illus.

 P.39-159 repro. of portrs.

N
7621
C4A7
NPG
I.D - EUROPE

Chicago. Art Institute
 European portraits,1600-1900 in the Art In-
stitute of Chicago.Exh. [Chicago,Art Inst.,1978]

FOR COMPLETE ENTRY
SEE MAIN CARD

I.D - DENMARK

Hillerød, Denmark. Nationalhistoriske museum
 paa Frederiksborg slot.
 Det Nationalhistoriske museum paa Frederiks-
borg,1928-1953...Katalog over et udvalg af dets
erhvervelser.Udg.af Museets bestyrelse i anled-
ning af 75 aars jubilaeet,1953.København,1954.
 355 p. illus.

Minnesota Univ.Library for LC

 NN

I.D - EUROPE - 17th c.
Heince, Zacharie, 1611-1669
 Les Portraicts av natvrel,avec...,nors et
qvalites de messievrs les plenipotentiaires as-
serbles à Mvnster et Osnabvrg povr fa're la
paix generale.Paris,Chez Henry Sara et Chez
Jean Paslé,et ches les auteurs:F.Pignon fecit
et excudit.1648.
 19 p. illus.

 Comprises 33 full page engr.portrs.by Fran-
cois Pignon after Heince & list of the plenipo-
tentiaries(more than 33)assembled to rake the
Peace of Westphalia

NN

VF
I.D -DENMARK

Hillerød, Denmark. Nationalhistoriske museum
 paa Frederiksborg slot
 Nyere Danske Forskerportraetter.I anledning
af Carlsbergfondets 100 års jubilaeum 1976.Cata-
logue
 29 p. illus.

MET
107.71
F87
 Exhib.Sept.15,1976-Jan.3,1977

I.D - FRANCE
Focillon, Henri
 Sur le portrait français

In:Formes
 :165-7 1931 illus.

 Elements which make for the continuity of
French portraiture fr.Middle Ages to 19th c. &
which make the difference between Fr.portr.,which
comes fr.sculpture, and Flemish,German or Italian.
 Incl:Statues of Charles V,Jeanne de Boulogne;
ptgs. by Fouquet,J.van Eyck,de lyon,Perronneau,
David,etc.
LC N1.F67 Rep.,1931=9

I.D - DENMARK

[Hofman, Tycho de,1714-1754
 Portraits historiques des hommes illustres
de Dannemark,remarquables par leur mérite,leurs
charges & leur noblesse,avec leurs tables géné-
alogiques....Copenhagen,1746
 6 v.in 1 illus.

 Contains 50 portrs.& vignettes by Folkema,
Fokke,Wili,etc.

DLC NN PPL Lewine.Bibl.of 18th c.art &
 illus.books.Z1023.L67 1969X
 NCFA p.262

I.D - FRANCE
George, Waldemar, 1893-
 Corps et visages féminins de Ingres à nos
jours.Paris.Editions d'art et industrie,1955
 [29]p. (160)illus(part col.)

 The majority of the artists represented
are French

Harvard uni.libr.for
LC N7630.G4 MOMA,p.434 v.11

H
5070
R5B59
NMAA
I.D - EUROPE

Bilder vom menschen in der kunst des Abend-
 landes.Jubilâumsausstellung der Preuss.
 Museen Berlin 1830-1980.Berlin,Mann,c.1980
 400 p. illus(part col.)

 Cat.of the exh.held May 7 to Sept.28,
1980 in the Nationalgal.Berlin Staatl.Mus.
(West Berlin)

Part.contents:L.Giuliani.Individual & ideal.
Antiquity.-H.-G.Severin.Portrs.betw.Antiquity
& Middle Ages.-P.Bloch.Portrs.in the Middle
Ages.Rulers'por' Sepulchral portrs.Donors.
H.Bock,R.Gross s.The portr.The autonomous

I.D - FRANCE

Heim Gallery. London
 French portraits in painting and sculp-
ture(1465-1800);summer exh.6th June-30th Aug.,
1969.London,1969.
 1 v.(unpaged) illus. (Heim exh.cats.no.9
 Label mounted on t.p.:Supplied by Worldwide
Books,N.Y.
 Review in:Conn.171:96-7,June,'69 illus.by
Mullaly:"Describes the qualities & aims typi-
cal for Fr.portrs:Reflection not only of the
external of their times,but also of its stand-
ards & ideals."

LC N6640.H4

I.D - FRANCE

Lelong, Jacques, 1665-1721
Bibliothèque historique de la France...l'histoire de ce royaume...Nouv.éd. Paris,Impr.Herissant,1768-78
5 v.

Tome 4 includes:"III.Table générale du recueil de portraits,fait par les soins du m.de Gaignières & maintenant dans la Bibliothèque du roi." IV."Liste de portraits des François illustres.":cf.Fontette, Fevret de.

LC Z2176.L54

Amsterdam,Rijksmus.cat.
Z5939A52,deel3,p.815

M
7628
C4795
NPG

I.D - FRANCE

Sherman, Claire Richter
Portraits of Charles V of France(1338-1380).
...New York,University Press...,1969
147 p. illus. (Monographs on archaeology and the fine arts,20)

Bibliography

."The portraits of Chs.V have..formal,iconographic & social characteristics of transitional stage betw. medieval & modern portraits"

I.D - FRANCE

Lenoir, Alexandre, 1761-1839
The Lenoir collection of original French portraits at Stafford House.Auto-lithographed by Lord Ronald Gower.London,Maclure & Macdonald...1874

illus.

From Francois I to Marie-Antoinette

LC N7604.L36
Rare book coll.

Amsterdam,Rijksmus.,cat.
Z5939A52,deel 1, p.146

705
C28
v.23

I.D - FRANCE - 15-16th c.

Bouchot, Henri François Xavier Marie, 1849-1906
Les nouvelles salles de portraits au musée de Versailles

In:Gaz Beaux Arts
23:365-82 May,1900 illus.

Main interests in portra of important French people of the 15th & 16th c.
Incl.Spanish,Flemish & Dutch portrs of the 17th c.

I.D - FRANCE

Marquet de Vasselot, Jean Joseph Marie Anatole
Histoire du portrait en France.Paris,Rouquette,1880
526 p.

LC W.C.L.
704.942M357H NcD InU etc.

Enc.of World Art N31E56Re
v.11,p.512

705
G28
v.36
1887

I.D - FRANCE - 16th c.

Bouchot, Henri François Xavier Marie, 1849-1906
Le portrait peint en France au 16e siècle

In:Gaz Beaux Arts
36:108-24, 218-26, 464-77 Illus.
Aug. Sept. Dec.,1887

Bourdichon,Perréal,Les Clouet,Corneille de Lyon
Incl.drags. and engrs.

Attempt to classify some works according to their period,starting with Pigouchet & Simon Vostre's time

I.D - FRANCE

Mélanges offerts à M.Nicolae Iorga...Paris, J.Gamber,1933
955 p. illus.

FOGG
Rom
5970.
26.5

Contents.-...Focillon,Henri. Origines monumentales du portrait français,p.259-85

Title from Yale Univ.
Printed by LC

Enc.of World Art
N31E56Ref. bibl.on portr
col.512

I.D - FRANCE - 16th c.

Delaborde, Henri,comte, 1811-99
La renaissance des arts à la cour de France; études sur le 16e siècle. Paris,Impr. de J.Claye, 1850
152 p.

MD MH FA

N
7604
P55x
NPG

I.D - FRANCE

Pinset,Raphael (& d'Auriac)
Histoire du portrait en France. Paris, A.Quantin,1884

274 p. illus.

Ouvrage couronné par la Soc.des études hist.

LC N7604.P55

Waetzoldt ND1300.W12

q DC
126
S86
1984
NPG

I.D - FRANCE - 17th c.

The Sun King,Louis XIV and the New World;an exh.,organized by the Louisiana State Museum...New Orleans,Louisiana State Museum, c.1984
343 p. illus(part col.) (Studies in Louisiana culture,v.3)
Incl.Index
Steven G.Reinhardt,ed.
Exh.dates:Louisiana State Mus.,New Orleans,La.,Apr.29-Nov.18,1984.The Corcoran Gall.of Art,Washington,D.C.,Dec.15,1984-Apr.7,1985
Incl.Ptg., sculpture,cameos

I.D - FRANCE - 18th c.

Bonneville, François, fl.1790
Portraits des personnages célèbres de la
Révolution avec tableau historique et notices
par P.Quénard,l'un des représentants de la com-
mune de Paris,en 1789 et 1790.Paris,Chez l'auteur
1796-1802
4 v. illus.

Partly the only authentic portrs.of celebri-
ties of this epoch
Repro.incl.:Fouquier-Tinville,Carrier,Char-
lotte Corday,Bonaparte,Kleber,Marceau,etc.

LC DC145.Q42 Lewine.Bibl.of 18th c.art &
illus.books.Z1023.L67 1969 v
no.X,p.78

N
5020
L418 I.D - FRANCE - 18th c.
NCFA Detroit. Institute of Arts
2 c. The French in America,1520-1880;an exh...
 Cat.Detroit,1951
 207 p. illus.

 Bibliography
 Incl.:article by Paul L.Grigaut,p.17-24
 "In any exh.using history as its theme,portrs.
 play a great part."-Paul L.Grigaut,p.18

I.D - FRANCE - 18th c.

Guiffrey, Jules Marie Joseph, 1840-1918
Table des portraits,peints,sculptés,dessinés
ou gravés,exposés aux Salons du 18e siècle.
Paris,1889
47 p.

Reprinted from the Revue de l'art français
Jan-Feb,'1889

LC Rev.de l'art fr.
see
Archives de l'art français C.Wildenstein In:Gaz Beaux
N6841.A9 Arts 61:9 & 15
Reprint in MB PPPM NN CtY

I.D - FRANCE - 18th c.
Recueil de dessins,portraits et figures sur la
Révolution de 1789
1 v. illus(part col.)

Portraits.-46 portrs.;incl.Louis XVI,Marie-
Antoinette,comte d'Artois,comte de Provence,
Barra,Pétion,Lafayette,Charl.Corday,duchesse de
Polignac,Drouot,etc.

Destailleur.Cat.de livres...
LC Z5939D42,p.43,no.178

I.D - FRANCE - 18th c.

Sénac de Meilhan, Gabriel,1736-1803
Portraits et caractères de personnages dis-
tingués de la fin du 18ieme siècle,suivis de
pièces sur l'histoire et la politique...;précé-
dés d'une notice sur sa personne et ses ouvrages
par M.de Lévis.Paris,J.G.Dentu,1813
Brit. 261 p.
Mus.

MiU CU CoU NjP NNU-W
 Wildenstein.Gaz.Beaux-Arts
 ser.6,58,v.51:98,note 4

I.D - FRANCE - 18-19th c.

Paris. Ecole nationale supérieure des Beaux-Arts
Catalogue de l'exposition de portraits du
siècle(1783-1883)...,le 25 Avril 1883.3e tirage.
Paris,1883

Amsterdam,Rijksmus.cat.
Z5939A52,deel 1, p.493

I.D - FRANCE - 18-19th c.

Staring, Adolph, 1890-
Fransche kunstenaars en hun Hollandsche
modellen,in de 18de en in den aanvang der 19de
eeuw.'s-Gravenhage,A.A.M.Stols,1947
120 p. illus.

LC N7604.S8 FOGG,v.11,p.317,col.3

I.D - FRANCE - 19th c.

Westfälisches Landesmuseum für Kunst und Kul-
turgeschichte,Münster
La caricature:Bildsatire in Frankreich
1830-1835 aus der Sammlung von Kritter.Aus-
stellung,16.März-10.Mai 1980.Kunstsammlung
der Universität Göttingen,26.Okt.-7.Dez.1980.
Gutenberg Mus.Mainz,20.Apr.-7.Juni 1981.:Kat.:
hrsg.von Gerd Unverfehrt.Göttingen:Kunstge-
schichtliches Seminar der Universität,c.1980
300 p. illus.
Bibliography

LC DC266.5.C37 Worldwide Art Cat.b. 705.
 *27 NCFA v.18,no.1,p.23

705
028
NCFA I.D - FRANCE - (begin.)19th c.
v.61
 Wildenstein, Georges, 1892-1963
 Table alphabétique des portraits peints,
 sculptés,dessinés et gravés,exposés à Paris au
 salon entre 1800 et 1826

 In:Gaz Beaux Arts
 61:9-60 Jan,'63 illus.

 Table is preceded by an article pointing out
 the changes in taste in portraiture.Works f'ly
 attr.to David are by artists then well known:
 Lefèvre,Romany,Ansiaux,etc.Miniat.drags.by Mon-
 saldy after exhibited portrs.were used for
 attributions Fogg,v.11,p.326

VF I.D - FRANCE - 19-20th c.

Bowdoin College. Museum of Fine Arts
The French visage; a century and a half of
portraiture and caricature from the Artine
Artinian collection. Brunswick,Me.,1969
20 p. illus.

Also shown at Currier Gallery(N.H.),Gorham (Me.)
State college, and Hopkins Center Art Gall's at Dart
mouth...

NPG
V F

I.D - FRANCE - (end)19-(beg)20th c.

London. Ferrers Gallery
Marcel Proust and his friends. Exhib.,1971

Princesse Marthe Bibesco by Boldini; Mme de
Noailles,Duchesse de Gramont,Count Rbt. de Mon-
esquiou by Helleu;drgs. by Helleu

Repro:Bérand,Blanche,Boldini,Gervex,Orasi

705
G28
NMAA
v.99

I.D - FRANCE - BURGUNDY - 15th c.

Smith, Jeffrey Chipps
Jean de Maisoncelles' portrait of Philippe
Le Bon for the Chartreuse de Champmol.A study
in Burgundian political symbolism

In:Gaz.Beaux-Arts
99:7-12 Jan.,'82 illus.

'...It is a political image. Ph.is
dressed in his Toison d'or robe...He is crowned'

I.D - FRANCE - 20th c.

Killy, Herta Elizabeth
Das französische porträt im 20.jhrh..Berlin
Akademie der Künste,1963.
70 p. illus(part col.)

Eine Ausst.der Association française d'ac-
tion artistique in der Akademie der Künste vom
1.bis 25.Juni,1963

LC760.4K5 Verzeichnis lieferbarer Bü-
cher 1973/4 NPG, p.556

I.D - FRANCE - PARIS - 20th c.

Cocteau, Jean, 1889-1963
Maria Lani by Bonnard.and other artists..
Paris,Editions des Quatre chemins.1929.
20 p. 51 pl.

.Exhib.at Brummer,N.Y.,Nov.1-? ,'29.
. also exhib.Leicester gall.,London,1930.

Incl.Bonnard,Bosshard,Bourdelle,Braque,Cha-
gall,Laborde,Chirico,Cocteau,Delaunay,Derain,
Despiau,Friesz,Goerg,Cromaire,Matisse,Kisling,
Leger,Lhote,Lurçat,Man Ray,
contin'd on next card

I.D - FRANCE - 20th c.

Maîtres de l'art indépendant,1895-1925:Por-
traits d'artistes

In:Le Point(Colmar)
2e année,no.3:81-144 1937 illus.

Pertains to exh.in Paris.Palais des beaux-
arts,Petit Palais,June-Oct.,1937

LC N2.P6 MONA,v.11,p.438

I.D - GERMANY

Bechstein, Ludwig, 1801-1860
Zweihundert bildnisse und lebensabrisse be-
rühmter deutscher männer. 4.verb.aufl. Leipzig,
G.Wigand,1880
200 p. illus.

NN Amsterdam,Rijksmus.cat.
Z5939A52,deel 1, p.147

I.D - FRANCE - 20th c.

Paris. Palais des beaux-arts
Les maîtres de l'art indépendant,1895-1925
.l'exposition juin-octobre,Petit Palais,Paris.
Éditions Arts et Métiers Graphiques,c.1937.
118 p. illus.

FOGG
60
P236
1937

DDO DNGA

I.D - GERMANY

Bielz, Julius
...Porträtkatalog der Siebenbürger Sachsen.
Marburg,V.Diepenbroick-Grüter & Schulz,1936
100 p. ports. (Historische Bildkunde,
Heft 5)

NN Muzeul Brukenthal Sibiu.
Cat.Patrimonial ND 921.M8
983K NMAA Bibl.p..7.

I.D - FRANCE - BURGUNDY - 14-16th c.

Le Recueil d'Arras,conservé à la bibliothèque
de l'Abbaye de Saint-Vaast.Paris,A.Giraudon,
1906
20 p.

A'dam Photographies.par A.Giraudon.de 280 portrs.,
Kunst-h. représentant des personnages ayant vécu aux
Bibl. cours de Flandre et de Bourgogne pendant les
14e,15e et 16e s..From Arras Codex.
V & A 'The Arras Codex is now preserved in the Bibl.
(under Municipale d'Arras,Recueil de portrs.MS266'.-
Giraudon) W.Gibson Cat.der Kunsthist.bibl.in
het Rijksmus.te A'dam Z5939
.A52 NCFA deel 1,p.13?

I.D - GERMANY

Castell-Rüdenhausen, Siegfried,Fürst su, 1916-
Die porträts im Schloss Rüdenhausen.hrsg.
von.Max Domarus.Würzburg, Freunde Main-fränki-
scher Kunst und Geschichte;(Volkach vor Würz-
burg,Hart.in Kommission.),1966
164 p. illus(part col.) (Main-fränki-
sche Hefte,46)

Bibliography

LC N7622.C33 Fogg,v.11,p.325

I.D - GERMANY

Hentzen, Alfred, 1903- ed.
 Die grossen Deutschen im bild;herausgegeben
von Alfred Hentzen und Niels v.Holst,mit 460
Abb. Berlin,Propyläen-verlag.1936.
 487 p. incl.illus.

N.Y.P.L.
MAMG Contains the portrs.of the exh.Grosse Deut-
sche in bildnissen ihrer seit,organ.by the
Staatl.museen and the Nationalgalerie on the
occasion of the Olympics

N.Y.P.L.for LC
 NN McD CLSU DAU Cty ⌒⌒OSt etc.

I.D - GERMANY - MEDIEVAL

Schramm, Percy Ernst,1894-1970
 Denkmale der deutschen könige und kaiser.
Ein beitrag zur herrschergeschichte von Karl
dem Grossen bis Friedrich II, 768-1250...
München,Prestel,1962

 484 p. illus.

LC DD85.6.S33 ☽

I.D - GERMANY

Steinberg; Sigfrid Heinrich, 1899-
 Bibliographie zur geschichte des deutschen
porträts. Hamburg,Diepenbroick-Grüter & Schulz,
1934
 166 p. (Historische Bildkunde,Heft 1)

LC Z5948.P8S8

 Encyclop.of World Art
 ◯ N31E56 Ref.Bibl.on portr.

I.D - GERMANY - MEDIEVAL

Steinberg, Sigfrid Heinrich, 1899-
 Grundlagen und entwicklung des porträts im
deutschen mittelalter (Veröffentlichungen der
forschungsinstitute an der universität Leipzig.
Inst.für kultur-& universalgeschichte:Fest-
schrift W.Goetz,1927,p.21-34).Berlin,Leipzig,
Teubner,1927

 (info:Rave.Kunstgesch.in Fest-
 schr.Z5931R25,Ref.p.36 & 264)

 Enc.of World Art v.11
 ⌒ N31E56 Ref. bibl.on portr
 col.512

I.D - GERMANY

Zorn, Wolfgang
 Das deutsche unternehmungsporträt in so-
zialgeschichtlicher bedeutung

In:Tradition
2/3:79 ff. 1962

LC HC281.T7 Die 20er jahre im portr.
 ⌒ N6868.5.E9Z97 NPG, p.141

I.D - GERMANY - RENAISSANCE

Röthel, K
 Le portrait allemand à la renaissance

In:Les arts plastiques
3-4:127-40 1948

LC N2.A94 ⌒Encyclp.of World Art
 ⌒Portr.Bibl.N31E56 Ref.

I.D - GERMANY - MEDIEVAL

Kiessling, Gerhard
 Deutsche kaiserbildnisse des mit-mittelalters.
Ein beitrag zur geschichte des mittelalterlichen
kaisertums und zur entwicklung der porträtkunst...
Leipzig,Bibliographisches Institut,1937

 55p. illus.(part col.) ₌Meyers bunte
bändchen.33₌
 Bibliography

LC N7605.K5 ☽ Rep.,1937:325

I.D - GERMANY - 14-15th c.
Lehmann, Alfred
 Das bildnis bei den altdeutschen meistern
bis auf Dürer. Leipzig,K.W.Hiersemann,1900

 252 p. illus.

LC N7575.L5 ⌒ Goldscheider 757.052

I.D - GERMANY - MEDIEVAL

Scheffler, Willy
 Die porträts der deutschen kaiser und könige
im späteren mittelalter von Adolf von Nassau bis
Maximilian I (1292-1519)

Met
100.53 In:Rep.Kunstwiss.
R29 33:222-32,318-38,424-42,509-24 1910
v33

 ☽

N
7605 I.D - GERMANY - 15-19th c.
297
1857 Zweihundert bildnisse und lebensbeschreibungen
NPG berühmter deutscher männer.2.verb.aufl.
 Leipzig,G.Wigand,1857
 200 l. illus.

 Index of sitters
 Chronological index

 ☽

I.D - GERMANY - 18-19th c.

Rave, Paul Ortwin, 1893-1962
Das geistige Deutschland im bildnis. Berlin,
Verlag des Druckhauses Tempelhof.1949-
v.2 illus.

Contents.- 2.Das jahrhundert Goethes

LC N7605.R38

N 7605 S31 NPG

I.D - GERMANY - SCHLESWIG-HOLSTEIN

Schleswig-Holsteinisches Landesmuseum, Schleswig
Schleswig-Holsteinische porträts. Neuerwer-
bungen für die porträtsammlung...seit 1964. Aus-
stellung vom 31.1.- 7.3.1971. Schleswig,1971.

53 p. illus.

Introduction by Ernst Schlee
Selection & cat.by Paul Zubek
Catalogue, illus. accompanied by short bio-
graphy of sitters & artists.

I.D - GERMANY - 19th c.

Das Antlitz der romantik;bildnisse & selbst-
bildnisse deutscher künstler;hrsg.& einge-
leitet von Paul Ortwin Rave..Stuttgart,H.E.
Günther,1948?, (Die Slg.Parthenon,n.F.)
40 portrs.

LC ND1317.A56

I.D - GREAT BRITAIN

Bindley, James, 1737-1818
A catalogue of the...coll.of British por-
traits...the property of...James Bindley...which
will be sold at auction by Mr.Sotheby.London,
Wright & Murphy,printers,1819,
3 v.in 1 illus.

At head of title:The Bindley Granger
Contents.-pt.1,From the reign of Egbert to
the Revolution of 1688.-Pt.2.From the Revolution
of1688 to the present period.-Pt.3.Miscellaneous

NN MH PP PPULC DLC
MBAt Fogg,v.11,p.333

I.D - GERMANY - 19th c.

Weiglin, Paul, 1884-
Berliner Biedermeier.Leben,kunst und kultur
in Alt-Berlin zwischen 1815 und 1848.2nd ed.
Bielefeld and Leipzig,Velhagen & Klasing,1942
illus(part col.)

V & A

Praz.Conversation pieces
ND1304P92E1971,p.118,foot-
note 4

757 .B95

I.D - GREAT BRITAIN

Burlington fine arts club, *London.*
... Exhibition illustrative of early English portraiture. Lon-
don, Printed for the Burlington fine arts club, 1909.
xvi, 149, [1] p. xxxviii pl. (incl. front., ports.) 41].

Each plate accompanied by guard sheet with descriptive letterpress.
"The catalogue of paintings and drawings has been compiled by Mr.
Lionel Cust ... assisted by Mr. C. F. Bell ... The catalogue of coins and
medals has been supplied by Mr. Max Rosenheim."—Prefatory note.
"Notes on the early history of the art of portrait-painting in England,"
signed L. C. [i. e. Lionel Cust]: p. [1]-67.

1. Portraits—Catalogs. 2. Art—Exhibitions. 3. Portrait painting—
Gt. Brit.—Hist. 4. Portrait painters. 5. Gt. Brit.—Biog.—Portraits.
i. Cust, Lionel Henry, 1859-1929. ii. Bell, Charles Francis, 1871-
iii. Rosenheim, Max.

12—7086

Library of Congress N7598.B8 1909
[a30b1]

I.D - GERMANY - 20th c.

Kuhirt, Ulrich
Vom bürgerlichen zum sozialistischen bildnis

In:Bild.Kunst
9:457-61,498 1968 illus.

The evolution of the portrait,especially
in E.Germany

IU MH WU
LC N3.B53

Die 20er jahre im portr.
N6868.5.E9Z97 NPG,p.138
also in Rep.1968#11679

I.D - GREAT BRITAIN

Caulfield, James, 1764-1826
The lives and portraits of remarkable cha-
racters,drawn from the most authentic sources.
New ed.London,W.Lewis,1819
2 v. illus.

NNC

Univ.cat.of books on Art
Z5931U58 NCFA v.1:The ec-
centric magazine,or lives
...
B.M.

N 6868.5 E9Z97 NPG

I.D - GERMANY - 20th c.

Die zwanziger jahre im porträt:porträts in
Deutschland 1918-1933:malerei,graphik,foto-
grafie,plastik..Rheinisches Landesmuseum
Bonn,Ausst.10.9-24.10.1976.Kat.:Joachim
Heusinger v.Waldegg unter mitarbeit von
Brigitte Lohkamp and Adam C.Oellers.Köln,
Rheinland-Verlag;Bonn,in kommission bei
R.Habelt,c.1976
277 p. illus(part col.) (Kunst und
Altertum am Rhein,no.68)
Bibliography

LC N2255.R5A5 no.68
,N6868.5.E9,

I.D - GREAT BRITAIN

Daniell, Walter Vernon comp.
A catalogue of engraved portraits of cele-
brated personages,chiefly connected with the
history and literature of Great Britain...Lon-
don,W.V.Daniell,1900
278 p. illus.

LC NE265.D3

Whitman's print coll.hdbk.
1921. NE885W61h 1912 NCFA
Bibl.III

N
7598
D5
1979X
NPG
Ref.
v.1-2

I.D.- GREAT BRITAIN

Dictionary of British portraiture;ed.by Richard
 Ormond and Malcolm Rogers.N.Y.,Oxford Uni.
 Press,c.1979-

 v

 1.Davies, Adriana.The middle ages to the
early Georgians.Historical fgs.born before 1700
2.Kilmurray, Elaine.Later Georgians and early
Victorians.Historical fgs.born betw.1700 and
1800

I.D - GREAT BRITAIN

GRANGER, JAMES, 1723-76
 A BIOGRAPHICAL HISTORY OF ENGLAND

Met
901.72
G761

Rodd, T.homas.& Rodd, H.oratio,,pub.
 A collection of portraits to illustrate
Granger's Biogr.hist.of England, and Noble's
continuation to Granger: forming a supplement to
Richardson's copies of rare Granger portraits.
London, T.& H.Rodd,1820-22

 2 v.in 1 illus.

LC N7598.C6 Rosenwald coll.
title main entry

I.D - GREAT BRITAIN

Du Bois, Guy Pène, 1884-
 English portraits in American collections

In:Arts & Dec
4:180-3 Mar,'14 illus.

LC N1.A85

 Cumulated Mag.subj.index
 A1/3/C76 Ref. v.2,p.444

UA
670
H37
1987X
v.1
NPG
Ref.

I.D - GREAT BRITAIN

Harrington, Peter, 1954-
 Cat.to the Anne S.K.Brown Military Collec-
tion...N.Y.,Garlan Pub.,1987-
 v.1:The British prints,drawings and water-
colours.
 392 p. illus. (Garland reference library
of the humanities;vol.741)
 Indexes
 Section 6:Portraits,p.295-358:A.Original
works;Single items by sitter,p.297-301;Sets by
artists,p.302-3.B.Published works;Single prints
by sitter,p.305-3 Sets by artists,p.332-58

N
7621.2
G7E23
NPG

I.D GREAT BRITAIN

Edinburgh. University.
 The University portraits;compiled by
D.Talbot Rice....Edinburgh,Published for the Uni-
versity Court by the University Press,1957
 239 p. illus(part col.)

LC N7621.E3

TNB
266
G7H53
1813
NPG

I.D - GREAT BRITAIN

Houbraken, Jacobus, 1698-1780
 The heads of illustrious persons of Great
Britain, engraven by Mr.Houbraken and Mr.Vertue;
with their lives and characters by Thomas Birch.
New ed. London, Printed for W.Baynes by C.Wood,
1813

 216 p. illus.

 'Jacobus H. & G.Vertue engraved afterArnold
Houbraken's drawings.(Thieme-Becker: Houbraken,
LC DA28.H6 1813 [Arnold

I.D - GREAT BRITAIN

Evans, Edward, 1789-1835
 Catalogue of a collection of engraved portraits
the largest ever submitted to the public;compris-
ing nearly 20000 portraits of persons connected
with the history & literature of this country,from
the earliest period to the present time...alpha-
betically arranged with the names of the painter
& engraver...Now on sale...London,E.Evans,etc.,
1836-53.

LC Rare Books dpt. Amsterdam,Rijksmus.cat.
 Z5939A52, deel 1,p.151

705
S94
NCFA
v.145

I.D - GREAT BRITAIN

Kerr, John O'Connell
 Kings & Queens,A.D.653-1953

In:Studio
145:184-7 June,'53 illus.

 Refers to Exh.of this title at London,
Royal academy of arts,till June 28,'53
 Repro.:Henry VII by unknown artist.Henry
VIII & family by Hans Eworth.James I.attr.to
Marcus Gheeraerts.Charles I by Edw.Bower.
George III by Reynolds.

 Rep.1953*1203

I.D - GREAT BRITAIN

Gensel, W.alther,1870-1910,
 Die klassische bildniskunst in England

In:Kunst für alle
22:153-76 1907 illus.

MET
100.53
K96
v.22

LC for Kunst für alle:
N3.K4 Waetzoldt 1300.W12

I.D - GREAT BRITAIN

Lodge, Edmund
 Portraits of illustrious personages of Great
Britain, engraved from authentic pictures in the
galleries of the nobility & the public collections
of the country, with biographical & historical me-
moirs of...London,Harding & Lepard,1835

 12 v. illus.

other eds. 1849-50 London,Bohn 8v. LC DA28.L6
 1902 Boston,D.Estes 12 v.

N
7621.2
C5L84 I.D – GREAT BRITAIN
NCFA London. National Portrait Gallery.
NPG British historical portraits;a selection
 from the National Portrait Gallery,with biogra-
 phical notes. Cambridge,Published for the Na-
 tional Portrait Gallery at the University Press,
 1957
 265 p. illus.

LC N1090.A575

N
7621.2
C5L84h I.D – GREAT BRITAIN
1888 London. National portrait gallery
NPG Historical and descriptive catalogue of the
 pictures,busts, etc. in the Nat'l portr.gall.,on
 loan at the Bethnal Green museum.By George Scharf..
 A new and enl.ed. Including every portrait up to
 the present date.London,Printed for H.M.Station-
 ery off.,by Eyre and Spottiswoode,1888
 608 p.

LC N1090.A6 1888 Amsterdam,Rijksmus.cat.,
 Z5939A52,deel 1,p.151

757
.L82 I.D – GREAT BRITAIN
1932 London. National portrait gallery
 Catalogue of the National portrait gallery,
 1932. Oxford,Printed for the Trustees at the Uni-
 versity press.1932.

 391 p. illus.

 Foreword signed:H.M.Hake

LC N1090.A6 1932

N
7621.2
C5L84h I.D – GREAT BRITAIN
1903 London. National Portrait Gallery.
NPG Historical and descriptive cat.of the pic-
 tures,busts,etc.in the Nat'l Portr.Call....
 12th ed.London,Printed for H.M.Stationery off.,
 by Darling & son,ltd.,1903
 621 p. illus.

 Supplement.April,1906; 39 p. bound with
 main work.

N
1090 I.D – GREAT BRITAIN
A55
NPG London. National Portrait Gallery
Ref. Complete illustrated cat.1856-1979;comp.by
 K.K.Yung.Fd.by Mary Pettman.London,NPG,1981
 749 p. illus.

 Index of artists,engravers and photogra-
 phers

 Repro.of all ptgs.,drags.,miniatures,sculp-
 tures,photographs

N
7621.2
C5L84h I.D – GREAT BRITAIN
1907 London. National portrait gallery
NPG Historical and descriptive catalogue of the
 pictures,busts &c. in the National portrait gal-
 lery....13th ed. London,Printed for H.M.Stationa-
 ry off.,by Darling & son,ltd.,1907
 562 p.

 Introduction by Lionel Cust

LC N1090.A6

N
7598 I.D – GREAT BRITAIN
L58
1970X London. National Portrait Gallery
NPG Concise catalogue,1856-1969;edited and
Ref. arranged by Maureen Hill.London,...1970
 v, 346 p.

 Arranged in alphabetical order by sitters.
 Appendix:Groups and collections. Appendix:Un-
 known sitters(by century). Index of artists

N
7621.2
C5L84n I.D – GREAT BRITAIN
1960 London. National Portrait Gallery
NPG National Portrait Gallery catalogue 1856-
 1947 with a supplement 1948-1959
 320 p. 57 p. illus.

 Bibliographical note;index of artists

 Yale ctr.f.Brit.art Ref.

N
7598 I.D – GREAT BRITAIN
L58
1977 London. National Portrait Gallery
NPG Concise catalogue,1970-76...London,The Gal-
Ref. lery,1977

 FOR COMPLETE ENTRY
 SEE MAIN CARD

757
.L84 I.D – GREAT BRITAIN
 London. National portrait gallery
 The National portrait gallery,ed.by Lionel
 Cust...London,New York,etc.. Cassell and company,
 ltd.,1901-02
 2 v. illus.

LC N1090.A7

QN
1090
A633X
NPC

I.D - GREAT BRITAIN

London. National Portrait Gallery
 National Portrait Gallery in colour,ed.by
Richard Ormond.Intro.by John Hayes.London,Studio
Vista,1979

**FOR COMPLETE ENTRY
SEE MAIN CARD**

q N
5247
W56M54
1977X
NPG

I.D - GREAT BRITAIN

Millar, Oliver, 1923-
 The Queen's pictures.1st American ed.
N.Y.,Macmillan,1977
 240 p. illus(part col.)

Incl.bibliographical references and index

Contents:The Tudors,The early Stuarts,
Charles I,The late Stuarts,The early Hanover-
ians,George III,George IV,Queen Victoria and
Prince Albert,Modern times

I.D - GREAT BRITAIN

London. National Portrait Gallery
 Treasures in the National Portrait Gallery..
1977
 ,68,p.of portrs.

LC ND1301.5.G7L644 1977 **FOR COMPLETE ENTRY
SEE MAIN CARD**

N
5245
M64
NCFA

I.D - GREAT BRITAIN

Millar, Oliver, 1923-
 The Tudor,Stuart and early Georgian pictures
in the collection of Her Majesty the Queen.
London,Phaidon Press,1963.
 227 p. illus.(part col.)v.1:text,v.2:plates
 First part of a cat.raisonné of the royal
collection of pictures

 Bibliography

LC N5245.M62

I.D - GREAT BRITAIN

London. Royal academy of arts
 Kings and queens,653-1953,Exhib.of royal
portraits.London,1953.
 95 p. illus.

LC N7598.L6 ,Fogg,v.11,p.333

I.D - GREAT BRITAIN

,Musgrave, Sir William, Bart., 1735-1800,
 A catalogue of a....collection of English
portraits consisting of the royal families...
lawyers...artists...from Egbert the Great to
the present time...works of Delaram...Hollar,
Loggan...with...remarks by an eminent collector
,Sir W.Musgrave....sold by....Mr.Richardson...7
Feb.3,1800,and the 17 ff.days...and Mar.3,and
the 12 ff.days...London 1800,
 323 p.

MET
212
F98

DLC Priced 3495 items Names of
 buyers

 Met.Sales Cat.17801.N54 NCFA v.25 p.6231372

N
1165
R6A6x
NPG

I.D - GREAT BRITAIN

London. Royal College of Surgeons of England
 A cat.of the portraits...drawings and sculp-
ture in the Royal College of Surgeons of Eng-
land,by William LeFanu,librarian.Edinburgh,
E.& S.livingstone,1960,i.e.1959.
 118 p. illus(part.col.)

 Bibliography

 Pt.2 incl.Racial types,anomalies

LC N1165.R646 Yale ctr.f.Brit.art Ref.
 N1165.R6A56

I.D - GREAT BRITAIN

Myers & Rogers, London
 Cat.of engraved portraits of noted person-
ages principally connected with the history,
literature, arts and genealogy of Great Britain.
...London,Myers & Rogers,1903
 156 p. illus.

DLC MN MdBJ PP Winterthur Mus.Library
 Z881.W78 NCFA v.6,p.228

I.D - GREAT BRITAIN

Middle Temple, London
 Cat.of paintings and engravings in the pos-
session of the Hon.Soc.of the Middle Temple,
prepared by Master Bruce Williamson.London,
The Society,1931
 62 p. illus.

LC N7598.M53 1931

I.D - GREAT BRITAIN

Norwich Castle Museum, Norwich,Eng.
 ...Cat.of the pictures,drawings,etchings...in
the picture gallery...Norwich,"Norwich mercury"
co.,ltd.,printers,1909

MET
108.2
N83M97

LC N1143.A6 1909 **FOR COMPLETE ENTRY
SEE MAIN CARD**

I.D - GREAT BRITAIN

Old England's worthies:a gallery of portraits...
statesmen,lawyers,warriors,men of letters
and science and artists.Accomp.by...biographies
...woodcuts and...engravings.London,C.Cox,1847
272 p. illus(part col.)

LC DA28.04 Fogg,v.11,p.332

I.D - GREAT BRITAIN

Woodburn, Samuel, 1785 or86-1853
 Gallery of rare portraits,consisting of
200 original plates and facsimile copies of
rare and curious portraits,illustrative of
Britisih history.London,1816
 2 v.

Prit.
Mus.

 Universal Cat.of Books on
 Art Z5931.U58 1964,v.2,
 p.2161
 I & A v.10 Pre-1890,p.505
 fZ921.V64 NCFA

N
7598.2
P55X
NPG

I.D - GREAT BRITAIN

Piper, David
 The English Face. London.Thames & Hudson
1957.
 352 p. illus.

 Bibliography

 Review In:Connoisseur
 140:267-8 Jan.,1958

 History of Engl.portraiture covering 5 cen
turies,1400-end of Victoria's reign from a
 Wimsatt. he portrs.of A.
 Pope N7628P82W7 NPG Bibl.

I.D - GREAT BRITAIN

Woodburn, Samuel, 1785 or 86-1853
 Woodburn's Gallery of rare portraits;con-
sisting of original plates by Cecil,Dalaram,
Droeshout...illustrative of Granger's Biograph.
hist.of England,Clarendon's Hist.of the rebel-
lion,burnet's Hist.of his own time,Pennant's
London,etc...containing 200 portrs.of persons
celebrated...London,G.Jones,1816
 2 v. illus.

 For full subtitle see(LC)Z881A1U525 1942
v.165,p.418 NPG Ref.

LC N7598.W6

I.D - GREAT BRITAIN

Royal College of Physicians of London
 a descriptive catalogue of the portraits,
busts,silver...in the Royal College of Physi-
cians of London.London,Harrison,Printers.1926
 70 p.

 Arnold Chaplin,the Harveian Librarian...is
responsible for the work in its present form

LC N189.A1R881 1926 Yale ctr.f.Brit.art Ref.
 CU-M CaBVau CtY N1165.R5A55
MiDA

I.D - GREAT BRITAIN - 9-17th c.

Granger, James, 1723-76
 A biographical history of England, from
Egbert the Great to the revolution:consisting of
characters disposed in different classes,and ad-
apted to a methodical catalogue of engraved
British heads:intended as an essay towards re-
ducing our biography to system and a help to the
knowledge of portraits...5th ed.London,W.Baynes
and son,1824

 6 v. illus.
 Annotated catalogue of engraved Engl.portrs.
LC DA28.G7 1824 Clowes.A grangerised book
 In:Conn.43,Sep,1915,p.21

I.D - GREAT BRITAIN

Salmon, Thomas, 1679-1767
 The chronological historian;containing...
all material...relating to the English affairs,
from the invasion of the Romans to the present
time...Illustrated with the effigies of all
our English monarchs,curiously engraven,by
Mr.Vertue.London,printed for W.Mears,1723
 422 p. illus.

LC(G42S172c)Rare book coll.
 (DA34S1733 2nd ed.495 p.illus.
 (DA34S2)3rd ed. 2 v. il. Brit.mus.Additions 1963
 v.5,p.677,Z921.B662 NCFA Ref
 Dept.of printed books

I.D - GREAT BRITAIN - 12-15th c.

Harvey, John Hooper
 The Plantagenets, 1154-1485. London,New York,
Batsford.1948.

 180 p. illus.
 Bibliography

 Review by Squire,John,in:Ill.London News
 2:p.94 illus 1948
 Paintings & sculptures of Richard II,Edward II
Edward III,Marguerite of France,Richard I & Elea-
nor of Aquitaine
LC DA177.H3 Rep.,1948-49*1031

927
.W21

I.D - GREAT BRITAIN

Walpole, Horace,Earl of Oxford, 1717-1797
 Anecdotes of painting in England;with some
account of the principal artists....Also a cata-
logue of engravers who have been born or resided
in England. Collected by the late George Vertue...
A new ed.,rev...by Ralph N.Wornum...London,
H.G.Bohn,1849
 3 v. illus.

 Library at NPG has v.3

I.D - GREAT BRITAIN - 14-17th c.

GRANGER, JAMES, 1723-76
 A BIOGRAPHICAL HISTORY OF ENGLAND

Caulfield, James, 1764-1826
 Portraits,memoirs and characters of remark-
able persons,from the reign of Edward III to the
revolution....A new ed.completing the 12th class
of Granger's biogr.history of England,with many
additional rare portraits...London,Pr.for R.S.
Kirby,1813
 3 v. illus.

ViW ...

 Earlier ed., London,1794-5 in 2 v. CtY

qDA
260
T82X
NPG

I.D - GREAT BRITAIN 4 15th c.

Tudor-Craig, Pamela
 Richard III.,(Cat.of an exh.held at the)National Portrait Gallery,27 June-7 Oct.,1973...
London,NPG,1973

FOR COMPLETE ENTRY
SEE MAIN CARD

I.D - GREAT BRITAIN - 16th c.

Bone, Henry, 1755-1834
 Cat.of portraits of illustrious characters in the reign of Elizabeth...painted in enamel by Henry Bone,R.A. London,G.Smeeton,1813
 7 p.

NB

705
B97
NCFA
v.5

I.D. - GREAT BRITAIN - 15th-(begin.)17th c.

Blakiston, Herbert E.D.
 The Oxford exhibition of historical portraits

In:Burl Mag
5:211-4 May,'04 illus.

 Pertains to exhib.at Oxford uni.,Apr.& May,'04

 Periods incl.James I & even a few persons who died after 1625.

 See:Oxford. University. Illus.cat.of loan col.
 Cumulated Mag.subj.index
 A1/3/C76 Ref. v.2,p.444

AP
1
W225
NCFA
v.2

I.D - GREAT BRITAIN - 16th c.

Cust, Lionel Henry, 1859-1929
 The painter HE ('Hans Eworth')

In:Walpole Soc.
2:1-44 1913 illus.
3:113-14 1914 illus.
 :114-17 " " (by Mary F.S.Hervey)
 :118-19 " " (by Rich.W.Goulding)

 Incl.List of portrs.by or attr.to Hans Eworth

 Strong.Engl.Icon. qND1314
 S924 Bibliography

N
7598
S92
NPG

I.D - GREAT BRITAIN - 15-17th c.

London. National Portrait Gallery
 The house of Tudor;by Roy C.Strong.London, H.M.stationery office,1967
 20 p. illus(part col.) (Its Kings and Queens series:1485-1603)

LC DA317.1.S7

I.D - GREAT BRITAIN - 16th c.

Hague. Gemeentemuseum
 De eeuw van Shakespeare.Toen Elizabeth regeerde(Age of Sh.When E.reigned)...exh.22 jan. -1 apr.1958.The Hague,1958

MET
107.32
H11

LC PR2910.H23

FOR COMPLETE ENTRY
SEE MAIN CARD

I.D - GREAT BRITAIN - 15-(begin.)17th c.

Oxford. University
 Illustrated catalogue of a loan collection of portraits of English historical personages who died prior to the year 1625,exhibited... under the auspices of a committee of the Oxford historical society,April and May,1904. Oxford, Clarendon press,1904
 60 p. illus.
 Cat.by C.F.Bell
 Introduction by Lionel Cust
 Review by Blakiston,H.E.D. In:Burl Mag 5:211-4
 1st in a series of three exhibitions.

LC N7598.09
 Waterhouse.Ptg.in Britain,
 1530-1790 ND465.W32 1962
 NCFA bibl.

I.D - GREAT BRITAIN - 16th c.

Judson, Alexander Corbin, 1883-
 Sidney's appearance;a study in Elizabethan portraiture.Bloomington,Ind.Univ.Press,1958
 98 p. illus (Ind.Univ.publ.Humanities ser. no.4)

LC AS36.I385 no.4
N7628.S5J8
 Fogg v.11,p.332

N
7598
S92t
NPG

I.D - GREAT BRITAIN - 15-(begin)17th c.

Strong, Roy C.
 Tudor & Jacobean portraits,...London, H.M.S.O.,1969
 2 v. illus(part col.)

 Bibliography

 Portrs.of all major historical figs.of Tudor & Jacobean period,including all portrs.in the National Portrait Gallery,London.to the year 1625

LC N7598.S7

I.D - GREAT BRITAIN - 16th c.

Yates, F.A.
 The allegorical portraits of Sir John Luttrell

In:Essays in the History of Art presented to Rud.Wittkower...London,Phaidon, 1967

LC N5303.E7
 Strong.Engl.icon qND1314
 S924.Bibl.:"Good ex.of com-
plexities of meaning to be extracted fr.a Tudor portr.

I.D - GREAT BRITAIN - 16-17th c.

Harding, George Perfect, died 1853
 Portraits of illustrious persons in English history,drawn by G.P.Harding from original pictures;with biographical and historical notices, by Thomas Moule.London,Smith,1869
 32 p. illus.

MR NN

N
6765
V82
NPG

I.D - GREAT BRITAIN - 16-(begin.)17th c.

Virginia Museum of Fine Arts, Richmond
 The world of Shakespeare:1564-1616.An exhibition organized by the Virginia Museum of Fine Arts and the Detroit Institute of Arts...
Richmond,1964
 71 p. illus.

I.D - GREAT BRITAIN - 16-17th c.

Holland, Henry, 1583-1650?
 Herologia Anglica,hoc est clarissimorvm et doctissimorvm aliqovt Anglorvm qvi flo-vervnt ab anno Cristi M.D. vsq' ad presentem annvm M.D.C XX viuae effigies vitae et elogia,authore H.H.
₌London,Impensis C.Passaei calcographus et Iansonii bibliopolae,1620₌
 2 v. illus.

 Engravings mostly by de Passe family

LC CT780.H6 Rosenwald coll Nijhoff cat.1941,no.623

I.D - GREAT BRITAIN - 16-(begin.)18th c.

Oxford. University
 Illustrated catalogue of a loan collection of portraits of English historical personages who died between 1625 and 1714 exhibited...Apr. and May 1905. Oxford,The Clarendon press,1905
 104 p. illus.

 Introduction by Lionel Cust

 ₌2d in a series of three exhibitions₌
 Review In:Burl Mag 7:238,243

LC N7598.09 Waterhouse,Ptg.in Britain,
1905 1530-1790 ND465.W32 1962,
 NCFA bibl.

I.D - GREAT BRITAIN - 16-17th c.

Morse, Harriet(Klamroth),1891- ed.
 Elizabethan pageantry,a pictorial survey of costume and its commentators from c.1560-1620...
London,The Studio,ltd.,New York,The Studio publications,inc.,1934
 128 p. illus(part col.)

 Special spring no.of "The Studio"

 Bibliography

LC CT585.M6 Fogg,v.11,p.324

I.D - GREAT BRITAIN - 17th c.

Caulfield, James, 1764-1826
 The gallery of British portraits,containing those of distinguished and noble personages during the reigns of James I.and Charles I.,and under the Commonwealth.London,1814
 illus(col.)

 Biographical notices

 Univ.cat.of books on Art
M R1 Z5931U58 NCFA v.1

I.D - GREAT BRITAIN - 16-17th c.

Personalities of the Tudor and Stuart periods: historical portraits in a notable exhibition

In:Illustr.London News
 ₌p.799 Oct.29,1938 illus.

 Incl:Charles I by Honthorst,his wife Henriette by Janssens, James II by Riley,James I by Jamesone Francis Bacon by van Somer

LC AP4I3 Rep.,1939-41*707

I.D - GREAT BRITAIN - 17th c.

Lewis, Lady Maria Theresa (Villiers)Lister, 1803-65
 Lives of the friends and contemporaries of Lord Chancellor Clarendon, illustrative of portraits in his gallery. London,J.Murray,1852

 3 v. illus.
 "The Clarendon gallery":v.1,p.15-64
 "Descriptive catalogue of the collection of portraits at the Grove:v.3,p.239-435"

 Hake,H.M. In:Proceedings of the Brit.Acad.1943
 p.144:"Clarendon ₌assembled the first NPG' "
LC DA400 C 62 ₌in his own house)

N
6765
S924
NPG

I.D - GREAT BRITAIN - 16-17th c.

Strong, Roy C.
 The Elizabethan image:painting in England 1540-1620₌a cat.....of an exh.organised by the Tate Gallery,28 Nov.1969-8 Feb.,1970.
London,Tate Gall.(Publ.Dept.),1969
 88 p. illus(part col.)

LC N6765.S7

N
7621.2
G5L84c
1963
NPG

I.D - GREAT BRITAIN - 17th c.

London. National portrait gallery
 Catalogue of 17th c.portraits in the National Portrait Gallery,1625-1714. Cambridge,Univ.press, 1963
 409 p. illus.

 Compiled by David Piper

 Bibliogr. references

LC N1090.A598 Encyclop.of World Arts,bibl.
 Portrs.N31E56 Ref.

I.D - GREAT BRITAIN - 17th c.

Macaulay, Thomas Babington, 1st baron, 1800-59
 The history of England from the accession of
James II...;with index by W.B.Gray & G.Davies.
London,Macmillan & co.,ltd,1913-15

 6 v. illus(part col.)c.1000 illus.,c.50 col.

 Other editions, 1849-1931 see LC DA435.M14 &
LC I.E8 no.34-36

705 {Review by Ronald Clowes, In:Connoisseur,43:21-28
C75 Sep,1915 illus.:"...one of the best & most com-
NCFA plete representation of English & French portrai-
v.43 ture..."Repro.:Miniature of Colin Lindsay
LC DA435.M14 1913

705 I.D - GREAT BRITAIN - 17-18th c.
B97
NCFA Ford, Brinsley
v.97 A portrait group by Gavin Hamilton with
 some notes on portraits of Englishmen in Rome

 In:Burl Mag
 97:372-8 Dec.,'55 illus.

 17 and 18th century portrs.of Englishmen
 depicted against a Roman background

 Math.Dance qN40.1.D16606
 NPG p.2.

I.D. - GREAT BRITAIN - 17th c.

Millar, Oliver, 1923-
 The Restoration portrait

In:J.Royal Soc.of arts
109:410-33 1961

 Encyclop.of World Art
 portrs.bibl.N31.E56 Ref.

I.D - GREAT BRITAIN - (end)17-(begin)18th c.

GRANGER, JAMES, 1723-76
A BIOGRAPHICAL HISTORY OF ENGLAND

Noble, Mark, 1754-1827
 A biographical history of England, from the
revolution to the end of George I's reign; being
a continuation of the Rev.J.Granger's work:con-
sisting of characters disposed in different clas-
ses,and adapted to a methodical catalogue of en-
graved British heads...The material being supplied
by the manuscripts left by Mr.Granger...London,
W.Richardson, 1806
 3 v. illus.
LC DA28.G75

I.D - GREAT BRITAIN - 17th c.

Norwich,Eng.-Strangers' Hall
 The restoration of King Charles II.,an exh.
...sponsored by the Friends of the Norwich Mus.
.May 28-July 27.1960

V & A
MET
197.6 Cat.of exh.
N83 1885-

 Dresser.Background of Colo-
 nial Amer.portraiture,p.34
 ND1311.1.D77 NPG

DA I.D - GREAT BRITAIN - 17-(begin)18th c.
758.3
S867x London. National Portrait Gallery
NCFA The house of Stuart,by David Gransby.Lon-
 don,H.M.stationery off.,1968

 20 p. illus(part col.) (Its Kings and
 Queens series;1603-1714.)
MET
276.5
L844

I.D - GREAT BRITAIN - 17th c.

The Stowe.Granger and other engravings;cat.of
 the remaining portion of the engr.British
 portrs.,comprising those fr.the reign of
 James II forming the illus.copy of the con-
 tinuation of the Biographical hist.of Engl.
 by the Rev.Mark Noble...engrs.of the English
MET school.Woollett,Strange,Hogarth...Sir Josh.
212 Reynolds...removed fr.Stowe house,Bucking-
K9 hamshire...sold...by...S.Leigh Sotheby & Co
 ...21st Mar.1849 & 5 ff.days...London 1849.
 62 p.

 Priced

Met.Sales cat.fZ881.N53 NCFA v.23,p.023318

705 I.D - GREAT BRITAIN - 17th-(begin.)19th c.
B97
NCFA Armstrong, Walter, 1850-1918
v.9 Art in Georgian England...Historical portraits
 Review of exhib. at Oxford. University,Apr.& May,
 1906

 In:Burl Mag
 9:114-7 May,'06

 In addition of the leaders of the great
 school comparatively unknown artists are repre-
 sented. See over
 See:Oxford. Uni. Ill.cat.of...portrs..of pers
 who died betw.1714 and 1837
 Cumulated Mag.subj.index
 A1/3/C76 Ref, v.2,p.444

I.D - GREAT BRITAIN - 17-18th c.

Caulfield, James, 1764-1826
 Portraits,memoirs and characters of remark-
able persons,from the revolution in 1688 to the
end of the reign of George II....London,T.H.
Whitely.etc.1819-20
 4 v. illus.

 "Caulfield's'remarkable characters'are per-
sons famous for their eccentricity,immorality,
dishonesty,etc."-Dict.nat.biog.

LC CT781.C3 Univ.cat.of books on Art
 Z5931.U58 NCFA v.1 S.K.

I.D - GREAT BRITAIN - 17th-(begin.)19th c.

Oxford. University
 Illustrated catalogue of a loan collection
of portraits of English historical personages
who died between 1714 and 1837,exhibited...
April and May,1906. Oxford,Clarendon press,1906
106 p. illus.

FOGG .3d in a series of three exhibitions.
FA983.1.22
 Review by Armstrong In:Burl Mag
 9:114-7 May,'06

 Waterhouse.Ptg.in Britain,
 1530-1790 ND465.W32 1962
 NCFA bibl.

N
7598
C23X
NPG

I.D - GREAT BRITAIN - 17-20th c.

Cambridge portraits from Lely to Hockney..Cat.
of an exhibition.Cambridge University Press
for the Fitzwilliam Museum,1978
52 p.text 94 illus. (Fitzwilliam Museum
catalogues)

Index of artists
Index of sitters,all are members of the Uni-
versity
Preface by Michael Jaffé

Incl.:Ptgs.,miniatures,silhouettes,drags.,
medals,busts

I.D - GREAT BRITAIN - 18th c.

Russell, Francis, 1910-
Portraits of classical informality.Batoni's
British sitters.II

In:Country Life
154,no.3964:1754-6 June 14,'73

LC S3.C9 FOR COMPLETE ENTRY
 SEE MAIN CARD

704.942
F499

I.D - GREAT BRITAIN - 18th c.

Fink, Frances Sharf.
Heads across the sea;an album of 18th c.
English literary portraits in America. Char-
lottesville,Bibliographical Society of the
University of Virginia;Distributed by the Uni-
versity of Virginia Press,1959
251 p. illus.

Bibliography

LC N7598.F5

I.D - GREAT BRITAIN - 18th c.

Russell, Francis, 1910-
Portrait on the Grand Tour.Batoni's British
sitters.I

In:Country Life
154,no.3963:1608-10 June 7,'73

LC S3.C9 FOR COMPLETE ENTRY
 SEE MAIN CARD

705
A784
NCFA
v.4

I.D - GREAT BRITAIN - 18th c.

Halsey, R.ichard.T.ownley.H.aines, 1865-1942.
Ceramic Americana of the 18th century

In:Art in Am
4,Pt.1:85-98 Feb.,1916 illus.
 Pt.2:224-32 June,1916 illus.
 Pt.3:276-88 Aug.,1916 illus.
5,Pt.4:141-56 Dec.,1916 illus.
Repro.incl.:Chelsea porcelain statuettes:Wm.Pitt
John Wilkes,Catharine Macaulay. Wedgwood medal-
lions of Franklin,Washington,Marie Antoinette,
etc.etc.

I.D - GREAT BRITAIN - 18th c.

Wind, Edgar, 1900-
Humanitätsidee & heroisiertes porträt in der
englischen kultur des 18.jahrhunderts

FCGG In:Warburg institute. Vorträge der Bibliothek
4353 Warburg,herausgegeben von Frits Saxl...1923-32
W76 Leipzig,etc.,B.G.Teubner 9v. illus.
 ,IX,:156-229 1930-31 illus.

LC Warburg inst.Vortr.d.Bibl.Warburg...
C33.W3

Enc.of World Art,v.11
col.512

qN
7598
K43X
v.1 & 2
NPG Ref.

I.D - GREAT BRITAIN - 18th c.

Kerslake, John comp.
Catalogue of early Georgian portraits.
London,H.M.Stationery Office,1977
2 v. illus(part col.)

Portrs.of celebrities fl.during reign of
George I & George II in the NPG,London

LC N7598.K43 London,NPG.Concise cat.
 1598.L58 1970 NPG Ref.
 p.V

DA
480
K4x
NPG

I.D - GREAT BRITAIN - 18-19th c.

London. National Portrait Gallery
The house of Hanover;by J.Kerslake and
Louise Hamilton.London,H.M.stationery office,
1968
,20,p. illus(part col.) (Its Kings and
Queens series:1714-1837)

Winterthur Mus.Library
f2881.W78 NCFA v.6,p.228

AP
1
A51A64
NMAA
v.15

I.D - GREAT BRITAIN - 18th c.

Miles, Ellen G.
Portraits of the heroes of Louisbourg,1745-
1751

In:Am Art J
15:48-66 Winter,'83 illus.

Bibl.notes
Repro.incl.:John Smibert,Ths.Hudson,Rbt.
Feke;Mezzotints by Peter Pelham,John Faber and
Js.McArdell

I.D - GREAT BRITAIN - 18-19th c.

Mayes, Ian
Samuel De Wilde,c.1751-1832;theatre in Geor-
gian Regency London.George James De Wilde,1804-
1871;the life and times of Victorian Northampton;
an exh.at Northampton Central Art Gallery,4 Sept.-
2 Oct.,1971.Northampton,1971
,367,p. illus.

MSP

Noon.Engl.portr.drags.&min.
NC860.N66X NPG Bibl. p.146

927
.S63

I.D - GREAT BRITAIN - 18-19th c.

Smith, John Thomas, 1766-1833
 Nollekens and his times and memoirs of con-
temporary artists fr...Roubiliac,Hogarth and
Reynolds to...Fuseli,Flaxman and Blake...ed.and
annotated by Wilfred Whitten with 85 illustr.
 2 v. illus.,London,N.Y.,John Lane cy.,1920

1st ed. Colburn publ.,1828,2nd ed.1829

List of Nollekens' sitters in v.2,p.10ff.
Incl.a biography of J.T.Smith

LC NB497.N8S7 1917 Foskett.John Smart...Bibl.
 N40.1S638F7 NCFA

q N
40.1
C18 O 9
NPC

I.D - GREAT BRITAIN - 19th c.

A Victorian album:Julia Margaret Cameron and her
 circle...;introd.essay by David Cecil...N.Y.,
 Da Capo Press,1975

LC TR681.F3V52 1975b **FOR COMPLETE ENTRY
 SEE MAIN CARD**

I.D - GREAT BRITAIN - 18-19th c.

Steegmann, John, 1899-
 The rule of taste,from George I to George IV..
London,Macmillan & co.,ltd.,1936
 202 p. illus.

Bibliography

Review by Charles Richard Cammell In:Conn.
98:175-6 Sep.,1936

LC N6766.S7

I.D - GREAT BRITAIN - 19th c.

Williamson, Mrs.,Emma Sara, editor
 The book of beauty(late Victorian era);a
collection of beautiful portraits with literary,
artistic and musical contributions by men and
women of the day.Edited and arranged by Mrs.F.
Harcourt Williamson.London,Hutchinson & Co.,1896

FOGG
FA 4353
W72 Portrs.& other illustr.(music)

 Fogg,v.11,p.333

I.D - GREAT BRITAIN - 19th c.

Hutchinson, Horatio Gordon, 1859-1932
 Portraits of the eighties...with 28 illus.
London,T.F.Unwin,ltd.,1920,
 301 p. illus.

LC DA562.H8 Books in print.Subject
 guide,1985-86,v.3,p.4864

DA
28.1
O 7X
NPC
2 c.

I.D - GREAT BRITAIN - 19-20th c.

London. National Portrait Gallery
 The house of Windsor;by Richard Ormond.
London,H.M.stationery office,1967
 ,20,p. illus(part col.) (Its Kings and
Queens series:1833-1966)

 Winterthur Mus.Library
 fZ881.W78 NCFA v.6,p.228

I.D - GREAT BRITAIN - 19th c.

Jerdan, William
 National portrait gallery of illustrious and
eminent personages of the 19th c.;with memoirs.
London,Fisher,son & Jackson,1830-34

5 v. illus.

184 portrs. by Robinson,Thomson,Fry,Freeman,
etc.after ptgs.by Lawrence,Reynolds,Shée,Beechey,
Jackson,etc.

LC DA531.1J5 From WW's desk
 Destailleur.LC Z5939D42
 p.150,no.601.Cat.de livres..

I.D - GREAT BRITAIN - 19-20th c.

West, Sir Algernon Edward, 1832-1921
 Contemporary portraits:Men of my day in
public life.London,T.F.Unwin,ltd.,1920,
 231 p. illus.

LC DA562.W4 1920 Books in print.Subject
 guide,1985-86,v.3,p.4865

I.D - GREAT BRITAIN - 19th c.

Thompson, Edward Raymond, 1872-1928
 Portraits of the nineties,by E.T.Raymond
,pseud.,London,T.F.Unwin,ltd.,1921,
 315 p. illus.

Bibliography

LC CT782.T5 1921 Yale ctr.f.Brit.art Ref.
 CT782.T46

I.D - GREAT BRITAIN - 20th c.

Gwynne-Jones, Allan, 1892-
 Portrait painters;European portraits to the
end of the 19th c. & English 20th c. portraits.
London,Phoenix House,,1950,
 39 p. 163 illus.

An anthology of portr.ptgs.from Greco-Roman
coffin-lids to end of 19th c. Also 20th c. Engl.
portrs. The critical appreciation of a practising
artist.

LC N7575.G9 R.L.Douglas in Conn.v.126
 p.162,footnote

757
.O 98

I.D - GREAT BRITAIN - OXFORD

Oxford historical society
Catalogue of portraits in the possession
of the university,colleges,city,and county of
Oxford, comp. by Mrs.Reginald Lane Poole...
Oxford,The Clarendon press,1912.1925
3 vol. illus.

lists portraits from 1266-1924

LC N7598.O8

I.D - GREAT BRITAIN - WALES

Steegmann, John, 1899-
A survey of portraits in Welsh houses.
Cardiff,Published by the National Mus.of Wales,
1957 and 1962
2 v. illus.

v.1.-Houses in North Wales. v.2.-Houses in
South Wales

LC N7622S73

I.D - GREAT BRITAIN - SCOTLAND

Caw, James Lewis, 1864-
Scottish portraits;with an historical and
critical introduction and notes by ...Edinburgh,&
London,T.C.& E.C.Jack,1903

2 v. illus.

In 5 portfolios

LC N7519.C4
1905 ed.by London,J.B.
Millet Co. NN

Waterhouse.Ptg.in Britain,
1530-1790 ND465.W32 1962
NCFA bibl.

705
B97
NCFA
v.90

I.D - GREAT BRITAIN - WALES

Waterhouse, Ellis Kirkham, 1905-
Portraits from Welsh Houses - The Exhibition
at the National Museum of Wales

In:Burl Mag
90:203-7 Jul,'48 illus.

Emphasis on 18th c.
Incl.:Sitters of particular interest in Welsh
history. Reynold,Romney,etc.& less known artists.

Cumulated Mag.subj.index
A1/3/C76 Ref.v.2,p.445

N
7621.2
G7F22
1951
NPG

I.D - GREAT BRITAIN - SCOTLAND

Edinburgh. Scottish national portrait gallery
Illustrated catalogue. Edinburgh,H.M.Sta-
tionery Off.,1951
159 p. illus.

"This cat...supersedes the cat.(last ed.1909,
LC N1285.A6 1909

Foot,v.11,p.321 (ed.1909)

I.D - GREAT BRITAIN - YORKSHIRE

Hailstone, Edward, 1818-1890
Portraits of Yorkshire worthies.Selected
from the National exh.of works of art at Leeds,
1868...London,Cundall & Fleming,1869
2 v. 200 port(phot.)

LC DA670.Y6H1

Ingamells.Engl.Episcopal
portr.N7598.2IL4 NPG p.80

I.D - GREAT BRITAIN - SCOTLAND(15-16th c.)

Paes, Elena
Unas muestras curiosas de iconografia regia
escocesa

In:R.Arch,Bibl.y museos
54:105-7 1948 illus.

Kings & queens of Scotland from James III to
Queen Anne

LC Z671.R41

Rep.,1948-49*1033

I.D - INDIA

Rohatgi, Pauline
India Office Library and Records.Portraits
in the India Office Library and Records...
London,British Library,c.1983
414 p. illus.(1 col.)

Bibliography p.407-14
Index

LC CT1504.5.I53 1983

Books in print.Subject
guide 1985-86,v.3,p.4865

I.D - GREAT BRITAIN - WALES

Cardiff, Wales. National Museum of Wales
Loan exhibition...June-July,1948; portraits
from Welsh houses;catalogue. Cardiff,1948
40 p. illus.

Compiled by John Steegman

FMCG
4J53
C26

LC (?)ND1314.C3
ICU

N
7600
C94
NPG

I.D - IRELAND

Crookshank, Anne
Irish portraits 1660-1860;cat.by Anne Crook-
shank and the Knight of Glin.London,Paul Mellon
Foundation for British Art,1969
106 p. illus.

Bibliography
Exh.held:Nat'l Gall.of Ireland,Dublin,14 Aug.-
14 Oct.,1969;NPG,London,30 Oct.,1969-4 Jan.,
1970;Ulster Museum,Belfast,28 Jan.-9 March,
1970
Supplied by Worldwide Books,N,Y.

LC N7600.C7

Yale ctr.f.Brit art. Ref.

I.D - IRELAND - DUBLIN

Dublin. University
A descriptive catalogue of the pictures,
busts, and statues in Trinity College, Dublin and
in the Provost's house, by W.G.Strickland. Dublin,
Univ.Press,1916
9? p.

Incl.index

MN CSmH
Yale ctr.f.Brit.art Ref.
N1265.A55

I.D - ITALY - RENAISSANCE

Leer, W.A.van
Portretten uit de Italiaansche renaissance.
Introduction by O.J.Hoogewerff. Zutphen,1930
159 p. illus.

Antiquariaat van Coevorden
Soest. Cat.,Jan.1973#428

I.D - ITALY

Molajoli, Bruno, 1905-
Ritratti a Capodimonte..Torino.ERI,Edi-
zioni RAI-Radiotelevisione italiana.1959.
104 p. illus(color)

In Italian and French

LC N2727.M6
Fogg,v.11,p.324

I.D - ITALY - RENAISSANCE

Meller, Peter
La cappella Brancacci;problemi ritrattistici
ed iconografici

In:Acropoli
4:186-227,273-312 1960/61 illus(part col.)

FOGG
FA1.1947
1960-61
&
3.#18

Prinz.Slg.d.selbstbildnis-
...N761.P95,bd.1 NPG.p.147.

I.D - ITALY

Rud, Einar, 1892-
Italienske kunstner portraetter fra Gotik s
Renaissance..København,Selskabet Bogvennerne
.1967.
105 p. illus.

Illus.and part of text fr.Vasari's Vite de
più eccelenti pittori,scultori e architetti.

NIC
LC N6922.R8 -København,Carit
Andersen.1967 Rep. 1967 #1151

I.D - ITALY - 16-17th c.

Atti del Convegno Paolo Ciovio;il Rinascimento
e la memoria.Como,Presso la Società a Villa
Gallia,c.1985
330 p. illus. (Raccolta storica,v.17)

Congress Paolo Giovio(1983,Como,Italy)

CU MN etc.

I.D - ITALY - 12th c.

Steinberg, Sigfrid Heinrich, 1899-
I ritratti dei re normanni di Sicilia

In:Bibliofilia(Rev.di storia del libro,delle arte
grafiche,di bibliografia e erudizione (Florenx).
39;29-57 1937 illus.

Seals,ptgs.,mosaics,sculptures,12th c.

FOGG
430
S56 Reprint:Florence,Olschki,1937

Enc.of World Art,v.11,512
Rep.,1937#326

I.D - ITALY - 17th c.

Ritratti et elogii di capitani illustri che
ne' secoli moderni hanno gloriosamente
guerreggiato.Descritti da Giulio Roscio,& altri.
Roma,Rossi,1646
404 p. illus.

FOGG
Widener

Fogg,v.11,p.325

705
A784
NCFA
v.12

I.D - ITALY - 15th c.

Bode, Wilhelm von, 1845-1929
Italian portrait paintings and busts of the
quattrocento

In:Art in Am
12:2-13 Dec.,'23 illus.

Repro.:Busts by Mino da Fiesole,Desiderio da
Settignano,Pollaiuolo,Verrocchio,Laurana. In v.4,
p.361;Desiderio.Ptgs.in v.2,p.45,51;Filippo Lippi.
v.2,p.76;Botticelli.v.7,p.231;Castagno.v.1,p.227;
Giorgione
Cumulated Mag.subj.index
A1/3/C76 Ref. v.2,p.444

708.1
L56
NCFA

I.D - ITLAY - 17-18th c.

Feinblatt, Ebria
Baroque portraits

In:L.A.Mus.of Art Bull.
1,no.3-4:18-24 Spring,'48 illus.

Repro:Busts by Angelo del Rossi,Jean-Jacque
Caffieri,Bernini; Painting by Bernini

Portr.bust.Renaiss.to En-
lightenment.NB1309.P6x NPG
Bibl.

I.D - ITALY - BRESCIA

Member, Giuseppe
Uomini illustri de Quinzano d'Oglio

In:Mon.Bresciana
10:65-132 1934 illus.

This article comprises the 13th - 19th c.,
illustr. with patgs.miniatures,sculptures and
engravings

Rep.,1936*354

I.D - ITALY - CAMPANIA

Lorenzo, Giuseppe de
I grandi Capani

In:Vie d'italia
:237-43 1938 illus.

Great men from the Campania. Repro.:Bernini,
Cavallino,Rosa,Giordano,Longhi.Portrs. of Cicero,
Tasso,St.Thomas Aquinas,Giordano Bruno

LC DC401.V48 Rep.,1936*352

705
P19
NCFA
v.15

I.D - ITALY - FLORENCE - RENAISSANCE

Pudelko, Georg
Florentiner porträts der frührenaissance

In:Pantheon
15:92-8 Mar,1935 illus.

Synopsis in English:pp.10-11

From Masaccio's static quiet to Castagno's
dynamics
Repro:Uccello,drg.& ptg,Filippo Lippi,Castagno

Enc.of World Art,v.11
N31E56Ref.col.513
bibl.on portr.

I.D - ITALY - VENICE

Foscari, Lodovico
Autoritratti di maestri della scuola vene-
siana

In:Riv.di Venezia
12:147-62 1933

MET
100.55
R525

Enc.of World Art
N31E56 Ref.v.11,col.513
bibl on portr.

I.D - JAPAN
Oriental Art only used by exception

708.1
C62
NCFA

I.D - JAPAN

Lee, Sherman E.
Varieties of portraiture in Chinese and
Japanese art

In:Cleve.Mus.of Art,B.
64,no.4:118-36 Apr.,'77 illus.

"True portrs."more common in Western art
than in that of the Far East.Western influence
started in the 17th c.,was particularly heavy
in the 19th c.- Scholarly attitudes,7en concepts
of transmittal and commemoration of the dead.

I.D NETHERLANDS (HOLLAND)
 (BELGIUM-FLANDERS)
 BELGIUM SEPARATED AFTER 1830

N
7620
H17
NPG

I.D - NETHERLANDS

Hall, H.van
Portretten van Nederlandsche beeldende
kunstenaars.Portraits of Dutch painters and
other artists of the Low Countries;specimen of
an iconography.Repertorium.Amsterdam,Swets en
Zeitlinger,1963
419 p.

I.D - NETHERLANDS

Moes, Ernst Wilhelm, 1864-1912
Iconographia Batava;beredeneerde lijst van
geschilderde en gebeeldhouwde portretten van
Noord-Nederlanders in vorige eeuwen. Amsterdam,
F.Muller & co.,1897-1905
2 v. illus.

LC N7607.M6 Amsterdam,Rijksmus.,cat.
Z5939A52,deel 1,p.139

I.D - NETHERLANDS

Muller, Frederik, 1817-1881
Beschrijvende catalogus van 7000 portretten
van Nederlanders,en van buitenlanders,tot Neder-
land in betrekking staande...Amsterdam,F.Muller,
1853
401 p.
Muller coll.in 1852
Part 1:Ruling fgs.& their families,in chro-
nological order.Pt.II.Exceptional individuals,
in alphabetical order,with biographical notes
& dates of the prints.

LC NE285.M8 Hijbroek.Frea.muller en
zijn prentenverzamelingen
In:Bull.Rijksmus.29:26
note 12 708.949s.A523 NMAA

I.D - NETHERLANDS - 14-16th c.

Le Recueil d'Arras,conservé à la bibliothèque
de l'Abbaye de Saint-Vaast.Paris,A.Giraudon,
1906
20 p.

A'dam
Kunst-h.
Bibl.

V & A
(under
Giraudon)

Photographies par A.Giraudon,de 280 portrs.
représentant des personnages ayant vécu aux
cours de Flandre et de Bourgogne pendant les
14e,15e et 16e s.«From Arras Codex»
'The Arras Codex is now preserved in the Bibl.
Municipale d'Arras,Recueil de portrs.MS266'.-
W.Gibson Cat.der Kunsthist.Bibl.in
 het Rijksmus.te A'dam Z5939
 A52 NCFA deel 1,p.132

N
7614
W7W66
NPG

I.D - POLAND

Wilanów,Poland.Palac.
 Portrety osobistości polskich snajdujące
się w pokojach i w Galerii Pałacu w Wilanowie;
katalog.Wyd.1. Warszawa, Muzeum Narodowe,1967
 396 p. illus. (katalogi portretów,wyda-
wane przez Muzeum Narodowe w Warszawie,1)

 Ptgs.busts,medallions

 Index of artists

 Index of sitters

PCamA

705
G28
1910
NCFA
v.3

I.D - NETHERLANDS - 15th c.

Durrieu, Paul, 1855-1925
 Quelques portraits historiques du début du
15e siècle

In:Gaz Beaux Arts
3:461-9 Jun,1910 illus.

 Identifications of persons in the "Heures
de Turin"& on the wing of the Ghent altar by
van Eyck:Knights of Christ,in Berlin

 Fogg,v.11,p.321

I.D - PORTUGAL

Keil, Luis
 Os retratos de personagens portuguesas da
colecçao do arquiduque Ferdinando do Tirol

In:b.Acad.nac.belas artes
15:18-22 1946 illus.

Portuguese personalities in the miniature coll.
of archduke Ferdinand of Tyrol,brought together
from 1563 on

LC N16.A6613 Rep.,1948-49*1027

N
7607
W54X
NPG

I.D - NETHERLANDS - 17th c.

John and Mable Ringling Museum of Art,Sarasota,
 Dutch 17th c.portraiture.The Golden «Fla.
Age;exh.Dec.4,,1980-Feb.8,1981;cat.by Wm.Harry
Wilson.The John and Mable Ringling Mus.of Art
Foundation,1980
(unpaged)140 items illus(col.front cover)

 Ptgs.,drags.,prints,medallions,earthenware,
glass
 ;index of subjects

I.D - SPAIN

Allende-Salazar, Juan
 ...Retratos del Museo del Prado,identifica-
ción y rectificaciones,por.J.Allende-Salazar y
F.J.Sánchez-Cantón.Madrid,Impr.de J.Cosano,1919
 303 p. illus.

 At head of title:Junta de iconografía na-
cional,memoria premiada en el concurso de 1914

LC N7592.A4 Fogg,v.11,p.320

I.D - NETHERLANDS - 19-20th c.

Amsterdam. Maatschappij'Arti et Amicitiae'
 Tentoonstelling Nederlandsche portretkunst,
1839-1929 ter gelegenheid van het 90-jarig be-
staan der maatschappij. Dec.,1929. Amsterdam,1929
 illus.

 Amsterdam,Rijksmus.cat.
 Z5939A52,deel 1,p.371

I.D - SPAIN

Camón Aznar, José
 El retrato español del siglo 14 al 19

In:Goya
 :200-7 1969-70 illus.

(Rés.anglais)

LC N7.06 Rep.,1970*2841

I.D - NETHERLANDS - 19-20th c.

Knipping, John Baptist, 1899-
 Het kind in Neerlands beeldende kunst,19& 20
eeuw. Wageningen,Gebr.Zomer en Keuning,1944-67

 225 p. illus(part col.)

LC N6931.K6 Rep.,1948-49*870

I.D - SPAIN

Spain. Junta de Iconografía Nacional
 Retratos de personajes españoles:Indice
illustrado. Madrid,1914-19
 2 v.

LC 1958-62:5pt in 1 v.
NJP Enc.of World Art
 N31E56Ref.v.11col.512
 bibl.on portr.

I.B.4.SWEDEN

Sinclair, G.A.
 Gripsholm:Swedens national portrait gallery

In:Chambers's Journal
20:423-5 7th ser.Jun,'30

DLC
 Cumulated Mag.subj.index
 A1/3/C76 Ref. v.2p.444

N
7593.1 I.D - U.S.
A52
NPG American Jewish Historical Society
 Early American Jewish portraiture. Exhibited
 Feb.-July,1952.at the Jewish Museum,New York
 .c.1952.
 20 p. illus.

I.D - SWEDEN

Stockholm,Nationalmuseum,svenska porträttarkivet.
 Index över svenska porträtt,1500-1850 i
 svenska porträttarkivets smålingar..Stockholm.
 Nordisk rotogravyr.1935-43.

Met
115.01 3 v. illus
st6 v.1:A-K, v.2:L-Z, v.3:royal portrs:medieval,
 Gustav I to Karl XIII; v.1 & 2 mostly ptgs,
 v.3:seals,murals,tombstones,wood,coins,medallions,
 MSS.,etc.

LC N7610.S9S8 Rep.,1936#347

N
7621 I.D - U.S.
P5A52
NCFA American Philosophical Society, Philadelphia
 A catalogue of portraits and other works
 of art in the possession of the American Philo-
 sophical Society.Philadelphia,...,1961
 173 p. illus(part col) (Memoirs of the
 American Philosophical Society,v.54)

LC Q11.P612 v.54

I.D - SWEDEN

Svenskt porträttgalleri...Stockholm,H.W.Tull-
 berg.1895-1911.
 45 v. illus.

 Ed.by Albin Hildebrand

 With a general register by Albin Hildebrand
 1913. 867 p.

 For contents see NUC pre-56

LC CT1322.S7

N
6505 I.D - U.S.
B62
NCFA Black, Mary C.
 What is American in American art.An exh...
 for the benefit of the Mus.of Amer.Folk Art
 .Feb.9-March 6,1971.Intro.by Lloyd Goodrich,
 cat.by Mary Black.N.Y.,M.Knoedler.1971.
 80 p. illus(part col.)

 Exh.in memory of Jos.B.Martinson

 Index of artists

 'Folk art contained the essence of native
 flavor continued on next card
 Art:in America H61c

I.D - SWEDEN - 19th c.

Hintze, Bertel, 1901-
 Modern konst,1800-talet.Helsingfors,
Söderström.1928.
 350 p. illus.(part col.)

MET Litteratur.343.-350
111.4
H39

MB NJP

I.D -.U.S.

Brown, William Henry, 1808-1883.
 Portrait gallery of distinguished American citizens, with
biographical sketches and fac-similes of original letters. By
William H. Brown. Hartford, E. B. & E. C. Kellogg, 1845.
 2 p. l., [4]-6, [0,-111 p. front., ports. facsims. 43½ᶜᵐ.
 Nos. 7-8 omitted from paging.
 Portraits in silhouette.

 NPG has facsimile reprint:fN7593.1.B88 1931

 1. U. S.—Biog. 2. Silhouettes. i. Title. 6-10173 Revised

 Library of Congress E176.B89
 [r30f2]

I.D - SWEDEN - 20th c.

Hintze, Bertel, 1901-
 ...Modern konst,1900-talet...Helsingfors,
Söderström.1930.
 360 p. illus.

 Litteratur p.[351.-357

NJP

I.D - U.S.

Buttre, Lillian C., 1858-1881
 The American portrait gallery.New York,J.C.
Buttre.c.1871-80.
 3 v. illus.

 Steel plate illustrations

133820-22B Cirker.Dict.of Am.portrs.
N.Y.P.L. N7593/C57/NPG Bibl.,p.713

N
7593
C49X
NPG

I.D - U.S.

Christman, Margaret C.S.
Fifty American faces from the collection
of the National Portrait Gallery,Washington,
D.C.,Smithsonian Inst.Press for NPG,1978
256 p. illus(part col.)

Foreword by Marvin Sadik

Bibliographies
Index of artists

LC N7593.C49

N
6505
D92
1965
NCFA

I.D - U.S.

Dunlap, William, 1766-1839
History of the rise and progress of the arts
of design in the United States.....New ed.,rev.
and enl. New York,B.Blom,1965,

3 v.

Bibliography

LC N6505.D9 1965

N
11
N27C9
NCFA

I.D - U.S.

Cummings, Thomas Seir, 1804-1894
Historic annals of the National academy
of design,New York drawing association,etc.,
with occasional dottings by the way-side,from
1825 to the present time.,.Philadelphia,
G.W.Childs,1865
364 p.

"Ranks next to Dunlap's 'History' in impor-
tance as source for info. concerning early
American artists."(Wehle.American min.,1730-1850,
bibl. ND1337U5W41NCFA)

LC N11.N25 1865a

705.75
W4F2
NGA

I.D - U.S.

Fairman, Charles Edwin, 1854-
...Art and artists of the Capitol of the U.S.
of America....1927
526 p. illus(incl.portrs.)

LC N853.F4

Weddell.A mem'l vol.of Va.
hist.portraiture.757.9.W38
NCFA Bibl. p.434

E
206
D33
NPG

I.D - U.S.

Delaplaine, Joseph, 1777-1824
Delaplaine's repository of the lives and
portraits of distinguished American characters.
Philadelphia,1815-.16.
2 v.in 1 illus.

Contents.-v.1.Columbus.Vesputius.Dr.Rej.Rush
Ames.Hamilton.Washington.Peyton Randolph.Thomas
Jefferson.John Jay.Rufus King.DeWitt Clinton.
Rbt.Fulton.-v.2.Samuel Adams.George Clinton.
Henry Laurens.Benj.Franklin.Francis Hopkinson.
Rbt.Morris.

LC E206.D32

N
7593
H56
1834
NPG

I.D - U.S.

Herring, James, 1794-1867,ed.
The national portrait gallery of distin-
guished Americans...Conducted by James Herring...
and James B.Longacre...under the superintendence
of the American academy of the fine arts...New
York,M.Bancroft;etc.,etc.,1834-39
4 v. illus.

Illustrated by engravings

LC E176.H56

N
7593
D33
NPG

I.D - U.S.

Delaplaine, Joseph, 1777-1824
Prospectus of Delaplaine's National Panzo-
graphia, for the reception of the portraits of
distinguished Americans. Philadelphia,Printed
by William Brown,1818
16 p.

NB
1310
H95
NPG

I.D. - U.S.

Hutton, Laurence,1843-1904
Portraits in plaster,from the collection of
Laurence Hutton. New York,Harper & brothers,1894
271 p. illus.

Masks;portraits

LC NB1310.H9

N
5020
D418
NCFA
2 c.

I.D - U.S.

Detroit. Institute of Arts
The French in America,1520-1880;an exh...
..Cat.Detroit,1951
207 p. illus.

Bibliography
Incl.:article by Paul L.Grigaut,p.17-24
"In any exh.using history as its theme,portrs.
play a great part."-Paul L.Grigaut,p.18

I.D. - U.S.

Jones, Abner Dumont, 1807-1872
The American portrait gallery;containing
correct portraits and brief notices of the
principal actors in American history...From
Christopher Columbus down to the present time.
The portraits engraved on wood by J.W.Orr,from
original drawings by S.Wallin...N.Y.,J.M.
Emerson & co.,1855
768 p. illus.

LC E176.J68

I.D - U.S.

Massachusetts Historical Society, Boston
Portraits of men, 1670-1936. Boston,1955
.32.p. illus. (A Massachusetts Histori-
cal Society picture book)

FCGC
4253
M41
1955

MiD Vi MH MHU ⟮Fogg,v.11.,p.328
IHi etc.

NPG
Ref.
coll.

I.D - U.S.

National Portrait Gallery, Washington, D.C.
Recent acquisitions...comp.by Robert G.
Stewart.Washington,D.C.Smithsonian Institution,
1966
unpaged illus. (Smithsonian publ.4885)

Cat of exh.Oct.4-Nov.28,1966 in the Arts
& Industries Bldg.

List of artists

LC N7593.N22

NPG

I.D - U.S.

National Portrait Gallery, Washington, D.C.
Checklist of the permanent collection/Na-
tional Portrait Gallery,Smithsonian Institution
Washington:Smithsonian Institution Press...,
1975
72 p.

Includes index

LC N8578.A55 1975

N
7593
N26
NPG

I.D - U.S.

National Portrait Gallery, Washington, D.C.
This new man:a discourse in portraits.
Edited by J.Benjamin Townsend and introd.by
Charles Nagel. With an essay by Oscar Handlin.
Washington,Published for the National Portrait G.
by the Smithsonian Institution Press;.distri-
buted by Random House,New York.1968
217 p. illus(part col.) (Smithsonian
publication 4752) (Exh.Oct.7-Dec.31,1968)
"This presentation is an effort to examine
ourselves dispassionately & to analyze the Americ.
character provocatively

NPG
N857.8
A66
1978X

I.D - U.S.

National Portrait Gallery, Washington, D.C.
National Portrait Gallery Smithsonian In-
stitution permanent collection,illustrated check-
list...1978

2nd edition

**FOR COMPLETE ENTRY
SEE MAIN CARD**

N
6505
N48
NPG

I.D - U.S.

Neuhaus, Eugen, 1879-
The history & ideals of American art...Stan-
ford University,Calif.,Stanford university press;
London,H.Milford,Oxford university press,1931
444 p. illus.

Bibliography
Author stresses Engl.influence which shaped
American art's course. Historical & esthetic
analysis. Survey of begin.& development of art
in the West & Pacific coast.

LC N605.N4 ⟮Whitehill.The Arts in ear-
 ⟮ly Amer.Hist.Z5935W59 NPG
 ⟮Bibl.,p.85

NPG
Ref.
coll.

I.D - U.S.

National Portrait Gallery, Washington, D.C.
Nucleus for a national collection...comp.
by Robert G.Stewart,Washington,D.C.,Smithsonian
Institution,1966
unpaged illus(part col.) (Smithsonian
publication 4653)
Cat.of exh.,Sep.15-Nov.14,1965 in the Arts
& Industries Bldg.

Index of artists

LC N7593.N213

N
7593
N5
1974X
NPG
Ref.

I.D - U.S.

New York Historical Society
Cat.of American portraits in the New York
Historical Society.New Haven;publ.for the N.Y.
Hist.Soc.by Yale Uni.Press,1974
2 v. illus.(2 col.)

Bibliography
Incl.:Index of artists

2420 portrs.by or of Americans:ptgs.,mini-
atures,silhouettes,marble,plaster etc.,arranged
alphabetically by sitter.

NPG

I.D - U.S.

National Portrait Gallery, Washington, D.C.
Portraits from The Americans:The Democratic
Experience; an exh....based on Daniel J.Boor-
stin's...book,with excerpts from the text and
a new intro. N.Y.,Random House.1975.
159 p. illus.

Foreword by Marvin S.Sadik

Exh.Nov.14, 1975 - Sept.6, 1976

LC E169.1.N3745 1975

704.942
N532

I.D - U.S.

New York historical society
Catalogue of American portraits in the New York
historical society:oil portraits,miniatures,
sculptures. New York city,the New York histori-
cal society,1941
374 p. illus.

LC N7593.N37

759.1
.N535 I.D - U.S.

New York. Metropolitan museum of art.
...Life in America;a special loan exhibition
of paintings held during the period of the New
York World's fair,April 24 to Oct.29 ,1939,.
New York.Scribner press,1939.
230 p. illus.

"A visual account of life in America",by
H.B.Wehle

705
A786
v.34 I.D - U.S.

Sayre, Ann Hamilton
Portrait painting in America today and its
ancestry

In:Art N
34:5,7 Apr.18,'36 illus.

Exh.at Downtown Gall.,New York,Apr.-May 2,'36
Repro.Anonymous,1810,Karfiol,Fiene,Brook,
Laurent,Zorach
Contemp.portraitists were represented by a
commissioned portr.& an independently ptd.one.
see over
Lipman.Amer.prim.ptg.759.1
L76 Bibl.p.142

I.D - U.S.

New York, Metropolitan museum of art
Portrait in history.Filmstrip..Chicago,Rand
McNally,c.1970

LC .N7628.

FOR COMPLETE ENTRY
SEE MAIN CARD

N
7621
Y18
NPG I.D - U.S.

Yale University
Yale University portrait index,1701-1951.
New Haven,Yale University Press,1951
185 p. illus.

Subject entries followed by index of artists

LC N590.A62

Whitehill.The Art in early
Amer.Hist.Z5935.W59 NPG
p.102

757
.P41 I.D - U.S.

Pennsylvania. University
Portraits in the University of Pennsylvania;
edited by Agnes Addison. Philadelphia,University
of Pennsylvania press,1940
67 p. illus.

LC N7593.P45

Fogg,v.11, p.328

757.9
.B69
NCFA I.D - U.S. - COLONIAL

Bolton, Charles Knowles, 1867-
The founders; portraits of persons born
abroad who came to the colonies in North America
before the year 1701, with an introduction,biogra-
phical outlines and comments on the portraits.
.Boston.The Boston athenaeum,1919-26

3 v. illus.

LC E187.5.B69

N
7593
P98
1969
NPG I.D - U.S.

Purdy, Virginia C
Presidential portraits,compiled and written
by Virginia C.Purdy and Daniel J.Reed...Washing-
ton,Published for the National Portrait Gallery
by the Smithsonian Press,1969
76 p. illus. (Smithsonian publication
4748)
First published 1968

LC N7593.P84

N
7593.1
B74
NPG I.D - U.S. - COLONIAL

Boston, Museum of fine arts.
...Loan exhibition of one hundred colonial
portraits...19 June-21 Sept.,1930..Boston?1930.
4 p. illus.(100 pl.)

Preface signed:Philip Hendy
Letter dated Oct.17,1965 from Mrs.Haven Parker
regarding portraits now considered suspect.

LC N7593.B65

W
7593.1
S19
NPG Ref. I.D - U.S.
NPG

Samuel, Bunford, 1857-
Index to American portraits .which were
published 1732-1852. Philadelphia,1901.
47-70,228-247,384-399 p

I.D - U.S. - COLONIAL

N
7593.1
C73
1986X
NPG Craven, Wayne
Colonial American portraiture.The econo-
mic,religious,social,cultural,philosophical,
scientific,and aesthetic foundations.Cambridge
University Press,1986
459 p. illus.

Bibliography,p.437-50

529.2
A20558
NPG

I.D - U.S. - COLONIAL

Glenn, Thomas Allen, 1864-
Some colonial mansions and those who lived
in them....1st-2d series.Philadelphia,H.T.
Coates,1857-59
2 v. illus.

LC E159.056

Winterthur Mus.Libr. fZ881
.W78 NCFA v.6,p.221

920 I
W31B78
NPG

I.D - U.S. - 18th c.

Bowen, Clarence Winthrop, 1852-1935, ed.
Notes on portraits

In,his,History of the Centennial celebration of
the Inauguration of George Washington

Chapter 22,pp.417-551 illus.

Sitters(people of the time of Washington,
are listed alphabetically with notes on each port

LC E312.6.B785

Kimball,S.F. N7628.J45K4
footnote,p.497 'The life
portrs.of Jefferson...

757
.G87
(RB)

I.D - U.S. - COLONIAL

Griswold, Rufus Wilmot, 1815-1857
The republican court or American society in
the days of Washington.With 21 portraits of dis-
tinguished women,engraved from original pic-
tures by Wollaston,Copley,Gainsborough,Stuart,
Peale,Trumbull,Pine,Malbone,and other contempo-
rary painters.N.Y.,etc.,D.Appleton & Co.,1855
408 p. illus.

Winterthur Mus.Libr. fZ881
W78 NCFA v.6,p.223

E302.5
C5
1989X
NPG

I.D - U.S. - 18th c.

Christman, Margaret C.S.
The first federal Congress,1789-1791...
Washington City:Smithsonian Inst.Press for the
NPG & the U.S.Congress,1989
375 p. illus(part col.)

Index
Bibliography,p.366-70

An exh.at the NPG,March2-July 23,1989

I.D - U.S. - COLONIAL

Smith, John Chaloner, 1827-1895
Twelve portraits of persons connected dur-
ing the last century with the States of America
(chiefly in their Colonial period)...from the
original mezzotint engravings in the coll.of
N.Y.P.L. J.Ch.Smith.London,H.Sotheran & co.,1884
3-AOW 2 p. 12 portrs. (American series)
Avery coll.

I.D - U.S. - 18th c.

Colonial Williamsburg,inc.
They gave us freedom;the American struggle
for life,liberty,and the pursuit of happiness,
as seen in portraits,sculptures,historical
paintings and documents of the period:1761-1789
.Williamsburg,Va.,Colonial Williamsburg and the
College of William & Mary in Va.,1951.
65 p. illus(1 in color)

Cat.of the exh.,held May-June 1951,:p.61-5
Index to artists & subjects

LC E302.5C64

Winterthur Mus.Libr. fZ881
W78 NCFA v.6,p.222

CT
275
J45E9
NPG.

I.D - U.S. - 18th c.

Adams, William Howard ed.
The eye of Thomas Jefferson.,Exh.,Washing-
ton,D.C.,NGA,1976
411 p. illus(part col.)

Incl.:Index

Bibliography

Exh.,June 5-Sept.6,1976.

LC E332.2.F88

Penn.Hist.Soc. Rembrandt
Peale...Bibl.p.117

NE
506
C92
1977a
NMAA

I.D - U.S. - 18th c.

Cresswell, Donald Howard, 1941-
Prints of the American Revolution:a histo-
ry and checklist of graphics produced from
1765-1790. 1977
606 p. illus.

Bibl.references
Reference sources,p.597-605
Thesis Ph.D.-Geo.Washington Univ.,1977
Photocopy of typescript
Pt.I,Ch.V a:Portraits,p.63-73
Pt.II,Ch.I:Portraits,p.140-2

E
249
P49
1983X
NPG

I.D - U.S. - 18th c.

Barber, James, 1952-
Blessed are the peace makers,a commemora-
tion of the 200th anniversary of the Treaty of
Paris.,Cat.,by James C.Barber and Frederick S.
Voss.Washington,Publ.for the Nat'l Portr.Gall.
by the Smithsonian Inst.Press,1983
47 p. illus(part col.)

An exh.at the Nat'l Portr.Gall.,Sept.3
through Nov.27,1983

I.D - U.S. - 18th c.

Du Simitière,.Pierre Eugène,ca.1736,-1784
Portraits of the generals,ministers,magis-
trates,members of Congress,and others,who have
rendered themselves illustrious in the revolu-
tion of the United States of North America.
Drawn from the life by M.D.simitier...and en-
graved by the most eminent artists in London.
London,.Wilkinson and W.Debrett,1782
2 p. 13 portrs.

Incl.:Washington, John Jay
'Set was signed P.P.F.'-Donnell

LC E206.D97

I.D - U.S. - 18th c.

Du Simitière, Pierre Eugène, ca.1736-1784
Thirteen portraits of American legislators,
patriots,and soldiers,who distinguished them-
selves in rendering their country independent;
...drawn from the life by Du Simitère...and en-
graved by Mr.B.Reading.London,E.Richardson
.1783.
13 plates

Incl.:Washington, John Jay

MB WJP MH CtY MiU-C Winterthur Mus.Libr. Z881
 PPL .W78 NCFA v.9,p.226

AP
1
A51A64 Miles, Ellen G.
NCFA Portraits of the heroes of Louisbourg,1745-
v.15 1751

In:Am Art J
15:48-66 Winter,'83 illus.

Bibl.notes
Repro.incl.:John Smibert,Ths.Hudson,Rbt.
Feke;Mezzotints by Peter Pelham,John Faber and
Js.McArdell

R
206
F59 Flexner, James Thomas, 1908-
1975X The face of liberty:founders of the U.S.,by
NPG J.Th.Flexner;biographies of sitters and pain-
 ters by Linda Bantel Samter.1st ed. N.Y.,Potter,
 c.1975
 310 p. illus(part col.)

Incl.a cat.of an art exh.held at Amon Car-
ter Museum of Western Art,Fort Worth,Tex.

Bibliography
Index

I.D - U.S. - 18th c.

Mitchell, James Tyndale, 1834-1915
The unequalled coll.of engraved portraits
of eminent American and some noted foreign-
ers belonging to Hon.James T.Mitchell...a
large coll.of lithographs engraved by A.Newsam
an unique coll.of American revolutionary and
political caricatures and numerous portraits
for extra illustrating,to be sold...Oct.28,
1913.Phila.,Pa..Stan v.Henkels,1913.
56 p. Plates
Cat.Stan v.Henkels,no.944,pt.13

LC Z999.H505 no.944,pt.13 Rosenwald coll.

705
A784 Halsey, Richard,Townley,H.aines, 1865-1942.
NCFA Ceramic Americana of the 18th century
v.4

In:Art in Am
4,Pt.1:85-98 Feb.,1916 illus.
 Pt.2:224-32 June,1916 illus.
 Pt.3:276-88 Aug.,1916 illus.
5,Pt.4:41-56 Dec.,1916 illus.
Repro.incl.:Chelsea porcelain statuettes:Wm.Pitt
John Wilkes,Catharine Macaulay. Wedgwood medal-
lions of Franklin,Washington,Marie Antoinette,
etc.etc.

705
A56
NCFA Mongin, Alfred
v.88 Forgotten founding fathers

In:Antiques
88:516-21 Oct.,'65 illus.

Repro.Incl.all commissioners to the Stamp
Act Congress,1765:John Dickinson;Eliphalet Dyer,attr.to
Wm.Johnston;Christopher Gadsden,attr.to Jeremiah
Theus;Wm.Sam.Johnson,by Ths.McIlworth;Phil.Li-
vingston,by Ths.McIlworth;Rbt.Livingston,attr.
to J.Wollaston,jr.;Oliver Partridge,tombstone por
trait;John Rutle dge,by J.Trumbull;

N
40.1
T86J2 Jaffe, Irma B.
NPG John Trumbull,patriot-artist of the Ameri-
 can Revolution.Boston,N.Y.,Graphic Society,
 1975
 346 p. illus(part col.)

Incl.:Index
Bibliography

Incl.:Cat.of illustrated works by Trumbull
Ch.1:Portrait(3 portrs.of Washington
 Carolina Art ass.,Charles-
 ton,S.C. Miniature portr.
 coll).
 Bibl.p.179

I.D - U.S. - 18th c.

E302.5
M27
1975 National Portrait Gallery,Washington,D.C.
NPG Historian's Office
 The dye is now cast;the road to American in
 dependence,1774-1776.Text by Lillian B.Miller
 and the staff of the Historian's Office.Russell
 Bourne,editor.Washington,publ.for the NPG by the
 Smithsonian Inst.Press,1975
 328 p. illus.
 Index
 Bibliography,p.295-304
 Exh.at NPG, 15-Nov.16,1975

I.D - U.S. - 18th c.

Maggs Bros., London
Choice engravings of American historical im-
portance(Portraits of famous American and Bri-
tish officers,statesmen and others connected
with the war of Independence)Rare political car-
toons,emblems....Washington portraits.Selected
from the stock of Maggs Bros...London,1909
23 p. illus.

At head of title:No.249 237 items

CSmH Levis,Descr.bibl.Z5947.A3
 L86 1974 NCFA p.212:"parti-
 cularly interesting list"

CT
275
W36N4 Nelson, Paul David, 1941-
NPG Anthony Wayne,soldier of the early Repub-
 lic.Bloomington,Ind.Univ.Press,c.1985
 368 p. illus.

Bibl.p.341-57

Repro.incl.:Edward Savage,John Trumbull,
Js.Peale,Chs.Willson Peale,c.B.Lambdin,Alonzo
Chappel,Js.Sharples,Henri Louis

I.D - U.S. - 18th c.

Philadelphia museum
Historical cat.of the paintings in the Phi-
ladelphia museum consisting chiefly of portraits
of revolutionary patriots and other distin-
guished characters..Phil.,1813

LC N25.M7 no.8 FOR COMPLETE ENTRY
 SEE MAIN CARD

N
40.1
T86Y18 I.D - U.S. - 18th c.
1864
RB Yale University
NPG Catalog of paintings by Colonel Trumbull
 including 8 subjects of the American Revolu-
 tion,with near 250 portrs.of persons distin-
 guished in that important period...on exh.in the
 picture gall.of Yale College...5th ed.1864(New
 Haven,Conn.,E.Hayes)
 35 p.

 Archives of American Art
 Portraits

I.D - U.S. - 18th c.

Sanderson, John, 1783-1844 ed.
 Biographies of the signers to the Declara-
tion of independence...Phila.,R.W.Pomeroy,1820-
1827
 9 v. illus.

LC E221.S21 Cirker.Dict.of Am.portrs.
 N7593C57NPG Ref. Bibl.

N
7593.1
A38 I.D - U.S. - 18-19th c.
NPG
 Alexandria Association
 Our town:1749-1865;likenesses of this place
 & its people taken from life,by artists known
 and unknown..Exhibition,...Apr.12-May 12,1956
 .1st ed. Alexandria,1956.
 114 p. illus.

LC N7593.A27

qE
209
U54 I.D - U.S. - 18th c.
1975X
NMAA U.S. Library of Congress
 The American Revolution in drawing and
 prints,a checklist of 1765-1790 graphics in
 the L.C. Comp. by Donald H.Cresswell,with a
 foreword by Sinclair H.Hitchings.Washington,
 1975
 455 p. illus.

 Bibliography p.414-22

mfm
184 I.D - U.S. - 18-19th c.
NPG
 Andrews, William Loring, 1837-1920
 An essay on the portraiture of the American
 revolutionary war...a number of...engraved por-
 traits...appendix:lists of portraits of revolu-
 tionary characters...in English and American pu-
 blications of the 18th and early 19th c....
 New York,Printed by Gillis brothers...sold by
 Dodd,Mead & co.,1896
 100 p. illus.

LC E209.A53 Ide.Portrs.of John Jay
 CT275/J42/I1 NPG
 Bibl.

I.D - U.S. - 18th c.

Whitmore, William Henry, 1836-1900
 Notes concerning Peter Pelham,the earliest
artist resident in New England and his succes-
sors prior to the Revolution.Cambridge,Press
of J.Wilson & son,1867
 31 p.

 Repr.with additions fr.the Proc.of the Mass
hist.soc,1866-67

LC N6515.W5 Dresser.Backgr.of Col.Amer.
 portraiture ND1311.1.D77
 NPG p.15

N
6507
M98 I.D - U.S. - 18-19th c.
1950
NMAA Boston. Museum of Fine Arts
 Eighteenth-century of American arts,the
 M.& M.Karolik coll.of paintings,drawings,en-
 gravings,furniture...gathered to illustrate
 the achievements of American artists and
 craftsmen of the period from 1720 to 1820 by
 Edwin J.Hipkiss.With notes on drawings and
 prints by Henry P.Rossiter,and comments on
 the coll.by Maxim Karolik.Cambridge,Mass.Publ
 for the MFA,Boston,Harvard Univ.Press,1950
 366 p. illus.
 Bibliography Worldwide Art Book:Biblio-
 graphy 25931.W92 NMAA 2,
 no.2-4 1967-71,v.III,no.1
 p.18

E
221
W57X I.D - U.S. - 18th c.
NPG
 Whitney, David C.
 Founders of freedom in America;lives of the
 men who signed the Declaration of Independence...
 Chicago,J.G.Ferguson Publ.Co..1964.
 253 p. illus(part col.)

N
7593
B88 I.D - U.S. - 18-19th c.
NPG
 Brown University. Dept.of Art.
 The classical spirit in American portrai-
 ture;an exhibition.Providence,R.I.,1976
 120 p. illus.

 Held at the Bell Gallery,List Art Bldg.,
 Feb.6-29,1976

 Bibliography

N
40.1
F43C7
NPG
3 c.

I.D - U.S. - 18-19th c.

Corcoran Gallery of Art, Washington, D.C.
Cat.of engraved portraits by Favret de
Saint Memin,1770-1852,in the permanent coll. of
the Corcoran gallery of art,Washington,D.C.
,Washington,W.F.Roberts co.,19--,
17 p.

LC NE650.F4C6

N
40.1
P35M3
NCFA

I.D - U.S. - 18-19th c.

Maryland Historical Society
Four generations of commissions:The Peale
coll.of the Maryland Historical Society.Exh.
3 Mar-29 June 1975.By Eugenia Calvert Holland
,et al.,Baltimore,Md.,Maryland Hist.Soc.,1975
187 p. illus.

126 works shown
Bibliography
Incl.:ptgs.,drags.,miniatures...,silhouettes
by 11 Peale artists

Rila Z5937.R105 NCFA
II/1 1976 #1978

AP
1
A788
v.7

I.D - U.S. - 18-(early)19th c.

Goodrich, Lloyd, 1897-
Early American portraits;an exhibition at
Dudensing Galleries

In:The Arts
7:46-7 Jan.,'25 illus.

N
7621
P51380
1855
NPG

I.D - U.S. - 18-19th c.

Philadelphia. Independence hall
Catalogue of the national portraits in Inde-
pendence hall,comprising many of the signers of
the Declaration of Independence and other dis-
tinguished persons...Philadelphia,John Coates,
1855
24 p.

I.D - U.S. - 18th c. - 19th c.

Henkels, Stanislaus Vincent, 1854-1926
Cat..of.oil portraits of Washington,
Lafayette,Lincoln...and other eminent Americans
...mezzotintos and stipples...original copper
plates...sold...Mar 27,1919...,by.Stan.V.
Henkels...Philadelphia,1919,

MET
276
H38

26 p. illus.

263 items (no.1232)

Met.Sales cat. fZ881.N53
NCFA v.25,p.023316

NPG
Ref.
coll.

I.D - U.S. - 18-19th c.

President Monroe's message.A cat.accompanying
an exhibition commemorating the 150th anni-
versary of the Monroe Doctrine 1823-1973.Washing-
ton,Publ.for the Nat'l Portr.Gall.by the Smith-
sonian Institution Press...1974
128 p. illus.

Prepared by O.Z.Levin & J.M.Hussey
Bibliography

Exh.Dec.3,1973 -

LC JX1425P83

705
A56
NCFA
v.108

I.D - U.S. - 18-19th c.

Jones, Karen M.
Museum accessions

In:Antiques
108:78-79 July,'75 illus.

Acquisitions made by the NPG in the past
two years
Repro.incl.:John Jay by G.Stuart and J.
Trumbull;P.Revere,Th.Jefferson by Févret de
Saint-Mémin;John Marshall by Wm.Hubard;Washing-
ton,Martha Washington by Rembrandt Peale

N
40.1
P74835
NCFA

I.D - U.S. - 18-19th c.

Simmons, Linda Crocker
Charles Peale Polk,1776-1822.A limner and
his likenesses...Washington,D.C.Corcoran Galle-
ry of Art,1981
92 p. illus(part col.)

Cat.of exh.at the Corcoran Gallery of Art,
July 18-Sept.6,1981,and at four other museums,
Sept.27,1981-Oct.15,1982

Incl.Bibl.references & index
Alphabetical list of sitters

705
A784
NCFA
v.38

I.D - U.S. - 18-19th c.

MacFarlane, Janet R.
Portraits

In:Art in Am.
38:90 Apr.,'50 illus.

Ptgs.in N.Y.State histor.assoc'n's Feni-
more House,Cooperstown,N.Y.

Repro.with captions incl.:B.West,G.Stuart,
S.F.B.Morse,E.Ames,R.Earl,Js.Peale

NPG
filed
NCFA
Ref.
coll.

I.D - U.S. - 18-19th c.

Smithsonian Institution
Profiles of the time of James Monroe,1758-
1831;an exhib.commemoration the 200th anniversary
of the birth of the 5th pres.of the U.S.,Oct.26-
Nov.23,1958.Washington,1958.
,29,p. illus. (Smithsonian publication
no.4348)

Cat.signed:Ths.M.Beggs

Exhib.held in the Natural History Bldg.

LC E372.S56 Fogg,v.11,p.330

E221
US5X
NPO
NCFA

I.D - U.S. - 18-19th c.

U.S.Constitution sesquicentennial commission
Loan exh.of portrs.of the signers and depu-
ties of the convention of 1787 and signers of
the Declaration of Independence,incl.their fa-
milies and associates...The Corcoran gall.of
art,city of Washington,Nov.27,1937-Feb.1,1938
₍Washington,1937₎
173 p. illus.

LC E221.U55

705
A56
NCFA
v.110

I.D - U.S. - 19th c.

Demer, John H.
The portrait busts of John H.I.Browere

In:Antiques
110:111-7 July,'76 illus.

"B.spent more than $12000.-attempt'g.with-
out success to establish a Nat'l Gall.of Busts
and Statues."-Demer

Incl.H.Clay;Ths.Jefferson;Js.Madison;Dolley
Madison;J.Adams;Lafayette;M.van Buren;J.Q.Adams..
Checklist of ₍B.'s sculptures

708.1
U61

I.D - U.S. - 18-19th c.

U.S. National gallery of art
The Thomas Jefferson bicentennial exhibi-
tion,1743-1943.April 13-May 15,1943....Washing-
ton, D.C.,Press of Gibson brothers,inc.,1943₎
₍11₎p. illus.

Grosvenor libr.for
LC E332.U6

Kimball.Life portrs.of Jef₋
ferson...N7628.J45K4,p.497

708.1
N52
NCFA

I.D - U.S. - 19th c.

Gardner, Albert Ten Eyck
A century of Women

In:Met Mus Bul
N.S.7:110-8 Dec.'48 illus.

Repro.incl.Miniature of Mrs.Coudry by
Sarah Goodridge.Rosa Bonheur by Anna Elisabeth
Klumpke.Mural & portrs.by Mary Cassatt.Front-
ispiece fr."Godey's Lady's Book";Portr.within
portr.

Dewhurst.Artists in aprons
Bibl.p.34

N
40.1
B878B4
NCFA

I.D - U.S. - 19th c.

Bennett, James O'Donnell, 1870-
The mask of fame;the heritage of historical
life masks made by John Browere,1825 to 1833
₍by₎...and Everett L.Millard. ₍Highland Park,Ill.
The Elm press₎c.1938₎
29 p. illus.

Bibliography

LC NB237.B7B4

NB
1310
H32
NPO

I.D - U.S. - 19th c.

Hart, Charles Henry, 1847-1918
Browere's life masks of great Americans, ...
₍New York.Printed at the De Vinne press for
Doubleday and McClure company,1899
123 p. illus.

LC NB1310.H3

I.D - U.S. - 19th c.

Brady, Mathew B., 1823-1896
Brady and Handy's album of the 50th Con-
gress of the U.S....designed and published
by M.B.Brady and Levin C.Handy.Washington,1888
₍84₎p.of mounted photos
illus.

LC.JK1059 50th .B8.MnHi

705
A56
NCFA
v.110

I.D - U.S. - 19th c.

Jensen, James F.
19th c.American ptg.& sculpture at the
State Historical Society of Wisconsin
Antiques
American painting ₍special issue₎
110:965-1070, Nov.,1976 illus(part col.)
Chiefly 18th-19th century
Partial contents:...Js.F.Jensen,19th c.Amer.
ptg.& sculpt.at the State Hist.Sec.of Wisconsin,
p.1012-19;...

731
.887
NB
237
B7F6Y
NPO

I.D - U.S. - 19th c.

Browere, John Henri Isaac, 1792-1834
Life masks of noted Americans of 1825...
exhib.,Feb.12-24,1940 under the sponsorship of
the New York state historical association,Coo-
perstown,New York.N.Y.,M.Knoedler and cy.₍1940₎
6 p. illus.

Foreword signed:Dixon Ryan Fox

LC NP237.B7F6

Kimball.Life portrs.of Jef
ferson..N7628.J45K4,p.532
NPO NCFA

I.D - U.S. - 19th c.

Lester, Charles Edwards, 1815-1890, ed.
The gallery of illustrious Americans,con-
taining the portraits...of 24 of the most emi-
nent citizens of the American republic,since
the death of Washington.From daguerreotypes by
Brady...by d'Avignon.N.Y.,M.B.Brady,F.d'Avig-
non,C.E.Lester,1850
3 p. illus.

₍Only 12 lithographs were completed.NPO Print
Dpt.Brady,M.B.The Gallery of illustrious Ameri-
cans,12 biographies₎

NPO
Print Dpt.
LC E302.5.147 Rare book

qCT
275
L73L8/
1969
NPG

I.D - U.S. - 19th c.

Lorant, Stefan, 1904-
Lincoln;a picture story of his life.Rev.
& enl.ed.N.Y.,Norton & Co.,Inc.:1969:
336 p. illus.

Repro.ptgs.,life masks,photographs
Contents & Bibliography. Index

Appendix...B:The photographer of Lincoln...
G:All of Lincoln's photographs in chronological
order

LC F457.6.L78 1969

qNC
910.5
E3 O44X
NPC

I.D - U.S. - 19th c.

Oliver, Andrew, 1906-
Auguste Edouart's silhouettes of eminent
Americans,1839-1844.Publ.for the NPG,Smiths.
Institution by Uni.Press of Virg.,Charlottes-
ville,1977
c553:p. illus.

Appendix:"Cat.of 3800 named & dated Ameri-
can silhouette portrn by August Edouart"by
F.Jackson.Mrs.F.Nevill.
Intro.by A.Hyatt Mayor

LC NC910.5.E3 O44

I.D - U.S. - 19th c.

Meserve, Frederick Hill, 1865-1962
Portraits of the Civil War period,photo-
graphs for the most part from life negatives
by M.B.Brady,now in the possession of F.H.
Meserve..N.Y.Corlies,Macy & Co.,incorp...1903:
36 p. illus.

LC N762h.M4

I.D - U.S. - 19th c.

Reaves, Wendy Wick, 1950-
Heroes,martyrs and villains;printed por-
traits of the Civil War

In:Print Council of America.Newsletter 1983
:8-12 Spring 1983,no.5

Pertains to exh.in the NPG,Sept.10,'82-
Apr.3,'83
Printed portrs.,sometimes based on photo-
graphs,were published as propaganda & as news.
Sometimes different heads were substituted on
the same body.

705
A784
NCFA
v.38

I.D - U.S. - 19th c.

Millard, Everett Lee
The Browere life masks

In:Art in Am.
38:69,71,74,76,78,80 Apr.,'50 illus.

Busts in N.Y.State hist.assoc'n's "Hall of
Life Masks"in Fenimore hse.,Cooperstown,N.Y.

This article is drawn fr.Millard's ms of a
life of J.H.I.Browere
Arts in America qZ5961.U5
A77X NCFA Ref. I72

I.D - U.S. - 19th c.

Strachey, Giles Lytton, 1880-1932
Eminent Victorians:Cardinal Manning,
Florence Nightingale,Dr.Arnold,General Gordon
N.Y.,Harcourt Brace & World,inc.c.1969
351 p. illus.
Incl.:Bibliographies

MdBP 'MCU-G CClCo
ODall etc.

NPG
7

I.D - U.S. - 19th c.

National Portrait Gallery, Washington, D.C.
A 19th-century gallery of distinguished
Americans..Exhibition 22 Feb.-1 May,1969.Cata-
logue by Robert G.Stewart.Washington,Published
for the National Portrait Gallery by Smithsonian
Institution Press...1969
93 p. illus. (Smithsonian publication
no.4762)
Bibliography.

An exhib.of most of the originals of portrs.
which were repro.

I.D - U.S. - 19th c.

U.S. 41st Cong.3d sess.House of Representatives
Report no.46,Mar3,1871
Brady's coll.of historical portraits

FOR COMPLETE ENTRY
SEE MAIN CARD

709.73
N575
NCFA
NPC

I.D - U.S. - 19th c.

Newark Museum Association, Newark,N.J.
Classical America,1815-1845.An Exh....
April 26 through Sept.2,1963.Newark,1963.
212 p. illus.

Essay "The Fine Arts"by Wm.H.Gerdts incl.
careers,styles,themes of this era's major prac-
titioners of portrs.,miniatures,etc.,p.166-205
with bibliography p.211-12

Arts in Am.q Z5961.U5A77X
NCFA Ref. I340

CT
275
L73W7
NPG

I.D - U.S. - 19th c.

Wilson, Rufus Rockwell, 1865-1949.
Lincoln in caricature; a historical collection, with descrip-
tive and biographical commentaries by Rufus Rockwell Wil-
son. Introd. by R. Gerald McMurtry. New York, Horizon
Press, 1953.

xix, 327 p. 168 illus. 26 cm.

1. Lincoln, Abraham, Pres. U. S.—Cartoons, satire, etc.

E457.63.W752 1953 923.173 53-9939

Library of Congress

705
M18
NCFA
v.37

I.D - U.S. - 19-20th c.

Kirstein, Lincoln, 1907-
American battle art:1588-1914.II.Portraits
and popular myths.

In:Mag.of Art
37:146-51 Apr.,'44 illus.

Repro.:Portrs.by Mendenhall,Chs.Baskerville,
Rbt.Weir. Busts by Saint Gaudens,Epstein

Cumulated Mag.subj.index
A1/3/C76 Ref. v.2,p.443

705
A784
NCFA

I.D - U.S. - 20th c.
Coldin, Amy
The Post-perceptual portrait

In:Art in Am
63:79-82 Jan.-Feb.,'75 illus.

"In its recent expansion into psychological &
narrative areas,Conceptual art has been drawn
back to the magnetic theme of human likeness.
While these examples are not portrs.in any tra-
ditional sense,they deal with appearance and/or
personality,showing that the impulse to depict
people persists even in seemingly inhospitable
forms."

757.9
.U58

I.D.- U.S.-- 19-20th c.

U.S. National gallery of art
Makers of history in Washington,1800-1950;
an exhibition celebrating the sesquicentennial
of the establishment of the Federal Government
in Washington,June29-Nov.19,1950.Washington,
,1950.
174 p. illus.(part col.)

Incl.complete coll.of portrs.of the presi-
dents of the U.S.

LC N5020.M45 Fogg,v.11,p.330

705
A784
NCFA

I.D - U.S. - 20th c.

Henry, Gerrit
The artist and the face:A modern American
sampling

In:Art in Am
63:34-41 Jan.-Feb.,'74 illus.(part col.)

Interviews with 10 artists"suggest that all
employ portr.making as a means to an end...They
use the portrayal of others as a means of dis-
placed self-portraiture."
Artists interviewed are:Elaine de Kooning,
Geo.Segal,A.Katz, Ph.Pavia,A.Leslie,S.Sleigh,
Geo.Schneeman,A. Neel,H.Sterne,Ch.Close

E747
B37
1983X
c.1-2

I.D - U.S. - 20th c.(New Deal)

Barber, James, 1952-
Portraits from the New Deal;an exh.at the
NPG,March4-Sept.7,1983;by Js.G.Barber and Fre-
derick S.Voss.Washington,publ.for the NPG by the
Smiths.Inst.Press,c.1982
40.p. illus.

223
MB
1985X
NPAA

I.D - U.S. - 20th c.

Munson, Gorham Bert, 1896-1969
The awakening twenties.A memoir-history
of a literary period.Baton Rouge,Louisiana
State Univ.Press,c.1985
317 p. illus.
Repro.incl.:Leading personalities of the
20th c.

Bibliography
Index

I.D - U.S. - 20th c.

Benedict, Brad comp.
Fame...N.Y.,Harmony Books,c.1980
119 p. illus(part col.)

Portraits,caricatures & cartoons

LC NC998.5.A1F35 1980 Books in print.Subject
guide,1985-6,v.3,p.4864

N
7593.3
N27
NPG

I.D - U.S. - 20th c.

National Portrait Gallery, Washington, D.C.
Portraits of American newsmakers,commissioned
for the cover of Time,the weekly newsmagazine;
,exh.,National Portrait Gallery,Smithsonian Inst.
Washington, D.C.,May 23-Aug.24,1969
,24,p. illus.

List of cover subjects.

Incl.photographs of some portraitists

LC N7593.N217

NPG
1984
Ref.

I.D - U.S. - 20th c.

Cox, Beverly J.
Miguel Covarrubias caricatures;by,B.J.Cox
and Denna Jones Anderson.Cat. of an exh.,held
at the NPG,Washington,D.C.,Nov.16,1984 to Jan.
13,1985.Publ.for the NPG by the Smiths.Inst.
Press,1985
163 p. illus(part col.)
Incl.:Index

bibliography
Foreword by Alan Fern.Incl.essays by Al
Hirschfeld & by Bernard C.Reilly,jr.

LC NC1460.C68A4 1984

N
7593.3
N53
NPG

I.D - U.S. - 20th c.

New York. New School of Social Research. New
School Art Center.
Portraits from the American art world.,Exhi-
bition,Feb.2-27,1965.,New York,1965,
,64,p. illus.

LC N7593.N47

N
6530
C8F87
NCFA

I.D - U.S. - CONNECTICUT

French, Henry Willard, 1854-
...Art and artists in Connecticut...Boston,
Lee & Shepard;N.Y.,C.T.Dillingham,1879
176 p. illus. (The pioneers of art in
America)

Biographies of many ptrs.& sculptors.

LC N6530.C8F8

Weddell.A mem'l vol.of Va.
hist.portraiture.757.9.W38
NCFA Bibl. p.435

ND
1311.8
I 8N27
NPG

I.D - U.S. - IOWA - 19th c.

National Society of the Colonial Dames of America.
Iowa
Portraits in Iowa;portraits of Americans,
made before 1900 and now located in Iowa.Limited
ed.,s.l.,:National Soc.of the Col.Dames of Ameri-
ca in the State of Iowa,1975
171 p. illus.

Incl.:Index by artist. Washington by
Gilbert Stuart;by Jane Stuart;reversed ptg.on
glass by unknown artist. All forms of original,
one-of-a-kind portraiture. Portrs.drawn or ptd.
over photographs.

N
7593
H67
NPG

I.D - U.S. - CONNECTICUT

Historical Records survey. Connecticut.
Preliminary checklist of American portraits,
1620-1825,found in Connecticut.
,n.p.,193-?,

Records sitter,artist,media,collection

ND
1311.8
I 8N27
Suppl.
NPG

I.D - U.S. - IOWA - 19th c.

National Society of the Colonial Dames of Ame-
rica. Iowa
Portraits in Iowa;portraits of Americans,
made before 1900 and now located in Iowa:a
supplement to the 1975 edition,Des Moines?,
1982
21 p. illus.

Incl.:Index by artists

LC N7593.N25 suppl.

N
6530
C8S55
NCFA

I.D - U.S. - CONNECTICUT

Sherman, Frederic Fairchild, 1874-1940
Early Connecticut artists and craftsmen.
N.Y.,Priv.print,1925
78 p. illus.

Bibliography
Lists cover period from 1600-1875
Miniature painters,p.33-4, Portraits in
oils,p.45-8, Sculptors,p.59

LC N6530.C8S5

Weddell.A mem'l vol.of Va.
hist.portraiture.757.9.W38
NCFA Bibl. p.438

927
.P94

I.D - U.S. - KENTUCKY

Price, Samuel Woodson, 1828-
...The old masters of the Bluegrass;Jouett,
Bush,Grimes,Frazer,Morgan,Hart...Louisville,Ky.
J.P.Morton & co.,1902
181 p. illus. (Filson club publ.,no.17)

Jouett,Matthew Harris,1788-1827;Bush,Jos.
Henry,1794?-1865;Grimes,John,1799-1837;Frazer,
Oliver,1808-1864;Morgan,Louis M.,1814-1852;
Hart,Joel Tanner,1810-1877,
Incl.cat.of Jouett's pictures & their owners

LC N6530.K4P8
F446.F48

Weddell.A mem'l vol.of Va.
hist.portraiture.757.9.W38
NCFA bibl. p.438

N
7593.8
D3D34
NPG

2 c.

I.D - U.S. - DELAWARE

Delaware. State portrait commission
Cat.of Delaware portraits collected by the
Delaware State portrait comm.in the capitol
buildings.Dover,Del.,Delaware portr.comm.,1941
64 p. illus.

Incl.:Index of artists and sitters

Repro.incl.:Washington,by Volozan

LC F163.D34 1941

Winterthur Mus.Libr.
fZ881.W78 NCFA v.6,p.225

N
40.1
H4 3G5
NPG

I.D - U.S. - LOUISIANA

Glasgow, Vaughn L.
G.P.A.Healy:famous figures and Louisiana
patrons.,Exh.,the Louisiana State Museum,Dec.
1976-May 1977.Cat.by Vaughn L.Glasgow and
Pamela A.Johnson.,New Orleans,The Museum,c.1976
74 p. illus.(part col.)

32 works shown

Bibliography

LC ND1329.H4G58

Rila IV/1 * 2914
1978

I.D - U.S. - IOWA

Iowa. Historical,Memorial & Art Department
Historical portrait collection in Iowa his-
torical department

In:Annals of Iowa
9:535-8 Jul.-Oct,'10

Cumulated Mag.subj.index
A1/3/C76 Ref. v.2,p.444

705
A56
NMAA
v.124

I.D - U.S. - LOUISIANA - NEW ORLEANS

Flanary, Sara E.
William Edward West in New Orleans and
Mississippi

In:Antiques
124:1010-15 Nov.,'83 illus(part col.)

Based on Master thesis "The Pre-European
career of Wm.Edw.West in New Orleans & Missis-
sippi.Richmond,Va.,Va.Commonwealth Univ.

N
7593.8
M2H67
NPG

I.D - U.S. - MAINE

Historical records survey. Massachusetts.
American portrait inventory.American por-
traits(1645-1850)found in the state of Maine.
(Preliminary vol.)Comp.by the Mass.Hist.records
survey...Works projects administration.Boston,
Mass.,The Historical records survey,1941
88 p.

Bibliography

Arranged by sitters

LC N7593.H5

E
186.5
B2
NPG

I.D - U.S. - Maryland - BALTIMORE

National Society of the Colonial Dames of Ameri-
ca.Chapter I.Baltimore
Ancestral records and portraits:a compila-
tion from the archives of Chapter I...N.Y.,The
Grafton press,1910.
2 v. illus.

Winterthur.Mus.Libr. fZ881
.W78 NCFA v.6,p.223

MET
119.6
C
1933³

MdBP

I.D - U.S. - MARYLAND

Eden, Sir Timothy Calvert,8th bart., 1893-
Catalogue of important English historical
and family portraits and pictures by the old
masters removed from Windlestone,co.Durham,incl.
the celebrated series of portraits of the Lords
Baltimore,proprietors of Maryland, the property
of Sir Timothy Calvert Eden,baronet of Maryland.
Which will be sold by auction,by Messrs.Sotheby
and co....the 26th of July,1933...London,Printed
by J.Davy & sons,ltd.,1933.
16 p. illus.
(Sotheby & Co.Sale cat.Jl.26,1933)
Priced
Met.Sales cat.fZ881.N53
NCFA p.023316

I.D - U.S. - MASSACHUSETTS

Champney, James Wells, 1843-1903 comp.
Massachusetts artists' Centennial album...
Boston,J.R.Osgood & co.,c.1876
illus.

Compiled by J.W.Champney & F.D.Millet

Pictures sent from Mass.to the Centennial
Exh.in Philadelphia

LC N4825.C5

Weddell.A mem'l vol.of Va.
hist.portraiture.757.9.W38
NCFA Bibl. p.434

ND
1311
M39
NPG

I.D - U.S. - MARYLAND - 18th c.

Maryland Commission on Artistic Property
"In grateful remembrance...":an exh.of por-
traits commemorating the founding of the State
and nation,1770-1788. March-Sept.,1976,State
House,Annapolis,Md. Exh.org.and cat.text written
by Sara B.Hanan.Annapolis,:Md.Comm.on Artistic
Property,1976
130 p. illus.

Bibliography p.111-14

Am.portr.in the grand man-
ner...ND1311.A47X NMAA Bibl.
p.217

N
7593.1
H67
NPG

I.D - U.S. - MASSACHUSETTS

Historical records survey. Massachusetts.
American portraits,1620-1825,found in Mass.
Prepared by the Historical records survey...
Works progress administration.Boston,Mass.,The
Historical records survey,1939
2 v. in one

Bibliography

Arranged by sitters.Index of artists.Index
of locations

LC N7593.H5

AP1
M39
NPG

I.D - U.S. - MARYLAND

Maryland Historical Society
Portraits in varied media in the coll...
by Anna Wells Rutledge

In:Md.Hist.Mag.
41,no.4:282-326 Dec,'46

Sellers.Archives of Amer.
art:Mezzotint prototypes..
In:Art Q 20,no.4,p.460

AP
1
D39
NCFA
v.6

I.D - U.S. - MASSACHUSETTS - BOSTON - 17-18th c.

Dresser, Louisa
Portraits in Boston,1630-1720

In:Detroit.Arch Am Art J.
6,no.3-4:1-34 July-Oct.,'66 illus.

Historical analysis of the limners & their
work in Boston,prior to 1720

LC N11.D513

Winterthur Mus.Library
Z881.W78,v.6 NCFA p.227

VF
St.-Mémin

I.D - U.S. - MARYLAND

Maryland Historical Society
St.Mémin in Maryland;loan exh.of portraits
of "Distinguished characters"in W.C.,crayon and
engraving.Baltimore,1951
15 p. illus.

Exh.Feb.15-Apr.15,1951

Alphabetical list of sitters

Dijon.Mus.municipal N40.1
F43D5 NPG Bibl.p.26

I.D - U.S. - MASSACHUSETTS - ESSEX CY.

Belknap, Henry Wyckoff, 1860-
Artists and craftsmen of Essex County,Mass.
Salem,Mass.,The Essex institute,1927
127 p. illus.

Bibliography
List of painters,engravers..photographers,
sculptors,silhouettists and wax portraits makers,
etc.
Period covered is fr.earliest days to ca.
1860

LC N6530.M4B4

Weddell.A mem'l vol.of Va.
hist.portraiture.757.9.W38
NCFA Bibl.p.433

705
A56
NMAA
v.124

I.D - U.S. - MISSISSIPPI

Flanary, Sara E.
 William Edward West in New Orleans and
Mississippi

In:Antiques
124:1010-15 Nov.'83 illus(part col.)

 Based on Master thesis "The Pre-European
career of Wm.Edw.West in New Orleans & Missis-
sippi.Richmond,Va.,Va.Commonwealth Univ.

I.D - U.S. - N.Y. - ALBANY

Albany Institute of History and Art
 Portrait index of Albany Inst.of Hist.&Art
"Mayors Collection","Ambrose Spencer Manning
Collection","James Manning Collection Albany
Portraits c.1897"
 Unpublished (Typewritten)

 Feigenbaum.Amer.portrs....
 N1311.2.F29 NPG Bibl.
 p.150

N
7593
A512
NPG

I.D - U.S. - NEW ENGLAND

American Antiquarian Society,Worcester,Mass.,
Library
 Checklist of the portraits in the library
of the American antiquarian society;by Frede-
rick L.Weis.Worcester,Mass.,published by the
society,1947
 76 p. illus.

 Reprinted fr. the Proceedings of the Amer.
Antiqu.Soc.for April 1946
 Alphabetical list of artists.
 Incl.:Washington,Franklin;marble busts.Co-
lumbus;oil,mosaic. John Adams;gold on glass

I.D - U.S. - N.Y. - ELMIRA - 19th c.

Arnot Art Museum
 Prominent Elmirans of the 19th century.cat.
of exh.held Nov.20-Dec.19,1971.
 32 p. illus.

 Intro.by Mary-Ellen Earl Perry & Herbert
Davidson
 Arranged in alphabetical order by sitter

757
H68

I.D - U.S. - NEW HAMPSHIRE

Historical records survey. Massachusetts.
 Preliminary checklist of American portraits.
1620-1860,found in New Hampshire.Prepared by
the Historical records survey...Work projects
administration.Boston,Mass.,The Historical re-
cords survey,1942
 30 p.

 Lists sitter,artist description,owner

LC N7593.H52

708.1
C5725
NCFA
v.3

I.D - U.S. - OHIO - CINCINNATI

Siple, Walter Heick, 1890-
 Notes on the exh.of Cincinnati portraits

In:Cincinnati Mus Bul
3:72-84 July,'32 illus.
 109-27 Oct.,'32 illus.

 Exh.:Portrs.of early Cincinnatians held
May 19-June 19,1932 at Cincinnati Art Museum

N
6530
N5G36
NCFA

I.D - U.S. - NEW JERSEY

Gerdts, William H.
 Painting and sculpture in New Jersey...
Princeton,N.J.,Van Nostrand,1964
 276 p. illus. (The N.J.histor.series,
v.24)
 Bibliogr.notes

 Partial contents:I.Colonial artists,p.1-12;
II.Portraiture:Three generations,p.13-49;VII.19th
century sculpture,p.180-95

ND
1311.2
A53
NPG

I.D - U.S. - OHIO - OBERLIN

Ancestors;an exh.of 19th c.American portraits.
Oberlin,Ohio,Allen Memorial Art Museum,Ober-
lin College,c.1980

 Exh.:May 14-Sept.7,1980.Cat.by Maria Gold-
berg and Molly Anderson
 All items from Oberlin collections
 List of sitters.Selection for the exh.was
made on the basis of the relationship of
the sitter to Oberlin or its citizens.

 Incl.Ch.on children's portraits.

ND
1311.8
N7F17
NPG

I.D - U.S. - NEW YORK - 18-19th c.

Faison, Samson Lane, 1907-
 Hudson Valley people,Albany to Yonkers,
1700-1900;by.S.L.Faison,Jr.and Sally Mills.
Poughkeepsie,N.Y.,Vassar college Art Gallery,
c.1982
 63 p. illus(col.cover)

 Exh.16 April - 6 June 1982.Albany,Inst.of
Hist.& Art,Albany,N.Y.,13 July - 29 Aug.,1982
 Bibl.ref.p.19
 Incl.Index of artists

VF
St.-Mémin

I.D - U.S. - PENNSYLVANIA

Colquitt, Dolores Boisfeuillet
 Pennsylvanians in St.-Mémin's miniatures

In:Daughters of the Amer.Rev.Mag.
60:217-25 Apr.,'26 illus.

LC E202.5.A12

I.D - U.S. - PENNSYLVANIA

Historical records survey. Pennsylvania.
 Inventory of American portraiture in the
permanent collection of the Penn.academy of
the fine arts.₂Comp.by.W.S.Work projects ad-
ministration,1942
 2 v. (Survey of American portraiture
in Pennsylvania)

Arch.
Am.Art
mfm Typescript
P51/67R-
P 2/84 Alphabetical by subject

 ⌒ Archives of American Art
 Portraits

I.D - U.S. - RHODE ISLAND

Arnold, John Nelson
 ...Art and artists in Rhode Island...Providence
₂Pawtucket,R.I.,Chronicle printing company,1905
 47 p. illus.

 At head of title:Rhode Island citizens' his-
torical association

LC N6530.R4A7 ⌒ Weddell.A Mem'l vol.of va.
 757.9.W38 NCFA Bibl.p.433

I.D - U.S. - PENNSYLVANIA - LANCASTER CY.

Lancaster County(Pa.)historical society
 Loan exhibition of historical and contempo-
rary portraits illustrating the Evolution of
portraiture in Lancaster Cy.,under the auspices
of the Iris club & the Lancaster Cy.hist.soc.,
Arch. Nov.23-Dec.13,1912.Lancaster,Pa.₂1912₂ Revised
Am.Art edition
mfm 142 p. illus.
P52
255-344
 Oils,W.C.,busts,medallions,miniatures.
 Artists incl.J.Eichholtz,Th.Eakins,B.Nevin

NJP RP ⌒ Groce & Wallace.N6536N53
 Ref. p.736

705
A56
NCFA
v.110
Antiques

I.D - U.S. - SOUTH - 18-19th c.
 Weekley, Carolyn J.
 Artists working in the South,1750-1820
 American painting ₂special issue₂ (card 2)
 ...Nov.,1976...

 Partial contents cont'd₂...C.J.Weekley,Ar-
tists working in the South,1750-1820,p.1046-551
...

 ⌒

705
A56
NCFA
v.17

I.D - U.S. - PENNSYLVANIA - PHILADELPHIA

Gillingham, Harrold Edgar, 1864-1954
 Notes on Philadelphia profilists

In:Antiques
17:516-8 June,'30 illus.

 Incl.:Sam.Folwell(min.ptr.in hair),J.H.Gil-
lespie,R.S.Biddle,H.Page,Wm.Verstille,Wm.Wil-
liams,Edm.Brewster,Aug.Day,Joshua C.Seckel

 London,H.R. Shades of my
 forefathers.741.7.L847
 ⌒ Bibliography

705
A56
NCFA
v.98

I.D - U.S. - SOUTH CAROLINA

McCormack, Helen Gardner
 Expatriate portraits.Charlestonians in mu-
seums outside of Charleston

In:Antiques
98:787-93 Nov.,'70 illus.

 ⌒ FOR COMPLETE ENTRY
 SEE MAIN CARD

N
8223
P54a
NCFA

I.D - U.S. - PENNSYLVANIA - PHILADELPHIA

Sellers, Charles Coleman, 1903-
 Conventions of medical portraiture

In:Philadelphia Museum of Art. The art of Phila-
delphia medicine.₂Exhib.₂Sept.15-Dec.6,1965₂Phi-
ladelphia,1965₂ 131 p. illus.
 pp.98-102
 Relationship betw.physician & artist.Attrib-
utes in portrs. of medical men.Developm't fr.sho.
ing social status to a freer use of conventions.
Photography makes ptrs.study anew their own tech-
niques,the value of light,the anatomy of men.
LC R314.P5P45 ⌒ Fogg,v.11,p.329

N8235
C3R98
NCFA
1949

I.D - U.S. - SOUTH CAROLINA

Rutledge, Anna Wells
 Artists in the life of Charleston,through
colony and state,from restoration to recon-
struction.Phila.,American Phila.,American Philo-
sophical Society,Nov.1949
 p.101-260 illus. (Transactions of the
American Philosophical Society...n.s.,v.39,pt.2,
1949)

Appendix:I.Artists' advertisements.II.Chronolog.
list of artists.III.Classified list of artists.
IV.Classified list of subjects.
 ⌒ Whitehill.The Arts in ear-
LC Q11.P6 ly Amer.Hist.Bibl.,p.86
 Z5935W59 NPG

I.D - U.S. - RHODE ISLAND

Appleton, Marguerite
 A portrait album of four great Rhode
Island leaders.Rhode Island Historical Socie-
ty,c.1978
 125 p. illus.
Rh.Isl.Col.,
Providence
CT258.A6 Publ.in cooperation with The National So-
 ciety of the Colonial Dames of America

 Hopkins, Stephen, 1707-1785.Howland,John,
1757-1854.Chace, Elizabeth(Buffum), 1806-1899
Williams, Roger 1604?-1683
RPBC etc. ⌒ Books in print,subject
 guide 1985-86,v.3,p.4864

N
7592
G24
NPG

I.D - U.S. - TENNESSEE

Nashville Art Club
 Exh.of portraits held under auspices of
Nashville Art Club from Feb.17-Feb.26,1908
 38 p.

 Paintings,miniatures,sculptures

 NPG copy bound with Garrick Club,London.
Cat.of the pictures...London,1909

 ⌒

ND
1311.1
N37
1977X
NPG

I.D - U.S. - TEXAS - 18-19th c.

National Society of the Colonial Dames of America.
Texas
A Texas collection.Portraits before 1882.
Edited by Margaret Wardlaw Rouer.1977
63 p. illus(part col.)

List of sitters. List of artists.

Ptgs.,miniatures,daguerreotypes

All portrs.are listed in NCFA,Bicent'l in-
ventory of American ptgs.

mfm
45n
NPG

I.D - U.S. - VERMONT

Historical records survey. Vermont
Vermont portrait survey,done by the Histo-
rical records survey,ca.1942.Montpelier,Vt.,
...1972
2 reels

Records sitter,media artist,coll.,litera-
ture,reproduction

705
M18
NCFA
v.20

I.D - U.S. - VIRGINIA

Berryman, Florence Seville
Exhibition of historical portraits at"Virgi-
nia House",Richmond,Va.

In:Mag Art
20:373-85 Jul,'29 illus.

Exh.of contemp.portrs.of personages asso-
ciated with the Colony & Commonwealth of Va.
betw.1585 & 1830;under auspices of Va.hist.soc.,
Apr.26-May27,1929

Incl.British, Dutch & American artists
see over Cumulated Mag.subj.index
 A1/3/C76 Ref. v.2,p.444

N
7593.8
V8H92
NPG

I.D - U.S. - VIRGINIA

Hummel, Ray Orvin
Portraits and statuary of Virginians owned
by the Va.State Library,the Medical College of
Va.,the Va.Mus.of Fine Arts and other state
agencies;an illustr.cat.by R.O.Hummele and Ka-
therine M.Smith.Richmond,The Va.State Library,
1977
160 p. illus. (Va.State Libr.publ.no.43)

Bibliography
Incl.indexes

Va.Hist.Soc.,Richmond
Portrs...QF225.V87 1981X
NPG p.XV

N
40.1
F43M8
NCFA
NPG

I.D - U.S. - VIRGINIA

Norfleet, Fillmore
Saint-Mémin in Virginia:portraits and bio-
graphies...Richmond,Va.,The Dietz press,1942
235 p. illus.

Bibliography

Repre.of 56 crayon portrs.& 142 engravings

Valdenuit is mentioned p.14-16

LC N7593.N7

mfm
143n
NPG
reel 10
and
AP
1.V81
NPG
v.37

I.D - U.S. - VIRGINIA

Stanard, William Glover, 1858-1933
An exh.of contemporary portraits of per-
sonages associated with the colony and common-
wealth of Virginia between the years 1585 and
1830. Apr.29-May 25,1929.Virginia Hse.,Richmond.

In:Va.Mag.Hist.Biogr.
37:193-216 July,'29 illus.

163 portrs. shown, paintings & miniatures.
Incl.:Lists of sitters & artists

Winterthur Mus.Library
Z7881.W78,v.6 NCFA p.205

N
40.1
F43V1
NPG
2 cops

I.D - U.S. - VIRGINIA

Valentine museum, Richmond,Va.
Exhibition of the works of Charles Baltha-
zar Julien Fevret de Saint-Mémin,a special loan
exhibition of crayons,engravings,copper plates,
w.c.,silhouettes.Valentine museum.Richmond.1941
69 p. illus.

Bibliography

Special emphasis on portrs. of Virginians

Exhib.,Apr.1-May 10,1941

LC N7593.F52V3 Tott,v.11,p.329

q F
225
V87
1981X
NPG

I.D - U.S. - VIRGINIA

Virginia Historical Society, Richmond
Portraits in the coll.of the Virginia His-
torical Society.Cat. comp.by Virginius Cornick
Hall,jr. Charlottesville,Univ.Press of Va.,1981
283 p. illus(part col.)

Index of artists & their subjects

Oils,W.C.,pastels,drags.,silhouettes,cameos,
reliefs,sculpture

757.0838
.V81

I.D - U.S. - VIRGINIA

Virginia historical society, Richmond
Portraiture in the Virginia historical socie-
ty, with notes on the subjects and artists by
Alexander Wilbourne Weddell. Richmond,Virginia
historical society, 1945
192 p. illus.

LC N716.V44A55

N
7621
788
1920
NPG

I.D - U.S. - VIRGINIA

Virginia. State library, Richmond
...A list of the portraits and pieces of sta-
tuary in the Va.state library...Richmond,
D.Bottom...,2nd ed.,1920
29 p. illus. (In its Bull.,Richmond,
1920,v.13,nos.1,2)

1st ed.was prepared by Earl Gregg Swem,Bull
v.6,no.2,Apr.2,1913(In NPG bound with Garrick
Club,London.Cat.of the pictures..London,1909call
no.N7592.024 NPG)

LC Z881.V81B no1.13 no.1/2 Weddell.A mem'l vol.of Va.
F225.V83 1920 hist.portraiture.757.9.W38
 NCFA Bibl. p.439

757.9
W38
NCFA

I.D - U.S. - VIRGINIA

Weddell, Alexander Wilbourne, 1876-1948,ed.
A memorial volume of Virginia historical
portraiture, 1585-1830...introduction by Ellen
Glasgow and a review of early American portrai-
ture by Thomas B.Clarke. Richmond,The William
Byrd press,incorp.,1930

556 p. illus(part col.)

Bibliography

LC N7593.W4

V
580
W83X
NPG
.v.1.

I.D - U.S. - WISCONSIN - 19th c.

Wisconsin. State Historical Society
Triennial cat.of the portrait gallery of
the State Historical Soc.of Wisconsin.Comp.by
Reuben G.Thwaites and Daniel S.Durrie.Madison,
Wis.,Democrat Printing Cy.,state printers,
1899-92
v.1

Index of sitters.Index of artists

Sculpture,painting,prints,photographs

AP
1
V81
NPG
v.76

I.D - U.S. - VIRGINIA - 18th c.

Reese, George Henkle
Portraits of Governor Francis Fauquier

In:Va.Mag.of Hist.& Biogr.
76:3-10 Jan.,'68 illus.

Repro.:Rich.Wilson,Wm.Hogarth

I.E. SPECIAL SUBJECTS, A-Z, Including works on
painting as well as general works. For
works primarily of photographic interest, see
II.E.4. For other special media, see
Special Subjects under Drawing, Sculpture,
Prints, etc

For list of SPECIAL SUBJECTS see "Guide to
Classified Arrangement"

ND
1311.8
V8L27
NPG

I.D - U.S. - VIRGINIA - 19th c.

Langhorne, Elizabeth C.
The golden age of Albemarle.A portrait
show,1800-1860;held at.University of Va.Art
Museum,Nov.4-Dec.16,1984.Sponsored by the mus.
and the Albemarle County Hist.Soc.,Charlottes-
ville,Va.,1984.
unpaged illus.

Incl.:Ptgs.,drags.,engr.,miniatures,busts

I.E - ALLEGORY & RELIGION
(incl.Portrait historié; emblems)

N
7593.1
A38
NPG

I.D - U.S. - VIRGINIA - ALEXANDRIA

Alexandria Association
Our town:1749-1865;likenesses of this place
& its people taken from life,by artists known
and unknown.:Exhibition...Apr.12-May 12,1956
.1st ed. Alexandria,1956.
114 p. illus.

LC N7593.A27

QN
40.1
A673A6
NMAA

I.E - ALLEGORY & RELIGION

The Arcimboldo effect.Transformation of the face
from the 16th to the 20th century.Publ.in
the U.S.by Abbeville Press,N.Y.,1987
402 p. illus(part col.)

Published on the occasion of the exh.in
Venice,Palazzo Grassi,till May 31,1987.
Artistic director & General Commissioner
Pontus Hulten.Ed.by Piero Falchetta

ND
1311.9
R5V15
NPG

I.D - U.S. - VIRGINIA - RICHMOND - 18-19th c.

Valentine museum, Richmond,Va.
Richmond portraits in an exhibition of
makers of Richmond,1737-1860. Richmond,Va.,...1949
286 p. illus.

Bibliography
Exh.started Nov.16,1948

Incl.:Biography of sitters & of artists.List
of lenders

705
A7832
NCFA

I.E - ALLEGORY & RELIGION(Christian)

Bainton, Roland,H.
Dürer and Luther as the man of sorrows

In:Art Bul.
29:269-72 1947 illus.

The religious atmosphere of the 16th c.
allowed to portray in the image of Christ.
Dürer's self-portr. and engravings of 1521 &
1545

Rep.,1945-47#906

I.E - ALLEGORY & RELIGION

Bergström, Ingvar
 On religious symbols in European portraiture
of the 15th & 16th c.

In:Arch Filosofia
 :335.43 1960 illus.

 Umanesimo e esoterismo (Atti del V convegno
internazionale di studi umanistici)Padua,1960

 Essay illustr. by works of Lippo Vanni,
Pleydenwurff,v.d.Weyden,Luini,Crivelli,Master of
Mary of Burgundy, Geisenegger,v.Cleve,Beham
 Rep.,1960*852

705
B97
v.24

I.E - ALLEGORY & RELIGION

Dimier, Louis, 1865-1943
 An idealised portrait of Diane de Poitiers

In:Burl.Mag.- Nov.1913 illus.
24:89-93
 Diane as goddess Diana
 School of Fontainebleau. List of drgs. of
Diane de Poitiers:1520; 1532 by J.Clouet,1537,
1543,1560 by F.Clouet

qAP
1
P975
NMAA

I.E - ALLEGORY & RELIGION

Peyer, Andreas
 Venice.Palazzo Grassi.Arcimboldo

In:Burl Mag
129:343-4 May,'87 illus.

 Discusses the exh.'The Arcimboldo effect'and
diverse articles in the book:The Arcimboldo ef-
fect,q:40.1.A673.A6 NMAA

705
G28
NCFA
v.45

I.E - ALLEGORY & RELIGION

Dowley, Francis Hotham, 1915-
 French portraits of ladies as Minerva

In:Gaz Beaux Arts
45:261-86 May-June, '55 illus.

 From the 1st portr.of a lady as Minerva(in
France):Margaret of Savoy on enamel by Jean De-
court,1555 to 18th c. examples.Diderot calls for
elimination of allegory
 Portrs.within portrs.important in France
since 17th c.
)Karla Langedijk

I.E - ALLEGORY & RELIGION

Bouvy, Eugène
 La gravure de portraits et d'allégories.
Paris et Bruxelles,Les Editions G.van Oest,19
 91 p. illus. (La gravure en France au
17e siècle)

FOOG
FA
5759
.4B5
.10F

 Bibliography

 Berlin.St.Mus.Kupferstich
 Ruhm des portrËts VF NJ
 Bibl.

708.1
P31
NMAA
v.83

I.E - ALLEGORY & RELIGION

Grace, Priscilla
 A celebrated miniature of the Comtesse
d'Olonne

In:Phila.Mus.Art B.
83,no.353:3-21 Fall,'86 illus(part col.)

 Comtesse d'Olonne.as Diana by Jean Petitot

 Incl.repr.of several miniatures by Petitot

I.E - ALLEGORY & RELIGION

Brinker, Helmut
 Die zen-buddhistische bildnismalerei in
China und Japan von den anfängen bis zum ende
des 16.jahrh.;eine untersuchung zur ikonogra-
phie,typen-und entwicklungsgeschichte.Wiesbaden
F.Steiner,1973
 279 p. illus. (Münchener ostasiatische
Studien,Bd.10)

 Bibliography

LC WD1326.B74 Lee.Varieties of portr.in
 Chin.& Japan,p.134,note 2
 CMA,Bull.Apr.1977.708.1.C6
 C62

705
C75
NCFA
v.192

I.E - ALLEGORY & RELIGION

Hall, Mariette van
 Messer Marsilio and his bride

In:Connoisseur
192:292-7 Aug.,'76 illus(part col.)

 Iconography of Lorenzo Lotto's ptg.
 Discussion incl.:Symbols in bridal portrs.
Relation to tradition of double portraiture

 Rila IV/I 1978 *1480

I.E - ALLEGORY & RELIGION

Brinton, Anna(Cox)
 Quaker profiles:pictorial and biographical,
1750-1850.:Wallingford,Pa.:Pendle Hill Publica-
tions.1964.
 55p. illus. (Pendle Hill publications:
art history,PH.P2)

LC BX7791.B7 Books in print.Subj.guide
 Z1215.P92 1975 v.2 NPG
 p.3:05

N
7605
K78
NPG

I.E - ALLEGORY & RELIGION

Hamburg. Kunsthalle
 Köpfe der Lutherzeit.:Exh..4.März-24.April,
1983.Hrsg.u.Ausw.Werner Hofmann.Kat.Eckhard
Schaar u.Gisela Hopp.München,Prestel Verlag,1983
 318 p. illus:part col.)
 Bibliography
 Iconographical register,p.27-36

 Cat.arranged alphabetically by artists

 Essays by Werner Hofmann,p.9-17 and Peter-
Klaus Schuster,p.18-24

708.1
W89
v.1-4
NCFA

I.E - ALLEGORY & RELIGION

Janson, Horst Waldemar
A mythological portrait of the Emperor
Charles V

In:Worcester Mus.Ann.
1:19.31 1935-36 illus.

Small equestrian portr. of Charles V as St.
James of Compostela,conquering the Moors in his
campaign in Tunis,given tentatively to Vermeyen.
Attr.also in succession to Dürer,van Orley,C.Engelbrechtsen. History of mythological portrs.

705
B97
NCFA
v.90

I.E - ALLEGORY & RELIGION

Millar, Oliver, 1923-
A subject picture by William Dobson

In:Burl Mag
90:97-9 Apr,1948 illus.

Portrs. by Engl.portr.ptrs.of 17th c. in subject pictures:Dobson's Woman taken in adultery
with portr.of Cowley, Decollation of St.John:
Saint portr.of Prince Rupert, Allegory of French
religious wars:The Four Kings of France:Francis II
Charles IX,Henry III & Henry IV(Newbottle Manor)
Rep.,1948-49*3374

NPC has
xerox
copy of
cont.
& exs.
of il-
lustr's
i4 VF
Portrs.,
Roman

I.E - ALLEGORY & RELIGION

Jucker, Hans, 1917-
Das bildnis im blätterkelch. Olten,Mrs Graf
Verlag. Geschichte und bedeutung einer römischen portrütform. 1961
2 v. illus.
(Bibliotheca Helvetica Romana,3)

Dissertation Zürich, 1955

over

NIC HH NJP CU
NB164.J8

I.Lavin in Art Q.,v.33
Autumn,1970,p.217

ND
1309.3
M648
1985
NMAA

I.E - ALLEGORY & RELIGION

Miller, Lillian B.
The Puritan portrait:its function in Old
and New England.Offprint from:her,Seventeenth
century New England.The Colonial Society of
Massachusetts,1985
p.153-84 illus.

Bibliographical references
English portrs.of the 16th & 17th c.are
prototypes for American portrs.of that period
in style and symbolism

N
40.1
E95L5
NPG

I.E - ALLEGORY & RELIGION

Leicester, Eng. Museum and Art Gallery
Hans Eworth:a Tudor artist and his circle
«Prepared by Dr.Roy Strong....»1965»
26 p. illus.

Catalogue of an exhibition
Bibliography

Repr.incl.:Baroness Dacre with portr.of 1st
husband by Holbein?;Sir John Luttrell,with allegorical scene:Peace caresses Sir John's arm,
by School of Fontainebleau;Queen Elizabeth in «

LC ND497.E9L4
source:Yale ctr.f.Brit.art Ref.

N
7593.1
W63
NPG
2 c.

I.E - ALLEGORY & RELIGION (Quaker)

Nickalls, John
Some Quaker portraits,certain and uncertain.
London,Friends' Hist.Soc.,1958
19 p. illus. (J.of the Friends'Hist.Soc.
Suppl.no.29)

Winterthur Mus.Libr. fZ881
W78 NCFA v.6,p.221

I.E - ALLEGORY & RELIGION

L'Orange, Hans Peter, 1903-
Apotheosis in ancient portraiture. Oslo,
H.Aschehoug,Cambridge,Mass.Harvard Univ.Press,
1947

156 p. illus.
(Instituttet for sammenlignende kulturforsknin
serie B-Skrifter 44)

Connection of portr.with dogma of divination
of sovereigns since Alexander,esp.in Egypt & Rome.
Hellenistic type continues in Rome until end of
antiquity,through Ottonian emperors & to
Frederick II
LC N7580.L6

708.1
D47
v.23-27
1943-48

I.E - ALLEGORY & RELIGION

Richardson, E.P.
Madame Henriette de France as a vestal virgin
by Jean-Marc Nattier

In:B.Detroit Inst.Arts
23:2-3 Oct,1943 illus.

see also article by E.P.Richardson

705 In:Art Q
A7875 6,no.4:238-56 Autumn,1943 illus.
1943

Rep.,1945-47*7741

I.E - ALLEGORY & RELIGION

L'Orange, Hans Peter, 1903
Severus-Serapis

In:Ber.6.Kongr.f.Archäol.Berlin
Met :p.495-6 1939.40 illus.
506
In816 Portr.of Septimus Severus,found at arch of
triumph of Leptis Magna & the arch of the Argentarii in Rome,shows that the emperor identifies himself with Serapis.(His predecessors with Jupiter &
in the 3rd c.with Sol invictus)

Rep.,1948-49*5076

AP
1
A64
NCFA
v.110

I.E - ALLEGORY & RELIGION

Robinson, William W.
Family portraits of the Golden Age

In:Apollo
110:490-7 Dec.'79 illus.

f:s.10 & 11:Portraits historiés

Schama,S.in:J.Interdisc.
Hist.v.17,no.1 AP1.J8654
NPG p.160,footnote 8

708.1
.W243
NCFA

I.E - ALLEGORY & RELIGION

Segall, Berta
　　Realistic portraiture in Greece and Egypt.
A portrait bust of Ptolemy I

In:J.Walters Art Gall.
9:53-67,106　1946　illus.

　　Coins of Ptolemy I
　　Ptolemy as Dionysos

I.E - ALLEGORY & RELIGION

Yates, F.A.
　　The allegorical portraits of Sir John
Luttrell

In:Essays in the History of Art presented to
Rud.Wittkower...London,Phaidon, 1967

LC N5303.E7　　　　Strong.Engl.icon qND1314
　　　　　　　　.B924.bibl.:"Good ex.of com-
plexities of meaning to be extracted fr.a Tudor portr.

AP
1
A51A64
NCFA
v.2

I.E - ALLEGORY & RELIGION

Sellers, Charles Coleman, 1903-
　　Charles Willson Peale as sculptor

In:Am Art J
2:5-12　Fall,'70　illus.

　　P.'s influence on Wm.Rush.-Their mutual in-
terest in the allegorical fg. or emblem
　　P.sculpture is now known only as it appears
in ptgs.& documentation.

AP1
L84
NCFA

I.E - ALLEGORY & RELIGION

Yates, Frances A.
　　Queen Elizabeth as Astraea

In:J.Warburg Inst.
10:27-82　1947　　illus.

　　Engravgs.16th c.,Rogers,de Passe, Vertue
(after Olivier),Ryther, Delaram(after Hilliard).
Ptgs.by Eworth,Geeraerts.
　　Elisabethan symbolism

　　　　　　　　Rep.,1946-47*1108

N
40.1
K682S8
NPG

I.E - ALLEGORY & RELIGION

Stewart, J.Douglas
　　Sir Godfrey Kneller.cat.of an exh.at the
NPG,London,Nov.-Dec.,1971....London,Bell;Nat'l
Portrait Gallery,1971
　　82 p.　illus(part col.)

　　Bibl.references
　　Incl.:Lady Eliz.Cromwell as St.Cecilia
　　Chapters incl.:Drawings;Ladies & children;
Lords & Gentry;Scholars & Poets;Army & Navy;
Parade portrait.Appendix:Kit-cat club portrs.

LC ND1329.K55S7

I.E - ANATOMY

Darwin, Charles Robert, 1809-1882
　　The expression of the emotions in man & ani-
mals...London,J.Murray,1872

　　374 p.　illus.
　　1st ed.The photographic illus.of the emotions
are by Oscar Gustav Reijlander(1813-1875)whom
Darwin commissioned.Reijlander & his wife act
the required emotions in many of the heliotypes
The publication indirectly produced a windfall

LC
QP401.D21
　　　　Waetzoldt ND1300.W12:Ger-
　　man translation:Ausdruck
　　der gemütsbewegungen...

I.E - ALLEGORY & RELIGION

Wind, Edgar, 1900-
　　Hume and the heroic portraits:Studies in
eighteenth-century imagery;edited by Jaynie
Anderson.Oxford,Clarendon Press,1986
　　139 p.　illus.

　　Bibl.references
　　Index

LC ND1314.4.W5　1986
　　　　　　Burl.Mag.Dec.'86,p.906-7.
　　　　　AP1B975 NMAA Book Rev.by
　　　　John Gage

705
A56
NMAA
v.122

I.E - ANATOMY

Ericson, Jack T.
　　Asa Ames,sculptor

In:Antiques
122:522-9　Sept.'82　illus(part col.)

　　Incl.:Phrenological head,Pl.VIII;Ears,eyes
& hair,fgs.8,8,10

　　　　　　　　M.Black.Phrenological asso-
　　　　　　　　ciations,p.50

AP1
L84
NCFA
v.1,1937

I.E - ALLEGORY & RELIGION

Wind, Edgar 1900-
　　Studies in allegorical portraiture I

In:J.Warburg & Courtauld Inst.
1:138-62　1937　　illus.

　　Historical,psychological & esthetical view
point of alleg.portrs.of all epochs
　　Cranach & school:Albrecht von Brandenburg as
St.Erasmus & St.Jerome. Largillière:Mme Duclos
as Ariadne, Charl.v.d.Pfalz as nymph. Mignard:
Molière as Julius Caesar.Bust of Commodus as Her-
cules
　　　　　　Rep.,1937*328

QM
535
L72
NPG

I.E - ANATOMY

Liggett, John
　　The human face.London,Constable.1974.
　　287 p.　illus.

　　　　　　　Piper;In:Wolstenholme,1977
　　　　　　　p.25

I.E - ANATOMY (EAR)

Elwert, Dorothee, 1935-
 Die Ohrmuschel in der malkunst an werken
von Leonardo da Vinci,Michelangelo,Tizian,Ve-
lásquez,Rembrandt,Dürer.Tübingen,1964
 136 p. illus.

 Bibliography

 Inaug.Diss. Tübingen

IU Rep. 1966 #1019

I.E - ANATOMY - EYE

1337
G7F4
1985X
NPG

Fitzwilliam Museum
 Cat.of portrait miniatures in the Fitzwil-
liam Mus.,Cambridge.by.Robert Bayne-Powell,
Cambridge;N.Y.:Cambridge Univ.Press;Cambridge:
Fitzwilliam Mus.,1985
 231 p. illus(part col.)

 Bibliography

 Incl.:Crosse,Richard,1742-1810,deaf-mute
miniaturist,p.54.- Eye-miniatures,p.25

I.E - ANATOMY (EYE)

Bellugue, P.
 L'oeil vu par les artistes

In:Aesculape
:52-63 1937 illus.

 Ptgs.& sculptures of all times & countries

LC W 1AE933 Rep.,1937#384

I.E - ANATOMY (EYE)

Goudard, Henry
 Quelques borgnes célèbres.

In:Aesculape
:148-55 1937 illus

 Incl:Clouet,Gourdelle,V.D.Helst,Darbès,Callega-
ri

LC W1AE933 Rep.,1937#363

ND
1337
A2B67
NCFA

I.E - ANATOMY - EYE

Boehn, Max von, 1860-1932
 Miniatures and silhouettes,...transl.by E.K.
Walker...London,and Toronto,J.M.Dent & sons,ltd.
New York,E.P.Dutton & co.,1928
 214 p. illus(part col.)

LC N7616.B6

AP
I
T683
NCFA
v.6

I.E - ANATOMY - EYE

Hickl-Szabo, Heribert, 1920-
 Portraits in miniature

In:Rotunda
6,no.3:37-40 Summer, '73 illus(part col.)

 Pertains to exh.of the Starr coll.,Wm.Rock-
hill Nelson Gall.of Art,Kansas City,at the Ro-
yal Ontario Mus.,Toronto,Dec.8,1972-Jan.14,1973
 Article incl.ROM's own miniatures,among
others eye miniatures
 Hickl-Szabo.In:Rotunda,c.11
 no.1 API.T683 NCFA,p.12

ND
2893
B7X
NPG

I.E - ANATOMY - EYE

Brooklyn Institute of Arts and Sciences. Museum
 Dept.of contemporary art
 ...Five centuries of miniature painting,...pr.3-
June 1,1936:Brooklyn,Brooklyn mus.press,1936.
 :50:p.

 :nos.272,272a,277 - Hair pictures
 nos.99-137 - Eye miniatures

 Detroit.I.A. N40.1.P35D4
 NPG Bibl.p.144

705
C75
NCFA
v.87
v.72

I.E - ANATOMY - EYE

Martin, Mary
 Eye portraits

In:Connoisseur
87:369-77 June,'31 illus.
72:140-5 July,'25 illus.

NPG

I.E - ANATOMY - EYE

Christie,Manson & Woods,ltd.
 Fine miniatures...London,...1980

 Incl.:...1 eye miniature(no.3,the eye of
Princess Charlotte Augusta)

 FOR COMPLETE ENTRY
 SEE MAIN CARD

757.7
.P41

I.E - ANATOMY - EYE

Pennsylvania society of miniature painters
 Golden jubilee fiftieth annual exh.of minia-
tures,antique and contemporary.The Pennsylva-
nia society of miniature painters at the Pennsylva-
nia academy of fine arts...1st ed.Oct.27 through
Dec.2,1951:Philadelphia,1951.
 87 p. illus.

 Incl.:Eye miniatures,p.68

I.E - ANATOMY - EYE

QN
6520
.P63
1983X

Poesch, Jessie J.
 The Art of the Old South,painting,sculp-
ture,architecture,and the products of crafts-
men,1560-1860...1st ed.N.Y.,Knopf,1983
 384 p. illus(part col.)

 Incl.index
 Bibliography,p.361-366

 Repro.incl.:Eye miniature by Malbone,p.162;
Portrs.of Amer.Indians by Curtis,p.272;by Rö-
mer & by Catlin,p.273.Ports.within portrs.,
p.265.Groups by F arl,p.171;by Johnson,
p.159

I.E - ANATOMY
 see also
I.H.4.a - PHYSIOGNOMY

I.E - ANATOMY (EYE)

Schütz, Roland
 Das auge in der antiken kunst

In:Kunst,A.K.
77:80-2 1937 illus.

 The eye in antique art & its association with
a head in the cathedral at Naumburg & a bust of
Goethe by Rauch

LC N3K5 Rep.,1937*383

I.E ANCESTRAL
 includes IMAGO CLIPEATA, Roman painted shield portraits

I.E - ANATOMY - EYE

ND
1337
C7W719
NPG

William Rockhill Nelson Gallery of Art and
 Mary Atkins Museum of Fine Arts, Kansas City,
Mo.
 The Starr Collection of miniatures in the
William Rockhill Nelson Gallery.With introd.by
Graham Reynolds.Kansas City,1971
 84 p. illus(part col.)

 ...patterned after...:Reynolds',book Lng-
lish portrait miniatures

LC ND1337.C7W47 Yale ctr.f.Brit.art Ref.

I.E - ANCESTRAL

Bethe, Erich, 1863-1940
 Ahnenbild und familiengeschichte bei Rö-
mern und Griechen.München,C.H.Beck'sche ver-
lagsbuchhandlung,1935
 121 p. illus.

 Bibliography

NNC etc. Hiesinger.Portr.in the Rom.
 Rep.Bibl.In:Temporini.Auf-
 stieg u.niederg..LC DG209
 T36.Bd.1.T.4.n.82a

I.E - ANATOMY - EYE

705
C75
NCFA
v.10

Williamson, George Charles, 1858-1942
 Miniature painting of eyes

In:Connoisseur
10:147-9 Nov.,'04 illus.

I.E - ANCESTRAL

Bolten, Johannes
 Die imago clipeata,ein beitrag zur portrait-
und typengeschichte...1937

 Clipeata imago-shield portr.:Painted ances-
tor portrs.hung in Roman houses.None survived

LC N7832.B6 Fogg,v.11,p.231

I.E - ANATOMY (HEAD)

Bridgman, George Brant, 1864-1943
 Heads, features & faces. Pelham,N.Y.,Bridgman
publishers inc.,1936.
 63 p. illus.

 Previously published under title:Features &
faces
 Second ed.

LC NC770.B7 Rep.,1936*392

I.E - ANCESTRAL

Brommer, Frank
 Zu den römischen ahnenbildern

In:Deutsch.Arch.Vol.Inst.Mitt.Röm.Abt.
50/51:163- 1953/54

LC DE2.D42 Kraus.Das römische welt-
 reich N5760.K92 Bibl. p.315

I.E - ANCESTRAL

Winkes, Rudolf
 Clipeata imago...1969

 Clipeata imago=shield portr.:Painted ances-
tor portrs.hung in Roman houses.None survived

LC NB1296.W56 1969

I.E - ARTISTS, PHYSICALLY HANDICAPPED

Gannon, Jack R.
 Deaf heritage.a narrative history of deaf
America.Silver Spring.Md.,Nat'l Assoc.of the
deaf,1981
 483 p. illus.

 Incl.:Ch.h:Artists. Incl.:Brewster,Carlin,
Freiman,Hannan,Moor,Sparks,Washburn,Whitcomb

 Index
 Bibliography

NASM HV2530.G36X

I.E - ANCESTRAL

Zadoks,Annie Nicolette (Josephus Jitta), 1904-
 Ancestral portraiture in Rome and the art of
the last century of the republic, Amsterdam,
N.v.Noord-Hollandsche uitgevers-mij.,1932

 119 p. illus.

Title fr.Univ.of Va.
Printed by LC Breckenridge.Likeness...
 N7580.B82 NPG bibl.notes

VF
NEWSAM

I.E - ARTISTS PHYSICALLY HANDICAPPED

 Intramuralia

 In:Huntington Library Quarterly
34,no.4:371 Aug.,'71 illus.

 Repro.:Lithograph of Andrew Jackson(1834)by
Albert Newsam

F
24
A34
1987X
NMAA

I.E - ARTISTS, PHYSICALLY HANDICAPPED

Agreeable situations:society,commerce and art
 in southern Maine,1780-1830;ed.by Laura
 Fecych Sprague;essays by Joyce Butler...
 ...et al..Kennebunk,Me.Brick Store Mus.
 Boston:Distributed by Northeastern Univ.
 Press,1987
 205 p. illus(part col.)
 Incl.Brewster,jr.,deaf artist,p.88,122,254
 Cat.of selected objects from the Brick
Store Mus.et al
 Index
 Bibliography

I.E - ARTISTS, PHYSICALLY HANDICAPPED

Mitchell, James Tyndale, 1834-1915
 The unequalled coll.of engraved portraits
of eminent American.and some noted foreign-
ers belonging to Hon.James T.Mitchell...a
large coll.of lithographs engraved by A.Newsam,
an unique coll.of American revolutionary and
political caricatures and numerous portraits
for extra illustrating,to be sold...Oct.28,
1913.Phila.,Pa..Stan v.Henkels.1913,
 56 p. Plates
 Cat.Stan v.Henkels,no.944,pt.13

LC Z999.H505 no.944,pt.13 Rosenwald coll.

E
89
C35
NPG

I.E - ARTISTS, PHYSICALLY HANDICAPPED

A catalogue of Indian portraits in the coll.
 of Jos.G.Butler,jr..on free exh.at the
 Y.M.C.A.bldg,Youngstown,O...s.n.,s.l.,
 ca.1907.(Youngtown,Ohio,Vidicator Press)
 39 p. illus.

 The greater part of the coll.is the work
of J.H.Sharp and E.A.Burbank.Other artists re-
presented are Frederick Remington,Bert Phillips
Deming and Gandy
 Smithsonian "National Museum"bought 11
Sharp ptgs.,Dec.1900. Sharp was deaf(see p.5)

I.E - ARTISTS, PHYSICALLY HANDICAPPED

Stauffer, David McNeely, 1845-1913
 Lithographic portraits of Albert Newsam...
Philadelphia,1901
 52 p.

 Reprinted fr.the Penn.magazine of history
and biography,Oct.1900 and Jan.and Apr.,1901

LC NE2415.N5S7 College of Physicians...
 Arch.Am.Art mfm P86 v.12
 References

1337
G7FW
1985X
NPG

I.E - ARTISTS, PHYSICALLY HANDICAPPED

Fitzwilliam Museum
 Cat.of portrait miniatures in the Fitzwil-
liam Mus.,Cambridge.by,Robert Payne-Powell,
Cambridge;N.Y.:Cambridge Univ.Press;Cambridge:
Fitzwilliam Mus.,1985
 231 p. illus(part col.)

 Bibliography

 Incl.:Crosse,Richard,1742-1810,deaf-mute
miniaturist,p.54.- Eye-miniatures,p.25

I.E - CARICATURE

Binsfeld, Wolfgang, 1928-
 Grylloi,ein beitrag zur geschichte der an-
tiken karikatur.Köln,1956
 1 v.

F000
FA5999
.122.301

 Inaug.-Diss. Köln,1956

 Winkes.Physiognomonia.In:
 Temporini.Aufstieg u.nieder
 gang...LC DG209.T36,Bd.1,T4
 p.910

I.E - CARICATURE

Bohne, Friedrich ed.
 Der Deutsche in seiner karikatur;hundert
jahre selbstkritik;kommentiert von Thaddäus
Troll.Mit einem essay von Theodor Heuss.Klagen-
furt,Kaiser,1967
 193 p. ,chiefly illus.,

 "Zur Ästhetik der Karikatur"von Theod. ,Heus,
p.169-90

 Thaddäus Troll pseud.for Hans Bayer

LC NC1500.B6 ,Rep- 1967 #1136

I.E - CARICATURE

Gianeri, Enrico, 1900-
 Storia della caricatura.Milano,Omnia.1959.
 333 p. illus(col.plates)
 (Storia di cose,1).

Harvard Univ.Libr.
D CL CC1 CFS WU : Rep.1959 #959

757.875 I.E - CARICATURE
D52
NCFA De Young Memorial Museum, San Francisco
 Meet the artist;an exhibition of self-por-
traits by living American artists.S.F.,M.H.de
Young memorial museum,1943
 150 p. illus.

 Foreword by Walter Heil
 "...Self portr.offers a deeper insight into
,the artist's,taste,the esthetical ideals...the
very fundamentals of ,his,art...There is a con-
nection betw.human types,he choses,,even types
of inanimate nature...& his own physiognomic cha-
LC N7575.D4 Fogg,v.11,p.325

N71 I.E - CARICATURE
G64X
NCFA Gombrich, Ernst Hans Josef, 1909-
 The mask and the face:The perception of
physiognomic likeness in life and in art

In:Art perception and reality.M.Mandelbaum,ed.
Baltimore,J.Hopkins university press,1972
 (Alvin & Fanny Blaustein Thalheimer lect.1970
 pp.1-46 illus.

 Discusses whether there can be an underlying
identity in the changing facial expressions
caused by emotions & by aging.-"Empathy plays a
part in the ,portr.,aitist's,response"(p.40)
LC N71:064 ,Kuspit.Art in Am 63:61

I.E - CARICATURE

Fleury, Jules, 1821-1889
 Histoire de la caricature antique par Champ-
fleury(pseud.).3 éd.très augm.Paris,E.Dentu
,1879,
 347 p. illus(part col)

LC NC1325.F6 Winkes.Physiognomia.In:
 Temporini.Aufstieg u.nie-
 dergang...LC DG209.T36,Bd.1,
 4.4,926

I.E - CARICATURE

Kris, Ernst, 1900- and E.H.Gombrich, 1909-
 The principles of caricature

In,his,Psychoanalytic explorations in art.New
York,Schocken Books,1964,1952,

 pp.189-203 . illus. Based on a paper read
to the Warburg Inst.of London uni.,May,1937,
publ.in Brit.J.of Medical psychology,XVII,1936

 Repro.incl.A.Carracci?,Bernini,Daumier

LC N70.K84 1964 Eller.Kong.portr.malere,
 p.513

I.E - CARICATURE

Fuchs, Eduard, 1870-1960
 Die karikatur der europäischen völker vom
altertum bis zur neuzeit.3.Aufl.Berling,A.Hof-
mann,1904
 479 p. illus.

 ,Bibliography,

NIC PP
LC NC1325.F91 (ed.1901) ,Winkes.Physiognomonia.In:
 Temporini.Aufstieg u.nieder:
 ,p.910 gang...LC DG209.T36,Bd.1,Th

I.F - CARICATURE

London. Queen's Gallery, Buckingham Palace
 Gainsborough,Paul Sandby and miniature-
 painters in the service of George III and his
 family,cat.of an exhibition. ,London,1970
 36 p. illus.

 ,Bibl.references,

LC ND1314.4.L6 Yale ctr.f.Brit.art Ref.

I.E - CARICATURE

Gianeri, Enrico, 1900-
 Storia della caricatura europea. ,Di.Gec
,pseud.,Firenze,Vallecchi,1967
 238 p. illus.

LC NC1465.G5 Rep. 1968 #1885

I.E - CARICATURE

Maggs Bros., London
 Choice engravings of American historical im-
portance(Portraits of famous American and Bri-
tish officers,statesmen and others connected
with the war of Independence)Rare political car-
toons,emblems....Washington portraits,Selected
from the stock of Maggs Bros...London,1909
 23 p. illus.

 At head of title:No.249 237 items

CSmH Levis.Descr.bibl.Z5947.A3
 L66 1974 NCFA p.212:"Parti-
 cularly interesting list"

374

I.E - CARICATURE

Porta, Gianbattista della, c.1540-1615
 De humana physiognomonico.Sequensa,Iosephi
Cacchi,1586
 ,272,p. illus.

MET
Print
dpt.
 Comparisons betw.a human type & an animal
species:the aquiline nose-noble like the eagle;
the bovine face-placid disposition...which in-
fluenced portr.caricature

 Gombrich.The mask & the
 face.In Art percp'n & re-
 ality.N71G64X.NCFA p.34

I.E - CHILDREN

Champigneulle, Bernard
 L'enfant vu par les peintres

In:Formes et couleurs
8:71-81 no.4-5 1946 illus.

 Incl.:Terborch,Fouquet,Ingres,Renoir,LeNain,
Vuillard,Nattier,Portail,LaTour,Corot,Gainsbo-
rough,Steen

LC N2F65 Rep.,1945-47#870

ND
1311.2
A53 I.E - CHILDREN
NPG
Ancestors:an exh.of 19th c.American portraits.
Oberlin,Ohio,Allen Memorial Art Museum,Ober-
lin College,c.1980

 Exh.:May 14-Sept.7,1980.Cat.by Maria Gold-
berg and Molly Anderson
All items from Oberlin collections
List of sitters.Selection for the exh.was
made on the basis of the relationship of
the sitter to Oberlin or its citizens.

 Incl.Ch.on children's portraits.

I.E - CHILDREN

Hale, Philip Leslie, 1865-1931
 Great portraits:Children...Boston,Mass.,
Bates & Guild co.,1909
 78 p. illus.

LC N7643.H3

. I.E - CHILDREN

Ariès, Philippe
 Centuries of childhood,a social history
of family life.N.Y.,Vintage Books,Random
House,1965.
 447 p. illus. (A Vintage giant,V-286)

 Translat.fr.'L'enfant et la vie familiale
sous l'Ancien Régime'

 Childhood representation from middle ages
through 17th c.family portrs.

OC Hughes,D.O.in J.of Interdis
LC HQ792.F7A73 1962 ed. cipl.Hist. AP1.J8654 NPG
 v.17,no.1,p.7 footnote 1

I.E - CHILDREN

Kinderbildnisse im rokoko und biedermeier. Wills-
bach Scherer Verlag,1948

 23 p. illus.

LC N7643.K7

705
C75
NCFA I.E - CHILDREN
v.99
Bishop, Roy
 Portraits of royal children at Windsor
Castle

In:Connoisseur
99:239-44 1937 illus.

 Incl.:van Dyck,Gainsborough,Barthélemy Du Pan,
Zoffany,Lawrence

 Rep.1937#346

N.
7643
K53 I.E - CHILDREN
1967
NCFA King, Marian
 A gallery of children;portraits from the
National Gallery of Art.Washington,D.C.,Acropoli
Books.1967.
 112 p. illus(part col.)

 Bibliography

LC N7640.K54 1967

705
M18
NCFA I.E - CHILDREN
v.9
Bragdon, Claude
 Wax portraits by Ethel Frances Mundy

In:Mag Art
9:490-3 Oct.,'18 illus.

 "Mundy's best...work....is.child portraiture"

 Cumulated Mag.subj.index
 A1/3/C76 Ref. v.2,p.445

I.E - CHILDREN

Laurin, Carl Gustaf Johannes, 1868-1940
 Barnet i liv och konst. Historisk framställ-
ning. Stockholm,1937(or 1938)

 328 p. illus.

 Historical survey of the child in life and
in art

 Rep.,1938#649

705
A786
NCFA
v.46
sec.2

I.E - CHILDREN

Louchheim, Aline Bernstein
 Children should be seen

In:Art N.
46:53,55-7, Nov,'47 illus(part col.)
60-1,64-5,68-9,72-3,76-7,81-2,134,136-8

 Ptrs.since the Renaissance,when portr.like-
ness vied with religious ptg.,portray the
changing aspects of childhood until to-day.

AP
1
S72
NPG
v.13

I.E - CHILDREN

Park, Lawrence, 1873-1924
 Joseph Badger of Boston,and his portraits
of children

In:Old Time N Engl
19:99-109 Jan,'23

 Incl. check list

LC F1.568 Whitehill.The Arts of ear-
 y Amer.Hist.Z5935.W59 NPG
 vol..p.87

I.E - CHILDREN

McLennan Hall, T.
 Children in art

In:Scottish Art Rev.
2,no.3:20-8 1949

MET
100.52
Sco8

WN OCl etc. Cowie,James N40.1.C868C16
 NMAA Bibl.p.20

N
40.1
P73x
W2
NPG

I.E - CHILDREN

Plunket, Jean Reasoner, 1923-
 Faces that won't sit still...Washington,D.C.
 Acropolis books,1978

FOR COMPLETE ENTRY
SEE MAIN CARD

I.E - CHILDREN

Martins Costa, Lygia
 Exposicao "A criança na arte"

In:Anu.Mus.nac.bel.Artes(Rio de Janeiro)
6:50-71 1944 illus.

 Exhibition:The child in ptg.& sculpture from
Middle Ages to our times

LC N910.R53.A2 Rep.,1948-49#869

708.1
M66
NCFA

I.E - CHILDREN

Portraits of women and children

In:B.Minneapolis Inst.Arts
30:1-7 Jan,1941 illus.

 General thoughts on portraiture

 Incl:Clouet,Mierevelt,Slaughter,Hannemann,
Ramsay,Theus,Courbet

 Rep.,1945-47#863

I.E - CHILDREN

Moreau-Vauthier, Charles, 1857-1924
 Les portraits de l'enfant..Paris,Hachette &
cie..1901.
 398 p. illus.

MET
115.2
M61

I.E - CHILDREN

Rubbra, Benedict
 Painting children.London,Studio Vista;N.Y.
Taplinger/Pentalic,1979
 104 p. ill(part col.)

LC ND1329.3.C45R82 1979 Books in print.Subject G.
 1985-86,v.3,p.4864

705
P256
NCFA

I.E - CHILDREN

Wirdlinger, Virginia
 Children now and then

In:Parnassus
3:4-6 Dec,1931 illus

 Incl:2 miniatures by Goya,etc.

 Rep.,1931#93

N
7648
S832
NCFA

I.E - CHILDREN

Sauerlandt, Max, 1880-1934
 Kinderbildnisse aus 5 Jahrhunderten der
europäischen malerei von etwa 1450 bis etwa
1850.Königstein im Taunus und Leipzig,K.R.
Langewiesche.1921.
 174 p. incl.illus. (Artis monumenta)

 Descriptive letterpress in German,English,
Spanish and French

 Die 20er jahre im portr.
 N6868.5.E9Z97 NPG, p.140

705
G28
NCFA
v.17

I.E - CHILDREN

Tourneux, Maurice
L'exposition des portraits de femmes et
d'enfants A' l'école des Beaux-Arts

In:Gaz.Beaux-Arts
17:445-60 June,1897 illus.

Organisé par la Société philanthropique

Repro.incl.:John Russell,Drouais,Gainsbo-
rough,Reynolds,Greuze,Élie Delaunay,Rembrandt

Tourneux.Exp.retro.d'art
féminin.Gaz.Beaux-Arts
v.39:291

I.E - CHILDREN - MEDIEVAL

Herlihy, David
Medieval children,in 'Essays on medieval
civilisation,by Rich.E.Sullivan...et al.;
introd.by Bryce Lyon,ed.by Bede Karl Lackner
& Kenneth Roy Philp.Austin,Univ.of Texas Press
c.1978 (The Walter Prescott Webb memorial lec-
tures 12)

LC CB351.E78

Hughes,D.O. Representing
the family,in:J.Interdisc.
Hist.AP1.J8654 NPO v.17,
no.1,p.8,footnote 3

I.E - CHILDREN

Waldmann, Emil,1880-.
Das bild des kindes in der malerei. Hrsg.v.Wof-
gang Gurlitt. Berlin,Genuis Verl.,1940

64 p. illus(part col.)

Rep.,1939-41*633

705
S94
NCFA
v.86

I.E - CHILDREN - EUROPE

Comstock, Helen
Children's portraits in European art

In:Studio
86:40-6 Feb.'27 illus(part col.)

Repro.:Clouet school,Goya,Moreelse,Gains-
borough,Lawrence,Reynolds

Cumulated Mag.Subj.Index
v.2,p.443 AI3C76 Ref.

I.E - CHILDREN

Weimar. Staatliche Kunstsammlungen
Das Kinderbild von meisterhand;wandlungen
eines themas der bildenden kunst von Lucas
Cranach bis zur gegenwart.Ausst....25.Mai bis
15.Okt.1972.Weimar,1972
124 p. chiefly illus.

MET
195.52
W43

I.E - CHILDREN - FRANCE

Grappe, Georges
L'enfant dans la peinture française

In:Art viv.
:490-2 1933 illus.

Incl.:Mignard,Nattier,LaTour,Drouais,Boucher,
Chardin,Greuze,Fragonard,Renoir,Courbet,Winter-
halter,Corot

LC N2.A65

Rep.,1933*150

I.E - CHILDREN

Wit, Frederik de,fl.c.1650 comp.
Lumen picturae et delineationis...Amstel-
odami,ex officina Frederici de Wit,1705?.
120 pl.

Incl.his schema of how to draw children's heads,
which is traceable to van de Passe & originally
to Dürer

Some plates are signed by H.Goltzius,C.Pass,
R.de Vorst and others

LC NC660.W5

Gombrich,Art & Illusion
N7CG63,p.166-7

I.E - CHILDREN - FRANCE

Mujica, Láinez Manuel, 1910-
El niño en la pintura francesa

In:Ars
:93-101 special no.,1946 illus.

Incl:Mignard,Watteau,Chardin,Perronneau,
Q.de la Tour,Winterhalter,Wertmüller,Vigée-Lebrun
Bouguereau,Grimou,Chaudet,Labille-Guiard,etc.

LC N7.A714

Rep.,1945-47*871

I.E - CHILDREN - ANTIQUITY - ROME

Gercke, Wendula Barbara Voss, 1940-
Untersuchungen zum römischen kinderporträt
von den anfängen bis in hadrianische zeit.Ham-
burg,1968
217 p.

Diss.Hamburg,1968

MiO OrU

Winkes.Physiognomonia.In:
Temporini.Aufstieg u.nied-
er-gang...LC DG209.T36,Bd.1,
T.4, p.912

I.E - CHILDREN, FRANCE - 18th c.

Vaillat, Léandre, 1878-
...La société du 18e siècle et ses peintres;
...Paris,Perrin et cie.,1912
272 p. illus.

Contents.-Le portrait et le costume.-La
femme.-L'enfant-Jean-Étienne Liotard.-J.-B.
Perronneau

LC ND1316.V3

Fogg,v.11,p.319

GT
1730
F87
NPG

I.E - CHILDREN - GREAT BRITAIN

Brooke, Iris
 English children's costume since 1775...
London, A.& C.Black, ltd. 1930.

FOR COMPLETE ENTRY
SEE MAIN CARD

705
C69
NCFA
v.29

I.E - CHILDREN - GREAT BRITAIN - 19th c.

Fuller, John
 'n un-Victorian photograph of the 1860's

In:Art Journal
29,no.3:303-8,400 Spring,1970 illus.

 Bibliography
 Edw.Draper's photograph'Boy with parrots're-
veals something of childhood.It shares common
ground with 20th c. portraiture rather than with
British portr.tradition of portraying a child
to transfer moral messages,sweet sentiment &
status symbols. Loma 1970,p.168 *70P5148

I.E - CHILDREN - GREAT BRITAIN

Lavauden, Thérèse
 L'enfant dans la vie anglaise

In:Formes et couleurs
8:27-43. no.4-5 1946 illus(part.col.)

 18th c.-mid 20th c.
 Incl.:Photo of Virginia Woolf

LC N2F65

qND
1329.3
C15M37X
NPG

I.E - CHILDREN - GREAT BRITAIN - SCOTLAND-17thc.

Marshall, Rosalind Kay
 Childhood in 17th c. Scotland;the Scottish
National Portrait Gallery,19 Aug.-19 Sept.,
1976...Edinburgh,Trustees of the National Gal-
leries of Scotland,1976
 67 p. illus.

 An Edinburgh Festival exh.

 Bibl.references

I.E - CHILDREN - GREAT BRITAIN

London. Queen's Gallery,Buckingham Palace
 Royal children.exhibition...1963.catalogue.
London,.1963.
 2 v.in 1

 Contents.-.1.Text.-.2.Plates

ICU Millar.The later Georgian
)pictures...qND466M64 Bibl.

I.E - COSTUME - GREAT BRITAIN - SCOTLAND - 17-
 .18th c.

Marshall, Rosalind Kay
 Scottish portraits as a source for the
costume historian

V & A

In:Costume
15:67-70 1981 illus.

 'Discusses problems to be born in mind
when using 17th & 18th c. Scottish portrs. as
a source for documentary evidence of costume.'

ICU MH etc. — Rila 1983 #5909

N
7598
W59
NPG

I.E - CHILDREN - GREAT BRITAIN - 17-19th c.

Colnaghi, P.& D.& co.,ltd.,London
 English ancestors,a survey of British por-
traiture 1650-1850.Cat.of exh.22 Feb.to 31
March 1983,ed.by Clovis Whitfield,assisted by
Ursula Lans.1983.
 109 p. illus(part col.)

 Arranged by artists in alphabetical order
 Foreword by John Harris

 Incl.:Groups,children & portr.busts

I.E - CHILDREN - NETHERLANDS

Amsterdam. Maatschappij 'Arti et Amicitiae'
 Tentoonstelling van .Hollandsche.kinder-
portretten. .Amsterdam,.1910
 illus.

Amsterdam.Rijksmus.cat.
25939A52,deel 1,p.375

I.E - CHILDREN - GREAT BRITAIN - 18th c.

Plumb, John Harold, 1911-
 The new world of the children in 18th c.
England

In:Past & present
no.67:65-95 1975

LC D1.P37 Robinson,D.Geo.Peare In:
 Lead Art Mus.Monographs
 v.6&7:19

I.E - CHILDREN - NETHERLANDS

Amsterdam. Rijks-Museum
 Kinderen in de Nederlandse schilderkunst,
1480-1700.Children,with English text.Amsterdam,
Rijksmuseum,1962
 40 p. illus. (Its Facetten der verza-
meling,2.serie,no.2)

 In Dutch and English

 Text by B.Haak

ICA PPPM
LC ND1329.3.C15A57 1962X-- -(Chm)

I.E - CHILDREN - NETHERLANDS(19-20th c.)

Knipping, John Baptist, 1899-
 Het kind in Neerlands beeldende kunst,19& 20'
eeuw. Wageningen,Gebr.Zomer en Keuning,1944-67

 225 p. illus(part col.)

LC N6931.K6 Rep.,1948-49*870

I.E - COSMETICS

Corson, Richard
 Fashions in makeup from ancient to modern
times.N.Y.,Universe Books,1972.
 614 p. illus.

 Incl.:Index
 Bibliography p.594-600

GT240.C67X NMAH
U.of Delaware Library

AP
1
W71
NPG

I.E - CHILDREN - U.S. - 17-19th c.

Calvert, Karin
 Children in American family portraiture,
1670-1810

In:Wm.& Mary Q
Ser.3,39:87-113 Jan.,'82 illus.

 Incl.:Table I:Distributed by period & sex.
Table II:Costume of boys.
 334 family portrs.were studied.Nuclear fa-
mily portrs.appear after 1770
 Dress indicates sex,status,age,leading
signs of chan- ging custom.Hairstyle in-
dicates period age.

1705
C75
NCFA
v.87

I.E - COSTUME

Beard, Charles R.
 Costume in portraiture

In:Connoisseur
87:316-8 May 1931 illus.

 Importance of costume in dating & identifying
portrs.is exemplified in reference to mistakes
made by C.H.C.Baker in his Engl.ptg.of the 16th &
17th c.

708.1
N42
1937

I.E - CHILDREN - U.S. - 18-19th c.

New York. Downtown Gallery
 Children in American art.Exh.Apr.13-May 1,
1937.Cat.by E.C.Halpert
 15 p. illus.

 Incl.17 portrs.of children,p.13-14

 Colon'Williamsburg,inc.
 Amer.Folk art N6507C72 no.20
 Bibl.p.49.Also:Ford.Pictorial
 folk art 759.1.F699,Bibl.

705
B97
NCFA

I.E - COSTUME

Kelly, F.M.,1879-
 The iconography of costume

In:Burl Mag
64:278-82 Jun,1934,I illus.

 Costume valuable in determination of attri-
butions

 Rep.,1934*91

qN
7644
H92
MPG

I.E - CHILDREN - U.S. - 18-20th c.

Humm, Rosamond Olmsted
 Children in America.A study of images and
attitudes...The High Mus.of Art,1978

 FOR COMPLETE ENTRY
 SEE MAIN CARD

I.E - COSTUME

Laver, James, 1899-
 A concise history of costume.London,Thames &
Hudson,1969
 288 p. 314 illus(part col.) (The World
of Art Library.General)

 Bibliography

LC GT510.L286

AP
1
H29
NCFA
v.101

I.E - CHILDREN - U.S. - 19th c.

Hart, Charles Henry, 1847-1918
 Jouett's Kentucky children

In:Harper's Mag
101:51-6 June,1900 illus.

 Jonas. M.H.Jouett
 3 J86J76 NCFA p.101

I.E - COSTUME

Lister, Margot
 Costume:an illustrated survey from ancient
times to the 20th century.1st American ed..
Boston,Plays,inc..1568.
 346 p. illus.

 Bibliography

LC GT513.L5 1968

I.E - COSTUME

Norris, Herbert
Costume and fashion. London & Toronto,J.M.
Dent & sons,ltd. New York,E.P.Dutton & co.,
1924-38

5 v. illus.(part col.)
v.6 by H.Norris & Oswald Curtis

v.1:Evolution of European dress through the
earlier ages.-v.2:Senlac to Bosworth,1066-1485.-
v.3:The Tudors,bk.I:1485-1547,bk.II:1547-1603
v.4 - - .v.6:19th c.
LC GT720.N6

qN
40.1
D368R8 I.E - COSTUME - mid-20th c.
NPG
De Meyer, Adolf, 1868-1949
DeMeyer,edited by Robert Brandau;with a bio-
graphical essay by Philippe Jullian.1st ed.N.Y.,
Knopf;dist.by Random House,1976
50 p. illus.

LC TR679.D45 1976

708.1
N52 I.E - COSTUME
NS v.3
Jul'44- Simonson, Lee
Jun,'45 Fashion and democracy
In:B.Metrop.Mus Art
3(NS):65-72 Nov 1944 illus.

Incl:Raleigh. Woodcuts by Amman

Notes on the history of men's fashion. Cloths
as mark of social status & affluence

Rep.,1942-44*697

I.E - COSTUME - FRANCE

Leloir, Maurice, 1853-1940 ed.
Histoire du costume de l'antiquité à 1914;
ouvrage pub.sous la direction de M.Leloir et
sous le patronage de la Société de l'histoire
du costume. Préf.de Henri Lavedan.Paris,H.Ernst
1933-1949
v. illus(part col.)

Bibliographies

Contents.-

t.8.Époque Louis XIII de 1610 à 1643.-
LC GT510.L37 Elle Kongel.portr.
NK4706.14 malere p.514

N
5610
L67X I.E - COSTUME - ANTIQUITY - ROME
NPG
L'Orange, Hans Peter, 1903-
Likeness and icon.Selected studies in clas
sical and early mediaeval art.Odense,Univ.Pres
1973
343 p. illus.

Articles in English,French,German & Italia
bibl.references

Partial contents:Pt.I:Portraits.10 article
p.1-102 incl.a.o.Zum frührömischen frauenpor-
trät,p.14-22;Der subtile stil.Eine Kunstströ-
mung aus der ze um 400 n.Chr.,p.54-71(per-
tains to coiffu.

I.E - COSTUME - FRANCE

Quicherat, Jules Étienne Joseph, 1814-1882
Histoire du costume en France depuis les
temps les plus reculés jusqu'à la fin du 18e s.
...Ouvrage contenant 481 gravures dessinées sur
bois d'après les documents authentiques par
Chevignard,Pauquet et P.Sellier.Paris,Hachette
et Cie.,1875
680 p. illus.

LC GT850.Q8 Bouchot.Portrs.aux crayons
7060.P23 NPG p.21,22 foot-
notes

I.E - COSTUME - 18-19th c.

Reynolds, Perceval William
Military costume in the 18th and 19th cen-
turies.MS kept in V & A Library n.d.

V & A

Johnson,E.M. Francis Cotes
N;o.1.C84J6 NPG Bibl.

I.E - COSTUME - FRANCE - 18th c.

Vaillat, Léandre, 1878-
...La société du 18e siècle et ses peintres;
...Paris,Perrin et cie.,1912
272 p. illus.

Contents.-Le portrait et le costume.-La
femme.-L'enfant-Jean-Etienne Liotard.-J.-B.
Perroneau

LC ND1316.V3 Fogg,v.11,p.319

4743
S848 I.E - COSTUME - 18-19th c.
NPG Stevenson, Sara
Van Dyck in check trousers.Fancy dress in
art and life,1700-1900.Scottish Nat'l Portrait
Gallery.The Trustees of the Nat'l Gallery of
Scotland,1978
117 p. illus(part col.)

3 chapters by Helen Pennett

Inserted:Cat.of exh.in Scott.Nat'l Portr.
Gall.,July 1-Sept.10,1978

I.E - COSTUME - FRANCE - 18-19th c.

Broadley, Alexander Meyrick, 1847-1916
Collectanea Napoleonica;being a cat. of the
coll....caricatures...portraits,naval and mili-
tary costume plates,etc.relating to Napoleon I.
and his time,1769-1821.Formed by A.M.Broadley...
comp.by Walter V.Daniell...Illustr.with a hither-
to unpublished portrait of Napoleon,by Detaille..
London,W.V.Daniell;etc.1905.
166 p. illus.
'Interesting,well illustrated volume.'-Levis

LC Z8612.B85 Levis.Descript.Bibliogr.
25947.A3L66 1974 NCFA
p.206

GT
1730
B87
NPG

I.E - COSTUME - GREAT BRITAIN

Brooke, Iris
English children's costume since 1775...
London,A.& C.Black,ltd.¿1930.

FOR COMPLETE ENTRY
SEE MAIN CARD

I.E - COSTUME - GREAT BRITAIN

Cunnington, Cecil Willett, 1878-1961
Handbook of English costume in the 16th -
19th century, by C.Willett & Phillis Cunnington..
London,Faber & Faber.1954-59.
4 v. illus.

LC GT732.C84

I.E - COSTUME - GREAT BRITAIN

Brooke, Iris
English costume from the 14th through the
19th c....N.Y.,The Macmillan co.,1937

LC GT733.B7

FOR COMPLETE ENTRY
SEE MAIN CARD

I.E - COSTUME - GREAT BRITAIN

Fairholt, Frederick William, 1814-66
Costume in England; a history of dress to
the end of the 18th c. 4th ed. London,G.Bell
and sons,1896

2 v. illus.(above 700 engravings

LC GT730.F2 1896

NK
928
C75
1968
NCFA

I.E - COSTUME - GREAT BRITAIN

Buck, Anne M.
Costume

In:The Connoisseur's Complete Period Guides
p.1221-30 illus. ¿Regency period.
p.1465-75 illus. ¿Early Victorian period.

N
7598.2
I44
NPG

I.E - COSTUME - GREAT BRITAIN(Episcopal dress)

Ingamells, John
The English Episcopal portrait,1559-1835.
A catalogue.Publ.privately by The Paul Mellon
Centre for Studies in British Art.1981.
491 p. illus.

Ch.on Episcopal dress
Index of artists

I.E - COSTUME - GREAT BRITAIN

Cotman, John Sell, 1782-1842
Engravings of sepulchral brasses in Norfolk
and Suffolk,tending to illustrate the ecclesias-
tical,military & civil costume ...with an intro-
ductory essay by Dawson Turner...2d ed....
London,H.G.Bohn,1839
2 v. illus.in color

LC NB1842.C7

Amsterdam,Rijksmus.,cat.
Z5939A52,deel 1,p.152

I.E - COSTUME - GREAT BRITAIN

Jarrett, Dudley
British naval dress.London,J.P.Dent & Sons,
1960
148 p. illus.

DSI NN etc.

Johnson,E.M. Francis Cotes
qN40.1.C84J6 NPG Bibl.

NK
928
C75
1968
NCFA

I.E - COSTUME - GREAT BRITAIN

Cunnington, Cecil Willett, 1878-1961
Costume

In:The Connoisseur's Complete Period Guides
p.179-87 illus. ¿Tudor period.
p.443-48,481-4 illus. ¿Stuart period.
p.717-28 illus. ¿Early Georgian period.
p.925-8,961-6 illus. ¿Late Georgian period.

391
.K29

I.E - COSTUME - GREAT BRITAIN

Kelly, Francis Michael, 1874-
A short history of costume & armour,chiefly
in England,1066-1800...New York,C.Scribner's
sons;London,B.T.Batsford,ltd.,1931

2 v.in 1 n.p. illus(part col.)

Bibliography

Schwabe,Randolph, joint author

LC GT730.K4

```
705      I.E - COSTUME - GREAT BRITAIN
S94
NCFA     Sandilands, G.S.
v.13        Royal robes and regalia

         In:Studio
         13:235-49  1937(ptI)  illus(part col.)

             Portrs. of Charles II,Georges I,II,III,Queen
         Victoria,Edward VII

                              Rep.,1937#365
```

```
         I.F - COSTUME - GREAT BRITAIN - 16-17th c.

         Reynolds, Graham, 1914-
             Elizabethan and Jacobean,1558-1625.London,
         G.C.Harrap.1951.  Ann Arbor,Mich.Univ.Micro-
         films,1970.
             24 p.  illus.  (Costume of the Western
         World.The Tudors to Louis XIII,v.3,no.3)

             Authorized facsimile

             Bibliography

MoMA
```

```
705      I.F - COSTUME - GREAT BRITAIN - 16th c.
C75
NCFA     Kelly, Francis Michael, 1879-
v.113       Queen Elizabeth and her dresses

         In:Connoisseur
         113:71-9  Jun,1944  illus.

             Incl.:Miniatures by Hilliard,ptg.by Zuccaro ?
         Marcus Geeraerts,younger,caricature,ca.1595,
         effigy by Powtrain & Crits

                              Rep.,1942-44#748
```

```
GT       I.E - COSTUME - GREAT BRITAIN - 18th c.
736
B82      Buck, Anne M.
1979T       Dress in 18th c. England...N.Y.,Holmes &
NPG      Meier Publ.,Inc.,1979
             240 p.  illus(part col.)

             Bibliography

             Illustr.incl.:Ptgd.p.69:Zoffany.Portrait
         within portrait.  Conversation pieces
```

```
705      I.E - COSTUME - GREAT BRITAIN - 16th c.
B97
NCFA     Rowlands, John
v.121       Holbein and the court of Henry VIII at the
         Queen's Gall.,Buckingham Palace

             In:Burl Mag
             121:53-4  Jan.,'79  illus.

             'This exh.is.. of the first importance...
         central core portr.drags.by Holbein fr.Windsor
         Castle.'-J.R.
             R.discusses in this article mainly the ptgs.
         & miniatures.      The cat.by Susan Foister
         has notes on ebe       tumes worn by the sitters.
```

```
         I.E - COSTUME - GREAT BRITAIN - 18th c.

         Ribeiro, Aileen
             The dress worn at masquerades in England,
         1730-1790 and its relationship to dress in
         portraiture

             Unpublished Ph.D.thesis Uni.of London.1973.

                              Isepp.In:Burl Mag.121:311
                                 ote 7
```

```
705      I.E - COSTUME - GREAT BRITAIN - 16-17th c.
C75
NCFA     Kelly, Francis Michael, 1879-
v.85        Costume at the National portrait gallery
         ,London.

         In:Connoisseur
         85:214-21  Ap.,'30  illus.

             Examples from 16-18th c.

             Repro.:Dan.Mytens,Luke Sullivan,Gottfried
         Kneller,Largillière

                              Cumulated Mag.subj.index
                              A1/3/C76 Ref.,v.2,p.443
```

```
GT       I.E - COSTUME - GREAT BRITAIN - 19th c.
C97h
1971     Cunnington, Cecil Willett, 1878-1961
NPG         Handbook of English costume in the 19th
         century...& Phillis Cunnington...1st American
         ed.,Boston,Plays,Inc.,1971,c.1970.
             617 p.  illus(part col.)

             Bibliography

         LC GT 737.C814  1971
```

```
         I.E - COSTUME - GREAT BRITAIN - 16-17th c.

         Morse, Harriet(Klamroth),1891-  ed.
             Elizabethan pageantry,a pictorial survey of
         costume and its commentators from c.1560-1620...
         London,The Studio,ltd.,New York,The Studio publi-
         cations,inc.,1934
             128 p.  illus(part col.)

             Special spring no.of "The Studio"

             Bibliography

LC GT585.M6               Fogg,v.11,p.324
```

```
GT       I.E - COSTUME - GREAT BRITAIN - 19th c.
595
G5X      Gibbs-Smith, Charles Harvard, 1909-
NPG         The fashionable lady in the 19th century,
         London,H.M.Stationery Off.,1960

                              FOR COMPLETE ENTRY
                              SEE MAIN CARD
```

705
B97
NCFA
v.69

I.E - COSTUME - GREAT BRITAIN - 19th c.

Holmes, (Sir)Charles John, 1868-1936
The heirs of Lawrence, 1825-1835

In:BurlMag.
69:195-201 Nov.,'36 illus.

Study of costume gives new attributions to
ptgs. which had been attributed to Harlow

Repro.:Margaret Carpenter,Geo.Henry Harlow,
Henry Wyatt
Steegmann,J.Burl.Mag.v.73
pp.177-8,183 Oct.,'38

AP
1
H66
NPG
v.39

I.E - COSTUME - U.S.

Blumenthal, Diane H.
Images of America's past

In:Hist.News
39:31-3 Nov.,'84 illus(part col.)

The Cat.of Amer.portrs.documents 70000
ptgs.in historical agencies & museums across
the country. It incl.also a file on historical
costumes as a method of dating.

The Cat.of Amer.portrs.is a dpt.of the NPG

I.E - COSTUME - GREAT BRITAIN - 20th c.

Brooke, Iris
English costume,1900-1950.London,Methuen
.1951.
90.p. illus.

LC GT738.B7

AP
1
J8867
NPG

I.E - COSTUME - U.S. - 17th c.

Trautman, Patricia
When gentlemen wore lace:Sumptuary legis-
lation and dress in 17th c.New England

In:J.Regional cultures
3,no.2:9-21 Fall/Winter,'83 illus.

Attempts to enact regulations regarding
dress

VF
Costume

I.E - COSTUME - NETHERLANDS - 17th c.

Dutch portraits.A photographer's art
Photographs by William Coupon

In:TWA Ambassador
76-81 Oct.,1985 illus.

GT
605
E12
NPG

I.E - COSTUME - U.S. - 17-18th c.

Earle, Alice (Morse), 1851-1911
Two centuries of costume in America,1620-1820
...New York,The Macmillan company;London Macmillan
& co.,ltd,1903
2 v. illus.

1910 edition: 2 v. in 1. No LC no.

Morgan,John H. 759.1.M84
Early Am.ptrs. bibl.

I.E - COSTUME - SWITZERLAND
Heierli, Julie
Was ist ein Schappel?

In:Indic.suisse
:224-34 1933 illus.

Women's hairdressing in Switzerland in the
Middle ages which stayed till 19th c.

LC DQ1.A72 Rep.,1933#173

391
.M12

I.E - COSTUME - U.S. - 17-18th c.

McClellan, Elisabeth, 1851-1920
History of American costume,1607-1870;with
an introductory chapter on dress in the Spanish
and French settlements in Florida and Louisiana...
New York,Tudor publishing company,1937
661 p. illus(part.col.)

Incl.photogrphs of rare portrs...

Title of previous ed.:Historic dress in Amer.
NPG copy from 1904.Phila.,G.W.Jacobs & co.
407 p.
LC GT607.M22 Morgan,John H. 759.1M84
Early Am.ptrs. bibl.

705
Z18
NMAA
v.38

I.E - COSTUME - SWITZERLAND

Schneider, Jenny
Hut ab vor so viel kopfbedeckungen!200 jah-
re frauenhüte und -hauben in der Schweiz

In:Z.f.schw.Arch&ol.Kunstgesch.
38:305-12 Dec.,'81 illus.

Repro.:Portrs.fr.the Portr.coll.of the
Schweizerisches Landesmuseum

391
.W29

I.E - COSTUME - U.S. - 17-18th c.

Warwick, Edward, 1881-
Early American costume,by Edward Warwick and
Henry C.Pitz;with illustrations by the authors.
New York,London,The Century co.,c.1929,
319 p. illus. (On cover:Century library
of American antiques)

Bibliographical notes

LC GT607.W3 Hist.rec.survey N7593.1
H67 v.2,p.514

AP
1
W71
NPG

I.E - COSTUME - U.S. - 17-19th c.

Calvert, Karin
Children in American family portraiture,
1670-1810

In:Wm.& Mary Q
Ser.3,39:87-113 Jan.,'82 illus.

Incl.:Table I:Distributed by period & sex.
Table II:Costume of boys.
334 family portrs.were studied.Nuclear fa-
mily portrs.appear after 1770
Dress indicates sex,status,age,leading
signs of chan⌒ging custom.Hairstyle in-
dicates period & age. ,

TR
647
B823P5
NMAA

I.E - CURIOSITIES

Philadelphia Museum of Art
P511 Brandt:Behind the camera,photographs
1928-1983,presented by the Alfred Stieglits
Center,Phila.Mus.of Art.Published to accompany
the retrospective exh.June 8 to Sept.21,1985.
Phila.Mus.of Art,Aperture,1985
99 p. illus.
Ch.on Portraits,p.40-51
Introductions by Mark Haworth-Booth
Essay by David Mellor
Bibliography

René Magritte,1966,p.47(holding his 'La
grande guerre')

QN
40.1
A673A6
NPG-A

I.E - CURIOSITIES

The Arcimboldo effect.Transformation of the face
from the 16th to the 20th century.Publ.in
the U.S.by Abbeville Press,N.Y.,1987
402 p. illus(part col.)

Published on the occasion of the exh.in
Venice,Palazzo Grassi,till May 31,1987.
Artistic director & General Commissioner
Pontus Hulten.Ed.by Piero Falchetta

I.E - CURIOSITIES

Le portrait de profil et de farce.Musée de
Chartres,juillet-août-septembre 1977.
Chartres,Musée des beaux-arts,1977
39 p. illus.

At head of title:Le Musée de Chartres et
Christian Zeimert présentent (220 portrs.from ma-
ny periods,portrs.of the dead,official portrs.,
etc.bizarre works by Zeimert,e.g.Philippe de
Champaigne's Turenne with face blotted out with
a balloon.)

LC ND1301.5.F8C4;86

qAP
1
P975
NMAA

I.E - CURIOSITIES

Peyer, Andreas
Venice.Palazzo Grassi.Arcimboldo

In:Burl Mag
129:343-4 May,'87 illus.

Discusses the exh.'The Arcimboldo effect'and
diverse articles in the book:The Arcimboldo ef-
.fect,q:N40.1.A673.A6 NMAA

N
7618
H75
NPG

I.E - DEATH

Holsten, Siegmar
Das bild des künstlers.Selbstdarstellun-
gen.Hamburg,Hans Christians verlag,1978
123 p. illus.

Zur Ausstellung in der Hamburger kunst-
halle vom 16.juni bis 27.august 1978

Bibliography

Incl.Ch.:Aug in aug mit sich selbst.Im ange-
sicht des todes.p.34 ff.Ch.Grimassenspiel,p.44ff

N
7618
H75
NPG

I.E - CURIOSITIES

Holsten, Siegmar
Das bild des künstlers.Selbstdarstellun-
gen.Hamburg,Hans Christians verlag,1978
123 p. illus.

Zur Ausstellung in der Hamburger kunst-
halle vom 16.juni bis 27.august 1978

Bibliography

Incl.Ch.:Aug in aug mit sich selbst.Im ange-
sicht des todes.p.34 ff.Ch.Grimassenspiel,p.44ff

I.E - DEATH

Lloyd, Phoebe
Death and American painting:Charles Willson
Peale to Albert Pinkham Ryder
336 p.

Ph.D.diss. City Univ.of N.Y.,1980

An investigation of the iconography of Ame-
rican death imagery...is.the life of a culture
is revealed in its death imagery...by isolating
the shift fr.one aspect of death to another..we
can best chart the changing attitudes to death
Diss.Abstr.Internat'l see over
v.41no.8,Feb.'81 p.3304-A Gerdts.Art of healing
 N8223.G36 NPG,p.112,note:13

qN
40.1
H878
I 9
NPG

I.E - CURIOSITIES

Iveagh Bequest, Hampstead, Eng.
Thomas Hudson,1701-1778...

Cat.no.66:Portr.of Miss Irons with scroll
over her face

COMPLETE ENTRY
SEE MAIN CARD

N
6510
P54
NMAA

I.E - DEATH

Pike, Martha V.
A time to mourn,expressions of grief in
19th century America;by M.V.Pike and Janice
Gray Armstrong.Brooklyn,N.Y.:Museums at Stony
Brook,1980
192 p. illus(part col.)

Exhibited May 24-Nov.16,1980 at Museums at
Stony Brook,Stony Brook,N.Y.
Incl.Posthumous mourning portraiture
Bibliography

Incl.Index
LC N6510.P54 Also in EHT Gerdts.Art of healing
 N8223.G36,p.112,note 13 NPG

I.E - DEATH

Le portrait de profil et de farce.Musée de
Chartres,juillet-août-septembre 1977.
Chartres,Musée des beaux-arts,1977
39 p. illus.

At head of title:Le Musée de Chartres et
Christian ?eirert présentent (?20 portrs.from many
periods,portrs.of the dead,official portrs.,
etc.bizarre works by Zeiwert,e.g.Philippe de
Champaigne's Turenne with face blotted out with
a balloon.)

LC ND1301.5.F8C4 86

705
A784
NCFA

I.E - DONOR PORTRAITS

Debs, Barbara K.
From eternity to here:Uses of the Renais-
sance portrait

In:Art in Am
63:48-55 Jan.,-Feb.,'75 illus(part col.)

Transformation of intention in portrs fr.
medieval to early 15th c. donors to mid 15th c.
& later portrs."in context"& individual portrs.

I.E - DEATH

Spanish Institute,Inc.,N.Y.
The Spanish golden age in miniature.Portraits
from the Rosenbach Museum & Library.Cat.of exh..
March 25-Apr.23,'88.New York,The Institute,1988
62 p. illus(part col.)
Bibliography

Incl.the miniatures of the Talbot Hughes
coll.
Exh.also in Philadelphia,Rosenbach Mus.&
Library,June 7-July 31,'88

MdBMA MB(ND1337S7S636 1988)

AP
1
J8654
NPG

I.E - DONOR PORTRAITS

Hughes, Diane Owen
Representing the family:Portraits and
purposes in early modern Italy

In:J.Interdisc.Hist
17,no.1:7-38 Summer,'86 illus.

Repro.incl.:Petrus Cristus:Portrs.of donors;
Lorenzo Lotto:Double portrait

Bibliographical references

708.1
M52
NMAA
v.43

I.E - DONOR PORTRAITS

Bauman, Guy
Early Flemish portraits,1425-1525

In:Met Mus Bul
43,no.4:1-65 Spring,'86 illus(part col.)

Repr.incl.:Donor portraits
Discusses the attitudes of early Flemish
artists and their patrons toward portraiture.
Investigates the uses of the genre at the tim

I.E - EQUESTRIAN

Davis, Frank
A question of horsemanship

In:Illustr.London News
:p.226 5 Feb,1938 illus.

Incl.:Clouet,Ridinger,Seymour

LC AP4.I3 Rep.,1939=704

M
5070
B5N59
NMAA

I.E - DONOR PORTRAITS

Bilder von menschen in der kunst des Abend-
landes.Jubiläumsausstellung der Preuss.
Museen Berlin 1830-1980.Berlin,Mann,c.1980
400 p. illus(part col.)

Cat.of the exh.held May 7 to Sept.28,
1980 in the Nationalgal.Berlin Staatl.Mus.
(West Berlin)

Part.contents:L.Giuliani.Individual & ideal.
Antiquity.-H.-G.Severin.Portrs.betw.Antiquity
& Middle Ages.-P.Bloch.Portrs.in the Middle
Ages.Rulers'por' Sepulchral portrs.Donors.-
H.Bock.,R.Gross. s.The portr.The autonomous

I.E - EQUESTRIAN

Grossmann, Otto
Das reiterbild in malerei und plastik.Berlin
Lankwits,Würfel Verlag,1931
136 p. illus.

Bibliography

NET
115.7
G91

IaU CSt CU ICU Eller,Povl.Kongel.port.ma-
 lere,p.511

705
P19
NCFA

I.E - DONOR PORTRAITS

Chamson, Lucie
Das porträt in der Avignoner schule des
15.jahrhunderts

In:Pantheon
11:118-24 Apr.1933 illus.

Enc.of World Art N31E56
Ref. vol.11,col.513
bibl.on portr.

N
1165
R6A6x
NPG

I.F - ETHNIC GROUPS

London. Royal College of Surgeons of England
A cat.of the portraits...drawings and sculp
ture in the Royal College of Surgeons of Eng-
land,by William LeFanu,librarian.Edinburgh,
E.& S.Livingstone,1960,i.e.1959,
118 p. illus(part.col.)

Bibliography

Pt.2 incl.Racial types,anomalies

LC N1165.R6A6 Yale ctr.f.Brit.art Ref.
 N1165.R6A56

AP
I
A64
NCFA

I.E - ETHNIC GROUPS - EAST INDIA

Archer, Mildred
 Renaldi and India.A romantic encounter

In:Apollo
104:98-105 Aug.,'76 illus.

Rila III/2 1977 #4983

E
89
C35
NPG

I.F - ETHNIC GROUPS - INDIANS

A catalogue of Indian portraits in the coll.
of Jos.G.Butler,jr.,on free exh.at the
 Y.M.C.A.bldg,Youngstown,O.:s.n.,s.l.,
 ca.1907.(Youngstown,Ohio,Vindicator Press)
 39 p. illus.

 The greater part of the coll.is the work
of J.H.Sharp and E.A.Burbank.Other artists re-
presented are Frederick Remington,Bert Phillips
Deming and Candy
 Smithsonian "National Museum"bought 11
Sharp ptgs.,Dec.1900

I.E - ETHNIC GROUPS - INDIANS

Adam, Leonhard, 1891-1960.
 The portrait in the art of ancient America

In:Cahiers d'art
5,no.10:519-24 1930

LC N2.C35 FOR COMPLETE ENTRY
 SEE MAIN CARD

N
40.1
C36
Alep
1979
NMAA

I.E - ETHNIC GROUPS - INDIANS

Catlin, George, 1796-1872
 Episodes from life among the Indians,and
last rambles.With 163 scenes and portrs.by
the artist.Ed.and with an intro.by Marvin C.
Ross.Norman,Univ.of Oklahoma Press,1979
 354 p. illus. (The Civilisation of
the American Indian series.55.)
 Bibliography

Worldwide Art Book Biblio-
graphy Z5931.W92 NMAA 2,
no.2-4 1967-71,v.IIIno.1
p.12

N
40.1
K52B6
NCFA

I.E - ETHNIC GROUPS - INDIANS

Birket-Smith, Kaj, 1893-
 Charles B.King's indianerportraetter i
Nationalmuseet. København,Bianco Lunos Bogtryk-
keri A/S, 1942
 39 p. illus(part col.)

Ewers.Ann.Rep...S.I.,1953
Bibl.,p.473

I.E - ETHNIC GROUPS - INDIANS

Cochran, George M.
 Indian portraits of the Pacific Northwest.
Thirty of the principal tribes.1st ed..Port-
land,Or.,Binfords & Mort,1959
 62 p. illus.

LC E78.N77C6 Books in print.Subject
 Guide,1985-86 v.3,p.4864

I.E - ETHNIC GROUPS - INDIANS

Browne, Charles Francis, 1859-
 Elbridge Ayer Burbank,a painter of Indian
portraits.Chicago,The Arts & crafts company,
n.d. p.16-35 illus.(part col.)

 From "Brush and pencil,v.III,no.1,Oct.1898"

MH-P

705
I 61
NCFA
v.82

I.E - ETHNIC GROUPS - INDIANS

Comstock, Helen
 Langdon Kihn,Indian painter

In:Studio
82:50-5 Oct.,'25 illus.

 '...there is no one who has given us quite
the same kind of Indian portraiture as that of
Langdon Kihn...These pictures have unusual va-
lue as portraits...'
 Repro.incl.:Medicine man of Gitwinkool;Boy &
Eagle chief of Kitwanga;woman chief of Gitsegul-
ka,woman of Kulde tribe

B
.S78R9

AP
1
S654
1924
pt.1
NCFA

I.E - ETHNIC GROUPS - INDIANS

Bushnell, David Ives, 1875-1941
 John Mix Stanley,artist explorer...

In:Smithsonian institution.Ann.rep.,1924
p.507-12 illus.

LC Q11.S66 1924 Kiniets.J.M.Stanley...
 N40.1.S788K5 NCFA p.17

N
40.1
C94783
NPG

I.E - ETHNIC GROUPS - INDIANS

Cress, Henry H., 1837-1918
 The T.B.Walker coll.of Indian portraits;125
reproductions of ptgs. by Henry H.Cress,of which
22 are in color.With historical commentary by
A.W.Schorger.Madison,State Historical Society
of Wisconsin,1948
 164 p. illus(part col.)

 Incl.Ch.:White men in the Indian Country...
p.140-64

I.E - ETHNIC GROUPS - INDIANS

qN
40.1
0748D3
NMAA

Dempsey, Hugh Aylmer, 1929-
History in their blood:The Indian por-
traits of Nicholas de Grandmaison;intro.by
J.Russell Harper;foreword by Frederick J.
Dockstader.1st American ed.N.Y.,Hudson Hill
Press.Distr.by Viking Penguin,c.1982
124 p. illus(part col.)

Index

LC NC143.068D46 1982 — Books in print.Subject
guide,1985-86,v.3,p.4864

I.E - ETHNIC GROUPS - INDIANS

AP
1
A51
A6L
NMAA
v.19

Fleischer, Roland Edward, 1928-
Gustavus Hesselius and Penn family portraits;
a conflict between visual and documentary evi-
dence

In:Am.Art J.
19,no.3:4-18 1987 illus.

Repro.incl.:Two Delaware chiefs.

I.E - ETHNIC GROUPS - INDIANS

N
40.1
C36D6
NCFA

Donaldson, Thomas Corwin, 1843-1898
The George Catlin Indian gallery in the
U.S.National museum(Smithsonian inst.)with me-
moirs and statistics...Washington, D.C.,1887
939 p. illus.

Bibliography by George Catlin

From the Smithsonian report for 1885

LC E77.C45 Viola.The Indian legacy...
N40.1/K52V7 NPG Bibl.

I.E - ETHNIC GROUPS - INDIANS

AP
1
P63
NPG
v.33

Goggin, John M.
Osceola:Portraits,features and dress

In:Florida Hist.Q.
33:161-92 Jan.-Apr.,'55 illus.

Bibliography

Repro.incl.:Portrs. by John Rogers Vinton,
Geo.Catlin,Robt.J.Curtis,Chs.Bird King?,Waldo &
Jewett

I.E - ETHNIC GROUPS - INDIANS

707
A786
NCFA
v.7

Eastman Johnson's Indians

Int'l Am.Art M
7,no.10:3 Dec.19,1908 1 illus.

(Clipping in NPG copy of:"A catalogue of
Indian portraits in the coll.of Joseph G.
Butler,Jr....E89.C35)

I.E - ETHNIC GROUPS - INDIANS

B
C36H1
NCFA

Haberly, Loyd, 1896-
Pursuit of the horizon,a life of George
Catlin,painter and recorder of the American
Indian.N.Y.,Macmillan Co.,1948
239 p. illus.

Ch.VIII & Ch.XXVI pertain to C.'s portrs.
of the American Indians

LC ND237.C35H3

I.E - ETHNIC GROUPS - INDIANS

AP
1
N547
NCFA
v.33

Ewers, John Canfield
An anthropologist looks at early pictures
of North American Indians

In:N.Y.Hist.Soc.Q.
33:223-34 Oct.,'49 illus.

Repr.J.LeMoyne,Anonym.portr.of Pocahontas,
G.Hesselius,Engr.by Kleinschmidt after Verelst,
Saint-Mémin,K.Bodmer,Catlin

I.E - ETHNIC GROUPS - INDIANS

N
8217
I5H63
1987
NMAA

Hight, Kathryn Sweeney
The frontier Indian in White art,1820-1876.
The develpment of a myth.Ann Arbor,Mich.Univ.
Microfilms International,1989
421 leaves illus.

Bibliography:leaves 387-421
Incl.:Discussion of the art work concerning
Indian subjects by Samuel Seymour,Js.Otto Lewis,
John Neagle,Chs.Bird King,P.Rindisbacher,Geo.Cat-
lin,Karl Bodmer,John Mix Stanley,Seth Eastman.
Some works were reproduced from daguerreotypes.
Ph.D.Disserta- tion.UCLA,1987

I.E - ETHNIC GROUPS - INDIANS

NPG
shelved
in Li-
brarian's
Office

Ewers, John Canfield
Charles Bird King, painter of Indian visi-
tors to the nation's capital

In:Ann.Rep.of the Board of Regents of the S.I.
463-73 1953 illus.

Incl.checklist of Indian portrs.attr.to King

Bibliography

Whitehill.The Arts of ear-
ly Amer.Hist.Z5935.W59 NPG
Bibl.,p.91

I.E - ETHNIC GROUPS - INDIANS

N
6507
H57X
NPG
NMAA

Hirschl & Adler Galleries,inc.,N.Y.
American art from the Colonial and Federal
periods.Cat.of an exh.,Jan.14-Feb.10,1982.In-
troduction by Stuart P.Feld...The Gallery,
c.1982.
102 p. illus(part col.)

Index of artists

Incl.:McKenney & Hall coll.of portrs.of
American Indians by Henry Inman,now in Harold
Byrd coll.Dallas,Texas(1984).

I.E - ETHNIC GROUPS - INDIANS

CN4
H74
NCFA

Hodge, Frederick Webb, 1864-
The origin and destruction of a National
Indian Portrait Gallery

In:Holmes anniversary volume,Washington,1916
pp.187-93 illus.

T.L.McKenney & L.Cass promoted a Nat'l Ind.
Portr.Gall.Ptgs.found their way finally to the
Smithsonian Inst.,where,in 1865 fire destroyed
most of them.Incl.were ptgs.by Chs.B.King,J.O.
Lewis,A.Ford,S.M.Charles,G.Cooke,Shaw

I.E - ETHNIC GROUPS - INDIANS

N
40.1
S788K5
NCFA

Kiniets, William Vernon, 1907-
John Mix Stanley and his Indian paintings.
Ann Arbor,University of Michigan press,1942?
40 p. illus(part col.)

Bibliography

The portrs.of North American Indians,p.13-

LC ND237.864 8K5

Viola.Indian legacy of
Ch.B.King N40.1.K52V7 NPG
Bibl.

ND
1311.2
P61x
NPG

Kenway, Mary M.
Portraits of Red Jacket
Miles, Ellen Gross comp.
Portrait painting in America.The nineteenth
century.N.Y....,1977 (card 4)

Partial contents cont'd:...M.M.Kenway,Portrs
of Red Jacket,p.160-1;...

I.F - ETHNIC GROUPS - INDIANS

Lewis, James Otto, 1799-1858
The aboriginal port-folio;a collection of
portraits of the most celebrated chiefs of the
North American Indians.72 colored plates...
Philadelphia,J.O.Lewis,1835.-36.
pts. illus(col.)

"Issued monthly untill 10 nos.are completed"

LC E89.L66

Viola.Ind.legacy of Chs.
Brd King N40.1K52V7 Bibl.

I.E - ETHNIC GROUPS - INDIANS

King, Charles Bird, 1785-1862
Cat.of 115 Indian portraits,representing
18 different tribes...Phila.,n.p.,1836
24 p.

Arch.
Am.Art
mfm
P24
181-193

The portrs.are copies by Inman,fr.the cele-
brated coll.in the War Dept.at Washington
Also cited in Nat'l M. & T.'s exh.cat.
"Perfect likenesses" qNE263.N37 1977X NCFA,
p.10,p.4

Arch.Am.Art mfm P24 181-
193

W
St.Mémin

I.E - ETHNIC GROUPS - INDIANS

Leekwood, Luke Vincent, 1872-
The St.-Mémih Indian portraits

In:N.Y.Hist Soc Q.B.
12,no.1:3-26 Apr.'28 illus.

LC F116.N638

Dijon.Mus.municipal N40.1
F43D5 NPG Bibl.p.25

017.37
P3
NCFA
sale no.
3056

I.E - ETHNIC GROUPS - INDIANS

King, Charles Bird, 1785-1862
The important collection of 21 portraits of
North American Indians by Chs.B.King,property
of the Redwood Library and Athenaeum,Newport,
R.I. Auction May 21.1970.Parke-Bernet Galleries,
New York,1970
49 p. illus(part col.)

Intro.by Marc Rosen

Bibliography

Fogg,v.11.,p.327

I.E - ETHNIC GROUPS - INDIANS

McCarthy, Joseph Edward
Portraits of Osceola and the artists who
painted them

In:Jacksonville Hist.Soc.,Papers
2:23-44 1949

LC F319.J1J3

Fogg.in.Osceola.AP1.F63
192

E98
M3K53
NPG

I.E - ETHNIC GROUPS - INDIANS

King, Jonathan C.H.
Portrait masks from the Northwest coast of
America.N.Y.,Thames & Hudson,1979

FOR COMPLETE ENTRY
SEE MAIN CARD

ND
1311.2
P61x
NPG

I.E - ETHNIC GROUPS - INDIANS

McDermott, John Francis, 1902-
Another Coriolanus:Portraits of Keokuk,
Chief of the Sac and Fox
Miles, Ellen Gross comp.
Portrait painting in America.The nineteenth
century.N.Y....,1977 (card 4)

Partial contents cont'd:J.F.McDermott,Ano-
ther Coriolanus,portrs.of Keokuk,Chief of the
Sac & Fox,p.158-9;...

E
77
M155
1848
RB
NPG

I.E - ETHNIC GROUPS - INDIANS

McKenney, Thomas Loraine, 1785-1859
 History of the Indian tribes of North America, with biogr.sketches...of the principal chiefs.Embellished with 120 portraits,fr.the Indian gall.in the Dept.of war,at Washington. Philadelphia,J.T.Bowen,1848-50
 3 v. illus(col.) octavo
 First ed.1836-44 was folio size
 "An essay on the history of the North American Indians.By James Hall":v.3,p.149-387

 From ptgs.chiefly by Charles Bird King
LC E77.M305 NMHT.Perfect likenesses
 p.3

q.NE
262
N37
1977X
NCFA

I.E - ETHNIC GROUPS - INDIANS

National Museum of History and Technology
 Perfect likenesses.Portraits for history of the Indian Tribes of North America (1837-44)..Washington,Smithsonian Institution Press,1977.
 27 p. Cover illus.(col.)

 Catalog essays by Peter C.Marzio and Wm. C.Sturtevant
 Exhib.April-Sept.,1977
 30 ptgs.and 160 lithographs;ptgs.chiefly by Charles Bird King

LC NE263.N37 1977

N
40.1
M8714
M2
NMAA

I.E - ETHNIC GROUPS - INDIANS

McGill, Jean S.,1920-
 Edmund Morris,frontier artist.Toronto and Charlottetown,Dundurn Press,1984
 208 p. illus(part col.) (Dundurn lives)

 Index
 Bibliography,p.197-201

LC ND249.M67M24 1984

N
40.1
H5755
F5
NMAA

I.E - ETHNIC GROUPS - INDIANS

New Jersey State Museum, Trenton
 Gustavus Hesselius,face painter to the Middle Colonies,cat. of the exh. by.Roland E. Fleischer.Feb.13-Apr.24,1988.Trenton,New Jersey State Mus.,1987
 88 p. illus(1 col.)

 Ch.:The Portraits,p.23-44,cat.nos.1-21
 no.5 / 6 Indian chiefs

759.1
.C37M4

I.E - ETHNIC GROUPS - INDIANS

Matthews, Washington, 1843-1905
 The Catlin collection of Indian paintings.

In:U.S. National museum. Annual report. 1890. Washington,1891 p.593-610 illus. Reprint, 1892.
 Reprint of a lecture delivered in...the National museum,Saturday,April 13,1889

LC Q11.U5 1890

qN
6520
.P63
1983X

I.E - ETHNIC GROUPS - INDIANS

Poesch, Jessie J.
 The Art of the Old South,painting,sculpture,architecture,and the products of craftsmen,1560-1860...1st ed.N.Y.,Knopf,1983
 384 p. illus(part col.)

 Incl.index
 Bibliography,p.361-366

 Repro.incl.:Eye miniature by Malbone,p.162; Portrs.of Amer.Indians by Curtis,p.272;by Römer & by Catlin,p.273.Ports.within portrs., p.265.Groups by Earl,p.171;by Johnson, p.159

AP
1
A51A64
NMAA
v.20

I.E - ETHNIC GROUPS - INDIANS

Miles, Ellen G.,ross.
 Saint-Mémin's portraits of American Indians, 1804-1807

In:Am Art J
20,no.4:2-33 1988 illus(1 col.)

CJ
5807
P97
NPG

I.E - ETHNIC GROUPS - INDIANS

Prucha, Francis Paul
 Indian peace medals in American history. Madison,State Historical Society of Wisconsin, 1971
 186 p. illus.

 Bibliography:p.165-72
 Repro.incl.:Geo.III;Chs.IV;'Presidential series';Ptgs.by Catlin & by Samuel M.Brookes & drawg.by St.-Mémin & photographs of Indians wearing the medals.

N
40.1
M8714
F5
NMAA

I.E - ETHNIC GROUPS - INDIANS

Morris, Edmund, 1871-1913
 The diaries of Edmund Montague Morris: Western journeys 1907-1910;transcribed by Mary Rits-Gibbon.Toronto,Royal Ontario Museum,1985
 179 p. illus(part col.)

 Bibliography p.167-70
 Index

NPG
Ref.
coll.
N
40.1
K5208
NCFA
2 cop.

I.E - ETHNIC GROUPS - INDIANS

Smithsonian Institution. National Collection of Fine Arts
 The paintings of Charles Bird King(1785-1862);Cat.of an exh.,Nov.4,1977-Jan.22,1978. by Andrew Joseph Cosentino.Washington,Published for the National Coll.of Fine Arts by the Smithsonian Institution Press,1977
 213 p. illus(part.col.)

 Bibliography
 Portrs.p.121-165. Indians p.165-186
 Foreword by Joshua C.Taylor

LC ND237.K53C67

qN
40.1
C36T8
NCFA
Ref.
2 copies

I.E - ETHNIC GROUPS - INDIANS

Truettner, William H.
The natural man observed:a study of Catlin's
Indian gallery...1st ed. Washington,Smithsonian
Inst.Press,1979.
323 p. illus(part col.)

Bibliography
Incl.indexes

Incl.a descriptive cat.of the Indian gall.
Portrs.p.142-232,p.293-99

N
7593.1
A52
NPG

I.E - ETHNIC GROUPS - JEWS

American Jewish Historical Society
Early American Jewish portraiture. Exhibited
Feb.-July,1952,at the Jewish Museum,New York
,c.1952,
20 p. illus.

I.E - ETHNIC GROUPS - INDIANS

Viola, Herman J.
The Indian legacy of Charles Bird King.
1st ed.Washington:Smithsonian Institution Press
c.1976
152 p. illus(part col.) (Smithsonian
Inst.Press publication;no.6256)

Bibliography

Incl.Cat.of War dept.Indian Gallery,p.143-5

LC ND237.K53V56

N
7593
A75
NPG

I.E - ETHNIC GROUPS - JEWS

American Jewish Historical Society
Paintings,daguerreotypes,artifacts;comp.
and ed.by Carlo M.Lamagna & Judith E. Endel-
man.Waltham,Mass.,Amer.Jew.Soc.,1974
48 p. illus.

AP
1
A51S2
NCFA

I.E - ETHNIC GROUPS - INDIANS

Viola, Herman J.
Portraits,presents,and peace medals:Thomas
L.McKenney and the Indian visitors to Washing-
ton

In:Am.Scene
11,no.2 June,1970 illus(part col.)

Incl.documentation of portrs.by Chs.Bird
King in the Ths.Gilcrease Inst.of Am.Hist.& Art,
Tulsa,Okla.

Viola.Ind.legacy...N40.1
K52V7 Bibl.

I.E - ETHNIC GROUPS - JEWS

Colquitt, Delores Boisfeuillet
Distinguished Jews in St.Mémin miniatures

In:Daughters of the Amer.Rev.Mag.
59 Feb.,1925

LC E202.5.A12

London,H.R. Shades of my
forefathers.741.7.L847 Bibl.

AP
1
N547
NCFA
v.33

I.E - ETHNIC GROUPS - INDIANS

Weitenkampf, Frank, 1866-1962
How Indians were pictured in earlier days

In:N.Y.Hist.Soc.Q.
33:213-21 Oct.,'49 illus.

Development of portraiture of Indians from
c.1500-1850,from fictitious...to realistic

Repr.German block print,c.1505,Engr.by de
Bry,after J.White,Catlin,Bartoli,Litho.Lehman
& Duval after Ch.B King,K.Bodmer

757
L85

I.E - ETHNIC GROUPS - JEWS

London, Hannah Ruth, 1894-
Portraits of Jews by Gilbert Stuart and other
early American artists...N.Y.,W.E.Rudge,1927
197 p. illus.

Bibliography

LC N7593.L6

VF

I.E - ETHNIC GROUPS - INDIANS

Winold Reiss:Plains portraits
,Cat.of,exh. at N.Y.,Kennedy Gall.,Inc.,
Oct.4-Oct.28,1972
5 p. text 23 p. illus(part col.)

Incl.,articles by John C.Ewers and by Rudolf
G.Wunderlich

40 works shown

I.E - ETHNIC GROUPS - JEWS

Walkowitz, Abraham, 1880-1965
Faces from the ghetto,by Abraham Walkowitz
,N.Y.,Machmadim Art Editions,inc.,1946
40 p. illus.

"These prints are reproduced from originals
in the coll.of the Gall.of Jewish art,N.Y.city"

LC NC1075.W29

I.E - ETHNIC GROUPS - JEWS - GREAT BRITAIN

Rubens, Alfred, 1903-
Anglo-Jewish portraits;a biographical catalogue of engraved Anglo-Jewish & colonial portraits from the earliest times to the accession of Queen Victoria,by...with a foreword by H.M.Hake. London,The Jewish museum,1935
191 p. illus.

Bibliography

LC DS135.E6A17

Waterhouse.Ptg.in Britain 1530-1790 ND465.W32 1962 NCFA bibl.

qML
2561
J3N27
NPG

I.E - ETHNIC GROUPS - NEGRO

National Portrait Gallery, Washington, D.C.
"A glimmer of their own beauty":Black sounds of the Twenties.Washington,1971
,32,p. illus.

Bibliography

Exh.June 15 - Oct.15,1971

LC ML141.W3N3

N
7593
D23
NPG

I.E - ETHNIC GROUPS - JEWS - U.S.

Daughters of the American Revolution Museum
The Jewish Community in Early America:1654-1830.Washington,D.C.,The Museum,1980
25 leaves

Cat.for exh.,Dec.11,1980-Mar.15,1981

Incl.:Portraits and miniature portraits

I.E - ETHNIC GROUPS - NEGRO

Snowden, Frank Martin,1911-
Blacks in Antiquity:Ethiopians in the Greco Roman experience.Cambridge,Mass.,Belknap Press of Harvard University Press,1970
364 p. illus.

LC DE71.S6

Winkes.Physiognomonia.In: Temporini.Aufstieg u.niedergang---LC DG209.T36,Bd.1,T.J ...p.908

N
7593
L84
NCFA

I.E - ETHNIC GROUPS - JEWS - U.S.

London, Hannah Ruth, 1894-
Miniatures and silhouettes of early American Jews.Rutland,Vt.,C.E.Tuttle Co.,1970,
2 v. in 1 illus.

Reprint of the author's Miniatures of early American Jews and Shades of my forefathers.

Bibliography

LC NC910.L59

Fogg.v.11,p.317,col.1

I.E - EYEGLASSES IN ART

Corson, Richard
Fashions in eyeglasses.Second impression with supplement.London,Peter Owen,ltd.,1980
304 p. illus.

Bibliography:p.293-6

Eyeglasses appeared in Europe ca.700 yrs.ago

GT2370.C82 1980 NMAH
GT2370.C6 1980 Uni.of Kentucky.Library

N
8232
B78
NCFA
NPG

I.E - ETHNIC GROUPS - NEGRO

Bowdoin College. Museum of Fine Arts.
The portrayal of the Negro in American painting; exhibition, the Bowdoin College Museum of Art. ,Catalogue. Brunswick? Me., 1964.
1 v. (unpaged) illus., ports. 26 cm.

1. Negroes in art. 2. Paintings, American—Exhibitions. I. Title.

N8232.B8 ,?, 64-4946
Library of Congress

I.E - EYEGLASSES IN ART

Roets, Hans
Bildnis und brille.Hrsg.von Carl Zeiss.Oberkochen/Württ.,1957
92 p. illus(part col.)

FOGG
FA
207.340.5P

DLC InU WU OCl Fogg,v.11,p.325

I.E - ETHNIC GROUP - NEGRO

Kaplan, Paul H.D.
Titian's Laura Dianti and the origins of the black page in portraiture

NCA
N 1
A3
v.21

In:Antichità viva
21,no.1:11-18 1982
21,no.4:10-18 1982 illus.

The black page has in instances functioned as an identifying attribute,alluding to the interests of the sitter or given a hint of the sitter's nationality.
Repro.incl.:

P
277
MAA
.37

I.E - EYEGLASSES IN ART

Schmerler, Todd
Glasses

In:Sculpt Rev
37,no.3:14-5 3rd Quarter,1988 illus.

Repro.incl.:Borglum:Th.Roosevelt;Face::Steph. Nicholson;Davidson:Aldous Huxley;Joan Sovern:Michael Sovern;Heino:Vanni

I.E - FAMILY

Ariès, Philippe
 Centuries of childhood,a social history
of family life.N.Y.,Vintage Books,Random
House.1965.
 447 p. illus. (A Vintage giant,V-280)

 Translat.fr.'L'enfant et la vie familiale
sous l'Ancien Régime'

 Childhood representation from middle ages
through 17th c.family portrs.

CC
LC HQ792.F7A73 1962 ed. Hughes,D.O.in J.of Interdis
 cipl.Hist. AP1.J8654 NPG
 v.17,no.1,p.7 footnote 1

I.E - FAMILY

Schubert, Dietrich
 Die Elternbildnisse von O.Dix

In:Städel-Jahrbuch N.F.
4:271 ff. 1973

FOGG
FA19.38

 Die 20er jahre im porträt
 N6868.5.E9Z97 NPG p.139

N
6512.5
P4506X
NMAA Goodyear, Frank Henry, 1944-
 Contemporary American realism since 1960.
Boston,New York Graphic Society,in association
with the Penn.Acad.of the Fine Arts,c.1981
 255 p. illus(part col.)

 Published in connection with the exh.opening
at the Penn.Acad.of the Fine Arts,Phila.,Sept.18
1981
 Bibliography:p.233-42
 Index
 Halle.In:Art J.v.46:225
 note 21

I.E - FAMILY - ANTIQUITY - ROME

Albizzati, Carlo, 1888-
 Vetri dorati del terzo secolo dopo Cristo

In:Deutsch Archäol Inst Mitt Röm Abt
29:240- 1914 illus.
 Family groups & individuals worked out in
gold leaf on glass,from the 3rd c.

LC DE2.D42 Swindler.Ancient painting
 759.93.S97NOA,p.319

I.E - FAMILY

Hinz, Berthold
 Das Familienbildnis des J.M.Molenaer in
Haarlem.Aspekte sur ambivalens der porträt-
funktion

In:Städel Jb.
4:207-16 1973 illus.

 Change from functional to aesthetic value
during Renaissance.
 The ambivalence of approach remains inhe-
rent in portrs. of bourgeois subjects
LC N9.S7 Rila I/1-2 1975 #2129

705
B97
NCFA I.E - FAMILY - FRANCE - 18th c.
v.113
 Cailleux, Jean ed.
 L'Art du dix-huitième siècle.Some family
and group portraits by François de Troy(1645-
1730)

 In:Burl Mag
113,suppl.no.26:I-XVIII Apr.,'71 illus.

 [L.6:Mme.de Franqueville & her children
with black servant and portr.within portrait

 Rosenfeld,M.N. L'Argillièr
 p.401,408

AP
1
J8654
NPG I.E - FAMILY

 Hughes, Diane Owen
 Representing the family:Portraits and
 purposes in early modern Italy

 In:J.Interdisc.Hist
 17,no.1:7-38 Summer,'86 illus.

 Repro.incl.:Petrus Cristus:Portrs.of donors;
 Lorenzo Lotto:Double portrait

 Bibliographical references

I.E - FAMILY - GERMANY - 20th c.

Scheffler, Karl, 1869-1951
 Elternbildnisse

In:K.u.K.
16:292-5 May,1918 illus.

 German contemporary artists'portrs.of
their parents

LC N3.K8 Die 20er jahre im portr.
 N6868.5.E9Z97 NBG, p.139

I.E - FAMILY

New York. Museum of modern art
 Family portraits from the museum collection
[N.Y.,The Museum,1964]
 2 p.

 Checklist of temporary exh.May 27,1964-Feb.
1965
 Ptgs. & sculpt.by Beckmann,Guglielmi,Mark-
avy,Lindner,Marisol,Moore,Quirt,Ruiz,Shahn,
Spencer,Stettheimer,Tanguy,Vuillard

 MOMA,v.11,p.435
 MOMA MMA733 and Archive
 MMA 733

N
7607
J66
1986X I.E - FAMILY - NETHERLANDS - 17th c.
NPG
 Haarlem. Frans Hals museum
 Portretten van echt en trouw.Huwelijk en
 gezin in de Nederlandse kunst van de 17e eeuw,
 exh.cat. by Eddy de Jongh.Zwolle,Waanders,
 1986
 333 p. illus(part col.)

 Exh.15 feb.-19 may,1986

AP
1
A64
NCFA
v.110

I.E - FAMILY - NETHERLANDS - 17th c.

Robinson, William W.
 Family portraits of the Golden Age

In:Apollo
110:490-7 Dec.'79 illus.

 fgs.10 & 11:Portraits historiés

Schama, S.in:J.Interdisc.
Hist.v.17,no.1 AP1.J8654
NPG p.160,footnote 8

I.E - FOLK ART - NETHERLANDS

Schilstra, J.J.
 De Oranjes op taai-en speculaasvormen(Members of the House of Orange on gingerbread moulds)

In:Antiek
10,pt.1:57-68 June-July,'75 illus.

LC NK1125.A25

AP
1
W71
NPG

I.E - FAMILY - U.S. - 17-19th c.

Calvert, Karin
 Children in American family portraiture, 1670-1810

In:Wm.& Mary Q
Ser.3,39:87-113 Jan.,'82 illus.

 Incl.:Table I:Distributed by period & sex.-
TableII:Costume of boys.
 334 family portrs.were studied.Nuclear fa-
mily portrs.appear after 1770
 Dress indicates sex,status,age,leading
signs of chan- ging custom.Hairstyle in-
dicates period & age.

NK
807
F64x
NCFA

I.E - FOLK ART- U.S.

Folk art in America, a living tradition
 Selections from the Abby Aldrich Rockefeller
Folk Art collection,Williamsburg,Va. Atlanta,
The High Museum of Art,1974
 96 p. illus(part col.)
 Exh.held at the High Mus.of art,Atlanta,etc.
 Exhibition cat.
 pp.19-33:Portraits

 Exhib.traveled Sept.'74-Nov.'75

 Bibliography

LC NK807.F64

705
A56
NCFA
v.110

I.E - FAMILY - U.S. - 18-19th c.

Luckey, Laura C.
 Family portraits in the MFA, Boston
Antiques
American painting special issue,
110:965-1070, Nov.,1976 illus(part col.)
Chiefly 18th-19th century
 Partial contents:...Luckey,L.6.,Family por-
traits in the MFA,Boston,p.1006-11;...

I.E - FOLK ART - U.S.

Pinckney, Pauline A.
 American figureheads and their carvers.
Port Washington,N.Y.,Kennikat Press,Inc. 1969
 223 p. illus.

 Bibliography

 '...actual portrs.,either the bust or the
full-length fig.became customary decoration on
a ship's prow.'p.28
 '...the ship carver.is,truly oneof our best
sources of American folk art.'p.32

LC VM308.P5 1969

ND
1304
W67
NPG

I.E - FAMILY - U.S. - N.Y.,N.Y.

Wildenstein & company, inc., New York
 Three hundred years of New York City fami-
lies. A loan exhibition of Conversation pieces
...Jan.12-Jan.29,1966
 n.p., illus.
 1 v.(pamphlet)

PPULC PPPM

Fres.Conversation pieces
ND1304.P92E1971,p.92,foot-
note26

ND
1311.5
S43
NPG

I.E - FOLK ART - U.S.

Sears, Clara Endicott,1863-
 Some American primitives:a study of New
England faces and folk portraits...Boston,
Houghton Mifflin company,1941
 291 p. illus.

 Bibliography

 Incl.references to the Fall River-Sturbridge
school of ptg.,see p.42-6 and illustrs.p.20-1,
23-6

LC ND1311.S4

I.E Folk Art
 For works on folk painting,including"primitive"ptg.
 see II.A.4

I.E - FUNERARY MEMORIALS

Pigler, Andor, 1899-
 Portraying the dead

In:Acta historiae artium
4,1-2:1-75 1956

LC N6.A25

I.E - FUNERARY MEMORIALS

Laude Jean.
 Problèmes du portrait:images funéraires et
images royales

In:J.Psychol.
 401-20 1965

 'Analyse du genre(toutes époques)'

LC BF2.J6 Rep. 1966 #898

ND
1311
D77
NPG
2 c.

I.E - GROUPS

Dresser, Louisa
 Likeness of America,1680-1820..Colorado
Springs,Colo.,Colorado Springs Fine Arts Center
.1949.
 1 v.(unpaged) illus.

 44 works shown, incl.groups

 Detroit.I.A. N40.1.P35D4
 NPG Bibl. p.144

I.E - FUNERARY MEMORIALS

Wilckens, Hans Jürgen von
 Porträtbilder in den leichenpredigten des
17.-18.Jahrhunderts...Hildesheim,A.Lax,1967
 91 p. illus.

 Alphabetical cat.of 1476 portrs.in prints
which accompanied printed funeral sermons.En-
tries incl.name of artist and location of prints
in 8 German collections of funeral sermons.

LC N7620.W5 Fogg,v.11,p.319

I.E - GROUPS

Edwards, Ralph, 1894-
 Early conversation pictures from the Middle
Ages to about 1730;a study in origins. London,
Country Life.1954.
 176 p. illus(part col.)

 Bibl.references

 Iveagh bequest ND1314.4
 E9. NCFA p.3."first.sys-
 tematic,scholarly critical
 consideration"
LC ND1300.E4

AP
1
A64
NCFA

I.E - GROUPS

Archer, Mildred
 Renaldi and India.A romantic encounter

In:Apollo
104:198-105 Aug.,'76 illus.

 Rila III/2 1977 #4983

I.E - GROUPS

Coern, Hermann, 1896-
 Das familienbildnis im abendlande.I.Vorstu-
fen in mittelalter...Halle,E.Kling,1936
 45 p.

 Thesis, Halle-Wittenberg
 "Teildruck" Gesamtausgabe erscheint mitte
FOGG 1936 im Akademischen verlag, Halle
FA 980.21

MMG CtY ICRL NN Fogg,v.11,p.322

ND
1301
A7X
NPG

I.E - GROUPS

Arts Council of Great Britain
 Portrait groups from National Trust col-
lections.exhibition,London,1960.
 27 p. illus.

 Incl.:Index of houses,Index of artists

 Exhs.:Eastbourne,Towner Art Gall.Nov.5-22/60
Luton,Art Gall.,Wardown Park,Dec.3 -Dec.24/60;
Coventry,Herbert Art Gallery,Dec.31-Jan.21,'61;
Wakefield,City Art Gallery,Jan.28-Feb.18,'61;
Cardiff,Nat.Mus.of Wales,Feb.25-Mar.18,'61
MH DLC

705
C75
NCFA
v.192

I.E - GROUPS

Hall, Mariette van
 Messer Marsilio and his bride

In:Connoisseur
192:292-7 Aug.,'76 illus(part col.)

 Iconography of Lorenzo Lotto's ptg.
 Discussion incl.:Symbols in bridal portrs.
Relation to tradition of double portraiture

 Rila IV/I 1978 #1480

705
C75
NCFA
v.99

I.E - GROUPS

Bishop, Roy
 Portraits of royal children at Windsor
Castle

In:Connoisseur
99:239-44 1937 illus.

 Incl.:van Dyck,Gainsborough,Barthélemy Du Pan
Zoffany,Lawrence

 Rep.1937#346

705
A784
NCFA
v.6

I.E - GROUPS

Hart, Charles Henry, 1847-1918
 The Gordon Family painted by Henry
Penbridge

In:Art in Am
6:191-200 June,'18 illus.

 Rutledge.In:Am Coll 705.A5
 17:23

I.E - GROUPS

Hautecoeur, Louis, 1884-
Les peintres de la vie familiale;évolution
d'un thème.Paris,Editions de la Galerie Char-
pentier,1945
159 p. illus(part col.)

LC ND1450.H3 Praz.Conversation pieces
)ND1304P92E1971,p.147,foot-
 note 19

I.E - GROUPS

Jullien, Jean Lucien,Adolphe, 1845-
Fantin-Latour;groupes...

MET In:Les Arts
100.54 5,no.53:25-32 May,1906 illus.
Ar72
1906

 FOR COMPLETE ENTRY
 SEE MAIN CARD
LC N2.185 Chicago,A.I. European ports.
 N7621.C4A7 NPG Bibl. p.177

I.E - GROUPS

Hins, Berthold
Studien sur geschichte des ehepaarbild-
nisses

In:Marburg Jahrb.
19:139-218 1974 74 illus.

From Flemish & S.German diptych & pendant
portrs.of the Middle Ages to 17th c.Netherlands
married couple portrs.

LC N9.M3 Rila I/1-2 1975 #508

I.E - GROUPS

Keller, Harald, 1903-
Entstehung und blütezeit des freundschafts-
bildes

In:Essays in the history of art,presented
to Rudolf Wittkower...part 2.London,Phaidon,1967
pp.161-73 illus.
Bibliography

LC N5303.E7 Praz.Conversation pieces
)ND1304P92E1971,p.161,foot-
 note 1

N
7630
H78 I.E - GROUPS
NCFA
2 cops. Hooton, Bruce, ed.
 Mother and child in modern art, edited by Bruce Hooton
 and Nina X. Kaiden. Foreword by A. Hyatt Mayor. Com-
 mentary by Frances L. Ilg. [1st ed.] New York, Duell,
 Sloan and Pearce [1964]

 17 p. 40 plates (part col.) 36 cm.

 Based on an exhibition sponsored by Clairol and presented on a
 two-year national tour by the American Federation of Art.

 1. Mothers in art. 2. Children in art. 3. Mothers. 4. Parent and
 child. I. Kaiden, Nina N., joint ed. II. American Federation of
 Arts. III. Title.

 N7630.H75 704.9424 64-21993

 Library of Congress

I.E - GROUPS

Keyserling, Hermann
Vom ewigen der familie

In:Atlantis
:708-15 1932 illus.

The family & its representation in art.
Tut Ankh Amon family, Jan Mostaert, Altdorfer,etc.

LC G1A776 Rep.,1932#113

AP
1
J8654 I.E - GROUPS
NPG
 Hughes, Diane Owen
 Representing the family:Portraits and
 purposes in early modern Italy

 In:J.Interdisc.Hist
 17,no.1:7-38 Summer,'86 illus.

 Repro.incl.:Petrus Cristus:Portrs.of donors;
 Lorenzo Lotto:Double portrait

 Bibliographical references

757.4
.K52 I.E - GROUPS
NCFA
 King, Marian
 A gallery of mothers and their children.
 Philadelphia,Lippincott,1958.
 62 p. illus.

LC N7630.K5

I.E - GROUPS

Jordan, Robert
The double portrait;a study of the pheno-
menon of duality

Master's Th.-N.Y.,Columbia Univ.,1952

 Lindsay,K.C. Harpur Ind.of
 master's theses in art...
 1955 Z5931.L74 1955 NCFA
 Ref. p.104 no.1915

I.E - GROUPS

Klau, Werner
Zweiklang von mutter und kind

In:Berlin,Rom,Tokio
:25-8 no.5,1941 illus.

Met Incl:Dürer,Michelangelo,Raphael,Reni
100.53
B45
Q

North West univ.libr.for
LC Rep.,1945-47#864

I.E - GROUPS

Klein, Dorothea
St.Lukas als maler der Madonna.Ikonographie
der Lukas Madonna..Berlin,O.Schloss,1933.
127 p. illus.

Bibliography Diss.Hamburg,1933

"Nachdem d.einzelnen Handwerke & Zünfte sich
...Schutzpatrone erwählt hatten,ist d.Patron d.
Maler,d.hl.Lukas,der die Madonna malt...seit d.
15.Jhr.in d.Niederlanden...v.Maler mit d.eigenen
Bildnissügen ausgestattet worden"(Prins)
Prins.Slg.d.selbstbildn.in
KM ICU MJP MB FBm d.Uffizien.N7618/P95 Bd.1
p.147,notes51

I.E - GROUPS

Ségard, Achille, 1872-
Un peintre des enfants et des mères,Mary
Cassatt...Paris,P.Ollendorff,1913
207 p. illus.

Documents et bibliographie p.199-201

LC ND237.O384 Isham.The History of Ameri-
can ptg.ND205.179 1933 NPO
R4h1 p.597

N
40.1
K9515
NPO

I.E - GROUPS

Leicester, Eng. Museum and Art Gallery
Hans Eworth:a Tudor artist and his circle
.Prepared by Dr.Roy Strong....1965.
26 p. illus.

Catalogue of an exhibition
Bibliography

Repr.incl.:Baroness Dacre with portr.of l.
husband by Holbein;Sir John Luttrell with al-
legorical scene:Peace caresses Sir John's arm;
by School of Fontainebleau;Queen Elizabeth in
LC ND497.E9L4
source:Yale ctr.f.Brit.art Ref.

I.E - GROUPS

Wiechert, Ernst Emil, 1887-
Von mutter und kind.Bilder alter und
neuer meister.Geleitwort von Ernst Wiechert.
2.Aufl.Leipzig,Seemann & co.,1949
10 p. illus(col.)

Holbein d.j.,Rubens,Chardin,Chodowiecki,
Waldmüller,u.a.

ICU Bibl.su kunst & kunstgesch
25931.B58 1945-53 NCFA
p.22 no.453

I.E - GROUPS

New York. Museum of modern art
Family portraits from the museum collection.
.N.Y.,The Museum,1964.
2 p.

Checklist of temporary exh.May 27,1964-Feb.7
1965
Ptgs. & sculpt.by Beckmann,Guglielmi,Hark-
avy,Lindner,Marisol,Moore,Quirt,Ruiz,Shahn,
Spencer,Stettheimer,Tanguy,Vuillard
MOMA,v.11,p.435
MOMA MMA733 and Archive
MMA 733

I.F - GROUPS

Winnipeg Art Gallery
Mother and child.Winnipeg Art Gallery,1967
47p. illus.

Exh.held May 14-Aug.13,1967

LC N5030.W5

ND
1304
P92
E1971
NFO

I.E - GROUPS

Praz, Mario, 1896-
Conversation pieces:a survey of the informal
group portrait in Europe and America.University
Park,Pennsylvania State University Press,1971.
287 p. illus(part col.)

Transl.on of Scene di conversazione
Includes references

LC ND1304.P713

I.E - GROUPS - ANTIQUITY - ROME

Kleiner, Diane E.E.
Roman group portraiture,the funerary reliefs

LC NB1296.3.K55 1977 **FOR COMPLETE ENTRY
SEE MAIN CARD**

VF
Rotterdam

I.E - GROUPS

Rotterdam. Museum Boymans-van Beuningen
Dubbelportret.Exh.4 oct.1980-4 jan.1981

Double portraits:1.Jean Bapt.de Champaigne
by Nicolas de Platte-Montagne and Nicolas de .
Platte-Montagne by Jean Bapt.de Champaigne
2.Hans Mardersteig & Carl Georg Heise by Oskar
Kokoschka

I.E - GROUPS - 18-(early)19th c.

Lankheit, Klaus
Das freundschaftsbild der Romantik.Heidel-
berg,C.Winter,1952.c.1951.
200 p. illus. (Heidelberger kunstge-
schichtliche abhandlungen,N.F.Bd.1)

Bibliographical notes

LC PN754.L3 Praz.Conversation pieces
ND1304P92E1971,p.161,foot-
note 1

I.E - GROUPS - AUSTRIA - VIENNA

Leitich, Ann Tizia, 1896-
　Wiener Biedermeier.Kultur,kunst und leben der alten kaiserstadt,vom Wiener kongress bis... 1848.Bielefeld and Leipzig,Velhagen & Klasing, ‚c.1941‚
　　159 p.　illus(part col.)

LC DB851.L4

Praz.Conversation Pieces
ND1304P92E1971‚P 195,footnote 17

ND
1314
S62
NPG
I.E - GROUPS - GREAT BRITAIN

Sitwell, Sacheverell, 1897-
　Conversation pieces; a survey of English domestic portraits and their painters...London, B.T.Batsford,ltd.‚1936‚
　　119p.　illus(part col.)

　18th & 19th c.　Incl:Gainsborough,Hogarth. Photographs by Hill,Fox-Talbot.　Zoffany,Devis, Stubbs,Turner,Leslie,Winterhalter, etc.

LC ND1314.S5 1936

705
B97
NCFA
v.113
I.E - GROUPS - FRANCE - 18th c.

Cailleux, Jean　ed.
　L'Art du dix-huitième siècle.Some family and group portraits by François de Troy(1645-1730)

In:Burl Mag
113,suppl.no.26:I-XVIII　Apr.,'71　illus.

　‚L.6:Mme.de Franqueville & her children with black servant and portr.within portrait‚

Rosenfeld,M.N. L'Argillièr

p.401,408

I.F - GROUPS - GREAT BRITAIN

Sotheby, firm,auctioneers, LONDON
　Cat.of the Mr.& Mrs.Jack R.Dick coll.of English sporting and conversation paintings: part 1;...auction.s.l.:s.n.:c.1973(Ipswich,Eng., W.S.Cowell)
　　108 p.　illus(part col.)
　Price list encl.

LC ND1388.07S68

I.E - GROUPS - GERMANY

Kronberger, Hanna Frentzen, 1887-
　Das deutsche familienbildnis. Leipzig,Asmus, 1940

　43 p.　80 p.illus.

LC ND1317.K7

Rep.,1939-41=636

N
40.1
D6285
R7
NPG
I.E - GROUPS - GREAT BRITAIN - 17th c.

Rogers, Malcolm
　William Dobson,1611-46.cat.of an exh.at NPG,London,Oct.21,1983 to Jan.8,1984.Publ.by the Gallery,1983.
　　92 p.　illus(part col.)

　Bibl.references
　Index

I.E - GROUPS - GERMANY - BERLIN

Weiglin, Paul, 1884-
　Berliner Biedermeier.Leben,kunst und kultur in Alt-Berlin zwischen 1815 und 1848.2nd ed. Bielefeld and Leipzig,Velhagen & Klasing,1942
V & A　　illus(part col.)

Praz.Conversation pieces
ND1304P92E1971,p.118,footnote 4

N
7598
W59
NPG
I.E - GROUPS - GREAT BRITAIN - 17-19th c.

Colnaghi, P.& D.& co.,ltd.,London
　English ancestors,a survey of British portraiture 1650-1850.Cat.of exh.22 Feb.to 31 March 1983.ed.by Clovis Whitfield,assisted by Ursula Lans.‚1983‚
　　109 p.　illus(part col.)

　Arranged by artists in alphabetical order
　Foreword by John Harris

　Incl.:Groups,children & portr.busts

NE
265
L8A5
NPG
I.E - GROUPS - GREAT BRITAIN

British museum. Dept.of prints and drawings
　Catalogue of engraved British portraits preserved in the Department of prints and drawings in the British museum, by Freeman O'Donoghue... London,Printed by order of the Trustees,1908-25

　6 v.

　incl.bibliographies

　v.5(Groups):...and Harry M.Hake
　v.6(Suppl't & indexes):by Harry M.Hake

LC NE265.L8A5 1908

Waterhouse.Ptg.in Britain, 1530-1790 ND465.W32 1962
NCFA bibl.

GT
736
B82
1979X
NPG
I.E - GROUPS - GREAT BRITAIN - 18th c.

Buck, Anne M.
　Dress in 18th c. England...N.Y.,Holmes & Meier Publ.,Inc.,1979
　　240 p.　illus(part col.)

　Bibliography

　Illustr.incl.:Ptgs.p.62:Zoffany.Portrait within portrait.　Conversation pieces

AP
1
V65
NCFA

I.E - GROUPS - GREAT BRITAIN - 18th c.

Burke, Joseph T., 1913-
Romney's Leigh family(1768):A link between the conversation piece and the Neo-Classical portrait group

In:Ann'l B.of NOA of Victoria
2:5-14 1960 illus.

AP
1
A64
NCFA
v.22

I.E - GROUPS - GREAT BRITAIN - 18th c.

Edwards, Ralph, 1894-
Conversation pictures of Marcellus Laroon (1679-1772)

In:Apollo
22:193-8 Oct.,'35 illus.

Source:
FOR COMPLETE ENTRY
SEE MAIN CARD

759.2
.D4 R

I.E - GROUPS - GREAT BRITAIN - 18th c.

Detroit. Institute of Arts
An exhibition of English conversation pieces of the 18th century.The Detroit Institute of Arts,Jan.27 through Febr.29,1948.,Detroit, 1948.
40 p. illus(part col.)

Text signed:E.P.Richardson

Incl.also furniture,silver,tapestries,porcelains

LC ND466.D4

I.E - GROUPS - GREAT BRITAIN - 18th c.

Harris Museum and Art Gallery, Preston,Eng.
Polite society,portraits of the English country gentleman and his family by Arthur Devis.Cat.of the exh.Oct.1st - Nov.12th,1983. NPG,London Nov.25th,1983-Jan.29th,1984,organ. by the Harris Mus.and Art Gall.,Preston...with financial assist.fr.the Arts Council of Great Britain.Preston,the Gallery.1983
122 p. illus(part col.)

Portrait within portrait p.52
Intro.by John Hayes,p.9-16.Cat.essay'Arthur Devis:His life & art'by Stephen V.Sartin, p.19-35

AP
1
A64
NMAA
v.114

I.E - GROUPS - GREAT BRITAIN - 18th c.

Devapriam, Emma
Two conversation pieces by Edward Haytley

In:Apollo
114:85-7 Aug.,'81 illus(part col.)

AP
1
A64
NCFA
v.98

I.E - GROUPS - GREAT BRITAIN - 18th c.

Holbrook, Mary
Painters in Bath in the 18th century

In:Apollo
98:375-84 Nov.,'73 illus.

Repro.incl.:Wm.Hoare,Prince Hoare,Ths. Hickey,Ths.Peach,Ths.Barker

Archer.Ind.& Brit.portraiture.ND1327.I44A72X NPG
Bibl.p.482

N
40.1
D49706
NCFA

I.E - GROUPS - GREAT BRITAIN - 18th c.

D'Oench, Ellen G.
The conversation piece:Arthur Devis and his contemporaries.New Haven,Yale Center for British Art,1980
99 p. illus(part col.)

Publ.on the occasion of an exh.at the Yale Ctr.for Brit.Art,New Haven,Conn.,Oct.1 to Nov. 30,1980
Bibliography

Harris Mus. Preston.
p.38

NK
928
C75
1968
NCFA

I.E - GROUPS - GREAT BRITAIN - (early)18th c.

Honour, Hugh
Painting and sculpture

In:The Connoisseur's Complete Period Guides
p.593-605 illus.

Incl.chapters on portraits,conversation pieces,busts(sculpture)during early Georgian per.

Repro.:Reynolds,Ramsay,Gainsborough,Roubillac,Rysbrack,Scheemakers,Kneller,Van Loo,Jervas, Richardson,Hudson,Knapton,Hogarth,Highmore,Devis

705
B97
NCFA
v.99

I.E - GROUPS - GREAT BRITAIN - 18th c.

Edwards, Ralph, 1894-
An attribution to Joseph Highmore

In:Burl.Mag.
99:234-7 July,'57 illus.

Some conversation pictures previously attr. to Hogarth

FOR COMPLETE ENTRY
SEE MAIN CARD

ND
1314.4
I94
1965
NCFA

I.E - GROUPS - GREAT BRITAIN - 18th c.

Iveagh Bequest, Hampstead,Eng.
The Conversation piece in Georgian England. ,London,Greater London Council,1965,
32 p. illus.

Bibliography

Catalog of an exhibition

NJP MiDA

W
40.1
H878
I 9
NPC

I.E - GROUPS - GREAT BRITAIN - 18th c.

Iveagh Bequest, Hampstead, Eng.
Thomas Hudson,1701-1778;portrait painter
and collector;a bicentenary exh.held.6 July
to 30 Sept.,1979.at.Iveagh Bequest.London,
Greater London Council,1979
,88,p. illus.

Exh.selected and intro.written by Ellen G.
Miles
Cat.nos.1-66;Hudsons' work;nos.67-78;Hudson's
collection

N
40.1
L328R15
NCFA

I.E - GROUPS - GREAT BRITAIN - 18th c.

Raines, Robert
Marcellus Laroon.London,Routledge & K.Paul
for Paul Mellon Foundation for British Art,1967
219 p. illus. (Studies in British art)

Bibliography

Chapter on portrs.:74-5;Conversation pieces:
75-81

LC ND497.L28R4 Noon.Engl.portr.drags.&min.
 NC860.N66X NPG Bibl.p.147

ND
1452
G72J64
1986X
NMAA

I.E - GROUPS - GREAT BRITAIN - 18th c.

Johnson, E.D.H.(Edw.Dudley Hume)
Paintings of the British social scene,from
Hogarth to Sickert.N.Y.,Rizzoli,1986
287 p. illus(part col.)

Incl.:Index
Ch.II,p.43-78:Domestic portraiture.(Mainly
Groups)

ND
465
W33
1962
NCFA

I.E - GROUPS - GREAT BRITAIN - 18th c.

Waterhouse, Ellis Kirkham,1905-
Bartholomew Dandridge;in.his.Painting in Bri-
tain,1530 to 1790.2nd ed. Baltimore,Penguin books
275 p. illus.

p.127 plate 110

I.E - GROUPS - GREAT BRITAIN - 18th c.

Loan exhibition of 18th century English conver-
sation pieces.London.1930
18 l

Foreword signed:Phillip Sassoon

Exhib.in aid of the Royal Northern Hospital,
March 4th to April 6th,1930

NN FOR COMPLETE ENTRY
 SEE MAIN CARD

ND
1314.4
W83
1985
v.1-2
NPG Ref.

I.E - GROUPS - GREAT BRITAIN - 18-19th c.

Walker, Richard
Regency portraits.London,NPG,1985
2 vols. illus. v.1;Text;v.2;Plates

Edited by Judith Sheppard
Indexes
Incl.:Sculpture,Medals,Engravings,Photo-
graphs

Groups p.597 f.

B
ZR5W2
NCFA

I.E - GROUPS.- GREAT BRITAIN - 18th c.

Manners, Lady Victoria, 1876-1933
John Zoffany,R.A.,his life and works,1735-
1810;by Lady V.Manners & Dr.G.C.Williamson.
London,John Lane,N.Y.,J.Lane Co.,1920
331 p. illus(part col.)

Bibliography

List of engravings after Zoffany...p.257-65

 Archer;India & Brit.portr...
 ND1327.I44A72X NPG Bibl.
 p.483

I.E - GROUPS - GREAT BRITAIN - 18-19th c.

Williamson, George Charles, 1858-1942
English conversation pictures of the 18th &
early 19th centuries.London,B.T.Batsford,ltd.,
,1931,
31 p. illus(part col.)

Foreword by Sir Philip Sassoon

LC ND466.W5 Iveagh Bequest ND131...
 I94 NCFA p.3

N
40.1
D495P3
NPG

I.E - GROUPS - GREAT BRITAIN - 18th c.

Pavière, Sydney Herbert, 1891-
The Devis family of painters...Leigh-on-Sea,
F.Lewis,1950,
148 p. illus(part col.)

Bibliography

Cat.of known and unknown works.Index of
owners of Arthur and Arthur William's pts.
'...Arthur;Devis remained faithful to his
one love-the conversation piece...'.p.32
Portrs. within portrs.Pl.24

LC ND497.D4P3 Archer.Arth.Wm.Devis.In;Art
 at Auction.AP1.S76,1971-2
 p.80,note 1

AP
1
A64
NCFA
v.65

I.E - GROUPS - GREAT BRITAIN - 19th c.

Piper, David
English 19th century conversation pieces

In:Apollo
65:163-8 May,'57 illus.

 McKerrow.The Faeds.N40.1
 F14782 NMAA Bibl.p.142

I.E - GROUPS - GREAT BRITAIN - SCOTLAND

Edinburgh. Scottish national portrait gallery
 Scottish groups and conversation pieces:
an exhibition arranged...for the Arts Council,
Scottish Committee.12th July to 16th Sept.,1956,
 19 p.

FOGG
4103
E23

Pras.Conversation pieces
ND1304P92E1971,p.54,foot-
note 8

I.E - GROUPS - NETHERLANDS

Würtenberger, Franzsepp, 1909-
 Das holländische gesellschaftsbild.Schram-
berg(Schwarzwald),Gatzer & Hahn,1937

MET
182
W96

FOGG
FA
4058.16

FOR COMPLETE ENTRY
SEE MAIN CARD

I.E - GROUPS - NETHERLANDS

Gerson, Horst
 Zes eeuwen Nederlandse schilderkunst.Amster-
dam,Contact,1962,
 3v.in 1 illus.

LC ND644.G4

N
7607
J66
1986X
NPG

I.E - GROUPS - NETHERLANDS - 17th c.

Haarlem. Frans Hals museum
 Portretten van echt en trouw.Huwelijk en
gezin in de Nederlandse kunst van de 17e eeuw,
exh.cat. by Eddy de Jongh.Zwolle,Waanders,
1986
 333 p. illus(part col.)
 Exh.15 feb.-19 may,1986

I.E - GROUPS - NETHERLANDS

Riegl, Alois, 1858-1905
 Das holländische gruppenporträt...Wien,
Osterreichische staatsdr.,1931

 2 v. illus.(88 pl.)

 Bibliography

LC ND1319.R45

Lipman.The Florentine pro-
file portr...:"for study of
outer unity of N.portrait-
ure as opposed to inner uni
ty of Italy"

N
7607
W54Y
NPG

I.E - GROUPS - NETHERLANDS - 17th c.

John and Mable Ringling Museum of Art, Sarasota,
 Dutch 17th c.portraiture.The Golden .Fla.
Age:exh.Dec.1,1980-Feb.8,1981;cat.by Wm.Harry
Wilson.The John and Mable Ringling Mus.of Art
Foundation,1980
 (unpaged)140 items illus(colfront cover)

 Ptgs.,drngs.,prints,medallions,earthenware,
glass
 Index of subjects
 Bibliographical references

I.E - GROUPS - NETHERLANDS

Schöne, Wolfgang, 1910-
 Peter Paul Rubens;die Geissblattlaube.Dop-
pelbildnis des künstlers mit Isabella Brant.
Stuttgart,Reclam,1956,
 32 p. illus. (Werkmonographien zur bil-
denden kunst,no.11)

 History of marriage portraiture fr.antiqui-
ty to the 17th c.

 Universal-bibliothek no.B9011

MIC MH

Daugherty.The self-portrs.
of P.P.Rubens.mfm161 NPG
p.158 footn.5

AP
1
A64
NCFA
v.110

I.E - GROUPS - NETHERLANDS - 17th c.

Robinson, William W.
 Family portraits of the Golden Age

 In:Apollo
110:490-7 Dec.'79 illus.

 figs.10 & 11:Portraits historiés

Schama,S.in:J.Interdisc.
Hist.v.17,no.1 AP1.J8654
NPG p.160,footnote 8

I.E - GROUPS - NETHERLANDS

Staring, Adolph, 1890-
 De Hollander thuis...;Dutch homes,three
centuries of Dutch conversation pieces.
's-Gravenhage,Nijhoff, 1956

 206 p. illus.

 Intro. in Dutch and English

LC ND644.S7

I.E - GROUPS - NETHERLANDS - 17th c.

Smith, David Ross
 The Dutch double and pair portrait:Studies
in the imagery of marriage in the 17th centu-
ry.Columbia University,1978
 506 p.

 Ph.D.-Dissertation,1978

 Ch.1-3 general;ch.4-6 focus on F.Hals and
Rembrandt

Diss.Abstr.Z5055-U49D57
no.7819440

705
A64
NCFA
v.89

I.E - GROUPS - U.S.

McClinton, Katharine Morrison
American furniture in family portraits of
the 18th and 19th centuries

In:Apollo
89:226-9 Mar.,'69 illus.

Repro.of groups by Earl,Savage,Davis,Field,Darby
Kittell,Hollingsworth

Pras.Conversation pieces
ND1304P92E1971,p.82,foot-
note 24

708.1
B762
NCFA
v.61

I.E - GROUPS - U.S. - NEW ENGLAND

Maytham, Thomas N.
Two faces of New England portrait painting,
Erastus Field and Henry Darby

In:Boston Mus Bul
61:31-43 1963 illus.

Article incl.comparison of a family group by
Field with one by Darby...

FOR COMPLETE ENTRY
SEE MAIN CARD

705
M18
NCFA
v.37

I.E - GROUPS - U.S. - 18th c.

Flexner, James Thomas, 1908-
The amazing William Williams:painter,
author,teacher,musician,stage designer,cast-
away

In:Mag Art
37:242-6 Nov.,'44 illus.
276-8

Incl.:Conversation pieces

705
C75
NCFA
v.111

I.E - GROUPS - U.S. - NEW ENGLAND - 18th c.

Comstock, Helen
Portrait painting in New England,1700-1775

In:Connoisseur
111:136-41 July,'43 illus.

Repro.incl.:Rbt.Feke,Nathaniel Smibert,John
Smibert,Jos.Blackburn,J.S.Copley

705
A56
NCFA
v.110

I.E - GROUPS - U.S. - 18-19th c.

Luckey, Laura C.
Family portraits in the MFA, Boston
Antiques
American painting ‹special issue›
110:965-1070, Nov.,1976 illus(part col.)
Chiefly 18th-19th century
Partial contents:...Luckey,L.C.,Family por-
traits in the MFA,Boston,p.1006-11;...

ND
1304
W67
NPG

I.E - GROUPS - U.S. - NEW YORK, N.Y.

Wildenstein & company, inc., New York
Three hundred years of New York City fami-
lies. A loan exhibition of Conversation pieces
...Jan.12-Jan.29,1966
‹n.p.› illus.
1 v.(pamphlet)

PPULC PPPM

Pras.Conversation pieces
ND1304P92E1971,p.92,foot-
note26

qN
40.1
W4,1979
NMAA

I.E - GROUPS - U.S. - 18-19th c.

Von Erffa, Helmut
The paintings of Benjamin West.by.Helmut
von Erffa and Allen Staxley.New Haven & London,
Yale Univ.Press,1986
606 p. illus(part col.) (a Barra foun-
dation book)
Index
Portraits:p.450-576(incl.groups)
Port.within portrait,p.453,501,567

LC 237.W45A4 1986

qN
6520
.P63
1983X

I.E - GROUPS - U.S. - SOUTHERN STATES - 19th c.

Poesch, Jessie J.
The Art of the Old South,painting,sculp-
ture,architecture,and the products of crafts-
men,1560-1860...1st ed.N.Y.,Knopf,1983
384 p. illus(part col.)

Incl.index
Bibliography,p.361-366

Repro.incl.:Eye miniature by Malbone,p.162;
Portrs.of Amer.Indians by Curtis,p.272;by Rö-
mer & by Catlin,p.273.Ports.within portrs.,
p.265.Groups by ‹ ›Earl,p.171;by Johnson,
p.159

VF
Brush,G.
de Forest

I.E - GROUPS - U.S. - 19-20th c.

Grand central art galleries, New York
Retrospective exh.of paintings by George
de Forest Brush;Jan.7-18,1930
16 p. illus.

Mother & child, Family groups, etc.

I.E - GROUPS see also I.E - FAMILY

I.E - HAIRDRESSING

Corson, Richard
Fashions in hair:the first thousand years
N.Y.,Hastings House.1965.
701 p. illus. (Communications Arts
books)

Bibliography:p.678-86
Index

'The cut of a wig...could identify a man's
profession & social status'.-Calvert

QT2290.C82 NMAH
LC QT2290.C6

Calvert.Children in Am.
family portr.1670-1810
AP1.W71 NPG,p.91,note 11

AP
1
A64
NCFA
v.14

I.E - INDIVIDUAL SITTERS - ADAMS, JOHN, 1735-
.1826

Meschutt, David
The Adams-Jefferson portrait exchange

In:Am Art J
14:47-54 Spring,'82 illus.

Bibl.footnotes

Repro incl.:Jefferson by Mather Brown and
by John Trumbull;John Adams by Mather Brown and
by John Singleton Copley(det.)

I.E - HAIRDRESSING - SWITZERLAND

Heierli, Julie
Was ist ein Schappel?

In:Indic.suisse
:224-34 1933 illus.

Women's hairdressing in Switzerland in the
Middle ages which stayed till 19th c.

LC DQ1.A72

Rep.,1933*173

N
7628
A21 O 4
NCFA

I.E - INDIVIDUAL SITTERS - ADAMS,JOHN,1735-1826

Oliver, Andrew, 1906-
Portraits of John and Abigail Adams. Cam-
bridge,Mass.,Belknap Press of Harvard University
Press, 1967
284 p. illus. (The Adams
papers, Series 4:Portraits)

LC N7628.A3055

AP
1
W71
NPG

I.E - HAIRDRESSING - U.S. - 17-19th c.

Calvert, Karin
Children in American family portraiture,
1670-1810

In:Wm.& Mary Q
Ser.3,39:87-113 Jan.,'82 illus.

Incl.:Table I:Distributed by period & sex.
TableII:Costume of boys.
334 family portrs.were studied.Nuclear fa-
mily portrs.appear after 1770
Dress indicates sex,status,age,leading
signs of chan- ging custom.Hairstyle in-
dicates period age.

NPG
Ref.
coll.

I.E - INDIVIDUAL SITTERS - ADAMS, JOHN QUINCY,
1767-1848
National Portrait Gallery, Washington, D.C.
The life portraits of John Quincy Adams.
Washington,1970
unpaged illus.

Cat.of loan exh.,Nov.6,'70-Jan3,'71

Intro.by Marvin Sadik

Index of artists

LC E377.M37

I.E
Individual sitters

For other references to portraiture of indi-
viduals, see section on "Iconographie Histo-
rique" in each vol. of Répertoire d'art et d'ar-
chéologie. Entries are arranged in alphabetical
order with names of individuals set off in bold
type.

N
7628
A22 O 4
NPG

I.E - INDIVIDUAL SITTERS - ADAMS,JOHN QUINCY,
1767-1848
Oliver, Andrew, 1906-
Portraits of John Quincy Adams & his wife.
Cambridge,Mass.,Belknap Press of Harvard Uni-
versity Press, 1970
335 p. illus. (The Adams
papers, Series 4:Portraits)

Incl.Bibl.references

LC E377.O4

N
7628
A21 O 4
NCFA

I.E - INDIVIDUAL SITTERS - ADAMS,ABIGAIL,1744-1818

Oliver, Andrew, 1906-
Portraits of John and Abigail Adams. Cam-
bridge,Mass.,Belknap Press of Harvard University
Press, 1967
284 p. illus. (The Adams
papers, Series 4:Portraits)

LC N7628.A3055

N
7628
A22 O 4
NPG

I.E - INDIVIDUAL SITTERS - ADAMS,LOUISA CATHERINE,
1775-1852
Oliver, Andrew, 1906-
Portraits of John Quincy Adams & his wife.
Cambridge,Mass.,Belknap Press of Harvard Uni-
versity Press, 1970
335 p. illus. (The Adams
papers, Series 4:Portraits)

Incl.Bibl.references

LC E377.O4

705
A784
NCFA
I.E - INDIVIDUAL SITTERS - ALESSANDRO DE MEDICI,
1510-1537

Steinberg, Leo, 1920-
Pontormo's Alessandro de'Medici,or,I only
have eyes for you

In:Art in Am
63:62-5 Jan.-Feb.,'75 illus.

Hypothesis that Pontormo's portr.of the
duke,drawing a lady,was used as a gift of devo-
tion;in contrast to political representation
for propaganda purposes

I.E - INDIVIDUAL SITTERS - AMHERST FAMILY

Trapp, Frank [Anderson]
British portrait paintings,in Amherst Col-
lege,Mead Art Bldg.,Amherst,Mass.,in:Mead Art
Mus.Monographs,v.6 & 7,Winter,'85-'86
p.1-15 illus.

VP
Amherst,
Mass.
Amherst
College
Incl.:Amherst Family portrs. See also:
Amherst College,Mead art bldg.:The Amherst
family portraits.Exh.Oct.23-Nov.12,'67

I.E - INDIVIDUAL SITTERS - ALEXANDER THE GREAT,
356-323 BC
Bieber, Margarete, 1879-
The portraits of Alexander the Great

In:Proceedings of the American philosophical soc.
93,no.5:373-427 Nov.,'49 illus.

LC Q11.P5 Fogg,v.11,p.330

705
A56
NCFA
v.73
I.E - INDIVIDUAL SITTERS - ANDERSON,ALEXANDER,
c.1775-1870
Chamberlain, Georgia S.,1910-1961,
John Gadsby Chapman:a reappraisal

In:Antiques
73:566-9 June,'58 illus.
Repro.incl.:Self-portr.;David Crockett;
Horatio Greenough;Alexander Anderson

'..his:psychological insight & competent ptg
make Ch.one of the most interesting,if not one
of the best of the artists...in the U.S...1830's
and 40's.'
Robert Hull Fleming Mus.
parlor bibl.p.39 Univ.of Vt. Faces in the

I.E - INDIVIDUAL SITTERS - ALEXANDER THE GREAT,
356-323 BC
Suhr, Elmer George, 1902-
...Sculptured portraits of Greek statesmen,
with a special study of Alexander the Great,...
Baltimore,The Johns Hopkins press;London,H.Mil-
ford,Oxford university press,1931
189 p. illus. (The Johns Hopkins univer-
sity studies in archaeology,no.13)

Dissertation.1926.

Bibliography
NPG has "extract"
733
894
LC NB164.S75
1979 ed.:LC NB1296.3.S93
Richter,G. Portrs of the
Greeks N7586.53,v.3,p.304

705
B97
NCFA
v.89
I.E - INDIVIDUAL SITTERS - ANNE, QUEEN

Esdaile, Katharine
The royal sisters:Mary II and Anne in sculp-
ture

In:Burl.Mag.
89:254-7 Sep,1947 illus.

Terracotta models:William III & Mary II by
John Nost. Statue of Anne by Andrew Carpenter
(1712)

Rep.,1945-47*7444

705
A7875
NCFA
I.E - INDIVIDUAL SITTERS - ALPHONSO I,KING OF
NAPLES,died 1458
Valentiner, W.R.
A portrait bust of King Alphonso I of Naples

In:Art Q
1:61-89 Spring 1938 illus.

Foreign influence in Naples
Frescoes by da Besozzo, reliefs by Mino da
Fiesole, busts by Laurana,drgs.by Pisanello

I.E - INDIVIDUAL SITTERS - THE ANTONINES

Saletti, Cesare
I ritratti antoniniani di Palazzo Pitti...
1 ed. Firenze,La nueva Italia,1974
69 p. illus. (Pubbl.Facoltà di lettere
e filosofia dell' Università di Pavia,17)

Bibl.references
Index

LC NB165.A57S24
Gesichter.NB1296.3.G38
1983 NPG p.316

VP
Amherst,
Mass.
Amherst
College
I.E - INDIVIDUAL SITTERS - AMHERST FAMILY

Amherst college. Mead art building
The Amherst family portraits.Feb.Oct.23-
Nov.12, 1967
21 p. illus.

Mead Art Mus.Monographs
v.6-7
p.1

FOOG
5005
R71w
MET
617
W42
pt.24
I.E - INDIVIDUAL SITTERS - THE ANTONINES

Wegner, Max, 1902-
Die herrscherbildnisse in antoninischer
seit. Berlin,Gebr.Mann,1939
305 p. illus (Das römische Herrscher-
bild,II.Abt.Bd.4

I.E - INDIVIDUAL SITTERS - AUGUSTUS, 63B.C.-14 .AD

Munich. Glyptothek
 Die Bildnisse des Augustus:Herrscherbild
und politik im kaiserlichen Rom.Sonderaus-
stellung der Glyptothek und des museums für
abgüsse klassischer bildwerke.München,Des.
1978-März.Antikenmuseum Berlin,Apr.-Juni 1979.
Hrsg.von Klaus Vierneisel und Paul Zanker.
München,1979
 119 p. illus.

MET
617
M92

Gesichter.NB1296.3.G38
1983 NPG p.316

CT
275
B415L9
NPG

I.E - INDIVIDUAL SITTERS - BEETHOVEN, 1770-1827

Stuttgart. Institute for foreign relations.
 Ludwig van Beethoven,1770-1827.an exh.
comp.and arranged by the Inst.for foreign
relations,Stuttgart.Responsible:Hermann Pollig.
Texts:Joseph Schmidt-Görg.Stuttgart,c.1970.
 unpaged illus.

 Biography:B.'s way of life & character;
the works.
 Incl.:Portrs.of Beethoven,his family & of
persons,important in his life.Ptgs.,graphic
works,silhouettes,miniatures

I.E - INDIVIDUAL SITTERS - BACH, JOHANN SEBAS-
.TIAN, 1685-1750

Sigismund, Ernst
 Der Porträtmaler Elias Gottlob Haussmann
und seine zeit;die Bachbildnisse

In:Zs.f.Kunst
4:126-35 1950(2) illus.

LC N3.Z5

Bibl.su kunst & kunstgesch
.Z5931.B58 1945-53 NCFA
p.217 no.4335

N
40.1
.886?3
.N'AA

I.E - INDIVIDUAL SITTERS - BICHE, EDMOND
.FRUMENCE, 1854-1892

Certiguy, Henry, 1919-
 Le douanier Rousseau et Frumence Biche.
Lausanne,la Bibliothèque des Arts,1973.
 116 p. illus(col.cover)

 English and French
 Bibl.references

I.E - INDIVIDUAL SITTERS - BALTIMORE, LORDS

Eden, Sir Timothy Calvert,8th bart., 1893-
 Catalogue of important English historical
and family portraits and pictures by the old
masters removed from Windlestone,co.Durham,incl.
the celebrated series of portraits of the Lords
Baltimore,proprietors of Maryland,the property
of Sir Timothy Calvert Eden,baronet of Maryland.
Which will be sold by auction,by Messrs.Sotheby
and co....the 26th of July,1933...London,Printed
by J.Davy & sons,ltd..1933.
 16 p. illus.
 (Sotheby & Co.Sale cat.Jl.26,1933)
 Priced

MET
119.6
0
1933³

MdBP

Met.Sales cat.rZ881.N53
NCFA p.023316

HD
3373.2
P61x
KPG

I.E - INDIVIDUAL SITTERS - BIDDLE, NICHOLAS,
.1786-1844

Wainwright, Nicholas B
 Nicholas Biddle in portraiture

Miles, Ellen Cross comp.
 Portrait painting in America.The nineteenth
century.N.Y....,1977 (card 2)

 Partial contents cont'd:P.L.Heard,Albert
Gallatin Hoit(1809-56),p.73-U;R.E.Grosseclose,
Eman.Leutze:Portraitist,p.79-86;H.H.Bishop,Thr
Tennessee ptrs.,p.86-90;A.Gilchrist,Dan.Hunting
ton,portr.ptr.over 7 decades,p.91-93;Z.Little
Anabel Peacers,ptr.of Vt.faces,p.94-97;N.B.Wain
wright, Nich.Biddle in portraiture,p.149-171
 cont'd on next card

757
.E59

I.E - INDIVIDUAL SITTERS - BALTIMORE, LORDS

Enoch Pratt free library, Baltimore
 The Lords Baltimore;contemporary portraits
of the founder and the five proprietaries of
Maryland,...Baltimore,The Enoch Pratt free libra-
ry,1942.
 13 p. illus.

 Text by James Foster and Beta K.Manakee

I.E - INDIVIDUAL SITTERS - BONAPARTE FAMILY

David, Yvan
 Napoléon et la famille impériale.Musée
Fesch,Ajaccio,juillet-septembre 1969..cat.
no.149 par Yvan David.Paris,Réunion des Musées
nationaux,1969
 58 p. illus.

LC DC197.5.D37

Hubert.In:Gaz.Beaux-Arts
jul/aug.'86,v.108,p,29
note 2

N
40.1
I55T7
NMAA

I.E - INDIVIDUAL SITTERS, BARTOLINI, LORENZO,
.1777-1850

Toussaint, Hélène
 Les portraits d'Ingres,peintures des musées
nationaux.Paris,Ministère de la Culture.Éditions
de la Réunion des musées nationaux,1985
 141 p. illus(part col.) (Monographies
des musées de France)

 Bibliography, p.136-9
 Repro incl.:Napoléon,1806,Luigi Cherubini,
1841,1842,Lorenzo Bartolini,1820,Jean-Pierre Cor-
tot,1815,1818

I.E - INDIVIDUAL SITTERS - BONNIE PRINCE CHARLIE
 see
 STUART,CHARLES EDWARD,the young pretender,
1720-1788

705
I61
NCFA
v.77

I.E - INDIVIDUAL SITTERS - BOWDOIN FAMILY

Robie, Virginia
 An American old master-Feke.Colonial ar-
tist's portraits of the Bowdoins are prized
possessions of the college of that name

In:Studio
77:430-33 Aug.,'23 illus.

 Moos.Art of Rbt.Feke M;C.7]
 F21218 1970a NPAA Bibl.
 p. CXXV

705
B97
NCFA
v.118

I.E - INDIVIDUAL SITTERS - BURNET, GILBERT,
 1643-1715

Whittingham, Selby
 Some portraits of Bishop Burnet around 1690

In:Burl Mag
118:649-50 Sept.,'76 illus.

 Repro.incl.Riley,Kneller,Beale

 Rila III/1 1977 #978

AP
1
N56
1967
NCFA

I.E - INDIVIDUAL SITTERS - BRAQUE, GEORGES,
 1882-1963

Barr, Alfred H.amilton,jr.,1902-1981
 Painting and sculpture acquisitions,1960

In:Mus.Mod.Art Bul.
28,no.2:3-5 illus.p.6-14

 Repro.incl.:Bouché's portr.of Braque,p.25

705
C75
NCFA

I.E - INDIVIDUAL SITTERS - BYRON,GEO.GORDON,1788-
 1824

Caolamanos, H.E.Demetrius
 Some plastic figures of Byron

In:Connoisseur
90:380-3 Dec,1932(pt.2) illus.

 Bronze medallion, brass relief(3/4 view),
pottery busts,Staffordshire busts,bisque,marble
statue by Mercié

 Rep.,1932#104

757
R31

I.E - INDIVIDUAL SITTERS - BRIGNOLE-SALE FAMILY

Reder, Jacob
 The portraits of the Brignole-Sale family in
the Palazzo Rosso in Genoa by Sir Anthony van
Dyck,in commemoration of the 300th Anniversary of
the death of Sir A.van Dyck,Dec.9,1641. Samuel
Hofmann from Zurich,pupil of Rubens;a first pre-
face to a rediscovered European art....New York,
Printed by Art press,1941.
 133 p. illus.

LC ND853.H64R4

I.E - INDIVIDUAL SITTERS - BYRON,GEO.GORDON,1788-
 1824

Shaw, Wm.A.
 The authentic portraits of Byron

In:Connoisseur
:155-61 Jul 1911 illus.

 Critical essay on the ptd. & engraved portrs.
& miniatures of Lord Byron

LC N1.C75

AP
1
A79
NCFA
v.1-3

I.E - INDIVIDUAL SITTERS - BRODNAX FAMILY

Black, Mary C.
 The case of the red and green birds.Thir-
teen persons,one of whom has never been identi-
fied,pose a picture puzzle wherin a cardinal &
a parakeet are vital clues.

In:Arts in Va.
3,no.2:2-4,7-8 Winter,'63 illus.
 Portrs.of members of two prominent fami-
lies by an unknown artist.Five facts.suggest
a Va.provenance,inspired by Engl.mezzotints.
 Black.The case reviewed.
 In:Arts in Va.,v.10,no.1

I.E - INDIVIDUAL SITTERS - CALVERT, BARONS OF
see BALTIMORE
I.E - INDIVIDUAL SITTERS - BALTIMORE, LORDS

705
C75
NCFA
v.120

I.E - INDIVIDUAL SITTERS - BRONTE SISTERS

Green, David Brontë
 Portraits of the Brontë sisters

In:Connoisseur
120:26-8,66 Sept.'47 illus.

I.E - INDIVIDUAL SITTERS - CARLYLE, THOMAS,
 1795-1881

London. National Portrait Gallery
 Thomas Carlyle,1795-1881,cat.for,an exh..
held at the NPG from 25 Sept.1981 to 10 Jan.,
1982,by Richard Ormond and John Cooper.London,
NPG,1981
 27 p. illus.

LC PR4433.07

N
7628
C3H3X
NPG

I.E - INDIVIDUAL SITTERS - CARROLL, CHARLES OF
CARROLTON FAMILY
Baltimore. Museum of art
Charles Carroll of Carrolton(1737-1832)
and his family.An exh.of portraits,furniture...
at the Baltimore Mus.of art,Sept.19-Oct.30,1937,
under the auspices of the U.S.Comm.for the ce-
lebration of the 200th anni.of the birth of Chs.
Carroll of Carrolton.:Balto.,Md.The Lord Balti-
more press,1937.
54 p. illus.

I.E - INDIVIDUAL SITTERS - Charles Edward
see
Stuart, Charles Edward,the young preten-
der,1720-1788

qCt
275
C298V?
NPG

I.E - INDIVIDUAL SITTERS - CARROLL, CHARLES,
1737-1832
Van Devanter, Ann C.
"Anywhere so long as there be freedom":
Charles Carroll of Carrollton,his family & his
Maryland;an exh.cat.;organized by Ann C. Van
Devanter.Baltimore,Baltimore Mus.of Art,c.1975
319 p. illus.

Co-sponsored by the Maryland Historical Soc
and the Peale Museum
Exh.held Sept.30-Nov.30,1975
Bibliography and index

LC CS71.C317 1975

705
B97
NCFA
v.91

I.E - INDIVIDUAL SITTERS - CHARLES I, 1600-1649
Charles I

In:Burl.Mag.
91:p.3 Jan.1949

Mytens, court painter, representative style,
most famous portr.ptr. until van Dyck

qCt
275
C298V?
NPG

I.E - INDIVIDUAL SITTERS - CARROLL FAMILY

Van Devanter, Ann C.
"Anywhere so long as there be freedom":
Charles Carroll of Carrollton,his family & his
Maryland;an exh.cat.;organized by Ann C. Van
Devanter.Baltimore,Baltimore Mus.of Art,c.1975
319 p. illus.

Co-sponsored by the Maryland Historical Soc
and the Peale Museum
Exh.held Sept.30-Nov.30,1975
Bibliography and index

LC CS71.C317 1975

705
B97
NCFA
v.91

I.E - INDIVIDUAL SITTERS - CHARLES I, 1600-1649
Esdaile, Katharine.
The busts & statues of Charles I

In:Burl.Mag.
91:9-14 Jan.1949 illus.

Busts by LeSueur,Besnier(attr.),Roubiliac
(terra-cotta & marble),Adey after Bernini, sta-
tues by LeSueur,Bushnell

Rep.,1948-49*1130

705
A56
NCFA
v.108

I.E - INDIVIDUAL SITTERS - CARROLL, CHARLES,
1737-1832
Van Devanter, Ann C.
Charles Carroll of Carrollton

In:Antiques
108:736-43 Oct.,'75 illus(part col.)

FOR COMPLETE ENTRY
SEE MAIN CARD

I.E - INDIVIDUAL SITTERS - CHARLES I, 1600-1649
Layard, George Somes, 1857-1925
The headless horseman,Pierre Lombart's en-
graving,Charles or Cromwell?...with an intro.
by Campbell Dodgson...London,P.Allan & co.,1922
125 p. illus.

7 states of an engr.,3 with Cromwell's head,
1 with the head of Charles I,2 with the head of
Louis XIV,1 without head;after v.Dyck's eques-
trian portr.of Charles I.
cf.Connoisseur bookshelf in Conn.63:247,
Aug.,'22:'...L.contends that Lombart never in-
tended to produce a portr.of Charles I
LC NE650.L4L3

705
C75
NCFA
v.109

I.E - INDIVIDUAL SITTERS - CATHERINE THE GREAT

Hanbury-Williams, Sir John, 1859-1946
Catherine the Great and some of her por-
traits

In:Connoisseur
109:3-13 Mar.,'42 illus.

The text is a description of her personali-
ty.Interesting portrs.incl.:Tchebanoff,v.Lampi,
Rotari,Rokotov,v.Loo,Roslin,Lante

705
B97
NCFA
v.91

I.E - INDIVIDUAL SITTERS - CHARLES I, 1600-1649
Toynbee, Margaret R.
Some early portraits of Charles I

In:Burl.Mag.
91:4-9 Jan 1949 illus

Incl:Ptgs.anonym.1610-11,Peake,1613,minia-
tures:Hilliard,1608-9, Oliver(attr.)1614-15,
engr.s.Delaram,equestrian,1616,Hondius?,Rathborne's
surveyor,1616 & from Dallington's Aphorismes Civil
and Militarie,1613

Rep.,1948-49*1131

I.E - INDIVIDUAL SITTERS - CHARLES I, 1600-1649

Vertue, George, 1684-1756
Prints. King Charles I & the heads of the noble earls,lords & others,who suffered for their loyalty in the rebellion & civil-wars of England. With their characters engraved under each print, extracted from Lord Clarendon.Taken from original pictures of the greatest masters.Many of them Sir Anthony van Dyke's & all the heads accurately engraved by Mr.Geo.Vertue.London,C.Davis,1746

LC N7598.V4 Rosenwald coll.

N
40.1
I55T7
NMAA

I.E - INDIVIDUAL SITTERS - CHERUBINI,LUIGI,1760-
.1842

Toussaint, Hélène
Les portraits d'Ingres,peintures des musées nationaux.Paris,Ministère de la Culture.Editions de la Réunion des musées nationaux,1985
141 p. illus(part col.) (Monographies des musées de France)

Bibliography, p.136-9
Repro incl.:Napoleon,1806,Luigi Cherubini, 1841,1842,Lorenzo Bartolini,1820,Jean-Pierre Cortot,1815,1818

N
7628
C4785
NPG

I.E - INDIVIDUAL SITTERS - CHARLES V, 1337-1380

Sherman, Claire Richter
Portraits of Charles V of France(1338-1380). ...New York,University Press...,1969
147 p. illus. (Monographs on archaeology and the fine arts,20)

Bibliography

."The portraits of Chs.V have,formal,iconographic & social characteristics of transitional stage betw. medieval & modern portraits"

AP
1
C27
NMAA

I.E - INDIVIDUAL SITTERS - CHRISTIAN IV,
1577-1640, King of Denmark and Norway

Frederiksborgmuseet
Engelske Christian IV-portrætter.I anledning af en gave.Af museumsinspektør Steffen Heiberg

In:Carlsbergfondet,Frederiksborgmuseet,Ny Carlsbergfondet.Arsakrift 1986,p.92-8 illus(part col.)

I.E - INDIVIDUAL SITTERS - CHARLES V, 1500-1558
card 3
Glück, Gustav
Bildnisse aus dem hause Habsburg. Pt.3 of 3

Met
100.53
J191
Q

In:J.Vienne
11:165-78 1937 illus.

Charles V by Orley,Titian,Rubens,Snayers etc.

LC N3.J4 Rep.,1939-41#746

I.E - INDIVIDUAL SITTERS - CLAY, HENRY, 1777-
.1852
Hart, Charles Henry, 1847-1918
Life portraits of great Americans...Henry Clay

In:McClure's Mag.N.Y.& London
9:939-48 Sept.,1897

LC AP2.M2 Pfister.Facing the light
 R680.P47X NPG p.365

708.1
W89
v.1-4
NCFA

I.E - INDIVIDUAL SITTERS - CHARLES V, 1500-1558

Janson, Horst Waldemar
A mythological portrait of the Emperor Charles V

In:Worcester Mus.Ann.
1:19.31 1935-36 illus.

Small equestrian portr. of Charles V as St. James of Compostela,conquering the Moors in his campaign in Tunis,given tentatively to Vermeyen. Attr.also in succession to Dürer,van Orley,C.Engelbrechtsen. History of mythological portrs.

I.E - INDIVIDUAL SITTERS - COLUMBUS

Gandia, Enrique de
Sintesis de los problemas colombinos

In:R.geogr.amer.
46:1-6 1937 illus.

Columbus,Toscanelli,Ficino

LC G1.R4 Rep.,1937*335

I.E - INDIVIDUAL SITTERS - CHE
see
I.E. - INDIVIDUAL SITTERS - GUEVARA ERNESTO(CHE)

I.E - INDIVIDUAL SITTERS, COLUMBUS, 1451-1506

Jones, Abner Dumont, 1807-1872
The American portrait gallery;containing correct portraits and brief notices of the principal actors in American history...From Christopher Columbus down to the present time. The portraits engraved on wood by J.W.Orr,from original drawings by S.Wallin...N.Y.,J.M. Emerson & co.,1855
768 p. illus.

LC E176.J68

I.E - INDIVIDUAL SITTERS - COLUMBUS, 1451-1506

.Lamb,Martha Joanna Read(Nash).1829-1893
A group of Columbus portraits

In:Mag Am.Hist.
26:.241.-260 1891 illus.

LC E171.M18
a copy detached E112.L21

I.E - INDIVIDUAL SITTERS - COOLIDGE, JOHN
.CALVIN, 1872-1933

VF
Presidents
U.S.

Pease, Clifford A.,jr.
Portraits of President and Mrs.Calvin
Coolidge.A preliminary report
10 p. illus.

Bibliographical references

I.E - INDIVIDUAL SITTERS - COLUMBUS, 1451-1506

Ponce de León y Laguardia, Néstor, 1837-1899
The Columbus gallery.The "discoverer of the
New world" as represented in portraits,nonu-
ments,statues,medals and paintings.Historical
description ...N.Y.,N.Ponce de León,1893
178 p. illus.

LC E112.P79

I.E - INDIVIDUAL SITTERS - COOLIDGE,MRS.GRACE
.GOODHUE

VF
Presidents
U.S.

Pease, Clifford A.,jr.
Portraits of President and Mrs.Calvin
Coolidge.A preliminary report

Bibliographical references

I.E - INDIVIDUAL SITTERS - COLUMBUS, 1451-1506

U S.Comm.to the Madrid exposition,1892
Report of the U.S.Comm.to the Columbian his-
torical exposition at Madrid,1892-93.With spe-
cial papers.Washington,Govt.print.off.,1895
411 p. illus(1 col.)

Incl.:p.215:Report of Wm.E.Curtis,upon Colum
bus iconography; p.215:The portrs.of Columbus
(77)incl.the originals or copies of all that he
been painted or published of any historical in-
terest or artistic value up to the 1st of Jan.,
1892.

LC E119.M35

I.E - INDIVIDUAL SITTERS - CORTOT,JEAN-PIERRE,
.1787-1843

M
40.1
I55T7
NMAA

Toussaint, Hélène
Les portraits d'Ingres,peintures des musées
nationaux.Paris,Ministère de la Culture.Editions
de la Réunion des musées nationaux,1985
141 p. illus(part col.) (Monographies
des musées de France)

Bibliography, p.136-9
Repro incl.:Napoleon,1806,Luigi Cherubini,
1841,1842,Lorenzo Bartolini,1820,Jean-Pierre Cor-
tot,1815,1818

I.E - INDIVIDUAL SITTERS - COMTESSE
see
.D'OLONNE
I.E - INDIVIDUAL SITTERS - OLONNE, CATHERINE
HENRIETTE D'ANGENNES,COMTESSE D',1634-
.1714

I.E - INDIVIDUAL SITTERS - CROCKETT,DAVID,1786-
.1836

705
A56
NCFA
v.73

Chamberlain, Georgia S.,tssm,1910-1961.
John Gadsby Chapman:a reappraisal

In:Antiques
73:566-9 June,'58 illus.
Repro.incl.:Self-portr.;David Crockett;
Horatio Greenough;Alexander Anderson

'..his:psychological insight & competent ptg
make Ch.one of the most interesting,if not one
of the best of the artists...in the U.S...1830's
and 40's.'
_ Robert Hull Fleming Mus.
parlor.Bibl.p.39 Univ.of Vt. Faces in the

I.E - INDIVIDUAL SITTERS - CONOVER, HENRY
.c.1770/80-1835

705
A56
NCFA
v.66

Cortelyou, Irwin F.
Collectors' Notes:Henry Conover:sitter not
artist

In:Antiques
66:481 Dec.,'54

Pertains to C.'s Aug.article:"A mysterious
pastellist indentified".He suggests,that Micah
Williams is the artist of the ptgs. from Mon-
mouth Cy& vicinity

I.E - INDIVIDUAL SITTERS - CROCKETT,DAVID, 1786-
.1836

CT
275
C934
K2
NPG

Kelly, James C.,1949- and Frederick Voss
Davy Crockett,gentleman from the cane:an exh.
commemorating Crockett's life and legend on the
200th anniversary of his birth...Washington,D.C.
NPG;Nashville,Tennessee State Museum,1986
51 p. illus.

Bibliography

Exh.at Washington,D.C.,June 14-Sept.14,1986.
at the Tennessee State Museum,Nashville,Oct.9-
Dec.31,1986

I.E - INDIVIDUAL SITTERS - CROMWELL, OLIVER

Layard, George Somes, 1857-1925
 The headless horseman, Pierre Lombart's engraving, Charles or Cromwell?...with an intro. by Campbell Dodgson...London,P.Allan & co.,1922
125 p. illus.

 7 states of an engr.,3 with Cromwell's head, 1 with the head of Charles I,2 with the head of Louis XIV,1 without head;after v.Dyck's equestrian portr.of Charles I.
 cf.Connoisseur bookshelf in Conn.63:247,
Aug.,'22:'...L.contends that Lombart never intended to produce a portr.of Charles I

LC NE650.L84L3 —see over

I.E - INDIVIDUAL SITTERS - DECATUR, STEPHEN, 1779-
 .1820
705
C75
NCFA Truettner, William H.
v.171 Portraits of Stephen Decatur by or after
 Gilbert Stuart

 In:Connoisseur
 171:264-73 Aug.'69 illus.

 7 changes attributions & dates proposed by
 Chs.L.Lewis
 Repro.incl.:Ths.Sully,J.W.Jarvis,R.Peale,Js.
 A.Simpson,Chs.Bird King,Js.H.Cafferty

AP
1
W225 I.E - INDIVIDUAL SITTERS - CROMWELL, OLIVER
NCFA
v.34 Piper, David
 The contemporary portraits of Oliver Cromwell

 In:Walpole Soc.
 36:27-41 1952-1954 illus.

 Repro.incl.:Rbt.Walker,van Dyck,Sam.Cooper,
 Lely; the Great Seal by Ths.Simon,the Dunbar
 medal by Ths.Simon,several medals by Ths.Simon,
 death mask;engravings;funeral effigy.

705
A56
NCFA I.E - INDIVIDUAL SITTERS - DE PEYSTER FAMILY

 Comstock, Helen
 Some Hudson valley portraits

 In:Antiques
 46:139-40 Sept.,'44 illus.

 FOR COMPLETE ENTRY
 SEE MAIN CARD

ND
1311.8 I.E - INDIVIDUAL SITTERS - CUSTIS FAMILY
V8W31
NCFA Washington and Lee University, Lexington,Va.
 Washington-Custis-Lee family portraits from
 the coll.of Washington & Lee univ.,Lexington,
 Va.,circulated by the International Exhibitions
 Foundation,1974-1976.Intro.by Alfred Franken-
 stein.Washington,D.C.,International Exh.Found'n,
 c.1974
 .10.p. illus(1col.)

 17 portrs.,representing 6 generations of
 men & women in the Washington,Custis and Lee
 families
 Rila I/1-2 1975 #1365

705
B97 I.E - INDIVIDUAL SITTERS - DIANE DE POITIERS,
v.24 1499-1566
 Dimier, Louis, 1865-1943
 An idealised portrait of Diane de Poitiers

 In:Burl.Mag.- Nov.1913 illus.
 24:89-93

 School of Fontainebleau. List of drgs. of
 Diane de Poitiers:1520; 1532 by J.Clouet,1537,
 1543,1560 by F.Clouet

705
A784 I.E - INDIVIDUAL SITTERS - DAVID, JACQUES LOUIS,
1915 .1748-1825
NCFA Hart, Charles Henry, 1847-1918
 Portrait of Jacques Louis David painted by
 Rembrandt Peale

 In:Art in Am
 3:257-8 Aug.,'15 1 illus.

I.E - INDIVIDUAL SITTERS - DIANE DE POITIERS,
 1499-1566
Taylor, Francis Henry
 La belle Diane. Two portraits of the French
Renaissance

In:Worcester Art Mus.Annual
3:45-56 1940 illus.

 Diane de Poitiers, ptg. by François Clouet
& statue by Jacques Goujon

LC N870.A42 Rep.,1945-47*1104

I.E - INDIVIDUAL SITTERS - DECATUR, STEPHEN,1779-
mfm .1820
345
NPG Lewis, Charles Lee
 Decatur in portraiture

 In:Md.Hist.Mag.
 35:365-73 Dec.,1940

 Truettner.Portra...In:Conn.
 171:272,note 2

I.E - INDIVIDUAL SITTERS - DICKINSON, EMILY,1830-
 1886
Graves, Louise B.
 The likeness of Emily Dickinson

In:Harvard Library B.
1:248-51 1947 illus.

 Incl:Miniature by Mrs. Lloyal Rogers

LC Z881.H3403 Rep.,1948-49*1143

I.E - INDIVIDUAL SITTERS - DUNCAN, ISADORA, 1878-
1927

Pueyrredón de Elizalde, Silvia
Isadora Duncan

In:Ars
5:12-16 1946 illus.

Drgs. by Segonzac,Bourdelle,A.F.Gorguet

LC N7.A714 C Rep.,1945-47#1107

I.E - INDIVIDUAL SITTERS - ELIZABETH I

O'Donoghue, Freeman Marius
A descriptive and classified cat.of por-
traits of Queen Elizabeth...London,B.Quaritch,
1894
121 p. illus.

N.Y.P.L.
ACT
(Elizabeth)

Auerbach.Portrs.of Elizabeth
Burl.Mag.v.9:197 1953

705
A7834
NCFA
v.53

I.E - INDIVIDUAL SITTERS - ELDER, ARCHBISHOP
WILLIAM HENRY, DIED 1904

Gerdts, William H.
Thomas Eakins and the Episcopal portrait:
Archbishop William Henry Elder

In:Arts Mag.
53,no.9:154-7 May'79 illus(part col.)

DA
356
B83X
NPG

I.E - INDIVIDUAL SITTERS - ELIZABETH I

Strong, Roy C.
The cult of Elizabeth;Elisabethan portrai-
ture and pageantry...London,Thames and Hudson,
1977
227 p. Illus(part col.)

Incl. bibliographical references and index

705
B97
NCFA
v.95

I.E - INDIVIDUAL SITTERS - ELIZABETH I

Auerbach, Erna
Portraits of Elizabeth I

In:Burl.Mag.
95:197-205 June,'53 illus.

Examples of Queen's likeness subdivided
into 3 phases:1558-1572;2nd:till 1584;3rd:till
1603
Repro.:Eworth,Hogenberg,M.Gheeraerts,elder,
Hilliard,Ryther,Delaram,Oliver,Rogers,M.Ghee-
raerts II,several unknown artists.

I.E - INDIVIDUAL SITTERS - ELIZABETH I

Strong, Roy C.
Portraits of Queen Elizabeth I. Oxford,
Clarendon Press,1963

173 p. illus(part col.)

Bibliographical references

Portrs.,caricatures, etc.

LC N7639.E4S8 Vict.& Albert mus., N.Hilliard
...p.30

708.1
.B762
NCFA
v.51

I.E - INDIVIDUAL SITTERS - ELIZABETH I

Boston. Museum of Fine Arts
An Elizabethan exhibition,by H.enry,
P.reston,R.ossiter.

In:Boston Mus Bul
51:18-20 June,'53 2 illus.

Repro.:Engr.by Crispin v.d.Passe and by
Wm.Rogers

Rep.1953#1214

AP1
LW1
NCFA

I.E - INDIVIDUAL SITTERS - ELIZABETH I

Yates, Frances A.
Queen Elizabeth as Astraea

In:J.Warburg Inst.
10:27-82 1947 illus.

Engravgs.16th c.,Rogers,de Passe, Vertue
(after Olivier),Ryther, Delaram(after Hilliard).
Ptgs.by Eworth,Geeraerts.
Elizabethan symbolism

Rep.,1946-47#1108

705
C75
NCFA
v.113

I.E - INDIVIDUAL SITTERS - ELIZABETH I

Kelly, Francis Michael, 1879-
Queen Elizabeth and her dresses

In:Connoisseur
113:71-9 Jun,1944 illus.

Incl.:Miniatures by Hilliard,ptg.by Zuccaro ?
Marcus Geeraerts,younger,caricature,ca.1595,
effigy by Powtrain & Crits

Rep.,1942-44#748

I.E - INDIVIDUAL SITTERS - EMERSON, RALPH WALDO,
1803-1882

Sanborn, Franklin Benjamin, 1831-1917
The portraits of Emerson

In:New Engl.Mag.
NS.15:449-68 Dec.,1896

LC AP2.N4 Pfister.Facing the light
TR680.P47X NPG p.366

I.E - INDIVIDUAL SITTERS - ENNIUS, QUINTUS,
239-?169 B.C.

Hafner, German
Das bildnis des Q.Ennius;studien zur römi-
schen porträtkunst des 2.jahrh.v.Chr. Baden-
Baden,B.Grimm,1968
52 p. illus. (Deutsche Beiträge zur
Altertumswissenschaft;Bd.20)

Bibl.footnotes

LC NB115.H28

Gazda.Etrusc.infl.in the
funerary reliefs...In:Tempori
ni.Aufstieg u.niedergang.
LC DG209.T36.Bd.1,T.1, p.856

AP
1
V81
NPG
v.76

I.E - INDIVIDUAL SITTERS - FAUQUIER, FRANCIS,
1704?-1768

Reese, George Henkle
Portraits of Governor Francis Fauquier

In:Va.Mag.of Hist.& Biogr.
76:3-10 Jan.,'68 illus.

Repro.:Rich.Wilson,Wm.Hogarth

I.E - INDIVIDUAL SITTERS - ERASMUS, DESIDERIUS,
1466?-1536

Gerlo, Aloïs
Erasme et ses portraitistes.Metsijs,Dürer,
Holbein.Bruxelles,Éditions du Cercle d'art,1950
70 p. illus.

Bibliography

LC N7628.E704

Enc.of World Art N31E56 Re:
v.11,p.513

AP
1
V81
NPG
v.75

I.E - INDIVIDUAL SITTERS - Fitzhugh family

Doud, Richard K.
The Fitzhugh portraits by John Hesselius

In:Va.Mag.Hist & Biogr.
75:159-73 Apr.'67 illus.

Incl.:Cat.of signed Fitzhugh portraits

Based on Doud's Master's thesis,Univ.of De-
laware,1963:"John Hesselius:his life and work"

Miles.Amer.Col.portrs.
p.73,note 121

705
G28
v.6
1911
NCFA

I.E - INDIVIDUAL SITTERS - ERASMUS, DESIDERIUS,
1466?-1536

Machiels, André
Les portraits d'Erasme

In:Gas Beaux Arts
6(4e ser):349-61 Nov.,'11 illus.

Repro.incl.:Medallion attr.to Quentin Metsys;
2 ptgs.by Quentin Metsys;engraving by Dürer;ptg.
by Holbein;woodcut after drag.by Holbein

I.E - INDIVIDUAL SITTERS - FLAVIAN DYNASTY

Daltrop, Georg
Die Flavier. Vespasian,Titus,Domitian,
Nerva,Julia Titi,Domitilla,Domitia,von G.Dal-
trop,Ulrich Hausmann,und Max Wegner.Berlin,
Gebr.Mann,1966
132 p. illus. (Das römische Herrscher-
bild,II.Abt.Bd.1)

Bibl.footnotes

LC DG286.D3

Kraus.Das römische welt-
reich.N5760.K92 Bibl.p.316
also:Winkes.Physiognommonia.In:
Temporini.Aufstieg u.nieder
gang.LC DG209.T36,Bd.1,T4,
p.913

705
B97
NCFA
v.99

I.E - INDIVIDUAL SITTERS - ESSEX, ROBERT (DEVE-
REUX)2nd EARL OF, 1566(or 67)-1601

Piper, David
The 1590 Lumley inventory:Hilliard,Segar
and the Earl of Essex-I & II

In:Burl.Mag.
99:224-31 July,'57 illus.
:299-303 Sept.,'57 illus.

I:Incl.:List of 22 portrs.bearing Lumley
labels.

Strong.The Engl.Icon ND1314
S924 NPG p.45 note 3

705
G28
NCFA
v.15

I.E - INDIVIDUAL SITTERS - FOUQUET, NICOLAS,
1615-1680

Cordey, Jean
Les portraits du surintendant Fouquet

In:Ga Beaux-Arts
15:219-28 Apr.,'27 illus.

FOR COMPLETE ENTRY
SEE MAIN CARD

I.E - INDIVIDUAL SITTERS - FAUQUIER, FRANCIS,
1704?-1768

A portrait of Governor Fauquier

In:B.Fauquier Hist.Soc.,Warrenton,Va.
no.4:343-50 July,'24 illus.

LC F221.F26

Reese,G.H. Portrs.of Gov.
Francis Fauquier,In:Va.Mag
of Hist.& Biogr.v.76

N
7628
F83A5
NPG

I.E - INDIVIDUAL SITTERS - FRANKLIN, BENJAMIN,
1706-1790

American Philosophical Society, Philadelphia
Exh.of portraits marking the 250th anniver-
sary of the birth of the society's founder,Benj.
Franklin,Jan.17-Apr.20,1956.Cat.of the portraits
by Chs.Coleman Sellers.Philadelphia,1956.
27 p. illus.

I.E - INDIVIDUAL SITTERS - FRANKLIN, BENJAMIN,
1706-1790
Boston. Public Library
Franklin portraits

In:Bull.
11:139-50 July,1892

Almost 240 prints are described in this
list...incl.book illus.& separately published
prints.Index

LC Z881.B75B

Arts in Am.qZ5961.U5A77X
NCFA Ref. v.2 K664

I.E --INDIVIDUAL SITTERS - FRANKLIN, BENJAMIN,
1706-1790
Fridenberg, Robert, 1860-
Cat.of the engraved portraits of Franklin...
N.Y.,The Grolier club of the city of N.Y.,1923
3 v.

N.Y.P.L.
AOT
(Frank-
lin)

Photostatic repro.of a ms.in the possession
of the Grolier club projected for publication
but never issued by the club.

"lists ca. 600 engravings".-Thorpe

Thorpe.In:Antiquarian v.8,
no.1:39 Feb.'27

I.E - INDIVIDUAL SITTERS - FRANKLIN, BENJAMIN,
1706-1790
Brubaker, Albert Philson, 1852-1943
The Martin portraits of Franklin

In:Penn.Mag.of Hist.& Biogr.
56:249-59 1932

Description of portr.of Franklin by David
Martin between 1764 and 1766

LC F146.P65

Arts in America qZ5961 USA
7X NCFA Ref. H667

N
7628
F8G08
NPG

I.F - INDIVIDUAL SITTERS - FRANKLIN, BENJAMIN,
1706-1790
Grolier club, New York
Cat.of an exh.commemorating the 200th anni-
versary of the birth of Benjamin Franklin...
January,1906,N.Y.,De Vinne press,1906.
200 p.

458 numbers:1-291 portrs.;292-303 medals;..
375-421 ceramic portrs.;422-443 paintings,etc..

LC Z8313.085

Levis.Descr.bibl.Z59473
L66 1974 NCFA p.385

I.E - INDIVIDUAL SITTERS - FRANKLIN, BENJAMIN,
1706-1790
Carson, Hampton Lawrence, 1852-1929
.. ...The Hampton L.Carson collection of en-
graved portraits of Jefferson,Franklin,and La-
fayette.Cat. comp. & sale conducted by Stan.V.
Henkels.At the art auction rooms of Davis &
Harvey...Phila.,Pa.......Press of W.F.Fell co.,
1904.
157 p. illus.
Cat.no.906,pt.II

To be sold Apr.20 & 21,.1904.

LC Z999.H505 no.906,pt.2 Amsterdam,Rijksmus.cat.
.5939A52, deel 1, p.154

705
A784
NCF
v.4

I.E - INDIVIDUAL SITTERS - FRANKLIN, BENJAMIN,
1706-1790
Halsey, Richard,T.ownley,H.aines, 1865-1942.
Ceramic Americana of the 18th century

In:Art in Am
4,Pt.1:85-98 Feb.,1916 illus.
Pt.2:224-32 June,1916 illus.
Pt.3:276-88 Aug.,1916 illus.
5,Pt.4:41-56 Dec.,1916 illus.
Repro.incl.:Chelsea porcelain statuettes:Wm.Pitt,
John Wilkes,Catharine Macaulay. Wedgwood medal-
lions of Franklin,Washington,Marie Antoinette,
etc.etc.

I.E - INDIVIDUAL SITTERS - FRANKLIN, BENJAMIN,
1706-1790
College of Physicians of Philadelphia.Wm.N.
Bradley Collection
Philadelphia physicians.and others.as re-
presented in art.Reproduced by photography.
1936.-1950.
Arch. 12 v. illus.
Am.Art Preceeded by an index vol.
mfm Typescript,supplemented by a v.of "Silhouet-
P84-P86 tes",1941,and a suppl."A-Z",1950

Bibliographies

.LC PP PPULC,Bradley,Wm.N.

I.E - INDIVIDUAL SITTERS - FRANKLIN, BENJAMIN,
1706-1790
Hart, Charles Henry, 1847-1918
Life portraits of great Americans...Benjamin
Franklin

In:McClure's Mag N.Y. & London
8:.263.-72 1897 illus.

LC AP2.M2

705
C75
NCFA
v.61

I.E - INDIVIDUAL SITTERS - FRANKLIN, BENJAMIN,
.1706-1790
Dibdin, E.Rimbault, 1853-1941
John Turmeau,miniaturist

In:Connoisseur
61:20,23-4 Sept.,'21 illus.

Repro.incl.:Portr.of Benjamin Franklin

FOR COMPLETE ENTRY
SEE MAIN CARD

N
40.1
W931H3
NPG
RB

I.F - INDIVIDUAL SITTERS - FRANKLIN, BENJAMIN,
1706-1790
Hart, Charles Henry, 1847-1918
Original portrait of Doctor Franklin,
painted by Joseph Wright,1782...
Philadelphia,1908

FOR COMPLETE ENTRY
SEE MAIN CARD

I.E - INDIVIDUAL SITTERS - FRANKLIN, BENJAMIN,
ɛ1706-1790

Harvard university. William Hayes Fogg art mus
Exhibition:Washington,Lafayette,Franklin:
portraits,books,manuscripts,prints...for the
most part from the university.ɛCambridge,Fogg
mus.of art,Harvard univ.,1944
53 p. illus.

Feb.22-May 28,1944
Preface signed:Agnes Mongan and Mary Wadsworth

LC N5020.C234

N
7628
F83N5
NPG

I.E - INDIVIDUAL SITTERS - FRANKLIN, BENJAMIN,
1706-1790

New York. Metropolitan museum of art.
Benjamin Franklin and his circle;a cata-
logue of an exhibition...fr.May 11 through
Sept.13,1936ɛNew York,Plantin press,1936ɛ
154 p. illus.

LC E302.6.F8N52
N7621.N53

Ida.Portrs.of John Jay
ɛ.J42I1 & CT275.J42I1NPG
Bibl.

705
A5
NCFA
v.8

I.E - INDIVIDUAL SITTERS - FRANKLIN,Benjamin,
ɛ1706-1790

Hopkins, Waldo
English portraiture in ceramics

In:Am Coll.
8:8-9,20 Sept.'39 illus.

Repro.incl:2 busts of Washington & 2 stand-
ing figs.of Franklin

Winterthur Mus.Libr. fZ881
W78 NCFA v.6,p.220

705
A56
NCFA
v.19

I.F - INDIVIDUAL SITTERS - FRANKLIN, BENJAMIN,
ɛ1706-1790

Nolan, J.Bennett
A long-lost Franklin.Some speculations con-
cerning the authorship of an unidentified wax
portrait

In:Antiques
19:184-7 March,'31 illus.

FOR COMPLETE ENTRY
SEE MAIN CARD

705
A56
NCFA
v.19

I.F - INDIVIDUAL SITTERS - FRANKLIN, BENJAMIN,
ɛ1706-1790

Lightning on Franklin waxes

In:Antiques
19:437 June,'31 illus.p.436

FOR COMPLETE ENTRY
SEE MAIN CARD

CT
275
F83
O8
NPG

I.E - INDIVIDUAL SITTERS - FRANKLIN, BENJAMIN,
1706-1790

Oswald, John Clyde, 1872-1938
Benjamin Franklin in oil and bronze...
N.Y.,W.E.Rudge,1926
58 p. illus.

Repro.incl.ptgs.,statues,statuettes,busts;
medals,medallions & snuff-boxes,bearing Frank-
lin's portrait.

LC E302.6.F808
N7628.F707

Weddell.A mem'l vol.of Va.
hist.portraiture.757.9.W38
NCFA Bibl. p.437

705
C75
NCFA
v.68

I.E - INDIVIDUAL SITTERS - FRANKLIN, BENJAMIN,
ɛ1706-1790

Mechlin, Leila, 1874-
Early American portrait painters

In:Connoisseur
68:127-32 Mar.,'24 illus.
Repro.:Franklin by Wright,Blackburn,Feke,C.W.
Peale,Rembrandt Peale,Neagle,Hamilton by Trumbull,
Waldo,Malbone,Harding,Copley,Stuart(p.135),West
(p.177)
Emphasis on close association of American &
British schools

Cumulated Mag.subj.index
A1/3/C76 Ref. v.2,p.443

705
A56
NCFA
v.22

I.F - INDIVIDUAL SITTERS - FRANKLIN, BENJAMIN,
ɛ1706-1790

Problems in waxes

In:Antiques
22:221-3 Dec.,'32 illus.

FOR COMPLETE ENTRY
SEE MAIN CARD

N
40.1
O84N9
NCFA

I.E - INDIVIDUAL SITTERS - FRANKLIN, BENJAMIN,
ɛ1706-1790

Munhall, Edgar
Jean-Baptiste Greuse,1725-1805...

Repro.incl:Portr.of Benj.Franklin('F.'s
finest portr.')

FOR COMPLETE ENTRY
SEE MAIN CARD

N
7628
F83S4
NPG
9201
F83IS46
NCFA

I.E - INDIVIDUAL SITTERS - FRANKLIN, BENJAMIN,
1706-1790

Sellers, Charles Coleman, 1903-
Benjamin Franklin in portraiture.New Haven &
London,1962
452 p. illus(part col.)

Bibl.footnotes

"A monumental work combining a biography and
a catalogue,bringing together all known like-
nesses of Franklin"(Whitehill)

LC N7628.F7S4

Whitehill.The Arts in ear-
ly Amer.Hist.25935.W59
Bibl.p.97

705
A56
NCFA
v.100

I.E - INDIVIDUAL SITTERS - FRANKLIN, BENJAMIN,
.1706-1790

Smith, Robert C.
Finial busts on 18th century Philadelphia
furniture

In:Antiques
100:900-905 Dec.,'71 illus.

Repro.incl.:B.Franklin;John Locke;John Milton;
Washington
'...study of all this furniture...could well
reveal ..resemblances linking it with the shop
of Benjamin Randolph. Saunders.Am.colonial portrs
W7593.1.S28,p.74,note 152

qZ
5961
USA77X
NCFA
Ref.
v.4

I.E - INDIVIDUAL SITTERS - FRANKLIN, BENJAMIN,
1706-1790

For additional books and articles see
Arts in America,Index,p.153

AP
1
A(area)
v.8

I.E - INDIVIDUAL SITTERS - FRANKLIN, BENJAMIN
1706-1790

Thorpe, Russell Walton
Benjamin Franklin, LL.D., F.R.S.

In:Antiquarian
8,no.1:39-43 Feb.'27 illus.

"B.F.appealed to limners,sculptors,engravers
of every shade of artistic ability".-Thorpe

see also:Antiquarian,v.8,no.2:27,March,'27

CS
71
F836
1968X
NPG

I.E - INDIVIDUAL SITTERS - FRANKS FAMILY

Franks, Abigail,1696-1756
The Lee Max Friedman coll.of American
colonial correspondence:letters of the Franks
family,1733-1748.Ed.by Leo Hershkowits and
Isidore S.Meyer.Waltham,Mass.,American Jewish
Histo.Soc.,1968
171 p. illus(1 col.) (Studies in Ame-
rican Jewish Hist.,no.5)

Bibliography
Index

I.E - INDIVIDUAL SITTERS - FRANKLIN, BENJAMIN,
1706-1790

Weitenkampf, Frank, 1866-1962 comp.
.Cat.of portraits of,and other engravings
relating to,Benjamin Franklin.

In:N.Y.P.L.Bull.
10,no.1:57-83 Jan.,1906

307 items:1-262 Portraits...296-307 Member
of Franklin's family

Index of patrs.and engravers

LC Z881.W68 Levis.Descr.bibl.Z5947.A3
L66 p.207

705
A784
NCFA
v.51

I.E - INDIVIDUAL SITTERS - FRANKS FAMILY

Gardner, Albert Ten Eyck
An old New York family

In:Art in Am
51 no.3:58-61 June,'63 illus.

Six portrs.of the Franks family,f'ly in
the Cpt.N.Taylor Phillips coll,now in the coll.
of the Am.Jew.Hist.Soc.,attr.by Waldron Phoe-
nix Belknap,jr.to Gerardus Duyckinck I ?;by
Virgil Barker to the Duyckinck Limner;by Flex-
ner "in the de Peyster Manner".They derive fr.
engravings by - Godfrey Kneller.

N
7628
W31W5
NCFA

I.E - INDIVIDUAL SITTERS - FRANKLIN, BENJAMIN,
1706-1790

Whelen, Henry,jr.
...The important collection of engraved por-
traits of Washington belonging to the late Hen-
ry Whelen, jr.,of Philadelphia...from whose co-
lection the late Wm.S.Baker compiled his...boo
..."Engraved portrs.of Washington"...also en-
graved portrs.of Franklin;to be sold...Apr.27,
1909...Cat.comp.and sale conducted by Stan V.
Henkels at...Samuel T.Freeman & co...Philadel-
phia.Phila.,Press of M.H.Power,1909.
102 p. illus.

Levis.Descr.bibl.Z5947A3
LC NE320.W2W5 L66 1974 NCFA p.250
E312.43.W64 incl.some prices.

I.E - INDIVIDUAL SITTERS - FREDERICK I,BARBAROS-
.SA, 1123?-1190

Appuhn, Horst
Beobachtungen und versuche zum bildnis
Kaiser Friedrich I. Barbarossa in Cappenberg.
.n.p.,1973?. (Aachener Kunstblätter,Bd.44,
1973,p.129-192, illus.)

"Einführung:Bildnis & kronleuchter Kaiser
Fr.Barbarossa's,von Erich Meyer..'p.130-9....
"Literatur z.bildnis K.F.'s..."p.188-92."An-
merkungen"(bibliographical):p.178-86

Chm DDI 49.7.A65 Rila I/1-?,pt.1 Abstracts
NN 1975 #952

768.1
F91
NCFA
v.44

I.E - INDIVIDUAL SITTERS,- FRANKLIN, BENJAMIN,
1706-1790

Zeigrosser, Carl,
Franklin portraits. The Rockefeller collection

In:The Philadelphia Mus.Bull.
44:18-31 no.220,1948 illus.

Show,built around a coll.of 151 portrs.given
to the Mus..F.'s wide-spread reputation is shown
graphically through portrs.from 9 different coun-
tries. Repro.:ptgs.by Peale,West,miniature by Du-
plessis,stipple engr.by Darcis,line-engrs.by Saint
Aubin after Cochin,Nasquelier after Moreau-le-
Jeune,color aquatint by Alix,etc.
Rep.,1948-49#1146

I.E - INDIVIDUAL SITTERS - FREDERICK II, the
Great,1712-1786

Campe, Edwin von
Die graphischen porträts Friedrichs des
Grossen aus seiner zeit und ihre vorbilder.
München,F.Bruckmann.1958.
105 p. illus(part col.)

FOGG
WIDENER

Harvard Univ.Libr.for LC Verzeichnis lieferbarer
ICU NN NbU DLC NjP Bücher 1973/74 NPG v.1,
NcD NIC MoU p.289

AP
1
B975
NCFA
v.68

I.E - INDIVIDUAL SITTERS - FREDERICK LOUIS, 1707-
.1751,and FAMILY

Trivas,N.S.
 Liotard's portraits of Frederick Lewis,
Prince of Wales,and his family

In:Burl Mag
68:117-8 March,'36 illus.

Schaffers-Bodenhausen.In:
B.Rijksmus.v.36,no.3:215
note 14

NE
218
R25
NPO

I.E - INDIVIDUAL SITTERS - GIOVIO,PAOLO,1483-1552

Rave, Paul Ortwin, 1893-1962
 Paolo Giovio und die bildnisvitenbücher des
Humanismus

In:Jb.der Berliner Mus.
I 1959:119-54 illus.

 Der bildnissammler und vitenschreiber Giovio.
Die ersten bücher mit bildnisreihen.Die "vera
effigies"und die frühen münsbildbücher.Die gros-
sen chroniken der jahrhundertmitte.Giovio,Vasari
(cont.on next cd.) Prins.Slg.d.selbstbildn.
LC N3.J16 in d.Uffizien N7618/P95
 Bd.1,p.146,note 42

AP
1
A51H7
NPO

I.E - INDIVIDUAL SITTERS - FULTON, ROBERT,
 .1765-1815

Philip, Cynthia Owen
 Adventurer armed with fortitude

In:Am.Hist.Illus.
21,no.8:8-23 Dec.,'86 illus(part col.)

 Incl.:'Robert Fulton...artist',p.10-12
 Repro.incl.:Fulton by Benj.West;by Vander-
lyn;Miniatures by Fulton

I.E - INDIVIDUAL SITTERS - GIOVIO, PAOLO,1483-
 1552
Schaeffer, Emil, 1874-
 Von bildern und menschen der renaissance;
mit 30 abbildungen.Berlin,J.Bard,1914
 222 p. illus.

 Incl.chapter:"Ein unbekanntes bildnis des
Paolo Giovio",p.179-190,with 2 portrs of Giovio.

LC ND615.S35

Rave.Jb.d.Berl.Mus. I 1959
LC N3.J16 fol. p.144 footr.
Paolo Gic..o & d.Bildnisvitenbücher...

I.E - INDIVIDUAL SITTERS - GALLATIN, ALBERT,
 .1761-1849
Gallatin, Albert Eugene, 1881-1952
 The portraits of Albert Gallatin;by A.E.
Gallatin.Boston.Priv.print,1917
 28 p. illus.

LC N7628.G3A3
E302.6.G16G16

Pfister.Facing the light
TR680.P47X NPO p.367

N
40.1
C628
W18
NCFA

I.E - INDIVIDUAL SITTERS - GLASS, PHILIP, 1937-

Close, Chuck, 1940-
 Close portraits.Walker Art Center,Minnea-
polis,exh..edited.by Lisa Lyons and Martin
Friedman.Minneapolis,The Center.c.1980.
 80 p. illus(part col.)

 Checklist inserted
 Bibliography

LC N6537.C54A4

Worldwide Art Cat.Bul.
705.W527 MMAA v.17no.2 198
p.53

705
C75
NCFA
v.11

I.E - INDIVIDUAL SITTERS - GARRICK, DAVID, 1717-
 .1779
Lawrence, William John, 1862-1940
 The portraits of David Garrick

In:Connoisseur
11:211-18 Apr.,'05 illus.

FOR COMPLETE ENTRY
SEE MAIN CARD

I.E - INDIVIDUAL SITTERS - GOETHE, 1749-1832

Blank, M.
 . Der medailleur Leonard Posch und seine
Goethebildnisse

In:Blätter f.Münzfreunde & -forschung,Lübeck
:213-7 1941

Rep.,1945-47*8299

NC
1473
W95
1867
NPO RB

I.E - INDIVIDUAL SITTERS - GEORGE I - (Kings
 .of England)
Wright, Thomas, 1810-1877
 Caricature history of the Georges.London,
J.C.Hotten.1867.
 639 p. illus.

DA
485
W95
1968(
NPO

----- Same
Benj.Blom,1968 .New York,

 1st ed.1848

ca.400 illus.on steel & wood

I.E - INDIVIDUAL SITTERS - GOETHE, JOHANN WOLF-
Gabrisch, Anne .GANG VON, 1749-1832
 Schattenbilder der Goethe-zeit.Leipzig,In-
sel Verlag,1966
 79 p. illus.

 Joh.Friedr.Anthing,nos.5,46;Christiane
Luise Duttenhofer,no.51;Goethe,nos.6,7,12;Ludw.
Jul.Friedr.Höpfner,no.54;Andr.Leonh.Moeglich,
no.55;Franz Wilh.Schellhorn,no.40;Starcke,nos.3
39,43,47,50;Joh.Wilh.Wendt,nos.15,17,20,22,23,
26
LC NC910.G3

I.E - INDIVIDUAL SITTERS - GOETHE, JOHANN WOLF-
GANG VON, 1749-1832
Kroeber, Hans Timotheus, 1863-
Die Goethezeit in silhouetten.74 silhouetten in
ganzer figur vornehmlich aus Weimar und um-
gebung...Weimar,G.Kiepenheuer,1911
180 p. illus.

LC NC910.K8

I.E - INDIVIDUAL SITTERS,- GOETHE, 1749-1832
Rademacher, Franz
Goethe's letztes bildnis. Krefeld,Scherpe
Verlag,1949

52 p. illus.

Drawing by Friedrich Preller

LC PT2143.P8R3

705
C75
NCFA
I.E - INDIVIDUAL SITTERS - GOETHE, 1749-1832
Roe, F.Gordon
Shades of Goethe

In:Connoisseur Apr,1932(pt.1) illus.
89:254-6

Rep.,1932*102

I.E - INDIVIDUAL SITTERS - GONZAGA FAMILY, MAN-
TUA,1328-1708
Vienna. Kunsthistorisches Museum. Schloss-
Sammlung Ambras
I Ritratti Gonzagheschi della collezione
di Ambras ,di.Giuseppe Amadei e di Ercolano
Marani.Mantova,Banca Agricola Mantovana,1980
284 p. illus(col.)

Bibliography p.255-71

RPB
Spike.Paroque portraiture..
N7606.S75 NPG Bibl.p.194

705
A784
NCFA
v.6
I.E - INDIVIDUAL SITTERS - GORDON FAMILY

Hart, Charles Henry, 1847-1918
The Gordon Family painted by Henry
Benbridge

In:Art in Am
6:191-200 June,'18 illus.

Rutledge.In:Am Coll 705.A5
17:23

NPG
Ref.
1985
I.E - INDIVIDUAL SITTERS - GRANT, ULYSSES S.,
1822-1885
Barber, James, 1952-
U.S.Grant,the man and the image.Cat.of
an exh.at the NPG,Washington,D.C.,July 23-
Nov.11,1985,by James G.Barber,Publ.Washington,
D.C. by the NPG,Smiths.Inst.,1985,
79 p. illus.

With an essay by John Y.Simon

Exh.also in Austin,Tex.,at the Lyndon
Baines Johnson Library and Museum,Jan.10-
May 6,1986

ND
1311.2
P6Lx
NPC
I.E - INDIVIDUAL SITTERS - GRATZ, REBECCA, 1781-
London, Hannah Ruth, 1894- 1869
Portraits of Rebecca Gratz by Ths.Sully
Miles, Ellen Gross comp.
Portrait painting in America.The nineteenth
century.N.Y....,1977 (card 4)

Partial contents cont'd:...H.London,Portrs.
of Rebecca Gratz by Ths.Sully,p.162-4;...

705
A56
NCFA
v.73
I.E - INDIVIDUAL SITTERS - GREENOUGH,HORATIO,
1805-1852
Chamberlain, Georgia S.tsmm,1910-1961.
John Gadsby Chapman:a reappraisal

In:Antiques
73:566-9 June,'58 illus.
Repro.incl.:Self-portr.;David Crockett;
Horatio Greenough;Alexander Anderson

'..his:psychological insight & competent ptg
make Ch.one of the most interesting,if not one
of the best of the artists...in the U.S...1830's
and 40's.'
Robert Hull Fleming Mus.
parlor.Bibl.p.39 Univ.of Vt. Faces in the

N
7628
.B5L4
NPG
I.E - INDIVIDUAL SITTERS - GRUNDTVIG, NICOLAI
SEVERIN, 1783-1872
Eller, Povl
N.F.S.Grundtvig portraetter.Med en indled-
ning af Steen Johansen.Frederiksborg,National-
historiske museum,1962
144 p. illus.

Bibliographical references

LC PT8130.25E4

I.E - INDIVIDUAL SITTERS - GUELPH FAMILY
London. New Gallery
Exhibition of the royal house of Guelph
.London. 1891
288 p. illus.

MET
A46L84
N422
V & A

705
A784
NCFA
v.63

I.E - INDIVIDUAL SITTERS - GUEVARA ERNESTO(CHE)

Kunzle, David
 Uses of the portrait:The Che poster

In:Art in Am.
63:66-73 Sept.,'75 illus(part col.)

 The Cuban posters provide special psycholo-
gical forms.They are intended to form a revolu-
tionary consciousness which is morally motivated
& internationally dedicated.They embrace styles
fr.Pop art to Neo-Art Nouveau,but exclude Soviet
& Chinese Socialist Realism.

qCT
275
H217B2

I.E - INDIVIDUAL SITTERS - HAMILTON, EMMA,lady,
 1761?-1815
Baily, James Thomas Herbert, 1865-1914
 Emma,lady Hamilton;a biographical essay
with a catalogue of her published portraits.
London,W.G.Menzies,1905
 127 p. illus(part col.)

 List of principal engravings,p.121-6

LC DA483.H3B2 Levis.Descr.bibl.Z5947.A3
 L66 p.191,206

I.E - INDIVIDUAL SITTERS - GUTENBERG, JOHANNES,
 1400?-1468
Grolier club, New York
 Portraits of Johannes Gutenberg.to be found
in the library. Gilliss press,19..?.
 p.123-138

MWC

I.E - INDIVIDUAL - SITTERS - HAMILTON, EMMA, lady
 1761?-1815
Frankau, Julia(Davis), 1864-1916
 The story of Emma,lady Hamilton.London,
McMillan & co.,ltd.,1911
 2 v. illus(part col.)
 Repro.:Ptgs.& engravings by and after Rey-
nolds, Lawrence,Romney,A.Kauffmann,Vigée Le bré
and others

 Incl.cat.of portrs.caricatures,engravings,
and sketches

MB OCU NN WaSp MiU-C
WaSpO Levis.Descr.bibl.Z5947.A3
 L66 1974 NCFA p.209

AP1
W71
NPG
ser.3
v.12

I.E - INDIVIDUAL SITTERS - HAMILTON, 1757-1804
 ALEXANDER
Bland, Harry MacNeill and Virginia W.Northcott
 The life portraits of Alexander Hamilton

In:William and Mary Quarterly
3rd ser.12:187-98 Apr,'55 illus.

 "A descriptive essay...incl.1 portr.of
Elis.Schuyler Hamilton"(Whitehill)

 Whitehill.The Arts in ear-
 y Amer.Hist.Z5935.W59
 Bibl.,p.97

I.E - INDIVIDUAL SITTERS - HAMMARSKJOLD, Dag,
 c1905-1961
Shahn, Ben, 1898-1969
 Concerning 'likeness'in portraiture

In:Nordenfalk, Carl Adam Johan, 1907-
Pen Shahn's portr.of Dag Hammarskjöld.Medde-
landen från Nationalmus.no.87.Stockholm.1962.

 States the Neo-Platonic idea"...the genius'
eyes can penetrate through the veil of mere ap-
pearances & reveal the truth."--Gombrich

LC N3540.A2 Gombrich.Mask & face.In:
 Art percept'n & reality
 N71/C64 NCFA p.2.footnote

705
C75
NCFA
v.68

I.E - INDIVIDUAL SITTERS - HAMILTON, ALEXANDER,
 c1757-1804
Mechlin, Leila, 1874-
 Early American portrait painters

In:Connoisseur
68:127-32 Mar.,'24 illus.
 Repro.:Franklin by Wright,Blackburn,Feke,C.W.
Peale,Rembrandt Peale,Neagle,Hamilton by Trumbull,
Waldo,Malbone,Harding,Copley,Stuart(p.135),West
(p.177)
 Emphasis on close association of American &
British schools

 Cumulated Mag.subj.index
 A1/3/C76 Ref. v.2,p.443

DA
480
K4x
NPG

I.E - INDIVIDUAL SITTERS - HANOVER FAMILY

London. National Portrait Gallery
 The house of Hanover;by J.Kerslake and
Louise Hamilton.London,H.M.stationery office,
1968
 c20.p. illus(part col.) (Its Kings and
Queens series:1714-1837)

 Winterthur Mus.Library
 Z881.W78 NCFA v.6,p.228

N
7639
H3A7X
NPG

I.E - INDIVIDUAL SITTERS - HAMILTON,EMMA, LADY,
 1761?-1815
Arts Council of Great Britain
 Lady Hamilton in relation to the art of
her time:catalogue of an exh.at the Iveagh
Bequest,Kenwood,16 July-16 Oct.1972.London,
Arts Council.1972.
 80 p. illus.

 Bibliography
 Exh.selected and catalogued by Patricia
Jaffé

LC N7639.H3A7

I.E - INDIVIDUAL SITTERS - HANOVER, HOUSE OF

London. Queen's Gallery, Buckingham Palace
 Gainsborough,Paul Sandby and miniature-
painters in the service of George III and his
family.cat.of an exhibition. London.1970
 30 p. illus.

 Bibl.references

LC ND1314.4.L6 Yale ctr.f.Brit.art Ref.

```
705
A63
NCFA        I.E - INDIVIDUAL SITTERS - HANOVER, HOUSE OF
v.38
         Sager, Walter de
             Historic portraits.Hanoverian likenesses
         of 17th and 18th centuries

         In:Ant.collector
         38:66-73   Apr/May,'67   illus(part col.)

             Repro.:Honthorst,Hannemann,Scheits,Vaillant,
         Kneller,Rigaud,Tischbein,v.Douven,Pesne,Batoni,
         Zoffany

         LC NK1125.A28           Eller.Kongel.portr.malere
                                 p.518
```

```
             I.E - INDIVIDUAL SITTERS - HAWTHORNE, NATHANIEL,
                                                    1804-1864
         Weitenkampf, Frank, 1866-1962   comp.
             ₍Descriptive list of portraits of Nathaniel
         Hawthorne₎

         In:N.Y.P.L.Bull.
         8,no.7:321,322   July,1904

         LC Z881.W6B             Levis.Descr.bibl.Z5947.A3
                                 L66 p.200
```

```
             I.E - INDIVIDUAL SITTERS - HAPSBURG, HOUSE OF
                                                    card 1
         Glück, Gustav
             Bildnisse aus dem hause Habsburg. Pt.1 of 3

Met      In:J.Vienne
100.53   7:183-210   1933   illus.
J151
Q            Empress Isabella in ptg.sculpt.,tapestry &
         medallions. Van Orley,Mor,Titian,Leoni,etc.

         LC N3.J4               Rep.,1933*127
```

```
AP
1
A51A62   I.E - INDIVIDUAL SITTERS - HENDERSON FAMILY,18th
NMAA
v.2      Black, Mary Childs, 1922-
             Tracking down John Watson:The Henderson por-
         traits at Boscobel

         In:Am Art & Antiques
         2,no.5:78-85   Sept.-Oct.,'79   illus(part col.)

             John Watson's portrs.,previously attr.to the
         Van Rensselaer Limner
             Repro.incl.:The Js.Henderson portrs.at Bos-
         cobel, the States Dyckman house at Garrison-on-
         Hudson,N.Y.
                           Black.In:Am Art J. AP1.A51
                           A64,v.12:6,footnote 5
```

```
             I.E - INDIVIDUAL SITTERS - HAPSBURG, HOUSE OF

         Heinz, Günther
             Studien zur porträtmalerei an den höfen
         der österreichischen erblande

         In:Jb.kunsthist.Samml.Wien
         23:99-224   1963   illus.

             Official portrs. of the different branches
         of the House of Habsbourg,mid.16-end 17th c. in
         the Kunsthist.Mus. in Vienna

             Repro.:Seisenegger,Arcimboldo,Vermeyen,Rota,
         L.van Valckenborch,Schöpfer · see over
         LC N3.J4               Eller.Kong.portr.malere
                                 p.517
```

```
708.1  I.E - INDIVIDUAL SITTERS - HENRIETTE OF FRANCE,
D47                                          1727-1752
v.23-27 Richardson, E.P.
1943-48     Madame Henriette de France as a vestal virgin
         by Jean-Marc Nattier

             In:B.Detroit Inst.Arts
             23:2-3   Oct,1943   illus.
705          see also article by E.P.Richardson
A7875        In:Art Q
1943         6,no.4:238-56   Autumn,1943   illus.

                                 dep.,1945-47*7741
```

```
             I.E - INDIVIDUAL SITTERS - HAPSBURG, HOUSE OF

         Klauner, Friderike
             Spanische porträts des 16.jahrhunderts

         In:Jb.kunsthist.Samml.Wien
         57:123-58   1961   illus.

             Portrs.of members of the hse.of Hapsburg in
         Spain in the Kunsthist.Mus.in Vienna by P.Leoni
         (head of Philip II in enameled silver,probably
         for a suit of armor),Coello,Sofonisba Anguiscio-
         la,Pantoja,López,González, etc.
                           Heinz,G.Portr.gal.N7621.2
                             A9V66 NPG Bibl.,p.39
                             Eller.Kong.portr.malere
                           N40.1.M265E4 NPG p.513
```

```
             I.E - INDIVIDUAL SITTERS - HENRY IV,EMPEROR OF
                                             GERMANY,1050-1106
         Stumpf, Johannes, 1500-1576?
             Keyser Heinrychs des vierdten...fünfftzig-
         järige historia...in vier bücher geteilt...
         Zürych,Christian Froschouer,1556
             CXXXVII numb.   illus.

             Woodcut portrs.by H.Vogtherr,the elder,
         V.Solis and others

         LC DD143.S9            Rave.Jb.d.Berl.Mus I 1959
                               LC N3.J16 fol. p.134
                               Paolo Giovio & d.Bildnis-
                               vitenbücher d.Humanismus
```

```
VF       I.E - INDIVIDUAL SITTERS - HARDING FAMILY
Harding
         Danforth Museum
             Family connections.Portraits by Chester
         Harding₍exh.,Jan.18-March 29,1981
             17 p.   illus.

             ₍Cat.by Leah Lipton₎
```

```
             I.E - INDIVIDUAL SITTERS - HENRY VIII,KING OF
                                             ₍ENGLAND,1491-1547
         Fielder, Martha Anne
             Iconographic themes in portraits of Hen-
         ry VIII
             232 p.

             Ph.D.diss.-Texas Christian University,1985

             This study enlarges Roy Strong's thesis in
         Holbein & Henry VIII that the English Reforma-
         tion signaled a change in the visual image of
         the king & expands that concept.The evolution
         of Henrician portrs.can be categorized into 3
         phases:           ₍cont'd on other side₎
```

N
40.1
H74389
NMAA

I.E - IDIVIDUAL SITTERS - HENRY VIII,KING OF
ENGLAND, 1491-1547

Strong, Roy C.
Holbein and Henry VIII.London,Routeledge
& K.Paul for the Paul Mellon Foundation for
British Art,1967
75 p. col.front;illus. (Studies in
British Art)

Bibl.references

LC ND588.H7S78

Schama,S.Domestication of
Majesty.In:J.Interdisc.Hist
AP1.J8654 NPG v.17,p.163
footnote 10

705
A784
1515
NCFA

I.E - INDIVIDUAL SITTERS - HOUDON,J.A.,1741-1828

Hart, Charles Henry, 1847-1918
Portrait of Jean-Antoine Houdon painted by
Rembrandt Peale

In:Art in Am
3:78-81 Feb.,'15 1 illus.

Réau-L'iconogr.de Houdon
Gaz Beaux Arts ser.6 1933
v.9:168,note 1

AP1
V81
NPG

I.E - INDIVIDUAL SITTERS - HENRY, PATRICK, 1736-
1799

Hall, Virginius Cornick,Jr.
Notes on Patrick Henry portraiture

In:Virginia Mag.of Hist.& Biogr.
71:168-84 Apr,'63 illus.

"Divided into a discussion of life portrs.,
posthumous portrs.,& lost portrs."(Whitehill)

Whitehill.The Arts in ear-
ly Amer.Hist.Z5935.W59
Bibl.,p.97

705
G28
v.9
1933
NCFA

I.E - INDIVIDUAL SITTERS - HOUDON, J.A.,1741-1828

Réau, Louis, 1881-
L'iconographie de Houdon

In:Gaz Beaux Arts
9:157-72 1933(pt.1) illus.

Chronological list of portrs.of Houdon
Incl:Robert,van loo, Peale,Capet,terra-cotta
self-portr.busts,miniatures by Lié-Perrin & Isabey
statue(maquette) by Rude,caricature by Thomas,
bronze medallion by d'Angers

Rep.,1933*144

I.E - INDIVIDUAL SITTERS - HENRY, PATRICK, 1736-
1759

Hart, Charles Henry, 1847-1918
Portraits of Patrick Henry...remarks before
the Numismatic & antiquarian soc.of Phila.,
Apr.17,1911.Philadelphia,1913
5 p. illus.

Reprinted from proceedings,1913

LC 302.6.H5H32

Weddell.A mem'l vol.of Va.
hist.portraiture.757.9.W38
NCFA Bibl. p.436

705
A7875
NCFA
v.16

I.E - INDIVIDUAL SITTERS - HOW-QUA(WU PING-
CHIEN, 1769-1843

Gardner, Albert Ten Eyck
Cantonese Chinnerys:Portraits of How-qua
and other China Trade paintings

In:Art Q
16:305-24 Winter,1953 illus.

Peabody Mus.of Salem,Mass.
o.Chinnery...N40.1.C53P3
FA Bibl.p.XII

I.E - INDIVIDUAL SITTERS - HITLER, ADOLF, 1889-
1945

Hanfstaengl, Ernst Franz Sedgwick, 1887-
Hitler in der karikatur der welt.Tat gegen
tinte,ein bildsammelwerk.Stuttgart,F.Basser-
mann,1965
157 p. illus. (Marginalien sur Geschic
te,1)
Reprint of the 1938 ed.

InU

Rep. 1966 *958

N
40.1
S9508
1986a
NPG

I.E - INDIVIDUAL SITTERS - HUDSON, Dr.HENRY EDW.
1772-1833

Greene, Margaret Harm
Dr.Edward Hudson and Maria Mackie Hudson:
Thomas Sully's portrait style,1810-1820. 1986
41 leaves illus.

Bibliography;Leaves 40-41
Photocopy
Masters essay-Univ.of Michigan,1986

I.E - INDIVIDUAL SITTERS - HOUDON, J.A.,1741-1828

David d'Angers, Pierre Jean, 1788-1856
Les médaillons de David d'Angers,réunis et
publiés par son fils.Paris,Lahure,1867
11 p. illus.

Preface signed Edmond About

Incl.:portrait of Houdon

ICN KU

Réau.L'iconogr.de Houdon
v.9:170 Gaz Beaux Arts ser.6 1933

N
40.1
S9508
1986a
NPG

I.E - INDIVIDUAL SITTERS - HUDSON, MARIA MACKIE,
1795-1862

Greene, Margaret Harm
Dr.Edward Hudson and Maria Mackie Hudson:
Thomas Sully's portrait style,1810-1820. 1986
41 leaves illus.

Bibliography;Leaves 40-41
Photocopy
Masters essay-Univ.of Michigan,1986

I.E - INDIVIDUAL SITTERS - HUMPHREY, REUBEN,
.1757-1832

AP
1
C76
NPG
v.37

Keihn,,P.hyllis,
The Reuben Humphrey portraits.by P.K.,

In:Conn.Hist.Soc.B.
37:42-50 Apr.,'72 illus.

Portrs.attr.to Richard Brunton

Report on restoration:examination,treatment

Winterthur Mus.Libr.
v.s.,p.230

I.F - INDIVIDUAL SITTERS - JACKSON, ANDREW,
.1767-1845

Hart, Charles Henry, 1847-1918
Life portraits of great Americans...Andrew
Jackson

In:McClure's Mag.N.Y.& London
9:795-804 July,1897

LC AP2.M2

Pfister.Facing the light
TR680.P47X NPG p.369

I.E - INDIVIDUAL SITTERS - IRVING, SIR HENRY,
.1838-1905

Menpes, Mortimer, 1859-1938
Henry Irving...with 12 portraits in colour.
London,A.and C.Black,1906
50 p. illus(col.)

LC PN2598.I7M4

Book in print.Subject
guide,1985-86 v.3,p.4865

I.E - INDIVIDUAL SITTERS - JACKSON, ANDREW, 1767-
.1845

VF
NEWSAM

Intramuralia

In:Huntington Library Quarterly
34,no.4:371 Aug.,'71 illus.

Repro.:Lithograph of Andrew Jackson(1834)by
Albert Newsam

I.E - INDIVIDUAL SITTERS - ISABELLA OF PORTUGAL;
wife of Charles V,1503-1539 card 1

Glück, Gustav
Bildnisse aus dem hause Habsburg. Pt.1 of 3

Met
100.53
J151
Q

In:J.Vienne
7:183-210 1933 illus.

Empress Isabella in ptg.sculpt.,tapestry &
medallions. Van Orley,Mor,Titian,Leoni,etc.

LC N3.J4

Rep.,1933*127

I.E - INDIVIDUAL SITTERS - JACKSON, ANDREW,1767-
.1845

705
A56
NCFA
v.100

Macbeth, Jerome R.
Portraits by Ralph E.W.Earl

In:Antiques
100:390-3 Sept.,'71 illus(part col.)

Incl.:Several portrs.of Andrew Jackson

705
B97
NCFA
v.88

I.E - INDIVIDUAL SITTERS - ISABELLA STUART,
c.1427-c.1494

Toynbee, Margaret R.
The portraiture of Isabella Stuart, duchesse
of Brittany (c.1427-c.94)

In:Burl Mag.
88:300-6 Dec 1946 illus.

Portrs. in hour books, missals, etc.

Rep.,1945-7*6322

I.E - INDIVIDUAL SITTERS - JACKSON, ANDREW,1767-
.1845

AP
1
C57
NPG
v.47

Stewart, Robert G.
Auguste Hervieu,a portrait painter in Cin-
cinnati

In:Queen City Heritage
47:23-31 Spring,'89 illus(part col.)

Repro incl.:Andrew Jackson

AP
1
A51A64
NMAA
v.18

I.E - INDIVIDUAL SITTERS - JACKSON, ANDREW,1767-
.1845

Bumgardner, Georgia Brady
Political portraiture:Two prints of Andrew
Jackson

In:Am Art J
18,no.4:84-95 1986 illus.

Engr.by Ja.Barton Longacre in 1828.
'The motives behind its publications were politi-
cal'.-Lithograph by the Pendleton firm,1832,
'created in the context of political events'.

F
234
L5W37
1977 X
NMAA

I.E - INDIVIDUAL SITTERS - JACKSON, THS, JONATHAN,
.1824-1863

Washington and Lee University, Lexington,Va.
American sculpture in Lexington;selected
examples from public collection;an exh.pre-
sented by Washington and Lee Univ.,Jan.4-21,
1977.Lexington,The Univ.c.1977
47 p. illus.

Bibliography

LC F234.L5W37

I.E - INDIVIDUAL SITTERS - JAMES I,, 1566-1625

AP
1
W225
NCFA
v.34

Reynolds, Graham, 1914-
Portraits by Nicholas Hilliard and his as-
sistants of King James I and his family

In:Walpole Soc.
34:14-26 1952-54 illus.

I.E - INDIVIDUAL SITTERS - JAY, JOHN, 1745-1829

CT
275
J42I1
NPG

Ide, John Jay
Portraits of John Jay...New York,New York
Historical Society,1938
69 p. illus(part col.) (The New York His-
torical Society.The John Divine Jones Fund series
of histories and memoirs,10)

Bibliography

LC E302.6.J414 A 19th c.gall.of distin-
 guished American.N7593.N26n
 NPG Bibl.

I.E - INDIVIDUAL SITTERS - JAMES I. FAMILY

AP
1
W225
NCFA
v.34

Reynolds, Graham, 1914-
Portraits by Nicholas Hilliard and his as-
sistants of King James I and his family

In:Walpole Soc.
34:14-26 1952-54 illus.

I.E - INDIVIDUAL SITTERS - JEFFERSON, THOMAS,
 1743-1826

CT
275
J45E9
NPG

Adams, William Howard ed.
The eye of Thomas Jefferson.Exh.,Washing-
ton,D.C.,NGA,1976
411 p. illus(part col.)

Incl.:Index

Bibliography

Exh.June 5-Sept.6,1976.

LC E332.2.F88 Penn.Hist.Soc. Rembrandt
 Peale...Bibl.p.117

I.E - INDIVIDUAL SITTERS - JAQUELIN FAMILY

AP
1
A79
NCFA
v.1-3

Black, Mary C.
The case of the red and green birds.Thir-
teen persons,one of whom has never been identi-
fied,pose a picture puzzle wherin a cardinal &
a parakeet are vital clues.

In:Arts in Va.
3,no.2:2-4,7-8 Winter,'63 illus.
Portrs.of members of two prominent fami-
lies by an unknown artist.Five facts suggest
a Va.provenance,inspired by Engl.mezzotints.
Black.The case reviewed.
In:Arts in Va.,v.10,no.1

I.E - INDIVIDUAL SITTERS - JEFFERSON, THOMAS,
 1743-1826

N
7628
J45C18
1966
NPG

Campbell, Orland, 1890-
The lost portraits of Thomas Jefferson
painted by Gilbert Stuart..Exhibition,Oct.1965,
Swirbul Library,Adelphi Uni.Rev.printing.Garden
City,N.Y.,Adelphi Uni.,1966
29 p. illus.

NPG A 19th c.gall.of disti-
guished Americans.Bibl.

I.E - INDIVIDUAL SITTERS - JAY,JOHN, 1745-1829

Du Simitière, Pierre Eugène,ca.1736,-1784
Portraits of the generals,ministers,magis-
trates,members of Congress,and others,who have
rendered themselves illustrious in the revolu-
tion of the United States of North America.
Drawn from the life by M.Dusiritier...and en-
graved by the most eminent artists in London.
London,R.Wilkinson and W.Debrett,1782
2 p. 12 portrs.

Incl.:Washington, John Jay
'Set was signed P.E.F.'-Donnell

LC E206.D97

I.E - INDIVIDUAL SITTERS - JEFFERSON,THOMAS,1743-
 1826

Carson, Hampton Lawrence, 1852-1929
.. ...The Hampton L.Carson collection of en-
graved portraits of Jefferson,Franklin,and La-
fayette.Cat. comp. & sale conducted by Stan.V.
Henkels.At the art auction rooms of Davis &
Harvey...Phila.,Pa.......Press of W.F.Fell co.,
1904.
157 p. illus.
Cat.no.906,pt.II

To be sold Apr.20 & 21,.1904.

LC Z999.H505 no.906,pt.2 Amsterdam,Rijksmus.cat.
 Z5939A52, deel 1, p.154

I.E - INDIVIDUAL SITTERS - JAY,John, 1745-1829

Du Simitière, Pierre Eugène, ca.1736-1784
Thirteen portraits of American legislators,
patriots,and soldiers,who distinguished them-
selves in rendering their country independent;
...drawn from the life by Du Simitière...and en-
graved by Mr.B.Reading.London,W.Richardson
.1783.
13 plates

Incl.:Washington, John Jay

MB MJP MH CtY MiU-C Winterthur Mus.Libr. Z881
PPL. W78 NCFA v.6,p.

705
S94
NCFA
v.96

I.E - INDIVIDUAL SITTERS - JEFFERSON, THOMAS,
 1743-1826

Comstock, Helen
Jefferson in his old age

In:Studio
96:17-18 June,'30 illus(part col.)

Painting by Thomas Sully,1821

Kimball.Life portrs.of Jef-
ferson...N7628.J45K4,p.529

N
7628.J4
C86X
NPG
2 c.

I.E - INDIVIDUAL SITTERS - JEFFERSON, THOMAS,
.1743-1826

Cunningham, Noble E., 1926-
The image of Thomas Jefferson in the public
eye:portraits for the people,1800-1809....Char-
lottesville,Univ.Press of Va.,1981
185 p. illus.

Incl.index
Incl.:Engravings,medallions,Liverpool potte;
caricatures,silhouettes.One portr.on glass,en-
graved in gold(fg.59)
Appendix:Sources of the People's image:Bust,
ptgs.,drag.

AP
1
A51
A64
NCFA
v.13

I.E - INDIVIDUAL SITTERS - JEFFERSON, THOMAS,
.1743-1826

Meschutt, David
Gilbert Stuart's portraits of Thomas
Jefferson

In:Am Art J
13:2-16 Winter,'81 ill.

Bibl. footnotes

I.E - INDIVIDUAL SITTERS - JEFFERSON, THOMAS,
.1743-1826

Hart, Charles Henry, 1847-1918
Life portraits of great Americans:::Thomas
Jefferson

In:McClure's Mag.N.Y.&London
11:47-56 May,1898 illus.

LC AP2.M2 ViU Rutledge.W.J.Coffee In:Gas.
Beaux-Arts v.28:307,note 12

VF
St.-Mémin

I.E - INDIVIDUAL SITTERS - JEFFERSON, THOMAS,
1743-1826

Rice, Howard Crosby, 1904-
Saint-Mémin's portrait of Jefferson

In:Princeton Uni Lib Chron
20:182-92 Summer,'59 illus.

Bibliography on Saint-Mémin

Note on the physiognotrace

LC Z733.P960S Whitehill.The Arts in ear-
ly Amer.Hist.Z5935.W59 NPG
Bibl.,p.93

N
7628
J45X4
NCFA
NPG

I.E - INDIVIDUAL SITTERS, JEFFERSON, THOMAS,1743-
1826

Kimball, Sidney Fiske, 1c88-
The life portraits of Jefferson and their
replicas...Philadelphia,The American philoso-
phical society,1944
p497-534 y. illus.

From the Proceedings of the Amer.Philos.
Soc.,v.88,no.6,1944

Bibl.footnotes

Harvard univ.Libr.for
LC Whitehill.The Arts in ear-
ly Amer.Hist.Z5935.W59
Bibl.,p.98

705
G28
NCFA
v.28

I.E - INDIVIDUAL SITTERS - JEFFERSON, THOMAS,
.1743-1826

Rutledge, Anna Wells
William John Coffee as a portrait sculptor

In:Gas:Deaux-Arts
28:297-312 Nov.,'45 illus.

Repro.incl.:Bust of Jefferson

705
G28
NCFA
6 ser.
v.23

I.E - INDIVIDUAL SITTERS - JEFFERSON, THOMAS,
.1743-1826

Kimball, Sidney Fiske, 1888-1955
The Stuart portraits of Jefferson

In:Gas Beaux Arts
6 ser.23:329-44 June,'43 illus.

Incl.:Corrections of errors in L.Park's 'Gilber
Stuart; 1926

N
7628
J449T4
NPG

I.E - INDIVIDUAL SITTERS - JEFFERSON, THOMAS,
1743-1826

Thomas Jefferson Memorial Foundation, inc.
The Monticello family.Catalogue of an exhi-
bition held at the University of Virginia Museum
of Fine Arts,Apr.12-May 13,1960.Charlottesville,
Va.,1960
14 p. illus.

"Ptgs.& busts,silhouettes & daguerreotypes
of Jefferson's family and descendants."(White-
hill)

ViU NJP Whitehill.The Arts in ear-
ly Amer.Hist.A5935.W59 NPG
Bibl.,p.98

AP
1
A64
NCFA
v.14

I.E - INDIVIDUAL SITTERS - JEFFERSON, THOMAS,
.1743-1826

Meschutt, David
The Adams-Jefferson portrait exchange

In:Am Art J
14:47-54 Spring,'82 illus.

Bibl.footnotes

Repro incl.:Jefferson by Mather Brown and
by John Trumbull;John Adams by Mather Brown and
by John Singleton Copley(det.)

708.1
U61

I.E - INDIVIDUAL SITTERS - JEFFERSON, THOMAS,
1743-1826

U.S. National gallery of art
The Thomas Jefferson bicentennial exhibi-
tion,1743-1943.April 13-May 15,1943....Washing-
ton,D.C.:Press of Gibson brothers,inc.,1943.
.11.p. illus.

Grosvenor libr.for
LC E332.U6 Kimball.Life portrs.of Jef-
ferson...N7628.J45X4,p.497

N
7628
J45V8
NPG

I.E - INDIVIDUAL SITTERS - JEFFERSON, THOMAS,
1743-1826
Virginia. University. Museum of Fine Arts
The life portraits of Thomas Jefferson,by
Alfred L.Bush.Catalogue of an exhib.at the Uni-
versity of Virginia Museum of Fine Arts,12-
26 April,1962.Charlottesville,Va.,Thomas Jeffer-
son Memorial Foundation,1962
101 p. illus.

"...cat.of 26 portrs.(some now lost)betw.
1786-1825"(Whitehill)

LC N7628.J4V58

Whitehill.The Arts in ear-
ly Amer.Hist.Z5935.W59
Bibl.,p.97

N
7628
J449T4
NPG

I.E - INDIVIDUAL SITTERS - JEFFERSON FAMILY
Thomas Jefferson Memorial Foundation, inc.
The Monticello family.Catalogue of an exhi-
bition held at the University of Virginia Museum
of Fine Arts,Apr.12-May 13,1960.Charlottesville,
Va.,1960
14 p. illus.

"Ptgs.& busts,silhouettes & daguerreotypes
of Jefferson's family and descendants."(White-
hill)

ViU NJP

Whitehill.The Arts in ear-
ly Amer.Hist.A5935.W59 NPG
Bibl.,p.98

I.E - INDIVIDUAL SITTERS - JOAN OF BURGUNDY
Focillon, Henri
L'art du portrait au moyen-âge. La statue de
Jeanne de Bourgogne

In:Pages françaises
no.1:130-2 1945

14th c. statue on the contrefort in the large
hall at Poitiers

.LC AP20.P24

Rep.,1945-47#5828

VF
Johann
Casimir

I.E - INDIVIDUAL SITTERS - JOHANN CASIMIR, Duke
of Saxony-Coburg, 1564-1633
Gebhardt, Mini
Betrachtungen su bildnissen Herzog Johann
Casimirs und seiner beiden gemahlinnen.Sonder-
druck aus Jahrbuch der Coburger Landesstiftung,
1965
p.89-106 illus.

Repro.incl.:Peter Sengelaub,Wolfgang
Bircknor,Peter Isselburg,P.Erichs

I.E - INDIVIDUAL SITTERS - JOHNSON, SAMUEL,
1709-1784
Grolier club, New York
Cat.of an exh.commemorative of the bicen-
tenary of the birth of Samuel Johnson...with
a large number of engraved portraits after pic-
tures by Sir.J.Reynolds,Js.Barry,J.Opie,Franc.
Bartolozzi,etc....Nov.11-Dec.11,1909.N.Y.,De
Vinne press,1909,
106 p. illus.

LC Z8455.8.C85

Levis.Descr.bibl.Z5947A3
L66 1974 NCFA p.386

I.E - INDIVIDUAL SITTERS - JOHNSON, SAMUEL,
1709-1784
Stewart, J.Douglas
English portraits of the 17th and 18th cen-
turies,papers read...Apr.14,'73 by J.D.Stewart
and Herman W.Liebert.Los Angeles,Wm.Andrews
Clark Memorial Library,Univ.of Calif.,1974
v. 95 p. illus. (Wm.Andr.Clark Mem'l
Library seminar papers)

Bibliographical references

Contents:Stewart,J.D.:Pin-ups or virtues?
The concept of the "beauties" in late Stuart
portraiture Continued on next card

LC ND1314.3.S73

Rila I/1-2 1975 #1456

ur
1
N547
NCFA
v.42

I.E - INDIVIDUAL SITTERS - JOHNSON, WILLIAM(SIR)
1715-1774
Hamilton, Milton Wheaton, 1901-
A new portrait of Sir William Johnson

In:N.Y. Hist.Soc.Q.
42:317-27 Oct.,'58 illus.

Bibl.footnotes

AP
1
A64
NCFA
v.92

I.E - INDIVIDUAL SITTERS - JULIUS II, 1443-1513
Gould, Cecil
The Raphael portrait of Julius II;problems
of versions and variants;and a goose that turned
into a swan

In:Apollo
92:187-9 Sep.,'70 illus(part col.)

Re-emergence of the original portr.of Julius
II

Oberhuber.Raphael...In:Burl
Mag.113:12..footnote 4

705
E97
NCFA
v.113

I.E - INDIVIDUAL SITTERS - JULIUS II, 1443-1513
Oberhuber, Konrad
Raphael and the State portrait.-I:The por-
trait of Julius II

In:Burl Mag
113:124,127-30 Mar.'71 illus.

Problems of the state portraiture.
One of the first informal portr.of the Ita-
lian Renaissance,going back to the change fr.for-
mal to informal in dedication pictures of Charle
V of France

Debs,b.From eternity to
here...In:Art in Am 63:53c
& footnote 9

705
897
NCFA
v.113

I.E - INDIVIDUAL SITTERS - LORENZO DE' MEDICI
Oberhuber, Konrad
Raphael and the State portrait.-II:The por-
trait of Lorenzo de' Medici

In:Burl Mag
113:436,439-40, 443 Aug.,'71 illus(part col.

Problems of state portraiture
Re-attribution fr. Bronzino to Raphael
Portrs.of royalty in 3/4 length.origin in
France,spread to Lombardy
Sitter as representative of a specific group

CT
275
K151
F8
NPC
NCFA

I.E - INDIVIDUAL SITTERS - KAMAMALU, QUEEN

Frankenstein, Alfred Victor, 1906-
The royal visitors..Portland,Oregon Historical Society,c.1963,
32 p. illus(part col.)

King Kamehameha II & Queen Kamamalu by
Eugénie Lebrun in the Iolani Palace,Honolulu

Winterthur Mus.Libr. f2881
W78 NCFA v.6,p.222

CT
275
K151
F8
NPC
NCFA

I.E - INDIVIDUAL SITTERS - KAMEHAMEHA II, KING

Frankenstein, Alfred Victor, 1906-
The royal visitors..Portland,Oregon Historical Society,c.1963,
32 p. illus(part col.)

King Kamehameha II & Queen Kamamalu by
Eugénie Lebrun in the Iolani Palace,Honolulu

Winterthur Mus.Libr. f2881
W78 NCFA v.6,p.222

I.E - INDIVIDUAL SITTERS - KEATS, JOHN, 1795-1821

Parson, Donald, 1882-
Portraits of Keats.1st ed.. Cleveland,World Pub.Co.,1954,
189 p. illus.

LC PR4836.P3

I.E - INDIVIDUAL SITTERS - KELEKIAN, DIKRAN, 1868-

Durand-Ruel galleries, New York
Kelekian as the artist sees him.Oct.17-Nov.4,1944..N.Y.,Durand-Ruel galleries,1944,
,24,p. illus.

14 ptgs.,5 sculptures,1 photograph,1 mosai
Artists incl.J.Graham,Scharl,Soyer,Derain,
Lintott,Blatas,Mascon,Kuhn,Avery. Lipchitz,Na-
kian,Ch.Cross,J.Davidson. Valenti

see also:Art Digest 19:9 0.15, '44 illus.
Art N 43:14 0.15,'44 illus.
LC ND1301.D8
NCMA, p.434,v.11

ND
1311.2
P61x
NPC

I.E - INDIVIDUAL SITTERS - KEOKUK
McDermott, John Francis, 1902-
Another Coriolanus:Portraits of Keokuk,
Chief of the Sac and Fox
Miles, Ellen Cross comp.
Portrait painting in America.The nineteenth
century.N.Y.....,1977 (card 4)

Partial contents cont'd:J.F.McDermott,Ano-
ther Coiolanus,portrs. of Keokuk,Chief of the
Sac & Fox,p.158-9;...

I.E - INDIVIDUAL SITTERS - LAFAYETTE,MARIE JOS.
PAUL YVES ROCH GILBERT DU MOTIER, 1757-1834
Carson, Hampton Lawrence, 1852-1929
.. ...The Hampton L.Carson collection of en-
graved portraits of Jefferson,Franklin,and La-
fayette.Cat. comp. & sale conducted by Stan.V.
Henkels.At the art auction rooms of Davis &
Harvey...Phila.,Pa.......,Press of W.F.Fell co.,
1904,
157 p. illus.
Cat.no.906,pt.II

To be sold Apr.20 & 21,,1904.

LC Z999.H505 no.906,pt.2 — Amsterdam,Rijksmus.cat.
Z5939A52, deel 1, p.154

705
A56
NCFA
v.100

~~I.E - INDIVIDUAL SITTERS - LAFAYETTE,MARIE JOS.~~
PAUL YVES ROCH GILBERT DU MOTIER, 1757-1834
Floyd, William Barrow, 1934-
The portraits and paintings at Mount Vernon
from 1754 to 1799. Part I and II

In:Antiques
100:768-74 Nov.,'71 illus(part col.)
:894-99 Dec.,'71 illus.

Repro.incl.:Lafayette,by Chs.W.Peale,1781;
Lawrence Washington;Martha Washington,by Wollas-
ton,1757;John and Martha Parke Custis,by Wollas-
ton,1757;Col.Geo.Washington,by Chs.W.Peale,1772;

I.E - INDIVIDUAL SITTERS - LAFAYETTE,MARIE JOS.
PAUL YVES ROCH GILBERT DU MOTIER, 1757-1834

Harvard university. William Hayes Fogg art mus
Exhibition:Washington,Lafayette,Franklin:
portraits,books,manuscripts,prints...for the
most part from the university..Cambridge,Fogg
mus.of art,Harvard univ.,1944
53 p. illus.

Feb.22-May 28,1944

LC H5020.C234

I.F - INDIVIDUAL SITTERS - LANI, MARIA

Cocteau, Jean, 1889-1963
Maria Lani by Bonnard,and other artists..
Paris,Editions des quatre chemins,1929,
20 p. 51 pl.

,Exhib.at Brummer,N.Y.,Nov.1-? ,'29.
,Also exhib.Leicester gall.,London,1930,

Incl.Bonnard,Bosshard,Bourdelle,Braque,Cha-
gall,Laborde,Chirico,Cocteau,Delaunay,Derain,
Despiau,Friesz,Goerg,Cromaire,Matisse,Kisling,
Leger,Lhote,Lurçat,Man Ray,
contin'd on next card

I.E - INDIVIDUAL SITTERS - LAURA DI 'DIANTI,
c.1522
Kaplan, Paul H.D.
Titian's Laura Dianti and the origins of the
black page in portraiture

NGA
N 1
A3
v.21

In:Antichità viva
21,no.1:11-18 1982
21,no.4:10-18 1982 illus.

The black page has in instances functioned
as an identifying attribute,alluding to the inter-
ests of the sitter or given a hint of the sit-
ter's nationality.
Repro.incl.:

759.1　I.E - INDIVIDUAL SITTERS - LEE FAMILY
K72a
and　　Knoedler,M.,& company, New York
ND　　　　Stratford;the Lees of Virginia and their
1311　contemporaries...April 29 through May 18,1946.
K5X　New York,Knoedler galleries.1946.
NPG　　　47 p.　illus.

　　　　　List of officials of the Rbt.E.Lee Memorial
　　Foundation inserted at end.

LC ND1311.K5

I.E - INDIVIDUAL SITTERS - LINCOLN

Grolier club, New York
　　Catalogue of a collection of engraved and
other portraits of Lincoln,exhib.at the Grolier
club,N.Y.,Apr.8-22,1899,introd.by Ch.H.Hart.
,N.Y.,De Vinne press.1899
　　66 p.

LC E457.6.G87

ND　　　I.E - INDIVIDUAL SITTERS - LEE FAMILY
1311.8
V8W31　Washington and Lee University, Lexington,Va.
NCFA　　Washington-Custis-Lee family portraits from
the coll.of Washington & Lee univ.,Lexington,
Va.,circulated by the International Exhibitions
Foundation,1974-1976.Intro.by Alfred Franken-
stein.Washington,D.C.,International Exh.Found'n,
c.1974
　　　　,10.p.　illus(1col.)

　　　17 portrs.,representing 6 generations of.
men & women in the Washington,Custis and Lee
families
　　　　　　　　Rila I/1-2 1975 #1365

AP　　I.E - INDIVIDUAL SITTERS - LINCOLN
1
W78　　Holzer, Harold
NCFA　　How the printmakers saw Lincoln.Not-so-
v.14　honest portraits of "Honest Abe"

In:Winterthur Port
14:143-70　Summer,'79　illus.

　　Incl.:altered plates

B　　I.E - INDIVIDUAL SITTERS - LEE, ROBERT EDWARD,
L4BM5　　　　　　　　　　　　　　　　　　c1807-1870
　　Meredith, Roy, 1908-
　　　The face of Robert E.Lee in life and legend.
N.Y.,C.Scribner's Sons,1947
　　　143 p.　illus.

LC E467.1.L4M5

705　　I.E - INDIVIDUAL SITTERS - LINCOLN
A56
NCFA　Holzer, Harold
v.107　　Some contemporary paintings of Abraham
Lincoln

In:Antiques
107:314-22　Feb.,'75　illus(part col.)

　　Most artists romanticized,stylised or create
reverential martyr ptgs.

　　　Repro.:Hicks,Conant,Clover,Wright,Atwood,
Marchant,Cogssell,Travers,Carpenter,Bowser

　　　　　　　　Rila II/2 1976 #5757

F　　I.E - INDIVIDUAL SITTERS - LEE, Robert Edward,
234　　　　　　　　　　　　　　　　　　c1807-1870
L5W37　Washington and Lee University, Lexington,Va.
1977 X　　American sculpture in Lexington...an exh....
NMAA　　...c.1977

　　Bibliography

LC F234.L5W37

AP　　I.E - INDIVIDUAL SITTERS - LINCOLN
1
K32　　Kennedy Galleries,inc., New York
NCFA　　Two hundred years of American portraits;a
v.9-10　selection of portraits from the early 18th to
the early 20th century.N.Y.,1970,

In:The Kenn.Gall.Q.
9,no.4:229,232-92　May,'70　illus(part col.)
　　Portr.of Lincoln by unknown primitive p.268
　　Intro.by Rud.G.Wunderlich
　　Alphabetical index of artists
　　The portrs.date fr.ca.1714 to 1932
　　Notes of the Carroll Family Portraits
LC N8640.K4　　　　　Art Books 1950-79 Z5937
v.9no.4　　　　　　　A775 NCFA　Ref.　p.897

B　　I.E - INDIVIDUAL SITTERS - LINCOLN
L73B9
　　Bullard, Frederic Lauriston
　　Lincoln in marble and bronze.New Brunswick,
N.J.,Rutgers Uni.Press.1952,

　　Bibliographies

LC E457.6.B88　　　　　Prown.Amer.art to 1900
　　　　　　　　　　QN6505.P76X NCFA　Bibl.
　　　　　　　　　　p.616

CT275　I.F - INDIVIDUAL SITTERS - LINCOLN
L73A1 al
NPG　　Lincoln, Abraham,Pres.U.S., 1809-1865
　　　An album of Lincoln.Photographs and words
　　　　　　　　　　　　(Eakins pocket album 3)

　　　Incl.7 portrs.of Lincoln from 1858-1865

　　　Photographs by A.M.Byers,T.P.Pearson,Lloyd
Ostendorf,C.S.German,M.B.Brady,A.Gardner,
A.Berger

CT
275
L73L8r
1969
NPG

I.E - INDIVIDUAL SITTERS - LINCOLN

Lorant, Stefan, 1904-
Lincoln;a picture story of his life.Rev.
& enl.ed.N.Y.,Norton & Co.,Inc.,1969.
336 p. illus.

Repro.ptgs.,life masks,photographs
Contents & Bibliography. Index

Appendix...B:The photographer of Lincoln...
C:All of Lincoln's photographs in chronological
order

LC F457.6.L78 1969

N
7628
L73
W7
NPG

I.E - INDIVIDUAL SITTERS - LINCOLN

Wilson, Rufus Rockwell, 1865-1949
Lincoln in portraiture.New York,The Press
of the Pioneers,Inc.,1935
317 p. illus.

LC E457.6.W55

N
7628
L73M2
NPG

I.E. - INDIVIDUAL SITTERS - LINCOLN

McMurtry, Robert Gerald, 1906-
Beardless portraits of Abraham Lincoln painted from
life. ¡Fort Wayne¡ Public Library of Fort Wayne and
Allen County, 1962.
45 p. ports. 22 cm.
Reprinted from Lincoln lore, no. 1468, 1470, 1471, and 1472, July
through Oct., 1960.

1. Lincoln, Abraham, Pres. U. S.—Portraits. i. Title.

E457.6.M27 62-24876

Library of Congress i4

I.E - INDIVIDUAL SITTERS - LINLEY FAMILY

Dulwich College,London - Dulwich Gallery
The Dulwich picture gallery...London,Philip
Wilson Publishers Ltd.,1980

Incl.:...A group of portraits of the Linley
family of musicians.

FOR COMPLETE ENTRY
SEE MAIN CARD
Cat.Sotheby Parke Bernet
Publications 1979-80 p.16

N
7628
L73T8
RB
NPG

I.E - INDIVIDUAL SITTERS - LINCOLN

Truesdell, Winfred Porter, 1877-
Engraved and lithographed portraits of
Abraham Lincoln,,,Champlain.N.Y.,Priv.print.at
the Troutsdale press,1933-
v.2(v.1 never appeared) illus(part col.)
List of more than 550 separately publ.prints
...based on "The photographs of A.Lincoln"
by Frederick Hill Meserve,...1911 & 2 suppls.

Incl.listing of prints after life ptgs.

Holzer.How the printmakers
LC E457.6.T78 saw Lincoln.Winterthur Port
c.2 NE320.L5T7 AP1.W78 NCFA v.14,p.143 fod
notes

I.E - INDIVIDUAL SITTERS - LIPSIUS, JUSTUS, 1547-
1606
Berryer, Anne-Marie
Essai d'une iconographie de Juste Lipse

Met In:A.Soc.Archéol. Bruxelles
664 43:5-67 1939-40 illus.
R83
Classification of very many ptd.,engr.,drawn,
sculpted portrs. & medallions of Lipsius

LC DH401.S52 Rep.,1945-47*1131

CT
275
L73U54
NPG

I.E - INDIVIDUAL SITTERS - LINCOLN

U.S. Library of Congress
Abraham Lincoln;an exh.at the Library of
Congress in honor of the 150th anniversay of
his birth.Washington,1959

FOR COMPLETE ENTRY
SEE MAIN CARD

F127
L73P58
1986X
NPG

I.E - INDIVIDUAL SITTERS - LIVINGSTON FAMILY

Piwonka, Ruth
A portrait of Livingston Manor,1686-1850...
Germantown,N.Y.:Friends of Clermont,1986
176 p. illus(part col.)

Bibliography,p.173-75

Incl.:Index of artists

CT
275
L73W7
NPG

I.E - INDIVIDUAL SITTERS - LINCOLN

Wilson, Rufus Rockwell, 1865-1949.
Lincoln in caricature; a historical collection, with descrip-
tive and biographical commentaries by Rufus Rockwell Wil-
son. Introd. by R. Gerald McMurtry. New York, Horizon
Press, 1953.
xix, 327 p. 166 illus. 29 cm.

1. Lincoln, Abraham, Pres. U. S.—Cartoons, satire, etc.

E457.63.W752 1953 923.173 53-3939

Library of Congress 60zh

705
A56
NCFA
v.100

I.E - INDIVIDUAL SITTERS - LOCKE, JOHN,1632-1704

Smith, Robert C.
Finial busts on 18th century Philadelphia
furniture

In:Antiques
100:900-905 Dec.,'71 illus.

Repro.incl.:B.Franklin;John Locke;John Milton;
Washington
'...study of all this furniture...could well
reveal ..resemblances linking it with the shop
of Benjamin Randolph.' Saunders.Am.colonial portr.
N7593.1.S28,p.74,note 152

705
C28
NCFA
v.29

I.E - INDIVIDUAL SITTERS - LOUIS XI, 1423-1483

Bouchot, Henri François Xavier Marie, 1849-1906
Les portraits de Louis XI

In:Gas Beaux Arts 3rd ser.
29:213-27 1903 illus.

N
7605
K78
NPG

I.E - INDIVIDUAL SITTERS - LUTHER, MARTIN, 1483-
.1546 & CONTEMPORARIES

Hamburg. Kunsthalle
Köpfe der Lutherzeit..Exh..4.MMrz-24.April,
1983.Hrsg.u.Ausw.Werner Hofmann.Kat.Eckhard
Schaar u.Gisela Hopp.München,Prestel Verlag,1983
318 p. illus(part col.)
Bibliography
Iconographical register,p.27-36

Cat.arranged alphabetically by artists

Essays by Werner Hofmann,p.9-17 and Peter-
Klaus Schuster,p.19-24

I.E - INDIVIDUAL SITTERS - LOUIS XIV

Magne, Emile
Les visages de Louis XIV

In:Illustration
3:67-70 1938 illus.

Incl:Ptg.by Rigaud,Le Brun,etc.,miniature by
Nic.Robert,medallion by Jean Varin,bust by Puget,
col.wax by Ant.Benoist

LC AP20.I3 Rep.,1938#632

I.E - INDIVIDUAL SITTERS - LUTTRELL, SIR JOHN

Yates, F.A.
The allegorical portraits of Sir John
Luttrell

In:Essays in the History of Art presented to
Rud.Wittkower...London,Phaidon, 1967

LC N5303.E7 Strong.Engl.icon qND1314
 S924.bibl.:"Good ex.of com-
plexities of meaning to be extracted fr.a Tudor portr.

I.E - INDIVIDUAL SITTERS - LOUIS XIV, 1638-1715

Mai, Ekkehard
Le portrait du roi...Bonn,1975

LC ND1316.3.M34 FOR COMPLETE ENTRY
 SEE MAIN CARD

705
A7832
NCFA
v.33

I.E - INDIVIDUAL SITTERS - LYON, PAT, 1769-

Patrick, Ransom R.
John Neagle,portrait painter and Pat Lyon,
blacksmith

In:Art Bul
33:187-92 Sept.,'51 illus.

q DC
126
S86
1984
NPG

I.E - INDIVIDUAL SITTERS, LOUIS XIV,1638-1715

The Sun King,Louis XIV and the New World:an
exh.,organized by the Louisiana State Mu-
seum...New Orleans,Louisiana State Museum,
c.1984
343 p. illus(part col.) (Studies in
Louisiana culture,v.3)
Incl.Index
Steven G.Reinhardt,ed.
Exh.dates:Louisiana State Mus.,New Or-
leans,La.,Apr.29-Nov.18,1984.The Corcoran
Gall.of Art,Washington,D.C.,Dec.15,1984-
Apr.7,1985
Incl.Ptg., sculpture,cameos

B
M18W7

I.E - INDIVIDUAL SITTERS - MADISON, JAMES, 1751-
 1836
Bolton, Theodore, 1889-
The life portraits of James Madison

In:William and Mary Quarterly
3rd ser.8:25-47 Jan.,'51 illus.

Incl.Chronological checklist;Cat.by artists;
Alleged portraits of Madison.

LC F221.W71 Whitehill.The Arts in ear-
 ly Amer.Hist.Z5935.W59 NPG
 Bibl.,p.98

705
C75
NCFA

I.E - INDIVIDUAL SITTERS - LOUIS XV(as child)
Leroy, Alfred
The portraits of Louis XV as a child

In:Connoisseur
102:283-7 & 325 Dec,1938,II illus.

Incl:Rigaud,Carriera,van Loo,etc.,bust by
Coysevox

 Rep.,1938#633

I.E - INDIVIDUAL SITTERS - MALLARMÉ, STÉPHANE,
 1842-1898
Autour de Mallarmé

In:Arts et Mét.graph.
56:48-51 1937 illus.

Photographs of different epochs;portr.by Manet,
etching by Gauguin,sketch by J.E.Blanche,ptg.by
Vuillard,illustr.by Mallarmé

LC Z119.A84 Rep.,1937#357

N
7628
M28 I9
NCFA

I.E - INDIVIDUAL SITTERS - MANSFIELD, LORD, 1705-1793

Jacob, John
 The true resemblance of Lord Mansfield. An exhibition devoted to portraits, drawings and prints of William Murray, 1st Earl of Mansfield (1705-1793) Lord Chief Justice for thirty-two years and of his contemporaries in the law, politics and architecture. London, Greater London Council, 1971. .33.p. illus.

- Portrs. illuminate the various character traits of Mansfield.
 Repro:Portrs.by Martin, van Loo, Reynolds, Copley busts by Rysbrack Nollekens

708.9493
B921
NMAA

I.E - INDIVIDUAL SITTERS - MARY II, QUEEN, 1662-1694

Benkö, Éva
 The archetype of Netscher's "Portrait of Mary II Stuart" in Brussels and its use

In:Mus.Royaux
 des Beaux-Arts
 de Belgique.B
30-33:123-34 1981-1984/1-3 illus.

 The portr.by Constantin or Caspar Netscher of Mary II Stuart could be copies after Sir Peter Lely
 Synopsis in Dutch and French

I.E - INDIVIDUAL SITTERS - MARIE ANTOINETTE, 1755-93

.Debrou, P..
 Catalogue des portraits imprimés en noir et en couleurs de la reine Marie-Antoinette et de la famille royale...composant la collection de m.P.D...vente le 8 mars, 1907.Paris,Hôtel Drouot 47 p. illus.

PPPM NjP

705
B97
NCFA
v.89

I.E - INDIVIDUAL SITTERS - MARY II, QUEEN, 1662-1694

Esdaile, Katharine
 The royal sisters:Mary II and Anne in sculpture

In:Burl.Mag.
89:254-7 Sep,1947 illus.

 Terracotta models:William III & Mary II by John Nost. Statue of Anne by Andrew Carpenter (1712)

Rep.,1945-47*7444

I.E - INDIVIDUAL SITTERS - MARIE ANTOINETTE, 1755-93

Gower, Ronald Charles Sutherland, 1845-1916
 Iconographie de la reine Marie-Antoinette. Catalogue descriptif et raisonné de la collection de portraits,...caricatures,etc..formée par R.Gower,précédé d'une lettre par m.G.Duplessis. Paris,A.Quantin,1883
 250 p. illus(part col.)

LC DC137.I207

Amsterdam,Rijksmus.,cat.
Z5939A52,deel 1,p.146

I.E - INDIVIDUAL SITTERS - MARY STUART, QUEEN OF THE SCOTS, 1542-1587

Cust, Lionel Henry, 1859-1929
 Notes on the authentic portraits of Mary Queen of Scots,based on the researches of ... George Scharf...London,J.Murray,1903
 157 p. illus.

LC N7639.M3C9

Stevenson.V.Dyck in check
trousers NK4743.S848NPG
p.115

N7628
M36 O4
NPG

I.E - INDIVIDUAL SITTERS - MARSHALL, JOHN, 1755-1835

Oliver, Andrew, 1906-
 The portraits of John Marshall.Charlottesville,Va.,Univ.press,1977.
 208 p. illus.

 124 illustrs.
 Contains a historical account of...all known portrs. of J.M.:oil,W.C.,plaster,marble, relief,silhouette.Biogr.sketches of all artists mentioned .makes it.an important contribution to the history of portraiture in America from 1800-1835

I.E - INDIVIDUAL SITTERS - MARY STUART, 1542-1587

Foster, Joshua James, 1847-1923
 Concerning the true portraiture of Mary, Queen of Scots...with a chapter by L.Dimier on the French court ptrs. of the 16th c. London, Dickinson's,1904
 illus.

LC N7639.M3F6
folio

I.E - INDIVIDUAL SITTERS - MARY, QUEEN OF HUNGARY, 1505-1558 (sister of Charles V) card 2

Glück, Gustav
 Bildnisse aus dem hause Habsburg. Pt.2 of 3

Met
100.53
J191
Q

In:J.Vienne
8:173-196 1934 illus.

 Queen Mary of Hungary,sister of Chs.V. Engravings by Schoen,Huys;ptgs.by Krell,Maler,Vermeyen, van Orley,Mor,etc.;St.glass by van Orley;bust by Leoni

LC N3.J4

Rep.,1934#94

I.E - INDIVIDUAL SITTERS - MARY STUART, 1542-1587

Foster, Joshua James, 1847-1923
 The Stuarts,being illustrations of the personal history of the family(especially Mary, queen of Scots)in 16th,17th and 18th c.art;portraits,miniatures,relics,etc...London,Dickinson's New York,E.P.Dutton & co.,1902
 2 v. illus.

 A short biogr.summary of the sovereign Stuart. Genealogical table:v.1,p..12-14. Portrs.of Mary Stuart:v.2,p.139-150

LC DA758.3.S8F5

428

I.E - INDIVIDUAL SITTERS - MATHER, INCREASE, 1639-
1723

N
7628
M42M9
NCFA
NPG
(RB)

Murdock, Kenneth Ballard, 1895-
The portraits of Increase Mather,with some
notes on Thomas Johnson,an English mezzotinter...
Cleveland,For private distribution by W.G.
Mather,1924
70 p. illus(part col.)

LC F67.M478
N7628.M3M8 (copy 2)

Whitehill.The Arts in ear-
ly Amer.Hist.Z5935.W59 NPG
Bibl.,p.98

I.E - INDIVIDUAL SITTERS - MILTON, JOHN, 1608-1674

Martin, John Rupert
The portrait of John Milton at Princeton,
and its place in Milton iconography. Princeton,
N.J.,Princeton university library,1961
34 p. illus(part col.)

Bibl.references included in "notes"

LC N7628.M5M3

I.E - INDIVIDUAL SITTERS - MEDICI FAMILY

...3.1
...43
NCFA
v.1-4

King, Edward S.
An addition to Medici iconography

In:J.Walters Art Gall.
3:75-84 1940 illus.

Incl:Maria Salviati & Cosimo in ptgs.& drgs.
by Pontormo,& in miniature & ptgs.by Vasari

Rep.1942-44#694

I.E - INDIVIDUAL SITTERS - MILTON, JOHN, 1608-
.1674

705
A56
NCFA
v.100

Smith, Robert C.
Finial busts on 18th century Philadelphia
furniture

In:Antiques
100:900-905 Dec.,'71 illus.

Repro.incl.:B.Franklin;John Locke;John Milton;
Washington
'...study of all this furniture...could we
reveal ..resemblances linking it with the shop
of Benjamin Randolph.
7
Saunders.Am.colonial port.
N7593.1.S28,p.74,note 152

N
7628
M48L2
NPG

I.E - INDIVIDUAL SITTERS - MEDICI FAMILY

Langedijk, Karla
De portretten van de Medici tot omstreeks
1600.Assen,v.Gorcum & cy...,1968.
175 p. 1 illus.

Thesis-Amsterdam,1968

Summary in English

705
B97
NCFA
v.115

I.E - INDIVIDUAL SITTERS - MONA LISA

Clark, Kenneth McKenzie, 1903-
Mona Lisa

In:Burl Mag
115:144-50 Mar,'73 illus.

First in a series of lectures on portraiture,
held Jan.17,1973 at Victoria and Albert mus.

I.E - INDIVIDUAL SITTERS - MILTON, JOHN, 1608-
.1674

Cambridge. University. Christ's college.
Milton Tercentenary.The portraits,prints and
writings of John Milton.Exhibited at Christ's
college,Cambridge,1908.,Cambridge,Printed by J.
Clay,1908.
168 p. illus.

Preface signed by John Peile
Account of the Milton portraits & of the ear-
ly editions of the poems,contributed by C.C.Wil-
liamson.Appendix on editions & on books about
Milton to be found at Cambridge,written by Chs.
Sayle
LC Z8578.C17

Lewis.Z5947.A3L66 1974 'NPG'
p.208

NPG
filed
NCFA
Ref.
coll.

I.E - INDIVIDUAL SITTERS - MONROE, JAMES, 1758-
1831

Smithsonian Institution
Profiles of the time of James Monroe,1758-
1831;an exhib.commemoration the 200th anniversary
of the birth of the 5th pres.of the U.S.,Oct.26-
Nov.23,1958.Washington.1958.
,29,p. illus. (Smithsonian publication
no.4348)

Cat.signed:Ths.M.Beggs

Exhib.held in the Natural History Bldg.

LC E372.S56

Fogg,v.11,p.330

I.E - INDIVIDUAL SITTERS, MILTON, JOHN, 1608-1674

Grolier club, New York
Catalogue of an exhibition commemorative of
the tercentenary of the birth of John Milton,
1608-1908...with 327 engraved portraits...Dec.,
1908-Jan.9,1909.New york,DeVinne press,1908.
116 p. illus.

449 numbers:1-330,portraits

LC Z8578.G85

Martin,J.R.Portr.of J.Mil-
ton at Princeton.Notes,no.3

I.E - INDIVIDUAL SITTERS - MORE, SIR THOMAS, 1478-
1535

Morison, Stanley, 1889-
The likeness of Thomas More;an iconographi-
cal survey of three centuries.Edited & supple-
mented by Nicolas Barker. New York,Fordham
University Press.1964,c1963.
96 p. illus(part col.)

LC N7628.M6M6

I.E - INDIVIDUAL SITTERS - MORE, SIR THS. FAMILY

The Family of Sir Thomas More.Facsimiles of
the drawings by Hans Holbein the younger
in the Royal Library,Windsor Castle.N.Y.,
Johnson Reprint Corp.,1978
8p.&8 pl. col.

Intro.by Jane Roberts

NPG VF Holbein,Hans,the
younger

I.E - INDIVIDUAL SITTERS - NAPOLÉON, 1769-1821

David, Yvan
Napoléon et la famille impériale.Musée
Fesch,Ajaccio, juillet-septembre 1969..cat.
no.149 par Yvan David.Paris,Réunion des Musées
nationaux,1969
58 p. illus.

LC DC197.5.D37 Hubert.In:Gas.Beaux-Arts
jul/aug.'86,v.108,p,29
note 2

I.E - INDIVIDUAL SITTERS - MURRAY, WILLIAM
see
MANSFIELD, LORD

I.E - INDIVIDUAL SITTERS - NAPOLEON; 1769-1821

Dayot, Armand Pierre Marie, 1856-1934
...Napoléon,illustrations d'après des pein-
tures,sculptures,gravures,objets,etc.,du temps.
Paris,E.Flammarion,193-?,
347 p. illus.

LC DC203.8D3

I.E - INDIVIDUAL SITTERS - NAPOLEON, 1769-1821

Baily, James Thomas Herbert, 1865-1914
Napoleon;illustrated with prints from con-
temporary and other portraits...London,Pub.by
the Connoiseur magazine,1908
126 p. illus(part col.)

LC DC203.B17 Levis.Descr.bibl.Z5947.A3
L66 p.209

I.E - INDIVIDUAL SITTERS - NAPOLEON, 1769-1821

Galeric de portraits de personnages célèbres.
Paris,Shez Ontervald l'aîné.n.d.,
1 v. illus.

Portrs.and caricatures of Napoleon

NcU

I.E - INDIVIDUAL SITTERS - NAPOLÉON I, 1769-1821

Broadley, Alexander Meyrick, 1847-1916
Collectanea Napoleonica;being a cat. of the
coll....caricatures...portraits,naval and mili-
tary costume plates,etc.relating to Napoleon I.
and his time,1769-1821.Formed by A.M.Broadley...
comp.by Walter V.Daniell...Illustr.with a hither-
to unpublished portrait of Napoleon,by Detaille..
London,W.V.Daniell;.etc.1905.
166 p. illus.
'Interesting,well illustrated volume.'-Levis

LC Z8612.B85 Levis.Descript.Bibliogr.
Z5947.A3L66 1974 NCFA
p.206

705
G28
NMAA
v.108

I.E - INDIVIDUAL SITTERS - NAPOLEON, 1769-1821

Hubert, Nicole
A propos des portraits consulaires de
Napoléon Bonaparte.Remarques complémentaires

In:Gaz Beaux Arts
108:23-30 Jul-Aug.,'86 illus.

Information of the big orders for consular
portrs. in 1803.'These portrs. can be classi-
fied in 3 groups which originated in the 3
Gros prototypes:Cambacérès portr.:Gros,Mme Be-
noist,Greuze.-Li''e portr.:Ingres,R.Lefèvre,
Vien.-Lyon port seated:Meynier,Dufau!

I.E - INDIVIDUAL SITTERS - NAPOLEON, 1769-1821

Cope, Edwin R.
...The magnificent coll.of engraved por-
traits formed by...Edwin R.Cope...being the
most important coll..to be sold...at Thos.
Birch's sons...Cat.comp.& sale conducted by
Stan V.Henkels....:Philadelphia,The Bicking
print,1896.,1899,
Pt.I:48p.;1126 items,portraits,illus.
Pt.II:68p.;1247 items,portraits,illus.
Pt.III:44p.;814 items,miscellaneous,illus.
Pt.IV:44p.;586 items,balance of coll.with
suppl.contain'g illus.

LC has pt.2:NE240.C7 Levis.Descr.bibl.Z5947.A3
L66 1974 NCFA p.244

I.E - INDIVIDUAL SITTERS - NAPOLEON, 1769-1821

109 x .Hundertneunmal.Napoleon.Miniaturen nach
J.L.David(Ausstellung)21.jan.-18.febr.1973
(Katalog von Klaus Hoffmann)Göttingen,Städti-
sches Mus.(1973)
16 p. illus.

LC ND1335.G3.G633

N
1455
A55
1983
NMAA

I.E - INDIVIDUAL SITTERS - NAPOLEON

Lady Lever art gallery, Port Sunlight
Cat.of foreign paintings,drawings,minia-
tures,tapestries,post-classical sculpture and
prints.Merseyside County Council,1983
322 p. illus.

Incl.Ch.Miniatures,p.57-87

Ch.Sculpture incl.:Deathmasks of Napoleon
by Antommarchi and Burton;Bust of Napoleon
by Chaudet;wax profile of Napoleon by Cinga-
nelli;Equestrian statuetteof Napoleaon by Du-
bray

N
40.1
I55T7
NMAA

I.E - INDIVIDUAL SITTERS - NAPOLEON,1769-1821

Toussaint, Hélène
Les portraits d'Ingres,peintures des musées
nationaux.Paris,Ministère de la Culture.Editions
de la Réunion des musées nationaux,1985
141 p. illus(part col.) (Monographies
des musées de France)

Bibliography, p.136-9
Repro incl.:Napoleon,1806,Luigi Cherubini,
1841,1842,Lorenzo Bartolini,1820,Jean-Pierre Cor-
tot,1815,1818

705
G28
NMAA
v.106

I.E - INDIVIDUAL SITTERS - NAPOLEON - 1769-1821

Lilley, Edward
Consular portraits of Napoleon Bonaparte

In:Gaz.Beaux-Arts
106:143-56 Nov.,'85 illus.

Repro.incl.:A.J.Gros,Ingres,Greuze,David,
Mme.Benoist,Vien fils.Engraving by Devillier
l'ainé(after Lefèvre)

N
7628
028E4
NPG

I.E - INDIVIDUAL SITTERS - OEHLENSCHLÄGER, ADAM
 GOTTLIEB, 1779-1850
Eller, Povl
Adam Oehlenschläger portraetter.:Hillerйd,
Nationalhistoriske museum paa Frederiksborg,
1968.
142 p. illus.

Incl.chronological cat.of portrs. of Oeh-
lenschläger:Ptgs,drnwgs.,sculpture.-Silhouettes.
Daguerreotypes.-Death-mask

LC PT8156.8.E4

I.E - INDIVIDUAL SITTERS - NAPOLEON, 1769-1821

Maggs Bros., London
Napoleonica:portraits,caricatures,views,
battles,etc. Selected from the stock of Maggs
Bros. London,1912
56 p. illus. (Its.catalogue.no.250)

LC Z999.1155 no.290
copy 2:Z8612.N25

N
7628
O 49 O4

I.E - INDIVIDUAL SITTERS - OLIVER FAMILY

Oliver, Andrew, 1906-
Faces of a family;an illustrated catalogue of
portraits and silhouettes of Daniel Oliver,1664-
1732,and Elizabeth Belcher,his wife,...,made
between 1727 and 1850.:Portland,Me.,1960
42 p. illus.

LC CS71.O47 1960

I.E - INDIVIDUAL SITTERS - NAPOLEON

Mitchell, James Tyndale, 1834-1915
...The unequaled collection of engraved por-
traits of eminent foreigners,embracing kings,
eminent noblemen & statesmen,great naval commandi-
ers...explorers,...reformers...;also a collection
of caricatures on Napoleon & a ...coll.of portrs.
engravings by the great masters of the last four
centuries in line,mezzotinto,stipple & etching.
to be sold...Oct.14,1912...and Oct.15,1912.Cat.
comp.& sale conducted by Stan.V.Henkels at the
book auction rooms of S.T.Freeman & co.,Phila.,Pa
.M.H.Power,printer,1912.
111p. illus.
Cat.no.944,pt. VII
LC NE240.M515

708.1
P31
NMAA
v.83

I.E - INDIVIDUAL SITTERS - OLONNE, CATHERINE
 HENRIETTE D'ANGENNES,COMTESSE D',1634-
 -1714
Grace, Priscilla
A celebrated miniature of the Comtesse
d'Olonne

In:Phila.Mus.Art B.
83,no.353:3-21 Fall,'86 illus(part col.)

Comtesse d'Olonne.as Diana by Jean Petitot

Incl.repr.of several miniatures by Petitot

760
.N21M68

I.E - INDIVIDUAL SITTERS - NAPOLEON

Mitchell, James Tyndale, 1834-1915
...The unequalled collection of engraved
portraits of Napoleon Bonaparte and his family
and marshals,belonging to Hon.J.T.Mitchell...
portraits in mezzotint,aquatint,line and stipple
...caricatures on Napoleon by Cruikshank,Gillray,
Rowlandson...to be sold...1908.Philadelphia,Pa.,
.Press of W.F.Fell,company,1908.
100 p. illus.
(Sold at book auction rooms of S.T.Freeman & co
(Catalogue compiled...by Stan V.Henkels,
Cat.no.944,pt.VII
LC DC203.8N5

Af
1
.F63
NPG
v.33

I.E - INDIVIDUAL SITTERS - OSCEOLA, 1800?-1838

Goggin, John M.
Osceola:Portraits,features and dress

In:Florida Hist.Q.
33:161-92 Jan.-Apr.,'55 illus.

Bibliography

Repro.incl.:Portrs. by John deLers Vinton,
Geo.Catlin,Rot.J.Curtis,Chs.Bird King?,Waldo &
Jewett

I.E - INDIVIDUAL SITTERS - OSCEOLA, 1800?-1838

McCarthy, Joseph Edward
 Portraits of Osceola and the artists who
painted them

In:Jacksonville Hist.Soc.,Papers
2:23-44 1949

LC F319.J1J3 Coggin.Osceola.AP1.F63
 :192

AP
1
J8654 Brown, Jonathan
NPG Enemies of flattery:Velásques' portraits
v.17 of Philip IV

 In:J.Interdisc.Hist
 17,no.1:137-54 Summer,'86 illus.

 Bibliographical references

I.E - INDIVIDUAL SITTERS - PHILIP IV, 1605-1665

705
C75 I.E - INDIVIDUAL SITTERS - OXENDEN FAMILY
NCFA
 Manners, Lady Victoria, 1876-
 The Oxenden collection.Pt.1,2,3

 In:Connoisseur
 40:3-12 Sep.,1914 illus.
 41:121-30 Mar.,1915 illus.(also opp.p.46)
 43:200-08 Dec.,1915 illus.

 Mainly Engl.portrs.of the 16-18th c.Espe-
 cially interesting for the study of early Engl.
 school of portraiture
 Repro.incl.:Corn.Janssens.van Ceulen,
 Mytens,John Eykes,Fayram,Aikman,Beach..

705
G28 I.E - INDIVIDUAL SITTERS - PHILIP THE GOOD
NMAA DUKE OF BURGUNDY FROM 1419-67
v.99 Smith, Jeffrey Chipps
 Jean de Maisoncelles' portrait of Philippe
 Le Bon for the Chartreuse de Champmol.A study
 in Burgundian political symbolism

 In:Gaz.Beaux-Arts
 99:7-12 Jan.,'82 illus.

 '...It is a political image. Ph.is
 dressed in his Toison d'or robe...He is crowned'

705
A7875 I.E - INDIVIDUAL SITTERS - PAGE(MRS.WILLIAM)
 (Sophie Candace Stevens Page)
 Taylor, Joshua Charles, 1917-
 The fascinating Mrs.Page

 In:Art Q
 20,no.4:347-62 winter '57 illus.

 Wm.Page's technique. Comparison with photo-
 graphy

929.2
P692D48 I.E - INDIVIDUAL SITTERS - PITTS FAMILY

 Detroit. Institute of Arts.
 Portraits of eight generations of the Pitts
 family,from the 17th to the 20th century.
 .Detroit.1959.
 59 p. illus.
 Exhibition Oct.6-Nov.8,1959
 "Catalogue by Elizabeth H.Payne."

 "Ancestral portrs.of the Pitts family,which
 included Bowdoins,Mountforts,and Warners of Mass.
 & New Hampshire in the 18th c.painted by see
 over
LC N7621.D4 Whitehill.The arts in ear-
 y Amer.Hist.Z5935.W59
 bibl.,p.98

AP
1
A51 I.E - INDIVIDUAL SITTERS - PENN FAMILY
A64
NMAA Fleischer, Roland Edward, 1928-
v.19 Gustavus Hesselius and Penn family portraits;
 a conflict between visual and documentary evi-
 dence

 In:PrArt J.
 19,no.3:4-18 1987 illus.

 Repro.incl.:Two Delaware chiefs.

705
C75 I.E - INDIVIDUAL SITTERS - POMPADOUR,MARQUISE DE
NCFA
 Leroy, Alfred
 The portraits of Mme de Pompadour

 In:Connoisseur
 103:301-9 Jun,1939 illus(part col.)

 Incl:Boucher,Nattier,van Loo,Q.de la Tour,
 Carriera,Drouais

 Rep.,1939-41*784

CT
275 I.E - INDIVIDUAL SITTERS - PEPYS, SAMUEL,1633-1703
P42B2
NPG Barber, Richard
 Samuel Pepys Esquire,Secretary of the Admi-
 ralty to King Charles & King James II .Berkeley.
 University of California Press.c.1970.
 64 p. illus(part col.)

 Four essays which form a catalog of the
 exhibition held Nov.,1970,at the National
 Portrait Gallery, London.

LC DA447.P4B3

N
7628 I.E - INDIVIDUAL SITTERS - POPE, ALEXANDER, 1688-
PS2W7 1744
NPG Wimsatt, William Kurtz, 1907-
 The portraits of Alexander Pope. New Haven,
 Yale University Press,1965
 391 p. illus(part col.)

 Bibliographical footnotes

LC PR3633.W5

708.9493
B921
NMAA
v.30-33

I.E - INDIVIDUAL SITTERS - POZZI, DR.SAMUEL
&JEAN

Goley, Mary Anne
Sargent's "Dr.Pozzi at home",exhibited
in Brussels in 1884

In:Mus.Royaux
des Beaux-Arts
de Belgique.B.
30-33:143-150 1981-1984/1-3 illus.

Synopsis in Dutch and French

ND
1311.2
P61x
NPG

I.E - INDIVIDUAL SITTERS - RED JACKET
Kenway, Mary M.
Portraits of Red Jacket
Niles, Ellen Cross comp.
Portrait painting in America.The nineteenth
century.N.Y....,1977 (card 4)

Partial contents cont'd:...M.M.Kenway,Portrs
of Red Jacket,p.160-1;...

I.E - INDIVIDUAL SITTERS - PTOLEMIES

Kyrieleis, Helmut
Bildnisse der Ptolemäer.Berlin,Mann,1975

190,108 p. illus. (Archäologische
Forschungen,Bd.2)

Bibliography

At head of title:Deutsch,Archäol.Inst.

A revision of the author's Habilitations-
schrift,Bonn,1972

LC DT92.K97 Gesichter.MB1296.3.G38
 1983 NPG p.315

705
B97
NCFA

I.E - INDIVIDUAL SITTERS - REYNOLDS,1723.- 1792

Steegmann, John
Portraits of Reynolds

In:Burl Mag.
88:33-4 Feb,1942 illus.

Incl:Selfportrs.ptgs.1773,1780;drg.1740
ptg. of Reynolds by C.F.von Breda(Swed.ptr.1759-
1818, was in London 1787-96),1791, etc.

Rep.,1942-44*780

708.1
.W243
NCFA

I.E - INDIVIDUAL SITTERS - PTOLEMY I, 367?-283 BC

Segall, Berta
Realistic portraiture in Greece and Egypt.
A portrait bust of Ptolemy I

In:J.Walters Art Gall.
9:53-67,106 1946 illus.

Coins of Ptolemy I
Ptolemy as Dionysos

I.E - INDIVIDUAL SITTERS - RICHARD II, 1367-1400

Scharf, George, 1820-1895
Description of the Wilton House diptych,
containing a contemporary portrait of King
Richard II..London.,Printed for the Arundel
society,1882
99 p. illus.

LC N12.A975 Amsterdam,Rijksmus.,cat.
 25939A52,deel 1,p.152

CT
275
Q7M4
NPG

I.E. - INDIVIDUAL SITTERS - QUINCY FAMILY

Massachusetts Historical Society, Boston
A pride of Quincys. Boston,1969
52 p. illus. (A Massachusetts Historical
Society picture book)

LC CS71.Q52 1969

N
7639
R89L8
NPG

I.E - INDIVIDUAL SITTERS - RUBINSTEIN, HELENA,
1870-1965

London. National Portrait Gallery
Portraits of Helena Rubinstein.London,Na-
tional Portrait Gallery,1977
&31.p. illus(part col.)

Publ.for the exh.held at the NPG from 6 May
to 19 June,1977

20 portrs.

AP
1
W225
NCFA
v.8

I.E - INDIVIDUAL SITTERS - RALEIGH,SIR WALTER,
1552?-1618

Cust, Lionel Henry, 1859-1929
The portraits of Sir Walter Ralegh

In:Walpole Soc
8:1-15 1919-20 illus.

Repro.incl.:N.Hilliard,Vertue,S.Passe,Th.de
Leu,Gheeraerts

705
C75
NCFA
v.100

I.E - INDIVIDUAL SITTERS - RUPERT,PRINCE, 1619-
1682

Casmell, Charles Richard
Rupert, Prince Palatine, portraits of a
royal artist

In:Connoisseur
100:59-64 Aug.,1937 Dec,1937:322-3 illus.

Repro.of portrs.of Prince Rupert by Mierevelt,
Honthorst,v.Dyck,Dobson,Lely,Kneller,miniature by
Cooper,Fulham pottery bust,attr.to Gibbons

Rep.,1937*345

I.E - INDIVIDUAL SITTERS - RUSH, BENJAMIN,1745?-
1813
Goodman, Nathan Gerson, 1899-
Benjamin Rush, physician and citizen,
1746-1813.2d printing 1936..Phila.,Uni.of Penn.
Press,1934
421 p. illus.

Bibliography

LC R154.R9065

College of physicians...
Arch.Am.Art mfm P86 v.12
References

I.E - INDIVIDUAL SITTERS - SHAKESPEARE

PR
2929
B6
1975X
NPG
Beaden, James, 1782-1839
An inquiry into the authenticity of various
pictures and prints,which,from the decease of
the poet to our own times,have been offered to
the public as portraits of Shakspeare(sic)...
illustrated by...engravings...from such origi-
nals as were of indisputable authority.N.Y.,
AMS Press,1975
206 p. illus.
Reprint of the 1824 ed.printed for R.Trip-
hook,London

Levis.Descriptive Bibl.
Z5947A3L66 1974 NCFA p.148

705
A56
NCFA
v.108
I.E - INDIVIDUAL SITTERS - RUSH, BENJAMIN, M.D.
1745?-1813
Jones, Robert Erwin,M.D.
Portraits of Benjamin Rush,M.D.,by his con-
temporaries

In:Antiques
108:94-113 July,'75 illus(part col.)

Paintings,silhouettes,prints,drawings,
medal,sculpture

705
R97
NCFA
v.124
I.E - INDIVIDUAL SITTERS - SHAKESPEARE
Edmond, Mary
The Chandos portrait:a suggested painter

In:Burl Mag
124:146-9 Mar,'82 illus.

Edmond suggests John Taylor as the painter
of the only supposed portr.of Shakespeare done
during his lifetime

Rila 1984/I #1991

I.E - INDIVIDUAL SITTERS - SACHS, HANS, 1494-1576

Stuhlfauth, G., 1870-
Die bildnisse des Hans Sachs von 16.bis
zum ende des 19. Jahrhunderts. Berlin,F.Kupfer-
berg.1939.
53 p. illus.

Wisc.Univ.Libr.for LC Rep.,1939-41*788

I.E - INDIVIDUAL SITTERS - SHAKESPEARE

Friswell, James Hain, 1825-1878
Life portraits of William Shakespeare:
a history of the various representations of
the poet,with an examination into their auther-
ticity...Illustrated by photographs of the
most authentic portraits,and with views,etc.
by Cundall,Downes,& co....London,S.Low,son,
& Marston,1864
128 p. illus.

LC PR2929.F73
Edmond.The Chandos portr.
In:Burl.Mag.v.124,March,'8
p.146,footnote 2

I.E - INDIVIDUAL SITTERS - SALTONSTALL FAMILY

Peabody museum of Salem, Salem,Mass.
A special exhibition of the Saltonstall
family portraits,Nov.15-Dec.31,1962.Salem,Mass.,
1962.
12 p. illus.

Cat.compiled by Carl Crossman

"...16 family portrs.recently given to the
Peabody mus....by Senator Leverett Saltonstall,
dating from the middle of the 17th c."(Whitehill)

MB CtY
Whitehill.The arts in ear-
ly Amer.Hist.Z5935.W59
Bibl.,p.59

705
C75
NCFA
v.47
I.E - INDIVIDUAL SITTERS - SHAKESPEARE
Hodgson, Mrs. Willoughby
Shakespeare in pottery and porcelain

In:Connoisseur
47:3-7 Jan,'17 illus.

Repro.incl.:Terra-cotta model of Roubiliac's
statue,1757;Statuette,earthenware,Staffordshire,
1800;Portr.in black transfer on Worcester mug,
c.1760;Medallion,Wedgwood Jasper,1780;Bust,
black basaltes;bust col.earthenware,Stafford-
shire,by Enoch Wood;-Js.Quin as Falstaff,
see over

I.E - INDIVIDUAL SITTERS - SCOTT,SIR WALTER, 1771-1832

Caw, James Lewis, 1864-
The Scott gallery;a series of 146 photogra-
vures...Edinburgh & London,T.C.& E.C.Jack,1903
2 v. illus.

,Iconography of Sir Walter Scott,

LC N7598.C4
Blanshard,F. The portrs. of
Wordsworth N7628W92B6 NPG

I.E - INDIVIDUAL SITTERS - SHAKESPEARE

Wivell, Abraham, 1786-1849
An inquiry into the history,authenticity &
characteristics of the Shakespeare portraits...
London,The author,1827
254 p. illus.

'Excellent engravings of the monument at
Stratford.The Felton portr.The Chandos portr.
Martin Droeshout's portr.Marshall's portr.Corne-
lius Jansen's portr.Two woodcuts of the monuments
The head of the bust of the monument:.-Levi
Supplement. Dawnkin & Marshall...1827
52 p. illus.

LC PR2929.W5
Levis.Descript.bibl.p.159
Z5947.A3L66 NCFA

I.E - INDIVIDUAL SITTERS - SIDNEY, SIR PHILIP,
 1554-1586
Judson, Alexander Corbin, 1883-
 Sidney's appearance;a study in Elizabethan
portraiture.Bloomington,Ind.Univ.Press,1958
 98 p. illus (Ind.Univ.publ.Humanities ser.
 no.4)

LC AS36.I385 no.4
N7628.S5J8 Fogg v.11,p.332

I.E. - INDIVIDUAL SITTERS - STUART, Charles Ed-
Bryden, H.A. ward,the young pretender,1720-1788
 A new portrait of Prince Charlie

In:Apollo
10:20-2 Jan.,1933 illus.

 Portr.by Largillière, iconography of the Pre-
tender. Engraved glass portr.;tombs of Stewarts
in St.Peter's,Rome
 Pretender.i.e. Bonny Prince Charlie,1720-88.

LC N1.A255 Rep.,1933*141

705
C75
NCFA
v.59
I.E - INDIVIDUAL SITTERS - SIDNEY, SIR PHILIP,
 1554-1586
Williamson, George Charles, 1858-1942
 Some notes on the portraits of Sir Philip
Sidney

In:Connoisseur
59:217-25 Apr.,'21 illus.

 FOR COMPLETE ENTRY
 SEE MAIN CARD

N
7628
W31F4
NCFA
R.B.
I.E - INDIVIDUAL SITTERS - STUART, GILBERT,
 c1755-1828
Fielding, Mantle, 1865-1941
 Gilbert Stuart's portraits of George
Washington...Philadelphia,Printed for the
subscribers,1923
 264 p. illus.

 Incl.:Cat.of 124 portrs.of Washington by
Stuart and one chapter on likenesses of
Gilbert Stuart

LC E312.43.F54 and F541

I.E - INDIVIDUAL SITTERS - SOCRATES
Kekule von Stradonitz, Reinhard, 1839-1911
 Die bildnisse des Sokrates..Berlin,Verl.der
königl.akademie der wissenschaften...1908.

 58 p. illus.

 Bibliogr. footnotes

Princeton univ.libr.for
LC (AS182.B34 1908) Pfuhl,E. Die anfänge der
 griech.bildniskunst

705
C75
NCFA
v.71
I.E - INDIVIDUAL SITTERS - STUART FAMILY
Beard, Charles R.
 Early Stewart portraits:a discovery

In:Connoisseur
71:5-15 Jan.,'25 illus.

 An attempt to find the origin of a number of
well-known Stuart portrs.,hitherto not definitely
attr.to any particular hand

 Cumulated Mag.subj.index
 A1/3/C76 Ref. v.2,p.443

705
C75
NCFA
v.207
I.E - INDIVIDUAL SITTERS - SPENCER, FAMILY
Barker, Godfrey
 The Spencer line

In:Connoisseur
207:179-83 July,'81 illus(part col.)

 Lady Diana Spencer's,now Princess of Wales;
ancestors

 Repro.:Geo.Knapton;Chs.Jervas;Reynolds;Geo.
Hayter;Copley;John Charlton;Wm.Orpen;Moynihan;
Lionel Edwards

N
7599
E23
NPG
I.E - INDIVIDUAL SITTERS - STUART FAMILY
Edinburgh. Scottish national portrait gallery
 The royal house of Stewart.Portraits...Notes
by R.E.Hutchison,keeper,Edinburgh,1958
 62 p. illus.

LC DA758.3S8E3

705
C75
NCFA
v.194
I.E - INDIVIDUAL SITTERS - STANLEY, EARLS OF DERB
 cBY
Mannings, David Michael
 Reynolds' portraits of the Stanley Family

In:Connoisseur
194:85-9 Feb.,'77 illus(1 col.)

 4 Kit-cat portrs.,based on v.Dyck & with
motifs derived fr.Brit.16-17th c. portraiture

 Rila III/2 1977 *4984

I.E - INDIVIDUAL SITTERS - STUART FAMILY
Foster, Joshua James, 1847-1923
 The Stuarts,being illustrations of the per-
sonal history of the family(especially Mary,
queen of Scots)in 16th,17th and 18th c.art;por-
traits,miniatures,relics,etc...London,Dickinson's;
New York,E.P.Dutton & co.,1902
 2 v. illus.

 A short biogr.summary of the sovereign Stuart.
Genealogical table:v.1,p.12-14. Portrs.of Mary
Stuart:v.2,p.139-150

LC DA758.3.S8F5

DÁ
758.3
S8G7x
NCFA

I.E - INDIVIDUAL SITTERS - STUART FAMILY

London. National Portrait Gallery
. The house of Stuart,by David Gransby.Lon-
don,H.M.stationery off.,1968

20 p. illus(part col.) (Its Kings and
Queens series;1603-1714)

MET
276.5
L844

AP
1
N547
NCFA
v.42

I.E - INDIVIDUAL SITTERS - STUYVESANT FAMILY
Vail,Robert William Glenroie, 1890-1966
The case of the Stuyvesant portraits

In:N.Y. Hist.Soc.Q.
42:171-204 Apr.,'58 illus.

Incl.:Checklist of the Stuyvesant portraits

I.E - INDIVIDUAL SITTERS - STUART FAMILY

London. New Gallery
Exhibition of the royal house of Stuart.
=London 1888.
216 p. illus.

MET
107.2
L245

Exh.reviewed by J.J.Foster in:
Antiquary XIX and XX,1889

V & A

Amsterdam,Rijksmus.cat.
25939A52,deel 1, p.152

AP
1
W78
NCFA
v.14

I.E - INDIVIDUAL SITTERS - SWAN FAMILY

DeLorme, Eleanor Pearson
The Swan Commissions.Four portraits by
Gilbert Stuart

In:Winterthur Port
14:361-95 Winter,'79 illus.

Bibl.references

mfm
124n:3
NCFA

I.E.- INDIVIDUAL SITTERS - STUART FAMILY

Murdoch, William Garden Blaikie, 1880-1934
A bequest of Stuart engravings to the Na-
tional Library of Scotland

In:Apollo
13:167-73 Mar,'31 illus.

400 items relating to the dynasty

I.E - INDIVIDUAL SITTERS - TRAJAN, .c.53-117

Gross, Walter Hatto, 1913-
Bildnisse Traians. Berlin,Gebr.Mann,1940
141 p. illus. (Das römische Herrscher-
bild,II.Abt.Bd.2)

FOGG
5005
R71g
MET
617
W42
pt.2²

705
C75
NCFA
v.42

I.E - INDIVIDUAL SITTERS - STUART FAMILY

Murdoch, William Garden Blaikie, 1880-1934
Early Stuart portraits

In:Connoisseur
42:67-75 Jun.,'15 illus.

Repro.:James I,James II,James III & wife,
drgs.Mary of Guise,James IV & wife,James V &
wife,(p.77:)Mary,Queen of Scots by Janet

Beard.Early Stewart port.
Conn. 71:5-15 Ja.,'25

PG

I.E - INDIVIDUAL SITTERS - TREADWELL, NICHOLAS

Portrayal or Betrayal;an exh.of portraits of
Nicholas Treadwell,oct.23-Nov.17,1973 at
Nicholas Treadwell gallery,London
4 p. folder illus.
26 artists portrayed N.Treadwell."The re-
sult is an interesting comparison of reality
through the eyes of each artist...Pop,New Fi-
guration,Realism combined with use of photogra-
phy have brought about a new style of port ai-
ture,appropriate to society now & valid as art.
-Treadwell.

AP
1
N547
NCFA
v.35

I.E - INDIVIDUAL SITTERS - STUYVESANT FAMILY
Sawitzky, Susan
Thomas McIlworth,act.1758 to c.1769,identi-
fied by William Sawitzky and Katharine Hastings
as the painter of the Gerardus Stuyvesant group
of portraits.Rediscovered and assembled by Wil-
liam Sawitzky,1929-1944

In:N.Y. Hist.Soc.Q.
35:117-39 Apr.,'51 illus.

Incl.:Checklist of the portrs.attr.by Wm.
Sawitzky to Ths.McIlworth.-Outline of McIlworth'
life from 1757- 1769

705
P19
v.6
1930
NCFA

I.E - INDIVIDUAL SITTERS - TRIVULZIO FAMILY

Kiel, Hanna
Oberitalienische porträts der sammlung
Trivulsio

In:Pantheon
6:441-8 sup.78-9 Oct.,'30 illus(1 col.)

Repro.incl.Antonello da Messina,Bernardino
dei Conti,Zanetto Bugatti,Baldass d'Este(Baldas-
sare Estense)Ambrogio de Predis?,Paolo Morando

705
A7875
NCFA
v.1

I.E - INDIVIDUAL SITTERS - TRUMBULL, JOHN, the
poet. Cousin of the painter, 1750-1831
Richardson, Edgar Preston, 1902-
. A portrait of John Trumbull, the poet

In:Art Q
1:213-24 Summer,'38 illus.

Incl.discussion of Flemish baroque influ-
ence on Trumbull.

I.E - INDIVIDUAL SITTERS - VESALIUS, ANDREAS, 1514-
1564
Lint, Jan Gerard de, 1867-
Iets over de portretten van Vesalius. Amster-
dam,1915

Reprint fr."Nederlandsch tijdschrift voor
geneeskunde"(Mag.for medicine)LC R39.N4

Amsterdam.Rijksmus.cat.
Z5939A52,deel 1, p.145

N
7598
S92
NPG

I.E - INDIVIDUAL SITTERS - TUDOR FAMILY

London. National Portrait Gallery
The house of Tudor;by Roy C.Strong.London,
H.M.stationery office,1967
20 p. illus(part col.) (Its Kings and
Queens series:1485-1603)

LC DA317.1.S7

705
R97
NCFA
v.84

I.E - INDIVIDUAL SITTERS - VESPUCCI, Amerigo,1451-
1512
Douglas, R.Langton
The contemporary portraits of Amerigo Ves-
pucci

In:Burl.Mag.
84:30-7 Feb,1944 illus.
Incl.:Ptgs. by Ghirlandaio, Botticelli,Piombo

Rep.,1942-44#736

MET
107.2
L8453

V & A

I.E - INDIVIDUAL SITTERS - TUDOR FAMILY

London. New Gallery
Exhibition of the royal house of Tudor
.London 1890.
319 p. · illus.

Amsterdam Rijksmus.cat.
Z5939A52,deel 1, p.152

705
C75
NCFA
v.98

I.E - INDIVIDUAL SITTERS - VILLIERS, GEORGE,
1st DUKE OF BUCKINGHAM, 1592-1628
Cammell, Charles Richard
George Villiers,1st duke of Buckingham...

In:Connoisseur
98:127-32, 296 Sept.,Nov.,'36 illus(part col)

FOR COMPLETE ENTRY
SEE MAIN CARD

I.E - INDIVIDUAL SITTERS - TUDOR FAMILY

Vertue, George, 1684-1756
A description of nine historical prints, re-
presenting kings,queens,princes,etc.of the Tudor
family. Selected,drawn & engraved,from the origi-
nal paintings by George Vertue....London.Republish.
by the Society,1776

21 p. illus.

LC NE642.V4A3

I.E - INDIVIDUAL SITTERS - VISCONTI FAMILY
Giovio, Paolo, 1483-1552
Vitae dvodecim Vicecomitvm Mediolani princi-
pvm.Lvtetiae,R.Stephani,1549
199 p. illus.

10 woodcuts after portrs. in Giovio's coll.
perhaps by Claude & Pierre Woeiriot.-Rave
Portrs.engr.on wood have the Lorraine cross
device of Geoffroy Tory.-LC
Portrs.of the Visconti family,Milan

LC DG657.7.G5 1549 Rave.Jb.d.Berl.Mus. I 1959
Rosenwald coll. LC N3.J16 fol. p.139-41
 Paolo Giovio & d.Bildnisvi-
 tenbücher d.Humanismus

705
A56
NCFA

I.E - INDIVIDUAL SITTERS - VAN CORTLANDT FAMILY

Comstock, Helen
Some Hudson valley portraits

In:Antiques
46:139-40 Sept.,'44 illus.

FOR COMPLETE ENTRY
SEE MAIN CARD

I.E - INDIVIDUAL SITTERS - VISCONTI FAMILY

Hagelstange, Alfred, 1874-
Eine folge von holzschnitt-porträts der
Visconti von Mailand

In:Nürnberg,Germ.nat.mus.-Mitt.
:85-100 1904 illus.

LC DD1.A7 Rave.Jb.d.Berl.Mus. I 1959
 LC N3.J16 fol.p.140 footn.
 Paolo Giovio & d.Bildnisvi-
 tenbücher d.Humanismus

I.E - INDIVIDUAL SITTERS - VOLLARD, AMBROISE

Vollard, Ambroise
 Mes Portraits

In:Arts et Métiers graph.
 :38-44 no.64 1938 illus.

Met
268.54
ar7 Incl:Renoir,Cézanne,Picasso,Bonnard,Rouault,
Denis,Dufy

LC Z119.A84 Rep.,1938*646

I.E - INDIVIDUAL SITTERS - WASHINGTON

Baker, William Spohn, 1824-1897
 Character portraits of Washington...Phila-
delphia, R.M.Lindsay,1887

FOR COMPLETE ENTRY
SEE MAIN CARD

I.E - INDIVIDUAL SITTERS - WAGNER, RICHARD,
 1813-1883

Tralbaut, Mark Edo
 Richard Wagner im blickwinkel fünf grosser
maler,Henri Fantin-Latour,Paul Cézanne,Odilon
Redon,Auguste Renoir,Vincent van Gogh.Dortmund
1965
 39 p. (Dortmunder Vortr.,69)

LC ML410.W12F744 Rep. 1966 *987

R
.W31B16

I.E - INDIVIDUAL SITTERS - WASHINGTON

Baker, William Spohn, 1824-1897
 The engraved portraits of Washington,with
notices of the originals and brief biographical
sketches of the painters...Philadelphia,Lindsay
& Baker,1880
 212 p.

 Arranged chronologically under the names of
the artists.Engravers after the artist's work
follow in alphabetical order.

LC E312.43.B155 Whitehill.The arts in ear-
ly Amer.Hist.Z5935.W59
Bibl.,p.99

I.E - INDIVIDUAL SITTERS - WALKOWITZ, Abraham

Brooklyn Institute of Arts and Sciences. Museum
 One hundred artists and Walkowitz.Feb.9-
Mar.26,1944.Brooklyn,1944.
 28 p. illus.

 "This is the presentation of an experiment:
100 artists and one subject...a unique opportu-
nity for study to layman...artist & psychologist
-Foreword
 Portrs.of A.Walkowitz:89 ptgs.,11 pieces of
sculpture,caricatures & photographs & 2 self-
portrs.Portrs.range fr.conservative

LC ND1301.B7 MOMA p.433 v.11

N
7628
W31B16
1965
NPG

I.E - INDIVIDUAL SITTERS - WASHINGTON

Baker, William Spohn, 1824-1897
 Medallic portraits of Washington,with...a
descriptive catalogue of the coins,medals,tokens,
and cards.Philadelphia,R.M.Lindsay,1885
 252 p. illus.

 Reprint,Iola,Wisc.Krause Publ.,1965

FOR COMPLETE ENTRY
SEE MAIN CARD

LC E312.43.B164 Whitehill.The Arts in ear-
ly Amer.Hist.Z5935.W59 NPG
Bibl.,p.99

795
B97
NCFA

I.E - INDIVIDUAL SITTERS - WALTER, LUCY(MRS.BARLOW)
 1630? - 1658
Fea, Allan
 Portraits of Lucy Walter

In:Burl.Mag.
87:192-6 Aug.1945 illus.
89:49-50 Feb.1947 illus.

 Mrs.Barlow by Lely,Copper & engr. by v.d.Berghe

 1947,p.49:O.R.Bagot contests that Lely's ptg.
depicts Lucy Walter,but that it is Mrs.Dorothy
Grahme

 Rep.,1945-47*1170

AP
1
A(area)

I.E - INDIVIDUAL SITTERS - WASHINGTON

Bolton, Theodore, 1889- and H.L.Binsse
 The Peale portraits of Washington

In:Antiquarian
16:24-7,58,60,62,64 Feb.,'31 illus(part col

 Miniatures, physionotrace
 Incl.cat.,comp.from ms.copy of C.W.Peale's
diary for the years 1775-1778 and part of 1788.
 Description & notes on the life portrs.of W
by members of the Peale family
 C.P.Polk copied many C.W.Peale portrs.of
 .1787
 Arts in Am.qZ5961
 USA77X NCFA Ref. H7??

NK
3712
S93E83a
NPG

I.E - INDIVIDUAL SITTERS - WASHINGTON

American heroes portrayed in ceramics;from the
 17th through the 20th century.Everson Mus.
 of Art of Syracuse and Onondaga County,
 Syracuse,N.Y.,9 April - 6 June 1976.cat.,
 s.l.,Visual Arts Publication,,1976,
 24 p. chiefly illus.

 Organized by M.Jessica Howe with assis-
tance of Jan Tropea

 Bibliography

AP
1
A--area

I.E - INDIVIDUAL SITTERS - WASHINGTON

Bolton, Theodore, 1889- and H.L.Binsse
 Trumbull,"Historiographer"of the Revolution

In:Antiquarian
17:13-18,50,52,54,56,58 July,'31 illus(1 col)

 Repro.incl.:Washington(drawing)

 Incl.:1st check list of portrs.by John Trumbull

N
7628
W31C3
NPG

I.E - INDIVIDUAL SITTERS - WASHINGTON

Carson, Hampton Lawrence, 1852-1929
...The Hampton L.Carson collection of en-
graved portraits of Gen.George Washington. Cat.
comp. & sale conducted by Stan.V.Henkels.At the
art auction rooms of Davis & Harvey...Phila.,Pa.,
...,Press of W.F.Fell co.,1904.
173 p. illus(part col.)
Cat.no.906,pt.I

Incl.St.Mémin personal coll.of proof mezzo-
tints...to be sold Jan.21 & 22, 1904

LC Z999.H505 no.906,pt.1 Amsterdam Rijksmus.cat.
c.2 E312.43.C32 Z5939A52, deel 1, p.154

N
7628
W31C719
RB
NPG

I.E - INDIVIDUAL SITTERS - WASHINGTON

Colony Club, New York
Exn.of portraits of George Washington...
.New York.,Colony Club.1922.

FOR COMPLETE ENTRY
SEE MAIN CARD

ND
1301
.C39p
NPG

I.E - INDIVIDUAL SITTERS - WASHINGTON

Century Association, New York
Portraits owned by clubs in New York..Exh.
Jan.9 to Feb.3,1937.N.Y.,The Century Club
unpaged illus.

23 items shown

Repro.incl.:Washington,by G.Stuart;Wm.Pitt,
by J.Hoppner;J.Q.Adams,and Js.Madison, by A.B.
Durand;Lincoln,by F.B.Carpenter;ets.

Winterthur Mus.Libr.fZ881
W78 NCFA v.6,p.226

705
C75
NCFA
v.94

I.E - INDIVIDUAL SITTERS - WASHINGTON

Comstock, Helen
The Connoisseur in America

In:Connoisseur
94:125-9 Aug.,'34 illus.

Incl.note on .Joseph.Wright's Washington
portraits,pp.128-9.".Washington.is known to have
preferred.Wright's portrs..to all others."

Thieme-Becker M40.T43,v.36
p.283.Lit.on Jos.Wright

NE
262
C59
NPG

I.E - INDIVIDUAL SITTERS - WASHINGTON

Clark, Charles Edward
Catalogue of the Dr.Charles E.Clark collec-
tion of American portraiture,including...Washing-
ton portraits...To be sold by auction...Jan15,16
and 17,1901...C.F.Libbie & co.,auctioneers...
Boston,Mass.Press of the Libbie show print,1901.
136 p. illus.

LC NE260.C6 Fogg,v.11,p.327

N
7593.8
D3D34
NPG

2 c.

I.E - INDIVIDUAL SITTERS - WASHINGTON

Delaware. State portrait commission
Cat.of Delaware portraits collected by the
Delaware State portrait comm.in the capitol
buildings.Dover,Del..Delaware portr.comm.,1941
64 p. illus.

Incl.:Index of artists and sitters

Repro.incl.:Washington,by Volosan

920 I
W31B78
NPG

I.E - INDIVIDUAL SITTERS - WASHINGTON

Coffin, William Anderson, 1855-1925
The loan exh.of historical portraits and re-
lics,exh.held at N.Y.,Metropolitan Opera House,
Assembly Rooms, Apr.,17-May 8,1889.

In:Bowen, Clarence Winthrop, 1852-1935, ed.
History of the Centennial celebration of
the Inauguration of George Washington as first
president of the U.S. N.Y.,D.Appleton & Co.,1892
672 p. illus.
p.131-48

List of sitters and artists

705
A7875
NCFA
v.26

I.E - INDIVIDUAL SITTERS - WASHINGTON

Desportes, Ulysse
Giuseppe Ceracchi in America and his busts
of George Washington

In:Art Q.
26:140-78 Summer,'63 illus.

'Over two dozen life portrait busts of Ame-
rica's founding fathers were left in .Florence
by their author Giuseppe Ceracchi...'

I.E - INDIVIDUAL SITTERS - WASHINGTON

Colonial Williamsburg, inc.
They gave us freedom;the American struggle
for life,liberty,and the pursuit of happiness,
as seen in portraits,sculptures,historical
paintings and documents of the period:1761-1789
.Williamsburg,Va.,Colonial Williamsburg and the
College of William & Mary in Va..1951.
65 p. illus(1 in color)

Cat.of the exh..held May-June 1951::p.61-5
Index to artists & subjects

LC E302.5C64 Winterthur Mus.Libr. fZ881
W78 NCFA v.6,p.222

705
A56
NCFA
v.119

I.E - INDIVIDUAL SITTERS - WASHINGTON

Deutsch, Davida Tenenbaum & Betty Ring
Homage to Washington in needlework and
prints

In:Antiques
119:402-17 Feb.,'81 illus(part col.)

Needlework after engravings:Washington Fami-
ly,W.'s resignation,W.crossing the Delaware...

Wick.Geo.Washington...
N7628.W3W5.NPG Bibl.p.173

705
A56
NCFA
v.111

I.E - INDIVIDUAL SITTERS - WASHINGTON

Deutsch, Davida Tenenbaum
 Washington memorial prints

In:Antiques
111:324-31 Feb., '77 illus.

 Bibl.footnotes

N
7628
W31E3
NCFA

I.E - INDIVIDUAL SITTERS - WASHINGTON

Eisen, Gustav, 1847-1940
 Portraits of Washington. New York,R.Hamilton
& associates, 1932

 3 v. illus.

 Bibliography

 Incl.:Ptgs.by Stuart,Peale,etc.,miniatures &
drgs. by Sharples,Saint Ménien,etc.,statues,
busts,reliefs,masks in wax,marble,plaster

LC E312.43.E37

705
A56
NCFA
v.24

I.E - INDIVIDUAL SITTERS - WASHINGTON

Donnell, Edna Bowden, 1891-
 Portraits of eminent Americans after draw-
ings by Du Simitière

In:Antiques
24:17-21 July,1933 illus.

 Repro.incl:Washington on ceramics;enamel
cloak hooks;printed cotton with portr.medal-
lions derived fr. engravings after Du Simitière
 Incl.list of Prévost's,Reading's & B.B.
Ellis' engravings.

705
S94
NCFA

I.E - INDIVIDUAL SITTERS - WASHINGTON

Eisen, Gustav, 1847-1940
 Stuart's three Washingtons

In:Intern.Studio
76:86-94 Feb,1923 illus

I.E - INDIVIDUAL SITTERS - WASHINGTON

Dougls, Susan Harvey
George Washington medals of 1889

In:Numismatist
62:274-83, 344-50, 395-409 May,July,1949

LC CJ1.N8

FOR COMPLETE ENTRY
SEE MAIN CARD

705
A786
NCFA
v.74

I.E - INDIVIDUAL SITTERS - WASHINGTON

Esterow, Milton
 Who painted the George Washington portrait
in the White House?

In:Art News
74:24-8 Feb.'75 illus(part col.)

FOR COMPLETE ENTRY
SEE MAIN CARD

I.E - INDIVIDUAL SITTERS - WASHINGTON

Du Simitière, Pierre Eugène,ca.1736.-1784
 Portraits of the generals,ministers,magis-
trates,members of Congress,and others,who have
rendered themselves illustrious in the revolu-
tion of the United States of North America.
Drawn from the life by M.Dusimitier...and en-
graved by the most eminent artists in London.
London,...Wilkinson and W.Debrett,1782
 2 p. 12 portrs.

 Incl.:Washington, John Jay
'Set was signed B.B.E.'-Donnell

LC E206.D97

N
7628
W31F4
NCFA
R.B.

I.E - INDIVIDUAL SITTERS - WASHINGTON

Fielding, Mantle, 1865-1941
 Gilbert Stuart's portraits of George
Washington...Philadelphia,Printed for the
subscribers,1923
 264 p. illus.

 Incl.:Cat.of 124 portrs.of Washington by
Stuart and one chapter on likenesses of
Gilbert Stuart

LC E312.43.F54 and F541

I.E - INDIVIDUAL SITTERS - WASHINGTON

Du Simitière, Pierre Eugène, ca.1736-1784
 Thirteen portraits of American legislators,
patriots,and soldiers,who distinguished them-
selves in rendering their country independent;
...drawn from the life by Du Simitière...and en-
graved by Mr.B.Reading.London,W.Richardson
1783.
 13 plates

 Incl.:Washington, John Jay

MB NjP MH CtY MiU-C Winterthur Mus.Libr. Z881
 PPL A78 NCFA v.?,p.??6

705
A784
NCFA

I.E - INDIVIDUAL SITTERS - WASHINGTON

Flexner, James Thomas, 1908-
 Early American painting:Stuart's full-lengths
of Washington

In:Art in Amer.
35:329-33 Oct.1947 Illus.

 Realistic vs. representational approach

 Rep.,1945-47*7561

I.E - INDIVIDUAL SITTERS - WASHINGTON

705
A56
NCFA
v.100

Floyd, William Barrow, 1934-
The portraits and paintings at Mount Vernon
from 1754 to 1799. Part I and II

In:Antiques
100:768-74 Nov.,'71 illus(part col.)
:894-99 Dec.,'71 illus.

Repro.incl.:Lafayette,by Chs.W.Peale,1781;
Lawrence Washington;Martha Washington,by Wollas-
ton,1757;John and Martha Parke Custis,by Wollas-
ton,1757;Col.Geo.Washington,by Chs.W.Peale,1772;

VF
Washington

I.E - INDIVIDUAL SITTERS - WASHINGTON

Hart, Charles Henry, 1847-1918
Life portraits of great Americans,George
Washington

In:McClure's Mag.N.Y.& London
8:291-307 Feb.,1897 illus.

Detroit.I.A. N.C.1.P357A
NPG
Sim............A
Bibl...

AP2.M2

705
A56
MMAA
v.129

I.E - INDIVIDUAL SITTERS - WASHINGTON

Garratt, Wendell D.
untitled article on George Washington,

In:Antiques
129:390-1 Feb.,'86 1 illus(col.)

Illus.is det.of G.W.by Gilbert Stuart,17c

I.E - INDIVIDUAL SITTERS - WASHINGTON

Hart, Charles Henry, 1847-1918
Paul Revere's portrait of Washington
4 p.

Reprinted from the proc.of the Mass.hist.
soc,Dec.,1903;Boston,1903,

LC E312.43.H328

Weddell.A mem'l vol.of Va.
hist.portraiture.757.9.W3?
NCFA Bibl. p.435

E
312.43
G87X
NPG

I.E - INDIVIDUAL SITTERS - WASHINGTON

Grolier Club, New York
Exhibition of engraved portraits of Washing-
ton commemorative of the centenary of his death,
on view at the Grolier Club...N.Y.,Dec.14th,
1899 to Jan.6th,1900..N.Y.,The De Vinne Press,.
1899.
51 p.

I.E - INDIVIDUAL SITTERS - WASHINGTON

Hart, Charles Henry, 1847-1918
Peale's original whole-length portrait of
Washington;a plea for exactness in historical
writings.
In:Am hist.ass. Annual report for the year 189c
Washington,1897
1:189-200

LC card div.E172.A60 1896, Weddell.A mem'l vol.of Va.
 v.1 hist.portraiture.757.9.W3?
LC--separate E312.43.H33 NCFA Bibl. p.435

705
A56
NCFA
v.112

I.E - INDIVIDUAL SITTERS - WASHINGTON

Grote, Susy Wetsel
Engravings of George Washington in the
Stanley deForest Scott collection

In:Antiques
112:128-33 July,'77 illus.

I.F - INDIVIDUAL SITTERS - WASHINGTON

Harvard university. William Hayes Fogg art mus
Exhibition:Washington,Lafayette,Franklin
portraits,books,manuscripts,prints...for the
most part from the university.,Cambridge,Fogg
mus.of art,Harvard univ.,1944
53 p. illus.

Feb.22-May 28,1944
Preface...Agnes Mongen and Mary Wads-
worth

LC N5020.C23?

QN
7628
W31H3
NCFA
NPG

I.F - INDIVIDUAL SITTERS - WASHINGTON

Hart, Charles Henry, 1847-1918
Catalogue of the engraved portraits of
Washington...N.Y.,The Grolier club,1904
406 p. illus. ,Grolier club,N.Y. Pub-
lications,no.42,

LC E312.43H32

N
7592
H513
RB
NPG

I.E - INDIVIDUAL SITTERS - WASHINGTON

Henkels, Stanislaus Vincent, 1854-1926
Cat.of the valuable autographic coll. and en-
graved portraits...gathered by...Col.Chs.Colcock
Jones...to be sold Tue.,Wed.,Thurs.,April 24,25,
26,1894.Cat.comp.,and sale conducted by Stan.V.
Henkels,at the book auction rooms of Thos.Birch's
Sons,Philadelphia
148 p. illus.
cat.no.720
16 engravings of Washington
Contains autographic sets of the signers of
the Declaration of Independence,Rulers & Govs.

N
7592
H513
RB
NPG

I.E - INDIVIDUAL SITTERS - WASHINGTON

Henkels, Stanislaus Vincent, 1854-1926
The rare and valuable coll.of portraits
and choice engravings gathered by J.Henry Clay
of Philadelphia embracing the most important
coll.of rare Washington portraits...also rare...
portraits,in line,mezzotint and stipple of emi-
nent Americans,artists,actors,authors,clergy-
men,lawyers,statesmen,etc...to be sold Fri.&
Sat.,Dec.3 & 4,1897,at the book & art auction
rooms of Davis & Harvey,Philadelphia
124 p. illus.
LC Z999 cat.no.799 priced
H505 no.799 Several hundr()eds portrs.of Washington,
p.77-102

B
.W31J7

I.E - INDIVIDUAL SITTERS - WASHINGTON

Johnston, Elizabeth Bryant, 1833-1907
Original portraits of Washington, including
statues,monuments and medals, by ...Boston,J.R.
Osgood and company,1882

257 p. illus.

LC E312.4J73

N
7592
H513
RB
NPG

I.E - INDIVIDUAL SITTERS - WASHINGTON

Henkels, Stanislaus Vincent, 1854-1926
Rare books and engravings illustrative of
national and local history....belonging to the
estate Thos.Donaldson,deceased and Henry S.
Cushing,late of Philadelphia....to be sold
March 14 & 15,1902 at the book auction rooms of
Davis & Harvey,Philadelphia
illus.
Cat.no.877

Incl.:Portr.ptgs,busts,prints of George /
Martha Washington,all presidents
continued on next card

705
A56
NCFA

I.E - INDIVIDUAL SITTERS - WASHINGTON

Kimball, Sidney Fiske, 1888-
Joseph Wright and his portraits of
Washington

In:Antiques
15:377-82 May,'29 illus.

Bibliographical footnotes

Kimball.Life portrs.of Jef-
ferson...N7628/J45/K4,p.49
footnote

705
A5
NCFA
v.8

I.E - INDIVIDUAL SITTERS - WASHINGTON

Hopkins, Waldo
English portraiture in ceramics

In:Am Coll.
8:8-9,20 Sept.'39 illus.

Repre.incl:2 busts of Washington & 2 stand-
ing figs.of Franklin

Winterthur Mus.Libr. fZ881
W78 NCFA v.6,p.220

706.1
.W243
NCFA

I.E - INDIVIDUAL SITTERS - WASHINGTON

King, Edward S.
Stuart's last portrait of Washington, its
history and technique

In:J.Walters Art Gall.
9:81-96 1946 illus.

Rep.,1945-47#7562

705
C75
NCFA

I.E - INDIVIDUAL SITTERS - WASHINGTON

Jackson, Mrs.F.Nevill,1861-
Contemporary silhouette portraits of George
Washington

In:Connoisseur
89:27-34 Jan,1932,I illus.
108 Feb,1932,I illus.(Washington in
shadow)

757
.W72
X939
N
7593
K6X
NPG

I.E - INDIVIDUAL SITTERS - WASHINGTON

Knoedler,M.,& company, New York
Portraits of George Washington and other
18th c. Americans,loan exhibition,sponsored by
the Sons of the American revolution,Feb.23 to
March 4,1939. New York city....1939.
30 p. illus.

N
40.1
T86J2
NPG

I.E - INDIVIDUAL SITTERS - WASHINGTON

Jaffe, Irma B.
John Trumbull,patriot-artist of the Ameri-
can Revolution.Boston,N.Y.,Graphic Society,
1975
346 p. illus(part col.)

Incl.:Index
Bibliography

Incl.:Cat.of illustrated works by Trumbull
Ch.1:Portrait(3 portrs.of Washington
Carolina Art ass.,Charles-
ton,S.C. Miniature portr.
col)
Bibl.p.179

927.5
.S44K74

I.E. - INDIVIDUAL SITTERS - WASHINGTON

Knox, Katharine(McCook)
The Sharples, their portraits of George
Washington & his contemporaries;a diary & an
account of the life & work of James Sharples &
his family in England and America...New Haven...
London,H.Milford...,1930
133 p. illus.

LC ND497.S445K6

I.E - INDIVIDUAL SITTERS - WASHINGTON

&Lamb, Martha Joanna Read(Nash),1829-1893
...Unpublished Washington portraits

In:Mag.Am.Hist.
19,no.4:273-85 Apr.,'88 illus.

Some of the early artists

Reprint fr.Magaz.
LC E312.43L25
LC E171.M181

Levis.Descr.bibl.Z5947.93
L66 p.203

I.E - INDIVIDUAL SITTERS - WASHINGTON

AP
1
AG4
NCFA
v.1

Mahey, John A.
The studio of Rembrandt Peale

In:Am Art J
1:20-40 Fall,'69 illus.

Incl.:List of ptgs.,drags.,prints,etc.com-
prising the contents of R.P.'s studio at the
time of his death.

Penn.Hist.Soc. Rembrandt
Peale...Bibl.,p.118

I.E - INDIVIDUAL SITTERS - WASHINGTON

705
A56
NMAA
v.129

Laughon, Helen and Mel
Shadow portraits of George Washington

In:Antiques
129:402-9 Feb.,'86 illus.

I.E - INDIVIDUAL SITTERS - WASHINGTON

Mitchell, James Tyndale, 1834-1915
...Collection of engraved portraits of Wa-
shington belonging to Hon.James T.Mitchell...
Cat.comp. & sale conducted by Stan.V.Henkels at
the art auction rooms of Davis & Harvey,Phila.,Pa
s...,1906.
 2 pts. illus.
 Cat.no.944,pt.I-II

v1. ...to be sold Jan.18 & 19,1906.-v.2...to
be sold May 3, 1906

LC E312.43.M68

I.E - INDIVIDUAL SITTERS - WASHINGTON

N
7593
L4X
NPG

Lewis, John Frederick, 1860-1932
 Coll.of John Frederick Lewis:American por-
traits,presented to the Pennsylvania academy of
fine arts and other institutions.Phila.&The Penn-
sylvania academy of fine arts,1934
 112 p. illus.

 Exh.of American portrs:Coll.J.F.Lewis,Apr.15-
May 6,1934.Cat.& foreword by Mantle Fielding
'Incl.portrs.of Washington by Rembrandt Peale,
Rbt.Street,K.H.Schmolze,John Trumbull.Washington
family by Edw.Savage.Martha W. by J.Wollaston.'-
Art Digest 8:18, May 1,'34

LC N7593.L4

I.E - INDIVIDUAL SITTERS - WASHINGTON

qND
205
W52C
NCFA

Moos, R.Peter
 Colonial art.in The Genius of American paint-
ing.N.Y.,Morrow,1973,
 p.26-79 illus(part col.)

 Repro.incl.:Washington at Verplanck's Point,
1794,by Trumbull;at Princeton,by Chs.Willson
Peale;the Lansdowne portr.,1796,by Gilbert Stuart

I.E - INDIVIDUAL SITTERS - WASHINGTON

Maggs Bros., London
 Choice engravings of American historical im-
portance(Portraits of famous American and Bri-
tish officers,statesmen and others connected
with the war of Independence)Rare political car-
toons,emblems....Washington portraits.Selected
from the stock of Maggs Bros...London,1909
 23 p. illus.

 At head of title:No.249 237 items

CSmH
Levis.Descr.bibl.Z5947.A3
L66 1974 NCFA p.212"Parti-
cularly interesting list"

I.E - INDIVIDUAL SITTERS - WASHINGTON

Morgan, John Hill, 1870-1945
 Joseph Wright

In.his.The life portraits of Washington and their
replicas...Mantle Fielding(joint author)...

 pp.69-75 illus.

LC N7628.W3M6
Groce-Wallace,N6536.N53
Ref.,p.705

I.E - INDIVIDUAL SITTERS - WASHINGTON

705.
A56
NCFA
v.97

Mahey, John A.
 Lithographs by Rembrandt Peale

In:Antiques
97:236-42 Feb.,'70 illus.

 Repro.incl.:Washington,Lord Byron

Penn.Hist.Soc. Rembrandt
Peale...Bibl.p.118

I.E - INDIVIDUAL SITTERS - WASHINGTON

B
.W31M8

Morgan, John Hill, 1870-
 The life portraits of Washington and their
replicas...Mantle Fielding(joint author).Phila-
delphia,printed for the subscribers...&1931.

 432 p. illus.

 Catalogue of original ptgs.& their replicas
 Biographies of the artists

LC N7628.W3M6

705
A56
NCFA
v.33

I.E - INDIVIDUAL SITTERS - WASHINGTON

Morgan, John Hill, 1870-1945
 Rembrandt Peale's life portrait of Washington

In:Antiques
33:70-2 Feb.,'38 illus.

Penn.Hist.Soc. Rembrandt
Peale...Bibl.,p.119

I.E - INDIVIDUAL SITTERS - WASHINGTON

Original portraits of Washington

In:Putnam's monthly
:336-49 Oct.6,1855

LC AP2.P97

Thistlethwaite.Image of Geo
Washington mfm205NPG p.356

B
.W31
M84

I.E - INDIVIDUAL SITTERS - WASHINGTON

Morgan, John Hill, 1870-
 Two early portraits of George Washington,
painted by Charles Willson Peale...Princeton,
N.J.:Univ.Press,1927
 29 p. illus.

 "The Wilson-Munn portrait",1779 and
"The Princeton portrait",1784,both at Princeton
university

LC ND237.P27M6

Weddell.A mem'l vol.of Va.
hist.portraiture.757.9.W38
NCFA Bibl. p.437

705
C75
NCFA

I.E - INDIVIDUAL SITTERS - WASHINGTON

Pape, T.
 The Washington coat of arms

In:Connoisseur
89:100-7 Feb,1932,I illus.
 :179-82 Mar,1932

Rep.,1932#92

N
7628
W31M9
NPG

I.E - INDIVIDUAL SITTERS - WASHINGTON

Munn, Charles Allen, 1859-1924
 Three types of Washington portraits:John
Trumbull,Charles Willson Peale,Gilbert Stuart..
N.Y.,Priv.print.The Gillis press,1908
 66p. illus.
 Munn aims to preserve in this book the his-
tory and the pedigree of three portrs.of Wash.,
which are beyond dispute.Authenticity of the
identity & genuineness rests partly on these
 of the portrs.
records.

LC E312.43.M96

Weddell.A mem'l vol.of Va.
hist.portaiture.757.9.W38
NCFA Bibl. p.437

708.1
C62
NCFA
v.7-8

I.E - INDIVIDUAL SITTERS - WASHINGTON

Park,Lawrence,1873-1924
 Joseph Wright's portrait of Washington

In:Cleveland Mus Bul
8:91-2 Jun-Jul,'21 illus.

ND
1311.8
I PN27
NPG

I.E - INDIVIDUAL SITTERS - WASHINGTON

National Society of the Colonial Dames of America.
 Iowa
 Portraits in Iowa;portraits of Americans,
made before 1900 and now located in Iowa.Limited
ed..s.l.:National Soc.of the Col.Dames of Ameri-
cs in the State of Iowa,1975
 171 p. illus.

 Incl.:Index by artist. Washington by
Gilbert Stuart;by Jane Stuart;reversed ptg.on
glass by unknown artist. All forms of original.
one-of-a-kind portraiture. Portrs.drawn or ptd.
over photographs.

N
7628
W31R2
NPG

I.E - INDIVIDUAL SITTERS - WASHINGTON

Raymond, Wayte, 1886-1956 comp.
 ...The early medals of Washington...N.Y.,
c.1941.
 16 p. illus. (The coin collector series
no.4)
 On cover:1776-1834

 Bibliography

LC E312.43.R3

I.E - INDIVIDUAL SITTERS - WASHINGTON

Original busts and portraits of Washington

In:Atlantic mag.
1 Oct.,1824

LC AP1.A79

Penn.Hist.Soc. Rembrandt
Peale...Bibl.p.119

705
C75
NCFA
v.44

I.E. - INDIVIDUAL SITTERS - WASHINGTON

Rhead, George Woolliscroft, 1854-1920
 Naval and military heroes in English pot-
tery

In:Connoisseur
44:183-93 Apr.,'16 illus.

 Repro.Incl.2 busts of Washington

Winterthur Mus.Libr. f2881
W78 NCFA v.6,p.221

I.E - INDIVIDUAL SITTERS - WASHINGTON

ND
207
H46
1986X
NMAA

Richardson, Edgar P.reston,1902-1985.
American paintings and related pictures
in the Henry Francis du Pont Winterthur Mus.
Charlottesville,Univ.Press of Va.,1986
157 p. illus(col.)

Bibliography:p.153-7

Partial contents:Ch.1:The Family Connec-
tion;-Ch.2:The Am.School to 1776.-Ch.3:The Am.
School from 1776
Repro.incl.:Washington Family by Edw.Savage.
Washington by Trumbull,Kemmelmeyer,Stuart

I.E - INDIVIDUAL SITTERS - WASHINGTON

N
40.1
R1695
NPG

Sherman, Frederik Fairchild, 1874-1940
John Ramage;a biographical sketch and list
of his portrait miniatures...N.Y.,Priv.print,
1929
25 p. illus.

Incl.:3 portrs.of Washington

LC ND1337.U6R37

I.E - INDIVIDUAL SITTERS - WASHINGTON

705
A5
NCFA
v.17

Rutledge, Anna Wells
Henry Bounetheau(1757-1877)Charleston,S.C.
miniaturist

In:Am Coll
17,no.6:12-15,23 July,'48 illus.

Incl.:List of B.'s miniatures & oil ptgs.

Incl.:List of works of Mrs.Bounetheau which
incl.Geo.Washington,oil

LC NK1125.A15 Carolina Art ass..Charles-
 on,S.C.Miniature portr.col.
 Bibl.p.179

I.E - INDIVIDUAL SITTERS - WASHINGTON

qN
40.1
P74835
NCFA

Simmons, Linda Crocker
Charles Peale Polk,1776-1822.A Limner and
his likenesses...Washington,D.C.Corcoran Galle-
ry of Art,1981
92 p. illus(part col.)

Cat.of exh.at the Corcoran Gallery of Art,
July 18-Sept.6,1981,and at four other museums,
Sept.27,1981-Oct.15,1982
Bibliography
Incl.Bibl.references & index
Alphabetical list of sitters

I.E - INDIVIDUAL SITTERS - WASHINGTON

67
275
W3133
NPG

Schwartz, Barry,1938-
George Washington.The making of an American
symbol.N.Y.,The Free Press,London,Collier Mcl-
lan Publ.,c.1987
250 p. illus.

Index
bibliography,p.209-42

Incl.:Ptgs.,coins,engravings

LC E312.S39 1987

I.E - INDIVIDUAL SITTERS - WASHINGTON

705
A56
NCFA
v.100

Smith, Robert C.
Finial busts on 18th century Philadelphia
furniture

In:Antiques
100:900-905 Dec.,'71 illus.

Repro.incl.:B.Franklin;John Locke;John Milton;
Washington
'...study of all this furniture...could well
reveal ..resemblances linking it with the shop
of Benjamin Randolph.Saunders.Am.colonial portr
 N7593.1.S28,p.74,note 152

708.1
N52
NCFA

I.E - INDIVIDUAL SITTERS - WASHINGTON

Sellers, Charles Coleman, 1903-
Charles Willson Peale's portraits of
Washington

In:Met Mus Bul
9:147-55 Feb.,'51 illus.

P.ptd.7 life portrs.of W. & many replicas.
Portrs.of W.by the Peale family

 Simmons.qN40.1.P74835 NCFA
 Bibl. p.20

705
A56
NMAA
v.135

I.E - INDIVIDUAL SITTERS - WASHINGTON

Stewart, Robert G.
Portraits of George and Martha Washington

In:Antiques
135,no.2:474-9 Feb.,'89 illus(part col.)

Repro.incl.:Washington:bas-relief by Jos.
Wright;miniature by Chs.W.Peale;bust by Houdon;
miniature by Marquise de' Bréhan;portr.by Rbt.E.
Pine;miniature by W.Robertson;portr.by Js.Sharp-
les.Martha W.:miniatures by Chs.W.Peale,Js.Peale,
Rbt,Field;portr.by .Sharples

705
A56
NCFA
v.95

I.E - INDIVIDUAL SITTERS - WASHINGTON

Shadwell, Wendy J.
An attribution for His Excellency and Lady
Washington

In:Antiques
95:240-1 Feb.,'69 illus.

FOR COMPLETE ENTRY
SEE MAIN CARD

AP
1
342
NCFA
v.12

I.E - INDIVIDUAL SITTERS - WASHINGTON

Stuart, Jane, 1812-1888
The Stuart portraits of Washington

In:Scribner's Monthly
12:367-74 July,1876 illus.(1)

The history of St.'s portrs.of W.& Mrs.
Washington after life & copies by Stuart of these.
St.'s 5 whole-lengths of W.& 20 others of dif-
ferent sizes.
Incl.:St.'s list of gentlemen who are to
have copies of the portrs.of the Pres.of the US
 Morgan.G.Stuart & his pupil
 N40.1S93M8 NPG p.29 note 2

708.1
B685S57
NPG
Ref.

I.E - INDIVIDUAL SITTERS - WASHINGTON

Swan, Mabel Munson
The unfinished Washington portraits, in her,
Boston Athenaeum Gallery,1827-1873...1940
Ch.V,p.74-84 illus.

Repro.:Gilbert Stuart's portraits of
Washington and of Martha Washington

qAP
M225
NPG
v.5

I.E - INDIVIDUAL SITTERS - WASHINGTON

Walters, Donald R.
Making faces:aspects of American portrai-
ture

In:Maine Ant.Dig.
5,no.10:1c-4c(pt.1) Nov.,'77 illus.

Pertains to exh.at Abby Aldrich Rockefel-
ler Folk Art Ctr.,Williamsburg,Va.,,Nov.7,-
Dec.4,1977
Repro.incl.:Asahel Powers,Jonathan Adams
Bartlett,Ammi Phillips(attr.),Jos.Whiting,Wm.
M.Prior,Sturtevant J.Hamblen. Portr.of
Washington(artist unidentified)

mfm
205
NPG

I.E - INDIVIDUAL SITTERS - WASHINGTON

Thistlethwaite, Mark Edward
The image of George Washington....Philadel-
phia,University of Pennsylvania,1977

FOR COMPLETE ENTRY
SEE MAIN CARD

F
234
L5W37
1977 X
NMAA

I.E - INDIVIDUAL SITTERS - WASHINGTON

Washington and Lee University, Lexington,Va.
American sculpture in Lexington;selected
examples from public collections;an exh.pre-
sented by Washington and Lee Univ.,Jan.4-21,
1977.Lexington,The Univ.c.1977
47 p. illus.

Bibliography

LC F234.L5W37

N
7628
W31T8

I.E - INDIVIDUAL SITTERS, WASHINGTON

Tuckerman, Henry Theodore, 1813-1871
The character and portraits of Washington..
N.Y.,G.P.Putnam,1859
104 p. illus.

Cont.-Publisher's note.-The character of
Washington.-The portraits of Washington.-Appen-
dix:1.Trumbull's list.-2.Greenough's statue by
A.H.Everett.-3.The Washington coins.-4.Personal
appearance of Washington

LC E312.4T89

Weddell.A mem'l vol.cf Va.
hist.portraiture.757.9.W38
NCFA Bibl. p.439

N
7628
W31W5
NCFA

I.E - INDIVIDUAL SITTERS - WASHINGTON

Whelen, Henry,jr.
...The important collection of engraved por-
traits of Washington belonging to the late Hen-
ry Wheelen,jr.,of Philadelphia...from whose col-
lection the late Wm.S.Baker compiled his...book
..."Engraved portrs.of Washington"...also en-
graved portrs.of Franklin;to be sold...Apr.27,
1909...Cat.comp.and sale conducted by Stan V.
Henkels at...Samuel T.Freeman & co...Philadel-
phia.Phila.,Press of M.H.Power,1909.
102 p. illus.

LC NE320.W245
E312.43.W64

Levis.Descr.bibl.Z5947A3
L66 1974 NCFA p.250
incl.some prices.

CT
275
W31U5
NPG

I.E. - INDIVIDUAL SITTERS - WASHINGTON

U.S. *George Washington bicentennial commission.*
George Washington bicentennial historical loan exhibition
of portraits of George Washington and his associates, also a
collection of Washingtoniana, at the Corcoran gallery of art,
Washington, D. C., March 5 to November 24, 1932; assembled
by the United States George Washington bicentennial commis-
sion, Washington, D. C. [Washington, Govt. print. off., 1932]
66 p. illus. (ports.) 23cm.

1. Washington, George, pres. U. S.—Portraits. t. Corcoran gallery
of art, Washington, D. C. II. Title: Exhibition of portraits of George
Washington.

Library of Congress E312.43.U57
——— Cop 2. [8041] 32—30411

APR 11

R
W31W6

I.E. - INDIVIDUAL SITTERS - WASHINGTON

Whittemore, Frances Dean(Davis), 1857-
George Washington in sculpture.Boston,
Marshall Jones,1933

LC E312.4.W47

FOR COMPLETE ENTRY
SEE MAIN CARD

q ND
205
W35X
NPG
NCFA

I.E - INDIVIDUAL SITTERS - WASHINGTON

Walker, John, 1906-
Great American paintings from Smibert to
Bellows,1729-1924,by J.Walker and Macgill
James...London,N.Y.,etc.,Oxford university
press,1943
36 p. illus(part col.)

Bibliography

Alphabetical list of artists

Repro.incl.:Washington by Gilbert Stuart,
Washington Family by Savage

N7628
W345X
NPG
2 c.

I.E - INDIVIDUAL SITTERS - WASHINGTON

Wick, Wendy C., 1950-
George Washington,an American icon.The 18th
century graphic portraits...with an intro.essay
by Lillian B.Miller.Washington,D.C.,Smiths.Inst
Travelling Exh.Service;NPG,S.I.,1982
186 p. illus. "A Barra Foundation Book"

Bibliography
Incl.:Index
Exh.at NPG:Feb.22-Apr.27,1982

qz
5561
U5A77X
v.4
NCFA Ref.

I.E - INDIVIDUAL SITTERS - WASHINGTON

For additional books and articles see
Arts in America,Index,p.393

N
7593
L4X
NPG

I.E - INDIVIDUAL SITTERS - WASHINGTON FAMILY

Lewis, John Frederick, 1860-1932
Coll.of John Frederick Lewis:American por-
traits,presented to the Pennsylvania academy of
fine arts and other institutions.Phila..The Penn-
sylvania academy of fine arts.1934
112 p. illus.

Exh.of American portrs:Coll.J.F.Lewis,Apr.15-
May 6,1934.Cat.& foreword by Mantle Fielding
'Incl.portrs.of Washington by Rembrandt Peale,
Rbt.Street,K.H.Schmolze,John Trumbull.Washington
family by Edw.Savage.Martha W. by J.Wollaston.'-
Art Digest 8:18, May 1,'34
1E N7593.L4

705
A784
NCFA
v.40

I.E - INDIVIDUAL SITTERS - WASHINGTON FAMILY

Dresser, Louisa.
Edward Savage,1761-1817. Some representa-
tive examples of his work as a painter

In:Art in Am
40:157-212 autumn,'52 illus.

Article written in connection with exh.at
the Worcester Art Museum,Jan.4-March 8,1953

Repro.incl.:Hancock,Washington,Martha Wa-
shington,Washington Family
Gerdts.Ptg.& sculpt.in N.J.
N6530.N5036 NCFA bibl.p.255

ND
1311
N53
c.3
NPG

I.E - INDIVIDUAL SITTERS - WASHINGTON FAMILY

New York. Union League Club
Exh.of portraits by early American por-
trait painters.N.Y..The Union league club
c1923-24.& Century Association,N.Y.c1925-28.
6 v. bound together
Title varies

Exh.dates:Jan.11,12,13,1923. Feb.14,15 and
21,22,1924. March 12,13,1924. Shown at Century
Ass'n N.Y.:Nov.7-29,1925. Nov.6-28,1926. Jan.14-
Feb.2,1928

Exh.Feb.'24:Repro. Washington Family by Savage

705
A56
NCFA
v.100

I.E - INDIVIDUAL SITTERS - WASHINGTON FAMILY

Floyd, William Barrow, 1934-
The portraits and paintings at Mount Vernon
from 1754 to 1799. Part I and II

In:Antiques
100:768-74 Nov.,'71 illus(part col.)
:894-99 Dec.,'71 illus.

Repro.incl.:Lafayette,by Chs.W.Peale,1781;
Lawrence Washington;Martha Washington,by Wollas-
ton,1757;John and Martha Parke Custis,by Wollaston,
1757;Col.Geo.Washington, by Chs.W.Peale,1772;

ND
207
H46
1986X
NMAA

I.E - INDIVIDUAL SITTERS - WASHINGTON FAMILY

Richardson, Edgar P.reston,1902-1985.
American paintings and related pictures
in the Henry Francis du Pont Winterthur Mus.
Charlottesville,Univ.Press of Va.,1986
157 p. illus(col.)

Bibliography:p.153-7

Partial contents:Ch.1:The Family Connec-
tion;-Ch.2:The Am.School to 1776.-Ch.3:The Am.
School from 1776
Repro.incl.:Washington Family by Edw.Savage.
Washington by Trumbull,Kemmelmeyer,Stuart

I.E - INDIVIDUAL SITTERS - WASHINGTON FAMILY

Hart, Charles Henry, 1847-1918
Original portraits of Washington,Including
hitherto unpublished portraits of General and
Mrs.Washington and Nelly Custis

In:Century Mag
43:593-99 illus. Feb.,'92

LC AP2.C4

CT
275
W31W2

I.E - INDIVIDUAL SITTERS - WASHINGTON FAMILY

Walter, James
Memorials of Washington and of Mary...,and
Martha...from letters and papers of Rbt.Cary
and Js.Sharples...portraits by Sharples.and.
Middleton.N.Y.,C.Scribner's sons,1887
362 p. illus.

NPG copy contains reprint of Boston Post,
Feb.,2,1887 & clippings:Letters by Wash.,Bryant,
Longfellow,Hawthorne,etc.,quoted by Walter de-
clared spurious'

Weddell.A mem'l vol.of Va.
hist.portraiture.757.9.W39
NCFA Bibl. p.439

AP
1
H62
NCFA
v.26-27

I.E - INDIVIDUAL SITTERS - WASHINGTON FAMILY

Landau, Ellen G.
Study in National Trust Portraits

In:Historic Preservation
27,no.2:30-7 Apr.-June,'75 illus(part col.)

Repro.incl.:Washington's Family by Savage
Development of Amer.portraiture:Simple,aus-
tere in the 17th c.;idealized,elegant early
18th c.;neo-classical style,revelation of the
inner life,early 19th c.;return to exactitude
to rival with photography in the 1840's-50's;
(see over)
Rila III/2 1977 *5606

q ND
205
W35X
NPG
NCFA

I.E - INDIVIDUAL SITTERS - WASHINGTON FAMILY

Walker, John, 1906-
Great American paintings from Smibert to
Bellows,1729-1924,by J.Walker and Macgill
James...London,N.Y..etc.Oxford university
press,1943
36 p. illus(part col.)

Bibliography

Alphabetical list of artists

Repro.incl.:Washington by Gilbert Stuart,
Washington Family bySavage

ND
1311.8
V8W31
NCFA

I.E - INDIVIDUAL SITTERS - WASHINGTON FAMILY

Washington and Lee University, Lexington, Va.
Washington-Custis-Lee family portraits from
the coll.of Washington & Lee univ.,Lexington,
Va.,circulated by the International Exhibitions
Foundation,1974-1976.Intro.by Alfred Franken-
stein.Washington,D.C.,International Exh.Found'n,
c.1974
[10,p. illus(1col.)

17 portrs.,representing 6 generations of
men & women in the Washington,Custis and Lee
families
Rila I/1-2 1975 #1365

705
A56
NCFA
v.95

I.E - INDIVIDUAL SITTERS - WASHINGTON, MARTHA
[DANDRIDGE CUSTIS
Shadwell, Wendy J.
An attribution for His Excellency and Lady
Washington

In:Antiques
95:240-1 Feb.,'69 illus.

FOR COMPLETE ENTRY
SEE MAIN CARD

705
215
NCFA
v.75

I.E - INDIVIDUAL SITTERS - WASHINGTON, LAWRENCE,
Roberts, W,illiam, 1862-1940. [OF GARSDON
The earliest Washington portrait:Lawrence
Washington of Garsdon

In:Connoisseur
75:67-71 June,'26 illus.

Lawrence Washington,c.1622-1661.Portr.bears
the Washington arms.The stars & stripes of the
U.S.flag might have developed from the W.Arms.
Portr. attr.to Cornelius Johnson

705
A56
NMAA
v.135

I.E - INDIVIDUAL SITTERS - WASHINGTON,MARTHA DAN-
DRIDGE CUSTIS
Stewart, Robert G.
Portraits of George and Martha Washington

In:Antiques
135,no.2:474-9 Feb.,'89 illus(part col.)

Repro.incl.:Washington:bas-relief by Jos.
Wright;miniature by Chs.W.Peale;bust by Houdon;
miniature by Marquise de Bréhan;portr.by Rbt.E.
Pine;miniature by W.Robertson;portr.by Js.Sharp-
les.Martha W.:miniatures by Chs.W.Peale,Js.Peale,
Rbt,Field;portr.by [..Sharples

705
A56
NCFA
v.100

I.E - INDIVIDUAL SITTERS - WASHINGTON,MARTHA
[DANDRIDGE CUSTIS
Floyd, William Barrow, 1934-
The portraits and paintings at Mount Vernon
from 1754 to 1799. Part I and II

In:Antiques
100:768-74 Nov.,'71 illus(part col.)
:894-99 Dec.,'71 illus.

Repro.incl.:Lafayette,by Chs.W.Peale,1781;
Lawrence Washington;Martha Washington,by Wollas-
ton,1757;John and Martha Parke Custis,by Wollas-
ton,1757;Col.Geo.Washington,by Chs.W.Peale,1772;

708.1
F685S97
NPG
Ref.

I.E - INDIVIDUAL SITTERS - WASHINGTON, MARTHA
[DANDRIDGE CUSTIS
Swan, Mabel Munson
The unfinished Washington portraits,in her,
Boston Athenaeum Gallery,1827-1873...1940
Ch.V,p.74-84 illus.

Repro.:Gilbert Stuart's portraits of
Washington and of Martha Washington

N
7593
L4X
NPG

I.E - INDIVIDUAL SITTERS - WASHINGTON,MARTHA DAN-
[DRIDGE CUSTIS
Lewis, John Frederick, 1860-1932
Coll.of John Frederick Lewis:American por-
traits,presented to the Pennsylvania academy of
fine arts and other institutions.Phila.,The Penn-
sylvania academy of fine arts.1934
112 p. illus.

Exh.of American portrs:Coll.J.F.Lewis,Apr.15-
May 6,1934.Cat.& foreword by Mantle Fielding
'Incl.portrs.of Washington by Rembrandt Peale,
Rbt.Street,K.H.Schmolze,John Trumbull.Washington
family by Edw.Savage.Martha W. by J.Wollaston.'-
Art Digest 8:18, May 1,'34
LC N7593.L4

AP
1
A51
A64
NMAA
v.15

I.E - INDIVIDUAL SITTERS - WAYNE, ANTHONY,1745-
[1796
Meschutt, David
Portraits of Anthony Wayne:Re-identifica-
tions and re-attributions

In:Am Art J
15:32-42 Spring,'83 illus.

Repro.incl.:Edw.Savage,Geo.Graham after
J.P.H.Elouis,Jean Pierre Henri Elouis,Js.Sharp-
les,Chs.W.Peale,Felix Sharples,Js.Peale

AP
1
C716
NPG

I.E - INDIVIDUAL SITTERS - WASHINGTON,MARTHA DAN-
[DRIDGE CUSTIS
Longsworth, Polly
Portrait of Martha,Belle of New Kent

In:Col.Williamsburg
10,no.4:4-11 Summer,'88 illus(col.)

Incl.:Wollaston,Chs.Wm.Peale

A biography

CT
275
W36N4
NPG

I.E - INDIVIDUAL SITTERS - WAYNE, ANTHONY,
[1745-1796
Nelson, Paul David, 1941-
Anthony Wayne,soldier of the early Repub-
lic.Bloomington.Ind.Univ.Press,c.1985
368 p. illus.

Bibl.p.341-57

Repro.incl.:Edward Savage,John Trumbull,
Js.Peale,Chs.Willson Peale,[.R.Lambdin,Alonzo
Chappel,Js.Sharples,Henri Elouis

N.
7628
W37B2
NPG
c.1-2

I.E - INDIVIDUAL SITTERS - WEBSTER, DANIEL, 1782-
.1852

Barber, James, 1952-
The godlike Black Dan;a selection of por-
traits from life in commemoration of the 200th
anniv.of the birth of Daniel Webster;an exh.at
the NPG,June 4-Nov.28,1982;by Js.Barber & Fre-
derick Voss;F.S.Wein,ed. Washington,Publ.for
the NPG by the Smiths.Press,1982
48 p. illus.

LC E340.W4B25

AP
1
H63
NPG

I.E - INDIVIDUAL SITTERS - WENTWORTH

Purvis, Doris F.
The Joseph Blackburn portraits of Lieute-
nant-Governor John Wentworth and Governor
Benning Wentworth

In:Hist New Hampshire
24,no.3:34-9 Fall,'69 illus.

Full standing patgs.from 1760 in the
New Hampshire Historical Society

I.E - INDIVIDUAL SITTERS - WEBSTER, DANIEL,
.1782-1852

Hart, Charles Henry, 1847-1918
Life portraits of great Americans...Daniel
Webster

In:McClure's Mag.N.Y.& London
9:619-30 May,1897

LC AP2.M2 Pfister.Facing the light
 TR680.P47X NPG p.373

705
C75
NCFA

I.E - INDIVIDUAL SITTERS - WESLEY, JOHN, 1703-91

Sargisson, C.S.
John Wesley busts in Staffordshire pottery

In:Conn.
19:11-7 Sep.,'07 illus.

Busts by Enoch Wood

AP
1
W225
NCFA

I.E - INDIVIDUAL SITTERS - WEDGWOOD, JOSIAH,
.1730-1795

Dibdin, Edward Rimbault, 1853-1941
Liverpool art and artists in the 18th cen-
tury

In:Walpole Soc.
6:59-91 1918 illus.

Repro.incl.Josiah Wedgwood on horseback

I.E - INDIVIDUAL SITTERS - WETTIN, HOUSE OF

Sponsel, Jean Louis, 1858-1930, comp.
Fürsten-bildnisse aus dem hause Wettin...
Dresden,W.Baensch,1906

MET
276.2
Sp.6

 FOR COMPLETE ENTRY
 SEE MAIN CARD

I.E - INDIVIDUAL SITTERS - WELLINGTON, ARTHUR
WELLESLEY, 1st DUKE OF, 1769-1852

Wellesley, Gerald, 1885- (& Steegmann,John)
The iconography of the first Duke of Welling-
ton. London, J.M.Dent & sons,ltd.,.1935.
87 p. illus(part col.)

LC DA68.12.W4W4

708.9492
A523
NMAA
v.36

I.E - INDIVIDUAL SITTERS - WILLIAM IV, 1711-1751

Schaffers-Bodenhausen, Karen E.
Een miniatuurportret van Willem IV,geschil-
derd door Jean-Etienne Liotard

In:B.Rijksmus.
36,no.3:211-15 1988 illus.(1 col.on cover)

Summary in English,p.271-2

705
W875
NCFA
v.25

I.E - INDIVIDUAL SITTERS - WENDELL FAMILY

MacFarlane, Janet R.
The Wendell family portraits

In:Art Q
25:385-88 Winter,'62 illus.p.384,369-92

Incl.:Checklist of Wendell portrs.before
1740

 Black.In:Am Art J AP1.A51
 A64 NMAA v.12:5 footnote 2

708.9492
A523
NMAA
v.26

I.E - INDIVIDUAL SITTERS - WILLIAM V,1748-1806,
and FAMILY

Tiethoff-Spliethoff, M.E.
De miniatuurschilder Pierre Le Sage en het
hof van Prins Willem V

In:B.Rijksmus.
36,no.3:216-24 illus.

Summary in English, p.272-3

I.E - INDIVIDUAL SITTERS - WINCKELMANN, JOHANN
JOACHIM, 1717-1768
Thiersch, Hermann, 1874-1939
Winckelmann und seine bildnisse;...München,
Beck,1918

FOGG
FA307.4.8

**FOR COMPLETE ENTRY
SEE MAIN CARD**

N
7628
W92B6
NPG

I.E - INDIVIDUAL SITTERS - WORDSWORTH, William,
1770-1850
Blanshard, Frances Margaret(Bradshaw) 1895-
Portraits of Wordsworth. London,G.Allen &
Unwin,1959.
208 p. illus.

Bibliography
Incl.brief account of portraiture in the 1st
half of the 19th c. & the taste of the period

LC PR5885.B55

DA
28.1
0 7X
NPG
2 c.

I.E - INDIVIDUAL SITTERS - WINDSOR FAMILY

London. National Portrait Gallery
The house of Windsor;by Richard Ormond.
London,H.M.stationery office,1967
[20]p. illus(part col.) (Its Kings and
Queens series:1838-1966)

Winterthur Mus.Library
fZ881.W78 NCFA v.6,p.228

fP
1
W225
NCFA
V.8

I.E - INDIVIDUAL SITTERS - WRIOTHESLEY FAMILY

Goulding, Richard William, 1868-1929
Wriothesley portraits

In:Walpole Soc.
8:17-94 1919-20 illus.

Repro.incl.:S.Tovey,Eworth,H.Bone,D.Mytens,P.Oli-
ver,S.Passe,J.Hoskins,S.Cooper,v.Dyck,Lely,Coch-
ran,G.Sykes,Harding,C.Boit,Kneller,Vanderbank,
I.Beckett

I.E - INDIVIDUAL SITTERS - WINSLOW FAMILY
Bowdoin College. Museum of Fine Arts
The Winslows:pilgrims,patrons,and portraits
a joint exhib.at Bowdoin Coll...and the Mus.of
Fine Arts,Boston....Brunswick,Me.:Bowdoin Col-
lege,1974.
40 p. illus.

Bibliographical references

LC ND1311.1B68 1974

Individual sitters

For other references to portraiture of indi-
viduals, see section on "Iconographie Histo-
rique" in each vol. of Répertoire d'art et d'ar-
chéologie. Entries are arranged in alphabetical
order with names of individuals set off in bold
type.

CT
275
W79M4
NPG

I.E - INDIVIDUAL SITTERS - WINTHROP FAMILY

Mayo, Lawrence Shaw, 1888-1947
The Winthrop family in America.Boston,Mass.
Historical Society,1948
507 p. illus.

Bibliographies.
Follows nine generations of the Winthrop
family,starting with John,1583-1649;Governor
of Mass.Bay

LC CS71.W79 1948

Dresser.Backgr.of Col'l
Amer.portraiture.ND1311.1
D77 NPG p.33(footnote)

705
B97
NCFA
v.119

I.F - LIGHTING IN PORTRAITURE

Bury, John
The use of candle-light for portrait paint-
ing in sixteenth-century Italy

In:Burl.Mag
119:434-7 June,'77

Refers to Francisco de Holanda's treatise
'Do tirar polo Natural',where is stated the
customary use of candle-light for portrs.by
Italian ptrs.in the 16th c.
Do tirar polo natural=On taking portraits
from life

N
7628
W65W3
1930
NMAA

I.E - INDIVIDUAL SITTERS - WOLFE, JAMES, 1727-1759

Webster, John Clarence, 1863-
Wolfe and the artists.A study of his portrai-
ture.Toronto,The Ryerson Press,1930
74 p. illus(part col.)

For artists'names see
main card

I.E - MASONS

Freemasons. England. United grand lodge.
Library and museum
Cat.of portraits and prints at Freemason's
hall in the possession of the United grand
lodge of England,comp.and arranged by Major Sir
Algernon Tudor-Craig...1938.London,The United
grand lodge of England.1938.
119 p. illus(1 col.)

LC N1165.F7A53

Winterthur Mus.Library
Z881.W78 NCFA v.6,p.227

I.E - MEN

Galerie Charpentier, Paris
Cent portraits d'hommes du 14e siècle à nos
jours. Paris, 1952

MET
107.4
O137
cno.50.
Pamphlet box

Enc.of World Art,v.11
31E56 Ref.col.513
Bibl.on portr.

I.E - MEN - GERMANY

Deutsche männer. 200 bildnisse und lebensbe-
schreibungen. Berlin,Steiniger,1938

424 p. illus.

Intro.Wilhelm Schüssler. Each illus. faces a
1-page biogr. note. From Gutenberg to von Richt-
hofen

LC DD85.D48 Rep.,1938*572bis

AP1
A64
NCFA
v.58

I.E - MEN

Godfrey, F.M.
Male portraits of the Venetian school

In:Apollo
58:96-7 Oct.,1953 illus.

In 5 youthful heads,here under discussion,the
way of Venet.portr.is curiously summarised.From
flat drawg.to sculpt.modelling;poetical fervor &
idealisation added later.Venet.portr.more uniform
than Florentine or Roman,but with some particular
human traits.
 Enc.of World Art
 M31E56Ref.,v.11,col.513
 bibl.on portr.

I.E - MUMMIES

Drerup, Heinrich
Die datierung der mumien-porträts...Pader-
born,F.Schöningh,1933
66 p. illus (Added t.-p.:Studien
zur geschichte und kultur des altertums,XIX.bd.
1.hft.)

Gekrönte preisschrift der Universität Bonn
Study of mummy portrs.fr.the time of
Augustus to the middle of the 4th c.

Bibliography
LC ND1327.E3D7 Fogg,v.11,p.321

I.E - MEN

Madrid. Museo Nacional de Pintura y Escultura
Retratos de hombres célebres del Museo del
Prado.Madrid,Fernando Fé,1929.
c4ep. 60 pl. (Los grandes maestros de
la pintura en España,7)

MET
156.1
M26
P991

I.E - MUMMIES

Edgar, Campbell Cowan
On the dating of the Fayum portraits

In:J Hell Stud
25:225 ff. 1905

LC DF10.J8 Richter,O. Portrs.of the
 Greeks N7586R53,v.3,p.296

I.E - MEN

Massachusetts Historical Society, Boston
Portraits of men, 1670-1936. Boston,1955
c32ep. illus. (A Massachusetts Histori-
cal Society picture book)

FOGG
4253
M41
1955

MiD Vi MH MHU
IHi etc. Fogg,v.11.,p.328

I.E - MUMMIES

Ehlich, Werner.
Vom hellenistischen mumienporträt zum
christlichen heiligenbild

In:Helikon
8:370-9 1968

NM 708.1.R471,p.7.Winkes.Mum-
 my portrs.In:Rh.InlSch.of
 Des. B.59

I.E - MEN - ANTIQUITY - ROME

Daltrop, Georg
Die stadtrömischen männlichen privatbild-
nisse trajanischer und hadrianischer zeit.
Münster,1958
131 p. illus.

Thesis - Münster, 1958
Bibl.ref.

LC NB115.D3 1958 Kraus.Das römische welt-
 reich N5760.K92 Bibl.316

I.E - MUMMIES

Forrer,cRobert, 1866-.
Un portrait de momie inconnu d'Achmim-Pano-
polis

Met In:Pro Arte
100.53 5:175-9 1946 illus.
P942
 An encaustic portr.of a young man,1st c.A.D.
 A look at "hellenistic"mummy-portrs;the first
found in Fayum,1887. Mummy portrs.from 1st to
4th c. or even later,first in encaustic,later in
distemper
 Rep.,1948-49*3336

I.E - MUMMIES

Grimm, Günter.
Thebanische Mumien porträts?

In:Arch.Anz.
86:246-52 1971

LC DE 1.A6

708.1.R471,p.7.Winkes.Mum
portrs.In:Rh.Isl.Sch.of
Des.B. 59,Jan73

I.E - MUMMIES

Thompson, David L.
Mummy portraits in the J.Paul Getty mu-
seum.2nd ed..Malibu,Calif.,The Museum,c.1982
70 p. illus(part col.)

Rev.ed.of:The artists of the mummy portrs.
c.1976 with new material added
Cat.p.31-63
Index

LC ND1327.E3T48 1982

I.E - MUMMIES

Paris. Musée national du Louvre
Les portraits romano-égyptiens du Louvre;
contribution à l'étude de la peinture dans
l'antiquité,par E.Coche de la Ferté...Paris,
Éditions des Musées nationaux,1952
31 p. illus(part col.)

Bibliographical references

"Rapport sommaire sur l'examen chimique
de 4 peintures romano-égyptiennes...p.23"

LC ND1327.E3P3

Richter,G.Portrs of the
Greeks N7586R53,v.3,p.295

708.1
R471
NCFA

I.E - MUMMIES

Winkes, Rudolf
Mummy portraits

In:Rh.Isl.Sch.of Des.B.
59,no.4:4-15 Jan.,'73 illus.

A.I.Nov.'73-Oct.'74,p.818

I.E - MUMMIES

Parlasca, Klaus
Mumienporträts und verwandte denkmäler..Hrsg:.
Deutsches arch.inst. Wiesbaden,Steiner,1966
294 p. illus(part col.)

Bibliography

LC DT62.M7P3

AP
1
A64
NCFA
v.79

I.E - MUMMIES

Zaloscer, Hilde
Mummy-portrait:An interpretation

In:Apollo
79:101-7 Feb,'64 illus.
Bibliographical footnotes

The author considers stylistic reasons or
the prohibition in the decalogue of sculptured
representation of nature as possible causes for
the change....

Praeger.Enc.of Art,v.2,
p.672 Fayum portrs. Bibl.

I.E - MUMMIES

Pavlov, Vsevolod Vladimirovich
Egipetskii portret I-IV vekov. Moskva,
Iskusstvo,1967
86 p. illus(part col.) (Iz istorii
mirovogo iskusstva)

English summary

Bibliography

LC ND1327.E3P33

Fogg,v.11,p.319

I.E - MUMMIES

Zaloscer, Hilde
Porträts aus dem Wüstensand.Mumienbildnisse
aus der oase Fayum.Vienna,München,Schroll,1961
66 p. illus(part col.) (Neue Sammlung
Schroll,I)

FOGG
3718
Z22

Praeger.Enc.of art.N33P89
NCFA Ref.,v.2,p.672:Fayum
portrs. Bibl.

708.1
R47b
NCFA

I.E - MUMMIES

Rowe, L.Earle
Graeco-Egyptian portraits

In:Rh.Isl.Sch.of Des. B.
5,no.4:26-7 Oct.,'17 illus.

708.1.R471,p.9
Winkes.mummy portrs.
In:Rh.Isl.Sch.of Des. B.59

I.E - MUMMIES

Zaloscer, Hilde
Von mumienbildnis zur ikone.Wiesbaden,
O.Harrassowitz,1969
85 p. illus(part col.)

Bibliography

LC N8187.5.Z3

I.E - OBJECT PORTRAITS
(abstract compositions,chiefly 20th c.)

I.E.-.OLD AGE

Günther, Herbert, 1906-
 Greise,ein bildbuch...erläuternde bild-
texte von Anni Wagner.München,K.Desch,1948.
 60 p. 48 pl. (Das Antlitz des Menschen,
Bd.8)

LC N8234.G408 Die 20er jahre im portr.
 N6868.5.E9Z97 NPG,p.140

705
A787
NCFA

I.E - OBJECT PORTRAITS - 20th c.

Agee, William C.
 New York Dada

In:Art N Annual
34:105-13 1968 illus(part col.)

I.E - ORIGAMI

Kenneway, Eric
 Folding faces.Making portraits in paper.
N.Y.& London,Paddington Press,ltd.,1978
 96 p. illus.

 Bibliography

LC TT670.K43 Cumulative Book index
 Z1219.C97 NPG Ref. 1978
 p.1373

N
7592.6
C72
NPG

I.E - OBJECT PORTRAITS - 20th c.

Columbia University. Dept.of Art History and
Archaeology
 Modern portraits.The self and others...
1976

 Exhibition...at Wildenstein,N.Y.,Oct.20-
Nov.28,1976

I.E - POSTAGE-STAMPS - U.S.

Thompson, Edmund Burke, 1897-
 Portraits on our post-ge stamps;some notes
on the paintings and sculptures from which they
derive,and as check-list.Windham,Conn.,E.B.
Thompson,printer,1533
 [16]p.

LC HE6185.U5T57

705
A7832
NCFA
v.57

I.E - OBJECT PORTRAITS - 20th c.

Homer, William Innes
 Picabia's 'Jeune fille américaine dans l'é-
tat de nudité'and her friends

In:Art Bull.
57:110-5 Mar.,'75 illus.

 Col.Uni.Dpt.Art Hist.,Mo-
 dern portrs.N7592.6.C72
 NPG, p.127

N
7624
J29
NPG

I.E - PROFESSIONS

Borg, James M.W.,Inc.,Chicago
 Gallery.Portraits of literary and histori-
cal figures.1962
 unpaged(121 nos. illus.

 Incl.:Caricatures;drawings,prints

VF
Christy

I.E - OLD AGE

Christy, Margaret Arlington(Marna Prior)
 Quest for centenarians.Publ.by Christy,
Norwalk,Ohio,1982
 128 p. illus.

Dayton,O. Dayton &
Montgomery P.L.

 Plain Dealer(Cleveland,O.)
 Dec.4,'83,p[3]31,35

705
C75
NCFA
v.14

I.E - PROFESSIONS

Calthrop, Dion Clayton
 Robert and Richard Dighton.Portrait etchers

In:Connoisseur
14:231-6 Apr.,1906 illus.

 Repro.incl.:Caricatures of George III;Duke
of Norfolk;Bishop of Bristol;Lord Nugent;Mr.Wil-
son;Admiral Young;Sir Wm.Curtis;W.Farren

 FOR COMPLETE ENTRY
 SEE MAIN CARD

I.E - PROFESSIONS

Desrochers, Étienne Jehandier
　　Recueil de portraits des personnes qui se
sont distinguées,tant dans les armes que dans
les belles-lettres et les arts.Comme aussi la
famille Royale de France et autres cours étran-
gères..Paris,1700-1730,or 1735?.
Brit.　　4 v.　illus.
Mus.
554.d.1,?
(2 v.)　　Engraved portrs.most of them by Desrochers

Levine.Bibliof 18th c.art
illus.books.Z1023.L67 1968
v.2　p.184

017.37　I.E - PROFESSIONS
.M68
Mitchell, James Tyndale, 1834-1915
　　...The unequaled collection of engraved
portraits of beautiful women of Europe and Ame-
rica,and actors,actresses,vocalists,musicians,
and composers,belonging to Hon.James T.Mitchell...
to be sold,,.Phila.,Pa.,M.H.Power,printer,1910.
144 p.　illus(part col.)

(Catalogue compiled...by Stan.V.Henkels)
(Sold at book auction rooms of S.T.Freeman & co
Cat.no.944,pt.X

LC NE240.M5

I.E - PROFESSIONS

Dreux du Radier, Jean François, 1714-1780
　　L'Europe illustre,contenant l'histoire abré-
gée des souverains,des princes,des prélats,des
ministres,des grands capitaines,des magistrats,
des savans,des artistes,& des dames célèbres en
Europe;dans le 15e siècle compris,jusqu'à présent
...Ouvrage enrichi de portraits,gravés par les
soins du Sieur Odieuvre...Paris,Odieuvre.et.Le
Breton,1755-65
　　6 v.　illus.
　　Planches par N.Dupuis,G.Duchange,J.G.Will.e.
NN　Pinssio,etc.
Amsterdam,Rijksmus.,cat.
Z5939A52,deel 1,p.131

I.E - PROFESSIONS

Mitchell, James Tyndale, 1834-1915
　　The unequalled coll.of engraved portraits
of eminent American,and some noted foreign-
ers belonging to Hon.James T.Mitchell...a
large coll.of lithographs engraved by A.Newsam
an unique coll.of American revolutionary and
political caricatures and numerous portraits
for extra illustrating,to be sold...Oct.28,
1913,Phila.,Pa..Stan v.Henkels,1913,
　　56 p.　Plates
Cat.Stan v.Henkels,no.944,pt.13

LC Z999.H505 no.944,pt.13　Rosenwald coll.

I.E - PROFESSIONS

Duyckinck, Evert Augustus, 1816-1878
　　Portrait gallery of eminent men and women
in Europe and America.Embracing history,states-
manship,naval and military life,philosophy,the
drama,science,literature and art...New York,
H.J.Johnson.c1873.
　　2 v.　illus.

LC CT104.D82

I.E - PROFESSIONS

Mitchell, James Tyndale, 1834-1915
　　...The unequaled collection of engraved por-
traits of eminent foreigners,embracing kings,
eminent noblemen & statesmen,great naval command-
ers...explorers,...reformers...;also a collection
of caricatures on Napoleon & a ...coll.of portrs.
engravings by the great masters of the last four
centuries in line,mezzotinto,stipple & etching..
to be sold...Oct.14,1912...and Oct.15,1912.Cat.
comp.& sale. conducted by Stan.V.Henkels at the
book auction rooms of S.T.Freeman & co.,Phila.,Pa.
.M.H.Power,printer,1912.
　　111p.　illus.
LC NE240.M515 Cat.no.944,pt.　XII

CT　I.E - PROFESSIONS
104
G16　...The Gallery of portraits;with memoirs...London,
NPG　C.Knight,1833-1837
RB　　7 v.　illus.(168 engravings)

　　　Afterwards publ.under title:The portrait
　　gallery of distinguished poets,philosophers,
　　statesmen,divines,painters,architects,phy-
　　sicians,and lawyers,since the arrival of art
　　London,1853　6 v.

Source for 1853 edition:
Tarkington.Some old portra.
LC CT104.P7　1833　　757.T2 NCFA bibl.

I.E - PROFESSIONS

Muller, Frederik & co., .Amsterdam.
　　Portraits de médecins,naturalistes,mathema-
ticiens,astronomes,voyageurs,etc. Au vente...
.1880?.

FOGG
FA977.5

Fogg,v.11,p.324

M
7592
H513　Henkels, Stanislaus Vincent, 1854-1926
RB　　The rare and valuable coll.of portraits
NPG　and choice engravings gathered by J.Henry Clay
　　of Philadelphia embracing the most important
　　coll.of rare Washington portraits...also rare...
　　portraits,in line,mezzotint and stipple of emi-
　　nent Americans,artists,actors,authors,clergy-
　　men,lawyers,statesmen,etc...to be sold Fri.&
　　Sat.,Dec.3 & 4,1897,at the book & art auction
　　rooms of Davis & Harvey,Philadelphia
　　　124 p.　illus.
LC Z999　cat.no.799　priced
H505 no.799　Several hundreds portrs.of Washington,
　　p.77-102

I.E - PROFESSIONS

Old England's worthies:a gallery of portraits...
　　statesmen,lawyers,warriors,men of letters
and science and artists.Accomp.by...biographies
...woodcuts and...engravings.London,C.Cox,1847
　　272 p.　illus(part col.)

LC DA28.O4　　Fogg,v.11,p.332

NE
250
O52
NPG

I.E - PROFESSIONS

Olschki, Leo Samuel, 1861-1940, firm, Florence
Portraits of artistic and iconographical
interest.Firenze,Libreria antiquaria...,1961
521 nos. illus.

Contents:Some choice portrs.:Artists;Kings
& soldiers;Men of letters;Musicians;Physicians
& men of science;Statesmen & magistrates;Various;Some books with portraits

Cat.no.139

I.E - PROFESSIONS

Thompson, Edward Raymond, 1872-1928
Portraits of the nineties,by E.T.Raymond
,pseud.,London,T.F.Unwin,ltd.,1921.
319 p. illus.

Bibliography

LC CT782.T5 1921 Yale ctr.f.Brit.art Ref.
CT782.T46

I.E - PROFESSIONS

Orsini, Fulvio, 1529-1600
Imagines et elogia virorum illustrium et
eruditorum. Rome,1570

The life of 133 famous poets,philosophers,
historians,orators,grammarians,jurists,doctors,
based on antique authors;with engr.after medals,
busts,statues,etc.
"The whole a step to pure archeology via the
'bildnisvitenbuch'."-Rave

Rave.Jb.d.Berl.Mus.I 1959
LC N3.J16 fol.p.146
~ Paolo Giovio & d.Bildnisvitenbücher d.Humanismus

I.E - PROFESSIONS -(GREAT BRITAIN)

Mitchell, James Tyndale, 1834-1915
...The unequaled collection of engraved portraits of the English royalty & English officers
...,statesmen,artists,authors,poets,dramatists,
doctors,lawyers,etc.,from the earliest to the
present time,belonging to Hon.James T.Mitchell...
to be sold...May 2d & 3d,1911.Cat.comp.& sale conducted by Stan.V.Henkels,at the book auction
rooms of S.T.Freeman & co...Phila.,Pa.,...M.H.
Power,printer,1911.
72 p. illus.
Cat.no.944,pt.XII

LC NE240.M52

I.E - PROFESSIONS

Rotterdam. Museum Boymans-Van Beuningen. Prentenkabinet
Denkers,dichters en mannen van de wetenschap:15-17e eeuw;tentoonstelling(Thinkers,poets
& scientists:15-17th c.;exh.)...Rotterdam,Mus.
Boymans-Van Beuningen,1974.

LC N2505.A29 nr.56 FOR COMPLETE ENTRY
SEE MAIN CARD

757
.W55

I.E - PROFESSIONS -(GREAT BRITAIN)

Wheatley, Henry Benjamin, 1838-1917
Historical portraits;some notes on the painted
portraits of celebrated characters of England,
Scotland and Ireland...London,G.Bell and sons,
1897

276 p. illus.

Introduction:Different ideas as to "portraits"
in different countries and times. From Holbein to
John Everett Millais. People in different professions.

N7598.W5

I.E - PROFESSIONS

Seidlitz, Woldemar von, 1850-1922
Allgemeines historisches porträtwerk.Eine
sammlung von 600 porträts der berühmtesten personen aller völker & stände seit 1300....-ca.1840.
München,Verlagsanstalt für kunst & wissenschaft,
vormals, F.Bruckmann,1884-90
6 v. illus.
Contents.-.ser.I-II.Fürsten & päpste(100 portr),
.ser.III-IV.Staatsmänner & feldherrn(100 portr.)-
.ser.V-VII.Dichter & schriftsteller(151 portr.)-
.VIII-IX.Künstler & musiker(100 portr.)-.ser.X-XI.
Gelehrte & männer der kirche(100 portr.)-.ser.XII.
Berühmte frauen.Var- schiedene(50 portr.)
LC N7575.S5 [A.L.A.cat.deal 1,p.131
Z5939.A52 ECFA

757
.C46
NGA

I.E - PROFESSIONS - U.S.

Duyckinck, Evert Augustus, 1816-1878
National portrait gallery of eminent Americans,incl.orators,statesmen,naval & military heroes,jurists,authors,etc.,from original full
length ptgs.by Alonzo Chappel...New York,Johnson
Fry & Co.,.1862.
. 2 v. illus.

LC E176.D98 Cirker,Dict.of Am.portrs.
N7593/C57/NPG Bibl,p.714
Ref.

AP
1
N277
NMAA
v.35

I.E - PROFESSIONS

Southwell, William
As the artist sees the artist

In:Sculpt Rev
35,no.3:16 Fall,'86 illus.p.16-23

Repro.incl.:Wm.Rush:Self-portr.-Buscaglia:
Rbt.Frost.-Malf.Hoffman:Self-portr.-Davidson:
Gertr.Stein.-and Gertr.Vanderbilt Whitney.-
Murray:Ths.Eakins.-Quinn:O'Neill.-Sherbell:
Copland

F
74
N55846
1986
NMAA

I.E - PROFESSIONS - U.S. - MASS. - 17-19th c.

Benes, Peter
Old-town and the waterside;200 years of tradition and change in Newbury,Newburyport and
West Newbury,1635-1835.Cat.of an exh.at the
Cushing House Mus.,Newburyport,Mass.,by P.Benes
,and Gregory H.Laing and Wilhelmina V.Lunt.Newburyport,Hist.Soc.of Old Newbury,1986
192 p. illus(part col.)

Exh.July 26-Oct.20,1985
Bibliography,p.184-89

I.E - PROFESSIONS - ACTORS

Abraham, Pierre, 1892-
...Le physique au théâtre;texte et mise en
images par Pierre Abraham.Paris,Coutan-Lambert
c.1933.
193 p. illus. (Masques,cahiers d'art
dramatique....XXVII.)

Includes "Le physique du comédien", "Le phy-
sique du dramaturge",and "Le physique du spec-
tateur"

LC PN2071.F3A3

PN
1583
A2N3X
NPG

I.E - PROFESSIONS - ACTORS

National Portrait Gallery, Washington, D.C.
Portraits of the American stage,1771-1971;
an exhibition in celebration of the inaugural
season of the John F.Kennedy Ctr.for the Per-
forming Art,Sept.11 to Oct.31,1971.Wash.,C.D.,
Smithsonian Inst.Press,1971
203 p. illus.

LC PN1583.A2N3

I.E - PROFESSIONS - ACTORS

Cope, Edwin R.
...The magnificent coll.of engraved por-
traits formed by...Edwin R.Cope...being the
most important coll..to be sold...at Thos.
Birch's sons...Cat.comp.& sale conducted by
Stan V.Henkels....Philadelphia,The Bicking
print,1896.-1899.
Pt.I:48p.;1126 items,portraits,illus.
Pt.II:68p.;1247 items,portraits,illus.
Pt.III:44p.;814 items,miscellaneous,illus.
Pt.IV:44p.;586 items,balance of coll.with
suppl.contain'g illus.
LC has pt.2:NE240.C7 continued on next card
Levis.Descr.bibl.25947.A3
L66 1974 NCFA p.244

I.E - PROFESSIONS - ACTORS

Paul, Howard and Gebbie, George, ed.
The stage and its stars,past and present;
a gallery of dramatic illustration...of distin-
guished English and American actors from the
time of Shakespeare till to-day.Philadelphia,
Gebbie & co.,c189-.
2 v. illus.

128 photogravure portraits & scenes from
steel plates & over 400 portrs.in the text

LC PN2597.P35 Cirker.Dict.of Am.portrs.
N7593/C57/NPG Bibl.p.715

N
7592
G24
:NPG

I.E - PROFESSIONS - ACTORS

Daly, Augustin, 1838-1899
The Augustin Daly collection of portraits
of eminent men and women of the stage.New York,
The Anderson Galleries,1912
30 p. illus.
NPG copy bound with the Garrick Club,London.Catal.of
the pictures...London,1909

qTR
647
P41289
NPG

I.E - PROFESSIONS - ACTORS

Penn, Irving,1917-
Irving Penn.by.John Szarkowski..Exh.at.Mus.
of modern art,N.Y.N.Y.,The Museum,c.1984
216 p. chiefly illus(part col.)

Bibliographical references

Incl.:Portrs.of artists,writers,theater
people

I.E - PROFESSIONS - ACTORS

Galeries Georges Petit
Exposition de portraits d'artistes drama-
tiques lyriques du siècle;catalogue. Paris,
G.Petit,1900
52 p.

FOGG
Widener

Fogg,v.11,p.322

I.E - PROFESSIONS - ACTORS

Society for Theatre Research.London Group.Cat.
of theatrical portraits in London public
collections.Comp.by the London Group of the
Society for Theatre Research,Mavis Bimson
.and others.Edited,with an intro.by J.F.
Kerslake.London,Society for Theatre Re-
search,1961
62 p.

LC PN2205.S65 Noon.Engl.portr.drags.&min.
NC860.N66X NPG Bibl. p.146

N
7621
H33
NPG

I.E - PROFESSIONS - ACTORS

Harvard University. Library. Theatre coll.
Cat.of dramatic portraits in the theatre
coll.of the Harvard college library.Cambridge,
Mass.Harvard univ.press,1930-34
4 v.
Compiled by Lillian Arvilla Hall
"A descriptive index to the engraved dra-
matic portrs.in the theatre coll....arranged
alphabetically according to names."-Pref.

Noon.Engl.portr.drags.&min.
NC860.N66X NPG Bibl. p.145

N
7610
D4N18
NPG

I.E - PROFESSIONS - ACTORS - DENMARK

Hillerød,Denmark. Nationalhistoriske Museum
paa Frederiksborg slot
Det Kongelige Teaters Kunstnere Maleri og
Skuptur.Kat.ved Kirsten Nannestad.Clostrup,L.
Levison Junr,A/S,1984
88 p. illus.
foreword by Povl Eller

Portrs.Ptgs.,sculpt.,drags.arranged in al-
phabetical order by sitter,p.10-75
Register of artists

I.E - PROFESSIONS - ACTORS - FRANCE

Galerie théâtrale,collection de 144 portraits
en pied des principaux acteurs et actrices
qui ont illustré la scène française depuis
1552 jusqu'à nos jours...Paris,A.Barraud,
1872.-73

Brit.mus.
1763.d.19

 2 v. illus.

N.Y.P.L.has similar:Paris,Hance.184?.
3 v. illus. ...gravés par les plus cé-
lèbres artistes...Stipple engr.by Godefroy,
Chaponnier,Lignon,etc..fr.ptgs.by Auret,A.de
Romance,A.Bosse,etc.

N.Y.P.L.
MWER

705
C75
NCFA
v.11

I.E - PROFESSIONS - ACTORS - GREAT BRITAIN-18th c.

Laurence, William John, 1862-1940
 The portraits of David Garrick

In:Connoisseur
11:211-18 Apr.,'05 illus.

FOR COMPLETE ENTRY
SEE MAIN CARD

ND
1314
G24
NCFA
(p.257-
310 mis-
sing)

I.E - PROFESSIONS - ACTORS - GREAT BRITAIN

Garrick Club, London
 Catalogue of pictures in the Garrick Club.
[London,1936?]
 310 p. illus.

The club's coll.now comprises some 400 ptgs.
& an approx.equal number of drags.which are with
a few exceptions portrs.of members of the thea-
trical profession,usually in character

Compiled by C.K.Adams
Bibliography

LC N7598G3

B
705M2
NCFA

I.E - PROFESSIONS - ACTORS - GREAT BRITAIN - 18
[th c.]

Manners, Lady Victoria, 1876-1933
 John Zoffany,R.A.,his life and works,1735-
1810;by Lady V.Manners & Dr.G.C.Williamson.
London,John Lane,N.Y.,J.Lane Co.,1920
 331 p. illus(part col.)

Bibliography

List of engravings after Zoffany...p.257-65

Archer;India & Brit.portr...
ND1327.I44A72X NPG Bibl.
p.483

N
7592
G24
NPG

I.E - PROFESSIONS - ACTORS - GREAT BRITAIN

Garrick Club, London
 Cat.of the pictures and miniatures in the
possession of the Garrick Club.Rev.ed.London,
Eyre and Spottiswoode,1909
 125 p.

Incl.:Index of sitters

N
1
A64
NMAA
v.114

I.E - PROFESSIONS - ACTORS - GREAT BRITAIN - 18-
[19th c.]

Ashton, Geoffrey
 Paintings in the Mander and Mitchenson
theatre collection

In:Apollo
114:88-92 Aug.,'81 illus.

Repro.:Wm.Hamilton,Mather Brown,Geo.Clint,
Rbt.Wm.Buss

705
C75
NCFA
v.111

I.E - PROFESSIONS - ACTORS - GREAT BRITAIN -
[17th c.]

Fea, Allan, 1860-
 Portraits of Nell Gwyn,Moll Davis and others

In:Connoisseur
111:29-33 Mar.,'43 illus.

Repro.incl.:Wm.Wissing;Lely studio,Lely,
Dixon

I.E - PROFESSIONS - ACTORS - GREAT BRITAIN -
[18-19th c.]

Mayes, Ian
 Samuel De Wilde,c.1751-1832;theatre in Geor-
gian Regency London.George James De Wilde,1804-
1871;the life and times of Victorian Northampton
an exh.at Northampton Central Art Gallery,4 Sept-
2 Oct.,1971.Northampton,1971
 [367]p. illus.

MJP

Noon.Engl.portr.drags.&min.
NC860.N66X NPG Bibl.p.146

NE
265
G87c
NPG

I.E - PROFESSIONS - ACTORS - GREAT BRITAIN - 18th c.

Grolier club, New York
 Catalogue of engraved portraits of actors
of olden time,Jan.24 to Feb.14,1907.New York,
The Grolier club,1907.
 46 p.

LC NE245.N6G8 1907 Fogg,v.11,p.322

I.E - PROFESSIONS - ACTORS - GREAT BRITAIN - 19th
[c.]

Craig, Edward Gordon, 1872-1966
 Henry Irving, Ellen Terry,etc.A book of
portraits.[Chicago,H.S.Stone & co.,c.1899.
 2 p. 19 pl.(part col.)

LC PN2598.I7C7

FOR COMPLETE ENTRY
SEE MAIN CARD

I.E - PROFESSIONS - ACTORS - GREAT BRITAIN - 19th c.

Menpes, Mortimer, 1859-1938
 Henry Irving...with 12 portraits in colour.
London,A.and C.Black,1906
 50 p. illus(col.)

LC PN2508.I7M4

Book in print.Subject
guide,1985-86 v.3,p.4865

N
40.1
H66x11
NPG

I.E - PROFESSIONS - ACTORS - U.S. - 20th c.

Hirschfeld, Albert, 1903-
 The American theatre as seen by Hirschfeld.
N.Y.,G.Braziller,1961
 unpaged (chiefly illus.)

LC NC1429.H527A48

I.E - PROFESSIONS - ADMINISTRATION - (NETHERLANDS)

Lübke, Wilhelm, 1826-1893
 Zur geschichte der holländischen schützen-
& regentenbilder

In:Rep Kunstwiss
1:

"Rep Kunstwiss"
LC N3R4

Waetzoldt MD1300.W12

H7618
P55
NPG
b.a.s.v.l

I.E - PROFESSIONS - ARCHITECTS

Prinz, Wolfram
 Die Sammlung der selbstbildnisse in den
Uffizien;hrsg.v.U.Middeldorf & U.Procacci.
Red.v.W.Prinz.Berlin, Mann verl.,1971-
3 v. illus. (Ital.Forsch.,Folge 3,Bd.5)

 Contents:1.-Geschichte der sammlung;2-Die
selbstbildnisse der ital.künstler;3.-Die selbst-
bildnisse der nicht ital.künstler
 v.1:Incl.Hist.develpm't of portrs.fr.repre-
senting famous fgs.of the past to actual portrs.

I.E - PROFESSIONS - ARCHITECTS - 20th c.

Ray, Man, 1890-
 Portraits.Hrsg.und eingeleitet von L.Fritz
Gruber..Gütersloh,S.Mohn,1963,
 15 p. illus.,73,

 Man Ray's commentary accompanies each portr.
Incl.Cocteau,Maar,Dali,Tanguy,Eisenstein,Le Cor-
busier,Loos,Pascin,Tanning,Derain,Braque,Léger,
Giacometti,Brancusi,Matisse,Picasso,etc.

LC TR680.R36

MOMA,v.11,p.437

I.E - PROFESSIONS - ARCHITECTS - GERMANY

Gerstenberg, Kurt, 1886-1968
 Die deutschen baumeisterbildnisse des mit-
telalters..Berlin,Deutscher verlag für kunstwis-
senschaft,1966.
 231 p. illus. (Deutscher Verein für kunst-
wissenschaft,Berlin. Jahresgabe...1966)

 The status of medieval architects.-Various
types of portrs.fr.12-late 15th c. Develom't fr.
heads on capitals & bosses to full ft.represen-
trtions.Most are busts on capitals & consoles.
15th c.innovation:setting in natural context.

FOGG
553
?

TY NPV MdP'a KyN MJP
(continued on next cd.)

ICU Prinz.Slg.d.selbst-
..ldnisse...H7618.P55,v.1
p.117,d footnote 57

I.E - PROFESSIONS - ARCHITECTS - ITALY

Rud, Einar, 1892-
 Italienske kunstner portraetter fra Gotik og
Renaissance..København,Selskabet Bogvennerne
,1967.
 105 p. illus.

 Illus.and part of text fr.Vasari's Vite de'
più eccelente pittori,scultori e architetti.

NIC
LC N6922.R8 -København,Carit
Andersen,1967.

Rep. 1967 #1151

I.E - PROFESSIONS - ARCHITECTS- ITALY

Vasari, Giorgio, 1512-1574
 Le vite de'piv eccellenti pittori,scvltori,
et architettori.scritte,& di nuouo ampliate da
m.Giorgio Vasari...Co' ritratti loro...Fiorenza,
appresso i Givnti,1568
 3 v. illus.

 c.150 woodcut portrs.-Rave
 1st ed.publ.1550 was not illustrated

LC N6922.V2 1568

Rave.Jb.d.Berl.Mus. I 1959
LC N3.J16 fol. p.146
Paolo Giovio & d.Bildnisvi-
teneucher d.Humanismus

I.E - PROFESSIONS - ART - 20th c.

Ray, Man, 1890-
 Portraits.Hrsg.und eingeleitet von L.Fritz
Gruber..Gütersloh,S.Mohn,1963,
 15 p. illus.,73,

 Man Ray's commentary accompanies each portr.
Incl.Cocteau,Maar,Dali,Tanguy,Eisenstein,Le Cor-
busier,Loos,Pascin,Tanning,Derain,Braque,Léger,
Giacometti,Brancusi,Matisse,Picasso,etc.

LC TR680.R36

MOMA,v.11,p.437

I.E - PROFESSIONS - ARTISANS

Comstock, Helen
 Portraits of American craftsmen

In:Antiques
76:320-7 Oct.,'59 illus.

 Incl.Chronological table of American artistic
works of artisans compared with those on the con-
tinent,from 1725-1825
 Incl.:Pollard Limner,John Smibert,Nathaniel
Smibert,Copley,Chs.W.Peale,Ralph Earl,Sarah Good-
ridge,Mather Brown,G.Stuart,Benj.Blyth,Ths.Sully,
John Neagle,J.W.Jarvis,Ezra Ames

Rep.1959 #977

I.E - PROFESSIONS - ARTISANS - U.S. - 18-19th c.

Comstock, Helen
Portraits of American craftsmen

In:Antiques
76:320-7 Oct.,'59 illus.

Incl.Chronological table of American artistic
works of artisans compared with those on the con-
tinent,from 1725-1825
Incl.:Pollard Limner,John Smibert,Nathaniel
Smibert,Copley,Chs.W.Peale,Ralph Earl,Sarah Good-
ridge,Mather Brown,G.Stuart,Benj.Blyth,Ths.Sully,
John Neagle,J.W.Jarvis,Ezra Ames

Rep.1959 #977

VF:
Florence
Gall.
degli
Uffizi

I.E - PROFESSIONS - ARTISTS

Buerkel, Ludwig von
Die selbstbildnisse von malern in den Uffi-
zien

In:Ueber Land & Meer
94,no.46:1065-7 Apr.-Oct.,1905 illus.

LC AP30.U2

FOR COMPLETE ENTRY
SEE MAIN CARD

I.E - PROFESSIONS - ARTISTS

Abin, Cesar
..."Leurs figures",56 portraits d'artistes,
critiques et marchands d'aujourd'hui avec un
commentaire de Maurice Raynal.Paris,l'Imprime-
rie Muller.n.d.
2 p. plus 56 ports.

LC NC1639.A24A54
Spanish translation(only)

MOMA, p.436, v.11
MOMA * 50.4/A14

I.E - PROFESSIONS - ARTISTS

Corner, John,fl.1788-1825
Portraits of celebrated painters,with medal-
lions from their best performances,engraved by
J.Corner,with authentic memoirs from established
authorities.London,Longman,Hurst,etc.,1825
52 p. illus.

Published also anonymously,under title:
Portrs.& lives of eminent artists...London,
182-?.
Contents:v.Dyck-Poussin-Both-Castelfranco-
Lanfranco-Snyders-Titian-Domenichino-da Cortona-

LC ND85.C75

RS ARTIS cat.41 Books on
Prints & drags. no.667

I.E - PROFESSIONS - ARTISTS

Arrigoni, Paolo e Bertarelli, Achille
Ritratti di musicisti ed artisti de teatro
conservati nella Raccolta delle stampe e dei di-
segni. Milano,Tip.del Popolo d'Italia,1934
455 p. illus.

Met
204.1
M58
C272

Descriptive catalogue

Rep.,1936#351

I.E - PROFESSIONS - ARTISTS

Dyck, Anthonie van, 1599-1641
Icones principvm virorvm doctorvm pictorvm...
Antverpiae,G.Hendricx,1646.
1p.l. 109 port

Best engravers of the period collaborated

LC ND673.D9A3

Rath.Porträtwerke p.40

I.E - PROFESSIONS - ARTISTS

Artists' portraits from exhibition at Roerich
Museum, New York

In:Studio
106:88-92 Aug.'33 illus.

Cumulated Mag.subj.index
A1/3/C76 Ref. v.2,p.443

ND
621
F6F52
ICFA

I.E - PROFESSIONS - ARTISTS

Firenze e l'Inghilterra.Rapporti artistici e
culturali dal 16 al 20 secolo.Firenze,Pa-
lazzo Pitti,luglo-settembre 1971.Firenze,
Centro Di,1971
77 l. illus(col.cover) (Cataloghi,23)

Cat.ed.by M.Webster

see also article by Ormond in Connoisseur
v.177:166-74

LC ND621.F7F57

NC
772
B86
NPG

I.E - PROFESSIONS - ARTISTS

British museum. Dept.of prints and drawings
Portrait drawings 15-20 centuries.cat.of.
an exh.held...Aug.2-Dec.31,1974.London,British
Museum,1974. 112 p. illus.
Intro.by J.A.Gere

Index of artist;index of sitters

pp.6-23;15-16th c.;24-35;17th c.;36-61;ar-
tists(many self-portraits);61-71;caricatures;
72-5;actors,singers,etc.;76-108;16-20th c.Engl.

LC NC772.B74 1974

708
M18
NCFA

I.E - PROFESSIONS - ARTISTS

Fischkin, Rose Mary
Portraits of artists

In:Mag of Art
16:528-32 Oct.,'25 illus.

Refers to portrs. in a special gall.in
Chicago's Art Institute

Repr.:Monet by A.André,Renoir by A.André,
Self-portr.by L.Simon,Manet by Fantin-Latour
N.Y.,MOMA.20th c.portrs.
by M.Wheeler N7592.6N53
NPG Bibl.

705
C75
NCFA
v.144

I.E - PROFESSIONS - ARTISTS

Fleming, John
Giuseppe Macpherson;a Florentine minia-
turist

In:Connoisseur
144:166-7 Dec.,'59 illus.

Repro.incl.:Group from the 224 miniatures
in the Royal coll.at Windsor Castle,all,but one,
copies of self-portrs.in the Uffizi

FOR COMPLETE ENTRY
SEE MAIN CARD

I.E - PROFESSIONS - ARTISTS

Lampsonius, Dominique, 1532-1599
Pictorvm Aliqvot celebrivm Germaniae Inferi-
oris Effigies...Anverpiae,Apud Vidvam Hieronymus
Cock,1572

23 full-page portrs.of artists north of Alps
Engravings by J.Wierix,C.Cort & probably H.Cock

Facsimile ed.,Liége,J.Puraye,1956

"Important source for Carel van Manders
Schilderboek"-Rave
Rave.Jb.d.Berl.Mus. I 1959
LC N3.J16 fol. p.148
Paolo Giovio & d.Bildnisvi
tenbücher d.Humanismus

MN

I.E - PROFESSIONS - ARTISTS

Gallery of great artists;a series of portraits
engraved on steel...Boston,J.R.Osgood and
company,1877
75 p. illus.

LC ND1170.C3

Fogg,v.11,p.322

I.E - PROFESSIONS - ARTISTS

Leirens, Charles
20 portraits d'artistes;préface de Robert
Poulet.Bruxelles,Editions de la Connaissance
S.A.,1936,
4 p. plus 20 plates

MOMA
77
L34

MOMA,v.11,p.437
MOMA #77L34

N
40.1
G519y
S4
NPG

I.E - PROFESSIONS - ARTISTS

Girtin, James, etcher, c.1780-after 1820
. Seventy-five portraits of celebrated
painters from authentic originals.Etched by
James Girtin.London,printed by J.M'Creery,1817
2 l. 75 plates

LC(J18.0445.817)
CtY NjP etc.

AP1
A64
NCFA

I.E - PROFESSIONS - ARTISTS

Lockspeiser, Edward
Painters and musicians

In:Apollo
25:336-8 Jun,1937 illus.

Relationship betw.musicians & ptrs. Gounod
by Ingres,Chopin by Delacroix,Berlioz by Courbet,
Chabrier by Manet,Debussy by Friesz

Rep.,1937*371

I.E - PROFESSIONS - ARTISTS

Jullien, Jean Lucien,Adolphe, 1845-
Fantin-Latour;groupes et portraits d'ar-
tistes...

In:Les Arts
5,no.53:25-32 May,1906 illus.

MFT
100.54
Ar72
1906

FOR COMPLETE ENTRY
SEE MAIN CARD

LC N2.A85

Chicago,A.I.European ports.
N7621.C4A7 NPG Bibl. p.177

I.E - PROFESSIONS - ARTISTS

Maywald, Wilhelm, 1907- ed.
Artistes chez eux,vus par Maywald...
Boulogne(Seine),Architecture d'aujourd'hui,
1949.
23 l. illus.
Leaves 1-21 are illus.

In special issue of L'Architecture d'au-
jourd'hui:"2e numéro hors-série...consacré
aux arts plastiques."

LC L
709.09.A74na

N.Y.P.L. MAN

MOMA,v.11,p.436

I.E - PROFESSIONS - ARTISTS

Künstler sehen Künstler:Gemälde,Pastelle,Hand-
zeichnungen und Grafik.Ausstellung vom
19.Nov.1973-13.Jan.1974.Berlin,Galerie Pels-
Leusden,n.d.,
36 p. illus.

MdU

I.E - PROFESSIONS - ARTISTS

Meyssens, Joannes, 1612-1670
The true effigies of the most eminent paint-
ers,and other famous artists that have flour-
ished in Europe,together with an account of the
time when they lived,etc..,by S.Resta,engraven
on 125 copper plates by J.Meyssens,&others.
London,1694
20 p. 126 engr.pl.

V & A

Published originally by J.M.at Antwerp,1649

See also:The portrs.of the most eminent
painters...London J.Duke,1739

460

I.E - PROFESSIONS - ARTISTS
Neumayer, Heinrich, 1905-
Erkenne dich selbst..Wien,Rosenbaum,1957,
64 p. illus. (Zeit und Bildnis,hrsg.von
H.Neumayer,1.Maler)

"Know thyself !"

FOGG
FA
3173.5

Fogg,v.11,p.324

N
40.1
D24353
NPG

I.E - PROFESSIONS - ARTISTS
Schazmann, Paul-Emile, 1902-
David d'Angers,profils de l'Europe.Genève,
Ed.de Bonvent,.1973,
136 p. illus.

Bibliography

I.E - PROFESSIONS - ARTISTS
Les peintres célèbres.collection pub.sous la
direction de Bernard Dorival avec la colla-
boration de Roger Adhémar et al.Genève,L.Maze-
nod,1948,
423 p. illus(part col.) (La Galerie des
hommes célèbres.4)

FOGG
FA3175
.4P

Yale Univ.Libr.for LC
NN MdBWA etc.
LC 2nd ed..1953-54, ND
50.P4

MOMA, p.436, v.11

NC
772
S78
NPG

I.E - PROFESSIONS - ARTISTS
Stampfle, Felice
Artists and writers;19th and 20th century
portrait drawings from the coll.of Benj.Sonnen-
berg.Cat. by Felice Stampfle and Cara Dufour.
With an introd.by Brendan Gill..Exh.held at
the Pierpont Morgan Library,N.Y.,May 13-July 30,
1971..New York,1971.
52 p. illus.

Bibliography

LC NC31.S6S8

MOMA,p.434, v.11

qN
647
P41289
NPG

I.E - PROFESSIONS - ARTISTS
Penn, Irving,1917-
Irving Penn.by.John Szarkowski..Exh.at.Mus.
of modern art,N.Y.N.Y.,The Museum,c.1984
216 p. chiefly illus(part col.)

Bibliographical references

Incl.:Portrs.of artists,writers,theater
people

AP
1
A83
NCFA

I.E - PROFESSIONS - ARTISTS
Stofflet-Santiago, Mary
Artists' portraits and self-portraits

In:Artweek
7,pt.3:3-4 Jan.17,1976 illus.

FOR COMPLETE ENTRY
SEE MAIN CARD

I.E - PROFESSIONS - ARTISTS
The portraits of the most eminent painters,and
other famous artists,that have flourished
in Europe.Curiously engraven on above 100
copper plates...From original paintings...
To which is now added,An historical and
chronological series of all the most eminent
painters for near 500 years.Chiefly collect
from a manuscript of...Father Resta.London,
J.Duke,1739
18 p. illus.
An histor.& chronol.series...has special t.
& separate paging
LC N40.P6 Published originally by Jean Meyssens at
Antwerp,1649

I.E - PROFESSIONS - ARTISTS
Weigel, Rudolph, 1804-1867
Eine grosse sammlung von künstler-portraits
in werken & in einzelnen blättern von frühester
seit bis sur gegenwart.Leipzig,R.Weigel.1857?.
(his Kunstcatalog,v.4,pt.2)

In all:...3832 portrs.of artists

LC Z5939.W41 v.4pt.2

N7618
P55
NPG
N 40 v.1

I.E - PROFESSIONS - ARTISTS
Prinz, Wolfram
Die Sammlung der selbstbildnisse in den
Uffizien;hrsg.v.U.Middeldorf & U.Procacci.
Red.v.W.Prinz.Berlin, Mann verl.,1971-
3 v. illus. (Ital.Forsch.,Folge 3,Bd.5)

Contents:1.-Geschichte der sammlung;2.-Die
selbstbildnisse der ital.künstler;3.-Die selbst-
bildnisse der nicht ital.künstler
v.1:Incl.Hist.develpom't of portrs.fr.repre-
senting famous figs.of the past to actual portrs.

I.E - PROFESSIONS - ARTISTS - RENAISSANCE
Galerie des artistes,ou portraits des hommes
célèbres dans la peinture,la sculpture,la
gravure et la musique,pendant les trois
siècles de la renaissance.52 gravures par
différents maîtres...avec decourtes notices
Paris,Société des amis des arts,1836
110 p. illus.

LC N7627.G2

QN
1619.5
E85P14
1988
NMAA

I.E - PROFESSIONS - ARTISTS - 16-20th c.

New York. National academy of design
 Painters by painters.N.Y.,Nat'l academy of
design.1988.
 168 p. illus(part col.)

 Cat.of an exh.held at the Nat'l acad.of des.,
May12-July 31,1988 & Mus of fine arts,Houston,
Aug.13-Oct.23,1988
 Bibliography
 List of portrs.of artists in the Uffizi
 Index to artists and plates
 Essays:The history of a collection by Cate-
rina Canova,p.8- Studio portrs.by Antonio
Natali,p.28-34.Por... within portr.:Cover & no.17

585
15
NCFA

I.E - PROFESSIONS - ARTISTS - 19-20th c.

Philadelphia Museum of Art
 A.E.Gallatin collection,"Museum of living
art".Philadelphia.1954.
 153 p. illus(part col.)

 Previous eds.iss.by N.Y.university.Gall.of
Living Art,A.E.Gallatin collection.

 Incl.photos by A.E.Gallatin of:Arp,1934;
Braque,1931;Léger,1931;Matisse,1932;Miró,1936;
Mondrian,1934;Picasso,1933..This is a different
set than in previous eds.,Life,May 2,'38,Bri-
tannica Book..39. ..147-53

N
40.1
D243P2
NCFA

I.E - PROFESSIONS - ARTISTS - 19th c.

Paris. Musée de la monnaie
 David d'Angers,1788-1856.Hôtel de la mon-
naie,Paris,juin-sept.,1966.Cat.par François
Bergot.Préfaces par Pierre Dehaye et Pierre
Pradel.Paris,Hôtel de la monnaie,1966
 151 p. illus.

 Bibliography
 Repro.incl.:Ptgs.miniatures,daguerreotype,
caricatures,drags.,prints by D.'s contempora-
ries.Bronze statuettes,busts,medallions by
David d'Angers of poets,military,clergy,states-
men,artists
 List of sit ters

592.6
.79
PC

I.E - PROFESSIONS - ARTISTS - 20th c.

Arts Club of Chicago.
 Sixty years on the Arts Club stage;a souve-
nir exh.of portraits,Nov.17,1975 through Jan.3,
1976..Chicago.,the Arts Club of Chicago.1975.
 64 p. illus.

 "A survey of special events...held on our
stage,featuring portrs.of eminent composers,
concert artists,writers,dancers,and other per-
sons connected with the arts."

 Incl.short biographical notes

VF

I.E - PROFESSIONS - ARTISTS - 19-20th c.

Artist portraits and self portraits, selections
from the Syracuse University Art collection
Exh.in the Joe and Emily Lowe Art gallery,
Oct.1-22,1978
 8 p. cover illus.

 Checklist of prints,drags.,ptgs.,sculptures

I.E - PROFESSIONS - ARTISTS - 20th c.

Avedon, Richard, 1923-
 Observations.Photographs by Richard Avedon,
comments by Truman Capote..N.Y.,Simon & Schus-
ter,1959,
 151 p. illus.

 Incl.:Individuals associated with fine arts
& films.

LC TR680.89 MCMA, p.436, v.11

N
6850
L69
1968
NCFA

I.E - PROFESSIONS - ARTISTS - 19-20th c.

Liberman, Alexander, 1912-
 The artist in his studio;text and photos
by Alexander Liberman,with a foreword by James
Thrall Soby.N.Y.,Viking Press.1968,
 284 p. illus(part col.) (A Studio book)

 "A.L.records & interprets with a camera
the personalities & ambiance of some of the
leading European .artists.of our time."-Soby

 MOMA,v.11,p.437

I.E - PROFESSIONS - ARTISTS - 20th c.

Georges-Michel, Michel, 1883-
 ...Peintres et sculpteurs que j'ai connus,
1900-1942...New York,Brentano's .1942.
 286 p. illus.

LC ND36.036 Fogg,v.11,p.322

I.E - PROFESSIONS - ARTISTS - 19-20th c.

New York university. Gallery of living art
 Gallery of living art,A.E.Gallatin col-
lection,N.Y.University....N.Y.,O.Grady press,
1936,
 .39.p. illus.

 Portrs.of Braque,Léger,Matisse,Picasso,
Mondrian,Miró;photographs by A.E.Gallatin

LC N620.N4A3 MOMA,v.11,p.438

I.E - PROFESSIONS - ARTISTS - 20th c.

Gernsheim, Helmut, 1913-
 The photographs of Ida Kar

In:Motif
9:90-95 Sept.,'62 illus.

 Photos of Gino Severini,Ivon Hitchens,Marc
Chagall,Geo.Braque,Ossip Zadkine

LC N1.M88 MOMA, v.11, p.436

I.E - PROFESSIONS - ARTISTS - 20th c.

Ouenne, Jacques
...Portraits d'artistes:R.-Th.Bosshard,André
Favory,Marcel Gromaire,Ch.Guérin,Kisling,André
Lhote,Matisse,Simon-Lévy,Vlaminck...Paris,
M.Seheur.1927.
307 p. illus. (L'art et la vie)

FOGG
3930.20

LC 759.4.C935p
art Lib'y
MOMA, p.435, v.11

I.E - PROFESSIONS - ARTISTS - 20th c.

Reiser, Walter
Begegnung;maler und bildhauer der gegen-
wart.Encounters;contemporary artists and sculp-
tors.Einführung von Dietrich Mahlow.Stuttgart,
Reiser Verlag.ca.1970.
1 v.(unpaged) mostly illus(part col.)

Photographic portrs.of 135 artists and
their works

Chronologies

Text in German
LC N40.R4
MOMA, v.11,p.439

I.E - PROFESSIONS - ARTISTS - 20th c.

Kassel. Documenta, 1st,1955
Documenta:Kunst des 20.jahrhunderts;inter-
nationale ausstellung im Museum Fridericianum
in Kassel.15.juli-18.sept.1955..München,Prestel
Verlag.1955.
1 v..63.p. illus(part col.)

Einleitung von Werner Haftmann

LC has 2nd "Künstlerbildnisse"p..111-28.
ed.N6070.K1.
K19 1955

NNC MH CU OClMa etc.
MOMA,v.11,p.437

I.E - PROFESSIONS - ARTISTS - 20th c.

Schweicher, Curt, 1908-
Künstler der gegenwart;maler,bildhauer,
architekten...Gütersloh,S.Mohn.1962.

LC N6490.S335
Fogg,v.11,p.325

I.E - PROFESSIONS - ARTISTS - 20th c.

Man, Felix H., 1893- ed.
Eight European artists photographed and
edited by Felix H.Man...Intro.by Graham Greene
and Jean Cassou...London,Heinemann.1954.
.240.p.incl.plates(part col.)

English,French,German

Incl.:Braque,Chagall,Léger,Le Corbusier,
Moore,Picasso,Sutherland

LC N6758.M35
MOMA,v.11,p.437

I.E - PROFESSIONS - ARTISTS - 20th c.

Sima, Michel
21 visages d'artistes.Paris,F.Nathan.1959.
159 p. illus(part col.)

Preface by Jean Cocteau

Contents:Arp.-Braque.-Chagall.-Cocteau.-De-
rain.-Dufy.-Gromaire.-Laurens.-Léger.-Lhote.-Mag-
nelli.-Matisse.-Miró.-Picabia.-Picasso.-Rouault.
Tsuguhari.-Utrillo.-Van Dongen.-Villon.-Zad-
kine

WN MB CLSU
MOMA,v.11,p.439

I.E - PROFESSIONS - ARTISTS - 20th c.

Maywald, Wilhelm, 1907-
Portrait+atelier;photos.Brattleboro,Vt..
Greene.c.1958.
1 v.(unpaged) illus.

English,German and French

Bibliography

Contents:Chagall,Léger,Rouault,Matisse,
Laurens,Picasso,Le Corbusier,Utrillo,Villon,
Arp,Braque,Miró

LC N6852.M3 1958

I.E - PROFESSIONS - ARTISTS - 20th c.

N
6490
S677
NCFA

Le Soleil noir. Positions.
Premier bilan de l'art actuel,1937-1955,
établi sous la direction artistique de Robert
Lebel. Paris,1953
360 p. illus (part col.)

"Notices biographiques":p.276-328,.157.por-
traits

Bibliography

LC N6490.L38
MOMA, v.11,p.437

I.E - PROFESSIONS - ARTISTS - 20th c.

Namuth, Hans, 1915-
Fifty-two artists.Photographs by Hans
Namuth.Scarsdale,N.Y..Committee for the visual
art.c.1973.
.4.p. illus.

MET
213
N15
Q

I.E - PROFESSIONS - ARTISTS - 20th c.

Témoignages pour l'art abstrait 1952,introd.de
Léon Degand...Photographies-portraits par
Serge Vandercam.Boulogne(Seine)Editions
"Art d'aujourd'hui.1952.
295 p. illus(part col.)

LC N6490.T45
MOMA, v.11, p.439

I.E - PROFESSIONS - ARTISTS - FRANCE

Fegdal, Charles, 1880-
...Ateliers d'artistes.:35 portraits d'ar-
tistes,80 repro.d'oeuvres,Paris,Stock.c.1925.,
v. .322.p. illus.

LC N6852.F4 MOMA,v.11,p.436

I.E - PROFESSIONS - ARTISTS - FRANCE - begin.
 20th c.
Maîtres de l'art indépendant,1895-1925:Por-
 traits d'artistes

In:Le Point(Colmar)
2⁰année,no.9:81-144 1937 illus.

 Pertains to exh.in Paris.Palais des beaux-
arts,Petit Palais,June-Oct.,1937

LC N2.P6 MOMA,v.11,p.438

I.E - PROFESSIONS - ARTISTS - FRANCE

Les grands peintres;a series.Geneva,R.Kister,
1956-
 v. illus.

 Some publ.in English with series title
'Great painters'

 Each booklet on individual artist,e.g.
 Villon,Atlan,Segonzac,Picasso,Rouault,Léger;
 text by Bernard Dorival,André Verdet,Michel
NPG has Ragon.Photogr.of artist by Roger Hauert,Rbt.
Villon Doisneau,Gilles Ehrmann
N40.1.V75D6
LC see ed.1953-7,1958-62: MOMA, v.11,p.436
Dorival,Ragon,Verdet

I.E - PROFESSIONS - ARTISTS - GERMANY

Breuer, Peter, 1896-
...Münchner künstlerköpfe...Geleitwort von
Adolf Wagner.München,Georg D.W.Callwey.1937.
355 p. illus.
FOGG
FA770.11
.35F

NN MH MOMA, p.436, v.11

I.E - PROFESSIONS - ARTISTS - FRANCE

Jouin, Henri Auguste, 1841-1913
 Musée de portraits d'artistes,peintres,
sculpteurs,architectes,graveurs,musiciens,
artistes dramatiques,amateurs,etc..nés en France
ou y ayant vécu,état de 3000 portraits,peints,
dessinés ou sculptés avec l'indication des col-
lections publiques ou privées qui les renfer-
ment...Paris,H.Laurens,1888
 241 p. illus.

LC N7004.J8

I.E - PROFESSIONS - ARTISTS - GERMANY

Lymant, Brigitte
 Künstlerbildnisse vom 16.bis 20.jahrhundert
Köln,Wallraf-Richarts-Museum,1982

LC N7618.K86 1982 Netuschil.Künstler unter
 sich...N7619.5.G3K86 1983X
 NMAA p.37

NU
1316
S819 I.E - PROFESSIONS - ARTISTS - FRANCE - 18-19th c
1982a
NPG Stein, Joanne Crown, 1940-
 The image of the artist in France:Artists'
 portraits and self-portraits around 1800
 c.1982 238 p.
 Thesis Ph.-D.-UCLA 1982
 Bibliography
 Photocopy of typescript
 List of illus.p.V-XVI.A copy with plates
 & 3 supplemental catalogues is on file at the
 UCLA library

 Ch.III:David's self-portrs....

I.E - PROFESSIONS - ARTISTS - GERMANY

Stein, Fred
 Deutsche portraits.von:Fred Stein:und:
Will Grohmann.Stuttgart,E.Battenberg.1961.
 1 v.(unpaged) illus.

 Text and captions in German,French & Engli

 Portrs.by Stein & biographies on opposite

 Incl.photos of artists

LC DD243.S8 MOMA, v.11,p.437

AP
1 I.E - PROFESSIONS - ARTISTS - FRANCE - 19th c.
C75
NMAA Bonafoux, Pascal
 (Portraits d'artistes)Regards croisés

 In:Conn.Arts
 no.419:28-34 Jan.,'87 illus(col.)

I.E - PROFESSIONS - ARTISTS - GERMANY - 20th c.

 Berliner secession
 Künstler unter sich.Frühjahrsausstellung
 .April-Mai 1931.malerei,plastik.Veröffent-
 lichungen des Kunstarchivs,v.64,no.57
MET 30 p. illus(incl. 24 portrs.)
107.3
B457
v.64

LC N5070.B4R4 Netuschil.Künstler unter
 sich.N7619.5.G3K86 1963X
 NMAA Anmerkungen p.37

N
7619.5
O3K86
1983X
NMAA

I.E - PROFESSIONS - ARTISTS - GERMANY - 20th c.

Netuschil, Claus K.
 Künstler unter sich:bildnisse von malern,
bildhauern und graphikern 1900-1930.Darmstadt
Verlag der Saalbau-galerie,1983
 137 p. illus.

 Bibliography

Issued in connection with an exh.held at the
Saalbau-Galerie
Cat.preparation by Bernd Freese
Incl.:Articles by Max Osborn,Curt Gravenkamp,
Herbert Hofmann, Rud.Grossmann,Max Oppen-
heimer,Gert Woll- heim,Ludw.Meidner

927
.863

I.E - PROFESSIONS - ARTISTS - GREAT BRITAIN

Smith, John Thomas, 1766-1833
 Nollekens and his times and memoirs of con-
temporary artists fr...Roubiliac,Hogarth and
Reynolds to...Fuseli,Flaxman and Blake...ed.and
annotated by Wilfred Whitten with 85 illustr.
 2 v. illus.,London,N.Y.,John Lane cy.,1920

1st ed. Colburn publ.,1828,2nd ed.1829

List of Nollekens' sitters in v.2,p.10ff.
Incl.a biography of J.T.Smith

LC NB497.N8S7 1917 Foskett.John Smart...Bibl.
 N40.1S638F7 NCFA

I.E - PROFESSIONS - ARTISTS _ GERMANY - 20th c.

 Wentzel, Hans, 1913-
 Bildnisse der Brücke-Künstler von einander
Einführung von Hans Wentzel.Stuttgart,Reclam
:1961.
 32 p. illus (Werkmonographien zur
bildenden Kunst no.63)

 Reclams Universal-Bibliothek,Nr.B9063

LC N6848.W4 Netuschil.N7619.5O3K86
 1963X NMAA p.136

I.E - PROFESSIONS - ARTISTS - ITALY

 Rud, Einar, 1892-
 Italienske kunstner portraetter fra Gotik og
Renaissance.:København,Selskabet Bogvennerne
:1967.
 105 p. illus.

 Illus.and part of text fr.Vasari's Vite de'
più eccelente pittori,scultori e architetti.

NIC
LC N69 22.R8 -København,Ca- Rep. 1967 #1151
 rit Andersen.1967.

qN
7628
B63C7
RB
NPG

I.E - PROFESSIONS - ARTISTS - GREAT BRITAIN

The Complete portraiture of William and Cathe-
rine Blake;with an essay and an iconogra-
phy by Geoffrey Keynes.:Clairvaux,France.
Trianon Press for the William Blake Trust,
1977
 155 p. chiefly illus.

 Limited first ed.of 562 copies

 Incl.bibliographical references

I.E - PROFESSIONS - ARTISTS - ITALY

 Vasari, Giorgio, 1512-1574
 Le vite de'piv eccellenti pittori,scvltori,
et architettori.scritte,& di nuouo ampliate da
m.Giorgio Vasari...Co' ritratti loro...Fiorenza,
appresso i Givnti,1568
 3 v. illus.

 c.150 woodcut portrs.-Rave
 1st ed.publ.1550 was not illustrated

LC N6922.V2 1568 Rave.Jb.d.Berl.Mus. I 1959
 LC N3.J16 fol. p.146
 Paolo Giovio,& d.Bildnisvi
 tenbücher d.Humanismus

I.E - PROFESSIONS - ARTISTS - GREAT BRITAIN

:Musgrave, Sir William, Bart., 1735-1800:
 A catalogue of a....collection of English
portraits consisting of the royal families...
lawyers...artists...from Egbert the Great to
the present time...works of Delaram...Hollar,
Loggan...with...remarks by an eminent collector
:Sir W.Musgrave....sold by....hr.Richardson...?
Feb.3.1800,and the 17 ff.days...and Mar.3,and
the 12 ff.days...London 1800:
 323 p.

MET
212
F98

DLC Priced 3495 items Names of
 buyers

Met.Sales Cat.[Z881.N53 NCFA v.25 p.72331?]

MET
175
L55

I.F - PROFESSIONS - ARTISTS - ITALY - 17th c.

Leoni, Ottavio, c.1578-1630
 Ritratti di alcuni celebri pittori del seco-
lo 17.,disegnati ed intaliati in rame dal Cava-
liere Ottavio Leoni...si e' aggiunta la vita di
Carlo Maratti...Roma,Antonio de'Rossi,1731
 272 p. illus.,12 engr.portr.

 Met,v.19, p.17200

I.E - PROFESSIONS - ARTISTS - GREAT BRITAIN

Myers & Rogers, London
 Cat.of engraved portraits of noted person-
ages principally connected with the history,
literature, arts and genealogy of Great Britain.
...London,Myers & Rogers,1903
 196 p. illus.

DLC NN MdBJ PP Winterthur Mus.Library
 :Z881.W78 NCFA v.6,p.228

N
7620
H17
NPG

I.E - PROFESSIONS - ARTISTS - NETHERLANDS

Hall, H.van
 Portretten van Nederlandsche beeldende
kunstenaars.Portraits of Dutch painters and
other artists of the Low Countries;specimen of
an iconography.Repertorium.Amsterdam,Swets en
Zeitlinger,1963
 419 p.

I.E - PROFESSIONS - ARTISTS - NETHERLANDS

Hondius, Hendrik, the elder, 1573-after 1649
 Pictorum aliquot celebrium praecipue Germaniae Inferioris, effigies.Hague, Comitis ex off Henrici Hondi.ca.1610.

 3 pt.

Brit.Mus.
555 d.22
565 g.8 Coll.of portrs.by Netherlandish artists.
565 f.4 Continuation of Cock's artist portrs.,Pictorum
.(2) aliquot celebrium...Antwerp,1572

 see also:Szwykowski,I.v. Historische skizze...
 "Iconographically very important."-Th.-B.

 Hall.Portr.v.Nederl.Beeld.
 Kunstenaars.N7620.H17 NPG
 p.XII

I.E - PROFESSIONS - ARTISTS(NETHERLANDS)

Houbraken, Arnold, 1660-1719
 Arnold Houbraken's Grosse schouburgh der niederländischen maler und malerinnen. Ubersetzt und mit einleitung,anmerkungen und inhalts-verzeichnissen versehen von dr.Alfred von Wurzbach. 1.band:Ubersetzung des textes nebst drei inhalts-verzeichnissen. Wien,W.Braumüller,1880.

 495 p. (Quellenschriften für kunstgeschichte und kunsttechnik XIV)

 Arnold H.'s drawings were engraved by son Jacobus (Thieme-Becker:Houbraken,Arnold)
LC ND652.H85 cobus Thieme-Becker:Houbraken,
 Jacobus

I.E - PROFESSIONS - ARTISTS - NETHERLANDS

Szwykowski, Ignaz von, 1807-1859
 Historische skizze über die frühesten sammel-werke altniederländischer maler-portraits von Hieronymus Cock und Hendrik Hondius,etc.
Brit.Mus. Reprint from Dr.Naumann-Weigel Archiv für zeich-
7854.f. nende Künste,II,1836,p.13-63.Leipzig,R.Weigel, 1856

760.5 I.E - PROFESSIONS - ARTISTS - NETHERLANDS - 16-
.P94 17th c.

The complete etched portrait work of Anthony van Dyck,from the collections of Sir Peter Lely and Prosper Henry Lankrink.N.Y.,M. Knoedler & co.,inc.,1934
 .44.p. illus. (The print collector's bulletin,v.3,no.3)

 Coll.Lely sold Apr.11-18,1688 under the direction of Sonnius,Lankrink & Thompson, London.-Coll.Lankrink sold May8,1693 & Feb. 22,1694,"At the Golden Triangle,in Long Acre,London

 Mostly portrs.of Flemish painters

I.E - PROFESSIONS - ARTISTS - SPAIN - 20th c.

Sánchez-Camargo, Manuel, 1914-
 Pintura española contemporánea.Madrid,Ediciones Cultura Hispánica,1954-
 v. illus.

 v.1:La nueva escuela de Madrid.-v.2:Diez pintores madileños,pintura española contemporánea...1966;208 p.

v.1:LC ND808.S3
v.2:LC ND811.M2S3
 MOMA, v.11,p.439
 MOMA 50.6326

927 I.E - PROFESSIONS - ARTISTS - U.S.
.L64
rare book Lester, Charles Edwards, 1815-1890
 The artists of America...with portraits and designs on steel...New York,Baker & Scribner, 1846
 257 p. illus.

 Contents.-W.Allston.-H.Inman.-B.West.- G.Stuart-J.Trumbull.-J.De Veaux.-R.Peale.- Th.Crawford.

LC N6536.L6 Cirker.Dict.of Am.portrs.
 N7593/C57/NPG Bibl.,p.714
 Ref.

qN7618 I.E - PROFESSIONS - ARTISTS - U.S.
N27
NPG New York. National academy of design (U.S.)
 Artists by themselves;artists' portraits from the Nat'l academy of design.N.Y.,The Academy;.Seattle.Univ.of Wash.Press.distributor.c.1983
 175 p. illus(part col.)
 Bibliographical references
 Index
 Cat.of an exh.held at the Nat'l academy of design Nov.3,1983-Jan1,1984,The NPG,Wash., D.C. Feb.10-Mar 25,1984 & 5 other mus.in 1984 and 1985. Introd.by Michael Quick
 Inventory of portrs.of artists & architects in the co. of the Nat'l acad.of des. p.161-73

qN I.E - PROFESSIONS - ARTISTS - U.S.
7618
D1116 New York. National academy of design
1987 Da pittore a pittore:rascelta di ritratti è
NPG autoritratti della National academy of design
 di New York.N.Y.,The Academy,c.1987
 160 p. illus(part col.)
 Index
 In Italian and English
 Cat.of an exh.held at Milan,Pinacoteca Ambrosiana,Oct.16-Dec.18,1987 and at Florence,Galleria degli Uffizi,Apr.15-Jne 15,1988
 "Mostra è cat.realizzati grazie a United Technologies Corp."
 Text by M.Quick p.28-59

N I.E - PROFESSIONS - ARTISTS -(U.S.)
7593.3
N53 New York. New School of Social Research. New
NPG School Art Center.
 Portraits from the American art world.:Exhibition:Feb.2-27,1965.:New York,1965.
 .64.p. illus.

LC N7593.N47

AP I.E - PROFESSIONS - ARTISTS - U.S. - 19-20th c.
1
I261 Carvey, Timothy J.
NPG Conferring status;Lorado Taft's portraits
v.78 of an artistic community

 In:Ill.Hist.J.
 78:162-78 Aut.,'85 illus.

VF
Amer.
Portr.
Soc.
Calif.
Hunting-
ton Har-
bour

I.E - PROFESSIONS - ARTISTS - U.S. - 19-20th c.

Doherty, M.Stephen
 Artists by themselves

In:Profile
 :3-5 1984 illus.

 Article pertains to traveling exh.In NPG
Feb.10-March 25,1984;from Nat'l Academy of De
sign,Nov.3,1983-Jan.1,1984

N
7624
J29
NPG

I.E - PROFESSIONS - AUTHORS

Borg, James M.W.,Inc.,Chicago
 Gallery.Portraits of literary and histori-
cal figures.1982
 unpaged(121 nos. illus.

 Incl.:Caricatures;drawings,prints

fAP
1
W3175
NMAA

I.E - PROFESSIONS - ARTISTS - U.S. - 20th c.

Photographers and their subjects.10 photogra-
 phers/17 artists

In:Wash Rev
12,no.2:3-25 Aug/Sept.,'86 illus.

I.E - PROFESSIONS - AUTHORS

Dangon, Georges
 Cent ans de journalisme (1839-1939)

In:Courrier graph.
 :3-7 1939,no.24 illus.

 Incl.:Portr. & caricatures of journalists by
Mailly,Nadar,Duran,Cohl,Humbert

LC 81007.C775 Rep.,1942=698

NB
212
S43s
NCFA

I.E - PROFESSIONS - ARTISTS - U.S. - 20th c.

Sculptors' guild, New York
 Sculptors' guild travelling exhibition,
1940-1941.N.Y.,N.Y.,The Sculptors' guild
:c.1940:
 9 p. illus.

 Photographs of the sculptors at work;
incl.portr.heads and busts by these sculptors.

LC NB212.833 MOMA v.11,p.440

I.E - PROFESSIONS - AUTHORS

Giovio, Paolo, 1483-1552
 ...Elogia virorum literis illustrium...Basileae
Petri Pernae...1577
 231 p. illus.

 60 woodcuts after portrs.in Giovio's coll.
by Tobias Stimmer,incl.1 of Giovio

LC CT95.G5 Rave.Jb.d.Berl.Mus. I 1959
 LC N3.J16 fol. p.150
 Paolo Giovio & d.Bildnisvi
 tenbücher d.Humanismus

NE
508
Z68
NCFA

I.E - PROFESSIONS - ARTISTS - U.S. - 20th c.

Zigrosser, Carl
 The artist in America.24 close-ups of con-
temporary printmakers.N.Y.,A.A.Knopf,1942?
 207 p. illus.

 Incl.Photographer Alfred Stieglitz
 Illus.:3 works and 1 portr.of each artist,
with the exception of Jasper Plum

 MOMA,v.11,p.439

I.E - PROFESSIONS - AUTHORS

Grolier club, New York
 Cat.of an exh.of engraved portraits of wo
men writers from Sappho to George Eliot...
March7-23,1895.N.Y.,The Gilliss press,1895
 24 p.

LC NE220-07 Levis,Descr.bibl.Z5947A3
 L66 1974 NCFA p.381

I.E - PROFESSIONS - ARTISTS
 see also
I.E - SELF-PORTRAITS

I.E - PROFESSIONS - AUTHORS

Jullien, :Jean Lucien:Adolphe, 1845-
 Fantin-Latour;;roupes et portraits...et
d'hommes de lettres

In:Les Arts
MET 5,no.53:25-32 May,1906 illus.
100.54
Ar72
1906
 FOR COMPLETE ENTRY
 SEE MAIN CARD

LC N2.A85 Chicago,A.I. European ports.
 N7621.C:A7 NPG Bibl. p.177

qtr
647
P41289
NPG

I.E - PROFESSIONS - AUTHORS

Penn, Irving,1917-
 Irving Penn.by.John Szarkowski..Exh.at.Mus.
of modern art,N.Y.N.Y.,The Museum,c.1984
 216 p. chiefly illus(part col.)

 Bibliographical references

 Incl.:Portrs.of artists,writers,theater
people

N
40.1
K682S8
NPG

I.E - PROFESSIONS - AUTHORS

Stewart, J.Douglas
 Sir Godfrey Kneller.cat.of an exh.at the
NPG,London,Nov.-Dec.,1971....London,Bell;Nat'l
Portrait Gallery,1971
 82 p. illus(part col.)

 Bibl.references
 Incl.:Lady Eliz.Cromwell as St.Cecilia
 Chapters incl.:Drawings;Ladies & children;
Lords & Gentry;Scholars & Poets;Army & Navy;
Parade portrait.Appendix:Kit-cat club portrs.

LC ND1329.K55S7

qN
7621.2
N4A52
NPG
2 c.

I.E - PROFESSIONS - AUTHORS

Regteren Altena, I.Q.van, 1899-
 De portret-galerij van de universiteit van
Amsterdam en haar stichter Gerard van Papen-
broeck,1673-1743...I.Q.van Regteren Altena en
P.J.van Thiel...met een voorwoord van H.
Engel.Amsterdam,Swets en Zeitlinger,1964
 387 p. illus(1 col.)

 Summary in English

I.E - PROFESSIONS - AUTHORS

Vienna. Nationalbibliothek
 Die vertreter des schöngeistigen schrifttums
mit literarhistorikern und philologen in der
porträtsammlung der österreichischen National-
bibliothek;ein nachweisschelf(ohne einzelanführ-
rung der vorhandenen bildnisse).Wien,G.Prachner,
1963
 344 p. (Museion:Veröffentlichungen der
österr.Nat'l bibl. 3.Reihe.Veröffentlichungen
der porträtsammlung,Bd.1)

DLC Fogg,v.11,p.326

I.E.- PROFESSIONS - AUTHORS

Renouvier, Jules, 1804-1860
 Des portraits d'auteurs dans les livres du
15e siècle. Avec un avant-propos par Georges
Duplessis. Paris,A.Aubry,1863
 22 p.

 Bibliogr.footnotes
 Illustrated with wood engravings

LC N7604.R4 Amsterdam,Rijksmus.,cat.
 Z5939A52,deel 1,p.138

I.E - PROFESSIONS - AUTHORS - 19th c.

Harris, Frank, 1856-1931
 Contemporary portraits,by Frank Harris.
N.Y.,M.Kennerley,1915
 346 p. illus.

 Contents.-Carlyle.-Renan.-Whistler:artist
& fighter.-Oscar Wilde.-John Davidson:ad memo-
riam.-Richard Middleton:ad memoriam.-Sir Rich.
Burton.-George Meredith.-Robt.Browning.-Swin-
burne:the poet of youth & revolt.-Talks with
Matthew Arnold.-Guy de Maupassant.-Talks with
Paul Verlaine.+Fabre.-Maurice Maeterlinck.-
Rodin.-Anatole France

LC PN761.H2

 Books in print.Subj.guide,1985-86

N
40.1
D243S3
NPG

I.E - PROFESSIONS - AUTHORS

Schazmann, Paul-Emile, 1902-
 David d'Angers,profils de l'Europe.Genève,
Ed.de Bonvent,c1973.
 136 p. illus.

 Bibliography

N
40.1
D243P2
NGZA

I.E - PROFESSIONS - AUTHORS - 19th c.

Paris. Musée de la monnaie
 David d'Angers,1788-1856.Hôtel de la mon-
naie,Paris,juin-sept.,1966.Cat.par François
Bergot.Préfaces par Pierre Dehaye et Pierre
Pradel.Paris,Hôtel de la monnaie,1966
 151 p. illus.

 Bibliography
 Repro.incl.:Ptgs.miniatures,daguerreotype,
caricatures,drags.,prints by D.'s contempora-
ries.Bronze statuettes,busts,medallions by
David d'Angers of poets,military,clergy,states-
men,artists
 List of sitters

NC
772
S78
NPG

I.E - PROFESSIONS - AUTHORS

Stampfle, Felice
 Artists and writers;19th and 20th century
portrait drawings from the coll.of Benj.Sonnen-
berg.Cat. by Felice Stampfle and Cara Dufour.
With an introd.by Brendan Gill..Exh.held at
the Pierpont Morgan Library,N.Y.,May 13-July 30,
1971..New York,1971.
 52 p. illus.

 Bibliography

LC NC31.S6S8

 MOMA,p.434,v.11

I.E - PROFESSIONS - AUTHORS - 20th c.

Texas. University at Austin. Art Museum
 The faces of authorship.An exh.of 20th c.
literary portraits.Nov.24,1968-Jan.4,1969
 44.p. illus.

 Text by Donald B.Goodall,David Farmer and
Harry Ranson. 117 works

 MOMA,v.11,p.435
 Library Museum Box(in MOM

I.E - PROFESSIONS - AUTHORS - FRANCE

Grolier club, New York
 Cat.of an exh.of engraved portraits of
French authors to the close of the 18th cen-
tury...Dec.5-Dec.28,1895.N.Y.,The De Vinne
press,1895.
 16 p.

 249 entries,showing name,dates,painter,
and engraver

FOGG
WIDENER

Title frcColumbia Univ.
Printed by LC Levis-Descr.bibl.Z5947.A3
 L66 1974 NCFA p.381

I.E - PROFESSIONS - AUTHORS - GREAT BRITAIN

Daniell, Walter Vernon comp.
 A catalogue of engraved portraits of cele-
brated personages,chiefly connected with the
history and literature of Great Britain...Lon-
don,W.V.Daniell,1900
 278 p. illus.

LC NE265.D3 Whitman's print coll.hdbk.
 1921. NE885W614 1912 NCFA
 Bibl.III

I.E - PROFESSIONS - AUTHORS(FRANCE)

Thomé, J.R.
 Les dessins d'écrivains:Alfred de Musset

In:Courrier graph.
:27-31 no.37 1949 illus.

 Repro:George Sand,1833 and caricature of
Foucher & Stendhal ,1833

LC Z1007.C775 Rep.,1948-49*9506

I.E - PROFESSIONS - AUTHORS (GREAT BRITAIN)

Evans, Edward, 1789-1835
 Catalogue of a collection of engraved portraits
the largest ever submitted to the public;compris-
ing nearly 20000 portraits of persons connected
with the history & literature of this country,from
the earliest period to the present time...alpha-
betically arranged with the names of the painter
& engraver...Now on sale...London,E.Evans,etc.,
1836-53.

LC Rare Books dpt. Amsterdam,Rijksmus.cat.
 Z5939A52, deel 1,p.151

705
028
NCFA
v.10

I.E - PROFESSIONS - AUTHORS - FRANCE - 19th c.

Bouchot, Henri François Xavier Marie, 1849-1906
 Exposition des portraits des écrivains et
journalistes du siècle

In:Gas Beaux-Arts
10:202-22 Sept,1893 illus.

NE
265
G87
NPG

I.E - PROFESSIONS - AUTHORS - GREAT BRITAIN

Grolier club, New York
 Effigies of the most famous English writers
from Chaucer to Johnson,exh....Dec.8-22,1891
:N.Y.,The De Vinne press,1891.
 78 p. illus.

LC N7598.G68
NE205.G75 Fogg,v.11,p.333

I.E - PROFESSIONS - AUTHORS(FRANCE,19th c.)

Mallarmé

In:Le Point
:1-98 no.29-40,1944

 Incl:Portrs.of Mallarmé,his family,Baudelaire,
Rimbaud,Méry Laurent,etc.,etchings,drgs.by Renoir,
Deroy,Fantin-Latour,Whistler,Raffaëlli,Manet,
Matisse,Gauguin

LC N2.P6 Rep.,1942-44*764

I.E - PROFESSIONS - AUTHORS - GREAT BRITAIN

Grolier club, New York
 Exhibition of English literary portraits..
Nov.4-19,1898.N.Y.,The De Vinne press,1898.
 28 p.

 Chiefly the portrs. that were engraved in
larger size and issued separately as prints

LC N7598.07 Levis.Descr.bibl.Z5947.A3
 L66 1974 NCFA p.382

I.E - PROFESSIONS - AUTHORS - FRANCE - 19-20th c.

New York. State University College, New Paltz.
 Art Gallery
 From Victor Hugo to Jean Cocteau.Portraits
of 19th and 20th century.French writers from
the Artinian collection.Cat.by P.J.Bohan and
A.Artinian.A loan exh.,May 26-Aug.6,1965,the
Art Gall...:New Paltz,1965.
 68 p. illus.

LC N7604.N45 Rep.1967 *1146

I.E - PROFESSIONS - AUTHORS - GREAT BRITAIN

Myers & Rogers, London
 Cat.of engraved portraits of noted person-
ages principally connected with the history,
literature, arts and genealogy of Great Britain.
...London,Myers & Rogers,1903
 196 p. illus.

DLC MN MdBJ PP Winterthur Mus.Library
 Z881.W78 NCFA v.6,p.228

I.E - PROFESSIONS - AUTHORS(GREAT BRITAIN)

Portraits of the British poets. Published Jan.1, 1824,by W.Walker,Grays Inn Square, London

Tarkington.Some old portrs.
757.T2 NCFA bibl.

I.E - PROFESSIONS - AUTHORS - RUSSIA

Ehrenburg, Il'ia Grigor'evich, 1891-1967
«Portrety russkikh poétov».Porträts russischer dichter.Nachdruck d.Ausg.Berlin,1922,m! einer einleitung von Friedr.Scholz.München, W.Fink.1972.' (Centrifuga,v.20)
160 p.

Preface in German
Contents:A.A.Akhmatova-K.D.Bal'mont'-fU.K. Baltrushaitis-A.A.Blok-V.Ya Brüisov-Andrei Belyi M.A.Voloshin-S.A.Esenin-V.I.Ivanov-O.E.Mandel'-shtam-V.V.Maiakovskii-V.L.Pasternak- see over

LC PG3016.E5 1972 Verzeichnis lieferbarer Bücher 1973/4 NPG v.1,p.444

I.E - PROFESSIONS - AUTHORS - GREAT BRITAIN

Thane, J.ohn.1748-1818, ed.
 The British gallery of historical portraits ...a coll.of...portraits...of...illustrious personages in English...literature...London,Edw. Daniell.1854?.

MET
276.5
T32
LC DA28.T3

FOR COMPLETE ENTRY
SEE MAIN CARD

708.1
C86
NCFA
v.6

I.E - PROFESSIONS - AUTHORS - U.S.

Breckenridge, James Douglas, 1926-
 Portraits of Americans.On American portraiture

In:Corcoran G.A.Bull
c.:1-14, Feb.,'53 chiefly illus.

Winterthur Mus.Libr. fZ881
W78 NCFA v.6,p.222

qN
7628
B63C7
RB
NPG

I.E - PROFESSIONS - AUTHORS - GREAT BRITAIN -»
«19th c.

The Complete portraiture of William and Catherine Blake;with an essay and an iconography by Geoffrey Keynes..Clairvaux,France, Trianon Press for the William Blake Trust, 1977
 155 p. chiefly illus.

Limited first ed.of 562 copies

Incl.bibliographical references

AP
1
I261
NFG
v.78

I.E - PROFESSIONS - AUTHORS - U.S. - 19-20th c.

Garvey, Timothy J.
 Conferring status;Lorado Taft's portraits of an artistic community

In:Ill.Hist.J.
78:162-78 Aut.,'85 illus.

757
.M16
(New ed.)

I.E - PROFESSIONS - AUTHORS(GREAT BRITAIN,19th c.)

Maclise, Daniel, 1806-1870
 The Maclise portrait-gallery of "illustrious literary characters"with memoirs biographical, critical,bibliographical...illustrative of the literature of the former half of the present century,by Wm.Bates...N.Y.,Scribner & Welford,1883
 540 p. illus.

Drgs.:Sir Walter Scott,Lockhart,Thackeray, Wordworth,Chs.Lamb,Carlyle,Disraeli,etc. Originally published in Fraser's Magazine,1830-38

LC457.M3 1883 Blanshard,F.The portrs.of
 Wordsworth N7628W92B6 NPG

ND
1311.9
PSF813
NPG
2 c.

I.E - PROFESSIONS - BUSINESSMEN - U.S.

Framing the board;a look at corporate portraiture;an exh.organized and sponsored by the Mutual Assurance Corp.with the cooperation of Independence National History Park;Second Bank of the U.S.,Oct.27,1982-Jan.17, 1983.Phila.,Pa.,The Mutual Assurance Comp., 1982
 16 p. illus.

 Essay on the history & style of corporate commissioned portraits.Foreign influences.

I.E - PROFESSIONS - AUTHORS - GREAT BRITAIN -
 «20th c.

Prochaska, Alice
 Young writers of the thirties.London,National Portrait Gallery,c.1976
 19 p. illus.

 Published for the exh. of 25 June to 7 Nov., 1976
 Bibliography

 Exh.on:Auden,Day Lewis,Isherwood,MacNeice, Spender

LC PR106.P7 Rila III/1 1977 #2078

I.E - PROFESSIONS - CLERGY

«Agricola, Johann,of Spremberg.
 Warhaffte bildnis etlicher...fürsten und herren...Wittenberg,Gabriel Schnellboltz,1562
 2v. illus.

Brit.mus.
11515 bb. Rave:v.1:Woodcut portrs.of Charles V & other
(2.)(3.) nobilities.-v.2:Woodcut portrs.of clergymen,incl Huss,Luther,Melanchthon,Erasmus
 Poems by Agricola in praise of portrayed persons

 Rave.Jb.d.Berl.Mus. I 155
 LC N3.J16 fol. p.147
NRU Paolo Giovio & d.Bildnisvitenbücher d.Humanismus

I.E - PROFESSIONS - CLERGY

Burchardus,provost of Ursperg, d.1230
Chronicum Abbatis Vrspergensis...Strassburg,
₂Crafft.₂Mylivm,1537
506 p. illus.

Woodcuts after medals

NN NjP CSmH NIC
Rave.Jb.d.Berl.Mus.I 1959
LC N3.J16 fol. p.130
Paolo Giovio & d.ᵇildnisvitenbücher...

705
G28
v.20

I.E - PROFESSIONS - CLERGY

Fillon, Benjamin, 1819-1881
La galerie de portraits de Du Plessis-Mornay
au Château de Saumur

In:Gas Beaux Arts
2pér.v.20:162-68 Aug.,1879
:212-28 Sep.,1879 illus.

Reprint issued(same title)Paris,Quentin,1879

Aug.article incl.list of sitters:Protestant
reformers,royalty,e°°. Bouchot.Portrs.aux crayons
MB(reprint ed.) NC860.P23NPG,p.1,footn.1

I.E - PROFESSIONS - CLERGY

Guerrini, Paolo
La congregazione dei Padri della Pace

In:Monografie di Storia Brescia
9:1-380 1933 illus.

Portraits of dignitaries from the Middle Ages
to the present time

Rep.,1936,*355

N
40.1
D24P2
NCFA

I.E - PROFESSIONS - CLERGY - 19th c.

Paris. Musée de la monnaie
David l'Angers,1788-1856.Hôtel de la mon-
naie,Paris, juin-sept.,1966.Cat.par François
Bergot.Préfaces par Pierre Dehaye et Pierre
Pradel.Paris,Hôtel de la monnaie,1966
151 p. illus.

Bibliography
Repro.incl.:Ptgs.miniatures,daguerreotype,
caricatures,drags.,prints by D.'s contempora-
ries.Bronze statuettes,busts,medallions by
David d'Angers of poets,military,clergy,states-
men,artists
List of sitters

BX
5197
I 53X
NPG

I.E - PROFESSIONS - CLERGY - GREAT BRITAIN

Ingamells, John
Catalogue of portraits at Bishopthorpe
Palace. York,Borthwick Inst.of Hist.Research,
1972
77 p. illus.

Portrs. of archbishops of York and of Hano-
verians

Incl.Bibliographical references
Incl.:Kneller,Hudson,Reynolds,West,Owen,etc.

LC BX5197.I 53

N
7598.2
I44
NPG

I.E - PROFESSIONS - CLERGY - GREAT BRITAIN

Ingamells, John
The English Episcopal portrait,1559-1835.
A catalogue.Publ.privately by The Paul Mellon
Centre for Studies in British Art₂1981₂
491 p. illus.

Ch.on Episcopal dress
Index of artists

I.E - PROFESSIONS - CLERGY - GREAT BRITAIN

Strong, Roy C., 1935-
Portraits of the Deans of Canterbury in the
Deanery

In:Canterbury Cathedral chronicle
65:102-11 1970

LC BX5195.C3A12
Ingamells.Engl.Episcopal
portrait N7598.?I44,p.84

757
S72
1866
(RB)

I.E - PROFESSIONS - CLERGY - GREAT BRITAIN

Victoria and Albert museum, South Kensington.
...Catalogue of the first special exhibition of
national portraits ending with the reign of King
James II...April 1866.London,Printed by Strange-
ways and Walden₂1866₂
202 p.

LC N7598.S6 1866
Ingamells.Cat.of portrs...
BX5197.I 53X P.XVI

757
S72
1867
(RB)

I.E - PROFESSIONS - CLERGY - GREAT BRITAIN

Victoria and Albert museum, South Kensington.
...Catalogue of the second special exhibition
of national portraits commencing with the reign
of William and Mary and ending with the year
1800...May 1, 1867.London,Printed by Strange-
ways and Walden₂1867₂
208 p.

LC N7598.S6 1867
Ingamells.Cat.of portrs...
BX5197.I p.XVI

757
S72
1868
(RB)

I.E - PROFESSIONS - CLERGY - GREAT BRITAIN

Victoria and Albert museum, South Kensington.
...Catalogue of the third and concluding exhi-
bition of national portraits commencing with the
fortieth year of the reign of George III and
ending with the year 1867...April 13,1868.London
Printed by Strangeways and Walden₂1868₂
209 p.

Ingamells.Cat.of portrs...
BX5197.I 53X p.XVI

I.E - PROFESSIONS - CLERGY - BISHOPS(FRANCE)

Lestocquoy, Jean
 Les évêques d'Arras,leurs portraits,leurs
armoiries,leurs sceaux

In:M.Comm.Monum.Hist.Pas-de-Calais
4:1-127 1942 illus(165 fig.)

Met
665
Ar6 Ptg.,miniatures,stained glass,enameld reli-
 quaries,seals from 6th c. to present

 Rep.,1942-44#692

I.E - PROFESSIONS - CLERGY - POPES

Hermanin, Federico
 Tre ritratti di pontefici

In:At.Pontif.Accad.rom.Archeol.R.C.
18:10-11 & 149-74 1941-42 illus.

Met
605
R667 Portraits of the 13th c.
Q

 Rep.,1945-47#1035

I.E - PROFESSIONS - CLERGY - BISHOPS - GREAT
 BRITAIN
Bevan, Gladys Mary, 1864- ed.
 Portraits of the archbishops of Canterbury.
London, A.R.Mowbray & co.,ltd.,1908
 119 p. illus.

LC BX198.B
CSmH NPuU MBAt KyLxCB PPULC
 Yale ctr.f.Brit.art Ref.
 CT782.B46

I.E - PROFESSIONS - CLERGY - POPES

Ladner, Gerhart Burian, 1905-
 I ritratti dei papi nell'antichità e nel
medioevo...Città del Vaticano,Pontificio istituto
di archeologia cristiana,1941-
 v. illus. (Monumenti di antichità cris-
tiana...II.ser.IV)

 Bibliography

 Contents.-1.Dalle origini fino alla fine della
lotta per le investiture

LC N7832.M64 ser.2,vol.4 Enc.of World Art N31E56Ref
also in German Bibl.on portr. col.512

705
A7834
NCFA I.E - PROFESSIONS - CLERGY - BISHOPS - U.S.
v.53
 Gerdts, William H.
 Thomas Eakins and the Episcopal portrait:
 Archbishop William Henry Elder

 In:Arts Mag.
 53,no.9:154-7 May'79 illus(part col.)

I.E - PROFESSIONS - CLERGY - POPES

Mann, H.K.
 The portraits of the popes

In:Papers Br.Sch.
9:159-204 c1932, illus.

LC DG12.B85 Rep.,1932#87

705
B97
NCFA I.E - PROFESSIONS - CLERGY - POPES
v.112
 Pershad, David L.
 A series of papal busts by Domenico Guidi

 In:Burl Mag
 112:805-9 Dec.,'70 illus.

 Spike.Baroque portraiture
 in Italy.N7606.S75NPG
 Bibl.p.154

705
G28
2per I.E - PROFESSIONS - CLERGY - POPES
v.36
NCFA Müntz, Eugène
 Les tombeaux des papes en France

 In:Gaz Beaux Arts
 36:275-85 1887(pt.2) illus.
 :367-87 illus.

 Popes of the 11th - 14th c.

I.E - PROFESSIONS - CLERGY - POPES

Hager, Werner
 Die ehrenstatuen der päpste. Leipzig,Poeschel
& Trepte,1929

 87 p. illus.

 "Literatur"

LC BX958.M6H3

I.E - PROFESSIONS - CLERGY - POPES

Panvinio, Onofrio, 1529-1568
 Accuratae effigies Pontificum Maximorum...
Argentorati,1573,2nd ed.(1st ed.1568)
 Durch Verdolmetschung J.Fischaert,gen.Ment-
V & A ser Teutsch beschriben,Strassburg,1573

 Printer & publisher:Bernard Jobin.Woodcuts
by Tobias Stimmer:Half-fgs. of Urban VI to
Gregory XIII;after engravings in the 1st ed.
 Fischart condemns onesidedness of Vasari.
Speaks for the 1st time in art-history of German
artists who are Rave.Jb.d.Berl.Mus. I 1959
still famous to- LC N3.J16 fol.p.146 & 149
day. Paolo Giovio & d.Bildnis-
 vitenbücher d.Humanismus

I.E - PROFESSIONS - CLERGY - POPES(7-8th c.)

Ladner, Gerart Burian, 1905-
Die bildnisse der östlichen päpste des 7.
und 8. jahrhunderts in römischen mosaiken und
Wandgemälden

In:Studi bizantini e neoellenici
6:169.82 1940

Incl: Honorius I(625-38),John IV(640-2),
Theodore I(642-9),John VII(705-7),St.Zacharias
(741-52)

LC
DF503.S8
 ◯ Rep.,1942-44*691

I.E - PROFESSIONS - EXPLORERS - U.S.

Carson, Hampton Lawrence, 1852-1929
...The Hampton L.Carson collection of en-
graved portraits of American naval commanders &
early American explorers & navigators...Cat. comp.
& sale conducted by Stan.V.Henkels at the art auc-
tion rooms of Davis & Harvey....Philadelphia,1905.
80 p. illus.
Cat.no.906,pt.IV

To be sold Oct.31 & Nov.1,:1905.

LC NE260.C26
 ◯ Amsterdam,Rijksmus.cat.
 25939A52, deel 1, p.154.

I.E - PROFESSIONS - CLERGY - RECTORS - U.S.

New York. Trinity Church
250th anniversary of the parish of Trinity
Church in the city of New York;cat.of the com-
memorative exh.of historical treasures from
the collections of the parish of Trinity Churc
and of the New York Historical Society,at the
N.Y.,Hist.Soc.,May6-July 18,1947.N.Y.,1947.
48 p. illus.

Incl.:Ch.:Portrs of the Rectors
Repro.incl.:Portrs.by John v.Johansen,
Ths.S.Duché,John Wollaston,unidentified artist
c.1710
LC BX5580.N5T65 1947 ◯

I.E - PROFESSIONS - GOVERNMENT - STATE AND LO-
 -CAL - FRANCE
705
B97 Blunt, Anthony, 1907-
N6FA Philippe de Champaigne's portraits of the
v.82 Echevins of Paris

In:Burl Mag
82:83-7 Apr.,'43 illus.

 Rosenfeld.Largillière
 ◯ Bibl.p.400

I.E - PROFESSIONS - CLERGY - REFORMERS

Hume, George
Portraits of leading reformers...with an...
essay by G.Hume.Containing:Knox,Wickliffe,Huss,
Jerome of Prague,Erasmus of Rotterdam,Luther,
Melanchton,Zuinglius,Wishart,Gustavus Adolphus
a.o.Edinburgh,A.Fullarton & co.,1851
9 p. 4pl.9 port.

NN IEN CoU MB MH ◯

I.E.- PROFESSIONS - GOVERNMENT - (STATE & LOCAL) -
 (NETHERLANDS)
Lübke, Wilhelm, 1826-1893
Zur geschichte der holländischen schützen-
& regentenbilder

In:Rep Kunstwiss
1:

"Rep Kunstwiss"
LC N3R4 ◯ Raetsoldt ND1300.W12

qN
7621.2 I.E - PROFESSIONS - CLERGY - REFORMERS
N4A52
NPG Regteren Altena, I.Q.van, 1899-
2 c. De portret-galerij van de universiteit van
 Amsterdam en haar stichter Gerard van Papen-
 broeck,1673-1743...I.Q.van Regteren Altena en
 P.J.J.van Thiel...met een voorwoord van H.
 Engel.Amsterdam,Swets en Zeitlinger,1964
 387 p. illus(1 col.)

 Summary in English

 ◯

fP
1 I.E - PROFESSIONS - GOVERNMENT - STATE AND LOCAL
025 .- U.S.
NPG McCoskey Goering, Karen
v.2 A Legacy from the Wyman museum:The Society's
 coll.of St.Louis mayors' portraits

In:Gateway Heritage
2:32-41 Spring,'82 illus(col.)

 Exhibited at City Hall.Owned by Missouri
Historical Society

 ◯

I.E - PROFESSIONS - CRAFTSMEN
see
I.E - PROFESSIONS - ARTISANS

 ◯

ND I.E - PROFESSIONS - GOVERNMENT - STATE AND LOCAL-
1311.8 .U.S.
I6P42 Peat, Wilbur David, 1898-
1978X Portraits and painters of the governors of
NPG Indiana,1800-1978...Indiana Histo.Soc.,1978

 ◯ FOR COMPLETE ENTRY
 SEE MAIN CARD

AP
1
H63
NPG

I.E - PROFESSIONS - GOVERNMENT - (STATE & LOCAL) - U.S.

Purvis, Doris F.
The Joseph Blackburn portraits of Lieutenant-Governor John Wentworth and Governor Benning Wentworth

In:Hist New Hampshire
24,no.3:34-9 Fall,'69 illus.

Full standing patgs.from 1760 in the New Hampshire Historical Society

I.E - PROFESSIONS - JURISTS - GREAT BRITAIN

Mitchell, James Tyndale, 1834-1915
...The unequaled collection of engraved portraits belonging to Hon.T.Mitchell...embracing the lord chancellors and chief justices of Great Britain,eminent English lawyers,kings & queens of Great Britain,English princes & princesses & members of royal families,mostly engraved in mezzotinto,to be sold...Feb.26...and...Feb.27,1908... Cat.comp.& sale conducted by Stan.V.Henkels.At the book auction rooms of Davis & Harvey,Phila.Pa. a...Press of W.F.Fell co.,1908.
93 p. illus.
Cat.no.944,pt. VI

LC NE265 M 5

AP
1
V81
NPG
v.76

I.E PROFESSIONS - GOVERNMENT - (STATE & LOCAL)- U.S.

Reese, George Henkle
Portraits of Governor Francis Fauquier

In:Va.Mag.of Hist.& Biogr.
76:3-10 Jan.,'68 illus.

Repro.:Rich.Wilson,Wm.Hogarth

I.E - PROFESSIONS - JURISTS - GREAT BRITAIN

.Musgrave, Sir William, Bart., 1735-1800.
A catalogue of a....collection of English portraits consisting of the royal families... lawyers...artists...from Egbert the Great to the present time...works of Delaram...Hollar, Loggan...with...remarks by an eminent collector .Sir W.Musgrave...sold by....Mr.Richardson...7 Feb.3,1800,and the 17 ff.days...and Mar.3,and the 12 ff.days...London 1800.
323 p.

MET
212
F98

DLC

Priced 3495 items Names of buyers

Met.Sales Cat.Z881.N53 NCFA v.25 p.[?]

I.E - PROFESSIONS - JURISTS

Hommel, Carl Ferdinand.1722-1781.
Effigies Jurisconsultorum in indicem redactae a C.F.Hommel.Lipsiae,1760

Listed in Universal Cat.of Zahn,Albert von,1836-1873
Books on Art.Suppl.p.312 Hist.Kunstslgn.In:Archiv f.
 Kstgeschnenden KVSte v.3iY8

I.E - PROFESSIONS - JURISTS - U.S.

Lewis, William Draper, 1867- ed.
Great American Lawyers, the lives and influences of judges and lawyers...Philadelphia, The John C.Winston Co.,1907-1909
8 v. illus.

LC E176.L67 Cirker.Dict.of Am.portrs.
 N7593/C57/NPG Bibl.,p.714
 Ref.

I.E - PROFESSIONS - JURISTS

Mantova Benevides, Marco,conte, 1489-1582
Illvstrivm ivreconsvltorvm imagines...Ex musaeo Marci Mantuae Benauidij patauini...Romae, Ant.Lafrerij...1558

25 engraved portrs.of jurists by Niccolò Nelli after portrs.in Mantova's "little"museum

MiU-L NNUT MH Rave.Jb.d.Berl.Mus. I 1959
 LC N3.J16 fol.p.146
 Paolo Giovio & d.Bildnisvitenbücher..

40.1
C872?.8
NPG

I.E - PROFESSIONS - JURISTS - U.S.

Loss, Bernice
Lawyers painted by Gardner Cox.Cambridge, Mass.,Harvard Law Library,1984
43 p. illus.

I.E - PROFESSIONS - JURISTS - CANADA

Halifax,N.S. Law Courts
Cat.of portraits of the judges of the Supreme Court of Nova Scotia and other portraits. Halifax,N.S.,1929?.
Nat.Gall. 111 p. illus.
of Canada
C N7594 The biographical notes have been collected
H17 by Reginald Vanderbilt Harris

DLC & CaNSWA(under Harris) Henry Francis duPont
 Winterthur Mus.Litr.
 Z881.W78 NCFA v.8,p.231 Ref.

I.E - PROFESSIONS - JURISTS - U.S.

Mitchell, James Tyndale, 1834-1915
...The unequaled collection of engraved portraits belonging to Hon.T.Mitchell...embracing statesmen of the colonial,revolutionary and present time,incl.the extens.coll. of portrs. of Benj. Franklin,Sam.Adams,John Hancock,Henry Laurens, Henry Clay,and Daniel Webster,also chief and associate justices of the Supreme court of the U.S, attorneys-general of the U.S.,judges,lawyers,etc. To be sold...Dec.5 and 6,1907...Cat.comp.and sale conducted by Stan.V.Henkels.At the book auction rooms of Davis & Harvey...Phila.Pa.:Phila.,1907.
134 p. illus.
Cat.no.944,pt.

LC E176 M68

I.E - PROFESSIONS - JURISTS - U.S.

Rosenthal, Albert, 1863-1939
 The chief justices of the supreme court of
Pennsylvania,reproductions of paintings by
Albert Rosenthal from life and authentic ori-
ginals.Phila.,Haeseler Photographic Studios,1907

Arch.
Am.Art
mfm
P29/32-60

Archives of American Art
"Portraits"

757
P35

I.E - PROFESSIONS - MARINE

Peabody museum of Salem, Salem,Mass.
 Portraits of shipmasters and merchants in
the Peabody museum of Salem,with an introduction
by Walter Muir Whitehill.Salem,Peabody museum,
1939
 185 p. illus.

LC N7593.P4

Whitehill.The Arts in ear-
ly Amer.Hist.Z5935.W59
Bibl.,p.101

I.E - PROFESSIONS - LABORERS

Brandt, Paul, 1861-1932
 Schaffende arbeit und bildende kunst.Leip-
zig,A.Kröner,1927-28
 2v.in 1 illus(part col.)

LC N8219.L2B7

Die 20er jahre im portr.
N6868.5.E9Z97 NPG,p.141

705
C75
NCFA
v.44

II.C.5 - PROFESSIONS - MARINE

Rhead, George Woolliscroft, 1854-1920
 Naval and military heroes in English pot-
tery

In:Connoisseur
44:183-93 Apr.,'16 illus.

 Repro.Incl.2 busts of Washington

Winterthur Mus.Libr. fZ881
W78 NCFA v.6,p.221

I.E - PROFESSIONS - LABORERS

Riess, Margot
 Der arbeiter in der bildenden kunst.Berlin-
Hessenwinkel,Verlag der Neuen Gesellschaft,
1925
 72 p. illus.

Die 20er jahre im portr.
N6868.5.E9Z97 NPG,p.141
also Rep.1925 #186

I.E - PROFESSIONS - MARINE - GREAT BRITAIN

Greenwich, Eng. National Maritime Museum
 Portraits at the National Maritime Museum,
selected by E.H.H.Archibald.London,H.M.Stationer
Off.,1954-55
 2 v.

 Contents:-Series I. 1570-1748. -Series II.
1748-1944

LC N7598.G63

Fogg,v.11,p.322

I.E - PROFESSIONS - LABORERS - GERMANY

Hütt, Wolfgang.
 Die entstehung des proletarierbildnisses
in der deutschen kunst

In:Bild.Kunst
11:586 ff. 1962

IU MH WU
LC N3.B53

Die 20er jahre im portr.
N6868.5.E9Z97 NPG,p.141

I.E - PROFESSIONS - MARINE - GREAT BRITAIN

Greenwich royal hospital, Greenwich,Eng.
 ...Descriptive catalogue of the portraits
of naval commanders...Exhibited in the Painted
hall of Greenwich hospital,and the Royal naval
museum, Greenwich.London,Printed for H.M.Sta-
tionery off.,by Eyre and Spottiswoode,ltd.,1912
 106 p.

LC DA89.G2G7 1912

Fogg,v.11,p.322

705
S94
NCFA

I.E - PROFESSIONS - MARINE

King, Cecil
 Naval portraits

In:Studio
124:1-11 Jul,1942 illus.(part col.)

 Incl:Raleigh,Grenville; ptgs.by Romney,Lely,
Copley,Wright(Charles II),Ramsay,Gainsborough,
Reynolds,Abbott & 20th c.ptrs.

Rep.,1942-44 #695

UA
670
H37
1987X
v.1
NPG
Ref.

I.E - PROFESSIONS - MARINE - GREAT BRITAIN

Harrington, Peter, 1954-
 Cat.to the Anne S.K.Brown Military Collec-
tion...N.Y.,Garlan Pub.,1987-
 v.1:The British prints,drawings and water-
colours.
 392 p. illus. (Garland reference library
of the humanities;vol.741)
 Indexes
 Section 6:Portraits,p.295-358:A.Original
works;Single items by sitter,p.297-301;Sets by
artists,p.302-3.B.Published works;Single prints
by sitter,p.305-32;Sets by artists,p.332-58

I.E - PROFESSIONS - MARINE - U.S.

Bramhall, Frank James, 1846-1909
 The military souvenir:A portrait gallery of
our military and naval heroes.New York,J.C.
Buttre,1863
 v. illus.

NIC PPULC DLC etc. Cirker.Dict.of Am.portrs.
 N7593/C57/NPG Bibl.,p.713
 Ref.

N
7592
C56 I.E - PROFESSIONS - MEDICINE
NPG Ciba Symposia
 The doctor's portrait. Issue containing
 articles on medical portraits. Summit,N.J.?1944.
 1780 p. illus. (Ciba symposia,v.6,no.1)

 Contents-The doctor's portr.fr.15-18th c.,by
 Grete de Francesco.-Medical portrs. of 18th c.,by
 Helen T.Konjias.-Medical portrs.of 19th c.,by
 Helen T.Konjias.-Historical notes

708.1
C86 I.E - PROFESSIONS - MARINE - U.S.
NCFA
v.6 Breckenridge, James Douglas, 1926-
 Portraits of Americans.On American por-
 traiture

 In:Corcoran G.A.Bull
 6:1-14, Feb.,'53 chiefly illus.

 Winterthur Mus.Libr. fZ881
 W78 NCFA v.6,p.222

I.E - PROFESSIONS - MEDICINE

Johns Hopkins University. John Work Garrett
 Library
 Medals relating to medicine...in the numis-
matic coll.of the Johns Hopkins Univ.,a cat.by
Sarah Elizabeth Freeman.Baltimore,Evergreen
House Foundation,1964
 430 p. illus. (Evergreen House Founda-
tion.Publication no.2)

 Bibliography

LC CJ5793.M4J6 Wolstenholme.The Royal Col-
 lege of Physicians of London
 1977 Bibl. p.VII

I.E - PROFESSIONS - MARINE - U.S.

Carson, Hampton Lawrence, 1852-1929
 ...The Hampton L.Carson collection of en-
graved portraits of American naval commanders &
early American explorers & navigators...Cat. comp.
& sale conducted by Stan.V.Henkels at the art auc-
tion rooms of Davis & Harvey....Philadelphia,1905.
 80 p. illus.
 Cat.no.906,pt.IV

 To be sold Oct.31 & Nov.1,1905.

LC NE260.C26 Amsterdam,Rijksmus.cat.
 Z5939A52, deel 1, p.154

I.E - PROFESSIONS - MEDICINE

Moehsen, Johann Karl Wilhelm, 1722-1795
 Verzeichnis einer samlung von bildnissen grös-
tentheils berühmter aerzte;so wohl in kupferstichen,
schwarzer kunst und holzschnitten,als auch in eini-
gen handzeichnungen...anmerkungen...vornehmlich
sur geschichte der künste...Berlin,C.F.Himburg,
1771
 240 p. illus.

 Vignetten von J.W.Meil nach B.Rode

LC NE240.M7 Amsterdam,Rijksmus.,cat.
 Z5939A52,deel 1,p.138

V
62
R48X I.E - PROFESSIONS - MARINE - U.S.
NPG
 Reynolds, Clark G.
 Famous American admirals.N.Y.,Cincinnati,etc
 Van Nostrand Reinhold Cy.,1978
 446 p. illus.

LC V62.R48

fN
7620
N53 I.E - PROFESSIONS - MEDICINE
NPG Ref. New York Academy of Medicine. Library.
 Portrait catalog. Boston,G.K.Hall,1960
 5 v.(4564 p.)

 ---- ---------. Supplement...
 1965-
 v. fN.7620.N53 Suppl.
 NPG Ref.
 Lib. has suppl.1-2

LC R153.5.N4

I.E - PROFESSIONS - MARINE - U.S.

Soldiers and sailors club of New York
 A loan exhib.of portraits of soldiers and
sailors in American wars...Nov.17-Dec.15,1945.
N.Y.,Duveen galleries.1945.
 95 p. illus.

 Bibliography

LC N7593.S6 Fogg,v.11,p.330

I.E - PROFESSIONS - MEDICINE

Royal College of Physicians of London
 Catalogue of engraved portraits in the
Royal College of Physicians of London,by A.H.
Driver.London,1952
 219 p.

F000
4353
L84p

 Fogg,v.11,p.324

I.E - PROFESSIONS - MEDICINE

Sambucus, Johannes, 1531-1584
 Icones vetervm aliqvot,ac recentivm medicorvm,
philosophorvmqve elogiolis svis editae...Nage-
drukt in fac-simile volgens de uitgave van Plantin
van 1574,met eene inleiding door...Max Rooses...
Antwerpen,Nederlandsche boekhandel etc.1901
7p,69:1,incl.illus. (Maatschappij der Antwerpsche
bibliophilen,no.21)
 Preface in Dutch and French
 "La manière des gravures indique...que Pierre
v.d.Borcht les exécuta à l'eau-forte..."

LC N7627.S2 Amsterdam,Rijksmus.,cat.
 Z5939A52,deel 1,p.138

N
1165
R6A6x
NPG
 I.E - PROFESSIONS - MEDICINE - GREAT BRITAIN

London. Royal College of Surgeons of England
 A cat.of the portraits...drawings and sculp-
ture in the Royal College of Surgeons of Eng-
land,by William LeFanu,librarian.Edinburgh,
E.& S.Livingstone,1960.i.e.1959.
 118 p. illus(part.col.)

 Bibliography

 Pt.2 incl.Racial types,anomalies

LC N1165.R6A6 Yale ctr.f.Brit.art Ref.
 N1165.R6A56

I.E - PROFESSIONS - MEDICINE

Society of the New York Hospital
 Biographical cat.descriptive of the por-
traits belonging to the Society of the New York
Hospital..N.Y.,1969
 49 p.

MET
276.7
N48 Compiled by Geo.L.Rives

NN NNC PP etc. Winterthur Mus.Libr. fZ881
 W78 NCFA v.6,p.225

I.E - PROFESSIONS - MEDICINE GREAT BRITAIN

Royal College of Physicians of London
 A cat. of the engraved portraits of British
medical men, compiled by Herbert Breun;by Arnold
Chaplin and W.J.Bishop.1930.
 Unpublished typescript

 London.Royal Coll.of Sur-
 geons of Engl.N1165.R6A6x
 NPG. Books quoted,p.IX

I.E - PROFESSIONS - MEDICINE

Westfälisches Landesmuseum für Kunst und Kul-
 turgeschichte, Münster
 Porträt 2:Der Ärztegraphische bildnisse
des 16.-20.Jahrhunderts aus dem Porträtarchiv
Diepenbroick.Ausstellung,17.12.1978-18.2.1979.
Westfälisches Landesmuseum für Kunst und Kul-
turgeschichte Münster,Landschaftsverband West-
falen-Lippe;8.3.1979-22.4.1979.Historische
Museen,Kölnisches Stadtmuseum,Köln,29.4.1979-
27.5.1979 Ritterhaus-Museum,Offenburg..Münster
Landschaftsverband Westfalen-Lippe,1978.
 310 p. illus.
 Ausstl.und Kat.:Peter Berghaus et al
MdBMA

I.E - PROFESSIONS - MEDICINE - GREAT BRITAIN

Royal College of Physicians of London
 A descriptive catalogue of the portraits,
busts,silver...in the Royal College of Physi-
cians of London..London,Harrison,Printers,1926
 70 p.

 Arnold Chaplin,the Harveian Librarian...is
responsible for the work in its present form

LC R489.A1R8?d 1926 Yale ctr.f.Brit.art Ref.
CU-M CtBVaU CtY N1165.R5A55
MiDA

AP
1
A64
NCFA
v.98
 I.E - PROFESSIONS - MEDICINE - GREAT BRITAIN

Holbrook, Mary
 Painters in Bath in the 18th century

In:Apollo
98:375-84 Nov.,'73 illus.

 Repro.incl.:Wm.Hoare,Prince Hoare,Ths.
Hickey,Ths.Beach,Ths.Barker

 Archer.Ind.& Brit.portrai-
 ture.ND1327.I44A72X NPG
 Bibl.p.482

705
C75
NCFA
v.84
 I.E - PROFESSIONS - MEDICINE - GREAT BRITAIN

Thompson, C.J.S.
 Historical portraits at the Royal College of
physicians

In:Connoisseur
84:3-11,94-101 Jul.,Aug.'29 illus.

 Repro.:v.Dyck,Calcar,J.Mich.Wright,Allan Ram-
say,Godfr.Kneller,Mary Beale,Chs.Jervas,bust by
L.F.Roubillac. J.Closterman,Ths.Lawrence,Gainsbo-
rough,Henry Monro,Mary Black,J.Zoffany
 Cumulated Mag.subj.index
 A1/3/C76 Ref. v.2,p.444

I.E - PROFESSIONS - MEDICINE - GREAT BRITAIN

London. Royal College of Surgeons of England
 Catalogue of portraits and busts in the
Royal College of Surgeons of England,with short
biographical notes.Revised to January,1930
.London,Printed by Taylor and Francis,1930.
 95 p. illus.

 Prepared by Fred.C.Hallett

 Bibliography

NN CU-M MiDW-M DNLM
PPU CtY Yale ctr.f.Brit.art Ref.
 N1165.R6A55

705
C75
NCFA
v.81
 I.E - PROFESSIONS - MEDICINE - GREAT BRITAIN

Thompson, C.J.S.
 Historical portraits at the Royal College of
surgeons of England

In:Connoisseur
81:78-92 Jun.'28 illus.

 Repro.:Romney,Balth.Gerbier,Jon.Richardson,
John Opie,Ozias Humphrey,Hogarth,Rbt.Edge Pine,
Reynolds,Gilb.Stuart,Ths.Lawrence,W.Hunt
 Cumulated Mag.subj.index
 A1/3/C76 Ref. v.2,p.444

qR
152.5
W44
1973x
NPG

I.E - PROFESSIONS - MEDICINE - GREAT BRITAIN

Wellcome Institute of the History of Medicine
 Portraits of doctors & scientists in the
Wellcome Institute of the History of Medicine;
a cat.,by Renate Burgess.London,Wellcome Inst.
of the Hist.of Medicine,1973
 459 p. illus. (Publications of the
Wellcome Inst.of the Hist.of Medicine.Mus.cat.3)

 Incl.index

 Bibliography

 Yale ctr.f.Brit.art Ref.
 R134.5+.W44

N
8223
G36
NPG
2 c.

I.E - PROFESSIONS - MEDICINE - U.S.

Gerdts, William H.
 The art of healing;medicine and science in
American art.Birmingham,Ala.,Birmingha Museum
of Art,1981
 119 p. illus.(part col.)

N
7598
W86
NPG

I.E - PROFESSIONS - MEDICINE - GREAT BRITAIN

Wolstenholme, Gordon E.W., ed.
 The Royal College of Physicians of London:
portraits.London,J.& A.Churchill,1964-77
 2 v. illus.
 v.2 publ.by Elsevier/Excerpta Medica,North
Holland,Amsterdam,and American Elsevier,N.Y.

 Bibliographies
 Index to artists
 Contents:v.1.The portrs.descr.by D.Piper.
 v.2Cat.by G.Wolstenholme & J.F.Kerslake,with es-
 says by R.E.O.Ekkart & D.Piper
 The portrs.are in alphabetical order by sit-
 ter See supp
LC RL89.A1W6

N
8223
P5La
NCFA

I.E - PROFESSIONS - MEDICINE - U.S.

Sellers, Charles Coleman, 1903-
 Conventions of medical portraiture

In:Philadelphia Museum of Art. The art of Phila-
delphia medicine..Exhib.Sept.15-Dec.6,1965.Phi-
ladelphia,1965. 131 p. illus.
 pp.98-102
 Relationship betw.physician & artist.Attrib-
utes in portrs. of medical men.Developm't fr.sho
ing social status to a freer use of conventions.
Photography makes ptrs.study anew their own tech-
niques,the value of light,the anatomy of men.
LC R314.P5P45 Fogg,v.11,p.329

R
315
C65
1984X
NMAA

I.E - PROFESSIONS - MEDICINE - U.S.

College of physicians of Philadelphia
 The College of physicians of Philadelphia
portrait catalogue.by.Julie S.Berkowitz;with
photographs by Rick Echelmeyer.Philadelphia,The
College,1984
 244 p. illus.

 Incl.:Indexes

I.E - PROFESSIONS - MILITARY

Bryden, H.A.
 The founders of Prussian militarism

In:Apollo
 :191-5 1933(pt.2) illus.

 Portr.of Frederick William,elector of Branden-
burg,1620-88,Frederick I,1st king of Prussia,1657-
1713,Frederick William I,1688-1740,FrederickII,
the Great,1712-1786

LC N1.A255 Rep.,1933*135

I.E - PROFESSIONS - MEDICINE - U.S.

College of Physicians of Philadelphia.Wm.M.
 Bradley Collection
 Philadelphia physicians.and others.as re-
presented in art.Reproduced by photography.
1936.-1950.
Arch. 12 v. illus.
Am.Art Preceeded by an index vol.
mfm Typescript,supplemented by a v.of "Silhouet-
P84-P86 tes",1941,and a suppl."A-Z",1950

 Bibliographies

.LC PP PPULC.Bradley,Wm.M.

I.E - PROFESSIONS - MILITARY

Giovio, Paolo, 1483-1552
 ..Elogia virorum bellica virtute illustrium...
.Basileae.Petri Pernae...1575
 391 p. illus.

 128 woodcuts after portrs.in Giovio's coll.
by Tobias Stimmer. 1 woodcut portr.of Giovio

LC CT93.G58 1575 Rave.Jb.d.Berl.Mus.I 1959
)LC N3.J16 fol. p.150
 Paolo Giovio & d.Bildnisvi
 tenbücher d.Humanismus

I.E - PROFESSIONS - MEDICINE - U.S.

Frankenberger, Charles, 1884-
 The collection of portraits belonging to
the college

In:The Jeffersonian
17,no.13?:1-10 Nov.,'15

 Jefferson Medical College,Philadelphia

DNLM(W1JE189) Gerdts.Art of healing
 N8223.G36 NPG p.114,note38

I.E - PROFESSIONS - MILITARY

Maggs Bros., London
 Choice engravings of American historical
importance.(Portraits of famous American and
British officers,statesmen and others connected
with the War of Independence)Rare political
cartoons,emblems....Washington portraits.Se-
lected from the Stock of Maggs Bros...London,
1909
 23 p. illus.
 no.249 237 items

CSmH Levis.Descr.bibl.Z5947.93
 .66,p.212:"Particularly in-
 teresting list"

705
M18
NCFA
v.12

I.E - PROFESSIONS - MILITARY

Mechlin, Leila, 1874-
War portraits by eminent artists

In:Mag Art
12:76-88 Mar,'21 illus.

Travel exhib.starting in the Met,N.Y.,Jan17-
Feb.14,'21 of portrs.to be presented to the NOA,
thus initiating in Wash.a "National Portr.Gall."

"Portr.is conceded to be the highest form of
art. ...man is to man invariably the most engag-
ing of exhibits." Cumulated Mag.subj.index
A1/3/C76 Ref. v.2,p.445

N
40.1
D24 3P2
NCFA

I.E - PROFESSIONS - MILITARY - 19th c.

Paris. Musée de la monnaie
David d'Angers,1788-1856.Hôtel de la mon-
naie,Paris,juin-sept.,1966.Cat.par François
Bergot.Préfaces par Pierre Dehaye et Pierre
Pradel.Paris,Hôtel de la monnaie,1966
151 p. illus.

Bibliography
Repro.incl.:Ptgs.miniatures,daguerreotype,
caricatures,drags.,prints by D.'s contempora-
ries.Pronze statuettes,busts,medallions by
David d'Angers of poets,military,clergy,states-
men,artists
List of sitters

757
.M27

I.E - PROFESSIONS - MILITARY

National art committee
Exhibition of war portraits;signing of the
Peace treaty,1919,and portrs.of distinguished
leaders of America and of the allied nations,
painted by eminent American artists for presenta-
tion to the National portrait gallery....New York,
1921.
64.p. illus.

Circulated by The American Federation of Arts
Cat.compiled by Florence N.Levy
On cover:National gall.of art under direction
of the Smithsonian Nat.,Wash.,D.C.,May5-22,1921
Review by Leila Mechlin

LC D507.N3

N.62
A56
NMAA
v.126

I.E - PROFESSIONS - MILITARY - EUROPE - 20th c.

Platt, Frederick, 1946-
The war portraits

In:Antiques
126:142-53 July,'84 illus(part col.)

'...American finest portr.ptrs.were...to re-
cord 22 Allied leaders...These ptgs....were to
form the basis of a Nat'l Portr.Gallery...'

Repro.incl.:Admiral Beatty,Cardinal Mer-
cier,Clemenceau by Cecilia Beaux

contin'd on next card

I.E - PROFESSIONS - MILITARY

Portraits of the Hungarians,Pandours,or Croats,
Waradins or Sclavonians,and Ulans,etc. who
are in the service of their Majesties the
Queen of Hungary and the King of Prussia,
designed after the life,by persons of dis-
tinction...London,William Meyer,1742
8 p. 6 plates

Winterthur
Mus.Libr.
GF301
94*

In English and French
Plates engraved by Hulett and Hickman

Winterthur Mus.Libr.
fZ881.W78 NCFA v.6,p.221

VF

I.E - PROFESSIONS - MILITARY - FRANCE

Chase, Joseph Cummings, 1878-1965
A portrait painter speaks and other articles

In:Sat.Eve.Post
199:14-5,177-8 June 18,'27 'A portr.ptr.speaks'
200:20-1,141-2 Aug.13, '27 'The adventure of
being painted'
200:16-7,81-2 Aug.27, '27 'Famous sitters'
200:16-7 Oct.15, '27 'What is this art
game?'
200:37,157-8,160 Apr.28,'28 'Ptg.the A.E.F.on the
Gallop'
A.E.F.=Amer.Expeditionary Forces;all illustrated

705
C75
NCFA
v.44

II.C.5 - PROFESSIONS - MILITARY

Rhead, George Woolliscroft, 1854-1920
Naval and military heroes in English pot-
tery

In:Connoisseur
44:183-93 Apr.,'16 illus.

Repro.Incl.2 busts of Washington

Winterthur Mus.Libr. fZ881
W78 NCFA v.6,p.221

AP
1
A64
NCFA
v.102

I.E - PROFESSIONS - MILITARY - GREAT BRITAIN

Archer, Mildred
Wellington and South India:portraits by
Thomas Hickey

In:Apollo
102:30-5 July,'75 illus.

Portr.studies...of Brit.officers in India

FOR COMPLETE ENTRY
SEE MAIN CARD

N
40.1
D243S3
NPG

I.E - PROFESSIONS - MILITARY

Schazmann, Paul-Emile, 1902-
David d'Angers,profils de l'Europe.Genève,
Ed.de Bonvent,1973.
136 p. illus.

Bibliography

UA
670
H37
1987X
v.1
NPG
Ref.

I.E - PROFESSIONS - MILITARY - GREAT BRITAIN

Harrington, Peter, 1954-
Cat.to the Anne S.K.Brown Military Collec-
tion...N.Y.,Garlan Pub.,1987-
v.1:The British prints,drawings and water-
colours.
392 p. illus. (Garland reference library
of the humanities;vol.741)
Indexes
Section 6:Portraits,p.295-358:A.Original
works;Single items by sitter,p.297-301;Sets by
artists,p.302-3.B.Published works;Single prints
by sitter,p.305-32.Sets by artists,p.332-58

UG
635
G7K45X
NPG

I.E - PROFESSIONS - MILITARY - GREAT BRITAIN

Kennington, Eric Henri, 1888-1960
Drawing the R.X.F. A book of portraits in-
troduced by Sir Ronald Storrs.p.11-32..London,
Oxford university press,1942
143 p. illus(part col.)

MOMA,p.434, v.11

N
7593.8
D3D34
NPG
2 c.

I.E - PROFESSIONS - MILITARY - U.S.

Delaware. State portrait commission
Cat.of Delaware portraits collected by the
Delaware State portrait comm.in the capitol
buildings.Dover,Del..Delaware portr.comm.,1941
64 p. illus.

Incl.:Index of artists and sitters

Repro.incl.:Washington,by Volozan

LC F163.D34 1941 Winterthur Mus.Libr.
 WZ881.W78 NCFA v.6,p.225

AP
1
W225
NCFA
v.34

I.E - PROFESSIONS - MILITARY - GREAT BRITAIN

Nevinson, John Lea
Portraits of gentlemen pensioners before
1625

In:Walpole Soc.
34:1-13 1952-4 illus.

Fogg,v.11,p.332

AP
1
W78
v.6
NCFA

I.E - PROFESSIONS - MILITARY - U.S.

Kaplan, Milton, 1918-
Heads of States

In:Winterthur Portf.
6:135-150 illus.

Altered plates

Repro.All of prints in the LC

I.E - PROFESSIONS - MILITARY - ITALY

Ritratti et elogii di capitani illustri che
ne' secoli moderni hanno gloriosamente
guerreggiato.Descritti da Giulio Roscio,& altri.
Roma,Rossi,1646
404 p. illus.

FOGG
Widener

Fogg,v.11,p.325

705
M18
NCFA
v.37

I.E - PROFESSIONS - MILITARY - U.S.

Kirstein, Lincoln, 1907-
American battle art:1588-1914.II.Portraits
and popular myths.

In:Mag.of Art
37:146-51 Apr.,'44 illus.

Repro.:Portrs.by Mendenhall,Chs.Baskerville,
Rbt.Weir. Busts by Saint Gaudens,Epstein

Cumulated Mag.subj.index
A1/3/C76 Ref. v.2,p.443

I.E - PROFESSIONS - MILITARY - U.S.

Bramhall, Frank James, 1846-1909
The military souvenir:A portrait gallery of
our military and naval heroes.New York,J.C.
Buttre,1863
v. illus.

NIC PPULC DLC etc. Cirker.Dict.of Am.portrs.
 N7593/C57/NPG Bibl.,p.713
 Ref.

I.E - PROFESSIONS - MILITARY - U.S.

Mitchell, James Tyndale, 1834-1915
...The unequaled collection of engraved por-
traits of officers...of the war of the revolu-
tion,2nd war with Great Britain and the Mexican
war,belonging to Hon.James T.Mitchell...to be
sold Nov.30 and Dec.1,1906...Cat.comp.& sale con-
ducted by Stan.V.Henkels,at the book auction
rooms of Davis & Harvey...Phila.,Pa...M.H.Power,
printer,1906.
131 p. illus.
Cat.no.944,pt.III

LC E181.M84

N
579
C3A3X
NPG

I.E - PROFESSIONS - MILITARY - U.S.

Charleston, S.C. City Council
Catalogue of painting and sculpture in the
Council Chamber,City Hall,Charleston,S.C.;by
Anna Wells Rutledge.Charleston.The City council,
ca.1943
30 p. illus(part col.)

LC N529.C3A3

I.E - PROFESSIONS - MILITARY - U.S.

Soldiers and sailors club of New York
A loan exhib.of portraits of soldiers and
sailors in American wars...Nov.17-Dec.15,1945.
N.Y.,Duveen galleries.1945.
95 p. illus.

Bibliography

LC N7593.S6 Fogg,v.11,p.330

CT
275
W36N4
NPG

I.E - PROFESSIONS - MILITARY - U.S. - 18th c.

Nelson, Paul David, 1941-
Anthony Wayne.soldier of the early Repub-
lic.Bloomington.Ind.Univ.Press,c.1985
368 p. illus.

Bibl.p.341-57

. Repro.incl.:Edward Savage,John Trumbull,
Js.Peale,Chs.Willson Peale,Js.R.Lambdin,Alonzo
Chappel,Js.Sharples,Henri Flouis

I.F - PROFESSIONS - MUSICIANS

Bellaigue, Camille, 1858-1930
Portraits and silhouettes of musicians;
transl.fr.the French by Ellen Orr.Boston,
Longwood Press,1978
302 p. illus.

Reprint of the 1898 ed.publ.by N.Y.,Dodd
Mead

LC ML390.B43 1978 Cumulative book index
 Z1219.C97 NPG 1979.p.217

705
A5
NCFA
v.13

I.E - PROFESSIONS - MILITARY - U.S. - 18th c.

Ormsbee, Thomas Hamilton, 1890-1969
18th century Anglo-American relations mir-
rored in prints

In:Am Coll
13:6-7,15 Feb.,'44 illus.

Portr.ptgs.& prints of political & military
leaders in America,England & France

Repro.incl.:Lafayette,Franklin,Lord North,
Wm.Pitt,Ths.Paine,J.Hancock

N
7621
H33
NPG

I.E - PROFESSIONS - MUSICIANS

Harvard University. Library. Theatre coll.
Cat.of dramatic portraits in the theatre
coll.of the Harvard college library.Cambridge,
Mass.Harvard univ.press,1930-34
4 v.
Compiled by Lillian Arvilla Hall
"A descriptive index to the engraved dra-
matic portrs.in the theatre coll....arranged
alphabetically according to names."-Pref.

Moon.Engl.portr.drags.&min.
NC860.N66X NPG Bibl. p.145

I.E - PROFESSIONS - MOTION PICTURES

Avedon, Richard, 1923-
Observations.Photographs by Richard Avedon,
comments by Truman Capote.:N.Y.,Simon & Schus-
ter,1959.
151 p. illus.

Incl.:Individuals associated with fine arts
& films. For names see over

LC TR680.A9 MOMA, p.436 , v.11

mfc
1277
NPG

I.E - PROFESSIONS - MUSICIANS

International repertory of musical iconography
(Organisation)
Portraits of composers and musicians on
prints and drawings.Coll.of Music Department,
Haags Gemeentemuseum,The Hague (P.784)
Zug,Swits.:Inter Documentation Company,c.1977
33 sheets only illus.

By composers' names in alphabetical order

I.E - PROFESSIONS - MOTION PICTURES

Ray, Man, 1890-
Portraits.Hrsg.und eingeleitet von L.Fritz
Gruber.:Gütersloh,S.Mohn:1963.
15 p. illus.:73.

Man Ray's commentary accompanies each portr
Incl.Cocteau,Maar,Dali,Tanguy,Eisenstein,Le Cor
busier,Loos,Pascin,Tanning,Derain,Braque,Léger,
Giacometti,Brancusi,Matisse,Picasso,etc.

LC TR680.R36 MOMA,v.11,p.437

I.E - PROFESSIONS - MUSICIANS

:Lindsay, W.B.:
Portraits of great composers, with biogra-
phical sketches. Chicago,Hall & McCreary Company
:1936:

40 p. illus.

LC ML87.P73 Rep.,1937*322

TR
647
H79W3
NMAA

I.E - PROFESSIONS - MOTION PICTURES - U.S.

Watters, James
Return engagement:Faces to remember-then
and now...with new photographs by Horst.1st
ed.N.Y.,C.N.Potter,inc.;distributes by Crown,
inc.Publishers,1984
168 p. illus.

Index

Books in print.subject
guide,1985-86,p.4865

AP1
A64
NCFA

I.E - PROFESSIONS - MUSICIANS

Lockspeiser, Edward
Painters and musicians

In:Apollo
25:336-8 Jun,1937 illus.

Relationship betw.musicians & ptrs. Gounod
by Ingres,Chopin by Delacroix,Berlioz by Courbet,
Chabrier by Manet,Debussy by Friess

Rep.,1937*371

N
7592
024
NPG

I.E - PROFESSIONS - MUSICIANS

New York. Metropolitan museum of art. Crosby
 Brown collection
 ...Cat.of the Crosby Brown coll.of musicians'
portraits...N.Y.,The Metrop'.mus.of art,1904.
 131 p. (The Metropolitan mus.of art.Hand-
book no.13,IV)
 Cat.by Clara Buffum

 Incl.:Classified,geographical and alphabe-
tical indexes
 NPG copy bound with Garrick club,London.Cat.
of the pictures...London,1909
LC ML390.N5 copy 2:N611.B7

705
B97
NCFA
v.69

I.E - PROFESSIONS - MUSICIANS - FRANCE

Glück, Gustav
 Some portraits of musicians by van Dyck

In:Burl Mag
69:147-8,153 Oct.,'36 illus.

 Jacques Gaultier,Nicolas Lanier identified
through prints by Jan Lievens & Lucas Vorsterman

 G.feels that music seems to come through to
us from some ptgs.
 Cum.Mag.Subj.Ind,1907-49
 A1/3/76/NPG Ref. p.444

N
40.1
D24S3
NPG

I.E - PROFESSIONS - MUSICIANS

Schazmann, Paul-Émile, 1902-
 David d'Angers,profils de l'Europe.Genève,
Ed.de Bonvent,1973.
 136 p. illus.

Bibliography

I.E - PROFESSIONS - MUSICIANS - GREAT BRITAIN -
 18th c.

Dulwich college,London - Dulwich Gallery
 The Dulwich picture gallery...1980

 ...A group of portraits of the Linley fami-
ly of musicians.

FOR COMPLETE ENTRY
SEE MAIN CARD

I.E - PROFESSIONS - MUSICIANS - AUSTRIA - 20th c.

Hague. Gemeentemuseum
 Schönberg,Webern,Berg.Portretten,partituren
documenten..Tentoonstelling....28 feb.-28 april
1969
 1 v.(unpaged) illus.
 Label on t.p.:supplied by Worldwide Books,
N.Y.
 Dutch or German

 Bibliography

LC ML141.H483
 MOMA, p.434, v.11

I.E - PROFESSIONS - MUSICIANS - GREAT BRITAIN -
 18th c.
Iveagh Bequest, Hampstead,Eng.
 Gainsborough and his musical friends;a ce-
lebration of the 250th anniversary of the ar-
tist's birth..Cat.of.exh.5 May-7 June,1977.
.London:Greater London Council.1977.
 36 p. illus.

 Bibliography

 Foreword by Ellis Hillman

 Discusses...possible affinities betw.G.'s
art and music Rila IV/1 1978 #1400

I.E - PROFESSIONS - MUSICIANS - BELGIUM

Galerie de portraits d'artistes musiciens du
 royaume de Belgique,lithographiés d'après
 nature par Baugniet...Imprimé par Degobert
 Bruxelles,V.Deprins,1842-43.
 .41.p. illus.

 Biographical sketches by F.J.Delhasse etc.

LC ML385.G15

I.E - PROFESSIONS - MUSICIANS - RUMANIA

Portrete și autoportrete:cîntăreți români...
 București:Editura muzicală,1974
 428 p. illus.
 Ed.by Dan Smântânescu
 Bibliographical references

 Cîntăreți - singers

LC ML400.P77

I.E.- PROFESSIONS - MUSICIANS - (FRANCE)

Dumesnil, René, 1879-
 Portraits de musiciens français. Paris,Ed.
d'histoire et d'art,Plon,.1938.

 248 p. illus.

 25 musicians who died betw.1918 and 1938

LC ML390.D85P7
 Rep.,1939-41#711

qML
3561
J3N27
NPG

I.E - PROFESSIONS - MUSICIANS - U.S. - 20th c.

National Portrait Gallery, Washington, D.C.
 "A glimmer of their own beauty":Black sounds
of the Twenties.Washington,1971
 .32.p. illus.

 Bibliography

 Exh.June 15 - Oct.15,1971

LC ML141.W3N3

I.E - PROFESSIONS - NOBILITY

₀Agricola, Johann, of Spremberg.
Warhaffte bildnis etlicher...fürsten und
herren...Wittenberg,Gabriel Schnelbolts,1562
2v. illus.
·Brit.mus.
11515 bb. Rave:v.1:Woodcut portrs.of Charles V & other
(2.)(3.) nobilities.-v.2:Woodcut portrs.of clergymen,incl.
Huss,Luther,Melanchton,Erasmus
Poems by Agricola in praise of portrayed per-
sons

Rave.Jb.d.Berl.Mus. I 1959
LC N3.J16 fol. p.147
NRU Paolo ⌒ Giovio & d.Bildnisvitenbü-
cher d. Humanismus

I.E - PROFESSIONS - NOBILITY - EUROPE - 17-18thc.

Berlin. Schloss Charlottenburg
Höfische bildnisse des Spätbarock.Exh.
Sept.15-Okt.10,1966.Cat.by Helmut Börsch-Supan
₀Berlin.Verwaltung der Staatl.Schlösser & Gärten,1966
208 p. illus.

Bibliography

LC ND1313.B6 Schoch.Herrscherbildnis...
⌒ND1313.5.S36X p.245

I.E - PROFESSIONS - NOBILITY

Copenhagen, Statens mus.um for kunst
Kunstmuseets aarsskrift,1921-23:Meng's
fürstenbildnisse,by C.Axdrup.København,1924

see also:Copenhagen,Statens mus.for kunst
Registre til Kunstmuseets Aarsskrift I-(XX
København,Gyldendalske boghandel-Nordisk for-
lag.etc.1945(Re:Indexes)
144 p.
CtY

LC N1915.A3

q N
7638
F8B75 Bouchot, Henri François Xavier Marie, 1849-1906
NPG Quelques dames du 16e siècle et leurs
peintres. Paris:Soc.de propagation des livres
d'art,1888

56 p. illus.

Court life in France;"Comment les dames de
Brantôme nous ont laissé leurs portraitures"

N.Y.P.L. MB CtY MBAt ⌒ NcD

I.E - PROFESSIONS - NOBILITY(FRANCE)

I.E - PROFESSIONS - NOBILITY

Official portraits

In:Verve
2:9-12 no.5-6,1939 illus.

Incl:Portrs.of St.Gregory the Great,Charles
the Bald,Francis I,Louis XIV,Napoleon. Ingres,
Delacroix,Chassériau,Corot,Millet,Th.Rousseau.
Prints by Hokusai & Utamaro

LC N1.V4 ⌒ Rep.,1939-41*620

I.E - PROFESSIONS - NOBILITY - FRANCE

Bouvy, Eugène, 1859-
...Nanteuil...Paris, Le Goupy,1924
8 p. illus. (Le portrait gravé et ses
maîtres)

Aperçu bibliographique sur Nanteuil:p.₀193.-
₀196₀

LC NE650.N4H6

705
C75
NCFA Pinto, Augusto Cardoso
v.137 Portuguese glass cameos

In:Connoisseur
137:32-4 Mar,1956 illus.

19th c.moulded cut glass with incrustations.
Also pressed glass plates with incrusted medals.
José F.Pinto Basto,1774-1839,founder of factory:
Fábrica Vista Alegre in 1824

I.E - PROFESSIONS - NOBILITY

I.E - PROFESSIONS - NOBILITY - (FRANCE)

Lenoir, Alexandre, 1761-1839
The Lenoir collection of original French
portraits at Stafford House.Auto-lithographed by
Lord Ronald Gower.London,Maclure & Macdonald...
1874

illus.

From Francis I to Marie-Antoinette

LC N7604.L36 Amsterdam,Rijksmus.,cat.
Rare book coll. ⌒ Z5939A52,deel 1, p.146

I.E - PROFESSIONS - NOBILITY - 16th c.

Hoop Scheffer, Dieuwke de
Vorstenportretten uit de eerste helft van
de 16de eeuw;houtsneden als propaganda...Amster-
dam,1972?
72 p. illus.

Cat.of exh.held at Rijksprentenkabinet,
Rijksmuseum,Amsterdam,Aug.16-Oct.20,1972

Bibliography

LC NE219.2.N4A574 ⌒

I.E - PROFESSIONS - NOBILITY -(FRANCE)

Mandach, L.de
Les Clouet et quelques portraits de Huguenots
refugiés en Suisse

In:Pro Arte
:129-34 1947 illus.

Jacqueline de Rohan,Marquise de Rothelin,
M.de Luxembourg-Martigues,Françoise d'Orléans,
Princesse de Condé,Louise de Coligny

LC N8.P75 ⌒ Rep.,1945-47*1050

I.E - PROFESSIONS - NOBILITY- (GERMANY)

Goets, Walter Wilhelm, 1867- ed.
 Die entwicklung des menschlichen bildnisses.
Leipzig & Berlin,B.G.Teubner,1928-
 ▼

 Contents.-1.Schramm,P.E.D.deutschen Kaiser &
König in bildern ihrer zeit.1.Bis zur mitte des
12.Jhrh(751-1152)2 v.1929.-2.Prochno.Joachim.Das
schreibor-& dedikationsbild in d.deutsch.buchma-
lerei,v.1,1929-3.Steinberg,S.H.,D,bildnisse geist-
licher & weltlicher fürsten & herren.1.Von d.mit-
te d 10.bis z.ende d.12.jahr(950-1200),1931
LC N7575.E6 v. II,III ◠

I.E - PROFESSIONS - NOBILITY - GERMANY

Maillinger, Joseph
 Bilder-Chronik der kgl.Haupt-und Residenz-
stadt München.Verzeichniss einer Sammlung von...
graphischen künste n...vom 15.-19.Jhrh.München,
Montmorillon,1876
 3v. in 1

 Every chapter has a list of portrs.of reign-
ing nobility & other personalities with artists'
names
 Index of sitters and artists

NN MiU(DD901.M95M2) ◠

I.E - PROFESSIONS - NOBILITY - GERMANY

Sponsel, Jean Louis, 1858-1930, comp.
 Fürsten-bildnisse aus dem hause Wettin...
Dresden,W.Baensch,1906

MET
276.2
Sp.6

 ◯ FOR COMPLETE ENTRY
 SEE MAIN CARD

I.E - PROFESSIONS - NOBILITY - GREAT BRITAIN

Chamberlaine, John, 1745-1812
 Imitations of original drawings by Hans
Holbein,in the collection of His Majesty.for the
portraits of illustrious persons of the court of
Henry VIII...London,Printed by W.Bulmer and co.,
1792
 .v.2,p. illus.in color

 The plates are stipple engravings printed
in colors,all but four by F.Bartolozzi,three by
G.Metz,one by J.Knight

LC NC1055.H7 ◡ .v.11,p.321

I.E - PROFESSIONS - NOBILITY - (GREAT BRITAIN)

 Drummond, Henry, 1786-1860
 Histories of noble British families, with
biographical notices of the most distinguished
individuals in each,illustrated by their armorial
bearings,portraits,monuments,seals,etc. London,
Wm.Pickering,1846
 2 v. illus. 56cm

LC CS419.D7 1846
LC has 1840 1843 ed. of
no.1 ◡

I.E - PROFESSIONS - NOBILITY - (GR.BRITAIN)

Earlom, Richard, 1743-1822, engr.
 Portraits of characters illustrious in Brit-
ish history, from the beginning of the reign of
Henry the eighth to the end of the reign of James
the second. Engraved in mezzotinto. Richard
Earlom & Charles Turner. From original pictures,
miniatures, etc. London,S.Woodburn, 1815?

 illus.(100 portrs.)

 Each portr.accompanied by brief biogr.sketch
Besides Earlom & Turner,plates by Rbt.Dunkarton
LC N7598.E3 ◖

I.E - PROFESSIONS - NOBILITY - (GREAT BRITAIN)

Images d'autrefois

In:Art vivant
 :3-6 no.223,1938 illus.

 Portr. of English sovereigns
 Incl.:Holbein,Pourbus,Largillière,Ouys,etc.

LC N2.A65 ◖ Rep.,1938#577

N
7598
S92t Strong, Roy C.
NPG Tudor & Jacobean portraits,...London,
 H.M.S.O.,1969
 2 v. illus(part col.)

 Bibliography

 Portrs.of all major historical fgs.of Tudor
 & Jacobean period,including all portrs.in the
 National Portrait Gallery,London.to the year 1625

I.E - PROFESSIONS - NOBILITY - (GREAT BRITAIN)

LC N7598.S7 ◡

757
S72
1866 Victoria and Albert museum, South Kensington.
(RB) ...Catalogue of the first special exhibition of
 national portraits ending with the reign of King
 James II...April 1866.London,Printed by Strange-
 ways and Walden 1866.
 202 p.

I.E - PROFESSIONS - NOBILITY - GREAT BRITAIN

LC N7598.S6 1866 ◡ Ingamells.Cat.of portrs...
 BX5197.I 53X P.XVI

757
S72
1867 Victoria and Albert museum, South Kensington.
(RB) ...Catalogue of the second special exhibition
 of national portraits commencing with the reign
 of William and Mary and ending with the year
 1800...May 1, 1867.London,Printed by Strange-
 ways and Walden 1867.
 208 p.

I.E - PROFESSIONS - NOBILITY - GREAT BRITAIN

LC N759 .S6 1867 ◡ Ingamells.Cat.of portrs...
 BX5197.I p.XVI

757
S72
1868
(RB)

I.E - PROFESSIONS - NOBILITY - GREAT BRITAIN

Victoria and Albert museum, South Kensington.
...Catalogue of the third and concluding exhi-
bition of national portraits commencing with the
fortieth year of the reign of George III and
ending with the year 1867...April 13,1868.London
Printed by Strangeways and Walden.1868.
209 p.

Ingamells.Cat.of portrs...
RX5197.I 53X p.XVI

I.E - PROFESSIONS - OUTLAWS - GREAT BRITAIN

Caulfield, James, 1764-1826
Portraits,memoirs and characters of remark-
able persons,from the revolution in 1688 to the
end of the reign of George II....London,T.H.
Whitely.etc.1819-20
4 v. illus.

"Caulfield's'remarkable characters'are per-
sons famous for their eccentricity,immorality,
dishonesty,etc."-Dict.nat.biog.

LC CT781.C3 Univ.cat.of books on Art
 Z5931U58 NCFA v.1 S.K.

705
C75
NCFA
v.75

I.E - PROFESSIONS - NOBILITY - (GREAT BRITAIN)

Ward, Frank
A fine group of needlework portraits

In:Connoisseur
75:39-40,43 May,'26 illus.

King Charles II,Queen Catherine of Braganza,
Duke of Buckingham,Earl of Rochester

I.F - PROFESSIONS - PHILOSOPHERS

Diogenes Laertius
Vite de philosophi moralissime...Venetijs,
apud Hieronymus Scotum,1544
62 leaves illus.

Woodcut illus.of the philosophers discussed
Rave mentions ed.1524 with ports.in bust-
form in front of a shell

LC T880.8D59vx NcU Rave.Jb.d.Berl.Mus.I 1955
 LC N3.J16 fol.p.127

I.E - PROFESSIONS - NOBILITY - NETHERLANDS

Schrijver, Pieter, 1576-1660
Principes Hollandiae,Zelandiae et Westfri-
siae ab 863 usque ad ultimun Philippum aeri
omnes incisi et descripti. Harlemi,1650
Plate and 36 portraits

FOOG
XFA Title taken from Brunet's Manuel de libraire
4650.8FF ton.5

LC Z1011.B9M51 6v. Fogg,v.11,p.325
 M4 5v.

I.E - PROFESSIONS - PHILOSOPHERS

Eisler, Robert
Sur les portraits anciens de Cratès, de
Diogène et d'autres philosophes cyniques

In:R.archéol.
:1-13 1931,I illus.

LC CC3.R4 Rep.,1931#57

N
7616
B55
NCFA

I.E. - PROFESSIONS - NOBILITY - (SPAIN)

Berwick, Jacobo María del Pilar Carlos Manuel
Stuart Fits-James, 10.duque de, 1878-
Catalogo de las miniaturas y pequeños retra-
tos pertenecientes al Excmo.Sr.duque de Berwick
y de Alba, por D.Joaquín Esquerra del Bayo.
.Madrid,Imprenta de los Sucesores de Rivadeneyra
(s.a.).1924.
180 p. illus(part col.)

LC N7616.B4

I.E - PROFESSIONS - PHILOSOPHERS
Lorenz, Thuri
Galerien von griechischen philosophen- und
dichterbildnissen bei den Römern. Mains,P.von
Zabern.1965.

MET
577 70 p. illus.
L88
 Bibliogr. footnotes

NNC

AP
1
A51A64
NCFA
v.6

I.E - PROFESSIONS - ORATORS

Crawford, John Stephens
The classical orator in 19th century Ameri-
can sculpture

In:Am.Art J.
6:56-72 Nov.,'74 illus.

Pt.3 examines the specific statues of Ame-
rican orators & their relationship to antique
prototypes,p.61-72

Am.Art J.,May'77,p.49

I.E - PROFESSIONS - PHILOSOPHERS

Lorenzo, Giuseppe de
I grandi Capani

In:Vie d'italia
:237-43 1938 illus.

Great men from the Campania. Repro.:Bernini,
Cavallino,Rosa,Giordano,Longhi.Portrs. of Cicero,
Tasso,St.Thomas Aquinas,Giordano Bruno

LC DG401.V48 Rep.,1936#352

I.E - PROFESSIONS - PHILOSOPHERS

Sambucus, Johannes, 1531-1584
Icones vetervm aliqvot,ac recentivm medicorvm,
philosophorvmqve elogiolis svis editas...Nage-
drukt in fac-simile volgens de uitgave van Plantin
van 1574,met eene inleiding door...Max Rooses...
Antwerpen,Nederlandsche boekhandel etc.1901
7p,69:1;incl.illus. (Maatschappij der Antwerpsche
bibliophilen,no.21)
Preface in Dutch and French
"La manière des gravures indique...que Pierre
v.d.Borcht les exécuta à l'eau-forte..."

LC N7627.S2 Amsterdam,Rijksmus.,cat.
 25939152,deel 1,p.138

page of I.E - PROFESSIONS - PHILOSOPHERS
contents
in NPG Schefold, Karl, 1905-
(xerox) Die bildnisse der antiken dichter,redner und
qN7585 denker. Basel,Benno Schwabe.1943.
S317 NPG
Met 2 v. 228 p. illus.
577 Bibliography
Sch24 Review by Alfons Wotschitzky,In:Ans.f.Altertums-
 wiss.,v1:23-4,1948.."important".Rep.1948-49*1012
 J.Walters Art Gall.v.9
 p.55 footnote "indispensable"
Yale Univ.Libr.
Jb53+943S
 Rep.,1948-49*1012
 Breckenridge.Likeness...
 N7580.B82 bibl.notes

I.E - PROFESSIONS - PHILOSOPHERS

Strobach, Wolfgang
Liebe zum wissen.Wien,Rosenbaum,1957.
64 p. illus. (Zeit un Bildnis,hrsg.von
H.Neumayer,5:Denker)

FOGG
Widener

ULS New ser'l titles:
DLC Fogg,v.11,p.325

I.E - PROFESSIONS - PRINTERS

Dangon, Georges
Sociologie du Maître imprimeur

In:Courrier graph.
:3-12 1936,no.1 illus.

Incl:Portrs. of Ulrich Gering,Etienne Dolet,
Robert Estienne,Firmin Didot

LC Z1007.C775
 Rep.,1936*359

I.E - PROFESSIONS - SCHOLARS

Bataillon, Marcel
Philippe Galle et Arias Montano. Matériaux
pour l'iconographie des savants de la Renaissance

In:Bibl.Humanisme et Ren.
2:132-60 1942 illus.

Album engraved & edited by Galle,Antwerp,1572-87;
commentary by Arias;alphabetical list of 94 portrs.

 Rep.,1942-44*686

I.E - PROFESSIONS - SCHOLARS

Boissard, Jean Jacques, 1528-1602
Icones virorum illustrium doctrina et eru-
ditione praestantium...Francfordii ad Moenum,
1597-99

4 v.in 2 illus.

Each v.with 50 portr-engravings of famous
humanists by Theodor de Bry

vols.3 & 4 text by Johann Adam Lonicerus

LC CT93.B6 = ed.1598-1630
NN MH Th:B.(Bry,Theodor)
 N40T43 1907a Bd.5,p.163,b

I.E - PROFESSIONS - SCHOLARS

Firth, Charles Harding, 1857-1936
The portraits of historians in the National
portrait gallery...

In:Royal historical society,London.Transactions.
London,1923. 4th ser.
6:93-125

Newberry libr.for Cumulated Mag.subj.index
LC.DA20.R9,v.6. A1/3/C76 Ref. v.2,p.444

I.E - PROFESSIONS - SCHOLARS

Galle, Philippe, 1537-1612
«Imagines L.doctorum virorum...cum singulo-
rum elogijs. «Antverpiae,1587.2nd ed.

50 engr.portrs.

1st ed."Effigies virorum doctorum..."1572
with 44 engr.portrs.

LC TYP Rave.Jb.d.Berl.Mus. I 1959
530 LC N3.J16 fol. p.148-9
72.415 MH Cty PU Paolo Giovio & d.Bildnisv:

I.E - PROFESSIONS - SCHOLARS

Giovio, Paolo, 1483-1552
An Italian portrait gallery;being brief bio-
graphies of scholars...transl.by Florence Alden
Cragg...Boston,Chapman & Grimes.c.1935.
187 p. illus.

On cover:Elogia of Paolo Giovio
This transl.is made fr.the ed.publ.in Antwer;
in 1557 under title:"Elogia doctorum virorum ab
avorum memoria publicatis ingenii monumentis il-
lustrium."
"Works":p.19

LC CT93.G518

VF I.E - PROFESSIONS - SCHOLARS -DENMARK

Hillerød, Denmark. Nationalhistoriske museum
paa Frederiksborg slot
Nyere Danske Forskerportraetter.I anledning
af Carlsbergfondets 100 års jubilaeum 1976.Cata-
logue
MET 29 p. illus.
107.71
F87 Exhib.Sept.15,1976-Jan.3,1977

I.E - PROFESSIONS - SCHOLARS - GERMANY

Janda-Bux, A
Die Entstehung der bildnissammlung an der
universität Leipzig und ihre bedeutung für die
geschichte des gelehrten-perträts.

In:Leipzig.Universität.Wissenschaftliche Zeit-
schrift.Gesellschafts und Sprachwissenschaftl.
Reihe.Leipzig.
4:143-68 1954-55

LC AS182.L18
Wolstenholme.N7598.W86 v.2
NPG p.22

I.E - PROFESSIONS - SCHOLARS - ROME

Hekler, Antal, 1882-1940
Philosophen- und gelehrtenbildnisse der
mittleren kaiserzeit

In:Die Antike
16:115-41 1940 illus.

LC DE1.A4
Richter, G. Portrs.of the
Greeks N7586R53,v.3,p.297

I.E - PROFESSIONS - SCHOLARS - GERMANY - 16th c.

Kusch, D
Die Rektoren-und professorenbildnisse des
16.Jhr.in der Friedrich-Schiller-universität,
Jena.

In:Jena.Universität.Wissenschaftliche Zeitsehr.
Gesellschafts-und Sprachwissenschaftl.Reihe
7:9-33 1957/58

LC AS182.J5
Wolstenholme.N7598.W86 NPG
v.2

MO
6320
H72
NPG

I.E - PROFESSIONS - SCHOLARS - U.S.

Holden, Reuben Andrus, 1918-
Profiles and portraits of Yale University
presidents,...Freeport,Me.,Bond Wheelwright Co.
1968,
184 p. illus. American university his-
tory series,

Bibliography

LC LD6320.H65

N
40.1
K682S8
NPG

I.E - PROFESSIONS - SCHOLARS - Great Britain

Stewart, J.Douglas
Sir Godfrey Kneller.cat.of an exh.at the
NPG,London,Nov.-Dec.,1971....London,Bell;Nat'l
Portrait Gallery,1971
82 p. illus(part col.)

Bibl.references
Incl.:Lady Eliz.Cromwell as St.Cecilia
Chapters incl.:Drawings;Ladies & children;
Lords & Gentry;Scholars & Poets;Army & Navy;
Parade portrait.Appendix:Kit-cat club portrs.

LC ND1329.K55S7

N
7621.2
G5L9r
1980
NPG

I.E - PROFESSIONS - SCIENTISTS

Royal Society of London
Royal Society cat.of portraits;by Norman H.
Robinson;with biographical notes by Eric G.
Forbes.London,The Royal Society,1980
143 p. illus(part col.)

Index of artists

I.E - PROFESSIONS - SCHOLARS - NETHERLANDS

Ekkart, Rudolf E.O.
Portraits in Leiden University Library

In:Quaerendo
5:52-65 1975

LC Z1007.Q13
WolstenholmeN7698.W86 v.2
NPG p.22

qR
153.5
W44
1973x
NPG

I.F - PROFESSIONS - SCIENTISTS - GREAT BRITAIN

Wellcome Institute of the History of Medicine
Portraits of doctors & scientists in the
Wellcome Institute of the History of Medicine;
a cat.,by Renate Burgess.London,Wellcome Inst.
of the Hist.of Medicine,1973
459 p. illus. (Publications of the
Wellcome Inst.of the Hist.of Medicine.Mus.cat.)

Incl.index

Bibliography

Yale ctr.f.Brit.art Ref.
N134.5+.W44

qN
7621.2
N4A52
NPG
2 c.

I.E - PROFESSIONS - SCHOLARS - NETHERLANDS

Regteren Altena, I.Q.van, 1899-
De portret-galerij van de universiteit van
Amsterdam en haar stichter Gerard van Papen-
broeck,1673-1743...I.Q.van Regteren Altena en
P.J.J.van Thiel...met een voorwoord van H.
Engel.Amsterdam,Swets en Zeitlinger,1964
387 p. illus(1 col.)

Summary in English

I.E - PROFESSIONS - SCIENTISTS - NORWAY

Norske portretter;vitenskapsmenn.Oslo,Gylden-
dal,1965
398 p. illus. (Norske minnesmerker)

Preface by Francis Bull
Published by Norsk portrettarkiv,Riksantik-
varen

LC CT1294.N6
Rep. 1966 #926

NPG
Ref.
coll.

I.E - PROFESSIONS - SCIENTISTS - U.S. - 19th c.

Miller, Lillian B.
The Lazzaroni,science & scientists in mid-
19th c.America;text by L.B.Miller,F.Voss,and
J.M.Hussey.Washington,Publ.for the Nat'l Portr.
Gall.by the Smithsonian Institutions Press,1972
121 p. illus.

Bibliography

Exh.Dec.27,1972-May 6,1973

LC Q149.U5M55

705
B97
NCFA
v.108

I.F - PROFESSIONS - SERVANTS

Michel, Marianne Roland
L'Art du dix-huitième siècle;of women and
flowers.Jean Cailleux,ed.,

In:Burl Mag
108,suppl.no.18:I-V July,'66 illus(1col.)

Repro.incl.:Largillière,Mlin de Fontenay,
Ant.Coypel,Hyacinthe Rigaud,Jean-Bapt.Monnoyer,
Juste d'Egmont
fg.1:Hélène Lambert de Thorigny with black
servant;fg.3:Portr.of lady with black servant

705
B97
NCFA
v.113

I.E - PROFESSIONS - SERVANTS

Cailleux, Jean ed.
L'Art du dix-huitième siècle.Some family
and group portraits by François de Troy(1645-
1730)

In:Burl Mag
113,suppl.no.26:I-XVIII Apr.,'71 illus.

fg.6:Mme.de Franqueville & her children
with black servant and portr.within portrait

Rosenfeld,M.N. L'Argillière
p.401,408

N
7606
S75
NPG

I.E - PROFESSIONS - SERVANTS

Spike, John T.
Baroque portraiture in Italy.Works from
North American collections.Cat.for an exh.at
The John and Mable Ringling Mus.of Art,Dec.7,
1984-Feb.3,1985.Printed by.Joe P.Klay & Sons,
Inc.,1985,
214 p. illus(part col.)

Bibliography
Ptgs.,medals,busts,drwgs.,prints.In alpha-
betical order by artist
Incl.:Introductory essays on 4 aspects of
Baroque portrai- ure
Portr.within , rtr.no.50.Black servant
no.68

705
A56
NMAA
v.135

I.E - PROFESSIONS - SERVANTS

Deutsch, Davida Tenenbaum
The polite lady:portraits of American
schoolgirls and their accomplishments,1725-1830

In:Antiques
135:742-53 March,'89 illus(part col.)

Repro.incl.:Ralph Earl,1783;Gilbert Stuart,
c.1807;Peticolas,1798;Corné,c.1805;M.B.Doyle,
c.1820;John Greenwood,c.1747;Js.Earl,1794-96
Pl.X:Evelyn Byrd with black servant

B
H21
H2

I.E - PROFESSIONS - STATESMEN

Hamilton, John McLure, 1853-1936
Men I have painted...London,T.F.Unwin,ltd.
,1921,
263 p. illus.

Hamilton describes his meetings with nume-
rous statesmen & other celebrities who sat for
him

Foreword by Mrs.Drew

LC ND497.H32A1

College of physicians...
Arch.Am.Art mfm P86 v.12
References

NGA
N 1
A3
v.21

I.E - PROFESSIONS - SERVANTS

Kaplan, Paul H.D.
Titian's Laura Dianti and the origins of the
black page in portraiture

In:Antichità viva
21,no.1:11-18 1982
21,no.4:10-18 1982 illus.

The black page has in instances functioned
as an identifying attribute,alluding to the inter-
ests of the sitter or given a hint of the sit-
ter's nationality.
Repro.incl.:

I.E - PROFESSIONS - STATESMEN

Jenkins, Marianna Duncan
The state portrait,its origin and evolution.
New York:College Art Assn.of America...,1947
47 p. illus.
(Monographs on archaeo-
logy and fine arts,3)
Thesis Bryn Mawr College

Bibliographical footnotes

Review by D.T.Piper In:Burl Mag. 90:302
Trends in heroic portrs.of 16th c.W.Europe
develop conventions indispensable ever since
LC N7592.J4

AP
1
J8643
NMAA
v.14

I.E - PROFESSIONS - SERVANTS

Meschutt, David
William Byrd and his portrait collection

In:J.early S.dec.arts
14,no.1:19-46 May,1988 illus.

fg.11:Boy with black servant

I.E - PROFESSIONS - STATESMEN

Koepf, Hans
Bildnisse und schicksale aus dem grossen
weltgeschehen,von Hans Koepf und Irmgard Koepf.
Stuttgart,Schuler,1965,
284 p. illus(part col.)

LC N7575.K6

Fogg,v.1p.323

VF
NPG

I.E - PROFESSIONS - STATESMEN

Leon Golub,portraits of power.Catalogue of exhibition at the Picker Gallery,Charles A. Dana Arts Center,Colgate University,Hamilton,N.Y.,Nov.11-Dec.10,1978
unpaged illus.

Bibliography

Preface by Edw.Bryant

N
40.1
D24J53
NPG

I.E - PROFESSIONS - STATESMEN

Schazmann, Paul-Emile, 1902-
David d'Angers,profils de l'Europe.Genève, Ed.de Bonvent,.1973.
136 p. illus.

Bibliography

I.E - PROFESSIONS - STATESMEN

Maggs Bros., London
Choice engravings of American historical importance.(Portraits of famous American and British officers,statesmen and others connected with the War of Independence)Rare political cartoons,emblems....Washington portraits.Selected from the Stock of Maggs Bros...London, 1909
23 p. illus.
no.249 237 items

CSmH

Levis.Descr.bibl.Z5947.L3 L66,p.212:"Particularly interesting list"

705
A6
NCFA
v.47

I.E - PROFESSIONS - STATESMEN

Tipping, Conrad H.
A pottery memorial bowl

In:Apollo
47:41-3 Feb 1948 illus.

Bowl with portrs. of Washington, Lafayette, Franklin after Cochin; probably Liverpool of c.1825. Washington after Peale (1795)

Black-printed under glass

Rep.,1948-49*9750

I.E - PROFESSIONS - STATESMEN

Neumayer, Heinrich, 1905-
Herrschen und lenken..Wien, Rosenbaum,1957.
64 p. illus. (Zeit und Bildnis,hrsg.von H.Neumayer,2.Herrscher)

FOGG
Widener

"To rule and to guide"

Fogg,v.11,p.324

I.E - PROFESSIONS - STATESMEN - ANTIQUITY

Lange, Kurt
Herrscherköpfe des altertums im münzbild ihrer zeit.Berlin,Zürich,Atlantis-verlag.c.1938.
161 p. illus.

Bibliography

LC N7580.L3

Fogg,v.11,p.323

705
A56
NMAA
v.126

I.E - PROFESSIONS - STATESMEN

Platt, Frederick, 1946-
The war portraits

In:Antiques
126:142-53 July,'84 illus(part col.)

'...American finest portr.ptrs.were...to record 22 Allied leaders...These ptgs....were to form the basis of a Nat'l Portr.Gallery...'

Repro.incl.:Admiral Beatty,Cardinal Mercier,Clemenceau by Cecilia Beaux

contin'd on next card

I.E - PROFESSIONS - STATESMEN - ANTIQUITY-GREECE

Suhr, Elmer George, 1902-
...Sculptured portraits of Greek statesmen, with a special study of Alexander the Great,...Baltimore,The Johns Hopkins press;London,H.Milford,Oxford university press,1931
189 p. illus. (The Johns Hopkins university studies in archaeology,no.13)

Dissertation.1926.

Bibliography
NPG has "extract"

733
S94
LC NB164.S75
1979 ed.:LC NB1296.3.S93

Richter,G. Portrs of the Greeks N7586.53,v.3,p.304

705
AP1
A788
NCFA

I.E - PROFESSIONS - STATESMEN

Robins, Corinne
Leon Golub:The Faces of power.

In:Arts
51:110-11 Feb.,'77 illus.

Leon Golub,portrs.of power VF NPG Bibliography

I.E - PROFESSIONS - STATESMEN - ANTIQUITY - ROME

Brilliant, Richard
Gestures & rank in Roman art. The use of gestures to denote status in Roman sculpture & coinage. New Haven,The Academy,1963
238 p. illus. (Memoirs of the Conn.Acad.of Arts & Sciences,v.14)

Bibliography

: NB115.B7

I.B - PROFESSIONS - STATESMEN - ANTIQUITY - ROME

L'Orange, Hans Peter, 1903-
 Die bildnisse der Tetrarchen

In:Act Arch
2:29-52 1931

LC CC1.A2

Winkes.Physiognomonia.In:
Temporini.Aufstieg u.niedergang...LC DG209.T36.Bd.1,T
p.905 4

H
5070
B5B59
NMAA

I.F - PROFESSIONS - STATESMEN - EUROPE

Bilder vom menschen in der kunst des Abendlandes.Jubiläumsausstellung der Preuss.
Museen Berlin 1830-1980.Berlin,Mann,c.1980
 400 p. illus(part col.)

 Cat.of the exh.held May 7 to Sept.28,
1980 in the Nationalgal.Berlin Staatl.Mus.
(West Berlin)

Part.contents:L.Giuliani.Individual & ideal.
Antiquity.-H.-G.Severin.Portrs.betw.Antiquity
& Middle Ages.-P.Bloch.Portrs.in the Middle
Ages.Rulers'por Sepulchral portrs.Donors.
H.Bock,R.Gross s.The portr.The autonomous

I.E - PROFESSIONS - STATESMEN - ANTIQUITY - ROME

Wegner, Max, 1902-
 Hadrian,Plotina,Marciana,Matidia,Sabina.
Berlin,Gebr.Mann,1956
 130 p. illus. (Das römische Herrscherbild,
II.Abt.Bd.3)

LC N8165.H3W4

N
7598
H67
NPG

I.E - PROFESSIONS - STATESMEN - GREAT BRITAIN

Historical portraits...the lives by C.R.L.Fletcher
'....the portraits chosen by Emery Walker...with
an introduction on the history of portraiture
in England by C.F.Bell. Oxford,Clarendon press,
1909-1919
 4 v. illus.

 v.1:Richard II to Henry Wriothesley,1400-1600
v.2:1600-1700. The lives by H.B.Butler & C.R.L.
Fletcher.-v.3:1700-1800.-v.4:1800-1850

LC N7598.H5

I.E - PROFESSIONS - STATESMEN - ANTIQUITY - ROME

Wegner, Max, 1902-
 Die herrscherbildnisse in antoninischer
zeit. Berlin,Gebr.Mann,1939
 305 p. illus (Das römische Herrscherbild,II.Abt.Bd.4)

FOGG
5005
RD11
MET
617
W842
p.24

I.E - PROFESSIONS - STATESMEN - GREAT BRITAIN

Holland, Henry, 1583-1650?
 Herologia Anglica,hoc est clarissimorvm et
doctissimorvm aliqovt Anglorvm qvi flovervnt ab
anno Cristi M.D. vsq' ad presentem annvm M.D.C
XX vivae effigies vitae et elogia,authore H.H.
,London,Impensis C.Passaei calcographus et
Iansonii bibliopolae,1620.
 2 v. illus.

 Engravings mostly by de Passe family

LC CT780.H6 Rosenwald coll. Nijhoff cat.1981,no.623

N
40.1
D243P2
NGA

I.E - PROFESSIONS - STATESMEN - 19th c.

Paris. Musée de la monnaie
 David d'Angers,1788-1856.Hôtel de la monnaie,Paris,juin-sept.,1966.Cat.par François
Bergot.Préfaces par Pierre Dehaye et Pierre
Pradel.Paris,Hôtel de la monnaie,1966
 151 p. illus.

 Bibliography
 Repro.incl.:Ptgs.miniatures,daguerreotype,
caricatures,drags.,prints by D.'s contemporaries.Bronze statuettes,busts,medallions by
David d'Angers of poets,military,clergy,statesmen,artists
 List of sitters

I.E - PROFESSIONS - STATESMEN - GREAT BRITAIN

Mitchell, James Tyndale, 1834-1915
 ...The unequaled collection of engraved portraits belonging to Hon.T.Mitchell...embracing
the lord chancellors and chief justices of Great
Britain,eminent English lawyers,kings & queens of
Great Britain,English princes & princesses & members of royal families,mostly engraved in mezzotinto,to be sold...Feb.26...and...Feb.27,,1908...
Cat.comp.& sale conducted by Stan.V.Henkels.At
the book auction rooms of Davis & Harvey,Phila.Pa
s...Press of W.F.Fell co.,1908.
 93 p. illus.
 Cat.no.944,pt. VI

LC NE265.M5

N
7621.2
A9V66
NPG

I.E - PROFESSIONS - STATESMEN - AUSTRIA

Heinz, Günther
 Porträtgalerie zur geschichte Österreichs
von 1400 bis 1800.Kat.der gemäldegalerie.Bearbeiter des kat.G.Heinz und Karl Schütz.Wien,
Kunsthist.Mus.,1976
 316 p. illus(part col.) (Führer durch
das Kunsthist.Mus.,no.22)

 1976:This "Porträt Galerie"is temporarily
exhibited in Schloss Ambras,near Innsbruck

 List of sitters,p.301-6;List of artists,
p.307-16;Genealo- gical tables,p.317ff.

I.E - PROFESSIONS - STATESMEN(GREAT BRITAIN)

Vertue, George, 1684-1756
 Prints. King Charles I & the heads of the
noble earls,lords & others,who suffered for their
loyalty in the rebellion & civil-wars of England.
With their characters engraved under each print,
extracted from Lord Clarendon.Taken from original
pictures of the greatest masters.Many of them Sir
Anthony van Dyke's & all the heads accurately engraved by Mr.Geo.Vertue.London,C.Davis,1746

LC N7598.V4 Rosenwald coll.

N
6765
V82
NPG

I.E - PROFESSIONS - STATESMEN - GREAT BRITAIN

Virginia Museum of Fine Arts, Richmond
The world of Shakespeare:1564-1616.An exhibition organized by the Virginia Museum of Fine Arts and the Detroit Institute of Arts...
Richmond,1964
71 p. illus.

N
7593.8
D3D34
NPG
2 c.

I.E - PROFESSIONS - STATESMEN - U.S.

Delaware. State portrait commission
Cat.of Delaware portraits collected by the Delaware State portrait comm.in the capitol buildings.Dover,Del..Delaware portr.comm.,1941
64 p. illus.

Incl.:Index of artists and sitters

Repro.incl.:Washington,by Volozan

LC F163.D34 1941 Winterthur Mus.Libr.
 YZ881.W78 NCFA v.6,p.225

705
C75
v.67
NCFA

I.E - PROFESSIONS - STATESMEN - GREAT BRITAIN

Way, Herbert W.L.
Apsley Pellatt's glass cameos in the collection of Mrs.Applewhaite-Abbott

In:Connoisseur
67:3-10 Sept.,1923 illus.

Repro.incl.:cameo portrs.of Nelson,Wellington,George IV,Rbt.Burns,Shakespeare,George III, Queen Charlotte,etc.
Apsley Pellatt,1791-1863,Brit.glass manufacturer.His process:Crystallo ceramie

708.1
N52
NCFA
v.37

I.E - PROFESSIONS - STATESMEN - U.S.

Donnell, Edna
Men who made America

In:B.Metrop.Mus.
37:64-70 Mar,1942 illus.

Incl.:Franklin,mezzotint by Will,Washington, mezzotint by Savage,Marshall,silhouette by W.H. Brown

Rep.,1942-44#696

705
A5
NCFA
v.13

I.E - PROFESSIONS - STATESMEN - GREAT BRITAIN - 18th c.

Ormsbee, Thomas Hamilton, 1890-1969
18th century Anglo-American relations mirrored in prints

In:Am Coll
13:6-7,15 Feb.,'44 illus.

Portr.ptgs.& prints of political & military leaders in America,England & France

Repro.incl.:Lafayette,Franklin,Lord North, Wm.Pitt,Ths.Paine,J.Hancock

CJ
5805
F16
NPG

I.E - PROFESSIONS - STATESMEN - U.S.

Failor, Kenneth M.
Medals of the United States;by K.M.Failor and Eleonora Hayden.Washington;For sale by the Supt.of Docs.,U.S.Govt.Print Off.,1969.
274 p. illus.

First printed Aug.,1969,revised 1972
Incl.History of the U.S.presidential medals series,by Francis Paul Prucha,S.J.,p.285-8.
The medallic sketches of Augustin Dupré in American collections,by Carl Zigrosser,p.289-304.

LC CJ5805.F3

708.1
C86
NCFA
v.6

I.E - PROFESSIONS - STATESMEN - U.S.

Breckenridge, James Douglas, 1926-
Portraits of Americans.On American portraiture

In:Corcoran G.A.Bull
6:1-14, Feb.,'53 chiefly illus.

Winterthur Mus.Libr. fZ881
W78 NCFA v.6,p.222

I.E - PROFESSIONS - STATESMEN - U.S.

Hart, Charles Henry, 1847-1918
Life portraits of great Americans.A series of articles from McClure's magazine,v.VIII,IX, reproducing portraits of Washington,Franklin, Jefferson,Hamilton,Webster,etc. N.Y.,1905

NN

I.E - PROFESSIONS - STATESMEN - U.S.

Carson, Hampton Lawrence, 1852-1929
...The Hampton L.Carson collection of engraved portraits of signers of the Declaration of independence,presidents & members of the Continental congress,officers in the American revolutionary war...Cat. comp. & sale conducted by Stan.V.Henkels.At the art auction rooms of Davis & Harvey...Phila.,Pa. ...1904.
93 p. illus.
Cat.no.906,pt.III

To be sold Dec.16 & 17, 1904
LC Z999.H505 no.906,pt.3 Amsterdam, Rijksmus.cat.
 25939A52, deel 1, p.154

AP
1
W78
v.6
NCFA

I.E - PROFESSIONS - STATESMEN - U.S.

Kaplan, Milton, 1918-
Heads of States

In:Winterthur Portf.
6:135-150 illus.

Altered plates

Repro.All of prints in the LC

I.E - PROFESSIONS - STATESMEN - U.S.

Mitchell, James Tyndale, 1834-1915
...The unequaled collection of engraved por-
traits belonging to Hon.J.T.Mitchell...embracing
statesmen of the colonial,revolutionary and pres-
ent time,incl.the extens.coll. of portrs. of Benj.
Franklin,Sam.Adams,John Hancock,Henry Laurens,
Henry Clay,and Daniel Webster,also chief and as-
sociate justices of the Supreme court of the U.S,
attorneys-general of the U.S.,judges,lawyers,etc.
To be sold...Dec.5 and 6,1907...Cat.comp.and sale
conducted by Stan.V.Henkels.At the book auction
rooms of Davis & Harvey...Phila,Pa..Phila.,1907,
134 p. illus.
Cat.no.944,pt.
LC K1764M68

N
7593
A512
NPG

I.E - PROFESSIONS - STATESMEN - U.S. - 18th c.

American Antiquarian Society,Worcester,Mass.,
Library
Checklist of the portraits in the library
of the American antiquarian society;by Frede-
rick L.Weis.Worcester,Mass.,published by the
society,1947
76 p. illus.

Reprinted fr. the Proceedings of the Amer.
Antiqu.Soc.for April 1946
Alphabetical list of artists.
Incl.:Washington,Franklin;marble busts.Co-
lumbus;oil,mosaic John Adams;gold on glass

708.1
.B87
v.5

I.E - PROFESSIONS - STATESMEN - U.S.

Morgan, John Hill, 1870-
The work of M.Fevret de Saint-Mémin

In:Brooklyn Mus. Q.
5:4-26 Jan,'18 illus.

."F.'s work portrays so many of those inti-
mately connected with...our government"
Repro.:Alex.Smith of Baltimore,Theod.Gourdin,
Timothy Pickering,Judge John Sam.Sherburne

E302.5
C5
1989X
NPG

I.E - PROFESSIONS - STATESMEN - U.S. - 18th c.

Christman, Margaret C.S.
The first federal Congress,1789-1791...
Washington City:Smithsonian Inst.Press for the
NPG & the U.S.Congress,1989
375 p. illus(part col.)

Index
Bibliography,p.366-70

An exh.at the NPG,March2-July 23,1989

CJ
5805
P47
1987
NPG

I.E - PROFESSIONS - STATESMEN - U.S.

Pessolano-Filos, Francis, 1900-
Medals of the presidents,secretaries of the
treasury and directors of the U.S.mint,1789-1981.
Edited by Armando de Trevera.1st ed. N.Y.,Eros
Publ.Cy.,1987
1 v. illus.

Incl.all presidents till Ford.

Bibliography

I.E - PROFESSIONS - STATESMEN - U.S. - 18th c.

Colonial Williamsburg,inc.
They gave us freedom;the American struggle
for life,liberty,and the pursuit of happiness,
as seen in portraits,sculptures,historical
paintings and documents of the period:1761-1789
.Williamsburg,Va.,Colonial Williamsburg and the
College of William & Mary in Va..1951.
65 p. illus(1 in color)

Cat.of the exh.held May-June 1951:.p.61-5
Index to artists & subjects

LC E302.5C64 .Winterthur Mus.Libr. fZ881
 178 NCFA v.6,p.222

NE
260
S64
NPG

I.E - PROFESSIONS - STATESMEN - U.S.

Smith, George D., firm,booksellers,New York
Catalogue of American historical portraits
and engravings,including rare revolutionary
prints...N.Y.,Geo.D.Smith.between 1905 and 1917.
29 p illus.

705
A56
NCFA
v.24

I.E - PROFESSIONS - STATESMEN - U.S. - 18th c.

Donnell, Edna.Bowden, 1891- .
Portraits of eminent Americans after draw-
ings by Du Simitière

In:Antiques
24:17-21 July,1933 illus.

Repro.incl:Washington on ceramics;enamel
cloak hooks;printed cotton with portr.medal-
lions derived fr. engravings after Du Simitière
Incl.list of Prévost's,Reading's & B.B.
Ellis' engravings.

N
853
U51
1965
NPG
Ref.

I.E - PROFESSIONS - STATESMEN - U.S.

U.S. Architect of the Capitol
Compilation of works of art...Washington,
U.S.Govt.Printing Off.,1965
426 p. illus. (88th Congr.,2nd session,
House document no.362

Incl.:Portrs.,p.1-115;Busts,p.169-98;Relief
portrs.,p.279-87;Pioneers of the Women's suf-
frage movem't,p.277;Portrs.p.309-13,315-19,320-1
Historical ptgs.incl.J.Trumbull's Declaration of
Independence,p.118,Gen.Geo.Washington resigning
his comm.as Commander in Chief,p.121,Surrender

LC N853A52 1965

I.E - PROFESSIONS - STATESMEN - U.S. - 18th c.

Du Siritière,.Pierre Eugène,ca.1736,-1784
Portraits of the generals,ministers,magis-
trates,members of Congress,and others,who have
rendered themselves illustrious in the revolu-
tion of the United States of North America.
Drawn from the life by M.Dusiritier...and en-
graved by the most eminent artists in London.
London,.J.Wilkinson and J.Debrett,1783
2 p. 12 portrs.

Incl.:Washington, John Jay
'Set was signed P.P.E.'-Donnell
LC E206.D97

I.E - PROFESSIONS - STATESMEN - U.S. - 18th c.

Du Simitière, Pierre Eugène, ca.1736-1784
 Thirteen portraits of American legislators,
patriots,and soldiers,who distinguished them-
selves in rendering their country independent;
...drawn from the life by Du Simitière...and en-
graved by Mr.B.Reading.London,W.Richardson
,1783.
 13 plates

 Incl.:Washington, John Jay

MB NjP MH CtY MiU-C Winterthur Mus.Libr. Z881
 PPL .W78 NCFA v.9,p.226

E
221
W57X
NPG

I.E - PROFESSIONS - STATESMEN - U.S. - 18th c.

Whitney, David C.
 Founders of freedom in America;lives of the
men who signed the Declaration of Independence...
Chicago,J.G.Ferguson Publ.Co.,1964.
 253 p. illus(part col.)

N
7592
H513
RB
NPG

I.E - PROFESSIONS - STATESMEN - U.S. - 18th c.

Henkels, Stanislaus Vincent, 1854-1926
 Cat.of the valuable autographic coll. and en-
graved portraits...gathered by...Col.Chs.Colcock
Jones...to be sold Tue.,Wed.,Thurs., April 24,25,
26,1894.Cat.comp.,and sale conducted by Stan.V.
Henkels,at the book auction rooms of Thos.Birch's
Sons,Philadelphia
 148 p. illus.
 cat.no.720
 16 engravings of Washington
Contains autographic sets of the signers of
the Declaration of Independence,Rulers & Govs.

ND
1337
U5N67
1976X
NPG

I.E - PROFESSIONS - STATESMEN - U.S. - 18-19th c.

Norton (R.W.) Art Gallery
 Portrait miniatures in early American his-
tory,1750-1840;a Bicentennial exhibition,Apr.18-
June 13,1976,the R.W.Norton Art Gallery.Shreve-
port,La.;The Gallery,c.1976
 41 p. illus(part col.)

 Biograph.references
 70 works shown

 Incl.:14 signers of the Declaration of Ind.
The first 3 presidents & other prominent Amer.
LC ND1337.U5N67 1976 Rila III/2 1977 #7289

705
A5
NCFA
v.13

I.E - PROFESSIONS - STATESMEN - U.S. - 18th c.

Ormsbee, Thomas Hamilton, 1890-1969
 18th century Anglo-American relations mir-
rored in prints

In:Am Coll
13:6-7,15 Feb.,'44 illus.

 Portr.ptgs.& prints of political & military
leaders in America,England & France

 Repre.incl.:Lafayette,Franklin,Lord North,
Wm.Pitt,Ths.Paine,J.Hancock

N
7621
P5J38c
1855
NPG

I.E - PROFESSIONS - STATESMEN - U.S. - 18-19th c.

Philadelphia. Independence hall
 Catalogue of the national portraits in Inde-
pendence hall,comprising many of the signers of
the Declaration of Independence and other dis-
tinguished persons...Philadelphia,John Coates,
1855
 24 p.

AP
1
A51A64
NCFA
v.11

I.E - PROFESSIONS - STATESMEN - U.S. - 18th c.

Palmer, Arlene M.
 American heroes in glass:The Bakewell sul-
phide portraits

In:Am.Art J.
11:4-26 Jan.,'79 illus.

 FOR COMPLETE ENTRY
 SEE MAIN CARD

CJ
5805
L88
1967
NPG

I.E - PROFESSIONS - STATESMEN - U.S. - 18th-19th
 c.
Loubat, Joseph Florimond,duc de, 1831-1927
 The medallic history of the U.S.of America,
1776-1876...New Milford,Conn.,N.Flayderman,1967.

 FOR COMPLETE ENTRY
 SEE MAIN CARD

CJ
161
K54M66X
NPG

I.E - PROFESSIONS - STATESMEN - U.S. - 18th c.

Paris. Musée de la monnaie
 La monnaie Miroir des Rois.Exh.,31 jan.-
29 avr.,1978.Paris,L'imprimerie nationale,1978
 622 p. illus.

 L'effigie des souverains dans les monnaies,
les médailles et les sceaux
 Preface by André Chastagnol.Intro.by Hélène
Nicolet
 Bibliographies
 Coins & medals from Antiquity to 20th c.,
grouped in : Portr.;Symbols;Events;(contains

E221
U55X
NPG
NCFA

I.E - PROFESSIONS - STATESMEN - U.S. - 18-19th c.

U.S. Constitution sesquicentennial commission
 Loan exhib.of portrs. of the signers & de-
puties to the convention of 1787 & signers of the
Declaration of independence,incl.their families
...in commemoration of the 150th anniversary of
the formation of the Constitution of the U.S.
The Corcoran gallery of art...Nov.27-Feb.1,1938
....[Washington?1937?, '4'
 173 p. illus.

LC E221.U55 Fogg,v.11,p.330

I.E - PROFESSIONS - STATESMEN - U.S. - 19th c.

Brady, Mathew B., 1823-1896
 Brady and Handy's album of the 50th Congress of the U.S....designed and published by M.B.Brady and Levin C.Handy.Washington,1888
 ₈84₎p.of mounted photos
 illus.

LC.JK1059. 50th .B8,MnHi

NPG
Ref.
coll.

I.E - PROFESSIONS - STATESMEN - PRESIDENTS - US

The American Presidency in political cartoons: 1776-1976.Thomas C.Blaisdall,jr.,Peter Selz, and seminar.Berkeley,University Art Museum,1976
 278 p. illus.

 Cat.of an exh.held at the Uni.Art Mus.,Berkeley,Jan.13-Feb.22,1976,National Portr.Gall., Wash.,D.C.,Oct.15-Nov.28,1976,and others...

 Bibliography

LC E176.1.A655

N
40.1
F33yUS

I.E - PROFESSIONS - STATESMEN - U.S. - 19th c.

U.S. Library of Congress. Prints and Photographs Division
 Charles Fenderich,lithographer of American statesmen:a cat.of his work,by Alice Lee Parker and Milton Kaplan.Washington,1959
 64 p. illus.

LC NE2415.F4U5

CT
215
B31
1977
NPG

I.E - PROFESSIONS - STATESMEN - PRESIDENTS - US

Bassett, Margaret Byrd, 1902-
 Profiles and portraits of American presidents.With an intro.by Dr.Henry F.Graff.New and updated ed. N.Y.,David McKay Cy.,Inc.,
 ₈1976,1977₎
 307 p. illus.
 ₍Encyclopedia ed.₎

 Bibliography

 Interspersed with full-color pictorial essays on themes from American history
LC E176.1B23 1976

E747
B37
1983X
c.1-2

I.E - PROFESSIONS - STATESMEN - U.S. - 20th c.

Barber, James, 1952-
 Portraits from the New Deal:an exh.at the NPG,March4-Sept.7,1983;by Js.G.Barber and Frederick S.Voss.Washington,publ.for the NPG by the Smiths.Inst.Press,c.1982
 40.p. illus.

AD
1
M972
NMAA

I.E - PROFESSIONS - STATESMEN - PRESIDENTS - U.S.

Beardsley, John
 Framing the Presidents

In:Illus.& Arts
5,no.1:44-48 Jan.,'89 illus(col.)

 Repro.incl.:Reagan by Shikler;John Adams by Copley;Washington by Stuart;Carter by Templeton; Johnson by Hurd

VF

I.E - PROFESSIONS - STATESMEN - U.S. - 20th c.

Chase, Joseph Cummings, 1878-1965
 A portrait painter speaks and other articles

In:Sat.Eve.Post
199:14-5,177-8 June 18,'27 'A portr.ptr.speaks'
200:20-1,141-2 Aug.13, '27 'The adventure of
 being painted'
200:16-7,81-2 Aug.27, '27 'Famous sitters'
200:16-7 Oct.15, '27 'What is this art
 game?'
200:37,157-8,160 Apr.28, '28 'Ptg.the A.E.F.on the
 Gallop'
A.E.F.=Amer.Expeditionary Forces all illustrated

ND
1301
C39p
NPG

I.E - PROFESSIONS - STATESMEN - PRESIDENTS - US

Century Association, New York
 Portraits owned by clubs in New York.:Exh. Jan.9 to Feb.3,1937.N.Y.,The Century Club
 unpaged illus.

 23 items shown
 Repro.incl.:Washington,by G.Stuart;Wm.Pitt, by J.Hoppner;J.Q.Adams,and Js.Madison, by A.B. Durand;Lincoln,by F.P.Carpenter;etc.

 Winterthur Mus.Libr.f2881
 ₊78 NCFA v.6,p.226

739
U58

I.E - PROFESSIONS - STATESMEN - PRESIDENTS - S.A

U.S. National gallery of art
 Presidents of the South American republics. Bronzes by Jo Davidson.Washington, D.C.,National gallery of art, 1942
 ₈27₎p. illus.

N
575
C3A3X
NPG

I.E - PROFESSIONS - STATESMEN - PRESIDENTS - US

Charleston, S.C. City Council
 Catalogue of painting and sculpture in the Council Chamber,City Hall,Charleston,S.C.;by Anna Wells Rutledge.Charleston.The City council, ca.1943
 30 p. illus(part col.)

LC N529.C3A3

I.E - PROFESSIONS - STATESMEN- PRESIDENTS - U.S.
Colonial Williamsburg,inc.
They gave us freedom;the American struggle for life,liberty,and the pursuit of happiness, as seen in portraits,sculptures,historical paintings and documents of the period:1761-1789 .Williamsburg,Va.,Colonial Williamsburg and the College of William & Mary in Va..1951.
65 p. illus(1 in color)

Cat.of the exh..held May-June 1951:p.61-5
Index to artists & subjects

LC E302.5C64 Winterthur Mus.Libr. fZ881
 N72 NCFA v.6,p.222

N
7592
H513
RB
NPG

I.E - PROFESSIONS - STATESMEN - PRESIDENTS - US

Henkels, Stanislaus Vincent, 1854-1926
Rare books and engravings illustrative of national and local history....belonging to the estate Thos.Donaldson,deceased and Henry S. Cushing,late of Philadelphia....to be sold March 14 & 15,1902 at the book auction rooms of Davis & Harvey,Philadelphia
illus.
Cat.no.877

Incl.:Portr.ptrs,busts,prints of George & Martha Washington, presidents

N
7593
D14
NPG
2 cops.

I.E - PROFESSIONS - STATESMEN - PRESIDENTS - U.S.

Dallas. Museum of Fine Arts.
Mr. President; ;a pictorial parade of Presidents from Washington to Eisenhower, 1789-1956. Exhibition; at Dallas Museum of Fine Arts for the State Fair of Texas, October, 1956. ;Dallas, 1956;
unpaged. illus. 26 cm.

1. Presidents—U. S.—Portraits. I. Title.

E176.1.D8 923.173 57-1850.1

Library of Congress A

I.E - PROFESSIONS - STATESMEN - PRESIDENTS - U.S.

Mitchell, James Tyndale, 1834-1915
...The unequaled collection of engraved portraits of the Presidents of the United States,belonging to Hon.James T.Mitchell...to be sold... May 16..&...May 17,1907...Cat.comp. and sale conducted by Stan.V.Henkels at the book auction rooms of Davis & Harvey...Phila.,Pa.,M.H. Power,printer,1907.
123 p. illus.
Cat.no.944,pt.IV

LC E176.1.M68

I.E - PROFESSIONS - STATESMEN - PRESIDENTS - U.S.

Duyckinck, Evert Augustus, 1816-1878
Lives and portraits of the presidents of the United States,from Washington to Arthur.The biographies by Evert A.Duyckinck...the portraits by Alonzo Chappel...New York, Henry J.Johnson .c.1881.
280 p. illus.

LC E176.1.D9

N
7593
N23
1979
NPG

I.F - PROFESSIONS - STATESMEN - PRESIDENTS - US

National Portrait Gallery, Washington, D.C.
A gallery of presidents;by Marc Pachter. Washington,D.C.Smiths.Inst.Press for NPG,1979
95 p. illus.

Foreword by Marvin Sadik

LC N7593.N23 1979

E
176.1
F52
NPG

I.E - PROFESSIONS - STATESMEN - PRESIDENTS - US

First Federal Savings and Loan Association of Worcester.
A book of the Presidents;with portraits from the White House Collection..1st ed. Worcester,Mass.,1971.
72 p. illus(part col.)

Cover title:The Presidents of the United States

LC E176.1F52

E
176
N2776
NPG

I.E - PROFESSIONS - STATESMEN - PRESIDENTS - U.S.

National Portrait Gallery, Washington, D.C.
'If Elected...'Unsuccessful candidates for the presidency,1796-1968;by the Staff of the Historian's Office.Wash.,D.C.,Nat'l Portr.Gall., Smithsonian Institution,1972
512 p. illus.

Bibliography
List of artists

Exh.May 3-Sept.4,1972

LC E176.N3

I.E - PROFESSIONS - STATESMEN - PRESIDENTS - US

Heckmann, M.
Changing the face of portraiture

In:Southwest Art
5,pt.11:44-9 May,'76 illus.

Multi-image portrs. by Wayne Ingram;incl.portraits of Presidents Johnson and Nixon

LC N6525.S58 FOR COMPLETE ENTRY
 SEE MAIN CARD

NPG
Ref.
coll.

I.E. - PROFESSIONS - STATESMEN - PRESIDENTS - US

National Portrait Gallery, Washington, D.C.
The president's medal,1789-1977,by Neil MacNeil. N.Y.,Clarkson N.Potter,Inc. In Association with the NPG,Smithsonian Inst.,1977
160 p. illus.

Intro.by Marvin S.Sadik

Exh.Jan.15-Sept.5,1977

LC CJ5802.2.W37M3 1977

ND
1337
USN67
1976X
NPG

I.E - PROFESSIONS - STATESMEN - PRESIDENTS - US

Norton (R.W.) Art Gallery
Portrait miniatures in early American history,1750-1840;a Bicentennial exhibition,Apr.18-June 13,1976,the R.W.Norton Art Gallery.Shreveport,La.;The Gallery,c.1976
41 p. illus(part col.)

Biograph.references
70 works shown

Incl.:14 signers of the Declaration of Ind.
The first 3 presidents & other prominent Amer.

LC ND1337.USN67 1976 Rila III/2 1977 #7289

CJ
5807
P97
NPG

I.E - PROFESSIONS - STATESMEN - PRESIDENTS - US

Prucha, Francis Paul
Indian peace medals in American history.
Madison,State Historical Society of Wisconsin,
1971
186 p. illus.

Bibliography:p.165-72
Repro.incl.:Geo.III;Chs.IV;'Presidential series';Ptgs.by Catlin & by Samuel M.Brookes & drawg.by St.-Mémin & photographs of Indians wearing the medals.

N
7628
A21 O 4
NCFA

I.E - PROFESSIONS - STATESMEN - PRESIDENTS - U.S.

Oliver, Andrew, 1906-
Portraits of John and Abigail Adams. Cambridge,Mass.,Belknap Press of Harvard University Press, 1967
284 p. illus. (The Adams
papers, Series 4:Portraits)

LC N7628.A3055

N
7593
P98
1969
NPG

I.E - PROFESSIONS - STATESMEN - PRESIDENTS - U.S.

Purdy, Virginia C
Presidential portraits,compiled and written by Virginia C.Purdy and Daniel J.Reed...Washington,Published for the National Portrait Gallery by the Smithsonian Press,1969
76 p. illus. (Smithsonian publication 4748)
First published 1968

LC N7593.P84

N
7628
A22 O 4
NPG

I.E - PROFESSIONS - STATESMEN - PRESIDENTS - U.S.

Oliver, Andrew, 1906-
Portraits of John Quincy Adams & his wife.
Cambridge,Mass.,Belknap Press of Harvard University Press, 1970
335 p. illus. (The Adams
papers, Series 4:Portraits

Incl.Bibl.references

LC E377.O4

N
853
U51
1965
NPG
Ref.

I.E - PROFESSIONS - STATESMEN - PRESIDENTS - US

U.S. Architect of the Capitol
Compilation of works of art...Washington,
U.S.Govt.Printing Off.,1965
426 p. illus. (88th Congr.,2nd session,
House document no.362

Incl.:Portrs.,p.1-115;Busts,p.169-98;Relief portrs.,p.279-87;Pioneers of the Women's suffrage movem't,p.277;Portrs.p.309-13,315-19,320-1
Historical ptgs.incl.J.Trumbull's Declaration of Independence,p.118,Gen.Geo.Washington resigning his comm.as Commander in Chief,p.121,Surrender

LC N853.A52 1965 cont'd on other side

VF
Presidents
U.S.

I.E - PROFESSIONS - STATESMEN - PRESIDENTS U.S.

Pease, Clifford A.,jr.
Portraits of President and Mrs.Calvin Coolidge.A preliminary report
10 p. illus.

Bibliographical references

757.9
.U58

I.E - PROFESSIONS - STATESMEN - PRESIDENTS - U.S.

U.S. National gallery of art
Makers of history in Washington,1800-1950;
an exhibition celebrating the sesquicentennial of the establishment of the Federal Government in Washington,June29-Nov.19,1950.Washington,
c1950,
174 p. illus.(part col.)

Incl.complete coll.of portrs.of the presidents of the U.S.

LC N5020.W45 Fogg,v.11,p.330

CJ
5805
P47
1587
NPG

I.E - PROFESSIONS - STATESMEN - PRESIDENTS - U.S.

Pessolano-Filos, Francis, 1900-
Medals of the presidents,secretaries of the treasury and directors of the U.S.mint,1789-1981.
Edited by Armando de Trevera.1st ed. N.Y.,Eros Publ.Cy.,1587
1 v. illus.

Incl.all presidents till Ford.

Bibliography

N
40.1
H43V8
NCFA
NPG

I.E - PROFESSIONS - STATESMEN - PRESIDENTS - U.S.

Virginia Museum of Fine Arts, Richmond
A souvenir of the exh.entitled Healy's sitters;or,A portr.panorama of the Victorian Age,
being a comprehensive coll.of the likenesses of some of the most important personages of Europe & America,as portrayes by Geo.Peter Alex.Healy
betw.the years 1837 and 1899,suppl.with documents relating to the artist's life & furnishings of the period,on view at the Va.M.f.A....
24 Jan.-5 March 1950..Richmond,1950,
94 p. illus.
Index

LC ND237.H4 V5 Art Books 1950-79 Z5937
 A775 NCFA Ref. p.898

fND
1311
15A
1901
NPG

I.E - PROFESSIONS - STATESMEN - PRESIDENTS -
U.S.

The White House gallery of official portraits
of the Presidents.N.Y.and Washington,The
Gravure Co.of America,1901
29 l. illus.
Compiled by George Raywood Devitt

Repro.portrs.by Stuart:Washington;by Heal:
John Adams,John Quincy Adams,Van Buren,Tyler,
Polk,Fillmore,Pierce;by Andrues:Jefferson,
Jackson,Harrison,Taylor,buchanan,Garfield;
by Carpenter:Lincoln;by LeClaire:Grant;by Hun-
tington:Hayes,Arthur;by Johnson:Cleveland,Har-
rison;by unknown artists:Madison,Monroe,An-
drew Johnson

I.F - PROFESSIONS - STATESMEN - ROYALTY

Gebwiler, Hieronymus, c.1480-1545
Epitome regii ac vetustissimi ortus sacrae
Caesareae a Catholica Maiestatis...Ferdinandi
Boemie regis.Strassburg,1527
illus.

48 portrs. of kings

LC Rare book room
Bq5 205

Rave.Jb.d.Berl.Mus.I 1959
LC N3.J16 fol.p.127
Paolo Giovio & d.Bildnisvitenbücher...

I.E - PROFESSIONS - STATESMEN - ROYALTY

Bara, Aline et Crick, Lucien
Un jeu de cartes en argent

In:B.Mus.Art Hist.Belgique
:98-105 1942 illus.

Incl.:Maximilian of Austria,Mary of Burgundy,
Ferdinand V & Isabella,the Catholic,Henry II &
Catherine de Médicis,Sigismund III Vasa,Anne of
Poland. 7cards by Alexander Mair

LC M1835.A3

Rep.,1942-44*7579

I.F - PROFESSIONS - STATESMEN - ROYALTY

Der Herrscher:graphische bildnisse...s.l.,:
Landschaftsverband Westfalen-Lippe.1977.

LC NE219.2.G3M833

FOR COMPLETE ENTRY
SEE MAIN CARD

705
C75
NCFA
v.99

I.E - PROFESSIONS - STATESMEN - ROYALTY

Bishop, Roy
Portraits of royal children at Windsor
Castle

In:Connoisseur
99:239-44 1937 illus.

Incl.:van Dyck,Gainsborough,Barthélemy Du Pan,
Zoffany,Lawrence

Rep.1937*346

I.E. - PROFESSIONS - STATESMEN - ROYALTY

Huttich, Johann, 1480?-1544
Imperatorum et Caesarum vitae....Argentorati
Vuolphgangus Caephalaeus excussit.1534
2pts.in 1 v. illus.

(Argentoratum-Strassbourg,Caephalius-Koepfel
1st ed.1525)
Woodcuts after medals, most of them by Hans
Weidits II
Contains portrs.of the Roman,Bys.& German
emperors to Charles V & archd.Ferdinand,etc.

LC DG203.H8 1534

Rave.Jb.d.Berl.Mus.I 1959
LC N3.J16 fol.p.128/9
Paolo Giovio & d.Bildnisvitenbücher...

N
40.1
M265E4
NPG

I.E - PROFESSIONS - STATESMEN - ROYALTY

Eller, Povl
Kongelige portraetmalere i Danmark 1630-82.
En undersøgelse af kilderne til Karel van Manders
og Abraham Wuchters' verksomhed..Udg.af.Selskabet
til Udgivelse af danske Mindesmaerker.København,
Dansk Historisk Faellesforening,1971
563 p. illus.

Thesis-Copenhagen
Summary in English
Bibliography
over

LC ND1328.E43

I.E - PROFESSIONS - STATESMEN - ROYALTY

Laude Jean,
Problèmes du portrait:images funéraires et
images royales

In:J.Psychol.
401-20 1965

'Analyse du genre(toutes époques)'

LC BF2.J6

Rep. 1966 *898

705
A786
NCFA
v.45

I.E - PROFESSIONS - STATESMEN - ROYALTY

Frankfurter, Alfred M.
International portraits of baroque royalty

In:Art N
45:32-5- March,'46 illus.

Discusses portrs.of Frenchmen painted by
Netherlanders;Englishmen by Dutchmen;Austrians
by Spaniards,etc.in the exh.at Duveen's:"15-18th
c.paintings"

705
G28
NCFA

I.E - PROFESSIONS - STATESMEN - ROYALTY

Lebel, Gustave
British-French artistic relations in the
16th century

In:Gaz Beaux Arts
33:267-80

Exchange of portrs.betw.court of France & that
of England,chiefly on occasion of projects of
princely marriages.Ptg.,drg.&engr.of Mary Tudor,
miniature of Henry VIII. Incl:de Bie,J.& F.Clouet,
Perréal,belliart-Milliart?(also Oeuillard)
Rep.,1948-49 * 6641

ND
1140
L66
NCFA

I.E - PROFESSIONS - STATESMEN - ROYALTY

Levey, Michael
 Painting at court..N.Y..N.Y.university press
.1971.
 228 p. illus(part col.) (Wrightsman
lectures,5)

 "Based on lect.given at Met.Mus.,N.Y.,in 1968
Incl.bibl.ref.

 Courtly uses of art & the interrelationship
of the monarch's vision of his role & .see over

LC ND1140.L46 Debs.Art in Am,63:54 foot-
 note1

AP
1
J8654
NPG
v.17

I.E - PROFESSIONS - STATESMEN - ROYALTY

Schama, Simon
 The Domestication of majesty:Royal family
portraiture,1500-1850

 In:J.Interdisc.Hist
17,no.1:155-83 Summer,'86 illus.

 Bibliographic references

705
B97
NCFA
v.94

I.E - PROFESSIONS - STATESMEN - ROYALTY

Millar, Oliver, 1923-
 The Brunswick Art Treasures at the Victoria
& Albert museum:The Pictures

 In:Burl Mag.
94:267-8 Sep,1952 illus.

 Repro:Honthorst, Cotes, Zoffany, Ramsay

 Enc.Of World Art,v.11
 N31E56 Ref.col.513
 bibl.on portr.

ND
1313.5
S36X
NPG

I.E - PROFESSIONS - STATESMEN - ROYALTY

Schoch, Rainer
 Das Herrscherbildnis in der malerei des
19.jahrh.München,Prestel-Verlag,1975
 366 p. illus. (Studien zur Kunst des
19.Jahrh.,23)
 Bibliography
 Index of persons

 Royalty during Absolutism,the Enlighten-
ment,the Restoration,the reigns of Napoleon I,
Queen Victoria,Napoleon III & the German mo-
narchs
 Representa- tion & propaganda.-
 RILA II/1 1976 #2107

CJ
161
K54M66X
NPG

I.E - PROFESSIONS - STATESMEN - ROYALTY

Paris. Musée de la monnaie
 La monnaie Miroir des Rois.Exh..31 jan.-
29 avr.,1978.Paris.L'imprimerie nationale,1978
 622 p. illus.

 L'effigie des souverains dans les monnaies,
les médailles et les sceaux
 Preface by André Chastagnol.Intro.by Hélène
Nicolet
 Bibliographies
 Coins & medals from Antiquity to 20th c.,
grouped in : Portrs.;Symbols;Events;(contains

I.E - PROFESSIONS - STATESMEN - ROYALTY

Soutman, Pieter Claesz, 1580-1657
 Effigies imperatorum domus Austriacae,ducum
Burgundiae,regum principumque Europae,comitum Nas-
saviae...Harlemi.1644-1650.
 .4 pts. illus.

 Compilation of portrs.1.16 emperors of the
house of Hapsburg.-2.Ferdinandus IIus et IIIus.-
3.Duces Burgundiae.-4.Comites Nassaviae
 Engravings by P.v.Sompel,P.v.Soutman,J.Suyder-
hoef,J.Louys

 Amsterdam,Rijksmus.,cat.
 Z5939A52,deel 1,p.135

I.E - PROFESSIONS - STATESMEN - ROYALTY

Roblot-Delondre, Louise
 Portraits d'Infantes,16ᵉsiècle (étude icono-
graphique). Paris,G.van Oest,1913
 237 p. illus.

FOGG
FA
985.15

 Portrs.of "Infantes"of the House of Hapsburg

 Enc.of World Art
 N31E56Ref.v.11,col.512
 bibl.on portraiture

I.E - PROFESSIONS - STATESMEN - ROYALTY

Strada, Jacobus de,à Rosberg, d.1588
 Epitome dv thresor des antiquitez,c'est à
dire,pourtraits des vrayes medailles des empp.
tant d'Orient que d'Occident...Tr.par Iean Lou-
veau d'Orleans.Lyon,Par I.de Strada,et T.Cverin,
1553
 394 p. illus.
 For revision see Keller, Diethelm
 485 portr.woodcuts by B.Salomon after Stradah
drags.,made from antique medals in Strada's coll.
 Emperors fr.Caesar to Charles V
 Rave.Jb.d.Berl.Mus.I 1959
LC CJ4975.S8 LC N3.J16 fol.p.131 Paolo
 Giovio & d.P Bildnisvitenbücher...
Rath.Porträtwerke,p.39

I.E - PROFESSIONS - STATESMEN - ROYALTY

Rubbrecht, Oswald.
 L'origine du type familial de la maison de
Habsbourg. Bruxelles,1910
 152 p. illus.

MET
195.3
R82

 Amsterdam,Rijksmus.,cat.
 Z5939A52,deel 1, p.148.

I.E - PROFESSIONS - STATESMEN - ROYALTY

Strada, Jacobus de, à Rosberg, d.1588
 Imperatorum romanorum...verissimae imagines
ex antiquis numismatis...Zürich,Andreas Gesner,
1559
 illus.
V & A 118 woodcuts by Rudolph Wyssenbach after
drags.by Hans Rudolf Manuel Deutsch

 Rave.Jb.d.Berl.Mus.I 1959
 LC N3.J16 fol. p.132
 Paolo Gio io & d.Bildnisvitenbücher.

705
C75
NCFA
v.62

I.E - PROFESSIONS - STATESMEN - ROYALTY

Way, Herbert W.L.
 Apsley Pellatt's glass cameos

In:Connoisseur
62:78-82 Feb,1922 illus.

 Portraits:George IV,Louis XVIII,Prince Leopold
Princess Charlotte,Fred.William III,Shakespeare
 Apsley Pellatt,1791-1863,Brit.glass manufac-
turer.His process:Crystallo ceramie

I.E - PROFESSIONS - STATESMEN - ROYALTY - ANTIQUI-
 TY - ROME

Delbrück, Richard, 1875-
 Bildnisse römischer Kaiser. Berlin,J.Bard
,1914,
 illus.

 (Bards Bücher der Kunst.Bd.3)

 Bibliography

 Incl.also:Numismatics

N.Y. P.L. DDO

I.E - PROFESSIONS - STATESMEN - ROYALTY

Wilenski, Reginald Howard, 1887-
 Royal portraits...;London,Faber & Faber
,1946,
24 p. col.illus. (The Faber gallery)

FOGG
4353
W68

Harvard Univ.Library
for LC Fogg,v.11,p.333

I.E - PROFESSIONS - STATESMEN - ROYALTY - ANTI-
 QUITY - ROME

Delbrück, Richard, 1875-
 Die Münzbildnisse von Maximinus bis Carinus.
Berlin,Gebr.Mann,1940

 240 p. illus.

 (Das römische Herrscherbild,III,Abt.Bd.2)

LC CJ1005.D4

I.E - PROFESSIONS - STATESMEN - ROYALTY(ANTIQUITY)

Delbrück, Richard, 1875-
 Spätantike kaiserporträts von Constantinus
Magnus bis zum ende des Westreichs. Berlin,
Leipzig,W.de Gruyter & Co.,1933

 250 p. illus.

 (Studien sur spätantiken kunstgeschichte...8)

 Bibliography

 Incl.also:Roman numismatics
LC N5903.S9 vol.8

I.E - PROFESSIONS - STATESMEN - ROYALTY - ANTIQUI-
 TY - ROME

Franke, Peter Robert, 1926-
 Römische kaiserporträts im münzbild...
München,Hirmer,1961.
 55 p. illus(part col.)

FOGG Bibliography
1180.66

 NN MoSW Enc.of World Art v.11,p.511
 Portraiture,bibl. N31E56Ref.

I.E - PROFESSIONS - STATESMEN - ROYALTY - ANTIQUI-
 TY

Wace, Alan John Bayard, 1879-1957
 Hellenistic royal portraits

In:J Hell Stud
25:86-105 1905 illus.

LC DF10.J8 Richter,G. Portrs.of the
 Greeks N7586R53,v.3,p.304

I.E - PROFESSIONS - STATESMEN - ROYALTY - ANTI-
 QUITY - ROME

Giacosa, Giorgio
 Women of the Caesars;their lives and por-
traits on coins.Milan,Edisioni arte e moneta,
,1977?,
 106 p. illus(part col.)

Incl.descriptive index,incl.photographs at na-
tural size of each coin,obverse and reverse

 .These coins are an,achievement of ..high
point in the history of portraiture.

MdBLN DAU CtY etc.

I.E - PROFESSIONS - STATESMEN - ROYALTY - ANTI-
 QUITY - ROME

Daltrop, Georg
 Die Flavier. Vespasian,Titus,Domitian,
Nerva,Julia Titi,Domitilla,Domitia,von G.Dal-
trop,Ulrich Hausmann,und,Max Wegner.Berlin,
Gebr.Mann,1966
 132 p. illus. (Das römische Herrscher-
bild,II.Abt.Bd.1)

 Bibl.footnotes
 Kraus.Das römische welt-
 reich.N5760.K92 Bibl.p.316
LC DG286.D3 also:Winkes.Physiognommonia.In:
 Temporini.Aufstieg u.nieder
 gang.LC DG209.T36,Bd.1,T4,
 p.913

I.E - PROFESSIONS - STATESMEN - ROYALTY - ANTI-
 QUITY - ROME

Hulsius, Levinus, d.1606
 XII Primorvm Caesarvm et IXIIII ipsorvm
vxorvm...ex antiquis numismatibus...collextae.
Sumptibus Pauli Brachfeldij,Francoforti ad Moe-
num,1597
 198 p. illus.

 Engr.after Vico by Theodor de Bry

 Vico's Le imagini of 1548 & 1557 combined

NN ICN CtY Lenox coll. Rath,in:Lex.d.ges.buchwe-
 sens,Bd.III,p.39
 LC Z118.L67(NPG xerox cc[?]

I.E - PROFESSIONS - STATESMEN - ROYALTY, - ANTIQUI-
.TY - ROME

Keller, Diethelm
 Kunstliche und aigendtliche bildtnussen der
Rhömischen Keysern,ihrer Weybern und Kindern
auch anderer berümpten personen wie die auff
alten Pfennigen erfunden sind...auss dem Latin
jets netüwlich vertheütst...Zürych,A.A.Gessner,
1558
 703 p. illus.

717 woodcut portrs.
Revision of Rouillé.Promptuaire & Strada.
Epitome
LC CJ985.K29 Rave.Jb.d.Berl.Mus.I 1959
 LC N3.J16 fol. p.132
 Paolo)Giovio & d.Bildnisvitenbü-
 cher.

I.E - PROFESSIONS - STATESMEN - ROYALTY - ANTI-
.QUITY - ROME

Schneider, B.
 Studien su den kleinformatigen Kaiserpor-
traits von den anfängen der Kaiserzeit bis ins
dritte jahrhundert

 Dissertation München 1976

 Gesichter.MB1296.3.G38
 1983 NPG p.316

I.E - PROFESSIONS - STATESMEN - ROYALTY - ANTI-
QUITY - ROME

Müller, Ernst, 1877-
 Caesarenporträts, von dr.med.Ernst Müller.
Bonn,A.Marcus & E.Weber,1914-27
 3 v. illus.

MET Bibliography
617
M91 Pt.3 has sub-title:Beiträge zur physiognom
.?K& pathographie der römischen kaiserhäuser nach
ihren münzen & andern antiken denkmälern.

 Incl.comparison,of photographs of insane
people with .Rom. .emperors.
LC no call number MH NN etc.

I.E - PROFESSIONS - STATESMEN - ROYALTY - ANTI-
.QUITY - ROME

Vico, Enea, 1523-1567
 Augustarum Imagines...Venetiis.Paul Manuce?.
1558
 192 p. illus.

55 engravings of Roman empresses after medals

1st ed.1557

LC DC276.5.V5 Rave.Jb.d.Berl.Bus.I 1959
 LC N3.J16 fol. p.145
 Paolo Giovio & d.Bildnisvitenbücher.

I.E - PROFESSIONS - STATESMEN - ROYALTY - ANTI-
.QUITY - ROME

Munich. Glyptothek
 Die Bildnisse des Augustus:Herrscherbild
und politik im kaiserlichen Rom.Sonderaus-
stellung der Glyptothek und des museums für
abgüsse klassischer bildwerke.München,Des.
1978-Märs.Antikenmuseum Berlin,Apr.-Juni 1979.
Hrsg.von Klaus Vierneisel und Paul Zanker.
München,1979
MET 119 p. illus.
617
M92

 Gesichter.MB1296.3.G38
 1983 NPG p.316

I.E - PROFESSIONS - STATESMEN - ROYALTY - ANTI-
QUITY - ROME

Wegner, Max, 1902-
 Die herrscherbildnisse in antoninischer
zeit. Berlin,Gebr.Mann,1939
 305 p. illus (Das römische Herrscher-
 bild,II.Abt.Bd.4

PCGO
5005
R717
FTT
K17
F12
nt.24

I.E - PROFESSIONS - STATESMEN - ROYALTY - ANTI-
.QUITY - ROME

Panvinio, Onofrio, 1529-1568
 Fasti et triumphi Romanorum a Romulo rege
usque Carolum V.Caes.Venetiis,Jac.Strada,1557

 Woodcuts after medals

V & A

 Rave.Jb.d-Berl.Mus.I 1959
 LC N3.J16 fol. p.132
 Paolo Giovio & d.Bildnisvi-
 tenbücher...

I.E - PROFESSIONS - STATESMEN - ROYALTY - ANTI-
.QUITY - ROME

Zantani, Antonio
 Le Imagini e le vite de gli imperatori tratte
dalle medaglie e dalle historie de gli antichi.
Florence,Enea Vico,1548

 From Caesar to Domitian,engravings after
 medals
Oxford
Uni.Bod- Vico, the publisher was an engraver
leian
libr. has latin ed.

 Rave.Jb.d.Berl.Mus. I 1959
 LC N3.J16 fol. p.141-2
 Paolo Giovio & d.Bildnisvitenbücher..

I.E - PROFESSIONS - STATESMEN - ROYALTY - ANTI-
.QUITY - ROME

Saletti, Cesare
 I ritratti antoniniani di Palazzo Pitti...
1 ed. Firense,La nueva Italia,1974
 69 p. illus. (Pubbl.Facoltà di lettere
e filosofia dell' Universita di Pavia,17)

 Bibl.references
 Index

LC MB165.A5782l Gesichter.MB1296.3.G38
 1983 NPG p.316

I.E - PROFESSIONS - STATESMEN - ROYALTY(1st-16th c.)

Goltzius, Hubert, 1526-1583
 Les images presqve de tovs les emperevrs,
depvis C.Ivlivs Caesar ivsqves à Charles V et
Ferdinanvs son frère,povrtraites av vif,prinses
des medailles anciennes...par Hvbert Gholts...
1557. Livre I
 .350.p. illus.
 149 portrs.by Joos Gietleughen after drags.by
 Goltzius(see over)
Italian edition:LC fJ G36.351 :early ex.of chiaroscuro prtg
Latin edition:LC N7627.G6

NO CLU-C PPPM FU-Mu Amsterdam,Rijksmus.cat.
 Z5939A52,deel 1,p.134

705
028
NCFA
v.97

I.E - PROFESSIONS - STATESMEN - ROYALTY - 15-16th

Lunenfeld, Marvin
 The Royal image:Symbol and paradigm in por-
traits of early modern female sovereigns and
regents

In:Gaz Beaux Arts
97:157-62 Apr.'81

I.E - PROFESSIONS - STATESMEN - ROYALTY(FRANCE)

Brecy, René
 Portraits des rois et reines de France. Mona-
co,les documents d'art,.1942.
 26 p. illus.

LC N7604.B68 Rep.,1942-44:689

I.E - PROFESSIONS - STATESMEN - ROYALTY(15-16th c)

Wescher, Paul
 Das höfische bildnis von Philipp dem Guten
bis su Karl V.

In:Pantheon
28:195-202 1941 illus.
 :272-7

 Incl:Isabella of Portugal by v.d.Weyden;John
the Fearless;Philip the Good by v.d.Weyden;
Charles the Bold by v.d.Weyden,etc.

LC temporary N3.P3 Rep.,1942-44:690

I.E - PROFESSIONS - STATESMEN - ROYALTY - FRANCE

.Debrou, P..
 Catalogue des portraits imprimés en noir et
en couleurs de la reine Marie-Antoinette et de
la famille royale...composant la collection de
m.P.D...vente le 8 mars,1907.Paris,Hôtel Drouot
 47 p. illus.

PPPN NJP

I.E - PROFESSIONS - STATESMEN - ROYALTY(AUSTRIA)

Domanig, Karl, 1851-1913 ed.
 Porträtmedaillen des erzhauses Österreich
von Kaiser Friedrich III.bis Kaiser Frans II.,aus
der medaillensammlung des allerhöchsten kaiser-
hauses. Wien,Gilhofer & Ranschburg,1896
MET 40 p. illus. (Kunsthistorische sammlungen
140.92 des allerhöchsten kaiserhauses)
D71
Q

MH NBuG CaOTP TU MiBJ Amsterdam,Rijksmus..cat.
 Z5939A52,deel 2,p.683

I.E - PROFESSIONS - STATESMEN - ROYALTY(FRANCE)

 Les effigies des Roys de France,tant antiques
 que modernes...Paris:François Des Pres,1565?

 62 woodcuts by Jean Cousin,the younger,all
waist-length

NN Rave.Jb.d.Berl.Mus.I 1959
 LC N3.J16 fol. p.141
 Paolo Giovio & d.Bildnisvitenbücher..

I.E - PROFESSIONS - STATESMEN - ROYALTY(FRANCE)

.Bernard, George.
 Effigies regum Francorum omnivm,a Pharamvndo
ad Henricum vsqve tertium...Caelatoribvs,Virgili
Solis & Iusto Amman...Noribergae...1576
 64 1 62 ports.

 Engraved portrs.with a scene in woodcut in-
serted in frame

 Title:Chronica regum Francorum

LC DC37.B5 1576 Rave.Jb.d.Berl.Mus. I 1959
Rosenwald coll. LC N3.J16 fol. p.149-50
 Paolo Giovio & d.Bildnisvi-
 tenbücher d.Humanismus

I.E - PROFESSIONS - STATESMEN - ROYALTY(FRANCE)

 Epitomes des roys de France en latin & en fran-
coys auec leur vrayes figures...Lvgdvni.-Lyo
Balthasar Arnoullet,1546
 159 p. illus.
 2nd issue.1st issue entitled:Epitome gestorv
lVIII.regvm Franciae,1546

 58 portrs,attr. to Corneille de Lyon,from
leg.king Pharamond to Francis I

LC Typ 515
46.366 MH Rave.Jb.d.Berl.Mus.I 1959
 LC N3.J16 fol. p.138
 Paolo Giovio & d.Bildnisvitenbücher....

I.E - PROFESSIONS - STATESMEN - ROYALTY - FRANCE

Bie, Jacob de, 1581-
 Les vrais portraits des rois de France,
...sceaux,médailles...2de éd.augm.de nouveaux
portraits,et enrichie des vies des rois...
(Down to Louis XIII).Paris,chez Jean Camvsat,
MET 1636
115.01
B471
Q

 Brit.mus.
 185.d.10
LC N7604.B47=1st ed.1634 FOR COMPLETE ENTRY
 NB NN MH=2nd ed.1636 SEE MAIN CARD

705
028
v.20

I.E - PROFESSIONS - STATESMEN - ROYALTY(FRANCE)

Fillon, Benjamin, 1819-1881
 La galerie de portraits de Du Plessis-Mornay
au Château de Saumur

In:Gaz Beaux Arts
2pér.v.20:162-68 Aug.,1879
 :212-28 Sep.,1879 illus.

 Reprint issued(same title)Paris,Quentin,1879

 Aug.article incl.list of sitters:Protestant
reformers,royalty,etc. Bouchot.Portrs.aux crayons
MB(reprint ed.) NC860.P23NPG,p.1,footn.1

I.E - PROFESSIONS - STATESMEN - ROYALTY(FRANCE)
Gauthier, Maximilian
 Le renouveau de la médaille française

In:Art et Industrie
 :21-4 no.15,1949 illus.

Repro.:Henry IV by Briot,Louis XIII by Varin,
Louis XIV by Roussel,Louis XV by Duvivier,Napo-
leon by Andrieu & works by Rodin,etc.

LC NK2.A498 Rep.,1948-49*712

I.E - PROFESSIONS - STATESMEN - ROYALTY - FRANCE
Paris, Bibliothèque Nationale
 Les Clouet et la cour des rois de France,
de François Ier à Henri IV.Paris,1970
 96 p. illus.

 Les notices...rédigées par M.Jean Adhémar

LC DC36.6P35

I.E - PROFESSIONS - STATESMEN - ROYALTY(FRANCE)
Gilles, Nicole, d.1503
 Frantzösische Chronica...bis auff diss gegen-
wirtige 1572 jar....transl.fr.latin by Nicolaus
Falckner & Heinrich Pantaleon.Basel,Nicolaus
Brylinger.1572
 2v.in 1.

 :Latin title:Gesta Francorum:

 Rave:61 portrs.of kings fr.Pharamund to
Charles IX(based on Epitomes des roys de France,
Lyon,1546)
French ed.in LC:DC37.G47 Rave.Jb.d.Berl.Mus. I 1959
PU :573 LC N3.J16 fol. p.149
 Paolo Giovio & d.Bildnisvi-

I.E - PROFESSIONS - STATESMEN - ROYALTY(FRANCE)
R.B.
 Une "iconographie" des rois de France

In:R.de l'art
 :198-200 1929 illus.

LC N2.R4 Rep.,1929*42

I.E - PROFESSIONS - STATESMEN - ROYALTY(FRANCE)
Grouvel, Mme.
 L'iconographie des reines de France au 17e
siècle

Met In:B.Mus.France
100.54 11:36-8 1946,no.6-7 illus.
M973
 Biographical notes,description of character,
habits & costumes,analysis of relations with art-
ists & main portrs.Cat.of 300 nos.:ptgs.,engravgs.
sculpt.,medallions,cameos. Incl.:Marie de Médicis
by Pourbus,Anne of Austria by de Champaigne & Ma-
ria Theresa of Austria
LC N2B94 Rep.,1945-47*1031
 "Thèse soutenue à l'école du Louvre"

705
A7832
NCFA I.E - PROFESSIONS - STATESMEN - ROYALTY (FRANCE)
v.34 Seymour, Charles, 1912-
 A group of royal portrait-busts from the
reign of Louis XIV.in the National gallery,Kress
collection.

In:Art Bull.
 34:285-96 Dec,1952 illus.

 Systematic evaluation of stylistic diversity
of official sculpture in France,ca.1700
 Repro:Coysevox,Prou,Girardon,etc.

 Enc.of World Art,v.11
 N31E56 Ref.,col.513
 bibl.on portr.

I.E - PROFESSIONS - STATESMEN - ROYALTY - FRANCE
Mai, Ekkehard
 Le portrait du roi....Bonn,1975

LC ND1316.3.M34 FOR COMPLETE ENTRY
 SEE MAIN CARD

I.E - PROFESSIONS - STATESMEN - ROYALTY(FRANCE)
Terline, Joseph de :1886-:
 Têtes sculptées aux clefs de voûte de la
chapelle au château de Saint-Germain

Met In:C.R.Acad.Inscrip.
506 :272-3 1949
P21? Sculptured bosses
 Identification of these heads of 1236 or 1237:
Louis IX,Blanche of Castile,Margaret of Provence,
Isabella of France,Robert of Artois,Alfonso of
Poitiers,Charles of Anjou

LC AS162.P315? Rep.,1948-49*1036

I.E - PROFESSIONS - STATESMEN - ROYALTY - FRANCE
Niel, P.G.J.
 Portraits des personnages français les plus
illustres du 16e siècle,reproduits,en facsimilé,
sur les originaux dessinés aux crayons de cou-
leur par divers artistes contemporains;recueil
publié avec notices par P.G.J.Niel...Paris,
M.A.Lenoir,1848-56
 2 v. illus(col.)

 Contents.1.sér.Rois et reines de France.Mai-
tresses des rois de France.2.sér.Personnages di-
vers
 1..facsimile ar Riffaut.'-Bouchot,p.11
LC DC35.5.N67 Bouchot.Portrs.aux crayons,p.11
 NC 860 P23 NPG

ND
1316.2
D97 I.E - PROFESSIONS - STATESMEN - ROYALTY(FRANCE)
NPG Tillet, Jean du, sieur de la Bussière,d.1570
 ...Portraits des rois de France de Recueil
de Jean du Tillet.Reproduction réduite des 32
miniatures du manuscrit français 2848 de la Bib-
liothèque nationale. Paris,Impr.Berthaud frères,
:1908:
 12 p. illus.

 Edited by Henri Omont

LC N7004.T5 Amsterdam,Rijksmus.cat.
 Z5939A52,deel 1, p.145

I.E - PROFESSIONS - STATESMEN - ROYALTY(GERMANY)

Bryden, H.A.
 The founders of Prussian militarism

In:Apollo
 :191-5 1933(pt.2) illus.

 Portr.of Frederick William,elector of Branden-
burg,1620-88,Frederick I,1st king of Prussia,1657-
1713,Frederick William I,1688-1740,FrederickII,
the Great,1712-1786

LC N1.A255 Rep.,1933*135

I.E - PROFESSIONS - STATESMEN - ROYALTY(GERMANY)

Scheffler, Willy
 Die porträts der deutschen kaiser und könige
im späteren mittelalter von Adolf von Nassau bis
Maximilian I (1292-1519)
Met
100.53 In:Rep.Kunstwiss.
R29 33:222-32,318-38,424-42,509-24 1910
v33

I.E - PROFESSIONS - STATESMEN - ROYALTY(GERMANY)

Goetz, Walter Wilhelm, 1867- ed.
 Die entwicklung des menschlichen bildnisses.
Leipzig & Berlin,B.G.Teubner,1928-

 Contents.-1.Schramm,P.E.D.deutschen Kaiser &
Könige in bildern ihrer zeit.1.Bis zur mitte des
12.jhrh(751-1152)2 v.1929.-2.Prochno,Joachim.Das
schreiber-& dedikationsbild in d.deutsch.buchma-
lerei,v.1,1929-3.Steinberg,S.H.,D.bildnisse geist-
licher & weltlicher fürsten & herren.1.Von d.mit-
te d 10.bis s.ende d.12.jarh(950-1200),1931
LC N7575.E6 v. II,III

I.E - PROFESSIONS - STATESMEN - ROYALTY(GERMANY)

Schramm, Percy Ernst,1894-1970
 Denkmale der deutschen könige und kaiser.
Ein beitrag zur herrschergeschichte von Karl
dem Grossen bis Friedrich II, 768-1250...
München,Prestel,1962

 484 p. illus.

LC DD85.6.S33

I.E - PROFESSIONS - STATESMEN - ROYALTY(GERMANY)

Kemmerich, Max, 1876-
 Die porträts deutscher kaiser & könige bis
auf Rudolf von Habsburg

 Reprint from Gesellschaft für ältere deutsche
Geschichtskunde.Neues Archiv,33,2.Hannover?
betw.1876-1922?

LC DD2.G31 Amsterdam,Rijksmus.,cat.
 Z5939A52,deel 1,p.147

I.E - PROFESSIONS - STATESMEN - ROYALTY - GR.BR.

A Booke containing the trve portraitvre of the
 covntenances and attires of the kings of
 England,from William conqveror,vnte vnr Sov-
 eraigne Lady Queene Elizabeth...London,
 Printed by Iohn de Beauchesne,1597

NN
MiU CoDU (Film)

I.E - PROFESSIONS - STATESMEN - ROYALTY(GERMANY)

Kiessling, Gerhard
 Deutsche kaiserbildnisse des mit-mittelalters.
Ein beitrag zur geschichte des mittelalterlichen
kaisertums und zur entwicklung der porträtkunst...
Leipzig,bibliographisches Institut,1937

 55p. illus.(part col.) Meyers bunte
bändchen.33.
 Bibliography

LC N7605.K5 Rep.,1937*325

705
S94
NCFA Denvir, Bernard
v.145 Her Britanic Majesty.Portraits of some
 British Queens

I.E - PROFESSIONS - STATESMEN - ROYALTY - GR.BR

In:Studio
145:177-83 June,'53 illus(part col.)

 Repro.:Mary Queen of Scots,medallion by
Jacopo Primavera,1572.Mary I.by Antonis Mor.
Elizabeth I.by unknown artist.MaryII.after Wm.
Wissing.Victoria & family by Edwin Landseer.
Henrietta Maria b~ v.Dyck.Elizabeth II.by Rod-
rigo Moynihan
 Rep.1953 *1206

I.E - PROFESSIONS - STATESMEN - ROYALTY(GERMANY)

Kohlrausch, Friedrich, 1780-1865
 Bildnisse der deutschen könige & kaiser von
Karl dem Grossen bis Maximilian I...gezeichnet
von Heinrich Schneider...Hamburg,& Gotha,F.& A.
Perthes,1846
 680 p. illus.

 37 woodcuts by Herburger,Kreuser & Rehle
after H.Schneider

LC DD85.6.K7 Amsterdam,Rijksmus.cat.
 Z5939A52,deel 1,p.147

I.E - PROFESSIONS - STATESMEN - ROYALTY - Great
 .BRITAIN
Dulwich college,London
 Cat.of the manuscripts and muniments of
Alleyn's college of God's gift at Dulwich...
London,Pub....by Longmans,Green & co.,1881-1903

 Edward Alleyn,founder of the college re-
corded betw.1618 and 1620 the purchase of 26
heads of English sovereigns fr.William I to
James I. Only 17 now survive.(p.175)

LC Z6621.D884 FOR COMPLETE ENTRY
 SEE MAIN CARD

I.E - PROFESSIONS - STATESMEN - ROYALTY - GREAT
BRITAIN

Dulwich college,London - Dulwich gallery
Cat.of the pictures in the gallery of Al-
leyn's college of God's gift at Dulwich...London
Printed by Darling & son,ltd.,1914

Set of Kings & Queens,with documentation for
its purchase,p.278,nos.521-36

LC N1270.A3 1914 FOR COMPLETE ENTRY
 SEE MAIN CARD

I.E - PROFESSIONS - STATESMEN - ROYALTY(GR.BRIT.)

Holland, Henry, 1583-1650?
Basiliωlogia, a booke of kings;notes on a
rare series of engraved English royal portraits
from William the Conqueror to James I, publ....
1618 & 1630. By H.C.Levis. New York,The Grolier
club,1913

188 p. illus.
Edition of 300 copies

LC NE1685.B315 Hake,H.M. The Engl.hist.
 portrait.

705
A63
NCFA
v.46

I.E - PROFESSIONS - STATESMEN - ROYALTY - GREAT
BRITAIN

Dunsmuir, Richard
Memorable mugs:commemorative subjects from
Charles II up to the Common Market

In:Antique collector
46:37-41 Aug.,'75 illus.

 FOR COMPLETE ENTRY
 SEE MAIN CARD

705
B97
NCFA
v.70

I.E - PROFESSIONS - STATESMEN - ROYALTY(GR.BRIT.)

Honey, W.B.
Royal portraits in pottery and porcelain

In:Burl Mag.
70:218-25,229 May,'37 illus.

Development of Engl.ceramic art,17-19th c.
Repro.:Lambeth earthenware;Fulham stoneware:
Dwight;Derby biscuit porc.:Stephan;Chelsea porc.:
Roubiliac;Wedgwood's black basalt:Hackwood & jas-
per:Flaxman;Battersea enamel:Ravenet

 Cumulated mag.subj.index
 A1/3/C76 Ref. v.2,p.444

VF in:
London
NPG

I.E - PROFESSIONS - STATESMEN - ROYALTY - GR.BR.

Gibson, Robin
The National Portrait Gallery's set of Kings
and Queens at Montacute House

In:Nat'l Trust Year Book
1:81-87 1975-76 illus.

LC NX28.G72N3716 1975-76 FOR COMPLETE ENTRY
 SEE MAIN CARD

N
5197
I 53X
NPG

I.E - PROFESSIONS - STATESMEN - ROYALTY(GR.BRIT.)

Ingamells, John
Catalogue of portraits at Bishopthorpe
Palace. York,Borthwick Inst.of Hist.Research,
1972
77 p. illus.

Portrs. of archbishops of York and of Hano-
verians

Incl.Bibliographical references
Incl.:Kneller,Hudson,Reynolds,West,Owen,etc.

LC BX5197.I 53

DA
28.1
H23
1977cX
NPG

I.E - PROFESSIONS - STATESMEN - ROYALTY - GR.BR.

Happy and glorious:130 years of royal photo-
 graphs;with contributions by Cecil Beaton.
 ...et al.ed.by Colin Ford.London,NPG,1977
 136 p. illus(part col.)

Exhibition at London NPG,1977,marking
Queen.Elisabeth's Silver Jubilee,March-Oct.

LC DA28.1.H23 1977c

705
S94
NCFA
v.145

I.E - PROFESSIONS - STATESMEN - ROYALTY - GR.BR.

Kerr, John O'Connell
Kings & Queens, A.D.653-1953

In:Studio
145:184-7 June,'53 illus.

Refers to Exh.of this title at London,
Royal academy of arts,till June 28,'53
Repro.:Henry VII by unknown artist.Henry
VIII & family by Hans Eworth.James I:attr.to
Marcus Gheeraerts.Charles I by Edw.Bower.
George III by Reynolds.

 Rep.1953#1203

I.E - PROFESSIONS - STATESMEN - ROYALTY(GR.BRIT.)

Harvey, John Hooper
The Plantagenets,1154-1485. London,New York,
Batsford.1948.

180 p. illus.
Bibliography

Review by Squire,John,in:Ill.London News
2:p.94 illus 1948
Paintings & sculptures of Richard II,Edward II
Edward III,Marguerite of France,Richard I & Elea-
nor of Aquitaine
LC DA177.H3 Rep.,1948-49#1031

I.E - PROFESSIONS - STATESMEN - ROYALTY - GR.BR.

Levis, Howard Coppuck
Notes on the early British engraved Royal
portraits issued in various series from 1521
to the end of the 18th c...London,The Chiswick
press,1917

LC N7598.L5 FOR COMPLETE ENTRY
 SEE MAIN CARD

I.E - PROFESSIONS - STATESMEN - ROYALTY - GR.BR.

Little, Wilfred
Royalty in English ceramics

In:Connoisseur.Antique dealers' no.:76-9
June,'53 illus.

Repro.incl.:Dish with portr.of Chs.I.,
Chs.II,William III.Busts of Js.II by John
Dwight of Fulham and Georges II.

In:Conn.Souvenir of the Antique
dealers'fair & other exhibition Rep.1953 #1204
LC NK1125.A357

DA
28.1
L63
1977X
NPG

I.E - PROFESSIONS - STATESMEN - ROYALTY - Gr.Br.

London. National Portrait Gallery
Royal faces;900 years of British monarchy.
.text by Hugh Clayton....London,H.M.S.O.,1977
56 p. illus(part col.)

Incl.Coins,ptgs.,miniatures,busts,statu-
ettes,tomb effigies,etc.photographs.
Geneal.table

LC DA28.1.L63 1977

DA
480
K4x
NPG

I.E - PROFESSIONS - STATESMEN - ROYALTY - GR.BR.

London. National Portrait Gallery
The house of Hanover;by J.Kerslake and
Louise Hamilton.London,H.M.stationery office,
1968
.20.p. illus(part col.) (Its Kings and
Queens series:1714-1837)

Winterthur Mus.Library
FZ881.W78 NCFA v.6,p.228

I.E - PROFESSIONS - STATESMEN - ROYALTY - Gr.Br.

London. Queen's Gallery,Buckingham Palace
Royal children.exhibition....1963.catalogue,
London,.1963.
2 v.in 1

Contents.-.1.Text.-.2.Plates

ICU

Millar.The later Georgian
pictures...qND466M64 Bibl.

DA
758.3
S867x
NCFA

I.E - PROFESSIONS - STATESMEN - ROYALTY - GR.BR.

London. National Portrait Gallery
The house of Stuart,by David Gransby.Lon-
don,H.M.stationery off.,1968

20 p. illus(part col.) (Its Kings and
Queens series;1603-1714)

MET
276.5
L844

I.E - PROFESSIONS - STATESMEN - Royalty - GREAT
BRITAIN

London. Royal academy of arts
Kings and queens,653-1953.Exhib.of royal
portraits.London.1953.
95 p. illus.

LC N7598.L6 Fogg,v.11,p.333

N
7598
S92
NPG

I.E - PROFESSIONS - STATESMEN - ROYALTY - GR.BR.

London. National Portrait Gallery
The house of Tudor;by Roy C.Strong.London,
H.M.stationery office,1967
20 p. illus(part col.) (Its Kings and
Queens series:1485-1603)

LC DA317.1.S7

705
C75
NCFA
v.188

I.E - PROFESSIONS - STATESMEN - ROYALTY - GR.BR.

Mayorcas, J.D.
English stumpwork

In:Connoisseur
188:254-9 Apr.,'75 illus.

Bibl.footnotes
Repro incl.:Charles I as a martyr,1649,a co-
py of the frontispiece of Eikon Basilike...the
Pourtraicture of his Sacred Majestie fr.an engr
by William Marshall
See also:Nevinson.Walpole Soc.28,PLVII

DA
28.1
O 7x
NPG
2 c.

I.E - PROFESSIONS - STATESMEN - ROYALTY - GR.BR.

London. National Portrait Gallery
The house of Windsor;by Richard Ormond.
London,H.M.stationery office,1967
.20.p. illus(part col.) (Its Kings and
Queens series:1838-1966)

Winterthur Mus.Library
FZ881.W78 NCFA v.6,p.228

I.E - PROFESSIONS - STATESMEN - ROYALTY(GR.BRIT.)

Mitchell, James Tyndale, 1834-1915
...The unequaled collection of engraved por-
traits belonging to Hon.T.Mitchell...embracing
the lord chancellors and chief justices of Great
Britain,eminent English lawyers,kings & queens of
Great Britain,English princes & princesses & mem-
bers of royal families,mostly engraved in mezzo-
tinto,to be sold...Feb.26...and...Feb.27,1908...
Cat.comp.& sale conducted by Stan.V.Henkels.At
the book auction rooms of Davis & Harvey,Phila.Pa.
....Press of W.F.Fell co.,1908.
93 p. illus.
Cat.no.944,pt. VI

LC NE265M5

DA
28.1
069X
NPG

I.E - PROFESSIONS - STATESMEN - ROYALTY - GR.BR.

Ormond, Richard
The face of monarchy;British royalty por-
trayed...Oxford,Phaidon,1977
207 p. illus(part col.)

Bibl.references

Index

LC DA28.1.069

705
S94
NCFA
v.13

I.E - PROFESSIONS - STATESMEN - ROYALTY(GR.BRIT.)

Sandilands, G.S.
Royal robes and regalia

In:Studio
13:235-49 1937(ptI) illus(part col.)

Portrs. of Charles II,Georges I,II,III,Queen
Victoria,Edward VII

Rep.,1937#365

I.E - PROFESSIONS - STATESMEN - ROYALTY(GR.BRIT.)

Paes, Elena
Unas muestras curiosas de iconografia regia
escocesa

In:R.Arch,Bibl.y museos
54:105-7 1948 illus.

Kings & queens of Scotland from James III to
Queen Anne

LC Z671.R41 Rep.,1948-49#1033

I.E - PROFESSIONS - STATESMEN - ROYALTY - GR.BR.

Sotheby, firm,auctioneers, LONDON
A catalogue of a most beautiful collection
of British portraits,from Edward the Third to
George the First...embracing the most rare and
esteemed works of Elstracke,Delaram,the Pass fa-
mily,Voerst,Vosterman,Blooteling,Loggan,White,
Valck,Smith,Williams,Becket,etc.and particular-
ly...Wm.Faithorne,incl.an unique impression of
Oliver Cromwell between Pillars.The Houbraken
heads...sold by Mr.Sotheby...on Wednesday,12th
day of Dec.,1827.London 1827
40 p.

CtY

705
A786
NCFA
v.36

I.E - PROFESSIONS - STATESMEN - ROYALTY - GR.BR.

Property from estates

In:Art N
36:23 Sept.17,'38. 1 illus.

Repro.:Stumpwork picture of James I & Anne
of Denmark

I.E - PROFESSIONS - STATESMEN - ROYALTY - GR.BR.

Thane, J.ohn,1748-1818, ed.
The British gallery of historical portraits
...a coll.of...portraits...of the royal...per-
sonages in English history...,from the reign of
Henry V(1420)to that of George II(1750)...Lon-
don,Edw.Daniell,1854?.

MET
276.5
T32

LC DA28.T3 FOR COMPLETE ENTRY
 SEE MAIN CARD

705
C75
NCFA
v.17

I.E - PROFESSIONS - STATESMEN - ROYALTY - GR.BR.

Rae, Olive Milne
Needlework pictures

In:Connoisseur
17:199-203 March,'07 illus.

Repro.incl.:Charles I & Henrietta Maria,
stumpwork,17th c.;Charles II,stumpwork,17th c.

705
A6
NCFA
v.57

I.E - PROFESSIONS - STATESMEN - ROYALTY - GR.BR

Tilley, Frank
Some royal portraits on English pottery
and porcelain

In:Apollo
57:192-7 June,'53 illus.

Widely used since the 16th c. & especial-
ly under William III.

Repro.incl.:English Delft royal charger:
Chs.I & 3 of his children,1653.Ths.Toft slip
ware dish:Chs.I
 Rep.1953 #1205

I.E - PROFESSIONS - STATESMEN - ROYALTY - GR.BR.

Salmon, Thomas, 1679-1767
The chronological historian;containing...
all material...relating to the English affairs,
from the invasion of the Romans to the present
time...Illustrated with the effigies of all
our English monarchs,curiously engraven,by
Mr.Vertue.London,printed for W.Mears,1723
422 p. illus.

LC(94.2S172c)Rare book col).
(DA34S.1733 2nd ed.495 p.illus.
(DA34S2)3rd ed. 2 v. il. Brit.mus.Additions 1965
 v.5,p.677,Z921.B862 NCFA Ref
 Dept.of printed books

708.1
R476
NCFA
v.16

I.E - PROFESSIONS - STATESMEN - ROYALTY - GR.BR.

Two needlework pictures in the museum,by M.A.B.

In:R I Sch Des Bull
16:16-8 Apr.,'28 illus.

Repro.incl.:Charles I & Henrietta Maria.
Stumpwork,17th c.

Description of stumpwork,p.15-6

I.E - PROFESSIONS - STATESMEN - ROYALTY(GR.BRIT.)

Vertue, George, 1684-1756
 A description of nine historical prints, representing kings,queens,princes,etc.of the Tudor family. Selected,drawn & engraved,from the original paintings by George Vertue....London.Republish. by the Society,1776

 21 p. illus.

LC NE642.V4A3

I.E - PROFESSIONS - STATESMEN - ROYALTY - NETHERLANDS

Schilstra, J.J.
 De Oranjes op taai-en speculaasvormen(Members of the House of Orange on gingerbread moulds)

 In:Antiek
 10,pt.1:57-68 June-July,'75 illus.

LC NK1125.A25

I.E - PROFESSIONS - STATESMEN - ROYALTY(GR.BRIT.)

Vertue, George, 1684-1756
 The heads of the kings of England;also 22 plates of the monuments of the kings of England. London, 1736

Brit.mus. Universal cat.of books

I.E - PROFESSIONS - STATESMEN - ROYALTY(SPAIN)

Sánches Cantón, F.J.
 Los retratos de los Reyes de España. Barcelona,Ed.Omega.1948.
 414 p. illus(part col.)
 Co-author Andrade,José Pita
 Foreword by duke de Alba

 Bibliography

LC N7611.S3 Rep.,1948-49*1025

705
S94
NCFA
v.135:6
I.E - PROFESSIONS - STATESMEN - ROYALTY(Great Britain)

Waterhouse, Ellis Kirkham, 1905-
 Portraits of our Kings and Queens. From Henry VIII to Queen Victoria

 In:Studio
 135:133-43 May 1948 illus(part col.)

 Different wishes of sitters:Representational; modest & intimate; effigy without personal character; domestic

 Rep.,1948-49*1030

I.E - PROFESSIONS - STATESMEN - ROYALTY
 see also
I.E - INDIVIDUAL SITTERS - HANOVER, HOUSE OF

I.E - PROFESSIONS - STATESMEN - ROYALTY(ITALY)

Ladner, Gerart Burian, 1905-
 The "portraits" of emperors in Southern Italian exultet rolls and the liturgical commemoration of the emperors

 In:Speculum
 17:181-200 Apr,1942

 Portrs.of emperors in MSS from end 10th c. to end 13th c.

LC PN661.S6 Rep.,1942-44*7203

I.E - PROFESSIONS - STATESMEN - ROYALTY
 see also
I.E - INDIVIDUAL SITTERS - HAPSBURG, HOUSE OF

I.E - PROFESSIONS - STATESMEN - ROYALTY(ITALY)

Steinberg, Sigfrid Heinrich, 1899-
 I ritratti dei re normanni di Sicilia

In:Bibliofilia(Rev.di storia del libro,delle arte grafiche,di bibliografia e erudizione (Florenz)
39 :29-57 1937 illus.

 Seals,ptgs.,mosaics,sculptures,12th c.

POGG Reprint:Florence,Olschki,1937
430
S56 Enc.of World Art,v.11,512
 Rep.,1937*326

I.E - PROFESSIONS - WOMEN ARTISTS

Dewhurst, C.Kurt
 Artists in aprons:Folk art by American women:y.C.K.Dewhurst,Betty MacDowell,Marsha MacDowell.1st ed.N.Y.,Dutton,c.1979
 202 p. illus(part col.)
 Intro.by Joan Mondale
 Exh.at N.Y.,Mus.of Amer.folk art,16 Jan.- 29 Apr.,'79.Also at Albany,N.Y.,Inst.of Hist. and Art,29 "pr.-?? June,'79
 Index
 Bibliography
 Incl.:oils,pastels,silhouettes,W.C.,18-19th
LC NK805.D48 1979 ?MAH Flint Inst.of Arts,Amer.naive
 pt(s. NB210.5.P7F5 1981X
 N744 4146.n.83.007

I.E - PROFESSIONS - WOMEN ARTISTS

Krull, Edith
 Kunst von frauen.Das berufsbild der bil-
denden künstlerinnen in vier jahrhunderten.
Edition Leipzig.1984.
 189 p. illus(part col.)

LC N8354.K78 1984

705
161
NCFA I.E - PROFESSIONS - WOMEN ARTISTS - U.S. - 17-18th

Willis, Eola
 The first woman painter in America

In:Studio
87:13-20,84 July,'27 illus.

 Incl.&List of pastel portrs.,by Henrietta
Johnston,ptd.in S.Carolina,171)-20

 Keyes.Coincidence and H.
 Johnston, In:Antiques,16

705
G28
NCFA I.E - PROFESSIONS - WOMEN ARTISTS - FRANCE
v.39
Tourneux, Maurice
 Une exposition rétrospective d'art féminin

In:Gas.Beaux-Arts
39:290-300 Apr.,1908 illus.

 Exh.at Hôtel du Lyceum-France,Club féminin,
20 feb - 15 march,1908
 Exh.ca.60 ptrs.by women

 Repro.incl.portrs.by Judith Leyster;Marie-
Gabrielle Capet;Mlle.Boulliard;Adèle Romany;
Mme.Vigée-Lebrun
 urneux.L'Exp.d.l'Q.pastels

NCFA
uncat. I.E - PROFESSIONS - WOMEN ARTISTS - U.S. - 17-18th

Willis, Eola
 Henrietta Johnston,South Carolina pastel-
list

In:The Antiquarian
11,no.?:46-7 Sep.,'28 illus.

 Several previously unknown portrs.by Ameri-
ca's 1st woman ptr.,H.J.,have been found re-
cently

I.E - PROFESSIONS - WOMEN ARTISTS - U.S.

Dexter, Elisabeth Williams (Anthony) 1887-
 Colonial women of affairs;a study of women
in business and the professions in America be-
fore 1776...Boston and N.Y.,Houghton Mifflin
company,1924
 203 p. illus.

References
 The author's doctoral diss.Clark Uni.,19
but not published as a thesis

 Dewhurst.Artists in aprons
LC K195.D52 Bibl.p.175

705
C75
NCFA I.E PROFESSIONS - WOMEN ARTISTS - U.S. - 18th c.

Hart, Charles Henry, 1847-1918
 Patience Wright,Modeller in wax

In:Conn.
19:18-22 Sep.,'07 illus.

 Repro.incl.:Washington,Earl of Chatham,
Franklin

708.1
N52
NCFA I.E - PROFESSIONS - WOMEN ARTISTS - U.S.

Gardner, Albert Ten Eyck
 A century of Women

In:Met Mus Bul
N.S.7:110-8 Dec.'48 illus,

 Repro.incl.:Miniature of Mrs.Goudry by
Sarah Goodridge.Rosa Bonheur by Anna Elizabeth
Klumpke.Mural & portrs.by Mary Cassatt.Front-
ispiece fr."Godey's Lady's Book":Portr.within
portr.

 Dewhurst.Artists in aprons
 Bibl.p.34

705
A784
NCFA I.E PROFESSIONS - WOMEN ARTISTS - U.S. - 18th c.

Lesley, Everett Parker
 Patience Lovell Wright,America's first
sculptor

In:Art in Am.
24:148-54,157 Oct.,'36 illus.

 Repro.:Franklin,Washington,Js.Johnson,Bi-
shop of Worcester,Lord Chatham

N
43
N53
NCFA I.E - PROFESSIONS - WOMEN ARTISTS - U.S.

Newark Museum Association, Newark,N.J.
 Women artists of America,1707-1964.Exh.
cat.,The Newark Museum,Apr.2-May 16,1965.
Newark,1965
 32 p. illus.

 Introductory essay by William H.Gerdts
 Bibliography

 Repro.incl.:Henrietta Johnston,Patience
Lovell Wright,Ann Hall,Sarah Goodridge,Mary
Cassatt,Marcia Marcus,Helena Simkhovitch
Cecilia Beaux Dewhurst.Artists in aprons
 Bibl.p.179

I.E - PROFESSIONS - WOMEN ARTISTS - U.S. - 18th c.

Munson, L.F.
 The celebrated Mrs.Wright,ingenious artist
in wax works and friend of statesmen

In:House Beautiful
62:392- Oct.,'27

LC NA7100.H65 Prentice.Waxmin.Phila.Mus.
 ill.v.42,no.213,March'47
 708.1.P31 NCFA Bibl.p.63

I.E - PROFESSIONS - WOMEN ARTISTS - U.S. - 18th c.

N
40.1
W933S4
NPG

Sellers, Charles Coleman, 1903-
Patience Wright:American artist and spy in
George III's London.Middletown,Wesleyan Univ.
press,c.1976
281 p. illus.

Incl.Bibl.ref. & index
Catalogue of works

'P.W.brought wax sculpture in the round to
prominence as a portrait art in a way unknown
before or since'
Rila III/2 1977 #5132

I.E - PROFESSIONS
see also
Other media,e.g. II.E.4 - PROFESSIONS

AP
1
S648
NCFA

I.E - PROFESSIONS - WOMEN ARTISTS - U.S. - 18th c.

Troop, Miriam
Two lady artists led the way for success
and fame

In:Smithsonian
8,no.11:114-24 Feb.,'78 illus(part.col.)

"Patience Lovell Wright,Mother of all New
Realism.Henrietta Johnston first portraitist
,in,pastel in the New World."-M.Troop

Patience Lovell Wright and her sister,Rachel
Wells had a waxworks in N.Y.City,Philadel-
phia & London

AP
1
P89
NCFA

I.E - SELF-PORTRAITS

Allhusen, E.L.
Self portraiture in etching (Some living
artists)

In:Print Coll Q
18:175,7,9,1 3,5,7-8,191,4,6 Apr.,'31 illus.

Reasons for Self-portraiture
In self-portrs. we get the artist's ideal of
himself.The artist does not copy nature but ex-
presses her;the greatest scope for such express'n
found in self-portraiture.
Descript'n of s.-portrs. by ...
Cum.mag.subj.ind. 1/3/76Ref
v.2.p.444

N
6505
R8
1982X
NMAA

c.1 NMAA
c.2 NMAA
Ref.

I.E - PROFESSIONS - WOMEN ARTISTS - U.S. - 18-
19th c.

Rubinstein, Charlotte Streifer
American women artists;from the Indian to
the present.N.Y.,Avon;Boston,Mass.,G.K.Hall,
c.1982
560 p. illus(part col.)

Portraits p.40-50

N
7575
P4x
NPG

I.E - SELF-PORTRAITS

Benkard, Ernst, 1883-
Das selbstbildnis vom 15.bis zum beginn des
18.jahrhunderts.Berlin,H.Keller,1927

82,58 p. illus(101 pl.)

First monograph on s.p.,says Benkard.Beginn-
ing & causes.Historical problem linked to socio-
logical events.Trends of time & circumstances
show in s.p.
Contents:Das problem.Unfreiheit.Entfaltung.
Soziale emanzipation.Emanzipation des gefühls.
LC N7575.B4 Goldscheider 757.G52

705
A56
NCFA
v.51

I.E - PROFESSIONS - WOMEN ARTISTS - U.S. - 19th c.

Dods, Agnes M.
Sarah Goodridge

In:Antiques
51:328-9 May,'47 illus.

List of sitters & owners of G.'s miniatures

Repro.incl.:David Webster,Gilbert Stuart

AP
1
D81
NMAA

I.E - SELF-PORTRAITS

Billeter, Erika, 1927-
Der Künstler und seine vorstellung vom ich

In:Du
3:33-63 1984 illus(part col.)

English summary,p. 1-2,
Self-portraits from 1515 to 1982

The article seeks to provide a concentrated
survey of the forms in which art has handed
the self-portr.down to us

Rep.1986 #4737

N
40.1
P354K5
NMAA

I.E - PROFESSIONS - WOMEN ARTISTS - U.S. - 19th c.

King, Joan
Sarah M.Peale,America 's first woman artist.
Brookline Village,MA,Branden Publ.Co.,c.1987
296 p. illus.

'This is a work of fiction...drawn from a stu-
dy of the...Peale family'-Introduction.

ND
1300
B613
1985X
NMAA

I.E - SELF-PORTRAITS

Bonafoux, Pascal
Portraits of the artist.The self-portrait
in painting.N.Y.,Sk'ra/Rizzoli,1985
158 p. illus(part col.)

Incl.Index
Bibliography,p.143-8

Translation of:Les peintres et l'autopor-
trait
Based on diss.Paris,1979

VF:
Florence
Gall.
degli
Uffizi

I.E - SELF-PORTRAITS

Buerkel, Ludwig von
Die selbstbildnisse von malern in den Uffi-
zien

In:Ueber Land & Meer
94,no.46:1065-7 Apr.-Oct.,1905 illus.

LC AP30.U2

FOR COMPLETE ENTRY
SEE MAIN CARD

I.E - SELF-PORTRAITS

Foscari, Lodovico
Autoritratti di maestri della scuola vene-
ziana

In:Riv.di Venezia
12:147-62 1933

MET
100.55
R525

Enc.of World Art
N31E56 Ref.v.11,col.513
Bibl on portr.

N
7592.6
C72
NPG

I.E - SELF-PORTRAITS

Columbia University. Dept.of Art History and
Archaeology
Modern portraits.The self and others..N.Y.,
Col.Univ..1976
201 p. illus(part col.)

Exhibition organized ...at Wildenstein,N.Y.,
Oct.20-Nov.28,1976

I.E - SELF-PORTRAITS

Franceschini, G.
La psicologia dell'autoritratto in arte

In:Emporium
27:442-57 1908

LC AP37.E5

Prinz.Slg.d.selbstbildnisse
..N7618P95,bd.1 NPG p.147,c
note 57

I.E - SELF-PORTRAITS

Darmstadt. Hessisches Landesmuseum
Repräsentation und selbstverständnis:Bild-
nisse vom 16.-20.jahrh.:Gemälde aus eigenem be-
stand;ausstellung 8.3-195,1974.Katalogtexte,
Rainer Schoch,Hans M.Schmidt.1974?.
23 leaves

LC ND1301.5.G3D372 1974

ND
1309
G25
E1963
NCFA

I.E - SELF-PORTRAITS

Gasser, Manuel
Self-portraits:from the 15th c.to the present
day. Translated by Angus Malcolm.1st ed..,New
York,Appleton-Century.1963.
302 p. illus.(part col.)

"with several errors as well abt.the history
of the coll.in Uffizi as also abt.early self-
portrs."-W.Prinz.D.Sammlung der Selbstbildn.in
den Uffizien N7618.P95,bd.1 NPG p.147d

LC N7592.C313

ND
621
F5F52
NCFA

I.E - SELF-PORTRAITS

Firenze e l'Inghilterra.Rapporti artistici e
culturali dal 16 al 20 secolo.Firenze,Pa-
lazzo Pitti,luglio-settembre 1971.Firenze,
Centro Di,1971
77.1. illus(col.cover) (Cataloghi,23)

Cat.ed.by M.Webster

see also article by Ormond in Connoisseur
v.177:166-74

LC ND621.F7F57

AP
1
S776
NPG
v.4

I.E - SELF-PORTRAITS

Geist, Sidney
Reflections on the mirror in Cézanne

In:Source
4,nos.2/3 Winter/Spring '85 illus.

Discusses the mirror image in self-portr.

705
C75
NCFA
v.144

I.E - SELF-PORTRAITS

Fleming, John
Giuseppe Macpherson;a Florentine minia-
turist

In:Connoisseur
144:166-7 Dec.,'59 illus.

Repro.incl.:Group from the 224 miniatures
in the Royal coll.at Windsor Castle,all,but one,
copies of self-portrs.in the Uffizi

FOR COMPLETE ENTRY
SEE MAIN CARD

N
40
G65I
NCFA

I.E - SELF-PORTRAITS

Goldscheider, Ludwig, 1896-
Five hundred self-portraits from antique times
to the present day, in sculpture,painting,drawing
and engraving...,translated by J.Byam Shaw. Vienna
Phaidon press;etc..,1937

526 p. illus.(part.col.)

Selected literature on the subject:p.59-60

History:From Egypt c.2650B.C. to Western art
of the beg. of the 20th c.

LC N40.G65

Rep.,1936*344(German)

510

I.E - SELF-PORTRAITS

Gravenkamp, Curt, 1893-
 Das rätsel des selbstporträts

In:Kunst für alle
45:376-8 1930

MET
100.53
K96
v.45

LC N3.K4

Die 20er jahre im portr.
N6868.5.E9Z97 NPO,p.139

N
7618
H75
NPO

I.E - SELF-PORTRAITS

Holsten, Siegmar
 Das bild des künstlers.Selbstdarstellungen.Hamburg,Hans Christians verlag,1978
 123 p. illus.

 Zur Ausstellung in der Hamburger kunsthalle vom 16.juni bis 27.august 1978

 Bibliography

I.E - SELF-PORTRAITS

Hartlaub, Gustav Friedrich, 1884-
 Das selbstbildnerische in der kunstgeschichte

In:Z.f.Kunstwiss.
9:97-124 1955 illus.

 The change in the trend of the self-portrait fr.15th c.to the present
 Repro.:Filippo,Filippino Lippi,Perugino,Delacroix,Feuerbach,Hans Thoma,Karl Haider

LC N3Z55

Rep.1955*860

I.E - SELF-PORTRAITS

Kauffmann, Hans
 Ein selbstporträt Rogers van der Weyden auf den Berner Trajansteppichen

In:Rep.Kunstwiss.
39:15-30 illus. 1916

MET
100.53
R29
P v.39

LC N3R4

Panofsky.Facies illa Rogeri..:"finest contribution to our literature"

I.E - SELF-PORTRAITS

Hartlaub, Gustav Friedrich, 1884-
 Zauber des spiegels.Geschichte und bedeutung des spiegels in der kunst.München,R.Piper,
 [1951]

FOOD
FA312.34
 231 p. illus(part col.)

 Bibl.references:179.-213

 The use of the mirror in self-portraits,p.181,f.

Holsten.N7618.H75 NPO
Bibl.p.119

I.E - SELF-PORTRAITS
Klein, Dorothea
 St.Lukas als maler der Madonna.Ikonographie der Lukas Madonna.:Berlin,O.Schloss,1933.
 127 p. illus.

 Bibliography Diss.Hamburg,1933

 "Nachdem d.einzelnen Handwerke & Zünfte sich ...Schutzpatrone erwählt hatten,ist d.Patron d.Maler,d.hl.Lukas,der die Madonna malt...seit d.15.Jhr.in d.Niederlanden...v.Maler mit d.eigenen Bildniszügen ausgestattet worden"(Prinz)

NN ICU MJP MB PBm

Prinz.Slg.d.selbstbildn.in d.Uffizien.N7618/P95 Bd.1 p.147,note51

I.E - SELF-PORTRAITS

Heine, L.
 Wie malten sich die alten meister selbst ?

In:Belvedere
:129-44 1932 illus.

LC(N3B4)
LC F705B419

Rep.,1932*135

I.E - SELF-PORTRAITS

Lerner, Sharon
 Self-portrait in art.Lerner Publications,
1965 (Fine arts book)
 64 p. illus.

 Designed by Rbt.Clark Nelson.Minneapolis,Lerner Publ.Co.[1965]

 Juvenile work

LC N7575.L4

I.E - SELF-PORTRAITS

Heine, L.
 Wie malten sich die neuzeitlichen meister?

In:Belvedere
:48-72 1934 illus.

 Repr.:Missfeldt,Mulsow,Reifferscheidt,Burmester,Spirod,Liebermann

LC (N3B4)
LC F705B419
 F705B419

Goldscheider 757.052
Rep.,1934

I.E - SELF-PORTRAITS

Lichtenstein, Isaac, 1888-
 Portraits of myself.:N.Y.:,Machmadim Art Editions,Inc.,1947
 1 v.(6 portrs.)

LC (N759.13.L617p) NjDW CCH

I.E - SELF-PORTRAITS

Lippert, Werner
 Das selbstporträt als bildtypus

In:Kunst Forum
14:99-124 1975

Die 20er jahre im portr.
N6868.5E9297 NPG, p.139

MH

I.E - SELF-PORTRAITS

Neumayer, Heinrich, 1905-
 Erkenne dich selbst..Wien,Rosenbaum,1957.
 64 p. illus. (Zeit und bildnis,hrsg.von
H.Neumayer,1.Kaler)

 "Know thyself !"

FOGG
FA
3173.5

ULS New ser'l titles:
DLC Fogp,v.11,p.324

I.E - SELF-PORTRAITS

Lus, Wilhelm August
 Künstler-selbstbildnisse.Leipzig,A.E.
Seemann.1923.
 10 p. 20 illus. (Bibliothek der Kunst-
geschichte,hrsg.von Hans Tietze,56)

(1300.L97)
NNC CtY OClMA Die 20er jahre im portr.
 N6868.5.E9297 NPG,p.139

N
72
P74P78 O'Connor, Francis V.
v.1 The Psychodynamics of the frontal self-por-
NMAA trait.in:Psychoanalytic perspectives on art.The
 Analytic Press,1987
 p.169-221 illus.

I.E- SELF-PORTRAITS

Marrini, Orazio, 1722-1790
 Serie di ritratti di celebri pittori dipinti
di propria mano in seguito a quella gia'pubbli-
cata nel Museo fiorentino esistente appreso
l'abate Antonio Pazzi...Firenze,Stamperia
Moückiana,1765-1766
 2 v. illus. (Museum florentinum...11-12)

LC N2571.06 vol.11-12 Amsterdam,Rijksmus.,cat.
 Z5939A52,deel 3,p.627

705
C75
NCFA Ormond, Richard
v-167 George Chinnery's image of himself

In:Connoisseur
167:89-93 Feb.,'68 illus.
160-4 Mar.,'68 illus.

FOR COMPLETE ENTRY
SEE MAIN CARD

I.E - SELF-PORTRAITS

Masciotta, Michelangelo, ed.
 Autoritratti dal 14 al 20 secolo. Milano,
Electa editrice.1955.
 20 p. illus(part col.) (Collana Sphaera,1)

 1st ed.publ.in 1949 under title:Autoritratti
FOGG del Quattrocento e del Cinquecento
FA
4353.40.5

Harvard Univ.Libr. Enc.of World Art,v.11
for LC N31E56 Ref.,col.514
 Bibl.on portr.

Xerox copy I.E - SELF-PORTRAITS
NPG
in VF Panofsky, Erwin, 1892-
Por- Facies illa Rogeri maximi pictoris
trai-
ture In:Late classical & medieval studies in honor of
 A.M.Friend,jr.Edited by Kurt Weitzmann...Prince-
 ton,N.J...1955 pp.392-400 illus.

 One of the figs.in "Miracle of the Tongue"in
 R.v.d.Weyden's tapestries "Examples of Justice"in
 Bern considered to be self-portr.(Testimony of
 Cardinal Nic.Cusanus)
LC N5975.M4 Encyclop.of World Art
 bibl.Portrs. N31E56 Ref.

I.E - SELF-PORTRAITS

Moücke, Francisco
 Serie di ritratti degli eccellenti pittori
dipinti di propria mano,che esistono nell'Imperial
Galleria di Firense...Firenze,Stamperia Moückiana,
1752-1762
 4 v. illus. (Museum florentinum...7-10)

LC N2571.G6 vol.7-10 Amsterdam,Rijksmus.,cat.
 Z5939A52,deel 3,p.626

I.E - SELF-PORTRAITS

Pevets, Georg, 1893-
 Das zeitgenössische selbst-porträt

In:Kunstwanderer
Met :3-5 May,1933 illus.
100.53
K967 Incl:Rembrandt,Hen(bust),Harta,Pevets

Rep.,1933=149

N7618
P95
NPG

I.E - SELF-PORTRAITS

Prins, Wolfram
Die Sammlung der selbstbildnisse in den
Uffizien;hrsg.v.U.Middeldorf & U.Procacci.
Red.v.W.Prins.Berlin,Mann verl.,1971-
3 v. illus. (ItalForsch.,Folge 3,Bd.5)

Contents:1.-Geschichte der sammlung;2.-Die
selbstbildnisse der ital.künstler;3.-Die selbst-
bildnisse der nicht ital.künstler
v.1:Incl.Hist.developm't of portrs.fr.repre-
senting famous fgs.of the past to actual portrs.

N
6512
R82
NCFA

I.E - SELF-PORTRAITS

Rosenberg, Bernard, 1923-
The vanguard artist,portrait and self-por-
trait,by Bernard Rosenberg and Norris Fliegel.
Chicago,Quadrangle Books,1965
366 p.

Bibliographical references

LC N6512.R67 Rep. 1966 #892

I.E - SELF-PORTRAITS

Prins, Wolfram
Vasari's sammlung von künstlerbildnissen

In:Florence,kunsthist.Inst.,Mitt.
12 suppl. 1966

On Vasari's woodcut portrs.,and their de-
pendence on self-portrs.

LC N14.F5515 Daugherty.Self-portrs.of
P.Rubens mfml61 NPG
p.XIII footnote 10

FOGG
4353
S78

I.E - SELF-PORTRAITS

Standen, Edith Appleton
Self-portraits. New York,Distributors Book-
of-the-Month Club,Inc.,c.1954
[28]p. col.illus. (The Metropolitan
Museum of Art Miniatures,Album MS)

Fogg,v.11,p.325

I.E - SELF-PORTRAITS

Ried, Fritz
Das selbstbildnis. Berlin,1931 (Die Buchge-
meinde, Bd.3 der jahresreihe 1931-32)

MET
195.3
R44 159 p. illus.

FOGG
985
R55s

Goldscheider 757.052

AP
1
A83
NCFA

I.E - SELF-PORTRAITS

Stofflet-Santiago, Mary
Artists' portraits and self-portraits

In:Artweek
7,pt.3:3-4 Jan.17,1976 illus.

FOR COMPLETE ENTRY
SEE MAIN CARD

NPG has
Xerox
copy of
contents
& pre-
face
in VF
Por-
trai-
ture

I.E - SELF-PORTRAITS

Ring, Grete
Beiträge zur geschichte niederländischer
bildnismalerei im 15.&16. jahrhundert. Leipzig,
E.A.Seemann,1913

173 p.

Appendix:1.systematical bibliography
2.list of mentioned portraits

LC ND1319.R5 Lipman.The Florentine
profile portr... also:
Goldscheider 757/.G52

I.E - SELF-PORTRAITS

Unold, Max, 1885-
Selbstbildnisse

In:Neue Rundschau
1 1944

Discusses the necessity of a mirror for
self-portraits.Photographies are no substitute
in their fixed state

LC AP30.N5 Hartlaub.Zauber des spie-
gels,p.18

705
A784
NCFA

I.F - SELF-PORTRAITS

Rose, Barbara
Self-portraiture:Theme with a thousand faces

In:Art in Am
63:66-73 Jan.-Feb.,'75 illus(part col.)

Self-portrs.record the artist's subjective
feelings abt.himself. He sees himself as Thinker
or Worker;equal to Royalty;devinely guided;Mar-
tyr or Madman,etc.

I.E - SELF-PORTRAITS

Viallet, Bice
Gli autoritratti femminili della R.Galleria
degli Uffizi in Firense.Florence,1923
137 p. illus.

MET
276
V65

Enc.of World Art
N31K56Ref.v.11col.512
bibl on portr.

N
7618
W214
NCFA

I.E - SELF-PORTRAITS

Wallis, Mieczyslaw
 Autoportret. Warszawa,Wydawn.Artystczne i
Filmowe,1964
 157 p. illus.

 English and Russian summaries

 Bibliography

 Author points out the differences of self-
portrs.with all other portrs.& carries on Waet-
sold's,Benkard's & Goldscheider's investigations
into this "extrem ly complex phenomenon."

VF

I.E - SELF-PORTRAITS - 19-20th c.

Artist portraits and self portraits, selections
 from the Syracuse University Art collection.
 Exh.in the Joe and Emily Lowe Art gallery,
 Oct.1-22,1978
 8 p. cover illus.

 Checklist of prints,drags.,ptgs.,sculptures

705
P256
NCFA
v.12

I.E - SELF-PORTRAITS

Whitehill, Virginia N.
 Consider the portrait

In:Parnassus
12:5-9 Apr,1940 illus.

 Incl:Rembrandt:Selfportrait, Degas:Selfportr.,
Roberti:Giovanni II, and Ginevra Bentivoglio,at
loan exhibition at Knoedler's,April,1940.
 Also discussion of 'Five hundred profile
portrs.& silhouettes'in the Metropolitan Museum
of art.& 'Self-portrait'exh.at Schaeffer Gall.,
Apr.'40 Rep.,1939-41#619

N
7618
B45
1985
NPG

I.E - SELF-PORTRAITS - 20th c.

L'Autoportrait à l'âge de la photographie,
 peintres et photographes en dialogue avec
 leur propre image,publié par Erika Bil-
 leter.Cat.of an exh.presented at the Musée
 cantonal des beaux-arts Lausanne,Jan.18-
 Mar.24,1985 and at the Württembergischer
 Kunstverein,Apr.11-June 9,1985.Lausanne
 Musée cantonal des beaux-arts,c.1985
 512 p. illus(part col.)

 Préface de Michel Tournier.Contribu-
 tions de Erika Billeter...et al.

CU MiEM
MoSW

 French and German
 Bibliography p.77-9

705
A786
NCFA
v.38
pt.2

I.E - SELF-PORTRAITS - end 16 - end 19th c.

Goldwater, Robert John, 1907-
 Artists painted by themselves.Self-portraits
from baroque to Impressionism

In:Art N
38,pt.2:7-12,23-4 Mar.,30,'40 illus(part col

 Pertains to exh.at Schaeffer gall,inc.,N.Y.,
Apr.2-30,1940
 Artist vs.society.Description of changes in
attitude in the modes of portraiture.
 Repr.incl.:P.Brill,Leyster,Rembrandt(1629)

I.E - SELF-PORTRAITS - 20th c.

Grossmann, Rudolf, 1882-1941
 Das selbstporträt der modernen

In:Kunstblatt
13:371 f. 1929

LC N3.K55

 Die 20er jahre im portr.
 N6868.5.E9297 NPG,p.139

QN
1619.5
E85P14
1988
NMAA

I.E - SELF-PORTRAITS - 16-20th c.

New York. National academy of design
 Painters by painters.N.Y.,Nat'l academy of
design,1988.
 168 p. illus(part col.)

 Cat.of an exh.held at the Nat'l acad.of des.
May12-July 31,1988 & Mus of fine arts,Houston,
Aug.13-Oct.23,1988
 Bibliography
 List of portrs.of artists in the Uffizi
 Index to artists and plates
 Essays:The history of a collection by Cate-
rina Caneva,p.8-27 Studio portrs.by Antonio
Natali,p.28-34.Por within portr.:Cover & no.17

I.E - SELF-PORTRAITS - BELGIUM

Honderd zelfportretten,voorgesteld door diverse
 auteurs,samengesteld onder leiding van Ant.
 de Pesserocy.Brussel,Arcade,1976
 310 p. illus(col.)

LC ND1319.6.H66

I.E - SELF-PORTRAITS - 17-20th c.

Pau,France. Musée des beaux-arts
 L'Autoportrait du 17e siècle à nos jours.
 Exh.avril-mai 1973.Préfaces par Denise de
Rochas d'Aiglun et Philippe Comte.Pau,Musée
des beaux-arts,1973
 72 p. illus.

LC ND1301.5.F8P382 Holsten.N7618.H75 NPG
 Bibl.p.119

705
B97
NCFA
v.89

I.E - SELF-PORTRAITS - FRANCE- 17th c.

Blunt, Anthony, 1907-
 Poussin Studies I. Self-Portraits

In:Burl Mag
89:219-22,225-6 Aug.,'47 illus.

 FOR COMPLETE ENTRY
 SEE MAIN CARD

I.E - SELF-PORTRAITS - FRANCE - 18-19th c.

Gurdus, Luba
 The self-portrait in French painting from
Neo-classicism to Realism.1962

 Ph.D.diss.-N.Y.,Inst.of Fine Arts,1962

 Summary in Marsyas,11:73 '62-'64

AP
1
M37
NCFA

 Stein,J.C. Image of the ar-
 tist in France...ND)316.S*
 1982a NPG p.3,footnote 3

ND
1316
S819
1982a
NPG

I.E - SELF-PORTRAITS - FRANCE - 18-19th c.

Stein, Joanne Crown, 1940-
 The image of the artist in France:Artists'
portraits and self-portraits around 1800
c.1982 238 p.
 Thesis Ph.-D.-UCLA 1982
 Bibliography
 Photocopy of typescript
 List of illus.p.V-XVI.A copy with plates
& 3 supplemental catalogues is on file at the
UCLA library

 Ch.III:David's self-portrs....

I.E - SELF-PORTRAITS - FRANCE - 19th c.

Adams, Harriet D.
 Self-portraits in French painting from
1830-1870

 Master's Th.-N.Y.Univ.,1937

 Lindsay,K.C. Marpur Ind.of
 Master's Theses in art...
 1955 Z5931.L74 1955 Ref.
 NCFA p.31 no.555

N
40.1
C8515
NCFA

I.E - SELF-PORTRAITS - FRANCE - 19th c.

Lemoyne de Forges, Marie Thérèse
 Autoportraits de Courbet.Cat.rédigé par
Marie-Thérèse de Forges.Etude au Laboratoire de
recherche des musées de France par Suzy Del-
bourgo et Lola Faillant.Paris,Editions des Mu-
sées nationaux,1973
 59 p. illus. (Dossiers du Departement d
des peintures,6)
 Bibliography

 Holsten N7618.H75 NPG
 Bibl.p.119

I.E - SELF-PORTRAITS - GERMANY

Bruhns, Leo, 1884-1957
 Deutsche künstler in selbstdarstellungen.
Königstein,i.T.,Langewiesche.1940.
 80 p. illus.

FOGG
983
G37b

 Wallis.N7618.W214 NCFA
 p.143

I.E - SELF-PORTRAITS - GERMANY

Cch(z)enkowski, Henryk August
 Die selbstbildnisse von A.Dürer. Strasbourg,
1910
 66p.

 Inaug.diss.Heidelberg

 Bibliography

LC 759.3D93Yo Goldscheider 757.G52
IU CtY PU MH 500 self-portrs.

I.E - SELF-PORTRAITS - GERMANY

Riess, Margot
 Vom deutschen selbstbildnis

 In:Kunst für alle
MET 44:172-6 1928-29
100.53
K96
v.44

LC N3.K4

I.E - SELF-PORTRAITS - GERMANY

Selbstbildnisse 1752-1962 von Chodowiecki bis
 zur gegenwart.Ausst.des Kupferstichkabi-
 netts der Staatl.Museen zu Berlin,Okt.-
 Des.1962.Kat.hrsg.von den Staatl.Mus.su
 Berlin,c.1962.
 55 p. illus.

 Bibliography

 Intro.by Werner Tism

CLU CSfST Netuschil.Künstler unter
 sich...N7619.5.03K86 1983X
 NMAA.Literatur p.136

I.E - SELF-PORTRAITS - GERMANY - 20th c.

Berliner secession
 Künstler unter sich.Frühjahrsausstellung
 ,April-Mai 1931,malerei,plastik.Veröffent-
 lichungen des Kunstarchivs,v.64,no.57
 30 p. illus(incl. 24 portrs.)

MET
107.3
B457
v.64

LC N5070.B4B4 Netuschil.Künstler unter
 sich.N7619.5.03K86 1963X
 NMAA Anmerkungen p.37

I.E - SELF-PORTRAITS - GERMANY - 20th c.

Hammer, Jutta
 Das szenisch gebundene selbstporträt in der
deutschen kunst des 20.jahrhunderts

 In:Bild.Kunst
 11:583-8 1968 illus.

IU MH WU Die 20er jahre im portr.
 N6868.5.E9Z97 NPG,p.139

I.E - SELF-PORTRAITS - GERMANY - 20th c.

Hodurek, J.
Die selbstbildnisse der nord- und mittel-
deutschen Expressionisten.

Thesis München,1976

Metuschil.N7619.503K86
1963X NMAA p.136

I.E - SELF-PORTRAITS - GERMANY - 20th c.

Schmidt, Diether
Otto Dix im selbstbildnis...2.ergänzte aufl.
Berlin,Henschelverlag,1981
320 p. illus(part col.)

Bibliography

LC N6888.D5A4 1981b Billeter.Selbstportraits
N7618.895 p.26,note 4

I.E - SELF-PORTRAITS - GERMANY - 20th c.

Hütt, Wolfgang
Wir,unsere zeit:Künstler der Deutschen De-
mokratischen Republik in ihren selbstbildnis-
sen.Berlin,Henschelverlag Kunst und Gesell-
schaft,1974
195 p. illus.

Chiefly illustrations

LC ND1317.7.H83

I.E - SELF-PORTRAITS - GREAT BRITAIN

Arts Council of Great Britain
British self portraits,c.1500-c,1860,exhit.,
London,1962
28 p. illus.

FOGG
4103
A79bp

LC N7598.B7
MH Fogg,v.11,p.333

N
7619.5
G3K86
1983X
NMAA

I.E - SELF-PORTRAITS - GERMANY - 20th c.

Metuschil, Claus K.
Künstler unter sich:bildnisse von malern,
bildhauern und graphikern 1900-1930.Darmstadt
Verlag der Saalbau-galerie,1983
137 p. illus.

Bibliography

Issued in connection with an exh.held at the
Saalbau-Galerie
Cat.preparation by Bernd Freese
Incl.:Articles by Max Osborn,Curt Gravenkamp,
Herbert Hofmann, — Rud.Grossmann,Max Oppen-
heimer,Gert Woll—neim,Ludw.Meidner

705
375
NCFA
v.177

I.E - SELF-PORTRAITS - GREAT BRITAIN

Ormond, Richard
Some little known English paintings on exhi-
bition in Florence

In:Connoisseur
177:166-74 July,'71 illus(part col.)

Exh.held at Palazzo Pitti,July-Sept.,1971

See also:Firenze e l'Inghilterra ND621.F6F52
NCFA

I.E - SELF-PORTRAITS - GERMANY - 20th c.

Olbricht, K.-H.
Analyse im selbstporträt oder künstlerische
metamorphose:zu den radierungen von Marwan

In:Kunst & d.schöne Heim
88,pt.5:281-8 May,'76 illus.

LC N3.K5 FOR COMPLETE ENTRY
SEE MAIN CARD

I.E - SELF-PORTRAITS - GREAT BRITAIN - 17th c.

Beale, Mary, 1632-1697
"The excellent Mrs.Mary Beale";13 Oct.-
21 Dec.1975,Geffrye Museum,London;10 Jan.-21 Feb
1976,Towner Art Gall.,Eastbourne;cat.by Eliza-
beth Walsh & Rich.Jeffree...London,Inner London
Education Authority,1975
72 p. illus(1 col.)

Bibliography
102 works shown,incl.5 self-portrs.
Incl.works by Charles Beale,Sarah Curtis-
Hoadley,Nathaniel Thache,Thomas Flatman

LC ND1329.B36W34 Rila III/1 1977 #1085

I.E - SELF-PORTRAITS - GERMANY - 20th c.

Schmidt, Diether
Ich war,ich bin,ich werde sein:Selbstbild-
nisse deutscher künstler des 20.jahrhunderts.
Berlin,Henschel,1968
287 p. illus. 100 pl.(part col.)

Bibliography

LC ND1317.83 Die 20er jahre im portr.
N6868.5.E9297 NPG,p.139

qN
7618
K45
1987X
NPG

I.E - SELF-PORTRAITS - GREAT BRITAIN - 20th c.

Kelly, Sean, 1955-
The self-portrait:a modern view.London,
Sarema Press,1987
152 p. illus(part col.)

Exh.at Artsite Gallery,Bath,Sept.19-Oct.26,
1987 and other galleries
Index
Bibliography
Essay by Edw.Lucie-Smith

I.E - SELF-PORTRAITS - MEXICO

Mexico(City) Instituto Nacional de Bellas
Artes. Departamento de Artes Plásticas
45 autorretratos de pintores mexicanos,
siglos 18 a 20...exposición del Museo Nacio-
nal de Artes Plásticas.México,1947.
118 p. illus.

LC ND1312.M4 MOMA,v.11,p.438

M40.1 I.E - SELF-PORTRAITS - NETHERLANDS
061E7
NPG Erpel, Frits
 Van Gogh, the self-portraits-With a pref.by
 H.Gerson...Greenwich,Conn.,New York Graphic
 Society.1969.
 66 p. illus(part col.)

I.E - SELF-PORTRAITS - NETHERLANDS

Boon, K.G.
 Het selfportret in de Nederlandsche en
Vlaamsche schilderkunst.Amsterdam,Van Holkema &
Warendorf.1947.
 83 p. illus. (Het onderwerp in de Ne-
derlandsche en Vlaamsche schilderkunst)

LC ND1319.B64 Hall.Portr.v.Nederl.beeld.
 kunstenaars.N7620.H17 NPG
 p.XI

I.E - SELF-PORTRAITS - NETHERLANDS

Evers, Hans Gerhard, 1900-
 Zu den selbstbildnissen und bildnissen
von Rubens

In:Jrb.der preussischen kunstslgn.
63:133ff. 1943

LC N3.J2 Daugherty.Self-portrs.of
 P.P.Rubens.mfml61 NPG

I.E - SELF-PORTRAITS - NETHERLANDS
mfm
161
NPG Daugherty, Frances Perry, 1938-
 The self-portraits of Peter Paul Rubens;some
 problems in iconography...Chapel Hill,N.C.,Uni-
 versity of N.C.,1976
 2 v. illus.

 Thesis.-University of North Carolina at
 Chapel Hill. Typescript.

 Bibliography

I.E - SELF-PORTRAITS - NETHERLANDS

Fraenger, Wilhelm, 1890-1964
 "Die Selbstbildnisse Boschs".In.his.Hiero-
nymus Bosch.Dresden,VEB Verlag der Kunst,1975
 pp.490-92

 An analysis of several self-portrs.in Bosch'
ptgs.,a.o.in the Arras Codex & Lampsonius' Ef-
figies of 1572

LC ND653.B65F719 1975 Gibson,W.S.Hieronymus Bosch
 8109.678.G5 1983 p.135
 LCZ

I.E - SELF-PORTRAITS - NETHERLANDS

Eckardt, Götz
 Selbstbildnisse niederländischer maler des
17.Jahrhunderts.Berlin,Henschelverlag,1971
 217 p. illus(part col.)

 "Incl.cat.with bibliographical references &
records differences of opinio,which has not
been done since Benkard's study."-Daugherty,
Self-portrs.of P.P.Rubens,p.XVIII,footn.21

LC ND1319.3E25 Rose,B.In:Art in Am
 63:73 footnote 3

I.E - SELF-PORTRAITS - NETHERLANDS

Hymans, Henri Simon, 1836-1912
 Rubens d'après ses portraits

In:Bull.Rubens(Anvers)
2:1-23 1885

LC (ND673.R9H9?)
MiU NcU Daugherty.Self-portrs.of
 P.P.Rubens mfml61 NPG,p.26

I.E - SELF-PORTRAITS - NETHERLANDS

Erpel, Frits
 Die Selbstbildnisse Rembrandts.Berlin,
Henschelverlag,1967
 233 p. illus.

LC ND653.R4E7 Daugherty.Self-portrs.of
 P.P.Rubens.mfml61 NPG
 Bibl.p.361

I.E - SELF-PORTRAITS - NETHERLANDS

Schöne, Wolfgang, 1910-
 Peter Paul Rubens;die Geissblattlaube.Dop-
pelbildnis des künstlers mit Isabella Brant.
Stuttgart,Reclam.1956.
 32 p. illus. (Werkmonographien zur bil-
denden kunst,no.11)

 History of marriage portraiture fr.antiqui-
ty to the 17th c.

 Universal-bibliothek no.B9011

NIC MH Daugherty.The self-portrs.
 of P.P.Rubens.mfml61 NPG
 p.158 footn.5

I.E - SELF-PORTRAITS - NORWAY. 19-20th c.

Langaard, Johan Henrik, 1899-
 Edvard Munchs selvportretter.Samlet av Ragn-
vald Vaering med en innledning av Johan H.Lang-
aard.Oslo,Cyldendal norsk forlag,1947
MOMA
 161 p. illus.
*
M86L2 Norwegian,French & English on versos facing
A10754 plates

 Wolsten. N7618.H75 NPG
 Bibl.p.119

qN I.E - SELF-PORTRAITS - U.S.
7618
D1116 New York. National academy of design
1987 Da pittore a pittore:rascelta di ritratti à
NPG autoritratti della National academy of design
di New York.N.Y.,The Academy,c.1987
 160 p. illus(part col.)
 Index
 In Italian and English
 Cat.of an exh.held at Milan,Pinacoteca Ambro-
siana,Oct.16-Dec.18,1987 and at Florence,Galle-
ria degli Uffizi,Apr.15-Jne 15,1988
 "Mostra è cat.realizzati grazie a United Tech-
nologies Corp."
 Text by M.Quiel p.28-59

I.E - SELF-PORTRAITS - POLAND

Wallis, Mieczyslaw
 Autoportrety artystów polskich.Warszawa,
Wydawn.Artystyczne i Filmowe,1966
 279 p. illus

 Bibl.references

LC N7608.W3

N I.E - SELF-PORTRAITS - U.S.
7619
S46 Self-portraits:the message,the material.Eleanor
1987 Antin....et al..Curated by Carolee Thea and
NMAA David Miller.Essay by Carolee Thea.s.l.,s.n.,
1987?
 [14]p. illus.

 Cat. of an exh. held at the Schick Art Gal-
lery,Skidmore College,Saratoga Springs,N.Y.,
Feb.19-March 13,1987 and at th Hofstra Mus,Hemp-
stead,N.Y.,March 29-May 17,1987

I.E - SELF-PORTRAITS - SWITZERLAND

Brüschweiler, Jura
 Ferdinand Hodler:Selbstbildnisse als
selbsthiographie.Bern,Benteli Verlag,1979
 198 p. illus(part col.) (Hodler Publi-
NMA kation 2)
N44 Bibliography
H69B72 June 17-Sept.16,1979 was an exh.under the
same title at Basel.Offentl.Kunstslg.Cat.by
Franz Meyer

N I.F - SELF-PORTRAITS - U.S. - 18-19th c.
40.1
W.9A16 Abrams, Ann Uhry
NMAA The valiant hero,Benjamin West and grand-
style history painting.Washington,D.C.,Smith-
sonian Institution Press,c.1986
 254 p. illus(part col.) (New direction
in American Art,v.1)
 Incl.Index
 Bibliography,p.231-42
 Ch.1:A hero for his time incl.:Self-por-
traits,p.18-26
 fg.8:Self-portr.with portr.of his wife

ND.... I.E - SELF-PORTRAITS - U.S.
1311
V36X National Portrait Gallery, Washington, D.C.
NPG American self-portraits,1670-1973.Intro.
and catalogue by Ann C.Van Devanter and Alfred
V.Frankenstein....Washington,D.C.,International
Exhibitions Foundation,1974
 247 p. illus(part col.)

 Exhibition in NPG,Feb.1-Mar 15,1974
 " " Indianapolis Museum of Art

 Bibliography
 In addition to biographical notes artists'
statements abt. self-portrs.,etc.

AP I.E - SELF-PORTRAITS - U.S. - 20th c.
1
A83 Ball, F.
NCFA Dalkey on Dalkey

 In:Artweek
 7,pt.9:4 Feb.28,'76 illus.

 Pertains to exh.of Fred Dalkey's self-portrs

 FOR COMPLETE ENTRY
 SEE MAIN CARD

qN7618 I.E - SELF-PORTRAITS - U.S.
N27
NPG New York. National academy of design (U.S.)
 Artists by themselves:artists' portraits
from the Nat'l academy of design.N.Y.,The
Academy;Seattle.Univ.of Wash.Press,distribu-
tor.c.1983
 175 p. illus(part col.)
 Bibliographical references
 Index
 Cat.of an exh.held at the Nat'l academy
of design Nov.3,1983-Jan1,1984,The NPG,Wash.,
D.C. Feb.10-Mar 25,1984 & 5 other mus.in 1984
and 1985. Introd.by Michael Quick
 Inventory portrs.of artists & archi-
tects in the coll. of the Nat'l acad.of des.
p.161-73

757.875 I.E - SELF-PORTRAITS - U.S. - 20th c.
D52
NCFA De Young Memorial Museum, San Francisco
 Meet the artist;an exhibition of self-por-
traits by living American artists.S.F.,M.H.de
Young memorial museum,1943
 150 p. illus.

 Foreword by Walter Heil
 "...Self portr.offers a deeper insight into
the artist's taste,the esthetical ideals...the
very fundamentals of his art...There is a con-
nection betw.human types.he choses,even types
of inanimate nature ...& his own physiognomic cha
LC N7575.D4 Fogg,v.11,p.329

705
M18
v.27

I.E - SELF-PORTRAITS - U.S. - 20th c.

Du Bois, Guy Pène, 1884-
Self-examination at the Whitney

In:Mag Art
27:116-23 Mar.'34 illus.

Pertains to the exh."Self-portrs.by living
American artists",Jan.17-Feb.5,1934.More than
100 self-portrs.
Criticism of approaches

Cum.Mag.subj.ind.A1/3/76
REF,v.2,p.444

705
628
NCFA

I.E - SKULLS

Breckenridge, James Douglas, 1926-
Portraiture and the cult of the skulls

In:Gaz Beaux Arts
6eper.63:275-88 May-June,'64 illus.

Defines the concept "portrait".Quotes
Schweitzer's complex definition.
The earliest occurence of "portraiture" is
ca.5000 B.C.:skulls modelled over to simulate a
fully formed human head.
Bibliography

Breckenridge.Likeness
N 7580+82p.270,I

N
6512.5
P4506X
NMAA

I.E - SELF-PORTRAITS - "U.S. - 20th c.

Goodyear, Frank Henry, 1944-
Contemporary American realism since 1960.
Boston,New York Graphic Society,in association
with the Penn.Acad.of the Fine Arts,c.1981
255 p. illus(part col.)

Published in connection with the exh.opening
at the Penn.Acad.of the Fine Arts,Phila.,Sept.18
1981
Bibliography:p.233-42
Index

Halle.In:Art J.v.46:225
note 21

I.E - WOMEN

Beaton, Cecil Walter Hardy, 1904-
The book of beauty.London,Duckworth,1930
67 p. illus.

NN MnU

Arts Council of Gr.Br.
The real thing TR646.C8L84
NPG,p.123

705
A784
NCFA
v.64

I.E - SELF-PORTRAITS - U.S. - 20th c.

Herrera, Hayden
Gorky's self-portraits:the artist by himself

In:Art in Am
64:56-64 Mar-Apr.,'76 illus(part col.)

FOR COMPLETE ENTRY
SEE MAIN CARD

I.E - WOMEN

Boccaccio, Giovanni, 1313-1375
De claris mulieribus.Venice,1506
illus.

Whole-length woodcut portrs.

Brit
Mus
10603
d

L'Opera de misser G.B. de mulieribus claris
.Transl.fr.the Latin by V.Bagli...Venetia,1506.
Woodcuts

Rave.Jb.d.Berl.Mus.I 1959
LC N3.J16 fol.,p.126/7
Paolo Giovi. & d.Bildnisvitenbücher...

705
A784
NCFA
v.54

I.E - SELF-PORTRAITS - U.S. - 20th c.

Willard, Charlotte
Eye to I

In:Art in Am
54:49-59 Mar.,'66 illus(part col.)

Self-portrs. by contemp.artists & their
statements accompanying them

"in...his self-portr.;the artist restates
his belief in that complex masterpiece of nature
the individual man.The eye penetrates the I to re-
veal its essence." NPG:Amer.self-portrs...'74
Bibliography

N
7630
C8X
NPG

I.E - WOMEN

Copley Society, Boston
Illustrated catalogue .of. a loan collec-
tion of portraits and pictures of fair women;
...Copley hall,Boston,Mass.,1902..Boston Press
of G.H.Ellis co.,1902.
58 p. illus.

LC N7630.C8

I.E - SELF-PORTRAITS - YUGOSLAVIA

Ljubljana. Moderna galerija.
Avtoportret na Slovenskem;katalog. Uvod,
biografski in bibliografski podatki:Luc Menase.
Ljubljana,1958
152 p. illus.

Summary in French

Includes bibliographies

LC N7613.5.L5 Fogg,v.11,p.320

I.E - WOMEN

Dayot, Armand Pierre Marie, 1856-1934
Beautiful women in art,from the earliest
times to the end of the 17th c...transl.by H.
Twitchell.Boston,L.C.Page.1906,c1901.
325 p. illus.

LC N7633.D3 1906

I.E - WOMEN

Dayot, Armand Pierre Marie, 1856-1934 ed.
 Cent portraits de femmes des écoles anglaise
et française.Paris,F.Petit,1910
 165 p. illus. (Maîtres de 18e siècle)

 Luxury ed.of cat.of exh.in Paris,Mus.du jeu
de paume,Spring,1910;intro.by A.Dayot & Claude
Phillips.Documentation by Léandre Vaillat & Ro-
bert Dell
 Exhibited portrs.offer a study in differen-
ces of temperament & character betw.2 nations
(see L.C.ust.in:Burl Mag,v.17:52,55)

LC N757.
.fD27c OC MdBWA NN

I.E - WOMEN

Galerie Beyeler, Basel
 La femme,peintures et sculptures.exposition
1966? Basel,1966?.
 .108.p. illus(part col.)

MET
115.1
0132

Rep. 1966 #899

757
.D27 I.E - WOMEN

Dayot, Armand Pierre Marie, 1856-1934
 Famous beauties in art,from the beg.of the
18th c. to the present day.Transl.by H.Twitchell
Boston,L.C.Page,c1901.
 364 p. illus.

 Continuation of Beautiful women in art

".reflects.the characteristics of races,technic
of schools & ideals of artists."-Preface

LC 757.D336 b1

I.E - WOMEN

Galerie Charpentier, Paris
 Cent portraits de femmes du 15e siècle à nos
jours..Paris,1950.
 .33.p. illus.

FOGG
4353 "Cette exposition a pu être réalisée grace à
C48 l'obligeant concours des musées Carnavalet,Marmot-
MET tan,Victor-Hugo,de Chartres,Cherbourg,Lyon,Quimper
107.4 et des grandes collections particulières"
G138

Enc.of World Art, v.11
N31E56 Ref.,col.513
Bibl.on portr.

AP1/
A788 I.E - WOMEN
NCFA

Du Bois, Guy Pène, 1884-
 Portraits of women.exh.'Romanticism to sur-
realism',N.Y.,Mus.of French Art,Jan.20-Feb.7,
1931.

 In:Arts
17:343-5 Feb.,'31 illus.

N.Y.,MOMA.20th c.portrs.
by M.Wheeler N7592.6N53
NPG Bibl.

I.E - WOMEN

Grolier club, New York
 Cat.of an exh.of engraved portraits of wo-
men writers from Sappho to George Eliot...
March7-23,1895.N.Y.,The Gilliss press,1895
 24 p.

LC NE220.G7

Levis,Descr.bibl.Z5947A3
L66 1974 NCFA p.381

I.E - WOMEN

.Florisone, Michel.
 The face of womankind as seen by Vigée-Lebrun,
Mattier, Hogarth, Greuze, Degas, Manet, Renoir,
Gainsborough. Paris,N.Y.,.etc...The Art book
publication,.c1939.

 .7.p. illus.(part col.)

 Issued in portfolio

LC N7630.F5

I.E - WOMEN

Hale, Philip Leslie, 1865-1931
 Great portraits,women...Boston,Mass.,Bates
& Guild co.,1909
 83 p. illus.

LC N7633.H3

I.E. - WOMEN

Foresti, Jacopo Filippo,da Bergamo, 1434-1520
 De claris mulieribus.Ferrars,Laurentius de
Rubeis,de Valentia...,1497
 illus.

 172 portrs;"7 have such strangely marked cha-
racteristics,that they are probably copies of ge-
nuine portrs."-J.P.Morgan.Cat.of MSS & early
printed books,v.2,no.382

LC Incun.1497.F6 Rosenwald Rave.Jb.d.Berl.Mus.I 1959
coll. LC N3.J16 fol.,p.126
 [Paolo Giovio & d.Bildnisvitenbücher...

I.E - WOMEN

Helleu, Paul César, 1859-1927
 A gallery of portraits,reproduced from ori-
ginal etchings,with an intro. by Frederick Wed-
more.London,L.Arnold,1907
 .3.p. 24 illus(part col.)

 Portrs.of women

 'Wedmore's intro....is important'.-Levis

NN (N.Y.,publ.etc.) IEN IU InU)
 Levis,Descr.bibl...Z5947.A3
 L66 1974 NCFA p.208

I.E - WOMEN

Madrid. Museo Nacional de Pintura y Escultura
 Retratos de mujeres célebres del Museo del
Prado.60 repro.de los majores cuadros.Madrid,
Fernando Fé.1929.
 45p. 60 pl. (Los grandes maestros de la
pintura en España,8)

NjP

I.E - WOMEN

Michaux, Henri
 Maidens' faces

In:Vorve
2:85-6 no.5-6,1939 illus.

 Incl:Bonnard,Matisse,Klee,Clouet,Cranach,
Dürer,Renoir,15th c.miniatures of heroines of
Boccaccio,prints of heroins of Balsac & Geo.Sand,
& stone head of Jeanne de Laval

LC N1V4 Rep;1939-41#628

I.E - WOMEN

Madrid. Sociedad española de amigos del arte
 ...Catálogo de la exposición de retratos
de mujeres españolas anteriores a 1850. Madrid,
mayo y junio de 1918.:Madrid,Blass y cía.,1918.
 65 p. illus.

 Intro.by A.de Beruete y Moret
 Incl. bibliographies

LC ND1322.S6 Amsterdam,Rijksmus.cat.
 Z5939A52,deel 1, p.155

C17.37 I.E - WOMEN
.M68
 Mitchell, James Tyndale, 1834-1915
 ...The unequaled collection of engraved
portraits of beautiful women of Europe and America,and actors,actresses,vocalists,musicians,
and composers,belonging to Hon.James T.Mitchell...
to be sold,..Phila.,Pa.,:M.H.Power,printer,1910.
 144 p. illus(part col.)

 (Catalogue compiled...by Stan.V.Henkels)
 (Sold at book auction rooms of S.T.Freeman & co
 Cat.no.944,pt.X

LC N2240.M5

I.E - WOMEN

The masque of beauty....London,1969?.

MET Cat.of portraits of famous women in the NPG,
196.6L84 London
N2422

CU

757 I.E - WOMEN
.M83
 Moreau-Vauthier, Charles, 1857-1924
 A gallery of beautiful women,masterpieces of
painting,...New York,E.P.Dutton & companym1923
 64 p. illus.

N
7634 I.E - WOMEN
M41
NPG Massachusetts Historical Society, Boston
 Portraits of women, 1700-1825. Boston,1954
 unpaged illus. (A Massachusetts Historical Society picture book)

LC N7634.M3

I.E - WOMEN

Passe,Crispijn van de,the younger,ca.1593-166?
 Les vrais pourtraits de quelques unes des
plus grandes dames de la chrestiente,desguisée
en bergères...Ware afbeeldighe van eenige der
aldergrootste ende doorchluchtigste vrouwen va:
heel christenrijck,vertoont in gedaente als he
derinnen...Amsterdam,Gedruckt by J.Broerss voc:
den autheur.1640
 4 v. illus.

LC NE670.P2A3

I.E - WOMEN

Mauclair, Camille, 1872-
 Le Problème de la ressemblance dans le
portrait féminin moderne

In:R.polit.et litt. (R.bleue,pol.et litt.)
39:751-5 ser.4 1902

LC AP20.R64 N.Y.,MOMA.20th c.portrs.by
 K.Wheeler.N7592.6N53 NPG
 Bibl.

708.1 I.E - WOMEN
M66.
NCFA Portraits of women and children

In:B.Minneapolis Inst.Arts
30:1-7 Jan,1941 illus.

 General thoughts on portraiture

 Incl:Clouet,Mierevelt,Slaughter,Hannemann,
Ramsay,Theus,Courbet

 Rep.,1945-47#863

I.E - WOMEN
Roe, F.Gordon
 Women in profile.A study in silhouette.
London,John Baker,1970
 69 p. illus.

LC NC910.R63

I.E - WOMEN

Viallet, Bice
 Oli autoritratti femminili della R.Galleria
degli Uffizi in Firenze.Florence,1923
 137 p. illus.

MET
276
V65

Enc.of World Art
N31E56Ref.v.11col.512
bibl on portr.

I.E - WOMEN

Sharp, William, 1855-1905
 Fairwomen in painting...London,Seeley & co.,
ltd.,N.Y.,Macmillan & co.,1894

LC N7630.S4

FOR COMPLETE ENTRY
SEE MAIN CARD

I.E - WOMEN - ANTIQUITY - ROME

Bartels, Heinrich
 Studien zum frauenporträt der augusteischen
zeit-Fulvia,Octavia,Livia,Julia.München,Feder,
1963
 113 p.

FOGG Diss.-Berlin,1960
638
R278

NJP MH NNMM DDO Kraus.Das römische welt-
 reich N5760.K92 Bibl.p.316

I.E - WOMEN

Singer, Joe, 1923-
 Painting women's portraits.N.Y.,Watson-
Guptill Publications,1977
 151 p. illus(part col.)

 Bibliography

LC ND1329.3.W6S56 1977

I.E - WOMEN - ANTIQUITY - ROME

Giacosa, Giorgio
 Women of the Caesars;their lives and por-
traits on coins.Milan,Edizioni arte e moneta,
.1977.
 106 p. illus(part col.)

Incl.descriptive index,incl.photographs at na-
tural size of each coin,obverse and reverse

 .These coins are an achievement of a high
point in the history of portraiture.

MdBLN DAU CtY etc.

705
G28
NCFA
v.17

I.E - WOMEN

Tourneux, Maurice
 L'exposition des portraits de femmes et
d'enfants A l'école des Beaux-Arts

In:Gaz.Beaux-Arts
17:445-60 June,1897 illus.

 Organisé par la Société philanthropique

 Repro.incl.:John Russell,Drouais,Gainsbo-
rough,Reynolds,Greuze,Élie Delaunay,Rembrandt

 Tourneux.Exp.retro.d'art
 féminin.Gaz.Beaux-Arts
 v.39:291

N
5610
L67X
NPG

I.E - WOMEN - ANTIQUITY - ROME

L'Orange, Hans Peter, 1903-
 Likeness and icon.Selected studies in clas-
sical and early mediaeval art.Odense,Univ.Press,
1973
 343 p. illus.

 Articles in English,French,German & Italian
bibl.references

 Partial contents:Pt.I:Portraits.10 articles
p.1-102 incl.a.o.Zum frührömischen frauenpor-
trät,p.14-22;Der subtile stil.Eine Kunstströ-
mung aus der ze um 400 n.Chr.,p.54-71(per-
tains to coiffur

I.E - WOMEN

Truc, Gonzague
 Histoire illustrée de la femme. Paris,Plon
.1940-41.

 2 v. illus(part col.)

 short bibliography,v.2,p.199

Harvard univ.libr.for LC Rep.,1939-41#626

I.E - WOMEN - ANTIQUITY - ROME

Meischner, Jutta, 1935-
 Das Frauenporträt der Severerzeit...
Berlin,Ernst Reuter Gesellschaft,1964
 194 p. illus.

 Bibliography,p.5-7
 Thesis - Berlin

Cty Roman portrs.Aspects of ...
 ...QHP1296.R75 NPG Bibl.
 p.107

705
028
NCFA
v.97

I.E - WOMEN - 15-16th c.

Lunenfeld, Marvin
 The Royal image:Symbol and paradigm in por-
traits of early modern female sovereigns and
regents

In:Gaz.Beaux Arts
97:157-62 Apr.'81

q N6544
.I46X
NCFA

I.F - WOMEN - 19-20th c.

Images of woman,the Winnipeg Art Gallery,Nov.14,
 1975 to Jan.4,1976.s.l.,s.n.,1976.
 27 p. illus.

 Cat.of an exh.in support of International
Women's Year

705
A56
NCFA
v.92

I.E - WOMEN - 18th c.

Bischoff, Ilse
 Vigée-Lebrun and the women of the French
court

In:Antiques
92:706-12 Nov.,'67 illus.

 "...V.-L.has her place among the masters of
portraiture,for she rendered an exact image of
her epoch...t is the French woman V.-L.knew
how to paint best."-Pierre de Nolhac in Mme.V.L
peintre de Marie Antoinette.

I.E.- WOMEN - 20th c.

Brieger, Lothar, 1879-
 Das Frauengesicht der gegenwart.Stuttgart,
F.Enke.1930.
 135 p. illus.

LC N7633.B7

705
028
v.1
1909
NCFA

I.E - WOMEN - 18th c.

Tourneux, Maurice
 Exposition de cent portraits de femmes du
18e siècle.Salle du jeu de paume,Paris.

In:Gaz.Beaux Arts
ser 4,v.1:481-95 June,'09 illus.

 Repro.incl.:Opie,Hoppner,Reynolds,Duplessis,
Perronneau,Danloux,Kucharsky.
 Exh.,Paris,Soc.de secours aux familles des
marins français naufragés,Apr.23-July 1,1909
 Almost all p s.from private collections
(See also 34 p. article at CSmH)

I.E - WOMEN - 20th c.

Hellwag, Frits
 Das moderne frauenbildnis

In:Kunst für alle
44:111-8 1928-29 illus.

M
ET
100.53
.96M
444

 Die 20er jahre im portr.
 N6868.5.E9297 NPG,p.140

705
028
v.2
1909
NCFA

I.E - WOMEN - 18-19th c.

Rosenthal, Léon
 Exposition de portraits de femmes à Baga-
telle

In:Gaz.Beaux-Arts
2:49-60 Jl.,1909 illus.

 FOR COMPLETE ENTRY
 SEE MAIN CARD

I.E - WOMEN - FRANCE

George, Waldemar, 1893-
 Corps et visages féminins de Ingres à nos
jours.Paris,Éditions d'art et industrie,1955
 .29.p. (160)illus(part col.)

 The majority of the artists represented
are French

Harvard uni.libr.for
LC N7630.G4 MOMA,p.434, v.11

I.E - WOMEN (19th c.)

Herrmann, H.
 Bildnis der frau im 19.jahrhundert.Freiburg,
Herder,1941
 12 p. illus. (Der Bilderkreis 14)

NB CU Rep.,1939-41*632

I.E - WOMEN - FRANCE

New York. French institute in the United States
 Women by French masters...from 1830-1930.
 .Loan exh..1931

 Romanticism to surrealism;from Géricault
and Courbet to Modigliani and Lurçat

In MOMA
1
xN424
no.13
 MOMA,p.432, v.11

I.E - WOMEN - FRANCE

Robiquet, Jean, 1874-
 La femme dans la peinture française,15e-20e
siècle. Paris,Les Éditions nationales,1938

 206 p. illus.(part col.)

Review by Rbt.Rey In:Renaissance :15-21 1939 11
Review by George, W. In:Am de l'art :295-7 1935"

 Emphasis on 18th c.women in art & literature
& the developm't fr. the Middle ages on. 15th c.
MS miniature, Watteau, Corot,Millet,David,etc.
LC N.Y.P.L.for LC ◯ Rep.,1939-41*627,1935*83

qNd I.E - WOMEN - FRANCE - 18th c.
1337
F8M44m Mauclair, Camille, 1872-
NPG Les miniatures du 18e siècle.Portraits de
 femmes.Paris,H.Piazza,1912.
 135 p illus(part col.)

 FOR COMPLETE ENTRY
 SEE MAIN CARD

qN I.E.- WOMEN - FRANCE(16th c.)
7638
F8B75 Bouchot, Henri François Xavier Marie, 1849-1906
NPO Quelques dames du 16e siècle et leurs
 peintres. Paris:Soc.de propagation des livres
 d'art,1888

 56 p. illus.

 Court life in France;"Comment les dames de
 Brantôme nous ont laissé leurs portraitures"

 N.Y.P.L. NB CtY MBAt ◯ NcD

705 I.E - WOMEN - FRANCE - 18th c.
B97
NCFA Michel, Marianne Roland
v.108 L'Art du dix-huitième siècle;of women and
 flowers.JeanCailleux,ed.;

 In:Burl Mag
 108,suppl.no.18:I-V July,'66 illus(1col.)

 Repro.incl.:Largillière,Blin de Fontenay,
 Ant.Coypel,Hyacinthe Rigaud,Jean-Bapt.Monnoyer,
 Juste d'Egmont
 fg.1:Hélène Lambert de Thorigny with black
 servant;fg.3:Portr.of lady with black servant

 I.E - WOMEN - FRANCE - 17th c.

 Paris. Musée national du Louvre. Dpt.des
 peintures,des dessins et de la chalcographie
 Les émaux de Petitot du Musée impérial du
 Louvre;portraits de personnages historiques
 et de femmes célèbres du siècle de Louis XIV,
 gravés au burin par M.L.Ceroni.Paris,Blaisot,
 1862-64
 2 v. illus.

 1st part:Jean Petitot(1607-1691)by Henri
 Bordier,31 p.,illus.
 Petitot was assisted in his miniature ptg.
 by his brother- ◯ in-law,Jacques Bordier
 NN CtY MB MdBWA,etc.

 I.E - WOMEN - FRANCE - 18th c.

 Guimont, Charles, 1883-
 ...J.E.Heinsius,1740-1812,peintre de mesdames
 de France...Paris,Hachette et cie,1913
 129 p. illus.(part col.)

 LC NO588.H4708 Reynolds.Portr.miniatures...
 Apollo,104:281

 I.E - WOMEN - FRANCE - (18th c.)

 Fair women of France in the eighteenth century.
 An exhibition in London

 In:Illustr.London News
 :p.871 14 May,1938 illus.

 Repr.:Prud'hon,Labille-Guiard,Nattier,Gérard,
 Drouais,Vallayer-Coster,Danloux,Boucher

 LC AP4 I3 Rep.,1939-41*631

B I.E - WOMEN - FRANCE(18th c.)
G83P6
NCFA Pilon, Edmond
 Greuze,J.-B.peintre de la femme et la jeune
 fille du 18e siècle. Paris,L'édition d'art,1912

 I.E - WOMEN - FRANCE - 18th c.

 Granges de Surgères, Anatole,marquis de, 1850-
 1902
 ...Les Françaises du 18e siècles,portraits gra-
 vés;avec une préface de M.le baron Roger Portalis
 ...Paris,E.Dentu,1887

 LC NE270.G7 FOR COMPLETE ENTRY
 SEE MAIN CARD

 I.E - WOMEN - FRANCE - 18th c.

 Vaillat, Léandre, 1878-
 ...La société du 18e siècle et ses peintres;
 ...Paris,Perrin et cie.,1912
 272 p. illus.

 Contents.-Le portrait et le costume.-La
 femme.-L'enfant-Jean-Etienne Liotard.-J.-B.
 Perroneau

 LC MD1316.V3 Fogg,v.11,p.319

ND
1337
F8M4
NPG

I.E - WOMEN - FRANCE - 19th c.

Mauclair, Camille, 1872-
...Les miniatures de l'empire et de la restaura-
tion, portraits de femmes. Paris,H.Piazza,1913
137 p. illus(part col.)

Cont.-Jean-Baptiste-Jacques Augustin et son
oeuvre.-La vie de Jean-Baptiste Isabey.-I.et ses
élèves.-Quelques figures de ce livre.-D'autres
portrs.de femme.-Miniatures et figures étran-
gères.

LC ND1337.F7M35

I.E - WOMEN - GREAT BRITAIN

Bouchot, Henri François Xavier Marie, 1849-1906
...La femme anglaise et ses peintres.Paris,
Librairie de l'art ancien et moderne,1903
230 p. illus.

Contents-Holbein,v.Dyck,Lely,Hogarth,
Reynolds,Lawrence,Hayter.La fin du 19esiècle

LC N7635.B6 Fogg,v.11,p.318

I.E - WOMEN - FRANCE - 20th c.

Poisson, Georges, 1924-
La femme dans la peinture française moderne
.Paris,Plon.1955.
95 p. illus(part col.)

NN MB VtMiM MsU FOMA, p.434, v.11

I.E - WOMEN - GREAT BRITAIN

Grafton Galleries, London
Summer exh.1894"Fair women".catalogue.
.London 1894.
142 p.

MB MdBWA NN Phila.Mus.of art Bul.83
p.19,note 2 708.1.P31
NMAA

I.E - WOMEN - GERMANY

Deutsche frauenbildnisse aus 4 jahrhunderten.
Einf.v.Elly Heuss-Knapp. Berlin,Hans E.
Günther & Co.,1941

2 p. 40 p.illus.

(Die Sammlung Parthenon)

Rep.,1939-41*630

I.E - WOMEN - GREAT BRITAIN - 17-18th c.

Stewart, J.Douglas
English portraits of the 17th and 18th cen-
turies,papers read...Apr.14,'73 by J.D.Stewart
.and.Herman W.Liebert.Los Angeles,Wm.Andrews
Clark Memorial Library,Univ.of Calif.,1974
v. 95 p. illus. (Wm.Andr.Clark Mem'l
Library seminar papers)

Bibliographical references

Contents:Stewart,J.D.:Pin-ups or virtues?
The concept of the "beauties" in late Stuart
portraiture
LC ND1314.3.S73 Rila I/1-2 1975 #1456

I.E - WOMEN - GERMANY

Ganzer-Gottschewski, Lydia
Das deutsche frauenantlits. Bildnisse aus
allen jahrhunderten deutschen lebens. München,
Berlin,J.F.Lehmanns Verlag,1939

126 p. illus.

LC N7638.G403 Rep.,1939-41*629

I.E - WOMEN - GREAT BRITAIN - 18-19th c.

Wilmott-Dixon, Willmott, 1843-
Dainty dames of society,a portrait gallery
of charming women by"Thormanby.pseud...Portraits
and illustrations from rare and famous pictures
by masters of British and French schools.London,
A.& C.Black,N.Y.,F.A.Stokes co..1903.
4 v. illus.
(Illustrated biographies of charming women)
Contents:v.1.2 duchesses of Devonshire."Sa-
charissa".Lady Holland.v.2.The Hornecks:"Little
Comedy","The Jessamy Bride".Countess of Blessing-
ton.Duchess of Queensberry,Duchess of Rutland
v.3.The Kembles. Countess of Cork & Orrery.
LC CT3320.W53(Wash.,D.C.
P.L.for LC)

I.E - WOMEN - GERMANY - BERLIN

Berlin Museum
Berlinerinnen:bekannte und unbekannte frau-
en in Berlin aus 3 jahrh.:Gemälde,plastik,gra-
phik,photographien...Ausst.26.april bis 29.juni,
1975...Katalog.von.Irmgard Wirth.Berlin,Das Mu-
seum,1975
36 p. illus.

Bibliography

LC N7638.G4B47 1975

N
7638
S35M3
NPG

I.E - WOMEN - GREAT BRITAIN - SCOTLAND - 17-18th

Marshall, Rosalind Kay
Women in Scotland,1660-1780...Edinburgh,
Trustees of the National Galleries of Scotland,
1979
72 p. illus(col.cover)

Cat..of the.exh.held at the Scottish Natio-
nal Portrait Gallery,June15-July 29,1979

I.E - WOMEN - ITALY

Calzini, Raffaele
La bella Italiana da Botticelli a Spadini.
Milano,Ed,Domus,1945.
108 p, illus.;

Met
174
C13
Q
138 illus. of master ptgs. of women from
1400 to 1700

Rep.,1936#346

I.E - WOMEN - RUSSIA

Mochalov, Lev Vsevolodovich
The female portrait in Russian art;12th-
early 20th centuries;by L.Mochalov and N.Bara-
banova...Leningrad,Aurora Art Publishers.1974.
232 p. illus(chiefly col.)

English & Russian

LC ND1320.M62

I.E - WOMEN - ITALY

Rodocanachi, Emmanuel Pierre, 1859-1934
La femme italienne avant,pendant et après
la renaissance;sa vie privée et mondaine,son
influence.Paris,Hachette,1922

439 p. illus.

N.Y.P.L.
SNB
♦
Bibliography

For source see main card

I.E - WOMEN - SPAIN

Jaen, Antonio, 1860-
Retratos de mujeres(estudio sintético de
la evolución del retrato en la pintura es-
pañola).Segovia,A.San Martin.1917.
199 p. illus. (Serie de monografias de
historia y arte,2)

Bibliography p.195-9

RPB CtY MB GPm CtY Mengs.M.0.1.M541M9NMAA
 p.191

I.E - WOMEN - ITALY - (RENAISSANCE)

Weisbach, Werner, 1873-1953
Das frauenbildnis in der malerei der itali-
enischen renaissance

In:Museum
4:

LC for Museum:
N7511.M7

Waetzoldt ND1300.W12

I.E - WOMEN - SPAIN - 19th c.

Esquerra del Rayo, Joaquin, 1863-
Retratos de mujeres españolas del siglo
XIX por Joaquin Esquerra del Rayo y Luis Pérez
Bueno.Madrid,J.Cosana,1924
383 p. illus.

At head of title:Junta de Iconografía Na-
cional;Memoria premiada en el concurso de 1921

Incl.:Index

LC HQ1692.E9x Mengs.M.0.1.M541M9 NCFA
 Bibl.p.190

I.E - WOMEN - ITALY - (VENICE)

Schaeffer, Emil, 1874-
Das weib in der venezianischen malerei.
Breslau,R.Galle Buchdruckerei,1898

103 p.

Inaug.diss.-Breslau

Bibliography

LC ND1318.S4 Petzoldt ND1300.W12

AP
1
JAA67
NPG
v.3

I.E - WOMEN - U.S. - 17-18th c.

Nichols, Norma
The illusionary female:Women in American
portraiture before 1800

In:J Regional cultures
3,no.2:23-32 Fall/Winter

Limners,Copley,Chs.W.Peale,G.Stuart,Benj.
West,Durand,Vanderlyn,Smibert,Blackburn

I.E - WOMEN - NORWAY

Gran, Henning, 1906- (& Revold, Reidar)
Kvinneportretter i norsk malerkunst. Oslo,
H.Aschehoug & co.(W.Nygaard)1945.i.e.1946.

93 p. illus.(part col.)

Review by Holm,Arne E.,In:Ord och Bild:23-29
1945 illus.

Portrs. as artform. Norwegian portrs.of women
fr.Renaissance to Munch,by Gran;fr.Munch to pres-
ent,by Revold
LC ND1321.G67 Rep.,1948-49*864

705
A56
NCFA
v.108

I.E - WOMEN - U.S. - 18th c.

Van Devanter, Ann C.
The Signers' ladies

In:Antiques
108:114-22 July,'75 illus(part col.)

Portrs.of wives of 9 signers of the Decla-
ration of Independence

Rila II/2 1976 #4674

I.E - WOMEN - U.S. - 18-20th c.

Evanston,Ill., Terra museum of American art
 Woman.cat.of exh..Feb.21-April 22,1984
 64 p. illus(col.)

 Incl.:Article "Seeing through women";by
Linda Nochlin

 Incl.:Portrs.of the 18-20th c.

I.F. 1 GENERAL

CT
3260
H23
1883
NPG

I.E - WOMEN - U.S. - 19th c.

Hanaford, Phebe Ann (Coffin), 1829-1921
 Daughters of America;or Women of the cen-
tury.Augusta,Me.,True & Co.,1883.1882.
 730 p. illus.

 Earlier ed.publ.in 1882.

LC E176.H25

Cirker.Dict.of Am.portrs.
N7593/C57/NPG Bibl.,p.714
Ref-

I.F.1

Brilliant, Richard
 Gestures & rank in Roman art. The use of
gestures to denote status in Roman sculpture &
coinage. New Haven,The Academy,1963
 238 p. illus. (Memoirs of the Conn.Acad.of
Arts & Sciences,v.14)

 Bibliography

NB115.B7

VF
Brockhurst

I.E - YOUTH

Albrecht Art Museum,St.Joseph,Mo.
 Gerald L.Brockhurst.Master of the etched
portrait..Exh..3 Sept.-10 Nov.,1985
 unpaged illus.

 Incl.:Pamphlet:'Adolescence'by G.L.Brock-
hurst, the five states and drawing

AP
1
A51A64
NCFA
v.6

I.F.1

Crawford, John Stephens
 The classical orator in 19th century Ameri-
can sculpture

 In:Am.Art J.
 6:56-72 Nov.,'74 illus.

 Pt.3 examines the specific statues of Ame-
rican orators & their relationship to antique
prototypes,p.61-72

705
A56
NPAA
v.135

I.E - YOUTH - U.S. - 18-19th c.

Deutsch, Davida Tenenbaum
 The polite lady:portraits of American
schoolgirls and their accomplishments,1725-1830

 In:Antiques
 135:742-53 March,'89 illus(part col.)

 Repro.incl.:Ralph Earl,1783;Gilbert Stuart,
c.1807;Peticolas,1798;Corné,c.1805;M.B.Doyle,
c.1820;John Greenwood,c.1747;Js.Earl,1794-96
 Pl.X:Evelyn Byrd with black servant

705
C75
NCFA
v.189

I.F.1

Mannings, David
 A well-mannered portrait by Highmore,dated
1747.

 In:Connoisseur
 189:116-9 June,'75 illus.

 Acceptable postures and attitudes pre-
scribed in 'Rudiments of Genteel Behaviour'
(1737);by Nivelon.His and others' writings on
etiquette influenced 18th c. portraiture.

 Rila II/2 1976 +5004

I.F. SPECIAL POSE OR LENGTH

I.F.1

Neville, Henry Garside, 1837-1910
 Gesture

 In:Campbell, Hugh,ed...,1895

LC PN4111.C3

Xerox I.F.1
copy
of
contents Ring, Grete
& pre- Beiträge sur geschichte niederländischer
face in bildnismalerei im 15.&16. jahrhundert. Leipsig,
in VP E.A.Seemann,1913
Por-
trai- 173 p.
ture
 Appendix:1.systematical bibliography
 2.list of mentioned portraits
 pp.101-23:Das selbstporträt

 Based on her dissertation.1912
LC ND1319.R5 Lipman:The Florentine
 profile portr... also:
 Goldscheider 757/.052

I.F.2

Simon, Karl, 1875-
 Vorderansicht & seitenansicht

In:Z Xsthetik
 3: 1907

"Z Xsthetik"
LC N3245 Waetsoldt ND1300.W12

I.F.1

ND
1314
546 Simon, Robin, 1947-
1987X The portrait in Britain and America;with a
NPG biographical dictionary of portrait painters
Ref. 1680-1914.Boston,G.K.Hall & Co.,1987
 255 p. illus(part col.)

 Ch.2:Poses

 bibliography,p.247-50

 Robert Hull Fleming Museum
 Univ.of Vt. Faces in the
 parlor,p.6,note 13

I.F.3. 3/4 VIEW

I.F.1

Sittl, Karl, 1862-1899
 Die gebärden der Griechen und Römer.Leipzig
B.G.Teubner,1890
 386 p. illus.

LC DF78.S6 Winkes.Physiognomonia.In:
 Temporini.Aufstieg u.nieder-
 gang...LC DG209.T36,Bd.1,T.
 p.925

I.F.4. PROFILE

I.F.2. FRONTAL

I.F.4.a. GENERAL

N
40.1
C628 Close, Chuck, 1940-
W18 Close portraits.Walker Art Center,Minnea-
MCFA polis,exh..edited.by Lisa Lyons and Martin
 Friedman.Minneapolis,The Center,c.1980.
 80 p. illus(part col.)

 Checklist inserted
 Bibliography

LC N6537.C54A4 Worldwide Art Cat.Bul.
 705.W927 MMAA v.17no.2 158
 p.53

Ar
1
572 Bolton, Ethel(Stanwood), 1873-1954
NPG Two notable wax portraits
v.13
 In:Old Time N.Engl.
 13:3,6,8,10,13 July,'22 illus.

 Two acquisitions by the Soc.for the Preser-
 vation of N.Engl.Antiquities

 Repro.:Rauschner;Washington,by Patience
 Wright;Geo.M.Miller;Ball-Hughes

LC F 1.S68

I.F.4.a

705
A784
NCFA
v.9

Bolton, Theodore, 1889-
 Saint-Mémin's crayon portraits

In:Art in Am
9:160-7 Jun,'21 illus.

 Incl.list of crayon drawings by St.-Mémin

I.F.4.a

N
7585
F97
1972
NPG

Fulvio, Andrea, fl.1510-1543
 Illustrium imagines.Portland,Ore.,Collegium
Graphicum.1972.
 CXX illus. (The printed sources of Wes-
tern art,no.9)

 Reprint of Rome,1517 ed.

 'The fine medallions are supposed to be by
Ugo da Carpi!'

I.F.4.a

N
7628
W31C3
NPG

Carson, Hampton Lawrence, 1852-1929
 ...The Hampton L.Carson collection of en-
graved portraits of Gen.George Washington. Cat.
comp. & sale conducted by Stan.V.Henkels.At the
art auction rooms of Davis & Harvey...Phila.,Pa.,
....,Press of W.F.Fell co.,1904.
 173 p. illus(part col.)
 Cat.no.906,pt.I

 Incl.St.Mémin personal coll.of proof mezzo-
tints...to be sold Jan.21 & 22, 1904

LC Z999.H505 no.906,pt.1 Amsterdam Rijksmus.cat.
c.2 E312.43.C32 25939A52, deel 1, p.154

I.F.4.a

705
A56
NCFA
v.17

Gillingham, Harrold Edgar, 1864-1954
 Notes on Philadelphia profilists

In:Antiques
17:516-8 June,'30 illus.

 Incl.:Sam.Folwell(min.ptr.in hair),J.H.Gil-
lespie,R.S.Biddle,H.Page,Wm.Verstille,Wm.Wil-
liams,Edm.Brewster,Aug.Day,Joshua C.Seckel

 London,H.R. Shades of my
 forefathers.741.7.L847
 Bibliography

I.F.4.a

VF
St.-Mémin

Colquitt, Dolores Boisfeuillet
 Pennsylvanians in St.-Mémin's miniatures

In:Daughters of the Amer.Rev.Mag.
60:217-25 Apr.,'26 illus.

LC E202.5.A12

I.F.4.a

N
40.1
C28x08
NPG
R.B.

Gruyer, François Anatole, 1825-
 Chantilly:les portraits de Carmontelle...
Paris,Plon-Nourrit et cie,1902
 388 p. illus.

 Incl.:Contents. List of sitters

LC N7604.C2 Winterthur Mus.Libr. fZ811
 W78 v.9,p.226

I.F.4.a

N
40.1
F43C7
NPG
3 c.

Corcoran Gallery of Art, Washington, D.C.
 Cat.of engraved portraits by Favret de
Saint Memin,1770-1852,in the permanent coll. of
the Corcoran gallery of art,Washington,D.C.
,Washington,W.F.Roberts co.,19--,
 17 p.

LC NE650.F4C6

I.F.4.a

Guignard, Philippe, 1820-1905
 Notice historique sur la vie et les travaux
de m.Fevret de Saint-Mémin...Dijon,Impr.Loireau
Feuchot,1853
 22 p.
 Extrait des Mémoires de l'Académie des
sciences,arts et belles-lettres de Dijon
LC NE650.F409
 (In Académie des sciences,arts et belles-
lettres de Dijon.Mémoires. Dijon,1854,sér.2,t.2
p.1-20)

LC DC611.B771.A3 Morgan,J.H. The work of
Wash.D.C, Corcoran Gall. m.Fevret de Saint-Mémin
 In:Brookl.m.Q.5,p.6 708.1

I.F.4.a

fN
40.1
F43D4
RB
NPG

Fevret de Saint-Mémin,Charles Balthasar Julien,
 1770-1852
 The St.-Mémin collection of portraits;...760
medallion portrs.,....of distinguished Americans,
photographed...from proof impressions of the ori-
ginal copperplates,engraved by M.de St.-Mémin,
from drwgs.taken from life by himself,...in the
U.S.from 1793 to 1814.To which are prefixed a me-
moir of M.de St.-Mémin,by Ph.Guignard...,compile
...by the publisher E.Dexter.New York,...1862
 104 p. illus.

LC N7593.F5 Morgan,J.H.,The work of M
 Fevret.Brooklyn mus.Q.,5:b
 708.1 BR7 NCFA

I.F.4.a

N
40.1
H514M2
NPG

Henning, John, 1771-1851
 John Henning,1771-1851:"...a very ingenious
modeller.",text John Malden;photography Alexan-
der Wilson.Paisley,Renfrew District Council
Museum and Art Galleria Dept.,1977
 ,139,p. illus(1 col.)

LC NK9582.H46A4 1977

RF
843
L39
E1789
NPG
RB

I.F.4.a

Lavater, Johann Caspar, 1741-1801
　　Essays on physiognomy;designed to promote the
knowledge and the love of mankind.Translated.fr.
German,by Ths.Holcroft;...100 physiognomonical
rules...& memoirs of the life of the author.
11th ed.,with upwards of 400 profiles,and other
engravings. London W.Tegg,1860
　　　507 p.　　illus.

　　　NPG ed.1789 5 vol.

LC RF843.L3　1860
LC lists several eds.　　　　N.Y.,Metro.mus.bull.v.35-6
　　　　　　　　　　　　　　　　　　.51

705
C75
NCFA
v.74

I.F.4.a

Martin, Mary
　　The Physionotrace in France and America

In:Connoisseur
74:144-52　Mar,'26　illus.

　　　Repro. incl.:Apparatus for making physiono-
trace from a drawing

　　　G.L.Chrétien invented the physionotrace,1786
　　　E.Quenedey-assistant of Chrétien
　　　Physionotrace portrs.most valuable historical
records

705
A7832
NCFA

I.F.4.a

Lipman,Mrs.Jean Herzberg, 1909-
　　The Florentine profile portrait in the
quattrocento

In:Art Bul
18:54-102　Mar,1936　illus.
　Master's Th.-N.Y.Univ.,1934, same title
　　Profile portrs.almost exclusively limited to
Florence in the 2nd half of 15th c.Esthetic mean-
ing of profile & reason for its use;its genesis &
history in Italy. Full-length portr.exclusively in
equestrian portr. Florentine bust-length portr. the
most static form of all portr.forms
　　　　Rep.1936*4432

705
C75
NCFA
v.75

I.F.4.a

Martin, Mary
　　The physionotrace in France and America:
Saint Mémin and others

In:Connoisseur
75:141-8　Jul,'26　illus.

ND
236
L76
NPG

I.F.4.a

Lipman,Mrs.Jean Herzberg, 1909-　comp.
　　Primitive painters in America,1750-1950;an
anthology,by J.Lipman & A.Winchester.N.Y.,Dodd,
Mead.1950.
　　　182 p.　illus(part col.)

　　　Contents.-2.N.F.Little, Primit.ptrs.of 18th
4.A.M.Dods, R.H.Bascom.-5.A.E.Eye, E.Hicks.-8.F.F.
Sherman, J.S.Ellsworth.-9.F.B.Robinson, E.S.Fiel
10.N.F.Little, W.M.Prior.-11.J.Lipman, D.Gold-
smith.-12.F.O.Spinney, J.H.Davis.-14.J.L.Clarke,
jr., J.W.Stock

N
7616
M47
NCFA

I.F.4.a

Mayne, Arthur
　　British profile miniaturists.London,Faber
.1970.
　　　131 p.　illus(part col.)　(Faber collectors
library)

　　　Bibliography

LC N7616.M37　　　　　FOGG v.11,col.2,p.317

VF
St.Mémin

I.F.4.a

Lockwood, Luke Vincent, 1872-
　　The St.-Mémin Indian portraits

In:N.Y.Hist Soc Q.B.
12,no.1:3-26　Apr.'28　illus.

LC F116.N638　　　　Dijon.Mus.municipal N40.1
　　　　　　　　　　F43D5 NPG Bibl.p.25

VF
St.-Mémin

I.F.4.a

Maryland Historical Society
　　St.Mémin in Maryland;loan exh.of portraits
of "Distinguished characters"in W.C.,crayon and
engraving.Baltimore,1951
　　　15 p.　illus.

　　　Exh.Feb.15-Apr.15,1951

　　　Alphabetical list of sitters

　　　　　　Dijon.Mus.municipal N40.1
　　　　　　　F43D5 NPG Bibl.p.26

N
40.1
F811B
E 1930
NMAA

I.F.4.a

Longhi, Roberto, 1890-
　　Piero della Francesca...London,N.Y.,F.Warne
& Co.,ltd..1930.
　　　176 p.　illus.

　　　Bibliography,p.143-53
　　　see pp.100ff for a discussion of the profile
portraits in Italy in the 15th c.

　　　　　　Lipman.The Florentine pro-
　　　　　　file portr.In:Art Bul.18:
　　　　　　63,footnote 13

708.1
N52
NCFA
v.35-36

I.F.4.a

Mayor, A.Hyatt
　　Silhouettes and profile portraits

In:Bull.of Met Mus
35:50-4　Mar,1940　illus.

　　　Incl:Sittoughton,Buncombe,Miers,Field,Mrs.
Beetham,Edouart

741.7
M49
I.F.4.a

Mégros, Rodolphe Louis, 1891-
Profile art through the ages...N.Y.,Philo-
sophical Library,1949,

FOR COMPLETE ENTRY
SEE MAIN CARD

NK
4210
W4N38
1976I
NPG
I.F.4.a

National Portrait Gallery, Washington, D.C.
Wedgwood portraits and the American Revolu-
tion..Washington,:National Portrait Gallery,
Smithsonian Institution,1976
134 p. illus.
Cat.of an exhibition,July 13-Oct.31,1976

Foreword by Marvin Sadik

Intro.by Bruce Tattersall

Bibliography

LC NK4210.W4N38 1976

I.F.4.a

AP
1
A51A64
N:AA
v.20

Miles, Ellen G.ross,
Saint-Mémin's portraits of American Indians,
1804-1807

In:Am Art J
20,no.4:2-33 1988 illus(1 col.)

N
40.1
F43N8
NCFA
NPG
I.F.4.a

Norfleet, Fillmore
Saint-Mémin in Virginia:portraits and bio-
graphies...Richmond,Va.,The Dietz press,1942
235 p. illus.

Bibliography

Repro.of 56 crayon portrs.& 142 engravings

Valdenuit is mentioned p.14-16

LC N7593.N7

705
A784
NCFA
v.41

I.F.4.a

Mitchell, Lucy B., 1901-
James Sanford Ellsworth:American minia-
ture painter

In:Art in Am
41:151-84 Autumn,'53 illus.

Bibliography

Abby Aldrich Rockefeller
Folk Art Ctr.Am.Folk portr:
N7593.A23 Bibl.p.294

757.7
.P72
NCFA

I.F.4.a

Pleasants, Jacob Hall, 1873-
Saint Mémin water color miniatures.
:Portland,Maine, Anthoensen Press,1947?,
29 p. illus.

"Reprinted from The Walpole Society Notebook
1947,by The Anthoensen Press,Portland,Maine..."

Fogg,v.11,p.325

N
40.1
E476M6
NPG
2 ccps.

I.F.4.a

Mitchell, Lucy B., 1901-
The paintings of James Sanford Ellsworth,
itinerant folk artist,1802-1873;cat.of an exh.
presented by the Abby Aldrich Rockefeller Folk
Art Coll.,Williamsburg,Va.,Oct.13-Dec.1,1974..
Colonial Williamsburg Foundation,:1974:
103 p. illus(part col.)

Bibliography
Incl:Checklist:Oil ptgs. and W.C.miniature
See also other,articles in Art in Am.v.41:
151-84(Autumn,'53) v.42:218-9(Oct.,'54)
LC ND1337.U6E495

I.F.4.a

Le portrait de profil et de farce.Musée de
Chartres...1977

LC ND1301.5.F8C486

FOR COMPLETE ENTRY
SEE MAIN CARD

708.1
.B87
v.5

I.F.4.a

Morgan, John Hill, 1870-1945
The work of M. Fevret de Saint-Mémin

In:Brooklyn Mus. Q.
5:4-26 Jan,'18 illus.

:F.'s:work portrays so many of those inti-
mately connected with...our government"
Repro.:Alex.Smith of Baltimore,Theod.Gourdin,
Timothy Pickering,Judge John Sam.Sherburne

Corcoran Gall: of Art,Washington,D.C. has
818 portrs.:p.21,

705
P19
NCFA
v.15

I.F.4.a

Pudelko, Georg
Florentiner porträts der frührenaissance

In:Pantheon
15:92-8 Mar,1935 illus.

Synopsis in English:pp.10-11

From Masaccio's static quiet to Castagno's
dynamics
Repro:Uccello,drg.& ptg,Filippo Lippi,Castagno

Enc.of World Art,v.11
N31E56Ref.col.513
bibl.on portr.

AP
1
W892
NCFA

I.F.4.a

Reutlinger, Dagmar E.
American folk art:two groups of family por-
traits by Ruth Henshaw Bascom and Erastus Salis-
bury Field

In:Worcester Art Mus.Bull.
5,no.3:1-12 May,'76 illus.

"Bascom cut out paper silhouette portrs.&
embellished them with charming color & imagina-
tive collage."-Reutlinger in Rila

Rila IV/1 1978 #4033

705
A784
v.32

I.F.4.a

Sherman, Frederic Fairchild, 1874-1940
The portraiture of the Sharples family

In:Art in Am
32:84-6 Apr.,'44 illus.

VF
St.-Mémin

I.F.4.a

Rice, Howard Crosby, 1904-
An Album of Saint Mémin portraits

In:Princeton Uni Lib Chron
13:23-31 Autumn, '51

Re:Valdenuit see p.24-5

LC Z733.P96C5

I.F.4.a

Simon, Karl, 1875-
Vorderansicht & seitenansicht

In:Z Ästhetik
3: 1907

"Z Ästhetik"
LC N3245 Waetzoldt ND1300.W12

VF
St.-Mémin

I.F.4.a

Rice, Howard Crosby, 1904-
Saint-Mémin's portrait of Jefferson

In:Princeton Uni Lib Chron
20:182-92 Summer,'59 illus.

Bibliography on Saint-Mémin

Note on the physiognotrace

LC Z733.P96C5 Whitehill.The Arts in ear-
ly Amer.Hist.Z5935.W59 NPO
Bibl.,p.93

705
A56
NCFA
v.21

I.F.4.a

Snow, Julia D.Sophronia
King versus Ellsworth

In:Antiques
21:118-21 Mar.,'32 illus.

Repro.:incl.Daguerreotypes
Snow identifies miniatures,f'ly given to
James Sanford Ellsworth as Josiah Brown King's
work.She presents evidence in support of her at-
tributions.

Sherman,F.F.,J.S.Ellsworth
In:Lipman,Prim.ptrs.in Amer
ND236.L76,p.71

705
M19
NCFA
v.21
or22

I.F.4.a

Roberts, William, 1862-1940
George Dance and his portraits recently
come to light

In:Mag Art
21:656-8 1898 illus.

Repro.:...Profiles...

FOR COMPLETE ENTRY
SEE MAIN CARD

705
A56
NCFA
v.44

I.F.4.a

Spinney, Frank O.
Joseph H.Davis:New Hampshire artist of the
1830's

In:Antiques
44:177-80 Oct.,'43 illus.

List of 20 ptgs.attr.to Jos.H.Davis

Abby Aldrich Rockefeller
Folk Art Ctr.Am.Folk por-
traits.N7593.A23 Bibl.p.294

705
M18
NCFA
v.11

I.F.4.a

Seaton-Schmidt, Anna
St.-Mémin and his portraits

In:Mag Art
11:438-41 Oct.,'20 illus.

705
A784
NCFA
v.29

I.F.4.a

Suida, Wilhelm Emil, 1877-1959
A Leonardo profile and dynamism in portrai-
ture

In:Art in Am
29:62-72 Apr.'41 illus.

Profile head,bust turned more or less toward
observer."Development of dynamic into the former
statical form of profile portraits"

Cumulated Mag.subj.index
A1/3/C76 Ref. v.2,p.444

I.F.4.a

705
C75
NCFA
v.98

Thomas, John
 Wedgwood ceramic portraits

In:Connoisseur
98:29-35 July,'36 illus(part col.)

 Repro.incl.:Jos.Wedgwood by Hackwood;Wm.Hershel by John Flaxman;Queen Charlotte by Flaxman; Adam Smith by Js.Tassie;Lord Nelson by Devaere; Linnaeus by Flaxman;Josh.Reynolds by Flaxman; Is.Newton by Flaxman

I.F.4.a
see also
II.C.5 - COINS & MEDALS
I.B.2 - FÉVRET DE SAINT-MÉMIN, 1770-1852

I.F.4.a

N
40.1
F:3V1
NPG
2 cops

Valentine museum, Richmond,Va.
 Exhibition of the works of Charles Balthazar Julien Fevret de Saint-Mémin,a special loan exhibition of crayons,engravings,copper plates, w.c.,silhouettes.Valentine museum,Richmond,1941
 68 p. illus.

 Bibliography

 Special emphasis on portrs. of Virginians

 Exhib.,Apr.1 ⌒ 10,1941

LC N7593.F52V3 Fogg,v.11,p.329

I.F.4.b. SILHOUETTE

qAP
1
M225
NPG

Walters, Donald R.
 Out of anonymity:Ruby Devol Finch(1804-1866)

In:Maine Ant.Dig.
6:1C-4C June,'78 illus.

 Discussion of all recorded works & details of Finch'life.

 Abby Aldrich Rockefeller
 Folk Art Ctr.Am.Folk portrs
 N7593.A23 Bibl.p.294

NPG
Print
Dpt.

I.F.4.b

Astre, John and Fraenckle, Herbert.
 Bernhard Albrecht Moll's European silhouettes/.Moll's American silhouettes.In:The German contribution to the building of the Americas:Studies in honor of Karl J.R.Arndt;ed.by Gerh. K.Friesen & Walter Schatzberg.Publ.by Clark University Press,Hanover,N.H.,1977.,Ch.,6.The American expedition of Joseph II and Bernh.Moll's silhouettes.
 p.158-63 illus.

 Silhouettes from 1783
 Pamphlet in ⌒NPG Print Dpt.

I.F.4.a

Weitenkampf, Frank, 1866-1962
 Sketch of the life of Charles Balthasar Julien Fevret de Saint-Mémin;issued to accompany an exh.of his engraved portraits at the Grolier club,March 9-25,1899
 10 p.

LC NE650.F4W4 Levis.Descr.bibl.Z5947A3
 L66 1974 NCFA p.383

I.F.4.b

Anthing, Johann Friedrich, 1753-1805
 Collection de cent silhouettes des personnes illustres et célèbres.Desinées d'après les originaux.Gotha,1791
 5 p. illus.(100 ports.)

 "Joh.Fr.Anthing;eine skisse von Carl Schüddekopf,Weimar,1913.Gesellschaft der bibliophilen" added at end.

 Cat.of B.Quaritch,ltd.London,1978;no.983,p.17,no.15
LC NC910.A5

705
P256
NCFA
v.12

I.F.4.a

Whitehill, Virginia N.
 Consider the portrait

In:Parnassus
12:5-9 Apr,1940 illus.

 Incl:Rembrandt:Selfportrait, Degas:Selfportr., Roberti:Giovanni II, and Ginevra Bentivoglio at loan exhibition at Knoedler's,April,1940.
 Also discussion of 'Five hundred profile portrs.& silhouettes'in the Metropolitan Museum of art.
 Rep.,1939-41*619

I.F.4.b

Beetham, Frederick
 Mrs.Beetham,silhouettist.c.1931

V.& A Typescript,86,p.41 Library V.& A.

 '...one of the finest of all profilists... ptd.profiles on glass & card...'-Hickman.N.Y., Walker,1968,p.27

 For illus.see Hickman."Silhouettes.London, NPG,1972 nos.25- ⌒29
 Piper.Shades.bibl.p.63

I.F.4.b

Pellaigue, Camille, 1858-1930
Portraits and silhouettes of musicians;
transl.fr.the French by Ellen Orr.Boston,
Longwood Press,1978
302 p. illus.

Reprint of the 1898 ed.publ.by N.Y.,Dodd
Mead

LC ML390.P43 1978 Cumulative book index
 Z1219.C97 NPC 1979.p.217

I.F.4.b

Brinton, Anna(Cox)
Quaker profiles:pictorial and biographical,
1750-1850.Wallingford,Pa.,Pendle Hill Publica-
tions.1964.
55p. illus. (Pendle Hill publications:
art history,PH.P2)

LC BX7791.B7 Books in print.Subj.guide
 Z1215.P92 1975 v.2 NPC
 p.3405

I.F.4.b

Bly
Silhouettes,their making,their collecting,
their value. ,c.1913
40 p.

LC(4NC175) DLC-P4 NUC,pre-'56,v.62,p.227

I.F.4.b

Brown, William Henry, 1808-1883.
Portrait gallery of distinguished American citizens, with
biographical sketches and fac-similes of original letters. By
William H. Brown. Hartford, E. B. & E. C. Kellogg, 1845.
2 p. L, [4],-6, [0],-111 p. front., ports., facsims. 48¼ᵐ.
Nos. 7-8 omitted from paging.
Portraits in silhouette.

NPC has facsimile reprint:fN7593.1.B88 1931

1. U. S.—Biog. 2. Silhouettes. 1. Title. 6-10172 Revised

Library of Congress E176.B89
 [r30f2]

ND
1337
A2B67 Boehn, Max von, 1860-1932
NCFA Miniatures and silhouettes,...transl.by E.K.
 Walker...London,and Toronto,J.M.Dent & sons,ltd.
 New York,E.P.Dutton & co.,1928
 214 p. illus(part col.)

I.F.4.b

LC N7616.B6

708.9492
A523
NMAA Bruijn Kops, C.J.de
v.30 Keuze uit de aanwinsten.Portretminiaturen
 uit de verzameling Mr.Adolph Staring

I.F.4.b

In:B.Rijksmus.
30,no.4:192-205 1982 illus.

Summary in English,p.209

Mainly Netherlandish miniatures,also 5 sil-
houettes on glass(3 verre églomisé)

 Bruijn Kops in B.Rijksmus.
 36:177,note 5

NK
9580
B69w Bolton, Ethel(Stanwood),1873-
1915 Wax portraits and silhouettes,...
NCFA Boston,The Massachusetts society of the colonial
 dames of America,1915(2nd ed.)
 88 p. illus.(part col.)

I.F.4.b

LC NK9580.B6

I.F.4.b
Buss, Georg, 1850-
 Aus der Blütezeit der Silhouette,eine kunst-
und kulturgeschichtliche studie.Leipzig,Xenien-
Verlag,cop.1913
 68 p. illus.

N.Y.P.L.
IFC

 Schwencke.Portretten in silh
 LC NC910.S34 IFIL.n.107

I.F.4.b

Brieger, Lothar, 1879-
Die Silhouette.München,Holbein-Verlag.1921.
64 p. illus.

FOGG
FA6553.4.35

705
A56
NCFA Carrick, Alice van Leer, 1875-
v.14 Novelties in old American profiles

I.F.4.b

In:Antiques
14:322-27 Oct.'28 illus.

Incl.:Engraved gold-on glass profiles of
Js.Madison and A.Gallatin by Chs.Peale Polk
and of John Adams by A.B.Doolittle.Hollow-cut
profiles by Wm.Chamberlain and Henry Williams;.
Published as separate article fr. her
"Shades of our ancestors",Ch.VI
 Amer.Ant.Soc.,Worcester,M.
 Library N7593.A512 NPC p.7

705
A56
NCFA
v.14

I.F.4.b

Carrick, Alice van Leer, 1875-
 The profiles of William Bache

In:Antiques
14:220-4 Sept.,'28 illus.

 Repro-:T.Nixon and Wm.Bache.Sitters incl.
celebrities of the time

741.7
E24c
NCFA

I.F.4.b

Édouart, Augustin Amant Constance Fidèle, 1789-
 Catalogue of 3800 named and dated c1861
American silhouette portraits.Discovered by
F.Nevill Jackson....London,1911?,
 31 p. illus.

 London,H.R. Shades of my
 forefathers 741.7/1847
 Bibliography

741.7
.C31

I.F.4.b

Carrick, Alice van Leer, 1875-
 Shades of our ancestors;American profiles
and profilists,...Boston,Little,Brown,and compa-
ny,1928
 205 p. illus.(part col.)

 Bibliography

NC Reprinted 1968 under the title:A History of
910 American silhoettes;a collector's guide,1790-
C316 1840.Rutland,Vt.,C.E.Tuttle
1968NPG

LC NC910.C3
S176.5.C3 copy 2

I.F.4.b

Édouart, Augustin Amant Constance Fidèle, 1789-
 Catalogue of 5200 named and dated c1861
English silhouette portraits....London,Walbrook,
1911,

N.Y.P.L. *ZM-41 Film repro

FOR COMPLETE ENTRY
SEE MAIN CARD

I.F.4.b

Coke, Desmond, 1879-1931
 The art of the silhouette...London,M.Secker,
c1913,
 230 p. illus.

Title from New Haven,Free Pub. Blanshard,F. The portrs. of
Libr. Printed by LC Wordsworth N7628W92B6 NPG

741.7
E24
and
N
7592
O24
NPG

I.F.4.b

Édouart, Augustin Amant Constance Fidèle, 1789-
 ...The collection of American silhouette.1861
portraits cut by August Edouart...with an
introduction by Arthur S.Vernay....New York,
Arthur S.Vernay,1913,
 183 p.

 On Exhibition at no.12 East 45th St.,N.Y.,
Oct.27th-Nov.,15th,1913...

 "A notable coll.of portrs.taken between
1839-1849"
 London,H.R. Shades of my
 forefathers 741.7/1847
 Bibliography

I.F.4.b

College of Physicians of Philadelphia.Wm.W.
 Bradley Collection
 Philadelphia physicians.and others.as re-
presented in art.Reproduced by photography.
1936.-1950.
Arch. 12 v. illus.
Am.Art Preceeded by an index vol.
mfm Typescript,supplemented by a v.of "Silhouet-
P84-P86 tes",1941,and a suppl."A-Z",1950

 Bibliographies

cLC PP PPULC,Bradley,Wm.W.,

I.F.4.b

Édouart, Augustin,1789-1861 (Silhouettist)
 Treatise on silhouette likeness.,London
1835,Longman and company,etc.,

Met has 122 p. illus.
book in
Miss Martin
coll. Chapter on hair pictures

LC NC910.E3

 708.1 N52 NCFA Bull.Met.
 v.35-6 p.54

I.F.4.b

Grimm, Anna
 Die Silhouette.Ihre geschichte,bedeuteng
und verwendung.2.auflage.Leipzig,Haberland,1909
 47 p. illus.

MET-----1st ed.1898
276
CCI

 MB OCI Schwencke.Portretten in
 silh.LC NC910.S34 Bibl.
 p.107

AP
1
A64
NCFA
v.98

I.F.4.b

Foskett, Daphne
 Miniaturists silhouettists in Bath

In:Apollo
98:315-9 Nov.'73 illus.

 Repro.incl.:Chs.Jagger,Abr.of Jos.Daniel,
Charlotte Jones,Sampson Towgood Roch(e),Chs.
Ford,Ozias Humphry,Ths.Redmond,Chs.Foot Taylor,
Nathaniel Hone,T.Hamlet,Jac.Spornberg,Elliott
Rosenberg

I.F.4.b
Gabrisch, Anne
 Schattenbilder der Goethe-zeit.Leipzig,In-
sel Verlag,1966
 79 p. illus.

 Joh.Friedr.Anthing,nos.5,46;Christiane
Luise Duttenhofer,no.51;Goethe,nos.6,7,12;Ludw.
Jul.Friedr.Höpfner,no.54;Andr.Leonh.Moeglich,
no.55;Frans Wilh.Schellhorn,no.40;Starcke,nos.3
38,43,47,50;Joh.Wilh.Wendt,nos.15,17,20,22,23,
26

LC NC910.03

NC
910
H47
1968 bX
NPG

I.F.4.b
Hickman, Peggy
 Silhouettes.New York,Walker,1968.
 60 p. illus(part col.) (Collectors'
pieces,12)

LC NC910.H47 1968b Books in print.Subj.guide
 Z1215.P92 1975 v.2 NPG
 p.3405

I.F.4.b
Groningen. Croninger Museum voor Stad en Lande
 De silhouette in Nederland.Tentoonstelling
22 nov.1963-5 jan.1964.Rotterdam,Mus.Boymans-
van Beuningen 11 jan.-16 feb.,1964.Groningen,
1963

FCCG
6553
C87
 20 p. illus.

 text by A.Staring

CtY Schwencke,J.Portr.in sil-
 houetten.bibl.p.106

705
C75
NCFA

I.F.4.b
Hickman, Peggy
 Some unknown silhouettes from the Christie
collection

In:Connoisseur
180:20-9 May,'72 illus.

 List of most represented artists, 1770-1820

 Incl.silhouettes on porcelain;jewelry:with
silhouettes;églomisé

I.F.4.b
Grünstein, Leo, 1876-
 Silhouetten aus der Goethezeit.Aus dem nach-
lasse Johann Heinrich Merick's.Wien,Hof-Kunst-
anstalt J.Löwy,1909
 46 p. illus.

DLC-P4 NJP etc. Schwencke,Portretten in
 silh.LC NC910.S34 bibl
 p.107

NC
910
H62
NPG

I.F.4.b
Hickman, Peggy
 Two centuries of silhouettes. Celebrities
in profile. London, A.& C.Black,1971.
 p. illus.

 Bibliography

NC
910
H47s
NPG

I.F.4.b
Hickman, Peggy
 Silhouettes;a guide to British silhouette
portraits.London.National Portrait Gallery.
1972
 1 v.(unpaged) illus.

 Cat.of an exh. at the NPG,London.

708.1
N38

I.F.4.b
Isaac Delgado Museum of Art, New Orleans
 A Loan collection of silhouettes.Exh.from
local collections,Jan.11-Feb.,10,1939

In:Is.Delg.Mus.of Art leaflet
3:1-13 June,'39 illus.

 Arranged by the Delgado Art Mus.Project,
Professional and Service Projects Division,
Works Progress Administration,Louisiana

NC
910
H473
1975X
NPG

I.F.4.b
Hickman, Peggy
 Silhouettes,a living art;with a foreword
by Roy Strong.N.Y.,St.Martin's Press,1975
 96 p. illus.

 Bibliography

 Development of silhouettes from pre-histo-
rical times to 20th c.

 Rila II/2 1976 #4136

N
40.1
E245
J2
NPG
RR

I.F.4.b
Jackson, Mrs.F.Nevill,1861-
 Ancestors in silhouette, cut by August
Edouart;illustrative notes and biographical
sketches...London,John Lane;New York John Lane
co.,1921

 239 p. illus.

 List of English silhouette portraits as
transcribed by Edouart. Edouart's list of portrs.
of Charles I and members of his court..taken at
Holyrood palace,1831. Complete list of 3600 portrs
of Americ. citizens betw.1839-49
LC NC910.J17

705
C75
NCFA

I.F.4.b

Jackson, Mrs.F.Neville,1861-
 Contemporary silhouette portraits of George Washington

In:Connoisseur
89:27-34 Jan,1932,I illus.
 108 Feb,1932,I illus.(Washington in shadow)

705
A56
NCFA
v.26

I.F.4.b

Jackson, Mrs.F.Nevill, 1861-
 Profiles on porcelain

In:Antiques
26:217-9 Dec.,'34 illus.

 Silhouettes on porcelain,most items in Mrs. Jackson's collection

I.F.4.b

Jackson, Mrs. F.Neville, 1861-
 The history of silhouettes. London,The Connoisseur,1911

 121 p. illus.(part col.)

 Alphabetical list of silhouettists
 Bibliography

LC NC910.J25

705
C75
NCFA
v.90

I.F.4.b

Jackson, Mrs.F.Nevill, 1861-
 The shadows of Scott

In:Connoisseur
90:169-71 Sept.,'32 illus.

 Repro.incl.:Silhouettes by Edouart

Quimby,Nellie Earles.Beauty in black & white.Oregon State Libr.,Salem 741Q41b Bibl.p.46

705
C75
NCFA
v.82

I.F.4.b

Jackson, Mrs.F.Nevill, 1861-
 Jack Dempsey,silhouettist

In:Connoisseur
82:154-61 Nov.'28 illus.

 Colored silhouette work

I.F.4.b

Jackson, Mrs.F.Nevill, 1861-
 Silhouette;notes and dictionary,...
New York,C.Scribner's sons,1938
 154 p. illus.(part col.)

NC
910
J26
1938ax
CHM
LC NC910.J26

705
C75
NCFA
v.88

I.F.4.b

Jackson, Mrs.F.Nevill, 1861-
 John Field,profilist

In:Connoisseur
88:316-321 Nov.,'31 illus.

 '...at the V.&A.Mus.is a double locket in which is on one side a signed profile by J.F. & on the other side a signed profile by W.W. Field'

Quimby,Nellie Earles.Beauty in black & white.Oregon State Libr.,Salem 741Q41b Bibl.p.46

705
C75
NCFA

I.F.4.b

Jackson, Mrs.F.Neville,1861-
 Silhouette portraits in the Royal collections

In:Connoisseur
90:359-67 Dec,1932,II illus.
 217-28 Oct,1932,II illus(part col.)
 287-98 Nov,1932,II illus.

 All known techniques represented:freehand scissor work,ptg.on underside of flat glass,ptg. on convex glass,plaster ptg.,ptd card work,ivory work in miniature for jewels,portrs.on porcelain etc.

705
C75
NCFA

I.F.4.b

Jackson, Mrs.F.Nevill, 1861-
 Major André-Silhouettist

In:Connoisseur
76:209-18 illus.

 Portrs. of Horatio Gates,Cathcart,Franklin, Burgoyne,André,Washington, Collection Mr.Rbt. Fredenberg, N.Y.

705
C75
NCFA
v.43

I.F.4.b

Jackson,Mrs.F.Nevill,1861-
 Silhouettes by F.Frith,
 Notes;by E.J.

In:Connoisseur
43:166-7 Nov.,1915 illus.

Roe.In:Conn.70:215-23,D'24

I.F.4.b

Jean Millette

In:Collector
47,no.12:121-2 Oct.,'33

 Adolph Buhler,Paris bought M.'s silhouettes
in 1890
 Catalogue of American Portrait has xerox
copy of article.
 The Nat'l Portr.Gallery's curatorial staff
regards .M.'s.silhouettes as...colonial revival
"fakes".

DCL

I.F.4.b

Lister, Raymond
 Silhouettes;an introduction to their history
and to the art of cutting and painting them.
With a foreword by Simon Lissim. London,Pitman
.1953.
 76 p. illus.

LC NC910.L58

Woodiwiss, J. Brit.silh.
bibl. NC910.W89 NPG deals
with both history [see over

I.F.4.b

Knapp, Martin, 1876-
 Deutsche schatten-und scherenbilder aus drei
jahrhunderten.Dachau bei München,Der Gelbe Ver-
lag.1916.
 119 p. illus.

 Repro.incl.:Friedr.v.Matthisson,Goethe,Char-
lotte von Stein,Schiller,Duchess Charlotte of
Gotha & children.Also "negative"silhouette by
Adolf Menzel

OCI(q741.7.K727d) Jackson.Silhouette LC:NC
 910.J26

N
7593
L84
NCFA

I.F.4.b

London, Hannah Ruth, 1894-
 Miniatures and silhouettes of early American
Jews.Rutland,Vt.,C.E.Tuttle Co..1970.
 2 v. in 1 illus.

 Reprint of the author's Miniatures of early
American Jews and Shades of my forefathers.

 Bibliography

LC NC910.L59 Fogg.v.11,p.317,col.1

I.F.4.b

Kroeber, Hans Timotheus, 1883-
 Die Goethezeit in silhouetten.74 silhouetten in
ganser figur vornehmlich aus Weimar und um-
gebung...Weimar,G.Kiepenheuer,1911
 180 p. illus.

LC NC910.K8

qNC
910
M15
NPG

I.F.4.b

McKechnie, Sue
 British silhouette artists...1760-1860....
Totowa,N.J.,Sotheby Parke Bernet,1978

 Bibliography p.782-785

FOR COMPLETE ENTRY
SEE MAIN CARD

705
A56
NMAA
v.129

I.F.4.b

Laughon, Helen and Nel
 Shadow portraits of George Washington

In:Antiques
129:402-9 Feb.,'86 illus.

705
C75
NCFA
v.74

I.F.4.b

Martin, Mary
 Some American profiles and their makers

In:Connoisseur
74:87-94 Feb.,'26 illus.

 Repre.incl.:Silhouettes(Hollow-cut profiles)
by Chs.Wilson Peale,J.H.Whitcomb,Wm.King,Wm.M.S.
Doyle.-Sam.Folwell,Miss de Hart,Wm.Bache,Hubard,
Hankes,Sam.Metford

ND
1337
G7L77
NPG

I.F.4.b

Lister, Raymond
 The British miniature, London,Pitman & Sons,
ltd.,1951

 114 p. 68pl.

 History of Engl.min.,trends & demands;tech-
nique. Subject miniature,portr.min,:Holbein,
Hilliard,Oliver,Hoskins,Cooper,Flatman,Smart,Cos-
way,Engleheart,etc.,contemporary:Montfort,Ayling,
etc.; silhouettes:Charles,Beetham,Cotes.etc.
 Bibliography :

I.F.4.b

May, Leonard Morgan
 A master of silhouette,John Miers;portrait
artist,1757-1821,...London,M.Secker.1938.
 107 p. illus.

 Bibliography

LC NC910.M5M3 Roe.Women in profile,p.27
 LC NC910.R63

N
7616
M47
NCFA
 I.F.4.b

Mayne, Arthur
 British profile miniaturists.London,Faber
.1970.
 131 p. illus(part col.) (Faber collectors
library)

 Bibliography

LC N7616.M37 FOGG v.11,col.2,p.317

705
C75
NCFA
v.70
 I.F.4.b

Roe, F.Gordon
 A family in silhouette

In:Connoisseur
70:215-23 Dec.,1924 illus.

 Repro:Rbt.Friend,of Tunbridge Wells:Members
of Friend family,drawn on paper.E.W.Foster,of Der-
by:Rbt.Friend drawn on convex card.A.Edouart:Ch.
Sp.Bunyon,full standing,cut in paper & mounted on
one of Unkles & Klasen's lithographs,1832,etc.

708.1 I.F.4.b
N52
NCFA
v.35-36 Mayor, A.Hyatt
 Silhouettes and profile portraits

In:Bull.of Met Mus
35:50-4 Mar,1940 illus.

 Incl:Sittoughton,Buncombe,Miers,Field,Mrs.
Beetham,Edouart

705
C75
NCFA
 I.F.4.b

Roe, F.Gordon
 Shades of Goethe

In:Connoisseur Apr,1932(pt.1) illus.
89:254-6

 Rep.,1932#102

741.7 I.F.4.b
M49

Mégros, Rodolphe Louis, 1891-
 Profile art through the ages;a study of the
use and significance of profile and silhouette
from the stone age to puppet films.N.Y.,Philoso-
phical Library.1949.
 131 p. illus.

 Ch.7:The human profile(incl.Lavater's pro-
files for character reading);Ch.8:Painted sha-
dows;Ch.9:The cut silhouette(18-19th c.);Ch.10:
Modern silhouette cutters.Appendix,B:Lavater's
LC N5303.M4 character reading

 I.F.4.b
Roe, F.Gordon
 Women in profile.A study in silhouette.
London,John Baker,1970
 69 p. illus.

LC NC910.R63

qNC
910.5
E3 O44X
NPG
 I.F.4.b

Oliver, Andrew, 1906-
 Auguste Edouart's silhouettes of eminent
Americans,1839-1844.Publ.for the NPG,Smiths.
Institution by Uni.Press of Virg.,Charlottes-
ville,1977
 .553.p. illus.

 Appendix:"Cat.of 3800 named & dated Ameri-
can silhouette portrs.by August Edouart"by
E.Jackson&Mrs.F.Nevill.
 Intro.by A.Hyatt Mayor

LC NC910.5.E3 O44

705
A7832
NMAA
 I.F.4.b

Rosenblum, Robert
 The origin of painting:a problem in the
iconography of Romantic classicism

In:Art Bull.
39:279-90 Dec.,'57 illus.

 Ref.to Pliny the elder's story in his Natural
History of a Corinthian maid who traced the sha-
dow of her lover's face cast upon the wall by
lamplight;the nature & meaning of the response
to this legend in the period of Romantic Clas-
sicism(end 18-beg. 19th c.)
 Piper.Shades
 Bibl.p.63

 I.F.4.b

Piper, David
 Shades,an essay on English portrait silhou-
ettes,N.Y.,Chilmark Press.c.1970.
 63 p. illus. (Clover Hill editions,4)

 Bibliography

CaOTP ICN Hickman.Silhouettes,a liv'g
 art.NC910.H473 1975X NPG
 Bibl.,p.91

 I.F.4.b

Schoeller, Wilfried
 Das Silhouetten-cabinet.Deutsche silhou-
etten aus zwei jahrhunderten.Konstans,Neue
Diana Press.c.1973.
 .57.p.of illus.incl.portrs.

LC NC910.S27

I.F.4.b

Schwencke, Johan
 Portretten in silhouetten.Zaltbommel,Euro-
pese Bibliotheek,1966
 136 p. illus.

 Bibliography

 A history of silhouettes in the Nether-
lands

LC NC910.S34

fNC
910
W45
NPC
Shelved
in NCFA
NPG
Libra-
rian's
office

I.F.4.b

Wellesley, Francis
 One hundred silhouette portraits selected from
the collection of Francis Wellesley, with a pre-
face by Weymer Mills.Oxford,printed by H.Hart
at the university press for F.Wellesley,1912
 20 p. illus.

 Contains list of silhouettists;list of sit-
ters
 Repro.of silh.painted on paper,glass,paste-
board,plaster,silk.Cut.Etched on metal
LC NC910.W4 Wellesley coll contains Lavater's own album

NPG
filed
NCFA
Ref.
coll.

I.F.4.b

Smithsonian Institution
 Profiles of the time of James Monroe,1758-
1831;an exhib.commemoration the 200th anniversary
of the birth of the 5th pres.of the U.S.,Oct.26-
Nov.23,1958.Washington,1958,
 ₍29₎p. illus. (Smithsonian publication
no.4348)

 Cat.signed:Ths.M.Beggs

 Exhib.held in the Natural History Bldg.

LC E372.S56 Fogg,v.11,p.330

NC
910
W89
NPG

I.F.4.b

Woodiwiss, John.
 British silhouettes. London, Country Life ₍1965₎
 96 p. illus. 20 cm.
 Bibliography: p. 91-92.

 1. Silhouettes. 2. Portraits, British. ɪ. Title.

NC910.W6

Library of Congress ₍4₎ 66-33230

705
A56
NCFA
v.15

I.F.4.b

Swan, Mabel Munson
 Master Hubard,profilist and painter

In:Antiques
15:496-500 June,'29 illus.

 Repro.:Silhouettes & ptgs.
 Incl.:"Hubard's gall.of silhouettes"From
his catalogue & memoirs published in N.Y.in 1825

 London,H.R.Shades of my
 forefathers.741.7.L847
 Bibliography

AP1
A64
NCFA
v.61

I.F.4.b

Woodiwiss, John
 19th c. profiles

In:Apollo
61:12-4 Jan,1955 illus.

 Color & bronze highlighting used.
 Repro:John Field,Edw.Foster,Dillon (on card)
J.Woodhouse,full length profiles(on glass)

 Enc.of World Art
 N31E56Ref.v.11,col.514
 bibl.on portr.

I.F.4.b

Auer, Andrew W.hite, 1838-1900,
 The Art of silhouetting

In:Engl.Ill.Mag.
7:747 1890 illus.

 Mainly abt. Edouart.Illus.all from Edouart's
treatise of 1835

LC AP4.E5 Mégroz.Profile art.741.7
 M49, p.93

I.F.5. LENGTH

757
.V64

I.F.4.b

Victoria and Albert museum, South Kensington.
 Dept.of paintings
 ...Hand-list of miniature portraits and silhou-
ettes,by Basil S.Long...1930
 114 p. illus. ₍Victoria and
Albert mus.,S.Kensington.Publication no.152₎

 Preface signed:Eric Maclagan

LC N7616.V65

I.F.5.a. BUST, see also II.C.5. - BUSTS

I.F.5.a

.Bernard, George.
 Effigies regum Francorum omnivm,a Pharamvndo
ad Henricum vsqve tertium...Caelatoribvs,Virgili:
Solis & Iusto Amman...Noribergae...1576
 64 1 62 ports.

 Engraved portrs.with a scene in woodcut in-
serted in frame

 Title:Chronica regum Francorum

LC DC37.B5 1576
Rosenwald coll.
 Rave.Jb.d.Berl.Mus. I 1959
 LC N3.J16 fol. p.149-50
 Paolo Giovio & d.Bildnisvi-
 tenbücher d.Humanismus

I.F.5.a

Vico, Enea, 1523-1567
 Augustarum Imagines...Venetiis.Paul Manuce?.
1558
 192 p. illus.

 55 engravings of Roman empresses after medal:

 1st ed.1557

LC DC276.5.V5
 Rave.Jb.d.Berl.Bus.I 1959
 LC N3.J16 fol. p.145
 Paolo Giovio & d.Bildnisvitenbücher

I.F.5.a

A Booke containing the trve portraitvre of the
 covntenances and attires of the kings of
England...collected by T.T. London,Printed
by Iohn de Beauchesne,1597

 23 full-page woodcuts(busts)

NN
MiU CoDU (Film) FOR COMPLETE ENTRY
 SEE MAIN CARD

I.F.5.a

Zantani, Antonio
 Le Imagini e le vite de gli imperatori tratt
dalle medaglie e dalle historie de gli antichi.
Florence,Enea Vico,1548

 From Caesar to Domitian,engravings after
 medals

Oxford
Uni.Bod- Vico,the publisher was an engraver
leian
libr. has latin ed.

 Rave.Jb.d.Berl.Mus. I 1959
 LC N3.J16 fol. p.141-2
 Paolo Giovio & d.Bildnisvitenbücher.

I.F.5.a

Epitome des roys de France en latin & en fran-
 coys auec leur vrayes figures...Lvgdvni.-Lyo.
Balthasar Arnoullet,1546
 159 p. illus.
 2nd issue.1st issue entitled:Epitome gestorv:
1VIII.regum Franciae,1546

 58 portrs,attr. to Corneille de Lyon,from
leg.king Pharamond to Francis I

LC Typ 515
 46.366 MH Rave.Jb.d.Berl.Mus.I 1959
 LC N3.J16 fol. p.138
 Paolo Giovio & d.Bildnisvitenbücher....

I.F.5.b. WAIST, HALF LENGTH
 (incl. KIT-KAT SIZE)

705
C75
NCFA I.F.5.a
v.103
 McGuire, Edward A.
 Pastel portrait painting in Ireland in the
18th century

 In:Connoisseur
 103:10-5 Jan.'39 illus.

 Incl.list of some Dublin pastelists of the
18th c.
 Repro.incl.:Hugh Douglas Hamilton;Ths.Hicke:
Chs.Forrester;John Cullen

 Noon.Engl.portr.drags.&min:
 NC860.N66X NPG Bibl. p.146:

I.F.5.b Half length includes Kit Cat size
 (Kit-Cat size is less than half-length,but includ-
 ing head and at least one hand)

F
158.65
I 3178 Milley, John C.
NPG Portraiture:Commemorative and symbolic

 In:Treasures of Independence:Independence Natio-
 nalHistorical Park & its collections,p.151-70 &
 notes p.179-80 illus(part col.)

 Bibl.:Painted & Printed material,p.185-7

 Incl.Chs.Willson & Rembrandt Peale's "museur
portrs.":bust portrs.;and commissions of privat
nature Miles.In:Am Art J,15:64
 footnote 4

AP
1
A51 Auerbach, Erna
NCFA The development of particular groups of
 German portrait painting.II.Plasticity and sym-
 metry about 1530

 In:Apollo
 22:3,5,7,9 July,'35 illus.

 Repro.:Strigel,Unknown Swabian artist,Cra-
nach the elder,v.Heemskerck,Brossmer,Pencs
 Desire to bring calmness and "monumentality
to the fig. Flemish influence is discussed.

I.F.5.b

Bote, Konrad, fl.1475-1501
Cronecken der Sassen.Mainz,Peter Schöffer,
1492
284 p. illus.

Woodcut half-length fgs.

LC Incun.1492.B74 Rosenwald coll. Rave.Jb.d.Berl.Mus.
I 1959 LC N3.J16 fol.
Paolo Giovio d.Bildnisvitenbücher,p.124

I.F.5.b

Giovio, Paolo, 1483-1552
..Elogia virorum bellica virtute illustrium...
.Basileae.Petri Pernae...1575
391 p. illus.

128 woodcuts after portrs.in Giovio's coll.
by Tobias Stimmer. 1 woodcut portr.of Giovio

LC CT93.G58 1575 Rave.Jb.d.Berl.Mus.I 1959
)LC N3.J16 fol. p.150
Paolo Giovio & d.Bildnisvi
tenbücher d.Humanismus

I.F.5.b

.Caulfield, James. 1764-1826
Memoirs of the celebrated persons composing
the Kit-Cat club;...illustr.with 48 portraits
from the original paintings by Sir Godfrey
Kneller...London,Jurst,Robinson,& co,1821
261 p. illus.

LC DA687.K6C3

I.F.5.b

Giovio, Paolo, 1483-1552
...Elogia virorum literis illustrium...Basilea.
Petri Pernae...1577
231 p. illus.

60 woodcuts after portrs.in Giovio's coll.
by Tobias Stimmer,incl.1 of Giovio

LC CT95.G5 Rave.Jb.d.Berl.Mus. I 1959
)LC N3.J16 fol. p.150
Paolo Giovio & d.Bildnisvi
tenbücher d.Humanismus

I.F.5.b

Cronycke van Hollandt,Zeelandt en Vrieslant be-
ghinnende vä Adams tiden tot die geboerte cr.
heren Jhū voertgaende tot die iare 1400...Leyden,
Jan Seuersz,1517

Brit Whole-length fgs.by Lucas van Leyden
Mus Half length fgs.

Rave.Jb.d.Berl.Mus.I 1959
)LC N3.J16 fol.p.127

Paolo Giovio & d.Bildnisvitenbüche

I.F.5.b

Giovio, Paolo, 1483-1552
Vitae dvodecim Vicecomitvm Mediolani princi-
pvm.Lvtetiae,R.Stephani,1549
199 p. illus.

10 woodcuts after portrs. in Giovio's coll.
perhaps by Claude & Pierre Woeiriot.-Rave
Portrs.engr.on wood have the Lorraine cross
device of Geoffroy Tory.-LC
Portrs.of the Visconti family,Milan

LC DG657.7.05 1549 Rave.Jb.d.Berl.Mus. I 1959
Rosenwald coll.)LC N3.J16 fol. p.139-41
Paolo Giovio & d.Bildnisvi
tenbücher d.Humanismus

I.F.5.b

Les effigies des Roys de France,tant antiques
que modernes...Paris.François Des Prez,1565?

62 woodcuts by Jean Cousin,the younger,all
waist-length

NN Rave.Jb.d.Berl.Mus.I 1959
)LC N3.J16 fol. p.141
Paolo Giovio & d.Bildnisvitenbücher..

I.F.5.b

Kneller, Godfrey & Faber, John
The Kit-Cat Club done from the original
paintings of Sir Godfrey Kneller by Mr.Faber.
London,J.Tonson & J.Faber,1735
p. illus.

LC ND497K47F3 Marlborough,London
cat.1972,no.17
(offered for £350.00)

I.F.5.b

Foresti, Jacopo Filippo,da Bergamo, 1434-1520
De claris mulieribus.Ferrara,Laurentius de
Rubeis,de Valentia...,1497
illus.

172 portrs;"7 have such strangely marked cha
racteristics,that they are probably copies of ge
nuine portrs."-J.P.Morgan.Cat.of MSS & early
printed books,v.2,no.382

LC Incun.1497.F6 Rosenwald Rave.Jb.d.Berl.Mus.I 1959
coll.)LC N3.J16 fol.,p.126
Paolo Giovio & d.Bildnisvitenbücher...

ND
236
L76
NPG

I.F.5.b

Lipman,Mrs.Jean Herzberg, 1909- comp.
Primitive painters in America,1750-1950;an
anthology,by J.Lipman & A-Winchester.N.Y.,Dodd,
Mead,1950.
182 p. illus(part col.)

Contents.-2.N.F.Little, Primit.ptrs.of 18th
4.A.M.Dods, R.H.Bascom.-5.A.E.Rye, E.Hicks.-8.F.F.
Sherman, J.S.Ellsworth.-9.F.B.Robinson, E.S.Fiel
10.N.F.Little, W.M.Prior.-11.J.Lipman, D.Gold-
smith.-12.F.O.Spinney, J.H.Davis.-14.J.L.Clarke,
Jr., J.W.Stock

757
L89
NCFA

I.F.5.b

London. National portrait gallery
 The portraits of members of the Kit Cat club,
painted...1700-1720,by Sir Godfrey Kneller for
Jacob Tonson...Presented to the nation in 1945...
London,,1945.

FOGG
56
L84p 1945
MET
196.6L84
N2492

 19 p. illus.

I.F.5.b

Schedel, Hartmann, 1440-1914
 ,Nuremberg chronicle.German,
 Das buch der Chroniken unnd geschichten mit
figuren und pildnissen von Anbeginn der Welt
biss auff onsere Zeyt.Cuts.Fol. 2nd ed.,Augsburg,
1496 (596)
 Innumerable,stylized representations of...&
people by M.Wohlgemut & W.Pleydenwurff

V&A

FOGG
KFA5767
788.210

1st ed. Nürnberg, 1493 in Latin

—·-Facsimile ed.,1967,093 ⌒S315 Prinz.Slg.d.selbst-
MET Print ip. " " = bildn.N7615/P95 .
279.1/Sch1/ Bd.1,p.20

705
C75
NCFA
v.194

I.F.5.b

Mannings, David Michael
 Reynolds' portraits of the Stanley Family

In:Connoisseur
194:85-9 Feb.,'77 illus(1 col.)

 4 Kit-cat portrs.,based on v.Dyck & with
motifs derived fr.Brit.16-17th c. portraiture

 Rila III/2 1977 #4984

N
40.1
K682S8
NPG

I.F.5.b

Stewart, J.Douglas
 Sir Godfrey Kneller.cat.of an exh.at the
NPG,London,Nov.-Dec.,1971....London,Bell;Nat'l
Portrait Gallery,1971
 82 p. illus(part col.)

 Bibl.references
 Incl.:Lady Eliz.Cromwell as St.Cecilia
 Chapters incl.:Drawings;Ladies & children;
Lords & Gentry;Scholars & Poets;Army & Navy;
Parade portrait.Appendix:Kit-cat club portrs.

LC ND1329.K55S7

705
B97
NCFA
v.105

I.F.5.b

Millar, Oliver, 1923-
 Marcus Gheeraerts the younger,a sequel throug
inscriptions

In:Burl Mag
105:533-41 Dec.,'63 illus.

 Gheeraerts's later oeuvre from 1600-1629

 Incl.list of sitters

 Strong.The English Icon
)qND1314S924,Bibl.

705
B97
NCFA
v.105

I.F.5.b

Strong, Roy C.
 Elizabethan painting:An approach through
inscriptions - I:Robert Peake the elder

In:Burl Mag
105:53-7 Fe.,'63 illus.

 "...In 1598 P.could be regarded as one of
the most important ptrs...in England"
 Serjeant ptr.from 1607 on

 Incl.list of sitters

I.F.5.b

Pantaleon, Heinrich, 1522-1595
 Teutscher Nation Heldenbuch.Basel,Brylingers
Erben,1567-1570

Brit.mus.
613.1.23

 Latin ed.(with Greek title):Prosopographiae,
1565-66 Brit.Mus.611.1.14

 1700 woodcut portrs.,only 50 on authentic
basis

 Rave.Jb.d.Berl.Mus. I 1959
 LC N3.J16 fol. p.147-8
 (Paolo Giovio & d.Bildnisvi-
 tenbücher d.Humanismus

705
B97
NCFA
v.105

I.F.5.b

Strong, Roy C.
 Elizabethan painting:An approach through
inscriptions - II:Hieronimo Custodis

In:Burl Mag
105:103-8 Mar.,'63 illus.

 Incl.list of sitters

I.F.5.b

Panvinio, Onofrio, 1529-1568
 Accuratae effigies Pontificum Maximorum...
Argentorati,1573,2nd ed.(1st ed.1568)
 Durch Verdolmetschung J.Fischaert,gen.Ment-
zer Teutsch beschriben,Strassburg,1573

V & A

 Printer & publisher:Bernard Jobin.Woodcuts
by Tobias Stimmer:Half-fgs. of Urban VI to
Gregory XIII;after engravings in the 1st ed.
 Fischart condemns onesidedness of Vasari.
Speaks for the 1st time in art-history of German
artists who are Rave.Jb.d.Berl.Mus. I 1959
still famous to- LC N3.J16 fol.p.146 & 149
day.) Paolo Giovio & d.Bildnis-
 vitenbücher d.Humanismus

705
B97
NCFA
v.105

I.F.5.b

Strong, Roy C.
 Elizabethan painting:An approach through
inscriptions - III:Marcus Gheeraerts the younge

In:Burl Mag
105:149-57 Apr.'63 illus.

Incl.list of sitters

 Gheeraerts'earlier oeuvre,1590-1600

 "In his full length,portrs.....he strikes a
new and exotic n "

705
B97
NCFA
v.128

I.F.5.b

Tscherny, Nadia
 Reynolds's Streatham portraits and the art
of intimate biography

In:Burl Mag
v.128:4-11 Jan.'86 ill s.

 Discussion of the natural association be-
tween portraiture and written biography
 'The Streatham portrs.are...remarkable...
for their honesty in representing...physical
imperfections..'thus distinguished from the
iconic pictorial records of Kneller's Kit-
Cat series.

705
B97
NCFA
v.113

I.F.5.c

Oberhuber, Konrad
 Raphael and the State portrait.-I:The por-
trait of Julius II

In:Burl Mag
113:124,127-30 Mar.'71 illus.

 Problems of the state portraiture.
 One of the first informal portr.of the Ita-
lian Renaissance,going back to the change fr.for-
mal to informal in dedication pictures of Charle
V of France Debs,b.From eternity to
 here...In:Art in Am. 63:5:c

I.F.5.c. 3/4 (KNEES INCL.)

705
B97
NCFA
v.113

I.F.5.c

Oberhuber, Konrad
 Raphael and the State portrait.-II:The por-
trait of Lorenzo de' Medici

In:Burl Mag
113:436,439-40, 443 Aug.,'71 illus(part col.

 Problems of state portraiture
 Re-attribution fr. Bronzino to Raphael
 Portrs.of royalty in 3/4 length,origin in
France,spread to Lombardy
 Sitter as representative of a specific group

I.F.5.c 3/4 length:Figures with knees included

I.F.5.d. FULL STANDING

705
328
NCFA
v.80

I.F.5.c

Adhémar, Jean
 Etienne Carjat

In:Gaz Beaux-Arts
80:71-81 Aug.'72 illus.

 '...il ne représente pas ses modèles en
pied,mais jusqu'au genou...'.-Adhémar

 Repre.incl.:photomontage:Courbet conversing
with himself,ca.1862
 Paris.Mus.Carnavalet.E.
 Carjat,p.3

I.F.5.d

Boccaccio, Giovanni, 1313-1375
 De claris mulieribus.Venice,1506
 illus.

 Whole-length woodcut portrs.

Brit L'Opera de misser G.B. de mulieribus claris
Mus :Transl.fr.the Latin by V.Bagli...Venetia,1506:
10603 Woodcuts
d

 Rave.Jb.d.Berl.Mus.I 1959
 LC N3.J16 fol.,p.126/7
 Paolo Giovi & d.Bildnisvitenbücher...

705
B97
NCFA
v.105

I.F.5.c

Millar, Oliver, 1923-
 Marcus Gheeraerts the younger,a sequel throu
inscriptions

In:Burl Mag
105:533-41 Dec.,'63 illus.

 Gheeraerts's later oeuvre from 1600-1629

 Incl.list of sitters

 Strong.The English Icon
 QND1314S924,Bibl.

I.F.5.d

Cronycke van Hollandt,Zeelandt en Vrieslant be-
ghinnende vä Adams tiden tot die geboerte on
heren Jhū voertgaende tot die iare 1400...Leyden,
Jan Seuersz,1517

Brit Whole-length fgs.by Lucas van Leyden
Mus

 Rave.Jb.d.Berl.Mus.I 1959
 LC N3.J16 fol.p.127

705
A784
NCFA

I.F.5.d

Flexner, James Thomas, 1908-
Early American painting:Stuart's full-lengths
of Washington

In:Art in Amer.
35:329-33 Oct.1947 Illus.

Realistic vs. representational approach

Rep.,1945-47*7561

I.F.5.d

Hart, Charles Henry, 1847-1918
Peale's original whole-length portrait of
Washington;a plea for exactness in historical
writings.
In:Am hist.ass. Annual report for the year 1896
Washington,1897
1:189-200

LC card div.E172.A60 1896, Weddell.A mem'l vol.of Va.
v.1 hist.portraiture.757.9.W38
LC--separate E312.43.H33 NCFA Bibl. p.435

I.F.5.d

Froning, Hubertus
Die Entstehung und entwicklung des stehen-
den ganzfigurenporträts in der tafelmalerei des
16.jhr.:Eine formalgeschichtliche untersuchung

Ph.D.diss.Julius-Maximilians Uni.Würzburg.
Krefeld,1971,Würzburg,1973

Amer.portr.in the Grand
Manner...ND1311.A47X NMAA
Bibl.p.217

I.F.5.d

Hurlbutt, Frank
Old Derby porcelain and its artist-workmen.
London,T.W.Laurie,ltd.,1925
312 p. illus.

Incl.:Ch.Modellers and figure-makers,p.25-52
"...He:Pierre Stephan...modelled most of the
statuettes of the national heroes..."
Pl.15:John Wilkes by Pierre Stephan;biscuit
figure
Bibliography

LC NK4399.D4H8 Groce.In:Am Coll v.15
 705.A5 NCFA May,'46,p.19,
 note 1

Prit.mus.
1763.d.19

N.Y.P.L.
MWER

I.F.5.d

Galerie théâtrale,collection de 144 portraits
en pied des principaux acteurs et actrices
qui ont illustré la scène française depuis
1552 jusqu'à nos jours...Paris,A.Barraud,
1872.-73
2 v. illus.

N.Y.P.L.has similar:Paris,Bance.1842,
3 v. illus. ...gravés par les plus cé-
lèbres artistes...Stipple engr.by Godefroy,
Chaponnier,Lignon,etc.,fr.ptgs.by Auret,A.de
Romance,A.Bosse,etc.

ND
236
L76
NPG

I.F.5.d

Lipman,Mrs.Jean Herzberg, 1909- comp.
Primitive painters in America,1750-1950;an
anthology,by J.Lipman & A.Winchester.N.Y.,Dodd,
Mead,1950.
182 p. illus(part col.)

Contents.-2.N.F.Little, Primit.ptrs.of 18th
4.A.M.Dods, R.H.Bascom.-5.A.E.Eye, E.Hicks.-8.F.F.
Sherman, J.S.Ellsworth.-9.F.B.Robinson, E.S.Fiel
10.N.F.Little, W.M.Prior.-11.J.Lipman, D.Gold-
smith.-12.F.O.Spinney, J.H.Davis.-14.J.L.Clarke,
jr., J.W.Stock

N
40.1
C28x08
NPG
R.B.

I.F.5.d

Gruyer, François Anatole, 1825-
Chantilly:les portraits de Carmontelle...
Paris,Plon-Nourrit et cie,1902
388 p. illus.

Incl.:Contents. List of sitters

LC N7604.C2 Winterthur Mus.Libr. fZ811
 W78 v.9,p.226

705
B97
NCFA
v.105

I.F.5.d

Millar, Oliver, 1923-
Marcus Gheeraerts the younger,a sequel throug
inscriptions

In:Burl Mag
105:533-41 Dec.,'63 illus.

Gheeraerts's later oeuvre from 1600-1629

Incl.list of sitters

Strong.The English Icon
QND1314S924,Bibl.

705
A784
NCFA
v.4

I.F.5.d

Halsey, Richard.Townley.Haines, 1865-1942.
Ceramic Americana of the 18th century

In:Art in Am
4,Pt.1:85-98 Feb.,1916 illus.
 Pt.2:224-32 June,1916 illus.
 Pt.3:276-88 Aug.,1916 illus.
5,Pt.4:41-56 Dec.,1916 illus.
Repro.incl.:Chelsea porcelain statuettes:Wm.Pitt,
John Wilkes,Catharine Macaulay. Wedgwood medal-
lions of Franklin,Washington,Marie Antoinette,
etc.etc.

N
40.1
D243P2
NCFA

I.F.5.d

Paris. Musée de la monnaie
David d'Angers,1788-1856.Hôtel de la mon-
naie,Paris,juin-sept.,1966.Cat.par François
Bergot.Préfaces par Pierre Dehaye et Pierre
Pradel.Paris,Hôtel de la monnaie,1966
151 p. illus.

Bibliography
Repro.incl.:Ptgs.miniatures,daguerreotype,
caricatures,drags.,prints by D.'s contempora-
ries.Bronze statuettes,busts,medallions by
David d'Angers of poets,military,clergy,states-
men,artists
List of sitters

AP
1
H63
NPG

I.F.5.d

Purvis, Doris F.
 The Joseph Blackburn portraits of Lieute-
nant-Governor John Wentworth and Governor
Benning Wentworth

In:Hist New Hampshire
24,no.3:34-9 Fall,'69 illus.

 Full standing patgs.from 1760 in the
New Hampshire Historical Society

/705
A784
NCFA
v.9

I.F.5.e

Roberts, William, 1862-1940
 English whole-length portraits in America

In:Art in Am
9:176-80 Aug.'21 illus. Reynolds
10:22-6 Dec.'21 illus. Gainsborough
10:70-5 Feb.'22 illus. Lawrence
10:109-16 Apr.'22 illus. Gainsborough
10:274-7 Oct.'22 illus. Gainsborough

 Cumulated Mag.subj.index
 A1/3/C76 Ref. v.2,p.444

705
A784
NCFA
v.9

I.F.5.d

Roberts, William, 1862-1940
 English whole-length portraits in America

In:Art in Am
9:176-80 Aug.'21 illus. Reynolds
10:22-6 Dec.'21 illus. Gainsborough
10:70-5 Feb.'22 illus. Lawrence
10:109-16 Apr.'22 illus. Gainsborough
10:274-7 Oct.'22 illus. Gainsborough

 Cumulated Mag.subj.index
 A1/3/C76 Ref. v.2,p.444

I.G. CONNOISSEURSHIP & EXAMINATION

705
B97
NCFA
v.105

I.F.5.d

Strong, Roy C.
 Elizabethan painting:An approach through
inscriptions - III:Marcus Gheeraerts the younger

In:Burl Mag
105:149-57 Apr.'63 illus.

Incl.list of sitters

 Gheeraerts'earlier oeuvre,1590-1600

 "In his full length.portrs.....he strikes a
new and exotic note"

I G CONNOISSEURSHIP & EXAMINATION

I.F.5.e. FULL SEATED

I.G.1. GENERAL

4
40.1
C28x08
NPG
R.B.

I.F.5.e

Gruyer, François Anatole, 1825-
 Chantilly:les portraits de Carmontelle...
Paris,Plon-Nourrit et cie,1902
 388 p. illus.

 Incl.:Contents. List of sitters

LC N7604.C2 Winterthur Mus.Libr. fZ811
 .78 v.9,p.226

705
C75
v.90

I.G.1

Baker, Charles Henry Collins, 1880-
 Some Velasquez problems

In:Conn
90:147-9,154,159 Sep.,'32 illus(part col.)

 A study of execution of portrs.ascribed to
Velasquez in order to attribute them to the mas-
ter or to his school

 Cum.Mag.subj.ind.A1/3/76
 Ref.v.2,p.444

I.G.1

705
A7832
NCFA
v.35

Belknap, W.aldron.Phoenix,1899-1949
 Feke and Smibert:a note on two portraits

In:Art Bul
35:225-6 Sept.,'53 illus.

 B.suggests that Smibert and Feke ptd.Henry
Collins.Feke's portr. formerly called to re-
present Gershom Flagg III

I.G.1

705
A56
NCFA
v.66

Cortelyou, Irwin F.
 Collectors' Notes:Henry Conover:sitter not
artist

In:Antiques
66:481 Dec.,'54

 Pertains to C.'s Aug.article:"A mysterious
pastellist identified".He suggests,that Micah
Williams is the artist of the ptgs. from Mon-
mouth Cy.& vicinity

I.G.1

708.9493
B921
NMAA

Benkö, Eva
 The archetype of Netscher's "Portrait of
Mary II Stuart"in Brussels and its use

In:Mus.Royaux
 des Beaux-Arts
 de Belgique.B
30-33:123-34 1981-1984/1-3 illus.

 The portr.by Constantin or Caspar Netscher
of Mary II Stuart could be copies after Sir
Peter Lely
 Synopsis in Dutch and French

I.G.1

705
A56
NCFA
v.66

Cortelyou, Irwin F.
 A mysterious pastellist identified

In:Antiques
66:122-4 Aug.,'54 illus.

 see also .his.Henry Conover,sitter,not ar-
tist,p.481,Dec.,'54 in Antiques,v.66

 New Jersey Hist.Soc.NC880
 N53 NPG note 6

I.G.1

AP
1
A79
NCFA
v.1-3

Black, Mary C.
 The case of the red and green birds.Thir-
teen persons,one of whom has never been identi-
fied,pose a picture puzzle wherin a cardinal &
a parakeet are vital clues.

In:Arts in Va.
3,no.2:2-4,7-8 Winter,'63 illus.
 Portrs.of members of two prominent fami-
lies by an unknown artist.Five facts suggest
a Va.provenance,inspired by Engl.mezzotints.
 Black.The case reviewed.
 In:Arts in Va.,v.10,no.1

I.G.1

705
G28
NCFA
v.32

Dorbec, Prosper, 1870-
 Le portraitiste Aved et Chardin portraitiste

In:Gaz.Beaux Arts
3rd per.v.32:89-100 1504 illus.
 :215-24 " "
 :341-52 " "

 Repr.Engravings after the ptgs.
 Pt.1 & 2 cn Aved,pt.3:Dorbec suggests attr.
to Aved of most of Chardin's portrs.(p.346ff)

 Dumont-Wilden.Le portr.en
 France ND1316D89,p.165

I.G.1

AP
1
A79
NCFA
v.10

Black, Mary C.
 The case reviewed. Fresh evidence suggests
a surprising authorship for a puzzling series
of family portraits.

In:Arts in Va.
10,no.1:12,15,20 Fall,'69 illus.

 Some portraits attr.to a limner of the Up-
per Hudson are now given to the Aetatis Sue Lim-
ner of Tidewater,Va. Refers to Black's "The
case of the red and green birds."

I.G.1

705
B97
NCFA
v.124

Edmond, Mary
 The Chandos portrait:a suggested painter

In:Burl Mag
124:146-9 Mar,'82 illus.

 Edmond suggests John Taylor as the painter
of the only supposed portr.of Shakespeare done
during his lifetime

 Rila 1984/I #1991

I.G.1

705
A784
NCFA
v.30

Burroughs, Alan, 1897-1965
 Notes on Smibert's development

In:Art in Am
30:109-21 Apr.,'42 illus.

 Incl.:Chronologically arranged list of S.'s
portrs.

I.G.1

705
B97
NCFA
v.121

Edmond, Mary
 Peter Cross limner,died 1724

In:Burl Mag
121:585-6 Sep.'79

 Bibliography

 E.establishes that there was no 'Lawrence
Cross;an English miniaturist,but only 'Peter'

705
B97
NCFA
v.99

I.G.1

Edwards, Ralph, 1894-
An attribution to Joseph Highmore

In:Burl.Mag.
99:234-7 July, '57 illus.

Some conversation pictures previously attr.
to Hogarth
Repro.:Family group,known as 'The Rich fa-
mily'and 'Pamela tells a musery tale'

705
B97
NCFA
v.69

I.G.1

Glück, Gustav
Some portraits of musicians by van Dyck

In:Burl Mag
69:147-8,153 Oct., '36 illus.

Jacques Gaultier,Nicolas Lanier identified
through prints by Jan Lievens & Lucas Vorsterman

G.feels that music seems to come through to
us from some ptgs.
Cum.Mag.Subj.Ind,1907-49
A1/3/76/NPG Ref. p.444

705
B97
NCFA
v.42

I.G.1

Esdaile, Katharine A.
Roubiliac and Rysbrack

In:Burl Mag
42:157-9 Apr.'23 illus.

Attribution changes from Rysbrack to Roubi-
liac and conversely from Roubiliac to Rysbrack
Repro.incl.:Bust of Charles I by Roubiliac.
Shakespeare by Roubiliac.Sir Hans Sloane by
Rysbrack

AP
1
S72
NPG

I.G.1

Gold, Sidney M.
A study in early Boston portrait attribu-
tion. Augustine Clement,painter-stainer of
Reading,Berkshire,and Massachusetts Bay
In:Old Time NE
58,no.3:61-78 Winter, '68 illus.

Green,S.M. Engl.origins of
N.E.ptg.In:Winterthur Conf.
ND207/W78/1971,p.60

AP
1
A51
A64
NMAA
v.19

I.G.1

Fleischer, Roland E.dward, 1928- ,
Gustavus Hesselius and Penn family portraits;
a conflict between visual and documentary evi-
dence

In:Am.Art J.
19,no.3:4-18 1987 illus.

Repro.incl.:Two Delaware chiefs.

AP
1
A64
NCFA
v.92

I.G.1

Gould, Cecil
The Raphael portrait of Julius II;problems
of versions and variants;and a goose that turned
into a swan

In:Apollo
92:187-9 Sep., '70 illus(part col.)

Re-emergence of the original portr.of Julius
II

Oberhuber,Raphael...In:Burl
Mag.113:124,footnote 4

705
B97
NCFA
v.116

I.G.1

Fletcher, John
Tree-ring dates for some panel paintings
in England

In:Burl Mag
116:250-8 May, '74 illus.

**FOR COMPLETE ENTRY
SEE MAIN CARD**

N
40.1
S9508
1986a
NPG

I.G.1

Greene, Margaret Harm
Dr.Edward Hudson and Maria Mackie Hudson:
Thomas Sully's portrait style,1810-1820. 1986
41 leaves illus.

Bibliography;Leaves 40-41
Photocopy
Masters essay-Univ.of Michigan,1986

VF in:
London
NPG

I.G.1

Gibson, Robin
The National Portrait Gallery's set of Kings
and Queens at Montacute House

In:Nat'l Trust Year Book
1:81-87 1975-76 illus.

...Tree-ring measurem'ts were applied to date
the portrs.

LC NX28.G72N3716 1975-76 **FOR COMPLETE ENTRY
SEE MAIN CARD**

AP
1
N547
NCFA
v.42

I.G.1

Hamilton, Milton Wheaton, 1901-
A new portrait of Sir William Johnson

In:N.Y. Hist.Soc.Q.
42:317-27 Oct., '58 illus.

Bibl.footnotes

705
A56
NMAA
v.126

I.C.1

Heslip, Colleen Cowles and Kellogg, Helen
 The Beardsley Limner identified as
Sarah Perkins

In:Antiques
126:548-65 Sept.,'84 illus(part col.)

705
028
NCFA
6 ser.
v.23

I.C.1

Kimball, Sidney Fiske, 1888-1955
 The Stuart portraits of Jefferson

In:Gaz Beaux Arts
6 ser.23:329-44 June,'43 illus.

Incl.:Corrections of errors in L.Park's 'Gilbert
Stuart; 1926

705
A786
NMAA
v.82

I.C.1

Homer, William Innes
 Who took Eakins' photographs?

In:Art W
82:112-9 May,'83 illus.

 Refers mainly to photographs of Walt
Whitman

mfm
345
NPG

I.C.1

Lewis, Charles Lee
 Decatur in portraiture

In:Md.Hist.Mag.
35:365-73 Dec.,1940

 Truettner.Portrs...In:Conn.
 171:272,note 2

705
A56
NCFA

I.C.1

Keyes, Homer Eaton, 1875-
 Coincidence and Henrietta Johnston

In:Antiques
16:490-4 Dec.,'29 illus(part col.)

 First portraitist in pastel in the U.S.

 Keyes searches for antecedents of H.J.

705
.C75
NCFA
v.92

I.C.1

Long, Basil Somerset, 1881-
 On identifying miniatures

In:Connoisseur
92:298-307 Nov,'33 illus.

 Critical methods of identifying English mini-
atures,chiefly of the 18th c.

 Repro.:I.Oliver,N.Hilliard,Chr.Richter,S.T.
Roche,G.Englehert,J.Smart,Jer.Meyer,A.Plimer,
J.Barry,R.Cosway,R.Drosse,N.Plimer,Wm.Wood, etc.
Almost all in Vic- toria and Albert mus.,S.
Kensington

705
A56
NCFA

I.C.1

Keyes, Homer Eaton, 1875-
 Doubts regarding Hesselius

In:Antiques
34:144-6 Sept.,'38 illus.

 Refers to exh. of 16 ptgs.by H.at Phila.
Mus.of Art,June 29-July 17,1938

 Richardson,E.P. Gust.Hess-
 lius.In:Art Q,12:226
 705.A7875 NCFA

AP
1
A51
A64
NMAA
v.15

I.C.1

Meschutt, David
 Portraits of Anthony Wayne:Re-identifica-
tions and re-attributions

In:Am Art J
15:32-42 Spring,'83 illus.

 Repro.incl.:Edw.Savage,Geo.Graham after
J.P.H.Elouis,Jean Pierre Henri Elouis,Js.Sharp-
les,Chs.W.Peale,Felix Sharples,Js.Peale

AP
1
C76
NPG
v.37

I.C.1

Kuhns, Phyllis,
 The Reuben Humphrey portraits,by P.K.,

In:Conn.Hist.Soc.B.
37:42-50 Apr.,'72 illus.

 Portrs.attr.to Richard Brunton

 Report on restoration:examination,treatment

 Winterthur Mus.Libr.
 Z5941 W78 NCFA v.6,p.230

705
B97
NCFA
v.105

I.C.1

Millar, Oliver, 1923-
 Marcus Gheeraerts the younger,a sequel throug
inscriptions

In:Burl Mag
105:533-41 Dec.,'63 illus.

 Gheeraerts's later oeuvre from 1600-1629

 Incl.list of sitters

 Strong.The English Icon
 ND1314S924,Bibl.

705
B97
NCFA
v.120

I.0.1

Murdoch, John, 1945-
Hoskins' and Crosses:Work in progress

In:Burl Mag
120:284-90 May,'78 illus.

Info.on miniatures with monograms of John
Hoskin & PC & LC of Peter & Lawrence Cross.e..
Proposes the Hoskins oeuvre should be devided
betw.the elder John H.& the younger & contribu-
tions fr.studio works & all works with PC or LC
marks should be classified together.
Bruijn Kops.In:B.Rijksmus.
30:196,note 3

I.0.1

Richardson, Jonathan, 1665-1745
The works of Jon.Richardson, containing
I.The theory of painting, II.Essay on the art
of criticism, III.The science of a connoisseur;
a new ed...Ornamented with portraits by Worlidge.
.London.T.& J.Egerton,1792

Met
171.1
R39

287 p. illus.

Forms supplement to Horace Walpole's Anec-
dotes of painters and engravers

705
B97
NCFA
v.44

I.0.1

Notes on various works of art.Bernini,Rysbrack
and Roubiliac.I.by Marguerite Devigne.
II.By Katherine A.Esdaile.III.by Margaret
R.Toynbee.

In:BurlMag
44:93-4,97 Jan,'24 illus.

I.0.1

Richter, Gisela Marie Augusta, 1882-
Who made the Roman portrait statues:Greek
or Romans ?

In:Amer.philosoph.soc.,Phila. Proceedings
95:184-208 1951

LC .Q11.P5.?

Hiesinger.Portr.in the Rom
Rsp.Bibl.In:Temporini.Auf-
stieg u.niederg....LC DG209
T36,Bd.1,T.4,p.825

705
B97
NCFA
v.113

I.0.1

Oberhuber, Konrad
Raphael and the State portrait.-I:The por-
trait of Julius II

In:Burl Mag
113:124,127-30 Mar.'71 illus.

Problems of the state portraiture.
One of the first informal portr.of the Ita-
lian Renaissance,going back to the change fr.for
mal to informal in dedication pictures of Charle
V of France
Debs,B.From eternity to
here...In:Art in Am 63:9
A footnote 9

705
A56
v.72

I.0.1

Rutledge, Anna Wells
Facts and fancy:Portraits from the Provin-
ces

In:Antiques
72:446-8 Nov.,'57 illus.

"The American look...may be anything but
American.It may be found in the work of many
a European provincial painter."
Repro.all of European paintings
Dresser.Background of Col.
Amer.portraiture ND1311.1
D77 NPG p.22 footnote

705
B97
NCFA
v.113

I.0.1

Oberhuber, Konrad
Raphael and the State portrait.-II:The por-
trait of Lorenzo de' Medici

In:Burl Mag
113:436,439-40, 443 Aug.,'71 illus(part col.

Problems of state portraiture
Re-attribution fr. Bronzino to Raphael
Portrs.of royalty in 3/4 length.origin in
France,spread to Lombardy
Sitter as representative of a specific group

705
A56
NCFA
v.104

I.0.1

Savage, Norbert .H.. and Gail Savage
J.A.Davis

In:Antiques
104:872-5 Nov.,'73 illus.

Abby Aldrich Rockefeller
Folk Art Ctr.Am.Folk portrs.
- N7593.A23 Bibl.-p.294

ND
1308
R18
NPG

I.0.1

Ramsden, E.H.
"Come,take this lute":a quest for identi-
ties in Italian Renaissance portraiture.Tis-
bury,Salisbury,Engl.:Element Books,ltd.,1983
219 p. illus(1 col.) ("A Nadder book")

Bibliography:p.207-212
Indexes

Books in print.Subject
guide,1985-86, p.4864

NP
1
N547
NCFA
v.35

I.0.1

Sawitzky, Susan
Thomas McIlworth,act.1758 to c.1769,identi-
fied by William Sawitsky and Katharine Hastings
as the painter of the Gerardus Stuyvesant group
of portraits.Rediscovered and assembled by Wil-
liam Sawitsky,1929-1944

In:N.Y. Hist.Soc.Q.
35:117-39 Apr.,'51 illus.

Incl.:Checklist of the portrs.attr.by Wm.
Sawitsky to Ths.McIlworth.-Outline of McIlworth'
life from 1757- 1769

705
C75
NCFA
v.54

I.G.1

Sée, Robert René Meyer
 Gouaches by George Chinnery

In:Connoisseur
54:141-51 July,'19 illus(part col.)

 Incl.study of the components of Ch's gou-
aches & discussion how to treat gouaches to
avoid discoloring,mildew,etc.,& possible reme-
dies for diseases.

705
B97
NCFA
v.105

I.G.1

Strong, Roy C.
 Elizabethan painting:An approach through
inscriptions - II:Hieronimo Custodis

In:Burl Mag
105:103-8 Mar.,'63 illus.

 Incl.list of sitters

705
A56
NCFA
v.95

I.G.1

Shadwell, Wendy J.
 An attribution for His Excellency and Lady
Washington

In:Antiques
95:240-1 Feb.,'69 illus.

 The mezzotints of Geo.Washington & Lady
Washington, once attr.to Chs.Willson Peale,
here attr.to Joseph Hiller,sr.

 Shadwell.Portr.engr.of Chs.
 Peale.NE50GP J6X NCFA
 p.143,note 7 (In:18th c.
 prints in Col'l America)

705
E97
NCFA
v.105

I.G.1

Strong, Roy C.
 Elizabethan painting:An approach through
inscriptions - III:Marcus Gheeraerts the young

In:Burl Mag
105:149-57 Apr.'63 illus.

Incl.list of sitters

 Gheeraerts'earlier oeuvre,1590-1600

 "In his full length portrs.....he strikes a
new and exotic note"

705
A56
NCFA
v.21

I.G.1

Snow, Julia D.Sophronia
 King versus Ellsworth

In:Antiques
21:118-21 Mar.,'32 illus.

 Repro.:incl.Daguerreotypes

 Four unsigned miniatures,f'ly given to
Samuel Lovett Waldo as Josiah Brown King's
Waldo is adduced as evidence in support of her at-
tributions.

 Sherman,F.F.,J.S.Ellsworth
 In:Lipman,Prim.ptrs.in Amer.
 ND236.L76,p.71

705
A56
NCFA
v.14

I.G.1

Tolman, Ruel Pardee, 1878-
 Attributing miniatures

In:Antiques
14:413-6(pt.1) Nov.,'28 illus.
 :523-6(pt.2) Dec.,'28 illus.

 Repro.incl.:(Gilbert Stuart by)Sarah Good-
ridge;Rbt.Field;Gilbert Stuart?;Raphaelle Peale

 Carolina Art ass.Charleston
 S.C.Miniature portr.coll.
 Bibl.,p.180

705
A56
NCFA
v.44

I.G.1

Spinney, Frank O.
 Joseph H.Davis:New Hampshire artist of the
1830's

In:Antiques
44:177-80 Oct.,'43 illus.

 List of 20 ptgs.attr.to Jos.H.Davis

 Abby Aldrich Rockefeller
 Folk Art Ctr.Am.Folk por-
 traits.N7593.A23 Bibl.p.294

705
A56
NCFA
v.27

I.G.1

Tolman, Ruel Pardee, 1878-
 The technique of Charles Fraser,miniatu-
rist

In:Antiques
27:18-22(pt.1) Jan.,'35 illus.
 :60-62(pt.2) Feb.,'35 illus.

 Careful analysis of the artist's stylistic
development

 Carolina Art ass.Charleston
 S.C.Miniature portr.coll.
 Bibl.,p.180

705
B97
NCFA
v.105

I.G.1

Strong, Roy C.
 Elizabethan painting:An approach through
inscriptions - I:Robert Peake the elder

In:Burl Mag
105:53-7 Fe.,'63 illus.

 "...In 1598 P.could be regarded as one of
the most important ptrs...in England"
 Serjeant ptr.from 1607 on

 Incl.list of sitters

705
C75
NCFA
v.171

I.G.1

Truettner, William H.
 Portraits of Stephen Decatur by or after
Gilbert Stuart

In:Connoisseur
171:264-73 Aug.,'69 illus.

 T.changes attributions & dates proposed by
Ch.L.Lewis

 see main card

705
A7875
NCFA

I.G.1

Valentiner, Wilhelm Reinhold, 1880-1958
 Isaac Luttichuys,a little known Dutch por-
trait painter

In:Art Q
1:151-2,155-8,161-2,167-8, Summer'38 illus.
171-4

 List of Luttichuys' work.established by
scholarly research.

705
A7832
NCFA

I.G.2

Breck, Joseph, 1885-1933
 The Picoroni medallion and some other
gilded glasses in the Metropolitan Museum of Art

In:Art Bull
9:3 53-6 June,'27 illus.

 Incl.forgeries

 Swindler.Ancient painting
 759.93.S97;p.461
 .Bibl.,

AP
1
J8643
NCFA
v.1

I.G.1

Weekley, Carolyn J.
 Further notes on William Dering,Colonial
Virginia portrait painter

In:J.early S.dec.arts
1:21-8 May,'75 illus.

 Abby Aldrich Rockefeller
 Folk Art Ctr.fm.folk portrs
 N7593.A23 NMAA Bibl.p.295

N
7575
F68
NPG

I.G.2

Foote, Henry Wilder, 1875-
 False faces;a study of the use and misuse
of portraits as historical documents..Boston,
Massachusetts Historical Society,1943.
 18 p.

 Reprint fr.the Proceedings of the Mass.
Historical Society,v.67

ND
207
W78
1971
NPG

I.G.1

Winterthur Conference on Museum Operation and
Connoisseurship. 17th. 1971
 American painting to 1776:A reappraisal.
Edited by Ian M.G.Quimby.Charlottesville,Publ.
for the Henry Francis du Pont Winterthur Mus.
.by.the University Press of Virginia.1971.
 384 p. illus. (Winterthur Conf.rep.1971)
 Bibl.references

 Incl.articles on Am.portrs.,17-18th c.,and
on technical aids for identification

LC ND207.W5 1971

I.G.2

Foskett, Daphne
 Collecting miniatures...Woodbridge,Eng.,
Antique Collectors' Club,c.1979
 498 p. illus(part col.)

 Bibliography p.476-81
 Incl.:Index

 Ch.12:Fakes,forgeries & facts,p.465-75

 N.Y.(city)P.L.Art & architect.
 div.Bibliographic guide to
 art & architecture 1980
 Z5939.A791 NCFA Ref..p.282

757.0974
.W92

I.G.1

Worcester art museum, Worcester,Mass.
 17th century painting in New England;a cat.
of an exhib.held at the Worcester art mus. in
collaboration with the American antiquarian soc.
July and August,1934,comp.& ed...by Louisa Dres-
ser...with a laboratory report by Alan Burroughs
Worcester,Mass....1935
 187 p. illus.

 Includes bibliographies

 Contents.-Rise & development of art in the
Mass.bay colony.-
LC ND1301.W6 continued on next card

ND
1337
07F74m
1987
NPG
Ref.

I.G.2

Foskett, Daphne, 1911-
 Miniatures:dictionary and guide.Printed in
England by the Antique Collectors' Club Ltd.,
1987
 702 p. illus(part col.)

 Index
 Bibliography,p.683-5

 Incl.:Fakes,forgeries & Facts,Ch.XII

I.G.2. FORGERIES

I.G.2

Garrucci, Raffaele, 1812-1885
 Vetri ornati di figure in oro trovati nei
cimiteri cristiani di Roma.Raccolti e spiegati
2nd ed.Roma,Tipografia delle belle arti,1864
 285 p. illus.

 Incl.forgeries

LC NK5108.G3 1st ed.1858 Breck.Art Bull.9:353
MB DDO PPD NN NJP 705.A7832
 Swindler.759.93.S97,p.461

N
7593
H32
NPG

I.G.2

Hart, Charles Henry, 1847-1918
 Frauds in historical portraiture,or spurious
portraits of historical personages. Washington,
American Historical Association,1915
 p.85-99

 Reprinted fr.the Annual report of the Ameri-
can Historical Association for 1913,v.1

949
1296.3
R65X
NPM

I.G.2

Roman portraiture,Ancient and modern revivals
 .exh.,Jan.28-Apr.15,1977,at,Kelsey Mus.of
Archaeology,the univ.of Michigan,Ann Arbor
The Museum,c.1977
 41 p. illus.

 Edited by Elaine Kathryn Gazda

 Incl.bibliographical references

 Incl.copies and forgeries
 Crawford.Physiognomy...
 In:Am.Art J.,v.9:60 May,'77

705
B97
NCFA

I.G.2

Hill, George Francis, 1867-1948
 Notes on Italian medals

In:Burl Mag
9:408-12 Sept.,'06 illus.
10:384,387 March,'07 "
12:141-50 Dec.,'07 "
13:274-86 Aug.,'08 "
14:210,215-7 Jan.,'09 "
15:31-2,35 Apr.,'09 " Wax models
 94,97-8 May,'09 "
16:24-6,31 Oct.,'09 " Frauds of 16-17th c.

I.G.2

Vopel, Hermann
 ...Die altchristlichen goldgläser.Ein beitrag
zur altchristlichen kunst-und kulturgeschichte
Freiburg,i.B.,Mohr,1899
 116 p. illus. (Archäol.studien zum
christlichen altertum & mittelalter,no.5)

F000
AndH

 Incl.forgeries

 Brock.In:Art Bull.9:353
 705.A7832

I.G.2

Jean Millette

In:Collector
47,no.12:121-2 Oct.,'33

 Adolph Buhler,Paris bought M.'s silhouettes
in 1890
 Catalogue of American Portrait has xerox
copy of article.
 The Nat'l Portr.Gallery's curatorial staff
regards .M.'s.silhouettes as...colonial revival
"fakes".

DCL

CT
275
W31W2

I.G.2

Walter, James
 Memorials of Washington and of Mary...,and
Martha...from letters and papers of Rbt.Cary
and Js.Sharples...portraits by Sharples,and.
Middleton.N.Y.,C.Scribner's sons,1887
 362 p. illus.

 NPG copy contains reprint of Boston Post,
Feb.,2,1887 & clippings:letters by Wash.,Bryant
Longfellow,Hawthorne,etc.,quoted by Walter de-
clared spurious'

 Weddell.A mem'l vol.of Va.
 hist.portraiture.757.9.W3
 NCFA Bibl. p.439

VF
Por-
traiture

I.G.2

London prints libeled patriots;series of por-
 traits of Revolutionary leaders were fic-
 ticious likenesses

In:Ar.Coll.
3,no.12:1 May 30,1935
 :5,11

LC NK1125.A15 Winterthur Mus.Libr. fZ881
 W78 NCFA v.6,p.223

I.G.3. MUTILATION (VANDALISM)

QNC
910
M15
NPG

I.G.2

McKechnie, Sue
 British silhouette artists and their work,
1760-1860...Totowa,N.J.,Sotheby Parke Bernet,
1978

 Incl.ch.on techniques,copies and fakes,p.9-
33

 FOR COMPLETE ENTRY
 SEE MAIN CARD

705
A56
NCFA
v.112

I.G.3

Grote, Susy Wetzel
 Engravings of George Washington in the
Stanley deForest Scott collection

In:Antiques
112:128-33 July,'77 illus.

AP
1
W78
NCFA
v.14

I.0.3

Holzer, Harold
 How the printmakers saw Lincoln.Not-so-
honest portraits of "Honest Abe"

In:Winterthur Port
14:143-70 Summer,'79 illus.

 Incl.:altered plates

VF
Por-
traiture

I.0.3

London prints libeled patriots;series of por-
 traits of Revolutionary leaders were fic-
 ticious likenesses

In:Am.Coll.
3,no.12:1 May 30,1935
 :5,11

LC NK1125.A15 Winterthur Mus.Libr. fZ881
 W78 NCFA v.6,p.223

AP
1
W78
v.6
NCFA

I.0.3

Kaplan, Milton, 1918-
 Heads of States

In:Winterthur Portf.
6:135-150 illus.

 Altered plates

 Repr.All of prints in the LC

I.0.3

Reaves, Wendy Wick, 1950-
 Heroes,martyrs and villains;printed por-
traits of the Civil War

In:Print Council of America.Newsletter 1983
 :8-12 Spring 1983,no.5

 Pertains to exh.in the NPG,Sept.10,'82-
Apr.3,'83
 Printed portrs.,sometimes based on photo-
graphs,were published as propaganda & as news.
Sometimes different heads were substituted on
the same body.

705
C75

I.0.3

Latham, H.M.
 Some altered mezzotint portraits

In:Conn.
91:37-41 Jan.,1933 illus.

 Examples of alterations for economical rea-
sons & to fill the demand of the time

 Repro.incl.John Smith,J.Faber,John Johnson,
Val.Green

 Th.-B.-Smith,John Lit.

I.G.4. CONSERVATION (X-RAY, etc.)

NE
265
L42
NCFA

I.0.3

Layard, George Somes, 1857-1925
 Catalogue raisonné of engraved British
portraits from altered plates, ...,arranged by
H.M.Latham,with an introduction by the Marquess
of Sligo. London,P.Allan & co.,ltd.,1927.
 133 p. illus.

 Marquess has c.60 sets in her collection

LC NE265.I3

705
C75
NCFA
v.54

I.G.4

Sée, Robert René Meyer
 Gouaches by George Chinnery

In:Connoisseur
54:141-51 July,'19 illus(part col.)

 Incl...discussion how to treat gouaches to
avoid discoloring,mildew,etc.,& possible reme-
dies for diseases

I.0.3

Layard, George Somes, 1857-1925
 The headless horseman,Pierre Lombart's en-
graving,Charles or Cromwell?...with an intro.
by Campbell Dogson...London,P.Allan & co.,1922
 125 p. illus.

 7 states of an engr.,3 with Cromwell's head,
1 with the head of Charles I,2 with the head of
Louis XIV,1 without head;after v.Dyck's eques-
trian portr.of Charles I.
 cf.Connoisseur bookshelf in Conn.63:247,
Aug.,'22:'...L.contends that Lombart never in-
tended to produce a portr.of Charles I
LC NE650.L4L3

I.H. INTELLECTUAL CONCEPTS

I.H.1. GENERAL (including the uses of portraits, portraits as historical document)

VF
NPG

I.H.1

Berlin. Staatliche museen. Kupferstichkabine?
 Ruhm des portrÄts.Nanteuil und der franzö-
sische portrÄtstich im Grand Siècle 1600-1750.
Sonderausstellung,1976.Text:Ekkehard Mai.Berlin
1976
 4 p. illus.

 125 portrs.exhibited
 Article is grouped:.The period;Portrait;
Nanteuil and the printmakers(Morin,Mellan,Bosse
Masson,Drevet;a.o.)
 ".Above all portraiture became,next to his-
torical ptg.the instrument of political
propaganda..."-Ma.

I.H.1 GENERAL INCL.PORTRS.AS HISTORICAL DOCUMENT
 THE USES OF PORTRS.

N
7580
B82
NPG

I.H.1

Breckenridge, James Douglas, 1926–
 Likeness; a conceptual history of ancient portraiture, by
James D. Breckenridge. Evanston ¡Ill.¡ Northwestern
University Press, 1968 ¡*1969¡

 xvi, 203 p. illus. 26 cm.

 Includes bibliographical references.

 1. Portraits, Ancient. 2. Title.

N7580.B7 731.7'4 68-29825
 MARC
Library of Congress ¡12¡

ND
1300
A98
NPG

I.H.1

Aymar, Gordon Christian, 1893–
 The art of portrait painting;portraits
through the centuries as seen through the eyes
of a practicing portrait painter...Philadelphia,
Chilton Book Co..1967.

 337 p. illus(part col.)

LC ND1300.A9

705
G28
NCFA

I.H.1

Breckenridge, James Douglas, 1926–
 Portraiture and the cult of the skulls

In:Gaz Beaux Arts
6eper.63:275-88 May-June,'64 illus.

 Defines the concept "portrait".Quotes
Schweitzer's complex definition.
 The earliest occurrence of "portraiture" is
ca.7000 B.C.:skulls modelled over to simulate a
fully formed human head.
 Bibliography Breckenridge.Likeness
 N7580•B92p.270,1

N
7575
B4x
NPG

I.H.1

Benkard, Ernst, 1883–
 Das selbstbildnis vom 15.bis zum beginn des
18.Jahrhunderts. Berlin,H.Keller,1927

 ¡82¡58 p. illus(101 pl.)

 First monograph on s.p..says Benkard..Begin-
ning & causes.Historical problem linked to socio-
logical events.Trends of time & circumstances
show in s.p.
 Contents:Das problem.Unfreiheit.Entfaltung.
Soziale emancipation.Emancipation des gefühls.
LC N7575.B4 Goldscheider 757.C52

I.H.1

Brückner, Wolfgang, fl.1958–
 Bildnis und brauch.Studien zur bildfunk-
tion der effigies(Berlin)E.Schmidt(1966)
 361 p. illus.

 Bibliography

 Revision of Habilitationsschrift Frankfurt
 ¡a.M

 Schoch.D.Herrscherbildnis..
LC QR600.B75 ND1313.5.S36I NPG p.204(9)

705
M18
NCFA

I.H.1

Benson, E.M.
 Problems of portraiture

In:Mag.of Art
30,no.11,supplement:1-28 Nov.,1937 illus.

 1300 BC - 20th c.
 Psychology or document. Sitter's point of view;
Artist's point of view; Concerning method & tech-
nique; Photography & film & their relation to the
plastic arts; Portraiture:its present and future
 Also published as ˉ separate pamphlet

AP
1
A51A64
NºAA
v.18

I.H.1

Bumgardner, Georgia Brady
 Political portraiture:Two prints of Andrew
Jackson

In:Am Art J
18,no.4:84-95 1986 illus.

 Engr.by Jd.Barton Longacre in 1828.
'The motives behind its publications were politi-
cal'.-Lithograph by the Pendleton firm,1832,
'created in the context of political events'.

I.H.1

Calas, Nicolas
Confound the wise.N.Y., Arrow editions,1942
275 p. illus.

Bibliographical notes

"All the essays in this book deal with spe-
cific problems of the time and space associat'n
of images"(p.9)

The salutary image p.191-231,portraits.

LC RH301.S75C3 ◯ MOMA p.433, v.11

N
7575
F68 I.H.1
NPG
Foote, Henry Wilder, 1875-
False faces;a study of the use and misuse
of portraits as historical documents.,Boston,
Massachusetts Historical Society,1943,
18 p.

Reprint fr.the Proceedings of the Mass.
Historical Society,v.67

�− ◯

705
A64 I.H.1
NCFA
v.73 Carter, Charles
A gallery of artists' portraits. A yardstick
of taste

In:Apollo
73:3-7 Jan,1961 illus.

Repro:Drgs.by Sambourne:Royal Academy banquet,1881,
Royal Academicians,1884. Self-portrs.by Frith,
Sargent,Tenniel. Sir John Everett Millais

Enc.of World Art,v.11,
⌐ col.514.N31E56 Ref.
⌐ bibl.on portr.

I.H.1

Gercke, Alfred, 1860-1922
Über deutung von porträts

In:Archäologischer Anzeiger
:cols 55 ff. 1890

LC DE1.A6 ◯ Richter,G. Portrs.of the
Greeks N7586R53,v.3,p.297

I.H.1

Castiglione:the ideal and the real in Renaissance
culture.Edited by Rbt.W.Hanning and David
Rosand.New Haven and London,Yale Univ.Press,
1983
215 p. illus.
Ch.6:Rosand,David.The portrait,the cour-
tier and death
Discusses the Renaissance portr.as a com-
memorative art,which finds in its develop-
ment its inspiration in antiquity
Portrs.within portrs,figs.2 & 10

LC BJ1604.C33C37 1983 ⌐ Woods-Marsden In:Art J.
46:215 note 31

705
A784 I.H.1
NCFA
Goldin, Amy
The Post-perceptual portrait

In:Art in Am
63:79-82 Jan.-Feb.,'75 illus.

"In its recent expansion into psychological &
narrative areas,Conceptual art has been drawn
back to the magnetic theme of human likeness.
While these examples are not portrs.in any tra-
ditional sense,they deal with appearance and/or
personality,showing that the impulse to depict
people persists even in seemingly inhospitable
forms."

I.H.1

Cust, Lionel Henry, 1859-1929
Portraits as historical documents

In:Saint George
8 20pp. 1905

LC HN381.S2 V.& A-Cust in v.2,p.743

◡

705
028 I.H.1
NCFA
v.53 Fournier, Fernand
Portrait anonyme et "portrait parlé"

In:Gaz Beaux Arts
53:345-50 May-Jun,1959 illus.

"...One may apply to the identificat:
ptd.portrs.,,,the scientific methods used
Criminal Records office...These methods
in late 19th c. by Alphonse Bertillon...
anthropometry."

⌐ Enc.of World A:
.31E56Ref.v.11,col

I.H.1

Deckert, H.ermann Joachim,1899-,
Zum begriff des porträts

In:Marburger Jahrb.für Kunstw.
5:261-82 1929

LC N9.M3 Enc.of World Art
N31E56Ref.v.11col.512
bibl on portr.

N71
C64X I.H.1
NCFA
Gombrich, Ernst Hans Josef, 1909-
The mask and the face:The perception of
physiognomic likeness in life and in art

In:Art perception and reality.M.Mandelbaum,ed.
Baltimore,J.Hopkins university press,1972
(Alvin & Fanny Blaustein Thalheimer lect.1970
pp.1-46 illus.

Discusses whether there can be an underlying
identity in the changing facial expressions
caused by emotions & by aging.-"Empathy plays a
part in the portr artist's response"(p.40)

LC N71.G64 ⌐ Kuspit.Art in Am 63:61

I.H.1

Grouvel, Mme.
L'iconographie des reines de France au 17ᵉ siècle

Met
100.54 In:B.Mus.France
M973 11:36-8 1946,no.6-7 illus.

LC N2B94

FOR COMPLETE ENTRY
SEE MAIN CARD

I.H.1

Hoop Scheffer, Dieuwke de
Vorstenportretten uit de eerste helft van
de 16de eeuw;houtsneden als propaganda...Amster-
dam,1972?
72 p. illus.

Cat.of exh.held at Rijksprentenkabinet,
Rijksmuseum,Amsterdam,Aug.16-Oct.20,1972

Bibliography

LC NE219.2.M4A574

I.H.1

Hartlaub, Gustav Friedrich, 1884-
Gestalt und gestaltung;das kunstwerk als
selbstdarstellung des künstlers,.von.G.F.Hart-
laub.und.Felix Weissenfeld..Krefeld.Agis.1958.
143 p. illus(part col.)

Bibliography

FOGG
FA 167.23.5

Fogg,v.11,p.323

705
G28
NCFA I.H.1
v.58
Jouan, Andrée
Thomas de Leu et le portrait français de
la fin du 16ᵉ siècle

In:Gaz Beaux Arts
58:203-22 Oct,'61 illus.
Summary in English
Chronological arrangement of more than 200
portrs of de Leu's engravings.Info.on how portr.
engravers proceeded to work,on the selling of
their prints & their utility in the study of ptgs
of that period. Eller.Kongelige portr.male-
re p.154

I.H.1

Hartlaub, Gustav Friedrich, 1884-
Das selbstbildnerische in der kunstgeschich-
te

In:Z.f.Kunstwiss.
9:97-124 1955 illus.

The change in the trend of the self-portrait
fr.15th c.to the present
Repro.:Filippo,Filippino Lippi,Perugino,
Delacroix,Feuerbach,Hans Thoma,Karl Haider

LC N3255

Rep.1955#860

I.H.1

Keller, Ulrich
Die deutsche portraitfotografie von 1918
bis 1933,p.37-66

In:Beiträge zur geschichte und aesthetik der
fotografie.Contributions to the history and
aesthetics of photography.Giessen,Anabas,1977
96 p. illus.

LC TR185.K39

Rila IV/Z 1978 #77

N
5760
K92
NCFA I.H.1

Heintze, Helga von
Römische bildniskunst

In:Kraus, Theodor.Das römische weltreich.Pro-
pyläen Kunstgeschichte II.Berlin,...1967
p.248-66 illus(part col.)

In portrs.of the 1st c.B.C.varied compo-
nents dominate:hellenistic,italic,the ancestor
portr.,the mask,till they become expressions of
court art in the Augustan per.,serving propa-
ganda first, then only individuality.

LC N5760.K7

I.H.1

Kuhirt, Ulrich
Vom bürgerlichen zum sozialistischen bildnis

In:Bild.Kunst
9:457-61,498 1968 illus.

The evolution of the portrait,especially
in E.Germany

IU MH WU Die 20er jahre im portr.
LC N3.B53 N6868.5.K9297 MPO,p.138
 also in Rep.1968#11679

705
A784
NCFA I.H.1

Henry, Gerrit
The artist and the face:A modern American
sampling

In:Art in Am
63:34-41 Jan.-Feb.,'74 illus.(part col.)

Interviews with 10 artists"suggest that all
employ portr.making as a means to an end...They
use the portrayal of others as a means of dis-
placed self-portraiture."
Artists interviewed:Elaine de Kooning,
Geo.Segal,A.Katz, Ph.Pearlstein,A.Leslie,R.Bleigh,
Geo.Schneeman,A. Leon Golub,M.Storrs,Ch.Close

705
A784
NCFA I.H.1
v.63
Kunzle, David
Uses of the portrait:The Che poster

In:Art in Am.
63:66-73 Sept.,'75 illus(part col.)

The Cuban posters provide special psycholo-
gical forms.They are intended to form a revolu-
tionary consciousness which is morally motivated
& internationally dedicated.They embrace styles
fr.Pop art to Neo-Art Nouveau,but exclude Soviet
& Chinese Socialist Realism.

I.H.1

Laskin, Myron, 1930-
The concept of portraiture in the Middle Ages from the Early Christian through the High Gothic..Cambridge,Mass.,,1952
96 p. illus.

Thesis,April,1952

FOGG
985
L34

Fogg,v.11,p.323

AP
1
A51464
NMAA
v.15

I.H.1

Miles, Ellen G.
Portraits of the heroes of Louisbourg,1745-1751

In:Am Art J
15:48-66 Winter,'83 illus.

Bibl.notes
Repre.incl.:John Smibert,Ths.Hudson,Rbt. Feke;Mezzotints by Peter Pelham,John Faber and Js.McArdell

I.H.1

London. National Portrait Gallery
Felix H.Man:reportage portraits 1929-76. Exh.1 Oct.,1976-2 Jan.,1977.Cat.text by Felix H.Man
17 p. illus.

Bibliography

74 works shown
'Photographs taken with the aim of portraying the sitters spontaneously...Artists,writers musicians,politicians...'-Rila

LC TR681.F3M36 Rila III/1 1977 # 2888

F
158.65
I 3778
NPG

I.H.1

Milley, John C.
Portraiture:Commemorative and symbolic

In:Treasures of Independence:Independence National Historical Park & its collections,p.151-70 & notes p.179-80 illus(part col.)

Bibl.:Painted & Printed material,p.185-7

Incl.Chs.Willson & Rembrandt Peale's "museum portrs.":bust portrs.;and commissions of private nature Miles.In:Am Art J,15:64
 footnote 4

Vr
Por-
traiture

I.H.1

London prints libeled patriots;series of portraits of Revolutionary leaders were fictious likenesses

In:Am.Coll.
3,no.12:1 May 30,1935
 :5,11

LC NK1125.A15 Winterthur Mus.Libr. fZ881
 W78 NCFA v.6,p.223

N
40.1
P352
Alp
R B
NCFA

I.H.1

Peale, Rembrandt., 1778-1860 comp.
Portfolio of an artist..Philadelphia,Henry Perkins,Boston,Perkins and Marvin, 1839
263 p.
.An anthology of writings which interested R.P..

Writings on portraiture by B.Cornwall,p.21, 72,99-100;by Wm.Cox,p.38-9;by M.A.Shee,p.62;by A.Cunningham,p.72;by J.D'Israeli,p.151;By J. Beattie,p.169;anonym.p.89,p.219-220 on Peale's Washington

LC PR 1109.P43

I.H.1

Mai, Ekkehard
Le portrait du roi.Staatsporträt und kunsttheorie in der epoche Ludwigs XIV;zur gestaltikonographie des spätbarocken herrscherporträts in Frankreich.Bonn,1975

LC ND1316.3.M34 FOR COMPLETE ENTRY
 SEE MAIN CARD

AP
1
A784
J8
NCFA

I.H.1

Phillips, Claude, 1846-1924
Great portrait-sculpture through the ages

In:Art J
:10-18,129-37,355-61 1903 illus.

Defines the essentials of monumental & intimate portr.sculpt.& their differences.Relationship with portr.ptg.& the characteristics of differences in aims & results.
From antiquity to 19th c.Repro.incl.:Antiquity,Sluter,J.D.Quercia,Donatello,Mino da Fiesole, Houdon,Leoni,Pilon Schlüter,Puget,Caffieri, Rodin

AP
1
J86
NCFA
v.20

I.H.1

Martin, F.David
On portraiture:Some distinctions

In:J.Aesthetics
20:61-72 Fall,'61 illus.

1.Portn,type & imaginary features.-2.Portraiture & non-portraiture.-3.The face,the mask & the effigy.-4.The character,mask,and effigy portrait. 5.Idealized & descriptive portraiture.

Breckenridge.Portr.& the cult of skulls.In:Gaz Beaux Arts.63:285;1:4

705
A787
NCFA
v.36

I.H.1

Porter, Fairfield
Speaking likeness

In:Art N Annual
36:40-51 Oct,'70 illus(part col.)
The issue is called "Narrative Art"

Under the title:"In its emphasis on particularity,on the individual sitter as well as on the individual work,portraiture reveals the weakness of modern dogma."

 MOMA,v.11,p.431

CJ
5807
P97
NPG

I.H.1

Prucha, Francis Paul
 Indian peace medals in American history.
Madison,State Historical Society of Wisconsin,
1971
 186 p. illus.

 Bibliography:p.165-72
 Repro.incl.:Geo.III;Chs.IV;'Presidential
series';Ptgs.by Catlin & by Samuel M.Brookes &
drawg.by St.-Mémin & photographs of Indians
wearing the medals.

705
G28
NMAA
v.99

I.H.1

Smith, Jeffrey Chipps
 Jean de Maisoncelles' portrait of Philippe
Le Bon for the Chartreuse de Champmol.A study
in Burgundian political symbolism

In:Gaz.Beaux-Arts
99:7-12 Jan.,'82 illus.

 '...it is a political image. Ph.is
dressed in his Toison d'or robe...He is crowned'

I.H.1

Reaves, Wendy Wick, 1950-
 Heroes,martyrs and villains;printed por-
traits of the Civil War

In:Print Council of America.Newsletter 1983
:8-12 Spring 1983,no.5

 Pertains to exh.in the NPG,Sept.10,'82-
Apr.3,'83
 Printed portrs.,sometimes based on photo-
graphs,were published as propaganda & as news.
Sometimes different heads were substituted on
the same body.

NX
650
M3S713
NPG

I.H.1

Sorell, Walter, 1905-
 The other face;the mask in the arts.Indi-
anapolis,Bobbs-Merrill.1973.
 240 p. illus(part col.)

 Bibliography

705
A784
NCFA

I.H.1

Rose, Barbara
 Self-portraiture:Theme with a thousand faces

In:Art in Am
63:66-73 Jan.-Feb.,'75 illus(part col.)

 Self-portrs.record the artist's subjective
feelings abt.himself. He sees himself as Thinker
or Worker;equal to Royalty;devinely guided;Mar-
tyr or Madman,etc.

AP1
C912
NCFA
v.7

I.H.1

Sparre, Louis, 1863-
 .Views on portraiture.

In:Creative Art
7:270-5 Oct.,'30 illus.

 Cumulated Mag.subj.index
 A1/3/C76 Ref. v.2,p.444

705
A63
NCFA
v.38

I.H.1

Sager, Walter de
 Historic portraits.Hanoverian likenesses
of 17th and 18th centuries

In:Ant.collector
38:66-73 Apr/May,'67 illus(part col.)

 Repro.:Honthorst,Hannemann,Scheits,Vaillant,
Kneller,Rigaud,Tischbein,v.Douven,Pesne,Batoni,
Zoffany

LC NK1125.A28 Eller.Kongel.portr.malere
 p.518

705
A784
NCFA

I.H.1

Steinberg, Leo, 1920-
 Pontormo's Alessandro de'Medici,or,I only
have eyes for you

In:Art in Am
63:62-5 Jan.-Feb.,'75 illus.

 Hypothesis that Pontormo's portr.of the
duke,drawing a lady,was used as a gift of devo-
tion;in contrast to political representation
for propaganda purposes

ND
1313.5
S36X
NPG

I.H.1

Schoch, Rainer
 Das Herrscherbildnis in der malerei des
19.jahrh.München,Prestel-Verlag,1975
 366 p. illus. (Studien zur Kunst des
19.Jahrh.,23)
 Bibliography
 Index of persons

 Royalty during Absolutism,the Enlighten-
ment,the Restoration,the reigns of Napoleon I,
Queen Victoria,Napoleon III & the German mo-
narchs
 Representa- tion & propaganda.
 Rila II/1 1976 *2107

NB
1310
T68
NPG

I.H.1

Toronto. Royal Ontario Museum. Art and Archae-
ology Division
 Masks,the many faces of man.An exh...,Feb.11
to April 5,1959.Toronto:1959:
 .79.p. illus.

LC NB1310.T6

I.H.1

Vollenweider, Marie Louise
Verwendung und bedeutung der porträtgemmen
für das politische leben der römischen republik

In:Museum Helveticum
12?:96-111 1955

LC PA3.M73

Hiesinger.Portr.in the Ro-
man Republ.LC DG209.T36
Bd.1,T4,Bibl.p.821

705
C69
NMAA
v.46

I.H.1

Woods-Marsden, Joanne
"Ritratto al Naturale":Questions of realism
and idealism in early Renaissance portraits

In:Art J.
46,no.3:209-16 Fall,1987 illus.

The"true likeness"had to be presented under
idealized guise. Comparison of portrs.in ptg.,
relief,medals. Discussion of use of portrs,p.213

N
7618
W211
NCFA

I.H.1

Wallis, Mieczyslaw
Autoportret. Warszawa,Wydawn.Artystcznz e
Filmowe,1964
157 p. illus.

English and Russian summaries

Bibliography

Author points out the differences of self-
portrs.with all other portrs.& carries on Waet-
sold's,Benkard's & Goldscheider's investigations
into this "extremely complex phenomenon."

NC
1473
W95
1867
NPG RB

I.H.1

Wright, Thomas, 1810-1877
Caricature history of the Georges.London,
J.C.Hotten,1867,
639 p. illus.
—— Same .New York,
Benj.Blom,1968

1st ed.1848

ca.400 illus.on steel & wood

705
028
NCFA
v.37A

I.H.1

Wildenstein, Georges
Le goût pour la peinture dans la bourgeoisie
parisienne au début du règne de Louis XIII.

In:Gaz Beaux Arts
37A:153-273 Oct-Dec,'50 illus.

1627 is the beginning of a new epoch in art
& of taste in France

List of Royal portrs.,p.194-203,Diverse portr
p.204-07

I.H.1

Zinger, Leonid Semenovich
O portrete;problemy realizma v iskusstve
portreta....Moskva,Sovetskii khudoshnik,1969.
463 p. illus(part col.)

Bibliography

LC N7575.Z5

Fogg,v.11,p.326

705
028
NCFA
v.38A

I.H.1

Wildenstein, Georges
Le goût pour la peinture dans la bourgeoisie
parisienne entre 1550 et 1610,d'après des inven-
taires après décès conservés au Minutier central
des Archives Nationales.

In:Gaz Beaux Arts
38A(6th ser):11-343 Jul-Dec,1951 illus.

Les portraits:pp.39-46

I.H.2. AESTHETICS

705
028
NCFA
v.48

I.H.1

Wildenstein, Georges
Le goût pour la peinture dans le cercle de
la bourgeoisie parisienne autour de 1700

In:Gaz Beaux Arts
48(6th ser):113-94 Sep,1956 illus.

Le portrait p.118-21. Repro.of engravings of
lost ptgs,which were bought solely for the sub-
ject matter.No interest in the artist. List of
some of the consulted inventories.Index of sit-
ters.Chronological list of inventories.Index of
cited names.Index of professions
Enc. of World Art.N31E56Ref.
v.11,col.514

I.H.2

Bohne, Friedrich ed.
Der Deutsche in seiner karikatur;hundert
jahre selbstkritik;kommentiert von Thaddäus
Troll.Mit einem essay von Theodor Heuss.Klagen-
furt,Kaiser,1967
193 p. chiefly illus..

"Zur Ästhetik der Karikatur"von Theod. Heuss
p.169-90

Thaddäus Troll pseud.for Hans Bayer

LC NC1500.B6

Rep- 1967 #1136

701
.081
I.H.2.

Greene, Theodore Meyer, 1897-
The portrayal of individuals in sculpture
and painting, and the rôle of specificity in art

In.his.The arts and the art criticism.Princeton,
Princeton uni.press,1940. 690 p. illus.
ch.18,pp.296-304

Definition of portraiture;Nature of portrai-
ture;Intent of portraitist
Human portraiture;Religious reverence;Social
interest;Reflective contemplation
N.Y.,MOMA.20th c.portrs.by
LC N66.0r4 M.Wheeler.N7592.6N53NPO.
Bibl.

I.H.2

Richardson, Jonathan, 1665-1745
An essay on the theory of painting. London,
1715, another edition 1725

Universal catal.Books on
art,v.II

British museum
London Institution quoted in Haka,H.M.The Engl
historic portr...p.145
LC /S122.I5 1943 see over

I.H.2

Kraemer, Paul, 1876-
Beitrag zum problem der porträtdarstellung.
Eine aesthetische studie...Gernrode(Harz),H.
Klöppel,1900

46 p.

Inaug.Diss.-Jena,1900

LC in 1942 ed.v.82
no call no. Waetzold ND1300.W12

ND
1300
W12
NCFA
I.H.2

Waetzoldt, Wilhelm
Die kunst des porträts.Leipzig,F.Hirt
& Sohn,1908
451 p. illus.

"Dieses Buch möchte als ein Beitrag zur
Ästhetik der Malerei betrachtet werden."

Bibliography

LC ND1300.W3

I.H.2

Krestovskaíã, Lidiíã Aleksandrovna
(Krestowsky, Lydie, 1889-)
La laideur dans l'art, à travers les âges.
Paris,éd.du Seuil.1947,

284 p. illus.

Ket
100.1 (Pierres vives,3) Bibliography
K88 Incl:Callot,Ensor,Bosch,Rouault,Toulouse,
Redon,Rops

Yale univ.library for
LC Rep.,1945-47=873

I.H.2

Woolnoth, Thomas, 1785-after 1836
Facts and faces;being an enquiry into the
connection between linear and mental portrai-
ture,with a dissertation on personal and rela-
tive beauty.?2nd ed. London, The author,1854
269 p. illus.

LC BF841.W93 V & A cat.

I.H.2

Krestovskaíã, Lidiíã Aleksandrovna
(Krestowsky, Lydie, 1889-)
Le problème spirituel de la beauté et de la
laideur. 1st ed. Paris,Presses universitaires
de France,1948

204 p.

LC BH301.U5K7

I.H.2 - 18th c.

Hogarth, William, 1697-1764
The analysis of beauty.Written with a view
of fixing the fluctuating idea of taste.London,
Printed by J.Reeves for the author,1753
153 p. illus.

LC N70.H7 1753

I.H.2

The masque of beauty....London,1969?.

MET
196.6L84
N2422

CU

920I
W516E92
NCFA
I.H.2 - 18-19th c.

Evans, Grose
Benjamin West and the taste of his times.
Carbondale,Southern Illinois University Press,
1959
144 p. illus(part col.)

Bibliography

Review by Rbt.Rosenblum in Art B.42:76-9
March,'60

LC ND237.W45E85 Whitehill.The Arts in ear-
ly Amer.Hist.Z5935.W59 KPG
Bibl.,p.96

I.H.2 - 18-19th c.

Steegmann, John, 1899-
 The rule of taste,from George I to George IV..
London,Macmillan & co.,ltd.,1936
 202 p. illus.

 Bibliography

Review by Charles Richard Cammell In:Conn.
98:175-6 Sep.,1936

LC N6766.S7

I.H.3. PHILOSOPHY

I.H.2 - 19th c.

Brasch, Ernst, 1901-
 Das nazarenische bildnis:ein beitrag zur
aesthetik und geschichte der porträtkunst.
Potsdam,R.Schneider,1927.
 64 p. illus.

FOGG
FA Inaug.-diss.Würzburg,1927
4353.8
 Bibliography

ICRL ICU CtY PU PPULC Fogg,v.11,p.318

701
.081 I.H.3.

Greene, Theodore Meyer, 1897-
 The portrayal of individuals in sculpture
and painting,and the rôle of specificity in art

In.his.The arts and the art criticism.Princeton,
Princeton uni.press,1940. 690 p. illus.
ch.18,pp.296-304

 Definition of portraiture;Nature of portrai-
ture;Intent of portraitist
 Human portraiture:Religious reverence;Social
interest;Reflective contemplation
LC N66.G74 N.Y.,MOMA.20th c.portrs.by
 M.Wheeler.N7592.6N53NPG.
 Bibl.

I.H.2 - 19th c.

Freund, Gisèle
 La photographie en France au 19ième siècle
étude de sociologie et d'esthétique...Paris,
Le maison des amis des livres,A.Monnier,1936
 154 p. illus.

 Thèse-Univ.de Paris

 Bibliography

 Disc.incl.the use of photography by portr.
ptrs. Scharf,A.Art & photography
LC TR71.F7 1936 N72.P5S31 NCFA p.260(14)

I.H.3

Keyserling, Hermann
 Vom ewigen der familie

In:Atlantis
 :708-15 1932 illus.

 The family & its representation in art.
Tut Ankh Amon family, Jan Mostaert, Altdorfer,etc.

LC C1A776 Rep.,1932#113

I.H.2 - 20th c.

Keller, Ulrich
 Die deutsche portraitfotografie von 1918
bis 1933,p.37-66

In:Beiträge zur geschichte und aesthetik der
fotografie.Contributions to the history and
aesthetics of photography.Giessen,Anabas,1977
 96 p. illus.

LC TR185.K39 Rila IV/I 1978 #77

AP
1
B599 I.H.3
NPG
v.6 Le Guin, Charles A.
 The language of portraiture

In:Biography
6:333-9 Fall,1983

 Examines the goals & possibilities of artists
in portraits and of authors in biography.Diffe-
rences & common problems in realizing their aims

I.H.2 - 20th c.

Spörl, Hans, 1867-
 Die porträtkunst in der photographie.Ein
lehrbuch über neuzeitliche porträtdarstellung
auf photographischem wege für fachleute und
liebhaber..I-.II.teil.Leipzig,E.Liesegangs
Verlag,M.Eger,1909
 2 v.in 1 illus.

 Contents--I.Teil,Aesthetik,124 p.,74 illus.
II.Teil,Praxis,125 p.,78 illus.

ICJ TxU Sander,August qTR647.S214
 K2 E1986 NPG,Bibl.p.62

I.H.3

Lohmann-Siems, Isa
 Begriff und interpretation des porträts in
der kunstgeschichtlichen literatur.Hamburg,
Hower verlag,1972
 147 p.

 Originally presented as the author's Thesis,
Hamburg,1972,under title:Die begriffliche Be-
stimmung des porträts in der kunstwissenschaft-
lichen literatur bis zur mitte des 20.jahrh.

 Bibliography
LC N7575.L63 1972 Die 20er jahre im portr.
 N6868.5.E9#97 NPG,p.138

I.H.3

Panofsky, Erwin, 1892-1968
.Connection between nominalist philosophy
and the emergence of individualized portraiture.

In.his.Gothic architecture and scholasticism,
Latrobe,Pa.,Archabbey Press,1951

pp-12-19

LC NA2563.P3

Sherman,Claire R. The portrs
of Chs.V of France N7628
.C4785NPG,p.3,footnote

I.H.4. PSYCHOLOGY

I.H.3

Schwarts, Marvin David, 1926-
The meaning of portraits:John Singleton
Copley's American portraits and 18th century
art theory.1954
69 p. illus.

Master's Th.-Univ.Del.,1954

Winterthur Mus.Libr.f4881
W78 NCF v.9,p.226

I.H.4.a. GENERAL (including
PATHOLOGY & PHYSIOGNOMY)

AP
1
Z48
MM'AA

I.H.3

Mannings, David
Shaftesbury,Reynolds and the recovery of
portrait-painting in 18th century England

In:Z Kunstgesch
48,no.3:319-28 1985 illus.

Discussion of two ideals in portr.ptg.:
Stoicism and sensibility

I.H.4.a GENERAL Incl.PATHOLOGY & PHYSIOGNOMY:
I.H.4.a - PHYSIOGNOMY

I.H.3

Stewart, J.Douglas
English portraits of the 17th and 18th cen-
turies,papers read...Apr.14,'73 by J.D.Stewart
.and.Herman W.Liebert.Los Angeles,Wm.Andrews
Clark Memorial Library,Univ.of Calif.,1974
v. 95 p. illus. (Wm.Andr.Clark Mem'l
Library seminar papers)

Bibliographical references

Contents:Stewart,J.D.:Pin-ups or virtues?
The concept of the "beauties" in late Stuart
portraiture
LC ND1314.3.S73 Rila I/1-2 1975 #1456

I.H.4.a

Andreola, Salvatore, 1890-
La psicologia nell'arte del ritratto.Modena,
Stabilimento poligrafico artioli.1955.
91 p. illus.

FOGG
6660.20.50

NN Fogg,v.11,p.320

I.H.3

Waetzoldt, Wilhelm
Zur philosophie des porträts

In:Berlin,Rom,Tokio
Met :p.13 no.3 1944 illus.
100.53
B45 Incl:Botticelli, Dürer
Q

North West univ.libr.for LC Rep.,1945-47*854

I.H.4.a

Berger, John
The changing view of man in the portrait

In.his.The look of things.Essays.N.Y.,Viking
Press.1974,c.1971."A Richard Seaver book".
Reprint of the 1972 ed.publ.by Penguin,Har-
mondsworth,in series:Pelican books.

LC AC8.B4737 1974 Robins,Corinne.Leon Golub:
The faces of power.In:Arts
51:111,footnote 2 Feb.'77
705 AP1 A788/NCFA

I.H.4.a

Brunswik, Egon, 1903-1955
Perception and the representative design of
psychological experiments.2nd ed. Berkeley,Univ.
of Calif.Press,1956
154 p. illus.

Bibliography

"...Study confirms the extreme sensitivity
of our physiognomic perception to small changes
of any part of the face,"-Gombrich

LC QP355.B83 1956

Gombrich.Mask & face.In:
Art,percept'n & reality
N71/C64X NCFA p.25

N
72
P74P78 Genné, Beth
v.2 Two self-portraits by Berthe Morisot.in.
NMAA Psychoanalytic perspectives on art.The Analytic
Press,1987
p.133-170 illus.

I.H.4.a

I.H.4.a

Chojecka, Ewa
Theorie und praxis des porträts der Früh-
renaissance.Die 'Phisionomia' des Johann von
Glogau(1518)

In:Jena Uni.Wiss.Z.,gesellschafts-& sprachwis-
senschaftliche Reihe,
18:177-80 1969

LC AS182.J5

I.H.4.a

George, Waldemar
L'enfant dans la sculpture et le mythe de
l'innocence

In:Formes et couleurs
8:83-90 no.4-5 1946 illus.

Egyptian,classical, medieval,renaissance and
20th c.approach

Incl.:Houdon,Ligier-Richier,Donatello,Deside-
derio,Despiau,etc.
LC N2F65 Rep.,1945-47*868

I.H.4.a

Darwin, Charles Robert, 1809-1882
The expression of the emotions in man & ani-
mals...London,J.Murray,1872

374 p. illus.
1st ed.The photographic illus.of the emotions
are by Oscar Gustav Reijlander(1813-1875)whom
Darwin commissioned.Reijlander & his wife act
the required emotions in many of the heliotypes
The publication indirectly produced a windfall

LC
QP401.D21

Waetzoldt ND1300.W12:Ger-
man translation:Ausdruck
der gemütsbewegungen...

I.H.4.a

George, Waldemar
Essai sur le portrait, suivi de quelques con-
sidérations sur l'art romain tardif et sur l'art
de ce temps

In:C.Belgique
:100-10 1931 illus.

The author thinks, that the individual has
lost his rights in our standardised world.With
their refinding the portr.could be reborn. It was
born in Roman times,has lived in begin.of Renaiss.
& had died again with Rodin.
LC DH Rep.,1931*7
682 C13 (?)

708.1
M66 I.H.4.a
NCFA
v.41 Davis, Richard S.
Loan exh. of great portraits...1952

In:B.Minneapolis I.A.
41:165-7 Nov.,'52

FOR COMPLETE ENTRY
SEE MAIN CARD

N71
C64X
NCFA Gombrich, Ernst Hans Josef, 1909-
The mask and the face:The perception of
physiognomic likeness in life and in art

In:Art perception and reality.M.Mandelbaum,ed.
Baltimore,J.Hopkins university press,1972
(Alvin & Fanny Blaustein Thalheimer lect.1970)
pp.1-46 illus.

Discusses whether there can be an underlying
identity in the changing facial expressions
caused by emotions & by aging.-"Empathy plays a
part in the portr aitist's response"(p.40)
LC N71.C64 Kuspit.Art in Am 63:61

I.H.4.a

I.H.4.a

Franceschini, G.
La psicologia dell'autoritratto in arte

In:Emporium
27:442-57 1908

LC AP37.E5

Prinz.Slg.d.selbstbildnisse
..N7618P95,bd.1 NPG p.147,c
note 57

796
596 I.H.4.a
NCFA
Gordon, Jan
"Psychologics" in portrait painting

In:Studio
122:153-65 Dec.1941 illus(part.col.)

Incl:Egyptian head fr.Tel Amarna;ptgs.of Hen-
ry IV,Raleigh,Velasques(?),Gainsborough,Raeburn,
van Gogh,Cézanne,Modigliani,etc.;drgs.by Holbein

Rep.,1942-44*673

705
C75
NCFA
v.99

I.H.4.a

Grant, M.H.
Medals of queer men

In:Connoisseur
99:142-4 1937 illus.

Medallions of 18th & 19th c.

Rep.,1937#362

I.H.4.a

L'identité et ses visages,..Lausanne,Le Musée
.1977.

LC N7575.I33

FOR COMPLETE ENTRY
SEE MAIN CARD

I.H.4.a

Grossmann, Rudolf, 1882-1941
Ausdrucksstudien bei den irren

In:Kunst u.K.
26:390-4 1928 illus.

Studies of physiognomy of insane people.
Prints and drags.by Rubens,Brueghel and by the
author.

LC N3.K8 Rep.,1928#56

I.H.4.a

Just, Oskar illus.
Nordisches blutserbe im süddeutschen
bauerntum mit...tafeln von Oskar Just und
Wolfgang Willrich.Geleitwort von R.Walther
Darré.München,F.Rruckmann.c.1938-39.
2 v. illus(part col.)

LC DD75.J8 MOMA, p.435, v.11

I.H.4.a

Gruhle, Hans Walter, 1880-
Das porträt.Eine studie sur einfühlung in
den ausdruck.Freiburg i.Br.,Zähringer verlag,
1948
63 p.

LC ND1300.G7 Die 20er jahre im portr.
 N6868.5E9Z97 NPG,p.138

N
1165
R6A6x
NPG

I.H.4.a

London. Royal College of Surgeons of England
A cat.of the portraits...drawings and sculp-
ture in the Royal College of Surgeons of Eng-
land,by William LeFanu,librarian.Edinburgh,
E.& S.Livingstone,1960,i.e.1959.
118 p. illus(part.col.)

Bibliography

Pt.2 incl.Racial types,anomalies

LC N1165.R6A6 Yale ctr.f.Brit.art Ref.
 N1165.R6A56

I.H.4.a

Hall, Edward Twitchell, 1914-
The hidden dimension. An anthropologist
examines man's use of space in public and
private..Garden City,N.Y.,Doubleday & co.,inc.,
1966
201 p. illus.

Discusses on pp.77-8 & 87-8 spacial relation-
ships in portraiture,especially between painter,
sitter & viewer.

Bibliography

LC B F469.H3

ND
1300
L8
1985X
NPG

I.H.4.a

Lubin, David M.
Act of portrayal:Eakins,Sargent,James.
New Haven,Yale Univ.Press,c.1985
208 p. illus. (Yale publications in
the history of art,32)
Index
Bibliography,p.177-83
Examination of three major works of por-
traiture,two ptgs.& one novel,from the 1880s.
L.probes the contradiction each artist sensed
betw.masculine power & feminine passivity.

LC ND1300.L8 1985 Books in print.Subject
 guide 1985-6 v.3,p.4864

I.H.4.a

Hartmann, Wolfgang
"Face farces" von Arnulf Rainer

In:Rainer, Arnulf, 1929-
Der grosse bogen.Cat.of the exh.Apr.30-June 15
1977 in Bern,Kunsthalle
p.17-27 illus.

A summary of the history of physiognomy.
Psychology of the expressionism.Influences of
psychical realism & Vienna actionists on Rainer.
R.seen as one of the most influential artists of
the present.Photography used by painters.

I.H.4.a

Müller, Ernst, 1877-
Caesarenporträts,von dr.med.Ernst Müller.
Bonn,A.Marcus & E.Weber,1914-27
3 v. illus.

MET
617
M91

Bibliography

Pt.3 has sub-title:Beiträge zur physiognomi
ik & pathographie der römischen kaiserhäuser nach
ihren münzen & andern antiken denkmälern.

Incl.comparison of photographs of insane
people with Rome emperors.
LC no call number MH NN etc.

q.NE. I.H.4.a
261.
N37 National Museum of History and Technology
1977X Perfect likenesses.Portraits for history
NCFA of the Indian Tribes of North America
 (1837-44)..Washington,Smithsonian Insti-
 tution Press,1977.
 27 p. Cover illus.(col.)

 Catalog essays by Peter C.Marzio and Wm.
 C.Sturtevant
 Exhib.April-Sept.,1977
 30 ptgs.and 160 lithographs;ptgs.chiefly b
 Charles Bird King

 LC NE263.N37 1977

705 I.H.4.a
M18
NPG Portraits of psychotics

 In:Mag Art
 30:485-9 Aug.,'37 illus.

 Contents:1.Art & psychiatry by O.E.Benson.-
 2.Psychological interpretation by Dr.E.Schachtel-
 3.Biogr.note on the artist,Gertrud Jacob

 Psychiatric thought fertilized 20th c."isms"

 N.Y.,MOMA.20th c.portrs.by
 M.Wheeler.N7592.6N53 NPG
 Bibl.

N
72 I.H.4.a
P74P78 O'Connor, Francis V.
v.1 The Psychodynamics of the frontal self-por-
NMAA trait.in:Psychoanalytic perspectives on art.The
 Analytic Press,1987
 p.169-221 illus.

N
40.1 I.H.4.a
R463H6 Reynolds, Sir Joshua, 1723-1792
NPG Portraits;character sketches of Oliver Gold-
 smith,Samuel Johnson,and David Garrick,together
 with other manuscripts of Reynolds discovered
 among the Boswell paper....1st ed..N.Y.,McGraw-
 Hill,1952.
 197 p. illus. (The Yale editions of
 the private papers of James Boswell)

 References to sources,p.185-90

 Winterthur Mus.Libr. fZ861
 .W78 NCFA v.6,p.221

 I.H.4.a

 Ölbricht, K.-H.
 Analyse im selbstporträt oder künstlerische
 metamorphose:su den radierungen von Marwan

 In:Kunst & d.schöne Heim
 88;pt5:281-8 May,'76 illus.

 Summary in English
 M.'s self-portrs.are projections of parti-
 cular mental states.He hopes to discover him-
 self through their expressive capacity

 LC N3.K5
 Artbibl.modern,v.7,no.2
 1976 qZ5935.L105 NCFA #5647

N
6512 I.H.4.a
R82
NCFA Rosenberg, Bernard, 1923-
 The vanguard artist,portrait and self-por-
 trait,by Bernard Rosenberg and Norris Fliegel.
 Chicago,Quadrangle Books,1965
 366 p.

 Bibliographical references

 LC N6512.R67 Rep. 1966 #892

 I.H.4.a

 Pfuhl, Ernst, 1876-1940
 Die anfänge der griechischen bildniskunst.
 Munich,1927 (F.Bruckmann,A.G.) Ein Beitrag
 sur Geschichte der Individualität.
 31.p. illus.

 Essay to clarify the often anachronistic
 idea of the beginning of Individual-portraits.
 Interpretation & valuation of individuality

 Yale univ.libr. J.Walters Art gall.v.9
 Jo26/927P p.55 footnote:"basic"

705 I.H.4.a
A63
NCFA Sager, Walter de
v.38 Historic portraits.Hanoverian likenesses
 of 17th and 18th centuries

 In:Ant.collector
 38:66-73 Apr/May,'67 illus(part col.)

 Repro.:Honthorst,Hannemann,Scheits,Vaillant,
 Kneller,Rigaud,Tischbein,v.Douven,Pesne,Batoni,
 Zoffany

 LC NK1125.A28 Eller.Kongel.portr.malere
 p.518

 I.H.4.a

 Piper, David
 Personality and the portrait.London,Brit.
 Broadcasting Corp.,1973

 LC N7575.P56 FOR COMPLETE ENTRY
 SEE MAIN CARD

 I.H.4.a

 Schormer, Alberto, 1928-
 Las fotos psicológicas...Madrid,Nueva Lente
 .1975?.

 LC TR680.S313 FOR COMPLETE ENTRY
 SEE MAIN CARD

I.H.4.a

Shahn, Ben, 1898-1969
Concerning 'likeness'in portraiture

In:Nordenfalk, Carl Adam Johan, 1907-
Ben Shahn's portr.of Dag Hammarskjöld.Medde-
landen från Nationalmus.no.87.Stockholm.1962.

States the Neo-Platonic idea"...the genius'
eyes can penetrate through the veil of mere appe-
arances & reveal the truth."--Gombrich

LC N3540.A2

Gombrich.Mask & face.In:
Art percept'n & reality
N71/C64 NCFA p.2.footnote

705
M18
NCFA Wight, Frederick S.
v.44 The eclipse of the portrait.
extra copy
v.44,no.4 In:Mag.of Art
in VF 44:129-31 Apr,1951 illus.
Por-
trai- Incl:Picasso,Kokoschka,Bérard,Watkins,etc.
ture

I.H.4.a

Slater, Frank
Adventuring into portrait painting

In:Artist
18:7-8 Sep.,'39 illus(part col.)

The mental outlook of the ptr.Incl.a compa-
rison of Sargent and Sickert

LC N1.A82

N.Y.,MOMA.20th c.portrs.by
M.Wheeler N7592.6N53 NPG
Bibl.

I.H.4.a - PHYSIOGNOMY

Abraham, Pierre, 1892-
Une figure,deux visages

In:Nouv.Rev.française
:409-29,585-614 Mar & Apr.,'34

"...generally the right side of the face is the
introverted side,and the left side...the extro-
verted side..."-Abraham

LC AP20.N85

Martin.Spiritual asymmetry
in portr.Brit.J.Aesth.v.5
Xerox copy in NPG p.11
footnote 3

AP
1
A64
NCFA Strong, Roy C.
V.79 The Elizabethan malady.Melancholy in Eliza-
bethan and Jacobean portraiture

In:Apollo
79:264-84 Apr.,'64 illus(part col.)

QND
1314 Also in:Strong.The English Icon...Appendix,with-
S924 out illustrations.
NPG
Relates the cult of melancholia in late Eliz.
Engl.to moods in portraiture.

I.H.4.a - PHYSIOGNOMY

Abraham, Pierre, 1892-
...Figures;recherches sur la création intellec-
tuelle..Paris.Gallimard..c.1929.
236 p. illus. (Les documents bleus..2.sé
L'homme,no.12)

LC BF852.83

I.H.4.a

Unvergängliches Antlitz.Versuch e.dichter.s..
Deutung u.Bild-Dokumentation.Manfred H.Ruhr-
mann.Steinfeld(Eifel),Salvator-Verlag.1974.
222 p. chiefly illus.

LC TR681.F3U57

I.H.4.a - PHYSIOGNOMY

Abraham, Pierre, 1892-
...Le physique au théâtre;texte et mise en
images par Pierre Abraham.Paris,Coutan-Lambert
.c.1933.
193 p. illus. (Masques,cahiers d'art
dramatique....:XXVII.)

Includes "Le physique du comédien","Le phy-
sique du dramaturge",and "Le physique du spec-
tateur"

LC PN2071.F3A3

I.H.4.a

Waetzoldt, Wilhelm, 1880-
Die Mimik des denkens in der malerei

In:Die Kunstwelt
Jhrg.II:293ff

OC1(=Cleve.P.L.)

Schaeffer.Von Bildern
Menschen der Ren.ND615.53
notes,p.220,no.27

NC
772
A23 Adhémar, Jean
NPG Les portraits dessinés du 16e siècle au ca-
binet des estampes;.by:J.Adhémar et Christine
Moulin.Paris,Gaz.des beaux-arts,1973
104 p. illus.

Extrait de la Gaz.des beaux-arts,Paris,sept.
et décembre,1973
Repros.of almost all drags.with name of sit-
ters,date,biographical note,artist,info.given by
other catalogers(bouchot,Dimier,etc.)
Alphabetical index of sitters
Alphabetical index of artists by Bou-
chot & Dimier

I.H.4.a - PHYSIOGNOMY

"Aristoteles"
 Physiognomics

In his Minor works,with an English translation
by W.S.Hett.Cambridge,Mass.,Harvard univ.press,
1963
 [pp.83-137 in 1968 ed.]
 (Loeb classical library,Greek authors,)

 Greek & English on opposite pages

earlier ed.in LC
PA3612.A8A13 1936-
MB DNLM etc. Crawford.Physiognomy...In:
 Am.Art J.,v.9,p.49 May,'77

743.49 I.H.4.a - PHYSIOGNOMY
.B87
 Brophy, John, 1899-1965
 The human face...N.Y.,Prentice-Hall,inc.,
 1946
 250 p. illus.

LC GN64.B7 1946 Piper.The English face
 47598.2.P55X MPG Bibl.

I.H.4.a - PHYSIOGNOMY

Barth, Suse
 Lebensalter-darstellungen im 19.und 20.
Jahrhundert;ikonographische studien.Bamberg,
Aku-Fotodruck,1971
 265 p.

 Inaug.-Diss.-Munich

 Bibliography

LC N8217.A47B37 Die 20er jahre im portr,
 N6868.5.E9Z97 MPG,p.140

NC I.H.4.a - PHYSIOGNOMY
1310
P9R47 Brown University. Dept.of Art.
NCFA Caricature and its role in graphic satire;
 an exhibition ...Providence,R.I.,1971.
 120 p. illus.

 Held at the Museum of Art,Rhode Island
School of Design,Apr.7-May 9,1971

 Bibl.references.

 In the intro.are the changes of the meaning
LC NC1310.P7R472 of caricature traced through history.Differences

I.H.4.a - PHYSIOGNOMY
Bell, Sir Charles, 1774-1842
 The anatomy and philosophy of expression as
connected with the fine arts.6th ed. London,
H.G.Bohn,1872
 275 p. illus.

 Enlarged form of'Essays on the anatomy of
expression in painting'.London,Longman,Hurst,
Rees & Orme,1806

LC NC760.B5 Hirsch.Family photographs.
 TR681.F28H57X MPG Bibl.
 ,135

I.H.4.a - PHYSIOGNOMY
Brunsvik, Egon, 1903-1955
 Perception and the representative design of
psychological experiments.2nd ed. Berkeley,Univ.
of Calif.Press,1956
 154 p. illus.

 Bibliography

 "...Study confirms the extreme sensitivity
of our physiognomic perception to small changes
,of any part of the face,"-Gombrich

LC QP355.P83 1956 Gombrich.Mask & face.In:
 Art,percept'n & reality
 N71/G64X NCFA p.25

I.H.4.a - PHYSIOGNOMY
Biddle, Richard
 The delineation of character in portrait
painting

 Master's Th.-Columbus,O.S.Univ.,1935

 Lindsay,K.C. Harpur Ind.of
 Master's theses in art...
 Z5931.L74 1955 MCFA Ref.
 p.26,no.450

AP
1
A51A64 Crawford, John Stephens
NCFA Physiognomy in classical and American por-
v.9 trait busts

 In:Am.Art J.
 9:49-60 May,'77 illus.
 Bibl.references
 "...Demonstrates 1.both classical & Ameri-
 can civilizations subscribed to similar theo-
 ries of physiognomics.2.The likeness of promi-
 nent Americans were consciously altered stylist
 cally to make them closer to the portrs. of th
 great personali es of Greece & Rome."

AP
1
C59 Black, Mary C,
NMAA Phrenological associations.Footnotes to
 the biography of two folk artists.J.Wh.Stock &
 A.Ames,
 In:Clarion
 1982-84:44-52 Fall,'84 illus.

 'The photograph became..a guide,providing ar-
 tists with inspiration for portraits.'

I.H.4.a - PHYSIOGNOMY

Curtius, Ludwig, 1874-1954
 Physiognomik des römischen porträts

 In:Die Antike
 7:226-54 1931

LC DE1.A4 Hiesinger.Portr.in the Rom
 Rep.Bibl.In:Temporini.Auf-
 stieg u.niederg...LC DG209
 T36,Bd.1,T.4,p.825

I.H.4.a - PHYSIOGNOMY

Darwin, Charles Robert, 1809-1882
 The expression of the emotions in man & ani-
mals...London,J.Murray,1872

 374 p. illus.
 1st ed.The photographic illus.of the emotions
are by Oscar Gustav Reijlander(1813-1875)whom
Darwin commissioned.Reijlander & his wife act
the required emotions in many on the heliotypes.
The publication indirectly produced a windfall
LC
QP401.D21
 Waetzoldt ND1300.W12:Ger-
 ⌒ man translation:Ausdruck
 der gemütsbewegungen...

AP
1
N547
NCFA
v.33

I.H.4.a - PHYSIOGNOMY

Ewers, John Canfield
 An anthropologist looks at early pictures
of North American Indians

In:N.Y.Hist.Soc.Q.
33:223-34 Oct.,'49 illus.

 Repr.J.LeMoyne,Anonym.portr.of Pocahontas,
G.Hesselius,Engr.by Kleinschmidt after Verelst,
Saint-Mémin,K.Bodmer,Catlin

 ⌒

I.H.4.a - PHYSIOGNOMY

Delestre, Jean,Baptiste,1800-1871
 De la physiognomie,texte-dessin-gravure,
....Paris,Vᵉ J.Renouard,1866
 508 p. illus.

DLC MH DNLM
 McCauley.Likenesses q TR
 ⌒ 575.M12 NPG p.21,note 14

I.H.4.a - PHYSIOGNOMY

Förster, Richard, 1843-1922
 Die physiognomik der Griechen.Rede zur
feier der geburtstages des deutschen kaisers
Wilhelm I.,gehalten am 22 März 1884.Kiel,
Schmidt & Klaunig,1884
 23 p.

MH CtY PPAN ICN TU NjP LC Pre-'56,v.176,p.478
DLC TGRL
 ⌒

705
A56
KMAA
v.122

I.H.4.a - PHYSIOGNOMY

Ericson, Jack T.
 Asa Ames,sculptor

In:Antiques
122:522-9 Sept.'82 illus(part col.)

 Incl.:Phrenological head,Pl.VIII;Ears,eyes
& hair,figs.8,8,10

 M.Black.Phrenological asso-
 ciations,p.50

I.H.4.a - PHYSIOGNOMY

Förster, Richard, 1843-1922, ed.
 Scriptores physiognomonici graeci et latini
recensuit Richardus Foerster...Lipsiae,...B.G.
Teubneri,1893
 2 v.

LC PA3403.P6 1893 Crawford.Physiognomy..in:
 Am.Art J.9:49-60,May'77,
 ,nomical theoi ⌒ p.50 and Moller.Physio;
 N21.I 61,p.59,footnote15

I.H.4.a - PHYSIOGNOMY

Evans, Elizabeth Cornelia, 1905-
 Physiognomics in the ancient world.Phila-
delphia,American Philosophical Society,1969
 101 p. (Transactions of the Am.Phil.Soc.
new ser.59,pt.5)

 Bibliographical footnotes

 "The best modern treatment of the literary
evidence.that there were practicing physiogno-
mists in Antiquity."-Crawford
 Crawford.Physiognomy...
LC Q11.P6 n.s.v.59,pt.5 In:Am.Art J.,9:50,May '77

705
G28
NCFA
v.53

I.H.4.a - PHYSIOGNOMY

Fournier, Fernand
 Portrait anonymes et "portrait parlé"

In:Gaz Beaux Arts
53:345-50 May-Jun,1959 illus.

 "...One may apply to the identification of
ptd.portrs.,,,the scientific methods used by the
Criminal Records office...These methods perfected
in late 19th c. by Alphonse Bertillon...based on
anthropometry."

 Enc.of World Art
 ⌒ 31:56Ref.v.11,col.514

I.H.4.a - PHYSIOGNOMY

Evelyn, John, 1620-1706
 Numismata.A discourse of medals ancient and
modern.Together with some account of heads and
effigies of illustrious and famous persons,in
sculps,and tailledouce of whom we have no me-
dals extant;and of the use to be derived from
them.To which is added a digression concerning
physiognomy...London,B.Tooke,1697
 342 p. illus.

LC CJ5538.E8
 Winterthur Mus.Libr.
 fZ861.W78 NCFA v.9,p.205

I.H.4.a - PHYSIOGNOMY

Grossmann, Rudolf, 1882-1941
 Ausdrucksstudien bei den irren

In:Kunst u.K.
26:390-4 1928 illus.

 Studies of physiognomy of insane people.
Prints and drags.by Rubens,Brueghel and by the
author.

LC N3.K8 ⌒ Rep.,1928=56

I.H.4.a - PHYSIOGNOMY

Ouenne, Jacques
 Le regard et l'expression dans la peinture

In:Formes et couleurs
 :13-73 no.1,1944 illus.

 From antique art to the present

LC M2F65 Rep.,1945-47#859

I.H.4.a - PHYSIOGNOMY

Kassner, Rudolf, 1873-
 Zahl und gesicht.Nebst einer einleitung;der
 umriss einer universalen physiognomik.2.verän-
 derte aufl.Leipzig,Insel-Verlag,1925

‹LC BF853.K38 1925›
V1U Winkes.Physiognomonia
1919 ed. IU McU NIC NjP LC DG209.T36 Bd.1,T.4,
 p.900

I.H.4.a - PHYSIOGNOMY

Halsman, Philippe, 1906-1979
 The Frenchman:A photographic interview.N.Y
Simon & Shuster,.1949.
 unpaged 24 portrs.

 24 portrs.in which by facial expression,
the model replies to questions asked in the
caption.The model is Fernandel

LC PN2638.C73H3 Arts in America q25961.U
 5A77X NCFA Ref. N600

I.H.4.a - PHYSIOGNOMY

Kris, Ernst, 1900-
 A psychotic sculptor of the 18th century

In:his.Psychoanalytic explorations in art.New
York,Schocken Books.1964,1952.

 pp.128-50 illus. Based on a paper read
to the Vienna Psychoanalytic Soc.,Nov,'32,publ.
in Imago,XIX,1933.Span.transl.in Revista de Psi-
coanalisis,III,1945/46

 Repro.:Busts by Messerschmidt
LC N70.K84 1964

I.H.4.a - PHYSIOGNOMY

Hartmann, Wolfgang
 "Face farces" von Arnulf Rainer

In:Rainer, Arnulf, 1929-
 Der grosse bogen.Cat.of the exh.Apr.30-June 15
1977 in Bern,Kunsthalle
 p.17-27 illus.

 A summary of the history of physiognomy.
Psychology of the expressionism.Influences of
psychical realism & Vienna actionists on Raine
R.seen as one of the most influential artists o
the present.Photography used by painters.

BF
843
L39
F1789
NPG
RB

I.H.4.a - PHYSIOGNOMY
Lavater, Johann Caspar, 1741-1801
 Essays on physiognomy;designed to promote the
knowledge and the love of mankind.Translated.fr.
German.by Ths.Holcroft;...100 physiognomical
rules...& memoirs of the life of the author.
11th ed.,with upwards of 400 profiles,and other
engravings. London W.Tegg,1860
 507 p. illus.

 NPG ed.1789

LC BF843.L3 1860 N.Y.,Metro.mus.bull.v.35-6
LC lists several eds. .51

I.H.4.a - PHYSIOGNOMY

Hough, E.K.
 Expressing character in photographic pic-
tures

In:Am.J.of Photo.& the Allied Arts
1,no.11:171-5 Nov.1,1858
 no.12:183-7 Nov.15,1858
 no.14:211-6 Dec.15,1858

LC TR1.A56 Pfister.Facing the light
 TR680.P47X NPG p.361

I.H.4.a - PHYSIOGNOMY

Lavater, Johann Caspar, 1741-1801
 Physiognomische fragmente,zur beförderung der
menschenkenntnis und menschenliebe...Leipzig &
Winterthur,1775-78.Bey Weidmanns Erben und Reich,
und Heinrich Steiner & Compagnie
4 v. illus.

 Illus.engraved & lithographed by or after
J.R.Lips,J.R.Schellenberg,D.N.Chodowiecki,Daniel
Berger,and others

DLC
 Stafford In:Art J. v.46
 p.186

N
40.1
R37J7
NCFA

Jones, Edgar Yoxall
 Father of art photography:O.G.Rejlander,
1813-1875.Greenwich,Conn.,N.Y.Graphic Soc.
.1973.
 112 p. illus.

 Bibl.references

 Darwin commissioned Rejlander to illustrate
his 'Expression of the emotions in man & animals

LC TR140.R4J66 Stevenson.V.Dyck in check
 trousers,NK4743.S648NPG
 p.116

I.H.4.a - PHYSIOGNOMY

Lavater, Johann Caspar, 1741-1801
 Von der physiognomik...Leipzig,Bey Weidmann
Erben & Reich,1772
 2 v. in 1

 Edited by J.C.Zimmermann

NNC TxU etc. Stafford In:Art J. v.46
 p.190,note 9

705
C75
NCFA
v.11

I.H.4.a - PHYSIOGNOMY

Lawrence, William John, 1862-1940
 The portraits of David Garrick

In:Connoisseur
11:211-18 Apr.,'05 illus.

FOR COMPLETE ENTRY
SEE MAIN CARD

VF
NPG

I.H.4.a - PHYSIOGNOMY

Leon Golub,portraits of power.Catalogue of ex-
hibition at the Picker Gallery,Charles A.
Dana Arts Center,Colgate University,Hamil-
ton,N.Y.,Nov.11-Dec.10,1978
 unpaged illus.

 Bibliography

 Preface by Edw.Bryant

I.H.4.a - PHYSIOGNOMY

LeBrun, Charles, 1619-1690
 A method to learn to design the passions
proposed in a conference on their general and
particular expression...London,1734
 .59. illus.

LC NC770.L453 Crawford.Physiognomy in
 classical & Am.portr.bus
 In:AmArt J.9:49

I.H.4.a - PHYSIOGNOMY

Lepelletier, Almire René Jacques, 1790-1880
 Traité complet de physiognomie;ou l'homme
moral positivement revelé par l'étude raisonné
de l'homme physique,aved des considérations s[?]
les tempéraments,les caratères,leurs influ-
ences réciproques.Paris,V.Masson,1864
 595 p.

MdBP McCauley.Likenesses qTR
 575.M12 NPG p.21,note 14

I.H.4.a - PHYSIOGNOMY

LeBrun, Charles, 1619-1690
 ...La physionomie humaine comparée à la phy-
sionomie des animaux,d'après les dessins de
Charles LeBrun;cent trente reproduction...

r000
FA3946
.2.7

2nd éd.Paris,H.Laurens,1927
 25 p. illus.

 .At head of title:Contribution à l'étude de
la caricature

 See also:Resemblances.in:Art Express,1,no12:
54 Sept.Oct>,'81 AP 1 A784E9 NMAA

705
A7832
NCFA

I.H.4.a - PHYSIOGNOMY

Levitine, George
 The influence of Lavater and Girodet's
"Expression des sentiments de l'Ame"

In:Art B.
36:33-44 March,'54 illus.

 Cresswell.Prints of the
 Am.Revol. NE506.C92 1977:
 NMAA p.70,note 115

I.H.4.a - PHYSIOGNOMY

Lendvai-Dircksen, Erna, 1883-
 Das deutsche volksgesicht.Mecklenburg
und Pommern.2nd ed.Bayreuth,Gauverlag.1st ed.
1940;
 unpaged 70 photos

CtU

QM
535
L72
NPG

I.H.4.a - PHYSIOGNOMY

Liggett, John
 The human face.London,Constable,1974.
 287 p. illus.

 Piper;In:Wolstenholme,1977
).25

I.H.4.a - PHYSIOGNOMY

Lendvai-Dircksen, Erna, 1883-
 Ein deutsches menschenbild.Antlits des
volkes.In 148 Bildern dargestellt von Erna
Lendvai-Dircksen.Frankfurt/M.,Umschau Verlag
.1961.
 156 p. illus.

LC DD76.L47 MN

I.H.4.a - PHYSIOGNOMY

Lohmann-Siems, Isa
 Der universale formbegriff in der physiog[?]
nomik des 18.jahrh. Ein beitrag zur geschichte
der gegenwärtigen kunsttheorie

In:Jrb.Hambg.Kunstslg.
9:49-74 1964 illus.
 Bibliography
 Interpretation of various texts of the 18
c.showing that the present revolutionary arti[?]
tic theories germinated already in the thought
of that epoch Winkes.Physiognomonia.In:
LC N9.J175 Temporini.Aufstieg u.nied[?]
 gang...LC DG209.T36,Ed.1,T
 p.936

Xerox copy I.H.4.a - PHYSIOGNOMY
NPG
In VF Martin, F.David
Portrai- Spiritual asymmetry in portraiture
ture

In:Brit.J.Aesth.
5:6-13 1965 illus.

 M.Discusses the duality of extroversion &
introversion in the right & left side of a face
& the revealing of this duality in a good portr.
 From portrs.in Fayum,with Giotto,Leonardo,
Rosso,the portraitists of the Renaissance to mo-
dern painters.
MDU-RH1.87 Rep.1966#894

I.H.4.a - PHYSIOGNOMY

Neubert, Fritz, 1886-
 Die volkstümlichen anschauungen über phy-
siognomik in Frankreich bis zum ausgang des
mittelalters

In:Romanische Forschungen
29:557-679. Erlangen,1911

 Phil.-Diss.,München.1910.

MB Meller.Physiognomical the-
 ory...N21.I 61 1961 NCFA
 p.60,footnote 23

I.H.4.a - PHYSIOGNOMY

Mauclair, Camille, 1872-
 Le Problème de la ressemblance dans le
portrait féminin moderne

In:R.polit.et litt. (R.bleue,pol.et litt.)
39:751-5 ser.4 1902

LC AP20.R64 N.Y.,MOMA.20th c.portrs.by
 M.Wheeler.N7592.6N53 NPG
 Bibl.

I.H.4.a - PHYSIOGNOMY

Olbricht, K.-H.
 Analyse in selbstporträt oder künstlerische
metamorphose:zu den radierungen von Marwan

In:Kunst & d.schöne Heim
88;pt.5:281-8 May,'76 illus.

 M.'s self-portrs.are projections of parti-
cular mental states.He hopes to discover him-
self through their expressive capacity

LC N3.K5 FOR COMPLETE ENTRY
 SEE MAIN CARD

741.7 I.H.4.a - PHYSIOGNOMY
M49

Mégros, Rodolphe Louis, 1891-
 Profile art through the ages;a study of the
use and significance of profile and silhouette
from the stone age to puppet films.N.Y.,Philoso-
phical Library.1949.
 131 p. illus.

 Ch.7:The human profile(incl.Lavater's pro-
files for character reading);Ch.8:Painted sha-
dows;Ch.9:The cut silhouette(18-19th c.);Ch.10:
Modern silhouette cutters.Appendix,B:Lavater's
LC N5303.M4 character reading

I.H.4.a - PHYSIOGNOMY
BF
591
P43
1987X Peck, Stephen Rogers, 1912-
NPG Atlas of facial expression,an account of
facial expression for artists,actors and wri-
ters...N.Y.,Oxford University Press,1987
 161 p. illus.

 Incl.Index

N
21
I 61 I.H.4.a - PHYSIOGNOMY
1961
NCFA Meller, Peter
 Physiognomical theory in Renaissance heroic
portraits.

In:International Congr.of the Hist.of Art,20th
N.Y.,1961
v.II:Renaissance & Mannerism:53-69 illus.

 Article examines some heroic portrs.which
show the linkage with the characteristics of
animals,after a theory of antique & medieval
physiognomics.
 Portr.bust.Renaiss.to En-
 lightenment.NB1309.P6x NPG Bibl.

I.H.4.a - PHYSIOGNOMY

Quintilianus, Marcus Fabius, c.35-c.95 A.D.
 The Institutio oratoria of Quintilian,
with an English translation by H.E.Butler...
London,W.Heinemann;N.Y.,G.P.Putnam's sons,
1921-22
 4 v. (The Loeb classical library.Latin
authors.)
 Bibliography
 Resources of the discipline of physiogno-
mics
 "...The most influential writing on the ap-
plication of the principles of physiognomics,
LCPA6156.Q5 1921
 PA6649.A2 1921

I.H.4.a - PHYSIOGNOMY

Montagu, Jennifer
 Charles LeBrun's Conférence sur l'expres-
sion général et particulière.London,Uni.of Lon-
don,1959
 2v.on reel Microfilm copy

 Diss.-Warburg Inst.,Uni.of London

 Chs.LeBrun was the first systematic student
of human expressions,who based himself on Carte-
sian mechanics & saw in the eyebrows real poin-
ters...see over
ICU Gombrich.Mask & face.In:
 Art percept'n & reality
 N71/G41X NCFA p.5

I.H.4.a - PHYSIOGNOMY

Picard, Max, 1888-1965
 Die grenzen der physiognomik...Erlenbach-
Zürich & Leipzig,E.Rentsch.c.1937.
 191 p. illus.

LC BF853.M47

I.H.4.a - PHYSIOGNOMY

Picard, Max, 1888-
The human face, translated from the German by Guy Endore. New York, Farrar & Rinehart, inc. ,1930,

221 p. illus.

LC BF853.P485

I.H.4.a - PHYSIOGNOMY

705
AP1
A788
NCFA
Robins, Corinne
Leon Golub:The faces of power

In:Arts
51:110-11 Feb.,'77 illus.

Leon Golub,portrs.of power
VF NPG Bibliography

I.H.4.a - PHYSIOGNOMY

Piderit, Theodor, 1826-1898
Mimik & physiognomik. Detmold,Meyer(H.Denecke, 2.aufl,1886

212 p. illus.

LC BF853.P5 Waetzoldt ND1200-W12

I.H.4.a - PHYSIOGNOMY

Rubbrecht, Oswald,
L'origine du type familial de la maison de Habsbourg. Bruxelles,1910
152 p. illus.

MET
195.3
R82

Amsterdam,Rijksmus.,cat.
45939A52,deel 1, p.148

N
6510
P54X
NMAA
I.H.4.a - PHYSIOGNOMY
Pike, Martha V.
A time to mourn,expressions of grief in 19th century America;by M.V.Pike and Janice Gray Armstrong.Brooklyn,N.Y.:Museums at Stony Brook,1980
192 p. illus(part col.)

Exh.held May 24-Nov.16,1980 at Museums at Stony Brook,Stony Brook,N.Y.
Incl.Posthumous mourning portraiture bibliography

Incl:Index
LC N6510.P54 (also in MHT) Gerdts.Art of healing
223.G36,p.112,note 13 NPG

I.H.4.a PHYSIOGNOMY

Schmidt, J.
Physiognomik

In:Paulys real-encycl.der class.altertumswissen.
20,1:1064-74 1941 ...schaft

Bibl.references

LC DE5.P33 suppl. 1914- Winkes.Physiognomonia.In:
Temporini.Aufstieg u.niede
gang...LC DG209.T36,Bd.1,TW
n 800

I.H.4.a - PHYSIOGNOMY

Porta, Gianbattista della, c.1540-1615
De humana physiognomonico.Aequensa,Iosephi Cacchi,1586
,272,p. illus.

MET
Print
dpt.

Comparisons betw.a human type & an animal species:the aquiline nose-noble like the eagle; the bovine face-placid disposition...which influenced portr.caricature

Gombrich.The mask & the face.In Art percp'n & reality.N71G64X.NCFA p.34 f8̶9̶4̶

I.H.4.a - PHYSIOGNOMY

Steinbrucker, Charlotte, 1886-
Lavater's physiognomische fragmente im verhältnis zur bildenden kunst.Berlin,W.Borngräber,1915
N.Y.P.L. 267 p. illus.
3-MAO

Eller.Hist.ikonografi
LC N7575.E45 p.49,no.13

I.H.4.a - PHYSIOGNOMY

Robertson, Janet, 1880-
Practical problems of the portrait painter. London,Darton,Longman & Todd,1962,
163 p. illus.

Describes certain relationships betw.the shape of the face and the dominant expression.

KU CaMW CaOH Gombrich.Mask & face.In:
Art,percep'n & reality
N71/G64X NCFA p.23

I.H.4.a - PHYSIOGNOMY

Toepffer, Rodolphe, 1799-1846
Enter the comics...Transl.of Essai de physiognomie,& edited with an introd.by E.Wiese. Lincoln Uni.of Nebr.press,1965,
80 p. illus.

Contents.-Introd.Rod.Töpffer & the language of physiognomy.-Essay on physiognomy.-The true story of Mr.Crépin.-List of works cited

LC NC1659.T633 Gombrich.Mask & face.In:Art
Percep'n A reality N71/
G64X NCFA p.24 footnote

705
C69
NMAA
v.46

I.H.4.a - PHYSIOGNOMY

Tscherny, Nadia
 Likeness in early Romantic portraiture

In:Art J.
46,no.3:193-99 Fall,1987 illus.

Portraits within portraits,fg.1

I.H.4.a - PHYSIOGNOMY
see also

II.B.4
I.E - CARICATURE
II.C.5 - CARICATURE

I.H.4.a - PHYSIOGNOMY

Winkes, Rolf
 Physiognomonia:Probleme der charakterinter
pretation römischer porträts

VF
Portrs.,
Roman

In:Temporini,Hildegard.Aufstieg und niedergang
der römischen welt...Berlin,N.Y.,Walter de Gr
ter,1973.Pt.I:Von den anfängen Roms bis zum a
gang der republik,v.4(in 2 parts,text & plate)
p.899-926(text),& p.217-242(plates)

 Bibliography
 'The best summary on the problem of physio
nomy in Roman p traiture...'.-Crawford
H3.1,T.4 .T36 Am.J.AP1.451.64.v.9,no.1
 May,'77

I.H.4.b. INTENTIONS OF SITTER AND/OR ARTIST

I.H.4.a - PHYSIOGNOMY

Woolnoth, Thomas, 1785-after 1836
 Facts and faces;being an enquiry into the
connection between linear and mental portrai-
ture,with a dissertation on personal and rela-
tive beauty.2nd ed. London, The author,1854
 269 p. illus.

LC BF841.W93 V & A cat.

I.H.4.b INTENTION OF SITTER AND/OR ARTIST

I.H.4.a - PHYSIOGNOMY

Woolnoth, Thomas, 1785-after 1836
 A study of the human face.Wm.Tweedie,1865
 260 p. illus.

V & A 26 steel engravings

 Blackwell's of Oxford cat.
 A1077 (1977),no.304
 p.30

705
M18
NCFA

I.H.4.b

Benson, E.M.
 Problems of portraiture

In:Mag.of Art
30,no.11,supplement:1-28 Nov.,1937 illus.

 1300 BC - 20th c.
 Psychology or document. Sitter's point of view;
Artist's point of view; Concerning method & tech-
nique; Photography & film & their relation to the
plastic arts; Portraiture:its present and future
 Also published as a separate pamphlet

I.H.4.a - PHYSIOGNOMY

Wundt, Wilhelm, 1832-1920
 Der ausdruck der gemütsbewegungen

In:his.Essays. 2.aufl. Leipzig,W.Engelmann,1906
Chapter 7

 Bibliography at end of chapters

LC B3383.E7 Waetzoldt ND1300.W12

AP
1
D81
NMAA

I.H.4.b

Billeter, Erika, 1927-
 Der Künstler und seine vorstellung vom ich

In:Du
3:33-63 1984 illus(part col.)

English summary,p.c1-2.
Self-portraits from 1515 to 1982

The article seeks to provide a concentrated
survey of the forms in which art has handed
the self-portr.down to us

 dep.1986 #4737

705
B97
NCFA
v.69

I.H.4.b

Bodkin, Thomas, 1887-
 Some problems of national portraiture

In:Burl.Mag.
69:246-51 illus. Dec.,1936

 Official Nat'l portr.coll originated in Eng-
land,1856. Policy of administration of a NPG.
Intentions of sitter,artist etc.Important factors
such as age,health,circumstances. Scientific needs
of historians & biographers better served by pho-
tographs & sound-film Encyclop.of World Art
 N31E56Ref. Bibl.on portr.

ND
1300
C5K
NPG

I.H.4.b

Chittock, Derek, 1922-
 Portrait painting...London,Batsford,1979
 120 p. illus(part col.)
 Incl.indexes
 Bibliography

 '...covers almost every aspect of portr.
ptg.'-D.C.in introduction

 Incl.:History of portr.ptg.;Intention of
sitter & artist;Use of photography

 Review in Am.Artist,v.44:24-5,Oct.'80

I.H.4.b

Bogardus, Abraham
 The lost art of the daguerreotype

In:The Century Mag.
68,no.1:83-91 May,1904

 Comments on portraiture & the public,noting
some of the practical operating tricks of the
trade for making people appear better

LC AP2.C4 Rudisill.Mirror image
 TR365.R916 NCFA p.240

705
P19
NCFA
v.13

I.H.4.b

Christoffel, Ulrich, 1891-
 Das deutsche bildnis der Dürerzeit

In:Pantheon
13:1-9 Jan,1934 illus(part col.)

 Synopsis in English,pp.1-3:"The German portrai-
tist did not paint so much the portrait of the
sitter, but rather his psychical power"...

 Repro:Kulmbach,Schäufelein,Holbein,Cranach,
Baldung,etc. Enc.of World Art,v.11
 N31E56 Ref.,col.513
 bibl.on portr.

705
A783h
v.19

I.H.4.b

Breuning, Margaret
 The cerebral approach to portraiture

In:Art Digest
19:13 Apr.15,'45 illus.

 Exh.at Mortimer Brandt Gall."Portrs.of to-
day by painters of today"April,1945,emphasizes
the tendency to present emotional or cerebral
ideas suggested by the sitter or a reflection
of the artist's reaction to the sitter"

I.H.4.b

Cocteau, Jean, 1889-1963
 Maria Lani by Bonnard,and other artists.
Paris,Éditions des Quatre chemins,1929.
 20 p. 51 pl.

 [Exhib.at Brummer,N.Y.,Nov.1-? ,'29.
 Also exhib.Leicester Gall.,London,1930.

 Incl.Bonnard,Bosshard,Bourdelle,Braque,Cha-
gall,Laborde,Chirico,Cocteau,Delaunay,Derain,
Despiau,Friesz,Goerg,Cromaire,Matisse,Kisling,
Léger,Lhote,Lurçat,Man Ray,

LC N7639C67

I.H.4.b

Brooklyn Institute of Arts and Sciences. Museum
 One hundred artists and Walkowitz.Feb.9-
Mar.26,1944.Brooklyn,1944.
 28 p. illus.

 "This is the presentation of an experiment:
100 artists and one subject...a unique opportu-
nity for study to layman...artist & psychologist
-Foreword
 Portrs.of A.Walkowitz:89 ptgs.,11 pieces of
sculpture,caricatures & photographs & 2 self-
portrs.Portrs.range fr.conservative

LC ND1301.B7 MOMA p.433, v.11

708.1
M66
NCFA
v.41

I.H.4.b

Davis, Richard S.
 Loan exh. of great portraits...1952

In:B.Minneapolis I.A.
41:181-2 Nov.,'52

 FOR COMPLETE ENTRY
 SEE MAIN CARD

AP
1
J8654
NPG
v.17

I.H.4.b

Brown, Jonathan
 Enemies of flattery:Velásquez' portraits
of Philip IV

In:J.Interdisc.Hist
17,no.1:137-54 Summer,'86 illus.

 Bibliographical references

705
A784
NCFA

I.H.4.b

Debs, Barbara K.
 From eternity to here:Uses of the Renais-
sance portrait

In:Art in Am
63:48-55 Jan.,-Feb.,'75 illus(part col.)

 Transformation of intention in portrs fr.
medieval to early 15th c. donors to mid 15th c.
& later portrs."in context"& individual portrs.

VF I.H.4.b

<u>Dobell, Byron,Maxwell,, 1927-</u>
<u>They had faces in those days</u>

In:Newsweek
95,no.22:17 June 2, 1980 illus(self-portr.)

 Discusses difference in feelin towards self-
commissioned portrs.betw.people of our times and
those of the 16th till 19th c....

LC AP2.N6772
LC Microfiche **FOR COMPLETE ENTRY**
 SEE MAIN CARD

927.3 I.H.4.b
E64

 Epstein, Jacob, 1880-
 Portraits

In.his.Let there be sculpture...N.Y.,O.P.Put-
nam's sons.1940.
 pp.58-91 illus.

 p.58-62,90-1:E.describes his workmethod & his
thoughts abt. portraiture.-p.63-89:Individual
sitters.

LC NP497.E6A2 Vincent,C.In search of like
 ness...Met Mus Bul 24ns:252

705 I.H.4.b
B97
NCFA Douglas, Lord
v.72 19th c. French portraiture

In:Burl Mag.
72:253-63 Jun,1938 illus(part col.)

 Realistic vs. psychological approach. Discusses
also the effect of invention of photography

 Enc.of World Art
 N31E56Ref.vol.11
 col.513.Bibl.on portr.

I.H.4.b

 Fielder, Martha Anne
 Iconographic themes in portraits of Hen-
ry VIII
 232 p.

 Ph.D.diss.-Texas Christian University,1985

 This study enlarges Roy Strong's thesis in
Holbein & Henry VIII that the English Reforma-
tion signaled a change in the visual image of
the king & expands that concept.The evolution
of Henrician portrs.can be categorised into 3
phases:

705 I.H.4.b
M18
NCFA Downes, William Howe, 1854-
v.17 Portraits and portrait painting

In:Mag Art
17:167-9 Apr.,'26

 Chicago.Art Inst.Ryerson
 Libr.Ind.to Art periodicals
 fZ5937.C53,v.8 NCFA Ref.
 p.7026

705 I.H.4.b
A784
NCFA Flexner, James Thomas, 1908-
 Early American painting:Stuart's full-lengths
of Washington

In:Art in Amer.
35:329-33 Oct.1947 Illus.

 Realistic vs. representational approach

 Rep.,1945-47*7561

I.H.4.b

 Durand-Ruel galleries, New York
 Kelekian as the artist sees him.Oct.17-
Nov.4,1944.N.Y.,Durand-Ruel galleries.1944.
 .24.p. illus.

 14 ptgs.,5 sculptures,1 photograph,1 mosai
Artists incl.J.Graham,Scharl,Foyer,Derain,
Lintott,Blatas,Masson,Kuhn,Avery. Lipchitz,Na-
kian,Ch.Gross,J.Davidson. Valenti

 see also:Art Digest 19:9 O.15, '44 illus.
 Art N 43:14 O.15,'44 illus.
LC ND1301.D8 MOMA, p.434, v.11

I.H.4.b

 Forster, John Wycliffe Lowes, 1850-1938
 The ideals and aims of the portrait painter

In:Dalhousie R
9:303-12 Oct,'29

 Cumulated Mag.subj.index
LC AP5.D3 A1/3/C76 Ref. v.2,p.444

N I.H.4.b
40.1
M694E2 Edinburgh. Scottish national portrait gallery
NPG A view of the portrait. Portraits by
Alexander Moffat 1968-1973. Intro.by R.E.
Hutchison..An exhibition 17 Aug.-16 Sept.,1973..
Edinburgh,...1973
 33 p. illus.

 Moffat's work "seems to illustrate the use of
the portr.as an art form in the true sense...Mof-
fat.achieves the basic ends of portraiture:a like-
ness & a personal interpretation of character..."
 Dialogue betw.organisers of exh.&A.Moffat abt
M.'s intentions & method

705 I.H.4.b
A786
NCFA Goldwater, Robert John, 1907-
v.38 Artists painted by themselves.Self-portraits
pt.2 from baroque to Impressionism

In:Art N
38,pt.2:7-12,23-4 Mar.,30,'40 illus(part col.

 Pertains to exh.at Schaeffer gall,inc.,N.Y.,
Apr.2-30,1940
 Artist vs.society.Description of changes in
attitude in the modes of portraiture.
 Repr.incl.:P.Brill,Leyster,Rembrandt(1629)

701
.G81 I.H.4.b

Greene, Theodore Meyer, 1897-
 The portrayal of individuals in sculpture
and painting, and the rôle of specificity in art

In his.The arts and the art criticism.Princeton,
Princeton uni.press,1940. 690 p. illus.
ch.18,pp.296-304

 Definition of portraiture;Nature of portrai-
ture;Intent of portraitist
 Human portraiture;Religious reverence;Social
interest;Reflective contemplation
LC N66.G74 N.Y.,MOMA.20th c.portrs.by
 M.Wheeler.N7592.6N53NPG.
 Bibl.

qN
7644
H9? I.H.4.b
NPG

Humm, Rosa and Olmsted
 Children in America.A study of images and
attitudes...1978

 FOR COMPLETE ENTRY
 SEE MAIN CARD

N
7598
H15 I.H.4.b
NPG

Hake, Henry Mendelssohn, 1892-
 The English historic portrait:document and
myth.London.Publ.for the British Academy by
Geoffrey Cumberlege.Oxford Univ.Press.1947,
 p..133,-152
 Photocopy of Proc.Brit.Acad.v.29:133-49
150-52 1943
 Annual lecture on aspects of art,Henriette
Hertz Trust,1943
 14th to 18th c.,historical development of
portr.ptg.in England.Family & official portrs.
Ptgs.used as pattern for sculptors
LC AS122.I5 vol.29 Rep.1945-47*1123

N
7592
K16 I.H.4.b
NCFA

Kansas. University. Museum of Art.
 Images:23 interpretations;an exhibition of
portrait and figure painting....Lawrence,1964.
56 p. illus. (University of Kansas.Misc.
publications of the Museum of Art,no.54)

- '"Image" points to universal qualities as well
as those unique to a single being'

LC N7592.K3

 I.H.4.b

Hinz, Berthold
 Das Familienbildnis des J.M.Molenaer in
Haarlem.Aspekte zur ambivalenz der porträt-
funktion

In:Städel Jb.
4:207-16 1973 illus.

 Change from functional to aesthetic value
during Renaissance.
 The ambivalence of approach remains inhe-
rent in portrs. of bourgeois subjects
LC N9.57 Rila I/1-2 1975 #2129

 I.H.4.b

Kirchbach, Wolgang, 1857-
 Über die Ähnlichkeit von bildnissen

In:Kunst für alle
4:

"Kunst für alle"
LC N3.K4 Waetzoldt MD1300.W12

705
A49
NCFA I.H.4.b
v.39

Holden, Donald
 Robert Gill's imaginary portraits

In:Am.Artist
39:24-9,58 July,'75 illus.

 FOR COMPLETE ENTRY
 SEE MAIN CARD

705
A784
NPAA I.H.4.b
v.75

Kozloff, Max
 Opaque disclosures.An examination of the for-
mal and informal modes of portrait photography
reveals some of the contradictions of the genre

In:Art in Am
75:144-53,157 Oct.'87 illus.

 Repro.incl.:Sander:Raoul Hausmann;Cartier-
Bresson:Candhi,Irène & Frédéric Joliot-Curie,
Jos.V.& Stewart Alsop,Edith Piaf;Brandt:Dylan
Thomas,Alec Guinness:Morath:Carter-Bresson. etc.

705
A56
NCFA I.H.4.b
v.107

Holzer, Harold
 Some contemporary paintings of Abraham
Lincoln

In:Antiques
107:314-22 Feb.,'75 illus(part col.)

 Most artists romsticized,stylized or create
reverential martyr ptgs.

 Repro.:Hicks,Conant,Clover,Wright,Atwood,
Marchant,Cogsell,Travers,Carpenter,Bowser

 Rila II/2 1976 *5757

AP
1
H62
NCFA I.H.4.b
v.26-27

Landau, Ellen G.
 Study in National Trust Portraits

In:Historic Preservation
27,no.2:30-7 Apr.-June,'75 illus(part col.)

 Repro.incl.:Washington's Family by Savage
 Development of Amer.portraiture:Simple,aus-
tere in the 17th c.;idealized,elegant early
18th c.;nco-classical style,revelation of the
inner life,early 19th c.;return to exactitude
to rival with photography in the 1840's-50's;

 Rila III/2 1977 *5606

ND
1140
L66
NCFA

I.H.4.b

Levey, Michael
Painting at court..N.Y..N.Y.university press
.1971.
228 p. illus(part col.) (Wrightsman
lectures,5)

"Based on lect.given at Met.Mus.,N.Y.,in 196
Incl.bibl.ref.

Courtly-uses of art & the interrelationship
of the monarch's vision of his role & see over

LC ND1140.L46 Rebs.Art in Am,63:54 foot-
note.

AP
1
A784.J8
NCFA

I.H.4.b

Maclean, Frank
Positions and accessories in portraiture

In:Art J.
56:369-73 1904 illus.

With every day subjects an attempt has been
made to show the motif or intention of the ar-
tist as regards the postures of the sitters &
the details with which he surrounded them.Em-
phasis on the difficulty of the position of the
hands
 Poole's index AI,3.P82 NCFA
 v.6,p.510

705
S94
v.163
NCFA

I.H.4.b

Levy, Mervyn
Public image or private face ? The dilemma
of a portrait painter

In:Studio
163:64-7 illus. 1962

Effigy rather than portr. The power of the
portraitist to convey a sense of the sitter's
psychological & emotive identity languishes on
account of the sitter's vanity.

 Encyclop.of World Art
 portrs.bibl.N31E56 Ref.

F
158.65
I 3I78
NPG

I.H.4.b

Milley, John C.
Portraiture:Commemorative and symbolic

In:Treasures of Independence:Independence Natio-
nalHistorical Park & its collections,p.151-70 &
notes p.179-80 illus(part col.)

Bibl.:Painted & Printed material,p.185-7

Incl.Chs.Willson & Rembrandt Peale's "museum
portrs.":bust portrs.;and commissions of private
nature Miles.In:Am Art J,15:64
 footnote 4

N
6850
L69
1968
NCFA

I.H.4.b

Liberman, Alexander, 1912-
The artist in his studio;text and photos
by Alexander Liberman,with a foreword by James
Thrall Soby.N.Y..Viking Press.1968,
284 p. illus(part col.) (A Studio book,

"A.L.records & interprets with a camera
the personalities & ambiance of some of the
leading European .artists.of our time."-Soby

 MOMA,v.11,p.437

I.H.4.b

New York. Metropolitan museum of art
Portrait in history.Filmstrip..Chicago,Rand
McNally,c.1970

Presents artists' impressions of Geo.Washing-
ton over a period of 2 centuries.Discusses rea-
sons for variations of their artistic represen-
tations...

LC.N7628.

FOR COMPLETE ENTRY
SEE MAIN CARD

705
A7832
NCFA
v.52

I.H.4.b

Light, Fred
Review of Thorvaldsen's portraetbuster,by
Else Kai Sass. Copenhagen,G.E.C.Gad Forlag,
1963-65

In:Art Bul
52:334-6 Sep.1970

Compares 18th c. representative portrs. with
19th c. portrs. of individual characters

705
C75
NCFA
v.167

I.H.4.b

Ormond, Richard
George Chinnery's image of himself

In:Connoisseur
167:89-93 Feb.,'68 illus.
160-4 Mar.,'68 illus.

FOR COMPLETE ENTRY
SEE MAIN CARD

705
B97
NCFA
v.72

I.H.4.b

Lord, Douglas
French portraiture of the 19th c.

In:Burl Mag
72:252-5,258-61,263 Jun,'38 illus.

Contrasts in portraiture:historical-fiction-
al(Baudelaire's division). Dynamic-static. Neo-
classic-romantic. Poetic-realistic. Sitter's per-
sonality-visual experience,artist's individuali-
ty. Line-color,volume. Dramatization-analyzation
Repro.: see over
 Cumulated Mag.subj.index
 A1/3/C76 Ref. v.2,p.444

705
B97
NCFA
v.8

I.H.4.b

Phillips, Claude, 1846-1924
Dramatic portraiture

In:Burl Mag
8:299-315 Feb.,1906 illus.

Compares intentions & achievements in por-
traiture from v.Eyck through 19th c.
 Repro.Ghirlandajo,J.v.Eyck,Lotto,Burgkmair,
Champaigne,Carrière

 Waetzoldt ND1300.W12

N
7598.2
P55X
NPG
Piper, David
The English Face. ₍London₎Thames & Hudson
₍1957₎
352 p. illus.

Bibliography

Review In:Connoisseur
140:267-8 Jan.,1958

History of Engl.portraiture covering 5 cen-
turies,1400-end of Victoria's reign from a
Wimsatt. he portrs.of A.
Pope N7623P82W7 NPG Bibl.

I.H.4.b

ND
1313.5
S36X
NPG
Schoch, Rainer
Das Herrscherbildnis in der malerei des
19.jahrh.München,Prestel-Verlag,1975
366 p. illus. (Studien zur Kunst des
19.Jahrh.,23)
Bibliography
Index of persons

Royalty during Absolutism,the Enlighten-
ment,the Restoration,the reigns of Napoleon I,
Queen Victoria,Napoleon III & the German mo-
narchs
Representa- tion & propaganda.
RILA II/1 1976 #2107

I.H.4.b

705
S94
NCFA
Portrait or caricature?

In:Studio
129:168 May,1945 illus.

"...the portr..is.concerned with the inner
spirit of the sitter,where a caricature...with
superficial outward appearances."

Repro:Portr.of Joshua Smith by William Dobell

I.H.4.b

705
C69
NMAA
v.46
Stafford, Barbara Maria, 1941-
"Peculiar marks":Lavater and the countenance
of blemished thought

In:Art J.
46,no.3:185-92 Fall,1987 illus.

I.H.4.b

705
C75
NCFA
v.111
Roe, F.Gordon
Austerity in art.The Puritan influence

In:Connoisseur
111:12-19 Apr.,'43 illus.

Repro.incl.:Oliver Cromwell by Rbt.Walker;
Henry Ireton by Houbraken after Sam.Cooper;
John Hampden by Rbt.Walker;Rich.Cromwell by
Cornelius Johnson;Geo.Monck,Duke of Albemarle
by Sam.Cooper;Albemarle by studio of Peter Lely;
Ths.Fairfax,3rd baron by Rbt.Walker;Oliver Crom-
well,silver medal Ths.Simon;etc.

I.H.4.b

N
7575
T58
NPG
Time, inc.
Famous likeness;an exh.co-ordinated by
Time,inc.,N.Y. and the Inst.of Contemp.Art,
Boston,in participation with the Columbus Gall.
of Fine Arts,Columbus,Ohio and the Milwaukee
Art center,Milwaukee,Wisc.,March-Aug.,1961.
₍Text:Francis Brennan₎ N.Y.,1961₎
unpaged illus.
drgs.
Portrs.(ptgs:& sculptures)of famous people
by great artists.

LC ND1301.T5 MOMA, p.435

I.H.4.b

AP
1
J8654
NPG
v.17
Schama, Simon
The Domestication of majesty:Royal family
portraiture,1500-1850

In:J.Interdisc.Hist
17,no.1:155-83 Summer,'86; illus.

Bibliographic references

I.H.4.b

705
C69
NMAA
v.46
Tscherny, Nadia
Likeness in early Romantic portraiture

In:Art J.
46,no.3:193-99 Fall,1987 illus.

Portraits within portraits,fg.1

I.H.4.b

page of I.H.4.b 1
contents
in NPG Schefold, Karl, 1905-
(xerox) Die bildnisse der antiken dichter,redner und
qN7585 denker. Basel,Benno Schwabe,1943₎
S317 NPG
Met 2 v. 228 p. illus.
577 Bibliography
Sch24 Review by Alfons Wotschitzky,In:Anz.f.Altertums-
wiss.,v1:23-4,1948..."important".
 Rep.1948-49*1012
 J.Walters Art Gall.v.9
 p.55 footnote "indispensable
Yale Univ.Libr.
Jb53+9438 Rep. 1948-49*1012
 Breckenridge.Likeness...
 N7580.B82 bibl.notes

705.1
N52
NCFA
Vincent, Clare
In search of likeness:Some European portrait
sculpture

In:Met Mus Bul Apr.,'66 illus.
24 ns:245-60
Comparisons of sculpt.with ptg.& photo.of
same sitter.
Difference betw.Fr.& Germ.art₍g., 24th C₎

Repr.:Balzac by Rodin & Seguin;Mme X by Rodin
& photo;G.B.Shaw by Epstein,Rodin & Steichen pho-
to;
 continued on next cd.

I.H.4.b

705
S94
NCFA
v.135 36

I.H.4.b

Waterhouse, Ellis Kirkham, 1905-
Portraits of our Kings and Queens. From
Henry VIII to Queen Victoria

In:Studio
135:133-43 May 1948 illus(part col.)

Different wishes of sitters:Representational;
modest & intimate; effigy without personal cha-
racter; domestic

Rep.,1948-49*1030

I.H.4.c. FORMAL vs. INFORMAL PORTRAITS

705
M18
NPG

I.H.4.b

Watson, Forbes
Uncommissioned portraits

In:Mag Art
33:665 Dec.,'40

A plea to the public to commission portrs.
free from compromise

N.Y.,MOMA.20th c.portrs.by
M.Wheeler N7592.6N53NPG
Bibl.

ND
1311
A47X
NMAA

I.H.4.c

American portraiture in the Grand Manner:1720-
1920....L.A.Cy.Mus.of Art,1981

see also:Goldberg.The column & the curtain
in:Antiques World.v.4:32-41.Dec.,'81

FOR COMPLETE ENTRY
SEE MAIN CARD

757
.W55

I.H.4.b

Wheatley, Henry Benjamin, 1838-1917
Historical portraits;some notes on the painted
portraits of celebrated characters of England,
Scotland and Ireland...London,G.Bell and sons,
1897

276 p. illus.

Introduction:Different ideas as to "portraits"
in different countries and times. From Holbein to
John Everett Millais. People in different profes-
sions.
N7598.W5

I.H.4.c

Calella, Ron
Offguard;a paparazzo look at the beautiful
people...N.Y.,McGraw-Hill,c.1976

LC TR681.F3G74

FOR COMPLETE ENTRY
SEE MAIN CARD

705
A784
NCFA
v.54

I.H.4.b

Willard, Charlotte
Eye to I

In:Art in Am
54:49-59 Mar.,'66 illus(part col.)

Self-portrs. by contemp.artists & their
statements accompanying them

"in...his self-portr.the artist restates
his belief in that complex masterpiece of nature
the individual man.The eye penetrates the I to re-
veal its essence." NPG:Amer.self-portrs...'74
Bibliography

NC
772.D66
NPG

I.H.4.c

Domanski, A.
Faces 1973.Santa Barbara,Calif.,Intelman
books,1974
116 p. (mostly illus.) (Intelman Library
no.5)

Drawings made from public television appear-
ances
Alphabetical list of sitters

705
C69
NMAA
v.46

I.H.4.b

Woods-Marsden, Joanne
"Ritratto al Naturale":Questions of realism
and idealism in early Renaissance portraits

In:Art J.
46,no.3:209-16 Fall,1987 illus.

The"true likeness"had to be presented under
idealized guise. Comparison of portrs.in ptg.,
relief,medals. Discussion of use of portrs,p.213

705
C75
NCFA
v.126

I.H.4.c

Douglas, R.Langton
Some portraits of ceremony of the Jacobean
school

In:Connoisseur
126:162-66,220 Jan,1951 illus.

Repro:1st & 2nd Lord Baltimore,etc.;Daniel
Mytens, the elder,van Soest,Marcus Geeraerts,jr.

Enc.of World Art, v.11
N31E56Ref. col.513
bibl.on portr.

705
B97
NCFA
v.72

I.H.4.e

Douglas, Lord
 19th c. French portraiture

In:Burl Mag.
72:253-63 Jun,1938 illus(part col.)

Realistic vs.psychological approach. Discusses
also the effect of invention of photography

 Enc.of World Art
 N31E56Ref.vol.11
 col.513.Bibl.on portr.

I.H.4.c

Jenkins, Marianna Duncan
 The state portrait,its origin and evolution.
New York.College Art Assn.of America...,1947
 47 p. illus.
 (Monographs on archaeo-
logy and fine arts,3)
 Thesis Bryn Mawr College

 Bibliographical footnotes

 Review by D.T.Piper In:Burl Mag. 90:302
 Trends in heroic portrs.of 16th c.W.Europe
develop conventions indispensable ever since
LC N7592.J4

ND
1311.3
F91
NCFA

I.H.4.c

Frumkin (Allan) Gallery
 Portrait painting 1970-1975;a survey of in-
formal portraiture in the U.S.A. N.Y.,Allan
Frumkin Gallery,between 1974 and 1977.
 28 p. illus.

705
A784
NMAA
v.75

I.H.4.c

Kozloff, Max
 Opaque disclosures.An examination of the for-
mal and informal modes of portrait photography
reveals some of the contradictions of the genre

In:Art in Am
75:144-53,197 Oct.'87 illus.

 Repro.incl.:Sander;Raoul Hausmann;Cartier-
Bresson;Candhi,Irène & Frédéric Joliot-Curie,
Jos.V.& Stewart Alsop,Edith Piaf;Prandt:Dylan
Thomas,Alec Guinn Korath:Carter-Presson. etc.

705
P19
NCFA
v.19

I.H.4.c

Gombosi, György
 Über venezianische bildnisse

In:Pantheon
19:102-10 Apr,1937 illus.

 In NCFA copy section with synopsis in Eng-
lish is missing

 Repro:Lotto,Giorgione,Moroni,Titian,Palma,Tin-
toretto,etc.

 Enc.of World Art,v.11
 N31E56Ref.col.513
 bibl.on portr.
 Development:

ND
1140
L66
NCFA

I.H.4.c

Levey, Michael
 Painting at court.,N.Y.,N.Y.university press
1971.
 228 p. illus(part col.) (Wrightsman
lectures,5)

 "Based on lect.given at Met.Mus.,N.Y.,in 1968
Incl.bibl.ref.

 Courtly uses of art & the interrelationship
of the monarch's vision of his role & ,see over
LC ND1140.L46 Debs.Art in Am,63:54 foot-
 note1

N
7621.2
A9V66
NPG

I.H.4.c

Heinz, Günther
 Porträtgalerie zur geschichte Österreichs
von 1400 bis 1800.Kat.der gemäldegalerie.Bear-
beiter des kat.G.Heinz und Karl Schütz.Wien,
Kunsthist.Mus.,1976
 316 p. illus(part col.) (Führer durch
das Kunsthist.Mus.,no.22)

 1976:This "Porträt Galerie"is temporarily
exhibited in Schloss Ambras,near Innsbruck

 List of sitters,p.301-6;List of artists,
p.307-16;Genealo- gical tables,p.317ff.

I.H.4.c

London. National Portrait Gallery
 Felix H.Man:reportage portraits 1929-76.
Exh.1 Oct.,1976-? Jan.,1977.Cat.text by Felix
H.Man
 17 p. illus.

74 works shown

 Bibliography
 'Photographs taken with the aim of portray-
ing the sitters spontaneously...Artists,writers,
musicians,politicians...'-Rila
LC TR681.F3M36 Rila III/1 1977 #2888

I.H.4.c

Heinz, Günther
 Studien zur porträtmalerei an den höfen
der österreichischen erblande

In:Jb.kunsthist.Samml.Wien
23:99-224 1963 illus.

 Official portrs. of the different branches
of the House of Habsbourg,mid.16-end 17th c. in
the Kunsthist.Mus. in Vienna

 Repr.:Seisenegger,Arcimboldo,Vermeyen,Mota,
L.van Valckenborch, Schöpfer
LC N3.J4 Miller.Konz.portr.malerei
 p.5??

705
C75
NCFA
v.189

I.H.4.c

Mannings, David
 A well-mannered portrait by Highmore:dated
1747.

In:Connoisseur
189:116-9 June,'75 illus.

 Acceptable postures and attitudes pre-
scribed in 'Rudiments of Genteel Behaviour'
(1737);by Nivelon.His and others' writings on
etiquette influenced 18th c. portraiture.

 Rila II/2 1976 #5004

I.H.4.c

Marr, Otto
Die grossindustriellen und ihre maler

In:Querschnitt
:618ff 1928

LC AP30.Q4

Die 20er jahre im portr.
N6868.5.B9Z97 NPG,p.141

N
40.1
R692M
NPG

I.H.4.c

Reynolds, Gary A.
Giovanni Boldini and society portraiture,
1880-1920..Cat.of an exh.held at.Grey Art
Gallery and Study Center,N.Y.Univ.,Nov.13-
Dec22,1984.N.Y.,The Gallery,1984
64 p. illus(part col.)

Bibliography

N
7575
M66
NCFA

I.H.4.c

Milwaukee. Art Center
The Inner circle;.exh..Sept.15 through Oct.23,
1966..Milwaukee,Printed by Arrow Press,1966.
unpaged illus.

Introduction by Tracy Atkinson
Portraits of intimate friends of artists, their
families & of other artists.

LC N5020.M53

705
C75
NCFA
v.113

I.H.4.c

Roe, F.Gordon
Austerity in art.The Puritan influence

In:Connoisseur
111:12-15 Apr.,'43 illus.

Repro.incl.:Oliver Cromwell by Rbt.Walker;
Henry Ireton by Houbraken after Sam.Cooper;
John Hampden by Rbt.Walker;Rich.Cromwell by
Cornelius Johnson;Geo.Monck,Duke of Albemarle
by Sam.Cooper;Albemarle by studio of Peter Lely;
Ths.Fairfax,3rd baron by Rbt.Walker;Oliver Crom-
well,silver medal Ths.Simon;etc.

705
B57
NCFA
v.113

I.H.4.c

Oberhuber, Konrad
Raphael and the State portrait.-I:The por-
trait of Julius II

In:Burl Mag
113:124,127-30 Mar.'71 illus.

Problems of the state portraiture.
One of the first informal portr.of the Ita-
lian Renaissance,going back to the change fr.for-
mal to informal in dedication pictures of Charles
V of France

Debs,H.From eternity to
here...In:Art in Am 63:53c
& footnote 9

I.H.4.c

Russell, Francis, 1910-
Portraits of classical informality.Batoni's
British sitters.II

In:Country Life
154,no.3964:1754-6 June 14,'73

LC S3.C9

Chicago.A.I. European port
N7621.C4A7 NPG Bibl.p.181

705
B57
NCFA
v.113

I.H.4.c

Oberhuber, Konrad
Raphael and the State portrait.-II:The por-
trait of Lorenzo de' Medici

In:Burl Mag
113:436,439-40, 443 Aug.,'71 illus(part col.

Problems of state portraiture
Re-attribution fr. Bronzino to Raphael
Portrs.of royalty in 3/4 length,origin in
France,spread to Lombardy
Sitter as representative of a specific group

I.H.4.c

Salomon, Erich .
Berühmte zeitgenossen in unbewachten augen-
blicken...mit 112 bildern.Stuttgart,J.Engel-
horns nachf..ca.1931.
46 p. illus.

Descriptive letterpress in German,English,
French and Italian...

LC TR680.S175

Die 20er jahre im portr.
N6868.5.B9Z97 NPG,p.143

I.H.4.c

Official portraits

In:Verve
2:9-12 no.5-6,1939 illus.

Incl:Portrs.of St.Gregory the Great,Charles
the Bald,Francis I,Louis XIV,Napoleon. Impres,
Delacroix,Chassériau,Corot,Millet,Th.Rousseau.
Prints by Hokusai & Utamaro

LC N1.V4

Rep.,1939-41:620

N
40.1
K68S8
NPG

I.H.4.c

Stewart, J.Douglas
Sir Godfrey Kneller.cat.of an exh.at the
NPG,London,Nov.-Dec.,1971....London,Bell;Nat'l
Portrait Gallery,1971
82 p. illus(part col.)

Bibl.references
Incl.:Lady Eliz.Cromwell as St.Cecilia
Chapters incl.:Drawings;Ladies & children;
Lords & Gentry;Scholars & Poets;Army & Navy;
Parade portrait.Appendix:Kit-cat club portrs.

LC ND1329.K55S7

I.H.4.c

Zorn, Wolfgang
Das deutsche unternehmungsporträt in so-
zialgeschichtlicher bedeutung

In:Tradition
2/3:79 ff. 1962

LC NC281.T7 Die 20er jahre im portr.
 N6868.5.E9Z97 NPG, p.141

I.H.5

Klein, Dorothea
St.Lukas als maler der Madonna.Ikonographie
der Lukas Madonna..Berlin,O.Schloss,1933.
127 p. illus.

Bibliography Diss.Hamburg,1933

"Nachdem d.einzelnen Handwerke & Zünfte sich
...Schutzpatrone erwählt hatten,ist d.Patron d.
Maler,d.hl.Lukas,der die Madonna malt...seit d.
15.Jhr.in d.Niederlanden...v.Maler mit d.eigenen
Bildniszügen ausgestattet worden"(Prins)

 Prins.Slg.d.selbstbildn.in
MM ICU MjP MB PBm d.Uffizien.N7618/P95 Bd.1
 p.147,note51

I.H.5. "DISGUISED" PORTRAITS: "ASSISTENZIA"

705
B97
NCFA I.H.5
v.90 Millar, Oliver, 1923-
 A subject picture by William Dobson

In:Burl Mag
90:97-9 Apr,1948 illus.

Portrs. by Engl.portr.ptrs.of 17th c. in sub-
ject pictures:Dubson's Woman taken in adultery
with portr.of Cowley, Decollation of St.John:
Saint portr.of Prince Rupert, Allegory of French
religious wars:The Four Kings of France:Francis II
Charles IX,Henry III & Henry IV(Newbottle Manor)
 Rep.,1948-49*8374

I.H.5 "DISGUISED" PORTRS. "ASSISTENZIA"

I.H.5

Passe,Crispijn van de,the younger,ca.1593-1667
Les vrais pourtraits de quelques unes des
plus grandes dames de la chrestiente,desguisées
en bergères...Ware afbeeldighe van eenige der
aldergrootste ende doorchluchtigste vrouwen van
heel christenrijck,vertoont in gedaente als her
derinnen...Amsterdam,Gedruckt by J.Broerss voor
den autheur.1640
 4 v. illus.

LC NE670.P2A3

705
A784
NCFA I.H.5

Debs, Barbara K.
From eternity to here:Uses of the Renais-
sance portrait

In:Art in Am
63:48-55 Jan.,-Feb.,'75 illus(part col.)

Transformation of intention in portrs fr.
medieval to early 15th c. donors to mid 15th c.
& later portrs."in context"& individual portrs.

N7618
P95
NPG I.H.5
has v.1 Prinz, Wolfram
Die Sammlung der selbstbildnisse in den
Uffizien;hrsg.v.U.Middeldorf & U.Procacci.
Red.v.W.Prinz.Berlin, Mann verl.,1971-
 3 v. illus. (Ital.Forsch.,Folge 3,Bd.5)

Contents:1.-Geschichte der sammlung;2-Die
selbstbildnisse der ital.künstler;3.-Die selbst-
bildnisse der nicht ital.künstler
v.1:Incl.Hist.develpom't of portrs.fr.repre-
senting famous fgs.of the past to actual portrs.

757
.F99 I.H.5

Furst,Herbert Ernest Augustus, 1874-
Portrait painting,its nature and function,..
London,John Lane.1927.

155 p. illus.(166 repro.)

ND 1300.F8

708.1
D47 I.H.5
v.23-27 Richardson, E.P.
1943-48 Madame Henriette de France as a vestal virgin
by Jean-Marc Nattier

In:B.Detroit Inst.Arts
23:2-3 Oct,1943 illus.

see also article by E.P.Richardson
705 In:Art Q
A7875 6,no.4:238-56 Autumn,1943 illus.
1943
 Rep.,1945-47*7741

705
A784
NCFA

I.H.5

Rose, Barbara
 Self-portraiture:Theme with a thousand faces

In:Art in Am
63:66-73 Jan.-Feb.,'75 illus(part col.)

 Self-portrs.record the artist's subjective
feelings abt.himself. He sees himself as Thinker
or Worker;equal to Royalty;devinely guided;Mar-
tyr or Madman,etc.

ND1337
A2B515
NPG

I.H.6

Berlin. Staatliche museen. Gemäldegalerie
 Miniaturen.1970
 56 p. illus(some col.) (Kleine Schrif-
ten,ne.13)

 Incl.:Chodowiecki.Self-portrait while draw-
ing with wife(who holds a min.portr.of Luise
Erman). Hockins.Oliver Cromwell. Parent.Nape-
leon

AP
1
A83
NCFA

I.H.5

Stefflet-Santiago, Mary
 Artists' portraits and self-portraits

In:Artweek
7,pt.3:3-4 Jan.,17,1976 illus.

 Incl.group scenes by Dürer & Goltsius with
self-portrs. in the crowd

FOR COMPLETE ENTRY
SEE MAIN CARD

I.H.6

qND
547.5
I4B6613
1986X
NPG

Bonafoux, Pascal, 1949-
 The Impressionists,portraits and confiden-
ces.N.Y.,Skira/Rizzoli,1986
 191 p. illus(part col.)

 Index

 Portrait within portrait,p.29

I.H.6. PORTRAITS WITHIN OTHER PORTRAITS

GT
736
B82
1979X
NPG

I.H.6

Buck, Anne M.
 Dress in 18th c. England...N.Y.,Holmes &
Meier Publ.,Inc.,1979
 240 p. illus(part col.)

 Bibliography

 Illustr.incl.:Ptgd.p.62:Zoffany.Portrait
within portrait. Conversation pieces

N
40.1
W49A16
NMAA

I.H.6

Abrams, Ann Uhry
 The valiant hero,Benjamin West and grand-
style history painting.Washington,D.C.,Smith-
sonian Institution Press,c.1986
 254 p. illus(part col.) (New directions
in American Art,v.1)
 Incl.Index
 Bibliography,p.231-42
 Ch.1:A hero for his time incl.:Self-por-
traits,p.18-26
 fg.8:Self-portr.with portr.of his wife

VF:
Florence
Gall.
degli
Uffizi

I.H.6

Buerkel, Ludwig von
 Die selbstbildnisse von malern in den Uffi-
zien

In:Ueber Land & Meer
94,no.46:1065-7 Apr.-Oct.,1905 illus.

 see Repro.Carlo Dolci,Adrian v.d.Werff,p.1066

LC AP30.U2

FOR COMPLETE ENTRY
SEE MAIN CARD

705
B97
NCFA
v.83

I.H.6

Asplund, Karl, 1890-
 Carl Fredrik von Breda

In:Burl Mag
83:296-301 Dec.,'43 illus.

 Repr.incl.:Self-portr.with sketched portr.
on easel

705
B97
NCFA
v.113

I.H.6

Cailleux, Jean ed.
 L'Art du dix-huitième siècle.Some family
and group portraits by François de Troy(1645-
1730)

In:Burl Mag
113,suppl.no.26:I-XVIII Apr.,'71 illus.

 fg.6:Mme.de Franqueville & her children
with black servant and portr.within portrait

 Rosenfeld,M.N. L'Argillière
 p.401,408

ND
1311.9
C47C3
NPG
1984X

I.H.6

Carolina art association, Charleston, S.C.
 The miniature portrait collection of the
Carolina art association;by Martha R.Severens
ed.by Chs.L.Wyrick,jr. Charleston,S.C.,Gibbes
Art Gallery,1984
 189 p. illus(part col.)

 Incl.:Index
 Bibliography

 Js.Peale painting a miniature by Chs.W.
Peale,p.XV

LC ND1311.9.C47C3 198

N
40.1
P35D4
NPG

I.H.6

Detroit. Institute of Arts
 The Peale family;three generations of Ame-
rican artists..Exh.;organized by Chs.H.Elam.
 Detroit,Detroit Inst.of Arts,1967
 150 p. illus(part col.)

 "Sponsored by Founders Soc.Detroit Inst.of
Arts & Munson-Williams-Proctor Inst.,Utica,N.Y."
 Exh.in Detroit,Jan.18-Mar.5,1967 and in
Utica,Mar.28-May 7,1967
 Cat.by Chs.H.Elam;articles by C.C.Sellers,
E.G.Paine,& E.H.Dwight
 Bibliography
 Index of si rs Simmons:Chs.P.Polk
 qN40.1.P748S5 Bibl.p.20

I.H.6

Castiglione:the ideal and the real in Renaissance
culture.Edited by Rbt.W.Hanning and David
Rosand.New Haven and London,Yale Univ.Press,
1983
 215 p. illus.
 Ch.6:Rosand,David.The portrait,the cour-
tier and death
 Discusses the Renaissance portr.as a com-
memorative art,which finds in its develop-
ment its inspiration in antiquity
 Portrs.within portrs,figs.2-4-10

LC BJ1604.C33C37 1983 Woods-Marsden In:Art J.
 46:215 note 31

705
G28
NCFA
v.45

I.H.6

Dowley, Francis Hotham, 1915-
 French portraits of ladies as Minerva

In:Gaz Beaux Arts
45:261-86 May-June,'55 illus.

 From the 1st portr.of a lady as Minerva(in
France):Margaret of Savoy on enamel by Jean De-
court,1555 to 18th c. examples.Diderot calls for
elimination of allegory
 Portrs.within portrs.important in France
since 17th c.

 Karla Langedijk

705
G28
NCFA
v.29

I.H.6

Chennevières, Henry de
 François Dumont.Miniaturiste de la reine
Marie Antoinette

In:Gaz Beaux Arts 3rd ser.
29:177-92 1903 illus.

 Portr.within portrait p.187

 Draper,Js.D.:Grétry Encore
 In:Met.Mus.J. 9:235 note 6

705
A56
NCFA
v.96

I.H.6

Dresser, Louisa
 Portraits owned by the American Antiqua-
rian Society

In:Antiques
96:717-26 Nov.,'69 illus(part col.)

 Repro.incl.Ths.Smith,Pelham,Copley,Chandler
Gullager,M'Kay(Mrs.Bush holding miniature),Ma-
ther Brown,Greenwood,A.Fisher,S.Goodridge,E.
Goodridge

qN
6756
C593
NMAA
2 c.

I.H.6

Clark, Jane, 1955-
 The great eighteenth century exhibition in
the National Gallery of Victoria..Melbourne,
Nat'l Gall.of Victoria,1983.
 179 p. illus.(part col.)

 Ch."The proper study of mankind is man",
some 18th c.people,pp.137-61
 Additional portrs.p.115,118,(Luigi Boccheri-
ni)p.123. Busts p.106. Miniatures p.48-9.
Groups p.18,p.22-3,p.28,30,110,122
 Portraits within portraits p.27,54

N
40.1
D12709
NPG

I.H.6

Du Pasquier, Jacqueline
 Dagoty,1775-1871,peintre de la société
Bordelaise.1973.
 26 p. illus.

 Extrait de la Revue historique de Bordeaux
et du département de la Gironde,tome ??,nou-
velle série,1973

 Portr.within portr.,p.19 & p.21

705
C75
NCFA
v.10

I.H.6

Clouston, Mrs.K.Warren
 The Duke of Fife's collection at Duff House
.rev.& completed by Mrs.Crosby Smith.

L.:Connoisseur
10:3-9 Sept.,'04 illus.
 :67-74 Oct., '04 "

 Repro.incl.Gainsboro,Velasquez(attr.),C.Pone,
Reynolds,P.van Somer

 'Almost every room in Duff House is a pic-
ture gallery'.There are portrs.fr.16th-19th c
including Jack

708.1
N52
NCFA

I.H.6

Gardner, Albert Ten Eyck
 A century of Women

In:Met Mus Bul
N.S.7:110-8 Dec.'48 illus,

 Repro.incl.:Miniature of Mrs.Coudry by
Sarah Goodridge.Rosa Bonheur by Anna Elisabeth
Klumpke.Mural & portrs.by Mary Cassatt.Front-
ispiece fr."Godey's Lady's Book":Portr.within
portr.

 Dewhurst.Artists in aprons
 Bibl.p.14

I.H.6

Gerson, Horst
 Zes eeuwen Nederlandse schilderkunst.Amsterdam,Contact,1962.
 3v.in 1 illus.

 Repro.incl.Portrs.within portrs. Deel III
Cornelis Troost,no.3;Philip van Dijk,no.5;
Adriaen de Lelie,no.17

LC ND644.G4

705
C75
NCFA
v.75

I.H.6

Manners, Lady Victoria, 1876-
 The later historical portraits in the collection of the Duke of Norfolk,E.M.,at Arundel Castle

In:Connoisseur
75:74-9 Jun,1926 illus.

 Incl.:Bernard Howard,12th Duke of Norfolk,by Gainsborough, Frances Howard,Duchess of Richmond & Lennox, Mary Blount,Duchess of Norfolk by Ang. Kauffmann, Charles Howard,10th D.o.N.,by Opie

qND
1314
G449
NPG

I.H.6

Gibson, Robin
 British portrait painters,.by.Robin Gibson and Keith Roberts.London,Phaidon,1971
 16 p. illus(col.)

 Distributed in the U.S.by Praeger Publ.N.Y.

 Pl.3:Eworth.Lady Dacre.In the background portr.of her husband

LC ND1314.G5

qN
1615.5
E85P14
1988
NMAA

I.H.6

New York. National academy of design
 Painters by painters.N.Y.,Nat'l academy of design,1988.
 108 p. illus(part col.)

 Cat.of an exh.held at the Nat'l acad.of des. May12-July 31,1988 & Mus of fine arts,Houston, Aug.13-Oct.23,1988
 Bibliography
 List of portrs.of artists in the Uffisi
 Index to artists and plates
 Essays:The history of a collection by Caterina Caneva,p.8-2___ Studio portrs.by Antonio Natali,p.28-34.Po___.within portr.:Cover & no.17

I.H.6

Harris Museum and Art Gallery, Preston,Eng.
 Polite society,portraits of the English country gentleman and his family by Arthur Devis.Cat.of the exh.Oct.1st - Nov.12th,1983. NPG,London Nov.25th,1983-Jan.29th,1984,organ. by the Harris Mus.and Art Gall.,Preston...with financial assist.fr.the Arts Council of Great Britain.Preston.the Gallery.1983
 122 p. illus(part col.)

 Portrait within portrait p.92
 Intro.by John Hayes,p.9-16.Cat.essay:Arthur Devis:His life & ___art by Stephen V.Sartin, p.19-35

TR
365
N54
1968
NPG

I.H.6

Newhall, Beaumont, 1908-
 The daguerreotype in America..Rev.ed. N.Y.. N.Y.Graphic Society.c.1961,1968.
 176 p. illus.

 Bibliography

 Incl.Biographies of photographers
 Pl.1:Sitter holds a daguerreotyped portr.

705
A7834
NMAA

I.H.6

Koslow, Susan
 Two sources for Vincent van Gogh's"Portrait of Armand Roulin":a character likeness and a portrait schema

In:Arts Mag.
56,no.1:156-63 Sept.,1981 illus.

 Hans Holbein the elder's portr.of a youth is considered the inspiration of "character likeness".The "schema"seems to come from Charles Bargue's "Cours de dessin"
 Portrs.within ___ portrs.,fgs.4,5,6
 Brilliant In:Art J.v.46
 no.3:172,note 14

N
7592
F35X
NPG

I.H.6

Paris. Musée des arts décoratifs
 La famille des portraits... Paris,1979

 Incl.:Portrs.within portrs.,p.55,66,96

FOR COMPLETE ENTRY
SEE MAIN CARD

N
40.1
E9515
NPG

I.H.6

Leicester, Eng. Museum and Art Gallery
 Hans Eworth:a Tudor artist and his circle .Prepared by Dr.Roy Strong....1965.
 26 p. illus.

 Catalogue of an exhibition
 Bibliography

 Repr.incl.:Baroness Dacre with portr.of 1st husband by Holbein?;Sir John Luttrell,with allegorical scene:Peace caresses Sir John's arm, by School of Font---nebleau;Queen Elizabeth in a

LC ND497.E914

 source:Yale ctr.f.Brit.art Ref.

N
40.1
D49SP3
NPG

I.H.6

Pavière, Sydney Herbert, 1891-
 The Devis family of painters...Leigh-on-Sea, F.Lewis.1950.
 148 p. illus(part col.)

 Bibliography

 Cat.of known and unknown works.Index of owners of Arthur and Arthur William's ptgs.
 '....Arthur.Devis remained faithful to his one love.the conversation piece...'.p.32
 Portrs. within portrs.Pl.24

LC ND497.D49P3 Archer.Arth.Wm.Devis.In:Art
 at Auction.AP1.S76,1971-2
 p.80,note 1

N
40.1
W49P5
NPG

I.H.6

Philadelphia Museum of Art
 Benjamin West,1738-1820.Phila.,Pennsylva-
nia museum of art,1938
 58 p. illus.

 See also article by Richard Graham in:
Art News,v.36,Mar 19,'38,p.12-13.Cover illus.:
West painting his wife

LC ND237.W45P4

AP
1
A5182
NCFA

I.H.6

Viola, Herman J.
 Portraits,presents,and peace medals:Thomas
L.McKenney and the Indian visitors to Washing-
ton

In:Am.Scene
11,no.2 June,1970 illus(part col.)

 Incl.documentation of portrs.by Chs.Bird
King in the Ths.Gilcrease Inst.of Am.Hist.& Art
Tulsa,Okla.

 Viola.Ind.legacy...N40.1
 K52V7 Bibl.

qN
6520
.P63
1983X

I.H.6

Poesch, Jessie J.
 The Art of the Old South,painting,sculp-
ture,architecture,and the products of crafts-
men,1560-1860...1st ed.N.Y.,Knopf,1983
 384 p. illus(part col.)

 Incl.index
 Bibliography,p.361-366

 Repro.incl.:Eye miniature by Malbone,p.162;
Portrs.of Amer.Indians by Curtis,p.272;by Rö-
mer & by Catlin,p.273.Ports.within portrs.,
p.265.Groups by Earl,p.171;by Johnson,
p.159

AP
1
366
NPG
v.3

I.H.6

Viola, Herman J.
 Washington's first museum:The Indian off:
collection of Ths.L.McKenney

In:Smiths.Jl.of Hist.
3,no.3:1-18 Fall 1968 illus.

 p.10-14:The gallery of 130 portrs.of In-
dian dignitaries by Athanasius Ford and Chs.
B.King,some after sketches by J.O.Lewis

 Viola.The Ind.legacy...B
 N40.1K52V7 NPG

I.H.6

Spanish Institute,Inc.,N.Y.
 The Spanish golden age in miniature.Portraits
from the Rosenbach Museum & Library.Cat.of exh.,
March 25-Apr.23,'88.New York,The Institute,1988
 62 p. illus(part col.)
 Bibliography

 Incl.the miniatures of the Talbot Hughes
coll.
 Exh.also in Philadelphia,Rosenbach Mus.&
Library,June 7-July 31,'88

MdBMA MB(ND1337.S7S636 ⟨1988)

qN
40.1
W49V9
NMAA

I.H.6

Von Erffa, Helmut
 The paintings of Benjamin West.by.Helmut
von Erffa and Allen Staaley.New Haven & London,
Yale Univ.Press,1986
 606 p. illus(part col.) (a Barra foun-
dation book)
 Index
 Portraits:p.450-576(incl.groups)
 Port.within portrait,p.453,501,567

LC 237.W45A4 1986

N
7606
S75
NPG

I.H.6

Spike, John T.
 Baroque portraiture in Italy.Works from
North American collections.Cat.for an exh.at
The John and Mable Ringling Mus.of Art,Dec.7,
1984-Feb.3,.985.Printed by.Joe R.Klay & Sons,
Inc..1985.
 214 p. illus(part col.)

 Bibliography
 Ptgs.,medals,busts,drags.,prints.In alpha-
betical order by artist
 Incl.:Introductory essays on 4 aspects of
Baroque portrai- ure
 Portr.within rtr.no.50.Black servant
 no.68

qND
1300
W37
1979X
NPG

I.H.6

Warner, Malcolm, 1953-
 Portrait painting.1st American ed. N.Y.,
Mayflower Books,c.1979
 80 p. illus(col.)

 Bibliography

 14th-20th c.
 Originally publ.in England by Phaidon Press
Oxford.
Repro.incl.:Rubens.Presentat'n of portr.of Marie de Medi
ci to Henry IV(detail) N.Y.(City).P.L.Art & architec
 Div. Bibliogr.guide to art
 & architecture A5939.A791
LC ND1300.W37 1979 1979 v.2,p.233

705
C69
NMAA
v.46

I.H.6

Tscherny, Nadia
 Likeness in early Romantic portraiture

In:Art J.
46,no.3:193-99 Fall,1987 illus.

 Portraits within portraits,fg.1

705
C69
NMAA
v.46

I.H.6

Wendorf, Richard
 Hogarth's dilemma

In:Art J.
46,no.3:200-8 Fall,1987 illus.

 W.discusses H.'s ambivalent commentary on
portraiture & examines his success in adapting
traditional forms & motifs.
 Portraits within portraits,fgs.1 & 8

I.H.6

Willmott-Dixon, Willmott, 1843-
Dainty dames of society,a portrait gallery
of charming women by"Thormanby.pseud...Portraits
and illustrations from rare and famous pictures
by masters of British and French schools.London,
A.& C.Black,N.Y.,F.A.Stokes ee..1903.
4 v. illus.
(Illustrated biographies of charming women)
Contents:v.1.2 duchesses of Devonshire."Sa-
charissa".Lady Holland.v.2.The Horneeks:"Little
Comedy","The Jessamy Bride".Countess of Blessing-
ten.Duchess of Queensberry,Duchess of Rutland
v.3.The Kembles. Countess of Cork & Orrery.

LC CT3320.W53(Wash.,D.C.
P.L.for LC)

I.J

Auerbach, Erna
Die deutsche bildnismalerei im 16.Jahrhun-
dert in Franken,Schwaben und Bayern

Thesis 1923. Frankfurt am Main

Source an main
List

I.J. THESES & DISSERTATIONS

mfm
99
NCFA

I.J

Averill, Louise Hunt, 1915-
John Vanderlyn,American painter(1775-1852)
.New Haven,Conn..Yale University,1949
389 leaves illus.

Incl.:Cat.raisonné
Bibliography:leaves 378-89

Thesis. Yale University

(Microfilm does not incl.illustrations)

I.J

Adams, Harriet D.
Self-portraits in French painting from
1830-1870

Master's Th.-N.Y.Univ.,1937

Lindsay,K.C. Harpur Ind.of
Master's Theses in art...
1955 Z5931.L74 1955 Ref.
NCFA p.31 no.555

I.J

Bachstits, Walter W.
Studien zum porträt des16.jahrhunderts. Ein
internationaler porträttyp. Würzburg,Konr.Triltsch
1934

FOGG
FA4353
.12
Met
195.3
B12

65 p.
Bibliography

Inaug.Diss.-Bonn

DLC.-Ph

Rep.,1936#345

AP
1
A51A64
NCFA

I.J

Ahrens, Jacob Edward Kent, 1939-
The portraits by Robert W.Weir

In:Amer.Art J.
6:4-17 May,'74 illus.

Repr.incl.Self-portrait

See also:Ahrens.Robt.W.Weir.Ph.D.thesis
Uni.of Delaware,1972 Ch.III.Portraits,p.36-65

mfm
103
NCFA

Rila I/1-2 1975 #4549

I.J

Bartels, Heinrich
Studien zum frauenporträt der augusteischen
seit-Fulvia,Octavia,Livia,Julia.München,Feder,
1963
113 p.

FOGG
638
B278

Diss.-Berlin,1960

NJP MH NNMM DDO

Kraus.Das römische welt-
reich N5760.K92 Bibl.p.316

I.J

Ambrose, Charles E.
Problems in portraiture

Master's Th.-Univ.of Alabama,1950

Lindsay,K.C.,Harpur Ind.of
master's theses in art...
Z5931.L74 1955 NCFA Ref.
p.84,no.1547

I.J

Barth, Suse
Lebensalter-darstellungen im 19.und 20.
jahrhundert;ikonographische studien.Bamberg,
Aku-Fotodruck,1971
265 p.

Inaug.-Diss.-Munich

Bibliography

LC N8217.A47B37

Die 20er jahre im portr.
N6868.5.E9297 MPO,p.140

I.J

Bergmann, Marianne
 Studien zum römischen porträt des 3.Jahr-
hunderts n.Chr...Bonn,Habelt,1977
 222,61,6 p. illus. (Antiquitas:Reihe 3
Abhandlungen zur Vor-und Frühgeschichte,zur
klassischen und provinzial-römischen Archäo-
logie und zur Geschichte des Altertums,Bd.18)

 Bibliography

 Originally Thesis,Bonn,1972
LC N7588.B48 Gesichter.NB1296.3.G38
 1977 1983 NPG p.315

I.J

Forland,Mrs.Belle(McCullough)
 Philippe de Lasalle,his contribution to
the textile industry of Lyons...Chicago,Ill.,
The univ.of Chicago press.1936.
 48 p. illus.

 This essay is a rearrangement of the author's
thesis
 Repro.incl.:woven portrs.of Philippe de
Lasalle,Catherine the Great
 Re:Portrs.woven in silk see p.41-42,46

LC NK8949.R6 1936

I.J

Biddle, Richard
 The delineation of character in portrait
painting

 Master's Th.-Columbus,O.S.Univ.,1935

 Lindsay,K.C. Harpur Ind.of
 Master's theses in art...
 Z5931.L74 1955 NCFA Ref.
 p.26,no.450

I.J

Brasch, Ernst, 1901-
 Das nazarenische bildnis:ein beitrag zur
aesthetik und geschichte der porträtkunst.
Potsdam,R.Schneider.1927.
FOGG 64 p. illus.
FA
4353.8 Inaug.-diss.Würzburg,1927

 Bibliography

ICRL ICU CtY PU PPULC Fogg,v.11,p.318

I.J

Binsfeld, Wolfgang, 1928-
 Grylloi,ein beitrag zur geschichte der an-
tiken karikatur.Köln,1956
 1 v.
FOGG
FA5999 Inaug.-Diss.Köln,1956
.122.301

 Winkes.Physiognomonia.In:
 Temporini.Aufstieg u.nieder-
 gang...LC DG209.T36,Bd.1,T4
 p.910

I.J

Brückner, Wolfgang, fl.1958-
 Bildnis und brauch.Studien zur bildfunk-
tion der effigies(Berlin)E.Schmidt(1966)
 361 p. illus.

 Bibliography

 Revision of Habilitationsschrift Frankfurt
 .a.M.

 Schoch,D.Herrscherbildnis...
LC GR600.B75 NDI313.5.S36X NPG p.244(9)

I.J

Bishop, Robert Charles
 The Borden Limner and his contemporaries.
Ann Arbor, University of Michigan,1975
 330 p. illus.

 Diss.Uni.of Mich.1975(resulted in an exh.
mfm 76- at Ann Arbor,Mus.of Art,Nov.14,1976-Jan.16,'77)
9345
 Indepth study & survey of the Borden Lim-
ner & the attribution of his portrs.to John S.
Blunt
 For cat.of exh.see qN40.1.B722B6 NPG 90 p.
illus(part col.)
 Rila III/1 1977 #2376
 Diss.Abstr.,Apr.1976

I.J

Busch, Frieda
 Bases of portrait painting

 Master's Th.-Columbus,O.,1938

 Lindsay,K.C.,Harpur Ind.of
 master's theses in art...
 Z5931.L74 1955 NCFA Ref.
 p.35,no.616

ND
1300
B613 I.J
1985X
NMAA Bonafoux, Pascal
 Portraits of the artist.The self-portrait
in painting.N.Y.,Skira/Rizzoli,1985
 158 p. illus(part col.)

 Incl.Index
 Bibliography,p.143-8

 Translation of:Les peintres et l'autopor-
trait
 Based on diss.Paris,1979

I.J

Caldwell, Henry Bryan
 John Frazee,American sculptor

 Master's thesis,N.Y.Uni.Graduate School,1951

I.J

Campbell, Edith
A discussion of certain aspects of the in-
fluence of the Renaissance on Netherlandish
portrait painting in the 1st half of the 16th
century

Master's Th.-Northampton,Mass.,Smith Coll.,
1934

Lindsay,K.C.,Harpur Ind.of
master's theses in art...
Z5931.L74 1955 NCFA Ref.
p.24,no.411

I.J

Cornelius, Carl, 1868-
Bildniskunst;2.teil, das mittelalter

Insug.diss.,Freiburg,i.B.,1901

LC no call no. NC ICRL PU WU Waetzoldt ND1300.W12

N
40.1
B67C4d
1974a
NMAA

Chambers, Bruce William,1941-
David Gilmour Blythe(1815-1865):an artist
at urbanisation's edge.Philadelphia,s.n.,1974
437 1. illus.

Index
Photocopy.Ann Arbor,Mich.
Ph.D.Thesis,Univ.of Pa.,1974
Bibliography,p.XVII-XXXIII
Checklist of ptgs.,drawings,sculpture

NE
506
C92
1977a
NMAA

Cresswell, Donald Howard, 1941-
Prints of the American Revolution:a histo-
ry and checklist of graphics produced from
1765-1790. 1977
606 p. illus.

Bibl.references
Reference sources,p.597-605
Thesis Ph.D.-Geo.Washington Univ.,1977
Photocopy of typescript
Pt.I,Ch.V a:Portraits,p.63-73
Pt.II,Ch.I:Portraits,p.140-2

N
40.1
S365C7
NPG

Comini, Alessandra
Egon Schiele's portraits...Berkeley.Uni.of
Calif.Press,c.1974
271 p. illus(part col.) (California stu-
dies in the history of art;17)

Bibliography

.Based on Ph.D.Dissertation,Columbia U.,
1969.

LC ND1329.S34C65 Diss.Abstr.Z5055.U45D57NPG
v.35,no.7,p.4330-A;Jan'75
no.74-29,573

I.J

Croquison, R.P.Pierre
Les origines du portrait frontispibe dans
les manuscrits à peintures. Paris,Thèse Ec.
Louvre,23 novembre 1949)

Rep.,1948-49:863

qN40.1
I55C7
NMAA

Condon, Patricia
Ingres,in pursuit of perfection;the art
of J.-A.-D.Ingres;the J.B.Speed Art Museum,
Louisville,Ky.,Dec.6,1983 to Jan.29,1984;
the Kimbell Art Museum,Fort Worth,Tex.,Mar.3-
May 6,1984;by P.Condon with Marjorie B.Cohn,
and Agnes Mongan,ed.by Debra Edelstein.
Bloomington,Ind.Indiana Univ.Press,1983
255 p. illus(part col.)
For portrs.see:Mongan,p.138-49 & cat.nos.57-78
Indexes
Bibliography
Based on diss. research by P.Condon for
Ph.D. at Brown Univ.,Providence,R.I.

ND
1311.9
S48C9s
NPG

Curran, Ona
Schenectady ancestral portraits early 18th
century

In:Schenectady Co.Hist.Soc.B.
10,no.1 Sept.'66

Based on Curran's Master Thesis,N.Y.State
Univ.College,Oneonta,N.Y.
Incl.:Van Epps Limner,Veeder Limner,Schuyler
Limner,Pierpont Limner,Gansevoort Limner,
Hudson Valley Patroon Painters,except Pier-
pont Limner Feigenbaum.Amer.portrs...
MM ND1311.2.F29 NPG Bibl.p.14

I.J

Cook, M.N.
Portraiture in Europe from 1780-1830

Master's Th.-Mills Coll.,Oakland,Calif.,
1939

Lindsay,K.C.,Harpur Ind.of
master's theses in art...
Z5931.L74 1955 NCFA Ref.
n.39,no.692

I.J

Daltrop, Georg
Die stadtrömischen männlichen privatbild-
nisse trajanischer und hadrianischer seit.
Münster,1958
131 p. illus.

Thesis - Münster, 1958
Bibl.ref.

LC NB115.D3 1958 Kraus.Das römische welt-
reich N5760.K92 Bibl.316

I.J
afa
161
NPG

Daugherty, Frances Perry, 1938-
 The self-portraits of Peter Paul Rubens;some
problems in iconography...Chapel Hill,N.C.,University of N.C.,1976
 2 v. illus.

 Thesis.-University of North Carolina at
Chapel Hill. Typescript.

 Bibliography

I.J

Drerup, Heinrich
 Die datierung der mumien-porträts...Paderborn,F.Schöningh,1933
 66 p. illus (Added t.-p.:Studien
zur geschichte und kultur des altertums,XIX.bd.
1.hft.)

 Gekrönte preisschrift der Universität Bonn
 Study of mummy portrs.fr.the time of
Augustus to the middle of the 4th c.

 Bibliography
LC ND1327.E3D7 Fogg,v.11,p.321

I.J

Davis, Marian Belle
 A study of Venetian portraiture of the
early renaissance
 illus.

 Thesis-Radcliffe,1948

FOGG
Widener

 Fogg,v.11,p.319

N
40.1
S72809
1981a
MMAA

I.J

Dunow, Esti
 Chaim Soutine,1893-1943...1981
 2 v.in 1 321 p. illus.

 Bibliography,p.305-321

 Ch.V:Portraits,p.216-287

 Thesis Ph.D.-N.Y.Univ.,1981
photocopy of typescript

I.J

Dexter, Elisabeth Williams (Anthony) 1887-
 Colonial women of affairs;a study of women
in business and the professions in America before 1776...Boston and N.Y.,Houghton Mifflin
company,1924
 203 p. illus.

 References
 The author's doctoral diss.Clark Uni.,192,
but not published as a thesis

 Dewhurst.Artists in apron
LC K195.D52 Bibl.p.175

I.J

Eckert, Karla, 1908-
 Das Bildnis der klassizistisch-romantischen
epoche in Deutschland.Köslin in Pommern,C.G.
Hendess G.m.b.H.,1936
 95 p.

FOGG
4013.1.5

 Inaug.-Dissertation-Königsberg/Pr.1936

 Literaturvers.,p.81-7

ICRL NNC MdU Fogg,v.11,p.319

AP
1
V81
NPG
v.75

I.J

Doud, Richard K.
 The Fitzhugh portraits by John Hesselius

In:Va.Mag.Hist & biogr.
75:159-73 Apr.'67 illus.

 Incl.:Cat.of signed Fitzhugh portraits

 Based on Doud's Master's thesis,Univ.of Delaware,1963:"John Hesselius:his life and work"

 Miles.Amer.Col.portrs.
 p.73,note 121

I.J

Elam, Charles H.
 The portraits of William Dunlap(1766-1839)
and a cat.of his works

 Master's Th.-N.Y.Univ.,1952

 Lindsay,K.C.Harpur Ind.of
 master's theses in art...
 1955 Z5931.L74 1955 NCFA
 Ref. p.102 no.1895

AP
1
W78
1969
NCFA

I.J

Doud, Richard K.
 John Hesselius,Maryland limner

In:Winterthur Portfolio
5:129-53 1969 illus.

 Incl.cat.of ptgs.in alphabetical order by
sitters

 Based on Master's thesis,Univ.of Del.,1963

N
40.1
K265
E4
NPG

I.J

Eller, Povl
 Kongelige portraetmalere i Danmark 1630-82.
En undersøgelse af kilderne til Karel van Manders
og Abraham Wuchters' verksomhed..Udg.af.Selskabet
til Udgivelse af danske Mindesmaerker.København,
Dansk Historisk Faellesforening,1971
 563 p. illus.

 Thesis-Copenhagen
 Summary in English
 Bibliography

LC ND1328.E43

I.J

Elwert, Dorothee, 1935-
Die Ohrmuschel in der malkunst an werken
von Leonardo da Vinci,Michelangelo,Tisian,Ve-
lásques,Rembrandt,Dürer.Tübingen.1964
136 p. illus.

Bibliography

Inaug.Diss. Tübingen

IU Rep. 1966 #1019

705
A56
NMAA
v.124

I.J

Flanary, Sara E.
William Edward West in New Orleans and
Mississippi

In:Antiques
124:1010-15 Nov.,'83 illus(part col.)

Based on Master thesis "The Pre-European
career of Wm.Edw.West in New Orleans & Missis-
sippi.Richmond,Va.,Va.Commonwealth Univ.

N
40.1
B8785
E9
NPG
NMAA

I.J

Evans, Dorinda
Mather Brown,early American artist in Eng-
land.A Barra Foundation/Kress Foundation Book.
Middletown,Conn.,Wesleyan Univ.Press,1982
297 p. illus(part col.)

Bibliography
Incl.:Cat.raisonné,incl.drags. & prints

Rivised & expanded from the Ph.D.disserta-
tion Courtauld Inst.of Art.Univ.of London,1972

I.J

Fleischer, Roland E.
Custavus Hesselius

Dr.diss. John Hopkins Univ.,1964

lles.In:Am Art J AP1.A51A61
IAA v.15:65 note 14

ND
1311.2
F29
N: 3

I.J

Feigenbaum, Rita
American portraits,1800-1850;a cat. of early
portraits in the collections of Union College.
Schenectady,N.Y.,Union College Pres,1972
155 p. illus(part col.)

originally presented as the author's thesis
(M.A.)Union College,1966-67
Bibliography p.143-50
Index

LC ND13311.2F4 1972 Art Books 1950-79 Z5937
A775 NCFA Ref. p.897

I.J

Forster-Hahn, Franziska
Johann Heinrich Ramberg als karikaturist
und satiriker.Hanover,1963
235 p. illus.

"Sonderdruck aus Hann.Geschichtsblättern,N.F.
Band 17(1963)"
Thesis Bonn

Bibliography:p.223-230

LC NC1509.R3F6 1963 Noon.Engl.portr.drags & Min
Bibl. p.145

I.J

Fielder, Martha Anne
Iconographic themes in portraits of Hen-
ry VIII
232 p.

Ph.D.diss.-Texas Christian University,1985

This study enlarges Roy Strong's thesis'in
Holbein & Henry VIII that the English Reforma-
tion signaled a change in the visual image of
the king & expands that concept.The evolution
of Henrician portrs.can be categorised int8 3
phases:

I.J

Fowble, Eleanor McSherry
Rembrandt Peale in Baltimore

Master's Thesis,Univ.of Delaware,Newark,
1965

Penn.Hist.Soc. Rembrandt
Peale...Bibl.p.118

N
40.1
O 4RP5
1981
NPG

I.J

Finsten, Jill
Isaac Oliver,art at the courts of Eliza-
beth I and James I. N.Y.,Garland Pub.1981
2 v. illus. (Outstanding dissertation
in the fine arts)

Originally presented as PH.D.-Thesis,Har-
vard,1979

Bibliography in v.1,p.220-34
Cat.raisonné in v.2

Fitzwilliam Mus. Cat.of por-
trait min. NM1337.G1F4 1975
IPG N149.p.222

I.J

Freund, Gisèle
La photographie en France au 19ième siècle
étude de sociologie et d'esthétique...Paris,
Le maison des amis des livres,A.Monnier,1936
154 p. illus.

Thèse-Univ.de Paris

Bibliography

Disc.incl.the use of photography by portr.
ptrs. Scharf,A.Art & photography
N72.P5S31 NCFA p.260(14)

LC TR71.F7 1936

I.J

Frouing, Hubertus
Die Entstehung und entwicklung des stehenden gansfigurenporträts in der tafelmalerei des 16.jhr.:Eine formalgeschichtliche untersuchung

Ph.D.diss.Julius-Maximilians Uni.Würzburg.
Krefeld,1971,Würzburg,1973

Amer.portr.in the Grand
Manner...ND1311.A47X NMAA
Bibl.p.217

I.J

Gill, P.R.B.
Critical analysis of the relationship of the portrait background to the portrait

Master's Th.-Pittburgh,Pa.,Univ.,1951

Lindsay,K.C.,Harpur Ind.of master's theses in art...
Z5931.L74 1955 NCFA Ref.
p.94,no.1728

I.J.

NB
210
F94
1984a
NPG

Fryd, Vivien Green
The public portrait monument,Ch.5.in her. Sculpture as history...1825-1865,p.163-247 illus.

Bibliography

Ph.D.diss.Univ.of Wisc.-Madison,1984

I.J

Olmser, Käte(Albrecht), 1897-
Das Bildnis im Berliner Biedermeier...Berlin Rembrandt.1932,
179 p. illus. (Berlinische bücher...4.bd

Bibliography

"Dieses buch entstand aus einer dissertation. Würzburg,1929

NJP NNC IaU Enc.of World Art N31E56Ref v.11,p.512

I.J

Gasda, Elaine Kathryn
Style and technique in the funerary reliefs of late Republican Rome..n.p.,1971
167 l. illus.

Doctoral Diss.Harvard,1971

MH

Gasda.Etrusc.infl.in the funerary reliefs...In:Temporini.Aufstieg u.niedergang...
LC DG209.T36.Bd.1.T.4.p.858

I.J

Geern, Hermann, 1896-
Das familienbildnis im abendlande.I.Vorstafen im mittelalter...Halle,E.Kling,1936
45 p.

Thesis, Halle-Wittenberg
"Teildruck" Gesamtausgabe erscheint mitte 1936 in Akademischen verlag, Halle

FCGG
FA 980.21

NNC CtY ICRL NN Fogg,v.11,p.322

I.J

Gercke, Wendula Barbara Voss, 1940-
Untersuchungen zum römischen kinderporträt von den anfängen bis in hadrianische zeit.Hamburg,1968
217 p.

Diss.Hamburg,1968

NIC OrU

Winkes.Physiognomonia.In: Temporini.Aufstieg u.niedergang...LC DG209.T36,Bd.1,
T.4,p.912

I.J

Goodall, Donald Bannard, 1912-
Gaston Lachaise,sculptor.1969
2 v.in 5 illus.

Ph.-D.thesis Harvard,1969

FCGG
Widener v.2-Plates

I.J

H
40.1
W57066
1973a
NMAA

Cordor, Judith Elaine, 1942-
James McNeill Whistler:a study of the oil paintings,1855-1869...Iowa City,1973
261 p. illus.

Bibliography

Thesis Ph.D.-Univ.of Iowa,1973
Photocopy of typescript

I.J

Goodfellow, Gavin L.M.
Cosmo Alexander:the art,life and times of Cosmo Alexander(1724-1772).Portrait painter in Scotland and America

M.A.thesis,Oberlin,1961

'This is at present the only monograph About Alexander.'-Geddy(Nov.,'77)

Geddy.In:Antiques 112:976
note 4

N
40.1.
S9568
1986a
NPG

I.J

Greene, Margaret Harm
Dr.Edward Hudson and Maria Mackie Hudson:
Thomas Sully's portrait style,1810-1820. 1986
41 leaves illus.

Bibliography;Leaves 40-41
Photocopy
Masters essay-Univ.of Michigan,1986

I.J

Hafner, German
Späthellenistische bildnisplastik.Versuch
einer landschaftlichen gliederung.Berlin,Gebr.
Mann,1954
121 p. illus.

At head of title:'Deutsch.ArchMol.Inst.'

Bibl.references

Habilitationsschrift-Mainz
Cincinnati Univ.Libr.for
LC NB154.H3 Kraus.Das römische welt-
DDO DLC, etc. reich.N5760.K92 Bibl.p.315

I.J

Grohn, Hans Werner
Das Porträt des Manierismus in der Toscana
1942
114 p.

Ph.D.Thesis-Humboldt Univ.,Berlin

Maschinenschr.

Bibl.su kunst & kunstgesch
Z5931.B58 1945-53 NCFA
p.97 no.1853

CT
275
H81H3
1968
NPG

I.J

Hastings, George Everett
The life and works of Francis Hopkinson.
N.Y.,Russell & Russell,1968.
516 p. ill s.

'A revision of a doctoral thesis written at
Harvard Univ.in 1917-18'-Pref.

Reprint of 1926 ed.

Alberts.Penj.West N40.1.W49
A3 NPG Bibl.p.491

I.J

Grouvel, Mme,
L'iconographie des reines de France au 17e
siècle

Met
100.54
M973

In:B.Mus.France
11:36-8 1946,no.6-7 illus.

Thèse soutenue à l'école du Louvre

LC N2B94 FOR COMPLETE ENTRY
SEE MAIN CARD

I.J

Heimeran, Ernst, 1902-1955
Michelangelo und das porträt.München,
F.Bruckmann,1925

Inaug.diss.-Erlangen

LC N6923.B9H47 FOR COMPLETE ENTRY
SEE MAIN CARD

I.J
Habercorn, R.B.
The Roman portrait statue

Master's Th.-Columbus,O.,1915

Lindsay,K.C.,Harpur Ind.of
master's theses in art...
Z5931.L74 1955 NCFA Ref.
p.3,no.33

I.J

Heins, Barbara
Florine Stettheimer and the avant-garde
American portrait

Ph.DD-thesis,Yale Univ.,1986

Archives of American Art
Journal.v.24no.4,1984
AP1.D39 NMAA,p.28

I.J

Gurdus, Luba
The self-portrait in French painting from
Neo-classicism to Realism.1962

Ph.D.diss.-N.Y.,Inst.of Fine Arts,1962

AP
1
M37
NCFA

Summary in Marsyas,11:73 '62-'64

Stein,J.C. Image of the
.tist in France...ND1316.S73
1982a NPG p.3,footnote 3

N
40.1
M956H47
1978a
NMAA

I.J

Heleniak, Kathryn Moore
William Mulready,R.A.,1786-1863.British
landscape and genre artist.N.Y.Univ.1978
546 p. illus.

Bibliography
Thesis Ph.D.-N.Y.University,1978
Photocopy of typescript

Ch.6 incl.:Portraiture,p.272-7
Portrs. in Sheepshanks & Swinburne colls.

I.J

Heslip, Colleen
Susan Waters

Masters Thesis,Cooperstown Program.c.197.

Woodward,American Folk p+
ND207.W66? NPG p.14 & 8?

I.J

Houchens, Douglas
Contributions of expressionists painting
to the art of portraiture

Master's Th.-Coll.of Wm.& Mary,Richmond,Va.,
1952

Lindsay,K.C.,Harpur Ind.of
master's theses in art...
Z5931.L74 1555 NCFA Ref.
p.103,no.1908

I.J

N
8217
I5H63
1967
NMAA

Hight, Kathryn Sweeney
The frontier Indian in White art,1820-1876.
The develpment of a myth.Ann Arbor,Mich.Univ.
Microfilms International,1989
421 leaves illus.

Bibliography:leaves 387-421
Incl.:Discussion of the art work concerning
Indian subjects by Samuel Seymour,Js.Otto Lewis,
John Neagle,Chs.Bird King,P.Rindisbacher,Geo.Cat-
lin,Karl Bodmer,John Mix Stanley,Seth Eastman.
Some works were reproduced from daguerreotypes.
Ph.D.Disserta- .ion.UCLA,1987

I.J

Howard, Betty J.
A cat.of 19th c. portraits in the Ohio
State archeological and Historical museums

Master's Th.-Columbus,O.S.Univ.,1948

Lindsay,K.C. Harpur Ind.of
master's theses in art...
.955 NCFA Ref.Z5931.L74
p.73 no.1330

I.J

Hodurek, J.
Die selbstbildnisse der nord- und mittel-
deutschen Expressionisten.

Thesis München,1976

Netuschil.N7619.5G3N86
1963X NMAA p.136

I.J

Jay, Margrit A.
Antonio Moro:Royal court painter,1519-1576
134 p.

Ph.D.Dissertation,Texas Christian Univ.,
1975

Diss.Abstr.no.76-4717 Diss.Abstr.Z5055.U49D57NPG
v.36,no.9,p.5607-A,March'76

I.J

N
40.1
S63H7c
1972a
NMAA

Holcomb III, Grant,1942-
A cat.raisonné of the paintings of John
Sloan,1900-1913.Univ.of Delaware,1972
163 p. illus.

Bibliography

Thesis Ph.D.-Univ.of Delaware,1972
Photocopy of typescript

I.J

Jenkins, Marianna Duncan
The state portrait,its origin and evolution.
.New York.College Art Assn.of America...,1947
47 p. illus.
(Monographs on archae-
logy and fine arts,3)
Thesis Bryn Mawr College

Bibliographical footnotes

Review by D.T.Piper In:Burl.Mag. 90:302
Trends in heroic portrs.of 16th c.W.Europe
develop conventions indispensable ever since
LC N7592.J4

I.J

ND
466.5
N4H67
1988X
NMAA

Hope, Ann M., 1936-
The theory and practice of neoclassicism in
English painting.The origins,development and de-
cline of an ideal.N.Y.& London,Garland,1988
417 p. illus.

Bibliography,p.226-38

Ch.13:Portraiture,p.116-31

Outstanding thesis in the Fine Arts from Bri-
tish universities

I.J

N
40.1
F63J6
NCFA

Johnson, Charlotte Buel
The life and works of Alvan Fisher..New
York,1951.
203 p. illus.

Thesis(M.A.)-New York University,Institute
of Fine Arts.

Incl.a chapter on F.as portr. ptr.

QN
40.1
C84J6
NPG

I.J

Johnson, Edward Mead
 Francis Cotes...complete ed..with critical
essay and catalogue.Oxford,Phaidon,1976
 178 p. illus(part col.)

 Originally presented as the author's thesis,
Stanford

 Bibliography

LC:
ND1329.068J64

I.J

Klein, Dorothea
 St.Lukas als maler der Madonna.Ikonographie
der Lukas Madonna...Berlin,O.Schloss,1933.
 127 p. illus.

 Bibliography Diss.Hamburg,1933

 "Nachdem d.einzelnen Handwerke & Zünfte sich
...Schutzpatrone erwählt hatten,ist d.Patron d.
Maler,d.hl.Lukas,der die Madonna malt...seit d.
15.Jhr.in d.Niederlanden...v.Maler mit d.eigenen
Bildniszügen ausgestattet worden"(Prinz)
NN ICU NJP MB PBm Prinz.Slg.d.selbstbildn.in
 d.Uffizien.N7618/P95 Bd.1
 p.147,note51

I.J

Jordan, Robert
 The double portrait;a study of the pheno-
menon of duality

 Master's Th.-N.Y.,Columbia Univ.,1952

Lindsay,K.C. Marpur Ind.of
master's theses in art...
1955 Z5931.L74 1955 NCFA
Ref. p.104 no.1915

M
40.1
C867K6a
1971a
NPAA

I.J

Klein, Michael ₍Eugene₎,1940-
 The art of John Covert...N.Y.s.n.,1971,
c.1974
 346 p. illus.

 Bibliography,p.222-228

 Thesis Ph.D.-Columbia Univ.,1971
 Photocopy of typescript

NPG has
xerox
copy of
cont.
& exs.
of il-
lustr's
in VF
Portrs.,
Roman

I.J

Jucker, Hans, 1917-
 Das bildnis im blätterkelch. Olten,Urs Graf
Verlag. Geschichte und bedeutung einer römi-
schen porträtform. 1961
 2 v. illus.
 (Bibliotheca Helvetica Romana,3)

 Dissertation Zürich, 1955

NIC MH NJP CU I.Levin in Art Q.,v.33
 NB164J8 Autumn,1970,p.217

I.J

Kleiner, Diane E.E.
 Roman group portraiture,the funerary reliefs

 Originally presented as the author's thesis,
Columbia,1975

LC NB1296.3.K55 1977 FOR COMPLETE ENTRY
 SEE MAIN CARD

I.J

Kämpfer, Fritz
 Die Entstehung des bildnisses in der deut-
schen plastik des Mittelalters.Jena,1949
 78 p.

 Thesis.Jena,1949?,
Maschinenschr.

Bibl.su kunst & kunstgesch.
Z5931.B58 1945-53 NCFA
p.205 no.4080

I.J

Kraemer, Paul, 1876-
 Beitrag zum problem der porträtdarstellung.
Eine aesthetische studie...Gernrode(Harz),H.
Klöppel,1900

 46 p.

 Inaug.Diss.-Jena,1900

LC in 1942 ed.v.82
no call no. Waetsold ND1300.W12

M
40.1
B5575K2
NPG

I.J

Kelly, Elisabeth K
 Moses Billings:19th century portrait paint-
er...1979
 69 p. illus.

 Reproduction of typescript.
 Incl.Cat.of artist's works
 Thesis Georgetown Univ.,Nov.5,1979
 Bibliography

I.J

Kyrieleis, Helmut
 Bildnisse der Ptolemäer.Berlin,Mann,1975

 190,108 p. illus. (Archäologische
Forschungen,Bd.2)

 Bibliography

 At head of title:Deutsch.Archäol.Inst.

 A revision of the author's Habilitations-
schrift,Bonn,1972
LC DT92.K97 Gesichter.NB1296.3.G38
 1983 NPG p.315

I.J

Lang, J.T.
Portrait painting including the historical
background of contemporary portrait painting

Master's Th.-Columbus,O.S.Univ.,1930

Lindsay,K.C. Harpur Ind.of
master's theses in art...
1955 Z5931.L74 1955 NCFA
Ref. p.14 no.222

705
A7832
NCFA

I.J

Lipman,Mrs.Jean Herzberg, 1909-
The Florentine profile portrait in the
quattrocento

In:Art Bul
18:54-102 Mar,1936 illus.
Master's Th.,N.Y.Univ.,1934, same title
Profile portrs.almost exclusively limited to
Florence in the 2nd half of 15th c. ...

FOR COMPLETE ENTRY
SEE MAIN CARD

N
7628
L812
NPG

I.J

Langedijk, Karla
De portretten van de Medici tot omstreeks
1600.Assen,v.Gorcum & cy...,1968.
175 p. 1 illus.

Thesis-Amsterdam,1968

Summary in English

I.J

Lloyd, Phoebe
Death and American painting:Charles Willson
Peale to Albert Pinkham Ryder
316 p.

Ph.D.diss. City Univ.of N.Y.,1980

An investigation of the iconography of Ame-
rican death imagery...is.the life of a culture
is revealed in its death imagery...by isolating
the shift fr.one aspect of death to another..we
can best chart the changing attitudes to death
Diss.Abstr.Internat'l
v.41no.8,Feb.'81 p.3304-A Nerdts.Art of healing
N8223.036 NPG,p.112,note 13

I.J

Laskin, Myron, 1930-
The concept of portraiture in the Middle
Ages from the Early Christian through the High
Gothic..Cambridge,Mass..,1952
96 p. illus.

Thesis,April,1952

FOGG
985
L34

Fogg,v.11,p.323

I.J

Lohmann-Siems, Isa
Begriff und interpretation des porträts in
der kunstgeschichtlichen literatur.Hamburg,
Hower verlag,1972
147 p.

Originally presented as the author's Thesis,
Hamburg,1972,under title:Die begriffliche Be-
stimmung des porträts in der kunstwissenschaft-
lichen literatur bis sur mitte des 20.jahrh.

Bibliography
LC N7575.L63 1972 Die 20er jahre im portr.
N6868.5.E9 W97 NPG,p.138

N
6512.5
P4515
1976a
NCAA

I.J

Lemon, Robert S.,jr.
The figurative pretext:A comparative ex-
plication of the fiction of Alain Robbe-
Grillet and the photo realists. 1976
145 p. illus.

Bibliography p.127-37
Photocopy of typescript
Thesis Ph.D.-Ohio Univ.,1976

fig.2:Self-portrait of Close

I.J

Lorr, John Siegbert
Present day portraiture

Master's Th.-Columbus,O.S.Univ.,1933

Lindsay,K.C. Harpur Ind.of
master's theses in art...
1955 Z5931.L74 1955 NCFA
Ref. p.22 no.367

I.J

Lewis, Alison Shepherd
Joseph Highmore,1692-1780(An 18th c.English
portrait painter)
959 p.

Ph.D.diss.-Harvard Univ.,1975

Incl.Cat.of His work

'H.'s contemporary reputation was high...His
best portrs. rank among the finest Engl.portrs.
of the early 18th c '
Miles.Portrs.of the heroes
of Louisbourg'PIA...

I.J

Lyon, Elizabeth Thompson
Payne Limner

Masters Thesis,Virginia Commonwealth Univ.
Richmond.c1977..,1981

Woodward.American folk pt.
NX207.W66X NPG p.14 / 22

I.J

N
40.1
D595
M12
NPG

McCaulay, Elisabeth Anne
A.A.E. Disderi and the carte de visite por-
trait photograph...1980
3 v.in 2(356,416 p.) illus.

Thesis(Ph.D)Yale Univ.,1980
Photocopy of typescript.Ann Arbor,Mich.:
Univ.microfilms international,1981
Contents:v.1.Text.v.2.Plates
Bibliography:p.327-56
TR647.D611M2 1985:Book with same title
Discussion incl.:The importance of the
carte de visite⌒ in breaking down the divi-
sion betw.port⌣ aiture and genre
source see over

I.J

Milley, John
Jacob Eichholtz,1776-1842,Pennsylvania por-
traitist

M.A.thesis Univ.of Delaware,1960

Arts in Am.q25961.U5A778
⌒FA Ref. T855

I.J

Mai, Ekkehard
Le portrait du roi...Bonn,1975

LC ND1316.3.M34 ⌒ FOR COMPLETE ENTRY
SEE MAIN CARD

I.J

Montagu, Jennifer
Charles LeBrun's Conférence sur l'expres-
sion général et particulière.London,Uni.of Lon-
don,1959
2v.on reel Microfilm copy

Diss.-Warburg Inst.,Uni.of London

Chs.LeBrun was the first systematic student
of human expressions,who based himself on Carte-
sian mechanics & saw in the eyebrows real poin-
ters...see over

TGU Gombrich.Mask & face.In:
⌒ Art percept'n & reality
N71/G4 X NCFA p.5

I.J

Pelsschuer, Jutta, 1945-
Das Frauenportrait der Goyernzeit...
Berlin,Ernst Reuter Gesellschaft,1971
154 p. illus.

Bibliography,p.5-7
Thesis - Berlin

.Cty Roman portrs.Aspects of art
⌒...qNB1296.R75 NPG Bibl.
p.107

I.J

Moore, Charles LeRoy
Two partners in Boston:the careers and da-
guerreian artistry of Albert Southworth and
Josiah Hawes.University of Michigan,1975
2 v. (652 p.)

Portraying according to Romantic ideals.The
daguerreotypist's most important task was to be
the interpreter of virtuous character...to guide
the nation,which in turn,by virtue of its super-
ior technology,was destined to lead the world.

mfm no. Ph.D.diss.Uni.of Mich.
76-11,676 Diss.Abstr. Sobieszek.The spirit of
Z5055U49D57 NPG fact.qN10.1S71686 NPG.p.162
v.36 no.11 Bibl.

AP
1
J8643
NMAA
v.14

I.J

Meschutt, David
William Byrd and his portrait collection

In:J.early S.dec.arts
14no.1:19-46 May,1988 illus.

Most portrs. in B.'s coll.have been attr.to Sir
Godfrey Kneller.Three(or more)attr.to Hans Hysing

This article..was presented in 1988 as...
completion of the Master's Degree...State Univ.
of N.Y.

N
40.1
F312MB
1970a
NPGA

I.J

Mooz, Ralph Peter, 1940-
The Art of Robert Feke.Phila.Univ.of Penn.
1970
334 p. illus.

Thesis Ph.D.-Univ.of Penn.,1970
Bibliography,p.27-36
Checklist of portraits
Photocopy of typescript

N
747
NPG

I.J

Miles, Ellen
Thomas Hudson(1701-1779)portraitist to the
British establishment.New Haven,Conn.:Yale Uni.
1976
2 v. illus.

Bibliography

Thesis Yale

Incl.:Cat.of Hudson's portraits

I.J

Murell, Dorothy G.
The effects of foreign influences upon
American portrait painting

Master's Th.-Columbus,O.S.Univ.,1948

Lindsay,K.C. Marpur Ind.of
⌒ master's theses in art...
1955 Z5931.L74 1955 NCFA Ref
p.74 no.1344

N
No.1
X 55xN2
NCFA

I.J

Naef, Hans, 1920-
Die bildniszeichnungen von J.-A.-D.Ingres.
Beiträge zu einer historisch-kritischen gesamt-
darstellung.Teildruck:Schweizer künstler in
bildnissen von Ingres.Zürich,Conzeit & Huber,
1962
101 p. illus.

Ph.D. Dissertation,Zürich,1962

I.J

Patrick, Ransom R.
The early life of John Neagle,Philadelphia
portrait painter
222 p. illus.

'...one of the most significant portr.ptrs.
in 19th c. American art!-Patrick

Ph.D.Dissertation,Princeton Univ.,1959

LC card no.Mic59-5210

Art in AmqZ5961.U5A77X
NCFA Ref. T 958
ss.Abstr.Z5055.U4SD5 NPG

I.J

Neubert, Fritz, 1886-
Die volkstümlichen anschauungen über phy-
siognomik in Frankreich bis zum ausgang des
mittelalters

In:Romanische Forschungen
29:557-679. Erlangen,1911

Phil.-Diss.,München.1910.

MB

Möller.Physiognomical the-
ory...N21.I 61 1961 NCFA
p.60,footnote 23

I.J

Pohl, Joseph, 1914-
...Die verwendung des naturabgusses in der
italienischen porträtplastik der renaissance.
Würzburg,Triltsch,1938
68 p.
Bibliogr.footnotes

FOGG
FA5098.11

Inaug.-Dissertation - Bonn

Portr.bust.Renaiss.to En-
lightenment.NB1309.P6x NP
Bibl.

I.J

Nisser, Wilhelm, 1887-
Michael Dahl and the contemporary Swedish
school of painting in England...Uppsala,Alm-
qvist & Wiksells,...1927
159 p. illus.

Inaug.-diss.-Upsala
Literature & sources of info.

Contents.-Michael Dahl.-Hans Hysing.-Charl.
Bolt.-Christian Richter

LC ND793.D3N5

Yale ctr.f.Brit.art Ref.
ND786+N57

TR
575
P93
1985a
NPG

I.J

Prescott, Gertrude Mae, 1955-
Fame and photography:Portrait publica-
tions in Great Britain,1856-1900
499 p. illus.

Incl.lists of portr.publications in the
engraved,lithographic & photographic media.

Ph.D.diss.-Univ.of Texas at Austin,1985
Bibliography:p.263-81

mf
Diss.Abstr.v.47no.03,Sept.
1986,p.691/92A

I.J

Nylander, Richard C.
Joseph Badger,American portrait painter

M.A.Thesis,State Univ.of N.Y.,college at
Oneonta,1972

Arts in Am.qZ5961.U5A77
NCFA Ref. T 926

I.J

Ribeiro, Aileen
The dress worn at masquerades in England,
1730-1790 and its relationship to dress in
portraiture

Unpublished Ph.D.thesis Uni.of London,1973.

Isopp.In:Burl Mag.121:311
ote 7

I.J

Och(s)enkowski, Henryk August
Die selbstbildnisse von A.Dürer. Strasbourg,
1910
66p.

Inaug.diss.Heidelberg

Bibliography

LC 759.3D93Yo
IU CtY PU MH

Goldscheider 757.052
500 self-portrs.

I.J

Richter, Ruth, 1912-
Zur entwicklung des porträtstils in der
deutschen malerei von 1830 bis 1880.Heidelberg,
Druckerei Winter,1936

Inaug.-Dissertation-Heidelberg

FOGG
FA
4353.15

Fogg,v.11,p.319

Xerox copy of contents & preface in VF Portraiture

I.M

Ring, Grete
Beiträge sur geschichte niederländischer bildnismalerei im 15.&16. jahrhundert. Leipzig, E.A.Seemann,1913

173 p.

Appendix:1.systematical bibliography
2.list of mentioned portraits
pp.101-23:Das selbstporträt

Based on her dissertation 1912

LC ND1319.R5

Lipman,The Florentine profile portr... also:
Goldscheider 757/.052

I.J

Schneider, B.
Studien su den kleinformatigen Kaiserportraits von den anfängen der Kaiserzeit bis ins dritte jahrhundert

Dissertation München 1976

Gesichter.MB1296.3.G38
1983 MPG p.316

I.J

Ryszkiewics, Andrsej
Polski portret sbiorowy. Wyd.1.Wroclaw, Zaklad Narodowy im.Ossolińskich,1961
206 p. illus.

At head of title:Instytut Sstuki Polskiej Akademii Nauk.
Dissertation
Bibl.footnotes

LC ND1320.R9

Fogg,v.11,p.320

I.J

Schuyler, Jane
Studies of Florentine Quattrocento portrait busts..n.p..1972.c.1975.
318 p. illus.

Ph.D.Dissertation,Columbia U.,1972

Bibliography

Photocopy of typescript, Ann Arbor,Mich., Uni.Microfilms,1975

MWiCA

Diss.Abstr.Z5055.U49D57MPG
v.35no.10,Apr.75p.6603A
no.75-9359

W
40.1
S64S2
NPG

Saunders, Richard Henry
John Smibert(1688-1751)Anglo-American portrait painter.1979
2 v.in one illus.

Ph.D.diss.-Yale Univ.,1979

Bibliography 257-69

Photocopy(Problems with illustrations)

Miles.Portrs.of the heroes of Louisbourg AP1A51A61.
NMAA v.15:65 footnote

I.J

Schwarts, Marvin David, 1926-
The meaning of portraits:John Singleton Copley's American portraits and 18th century art theory.1954
69 p. illus.

Master's Th.-Univ.Del.,1954

Winterthur Mus.Libr. fZ881
W78 NCFA v.9,p.226

I.J

Schaeffer, Emil, 1874-
Das weib in der venesianischen malerei.
Breslau,R.Galle Buchdruckerei,1898

103 p.

Inaug.diss.-Breslau

Bibliography

LC ND1318.S4

Westsoldt ND1300.W12

I.J

Shaffer, Sandra C.
Deborah Goldsmith,1808-1836:a naive artist in Upstate New York

MA thesis,State Uni.of N.Y.,College at Oneonta,1968

Abby Aldrich Rockefeller
Folk Art Ctr.Am.Folk portrs
N7593.A23 Bibl. p.294

W
72
P5S31
1969
NCFA

Scharf, Aaron, 1922-
Art and photography.Baltimore,Allen Lane, The Penguin Press,1969.c.1968.
314 p. illus.

Bibl.references
Based on thesis for Ph.D.,Courtauld Inst. of art,Univ.of London

The problems of style caused by exchange betw.the different media.Chapter on Portraiture,p.18-51.Use of daguerreotype by ptrs.in

LC N72.P5S3

Moks,Ptr,& Photograph qN72
P5S68 NCFA Preface

N
40.1
O816S5
NMAA

Sheehy, Jeanne
Walter Osborne..Cat.of exh..The National Gallery of Ireland,1983
184 p. illus(part col.)

Bibliography
Index

Exh.held at The Nat'lGall.of Ireland 16 Now. to 31 Dec.,1983.The Ulster Mus.,Belfast 20 Jan. to 29 Feb.,1984

Based on thesis.Trinity College..Dublin?.1974

N
40.1
F95285
NPG
2 c.

I.J

Simmons, Linda Crocker
 Jacob Frymire,American limner...Washington,
Corcoran Gall.of Art,c.1975
 56 p. illus(part col.)

 Based on M.A.Thesis at Uni.of Delaware,1975
 Incl.Ch.on 'Works by Chs.Peale Polk and
other contemporaries'
 Exh.at Corcoran Gall.,Oct.4-Nov.16,1975,
Kauffman Gall.,Shippensburg,Pa.,Winston-Salem,
N.C.,Mus.of Early South.Dec.Arts,Abby Aldrich
Rockefeller Folk Art Coll.,Williamsburg,Va.

I.J

Suhr, Elmer George, 1902-
 ...Sculptured portraits of Greek statesmen,
with a special study of Alexander the Great,...
Baltimore,The Johns Hopkins press;London,H.Mil-
ford,Oxford university press,1931
 189 p. illus. (The Johns Hopkins univer-
sity studies in archaeology,no.13)

 Dissertation,1926.

 Bibliography
 NPG has "extract"

733
894
LC NB164.S75
1979 ed.:LC NB1296.3.S93

Richter,G. Portrs of the
Greeks N7586.53,v.3,p.304

I.J

Smith, David Ross
 The Dutch double and pair portrait:Studies
in the imagery of marriage in the 17th centu-
ry.Columbia University,1978
 506 p.

 Ph.D.-Dissertation,1978

 Ch.1-3 general;ch.4-6 focus on F.Hals and
Rembrandt

 Diss.Abstr.Z5055-U49D57
 no.7819440

I.J

Sydow, Wilhelm von
 Zur kunstgeschichte des spätantiken por-
träts im 4.jhrh.A.D. Bonn,R.Habelt,1969
 165 p. illus. (Antiquas,Reihe 3(Serie
in 4to):Abhandlungen zur Vor-& Frühgeschichte,
zur klassischen & provinzial-römischen Archäolo-
gie & zur Geschichte des Altertums,Bd.8)

 Diss.Tübingen,1967

 Bibliography

LC N7588.S95 1969 Verzeichnis lieferbarer Bü-
 cher 1973/74 NPG v.1,
 p.1898

I.J

Spencer, B.M.
 William Dobson

 Th.for the degree MA.Uni.of London,1937

 Rogers,Malcolm.Wm.Dobson
 p.20,note?
 N40.1.D6285R7 Npg

mfm
205
NPG

I.J

Thistlethwaite, Mark Edward
 The image of George Washington....Philadel-
phia,University of Pennsylvania,1977

 Thesis-Univ.of Pennsylvania

 **FOR COMPLETE ENTRY
 SEE MAIN CARD**

ND
1316
S819
1982a
NPG

I.J

Stein, Joanne Crown, 1940-
 The image of the artist in France:Artists'
portraits and self-portraits around 1800
c.19? 238 p.
 Thesis Ph.-D.-UCLA 1982
 Bibliography
 Photocopy of typescript
 List of illus.p.V-XVI.A copy with plates
& 3 supplemental catalogues is on file at the
UCLA library

 Ch.III:David's self-portrs....

I.J

Tschaegle, Robert
 Actualism in portrait sculpture:a problem
of style based on examination of the natural-
ism of French 18th c.portrait busts with empha-
sis on the style of Houdon

 Master's Th.-Chicago,Ill.,1937

 Lindsay,K.C.,Harpur Ind.of
 master's theses in art...
 Z5931.L74 1955 NCFA Ref.
 p.33,no.591

N
40.1
B6766
S8
NPAA

I.J

Stocker, Mark, 1956-
 Royalist and realist.The life and work of
Sir Joseph Edgar Boehm.N.Y.,Garland,1988
 447 p. illus.

 Ph.D.thesis,Univ.of Hull,1986
 Bibliography:p.386-95

 Ch.2:Portraiture,Ch.4:Portrait statues
 Cat.of works,p.396-422
 Excerpts of Boehm's lectures:"Portraiture in
sculpture",p.423-3?

I.J

Tucker, Mary Louise
 Jacques G.L.Amans,portrait painter in
Louisiana,1836-1856

 M.A.-Thesis,Tulane,Univ.,1970

 Arts in Am.qZ5961.U5A77X
 NCFA Ref. T 1247

I.J

Uithol, Ruthann
Cecilia Beaux

Masters Thesis-American Univ.,1985

Archives of American Art
Journal AP1.D39 NMAA v.24,
no.4,1984,p.25

I.J

Westendorp, Karl, 1873-
Die anfänge der fransösisch-niederländischen
porträttafel. Köln,Druck der Kölner verlags-an-
stalt und druckerei,a.-g-.1906

78 p.

Inaugural diss.Strassburg,Cologne,1906

Ring,Grete LC ND1319M5
LC ND1303.W5

I.J

Vessberg, Olof, 1909-
Studien sur kunstgeschichte der rümischen
republik.Lund,C.W.K.Gleerup,1941
304 p. illus. (Svenska institutet i Rom.
Skrifter 8)

MET Bibliography
617 -Based on.Diss.-Uppsala.1941.
V63

LC DG12.88 v.8,etc. Casda.Etrusc.infl.in fune-
 rary reliefs...In:Temporini
 -Aufstieg u.niedergang...
 LC DG209.T36.Bd.1.T.4 p.855

I.J

Winkes, Rudolf
Clipeata imago.Studien su einer rümischen
bildnisform.Bonn,Habelt,1969
265 p. illus. (Habelt's Dissertation-
drucke.Reihe klassische Archäologie,Heft 1)

Originally presented as the author's thesis,
Giessen
Bibl. references
Clipeata imago:shield portr.:Painted ances-
tor portrs.hung in Roman houses.None survived
LC NB1296.W56 1969 Winkes.Mummy portre.In:
 Rh.Isl.Sch.of Des. B.59
 708.1R471,p.7

I.J

Vriss, Ary Bob de, 1905-
Het Moord-Nederlandsch portret in de 2º
helft van de 16º eeuw.Amsterdam,N.V.Uitgevers
Maatschappij,Emma,1934
illus .

FOGG Proefschrift-Utrecht
FA
4353.13

Fogg,v.11,p.319

I.J

Würtenberger, Franzsepp, 1909-
Das holländische gesellschaftsbild.Schram-
berg(Schwarzwald),Gatser & Hahn,1937

Thesis-Freiburg i.Br.

MET
182
W96

FOGG
FA
4058.16
 FOR COMPLETE ENTRY
 SEE MAIN CARD

I.J

Wassenbergh, Abraham, 1897-
L'art du portrait en Frise su 16º siècle.
Leyde,Leidsche Uitgeversmaatschappij,S.A.,1934
illus.

FOGG Thèse-Paris
FA
4058.8.10 Bibliography

Fogg,v.11,p.319

I.J

Zinserling, Gerhard
Die Stilentwicklung der stadtrümischen
porträtkunst vom ausgang des 2.jahrhunderts
n.Chr.bis sum beginn der spätantike.Jena,1950
328 p.

Phil.Diss.,Jena,1950
Maschinenschr.

Bibl.su kunst & kunstgesch
Z5931.B58 1945-53 NCFA
p.90 no.1734

N
40.1 I.J
W863W3
NPG Weekley, Carolyn Jeanette
 John Wollaston....Newark,Del.,Uni.of Dela-
 ware.,1976

 Thesis(M.A.) - Uni.of Delaware

FOR COMPLETE ENTRY
SEE MAIN CARD

II. Special Media

II. SPECIAL MEDIA

II.A.1

Apropos;a series of art books,no.3,Portrait
painting.London,Pilot Press,ltd.;Lund
Humphries;Transatlantic Arts,Co.,1945?.
illus.

Contents:Portr.paintg.and portr.photography,
by E.H.Gombrich.-Picasso's treatment of the
head,by Rbt.Melville.-To start a ball rolling,
by Peter Ustinov.-The portr.in the past & pre-
sent,by Osk.Kokoschka.-Intro.to the exh.of por-
traits at the Arcade gall.London,March 1945.-
Catalogue

LC N7445.A7 MOMA, v.11,p.431

II.A. PAINTING

ND
1300
A98
1967

II.A.1

Aymar, Gordon Christian.
 The art of portrait painting; portraits through the cen-
turies as seen through the eyes of a practicing portrait
painter ₍by₎ Gordon C. Aymar. ₍1st ed.₎ Philadelphia,
Chilton Book Co. ₍1967₎

 xiv, 337 p. illus. (part col.), ports. 28 cm.

 1. Portrait painting. ı Title.

ND1300.A9 757 67-26026
Library of Congress ₍10-2₎

II.A.1. GENERAL

II.A.1

Barcelona
 Exposición de retratos y dibujos antiguos
y modernos 1910.Catálogo illustrado....Barce-
lona 1910.
 203 p. illus.

MET
107.6
B237

II.A.1 GENERAL Dictionary History Technique Theory

N40.1
B79B3
1973
NCFA

II.A.1

Bates, Kenneth, 1895-
 Brackman,his art and teaching.Rev.enl.ed.,
₍Madison,Conn.,Madison Art Gall.Pub.Co.,....1973.
81 p. illus(part col.)

 A discussion of this conservative portrait-
ist,incl.his working methods

 Bibliography

 Arts in Am qZ5961.U5A77X
 CFA Ref. J 496

II.A.1

Ansbacher, Jessie
 Portraits. N.Y.,Pitman Pub.Corp.,1959.
 illus. (Pitman art series,23)

LC ND1302.A5 Books in print A1215.P92
 1975,v.2 NPO p.2959

II.A.1

Bremen, Kunsthalle
 Das Bildnis,seine entwicklung,seine gestalt.
...Bremen,Kunsthalle,1977

LC N7623.2.G3B733 FOR COMPLETE ENTRY
 SEE MAIN CARD

II.A.1

Crock, Alexander
 Portrait painters incognito

In:Charm
3:38-9,89 Feb.,'25

 Title of mag.varies:Dec.'15-Feb.'27:Pic-
ture play magazine.

 Article pertains to Portrait limners

LC PN1993.Y6 N.Y.,MOMA 709.73.N5 NCFA
 Bibl.p.51

II.A.1

Covino, Frank
 The fine art of portraiture;an academic
approach.Westpoint,Conn.,Fletcher Art Services,
distr.by van Nostrand Reinhold,N.Y.,1970.
 168 p. illus(part col.)

LC ND1302.C68 Art Books 1950-79 Z5937
 A775 NCFA Ref. p.895

II.A.1

Browne, Margaret Fitzhugh, 1884-1972
 Portrait painting...with foreword by Royal
Cortissos.N.Y.,I.Pitman & sons,1933
 101 p illus(part col.)

 Repro.incl.:Velasques,Raeburn,Bronsino,Orpen,
Sargent,Ingres,F.Hals,L.Seyffert,M.F.Browne,etc,
Incl.Ch.on Portr.ptg.as a profession

 Miss B.,a noted portraitist,gives an account
of her methods. Rev.in Art Dig.7:21,Jl.'33 &
Conn.92:46 Jl.'33

LC ND1300.B7 Art Books 1876-1949.Z5937
 A775 NCFA Ref. p.495

N
40.1
J28
NCFA
2 c.

II.A.1

Currier Gallery of Art, Manchester,N.H.
 Memorial exh.:Alexander James,1890-1946.
Manchester,N.H.,The Currier Gall.of Art,July 15-
Sept.15,1947.Boston,Mass.,Mus.of Fine Arts,Oct.
15-Nov.16,1947,Wash.D.C.,The Corcoran Gall.of
Art,Dec.7-Jan.4,1948.Manchester,1947.
 20 p. illus.

 Cat.incl.notes on J.'s methods of working

LC ND237.J3C8 Arts in Am.q25961.U5A77X
 NCFA Ref. J 631

ND
1300
C5X
NPG

II.A.1

Chittock, Derek, 1922-
 Portrait painting...London,Batsford,1979
 170 p. illus(part col.)
 Incl.indexes
 Bibliography

 '...covers almost every aspect of portr.
ptg.'-D.C.in introduction

 Incl.:History of portr.ptg.;Intention of
sitter & artist;Use of photography

 Review in Am.Artist,v.44:24-5,Oct.'80

N
7623
H15D22
NPG

II.A.1

Dartmouth College. Hopkins Center
 Portraits at Dartmouth;cat.by Arthur R.
Blumenthal..Exh..10 March to 16 April 1978.
Hanover,N.H.,Dartmouth College,1978
 137 p. illus.(col.cover illus.)

 Bibliography

 Development of portraiture fr.16th c.to ear-
ly 20th c. shown by works of Dartmouth College
collection.
 Appendices are checklists of portrs.in all
media which are not in this exhibition.

705
A784
NCFA
v.49

II.A.1

Coke, Van Deren, 1921-
 Camera and canvas

In:Art in Am.
49,no.3:68-73 1961 illus.
 Development of the influence of photogra-
phy on art as a profession.Quoted are the por-
traitists Ch.Harding,Rembrandt Peale,Tha.Sully,
Wm.Page,G.P.A.Healy and Whistler
 Repros.show ptgs.& the photographs used for
them
 Rudisill.Mirror image
 TR365.R916 NCFA,p.242

ND
1311.3
D38X
NPG

II.A.1

Daugherty, Charles Michael, 1914- ed.
 Six artists paint a portrait...Westport,Conn.
North Light Publ.;N.Y.,distr.by Watson-Guptill
Publ.,1974

 FOR COMPLETE ENTRY
 SEE MAIN CARD

qN
72
P5C68
NCFA

II.A.1

Coke, Van Deren, 1921-
 The painter and the photograph from Dela-
croix to Warhol.2nd rev. & enl.ed..Albuquerque,
Uni.of New Mexico Press,1972.
 324 p. illus.

 Bibl.references

 "...a history,pictorial & verbal,of various
ways in which artists of many countries have
used photographs...in their works since the per-
fection of photography in 1837."

LC N72.P5C6 1972 MOMA,p.431, v.11

708.1
M66
NCFA
v.41

II.A.1

Davis, Richard S,
 Loan exh.of: great portraits...1952

In:B.Minneapolis I.A.
41:149-54 Nov.,'52 illus.

 From Titian to Picasso

 FOR COMPLETE ENTRY
 SEE MAIN CARD

II.A.1

Dawley, Joseph
 Character studies in oil.N.Y.,Watson-Gup-
till Publications,1972.
 141 p. illus(part col.)

LC ND1300.D35 1972 Books in print.Subj.guide
 Z1215.P92 1975 v.2 NPG
 p.2959

N
7425
G73
1971
NCFA

mfm
NCFA
23

II.A.1

Graham, John David, 1881-1961
 What is a portrait painting?

In,his,System and dialectics of art.,New ed.,
Paltimore & London,John Hopkins Press,1971
(1st ed.Delphic Studios,1937)

 pp.182-3

 In 3 paragraphs,Graham denies that portr.pt,
(likeness)can be a work of art

LC N7425.G7 1971 N.Y.,MOMA,20th c.portrs.by
 M.Wheeler.N7592.6N53 NPG
 Bibl.

II.A.1

De Ruth, Jan
 Portrait painting.N.Y.,Pitman pub.corp.
,1964,
 32 p. illus(part col.) (Pitman $1.60
art books,48)

LC ND1290.D4 Books in print.Subj.guide
 Z1215.P92 v.2 NPG p.2959

II.A.1

Grenier, Jean
 In contemplation of portraits

In:Verve
2:p.34 1939(no.5-6) illus.

 Incl.:Marinus,Rubens,Rembrandt,Corneille de
Lyon,Baldovinetti,Pollaiuolo,Reynolds

LC N1.V4 Rep.,1939-41=618

II.A.1

Freund, Gisèle
 La photographie en France au 19ième siècle
étude de sociologie et d'esthétique...Paris,
Le maison des amis des livres,A.Monnier,1936
 154 p. illus.

 Thèse-Univ.de Paris

 Bibliography

 Disc.incl.the use of photography by portr.
ptrs. Scharf,A.Art & photography
LC TR71.F7 1936 N72.P5S31 NCFA p.260(14)

II.A.1

Grosser, Maurice Richard, 1903-
 The painter's eye.,New York,New American
Library,1956,1955.
 192 p. illus. (A Mentor book,M159)

 "...affords one...to learn...how,the artist,
'sees'his subject and uses his medium to convey
this perception."-Hall

 Incl.discussion of portraiture

LC ND1135.G7 1956 Hall,Edw.T.The hidden di-
 mension LC BF469.H3,bibl.

758.1 II.A.1
F91

Friedländer, Max J., 1867-1958
 ,The,Portrait

In,his,Landscape,portrait,still-life;their origin
& development. N.Y.,Philosophical library,1950?,
 pp.230-62 illus.

 "...principles & history of portraiture"

LC ND1140.F7 Encyclop.of World Art
 N31.E56 Ref.Bibl.on portr.

II.A.1

Guerlin, Henri, 1867-1922
 L'art enseigné par les maîtres.Le portrait;
choix de textes précédés d'une étude par Henri
Guerlin...Ce qu'ont écrit,dit,pensé artistes et
écrivains sur la technique des arts.Paris,Henri
Laurens,éditeur,1936
 174 p. illus.

N.Y.,P.L.for LC N.Y.,MOMA.20th c.portrs.by
 M.Wheeler.N7592.6N53NPG
 Ribl.

757 . II.A.1
.F99

Furst, Herbert Ernest Augustus, 1874-
 Portrait painting, its nature and function, by Herbert Furst.
Illustrated with 166 reproductions of portraits. London, John
Lane ,1927,

 xviii p., 1 L., 155 p. xlix pl. (ports.) 29½ x 22ᵐ.

 1. Portrait painting.

 Library of Congress ND1300.F8
 ,34l2, 37—30078

II.A.1

Guillim, John, 1565-1621
 The way howe to lymne & howe thou shalt
lay thy colours.MS,c.1582-1600

V & A A compilation of artists' techniques

 Murrell,V.James(Jim).The
 way how to lymne ND1337.
 G7M98 o983 NPG p.XI

II.A.1

705
.C88
NCFA

Hall, Lee
 The sullen art and craft of portraiture

In:Craft Horis
14:40-3 - Dec.,'74 illus(part col.)

 Discussion of the concept,history and us
of portraiture.Focus is on Elaine de Kooning
Alice Neel and Andy Warhol.
 Incl.quotations of Baudelaire and Pope-
Hennessy

II.A.1

Humbert, Édouard, 1823-1899
 La vie et les oeuvres de Jean Etienne
Liotard(1702-1789)étude biographique et icono-
graphique par...Ed.Humbert et m.Alphonse Revil-
liod...et...J.W.R.Tilanus...Amsterdam,C.M.van
Gogh;.etc,etc.,1897
 220 p. illus.

 Traité des principes et des règles de la
peinture par m.J.E.Liotard...1781,p.51-100
Principaux écrits sur J.E.Liotard,p.218.

LC ND853.L5H8 Heath.Miniatures.ND1330H4J
 NCFA bibl.p.XXXVII

IN
7570
H215
NCFA

II.A.1

Hamerton, Philip Gilbert, 1834-1894
 .The.Portrait

In.his.Man in art;studies in religious and his-
torical art,portrait and genre...London and N.Y.,
Macmillan and co.,1892
 pt.5 illus. pp.211-277

LC N7570.H25

II.A.1

Hurll, Estelle May, 1863-1924
 Portraits and portrait painting;being a
brief survey of portrait painting from the
middle ages to the present day...Boston,
L.C.Page & company,1907
 333 p. illus.

LC N7575 H8

ND
1302.H318
NPG

II.A.1

Harrison, Claude, 1922-
 The portrait painter's handbook.London,
Studio Vista;N.Y.,Watson-Guptill Publ.,1978
 96 p. illus(part col.

 Bibliography

 1st ed.1968

LC ND1302.H3 1968

II.A.1

Jacobs, Michel, 1877-
 Portrait painting. New York,Pitman Pub.Corp.
.1947.
 151 p. illus(part col.)

 Color in portrait painting

LC ND1300.J3 Fogg,v.11,p.318

II.A.1

Herkomer, Hubert von, 1849-1914
 Bildnismalerei

 (Photographische mitteilungen,
 37.jahrgang,heft 22)

"Photogr.mitt."
LC TR1.P85 Waetzoldt ND1300.W12

II.A.1
Jaffé, Albert
 Cat.of the important coll.of miniatures and
paintings of Mr.Albert Jaffé,Hamburg,which will
be sold by auction by Messrs.J.M.Heberle(H.Lem-
pertz'sons)Cologne...March 27th to April 1st,
1905....The direction of the auction will have
Mr.Henry Lempertz...Cologne,M.D.Schauberg,1905
 59 p.

LC N5265.J3

II.A.1

Hofstede de Groot, Cornelis, 1863-1930
 Meisterwerke der porträtmalerei auf der Aus-
stellung im Haag,1903. München,F.Bruckmann,1903
 46 p. illus.

 Exhibition held at The Hague,Kunstkring.Jul.1-
Sep.1,1903.

FOGG
4353
H71*

 Repro.are almost all of Netherlandish masters

NUC pre-56:NYPL for LC Amsterdam Rijksmuseum cat.
 Z5939A52,deel 1,p.126

II.A.1

Johnson, Eastman, 1824-1906
 Cat.of finished pictures,studies and draw-
ings by the late Eastman Johnson,N.A.,to be sold
at unrestricted public sale...at the American
Art galleries...on.Feb.26 & 27,1907....The sale
will be conducted by Mr.Ths.E.Kirby of the Ame-
rican art assoc'n...N.Y.,Americ.art assoc'n
.Press of J.J.Little & co.,1907
 .98.p. illus.
 'Shows...his unusual accomplishm't as por-
traitist & fig.ptr..&.illustrates his method of
work...'-J.Benj.Townsend

LC ND237.J7 Arts in Am qZ5961.U5A77X
 NCFA Ref. I 1015

IIIA.1

Knight, Charles, 1791-1873
...The gallery of portraits,with memoirs.
London,1833-1837
7 v. illus.

Portrs.engraved from noted paintings
Biographies by Arthur Ths.Malkin

From ancient Rome to U.S.
Incl.Kosciusko,Franklin,Washington,Jos.
Priestley

CSmH
Herring.Nat'l portr.gall.
of disting.Americans v.1
N7593.H56 1834 NPG p.V

filed
with
N40.1
S93

II.A.1

Mason, George Champlin, 1820-1894
The life and works of Gilbert Stuart,...
New York,C.Scribner's sons,1879
286 p. illus.(reproduced on steel & by
photogravure)

Stuart's remarks on art p.67-70 See also:
Morgan.G.Stuart & his pupils...1939:Notes taken
by M.H.Jouett...fr.conversations...with G.Stuart,
p.81-93

LC ND237.S8M4

ND
1302
K56
NPG

II.A.1

Kinstler, Everett Raymond, 1926-
Painting portraits. New York,Watson-Guptill
publ.,1971

170 p. illus.

Chapters incl:Material & tools;setting up th
studio;your attitude toward the portr.;preparing
the composition;getting a likeness;...demonstra-
tions;etc.

LC 76-159563

N
40.1
S9 M8
1969
NPG
2 c.

II.A.1

Morgan, John Hill, 1870-1945
Gilbert Stuart and his pupils,...;together
with the complete notes on painting by Matthew
Harris Jouett from conversations with Gilbert
Stuart in 1816.N.Y.,Kennedy Galleries,Da Capo
Press,1969
102 p. illus.

Incl.:Information concerning Jane Stuart,
p.49-51 illus.

Reprint of 1939

LC ND237.S8M6

757
L41

II.A.1

László, Fülöp, 1869-
...Painting a portrait....recorded by
A.L.Baldry. London,The Studio,ltd.;N.Y.,The
Studio publications,inc.,1937
79 p. illus.(part col.) ("How to do it"
series,6.)

LC ND1300.L3

757
.M98

II.A.1

Murray, Henry
The art of portrait painting in oil colours
...London,Winsor and Newton,ltd.,n.d.,
72 p. (One shilling hand-books on art,
no.11)

1st publ.1851

LC(ND1302.M87)CABVaU 1851a

II.A.1

Lohmann-Siems, Isa
Begriff und interpretation des porträts in
der kunstgeschichtlichen literatur.Hamburg,
Hower verlag,1972
147 p.

Originally presented as the author's Thesis,
Hamburg,1972,under title:Die begriffliche Be-
stimmung des porträts in der kunstwissenschaft-
lichen literatur bis zur mitte des 20.jahrh.

Bibliography
LC N7575.L63 1972
Die 20er jahre im portr.
N6860.5.E9 97 NPG,p.138

705
H19
NCFA
v.42

II.A.1

Newhall, Beaumont, 1908-
The Daguerreotype and the painter

In:Mag.Art
42:249-51 Nov.,'49 illus.

Discusses the uses & problems of daguerreo-
types for ptrs.of portrs. 1843 a "Nat'l Daguer-
reotype miniatures Gall"was founded in N.Y. &
M.H.Brady's "Valhalla of America"on Broadway,fr.
which F.d'Avignon made 12 lithographs for Bra-
dy's book,"Gall.of Illustrious Americans"(ed.by
Lester)
Rudisill.TR365.R916 NCFA
p.250

II.A.1

London. Royal academy of arts
Portraits exhibited at the Royal academy,
1769-1904,comp.by William Roberts;introd.by
Maurice W.Brockwell.

MET
115.01
L84

2 v.

Contents.-1.A-L. - 2.M-Z

Unpublished typewritten manuscript

705
C91
NCFA
v.4

II.A.1

Peale, Rembrandt, 1778-1860
Portraiture

In:The Crayon
4:44-5 1857

'Observations on the quality of photographic
portraiture compared with ptgs. Also reflects
attitudes on visual art relative to photogra-
phy.'-Rudisill,Mirror image,p.251

Sqbieszek.Spirit of fact
LC N1.C9
qN40.1.S716S6 NPG p.162

757.9
.P41

II.A.1

Pennsylvania academy of the fine arts, Phila-
delphia
Loan exhibition of historical portraits,
Dec.1,1887-Jan.15,1888;catalogue;2nd ed.
Philadelphia,1887
148 p.

MET
195.37
P53

Intro.by Charles Henry Hart

Ki...1,S.F. N7628.J45K4
footnote p.457
The life portrs.of
Jefferson...

II.A.1

The portrait in painting..Motion picture....
Lawrence,Kan.,Centron Films,1978

LC/.ND1300.

FOR COMPLETE ENTRY
SEE MAIN CARD

II.A.1

Piles, Roger de, 1635-1709
The principles of painting.Cours de pein-
ture par principes.Paris,J.Estienne,1708..First
tr.into English.London,Printed for J.Osborn,1743
300 p. illus.

"First detailed discussion of the Theory of
portrait ptg."--Gombrich

LC ND1130.P6

Gombrich.Mask & face.In:Art
perception & reality N71/G64
p.21,ft.note.

II.A.1

Portraits by the masters.comp.by Margaret
Harold.With commentaries by Gus Baker.Fort
Lauderdale,Fla.,Allied Publications,c.1963.
39 p. illus(part col.)

In:Paintings by the masters,a treasury of
famous ptgs.:portrs.,landscapes,still lifes...
.1966. LC N7592.P23

LC N7592.P63

Art Books,1950-79 Z5937
A775 NCFA p.897 Ref.

II.A.1

Piper, David
Personality and the portrait.London,Brit.
Broadcasting Corp.,1973

LC N7575.P56

FOR COMPLETE ENTRY
SEE MAIN CARD

N
7624
R26
NPG
2 cops.

II.A.1

Raydon Gallery, New York
Masters in portraiture.Cat.of exh. Spring,
1971
24 p. illus.

Mainly ptgs.,some busts

II.A.1

Pitkänen, R.
The resemblance view of pictorial represen-
tation

In:Brit.J.Aesth.
16;no.4:313-23 1976

Theoretical reflections.In particular the
art of the portrait

LC BH1.B7

Rep.1977 #3351

ND
1301
O35 O4
1979
NPG
2 c.

II.A.1

Reeve, James K.
Masters of the portrait.cat.of an exh.held
at the Oklahoma Museum of Art,March 4 through
April 29,1979,written and designed by J.K.
Reeve.Oklahoma City,The Museum.1979?.
51 p. illus.

Incl.14 sculptures

LC ND1301.O5R4

N
40.1
P73x
W2
NPG

II.A.1

Plunket, Jean Reasoner,1923-
Faces that won't sit still...Washington,D.C.
Acropolis books,1978

FOR COMPLETE ENTRY
SEE MAIN CARD

II.A.1

Richardson, Jonathan, 1665-1745
An essay on the theory of painting. London,
1715, another edition 1725

Universal catal.Books on
art,v.II

British museum
London Institution

quoted in Haka,H.M.The Engl
historic portr...p.145
LC AS122.I5 1943

II.A.1

Richardson, Jonathan, 1665-1745
 The works of Jon.Richardson, containing
I.The theory of painting, II.Essay on the art
of criticism, III.The science of a connoisseur;
a new ed...Ornamented with portraits by Worlidge.
Met London,T.& J.Egerton,1792
171.1
R39
 287 p. illus.

 Forms supplement to Horace Walpole's Anec-
dotes of painters and engravers

II.A.1

.Scheffler, Karl, 1869-1951.
 Bildnisse aus drei jahrhunderten der alten
deutschen und niederländischen malerei. Königstein
& Leipzig,Langewiesche,1940(Die blauen Bücher)

 104 p. illus.

NUC also list .1916?.ed.,112p. in Cty,MiD OCl NBB MH CFS
NUC cites:1925 edn,80 p. WaPs IaU NRU WU OC OCPMA DLC-P4
LC has 1925 ed.(80 p.)i.proc. Rep.,1939-41=621

II.A.1

Robertson, Emily ed.
 ...Letters and papers of Andrew Robertson,
miniature painter...also treatise on the art by
...Archibald Robertson.London,Eyre & Spettis-
woode.pref.1895.
 285 p. illus.

 2nd ed..pref.1897.contains 12 excellent
repros.of R.'s larger miniatures on ivory.
LC Mellon Reference MJ18.R546R63 1897

LC ND1337.G8R7 Heath.Miniatures.ND1330.H43
 CFA Bibl. p.XXXIX

II.A.1

Schmidt-Thomas, Kurt
 Porträtmalerei;eine kleine malschule.Ra-
vensburg,Otto Maier.1957.3rd ed.,1966
 110 p. illus(part col.)

FOGG
FA4353.55

 Verzeichnis lieferbarer Bü-
 cher 1973/74 NPG v.1,
 p.1710

II.A.1

Robertson, Janet, 1880-
 Practical problems of the portrait painter.
London,Darton,Longman & Todd.1962.
 163 p. illus.

 Describes certain relationships betw.the
shape of the face and the dominant expression.

KU CaMW CaOH Gombrich.Mask & face.In:
 Art,percept'n & reality
 N71/G64 X NCFA p.23

705
C75
NCFA
v.61

II.A.1

Shaw, Wm.A.
 How did George Jamesone paint?

In:Connoisseur
61:127-34 Nov.,'21 illus(part col.)

II.A.1

Rubbra, Benedict
 Painting children.London,Studio Vista;N.Y.,
Taplinger/Pentalic,1979
 104 p. ill(part col.)

LC ND1329.3.C45R82 1979 Books in print.Subject G.
 1985-86,v.3,p.4864

II.A.1

Singer, Joe, 1923-
 Painting women's portraits.N.Y.,Watson-
Guptill Publications,1977
 151 p. illus(part col.)

 Bibliography

LC ND1329.3.W6S56 1977

N
72
P5S31
1969
NCFA

II.A.1

Scharf, Aaron, 1922-
 Art and photography.Baltimore,Allen Lane,
The Penguin Press,1969.c.1968.
 314 p. illus.

 Bibl.references
 Based on thesis for Ph.D.,Courtauld Inst.
of art,Univ.of London

 The problems of style caused by exchange
betw.the different media.Chapter on Portrai-
ture,p.18-51.Use of daguerreotype by ptrs.in
LC N72.P5S3

 Coke.Ptr.& photograph qN72
 P5C6A NCFA Preface

II.A.1

Singleton, Esther,d.1930, ed.and tr.
 Great portraits as seen and described by
great writers;...New York,Dodd,Mead & company,
1905
 342 p. illus.

LC N7575.S6 Fogg,v.11,p.325

705
R97
NCFA
v.99

II.A.1

Some little-known portraits at the Royal Academy

In:Burl Mag
99:24,27 Jan.'57 illus.

Pertains to winter exh.at London,Royal academy of arts,1956-57

Repro.:Gheeraerts,the younger,Wm.Dobson(Family group),Massimo Stansione,Godfr.Kneller,
Wright of Derby, Graham Sutherland

N
40.1
S95A1
NCFA

II.A.1

Sully, Thomas, 1783-1872
Hints to young painters;a historic treatise
on the color,expression,and painting techniques
of American artists of the Colonial and Federal
periods.Reprinted in new format from the original
ed.of 1873...N.Y.,Reinhold Pub.Corp.,1965
46 p. illus.

ND1262.S9 1965

II.A.1

Sonnenfels, Josef von, 1732 or 3 -1817
4 Von dem verdienste des porträtmalers. Wien,
1768

Waetzoldt ND1300-W12
Universal cat.of books on
art 2/5931/U58

T2
NCFA

II.A.1

Tarkington, Booth
Some old portraits; a book about art and
human beings. New York,Doubleday,Doran & co.,Inc.
1939

249 p. illus(part col.)

Bibliography
Art-historical notes

LC N7598.T3 Rep.,1939-41:625

II.A.1

South African National Gallery, Cape Town
Portraits from the permanent collection,cat.
of special exh.at the occasion of Cape Town's
2nd festival,April 1977
49 numbers

Intro.by L.McClelland incl.a brief consideration of the history of portr.painting

English and Afrikaans

OCIMA

II.A.1

Taylor, Joshua Charles, 1917-
La fotografia e la macchia;in.his.Vedere
prima di credere;saggi sull'arte del primo ottocento...Parma,Università di Parma,Istituto di
storia dell'arte.1970.
pp.73-94 illus. (Quaderni di storia
dell'arte 7)

WU

mfm
143n
NPG
reel 10
and
AP
1.V81
NPG
v.37

II.A.1

Stanard, William Glover, 1858-1933
An exh.of contemporary portraits of personages associated with the colony and commonwealth of Virginia between the years 1585 and
1830. Apr.29-May 25,1929.Virginia Hse.,Richmond.

In:Va.Mag.Hist.Biogr.
37:193-216 July,'29 illus.

163 portrs. shown, paintings & miniatures.
Incl.:Lists of sitters & artists
Winterthur Mus.Library
f7851.W77,v.6 NCFA p.225

II.A.1

Versailles. Musée national
Portraits

In:Versailles. Musée national
Notice historique des peintures et des
sculptures du Palais de Versailles.Paris,Impr.
de L.Thomassin et cie.,1838
766 p.

3.ptie.-Portraits

LC N2180.A6 Fogg,v.11,p.326

II.A.1

Stelzer, Otto
Kunst und photographie.Kontakte,einflüsse,
wirkungen.München,Piper(1966)
192 p. illus.

Bibliography

Photography fostered international art
styles by publishing ptgs. in magazines around
the world

LC N72.P5S8 Coke.Ptr.& photograph...
qN72.P5C68 Preface

II.A.1

Vigneau, André, 1892-
Une brève histoire de l'art de Niepce à
nos jours.Préf.de Jean Cassou.Paris,R.Laffont
,1963,
190 p. illus(part col.)

Various ways photography has interacted
with art

LC N6450.V45 Coke.Ptr.& photograph...
qN72.P5C68 Preface

ND
2301
W3W37X
NPG

II.A.1

Washington County Museum of Fine Arts. Hagers-
town,Md.
Portraits through the ages
12 p. chiefly illus.

Cat.of the exh.held Aug.11th-Sept.11,1961...

II.A.2 - ANTIQUITY

British Museum. Dept.of Egyptian and Assyrian
antiquities
Portrait painting from Roman Egypt, by A.F.
Shore. London...,1962
48 p. illus.

CLU FTaSU

II.A.1

Waterhouse, Ellis Kirkham, 1905-
Paintings.Fribourg,Swits..Office du livre
.London,National trust for places of historic
interest or natural beauty.1967
334 p. illus(part col.) (The James A.de
Rothschild coll.at Waddesdon Manor,ed.by Anthony
Blunt,1)

MET
108.2
Ay4W11
v.1

II.A.2 - ANTIQUITY

Coche de la Ferté, Etienne
La peinture des portraits romano-égyptiens
au Musée du Louvre

In:Boo.fr.Egyptol.
no.13:69-78 Jun,1953 illus.

Problems of technique & chronology.Portrs.
of end 3rd c. (Rep.1953=3460)

ULS:"DLC"

Richter,G. Portrs of the
Greeks N7586R53,c.3p.295

757.9
W38
NCFA

II.A.1

Weddell, Alexander Wilbourne, 1876-1948,ed.
A memorial volume of Virginia historical
portraiture, 1585-1830...introduction by Ellen
Glasgow and a review of early American portrai-
ture by Thomas B.Clarke. Richmond,The William
Byrd press,incorp.,1930

556 p. illus(part col.)

Bibliography

LC N7593.W4

II.A.2 - ANTIQUITY

Graf, Theodor
Cat.of the Theodor Graf coll.of unique an-
cient Greek portraits 2000 years old recently
discovered and now on view in Old Vienna,Mid-
way Plaisance at the World's Columbian exposi-
tion.Chicago?,1893.
49 p.

FOOO
3718
G75c

Cat.by F.H.Richter and F.von Ostini.
The encaustic ptg.of the ancients,by Otto
Donner von Richter pp.45.-49

MET
590.8
ZX
N.Y.P.L. MCD p.v.1

Winterthur Mus.Libr. fZ581
f78 NCFA v.3,p.227

qAP
2
M225
NPG

II.A.1 - COLLAGE

Savage.Norbert H..Bert and Gail Savage
Mrs.R.W.and S.A.Shute

In:Maine Ant.Dig.
6:1B-3B Aug.,'78 illus.

Repro.p.3B:Portr.of a woman,c.1829'has
gilt paper appliques for jewelry which are
found on a number of Shute W.C.& perhaps
one oil'.
'Collage technique.was used.to give three
dimensional effect.'-Walters & Weekley in:Abbey
Aldrich Rockefel. Art Ctr.Am.Folk portrs.p.3

II.A.2 - ANTIQUITY

Paris. Musée national du Louvre
Les portraits romano-égyptiens du Louvre;
contribution à l'étude de la peinture dans
l'antiquité,par E.Coche de la Ferté...Paris,
Éditions des Musées nationaux,1952
31 p. illus(part col.)

Bibliographical references

"Rapport sommaire sur l'examen chimique
de 4 peintures romano-égyptiennes...p.23"

LC ND1327.E3P3

Richter,G.Portrs of the
Greeks N7586R53,v.3,p.295

II.A.2. CHRONOLOGICAL

759.93
S97
NCA

II.A.2 - ANTIQUITY

Swindler, Mary Hamilton, 1884-1967
Ancient painting,from the earliest times to
the period of Christian art...New Haven,Yale
uni.press;London,H.Milford,Oxford uni.press,
1929
488 p. illus(part col.)

Bibliography p.433-70

Portraiture in Hellenistic times,Graeco-
Roman,p.319-24

Index has several other references to portrs.
etc.
Martin.Spiritual Asymmetry
in Portraiture.Xerox NPG,p.12
footnote 7

LC ND 70.S8

II.A.2 - ANTIQUITY - ROME

Bolten, Johannes
Die imago clipeata,ein beitrag sur portrait
und typengeschichte...Paderborn,F.Schöningh,
1937
131 p. (Added t.p.:Studien sur
geschichte und kultur des altertums,XII.bd.1.hf

Literaturangaben
Clipeata imago-shield portr.:Painted ances-
tor portrs.hung in Roman houses.None survived

LC N7832.B6 Fogg,v.11,p.221

II.A.2 - EARLY CHRISTIAN, COPTIC, BYZANTINE

II.A.2 - ANTIQUITY - ROME

Brommer, Frank
Zu den römischen ahnenbildern

In:Deutsch.Archäol.Inst.Mitt.Röm.Abt.
50/51:163- 1953/54

LC DE2.D42 Kraus.Das römische welt-
 reich N5760.K92 Bibl. p.315

II.A.2
 see also
I.E - MUMMIES
I.C.1
I.C.2

ND
120
M23
1953
NCFA

II.A.2 - ANTIQUITY - ROME

Maiuri, Amadeo, 1886-
The portrait

In.his.Roman painting.Skira,1953,p.99-103,illus.
(col.)

Incl.Mosaic portr.of a lady

LC ND120.M23(or25) Martin.Spiritual asymmetry
 in portr.In:Brit.J.Aesth.
 9:112,footnote 6 Xerox copy NPG

7C5
b97
NCFA
v.110

II.A.2 - RENAISSANCE

Gilbert, Creighton
The renaissance portrait

In:Burl Mag
110:278,281-5 May,'68

Review of J.Pope-Hennessy's The portrait
in the renaissance

 Oberhuber.In:Burl Mag 113:
 440 footnote 17

II.A.2 - ANTIQUITY - ROME

Winkes, Rudolf
Clipeata imago.Studien su einer römischen
bildnisform.Bonn,Habelt,1969
265 p. illus. (Habelt's Dissertation-
drucke.Reihe klassische Archäologie,Heft 1)

Originally presented as the author's thesis
Giessen
Bibl. references
Clipeata imago-shield portr.:Painted ances-
tor portrs.hung in Roman houses.None survived
LC NB1296.W56 1969 Winkes.Mummy portrs.In:
 Rh.Isl.Sch.of Des. B.59
 708,1R471,p.7

ND
1308
P82
NCFA
NPG

II.A.2 - RENAISSANCE

Pope-Hennessy, John, 1913-
The portrait in the renaissance..New York,
.Bollingen Foundation,distr.by.Pantheon Books.1966,

348 p. illus.

Bibliographical references in "Notes"

Review by C.Gilbert In:Burl Mag
 110:278,281-5 May,'68

LC ND1308.P6

II.A.2 - ANTIQUITY - ROME

Zinserling, Gerhard
Altrömische traditionselemente in porträt-
kunst und historienmalerei der ersten hälfte des
3.jhs.unserer seitrechnung

in:Klio
41:196-220 1963 illus.

'Continuité des traditions dans le portrait
romain,de l'époque républicaine jusqu'à celle
de Gallienus.'-Rep.

LC D51.K6 Rep.1963 *4448 and Kraus.
 Das römische weltreich.
 N5760.K92 Bibl.p.316

II.A.2 - RENAISSANCE

Schaeffer, Emil, 1874-
Von bildern und menschen der renaissance;
mit 30 abbildungen.Berlin,J.Bard,1914
222 p. illus.

Incl.chapter:"Ein unbekanntes bildnis des
Paolo Giovio",p.179-190,with 2 portrs of Giovio.

LC ND615.S35 Rave.Jb.d.Berl.Mus. I 1959
)LC N3.J16 fol. p.144 footr.
 Paolo Giovio & d.Bildnisvitenbücher...

705
B97
NCFA
v.91

II.A.2 - 16th c.(Mannerism)

Auerbach, Erna
Notes on some Northern Mannerist Portraits

In:Burl Mag.
91:218-22 Aug.1949 illus.

The importance of Seisenegger.
Same formula in official portrs.in Austria,
Flanders & France. English version modified by
Holbein's influence
Repro.:Amberger, Seisenegger

AP
1
W225
NB'AA

II.A.2 - 16-17th c.

Edmond, Mary
Limners and picture makers;new light on
the lives of miniaturists and large-scale por-
trait-painters working in London in the 16th
and 17th centuries

In:Walpole Soc.
47:60-242 1978-1980 illus.

Incl.:Discussion of Lawrence Hilliard,
Isaac Oliver,John Bettes the younger,Samuel
Cooper,David Des Granges and ptrs.fr.the Low
Countries working in London.Some serjeant-
painters.(see ov.
RILA 1983 #5715

N
7598
W86
NPG

II.A.2 - 15th c.

Knoedler, M., & company, inc.
Fifteenth century portraits; loan exhibition, April 15
through April 27, 1935, at the galleries of M. Knoedler and
company ... New York city. New York, The Spiral press,
1935.

13, p. 18 port. on 9 l. 28½ x 20½°.
Includes bibliographies.

705
M18
NCFA

Review of exhib.by Forbes Watson in:Mag of Art
28:285-7 May 1935 illus.
1. Portraits—Exhibitions. 2. Title.
40-28002

Library of Congress ND1301.K8
3a
757.0808

qND
1301.5
G7L667
1975X
NPG

II.A.2 - 16-17th c.

Ranger's House.
The Suffolk collection;cat.of paintings
...compiled by John Jacob and Jacob Simon;
photographs by Robert Evans..London,Greater
London Council.1975.
86,p. illus.

Bibliography

FOGG
FA4353
..12

Met
195.3
B12

II.A.2 - 16th c.

Bachstits, Walter W.
Studien zum porträt de 16.jahrhunderts. Ein
internationaler porträttyp. Würzburg,Konr.Triltsch
1934

65 p.
Bibliography

Inaug.Diss.-Bonn

DLC-P4 Rep.,1936#345

705
C75
NCFA
v.55
v.57

II.A.2 - 16-18th c.

Baker, Charles Henry Collins, 1880-1959
Syon house and its treasures

In:Connoisseur
55:3-9 Sep.,'19 illus.(also Pl.on p.13)
57:191-4,196,198 Aug.,'20 Illus.(also Pl.on
p.239)
Contents:1 Portraits at Syon House
2 Notes on Syon House pictures

705
G28
v.29
NCFA

II.A.2 - 16th c.

Nolhac, Pierre de, 1859-1936
Une galerie de peinture au 16ᵉsiècle.Les col-
lections de Fulvio Orsini

In:Gaz Beaux Arts
2s29:427-36 1884

Incl.list of paintings,cartoons & drawings
(some portraits)
"Un véritable musée d'antiquité".-Nolhac

List is part of cat.of the whole collection

ND
1301
C39
NPG

II.A.2 - 16-19th c.

Century Association, New York
Masters of portraiture.Exh.March 6 to April
3,1938.N.Y.,The Century Club
unpaged illus.

11 items shown:Italian,Spanish,Netherlan-
dish,English

705
B97
NCFA
v.121

II.A.2 - 16th c.

Rowlands, John
Holbein and the court of Henry VIII at the
Queen's Gall.,Buckingham Palace

In:Burl Mag
121:53-4 Jan.,'79 illus.

'This exh.is of the first importance...
central core portr.drags.by Holbein fr.Windsor
Castle.'-J.R.
R.discusses in this article mainly the ptgs.
& miniatures. The cat.by Susan Foister
has notes on costumes worn by the sitters.

705
C75
NCFA
v.10

II.A.2 - 16-19th c.

Clouston, Mrs.K.Warren
The Duke of Fife's collection at Duff House
rev.& completed by Mrs.Crosby Smith.

In:Connoisseur
10:3-9 Sept.,'04 illus.
:67-74 Oct., '04

Repro.incl.Jamesone,Velasquez(attr.),C.Pope,
Reynolds,P.van Somer

'Almost every room in Duff House is a pic-
ture gallery'.There are portrs.fr.16th-19th c.
including see even
Jackson.Silhouette TC P.C.15.J75

ND
1314
G449c
NPG

II.A.2 - 16-19th c.

Gibson, Robin
Catalogue of portraits in the collection of
the Earl of Clarendon.London,Paul Mellon Center
for studies in British art.1977.
147 p. &(146)illus.

Index of artists

ND
180
D93
E1951
NCFA

II.A.2 - 17th c.

Dupont, Jacques
The portrait

In.his.The seventeenth century;the new develop-
ments in art from Caravaggio to Vermeer...Skira
.1951.,p.70-78 illus.(col.)

Discussion of the difference of approach to
portraiture in Spain,Flanders,France & Holland

LC
ND180.D8 1951a

ND
1301
M5M52X
NPG

II.A.2 - late 16th - mid 19th c.

Milwaukee. Art Center
Portraits from Milwaukee collections;an
exh.presented by the Milwaukee Art Center in
co-sponsorship with the National Society of
the Colonial Dames of America in the State of
Wisconsin.Sept.3 through Oct.10,1971.Milwaukee,
Arrow press,1971
1 v.(unpaged) illus.

Intro.by Tracy Atkinson

II.A.2 - 17th c. 1

Macaulay, Thomas Babington,1st baron,1800-59
The history of England from the accession of
James II...;with index by W.B.Gray & G.Davies.
London,Macmillan & co.,ltd,1913-15

6 v. illus(part col.)c.1000 illus.,c.50 col.

Other editions, 1849-1931 see LC DA435.M14 &
LC I.E8 no.34-36

705 { Review by Ronald Clowes, In:Connoisseur,43:21-28
C75 { Sep,1915 illus.:"...one of the best & most com-
NCFA { plete representation of English & French portrai-
v.43 { ture..."Repro.:Mini ture of Colin Lindsay
LC DA435.M14 1913 continued on next card

CT
817.5
S26
1985X
NPG

II.A.2 - 16-20th c.

Edinburgh. Scottish national portrait gallery
Great Scots.Publ.by the Trustees of the
National Galleries of Scotland.,n.d.,

73 p. illus(col.)

Comp. by James Holloway
Index of sitters
Index of artists

705
C75
NCFA
v.43

II.A.2 - 17-18th c.

Baker, Charles Henry Collins, 1880
Some pictures in Mr.George Leon's collection.

In:Connoisseur
43:2-11 Sep,1915 illus(part col.)

Chief interest of collection:Portraits of 17th
& early 18th c.

Incl:Edwards:Sir Edward Walpole; Miereveld,
Soest, Greenhill, etc.

N
7592
F35X
NPG

II.A.2 - 16-20th c.

Paris. Musée des arts décoratifs
La famille des portraits.Cat.of exh....
Paris,1979

FOR COMPLETE ENTRY
SEE MAIN CARD

VF
Amherst,
Mass.
Amherst
College

II.A.2 - 17-18th c.

Amherst college. Mead art building
The Amherst family portraits.Exh.Oct.23-
Nov.12, 1967
21 p. illus.

Mead Art Mus.Monographs
v.6&7
p.1

705
C75
NCFA
v.126

II.A.2 - 17th c.

Douglas, R.Langton
Some portraits of ceremony of the Jacobean
school

In:Connoisseur
126:162-66,220 Jan,1951 illus.

Repro:1st & 2nd Lord Baltimore,etc.;Daniel
Mytens,the elder,van Soest,Marcus Geeraerts,jr.

Enc.of World Art, v.11
N31E56Ref. col.513
bibl.on portr.

II.A.2 - 17-18th c.(LATE BAROQUE)

Berlin. Schloss Charlottenburg
Höfische bildnisse des Spätbarock.Exh.
Sept.15-Okt.10,1966.Cat.by Helmut Börsch-Supan
.Berlin.Verwaltung der Staatl.Schlösser & Gär-
ten,1966
208 p. illus.

Bibliography

LC ND1313.B6 Schoch.Herrscherbildnis...
 ND1313.5.S36X p.245

II.A.2 - 17-18th c.

ND
466.5
Mu67
1988X
NMAA

Hope, Ann M., 1936-
The theory and practice of neoclassicism in
English painting.The origins,development and de-
cline of an ideal.N.Y.& London,Garland,1988
417 p. illus.

Bibliography,p.226-38

Ch.13:Portraiture,p.116-31

Outstanding thesis in the Fine Arts from Bri-
tish universities

II.A.2 - 17-18th c.

Notre Dame, Ind. University. Art Gallery
Sobriety and elegance in the Baroque:an exh
of portraits from the University of Notre Dame
Coll.presented by the Renaissance Soc.at the
University of Chicago,Goodspeed Hall,Apr.5-
May 10,1961:s.l.,s.n.,1961?:
.48.p. illus.

Incl.index

Cty MoU Yale ctr.f.Brit.art ref.
 ND1313.N68

705
A63
NCFA
v.38

Sager, Walter de
Historic portraits.Hanoverian likenesses
of 17th and 18th centuries

In:Ant.collector
38:66-73 Apr/May,'67 illus(part col.)

Repro.:Honthorst,Hannemann,Scheits,Vaillant,
Kneller,Rigaud,Tischbein,v.Douven,Pesne,Batoni,
Zoffany

LC NK1125.A28 Eller.Kongel.portr.malere
 p.518

M
516
B5A53
1971X
NMAA

Anglo-American Art Museum
Cat.paintings,prints,drawings.Baton Rouge.
Louisiana State University.1971.
.39.p. illus.

Arranged alphabetically by artists'names

II.A.2 - 17-19th c.

Musée Fabre
Le portrait à travers les collections du
Musée Fabre,17e-18e-19e siècles.exposition.,Mont-
pellier,4 juillet-31 octobre 1979.Montpellier,
Musée Fabre,1979.
130.p. illus.

Bibliography,p.121-4
Index
.exposition organ.par A.Dejean.

LC N7623.2.F8M665 Psychoanalytic perspectives
 on art N72.P74P78,v.2,p.168

II.A.2 - 18th c.

Dayot, Armand Pierre Marie, 1856-1934 ed.
Cent portraits de femmes des écoles anglaise
et française.Paris,F.Petit,1910
165 p. illus. (Maîtres de 18e siècle)

Luxury ed.of cat.of exh.in Paris,Mus.du jeu
de paume,Spring,1910;intro.by A.Dayot & Claude
Phillips.Documentation by Léandre Vaillat & Robert
Dell
Exhibited portrs.offer a study in differen-
ces of temperament & character betw.2 nations
(see L.C.ust.in:Burl Mag.v.17:52,55)

LC R757
 fD27c OC MdBWA NN

qN
6110
S813X
NMAA

Starobinski, Jean
The secret of the human face

In.his.The invention of liberty,1700-1789.
Geneva:Skira,c.1964. (Art Ideas History)

pp.134-7 illus(col.)

ND
1301
C39p
NPG

Century Association, New York
Portraits owned by clubs in New York.:Exh.
Jan.9 to Feb.3,1937.N.Y.,The Century Club
unpaged illus.

23 items shown
Repro.incl.:Washington,by G.Stuart;Wm.Pitt,
by J.Hoppner;J.Q.Adams,and Js.Madison, by A.B.
Durand;Lincoln,by F.B.Carpenter;etc.

Winterthur Mus.Libr.fZ881
W78 NCFA v.6,p.226

705
C75
NCFA
v.90

Rayner, Stanford
Ancestors

In:Connoisseur
90:27-30 Jul.,'32 illus.

Repro.:Guttenbrun,Pickering,Cosway(all in
H.Cary-Barnard coll.)

"Portraiture...popular form of ptg. as well
as an illuminating manual of unwritten history"

Cumulated Mag.subj.index
A1/3/C76 Ref. v.2,p.443

705
A7832
NMAA

Rosenblum, Robert
The origin of painting:a problem in the
iconography of Romantic classicism

In:Art Bull.
39:279-90 Dec.,'57 illus.

Ref.to Pliny the elder's story in his Natural
History of a Corinthian maid who traced the sha-
dow of her lover's face cast upon the wall by
lamplight;the nature & meaning of the response
to this legend in the period of Romantic Clas-
sicism(end 18-beg 19th c.)
Piper.Shades
Bibl.p.61

ND
1313.5
836X
NPG

II.A.2 - 18-19th c.

Schoch, Rainer
 Das Herrscherbildnis in der malerei des
19.jahrh.München,Prestel-Verlag,1975
 366 p. illus. (Studien zur Kunst des
19.Jahrh.,23)
 Bibliography
 Index of persons

 Royalty during Absolutism,the Enlighten-
ment,the Restoration,the reigns of Napoleon I,
Queen Victoria,Napoleon III & the German mo-
narchs
 Representa- tion & propaganda.-
 RILA 11/1 1976 #2107

II.A.2 - 19th c.

Howard, Betty J.
 A cat.of 19th c. portraits in the Ohio
State archeological and historical museums

 Master's Th.-Columbus,O.S.Univ.,1948

 Lindsay,K.C. Harpur Ind.of
 master's theses in art...
 .955 NCFA Ref. Z5931.L74
 p.73 no.1330

II.A.2 - 18-19th c.

Siegfried, J
 The romantic artist as a portrait painter

In:Marsyas
8:30-42 1959

N9.M34 Encyclop.of World Art
 Portrs.bibl.N31.E56 Ref.

705
G28
NCFA
v.31

II.A.2 - 19th c.

Mantz, Paul
 Les portraits du siècle

In:Gaz.Beaux-Arts
31:497-511 June,1885 illus.

 Repro.incl.:Prud'hon

 2nd exh.of Portraits du siècle at l'école
des Beaux-Arts.For 1st exh.see Lostalot,A.de
Gaz.Beaux-Arts,v.28:81-91,July,1883

705
C69
NPAA
v.46

II.A.2 - 18-19th c.

Tscherny, Nadia
 Likeness in early Romantic portraiture

In:Art J.
46,no.3:193-99 Fall,1987 illus.

 Portraits within portraits,fg.1

II.A.2 - 19th c.

Pierce, Catherine W.
 Francis Alexander

In:Old Time N.Engl.
44:29-46 Oct.-Dec.,'53 illus.

 Incl.:List of A.'s portrs.with their loca-
tions

LC F 1.868 Arts in America q25961.U5
 A77X NCFA Ref. I 385

N
7592.5
B82
NPG

II.A.2 - 19th c.

Brandt Dayton Gallery, New York
 Portraits and people.19th c. paintings and
drawings.exh.,Oct.12-Dec.3,1983.,1983.
 unpaged 40 works shown illus(part col.)

 Incl.:Index to cat.nos. of artists repre-
sented in the exhibition

II.A.2 - 19-20th c.

Blanche, Jacques Émile, 1861-1942
 Faces:portraits by Degas

In:Formes
12:21-3 Feb.,'31 illus.

 Commentary on the nature of 19th & 20th c.
portraiture

LC N1.F67 N.Y.,MOMA.20th c.portrs.
 by M.Wheeler N7592.6N53
 Bibl. NPG

II.A.2 - 19th c.

Brasch, Ernst, 1901-
 Das nazarenische bildnis:ein beitrag zur
aesthetik und geschichte der porträtkunst.
Potsdam,R.Schneider,1927.
 64 p. illus.

FOGG
FA
4353.8

 Inaug.-diss.Würzburg,1927

 Bibliography

ICRL ICN Cat. of PPING Fogg.,11,p.318

N
7592
O24
NPG

II.A.2-19-20th c.

Chicago. Art Institute.
 Cat.of loan exh.of portraits at the Art
Institute of Chicago for the benefit of the
Passavant Memorial Hospital,March 7th to 27th,
1910.Chicago,1910
 172 nos. 1 illus.

 Alphabetical lists of artists,owners,sitters
 Mainly 19-20th c.
 NPG copy bound with Garrick Club,London.
Cat.of the pictures...London,1909

ND
1301
N5K72
NCFA

II.A.2 - 19-20th c.

Knoedler,M.& company, New York
　　Pictures of people,1870-1930:a loan exhibi-
tion for the benefit of Hope Farm

　　illus.cat.of an exh., April6-18,1931

　　Portrs. by Manet,v.Gogh,Fantin-Latour,
Whistler,Cézanne,Degas,Renoir,Sargent,Pellows,
Eakins,Peal,John,Matisse,Orpen,Orden,Picasso,
Speicher

MOMA,p.433, v. 11

II.A.2 - 20th c.

Lorr, John Siegbert
　　Present day portraiture

　　Master's Th.-Columbus,O.S.Univ.,1933

Lindsay,K.C. Harpur Ind.of
master's theses in art...
1955 Z5931.L74 1955 NCFA
Ref. p.22 no.367

II.A.2 - 19-20th c.

Leicester Galleries, London
　　Fifty years of portraits,1885-1935

　　Illus.cat.of an exh., May-June,1935

V&A
Leicester
no.604

MOMA,p.433, v.11
5u
x1645

II.A.3.　BY COUNTRY, A-Z, subdivided -
　　　　　chronological & regional

AP
1
A784J8
NCFA

II.A.2 - 19-20th c.

Rinder, Frank
　　J.J.Shannon,A.R.A.

In:Art J.
　　:41-5　1901　illus.

II.A.3　COUNTRY
　　see also
I.D　　SPECIAL COUNTRIES (no media or more than one me-
　　　　dium or specifi country's ap-
　　　　proach to portraiture.)

705
A786
NCFA
v.36
pt.2

II.A.2 - 20th c.

Davidson, Martha
　　Impressionist and later portraits

In:Art N
36:10-11,24　Mar.5,1938　illus.

　　From Manet to Dali

FOR COMPLETE ENTRY
SEE MAIN CARD

II.A.3 - AUSTRALIA

Nan Kivell, Rex
　　Portraits of the famous and infamous:Austra-
lia,New Zealand and the Pacific,1492-1970:by
Rex Nan Kivell and Sydney Spence...London:distr.
by:Maggs Bros.,ltd.,1974
　　271 p.　illus(part col.)

LC N7615.4.N36 fol.

Buscombe.Australian colon'l
portrs. ND1327.A85B97 MPO
Bibl.note p.72

II.A.2 - 20th c.

Lang, J.T.
　　Portrait painting including the historical
background of contemporary portrait painting

　　Master's Th.-Columbus,O.S.Univ.,1930

Lindsay,K.C. Harpur Ind.of
master's theses in art...
1955 Z5931.L74 1955 NCFA
Ref. p.14 no.222

ND
1327.A85
B97
NPG

II.A.3 - AUSTRALIA - 18th c.

Buscombe, Eve, 1944-　　comp.
　　Australian colonial portraits.Hobart,Tasma-
nian Mus.& Art Gallery,1979.

　　Index
　　Bibliography

FOR COMPLETE ENTRY
SEE MAIN CARD

N7615.4
A87X
NPG

II.A.3 - AUSTRALIA - 19th c.

Ruscoder, Eve, 19hh-
Artists in early Australias and their por-
traits.Sydney,Eureka Research,1978(1979)
421 p. illus(more than 600 illus.)

Emphasizes the portr.ptrs.of New South
Wales & Van Diemen's Land for the period 1820-
1850.
Info.abt. 100 artists who worked in Austra-
lia before 1860
Index of artists
Index of sitters Buscombe.Austr.colon.ports
ND1327.A85B97 NPG p.72

BELGIUM after 1830 (before 1830 NETHERLANDS)

II.A.3 - AUSTRALIA - 20th c.

Sydney. Art Gallery of New South Wales
The Archibald Prize.An illustrated histo-
ry 1921-1981;by Anna Waldmann..The Gallery,
1982.
.23.p. illus(part col.)

Reprint of Art & Australia,v.20,no.2:13-36

'...the very existence of the Archibald Pri-
ze has sustained an interest in the art of por-
traiture...which.has progressed noticeably in
recent years...'—Edm.Capon in the Foreword

II.A.3 - BELGIUM

Honderd selfportretten,voorgesteld door diverse
auteurs,samengesteld onder leiding van Ant.
de Pesseroey.Brussel,Arcade,1976
310 p. illus(col.)

LC ND1319.6.H66

II.A.3 - AUSTRIA

Kenner, Dr.Fr.
Die porträtsammlung des Erzherzogs Ferdinand
von Tirol

In:Jb.d.kunsthist.sammlungen des österr.kaiserh.
Bd.XIV:37-186:Geschichte, der Slg:D.Bildnisse d.
Erzhauses Habsburg(1893);Bd.XV:147-259:D.deut-
schen Bildnisse,Wundermenschen(1894);Bd.XVII:101-
274:Ital.Bildn.(1896);Bd.XVIII:135-261:D.Medici.
Neapel,Celebritäten(1897);Bd.XIX:6-146:Spanien,
Portugal,Frankr.Engl.,Schottld. Der Orient(1898)
LC N3.J4 Rave,P.O. Paolo Giovio u.
d.bildnisvitenbücher...
Jb.d.Berl.Mus. I 1959:144
footnote LC N3.J16 fol.

II.A.3 - BELGIUM - 19th c.

Brussels. Musées royaux des beaux-arts de
Belgique. Musée moderne
Regards et attitude d'un siècle.Portraits et
figures de Navez à Evenepoel(Expo.)...Bruxelles,
23 nov.1967-18 févr.1968.Pruxelles,...1967
1 v.(unpaged) illus.

Catalogue by André A.Moerman

Bibl.references

LC N7603.B7 Fogg,v.11,p.330

II.A.3 - AUSTRIA - 20th c.

Das Porträt im phantastischen Realismus...
Wien,Hauska,1972

LC N6808.5.M3P67 FOR COMPLETE ENTRY
SEE MAIN CARD

II.A.3 - BELGIUM - 19th c,

Lambotte, Paul, 1862-1939
Les peintres de portraits.Bruxelles,Van Oest
1913
142 p. Illus. (Collection de l'art
belge au 19e siècle)

FOGG
FA
4059.20

Fogg,v.11,p.318

II.A.3 - AUSTRIA

Vienna. Kunsthistorisches Museum. Schloss-
Sammlung Ambras
I Ritratti Gonzagheschi della collezione
di Ambras .di.Giuseppe Amadei e di Ercolano
Marani.Mantova,Banca Agricola Mantovana,1980
284 p. illus(col.)

Bibliography p.255-71

NPG Spike.Baroque portraiture..
N7606.S75 NPG Bibl.p.194

II.A.3 - BELGIUM - 19-20th c.

Muls, Jozef, 1862-
Een eeuw portret in Pelgië,van het classi-
cisme tot het expressionisme.Diest,Pro arte,1944
.1.e.1945.
173 p. illus.

LC ND1319.M8 Fogg,v.11,p.330

II.A.3 - BULGARIA

Mikhalcheva, Irina
 Portretut v bulgarskata shivopis.Sofia,
Izdatelstvo na Bulgarskata akademiia na naukite,
1968-
 v. illus(part col.)

FOGG Added t.p. in French:Le portrait dans la
PA peinture bulgare
4202 French & Russian summaries
.800.1 Contents.-1. 1878-1918

 Bibliography v.1,p.164-5
 Fogg,v.11,p.319

II.A.3 - CANADA - NOVA SCOTIA

Halifax,N.S. Law Courts
 Cat.of portraits of the judges of the Su-
preme Court of Nova Scotia and other portraits.
Halifax,N.S.1929?
Nat.Gall. 111 p. illus.
of Canada
C N7594 The biographical notes have been collected
H17 by Reginald Vanderbilt Harris

 Henry Francis duPont
 Winterthur Mus.Libr.
DLC & CaNSWA(under Harris) Z881.W78 NCFA v.6,p.231 Ref.

VF II.A.3 - CANADA
Canada
Ottawa Ottawa. National Gallery of Canada
NG Early Canadian portraits.Exh.,prepared by
Wayne J.Ready,under the supervision of Pierre
Théberge,and circulated by the Extension Ser-
vice of the N.G.of Canada,Ottawa,1969-1970.
Ottawa,Publ.by the Gallery,for the Queen's
Printer,1969.
 12.p. illus. (Its Extension Services
travelling exhibitions,1969-70,cat.no.1)
 English and French
 26 works shown
CaOONG:C N910.07A869,no.1

VF II.A.3 - CANADA - NOVA SCOTIA - HALIFAX
Portrs.
Cana- Halifax,N.S. Centennial Art Gallery
dian Halifax portraits.Exh.,Centennial Art Gal-
lery,Nova Scotia Museum of Fine Art,Citadel
Hill,Halifax,9 March to 26 March,1972.Halifax,
1972.
Nat.Gall. 11.p. 1 illus.
of Canada
C 7595
H2H17

qN II.A.3 - CANADA - 20th c.
40.1
G748D3
NMAA Dempsey, Hugh Aylmer, 1929-
 History in their blood:The Indian por-
traits of Nicholas de Grandmaison;intro.by
J.Russell Harper;foreword by Frederick J.
Dockstader.1st American ed.N.Y.,Hudson Hill
Press.Distr.by Viking Penguin,c.1982
 124 p. illus(part col.)

 Index

LC NC143.G68D46 1982 Books in print.Subject
 guide,1985-86,v.3,p.4864

II.A.3 - CHINA

Oriental Art only used by exception

N II.A.3 - CANADA - 20th c.
40.1
M8714
M2 McGill, Jean S.,1920-
NMAA Edmund Morris,frontier artist.Toronto
and Charlottetown,Dundurn Press,1984
 208 p. illus(part col.) (Dundurn lives)

 Index
 Bibliography,p.197-201

LC ND249.M67M24 1984

II.A.3 - CHINA

Brinker, Helmut
 Die zen-buddhistische bildnismalerei in
China und Japan von den anfängen bis zum ende
des 16.jahrh.:eine untersuchung zur ikonogra-
phie,typen-und entwicklungsgeschichte.Wiesbaden
F.Steiner,1973
 279 p. illus. (Münchener ostasiatische
Studien,Bd.10)

 Bibliography

LC ND1326.B74 Lee.Varieties of portr.in
 Chin.& Japan,p.11/,note 2
 CMA,Bull.Apr.1977.708.1.20
 C62

N II.A.3 - CANADA - 20th c.
40.1
M8714
F5 Morris, Edmund, 1871-1913
NMAA The diaries of Edmund Montague Morris:
Western journeys 1907-1910;transcribed by
Mary Ritz-Gibbon.Toronto,Royal Ontario Mu-
seum,1985
 179 p. illus(part col.)

 Bibliography p.167-70
 Index

705 II.A.3 - CHINA - 19th c.
A875
NCFA Gardner, Albert Ten Eyck
7.16 Cantonese Chinnerys:Portraits of How-qua
and other China Trade paintings

 In:Art Q
16:305-24 Winter,1953 illus.

 Peabody Mus.of Salem,Mass.
 no.Chinnery...N40.1.C53P3
 FA Bibl.p.XII

N
40.1
CS3116
NPG

II.A.3 - CHINA - 19th c.

Hill, Henry D., 1899-
George Chinnery,1774-1852,artist of the
China coast,by Henry & Sidney Berry-Hill,with
foreword by Alice Winchester.Leigh-on-Sea,F.
Lewis.1963.
63 p. illus.

Bibliography

Archer.India & Brit.por-
traiture.ND1327.I44A72X NPG
Bibl.p.477

II.A.3 - DENMARK

Eller, Povl
Hvad blev der af portraetterne pa Hirsch-
holm Slot.Hørsholm,Museumsforeningen for Hørs-
holm og Omegn,Folehavevej 21,1972
92 p. illus.

Bibliography

LC N7638.D4E44

N
40.1
CS3H9
NCFA

II.A.3 - CHINA - 19th c.

Hutcheon, Robin
Chinnery., the man and the legend....Hong-
kong,South China Morning Post,1975
180 p. illus(part col.)

Incl.chapter on Lamqua(real name Kwan Kiu-
chin)

N
40.1
M265
E4 NPG

II.A.3 - DENMARK

Eller, Povl
Kongelige portraetmalere i Danmark 1630-82.
En undersøgelse af kilderne til Karel van Manders
og Abraham Wuchters' verksomhed.:Udg.af.Selskabet
til Udgivelse af danske Mindesmaerker.København,
Dansk Historisk Faellesforening,1971
563 p. illus.

Thesis-Copenhagen
Summary in English
Bibliography

LC ND1328.E43

II.A.3 - CHINA

National Palace Museum, T'ai-pei
Masterpieces of Chinese portrait painting
in the National Palace Museum, T'ai-pei ₂1971₎
112 p. illus(part col.)

Chinese,English,& Japanese

LC N7615.C6K86

Books in print.Subj.guide
Z1215.P92 1975 v.2 NPG
p.2768

ND
1321
E44K
NPG

II.A.3 - DENMARK

Eller, Povl
Portraetsamlingen pa Gammelkjøgegaard.:Hil-
lerød,Det nationalhistoriske Museum pa Frede-
riksborg,1970
91 p. illus.

A typical mannerhouse collection:Portrs.
from 1576-1863

LC ND1321.E44

705
161
NCFA
v.72

II.A.3 - CHINA - 19th c.

Orange, James
The life and work of George Chinnery in
China

In:Studio
72:81-92 Nov.,'20 illus(part col.)

Ch.moved to Canton,China, ca.1825

FOR COMPLETE ENTRY
SEE MAIN CARD

N.Y.P.L.
3-MCY

II.A.3 - DENMARK - 18th c.

Elling, Christian, 1901-
Rokokoens portraetmaleri i Danmark...
København,G.E.C.Cad.s.,1935
84 p. illus. (Kunst i Danmark.Ny Raekke,
.11
Bibliography p.83-4

Eller.Historisk ikonografi
LC N7575.E45 p.67

II.A.3 - CZECHOSLOVAKIA - BOHEMIA - BAROQUE

Strettiová, Olga
Barockporträt in Böhmen.Prag,Artia.1957.
1 v.unpaged illus(part col.)

Bibliography

78 leaves,70 illus.,26 in color

LC N7614.C98713

AP
1
C27
NMAA

II.A.3 - DENMARK - 19-20th c.

Frederiksborgmuseet
Det nationalistorisk Museum paa Frederiks-
borg.Beretning om året 1984-85.by Mogens Wahl,
Kristof Glamann,Olaf Olsen,Povl Eller

In:Carlsbergfondet,Frederiksborgmuseet,Ny Carls
bergfondet.Arsskrift 1986,p.81-91 illus(part
col.)
Report of purchases & gifts.
Repro.incl.:Drags.:Frederik VI by Christof-
fer Wilhelm Eckersberg.Frederik IX & other
portrs.by Johannes Ejner Glob.Ptgs.by Victor
Isbrand,etc.

II.A.3 - DENMARK

Lund, Emil.Ferdinand.Svitser.,1858- ed.
 Danske malede portraeter,en beskrivende ka-
talog...under medvirkning af C.Chr.Andersen.
Kjøbenhavn,Gyldendalske boghandel,1895-1910
 10 v. illus.

MET
195.36
L97

LC
 Eller.Kongel.portr.malere
 p.514

II.A.3 - EUROPE - 18-19th c.

Aijazuddin, F.S.
 Sikh portraits by European artists...London,
Philip Wilson Publishers Ltd.,1979

II.A.3 - EUROPE

Brinckmann, Albert Erich, 1881-1958
 Porträtdarstellungen als symbola des Euro-
päischen.in.Olsson,Martin,1886- ed. Studier
tillägnade Henrik Cornell pa sextioårsdagen...
Stockholm,Nordiska museet,Bokförmedlingen,1950
 271 p. illus.

 p.165-71

 General survey of the successive tenden-
cies of portraiture in the different European
countries,fr.Carolingian times to the 19th c.
 (see over)
 - Rep.1950-51 #142

II.A.3 - EUROPE - 18-19th c.

Cook, M.M.
 .Portraiture in Europe from 1780-1830

 Master's Th.-Mills Coll.,Oakland,Calif.,
1939

 Lindsay,K.C.,Harpur Ind.of
 master's theses in art...
 Z5931.L74 1955 NCFA Ref.
 p.39,no.692

II.A.3 - EUROPE

Huemer, Frances
 Portraits.Brussels,Arcade Press,N.Y.,
Phaidon,1977
 v. illus. (Corpus Rubenianum Ludwig
Burchard,pt.19)

LC ND673.R9C63 Pt.19
 ND1329.R8

757
.M51 II.A.3 - FINLAND

Meinander, Karl Konrad,1872-
 ...Porträtt i Finland före 1840-talet av
K.K.Meinander. Helsingfors,Söderström & c:o:för-
lagsaktiebolag,1931-
 2 v. illus.

II.A.3 - EUROPE

Krull, Edith
 Kunst von frauen.Das berufsbild der bil-
denden künstlerinnen in vier jahrhunderten.
Edition Leipzig.1984.
 189 p. illus(part col.)

LC N8354.K78 1984

II.A.3 - FINLAND

Meinander, Dr.K.K.?.(Finland)
 .study on the art of the portrait in Scandi-
navia.. n.p. n.d.

 illus.

Review by Strömbom,Sixten, In:Ord och Bild
 :260-6 1933 illus.

 "oeuvre monumentale", portraits pre-1840,
classified. Incl.Desmarées,Dahl,Wertmüller,etc.
Ord och Bild
LC AP48.06 Rep.,1933#147

N
2030
A56 II.A.3 - EUROPE
1979
v.2
NMAA Paris. Musée national du Louvre
 Cat.sommaire illustré des peintures du
 Mus.du Louvre.Paris.Editions de la Réunion
 des musées nationaux
 v.2 illus.

 v.2:Italie,Espagne,Allemagne,Grande-Bre-
 tagne et divers

 Coordination par Arnauld Bréjon de Laver-
 gnée et Dominique Thiébaut
 For list of portrs.see:Index iconogra-
 phique,p.400-40.

II.A.3 - FRANCE

Cogniat, Raymond, 1896- ed.
 Orientations de la peinture française de
David à Picasso.Textes de:E.Souriau.et al..
Nice,La Diane française.1950.
 201 p. illus(part col.)

FOGG
FA
3924
.703
.85F

Harv.Uni.for LC MOMA p.432, v.11
 IdPI MhD NjR
 KMK

II.A.3 - FRANCE

Dimier, Louis, 1865-1943
　Die französischen bildnisse in der porträt-
sammlung des Erzherzogs Ferdinand von Tirol.
Portraits.

MET
100.53　In:.Jahrbuch der kunsthistor.Sammlungen des aller-
J191　höchsten Kaiserhauses
Q　　25:219-25　Wien　1904　illus.
v.25

ND　MB　NN
LC N3.J4

II.A.3 - FRANCE

Galerie Bernheim,jeune, Paris
　Painters of portraits..exh.,Oct.,1952

705
594　　Review by Alexander Watt in Paris Commentary;
NCFA　In:Studio
　　143-4:121　Oct.1952　illus.
　"...Different forms of expression in French
portraiture since the time of the classical re-
vival of the Revolution. From academic to ab-
stract..."

II.A.3 - FRANCE

Dimier, Louis, 1865-1943
　Histoire de la peinture française. Paris,
Librairie nationale d'art et histoire,1925,26
　3 v. in 5　illus. Portraits

FOGG
For call　Contents.-1.Des origines au retour de Vouet,
nos.see　1300 à 1627, par L.Dimier.-2.partie 1,2.Du retour
indiv.　de Vouet à la mort de Lebrun,1627 à1690,par L.
entries　Dimier.-3.partie 1,2.Au 18e siècle,par Louis
　　Réau.　Includes bibliographies

　　　　Eller,Povl.Kongelige portr
MB　　　　　　malere
　　　　　Bibl.p.510

M
1316.3
G67　Gordon, Alden R.
1983X　　Masterpieces from Versailles.Three centuries
NPG　of French portraiture.Cat.of Exh.at the Nat'l
2 c.　Portrait Gall.,Washington,D.C.,Nov.11,1983 to
　Jan.8,1984.Washington,D.C.,Publ.for the NPG by
　Smithsonian Inst.Press,1983
　　　127 p.　illus(part col.)

　　　Incl.:Index:Artists and sitters
　　　Bibliography
　　　Foreword by Alan Fern
　　　Preface by Pierre Lemoine

ND
544Q56
1984X　Dublin. National Gallery of Ireland
NMAA　　Fifty French paintings.described.by Honor
　Quinlan.Dublin,Nat'l Gall. of Ireland,c.1984
　　50 p.　illus(col.)

　　　Indexes
　　　Incl.:Portrs. by Largillière,J.M.Nattier,
M.Q.de la Tour,Perroneau,A.S.Belle,Roslin,
Baron Gérard,Morisot,Kees van Dongen

II.A.3 - FRANCE

Kenner, Dr.Fr.
　Die porträtsammlung des Erzherzogs Ferdinand
von Tirol

In:Jb.d.kunsthist.sammlungen des österr.kaiserh.
Bd.XIV:37-186:Geschichte der Slg:D.Bildnisse d.
Erzhauses Habsburg(1893);Bd.XV:147-259:D.deut-
schen Bildnisse,Wundermenschen(1894);Bd.XVII:101-
274:Ital.Bildn.(1896);Bd.XVIII:135-261:D.Medici.
Neapel,Celebritäten(1897);Bd.XIX:6-146:Spanien,
Portugal,Frankr.Engl.,Schottld. Der Orient(1898)
LC N3.J4　　　　Rave,P.O. Paolo Giovio u.
　　　　　　　d.bildnisvitenbücher...
　　　　　　　Jb.d.Berl.Mus. I 1959:144
　　　　　　　footnote LC N3.J16 fol.

ND
1316　II.A.3 - FRANCE
D89
NPG　Dumont-Wilden, Louis, 1875-
　　Le portrait en France. Bruxelles,G.van Oest
　& Cie,1909

　　276 p.　illus.

　　Biography & short bibliography of artists &
register of their most important works

LC ND1316.D8

705
G28　II.A.3 - FRANCE
NCFA
2nd per.　Mantz, Paul
v.18²　　Exposition Universelle.Les portraits histo-
　riques au Trocadéro

　In:Gaz.Beaux-Arts
　2nd per.18²:857-82　Dec.,1878　illus.

　　Repro.incl.:Charles V,miniature by Jean de
Bondel(Jean de Bruges).Diane de Poitiers,16the.
Molière,c.1657.Portrs.by François de Troy,
Greuze,Lagneau,Jacques Louis David,Watteau
　　　　Tourneux.Exh.retr.d'art fé-
　　　　　minin.Gaz.Beaux-Arts,v.39
　　　　　p.291 note 1

II.A.3 - FRANCE

Florisone, Michel
　　Portraits français. Paris,Galerie Charpentier,
1946

　　151 p.　illus.

LC ND553.M3F54　　Rep.,1945-47:856

ND
544　II.A.3 - FRANCE
M383
NCFA　Martin-Méry, Gilberte
　　La peinture française en Suède,hommage à
　Alexandre Roslin et à Adolf-Ulrik Wertmüller,
　Bordeaux,19 mai-15 sept.1967..Musée de Bordeaux
　Cat.par Gilberte Martin-Méry,avec le concours d
　Gunnar W.Lundberg.Bordeaux,le Musée,1967
　　　151 p.　illus.

LC ND546.M4

II.A.3 - FRANCE

Musée Leblanc-Duvernoy, Auxerre
 Portraits du Musée d'Auxerre:Musée Leblanc-
Duvernoy,1er juin-31 oct.1984.Auxerre,le Musée
.1984.
 52 p. illus(part col.)

 Essay by Micheline Durand

LC N7621.2.F8A89 1984 Additional short-listed
 titles of worldwide art
 cat.Bull.

II.A.3 - FRANCE

Robiquet, Jean, 1874-
 La femme dans la peinture française,15e-20e
siècle. Paris,Les Éditions nationales,1938

 206 p. illus.(part col.)

Review by Rbt.Rey In:Renaissance :15-21 1939 il.
Review by George, W. In:Am de l'art :295-7 1935"

 Emphasis on 18th c.women in art & literature
& the develop't fr. the Middle ages on. 15th c.
MS miniature, Watteau, Corot,Millet,David,etc.
LC N.Y.P.L.for LC Rep.,1939-41*627,1935*83

II.A.3 - FRANCE

New York. French institute in the United States
 Women by French masters...from 1830-1930.
.Loan exh..1931

 Romanticism to surrealism;from Géricault
and Courbet to Modigliani and Lurçat

In MOMA
1
xN424
no.13

 MOMA,p.432, v.11

II.A.3 - FRANCE

Rome. Palazzo Venezia
 Il ritratto francese da Clouet a Degas.cat.
di mostra 1962;premessa e introd. di Germain
Bazin..Roma,1962
MET 120 p. illus.
sup2
195.37 cat.,annotations by O.Dutilh & P.Rosenberg
R66
entry only
under
Bazin
 Encyclop.of World Art
 Portrs.bibl.N31E56 Ref.

II.A.3 - FRANCE

Paris. Bibliothèque nationale
.. ..Exposition de portraits peints et dessi-
nés du 13e au 17e siècle.Avril-juin,1907.Cat.
2nd éd.Paris,E.Lévy,1907
 220 p. illus.

 Le cat.a été rédigé par François Courboin...
assisté de mm.Jos.Guibert,Paul André Lemoisne,
François Bruel..et Jean Laran

 See also Lemoisne,P.A.'s Notes in Rev.des
bibl. Paris,1907
LC N7604.P3 1907

II.A.3 - FRANCE - 14-16th c.

Paris. Musée national du Louvre
 Portraits français 14e,15e et 16e siècles,
par Hélène Adhémar. Paris,F.Hazan,1950.
.26.p. illus.(col.) (Bibl.aldine des arts,14

LC ND1316.P37 Encyclop.of World Art
 Portrs.bibl.N31E56 Ref.

II.A.3 - FRANCE

Paris. Musée de l'Orangerie
 Le portrait français de Watteau à David.
.Exposition.Orangerie des Tuileries,déc.1957-
mars 1958,2e éd.,rev.et corr..Paris,Éditions des
Musées Nationaux.1957.
 103 p. illus.

 Bibliography

 Article by Maurice Sérullaz in:La Revue des
Arts 7:283-90 illus. 1957 (LC N2.R42 v.7)

in LC 1958-62,p.115 Encyclop.of World Art
(no call no.) Ports.bibl.N31E56 Ref.
 under Bazin,Germain

705 II.A 3 - FRANCE - 15th c.
P19
NCFA Chamson, Lucie
 Das porträt in der Avignoner schule des
 15.jahrhunderts

 In:Pantheon
 11:118-24 Apr.1933 illus.

 Enc.of World Art N31E56
 Ref. vol.11,col.513
 bibl.on portr.

ND II.A.3 - FRANCE
544
P57X Pittura francese nelle collezioni pubbliche
1977 fiorentine:Firenze,Palazzo Pitti,24 aprile-
NMA? 30 giugno 1977.Firenze,Centro Di,1977.(Cat.85
 296 p. illus(part col.)

 Cat.a cura di Pierre Rosenberg,con la col-
 laborazione di Silvia Meloni Trkulja,Isabelle
 Julia,Nicole Reynaud
 Indexes
 Bibliography:p.283-92
 Ch.:Self-portraits,p.33-85
 Ch.:Self-portraits not in exh.(from the
 Galleria di Firenze)p.86-92
 cont'd on next card

759.4 II.A.3 - FRANCE - 14-17th c.
.H97
 Huyghe, René
 ...La peinture française du 14me au 17me s.
 (figures et portraits).Paris,A.Calavas,1937.
 .8.p. illus. (Les chefs-d'oeuvres de l'art
 français à l'Exposition internationale de 1937)

LC ND541.H8

II.A.3 - FRANCE - 15-16th c.

Dilke, Emilia Frances (Strong)Lady,formerly Mrs.
 Mark Pattison, 1840-1904
 The renaissance of art in France by Mrs.
Mark Pattison...London,C.Kegan Paul & co.,1879
 2 v. illus.

 'Contains description and criticism of the
work of Fouquet, the Clouets,etc.'-Heath

LC N6845.D5 Heath.Miniatures.ND1330
 H43 NCFA Bibl.p.XXXIX

II.A.3 - FRANCE - 16th c.

Dimier, Louis, 1865-1943
. ...Le portrait du 16e siècle aux primitifs
français;notes et corrections au cat.officiel
sur cette partie de l'exposition d'avril-
juillet,1904. Paris,J.Schemit,1904
 56 p.

 Supplement to cat.:Paris. Exposition des
"primitifs français",1904 au Palais du Louvre...
et à la Bibl.nat. LC N6845.P3 1904 a

LC ND1316.D582

705
P19
NCFA
v.21

II.A.3 - FRANCE - 15-16th c.

Wescher, Paul
 Das französische bildnis von Karl VII bis zu
Frans I.(The French portr.from Charles VII to
Francis I)

In:Pantheon
21:1-11 Jan.1938 illus(part col.)
Synopsis in English pp.1-2

 Repro:Master of Moulins,Jean Fouquet,Bourdi-
chon,etc.

 Enc.of World Art
 N31E56Ref.vol.11
 col.513 bibl.on portr.

II.A.3 - FRANCE-16th c.

Gower, Ronald Charles Sutherland, 1845-1916
 Three hundred French portraits representing
personages of the courts of Francis I,Henry II &
François II by Clouet.Auto-lithographed from the
originals at Castle Howard,Yorkshire.London,
S.Low,Marston & Searle,Paris,Hachette & cie.,
1875
 2 v. illus.

LC N7604.C6 Amsterdam,Rijksmus.cat.
 Z5939A52,deel 1, p.509

QN
7638
F8B75
NPG

II.A.3 - FRANCE - 16th c.

Bouchot, Henri François Xavier Marie, 1849-1906
 Quelques dames du 16e siècle et leurs
peintres. Paris:Soc.de propagation des livres
d'art,1888

 56 p. illus.

 Court life in France;"Comment les dames de
Brantôme nous ont laissé leurs portraitures"

N.Y.P.L. NB CtY MBAt NcD

II.A.3 - FRANCE - 16th c.

Horsin-Déon, Léon
 Essai sur les portraitistes français de la
renaissance,contenant un inventaire raisonné de
tous les portraits du 16e siècle des musées de
Versailles et du Louvre.Paris,Impr.Ve P.Larousse
et cie.,1888
 212 p.

MFT
186
H78
FOGG
Deposit libr.

 Amsterdam,Rijksmus.cat.
 Z5939A52,deel 1,p.489

II.A.3 - FRANCE - 16th c.

Dimier, Louis, 1865-1943
 Histoire de la peinture de portrait en France
au 16e siècle. Paris et Bruxelles,G.van Oest
et Cie,1924-26

 3 v. illus.
 Bibliography v.3

 With catalogue of all existing works in this
genre, in drawgs.,oil ptgs.,miniatures,enamels,
tapestries & wax medallions

LC ND1316.D5

II.A.3 - FRANCE - 16th c.

Laborde, Léon Emmanuel Simon Joseph de, 1807-
 La Renaissance des Arts à la cour .1869
de France.Paris,1850
 152 p.

 "Les trois Clouet.s.,p.1-152

FOGG
728
L11(?)

 'Tries to substantiate the tradit'l hist.of
French portraiture,incl.the role .of.the Clouet.
-Risatti

 Risatti.A French court ptr.
 AP 1 K86.v-II,no.1,'76
 Footnote 15

II.A.3 - FRANCE - 16th c.

Dimier, Louis, 1865-1943
 Histoire
 ____Supplément;Douze crayons de François Quesnel,
provenant des collections Fontette.
Paris & Bruxelles,1927
 13 p. illus.

MET
186
D594

Review by G.de Gerles,In:Gaz Beaux Arts 705
15:311-16 ser.5 1927 illus. G28
 NCFA

II.A.3 - FRANCE - 16th c.

Moreau-Nélaton, Étienne,1859-1927
 Les Clouet et leurs émules. Paris,H.Laurens,
1924

 3 v. illus.

 Bibliography in v.1

 Paintings and drawings

LC ND553.C7M6

II.A.3 - FRANCE - 16th c.

Paris, Bibliothèque Nationale
Les Clouet et la cour des rois de France,
de François I^{er} à Henri IV.Paris,1970
96 p. illus.

Les notices...rédigées par M.Jean Adhémar

LC DC36.6P35

705
B97
NCFA
v.89

II.A.3 - FRANCE - 17th c.

Blunt, Anthony, 1907-
Poussin Studies I. Self-Portraits

In:Burl Mag
89:219-22,225-6 Aug.,'47 illus.

Portrs.of Poussin by himself and by others

Wallis.Autoportret
N7618.W214 NCFA Bibl.p.143

AP
1
K86
NCFA

II.A.3 - FRANCE - 16th c.

Risatti, Howard
A French court portrait

In:Krannert Art Mus.B.
II,no.1:12-27 1976 illus(part col.)

Chaps.:Portr.tradition.Rebirth of Humanism.
Ital.influence in France.The Clouets.Other por-
traitists.Court portr.style.François Clouet. .
A lady of the court.Portr.drag.colls.Conclusion

q DC
126
S86
1984
NPG

II.A.3 - FRANCE - 17th c.

The Sun King,Louis XIV and the New World;an
exh.,organized by the Louisiana State Mu-
seum...New Orleans,Louisiana State Museum,
c.1984
343 p. illus(part col.) (Studies in
Louisiana culture,v.3)
Incl.Index
Steven G.Reinhardt,ed.
Exh.dates:Louisiana State Mus.,New Or-
leans,La.,Apr.29-Nov.18,1984.The Corcoran
Gall.of Art,Washington,D.C.,Dec.15,1984-
Apr.7,1985
Incl.Ptg., sculpture,cameos

705
G28
NCFA
v.38A

II.A.3 - FRANCE - 16th c.

Wildenstein, Georges
Le goût pour la peinture dans la bourgeoisie
parisienne entre 1550 et 1610.d'après des inven-
taires après décès conservés au Minutier central
des Archives Nationales.

In:Gas Beaux Arts
38A(6th ser):11-343 Jul-Dec,1951 illus.

Les portraits:pp.39-46

705
G28
NCFA
v.37A

II.A.3 - FRANCE - 17th c.

Wildenstein, Georges
Le goût pour la peinture dans la bourgeoisie
parisienne au début du règne de Louis XIII.

In:Gas Beaux Arts
37A:153-273 Oct-Dec,'50 illus.

1627 is the beginning of a new epoch in art
& of taste in France

List of Royal portrs.,p.194-203,Diverse portr
p.204-07

759.4
W67

II.A.3 - FRANCE - 16th c.

Wilenski, Reginald Howard, 1887-
French Renaissance portraits

In:his.French painting.Boston,Hale,Cushman &
Flint,inc.,1931.

pp.32-4 illus(part col.)
The portrait albums.The Clouets and Cor-
neille de Lyons

LC ND541.W5

705
G28
NCFA
v.45

II.A.3 - FRANCE - 17-18th c.

Dowley, Francis Hotham, 1915-
French portraits of ladies as Minerva

In:Gaz Beaux Arts
45:261-86 May-June,'55 illus.

From the 1st portr.of a lady as Minerva(in
France):Margaret of Savoy on enamel by Jean De-
court,1555 to 18th c. examples.Diderot calls for
elimination of allegory
Portrs.within portrs.important in France
since 17th c.

Karla Langedijk

ND
544
F56
1987X
NMAA

II.A.3 - FRANCE - 16-18th c.

Fine Arts Museums of San Francisco
French paintings 1500-1825:The Fine Arts Mu-
seums of San Francisco.Pierre Rosenberg,Marion
C.Stewart.San Francisco,The Museum,1987
373 p. illus(part col.)

Index
Bibliography:p.356-64

ND
1316.3
L38X
NPG

II.A.3 - FRANCE - 17-18th c.

Karlsruhe. Staatliche Kunsthalle
Französische bildnisse des 17.und 18.Jahr-
hunderts,von Jan Lauts. Karlsruhe,1971
75 p. illus(part col.) (Bildhefte der
Staatlichen Kunsthalle,Karlsruhe,nr.8)

Contents.-1.Phil.de Champagne.-2.H.Rigaud.-
3.N.de Larguillière.-4.J.-B.Perronneau.-5.P.P.
Prud'hon

LC ND1316.3L38

705
G28
v.15
1927
NCFA

II.A.3 - FRANCE - 17-18th c.

Ratouis de Limay, Paul
L'exposition de pastels français du 17e et
du 18e siècle

In:Gas Beaux Arts
15:321-38 ser.5,1927 illus.
Exhibition at Hôtel Charpentier,1927
Incl:Nanteuil,Vaillant,Vivien,Coypel,La Tour,
Perronneau,Chardin,Boucher,Ducreux,Bose,Labille-
Guiard,V.Le Brun,M.S.Giroust Roslin,Valade,N.Loir,
S.B.Le Noir,Rognault,Sergent-Marceau,Prud'hon
Portr.of LaTour by Perronneau & by himself

705
B97
NCFA
v.108

II.A.3 - FRANCE - 18th c.

Michel, Marianne Roland
L'Art du dix-huitième siècle;of women and
flowers.Jean Cailleux,ed.,

In:Burl Mag
108,suppl.no.18:I-V July,'66 illus(1col.)

Repro.incl.:Largillière,Blin de Fontenay,
Ant.Coypel,Hyacinthe Rigaud,Jean-Bapt.Monnoyer,
Juste d'Egmont
fg.1:Hélène Lambert de Thorigny with black
servant;fg.3:Portr.of lady with black servant

II.A.3 - FRANCE - 17-18th c.

Thomas, Thomas Head, 1881-
French portrait engraving of the 17th and
18th centuries...London,G.Bell & sons,ltd,1910
211 p. illus.

List of French portr.engravers & painters,
p.175-211
"1761 distinct change in portr.engr.in France.
Medallion portrs...became the fashion...a new
form,that of miniatures is developed."
Attention upon portr not upon accessories.
Influence of St.Mémin shows

LC NE647.T4 Morgan.The work of M.Févret
 Brooklyn mus.Q.v.5,Jan'18

N
C.1
L314R8
NPG

II.A.3 - FRANCE - 18th c.

Rosenfeld, Myra Nan
Largillière and the 18th century portrait
Exh.Montreal Mus.of Fine Arts,Sept.15 to Nov.1
1981.Montreal,Quebec,The Museum,1982.
418 p. illus(part col.)

Foreword by Pierre Rosenberg
Contributions by Inna S.Nemilova,Hal N.
Opperman,Ant.Schnapper

Bibliography p.400-10
 Gordon.Masterpieces from
LC ND1329.L37A1 1982 Versailles.Notes p.34
 no.2

705
G28
NCFA
v.48

II.A.3 - FRANCE - 17-18th c.

Wildenstein, Georges
Le goût pour la peinture dans le cercle de
la bourgeoisie parisienne autour de 1700

In:Gas Beaux Arts
48(6th ser):113-94 Sep,1956 illus.

Le portrait p.118-21. Repro.of engravings of
lost ptgs,which were bought solely for the sub-
ject matter.No interest in the artist. List of
some of the consulted inventories.Index of sit-
ters.Chronological list of inventories.Index of
cited names.Index of professions
 N31E56Ref.

705
G28
v.1
1909
NCFA

II.A.3 - FRANCE - 18th c.

Tourneux, Maurice
Exposition de cent portraits de femmes du
18e siècle.Salle du jeu de paume,Paris.

In:Gas Beaux Arts
ser 4,v.1:461-95 June,'09 illus.

Repro.incl.:Opie,Hoppner,Reynolds,Duplessis,
Perronneau,Danloux,Kucharsky.
Exh.,Paris,Soc.de secours aux familles des
marins français naufragés,Apr.23-July 1,1909
Almost all portr. s.from private collections
(See also 34 p. article at C3mH)

705
B97
NCFA
v.113

II.A.3 - FRANCE - 18th c.

Cailleux, Jean ed.
L'Art du dix-huitième siècle.Some family
and group portraits by François de Troy(1645-
1730)

In:Burl Mag
113,suppl.no.26:I-XVIII Apr.,'71 illus.

fg.6:Mme.de Franqueville & her children
with black servant and portr.within portrait

 Rosenfeld,M.N. L'Argillièr
 p.401,408

II.A.3 - FRANCE - 18th c.

Vaillat, Léandre, 1878-
...La société du 18e siècle et ses peintres;
...Paris,Perrin et cie.,1912
272 p. illus.

Contents.-Le portrait et le costume.-La
femme.-L'enfant-Jean-Etienne Liotard.-J.-B.
Perronneau

LC ND1316.V3 Fogg,v.11,p.319

MD
546
D5X
NMAA

II.A.3 - FRANCE - 18th c.

Dilke, Emilia Frances(Strong),Lady,formerly
Mrs.Mark Pattison, 1840-1904
French painters of the 18th century...
London,G.Bell & sons,1899
231 p. illus.

Ch.6:The ptrs. of portrait:Rigaud,Largil-
lière,Nattier,Torqué,Roslin,Drouais,Latour,
Perronneau,& others

LC ND546.D5

N
7604
Z86
NPG

II.A.3 - FRANCE - 18th c.

Zolotov, Iurii Konstantinovich
Frantsuzskii portret 18 veka...Moskva,
Iskusstvo,1968
275 p. illus(part col.) (Iz istorii miro-
vogo iskusstva)

Bibliography

LC N7604.Z63 Fogg,v.11,p.319

705
G28
NCFA
v.10

II.A.3 - FRANCE - 18-19th c.

Dorbec, Prosper, 1870-
 Les influences de la peinture anglaise sur
le portrait en France(1750-1850)

In:Gaz Beaux-Arts
10:85-102 1913 illus.

**FOR COMPLETE ENTRY
SEE MAIN CARD**

705
A786
NCFA
v.36
pt.2

II.A.3 - FRANCE - 19th c.

Davidson, Martha
 Impressionist and later portraits

In:Art N
36:10-11,24 Mar.5,1938 illus.

 From Manet to Dali

**FOR COMPLETE ENTRY
SEE MAIN CARD**

II.A.3 - FRANCE - 18-19th c.

Gurdus, Luba
 The self-portrait in French painting from
Neo-classicism to Realism.1962

 Ph.D.diss.-N.Y.,Inst.of Fine Arts,1962

 Summary in Marsyas,11:73 '62-'64

AP
1
M37
NCFA

 Stein,J.C. Image of the ar
 tist in France...ND1316.S8
 1582a NPG p.3.footnote 3

705
B97
NCFA
v.72

II.A.3 - FRANCE - 19th c.

Douglas, Lord
 19th c. French portraiture

In:Burl Mag.
72:253-63) Jun,1938 illus(part col.)
 Realistic vs.psychological approach.Discusses
also the effect of invention of photography

 Enc.of World Art
 N31E56Ref.vol.11
 col.513.Bibl.on portr.

759.4
.H98

II.A.3 - FRANCE - 18-19th c.

Huyghe, René
 ...La peinture française,18me et 19me s.
(figures et portraits). Paris,A.Calavas,1937.
 8.p. illus. (Les chefs-d'oeuvre de l'art
français à l'Exposition internationale de 1937)

LC ND541.H82

705
328
v.40
1908
NCFA

II.A.3 - FRANCE - 19th c.

Hepp, Pierre
 L'Exposition de portraits d'hommes et de
femmes célèbres(1830-1900)à Bagatelle

In:Gaz.Beaux-Arts
40:38-43 Jl.,1908 illus.

 Repro.incl.:Flandrin,Delaroche,Baudry,
Bastien-Lepage
 Critical review

ND
1316
S819
1982a
NPG

II.A.3 - FRANCE - 18-19th c.

Stein, Joanne Crown, 1940-
 The image of the artist in France:Artists'
portraits and self-portraits around 1800
 c.1982 238 p.
 Thesis Ph.-D.-UCLA 1982
 Bibliography
 Photocopy of typescript
 List of illus.p.V-XVI.A copy with plates
& 3 supplemental catalogues is on file at the
UCLA library

 Ch.III:David's self-portrs....

705
028
NMAA
v.108

II.A.3 - FRANCE - 19th c.

Hubert, Nicole
 A propos des portraits consulaires de
Napoléon Bonaparte.Remarques complémentaires

In:Gaz Beaux Arts
108:23-30 Jul-Aug.,'86 illus.

 Information of the big orders for consular
portrs. in 1803.'These portrs. can be classi-
fied in 3 groups which originated in the 3
Gros prototypes:Cambacérès portr.:Gros,Mme Be-
noist,Greuze.-Lille portr.:Ingres,R.Lefèvre,
Vien.-Lyon port seated:Meynier,Dufaul

qND
547.5
14B6613
1986X
NPG

II.A.3 - FRANCE - 19th c.

Bonafoux, Pascal, 1949-
 The Impressionists,portraits and confiden-
ces.N.Y.,Skira/Rizzoli,1986
 191 p. illus(part col.)

 Index

 Portrait within portrait,p.29

705
G28
NMAA
v.106

II.A.3 - FRANCE - 19th c.

Lilley, Edward
 Consular portraits of Napoleon Bonaparte

In:Gaz.Beaux-Arts
106:143-56 Nov.,'85 illus.

 Repro.incl.:A.J.Gros,Ingres,Greuze,Paint-
the Benoist,Vien etc.Engraving by Devilliers
l'ainé(after Lefèvre)

705
B97
NCFA
v.72

II.A.3 - FRANCE - 19th c.

Lord, Douglas
French portraiture of the 19th c.

In:Burl Mag
72:252-5,258-61,263 Jun,'38 illus.

Contrasts in portraiture:historical-fiction-
al(Baudelaire's division). Dynamic-static. Neo-
classic-romantic. Poetic-realistic. Sitter's per-
sonality-visual experience,artist's individuali-
ty. Line-color,volume. Dramatization-analyzation
Repro.: see over
Cumulated Mag.subj.index
A1/3/C76 Ref. v.2,p.444

II.A.3 - FRANCE - 19-20th c.

Bazin, Germain
Le portrait sans âme

In:Art viv.
:254-5 1934 illus.

A look upon influence of the English portr. on
French ptg. in the 19th c. & especially since
1900. Incl.:Lawrence,Hogarth,Gainsborough,
Reynolds

LC N2.A65 Rep.,1934#57

qND
547.5
I4.M17
1986
NPG

II.A.3 - FRANCE - 19th c.

McQuillan, Melissa
Impressionist portraits.1st U.S.ed. Boston,
Little,Brown & Co.,1986
200 p. illus(part col.) (A N.Y.Graphic Soc
book)

Index

Bibliography

II.A.3 - FRANCE - 19-20th c.

Galerie Schmit, Paris
Portraits français,19e et 20e siècles;expo.
15 mai-15 juin 1974...Paris,La Galerie,1974:
58 p. chiefly illus(part col.)

LC ND1316.5.G34 1974

II.A.3 - FRANCE - 19th c.

Tralbaut, Mark Edo
Richard Wagner im blickwinkel fünf grosser
maler,Henri Fantin-Latour,Paul Cézanne,Odilon
Redon,Auguste Renoir,Vincent van Gogh.Dortmund
1965
39 p. (Dortmunder Vortr.,69)

LC ML410.W12F744 Rep. 1966 #987

II.A.3 - FRANCE - 20th c.

Guenne, Jacques
...Portraits d'artistes:R.-Th.Bosshard,André
Favory,Marcel Gromaire,Ch.Guérin,Kisling,André
Lhote,Matisse,Simon-Lévy,Vlaminck...Paris,
M.Seheur,1927.
FCGG
393C.20 307 p. illus. (L'art et la vie)

LC 759.4.G935p
Art Lib'y MOMA, p.435, v.11

II.A.3 - FRANCE - 19th c.

Wildenstein & company,inc.,New York
Consulat,Empire,Restauration;art in early
19th c.France...cat.by Georges Bernier for a
loan exh.for the benefit of the Lycée français
of New York,Apr.21 through May 28,1982.N.Y.,
Wildenstein & Co.,1982
125 p. illus(part col.) cat.no.109

LC N6847.W35A77 Hubert,Nicole In:Gaz
Beaux-arts Jul/Aug,'86,v.
108,p.30,note 25

II.A.3 - FRANCE - 20th c.

Poisson, Georges, 1924-
La femme dans la peinture française moderne
.Paris,Plon.1955.
95 p. illus(part col.)

NN MB VtMiM MnU MOMA, p.434, v.11

AP1
A784
A4
NCFA
v.28

II.A.3 - FRANCE - 19th c.

Zabel, Morton Dauwen
The portrait methods of Ingres

In:Art & Archaeol
28:102-16 Oct,'29 illus.

I.perfected methods to describe wealth,social
rank,intellectual eminence of sitters,as well as
to build up compact,organised composition.He uses
robes,biographical details,costume,hairdress of-
ten as pattern & design & chromatic relationship;
later portrs. rely solely on character presenta-
tion & solidity of design
Cumulated.subj.ind.A1/3/C76 Ref.
v.2,p.444

II.A.3 - FRANCE - 20th c.

Le portrait de profil et de farce.Musée de
Chartres...1977

LC ND1301.5.F8C486 FOR COMPLETE ENTRY
SEE MAIN CARD

630

705
P19
NCFA

II.A.3 - FRANCE - AVIGNON

Chamson, Lucie
 Das porträt in der Avignoner schule des
15.jahrhunderts

In:Pantheon
11:118-24 Apr.1933 illus.

Enc.of World Art N31E56
Ref. vol.11,col.513
bibl.on portr.

II.A.3 - GERMANY - MEDIEVAL

Goetz, Walter Wilhelm, 1867- ed.
 Die entwicklung des menschlichen bildnisses.
Leipzig & Berlin,B.G.Teubner,1929-
 v

Contents.-1.Schramm,P.E.D.deutschen Kaiser &
Könige in bildern ihrer zeit.1.Bis zur mitte des
12.jhrh(751-1152)2 v.1929.-2.Prochno,Joachim.Das
schreiber-& dedikationsbild in d.deutsch.buchma-
lerei,v.1,1929-3.Steinberg,S.H.,D,bildnisse geist-
licher & weltlicher fürsten & herren.1.Von d.mit-
te d 10.bis z.ende d.12.jhrh(950-1200),1931
LC N7575.E6 v. II,III

II.A.3 - FRANCO-FLEMISH

Wostendorp, Karl, 1873-
 Die anfänge der französisch-niederländischen
porträttafel. Köln,Druck der Kölner verlags-an-
stalt und druckerei,a.-g-.1906

 78 p.

 Inaugural diss.Strassburg,Cologne,1906

LC ND1303.W5 Ring,Grete LC ND1319R5

II.A.3 - GERMANY - MEDIEVAL

Kemmerich, Max, 1876-
 Die frühmittelalterliche porträtmalerei in
Deutschland bis zur mitte des 13.jahrhunderts.
München,G.D.W.Callwey,1907

 167 p. illus.

 Bibliography

LC ND1317.K4 Waetzoldt ND1300.W12

II.A.3 - GERMANY

Kassner, Rudolf, 1873-
 Das deutsche Antlitz in fünf Jahrhunderten
deutscher Malerei..Zürich,Atlantis Verlag.1954.
 108 p. illus(part col.)
 (Atlantis mus.Bd.10)

 Text:"Zur Physiognomik des Porträts." Very
theoretical,philosophical approach.

 Repro.incl. well known as well as obscure
German artists
LC N7605.K3

II.A.3 - GERMANY - MEDIEVAL

Kemmerich, Max, 1876-
 Malerische porträts aus dem deutschen mittel-
alter vom 8.bis zum ende des 13.jahrhunderts.
Nachtrag & berichtigungen

In:Rep.Kunstw.
29:532-52 1906
31:120-31 1908

LC N3R4

II.A.3 - GERMANY

Kenner, Dr.Fr.
 Die porträtsammlung des Erzherzogs Ferdinand
von Tirol

In:Jb.d.kunsthist.sammlungen des Österr.kaiserh.
Bd.XIV:37-186:Geschichte/ der Slg:D.Bildnisse d.
Erzhauses Habsburg(1893);Bd.XV:147-259:D.deut-
schen Bildnisse,Wundermenschen(1894);Bd.XVII:101-
274:Ital.Bildn.(1896);Bd.XVIII:135-261:D.Medici.
Neapel,Celebritäten(1897);Bd.XIX:6-146:Spanien,
Portugal,Frankr.Engl.,Schottld. Der Orient(1898)
LC N3.J4 Rave,P.O. Paolo Giovio u.
 d.bildnisvitenbücher...
 Jb.d.Berl.Mus. I 1959:144
 footnote LC N3.J16 fol.

mfm
12hn:4
NCFA

II.A.3 - GERMANY - (late)GOTHIC

Auerbach, Erna
 The development of particular groups of
German portait painting.I.Bavarian group about
1530

In:Apollo
20:235-41 1934,Nov. illus.

 Incl:M.Wohlgemuth,Dürer,B.Strigel,Ludwig
Rafinger(?),etc.

LC N1.A255 Rep.,1934#1805

II.A.3 - GERMANY

Rümpler, Karl
 Das bildnis in Deutschland von 1800 bis
zur gegenwart.Dresden,Verlag der Kunst.1957.
 54 p. illus.

 Bibliography

LC ND1317.R6 Fogg,v.11,p.319

AP
1
A64
NCFA

II.A.3 - GERMANY - (late)GOTHIC

Auerbach, Erna
 The development of particular groups of
German portrait painting.II.Plasticity and sym-
metry about 1530

In:Apollo
22:3,5,7,9 July,'35 illus.

 Repro.:Strigel,Unknown Swabian artist,Cra-
nach the elder,v.Heemskerck,Brosamer,Pencz
 Desire to bring calmness and "monumentality
to the fig. Flemish influence is discussed.

II.A.3 - GERMANY - 16th c.

Auerbach, Erna
 Die deutsche bildnismalerei im 16.Jahrhundert in Franken,Schwaben and Bayern

 Thesis 1923. Frankfurt am Main

II.A.3 - GERMANY - 16th c.

Winkler, Friedrich, 1888-1965
 Augsburger malerbildnisse der Dürerzeit.Berlin,
 Deutscher verein für kunstwissenschaft,1948
 30 p. illus.

LC ND586.A8W5

Enc.of World Art
N31E56Ref.v.11col.513
bibl.on portr.

II.A.3 - GERMANY - 16th c.

Buchner, Ernst, 1892-
 Das deutsche bildnis der spätgotik und der
 frühen Dürerzeit. Berlin,Deutscher verlag für
 kunstwissenschaft,1953

 226 p. illus.(207 pl.)

MiU PHC NjP
OO OC OU CtY
ICU CU NN

Harvard univ.libr.for
LC

VF
Johann
Casimir

II.A.3 - GERMANY - 16-17th c.

Gebhardt, Mini
 Betrachtungen su bildnissen Herzog Johann
 Casimirs und seiner beiden gemahlinnen.Sonderdruck aus Jahrbuch der Coburger Landesstiftung,
 1965
 p.89-146 illus.

 Repro.incl.:Peter Sengelaub,Wolfgang
 Birckner,Peter Isselburg,F.Erichs

705
P19
NCFA
v.13

II.A.3 - GERMANY - 16th c.

Christoffel, Ulrich, 1891-
 Das deutsche bildnis der Dürerzeit

In:Pantheon
13:1-9 Jan,1934 illus(part col.)

 Synopsis in English,pp.1-3:"The German portraitist did not paint so much the portrait of the
 sitter, but rather his psychical power"...

 Repro:Kulmbach,Schäufelein,Holbein,Cranach,
Baldung,etc. Enc.of World Art,v.11
 N31E56 Ref.,col.513
 bibl.on portr.

II.A.3 - GERMANY - 18th c.

Oettingen, W.v.
 Die deutsche bildnismalerei im 18.jahrhundert

In:Museum
 6:

"Museum"
LC N7511.M7

Waetsoldt ND1300.W12

II.A.3 - GERMANY - 16th c.

Holst, Niels von, 1907-
 ...Die deutsche bildnismalerei sur seit des
manierismus...Strassburg,J.H.E.Heits,1930
 88 p. illus (Studien sur deutschen kunstgeschichte,hft.273)

 Bibliography

LC ND1317.H6

Enc.of World Art N31E56
Ref. v.11col512
bibl.on portr.

II.A.3 - GERMANY - end 18-19th c.

Schmidt, Paul Ferdinand, 1878-
 ...Bildnis und komposition vom rokoko bis su
Cornelius.Mit 110 abb.München,R.Piper & co.,
1928
 168 p. illus. (Half-title:Paul Ferdinand Schmidt.Deutsche malerei um 1800,2.bd.)

 Bibliography

Grosvenor library for
LC ND567.S3
 OClMA has both vols.

Die 20er jahre im portr.
N6868.5.E9Z97 NPG,p.138

705
A784
NCFA

II.A.3 - GERMANY - 16th c.

Kuspit, Donald B.
 Dürer and the Lutheran image

In:Art in Am
63:56-61 Jan.-Feb.,'75 illus(part col.)

 Cultural & stylistic reasons for the impact
of Dürer's late portrs.,1524,1526

II.A.3 - GERMANY - 19th c.

Eckert, Karla, 1908-
 Das Bildnis der klassizistisch-romantischen
epoche in Deutschland.Köslin in Pommern,C.G.
Hendess G.m.b.H.,1936
 95 p.

FCGG
4013.1.5

 Inaug.-Dissertation-Königsberg/Pr.1936

 Literaturvers.,p.81-7

ICRL NNC MdU

Fogg,v.11,p.319

II.A.3 - GERMANY - (begin.)19th c.

Geller, Hans, 1894- comp.
 Die bildnisse der deutschen künstler in Rom,
1800-1830.Mit einer einführung in die kunst der
Deutschrömer von Herbert von Einem. Berlin,
Deutscher Verein f.Kunstwissenschaft,1952
 149 p. illus.

Harvard Univ.Libr. for
LC
 ◯ Encyclp.for World Art
 Portrs.bibl.N31.E56 Ref.

II.A.3 - GERMANY - 19th c.
Tschudi, Hugo von, 1851-1911 ed.
 Das porträt. Berlin,J.Bard & B.Cassirer,
1906-07
 4 pts. illus.(part col.)

MET
195.3
T78
3pts.
in 1 v.
 Contents.-1.Gurlitt,Cornelius.D.englische por-
trät im 18.jahrh:Gainstorough,Romney,Raeburn.-
2-G.,C. D.engl.portr...:Reynolds,Hoppner,Lawrence.
3.Bie,Oscar.D.bürgerliche portr.des 19.jahrh.in
Deutschland:Chodowiecki,Graff,Krüger,Runge,Oldnach
4.Schaeffer,Emil:D.portr.der italienischen hochren-
naissance
 ◯ Amsterdam.Rijksmus.Kunsth.
 bibl.Cat.Z5939.A52deel 1
 CFA p.125

II.A.3 - GERMANY - 19th c.

Geller, Hans, 1894-
 Künstler und werk im spiegel ihrer seit:
bildnisse und bilder der deutschen maler des
19.Jhr. Dresden,W.Jess.1956.
 171 p. illus.

FOGG
4008.76F

Harvard Univ.Libr.for LC
ICA
 Heinsel,E.Lexikon d.kultur-
 gesch.Bibl.for "porträt...'
)LC CT143.H4

II.A.3 - GERMANY - 19-20th c.

Berlin. National-Galerie(East Berlin)
 Deutsche bildnisse,1800-1960.Ausstellung
der Lucas Cranach-Kommission.Berlin,1962
 66 p. illus.

PPPM MBGM MBS MH CtY
 Die 20er jahre im portr.
 ◯ N6868.5.E9297 NPG,p.142

II.A.3 - GERMANY - 19th c.

Grimschits, Bruno, 1892-
 Deutsche bildnisse von Runge bis Menzel...
Wien,W.Frick.1941.
 49 p. illus(part col.)

.ND1317.G884d.
CLU MH
 ◯Die 20er jahre im portr.
 N6868.5.E9297 NPG,p.138

qN
6868.5
R.037
NMAA

II.A.3 - GERMANY - 20th c.

German realism of the twenties.The artist as
 social critic.The minneapolis Inst.of
 Arts,1980
 183 p. illus(part col.)

 Exh.Minn.Inst.of Arts,Sept.18-Nov.9,1980.
Chicago.Mus.of contemp.art,Nov.22,1980-Jan.17,
1981

 Ch.on Portraiture by Robert Jensen,p.79.
Illus.p.80-95:Dix,Hubbuch,Schad,Gross,Schlich-
ter with biogr.& descriptive explanations.
 ◯

II.A.3 - GERMANY - 19th c.

Pecht,.August.Friedrich, 1814-1903
 Über die deutsche malerei der gegenwart

In:Kunst für alle
1:1-5 illus. 1885

MET
100.53
K96
v.1

LC for Kunst für alle:
N3K4
 ◯

II.A.3.- GERMANY - 20th c.

Wuppertal(W.Elberfeld,Ger.)-Kunst-und
Museumsverein
 Deutsche bildnisse des 20.Jahrhunderts,
malerei und plastik.ausstellung.8.März-26.April,
1964.Wuppertal.1964.
 1v.(unpaged) illus.

MET
115.01
W96

 .Cat.by Günter Aust.
 ◯Die 20er jahre im portr.
 N6868.5.E9297 NPG,p.22

II.A.3 - GERMANY - 19th c.

Richter, Ruth, 1912-
 Zur entwicklung des porträtstils in der
deutschen malerei von 1830 bis 1880.Heidelberg,
Druckerei Winter,1936

 Inaug.-Dissertation-Heidelberg

FOGG
FA
4353.15
 Fogg,v.11,p.119

mfm
124n:4
NCFA

II.A.3 - GERMANY - BAVARIA

Auerbach, Erna
 The development of particular groups of
German portrait painting.I.Bavarian group about
1530

In:Apollo
20:235-41 1934,Nov. illus.

 Incl:M.Wohlgemuth,Dürer,B.Strigel,Ludwig
Refinger(?),etc.

LC N1.A255
 Rep.,1934*1805

705
P19
NCFA

II.A.3 - GERMANY - BAVARIA - AUGSBURG - 16th c.

Baldass, Ludwig von, 1887-
Studien zur Augsburger porträtmalerei des
16.jahrh.

In:Pantheon
4:393-40,sup.70:Bildnisse der Künstlerfamilie
1929 illus(1 col.) .Apt
6:395-402,sup.70-1:Bildnisse von Leonhard Beck
1930 illus.
9:177-84,sup.41-3:Christoph Amberger als bild-
1932 illus(1 col.) .nismaler
Summary in English

II.A.3 - GERMANY - NUREMBERG

Panzer, Georg Wolfgang.1729-1804.
Verzeichnis von Nürnbergischen portraiten
aus allen ständen,nebst fortsetzung.Nürnberg,
1790-1801

Listed in Universal Cat.of
Books on Art.Suppl.p.469

Zahn, Albert von,1836-1873
Hist.Kunstslgn.In:Archiv f.
d.zeichnenden Künste.Univ.
of Ky.Marg.I.King Libr.
760.5 Ar253 v.5,p.181

II.A.3 - GERMANY - BERLIN

Munich. Städtische Galerie
Berliner bildnisse aus 3 jahrh. Ausstellung
vom 1.juni-1.juli 1962....Berlin,Elsnerdruck,
1962.
.56.p. illus(part col.)

Katalog-texte:Irmgard Wirth,Dora Lüttgen

ICA OClMA MOMA, p.435, v.11

II.A.3 - GERMANY - NUREMBERG (16th c.)

Strieder, Peter
Zur Nürnberger bildniskunst des 16.jahrhun-
derts

In:Münch Jahr Bild Kunst
9,(3rd ser.):120-37 1956

LC N9.M8

Enc.of World Art,v.11
N31E56 Ref.,col.514
bibl.on portr.

II.A.3 - GERMANY - BERLIN - 19th c.

Glaser, Kurt(Albrecht), 1897-
Das Bildnis im Berliner Biedermeier...Berlin.
Rembrandt.1932.
179 p. illus. (Berlinische bücher...4.bd

Bibliography

"Dieses buch entstand aus einer dissertation."
Würzburg,1929

NJP NNC IaU Enc.of World Art N31E56Ref
v.11,p.512

II.A.3 - GERMANY - TUBINGEN

Scholl, Reinhold
Die bildnissammlung der Universität Tübin-
gen, 1477-1927.Stuttgart,Müller,1927
63 p. illus. (Verein für Württembergi-
sche Familienkunde,Schriften,v.?)

MET
276.2
Sch62

Bibliography

MH Ekkart in:Wolstenholme,
1977 p.22

II.A.3 - GERMANY - HAMBURG

Lichtwark, Alfred, 1852-1914
Das bildnis in Hamburg. Leipzig,kunstgesch.
verlag K.W.Hiersemann

MET
115.01
L61

2 v. illus.

Social,political & artistic function of the
portr.Appendix with short chapters on miniatures,
silhouettes,prints & daguerreotype. (Advert.in
A.Lehmann,Das bildnis bei d.altdeutschen meistern)

Waetzold MD1300.W12

qND
454
L86
1986
NHAA

II.A.3 - GREAT BRITAIN

Arts Council of Great Britain
Looking into paintings.A series of three
Arts Council exhibitions.Looking into landsca-
pe,,portrait and narrative painting..London,The
Council,c.1986-c.1987
3 pamphlets (no.2:portraits) illus.
postcards in color

Cat.of exh.held at Castle Museum,Nottingham,
and other places

II.A.3 - GERMANY - LEIPZIG - 17-19th c.

Kurzwelly, Albrecht, 1868- ed.
Das bildnis in Leipzig vom ende des 17.
Jahrhunderts bis zur Biedermeierzeit.Aus an-
lass der vom Stadtgeschichtlichen museum zu
Leipzig veranstalteten porträtausstellung,hrsg.
von Prof.Dr.A.Kurzwelly unter mitwirkung von
Dr.Eduard Eyssen,Dr.Walther Biehl und Hildegard
Heyne...Leipzig,Hiersemann,1912
68 p. 174 illus on 162 pl.

MET
115.01
K96

FOGG
FA975
59F

Siegel.In:Pantheon v.41
1983 p.21 footnote 22 in
VP Stock,D. NPG

qN
5247
S16A9
NCFA

II.A.3 - GREAT BRITAIN

Auerbach, Erna
Paintings and sculpture at Hatfield House...
.London,Constable.1971.

757
.H54

II.A.3 - GREAT BRITAIN

Bertram, Anthony, 1897-
English portraiture in the National portrait
gallery,...London,John Lane.1924.
154.p. illus.

LC ND1314.B4

II.A.3 - GREAT BRITAIN

Constable, William George, 1887-
...Collections of historical portraits and
other forms of iconography...in Great Britain...
London,Pub.for the Historical association by
G.Bell and sons,ltd.,1934
23 p. (Historical association leaflet,
No.96)

Yale Univ.:D1.H25 no.96

II.A.3 - GREAT BRITAIN

Bouchot, Henri François Xavier Marie, 1849-1906
...La femme anglaise et ses peintres.Paris,
Librairie de l'art ancien et moderne,1903
230 p. illus.

Contents-Holbein,v.Dyck,Lely,Hogarth,
Reynolds,Lawrence,Hayter.La fin du 19esiècle

LC N7635.B6 Fogg,v.11,p.318

757.0942 II.A.3 - GREAT BRITAIN
.D98

Duveen brothers.
Catalogue of forty British portraits,with an
introduction by W.G.Constable;exhibited by
Duveen brothers at their galleries...New York...
Apr.9 to Apr.30,1940..New York,Publishers print-
ing company,c.1940.
.24.p. illus.

LC N7598.D85

II.A.3 - GREAT BRITAIN

British portraiture to-day illustrated by works
from the Royal society of portrait painters

In:Studio
103:131-9 March '32 illus(part col.)

LC N1.I6
or N1.S9 Cumulated Mag.subj.index
 A1/3/C76 Ref. v.2,p.443

II.A.3 - GREAT BRITAIN

Eden, Sir Timothy Calvert,8th bart., 1893-
Catalogue of important English historical
and family portraits and pictures by the old
masters removed from Windlestone,co.Durham,incl.
the celebrated series of portraits of the Lords
Baltimore,proprietors of Maryland,the property
of Sir Timothy Calvert Eden,baronet of Maryland.
Which will be sold by auction,by Messrs.Sotheby
and co....the 26th of July,1933...London,Printed
by J.Davy & sons,ltd.:1933.
16 p. illus.
(Sotheby & Co.Sale cat.Jl.26,1933)
Priced Met.Sales cat.fZ881.N53
MdBP NCFA p.023316

MET
119.6
O
1933³

II.A.3 - GREAT BRITAIN

Cambridge. University. King's College
Cat.of the plate,portraits and other
pictures at King's College,Cambridge.Cambridge
.Eng..Univ.Press,1933
93 p.

MET
146.5
C14

MH CtY Winterthur Mus.Library
 fZ881.W78 NCFA v.6,p.227

ID
621
F8F52
NCFA

II.A.3 - GREAT BRITAIN

Firenze e l'Inghilterra.Rapporti artistici e
culturali dal 16 al 20 secolo.Firenze,Pa-
lazzo Pitti,luglio-settembre 1971.Firenze,
Centro Di,1971
.77,1. illus(col.cover) (Cataloghi,23)

Cat.ed.by M.Webster

see also article by Ormond in Connoisseur
v.177:166-74

LC ND621.F7F57

AP
1
A784J8
NCFA
v.68
v.66

II.A.3 - GREAT BRITAIN

Chamberlain, Arthur Bensley, 1859?-1931
Historical portraits at Oxford

In:Art J.
68:196-200 July,1906 illus.
66:161-6 May,1904 illus. .Exh.of

II.A.3 - GREAT BRITAIN

Freemasons. England. United grand lodge.
Library and museum
Cat.of portraits and prints at Freemason's
hall in the possession of the United grand
lodge of England,comp.and arranged by Major Sir
Algernon Tudor-Craig...1938.London,The United
grand lodge of England.1938.
119 p. illus(1 col.)

LC N1165.F7A53 Winterthur Mus.Library
 Z881.W78 NCFA v.6,p.227

ND
1315
G24
NCFA
p.257-
310 mis-
sing)

II.A.3 - GREAT BRITAIN

Garrick Club, London
Catalogue of pictures in the Garrick Club.
=London,1936?=
310 p. illus.

The club's coll.now comprises some 400 ptgs.
& an approx.equal number of drags.which are with
a few exceptions portrs.of members of the thea-
trical profession,usually in character

Compiled by C.K.Adams
Bibliography

LC N759803

N
7598
H15
NPG

II.A.3 - GREAT BRITAIN

Hake, Henry Mendelssohn, 1892-
The English historic portrait:document and
myth.London.Publ.for the British Academy by
Geoffrey Cumberlege.Oxford Univ.Press.194?.
p.=133.=152
Photocopy of Proc.Brit.Acad.v.29:133-49
150-52 1943
Annual lecture on aspects of art,Henriette
Hertz Trust,1943
14th to 18th c.,historical development of
portr.ptg.in England.Family & official portrs.
Ptgs.used as pattern for sculptors

LC AS122.15 vol.29 Rep.1945-47*1123

QND
1314
C449
NPG

II.A.3 - GREAT BRITAIN

Gibson, Robin
British portrait painters,=by=Robin Gibson
and Keith Roberts.London,Phaidon,1971
16 p. illus(col.)

Distributed in the U.S.by Praeger Publ.N.Y.

LC ND1314.G5

II.A.3 - GREAT BRITAIN

Harding, George.P.=erfect,died 1853.
Lists of portraits,pictures in various man-
sions of the United Kingdom,MS at NPG.London,
before 1854

Derived from Warner's and Neale's lists

Ranger's House.qND1301.S
071667 1977X NPG Literatur

II.A.3 - GREAT BRITAIN

Goodison, Jack Weatherburn
Catalogue of Cambridge portraits. Cambridge,
University Press,1955-
v. illus.

Bibliography

LC N7621.G6

Footnote in G.'s article:
Cambridge portrs.16 & 17th c

N
7598
H67
NPG

II.A.3 - GREAT BRITAIN

Historical portraits...the lives by C.R.L.Fletcher
'....the portraits chosen by Emery Walker...with
an introduction on the history of portraiture
in England by C.F.Bell. Oxford,Clarendon press,
1909-1919
4 v. illus.

v.1:Richard II to Henry Wriothesley,1400-1600
v.2:1600-1700. The lives by H.B.Butler & C.R.L.
Fletcher.-v.3:1700-1800.-v.4:1800-1850

LC N7598.H5

II.A.3 - GREAT BRITAIN

Goulding, Richard William, 1868-1929 and
C.K.Adams
Cat.of the pictures belonging to His Grace
the Duke of Portland,at Welbeck Abbey...comp.
by R.W.Goulding and revised...by C.K.Adams.
Cambridge,Eng.,The University Press,1936
495 p.

Consists mainly of portrs.

LC N7622.P6

II.A.3 - GREAT BRITAIN

Huntington Galleries
The Bagby collection:Portraits in the grand
manner of the Huntington Galleries.Huntington,
W.Va.,The Galleries,1962?,
=24=p. illus.

CtY Yale ctr.f.Brit.art Ref.
ND1314.H85

II.A.3 - GREAT BRITAIN

Greenwich, Eng. National Maritime Museum
Portraits at the National Maritime Museum,
selected by E.H.H.Archibald.London,H.M.Stationer
Off.,1954-55
2 v.

Contents:-Series I. 1570-1748. -Series II.
1748-1944

LC N7598.G63 Cell.,v.33,p.331

705
A784
NCFA
v.33

II.A.3 - GREAT BRITAIN

Kaldis, Laurie Eglington
American and English portraiture:democracy
versus aristocracy

In:Art in Amer.
33:48-63 Apr.,'45 illus.

Pertains to exh."Old & New England"in Rhode
Island school of des.For cat.see 757.6R47NCFA

Repro.:Winthrop Chandler,Ralph Earl,Reynolds,
Gainsborough,Feke,Moulthrop,Gilb.Stuart

Cumulated Mag.subj.index
A1/3/C76 Ref. v.2,p.443

636

II.A.3 - GREAT BRITAIN

Kenner, Dr.Fr.
 Die porträtsammlung des Erzherzogs Ferdinand
von Tirol

In:Jb.d.kunsthist.sammlungen des österr.kaiserh.
Bd.XIV:37-186;Geschichte/ der Slg:D.Bildnisse d.
Erzhauses Habsburg(1893);Bd.XV:147-259:D.deut-
schen Bildnisse,Wundermenschen(1894);Bd.XVII:101-
274:Ital.Bildn.(1896);Bd.XVIII:135-261:D.Medici
Neapel,Celebritäten(1897);Bd.XIX:6-146:Spanien,
Portugal,Frankr.Engl.,Schottld. Der Orient(1898)

LC N3.J4

 Rave,P.O. Paolo Giovio u.
 d.bildnisvitenbücher...
 Jb.d.Berl.Mus. I 1959:144
 footnote LC N3.J16 fol.

705
C75
NCFA

II.A.3 - GREAT BRITAIN

Manners, Lady Victoria, 1876-
 The Oxenden collection.Pt.1,2,3

In:Connoisseur
40:3-12 Sep.,1914 illus.
41:121-30 Mar.,1915 illus.(also opp.p.46)
43:200-08 Dec.,1915 illus.

 Mainly Engl.portrs.of the 16-18th c.Espe-
cially interesting for the study of early Engl.
school of portraiture
 Repro.incl.:Corn.Janssens.van Ceulen.,
Mytens,John Eykes,Fayram,Aikman,Beach..

AP
1
A64
NCFA

II.A.3 - GREAT BRITAIN

Liscombe, R.W.
 Three centuries of British portrait paint-
ing

In:Apollo
103:406-11 May, '76 illus.

 This issue pertains to the Montreal M'A

 Repro.:Hilliard,Watts,Hogarth,Reynolds,High-
more,Romney,Gainsborough,Lawrence,Raeburn

II.A.3 - GREAT BRITAIN

Michael, Wolfgang
 Die anfänge der englischen porträtmalerei

In:Z bildende Kunst
 1903

LC for Z bild.kunst:
N3.Z5

 Waetzoldt ND1300.W12

ND
1314
R88
NPG

II.A.3 - GREAT BRITAIN

London. Royal academy of arts
 British portraits.Illustrated supplement to
Winter exhibition.1956-57. London.1956.
 .l.p. 61 plates

FOGG
4103
L84ra

DLC-P4 MiDA CLU

 Waterhouse.Ptg.in Britain,
 1530-1790,ND465.W32 1962
 NCFA bibl.

705
C75
NCFA
v.177

II.A.3 - GREAT BRITAIN

Ormond, Richard
 Some little known English paintings on exhi-
bition in Florence

In:Connoisseur
177:166-74 July,'71 illus(part col.)

 Exh.held at Palazzo Pitti,July-Sept.,1971

 See also:Firenze e l'Inghilterra ND621.F6F52
 NCFA

II.A.3 - GREAT BRITAIN

London. Royal academy of arts
 British portraits.Winter exhibition,1956-57.
2d ed. London.1956.
 252 p.

 Bibliography

FOGG
4103
L84r

 Report in:Gas Beaux Arts,v.49:249-52,Apr,
1957,illus. by J.A..Jean Adhémar.

DLC-P4 MiDA CL U

 Waterhouse.Ptg.in Britain,
 1530-1790,ND465.W32 1962
 NCFA bibl.

II.A.3 - GREAT BRITAIN

Pattison, James William, 1844-1915
 Old portraits by British artists and other
pictures

In:Fine Arts J.
27:651-71 Oct.,12 illus.

LCM1.F5

 Cumulated Mag.subj.index
 A1/3/C76 Ref.v.2,p.444

II.A.3 - GREAT BRITAIN

London. Royal College of Surgeons of England
 Catalogue of portraits and busts in the
Royal College of Surgeons of England,with short
biographical notes.Revised to January,1930
.London,Printed by Taylor and Francis,1930,
 95 p. illus.

 Prepared by Fred.C.Hallett

 Bibliography

WN CtY-M MiDW-M DNLM
PPJ CtY

 Yale ctr.f.Brit.art Ref.
 N1165.R6A55

II.A.3 - GREAT BRITAIN

Pittsburgh. Carnegie Institute. Dept.of
 Fine Arts
 Cat.of an exh.of early English portraits...
April 26 through June 15,1917.Pittsburgh,Carne-
gie inst.dept.of fine arts,1917.

LC ND464.P5

 FOR COMPLETE ENTRY
 SEE MAIN CARD

757.6
.R47
NCFA

II.A.3 - GREAT BRITAIN

Rhode Island school of design,Providence. Mus.of
art
 The cat. of old & New England,an exh.of Amer.
ptg. of colonial & early Republican days together
with English ptg.of the same time...fr.Jan.19
through Feb.18,1945.Providence,Akerman-Standard
press,1945?.
 ₂75₂p. illus.

 Review by E.P.Richardson:"Old & New England"
In:Art Q.,v.8:3-15, winter 1945 illus.

ND
1314
546
1987X
NPG
Ref.

II.A.3 - GREAT BRITAIN

Simon, Robin, 1947-
 The portrait in Britain and America;with a
biographical dictionary of portrait painters
1600-1914.Boston,G.K.Hall & Co.,1987
 255 p. illus(part col.)

 Ch.2:Poses

 bibliography,p.247-50

 Robert Hull Fleming Museum
 Univ. of Vt. Faces in the
 parlor,p.6,note 13

705
A7875

II.A.3 - GREAT BRITAIN

Richardson, E.P.
 Old and new England

In:Art Q.
 8:3-15 Winter 1945 illus.

 Illuminates certain traits in Amer.art by deli-
berate comparisons with their opposites in Eng-
lish art,17th to 19th c.,main emphasis 2nd half
18th c.
Pertains to Exhib. in Rhode Island school of de-
sign. For catalogue see 757.6/.R47/NCFA
 Rep.,1945-47#1055

II.A.3 - GREAT BRITAIN

Sotheby, firm,auctioneers, LONDON
 Cat.of the Mr.& Mrs.Jack R.Dick coll.of
English sporting and conversation paintings:
part 1;...auction.s.l.:s.n.:c.1973(Ipswich,Eng.,
W.S.Cowell)
 108 p. illus(part col.)
 Price list encl.

LC ND1388.S7S68

II.A.3 - GREAT BRITAIN

Rohatgi, Pauline
 India Office Library and Records.Portraits
in the India Office Library and Records...
London,British Library,c.1983
 414 p. illus.(1 col.)

 Bibliography p.407-14
 Index

LC CT1504.5.I53 1983 Books in print.Subject
 guide 1985-86,v.3,p.4865

II.A.3 - GREAT BRITAIN

Spielmann, Marion Harry, 1858-
 British portrait painting to the opening of
the 19th c. London,Berlin Photographic cy.,1910
2 v. illus.

 Review by L.Cust in Burl Mag.v.17:371-73,191.
Cust regrets omission of Holbein,v.Dyck,Kneller,
Lely,schools of Thornhill,St.Martin's Lane Acad.
Jack Ellis,perfunctory way in dealing with lim-
ning or portrs.in miniature,mentions some error:
From Hogarth on "illuminating & adequate account.

MET
188
Sp4
Q

 Williamson.Life & work of
 Ozias Humphry.N40.1H92W7
 Bibl.

II.A.3 - GREAT BRITAIN

Russell, John, 1919-
 British portrait painters...London,W.Collins
1944
 46 p. illus(part col.)

FOGG
4353.25

Harv.uni.library for FOGG,v.11,p.317,col.2
LC

II.A.3 - GREAT BRITAIN

Trapp, Frank ₂Anderson₂
 British portrait paintings₂in Amherst Col-
lege,Mead Art Bldg.,Amherst,Mass.₂in Mead Art
Mus.Monographs,v.6 & 7,Winter,'85-'86
 p.1-15 illus.

VF
Amherst,
Mass.
Amherst
College

 Incl.:Amherst family portrs. See also:
Amherst College,Mead art bldg.:The Amherst
family portraits.Exh.Oct.23-Nov.12,'67

QND
1314
S116
NPG

II.A.3 - GREAT BRITAIN

Sabin Galleries Ltd.
 English portrait 1500-1830₂Exhibition₂Nov.
18th-Dec.19th,1970₂.London 1970₂
 38 p. illus(part col.)

757
S72
1866
(RB)

II.A.3 - GREAT BRITAIN

Victoria and Albert museum, South Kensington.
 ...Catalogue of the first special exhibition of
national portraits ending with the reign of King
James II...April 1866.London,Printed by Strange-
ways and Walden₂1866₂
 202 p.

LC N7598.S6 1866 Ingamells.Cat.of portrs...
 BX5197.I 53X P.XVI

II.A.3 - GREAT BRITAIN

Victoria and Albert museum, South Kensington
Dept.of paintings
Paintings,water-colours and miniatures/C.M.
Kauffmann.London,H.M.Stationery Off.,1978
24 p. illus. (V.&A.Mus.departmental
Guides)

N.Y.(city)P.L.Art & archi-
tecture Div.Bibl.guide to
art & architecture Z5939
.A7x1 1980 NCFA Ref. p.252

LC N1150.A85

705
B97
NCFA
v.65

II.A.3 - GREAT BRITAIN - 15-16th c.

Shaw, Wm.A.
The early English school of portraiture

In:Burl.Mag.
65:171-84 Oct,1934 illus.

The Englportr.from mid 15th c.to end 16th c.
Wilton diptych is initial stage of development
which produced Engl.small secular portrs.Its in-
sular charaoteristics:Tempera on gesso-prepared
panel,color-loaded varnish.
(Painters mentioned:in V.F. under Portrs.-Gr.Brit.)
Enc.of World Art,v.11
N31E56Ref.col.513
bibl.on portr.

ND
465
W32
1962
NCFA

II.A.3 - GREAT BRITAIN

Waterhouse, Ellis Kirkham, 1905-
Painting in Britain,1530-1790,2nd ed.,Har-
mondsworth,Middlesex.Penguin book.1962.
274 p. illus. (The Pelican hist.of art,
21)

Bibliography

N
7598
S92
NPG

II.A.3 - GREAT BRITAIN - 15-17th c.

London. National Portrait Gallery
The house of Tudor;by Roy C.Strong.London,
H.M.stationery office,1967
20 p. illus(part col.) (Its Kings and
Queens series:1485-1603)

LC DA317.1.S7

757
.W55
N.G.A.

II.A.3 - GREAT BRITAIN

Wheatley, Henry Benjamin, 1838-1917.
Historical portraits; some notes on the painted portraits of
celebrated characters of England, Scotland and Ireland, by
Henry B. Wheatley ... London, G. Bell and sons, 1897.
xii, 276 p. front., 70 port. 22½ᶜᵐ. (Half-title: The connoisseur se-
ries)

1. Gt. Brit.—Biog.—Portraits. 2. Portrait-painters. I.Title.
II.Series.
Library of Congress N7598.W5 1—4000
(a10-27d1)

II.A.3 - GREAT BRITAIN - 16th c.

Burlington fine arts club, London.
...Catalogue of an exhibition of late Elisa-
bethan art...London,...,1926
100 p. illus.

Introduction-Painting,by Wm.George Constable

LC N6765.B81 L.Douglas in:Conn.v.126
p.163,footnote

N
928
G75
1968
NCFA

II.A.3 - GREAT BRITAIN - 15-16th c.

Piper, David
Painting

In:The Connoisseur's Complete Period Guides
p.59-64 & p.97-99 illus.

Incl.chapters on portrs.during Tudor period

Repro.:Holbein,Eworth,Scrots,Ketel,Flicke,
Mor,Zuccari,Crits,Custodis,Segar,Gower,etc.
R.Strong.The English Icon.
qND1314S924NPG,p.357:"the
best concise intro.survey

705
B97
NCFA
v.99

II.A.3 - GREAT BRITAIN - 16th c.

Piper, David
The 1590 Lumley inventory:Hilliard,Segar
and the Earl of Essex-I & II

In:Burl.Mag.
99:224-31 July, '57 illus.
:299-303 Sept., '57 illus.

I:Incl.:List of 22 portrs.bearing Lumley
labels.

Strong.The Engl.Icon ND1314
S924 NPG p.45 note 3

705
G75
NCFA
v.31

II.A.3 - GREAT BRITAIN - 15-16th c.

Shaw, Wm. A.
An early English pre-Holbein school of
portraiture

In:Connoisseur
31:72-81 Oct,Nov., '11 illus.in color,pp.73,97
& Nov., '11,pp.130,177
"National Engl.school of portr.emerges fr.
medieval art of the illuminator,rises to a height
...& dies .end.16th c.in the art of the miniatur-
ist...entirely native,indigenous,national,tech-
nical & spiritual.". List of Engl.artists 1430-
1600.
Cum.Mag.subj.ind.A1/3/C76
Ref.v.2,p.443

DA
356
883X
NPG

II.A.3 - GREAT BRITAIN - 16th c.

Strong, Roy C.
The cult of Elizabeth;Elizabethan portrai-
ture and pageantry...London,Thames and Hudson,
1977
227 p. Illus(part col.)

Incl. bibliographical references and index

II.A.3 - GREAT BRITAIN - 16th c.
Strong, Roy C.
 Portraits of Queen Elizabeth I. Oxford,
Clarendon Press,1963

 173 p. illus(part col.)

 Bibliographical references

 Portrs.;caricatures, etc.

LC N7639.E4S8 Vict.& Albert mus, N.Hilliar
 ...p.30 2 nd ed.

II.A.3 - GREAT BRITAIN - 16-17th c.

Dulwich college,London - Dulwich gallery
 Cat.of the pictures in the gallery of Al-
leyn's college of God's gift at Dulwich...London
Printed by Darling & son,ltd.,1914

 Set of Kings & Queens,with documentation for
its purchase,p.278,nos.521-36

LC N1270.93 1914 FOR COMPLETE ENTRY
 SEE MAIN CARD

II.A.3 - GREAT BRITAIN - 16th c.(Tudor)

Auerbach, Erna
 Tudor artists; a study of painters in the
royal service and of portraiture on illuminated
documents from the accession of Henry VIII to the
death of Elizabeth I..London.,Univ.of London,
Athlone press,1954

 222 p. illus.

 Documentation.Biographical notes on the ptrs.

 Bibliography
LC ND1314.A8 Chamberlin,M.W.Guide to
 art reference books #1278

II.A.3 - GREAT BRITAIN - 16-17th c.
Earlom, Richard, 1743-1822, engr.
 Portraits of characters illustrious in Brit-
ish history, from the beginning of the reign of
Henry the eighth to the end of the reign of James
the second. Engraved in mezzotinto. Richard
Earlom & Charles Turner. From original pictures,
miniatures, etc. London,S.Woodburn,.1815?.

 illus.

 Each portr.accompanied by brief biogr.sketch

LC N7598.E3

705
B97
NCFA
v.99

II.A.3 - GREAT BRITAIN, 16-early 17th c.

Auerbach, Erna
 Some Tudor portraits at the Royal Academy

In:Burl.Mag.
99:9-13 Jan.,'57 illus.

 Refers to two rooms in the Exh.British
Portraits,winter 1956-57

 Repro.incl.:Zuccari,Eworth,John Bettes II,
Holbein,v.d.Passe,Nicholas Locky,Rowland Locky

VP in:
London
NPG

II.A.3 - GREAT BRITAIN-16-17th c.

Gibson, Robin
 The National Portrait Gallery's set of Kings
and Queens at Montacute House

In:Nat'l Trust Year Book
1:81-87 1975-76 illus.

LC NX28.072N3716 1975-76 FOR COMPLETE ENTRY
 SEE MAIN CARD

757
.B2

II.A.3 - GREAT BRITAIN - 16-17th c.

Baker, Charles Henry Collins, 1880-
 English painting of the 16th and 17th c.,...
Firenze,Pantheon,casa editrice.etc...1930.
88.1.p. Illus. (The Pantheon series)

 Bibliography

 "To write the history of ptg.in Engl.during
the 2 centuries following the close of the middle
ages is to describe a series of ptrs...whose work
is nearly all portraiture."

LC ND1314.B23

AP
1
A64
NCFA
v.91

II.A.3 - GREAT BRITAIN-16-17th c.

Reynolds, Graham, 1914-
 The Elizabethan image

In:Apollo
91:138-143 Feb.,1970 illus(part col.)

 Critical notes on the exh.at Tate Gallery,
Nov.28,'69-Feb.8,1970
 Exh.:display of Elizabethan & Jacobean ptg.

 Rep.1970 #6938

II.A.3 - GREAT BRITAIN - 16-17th c.

Dulwich college,London
 Cat.of the manuscripts and muniments of
Alleyn's college of God's gift at Dulwich...
London,Pub....by Longmans,Green & co.,1881-1903

 Edward Alleyn,founder of the college re-
corded betwe.1618 and 1620 the purchase of 26
heads of English sovereigns fr.William I to
James I. Only 17 now survive.(p.175)

LC Z6621.D884 FOR COMPLETE ENTRY
 SEE MAIN CARD

N
6765
3924
NPG

II.A.3 - GREAT BRITAIN - 16-17th c.

Strong, Roy C.
 The Elizabethan image:painting in England,
1540-1620..a cat.....of.an exh.organised by
the Tate Gallery,28 Nov.1969-8 Feb.,1970.
London,Tate Gall.(Publ.Dept.),1969
 88 p. illus(part col.)

LC N6765.S7

AP
1
A64
NCFA
V.79

II.A.3 - GREAT BRITAIN - 16-17th c.

Strong, Roy C.
 The Elizabethan malady.Melancholy in Elisa-
bethan and Jacobean portraiture

In:Apollo
79:264-84 Apr.,'64 illus(part col.)

qND
1314
S924
NPG

Also in:Strong.The English Icon...Appendix,with-
out illustrations.

 Relates the cult of melancholia in late Eliz
Engl.to moods in portraiture.

ND
207
W78
1971
NPG

II.A.3 - GREAT BRITAIN - 17th c.

Green, Samuel M.
 English origins of 17th c.painting in New
England

In:Winterthur Conf.on Mus.Oper'n and Conn'ship
17th:15-69 1971 illus.

 Bibliographical notes
 Incl.:Chronological checklist of English
antecendents to N.E.ptg.

LC ND207.W5 1971

qND
1314
S924
NPG

II.A.3 - GREAT BRITAIN - 16th & 17th c.

Strong, Roy C.
 The English icon:Elizabethan & Jacobean por-
traiture ...London,Paul Mellon Foundation for
British Art...New York,Pantheon Books,1969

 388 p. illus.(part col.)

 Bibliography

 1540-1620

ND 1314.S7

II.A.3 - GREAT BRITAIN - 17th c.

London. Royal academy of arts
 The age of Charles II.Winter exh.,1960-61.
London,1960

MiDA McU CaOONG

FOR COMPLETE ENTRY
SEE MAIN CARD

qND
461
G46X
NCFA

II.A.3 - GREAT BRITAIN - 16-18th c.

The Genius of British painting.Editor David
 Piper.London,Weidenfeld & Nicolson,c.1975
 352 p. illus(part col.)
 Bibliography

 Incl.Index

 Partial contents:Ch.2:Tudor & Early Stuart
ptg.by D.Piper,p.62-110;Ch.3:Ptg.under the
Stuarts,by G.Millar,p.111-144;Ch.4:The 11th c.,
by Mary Webster,p.145-197
 Archer.India & Brit.Portr..
 ND1327.I44A72X NPG Bibl.
 p.483

NK
928
C75
1968
NCFA

II.A.3 - GREAT BRITAIN - 17th c.

Millar, Oliver, 1923-
 Painting and portrait miniatures

In:The Connoisseur's Complete Period Guides
p.337-52 illus.

 Pertains to Stuart period

 Repro.:Hoskins,Cooper,Greenhill,Closterman,
Kneller,Dahl,Maratti

AP
1
A64
NCFA
v.105

II.A.3 - GREAT BRITAIN -(mid)16-(mid)19th c.

Waterhouse, Ellis Kirkham, 1905-
 An impressive panorama of British portrai-
ture

In:Apollo
105:238-9,244-5,247,249,251 Apr.'77 illus.
 (part col.)

 Discusses some portrs. in the
Paul Mellon coll.at Yale Center for British Art
ranging from c.1550-c.1850

 Rila IV/1 #1133
 1978

705
B97
NCFA
v.90

II.A.3 - GREAT BRITAIN - 17th c.

Millar, Oliver, 1923-
 A subject picture by William Dobson

In:Burl Mag
90:97-9 Apr,1948 illus.

 Portrs. by Engl.portr.ptrs.of 17th c. in sub-
ject pictures:Dobson's Woman taken in adultery
with portr.of Cowley, Decollation of St.John:
Saint portr.of Prince Rupert, Allegory of French
religious wars:The Four Kings of France:Francis II
Charles IX,Henry III & Henry IV(Newbottle Manor)
 Rep.,1948-49*8374

757
.B16

II.A.3 - GREAT BRITAIN - 17th c.

Baker, Charles Henry Collins, 1880-
 Lely & the Stuart portrait painters;a study
of English portraiture before & after van Dyck:
with 240 reproductions after the original pic-
tures...London,P.L.Warner,publisher to the Medici
society,limited,1912

 2 v. illus.(part.col.)

 "Dated but still an immensely valuable pio-
neer study".-R.Strong in The Engl.Icon.Bibl.

LC ND1314.B25

qND
1301.5
G7L667
1975X
NPG

II.A.3 - GREAT BRITAIN - 17th c.

Ranger's House.
 The Suffolk collection;cat.of paintings
....compiled by John Jacob and Jacob Simon;
photographs by Robert Evans..London,Greater
London Council.1975.
 .86.p. illus.

 Bibliography

AP
1
W225
NCFA
v.34

II.A.3 - GREAT BRITAIN - 17th c.

Reynolds, Graham, 1914-
 Portraits by Nicholas Hilliard and his assistants of King James I and his family

In:Walpole Soc.
34:14-26 1952-54 illus.

N
40.1
K682Ki
NPG

II.A.3 - GREAT BRITAIN - 17-18th c.

Killanin, Miachael Morris, 1914-
 Sir Godfrey Kneller and his times,1646-1723,
being a review of English portraiture of the
period. London,New York,Batsford,1948.
 117 p. illus(part col.)

 Chronological cat.of some of G.Kneller's principal works which can be attributed and dated
 Bibliography

ND497.K47K5

705
C75
NCFA
v.48

II.A.3 - GREAT BRITAIN - 17-18th c.

Baker, Charles Henry Collins, 1880-
 Notes on some portraits in Mr.John Lane's
collection

In:Connoisseur
48:127-36 Jul.'17 illus.

 Collection of 100 portrs.by obscure British
painters

 Repro.:John Betts,Ths.Lawranson,Ths.Hudson,
Isaac Whood,Jos.Highmore,Js.Worsdale,Benj.Wilson
 Cumulated Mag.subj.index
 A1/3/C76 Ref. v.2,p.444

DA
758.3
S8G7x
NCFA

MET
276.5
L844

II.A.3 - GREAT BRITAIN - 17-(begin)18th c.

London. National Portrait Gallery
 The house of Stuart,by David Gransby.London,H.M.stationery off.,1968

 20 p. illus(part col.) (Its Kings and
Queens series;1603-1714)

II.A.3 - GREAT BRITAIN - 17-18th c.

Beale, Mary, 1632-1697
 "The excellent Mrs.Mary Beale";13 Oct.-
21 Dec.1975,Geffrye Museum,London;10 Jan.-21 Feb
1976,Towner Art Gall.,Eastbourne;cat.by Elisabeth Walsh & Rich.Jeffree...London,Inner London
Education Authority,1975
 72 p. illus(1 col)

 Bibliography
 102 works shown,incl.5 self-portrs.
 Incl.works by Charles Beale,Sarah Curtis-
Hoadley,Nathaniel Thache,Thomas Flatman

LC ND1329.B36W34 Rila III/1 1977 #1085

N
1090
A612
NPG

II.A.3 - GREAT BRITAIN - 17-18th c.

London. National Portrait Gallery
 National Portrait Gallery at Beningbrough
Hall.London,National Portrait Gallery,1979
 32 p. illus(part col.)

 Incl.:List of sitters

705
C75
NCFA
v.13

II.A.3 - GREAT BRITAIN - 17-18th c.

Duleep Singh, Frederick, prince, 1868-1926
 A county collection

In:Connoisseur
13:3-10 Sep.,'05 illus.

 Repro.incl:portrs.by J.ohn.M.ichael.Wright,
D.Heins,Theodor Netcher

FOR COMPLETE ENTRY
SEE MAIN CARD

705
B97
NCFA
v.76-77

II.A.3 - GREAT BRITAIN - 17-18th c.

Sewter, A.C.
 Kneller and the English Augustan portrait

In:Burl Mag
77:106-11 Oct,1940 illus.

 Kneller's severity,sombre colors,generally angular drapery & 2 dimensional style of design is
in contrast to Lely's elegance & subtle romanticism & Rigaud's flamboyant drapery & 3 dimensional
movements. Repro.see over
 Enc.of World Art
 N31E56Ref.v.11
 col.513 bibl.on portr.

AP
1
NCFA
v.101

II.A.3 - GREAT BRITAIN, 17-18th c.

Jacob, John
 Ranger's House,Blackheath,a new gallery of
English portraits

In:Apollo
101:14-8 Jan.,'75 illus(1 col.)

 Discusses the Suffolk coll.of Tudor,Stuart
and later portrs.Gift to the Greater London
Council;displayed at Ranger's House,Blackheath.
 Coll.contains group of full-length portrs.
by Wm.Larkin
 Rila II/1 1976#4,81

II.A.3 - GREAT BRITAIN - 17-18th c.

Stewart, J.Douglas
 English portraits of the 17th and 18th centuries,papers read...Apr.14,'73 by J.D.Stewart
and Herman W.Liebert.Los Angeles,Wm.Andrews
Clark Memorial Library,Univ.of Calif.,1974
 v. 95 p. illus. (Wm.Andr.Clark Mem'l
Library seminar papers)

 Bibliographical references

 Contents:Stewart,J.D.:Pin-ups or virtues?
The concept of the "beauties" in late Stuart
portraiture
LC ND1314.3.S73 Rila I/1-2 1975 #1456

757
S72
1867
(RB)

II.A.3 - GREAT BRITAIN - 17-18th c.

Victoria and Albert museum, South Kensington.
...Catalogue of the second special exhibition
of national portraits commencing with the reign
of William and Mary and ending with the year
1800...May 1, 1867.London,Printed by Strange-
ways and Walden.1867.
208 p.

LC N759X .S6 1867

Ingamells.Cat.of portrs...
R75197.I p.XVI

AP
1
V65
NCFA

II.A.3 - GREAT BRITAIN - 18th c.

Burke, Joseph ?., 1913-
Romney's Leigh family(1768):A link between
the conversation piece and the Neo-Classical
portrait group

In:Ann'l B.of NGA of Victoria
2:5-14 1960 illus.

'...Romney,like Reynolds established the
classical context by introducing antique sculp-
ture into the composition.'-Burke

N
7598
W59
NPG

II.A.3 - GREAT BRITAIN - 17-19th c.

Colnaghi, P.& D.& co.,ltd.,London
English ancestors,a survey of British por-
traiture 1650-1850.Cat..of exh.22 Feb.to 31
March 1983.ed.by Clovis Whitfield,assisted by
Ursula Lans..1983.
109 p. illus(part col.)

Arranged by artists in alphabetical order
Foreword by John Harris

Incl.:Groups,children & portr.busts

759.2
.D48

II.A.3 - GREAT BRITAIN - 18th c.

Detroit. Institute of Arts
An exhibition of English conversation pie-
ces of the 18th century.The Detroit Institute
of Arts,Jan.27 through Febr.29,1948..Detroit,
1948.
40 p. illus(part col.)

Text signed:E.P.Richardson

Incl.also furniture,silver,tapestries,porce-
lains

LC ND466.D4

.5
.57
NCFA
v.3

II.A.3 - GREAT BRITAIN - 18th c.

Birmingham, England. Museum and Art Gallery
Exhibition of English portraits of the 18th c.
in the Birmingham Art Gallery

In:Burl Mag
3:117-29 Nov,'03 illus.
see also: Illustr.cat.of a loan coll.of portrs...
Incl.10 Hoppner, 17 Reynolds,9 Gainsborough,
16 Romney, etc.
Repro.:Gainsborough,Hoppner,Raeburn,Reynolds
Romney
Cumulated Mag.subj.index
A1/3/C76 Ref. v.2,p.444

N
40.1
D49736
NCFA

II.A.3 - GREAT BRITAIN - 18th c.

D'Oench, Ellen G.
The conversation piece:Arthur Devis and his
conterporaries.New Haven,Yale Center for Bri-
tish Art,1980
99 p. illus(part col.)

Publ.on the occasion of an exh.at the Yale
Ctr.for Brit.Art,New Haven,Conn.,Oct.1 to Nov.
30,1980
Bibliography

Harris Mus. Preston.
p.38

FOGG
4353B61

II.A.3 - GREAT BRITAIN - 18th c.

Birmingham, England. Museum and Art Gallery
Illustrated catalogue of a loan coll.of por-
traits by ...Reynolds,Cainsborough,Romney,Hoppne
Raeburn...comp.by Whitworth Wallis and Arthur
Bensley Chamberlain.Birmingham,1903
79 p. illus.

Review In:Burl Mag 3:117-29 Nov.,'03 illus
Birmingham,Engl. Mus. and Art Gall.Exh.of Engl.
portrs.of the 18th c. ...

NN MH

Fogg,v.11,p.333

759.2
.D98

II.A.3 - GREAT BRITAIN - 18th c.

Duveen brothers
Catalogue of the special loan exh.of old
masters of the British school in aid of "The
artists' fund"and "Artists' aid"societies,be-
ing a selection from pictures acquired from
Messrs.Duveen brothers...New York,January,1914.
.P..t.,Bishop & Garrett,printers,1914.
28 l. 17 pl.

Portraits by Gainsborough,Reynolds,Romney,
Lawrence,Raeburn,Hoppner

LC N7598.D96

Yale ctr.f.Brit.art Ref.
N7598+D88

N.Y.P.L.
Art div.
Avery coll.
MAVZ
(Birmingham)

II.A.3 - GREAT BRITAIN - 18th c.

Birmingham, Eng. Museum and art gallery
Illustr.cat.of a loan coll.of portraits,by
Sir Joshua Reynolds,Ths.Gainsborough,Geo.Romney,
John Hoppner,Sir Henry Raeburn,and other artists
...Birmingham,Printed at the Guild press.1900.

LC(N7598.B6 1900)
CSmH PPULC CtY

FOR COMPLETE ENTRY
SEE MAIN CARD

705
C75
NCFA
v.113

II.A.3 - GREAT BRITAIN - 18th c.

English portraits in the Jules Bache collection
In:Connoisseur
113:51-5 Mar,1944 illus.

Incl.:van Dyck,Gainsborough,Reynolds,Romney,
Raeburn

IN
7598
C67
NCFA

II.A.3 - GREAT BRITAIN - 18th c.

Gosse, Edmund William, 1849-1928
 British portrait painters and engravers of
the 18th century, Kneller to Reynolds.New York,
Goupil & co.,1906. Plates,Asnières-sur-Seine,
Manzi,Joyant & co.,1905
 90 p. illus(part col.)

 Biographical notes

LC ND1314.G7
or BF639.C82 1905

Fogg,v.11,p.317,col.2
Adair.18th c.pastel portrs.
NC885.A32 1971X Bibl.p.202

124 nt3
NCFA

II.A.3 - GREAT BRITAIN - 18th c.

Jourdain, Margaret
 The Georgian art exh.at Sir Philip Sassoon's
house

 In:Apollo
13:174-6 Mar,'31 illus.

 Exh.in aid of the Royal Northern Hospital,
concentrated upon portrs.& portr.groups by Rey-
nolds,Gainsborough & Hoppner & incl.items of P.
Sassoon's own coll.
 In Burl Mag v.58 Repro.:Gainsborough;E.F.
Burney;Reynolds----(Sassoon coll.)

705
B97
NCFA

II.A.3 - GREAT BRITAIN - 18th c.

Hayes, John T.
 Some unknown early Gainsborough portraits

In:Burl Mag
107:62-74 Feb.,'65 illus.

 Incl.:List of Suffolk period portrs. not in-
cluded in Ellis Waterhouse:Gainsborough, London
,1958.
 Repro.incl.:Gainsborough,van Loo,Ramsay,
Hogarth,Perroneau,van Dyck,Reynolds

AP
1
Z48
MMAA

II.A.3 - GREAT BRITAIN - 18th c.

Mannings, David
 Shaftesbury,Reynolds and the recovery of
portrait-painting in 18th century England

 In:Z Kunstgesch
48,no.3:319-28 1985 illus.

 Discussion of two ideals in portr.ptg.:
Stoicism and sensibility

NK
928
C75
1968
NCFA

II.A.3 - GREAT BRITAIN - (early)18th c.

Honour, Hugh
 Painting and sculpture

In:The Connoisseur's Complete Period Guides
p.593-605 illus.

 Incl.chapters on portraits,conversation
pieces,busts(sculpture)during early Georgian per

 Repro.:Reynolds,Ramsay,Gainsborough,Roubil-
lac,Rysbrack,Scheemakers,Kneller,Van Loo,Jervas,
Richardson,Hudson,Knapton,Hogarth,Highmore,Devis

705
C75
NCFA
v.189

II.A.3 - GREAT BRITAIN - 18th c.

Mannings, David
 A well-mannered portrait by Highmore,dated
1747.

In:Connoisseur
189:116-9 June,'75 illus.

 Acceptable postures and attitudes pre-
scribed in 'Rudiments of Genteel Behaviour'
(1737);by Nivelon.His and others' writings on
etiquette influenced 18th c. portraiture.

 Rila II/2 1976 #5004

NK
928
C75
1968
NCFA

II.A.3 - GREAT BRITAIN - (late)18th c.

Honour, Hugh
 Painting and sculpture

In:The Connoisseur's Complete Period Guides
p.837-50 illus.

 Incl.portraiture during the late Georgian
period

 Repro.:Reynolds,Gainsborough,Cotes,Copley,
Romney; Bacon,Nollekens,Hewetson

705
C75
NCFA
v.16

II.A.3 - GREAT BRITAIN - 18th c.

Roberts, William, 1862-1940
 Mr.J.Pierpont Morgan's pictures. The early
English school.I.II.III.

In:Connoisseur
16:134-43 Nov.,'06 illus(part col.)
16:66-74 Feb.,'06 "
17:71-75 Dec.,'06 "
 Incl.:Gainsborough:Duchess of Devonshire,
and others. Hoppner

ND
1452
C72J64
1986X
NMAA

II.A.3 - GREAT BRITAIN - 18th c.

Johnson, E.D.H.(Edw.Dudley Hume)
 Paintings of the British social scene,from
Hogarth to Sickert.N.Y.,Rizzoli,1986
 287 p. illus(part col.)

 Incl.:Index
Ch.II,p.43-78:Domestic portraiture.(Mainly
Groups)

705
C75
NCFA
v.83

II.A.3 - GREAT BRITAIN - 18th c.

Rutter, Frank Vane Phipson, 1876-1937
 Sir Gomer Berry's paintings at Chandos
House

In:Connoisseur
83:59-70 May,'29 illus(part col.)

 Repro.incl.:Raeburn, Michael Dahl, Nathaniel
Dance, Simon Verelst, Mattier, Jos.Highmore,
Hogarth, Reynolds, Cotes, Zoffany

741.23
S45

II.A.3 - GREAT BRITAIN - 18th c.

Sée,Robert René Meyer
English pastels,1750-1830...London,G.Bell &
sons,ltd.,1911
373 p. illus.(part col.)

'...representative of the work of the English
portrait painter of the 18th c....'

LC NC880.S4

927
.W58

II.A.3 - GREAT BRITAIN - 18th c.

Whitley, William Thomas
Artists and their friends in England,
1700-1799...London & Boston,The Medici society
.1928.
2 v. illus.

LC N6766.W5

Hagen,O.F.L.The birth of
Amer.trad'n.759.1.H2 in
preface:"invaluable source
of information"

MET
195.3
T78
3pts.
in 1 v.

II.A.3 - GREAT BRITAIN - 18th c.

Tschudi, Hugo von, 1851-1911 ed.
Das porträt. Berlin,J.Bard & B.Cassirer,
1906-07
4 pts. illus.(part col.)

Contents.-1.Gurlitt,Cornelius.D.englische por-
trät im 18.jahrh:Gainstorough,Romney,Raeburn.-
2-G.,C. D.engl.portr...:Reynolds,Hoppner,Lawrence.-
3.Bie,Oscar.D.bürgerliche portr.des 19.jahrh.in
Deutschland:Chodowiecki,Graft,Krüger,Runge,Oldnach
4.Schaeffer,Emil:D.portr.der italienischen hochren-
naissance

Amsterdam.Rijksmus.Kunsth.
bibl.Cat.25939.A52deel 1
.CFA p.125

II.A.3 - GREAT BRITAIN - 18th c.

Wind, Edgar, 1900-
Hume and the heroic portraits:Studies in
eighteenth-century imagery;edited by Jaynie
Anderson.Oxford,Clarendon Press,1986
139 p. illus.

Bibl.references
Index

LC ND1314.4.W5 1986

Burl.Mag.Dec.'86,p.906-7.
AP1B975 NMAA Book Rev.by
John Gage

705
028
v.1
1909
NCFA

II.A.3 - GREAT BRITAIN - 18th c.

Tourneux, Maurice
Exposition de cent portraits de femmes du
18e siècle.Salle du jeu de paume,Paris.

In:Gaz.Beaux Arts
ser 4,v.1:481-95 June,'09 illus.

Repro.incl.:Opie,Hoppner,Reynolds,Duplessis,
Perronneau,Danloux,Kucharsky.
Exh.,Paris,Soc.de secours aux familles des
marins français naufragés,Apr.23-July 1,1909
Almost all p s.from private collections
(See also 34 p. article at C3mH)

II.A.3 - GREAT BRITAIN - 18-19th c.

Agnew (Thos.) & Sons,ltd.,London
English life and landscape;an exh.of Eng-
lish pictures,1730-1870, 8th March-8th April,
1971.London,1971.
32 p. illus.

LC ND1314.4.A7

Yale ctr.f.Brit.art Ref.
ND1314.4+.35

ND
466
W32
NPG
Ref.

II.A.3 - GREAT BRITAIN - 18th c.

Waterhouse, Ellis Kirkham, 1905-
Dictionary of British 18th c.painters in
oils and crayons...Woodbridge,Engl.:Antique
Collectors' Club,c.1981
442 p. illus(part col.)

Bibliography p.436-9

'...pictorial feast of signed and ascribed
portraits.'-John Harris

Colnaghi.Engl.ancestors..
foreword

ND
1327
I 44A72X
NPG

II.A.3 - GREAT BRITAIN - 18-19th c.

Archer, Mildred
India and British portraiture,1770-1825.
London,Philip Wilson Publishers Ltd.,c1979-80.
528 p. illus(part col.)

FOR COMPLETE ENTRY
SEE MAIN CARD

N
6766
W3X
NCFA

II.A.3 - GREAT BRITAIN - 18th c.

Waterhouse, Ellis Kirkham, 1905-
Three decades of British art, 1740-1770.
Philadelphia,American Philosophical Society,
1965
77 p. illus. (Jayne lectures,1964)
Memoirs of the American Philosophical
Society,v.63)
Lecture at the Philadelphia Mus.of Art,
March,1964,provided for through the American
Philosophical Society,Philadelphia
Bibliographical footnotes

Moor.The Art of Rbt.Peke
N6,0.1.F312X8 1970a NMAA
Bibl.p.XXXII

II.A.3 - GREAT BRITAIN - 18-19th c.

Cust, Lionel Henry, 1859-1929
Eton college portraits...London,Spottiswoode
& co.,1910
81 p. illus.

Incl:Ramsay,Nath.Dance,Reynolds,Romney,
Hoppner,Beechey,Opie,Northcote,Lawrence,Carpenter
Phillips,etc.

LC N598.C8

David Piper:Eton leaving portr.
in:Burl.Mag.v.93:201:
"Standard work"

705
028
NCFA
v.10

II.A.3 - GREAT BRITAIN - 18-19th c.

Dorbec, Prosper, 1870-
Les influences de la peinture anglaise sur le portrait en France(1750-1850)

In:Gaz.Beaux-Arts
10:85-102 1913 illus.

French portraitists in England,Engl.portraitists in France,their success.Reynolds,Lawrence.
...

FOR COMPLETE ENTRY
SEE MAIN CARD

DA
480
Klx
NPG

II.A.3 - GREAT BRITAIN - 18-19the.

London. National Portrait Gallery
The house of Hanover;by J.Kerslake and Louise Hamilton.London,H.M.stationery office, 1968
.20.p. illus(part col.) (Its Kings and Queens series:1714-1837)

Winterthur Mus.Library
Z881.W78 NCFA v.6,p.228

ND
1314.4
F96
NPG

II.A.3 - GREAT BRITAIN - 18-19th c.

Eton college
Exhibition of the Eton leaving portraits.
The Tate gallery, London,Apr.-May,1951
28 p. illus.

FOGG
4103
L84

Review by David Piper,In:Burl.Mag.
93:201-2 June,1951 illus. Repro:Fabre,Reynolds Romney,Carpenter

ME MM

II.A.3 - GREAT BRITAIN - 18-19th c.

London. Queen's Gallery, Buckingham Palace
Gainsborough,Paul Sandby and miniature-painters in the service of George III and his family.cat.of an exhibition. .London.1970
30 p. illus.

Bibl.references

LC ND1314.4.L6 Yale ctr.f.Brit.art Ref.

AP
1
W225
NCFA
v.19
v.21

II.A.3 - GREAT BRITAIN - 18-19th c.

Foster, Sir William, 1863-1951
British artists in India,1760-1820

In:Walpole Soc.
19:1-88 1930-31 illus.
21:108-9 1933

Repro.incl.:Geo.Chinnery,self-portr.;A.W.Devis:Reception of the sons of Tipo; Portrs.by Ths.Hickey,Rbt.Home,John Smart,Diana Hill,Geo.Willison,John Zoffany
Chronological list of artists
New Orleans Mus.of Art.Engl & cont'l miniatures.ND1337 G7N48X NCFA Bibl. p.118

QND
466
M64
NCFA

II.A.3 - GREAT BRITAIN - 18-19th c.

Millar, Oliver, 1923-
The later Georgian pictures in the collection of Her Majesty the Queen..London.Phaidon, .1969.
2 v. illus(part col.)

Contents:1.Text.-2.Plates

Third part of the new cat.raisonné of the royal coll.of pictures

Bibliography

LC ND466.M5 Fogg,v.11,p.332

II.A.3 - GREAT BRITAIN - 18-19th c.

Fry, Roger Eliot, 1866-1934
...Georgian art(1760-1820)an introductory review of English painting,architecture,sculpture ...during the reign of George III;by R.Fry,J.B.Manson,and others.London,B.T.Bataford,ltd., 1929
.68.p. illus(part col.) (BurlMag monograph III)

Intro and Ch.on ptg. by R.Fry

LC N6766.F7 Redgrave.A century of Brit.
ptrs.ND464.R316 NMAA
Bibl.p.595

ND
464.R316
1981
NMAA

II.A.3 - GREAT BRITAIN - 18-19th c.

Redgrave, Richard, 1804-1888
A century of British painters;by R.Redgrave and Samuel Redgrave.Ithaca,N.Y.,Cornell Uni.Press,1981
612 p. illus (Landmarks in Art History)

Reprint of Phaidon ed.of 1947
Bibliography,p.595-612
Chapters on 18thc.and on 19th c.portraitists;17-19th c.miniatures;early Victorian portr.ptrs. Influence of foreigners on English art.

709
C75
v.143
NMAA

II.A.3 - GREAT BRITAIN - 18th-19th c.

Goodison, J.W.
Cambridge portraits,III:later 18th and early 19th c.

In:Connoisseur
143:84-90 illus. Apr.,1959

3rd article in a series of 4
Repro.:Ptgs.by Reynolds,Benj.Wilson,Gainsborough,Matt.Wm.Peters,G.Stuart,Henry Walton,Romney, John Opie,John Hoppner,Lawrence,Js.Lonsdale

Encyclop.of World Art
Portr.bibl. N31E56 Ref.
v.11

705
A784
NCFA
v.9

II.A.3 - GREAT BRITAIN - 18-19th c.

Roberts, William, 1862-1940
English whole-length portraits in America

In:Art in Am
9:176-80 Aug.'21 illus. Reynolds
10:22-6 Dec.'21 illus. Gainsborough
10:70-5 Feb.'22 illus. Lawrence
10:109-16 Apr.'22 illus. Gainsborough
10:274-7 Oct.'22 illus. Gainsborough

Cumulated Mag.subj.index
A1/3/C76 Ref. v.2,p.444

705
C75
NCFA
v.52

II.A.3 - GREAT BRITAIN - 18-19th c.

Roberts, William, 1862-1940
 The John H.H.McFadden collection.I.-Portrait

In:Conn.
52:125-30,134,137 Nov.,'18 illus.

 18th & 19th c. paintings
 Repro.incl.:Hogarth,Reynolds,Gainsborough,
Romney,Raeburn,Harlow,Hoppner,J.W.Gordon,etc.

 Cum.Mag.subj.index A1/3/7(
 Ref. v.2,p.444

705
397
NCFA
v.69

II.A.3 - GREAT BRITAIN - 19th c.

Holmes,(Sir)Charles John, 1868-1936
 The heirs of Lawrence, 1825-1835

In:BurlMag.
69:195-201 Nov.,'36 illus.

 Study of costume gives new attributions to
ptgs. which had been attributed to Harlow

 Repro.:Margaret Carpenter,Geo.Henry Harlow,
Henry Wyatt
 Steegmann,J.Burl.Mag.v.73
 pp.177-8,183 Oct.,'38

ND
1314
S62
NPG

II.A.3 - GREAT BRITAIN - 18-19th c.

Sitwell, Sacheverell, 1897-
 Conversation pieces; a survey of English
domestic portraits and their painters...London,
B.T.Batsford,ltd.:1936:

 119p. illus(part col.)

 18th & 19th c. Incl:Gainsborough,Hogarth.
Photographs by Hill,Fox-Talbot. Zoffany,Devis,
Stubbs,Turner,Leslie,Winterhalter, etc.

LC ND1314.S5 1936

705
B97
NCFA
v.73

II.A.3 - GREAT BRITAIN - 19th c.

Steegmann, John, 1899-
 Early 19th c. portraitists

In:Burl.Mag.
73:177-8,183 Oct.,'38 illus.

 "Phillips...perhaps best portraitist.of men.
of his day with the exception of Lawrence"

 Repro.:Ths.Phillips,Wm.Owen

 Cumulated Mag.subj.index
 A1/3/C76 Ref. v.2,p.443

ND
466
V81
NCFA

II.A.3 - GREAT BRITAIN - 18-19th c.

Virginia Museum of Fine Arts, Richmond.
 Painting in England 1700-1850:collection o
Mr.& Mrs.Paul Mellon.:Cat.by Basil Taylor.
Richmond,1963
 2 v. illus(part col.)

 v.1:Intro.,cat.,small illus.-v.2:Repro.in
alphabetical order.

 Exh.divided into 4 parts.2:Portrs.,convers
tion pieces,scenes fr.contemp.life

LC ND466.V5 MOMA,v.11,p.432

757
S72
1868
(RB)

II.A.3 - GREAT BRITAIN - 19th c.

Victoria and Albert museum, South Kensington.
 ...Catalogue of the third and concluding exhi-
bition of national portraits commencing with the
fortieth year of the reign of George III and
ending with the year 1867...April 13,1868.London
Printed by Strangeways and Walden:1868.
 209 p.

 Ingamells.Cat.of portrs...
 PX5197.I 53X p.XVI

ND
1314.4
W183
1985
v.1-2
NPG Ref.

II.A.3 - GREAT BRITAIN - 18-19th c.

Walker, Richard
 Regency portraits.London,NPG,1985
 2 vols. illus. v.1:Text;v.2:Plates

 Edited by Judith Sheppard
 Indexes
 Incl.:Sculpture,Medals,Engravings,Photo-
graphs
 Groups p.597 f.

NK
928
C75
1968
NCFA

II.A.3 - GREAT BRITAIN - 19th c.

Woodward, John
 Painting and sculpture

In:The Connoisseur's Complete Period Guides
p.1333-44, 1377-9 illus.

 Incl.portraiture during early Victorian per.

 Repro.:Wilkie,Hayter,Partridge,Eastlake,Etty,
Rossetti(drg.),Landseer,Watts,Winterhalter;
Carew,Behnes,Woolner,Gibson

NK
928
C75
1968
NCFA

II.A.3 - GREAT BRITAIN - (early)19th c.

Denvir, Bernard
 Painting and sculpture

In:The Connoisseur's Complete Period Guides
p.1087-99

 Incl. portraiture during Regency period

 Repro.:Leslie,Phillips,Westall,Raeburn,Geddes
Edridge(drg.),Etty(drg.); Chantrey,Behnes,Joseph

DA
28.1
O 7x
NPG
2 c.

II.A.3 - GREAT BRITAIN - 19-20th c.

London. National Portrait Gallery
 The house of Windsor;by Richard Ormond.
London,H.M.stationery office,1967
 :20:p. illus(part col.) (Its Kings and
Queens series:1838-1966)

 Winterthur Mus.Library
 Z881.W78 NCFA v.6,p.228

ND
1314.5
M129
1987
NPG

II.A.3 - GREAT BRITAIN - 19-20th c.

McConkey, Kenneth
Edwardian portraits.Images of an age of opulence.Woodbridge,Antique Collecter's Club,1987
263 p. illus(part col.)

Index
Bibliography

II.A.3 - GREAT BRITAIN - 20th c.

Royal society of portrait painters
Cat.of the 71st annual exh..11-29th of
May,1965.London,"oyal Inst.Gall.:1965.
40.p. illus.

Index

ND
1314.6
B38
NPG

II.A.3 - GREAT BRITAIN - 20th c.

Beaverbrook Art Gallery, Fredeicton, N.B.
From Sickert to Dali;interntional portraits;an exh.,organized by the Beaverbrook Art
Gallery,Fredericton,New Brunswick,summer 1976
31 p. illus.

Bibliography
41 works shown
Cat.by Ian G.Lumsden
The portrs.are mainly from the coll.donated
by Lord Beaverbrook and Sir James Dunn.
Exh.in commemoration of the visit of Queen
Elisabeth II;July 15th and 16th,1976
Rila II/2 1976 #5750

AP
1
A64
NCFA
V.58

II.A.3 - GREAT BRITAIN - BATH - 18th c.

Holbrook, Mary
Painters in Bath in the 18th century

In:Apollo
98:375-84 Nov.,'73 illus.

Repro.incl.:Wm.Hoare,Prince Hoare,Ths.
Hickey,Ths.Beach,Ths.Barker

Archer.Ind.& Brit.portraiture.ND1327.I44A72X NPG
Bibl.p.482

705
S94
NCFA
v.16

II.A.3 - GREAT BRITAIN - 20th c.

Bury, Adrian
Who's who in British portrait painting

In:Studio
16:71-83 Aug.,'38 illus.

"...The best portr.ptrs.in .England.to-day...
Several from Royal Academy Exhibition.1938."

Cumulated Mag.subj.index
A1/3/C76 Ref. v.2,p.443

N
7621.?
G71L2
NPG

II.A.3 - GREAT BRITAIN - LEICESTER

Leicester, Eng. Museum and Art Gallery
Catalogue of local portraits.Leicester,
E.Collingwood & son,Ltd.1956
59 p. illus.

Foreword by Colin D.B.Ellis
Bibliography

Index of artists, Index of sitters

705
I61
NCFA
v.70

II.A.3 - U.S. - 20th c.

Nelson, W.H.de B.
The Hannevig Foundation

In:Studio
70:LXXX-LXXXIV Jun,'20 illus.

Christoffer Hannevig commissioned 25 portrs.
of eminent men, the collection to be donated to
Washington as the nucleus of "a NPG." Chrm.of artists' selection comm.was J.W.v.R.Quistgaard.
Repro.:Chs.Dana Gibson by Speicher,Chs.M.
Schwab Judge Elbert H.Gary by Quistgaard,Sam.
Gompers by Seyffert Cum.Mag.subj.ind.A1/3/C76
Ref. v.2,p.444 see over

AP
1
W225
NCFA

II.A.3 - GREAT BRITAIN - LIVERPOOL - 18th c.

Dibdin, Edward Rimbault, 1853-1941
Liverpool art and artists in the 18th century

In:Walpole Soc.
6:59-91 1918 illus.

FOR COMPLETE ENTRY
SEE MAIN CARD

W
NPG

II.A.3 - GREAT BRITAIN - 20th c.

Portrayal or Betrayal;an exh.of portraits of
Nicholas Treadwell,oct.23-Nov.17,1973 at
Nicholas Treadwell gallery,London
4 p. folder illus.
26 artists portrayed N.Treadwell."The result is an interesting comparison of reality
through the eyes of each artist...Pop,New figuration,Realism combined with use of photography have brought about a new style of portraiture,appropriate to society now & valid as art.
-Treadwell.

757
.S61
N.G.A.

II.A.3 - GREAT BRITAIN - NORFOLK

Duleep Singh, Frederick, prince, 1868-1926
Portraits in Norfolk houses,by...ed.by Rev.
Edmund Farrer...Norwich,Jarrold and sons,ltd.
.1928.
2v. illus.

Portraits from 16th c. to 20th c.
Index to all portrs.(4000)recorded
Index of all artists mentioned, with dates

LC

II.A.3 - GREAT BRITAIN - NORFOLK - 18th c.

Norfolk and Norwich archaeological society,
Norwich, Eng.
Mrs.Sarah Baxter,née Buck(1770-?),Norfolk
portrait painter and miniaturist;by M.C.Evans.
Norfolk and Norwich archaeological Soc.,1972,
v.25:400-9

For biography of Sarah Baxter see:Archer.
India & Brit.portraiture,1770-1825,p.400-2,
illustrated

LC DA670.N59N8?

Archer.Ind.& Brit.portrait
ure...ND1327.I 44A72X NPG
Bibl.p.480

757
.E26

II.A.3 - GREAT BRITAIN - SCOTLAND

Edinburgh. Scottish national portrait gallery
Scottish history told by portraits,a popular
guide to the Scottish national portrait gallery,
Edinburgh...Edinburgh,printed under the autho-
rity of H.M.Stationery off.,1934
23 p. illus.
2d ed.
Signed:James L.Caw

II.A.3 - GREAT BRITAIN - NORWICH

Dickes, William Frederick
· The Norwich school of painting;being a full
account of the Norwich exhibitions,the lives of
the painters,,, and description of the pictures
...London,Jarrold & sons;.etc.etc.,1906.
616 p. illus.
Incl.:Thirtle,Stannard

MET
188D55

DLC PPPM (Cleve.CMA has 1905 ed.)
Redgrave.A century of Brit
ptrs.ND464.R316 NMAA
Bibl.p.595

N'
40.1
M694E2
NPG

II.A.3 - GREAT BRITAIN - SCOTLAND

Edinburgh. Scottish national portrait gallery
A view of the portrait. Portraits by
Alexander Moffat 1968-1973. Intro.by R.E.
Hutchison..An exhibition 17 Aug.-16 Sept.,1973..
Edinburgh,...1973
33 p. illus.

Moffat's work "seems to illustrate the use of
the portr.as an art form in the true sense...Mof-
fat,achieves the basic ends of portraiture:a like
ness & a personal interpretation of character..."
Dialogue betw.organisers of exh.&A.Moffat abt
M.'s intentions & method

II.A.3 - GREAT BRITAIN - SCOTLAND

Bate, Percy H, 1868-1913
Modern Scottish portrait painters...Edin-
burgh,O.Schulze,1910
24 p. illus.

LC ND1314.B3

Yale ctr.f.Brit.art Ref.
ND1314◆B37

705
S94
NCFA
v.94

II.A.3 - GREAT BRITAIN - SCOTLAND

Murdoch, William Garden Blaikie, 1880-1934
The portrait painters of Edinburgh

In:Studio
94:44-7 Oct.'29 illus.

Contemporaries of Raeburn
Repro.:Smith,Geddes,Watson-Gordon,Wilkie,etc.

Cumulated Mag.subj.index
A1/3/C76 Ref. v.2,p.443

759.2
C38

II.A.3 - GREAT BRITAIN - SCOTLAND

Caw, James Lewis, 1864-1950
Scottish painting,past and present,1620-
1908.Edinburgh,T.C.& E.C.Jack,1908
503 p. illus.

Incl.portraitists from George Jameson to
W.J.Yule,Rbt.Brough

Redgrave.A Century of Brit.
ptrs.ND464.R316 NMAA
Bibl.p-595

ND
1314
T14
1981
NPG

II.A.3 - GREAT BRITAIN - SCOTLAND

Talbot Rice Art Centre
Masterpieces of Scottish portrait paint-
ing.Edinburgh,The Art Centre,1981
44 p. illus.

Cat.of an exh.at the Talbot Rice Art Centr

Intro.:The tradition of portrait painting
in Scotland,by Duncan Macmillan

CU DeWint WaU

757
.E23
1928

II.A.3 - GREAT BRITAIN - SCOTLAND

Edinburgh. Scottish national portrait gallery
...Illustrated list with 97 illustrations and
index of artists.Edinburgh,Printed under autho-
rity of H.M.Stationery off.,1928
36 p. illus.

II.A.3 - GREAT BRITAIN - SCOTLAND - 16-17th c.

Thomson, Duncan
Painting in Scotland,1570-1650;.cat.of an
exh.held at.the Scottish National Portrait Gal-
lery,21 Aug.-21 Sept..1975....Edinburgh,Trustee
of the National Galleries of Scotland,1975
75 p. illus(part col.)

LC ND1314.2.T49

QND
1329.3
Ch5M37X
NPG

II.A.3 - GREAT BRITAIN - SCOTLAND - 17th c.

Marshall, Rosalind Kay
 Childhood in 17th c. Scotland;the Scottish
National Portrait Gallery,19 Aug.-19 Sept.,
1976...Edinburgh,Trustees of the National Gal-
leries of Scotland,1976
 67 p. illus.

An Edinburgh Festival exh.

Bibl.references

N
40.1
F14.7V2
NMAA

II.A.3 - GREAT BRITAIN - SCOTLAND - 19-20th c.

McKerrow, Mary
 The Faeds.A biography.Edinburgh,Canongate,
1982
 158 p. illus.

Bibliography

Incl.:Cat.of major Faed works.List of pic-
tures in permanent collections

N
7638
S35M3
NPG

II.A.3 - GREAT BRITAIN- SCOTLAND - 17-18th c.

Marshall, Rosalind Kay
 Women in Scotland,1660-1780...Edinburgh,
Trustees of the National Galleries of Scotland,
1979
 72 p. illus(col.cover)

Cat..of the.exh.held at the Scottish Natio-
nal Portrait Gallery,June15-July 29,1979

II.A.3 - GREAT BRITAIN - SUFFOLK

Farrer, Edmund, 1848-
 Portraits in Suffolk houses(East)...index to
the manuscript volume in the Ipswich(England)
public library,made in 1925 by Charles K.Bolton.
Presented by the trustees of the Boston Atheneum.
.Boston?1926.
 7 p.

"The volume for the eastern part of County
Suffolk is to remain in manuscript"

LC N7598.F18 Fogg,v.11,p.331

705
S94
NCFA
v.87

II.A.3 - GREAT BRITAIN - SCOTLAND - 17-18th c.

Murdoch, William Garden Blaikie, 1880-1934
 Scottish portrait painters before Raeburn

In:Studio
87:69-72 Aug.'27 illus.

 Repro.incl.:Jamesone,Allan Ramsay,Wm.Aikman,
Skirving,David Martin,John Michael Wright,Alex.
Nasmyth

II.A.3 - INDIA

Rohatgi, Pauline
 India Office Library and Records.Portraits
in the India Office Library and Records...
London,British Library,c.1983
 414 p. illus.(1 col.)

 Bibliography p.407-14
 Index

LC CT1504.5.I53 1983 Books in print.Subject
 guide 1985-86,v.3,p.4865

II.A.3 - GREAT BRITAIN - SCOTLAND - 18th c.

Edinburgh. Scottish national portrait gallery
 Treasures of Fyvie,exh.14 July-29 Sept.
1985.Publ.by the Trustees of the National
Galleries of Scotland.1985.
 79 p. illus(part col.)

 Exh.organised by Js.Holloway

 Alexander Forbes-Leith was the founder of
the Fyvie Castle coll.

VIMC-Norfolk Chrysler
 Mus.Libr.

AP
1
S76
1971-72
NCFA

II.A.3 - INDIA - 18th c.

Archer, Mildred
 Arthur William Devis;portrait painter in
India(1785-95)

In:Art at Auction
:84-3 1971-2 illus.
 Lived in Bengal,1785-95

 Archer.India & Brit.portrai-
 ture.ND1327.I44A72XNPO
 Bibl.p.477

ND
475
M16
1986
NPG

II.A.3 - GREAT BRITAIN - SCOTLAND - 18-19th c.

Macmillan, Duncan
 Painting in Scotland.The golden age.Oxford,
Phaidon in association with the Talbot Rice Art
Centre,the Univ.of Edinburgh and the Tate Galle-
ry,London,1986.
 206 p. illus(part col.)
 Index
 Bibliography
 Ch.II:Empirical portraiture,p.18-30
 Ch.VI:The portraiture of common sense,18-
 19th c.,p-74-90,129-36

N
285M2
NCFA

II.A.3 - INDIA - 18th c.

Manners, Lady Victoria, 1876-1933
 John Zoffany,R.A.,his life and works,1735-
1810;by Lady V.Manners & Dr.G.C.Williamson.
London,John Lane,N.Y.,J.Lane Co.,1920
 331 p. illus(part col.)

Bibliography

List of engravings after Zoffany...p.257-65

 Archer;India & Brit.portr...
 ND1327.I44A72X NPG Bibl.
 p.483

II.A.3 - INDIA - 18th c.

Norfolk and Norwich archaeological society,
Norwich, Eng.
Mrs.Sarah Baxter,née Buck(1770-?),Norfolk
portrait painter and miniaturist;by M.C.Evans.
Norfolk and Norwich archaeological Soc.,1972,
v.25:h:00-9

For biography of Sarah Baxter see:Archer.
India & Brit.portraiture,1770-1825,p.400-2,
illustrated

LC DA670.N59N8? Archer.Ind.& Brit.portrait
ure...ND1327.I 44A72X NPO
Bibl.p.480

705
C75
NCFA
v.91

II.A.3 - INDIA - 18-19th c.

Long, Basil Somerset, 1881-1937
Charles Shirreff, the deaf-mute

In:Connoisseur
91:83-8 Feb., '33 illus.

Archer.India & Brit.portrai-
ture...ND1327.I44A72X NPO
Bilb.p.482

II.A.3 - INDIA - 18-19th c.

Aijazuddin, F.S.
Sikh portraits by European artists...London,
Philip Wilson Publishers Ltd.,1979

FOR COMPLETE ENTRY
SEE MAIN CARD

Cat.Sotheby Parke Bernet
Publications 1979-80 p.40

AP
1
W225
v.15
NCFA

II.A.3 - INDIA - 18-19th c.

Milnur, James D.
Tilly Kettle, 1735-1786

In:Walpole Soc.
15:47-103 1926-27 illus.

Incl.Chronological list of K.'s paintings

ND
1327
I 44A72X
NPG

II.A.3 - INDIA - 18-19th c.

Archer, Mildred
India and British portraiture,1770-1825.
London,Philip Wilson Publishers Ltd.,c1979-80,
528 p. illus(part col.)

FOR COMPLETE ENTRY
SEE MAIN CARD

705
C75
NCFA
v.167

II.A.3 - INDIA - 19th c.

Ormond, Richard
George Chinnery's image of himself

In:Connoisseur
167:89-93 Feb., '68 illus.
160-4 Mar., '68 illus.

Ch.went to India in 1802

FOR COMPLETE ENTRY
SEE MAIN CARD

AP
1
A64
NCFA
v.102

II.A.3 - INDIA - 18-19th c.

Archer, Mildred
Wellington and South India;portraits by
Thomas Hickey

In:Apollo
102:30-5 July,'75 illus.

FOR COMPLETE ENTRY
SEE MAIN CARD

ND
482
N37
1983X
NMAA

II.A.3 - IRELAND

Dublin. National Gallery of Ireland
Fifty Irish painters;by Michael Wynne.The
National Gall.of Ireland,1983
52 p. illus(col.)

Incl.:Index

Incl.portr.ptrs.:p.1-12,22,24,37,42,43,45

AP
1
W225
NCFA
v.19
v.21

II.A.3 - INDIA - 18-19th c.

Foster, Sir William, 1863-1951
British artists in India,1760-1820

In:Walpole Soc.
19:1-88 1930-31 illus.
21:108-9 1933

FOR COMPLETE ENTRY
SEE MAIN CARD

N
7600
N27
1984
NPG

II.A.3 - IRELAND

Dublin. National Gallery of Ireland
Fifty Irish portraits;by Ann Stewart.
Dublin,Nat'l Gall.of Ireland,1984
50 p. illus(col.)

Index

q ND
1124
16D814
NPG

II.A.3 - IRELAND

Dublin. National Gallery of Ireland
The Irish,1870-1970;a portrait exh.for the
Dublin Arts Festival,7th March-30th Apr.,1974.
Dublin,National Gallery of Ireland,1974
.45.leaves

Incl.:Indexes

LC ND1314.5.D8 1974

AP1
C912
NCFA
v.6

II.A.3 - ITALY

Earp, T.W.
Italian portraiture at Burlington house,
London

In:Creat.Art
6:85-94 Feb,'30 illus.

Pertains to exhib.of Ital.art,Jan.-March,'30

For cat.see London. Royal academy of arts
in NPG 709.45.L84
Repro.: see over Cumulated Mag.subj.index
 A1/3/C76 Ref. v.2,p.444

II.A.3 - IRELAND

Watson, Ross
Irish portraits in American collections

In:Irish Georgian Soc.B.
12,no.2:31-60 April-June,1969

LC DA900.I6295.A34 Winterthur Mus.Libraries
DLC NN MH Z881.W78 NCFA v.6,p.231

II.A.3 - ITALY

Jahn-Rusconi, Art
Exposition des portraits italiens à Florence

In:Arts
10,no.120:2-32 Dec.,1911

LC N2.A85 Chicago,A.I. European ports.
 N7621.C4A7 NPG Bibl.p.176

q N
40.1
A673A6
NM1A

II.A.3 - ITALY

The Arcimboldo effect.Transformation of the face
from the 16th to the 20th century.Publ.in
the U.S.by Abbeville Press,N.Y.,1987
402 p. illus(part col.)

Published on the occasion of the exh.in
Venice,Palazzo Grassi,till May 31,1987.
Artistic director & General Commissioner
Pontus Hulten.Ed.by Piero Falchetta

II.A.3 - ITALY

Kenner, Dr.Fr.
Die porträtsammlung des Erzherzogs Ferdinand
von Tirol

In:Jb.d.kunsthist.sammlungen des Österr.kaiserh.
Bd.XIV:37-186:Geschichte; der Slg:D.Bildnisse d.
Erzhauses Habsburg(1893);Bd.XV:147-259:D.deut-
schen Bildnisse.Wundermenschen(1894);Bd.XVII:101-
274:Ital.Bildn.(1896);Bd.XVIII:135-261:D.Medici.
Neapel,Celebritäten(1897);Bd.XIX:6-146:Spanien,
Portugal,Frankr.Engl.,Schottld. Der Orient(1898)
LC N3.J4 Rave,P.O. Paolo Giovio u.
 d.bildnisvitenbücher...
 Jb.d.Berl.Mus. I 1959:144
 footnote LC N3.J16 fol.

II.A.3 - ITALY

Burckhardt, Jacob, 1818-1897
Das porträt in der malerei

xerox In:his:Beiträge zur kunstgeschichte von Italien.
of con- Basel,G.F.Lendorff,1898
tents
in.VF pp.143-294
Por-
trai-
ture

LC N6911.B9 Goldscheider 757.052

II.A.3 - ITALY
Offner, Richard, 1889-
Italian primitives at Yale university,
comments & revisions. New Haven,Yale university
press,1927

48 p. illus.

LC ND615.04 Lipman.The Florentine pro-
 file portr...:"..formulate
 difference betw.primitive
 abstract viewpoint & modern
 optical vision.."

II.A.3 - ITALY

Calsini, Raffaele
La bella Italiana da Botticelli a Spadini.
Milano,Ed.Domus,1945
108 p. illus.

Met
174 138 illus. of master ptgs. of women from
C13 1400 to 1700
Q

Rep.,1936*346

II.A.3 - ITALY

I Ritratti dei benefattori dell'Ospedale Maggio-
re di Milano(secoli 15-20)illustrati da Pio
Pecchiai;con introduzione di Corrado Ricci.
Milano,Pizzi & Pizio,1927
24 p. illus(part col.)

London,Wellcome Inst.

II.A.3 - ITALY - RENAISSANCE

Budapest. Szépmüvésseti Múseum.
Italian Renaissance portraits.Mus.of Fine
Arts,Budapest;by Klára Garas.2nd enl.ed. Buda-
pest,Corvina Press,c.1965,1974 printing.
26 p. col.illus.(48 l.of plates)

CtY Rép.1975 #13508(:98 p.)

MD
1308
R18
NPG

II.A.3 - ITALY - RENAISSANCE

Ramsden, E.H.
"Come, take this lute":a quest for identi-
ties in Italian Renaissance portraiture.Tis-
bury,Salisbury,Engl.:Element Books,ltd.,1983
219 p. illus(1 col.) ("A Madder book")

Bibliography:p.207-212
Indexes

Books in print.Subject
guide,1985-86, p.4864

II.A.3 - ITALY - RENAISSANCE

Castiglione:the ideal and the real in Renaissance
culture.Edited by Rbt.W.Hanning and David
Rosand.New Haven and London,Yale Univ.Press,
1983
215 p. illus.
Ch.6:Rosand,David.The portrait,the cour-
tier and death
Discusses the Renaissance portr.as a com-
memorative art,which finds in its develop-
ment its inspiration in antiquity
Portrs.within portrs,figs.2 & 10

LC BJ1604.C33C37 1983 Woods-Marsden In:Art J.
 46:215 note 31

II.A.3 - ITALY - RENAISSANCE

Smith, Alistair
Renaissance portraits.London,National Galle-
ry,1973
48 p. illus. (Themes and painters in
the National Gallery,no.5)

LC ND1309.2S64

II.A.3 - ITALY - RENAISSANCE

Davis, Marian Belle
A study of Venetian portraiture of the
early renaissance
illus.

Thesis-Radcliffe,1948

FOGG
Widener

Fogg,v.11,p.319

II.A.3 - ITALY - (High)RENAISSANCE

Tschudi, Hugo von, 1851-1911 ed.
Das porträt. Berlin,J.Bard & B.Cassirer,
1906-07
4 pts. illus.(part col.)

M&T
195.3
T78
3pts..
in 1 v.
Contents.-1.Gurlitt,Cornelius.D.englische por-
trät im 18.jahrh:Gainsborough,Romney,Raeburn.-
2-G.,C. D.engl.portr... :Reynolds,Hoppner,Lawrence.
3.Gie,Oscar.D.bürgerliche portr.des 19.jahrh.in
Deutschland:Chodowiecki,Graft,Krüger,Runge,Oldnach
4.Schaeffer,Emil:D.portr.der italienischen hochren
naissance

Amsterdam.Rijksmus.Kunsth.
bibl.Cat.25939.A52deel 1
CFA p.125

205
P19
NCFA
v.19

II.A.3 - ITALY - RENAISSANCE

Gombosi, György
Uber venezianische bildnisse

In:Pantheon
19:102-10 Apr,1937 illus.

In NCFA copy section with synopsis in Eng-
lish is missing

Repro:Lotto,Giorgione,Moroni,Titian,Palma,Tin-
toretto,etc.

Enc.of World Art,v.11
N31E56Ref.col.513
bibl.on portr.

II.A.3 - ITALY - RENAISSANCE

Vienna. Kunsthistorisches Museum. Schloss-
Sammlung Ambras
I Ritratti Gonzagheschi della collesione
di Ambras ,di,Giuseppe Amadei e di Ercolano
Marani.Mantova,Banca Agricola Mantovana,1980
284 p. illus(col.)

Bibliography p.255-71

RPB

Spike.Baroque portraiture..
N7606.S75 NPG Bibl.p.194

II.A.3 - ITALY - RENAISSANCE

La Sizeranne, Robert de, 1866-1932
Celebrities of the Italian renaissance in
Florence and in the Louvre,,...London,New York,
Brentano's,1926.
363 p. illus.

Translation of Les masques et les visages à
Florence et au Louvre

Contents.-Giovanna Tornabuoni in the Louvre.-
La Bella Simonetta at Chantilly.-Lucresia de Me-
dici at Santa Maria Novella.-Tullia d'Aragon at
Brescia.-Eleanor of Toledo in the Uffizi.-
LC DG540.L33 Fogg,v.11,p.323

II.A.3 - ITALY - RENAISSANCE

Weisbach, Werner, 1873-1953
Das frauenbildnis in der malerei der itali-
enischen renaissance

In:Museum
4:

LC for Museum:
N7511.M7

 Waetzoldt ND1300.W12

II.A.3 - ITALY - RENAISSANCE

Woermann, Karl, 1844-1933
Die italienische bildnismalerei der renais-
sance. Esslingen,P.Neff(M.Schreiber),1906

94 p. illus.

Bibliography

LC ND1318.W6 Waetzoldt ND1300.W12

705
A786
NCFA

II.A.3 - ITALY - 15-16th c.

Frankfurter, Alfred M.
Great Renaissance portraits

In:Art N
38,no.24:6-9,21 Mar.6,'40 illus.

Pertains to exh.at Knoedler & co.,N.Y.,
March 18 - April 6, 1940

Repro.:Antonio Pollaiuolo, Jac.Bellini,
Roberti, Raphael, Titian

II.A.3 - ITALY - RENAISSANCE

Zervos, Christian
Notes sur les portraits et les figures de la
renaissance italienne

In:Cahiers d'art
25,no.2:365-82 1950 illus.
26:97-114 1951 illus.

Repro.:From Giotto to Tintoretto
Sitters incl.:Elisabetta da Montefeltro,du-
chesse d'Urbin & Lionello d'Este

LC N2.C35 Enc.of World Art Portrs.
 bibl.N31E56 Ref.
 Rep.1950-51*10441 & 10442

705
P19
v.6
1930
NCFA

II.A.3 - ITALY - 15-16th c.

Kiel, Hanna
Oberitalienische porträts der sammlung
Trivulsio

In:Pantheon
6:441-8 sup.78-9 Oct.,'30 illus(1 col.)

Repro.incl.Antonello da Messina,Bernardino
dei Conti,Zanetto Bugatti,Baldass d'Este(Baldas
sare Estense)Ambrogio de Predis?,Paolo Morando

II.A.3 - ITALY - 15th c.

Hill, George Francis, 1867-
...Italian portraits of the 15th century...
London,Pub.for the British academy by H.Milford,
Oxford university press.1925.
20 p. illus. (.The British academy.,
Annual Italian lecture)

LC ND1318.H5 Fogg,v.11,p.320

705
B97
NCFA
v.119

II.A.3 - ITALY - 16th c.

Bury, John
The use of candle-light for portrait paint-
ing in sixteenth-century Italy

In:Burl.Mag
119:434-7 June,'77

Refers to Francisco de Holanda's treatise
'Do tirar polo Natural',where is stated the
customary use of candle-light for portrs.by
Italian ptrs.in the 16th c.
Do tirar polo natural=On taking portraits
from life

ND
1308
S63
NPG

II.A.3 - ITALY - 15th c.

Sleptsoff, L.M.
Men or supermen ? The Italian portrait in
the 15th century.Jerusalem,The Magnes Press,
the Hebrew University,1978
159 p. illus.

Bibliography

The new individualistic approach to por-
*traiture in Italy in the 15th c.

V:
Portrs.
Italian

II.A.3 - ITALY - 16th c.

Monsen, Christine
A comparative study of 16th c.Italian
male portraits in the National Gallery with
a brief discussion of General Portraiture.
Typewritten MS.,1984
12 p. illus.

Bibliography

AP
1
A784J8
NCFA

II.A.3 - ITALY - 15-16th c.

Armstrong, Walter, 1850-1918
Early Italian portraits

In:Art J.
:46-8 1901 illus.

FOR COMPLETE ENTRY
SEE MAIN CARD

II.A.3 - ITALY - 16th c.

Zappella, Giuseppina
Il Ritratto nel libro Italiano del cinquecen-
to.Milan,Editrice Bibliografica,1988
2 vls. v.1,405 p., v.2,374 plates

MET

AP
1
J8654
NPG

II.A.3 - ITALY - 16-18th c.

Hughes, Diane Owen
Representing the family:Portraits and purposes in early modern Italy

In:J.Interdisc.Hist
17,no.1:7-38 Summer,'86 illus.

Repro.incl.:Petrus Cristus:Portrs.of donors;
Lorenzo Lotto:Double portrait

Bibliographical references

II.A.3 - ITALY - LOMBARDY - 19th c.

Verbania, Italy. Kursaal di Pallanza
Il Ritratto nella pittura lombarda dell'Ot-
tocento;cat.a cura di Marco Valsecchi.Verbania-
Kursaal,agosto - settembre,1953..Milano,Edizioni
del Milione,1953.
32 p. illus.

FCGC
3812
V21

Bibl.p.29-e33.

Bibliografia del libro d'ar
te Italiano.Z5961 1952-62
I 8 B58v.2,t.2,NCFA p.564

II.A.3 - ITALY = 16-18th c.

Ojetti, Ugo, 1871-1946
Il ritratto italiano dal Caravaggio al Tie-
polo alla mostra di Palazzo Vecchio nel 1911
sotto gli auspici cel comune di Firenze.Bergamo,
Istituto italiano d'arti grafiche,1927
282 p. illus.

MET
174
Oj24
Q

Eller.Kongel.portr.malere
p.516

II.A.3 - ITALY - TUSCANY - 16th c.

Grohn, Hans Werner
Das Porträt des Manierismus in der Toscana.
1942
114 p.

Ph.D.Thesis-Humboldt Univ.,Berlin

Maschinenschr.

Bibl.su kunst & kunstgesch.
Z5931.B58 1945-53 NCFA
p.97 no.1853

ND
1318.2
A32
E1968
NPG

II.A.3 - ITALY - FLORENCE

Alazard, Jean, 1887-1960
The Florentine portrait. New York,Schooken
Books,1968.
235 p. illus.

Translation of Le portrait florentin de Botticel-
li à Bronzino.
Bibliography:p.229-35

LC ND1318.A515

AP1
A64
NCFA
v.58

II.A.3 - ITALY - VENICE

Godfrey, F.M.
Male portraits of the Venetian school

In:Apollo
58:96-7 Oct.,1953 illus.

In 5 youthful head,here under discussion,the
way of Venet.portr.is curiously summarized.From
flat drawg.to sculpt.modelling;poetical fervor &
idealisation added later.Venet.portr.more uniform
than Florentine or Roman,but with some particular
human traits.

Enc.of World Art
N31E56Ref.,v.11,col.513
bibl.on portr.

II.A.3 - ITALY - FLORENCE

Schaeffer, Emil, 1874-
Das Florentiner bildnis. Munich,F.Bruckmann,
1904

237 p. illus.

Das portr.as chronicler of the Flor.Renaiss.
Understanding of the human being as a physical &
spiritual unit. From Giotto to Bronzino.
The portr.in frescoes.Religious ptgs.(donors;
sitters as SS.).Secular portrs.of the 15th c.
(equestrian;imitation of sculpture
LC ND1318.S35 Goldscheider 757.G52
Waetzoldt ND1300W12

705
P19
NCFA
v.19

II.A.3 - ITALY - VENICE

Gombosi, György
Uber venezianische bildnisse

In:Pantheon
19:102-10 Apr,1937 illus.

In NCFA copy section with synopsis in Eng-
lish is missing

Repro:Lotto,Giorgione,Moroni,Titian,Palma,Tin-
toretto,etc.

Enc.of World Art,v.11
N31E56Ref.col.513
bibl.on portr.

705
A7832
NCFA

II.A.3 - ITALY - FLORENCE(15th c.)

Lipman,Mrs.Jean Herzberg, 1909-
The Florentine profile portrait in the
quattrocento

In:Art Bul
18:54-102 Mar,1936 illus.
Master's Th.-N.Y.Univ.,1934, same title.
Profile portrs.almost exclusively limited to
Florence in the 2nd half of 15th c.Esthetic mean-
ing of profile & reason for its use;its genesis &
history in Italy. Full-length portr.exclusively in
equestrian portr. Florentine bust-length portr. the
most static form of all portr.forms
Rep.1936*4432

II.A.3 - ITALY - VENICE

Ridolfi, Carlo, 1594-1658
Le maraviglie dell'arte,ovvero Le vite
degli illustri pittori veneti,e dello stato...
herausgegeben von Detlev freiherrn von Hadeln...
Berlin,G.Grote,1914-24
2 v. illus.

Bibliography
Incl.repro.of title-page of original edi-
tion,Venetia,1648.This ed.incl.48 copper-engr.
portraits

C ND34.R5 1914 Daugherty.Self-portrs.of
P.P.Rubens mfm161 NPG,p.XIV
footnote 12

II.A.3 - ITALY - VENICE

Schaeffer, Emil, 1874-
Das weib in der venezianischen malerei.
Breslau,R.Galle Buchdruckerei,1898

103 p.

Inaug.diss.-Breslau

Bibliography

LC ND1318.S4 Waetzoldt ND1300.W12

II.A.3 - JAPAN

Prinker, Helmut
Die zen-buddhistische bildnismalerei in
China und Japan von den anfängen bis zum ende
des 16.jahrh.;eine untersuchung zur ikonogra-
phie,typen-und entwicklungsgeschichte.Wiesbaden,
F.Steiner,1977
279 p. illus. (Münchener ostasiatische
Studien,Bd.16)

Bibliography

LC ND1326.B74 Lee.Varieties of portr.in
China & Japan,p.174,note 2
CPA,Bull.Apr.1977.708.1.G6
c62

II.A.3 - ITALY - VENICE

Valcanover, Francesco
Il ritratto veneto da Tisian al Tiepolo a
Varsavia

In:Arte veneta
10:240-4 1956 illus.

Repro:Tintoretto,Strossi,P.della Vecchia,Grassi
etc.

FOGG
3806 Pertains to exh:Portret wenecki od Tycjana
v45wa do Tiepola.Warsaw.Museum narodowe,15kwie-30maj 1956
cat.by F.Valcanover:137p. illus. Bibl.

N6921.V5.A6 Enc.of World Art.bibl.on
portr. a.136 Ref.v.11,col.514

II.A.3 - LATVIA

Padomju Latvijas portretu glesnieciba..Sastadiju-
si O.Kärklina.Makslinieks H.Šeiers. Riga,
Liesma,1970
.56 p.. illus.(colored)

Russian title:Portretnaia zhivopis' Sovets-
koi Latvii
Latvian and Russian text. Engl.French,Ger-
man summaries
Translation:Portraits by Soviet-Latvijan
artists. Compiled by O.Karklina...

LC ND1320.6P32 Fogg,v.11,p.320

II.A.3 - ITALY - VENICE - RENAISSANCE

Davis, Marian Belle
A study of Venetian portraiture of the
early renaissance
illus.

Thesis-Radcliffe,1948

FOGG
Widener

Fogg,v.11,p.319

II.A.3 - MEXICO - 18-20th c.

Mexico(City) Instituto Nacional de Bellas
Artes. Departamento de Artes Plásticas
45 autorretratos de pintores mexicanos,
siglos 18 a 20...exposición del Museo Nacio-
nal de Artes Plásticas.México,1947.
118 p. illus.

LC ND1312.M4 MOMA,v.11,p.438

VF
London
Royal II.A.3 - ITALY - VENICE - 16th c.
acad.
of arts Popham, Hugh
The genius of Venice

In:The Lamp
66:22-7 Spring,'84 illus(col.)

Pertains to exh. at London.Royal academy
of arts:The genius of Venice,1500-1600

759.972 II.A.3 - MEXICO - 19th c.
M77
Montenegro, Roberto, 1887-
...Pintura mexicana(1800-1860).Mexico,1934
19 p. illus(part col.)
Second edition

53 Repro.of portrs.,most of them by José
María Estrada

LC .N7596.M6. MOMA p.432,n.s

II.A.3 - JAPAN
Oriental art only used by exception

705
A784 II.A.3 - MEXICO - 19th c.
NCFA
v.31 Pach, Walter, 1883-1958
A newly found American painter:Hermenegildo
Bustos

In:Art in Am
31:32-43 Jan.,'43 illus.

Most of bustos'work in Muños collection

II.A.3 NETHERLANDS (HOLLAND)
(BELGIUM-FLANDERS)
(BELGIUM is separated after 1830)

qN
7621.2
N4A52
NPG
2 c.

II.A.3 - NETHERLANDS

Regteren Altena, I.Q.van, 1899-
De portret-galerij van de universiteit van
Amsterdam en haar stichter Gerard van Papen-
broeck,1673-1743...I.Q.van Regteren Altena en
P.J.J.van Thiel...met een voorwoord van H.
Engel.Amsterdam,Swets en Zeitlinger,1964
387 p. illus(1 col.)

Summary in English

II.A.3 - NETHERLANDS

Gerson, Horst
Zes eeuwen Nederlandse schilderkunst.Amster-
dam,Contact,1962.
3v.in 1 illus. (De schoonheid van ons
land,deel 8,11,17)

Deel I:Van Geertgen tot Frans Hals.Deel II:
Het tijdperk van Rembrandt en Vermeer.Deel III:
Schilderkunst voor en na van Gogh

LC ND644.G4

II.A.3 - NETHERLANDS

Riegl, Alois, 1858-1905
Das holländische gruppenporträt...Wien,
Osterreichische staatsdr.,1931

2 v. illus.(88 pl.)

Bibliography

Lipman.The Florentine pro-
file portr...:"for study of
outer unity of N.portrait-
ure as opposed to Inner uni
ty of Italy"

LC ND1319.R45

II.A.3 - NETHERLANDS

Hofstede de Groot, Cornelis, 1863-1930
Meisterwerke der porträtmalerei auf der Aus-
stellung im Haag,1903. München,F.Bruckmann,1903
46 p. illus.

Exhibition held at The Hague,Kunstkring.Jul.1-
Sep.1,1903.

Repro.are almost all of Netherlandish masters

FOGG
4353
H71*

NUC pre-56:NYPL for LC Amsterdam Rijksmuseum cat.
25939A52,deel 1,p.126

II.A.3 - NETHERLANDS

Staring, Adolph, 1890-
De Hollander thuis....Dutch homes,three
centuries of Dutch conversation pieces.
's-Gravenhage,Nijhoff, 1956

206 p. illus.

Intro. in Dutch and English

LC ND644.S7

II.A.3 - NETHERLANDS

Lübke, Wilhelm, 1826-1893
Zur geschichte der holländischen schützen-
& regentenbilder

In:Rep Kunstwiss
1:

"Rep Kunstwiss"
LC N3R4 Waetsoldt ND1300.W12

II.A.3 - NETHERLANDS

Staring, Adolph, 1890-
Kunsthistorische verkenningen:een bundel
kunsthistorische opstellen.'sGravenhage,
A.A.M.Stolz,1948
150 p. illus. (Onbetreden gebieden
der Nederlandsche kunstgeschiedenis,deel 3)

Incl.:Nederlandsche portretminiaturen,p.73-87

LC ND1319.S8 Bruijn Kops in:B.Rijksmus.
30:196,note 3

ND
1319
P23
NPG

II.A.3 - NETHERLANDS

Paris. Musée de l'Orangerie
Le portrait dans l'art Flamand;de Memling
à Van Dyck.Exposition.Orangerie des Tuileries,
Paris;21 octobre 1952-5 Janvier 1953.intro.by
Paul Fierens..Bruxelles,Editions de la Connais-
sance,1952
70 p. illus(part col.)

Index of sitters

II.A.3 - NETHERLANDS

Wirtenberger, Franssepp, 1909-
Das holländische gesellschaftsbild.Schram-
berg(Schwarzwald),Gatwser & Hahn,1937
v,104 p. illus.

MET
182
W96

FOGG
FA
4058.16

FOR COMPLETE ENTRY
SEE MAIN CARD

II.A.3 - NETHERLANDS - 15th c.

Lavalleye, Jacques, 1900-
Le portrait au 15ᵐᵉ siècle.2.éd..Bruxelles,
Éditions du Cercle d'art,1945
27 p. illus. (L'art en Belgique)

Bibliography

LC ND1319.L3 ◖ Fogg,v.11,p.323

II.A.3 - NETHERLANDS - 16th c.

Vries, Ary Bob de, 1905-
Het Noord-Nederlandsch portret in de 2ᵉ
helft van de 16ᵉ eeuw.Amsterdam,N.V.Uitgevers
Maatschappij Enum,1934
illus .

FOGG
FA
4353.13 Proefschrift-Utrecht

Fogg,v.11,p.319

708.1
M52
NMAA
v.43

II.A.3 - NETHERLANDS - 15-16th c.

Bauman, Guy
Early Flemish portraits,1425-1525

In:Met Mus Bul
43,no.4:1-65 Spring,'86 illus(part col.)

Repr.incl.:Donor portraits
Discusses the attitudes of early Flemish
artists and their patrons toward portraiture.
Investigates the uses of the genre at the time.

II.A.3 - NETHERLANDS - 17th c.

Bie, Cornelis de, 1627-1716?
Het gulden cabinet van de edel vrij schil-
der-const inhovdende den lof van de vermaerste
schilders,...beldthowers en de plaetsnijders
van dese eeuw door Corn.de Bie...T'Antwerpen
gedruckt by Ian Meyssens,1661
3 l. 120 ports.
Engraved t.-p.;added engraved t-pages in
Latin and French.French t.-p. has imprint:An-
vers, Jean Meyssens,1649

NNC NjP ◖ Goldscheider.N40.G65X NCFA
Bibl.p.59

Xerox II.A.3 - NETHERLANDS - 15 & 16th c.
copy
of Ring, Grete
contents Beiträge sur geschichte niederländischer
& pre- bildnismalerei im 15.&16. jahrhundert. Leipzig,
face in E.A.Seemann,1913

173 p.

Appendix:1.systematical bibliography
2.list of mentioned portraits
pp.101-23:Das selbstporträt

Based on her dissertation,1912 Florentine
profile portr... also:
LC ND1319.R5 ◖ Goldscheider 757/.052

II.A.3 - NETHERLANDS - 17th c.

Bie, Cornelis de, 1627-1711?
Het gulden cabinet vande edele vrij schil-
der-const...waer-inne begrepen is den...loff
vande vermaerste...schilders van dese eeuw...
Antwerpen,1662

LC Rare book room J16.662B ◖ FOR COMPLETE ENTRY
SEE MAIN CARD

II.A.3 - NETHERLANDS - 16th c.

Campbell, Edith
A discussion of certain aspects of the in-
fluence of the Renaissance on Netherlandish
portrait painting in the 1st half of the 16th
century

Master's Th.-Northampton,Mass.,Smith Coll.,
1934

Lindsay,K.C.,Harpur Ind.of
master's theses in art...
Z5931.L74 1955 NCFA Ref.
p.24,no.411

II.A.3 - NETHERLANDS - 17th c.

Bie, Cornelis de, 1627-17 ?
Het gulden cabinet van de edele sthilder-
const ontsloten door den lanck ghewenschten vre-
de tusschen de twee machtighe croonen van
Spaignien en Francrijk...2de ed..Antwerpen,1662

MET
182
B471 'Contains the portr.coll.of Jan Meyssens of
1648/49'.-Goldscheider

UkOxU

II.A.3 - NETHERLANDS - 16th c.

Sterck, Johannes Franciscus Maria, 1859-1941
Portraits of the 16th century

In:Oud Holland
43,no.6:249-66 1926

LC DJ1.09 Chicago.Art Inst.Ryerson
Libr.Ind.to Art periodicals
f255.37.C53,v.6 NCFA Ref.
p.7029

II.A.3 - NETHERLANDS - 17th c.

Eckardt, Götz
Selbstbildnisse niederländischer maler des
17.jahrhunderts.Berlin,Henschelverlag,1971
217 p. illus(part col.)

"Incl.cat.with bibliographical references &
records differences of opinion,which has not
been done since Benkard's study."-Daugherty,
Self-portrs.of P.P.Rubens,p.XVIII,footn.21

LC ND1319.3E25 Rose,B.In:Art in Am
63:73 footnote 3

II.A.3 - NETHERLANDS - 17th c.

Gerson, Horst
Hollandse portretschilders van de 17e eeuw.
Maarssen,G.Schwartz.1975.
24 p. illus.

Bibl.references

LC ND1319.3.G47

DA
758.3
S807x
NCFA

II.A.3 - NETHERLANDS - 17-(begin)18th c.

London. National Portrait Gallery
The house of Stuart,by David Gransby.London,H.M.stationery off.,1968

20 p. illus(part col.) (Its Kings and
Queens series;1603-1714)

MET
276.5
L844

N
7607
J66
1986X
NPG

II.A.3 - NETHERLANDS - 17th c.

Haarlem. Frans Hals museum
Portretten van echt en trouw.Huwelijk en
gesin in de Nederlandse kunst van de 17e eeuw,
exh.cat. by Eddy de Jongh.Zwolle,Waanders,
1986
333 p. illus(part col.)

Exh.15 feb.-19 may,1986

II.A.3 - NETHERLANDS - 19th c.

Hague. Haagsche Kunstkring
Tentoonstelling van portretten van Nederlandsche meesters. 2e gedeelte. 1850-1900
's-Gravenhage,1900.

Amsterdam,Rijksmus.cat.
25939,deel 1,p.375

II.A.3 - NETHERLANDS - 17th c.

Huemer, Frances
Portraits.Brussels,Arcade Press,N.Y.,
Phaidon,1977
v. illus. (Corpus Rubenianum Ludwig
Burchard,pt.19)

LC ND676.R9C63 Pt.19
ND1329.R8

FOR COMPLETE ENTRY
SEE MAIN CARD

II.A.3 - NETHERLANDS - 20th c.

Arnhem,Netherlands. Gemeentemuseum
Portrettisten:Nederlandse kunstenaars van
nu.Arnhem,1959
47 p. illus.

Cat.of exhibit,22 Mar-14 June.
Foreword by Hans Redeker

PPPM

MOMA, p.434, v.11
OMA 1.9/xA83

AP
1
A64
NCFA
v.110

II.A.3 - NETHERLANDS - 17th c.

Robinson, William W.
Family portraits of the Golden Age

In:Apollo
110:490-7 Dec.'79 illus.

figs.10 & 11:Portraits historiés

Schama,S.in:J.Interdisc.
Hist.v.17,no.1 AP1.J8654
NPG p.160,footnote 8

II.A.3 - NETHERLANDS - FRIESLAND - 16th c.

Wassenbergh, Abraham, 1897-
L'art du portrait en Frise au 16e siècle.
Leyde,Leidsche Uitgeversmaatschappij,S.A.,1934
illus.

FCCO
FA
4058.8.10

Thèse-Paris

Bibliography

Fogg,v.11,p.319

II.A.3 - NETHERLANDS - 17 & 18th c.

Arschot-Schoonhoven, Philippe Paul Alexis
Guillaume,comte d',1908-
...Le portrait aux 17eet 18e siècles.
Bruxelles,Editions du Cercle d'art,1945
45 p. illus. [L'art en Belgique]

Bibliography

LC ND1319.A7

Martin Nijhoff,list 638
[March,'73] no.6

II.A.3 - NETHERLANDS - FRIESLAND - 17th c.

Wassenbergh, Abraham, 1897-
De portretkunst in Friesland in de 17e eeuw.
Lochem,De Tijdstoom,1967,1968.
140 p. illus.(part col.)

Summary in English

LC ND1319.W32

Fogg,v.11,p.319

II.A.3 - NEW ZEALAND

Nan Kivell, Rex
 Portraits of the famous and infamous:Austra-
lia,New Zealand and the Pacific,1492-1970.by.
Rex Nan Kivell and Sydney Spence...London.distr.
by.Maggs Bros.,ltd.,1974
 271 p. illus(part col.)

LC N7615.4.W36 fol. Buscombe.Australian colon'l
 portrs. ND1327.A85B97 NPG
 Bibl.note p.72

II.A.3 - NORWAY

Gran, Henning, 1906- (& Revold↓ Reidar)
 Kvinneportretter i norsk malerkunst. Oslo,
H.Aschehoug & co.(W.Nygaard)1945.i.e.1946.

 93 p. illus.(part col.)

Review by Holm,Arne E., In:Ord och Bild:23-29
1945 illus.

 Portrs. as artform. Norwegian portrs.of women
fr.Renaissance to Munch,by Gran;fr.Munch to pres-
ent,by Revold Rep.,1948-49*864
LC ND1321.G67

II.A.3 - NORWAY

Østby, Leif
 Das bidnis in Norwegen. Hamburg,v.Diepen-
broick-Grüter & Schuls,1937

Met 90 p. illus.
195.3
Os7 Bibliography

II.A.3 - OCEANICA

Nan Kivell, Rex
 Portraits of the famous and infamous:Austra-
lia,New Zealand and the Pacific,1492-1970.by.
Rex Nan Kivell and Sydney Spence...London.distr.
by.Maggs Bros.,ltd.,1974
 271 p. illus(part col.)

LC N7615.4.W36 fol. Buscombe.Australian colon'l
 portrs. ND1327.A85B97 NPG
 Bibl.note p.72

II.A.3 - POLAND

Dobrowolski, Tadeusz
 Polskie malarstwo portretowe;ze studiów nad
sztuka epoki sarmatyzmu(Polish portrait painting
Kraków,1948
 239 p. illus.

 Summary in French

 Bibl.footnotes

LC ND1320.D6 Enc.of World Art N31E56Ref
 v.11,p.513

II.A.3 - POLAND

Ryszkiewics, Andrsej
 Polski portret sbiorowy. .Wyd.1.Wroclaw,
Zaklad Narodowy im.Ossolińskich,1961
 206 p. illus.

 At head of title:Instytut Sztuki Polskiej
Akademii Nauk.
 Dissertation
 Bibl.footnotes

LC ND1320.R9 Fogg,v.11,p.320

ND II.A.3 - POLAND - 17-18th c.
1324
P7P85 Portret polski;17 i 18 wieku;Katalog wystawy.
NCFA Muzeum Narodowe w Warszawie,kwiecień-maj
 1977--.Warszawa,Muzeum Narodowe,197775
 72 p. illus.

 Index of sitters

705 II.A.3 - PORTUGAL
C75
NCFA Asevedo, Carlos
v.137 Masters of Portuguese portraiture

 In:Connoisseur
 137:3-9 Mar,1956 illus(part col.)

 Pertains to portrs.in exhib.:Portuguese art from
 800-1800. London.Royal academy of arts;Oct. ,1955-
 Feb.19,1956. Held in Burlington House

 Repro:Nuno Gonçalves,Domingos Vieira,Domingos
 Sequeira,Vieira Portuense,Lupi,etc.
 Enc.of World Art,v.11
 Bibl. on portr.col.514.N31E56Ref.

II.A.3 - PORTUGAL

Kenner, Dr.Fr.
 Die porträtsammlung des Erzherzogs Ferdinand
von Tirol

In:Jb.d.kunsthist.sammlungen des österr.kaiserh.
Bd.XIV:37-186:Geschichte/ der Slg:D.Bildnisse d.
Erzhauses Habsburg(1893);Bd.XV:147-259:D.deut-
schen Bildnisse.Wundermenschen(1894);Bd.XVII:101-
274:Ital.Bildn.(1896);Bd.XVIII:135-261:D.Medici.
Neapel,Celebritäten(1897);Bd.XIX:6-146:Spanien,
Portugal,Frankr.Engl.,Schottld. Der Orient(1898)
LC N3.J4 Rave,P.O. Paolo Giovio u.
 J.bildnisvitenbücher...
 Jb.d.Berl.Mus. I 1959:144
 footnote LC N3.J16 fol.

II.A.3 - RUMANIA

Bertalan, Karin
 Catalagui expozitici comemorative Arthur
Coulin.Muzeul Brukenthal Sibiu,1969

 Muzeul Brukenthal Sibiu
 Cat.Patrimonial ND921.M8
 1983X NMAA Bibl. p. 7.

II.A.3 - RUMANIA

Bertalan, Karin
Catalogui expozitiei comemorative Carl
Dörschlag.Sibiu

Muzeul Brukenthal Sibiu
Cat.Patrimonial ND921.M8
1983X NMAA bibl.p.7.

II.A.3 - RUSSIA - 17th c.

Ovchinnikova, Ekaterina Sergeevna
Portret v russkom iskusstve 17 veka (Portrai-
ture in 17th c. Russian art).Moskow,1955
138 p. illus.

In Russian

LC ND1320.09 Enc.of World Art,v.11
 Y31E56 Ref.col.514
 bibl.on portr.

II.A.3 - RUMANIA

Drăgoi, Livia
Ioan Agotha,portretist din Transilvania

In:Revista Muzeelor
3:65-6 1979 illus.

NCA
M1.R523 Summary in French

LC AM69.R8N;3 Muzeul Brukenthal Sibiu
 Cat.Patrimonial ND921.M8
 1983X NMAA Bibl.p.7.

AP1
A64
NCFA
v.98

II.A.3 - RUSSIA - 18th c.

Bowlt, John E.
 Russian portrait painting in the late 18th c.

In:Apollo
98:5-13 Jul.,'73 illus.

Repro.:Antropov,Rokotov,Levitzky,Borovikowsky

ND
921
M8
1983X
NMAA

II.A.3 - RUMANIA

Muzeul Brukenthal
Catalog patrimonial de pictura românească
Maria Olimpia Tudoran.Sibiu,Muzeul Brukenthal
Sibiu.Galeria de Artă.1983?-
 v. 2 illus(part col.)

Bibliography:v.1,p.7.

705
C75
NCFA
v.83

II.A.3 - RUSSIA - 18th c.

Volkov, Nicholas
 Russian portrait painters of the age of
Catherine the Great

In:Conn
83:3-9 Jan.,'29 illus.

 Incl.:Argunov,Ivan;Antropov,Alexey;Losenko,
Anton P.;Stchukin, Stephen S;Shibanov(Schibanof;
Shebanov),Michail

 Cum.Mag.subj.ind.Al/3/76
 Ref.v.2,p.444

II.A.3 - RUSSIA

Mochalov, Lev Vsevolodovich
 The female portrait in Russian art;12th-
early 20th centuries;by L.Mochalov and N.Bara-
banova...Leningrad,Aurora Art Publishers.1974.
 232 p. illus(chiefly col.)

English & Russian

LC ND1320.M62

705
C75
NCFA
v.79

II.A.3 - RUSSIA - 18th c.

Volkov, Nicholas
 Russian portrait painting in the 18th c.
Rokotov,Levitzky and Borovikovsky

In:Conn
79:69-77 Oct.,'27 illus.

 Comparison with English school

 Cum.Mag.subj.ind.Al/3/76 Re'
 v.2,p.444

II.A.3 - RUSSIA

Zimenko, Vladislav Mstislavovich
 Sovetskaia portretnaia zhivopis'(Soviet
portrait painting). Moscow,...1951
 169 p. illus(part col.) (Sovetskoe isobra-
sitel'noe iskusstvo)

In Russian

LC ND1320.Z5 Enc.of World Art,v.11
 Y31E56 Ref.col.513
 Bibl.on portr.

ND
1320
I115
NPG

II.A.3 - RUSSIA - KOSTROMA - 18-19th c.

Ilmshchikov, Savelii Vasil'evich
 Kostromskie portrety(Kostroma portraits)-
18-19th centuries;new discoveries.Cat.of an
exhibition of portraits from the Soligalich
Regional Museum of the Kostroma Oblast...exhi-
bited at the State Russian Museum in Leningrad.
Leningrad,1974
 4 p.(text) 31 illus.(col.cover)

In Russian

II.A.3 - RUSSIA - UKRAINE

Kiev. Vseukrains'kyi istorychnyi musei imeni
T.Shevchenka
Ukrains'kyi portret...1925
63 p. illus.

Summary & list of illus. in French

.Exhibition catalogue.

LC ND1320.K5 ◖ Fogg,v.11,p.320

II.A.3 - SPAIN

Madrid. Museo Nacional de Pintura y Escultura
 Retratos de mujeres célebres del Museo del
Prado.60 repro.de los majores cuadros.Madrid,
Fernando Fé,1929.
 ¿4¿p. 60 pl. (los grandes maestros de
la pintura en España,8)

NJP ◗

II.A.3 - SPAIN

Herrero, José J.
 Retratos del Museo de la Real Academia de
San Francisco.Madrid,Impr.Aldecoa,1930
 41 p. illus.

At head of title:Junta de Iconografia Na-
cional
"Estudio preliminar por José J.Herrero":p.5.
-28

LC N7621.2.S6 NNU-W NJP ◖ Mengs.M40.1.M541M9.Bibl.
 p.191

II.A.3 - SPAIN

Madrid. Sociedad española de amigos del arte
 ...Catálogo de la exposición de retratos
de mujeres españolas anteriores a 1850. Madrid,
mayo y junio de 1918..Madrid,Blass y cia.,1918.
 65 p. illus.

Intro.by A.de Beruete y Moret
Incl. bibliographies

LC ND1322.S6 Amsterdam,Rijksmus.cat.
 ◖ Z5939A52,deel 1, p.155

II.A.3 - SPAIN

Jaon, Antonio, 1860-
 Retratos de mujeres(estudio sintético de
la evolución del retrato en la pintura es-
pañola).Segovia,A.San Martin,1917.
 199 p. illus. (Serie de monografias de
historia y arte,2)

Bibliography p.195-9

RPB CU MB PBm CU ◖ Mengs.M40.1.M541M9NMAA
 p.191

II.A.3 - SPAIN

Sentenach Y Cabañas, Narciso, 1856-1925
 Los grandes retratistas en España...Madrid.
Fototipia de Hauser y Menzet,1914
 147 p. illus.

N.Y.P.L.
Art dpt.
3-MCP

 ◯

II.A.3 - SPAIN

Kenner, Dr.Fr.
 Die portrātsammlung des Erzherzogs Ferdinand
von Tirol

In:Jb.d.kunsthist.sammlungen des österr.kaiserh.
Bd.XIV:37-186:Geschichte der Slg:D.Bildnisse d.
Erzhauses Habsburg(1893);Bd.XV:147-259:D.deut-
schen Bildnisse,Wundermenschen(1894);Bd.XVII:101-
274:Ital.Bildn.(1896);Bd.XVIII:135-261:D.Medici.
Neapel,Celebritäten(1897);Bd.XIX:6-146:Spanien,
Portugal,Frankr.Engl.,Schottld.Der Orient(1898)
LC N3.J4 Rave,P.O. Paolo Giovio u.
 ◖ i.bildnisvitenbücher...
 Jb.d.Berl.Mus. I 1959:144
 footnote LC N3.J16 fol.

II.A.3 - SPAIN - 16th c.

Klauner, Friderike
 Spanische portraits des 16.jahrhunderts

In:Jb.d.kunsthist.Samml.,Wien
57:123-58 1961 illus.

Portrs.of members of the hse.of Hapsburg in
Spain in the Kunsthist.Mus.in Vienna by P.Leoni
(head of Philip II in enameled silver,probably
for a suit of armor),Cello,Sofonisba Anguisciola
Pantoja,López,Gonzáles, etc.
LC N3.J4 Heins,G. Portr.gal.N7621.2
 ◖ A9V66 MPG Bibl.,p.39
 see over

II.A.3 - SPAIN

Madrid. Museo Nacional de Pintura y Escultura
 Retratos de hombres célebres del Museo del
Prado.Madrid,Fernando Fé,1929.
 ¿4¿p. 60 pl. (Los grandes maestros de
MET la pintura en España,7)
196.1
M26
P991

 ◖

II.A.3 - SPAIN - MADRID - 20th c.

Sánches-Camargo, Manuel, 1914-
 Pintura española contemporánea.Madrid,Edi-
ciones Cultura Hispánica,1954-
 v. illus.

 v.1:La nueva escuela de Madrid.-v.2:Diez
pintores madrileños,pintura española contemporá-
nea...1966;208 p.

v.1:LC ND808.S3
v.2:LC ND811.M25S3
 MOMA, v.11,p.439
 ◖ MOMA 50.6S26

II.A.3 - SWEDEN

Gripsholm slott. Statens porträttsamling
Katalog över Statens porträttsamling på
Gripsholm...Stockholm,1951-
2 v. illus.

Compiled by Boo von Malmborg

Contents.-1.Porträtt före 1809.-2.Porträtt
after 1809

LC N1935.G7A55

705
B97
NCFA
v.83

II.A.3 - SWEDEN - 18th c.

Asplund, Karl, 1890-
Carl Fredrik von Breda

In:Burl Mag
83:296-301 Dec.,'43 illus.

Repr.incl.:Self-portr.with sketched portr.
on easel

NPG
Ref.
Coll.

II.A.3 - SWEDEN

Johnsson, Ulf G.
Masterpieces from Gripsholm Castle:The Swe-
dish National Portrait Collection.Cat. of an exh.
at the National Portrait Gallery,Washington,D.C.,
Apr.13-July 10,1988.Stockholm,The National Swe-
dish Art Museums,1988
134 p. illus(part col.)

Incl.:Index:Artists and sitters
Foreword by Alan Fern
Intro.by Per Pjurström & Ulf G.Johnsson

II.A.3 - SWEDEN - 18th c.

Hultmark, Emil, 1872-1943
Carl Fredrik von Breda,sein leben und sein
schaffen.Stockholm,Centraltryckeriet,1915
234 p. illus.

LC ND793.B8H8

Asplund,C.F.von Breda,in:
Burl.Mag.83:299

II.A.3 - SWEDEN

Malmborg, Boo von
Svensk porträttkonst under fem århundraden.
Malmö,Allhem.Stockholm,Nationalmus.,1978
451 p. illus. (Nationalmusei skriftserie
no.18)

Incl.bibliogr.references and indexes

Summary in English

LC N7610.S9M34

705
C75
NCFA
v.35

II.A.3 - SWEDEN - 18th c.

Hultmark, Emil, 1872-1943
An interesting portrait by the Swedish pain-
ter Hans Hysing

In:Connoisseur
35:103-5 Feb.,1913 1 illus.

H.mentions several Swedish portraitists:
Georg Schröder,Lorens Pasch,Christian Richter,
Charles Boit,Frédéric Peterson,Charles Banoks,
Elias Martin,Carl Froderik van Breda

II.A.3 - SWEDEN

Svenskt porträttgalleri...Stockholm,H.W.Tull-
berg.1895-1911.
45 v. illus.

Ed.by Albin Hildebrand

With a general register by Albin Hildebrand
...1913. 867 p.

For contents see NUC pre-56

LC CT1322.S7

ND
544
M383
NCFA

II.A.3 - SWEDEN - 18th c.

Martin-Méry, Gilberte
La peinture française en Suède,hommage à
Alexandre Roslin et à Adolf-Ulrik Wertmüller,
Bordeaux,19 mai-15 sept.1967.Musée de Bordeaux
Cat.par Gilberte Martin-Méry,avec la concours d
Gunnar W.Lundberg.Bordeaux,le Musée,1967
151 p. illus.

LC ND546.M34

II.A.3 - SWEDEN - 17-18th c.

Nisser, Wilhelm, 1897-
Michael Dahl and the contemporary Swedish
school of painting in England...Uppsala,Alm-
qvist & Wiksells,...1927
159 p. illus.

Inaug.-diss.-Upsala
Literature & sources of info.

Contents.-Michael Dahl.-Hans Hysing.-Charl
Bolt.-Christian Richter

LC ND793.D3N5

Yale ctr.f.Brit.art Ref.
ND786+N57

II.A.3 - SWEDEN - 18th c.

Stockholm. National Museum
Carl Gustaf Pilo i Danmark.Utstallning i
Nationalmuseum,1985.inledning Bo G.Wennberg;
katalogtext Lars Rostrup Boyesen.Oversättning
och katalogredaktion Ulf G.Johnsson.Uddeval-
la,Risbergs Tryckeri.1985.
94 p. illus(part col.) (Nationalmusei
utställningskatalog no.488)

NGA
N3540
A2 v.488

II.A.3 - SWEDEN - 19-20th c.

Stockholm. Nationalmuseum
 Talande porträtt.Kända svenskar under hundra ar,1866-1966.Stockholm,1966
 59 p. illus. (Nationalmusei utställningskatalog nr.307)

LC N3540.A27 Rep. 1967 #1162

II.A.3 - U.S.

N
7593
A75
NPG

American Jewish Historical Society
 Paintings,daguerreotypes,artifacts;comp.
and ed.by Carlo M.Lamagna & Judith E.Endelman.Waltham,Mass.,Amer.Jew.Soc.,1974
 48 p. illus.

II.A.3 - SWITZERLAND

Wüthrich, Lukas Heinrich
 Schweizerische portraitkunst.Von der Renaissance bis zum Klassizismus...Bern,Paul Haupt,
1971
 16 p. illus. (Aus dem Schweizerischen
Landesmuseum,29)

LC N3650.A96 no.29 Verzeichnis lieferbarer Bü-
‹ ND1323.› cher 1973/74 NPG v.1,
 p.214

II.A.3 - U.S.

ND
205
A684
NCFA

Amon Carter Museum of Western Art, Fort Worth,
 American art from the coll.of the .To
Worcester Art Mus.,exh.,April 27-June 24,1979;
with an intro.by Rich.Stuart Telts.Fort Worth,
Tex.,Amon Carter Mus.,1979
 117 p. illus.

 Incl. index

LC ND1311.W6 1979 N.Y.(city)P.L.Art & archi-
 tecture Div.Bibliographic
 guide to art & architecture
 ICN Z5939.A791 NCFA Ref.p.202

II.A.3 - SWITZERLAND - 18-19th c.

Fuessli, Johann Caspar, 1706-1782
 Geschichte der besten künstler in der
Schweiz,nebst ihren bildnissen.with 152 portrs.
by Johann Rudolf Fuessli,Joh.Rud.Schellenberg,
N.Y.P.L. Joh.Heinr.Lips,etc..Zürich,Orell,Gessner,Füssli,
3-MAMG 1769-79
 5 v.

 ,Earlier ed.under title'Geschichte und abbil-
dungen der besten maler in der Schweis. 2v.
Zürich,1755-56.
 (Einleitung in d.geschichte der künstler
des Schweizerlan- des,by J.G.Wille.Anhang)

MH McU DLC

II.A.3 - U.S.

ND
205
B25
1961
NCFA

Barker, Virgil, 1890-
 American painting:History and interpretation
N.Y.,Macmillan Co.,1950
 717 p. illus.
 Bibliographical notes

 Incl.:Portraits by artisans & amateurs.
The Master of the Freakes. Portraits of children

LC ND205.B29 Fleischer.In Winterthur conf
 ‹ND207.W78 p.158

II.A.3 - SWITZERLAND - BERNE

Trenschel, Hans Peter
 Die bildnisse im Bernischen historischen
Museum.Zuwachs der jahre 1955-1966

In:Jb.Bern.Hist.Mus.
45-46:73-183 1965-66 illus.

 Descriptive cat.of recent acquisitions(por-
traits of Berne)

LC DQ401.B41 Rep.1969 #190

II.A.3 - U.S.

759.1
B25
NCFA

Barker, Virgil, 1890-
 Critical introduction to American painting.
N.Y.,Pub.by W.E.Rudge for the Whitney mus.of
American art,1931.
 52 p.
 Incl.selective,chronological list of Americ.
ptrs.,underdivided by styles,subject matter,form
etc.
 Discusses national modifications of portrai-
ture

 Lipman,J.Amer.primit.ptg.
LC ND205.B3 759.1.L76,Bibl.

7 II.A.3 - TURKEY - 18th c.

Boppe, Auguste, 1862-1922
 Les peintres du Bosphore au 18ᵉ siècle.
Paris,Hachette et cie.,1911
 231 p.

 Works by van Mour,A.Favray,Hilaire

 Bibliography & list of works

LC ND180.B73

II.A.3 - U.S.

Biddle, Edward
 Early American portrait painters,including
local annals connected with a number of them
(Read at the meeting of the Society).Philadel-
phia,the Numismatic and Antiquarian Soc.of Phila
1916.
 pp.64-87 illus.

 Extract

Winterthur
Mus.Libr.
ND1311.B58 Winterthur Mus.Libr.fZ881
 W78 NCFA v.6,p.217

ND
210
R62
E1960
NCFA

II.A.3 - U.S.

Bisardel, Yvon
 American painters in Paris...New York, Mac-
millan,1960
 177 p. illus.

 "...influence of Paris on...Amer.artists
(e.g.West,Copley,Trumbull,Mather Brown,Patience,
Jos.Wright,Peale,Vanderlyn,Fulton,etc.)....re-
lates.these artists to the European scene & con-
temp.trends in ptg...."(Whitehill)

LC ND207.F57

Whitehill.The Arts in ear-
ly Amer.Hist.Z5935.W59
Bibl.,p.82

II.A.3 - U.S.

Bowdoin College. Museum of Fine Arts
 The Winslows:pilgrims,patrons,and portraits
a joint exhib.at Bowdoin Coll...and the Mus.of
Fine Arts,Boston....:Brunswick,Me.:Bowdoin Col-
lege,1974.
 40 p. illus.

 Bibliographical references

LC ND1311.1B68 1974

ND
205
B62
NCFA
NPG

II.A.3 - U.S.

Black, Mary C. and Jean Lipman
 American folk painting,...New York,C.N.Potter
:1966:
 244 p. illus(part col.)

 Bibliography

LC ND1311.B55

N
7622
B87
NPG

II.A.3 - U.S.

The Brook, New York
 The collection of portraits of American
celebrities and other paintings belonging to
The Brook. A catalogue compiled by Diego Suares,
together with a history of The Brook...New York,
:George Grady Press,1962.
 105 p. illus(part col.)

N
6505
B62
NCFA

II.A.3 - U.S.

Black, Mary C.
 What is American in American art.An exh...
for the benefit of the Mus.of Amer.Folk Art
:Feb.9-March 6,1971.Intro.by Lloyd Goodrich,
cat.by Mary Black.N.Y.,M.Knoedler.1971.
 80 p. illus(part col.)

Exh.in memory of Jos.B.Martinson

 Index of artists

 'Folk art contained the essence of native
flavor
 Artain America H61c

N
7593
B87
NPG
NCFA

II.A.3 - U.S.

Brooklyn Institute of Arts and Sciences. Museum.
 Face of America,the history of portraiture
in the United States;an exhibition at the Brook-
lyn Museum,Nov.14,1957-Jan 26,1958 :Brooklyn,1957.
 unpaged illus.

 Introduction by John Gordon

LC N7593.B74

AP
1
H66
NPG
v.39

II.A.3 - U.S.

Blumenthal, Diane H.
 Images of America's past

In:Hist.News
39:31-3 Nov.,'84 illus(part col.)

 The Cat.of Amer.portrs.documents 70000
ptgs.in historical agencies & museums across
the country. It incl.also a file on historical
costumes as a method of dating.

 The Cat.of Amer.portrs.is a dpt.of the NPG

II.A.3 - U.S.

Bryant, Lorinda(Munson), 1855-1933
 American pictures and their painters...N.Y.
John Lane co.,London,John Lane;.etc.etc..1917
and 1921
 307 p. illus.

 see chs.I and II

LC ND205.B7

Weddell.A mem'l vol.of Va.
hist.portraiture.757.9.W38
NCFA Bibl.p.434

N
8232
B78
NCFA
NPG

II.A.3 - U.S.

Bowdoin College. *Museum of Fine Arts.*
 The portrayal of the Negro in American painting; ex-
hibition, the Bowdoin College Museum of Art, :Catalogue.
Brunswick: Me., 1964.
 1 v. (unpaged) illus.,ports. 28 cm.

 1. Negroes in art. 2. Paintings, American—Exhibitions. 3. Title.

N8232.R6

Library of Congress

64-4946

ND
205
B97
1965
NCFA

II.A.3 - U.S.

Burroughs, Alan, 1897-1965
 Limners and likenesses;three centuries of
American painting. New York, Russell & Russell,
1965 :1936.
 246 p. illus.

 Bibliography

LC ND205.B8 1965

II.A.3 - U.S.

Butler, Joseph Green
Autographed portraits, collection of Jos.G.
Butler,jr.,the Butler art institute,Youngstown,
Ohio, with biographies. Youngtown,O.,The Butler
art institute,1927.
470 p. illus.

LC K176.B98

N
7593
C53
NPG

II.A.3 - U.S.

Childs Gallery
Portraits.Childs Gallery.Boston,The Gallery
₁1979₎
₁33₎leaves illus.

Sales cat.

759.1
.C14
1907

II.A.3 - U.S.

Caffin, Charles Henry, 1854-1918
The story of American painting;the evolu-
tion of painting in America from colonial
times to the present...London,Hodder & Stoughton
₁1907₎
396 p. illus.

Ch.I.Colonial & Revolutionary conditions.-
Ch.II.Ptrs.in America after conclusion of
peace.-Ch.III.The growth of the national spi-
rit.-Ch.V.Remnants of English influence.-Ch.VI.
Influence of Düsseldorf & Munich

LC ND205.C2 1907a Weddell.A mem'l vol.of Va.
hist.portraiture.757.9.W36
NCFA Bibl. p.434

ND
205
C57m
NCFA

II.A.3 - U.S.

Cincinnati. Art Museum
Masterpieces of American painting from the
Pennsylvania academy of the fine arts,Philadel-
phia...₁Cincinnati Art Museum,c.1974₎

FOR COMPLETE ENTRY
SEE MAIN CARD

705
S94
NCFA
v.86

II.A.3 - U.S.

Carroll, Dana
Early American portrait painting

In:Studie
86:64-71 Feb.'27 illus.

Portrs.from 1641 to mid-19th c. in the
Th.B.Clarke coll.
Repro.:Wm.Read,Evert & Gerardus Duyckinck,
Couturier,Pieter Vanderlyn,Smibert,Strycker

Cumulated Mag.subj.index
A1/3/C76 Ref. v.2,p.443

017.37
.C59

II.A.3 - U.S.

Clarke, Thomas Benedict, 1848-
De luxe illustrated catalogue of early Ameri-
can portraits collected by Mr.Thomas B.Clarke,
New York city;to be sold...,Jan.7th,1919,.New
York,Lent & Graff co.,printers,1919
₁113₎p. illus.

The sale will be conducted by Mr.Thomas E.
Kirby of the Americ.art association,managers

LC N7593.C6

II.A.3 - U.S.

Cary, Elisabeth Luther, 1867-1936
The gallery of national portraiture in the
Pennsylvania academy of fine arts

MET
100.51
Scr.7
1906-07

In:The Scrip
2:363-6 1907 illus.

LC N1.S4

757.6
C61
NCFA

II.A.3 - U.S.

Clarke, Thomas Benedict, 1848-1931
Portraits by early American artists of the
17th,18th and 19th centuries,collected by Th.B.
Clarke...₁Philadelphia(?)c.1928₎
₁68₎p.

708.1
C536

II.A.3 - U.S.

Chicago, Art Institute
From colony to "ation; an exhibition of
American painting, silver and architecture from
1650 to the War of 1812, April 21 through June 19,
1949. ₁Chicago,1949₎

140 p. illus.

New England's provincial version of Tudor
court style in two dimensional, linear manner;
Feke's stylization of Highmore;Copley's realism.
Americ.portr.ptg. gets its own character:
Stuart,Peale,Trum- bull.

LC N5020.C613

ND
1311
D55
NPG

II.A.3 - U.S.

Dickson, Harold Edward, 1900-
Portrait USA,1776-1976;an exh.celebrating
the nation's bicentennial,Apr.18-June 6,1976...
University Park,Pa.,Mus.of Art,Penn.State Uni.
₁1976₎
133 p. illus(col.)

Incl.index

Rila III/1 #969
1977

ND
1311
D77
NPG
2 c.

II.A.3 - U.S.

Dresser, Louisa
Likeness of America,1680-1820..Colorado
Springs,Colo.,Colorado Springs Fine Arts Center
,1949.
1 v.(unpaged) illus.

44 works shown,incl.groups

Detroit.I.A. M40.1.P35D4
NPG Bibl. p.144

II.A.3 - U.S.

Grand central art galleries, New York
Portraits by distinguished American artists.
N.Y.,Grand central art galleries,inc.,1942.
87 p. illus.

LC N7593.G7

Art Books 1876-1949.Z5937
.775 NCFA Ref. p.496

705
A56
NCFA
v.96

II.A.3 - U.S.

Dresser, Louisa
Portraits owned by the American Antiqua-
rian Society

In:Antiques
96:717-26 Nov.,'69 illus(part col.)

Repro.incl.Ths.Smith,Pelham,Copley,Chandler
Gullager,M'Kay(Mrs.Bush holding miniature),Ma-
ther Brown,Greenwood,A.Fisher,S.Goodridge,E.
Goodridge

II.A.3 - U.S.

Hart, Charles Henry, 1847-1918
Hints on portraits and how to catalogue them.
...Philadelphia,Press of J.B.Lippincott company,
1898
32 p.

LC ND1311.H3

Fog.,v.11,p.322

757.3
.E28

II.A.3 - U.S.

Egbert, Donald Drew, 1902-
Princeton portraits...with the assistance of
Diane Martindell Lee. Princeton, Princeton Univ.
Press,1947

360 p. illus.

Portrs. owned by Princeton University

LC N7593.E36

.H33

II.A.3 - U.S.

Harvard university.
Harvard portraits;a catalogue of portrait
paintings at Harvard university,comp.by Laura
M.Huntsinger under the direction of Edward Waldo
Forbes.Edited by Alan Burroughs.Cambridge,Mass.,
Harvard university press,1936
158 p. illus.

Arranged alphabetically according to the
names of the sitters.Index of artists.

LC N7621.H32

Hist.rec.survey,Mass.v.2
N7593.1H67 p.511

II.A.3 - U.S.

Frankenberger, Charles, 1884-
The collection of portraits belonging to
the college

In:The Jeffersonian
17,no.13?:1-10 Nov.,'15

Jefferson Medical College,Philadelphia

DNLM(W1JE189)

Gerdts.Art of healing
N8223.G36 WPG p.114,note38

II.A.3 - U.S.

Harvard University William Hayes Fogg art mus.
Exhibitions
The American spirit in portraiture,1675-1900
Jan.19-Feb.24,1951..Cambridge,Mass.,,1951
13 p.

Mimeographed sheets.
Text by W.illiam.H.G.erdts & E.van.H.T.urner

FOGG
47
C17fe
1951

Fogg,v.11,p.329

ND
1311.3
G75
NPG
2 c.

II.A.3 - U.S.

Grand central art galleries, New York
Portraits by American artists.N.Y.Grand
central art galleries,inc.,1941
87 p. illus.

ND
1311.2
H515
NPG

II.A.3 - U.S. -

Hennessey, William James, 1901-
The American portrait:From the death of
Stuart to the rise of Sargent.Cat.(Exhib.)April
26,1973-June 3,1973.Worcester Art Museum
63 p. illus.

II.A.3 - U.S.

Historical Society of Western Pennsylvania,
Pittsburgh
An exh.of historical portraits,paintings,
prints,drawings and relics at the Carnegie
Institute,Pittsburgh 29 Oct.-30 Nov.,1916
69 p.

PW1 Chambers.David Gilmour
 Blythe..N40.1.B67C4d 1974a
 NMAA.Bibl.p.XXVI

705
M18
NCFA
v.19

II.A.3 - U.S.

Lee, Cuthbert, 1891-
The Thomas B. Clarke collection of early
American portraits

In:Mag Art
19:293-305 June,'28 illus.

In inaugural exh.of Philadelphia Mus. of Art

Incl.:earliest known portr.ptd.in this coun-
try:Rich.Bellingham by Wm.Read,1641
Repro.:see over Cumulated Mag.subj.index
 A1/3/C76 Ref.,v.2,p.443

ND
205
HR6
1976x
NCFA

II.A.3 - U.S.

Huntington Galleries
American art:from the limners to the Eight.
Exh..Feb.1 through May 2,1976,Huntington Gal-
leries,Huntington,W.Va. Ashland Oil,1976
120 p. illus(part col.)

Bibliography

Ptgs.are fr.private & public colls.in East
Kentucky,South Ohio & West Virginia.

LC ND205W R6 Grouped:Portraiture,p.30-53;landsc.,Folk art
1976 The West;The Eight continued on next card

N
7593
L4X
NPG

II.A.3 - U.S.

Lewis, John Frederick, 1860-1932
Coll.of John Frederick Lewis:American por-
traits,presented to the Pennsylvania academy of
fine arts and other institutions.Phila..The Penn-
sylvania academy of fine arts.1934
112 p. illus.

Exh.of American portrs:Coll.J.F.Lewis,Apr.15-
May 6,1934.Cat.& foreword by Mantle Fielding
'Incl.portrs.of Washington by Rembrandt Peale,
Rbt.Street,K.H.Schmolze,John Trumbull.Washington
family by Edw.Savage.Martha W. by J.Wollaston.'-
LC N7593.14 Art Digest 8:18, May 1,'34

ND
1311
K72
NPG

II.A.3 - U.S.

Knoedler, M.and company, New York
Masterpieces of American historical portrai-
ture.Loan exh.,Nov.5 to Nov.21,1936,at the gal-
leries of M.Knoedler and company...New York,1936
34 p. illus.

Foreword by John Hill Morgan

Incl.limners working before 1800
Foreword comments on Amer.portraiture,parti-
cular the school of Benjamin West

II.A.3 - U.S.

Long Beach, Calif. Museum of Art
American portraits old and new.Aug.22-
Sept.19,1971
folder illus.

MOMA
Libr. Text by W.T.Robinson - 46.works
Mus.box

 M:MA,p.43,v.11
 (Library Museum box)

ND
1311
L16
NPG

II.A.3 - U.S.

Lafayette College, Easton,Pa.
The Kirby collection of historical paintings
located at Lafayette College,....Easton,1963.
54 p. illus(part col.)

"The philosophy behind this collection,by
Allan P.Kirby":p.9-10

Bronze busts of four "Pioneers of the Indepen-
dence"after Houdon...

705
A56
NCFA
v.110

II.A.3 - U.S.

Mandel, Patricia C.F.
Amer.paintings at the Mus.of Art,Rh.Isl.
school of design.Providence.
Antiques
American painting.special issue.
110:965-1050, Nov.,1976 illus(part col.)
Chiefly 18th-19th century
Partial contents:P.C.F.Mandel,Amer.ptgs.at
the Mus.of Art,Rh.Isl.sch.of des.,p.966-75....

AP
1
H62
NCFA
v.26-27

II.A.3 - U.S.

Landau, Ellen G.
Study in National Trust Portraits

In:Historic Preservation
27,no.2:30-7 Apr.-June,'75 illus(part col.)

Repro.incl.:Washington's Family by Savage
Development of Amer.portraiture:Simple,aus-
tere in the 17th c.;idealized,elegant early
18th c.;neo-classical style,revelation of the
inner life,early 19th c.;return to exactitude
to rival with photography in the 1840's-50's;
 Rila III/2 1977 #5606

708.1
B87
v.4

II.A.3 - U.S.

Morgan, John Hill, 1870-1945
Exhibition of early American paintings.at
Brooklyn mus.,1917.

In:Brooklyn Mus.Q
4:67-96 Apr,'17 illus.

Repro.:Washington by C.W.Peale; Feke,Black-
burn,Copley,West,Trumbull,Stuart,Sully,Harding,
Waldo

II.A.3 - U.S.

Marell, Dorothy C.
 The effects of foreign influences upon
American portrait painting

 Master's Th.-Columbus,O.S.Univ.,1948

 Lindsay,K.C. Harpur Ind.of
 master's theses in art...
 1955 Z5931.L74 1955 NCFA Ref
 c.74 no.1344

II.A.3 - U.S.

Pittsburgh. Carnegie Institute. Dept. of
 Fine Arts
 Exh. of early American portraits,Jan.20th
to March 8th,1925..Pittsburgh.Dept.of fine
arts,Carnegie institute.1925?.
 8 l. illus.

MN

759.1
.N535

II.A.3 - U.S.

New York. Metropolitan museum of art.
 ...Life in America;a special loan exhibition
of paintings held during the period of the New
York World's fair,April 24 to Oct.29 ;1939;.
New York;Scribner press,1939.
 230 p. illus.

 ;"A visual account of life in America",by
H.B.Wehle

ND
207
H46
1986X
NMAA

II.A.3 - U.S.

Richardson, Edgar P.reston,1902-1985.
 American paintings and related pictures
in the Henry Francis du Pont Winterthur Mus.
Charlottesville,Univ.Press of Va.,1986
 157 p. illus(col.)

 Bibliography:p.153-7

 Partial contents:Ch.1:The Family Connec-
tion;-Ch.2:The Am.School to 1776.-Ch.3:The Am.
School from 1776
Repro.incl.:Washington Family by Edw.Savage.
Washington by Trumbull,Kemmelmeyer,Stuart

qN
7618
D1116
1987
NPG

II.A.3 - U.S.

New York. National academy of design
 Da pittore a pittore:raccolta di ritratti è
autoritratti della National academy of design
di New York.N.Y.,The Academy,c.1987
 160 p. illus(part col.)
 Index
 In Italian and English
 Cat.of an exh.held at Milan,Pinacoteca Ambre-
siana,Oct.16-Dec.18,1987 and at Florence,Galle-
ria degli Uffizi,Apr.15-Jne 15,1988
 "Mostra è cat.realizzati grazie a United Tech-
nologies Corp."
 Text by M.Quiel p.28-59

ND
205
R52
1965
NCFARef.
NPG

II.A.3 - U.S.

Richardson, Edgar Preston, 1902-
 Painting in America,from 1502 to the present
New York,Crowell,1965.
 456 p. illus(part col.)

 Bibliography

 Portraiture is discussed separately in each
period

 Whitehill.The Arts in ear-
 ly Amer.Hist.Z5935W59 NPG
LC ND205.R53 Bibl.,p.86

ND
1311.1
N53
NPG

II.A.3 - U.S.

Newark Museum Association, Newark, N.J.
 Early American portraits;an exhibition,
Oct.15-Nov.30,1947. Newark;1947;
 13 p. illus.

Harvard Univ.Libr.for LC

705
C75
v.141
NCFA

II.A.3 - U.S.

Rutledge, Anna Wells
 Portraits of American interest in British
Collections

 In:Connoisseur
141:266-70 illus. June,1958

 Chiefly Americans of European descent;incl.
also two Indian chiefs.

 Encyclop.of World Art
 Portrs.bibl.N31E56 Ref.

II.A.3 - U.S.

Pennsylvania Academy of the Fine Arts, Philadel-
 phia
 Gallery of national portraiture opening ex-
 hibition,Nov.18 to December 23, 1905
 Philadelphia, 1905
MET 74 p.
195.37
P532

AP
1
A area
v.12

II.A.3 - U.S.

Salisbury, William
 The Clarke collection of paintings

 In:Antiquarian
12:46-7,74 June,'29 illus.

 Three centuries of American portrs.(164 por-
traits by 77 artists)

 Repro.incl.:Chs.Bird King,Couturier,Gilbert
Stuart,David Johnson,Duveneck

 Winterthur Mus.Libr. fZ881
 .W78 NCFA v.6,p.224

759.1
S55

II.A.3 - U.S.

Sherman, Frederic Fairchild, 1874-1940
Early American painting...N.Y.,London,
The Century co...c.1932.
289 p. illus.

Bibliography

q ND
205
W35X
NPG
NCFA

II.A.3 - U.S.

Walker, John, 1906-
Great American paintings from Smibert to
Bellows,1729-1924;by J.Walker and Macgill
James...London,N.Y..etc..Oxford university
press,1943
36 p. illus(part col.)

Bibliography

Alphabetical list of artists

Repro.incl.:Washington by Gilbert Stuart,
Washington Fami bySavage

ND
1311
S55
NPG

II.A.3 - U.S.

Sherman, Frederic Fairchild, 1874-1940
Early American portraiture... N.Y.,Priv.
print.,1930
65 p. illus.

LC ND1311.S5

qND
1328
B35
NCFA

II.A.3 - U.S. - COLONIAL

Bayley, Frank William, 1863-1932
Five colonial artists of New England:Joseph
Badger,Joseph Blackburn,John Singleton Copley,
Robert Feke,John Smibert...Boston,Priv.print,1929
448 p. illus.

Bibliography

LC N6536.B3

ND
1314
S46
1987X
NPG
Ref.

II.A.3 - U.S.

Simon, Robin, 1947-
The portrait in Britain and America;with a
biographical dictionary of portrait painters
1680-1914.Boston,G.K.Hall & Co.,1987
255 p. illus(part col.)

Ch.2:Poses

Bibliography,p.247-50

Robert Hull Fleming Museum
Univ.of Vt. Faces in the
parlor,p.6,note 13

ND
1311.1
B43
NPG
NCFA

II.A.3 - U.S. - COLONIAL

Belknap, Waldron Phoenix, 1899-1949
American colonial painting...Cambridge,Mass.
Belknap press,Harvard Univ.,1959

FOR COMPLETE ENTRY
SEE MAIN CARD

NE
260
S64
NPG

II.A.3 - U.S.

Smith, George D., firm,booksellers,New York
Catalogue of American historical portraits
and engravings,including rare revolutionary
prints...N.Y.,Geo.D.Smith,between 1905 and 1917.
29 p. illus.

II.A.3 - U.S. - COLONIAL

Boswell, Peyton, 1879-1936
Colonial portraits as decorations in modern
homes

In:House & Garden
36,no.4:401-41,82-4 Oct.,'19

LC NA7100.H6

Winterthur Mus.Libr. fZ881
J78 NCFA v.6,p.222

ND
1311
U52
1900

II.A.3 - U.S.

U.S. Department of State
Descriptive catalogue of the collection of
portraits in the Department of state.Washing-
ton,Govt.print.off.,1900
13 p.

LC N7593.A2 1900

N
7593.1
C73
1986X
NPG

II.A.3 - U.S. - COLONIAL

Craven, Wayne
Colonial American portraiture.The econo-
mic,religious,social,cultural,philosophical,
scientific,and aesthetic foundations.Cambridge
University Press,1986
459 p. illus.

Bibliography,p.437-50

II.A.3 - U.S. - COLONIAL

De Kay, Charles, 1848-1935
 Old American portraitists

In:Art world & Arts & Dec.
9:202-6,244 Aug.,'18

LC N1.A85 Chicago Art Inst. Ryerson
 Libr. Ind.to Art periodical
 fZ5937.C5﹐,v.8 NCFA Ref.
 p.7029

AP
1
C284
NCFA
v.19-20
 II.A.9 - U.S. - COLONIAL

Hovey, Walter Read, 1855-
 American provincial painting

In:Carn.Mag.
20:240-4 March,'47 illus.

Ptgs.from the coll. of Edw.Duff Balken

II.A.3 - U.S. - COLONIAL

Dexter, Elisabeth Williams (Anthony) 1887-
 Colonial women of affairs;a study of women
in business and the professions in America be-
fore 1776...Boston and N.Y.,Houghton Mifflin
company,1924
 203 p. illus.

References
 The author's doctoral diss.Clark Uni.,192?
but not published as a thesis

LC K195.D52 Dewhurst.Artists in apror
 Bibl.p.175

927.5
.S44K74
 II.A.3 - U.S. - COLONIAL

Knox, Katharine(McCook)
 The Sharples, their portraits of George
Washington & his contemporaries;a diary & an
account of the life & work of James Sharples &
his family in England and America...New Haven...
London,H.Milford...,1930
 133 p. illus.

LC ND497.S445K6

ND
1311.1
D77
NPG
 II.A.3 - U.S. - COLONIAL

Dresser, Louisa
 The background of colonial American por-
traiture:some pages from a European notebook

In:Proc.Am.Ant.Soc,Worcester,Mass.
76,pt.1:19.-58 1966

 Bibliographical footnotes

LC E172.A35 vol76,pt.1 Green,S.M.Engl.orig.of N.E.
Newberry Library ptg.In:Winterthur Conf....
 ND207/W78/1971,p.56

759.1
M131
NCFA
 II.A.3 - U.S. - COLONIAL

McCoubrey, John W
 The colonial portrait

In.his.American tradition in painting.New York,
G.Braziller,1963
 pp.13-21 illus.

LC ND205.M23 Whitehill.The Arts in ear-
 ly Amer.Hist.Z5935W59 NPG
 Bibl.,p.65

705
A786
NCFA
v.24
 II.A.3 - U.S. - COLONIAL

First of colonial portraits placed

In:Art News
24,no.10:2 Dec.12,'25

 William Read,1607-1679,the earliest portr.
ptr.in the English-American colonies

FOR COMPLETE ENTRY
SEE MAIN CARD

QND
205
W52X
NCFA
 II.A.3 - U.S. - COLONIAL

Woos, R.Peter
 Colonial art.in The Genius of American paint-
ing.N.Y.,Morrow,1973.
 p.26-79 illus(part col.)

 Repro.incl.:Washington at Verplanck's Point,
1794,by Trumbull;at Princeton,by Chs.Willson
Peale;the Lansdowne portr.,1796,by Gilbert Stuart

II.A.3 - U.S. - COLONIAL

Fisher, Leonard Everett
 The limners;America's earliest portrait
painters...N.Y.,F.Watts,1969.
 47 p. illus. (Colonial Americans)

 Discusses the motivations,materials,and tech-
niques of the first "artists"in Colonial America.
The sign painters & how their works contribute
to a better understanding of early American his-
tory & society

LC ND1311.F5 Art Books 1950-79 Z5937
 .775 NCFA Ref. p.896

F
7
N476
1982(
NPG
 II.A.3 - U.S. - COLONIAL

New England begins:the 17th century.Dpt.of Am-
rican Decorative Arts and Sculpture.Jona-
than L.Fairbanks,curator;Robt.F.Trent,re-
search associate.Boston,MFA,c.1982
 3 v.(575 p.) illus(part col.)

 Cat.of exh.held at MFA,Boston,May 5 -
Aug.22,1982
 Bibliography,v.3,p.551-69
 Partial contents:Portrs.v.1(cat.nos.1,3).
v.2(cat.nos.111,139,309,353.-v.3:Portr.ptg.
in 17th c.Boston:Its history,methods,& ma-
terials,p.413 -479
 Index of subjects(Paintings,p.573)

N
613
A5
NCFA

II.A.3.a U.S. - COLONIAL

New York Historical Society
The Waldron Phoenix Belknap, jr.collection of
portraits and silver,with a note on the discove-
ries of Waldron Phoenix Belknap,jr.concerning the
influence of the English mezzotint on colonial
painting....Cambridge,Harvard University Press,
1955.
177 p. illus.

Catalogue of the coll.which was bequeathed to
the N.Y.Historical Soc. in 1949

LC N613.A65

II.A.3 - U.S. - COLONIAL

Poland, William Carey, 1846-1929
Robert Feke, the early Newport portrait
painter and the beginnings of colonial paint-
ing;a paper read before the Rhode Island hist.
soc., Apr.5,1904...Providence,1907
26 p.

"150 copies reprinted from the Proceedings
of the Hist.Soc.,1904-05"

MdHP MiU MB RPD MH etc.
Moes,The art of Rbt.Feke
Bibl.n.XXXV

ND
1311.1
N52
NPG

II.A.3 - U.S. - COLONIAL

New York. Metropolitan museum of art.
... Catalogue of an exhibition of colonial portraits, New York,
November 6 to December 31, MCMXI. (New York, The Gillius
press, '1911,
x, 70 p. 12 port. (incl. front.) 22ᶜᵐ.
Bibliography: p. 67-68.

1. Portraits, American—Catalog.

11-30784

Library of Congress N7593.N4

AP
1
A area
v.12

II.A.3 - U.S. - COLONIAL

Salisbury, William
Colonial American old masters

In:Antiquarian
12:48-50,121-2 Apr.,'29 illus.

Repro.incl.:J.S.Copley, Jacobus Gerritson
Stycker,Gerret Duyckinck,Wm.Read

'...Wm.Read(1607-79)...the first ptr. in the
British colonies...'.-Salisbury

Winterthur Mus.Libr. fz881
N7593 NCFA v.C,p.228

AP
1
N547
NCFA
v.35

II.A.3 - U.S. - COLONIAL

Phillips, John Marshall
Portraits in the Prentis collection

In:N.Y. Hist.Soc.Q
35:157-64 Apr.,'51 illus.

'Portrs.representative of New England and
the South'

Winterthur Mus.Libr. 1

N
7593.1
S28
1987X

II.A.3 - U.S. - COLONIAL

Saunders, Richard,1941-
American colonial portraits:1700-1776;R.H.
Saunders,Ellen Miles.Cat.of an exh.held at the
NPG,Oct.9,1987 through Jan 10,1988.Washington,
D.C..Publ. by the Smiths.Inst.Press for the NPG,
1987
342 p. illus(part col.)
Incl.Index
Bibliography, p.325-32

II.A.3 - U.S. - COLONIAL

Philobiblon club, Philadelphia
Cat.of a collection of portraits of the
colonial period, exhibited by the Philobiblon
club.at.the Academy of the fine arts,Phila.,
Nov.??,1893.Phila.?1893.
63 p.

LC ND1311.P5

705
A7875
v.20

II.A.3 - U.S. - COLONIAL

Sellers, Charles Coleman, 1903-
Archives of American art:Mezzotint proto-
types of colonial portraiture;a survey based on
the research of Waldron Phoenix Belknap,jr.

In:Art Q
20,no.4:407-68 winter,'57 illus.
Bibliography

Grouped:Prtrs.of men;women;children.The
painters.
Incl.cat.:Colonial ptgs.side by side with
mezzotint prototyp, all illustrated

II.A.3 - U.S. - COLONIAL

Pittsburgh, Carnegie Institute. Dept.of Fine
Arts
American provincial paintings,1790-1877,
from the coll.of Edward Duff Balken.Jan.9
through Feb.23,1947,Dept.of Fine Arts,Carnegie
Institute.Pittsburgh?1946 or 7.
1 v.(unpaged) illus.

FMI Colonial Williamsbg.inc.
The Abby Aldrich Rockefel-
ler folk art coll.N6510.C7
NCFA Bibl.p.394a

ND
205
S811
NMAA

II.A.3 - U.S. - COLONIAL

Stebbins, Theodore Ellis,jr., 1938-
Colonial genius and the New Nation

In:his,A new world:Masterpieces of American
painting,1760-1910.cat. of exh.held in Boston,
MFA,Sept.7-Nov.13,1983;Corcoran Gall.of Art,
Washington, D.C.,Dec.7,1983-Feb.12,1984;Paris,
Grand Palais,Mar.16-June 11,1984,Boston,Mus.of
Fine Arts,1983
pp.33-49 illus(col.)
Repro.incl.:Copley,Chs.W.Peale,C.Stuart,
Rembrandt Peale

705
A7875
v.14
NCFA

II.A.3 - U.S. - COLONIAL

Sweet, Frederick A.
 Mezzotint sources of American colonial
portraits

In:Art Q
14:148-57 illus. Summer,1951

 Amer.portr.painters, espec.J.S.Copley, used
mezzotints & engravings, done after English portra
to keep up with current trends

 Encyclop.of World Art
 Portrs.bibl. N31E56 Ref.

ND
207
F61 1
1969
NCFA

II.A.3 - U.S. - 17-18th c.

Flexner, James Thomas, 1908-
 The light of distant skies,American painting
1760-1835.New York,Dover Publications.1969.
 307 p. illus. (His.American painting 2)

 "...continuing vol.to "First flowers".These
are pioneering...studies of the hist.of Amer.ptg.
 (Whitehill)

LC ND207.F58 1969 Whitehill.The Arts in ear-
 ly Amer.Hist.Z5935.W59
 Bibl.,p.84

ND
1311.1
A512
1983
NPG

2 c.

II.A.3 - U.S. - COLONIAL

Vogel, Anne H.
 American Colonial portraits from the Fogg
Art Museum and Harvard University.Cat.of exh.
at Milwaukee Art Museum.Milwaukee Art Mus.,
June 30,1983
 14 p. illus(col.cover)

 Bibliography

759.1
.H2

II.A.3 - U.S. - 17-18th c.

Hagen, Oskar Frank Leonard, 1888-
 The birth of the American tradition in art..
New York,C.Sribner's sons;London,C.Sribner's
sons,ltd.,1940
 159 p. illus.

 "The present vol.covers the history of ptg.
in America fr.ca.1670 to the revolution."(Pref.)
 "An early attempt to define what is particular
ly American in U.S.Colonial ptg.Emphasis on the w
works of Smibert,Feke,Copley & West."-Keaveney.
Am.ptg.A5949.A15K4xRef.
 p.25 Whitehill.The Arts in ear-
LC ND207.H3 ly American Hist.Z5935W59
 Bibl.,p.84

N
6507
A79
NCFA

II.A.3 - U.S. - COLONIAL

Wright, Louis Booker, 1899-
 The arts in America:the Colonial period
by L.B.Wright.and others.N.Y.,Sribner.1966.

 368 p. illus.

 "Painting"by John W.McCoubrey,p.149-249

LC N6507.A7 Alberts.Benj.West N40.1
 .W49A3 NPG Bibl.p.507

AP
1
J8867
NPG
v.3

II.A.3 - U.S.-17-18th c.

Nichols, Norma
 The illusionary female/men in American
portraiture before 1800

In:J Regional cultures
3,no.2:23-32 Fall/Winter

 Limners,Copley,Chs.W.Peale,G.Stuart,Benj.
West,Durand,Vanderlyn,Smibert,Blackburn

II.A.3 - U.S. - 17-18th c.

Anderson Galleries, New York
 A cat.of paintings of American celebrities.
of the Colonial and Revolutionary periods,and
of other...portraits...from a private collec-
tion...sale April.26,1905 by the Anderson auc-
tion company....N.Y.1905.
 35 p. illus.

MET
199.8
Q511

 Met.v.25,Sales cat. fZ881
 N53 NCFA p.02331h

ND
207
W78
1971
NPG

II.A.3 - U.S. - 17-18th c.

Winterthur Conference on Museum Operation and
 Connoisseurship. 17th. 1971
 American painting to 1776:A reappraisal.
Edited by Ian M.G.Quimby.Charlottesville,Publ.
for the Henry Francis du Pont Winterthur Mus.
by the University Press of Virginia.1971.
 384 p. illus. (Winterthur Conf.rep.1571)
 Bibl.references

 Incl.articles on Am.portrs.,17-18th c.,and
on technical aids for identification

LC ND207.W5 1971

ND
207
F61f
1947
NMAA

II.A.3 - U.S. - 17-18th c.

Flexner, James Thomas, 1908-
 First flowers of our wilderness,American
painting.Boston,Houghton Mifflin Co.,1947
 367 p. illus(part col.) (A life-in-
America prize book)

 Bibliography
 "...good assemblage of repro..of ptgs.,most-
ly portrs..ptd..in America.before.1775...written
in...popular style..."(Whitehill)

 Patroon Painters,p.68-89,etc.

LC ND207.F57 Whitehill.The Arts in ear-
 ly Amer.Hist.Z5935.W59
 Bibl. . 83

N
7593.1
B78
NPG

II.A.3 - U.S. - 17-19th c.

Bowdoin College. Museum of Fine Arts
 Colonial and Federal portraits at Bowdoin
College by Marvin S.Sadik director.Brunswick,
Me..1966
 222 p. illus(part col.)

 Bibliography

LC N7634.B6

927
.C82
II.A.3 - U.S. - 17-19th c.

Cortissoz, Royal, 1869-1948
Early American portraiture

In.his.Personalities in art.N.Y.,London,Chs.
Scribner's Sons,1925

pp.321-33

AP
1
O 28
NMAA
II.A.4 - U.S. - 17-19th c.

Meyer, Laure
Un trésor de l'Amérique profonde:les por-
traits primitifs

In:L'oeil
no.375:24-31,86 Oct.,'86 illus(part col.)

M.analyses some significant examples.
Repro.incl.:Phillips,A.,Beardsley Limner,
Vanderlyn,Smith,Ths.,De Peyster Limner,Chand-
ler,W.Bundy,H.,Brewster,J.,Field,E.S.,North,N.
Hathaway,R.,Moulthrop,R.

N
7593
D23
NPG
II.A.3 - U.S. - 17-19th c.

Daughters of the American Revolution Museum
The Jewish Community in Early America:1654-
1830.Washington,D.C.,The Museum,1980
25 leaves

Cat.for exh.,Dec.11,1980-Mar.15,1981

Incl.:Portraits and miniature portraits

ND
1301
H5M52X
NPG
II.A.3 - U.S. - late 17 - mid 19th c.

Milwaukee. Art Center
Portraits from Milwaukee collections;an
exh.presented by the Milwaukee Art Center in
co-sponsorship with the National Society of
the Colonial Dames of America in the State of
Wisconsin.Sept.] through Oct.10,1971.Milwaukee,
Arrow press,1971
1 v.(unpaged) illus.

Intro.by Tracy Atkinson

N
6505
G65
NCFA
II.A.3 - U.S. - 17-19th c.

Goodrich, Lloyd, 1897-
From Colonies to Nation

In.his.Three centuries of American art.N.Y.,
Publ.for the Whitney Mus.of Amer.Art by Praeger,
c1966.p.7-12 Portrs.illus.p.13-8,22-3(part col.)
Based on the...exh.Art of the U.S.:1670-1966:
Whitney Mus.of American Art,N.Y.in 1966
Analyzes changing relation betw.native crea-
tivity & internat'l influences,forces which con-
tinued through the 19th c.

LC N6503.G6 1966

705
A56
NCFA
v.104
II.A.3 - U.S. - 17-19th c.

Moos, R.Peter
Colonial and 19th c.American paintings at
the Bowdoin College Museum of Art

In:Antiques
104:854-5,859,862,865 Nov.,1973 illus(part
.col.)

Repro.incl.:Copley,Stuart,Feke,R.Peale,
Smibert,Sully,Eakins,Healy,etc. Portrs.of Jef-
ferson,etc.

ND
207
H18
NCFA
II.A.3 - U.S. - (end)17-19th c.

Halladay, J.Stuart.
American provincial paintings,1680-1860,from
the collection of J.Stuart Halladay and Herrel
Georgo Thomas. April 17 to June 1, 1941,Depart-
ment of fine arts,Carnegie institute..:n.p.::1941.
40 p. illus.

LC ND207.H33

759.1
.M84
II.A.3 - U.S. - 17-19th c.

Morgan, John Hill, 1870-
Early American painters;illustrated by
examples in the collection of the New York histo-
rical society,...New York,The N.Y.histor.society,
1921
136 p. illus. (The John Divine Jones fund
series of histories and memoirs,IV)

Bibliography

LC ND205.M6

759.1
K72s
and
ND
1311
K5X
NPG
II.A.3 - U.S. - 17-19th c.

Knoedler,M.,& company, New York
Stratford;the Lees of Virginia and their
contemporaries...April 29 through May 18,1946.
New York,Knoedler galleries.1946. .
47 p. illus.

List of officials of the Rbt.E.Lee Memorial
Foundqtion inserted at end.

LC ND1311.K5

708.1
D47
v.12-14
1930-35
II.A.3 - U.S. - 17-19th c.

Richardson, E.P.
American portrait painting

In:B.Detroit Inst.Arts
14:11-14 Oct.,'34

Exhib.of privately owned paintings. List of
portrs. and lenders, mostly Detroit collectors

705
A784
NCFA
v.24
see also article by E.P.Richardson
Three American portrs. in Detroit
In:Art in Amer.
24:28-32 Ja.,'36 illus.(Badger,Whistler)

N
8223
D36
NTC
2 c.

II.A.3 - U.S. - 17-20th c.

Gerdts. William H.
 The art of healing;medicine and science in
American art.Birmingham,Ala.,Birmingham Museum
of Art,1981
 119 p. illus(part col.)

E
206
F59
1975X
MPO

II.A.3 - U.S. - 18th c.

Flexner, James Thomas, 1908-
 The face of liberty:founders of the U.S.,by
J.Th.Flexner;biographies of sitters and pain-
ters by Linda Bantel Samter.1st ed. N.Y.,Potter
c.1975
 310 p. illus(part col.)

 Incl.a cat.of an art exh.held at Amon Car-
ter Museum of Western Art,Fort Worth,Tex.

 Bibliography
 Index

II.A.3 - U.S. - 18th c.

Albany Institute of History and Art
 Merchants and planters of the upper Hudson
valley,1700-1750,exh.Jan.15-Feb.26,1967,
 6 p. cover illus(portrait)

MET
195.37
Ab2

 Exhibited also at Abby Aldrich Rockefeller
Folk Art coll. & at the N.Y.hist. soc. and the
Mus.of American Folk Art

 Black.In:Am art J AP1.A51
 '64 NMAA v.12:5

705
A784
NCFA
v.51

II.A.3 - U.S. - 18th c.

Gardner, Albert Ten Eyck
 An old New York family

In:Art in Am
51 no.3:58-61 June,'63 illus.

 Six portrs.of the Franks family,f'ly in
the Cpt.N.Taylor Phillips coll.now in the coll.
of the Am.Jew.Hist.Soc.,attr.by Waldron Phoe-
nix Belknap,jr.to Gerardus Duyckinck I ?;by
Virgil Barker to the Duyckinck Limner;by Flex-
ner "in the de Peyster Manner".They derive fr.
engravings by Godfrey Kneller.

705
A56
NCFA
v.54

II.A.3 - U.S. - 18th c.

Childs, Charles D.
 The 18th century portrait painter and his
public

In:Antiques
54:49-51 Jan.'48 illus.

705
A56
NCFA
v.104

II.A.3 - U.S. - 18th c.

Hanks, David A.
 American paintings at the Art Institute
of Chicago.Part I:The 18th century

In:Antiques
104:408 Sept.,1973. illus(part col.)

 Illustrations p.408-17 incl.:Smibert,Wol-
laston,Copley,Hesselius,Chs.W.Peale,Earl,Phil-
lips,Sully,Stuart

QN
6507
C68
MPO

II.A.3 - U.S. - 18th c.

Colby College,Waterville,Me. Art Museum
 American arts of the 18th century..Exh.Aug.8
through Sept.30,1967,.Boston,Thomas Todd Cy.1967
 36 p. illus.

 25 portrs.,listed on p. 7-12

757
.K72
1939
N
7593
K6X
NPG

II.A.3 - U.S. - 18th c.

Knoedler,M.,& company, New York
 Portraits of George Washington and other
18th c. Americans,loan exhibition,sponsored by
the Sons of the American revolution,Feb.7] to
March 4,1939. New York city....:1939,
 30 p. illus.

705
A56
NCFA
v.89

II.A.3 - U.S. - 18th c.

Etchison, Bruce
 The Glen-Sanders portraits of Scotia,N.Y.

In:Antiques
89:245-6 Feb., '66 illus(part col.)

 Abby Aldrich Rockefeller
 Folk Art Ctr.N7593.A23
 Am.folk portrs.Bibl.p.293

705
P18
NCFA
v.3

II.A.3 - U.S. - 18th c.

Little, Nina Fletcher, 1903-
 The development of American portraiture
in the 18th century

In:Panorama
3,no.3:27-36 Jan.,'48 illus.

 Repro.incl.:Badger,Durand,Gullagher

AP
1
A51
A64
NYMA
v.15

II.A.3 - U.S. - 18th c.

Meschutt, David
 Portraits of Anthony Wayne:Re-identifica-
tions and re-attributions

In:Am Art J
15:32-42 Spring,'83 illus.

 Repro.incl.:Edw.Savage,Geo.Graham after
J.P.H.Elouis,Jean Pierro Henri Elouis,Js.Sharp-
les,Chs.W.Peale,Felix Sharples,Js.Peale

705
A56
NCFA
v.100

II.A.3 - U.S. - 18th c.

Sweeney, John A.H.
 Paintings in the Winterthur collection

In:Antiques
100:758-67 Nov.,'71 illus(part col.)

Repr.incl.:Portrs.by Henry Benbridge,1775-6,
R.Peale,1813,Willem Verelst,1734-6,Benj.West,
1782-4,Ch.W.Peale,1771,Feke,1746,Wm.Williams,
1775.TheWashington family by Edw.Savage,1789-90,
Washington by G.Stuart,1795-6

CT
275
W36N4
NPG

II.A.3 - U.S. - 18th c.

Nelson, Paul David, 1941-
 Anthony Wayne.soldier of the early Repub-
lic.Bloomington,Ind.Univ.Press,c.1985
 368 p. illus.

 Bibl.p.341-57

 Repro.incl.:Edward Savage,John Trumbull,
Js.Peale,Chs.Willson Peale,'C.R.Leslie?,Alonzo
Chappel,Js.Sharples,Henri Elouis

705
A56
NCFA
v.108

II.A.3 - U.S. - 18th c.

Van Devanter, Ann C.
 The Signers' ladies

In:Antiques
108:114-?? July,'75 illus(part col.)

 Portrs.of wives of 9 signers of the Decla-
ration of Independence

 Rila II/2 1976 #4674

II.A.3 - U.S. - 18th c.

New York. Metropolitan museum of art
 ...A catalogue of portraits and possessions
of original members of the Society of the Cincin-
nati,shown...on the occasion of the triennial
meeting of the society,N.Y.,May 10-June 9,1935
,N.Y.,The Museum press,1935,
 13 p.

LC F202.1.A7N5 Foce,v.11,p.329

N
7628
C3H3X
NPG

II.A.3 - U.S. - 18-19th c.

Baltimore. Museum of art
 Charles Carroll of Carrolton(1737-1832)
and his family.An exh.of portraits,furniture...
at the Baltimore Mus.of art,Sept.19-Oct.30,1937,
under the auspices of the U.S.Comm.for the ce-
lebration of the 200th anni.of the birth of Chs.
Carroll of Carrolton.,Balto.,Md.The Lord Balti-
more press,1937,
 54 p. illus.

N
7621
P54
NCFA
NPG

II.A.3 - U.S. - 18th c.

Philadelphia. Independence hall
 Catalogue of the portraits and other works
of art,Independence hall,Philadelphia,....Phila-
delphia,Press of Geo.H.Buchanan company,c.1915,
 187 p. illus.

 "The James Sharpless coll.of portrs.in pastel"
p.,175,-186

LC F158.8.I3P55

AP
1
A788
NCFA
v.13

II.A.3 - U.S. - 18-19th c.

Barker, Virgil, 1890-
 Portraiture in America before 1876

In:Arts
13:275-88 May,'28 illus.

 FOR COMPLETE ENTRY
 SEE MAIN CARD

AP
1
N859
NPG
v.44

II.A.3 - U.S. - 18th c.

Smith, Helen Burr and Elizabeth V.Moore
 John Mare:A composite portrait

In:N.C.Hist Rev
44:18-52 Jan.,'67 illus.

 The most complete account of Mare's life.
M.'s work listed p.33

 Arts in Amer..q25961 U8A77
 NCFA Ref. H407

705
A56
NCFA
v.104

II.A.3 - U.S. - 18-19th c.

Bell, Whitfield Jenks,jr.
 Painted portraits and busts in the American
Philosophical Society

In:Antiques
104:878,882-3,886-7,890-1 Nov.,'73 illus(part
 ,col.

 Repro.incl.:Busts of Jefferson by Houdon,Ritten-
house by Ceracchi,J.Q.Adams by Gardelli,etc.
Ptgs.of Franklin by Ch.W.Peale,Rittenhouse by
Ch.W.Peale,Deborah Franklin attr.to B.Wilson,etc
Self-portr.of Sully

II.A.3 - U.S. - (begin.)18-(begin.)19th c.

Boston. Childs Gallery
Portraits from Smibert to Sully. Cat.of an
exhibition, March, 1949 no.7

16 early American portrs.fr.early 18th to
early 19th c.,incl.Stuart;double portr:The Mis-
ses Dick,c.1790;Copley,Mrs.Sarah Clayton

Dresser.C.Gullager.in:Art
in Am 37:118 Jul,'49

N
529
C27A67X
NPG

II.A.3 - U.S. - 18-19th c.

Carolina art association, Charleston, S.C.
Selections from the collection.Charleston,
S.C.,Carolina Art Ass.,1977
127 p. illus.

Bibliography

708.1
C86
NCFA
v.6

II.A.3 - U.S. - 18-19th c.

Breckenridge, James Douglas, 1926-
Portraits of Americans.On American por-
traiture

In:Corcoran G.A.Bull
6:1-14, Feb.,'53 chiefly illus.

Winterthur Mus.Libr. f2881
J78 NCFA v.6,p.222

qNd
1311
C39e
NPG
R H

II.A.3 - U.S. - 18-19th c.

Century Association, New York
Early American portraits,January,1928
unpaged illus.

Cat.of loan exh.Jan.15-31,1928;illustrated
by photographs & clippings

q N
6505
B76X
NCFA

II.A.3 - U.S. - 18-19th c.

Brown, Milton Wolf, 1911-
American art to 1900,...N.Y.,Harry N.Abrams,
Inc.,Publ.1977

Early Colonial ptg...Artisans & Limners,
p.32-8.18th c.colonial ptg...p.90-106.Ptgs.Icons
for a New Nation,Portraiture,p.177-94...Decline
of portraiture,p.366-70

FOR COMPLETE ENTRY
SEE MAIN CARD

N
579
C3A3X
NPG

II.A.3 - U.S. - 18-19th c.

Charleston, S.C. City Council
Catalogue of painting and sculpture in the
Council Chamber,City Hall,Charleston,S.C.;by
Anna Wells Rutledge.Charleston.The City council,
ca.1943
30 p. illus(part col.)

LC N529.C3A3

.CFA has

II.A.3 - U.S. - 18-19th c.

Burlingham, Hiram
American portraits,incl.Abraham Lincoln by
Lambdin,Thos.Jefferson by Bass Otis & works by
Peale,Copley,Mare,Vanderlyn,Audubon...,minia-
tures,ship paintings...property of H.Burling-
ham...sale Jan.11,N.Y.,American Art Ass.,Ander-
son Galleries,1934
56 p. illus
Sale no.4076 priced.

ET
99.8
.22
.934

FMU MBAt IU PPULC
Cty PPPM

Mot.v.25,Sales cat.
2881.W53 NCFA p..023319

II.A.3 - U.S. - 18-19th c.

Comstock, Helen
Portraits of American craftsmen

In:Antiques
76:320-7 Oct.,'59 illus.

Incl.Chronological table of American artistic
works of artisans compared with those on the con-
tinent,from 1725-1825
Incl.:Pollard Limner,John Smibert,Nathaniel
Smibert,Copley,Chs.W.Peale,Ralph Earl,Sarah Good-
ridge,Mather Brown,G.Stuart,Benj.Blyth,Ths.Sully,
John Neagle,J.W.Jarvis,Esra Ames

Rep.1959 #977

705
A784
NCFA
v.17

II.A.3 - U.S. - 18-19th c.

Burroughs, Clyde Huntley, 1882-
Early American portraits at Detroit Insti-
tute of Arts

In:Art in Amer.
17:258-74 Oct.,'29 illus.

"...The portr.is art's lucid interpreter of
a.period..."

Repr.:Blackburn,Badger,Woolaston,Trumbull,
Neagle,Harding,Sully

Cumulated Mag.subj.index
A1/3/C76 Ref. v.2,p.443

ND
1311.1
B35
NPG has
no.2-3

II.A.3 - U.S. - 18-(begin.)19th c.

Copley gallery, Boston
...Little known American portrait painters,
no. Boston,Copley gallery,193-?
v. illus

FPOO
46
B747e

.no.1:Blackburn,Earl,Gullager,Feke,Johnston,
Badger,Savage,Woolaston.-no.2:Greenwood,Emmons,
Chandler,Blyth--no.3:Theus,King,Wright,Pine,Fur-
nass,Ramage,Trott,Pratt,Metcalf. No.1,2,3 in
OClMA

Text by F.W.Bayley

DSI
LC reports "no.1-5"1916.'?
MWA NN PPULC

Fogg,v.11,p.327

N
7593.8
D3D34
NPG
2 c.

II.A.3 - U.S. - 18-19th c.

Delaware. State portrait commission
Cat.of Delaware portraits collected by the
Delaware State portrait comm.in the capitol
buildings.Dover,Del..Delaware portr.comm.,1541
64 p. illus.

Incl.:Index of artists and sitters

Repro.incl.:Washington,by Volozan

LC F163.D34 1941

Winterthur Mus.Libr.
Z881.W78 NCFA v.6,p.225

ND
207
F61
1967
NPG

II.A.3 - U.S.- 18-19th c.

Flexner, James Thomas, 1908-
America's old masters. Rev..i c.2d.ed. New ..
Dover Publications .1967.

365 p. illus.

Bibliography p.343-352

Incl.:West,Copley,Singleton,Peale,Stuart

LC ND207.F55 1967

705
A56
NMAA
v.135

II.A.3 - U.S. - 18-19th c.

Deutsch, Davida Tenenbaum
The polite lady:portraits of American
schoolgirls and their accomplishments,1725-1830

In:Antiques
135:742-53 March, '89 illus(part col.)

Repro.incl.:Ralph Earl,1783;Gilbert Stuart,
c.1807;Peticolas,1798;Cornè,c.1805;M.B.Doyle,
c.1820;John Greenwood,c.1747;Js.Earl,1794-96
Pl.X:Evelyn Byrd with black servant

ND
207
F61 1
1969
NCFA

II.A.3 - U.S. - 18-19th c.

Flexner, James Thomas, 1908-
The light of distant skies,American painting
1760-1835.New York,Dover Publications.1969.
307 p. illus. (:His:American painting 2)

"...continuing vol.to "First flowers".These
are pioneering...studies of the hist.of Amer.ptg.
(Whitehill)

LC ND207.F58 1969

Whitehill.The Arts in ear-
y Amer.Hist.Z5935.W59
Bibl.,p.84

6507
D77
1970
NCFA

II.A.3 - U.S. - 18-19th c.

Drepperd, Carl William, 1898-
American pioneer portraits

In.his.American pioneer arts & artists.Watkin
Glen,N.Y.,Century House,1970
pp.105-23 illus.

705
A56
NCFA
v.100

II.A.3 - U.S. - 18-19th c.

Goodyear, Frank H.enry, 1944-
The Painting collection of the Rhode Island
Historical Society

In:Antiques
100:749-57 Nov., '71 illus(part col.)

Central portr.gall. added in 1891
Cat.of portrs. & landscapes,1895
'Life-like portrs...may serve the cause of
history better than elaborate essays.'-Amos
Perry,keeper to the Society.

927
E33

II.A.3 - U.S. - 18-19th c.

Ehrich galleries, New York
One hundred early American paintings.New
York,The Ehrich galleries,1918
176 p. illus.

Bibliography

"Book arranged by W.A.Bradley,Yale University
Press,New Haven"
Portraits of the 18th & 19th c.
List of ptrs.& their dates,in alphabetical
order

LC ND207.E5

Fogg,v.11,p.327

N
6507
H57K
NPG
NMAA

II.A.3 - U.S. - 18-19th c.

Hirschl & Adler Galleries,inc.,N.Y.
American art from the Colonial and Federal
periods.Cat.of an ech..Jan.14-Feb.10,1982.In-
troduction by Stuart P.Feld..The Gallery,
c.1982.
102 p. illus(part col.)

Index of artists

Incl.:McKenney & Hall coll of portrs.of
American Indians by Henry Inman-now in Harold
Byrd coll,Dallas Texas(1984).

NPG

II.A.3 - U.S. - 18-19th c.

Evans, Dorinda
Benjamin West and his American students.
.Publ.for.an exh.at the National Portrait Galle-
ry,Oct.16,1980 to Jan.4,1981 and at the Pennsyl-
vania Academy of the Fine Arts,Jan.30 to Apr.19
1981.Publ.for NPG by the Smiths.Inst.Press,City
of Washington,1980
203 p. illus(part col.)

Bibliography
Incl.index

LC ND207.E94

705
A56
NCFA
v.110

II.A.3 - U.S. - 18-19th c.

Holzer, Edith & Harold
Portraits in City Hall,New York
Antiques
American painting .special issue. (card 2)
...Nov.,1976...

Partial contents cont'd:E.& H.Holzer,Portrs.
in City Hall,N.Y.,p.1030-39:...

705
A56
NCFA
v.108

II.A.3 - U.S. - 18-19th c.

Jones, Karen M.
 Museum accessions

In:Antiques
108:78-79 July,'75 illus.

 Acquisitions made by the NPG in the past
two years
 Repro.incl.:John Jay by G.Stuart and J.
Trumbull;P.Revere,Th.Jefferson by Févret de
Saint-Mémin;John Marshall by Wm.Hubard;Washing-
ton,Martha Washington by Rembrandt Peale

705
C75
NCFA
v.68

II.A.3 - U.S. - 18-19th c.

Mechlin, Leila, 1874-
 Early American portrait painters

In:Connoisseur
68:127-32 Mar.,'24 illus.
 Repro.:Franklin by Wright,Blackburn,Feke,C.W.
Peale,Rembrandt Peale,Neagle,Hamilton by Trumbull,
Waldo,Malbone,Harding,Copley,Stuart(p.135),West
(p.177)
 Emphasis on close association of American &
British schools

 Cumulated Mag.subj.index
 A1/3/C76 Ref. v.2,p.443

N
40
L47
NPG

II.A.3 - U.S. - 18-19th c.

Lee, Cuthbert, 1891-
 Early American portrait painters;the fourteen
principal earliest native-born painters...
New Haven,Yale univ.press,1929

 350 p. illus.

 Bibliography

LC ND1311.L46

N
40.1
S93M8
1969
NPG
2 c.

II.A.3 - U.S. - 18-19th c.

Morgan, John Hill, 1870-1945
 Gilbert Stuart and his pupils,...;together
with the complete notes on painting by Matthew
Harris Jouett from conversations with Gilbert
Stuart in 1816.N.Y.,Kennedy Galleries,Da Capo
Press,1969
 102 p. illus.

 Incl.:Information concerning Jane Stuart,
p.49-51 illus.

 Reprint of 1939
LC ND237.S8M6

705
A56
NCFA
v.98

II.A.3 - U.S. - 18-19th c.

McCormack, Helen Gardner
 Expatriate portraits.Charlestonians in mu-
seums outside of Charleston

In:Antiques
98:767-93 Nov.'70 illus.

**FOR COMPLETE ENTRY
SEE MAIN CARD**

N
7593
N27
NPG

II.A.3 - U.S. - 18-19th c.

National Society of the Colonial Dames of America.
 Delaware
 Portraits in Delaware,1700-1850;a check list.
Wilmington,1951
 176 p. illus.

 Bibliography

LC N7593.N25

N
7634
M41
NPG

II.A.3 - U.S. - 18-(beg.)19th c.

Massachusetts Historical Society, Boston
 Portraits of women, 1700-1825. Boston,1954
 unpaged illus. (A Massachusetts Histori-
cal Society picture book)

LC N7634.M3

N
7593.8
N8N27
NPG

II.A.3 - U.S. - 18-19th c.

National Society of the Colonial Dames of America.
North Carolina
 The North Carolina portrait index,1700-1860.
Compiled by Laura MacMillan,...Chapel Hill,Uni-
versity of North Carolina Press.1963.
 272 p. illus.

LC N7593.N27

-
178.5
P13
v.12
NPG

II.A.3 - U.S. - 18-19th c.

Mather, Frank Jewett, 1868-1953
 ...The American spirit in art,by F.J.Mather,
jr.,Charles Rufus Morey,William James Henderson.
New Haven,Yale univ.press;.etc.,etc.,1927
 354 p. illus.(part col) (The Pageant of
America,v.12)

 1.Colonial portraiture.-2.Early Republican
portraiture.-9.Intermediate portraiture,1860 to
1876.-12.Portraitists of Parisian tendency,1876-.
15.Portrait & figure ptg.,1880-1895

LC N6505.M3

N
7593.8
T2
N27
NPG

II.A.3 - U.S. - 18-19th c.

National Society of the Colonial Dames of America.
Tennessee. Portrait Committee.
 Portraits in Tennessee painted before 1866;
preliminary checklist ,compiled by Eleanor
Fleming Morrissey,chairman..Nashville?,...1964
 147 p. illus.

LC N7593.N29

708.1
N516

II.A.3 - U.S. - 18-19th c.

New York. Metropolitan museum of art
 The Hudson-Fulton celebration.Cat.of an exh.
...Sept.20-Nov.30,1909.N.Y.,1909
 2 v.

 v.2,Pt.I:American ptgs...by Henry Watson
Kent.Artists born before 1800,arranged in al-
phabetical order

LC N5020.M43 1909

705
A56
NCFA
v.104

II.A.3 - U.S. - 18-19th c.

Oliver, Andrew, 1906-
 Connecticut portraits at the Connecticut
Historical Society

In:Antiques
104:418 Sept.,1973 illus(part col.)

 Illustrations p.419-35 incl.:Durand,Earl,
Steward,Jennys,Morse,Moulthrop,etc.

ND
1311
N53
NPG

II.A.3 - U.S. - 18-19th c.

New York. Union League Club
 Exhibition of paintings by early American
portrait painters.New York,The Union league club
₅1921-22₎
 5 v. in 1 illus.

 Exhib.dates:Nov.10-24,1921;Dec.5-12,1921;
Portrs.ptd.in Europe by early Am.artists,Jan.12-
16,1922;Portrs.painted in the U.S.by early Am.
artists,Feb.,9-13,1922;Exh.of portrs.of early
Am.artists,March,9-11,1922
 Bound together with news paper clippings

N
683
A5
1974X
NPG
Ref.

II.A.3 - U.S. - 18-19th c.

Pennsylvania. Historical society
 Paintings and miniatures at the Historical
society of Pennsylvania.Rev.ed.comp.by Nicholas
B.Wainwright.Philadelphia,1974
 334 p. illus(part col.)

 Publ.in 1942 under title:Cat.,descriptive
and critical of the ptgs.& miniatures...
 1942:615 items by 166 artists.1974:791 items
by 201 artists.
 Portrs.arranged alphabetically by sitters.
 Index of artists.
 ⌒rts in Am.qZ5961.U5A77X
 CFA Ref. I 257

ND
1311
N53
c.3
NPG

II.A.3 - U.S. - 18-19th c.

New York. Union League Club
 Exh.of portraits by early American por-
trait painters.N.Y.,The Union league club
₅1923-24₎& Century Association,N.Y.,1925-28₎
 6 v. bound together
 Title varies

 Exh.dates:Jan.11,12,13,1923. Feb.14,15 and
21,22,1924. March 12,13,1924. Shown at Century
Ass'n N.Y.:Nov.7-29,1925. Nov.6-28,1926. Jan.14-
Feb.2,1928

 Exh.Feb.'24:Repro.──Washington Family by Savage

N
7592
024
NPG

II.A.3 - U.S. - 18-19th c.

Rhode Island School of Design, Providence
 Exh.of early American art in honor of the
150th anniversary of the founding of Brown
University,Oct.3rd to 21st,1914.₅Providence,
1914?
 11 p.

 Exh.incl.:portrs.by Alexander,Copley,Earle,
Harding,Jarvis,Chs.W.Peale,Smibert,Sully,Stuart,
West.Miniatures by Allston,Copley,Malbone,₮₮₮₮₮
R.Peale,etc.
 NPG copy:"Owners of ptgs.by Gilbert Stuart"
inserted.Bound wi⌒th Garrick Club,London.Cat.
of the pictures...₌ondon,1909

759.13
.N55

II.A.3 - U.S. - 18-19th c.

Newark museum association, Newark; N.J.
 American primitives,an exhibit of the paint-
ings of 19th c. folk artists,Nov.4,1930-Feb.1,
1931. Newark,N.J.,The Newark museum,1930
 75 p. illus.

 Reading list
 Portraits;Descriptive notes,pp.13-15;Portrs.
cat.,pp.15-20

 Article pertaining to this exh. by E.B.Robin-
son In:Antiques
19:33-6 Jan.,'31 ◡)illus.

N
7593.1
R47
NPG

II.A.3 - U.S. - 18-19th c.

Rhode Island School of Design, Providence. Mus.
 of art
 Early portraits in Rhode Island,1700-1850;
an exhibition to honor the 75th anniversary of
the National Society of the Colonial Dames of
America in the State of Rhode Island and Pro-
vidence Plantations,8 March-9 April,1967.
₅Providence,1967₎
 24 p. illus.

LC N7593.R5

ND
210
N86
1966
NMAA

II.A.3 - U.S. - 18-19th c.

North Carolina. Museum of Art, Raleigh
 American paintings to 1900.2nd ed.,Raleigh,
N.C.:North Carolina Mus.of Art,1966
 117 p. chiefly illus(part col.)

 Cat.of ptgs.,v.1
 Incl.:Portrs.by Wm.M.Chase,J.S.Copley,Wm.
Dunlap,F.Duveneck,R.L.W.Earl,J.A.Elder,Wm.H.Fair-
fax,J.Hesselius,J.W.Jarvis,J.Farling.Washington
by R.Peale,J.S.Sargent,G.Stuart,Ths.Sully,A.U.
Wertmuller

705
A56
NCFA
v.19

II.A.3 - U.S. - 18-19th c.

Robinson, Elinor B
 American primitive painting

In:Antiques
19:33-6 Jan.,'31 illus.

 "Many.itinerant painters....unhampered by
their limitations,were able to grasp the essen-
tials of their subjects with...simplicity & a vi-
gorous creative sense"(pertains to:Newark mus.
ass.,Newark,N.J.Exh.:Amer.primitives...1930

 ◡)Lipman,Mrs.Jean.Am.prim.
 ◡)ptg. 759.1/L76 Bibl.

705
A56
NCFA
v.98

II.A.3 - U.S. - 18-19th c.

Rutledge, Anna Wells
 Paintings in the Council Chamber of Charleston's City Hall

In:Antiques
98:794-99 Nov.,'70 illus.

FOR COMPLETE ENTRY
SEE MAIN CARD

705
A784
NCFA
v.16

II.A.3 - U.S. - 18-19th c.

Sherman, Frederic Fairchild, 1874-1940
 Portraits and miniatures by Copley,Dunlap,
Eichholts and Robert Street

In:Art in Amer.
16:122-9 Apr.,'28 illus.

 Repro.:Copley,Dunlap,Eichholts,Street

Biographical notes for Jacob Eichholts and
Robert Street
 Cumulated Mag.subj.index
 A1/3/C76 Ref. v.2,p.443

MD
205
337
1981X
NMAA

II.A.3 - U.S. - 18-19th c.

Santa Barbara,Calif. Museum of art
 The Preston Morton collection of American
art;Katherine Harper Mead,editor.Santa Barbara,
Calif...Mus.of Art,c.1981
 272 p. illus(part col.)

 Bibliography p.267-72
 Incl.:Essays on:J.S.Copley,by M.W.Sehants;
Benj.West,by M.W.Sehants;Chr.Gullager,by E.G.
Miles;Js.Peale,by E.G.Miles;Ths.Sully,by E.G.
Miles;Geo.P.A.Healy,by E.G.Miles;Wm.M.Hunt,by
P.Bermingham;Ths.Eakins,by R.Bowman;Wm.M.Chase,
by G.M.Ackerman;R. Henri,by K.H.Mead

705
A784
v.22

II.A.3 - U.S. - 18-19th c.

Sherman, Frederic Fairchild, 1874-1940
 Unrecorded early American portrait painters

In:Art in Am
22:26-31 Dec.,'33 illus.
 :145-50 Oct.,'34 illus. title :Unrecorded early American painters
 Miniature ptrs.& portr.ptrs.in oil
Most of these artists are in Groce & Wallace:
N.Y.Hist.Soc. Dict.of artists in Amer.,1564-1860

N6536
N53
v.3
REF

705
A784
NCFA
v.15

II.A.3 - U.S. - 18-19th c.

Sherman, Frederic Fairchild, 1874-1940
 Four cabinet portraits by early American
artists

In:Art in Amer.
15:264-70 Oct.,'27 illus.

 Repro.:Jos.Wood,John Paradise,Chs.Willson
Peale,John Rubens Smith

 A1/3/C76 Ref.,v.2,p.443
 Cumulated Mag.subj.index

N
40.1
F95285
NPG
2 c.

II.A.3 - U.S. - 18-19th c.

Simmons, Linda Crocker
 Jacob Frymire,American limner...Washington,
Corcoran Gall.of Art,c.1975
 56 p. illus(part col.)

 Based on M.A.Thesis at Uni.of Delaware,1975
 Incl.Ch.on 'Works by Chs.Peale Polk and
other contemporaries'
 Exh.at Corcoran Gall.,Oct.4-Nov.16,1975,
Kauffman Gall.,Shippensburg,Pa.,Winston-Salem,
N.C.,Mus.of Early South.Dec.Arts,Abby Aldrich
Rockefeller Folk Art Coll.,Williamsburg,Va.

705
A784
NCFA
v.11

II.A.3 - U.S. - 18-19th c.

Sherman, Frederic Fairchild, 1874-1940
 Four examples of American portraiture

In:Art in Amer.
11:328-35 Oct.,'23 illus.

 Repro.:Feke,Wollaston,Chs.Willson Peale,
Chester Harding

 "Shown last Jan.at the Union League Club,N.Y.
Exh.arranged by Ths.B.Clarke
 Cumulated Mag.subj.index
 A1/3/C76 Ref. v.2,p.443

708.1
C5725
NCFA
v.3

II.A.3 - U.S. - 18-19th c.

Siple, Walter Heick, 1890-
 Notes on the exh.of Cincinnati portraits

In:Cincinnati Mus Bul
3:72-84 July,'32 illus.
 109-27 Oct.,'32 illus.

 Exh.:Portrs.of early Cincinnatians held
May 19-June 19,1932 at Cincinnati Art Museum

705
A784
NCFA
v.29

II.A.3 - U.S. - 18-19th c.

Sherman, Frederic Fairchild, 1874-1940
 Newly discovered American portrait painters

In:Art in Am
29:234-5 Oct.'41

 Frymire,Jacob;Hamilton,Amos;Cross,H.H.;
Clark,M.W.;Moore;Abel Buell;Roberts,B.;Schnable,
E.;Smith,Capt.Ths.;Gill,E.W.;Weedward,David A.;
Drexel,Anthony;Jones;Tuqua,Edw.;Harrington,G.;
Young,B.;Frost;Leck,F.W.;Morris,Rbt.;Hern,H.J.

ND
1311
S66
NCFA
NPG

II.A.3 - U.S. - 18-19th c.

Smithsonian institution. National collection
 of fine arts
 Exh.of early American paintings,miniatures
and silver,assembled by the Washington loan
exh.comm.,Dec.5,1925-January 3,1926.Washington
D.C.,National gallery of art,National museum
c1925.
 107 p. illus.

 With introductions on early American portraits by Miss Leila Mechlin,Washington;early
American miniatures by Mr.Albert Rosenthal
LC N857.A6 1925
 Bolmer.Attributing miniatur

N
40.1
S95A1
NCFA

II.A.3 - U.S. - 18-19th c.

Sully, Thomas, 1783-1872
 Hints to young painters;a historic treatise
on the color,expression,and painting techniques
of American artists of the Colonial and Federal
periods.Reprinted in new format from the original
ed.of 1873...N.Y.,Reinhold Pub.Corp.,1965
 46 p. illus.

ND1262.S9 1965

705
A56
NCFA
v.69

II.A.3 - U.S. - (end)18-(begin)19th c.

Warren, William Lamson
 Portraits by William Jennys

In:Antiques
69:153 Feb.,'56 illus.

 Pertains to exh."Portrs.by Richard & William
Jennys" at Connecticut historical society,Hart-
ford,Nov.,'55-Jan.,'56

 "...shows a mastery of paint application &
drg.with the brush,that one is almost tempted to
call him an Amer. Frans Hals."

ND
1311.9
R5V15
NPG

II.A.3 - U.S. - 18-19th c.

Valentine museum, Richmond,Va.
 Richmond portraits in an exhibition of
makers of Richmond,1737-1860. Richmond,Va.,..1949
 286 p. illus.

 Bibliography
 Exh.started Nov.16,1948

 Incl.:Biography of sitters & of artists.List
of lenders

VF
NPG
N.Y.

II.A.3 - U.S. - 18-19th c.

Washburn Gallery, New York
 Ancestors;an exh.of American portraits,
c.1760-c.1840...June4 - June 27,1980
 (7)p. illus(color)

705
A56
NCFA
v.102

II.A.3 - U.S. - 18-19th c.

Wainwright, Nicholas B.
 Early American paintings at the Historical
Society of Pennsylvania

In:Antiques
102:831-9 Nov.'72 illus(part col.)
 Repro.incl.:Gust.Hesselius,John Meng,Rbt.
Feke,Ths.Spence Duché;Benj.Franklin by Chs.Wm.
Peale;Geo.Washington by Rembrandt Peale;Rbt.
Edge Pine,John Wollaston,Ben.West,Jas.Eichholtz,
Js.Peale,J.S.Copley;Geo.Washington by J.Wright.

ND
1311
Y18
NPG

II.A.3 - U.S. - 18-19th c.

Yale University. Art Gallery
 Early American portrait painting;by A.E.C.,
New Haven,1944
 12 p. 1 illus(Roger Sherman by Ralph Earl)

 Bibliography

 Incl.Description of "factory system",a work-
shop system by Godfrey Kneller

 Reproduction of typescript

AP1
C76
NPG
v.21-25

II.A.3 - U.S. - 18-19th c.

Warren, William Lamson
 A checklist of Jennys portraits

In:Conn.Hist.Soc.B.
21:33-64 Apr.,'56 illus.

 Article p.34-41.Check list:Richard Jennys,
p.42-6,William Jennys,p.46-64

ND
1311
A47X
NPAA

II.A.3 - U.S. - 18-20th c.

American portraiture in the Grand Manner:1720-
 1920.Essays by Michael Quick,Marvin Sadik,
 Wm.H.Gerdts.Cat.by M.Quick.L.A.Cy.Mus.of
 Art,1981
 228 p. illus(col.)

 Exh.Los Angeles County Museum of Art
Nov.17,1981-Jan.31,1982.National Portrait
Gallery, Washington, D.C.March 17-June 6,'82

 Bibliography p.217-227
 see also:Goldberg.The column & the cur-
tain in:Antiques World.v.4:32-41.Dec.'81

II.A.3 - U.S. - 18-19th c.

Warren, William Lamson
 The Jennys portraits

In:Conn.Hist.Soc.B.
20:97-128 Oct.,'55 illus.

 Cat.of exh.."Portraits by Richard & William
Jennys".Nov.'55-Jan.,'56

LC F91.C67

705
A56
NCFA
v.98

II.A.3 - U.S. - 18-20th c.

Bilodeau, Francis W.
 American art at the Gibbes Art Gallery in
Charleston

In:Antiques
98:782-6 Nov.,'70 illus.

FOR COMPLETE ENTRY
SEE MAIN CARD

VF
Calif.
San
Marino

II.A.3 - U.S. - 18-20th c.

Henry E.Huntington Library and Art Gallery,
San Marino,Calif. The Virginia Steele
Scott Gallery
A gift to the Huntington Art Gallery.Pasa-
dena,The Castle Press,1984
24 p. illus(col.)

Incl.:Checklist of ptgs.& W.C.,June,1984
(incl.American portrs.,18-20th c.)

QT
217.5
M37
1988X
NPG

II.A.3 - U.S. - 18-20th c.

Massachusetts Historical Society, Boston
Portraits in the Mass.Hist.Soc. An ilustr.
cat...by Andrew Oliver,Ann Millspaugh Huff,
Edw.W.Hanson.Boston,The Society,1988
163 p. illus(part col.)

Index
Bibliography

qND205
A645
NMAA

II.A.3 - U.S. - 18-20th c.

Kennedy Galleries,inc., New York
American portrait,landscape,seascape,still
life & genre.Paintings from 1770-1922..Exh..
Nov.1-Dec.31,1983.Kennedy Galleries,1983
60 pl.(col.)

12 portraits

N
7593.8
C2S23
NPG
2 cops.

II.A.3 - U.S. - 18-(begin.)20th c.

Santa Barbara,Calif. Museum of art
American portraits in California collections.
.Exhibition.April 6-May 8,1966..Santa Barbara,
1966.
.16.p. illus.(part col.)

AP
1
K32
NCFA
v.9-10

II.A.3 - U.S. - 18-20th c.

Kennedy Galleries,inc., New York
Two hundred years of American portraits;a
selection of portraits from the early 18th to
the early 20th century.N.Y..1970.

In:The Kenn.Gall.Q.
9,no.4:229,232-92 May,'70 illus(part col.)
Portr.of Lincoln by unknown primitive p.268
Intro.by Rud.C.Wunderlich
Alphabetical index of artists
The portrs.date fr.ca.1714 to 1932
Notes of the Carroll Family Portraits
LC N8640.K4 Art Books 1950-79 Z5937
v.9no.4 A775 NCFA Ref. p.897

ND
1311.2
A53
NPG

II.A.3 - U.S. - 19th c.

Ancestors;an exh.of 19th c.American portraits.
Oberlin,Ohio,Allen Memorial Art Museum,Ober-
lin College,c.1980

Exh.:May 14-Sept.7,1980.Cat.by Maria Gold-
berg and Molly Anderson
All items from Oberlin collections
List of sitters.Selection for the exh.was
made on the basis of the relationship of
the sitter to Oberlin or its citizens.

Incl.Ch.on children's portraits.

757
.K73

II.A.3 - U.S. - 18-20th c.

Knoedler (M.) and company, inc.
...A loan exhibition of American portraits by
American painters,1730-1944;1730-1921 group at
Knoedler galleries...New York; 1921-1944 group at
Portraits,inc....New York..New York,The William
Bradford press,1944.
.28.p. illus.

LC N7593.K58

705
A56
NCFA
v.102

II.A.3 - U.S. - 19th c.

Banks, William Nathaniel
George Cooke,painter of the American scene

In:Antiques
102:448-54 Sept.,'72 illus(part col.)

Portraiture was always the mainstay of C.
Repro.incl.:Mrs.Rbt.Donaldson,Mrs.Mann S.
Valentine & children,Henry Clay,Mrs.Daniel
Pratt,daughter & nurse,Kish-ke-kosh/A Fox Brave

Arts in America qZ5961.U5
A77X NCFA Ref. I625

ND
236
L76
NPG

II.A.3 - U.S. - 18-20th c.

Lipman,Mrs.Jean Herzberg, 1909- comp.
Primitive painters in America,1750-1950;an
anthology,by J.Lipman & A.Winchester.N.Y.,Dodd,
Mead,.1950.
182 p. illus(part col.)

Contents:-2.N.F.Little, Primit.ptrs.of 18th
4.A.M.Dods, R.H.Bascom.-5.A.E.Eye, E.Hicks.-8.F.F.
Sherman, J.S.Ellsworth.-9.F.B.Robinson, E.S.Fiel
10.N.F.Little, W.M.Prior.-11.J.Lipman, D.Gold-.
smith.-12.P.O.Spinney, J.H.Davis.-14.J.L.Clarke,
jr., J.W.Stock

ND
236
B5X
NCFA
RB

II.A.3 - U.S. - 19th c.

Benjamin, Samuel Greene Wheeler, 1837-1914
Our American artists...;with portraits,
studios, and engravings of paintings.Boston,
D.Lothrop and co..c.1886.
193 p. illus.

Contents.Beard,Bellows,R.S.Gifford,Chase,W
S.R.Gifford,Shirlaw,Enneking,Wood,Coleman,
Thompson,Brown,Neal,D.

Earlier ed.publ.in 1879

LC ND236.D5 1886

ND
210
B74s
NMAA

II.A.3 - U.S. - 19th c.

Boston. Museum of Fine Arts
M. & M.Karolik coll.of American paintings,
1815-1865.Boston,Mus.of Fine Arts,c.1976
60 p. chiefly illus(part col.)

Colonial Williamsbg.,inc.
The Abby Aldrich Rockefeller folk art coll.N6510.C7
NCFA Bibl. p.394a

ND
210
F62
NCFA

II.A.3 - U.S. - 19th c.

Flexner, James Thomas, 1908-
The decline of the portrait.In,his,That wilder image...p.250-20

Discusses Inman,Elliott,Stock,Brady,Healy,
Ths.Hicks,Hardy,Johnson

Repro:Inman,Hardy,Ths.Hicks,Healy,Johnson

FOR COMPLETE ENTRY
SEE MAIN CARD

705
A56
NCFA
v.58

II.A.3 - U.S. - 19th c.

Chicago Historical Society
Primitives on view in Chicago

In:Antiques
58:392-3 Nov.,'50 illus.

Exh.Nov.,1950-Feb.,1951

Repre.incl.:Prymeier,Krans,Rester,Ambroise Andrews

705
A76
NCFA
v.89

II.A.3 - U.S. - 19th c.

Gaines, Edith ed.
Collector's notes

In:Antiques
89:238-9 Feb.,'66 illus.

Incl.checklist of portrs.by Jefferson
Gauntt(fl.1826-1857)

II.A.3 - U.S. - 19th c.

Des Moines Art Center
19th century American portraits from Iowa collections.Exh.14 Sept.-17 Oct.'76.:Cat.:by Js.T.Demetrion
4 p. illus.

Incl.portrs.from G.Stuart to M.Cassatt

34 works shown

RILA IV/X 1978 #2122

708.9493
B921
NMAA
v.30-33

II.A.3 - U.S. - 19th c.

Coley, Mary Anne
Sargent's "Dr.Pozzi at home",exhibited in Brussels in 1884

In:Mus.Royaux
des Beaux-Arts
de Belgique.B.
30-33:143-150 1981-1984/1-3 illus.

Synopsis in Dutch and French

N7
.D6
NPGA

II.A.3 - U.S. - 19th c.

Duyckinck, Evert Augustus, 1816-1878
National portrait gallery of eminent Americans,incl.orators,statesmen,naval & military heroes,jurists,authors,etc.,from original full length ptgs.by Alonzo Chappel...New York,Johnson Fry & Co.,1862.
2 v. illus.

LC E176.D98

Cirker.Dict.of Am.portrs.
N7593/C57/NPG Bibl, p.714
Ref.

759.1
L76

II.A.3 - U.S. - 19th c.

Lipman, Mrs.Jean Herzberg, 1909-
American primitive painting.London,N.Y.,etc.
Oxford univ.press,1942
158 p. illus(part col.)

Bibliography
List of important exhibitions & list of primitive painters.(Exhibitions 1924-1942)
"Brings together for the 1st time in book form some of the best examples of a.n....aspect of American heritage."-J.T.Flexner in his review in:Antiques,v.42:159.3
LC ND205.L5

ND
1311.2
F29
NPG

II.A.3 - U.S. - 19th c.

Feigenbaum, Rita
American portraits,1800-1850;a cat. of early portraits in the collections of Union College.
Schenectady,N.Y.,Union College Press,1972
155 p. illus(part col.)

originally presented as the author's thesis
(M.A.)Union College,1966-67
Bibliography p.143-50
Index

LC ND1311.2F4 1972

Art Books 1950-79 Z5937
A775 NCFA Ref. p.897

II.A.3 - U.S. - 19th c.

Livingston, John
Portraits of eminent Americans now living...
New York,Cornish,Lamport & co.,1853-54
4 v. illus.

Originally issued in parts,with cover title:
American portrait gallery,containing portrs.of men now living... LC E339.L68

LC E339.L69

Cirker.Dict.of Am.portrs.
N7593/C57/NPG Bibl.,p.714
Ref.

161
NCFA
v.77

II.A.3 - U.S. - 19th c.

M'Cormick, William b.
A "backwater" of American art. New York
hist.soc.'s coll.of 374 portraits,an almost
unknown treasury

In:Studio
77:110-16 May,'23 illus.

Repro.incl.:Rembrandt Peale,Chs.Willson
Peale,Benj.West,Sam.F.B.Morse,Vanderlyn,Trum-
bull,Durand,Wm.O.Stone,A.P.Healy

705
C75
NCFA
v.192

II.A.3 - U.S. - 19th c.

Sadik, Marvin S.
Paintings from the White House

In:Connoisseur
192:22-31 May,'76 illus(part col.)

Repro.incl.:John Tyler by Healy;Sharitar-
rish by Chs.Bird King;Taft by Zorn;Mrs.van
Puren by Inman;Audubon by Syme;Jefferson by
R.Peale;Ruth Harding by Eakins

Rila III/2 1977 #7310

ND
1311.2
P61x
NPG

II.A.3 - U.S. - 19th c.

Miles, Ellen Gross comp.
Portrait painting in America.The nineteenth
century.N.Y.,Main Street/Universe Books,1977
174 p. illus(part col.)

Anthology of articles from ...Antiques...;
covers period 1800-1860:Collections,Trained ar-
tists,Folk artists,Sitters. Introductory mate-
rial by Ellen G.Miles
Bibl.references;Suggestions for further
reading

705
A784
NCFA
v.22

II.A.3 - U.S. - 19th c.

Sherman, Frederic Fairchild, 1874-1940
Unrecorded early American painters

In:Art in Amer.
22:145-50 Oct.,'34 illus.

List of portrait painters, mainly 19th c.

ND
205
N53
v.1
NPG
NCFA
3rd c.Ref.

II.A.3 - U.S. - 19th c.

New York. Metropolitan museum of art
American paintings;a cat.of the coll.of the
Metrop.mus.of art..By.Albert Ten Eyck Gardner &
Stuart P.Feld.Greenwich,Conn.,Distr.by N.Y.Gra-
phic Soc..1965-
v. illus.

Contents.-1.Painters born by 1815

Index of titles & artists

Arts in America qZ5961.U5
A77X NCFA Ref. I 121

mfm
205
NPG

II.A.3 - U.S. - 19th c.

Thistlethwaite, Mark Edward
The image of George Washington;studies in
mid-nineteenth-century American history paint-
ing.Philadelphia,University of Pennsylvania,
1977

FOR COMPLETE ENTRY
SEE MAIN CARD

N
40.1
P558H7
NPG
NCFA

II.A.3 - U.S. - 19th c.

Phillips, Ammi, 1788-1865
Ammi Phillips:portrait painter,1788-1865.
Intro.by Mary Black.Cat.by Barbara C.& Lawrence
B.Holdridge.New York,C.N.Potter for the Mus.of
American Folk Art;distr.by Crown Publishers.1969
56 p. illus(part col.)

Exhib.at Mus.of Amer.Folk Art, New York,Oct.
14-Dec.1,1968 & at Albany Inst.of Hist.& Art,
Dec.9,1968-Jan.7,1969
Bibliography

LC ND237.P47A6 Folk art in America NK807
F61x NCFA Bibl.

705
C75
NCFA
v.171

II.A.3 - U.S. - 19th c.

Truettner, William N.
Portraits of Stephen Decatur by or after
Gilbert Stuart

In:Connoisseur
171:264-73 Aug.'69 illus.

Tichbanges attributions & dates proposed by
Chs.L.Lewis
Repro.incl.:Ths.Sully,J.W.Jarvis,R.Peale,Js.
A.Simpson,Chs.Bird King,Js.H.Cafferty

ND
1311.2
P61x
NPG

II.A.3 - U.S. - 19th c.

Rutledge, Anna Wells
Ptgs.in the Council Chamber of Charles-
ton's City Hall
Miles, Ellen Gross comp.
Portrait painting in America.The nineteenth
century.N.Y....,1977 (card 2)

Partial contents:A.W.Rutledge,Ptgs.in the
Council Chamber of Charleston's City Hall,p.25-
30;...

705
A784
NCFA
v.23

II.A.3 - U.S. - 19th c.

Unrecorded early American portrait painters

In:Art in Am
23:82 Mar.,'35

N6536
N53
c.3
REF

Most of these artists are in Groce & Wallace:
N.Y.Hist.Soc.Dict.of artists in Amer.,1564-1860

qAP
M225
NPG
v.5

II.A.3 - U.S. - 19th c.

Walters, Donald R.
 Making faces:aspects of American portrai-
ture

In:Maine Ant.Dig.
5,no.10:1c-4c(pt.1) Nov.,'77 illus.

 Pertains to exh.at Abby Aldrich Rockefel-
ler Folk Art Ctr.,Williamsburg,Va.,.Nov.?,-
Dec.4,1977
 Repro.incl.:Asahel Powers,Jonathan Adams
Bartlett,Ammi Phillips(attr.),Jos.Whiting,Wm.
M.Prior,Sturtev___ nt J.Hamblen. Portr.of
Washington(arti. unidentified)

E
89
C35
NPG

II.A.3 - U.S. - 19-20th c.

A catalogue of Indian portraits in the coll.
of Jos.G.Butler,jr.,on free exh.at the
Y.W.C.A.bldg,Youngstown,O..:s.n.,s.l.,
ca.1907.(Youngstown,Ohio,Vindicator Press)
39 p. illus.

 The greater part of the coll.is the work
of J.H.Sharp and E.A.Burbank.Other artists re-
presented are Frederick Remington,Bert Phillips
Deming and Gandy
 Smithsonian "National Museum"bought 11
Sharp ptgs.,Dec.1900

II.A.3 - U.S. - 19th c.

Walters, Donald R.
 Making faces:aspects of American portrai-
ture

In:Maine Ant.Dig.
5(pt.2) Dec.,'77
6(pt.3) Jan.-Feb.,'78

 Pertains to exh.at Abby Aldrich Rockefel-
ler Folk Art Ctr.,Williamsburg,Va.,.Nov.?,-
Dec.4,1977
ICA MB Abby Aldrich Rockefeller
 Folk Art Ctr..Amer.Folk
 portrs.N7593.A23 1981 NPG
 Ref. Bibl.p.294

ND
205
I79
1933
NPG

II.A.3 - U.S. - 19-20th c.

Isham, Samuel, 1855-1914
 The modern portraits painters,in.his,The his-
tory of American painting,Ch.XXXVI,p.513-37.
N.Y.,MacMillan co.,c.1933. illus.

 Repro.incl.:Eakins,Beaux,Lockwood,Porter,
Wiles,L.F.Emmet,Fuller,Hills

ND
210.5
R6W6
1982X
HMAA

II.A.3 - U.S. - 19th c.

Wolf, Bryan Jay, 1947-
 Romantic re-vision.Culture and conscious-
ness in 19th c.American painting and litera-
ture.Chicago and London,The Univ.of Chicago
Press,1982
 272 p. illus.
 Bibl.references
 Index

 Incl.:Discussion on portrs.by Ths.Smith,
Chs.Willson Peale,Washington Allston,Copley
and Poussin

ND
1311.8
I6P42
1978X
NPG

II.A.3 - U.S. - 19-20th c.

Peat, Wilbur David, 1898-
 Portraits and painters of the governors of
Indiana,1800-1978...Indiana Histor.Soc.,1978

FOR COMPLETE ENTRY
SEE MAIN CARD

705
A782
NCFA

II.A.3 - U.S. - 19-20th c.

Berry, Rose V.S.
 One hundred years of American art.I.Figure
painting and portraiture

In:Art & Archeology
20:185-203 Oct.,'25 illus.

FOR COMPLETE ENTRY
SEE MAIN CARD

N
40.1
A363P6
NCFA

II.A.3 - U.S. - 19-20th c.

Pittsburgh. Carnegie institute. Dept.of fine
 Cat.of paintings,John White Alexan- .arts
der memorial exh.,March 1916,Dept.of fine arts
Carnegie institute,Pittsburgh..Pittsburgh,Mur-
doch-Kerr press,c.1916.
 66 p illus.

 Bibliography

 Incl.Record of paintings by J.W.Alexander:
Portrs.before 1887-1913,p.37-55,...
 See also:Mag.Art,v.7:345-73,Memorial numbe
LC ND237.A35P5

II.A.3 - U.S. - 19-20th c.

Caffin, Charles Henry, 1854-1918
 Some American portrait painters

In:Critic
44:31-48 Jan.,1904 illus.

 Portr.exh."Treasures of art worth millions"
Repro.incl.:Sargent,J.Shannon,Beaux,Amanda
Brewster Sewell,F.Duveneck,Rbt.Henri,F.D.Millet,
J.W.Alexander,Alden Weir,Wilton Lockwood,DeFo-
rest Brush,Louis Loeb,
LC AP2.092 Poole's index AI.3.P82 NCFA
D.C.P.L. Lit.mf. v.6,p.510

II.A.3 - U.S. - 19-20th c.

U.S.Commission to the Paris exposition,1900.
 Dept.of fine arts.
 Official illustrated cat.,fine arts exh.,
United States of America,Paris expo.of 1900.
Boston,Noyes,Platt & Co.,c.1900.
 110 p. illus.

 "Biographical":p.,1.-49

 Also issued in French
 The exh.incl...Sargent,Geo.de Forest Brush,
Cecilia Beaux,Wyant,Chase,Eakins among the por-
traitists
LC N4804.U7 Arts in Am.qZ5961.U5A77x
 NCFA Ref. I 129

ND
1311.3
D38X
NPG

II.A.3 - U.S. - 20th c.

Daugherty, Charles, Michael, 1914-　　ed.
　　Six artists paint a portrait:Alfred Chad-
bourn,George Passantino,Charles Reid,Ariane
Beigneux,Robert Baxter,Ann Toulmin-Rothe....
Westport,Conn.,North Light Publ.;N.Y.,distr.by
Watson-Guptill Publ.,1974

FOR COMPLETE ENTRY
SEE MAIN CARD

II.A.3 - U.S. - 20th c.

Heins, Barbara
　　Florine Stettheimer and the avant-garde
American portrait

　　Ph.D.-thesis,Yale Univ.,1986

Archives of American Art
Journal.v.24no.4,1984
AP1.D39 NMAA,p.28

705
.M8
NCFA
v.20

II.A.3 - U.S. - 20th c.

Eggers, George William, 1883-1958
　　Leopold Seyffert and his place in American
portraiture

In:Mag Art
20:64-73　Feb,'29　illus.

　　Points out that in times of experimentation
portraiture needs a discipline which is not neces-
sary for landsc.-or still life ptg. Compares
S.'s work with contemporaries'. Evaluates S.'s
portrs. as to technique & contents
　　　　Cumulated Mag.subj.index
　　　　A1/3/C76 Ref. v.2,p.443

ND
1311
L47
NPG

II.A.3 - U.S. - 20th c.

Lee, Cuthbert, 1891-
　　Contemporary American portrait painters,
illustrating and describing the work of fifty
living painters. New York,W.W.Norton,1929
　　108 p.　illus.

LC ND1311.L4

ND
1311.3
F94
NCFA

II.A.3 - U.S. - 20th c.

Frumkin (Allan) Gallery
　　Portrait painting 1970-1975.A survey of
informal portraiture in the U.S.A.,1975,
,28,p.　illus.

　　Text by G.W.Barrette and Allan Frumkin
31 works

　,Exh.Jan.7-31,1975,
　　Perceptive contemp.realism.Incl.:Close,
Leslie,Neel,Pearlstein,Dean,Elaine de Kooning,
Kats,Koch,Porter,etc.
　　　　MOMA,v.11,p.432

ND
1311.3
L913
NPG

II.A.3 - U.S. - 20th c.

Lowe Art Museum
　　Contemporary portraits by American painters
...1974

FOR COMPLETE ENTRY
SEE MAIN CARD

N
6512.5
P4506X
NMAA

II.A.3 - U.S. - 20th c.

Goodyear, Frank Henry, 1944-
　　Contemporary American realism since 1960.
Boston,New York Graphic Society,in association
with the Penn.Acad.of the Fine Arts,c.1981
　　255 p.　illus(part col.)

　　Published in connection with the exh.opening
at the Penn.Acad.of the Fine Arts,Phila.,Sept.18
1981
　　Bibliography:p.233-42
　　Index
　　　　Halle.In:Art J.v.46:225
　　note 21

705
.M8
NCFA
v.12

II.A.3 - U.S. - 20th c.

,Mechlin, Leila, 1874-
　　War portraits by eminent artists

In:Mag Art
12:76-88　Mar,'21　illus.

　　Travel exhib.starting in the Met,N.Y.,Jan17-
Feb.14,'21 of portrs.to be presented to the NGA,
thus initiating in Wash.a "National Portr.Gall."

　　"Portr.is conceded to be the highest form of
art. ...man is to man invariably the most engag-
ing of exhibits."　Cumulated Mag.subj.index
　　　　A1/3/C76 Ref. v.2,p.445

705
.C88
NCFA

II.A.3 - U.S. - 20th c.

Hall, Lee
　　The sullen art and craft of portraiture

In:Craft Horis
34:40-3 -　Dec.,'74　illus(part col.)

　　Discussion of the concept,history and uses
of portraiture.Focus is on Elaine de Kooning,
Alice Neel and Andy Warhol.
　　Incl.quotations of Baudelaire and Pope-Hen-
nessy

757
.N27

II.A.3 - U.S.-20th c.

National art committee
　　Exhibition of war portraits;signing of the
Peace treaty,1919,and portrs.of distinguished
leaders of America and of the allied nations,
painted by eminent American artists for presenta-
tion to the National portrait gallery....New York
1921,
　,64,p.　illus.

　　Circulated by The American Federation of Arts
Cat.compiled by Florence N.Levy
　　On cover:National gall.or art under direction
of the Smithsonian Inst.,Wash.,D.C.,May5-22,1921
　　Review by Leila Mechlin
LC D507.N3

II.A.3 - U.S. - 20th c.

National association of portrait painters
 Cat.of the exh.of the National association
of portrait painters,inc.,Feb.2-Feb.14 incl.,
1914,gall.of Knoedler & co...N.Y.,N.Y.,Publi-
shers printing co.,1914.
 48 p. illus.

LC N5015.N3 Winterthur Mus.Libr.fZ881
 .W78 NCFA v.6,p.217

ND II.A.3 - U.S. - ALABAMA
1311.8
A2N27 National Society of the Colonial Dames of America,
NPG Alabama
 Alabama portraits prior to 1870,comp.by ...
 Mrs.Orville Lay....Mobile,Ala.,Printed by Gill
 Printing and Stationery Co.,1969
 417 p. illus.

AAP

II.A.3 - U.S. - 20th c.

National association of portrait painters
 Cat.of the 12th annual exh.of the National
assoc.of portrait painters,held at the Duveen
galleries, 720 Fifth ave.,N.Y.city,Jan15 to 31,
1925.N.Y.,1925.
 ₍66₎p. illus.

LC N5015.N6 1925 Art Books 1876-1949. Z5937
 A775 NCFA Ref. p.495

757 II.A.3 - U.S. - CONNECTICUT
C75
 Connecticut. Tercentenary commission
 ...Connecticut portraits by Ralph Earl,
 1751-1801. Aug.1-Oct.15₍1935₎.Gall.of fine arts,
 Yale university.New Haven,Yale uni.press,1935.
 30 p. illus

 Biogr.sketch of artist signed:William
 Sawitzky

LC ND237.E18C6

ND II.A.3 - U.S.- 20th c.
1311
N27 National association of portrait painters
1945 Portraits of Americans by Americans;exhibition
NPG ...April 1-May 5,1945...Under the auspices of the
 New York historical society. New York,1945.
 129 p. illus.

 Biographical notes compiled by Bartlett
 Cowdrey and Helen Comstock

LC ND1311.N3

705 II.A.3 - U.S. - CONNECTICUT
A786
NCFA Green, Samuel M.
v.51 Uncovering the Connecticut school

 In:Art N
 51:38-41,57-8 Jan.,'53 illus.

 "The qualities & characteristics of a little-
 known group of ₍portr₎.ptrs.,often associated
 with Ralph Earl,are examined in Wesleyan Univ's
 exh."
 Repr.:Earl,R.,Jennys,Wm.,Stuart,G.,Chandler
 Moulthrop,R.,Phillips,J.,Johnston,W.
 Beardsley Limner.N40.1B372
 S3 NPG ,p.10,footn.5

705 II.A.3 - U.S. - 20th c.
A56
NMAA Platt, Frederick, 1946-
v.126 The war portraits

 In:Antiques
 126:142-53 July,'84 illus(part col.)

 '...American finest portr.ptrs.were...to re-
 cord 22 Allied leaders...These ptgs....were to
 form the basis of a Nat'l Portr.Gallery...'

 Repro.incl.:Admiral Beatty,Cardinal Mer-
 cier,Clemenceau by Cecilia Beaux

AP II.A.3 - U.S. - CONNECTICUT
1
C76 Little-known Connecticut artists,1790-1810
NPG
 In:Conn.Hist.Soc.Bull.
 22:97-103 Oct.,'57 illus.

 Cat.of 31 ptgs.of exh.at The Conn.Hist.Soc.,
 Nov3,1957-Feb.1,1958

 Intro.by Nina Fletcher Little
 List of portrs.,all reproduced,pp.104-28 &
 frontispiece
 Identified artists:Budington,J.,Wales,N.F.,
 Brown,U.
 Beardsley Limner,N40.1
 B372S3 NPG p.10,footn.8

II.A.3 - U.S. - 20th c.

St.Louis. City Art Museum
 An exh.of portraits by American artists.
Opening Feb.6, '16.St.Louis,1916.
 8 p. (Special exh.cat. Series 1916,
 no.3)
N.Y.P.L. Exh. till Feb.28,1916
3 MAVZ
(St.Louis) For repro.see Mag Art,705M18 NCFA,v.7:193-6:
 Chs.Noel Flagg,John C.Johannes,John Elliott,
 Henry R.Rittenberg
 Circulated by The American Federation of
 Arts

AP II.A.3 - U.S. - CONNECTICUT - 18-19th c.
1
C76 Joseph Steward and the Hartford museum
NPG
v.18 In:Conn.Hist.Soc.B.
 18:1-16 Jan.-Apr.,'54 Illus.

 Pertains to exh. of Steward's portraits.
 Biographical treatment of this Conn.portraitist
 and museum owner

 Arts in America q25961
 A77X NCFA Ref. H492

AP
1
C76
NPG
v.26

II.A.3 - U.S. - CONNECTICUT - 18-19th c.

Warren, William Lamson
 Captain Simon Fitch of Lebanon,1758-1835.
Portrait painter

In:Conn.Hist.Soc.B.
26:97-120 Oct.,'61 illus.

 ...incl.lists of portrs.by Fitch,Reuben
Moulthrop,John Trumbull,Rich.& Wm.Jennys:in exh.
at Conn.Hist.Soc.Nov.6,'61-Feb.1,'62.

FOR COMPLETE ENTRY
SEE MAIN CARD

II.A.3 - U.S. - DELAWARE

Delaware Historical Society
 List of portraits owned by the Historical
Society of Delaware..August,1967.
 3 p.

 (xerox copy

 See also Nat'l Soc.of the Colonial Dames of
America. Delaware N7593.N27 NPG

Winterthur Winterthur Mus.Library
Mus.Libr. fZ881.W78 NCFA v.6,p.230
Pamphlet File

AP
1
C76
NPG
v.24

II.A.3 - U.S. - CONNECTICUT - 18-19th c.

Warren, William Lamson
 Connecticut pastels,1775-1820

In:Conn.Hist.Soc.B.
24:97-114 Oct.,'59 illus.no.1-31,cover &
 p.115-28

FOR COMPLETE ENTRY
SEE MAIN CARD

N
7593
N27
NPG

II.A.3 - U.S. - DELAWARE

National Society of the Colonial Dames of America.
 Delaware
 Portraits in Delaware,1700-1850;a check list.
Wilmington,1951
 176 p. illus.

 Bibliography

LC N7593.N25

705
A56
NCFA
v.46

II.A.3 - U.S. - CONNECTICUT - 19th c.

Dods, Agnes M.
 Connecticut Valley painters

In:Antiques
46:207-9 Oct.,'44 illus.

 Rpro.incl.:Augustus Fuller,Nathan Negus,
Josph Goodhue Chandler

ND
1311.8.G4
N37
1975X
NPG

II.A.3 - U.S. - GEORGIA - 18-19th c.

National Society of the Colonial Dames of
 America. Georgia. Historical Activities
 Committee
 Early Georgia portraits,1715-1870,comp.by
...Marion Converse Bright...Athens,Univ.of Ga.
Press,1975.
 338 p. illus.(col.repro.on jacket)

 Arranged in alphabetical order by sitters
 Index of artists

LC ND1311.8.N37 1975

705
S94
NCFA
v.80

II.A.3 - U.S. - CONNECTICUT - 19th c.

Nelson, Mrs.H.C.
 Early American primitives

In:Studio
80:454-9 Mar.,'25 illus.

 Pertains to exh.held in Kent,Conn.,Summer,'2

 "...initial florescence of purely American
ptg...which sprang fr.native soil & flowered un-
influenced by foreign climes..."

 Phillips,Ammi...N40.1P558
 H7,Bibl.

ND
1311.8
I3N27
NPG

II.A.3 - U.S. - ILLINOIS

National Society of Colonial Dames of America.
 Illinois
 Illinois portrait index.1972
 72 p.

LC N7593.N26

705
A56
NCFA
v.109

II.A.3 - U.S. - CONNECTICUT - WETHERSFIELD - 18-
 -19th c.

Reynolds, Ronna L.
 Wethersfield people and their portraits

In:Antiques
109:528-33 Mar.,'76 illus(part col.)

 Portrs.ptd.on canvas,ivory,paper betw.1760-
1825 illustrate changes in the artistic atti-
tudes during the transition fr.colonial to fe-
deral America

 Rila III/2 1977 #567B

II.A.3 - U.S. - ILLINOIS - CHICAGO

[Chicago. Exhibition by Chicago portrait painters

In:Fine arts j.
36:37-40 Nov.,'18 illus.

LC N1.F5

 Cumulated Mag.subj.index
 A1/3/C76 Ref. v.2,p.443

II.A.3 - U.S. - INDIANA

Peat, Wilbur David, 1898-
Pioneer painters of Indiana. Indianapolis,
Art Association of Indianapolis, Indiana, 1954
254 p. illus.

Bibl.references included in "Notes"(p.211-
219)"Bibl.guide:books referred to in the ros-
ter of ptrs.that follow".p.221-3

LC ND230.I5P4 Am.Folk ptg.selected fr.
 the coll.of Mr.&Mrs.Wm.E.
 Wiltshire IJJ ND207.W66X
 NPG Notes p.107

705
A56
NCFA
v.92

II.A.3 - U.S. - KENTUCKY - 19th c.

Bridwell, Margaret M.
Oliver Fraser,early Kentucky portrait
painter

In:Antiques
92;718-21 Nov.,'67 illus.

"...one of the most distinguished...early Ken-
tucky artists."-Bridwell

 Arts in America q Z5961.U5
 477X NCFA Ref. I773

757
P36

II.A.3 - U.S. - INDIANA

Peat, Wilbur D.
Preliminary notes on early Indiana portraits
and portrait painters...

In:Indiana history bull.
17;no.2:77-93 Feb.,1940

M
7593.8
L8L68
1979X
NPG

II.A.3 - U.S. - LOUISIANA

Louisiana State Museum, New Orleans
The Louisiana Portrait Gallery;by John
Burton Harter and Mary Louise Tucker.New Orleans,
Louisiana State Mus.,c.1979-
v. 1 illus(part col.)

Bibliography v.1,p.126-30
Incl.index
Contents.-v.1.from c.1775.to 1870

N
40.1
J86F6
NPG
NCFA

II.A.3 - U.S. - KENTUCKY

Floyd, William Barrow, 1934-
Jouett-Bush-Frazer:early Kentucky artists.
Lexington,Ken..privately printed.1968
204 p. illus.

Bibliography

LC ND236.F5 NPG A 19th c.gall.of distin-
 guished Americans.Bibl.

ND
1311.8
L8N27
NPG

II.A.3 - U.S. - LOUISIANA

National Society of Colonial Dames of America.
Louisiana. Historical Activities Committee
Louisiana Portraits;comp.by Mrs.Thomas Nelso
Carter Bruns.New Orleans,Wetsel Printing,Inc.,
1975.
315 p. illus(part col.)

most.portrs.prior to 1869

"The prints of all portrs....are in the Bel-
knap Library of The Henry Francis du Pont Win-
terthur Mus.,Winterthur,Del."-Preface

ND
1311.2
P61x
NPG

II.A.3 - U.S. - KENTUCKY
Floyd, William Barrow, 1934-
Portraits of ante-bellum Kentuckians
Miles, Ellen Gross comp.
Portrait painting in America.The nineteenth
century.N.Y....,1977 (card 4)

Partial contents cont'd:...Wm.B.Floyd,Portrs
of ante-bellum Kentuckians,p.165-74

ND
1311.2
P61x
NPG

II.A.3 - U.S. - LOUISIANA - NEW ORLEANS - 18-19th
Toledano, Roulhac B. & W.Jos.Fulten
Portr.ptg.in colonial & ante-bellum New
Orleans
Miles, Ellen Gross comp.
Portrait painting in America.The nineteenth
century.N.Y....,1977 (card 2)

Partial contents:...R.B.Toledano & W.J.Ful-
ten,Portr.ptg.in colonial & ante-bellum New Or-
leans,p.31-8;...

N
7593.8
K4W61
NPG

II.A.3 - U.S. - KENTUCKY

Whitley, Edna Talbott, 1891-
Kentucky ante-bellum portraiture;illus.by
photos from the coll. of the Nat'l Soc.of the
Colonial Dames of America in the Commonwealth
of Kentucky. .Paris?Ky.,1956.
848 p. illus.

Bibliography

LC N7593.W45

P
24
A34
1987X
NMAA

II.A.3 - U.S. - MAINE - 19th c.

Agreeable situations:society,commerce and art
in southern Maine,1780-1830;ed.by Laura
Fecych Sprague;essays by Joyce Butler...
et al..Kennebunk,Me.Brick Store Mus.
Boston:Distributed by Northeastern Univ.
Press,1987
209 p. illus(part col.)
Incl.Brewster,jr.,deaf artist,p.88,122,254
Cat.of selected objects from the Brick
Store Mus.et al
Index
Bibliography

N
7523.9
K3K34
NPG

II.A.3 - U.S. - MAINE - KENNEBUNK

Kennebunk, Me. Brick store museum.
Old family portraits in Kennebunk....1944
.24.p. illus. (Its Publication no.4)

Bibliography

LC F29.K3K38
N7593.K4 (copy 2)

757
.B18
NCFA

II.A.3 - U.S. - MARYLAND

Baltimore. Museum of art
Two hundred and fifty years of painting in
Maryland. The Baltimore mus.of art...May 11
through June 17th,1945.....c.1945.
78 p. illus.

757.7
R98

AP1
M39
NPG

II.A.3 - U.S. - MARYLAND

Maryland Historical Society
Handlist of miniatures in the coll...by
Anna Wells Rutledge.Balto.,Md.,1945
18 p. illus (Repr.fr.Md.Hist.Mag.
v.40,no.2,June,1945,pp.119-36)

Sellers.Archives of Amer.
art:Mezzotint prototypes...
In:Art Q 20,no.4,p.468

N7621
M39p
NPG

N7621-
M39
NPG

II.A.3 - U.S. - MARYLAND

Maryland Historical Society
Portraits painted before 1900 in the coll...
by Anna Wells Rutledge.1946.
.39.p. illus. (Repr.fr.Md.Hist.Mag.
v.41,1,March,1946)
A----Oil portraits in the coll...;a supplement to
the cat.of portraits,published in 1946;incl.all
those acquired to Nov.,'55
.26.p. (Repr.fr.Md.Hist.Mag.
v.50,no.4,Dec.,'55

Sellers.Archives of Amer.
art:Mezzotint prototypes..
In:Art Q 20,no.4,p.468

705
A56
NCFA
v.111

II.A.3 - U.S. - MARYLAND - ANNAPOLIS - 18th c.

Weekley, Carolyn J.
Portrait painting in 18th c.Annapolis

In:Antiques
111:345-53 Feb.,'77 illus(part col.)

Incl.:Engelhardt,Kühn,Hesselius,Wollaston,
Chs.W.Peale,Js.Peale,Paris

RILA IV/I 1978 #1138

II.A.3 - U.S. - MASSACHUSETTS

Society of the Cincinnati. Massachusetts
Memorials of the Mass.Society of the Cincin-
nati. Ed.by Frank Smith.Boston,Priv.print.Press
of Geo.H.Ellis co.(inc.)1931
569 p. illus.

LC E202.1.M383

II.A.3 - U.S. - MASSACHUSETTS

Society of the Cincinnati. Massachusetts
Memorials of the Mass.Society of the Cincin-
nati.Ed.by James M.Bugbee.Printed for the Socie-
ty,1890
575 p. illus.

LC E202.1/M382 Cirker.Dict.of Am.portrs.
N7593/C57/NPG Bibl.,p.713

N40.1
1427C6
NPG

II.A.3 - U.S. - MASSACHUSETTS - 19th c.

Coburn, Frederick William, 1870-
Thomas Bayley Lawson;portrait painter of
Newburyport and Lowell.Salem,Mass.,Printed by
Newcomb & Gauss,1947.
59 p. illus.

"Reprinted fr.Essex inst.hist.colls.,v.83,
Oct.,'47"

Incl.Lawson Register

ND
235
B787h
NCFA

II.A.3 - U.S. - MASSACHUSETTS - BOSTON

Boston University. School of Fine & Applied
Arts.
Boston painters:1720-1940.Exhibition.1968.
.Boston,1968.
70 p. illus.

Text by William B.Stevens,jr.

Biographical footnotes

More than half of the exhibited ptgs.are
portraits

AP
1
S72
NPG

II.A.3 - U.S. - MASSACHUSETTS - BOSTON - 17th c.

Gold, Sidney M.
A study in early Boston portrait attribu-
tion. Augustine Clement,painter-stainer of
Reading,Berkshire,and Massachusetts Bay
In:Old Time NE
58,no.3:61-78 Winter,'68 illus.

Green,S.M. Engl.origins of
N.E.ptg.In:Winterthur Conf.
ND207/W78/1971,p.60

AP
1
D39
NCFA
v.6

II.A.3 - U.S. - MASSACHUSETTS - BOSTON - 17-18th

Dresser, Louisa
Portraits in Boston,1630-1720

In:Detroit.Arch Am Art J.
6,no.3-4:1-14 July-Oct.,'66 illus.

Historical analysis of the limners & their
work in Boston,prior to 1720

LC N11.D513

Winterthur Mus.Library
Z881.W78,v.6 NCFA p.227

AP
1
G25
NPG
v.2

II.A.3 - U.S. - MISSOURI - 19-20th c.

McCoskey Goering, Karen
A Legacy from the Wyman museum:The Society's
coll.of St.Louis mayors' portraits

In:Gateway Heritage
2:32-41 Spring,'82 illus(col.)

Exhibited at City Hall.Owned by Missouri
Historical Society

N
40.1
T192P6
NMAA

II.A.3 - U.S. - MASSACHUSETTS - BOSTON - 19-20
c.

Pierce, Patricia Jobe
Edmund C.Tarbell and the Boston School of
painting,1889-1980...ed.by John Douglas Ingra-
ham.Hingham,Mass.,Pierce Galleries,c.1980
253 p. illus(part col.)

Index
Bibliography,p.236-45

Ch.7:Tarbell's portraiture,p.119-28
Ch.8 incl.:Photographs of E.C.Tarbell
paintings,p.141-49
Nat'l academy of design
Artists by themselves

N
40.1
M1292B3
NMAA

II.A.3 - U.S. - NEVADA - 19th c.

Basso, Dave comp.
The works of C.B.McClellan,19th century Neva-
da portrait and landscape artist.Bibliographical
catalog.Sparks,NV,Falcon Hill Press,1987
35 p. illus.

ND
1311.2
S76
NPG

II.A.3 - U.S. - MASSACHUSETTS - CONNECTICUT VAL-
LEY 19th c.
Springfield,Mass. Museum of fine arts.
Somebody's ancestors;paintings by primi-
tive artists of the Connecticut valley.Spring-
field mus.of fine arts,Springfield,Mass.,Feb.7-
March 8,1942?.Springfield,1942.
23 p. illus.
5 portraits by Jos.Goodhue Chandler(1813-?)
19 " " E.S.Field(1805-1900)
4 " " Augustus Fuller(1812-1873)
2 " " J.Atwood
2 " " Nathan Negus(1801-1825)
3 " " Ruth Henshaw Bascom(1772-1848)
8 " " unknown artists
LC ND1311.S68

ND
1337
U5H74
NCFA
NPG

II.A.3 - U.S. - NEW ENGLAND

Boston. Museum of Fine Arts
New England miniatures,1750 to 1850. Exhib.
April 24 to May 28,1957...Boston,1957
illus(part col.)

The art of miniature ptg. in New England,by
Barbara Neville Parker,pp.8-18
Bibliography

see cat.cds.in NPG

ND
1311.5
L48
1977X
NPG

II.A.3 - U.S. - MASSACHUSETTS - LEXINGTON - 18-
19th c.
Lexington Historical Society, Lexington, Mass.
Lexington portraits;a cat.of American por-
traits at the Lexington Historical Society,
1734-1884.by.Dean T.Lahikainen.Lexington,Mass.,
...1977
72 p. illus(part col.)

Bibl.references

N
4
D814
1984
NMAA

II.A.3 - U.S. - NEW ENGLAND

Dublin Seminar for New England Folklife (9th:
1984;Salem,Mass.)
Itinerancy in New England and New York;
editor Peter Benes & Jane M.Benes.Boston.
Boston Univ.,8.1986
256 p. illus. (Annual proceedings,
Dublin Seminar for New England Folklife,1984)

Sect.IV:Portraits,Profiles & Daguerreo-
types:New England Itinerant portraitists,by
Joyce Hill.Ralph Earl as an itinerant artist,
by Eliz.Mankin Kornhauser.
cont'd on next card

705
A56
NCFA
v.56

II.A.3 - U.S. - MASSACHUSETTS - MARBLEHEAD -
19th c.

Davis, Agnes M.
A Marblehead painter

In:Antiques
56:372 Nov.,'49 illus.

Colonial Williamsburg,inc.
Abby Aldrich Rockefeller
folk art coll.N6510.C71
NCFA p.84

705
A784
NCFA
v.33

II.A.3 - U.S. - NEW ENGLAND

Kaldis, Laurie Eglington
American and English portraiture:democracy
versus aristocracy

In:Art in Amer.
33:48-63 Apr.,'45 illus.

Pertains to exh."Old & New England"in Rhode
Island school of des.For cat.see 757.6R47NCFA

Repro.:Winthrop Chandler,Ralph Earl,Reynolds,
Gainsborough,Feke,Moulthrop,Gilb.Stuart
Cumulated Mag.subj.index
A1/3/C76 Ref. v.2,p.443

757.6
.R47
NCFA

II.A.3 - U.S. - NEW ENGLAND

Rhode Island school of design,Providence. Mus.of
art
 The cat. of old & New England,an exh.of Amer.
ptg. of colonial & early Republican days together
with English ptg.of the same time...fr.Jan.19
through Feb.18,1945=Providence,Akerman-Standard
press,1945?.
 ₅75₌p. illus.

 Review by E.P.Richardson:"Old & New England"
In:Art Q.,v.8:3-15, winter 1945 illus.

ND
-207
W78
1971
NPG

II.A.3 - U.S. - NEW ENGLAND - 17th c.

Green, Samuel M.
 English origins of 17th c.painting in New
England

In:Winterthur Conf.on Mus.Oper'n and Conn'ship
17th:15-69 1971 illus.

 Bibliographical notes
 Incl.:Chronological checklist of English
antecedents to N.E.ptg.

LC ND207.W5 1971

705
A7875

II.A.3 - U.S. - NEW ENGLAND

Richardson, E.P.
 Old and new England

In:Art Q.
8:3-15 Winter 1945 illus.

 Illuminates certain traits in Amer.art by deli-
berate comparisons with their opposites in Eng-
lish art,17th to 19th c.,main emphasis 2nd half
18th c.
Pertains to Exhib. in Rhode Island school of de-
sign. For catalogue see 757.6/.R47/NCFA
 Rep.,1945-47*1055

757.0974 II.A.3 - U.S. - NEW ENGLAND - 17th c.
.W92

Worcester art museum, Worcester,Mass.
 17th century painting in New England;a cat.
of an exhib.held at the Worcester art mus. in
collaboration with the American antiquarian soc.
July and August,1934,comp.& ed...by Louisa Dres-
ser...with a laboratory report by Alan Burroughs
Worcester,Mass....1935
 187 p. illus.

 Includes bibliographies

 Contents.-Rise & development of art in the
Mass.bay colony.-
LC ND1301.W6 continued on next card

ND
1311.5
S43
NPG

II.A.3 - U.S. - NEW ENGLAND

Sears, Clara Endicott,1863-
 Some American primitives:a study of New
England faces and folk portraits...Boston,
Houghton Mifflin company,1941
 291 p. illus.

Bibliography

Incl.references to the Fall River-Sturbridge
school of ptg.,see p.42-6 and illus.p.20-1,
23-6

LC ND1311.S4

705
A56
NCFA
v.110

II.A.3 - U.S. - NEW ENGLAND - 17-18th c.

Bell, James B. & Fleming,C.Dunn
 Paintings at the New England Hist.Genealo-
gical Society
Antiques
 American painting ₌special issue₌
 110:965-1070, Nov.,1976 illus(part col.)
Chiefly 18th-19th century
 Partial contents:...;Js.B.Bell & C.Dunn Fle-
ming,Ptgs.at the New England Hist.Genealogical
Soc.,p.980-93;...

ND
1309.3
F648
1985
NMAA

II.A.3 - U.S. - NEW ENGLAND - 16-17th c.

Miller, Lillian B.
 The Puritan portrait:its function in Old
and New England.Offprint from:her,Seventeenth
century New England.The Colonial Society of
Massachusetts,1985
 p.153-84 illus.

 Bibliographical references
 English portrs.of the 16th & 17th c.are
prototypes for American portrs.of that period
in style and symbolism

QND
1328
B35
NCFA

II.A.3 - U.S. - NEW ENGLAND - 18th c.

Bayley, Frank William, 1863-1932
 Five colonial artists of New England:Joseph
Badger,Joseph Blackburn,John Singleton Copley,
Robert Feke,John Smibert...Boston,Priv.print,192
 448 p. illus.

 Bibliography
 Index to portrs.by sitter & artist

LC N6536.B3

708.1
W92

II.A.3 - U.S. - NEW ENGLAND - 17th c.

Barker, Virgil, 1890-
 Puritan portraiture

In:Worcester art mus.,Bull.
25:42-53 Jul.,'34 illus.
 Reprinted fr.Mag Art,v.27:506-14,Oct.,'34

 Pertains to exhibition:17th c.ptg.in New Eng-
land,summer,1934 at Worc.art mus. For cat.see
757.0 974.W92

705
C75
NCFA
v.111

II.A.3 - U.S. - NEW ENGLAND - 18th c.

Comstock, Helen
 Portrait painting in New England,1700-1775

In:Connoisseur
111:136-41 July,'43 illus.

 Repro.incl.:Robt.Feke,Nathaniel Smibert,John
Smibert,Jos.Blakburn,J.S.Copley

705
M18
NCFA
v.36

II.A.3 - U.S. - NEW ENGLAND - 18th c.

Forbes, Esther
 Americans at Worcester - 1700-1775

In:Mag Art
36:83-4,86-8 Mar,'43 illus.

 Pertains to exh."New England painting,1700-
1775"at Worcester,Mass. Art Mus.in collabora-
tion with the American Antiquarian Soc.,Fb.18-
Mar,31,1943
 Repro.:P.Pelham,Jos.Badger,J.Smibert,Feke,
Blackburn,John S.Copley,R.Earl

 /Dresser.Backgr.of Col.Amer.

N
40.1
B372S3
NPG

II.A.3 - U.S. - NEW ENGLAND - 18th c.

Schloss, Christine Skeeles
 The Beardsley Limner and some contemporaries:
post-revolutionary portraiture in New England,
1785-1805.«Williamsburg,Va.,Colonial Williamsbur-
Foundation,1972.
 47 p. illus(part col.)

 Exhib.cat.
 Exhib.organized by Abby Aldrich Rockefeller
Folk Art coll.,Oct.'72-Dec.'72;traveled -Mar.'73
 Incl.bibl.references

LC ND1329.B38S34 }Folk Art in America NK807
 }F64xNCFA Bibl.

705
A56
NCFA
v.110

II.A.3 - U.S. - NEW ENGLAND - 18th c.

Little, Nina Fletcher, 1903-
 Paintings by New England provincial ar-
tists,1775-1800
Antiques
 American painting «special issue»
110:965-1070, Nov.,1976 illus(part col.)
Chiefly 18th-19th century
Partial contents:...Little,N.F.,Ptgs.by New
England provincial artists,1775-1800,p.994-1005;
...

AP
1
C76
NPG
v.21-25

II.A.3 - U.S. - NEW ENGLAND - (early)18th c.

Warren, William Lamson
 The Pierpont Limner and some of his con-
temporaries

In:Conn.Hist.Soc.B.
23:97-128 Oct.,'58 illus.

 Pertains to exh.,Fall;'58 at the Conn.Hist.
Soc.. Catalogue p.113-9

 A critical study of a group of portrs.,
painted 1710-15 i New England

ND
1311.5
L77
NPG

II.A.3 - U.S. - NEW ENGLAND - end 18th c.

Little, Nina Fletcher, 1903-
 Paintings by New England provincial artists,
1775-1800.Exh.21 July-17 Oct.,1976.By Nina
Fletcher Little.Boston,Museum of Fine Arts,1976.
 173 p. illus(part col)

 76 works shown.

 Bibliographical references

 Rila IV/1 1978 #1041

qND
207.5
P7C49
1575X
NCFA

II.A.3 - U.S. - NEW ENGLAND - 18-19th c.

Chrysler Museum at Norfolk
 48 masterpieces from the Collection of
Edgar William & Bernice Chrysler Garbisch.
Norfolk,Va.,Chrysler Museum at Norfolk.1975.
 68 p. illus.

 American naive ptg.of the 18th and 19th c.

 Preface by Dennis R.Anderson

 Rila III/1 1977 #3517

974.06
N7
v.39

II.A.3 - U.S. - NEW ENGLAND - 18th c.

Lyman, Lila Parrish
 William Johnston,1732-1772,a forgotten por-
trait painter of New England

In:N.Y.Hist Hist Soc Q
39:63-78 Jan.'55 illus.

 Beardsley Limner N40.1B372
)S3 NPG p.9,footnote 2

AP
1
C565

II.A.3 - U.S. - NEW ENGLAND - 18-19th c.

Chrysler Museum at Norfolk
 Naive gift grows to unprecedented eighty
paintings;by DRA«Dennis R.Anderson.

In:Chrysler Mus.Norfolk.Bull.
5,no.4:2-4 Apr.,'76 illus.

 Incl.:Ammi Phillips,Wm.Jennys,Erastus Salis-
bury Field
 Gift of Edg.Wm.& Bernice Chrysler Garbisch

 Rila IV/1 1978 #3927

974.06
N7
v.39

II.A.3 - U.S. - NEW ENGLAND - 18th c.

Sawitaky, Susan
 The portraits of William Johnston:A preli-
minary checklist

In:N.Y.Hist Soc Q
39:79-89 Jan.,'55 illus.

 Beardsley Limner N40.1.B3
)S3 NPG p.9 footnote 2

qND
205
F17
NMAA

II.A.3 - U.S. - NEW ENGLAND - 18-19th c.

Williams College. Museum of Art
 The New England eye,master American paint-
ings from New England school,college & univer-
sity collections.An exh«Sept.11-Nov.6,'83«cu-
rated by S.Lane Faison,jr.«Williamstown,Mass.,
Williams College,1983.
 61 p. illus(part col.)

 Preface by Thomas Krens

 Incl.:Chronological list of artists

II.A.3 - U.S. - NEW ENGLAND - 19th c.

Bishop, Robert Charles
 The Borden Limner and his contemporaries.
Ann Arbor,University of Michigan,1975
 330 p. illus.

mfm 76-
9345
 Diss.Uni.of Mich,1975(resulted in an exh.
at Ann Arbor,Mus.of Art,Nov.14,1976-Jan.16,'77)

 In-depth study & survey of the Borden Lim-
ner & the attribution of his portrs.to John S.
Blunt
 For cat.of exh.see qN40.1.B722B6 NPG. 90 p
illus(part col.) RILA III/1 1977 #2176
 Diss.Abstr.,Apr.1976

N
40
H67
NPG
II.A.3 - U.S. - NEW JERSEY

Historical records survey. New Jersey.
 American portrait inventory.1440 early
American portrait artists(1633-1860) (Prelimi-
nary vol.)Comp.by the New Jersey Historical
records survey project...Work projects admini-
stration...Newark,N.J.,The Historical records
survey,1940
 (308 p.)

 Bibliography
 Incl.Chronological index,Geographical index

LC ND236.N5

N
40.1
E91C5
NCFA
II.A.4 - U.S. - NEW ENGLAND - 19th c.

Chicago. Art Institute
 Three New England watercolor painters.Cat.
by Gail and Norbert H.Savage and Esther Sparks.
Chicago,A.I.,1974
 72 p. illus(part col.)

 78 works shown;W.C.portrs. by Jos.H.Davis,
J.Evans,J.A.Davis.The cat.documents all the
known ptgs.by the three.
 Rev.In:Art Gallery,v.18:54-6 Jan.'75 illus.,
by Esther Sparks
 Exh.at Chicago A.I. Nov.16-Dec.22,1974;Art
Mus.St.Louis,Jan. 17-March 2,1975;
LC ND1810.28 RILA I/1-2 1975 #2940/41
(Savage,Gail)

ND
230
N7A32
NPG
II.A.3 - U.S. - NEW YORK - 18th c.

Albany Institute of History and Art
 Hudson Valley painting 1700-1750,in the Al-
bany Inst.of Hist.and Art.Albany,1959.
 48 p. illus. (Cogswell Fund series,pu-
lication no.1)

 Bibliography

 Incl.Vanderlyn,Watson,Wollaton,Pierpont
Limner,Schuyler Painter,Gansevoort Limner,
Aetatis Suae ptgs.,etc.

LC ND230.N4A4

705
A56
NCFA
v.116
II.A.3 - U.S. - NEW ENGLAND - 19th c.

Curtis, John Obed
 Portraits at Old Sturbridge Village

In:Antiques
116:880-9 Oct.,'79

FOR COMPLETE ENTRY
SEE MAIN CARD

705
A56
NCFA
II.A.3 - U.S. - NEW YORK - 18th c.

Comstock, Helen
 Some Hudson valley portraits

In:Antiques
46:138-40 Sept.,'44 illus.

FOR COMPLETE ENTRY
SEE MAIN CARD

A704
NCFA
v.38

also:
N40.1
M3978
NPG
NCFA
II.A.3 - U.S. NEW ENGLAND - 19th c.
Frankenstein, Alfred Victor, 1906 and Arthur K.
 D.Healy
 Two journeyman painters

In:Art in Am.
38:7-63 Feb.,'50 illus.

 Benjamin Franklin Mason,Vermonter,p.7-43
Abraham G.D.Tuthill,p.47-63

 Bibliography
 Chronological list of known portrs.
J.G.Cole,teach er of Mason,see p.10-11,13

ND
1311.8
N7F17
NPG
II.A.3 - U.S. - NEW YORK - 18-19th c.

Faison, Samson Lane, 1907-
 Hudson Valley people,Albany to Yonkers,
1700-1900;.by.S.L.Faison,jr.and Sally Mills.
Poughkeepsie,N.Y.,Vassar college Art Gallery,
c.1982
 63 p. illus(col.cover)

 Exh.16 April - 6 June1982.Albany,Inst.of
Hist.& Art,Albany,N.Y.,13 July - 22 Aug.,1982
 Bibl.ref.p.19
 Incl.Index of artists

II.A.3 - U.S. - NEW ENGLAND - 19th c.

Rathbone, Perry Townsend, 1911-
 Itinerant portraiture in New York and New
England,1820-1840.(Unpublished MS)New York,Frick
Reference Library,1933

Lipman,Mrs.Jean.Am.prim.ptg
759.1.L76 Bibl.p.141

709.74
N7R317
II.A.3 - U.S. - NEW YORK - 18-19th c.

Rediscovered painters of upstate New York,1700-
 1875.Exh.schedule:New York State Hist.Ass.,
Cooperstown,June 14-Sept.15,1958,Rochester Mem.
Art gall.,Sept.26-Oct.21,1958,and others.Utica?
1958.
 80 p. illus.

 Cat.comp.by Agnes H.Jones
 Bibliography
 Incl.:the first indigenous school of ptg.in
America,The Hudson Valley Patroon Painters;
Groups,etc.

LC ND230.N4R4 Ammi Phillips N40.1P558H7
 Bibl.

II.A.3 - U.S. - NEW YORK STATE - 19th c.

Rathbone, Perry Townsend, 1911-
Itinerant portraiture in New York and New England,1820-1840.(Unpublished MS)New York,Frick Reference Library,1933

Lipman,Mrs.Jean.Am.prim.pt. 759.1.L76 Bibl.p.141

ND
1311.8
N7L6
1981X
NPG

II.A.3 - U.S. - NEW YORK - LONG ISLAND - 19-20th

Long Island painters and portraits.Huntington, N.Y.,Heckscher Museum,1981.
16 p. illus.

Cat.of an exh.held at the Heckscher Museum, Sept.27-Nov.1,1981

Bibliography

Arranged by ptrs.in alphabetical order.

II.A.3 - U.S. - N.Y. - BUFFALO

Sprague, Henry Ware
Lars Gustaf Sellstedt

In:Buffalo & Erie Cy.Hist.Soc. Publications
17:37-74 1913 illus.

LC F129.B8B88

Arts in Am.qZ5961.U5A77X
CFA Ref. I 1309

ND
207
W78
1971
NPG

II.A.3 - U.S. - NEW YORK,N.Y. - 18th c.(3rd quarter)

Craven, Wayne
Painting in New York City,1750-1775

In:Winterthur Conf.on Mus.Oper'n and Conn'ship
17th:251-97 1971 illus.

Bibliographical notes
G.Duyckink,J.Wollaston,L.Kilburn,Th.McIlworth,B.West,J.Mare,A.Delanoy,J.Durand,J.S.Copley

LC ND207.W5 1971

II.A.3 - U.S. - NEW YORK - BUFFALO - 19th c.

Viele, Chase
. Four artists of mid-19th century Buffalo
Cooperstown?,N.Y.,196-.
49-78 p. illus.

Bibl.references

Reprinted fr.N.Y.history,43,no.1,Jan.1962

Survey of the life and work of Sellstedt,
Wilgus, Le Clear, Beard
Arts in Am qZ5961.U5A77X
NCFA Ref. I 1072

N
6505
G69
v.2
NCFA

II.A.3 - U.S. - NEW YORK,N.Y. - 18th c.

Gottesman, Rita Susswein
The Arts and Crafts in New York,1777-1799
Advertisements and News Items ...New York,
The New-York Historical Society,1954

Contains list of portraitists.

Groce & Wallace N6536N53
NPG Ref. p.705

ND
N1311.8
N7P97
NPG

II.A.3 - U.S. - NEW YORK - DUTCHESS CO. - COLONIAL

Pugsley, S.Velma
Portraits of Dutchess,1680-1807...Poughkeepsie,N.Y.,Dutchess County American Revolution Bicentennial Commission,1976

FOR COMPLETE ENTRY
SEE MAIN CARD

F
128.25
K53
NPG

II.A.3 - U.S. - NEW YORK,N.Y. - 19th c.

King, Moses, 1853-1909 ed.
Notable New Yorkers of 1896-1899;a companion vol. to King's handbook of N.Y.city. New York,
N.Y.,Boston,Mass.,M.King,1899
676 p. illus.

2336 names and portrs.,classified and indexed

LC F128.25K52

Cirker.Dict.of Am.portrs.
N7593/C57/NPG Bibl.,p.714
Ref.

QND
1311.8
N7B95
NPG

II.A.3 - U.S. - NEW YORK - LAKE CHAMPLAIN

Burdick, Virginia Mason
Portraits and painters of the early Champlain Valley,1800-1865.by V.Burdick and Katherine Lochridge.;an exh....by the Student Assoc'n and the Art Gall.ef the State Univ.College,Plattsburgh,N.Y.,Apr.12-May 2,1975.Plattsburgh,N.Y.,
The College,1975
38 p. illus.

Bibliography p.36-8

Long Isl.ptrs.&portrs.1981
D1311.8.N7L6 1981X NPG,p16

F
4
D814
1984
NMAA

II.A.3 - U.S. - NEW YORK STATE

Dublin Seminar for New England Folklife (9th: 1984;Salem,Mass.)
Itinerancy in New England and New York;
editor Peter Benes & Jane M.Benes..Boston.
Boston Univ.,b.1986
256 p. illus. (Annual proceedings,
Dublin Seminar for New England Folklife,1984)

Sect.IV:Portraits,Profiles & Daguerreotypes:New England Itinerant portraitists,by Joyce Hill.Ralph Earl as an itinerant artist,
by Eliz.Mankin Kornhauser,
cont'd on next card

AP
1
A51A64
NMA)
v.12

II.A.3 - U.S. - NEW YORK STATE - 18th c.

Black, Mary C.
Contributions toward a history of early
18th c. New York portraiture:The identification
of the Aetatis Suae and Wendell Limners

In:Am Art J
12:4-31 Autumn,'80 illus.

Black identifies Nehemiah Partridge as the
Aetatis Sue limner and John Heaten as the ptr.
of Abraham Wendell and his brothers as well as
of a dozen or more Albany area portrs. ascr.un-
til now to the () ndell limner. (See over
Am () :5 footnote 1]

ND
230
P4D55
NCFA

II.A.3 - U.S. - PENNSYLVANIA

Dickson, Harold Edward, 1900-
Masterworks by Pennsylvania painters in
Pennsylvania colls.....exh.inaugurating the
opening of the Mus.of Art,The College of Arts &
Architecture,The Pennsylvania State University,
University Park,on Oct.8, 1972...til Nov.5,1972.
University Park,Pa.,Museum of Art,Penn.State
University,1972.
.71.p. illus(col.)

Incl.:Portrs.by Hesselius,West,Ch.W.Peale,
Rembrandt Peale,Sully,Eichholtz,Neagle,Eakin,
Cassatt,Cecilia () Beaux
ts in Am.qZ5961.U5A77X
NCFA Ref. 1324

ND
1311.9
S48C9s
NPG

II.A.3 - U.S. - N.Y. - SCHENECTADY - 18th c.

Curran, Ona
Schenectady ancestral portraits early 18th
century

In:Schenectady Co.Hist.Soc.B.
10,no.1 Sept.'66

Feigenbaum.Amer.portrs...
ND1311.2.F29 NPG Bibl.p.140

II.A.3 - U.S. - PENNSYLVANIA

Historical records survey. Pennsylvania.
Inventory of American portraiture in the
permanent collection of the Penn.academy of
the fine arts..Comp.by.U.S.Work projects ad-
ministration,1942
2 v. (Survey of American portraiture
in Pennsylvania)

Arch.
Am.Art
mfm
PC1/678-
PC2/04

Typescript

Alphabetical by subject

Archives of American Art
Portraits

N
7593.8
N8N27
NPG

II.A.3 - U.S. & NORTH CAROLINA

National Society of the Colonial Dames of America.
North Carolina
The North Carolina portrait index,1700-1860.
Compiled by Laura MacMillan,...Chapel Hill,Uni-
versity of North Carolina Press,1963.
272 p. illus.

LC N7593.N27

N
40.3
P0575X2
NPG

II.A.3 - U.S. - PENNSYLVANIA - ERIE - 19th c.

Kully, Elisabeth K
Moses Billings:19th century portrait paint-
er...1979
69 p. illus.

Reproduction of typescript.
Incl.Cat.of artist's works
Thesis Georgetown Univ.,Nov.5,1979
Bibliography

Z1251
N7
A63X
NPG

II.A.3 - U.S. - NORTHWEST, PACIFIC

Appleton, Marion Brymner
Index of Pacific Northwest portraits...
Seattle,published for Pacific NW Libr.Ass.,Ref.
Div.by The Univ.of Washington Press,1972.
210 p.

Bibliography

Arranged alphabetically by sitters

LC Z1251.N7A63

Books in Print Subject guide
Z1215.P92 1975 v.2 NPG
p.2960

ND
1311.9
P5P813
+50
2 c.

II.A.3 - U.S. - PENNSYLVANIA - PHILADELPHIA

Framing the board;a look at corporate portrai-
ture;an exh.organized and sponsored by the
Mutual Assurance Corp.with the cooperation
of Independence National History Park;Sec-
ond Bank of the U.S.,Oct.27,1982-Jan.17,
1983,Phila.,Pa.,The Mutual Assurance Comp.,
1982
16 p. illus.

Essay on the history & style of corporate
commissioned portraits.Foreign influences.

Z1251
N7
A63X
NPG

II.A.3 - U.S. - PACIFIC NORTHWEST see
II.A.3 - U.S. - NORTHWEST, PACIFIC
Appleton, Marion Brymner
Index of Pacific Northwest portraits...
Seattle,published for Pacific NW Libr.Ass.,Ref.
Div.by The Univ.of Washington Press,1972.
210 p.

Bibliography

Arranged alphabetically by sitters

LC Z1251.N7A63

Books in Print Subject guide
Z1215.P92 1975 v.2 NPG
p.2960

II.A.3 - U.S. - PENNSYLVANIA - PHILADELPHIA

King, Moses, 1853-1909 pub.
Philadelphia and notable Philadelphians.
New York,1903
v. p.

PPP

Cirker.Dict.of Am.portrs.
N7593/C57/NPG Bibl.,p.714
Ref.

N
8640
F82A4
no.17
NMAA

II.A.3 - U.S. - PENNSYLVANIA - PHILADELPHIA

Schwarz, Robert D. comp.
 Philadelphia portraiture,1740-1910

In:Frank S.Schwarz & Son
. Philadelphia Collection
17:1-40 Nov.,'82 illus(part col.)

 Incl.:List of artists

 Exh.celebrating Philadelphia's tricenten-
nial

N
6527
C4R
1984
NMAA

II.A.3 - U.S. - SOUTHERN STATES - 19-20th c.

Chambers, Bruce W.
 Art and artists of the South:the Robert
P.Coggins coll.,essay and cat.entries by Bruce
W.Chambers.Columbia,S.C.:Univ. of South Caro-
lina Press,c.1984
 149 p. illus(part col.)

 Bibliography
 Cat.of an exh.organized by the Columbia
Museum of Art
 Incl.:Portraiture in the Antebellum South,
p.5-12;Twentieth century portraiture,p.117-126

N
7593.1
R47
NPG

II.A.3 - U.S. - RHODE ISLAND

Rhode Island School of Design, Providence. Mus.
of art
 Early portraits in Rhode Island,1700-1850;
an exhibition to honor the 75th anniversary of
the National Society of the Colonial Dames of
America in the State of Rhode Island and Pro-
vidence Plantations,8 March-9 April,1967.
:Providence,1967:
 24 p. illus.

LC N7593.R5

N
7593.8
T2
N27
NPG

II.A.3 - U.S. - TENNESSEE

National Society of the Colonial Dames of America.
Tennessee. Portrait Committee.
 Portraits in Tennessee painted before 1866;
preliminary checklist ,compiled by Eleanor
Fleming Morrissey,chairman.:Nashville?:...1964
 147 p. illus.

LC N7593.N29

ND
1311.8
H6
NPG

II.A.3 - U.S. - RHODE ISLAND - 17-(begin)19th c.

Historical records survey. Rhode Island
 Preliminary check list of American por-
traits,1620-1825.Found in Rhode Island,1939

 (NPG:Typewritten copy)with Preliminary
Check of American artists,1620-1825

705
A56
NCFA
v.100

II.A.3 - U.S. - TENNESSEE - 19th c.

Bishop, Budd H.,arris.,:1936- :
 Three Tennessee painters:Samuel M.Shaver,
Washington B.Cooper, and James Cameron

In:Antiques
100:432-7 Sept.,'71 illus.

II.A.3 - U.S. - SOUTHERN COLONIES - 18th c.

Gallaway, Margaret
 Eighteenth century portrait painters in the
southern colonies

In:Americana
34:558-66 Oct,'40 illus.

LC E171.A53 Cumulated Mag.subj.index
 A1/3/C76 Ref. v.2,p.444

ND
1311.8
T2K29
1987
NPG
2 c.

II.A.3 - U.S. - TENNESSEE - 19-20th c.

Kelly, James C.,1949-
 Portrait painting in Tennessee.Cat.of an
exh.organized by the Tennessee State Mus.,Nash-
ville,Tenn.,March 11-June 5,1988

In:Tenn Hist Q
46no.4:192-286 Winter,'87 illus(col.)

 bibl.references
 Index
 Exh.also:Dixon Gall. & Gardens,Memphis,Tenn.
Jul.12-Aug.28,'88.East Tenn.Hist.Ctr.,Knoxville,
Tenn.,Sept.15-Nov. 11,'88

qN
6520
.P63
1983X

II.A.3 - U.S. - SOUTHERN STATES

Poesch, Jessie J.
 The Art of the Old South,painting,sculp-
ture,architecture,and the products of crafts-
men,1560-1860...1st ed.N.Y.,Knopf,1983
 384 p. illus(part col.)

 Incl.index
 Bibliography,p.361-366

 Repro.incl.:Eye miniature by Malbone,p.162;
Portrs.of Amer.Indians by Curtis,p.272;by Rö-
mer & by Catlin,p.273.Ports.within portrs.,
p.265.Groups by Earl,p.171;by Johnson,
p.159

N
6535
F4P74
1983X
NMAA

II.A.3 - U.S. - TEXAS - EL PASO - 20th c.

Price, Carol Ann
 Early El Paso artists...Intro.by Nancy
Hamilton.ElPaso,Texas Western Press,1983
 115 p. illus(part col.)

 Outgrowth of an exh...Oct.,1981 at the
El Paso Centennial Museum

 Incl.Bibl.references

 For list of portraitists see next card

II.A.3 - U.S. - VERMONT

Historical records survey. Vermont.
Preliminary checklist of early American
portraits owned in Vermont, painted before 1850
on.p., 193-?.
.1.p.

FC00
4253
H67z

AP
1
V81
NPG
v.35

II.A.3 - U.S. - VIRGINIA

Virginia Historical Society, Richmond
Cat.of portraits in the coll.of the Virginia Historical Society.With a tentative plan
for their Arrangement in Virginia House

In:Va.Mag.Hist.Bicgr.
35:57-69 Jan., '27

Winterthur Mus.Libr.
f2881.W78 v.6 NCFA,p.225

AP
1
C59
NMAA

II.A.3 - U.S. - VERMONT - 19th c.

Kern,Arthur B. & Sybil B.
Thomas Ware:Vermont portrait painter

In:Clarion
1982-84:36-45 Winter,'83/84 illus.

Incl.:Checklist

Robert Hull Fleming Museum
Univ.of Vt. Faces in the
Past..151.p.39

N
40.1
B847H7
NPG

II.A.3 - U.S. - VIRGINIA - 18th c.

Hood, Graham, 1936-
Charles Bridges and William Dering.Two Virginia painters,1735-1750.Williamsburg,Va.,The
Colonial Williamsburg Foundation,1978.
125 p. illus(part col.)

LC ND1329.B79H66

AP
1
A79
NCFA
v.1-3

II.A.3 - U.S. - VIRGINIA

Black, Mary C.
The case of the red and green birds.Thirteen persons,one of whom has never been identified,pose a picture puzzle wherin a cardinal &
a parakeet are vital clues.

In:Arts in Va.
3,no.2:2-4,7-8 Winter,'63 illus.
Portrs.of members of two prominent families by an unknown artist.Five facts suggest
a Va.provenance,inspired by Engl.mezzotints.
Black.The case reviewed.
In:Arts in Va.,v.10,no.1

N
40.1
W36343
NPG

II.A.3 - U.S. - VIRGINIA - 18th c.

Weekley, Carolyn Jeanette
John Wollaston,portrait painter;his career
in Virginia,1754-1758.Newark,Del.,Uni.of Delaware.,1976

FOR COMPLETE ENTRY
SEE MAIN CARD

759.1
K72s
and
ND
1311
K5X
NPG

II.A.3 - U.S. - VIRGINIA

Knoedler,M.,& company, New York
Stratford;the Lees of Virginia and their
contemporaries...April 29 through May 18,1946.
New York,Knoedler galleries.1946.
47 p. illus.

List of officials of the Rbt.E.Lee Memorial
Foundation inserted at end.

LC ND1311.K5

XXXX
.XXX
ND
1311.9
R5V15
NPG

II.A.3 - U.S. - VIRGINIA - RICHMOND - 18-19th c.

Valentine museum, Richmond,Va.
Richmond portraits in an exhibition of
makers of Richmond,1737-1860. Richmond,Va.,.,1949
286 p. illus.

Bibliography
Exh.started Nov.16,1948

Incl.:Biography of sitters & of artists.List
of lenders

II.A.3 - U.S. - VIRGINIA

National Society of the Colonial Dames of
America. Virginia. Blue Ridge Committee
An exh.of portraits owned in Albemarle Cy.,
Va.,painted before the year 1830.Presented...
April 8-30,1951,Mus.of Fine Arts,Bayley Memorial Building,Uni.of Va.,Charlottesville,Va.,
1951.
10 p.

CAP has
NPG copy

For the benefit of Gunston Hall

.LC ND1301.N3 1951.
V1U

II.A.3 - YUGOSLAVIA - SERBIA

Sarajevo. Musej grada.
Portreti starih sarajevskih gradana Maj 1968.
Izlozba i katalog:Ljubica Mladenović...Sarajevo,
Musej grada Sarajeva,1968.
12 p. illus.

LC ND1324.Y882

Fogg,v.11,p.320

II.A 3 - YUGOSLAVIA - SERBIA - 18th c.

Novi Sad, Yugoslavia. Galerija Matice srpske
　Portreti Srba 18 veka .katalog izlosbe..
Novi Sad, 1965
　　163 p.　illus.

FOOO
FA
4204.738　.Exhibition catalogue.

○ Fogg,v.11,p.320

II.A.3 - YUGOSLAVIA - SLOVENIA

Ljubljana. Moderna galerija.
　Avtoportret na Slovenskem;katalog. Uvod,
biografski in bibliografski podatki:Lss Menase.
Ljubljana,1958
　　152 p.　illus.

　Summary in French

　Includes bibliographies

LC N7613.5.15　　　○ Fogg,v.11,p.320

II.A.4.　PRIMITIVE PAINTING (including all folk
　　　　painting; subdivided by country only)
　　　　see also I.F. FOLK ART

II.A.4　Primitive painting includes all folk painting
　　　　(subdivided only by country)
　　　　see also I.E - FOLK ART

○

ND
205　II.A.4 - U.S.
M62　Black, Mary C. and Jean Lipman
NCFA　　American folk painting,...New York,C.N.Pctt.
NPO　　.1966.
　　　244 p.　illus(part col.)

　Bibliography

LC ND1311.B55

◡

MK
PO5
0719　II.A.4 - U.S.
NCFA
　Colonial Williamsburg, inc.
　　A cat.of the American folk art coll. of Co
lonial Williamsburg;collected and presented by
Mrs.John D.Rockefeller,jr. Comp.by Edith Grego
Halpert with a foreword by James L.Cogar.
Williamsburg,Va..c.1947.
　　49 p.　illus.

　Repro.incl.:Portr.of Washington,ca.1785

　Cat.lists portrs.in oil,pastel and W.C.

○ Flint Inst.of arts.Pro-mitive
ptgs. ND210.5 .F785 .1942A
NCFA bibl.p.91

759.1　II.A.4 - U.S.
F709
NCFA　Ford, Alice Elizabeth, 1906-
　　Pictorial folk art:New England to Califor-
nia.N.Y.City,Studio Publishers,1949.
　　172 p.　illus(part col.)　(An American
audio book)

　Bibliography

　Incl.Ch.on portraiture:p.7-17;illus.p.51-61

○

759.1　II.A.4 - U.S.
L76
　Lipman, Mrs.Jean Herzberg, 1909-
　　American primitive painting.London,N.Y..etc.
Oxford univ.press,1942
　　158 p.　illus(part col.)

　Bibliography
List of important exhibitions & list of primitiv
painters. (Exhibitions 1924-1942)
　"Brings together for the lst time in book
form some of the best examples of a:ns...aspect
of American heritage."-J.T.Flexner in his review
in:Antiques,v.42:150-3
LC ND205.L5　　○

ND
236　II.A.4 - U.S.
L76
NPO　Lipman,Mrs.Jean Herzberg, 1909-　comp.
　　Primitive painters in America,1750-1950;an
anthology,by J.Lipman & A-Winchester.N.Y.,Dodd,
Mead.1950.
　　182 p.　illus(part col.)

　　Contents.-?.N.F.Little, Primit.ptrs.of 18th
4.A.M.Dods, R.H.Hascom.-5.A.E.Pye, L.Hicks.-8.F.F.
Sherman, J.S.Ellsworth.-9.F.R.Robinson, E.S.Fie'
10.N.F.Little, W.M.Prior.-11.J.Lipman, D.Gold-
smith.-12.F.O.Spinney, J.H.Davis.-14.J.L.Clarke,
jr., J.W.Stock

◡

705　II.A.4 - U.S.
594
NCFA　Nelson, Mrs.H.C.
v.46　　Early American primitives

　In:Studio
80:454-9　Mar.,'25　illus.

　Pertains to exh.held in Kent,Conn.,Summer,'2

　"...initial florescence of purely American
ptg...which sprang fr.native soil & flowered un-
influenced by foreign climes..."

◡ Phillips,Ammi...N40.1P556
H7,Bibl.

759.13
.N55

II.A.4 - U.S.

Newark museum association, Newark, N.J.
American primitives,an exhibit of the paint-
ings of 19th c. folk artists,Nov.4,1930-Feb.1,
1931. Newark,N.J.,The Newark museum,1930
75 p. illus.

Reading list
Portraits;Descriptive notes,pp.13-15;Portrs.
cat.,pp.15-20

Article pertaining to this exh. by E.B.Robin-
son In:Antiques
19:33-6 Jan.,'31)illus.

NK
805
W35
1983X
NMAA

II.A.4 - U.S.

Washington Meeting on Folk Art (1983)
Folk art and art worlds;essays drawn from
the Washington meeting on Folk art,organ.by the
Amer.Folklife Ctr.of the Library of Congress;
ed.by John Michael Vlach and Simon J.Bronner.
Ann Arbor,Mich.UMI Research Press,c.1986
293 p. illus. (Amer.material culture and
folklife)
(Meeting held Dec.5-6,1983)
Index
Bibliographies
Ch.4:Finished to the utmost nicety:Plain por-
traits in America, 1760-1860;p.85-120

AP
1
W892
NCFA

II.A.4 - U.S.

Reutlinger, Dagmar E.
American folk art:two groups of family por-
traits by Ruth Henshaw Bascom and Erastus Salis-
bury Field

In:Worcester Art Mus.Bull.
5,no.3:1-12 May,'76 illus.

"Bascom cut out paper silhouette portrs.&
embellished them with charming color & imagina-
tive collage."-Reutlinger in Rila

 Rila IV/1 1978 #4033

ND
205
F23X
NCFA

II.A.4 - U.S. - 17th-19th c.

Ebert, John and Katherine
American folk painters...N.Y.,Scribner,1975,

 FOR COMPLETE ENTRY
 SEE MAIN CARD

705
A56
NCFA
v.19

II.A.4 - U.S.

Robinson, Elinor B
American primitive painting

In:Antiques
19:33-6 Jan.,'31 illus.

"Many itinerant painters....unhampered by
their limitations,were able to grasp the essen-
tials of their subjects with...simplicity & a vi-
gorous creative sense"(pertains to:Newark mus.
ass.,Newark,N.J.Exh.:Amer.primitives...1930

)Lipman,Mrs.Jean.Am.prim.
)ptg. 759.1/1.76 Bibl.

ND
1311.5
L77
NPG

II.A.4 - U.S. - end 18th c.

Little, Nina Fletcher, 1903-
Paintings by New England provincial artists
1775-1800.Exh.21 July-17 Oct.,1976.By Nina
Fletcher Little.Boston,Museum of Fine Arts,1976
173 p. illus(part col)

76 works shown.

Bibliographical references

 Rila IV/1 1978 #1041

N
40.1
B37283
NPG

II.A.4 - U.S.

Schloss, Christine Skeeles
The Beardsley Limner and some contemporaries
post-revolutionary portraiture in New England,
1785-1805.Williamsburg,Va.,Colonial Williamsburg
Foundation,1972.
47 p. illus(part col.)

Exhib.cat.
Exhib.organized by Abby Aldrich Rockefeller
Folk Art coll.,Oct.'72-Dec.'72;traveled -Mar.'73
Incl.bibl.references

LC ND1329.B38S34 Folk Art in America NK807
 /F64xNCFA Bibl.

N
7593
A23
1981X
NMAA
c.1
c.2 Ref.

II.A.4 - U.S. - 18-19th c.

Abby Aldrich Rockefeller Folk Art Center
American folk portraits;paintings and
drawings from the Abby Aldrich Rockfeller
Folk Art Center.1st ed. Boston,N.Y.Graphic
Society,c.1981
295 p. illus(part col.) (The Center's
series 1)

Incl:Bibliographical references & index

ND
1311.5
S43
NPG

II.A.4 - U.S.

Sears, Clara Endicott,1863-
Some American primitives:a study of New
England faces and folk portraits..Boston,
Houghton Mifflin company,1941
291 p. illus.

Bibliography

Incl.references to the Fall River-Sturbridge
school of ptg.,see p.42-6 and illustrs.p.20-1,
23-6

LC ND1311.S4

ND
207
P37
F 1969
NCFA

II.A.4 - U.S. - 18-19th c.

American naive painting of the 18th and 19th
centuries;111 masterpieces from the coll.
of Edgar William and Bernice Chrysler Gar-
bisch.Foreword by John Walker.Pref.by
Lloyd Goodrich.Introd.by Albert Ten Eyck
Gardner.,New York,American Federation of
Arts,1969,
159 p. illus(part col.)
Cat.of an exh.being circulated through
the U.S.and Europe 1968-70 under the auspi-
ces of the American Federation of Arts

 Flint Inst.of Arts.Am.naive
 ptg. ND210.5.P7F5 1961X
 NMAA Bibl.p.92

II.A.4 - U.S. - 18-19th c.

ND
207
A7X
NCFA

Arts Council of Great Britain
American naive painting of the 18th and 19
centuries from the coll. of Edgar William and
Bernice Chrysler Garbisch at the Royal Academy
of Arts,London,6 Sept.to 20 Oct.,,1968,,London,
Arts Council,1968
,65,p. illus(part col.)

Intro.by Robert Melville

Flint Inst.of Arts.Am.naive
ptgs-ND210.5.P7F5 1981X
NMAA Bibl.,p.92

II.A.4 - U.S. - 18-19th c.

ND
207
G21
1962
NPG
NCFA

Garbisch, Edgar William
101 masterpieces of American primitive paint
ing...,N.Y.,American Federation of Arts,1962,

FOR COMPLETE ENTRY
SEE MAIN CARD

II.A.4 - U.S. - 18-19th c.

qND
207.5
P7C49
1975X
NCFA

Chrysler Museum at Norfolk
48 masterpieces from the Collection of
Edgar William & Bernice Chrysler Garbisch.
Norfolk,Va.,Chrysler Museum at Norfolk,1975,
68 p. illus.

American naive ptg.of the 18th and 19th c.

Preface by Dennis R.Anderson

Rila III/1 1977 #3517

II.A.4 - U.S. - 18-19th c.

NK
806
L52
1974X
NCFA

Lipman,Mrs.Jean Herzberg, 1909-
The flowering of American folk art,1776-
1876.by,J.Lipman and Alice Winchester,N.Y.,
Viking Press,,1974,
288 p. illus(part col.) (a studio book)
Bibliography p.284-7

Portraits p.15-49,sculpture p.119-28,
figureheads p.129-36

Flint Inst.of Arts.Am.naive
ptgs.ND210.5.P7F5 1981X
NMAA Bibl.p.92

II.A.4 - U.S. - 18-19th c.

AP
1
C565

Chrysler Museum at Norfolk
Naive gift grows to unprecedented eighty
paintings;by DRA.Dennis R.Anderson,

In:Chrysler Mus.Norfolk.Bull.
5,no.4:2-4 Apr.,'76 illus.

Incl.:Ammi Phillips,Wm.Jennys,Erastus Salis-
bury Field
Gift of Edg.Wm.& Bernice Chrysler Garbisch

Rila IV/1 1978 #3927

II.A.4 - U.S. - 18-19th c.

706.1
B42
1937

New York. Downtown Gallery
Children in American art.Exh.Apr.13-May 1,
1937.Cat.by E.G.Halpert
15 p. illus.

Incl.17 portrs.of children,p.13-14,

Colon'lWilliamsburg,inc.
Amer.Folk art N6507C72 NCFA
Bibl.p.49.Also:Ford.Picture
folk art 759.1.F659.P1b1.

II.A.4 - U.S. - 18-19th c.

Dewhurst, C.Kurt
Artists in aprons:Folk art by American
women.,y.,C.K.Dewhurst,Betty MacDowell,Marsha
MacDowell.1st ed.N.Y.,Dutton,c.1979
202 p. illus(part col.)
Intro.by Joan Mondale
Exh.at N.Y.,Mus.of Amer.folk art,16 Jan.-
29 Apr.,'79.Also at Albany,N.Y.,Inst.of Hist.
and Art,29 Apr.-22 June,'79
Index
Bibliography
Incl.:oils,pastels,silhouettes,W.C.,18-19th
LC NK805.D48 1979 NMAH pts. ND210.5.P7F5 1981X
NMAA Bibl.p.92087

II.A.4 - U.S. - 18-19th c.

qNK
835
C8T48X
NCFA

Three centuries of Connecticut folk art
an exh.organized by Art Resources of Conn.
by Alexandra Grave..New Haven,Art Resources
of Connecticut,,c.1979
104 p. illus(part col.)
Exh.held at the Wadsworth Atheneum and 2
other Conn.museums betw.Sept.25,1979,and
July 12,1980
Incl.index
Bibliography

Incl.section on portrs.:p.8-11;42-50
Worldwide Art cat.Bul.
705.W927 NMAA v.17,1981
p.50

II.A.4 - U.S. - 18-19th c.

VF
Evanston,
Illinois

Evanston,Ill., Terra Museum of American Art
American naive painting from the National
Gallery of Art.Cat.by Ronald McKnight Melvin.
Foreword by John Wilmerding.Exh.Dec.19,1981-
March 4,1982
32 p. illus(part col.)

Bibliography

(Paintings from the Garbisch collection)

II.A.4 - U.S. - 18-19th c.

ND
207
U56
pt.1-2
NCFA
NPG

U.S. National Gallery of Art
American primitive paintings from the coll
of Edgar William and Bernice Chrysler GARBISCH
pt.I and II.Washington,NGA,1954 and 1957
2 v.in 1 illus.

Pt.I:Exh.of the gift of 300 ptgs.& 200 mi-
niatures
Pt.II:Exh.of a selection of the Garbisch
collection

Flint Inst.of Arts.ND210.5
P7F5 1981X NMAA Bibl.p.91

ND
207
W66X
NPG

II.A.4 - U.S. - 18-19th c.

Woodward, Richard P., 1950-
 American folk painting;selections from
the coll.of Mr.and Mrs.William E.Wiltshire III;
an exh.organized by the Virginia Museum...Cat.
comp.by Richard P.Woodward.Richmond,The Museum
,1977.
 110 p. illus(col.)

Introd.by Mary Black

Exh.Nov.29,1977-Jan.8,1978
 Flint Inst.of Arts.Am.naive
 ptgs..ND210.5.P7F5 1981X
 NMAA Bibl.p.93

II.A.4 - U.S. - 19th c.

Chicago Historical Society
 American primitive paintings,19th century.
The Chicago Historical Society's collection.
,Chicago,1950
 24 p. illus.

WHi-W NNC DLC etc.
LC ND210.C45
 Flint Inst.of Arts.Am.naive
 ptgs..ND210.5.P7F5 1981X
 NMAA Bibl.p.91

ND
205.5
P74A43X
NMAA

II.A.4 - U.S. - 18-20th c.

American folk painters of three centuries.
 Jean Lipman,Tom Armstrong editors.1st ed.
N.Y.,Hudson Hill Press,c.1980
 233 p. illus(col.)

Exh.organized by the Whitney Museum of
American Art,N.Y.,Feb.26-May 13,1980

Incl.bibliographies & index

 Abby Aldrich Rockefeller
 Folk Art Ctr.Am.folk portra
 N7593.A23 NMAA Bibl.p.294

705
A56
NCFA
v.58

II.A.4 - U.S. - 19th c.

Chicago Historical Society
 Primitives on view in Chicago

In:Antiques
58:392-3 Nov.,'50 illus.

Exh.Nov.,1950-Feb.,1951

Repro.incl.:Prymeier,Krans,Reeter,Ambroise,
Andrews

705
A784
NCFA
v.42

II.A.4 - U.S. - 19th c.

American primitive painting.,An anthology of
 the,coll.of Edg.Wm.& Bernice Chrysler
 Garbisch

In:Art in Am
42:95-170 May,'54 · illus.

 Incl.:Foreword by Edg.Wm.& Bernice Chrys-
ler Garbisch,refers to the fact that their
coll.is going to the National Gallery of Art,
p.95;Ptgs.for the people by Alice Winchester,
p.96;Portr.gall.of provincial America by Frank
O.Spinney,p.98 Illus.p.97,99-105
154-6

705
A56
NCFA
v.34

II.A.4 - U.S. - 19th c.

Clarke, John Lee,jr.
 Joseph Whiting Stock,American primitive
painter(1815-1855)

In:Antiques
34:163-4 Aug.,'38 illus.

 Stock.Ptgs.& journal N.0.1
 S853A1 NCFA Bibl.,p.167

II.A.4 - U.S. - 19th c.

Bishop, Robert Charles
 The Borden Limner and his contemporaries.
Ann Arbor,University of Michigan,1975
 330 p. illus.

 Diss.Uni.of Mich,1975(resulted in an exh.
at Ann Arbor,Mus.of Art,Nov.14,1976-Jan.16,'77)

mfm 76-
9345

 In-depth study & survey of the Borden Lim-
ner & the attribution of his portrs.to John S.
Blunt
 For cat.of exh.see qN40.1.B722B6 NPG. 90 p
illus(part col.). RILA III/1 1977 #2376
 Diss.Abst.,Apr.1976

ND
210
C67X
NCFA

II.A.4 - U.S. - 19th c.

Colby College, Waterville,Me.
 A group of paintings from the American
heritage collection of Edith Kemper Jetté and
Ellerton Marcel Jetté.Waterville,Colby College
Press,1956
 94 p. illus.

 Mainly reproductions of ptgs.,silhouettes,
etc. 19th c.

 Dewhurst.Artists in apron
 Bibl.p.186

N
6510
B74
NCFA
c.1Ref.
c.2NCFA

II.A.4 - U.S. - 19th c.

Boston. Museum of Fine Arts
 M.& M.Karolik coll.of American Water co-
lors & drawings,1800-1875.Boston,1962
 2 v. illus(part col.)

 v.2,p.96-136:Portraits

 Exh.held...Oct.18,1962-Jan.6,1963
 Incl.bibliographies

N
6510
C71
NCFA

II.A.4 - U.S. - 19th c.

Colonial Williamsburg, inc.
 The Abby Aldrich Rockefeller folk art col
a descriptive cat.by Nina Fletcher Little
.1st ed.Williamsburg,Va.,Publ.by.Colonial
Williamsburg;distributed by Little,Brown,
Boston,1957.
 402 p. illus.(col.)

 Bibliography
 Incl.:Portrs.in oil and W.C.

 List of artists

LC N6510.C66

705
A56
NCFA
v.108

II.A.4 - U.S. - 19th c.

Feldman, Howard A.
 A collection of American folk painting

In:Antiques
108:764-71 Oct.,'75 illus(part col.)

 Mostly illustrations.Repro:Wm.Prior,Sturte-
vant Hamblen,Ammi Phillips,Jacob Maentel,J.Park
L.K.Rowe and anonymous works

 Rila III/1 1977 #3631

N
40.1
E476M6
NPG
2 ccps.

II.A.4 - U.S. - 19th c.

Mitchell, Lucy B., 1901-
 The paintings of James Sanford Ellsworth,
itinerant folk artist,1802-1873;cat.of an exh.
presented by the Abby Aldrich Rockefeller Folk
Art Coll.,Williamsburg,Va.,Oct.13-Dec.1,1974...
Colonial Williamsburg Foundation,c1974,
 103 p. illus(part col.)

 Bibliography
 Incl.Checklist:Oil ptgs. and W.C.miniature
 See also her.articles in Art in Am.v.41:
151-84(Autumn,'53) v.42:218-9(Oct.,'54)
LC ND1337.U6E495

qND
1311.2
D15
1987
NPG

II.A.4 - U.S. - 19th c.

D'Ambrosio, Paul S. and Charlotte M.Emans
 Folk art's many faces:portraits in the New
York State Historical Association.Cooperstown,
N.Y.,The Association,1987
 224 p. illus(part col.)

 Incl.bibliographical references and index

 Incl.:Ch.:Folk art at Fenimore House,p.9-13

709.73
N5
NCFA
NPG

II.A.4 - U.S. - 19th c.

New York. Museum of modern art
 American folk art;the art of the common
man in America,1750-1900.N.Y.,The Mus.of modern
art,c.1932.
 52 p. illus.

 "American folk art"(p.3-28)signed Holger
Cahill

 Bibliography p.47-52

LC N6505.N44 Flint Inst.of Arts.Amer.
 naive ptgs.ND210.5P7F5
 1981X NMAA Bibl.p.91

ND
210.5
P7F5
1981X
NMAA
2 c.

II.A.4 - U.S. - 19th c.

Flint Institute of Arts
 American naive painting:the Edgar William
and Bernice Chrysler Garbisch collection:Flint
Inst.of Arts,Dec.6,1981-Jan.24,1982,cat.by
Alain G.Joyaux.,Flint,Mich.,The Institute,
c.1981
 55 p. illus.

 Bibliography

 Intro.by Richard J.Wattenmaker

 Worldwide Art Cat.Bull.
 19:no.1:64 705.W972 NMAA

705
A56
NMAA
v.122

II.A.4 - U.S. - 19th c.

Oak, Jacquelyn
 American folk portraits in the coll.of Sybil
B.& Arthur B.Kern

In:Antiques
122:564-70 Sept.,'82 illus(mostly col.)

 Repro.incl.:J.Dalee,J.Maentel,Z.Belknap,
B.Greenleaf,R.Whittier Shute,R.B.Smith,N.W.Hop-
kins,S.Peck,E.S.Field,R.H.Bascom,J.S.Ellsworth,
J.A.Davis,J.W.Stock,M.Williams,R.Porter,

705
A56
NCFA
v.40

II.A.4 - U.S. - 19th c.

Lipman,Mrs.Jean Herzberg, 1909-
 American primitive portraiture.A Revalua-
tion

In:Antiques
40:142.4 Sept.,'41 illus.

 Mitchell.Ptgs.by Js.Sanford
 Ellsworth.N40.1.E476M6 NPG
 Bibl.p.103

ND
1311.2
S76
NPG

II.A.4 - U.S. - 19th c.

Springfield,Mass. Museum of fine arts.
 Somebody's ancestors;paintings by primi-
tive artists of the Connecticut valley.Spring-
field mus.of fine arts,Springfield,Mass.,Feb.7-
March 8,1942.Springfield,1942.
 ,23,p. illus.
 5 portraits by Jos.Goodhue Chandler(1813-?)
 19 " " E.S.Field(1805-1900)
 4 " " Augustus Fuller(1812-1873)
 2 " " J.Atwood
 2 " " Nathan Negus(1801-1825)
 3 " " Ruth Henshaw Bascom(1772-18th
 8 " r— unknown artists
LC ND1311.S68

NK
805
L77
1984
NMAA

II.A.4 - U.S. - 19th c,

Little, Nina Fletcher, 1903-
 Pictures:Pictorial documents of the past
in.her.Little by Little
 Ch.IV,p.112-36 illus(part col.)

N
40.1
S353A1
NCFA

II.A.4 - U.S. - 19th c.

Stock, Joseph Whiting, 1815-1855
 The paintings and the journal of Joseph
Whiting Stock;ed.by Juliette Tomlinson;with
checklist of his works comp.by Kate Steinway.
1st ed.Middletown,Conn.,Wesleyan Univ.Press,
c.1976
 180 p. illus(part col.)

 Bibliography
 Index

LC ND1329.S69A25

ND
210
T57
NPO

II.A.4 - U.S. - 19th c.

Tillou, Peter H.
 Nineteenth-century folk painting: our spi-
ritual national heritage.Works of art from the
coll.of Mr.and Mrs.Peter Tillou.Selection and
cat.by Peter H.Tillou.The Univ.of Conn.,The
William Benton Mus.of Art.1973.
 209 p. illus(part col.)
 Organised by Paul F.Rovetti
 Bibliography
 Incl.complete cat.of the Tillou coll.incl.
works not in the exhibition
 Dewhurst.Artists in apron.
 bibl.p.187

II.A.5 - ENAMEL

Dussieux, Louis.Étienne.,1815-1894
 Recherches sur l'histoire de la peinture
sur émail dans les temps anciens et modernes
et spécialement en France...Paris,Leleux,1841
 171 p.

ICJ NN Clousot.Dict.N7616.C64NCFA
 p.XVII

II.A.5. SPECIFIC MEDIA, A-Z (if not
 specifically listed, paintings are
 in oil or tempera)

 For list of SPECIFIC MEDIA see
 "Guide to Classified Arrangement"

II.A.5 - ENAMEL - 18-19th c.

David-Weill, David, 1871-1952
 Miniatures and enamels from the D.David-
Weill collection.Paris,Les Beaux-Arts,édition
d'études et de documents,1957

 Cat.of that part of the collection which
was sold to Messrs.Wildenstein

LC N7616.D33 FOR COMPLETE ENTRY
 SEE MAIN CARD

N
40.1
C628
W18
NCFA

II.A.5 - ACRYLIC

Close, Chuck, 1940-
 Close portraits.Walker Art Center,Minnea-
polis,exh..edited.by Lisa Lyons and Martin
Friedman.Minneapolis,The Center,c.1980.
 80 p. illus(part col.)

 Checklist inserted
 Bibliography

LC N6537.C54A4 Worldwide Art Cat.Bul.
 705.W927 NMAA v.17no.2 198
 p.53

N
7616
P23
NCFA

II.A.5 - ENAMEL - 18-19th c.

Paris. Musée national du Louvre.Cabinet des
 dessins
 Donation de D.David-Weill au Musée du
Louvre.Miniatures et émaux..Exposition.Oct.'56-
janvier 1957.Paris,Editions des Musées natio-
naux.1956.
 186 p. illus.
 Miniatures p.3-90; Enamels p.93-170
 Cat.by Maurice Sérullas
 Bibliography
 Index of artists and of sitters
 Repro.incl.:(A)Miniaturists:Hall,Dumont,

N
7616
C64
NCFA

II.A.5 - ENAMEL

Clousot, Henri, 1865-1941
 ...Dictionnaire des miniaturistes sur émail...
.Paris,A.Morancé,c.1924.
 241 p. illus. (Archives de l'amateur)

 Bibliography

 Covers the period 1630-c.1860

LC N7616.05 Th.B.-Petitot Lit.

II.A.5 - ENAMEL - FRANCE

Clousot, Henri, 1865-1941
 La miniature sur émail en France.Paris.
A.Morancé.1928.
 226 p. illus. (Archives de l'amateur)

 Covers the period 1630-1830

LC ND1337.F8C57 Clousot.Dict. N7616/C64
 NCFA

705
028
NCFA
v.8

II.A.5 - ENAMEL

Clousot, Henri, 1865-1941
 Les Maîtres de la miniature sur l'émail au
musée Galliéra

 In:Gas Beaux Arts
8:53-62 , jul.-aug.,'23 illus.

 Exhib.June & July,1923

 Description of technique which was invented
in Châteaudun in 1630 & in Blois in 1643.Histo-
rical develop't in France,Engl.,Germany,etc.

 Th.-B.Petitot,Lit.

705
028
NCFA
v.22

II.A.5 - ENAMEL - FRANCE - 17th c.

Bordier, Henri .Leonard,1817-1888.
 Les émaux de Petitot en Angleterre

 In:Gas Beaux Arts
22:168-79 1867 1 illus.

 Phila.M.of art Bul.83:19
 note 2

708.1
P31
NMAA
v.83

II.A.5 - ENAMEL - FRANCE - 17th c.

Grace, Priscilla
 A celebrated miniature of the Comtesse
d'Olonne

In:Phila.Mus.Art B.
83,no.353:3-21 Fall,'86 illus(part col.)

 Comtesse d'Olonne.as Diana by Jean Petitot

 Incl.repr.of several miniatures by Petitot

II.A.5 - ENCAUSTIC

Caylus, Anne Claude Philippe, comte de,
 .1692-1765
 Mémoire sur la peinture à l'encaustique
et sur la peinture à la cire.ParM.le comte de
Caylus...et M.Majault...Genève,Veuve Tilliard
.etc..1780
 133 p. illus.

LC ND2480.C3 Williamson.Portr.work in
 wax.In:Apollo,July,'36
 p.33

II.A.5 - ENAMEL - FRANCE - 17th c.

Paris. Musée national du Louvre. Dpt.des
 peintures,des dessins et de la chalcographie
 Les émaux de Petitot du Musée impérial du
Louvre;portraits de personnages historiques
et de femmes délèbres du siècle de Louis XIV,
gravés au burin par M.L.Ceroni.Paris,Blaisot,
1862-64
 2 v. illus.

 1st part:Jean Petitot(1607-1691)by Henri
Bordier,31 p.,illus.
 Petitot was assisted in his miniature ptg.
by his brother- in-law,Jacques Bordier
MM CtY MB MdBWA,etc.

II.A.5 - ENCAUSTIC

Graf, Theodor
 Cat.of the Theodor Graf coll.of unique an-
cient Greek portraits 2000 years old recently
discovered and now on view in Old Vienna,Mid-
way Plaisance at the World's Columbian exposi-
tion.Chicago?,1893.
 49 p.

?000 Cat.by F.H.Richter and F.von Ostini.
3718 The encaustic ptg.of the ancients,by Otto
075e Donner von Richter pp..45.-49
ET
590.8 Winterthur Mus.Libr. fZ581
ZX 78 NCFA v.?.p.227
N.Y.P.L. MCD p.v.1

II.A.5 - ENAMEL - FRANCE-19th c.
Falize, Lucien, 1842-1897
...Claudius Popelin et la ronaissance des
émaux peints.Paris,Gaz.des beaux-arts,1893
 104 p. illus.

 Originally published in Gas Beaux Arts.See:
705.028 NCFA:v.9:418-35,Apr.,'93;v.9:502-48,
June,'93;v.10:60-76,July,'93,426-37,Nov.,'93,
478-89,Dec.,'93;v.11:130-48,Feb.,'94

WSP

II.A.5 - ENCAUSTIC

Sartain, John, 1808-1897
 On the ancient art of painting in encaustic
Abstract of a lecture delivered before the
Franklin Institute,Apr.9,1885.Philadelphia,The
Franklin Inst.,1885.
 12 p. illus.

 Reprinted from the Journal of the Franklin
Inst.,Sept.,1885

PU-F Penn.Hist.Soc. Rembrandt
 Peale...Bibl.p.119

705
075
NCFA
v.56

 ENAMEL - 18-19th c.

Williamson, George Charles, 1858-1942.
 The Bontinck-Hawkins coll.of enamels at
the Ashmolean museum;Oxford

In:Connoisseur
56:34,36-7 Jan.,'20 illus.

 Repro.:H.Bone,the younger,Birch,Craft,Hone,
Spicer,Zincke,H.Bone,the elder,Hatfield,Spencer

II.A.5 - ENCAUSTIC
 see also
I.F - MUMMIES
I.C.2

II.A.5 - ENAMEL - SWITZERLAND - GENEVA - 17-18th

Schneeberger, Pierre Francis
 Les peintres sur émail genevois au 17e et
au 18e siècle.Genève,Mus.d'art et d'histoire,
1958

MET
195.4
Sch5

MdDA **FOR COMPLETE ENTRY
 SEE MAIN CARD**

II.A.5 - GOUACHE

Geneva. Musée d'art et d'histoire
 Chefs-d'oeuvre de la miniature et de la
gouache...Genève.1956.

?000
4490
032

 see also Connoisseur,v.138:82-3 9 illus.

ICA NN PPPM CLU **FOR COMPLETE ENTRY
 SEE MAIN CARD**

II.A.5 - GOUACHE - GREAT BRITAIN - 18th c.

Williamson, George Charles, 1858-1942
Daniel Garnder, painter in ... gouache...
London, N.Y.,John Lane company,1921
150 p. illus(part col.)

LC ND497.G3W5

FOR COMPLETE ENTRY
SEE MAIN CARD

705
A56
NCFA
v.17

II.A.5 - HAIR

Gillingham, Harrold Edgar, 1864-1954
Notes on Philadelphia profilists

In:Antiques
17:516-8 June,'30 illus.

Incl.:Sam.Folwell(min.ptr.in hair),J.H.Gil-
lespie,R.S.Biddle,H.Page,Wm.Verstille,Wm.Wil-
liams,Edm.Brewster,Aug.Day,Joshua C.Seckel

London,H.R. Shades of my
forefathers.741.7.L847
Bibliography

705
C75
NCFA
v.54

II.A.5 - GOUACHE - GREAT BRITAIN - 18-19th c.

Sée, Robert René Meyer
Gouaches by George Chinnery
In:Connoisseur
54:141-51 July,'19 illus(part col.)

Incl.study of the components of Ch.'s gou-
aches...

705
C75
NCFA
v.90

II.A.5 - HAIR

Ritchan
Hair portraiture

In:Connoisseur
90:392-3 Dec,1932 illus.(dogs)

Augustin Edouart, silhouettist, artist in hair
work:portrs.,etc. & bas-relief

ND
2893
B7X
NPG

II.A.5 - HAIR

Brooklyn Institute of Arts and Sciences. Museum
Dept.of contemporary art
...Five centuries of miniature painting, Apr.3-
June 1,1936.Brooklyn,Brooklyn mus.press,1936.
.50.p.

nos.272,272a,277 - Hair pictures
nos.99-137 - Eye miniatures

Detroit.I.A. N40.1.P35D4
NPG Bibl.p.144

II.A.5 - PASTEL

Krieger, Lothar, 1879-
...Das pastell,seine geschichte und seine meis-
ter.Berlin, Verlag für Kunstwissenschaft.1939.
430 p. illus(part col.)

FOOO
FA6448.1

Peabody inst.Baltimore for
LC

Bildnisminiatur & ihre
meister 757.B59,v.4,Bibl.

AP
1
C76
NPG

II.A.5 - HAIR

Dunbar, Philip H.
Portrait miniatures on ivory,1750-1850;from
the coll.of the Connecticut historical society

In:Conn.Hist.Soc.B.
29:97-144 Oct.,'64 illus.

Incl.Checklist
Pertains to an exh.at the Conn.Hist.Soc.

Incl.Hair painting
Winterthur Mus.Libr.fZ861
W78 NCFA v.6,p.217

II.A.5 - PASTEL

Norgate, Edward, d.1650
An exact and compendious discours concern-
ing the art of Miniatura or Limning....1621-
1626.

The treatise is in the Brit.Mus.(MS.Harl.
6000)

Norgate.Miniatura.750.N83
.XII ff
Walpole Soc.AP1W225,v.3,
p.83

II.A.5 - HAIR

Edouart, Augustin,1789-1861 (Silhouettist)
Treatise on silhouette likeness.London
1835,Longman and company.etc..

Met has 122 p. illus.
book in
Miss Martin
coll. Chapter on hair pictures

LC NC910.E3

708.1 N52 NCFA Bull.Met
v.35-6 p.54

II.A.5 - PASTEL

Propert, John Lumsden, 1834-1902.
Cat.of miniatures,enamels,pastels,and
waxes,at 112 Gloucester place,Portman Square
.London,Printed by W.Clowes & sons,ltd.,189-?.

"Coll.of Dr.J.Lumsden Propert(ca.1890)".

CSmH MdBWA

NC
880
S617
NPG

II.A.5 - PASTEL

Singer, Joe, 1923-
How to paint portraits in pastel.N.Y.,
Watson-Guptill Publications.1972.
175 p. illus(part col.)

LC NC880.S5

Books in print.Subj.guide
Z1215.P92 1975 v.2 NPG
p.2772

N
40.1
M8714
F5
NMAA

II.A.5 - PASTEL - CANADA - 20th c.

Morris, Edmund, 1871-1913
The diaries of Edmund Montague Morris:
Western journeys 1907-1910;trancribed by
Mary Ritz-Gibbon.Toronto,Royal Ontario Mu-
seum,1985
179 p. illus(part col.)

Bibliography p.167-70
Index

qNC
885
A32
1971X
NPG

II.A.5 - PASTEL - 18th c.

Adair, Virginia
Eighteenth century pastel portraits.by.Vir-
ginia and Lee Adair.London,John Gifford,1971
203 p. illus(part col.)

Bibliography

Index of artists

Partial contents:Italian school.French
school.English school

LC NC885.A32 1971

705
G28
v.15
1927
NCFA

II.A.5 - PASTEL - FRANCE

Ratouis de Limay, Paul
L'exposition de pastels français du 17e et
du 18e siècle
Exhibition at Hôtel Charpentier,1927
In:Gaz Beaux Arts
15:321-38 ser.5,1927 illus.

Incl:Nanteuil,Vaillant,Vivien,Coypel,La Tour,
Perronneau,Chardin,Boucher,Ducreux,Boze,Labille-
Guiard,V.Le Brun,M.S.Giroust Roslin,Valade,N.Loir,
S.B.Le Noir,Regnault,Sergent-Marceau,Prud'hon
Portr.of LaTour by Perronneau & by himself

II.A.5 - PASTEL - 18th c.

Galeries Georges Petit, Paris
Exposition de cent pastels du 18e siècle...
.Paris.Gal.Georges Petit.1908.

FOCO
6448
P48

FOR COMPLETE ENTRY
SEE MAIN CARD

705
G28
NCFA
v.49

II.A.5 - PASTEL - FRANCE - 17th c.

Fromrich, Yane
Robert Nanteuil dessinateur et pastelliste

In:Gaz Beaux Arts
49:209-17 Apr.,'57 illus.

English summary
...one of the great masters of French por-
traiture in the 17th c.& the precursor of the
art of the pastellists of the 18th c.

Noon.Engl.portr.drag...
NC860.N66X NPG p.X1
footnote 12

qN
40.1
G748D3
NMAA

II.A.5 - PASTEL - CANADA - 20th c.

Dempsey, Hugh Aylmer, 1929-
History in their blood:The Indian por-
traits of Nicholas de Grandmaison;intro.by
J.Russell Harper;foreword by Frederick J.
Dockstader.1st American ed.N.Y.,Hudson Hill
Press.Distr.by Viking Penguin,c.1982
124 p. illus(part col.)

Index

LC NC143.G68D46 1982

Books in print.Subject
guide,1985-86,v.3,p.4864

AP
1
P89
NCFA
v.4

II.A.5 - PASTEL - FRANCE - 17th c.

Thomas, Thomas Head, 1881-
The drawings and pastels of Nanteuil

In:Print Coll Q
4:327-61 Dec.,'14 illus.

Repro incl.a pastel of Louis XIV

Fromrich.Rbt.Nanteuil in:
Gaz Beaux Arts 49:209,foot-
note 1

N
40.1
M8714
M2
NMAA

II.A.5 - PASTEL - CANADA - 20th c.

McGill, Jean S.,1920-
Edmund Morris,frontier artist.Toronto
and Charlottetown,Dundurn Press,1984
208 p. illus(part col.) (Dundurn lives)

Index
Bibliography,p.197-201

LC ND249.M67M24 1984

N
40.1
L35xB9
NCFA

II.A.5 - PASTEL - FRANCE - 18th c.

Bury, Adrien, 1891-
Maurice-Quentin de La Tour:the greatest
pastel portraitist.London,Skilton,1971
201 p. illus(part col.)

Bibliography

Incl.:List of sitters

II.A.5 - PASTEL - FRANCE - 18th c.

Macfall, Haldane, 1860-1928
The French pastellists of the 18th century,
their lives, their times, their art, and their sig-
nificance...ed.by T.L.Hare...London, Macmillan
& co.,ltd.,1909
211 p. illus.

LC NC880.M3 Amsterdam.Rijksmus.cat.
 Z5939A52,deel 1, p.492 &
 p.502

705
C75
NCFA II.A.5 - PASTEL - GREAT BRITAIN - 18th c.
v.89
 Manners, Lady Victoria, 1876-1933
 Catherine Read and Royal patronage

 In:Connoisseur
 89:35-40 Jan.,'32 illus.

705
G28 II.A.5 - PASTEL - FRANCE - 18th c.
v.40
1908 Tourneux, Maurice
NCFA L'Exposition des cent pastels du l siècle
 et de bustes,

 In:Gaz.Beaux-Arts
 40:5-16 Jl.,1908 illus.

 Pertains to exh.of 100 pastels of the 18thc.
 organized by the Marquise de Ganay at the Gale-
 ries Georges Petit,May 18-June 15,1908
 Repro.incl.:de la Tour:self-portr.,Mme Masse.
 Perronneau:Comte de Bastard. Pajou:bust of Duc
 de Vendome.Mérard...t of Prince de Conti

705
C75 II.A.5 - PASTEL - GREAT BRITAIN - 18th c.
NCFA
v.88 Manners, Lady Victoria, 1876-1933
v.89 Catherine Read:The English Rosalba"

 In:Connoisseur
 88:37686 Dec.,'31 illus.
 89:171-8 March,'32 illus.

 Archer.India & Brit.portr...
 ND1327.I44A72X NPG Bibl.
 p.483

II.A.5 - PASTEL - FRANCE - 18th c.

Vaillat, Maurice, 1876-
 J.-B.Perronneau,sa vie et non oeuvre:par
L.V.et Paul Ratouis du Limay.2.éd.rev.et augm.
Paris,G.van Oest,1923
 253 p. illus. (Bibliothèque de l'art
du 18e siècle)

LC(ND553.P43V3 1923) Smart.Life & art of A.Ram-
 say N40.1R17386 NCFA
 Bibl.p.204

705
C75 II.A.5 - PASTEL - GREAT BRITAIN - 18th c.
NCFA
v57 Sée, Robert René Meyer
 How Russell executed his pastels

 In:Connoisseur
 57:161-2,164,166 Jly,'20 illus(part col.)

 '...pastel artist"par excellence".-Sée

SP
1 II.A.5 - PASTEL - GREAT BRITAIN
W225
v.3 Baker, Charles Henry Collins, 1880-
NCFA Notes on Edmund Ashfield

 In:Walpole Soc.
 3:83-7 1913-14 illus.

705
C75 II.A.5 - PASTEL - GREAT BRITAIN - 18th c.
NCFA
v.52 Sée, Robert René Meyer
 Portraits of children of the Russell family
 by John Russell

 In:Connoisseur
 52:183-4.;86,188,192 Dec.,'18 illus(part col.)

 'Prince of pastellists'.-Sée

705
C75 II.A.5 - PASTEL - GREAT BRITAIN
NCFA
 Edwards, Ralph, 1894-
 Pastel portraits by J.R.Smith

 In:Conn.
 90:299-307 Nov.,'32 illus.
 93:96,98-101 Feb.,'34 illus. (J.R.Smith & his
 pupils)

 Cumulated Mag.subj.index
 A1/3/C76 Ref.v.2,p.444

II.A.5 - PASTEL - GREAT BRITAIN - 18th c.

Williamson, George Charles, 1858-1942
 Daniel Gardner,painter in pastel...London,
N.Y.,John Lane company,1921
 150 p. illus(part col.)

LC ND497.G3W5 FOR COMPLETE ENTRY
 SEE MAIN CARD

705
M19
NCFA
v.15

II.A.5 - PASTEL - GREAT BRITAIN - 18th c.

Williamson, George Charles, 1858-1542
 John Russell,"the prince of crayon portrait-
painters"

In:Mag Art
15:72-8 illus. 1892

 Mainly a biography of J.Russell

705
A56
NCFA

II.A.5 - PASTEL - U.S.

Keyes, Homer Eaton, 1875-
 Coincidence and Henrietta Johnston

In:Antiques
16:490-4 Dec.,'29 illus(part col.)

 First portraitist in pastel in the U.S.

 Keyes searches for antecedents of H.J.

741.23
S45

II.A.5 - PASTEL - GREAT BRITAIN - 18-19th c.

Sée,Robert René Meyer
 English pastels,1750-1830...London,G.Bell &
sons,ltd.,1911
 373 p. illus.(part col.)

 '...representative of the work of the English
portrait painter of the 18th c....'

LC NC880.S4

705
A56
NCFA
v.51

II.A.5 - PASTEL - U.S.

Rutledge, Anna Wells
 Who was Henrietta Johnston ?

In:Antiques
51:183-5 Mar.,'47 illus.

 1st woman artist in the U.S. Pioneer in the
art of pastel

705
C75
NCFA
v.103

II.A.5 - PASTEL - GREAT BRITAIN - IRELAND - 18th

McGuire, Edward A.
 Pastel portrait painting in Ireland in the
18th century

In:Connoisseur
103:10-5 Jan.'39 illus.

 Incl.list of some Dublin pastelists of the
18th c.
 Repro.incl.:Hugh Douglas Hamilton;Ths.Hickey
Chs.Forrester;John Cullen

 Noon.Engl.portr.drags.&min
 NC860.N66X NPG Bibl. p.146

705
I61
NCFA

II.A.5 - PASTEL - U.S.

Willis, Eola
 The first woman painter in America

In:Studio
87:13-20,84 July,'27 illus.

 Incl.:List of pastel portrs.,by Henrietta
Johnston,ptd.in S.Carolina,1710-70

 Keyes.Coincidence and H.
 Johnston.In:Antiques,16

AP
1
W225
NCFA
v.2

II.A.5 - PASTEL - GREAT BRITAIN - IRELAND - 18th

Strickland, Walter George, 1850-1928
 Hugh Douglas Hamilton,portrait painter

In:Walpole Soc.
2:99-110 1912-13 illus.

 Incl.:List of sitters in alphabetical order,
with medium and owner
 Strickland mentions H.'s daughter,Harriott,
portraitist who finished one of H.'s portrs.

 Noon.Engl.portr.drags.&min
 NC860.N66X NPG Bibl.p.148

NCFA
uncat.

II.A.5-PASTEL - U.S.

Willis, Eola
 Henrietta Johnston,South Carolina pastel-
list

In:The Antiquarian
11,no.2:46-7 Sep.,'28 illus.

 Several previously unknown portrs.by Ameri-
ca's 1st woman ptr.,H.J.,have been found re-
cently

II.A.5 - PASTEL - ITALY

Malamani, Vittorio, 1860-1934
 Rosalba Carriera.Bergamo,Istituto italiano
d'arti grafiche,1910
 120 p. illus. (Collezione di monografie
illustrate:Pittori,scultori,architetti,8)

 'Carriera introduced pastel to the world'.-
Adair
 'Best book on Carriera'.-Adair

ND623.C43.M3.
NNU ICU NRU CtY NjP Adair.18th c.pastel portrs.
 qNC885.A32 1971X Bibl
 p.203

705
A56
NCFA
v.69

II.A.5 - PASTEL - U.S. - 18th c.

Cole, Ruth Townsend
 Limned by Blyth

In:Antiques
69:331-3 Apr.'56 illus.

II.A.5 - PASTEL - U.S. - 18th c.

Foote, Henry Wilder, 1875-
 Benjamin Blyth, of Salem:eighteenth century
artist.Boston,1957
 46 p. illus.

MET
Dpt.Am. Incl.:Checklist of portrs.known in 1957
ptgs.&
sculpt. Publ.in Mass.Hist.Soc.Proceedings,71:64-107
192B623 Oct.53-May '57
F73

 Little.In:Essex Inst.Hist.
 coll.AP1.E78.v.108:49 foot-
 note 1

AP II.A.5 - PASTEL - U.S. - 18th c.
1
E78 Little, Nina Fletcher, 1903-
NPG The Blyths of Salem:Benjamin,Limner in cra-
v.108 yons and oil,and Samuel,Painter and cabinetmaker

 In:Essex inst.hist.coll.
 108:49-57 Jan.,'72 illus.

 Payson.Mus.colls.of the
 Essex Inst.N65D5,P34X NPG
 p.65,note 34

II? II.A.5 - PASTEL - U.S. - 18-19th c.
550
N53 New Jersey Historical Society
NPG Painted in crayon:Pastel portraits from the
 collection.By S.Gail Fuller.An exh.at the New
 Jersey Historical Society,19 May-27 Nov.1982.
 Newark,N.J.,The Society,1980,
 16,p. illus(part col.)

 Reprinted from New Jersey History

705 II.A.5 - PASTEL - U.S. - 18-19th c.
A56
NCFA Schmiegel, Karol A.
v.107 Pastel portraits in the Winterthur museum

 In:Antiques
 107:323-31 Feb.,'75 illus(part col.)

 Rila II/2 1976 #7092

AP II.A.5 - PASTEL - U.S. - 18-19th c.
1
C76 Warren, William Lamson
NPG Connecticut pastels,1775-1820
v.24
 In:Conn.Hist.Soc.B.
 24:97-114 Oct.,'59 illus.no.1-31,cover &
 p.115-28

 FOR COMPLETE ENTRY
 SEE MAIN CARD

705 II.A.5 - PASTEL - U.S. - 19th c.
A56
NCFA Cortelyou, Irwin F.
v.78 Micah Williams,pastellist

 In:Antiques
 78:459-61 Nov.,'60 illus.

705 II.A.5 - PASTEL - U.S. - 19th c.
A56
NCFA Cortelyou, Irwin F.
v.66 A mysterious pastellist identified

 In:Antiques
 66:122-4 Aug.,'54 illus.

 see also his,Henry Conover,sitter,not ar-
 tist,p.461,Dec.,'54 in Antiques,v.66

 New Jersey Hist.Soc.MC880
 N53 NPG note 6

705 II.A.5 - PASTEL - U.S. - 19th c.
A56
NCFA Cortelyou, Irwin F.
v.74 Notes on Micah Williams,native of New
 Jersey

 In:Antiques
 74:540-1 Dec.,'58. illus.

ND II.A.5 - WATERCOLOR
2200
R44X Reid, Charles, 1937-
NPG Portrait painting in watercolor.N.Y.,Watson-
 Guptil Publications,1973.
 156 p. illus(part col.)

 Bibliography

 Cumulative Book Index 1974
 Z1219C97 NPG p.1682

ND II.A.5 - WATERCOLOR
2200
W3 Walker, Phoebe Flory, 1914-
1949X Watercolor portraiture,by Phoebe Flory
NPG Walker with Dorothy Short and Eliot O'Hara.
 N.Y.,G.P.Putnam's Sons,1949.
 143 p. illus(part col.)

 Incl.:A suggested reference list of books
 for the painter of watercolor portraits,p.139-
 143

ND
2202
O7E5X
NMAA

II.A.5 - WATERCOLOR - GREAT BRITAIN

The English miniature;by John Murdoch....et a
New Haven,Yale University Press,1981
240 p. illus(part col.)

Incl.:bibliographical references and inde

'.For.the most concise...surveys of the
development of miniature portrs. see...Murdoch
The English miniature.'-M.R.Severens

Carolina art association.
Miniature portr.coll...
p.XI footnote
by M.R.Severens

705
A56
NCFA
v.104

II.A.5 - WATERCOLOR - U.S. - NEW ENGLAND - 19th.

Savage, Norbert .H.. and Gail Savage
J.A.Davis

In:Antiques
104:872-5 Nov.,'73 illus.

Abby Aldrich Rockefeller
Folk Art Ctr.Am.Folk portrs.
N7593.A23 Bibl.-p.294

II.A.5 - WATERCOLOR - GREAT BRITAIN

Victoria and Albert museum, South Kensington
Dept.of paintings
Paintings,water-colours and miniatures/C.M.
Kauffmann.London,H.J.Stationery Off.,1978
24 p. illus. (V.&A.Mus.departmental
guides)

N.Y.(city)P.L.Art & archi-
tecture Div.Bibl.guide to
art & architecture 25939
.A791 1980 NCFA Ref. p.259

LC N1150.A85

705
A56
NCFA
v.44

II.A.5 - WATERCOLOR - U.S. - NEW ENGLAND - 19th

Spinney, Frank O.
Joseph H.Davis:New Hampshire artist of the
1830's

In:Antiques
44:177-80 Oct.,'43 illus.

List of 20 ptgs.attr.to Jos.H.Davis

Abby Aldrich Rockefeller
Folk Art Ctr.Am.Folk por-
traits.N7593.A23 Bibl.p.294

705
A784
NCFA
v.20

II.A.5 - WATERCOLOR - U.S. - 19th c.

Sherman, Frederic Fairchild, 1874-1940
Two newly discovered watercolor portraits
by Robert Field

In:Art in Am
20:84-6 Feb.,'32 illus.

Field, Robert N40.1.F45A7
p.123

qAP
1
M225
NPG

II.A.5 - WATERCOLOR - U.S. - NEW ENGLAND - 19th

Walters, Donald R.
Out of anonymity:Ruby Devol Finch(1804-
1866)

In:Maine Ant.Dig.
6:10-4C June,'78 illus.

Discussion of all recorded works & details
of Finch'life.

Abby Aldrich Rockefeller
Folk Art Ctr.Am.Folk portrs
N7593.A23 Bibl.p.294

N
6510
B74
NCFA
clRef.
c.2NCFA

II.A.5 - WATERCOLOR - U.S. - 19th c.

Boston. Museum of Fine Arts
M. & M.Karolik coll.of American Water co-
lors & drawings,1800-1875.Boston,1962
2 v. illus(part col.)

v.2,p.96-136:Portraits

Exh.held...Oct.18,1962-Jan.6,1963
Incl.bibliographies

II.A.6. SPECIAL FORMS, A-Z

For list of SPECIAL FORMS see
"Guide to Classified Arrangement"

N
40.1
E91C5
NCFA

II.A.5 - WATERCOLOR - U.S. - NEW ENGLAND - 19thc

Chicago. Art Institute
Three New England watercolor painters.Cat.
by Gail and Norbert H.Savage and Esther Sparks.
Chicago,A.I.,1974
72 p. illus(part col.)

78 works shown;W.C.portrs. by Jos.H.Davis,
J.Evans,J.A.Davis.The cat.documents all the
known ptgs.by the three.
Rev.In:Art Gallery,v.18:54-6 Jan.'75 illus.,
by Esther Sparks
Exh.at Chicago A.I. Nov.16-Dec.22,1974;Art
Mus.St.Louis,Jan. 17-March 2,1975;
LC ND1810.28 Rila 1/1-2 1975 #2940/41
(Savage,Gail)

II.A.6 - GLASS
(e.g.Hinterglasmalerei,gilded glasses,verre églomisé)

708.9492
A523
NMAA
v.30

II.A.6 - GLASS

Bruijn Kops, C.J.de
 Keuze uit de aanwinsten.Portretminiaturen
uit de verzameling Mr.Adolph Staring

In:B.Rijksmus.
30,no.4:192-205 1982 illus.

Summary in English,p.209

Mainly Netherlandish miniatures,also 5 sil-
houettes on glass(3 verre églomisé)

Bruijn Kops in B.Rijksmus.
 6:177,note 5

NK
5435
O3B78
1983X
NPG

II.A.6 - GLASS - GERMANY - 18th c.

Brückner, Wolfgang, 1930-
 Hinterglasbilder aus unterfränkischen
sammlungen,zur sonderausstellung des Main-
fränkischen Museums,Würsburg(25.Feb.-1.Mai
1983),by.W.Brückner,Hansvernfried Muth,Hans-
Peter Trenschel.Würsburg,Freunde Mainfränki-
scher Kunst und Geschichte,1983
 335 p. illus. (Mainfränkische Hefte,
Heft 79)
 Index
 Bibliography
 Portraits 18th c. p.38-41,256-7

705
A7832
NCFA

II.A.6 - GLASS - ANTIQUITY

Breck, Joseph, 1885-1933
 The Ficoroni medallion and some other
gilded glasses in the Metropolitan Museum of Art

In:Art Bull
9:3 53-6 June,'27 illus.

Incl.forgeries

Swindler.Ancient painting
759.93.897;p.461
Bibl.,

751.2261
.C61

II.A.6 - GLASS- GREAT BRITAIN

Clarke, Harold George
 The story of old English glass pictures,
1690-1810,...London,Courier press.1928.
 107 p. illus.(part col.)

 Alphabetical catalogue of glass pictures:
p.89-97
 Alphabetical catalogue of engravers:p.98-104

LC ND1590.C5

II.A.6 - GLASS - ANTIQUITY

Garrucci, Raffaele, 1812-1885
 Vetri ornati di figure in oro trovati nei
cimiteri cristiani di Roma.Raccolti e spiegati
2nd ed.Roma,Tipografia delle belle arti,1864
 285 p. illus.

 Incl.forgeries

LC NK5108.G3 1st ed.1858
MB DDO PPD NN NjP

Breck.Art Bull.9:353
705.A7832
Swindler.759.93.897,p.461

P
A64
NCFA
v.98

II.A.6 - GLASS - GREAT BRITAIN - 18-19th c.

Foskett, Daphne
 Miniaturists silhouettists in Bath

In:Apollo
98:155-9 Nov.'73 illus.

 Repro.incl.:Chs.Jagger,Abr.of Jos.Daniel,
Charlotte Jones,Sampson Towgood Roch(e),Chs.
Ford,Ozias Humphry,Ths:Redmond,Chs.Foot Taylor,
Nathaniel Hone,T.Hamlet,Jac.Spornberg,Elliott
Rosenberg

II.A.6 - GLASS - ANTIQUITY

Vopel, Hermann
 ...Die altchristlichen goldgläser.Ein beitrag
zur altchristlichen kunst-und kulturgeschichte
Freiburg,i.B.,Mohr,1899
 116 p. illus. (Archäol.studien zum
christlichen altertum & mittelalter,no.5)

FOGG
AndH

 Incl.forgeries

Breck.In:Art Bull.9:353
705.A7832

P
1
J8643
NCFA
v.3

II.A.6 - GLASS - U.S. - 19th c.

Bateson, Whaley
 Charles Peale Polk:gold profiles on glass

In:J.early S.dec.arts
3:51-7 Nov.,'77 illus.

 Verre églomisé

Simmons.Chs.P.Polk N40.1
P74895 NCFA Bibl.p.20

II.A.6 - GLASS - ANTIQUITY - ROME

Albizzati, Carlo, 1888-
 Vetri dorati del terzo secolo dopo Cristo

In:Deutsch ArchMol Inst Mitt Röm Abt
29:240- 1914 illus.
 Family groups & individuals worked out in
gold leaf on glass,from the 3rd c.

LC DE2.D42

Swindler.Ancient painting
759.93.897NGA,p.319

705
A56
NCFA
v.14

II.A.6 - GLASS - U.S. - 19th c.

Carrick, Alice van Leer, 1875-
 Novelties in old American profiles

In:Antiques
14:322-27 Oct.'28 illus.

 Incl.:Engraved gold-on glass profiles of
Js.Madison and A.Gallatin by Chs.Peale Polk
and of John Adams by A.B.Doolittle.Hollow-cut
profiles by Wm.Chamberlain and Henry Williams;.
 Published as separate article fr. her
"Shades of our ancestors",Ch.VI
 Amer.Ant.Soc.,Worcester,M.
 Library N7593.A512 NPG p.7

705
A56
NCFA
v.52

II.A.6 - GLASS - U.S. - 19th c.

Lipman, Mrs.Jean Herzberg,1909-
Benjamin Greenleaf;New England limner

In:Antiques
52:195-7 Sept.,'47 illus.

Portraits on glass

List of Greenleaf's portraits

II.A.6 - MANUSCRIPTS

Gesellschaft der bilder-und miniaturfreunde
,Vienna

Das gemalte kleinporträt.IDas kleinporträt
in den handschriften der Nationalbibliothek...
Wien,Selbstverlag,1931

.LC Jd045.931G. CtY

FOR COMPLETE ENTRY
SEE MAIN CARD

705
A56
NCFA
v.26

II.A.6 - GLASS - U.S. - 19th c.

Lyman, Grace Adams
William M.Prior,The "Painting Garret"
artist

In:Antiques
26:180 Nov.,'34 illus.

Portrs.on glass

Abby Aldrich Rockefeller
Folk Art Ctr.Am.folk portra
N7593.A23 NMAA Bibl.p.294

705
D97
NCFA
v.88

II.A.6 - MANUSCRIPTS

Toynbee, Margaret R.
The portraiture of Isabella Stuart, duchesse
of Brittany (c.1427-c.94)

In:Burl Mag.
88:300-6 Dec 1946 illus.

Portrs. in hour books, missals, etc.

Rep.,1945-7#6322

ND
236
L76
NPG

II.A.6 - GLASS- U.S. - NEW ENGLAND - 19th c.

Lipman,Mrs.Jean Herzberg, 1909- comp.
Primitive painters in America,1750-1950;an
anthology,by J.Lipman & A.Winchester.N.Y.,Dodd,
Mead,1950.
182 p. illus(part col.)

Contents.-2.N.F.Little, Primit.ptrs.of 18th
4.A.M.Dods, R.H.Bascom.-5.A.E.Rye, E.Hicks.-8.F.F.
Sherman, J.S.Ellsworth.-9.F.B.Robinson, E.S.Fiel
10.N.F.Little, W.M.Prior.-11.J.Lipman, D.Golde
smith.-12.F.O.Spinney, J.H.Davis.-14.J.L.Clarke,
jr., J.W.Stock

ND
1316.2
D97
NPG

II.A.6 - MANUSCRIPTS - FRANCE

Tillet, Jean du, sieur de la Bussière,d.1570
...Portraits des rois de France du Recueil
de Jean du Tillet.Reproduction réduite des 32
miniatures du manuscrit français 2848 de la bib-
liothèque nationale. Paris,Impr.Berthaud frères,
.1908,
12 p. illus.

Edited by Henri Omont

LC N7004.75

Amsterdam,Rijksmus.cat.
Z5939A52,deel 1, p.145

II.A.6 - MANUSCRIPTS

Coudero, Camille, 1860-
Album de portraits d'après les collections
du département des manuscrits...Paris,Impr.
Berthaud frères.1910.
86 p. illus.

LC ND3399.A6C7

Amsterdam,Rijksmus.cat.
Z5939A52,deel 1,p.133

II.A.6 - MANUSCRIPTS - GERMANY

Goetz, Walter Wilhelm, 1867- ed.
Die entwicklung des menschlichen bildnisses.
Leipzig & Berlin,B.G.Teubner,1928-
v

Contents.-1.Schramm,P.E.D.deutschen Kaiser &
Könige in bildern ihrer zeit.1.Bis sur mitte des
12.jhrh(751-1152)2 v.1929.-2.Prochno,Joachim.Das
schreiber-& dedikationsbild in d.deutsch.buchma-
lerei,v.1,1929-3.Steinberg,S.H.,D.bildnisse geist-
licher & weltlicher fürsten & herren.1.Von d.mit-
te d 10.bis s.ende d.12.jhrh(950-1200),1931
LC N7575.E6 v. II,III

II.A.6 - MANUSCRIPTS

Croquison, R.P.Pierre
Les origines du portrait frontispice dans
les manuscrits à peintures. Paris,Thèse Ec.
Louvre,23 novembre 1949)

Rep.,1948-49:863

705
D97
NCFA
v.65

II.A.6 - MANUSCRIPTS - GREAT BRITAIN

Shaw, Wm.A.
The early English school of portraiture

In:Burl.Mag.
65:171-84 Oct,1934 illus.

The Engl.portr.from mid 15th c.to end 18th c.
Wilton diptych is initial stage of development
which produced Engl.small secular portrs.Its in-
sular characteristics:Tempera on gesso-prepared
panel,color-loaded varnish.
(Painters mentioned:in V.F. under Portrs.-Gr.Brit.)
Enc.of World Art,v.11
N31E56Ref.col.513
bibl.on portr.

II.A.6 - MANUSCRIPTS - GREAT BRITAIN - 16th c.

Guillim, John, 1568-1621
The way howe to lymne & howe thow shalt
lay thy colours.MS,c.1582-1600

V & A A compilation of artists' techniques

Murrell,V.James(Jim).The
way howe to lymne ND1337.
G7M58 1983 NPG p.XI

ND
1337
A2B67
NCFA

II.A.6 - MINIATURES

Boehn, Max von, 1860-1932
Miniatures and silhouettes,...transl.by E.K.
Walker...London,and Toronto,J.M.Dent & sons,ltd.
New York,E.P.Dutton & co.,1928
214 p. illus(part col.)

LC N7616.B6

II.A 6 - MANUSCRIPTS - GREAT BRITAIN - 18th c.

Vertue, George, 1684-1756
Alphabetical list of portraits mentioned
in the collections of George Vertue,preceded
by a brief description of the contents of the
several volumes,about 1752.Autograph.29 folios.
...Contains index,made by Vertue,of portraits
with references to the volumes in which they
are noted.

MS owned by the British mus.(MS.Add.23097)

Walpole Soc.AP1.W225 NCFA
v.3,p.131 & 139

II.A.6 - MINIATURES

Pourgoing, Jean de, 1877-
...Miniaturen von Heinrich Friedrich Füger
und anderen meistern aus der sammlung Bourgoing.
Vorwort von Dr.Leo Grünstein.Zürich,Amalthea-Ver-
lag.,1925.
83 p. illus(part col.)

Bibliogr.references

LC N7616.B72 Bildnismin.& ihre meister
757.B59,v.4,Bibl.

II.A.6 - MANUSCRIPTS - ITALY

Ladner, Gerart Burian, 1905-
The "portraits" of emperors in Southern
Italian exultet rolls and the liturgical comme-
moration of the emperors

In:Speculum
17:181-200 Apr,1942

Portrs.of emperors in MSS from end 10th c. to
end 13th c.

LC PN661.S6 Rep.,1942-44 #7203

757
B85

II.A.6 - MINIATURES

Brieger, Lothar, 1879-
Die Miniatur...München,Holbein-Verlag.,n.d.,
56 p. illus(col.)

Bibliography

ND1337
A2B515
NPG

II.A.6 - MINIATURES

Berlin. Staatliche museen. Gemäldegalerie
Miniaturen.1970
56 p. illus(some col.) (Kleine Schrif-
ten,ne.13)

Incl.:Chodowiecki.Self-portrait while draw-
ing with wife(who holds a min.portr.of Luise
Erman). Hoskins.Oliver Cromwell. Parent.Napo-
leon

ND
2893
B7X
NPG

II.A.6 - MINIATURES

Brooklyn Institute of Arts and Sciences. Museum
Dept.of contemporary art
...Five centuries of miniature painting,*pr.3-
June 1,1936.Brooklyn,Brooklyn mus.press,1936.
,50,p.

nos.272,272a,277 - Hair pictures
nos.99-137 - Eye miniatures

Detroit.I.A. N40.1.P35D4
NPG Bibl.p.144

757
.B59

II.A.6 - MINIATURES

Die Bildnisminiatur und ihre meister.Wien,A.Wolf
&o.1925-1923.
6 v. illus(part col.)

Bibliography:v.4

Contents.v1.Samml.Ullmann by L.Grünstein;
Füger & sein kreis;Daffinger & sein kreis; östern
min.maler ital.herkunft.-v.2.Samml.cont'd:Franz.
miniat.maler...17.&18.Jh.,Augustin,Isabey & ihr
kreis.-v.3.Samml.cont'd:franz.min.maler,18.& 19.
Jh.;Engl.min.maler,18.&19.Jh.;Deutsche min.ma-
ler,18.& 19.Jh.

II.A.6 - MINIATURES

Brussels. Exposition de la miniature,1912

LC ND1335.B7
copy 2 Rosenwald coll.

FOR COMPLETE ENTRY
SEE MAIN CARD

757
B96

II.A.6 - MINIATURES

Burlington fine arts club, London.
...Exhibition of portrait miniatures.
London,...1889
160 p. illus.

Introduction by J.L.Propert.

LC N7616.B8 757.7.B85. Brieger.Minia-
 tur. Literatur

II.A.6 - MINIATURES

Colding, Torben Holck
 Aspects of miniature painting, its origins
and development. Copenhagen,E.Munksgaard,1953

 218 p. illus.

 Bibliography

 "Relates the Brit.school of miniaturists to
its European context".J.Mayne,Portr.min.In:Conn.
Compl.Per.Guides,p.734

LC MD1337.A2C6 Reynolds,Graham.N.Hilliard
 Vict.& Alb.Mus. p.30
 2nd edition

757.7
C55
NCFA

II.A.6 - MINIATURES

Christie,Manson & Woods
 Cat.of the famous coll.of miniatures of the
Brit.and foreign schools,the property of J.Pier-
pont Morgan...to be sold at auction by Messrs.
Christie,Manson & Woods...June 24,1935 & three
following days...London,...1935
 272 p. illus(part col.)

 Based on descriptive & illus.cat.in 4 v.,
comp.by G.C.Williamson for the late J.Pierpont
Morgan,father of the present owner.
 16-19th c.miniatures of Royalties,statesmen
ladies of the court,etc.

705
C75
NCFA
v.46

II.A.6 - MINIATURES

Cundall, Herbert Minton, 1848-1940
 The Buccleuch miniatures

In:Connoisseur

FOR COMPLETE ENTRY
SEE MAIN CARD

ND
1337
U5C63
NCFA
NPG

II.A.6 - MINIATURES

Cleveland Museum of Art
 Portrait miniatures;the Edw.B.Greene coll.
Cleveland,1951
 36 p. illus.(part col.)

Cat.by Louise H.Burchfield
"Portr.miniatures,origin and technique"by L.H.
Burchfield. "Portr.miniatures,their history"by
Harry B.Wehle

LC N7616.C49

II.A.6 - MINIATURES

Darmon, J.E.
 Dictionnaire des peintres miniaturistes sur
vélin,parchemin,ivoire et écaille..Paris.Morancé
.1927.
 121 p. illus. (Aide mémoire de l'amateur
et du professionel)
 Fogg edition .1927.

FOGG
FA3930
62

LC MD1330.D3 Amsterdam,Rijksmuseum cat.
 25939A52,deel 1 NCFA
 p.128 ed..1930?.

N
7616
C64
NCFA

II.A.6 - MINIATURES

Clouzot, Henri, 1865-1941
 ...Dictionnaire des miniaturistes sur émail...
.Paris.A.Morancé,c.1924.
 241 p. illus. (Archives de l'amateur)

 Bibliography

 Covers the period 1630-c.1860

LC N7616.C5 Th.B.-Petitot Lit.

757.7
D24

II.A.6 - MINIATURES

Davenport, Cyril James Humphries, 1848-1941
 Miniatures, ancient and modern. .Chicago,
McClurg,1908

 174 p. illus.

 Emphasis on portrs.
 English,16th-19th c. Foreign miniatures,
enamels, wax miniatures
 Bibliography

LC N7616.D3

705
G28
NCFA
v.8

II.A.6 - MINIATURES

Clouzot, Henri, 1865-1941
 Les Maîtres de la miniature sur l'émail au
musée Galliéra

In:Gas Beaux Arts
8:53-62 jul.-aug.,'23 illus.

 Exhib.June & July,1923

 Description of technique which was invented
in Châteaudun in 1630 & in Blois in 1643.Histo-
rical developm't in France,Engl.,Germany,etc.

 Th.-B.Petitot,Lit.

II.A.6 - MINIATURES

Ernst August,duke of Cumberland and Brunswick-
Lüneburg, 1845-1923
 Cat.of a coll.of miniatures,the property of
His Royal Highness Prince Ernest Augustus...
duke of Cumberland...London,Priv.print,at the
Chiswick press,1914

LC N7616.E68 FOR COMPLETE ENTRY
 SEE MAIN CARD

II.A.6 - MINIATURES

Fine Art Society, London
...Cat.of the historical coll.cf miniatures
formed by Mr.J.Lumsden Propert and exh.at the
Fine Art Society's...May,1897.London,1897
40 p. (Exh.no.164)

MET
155.4
P942

CSmH Moon.Engl.portr.drags.&min.
 NC860.N66X NPG Bibl. p.145

757.7 II.A.6-MINIATURES 1
.F75
Foster, Joshua James, 1847-1923
 Miniature painters, British and foreign,with
some account of those who practised in America in
the 18th c...., New York,E.P.Dutton & co.;London,
Dickinsons,1903

 2 v. 123 pl.(part col)

 Missal ptgs.,Early portr.ptrs.,Hans Holbein,
Hilliard. The Olivers & Hoskins. S.Cooper. Enam-
els. Petitot. From death of Cooper onwards. Cos-
way,Robertson,W.C.Ross,R.Thorburn. List of portr.
min.,exh.at Burlington fine arts club,1889

705 II.A.6 - MINIATURES
C75
NCFA Foster, Joshua James, 1847-1923
v.73 The Alnwick coll. of miniatures

In:Connoisseur
73:209-17 Dec., '25 illus.

 Repro.incl.:Oliver,Hoskins,Gerbier,Snelling,
Cooper,Zincke,Bouvier

705 II.A.6 - MINIATURES
C75
v.67 Foster, Joshua James, 1847-1923
NCFA The Wicanders collection of miniatures

In:Connoisseur
67:13-8 Sept.,1923 illus.

 Coll.of 400-500 miniatures,mostly Swedish.
Also English,French,Italian,Austrian,Danish,
Russian pieces.
 Repro.incl.miniatures by P.A.Hall,Augustin
Ritt,R.Cosway,I.and P.Oliver,J.Petitot,Lafren-
sen the younger

II.A.6 MINIATURES

Foster, Joshua James, 1847-1923
 A cat.of miniatures,the property of His
Grace the Duke of Northumberland.London,Priv.
printed,1921
V & A 72 p. illus.

 Foskett.Dict.of Brit.min.
 ptrs.ND1337.G7F74d NPG
 Bibl.p.593

II.A.6 - MINIATURES

Geneva. Musée d'art et d'histoire
 Chefs-d'oeuvre de la miniature et de la
gouache...Genève,1956.

FOGG
4490
G32 see also Connoisseur,v.138:82-3 9 illus.

ICA NN PPPM CLU FOR COMPLETE ENTRY
 SEE MAIN CARD

ND II.A.6 - MINIATURES
1337
A2F75
NPG Foster, Joshua James, 1847-1923
 Chats on old miniatures, ...London,T.F.Unwin,
1908

 374 p. illus.

 "Works of reference"

LC N7616.F6

II.A.6 - MINIATURES

Gesellschaft der bilder-und miniaturfreunde,
 Vienna
 Das gemalte kleinporträt.I....II.Zwei Wiener
miniatursammlungen...Wien,Selbstverlag,1931

.LC Jdc45.9310. FOR COMPLETE ENTRY
 CtY SEE MAIN CARD

ND II.A.6 - MINIATURES
1336
F75 Foster, Joshua James, 1847-1923
1968 A dictionary of painters of miniatures
NPG (1525-1850), with some account of exhibitions,
collections, sales, etc. ... Edited by Ethel M.
Foster. New York,B.Franklin,.1968,

 330 p. (Art history & reference series,no.19)

LC 17616.F72 1968

II.A.6 - MINIATURES

Cramantieri, Tullo
 La miniatura e il ritratto miniato in
Europa. Roma,Fratelli Palombi,1947,
 189 p. illus(part col.)

LC ND1330.G74 Lister,R. Title-list...
 NPG has xerox copy

II.A.6 - MINIATURES

Guglia, Eugen, 1857-1919
 Die porträtsammlung der Fürstin Melanie
Metternich, verzeichnis der porträtminiaturen

In:Die graph.künste
40:71-112 1917 illus.

MET
100.53
G76
Q
v.39-40

LC N3.G7

Bildnismin.& ihre meister
757.H59,v.4,Bibl.

ND
1335.C2
T677
1981X
NPG

II.A.6 - MINIATURES

Hickl-Szabo, Heribert, 1920-
 Portrait miniatures in the Royal Ontario
Museum....1981.
 60 p. chiefly illus(part col.)

16-19th c., arr.chronologically

ND
1330
H43
NCFA

II.A.6 - MINIATURES

Heath, Dudley.
 Miniatures,...New York,Putnam,London,Methuen,
1905
 319 p. illus(part col.)

Bibliography

LC N7616.H4

AP
I
T683
NCFA
v.6

II.A.6 - MINIATURES

Hickl-Szabo, Heribert, 1920-
 Portraits in miniature

In:Rotunda
6,no.3:37-40 Summer,'73 illus(part col.)

 Pertains to exh.of the Starr coll.,Wm.Rock-
hill Nelson Gall.of Art,Kansas City,at the Ro-
yal Ontario Mus.,Toronto,Dec.8,1972-Jan.14,1973
 Article incl.ROM's own miniatures,among
others eye miniatures

Hickl-Szabo.In:Rotunda,v.11
no.1 API.T683 NCFA,p.12

705
C75
NCFA
v.18

II.A.6 - MINIATURES

Heath, Dudley
 Some ancestors of Alphonso XIII and other
miniatures in oil in the coll.of his Grace the
Duke of Buccleuch at Montagu House

In:Connoisseur
18:137-42 July,1907 illus(part col.)

 This coll.is a valuable moment of Spain's
power in the 16th c.-Compares Northern schools
with Southern & professional miniaturists with
ptrs.who ptd.miniatures as a diversion fr.lar-
ger work

II.A.6 - MINIATURES

109 x «Hundertneunmal.Napoleon.Miniaturen nach
J.L.David(Ausstellung)21.jan.-18.febr.1973
(Katalog von Klaus Hoffmann)Göttingen,Städti-
sches Mus.(1973)
 16 p. illus.

LC ND1335.G3.G633

II.A.6 - MINIATURES

Hesse, Ernst Ludwig,grand duke of, 1868-1937
 Die miniaturen-sammlung...des Grossherzogs
Ernst Ludwig von Hessen und bei Rhein....Mün-
chen,Kurt Wolff,1917.

MET
195.4
H46
Q

FOR COMPLETE ENTRY
SEE MAIN CARD

II.A.6 - MINIATURES

Jaffé, Albert
 Cat.of the important coll.of miniatures and
paintings of Mr.Albert Jaffé,Hamburg,which will
be sold by auction by Messrs.J.M.Heberle(H.Lem-
pertz'sons)Cologne...March 27th to April 1st,
1905...The direction of the auction will have
Mr.Henry Lemperts...Cologne,M.D.Schauberg,1905
 59 p.

LC N5265.J3

AP
I
T683
NCFA
v.11

II.A.6 - MINIATURES

Hickl-Szabo, Heribert, 1920-
 Portrait miniatures.Amassing a collection

In:Rotunda
11,no.1:12-7 Spring,'78 illus(part col.)

 Six miniatures, acquired by the Royal
Ontario Museum,Toronto

II.A.6 - MINIATURES

Jaffé, Albert
 Kat.der...miniaturen-sammlung des herrn
Albert Jaffé in Hamburg...Versteigerung zu
Köln a.Rh.den 27.-30.März 1905 bei J.M.Heberle
(H.Lempertz'söhne)...Der amtierende notar:Theo-
dor Lemperts...Leiter der versteigerung dr.phil
Heinrich G.Lemperts...Köln,Druck von M.D.Schau-
berg,1905
 89 p. illus(1 col.)

LC N7616.13

II.A.6 - MINIATURES

Jaffé, Albert
 Miniaturen-katalog, zusammengestellt von
A.Jaffé.Hamburg.1900.
 .27.p. illus.

YET
195.4
J181 Text in German, English and French.no.175
Q

 Moon.Engl.portr.drags.&min.
 NC860.N66X NPG bibl. p.146

II.A.6 - MINIATURES

Lemberger, Ernst, 1866-
 Beiträge sur geschichte der miniaturmalerei.
Ein handbuch für sammler, museen...Anhang:Künst-
ler-register,orts-verzeichnis,monogramm-liste...
Berlin,Druck von O.Bernstein,1907
 200 p.

 "Als manuscript gedruckt"
 "Moderne literatur"

LC ND1337.A214 Schidlof 757.7/.S33

II.A.6 - MINIATURES

Kende-Ehrenstein, A
 Das Miniaturporträt. Wien, Leipzig, 1908
 95 p. illus. (Sammler-Kompendien I)

 Bibliography

 *Wien,Halm & Goldmann,1908

LC ND1330.K4 Amsterdam,Rijksmus.cat.
 Z5939A52,deel 1,p.127

II.A.6 - MINIATURES

Lemberger, Ernst, 1866-
 Meisterminiaturen aus fünf jahrhunderten...
Anhang:Künstler-lexikon der miniaturmalerei mit
den biographischen daten von mehr als 6000 mini-
aturisten.Stuttgart,Deutsche verlags-anstalt,
1911
 111 p. illus.(in col.)

LC N7616.L4

II.A.6 - MINIATURES

Kestner-Gesellschaft
 Katalog nr.64
 Bildnisminiaturen aus Niedersächsischem pri-
vatbesits.Hannover,1918
 v. illus.

.Katalogs.Prior to 1955/56 issued without.title
and numbering..Title and number found in Bruijn
Kops..

LC N5070.H3K4 Bruijn Kops.In B.Rijksmus.
 36,p.179,note 45

157
.L54 II.A.6 - MINIATURES

 Lemberger, Ernst, 1866-
 Portrait miniature of five centuries,...
London,N.Y..etc..,Hodder and Stoughton .n.d..

 36 p. illus.in color

 In NPG book some plates missing

LC N7616.L4 1911 in German 111 p.

N
1455
A55 II.A.6 - MINIATURES
1983
NMAA
 Lady Lever art gallery, Port Sunlight
 Cat.of foreign paintings,drawings,minia-
 tures,tapestries,post-classical sculpture and
 prints.Merseyside County Council,1983
 322 p. illus.

 Incl.Ch.Miniatures,p.57-87

 Ch.Sculpture incl.:Deathmasks of Napoleon
 by Antommarchi and Burton;Bust of Napoleon
 by Chaudet;wax profile of Napoleon by Cinga-
 nelli;Equestrian statuetteof Napoleon by Du-
 bray

Z5948 II.A.6 - MINIATURES
M6L5X
NMAA
 Lister, Raymond
 A title-list of books on miniature painting,
 compiled for the use of artists,collectors,and
 Connoisseurs .Cockertons,Linton,Cambridge,1952.
 18 p.

 Contents:General & introductory handbooks,p.5;
 Enamels-Histories & monographs,p.5-6;Illumin.mi-
 niatures-Hist.&monogr.,p.6-10;Portr.min.-Hist.&
 monogr.,p.10-12;...Oriental min.,p.12-13;Treatises
 on technique,p.13-14;Dictionarie of artists;cats.
LC p.14-18.Miscellaneous ,p.18
Z5948.M6L5

II.A.6 - MINIATURES

Leisching, Eduard, 1858-
 Die bildnis-miniatur in Österreich von 1750-
1850;mit einer einleitung über die allgemeinen
zustände der kunstpflege in Österreich bis 1850
& über die miniaturen in den andern ländern...
Wien,Artaria & co.,1907
 297 p. illus(part col.)

 Bibliography

LC ND1337.A8L4 LEmberger,Ernst 757.7 L54
 Lister,R. Title-list...
 xerox copy in NPG

II.A.6 - MINIATURES

Liverpool, Cecil George Savile Foljambe,4th
 Earl of, 1846-1907
 Cat.of portraits,miniatures,etc.in the pos-
 session of Cecil George Savile,4th Earl of Li-
 verpool.Lord Steward,etc. Hull Browns:Savile
 Press,1905
Yale Ctr. 167 p. illus.
F.Brit.Art For private circulation only
Ref. N Incl.Index
7622.?
.C7L58

II.A.6 - MINIATURES

Ljubljana. Narodni musej
Portretna miniatura;katalog rasstave.Izbor
gradiva,basedilo in katalog:Mirjam Poljansek.
ured.kataloga:Vesna Bucic..Ljubljana,Narodni
musej,1965
22 p. illus.

German summary

MH Rep. 1966 #897

II.A.6 - MINIATURES

«Nachemsohn, Jacob»
Signed enamel miniatures of the 17th,18th &
19th centuries.London,J.Nachemsohn,1926»
44 p. illus(1 col.)

Intro.by Dr.G.C.Williamson

N.Y.P.L. MDO Art div.254496B
 CSmH FOR COMPLETE ENTRY
 SEE MAIN CARD

757.7
L95 II.A.6 - MINIATURES

Lugt, Frits
Le portrait-miniature, illustré par la col-
lection de S.M.la reine des Pays-bas...
Amsterdam,P.N.van Kampen & fils,1917
108 p. incl illus.(part col.)

II.A.6 - MINIATURES

Norgate, Edward, d.1650
An exact and compendious discours concern-
ing the art of Miniatura or Limning....1621-
1626»

The treatise is in the Brit.Mus.(MS.Harl.
6000)

Norgate.Miniatura.750.N83
.XII ff
Walpole Soc.AP1W225,v.3,
p.83

II.A.6 - MINIATURES

MacKay, Andrew
The coll.of miniatures in the Montagu
House(The property of the Duke of Buccleuch and
Queensberry) London,1896

V.&A.

Fitzwilliam Mus. Cat of
portr.miniatures...ND1337
17th; 1985X NPG bibl.p.222

750
.N83 II.A.6 - MINIATURES

Norgate, Edward, d.1650
Miniaturajor, The art of limning;...Oxford,
Clarendon press, 1919
Ed.& introd.by Martin Hardie
111 p.

The treatise dates from 1648-50 and is in
the Bodleian Library,Oxford(MS.Tanner 326)
Reviewed in Burl.Mag.v.37:207-8 Oct.,1920

Wartburg J.v.6,1943,p.89
LC ND1330.N7 footnote

757.7
.M64 II.A.6 - MINIATURES

Morgan, John Pierpont, 1837-1913
Catalogue of the collection of miniatures
the property of J.Pierpont Morgan;comp....by
G.C.Williamson...London,Priv.print.at the Chis-
wick press,1906-1908
4 v. illus.

LC N7616.M8 Pittsburgh.Carn.Inst.Dpt.
 Fine Arts.Four c.of portr.
 min.ND1333P6C28 Bibl.

AP
1
S878 Olausson, Magnus
NMAA Mme Caspan and her family in miniature
v.13
 In:B.Nat Mus.Stockholm

 Miniatures attr. to Ignazio Vittoriano Cam-
 pana and by Peter Adolf Hall

II.A.6 - MINIATURES

Munich. Bayerisches Nationalmuseum
Katalog der miniaturbilder im Bayer.Nat.
mus..von.Hans Buchheit.1911
141 p. illus. (Its Katalogs,12.Bd.)

F060
57
M96b
v.12

ViU Winter.Holbein's minist...
 in:Burl.Mag.83:966 ff

AP
1
W225 Ormond, Richard
NCFA Chinnery and his pupil;Mrs.Browne
v.44
 In:Walpole Soc.
 44:123-214 1972-1974 illus.

 '...the letters are very largely concerned
 with the practice of miniature ptg...'p.126

Hutcheon.Chinnery...N40.1
C53H9 NCFA Bibl.p.173

II.A.6 - MINIATURES

Paris. Musée national du Louvre.Dpt.des objets
d'art du moyen-âge,de la renaissance et des
temps modernes.
Notice des émaux exposés dans les galeries
du Musée du Louvre,par M.de Laborde...Paris,
Vinchon,imprimeur des musées nationaux,1852-53
2 v.

NN
Part 1:Histoire et descrip Heath.Miniatures.ND1330.H43
tion,1852.348 p. illus. NCFA Bibl. p.XXVII
LC NK4999.P3M85

II.A.6 - MINIATURES

Propert, John Lumsden
A history of miniature art.With notes on
collectors and collections...London & New York,
Macmillan & co.,1887
285 p. illus.

Bibliography

LC N7616.P8 757.7.B85. Brieger.Die Min
 iatur Literatur

757.7 II.A.6 - MINIATURES
.P41
Pennsylvania society of miniature painters
Golden jubilee fiftieth annual exh.of minia-
tures,antique and contemporary.The Pennsylva-
nia society of miniature painters at the Pennsylvan
nia academy of fine arts...1st ed.Oct.27 through
Dec.2,1951.Philadelphia,1951.
87 p. illus.

Incl.:Eye miniatures,p.68

705 II.A.6 - MINIATURES
M19.
NCFA Propert, John Lumsden, 1834-1902
1897 The renaissance of miniature painting

In:Mag Art
:189-91 Jan.,1897 illus.

ND II.A.6 - MINIATURES
1333
P6C28 Pittsburgh. Carnegie Institute. Dept.of
NCFA Fine Arts
Four centuries of portrait miniatures:from
the Heckett collection,Heckrezes Highlands,
Valencia,Pennsylvania..Pittsburgh,1954
.39.p. illus.

Cat.of an exh.,compiled by Herbert Missa-
berger
Bibliography
Notes incl.etymology of "miniature";tech-
niques;uses.
LC ND1333.P55

AP II.A.6 - MINIATURES
2
A64 Reynolds, Graham, 1914-
NCFA Portrait miniatures from Holbein to Augustin
v.104 in the Luft collection.

In:Apollo
104:274-81 Oct.,1976 illus(part col.)

705 II.A.6 - MINIATURES
M19.
NCFA Praga, Alfred, 1867-1949
TN v.1897 The renaissance of miniature painting

In:Mag Art
:187-9 Dec.,1896 illus.

II.A.6 - MINIATURES

Rieben, Hans, 1915-
Portraits en miniature.Lausanne,Payot
.1952.
7 p. 20 col.pl. (Orbis pictus,9)

N.Y.
Publ.Libr.
MAR p.v.
1269

II.A.6-MINIATURES

.Propert, John Lumsden, 1834-1902.
Cat.of miniatures,enamels,pastels,and
waxes,at 112 Gloucester place,Portman Square
.London,Printed by W.Clowes & sons;ltd.,189-?.

"Coll.of Dr.J.Lumsden Propert(ca.1890)"

CSmH MdBWA

II.A.6 - MINIATURES

Sabin, V.Philip
An illustrated cat.of a fine sell.of inter-
esting and rare engravings of American and Ca-
nadian portraits and views.London,Frank T.Sabin,
1932
105 p. illus.(col.front)

NCG Incl.:Miniatures
NA5800
218

MB MdBP Cty CSmH NN Winterthur Mus.Libr. fZ881
MiD :78 NCFA v.6,p.224

II.A.6 - MINIATURES

Sarasino, Ernesto
L'amatore di miniature su avorio(secoli 17,
18,19).di.L.De Mauri,pseud...Milano,Ulrico
Hoepli,1918
544 p. illus(part col.)

MET
195.4
D39
FOGG
4490
S24

Bildnismin.& ihre meister
757.B59,v.4,Bibl.

II.A.6 - MINIATURES

Victoria and Albert museum, South Kensington
...A cat.of the miniatures.London,Printed for
H.M.Stationery off.,by Wyman and sons,ltd.,1908
66 p. illus.

Bibliography

LC N7616.V6

ND
1337
E8S33
E1964
NCFA

II.A.6 - MINIATURES

Schidlof, Leo
The miniature in Europe in the 16th,17th,
18th and 19th centuries. Graz,Austria,Akademi-
sche Druck-& Verlagsanstalt,1964
4 v. illus.(part col.)

757
S75
NCFA

II.A.6 - MINIATURES

Victoria and Albert museum, South Kensington.
...Catalogue of the special exhibition of por-
trait miniatures ...June,1865.London,Printed by
Whittingham and Wilkins,1865
340 p.

Intro.by Samuel Redgrave

For nearly 3 centuries min.portr.ptg.had
been practiced,when the interest in it declined
through the invention of photography.The exh.ho-
pes to revive this interest.

LC N7616.S6
Ingamells.Cat.of portrs...
BX5197.I 53X p.XVI

757.7
S86

II.A.6 - MINIATURES

Stockholm. Nationalmuseum
Nationalmusei miniatyrsamling,den Wican-
derska samlingen och museets övriga miniatyrer.
Stockholm,P.A.Norstedt & söner,1929
100 p. illus.

"Inledning"signed:Axel Sjöblom

LC ND1335.S8

708.2
V622
.11.
NCFA

II.A.6 - MINIATURES

Victoria and Albert museum, South Kensington
...Portrait miniatures.London,1948.

MiD OC1MA have reprint 1959 FOR COMPLETE ENTRY
SEE MAIN CARD

II.A.6 - MINIATURES

Stollreither, Eugen
Bildnisse des 9.-18.jahrhunderts. München,1928

Contents:Part I.9-14.jahrh.(Miniaturen aus
FOGG handschriften der kgl.Hof-& Staatsbibl.in
FA München,9)
1120.
229(9)F

Enc.of World Art
N31K56Ref.bibl.on portr.
col.512

II.A.6 - MINIATURES

Victoria and Albert museum, South Kensington
Dept.of paintings
Cat.of a collection of miniatures lent in
1914-15 by Henry J.Pfungst...London,1915

LC N7616.P5 FOR COMPLETE ENTRY
SEE MAIN CARD

705
I61
NCFA
v.39

II.A.6 - MINIATURES

Uzanne, Louis Octave, 1852-1931
Mme.Debillemont-Chardon's miniatures

In:Studio
39:210-6 Jan.,1910 illus(part col.)

Incl.historical essay on miniatures

757
.V64

II.A.6 - MINIATURES

Victoria and Albert museum, South Kensington.
Dept.of paintings
...Hand-list of miniature portraits and silhou-
ettes,by Basil S.Long...1930
114 p. illus. .Victoria and
Albert mus.,S.Kensington.Publication no.192.

Preface signed:Eric Maclagan

LC N7616.V65

II.A.6 - MINIATURES

Wallace Collection, London
 Miniatures and illuminations...London,...
Wallace coll....1935

LC ND1335.L6

**FOR COMPLETE ENTRY
SEE MAIN CARD**

II.A.6 - MINIATURES

Wicander, Hjalmar
 Hjalmar Wicanders miniatyrsamling;beskri-
vande katalog.Stockholm,1920-29
 2 v. 242 pl.(57 col.)

 At head of title:Karl Asplund

MET
195.4
W63
Q

ND
1337
U5W23
NCFA
II.A.6 - MINIATURES

Walters Art Gallery, Baltimore
 A selection of portrait miniatures. Balti-
more.1966.
 1 v.(unpaged) illus. (A Walters Art Gallery
picture book)

LC N7616.W3

757
.W72
II.A.6 - MINIATURES

Williamson, George Charles, 1858-1942
 ... The art of the miniature painter, by George C. William-
son and Percy Buckman, R. M. S. London, Chapman and Hall,
ltd., 1926.

 xx, 261 p. col. front., illus., ports. (part col.) 22½ᵐ. (Universal art
series, ed. by F. Marriott)

 The colored portraits are each accompanied by guard sheet with de-
scriptive letterpress.
 —Erratum slip inserted between p. 228 and 229.—
 Bibliography: p. xvii-xx.

 1. Miniature painting. i. Buckman, Percy, joint author. ii. Title.

Library of Congress ND1330.W65 26—17785
 ,32e1,

II.A.6 - MINIATURES

Wellesley, Francis
 Cat.of the ... coll.of...and miniatures...
sold by Sotheby,Wilkinson & Hodge,June 28,1920
and 4 ff days.,London,Riddle,Smith & Duffus,1920

LC N5245.W45 NN MH MiU

**FOR COMPLETE ENTRY
SEE MAIN CARD**

II.A.6 - MINIATURES

Williamson, George Charles, 1858-1942 comp.
 Catalogue of a collection of miniatures
belonging to the Lord Hothfield.London,Privately
printed at the Chiswick Press,1916

MET
195.4
W678

 no.6 of 60 copies printed

**FOR COMPLETE ENTRY
SEE MAIN CARD**

II.A.6 - MINIATURES

Wellesley, Francis
 A hand-list of the miniatures and portraits
in plumbago or pencil belonging to Francis and
Minnie Wellesley,with a foreword by Dr.G.C.
Williamson.Oxford.H.Hart,printer.1914
 85 p.

LC N7616.W43 Fogg,v.11,p.326

757.7
W72
II.A.6 - MINIATURES

Williamson, George Charles, 1858-1942
 An essay on portrait miniatures,with a brief
note on the work of Alyn Williams...
London,Women's printing society,ltd.,19--.
 .40.p. illus.

757.7
W55
NCFA
II.A.6 - MINIATURES

Wharton, Anne Hollingsworth,1845-1928
 Heirlooms in miniatures...with a chapter on
miniature painting by Emily Drayton Taylor...
Philadelphia & London,J.B.Lippincott co.,.1897.
 259 p. illus.

 "Authorities consulted:p.IX"

LC N7616.W5 London,Hannah Ruth.Min.&
 silh. Bibl. N7593.L84

fN
7616
W7 X
1904
NPG
II.A.6 - MINIATURES

Williamson, George Charles, 1858-1942
 The history of portrait miniatures,...
London,G.Bell and sons,1904

 2 v. illus(part col.)

 Standard work on portr.miniatures covering
1531-1860

LC N7616.W7

705
C75
NCFA
v.23

II.A.6 - MINIATURES

Williamson, George Charles, 1858-1942
 Miniatures belonging to the Earl of Mayo

In:Connoisseur
23:259-64 Apr,1909 illus.

 On enamel:Chs.Boit,C.F.Zincke,Jos.Lee,P.C.
Bone,Wm.Essex,etc.On ivory:Henry Bone.Ink drg.
of Wordsworth by D.B.Murphy

 Blanshard,F. The portrs.of
 Wordsworth N7628W92B6

705
S94
NCFA
v.60

II.A.6 - MINIATURES

Wood, T.Martin
 The Buccleuch miniatures at the Victoria
and Albert museum

In:Studio Feb., '17

 **FOR COMPLETE ENTRY
 SEE MAIN CARD**

705
C75
NCFA
v.51
v.52
v.53

II.A.6 - MINIATURES

Williamson, George Charles, 1858-1942
 Mr.Francis Wellesley's collection of minia-
tures ...

In:Connoisseur

 **FOR COMPLETE ENTRY
 SEE MAIN CARD**

705
S94
NCFA
v.62

II.A.6 - MINIATURES

Wood, T.Martin
 The Beauchamp miniatures at the Victoria
and Albert museum

In:Studio Sept., '17

 **FOR COMPLETE ENTRY
 SEE MAIN CARD**

ND
1337
A2W72
1897
NCFA

II.A.6 - MINIATURES

Williamson, George Charles, 1858-1942
 Portrait miniatures from the time of Holbein
1531 to that of Sir William Ross 1860. A hand-
book for collectors...London,Geo.Bell & sons...
1897
 .170.p. illus.

 Bibliography

757
.Y83

II.A.6 - MINIATURES

Yoxall, James Henry, 1857-
 Collecting old miniatures,...New York,
G.H.Doran company,1916
 95 p. illus. (Half-title:The collectors'
pocket series,ed. by Sir J.Yoxall)

LC N7616.Y6

757.7
.W727

II.A.6 - MINIATURES

Williamson, George Charles, 1858-1942
 Portrait miniatures...London,N.Y.,etc.,
'The Studio',ltd.,1910

LC N7616.W82 The Studio **FOR COMPLETE ENTRY
 SEE MAIN CARD**

II.A.6 - MINIATURES see also individual artists
I.B.? ,e.g.Hilliard.

705
C75
NCFA
v.64

II.A.6 - MINIATURES

Williamson, George Charles, 1858-1942
 Two important miniatures in the possession
of the Rt.Hon.the earl Spencer,K.G.

In:Connoisseur
64:40-5 Sep., '22 illus.

705
A56
NCFA
v.23

II.A.6 - MINIATURES - 17th c.

Long, Basil Somerset, 1881-1937
 Costumed miniatures

In:Antiques
23:222-3 June, '33 illus.

 Repro.:Miniature & a sequence of the same
miniature with talc(mica)disguises;from the
Leonard Twinton Davies coll.

qN
5247
S16A9
NCFA

II.A.6 - MINIATURES - 17-18th c.

Auerbach, Erna
Paintings and sculpture at Hatfield House;...
London,Constable,1971.

II.A.6 - MINIATURES - 17-19th c.

Jaffé, Albert
Sammlung A.Jaffé...Miniaturbildnisse des
17.bis 19.Jahrhunderts...versteigerung...den
23.-24.Okt.1912...Rudolph Lepke's kunst-auk-
tions-haus.Berlin,1912.

MET
295.4
J18

F. pt.2 36 pl.

757
.C39

II.A.6 - MINIATURES - 17-18th c.

Carolina art association, Charleston, S.C.
Exh.of miniatures from Charleston and its
vicinity painted before the year 1860.Carolina
art association,Gibbes memorial art gallery,
Charleston,South Carolina,1935..Charleston,S.C.
Southern ptg.& pub.co.,1935.
75.p.

Preface signed:Rbt.N.S.Whitelaw

List of artists;list of sitters

Largest 18th c.group by Henry Benbridge
or his wife Rutledge.In:Am Coll 705.A5
17:23

705
A63
NCFA
v.59

II.A.6 - MINIATURES - 17-19th c.

Speel, Erika
Enamel portrait miniatures

In:Ant.collector
59,no.12:54-7 Dec.,'88 illus(col.)

N
7333
C4C2
NCFA

II.A.6 - MINIATURES - 17-18th c.

Carolina Art Association, Charleston, S.C.
Exh.of miniatures owned in South Carolina
and miniatures of South Carolinians owned else-
where painted before the year 1860.Carolina Art
Association,Gibbes Memorial Art Gallery,Charles
town,South Carolina...1936
77.p.

Preface signed:Rbt.N.S.Whitelaw

List of artists;list of sitters

Rutledge.In:Am Coll 705.A5
17:23

II.A.6 - MINIATURES - 18th c.

Villot, Frédéric, 1809-1875
Hall célèbre miniaturiste du 18e s....Obser-
vations sur la technique de la miniature...
Paris,Librarie française et étrangère,1867

MET
180H14
V71

MH MdBWA MdBP MB ICU **FOR COMPLETE ENTRY
SEE MAIN CARD**

II.A.6 - MINIATURES - 17-18th c.

Jeannerat, Carlo
Les origines du portrait'à miniature'sur
ivoire.J.B.Massé et Rosalba Barriera

In:B.art fr.
57:80-8 1931

LC N6811.A92 Bruijn Kops In:B.Rijksmus.
36:206,note 13

II.A.6 - MINIATURES - 18-19th c.

David-Weill, David, 1871-1952
Miniatures and enamels from tne D.David-
Weill collection.Paris,Les Beaux-Arts,édition
d'études et de documents,1957

Cat.of that part of the collection which
was sold to Messrs.Wildenstein

LC N7616.D33 **FOR COMPLETE ENTRY
SEE MAIN CARD**

NPG

II.A.6 - MINIATURES - 17-19th c.

Christie,Manson & Woods,ltd.
Fine miniatures,...to be sold at Christie's
...London...1980

**FOR COMPLETE ENTRY
SEE MAIN CARD**

II.A.6 - MINIATURES - 18-19th c.

Emden, Hermann
...Sammlung Hermann Emden,Hamburg,Versteige-
rung.Rudolph Lepke's Kunst-Auctions-Haus,2.,
3.Mai,1911.Berlin,1908-11.

MET
119.2
R83

3.Teil.
4.Miniaturbildnisse,18 & 19.Jahrhundert

II.A.6 - MINIATURES - 18-19th c.

Jeannerat, Carlo
L'exposition internationale de miniatures
de Vienne

In:Gas Beaux-Arts
5ser.10:353-60 Dec.,'24 illus.

Exh.in Albertina,May-June,1924

705
028
NCFA
v.35

II.A.6 - MINIATURES - 18-19th c.

Rutledge, Anna Wells
A French priest,painter and architect in
the United States:Joseph-Pierre Picot de
Limoëlan de Clorivière

In:Ga Beaux Arts
33:159-76 March,'48 illus.

Incl:List of Clorivière's miniatures
Biography.Appendix refers to his miniature

Carolina Art ass.,Charles-
ton,S.C.Miniature portr.co
Bibl.p.179

757.8
.0 13

II.A.6 - MINIATURES - 18-19th c.

O'Brien, Donough, 1879-
Miniatures in the 18th and 19th centuries;
an historical and descriptive record. London,New
York,Batsford.1951.
193 p. illus.

LC MD1330.02

II.A.6 - MINIATURES - 18-19th c.

Vienna. Albertina
Katalog der Internationalen Miniaturen-
Ausstellung Mai-Juni 1924,bearbeitet von Leo
Schidlof.Wien,Verlag der Ges. d. Bilder-und
Miniaturenfreunde.1924.
131 p. illus.

FOOO
4490
V 6ab
1924

Verzeichnis der künstler,p.-121.-131

LC MD1335.046 NN

Pittsburgh.Carn.Inst.Dpt.
ine Arts.Pour c.of portr.
min.MD133.6C28 Bibl.

II.A.6 - MINIATURES - 18-19th c.

Paris. Musée national du Louvre
Cat.de la donation Félix Doïstau,miniatures
des 18e et 19e siècles...Paris,1922

MFT
196.5
P21
L958

FOR COMPLETE ENTRY
SEE MAIN CARD

N
7616
W72
NPG

II.A.6 - MINIATURES - 18-19th c.

Williamson, George Charles, 1858-1942?
How to identify portrait miniatures...with
chapters on how to paint miniatures by Alyn
Williams.London,G.Bell & sons,1904
126 p. illus.

Bibliography

Partial contents:XI.Portrs.in enamel and
plumbago;XIV.Collectors and collections.

Noon.Engl.portr.drags.& min-
2860.N66X NPG bl.p.148

N
7616
P23
NCFA

II.A.6 - MINIATURES - 18-19th c.

Paris. Musée national du Louvre.Cabinet des
dessins
Donation de D.David-Weill au Musée du
Louvre.Miniatures et émaux..Exposition.Oct.'56-
janvier 1957.Paris,Editions des Musées natio-
naux.1956.
186 p. illus.
Miniatures p.3-90; Enamels p.93-170
Cat.by Maurice Sérullas
Bibliography
Index of artists and of sitters
Repro.incl.:(A)Miniaturists:Hall,Dumont,

VF
Collec-
tions

II.A.6 - MINIATURES - 18-(early)20th c.

The Norton Gallery and School of Art, West Palm
Beach, Fla.
The Tannenbaum collection of miniatures.
Exh.May 22-June 27,1982
32 p. illus.

Develom't of the art of min.ptg.from the
18th to the early 20th c.
Intro.by Robin Bolton-Smith
Article:Private romances:The Tannenbaum coll.
& the art of the miniature,by Bruce Weber,p.7-10
List of artists

AP
1
W78
v.9
1974

II.A.6 - MINIATURES - 18-19th c.

Richards, Nancy E.
A most perfect resemblance at moderate
prices

In:Winterthur Portfolio
9:77-101 1974 illus.

An article on David Boudon,who worked mos
ly in silverpoint and W.C.on ivory

Checklist of 51 portrs. 24 reproduced

705
A784
NCFA
v.22

II.A.6 - MINIATURES - 19th c.

Sherman, Frederic Fairchild, 1874-1940
Unrecorded early American portrait painters

In:Art in Amer.
22:26-31 Dec.,'33 illus.

Alphabetical lists of miniature ptrs. & of
portr.ptrs.in oil, mainly of the 19th c.

Cumulated Mag.subj.index
A1/3/C76 Ref.,v.2,p.443

708.1
R685S97
NFC Ref.

II.A.6 - MINIATURES - 19th c.

Swan, Mabel Munson
 Miniatures.in her.Boston Athenaeum Gallery,
1827-1873...1940
 Appendix I,p.179-92

 Refers to annual exh.List of miniaturists
& Miniatures exh.betw.1827 and 1873

ND
1337
C7N48
1978X
NCFA

II.A.6 - MINIATURES - EUROPE

New Orleans Museum of Art
 <u>English and continental portrait miniatures;
the Latter-Schlesinger collection...1978</u>

LC ND1337.C7N48 1978 **FOR COMPLETE ENTRY
SEE MAIN CARD**

II.A.6 - MINIATURES - AUSTRIA

Leisching, Eduard, 1858-
 Die bildnis-miniatur in Österreich von 1750-
1850;mit einer einleitung über die allgemeinen
zustände der kunstpflege in Österreich bis 1850
& über die miniaturen in den andern ländern...
Wien,Artaria & co.,1907
 297 p. illus(part col.)

 Bibliography

LC ND1337.A8L4 LEmberger,Ernst 757.7 L54
 Lister,R. Title-list...
 xerox copy in NPG

705
C28
NCFA
v.8
v.10

II.A.6 - MINIATURES - FRANCE

Bouchot, Henri François Xavier Marie, 1849-1906
 La portrait-miniature en France

 In:Gaz Beaux Arts
 8:115-27,400-13 Aug.,Nov.,1892 illus.
 10:392-415 Nov.,1893 illus.

V & A ? 1894,1895
has 1892-5
 Les origines. La tradition. La technique

LC N2.C3 Krieger.Miniatur. Literatur
 757.7.B85

II.A.6 - MINIATURES - DENMARK

Colding, Torben Holck
 Danish miniaturists.Copenhagen,Gyldendal,
1948
 35 p. illus.

LC ND1337.D4C6 Foskett.Dict.of Brit.min.
 ptrs.ND1337.G7F4d NPG bibl.
 p.592

II.A.6 - MINIATURES - FRANCE

Clouzot, Henri, 1865-1941
 La miniature sur émail en France.Paris,
A.Morancé,1928.
 226 p. illus. (Archives de l'amateur)

 Covers the period 1630-1830

LC ND1337.F8C57 Clouzot.Dict. N7616/C64
 NCFA

1337
C7F4
1985X
NPG

II.A.6 - MINIATURES - EUROPE

Fitzwilliam Museum
 Cat.of portrait miniatures in the Fitzwil-
liam Mus.,Cambridge.by,Robert Bayne-Powell)
Cambridge;N.Y.:Cambridge Univ.Press;Cambridge:
Fitzwilliam Mus.,1985
 231 p. illus(part col.)

 Bibliography

 Incl.:Crosse,Richard,1742-1810,deaf-mute
miniaturist,p.54.- Eye-miniatures,p.25

II.A.6 - MINIATURES - FRANCE

Lemoisne, Paul André, 1875-1964
 Notes sur l'évolution du portrait enluminé
en France du 13e au 17e siècle à propos de l'ex-
position de la Bibliothèque nationale

 In:Revue des bibliothèques...Paris
 17e année:153-82 1907

Title fr.Clev.P.L.
LC.Z671.R45 1907a

ND
1335
R9L46
NPG

II.A.6 - MINIATURES - EUROPE

Leningrad. Ermitazh
 Western European miniatures,16-19th centu-
ries.Cat.of.an.exh.from the coll.of the State
Hermitage,Leningrad,1982.The museum.,1982
 47 p. illus.

 Gosudarstvennyĭ Ermitazh
 Zapadnoevropeĭskaia miniatiura 16-19 vekov

 In Russian

ND
544
P57X
1977
NMAA

II.A.6 - MINIATURES - FRANCE

Pittura francese nelle collezioni pubbliche
 fiorentine:Firenze,Palazzo Pitti,24 aprile-
30 giugno 1977.Firenze,Centro Di,1977.(Cat.85)
 296 p. illus(part col.)

 Cat.a cura di Pierre Rosenberg,con la col-
laborazione di Silvia Meloni Trkulja,Isabelle
Julia,Nicole Reynaud
 Indexes
 Bibliography:p.283-92
 Ch.:Self-portraits,p.33-85
 Ch.:Self-portraits not in exh.(from the
 Galleria di Firenze)p.86-92
 cont'd on next card

757.7
.P72
NCFA

II.A.6 - MINIATURES - FRANCE

Pleasants, Jacob Hall, 1873-
Saint Mémin water color miniatures.
.Portland,Maine, Anthoensen Press,1947?.
29 p. illus.

"Reprinted from The Walpole Society Notebook,
1947,by The Anthoensen Press,Portland,Maine..."

Fogg,v.11,p.325

II.A.6 - MINIATURES - FRANCE 17th c.

Paris. Musée national du Louvre. Dpt.des
peintures,des dessins et de la chalcographie
Les émaux de Petitot du Musée impérial du
Louvre;portraits de personnages historiques
et de femmes célèbres du siècle de Louis XIV,
gravés au burin par M.L.Ceroni.Paris,Blaisot,
1862-64
2 v. illus.

1st part:Jean Petitot(1607-1691)by Henri
Bordier, 31 p.,illus.
Petitot was assisted in his miniature ptg.
by his brother- in-law, Jacques Bordier
NN CWY MB MdBWA,etc.

II.A.6 - MINIATURES - FRANCE

Réau, Louis, 1881-
Histoire de la peinture au moyen-age. Melun,
Librairie d'Argences,1946-
v. illus(part col.)

Bibliography

Contents-.1.La miniature

LC MD140.R4

Lister.Raymond.Title list
...Xerox copy in NPG

N
40.1
F44 3y
A5
NPG
RB

II.A.6 - MINIATURES - FRANCE - 18th c.

Andrews, William Loring, 1837-1920
A trio of 18th century French engravers of
portraits in miniature.Ficquet,Savart,Grateloup.
N.Y..Dodd,Mead & co.,1899
123 p. illus(1 col.)
Contents.-Intro.,giving a short account of
the various methods of engr.on metal.-A trio of
18th c.French engravers...-Extracts fr.La Calco-
grafia of Giuseppe Longhi.-List of portrs.engr.
by Etienne Ficquet, Pierre Savart, Jean Baptiste
de Grateloup

LC NE647.A5

evi.Descript.bibl.Z5947.A3
L66 1974 NCFA p.205

757.7
.S33

II.A.6 - MINIATURES - FRANCE

Schidlof, Leo.
Die bildnisminiatur in Frankreich im XVII., XVIII. und
XIX. jahrhundert. Als anhang: Allgemeines lexikon der
miniaturisten aller länder. Von Leo Schidlof. Mit 10
farbigen und 47 getönten tafeln. Wien und Leipzig, Edu-
ard Beyers nachfolger, g. m. b. h., 1911.

2 p. l, 391, (1) p. LVII pl. (chiefly ports, 10 col, incl. front.) 29cm.

Plates accompanied by guard sheets with descriptive letterpress.
"Dieses werk erschien auf subskription in einer aufl:ge von 400 exem-
plaren. nrx9X 99."
"Benützte literatur": p. 379.

1. Miniature painting—France. 2. Portrait painters—Dictionaries. 3.
Portraits.

11-30345

Library of Congress N7616.S4

705
G28
NCFA
v.22

II.A.6 - MINIATURES - FRANCE 17th c.

Bordier, Henri .Leonard,1817-1888.
Les émaux de Petitot en Angleterre

In:Gaz Beaux Arts
22:168-79 1867 1 illus.

Phila.M.of art Bul.83:19
note 2

705
C75
NCFA
v.20

II.A.6 - MINIATURES - FRANCE - 18th c.

Foster, Joshua James, 1847-1923
The recent exhibition of art of the 18th
century at the Bibliothèque Nationale,Paris

In:Conn.
20:77-84 Feb.,'08 illus.

The article concentrates on the 700 minia-
tures in the exh.Mostly French,ca.20 English.
Repro.:Isabey,Augustin,Hall,Engleheart,Au-
bry,Guérin,Prud'hon

757
.L63

II.A.6 - MINIATURES - FRANCE - 18th c.

Lespinasse, Pierre, 1881-
...La miniature en France au 18e siècle,...
Paris et Bruxelles, Les Éditions G.van Oest,1929
242 p. illus. (Bibliothèque de l'art du
18e siècle. Nouv.sér.)

LC MD1337.F7L4

Amsterdam,Rijksmus.,cat.
Z5939A52,deel 1, p.146

708.1
P31
NMAA
v.83

II.A.6 - MINIATURES - FRANCE - 17th c.

Grace, Priscilla
A celebrated miniature of the Comtesse
d'Olonne

In:Phila.Mus.Art B.
83,no.353:3-21 Fall,'86 illus(part col.)

Comtesse d'Olonne.as Diana by Jean Petitot

Incl.repr.of several miniatures by Petitot

q ND
1337
F8M44m
NPG

II.A.6 - MINIATURES - FRANCE - 18th c.

Mauclair, Camille, 1872-
Les miniatures du 18e siècle.Portraits de
femmes.Paris,H.Piazza,1912.
135 p. illus(part col.)

FOR COMPLETE ENTRY
SEE MAIN CARD

II.A.6 - MINIATURES - FRANCE - 18-19th c.

Belleudy, Jules, 1855-
Louis Sicardi,miniaturiste...1932

LC N6811.A92 FOR COMPLETE ENTRY
 SEE MAIN CARD

II.A.6 - MINIATURES - FRANCE - 19th c.

705
028
v.35
1906
NCFA
Jean, René, 1879-
Madame de Mirbel

In:Gas Beaux-Arts
35(3ième ser):131-46 1906 illus.

757
B75
II.A.6 - MINIATURES - FRANCE - 18-(begin.)19th c.

Bouchot, Henri François Xavier Marie, 1849-1906
La miniature française, 1750-1825. Paris,
Goupil & cie,1907
2v. 245 p. illus.(part.col.)

LC N7616.B7

MD
1337
F8M44
NPG
II.A.6 - MINIATURES - FRANCE - 19th c.

Mauclair, Camille, 1872-
...Les miniatures de l'empire et de la restaura-
tion, portraits de femmes. Paris,H.Piazza,1913
137 p. illus(part col.)

Cont.-Jean-Baptiste-Jacques Augustin et son
oeuvre.-La vie de Jean-Baptiste Isabey.-I.et ses
élèves.-Quelques figures de ce livre.-D'autres
portrs.de femme.-Miniatures et figures étran-
gères.

LC MD1337.F7M35

705
028
NCFA
v.6
II.A.6 - MINIATURES - FRANCE - 18-19th c.

Brual, François Louis, 1881-1912
Un miniaturiste de l'émigration:Pierre-Noël
Violet(1749-1819)

In:Gas Beaux Arts
ser.4,v.6:19-44 July,'11 illus.

II.A.6 - MINIATURES - FRANCE - (end)19-20th c.

Debillemont-Chardon, Mme.Gabrielle, 1865-1957
La miniature sur ivoire;essai historique et
traité pratique...Paris,H.Laurens.1909.

FOGG
4490
D28

LC(W7775.22) ICN NjU NIC MB FOR COMPLETE ENTRY
 SEE MAIN CARD

705
028
NCFA
v.29
II.A.6 - MINIATURES - FRANCE - 18-19th c.

Chennevières, Henry de
François Dumont.Miniaturiste de la reine
Marie Antoinette

In:Gas Beaux Arts 3rd ser.
29:177-92 1903 illus.

Portr.within portrait p.187

Draper,Ja.D.:Grétry Encore
In:Met.Mus.J. 9:235 note 6

II.A.6 - MINIATURES - GERMANY

Goetz, Walter Wilhelm, 1867- ed.
Die entwicklung des menschlichen bildnisses.
Leipzig & Berlin,B.G.Teubner,1929-
v

Contents.-1.Schramm,P.E.D.deutschen Kaiser &
Könige in bildern ihrer zeit.1.Bis zur mitte des
12.jhrh(751-1152)2 v.1929.-2.Prochno,Joachim.Das
schreiber-& dedikationsbild in d.deutsch.buchma-
lerei,v.1,1929-3.Steinberg,S.H.,D.bildnisse geist-
licher & weltlicher fürsten & herren.1.Von d.mit-
te d 10.bis s.ende d.12.jhrh(950-1200),1931
LC N7575.E6 v. II,III

N
40.1
D127D9
NPG
II.A.6 - MINIATURES - FRANCE - 19th c.

Du Pasquier, Jacqueline
Dagoty,1775-1871,peintre de la société
Bordelaise.1973.
26 p. illus.

Extrait de la Revue historique de Bordeaux
et du département de la Gironde,tome 22,nou-
velle série,1973

Portr.within portr.,p.19 & p.21

II.A.6 - MINIATURES - GERMANY

Lemberger, Ernst, 1866-
Die bildnis-miniatur in Deutschland von 1550-
1850...München,F.Bruckmann a.-g.,1909.
396 p. illus(part col.)

Bibliography

LC MD1337.G315 Schidlof 757.7/S33
 Lister.Title-list.Xerox
 copy in NPG

705
B97
NCFA
v.83

II.A.6 - MINIATURES - GERMANY- 16th c.

Winter, Carl, 1906-1966
Holbein's miniatures

In:Burl Mag
83:266-9 Nov.,'43 illus.

'Holbein, the progenitor of the British
school of miniature-painters'

Reynolds.Portr.miniatures..
Apollo,v.104:281
AP1.A64 NCFA

2202
0785X
NMAA

II.A.6 - MINIATURES - GREAT BRITAIN

The English miniature,by John Murdoch...et al
New Haven,Yale University Press,1981
240 p. illus(part col.)

Incl.:bibliographical references and index

'.For,the most concise...surveys of the
development of miniature portrs. see...Murdoch
The English miniature.'-M.R.Severens

Carolina art association..
Miniature portr.coll...
p.XI footnote
by M.R.Severens

708.9492
A523
NMAA
v.36

II.A.6 - MINIATURES - GERMANY - 18th c.

Bruijn Kops, C.J.de
Twee Amsterdamse portretminiaturen van Bal-
thasar Denner(1685-1749)

In:B.Rijkmus.
36,no.3:163-80 1988 illus.(2 col.on cover)

Summary in English,p.266-8

ND
1337
G7F74
1968
NCFA

II.A.6 - MINIATURES - GREAT BRITAIN

Foskett, Daphne.
British portrait miniatures: a history. Feltham, Spring
Books, 1968.
199 p. 50 plates, illus. (some col.), index. 27 cm. 35/-
Bibliography: p. 195-196.

1. Miniature painting, British—History. 2. Portrait painters, Brit-
ish. I. Title.

ND1337.G7F46 1968 757'.7'0942 70-421469
SBN 600-00851-5 MARC

Library of Congress 69 (4)

ND
1337
G7A79
NCFA

II.A.6 - MINIATURES - GREAT BRITAIN

Arts Council of Great Britain. Scottish Committee
British portrait miniatures, an exhibition
arranged for the period of the Edinburgh Inter-
national Festival,1965. The Arts Council Gallery.
Edinburgh,20th Aug.-18th Sept. .Edinburgh,1965.
1 v. (unpaged) illus.

Foreword and cat. by Daphne Foskett

Bibliography
Exhibiton of miniatures from 16th c.- 19th c.

ND
1337
G7F74c
NCFA

II.A.6 - MINIATURES - GREAT BRITAIN

Foskett, Daphne.
Collecting miniatures...Woodbridge,Eng.,
Antique Collectors' Club,c.1979
498 p. illus(part col.)

Bibliography p.476-81
Incl.:Index

Ch.12:Fakes,forgeries & facts,p.465-75

N.Y.(city)P.L.Art & architect.
div.Bibliographic guide to
art & architecture 1980
Z5939.A791 NCFA Ref..p.282

757
G7B6

II.A.6 - MINIATURES - GREAT BRITAIN

Bourgoing, Jean de, 1877-
...English miniatures, with an introduction
by G.C.Williamson. London,E.Benn,ltd.,1928
45 p. illus.(part col.)

...the English edition of Die englische bild-
nisminiatur...

LC ND1337.G7B6

ND
1337
G7F74d
NPG

II.A.6 - MINIATURES - GREAT BRITAIN

Foskett, Daphne
A dictionary of British miniature painters.
London,Faber & Faber,1972.
2 v. illus(part col.)

II.A.6 - MINIATURES - GREAT BRITAIN

Cust, Lionel Henry, 1859-1929
Windsor Castle.Portrait miniatures.Privately
printed 1910

V & A

Arts Counc.of Gr.Britain
Brit.portr.min.ND1337G7A79
Bibliography

ND
1337
G7F74m
1987
NPG
Ref.

II.A.6 - MINIATURES - GREAT BRITAIN

Foskett, Daphne, 1911-
Miniatures:dictionary and guide.Printed in
England by the Antique Collectors' Club Ltd.,
1987
702 p. illus(part col.)

Index
Bibliography,p.683-5

Incl.:Fakes,Forgeries & Facts,Ch.XII

II.A.6 - MINIATURES - GREAT BRITAIN

Foster, Joshua James, 1847-1923
British miniature painters and their works,...
London,S.Low,Marston & co.,ltd.,etc.,1898
146 p. illus.

Appendices-cat...min.sold at Strawberry Hill,
1842.-Cat...exh...Sir W.C.Ross at Soc.of arts,
1860.-Alphabet.list of min.at loan exh.,S.Kensington,1865.-Cat...exh.of min.at winter exh.,Royal
acad.,1879.-Cat.of Dickinsons'loan exh.,1880.-
Cat.of min...at Stuart,Tudor & Guelph exh's.1889-

LC N7616.F55 Lister.Title list... ,91
 xerox copy NPG

ND
1337
G7L77 Lister, Raymond
NPG The British miniature, London,Pitman & Sons,
 ltd.,1951

 114 p. 68pl.

 History of Engl.min.,trends & demands;technique. Subject miniature,portr.min.,:Holbein,
 Hilliard,Oliver,Hoskins,Cooper,Flatman,Smart,Cosway,Engleheart,etc.,contemporary:Montfort,Ayling,
 etc.; silhouettes:Charles,Beetham,Cotes,etc.
 Bibliography

AP
1
W225 Goulding, Richard William, 1868-1929
NCFA The Welbeck Abbey miniatures belonging to
v.4 His Grace the Duke of Portland;a catalogue raisonné,Oxford,The University Press,1916.Reprinted
1914/15 London,Wm.Dawson & sons,ltd.1969
 224 p. illus. (Half-title:The fourth
 annual vol.of the Walpole Society)

LC N12.W3 Fogg,v.11,p.331

757
.0716 Long, Basil Somerset, 1881-
 British miniaturists,...London, O.Bles,1929

 475 p. illus.

 Bibliography

 1520-1860
 Incl: some American miniaturists

LC ND1337.0716

HD
1329.8
H54 Hilliard, Nicholas, ca.1547-1619
1981X A treatise concerning the arte of limning.
NPG Together with a more compendious discourse
 concerning ye art of limning,sic,by Edw.Norgate,
 with a parallel modernized text edited by
 R.K.R.Thornton and T.G.S.Cain.Ashington,Mid
 Northumberland Arts Group in ass.with Carcanet
 New Press,1981
 139 p. illus(part col.)

 Bibliography p.137-9

705
.C75 Long, Basil Somerset, 1881-
NCFA On identifying miniatures
v.92
 In:Connoisseur
 92:298-307 Nov,'33 illus.

 Critical methods of identifying English miniatures,chiefly of the 18th c.

 Repro.:I.Oliver,N.Hilliard,Chr.Richter,S.T.
 Roche,G.Engleheart,J.Smart,Jer.Meyer,A.Plimer,
 J.Barry,R.Cosway,R.Crosse,N.Plimer,Wm.Wood,etc.
 Almost all in Victoria and Albert mus.,S.
 Kensington

II.A.6 - MINIATURES - GREAT BRITAIN

Hughes, George Bernard, 1896-
 Old English miniature portrait

In:Country Life annual
 :80-9 Christmas 1952 col.illus.

LC AY14.C68 OCLMA

N
7616
M47 Mayne, Arthur
NCFA British profile miniaturists.London,Faber
 ,1970,
 131 p. illus(part col.) (Faber collectors
 library)

 Bibliography

LC N7616.M37 FOGG v.11,col.2,p.317

ND
1337
G7K35 Kennedy, H A
NCFA Early English portrait miniatures in the
 collection of the Duke of Buccleuch,ed.by Charles
 Holme,...London,New York,etc.,"The Studio"ltd.,
 1917
 44 p. illus(part col.)

LC N7616.K4

ND
1337
G7N48 New Orleans Museum of Art
1978X English...portrait miniatures;the Latter-
NCFA Schlesinger collection...1978

LC ND1337.G7N48 1978 FOR COMPLETE ENTRY
 SEE MAIN CARD

NC
860
N66X
NPG

II.A.6 - MINIATURES - GREAT BRITAIN

Noon, Patrick J.
English portrait drawings and miniatures.
New Haven,Ct.,Yale Center for British Art,1979
152 p. illus.

FOR COMPLETE ENTRY
SEE MAIN CARD

II.A.6 - MINIATURES - GREAT BRITAIN

Reynolds, Graham, 1914-
Wallace collection:Cat.of miniatures.
London,Trustees of the Wallace Coll.,1980
366 p. illus(part col.)

Incl.:Indexes
Bibliography

Review by Murdoch in:Burl.Mag.v.124:450-1,
July,1982

LC ND1335.07L68 1980

AP
1
W225
v.1
NCFA

II.A.6 - MINIATURES - GREAT BRITAIN

Norman, Philip ed.
Nicholas Hilliard's treatise concerning
'The Arte of Limning'with introduction and
notes by Philip Norman,L.L.D.

In:Walpole Soc.
1:1:1-54 1911-12 illus.

II.A.6 - MINIATURES - GREAT BRITAIN

Victoria and Albert museum, South Kensington
Dept.of paintings
Paintings,water-colours and miniatures/C.M.
Kauffmann.London,H.M.Stationery Off.,1978
24 p. illus. (V.&A.Mus.departmental
guides)

N.Y.(city)P.L.Art & archi-
tecture Div.Bibl.guide to
art & architecture Z5935
.A79 1980 NCFA Ref. p.282

LC N1150.AR5

705
M19
NCFA
1891

II.A.6 - MINIATURES - GREAT BRITAIN

Propert, John Lumsden, 1834-1902
The English school of miniature art.With
special reference to the exh.at the Burlington
Fine Arts Club

In:Mag Art
:7-11 1891 illus.
From the origin to Sir Antonio More
:66-72 1891 illus.
From Nicholas Hilliard(1547-1619)to the end
of 17th c.
:170-5 1891 illus.

raga.Mag Art 1896 footnote
p.87

ND
1337
C7W719
NPG

II.A.6 - MINIATURES - GREAT BRITAIN

William Rockhill Nelson Gallery of Art and
Mary Atkins Museum of Fine Arts, Kansas City,
Mo.
The Starr Collection of miniatures in the
William Rockhill Nelson Gallery.With introd.by
Graham Reynolds.Kansas City,1971
84 p. illus(part col.)

...patterned after....Reynolds'.book Eng-
lish portrait miniatures

LC ND1337.C7W47

Yale ctr.f.Brit.art Ref.

ND
464R316
1981
NMAA

II.A.6 - MINIATURES - GREAT BRITAIN

Redgrave, Richard, 1804-1888
A century of British painters;by R.Redgrave
and Samuel Redgrave.Ithaca,N.Y.,Cornell Uni.
Press,1981
612 p. illus (Landmarks in Art History)

Reprint of Phaidon ed.of 1947
Bibliography,p.595-612
Chapters on 18thc.and on 19th c.portrait-
ists;17-19th c.miniatures;early Victorian portr.
ptrs. Influence of foreigners on English art.

757.7
W79

II.A.6 - MINIATURES - GREAT BRITAIN

Winter, Carl, 1906-66
The British school of miniature portrait
painters. London,G.Cumberlege,1948?

19 p. illus.(10 pl.)(Annual lecture on as-
pects of art,Henriette Hertz Trust of the British
Academy,1948)

Reprint from British Academy,London.Proceed-
ings,v.34

LC ND1337.C7W5

757.7
R463

II.A.6 - MINIATURES- GREAT BRITAIN

Reynolds, Graham, 1887- 1914-
English portrait miniatures. London,
A.& C.Black,1952
212 p. illus. (The Library of English art)

LC ND1337.C7R46

N
40.1
C 48F5
1981
NPG

II.A.6 - MINIATURES - GREAT BRITAIN - 16th c.

Finsten, Jill
Isaac Oliver,art at the courts of Eliza-
beth I and James I. N.Y.,Garland Pub.,1981
2 v. illus. (Outstanding dissertation
in the fine arts)

Originally presented as PH.D.-Thesis,Har-
vard,1979

Bibliography in v.1,p.220-34
Cat.raisonné in v.2

Fitzwilliam Mus. Cat.of por-
trait min. ND1337.C7F4 1977
NPG Bibl.p.222

II.A.6 - MINIATURES - GREAT BRITAIN - 16th c.

Foskett, Daphne
 Elizabethans in miniature

In:Discovering Antiques
Uni.Cal. 1,no.1:19-24 1970 illus.
Riverside

Winterthur Mus.Library
fZ881.W78 NCFA v.6,p.227

705
B97
NCFA
v.9

II.A.6 - MINIATURES - GREAT BRITAIN - 16-17th c.

Holmes, Richard R.
 The English miniature painters illustrated
by works in the Royal & other collections.Ar-
ticle III. Isaac Oliver

In:Burl Mag
9:22-8 Apr,'06 illus.

 Repro.:Self portr.,Anne of Denmark,Henry,
Prince of Wales,Mary,Queen of Scots,Phil.Sidney,
Ths.Howard,Earl of Arundel

N
7616
S92
MMAA

II.A.6 - MINIATURES - GREAT BRITAIN - 16th c.

Strong, Roy C.
 The English Renaissance miniature...London,
Thames and Hudson,c.1983
 208 p. illus(part col.)

 Bibl.references
 Index
 Incl.:Horenbolte,Cast Shadow Master,Holbei
Levina Teerline,John Bettes,Nicholas Hilliard,
Isaac Oliver,Laurence Hilliard,Peter Oliver,
Goltzius.
 Incl.Checklist of min.attr.to Lucas Horne-
bolte,p.189-90 Fitzwilliam Mus.Cat.of por
trait min. ND1337.F7Fn 'Hk

705
C75
NCFA
v.112

II.A.6 - MINIATURES - GREAT BRITAIN - 16-17th c.

Jones, E.Alfred
 Some notes on Nicholas Hilliard,Miniaturist
and Goldsmith,c.1547-1617

In:Connoisseur
112:3-6 Sept.'43 illus(part col.)

 Repro.incl.:Queen Elizabeth,the'Pelican por-
trait'.Second Great Seal of England.Miniatures:
Self portr.Queen Elizabeth.A gentleman.Alice
Brandon,wife of N.H. The Armada jewel

757.7
W78

II.A.6 - MINIATURES - GREAT BRITAIN - 16th c.

Winter, Carl, 1906-66
 Elizabethan miniatures. London and N.Y.,
Penguin books,ltd,1943

 32 p. illus(part col.)

 Bibliographical note

Harvard univ.libr.for
LC ND1337.07W51

ND
1337
07W78
1983
MMO

II.A.6 - MINIATURES - GREAT BRITAIN - 16-begin
 17th c.

Murrell, V.James(Jim)
 The Way howe to lymne,Tudor miniatures
observed...London,Victoria & Albert Mus.,1983
 100 p. illus(part col.)

 Publ.to accompany the exh.'Artists of the
Tudor Court:The portr.miniature rediscovered
1500-1620,held at the Vict.& Alb.Mus.9 July-
9 Nov.1983
 Foreword by Roy Strong
 Incl.:Horenbout,Holbein,Levina Teerline,
Benninck,Hilliard,Oliver,Hoskins,Tworth
 Fitzwilliam Mus. Cat.of p
trait min. ND1337.07Fn 'Hk

705
B97
NCFA
v.89

II.A.6 - MINIATURES - GREAT BRITAIN - 16th c.

Winter, Carl, 1906-1966
 Hilliard and Elizabethan miniatures.

In:Burl Mag.
89:175-88 Jul 1947 illus.

 Queen Elizabeth, self-portr., etc. by Hilliard
.Self-portr.,etc.,by Oliver
 Review of exhibition in Victoria and Albert m.
Nicholas Hilliard and Isaac Oliver

Rep.,1945-47#6389

AP
1
A64
NCFA
v.79

II.A.6 - MINIATURES - GREAT BRITAIN - 16-17th c.

Reynolds, Graham
 The painter plays the spider

In:Apollo
79:279-84 Apr.,'64 illus.
 Title refers to Shakespeare:"The painter
plays the spider,and has woven a golden mesh
to entrap the hearts of men."
 '...the min.was a fetish,a representation of
the beloved akin to the religious tokens of
saints,but also redolent...of magic & witchcraft'

 Fitzwilliam Mus. ND1337.07W
 1985(NPG Bibl.

705
B97
NCFA
v.8

II.A.6 - MINIATURES - GREAT BRITAIN - 16-17th c.

Holmes, Richard R.
 The English miniature painters illustrated
by works in the Royal & other collections.Ar-
ticle I & II. Nicholas Hilliard,Pt.I,Pt.II

In:Burl Mag
8:229-35 Jan,'06 illus.
8:316-25 Feb,'06 illus.

 Contains excerpts of Hilliard's 'Treatise
on the Art of Limning'

NK
928
C75
1968
NCFA

II.A.6 - MINIATURES - GREAT BRITAIN - 16-17th c.

Reynolds, Graham, 1887-
 Portrait miniatures

In:The Connoisseur's Complete Period Guides
p.189-92 & p.225-9 illus.

 Incl.chapters on Horenbout,Holbein,Hilliard,
Hilliard's pupils,etc.

 Repro.:Horenbout,Holbein,N.Hilliard,I.Olivier,
etc.

II.A.6 - MINIATURES - GREAT BRITAIN - 16-17th c.

Strong, Roy C.
 Artists of the Tudor court:the portrait
miniature rediscovered,1520-1620.Exh.held at
the Victoria and Albert mus.9 july-6 nov.,1983.
By R.C.Strong with contributions from V.J.
Murrell.London,Vict.& Alb.mus.,1983
 168 p. illus(part col.)
 277 works shown
 Bibliography
 Index
 Focuses particularly on Hornebolt,Holbein,
Levina Teerline(or Bening,Lievine),Hilliard,
Iockey,Oliver
LC ND1317.07S84 1983.DCW, DCU DHU NCA MdU etc.

705
B97
NCFA
v.20

II.A.6 - MINIATURES - GREAT BRITAIN - 17th c.

Goulding, Richard William, 1868-1929
 Nicholas Dixon, the limner

 In:Burl Mag
20:24-5 Oct.,'11

705
C75
NCFA
v.94

II.A.6 - MINIATURES - GREAT BRITAIN - 16-19th c.

Furst,Herbert Ernest Augustus, 1874-1945
 English miniaturists

In:Connoisseur
94:221-9 Oct.,'34 illus.

 Repro.incl.:Nich.Hilliard,Is.Oliver,Peter
Oliver,Christ.Richter,Chs.Shirreff,Lewis Crosse,
John Hoskins,Rich.Cosway,John Smart,Andrew
Plimer,Geo.Engleheart,Ths.Forster

705
B97
NCFA
v.9

II.A.6 - MINIATURES - GREAT BRITAIN - 17th c.

Holmes, Richard R.
 The English miniature painters illustrated
by works in the Royal & other collections. Ar-
ticle IV. Peter Oliver & John Hoskins

 In:Burl Mag
9:108-13 May,'06 illus.

 Repro.:P.Oliver:Eliz.of Bohemia,Arabella
Stuart,Chs.I,Henr.Maria,Marquis Guasto & his mis-
tress after Titian,B.Jonson. Hoskins:Falkland,
Mrs.Cromwell,Charles I

qN
40.1
C769W7s
NPG

II.A.6 - MINIATURES - GREAT BRITAIN - 17th c.

Foskett, Daphne
 Samuel Cooper and his contemporaries.Lon-
don,H.M.Stationery Off....1974
 140 p. illus(part col.)
 Cat.of exh.held at the NPG,London,15 March-
30 May,1974
 Incl.List of sitters;biogr.sketch by D.F.;
S.C.:an Engl.baroque'man for his century', by
J.Douglas Stewart;C.'s ptg.technique by V.J.
Murrell;Fashion,by Diana de Marly

 Yale ctr.f.brit.art Ref.

705
B97
NCFA
v.9

II.A.6 - MINIATURES - GREAT BRITAIN - 17th c.

Holmes, Richard R.
 The English miniature painters illustrated
by works in the Royal & other collections. Ar-
ticle V & VI. Samuel Cooper,Pt.I,Pt.II

 In:Burl Mag
9:294,296-303 Aug,'06 illus.
9:366-75 Sep,'06 illus.

II.A.6 - MINIATURES - GREAT BRITAIN - 17th c.

Foster, Joshua James, 1847-1923
 A list, alphabetically arranged,of works of
English miniature painters of the 17th century,
...Supplementary to Samuel Cooper and the Eng-
lish miniature painters of the 17th century.Lon-
don,Dickinsons,1914-16

LC ND1337.07F6 FOR COMPLETE ENTRY
 SEE MAIN CARD

N.
928
C75
1968
NCFA

II.A.6 - MINIATURES - GREAT BRITAIN - 17th c.

Millar, Oliver, 1923-
 Painting and portrait miniatures

In:The Connoisseur's Complete Period Guides
p.337-52 illus.

 Pertains to Stuart period

 Repro.:Hoskins,Cooper,Greenhill,Closterman,
Kneller,Dahl,Maratti

II.A.6 - MINIATURES - GREAT BRITAIN - 17th c.

Foster, Joshua James, 1847-1923
 Samuel Cooper and the English miniature pain-
ters of the 17th c. London,Dickinsons,1914-16

 96,p. illus.
 .v.2.alphabetical list of works of English
min.ptrs.of 17th c. 181 p.

 Illustrated by over 200 examples from the
most celebrated collections.

LC ND1337.07F5

705
B97
NCFA
v.120

II.A.6 - MINIATURES - GREAT BRITAIN - 17th c.

Murdoch, John, 1945-
 Hoskins' and Crosses:Work in progress

In:Burl Mag
120:284-90 May,'78 illus.

 Info.on miniatures with monograms of John
Hoskin & PC & LC of Peter & Lawrence Crosses.
Proposes the Hoskins oeuvre should be devided
betw.the elder John H.& the younger & contribu-
tions fr.studio works & all works with PC or LC
marks should be classified together.
 Bruijn Kops.In:B.Rijksmus.
 30:196,note 3

705
B97
NCFA
v.91

II.A.6 - MINIATURES - GREAT BRITAIN - 17th c.

Reynolds, Graham, 1914-
A newly identified miniaturist of the early
seventeenth century, probably Sir James Palmer

In:Burl Mag.
91:196-7 Jul,1949 illus.

Rep.,1948-49=8405

II.A.6 - MINIATURES - GREAT BRITAIN - 18th c.

Huntington, Henry Edwards,1850-1927
English portrait miniatures of the 18th
century,painted by Richard Cosway,George Engle-
heart,Andrew Plimer,and others....San Marino,
California.Privately printed.1927.
.12.p. illus.

Winterthur
Mus.Libr.
ND1337.G78h

Winterthur Mus.Libr.fZ881
.W78 NCFA v.6,p.218

705
C75
NCFA
v.147

II.A.6 - MINIATURES - GREAT BRITAIN - 17th c.

Reynolds, Graham, 1914-
Samuel Cooper:some hallmarks of his abili-
ty

In:Connoisseur
147:17-21 March,'61 illus.

Murdoch.Engl.miniatures.
ND7202.67E5X NMAA Abbrevia-
tions.

705
C75
NCFA
v.74

II.A.6 - MINIATURES - GREAT BRITAIN - 18th c.

Long, Basil Somerset, 1881-1937
John Smart, miniature painter

In:Connoisseur
74:196-200 Apr.,'26 illus.

II.A.6 - MINIATURES - GREAT BRITAIN - 17th c.

Reynolds, Graham, 1914-
Samuel Cooper's pocket-book...London,Victo-
ria and Albert Museum,1975
21 p. illus. (Victoria and Albert Mus.
brochure 8)

Bibl.references

LC ND1337.G8C667

MK
928
C75
1968
NCFA

II.A.6 - MINIATURES - GREAT BRITAIN - (early)18th

Mayne, Jonathan
Portrait miniatures

In:The Connoisseur's Complete Period Guides
p.729-34 illus.

Pertains to early Georgian period

Repro.:Richter,B.Lens,A.B.Lens,P.P.Lens,
Boit,Zincke,Spencer,Hone,Sullivan,Prewett,Cotes,
Hamilton

705
B97
NCFA
v.121

II.A.6 - MINIATURES - GREAT BRITAIN - 17-18th c

Edmond, Mary
Peter Cross limner,died 1724

In:Burl Mag
121:585-6 Sep.'79

Bibliography

E.establishes that there was no 'Lawrence
Cross.e.,English miniaturist,but only 'Peter'

MK
928
C75
1968
NCFA

II.A.6 - MINIATURES - GREAT BRITAIN - (late)18thc.

Mayne, Jonathan
Portrait miniatures

In:The Connoisseur's Complete Period Guides
p.967-73 illus.

Pertains to late Georgian period

Repro.:Meyer,Crosse,Cosway,Smart,G.Engleheart,
Saunders,Humphrey,Wood,Barry,Plimer,Shelley,Chin-
nery,C.Robertson,A.Robertson,J.C.D.Engleheart,
Comerford

ND
621
36F52
NCFA

II.A.6 - MINIATURES - GREAT BRITAIN - 17-18th c.

Firenze e l'Inghilterra.Rapporti artistici e
culturali dal 16 al 20 secolo.Firenze,Pa-
lazzo Pitti,luglio-settembre 1971.Firenze,
Centro Di,1971
.77.l. illus(col.cover) (Cataloghi,23)

Cat.ed.by M.Webster

see also article by Ormond in Connoisseur
v.177:166-74

LC ND621.F7F57

B
.C84W7

II.A.6 - MINIATURES - GREAT BRITAIN - 18th c.

Williamson, George Charles, 1858-1942
Richard Cosway and his wife and pupils,min-
iaturists of the 18th century...London,G.Bell &
sons,1897

LC ND1337.G8C8

FOR COMPLETE ENTRY
SEE MAIN CARD

II.A.6 - MINIATURES - GREAT BRITAIN - 18-19th c.

Bone, Henry, 1755-1834
 A cat.of miniature-portraits in enamel by
Henry Bone...In the coll.of the Duke of Bedford
at Woburn Abbey.London,1825
 63 p. illus.

MET
155.4
B64

Clouzot.Dict.miniaturistes
N7616.C64 NCFA Bibl.p.XVIII

II.A.6 - MINIATURES - GREAT BRITAIN - 18-19th c.

Joseph, Edward
 Cat.of a coll.of miniatures by Richard
Cosway,and contemporary miniaturists....London?
1883

LC ND1337.G8C75

**FOR COMPLETE ENTRY
SEE MAIN CARD**

II.A.6 - MINIATURES - GREAT BRITAIN - 18-19th c.

Bone, Henry, 1755-1834
 Cat.of portraits of illustrious characters
in the reign of Elisabeth...painted in enamel
by Henry Bone,R.A. London,G.Smeeton,1813
 7 p.

MB

II.A.6 - MINIATURES - GREAT BRITAIN, 18-19th c.

London. Queen's Gallery, Buckingham Palace
 Gainsborough,Paul Sandby and miniature-
 painters in the service of George III and his
 family.cat.of an exhibition. London.1970
 30 p. illus.

 Bibl.references

LC ND1334.L.L.16

Yale ctr.f.Brit.art Ref.

705
C75
NCFA
v.61

II.A.6 - MINIATURES - GREAT BRITAIN - 18-19th c.

Dibdin, E.Rimbault, 1853-1941
 John Turmeau,miniaturist

In:Connoisseur
61:20,23-4 Sept.,'21 illus.

FOR COMPLETE ENTRY
SEE MAIN CARD

705
C75
NCFA
v.91

II.A.6 - MINIATURES - GREAT BRITAIN - 18-19th c.

Long, Basil Somerset, 1881-1937
 Charles Shirreff,the deaf-mute

In:Connoisseur
91:83-8 Feb.,'33 illus.

Archer.India & Brit.portrai-
ture...ND1327.I44A72X NPG
Bilb.p.482

AP
1
A64
NCFA
v.98

II.A.6 - MINIATURES - GREAT BRITAIN - 18-19th c.

Foskett, Daphne
 Miniaturists silhouettists in Bath

In:Apollo
98:45-9 Nov.'73 illus.

 Repro.incl.:Chs.Jagger,Abr.of Jos.Daniel,
Charlotte Jones,Sampson Towgood Roch(e),Chs.
Ford,Ozias Humphry,Ths:Redmond,Chs.Foot Taylor,
Nathaniel Hone,T.Hazlet,Jac.Spornberg,Elliott
Rosenberg

AP
1
W225
NCFA
v.17

II.A.6 - MINIATURES - GREAT BRITAIN - 18-19th c.

Long, Basil Somerset, 1881-1937
 Richard Crosse,miniaturist and portrait-
painter

In:Walpole Soc.
17:61-94 1928-1929 illus.

Dict.of Brit.ptrs.by Fos-
kett.ND1337.07V74 NCFA
Bibl.p.594

757
H23
(NGA)
NCFA

II.A.6 - MINIATURES - GREAT BRITAIN - 18-19th c.

Hand, Sidney, 1877-
 Signed miniatures.London,S.Hand,1924
 26 p. illus(col.front)

 Index of artists

 Repro.incl.:Louis Napoleon by Wm.Ross,lar-
gest ivory miniature in the world,17 3/4.X13 1/2"

FOR COMPLETE ENTRY
SEE MAIN CARD

705
C75
NCFA
v.195

II.A.6 - MINIATURES - GREAT BRITAIN - 18-19th c.

Noakes, Aubrey
 John Thomas Barber Beaumont miniaturist and
art tutor of Henry Alken

In:Connoisseur
195:189-90,194 July,'77 illus(part col.)

 Barber Beaumont stopped painting 1806

II.A.6 - MINIATURES - GREAT BRITAIN - 18-19th c.

Robertson, Emily ed.
...Letters and papers of Andrew Robertson,
miniature painter...also treatise on the art by
...Archibald Robertson.London,Eyre & Spottis-
woode,pref.1895.
285 p. illus.

2nd ed..pref.1897.contains 12 excellent
repros.of R.'s larger miniatures on ivory.
LC Mellon Reference NJ18.R546R63 1897

LC ND1337.O8R7 Heath,Miniatures.ND1330.H43
 NCFA Bibl. p.XXXIX

705
C75
NCFA
v.34

II.A.6 - MINIATURES - GREAT BRITAIN - IRELAND -
.17-19th c.

Cronin, William Vine
 The Fine Arts in Ireland.Foundation of the
Irish school of miniature painting with notes
on some of its distinguished members

In:Connoisseur
34:95-100 Oct.,'12 illus.

 Repro.incl.:Chs.Robertson,J.Comerford,Simon
Digby,Sam.Lover,Sampson Towgood Roch(e),Edward
Hayes

B
.P72W7

II.A.6 - MINIATURES - GREAT BRITAIN - 18-19th c.

Williamson, George Charles, 1858-1942
 Andrew and Nathaniel Plimer,miniature paint-
ers...London,G.Bell & sons,1903

LC ND1337.06P5 FOR COMPLETE ENTRY
 SEE MAIN CARD

II.A.6 - MINIATURES - ITALY - 16th c.

Bradley, John William, 1830-1916
 The life and work of Giorgio Giulio Clovio,
miniaturist,with notices of his contemporaries..
London, B.Quaritch,1891
 400 p. illus.

 A list of C.'s work by Vasari,p.343-5;of
works attr. to C.,p.350-9;Engravings on copper
fr.pictures by C.,p.359-68

 '...excellent portrs.of his patrons...ear-
liest examples of real portr.miniatures in Ita-
lian illumination...a skilled portr.ptr.'-
Heath,p.49 Heath.Miniatures.ND1330.H
LC ND11..1..... NCFA Bibl....

AP
1
A784
J8
NCFA

II.A.6 - MINIATURES & GREAT BRITAIN - 18-19th c.

Williamson, George Charles, 1858-1942
 Four miniatures of the Keppel family

In:Art J.
73(?):222-4 July,'11 illus.

 FOR COMPLETE ENTRY
 SEE MAIN CARD

708.9492
A523
NMAA
v.36

II.A.6 - MINIATURES - ITALY - 17-18th c.

Bruijn Kops, C.J.de
 Een portretminiatuur door Rosalba Carriera
(1675-1757)en de oorsprong van haar schilder-
kunst op ivoor

In:B.Rijksmus.
36,no.3:181-210 1988 illus.(1 eel.en sever)

 Summary in English,p.268-71

705
C75
NCFA
v.10

II.A.6 - MINIATURES - GREAT BRITAIN - 18-19th c.

Williamson, George Charles, 1858-1942
 Miniature painting of eyes

In:Connoisseur
10:147-9 Nov.,'04 illus.

708.9492
A523
NMAA
v.30

II.A.6 - MINIATURES - NETHERLANDS

Bruijn Kops, C.J.de
 Keuze uit de aanwinsten.Portretminiaturen
uit de verzameling Mr.Adolph Staring

In:B.Rijksmus.
30,no.4:192-205 1982 illus.

 Summary in English,p.209

 Mainly Netherlandish miniatures,also 5 sil-
houettes on glass(3 verre églomisé)

 Bruijn Kops in B.Rijksmus.
 36:177,note 5

NK
928
C75
1968
NCFA

II.A.6 - MINIATURES - GREAT BRITAIN - (early)19th

Mayne, Jonathan
 Miniatures

In:The Connoisseur's Complete Period Guides
p.1101-04 illus.
 Pertains to Regency period

 Repro.:Cruickshank,A.Robertson,Linnell,
Collen,Chalon,Ross,Rochard

II.A.6 - MINIATURES - NETHERLANDS

Staring, Adolph, 1890-
 Kunsthistorische verkenningen:een bundel
kunsthistorische opstellen.'sGravenhage,
A.A.M.Stols,1948
 150 p. illus. (Onbetreden gebieden
der Nederlandsche kunstgeschiedenis,deel 3)

 Incl.:Nederlandsche portretminiaturen,p.73-
 .87

LC ND1319.S8 Bruijn Kops in:B.Rijksmus.
 30:196,note 3

II.A.6 - MINIATURES - NETHERLANDS

Staring,Adolph, 1890-
 Het portretminiatuur in Nederland.

In:Oude Kunst
4 1918-1919

MET
100.532
Ou22

CST OCI NJP Bruijn Kops In:B.Rijksmus.
 36,no.3:210,note 86

757.7
.L54

II.A.6 - MINIATURES - SCANDINAVIA

Lemberger, Ernst, 1866-
 Die bildnis-miniatur in Skandinavien,...
Berlin,G.Reimor,1912

 2 v. illus(part col.)

ND 1337.S3L4

705
B97
NCFA
v.61

II.A.6 - MINIATURES - NETHERLANDS - 17th c.

Edwards, Ralph, 1894-
 Oil miniatures by Cornelius Johnson

In:Burl Mag.
61:131-2 Sept.,'32 illus.

Moon.Engl.Portr.drags.&min
MC860.N66X NMM) bibl.p.145

VF
Stock-
holm
Nat'l
mus.

II.A.6 - MINIATURES - SCANDINAVIA

Stockholm Nationalmuseum
 Svenskt miniatyrmåleri.Teknik.Exh.cat.by.
Görel Cavalli-Björkman.Stockholm,Andrén & Holms
Boktryckeri AB,1981
 .13.p. illus(col.) Nationalmuseums ut-
ställningskatalog 449

 Grouped:Technique & execution. Mountings &
function. Renewal

II.A.6 - MINIATURES - PORTUGAL

Keil, Luis
 Os retratos de personagens portuguesas da
colecçao do arquiduque Ferdinando do Tirol

In:B.Acad.nac.belas artes
15:18-22 1946 illus.

Portuguese personalities in the miniature coll.
of archduke Ferdinand of Tyrol,brought together
from 1563 on

LC N16.A6613 Rep.,1948-49:1027

N
7616
.B55 B55
NCFA

II.A.6 - MINIATURES - SPAIN

Berwick, Jacobo María del Pilar Carlos Manuel
Stuart Fitz-James, 1o.duque de, 1878-
 Catalogo de las miniaturas y pequeños retra-
tos pertenecientes al Excmo.Sr.duque de Berwick
y de Alba, por D.Joaquin Esquerra del Bayo.
.Madrid,Imprenta de los Sucesores de Rivadeneyra
(s.a.),1924
 180 p. illus(part col.)

LC N7616.B4

II.A.6 - MINIATURES - RUSSIA

Vrangel',Nikolai Nikolaevich,baron, 1882-1915
 La miniature en Russie.en russe..
Staryé Gody,Oct.1909,pp.509-73

[reproduction of Library of Congress catalog card]

Clouzot.Dict. N7616.C64
NCFA,p.XVII

II.A.6 - MINIATURES - SPAIN

Tomás, Mariano
 La miniatura retrato en España.Madrid....
1953

LC ND1335.T6 FOR COMPLETE ENTRY
 SEE MAIN CARD

II.A.6 - MINIATURES - RUSSIA - 18-20th c.

Leningrad. Gosudarstvennyi russkii muzei
 Portretnaia miniatiura:iz sobraniia
Gosudarstvennogo Russkogo muzeia,18-nachalo
20 veka=Portrait miniatures from the coll.of
the Russian museum,18-early 20th c.,:Al'bom/
avtory vstup.stat'i i kataloga K.V.Mikhailova
i G.V.Smirnov,:2-aisd.Leningrad,Khudozhnik
RSFSR,1979
 451 p. illus(col.)

 Summary in English;legends in Russian and
English
LC ND1335.R9L464 1979 Books in print.Subject
 guide,1985-86,v.3,p.4865

II.A.6 - MINIATURES - SPAIN - 16-17th c.

Spanish Institute,Inc.,N.Y.
 The Spanish golden age in miniature.Portraits
from the Rosenbach Museum & Library.Cat.of exh.,
March 25-Apr.23,'88.New York,The Institute,1988
 62 p. illus(part col.)
 Bibliography

 Incl.the miniatures of the Talbot Hughes
coll.
 Exh.also in Philadelphia,Rosenbach Mus.&
Library,June 7-July 31,'88

738

II.A.6 - MINIATURES - SPAIN - 17th c.

Abbad Rios, Francisco
 Notas sobre la miniatura española de retrato
en el siglo 17

In:B.Semin.Est.arte archeol.
 7:121-29 1940-41 illus.

Incl.:Cardinal Infant Don Fernando,Marie Christine
of Transylvania,Philip IV as child,Sta.Theresa,
Mariana of Austria,Carlos II,Marianne of Neuberg

LC N7.V3 Rep,1945-47=7494

N
7593
L84
NCFA

II.A.6 - MINIATURES - U.S.

London, Hannah Ruth, 1894-
 Miniatures and silhouettes of early American
Jews.Rutland,Vt.,C.E.Tuttle Co.,1970.
 2 v. in 1 illus.

 Reprint of the author's Miniatures of early
American Jews and Shades of my forefathers.

 Bibliography

LC NC910.L59 Fogg.v.11,p.317,col.1

II.A.6 - MINIATURES - SWITZERLAND - GENEVA -
 ,17-18th c.
Schneeberger, Pierre Francis
 Les peintres sur émail genevois au 17e et
au 18e siècle.Genève,Mus.d'art et d'histoire,
1958

MET
195.4
Sch5

M1DA FOR COMPLETE ENTRY
 SEE MAIN CARD

757.7
R98

II.A.6 - MINIATURES - U.S.

Maryland Historical Society
 Handlist of miniatures in the coll...by
Anna Wells Rutledge,Balto.,Md.,1945
 18 p. illus (Repr.fr.Md.Hist.Mag.
AP1 v.40,no.2,June,1945,pp.119-36)
M39
NPG

 Sellers.Archives of Amer.
 art:Mezzotint prototypes...
 In:Art Q 20,no.4,p.468

705
B97
NCFA

II.A.6 - MINIATURES - TURKEY

Sakisian, A.
 Turkish miniatures.

In:Burl.Mag.
 87:224-32 1945 illus.

 16th to 18th c.

 Incl:Portrs.of Mohammed II,II,Selim II;works
by Haidar,Wali Dschân(Persian),Kemâl(Persian).
Connection with Persian ptg;influence in 15 & 16th
c.by Italian ptg. Rep.,1945-47=10850

ND
1337
USN3
1984X
NMAA

II.A.6 - MINIATURES - U.S.

National Museum of American Art
 Portrait miniatures in the National Mus.
of American Art,by,Robin Bolton-Smith.Chicago,
Univ.of Chicago Press,1984
 80 p. illus(part col.) (Chicago visual
library text-fiche series,no.46

 Microfiches in pocket;illus.on fiche
 Index

 Books in print.Subject
 Guide,1985-86 v.3,p.4864

ND
1337
USB6X
NMAA
Ref.

II.A.6 - MINIATURES - U.S.

Bolton, Theodore, 1889-
 Early American portrait painters in minia-
ture...New York,F.F.Sherman, 1921

 180 p. illus.

 Lists native American ptrs. & foreign,working
in America, from the earliest times until 1850.
Ivory miniatures & small portrs. in oil & W.C.
Biographical info. & listing of some of their
works.
For checklist see:Old-Time New England,v.12:131-4
LC ND1337.U5B6 ,Jan.'22 illus.

757
.R81H5

II.A.6 - MINIATURES - U.S.

Rosenthal, Albert, 1863-
 The Albert Rosenthal collection of miniatures
and small oil portraits including a few from
other sources with a list of miniature painters
identified with America from the earliest periods,
catalogued by Stan V.Henkels. Philadelphia,1920
 31 p. illus.

 "A list of all the known miniaturists, living
and deceased,who have practised their art in this
country"

ND
1311.9
C47C3
1984X
NPG

II.A.6 - MINIATURES - U.S.

Carolina art association, Charleston, S.C.
 The miniature portrait collection of the
Carolina art association;by Martha R.Severens;
ed.by Chs.L.Wyrick,jr. Charleston,S.C.,Gibbes
Art Gallery,1984
 189 p. illus(part col.)

 Incl.:Index
 Bibliography

 Js.Peale painting a miniature by Chs.W.
Peale,p.XV

LC ND1311.9.C47C3 198

705
A784
NCFA
v.19

II.A.6 - MINIATURES - U.S.

Sherman, Frederic Fairchild,1874-1940
 John Trumbull's portrait miniatures on wood

In:Art in America
 19:257-61 Oct,1931 illus.

 Chronological list

 Ptd.in oil. Comparison of W.C. on ivory &
oil on wood

ND
1337
U5W41
1937
NCFA
NPG
2 cops.

II.A.6 - MINIATURES - U.S.

Wehle, Harry Brandeis, 1887-
American miniatures,1730-1850;one hundred
and seventy-three portraits ...& a biographical
dictionary of the artists by Theodore Bolton.
Garden City publishing company,inc.,.1937.
127 p. illus.(part col.)

Bibliography

LC ND1337.U5W4 1937

705
A5
NCFA
v.17

II.A.6 - MINIATURES - U.S. - 18th c.

Rutledge, Anna Wells
Henry Benbridge(1743-1812?);American por-
trait painter

In:Am.Coll.
17:8-10,23 Oct.,'48 illus.
:9-11,23 Nov.,'48 illus(miniatures)

Tentative list of portrs.in oil
" " " miniatures,probably by
Letitia Sage Benbridge

N
7593
D23
NPG

II.A.6 - MINIATURES - U.S. - 17-19th c.

Daughters of the American Revolution Museum
The Jewish Community in Early America:1654-
1830.Washington,D.C.,The Museum,1980
25 leaves

Cat.for exh.,Dec.11,1980-Mar.15,1981

Incl.:Portraits and miniature portraits

705
A784
NCFA
v.24

II.A.6 - MINIATURES - U.S. - 18th c.

Sherman, Frederic Fairchild, 1874-1940
American miniatures of revolutionary times

In:Art in Amer.
24:39-43 Jan.,'36 illus.

Repro.:Peale,Ramage,West,King

Miniatures on ivory

NCFA
Ref.

II.A.6 - MINIATURES - U.S. - 17-19th c.

Smithsonian Institution. National Collection of
Fine Arts
Portrait miniatures from private collec-
tions.Exh.25 June 1976-9 Jan.,1977.Cat.by
Robin Bolton-Smith
15 p. illus.

125 works by over 50 American artists shown

Evolution of American miniature fr.the Colo-
nial period to the Civil War
Rila III/1 1977 #975

N
40.1
R16S5
NPG

II.A.6 - MINIATURES - U.S. - 18th c.

Sherman, Frederik Fairchild, 1874-1940
John Ramage;a biographical sketch and list
of his portrait miniatures...N.Y.,Priv.print,
1929
25 p. illus.

Incl.:3 portrs.of Washington

LC ND1337.U6R37

AP
1
A(area)

II.A.6 - MINIATURES - U.S. - 18th c.

Bolton, Theodore, 1889- and H.L.Binsse
The Peale portraits of Washington

In:Antiquarian
16:24-7,58,60,62,64 Feb.,'31 illus(part col

Miniatures, physionotrace
Incl.cat.,comp.from ms.copy of C.W.Peale's
diary for the years 1775-1778 and part of 1788.
Description & notes on the life portrs.of W
by members of the Peale family
C.P.Polk copied many C.W.Peale portrs.of
.1787
Arts in Am.q25;61
USA77X NCFA Ref. H722

705
A784
NCFA
v.23

II.A.6 - MINIATURES - U.S. - 18th c.

Sherman, Frederic Fairchild, 1874-1940
Recently recovered miniatures by John
Singleton Copley

In:Art in Am
23:34-8 Dec.,'34 illus.

C.'s miniatures date from 1755-1790

N
40.1
R16N8
NPG.
2 c.

II.A.6 - MINIATURES - U.S. - 18th c.

Morgan, John Hill, 1870-1945
A sketch of the life of John Ramage,Mini-
ture painter.N.Y.,The N.Y.Historical Society,
1930
55 p. illus.

LC ND1337.U6R3

Carolina art association..
Miniature portr.coll...
p.XVI footnote 5

mfm
143n
NPG
reel 10
and
AP
1.V81
N2G
v.37

II.A.6 - MINIATURES - U.S. - 18th c.

Stanard, William Glover, 1858-1933
An exh.of contemporary portraits of per-
sonages associated with the colony and common-
wealth of Virginia between the years 1585 and
1830. Apr.29-May 25,1929.Virginia Hse.,Richmond,

In:Va.Mag.Hist.Biogr.
37:193-216 July,'29 illus.

163 portrs. shown, paintings & miniatures.
Incl.:Lists of sitters & artists

Winterthur Mus.Library
f789; ... v.. NCFA p.205

ND
1337
U5B74
NCFA
NPG

II.A.6 - MINIATURES - U.S. - 18-19th c.

Boston. Museum of Fine Arts
New England miniatures,1750 to 1850. Exhib.
April 24 to May 28,1957...Boston,1957
illus(part col.)

The art of miniature ptg. in New England,by
Barbara Neville Parker,pp..8..-18

Bibliography

see cat.cds.in NPG

ND
1337
U5N67
1976X
NPG

II.A.6 - MINIATURES - U.S. - 18-19th c.

Norton (R.W.) Art Gallery
Portrait miniatures in early American his-
tory,1750-1840;a Bicentennial exhibition,Apr.18-
June 13,1976,the R.W.Norton Art Gallery.Shreve-
port,La.;The Gallery,c.1976
41 p. illus(part col.)

Biograph.references
70 works shown

Incl.:14 signers of the Declaration of Ind.
The first 3 presidents & other prominent Amer.

LC ND1337.U5N67 1976 Rila III/2 1977 #7289

705
A56
NCFA
v.2?

II.A.6 - MINIATURES - U.S. - 18-19th c.

Brockway, Jean Lambert
The miniatures of James Peale

In:Antiques
22:130-4 Oct.,'32 illus.

Incl.checklist of miniatures

N
7592
O24
NPG

II.A.6 - MINIATURES - U.S. - 18-19th c.

Rhode Island School of Design, Providence
Exh.of early American art in honor of the
150th anniversary of the founding of Brown
University,Oct.3rd to 21st,1914..Providence,
1914?
11 p.

Exh.incl.:portrs.by Alexander,Copley,Earle,
Harding,Jarvis,Chs.W.Peale,Smibert,Sully,Stuart,
West.Miniatures by Allston,Copley,Malbone,Kühns
R.Peale,etc.
NPG copy:"Owners of ptgs.by Gilbert Stuart"
inserted.Bound with Garrick Club,London.Cat.
of the pictures... London,1909

N
6507
D77
1970
NCFA

II.A.6 - MINIATURES - U.S. - 18-19th c.

Drepperd, Carl William, 1898-
Pioneer and amateur miniatures

In:his.American pioneer arts & artists,Watkin
Glen,N.Y.,Century House,1970
pp.93-103 illus.

705
A784
NCFA
v.16

II.A.6 - MINIATURES - U.S. - 18-19th c.

Sherman, Frederic Fairchild, 1874-1940
Portraits and miniatures by Copley,Dunlap,
Eichholtz and Robert Street

In:Art in Amer.
16:122-9 Apr.,'28 illus.

Repro.:Copley,Dunlap,Eichholtz,Street

Biographical notes for Jacob Eichholtz and
Robert Street

Cumulated Mag.subj.index
11/3/C76 Ref. v.2,p.443

AP
1
C76
NPG

II.A.6 - MINIATURES - U.S. - 18-19th c.

Dunbar, Philip H.
Portrait miniatures on ivory,1750-1850;from
the coll.of the Connecticut historical society

In:Conn.Hist.Soc.B.
29:97-144 Oct.,'64 illus.

Incl.Checklist
Pertains to an exh.at the Conn.Hist.Soc.

Incl.Hair painting

Winterthur Mus.Libr.f2881
W78 NCFA v.6,p.217

VF
Malbone

II.A.6 - MINIATURES - U.S. - 18-19th c.

Smithsonian Institution.National Collection of
Fine Arts
Catalogue of an exhibition of miniatures
and other works by Edward Greene Malbone, Feb.23-
April 21,1929.Washington,1929
21 p. illus.

Boston,Mus of F.A. New En
min.1750-1850 ND1337.U5B74
Bibl.

757.7
.N53

ND
1337
U5M4X
NPG

II.A.6 - MINIATURES - U.S. - 18-19th c.

New York. Metropolitan museum of art
...Catalogue of an exhibition of miniatures
painted in America 1720-1850, New York,March 14
through April 24,1927..New York,1927.
75 p. illus.

Intro.by H.B.Wehle

LC ND1337.U5M4

London,Hannah Ruth.Min. &
silh.'N7593.L84 NCFA bibl.

ND
1111
S66
NCFA
NPG

II.A.6 - MINIATURES - U.S. - 18-19th c.

Smithsonian institution. National collection
of fine arts
Exh.of early American paintings,miniatures
and silver,assembled by the Washington loan
exh.comm.,Dec.5,1925-January 3,1926.Washington,
D.C.,National gallery of art,National museum
.1925.
107 p. illus.

With introductions on early American por-
traits by Miss Leila Mechlin,Washington;early
American miniatures by Mr.Albert Rosenthal

LC N857.A6 1925

Tolman.Attributing miniatures

705
A56
NCFA
v.14

II.A.6 - MINIATURES - U.S. - 18-19th c.

Tolman, Ruel Pardee, 1878-
 Attributing miniatures

In:Antiques
14:413-6(pt.1) Nov.,'28 illus.
 :523-6(pt.2) Dec.,'28 illus.

 Repro.incl.:(Gilbert Stuart by)Sarah Good-
 ridge;Rbt.Field;Gilbert Stuart?;Raphaelle Peale

 Carolina Art ass.Charleston
 S.C.Miniature portr.coll.
 Bibl.,p.180

705
A56
NMAA
v.124

II.A.6 - MINIATURES - U.S. - 19th c.

Dearborn, Mona Leithiser
 Anson Dickinson,painter of miniatures

In:Antiques
124:1004-09 Nov.,'83 illus(part col.)

 Repro.incl.:Gilbert Stuart

N
40.1
M74B76
c.NPG
c.2MMAA

II.A.6 - MINIATURES- U.S. - 18-19th c.

Tolman, Ruel Pardee, 1878-
 The life and works of Edward Greene Malbone
1777-1807...New York,New-York Historical Socie-
ty,1958
 322 p. illus. (New York Historical Socie-
ty.The John Divine Jones Fund series of histo-
ries and memoirs,13)

 Bibliography
 Incl.:Checklist of misattributed miniatures
Descriptive list of known works by Malbone

 Whitehill.The Arts of early
 Amer.Hist.Z59J5.W59 NPG
LC ND1337.U6M32 Bibl.,p.92

705
A56
NCFA
v.51

II.A.6 - MINIATURES - U.S. - 19th c.

Dods, Agnes M.
 Sarah Goodridge

In:Antiques
51:328-9 May,'47 illus.

 List of sitters & owners of G.'s miniatures

 Repro.incl.:David Webster,Gilbert Stuart

708.1
N52
v.22

II.A.6 - MINIATURES - U.S. - 18-19th c.

Wehle, Harry Brandeis, 1887-
 Exhibition of early American miniatures

In:Met B.
22:66-9 Mar,1927 illus.

 Loan exhibition of 300 miniatures of 58
artists,a survey of American aspect of minia-
tures,1730-1850

 Repro.:Malbone,Dunkerley,Pratt,Robertson,
Inman,Raphaelle Peale

VF

II.A.6 - MINIATURES - U.S. - 19th c.

Dunlap, William, 1766-1839
 Collection of ivory miniatures...cat.comp.
and sale conducted by Stan V.Henkels at the
book auction rooms of Davis & Harvey,Phila.,Pa.,
Mar.10,1905
 26 p. illus(1 col.)

 Cat.no.927

 Incl.:Scarce American portrs.:Americus Ves-
pucius,Washington & family,Franklin,Lincoln,
Wm.Penn... engravings,ptgs. by other artists.

N
40.1
F84C4
NPG

II.A.6 - MINIATURES - U.S. - 19th c.

Carolina art association, Charleston,S.C.
 Charles Fraser of Charleston.Essays on the
man,his art and his times;comp.& ed.by Martha
R.Severens & Chs.L.Wyrick,jr. 1983
 168 p. illus(part col.)

 Gibbes art gallery

 Ch.III.:F.'s place in the evolution of mini-
ature portrs.by Robin Bolton-Smith,p.39-56.Ch.IV
The miniature by Paula Welshimer,p.57-74

afm
264
NCFA
Reel 15

II.A.6 - MINIATURES - U.S. - 19th c.

King, Pauline
 American miniature painting

In:Century
60 New ser.:38,no.6:820-30 Oct.,1900 illus.

 Repro.incl.:John A.MacDougall,W.J.Baer,Theo-
dore W.Thayer,Marie Champney Humphreys,Virginia
Reynolds,Laura C.Hills,Lucia Fairchild Fuller,
I.A.Josephi,Florence Maskubin,Lydia Field Emmet,
W.J.Whittemore

 VF Collections.Tannenbaum
 .10

B
F84C2
NCFA

II.A.6 - MINIATURES - U.S. - 19th c.

Carolina art association, Charleston, S.C.
 A short sketch of Charles Fraser and a list
of miniatures and other works,exh.by the Caro-
lina art association,Gibbes art gallery,Charles-
ton,S.C.,Jan.29th-Feb.26th,1934.n.p.,1934?
 33 p.

 Incl.:List of located miniatures not on ex-
hibit & list of unlocated,damaged or destroyed
ones.

705
A784
NCFA
v.41

II.A.6 - MINIATURES - U.S. - 19th c.

Mitchell, Lucy B., 1901-
 James Sanford Ellsworth:American minia-
ture painter

In:Art in Am
41:151-84 Autumn,'53 illus.

 Bibliography
 Incl.:List of miniatures signed by or attr
to Ellsworth & oil ptgs. p.173-82.See also:
Art in Am. v.42:218-9 Oct.,'54 illus.

 Abby Aldrich Rockefeller
 Folk Art Ctr.Am.Folk portr.
 N7593.A23 Bibl.p.294

40.1
E476M6
NPG
2 cps.
II.A.6 - MINIATURES - U.S. - 19th c.

Mitchell, Lucy B., 1901-
The paintings of James Sanford Ellsworth, itinerant folk artist,1802-1873;cat.of an exh. presented by the Abby Aldrich Rockefeller Folk Art Coll.,Williamsburg,Va.,Oct.13-Dec.1,1974.. Colonial Williamsburg Foundation,c1974
103 p. illus(part col.)

Bibliography
Incl:Checklist:Oil ptgs. and W.C.miniature
See also other articles in Art in Am.v.41:
151-84(Autumn,'53) v.42:218-9(Oct.,'54)
LC ND1337.U6E495

705
A784
NCFA
v.24
II.A.6 - MINIATURES - U.S. - 19th c.

Sherman, Frederic Fairchild, 1874-1940
American miniaturists of the early nineteenth century

In:Art in Amer.
24:76-83 Apr.,'36 illus.

Repro.:Jarvis,Fairchild,Morse,Gimbrede,Kimberly,Inman,Lane,Leslie,Sheffield,Emmons

705
A784
v.23
II.A.6 - MINIATURES - U.S. - 19th c.

Nathaniel Rogers and his miniatures

In:Art in Am
23:158-9,161-2 Oct,'35 illus.

Incl.list of Rogers' miniatures

705
A56
NCFA
v.7
II.A.6 - MINIATURES - U.S. - 19th c.

Sherman, Frederic Fairchild, 1874-1940
A family painted in miniature

In:Antiques
7:18-19 Jan.,'25 illus.

Here attr.to Ellsworth

Mitchell.Js.S.Ellsworth
N40.1.E476M6 NPG Bibl.
p.103

II.A.6 - MINIATURES - U.S. - 19th c.

Ross, Marvin Chauncey, 1904-
William Birch,enamel miniaturist

In:Am.Coll.
9:6,20 July,'40 illus.

Brief biographical note

LC NK1125.A15
Arts in America q25961USA
77X NCFA Ref. N218

705
A56
NCFA
v.11
II.A.6 - MINIATURES - U.S. - 19th c.

Sherman, Frederic Fairchild, 1874-1940
Some recently discovered early American portrait miniaturists

In:Antiques
11:293-6 Apr.,'27 illus.

Mainly 19th c.

705
A5
NCFA
v.17
II.A.6 - MINIATURES - U.S. - 19th c.

Rutledge, Anna Wells
Henry Bounetheau(1797-1877)Charleston,S.C. miniaturist

In:Am Coll
17,no.6:12-15,23 July,'48 illus.

Incl.:List of B.'s miniatures & oil ptgs.

Incl.:list of works of Mrs.Bounetheau which incl.Geo.Washington,oil

LC NK1125.A15
Carolina Art ass..Charleston,S.C.Miniature portr.col.
Bibl.p.179

705
A56
NCFA
v.4
II.A.6 - MINIATURES - U.S. - 19th c.

Sherman, Frederic Fairchild, 1874-1940
Three New England miniatures

In:Antiques
4:275-6 Dec.,'23 illus.

Miniatures attr.to Alexander Hamilton Emmons

Repr.:Emmons,J.S.Ellsworth

Robinson.Amer.primit.ptg.
In:Antiques,19:33 705A56

705
A56
NCFA
v.17
II.A.6 - MINIATURES - U.S. - 19th c.

Sherman, Frederic Fairchild, 1874-1940
American miniatures by minor artists

In:Antiques
17:422-5 May,'30 illus.

Incl.:Ludlow,Gulian,sr.,Plummer,Wm.,Wentworth,T.H.,Emmons,A.H.,Ellsworth,J.S.

Lipman,J. Americ.primitive
ptg. 759.1.L76 Bibl.

705
A56
NCFA
v.23
II.A.6 - MINIATURES - U.S. - 19th c.

Sherman, Frederic Fairchild, 1874-1940
Unrecorded early American portrait miniaturists and miniatures

In:Antiques
23:12-14 Jan.,'33 illus.

Mainly 19th c.

705
A784
v.22

II.A.6 - MINIATURES - U.S. - 19th c.

Sherman, Frederic Fairchild, 1874-1940
 Unrecorded early American portrait painters

In:Art in Am
22:26-31 Dec.,'33 illus.
 :145-50 Oct.,'34 illus. title :Unrecor-
ded early American painters
 Miniature ptrs.& portr.ptrs.in oil
Most of these artists are in Groce & Wallace:

N6536
N53
c.3
REF

N.Y.Hist.Soc. Dict.of artists in Amer.,1564-1860

705
A56
NCFA
v.21

II.A.6 - MINIATURES - U.S. - 19th c.

Snow, Julia D.Sophronia
 King versus Ellsworth

In:Antiques
21:118-21 Mar.,'32 illus.

 Repro.:incl.Daguerreotypes
 Snow identifies miniatures,f'ly given to
James Sanford Ellsworth as Josiah Brown King's
work.She presents evidence in support of her at-
tributions.
 Sherman,F.F.,J.S.Ellsworth
 In:Lipman,Prim.ptrs.in Amer
 ND236.L76,p.71

705
A784
NCFA
v.23

II.A.6 - MINIATURES - U.S. - 19th c.

Smith, Alice Ravenel Huger, 1876-
 Charles Fraser

In:Art in Am
23:22-34 Dec.'34 illus.

 Carolina Art ass.,Charles-
 ton,S.C.Miniature portr.co
 Bibl.p.180

Ap
1
O57
MPO
v.47

II.A.6 - MINIATURES - U.S. - 19th c.

Stewart, Robert G.
 Auguste Hervieu,a portrait painter in Cin-
cinnati

In:Queen City Heritage
47:23-31 Spring,'89 illus(part col.)

 Repro incl.:Andrew Jackson

N
40.1
F84X86
MPO

II.A.6 - MINIATURES - U.S. - 19th c.

Smith, Alice Ravenel Huger, 1876-
 Charles Fraser;by Alice R.H.Smith and D.E.
Huger Smith.N.Y.,F.F.Sherman,1924
 58 p. illus.

 Incl.:Ch.'Review of F.'s work in miniature
painting'

LC ND1337.U6F7

 Art Gall.of Nova Scotia.
 bt.Field
 p.18

705
A56
NCFA
v.27

II.A.6 - MINIATURES - U.S. - 19th c.

Tolman, Ruel Pardee, 1878-
 The technique of Charles Fraser,miniatu-
rist

In:Antiques
27:19-22(pt.1) Jan.,'35 illus.
 :60-62(pt.2) Feb.,'35 illus.

 Careful analysis of the artist's stylistic
development
 Carolina Art ass.Charleston
 S.C. Miniature portr.coll.
 Bibl.,p.180

705
A784
NCFA
v.3

II.A.6 - MINIATURES - U.S. - 19th c.

Smith, Alice Ravenel Huger, 1876-
 Charles Fraser,the friend and contemporary
of Malbone

In:Art in Am
3:174-83 June,'15 illus.

 Carolina Art ass.,Charles-
 ton,S.C.Miniature portr.col
 Bibl. p.180

705
M18
NCFA
v.7

II.A.6 - MINIATURES - U.S. - 19-20th c.

Mechlin, Leila, 1874-1949.
 Laura Coombs Hills

In:Mag Art
7:458-61 Sept.,'16 illus.

 FOR COMPLETE ENTRY
 SEE MAIN CARD

705
M18
NCFA
v.27

II.A.6 - MINIATURES - U.S. - 19th c.

Smith, Alice Ravenel Huger, 1876-
 The miniatures of Charles Fraser

In:Mag Art
27:198-202 Apr.,'34 illus.

 Carolina Art ass.,Charles-
 ton,S.C.Miniature portr.col
 Bibl.,p.180

N
40.1
F84S6
1967
MPO

II.A.6 - MINIATURES - U.S. - SOUTH CAROLINA - 19t

Smith, Alice Ravenel Huger, 1876-
 Charles Fraser,by A.R.Huger Smith and D.E.
Huger Smith.Charleston,S.C.,Garnier,1967.
 58 p. illus.

 Republication of 1924 ed.(N 40.1.F84x36 MPO)

ND
1333
V8V817
NPG

II.A.6 - MINIATURES - U.S. - VIRGINIA

Virginia Museum of Fine Arts, Richmond
An exhibition of Virginia miniatures,Dec.3,
1941-Jan.5,1942....Richmond, The Virginia
museum of fine arts,1941.
55 p. illus.

Miniatures ptd.prior to 1830

Index of sitters

LC ND1333.V5

Rutledge.In:Am Coll.705.A5
17:23
London,Hannah Ruth.Min.&
silh.Bibl. N7593.L84

II.B. DRAWINGS & PRINTS

II.A.6 - MOSAICS - BYZANTINE(7-8th c.)

Ladner, Gerart Burian, 1905-
Die bildnisse der östlichen päpste des 7.
und 8. jahrhunderts in römischen mosaiken und
Wandgemälden

In:Studi bizantini e neoellenici
6:169.82 1940

Incl: Honorius I(625-38),John IV(640-2),
Theodore I(642-9),John VII(705-7),St.Zacharias
(741-52)

LC
DF503.88

Rep.,1942-44#691

II.B.1. GENERAL

II.A.6 - MURALS - BYZANTINE(7-8th c.)

Ladner, Gerart Burian, 1905-
Die bildnisse der östlichen päpste des 7.
und 8. jahrhunderts in römischen mosaiken und
Wandgemälden

In:Studi bizantini e neoellenici
6:169.82 1940

Incl: Honorius I(625-38),John IV(640-2),
Theodore I(642-9),John VII(705-7),St.Zacharias
(741-52)

LC
DF503.S8

Rep.,1942-44#691

II.B Books and articles on portrait-graphics
" " " with illustrations in the graphic
media,when the graphic media is of interest

II.A.6 - MURALS - GERMANY - MEDIEVAL

Gerstenberg, Kurt, 1886-1968
Die deutschen baumeisterbildnisse des mit-
telalters..Berlin,Deutscher verlag für kunstwis-
senschaft.1966.
231 p. illus. (Deutscher Verein für kunst-
wissenschaft.Berlin. Jahresgabe...1966)

FOGG
5553
G38

The status of medieval architects.-Various
types of portrs.fr.12-late 15th c. Develpm't fr.
heads on capitals & bosses to full fg.represen-
tations.Most are busts on capitals & consoles.
15th c.innovation:setting in natural context.
CTY NPV MdPWa KyU NjP ICU Prins.Slg.d.selbst-
bildnisee...N7618.P95,v.1
p.147,d footnote 57

II.B.1

Moehsen, Johann Karl Wilhelm, 1722-1795
Verzeichnis einer samlung von bildnissen grös-
tentheils berühmter aerste;so wohl in kupferstichen,
schwarzer kunst und holzschnitten,als auch in eini-
gen handzeichnungen...anmerkungen...vornehmlich
zur geschichte der künste...Berlin,C.F.Himburg,
1771
240 p. illus.

Vignetten von J.W.Meil nach B.Rode

LC NE240.M7

Amsterdam,Rijksmus.,cat.
E5939A52,deel 1,p.138

N
853
U51
1965
NPG
Ref.

II.A.6 - MURALS - U.S.

U.S. Architect of the Capitol
Compilation of works of art...Washington,
U.S.Govt.Printing Off.,1965
426 p. illus. (88th Congr.,2nd session,
House document no.362)

Incl.:Portrs.,p.1-115;Busts,p.169-98;Relief
portrs.,p.279-87;Pioneers of the Women's suf-
frage move't,p.277;Portrs.,p.309-13,315-19,320-1
Historical ptgs.incl.J.Trumbull's Declaration of
Independence,p.118,Gen.Geo.Washington resigning
his comm.as Commander in Chief,p.121,Surrender

LC N853A52 1965

II.B.1

Sutherland, Alexander Hendras
Catalogue of the Sutherland collection of
portraits,views,and miscellaneous prints...Lon-
don,Payne & Foss,and P.& D.Colnaghi & co.,1837-
38.
2 v.
Cat.of 19084 engravings & drgs....with the
text of Clarendon's History of the rebellion,
and Life,and Burnet's History of his own time.
The coll.completed by Mrs.Charlotte Hussey Suther-
land,who compiled the cat.& presented the extra
illustrated sets...to the Bodleian library

LC NE215.C7S6

QNE
230
Y18
NPG

II.B.1

Yale university. Art gallery
The Edward B.Greene collection of engraved
portraits and portrait drawings at Yale univer-
sity.A catalogue comp.by Alice Wolf,with a pre-
face by Theodore Sizer.New Haven,Yale university
press;London,H.Mildford,Oxford university press,
1942
141 p. illus.

Bibliography

Prints are alphabetically arranged according
to the sitters
LC NE230.Y9
Yale Univ.Libr.for LC Fogg,v.11,p.326

II.B.1.a. CHRONOLOGICAL (number not used presently)

II.B.1.b. BY COUNTRY, A-Z

II.B.1.b - GERMANY - 16th c.

Beham, Hans Sebald, 1500-1550
Das Kunst vnd Lere-Büchlin...Malen und Reis-
sen zu lernen...Franckfurt,Bei Christian Egen-
olff.1552.
illus.

Incl.schema of profiles

LC Typ 520/82.201 1582 MH Source:Gombrich,Art & Illu
53 p. illus. sion N7003),p.166-7
NC705.B4 Rare bk. 1594
55 p. illus. NN│ ed.1557 55 p. illus.
 │ in MH

N
7605
K78
NPG

II.B.1.b - GERMANY - 16th c.

Hamburg. Kunsthalle
Köpfe der Lutherzeit..Exh..4.März-24.April,
1983.Hrsg.u.Ausw.Werner Hofmann.Kat.Eckhard
Schaar u.Gisela Hopp.München,Prestel Verlag,1983
318 p. illus(part col.)
Bibliography
Iconographical register,p.27-36

Cat.arranged alphabetically by artists

Essays by Werner Hofmann,p.9-17 and Peter-
Klaus Schuster,p.18-24

II.b.1.b - GREAT BRITAIN.

British museum. Dept.of prints and drawings
Catalogue of prints & drawings in the
British museum.Division I.Political and personal
satires(no.1 to no.4838)....London.Printed by the
order of the Trustees,1870-1942
7 v.in 8(v.5-7)

Contents.-1.1320-Apr.11,1689.-II.June 1689-
1733.-IIIpt.1March 28,1734-c.1750,pt.II.1751 to
c.1760.-IV.1761 to 1770.-V.1771-1783.-VI.1784-
1792.-VII.1793-1800

LC NE55.L7A3 msatt.Portrs.of A.Pope
 7628.P83W7 NPG bibl.

II.B.1.b - IRELAND

Dublin. National Library of Ireland.
...Catalogue of engraved Irish portraits,main-
ly in the Joly collection,and of original draw-
ings.By Rosalind M.Elmes...Dublin,The Stationa-
ry off.1937.
279 p.

Bibliography

LC NE265.D8 Yale ctr.f.Brit.art Ref.
 NE265.D8

II.B.1.b - NETHERLANDS

Houbraken, Arnold, 1660-1719
Arnold Houbraken's Grosse schouburgh der nie-
derländischen maler und malerinnen. Ubersetzt
und mit einleitung,anmerkungen und inhalts-ver-
zeichnissen versehen von dr.Alfred von Wurzbach.
1.band:Ubersetzung des textes nebst drei inhalts-
verzeichnissen. Wien,W.Braumüller,1880.

495 p. (Quellenschriften für kunstgeschichte
und kunsttechnik XIV)

Arnold H.'s drawings were engraved by son Ja-
LC ND652.H85 cobus(Thieme-Becker:Houbraken,Arnold)
 Thieme-Becker:Houbraken,
 Jacobus

II.B.1.b - NETHERLANDS - 16th c.

Wit, Frederik de,fl.c.1650 comp.
Lumen picturae et delineationis...Amstel-
odami,ex officina Frederici de Wit.1705?.
120 pl.

Incl.his schema of how to draw children's heads,
which is traceable to van de Passe & originally
to Dürer

Some plates are signed by H.Goltzius,C.Pass,
R.de Vorst and others

LC NC660.W5 Gombrich,Art & Illusion
 N7003),p.166-7

II.B.1.b - POLAND

Hutten-Czapski, Emeryk, hrabia, 1828-1896
Spis rycin przedstawiających portrety prze-
ważnie polskich osobistości w zbiorze Emeryka
hrabiego Hutten-Czapskiego w Krakowie.Z rękopisu
Emeryka Hutten-Czapskiego.wyd.F.Kopera.Kraków,
Nakł.Emerykowej Hutten-Czapskiej.1901

FOGG 382 p.
AM 340.7 List of graphic works representing portrs. of
mostly Polish personalities in the coll.of Count
Emeryk Hutten-Czapski in Krakau.From manuscript
...publ.F.Koper.Krakau.commissioned by Mrs.
Emeryk Hutten-Czapski,1901
 Fogg,v.11,p.323

II.B.1.b - U.S.

Historical Society of Western Pennsylvania,
Pittsburgh
An exh.of historical portraits,paintings,
prints,drawings and relics at the Carnegie
Institute,Pittsburgh 29 Oct.-30 Nov.,1916
69 p.

PH1

Chambers.David Gilmour
Blythe..N40.1.B67C4d 1974a
NMAA.Bibl.p.XXVI

II.B.1.c - PROFESSIONS - FRANCE - 19th c.

Tournachon, Félix, 1820-1910
Panthéon Nadar.1e feuille.Paris,1854

Caricature portraits of contemporary French
celebrities

NB

Stelzer.Kunst & photogr.
LC N72.P588,p.34

qE
209
U54
1975X
NMAA

II.B.1.b - U.S. - 18th c.

U.S. Library of Congress
The American Revolution in drawing and
prints,a checklist of 1765-1790 graphics in
the L.C. Comp. by Donald H.Cresswell,with a
foreword by Sinclair H.Hitchings.Washington,
1975
455 p. illus.

Bibliography p.414-22

II.B.1.c - SELF-PORTRAITS

Kunstverein Ulm
Graphische selbstbildnisse aus der samm-
lung Dr.Theobald Simon,Bitburg.Ausst..Kunst-
verein Ulm im Rathaus,7.Mai bis 4.Juni 1972
.Ulm,1972.
.31.p. illus.

Essay by Wilhelm Weber

MH

Metuschil.Künstler unter
sich N7619.5.03K86 1983X
NMAA p.136

N
40.1
F33yUS

II.B.1.b - U.S. - 19th c.

U.S. Library of Congress. Prints and Photo-
graphs Division
Charles Fenderich,lithographer of American
statesmen:a cat.of his work,by Alice Lee Par-
ker and Milton Kaplan.Washington,1959
64 p. illus.

LC NE2415.F4US

NE
275
K83X
NPG

II.B.1.c - SELF-PORTRAITS - GERMANY - 20th c.

Künstler sehen sich selbst:Graphische selbst-
bildnisse unseres jahrhunderts,Privatsamm-
lung.Ausst.im Städtischen Mus.,Braunschweig
vom 5.Des.1976 bis 23 Jan.1977.1976
192 p. illus.(part col.)

Collection Adolf Dörries
Incl.index
Bibliography

Notizen über das Selbstbildnis by Heinrich
Mersmann,p.9-19

LC NE275.K83

II.B.1.c. SPECIAL SUBJECTS

II.B.1.d. SPECIFIC MEDIA (Number not used
presently)

fN
40.1
R84R8
1927
NPG

II.B.1.c - PROFESSIONS - 19-20th c.

Rothenstein, (Sir)William, 1872-1945
The portrait drawings of William Rothen-
stein,1889-1925;an iconography...N.Y.,Viking
Press,1927

FOR COMPLETE ENTRY
SEE MAIN CARD

II.B.1.e. SPECIAL FORMS (e.g. Physionotrace)
(Silhouettes, see I.F.4.b.)

II.B.1.e - PHYSIONOTRACE

AP
1
A(area)

Bolton, Theodore, 1889- and H.L.Binsse
 The Peale portraits of Washington

In:Antiquarian
16:24-7,58,60,62,64 Feb.,'31 illus(part col)

 Miniatures, physionotrace
 Incl.cat.,comp.from ms.copy of C.W.Peale's
diary for the years 1775-1778 and part of 1788.
 Description & notes on the life portrs.of W
by members of the Peale family
 C.P.Polk copied many C.W.Peale portrs.of
 c.1787
 Arts in Am.q25961
 USA77X NCFA Ref. H72?

II.B.1.e - PHYSIONOTRACE

705
C75
NCFA
v.75

Martin, Mary
 The physionotrace in France and America:
Saint Mémin and others

In:Connoisseur
75:141-8 Jul,'26 illus.

II.B.1.e - PHYSIONOTRACE

705
A56
NCFA
v.9

Chamson, André
 Physionotrace profiles

In:Antiques
9:147-9,frontispiece Mar.,'26 illus(part col)

 Chicago.Art Inst.Ryerson
 Libr.Ind.to Art periodicals
 f25937.C53,v.8 NCFA Ref.
 p.7031

II.B.1.e - PHYSIONOTRACE

VF
St.-Mémin

Rice, Howard Crosby, 1904-
 Saint-Mémin's portrait of Jefferson

In:Princeton Uni Lib Chron
20:182-92 Summer,'59 illus.

 Bibliography on Saint-Mémin

 Note on the physiognotrace

LC Z733.P96C5 Whitehill.The Arts in ear-
 ly Amer.Hist.Z5935.W59 NPG
 Bibl.,p.93

II.B.1.e - PHYSIONOTRACE

Hennequin, René
 Avant les photographies;les portraits au
physionotrace,gravés de 1788 à 1830.Cat.nomina-
tif,biographique et critique illustré des deux
premières séries de ees portraits comprenant les
1800 estampes cotées de "1"à"R27".Troyes,J.L.
Paton,1932
 345 p. illus.
 Contents.-La société parisienne à la veille
de la Révolution;portrs.dess.par Quenedey et gra-
vés par Chrétien,1788-1789.-Au temps de la Révo-
lution ···portrs.dess.et gravés par Quenedey,
1789-1796
C NE270.H4

II.B.1.e - PHYSIONOTRACE

Vivares, Henry
 Le Physionotrace

In:Le Vieux papier,Paris. Bulletin
1906

 Bulletin de la société archéologique,his-
torique & artistique...

LC DC701.V52 Martin,M. In:Connoisseur
 Index t.1-17 75:148 1926

II.B.1.e - PHYSIONOTRACE

Hennequin, René, 1869-
 Un "photographe"de l'époque de la Révolution
et de l'Empire,Edme Quenedey des Ricoys(Aube),
portraitiste au physionotrace.Troyes,J.L.Paton,
1926
 170 p. illus.

FOGG
FA
6553.7

 At head of title:Société académique d'agri-
culture,des sciences,arts et belles lettres du
dép.de l'Aube,Troyes Nov.12,1928

MM NjP

II.B.2. DRAWINGS

II.B.1.e - PHYSIONOTRACE

705
C75
NCFA
v.74

Martin, Mary
 The Physionotrace in France and America

In:Connoisseur
74:144-52 Mar,'26 illus.

 Repro. incl.:Apparatus for making physiono-
trace from a drawing

 G.L.Chrétien invented the physionotrace,1786
 E.Quenedey-assistant of Chrétien
 Physionotrace portrs.most valuable historical
records

II.B.2.a. GENERAL

II.B.2.a

Ansbacher, Jessie
Portraits. N.Y.,Pitman Pub.Corp.,1959.
illus. (Pitman art series,23)

LC ND1302.A5 Books in print A1215.P92
 1975,v.2 NPG p.2959

741
.M5

II.B.2.a

Nader, Joseph, 1857-1934
Die Bildniszeichnung

In his,Die Handzeichnung,ihre technik und ent-
wicklung...Wien, A.Schroll & Co.G.m.b.H.,1923,
p.458-70 illus.

LC NC710.M4 Bell.Engl.17th c.portr.
 drawg. In:Walpole Soc.
 AP1.W225,v.14:44

II.B.2.a

Barcelona
Exposición de retratos y dibujos antiguos
y modernos 1910.Catálogo illustrado....Barce-
lona 1910.
203 p. illus.

MET
107.6
B237

II.B.2.a

Parramón, José Maria
Cómo dibujar la cabeza humana y el retrato.
Barcelona,Instituto Parramón.Ediciones,1964.
87 p. illus. (Colección aprender hacien-
do)

7000
3433
P25c

 Fogg,v.11,p.324

NC
772
B86
NPG

II.B.2.a

British museum. Dept.of prints and drawings
Portrait drawings 15-20 centuries.cat.of.
an exh.held...Aug.2-Dec.31,1974.London,British
Museum,1974. 112 p. illus.
Intro.by J.A.Gere

Index of artist;index of sitters

pp.6-23:15-16th c.;24-35:17th c.;36-63:ar-
tists(many self-portraits);64-71:caricatures;
72-5:actors,singers,etc.;76-108:18-20th c.Engl.

LC NC772.B74 (

II.B.2.a

The Portrait in art.Introd.by Stephen Long-
street.1st ed..Alhambra,Calif.,Borden
Pub.Co.,1965.
1 v. chiefly illus. (Master draughts-
man series)

LC NC1060.P6 Books in print.Subject
 guide,1985-6,v.3,p.4864

NC
80
V57X
NCFA

II.B.2.a

Florence, Loggia Rucellai
Visi e Figure in Disegni Italiani e Stranieri
dal Cinquecento all'Ottocento.(Faces and Figures
in Foreign and Italian Drawings from the Sixteenth
to the Nineteenth Century.).Milano,Ed.della Stam-
pa della Stanza del Borgo,1970
150 p. illus.
Intro.:Liliana dal Pozzo

Exhibition,Apr.30-May 31,1970
Exhibited also in Milan,Stanza del borgo

Bibliographical references
LC NC80.V57

II.B.2.a

Rubbra, Benedict
Draw portraits.N.Y.,Taplinger Pub.Co.,1979
47 p. illus. ("A Pentalic book")

LC NC773.R8 1979

II.B.2.a

Graves, Douglas R.
Drawing portraits...N.Y.,Watson-Guptill
Publ.,1974.
159 p. illus.

Bibliography

LC NC773.G72 1974 Books in print.Subj.guide
 Z1215.P92 1975 v.2 NPG
 p.2960

II.B.2.a

Saint-Igny, Jean de
Elemens de povrtraitvre.Privilege dated
Lyons,18 octobre,1630
43 p.

N.Y.P.L.
MFM S142
78-448no.1

NNH For source see main card

II.B.2.a

Sotheby, firm, auctioneers, LONDON
The cat. of the memorable Cabinet of draw-
ings by the old masters...1866

MFT
212
G
1866

Sale:June 25-July 10,1866

Italian,Spanish,French,German,Ditch,Flemish,
English schools,incl.c.200 by Claude

**FOR COMPLETE ENTRY
SEE MAIN CARD**

II.B.2.b. CHRONOLOGICAL

708.2
V622
c12s
NCFA

II.B.2.a

Victoria and Albert Museum, South Kensington
Portrait drawings.London,H.M.Stationery
Off.,1948,1963 printing
c32sp. chiefly illus. (Small picture
book,12)

Yale ctr.f.Brit.art Ref.

II.B.2.b - 16th c.

Chamberlaine, John, 1745-1812
Imitations of original drawings by Hans
Holbein,in the collection of His Majesty,for the
portraits of illustrious persons of the court of
Henry VIII...London,Printed by W.Bulmer and co.,
1792
c142sp. illus.in color

The plates are stipple engravings printed
in colors,all but four by F.Bartolozzi,three by
C.Metz,one by C.Knight

LC NC1055.H7 Fogg,v.11,p.321

II.B.2.a

Wellesley, Francis
Cat.of the ... coll.of...pen and ink and col
loured pencil drawings...sold by Sotheby,Wilkin-
son & Hodge,June 28,1920 and 4 ff days..London,
Riddle,Smith & Duffus,1920.

LC N5245.W45 MM MH MiU **FOR COMPLETE ENTRY
SEE MAIN CARD**

705
C75
NCFA
v.34

II.B.2.b - 17-18th c.

Mills, Weymer Jay, 1880-
Plumbagos

In:Connoisseur

**FOR COMPLETE ENTRY
SEE MAIN CARD**

II.B.2.a

Wellesley, Francis
A hand-list of the miniatures and portraits
in plumbago or pencil belonging to Francis and
Minnie Wellesley,with a foreword by Dr.G.C.
Williamson.Oxford,H.Hart,printer,1914
85 p.

LC N7616.W43 Fogg,v.11,p.326

N
7592.5
R82
NPG

II.B.2.b - 19th c.

Brandt Dayton Gallery, New York
Portraits and people.19th c. paintings and
drawings,exh.,Oct.12-Dec.3,1983.c1983,
unpaged 40 works shown illus(part col.)

Incl.:Index to cat.nos. of artists repre-
sented in the exhibition

705
C75
NCFA
v.51
v.52
v.53

II.B.2.a

Williamson, George Charles, 1858-1942?
Mr.Francis Wellesley's collection of ---
and drawings

In:Connoisseur

**FOR COMPLETE ENTRY
SEE MAIN CARD**

NC
772
S78
NPG

II.B.2b- 19-20th c.

Stampfle, Felice
Artists and writers;15th and 20th century
portrait drawings from the coll.of Benj.Sonnen-
berg.Cat. by Felice Stampfle and Cara Dufour.
With an introd.by Brendan Gill..Exh.held at.
the Pierpont Morgan Library,N.Y.,May 13-July 30,
1971.cNew York,1971.
52 p. illus.

Bibliography

LC NC31.S6S8

MOMA,p.434,v 11

NC
773
P85
NPG

II.B.2.b - 20th c.

Portraits, Inc., New York
 Portrait drawings 1900-1966. ﹛Catalog of
exhibition....New York,1966.
 ﹛28﹜p. illus.

705
B97
v.18

II.B.2.c - FRANCE

Dimier, Louis,1865-1943
 French portrait-drawings at Knowsley

In:Burl.Mag.
18:162-8 Dec.,1910

 A 'Court Album', copies of drawings which al-
so served enamelers; list of sitters & name of
artist of original drg.;Facsimile of handwritten
descriptions

II.B.2.c. BY COUNTRY, A-Z

II.B.2.c - FRANCE

Paris. Bibliotnèque nationale
 ...Exposition de portraits peints et dessi-
nés du 13ᵉ au 17ᵉ siècle.Avril-juin,1907.Cat.
2nd éd.Paris,E.Lévy,1907
 220 p. illus.

 Le cat.a été rédigé par François Courboin...
assisté de mm.Jos.Guibert,Paul André Lemoisne,
François Bruel..et Jean Laran

 See also Lemoisne,P.A.'s Notes in Rev.des
bibl. Paris,1907

LC N7604.P3 1907

N
40.1
J934x
P8
NPG

II.B.2.c - DENMARK

Poulsen, Ellen
 Tegninger af Jens Juel;illustreret katalog.
København,Statens Mus.for kunst,1975
 ﹛284﹜p. illus.

 Bibliography

NC
772
A23
NPG

II.B.2.c - FRANCE - 16th c.

Adhémar, Jean
 Les portraits dessinés du 16ᵉ siècle au ca-
binet des estampes;by J.Adhémar et Christine
Moulin.Paris,Cas.des beaux-arts,1973
 104 p. illus.

 Extrait de la Cas.des beaux-arts,Paris,sept.
et décembre,1973
 Repros.of almost all drags.with name of sit-
ters,date,biographical note,artist,info.given by
other catalogers(Bouchot,Dimier,etc.)
 Alphabetical i⌐⌐x of sitters
 Alphabetical ,index of artists by Bou-
chot & Dimier

AP
1
C27
NMAA

II.B.2.c - DENMARK - 19-20th c.

Frederiksborgmuseet
 Det nationalhistorisk Museum paa Frederiks-
borg.Beretning of året 1984-85.by Mogens Wahl,
Kristof Glamann,Olaf Olsen,Povl Eller

In:Carlsbergfondet,Frederiksborgmuseet,Ny Carls
bergfondet.Arsskrift 1986,p.81-91 illus(part
col.)
 Report of purchases & gifts.
 Repro.incl.:Drags.:Frederik VI by Christof-
fer Wilhelm Eckersberg.Frederik II & other
portrs.by Johannes Ejner Glob.Ptgs.by Victor
Isbrand,etc.

705
G28
NCFA
v.77

II.B.2.c - FRANCE - 16th c.

Broglie, Raoul de
 Les Clouet de Chantilly;Catalogue illustré
(coll.de Catherine de Médicis)

In:Cas Beaux Arts
77:257-336 May,1971 illus.

 Bibliogr.footnotes
 Cat.classified according to costume
 Alphabetical list of sitters

 Adhémar.Cas Beaux Arts
 Sept.&Déc,1973

II.B.2.c - FRANCE

Bouchot-Saupique, Jacqueline
 Le portrait dessiné français

In:Arts plastiques
﹛427-40 1949 illus.

 Incl.:Charles V ("parement de Narbonne)
Charles IX by Clouet,Gabrielle d'Estrées by Mas-
ter I.D.C.,Marquise de Brinvilliers by Lebrun,
Joseph Vernet by Q.de la Tour,etc.,to 19th c.

LC N2.A94

 Rep.,1948-49*1.020

II.B.2.c - FRANCE - 16th c.
Chantilly. Musée Condé
 Chantilly;crayons français du 16ᵉ siècle.
Catalogue précédé d'une introduction par
Étienne Moreau-Nélaton.Paris,Librairie centrale
des beaux-arts Émile Lévy,éd.,1910
 282 p. illus.

MET
102.71
C36

NNC MoD PPULC OClMA Pⁿ PPPM Broglie.In:Cas
 ﹛eaux Arts,77:269

II.B.2.c - FRANCE - 16th c.

Mongan, Agnes
 A group of newly discovered sixteenth century French portrait drawings

In:Harvard Library B.
1:155-75 1947 illus.

 Portr.drgs. of Francis II,Mary Stuart,Laval, Marshal Montmorency,etc. Very little known part of portr.group around Clouet. Disbursed to different American coll.after exhib. in The Fogg mus.in 1946

LC Z881H3403 Rep.,1948-49×6890

NC
860
P23
NPG

II.B.2.c - FRANCE - 16-17th c.

Bouchot, Henri François Xavier Marie, 1849-1906
 Les portraits aux crayons de 16e et 17es. conservés à la Bibl.Nat.(1525-1646). Paris, H.Oudinet Cie,1884
 illus.

LC N7621.P3

II.B.2.c - FRANCE - 16th c.

Moreau-Nélaton, Étienne, 1859-1927
 Le portrait à la cour des Valois. Crayons français du 16me siècle,conservés au Musée Condé à Chantilly:introduction & notices...Paris, Librairie centrale des beaux-arts,1908.
 5 v. illus.

 v.2-5:portraits in portfolios

LC N7604.C5 Amsterdam,Rijksmus.cat.
 X5939A52,deel 1,p.501

705
G28
NCFA
v.49

II.B.2.c - FRANCE - 17th c.

Fromrich, Yane
 Robert Nanteuil dessinateur et pastelliste

In:Gas Beaux Arts
49:209-17 Apr.,'57 illus.

 English summary
 ...one of the great masters of French portraiture in the 17th c.& the precursor of the art of the pastellists of the 18th c.

 Moon.Engl.portr.drag...
 NC860.N66X NPG p.X1
 footnote 12

II.B.2.c - FRANCE - 16th c.

Moreau-Nélaton, Étienne, 1859-1927
 Le portrait en France à la cour des Valois. Crayons français du 16me siècle conservés dans la collection de M.G.Salting à Londres,introduction & notices...Paris,Librairie centrale des beaux-arts,1909.
 26 p. illus.

LC N7604.83 Amsterdam,Rijksmus.cat.
 X5939A52,deel 1, p.501

705
G28
NCFA
v.97

II.B.2.c - FRANCE - 17th c.

Schenk su Schweinsberg, Eberhard, 1893-
 Un album de "Lagneau"prevenant de Thouars?

In:Gas Beaux-Arts
97:189-200 May-June,'81 illus.

II.B.2.c - FRANCE - 16th c.

New York. French institute in the United States
 Le portrait français au 16e siècle du temps des Valois.Loan exh. N.Y.,French inst., 1939
 3-8 p.

NNC

AP
1
P89
NCFA
v.4

II.B.2.c - FRANCE - 17th c.

Thomas, Thomas Head, 1881-
 The drawings and pastels of Nanteuil

In:Print Coll Q
4:327-61 Dec.,'14 illus.

 Repro incl.a pastel of Louis XIV

 Fromrich.Rbt.Nanteuil in:
 Gas Beaux Arts 49:209,footnote 1

705
C75
NCFA
v.60

II.B.2.c - FRANCE - 16th c.

Popham, Arthur Ewart, 1889-
 French portrait drawings of the 16th century

In:Connoisseur
60:139-45 Jul.'21 illus.

 Repro.:Clouet, Jean Perréal?

 Cumulated Mag.subj.index
 A1/3/C76 Ref. v.2,p.444

II.B.2.c - FRANCE - 17th c.

Vulson de la Colombière, Marc, d.1658
 Les hommes illustres et grands capitaines françois qui sont peints dans la Galerie du Palais Royal...avec leurs portraits...dessignes & graves par les sieurs Heince & Bignon..Paris, Estienne Loyson,1690
 66 p. illus.

 Publ.previously in 1650 with title:Les portraits des hommes illustres françois...400 p. LC has 1668 ed.:DC36.V8

CSt Winterthur Mus.Libr. f2881
 .W78 NCFA v.9,p.226

N
40.1
G28x08
NPG
R.B.

II.B.2.c - FRANCE - 18th c.

Gruyer, François Anatole, 1825-
Chantilly:les portraits de Carmontelle...
Paris,Plon-Nourrit et cie,1902
388 p. illus.

Incl.:Contents. List of sitters

LC N7604.C2

Winterthur Mus.Libr. f2811
.78 v.9,p.226

741.91
.P23

II.B.2.c - GERMANY - 16th c.

Parker, Karl Theodore, 1895-
The drawings of Hans Holbein in the col-
lection of His Majesty the King at Windsor
castle...London,The Phaidon press ltd.,1945.N.Y.
Oxford Univ.Pr.
62 p. illus.

Bibliographical footnotes

LC NC1055.H7P3

QN
40.1
C42xA5
NCFA

II.B.2.c- FRANCE - 19th c.

Andersen, Wayne V
Cézanne's portrait drawings .by Wayne An-
dersen.Cambridge,MIT Press,1970,
247 p. illus.

Bibliography

Incl.Chronology for the portr.drags.
Cat.raisonné
Self-portrs.,Mme Cézanne,Cézanne's father,
mother,friends,etc.
LC NC1135.C45A7

MOMA, p.434 v.11

705
H97
NCFA
v.15

II.B.2.c - GERMANY - 19th c.

Baillie-Grohman, William A.
Some historical portraits of the Biedermaier
period of German art

In:Burl Mag
15:114,118-9 May,'09 illus.

Repro.:Archduke of Austria,Emperor Francis I
of Austria,drgs.by Louis Schnorr von Carolsfeld

Cumulated mag.subj.index
A1/3/C76 Ref. v.2,p.444

IN
40.1
I 55xN2
NCFA

II.B.2.c - FRANCE - 19th c.

Naef, Hans, 1920-
Die bildniszeichnungen von J.-A.-D.Ingres.
Beiträge zu einer historisch-kritischen gesamt-
darstellung.Teildruck:Schweizer künstler in
bildnissen von Ingres.Zürich,Conzett & Huber,
1962
101 p. illus.

Ph.D. Dissertation,Zürich,1962

QN40.1
H5194xN2
NPG

II.B.2.c - GERMANY - 19th c.

Berlin. National-Galerie
Preussische bildnisse des 19.jahrhunderts.
Zeichnungen von Wilhelm Hensel.Ausstellung Na-
tionalgalerie Berlin...21.Aug.-18.Okt.,1981.
Berlin,1981,
167 p. illus.
Personenregister p.161-7
Einführung zu Wilhelm Hensel & Kat.by
Cécile Lowenthal-Hensel
Die bildnissammlung Wilhelm Hensels in der
Nationalgalerie by Lucius Grisebach

Exh. also at Nuremberg.Germ.Nat'l Mus.
30.Okt.1981-3.Jan. 1982, etc.

N
40.1
I55x
N2b
NMAA

II.B.2.c - FRANCE - 19th c.

Naef, Hans, 1920-
Die Bildnisszeichnungen von J.A.D.Ingres...
Bern,Benteli,cop.1977-cop.1980
5 vols. illus.

Incl.text in English,French,German,or
Italian
bibl.ref.
Index

NC
860
N66X
NPG

II.B.2.c - GREAT BRITAIN

Noon, Patrick J.
English portrait drawings and miniatures.
New Haven,Ct.,Yale Center for British Art,1979
152 p. illus.

FOR COMPLETE ENTRY
SEE MAIN CARD

II.B.2.c - GERMANY - 16th c.

The Family of Sir Thomas More.Facsimiles of
the drawings by Hans Holbein the younger
in the Royal Library,Windsor Castle.N.Y.,
Johnson Reprint Corp.,1978
8p.&8 pl. col.

Intro.by Jane Roberts

NPG VF Holbein,Hans,the
younger

II.B.2.c - GREAT BRITAIN - 16-17th c.

Woodward, John O.
Tudor and Stuart drawings.London,Faber and
Faber,1951.
57 p. illus.

Bibliogr.footnotes

.W..stresses the light that can be thrown by
a study of drags.on the developm't of portrait
practice & on some phases in the history of
taste.'-Oliver Millar in Review. Burl.Mag.93:332

LC NC1025.W6 1951

Noon,Brit.portr.drags.& min.
NC860.N66X NPG Bibl.,p.149
(cont'd on next card)

II.B.2.c - GREAT BRITAIN - 17th c.

Bell, Charles Francis,1871- and Rachel Poole
 English 17th-century portrait drawings in
Oxford collections.Pt.I

In:Walpole Soc.
5:1-18 1915-17

 General account of the collections

LC N12.W3

705
C75
NCFA II.B.2.c - GREAT BRITAIN - 17-19th c.
v.92
Cundall, Herbert Minton, 1848-1940
 Drawings at Windsor Castle.III.Some portraits

In:Connoisseur
92:75-82 Aug,'33 illus.
 Repro.:Sam.Cooper,Bartolozzi,Cipriani,
Hamilton,Cosway,Edridge,Huck,Ross,Lely

AP
1
W225 II.B.2.c - GREAT BRITAIN - 17th c.
NCFA
v.14 Bell, Charles Francis, 1871- and Rachel Poole
 English 17th-century portrait drawings in
Oxford collections.Pt.II:Miniature portraiture
in black lead and Indian ink

In:Walpole Soc.
14:43-80 1925-26 illus.

 Incl.chapter on Wm.Faithorne,p.49-55;David
Loggan,p.55-64;Rbt.White,p.64-71;Portr.of Arch-
bishop Oliver Plunket,p.71-73;Ths.Forster,p.73-
76. Lists of dated or named drags.& engrs.'ad
vivum'& signed engravers,not inscribed 'ad vivum'

705
C85
NCFA II.B.2.c-GREAT BRITAIN - 18th c.
v.141
Hammelmann, Hanns A.
 A draughtsman in Hogarth's shadow.The draw-
ings of John Vanderbank

In:Country Life
141:32-3 Jan.5,'67 illus.

705
C75
NCFA II.B.2.c - GREAT BRITAIN - 17th c.
v.147
Reynolds, Graham, 1914-
 Samuel Cooper:some hallmarks of his abili-
ty

In:Connoisseur
147:17-21 March,'61 illus.

 Murdoch.Engl.miniatures
 ND2202.67E5X NMAA Abbrevia-
 tions

q N
40.1
G14xH4 II.B.2.c - GREAT BRITAIN - 18th c.
NCFA
 Hayes, John T.
 The drawings of Thomas Gainsborough...
New Haven,Yale Univ.Press,1971,c.1970.
 2 v. illus.

 Portr.drawings vl.I,p.109-29

 FOR COMPLETE ENTRY
 SEE MAIN CARD

N
40.1
K68S8 II.B.2.c - GREAT BRITAIN - 17th c.
NPG
 Stewart, J.Douglas
 Sir Godfrey Kneller.cat.of an exh.at the
NPG,London,Nov.-Dec.,1971...London,Bell;Nat'l
Portrait Gallery,1971
 82 p. illus(part col.)

 Bibl.references
 Incl.:Lady Eliz.Cromwell as St.Cecilia
 Chapters incl.:Drawings;Ladies & children;
Lords & Gentry;Scholars & Poets;Army & Navy;
Parade portrait.Appendix:Kit-cat club portrs.

LC ND1329.K55S7

II.B.2.c - GREAT BRITAIN - 18th c.

Hogarth, William, 1697-1764
 The drawings of William Hogarth,by A.P.Oppé
London,Phaidon Press,1948
 65 p. illus.

 Cat.p..26.-65

 Bibliography

LC NC1115.H65 O6 Moon.Engl.portr.drags.&min.
 NC860.N66X Bibl. p.147
 NPG

II.B.2.c-GREAT BRITAIN - 17-18th c.

Oppé, Adolf Paul, 1878-1957
 English drawings,Stuart and Georgian pe-
riods,in the coll.of H.M.the King at Windsor
Castle.London,Phaidon Press,1950.
 215 p. illus.

LC NC1025.O6 Moon.Engl.portr.drags.&min.
 NC860.N66X NPG Bibl. p.147

705
M19
NCFA II.B.2.c - GREAT BRITAIN - 18-19th c.
v.22
Roberts, William, 1862-1940.
 George Dance and his portraits,recently
come to light

In:Mag Art
22:656-8 1898 illus

 Over 200 portr.drags....

 FOR COMPLETE ENTRY
 SEE MAIN CARD

B
.D75W7

II.B.2.c - GREAT BRITAIN - 18-19th c.

Williamson, George Charles, 1858-1942
...John Downman...with a cat.of his drawings.
London,Otto,ltd.,1907

LC ND497.D6W5 FOR COMPLETE ENTRY
 SEE MAIN CARD

II.B.2.c - GREAT BRITAIN - SCOTLAND

Edinburgh. Scottish national portrait gallery
 Portrait drawings by Scottish artists,1750-
1850;and exhibition...24th July-11th Sept.1955.
Edinburgh,1955
 34 p.

FOGG
6233
E23

LC 741.041E23p MiDA MH Fogg,v.11,p.333

AP
1
A64
NCFA
v.102

II.B.2.c - GREAT BRITAIN - 19th c.

Archer, Mildred
 Wellington and South India;portraits by
Thoma Hickey

In:Apollo
102:30-5 July,'75 illus.

 Portr.studies in charcoal & chalk...

 FOR COMPLETE ENTRY
 SEE MAIN CARD

II.B.2.c - NETHERLANDS - 16-17th c.

Les Mémoriaux d'Antoine de Succa...Bruxelles,
Bibliothèque Albert 1er,1977

LC ND655.P664 t.7 FOR COMPLETE ENTRY
 SEE MAIN CARD

AP
1
W225
NCFA
v.21

II.B.2.c - GREAT BRITAIN - 19th c.

Kitson, Sydney Decimus, 1871-
 Notes on a collection of portrait drawings
formed by Dawson Turner

In:Walpole Soc.
21.:67.-104 illus. 1932-1933

 "In 1927 2 v.of portr.drawgs.were sold at
Sotheby's & bought by the V.& A.mus. ..."

 Repro.incl.J.P.Davis,Cotman,Chantrey,Varley,
etc.
LC N12.W3,v.21 Fogg,v.11,p.323

II.B.2.c - SWEDEN - 18th c.

Lindwall, Bo, 1915-
 Svenska teckningar 1800-talet.Stockholm,
Rabén & Sjögren,1984
 207 p. illus(part col.) (Arsbok för
Statens konstmuseer 30)

 Bibliography

 Incl.:Porträttecknare p.66-72

 Summary in English,p.201-4

LC NC282.L56 1984

N
40.1
M956xR7
NCFA

II.B.2.c - GREAT BRITAIN - 19th c.

Mulready, William, 1786-1863
 Drawings by William Mulready..Cat.of draw-
ings in the Victoria and Albert Museum.by.Anne
Rorimer.London,Victoria and Albert Museum,1972
173 p. illus.

 Incl.bibliography

 Ch.VI.Portraits and heads,p.108-20

 Noon.Engl.portr.drags.&min.
 NC860.N66X NPG Bibl. p.147

N
7593.1
B69
1969
NPG

II.B.2.c - U.S.

Bolton, Theodore, 1889-
 Early American portrait draughtsmen in
crayons...Charleston,S.C.,Garnier & Co.:1969.

 111 p. illus.

 Lists artists up to 1860,incl.foreign ptrs.
working in America. Index of sitters

LC N7593.B6

II.B.2.c - GREAT BRITAIN - 20th c.

Rothenstein, (Sir)William, 1872-1945
 Contemporaries; portrait drawings by Sir
William Rothenstein, with appreciations by
various hands. London,Faber & Faber ltd.:1937.

 112 p. illus.

 Incl:Viscount Allenby, Austen Chamberlain,
Kipling,Macmillan,Maugham,Munthe,Aurel Stein,
Tagore,Tovey,Yeats

LC N7598.R49 Rep.,1938#57?

705
C75
NCFA
v.109

II.B.2.c - U.S. - 18th c.

Comstock, Helen
 Drawings by J.S.Copley in the Karolik col-
lection

In:Connoisseur
109:150-5 June,'42 illus.

 FOR COMPLETE ENTRY
 SEE MAIN CARD

705
P18
NCFA

II.B.2.c - U.S. - 18th c.

Comstock, Helen
<u>Drawings by John Singleton Copley</u>

In:Panorama
2:99-108 May,1947 illus.

FOR COMPLETE ENTRY
SEE MAIN CARD

II.B.2.c - U.S. - 19th c.-20th c.

Gibson, Charles Dana, 1867-1944
Pictures of people,by Charles Dana Gibson
N.Y.,R.H.Russell & Son,1896
1 l. 43pl.

MM OEac PP OCIW etc. Books in print,Subject
Guide,1985-6,v.3,p.4864

705
B97
NCFA
v.114

II.B.2.c - U.S. - 18-19th c.

Evans, Dorinda
1. Twenty-six drawings attributed to Mather
Brown

In:Burl Mag
114:534-41 Aug.,'72 illus.

The drags.are in Edinburgh. Scottish N.P.G.

Moon.Engl.portr.drags...
NC860.M66X NPG p.XIII
footnote 19

II.B.2.c - U.S. - 19-20th c.

Sargent, John Singer, 1856-1925
Sargent portrait drawings...N.Y.,Dover,
1983
48 p. illus. (Dover Art Library)

42 works

LC NC139.S27A4 1983 Books in print,subject
guide 1985-86,v.3,p.4864

N
7592
H513
RB
NPG

II.B.2.c - U.S. - 18-19th c.

Henkels, Stanislaus Vincent, 1854-1926
Cat.of the very important coll.of studies
and sketches,made by Col.John Trumbull...as
well as his important coll.of engravings and
portraits in mezzotint,line and stipple...to
be sold Thur,Dec.17,1896.Cat.comp.,and sale
conducted by Stan.V.Henkels at the art auction
rooms of Thos.Birch's Sons,Philadelphia
39 p. illus.
cat.no.770

Sale by order of B.Silliman,who inherited
the effects of Col.John Trumbull

N
40.1
B1195xL8
NPG

II.B.2.c - U.S. - 20th c.

Bachardy, Don, 1934-
<u>Don Bachardy,drawings.exh..Los Angeles,</u>
Municipal Art Gallery.pref.1973.

FOR COMPLETE ENTRY
SEE MAIN CARD

NPG
NC
772
S2I

II.B.2.c - U.S. - 18-20th c.

Sadik, Marvin S.and Harold Francis Pfister
American portrait drawings.An exh.at the Na
tional Portrait Gallery,May 1-Aug.3,1980.Publ.
for NPG by the Smiths.Inst.Press.City of Wa-
shington,1980
214 p. illus.

Incl.Biography of the artists

LC NC772.S2

II.B.2.c - U.S. - 20th c.

Bachardy, Don, 1934-
70 x 1:drawings.Illuminati,1983
80 p. illus.

CVala CStmo Books in print.Subject
guide,1985-6,v.3,p.4864

N
6510
P74
NCFA
c.1Ref.
c.2NCFA

II.B.2.c - U.S. - 19th c.

Boston. Museum of Fine Arts
M. & M.Karolik coll.of American Water co-
lors & drawings,1800-1875.Boston,1962
2 v. illus(part col.)

v.2,p.96-136:Portraits

Exh.held...Oct.18,1962-Jan.6,1963
Incl.bibliographies

NC
772.D66
NPG

II.B.2.c - U.S. - 20th c.

Domanski, A.
Faces 1973.Santa Barbara,Calif.,Intelman
books,1974
116 p. (mostly illus.) (Intelman Library
no.5)

Drawings made from public television appear-
ances
Alphabetical list of sitters

II.B.2.d. SPECIAL SUBJECTS, A-Z

II.B.2.d - SELF-PORTRAITS

Self-portraits of great artists.Intro.by
 Stephen Longstreet..1st ed..Alhambra,Calif.
Borden Pub.Co..1973,
 ،48،p. (chiefly illus.) (Master
draughtsman series)

LC NC772.S44

Books in print.Subj.guide
Z1215.P52 1975 v.2 NPG
p.2960

705
M19
NCFA
v.22

II.B.2.d - PROFESSIONS

Roberts, W.illiam, 1862-1940.
 George Dance and his portraits,recently
come to light

In:Mag Art
22:656-8 1898 illus.

 Over 200 portr.drags.,53 of artists in Royal
Academy.Authors,actors,medical men,etc.sold at
Christie's,Jl.1,1898...

FOR COMPLETE ENTRY
SEE MAIN CARD

II.B.2.d - WOMEN - GREAT BRITAIN - 20th c.

Some beautiful women of to-day.Drawn by Nicho-
 las Egon.London,Putnam.1952,
 10 p. illus.(48 portrs.)

Introd.by Maurice Collis

 'The psychology of these faces is quite
unlike that in any other epoch.'-Collis

MoK ILfC etc.

Book review.Studio,July,'5
 v.146:32
 " " Apollo,Feb.'53
 v.57:64

VF

II.B.2.d - PROFESSIONS - ARTISTS

Amsterdam, Rijksmuseum. Prentenkabinet
Getekende kunstenaarsportretten...1975
 (Rijksprentenkabinet no.XI)

FOR COMPLETE ENTRY
SEE MAIN CARD

II.B.2.e. SPECIFIC MEDIA

II.B.2.d - PROFESSIONS - MUSICIANS

Hague. Gemeentemuseum
 Portraits of composers and musicians on
prints and drawings....Zug,Switzerland,Inter
Documentation Co.,1977,

N.Y.P.L. *XML-1269 microfiche

FOR COMPLETE ENTRY
SEE MAIN CARD

VF
Christy

II.B.2.e - CHARCOAL - U.S. - 20th c.

Christy, Margaret Arlington(Marna Prior)
 Quest for centenarians.Publ.by Christy,
Norwalk,Ohio,1982
 128 p. illus.

Dayton,O. Dayton &
Montgomery P.L.

Plain Dealer(Cleveland,O.)
Dec.4,'83,pg. 31,35

II.B.2.d - SELF-PORTRAITS

The artist by himself:self portrait drawings
from youth to old age;ed.by John Kinneir;
intro.by David Piper.N.Y.,St.Martin's
press,1980
 224 p. illus.

N.Y.(City).P.L.Art & architect
Div. Bibliogr.guide to art &
architecture.1979. Z5939
A791 1979 v.2,p.233

LC NC772.A77

705
A784
NCFA
v.9

II.B.2.e - CRAYON - FRANCE

Bolton, Theodore, 1889-
 Saint-Mémin's crayon portraits

In:Art in Am
9:160-7 Jun,'21 illus.

 Incl.list of crayon drawings by St.-Mémin

II.B.2.e - CRAYON - FRANCE - 16th c.

Miel, P.G.J.
Portraits des personnages français les plus
illustres du 16e siècle, reproduits, en facsimilé,
sur les originaux dessinés aux crayons de cou-
leur par divers artistes contemporains; recueil
publié avec notices par P.G.J.Miel...Paris,
M.A.Lenoir, 1848-56
2 v. illus(col.)

Contents.1.sér.Rois et reines de France.Mai-
tresses des rois de France.2.sér.Personnages di-
vers
1..facsimile ar Riffaut.'-Bouchot,p.11
 Bouchot.Portrs.aux crayons,p.11
LC DC35.5.N67

II.B.2.e - GRAPHITE

N
7616
W72,
NPG

Williamson, George Charles, 1858-1942
How to identify portrait miniatures...with
chapters on how to paint miniatures by Alyn
Williams.London,G.Bell & sons,1904
126 p. illus.

Bibliography

Partial contents:XI.Portrs.in enamel and
plumbago;XIV.Collectors and collections.

 Moon.Engl.portr.drags.& min-
 C860.N66X NPG "ibl.p.148

NC
660
23
NPG

II.B.2.e - CRAYONS - FRANCE - 16-17th c.

Bouchot, Henri François Xavier Marie, 1849-1906
Les portraits aux crayons de 16e et 17e s.
conservés à la Bibl.Nat.(1525-1646). Paris,
H.Oudinet Cie,1884
412 p. illus.

Incl.:Listes de crayons ou peintures conservés
dans des coll.publ.ou privées.Étrangères.A la
Bibl.nat.:France:Bibl.d'Arras-Bibl.des Arts-et-Mé-
tiers-Coll.de ?.Courajod-Ancien Cabinet Fontette-
Mus.du Louvre(dessins et peinture)-Portrs.peints
du Mus.de Versailles see over
LC N7621.P3 nd contin'd on next card

705
C75
NCFA
v.51
v.52
v.53

II.B.2.e - GRAPHITE

Williamson, George Charles, 1858-1942
Mr.Francis Wellesley's collection of ...
and drawings

In:Connoisseur

FOR COMPLETE ENTRY
SEE MAIN CARD

705
C75
NCFA
v.34

II.B.2.e - GRAPHITE

Mills, Weymer Jay, 1880-
Plumbagos

In:Connoisseur

FOR COMPLETE ENTRY
SEE MAIN CARD

AP
1
W225
NCFA
v.14

II.B.2.e - GRAPHITE - GREAT BRITAIN - 17th c.

Bell, Charles Francis, 1871- and Rachel Poole
English 17th-century portrait drawings in
Oxford collections.Pt.II:Miniature portraiture
in black lead and Indian ink

In:Walpole Soc.
14:43-80 1925-26 illus.

FOR COMPLETE ENTRY
SEE MAIN CARD

II.B.2.e - GRAPHITE

Wellesley, Francis
Cat.of the ... coll.of plumbago...sold by
Sotheby,Wilkinson & Hodge,June 28,1920 and 4 ff
days..London,Riddle,Smith & Duffus.1920.

LC N5245.W45 NN MH MiU FOR COMPLETE ENTRY
 SEE MAIN CARD

705
G28
NCFA
v.3

II.B.2.e - STIPPLE - FRANCE

Hédouin, Pierre, 1789-1868
Hilaire Ledru;détails biographiques sur ce
dessinateur

In:Gaz.Beaux Arts
3:230-6 Aug.,1859 illus.

Lists 4 ptgs. & 12 drawgs.

"During the Directory the most sought after
portraitists."-Th.B.

II.B.2.e - GRAPHITE

Wellesley, Francis
A hand-list of the miniatures and portraits
in plumbago or pencil...Oxford,H.Hart, printer,
1914

LC N7616.W43 FOR COMPLETE ENTRY
 SEE MAIN CARD

705
G28
NCFA
v.9

II.B.2.e - STIPPLE - FRANCE

Saunier, Charles, 1865-
Les oubliés.Hilaire Ledru

In:Gaz.Beaux Arts
9:45-68 Jan.,1913 illus.

List of ptgs.& drawgs.sent to the Salon,
1795-1824
"L.doit surtout ses succès aux portrs.au cra-
yon exécutés "au pointillé".-Rep.
"During the Directory the most sought after
portraitist:-Th.-B.

II.B.2.f. SPECIAL FORMS

II.B.3.a

Avezac-Lavigne, Charles
 L'histoire moderne par la gravure;ou,Cata-
logue raisonné des portraits historiques avec
renseignements iconographiques...Paris,E.Leroux,
1878
 238 p.

LC NE220.A8 Fogg,v.11,p.320

II.B.3. PRINTS

II.B.3.a

Diepenbroick-Grüter, Hans Dietrich von, firm
 Allgemeiner portrüt-katalog;verzeichnis
einer sammlung von 30000portrüts des 16.bis 19.
jahrhunderts in holzschnitt,kupferstich,schab-
kunst und lithographie,mit biographischen notizen.
Hamburg,...1931

 902 p. issued in 5 parts.

 Index of professions & subjects(äSchlagwort")
list of places & countries.Index of hidden names

LC NE220.D5

II.B.3.a. GENERAL

N
7624
H24
NPG

II.B.3.a

Diepenbroick-Grüter, Hans Dietrich von, firm
 Portrütsammlung. Tecklenburg in Westfalen,
1954-

 Cat.with price-list of portrait prints,
grouped mainly by regions in Germany.Published
in sections(1)Niedersachsen,1954,(2)Schöne,sel-
tene und interessante portrüts,1955,(3)Westfa-
len nebst Lippe,1956,(4)Nordrhein...1956,(5)
Rheinland-Pfalz,1956,(6)Hessen,1956,(7)Grosse,
dekorative portrüts.grouped by professionn1958,
(8)Schleswig-Holstein Hamburg,Lübeck,Bremen,
(9)Württemberg, nebst Hohenzollern

II.B.3.a see also II.B.3.e - ENGRAVING
 (Some authors use Engraving as generic term
 instead of Prints)

NE
218
H37
1987X
NPG

II.B.3.a

Harris, Constance
 Portraiture in prints.Jefferson,N.C.,McFar-
land,c.1987
 335 p. illus.

 Index
 Bibl.,p.311-16

LC NE218.H37 1987

YY
Brockhurst

II.B.3.a

Albrecht Art Museum, St.Joseph,Mo.
 Gerald L.Brockhurst.Master of the etched
portrait..Exh..3 Sept.-10 Nov.,1985
 unpaged illus.

 Incl.:Pamphlet:'Adolescence'by G.L.Brock-
hurst, the five states and drawing

II.B.3.a

Der Herrscher:graphische bildnisse....s.l..:
 Landschaftsverband Westfalen Lippe,1977.

LC NE219.2.G3H833 FOR COMPLETE ENTRY
 SEE MAIN CARD

NE
70
K35m
NCFA

II.B.3.a

Kennedy Galleries,inc., New York
 Master Prints Twelve.Portraits in prints.
From Nov.1 to Dec.30,1983.N.Y.,Kennedy Galleries,1983
 111 numbers illus.

 Index by sitters.Index by artists

NE
250
O52
NPG

II.B.3.a

Olschki, Leo Samuel, 1861-1940,firm, Florence
 Portraits of artistic and iconographical
interest.Firenze,Libreria antiquaria...,1961
 521 nos. illus.

 Contents:Some choice portrs.:Artists;Kings
& soldiers;Men of letters;Musicians;Physicians
& men of science;Statesmen & magistrates;Various;Some books with portraits

 Cat.no.139

NE
250
M105
1925
NMAA

II.B.3.a

Knoedler,M.and company, New York
 Cat.of an exh.of portrait etchings by
Van Dyck,Rembrandt,Whistler,Degas,Rodin and
Zorn;together with four lithographs by Jean
Dominique Ingres,Oct.,1925.M.Knoedler & Co.
1925
 16 p.

763
O 82

II.B.3.a

Oslo, Nasjonalgalleriet
 Katalog over kobberstukne portretter...Oslo,
Kirstes boktrykkeri,1927,

**FOR COMPLETE ENTRY
SEE MAIN CARD**

II.B.3.a

Mitchell, James Tyndale, 1834-1915
 ...The unequaled collection of engraved portraits of eminent foreigners,embracing kings,
eminent noblemen & statesmen,great naval commanders...explorers,...reformers...;also a collection
of caricatures on Napoleon & a ...coll.of portrs.
engravings by the great masters of the last four
centuries in line,mezzotinto,stipple & etching..
to be sold...Oct.14,1912...and Oct.15,1912.Cat.
comp.& sale: conducted by Stan.V.Henkels at the
book auction rooms of S.T.Freeman & co.,Phila.,Pa.
,M.H.Power,printer,1912,
 111p. illus.
Cat.no.944,pt. XII
LC NE240.M515

II.B.3.a

Paris. Bibliothèque Nationale. Département des
 estampes.
 Cat.de la coll.des portraits français et
étrangers conservée au Département des estampes
de la Bibliothèque nationale...Paris,G.Rapilly,
1896-1912(1919)
 ,7,vols.

 Commencé par Georges Duplessis,continué par
Georges Riat,,P.A.Lemoisne,Jean Laran.

 Amsterdam,Rijksmus.cat.
LC NE230.P2A6 75939X52,deel 1,p.133

760
.N21M68

II.B.3.a

Mitchell, James Tyndale, 1834-1915
 ...The unequalled collection of engraved
portraits of Napoleon Bonaparte and his family
and marshals,belonging to Hon.J.T.Mitchell...
portraits in mezzotinto,aquatint,line and stipple
...caricatures on Napoleon by Cruikshank,Gillray,
Rowlandson...to be sold...1908.Philadelphia,Pa.,
,Press of W.F.Fell,company,1908,
 100 p. illus.
 (Sold at book auction rooms of S.T.Freeman & co
(Catalogue compiled...by Stan V.Henkels)
Cat.no.944,pt.VII
LC DC203.EN5

II.B.3.a

Bauer, Hans
 Das Bildarchiv der Österreichischen Nationalbibliothek,ein Institut zur öffentlichen
pflege der dokumentarphotographie.Geschichte
und programm.Wien,Gallus-Verlag,c.1947,
 130 p. illus.

 Repro.incl.:Photo of Leon Gambetta;Johann
Strauss with Johannes Brahms
 Appendix p.117 lists :Reproduktionsplatten
aus abteilungen der Österr.Nat'lbibl.500001-
600000 Porträtsammlung(Graphik und foto)
LC Z794.V66P3

N
7592
G24
NPG

II.B.3.a

New York. Metropolitan museum of art. Crosby
 Brown collection
 ...Cat.of the Crosby Brown coll.of musicians'
portraits...N.Y.,The Metrop.mus.of art,1904
 131 p. (The Metropolitan mus.of art.Handbook no.13,IV)
 Cat.by Clara Buffum

 Incl.:Classified,geographical and alphabetical indexes
 NPG copy bound with Garrick club,London.Cat.
of the pictures...London,1909
LC ML390.N5 copy 2:N611.B7

NE
240
K64S72X
NPG

II.B.3.a

Stanford University. Libraries. Division of
 Special Collections
 Portraits:a cat.of the engravings,etchings,
mezzotints,and lithographs presented to the
Stanford Univ.Library by Dr.and Mrs.Leon Kolb.
Comp.by Susan V.Lenkey.Stanford,Calif.,Stanford University,1972
 373 p. 1 illus.

 Listed by sitters,indexed by social and
historical positions of the subjects; painters
with their sitters: engravers; techniques
LC NE240.K64S72

AP
1
A83
NCFA

II.B.3.a

Stefflet-Santiago, Mary
 Artists' portraits and self-portraits

In:Artweek
7,pt.3:3-4 Jan.17,1976 illus.

 Pertains to exh.at Achenbach Foundation
for Graphic Arts,San Francisco,comprising prints
fr.their coll. & a private coll.

FOR COMPLETE ENTRY
SEE MAIN CARD

II.B.3.b RENAISSANCE

Goldschmidt, Ernst Philip, 1887-1954
 The printed book of the Renaissance.Cambridge
‚Eng.University Press,1950
 92 p. illus.
 Survey of early illustrated printed books

LC Z124.G6

Rave.Jb.d.Berl.Mus.I 1959
C N3.J16 fol.p.122 footn.
Paolo Giovio & d.Bildnisvitenbü-
 cher...

N
7628
W31W5
NCFA

II.B.3.a

Whelen, Henry,jr.
 ...The important collection of engraved por-
traits of Washington belonging to the late Hen-
ry Whelen,jr.,of Philadelphia...from whose co-
llection the late Wm.S.Baker compiled his...boo
..."Engraved portrs.of Washington"...also en-
graved portrs.of Franklin;to be sold...Apr.27,
1909...Cnt.comp.and sale conducted by Stan V.
Henkels at...Samuel T.Freeman & co...Philadel-
phia,Phila.,Press of M.H.Power,1909.
 102 p. illus.

LC NE320.W2W5
E312.43.W64

Levis.Descr.bibl.Z5947A3
L66 1974 NCFA p.250
incl.some prices.

II.B.3.b - RENAISSANCE

Rotterdam. Museum Boymans-Van Beuningen. Pren-
 tenkabinet
 Denkers,dichters en mannen van de weten-
schap:15-17e eeuw;tentoonstelling(Thinkers,poets
& scientists:15-17th c.;exh.)...Rotterdam,Mus.
Boymans-Van Beuningen,1974.

FOR COMPLETE ENTRY
SEE MAIN CARD

II.B.3.a

Westfälisches Landesmuseum für Kunst und Kul-
 turgeschichte, Münster
 Porträt 2;Der Arztigraphische bildnisse
des 16.-20.Jahrhunderts aus dem Porträtarchiv
Diepenbroick.Ausstellung,17.12.1974-18.2.1979.
Westfälisches Landesmuseum für Kunst und Kul-
turgeschichte Münster,Landschaftsverband Westf-
falen-Lippe;8.3.1979-22.4.1979.Historische
Museen,Kölnisches Stadtmuseum,Köln,29.4.1979-
27.5.1979 Ritterhaus-Museum,Offenburg..Münster
Landschaftsverband Westfalen-Lippe,1978.
 319 p. illus.
 Ausstl.und Kat.:Peter Berghaus et al

NCFA

NE
230
B7B675
1979X
NPG
2 c.

II.B.3.b - 15-20th c.

Boston. Museum of Fine Arts
 Printed portraits...boston,Mus.of Fine Arts,
c.1979

FOR COMPLETE ENTRY
SEE MAIN CARD

II.B.3.a

Wivell, Abraham, 1786-1849
 An inquiry into the history,authenticity &
characteristics of the Shakespeare portraits...
London,The author,1827
 254 p. illus.

 Excellent engravings of the monument at
Stratford.The Felton portr.The Chandos portr.
Martin Droeshout's portr.Marshall's portr.Corne-
lius Jansen's portr.Two woodcuts of the monuments
The head of the bust of the monument!.-Levi
Supplement. Parekin & Marshall...1827
 52 p. illus.

LC PR2929.W5

Levis,Descript.bibl.p.159
Z5947.A3L66 NCFA

II.B.3.b - 16-19th c.

Ellis's cat.of rare historical portraits of the
 16th,17th,18th and 19th centuries.London,
 J.J.Holdsworth & G.Smith,1909
 2 pts.in 1

 Contents:Pt.1,no.14. Abbot-Lehmann 844 items
 Pt.2,no.15. Leigh-Zwingli - Addenda,items
 845 to 1620

LC NE250.E47
LC mf87/6105(N) MicRR

Levis.Descr.bibl.Z5947.A3
L66 1974 NCFA p.212

II.B.3.b. CHRONOLOGICAL

II.B.3.b - 17th c.

‚Hind, Arthur Mayger,1880-1957
 Van Dyck and portrait engraving and etch-
ing in the 17th c. N.Y.,Frederick A.Stokes co.
‚1911.
 15 p. illus. (Half-title:Great engrav-
ers,ed.by Arthur M.Hind)

 Bibliography,p.11-12

 65 illus.

LC NE440.H6

Levis.Descr.bibl.Z5947.A3
L66 1974 NCFA p.265

Portraiture

II.B.3.b - 18th c.

London prints libeled patriots;series of portraits of Revolutionary leaders were fictitious likenesses

In:Am.Coll.
3,no.12:1 May 30,1935
:5,11

LC NE1125.A15

Winterthur Mus.Libr.
NCFA v.0.p.174

NE
541.3
AllK
NMAA

II.B.3.c - CANADA - 19th c.

2 c.

Allodi, Mary
Printmaking in Canada;the earliest views and portraits;les débuts de l'estampe imprimé au Canada:vues et portraits...with contributions from Peter Winkworth...et al..Toronto, Royal Ontario Museum,c.1980
244 p. illus.
Cat.of an exh. held at the Royal Ontario Mus.Apr.18-May 25;McCord Mus.,Montreal,June 1 July 13,and the Public Archives of Canada,Ottawa,July 25-Sept.1,1980

Index
bibllp.238- 242

705
A5
NCFA
v.13

II.B.3.b - 18th c.

Ormsbee, Thomas Hamilton, 1890-1969
18th century Anglo-American relations mirrored in prints

In:Am Coll
13:6-7,15 Feb.,'44 illus.

Portr.ptgs.& prints of political & military leaders in America,England & France

Repre.incl.:Lafayette,Franklin,Lord North, Wm.Pitt,Ths.Paine,J.Hancock

II.B.3.c - FRANCE

.Debrou, P..
Catalogue des portraits imprimés en noir et en couleurs de la reine Marie-Antoinette et de la famille royale...composant la collection de m.P.D...vente le 8 mars,1907.Paris,Hôtel Drouot
47 p. illus.

PPPM NJP

II.B.3.b - 18-19th c.

Maggs Bros., London
A choice collection of engraved portraits and decorative engravings (by and after the most distinguished artists of the 18th and 19th centuries,in mezzotint,stipple,and line manner) ...Selected from the stock of Maggs Bros. London,1912
88 p. illus. (Its.catalogue..no.297)

LC Z999.M195 no.297
copy 2:NE70.M3

II.B.3.c - FRANCE

Didot, Ambroise Firmin, 1790-1876
Les graveurs de portraits en France;catalogue raisonné de la collection des portraits de l'école française appartenant à A.Firmin-Didot... ouvrage posthume. Paris,1875-77

2 v.in one

LC NE270.D5 (reprint of 1970 not listed in LC)

II.B.3.c. BY COUNTRY, A-Z

II.B.3.c - FRANCE-17-18th c.

Maggs Bros., London
A choice collection of engraved portraits and decorative engravings of the English and French schools(by and after the most distinguished artists of the 17th and 18th centuries in mezzotint,stipple and line manner)Selected from the stock of Maggs Bros. London,1914
76 p. illus. (Its.catalogue.no.323)

LC Z999.M195 no.323
copy 2:NE70.M28

II.B.3.c

Emmet, Thomas Addis, 1828-1919
Foreign portraits,collected by Thomas Addis Emmet.N.Y.,1896
11 vols.

N.Y. P.L.
ACK 3 vols.
ACK
x 6 vols.
ACK
xx 2 vols.

II.B.3.c - FRANCE - 18th c.

Granges de Surgères, Anatole,marquis de, 1850-
...Les Françaises du 18e siècles, .1902
portraits gravés...Paris,F.Dentu,1887

LC NE270.G7

FOR COMPLETE ENTRY
SEE MAIN CARD

II.B.3.c - FRANCE - 19th c.

Chennevières-Pointel, Charles Philippe, Marquis
de, 1820-1899
Portraits inédits français...lithographies
et gravures par F.Legrip.Paris.1853-69.

Brit.
Mus. in progress
1757.b
 4 etchings & 26 lithographs

V & A

Bouchot.Portrs.aux crayons
NC860.P2; NPG p.77 footn.1

II.B.3.c - GREAT BRITAIN

Ames, Joseph, 1689-1759
A catalogue of English heads:or,an account
of about 2000 prints...name,title or office of
the person...name of painter,graver,etc...
London,Printed by W.Faden for the editor,1748
182 p.

An index to the collection of 2000 prints,
bound in 10 v.,belonging to Mr.John Nickolls

LC NE265.A5 Fogg,v.11,p.320

II.B.3.c - GERMANY - 16th c.

Bernard, George.
Effigies regum Francorum omnivm,a Pharamvndo
ad Henricum vsqve tertium...Caelatoribvs,Virgili
Solis & Iusto Amman...Noribergae...1576
64 1 62 ports.

Engraved portrs.with a scene in woodcut in-
serted in frame

Title:Chronica regum Francorum

LC DC37.B5 1576 Rave.Jb.d.Berl.Mus. I 1959
Rosenwald coll. LC N3.J16 fol, p.149-50
 Paolo Giovio & d.Bildnisvi-
 tenbücher d.Humanismus

NE
265
L8A5 II.B.3.c- GREAT BRITAIN
NPG
British museum. Dept.of prints and drawings
Catalogue of engraved British portraits pre-
served in the Department of prints and drawings
in the British museum, by Freeman O'Donoghue...
London,Printed by order of the Trustees,1908-25

6 v.

incl.bibliographies

LC NE265.L8A5 1908

II.B.3.c - GERMANY - 17-18th c.

Wilckens, Hans Jürgen von
Porträtbilder in den leichenpredigten des
17.-18.Jahrhunderts...Hildesheim,A.Lax,1967
91 p. illus.

Alphabetical cat.of 1476 portrs.in prints
which accompanied printed funeral sermons.En-
tries incl.name of artist and location of prints
in 8 German collections of funeral sermons.

LC N7620.W5 Fogg,v.11,p.319

NE
265
L42 II.B.3.c - GREAT BRITAIN
NCFA
Layard, George Somes, 1857-1925
Catalogue raisonné of engraved British
portraits from altered plates, ...,arranged by
H.M.Latham,with an introduction by the Marquess
of Sligo. London,P.Allan & co.,ltd.,1927.
133 p. · illus.

LC NE265.L3

II.B.3.c - GERMANY - 18th c.

Lavater, Johann Caspar, 1741-1801
Physiognomische fragmente,zur beförderung der
menschenkenntnis und menschenliebe...Leipzig &
Winterthur,1775-78.Bey Weidmanns Erben und Reich,
und Heinrich Steiner & Compagnie
4 v. illus.

Illus.engraved & lithographed by or after
J.R.Lips,J.R.Schellenberg,D.N.Chodowiecki,Daniel
Berger,and others

DLC
Stafford Int/Art J. v.46
p.186

II.B.3.c- GREAT BRITAIN

Vertue, George, 1684-1756
A description of nine historical prints, re-
presenting kings,queens,princes,etc.of the Tudor
family. Selected,drawn & engraved,from the origi-
nalpaintings by George Vertue....London.Republish.
by the Society,1776

21 p. illus.

LC NE642.V4A3

II.B.3.c- GERMANY - MUNICH - 15-19th c.

Maillinger, Joseph
Bilder-Chronik der kgl.Haupt-und Residenz-
stadt München.Verzeichniss einer Sammlung von...
graphischen künsten....vom 15.-19.Jahrh.München,
Montmorillon,1876
3v. in 1

Every chapter has a list of portrs.of reign-
ing nobility & other personalities with artists'
names
Index of sitters and artists

NN MiU(DD901.M95M2)

II.B.3.c- GREAT BRITAIN

Walpole, Horace, Earl of Orford, 1717-1797
The collection of rare prints & illustrated
works,removed from Strawberry Hill...catalogue
of the ...collection of engraved portraits of ...
British characters that figure in ...history and
biography from the time of Egbert the great,in
the 8th c...to the termination of the 18th...as...
collected by H.Walpole,...sold...13th...of June
1842....London 1842.
131 p.

MET
Print
Dept.

II.B.3.c - GREAT BRITAIN - 17th c.

Evelyn, John, 1620-1706
Extracts from the diaries and correspond-
ence of John Evelyn and Samuel Pepys relating
to engraving,with notes by Howard C.Levis.
London,Ellis,1915
166 p. illus.

Contents...-Portraits of John & Mary Evelyn
and Samuel & Elisabeth Pepys. ...John Evelyn's
etchings
Bibliography

LC NE440.E8

N
40.1
K24y
A1
1877

II.B.3.c - GREAT BRITAIN - SCOTLAND - EDINBURGH

Kay, John, 1742-1826
A series of original portraits and cari-
cature etchings...New ed.Edinburgh, A.& C.Black,
1877
2 v. illus.

Incl.Index of sitters

LC N7599.K3 1877 Yale ctr.f.Brit.art Ref.
NJ18.K24.A12 1877

II.B.3.c - GREAT BRITAIN - 17-18th c.

Maggs Bros., London
A choice collection of engraved portraits
and decorative engravings of the English and
French schools(by and after the most distin-
guished artists of the 17th and 18th centuries
in mezzotint,stipple and line manner)Selected
from the stock of Maggs Bros. London,1914
70 p. illus. (Its catalogue,no.323)

LC Z999.M195 no.323
copy 2:NE70.M28

II.B.3.c ITALY - NORTHERN - 18th c.

Mallè, Luigi
Giacomo Ceruti e la ritrattistica del suo
tempo nell' Italia Settentrionale a cura di L.
Mallè e Giovanni Testori.Mostra.Torino,Galleria
Civica d'arte moderna,febbraio-marzo,1967.Tori-
no,Galleria civica d'arte moderna,1966.
169 p. illus(part col.)

FOGG
Fs
3892
271
2

Bibliography

Fogg,v.11,p.320

ND
1314.4
W183
1985
v.1-2
NYG Ref.

II.B.3.c - GREAT BRITAIN - 18-19th c.

Walker, Richard
Regency portraits.London,NPG,1985
2 vols. illus. v.1:Text;v.2:Plates

Edited by Judith Sheppard
Indexes
Incl.:Sculpture,Medals,Engravings,Photo-
graphs

Groups p.597 f.

II.B.3.c - NETHERLANDS - 16th c.

Goltzius, Hubert, 1526-1583
Les images presqve de tovs les emperevrs,
depvis C.Ivlivs Caesar ivsqves à Charles V et
Ferdinanvs son frère,povrtraites av vif,prinses
des medailles anciennes...par Hvbert Gholts...
1557. Livre I
350 p. illus.
149 portrs.by Joos Gietleughen after drags.by
Goltzius(see Over)
Italian edition:LC fJ 036.351:early ex.of chiaroscuro prts
Latin edition:LC N7627.G6

NO CLU-C PPPM PU-Ma msterdam,Rijksmus.cat.
25939A52,deel 1,p.134

B
W93RM

II.B.3.c - GREAT BRITAIN - 19th c.

Bemrose, William
The life and works of Joseph Wright,A.R.A.,
commonly called "Wright of Derby"...with a pre-
face by Cosmo Monkhouse.Illus.with two etchings
by Mr.F.Seymour Haden,and other plates and wood
cuts.London and Derby,Bemrose & sons,1885
128 p. illus

LC ND497.W8B4 Grundy In:Connoisseur
86:347

FET
201.4
H87

FOGG
FA5783
.203

II.B.3.c - SWEDEN

Hultmark, Emil, 1872-1943 comp.
Svenska kopparstickare och etsare,1500-1944
.av.Emil Hultmark,Carna Hultmark .och.Carl David
Moselius.Uppsala.Almqvist & Wiksell;distribution:
Ab.C.E.Fritzes kungl.hovbokhandel,Stockholm,1944
391 p. illus.

"Litteratur":p.380-1

N
40.1
K24y
E9
NCFA

II.B.3.c GREAT BRITAIN - SCOTLAND - EDINBURGH

Evans, Hilary, 1929-
John Kay of Edinburgh,barber,miniaturist
and social commentator,1742-1826,by.Hilary and
Mary Evans.Aberdeen,Impulse Publ.,Ltd.,1973
53 p. illus(1 col.)

Bibliography and iconography

LC NE642.K39E92 1973 Yale ctr.f.Brit.art Ref.

II.B.3.c - SWITZERLAND - 18-19th c.

Fuessli, Johann Caspar, 1706-1782
Geschichte der besten künstler in der
Schweits,nebst ihren bildnissen.with 152 portrs.
by Johann Rudolf Fuessli,Joh.Rud.Schellenberg,
Joh.Heinr.Lips,etc..Zürich,Orell,Gessner,Füssli,
1769-79
5 v.

N.Y.P.L.
1-MAMG

.Earlier ed.under title'Geschichte und abbil-
dungen der besten maler in der Schweis. 2v.
Zürich,1755-56.
(Einleitung in d.geschichte der künstler
des Schweizerlan- des.by J.G.Wille.Anhang)
MH MoU
DLC Source see over

NE
260
A43X
NPG
2 c.&
lc.in
Reference

II.B.3.c - U.S.

American print conference(10th:1979:National
 Portrait Gallery)
 American portrait prints;ed.by Wendy Wick
Reaves.Publ.for the NPG,Charlottesville,Univ.
Press of Va.,1984
 285 p. illus.
 Incl.index

 Eight essays on American portr.prints from
 late 18th to early 20th c.
 Review in:Antiques,v.126:633-4,Sept.'84,
by Peter C.Marcio

N7628
W3W5X
NPG
2 c.

II.B.3.c - U.S. - 18th c.

Wick, Wendy C., 1950-
 George Washington,an American icon.The 18th
century graphic portraits...with an intro.essay
by Lillian B.Miller.Washington,D.C.,Smiths.Inst.
Travelling Exh.Service:NPG,S.I.,1982
 186 p. illus. "A Barra Foundation Book"

 Bibliography
 Incl.:Index
 Exh.at NPG:Feb.??-Apr.27,1982

II.B.3.c - U.S.

Emmet, Thomas Addis, 1828-1919
 American portraits collected by Thomas
Addis Emmet.A-Z.N.Y.,1896
 9 v.

N.Y. P.L.
AOH

Rosenthal,Albert...List of
portrs.N40.1.R734yR8 NPG
p.6

40.1
B8557y
F6
NMAA

II.B.3.c - U.S. - 20th c.

Fletcher, William Dolan
 Complex simplicity:Gerald Leslie Brock-
hurst and his graphic work.New Haven,Conn.,
The sign of the arrow,1984
 95 p. illus.
 Index
 Cat.raisonné 1914-1947

NE
506
C92
1977a
NMAA

II.B.3.c - U.S. - 18th c.

Cresswell, Donald Howard, 1941-
 Prints of the American Revolution:a histo-
ry and checklist of graphics produced from
1765-1790. 1977
 606 p. illus.

 Bibl.references
 Reference sources,p.597-605
 Thesis Ph.D.-Geo.Washington Univ.,1977
 Photocopy of typescript
 Pt.I,Ch.V a:Portraits,p.63-73
 Pt.II,Ch.I:Portraits,p.140-2

II.B.3.c - U.S. - MASSACHUSETTS - BOSTON

Coburn, Frederick William, 1870-
 The Johnstons of Boston

In:Art in Am
21:29-36 Dec.,'32
 :132-8 Oct.,'33

LC N1.A43

N.Y.Hist.Soc.Q,39:63 footn.
2 1955
974.06.N7v.39

705
A56
NCFA
v.111

II.B.3.c - U.S. - 18th c.

Deutsch, Davida Tenenbaum
 Washington memorial prints

In:Antiques
111:324-31 Feb.,'77 illus.

 Bibl.footnotes

II.B.3.d. SPECIAL SUBJECTS, A-Z

N
7592
H513
RB
NPG

II.B.3.c - U.S. - 18th c.

Henkels, Stanislaus Vincent, 1854-1926
 Rare books and engravings illustrative of
national and local history...belonging to the
estate Thos.Donaldson,deceased and Henry S.
Cushing,late of Philadelphia....to be sold
March 14 & 15,1902 at the book auction rooms of
Davis & Harvey,Philadelphia
 illus.
 Cat.no.877

 Incl.:Portr.ptgs,busts,prints of George &
Martha Washington,'1 presidents

II.B.3.d - PROFESSIONS - ARTISTS - NETHERLANDS
 - 17th c.
Dyck, Anthonie van, 1599-1641
 Le cabinet des plus beaux portraits de plu-
sieurs princes et princesses,des hommes il-
lustres,fameux peintres,sculpteurs,architectes,
amateurs de la peinture & autres,faits par le
fameux faict graver à ses propres despens par
les melieurs graveurs de son temps.Antwerp,
Henry & Corneille Verdussen,173-?.
 4 p. 125 plates

NeD

Winterthur Mus.Libr. fZ881
W78 NCFA v.9,p.225

AP
1
P892
NCFA
v.2

II.B.3.d - PROFESSIONS - MARINE - U.S.

Fielding, Mantle, 1865-1941
American naval portraits engraved by David
Edwin after Gilbert Stuart and others

In:Print Connoisseur Dec.,'21
2:123-30 illus.p.122,125,127,129,131-7

LC NE1.P75 Arts in Amer.v.2 K666
 q Z5961.U5A77X NCFA Ref.

II.B.3.d - PROFESSIONS - SCHOLARS

Verheiden, Jacob, fl.1590
Af-Beeldingen van sommighe in Godts Woort
ervarene Mannen,die bestreden hebben den Room-
schen Antichrist.Waer by ghevoecht sijn de Lof-
Spreucken ende Registers harer Boecken...ende na
in Neer-Duijtsch overgheset door P.D.K....
s'Graven-Haghe,by Beuckel Cornelissoon Nieulandt,
1603,148ff.
illus.
Depicts & praises men who have opposed Roman
Catholicism:Wycliffe,Huss,Erasmus,Luther,Melanch-
thon,etc.
Brit. Also in Latin:Prae- stantium aliquot Theolog-
Mus. rum... ondy,London,cat.83,no.27
V.& A. 1973

II.B.3.d - PROFESSIONS - MILITARY - U.S. - 19th

Reaves, Wendy Wick, 1950-
Heroes,martyrs and villains;printed por-
traits of the Civil War

In:Print Council of America.Newsletter 1983
:8-12 Spring 1983,no.5

Pertains to exh.in the NPG,Sept.10,'82-
Apr.3,'83
Printed portrs.,sometimes based on photo-
graphs,were published as propaganda & as news.
Sometimes different heads were substituted on
the same body.

II.B.3.d - PROFESSIONS - SCHOLARS

Verheiden, Jacob, fl.1590
Jacobi Verheidenii...Imagines et elogia prae-
stantivm aliqvot theologorvm,cvm catalogis libro-
rvm ab iisdem editorvm.Opera Friderici Roth-
Scholtsii. 2.ed. Hagae-Comitvm,apvd haeredes
J.D.Tavberi,1725
6 p. illus. .With Roth-Scholts,F. Icones viro-
rvm omnivm ordinvm ervditione...Norimbergae et
Altdorfii,1725-28.

LC N7627.R8

II.B.3.d - PROFESSIONS - MUSICIANS

Hague. Gemeentemuseum
Portraits of composers and musicians on
prints and drawings....Zug,Switzerland,Inter
Documentation Co.,1977.

N.Y.P.L. *XML-1269 microfiche FOR COMPLETE ENTRY
 SEE MAIN CARD

II.B.3.d - PROFESSIONS - STATESMEN

Muller, Frederik, 1817-1881
Beschrijvende catalogus van 7000 portretten
van Nederlanders,en van buitenlanders,tot Neder-
land in betrekking staande...Amsterdam,F.Muller,
1853
401 p.
Muller coll.in 1852
Part I:Ruling fms.& their families,in chro-
nological order.Pt.II.Exceptional individuals,
in alphabetical order,with biographical notes
& date of the prints. (cont'd on next cd.)
 Hijbroek.Fred.Muller en
 zijn prentenverzamelingen
LC NE285.M8 In:Bull.Rijksmus.29:26
 note 12 708.949z.A523 NMAA

II.B.3.d - PROFESSIONS - NOBILITY - NETHERLANDS
 - 17th c.
Dyck, Anthonie van, 1599-1641
Le cabinet des plus beaux portraits de plu-
sieurs princes et princesses,des hommes il-
lustres,fameux peintres,sculpteurs,architectes,
amateurs de la peinture & autres,faits par le
fameux faict graver à ses propres despens par
les meilleurs graveurs de son temps.Antwerp,
Henry & Corneille Verdussen,173-?,
.4.p. 125 plates.

MeD Winterthur Mus.Libr. fZ881
 .W78 NCFA v.9,p.225

VF
Por-
traiture

II.B.3.d - PROFESSIONS - STATESMEN - U.S.

London prints libeled patriots;series of por-
traits of Revolutionary leaders were fic-
ticious likenesses

In:Ant.Coll.
3,no.12:1 May 30,1935
:5,11

LC NK1125.A15 Winterthur mus.Libr. fZ881
 W78 NCFA v.6,p.223

II.B.3.d - PROFESSIONS - SCHOLARS

Roth-Scholts, Friedrich, 1687-1736
Icones virorvm ordinvm ervditione omnivqve
item genere et varietate artivm de repvblica
litteraria et speciatim de academiis ev gymna-
siis totivs penø Evropae ab aliqvot seøvlis ad
nostra vsqve tempora optime meritorvm....collec-
tae stvdio atqve opera Friderici Roth-Scholtaii..
Norimbergae et Altdorfii,apvd haeredes J.D.
Tavberi,1725-28
5 pt.in 1 v. 225 illus.

LC N7627.R8

AP
1
P89
NCFA

II.B.3.d - SELF-PORTRAITS

Allhusen, E.L.
Self portraiture in etching (Some living
artists)

In:Print Coll Q
18:175,7,9,183,5,7-8,191,4,6 Apr.,'31 illus.

Reasons for Self-portraiture
In self-portrs.we get the artist's ideal of
himself.The artist does not copy nature but ex-
presses her;the greatest scope for such expres-
sion found in self-portraiture.
Descript'n of s.-portrs.by...
 CumMag.subj.ind.A1/3/76 Ref.
 v.2,p.444

705
M18
NCFA
II.B.3.d - SELF-PORTRAITS

Grafly, Dorothy
 Self-portraits in prints

In:Mag Art
25:167-72 Sep.1932 illus.

Enc.of World Art N31E56
Ref. v.11,col.513
Bibl.on portr.

B
.W31B16
II.B.3.e - ENGRAVING

Baker, William Spohn, 1824-1897
 The engraved portraits of Washington,with
notices of the originals and brief biographical
sketches of the painters...Philadelphia,Lindsay
& Baker,1880
 212 p.

 Arranged chronologically under the names of
the artists.Engravers after the artist's work
follow in alphabetical order.

LC E312.43.B155

Whitehill.The arts in ear-
ly Amer.Hist.Z5935.W59
Bibl.,p.99

II.B.3.e. SPECIFIC MEDIA

 For list of SPECIFIC MEDIA
see " Guide to Classified
Arrangement"

II.B.3.e - ENGRAVING

Béraldi, Henri, 1849-1931
 Catalogue des très beaux portraits...compo-
sant la collection de Monsieur H.B...La vente
aura lieu à Paris,Galerie Georges Petit...
.Paris,G.Petit,1928.
 2 v. illus.

 v.2,sale held at Hôtel Drouot,1930

 Contents.-Très beaux portrs. des 17e,18e,et
19e siècles.La vente,30 Nov.et 1er déc.,1928.-
v.2. ...du 16e au 19e s. La vente,7 et 8 Avr,'30

MiDA NNC CtY

MET
276.5
Ag6
II.B.3.e - ENGRAVING

Agnew(Thos.) & Sons,ltd.,London
 Cat.of engraved portraits from the royal
collection,Windsor Castle on exhibition...May &
June 1906..London,n.d.
 55 p.

II.B.3.e - ENGRAVING

Boissard, Jean Jacques, 1528-1602
 Bibliotheca chalcographica,hoc est virtute
et eruditione clarorum virorum imagines, collec-
tore Iano-Iacobo Boissardo,Vesunt.,sculptore
Theodoro de Bry,Leod.,primum editae,et ab ipso-
rum obitu hactenus continuatae.Heidelbergae,im-
pensis Clementis Ammoni,1669
 5 v. illus.

LC NE218.B6 1669

Poll.v.11.p.321

NE
250
A63
NPG
II.B.3.e - ENGRAVING

Antiquariat Dieter Grosse-Wortmann
 Alte porträt-graphik
 141 p. illus.

 cat.no.38

 Arranged in alphabetical order by sitter

II.B.3.e - ENGRAVING

Boston. Public Library
 The Tosti engravings.Portraits.

In:Full.
 22 p. 1871

 List of 676 portrs.Gift of Ths.G.Appleton,
1869.Formerly in the coll.of Cardinal Antonio
Tosti

LC NE57.B7T7 1871

Levi.Descript.bibliography
Z5947.A3L66 1974 NCFA
p.200

qCT
275
H217B2
II.B.3.e - ENGRAVING

Baily, James Thomas Herbert, 1865-1914
 Emma,lady Hamilton;a biographical essay
with a catalogue of her published portraits..
London,W.G.Menzies,1905
 127 p. illus(part col.)

 List of principal engravings,p.121-6

LC DA483.H3B2

Levi.Descr.bibl.Z5947.A3
L66 p.191,205

II.B.3.e - ENGRAVING

Cambridge. University. Magdalene college.
 Pepysian library.
 A catalogue of the engraved portraits in
the library of Samuel Pepys...compiled by John
Charrington...Cambridge,Eng.,The University
press,1936
 203 p. illus.

 Bibliography

LC NE240.P4

Porr.v.11,p.321

II.B.3.e - ENGRAVING

Carson, Hampton Lawrence, 1852-1929
...The Hampton L.Carson collection of en-
graved portraits of American naval commanders &
early American explorers & navigators...Cat. comp.
& sale conducted by Stan.V.Henkels at the art auc-
tion rooms of Davis & Harvey...Philadelphia,1905.
80 p. illus.
Cat.no.906,pt.IV

To be sold Oct.31 & Nov.1,.1905.

LC NE260.C26 Amsterdam,Rijksmus.cat.
 Z5939A52, deel 1, p.154

II.B.3.e - ENGRAVING

Cope, Edwin R.
...The magnificent coll.of engraved por-
traits formed by...Edwin R.Cope...being the
most important coll..to be sold...at Thos.
Birch's sons...Cat.comp.& sale conducted by
Stan V.Henkels....Philadelphia,The Bicking
print,1896..1899.
Pt.I:48p.;1126 items,portraits,illus.
Pt.II:68p.;1247 items,portraits,illus.
Pt.III:44p.;814 items,miscellaneous,illus.
Pt.IV:44p.;586 items,balance of coll.with
supl.contain'g illus.

LC has pt.?:NE240.C7 Levis.Descr.bibl.Z5947.A3
 L66 1974 NCFA p.244

N
7628
W31C3 II.B.3.e - ENGRAVING
NPG
Carson, Hampton Lawrence, 1852-1929
...The Hampton L.Carson collection of en-
graved portraits of Gen.George Washington. Cat.
comp. & sale conducted by Stan.V.Henkels.At the
art auction rooms of Davis & Harvey...Phila.,Pa.,
...,Press of W.F.Fell co.,1904.
173 p. illus(part col.)
Cat.no.906,pt.I

Incl.St.Memin personal coll.of proof mezzo-
tints...to be sold Jan.21 & 22, 1904
LC Z999.H505 no.906,pt.1 Amsterdam Rijksmus.cat.
c.2 E312.43.C32 Z5939A52, deel 1, p.154

II.B.3.e - ENGRAVING

.Delabère Family.
A cat.of a most singular,rare and valuable
collection of portraits...in.a very celebrated
book that has been preserved 15 years in the
Delabère family...London,G.Smeeton,1811.
44 p.

152 items Priced Names of buyers

Auction sale,Christie,March 29,1811

(For more locations of this cat. see:Lugt
PU-R Rép.des cat.de ...ontes,1600-1825;017.195
NCFA Ref.,no.7955

II.B.3.e - ENGRAVING

Carson, Hampton Lawrence, 1852-1929
.. ...The Hampton L.Carson collection of en-
graved portraits of Jefferson,Franklin,and La-
fayette.Cat. comp. & sale conducted by Stan.V.
Henkels.At the art auction rooms of Davis &
Harvey...Phila.,Pa.......Press of W.F.Fell co.,
1904.
157 p. illus.
Cat.no.906,pt.II

To be sold Apr.20 & 21,.1904.

LC Z999.H505 no.906,pt.2 Amsterdam,Rijksmus.cat.
 Z5939A52, deel 1, p.154

NE
218 II.B.3.e - ENGRAVING
S84
NPG Edinburgh. Scottish national portrait gallery
A face for any occasion.Some aspects of
portrait engraving;by Sara Stevenson..Glasgow,
for H.M.Stationery off.by Bell & Bain,ltd.,
1976.
127 p. illus.

Based on an exh.,summer,1974,which demon-
strated how various factors influenced the way
in which both portr.ptrs.& engravers have shown
their sitters

II.B.3.e - ENGRAVING

Carson, Hampton Lawrence, 1852-1929
...The Hampton L.Carson collection of en-
graved portraits of signers of the Declaration
of independence,presidents & members of the Con-
tinental congress,officers in the American revo-
lutionary war...Cat. comp. & sale conducted by
Stan.V.Henkels.At the art auction rooms of Davis
& Harvey...Phila.,Pa.1904.
93 p. illus.
Cat.no.906,pt.III

To be sold Dec.16 & 17, .1904
LC Z999.H505 no.906,pt.3 Amsterdam, Rijksmus.cat.
 Z5939A52, deel 1, p.154

II.B.3.e - ENGRAVING

Ellis,firm,booksellers, London
A cat.of engravings and etchings...engraved
portraits...on sale London.18...

N.Y.P.L.
.MDF77-737.

FOR COMPLETE ENTRY
SEE MAIN CARD

II.B.3.e - ENGRAVING

Chamberlaine, John, 1745-1812
Imitations of original drawings by Hans
Holbein,in the collection of His Majesty,for the
portraits of illustrious persons of the court of
Henry VIII...London,Printed by W.Bulmer and co.,
1792
.142.p. illus.in color

The plates are stipple engravings printed
in colors,all but four by F.Bartolozzi,three by
C.Metz,one by C.Knight

LC NC1055.H7 Fogg,v.11,p.321

II.B.3.e - ENGRAVING

Evelyn, John, 1620-1706
Numismata.A discourse of medals ancient and
modern.Together with some account of heads and
effigies of illustrious and famous persons,in
sculps,and tailledouce of whom we have no me-
dals extant;and of the use to be derived from
them.To which is added a digression concerning
physiognomy...London,B.Tooke,1697
342 p. illus.

LC C.J5538.E8 Winterthur Mus.Libr.
 fZ861.W78 NCFA v.9,p.225

760.5
.P94

II.B.3.e - ENGRAVING

Fifty men and women.Engraved portraits of cer-
tain persons of importance of the 16-19th
centuries.N.Y.,M.Knoedler & co.,inc.,1930
(57)p. illus. (The print collec-
tor's bulletin,v.1,no.3)

Repro.incl.Benjamin Franklin by Js.McArdell,
John Evelyn by Nanteuil,Amelia Elizabeth of
Hesse by Ludw.von Siegen(earliest mezzotint
known-1642)

N
7621
H33
NPG

II.B.3.e - ENGRAVING

Harvard University. Library. Theatre coll.
Cat.of dramatic portraits in the theatre
coll.of the Harvard college library.Cambridge,
Mass.Harvard univ.press,1930-34
4 v.
Compiled by Lillian Arvilla Hall
"A descriptive index to the engraved dra-
matic portrs.in the theatre coll....arranged
alphabetically according to names."-Pref.

Moon.Engl.portr.drags.&min.
NC860.N66X NPG Bibl. p.145

II.B.3.e - ENGRAVING

Gallery of great artists;a series of portraits
engraved on steel...Boston,J.R.Osgood and
company,1877
75 p. illus.

LC ND1170.C3 Foet,v.11,p.322

II.B.3e - ENGRAVING

Harvey,Francis, art dealer, London
A general cat.of rare & valuable engraved
portraits,on sale by Francis Harvey....London,
J.Davy & sons,1896?.
703 p.

'This is an excellent cat.of 4849 items...'-
.Levi

CSmH Levi.Descript.bibl.Z5947.
A3L66 NCFA p.205

II.B.3.e - ENGRAVING

Grolier club, New York
Cat.of an exh.of engraved portraits of wo
men writers from Sappho to George Eliot...
March7-23,1895.N.Y.,The Gilliss press.1895
24 p.

Levis,Descr.bibl.Z5947A3
LC NE220.G7 L66 1974 NCFA p.381

N
7593
H56
1834
NPG

II.B.3.e - ENGRAVING

Herring, James, 1794-1867,ed.
The national portrait gallery of distin-
guished Americans...Conducted by James Herring...
and James B.Longacre...under the superintendence
of the American academy of the fine arts...New
York,M.Bancroft;etc.,etc..1834-39
4 v. illus.

Illustrated by engravings

LC E176.H56

II.B.3.e - ENGRAVING

Grolier club, New York
Exhibition of English literary portraits..
Nov.4-19,1898.N.Y.,The De Vinne press,1898.
28 p.

Chiefly the portrs. that were engraved in
larger size and issued separately as prints

Levis.Descr.bibl.Z5947.A3
LC N7598.G7 L66 1974 NCFA p.382

TNE
266
G7H83
1813
NPG

II.B.3.e - ENGRAVING

Houbraken, Jacobus, 1698-1780
The heads of illustrious persons of Great
Britain, engraven by Mr.Houbraken and Mr.Vertue;
with their lives and characters by Thomas Birch.
New ed. London, Printed for W.Baynes by C.Wood,
1813

216 p. illus.

'Jacobus H. & G.Vertue engraved afterArnold
Houbraken's drawings.(Thieme-Becker: Houbraken,
LC DA28.H6 1813 (Arnold

qN
7628
W31H3
NCFA
NPG

II.B.3.e - ENGRAVING

Hart, Charles Henry, 1847-1918
Catalogue of the engraved portraits of
Washington...N.Y.,The Crolier club,1904
406 p. illus. (Crolier club,N.Y. Pub-
lications,no.42)

LC E312.43H32

Z
5947
A3L66
1974
NCFA

II.B.3.e - ENGRAVING

Levis, Howard Coppuck
A descriptive bibliography of the most im-
portant books in the English language relating
to the art & history of engraving and the col-
lection of prints.With supplement and index.
(Folkestone,Kent,Eng.)Dawsons of Pall Mall.1974.
141 p. illus.

First published 1912 and 1913
Numerous references to portrs.,e.g."Books
about portrs."p.190-240;"Private colls."p.214-
27;"Sale catalogues"p.228-53

II.B.3.e - ENGRAVING

Lodge, Edmund
 Portraits of illustrious personages of Great
Britain, engraved from authentic pictures in the
galleries of the nobility & the public collections
of the country, with biographical & historical me-
moirs of...London,Harding & Lepard,1835

 12 v. illus.

other eds. 1849-50 London,Bohn 8v. LC DA28.L6
 1902 Boston,D.Esten 12 v.

II.B.3.e - ENGRAVING

Mitchell, James Tyndale, 1834-1915
 ...The unequaled collection of engraved por-
traits of officers...of the war of the revolu-
tion,2nd war with Great Britain and the Mexican
war,belonging to Hon.James T.Mitchell...to be
sold Nov.30 and Dec.1,1906...Cat.comp.& sale con-
ducted by Stan.V.Henkels,at the book auction
rooms of Davis & Harvey...Phila.,Pa...M.H.Power
printer,1906.
 131 p. illus.
 Cat.no.944,pt.III

LC E181.M84

II.B.3.e - ENGRAVING

London. Guildhall library
 A cat.of engraved portraits...exhibited
at the opening of the new library and mus.of
the Corp.of London,Nov.,1872.Ed.by W.H.Overall
...London.Printed by Blades,East and Blades.
1872
 644 p.

LC N1033.A75 Yale ctr.f.Brit.art Ref.
 N1033.A53

II.B.3.e - ENGRAVING

Mitchell, James Tyndale, 1834-1915
 ...The unequaled collection of engraved por-
traits of the English royalty & English officers
...,statesmen,artists,authors,poets,dramatists,
doctors,lawyers,etc.,from the earliest to the
present time,belonging to Hon.James T.Mitchell...
to be sold...May 2d & 3d,1911.Cat.comp.& sale con-
ducted by Stan.V.Henkels,at the book auction
rooms of S.T.Freeman & co...Phila.,Pa...M.H.
Power,printer,1911.
 72 p. illus.
 Cat.no.944,pt.XII

LC NE240.M52

II.B.3.e - ENGRAVING

Mitchell, James Tyndale, 1834-1915
 ...Collection of engraved portraits of Wa-
shington belonging to Hon.James T.Mitchell...
Cat.comp. & sale conducted by Stan.V.Henkels at
the art auction rooms of Davis & Harvey,Phila.,Pa.
...,1906.
 2 pts. illus.
 Cat.no.944,pt.I-II

 v1. ...to be sold Jan.18 & 19,1906.-v.2...to
be sold May 3, 1906

LC E312.43.M68

II.B.3.e - ENGRAVING

Mitchell, James Tyndale, 1834-1915
 ...The unequaled collection of engraved por-
traits of the Presidents of the United States,be-
longing to Hon.James T.Mitchell...to be sold...
May 16...&...May 17,1907...Cat.comp. and sale con-
ducted by Stan.V.Henkels at the book auction
rooms of Davis & Harvey...Phila.,Pa. ...,M.H.
Power,printer,1907.
 123 p. illus.
 Cat.no.944,pt.IV

LC E176.1.M68

II.B.3.e - ENGRAVING

Mitchell, James Tyndale, 1834-1915
 ...The unequaled collection of engraved por-
traits belonging to Hon.T.Mitchell...embracing
statesmen of the colonial,revolutionary and pres-
ent time,incl.the extens.coll. of portrs. of Benj.
Franklin,Sam.Adams,John Hancock,Henry Laurens,
Henry Clay,and Daniel Webster,also chief and as-
sociate justices of the Supreme court of the U.S,
attorneys-general of the U.S.,judges,lawyers,etc.
To be sold...Dec.5 and 6,1907...Cat.comp.and sale
conducted by Stan.V.Henkels.At the book auction
rooms of Davis & Harvey...Phila,Pa..Phila.,1907.
 134 p. illus.
 Cat.no.944,pt.

LC E176.M68

II.B.3.e - ENGRAVING

Mitchell, James Tyndale, 1834-1915
 ...The valuable collection of books on en-
graved portraits owned by the Hon.Js.T.Mitchell
...Also an unique coll.of caricatures by Cruik-
shank,Gillray,Heath,Seymour...and others.To be
sold...Jan.4,1909...and...Jan.5,1909...Cata-
logued & sales conducted by Stan.V.Henkels.At
the book auction rooms of Sam.T.Freeman & co...
Philadelphia...Press of M.H.Power,1909.
 91 p.
 Cat.no.944,pt.VIII
 715 items Levis.Descr.bibl...Z5947
LC NE240.M54 .3L66 1974 NCFA p.250:
 "A valuable bibliography of engraved portraiture"

C17.37 II.B.3.e - ENGRAVING
.M68
Mitchell, James Tyndale, 1834-1915
 ...The unequaled collection of engraved
portraits of beautiful women of Europe and Ame-
rica,and actors,actresses,vocalists,musicians,
and composers,belonging to Hon.James T.Mitchell...
to be sold,,.Phila.,Pa.,.M.H.Power,printer,1910.
 144 p. illus(part col.)

 (Catalogue compiled...by Stan.V.Henkels)
 (Sold at book auction rooms of S.T.Freeman & co
 Cat.no.944,pt.X

LC NE240.M5

II.B.3.e - ENGRAVING

Muller, Frederik, 1817-1881
 Beschrijvende catalogus van 7000 portretten
van Nederlanders,en van buitenlanders,tot Neder-
land in betrekking staande...Amsterdam,F.Muller
1853
 401 p.
 Muller coll.in 1852
 Part 1:Ruling fgs.& their families,in chro-
nological order.Pt.II.Exceptional individuals,
in alphabetical order,with biographical notes
& dates of the prints.
 Hijbroek.Fred.Muller en
 zijn prentenverzamelingen
LC NE285.M8 In:Bull.Rijksmus.29:26
 note 12 708.949z.A523 NCFA

TR
575
P93
1985a
NPG

II.B.3.e - ENGRAVING

Prescott, Gertrude Mag, 1955-
Fame and photography:Portrait publica-
tions in Great Britain,1856-1900
469 p. illus.

Incl.lists of portr.publications in the
engraved,lithographic & photographic media.

Ph.D.diss.-Univ.of Texas at Austin,1985
Bibliography:p.263-81

mf
Diss.Abstr.v.47no.03,Sept.
1986,p.691/92A

.II.B.3.e - ENGRAVING

Someren, Jan Frederik van, 1852-1930
Beschrijvende catalogus van gegraveerde
portretten van Nederlanders...vervolg op Fred.
Mullers catalogus van 7000 portretten van N....
Amsterdam,F.Muller & cie,1888-91

3 v.

LC NE285.S7 Chamberlin.Guide to art
reference books #105

II.B.3.e - ENGRAVING

Raphael, Herbert Henry, 1859-
Horace Walpole;a descriptive catalogue of
the artistic and literary illustrations col-
lected by Herbert H.Raphael,M.P.Trustee of the
Nat'l Portr.Gall...Bristol,Edw.Everard,1909
659 p. illus.

...a remarkable coll.of portrs.

Mezzotint portrs.are described according
Chaloner Smith.
Frontispiece portr.of Walpole

LC DA483.W2R2 ICU CSmH Levis,Descr.bibl.Z5947A3
OCTW NIC L66 1974 p.224
MH DeU

NE
218
S95
1875
NPG

II.B.3.e - ENGRAVING

Sumner, Charles, 1811-1874
The best portraits in engraving...4th ed.
New York,F.Keppel&c.1875,
31 p.
Originally published in the "City"

LC NE218.S9 1875c

II.B.3.e - ENGRAVING

Rose, James Anderson, 1819-1890
A collection of engraved portraits...
exhibited...at the opening of the new library
and mus.of the Corp.of London,Nov.,1872...intro-
duction by Gordon Goodwin.London,New York.etc.,
M.Ward & co.,ltd.,1894
366 p. illus.

LC N7592.R6 2 v. Fogg,v.11,p.325

II.B.3.e - ENGRAVING

Tiffin, Walter, F.
Gossip about portraits,including engraved
portraits...1867
223 p. illus.

LC N7575.T6 Yale ctr.f.Brit.art Ref.
N7575.T5 1867

II.B.3.e - ENGRAVING

Royal College of Physicians of London
Catalogue of engraved portraits in the
Royal College of Physicians of London,by A.H.
Driver.London,1952
219 p.

FOGG
4353
L84p

Fogg,v.11,p.324

NE
53
W3U554
NCFA

II.B.3.e - ENGRAVING

U.S. Library of Congress. Prints and photo-
graphs division.
...Catalog of the Gardiner Greene Hubbard
collection of engravings...compiled by Arthur
Jeffrey Parsons...Washington,Govt.print off.,
1905
517 p. illus.

Contents.:...Catal.of engravers...Portrait
index...

LC NE53.U5H8 1905 Levis.Descr.bibl.Z5947A3
L66 1974 p.221

II.B.3.e - ENGRAVING

Royal College of Physicians of London
A cat. of the engraved portraits of Britis
medical men, compiled by Herbert Breun;by Arno
Chaplin and W.J.Bishop.1930.
Unpublished typescript

London.Royal Coll.of Sur-
geons of Engl.N1165.R6AGx
NPG. Books quoted,p.IX

AP1
A784
A4
NCFA
v.5

II.B.3.e - ENGRAVING

Wright, Helen
Some rare old portraits

In:Art & Archaeol
5:275-84 May,'17 illus.

Pertains to coll.at U.S.Library of Congress
of ca.500 engr.portrs.of noted men,fr.3rd-18th c.

Repro.:Drevet after Bossuet;Bracquemond after
Holbein;Steinla after Raphael;Forster after Dürer;
Benj.Smith after Hogarth;Masson after Mignard;
Goya after Velasquez Cumulated Mag.subj.index
21/3/C76 Ref. v.2,p.444

II.B.3.e - ENGRAVING - 16th c.
Stirling-Maxwell, Sir William,bart.,1818-1878,
 Examples of the engraved portraiture ...ed.
of the 16th century.London,Privately printed,
1872
 120 l.(chiefly illus.)

LC NE218.875 Rosenwald coll. Ars Artis cat.41 Books on
 Prints Drgs. no.684

N
7592
H513
RB
NPG
II.B.3.e - ENGRAVING - 18th c.

Henkels, Stanislaus Vincent, 1854-1926
 Cat.of the valuable autographic coll. and en-
graved portraits...gathered by...Col.Chs.Colcock
Jones...to be sold Tue.,Wed.,Thurs.,April 24,25,
26,1894.Cat.comp.,and sale conducted by Stan.V.
Henkels,at the book auction rooms of Thos.Birch's
Sons,Philadelphia
 148 p. illus.
 cat.no.720
 16 engravings of Washington
Contains autographic sets of the signers of
the Declaration of Independence,Rulers & Govs.

II.B.3.e - ENGRAVING - 16th c.
Verheiden, Jacob, fl.1590
 Af-Beeldingen van sommighe in Godts Woort
ervarene Mannen,die bestreden hebben den Room-
schen Antichrist.Waer by ghevoecht sijn de Lof-
Spreucken ende Registers harer Boecken...ende nu
in Neer-Duijtsch overgheset door P.D.N....
s'Graven-Haghe,by Beuckel Cornelissoon Nieulandt,
1603,148ff.
 illus.
 Depicts & praises men who have opposed Roman
Brit. Catholicism:Wycliffe,Huss,Erasmus,Luther,Melanch-
Mus. thon,etc.
V.& A. Also in Latin:Prae- stantium aliquot Theologo-
 rum... rum,London,cat.83,no.27
 1973

N
7592
H513
RB
NPG
II.B.3.e - ENGRAVING - 18th c.

Henkels, Stanislaus Vincent, 1854-1926
 The rare and valuable coll.of portraits
and choice engravings gathered by J.Henry Clay
of Philadelphia embracing the most important
coll.of rare Washington portraits...also rare...
portraits,in line,mezzotint and stipple of emi-
nent Americans,artists,actors,authors,clergy-
men,lawyers,statesmen,etc...to be sold Fri.&
Sat.,Dec.3 & 4,1897,at the book & art auction
rooms of Davis & Harvey,Philadelphia
 124 p. illus.
LC Z999 cat.no.799 priced
H505 no.799 Several hundreds portrs.of Washington,
 p.77-102

II.B.3.e - ENGRAVING - 17th c.

Ederheimer, Richard, firm,N.Y.
 Illus.cat.of portraits by the master engra-
vers of the 17th century...N.Y.,Amer.Art Asso-
ciation,1916.

LC(769.E22)MiU MH MA FOR COMPLETE ENTRY
 SEE MAIN CARD

II.B.3.e - ENGRAVING - 18th c.
Roth-Scholts, Friedrich, 1687-1736
 Icones vivorvm ordinvm ervditione omniqve
item genere et varietate artivm de repvblica
litteraria et speciatim de academiis et gymna-
siis totivs pene Evropae ab aliqvot secvlis ad
nostra vsqve tempora optime meritorvm...collec-
tae stvdio atqve opera Friderici Roth-Scholtzii..
Norimbergae et Altdorfii,apvd haeredes J.D.
Tavberi,1725-28
 5 pt.in 1 v. 225 illus.

LC N7627.R8

II.B.3.e - ENGRAVING - 17-18th c.
Boydell, John, 1719-1804
 Ancient British portraits...comprehending
the choicest works of Vertue,van Gunst,Lombart,
Baron...& engraved by them from the original
paintings of Hans Holbein,Isaac Oliver,Sir
Anthony More,Vandyke...London,Boydell,1812

PP PPULC

II.B.3.e - ENGRAVING - 18th c.
Verheiden, Jacob, fl.1590
 Jacobi Verheidenii...Imagines et elogia prae-
stantivm aliqvot theologorvm,cvm catalogis libro-
rvm ab iisdem editorvm.Opera Friderici Roth-
Scholtzii. 2.ed. Hagae-Comitvm,apvd haeredes
J.D.Tavberi,1725
 6 p. illus. .With Roth-Scholts,F. Icones vire-
rvm omnivm ordinvm ervditione...Norimbergae et
Altdorfii,1725-28.

LC N7627.R8

705
A56
NCFA
v.24
II.B.3.e - ENGRAVING - 18th c.
Donnell, Edna.Bowden, 1891- .
 Portraits of eminent Americans after draw-
ings by Du Simitière

In:Antiques
24:17-21 July,1933 illus.

 Repro.incl:Washington on ceramics;enamel
cloak hooks;printed cotton with portr.medal-
lions derived fr. engravings after Du Simitière
 Incl.list of Prévost's,Reading's & B.B.
Ellis' engravings.

705
A56
NCFA
v.112
II.B.3.e - ENGRAVING - 18-19th c.
Crote, Suzy Wetzel
 Engravings of George Washington in the
Stanley deForest Scott collection

In:Antiques
112:128-33 July,'77 illus.

II.B.3.e - ENGRAVING - 19th c.

Henkels, firm, auctioneers, Philadelphia
Cat.of rare & choice engravings;incl.an ex-
traordinary coll.of portraits of Washington &
other notable Americans & of European celebri-
ties,a coll.of Napoleoniana & misc.engravings
to be sold Nov.24 & 25,1896 at the rooms of
Thos.Birch's Sons,Phila.,Pa....1896
52 p. illus.

940 engravings,18 photographs (no.768)
(For more locations of this cat.,see:Lugt
Rép.des cat.de ventes,1861-1900;013.37.L95 NCFA
MH MdBP CCl NIC MiU p.615,no.54768) Ref.

II.B.3.e - ENGRAVING - FRANCE

Galerie théâtrale,collection de 144 portraits
en pied des principaux acteurs et actrices
qui ont illustré la scène française depuis
1552 jusqu'à nos jours...Paris,A.Barraud,
Brit.mus. 1872.-73
1763.d.19 2 v. illus.

N.Y.P.L.has similar:Paris,Bance.1842.
N.Y.P.L. 3 v. illus. ...gravés par les plus cé-
MH&R lèbres artistes...Stipple engr.by Godefroy,
♦ Chaponnier,Lignon,etc.,fr.ptgs.by Auret,A.de
 Romance,A.Bosse,etc.

II.B.3.e - ENGRAVING - 19-20th c.

Mariani, Angelo
Figures contemporaines,tirées de l'album
Mariani...Paris,E.Flammarion,1894-
11 v. illus.

v.2.- published by H.Floury

Each plate has engraved portr. ...

LC CT148.M3 Fogg,v.11,p.324

NE II.B.3.e - ENGRAVING - FRANCE
270
G87 Grolier club, New York
NPG Cat.of an exh.of engraved portraits of
French authors to the close of the 18th cen-
tury...Dec.5-Dec.28,1895.N.Y.,The De Vinne
press,1895.
FOGG 16 p.
WIDENER
249 entries,showing name,dates,painter,
and engraver

Title fr.Columbia Univ. Levis.Descr.bibl.Z5947.A3
Printed by LC L66 1974 NCFA p.381

II.B.3.e - ENGRAVING - CANADA

Sabin, V.Philip
An illustrated cat.of a fine coll.of inter-
esting and rare engravings of American and Ca-
nadian portraits and views.London,Frank T.Sabin,
1932
105 p. illus.(col.front)
FOGG
FA5800
218 Incl.:Miniatures

MB MdBP Cty CSmH NN Winterthur Mus.Libr. fZ881
MiD .W78 NCFA v.6,p.224

II.B.3.e - ENGRAVING - FRANCE

Lieutaud, Soliman, b.1795
Liste alphabétique de portraits français
gravés jusque et y compris l'année 1775,faisant
le complément de celle de la bibliothèque hist.
de la France du P.Lelong,5 v. 2e éd.,rev.,cor.
et considérablement augm...Paris,1846
105 p.

1st ed.1844

LC NE270.L4 Amsterdam,Rijksmus.cat.
 Z5939A52,deel 1,p.145

II.B.3.e - ENGRAVING - FRANCE

Duplessis, Georges, 1834-1899
De la gravure de portrait en France...,mé-
moire couronné par l'Institut de France(Acadé-
mie des beaux-arts).Paris,Rapilly,1875
162 p.

"Liste des ouvrages du même auteur et des
éditions publiées par ses soins"

LC NE647.D8 Amsterdam,Rijksmus.cat.,
 Z5939A52,deel 1,p.145

II.B.3.e - ENGRAVING - FRANCE - RENAISSANCE

Galerie des artistes,ou portraits des hommes
célèbres dans la peinture,la sculpture,la
gravure et la musique,pendant les trois
siècles de la renaissance.52 gravures par
différents maîtres...avec de courtes notices
Paris,Société des amis des arts,1836
110 p. illus.

LC N7627.G2

II.B.3.e - ENGRAVING - FRANCE

Fontette, Fevret de
Liste générale et alphabétique des por-
traits gravés des françois et françoises illus-
tres jusqu'en 1775;publiée par Barbou de la
Bruyère.Paris,1809

.Suppl.by Lieutaud,1846.
cf.Lelong.v.IV

Listed in Universal Cat.of Zahn,Albert von,1836-1873
Books on Art.Suppl.p.224; Hist.Kunstslgn.In:Archiv f.
Fevret de Fontelle d.zeichnenden Künste.Univ.Ky
 Marg.I.King Libr.v.5,p.179

II.B.3.e - ENGRAVING - FRANCE - 16th c.

Epitomes des roys de France en latin & en fran-
coys auec leur vrayes figures...Lugduni.-Lyc
Balthasar Arnoullet,1546
159 p. illus.
2nd issue.1st issue entitled:Epitome gestorv
lVIII.regvm Franciae,1546

58 portrs,attr. to Corneille de Lyon,from
leg.king Pharamond to Francis I

LC Typ 515
46.366 MH Rave.Jb.d.Berl.Mus.I 1959
 LC N3.J16 fol. p.138
 Paolo Giovio & d.Bildnisvitenbücher....

705
G28
NCFA
v.58

II.B.3.e - ENGRAVING - FRANCE - (end)16th c.

Jouan, Andrée
Thomas de Leu et le portrait français de
la fin du 16e siècle

In:Gaz Beaux Arts
58:203-22 Oct,'61 illus.
Summary in English
Chronological arrangement of more than 200
portrs of de Leu's engravings.Info.on how portr.
engravers proceeded to work,on the selling of
their prints & their utility in the study of ptgs
of that period. Eller.Kongelige portr.male-
 re p.154

II.B.3.e - ENGRAVING - FRANCE - 17th c.
Heince, Zacharie, 1611-1669
Les Portraicts av natvrel,avec...,nors et
qvalites de messievrs les plenipotentiaires as-
serbles à Mvnster et Osnabvrg povr fa're la
paix generale.Paris,Chez Henry Sars et Chez
Jean Paslé,et ches les auteurs:F.Bignon fecit
et excudit.1648.
19 p. illus.

Comprises 33 full page engr.portrs.by Fran-
cois Pignon after Heince & list of the plenipo-
tentiaries(more than 33)assembled to make the
Peace of Westphal ia
NN

FOOO
FA
5759
.485
.10F

II.B.3.e - ENGRAVING - FRANCE - 17th c.
Bouvy, Eugène
La gravure de portraits et d'allégories.
Paris et Bruxelles,Les Éditions G.van Oest,19.
91 p. illus. (La gravure en France au
17e siècle)

Bibliography

Berlin.St.Mus.Kupferstic'
Ruhm des porträts VP N/
Bibl.

II.B.3.e - ENGRAVING - FRANCE - 17th c.
Hornibrook, Murray and Ch.Petitjean
Cat.of the engraved portraits by Jean Morin
...Cambridge.Eng.The University press,1945
55 p. illus.

LC NE650.M68H6

II.B.3.e - ENGRAVING - FRANCE - 17th c.
Bouvy, Eugène, 1859-
...Nanteuil...Paris,Le Goupy,1924
8 p. illus. (Le portrait gravé et ses
maitres)

Aperçu bibliographique sur Nanteuil:p..193,-
.196.

LC NE650.N4H6

AP
1
P89
NCFA
v.2

II.B.3.e - ENGRAVING - FRANCE - 17th c.
Metcalfe, Louis R.
Jean Morin, 1600-1666

In:Print Coll Q
2:1-30 Feb.,'12 illus.

Incl.:Description of development of en-
graved portrs.in France
'.Morin's.technique is chiefly etching com-
bined with burin work'-p.17

Metcalfe.Pr.coll.Q.3:119

705
G28
NCFA
v.62

II.B.3.e - ENGRAVING - FRANCE - 17th c.

Claude Lefebvre restitué par l'estampe

In:Gaz.Beaux-Arts
62:305-13 Dec.'63 illus.

Self-portrait,fig.1

1
P89
NMAA
v.1

II.B.3.e - ENGRAVING - FRANCE - 17th c.
Metcalfe, Louis R.
Robert Nanteuil(1630-1678)

In:Print Coll.Q.
1,no.5:526-61 Dec.,'11 illus.

II.B.3.e - ENGRAVING - FRANCE - 17th c.

Grolier club, New york
17th century line engraved portraits,an
exh....Nov.21-Dec.11,1935.Philadelphia, :Printe
and designed by E.Stern & co.,inc.,1935.
11 p.

"...centers around the work of Robert
Nantcuil."

N.Y.P.L.

II.B.3.e - ENGRAVING - FRANCE - 17th c.

Perrault, Charles, 1628-1703
Les Hommes illustres qui ont paru en France
pendant ce siècle;avec leurs portraits au natu-
rel.Paris,A.Desallier,1696-1700
2v.in 1 illus.

Portrs.engr.by Gérard Edelinck,Jacques Lubin
& others

LC CT1011.P4 1696

II.B.3.e - ENGRAVING - FRANCE - 17th c.

Petitjean, Charles and Ch.Wickert
 Cat.de l'oeuvre gravé de Robert Nanteuil.
Paris,L.Delteil et M.Le Garrec,1925
 411 p. illus.

 234 portrs.
 Bibliography

LC NE650.N4P4 Berlin.St.Mus.Kupferst.K.
 Ruhm des portraïts VF NPG
 Bibl.

II.B.3.e - ENGRAVING - FRANCE - 17-18th c.

Thomas, Thomas Head, 1881-
 French portrait engraving of the 17th and
18th centuries...London,G.Bell & sons,ltd,1910
 211 p. illus.

 List of French portr.engravers & painters,
p.175-211
 "1761 distinct change in portr.engr.in France.
Medallion portrs...became the fashion...a new
form,that of miniatures is developed."
 Attention upon portr not upon accessories.
 Influence of St.Mémin shows
LC NE647.T4 Morgan.The work of M.Fèvre.
 Brooklyn mus.Q.v.5,Jan'18

II.B.3.e - ENGRAVING - FRANCE - 17th c.

Robert-Dumesnil, Alexandre Pierre François,
 Nanteuil,Robert in «his» «1778-1864
Le peintre-graveur français ou cat.raisonné
des estampes gravées par les peintres et les
dessinateurs de l'école française;ouvrage fai-
sant suite au Peintre-Graveur de M.Bartsch.
Paris,G.Warée.etc.,etc.,1835-71 (11 v.)

 v.4:Nanteuil, Robert(234 items)

LC NE149.R6 Metcalfe,L.R. In:Print Col
 Q. 1,no.5:529
 AP1.P89 NMAA

II.B.3.e - ENGRAVING - FRANCE - 18th c.

N
40.1
F44 3y Andrews, William Loring, 1837-1920
A5 A trio of 18th century French engravers of
NPG portraits in miniature.Ficquet,Savart,Grateloup..
RB N.Y.,Dodd,Nead & co.,1899
 123 p. illus(1 col.)
 Contents.-Intro.,giving a short account of
the various methods of engr.on metal.-A trio of
18th c.French engravers...-Extracts fr.La Calco-
grafia of Giuseppe Longhi.-List of portrs.engr.
by Étienne Ficquet, Pierre Savart, Jean Baptiste
de Grateloup

LC NE647.A5 evi.Descript.bibl.Z5947.A3
 166 1974 NCFA p.205

II.B.3.e - ENGRAVING - FRANCE - 17th c.

Vulson de la Colombière, Marc, d.1658
 Les hommes illustres et grands capitaines
françois qui sont peints dans la Galerie du Pa-
lais Royal...avec leurs portraits...dessipnes
& graves par les sieurs Heince & Bignon..Paris,
Estienne Loyson,1690
 «66»p. illus.

 Publ.previously in 1650 with title:Les por-
traits des hommes illustres françois...400 p.
LC has 1668 ed.:DC36.V8

CSt Winterthur Mus.Libr. fZ861
 .W78 NCFA v.5,p.226

II.B.3.e - ENGRAVING - FRANCE - 18th c.

Blin, Pierre
 Portraits des grands hommes,femmes illus-
tres et sujets mémorables de France,gravés et
imprimés en couleurs...Paris,Chez Blin,impri-
meur en Taille-douce,1792.
Brit. 2 vols. 192 col.pl.in 3 v.
mus. Originally publ.in 50 parts.
1260 c. 96 portrs.& 96 histor.scenes.Designed by
Sergent,Desfontaine,Naigeon,P.Barbier,Bénard,
F.Gérard,Deplessis-Berteaux & engraved by Ser-
gent,Mme.de Cernel,J.Morret,Ridé,L.Roger,
Le Coeur
HN Source:Lewine.Bibl. of art & illus.Books
 A1023.L67 1969. NCFA p.505

II.B.3.e - ENGRAVING - FRANCE - 17-18th c.

VF
NPG

Berlin. Staatliche museen. Kupferstichkabinet
 Ruhm des portraïts.Nanteuil und der franzö-
sische porträtstich im Grand Siècle 1600-1750.
Sonderausstellung,1976.Text:Ekkehard Mai.Berlin
1976
 4 p. illus.

 125 portrs.exhibited
 Article is grouped:The period;Portrait;
Nanteuil and the printmakers(Morin,Mellan,Bosse
Masson,Drevet;a.o.)
 "«Above all portraiture became»,next to his-
torical ptg.the () instrument of political
propaganda..»-Ma»

II.B.3.e - ENGRAVING - FRANCE (18th c.)

Dreux du Radier, Jean François, 1714-1780
 L'Europe illustre,contenant l'histoire abré-
gée des souverains,des princes,des prélats,des
ministres,des grands capitaines,des magistrats,
des savans,des artistes,& des dames célèbres en
Europe;dans le 15e siècle compris,jusqu'à présent
...Ouvrage enrichi de portraits,gravés par les
soins du Sieur Odieuvre...Paris,Odieuvre.et.Le
Breton,1755-65
 6 v. illus.
 Planches par N.Dupuis,G.Duchange,J.G.Will.e.
NN Pinssio,etc.
 Amsterdam,Rijksmus.,cat.
 Z5939A52,deel 1,p.131

II.B.3.e - ENGRAVING - FRANCE - 17-18th c.

Desrochers, Étienne Johandier
 Recueil de portraits des personnes qui se
sont distinguées,tant dans les armes que dans
les belles-lettres et les arts.Concerne aussi la
famille Royale de France et autres cours étran-
gères..Paris,1700-1730,or 1735?»
Brit. 4 v. illus.
Mus.
554.d.1,2
(2 v.) Engraved portrs.most of them by Desrochers

 Lewine.Bibl.f 18th c.art
 ...books.Z1023.L67 1969
 p.144

II.B.4 - FRANCE - 18-19th c.

Broadley, Alexander Meyrick, 1847-1916
 Collectanea Napoleonica;being a cat. of the
coll....caricatures...portraits,naval and mili-
tary costume plates,etc.relating to Napoleon I.
and his time,1769-1821.Formed by A.M.Broadley...
comp.by Walter V.Daniell...Illustr.with a hither
to unpublished portrait of Napoleon,by Detaille.
London,W.V.Daniell;.etc.1905.
 166 p. illus.
 'Interesting,well illustrated volume.'-Levis

LC Z8612.B85 evis.Descript.Bibliogr.
 Z5947.A3L66 1974 NCFA
 p.206

II.B.3.e - ENGRAVING - FRANCE, 18-19th c.

Hennequin, René
Avant les photographies;les portraits au
physionotrace,gravés de 1788 à 1830.Cat.nomina-
tif,biographique et critique illustré des deux
premières séries de ces portraits comprenant les
1800 estampes cotées de "1"à"R27".Troyes,J.L.
Paton,1932
345 p. illus.
Contents.-La société parisienne à la veille
de la Révolution;portrs.dess.par Quenedey et gra-
vés par Chrétien,1788-1789.-Au temps de la Révo-
lution ...portrs.dess.et gravés par Quenedey,
1789-1796

LC NE270.H4

NE
265
L8A5
NPG
II.B.3.e - ENGRAVING - GREAT BRITAIN
British museum. Dept.of prints and drawings
Catalogue of engraved British portraits pre-
served in the Department of prints and drawings
in the British museum, by Freeman O'Donoghue...
London,Printed by order of the Trustees,1908-25

6 v.

incl.bibliographies

v.5(Groups):...and Harry E.Hake
v.6(Suppl't & indexes)by Harry M.Hake

LC NE265.L8A5 1908 Waterhouse.Ptg.in Britain,
530-1790 ND465.W32 1962
NCFA bibl.

II.B.3.e - ENGRAVING - GERMANY

Geisberg, Max, 1875-1943
Geschichte der deutschen graphik vor Dürer.
Berlin,Deutscher verein für kunstwissenschaft,
1939
217 p. illus.

Bibliography

Survey of early illustrated printed books

LC NE651.G44 Rave.Jb.d.Berl.Mus.I 1959
LC N3.J16 fol.p.122 footnote
Paolo Giovio & d.Bildnisvitenbücher..

NE
265
W747
RB
NPG
II.B.3.e - ENGRAVING - GREAT BRITAIN

Bromley, Henry
A catalogue of engraved British portraits from
Egbert the Great to the present time...with an
appendix containing the portraits of .certain.
foreigners...London,T.Payne,1793

MET
276.5
B78
copy 2 in
print dpt.

LC NE265.W5 AMSTERDAM,Rijksmus.,cat.
Z5939A52,deel 1,p.150

II.B.3.e - ENGRAVINGS - GERMANY - 16th c.

Boissard, Jean Jacques, 1528-1602
Icones virorum illustrium doctrina et eru-
ditione praestantium...Francfordii ad Moenum,
1597-99
4 v.in 2 illus.

Each v.with 50 portr-engravings of famous
humanists by Theodor de Bry

vols.3 & 4 text by Johann Adam Lonicerus

LC CT93.B6 = ed.1598-1630
NN MH Th:B.(Bry,Theodor)
N40T43 1907a Bd.5,p.163,b

NE
265.C4X
NPG
II.B.3.e - ENGRAVING - GREAT BRITAIN

Caulfield, James, 1764-1826
Calcographiana:the printsellers chronicle and
collectors guide to the knowledge and value of
engraved British portraits.London,G.Smeeton,...
1814
163 p. illus.

Repro.:J.Caulfield by Cooper after Walton

VLC NE265.C4 Amsterdam,Rijksmus. cat.
Z5939A52,deel 1, p.150

II.B.3.e - ENGRAVING - GERMANY (18th c.)

Roth-Scholtz, Friedrich,1687-1736
Icones consiliariorvm de illvstri Repvblica
Noribergensi optime meritorvm qvi ab anno
MCCCLXVI ad hvnc vsqve diem clarvervnt;ex monv-
mentis,nvnlis plasmatibvs,cereis tabvlisqve item
pictis et aeneis,hinc inde collectae stvdio atqve
opera Friderici Roth-Scholtzii...Noribergae et
Altdorfii,apvd haeredes J.D.Tavberi,1723
.8.p. 152 illus.

LC N7605.R8 (contains only 147 illus.)

II.B.3.e - ENGRAVING - GREAT BRITAIN

Daniell, Walter Vernon comp.
A catalogue of engraved portraits of cele-
brated personages,chiefly connected with the
history and literature of Great Britain...Lon-
don,W.V.Daniell,1900
278 p. illus.

LC NE265.D3 Whitman's print coll.hdbk.
1921. NE885W614 1912 NCFA
Bibl.III

II.B.3.e - ENGRAVING - GERMANY - NUREMBERG
Panzer, Georg Wolfgang,1729-1804.
Verzeichnis von Nürnbergischen portraiten
aus allen ständen,nebst fortsetzung.Nürnberg,
1790-1801

Listed in Universal Cat.of
Books on Art.Suppl.p.469

Zahn,Albert von,1836-1873
Hist.Kunstslgn.In:Archiv f.
d.zeichnenden Künste.Univ.
of Ky.Marg.I.King Libr.
760.5 Ar253 v.5,p.181

II.B.3.e - ENGRAVING - GREAT BRITAIN

Evans, Edward, 1789-1835
Catalogue of a collection of engraved portraits
the largest ever submitted to the public;compris-
ing nearly 20000 portraits of persons connected
with the history & literature of this country,from
the earliest period to the present time...alpha-
betically arranged with the names of the painter
& engraver...Now on sale...London,E.Evans,etc.,
1836-53.

LC Rare Books dpt. Amsterdam,Rijksmus.cat.
Z5939A52, deel 1,p.151

II.B.3.e - ENGRAVING - GREAT BRITAIN

Flindall, John Morris
 The amateur's pocket companion;or, A description of scarce and valuable engraved British portraits.Also...books,as mentioned....by. Granger,Bromley,Noble,etc.Alphabetically arranged ...London,J.M.Flindall.etc.1813
 141 p.

LC NE265.F6

NE
265
G67
NPG

II.B.3.e - ENGRAVING - GREAT BRITAIN

Grolier club, New York
 Effigies of the most famous English writers from Chaucer to Johnson,exh....Dec.8-22,1891 .N.Y.,The De Vinne press,1891.
 78 p. illus.

LC N7598.G68
 NE205.G75 Fogg,v.11,p.333

II.B.3.e - ENGRAVING - GREAT BRITAIN

Freemasons. England. United grand lodge.
 Library and museum
 Cat.of portraits and prints at Freemason's hall in the possession of the United grand lodge of England,comp.and arranged by Major Sir Algernon Tudor-Craig...1938.London,The United grand lodge of England.1938.
 119 p. illus(1 col.)

LC N1165.F7A53 Winterthur Mus.Library
 Z881.W78 NCFA v.6,p.227

II.B.3.e - ENGRAVING - GREAT BRITAIN

Madrid, Biblioteca Nacional
 Iconografía britana;catálogo de los retratos grabados de personajes ingleses...por Elena Páez Ríos...Madrid,1948
 839 p. illus.

 Bibliography

LC NE55.M3A45 Fogg,v.11,p.332

II.B.3.e - ENGRAVING - GREAT BRITAIN

Granger, James, 1723-76
 A biographical history of England, from Egbert the Great to the revolution;consisting of characters disposed in different classes,and adapted to a methodical catalogue of engraved British heads;intended as an essay towards reducing our biography to system and a help to the knowledge of portraits...5th ed.London,W.Baynes and son,1824

 6 v. illus.
 Annotated catalogue of engraved Engl.portrs.
LC DA28.G7 1824 Clowes.A grangerised book
 In:Conn.43,Sep,1915,p.21

II.B.3.e - ENGRAVING - GREAT BRITAIN

Myers & Rogers, London
 Cat.of engraved portraits of noted personages principally connected with the history, literature, arts and genealogy of Great Britain. ...London,Myers & Rogers,1903
 156 p. illus.

DLC NN MdBJ PP Winterthur Mus.Library
 Z881.W78 NCFA v.6,p.228

II.B.3.e - ENGRAVING - GREAT BRITAIN

GRANGER, JAMES, 1723-76
A BIOGRAPHICAL HISTORY OF ENGLAND

Noble, Mark, 1754-1827
 A biographical history of England, from the revolution to the end of George I's reign; being a continuation of the Rev.J.Granger's work;consisting of characters disposed in different classes,and adapted to a methodical catalogue of engraved British heads...The material being supplied by the manuscripts left by Mr.Granger...London, W.Richardson, 1806
 3 v. illus.
LC DA28.G75

mfm
124n13
NCFA

II.B.3.e - ENGRAVING - GREAT BRITAIN

Murdoch, William Garden Blaikie, 1880-1934
 A bequest of Stuart engravings to the National Library of Scotland

In:Apollo
13:167-73 Mar,'31 . illus.

 400 items relating to the dynasty

II.B.3.e - ENGRAVING - GREAT BRITAIN

GRANGER, JAMES, 1723-76
A BIOGRAPHICAL HISTORY OF ENGLAND

Rodd, T.homas.& Rodd, H.oratio,,pub.
Met A collection of portraits to illustrate
901.72 Granger's Biogr.hist.of England, and Noble's
G761 continuation to Granger; forming a supplement to Richardson's copies of rare Granger portraits. London, T.& H.Rodd,1820-22

 2 v.in 1. illus.

LC N7598.C6 Rosenwald coll.
title main entry

II.B.3.e - ENGRAVING - GREAT BRITAIN

Rubens, Alfred, 1903-
 Anglo-Jewish portraits;a biographical catalogue of engraved Anglo-Jewish & colonial portraits from the earliest times to the accession of Queen Victoria,by...with a foreword by H.M.Hake. London,The Jewish museum,1935
 191 p. illus.

 Bibliography

LC DS135.E6A17 Waterhouse.Ptg.in Britain
 1530-1790 ND465.W32 1962
 NCFA bibl.

II.B.3.e - ENGRAVING - GREAT BRITAIN

Smith, John Russell, 1810-1894
 A catalogue of 10000 engraved portraits,
chiefly of personages connected with the his-
tory and literature of Great Britain on sale by
J.R.Smith,London,1875

FOGG
FA983.1.7

Fogg,v.11,p.325

II.B.3.e - ENGRAVING - GREAT BRITAIN

Thane, John,1748-1818, ed.
 The British gallery of historical portraits
...a coll.of ca. 300...portraits...of the ro-
yal and illustrious personages in English histo-
ry and literature,from the reign of Henry V
(1420)to that of George II(1750)...London,Edw.
Daniell,1854?.
 4 v. illus.

MET
276.5
T32
 4 v. 269 engr.portrs.

LC DA28.T3

II.B.3.e - ENGRAVING - GREAT BRITAIN

Smith, John Russell, 1810-1894
 A catalogue of 20000 engraved portraits,
chiefly of personages connected with the his-
tory and literature of Great Britain,on sale...
by John Russell Smith...London,1883

LC NE265.S5

Fogg,v.11,p.325

II.B.3.e- ENGRAVING - GREAT BRITAIN

Vertue, George, 1684-1756
 Prints. King Charles I & the heads of the
noble earls,lords & others,who suffered for their
loyalty in the rebellion & civil-wars of England.
With their characters engraved under each print,
extracted from Lord Clarendon.Taken from original
pictures of the greatest masters.Many of them Sir
Anthony van Dyke's & all the heads accurately en-
graved by Mr.Geo.Vertue.London,C.Davis,1746

LC N7598.V4 Rosenwald coll.

II.B.3.e - ENGRAVING - GREAT BRITAIN

Stenson, John
 Catalogue of engraved British portraits con-
nected with the history and literature of Great
Britain,the British colonies and the United
States.London,186-.

FOGG
FA
983.1.11

Fogg, v.11,p.333

II.B.3.e - ENGRAVING - GREAT BRITAIN

Victoria and Albert Museum, South Kensington.
National art library.
 A catalogue of engraved national portraits
in the National Art Library, with a prefatory
note by Julian Marshall. London,1895
 523 p.

MET
276.5
V66

Amsterdam,Rijksmus.cat.
25939A52,deel 1,p.151

II.B.3.e - ENGRAVING - GREAT BRITAIN

The Stowe,Oranger and other engravings;cat.of
the remaining portion of the engr.British
portrs.,comprising those fr.the reign of
James II forming the illus.copy of the con-
tinuation of the Biographical hist.of Engl.
by the Rev.Mark Noble...engrs.of the English
school.Woollett,Strange,Hogarth...Sir Josh.
Reynolds...removed fr.Stowe house,Bucking-
hamshire...sold...by...S.Leigh Sotheby & Co.
...21st Mar.1849 & 5 ff.days...London 1849.
62 p.

MET
212
K9

 Priced

Met.Sales cat.fZ881.N53 NCFA v.25,p.023318

II.B.3.e - ENGRAVING - GREAT BRITAIN

.Walmsley, Edward.
 One hundred distinguished characters,from
undoubted originals.Engraved in the line manne
by the most eminent British artists,MDCCCXX..
 2 v.in 1 illus. London,The proprietor,
 .1824.
 Text in French

LC N7627.W3

Cat.of B.Quaritch,ltd.Lon-
don,1978;no.983,p.30,no.2
 272

II.B.3.e - ENGRAVING - GREAT BRITAIN

Sykes, Sir Mark Masterman, 1771-1823
 A cat.of the highly valuable collection of
prints,the property of Sir M.M.Sykes...sold by
Mr.Sotheby,March-Dec...1824..London:J.Davy,prin-
ter.1824.
 5 pt.in 1 v. illus.
 Priced

MET
212
I4
 Pt.1
 Partial contents.-Series of Brit.portrs.,fr
the heptarchy to the end of the reign of Williar
III.-Pt.4.Continuation of a series of Brit.ports
fr.the commencem't of the reign of Queen Ann to
the present time

LC NE59.S82

Met.Sales cat.fZ881.N53 NCFA v.25,p.023561

II.B.3.e - ENGRAVING - GREAT BRITAIN

Walpole, Horace, Earl of Orford, 1717-1797
 A catalogue of engravers,who have been born,
or resided in England;digested...from the mss.of
Mr.George Vertue...London,J.Caulfield.etc.1794
 230 p. illus.

LC NE628.W2
LC NE628.W2 ed.1782;344 p.
LC NE628.W18 ed.1765;160p. illus.

Martin,J.R. Notes
no.16

II.B.3.e - ENGRAVING.- GREAT BRITAIN

Woodburn, Samuel, 1785 or86-1853
Cat.of splendid and capital coll.of en-
graved British portraits...for sale...at
S.Woodburn's,no.112,St.Martin's Lanes,London.
London,1815(or1816)
2 v.

W.'s Gall.of rare portrs.(fr.original plates
& facsimiles)
see Hind.Hist.of engr.& etching; fr.the 15th
c.to the yr.1914 NE400.H66 1963 NCFA p.410

Ars Artis cat.41 Books on
Prints Drags. no.689

II.B.3.e - ENGRAVING - GREAT BRITAIN - 16-17th c

Sotheby, firm,auctioneers, LONDON
Cat.of a...coll.of engraved British por-
traits formed by the late proprietor for the
illustration of Granger's history of England;
many...originally in the Sykes,Bindley & Dela-
bère collections...by...Elstracks...Cecil...
Vaughan...Faithorne....London,1863.
19 p.
Sale cat.Jl.22,1863 & ff.day
¿The proprietor was E.Rose TUNNO!-Lugt.In¡
Marques de collections.N8380.L95,NCFA,p.159,no.
.902

MET
212
1853
50-61
53-64

Met.sales ca c.fZ881.N53 NCFA v.2, p.
c023315

II.B.3.e - ENGRAVING - GREAT BRITAIN

Woodburn, Samuel, 1785 or86-1853
Gallery of rare portraits,consisting of
200 original plates and facsimile copies of
rare and curious portraits,illustrative of
Britisih history.London,1816
2 v.

Brit.
Mus.

Universal Cat.of Books on
Art Z5931.U58 1964,v.2,
p.2161
7 & A v.10 Pre-1890,p.505
fZ921.V64 NCFA

II.B.3.e - ENGRAVING - GREAT BRITAIN - 16-18 th

Levis, Howard Coppuck
Notes on the early British engraved Royal
portraits issued in various series from 1521
to the end of the 18th c...London,The Chiswick
press,1917

LC N7598.L5 FOR COMPLETE ENTRY
SEE MAIN CARD

II.B.3.e - ENGRAVING - GREAT BRITAIN (11-15th c.)

Holland, Henry, 1583-1650?
Baziliωlogia, a booke of kings;notes on a
rare series of engraved English royal portraits
from William the Conqueror to James I, publ....
1618 & 1630. By H.C.Levis. New York,The Grolier
club,1913

188 p. illus.
Edition of 300 copies

LC NE1685.B315

Hake,H.M. The Engl.hist.
portrait.

II.B.3.e - ENGRAVING - GREAT BRITAIN - 17th c.

Grolier club, New York
Cat.of an exh.of portraits engraved by
William Faithorne...Feb.16-Mar.4.N.Y.De Vinne
press,1893
38 p.

LC NE642.F207

Levis, Descr.bibl.Z5947A3
L66 1974 NCFA p.380

II.B.3.e - ENGRAVING - GREAT BRITAIN - 16-17th c.

British museum. Dept.of prints and drawings
Early engraving & engravers in England
(1545-1695)a critical and historical essay by
Sidney Colvin...London,Printed by order of the
Trustees,1905
170 p. illus.

Appendix I.List of engravers' works

Incl.account of Faithorne's life

LC NE628.B8

Hind.Studies in English
Engraving.In:Connoisseur
92:92, 1933

705
C75
NCFA
v.92

II.B.3.e - ENGRAVING - GREAT BRITAIN - 17th c.

Hind, Arthur Mayger, 1880-1957
Studies in English engraving. IV.William
Faithorne

In:Connoisseur
92:92-105 Aug,'33 illus.

705
C75
NCFA
v.91

II.B.3.e - ENGRAVING - GREAT BRITAIN - 16-17th c.

Hind, Arthur Mayger, 1880-1957
Studies in English engraving. III.The first
century of line-engraving in England

In:Connoisseur
91:361,363-74 Jun,'33 illus.

Repro.:Tudor family by Wm.Rogers;Pocahontas
by Sim.v.d.Passe;ElizaTriumphans by Wm.Rogers;etc.

705
C75
NCFA
v.92

II.B.3.e - ENGRAVING - GREAT BRITAIN - 17th c.

Hind, Arthur Mayger, 1880-1957
Studies in English engraving. VI.Prince
Rupert and the beginnings of mezzotint

In:Connoisseur
92:382-91 Dec,'33 illus.

Incl.:Catalogue of mezzotints by and attri-
buted to Prince Rupert

779

II.B.3.e - ENGRAVING - GREAT BRITAIN - 17th c.

Layard, George Somes, 1857-1925
 The headless horseman,Pierre Lombart's en-
graving,Charles or Cromwell?...with an intro.
by Campbell Dodgson...London,P.Allan & co.,1922
 125 p. illus.

 7 states of an engr.,3 with Cromwell's head,
1 with the head of Charles I,2 with the head of
Louis XIV,1 without head;after v.Dyck's eques-
trian portr.of Charles I.
 cf.Connoisseur bookshelf in Conn.63:247,
Aug.,'22:'...L.contends that Lombart never in-
tended to produce a portr.of Charles I
LC NE650.L84L3

II.B.3.e - ENGRAVING - GREAT BRITAIN - 18th c.

Blum, André, 1881-
 La gravure en Angleterre au 18e siècle...
avec une préface de m.Campbell Dodgson...
Paris,G.van Oest,1930
 89 p. illus.

 Bibliography

LC NE628.B6 Winterthur Mus.Library
 Z2881.W78 NCFA v.6,p.230

II.B.3.e - ENGRAVING - GREAT BRITAIN - 17th c.

Musgrave, Sir William, Bart., 1735-1800.
 A catalogue of a....collection of English
portraits consisting of the royal families...
lawyers...artists...from Egbert the Great to
the present time...works of Delaram...Hollar,
Loggan...with...remarks by an eminent collector
Sir W.Musgrave...sold by...Mr.Richardson...
Feb.3.1800.and the 17 ff.days...and Mar.3,and
the 12 ff.days...London 1800.
 323 p.

MET
212
F98

 Priced 3495 items Names of
DLC buyers
 (For more locations of this cat.see over)
 Mus.Sales cat.Z881.N53 NCFA v.35 p.62???

II.B.3.e - ENGRAVING - GREAT BRITAIN - 18th c.

Du Siritière, Pierre Eugène,ca.1736.-1784
 Portraits of the generals,ministers,magis-
trates,members of Congress,and others,who have
rendered themselves illustrious in the revolu-
tion of the United States of North America.
Drawn from the life by M.Dusimitier...and en-
graved by the most eminent artists in London.
London,R.Wilkinson and W.Debrett,1782
 2 p. 12 portrs.

 Incl.Washington, John Jay
 'Set was signed P.E.'-Donnell
LC E206.D97

II.B.3.e - ENGRAVING - GREAT BRITAIN - 17th c.

Ollier, Edmund, 1827-1886
 Our British portrait painters,1617-18;16 en-
gravings on steel with descriptive and histori-
cal notices...Phila.,J.B.Lippincot & co.1874?.
 101 p. illus.

LC N7598.O5
 Art Books 1876-1949.Z5937
 A775 NCFA Ref. p.495

II.B.3.e - ENGRAVING - GREAT BRITAIN - 18th c.

Du Siritière, Pierre Eugène, ca.1736-1784
 Thirteen portraits of American legislators,
patriots,and soldiers,who distinguished them-
selves in rendering their country independent;
...drawn from the life by Du Simitère...and en-
graved by Mr.P.Reading.London,W.Richardson
1783.
 13 plates

 Incl.:Washington, John Jay

MB NJP MH CtY MiU-C Winterthur Mus.Libr. Z881
PPL W78 NCFA v.6,p.226

II.B.3.e - ENGRAVING - GREAT BRITAIN - 17th c.

Sotheby, firm, auctioneers, LONDON
 A catalogue of a most beautiful collection
of British portraits,from Edward the Third to
George the First...embracing the most rare and
esteemed works of Elstracke,Delaram,the Pass fa-
mily,Voerst,Vosterman,Blootelling,Loggan,White,
Valck,Smith,Williams,Becket,etc.and particular-
ly...Wm.Faithorne,incl.an unique impression of
Oliver Cromwell between Pillars.The Houbraken
heads...sold by Mr.Sotheby...on Wednesday,12th
day of Dec.,1827.London 1827
 40 p.

CtY

II.B.3.e - ENGRAVING - GREAT BRITAIN - 18th c.

CN
7598
C67
NCFA Cosse, Edmund William, 1849-1928
 British portrait painters and engravers of
the 18th century, Kneller to Reynolds.New York,
Goupil & co.,1906. Plates,Asnières-sur-Seine,
Manzi,Joyant & co.,1905
 90 p. illus(part col.)

 Biographical notes

LC ND1314.G7 Fogg,v.11,p.317,col.2
orBF639.C82 1905 Adair.18th c.pastel portrs.
 NC885.A32 1971X Bibl.p.202

II.B.3.e - ENGRAVING - GREAT BRITAIN,- 17th c.

Woodburn, Samuel, 1785 or 86-1853
 Woodburn's Gallery of rare portraits;con-
sisting of original plates by Cecil,Delaram,
Droeshout...illustrative of Granger's Biograph.
hist.of England,Clarendon's Hist.of the rebel-
lion,Burnet's Hist.of his own time,Pennant's
London,etc...containing 200 portrs.of persons
celebrated...London,G.Jones,1816
 2 v. illus.

 For full subtitle see(LC)Z881A1U525 1942
 v.165,p.418 NPG Ref.

LC N7598.W6

II.B.3.e - ENGRAVING - GREAT BRITAIN - 18th c.

Grolier club, New York
 Cat.of an exh.commemorative of the bicen-
tenary of the birth of Samuel Johnson...with
a large number of engraved portraits after pic-
tures by Sir.J.Reynolds,Js.Barry,J.Opie,Franc.
Bartolozzi,etc.....Nov.11-Dec.11,1909.N.Y.,De
Vinne press,1909.
 108 p. illus.

LC Z8455.8.G85 Levis.Descr.bibl.Z5947.L3
 L66 1974 NCFA p.386

NE
265
G87c
NPG

II.B.3.e - ENGRAVING - GREAT BRITAIN - 18th c.

Grolier club, New York
Catalogue of engraved portraits of actors
of olden time,Jan.24 to Feb.14,1907.New York,
The Grolier club.1907.
46 p.

LC NE45.N608 1907 Fogg,v.11,p.322

II.B.3.e - ENGRAVING - GREAT BRITAIN - 18-19th c.

Corner, John, fl.1788-1825
Portraits of celebrated painters,with medal-
lions from their best performances,engraved by
J.Corner,with authentic memoirs from established
authorities.London,Longman,Hurst,etc.,1825
52.p. illus.

Published also anonymously,under title:
Portrs.& lives of eminent artists...London,
182-?.
Contents:v.Dyck-Poussin-Both-Castelfranco-
LC ND85.C75 Lanfranco-Snyders-Titian-Domenichino-da Cortona-
IRS ARTIS cat.41 Books on
Prints & drags. no.667

N
7592
H513
RB
NPG

II.B.3.e - ENGRAVING - GREAT BRITAIN - 18th c.

Henkels, Stanislaus Vincent, 1854-1926
Cat.of the very important coll.of studies
and sketches,made by Col.John Trumbull...as
well as his important coll.of engravings and
portraits in mezzotint,line and stipple...to
be sold Thur,Dec.17,1896.Cat.comp.,and sale
conducted by Stan.V.Henkels at the art auction
rooms of Thos.Birch's Sons,Philadelphia
39 p. illus.
cat.no.770

Sale by order of B.Silliman,who inherited
the effects of Col.John Trumbull

II.B.3.e - ENGRAVING - GREAT BRITAIN - 18-19th c.

Dance, George, 1740(or 41)-1825
A coll.of portraits sketched from life
since the year 1793 by George Dance...and en-
graved in imitation of the original drags.by
William Daniell...London,Longman(etc.)1808-14

LC N7598.D3 FOR COMPLETE ENTRY
SEE MAIN CARD

II.B.3.e - ENGRAVING - GREAT BRITAIN - 18th c.

Portraits of the Hungarians,Pandours,or Croats,
Maradins or Sclavonians,and Ulans,etc. who
are in the service of their Majesties the
Queen of Hungary and the King of Prussia,
designed after the life,by persons of dis-
tinction...London,William Meyer,1742
8 p. 6 plates

Winterthur In English and French
Mus.Libr. Plates engraved by Hulett and Pickhar
SP303
R94#
Winterthur Mus.Libr.
f2581.W78 NCFA v.5,p.241

II.B.3.e - ENGRAVING- GREAT BRITAIN - 18-19th c.

Frankau, Julia(Davis), 1864-1916
William Ward,A.R.A.,James Ward,R.A.,their
lives and works.London,N.Y.,Macmillan & co.,ltd
1904
333 p. illus. and portfolio of 40 pl.
(part col.) (18th c.artists and engravers)

LC NE642.W3F7 Noon,Engl.portr.drags.&min.
NC860.N66X NPG Bibl.p.145

II.B.3.e - ENGRAVING - GREAT BRITAIN - 18th c.

Salmon, Thomas, 1679-1767
The chronological historian;containing...
all material...relating to the English affairs,
from the invasion of the Romans to the present
time...Illustrated with the effigies of all
our English monarchs,curiously engraven,by
Mr.Vertue.London,printed for W.Mears,1723
422 p. illus.

LC(94;2S172c)Rare book coll.
(DA34;S1733 2nd ed.495 p.illus.
(DA34S2)3rd ed. 2 v. il. Brit.mus.Additions 1965
v.5,p.677,2921.H862 NCFA Ref
Dept.of printed books

CC
1473
W95
1867
NPG PH

II.B.3.e - ENGRAVING - GREAT BRITAIN - 18-19thc.

Wright, Thomas, 1810-1877
Caricature history of the Georges.London,
J.C.Hotten,1867.
639 p. illus.
_____ Same .New York,
Benj.Blom,1968

1st ed.1848

ca.400 illus.on steel & wood

II.B.3.e - ENGRAVING - GREAT BRITAIN - 18-19th c.

The British gallery of contemporary portraits;
being a series of engravings of the most eminent
persons now living or lately deceased in Great
Britain and Ireland,from drawings...or pictures.
London...1822
FOGG 2 v. illus.
Houghton
Library
Portrs.engr.by G.S.Bartolozzi,A.Cardon,
T.Cheesman,R.Cooper,J.Godby,R.Smith,C.Wendramini,
and others

Fogg,v.11,p.331

II.B.3.e - ENGRAVING - GREAT BRITAIN - 19th c.

Cooper, Robert, fl.1800-1836
Fifty wonderful portraits.Engraved by R.
Cooper and R.Page,from authentic originals.
London,J.Robins & co.,1824
8 p. plates

Winterthur
E330
C77

H NN Winterthur Mus.Libr.
f2581.W78 NCFA v.5,p.225

II.B.3.e - ENGRAVING - GREAT BRITAIN - 19th c.

Jerdan, William
 National portrait gallery of illustrious and
eminent personages of the 19th c.;with memoirs.
London,Fisher,Son & Jackson,1830-34

 5 v. illus.

 184 portrs.by Robinson,Thomson,Fry,Freeman,
etc.after ptgs.by Lawrence,Reynolds,Shee,Beechey,
Jackson,etc.

LC DA531.1J5

From H's desk
Destailleur.LC Z5939D42
p.150,no.601.Cat.de livres..

II.B.3.e - ENGRAVING - ITALY - 17th c.

Leoni, Ottavio, c.1578-1630
 Ritratti di alcuni celebri pittori del seco-
lo 17.,disegnati ed intaliati in rame dal Cava-
liere Ottavio Leoni...si e' aggiunta la vita di
Carlo Maratti...Roma,Antonio de'Rossi,1731
 272 p. illus.,12 engr.portr.

MET
175
L55

Met,v.19, p.17200

II.B.3.e - ENGRAVING - ITALY - 16th c.

Orsini, Fulvio, 1529-1600
 Imagines et elogia virorum illustrium et
eruditorum. Romae,1570

 The life of 133 famous poets,philosophers,
historians,orators,grammarians,jurists,doctors,
based on antique authors;with engr.after medals,
busts,statues,etc.
 "The whole a step to pure archeology via the
'bildnisvitenbuch".-Rave

r2.Mus.
51 c.
.(3.)

Rave.Jb.d.Berl.Mus.I 1959
LC N3.J16 fol.p.146
Paolo Giovio & d.Bildnisvi-
tenbücher d.Humanismus

II.B.3.e - ENGRAVING - ITALY - 17th c.

Ridolfi, Carlo, 1594-1658
 Le maraviglie dell'arte,ovvere Le vite
degli illustri pittori veneti,e dello stato...
herausgegeben von Detlev freiherrn von Hadeln...
Berlin,G.Grote,1914-24
 2 v. illus.

 Bibliography
 Incl.repro.of title-page of original edi-
tion,Venetia,1648.This ed.incl.48 copper-engr.
portraits

ND34.R5 1914

Daugherty.Self-portrs.of
.P.Rubens mfm161 NPG,p.XIV
footnote 12

II.B.3.e - ENGRAVING - ITALY - 16th c.

Vico, Enea, 1523-1567
 Augustarum Imagines...Venetiis.Paul Manuce?,
1558
 192 p. illus.

 55 engravings of Roman empresses after medals

 1st ed.1557

LC DG276.5.V5

Rave.Jb.d.Berl.Mus.I 1959
LC N3.J16 fol. p.145
Paolo Giovio & d.Bildnisvitenbücher

II.B.3.e - ENGRAVING - ITALY - 18-19th c.

Longhi, Giuseppe, 1766-1831
 La calcografia propriamente detta;ossia
L'arte d'incidere in rame coll'acqua-forte,col
bulino e colla punta...Opera...da Guiseppe
Longhi...Volume I.Concernente la teorica dell'
arte.Milano.Stamperia reale,1830
 436 p. illus.
 Notizie biografiche di Giuseppe Longhi,
raccolte da Francesco Longhena,p.:387-431.
 The chalcography or the art of engraving on
copper with aquaforte with burin or graver...
 Biographical inf.on G.L. collected by Fran-
cesco Longhena p.:387-421

MET
200
L86

NN MH oct.

II.B.3.e - ENGRAVING - ITALY - 16th c.

Zantani, Antonio
 Le Imagini e le vite de gli imperatori tratti
dalle medaglie e dalle historie de gli antichi.
Florence,Enea Vico,1548

 From Caesar to Domitian,engravings after
medals

 Vico,the publisher was an engraver

 has latin ed.

Oxford
Uni.Bod-
leian
libr.

Rave.Jb.d.Berl.Mus.I 1959
LC N3.J16 fol. p.141-2
Paolo Giovio & d.Bildnisvitenbücher.

II.B.3.e - ENGRAVING - ITALY - 19th c.

Paris. Musée national du Louvre. Dpt.des
 peintures,des dessins et de la chalcographie
 Les émaux de Petitot du Musée impérial du
Louvre;portraits de personnages historiques
et de femmes célèbres du siècle de Louis XIV,
gravés au burin par M.L.Ceroni.Paris,Blaisot,
1862-64
 2 v. illus.

 1st part:Jean Petitot(1607-1691)by Henri
Bordier, 31 p.,illus.
 Petitot was assisted in his miniature ptg.
by his brother- in-law,Jacques Bordier

NN CtY MB MdBWA,etc.

II.B.3.e - ENGRAVING - ITALY - 17th c.

Bellori, Giovanni Pietro, 1615?-1696
 Le vite de' pittori,scultori,ed architetti
moderni,co' loro ritratti al naturale,...2 ed.
accresciute colla vita e ritratto del cavaliere
D.Luca Giordano...Roma,F.Ricciardo,e G.Buono,
1728
 394 p. illus.

 1st.ed.Roma,Per il successo.al Mascardi,1672

LC N40.B44 1728

Daugherty.Self-portrs.of
P.P.Rubens mfm161NPG,p.XIV
footnote 12

II.B.3.e - ENGRAVING - NETHERLANDS

Hondius, Hendrik,the elder,1573-after 1649
 Pictorum aliquot celebrium praesipue Ger-
maniae Inferioris,effigies.Hague,Comitis ex off
Henrici Hondii.ca.1610.
 3 pt.

 Coll.of portrs.by Netherlandish artists.
Continuation of Cock's artist portrs.,Pictorum
aliquot celebrium...Antwerp,1572
 see also:Szwykowski,I.v. Historische skizze..
 "Iconographically very important."-Th.-B.

Brit.Mus.
555 d.22
565 g.8
565 f.4
.(2)

Hall.Portr.v.Nederl.Beeld.
Kunstenaars.N7620.H17 NPG
p.XII

II.B.3.e - ENGRAVING - NETHERLANDS

Mauquoy-Hendrickx, Marie
Portraits gravés belges.Bruxelles,Office de
publicité,1960
62 p. illus. (Bibl.royale de Belgique.
Documents choisis,3)

LC NE285.M3 Fogg,v.11,p.330

II.B.3.e - ENGRAVING - NETHERLANDS - 17th c.

Dyck, Anthonie van, 1599-1641
Le cabinet des plus beaux portraits de plu-
sieurs princes et princesses,des hommes il-
lustres,fameux peintres,sculpteurs,architectes,
amateurs de la peinture & autres,faits par le
fameux faict graver à ses propres despens par
les meileurs graveurs de son temps.Antwerp,
Henry & Corneille Verdussen.173-?,
.4.p. 125 plates

MeD Winterthur Mus.Libr. f2881
.W78 NCFA v.9,p.225

II.B.3.e - ENGRAVING - NETHERLANDS

Sswykowski, Ignas von, 1807-1859
Historische skisse über die frühesten sam-
mel-werke altniederländischer malor-portraits
von Hieronymus Cock und Hendrik Hondius,etc.
Brit.Mus. Reprint from Dr.Naumann-Weigel Archiv für zeich-
785a.f. nende Künste,II,1836,p.13-63.Leipzig,R.Weigel,
1856

II.B.3.e - ENGRAVING - NETHERLANDS - 17th c.

Dyck, Anthonie van, 1599-1641
Icones principvm virorvm doctorvm pictorvm...
Antverpiae,G.Hendricx.1646.
1p.l. 109 port

Best engravers of the period collaborated

LC ND673.D9A3 Rath.Porträtwerke p.40

II.B.3.e - ENGRAVING - NETHERLANDS - 16th c.

Galle, Philippe, 1537-1612
.Imagines L.doctorum virorum...cum singulo-
rum elogijs. .Antverpiae,1587.2nd ed.

50 engr.portrs.

1st ed."Effigies virorum doctorum.."1572
with 44 engr.portrs.

LC TYP
530
72.419 MH Cty PU
Rave.Jb.d.Berl.Mus. I 1959
LC N3.J16 fol. p.148-9
Paolo Giovio & d.Bildnisvi-
tenbücher d.Humanismus

II.B.3.e - ENGRAVING - NETHERLANDS - 17th c.
Holland, Henry, 1583-1650?
Herologia Anglica,hoc est clarissimorvm et
doctissimorvm aliqovt Anglorvm qvi flo
vervnt ab anno Cristi M.D. vsq' ad presentem annvm M.D.C
IX viuae effigies vitae et elogia,authore H.H.
.London,Impensis C.Passaei calcographus et
Iansonii bibliopolas.1620,
2 v. illus.

Engravings mostly by de Passe family

LC CT780.H6 Rosenwald coll. Nijhoff cat.1981,no.623

II.B.3.e - ENGRAVING - NETHERLANDS - 16th c.

Lampsonius, Dominique, 1532-1599
Pictorvm Aliqvot celebrivm Germaniae Inferi-
oris Effigies... Anverpiae,Apud Viduam Hieronymus
Cock,1572

23 full-page portrs.of artists north of Alps
Engravings by J.Wierix,C.Cort & probably H.Cock

Facsimile ed.,Liège,J.Puraye,1956

"Important source for Carel van Manders
Schilderboek"-Rave
NN FOR COMPLETE ENTRY
 SEE MAIN CARD
Rave.Jb.d.Berl.Mus. I 1959
LC N3.J16 fol. p.148
Paolo Giovio & d.Bildnisvi-
tenbücher d.Humanismus

705
C75
NCFA
v.57

II.B.3.e - ENGRAVING - NETHERLANDS - 17th c.

Mallett, John
The portraits in line of Willem Jacobssoon
Delff

In:Connoisseur
57:213-4,218,222 Aug.,'20 Illus.(also Pls.
.p.229 & p.209)

II.B.3.e - ENGRAVING - NETHERLANDS - 17th c.

Bie, Cornelis de, 1627-1716?
Het gulden cabinet van de edel vrij schil-
der-const inhovdende den lof van de vermaerste
schilders,...beeldthowers en de plaetsnijders
van dese ecuw door Corn.de Bie...T'Antwerpen
gedruckt by Ian Meyssens,1661
3 l. 120 ports.
Engraved t.-p.;added engraved t-pages in
Latin and French.French t.-p.has imprint:An-
vers,Jean Meyssens,1649

NNC NJP Goldscheider.N.O.G65X NCFA
Bibl.p.59

AP
1
P89
NCFA
v.3

II.B.3.e - ENGRAVING - NETHERLANDS - 17th c.

Metcalfe, Louis R.
.. .Willem Jacobsz.Delff(1580-1638)and his
father-in-law

In:Print Coll Q
3:117-53 Apr.,'13 illus.

Delff engraved many portr.ptgs.by Mierevelt,
his father-in-law

Thomas.Drwgs.& pastels of
Nanteuil in Pr.coll.Q.
4:332

II.B.3.e - ENGRAVING - NETHERLANDS - 17th c.

Meyssens, Joannes, 1612-1670
 The true effigies of the most eminent paint-
ers, and other famous artists that have flour-
ished in Europe, together with an account of the
time when they lived, etc.., by S.Resta, engraven
on 125 copper plates by J.Meyssens.&others.
London, 1694
 20 p. 126 engr.pl.

 Published originally by J.M.at Antwerp, 1649

 See also: The portrs.of the most eminent
painters...London, J.Duke, 1739

V & A

II.B.3.e - ENGRAVING - RUSSIA

Rovinskii, Dmitrii Aleksandrovich, 1824-1895
 Detailed dictionary of Russian engraved
portraits.With 700 phototyped portraits.St.Pe-
tersburg, 1886-89
 4 v. illus.
 v.4 is appendix, conclusion and alphabetic
index

 In Russian.Title tranliterated: Podrobnyĭ
slovar' russkikh gravirovannikh portretov.

LC NE290.R62 Th.-B.Faithorne, Lit.
 v.11, p.206, d

II.B.3.e - ENGRAVING - NETHERLANDS - 17th c.

Passe, Crispijn van de, the younger, ca.1593-1667
 Les vrais pourtraits de quelques unes des
plus grandes dames de la chrestiente, desguisée.
en bergères...Ware afbeeldighe van eenige der
aldergrootste ende doorchluchtigste vrouwen van
heel christenrijck, vertoont in gedaente als her-
derinnen...Amsterdam, Gedruckt by J.Broersz voor
den autheur.1640
 4 v. illus.

LC NE670.P2A3

II.B.3.e - ENGRAVING - U.S.

Buttre, Lillian C., 1858-1881
 The American portrait gallery.New York, J.C.
Buttre, c.1871-80.
 3 v. illus.

 Steel plate illustrations

133820-22B Cirker.Dict.of Am.portrs.
N.Y.P.L. N7593/C57/NPG Bibl., p.713

II.B.3.e - ENGRAVING - NETHERLANDS - 17th c.

The portraits of the most eminent painters, and
other famous artists, that have flourished
in Europe.Curiously engraven on above 100
copper plates...From original paintings...
To which is now added, An historical and
chronological series of all the most eminent
painters for near 500 years.Chiefly collecte
from a manuscript of...Father Resta.London,
J.Duke, 1739
 18 p. illus.
 An histor.& chronol.series...has special t.,
& separate paging
LC N40.P6 Published originally by Jean Meyssens at
Antwerp, 1649

NE
262
C55
NPG

II.B.3.e - ENGRAVING - U.S.

Clark, Charles Edward
 Catalogue of the Dr.Charles E.Clark collec-
tion of American portraiture, including...Washing-
ton portraits...To be sold by auction...Jan15, 16
and 17, 1901...C.F.Libbie & co., auctioneers...
Boston, Mass.Press of the Libbie show print, 1901.
 136 p. illus.

LC NE260.C6 Fogg, v.11, p.327

II.B.3.e - ENGRAVING - NETHERLANDS - 17th c.

Smith, William
 A catalogue of the works of Cornelius
Visscher...Bungay, J.Childs & son, printers, 1864
 73 p.
 198 items

 Reprinted fr.the Fine arts quarterly re-
view, for private circulation only

 "...one of the most important portr.engra-
vers of his time..."-Th.B.

LC NE670.V5S5 Levis, Descr.bibl.Z5947.A3
 L66 p.281

II.B.3.e - ENGRAVING - U.S.

Henkels, firm auctioneers, Philadelphia
 (1895.Stan.V.Henkels)
 ...Cat.of autograph letters, historical docu-
ments, and rare engraved portraits; being the
coll.of J.Henry Rogers, of Newcastle, Del., and
of a Western gentleman...Also an extraordinary
coll.of rare and scarce engraved portraits.To
be sold...May 8th, 9th and 10th, 1895...Cat.comp.
and sale conducted by Stan.V.Henkels at the
book auction rooms of Thos.Birch's Sons..Phila-
delphia, The Bicking print, 1895.
 109 p. illus. Winterthur Mus.Libr.
LC Z42.R72 Z881.W78 NCFA v.6, p.229
Z909.H505 no.738

II.B.3.e - ENGRAVING - NETHERLANDS (17th c.)

Soutman, Pieter Claesz, 1580-1657
 Effigies imperatorum domus Austriacae, ducum
Burgundiae, regum principumque Europae, comitum Nas-
saviae...Harlemi.1644-1650.
 4 pts. illus.

 Compilation of portrs.1.16 emperors of the
house of Hapsburg.-2.Ferdinandus IIus et IIIus.-
3.Duces Burgundiae.-4.Comites Nassaviae
 Engravings by P.v.Sompel, P.C.Soutman, J.Suyder-
hoef, J.Louys
 Amsterdam, Rijksmus., cat.
 Z5939A52, deel 1, p.135

927
.L64
rare book

II.B.3.e - ENGRAVING - U.S.

Lester, Charles Edwards, 1815-1890
 The artists of America...with portraits and
designs on steel...New York, Baker & Scribner,
1846
 257 p. illus.

 Contents.-W.Allston.-H.Inman.-B.West.-
G.Stuart-J.Trumbull.-J.De Veaux.-R.Peale.-
Th.Crawford.

LC N6536.L6 Cirker.Dict.of Am.portrs.
 N7593/C57/NPG Bibl., p.714
 Ref.

II.B.3.e - ENGRAVING - U.S.

Sabin, V.Philip
An illustrated cat.of a fine coll.of inter-
esting and rare engravings of American and Ca-
nadian portraits and views.London,Frank T.Sabin,
1932
105 p. illus.(col.front)

FCOO
FA5800 Incl.:Miniatures
218

MB MdBP Cty CSmH NN Winterthur Mus.,Libr. fZ881
MiD .W78 NCFA v.6,p..224

II.B.3.e - ENGRAVING - U.S. - 18th c.

Fridenberg, Robert, 1860-
Cat.of the engraved portraits of Franklin...
.N.Y..The Grolier club of the city of N.Y.,1923
3 v.

N.Y.P.L. Photostatic repro.of a ms.in the possession
AOT of the Grolier club projected for publication
(Frank- but never issued by the club.
lin)
"lists ca. 600 engravings".-Thorpe

Thorpe.In:Antiquarian v.8,
no.1:39 Feb.'27

NE II.B.3.e - ENGRAVING - U.S.
260
S64 Smith, George D., firm,booksellers,New York
NPG Catalogue of American historical portraits
and engravings,including rare revolutionary
prints...N.Y.,Geo.D.Smith,between 1905 and 1917,
29 p illus.

N II.B.3.e - ENGRAVING - U.S. - 18th c.
7628
F83G8 Grolier club, New York
NPG Cat.of an exh.commemorating the 200th anni-
versary of the birth of Benjamin Franklin...
January,1906,N.Y.,De Vinne press,1906,
100 p.

458 numbers:1-291 portrs.;292-303 medals;..
375-421 ceramic portrs.;422-443 paintings,etc..

LC Z8313.085 Levis.Descr.bibl.Z5947*3
L66 1974 NCFA p.385

NE II.B.3.e - ENGRAVING - U.S.
505
J51 Stauffer, David McNeely, 1845-1913
1964 American engravers upon copper and steel.
Ref. N.Y.,Burt Franklin,1964.
3 v. (Burt Franklin:Bibliography and Refe-
rence Series,54)

v.1 & 2, 1st ed.1907;v.3 by Mantle Fielding,
1st ed.1917
Contents:1.-Biogr.sketches illus.;2.-Check-
list of the work of earlier engravers;3.-Biogr.
sketches & check-list of engravings
NPG A 19th c.,coll.of distin
guished American..bibl.

Z II.B.3.e - ENGRAVING - U.S. - 18th c.
312.43
G87X Grolier Club, New York
NPG Exhibition of engraved portraits of Washing-
ton commemorative of the centenary of his death,
on view at the Grolier Club...N.Y.,Dec.14th,
1899 to Jan.6th,1900..N.Y.,The De Vinne Press,.
1899.
51 p.

Z II.B.3.e - ENGRAVING - U.S. - 18th c.
206
D33 Delaplaine, Joseph, 1777-1824
NPG Delaplaine's repository of the lives and
portraits of distinguished American characters.
Philadelphia,1815-.16.
2 v.in 1 illus.

Contents.-v.1.Columbus.Vesputius.Dr.Bej.Rush
Ames.Hamilton.Washington.Peyton Randolph.Thomas
Jefferson.John Jay.Rufus King.DeWitt Clinton.
Rbt.Fulton.-v.2.Samuel Adams.George Clinton.
Henry Laurens.Benj.Franklin.Francis Hopkinson.
Rbt.Morris.
LC E206.D32

II.B.3.e - ENGRAVING - U.S. - 18th c.

Henkels, firm,auctioneers, Philadelphia
Cat.of rare & choice engravings;incl.an ex-
traordinary coll.of portraits of Washington &
other notable Americans & of European celebri-
ties,a coll.of Napoleoniana & misc.engravings
to be sold Nov.24 & 25,1896 at the rooms of
Thos.Birch's Sons,Phila.,Pa....1896
52 p. illus.

940 engravings,18 photographs (no.768)
(For more locations of this cat.see:Lugt
Rép.des cat.de ventes,1861-1900;U1% Y7.L95 NCFA
MH MdBP OCl NIC MiU p.615,no.5476d) Ref.

705 II.B.3.e - ENGRAVING - U.S. - 18th c.
M18
NCFA Early American engraved portraits.An exh.at
v.7 the N.Y.Public Library

In:Mag Art
7:452-7 Sept.,'16 illus.

Exh.May-Oct.15,1916.First public exh.of
early Amer.engr.portrs.in N.Y. Incl.the first
engr.published in the U.S.:Ths.Emmes' Increase
Mather,1701;Washington as central fg.in a Toile
de Jouy(Printed fabric)which also shows medal-
lion portrs. of distinguished Americans

N II.B.3.e - ENGRAVING - U.S. - 18th c.
7592
H513 Henkels, Stanislaus Vincent, 1854-1926
RB Cat.of the valuable autographic coll. and en-
NPG graved portraits...gathered by...Col.Chs.Colcock
Jones...to be sold Tue.,Wed.,Thurs.,April 24,25,
26,1894.Cat.comp.,and sale conducted by Stan.V.
Henkels,at the book auction rooms of Thos.Birch's
Sons,Philadelphia
148 p. illus.
cat.no.720
16 engravings of Washington
Contains autographic sets of the signers of
the Declaration of Independence,Rulers & Govs.

M
7592
N513
NB
NPG

II.B.3.e - ENGRAVING - U.S. - 18th c.

Henkels, Stanislaus Vincent, 1854-1926
The rare and valuable coll.of portraits
and choice engravings gathered by J.Henry Clay
of Philadelphia embracing the most important
coll.of rare Washington portraits...also rare...
portraits,in line,mezzotint and stipple of emi-
nent Americans,artists,actors,authors,clergy-
men,lawyers,statesmen,etc...to be sold Fri.&
Sat.,Dec.3 & 4,1897,at the book & art auction
rooms of Davis & Harvey,Philadelphia
124 p. illus.

LC Z999 cat.no.799 priced
H505 no.799 Several hundreds portrs.of Washington,
p.77-102

AP
1
P892
NCFA
v.2

II.B.3.e - ENGRAVING - U.S. - 18-19th c.

Fielding, Mantle, 1865-1941
American naval portraits engraved by David
Edwin after Gilbert Stuart and others

In:Print Connoisseur Dec.,'21
2:123-30 illus.p.122,125,127,129,131-7

LC NE1.P75 Arts in Amer.v.2 K668
q Z5961.U5A77X NCFA Ref.

II.B.3.e - ENGRAVING - U.S. - 18th c.

Lamb, Martha Joanna Read(Nash),1829-1893
...Unpublished Washington portraits

In:Mag.Am.Hist.
19,no.4:273-85 Apr.,'88 illus.

Some of the early artists

Reprint fr.Magas.
LC E312.43L25
LC E171.M181 Levis.Descr.bibl.Z5947.83
L66 p.203

mfm
41
NCFA

II.B.3.e - ENGRAVING - U.S. - 18-19th c.

Fielding, Mantle, 1865-1941
Cat.of the engraved work of David Edwin...
Philadelphia,Priv.print.,1905
61 p.

LC NE539.E2F4 Winterthur Mus.Libr.
Z881.W78 NCFA v.6,p.229

II.B.3.e - ENGRAVING - U.S. - 18th c.

Maggs Bros., London
Choice engravings of American historical im-
portance(Portraits of famous American and Bri-
tish officers,statesmen and others connected
with the war of Independence)Rare political car-
toons,emblems....Washington portraits.Selected
from the stock of Maggs Bros...London,1909
23 p. illus.

At head of title:No.249 237 items

CSmH Levis.Descr.bibl.Z5947.A3
L66 1974 NCFA p.212:"Parti-
cularly interestin list"

AP
1
P41
NPG
v.29

II.B.3.e - ENGRAVING - U.S. - 18-19th c.

Fielding, Mantle, 1865-1941
David Edwin,engraver

In:Penn Mag of Hist & Biogr.
29:79-88,320-25 1905

List of portrs.,not in Hildeburn's list,
p.321-2

"E...the 1st good engraver of portrs....in Ame-
rica."

mfm
184
NPG

II.B.3.e - ENGRAVING - U.S. - 18-19th c.

Andrews, William Loring, 1837-1920
An essay on the portraiture of the American
revolutionary war...a number of...engraved por-
traits...appendix:lists of portraits of revolu-
tionary characters...in English and American pu-
blications of the 18th and early 19th c....
New York,Printed by Gillis brothers...sold by
Dodd,Mead & co.,1896
100 p. illus.

LC E209.A53 Ide.Portrs.of John Jay
CT275/J42/I1 NPG
Bibl.

AP
1
P41
NPG
v.28

II.B.3.e - ENGRAVING - U.S. - 18-19th c.

Fielding, Mantle, 1865-1941
Engraved works by David Edwin (not men-
tioned in Mr.Hildeburn's list)

In:Penn Mag of Hist & Biogr.
28:420-27 1904
List of portrs.p.420-4

705
A56
NCFA
v.119

II.B.3.e - ENGRAVING - U.S. - 18-19th c.

Deutsch, Davida Tenenbaum & Betty Ring
Homage to Washington in needlework and
prints

In:Antiques
119:402-17 Feb.,'81 illus(part col.)

Needlework after engravings:Washington Fami-
ly,W.'s resignation,W.crossing the Delaware...

Wick.Geo.Washington...
N7628.W3W5 NPG Bibl.p.173

NE
506
G87
NPG

II.B.3.e - ENGRAVING - U.S. - 18-19th c.

Grolier club, New York
Catalogue of an exhibition of early Ameri-
can engraving upon copper,1727-1850,with 296
examples by 147 different engravers...Jan.24-
Feb.15,1908...N.Y.,The De Vinne press,1908.
100 p. illus.

Incl.John Quincy Adams,Simon Bolivar,
Washington Irving,Andrew Jackson,Ths.Jefferson
Lafayette,Ja.Madison,Geo.Washington,Daniel
Webster,etc. - List of portrs.of Americ.engra-
LC NE1410.N508 1908 .vers

II.B.3.e - ENGRAVING - U.S. - 18-19th c.

Henkels, Stanislaus Vincent, 1854-1926
Cat..of.oil portraits of Washington,
Lafayette,Lincoln...and other eminent Americans
...mezzotintos and stipples...original copper
plates...sold...Mar 27,1919....by,Stan.V.
Henkels...Philadelphia.1919.
26 p. illus.

MET
276
H38

263 items (no.1232)

Met.Sales cat. fZ881.N53
NCFA v.25,p.023316

II.B.3.e - ENGRAVING - U.S. - 18-19th c.

AP
1
P41
NPG
v.18

Hildeburn, Charles R.
A contribution to a cat.of the engraved
works of David Edwin

In:Penn Mag of Hist & Biogr
18:97-118,223-38 1894

II.B.3.e - ENGRAVING - U.S. - 18-19th c.

705
A56
NCFA
v.108

Jones, Karen M.
Museum accessions

In:Antiques
108:78-79 July,'75 illus.

Acquisitions made by the NPG in the past
two years
Repro.incl.:John Jay by G.Stuart and J.
Trumbull;P.Revere,Th.Jefferson by Févret de
Saint-Mémin;John Marshall by Wm.Hubard;Washing-
ton,Martha Washington by Rembrandt Peale

II.B.3.e - ENGRAVING - U.S. - 19th c.

AP
1
A51A64
NCFA
v.3

Craven, Wayne
Asher B.Durand's career as an engraver

In:Am Art J
3:39-57 Spring,'71 illus.

Jaffe,I.B. John Trumbull..
V40.1.T86J2 NPG Bibl.p.334

II.B.3.e - ETCHING ± 20th c.

AP
1
P89
NCFA

Allhusen, E.L.
Self portraiture in etching (Some living
artists)

In:Print Coll Q
18:175,7,9,183,5,7-8,191,4,6 Apr.,'31 illus.

Reasons for Self-portraiture
In self-portrs. we get the artist's ideal of
himself.The artist does not copy nature but ex-
presses her;the greatest scope for such express'n
found in self-portraiture.
Descript'n of s.-portrs. by ...
Cum.mag.subj.ind.A1/3/76Ref
v.2.p.444

II.B.3.e - ETCHING - FRANCE- 19-20th c.

705
G28
NCFA
v.17

Bouvy, Eugène, 1859-
Jules Lieure

In:Gaz.Beaux-Arts
17:119-25 Feb.,'28 illus.

Repro.incl.:Geo.Clemenceau

II.B.3.e - ETCHING - FRANCE - 19-20th c.

Helleu, Paul César, 1859-1927
A gallery of portraits,reproduced from ori-
ginal etchings,with an intro. by Frederick Wed-
more.London,L.Arnold,1907
.8.p. 24 illus(part col.)

Portrs.of women

'Wedmore's intro....is important'.-Levis

NM (N.Y.publ.NB ILN IU InU)
Levis.Descr.bibl...Z5947.A3
L66 1974 NCFA p.208

II.B.3.e - ETCHING - GERMANY - 20th c.

Olbricht, K.-H.
Analyse im selbstporträt oder künstlerische
metamorphose:zu den radierungen von Marwan

In:Kunst & d.schöne Heim
88,pt.5:281-8 May,'76 illus.

LC N3.K5

FOR COMPLETE ENTRY
SEE MAIN CARD

II.B.3.e - ETCHING - GREAT BRITAIN - 17th c.

Boydell, John, 1719-1804
Boydell's heads of illustrious and cele-
brated persons generally connected with the
history of Great Britain in the reigns of
James I,Charles I,Charles II and James II;with
biographical memoirs by J.Watkins.London,1811

Listed in Universal Cat.of
Books on Art,p.155

II.B.3.e - ETCHING - GREAT BRITAIN - 18-19th c.

705
C75
NCFA
v.14

Calthrop, Dion Clayton
Robert and Richard Dighton.Portrait etchers

In:Connoisseur
14:231-6 Apr.,1906 illus.

FOR COMPLETE ENTRY
SEE MAIN CARD

II.B.3.e - ETCHING - ITALY - 18th c.

Longhi, Alessandro, 1733-1813
 Compendio delle vite de' pittori venesiani istorici più rinomati del presente secolo con suoi ritratti tratti dal naturale delineati ed incisi da Alessandro Longhi...Venesia,Appresso l'autore,1762
 53 l. illus.

NN IU MH

qN40.1
K62yJ5
NPG

II.B.3.e - LITHOGRAPHY - AUSTRIA - 20th c.

Kokoschka, Oskar, 1886-
 Jerusalem faces.Vadus,Marlborough Graphics, 1974.
 .17.p. illus.

 For the benefit of the Jerusalem Foundation

 Portr.-lithographs of Golda Meir,Dr.Agranat, Benedictos I,Moshe Dayan,Sheikh Ansari,Teddy Kollek,created in April 1973

InU

760.5
.P94

II.B.3.e - ETCHING - NETHERLANDS - 17th c.

The complete etched portrait work of Anthony van Dyck,from the collections of Sir Peter Lely and Prosper Henry Lankrink.N.Y.,M. Knoedler & co.,inc.,1934
 .44.p. illus. (The print collector's bulletin,v.3,no.3)

 Coll.Lely sold Apr.11-18,1688 under the direction of Sonnius,Lankrink & Thompson, London.-Coll.Lankrink sold May 8,1693 & Feb. 22,1694,"At the Golden Triangle,in Long Acre,London
 Mostly portrs.of Flemish painters

II.B.3.e - LITHOGRAPHY - BELGIUM - 19th c.

Galerie de portraits d'artistes musiciens du royaume de Belgique,lithographiés d'après nature par Baugniet...Imprimé par Degobert Bruxelles,V.Deprins.1842-43.
 .41.p. illus.

 Biographical sketches by F.J.Delhasse etc.

LC ML385.G15

II.B.3.e - ETCHING - U.S. - 19th c.

Graul, Richard, 1862- ed.
 Die Radierung

In:Die graphischen künste,hrsg.von der Gesell-schaft für vervielfältigende kunst.Vienna,1892

 v.3:Koehler, Sylvester Rosa, 1837-1900
Vereinigte Staaten von Nordamerika
 K.gives the history of etching in the U.S. fr.1866 through the 1850s.Etchers are grouped: portraitists,...

LC N3.G7 Arts in America qZ5961.U5
LC NE940.G1 77X NCFA Ref. K91b

II.B.3.e - LITHOGRAPHY - FRANCE

Vatout, Jean, 1792-1848
 Histoire lithographiée du Palais-Royal. Dédiée au roi. Paris,Charles Motte.1834.
 .91.p. illus(45 pl.)

CtY Winterthur Mus.Libr. fZ881
 .78 NCFA v.6,p.221

VF
Brockhurst

II.B.3.e - ETCHING - U.S. - 20th c.

Albrecht Art Museum, St.Joseph,MO.
 Gerald L.Brockhurst.Master of the etched portrait..Exh.,3 Sept.-10 Nov.,1985
 unpaged illus.

 Incl.:Pamphlet:'Adolescence'ty G.L.Brock-hurst, the five states and drawing

II.B.3.e - LITHOGRAPHY - GREAT BRITAIN

Gower, Ronald Charles Sutherland, 1845-1916
 Three hundred French portraits representing personages of the courts of Francis I,Henry II & Francis II by Clouet.Auto-lithographed from the originals at Castle Howard,Yorkshire.London, S.Low,Marston & Searle,Paris,Hachette & cie., 1875
 2 v. illus.

LC N7604.C6 Amsterdam,Rijksmus.cat.
 Z5939A52,deel 1, p.509

TR
575
P93
1985a
NPG

II.B.3.e - Lithography

Prescott, Gertrude Mae, 1955-
 Fame and photography:Portrait publications in Great Britain,1856-1900
 460 p. illus.

 Incl.lists of portr.publications in the engraved,lithographic & photographic media.

 Ph.D.diss.-Univ.of Texas at Austin,1985
 Bibliography:p.263-81
 mf
 Diss.Abstr.v.47no.03,Sept.
 1986,p.691/92A

II.B.3.e - LITHOGRAPHY - GREAT BRITAIN

Lenoir, Alexandre, 1761-1839
 The Lenoir collection of original French portraits at Stafford House.Auto-lithographed by Lord Ronald Gower.London,Maclure & Macdonald... 1874
 illus.

 From Francis I to Marie-Antoinette

LC N7604.L36
Rare book coll. Amsterdam,Rijksmus.,cat.
 Z5939A52,deel 1, p.146

788

II.B.3.e - LITHOGRAPHY - GREAT BRITAIN - 20th c.

Pittsburgh. Carnegie Institute. Dept. of
Fine Arts
Exh.of portrait lithographs by William
Rothenstein.Dept.of Fine Arts,Carnegie Insti-
tute,Dec.4th through Dec.31st,1916.Pittsburgh,
1916.
3 l.

NN

QNE
261
N37
1977X
NCFA

II.B.3.e - LITHOGRAPHY - U.S. - 19th c.

National Museum of History and Technology
Perfect likenesses.Portraits for history
of the Indian Tribes of North America
(1837-44)..Washington,Smithsonian Insti-
tution Press,1977.
27 p. Cover illus.(col.)

Catalog essays by Peter C.Marzio and Wm.
C.Sturtevant
Fxhib.April-Sept.,1977
30 ptgs.and 160 lithographs;ptgs.chiefly b
Charles Bird King

LC NE263.M37 1977

II.B.3.e - LITHOGRAPHY - U.S. - 19th c.

Jackson, Joseph, 1867-
Bass Otis,America's first lithographer

In:Penn Mag of Hist & Biogr
37 1913

LC F146.P65 Penn.Hist.Soc. Rembrandt
Peale... Bibl.p.118

II.B.3.e - LITHOGRAPHY - U.S. - 19th c.

Stauffer, David McNeely, 1845-1913
Lithographic portraits of Albert Newsam...
Philadelphia,1901
52 p.

Reprinted fr.the Penn.magazine of history
and biography,Oct.1900 and Jan.and Apr.,1901

LC NE2415.N587 College of Physicians...
Arch.Am.Art mfm P86 v.12
References

II.B.3.e - LITHOGRAPHY - U.S. - 19th c.

Lewis, James Otto, 1799-1858
The aboriginal portfolio;a collection of
portraits of the most celebrated chiefs of the
North American Indians.72 colored plates...
Philadelphia,J.O.Lewis,1835.-36.
pts. illus(col.)

"Issued monthly untill 10 nos.are completed"

LC E89.L66 Viola.Ind.legacy of Chs.
Bird King N40.1:52V7 Bibl.

N
40.1
F33yU5

II.B.3.e - LITHOGRAPHY - U.S. - 19th c.

U.S. Library of Congress. Prints and Photo-
graphs Division
Charles Fenderich,lithographer of American
statesmen:a cat.of his work,by Alice Lee Par-
ker and Milton Kaplan.Washington,1959
64 p. illus.

LC NE2415.F4U5

705.
A56
NCFA
v.97

II.B.3.e - LITHOGRAPHY - U.S. - 19th c.

Mahey, John A.
Lithographs by Rembrandt Peale

In:Antiques
97:236-42 Feb.,'70 illus.

Repro.incl.:Washington,Lord Byron

Penn.Hist.Soc. Rembrandt
Peale...Bibl.p.118

VF

II.B.3.e - LITHOGRAPHY - U.S. - 20th c.

Philadelphia Museum of Art
Dept.of prints and drawings
Alfred Bendiner;lithographs,complete cata-
log..Exh..Jan.21-March 4,1965...Phila.,Mus.of
Art.1965?.
1 v.(unpaged) illus.

NMAH:NE2415.P45A1

II.B.3.e - LITHOGRAPHY - U.S. - 19th c.

Mitchell, James Tyndale, 1834-1915
The unequalled coll.of engraved portraits
of eminent American and some noted foreign-
ers belonging to Hon.James T.Mitchell...a
large coll.of lithographs engraved by A.Newsam.
an unique coll.of American revolutionary and
political caricatures and numerous portraits
for extra illustrating,to be sold...Oct.28,
1913.Phila.,Pa.,Stan v.Henkels,1913.
56 p. Plates
Cat.Stan v.Henkels,no.944,pt.13

LC Z999.H5U5 no.944,pt.13 Rosenwald coll.

N
7628
W31C3
NPG

II.B.3.e - MEZZOTINT

Carson, Hampton Lawrence, 1852-1929
...The Hampton L.Carson collection of en-
graved portraits of Gen.George Washington. Cat.
comp. & sale conducted by Stan.V.Henkels.At the
art auction rooms of Davis & Harvey...Phila.,Pa.,
....,Press of W.F.Fell co.,1904.
173 p. illus(part col.)
Cat.no.906,pt.I

Incl.St.Mémin personal coll.of proof mezzo-
tints...to be sold Jan.21 & 22, 1904
LC Z999.H5U5 no.906,pt.1 Amsterdam Rijksmus.cat.
c.2 E312.43.C32 Z5939A52, deel 1, p.154

705
C75
NCFA
v.34

II.B.3.e - MEZZOTINT

Grundy, Cecil Reginald, 1870-
Mr.Frits Reiss's mezzotint portraits. I.II.

In:Connoisseur
34:71-83 Oct.,'12 illus.
34:209-26 Dec.,'12 "
Coll.includes works fr. the time of Prince
Rupert to Samuel Cousins.
Article I treats mainly early mezzotints.
Repro.:Prince Rupert,John Smith,McArdell,
John Faber,Rich.Huston,etc.

II.B.3.e - MEZZOTINT

Smith, John Chaloner, 1827-1895
Twelve portraits of persons connected dur-
ing the last century with the States of America
(chiefly in their Colonial period)...from the
original mezzotint engravings in the coll.of
N.Y.P.L. J.Ch.Smith.London,H.Sotheran & co.,1884
3-AOW 2 p. 12 portrs. (American series)
Avery coll.

II.B.3.e - MEZZOTINT

Laborde, Léon Emmanuel Simon Joseph de, 1807-1869
Histoire de la gravure en manière noire...
Paris,Impr.de J.Didot l'aîné,1839
413 p. illus.

Bibliography

Genesis of the art.The work of Ludwig von
Siegen.Incl.descriptive catalogue of mezzotints
made before 1720 by Dutch,German,English,French,
Spanish & Russian engravers. List of early mezz.
printed in color.
LC NE1815.L2
 Davenport.Mezzotints.NE1815
 .D24 NPG:"The most important
book.on.mezzotints" p.46 & p.XVII

II.B.3.e - MEZZOTINT

Whitman, Alfred, 1860-1910
The masters of mezzotint;the men and their
work...London,G.Pell & sons,1898
55 p. illus.

Bibliography

Appendix:Cat.of portrs...in mezzotint by
Charles Turner,1774-1857

LC NE1815.W5
 Sellers.Archives of Amer.
 art:Mezzotint prototypes...
 In:Art Q 20no.4,p.467

II.B.3.e - MEZZOTINT

Mitchell, James Tyndale, 1834-1915
...The unequaled collection of engraved por-
traits belonging to Hon.T.Mitchell...embracing
the lord chancellors and chief justices of Great
Britain,éminent English lawyers,kings & queens of
Great Britain,English princes & princesses & mem-
bers of royal families,mostly engraved in mezzo-
tinto,to be sold...Feb.26...and...Feb.27,,1908...
Cat.comp.& sale conducted by Stan.V.Henkels.At
the book auction rooms of Davis & Harvey,Phila.Pa.
...Press of W.F.Fell co.,1908.
93 p. illus.
 Cat.no.944,pt. VI
LC NE265M5

NE
1815
D24
NPG

II.B.3.e - MEZZOTINT - 17-19th c.

Davenport, Cyril James Humphries, 1848-1941
Mezzotints...London,Methuen & co.,1904
207 p. illus. (The connoisseur's library)

Bibliography

17-19th c.-Technique,incl.experimenters in
color printing

LC NE1815.D3
 Sellers.Archives of Amer.
 art:Mezzotint.prototypes...
 In:Art Q 20:no.4,p.464

II.B.3.e - MEZZOTINT

Parsons, E. & sons, London
Cat.of English mezzotint portraits from the
earliest period of the art to the end of the
18th c.,with a small addenda of rare American
MET portraits.London,1900
207.5 40 p.
P25
Cover portrait

II.B.3.e - MEZZOTINT - FRANCE - 18th c.

Gautier d'Agoty, Jean Baptiste André, 1740-1786
Galerie françoise,ou Portraits des hommes
et des femmes célèbres qui ont paru en France...
On y a joint un abrégé de leur vie...A Paris,
gravé par m.Gautier Dagoty le fils...1770
11 pts.in 1 v. illus.
FOGG
Houghton Consists of pts.1 & 2....of a proposed coll.
Libr.
Portrs.incl.:Louis XV,Louis IX,Phil.d'Orléans,
Louis XIV,Louis XIII,Henri IV,Stan.Leszynski,etc.
LC *fFC7.G2396
 770g MH Fogg,v.11,p.338

II.B.3.e - MEZZOTINT

Smith, John Chaloner, 1827-1895
Cat.of the coll.of mezzotint engravings
formed by J.C.Smith...sold...by Messrs.Sotheby,
Wilkinson & Hodge,1887/8
2 pt.in 1 v.(1 illus.)

MET
212 Pt.1 March 21-30,1887. Pt.2 Apr.25-May 4,'88
C7 Priced

(Lugt nos.46377 &47324)

FU MiU-C PP ICN Ars Artis cat.41 Books on
CSmH NBuO prints,drags. nc.681

705
C75
NCFA
v.92

II.B.3.e - MEZZOTINT - GERMANY - 17th c.

Hind, Arthur Mayger, 1880-1957
Studies in English engraving. VI.Prince
Rupert and the beginnings of mezzotint

In:Connoisseur
92:382-91 Dec,'33 illus.

Incl.:Catalogue of mezzotints by and attri-
buted to Prince Rupert

ND
1311.1
B43
NPG
NCFA

II.B.3.e - MEZZOTINT - GREAT BRITAIN

Belknap, Waldron Phoenix, 1899-1949
 American colonial painting....Cambridge,Mass.
Belknap press,Harvard Univ.,1959

 Partial contents:...Pt.VI.Discovery of the
English mezzotint as prototype of American por-
traiture...(see also:Sellers.In:Art.Q.v.20:407-
468,winter,'57

 FOR COMPLETE ENTRY
 SEE MAIN CARD

705
C75

II.B.3.e - MEZZOTINT - GREAT BRITAIN

Latham, H.M.
 Some altered mezzotint portraits

In:Conn.
91:37-41 Jan.,1933 illus.

 Examples of alterations for economical rea-
sons & to fill the demand of the time

 Repro.incl.John Smith,J.Faber,John Johnson,
Val.Green

 Th.-B.-Smith,John Lit.

AP
1
A79
NCFA
v.1-3

II.B.3.e - MEZZOTINT - GREAT BRITAIN

Black, Mary C.
 The case of the red and green birds.Thir-
teen persons,one of whom has never been identi-
fied,pose a picture puzzle wherin a cardinal &
a parakeet are vital clues.

In:Arts in Va.
3,no.2:2-4,7-8 winter,'63 illus.
 Portrs.of members of two prominent fami-
lies by an unknown artist.Five facts suggest
a Va.provenance,inspired by Engl.mezzotints.
 Black.The case reviewed.
 In:Arts in Va.,v.10,no.1

N
613
A5
NCFA

II.B.3.e - MEZZOTINT - GREAT BRITAIN

New York Historical Society .
 The Waldron Phoenix Belknap,jr.collection of
portraits and silver,with a note on the discove-
ries of Waldron Phoenix Belknap,jr.concerning the
influence of the English mezzotint on colonial
painting....Cambridge,Harvard University Press,
1955.
 177 p. illus.

 Catalogue of the coll.which was bequeathed to
the N.Y.Historical Soc. in 1949

LC N613.A65

751.2261
.C61

II.B.3.e - MEZZOTINT - GREAT BRITAIN

Clarke, Harold George
 The story of old English glass pictures,
1690-1810,...London,Courier press,1928.
107 p. illus.(part col.)

 Alphabetical catalogue of glass pictures:
p.89-97
 Alphabetical catalogue of engravers:p.98-104

LC ND1590.C5

NE
1815
R96
NPG

II.B.3.e - MEZZOTINT - GREAT BRITAIN

Russell, Charles E
 English mezzotint portraits and their states from the
invention of mezzotinting until the early part of the 19th
century, by Charles E. Russell ... London, Halton & T.
Smith, ltd.; New York, Minton Balch & company, 1926.
 2 v. 64 pl. (ports.) 39 cm. (v. 2 : 38½ cm.)
 "This edition is limited to six hundred and twenty-five copies of
which this is number 108."
 Vol. II has title: English mezzotint portraits and their states;
catalogue of corrections and additions to Chaloner Smith's "British
mezzotinto portraits.
 1. Mezzotints, English. 2. Portraits, English. 3. Gt. Brit.—
Biog.—Portraits. I. Smith, John Chaloner, 1827-1895. British
mezzotinto portraits.

NE1815.R8 27-2960
Library of Congress

NE
1815
C717
NPG

II.B.3.e - MEZZOTINT - GREAT BRITAIN

Colnaghi (P.& D.)& co.,ltd., London
 The mezzotint rediscovered;:exh. 24 June -
1 Aug.,1975,at Colnaghi's..London,P.& D.Colnaghi
&c.1975.
 118 p. illus.

LC NE1816.07C64

705
A7875
v.20

II.B.3.e - MEZZOTINT - GREAT BRITAIN

Sellers, Charles Coleman, 1903-
 Archives of American art:Mezzotint proto-
types of colonial portraiture:a survey based on
the research of Waldron Phoenix Belknap,jr.

In:Art Q
20,no.4:407-68 winter,'57 illus.
 Bibliography

 Grouped:Portrs.of men;women;children.The
painters.
 Incl.cat.:Colonial ptgs.side by side with
mezzotint prototype all illustrated

705
A7834
NMAA
v.55

II.B.3.e - MEZZOTINT - GREAT BRITAIN

Fairbrother, Trevor J.
 John Singleton Copley's use of British
mezzotins for his American portraits:A reap-
praisal prompted by new discoveries

In:Arts Mag
55:122-30 March,'81 illus.

NE
265
S652
NPG

II.B.3.e - MEZZOTINT - GREAT BRITAIN

Smith, John Chaloner, 1827-95
 British mezzotint portraits;being a des-
criptive catalogue...from the introduction of
the art to the early part of the present century.
Arranged according to the engravers;...biographi-
cal notes...London,H.Sotheran & co.,etc.,1883

 4 v.in 5 illus.

 Bibliography

 Chamberlin,M.W. Guide to
 art reference books #1572
LC NE265.S6

791

705
A7875
v.14
NCFA

II.B.3.e - MEZZOTINT - GREAT BRITAIN

Swoet, Frederick A.
　　Mezzotint sources of American colonial
portraits

In:Art Q
14:148-57　illus.　Summer,1951

　　Amer.portr.painters, espec.J.S.Copley, used
mezzotints & engravings, done after English portra
to keep up with current trends

　　　　　Encyclop.of World Art
　　　　　Portrs.bibl. N31b56 Ref.

II.B.3.e - MEZZOTINT - GREAT BRITAIN - 18th c.

British mezzotinto portraits of the 18th cen-
　tury.N.Y.,M.Knoedler & Co.,Inc.,1930.
　　61 p.　illus.　(The print collector's
　bulletin,v.1no.,6.)

LC NE1.P67

II.B.3.e - MEZZOTINT - GREAT BRITAIN

Tiffin, Walter F.
　　Cat.of a coll.of English portraits in mez-
sotint(from the beginning of that style of en-
graving to the end of the 18th c.)...portion...
of a coll.of portrs.formed by Walter R.Tiffin...
Salisbury,Bennett brothers,printers,1883
　　136 p.　illus.
　　Cat.of 1202 items
　　List of engravers
　　Frontispiece by Ludw.v.Siegen,earliest publ.
mezzotint

LC NE265.T5

　　　　　Levis.Descr.bibl.Z5947.A3
　　　　　L66　p.198 and p.202,127

II.B.3.e - MEZZOTINT - GREAT BRITAIN - 18th c.

Goodwin, Gordon
　　...James McArdell...London,A.H.Bullen,1903
　　168 p.　illus.　(British mezzotinters,
　ed.by Alfred Whitman)

　　Cat.of portrs.p.,17.-136

LC NE642.M206

　　　　　Levis.Descr.bibl.A5947.A3
　　　　　L66　1974　NCFA　p.133

705
C75
NCFA
v.92

II.B.3.e - MEZZOTINT - GREAT BRITAIN - 17th c.

Hind, Arthur Mayger, 1880-1957
　　Studies in English engraving. VI.Prince
Rupert and the beginnings of mezzotint

In:Connoisseur
92:382-91　Dec,'33　illus.

　　Incl.:Catalogue of mezzotints by and attri-
buted to Prince Rupert

N
40.1
W334y
G6
NPG

II.B.3.e - MEZZOTINT - GREAT BRITAIN - 18th c.

Goodwin, Gordon
　　Thomas Watson,James Watson,Elizabeth
Judkins.London,A.H.Bullen,1904
　　230 p.　illus.　(British mezzotinters,
　ed.by Alfred Whitman)

　　Contents:Thomas Watson,cat.of portrs.p.,7.
　48...James Watson,cat.of portrs.,p.,81.-196...
　Elizabeth Judkins,cat.of portrs.,p.225-30

LC NE642.W406

　　　　　Levis.Descr.bibl.Z5947.A3
　　　　　L66　1974　NCFA　p.133

II.B.3.e - MEZZOTINT - GREAT BRITAIN - 17-18th c.

Faber, John, the elder, fl.1650(or'60)-1721
　　Portraits of the founders of Colleges in
Oxford and Cambridge;in mezzotinto.London,
1712-14
　　　　illus.
Brit.Mus.

　　　　　Levis.Bibl.of 18th c.art
　　　　　illus.books.Z1023.L67 1969
　　　　　NCFA　p.175

II.B.3.e - MEZZOTINT - GREAT BRITAIN - 18th c.

Hind, Arthur Mayger, 1880-1957
　　John Raphael Smith and the great mezzotin-
ters of the time of Reynolds. N.Y.,Frederick
A.Stokes co.,1911.
　　15 p.　illus.　(Half-title:Great engrav-
ers:ed.by A.M.Hind)

　　Bibliography p.12

　　64 illus.

LC NE628.H6

　　　　　Levis.Descr.bibl.Z5947.A3
　　　　　L66　1974　NCFA　p.265

II.B.3.e - MEZZOTINT - GREAT BRITAIN - 17-18th c.

Wessely, Joseph,Eduard., 1826-1895
　　John Smith,verzeichnis seiner schabkunstblät-
ter.Hamburg,Haendcken & Lehmkuhl,1887
　　156 p.　illus.　(Kritische verzeichnisse
von werken hervorragender kupferstecher.v.3)

MET
201
K89
v.3
Print Dpt.

DLC CSt PP MM

II.B.3.e - MEZZOTINT - GREAT BRITAIN - 18th c.

Hornbogen, Alfred
　　Englische porträts des 18.jahrh.;schabkunst-
blätter aus der staatlichen bücher-und kupfer-
stichsammlung Greiz.Berlin,Henschelverlag,1959
　　42 p.　illus.　(Museumsschriften,Bd.1)

　　Bibliography

LC NE1815.H6

　　　　　Fogg v.11,p.332

NE
1815
L18
NPG

II.B.3.e - MEZZOTINO - GREAT BRITAIN - 18th c.

Karlsruhe. Staatliche Kunsthalle
　　Schwarze kunst:englische schabkünstler des
18.jahrhunderts.Ausstellung in der Staatlichen
Kunsthalle Karlsruhe vom 16.Okt.-28.Nov.1976..
　84 p.　illus.

Bibliography
46 works shown

Vorwort von Joh.Eckhart von Borries.
Kat.:Burkhard Richter

Rila III/2 1977 #7157

II.B.3.e - MEZZOTINT - GREAT BRITAIN - 19th c.

Whitman, Alfred, 1860-1910
...Charles Turner...London,O.Bells & sons,
1907
　293 p.　illus.　(Nineteenth century mez-
zotinters)

Incl.Cat.of portrs.,p..31.-220

3　LC NE642.T8W5　　Levis.Descr.bibl.A5947.A3
　　　　　　　　　　　　L66 1974 NCFA p.133

II.B.3.e - MEZZOTINT - GREAT BRITAIN {18th c.}

Kneller, Godfrey & Faber, John
　The Kit-Cat Club done from the original
paintings of Sir Godfrey Kneller by Mr.Faber.
London,J.Tonson & J.Faber,1735
　　p.　illus.

LC ND497K47F3　　　Marlborough,London
　　　　　　　　cat.1972,no.17
　　　　　　　　(offered for £350.00)

II.B.3.e - MEZZOTINT - GREAT BRITAIN - 19th c.

Whitman, Alfred, 1860-1910
...Samuel Cousins...London,G.Bell & sons,190
　143 p.　illus.　(Nineteenth century mez-
zotinters)

Incl.Cat.of portrs.-Appendix...Cat.of the
plates after Sir Joshua Reynolds...

LC NE642.C8W6　　　Levis.Descr.bibl.Z5947.A3
　　　　　　　　　L66 1974 NCFA p.132

II.B.3.e - MEZZOTINT - GREAT BRITAIN - 18th c.

Whitman, Alfred, 1860-1910
...Valentine Green.London,A.H.Bullen,1902
　204 p.　illus.　(British mezzotinters)

Cat.of 325 prints

Incl.Index "Portraits"

LC NE642.G8W6　　　Levis,Descr.bibl. A5947.A
　　　　　　　　　L66 1974 NCFA p.132

qN
40.1
R465yW6
NPG

II.B.3.e - MEZZOTINT - GREAT BRITAIN - 19th c.

Whitman, Alfred, 1860-1910
...Samuel William Reynolds,...London,G.Bell
& sons,1903.
　167 p.　illus.　(Nineteenth century mez-
zotinters)

29 illustrations
Contents:...Cat.of portrs.p.21-94...
Samuel William Reynolds,jr.:cat.of portrs.p.1?
the...Appendix...Cat.of portr..of S.Wm.Reynol?
son.after works by Joshua Reynolds,p.150-161

LC NE642.R5W6　　Levis.Descr.bibl.Z5947.A3
　　　　　　　　　L66 1974 NCFA p.132

fNE
1815
B8
1902x
NCFA

II.B.3.e - MEZZOTINT - GREAT BRITAIN - 18-19th c.

Burlington fine arts club, London.
...Exhibition of English mezzotint portraits,
from ca. 1750 to ca.1830. London,...1902
　70 p.　illus.

Intro.signed Frederick Wedmore
"Notes chiefly on the technique of mezzo-
tint engraving"by W.O.Rawlinson...
Bibliography

LC NE1815.B8 1902

705
A56
NCFA
v.52

II.B.3.e - MEZZOTINT - U.S. - 18th c.

Allison, Anne
　Peter Pelham-engraver in mezzotints

In:Antiques
52:441-3　Dec.,'47　illus.

N
40.1
S654yF8
1975
NPG

II.B.3.e - MEZZOTINT - GREAT BRITAIN - 18-19th c.

Frankau, Julia(Davis), 1864-1916
　John Raphael Smith,1752-1812;a cat.raison-
né:The life and works of an 18th c.English ar-
tist and engraver of mezzotints...Amsterdam,
G.W.Hissink,1975
　259 p.　illus.　(Scripta artis
monographia,10)

Reprint of 1902 ed.
Index of titles.

Noon.Engl.Portr.drags.&
min. NC860.N66X NPG Bibl.
p.145

705
M18
NCFA
v.7

II.B.3.e - MEZZOTINT - U.S. - 18th c.

Early American engraved portraits.An exh.at
　the N.Y.Public Library

In:Mag Art
7:452-7　Sept.,'16　illus.

Exh.May-Oct.15,1916.First public exh.of
early Amer.engr.portrs.in N.Y. Incl.the first
engr.published in the U.S.:Tho.Emmes' Increase
Mather,1701;Washington as central fg.in a Toile
de Jouy(Printed fabric)which also shows medal-
lion portrs. of distinguished Americans

AP
1
W78
NCFA

II.B.3.e - MEZZOTINT - U.S. - 18th c.

Richardson, Edgar Preston, 1902-
 Charles Willson Peale's engravings in the
year of national crisis,1787

In:Winterthur Portfolio
1:166-81 1964 illus.

 Repro.incl.:Mezzotints of Franklin,Lafa-
yette,Rev.Pilmore,Washington

II.B.3.e - WOOD ENGRAVING

Renouvier, Jules, 1804-1860
 Des portraits d'auteurs dans les livres du
15e siècle. Avec un avant-propos par Georges
Duplessis. Paris,A.Aubry,1863
 22 p.

 Bibliogr.footnotes

 Illustrated with wood engravings

LC N7604.R4 Amsterdam,Rijksmus.,cat.
 Z5939A52,deel 1,p.138

705
A56
NCFA
v.95

II.B.3.e - MEZZOTINT - U.S. - 18th c.

Shadwell, Wendy J.
 An attribution for His Excellency and Lady
Washington

In:Antiques
95:240-1 Feb.,'69 illus.

 The mezzotints of Geo.Washington & Lady
Washington, once attr.to Chs.Willson Peale,
here attr.to Joseph Hiller,sr.

 Shadwell.Portr.engr.of Chs.
 W.Peale.NE506E36X NCFA
 p.143,note 7 (In:18th c.
 prints in Col'l America)

II.B.3.e - WOOD ENGRAVING

Schramm, Albert, 1880-
 Der bilderschmuck der frühdrucke.Leipzig,
Deutsches museum für buch & schrift,1920-23,
K.W.Hiersemann,1924-.40,
 .22.v. illus.

 Bibl.footnotes

 Survey of early illustrated printed books

LC Z1023.S37 Rave.Jb.d.Berl.Mus.I 1959
 LC N3.J16 fol.,p.122,footn.
 Paolo Giovio & d.Bildnisvitenbücher

NE
506
E36X
NCFA

II.B.3.e - MEZZOTINT - U.S. - 18th c.

Shadwell, Wendy J.
 The portrait engravings of Charles Willson
Peale

In:18th c.prints in Colonial America.Uni.Press
of Va.1979,p.123-44 illus.

 List of the engravings & their location

 Repro.incl.:Mezzotints of Geo.Washington,
Benj.Franklin,Lafayette,Rev.Jos.Pilmore
 Paper originally presented at symposium in
Williamsburg,Va. March,1974

II.B.3.e - WOOD ENGRAVING - GERMANY - 16th c.

Geisberg, Max, 1875-1943
 Bilder-katalog zu .his.Der deutsche einblatt
holzschnitt in der 1.hälfte des 16.jahrh;1600
verkleinerte wiedergaben...München,H.Schmidt
.c.1930.
 299 p. illus.

 Bibliography

 Geisberg's Der deutsche einblatt-holzschnitt
in d.1.hälfte d.16 jahrh. 43 v. 1600 pl.(part
col.) LC NE1150.A105
LC NE1150.A106

AP
1
A625
NMAA
v.5-6

II.B.3.e - MEZZOTINT - U.S. - 18th c.

Thorpe, Russell Walton
 Peter Pelham,founder of the arts of paint-
ing and engraving in America

In:Antiquarian
5-6:22-5 Aug.,'25 illus.

 Incl.:list of P.'s American mezzotints

 '...the 1st American mezzotinto artist...
.of.exquisite quality...'

 Moon.Art of Rbt.Feke N40.1
 F312FB 1970a NMAA Bibl.
 p.XXXV

II.B.3.e - WOOD ENGRAVING - U.S.

Burr, Frederic Martin
 Life and works of Alexander Anderson,M.D.,
the first American wood engraver...Three portrs.
of Dr.A.,and over 30 engravings by himself.
N.Y.,Burr brothers,1893
 210 p. illus.

 Appendix A. A brief sketch of Dr.A.'s life,
written by himself in 1848,p.77-90
 Appendix B. Extracts fr. the diary of A.
for 1795-1798,p.91-210
LC NE1215.A5B8

II.B.3.e - PRINTED FABRICS
see
II.D - FABRICS

N
6505
D92
1965
NCFA

II.B.3.e - WOOD ENGRAVING - U.S.

Dunlap, William, 1766-1839
 Alexander Anderson

In .his.History of the Rise and Progress of the
Art of Design in the United States,v.2:134-7
biography of A.Anderson,"who introduced the art
.wood engraving.into our country..."

II.B.3.e - WOOD ENGRAVING - U.S.

Duyckinck, Evert Augustus, 1816-1878
 A brief catalogue of books illustrated with engravings by Dr.Alexander Anderson.N.Y..Thompson & Moreau,1885.
 35 p. illus.

LC NE1215.A5D8

II.B.3.e - WOODCUT

Burchardus,provost of Ursperg, d.1230
 Chronicum Abbatis Urspergensis...Strassburg, .Crafft.Mylivm,1537
 506 p. illus.

Woodcuts after medals

NN NJP CBmH NIC Rave.Jb.d.Berl.Mus.I 1959
 LC N3.J16 fol. p.130
 Paolo Giovio & d.Bildnisvitenbücher...

II.B.3.e - WOOD ENGRAVING - U.S.

Lossing, Benson John, 1813-1891
 A memorial of Alexander Anderson,M.D.,the first engraver on wood in America..Read before the N.Y.Hist.Soc.,Oct.5,1870. N.Y.,1872
 107 p. illus. (Amer.culture series, 74:5)

LC Microfilm 01291 reel74
 no.5E

II.B.3.e - WOODCUT

Franck, Sebastian, 1499-1542
 Germaniae Chronicon.Von des gantzen Teutschlands.Frankfurt..Egenolff.1539

Woodcut portrs.after antique medals

LO DD87.F82)1538 and others
LC has also Augspurg ed., For source see over

2
1023
P95 II.B.3.e - WOOD ENGRAVING - U.S.
1968
NCFA Princeton University. Library
 Alexander Anderson
 its
 In.Early American book illustrators and wood engravers,1670-1870,
 v.1:48-66 and v.2:28-40. List of books illustrated by Alexander Anderson

LC Z1023.P9 1968

II.B.3.e - WOODCUT

Gebwiler, Hieronymus, c.1480-1545
 Epitome regii ac vetustissimi ortus sacrae Caessareae a Catholice Maiestatis...Ferdinandi Boemie regis.Strassburg,1527
 illus.

 48 portrs. of kings

LC Rare book room Rave.Jb.d.Berl.Mus.I 1959
Bq5 205 LC N3.J16 fol.p.127
 Paolo Giovio & d.Bildnisvitenbücher...

II.B.3.e - WOOD ENGRAVING - U.S. - 19th c.

Jones, Abner Dumont, 1807-1872
 The American portrait gallery;containing correct portraits and brief notices of the principal actors in American history...From Christopher Columbus down to the present time. The portraits engraved on wood by J.W.Orr,from original drawings by S.Wallin...N.Y.,J.M. Emerson & co.,1855
 768 p. illus.

LC E176.J68

II.B.3.e - WOODCUT

Ochsenbrunner, Thomas
 Priscorum Heroum stemmata...Rome,Joh. Besicken & Sygism.Mayr,1494
 illus.

Brit.
Mus. 72 woodcuts
9040d
 Viten of the Roman history from Romulus to Theodosius

 Rave.Jb.d.Berl.Mus.I 1959
 LC N3.J16 fol.,p.125
 Paolo Giovio & d.Bildnisvitenbücher.

II.B.3.e - WOODCUT

.Agricola, Johann,of Spremberg.
 Warhaffte bildnis etlicher...fürsten und herren...Wittenberg,Gabriel Schneltoltz,1562
 2v. illus.
Brit.mus.
11515 bb. Rave:v.1:Woodcut portrs.of Charles V & other
(2.)(3.) nobilities.-v.2:Woodcut portrs.of clergymen,incl
 Huss,Luther,Melanchton,Erasmus
 Poems by Agricola in praise of portrayed persons

 Rave.Jb.d.Berl.Mus. I 195
 LC N3.J16 fol. p.147
NRU Paolo Giovio & d.Bildnisvitenbücher d.Humanismus

II.B.3.e - WOODCUT

Pantaleon, Heinrich, 1522-1595
 Teutscher Nation Heldenbuch.Basel,Brylingers Erben,1567-1570
Brit.mus.
613.1.23 Latin ed.(with Greek title):Prosopographiae,
 1565-66 Brit.Mus.611.1.14

 1700 woodcut portrs.,only 50 on authentic basis

 Rave.Jb.d.Berl.Mus. I 1959
 LC N3.J16 fol. p.147-8
 Paolo Giovio & d.Bildnisvitenbücher d.Humanismus

II.B.3.e - WOODCUT

Prins, Wolfram
 Vasari's sammlung von künstlerbildnissen

In:Florence,kunsthist.Inst.,Mitt.
12 suppl. 1966

 On Vasari's woodcut portrs.,and their de-
pendence on self-portrs.

LC N14.F5515 Daugherty.Self-portrs.of
 P.P.Rubens mf:1161 NPG
 p.XIII foonote 10

II.B.3.e - WOODCUT - FRANCE - 16th c.

Les effigies des Roys de France,tant antiques
 que modernes...Paris,François Des Prez,1565?

 62 woodcuts by Jean Cousin,the younger,all
waist-length

MN Rave.Jb.d.Berl.Mus.I 1959
 LC N3.J16 fol. p.141
 Paolo Giovio & d.Bildnisvitenbücher...

II.B.3.e - WOODCUT - 16th c.

Burckhardt, Jacob, 1818-1897
 Die Sammler

In:his.Beiträge zur kunstgeschichte von Italien.
Basel,C.F.Lendorff,1898
 pp.564 ff.

 ..."Giovio's books with woodcuts are the
1st & generally accessible main source for the
looks of people in which the whole culture of th:
time was interested...".

LC N6911.B9 Rave.Jb.d.Berl.mus. I 1959
 LC N3.J16 fol.p.153

II.B.3.e - WOODCUT - FRANCE - 16th c.

Espinosa de los Monteros, Thomas de
 Heroicos hechos y vidas de varones yllvstres
asy Griegos,como Romanos...Paris,Por Françisco
de Prado,1576
 52 f. portrs.

 52 heroes since Theseus,probably by Jean
Cousin,the younger

MN NNH Rave.Jb.d.Berl.Mus. I 1959
 LC N3.J16 fol. p.141
 Paolo Giovio & d.Bildnisvitenbücher...

II.B.3.e - WOODCUT - 16th.c.

Hoop Scheffer, Dieuwke de
 Vorstenportretten uit de eerste helft van
de 16de eeuw;houtsneden als propaganda...Amster-
dam,1972?
 72 p. illus.

 Cat.of exh.held at Rijksprentenkabinet,
Rijksmuseum,Amsterdam,Aug.16-Oct.20,1972

 Bibliography

LC NE219.2.M4A574

II.B.3.e - WOODCUT - FRANCE - 16th c.
Giovio, Paolo, 1483-1552
 Vitae dvodecim Vicecomitvm Mediolani princi-
pvm.Lvtetiae,R.Stephani,1549
 199 p. illus.

 10 woodcuts after portrs. in Giovio's coll.
perhaps by Claude & Pierre Woeiriot.-Rave
 Portrs.engr.on wood have the Lorraine cross
device of Geoffroy Tory.-LC
 Portrs.of the Visconti family,Milan

LC DG657.7.O5 1549 Rave.Jb.d.Berl.Mus. I 1959
Rosenwald coll. LC N3.J16 fol. p.139-41
 Paolo Giovio & d.Bildnisvi-
 tenbücher d.Humanismus

II.B.3.e - WOODCUT - FRANCE

La mer des hystoires.a translation of the Rudi-
 mentum Novicorum.Paris,Pierre le Rouge,1488
 2 v. illus.

 "A masterpiece of the art of printing books.
 Actual portrs."-Rave

Brit
Mus
C384.1

LC D17.M4 1506 Rosenwald coll Rave.Jb.d.Berl.Mus.I 1959
LC D17.M4 LC N3.J16 fol.p.124
 Paolo Giovio & d.Bildnisvitenbücher...

II.B.3.e - WOODCUT - FRANCE - 16th c.
Hagelstange, Alfred, 1874-
 Eine folge von holzschnitt-porträts der
Visconti von Mailand

In:Nuremberg,Germ.nat.mus.-Mitt.
 :85-100 1904 illus.

LC DD1.A7 Rave.Jb.d.Berl.Mus. I 1959
 LC N3.J16 fol.p.140 footn.
 Paolo Giovio & d.Bildnisvi-
 tenbücher d.Humanismus

II.B.3.e - WOODCUT - FRANCE - 16th c.

Cousin, Jean, the younger, c.1522-c.1594
 Livre de Pourtraicture....Paris:,1560

 Woodcuts by author

Oxford
Uni.Bod- Later eds.called:La vraye Science de la
leian Pourtraicture
libr.

LC has several later eds. Rave.Jb.d.Berl.Mus.I 1959
 LC N3.J16 fol. p.141
 Paolo Giovio & d.Bildnisvitenbücher

II.B.3.e - WOODCUT - FRANCE - 16th c.
Rouillé, Guillaume, 1518?-1589
 ...La première.-la seconde.partie du promptv-
aire des medalles des plus renommées personnes
qui ont esté depuis le commencement du monde...
 end with king Henry II.Lyon,G.Roville,1553
 2v.in 1 illus.

 Title:Promptvaire des medalles
 For revision see Keller,Diethelm
 Dedication v.2...signed:Charles Fontaine

 Over 600 illus.by Georges Reverdy
LC CJ5569.R74
LC has also Italian ed.CJ556 .R7

II.B.3.e - WOODCUT - FRANCE - 16th c.

Strada, Jacobus de, à Rosberg, d.1588
 Epitome dv thresor des antiquitez, c'est à dire, pourtraits des vrayes medailles des empp. tant d'Orient que d'Occident...Tr.par Iean Louveau d'Orleans.Lyon, Par I.de Strada,et T.Cverin, 1553
 394 p. illus.
 For revision see Keller, Diethelm
 485 portr.woodcuts by B.Salomon after Strada's drags.,made from antique medals in Strada's coll.
 Emperors fr.Caesar to Charles V

LC CJ4975.S8
 Rave.Jb.d.Berl.Mus.I 1959
 LC N3.J16 fol.p.131 Paolo
Giovio & d.Bildnisvitenbücher...
Rath.Porträtwerke,p.39

II.B.3.e - WOODCUT - GERMANY - 16th c.

Keller, Diethelm
 Kunstliche und aigeadtliche bildtnussen der Römischen Keysern,ihrer Weybern und Kindern auch anderer berümpten personen wie die auff alten Pfennigen erfunden sind...auss dem Latin jets neülich vertheütst...Zürych,A.A.Gessner, 1558
 703 p. illus.

 717 woodcut portrs.
 Revision of Rouillé.Prompvaire & Strada.Epitome
 Rave.Jb.d.Berl.Mus.I 1959
 LC N3.J16 fol. p.132
LC CJ985.K29 Paolo Giovio & d.Bildnisvitenbücher.

II.B.3.e - WOODCUT - GERMANY

Bote, Konrad, fl.1475-1501
 Cronecken der Sassen.Mainz;Peter Schöffer, 1492
 284 p. illus.

 Woodcut half-length fgs.

LC Incun.1492.B74 Rosenwald coll. Rave.Jb.d.Berl.Mus. I 1959 LC N3.J16 fol.
Paolo Giovio & d.Bildnisvitenbücher,p.124

II.B.3.e - WOODCUT - GERMANY - 16th c.

Stumpf, Johannes, 1500-1576?
 Keyser Heinrychs des vierdten...fünfftzigjärige historia...in vier bücher geteilt... Zürych,Christian Froschouer,1556
 CXXIVII numb. illus.

 Woodcut portrs.by H.Vogtherr,the elder, V.Solis and others

LC DD143.S9
 Rave.Jb.d.Berl.Mus I 1959
 LC N3.J16 fol. p.134
 Paolo Giovio & d.Bildnisvitenbücher d.Humanismus

II.B.3.e - WOODCUT - GERMANY

Cronica van der hilliger Stat van Coellen. ⌈Cologne⌉Joh.Koelhoff the younger,1499 illus.

 Woodcut portrs.set at the beginning of each biography in the tradition of illuminated initials in MS

Yale univ.
LC Beinecke Libr. Rave.Jb.d.Berl.Mus.I 1959
Zi +1464 LC N3.J16 fol. p.125
 Paolo Giovio & d.Bildnisvitenbücher
 ...

II.B.3.e - WOODCUT - GREAT BRITAIN - 16th c.

A Booke containing the trve portraitvre of the covntenances and attires of the kings of England,...collected by T.T. London,Printed by Iohn de Beauchesne,1597

 23 full-page woodcuts(busts)

NN
MiU CoDU (Film) FOR COMPLETE ENTRY
 SEE MAIN CARD

II.B.3.e - WOODCUT - GERMANY

Huttich, Johann, 1480?-1544
 Imperatorum et Caesarum vitae....Argentorati Vuolphgangus Caephalaeus excussit.1534
 2pts.in 1 v. illus.

 (Argentoratum-Strassbourg,Caephalius-Koepfel 1st ed.1525)
 Woodcuts after medals, most of them by Hans Weiditz II
 Contains portrs.of the Roman,Byz.& German emperors to Charles V & archd.Ferdinand,etc.

LC DG203.H8 1534
 Rave.Jb.d.Berl.Mus.I 1959
 LC N3.J16 fol.p.128/9
 Paolo Giovio & d.Bildnisvitenbücher...

II.B.3.e - WOODCUT - ITALY

Boccaccio, Giovanni, 1313-1375
 De claris mulieribus.Venice,1506
 illus.

 Whole-length woodcut portrs.

Brit L'Opera de misser G.B. de mulieribus claris
Mus ⌈Transl.fr.the Latin by V.Bagli...Venetia,1506⌉
10603 Woodcuts
d
 Rave.Jb.d.Berl.Mus.I 1959
 LC N3.J16 fol.,p.126/7
 Paolo Giovio & d.Bildnisvitenbücher...

II.B.3.e - WOODCUT - GERMANY

Schedel, Hartmann, 1440-1514
 ⌈Nuremberg chronicle.German⌉
 Das buch der Chroniken unnd geschichten mit figuren und pildnissen von Anbeginn der Welt biss auff onsere Zeyt.Cuts.Fol. 2nd ed.,Augsburg, 1496
V&A Innumerable stylized representations of...& people by M.Wohlgemut & W.Pleydenwurff

5000 1st ed. Nürnberg,1493 in Latin
KFA5767
788.210
DWP-Facsimile ed.,1967.093 9315 Prins.S:g.d.selbst-
ET Print dpt " " " bildn.N'618/P95
.75.1/Schl? Bd.1,p.30

II.B.3.e - WOODCUT - ITALY

Foresti, Jacopo Filippo,da Bergamo, 1434-1520
 De claris mulieribus.Ferrara,Laurentius de Rubeis,de Valentia...,1497
 illus.

 172 portrs;"7 have such strangely marked characteristics,that they are probably copies of genuine portrs."-J.P.Morgan.Cat.of MSS & early printed books,v.2,no.382

LC Incun.1497.F6 Rosenwald Rave.Jb.d.Berl.Mus.I 1959
 coll. LC N3.J16 fol.,p.126
 Paolo Giovio & d.Bildnisvitenbücher...

II.B.3.e - WOODCUT - ITALY
Panvinio, Onofrio, 1529-1568
 Fasti et triumphi Romanorum a Romulo rege
usque Carolum V.Caes.Venetiis,Jac.Strada,1557

 Woodcuts after medals

V & A

 Rave.Jb.d-Berl.Mus.I 1959
 LC N3.J16 fol. p.132
 Paolo Giovio & d.Bildnisvi-
 tenbücher...

II.B.3.e - WOODCUT - ITALY - 16th c.

Diogenes Laertius
 Vite de philosophi moralissime....Venetija,
apud Hieronymus Scotum,1544
 62 leaves illus.

 Woodcut illus.of the philosophers discussed
Rave mentions ed.1524 with portrs.in bust-
form in front of a shell

LC T880.8D59vx NcU Rave.Jb.d.Berl.Mus.I 1959
 LC N3.J16 fol.p.127

N
7585
F97
1972
NPG

II.B.3.e - WOODCUT - ITALY - 16th c.

Fulvio, Andrea, fl.1510-1543
 Illustrium imagines.Portland,Ore.,Collegium
Graphicum.1972.
 CXI illus. (The printed sources of Wes-
tern art,no.9)

 Reprint of Rome,1517 ed.

 'The fine medallions are supposed to be by
Ugo da Carpi!'

II.B.3.e - WOODCUT - ITALY - 16th c.

Vasari, Giorgio, 1512-1574
 Le vite de'piv eccellenti pittori,scvltori,
et architettori.scritte,& di nuovo ampliate da
m.Giorgio Vasari...Co' ritratti loro...Fiorenza,
appresso i Givnti,1568
 3 v. illus.

 c.150 woodcut portrs.-Rave
 1st ed.publ.1550 was not illustrated

LC N6922.V2 1568 Rave.Jb.d.Berl.Mus. I 1959
 LC N3.J16 fol. p.146
 Paolo Giovio & d.Bildnisvi-
 tenbücher d.Humanismus

II.B.3.e - WOODCUT - NETHERLANDS - 16th c.

Cronycke van Hollandt,Zeelandt en Vrieslant be-
ghinnende vā Adams tiden tot die geboerte cn:
heren Jhū voertgaende tot de iare 1400...Leyden,
Jan Seuersz,1517

Brit
Mus Whole-length fgs.by Lucas van Leyden
 Half length fgs.

 Rave.Jb.d.Berl.Mus.I 1959
 LC N3.J16 fol.p.127

 Paolo Giovio & d.bildnisvitenbüche

II.B.3.e - WOODCUT - SWITZERLAND - 16th c.

Giovio, Paolo, 1483-1552
 ..Elogia virorum bellica virtute illustrium...
Basileae.Petri Pernae...1575
 391 p. illus.

 128 woodcuts after portrs.in Giovio's coll.
by Tobias Stimmer. 1 woodcut portr.of Giovio

LC CT93.G58 1575 Rave.Jb.d.Berl.Mus.I 1959
 LC N3.J16 fol. p.150
 Paolo Giovio & d.Bildnisvi
 tenbücher d.Humanismus

II.B.3.e - WOODCUT - SWITZERLAND - 16th c.

Giovio, Paolo, 1483-1552
 ...Elogia virorum literis illustrium...Basileae
Petri Pernae...1577
 231 p. illus.

 60 woodcuts after portrs.in Giovio's coll.
by Tobias Stimmer,incl.1 of Giovio

LC CT95.G5 Rave.Jb.d.Berl.Mus. I 1959
 LC N3.J16 fol. p.150
 Paolo Giovio & d.Bildnisvi
 tenbücher d.Humanismus

II.B.3.e - WOODCUT - SWITZERLAND - 16th c.

Strada, Jacobus de, à Rosberg, d.1588
 Imperatorum romanorum...verissimae imagines.
ex antiquis numismatis...Zürich,Andreas Gesner,
1559
 illus.
V & A 118 woodcuts by Rudolph Wyssenbach after
 drags.by Hans Rudolf Manuel Deutsch

 Rave.Jb.d.Berl.Mus.I 1959
 LC N3.J16 fol. p.132
 Paolo Gio vio & d.Bildnisvitenbücher.

II.B.3.f. SPECIAL FORMS (e.g. GLASS
 (Engraved), POSTERS)

II.B.3.f - BILDNISVITENBUCHER

Agricola, Johann, of Spremberg.
 Warhaffte bildnis etlicher...fürsten und
herren...Wittenberg,Gabriel Schnelbolts,1562
 2v. illus.
Brit.mus.
11515 bb. Rave:v.1:Woodcut portrs.of Charles V & other
(2.)(3.) nobilities.-v.2:Woodcut portrs.of clergymen,incl
 Huss,Luther,Melanchton,Erasmus
 Poems by Agricola in praise of portrayed per-
 sons

 Rave.Jb.d.Berl.Mus. I 195
 LC N3.J16 fol. p.147
NRU Paolo Giovio & d.Bildnisvitenbü-
 cher d.Humanismus

II.B.3.f - BILDNISVITENBÜCHER

Bellori, Giovanni Pietro, 1615?-1696
 Le vite de' pittori,scultori,ed architetti
moderni,co' loro ritratti al naturale,...2 ed.
accresciute colla vita e ritratto del cavaliere
D.Luca Giordano...Roma,F.Ricciardo,e G.Buono,
1728
 394 p. illus.

 1st.ed.Roma,Per il succeso.al Mascardi,1672

LC N40.B44 1728 Daugherty.Self-portrs.of
 P.P.Rubens mfm161NPG,p.XIV
 footnote 1?

II.B.3.f - BILDNISVITENBUCHER

Burchardus,provost of Ursperg, d.1230
 Chronicum Abbatis Vrspergensis...Strassburg,
.Crafft.Mylivm,1537
 506 p. illus.

 Woodcuts after medals

NN MJP C&mH NIC Rave.Jb.d.Berl.Mus.I 1959
 LC N3.J16 fol. p.130
 Paolo Giovio & d.Bildnisvitenbücher...

II.B.3.f - BILDNISVITENBUCHER
.Bernard, George.
 Effigies regum Francorum omnivm,a Pharamvndo
ad Henricum vsqve tertium...Caelatoribvs,Virgili
Solis & Iusto Amman...Noribergae...1576
 64 1 62 ports.

 Engraved portrs.with a scene in woodcut in-
serted in frame

 Title:Chronica regum Francorum

LC DC37.B5 1576 Rave.Jb.d.Berl.Mus. I 1959
Rosenwald coll. LC N3.J16 fol. p.149-50
 Paolo Giovio & d.Bildnisvi
 tenbücher d.Humanismus

II.B.3.f - BILDNISVITENBUCHER

Cousin, Jean, the younger, c.1522-c.1594
 Livre de Pourtraicture....Paris.,1560

 Woodcuts by author

Oxford
Uni.Bod- Later eds.called:La vraye Science de la
leian Pourtraicture
libr.

LC has several later eds. Rave.Jb.d.Berl.Mus.I 1959
 LC N3.J16 fol. p.141
 Paolo Giovio & d.Bildnisvitenbüche...

II.B.3.f - BILDNISVITENBUCHER

Boccaccio, Giovanni, 1313-1375
 De claris mulieribus.Venice,1506
 illus.

 Whole-length woodcut portrs.

Brit L'Opera de misser G.B. de mulieribus claris
Mus .Transl.fr.the Latin by V.Bagli...Venetia,1506.
10603 Woodcuts
d

 Rave.Jb.d.Berl.Mus.I 1959
 LC N3.J16 fol.,p.126/7
 Paolo Giovi.)& d.Bildnisvitenbücher...

II.B.3.f - BILDNISVITENBUCHER

Cronica van der hilliger Stat van Coellen.
 .Cologne.Joh.Koelhoff the younger,1499
 illus.

 Woodcut portrs.set at the beginning of each
biography in the tradition of illuminated ini-
tials in MS

Yale univ.
LC Beinecke Libr. Rave.Jb.d.Berl.Mus.I 1959
Zi +1464 LC N3.J16 fol. p.125
 Paolo Gi.)iovio & d.Bildnisvitenbüche...

II.B.3.f - BILDNISVITENBUCHER

Boissard, Jean Jacques, 1528-1602
 Icones virorum illustrium doctrina et eru-
ditione praestantium...Francfordii ad Moenum,
1597-99
 4 v.in 2 illus.

 Each v.with 50 portr-engravings of famous
humanists by Theodor de Bry

 vols.3 & 4 text by Johann Adam Ionicerus

LC CT93.B6 = ed.1598-1630
NN MH) Th:B.(Bry,Theodor)
 N40T43 1907a Bd.5,p.163,b

II.B.3.f - BILDNISVITENBUCHER

Cronycke van Hollandt,Zeelandt en Vrieslant be-
ghinnende vä Adams tiden tot die geboerte on
heren Jhü voertgaende tot die iare 1400...Leyden,
Jan Seuerss,1517

Brit Whole-length fgs.by Lucas van Leyden
Mus

 - Rave.Jb.d.Berl.Mus.I 1959
 LC N3.J16 fol.p.127

II.B.3.f - BILDNISVITENBÜCHER

 Bote, Konrad, fl.1475-1501
 Cronecken der Sassen.Mainz;Peter Schöffer,
1492
 284 p. illus.

 Woodcut half-length fgs.

LC Incun.1492.B74 Rosenwald coll. Rave.Jb.d.Berl.Mus.
 I 1959 LC N3.J16 fol.
 Paolo Giovio d.Bildnisvitenbücher,p.124

II.B.3.f - BILDNISVITENBUCHER

Destailleur, Hippolyte, 1822-1893
 Cat.de livres rares et précieux,compos.la
bibl.de m.H.Destailleur.Paris,D.Morgand,1891
 Auctioned by M.Delestre.Paris,Rue Drouot,27
Apr.13-24,1891

 Incl.V:Rapports avec les personnes,p.110-153
(entries no.435-614):a.-Recueils de portrs.de
personnages divers(divided by nationality of ar-
tists).b.-Portrs.des papes,cardinaux,personnages
religieux.c.-Portrs.des Empereurs Romains,Capi-
taines,Jurisconsultes,Ambassadeurs,

LC Z5939.D42 Rath.Porträtwerke.Bibl.:
 ..ch coll.of "Porträtwerken"

II.B.3.f - BILDNISVITENBÜCHER

Diogenes Laertius
 Vite de philosophi moralissime...Venetijs,
apud Hieronymus Scotum,1544
 62 leaves illus.

 Woodcut illus.of the philosophers discussed
Rave mentions ed.1524 with ports.in bust-
form in front of a shell

LC T880.8D59vx NcU Rave.Jb.d.Berl.Mus.I 1959
 LC N3.J16 fol.p.127

II.B.3.f - BILDNISVITENBÜCHER

Facius, Bartholomaeus, died 1457
 De viris illustribus liber,nunc primum ex
MS.Cod.in lucem erutus.Recensuit,praefationem,
vitamque auctoris addidit L.M....qui nonnullas F.
aliorumque ad ipsum epistolas adjecit.Florentiae,
‹1457›

Brit.
Mus.

 Rave.Jb.d.Berl.Mus.I 1959
 LC N3.J16 fol.p.121
 Paolo Giovio & d.Bildnisvitenbücher...

II.B.3.f - BILDNISVITENBÜCHER

Dyck, Anthonie van, 1599-1641
 Icones principvm virorvm dictorvm pictorvm...
Antverpiae,G.Hendricx.1646.
1p.1. 109 port

 Best engravers of the period collaborated

LC ND673.D9A3 Rath.Porträtwerke p.40

II.B.3.f - BILDNISVITENBÜCHER

Foresti, Jacopo Filippo,da Bergamo, 1434-1520
 De claris mulieribus.Ferrara,Laurentius de
Rubeis,de Valentia...,1497
 illus.

 172 portrs;"7 have such strangely marked cha
racteristics,that they are probably copies of ge
nuine portrs."-J.P.Morgan.Cat.of MSS & early
printed books,v.2,no.382

LC Incun.1497.F6 Rosenwald Rave.Jb.d.Berl.Mus.I 1959
 coll. LC N3.J16 fol.,p.126
 [Paolo Giovio & d.Bildnisvitenbücher

II.B.3.f - BILDNISVITENBÜCHER

Les effigies des Roys de France,tant antiques
 que modernes...Paris,François Des Prez,1565?

 62 woodcuts by Jean Cousin,the younger,all
waist-length

NN Rave.Jb.d.Berl.Mus.I 1959
 LC N3.J16 fol. p.141
 Paolo Giovio & d.Bildnisvitenbücher...

II.B.3.f - BILDNISVITENBÜCHER

Franck, Sebastian, 1499-1542
 Germaniae Chronicon.Von des gantsen Teutsch-
lands.Frankfurt,Egenolff.1539

 Woodcut portrs.after antique medals

LC DD87.F82
LC has also Augspurg ed.,)1538 and others

II.B.3.f - BILDNISVITENBÜCHER

Epitomes des roys de France en latin & en fran-
 coys auec leur vrayes figures...Lvgdvni-Lyo
Balthasar Arnoullet,1546
 159 p. illus.
 2nd issue.1st issue entitled:Epitome gestorv
1VIII.regvm Franciae,1546

 58 portrs,attr. to Corneille de Lyon,from
leg.king Pharamond to Francis I

LC Typ 515
46.366 MH Rave.Jb.d.Berl.Mus.I 1959
 LC N3.J16 fol.p.138
 Paolo Giovio & d.Bildnisvitenbücher....

II.B.3.f - BILDNISVITENBÜCHER

Fulvio, Andrea, fl.1510-1543
 Illvstrivm imagines...Romae,Jacopo Mazochio,
1517
 illus.

 202 portrs.Woodcuts by Ugo da Carpi or work-
shop after antique medals of Mazochio's coll.
 "One of the oldest publications...with portrs
-Prinz
 "this work became the example for numerous
portr.works".-Rath Prinz.Slg.d.selbstbildn.in d.
 Uffizien N7618/P95 Bd.1,p.146
LC N7585.F8 ote 43.Rave.In:Jb.d.Berl.m.
also in: ,1959 LC N3.J16 fol.p.128
Rath.Portr.werke in Lex.d.ges.Buchwesens,III,p.39 NPCxerox

II.B.3.f - BILDNISVITENBÜCHER

Espinosa de los Monteros, Thomas de
 Heroicos hechos y vidas de varones yllvstres
asy Griegos,como Romanos...Paris,Por Francisco
de Prado,1576
 52 f. portrs.

 52 heroes since Theseus,probably by Jean
Cousin,the younger

NN NNH Rave.Jb.d.Berl.Mus. I 1959
 LC N3.J16 fol. p.141
 Paolo Giovio & d.Bildnisvitenbücher..

II.B.3.f - BILDNISVITENBÜCHER

Galle, Philippe, 1537-1612
 ‹Imagines L.doctorum virorum...cum singulo-
rum elogijs. ‹Antverpiae,1587. 2nd ed.

 50 engr.portrs.

 1st ed."Effigies virorum doctorum..."1572
with 44 engr.portrs.

LC TYP
530
72.419 MH Cty PU Rave.Jb.d.Berl.Mus. I 1959
 LC N3.J16 fol. p.148-9
 Paolo Giovio & d.Bildnisv
 tenbücher d.Humanismus

II.B.3.f - BILDNISVITENBÜCHER

Gebwiler, Hieronymus, c.1480-1545
 Epitome regii ac vetustissimi ortus sacrae
Caesareae a Catholice Maiestatis...Ferdinandi
Boemie regis.Strassburg,1527
 illus.

 48 portrs. of kings

LC Rare book room Rave.Jb.d.Berl.Mus.I 1959
Bq5 205 LC N3.J16 fol.p.127
 Paolo Giovio & d.Bildnisvitenbücher...

II.B.3.f - BILDNISVITENBÜCHER

Goltzius, Hubert, 1526-1583
 Les images presqve de tovs les emperevrs,
depvis C.Ivlivs Caesar ivsqves à Charles V et
Ferdinanvs son frère,povrtraites av vif,prinses
des medailles anciennes...par Hvbert Gholts...
 1557. Livre I
 ꞏ350ꞏp. illus.
 149 portrs.by Joos Gietleughen after drags.by
 Goltzius(see over)
Italian edition:LC fJ 036.352:early ex.of chiaroscuro ptg
Latin edition:LC N7627.C6

 NG CLU-C PPPM PU-Mu Amsterdam,Rijksmus.cat.
 Z5939.52,deel 1,p.134

II.B.3.f - BILDNISVITENBÜCHER

Gilles, Nicole, d.1503
 Frantzösische Chronica...bis auff diss gegen-
wirtige 1572 jar....transl.fr.latin by Nicolaus
Falckner & Heinrich Pantaleon.ꞏBasel,Nicolaus
Brylinger.1572
 2v.in 1.

 ꞏLatin title:Gesta Francorum.

 Rave:61 portrs.of kings fr.Pharamund to
Charles IX(based on Epitomes des roys de France,
Lyon,1546)
French ed.in LC:DC37.G47 Rave.Jb.d.Berl.Mus.I 1959
PU ꞏ1573 LC N3.J16 fol.p.149
 Paolo Giovio & d.Bildnisvi-
 tenbücher d.Humanismus

II.B.3.f - BILDNISVITENBÜCHER

Hagelstange, Alfred, 1874-
 Eine folge von holzschnitt-porträts der
Visconti von Mailand

In:Nürnberg,Germ.nat.mus.-Mitt.
 :85-100 1904 illus.

LC DD1.A7 Rave.Jb.d.Berl.Mus. I 1959
 LC N3.J16 fol.p.140 footn.
 Paolo Giovio & d.Bildnisvi-
 tenbücher d.Humanismus

II.B.3.f - BILDNISVITENBÜCHER

Giovio, Paolo, 1483-1552
 ..Elogia virorum bellica virtute illustrium...
ꞏBasileae.Petri Pernae...1575
 391 p. illus.

 128 woodcuts after portrs.in Giovio's coll.
by Tobias Stimmer. 1 woodcut portr.of Giovio

LC CT93.G58 1575 Rave.Jb.d.Berl.Mus.I 1959
 LC N3.J16 fol. p.150
 Paolo Giovio & d.Bildnisvi-
 tenbücher d.Humanismus

II.B.3.f - BILDNISVITENBÜCHER

Heidelberger Liederhandschrift, grosse
 Sammlung von minnesingern aus dem schwäbi-
schen zeitpunkte 140 dichter enthaltend;durch
Ruedger Manessen...Zyrich,C.Orell & comp.,1758-59
 2 v. in 1

 Edited by J.J.Bodmer & J.J.Breitinger

 "Schon in Handschriften profaner Gattung
finden sich...Bildnisreihen"-Rave.

LC PT1419.H4B6 Rave.Jb.d.Berl.Mus. I 1959
 LC N3.J16 fol. p.124
 Paolo Giovio & d.Bildnisvi-
 tenbücher d.Humanismus

II.B.3.f - BILDNISVITENBÜCHER

Giovio, Paolo, 1483-1552
 ...Elogia virorum literis illustrium...ꞏBasileae
Petri Pernae...1577
 231 p. illus.

 60 woodcuts after portrs.in Giovio's coll.
by Tobias Stimmer,incl.1 of Giovio

LC CT95.G5 Rave.Jb.d.Berl.Mus. I 1959
 LC N3.J16 fol.p.150
 Paolo Giovio & d.Bildnisvi-
 tenbücher d.Humanismus

II.B.3.f - BILDNISVITENBÜCHER

Hondius, Hendrik,the elder,1573-after 1649
 Pictorum aliquot celebrium praesipue Ger-
maniae Inferioris,effigies.Hague,Comitis ex off.
Henrici Hondi.ca.1610. *)
Brit.Mus. 3 pt.
555 d.22
565 g.8 Coll.of portrs.by Netherlandish artists.
565 f.4 Continuation of Cock's artist portrs.,Pictorum
 ꞏ(2) aliquot celebrium...Antwerp,1572
 see also:Szwykowski,I.v. Historische skizze,...
 *)"Iconographically very important."-Th.-B.
 Hall.Portr.v.Nederl.Beeld.
 kunstenaars.N7620.H17 NPG
 p.XII

II.B.3.f - BILDNISVITENBÜCHER

Giovio, Paolo, 1483-1552
 Vitae dvodecim Vicecomitvm Mediolani princi-
pvm.Lvtetiae,R.Stephani,1549
 199 p. illus.

 10 woodcuts after portrs. in Giovio's coll.
perhaps by Claude & Pierre Woeiriot.-Rave
 Portrs.engr.on wood have the Lorraine cross
device of Geoffroy Tory.-LC
 Portrs.of the Visconti family,Milan

LC DG657.7.G5 1549 Rave.Jb.d.Berl.Mus. I 1959
Rosenwald coll. LC N3.J16 fol. p.139-41
 Paolo Giovio & d.Bildnisvi
 tenbücher d.Humanismus

II.B.3.f - BILDNISVITENBÜCHER

Hulsius, Levinus, d.1606
 XII Primorvm Caesarvm et LXIIII ipsorvm
vxorvm...ex antiquis numismatibus...collextae.
Svmptibus Pauli Brachfeldij,Francoforti ad Moe-
num,1597
 198 p. illus.

 Engr.after Vico by Theodor de Bry

 Vico's Le imagini of 1548 & 1557 combined

NN ICN CtY Lenox coll. Rath,in:Lex.d.ges.buchwe-
 sens,Bd.III,p.39
 LC Z118.I67(NPG xerox cop

II.B.3.f - BILDNISVITENBÜCHER

Huttich, Johann, 1480?-1544
Imperatorum et Caesarum vitae....Argentorati
Vuolphgangus Caephalaeus excussit.1534
2pts.in 1 v. illus.

(Argentoratum-Strassbourg,Caephalius-Koepfel
1st ed.1525)
Woodcuts after medals, most of them by Hans
Weidits II
"Contains portrs.of the Roman,Byz.& German
emperors to Charles V & archd.Ferdinand,etc.

LC DG203.H8 1534 Rave.Jb.d.Berl.Mus.I 1959
 LC N3.J16 fol.p.128/9
 Paolo Giovio & d.Bildnisvitenbücher...

II.B.3.f - BILDNISVITENBÜCHER

Orsini, Fulvio, 1529-1600
Imagines et elogia virorum illustrium et
eruditorum. Rome,1570

rit.Mus. The life of 133 famous poets,philosophers,
51 e. historians,orators,grammarians,jurists,doctors,
.(3.) based on antique authors;with engr.after medals,
 busts,statues,etc.
 "The whole a step to pure archeology via the
 'bildnisvitenbuch".-Rave

 Rave.Jb.d.Berl.Mus.I 1959
(LC N3.J16 fol.p.146
 Paolo Giovio & d.Bildnisvi-
 tenbücher d.Humanismus

II.B.3.f - BILDNISVITENBÜCHER

Keller, Diethelm
Kunstliche und aigendtliche bildtnussen der
Römischen Keysern,ihrer Weybern und Kindern
auch anderer berümpten personen wie die auff
alten Pfennigen erfunden sind...auss dem Latin
jets neüwlich verthettst...Zürych,A.A.Gessner,
1558
703 p. illus.

717 woodcut portrs.
Revision of Touillé.Promptuaire & Strada.Epi-
tome Rave.Jb.d.Berl.Mus.I 1959
 LC N3.J16 fol. p.132
LC CJ985.K29 Paolo)Giovio & d.Bilinisvitenbü-
 cher

II.B.3.f - BILDNISVITENBÜCHER

Pantaleon, Heinrich, 1522-1595
Teutscher Nation Heldenbuch.Basel,Brylingers
Erben,1567-1570
rit.mus.
613.1.23
 Latin ed.(with Greek title):Prosopographiae,
 1565-66 Brit.Mus.611.1.14

 1700 woodcut portrs.,only 50 on authentic
basis

 Rave.Jb.d.Berl.Mus. I 1959
 LC N3.J16 fol. p.147-8
(Paolo Giovio & d.Bildnisvi-
 tenbücher d.Humanismus

II.B.3.f - BILDNISVITENBÜCHER

Lampsonius, Dominique, 1532-1599
Pictorvm Aliqvot celebrivm Germaniae Inferi-
oris Effigies...Anverpiae,Apud Viduam Hieronymus
Cock,1572

23 full-page portrs.of artists north of Alps
Engravings by J.Wierix,C.Cort & probably H.Cock

Facsimile ed.,Liége,J.Puraye,1956

"Important source for Carel van Manders
Schilderboek"-Rave
 Rave.Jb.d.Berl.Mus. I 1959
XN FOR COMPLETE ENTRY LC N3.J16 fol. p.148
 SEE MAIN CARD Paolo Giovio & d.Bildnisvi
 tenbücher d.Humanismus

II.B.3.f - BILDNISVITENBÜCHER

Panvinio, Onofrio, 1529-1568
Accuratae effigies Pontificum Maximorum...
Argentorati,1573,2nd ed.(1st ed.1568)
 Durch Verdolmetschung J.Fischaert,gen.Ment-
V & A zer Teutsch beschriben,Strassburg,1573

 Printer & publisher:Bernard Jobin.Woodcuts
 by Tobias Stimmer:Half-fgs. of Urban VI to
 Gregory XIII;after engravings in the 1st ed.
 Fischart condemns onesidedness of Vasari.
 Speaks for the 1st time in art-history of German
artists who are Rave.Jb.d.Berl.Mus. I 1959
still famous to- LC N3.J16 fol.p.146 & 149
day. Paolo Giovio & d.Bildnis-
 vitenbücher d.Humanismus

II.B.3.f - BILDNISVITENBÜCHER

La mer des hystoires.a translation of the Rudi-
mentum Novicorum..Paris,Pierre le Rouge,1488
2 v. illus.

Brit "A masterpiece of the art of printing books.
Mus Actual portrs."-Rave
C384.1

LC D17.M4 1506 Rosenwald coll Rave.Jb.d.Berl.Mus.I 1959
LC D17.M4 LC N3.J16 fol.p.124
 Paolo Gio & d.Bildnisvitenbücher...

II.B.3.f - BILDNISVITENBÜCHER

Panvinio, Onofrio, 1529-1568
Fasti et triumphi Romanorum a Romulo rege
usque Carolum V.Caes.Venetiis,Jac.Strada,1557

Woodcuts after medals
V & A

 Rave.Jb.d.Berl.Mus.I 1959
 LC N3.J16 fol. p.132
 Paolo Giovio & d.Bildnisvi
 tenbücher...

II.B.3.f - BILDNISVITENBÜCHER

Ochsenbrunner, Thomas
Priscorum Heroum stemmata...Rome,Joh.
Besicken & Sygism.Mayr,1494
illus.

Brit 72 woodcuts
Mus.
9040d Viten of the Roman history from Ramulus to
Theodosius

 Rave.Jb.d.Berl.Mus.I 1959
 LC N3.J16 fol.,p.125
 Paolo Giovio & d.Bildnisvitenbücher.

PG II.B.3.f - BILDNISVITENBÜCHER
xerox copy
in VF Rath, Erich von, 1881-
Por- Porträtwerke
trai-
ture In:Lexikon des gesamten Buchwesens,Bd.III,1937
 p.38-41

 "Porträtwerke"as discussed here,is essentially
 the same concept as Rave's discussion of "Bild-
 nisvitenbücher"
 Rath describes biographies of men & women of the
 past with added portrs.or vice versa portrs.with
 short biogr.notes.From 15th c.(see Ochsenbrunner,
 1494)to 17th c. Rave.Jb.d.Berl.Mus. I 1959
LC Z118.L67 LC N3.J16 fol. p.141 footn.
 Paolo Giovio & d.Bildnisvi-
 tenbücher d.Humanismus

II.B.3.f - BILDNISVITENBÜCHER

NE
218
R25
NPG

Rave, Paul Ortwin, 1893-1962
Paolo Giovio und die bildnisvitenbücher des
Humanismus

In:Jb.der Berliner Mus.
I 1959:119-54 illus.

Der bildnissammler und vitenschreiber Giovio.
Die ersten bücher mit bildnisreihen.Die "vera
effigies"und die frühen münsbildbücher.Die gros-
sen chroniken der jahrhundertmitte.Giovio,Vasari
(cont.on next cd.) Prins.Slg.d.selbstbildn.
LC N3.J16 in d.Uffizien N7618/P95
Bd.1,p.146,note 42

II.B.3.f - BILDNISVITENBÜCHER

Strada, Jacobus de, à Rosberg, d.1588
Epitome dv thresor des antiquites,c'est à
dire,pourtraits des vrayes medailles des empp.
tant d'Orient que d'Occident...Tr.par Iean Lou-
veau d'Orleans.Lyon,Par I.de Strada,et T.Cverin,
1553
394 p. illus.
For revision see Keller, Diethelm
485 portr.woodcutz by B.Salomon after Stradaº
drags.,made from antique medals in Strada's coll.
Emperors fr.Caesar to Charles V
 "ave.Jb.d.Berl.Mus.I 1959
LC CJ4975.S8 LC N3.J16 fol.p.131 Paolo
Giovio & d.B ildnisvitenbücher...
Rath.Porträtwerke,p.39

II.B.3.f - BILDNISVITENBÜCHER

Roth-Scholtz, Friedrich,1687-1736
Icones consiliariorvm de illvstri Repvblica
Noribergensi optime meritorvm qvi ab anno
MCCCLXVI ad hvnc vsqve diem clarvervnt;ex monv-
mentis,nvnlis plasmatibvs,cereis tabvlisqve item
pictis et aeneis,hinc inde collectae stvdio atqve
opera Friderici Roth-Scholtzii...Noribergae et
Altdorfii,apvd haeredes J.D.Tavberi,1723
«8»p. 152 illus.

C N7605.R8 (contains only 147 illus.)

II.B.3.f - BILDNISVITENBÜCHER

Strada, Jacobus de, à Rosberg, d.1588
Imperatorum romanorum...verissimae imagines.
ex antiquis numismatis...Zürich,Andreas Gesner,
1559
 illus.
V & A 118 woodcuts by Rudolph Wyssenbach after
drags.by Hans Rudolf Manuel Deutsch

 Rave.Jb.d.Berl.Mus.I 1959
 LC N3.J16 fol. p.132
Paolo Gio vio & d.Bildnisvitenbücher.

II.B.3.f - BILDNISVITENBÜCHER

Roth-Scholts, Friedrich, 1687-1736
Icones virorvm ordinvm ervditione omniqve
item genere et varietate artivm de repvblica
litteraria et speciatim de academiis et gymna-
siis totivs pene Evropae ab aliqvot secvlis ad
nostra vsqve tempora optime meritorvm...collec-
tae stvdio atqve opera Friderici Roth-Scholtzii..
Norimbergae et Altdorfii,apvd haeredes J.D.
Tavberi,1725-28
5 pt.in 1 v. 225 illus.

C N7627.R8

II.B.3.f - BILDNISVITENBÜCHER

Stumpf, Johannes, 1500-1576?
Keyser Heinrychs des vierdten...fünfftzig-
järige historia...in vier bücher geteilt...
Zürych,Christian Froschouer,1556
CXXXVII numb. illus.

Woodcut portrs.by H.Vogtherr,the elder,
V.Solis and others

 Rave.Jb.d.Berl.Mus I 1959
LC DD143.S9 LC N3.J16 fol. p.134
Paolo Giovio & d.Bildnis-
vitenbücher d.Humanismus

II.B.3.f - BILDNISVITENBÜCHER

Rouillé, Guillaume, 1518?-1589
...La première...la seconde.partie du promptv-
aire des medalles des plus renommées personnes
qui ont esté depuis le commencement duemonde...
»end with king Henry II.Lyon,G.Roville,1553
2v.in 1 illus.

Title:Promptvaire des medalles
For revision see Keller, Diethelm
Dedication v.2...signed:Charles Fontaine

Over 600 illus.by Georges Reverty
LC CJ5569.R74
LC has also Italian ed.CJ556 9.R7

II.B.3.f - BILDNISVITENBÜCHER

Thevet, André, 1502-1590
Les vrais povrtraits et vies des hommes
illvstres,grecz,latins,et payens recveilliz de
levr tableavx,liures,medalles antiques et modernes
par André Thevet Angovmoysin...Paris,Par la ve-
sue I.Kervert et Guillaume Chaudiere,1584
2 v.in 1

2d ed.appeared under title:Histoire des plus
illustres et savants hommes de leurs siècles,
Paris,1670-71

Review by Adhémar,Jean. In:R.archéol.
LC no see card for Adhémar, Jean

II.B.3.f - BILDNISVITENBÜCHER

Schedel, Hartmann, 1440-1514
»Nuremberg chronicle.German.
Das buch der Chroniken unnd geschichten mit
figuren und pildnissen von Anbeginn der Welt
biss auff onsere Zeyt.Cuts.Fol. 2nd ed.,Augsburg,
1496
 (596)
V&A Innumerable stylised representations of...&
people by M.Wohlgemut & W.Pleydenwurff

7000 1st ed. Nürnberg,1493 in Latin
KFA5767
788.210
CWP-Facsimile ed.«1967.093 (J315 Prins.Slg.d.selbst-
MET Print dpt " " bildn.N7618/P95 I
279.1/Schl? Bd.1,p.20

II.B.3.f - BILDNISVITENBÜCHER

Vasari, Giorgio, 1512-1574
Le vite de'piv eccellenti pittori,scvltori,
et architettori.scritte,& di nuovo ampliate da
m.Giorgio Vasari...Co' ritratti loro...Fiorenza,
appresso i Givnti,1568
3 v. illus.

c.150 woodcut portrs.-Rave
1st ed.publ.1550 was not illustrated

 Rave.Jb.d.Berl.Mus.I 19
LC N6922.V2 1568 LC N3.J16 fol. p.146
Paolo Giovio & d.Bildnis-
vitenbücher d.Humanismus

II.B.3.f - BILDNISVITENBÜCHER

Vico, Enea, 1523-1567
 Augustarum Imagines...Venetiis.Paul Manuce?,
1558
 192 p. illus.

 55 engravings of Roman empresses after medals

 1st ed.1557

LC DC276.5.V5 Rave.Jb.d.Berl.Mus.I 1959
)LC N3.J16 fol. p.145
 Paolo Giovio & d.Bildnisvitenbücher

N
7593
A512 II.B.3.f - GLASS - U.S.
NPG
 American Antiquarian Society,Worcester,Mass.,
 Library
 Checklist of the portraits in the library
 of the American antiquarian society,by Frede-
 rick L.Weis.Worcester,Mass.,published by the
 society,1947
 76 p. illus.

 Reprinted fr. the Proceedings of the Amer.
 Antiqu.Soc.for April 1946
 Alphabetical list of artists.
 Incl.:Washington,Franklin;marble busts.Co-
 lumbus;oil,mosai John Adams;gold on glass

II.B.3.f - BILDNISVITENBÜCHER

Zantani, Antonio
 Le Imagini e le vite de gli imperatori tratt.
 dalle medaglie e dalle historie de gli antichi.
 Florence,Enea Vico,1548

 From Caesar to Domitian,engravings after
 medals
Oxford
Uni.Bod- Vico,the publisher was an engraver
leian
libr. has latin ed.

 Rave.Jb.d.Berl.Mus. I 1959
)LC N3.J16 fol. p.141-2
 Paolo Giovio & d.Bildnisvitenbücher.

N
7628.J4 II.B.3.f - GLASS - U.S.
C86K
NPG Cunningham, Noble E., 1926-
2 c. The image of Thomas Jefferson in the public
 eye:portraits for the people,1800-1809....Char-
 lottesville,Univ.Press of Va.,1981
 185 p. illus.

 Incl.index
 Incl.:Engravings,medallions,Liverpool pette:;
 caricatures,silhouettes.One portr.on glass,en-
 graved in gold(fg.59)
 Appendix:Sources of the People's image:Bust,
 ptgs.,drag.

II.B.3.f - GLASS
(engraved; engraved gold on glass)

II.B.3.f - PLAYING CARDS

Bara, Aline et Crick, Lucien
 Un jeu de cartes en argent

In:B.Mus.Art Hist.Belgique
 :98-105 1942 illus.

Incl.:Maximilian of Austria,Mary of Burgundy,
Ferdinand V & Isabella,the Catholic,Henry II &
Catherine de Médicis,Sigismund III Vasa,Anne of
Poland. 7 cards by Alexander Mair

LC N1835.A3 Rep.,1942-44 #7579

II.B.3.f - GLASS

 Stockholm - Nationalmuseum - Glass
 Nationalmusei småskrifter 11
Hernmarck, Carl
 Graverade glas i Nationalmusei samlingar.
Stockholm.National museum,,1946
Net
142.6 19 p. illus.
H43
 Bibliography

 German & Scandinavian engraved glasses from
 17th c. to present. Incl:portrs.:Charles VI, Gus-
 tavus Adolphus,Fre erick William I,Francis I,
 etc.)Rep.,1945-47#721

705
A784 II.B.3.f - POSTERS
NCFA
v.63 Kunzle, David
 Uses of the portrait:The Che poster

 In:Art in Am.
 63:66-73 Sept.,'75 illus(part col.)

 The Cuban posters provide special psycho-
 logical forms.They are intended to form a revolu-
 tionary consciousness which is morally motivate
 & internationally dedicated.They embrace styles
 fr.Pop art to Neo-Art Nouveau,but exclude Sovic
 & Chinese Socialist Realism.

705
A6 II.B.3.f - GLASS - GREAT BRITAIN
NCFA
v.47 Elville, E.M.
 Famous English glasses.IV.Jacobite glasses

 In:Apollo
 47:18-9 Jan,1948 illus.

 18th c. commemorative glasses,engr.with portr.
 provide a history in glass over a hundred years.
 Repro.Chas.Edw., the "young pretender"& emblem
 under the foot of the glass

 Rep.,1948-49#9015

II.B.4. CARICATURE (see also other media)

CARICATURE SEE ALSO OTHER MEDIA

NC
1310
P9R47 II.B.4
NCFA Brown University. Dept.of Art.
 Caricature and its role in graphic satire;
an exhibition ...Providence,R.I.,1971.
 120 p. illus.

 Held at the Museum of Art,Rhode Island
School of Design,Apr.7-May 9,1971

 Bibl.references.

 In the intro.are the changes of the meaning
of caricature traced through history.Differences

LC NC1310.P7R472

NPO II.B.4
Ref.
coll.
 The American Presidency in political cartoons:
1776-1976.Thomas C.Blaisdell,jr.,Peter Selz,
and seminar.Berkeley,University Art Museum,1976
 278 p. illus.

 Cat.of an exh.held at the Uni.Art Mus.,Ber-
keley,Jan.13-Feb.22,1976,National Portr.Gall.,
Wash.,D.C.,Oct.15-Nov.28,1976,and others...

 Bibliography

LC E176.1.A655

708.1 II.B.4
818
NCFA Caricaturist - Sophisticated and gay
v.8
 In:Balto.M.A.News
8:6 Feb.,'46

 Short note on Aline Fruhauf.
Exh.at Theatre gall.

 II.B.4

Beerbohm, Max, 1872-1956
 Caricatures of 25 gentlemen...London,
L.Smithers,1896
 5 p. 25 pl.

LC NC1479.R432

 II.B.4
Dangon, Georges
 Cent ans de journalisme (1839-1939)

In:Courrier graph.
 :3-7 1939,no.24 illus.

 Incl.:Portr. & caricatures of journalists by
Mailly,Nadar,Duran,Cohl,Humbert

LC Z1007.C775 Rep.,1942=698

 II.B.4

Benedict, Brad comp.
 Fame...N.Y.,Harmony Books,c.1980
 119 p. illus(part col.)

 Portraits,caricatures & cartoons

LC NC998.5.A1F35 1980 Books in print.Subject
 Guide,1905-6,v.3,p.4864

N
40.1
F574X II.B.4
A1 Flagg, James Montgomery, 1877-1960
NCFA Celebrities:a half-century of caricature and
portraiture,with comments by the artist.Watkins
Glen,N.Y.,Century House,1951
 104 p. illus.

 Alphabetical list of sitters

LC NC1429.F53 Art Books 1950-79 Z5937
 A775 NCFA Ref. p.897

VF II.B.4

Bowdoin College. Museum of Fine Arts
 The French visage; a century and a half of
portraiture and caricature from the Artine
Artinian collection. Brunswick,Me.,1969
 20 p. illus.

 Also shown at Currier Gallery(N.H.),Gorham (Me.)
State college, and Hopkins Center Art Gall's at Dart
mouth...

 II.B.4

 Galerie de portraits de personnages célèbres.
Paris,Shes Ostervald l'aîné.n.d.,
 1 v. illus.

 Portrs.and caricatures of Napoleon

McU

II.B.4

Hanfstaengl, Ernst Frans Sedgwick, 1887-
 Hitler in der karikatur der welt.Tat gegen
tinte,ein bildsammelwerk.Stuttgart,F.Basser-
mann,1965
 157 p. illus. (Marginalien zur Geschic.
te,1)
 Reprint of the 1938 ed.

InU Rep. 1966 #958

II.B.4

Lynch, John Gilbert Bohun, 1884-1928
 Max Beerbohm in perspective...N.Y.,Haskell
House Publishers,1974

 185 p. illus.

 Bibliography

 Reprint of the 1922 ed.publ.by Knopf,N.Y.

LC PR6003.E4Z7 1974 Cumulative book index 1974
 The World list by author...
 Z1219.C97 NPG p.1296

II.B.4

Harris, Eileen
 Carlos Pellegrini:Man and 'Ape'

In:Apollo
103:53-7 Jan.,1976 illus.

 'Ape' sobriquet under which Pellegrini was
known

 Ormond.Vanity Fair qNC1478
 V36D75X,p.13,footnote 10

II.B.4

Maggs Bros., London
 Napoleonica:portraits,caricatures,views,
battles,etc. Selected from the stock of Maggs
Bros. London,1912
 56 p. illus. (Its:catalogue,no.290)

LC Z999.M155 no.290
copy 2:Z8612.M25

II.B.4

109 x .Hundertneunmal.Napoleon.Miniaturen nach
J.L.David(Ausstellung)21.jan.-18.febr.1973
(Katalog von Klaus Hoffmann)Göttingen,Städti-
sches Mus.(1973)
 16 p. illus.

LC ND1335.G3.0633

II.B.4

Malcolm, James Peller, 1767-1815
 Historical sketch of the art of caricaturing
...London,...1813

 Illustrated by Malcolm's engravings

LC NC1325.M3 FOR COMPLETE ENTRY
 SEE MAIN CARD

II.B.4

LeBrun, Charles, 1619-1690
 ...La physionomie humaine comparée à la phy-
sionomie des animaux,d'après les dessins de
Charles LeBrun;cent trente reproduction...
2nd éd.Paris,H.Laurens,1927
 25 p. illus.

 At head of title:Contribution à l'étude de
la caricature

 See also:Resemblances.in:Art Express,1,no.2:
54 Sept.Oct.,'81 AP 1 A784E9 NMAA

FOCO
FA3946
.2.7

II.B.4

Mitchell, James Tyndale, 1834-1915
 ...The unequaled collection of engraved por-
traits of eminent foreigners,embracing kings,
eminent noblemen & statesmen,great naval command-
ers...explorers,...reformers...;also a collection
of caricatures on Napoleon & a ...coll.of portrs.
engravings by the great masters of the last four
centuries in line,mezzotinto,stipple & etching.
to be sold...Oct.14,1912...and Oct.15,1912.Cat.
comp.& sale. conducted by Stan.V.Henkels at the
book auction rooms of S.T.Freeman & co.,Phila.,Pa.
.M.H.Power,printer,1912.
 111p. illus.
LC NE240.M515 Cat.no.944,pt. XII

741
L98

II.B.4

Lynch, John Gilbert Bohun, 1884-1928
 A history of caricature...London,Faber &
Gwyer,1926
 126 p. illus.

 Bibliography,p.121-123

LC NC1325.L9 1926 Cumulative book index 1974
 The World list by author...
 Z1219.C97 NPG p.308

II.B.4

Mitchell, James Tyndale, 1834-1915
 ...The unequalled collection of engraved
portraits of Napoleon Bonaparte and his family
and marshals,belonging to Hon.J.T.Mitchell...
portraits in mezzotinto,aquatint,line and stipple
...caricatures on Napoleon by Cruikshank,Gillray,
Rowlandson...to be sold...1908.Philadelphia,Pa.,
.Press of W.F.Fell,company,1908.
 100 p. illus.
 (Sold at book auction rooms of S.T.Freeman & co
 (Catalogue compiled...by Stan V.Henkels)
 Cat.no.944,pt.VII
LC DC203.EK5

II.B.4

Mitchell, James Tyndale, 1834-1915
...The valuable collection of books on en-
graved portraits owned by the Hon.Ja.T.Mitchell
...Also an unique coll.of caricatures by Cruik-
shank,Gillray,Heath,Seymour...and others.To be
sold...Jan.4,1909...and...Jan.5,1909...Cata-
logued & .sales.conducted by Stan.V.Henkels.At
the book auction rooms of Sam.T.Freeman & co...
Philadelphia.....Press of M.H.Power,1909.
 91 p.
 Cat.no.944,pt.VIII
 715 items Levis.Descr.bibl...Z5947
 .3L66 1974 NCFA p.250.
LC NE240.M54
"A valuable bibliography of engraved portraiture"

II.B.4

Tournachon, Félix, 1820-1910
 Panthéon Nadar.1e feuille.Paris,1854

 Caricature portraits of contemporary French
celebrities

MB Stelzer.Kunst & photogr.
 LO N72.P588,p.34

2NC
1478
V36 Ormond, Richard
D75X Vanity Fair;an exh.of original cartoons;
NPG intro.by Eileen Harris.Cat.by R.Ormond.London,
 NPG,1976
 31 p. illus.

 Exh.held at NPG 9 July-30 Aug.,1976

 Incl.List of sitters
 List of artists

II.B.4 - 20th c.

Holme, Geoffrey, 1887-1954 ed.
 Caricature of to-day...N.Y.,...1928.Detroit,
Gale Res.Co.,1974

LC NC1355.H6 1974 FOR COMPLETE ENTRY
 SEE MAIN CARD

AP
1
B96 Sherry, James
NPG Four modes of caricature:Reflections upon a
v.87 genre

 In:B.Research in Humanities
 87,no.1:29-61 1986-87 illus.

 Incl.:Portrait caricature,p.32-9

II.B.4 - FRANCE - 19th c.

Nancy. Musée des beaux-arts
 Grandville:caricatures et illustrations
.exposition.Mus.des beaux-arts,Nancy,du 4 juil
let au 15 septembre 1975.Nancy,Mus.des beaux-
arts,1975.
 110 p. illus.

LC NC1499.G66N16 1975 Worldwide art cat.B.
 705.W927 NCFA v.13,no.4
 p.24

II.B.4

Tournachon, Félix, 1820-1910
 Nadar;Karikaturist,fotograf,aeronaut.Organi-
sation der ausstellung Katharina Schmidt und
Max Vilette..Düsseldorf,Institute française und
Kunsthalle,1976
 29 p. illus.

MET Cat.of exh.Nov.5-Dec.5,1976 at Städtische
107.3 Kunsthalle,Düsseldorf
D9444
.10.

NNMM

II.B.4 - FRANCE - 20th c.

Westfälisches Landesmuseum für Kunst und Kul-
turgeschichte,Münster
 La caricature:Militaire in Frankreich
1830-1851 aus der sammlung von Kritter.Aus-
stellung,16.März-20.Mai 1980.Kunstsammlung
der Universität Göttingen,26.Okt.-7.Dez.1980.
Gutenberg Mus.Mainz,20.Apr.-7.Juni 1981..Kat.
hrsg.von Gerd Unverfehrt.Göttingen:Kunstge-
schichtliches seminar der Universität,c.1980
 300 p. illus.
 Bibliography
LC DC266.5.C37 Worldwide Art Cat.b. 705.
 W927 NCFA v.18,no.1,p.23

II.B.4

Tournachon, Félix, 1820-1910
 Nadar:photographe,caricaturiste,journaliste;
photographies,textes et dessins rassemblés par
Catherine et Bertrand Meyer.Paris,Encre,c.1979
 75 p. illus. (Les arcanes du Temps)

LC TR681.F3T69 1979

II.B.4 - GERMANY - 18-19th c.

Forster-Hahn, Franziska
 Johann Heinrich Ramberg als karikaturist
und satiriker.Hanover,1963
...235 p. illus.

 "Sonderdruck aus Hann.Geschichtsblättern,N.F.
Band 17(1963)"
 Thesis Bonn

 Bibliography:p.223-230

LC NC1509.R3F6 1963 Noon.Engl.portr.drags & Min.
 Bibl. p.145

II.B.4 - GREAT BRITAIN

British museum. Dept.of prints and drawings
Catalogue of prints & drawings in the
British museum.Division I.Political and personal
satires(no.1 to no.4838)....London.Printed by the
order of the Trustees,1870-1942
7 v.in 8(v.5-7)

Contents.-1.1320-Apr.11,1689.-II.June 1689-
1733.-IIIpt.1March 28,1734-c.1750.pt.II.1751 to
c.1760.-IV.1761 to 1770.-V.1771-1783.-VI.1784-
1792.-VII.1793-1800

LC NE55.L7A3

Wimsatt.Portrs.of A.Pope
.7628.P83W7 NPG bibl.

705
C75
NCFA
v.14

II.B.4 - GREAT BRITAIN - 18-19th c.

Calthrop, Dion Clayton
Robert and Richard Dighton.Portrait etchers

In:Connoisseur
14:231-6 Apr.,1906 illus.

FOR COMPLETE ENTRY
SEE MAIN CARD

II.B.4 - GREAT BRITAIN

Rubens, Alfred, 1903-
Anglo-Jewish portraits;a biographical cata-
logue of engraved Anglo-Jewish & colonial por-
traits from the earliest times to the accession
of Queen Victoria,by...with a foreword by
H.M.Hake. London,The Jewish museum,1935
191 p. illus.

Bibliography

LC DS135.E6A17

Waterhouse.Ptg.in Britain
1530-1790 ND465.W32 1962
NCFA bibl.

qNC
1477
C4C53
NCFA

II.B.4 - GREAT BRITAIN - 18-19th c.

Chicago. Art Institute
British caricatures of the 18th and early
19th century from the William McCallin McKee
collection held at the Art Institute of Chi-
cago in honor of the late Thomas Foster Furness
May 12-June 30,1977.Chicago,The Art Inst.,c1977
24 p. illus.

II.B.4 - GREAT BRITAIN

Yale Center for British Art
English caricature,1620 to the present;
caricaturists and satirists,their art,their
purpose and influence.Organised & published
London,Victoria and Albert Mus.,1984
144 p. illus(part col.)
Bibliography p.138-41
Publ.to accompany an exh.at the Yale Ctr.
for Brit.Art,Sept.11,1984;the LC,Wash.,D.C.,
Dec.5-Feb.17,'85;the Nat'l Libr.of Canada,Otta-
wa,March 14-May8,'85 & the V.& A.Mus.,London,
June 4-Sept.15, 1985

LC CtW IU NsyU NCh. r.71,no.1954 in Worldwide
Books.Mus.&Gall.publications
European Art 19th c.

NC
1473
W95
1867
NPG RB

II.B.4 - GREAT BRITAIN - 18-19th c.

Wright, Thomas, 1810-1877
Caricature:history of the Georges.London,
J.C.Hotten,1867,
639 p. illus.
—— Same .New York.
Benj.Blom,1968

1st ed.1848

ca.400 illus.on steel & wood

705
C75
v.94

II.B.4 - GREAT BRITAIN - 18th c.

Grundy, Cecil Reginald, 1870-
An 18th century caricaturist George,1st
Marquess Townshend

In:Conn.
94:194-7 Aug.,'34 illus.

London.NPG.Townshend album
N40.1T75XL8 NPG Bibl.

q4
40.1
C953x'72
1978
NPG

II.B.4 - GREAT BRITAIN - 19th c.

Wardroper, John
The caricatures of George Cruikshank.text
by:John Wardroper.Boston,D.R.Godine,c1978
144 p. illus(part col.)

Bibliography

Cumulative book index
Z1219.C97 NPG 1979.p.609

N
40.1
T75XL8
NPG

II.B.4 - GREAT BRITAIN - 18th c.

London. National portrait gallery
The Townshend album/Eileen Harris;.for the
National portrait galley.London,H.M.S.O.,1974
26 p. illus.

Bibliography

LC NC1479.T66L66 1974

q
40.1
K243y
E9
NCFA

II.B.4 - GREAT BRITAIN - SCOTLAND

Evans, Hilary, 1929-
John Kay of Edinburgh,barber,miniaturist
and social commentator,1742-1826,by:Hilary and
Mary Evans.Aberdeen,Impulse Publ.,Ltd.,1973
53 p. illus(1 col.)

Bibliography and iconography

LC NE642.K39E92 1973 Yale ctr.f.Brit.art Ref.

N
40.1
K243y
A1
1877

II.B.4 - GREAT BRITAIN - SCOTLAND

Kay, John, 1742-1826
A series of original portraits and cari-
cature etchings...New ed.Edinburgh,A.& C.Black,
1877
2 v. illus.

Incl.Index of sitters

LC N7599.K3 1877 Yale ctr.f.Brit.art Ref.
 NJ18.K24.A1? 1877

N
40.1
B297xN1
NPG

II.B.4 - U.S. - 20th c.

Barton, Ralph, 1891-1931
The jazz age,as seen through the eyes of
Ralph Barton,Miguel Covarrubias, and John Held,Jr.
.Providence, 1968.
.? ?p. illus.

Cat.of exh.of the jazz age in caricature...
held at the Mus.of Art,R..Isl.School of Design,
Sept.25-Nov.10,1968,and at the Art Gall,State
Univ.of N.Y.College at Potsdam,Nov.15-Dec.15,'68

Repro.incl.actors,authors,musicians,ptrs.,
politicians,journalists,etc...

LC NC1427.P74B3

II.B.4 - U.S. - 19th c.

Mitchell, James Tyndale, 1834-1915
The unequalled coll.of engraved portraits
of eminent American,and some noted foreign-
ers belonging to Hon.James T.Mitchell...a
large coll.of lithographs engraved by A.Newsam,
an unique coll.of American revolutionary and
political caricatures and numerous portraits
for extra illustrating,to be sold...Oct.28,
1913,Phila.,Pa..Stan v.Henkels,1913,
56 p. Plates
Cat.Stan v.Henkels,no.944,pt.13

LC Z999.H505 no.944,pt.13 Rosenwald coll.

705
A786
NCFA
v.24

II.B.4 - U.S. - 20th c.

Caricatures by Covarrubias;exh.at Dudensing
Galleries,N.Y.:"The Prince of Wales and
other famous Americans"

In:Art N
24,no.9:3 Dec.5,'25

Exh.incl.caricatures of Pres.Coolidge,Otto
Kahn,Mary Pickford,Rud.Valentino,Heywood Broun,
Alfred Stieglitz,Theo.Dreiser,I.Stravinsky

(see also Parnassus,v.2:17,Ap.'30)
(Biography in Am.Artist,v.12:21-4,Jan,'48

E
337.5
N48
1575X
NCFA

II.B.4 - U.S. - 19th c.

Nevins, Allan, 1890-1971 and Frank Weitenkampf
A century of political cartoons.Caricature
in the United States from 1800-1900.N.Y.,Octa-
gon books,a division of Farrar,Straus and Gi-
roux,1975
191 p. incl.illus.

Reprint of the ed.published by Scribner,N.Y.

LC E337.5.N48 1975

NPG
1984
Ref.

II.B.4 - U.S. - 20th c.

Cox, Beverly J.
Miguel Covarrubias caricatures,by B.J.Cox
and Denna Jones Anderson.Cat. of an exh.,held
at the NPG,Washington,D.C.,Nov.16,1984 to Jan.
13,1985.Publ.for the NPG by the Smiths.Inst.
Press,1985
163 p. illus(part col.)
Incl.:Index

bibliography
Foreword by Alan Fern.Incl.essays by Al
Hirschfeld & by Bernard C.Reilly,jr.

LC NC1460.C68A4 1984

CT
275
L73W7
NPG

II.B.4 - U.S. - 19th c.

Wilson, Rufus Rockwell, 1865-1949.
Lincoln in caricature; a historical collection, with descrip-
tive and biographical commentaries by Rufus Rockwell Wil-
son. Introd. by R. Gerald McMurtry. New York, Horizon
Press, 1953.
xix, 327 p. 165 illus. 26 cm.

1. Lincoln, Abraham, Pres. U. S.—Cartoons, satire, etc.

E457.63.W752 1953 923.173 53—3939
Library of Congress [80q]

N
40.1
F9396x
V9
NMAA

II.B.4 - U.S. - 20th c.

Fruhauf, Aline, 1907-1978
Making faces.Memoirs of a caricaturist;ed.
by Erwin Vollmer.Cabin John,Md./Washington,D.C.,
Seven Locks Press,c.1987
254 p. illus.

Incl.:Index

qN
40.1
A913xA1
NPG

II.B.4 - U.S. - 20th c.

Auerbach-Levy, William, 1889-
Is that me? A book about caricature...
assisted by Florence Von Wien,N.Y.,Watson-
Guptill Publ.,1947.
155 p. illus(part col.)

LC NC1320.A8

N
40.1
H66xA1
NPG

II.B.4 - U.S. - 20th c.

Hirschfeld, Albert, 1903-
The American theatre as seen by Hirschfeld.
N.Y.,G.Braziller,1961
unpaged (chiefly illus.)

LC NC1429.H527A48

qN
40.1
H66xAlw
NPC

II.B.4 - U.S. - 20th c.

Hirschfeld, Albert, 1903-
The world of Hirschfeld .by. Al Hirschfeld.
Intrcd.by Lloyd Goodrich.N.Y.,H.N.Abrams
.1970?.
233 p. illus(part col.)

LC NC1429.H527A57

705
I61
NCFA

II.C.1

Agard, Walter
The sculptural portrait

In:Studio(International)
81,no.335:22-28 Apr.,'25 illus.

Repro.:Vespasian,Egyptian portr.of a woman
Houdon,Epstein,Rodin,Phidias,Bourdelle,Maillol
Mestrovic,Sheldon,Cecere

Essay on diverse aims of portr.sculptors:
a realistic likeness;a psychological character
study;or a source of esthetic delight
Portr.bust.Renaiss.to Enl-
lightenment.NB1309.P6x NPC Bibl.

II.B.4 - U.S. - 20th c.

Langsam, Walter Consuelo, 1906-
The world and Warren's cartoons...1st ed.
Hicksville,N.Y.,Exposition Press,c.1977
302 p. illus. (An Exposition-Banner
book)

Incl.history of caricature(later called
cartoon)p.11-17

LC D840.L28 Cumulative book index 1977
 Z1219.C97 NPC p.1364

MET
107.3
B451
v.1

II.C.1

Berlin. National-Galerie
Das bildnis in der plastik,ausstellung
Prinsessinnen-palais,Nov.-Dez.1934.Vorwort
von H.Mackowsky..Berlin,1934.
24 p. illus. (Its Ausstellungs-folge D.
Deutsche kunst seit Dürer v.1)

Die 20er jahre im portr.
N6868.5.E9297 NPG,p.142

II.B.4 - U.S. - 20th c.
Philadelphia Museum of Art
Dept.of prints and drawings
Alfred Bendiner;lithographs,complete cata-
log..Exh.,Jan.21-March 4,1965...Phila.,Mus.of
Art.1965?.
1 v.(unpaged) illus.

NMAH:NE2415.B45A1

AP
1
N277
NCFA
v.12

II.C.1

D'Andrea, Albert, 1897-
On Portraiture...Something old and some-
thing new

In:Nat Sculp R
12:6-12,26-8 Spring,'63 illus.

Discusses portrait sculpture through the
ages. Illustrations all U.S.,20th c.

II.C. SCULPTURE

927.3
E64

II.C.1

Epstein, Jacob, 1880-
Portraits

In.his.Let there be sculpture...N.Y.,G.P.Put-
nam's sons.1940.
pp.58-91 illus.

p.58-62,90-1:E.describes his workmethod & his
thoughts abt. portraiture.-p.63-89:Individual
sitters.

LC NB497.E6A2 Vincent,C.In search of like-
 ness...Met Mus Bul 24ns:252

II.C.1. GENERAL

II.C.1

Evelyn, John, 1620-1706
Numismata.A discourse of medals ancient and
modern.Together with some account of heads and
effigies of illustrious and famous persons,in
sculps,and tailledouce of whom we have no me-
dals extant;and of the use to be derived from
them.To which is added a digression concerning
physiognomy...London,B.Tooke,1697
34? p. illus.

LC CJ3538.E8 Winterthur Mus.Libr.
 fZ861.W78 NCFA v.9,p.225

II.C.1

Huxley-Jones, T.B.
 Modelled portrait heads.N.Y.,Studio Publica-
tions.1955.
 95 p. illus (How to do it series,60)

LC 1180.48 Books in prints.Subj.guide
 Z1215.P92 1975 v.2 NPG
 p.2960

II.C.1

Sartre, Jean-Paul
 Faces

In:Verve
 2:43-4 no.5-6,1939 illus.

 Incl:Sclpt.by Pigalle,Coysevox,Couston,
Bernini,Benoist,de Fernex,Houdon,Caffieri,ptg. by
Bose

LC N1.V4 Rep.,1939.41*703

NB
1293
M35 II.C.1
NPG
 Marrits, Louis E. -1971
 Modeled portrait sculpture...South Brunswick,
A.S.Barnes.1970.
 374 p. illus.

LC NB1293.M3 1970

II.C.1

Weiss, Konrad
 Rodin über porträtplastik

In:Hochland
 1:476-82 Jan.,1914 illus.

 The art of portrait sculpture in conversa-
tions with Rodin about art, brought together
by Paul Osell

LC AP30.W67 Rep.1914-19 #139

AP
1
A784 II.C.1
J6
NCFA
 Phillips, Claude, 1846-1924
 Great portrait-sculpture through the ages

In:Art J
 :10-18,129-37,355-61 1903 illus.

 Defines the essentials of monumental & inti-
mate portr.sculpt.& their differences.Relation-
ship with portr.ptg.& the characteristics of dif-
ferences in aims & results.
 From antiquity to 19th c.Repro.:incl.:Antiqui-
ty,Sluter,J.D.Quercia,Donatello,Mino da Fiesole,
Houdon,Leoni,Pilon Schlüter,Puget,Caffieri,
Rodin

II.C.2. CHRONOLOGICAL

II.C.1

Read, H.elen.,Appleton.
 Portraits in sculpture

In:Vogue
 77:36-7,94 Feb1,'31

LC TT500.V7 Chicago.Art Inst.Ryerson
 Libr.Ind.to Art periodicals
 fZ5937.C53,v.8 NCFA Ref. p.7030

II.C.2 - ANTIQUITY

Arndt, Paul, 1865-1937 ed.
 Griechische und römische porträts nach aus-
wahl und anordnung von Heinrich Brunn Und Paul
Arndt;herausgegeben von Friedrich Bruckmann.
München,F.Bruckmann,1891-1942
FCGG 123 fascs illus.
Arc 1050.3
PP Later fascicules edited by Paul Arndt &
Georg Lippold
 Ceased publication with fasc.123

NA MH PU-FA PPULC
PPAmP

II.C.1

Rome. Protomoteca Capitolina
 La Protomoteca Capitolina.A cura di V.Mar-
tinelli e C.Pietrangeli.Rome,1955 (Cataloghi
dei musei comunali di Roma.ser.II.5)
FCGG 100 p. illus.
62
R76pro Bibl.footnotes
1955
PA62.10 'The Protomoteca Capitolina,a coll.of
 sculpted portrs.of famous men'-Hodgkinson
MCT
138.7
M36
(LC 708.5.R763Mp) TxDaM Hodgkinson.Walpole Soc.34:
VU-FA CU MiP 45 1952-54

II.C.2 - ANTIQUITY

Bianchi Bandinelli, Ranuccio, 1900-
 L'origine del ritratto in Grecia e in Roma.
Roma,Edizioni "Ricerche".1960.
 151 p. (Corsi universitari)

LC N7585.B5 Kraus.Römische weltreich
 N5760.K92 Bibl.p.315

II.C.2 - ANTIQUITY

Bianchi Bandinelli, Ranuccio, 1900-
Ritratto

In:Enc.dell'arte antica classica e orientale
v.6:695 ff. 1965

LC N31.E48,v.6 Kraus.Das römische welt-
reich N5760.K92 Bibl.p.315

II.C.2 - ANTIQUITY

Calza, Raissa
I ritratti..Roma.Istituto poligrafico dello
stato,Libraria dello stato.1964-
v. illus(part col.) (Scavi di Ostia,5)

Contents.-1.Ritratti greci e romani fino
al 160 ca.d.C.-

MH

NB
1296
B78
NPG

II.C.2 - ANTIQUITY

Bousek, Jan
Antický portrét.Katalog vystav,.Národ-
niho musea v Prae,25.5-3.9,1972,vPrase,c.1972,
64 p. illus.

Bibliography

Greek & Roman portraits in Czechoslova-
kian collections.Sculpture & Coins & medals.

Summary in English,p.61-4

II.C.2 - ANTIQUITY

Delbrück, Richard, 1875-
Spätantike Germanenbildnisse

In:Bonner Jahrbücher des Rheinischen Landesmus.
in Bonn...Kevelaer,Rhld...Heft 149:.66,-81
1949 illus.

Roman terra-cottas & portraits

LC .DD491.R4B7 Heft 149.
Chicago,Univ.Libr. for LC

N
7580
B82
NPG

II.C.2 - ANTIQUITY

Breckenridge, James Douglas, 1926-
Likeness;a conceptual history of ancient
portraiture,...Evanston.Ill.Northwestern Universi-
ty Press,1968,c.1969.
293 p. illus.

Bibliographical notes

LC N7580.B7

II.C.2 - ANTIQUITY

Delbrück, Richard, 1875-
Spätantike kaiserporträts von Constantinus
Magnus bis zum ende des Westreichs. Berlin,
Leipzig,W.de Gruyter & Co.,1933

250 p. illus.

(Studien zur spätantiken kunstgeschichte...8)

Bibliography

Incl.also:Roman numismatics
LC N5903.89 vol.8

.II.C.2 - ANTIQUITY

British museum. Dept.of Greek and Roman anti-
quities
Greek and Roman portrait-sculpture, by
R.P.Hinks. London, Brit.mus.,1935

35 p. illus.

LC NB164.B7

II.C.2 - ANTIQUITY

Deonna, Waldemar
Portraits antiques

In:Mus.de Genève
2:p.2 1945 illus.

Incl.:Augustus, Demostenes,Alexander the
Great

LC DQ441.A3 Rep.,1945-47:2914bis

II.C.2 - ANTIQUITY

British museum. Dept.of Greek and Roman anti-
quities
Greek and Roman portrait-sculpture...
London,Brit.mus.,...1976

LC NB1296.3.B72 1976 FOR COMPLETE ENTRY
SEE MAIN CARD

NB
1296.3
G38
1983
NPG

II.C.2 - ANTIQUITY

Gesichter:griechische und römische bildnisse
aus Schweizer besitz.Ausst.im römischen
Hist.Mus.vom 6.Nov.1982 bis 6.Febr.1983.
Hrsg.von Hans Jucker und Dietrich Willers.
3.erneut verb.aufl.Bern,Archäologisches
seminar der Univ.Bern,1983,c.1982
316 p. illus.

II.C.2 - ANTIQUITY

Heintze, Helga von
Die antiken porträts in Schloss Fasanerie
bei Fulda...Mainz,von Zabern.1968.
121 p. illus.

Half-title:Deutsches archäologisches Inst.

From the coll.of Philip,Landgrave of Hesse

Bibliography

LC N7580.H4 Foeg,v.11,p.330

II.C.2 - ANTIQUITY

North Carolina. University. William Hayes
 Ackland Memorial Art Center
 Ancient portraits;a show of Greek,Etruscan
 and Roman sculptured portraits in honor of the
 70th birthday of T.R.S.Broughton.Ackland Art Cen
FOOO ter,Uni.of N.C.at Chapel Hill,Apr.5-May 17,1970
FA4623.3 .Chapel Hill,N.C.,1970.
 unpaged illus.

 Bibliographies

 Winkes.Physiognomonia.In:
 Temporini.Aufstieg u.niede
 gang...LC DG209.T36,Bd.1,T
 p.908

QNB II.C.2 - ANTIQUITY
164
H47 Hekler, Antal, 1882-1940
E1972 Greek and Roman portraits;by Anton Hekler.
NPG New York,Hacker Art Books,1972
 335 p. illus.

 Translation of Die bildniskunst der Griechen
 und Römer...Reprint of the 1912 ed.

 Bibliography

LC NB164.H4 1972 Enc.of World Art v.11,p.511
 Portraiture,bibl. N31E56Ref.

II.C.2 - ANTIQUITY

Paribeni, Roberto, 1876-1956
 ...Il ritratto nell'arte antica..Milano.Fratel
 li Treves editori,1934
 40 p. illus.,365 pl.on 183 l.

 Bibliography

N.Y.P.L.
MCH
-
FOOO
Aro1053.19P

 NNC CU McD CtY OCU Kraus.Das römische welt-
 CU MiU reich.N5760.K92 Bibl.p.315

II.C.2 - ANTIQUITY

Herbig, Reinhard, 1898-
 Die italische wurzel der römischen bildnis-
kunst

In:Das neue bild der antike,hrsg.H.Berve,Bd.2
p.85- 1942 illus. Bibl.footnotes

LC DE71.B45,Bd.2 Kraus.Das römische welt-
 reich.N5760.K92 Bibl.p.316

II.C.2 - ANTIQUITY

Poulsen, Frederik, 1876-
 Greek and Roman portraits in English coun-
try houses...transl.by the Rev.G.C.Richards.
Oxford,The Clarendon press,1923
 112 p. illus.

LC NB164.P6

II.C.2 - ANTIQUITY

Kern, J.H.C., 1833-1917
 Antieke portretkoppen, een vergelijkend ge-
tuigenis van de oude beschaving van Egypte,Baby-
lonië,Assyrië,Griekenland en Rome. The Hague,
M.Nijhoff,1947

 119 p.

Summary in English. Bibliographical footnotes

LC N7580.K4 Rep.,1948-49#860

II.C.2 - ANTIQUITY

Richter, Gisela Marie Augusta, 1882-
 Who made the Roman portrait.statues:Greek
or Romans ?

In:Amer.philosoph.soc.,Phila. Proceedings
95:184-208 1951

LC .Q11.P5.? Hiesinger.Portr.in the Rom
 Rep.Bibl.In:Temporini.Auf-
 stieg u.niederg....LC DG209
 T36,Bd.1,T.4,p.825

II.C.2 - ANTIQUITY

Michalowski, Casimir (Kazimierz)
 ...Les portraits hellénistiques et romains.
Paris,E.de Boccara,1932
 66 p. illus. (Ecole française d'Athènes
Exploration archéologique de Delos....fasc.XIII)

 Bibl.footnotes

 MiU MdBWA NN:MTR etc. Hiesinger.Portr.in the Rom
LC:DF261.f.D3E2 v.13(C1) Rep.Bibl.In:Temporini.Auf-
 stieg u.niederg...LC DG209
 T36,Bd.1,T.4,p.824

II.C.2 - ANTIQUITY

Rome. Museo nazionale romano
 I ritratti..Catalogo di.Bianca Maria
Felletti Maj.Roma.Libreria dello Stato,1953

LC NB87.R6A35 Richter,G. Portrs. of the
 Greeks N7586R53,v.3,p.296

page of II.C.2 - ANTIQUITY
contents
in NPG Schefold, Karl, 1905-
(xerox) Die bildnisse der antiken dichter,redner und
q N denker. Basel,Benno Schwabe.1943.
7585.S317
.et1 NPG 2 v. 228 p. illus.
577
Sch24 Bibliography
Review by Alfons Wotschitzky,In:Ans.f.Altertums-
wiss.,v1:23-4,1948.."important". Rep.1948-49*1012

J.Walters Art Gall.v.9
p.55 footnote "indispensable"

Yale Univ.Libr.
Jb53*9433 Rep. 1948-49*1012
Breckenridge..Likeness...
N7580.B82 bibl.notes

II.C.2 - ANTIQUITY - CYRENAICA

Rosenbaum, Elisabeth
A cat. of Cyrenaican portrait sculpture.
London,Publ.for the Brit.Acad.by Oxford Univ.
Press,1960
140 p. illus.

Bibliography p.29-.31.

LC NB118.C9R6 Gesichter.NB1296.3.G38
1983 NPG p.316
.also:Kraus.D.röm.weltreich.N5760.K92Bibl.p.315

708.1 II.C.2 - ANTIQUITY
.W243
NCFA Segall, Berta
Realistic portraiture in Greece and Egypt.
A portrait bust of Ptolemy I

In:J.Walters Art Gall.
9:53-67,106 1946 illus.

Coins of Ptolemy I
Ptolemy as Dionysos

II.C.2 - ANTIQUITY - EGYPT

Birmingham Museum of Art (Ala.)
Through ancient eyes:Egyptian portraiture.
.Cat.of an.exh.Apr.21-July 31,1988,organ.by
Donald B.Spanel.Distributed by the Univ.of Wa-
shington Press,Seattle & London.1988.
159 p. illus(part col.)

Bibliography,p.153-6.

LC NB1296.2.S63 1988

II.C.2 - ANTIQUITY

Venice. Museo archeologico
I ritratti..Di.Gustavo Traversari.Roma,Ist.
poligrafico dello Stato.Libreria,1968
129 p. illus. (Cataloghi dei musei e gal-
lerie d'Italia)

Bibliography

LC N7585.V4 Fogg,v.11,p.330

II.C.2 - ANTIQUITY - EGYPT

Charbonneaux, Jean, 1895-
Portraits ptolémaïques au Musée du Louvre

In:Acad Inscr Paris Mon et Mém
47:99-129 1953 illus.

Style & chronology of 7 portrs.of Kings &
Queens are identifiable by means of monetary
effigies.Works of the 3rd c.,they still have the
grand pathos & the idealising traits of the 4th c
(Ptolemy I,II,III,IV,Arsinoë II;III,Berenice II)

LC N13.A25 fol. Richter,G. Portrs. of the
Greeks N7586R53,v.3,p.295
Rep.1953*3438

II.C.2 - ANTIQUITY

Vermeule, Cornelius Clarkson, 1925-
A Graeco-Roman portrait of the third century
A.D.and the Graeco-Asiatic tradition in imperial
portraiture from Gallienus to Diocletian

In:Dumbarton Oaks papers.Cambridge,Mass.
no.15:1-22 1961 illus.

Bibl.footnotes

LC N5970.D8 no.15 Fogg,v.11,p.330

II.C.2 - ANTIQUITY _ EGYPT

Drerup, Heinrich, 1908-
Ägyptische bildnisköpfe griechischer und
römischer zeit.Münster in Westfalen,Aschen-
dorffsche verlagsbuchhandlung,1950
28 p. illus. (Orbis antiquus.Hft.3)

Schriften der altertumswissenschaftlichen
gesellschaft an der Universität Münster

Bibliography

Review in:Am J Archaeol 56:86-7 ja'52
Richter,G. Portrs. of the
IU CU RPB OCU NN etc. Greeks N7586R53,v.3,p.296

II.C.2 - ANTIQUITY - ASIA MINOR

Inan,Jale and Rosenbaum, Elisabeth
Roman and early Byzantine portrait sculpture
in Asia Minor.London,Published for the British
Academy by Oxford U.P.,1966
245 p. illus.

Bibliography

LC N7588.I5 Hiesinger.Portr.in the Rom
Rep.Bibl.In:Temporini.Auf-
stieg u.nieder...LC DG209
T36,Bd.1,T.4,p.824

II.C.2 - ANTIQUITY - EGYPT

Graindor, Paul, 1877-1938
...Bustes et statues-portraits d'Égypte
romaine...Le Caire,Imprimerie P.Barbey.1939?.
146 p. illus. (Université égyptienne,
Recueil de travaux publiés par la faculté des
lettres...)

Bibliography
Review in J Rom Stud 29:134 '39
Review by V.Müller In:Am J Archaeol
43:363-4 Apr,'39
Yale U.Library for Richter,G. Portrs of the
LC AS693.C3 Greeks N7586R53,v.3,p.297

II.C.2 - ANTIQUITY - EGYPT

Kyrieleis, Helmut
 Bildnisse der Ptolemäer.Berlin,Mann,1975

 190,108 p. illus. (Archäologische
Forschungen,Bd.2)

 Bibliography

 At head of title:Deutsch,Archäol.Inst.

 A revision of the author's Habilitations-
schrift,Bonn,1972

LC DT92.K97 Gesichter.NB1:96.J.G38
 1983 NPG p.315

708.1
N52
N3 v.7 II.C.2 - ANTIQUITY - EGYPT
 Simpson, William K.
 A 4th dynasty portrait head

 In:B-Metrop.Mus.Art
7(NS):286-92 May 1949 illus.

 Individual character of heads at Giseh,4th
dyn.derived fr.3rd dyn;use of plaster to model
limestone surface. Influence on realistic sculpt.
of 5th dyn. In Old Kingdom also use of masks for
mummies. Comparison with bronze heads of Ile-Ife
in Nigeria

 Rep.,1948-49*3265

II.C.2 - ANTIQUITY - ETRURIA

Gazda, Elaine K.
 Etruscan influence in the funerary reliefs
of late Republican Rome:A study of Roman verna-
cular portraiture

VF
Portrs., In:Temporini,Hildegard.Aufstieg und niedergang
Roman der römischen welt...Berlin,N.Y.,Walter de Gruy-
ter,1973.Pt.I:Von den anfängen Roms bis zum aus
gang der republik,v.4(in 2 parts,text & plates)
p.189-205(plates),& p.855-870(text)

 Bibl.footnotes
LC DG209.T36
Bd.1,T.4 Temporini.Aufstieg und nie
 dergang...LC DG209.T36

II.C.2 - ANTIQUITY - ETRURIA

Hafner, German.
 Bildnisse des 5.jahrhunderts v.Chr.aus Rom
und Etrurien

 In:Deutch.Archäol.Inst.Mitt.Röm.Abt.
76:14-50 1969

 Hiesinger.Portr.in the Rom.
 Rep.Bibl.In:Temporini.Auf-
LC DE2.D42 stieg u.niederg....LC DG20
 T36,Bd.1,T.4,p.822

II.C.2 - ANTIQUITY - ETRURIA

Karo, G.
 Etruskisch-römische bildniskunst

 In:Antike Plastik.Festschrift.Walther Amelung
zum 60.Geburtstag.Berlin,Leipzig,W.de Gruyter.
co.,1928
 p.100-105 .illus.?.

LC NB70.A5 Hiesinger.Portr.in the Rom
 Rep.Bibl.In:Temporini.Auf-
 stieg u.niederg....LC DG20
 T36,Bd.1,T.4,p.822

II.C.2 - ANTIQUITY - ETRURIA

Kaschnits-Weinberg, Guido von, 1890-1958
 Studien zur etruskischen und frührömischen
porträtkunst

 In:Deutsch ArchÄol Inst Mitt Röm
41:133-211 1926 illus.

 Author studies the Etruscan portr & looks
for its survival in the Roman portr."Etruscan
cubism"resisted the Greek influences

 Richter,G. Portrs of the
LC DE2.D42 Greeks N7586R53,v.3,p.298
 Rep.1927*721

II.C.2 - ANTIQUITY - ETRURIA

Richardson, Emeline Hill
 The Etruscan origins of early Roman sculp-
ture...Rome,American academy in Rome,1953
 p.,77.-124 illus.

 This is v.21,1953 of the Memoirs of the
Academy in Rome

 Hiesinger.Portr.in the Rom.
 Republic.In:Temporini.Aufst.
 u.niedergang...LC DG209.T36
OCIMA Bd.1,T4,p.823

II.C.2 - ANTIQUITY - GREECE

Bernoulli, Johann Jakob, 1831-1920
 Griechische ikonographie...München,F.Bruck-
mann,a.-g.,1901

 2 v. illus.

 Portrs. of famous Greeks until the Roman period
"mit ausschluss Alexanders & der Diadochen"
 Bibliography

LC N7586.B5 Chamberlin,M.W. Guide to
 art reference books *961

II.C.2 - ANTIQUITY - GREECE

Bianchi Bandinelli, Ranuccio, 1900-
 Il problema del ritratto greco.....Firenze,
Soc.editrice universitaria,1952.
 113 p.

 Bibliography

Cincinnati Uni.Libr.
N7586.B5

II.C.2 - ANTIQUITY - GREECE

Buschor, Ernst, 1886-
 Das hellenistische bildnis. München,Bieder-
stein .1949.

 70 p. illus.

LC NB90.B78 Schefold,Karl.D.bildnisse
 d.antiken dichter,redner
 und denker

II.C.2 - ANTIQUITY - GREECE

California State University, Northridge.
 Fine Arts Gallery
 Greek and Roman portraits from the J.Paul
Getty Museum.cat.of the exh.,Oct.16-Nov.11,
1973.Northridge,Calif.,1973?.
 32 p. illus.
 Incl.Bibliography

 Introd. by Jiří Frel

UN CMoS
 Roman portrs.,aspects of
 self...qNB1296.R75 NPG Ref
 p.107

II.C.2 - ANTIQUITY - GREECE

Harrison, Evelyn Byrd
 Ancient portraits from the Athenian Agora.
Princeton,N.J.,American School of Classical
Studies at Athens,1960
 ‹32›p. 43 illus. (Amer.Sch.of Class.
Studies at Athens.Excavations of the Athenian
Agora;picture books,5)

NNMH
 Books in print.Subj.guide
 Z1215.P92 1975 v.2 NPG
 p.2560

II.C.2 - ANTIQUITY - GREECE

Copenhagen. Ny Carlsberg glyptotek
 Les portraits grecs par Vagn Poulsen.
Copenhagen,1954
 86 p. illus. (Its publication,no.5)

 Bibliographical references

LC N7585.C6
 Breckenridge.Likeness...
 N7580.B82 NPG bibl.notes

II.C.2 - ANTIQUITY - GREECE

Harrison, Evelyn Byrd
 Archaic and archaistic sculpture.Princeton,
N.J,American School of Classical Studies at
Athens,1965
FOGG 192 p. illus. (The Athenian Agora;re-
Arc716.4 sults of excavations...v.11)
.1C(11)
 Bibliography

 ICU NNC MH NcD
 NIC LU ViU
 PPULC

II.C.2 - ANTIQUITY - GREECE

Esdaile, Katharine A.
 Some Greek portraits

Int.J.Hell.Stud.
24:81-98 1904 illus.

LC DF10.J8

II.C.2 - ANTIQUITY - GREECE

Harrison, Evelyn B
 Portrait sculpture.Princeton,N.J.,American
School of Classical Studies at Athens,1953
 114 p. illus (The Athenian Agora;results
of excavations...v.1)

 Bibliography

Mount Holyoke coll libr. Enc.of World Art N31E56Ref
for LC v.11,p.511

II.C.2 - ANTIQUITY - GREECE

Förster, Richard, 1843-1922
 Das portrait in der griechischen plastik.
Rede zur feier des geburtstages des deutschen
kaisers Wilhelm I.,gehalten zu Kiel am 22.März
1882.Kiel,C.F.Mohr,1882
 22 p.

MH NjP
 LC Pre-'56,v.176,p.478

II.C.2 - ANTIQUITY - GREECE

Hekler, Antal, 1882-1940
 Bildnisse berühmter Griechen. 3.erweiterte
Aufl.bearb.v.Helga von Heintze.,Berlin,F.Kupfer-
berg,1962.
 81.p. illus.

 Bibliography

C NB164.H42 1962 Enc.of World Art v.11,p511
 Portraiture,bibl.N31E56
 Ref

II.C.2 - ANTIQUITY - GREECE

Hafner, German
 Späthellenistische bildnisplastik.Versuch
einer landschaftlichen gliederung.Berlin,Gebr.
Mann,1954
 121 p. illus.

 At head of title:Deutsch.ArchÄol.Inst.'

 Bibl.references

 Habilitationsschrift-Mainz
Cincinnati Univ.Libr.for
LC NB154.H3
 DDO DLC, etc. Kraus.Das römische welt-
 reich.N5760.K92 Bibl.p.315

II.C.2 - ANTIQUITY - GREECE

J.Paul Getty Museum
 Greek portraits in the J.Paul Getty museum
.cat.by.Jiří Frel.Malibu,Calif.,The Museum,
c.1981
 121 p. illus.

 Cat.p.38-118

 Index

LC NB1296.3.J18 1981 Books in Print.Subject
 Guide,1985-6,v.3,p.4864

II.C.2 - ANTIQUITY - GREECE

Kekule von Stradonitz, Reinhard, 1837-1911
 Die griechische skulptur. 3.aufl...Berlin
& Leipzig,Vereinigung wissenschaftlicher verleger
1922

 396 p. illus.(166 illustr.)

LC NB90.K4 1922 Pfuhl,E. Die anfänge der
 griech.bildniskunst

II.C.2 - ANTIQUITY - GREECE

Pfuhl, Ernst, 1876-1940
 Die anfänge der griechischen bildniskunst.
Munich,1927 (F.Bruckmann,A.G.) Ein Beitrag
zur Geschichte der Individualität.
 31.p. illus.

 Essay to clarify the often anachronistic
idea of the beginning of Individual-portraits.
 Interpretation & valuation of individuality

Yale univ.libr. J.Walters Art gall.v.9
Jb26/927P p.55 footnote:"basic"

II.C.2 - ANTIQUITY - GREECE

Kyrieleis, Helmut
 Bildnisse der Ptolemäer.Berlin,Mann,1975

 190,108 p. illus. (Archäologische
Forschungen,Bd.2)

 Bibliography

 At head of title:Deutsch,Archäol.Inst.

 A revision of the author's Habilitations-
schrift,Bonn,1972
LC DT92.K97 Gesichter.MB1296.3.G38
 1983 NPG p.315

N
7586
R53 Richter, Gisela Marie Augusta, 1882-
NPG The portraits of the Greeks....London.Phaidon
 Press.1965.
 3 v. illus.

 Contents.-v.1.The early period.The 5th c.-
 v.2.The 4th & 3rd c. The 3rd & 2nd c.-v.3.The Hel-
 lenistic rulers. Greeks of the Roman period
 Bibliography

LC N7586.R5 Enc.of World Art v.11
 p.511 Portraiture,bibl.
 N31E56Ref.

II.C.2 - ANTIQUITY - GREECE

Lange, Julius Henrik, 1838-1896
 Darstellung des menschen in der älteren
griechischen kunst. Strassburg,Heitz,1899

 225 p. illus.

 Translated from the Danish

 ND
LC NB90.L3 Waetsold 1300
 W12

II.C.2 - ANTIQUITY - GREECE

Rodenwaldt, Gerhart, 1886-1945
 Griechische porträts aus dem ausgang der
antike...Berlin,W.de Gruyter & Co.,1919
 30 p. illus. (Programm zum Winckelmanns-
feste der archäologischen gesellschaft zu Ber-
lin. 76)

Title from Univ.of Chicago
45325.B37. v.76 Kraus.Das römische welt-
LC ₊N5325.A8 no.76. eich.N5760.K92 Bibl.p.316

II.C.2 - ANTIQUITY - GREECE

Laurensi, Luciano comp.
 ..Ritratti greci.Firenze,Sansoni.1941.
 148 p. illus. (Quaderni per lo studio
dell'archeologia...3-5)

 Bibliography

LC NB90.L35 Enc.of World Art N31E56Ref.
 v.11,p.511

II.C.2 - ANTIQUITY - GREECE

Suhr, Elmer George, 1902-
 ...Sculptured portraits of Greek statesmen,
with a special study of Alexander the Great,...
Baltimore, The Johns Hopkins press;London,H.Mil-
ford,Oxford university press,1931
 189 p. illus. (The Johns Hopkins univer-
sity studies in archaeology,no.13)

 Dissertation.1926.

 Bibliography
733 NPG has "extract"
894 Richter,G. Portrs of the
LC NB164.875 Greeks N7586.53,v.3,p.304
1979 ed.:LC NB1296.3.S93

II.C.2 - ANTIQUITY - GREECE

Lippold, Georg, 1885-
 Griechische porträtstatuen. München,1912

Met
577
L66

 Pfuhl,E. Die anfänge der
 griech. bildni.kunst

II.C.2 - ANTIQUITY - POMPEII

Franciscis, Alfonso de
 Il ritratto romano a Pompei. Napoli,G.Macchi-
aroli,1951
 84 p. illus. (Memorie dell'Accademia di
archeologia,lettere e belle arti di Napoli.N.s..

 Bibl.references

LC NB164.F7 Enc.of World Art N31E56Ref
 v.11,p.513

II.C.2 - ANTIQUITY - ROME

Bartels, Heinrich
 Studien sum frauenporträt der augusteischen
 seit-Fulvia,Octavia,Livia,Julia.München,Feder,
 1963
 113 p.

 Diss.-Berlin,1960

F000
538
3278

NJP MH NNMM DDO Kraus.Das römische welt-
 reich N5760.K92 Bibl.p.316

II.C.2 - ANTIQUITY - ROME

Breckenridge, James Douglas, 1926-
 Origins of Roman Republican portraiture:Re-
 lations with the Hellenistic world

VF In:Temporini,Hildegard.Aufstieg und niedergang
Portrs. der römischen welt...Berlin,N.Y.,Walter de Gruy
Roman ter,1973.Pt.I:Von den anfängen Roms bis zum aus
 gang der republik,v.4(in 2 parts,text & plates)
 p.826-854(text),& p.173-187(plates)

 Bibl.footnotes

LC DG209.T36 Temporini.Aufstieg & Nie-
Bd.1,T.4 dergang...LC DG209.T36

II.C.2 - ANTIQUITY - ROME

Bergmann, Marianne
 Studien sum römischen porträt des 3.Jahr-
 hunderts n.Chr....Bonn,Habelt,1977
 222,61,6 p. illus. (Antiquitas:Reihe 3
 Abhandlungen sur Vor-und Frühgeschichte,sur
 klassischen und provinzial-römischen Arahäo-
 logie und sur Geschichte des Altertums,Bd.18)

 Bibliography

 Originally Thesis,Bonn,1972
LC N7588.B48 1977
 Gesichter.NB1296.3.G38
 1983 NPG p.315

II.C.2 - ANTIQUITY - ROME

Brilliant, Richard
 Gestures & rank in Roman art. The use of
gestures to denote status in Roman sculpture &
coinage. New Haven,The Academy,1963
 238 p. illus. (Memoirs of the Conn.Acad.of
Arts & Sciences,v.14)

 Bibliography

LC NB115.B7

II.C.2 - ANTIQUITY - ROME

Bernoulli, Johann Jakob, 1831-1920
 Römische ikonographie...Stuttgart,W.Spemann,
1882-94

 2 v.in 4 illus.

 Portrs. of famous Romans until Pertinax &
Theodosius

 Chamberlin,M.W. Guide to
LC N7588.B5 art reference books #962
 25931C44 1959 Ref.

II.C.2 - ANTIQUITY - ROME

California State University, Northridge.
 Fine Arts Gallery
 Greek and Roman portraits from the J.Paul
Getty Museum,cat.of the exh.,Oct.16-Nov.11,
1973.Northridge,Calif.,1973?
 32 p. illus.
 Incl.Bibliography

 Introd. by J.M. Frel

LN CHoS Roman portrs.Aspects of
 self...NB1296.R75 NPG Bibl
 p.107

II.C.2 - ANTIQUITY - ROME

Bianchi Bandinelli, Ranuccio, 1900-
 Sulla formazione del ritratto romano

In.his.Archeologia e cultura.Milano,R.Ricciardi,
1961
 v.5,p.172 ff.

 Reprint of article in Società,13:18- 1957

ICN Kraus.Das römische welt-
 reich N5760.K92 Bibl.p.315

II.C.2 - ANTIQUITY - ROME

Charbonneaux, Jean, 1895-1969
 Portraits du temps des Antonins

In:Acad Inscr Paris Mon et Mém
49:67-82 1957 illus.

 Bibl.footnotes

 ...étude d'un groupe de portrs.à placer entre
150 et 170 et attribuables à deux artistes grecs
de l'entourage d'Hadrien et d'Hérode Atticus qui
ont eu une influence décisive sur l'évolution
du portr.romain
N13.A25 fol.

II.C.2 - ANTIQUITY- ROME

Blümel, Carl, 1893-
 Römische bildnisse. Berlin,Verlag für kunst-
wissenschaft,1933
 57 p. illus.

 (Berlin,Staatl.Mus. Kat.der sammlung antiker
skulpturen)

LC f733B625r

II.C.2 - ANTIQUITY - ROME

Copenhagen. Ny Carlsberg glyptotek
 Les portraits romains;par Vagn Poulsen.
Copenhagen, 1962
 illus. (Its publications no.7)

 Bibliogr.references
 Catalogue v.1 p.39,-148
 Contents:-1.République et dynastie Julienne

 Enc.of World Art v.11
LC NB115.C6 p.511 Portraiture,bibl.
 N31E50 Ref.

II.C.2 - ANTIQUITY - ROME card 1

Curtius, Ludwig, 1874-1954
 Ikonographische beiträge zum porträt der rö-
mischen republik und der Julisch-Claudischen fami-
lie (cont.)

In:Deutsch ArchMol.Inst.Mitt.Röm.
54:112-29 no.1-2 1939 illus.
 ::-131-44 no.3-4

 English abstract

LC DE2.D42 Art Ind.,1938-41,p.338

II.C.2 - ANTIQUITY - ROME

Delbrück, Richard, 1875-
 Bildnisse römischer Kaiser. Berlin,J.Bard
,1914,
 illus.

 (Bards Bücher der Kunst.Bd.3)

 Bibliography

 Incl.also:Numismatics

N.Y. P.L. DDO

II.C.2 - ANTIQUITY - ROME card 2

Curtius, Ludwig, 1874-1954
 Ikonographische beiträge zum porträt der rö-
mischen republik und der Julisch-Claudischen fami-
lie.XIII.Die söhne des Agrippa.XIV.Germanicus

In:Deutsch.ArchMol.Inst.Mitt.Röm.
:53-94 1948 illus.

 Heads,busts,statues,bas-reliefs,gems,coins,
bronze weights

LC DE2.D42 Rep.,1948-49#5039

II.C.2 - ANTIQUITY - ROME

Dohrn, Tobias, 1910-
 Zur geschichte des italisch-etruskische
porträts

In:Deutsch.ArchMol.Inst.Mitt.Röm.Abt.
52:119-39 1937

 Hiesinger.Portr.in the
LC DE2.D42 Rom.Rep.Bibl.In:Temporini.l
 Aufstieg u.niederg...LC IX
 D209.T36,Bd.I,T.4,p.822

II.C.2 - ANTIQUITY - ROME

Curtius, Ludwig, 1874-1954
 Physiognomik des römischen porträts

In:Die Antike
7:226-54 1931

 Hiesinger.Portr.in the Rom
LC DE1.A4 Rep.Bibl.In:Temporini.Auf-
 stieg u.niederg...LC DG209
 T36,Bd.1,T.4,p.825

II.C.2 - ANTIQUITY - ROME

Garcia y Bellido, Antonio, 1903-
 Catálogo de los retratos romanos del Museo
Arqueológico Provincial.Sevilla.,Madrid,1951
 25 p. illus.

N.Y.P.L. Bibliogr.footnotes
3-MAR
p.v.1322

II.C.2 - ANTIQUITY - ROME

Daltrop, Georg
 Die Flavier. Vespasian,Titus,Domitian,
Nerva,Julia Titi,Domitilla,Domitia, von G.Dal-
trop,Ulrich Hausmann und Max Wegner.Berlin,
Gebr.Mann,1966
 132 p. illus. (Das römische Herrscher-
bild,II.Abt.Bd.1)

 Bibl.footnotes

 Kraus.Das römische welt-
 reich.N5760.K92 Bibl.p.316
 also:Winkes.Physicgnomonia.In:
LC DG286.D3 Temporini.Aufstieg u.nieder
 gang.LC DG209.T36,Bd.1,T4,
 p.913

II.C.2 - ANTIQUITY - ROME

Garcia y Bellido, Antonio, 1903-
 Retratos romanos del Museo Arqueológico
Nacional de Madrid.Madrid,1950
 34 p. illus.

 Bibliography

LC sN7588.G37s CU NNC Kraus.Das römische welt-
 reich N5760.K92 Bibl. p.315

II.C.2 - ANTIQUITY - ROME

Daltrop, Georg
 Die stadtrömischen männlichen privatbild-
nisse trajanischer und hadrianischer zeit.
Münster,1958
 131 p. illus.

 Thesis - Münster, 1958
 Bibl.ref.

LC NB115.D3 1958 Kraus.Das römische welt-
 reich N5760.K92 Bibl.316

II.C.2 - ANTIQUITY - ROME

Geneva. Musée d'Art et d'Histoire
 Le Monde des Césars,portraits romains,pré-
sentés par.Jiří Frel,Jacques Chamay,Jean-Louis
Maier..Le musée.c.1982
 323 p. illus.
 Bibliography
 Index
Summary in English
Exposition organisée au Mus.d'art et d'his-
toire de Genève,28 oct.1982-30 jan.1983

 1ère ptie,Portrs.romains du Mus.J.Paul Getty,
 à Malibu,Calif. 2e ptie,Portrs.romains du
 mus.d'art et d' st.de Genève
LC NB1296.3M66 1982

II.C.2 - ANTIQUITY - ROME

Geneva. Musée d'Art et d'Histoire
 Les portraits romains du Musée d'Art et
d'Histoire.by.Isabelle Rilliet-Maillard.
Genève,Mus.d'Art et d'Histoire,1978
 79 p. illus.

Met
617.9
028M97

Gesichter.NB1296.3.G38
1983 MPG p..316

II.C.2 - ANTIQUITY - ROME

Hafner, German
 Das bildnis des Q.Ennius;studien sur rö
mischen porträtkunst des 2.jahrh.v.Chr. Bade
Baden,B.Grimm,1968
 52 p. illus. (Deutsche Beiträge su
Altertumswissenschaft;Bd.20)

 Bibl.footnotes

LC NB115.H28

Casda.Etrusc.infl.in t
funerary reliefs...In:Tem
porini.Aufstieg u.niederg
p.856LC DG209.T36,Bd.1,T.4,

II.C.2 - ANTIQUITY - ROME

Giuliano, Antonio
 Catalogo dei ritratti romani del museo pro
fano lateranense,con prefazione di Filippo Mag
Città del Vaticano.Tipografia poliglotta vatica
na,1957
 103 p. illus. (Monumenti vaticani di
archeologia e d'arte. 10)

 Bibliography

NNC CU DDO MdBWA etc.

Hiesinger.Portr.in the Rom
Rep.Bibl.In:Temporini.Auf
stieg u.niederg. LC DG2
T36,Bd.1,T4,p.824

II.C.2 - ANTIQUITY - ROME

Hafner, German.
 Bildnisse des 5.jahrhunderts v.Chr.aus Rom
und Etrurien

In:Deutch.Archäol.Inst.Mitt.Röm.Abt.
76:14-50 1969

LC DE2.D42

Hiesinger.Portr.in the Rom.
Rep.Bibl.In:Temporini.Auf
stieg u.niederg. LC DG20
T36,Bd.1,T.4,p.822

II.C.2 - ANTIQUITY - ROME

NB
115
G62
NNAA

Goldscheider, Ludwig, 1896-
 Roman portraits.Oxford & London,Phaidon
press,ltd.,1945
 14 p. 120 illus.

 Bibliography

'Roman portraiture-fountainhead of European
&...all later schools.Intense realism,but women
expected flattery'.Augustan,Trajan to 4th c.

II.C.2 - ANTIQUITY - ROME

Hafner, German.
 Römische und italische porträts des 4.jahr
v.Chr.

In:Deutsch.Archäol.Inst.Mitt.Röm.Abt.
77:46-71 1970

LC DE2.D42

Hiesinger.Portr.in the Ro
Rep.Bibl.In:Temporini.Auf
stieg u.niederg....LC DG2
T36,Bd.1,T.4,p.822

II.C.2 - ANTIQUITE - ROME

Gross, Walter Hatto, 1913-
 Bildnisse Traians. Berlin,Gebr.Mann,1940
 141 p. illus. (Das römische Herrscher-
bild,II.Abt.Bd.2).

FOGG
5005
R71g
MET
617
W42
pt.2²

II.C.2 - ANTIQUITY - ROME

Hanfmann, George Maxim Anossov, 1911-
 Observations on Roman portraiture. Bruxelles,
Latomus,Revue d'études latines,1953
 50 p. illus. (Collection Latomus,v.11)

 Bibliogr.footnotes

Descriptive essay on Roman portrait sculpture
based on three examples acquired by the Fogg
Art mus.

LC NB1543.H3

II.C.2 - ANTIQUITY - ROME
Habercorn, R.B.
 The Roman portrait statue

 Master's Th.-Columbus,O.,1915

Lindsay,K.C.,Harpur Ind.cf
master's theses in art...
Z5931.L74 1955 NCFA Ref.
p.3,no.33

II.C.2 - ANTIQUITY - ROME

Hausmann, Ulrich, 1917-
 Römerbildnisse..Hrsg.vom Württembergischen
Landesmuseum,Stuttgart.Stuttgart,Das Museum,
1975
 132 p. illus.

 Bibl.references

DDO MBU NNU etc.
ViU

Gesichter.NB1296.3.G38
1983 MPG p.315

N
5760
K92
NCFA

II.C.2 - ANTIQUITY - ROME

Heintze, Helga von
Römische bildniskunst

In:Kraus, Theodor.Das römische weltreich.Pro-
pyläen Kunstgeschichte II.Berlin,...1967
p.248-66 illus(part col.)

In portrs.of the 1st c.B.C.varied compo-
nents dominate:hellenistic,italic,the ancestor
portr.,the mask,till they become expressions of
court art in the Augustan per.,serving propa-
ganda first, then only individuality.

LC N5760.K7

II.C.2 - ANTIQUITY - ROME

Hiesinger, Ulrich W.
Portraiture in the Roman Republic

VF
Portrs.,
Roman

In:Temporini,Hildegard.Aufstieg und niedergang
der römischen welt...Berlin,N.Y.,Walter de Gru-
ter,1973.Pt.I:Von den anfängen Roms bis zum au-
gang der republik,v.4(in 2 parts,text & plates)
p.805-825(text), & p.159-171(plates)

Bibliography

LC DG209.T36
Bd.1,T.4

Temporini.Aufstieg und nie-
dergang...LC DG209.T36

II.C.2 - ANTIQUITY - ROME

Heintze, Helga von
Römische porträt-plastik aus 7 jahrhunder-
ten.1.aufl..Stuttgart,H.E.Günther.1961.
19 p. illus. (Die Sammlung Parthenon,
Neue Folge)

N.Y.P.L.
B-MOH

MN InU CSt NNC DCU
CU

Kraus.Das römische welt-
reich.N5760.K92 Bibl.p.315

II.C.2 - ANTIQUITY - ROME

Inan, Jale and Rosenbaum, Elisabeth
Roman and early Byzantine portrait sculpture
in Asia Minor.London,Published for the British
Academy by Oxford U.P.,1966
245 p. illus.

Bibliography

LC N7588.I5

Hiesinger.Portr.in the Rom.
Rep.Bibl.In:Temporini.Auf-
stieg u.niederg...LC DG209
T36,Bd.1,T.4,p.824

II.C.2 - ANTIQUITY - ROME

Heintze, Helga von
Studien zu den porträts des 3.jhs.n.Chr.

In:Deutsch.Archäol.Inst.Mitt.Röm.Abt.
62:174- 1955
63:56- 1956
64:69- 1957
66:175- 1959
69:164- 1962
73/74:190- 1966

LC DE2.D42

Kraus.Das römische welt-
reich.N5760.K92 Bibl.p.316

NB
1296.3
F73
NPG

II.C.2 - ANTIQUITY - ROME

J.Paul Getty Museum
Roman portraits in the Getty mus.Cat.pre-
pared for the special loan exh."Caesars and Ci-
tizens"Philbrook Art Center,Tulsa,Okla.,Apr.26-
July 12,1981...by Jiří Frel in collaboration
with S.K.Morgan.Philbrook Art Ctr.& The J.Paul
Getty Mus.,1981
137 p. illus.

Statues,busts,heads,funerary reliefs,sarco-
phagi

II.C.2 - ANTIQUITY - ROME

Hekler, Antal, 1882-1940
Philosophen- und gelehrtenbildnisse der
mittleren kaiserzeit

In:Die Antike
16:115-41 1940 illus.

LC DE1.A4

Richter, G. Portrs.of the
Greeks N7586R53,v.3,p.297

CJ
161
P65.M46
NPG

II.C.2 - ANTIQUITY - ROME

Jentoft-Nilsen, Marit, 1938-
Ancient portraiture:the sculptor's art in
coins and marble.A loan exh.on display at the
Virginia Museum,Apr.29 to July 20,1980...
Richmond,Virginia Museum,c.1980
64 p. illus.

Most items from the coll.of Jeffrey H.
Miller and the Getty Museum
Excellent introd.to the numismatic portrai-
ture in relation to work in marble.
Discussion of the develop't of portrs.by the
Romans
Worldwide Art cat.H. v.17
705.W527 UMAA p.60

II.C.2 - ANTIQUITY - ROME

Herbig, Reinhard, 1898-
Die italische wurzel der römischen bildnis-
kunst

In:Das neue bild der antike,hrsg.H.Berve,Bd.2
p.85- 1942 illus. Bibl.footnotes

LC DE71.B45,Bd.2

Kraus.Das römische welt-
reich.N5760.K92 Bibl.p.316

II.C.2 - ANTIQUITY - ROME

Karo, G.
Etruskisch-römische bildniskunst

In:Antike Plastik.Festschrift.Walther Amelung
zum 60.Geburtstag.Berlin,Leipzig,W.de Gruyter
co.,1928
p.100-105 :illus.?.

LC NB70.A5

Hiesinger.Portr.in the Rom.
Rep.Bibl.In:Temporini.Auf-
stieg u.niederg....LC DG209
T36,Bd.1,T.4,p.822

II.C.2 - ANTIQUITY - ROME

Kaschnitz-Weinberg, Guido von, 1890-1958
Römische bildnisse
137 p. illus.

In his Ausgewählte schriften.Berlin,Gebr.Mann
,1965- Bd.2

Deutsches Archäologisches Institut

Bibl.references
Incl.Reprint of his Spätrömische porträts

LC N8375.K34A22 1965 v.2

II.C.2 - ANTIQUITY - ROME

Lorenz, Thuri
Galerien von griechischen philosophen- und
dichterbildnissen bei den Römern. Mainz,P.von
Zabern,1965.

70 p. illus.

Bibliogr. footnotes

NNC

II.C.2 - ANTIQUITY - ROME

Kaschnitz-Weinberg, Guido von, 1890-1958
Spätrömische porträts..Berlin,De Gruyter,
1926?.
p..36,-60 illus.
"Sonderabzug aus 'Die Antike',II"
Reprinted in his Römische bildnisse...1965
Evolution of the portr.in Rome during 3rd c.
Transition fr.naturalism to expressionism.Infl.
of the Orient.Barbarization of the Empire. The
portr.in the 4th c.Diverse tendencies.Constantine
classicist art.Manerism precursor of Byz.art.Re-
search of expression & character.Refinement of de-
cadence & enthousiasm of the revolution com-
bine & meet in this c....Antique form survives
Rep.,1926*641

NJP

II.C.2 - ANTIQUITY - ROME

Mansuelli, Guido,Achille,
Il ritratto romano nell'Italia settentrio-
le,Formazione e Correnti Artistiche

In:Deutch.Archäol.Inst.Mitt.Röm.Abt.
65:67-99 1958

LC DE2.D42

Hiesinger.Portr.in the R
Rep.Bibl.In:Temporini.Au
stieg u.niederg...LC DO2
T36.Bd.1,T.4,p.825

II.C.2 - ANTIQUITY - ROME

Kaschnitz-Weinberg, Guido von, 1890-1958
Studien zur etruskischen und frührömischen
porträtkunst

In:Deutsch Archäol Inst Mitt Röm
41:133-211 1926 illus.

Author studies the Etruscan portr & locks
for its survival in the Roman portr."Etruscan
cubism"resisted the Greek influences

LC DE2.D42

Richter,G. Portrs of the
Greeks N7586R53,v.3,p.298
Rep.1927*721

II.C.2 - ANTIQUITY - ROME

Meischner, Jutta, 1935-
Das Frauenporträt der Severerzeit...
Berlin,Ernst Reuter Gesellschaft,1964.
194 p. illus.

Bibliography,p.5-7
Thesis - Berlin

Cty

Roman portrs.Aspects of sc
...qNB1296.R75 NPG Bibl.
p.107

II.C.2 - ANTIQUITY - ROME

L'Orange, Hans Peter, 1903-
Die bildnisse der Tetrarchen

In:Act Arch
2:29-52 1931

CO1.A2

Winkes.Physiognomonia.In:
Temporini.Aufstieg u.nieder-
gang...LC DO209.T36.Bd.1,T4
p.905

II.C.2 - ANTIQUITY - ROME

Munich. Glyptothek
Die Bildnisse des Augustus:Herrscherbild
und politik im kaiserlichen Rom.Sonderaus-
stellung der Glyptothek und des museums für
abgüsse klassischer bildwerke.München,Dez.
MET 1978-März.Antikenmuseum Berlin,Apr.-Juni 1979.
617 Hrsg.von Klaus Vierneisel und Paul Zanker.
M92 München,1979
119 p. illus.

Gesichter.NB1296.3.G38
1983 NPG p.316

II.C.2 - ANTIQUITY - ROME

N
5610
L67X
NPG
L'Orange, Hans Peter, 1903-
Likeness and icon.Selected studies in clas-
sical and early mediaeval art.Odense,Univ.Pres
1973
343 p. illus.

Articles in English,French,German & Italia
Bibl.references

Partial contents:Pt.I:Portraits.10 article
p.1-102 incl.a.o.Zum frührömischen frauenpor-
trät,p.14-22;Der subtile stil.Eine Kunstströ-
mung aus der ze um 400 n.Chr.,p.54-71(per-
tains to coiffu

II.C.2 - ANTIQUITY - ROME

733.574
N53
New York. Metropolitan museum of art
Roman portraits.by,Gisela M.A.Richter.N.Y.
1948
,71,p. illus.

Bibl.ref.incl.in "Notes"

Rev.ed.of 2 picture books,iss.in 1941

LC N7588.M42

Hiesinger.Portr.in the R
Rep.Bibl.In:Temporini.Auf
stieg u.niederg...LC DO2
T36.Bd.1,T.4,p.824

705
A784
NCFA

II.C.2 - ANTIQUITY - ROME

Nodelman, Sheldon
How to read a Roman portrait.

In:Art in Am
63:27-33 Jan.-Feb.,'75 illus.

'...the portr.is a system of signs...Portr.
art's shifting montage of abstractions from hu-
man appearance & character forms a language in
which the history of a whole society can be read'

II.C.2 - ANTIQUITY - ROME

Riegl, Alois, 1858-1905
Zur spätrömischen porträtskulptur

In:Strena Helbigiana sexagenario obtulerunt
amici a.d.4.non.febr.a.1898.Leipzig,Teub-
ner,1900. p.250-

LC N5605.S9 Kraus.Das römische welt-
 reich.N5760.K92 Bibl.p.316

II.C.2 - ANTIQUITY - ROME

Paris. Musée national du Louvre
Dept. des antiquités grecques et romaines
Cat. des portraits romains.Paris,Ministère
de la culture et de la communiation.Éditions de
la Réunion des musées nationaux,1986-
v. illus.

Incl.:Index (Worldwide Books no.51797(v.1)
Bibliography,v.1,p.244-6
t.I.Prtrs.de la République et d'époque Julio-
Claudienne par Kate de Kersauson

LCNB1296.3.M874 1986

q NB
1296
R75
NPG

II.C.2 - ANTIQUITY - ROME

Roman portraits;aspects of self and society,
1st c.B.C.-3rd c.A.D.;a loan exh.;Los An-
geles,Calif.?,Regents of the Univ.of Cal.,
Loyola Marymount Univ.,and the J.Paul
Getty Mus.,1980.
108 p. illus.
Bibliography
Exh.schedule:Mary Porter Sesnon art
Gall.,College V,Univ.of Calif.,Santa Cruz,
Calif.Feb.20-Apr.9,1980;Art Gall.Loyola
Marymount Univ.,L.A.,Cal.,Oct.14-Nov.10,
1980
 Worldwide art cat.B.705.
 W927 NMAA v.17,no.3,1981
 p.61

II.C.2 - ANTIQUITY - ROME

Poulsen, Frederik, 1876-1950
Porträtstudien in norditalienischen pro-
vinzmuseen.København,A.F.Høst,1928
81 p. illus. (Det Kgl.Danske videnskab-
ernes selskab.Historisk filologiske meddelelser
15,4)

LC NB164.P615, NOT NN LC? Kraus.Das römische welt-
NNU CLU MdBWA PBm reich.N5760.K92 Bibl.p.315
ViU TxU AU

II.C.2 - ANTIQUITY - ROME

Roman portraits in New York

In:Archaeology
1:104-14 1948 illus.

Busts in Metrop.Mus.of Art

LC GN700.A725 Rep.,1948-49#5036

ET
100.671
C792
v25

II.C.2 - ANTIQUITY - ROME

Poulsen, Frederik, 1876-1950
Römische privatporträts und prinzenbildnis-
se...København,Ejnar Munksgaard,1939
46 p. illus.,46 pl.on 28 l. (Det Kgl.
danske videnskaberrnes selskab.Archaeol.-kunst-
hist.meddelelser,2,5)

Bibl.footnotes

Columbia Univ.Libr.for LC
NNC CU-S TxU OC1MA
OC1W PU DDO

NB
1296.3
R65X
NPG

II.C.2 - ANTIQUITY - ROME

Roman portraiture,Ancient and modern revivals
;exh.,Jan.28-Apr.15,1977,at,Kelsey Mus.of
Archaeology,the univ.of Michigan,Ann Arbor,
The Museum,c.1977
41 p. illus.

Edited by Elaine Kathryn Gazda

Incl.bibliographical references

Incl.copies and forgeries

 Crawford.Physiognomy...
 In:Am.Art J.v.9:60 May,'77

II.C.2 - ANTIQUITY - ROME

Richardson, Emeline Hill
The Etruscan origins of early Roman sculp-
ture...Rome,American academy in Rome,1953
p.:77.-124 illus.

This is v.21,1953 of the Memoirs of the
Academy in Rome

 Hiesinger.Portr.in the Rom.
 Republic.In:Temporini.Aufst.
 ,niedergang...LC DG209.T36
OCIMA Bd.1,T4,p.823

II.C.2 - ANTIQUITY - ROME

Saletti, Cesare
I ritratti antoniniani di Palazzo Pitti...
1 ed. Firenze,La nueva Italia,1974
69 p. illus. (Pubbl.Facoltà di lettere
e filosofia dell' Universita di Pavia,17)

Bibl.references
Index

LC NB165.A57824 Gesichter.NB1296.3.G38
 1983 NPG p.316

II.C.2 - ANTIQUITY - ROME

Schneider, B.
 Studien su den kleinformatigen Kaiserpor-
traits von den anfängen der Kaiserzeit bis ins
dritte jahrhundert

 Dissertation München 1976

Gesichter.NB1296.3.G38
1983 NPG p.316

II.C.2 - ANTIQUITY - ROME

Wegner, Max, 1902-
 Die herrscherbildnisse in antoninischer
zeit. Berlin,Gebr.Mann,1939
 305 p. illus (Das römische Herrscher-
bild,II.Abt.Bd.4

FOGG
5005
R71w
MET
617
W42
pt.24

II.C.2 - ANTIQUITY - ROME

Schweitzer, Bernhard, 1892-1966
 Die bildniskunst der römischen republik.
Leipsig,Koehler & Amelang,1948
 163 p. illus.

Met
617
Sch92
FOGG
FA5005.74F

 Bibl.footnotes

Richter,G. Portrs of the
Greeks N7586I53,v.3,p.303

II.C.2 - ANTIQUITY - ROME

West, Robert
 Römische portraitplastik. Munich,F.Bruck-
mann.1933-41.
 2 v. illus.

MET
617
W52

Enc.of World Art N31
v.11,p.511 E56Ref
Portraiture,bibl.

NB
1296.3
T69
1978 bX
NPG

II.C.2 - ANTIQUITY - ROME

Toynbee, Jocelyn M.C.
 Roman historical portraits.London,Thames &
Hudson ltd.;Ithaca,Cornell Uni.Press,1978
 208 p. illus. (Aspects of Greek and
Roman life.General editor H.H.Scullard)

 Bibliographical sources

II.C.2 - ANTIQUITY - ROME

Zürich. Kunsthaus
 Altrömische porträt plastik..Ausstellung.
8.Aug.bis 19.Sept.1953..Zürich,1953.
 55 p. illus.

 .Cat.by Hans Jucker.

NN NjR MiDA OClMA etc. Gesichter.NB1296.3.G38
 1983 NPG p.315

II.C.2 - ANTIQUITY - ROME

Vessberg, Olof, 1909-
 Studien sur kunstgeschichte der römischen
republik.Lund,C.W.K.Gleerup,1941
 304 p. illus. (Svenska institutet i Rom.
Skrifter 8)

MET
617
V63

 Bibliography
..Based on.Diss.-Uppsala.1941.

LC DG12.88 v.8,etc. Casda.Etrusc.infl.in fune-
 rary reliefs....In:Temporini
 .Aufstieg u.niedergang...
 LC DG209.T36.Bd.1.T.4. p.855

II.C.2 - ANTIQUITY - ROME - SICILY

Bonacasa Carra, Rosa Maria
 Nuovi ritratti romani della Sicilia...
Palermo,Istituto di archeologia,Università di
Palermo,1977
 33 p. illus.

 Bibl.references

ClSU CU-SB NNU ViU Gesichter.NB1296.3.G38
 1983 NPG p.315

II.C.2 - ANTIQUITY - ROME

Wegner, Max, 1902-
 Hadrian,Plotina,Marciana,Matidia,Sabina.
Berlin,Gebr.Mann,1956
 130 p. illus. (Das römische Herrscherbild,
II.Abt.Bd.3)

LC NB165.H3W4

II.C.2 - ANTIQUITY- SICILY

Bonacasa, Nicola
 Ritratti greci e romani della Sicilia;cata-
logo.Palermo,Fondazione I. Mormino del Banco
di Sicilia,1964
 187 p. illus.

 Bibliography,p.XIII-XIX

NNC 3-MOH

LC NB164.B66 Hiesinger.Portr.in the Rom.
 Rep.Bibl.In:Temporini.Auf-
 stieg u.niederg...LC DG209
 T36,Bd.1,T.4,p.824

II.C.2 - BYZANTINE

Inan, Jale and Rosenbaum, Elisabeth
· Roman and early Byzantine portrait sculpture
in Asia Minor.London,Published for the British
Academy by Oxford U.P.,1966
245 p. illus.

Bibliography

LC N7588.I5

Hiesinger.Portr.in the Ror.
Rep.Bibl.In:Temporini.Auf-
stieg u.niederg...LC DG209
T36,Bd.1,T.4,p.824

705
B97
NCFA
v.44

II.C.2 - 17-18th c.

Notes on various works of art.Bernini,Rysbrack
and Roubiliac.I.by Marguerite Devigne.
II,By Katherine A.Esdaile.III.by Margaret
R.Toynbee

In:BurlMag
44:93-4,97 Jan,'24. illus.

II.C.2 - MEDIEVAL

Luxemburg(City). Musée d'histoire
La sculpture médiévale figurée...Luxemburg,
Mus. d'histoire et d'art,1977,

LC NB1297.L89 1977

FOR COMPLETE ENTRY
SEE MAIN CARD

AP
1796.3
R65X
NPG

II.C.2 - 19-20th c.

Roman portraiture.Ancient and modern revivals
,exh.,Jan.28-Apr.15,1977,at,Kelsey Mus.of
Archaeology,the univ.of Michigan,Ann Arbor
The Museum,c.1977
42 p. illus.

Edited by Elaine Kathryn Gazda

Incl.bibliographical references

Incl.copies and forgeries

Crawford.Physiognomy...
In:Am.Art J.v.9:160 May,'77

II.C.2 - RENAISSANCE

Burckhardt, Jacob, 1818-97
· Gesamtausgabe. Stuttgart,Deutsche Verlagsan-
stalt,1929-.1934.

v.13,pp.302 ff.:Survey of Renaissance portr.
sculpture

LC D7B95

Irving Lavin in Art Q v.33
autumn 1970,p.215 footnote1
"most useful survey...Ren.
portr scupt."

B
W31W6

II.C.2 - 19th c.

Whittemore, Frances Dean(Davis), 1857-
George Washington in sculpture.Boston,
Marshall Jones,1933

LC E312.4.W47

FOR COMPLETE ENTRY
SEE MAIN CARD

NB
1309
P6x
NPG

II.C.2 - 14-18th c.

The Portrait bust; Renaissance to Enlightenment.
,Providence?1969?,
,64,p. illus.

Cat.of an exhib.prepared by students in the
Dept.of Art,Brown Univ.,and held at the Mus.of
Art,Rhode Island School of Design,Mar.5-30,1969

Biographical references

LC NB1309.P6

AP
1
N277
NCFA
v.11

II.C.2 - 20th c.

Bleck, Adolph
Portraiture in sculpture

In:Nat Sculp R
11:6-10,24 Spring,'62 illus.

Discusses portrait sculpture through the
ages.The illustrations are all 20th c.

NB
185
K43
E1969
NCFA

II.C.2 - 15-18th c.

Keutner, H.
,The tasks of the sculptor in the secular
world: the bust; the portrait statue; the eques-
trian monument.,

In:his,Sculpture;Renaissance to rococo. Green-
wich, Conn.,New York Graphic Society,1969,
pp.27-32

Incl:Some equestrian,standing,seated portr.
statues,busts. Description of each plate

LC NB185.K413

II.C.3. BY COUNTRY, A-Z, subdivided -
chronological & regional

II.C.3 - BELGIUM. ANTWERP

Lattin, Amand de, 1880-1959
Beroemde medeburgers, Antwerpsch volkje in
brons en steen. Antwerpen,De Vos-van Kleef,1937

151 p. illus.

Sculptures of people from Antwerp in bronze
and stone

Rep.,1938#578

4 DC
126
S86
1984
NPG

II.C.3 - FRANCE - 17th c.

The Sun King,Louis XIV and the New World;an
exh.,organized by the Louisiana State Mu-
scum...New Orleans,Louisiana State Museum.
c.1984
343 p. illus(part col.) (Studies in
Louisiana culture,v.3)
Incl.Index
Steven G.Reinhardt,ed.
Exh.dates:Louisiana State Mus.,New Or-
leans,La.,Apr.29-Nov.18,1984.The Corcoran
Gall.of Art,Washington,D.C.,Dec.15,1984-
Apr.7,1985
Incl.Ptg., sculpture,cameos

NB
450
M4
1983X
NMAA

II.C.3 - EUROPE

Trapp, Frank .Anderson. ed.
Masterworks of European sculpture.in Am-
herst College,Mead Art Bldg.,Amherst,Mass.,
.in.Mead Art Mus.Monographs,v.4,Summer,1983
30.p. illus.

Incl.:"Imported icons of the Early Repub-
lic",p.13,14;"Two portrs.by "odin",p.19-21;
"Three French monuments",incl."Head of Beet-
hoven"by Bourdelle,1861-1929

II.C.3 - FRANCE - 18th c.
Esdaile, Katharine A.
. . .,The life and works of Louis François Roubi-
liac...London,Oxford university press,H.Milford
1928
249 p. illus.

Bibliography

Bookreview by M.H.L.in Burl.Mag.55:100:'...
the illus...alone...form a strikingly comprehen-
sive "National portr.gall."...'

LC NB553.R75E65

Noon.Engl.portr.drags.&min.
NC860N66X NPG Bibl.p.145

II.C.3 - FRANCE

Bie, Jacob de, 1581-
Les vrais portraits des rois de France,
tires de ce qui nous reste de leurs monumens,...
Paris,chez Jean Camvsat,1636

MET
115.01
B471
Q

Brit.mus.
185.d.10

LC N7604.B47.1st ed.1634
NB NN MH-2nd ed.1636

FOR COMPLETE ENTRY
SEE MAIN CARD

705
G28
v.40
1908
NCFA

II.C.3 - FRANCE - 19th c.

Hepp, Pierre
L'Exposition de portraits d'hommes et de
femmes célèbres(1830-1900)à Bagatelle

In:Gaz.Beaux-Arts
40:38-43 Jl.,1908 illus.

Repro.Incl.:Flandrin,Delaroche,Faudin,
Bastien-Lepage
Critical review

II.C.3 - FRANCE

Dowley, Francis Hotham, 1915-
A series of statues of grands hommes ordered
by the Académie royale de peinture et de sculp-
ture.1953
352 l.

Thesis. Univ.of Chicago

LC NB1999 ICU

II.C.3 - FRANCE - 19th c.

Jouin, Henri Auguste, 1841-1913
David d'Angers,sa vie,son oeuvre,ses écrits
et ses contemporains...Paris,E.Plon et cie.,
1878
2 v. illus.
Bibliography v.2,523-8

v.1:Vie du maître,ses contemporains.-v.2:
Écrits du maître.Son oeuvre sculpté

LC NB553.D3J8

708.1
W243
NCFA

II.C.3 - FRANCE - 15th c.

Weinberger, Martin
A french model of the fifteenth century

In:J.Walters Art Gall.
9:9-21 1946 illus.

Incl:Jean II,Duke of Bourbon by school of
Jacques Morel;Jean,Duke of Berry by Jean de Cam-
brai,Philip the Bold by Sluter;tomb effigies of
Charles I,Duke of Bourbon & Agnes of Burgundy by
Jacques Morel & Louis II,Duke of Bourbon & Anne of
Auvergne;Thomas de Plaine by Le Moiturier

II.C.3 - FRANCE - 20th c.

Jeunes sculpteurs français:Le portrait sculpté,
par Marcel Gimond;Jeunes sculpteurs,par
Waldemar George..Paris,Imprimerie Paul Dupont,
1945.
66 p. illus.

Refers to exh.:Jeunes sculpteurs français
at the Galerie de l'orfèvrerie Christofle

LC NB552.J4

MCMA p.433, v.11

II.C.3 - GERMANY - MEDIEVAL

Gerstenberg, Kurt, 1886-1968
 Die deutschen baumeisterbildnisse des mit-
telalters.⌐Berlin⌐Deutscher verlag für kunst-
wissenschaft⌐1966⌐
 231 p. illus. (Deutscher Verein für kunst-
wissenschaft.Berlin. Jahresgabe...1966)

FOGG
5553
G38 The status of medieval architects.-Various
types of portrs.fr.12-late 15th c. Develpm't fr.
heads on capitals & bosses to full fg.represen-
tations.Most are busts on capitals & consoles.
15th c.innovation:setting in natural context.

CTY NPV MdPWa KyU NjP | ICU| Prinz.Slg.d.selbst-
 bildnisse...N7618.P95,v.1
 p.147⌐d footnote 57

II.C.3 - GERMANY - MEDIEVAL

Kämpfer, Frits
 Die Entstehung des bildnisses in der deut-
schen plastik des Mittelalters.Jena,1949
 78 p.

 Thesis.Jena⌐1949?⌐
 Maschinenschr.

 Bibl.zu kunst & kunstgesch.
 Z5931.B58 1945-53 NCFA
 p.205 no.4080

II.C.3 - GERMANY - MEDIEVAL

Kemmerich, Max, 1876-
 Die frühmittelalterliche porträt plastik in
Deutschland bis zum ende des 13.Jahrhunderts.
Leipzig,Klinkhardt & Biermann,1909

 253 p. illus.

 Bibliography

LC NB565.K4

II.C.3 - GERMANY - RENAISSANCE
Schmitt, Otto, 1890-1951 ed.
 Reallexikon zur deutschen kunstgeschichte.
Stuttgart,J.B.Metzler,1937-⌐58⌐
 4 v. illus.
 Bibliographies
 v.1-2(only)ed.by Otto Schmitt

 Survey of Renaissance portr.-sculpture:
⌐a⌐Gerstenberg,K. Bildhauerbildnis,in v.2
⌐b⌐Rave,P.O. Bildnis, in v.2,cols639ff;⌐c⌐Keller,
H. Büste, in v.3,cols.255ff;⌐d⌐Keller,H. Denkmal.
in v.3,cols.1257ff Irving Lavin in Art Q v.33
LC N6861.S45 autumn 1970,p.215,footnote
LC N6861.R4 1.
LC N 6861.R42

II.C.3 - GERMANY - 20th c.

Seitz, Gustav ed.
 Deutsche porträtplastik des 20.Jahrhun-
derts.40 bildtafeln.Mit erläuterungen von
Erhard Göpel.Leipzig⌐Insel,1958
 58 p. illus. (Insel-Bücherei,no.650)

MB Die 20er Jahre im portr.
 N6868.5.E9297 NPG, p.142

II.C.3 - GERMANY - 20th c.

Wuppertal(W.Elberfeld,Ger,)-Kunst-und
 Museumsverein
 Deutsche bildnisse des 20.Jahrhunderts,
malerei und plastik.ausstellung.8.März-26.April,
MET 1964.Wuppertal.1964.
115.01 1v.(unpaged) illus.
W96 ⌐Cat.by Günter Aust⌐

 Die 20er Jahre im portr.
 N6868.5.E9297 NPG,p.22

II.C.3 - GERMANY - BERLIN - 18-20th c.

Neuer Berliner Kunstverein
 Abbilder,leithilder;Berliner skulpturen von
Schadow bis heute...1978

LC NB1305.G3N48 1978 FOR COMPLETE ENTRY
 SEE MAIN CARD

II.C.3 - GREAT BRITAIN

Society of Portrait Sculptors
 Twenty first annual exh.of the Society of
Portrait Sculptors...London,The Society⌐1974⌐

LC NB1305.G7S6 1974 FOR COMPLETE ENTRY
 SEE MAIN CARD

NB II.C.3 - GREAT BRITAIN
464
W57 Whinney, Margaret Dickens
NCFA Sculpture in Britain,1530-1830...Baltimore
 Penguin Books⌐1964⌐
 314 p. illus. (The Pelican hist.of art
 723)

 Bibliography,p.281-4

 Incl.:Bacon,Chantrey,Cheere,Delvaux,Hewet-
 son,Nollekens,Pierce,Roubiliac,Rysbrack,Schee-
 ⌐makers,etc.

 Waterhouse.Three decades..
 N6766.W3X NCFA p.39,note 2
 40,note 25;74,note 35

NK II.C.3 - GREAT BRITAIN - 17th c.
923
C75 Whinney, Margaret Dickens
1968 Sculpture
NCFA
 In:The Connoisseur's Complete Period Guides
 p.353-7 illus.
 Pertains to Stuart period
 Repro.:Cure,Stone,Le Sueur,Bushnell,Marshall
 Colt,Pierce,Gibbons,Cibber

N
6766
W3X
NCFA
II.C.3 - GREAT BRITAIN - 18th c.

Waterhouse, Ellis Kirkham, 1905-
Three decades of British art, 1740-1770.
Philadelphia, American Philosophical Society,
1965
77 p. illus. (Jayne lectures,1964)
Memoirs of the American Philosophical
Society,v.63)
Lecture at the Philadelphia Mus.of Art,
March,1964,provided for through the American
Philosophical Society,Philadelphia
Bibliographical footnotes.

Moor.The Art of Rbt.Feke
N40.1.F312PB 1970a NMAA
Bibl.p.XXXII

705
028
NCFA
v.28
II.C.3 - GREAT BRITAIN - 19th c.

Rutledge, Anna Wells
William John Coffee as a portrait sculptor

In:Gaz.Beaux-Arts
28:297-312 Nov.,'45 illus.

Repro.incl.:Bust of Jefferson

ND
1334.4
W183
1985
v.1-2
NPG Ref.
II.C.3 - GREAT BRITAIN - 18-19th c.

Walker, Richard
Regency portraits.London,NPG,1985
2 vols. illus. v.1:Text;v.2:Plates

Edited by Judith Sheppard
Indexes
Incl.:Sculpture,Medals,Engravings,Photo-
graphs

Groups p.597 f.

N
40.1
T486M2
NMAA
II.C.3 - GREAT BRITAIN - 19-20th c.

Manning, Elfrida
Marble and bronze:the art and life of
Hamo Thornycroft...introd.by Benedict Read.
London,Trefoil Books;Westfield,N.J.:Eastview
Editions,1982
216 p. illus.

Index
Bibliography
Cat.of works(incl.many portrs.)

NB
1305
B7W45x
NPG
II.C.3 - GREAT BRITAIN - 18-19th c.

Whinney, Margaret Dickens
English sculpture 1720-1830...London,H.M.
Stationery Off.,1971
160 p. illus. (Victoria & Albert Museum
Museum monograph,no.17)

Bibliographical references

Yale ctr.f.Brit.art Ref.

NB
1305
G7S67
NPG
II.C.3 - GREAT BRITAIN - 20th c.

Society of Portrait Sculptors
Twenty seventh annual exh.of the Society
of Portrait Sculptors.Cat.of the exh.at the
Guildhall Art Gallery,London,16th April -
1st May,1980..London,The Society,1980.
cat.p.9-13 illus.p.14-41

NK
928
C75
1968
NCFA
II.C.3 - GREAT BRITAIN - (early)19th c.

Denvir, Bernard
Painting and sculpture

In:The Connoisseur's Complete Period Guides
p.1087-99

Incl. portraiture during Regency period

Repro.:Leslie,Phillips,Westall,Raeburn,Geddes
Edridge(drg.),Etty(drg.); Chantrey,Behnes,Joseph

N
40.1
B6766
S8
NMAA
II.C.3 - GREAT BRITAIN - 19th c.

Stocker, Mark, 1956-
Royalist and realist.The life and work of
Sir Joseph Edgar Boehm.N.Y.,Garland,1988
447 p. illus.

Ph.D.thesis,Univ.of Hull,1986
Bibliography:p.386-95

Ch.2:Portraiture,Ch.4:Portrait statues
Cat.of works,p.396-422
Excerpts of Boehm's lectures:"Portraiture in
sculpture",p.423-31

AP
1
A64
NMAA
v.127
II.C.3 - GREAT BRITAIN - 19th c.

Bitner, David C.
Nineteenth-century English portrait sculp-
ture:Marble busts in the Nat'l Gall.of Canada.

In:Apollo
127:334-8 May,'88 illus.

Repro.incl.:Nollekens,Chantrey

II.C.3 - GREAT BRITAIN - LONDON

Gleichen, Lord Edward, 1863-1937
London's open-air statuary.London,N.Y.,etc.
Longmans,Green and Co.,ltd.,1928
258 p. illus.

Bibliography

IndexI:Statues & monuments;II:Sculptors,ar-
chitects,designers,writers,donors,etc.

Repro.incl.portr.statuary 17-20th c.(see
next card)

NB470.05

NB
27
I 6D81
1975
NCFA

II.C.3 - IRELAND

Dublin. National Gallery of Ireland
Cat.of the sculptures.Comp.by Michael Wynne.
Foreword by James White.Dublin,The Gallery,1975
54 p.

Summary cat.of the sculptures in the gal-
lery,most of them portraits of distinguished
persons of Ireland

⌒Rila II/2 1976 #6930

II.C.3 - ITALY - 16th c.

Grisebach, August
Römische porträtbüsten der gegenreformation.
Leipzig,H.Keller,1936
176 p. illus. *)
16th c.busts on tombs in Rome.
Biographical outlines,art-historical notes
Review by Middeldorf In:Art Bull
20:111-17 1938 illus.
*) (Römische Forschungen der Bibliotheca Hertziana)
v.XIII

LC N7606.07 ⌒Rep.,1936#332

AP
1
W225
NCFA
v.34

II.C.3 - IRELAND - 18th c.

Hodgkinson, Terence
Christopher Hewetson,an Irish sculptor in
Rome

In:Walpole Soc.
34:42-54 1952-1954 illus.

II.C.3 - ITALY - 16th c.

Keutner, H.
Über die entstehung und die formen des
standbildes im cinquecento

In:Münch Jahr Bild Kunst
7:138-68 1956 illus.

Illustr.by drgs.,ptgs.engrs.medals & esp.
sculpture. Bellini,Mantegna,Montorsoli,Leoni,
Bandini,etc.Portrs sculpt.of Vergil,Andr.Doria,
Charles V,Henry V,Louis XIV,etc.

I et
100.53
M92

LC N9.M8

II.C.3 - ITALY - RENAISSANCE

Pohl, Joseph, 1914-
...Die verwendung des naturabgusses in der
italienischen porträtplastik der renaissance.
Würzburg,Triltsch,1938
68 p.
Bibliogr.footnotes

Inaug.-Dissertation - Bonn

FOGG
FA5098.11

Portr.bust.Renaiss.to En-
lightenment.NB1309.P6x NP
Bibl.

705
A7832
NCFA

II.C.3 - ITALY - 16th c.

Middeldorf, Ulrich
Römische porträtbüsten der gegenreformation;
August Grisebach,ed.

In:Art Bull
20:111-17 May,1938 illus.

16th c.busts on tombs in Rome

II.C.3 - ITALY - 15th c.

Berlin. K.Museen. Sammlung von bildwerken & ab-
güssen des christlichen zeitalters.
Italienische portraitssculpturen des 15.jahr-
hunderts in den königlichen museen zu Berlin,
hrsg.von Wilhelm Bode.Berlin,Druck der Reichs-
druckerei,1883.
53 p. illus.

Heliographien etc.& radierungen von Ludwig
Otto

LC NB615.B4

Amsterdam,Rijksmus.,cat.
25939452,deel 1,p.607

II.C.3 . ITALY - NORTH

Mansuelli, Guido.Achille.
Il ritratto romano nell'Italia settentriona-
le,Formazione e Correnti Artistiche

In:Deutch.Arch.Col.Inst.Mitt.Röm.Abt.
65:67-99 1958

LC DE2.D42

Hiesinger.Portr.in the Ro-
Rep.Bibl.In:Temporini.Auf-
stieg u.niederg...LC DG20
T36.Bd.1.T.4 n.825

705
A7875
NCFA

II.C.3 - ITALY - 15th c.

Valentiner, W.R.
A portrait bust of King Alphonso I of Naples

In:Art Q
1:61-89 Spring 1938 illus.

Foreign influence in Naples
Frescoes by da Besozzo, reliefs by Mino da
Fiesole, busts by Laurana,drgs.by Pisanello

II.C.3 - NETHERLANDS - 17th c.

Bie, Cornelis de, 1627-1716?
Het gulden cabinet van de edel vrij schil-
der-const inhovdende den lof van de vermarste
schilders,...beldthowers en de plaetsnijders
van dese eeuw door Corn.de Bie...T'Antwerpen
gedruckt by Ian Meyssens,1661
3 l. 120 ports.
Engraved t.-p.;added engraved t-pages in
Latin and French.French t.-p.has imprint:An-
vers, Jean Meyssens,1649

NNC NJP

Goldscheider.N40.G65X NCFA
Bibl.p.59

NB
691
W29
NCFA

II.C.3 - POLAND

Warsaw. Museum Narodowe
Rzeźba polska od 16 do poczatku 20 wieku.
Katalog sbiorów opracował Dariusz Kaczmarzyk,
Warszawa,1973
148 p. illus.

Added t.p.:La sculpture polonaise du 16e
siècle au début du 20e siècle

Bibliography
List of sitters
In Polish

MWiCA

F
234
L5W37
1977 X
NMAA

II.C.3 - U.S.

Washington and Lee University, Lexington,Va.
American sculpture in Lexington;selected
examples from public collections;an exh.pre-
sented by Washington and Lee Univ.,Jan.4-21,
1977.Lexington,The Univ.c.1977
47 p. illus.

Bibliography

LC F234.L5W37

II.C.3 - SWEDEN - 20th c.

Asplund, Karl, 1890-
Carl Eldh.Stockholm,Norstedt,1943.
271 p. illus.

LC NB793.E55A8 1943

705
A56
NCFA
v.104

II.C.3 - U.S. - 18-19th c.

Bell, Whitfield Jenks,jr.
Painted portraits and busts in the American
Philosophical Society

In:Antiques
104:878,882-3,886-7,890-1 Nov.,'73 illus(part
.col.

Repro.incl.:Busts of Jefferson by Houdon,Ritten-
house by Ceracchi,J.Q.Adams by Cardelli,etc.
Ptgs.of Franklin by Ch.W.Peale,Rittenhouse by
Ch.W.Peale,Deborah Franklin attr.to B.Wilson,etc.
Self-portr.of Sully

705
A56
NCFA
v.56

II.C.3 - U.S.

Larkin, Oliver
Early American sculpture

In:Antiques
56:176-8 Sep,1949 illus.

Repro:Washington by Rush,Lafayette,bust by
Rush,wood bust by McIntire,bust by Frazee

p.,1948-49#7984

qN
6505
B76X
NCFA

II.C.3 - U.S. - 18-19th c.

Brown, Milton Wolf, 1911-
American art to 1900....N.Y.,Harry N.Abrams,
Inc.,Publ.1977

Early Colonial ...Sculpture..p.32-8.18th c.
colonial ...sculpt.p.90-106.Emergence of an
Americ.sculpture,p.210-21.Portraiture(Sculpture)
p.414-5

FOR COMPLETE ENTRY
SEE MAIN CARD

N
853
U51
1965
NPG
Ref.

II.C.3 - U.S.

U.S. Architect of the Capitol
Compilation of works of art...Washington,
U.S.Govt.Printing Off.,1965
426 p. illus. (88th Congr.,2nd session,
House document no.362

Incl.:Portrs.,p.1-115;Busts,p.169-98;Relief
portrs.,p.279-87;Pioneers of the Women's suf-
frage movem't,p.277;Portrs.p.309-13,315-19,320-1
Historical ptgs.incl.J.Trumbull's Declaration of
Independence,p.118,Gen.Geo.Washington resigning
his comm.as Commander in Chief,p.122,Surrender

LC N853A52 1965 ...'d on other side

N
579
C3A3X
NPG

II.C.3 - U.S. - 18-19th c.

Charleston, S.C. City Council
Catalogue of painting and sculpture in the
Council Chamber,City Hall,Charleston,S.C.;by
Anna Wells Rutledge.Charleston.The City council,
ca.1943
30 p. illus(part col.)

LC N529.C3A3

II.C.3 - U.S.

Quintilianus, Marcus Fabius, c.35-c.95 A.D.
The Institutio oratoria of Quintilian,
with an English translation by H.E.Butler...
London,W.Heinemann;N.Y.,G.P.Putnam's sons,
1921-22
4 v. (The Loeb classical library.Latin
authors.)
Bibliography
Resources of the discipline of physiogno-
mics
"...The most influential writings on the ap-
plication of the principles of physiognomics,

LC PA6156.Q5 1921
PA6649.A2 1921

AP
1
C59
NMAA

II.C.3 - U.S. - 19th c.

Black, Mary C.
Phrenological associations.Footnotes to
the biography of two folk artists.J.Wh.Stock &
A.Ames.
In:Clarion
1982-84:44-52 Fall,'84 illus.

'The photograph became..a guide,providing.ar-
tists.with inspiration for portraits.'

B
L73B9

II.C.3 - U.S. - 19th c.

Bullard, Frederic Lauriston
Lincoln in marble and bronze. New Brunswick,
N.J., Rutgers Uni.Press. 1952.

Bibliographies

LC E457.6.B88

Brown. Amer.art to 1900
qN6505.B76X NCFA Bibl.
p.616

II.C.3 - U.S. - 19th-20th c.

Pennsylvania academy of the fine arts, Phila-
delphia
Memorial exh.of work by Charles Grafly,
Jan.26-March 16,1930,Philadelphia.1930.
15 p. illus.

LC(NB237.G7P4) DSI MiD etc.

AP
1
A51A64
NCFA
v.9

II.C.3 - U.S. - 19th c.

Crawford, John Stephens
Physiognomy in classical and American por-
trait busts

In:Am.Art J.
9:49-60 May,'77 illus.
Bibl.references
"...Demonstrates 1.both classical & Ameri-
can civilizations subscribed to similar theo-
ries of physiognomics.2.The likeness of promi-
nent Americans were consciously altered stylist-
cally to make them closer to the portrs. of the
great personalities of Greece & Rome."

AP
1
N277
NMAA
v.35

II.C.3 - U.S. - 19th-20th c.

Southwell, William
As the artist sees the artist

In:Sculpt Rev
35,no.3:16 Fall,'86 illus.p.16-23

Repro.incl.:Wm.Rush:Self-portr.-Buscaglia:
Rbt.Frost.-Malf.Hoffman:Self-portr.-Davidson:
Gertr.Stein.-and Gertr.Vanderbilt Whitney.-
Murray:Ths.Eakins.-Quinn:O'Neill.-Sherbell:
Copland

NB
210
F94
1984a
NPG

II.C.3 - U.S. - 19th c.

Fryd, Vivien Green
The public portrait monument,Ch.5,in her:
Sculpture as history...1825-1865,p.163-247
illus.

Bibliography

Ph.D.diss.Univ.of Wisc.-Madison,1984

N
40.1
P475B6
NPG

II.C.3 - U.S. - 20th c.

Bliss, Patricia Lounsbury
Christian Petersen remembered.1st ed.
Ames,Iowa State University Press,1986
217 p. illus.

Incl.Index
Bibliography,p.208-11

'Christian was a superb portraitist-probab-
ly one of the best in America.'-Charlotte
Petersen.
Full-length sculpture,Busts,Reliefs,Medal-
lions,Plaques.

705
A56
NCFA
v.103

II.C.3 - U.S. - 19th c.

Whitehill, Walter Muir, 1905-
Portrait busts in the Library of the Boston
Athenaeum

In:Antiques
103:1141-56 June,'73 illus(part col.)

Walker,Wm.in:
Arts in America,v.1,F1424d
qZ5961.U5A77X NCFA Ref.

AP
1
N277
NCFA
v.12

II.C.3 - U.S. - 20th c.

D'Andrea, Albert, 1897-
On Portraiture...Something old and some-
thing new

In:Nat Sculp R
12:6-12,26-8 Spring,'63 illus.

Discusses portrait sculpture through the
ages. Illustrations all U.S.,20th c.

N
40.1
C847C8
NMAA

II.C.3 - U.S. - 19-20th c.

Couper, Greta Elena
An American sculptor on the grand tour:the
life and works of William Couper(1853-1942).
Los Angeles,TreCavalli Press,c.1988
147 p. illus.

Index
Ch.on portraiture,p.80-4

Medallions,busts,statues,reliefs

LC NB237.C64C68 1988

AP
1
N277
NCFA
v.18

II.C.3 - U.S. - 20th c.

Platt, Eleanor, 1910-1974
Portraiture-The artist as biographer

In:Nat Sculp R
18,no.3:18-21 Fall,'69 illus.

FOR COMPLETE ENTRY
SEE MAIN CARD

NB
212
843s
NCFA
II.C.3 - U.S. - 20th c.

Sculptors' guild, New York
Sculptors' guild travelling exhibition,
1940-1941.N.Y.,N.Y.,The Sculptors' guild
c.1940.
9 p. illus.

Photographs of the sculptors at work;
incl.portr.heads and busts by these sculptors.

LC NB212.833 MOMA v.11,p.140

II.C.4. SPECIFIC MATERIAL, A-Z

For list of SPECIFIC MATERIAL see
"Guide to Classified Arrangement"

AP
1
N277
NCFA
v.15
II.C.3 - U.S. - 20th c.

Weinman, Robert A.
Children in sculpture

In:Nat Sculp R
15:18-21 Spring,'66 illus.

II.C.4 - CERAMICS

Lee, Albert, 1868-1946
Portraits in pottery,with some account of
pleasant occasions incident to their quest...
Boston,Mass.,The Stratford company,c.1931.
272 p. Illus.

LC NK4659.L4 Lee.In:Antiques 20:274
Nov.,'31

F
73.64
W59
NCFA
II.C.3 - U.S. - MASSACHUSETTS - Boston

Whitehill, Walter Muir, 1905-
Boston Statues. With photographs by Katha-
rine Knowles. Barre,Mass.,Barre Publishers,1970
120 p. illus.

LC F73.64.A1W45 Fogg,v.11,p.329

II.C.4 - CERAMICS - GREAT BRITAIN

Doulton and company,ltd.,Lambeth(Eng.)
Character jugs and Toby jugs.Manchester,
195-?.
20 p. illus. (Its Collectors book,3)

MET
143.02
D74

II.C.3 - U.S. - NEW ENGLAND

Forbes, Mariette Merrifield, 1856-
Early portrait sculpture in New England

In:Old Time N Engl
19:159-73 Apr,'29

LC F1.868 Whitehill.The Arts in Ear-
ly Amer.Hist.25935W59 NPG
p.102

705
B97
NCFA
v.89
II.C.4 - CERAMICS - GREAT BRITAIN

Esdaile, Katharine A.
The royal sisters:Mary II and Anne in sculp-
ture

In:Burl.Mag.
89:254-7 Sep,1947 illus.

Terracotta models:William III & Mary II by
John Nost. Statue of Anne by Andrew Carpenter
(1712)

Rep.,1945-47*7444

qN
6520
.P63
1983X
II.C.3 - U.S. - SOUTHERN STATES

Poesch, Jessie J.
The Art of the Old South,painting,sculp-
ture,architecture,and the products of crafts-
men,1560-1860...1st ed.N.Y.,Knopf,1983
384 p. illus(part col.)

Incl.index
Bibliography,p.361-366

Repro.incl.:Eye miniature by Malbone,p.162;
Portrs.of Amer.Indians by Curtis,p.272;by Rö-
mer & by Catlin,p.273.Ports.within portrs.,
p.265.Groups by Earl,p.171;by Johnson,
p.159 see cover

II.C.4 - CERAMICS - GREAT BRITAIN

Eyles, Desmond
"Good Sir Toby";the story of Toby jugs and
character jugs through the ages.London,Doulton,
1955
108 p. illus(part col.)

Bibliography

LC NK4087.96E9

II.C.4 - CERAMICS - GREAT BRITAIN - 17-18th c.

Little, Wilfred
 Royalty in English ceramics

In:Connoisseur.Antique dealers' no.:76-9
 June,'53 illus.

 Repro.incl.:Dish with portr.of Chs.I.,
Chs.II,William III.Busts of Js.II by John
Dwight of Fulham and Georges II.

In:Conn.Souvenir of the Antique
dealers'fair & other exhibition
LC NK1125.A357 Rep.1953 #1204

705
A784
NCFA
v.4

II.C.4 - CERAMICS - GREAT BRITAIN - 18th c.

Halsey, R.ichard.T.ownley.H.aines, 1865-1942.
 Ceramic Americana of the 18th century

In:Art in Am
4,Pt.1:85-98 Feb.,1916 illus.
 Pt.2:224-32 June,1916 illus.
 Pt.3:276-88 Aug.,1916 illus.
5,Pt.4:41-56 Dec.,1916 illus.
Repro.incl.:Chelsea porcelain statuettes:Wm.Pitt
John Wilkes,Catharine Macaulay. Wedgwood medal-
lions of Franklin,Washington,Marie Antoinette,
etc.etc.

705
B97
NCFA
v.70

II.C.4 - CERAMICS- GREAT BRITAIN - 17-19th c.

Honey, W.B.
 Royal portraits in pottery and porcelain

In:Burl Mag.
70:218-25,229 May,'37 illus.

 Development of Engl.ceramic art,17-19th c.
 Repro.:Lambeth earthenware;Fulham stoneware:
Dwight;Derby biscuit porc.:Stephan;Chelsea porc.:
Roubiliac;Wedgwood's black basalt:Hackwood & jas-
per;Flaxman;Battersea enamel:Ravenet

 Cumulated mag.subj.index
 A1/3/C76 Ref. v.2,p.444

705
C75
NCFA
v.47

II.C.4 - CERAMICS - GREAT BRITAIN - 18th c.

Hodgson, Mrs. Willoughby
 Shakespeare in pottery and porcelain

In:Connoisseur
47:3-7 Jan,'17 illus.

 Repro.incl.:Terra-cotta model of Roubiliac's
statue,1757;Statuette,earthenware,Staffordshire,
1800;Portr.in black transfer on Worcester mug,
c.1760;Medallion,Wedgwood Jasper,1780;Bust,
black basaltes;Bust col.earthenware,Stafford-
shire,by Enoch Wood;-Js.Quin as Falstaff,

704
A5
NCFA

II.C.4 - CERAMICS - GREAT BRITAIN - 17-19th c.

Hopkins, Waldo
 English portraiture in ceramic

In:Am Coll.
8:8-9,20.. Sept.'39 illus.

 Repro.incl:2 busts of Washington & 2 stand-
ing figs.of Franklin

 Winterthur Mus.Libr. fZ881
 W78 NCFA b.6,p.220

II.C.4 - CERAMICS - GREAT BRITAIN - 18th c.

Hurlbutt, Frank
 Old Derby porcelain and its artist-workmen.
London,T.W.Laurie,ltd.,1925
 312 p. illus.

 Incl.:Ch.Modellers and figure-makers,p.25-52
"...He.Pierre Stephan....modelled most of the
statuettes of the national heroes..."
 Pl.15:John Wilkes by Pierre Stephan;biscuit
figure
 Bibliography

LC NK4399.D4H8 Grees.In:Am Coll v.15
 705.A5 NCFA May,'46,p.19,
 note 1

MET
143.62
An24

II.C.4 - CERAMICS - GREAT BRITAIN - 18th c.

Andrade, Cyril
 Old English pottery,Astbury,Whieldon,Ralph
Wood;Cyril Andrade collection..London,n.d.
 .11.p. illus.(32 phot.on 29 pl.)

II.C.4 - CERAMICS - GREAT BRITAIN - 18th c.

Price, Robert Kenrick
 Astbury,Whieldon,and Ralph Wood figures,
and Toby jugs,coll.by Captain R.K.Price...with
an intro.by Frank Falkner...London,John Lane,
1922
 140 p. illus(part col.)

 'Largest coll.of tobies in the world.'-North-
end in:The joly old toby

LC NK4087.S6P7

705
C75
NCFA
v.8

II.C.4 - CERAMICS - GREAT BRITAIN - 18th c.

Calthrop, Dion Clayton
 The Toby jug;an 18th century grotesque

In:Connoisseur
8:140-4 March,'04 illus.

705
C75
NCFA

II.C.4 - CERAMICS - GREAT BRITAIN - 18th c.

Sargisson, C.S.
 John Wesley busts in Staffordshire pottery

In:Conn.
19:11-7 Sep.,'07 illus.

 Busts by Enoch Wood

705
I 61
NCFA
v.75

II.C.4 - CERAMICS - GREAT BRITAIN - 18-19th c.

Northend, Mary Harrod
The jolly old toby

In:Studio
75:154-6 Apr.,'22 illus.

'These queer little fgs.often bore likenes-
ses of famous military & naval heroes...Staf-
fordshire potters also'made likenesses of some
of the kings of England as of Geo.II & Geo.IV...
Collectors now prefer the portr.tobies.'

II.C.4 CERAMICS - GREAT BRITAIN(19th c.)

Oliver, Anthony
The Victorian Staffordshire figure:a guide
for collectors.London,Heinemann,1971
179 p. illus(part ccl.)

Bibliography

LC NK4087.S6045

Books in print.subj.guide
Z1215.P52 1975 v.2 NPG
p.2960

705
C75
NCFA
v.44

II.C.4 - CERAMICS - GREAT BRITAIN - 18-19th c.

Rhead, George Woolliscroft, 1854-1920
Naval and military heroes in English pot-
tery

In:Connoisseur
44:183-93 Apr.,'16 illus.

Repro.Incl.2 busts of Washington

Winterthur Mus.Libr. fZ881
W78 NCFA v.6,p.221

NK
4087
S6P97
NPG

II.C.4 - CERAMICS - GREAT BRITAIN(19th c.)

Pugh, P.D.Gordon
Staffordshire portrait figures and allied
subjects of the Victorian era. Praeger,1971

659 p. illus.
Bibliography
Standard work on portr.figs. Catalogue of
1500 figures of royal family & the military,
theatrical & sports personalities, with info.on
the makers & methods.

705
A6
NCFA
v.57

II.C.4 - CERAMICS - GREAT BRITAIN - 18-20th c.

Tilley, Frank
Some royal portraits on English pottery
and porcelain

In:Apollo
57:192-7 June,'53 illus.

Widely used since the 16th c. & especial-
ly under William III.

Repro.incl.:English Delft royal charger:
Chs.I & 3 of his children,1653.Ths.Toft slip
ware dish:Chs.
cont'd on next card. Rep.1953 #1205

705
B97
NCFA
v.43

II.C.4 - CERAMICS - ITALY - 15th c.

Dussler, Luitpold, 1895-
Unpublished terra-cottas of the quattrocen-
to

In:Burl.Mag.
43:129-30 Sept.,'23 illus.

Busts in the coll.of Michel van Gelder,
Château Zeebrugge(near Brussels).

Portr.bust.Renaiss.to En-
lightenment.NB1309.P6x NPG
Bibl.

NK
4087
B19
1960
NPG

II.C.4 - CERAMICS - GREAT BRITAIN - 19th c.

Balston, Thomas
Staffordshire portrait figures of the Vic-
torian age.Newton,Mass,C.T.Branford,c1960,
c.1958,
93 p. illus(part col.)

The cat.is divided in chapters:Royal family;
Statesmen;Naval & military;Religious;Authors;
Stage;Sport;Crime;Miscellaneous

LC NK4087.S6B3 (London,Faber Winterthur Mus.Libr.fZ881
& Faber,:1958.) W78 NCFA v.5,p.220

705
A5
NCFA
v.15

II.C.4 - CERAMICS - U.S. - 19th c.

Gross, George Cuthbert, 1899-
William John Coffee,long-lost sculptor

In:Am Coll
15:14-5,19,20 May,'46 illus.

Repro.incl.:Terra-cotta bust,1824;Dr.Hugh
Williamson,plaster,before 1816;"So far as is
known,this is the earliest extant bust of an
American sculptured...in the U.S.";Pierre van
Cortlandt
Coffee made busts of Ths.Jefferson,his
daughter & grand- daughter

II.C.4 - CERAMICS - GREAT BRITAIN(19th c.)

Latham, Bryan
Victorian Staffordshire portrait figures,
for the small collector. London,A.Tiranti,1953
(Chapters on art,v.23)
41 p. illus.

LC NK408786LJ3

Blanshard,F.The portrs. of
Wordsworth N7628W92B6 NPG

AP
1
W78
v.7
NCFA

II.C.4 - CERAMICS - U.S. - 19th c.

Mitchell, James
Ott & Brewer:Etruria in America

In:Winterthur Portfolio
7:217-28 illus.

Etruria Pottery,Trenton,N.J.,1863-1893,
established by Bloor,Ott & Booth,later C.S.
Burroughs & John Hart Brewer became partners

Repr.incl.:Busts of U.S.Grant,Lincoln,all
Parian porcelain:Washington,bisque metallic
green porcelain Pitcher with head of Wa-
shington.Ivory porcelain. All in N.J.State m

II.C.4 - CERAMICS - U.S. - 19th c.

AP
1
J8643 Rauschenberg, Bradford L.
NYAA William John Coffee,sculptor-painter:His Sou-
v.4 thern experience

 In:J.Early So.dec.arts
 4,no.2:26-48 Nov.,'78 illus.

NB II.C.4 - PLASTER
1310
H98 Hutton, Laurence,1843-1904
NPG Portraits in plaster,from the collection of
 Laurence Hutton. New York,Harper & brothers,1894
 271 p. illus.

 Masks;portraits

 LC NB1310.H9

II.C.4 - MARBLE - GREAT BRITAIN - 19th c.

AP
1
A14 Ditner, David C.
NPAA Nineteenth-century English portrait sculp-
v.127 ture.Marble busts in the Nat'l Gall.of Canada.

 In:Apollo
 127:334-8 May,'88 illus.

 Repro.incl.:Nollekens,Chantrey

II.C.4 - STONE - FRANCE - 13th c.

 Terline, Joseph de .1886-.
 Têtes sculptées aux clefs de voûte de la
 chapelle au château de Saint-Germain

Met In:C.R.Acad.Inscrip.
506 :272-3 1949
P217 Sculptured bosses
 Identification of these heads of 1236 or 1237:
 Louis IX,Blanche of Castile,Margaret of Provence,
 Isabella of France,Robert of Artois,Alfonso of
 Poitiers,Charles of Anjou

 LC AS162.P315? Rep.,1948-49*1036

II.C.4 - METAL - BRONZE

N
40.1
B8537 Brilliant, Fredda
S5 Biographies in bronze...1st ed. N.Y.,Shapels-
NPG ky,c.1986
 159 p. illus.

 Originally published by Vikas,1986

705 II.C.4 - WAX
C75
NCFA Bate, Percy H.,1868-1913
v.26 Mr.Lewis Harcourt's collection of waxes

 In:Connoisseur
 26:135-42 Mar.,'10 illus.

 FOR COMPLETE ENTRY
 SEE MAIN CARD

II.C.4 - METAL - IRON

In sect.
AP
1 Stow, Charles Messer, 1880-
A A portrait in iron:Stiegel

 In:Antiquarian
 14:29-31 June,'30 illus.

 N.Y.,MOMA 709.73.N5
 Bibl.p.52

705 II.C.4 - WAX
G28
2.pér. Blondel, Spire, 1836-1900
v.24 Collections de M.Spitzer.-Les cires
NCFA
 In:Gaz.Beaux-Arts
 2nd pér.,24:289-96 1881 illus.

 16th c. Italian,French

 FOR COMPLETE ENTRY
 SEE MAIN CARD

II.C.4 - METAL - LEAD

705
B97
NCFA Weaver, Lawrence
v.9 Some English leadwork...Portrait statues

 In:Burl Mag
 9:97-106 May,'06 illus.

 Accurate portraiture was not universal in
 the statues of the 18th c.
 Artists who worked in lead:Cheere,van Nost,
 the younger,Roubiliac
 Repro.:Queen Charlotte,Pr.Eugène,Duke of
 Marlborough,Charles I,William III

NK II.C.4 - WAX
9580
B69 Bolton, Ethel(Stanwood), 1873 -
NPG American wax portraits. Boston & N.Y.,
2 cops. Houghton Mifflin,1929

 68 p. illus.

 A record of American wax portraits,p..35.-68

 W.Craven. Sculpt.in America
 LC NK9580.B5 NB205.C89 NCFA Ref.

AP
1
S72
NPG
v.13

II.C.4 - WAX

Bolton, Ethel(Stanwood), 1873-1954
Two notable wax portraits

In:Old Time N.Engl.
13:3,6,8,10,13 July,'22 illus.

Two acquisitions by the Soc.for the Preservation of N.Engl.Antiquities

Repro.:Rauschner;Washington,by Patience
Wright;Geo.M.Miller;Ball-Hughes

LC F 1.868

705
C75
NCFA
v.23

II.C.4 - WAX

Farrer, Edmund, 1848-1935
Lady de Gex's collection of reliefs in coloured wax

In:Connoisseur
23:225-32 Apr.,'09 illus.

FOR COMPLETE ENTRY
SEE MAIN CARD

NK
9580
B69w
1915
NCFA

II.C.4 - WAX

Bolton, Ethel(Stanwood), 1873-
Wax portraits and silhouettes,...
Boston,The Massachusetts society of the colonial
dames of America,1915(2nd ed.)
88 p. illus.(part col.)

LC NK9580.B6

705
C75
NCFA

II.C.4 - WAX

Hart, Charles Henry, 1847-1918
Patience Wright,Modeller in wax

In:Conn.
19:18-22 Sep.,'07 illus.

Repro.incl.:Washington,Earl of Chatham,
Franklin

705
M18
NCFA
v.9

II.C.4 - WAX

Bragdon, Claude
Wax portraits by Ethel Frances Mundy

In:Mag Art
9:490-3 Oct.,'18 illus.

"Mundy's best...work....is,child portraiture"

Cumulated Mag..subj.index
A1/3/C76 Ref. v.2,p.445

40.1
H514M2
NPG

II.C.4 - WAX

Henning, John, 1771-1851
John Henning,1771-1851:"...a very ingenious
modeller..":text John Malden;photography Alexander Wilson;.Paisley,Renfrew District Council
Museum and Art Galleris Dept.,1977
.139:p. illus(1 col.)

LC NK9582.H46A4 1977

II.C.4 - WAX

Caylus, Anne Claude Philippe, comte de,
.1692-1765
Mémoire sur la peinture à l'encaustique
et sur la peinture à la cire.ParM.le comte de
Caylus...et M.Majault...Genève,Veuve Tilliard
.etc..1780
133 p. illus.

LC ND2480.C3

Williamson.Portr.work in
wax.In:Apollo,July,'36
p.33

705
B97
NCFA

II.C.4 - WAX

Hill, George Francis, 1867-1948
Notes on Italian medals

In:Burl Mag
9:408-12 Sept.,'06 illus.
10:384,387 March,'07 "
12:141-50 Dec.'07 "
13:274-86 Aug.,'08 "
14:210,215-7 Jan.,'09 "
15:31-2,35 Apr.,'09 " Wax models
 94,97-8 May,'09 "
16:24-6,31 Oct.,'09 " Frauds of 16-17th c.

705
G28
?.per.
1884
NCFA

II.C.4 - WAX

Courajod, Louis Charles Jean, 1841-1896
La collection de médaillons de cire...

In:Gaz.Beaux-Arts
2nd per.,29:236-41 1884 illus.

16th c. wax medallions

FOR COMPLETE ENTRY
SEE MAIN CARD

II.C.4 - WAX

Hughes, George Bernard, 1896-
Portraits modelled in wax

In:Country Life
131,no.3394:658-9 March 22,'62

LC S3.C9

Chicago,A.I. European ports.
N7621.Cl.A7 NPG Bibl. p.176

705
S94
NCFA
v.87

II.C.4 - WAX

Karnaghan, Anne Webb
 Portrait miniatures modeled in Wax

In:Studio
87:45-51 May,'27 illus.

 Italian,French,American wax portrs.,16th c.
-present

FOR COMPLETE ENTRY
SEE MAIN CARD

705
A56
NCFA
v.20

II.C.4 - WAX

Levy, David J.
 Italian wax miniaturists

In:Antiques
20:354-7 Dec.,'31 illus.

 Italian wax portrs.15-18th c.

FOR COMPLETE ENTRY
SEE MAIN CARD

705
C75
NCFA
v.8

II.C.4 - WAX

Kendell, B.
 Jewelled waxes and others

In:Connoisseur
8:133-40 March,1904 illus.

FOR COMPLETE ENTRY
SEE MAIN CARD

705
A56
NCFA
v.19

II.C.4 - WAX

Lightning on Franklin waxes

In:Antiques
19:437 June,'31 illus.p.436

FOR COMPLETE ENTRY
SEE MAIN CARD

705
A56
NCFA
v.31

II.C.4 - WAX

Keyes, Homer Eaton, 1875-
 More waxes by Rauschner

In:Antiques
31:186-7 Apr.,'37 illus.

FOR COMPLETE ENTRY
SEE MAIN CARD

II.C.4 - WAX

Munson, L.F.
 The celebrated Mrs.Wright,ingenious artist
in wax works...

In:House Beautiful
62:392- oct.,'27

LC NA7100.H65

FOR COMPLETE ENTRY
SEE MAIN CARD

705
C75
v.94

II.C.4 - WAX

Lederer, Philipp, 1872-
 Portraits in wax.The collection of Mrs.
A.E.Hamill

In:Conn.
94:101-5 Aug.,'34 illus.

 History of wax-modelling,which reached its
zenith in the 16th c.in Italy,16-17th c.in
France,18th c.in Britain.Repro.:Low-relief full
face & profile.Artists:Caspar Hardy,Curtius,Ch,
Claude Dubut,Sam.Percy

II.C.4 - WAX

Munson, L.F.
 The gentle art of wax modeling

In:House Beautiful
62:258- Sept.,'27

LC NA7100.H65

Prentice.Wax min. Phila.
Mus.B.,v.42,no.213,March,47.708.1.P31

705
A784
NCFA

II.C.4 - WAX

Lesley, Everett Parker
 Patience Lovell Wright,America's first
sculptor

In:Art in Am.
24:148-54,157 Oct.,'36 illus.

 Repro.:Franklin,Washington,Js.,Johnson,Bi-
shop of Worcester,Lord Chatham

705
A56
NCFA
v.19

II.C.4 - WAX

Nolan, J.Bennett
 A long-lost Franklin.Some speculations con-
cerning the authorship of an unidentified wax
portrait.

In:Antiques
19:184-7 March,'31 illus.

FOR COMPLETE ENTRY
SEE MAIN CARD

708.1
P31
NCFA

II.C.4 - WAX

Prentice, Joan
<u>Wax miniatures</u>

In:Phila.Mus.R.
42,no.213:50-62 March,'47 illus.

**FOR COMPLETE ENTRY
SEE MAIN CARD**

708.1
N52
NCFA
v.35-36

II.C.4 - WAX

Remington, Preston
Miniature portraits in wax:a recent gift

In:Bull.of Met mus.
35:54-6 Mar,1940 illus.

Incl:Samuel Percy, Joachim Smith(?)

705
A56
NCFA
v.22

II.C.4 - WAX

Problems in waxes

In:Antiques
22:221-3 Dec.,'32 illus.

18th c. wax portrs.

**FOR COMPLETE ENTRY
SEE MAIN CARD**

AP
1
C76
NPG

II.C.4 - WAX

Reuben Moulthrop, 1763-1814

In:Conn.Hist.Soc.Bull.
20,no.2:44-51 Apr.,1955 illus.

"...Moulthrop was best remembered,in his
life-time,as a maker of wax figures...None have
survived...Ptgs.are in Yale Uni; Conn.Hist.Soc.,
Hartford"

Beardley Limner N40.1B372
S3 NPG,p.16 footnote 14

II.C.4 - WAX

Propert, John Lumsden, 1834-1902.
Cat.of miniatures,enamels,pastels,and
waxes,at 112 Gloucester place,Portman Square
London,Printed by W.Clowes & sons,ltd.,189-?.

"Coll.of Dr.J.Lumsden Propert(ca.1890)"

CSmH MdBWA

II.C.4 - WAX

Schlosser, Julius, ritter von, 1866-1938
Geschichte der porträtbildnerei in wachs

MET
100.
53
J191
Q v.29

In:Jahrb.kunsthist.samml.Wien
29,pt.1:171-258 1911 illus.

LC N3.J4

Enc.of World Art
N31E56Ref.bibl.on portr.
col.512

NK
9580
P94X
NPG

II.C.4 - WAX

Pyke, E.J.
A biographical dictionary of wax modellers.
London:Oxford University Press/Clarendon Press.
1973.
216 p. illus

Review by H.L.Blackmore In:Connoisseur
185:14-6 Apr.,'74

...contains "good technical introduction...
bibliography..."

N
40.1
W933S4
NPG

II.C.4 - WAX

Sellers, Charles Coleman, 1903-
Patience Wright:American artist and spy in
George III's London.Middletown,Wesleyan Univ.
press,c.1976
281 p. illus.

Incl.Bibl.ref. & index
Catalogue of works

'P.W.brought wax sculpture in the round to
prominence as a portrait art in a way unknown
before or since'
Rila III/2 1977 *5132

NK
9580
R36
NCFA

II.C.4 - WAX

Reilly, David Robin.
Portrait waxes, an introduction for collectors. London,
Batsford,1953,
xvi, 160 p. illus. 26 cm.
Bibliography: p. 153.

1. Wax-modeling. 2. Portraits. 1. Title.

NK9580.R4 731.74 53-35048
Library of Congress

VF
Mundy

II.C.4 - WAX

Syracuse,N.Y. Museum of Fine Arts
Wax miniatures,antique and modern;with re-
cent portraits by Ethel Mundy.Exh.May4-31,1944
.6.p. cover illus.

Repro.:Henry II of Valois,16th c.,Elizabeth,
Queen of England,by Ethel Mundy

Foreword by Claude Bragdon

II.C.4 - WAX

Tussaud, John Theodore, 1850-1943
 The romance of Madame Tussaud's by John The-
odore Tussaud;with an intro.by Hilaire Belloc...
New York,George H.Doran company(c.1920)
 368 p. illus.

 Rev.:Connoisseur,57:61-2,May,1920

LC DC146.T9T9

II.C.4 - WOOD

Pinckney, Pauline A.
 American figureheads and their carvers.
Port Washington,N.Y.,Kennikat Press,Inc. 1969
 223 p. illus.

 Bibliography

 '...actual portrs.,either the bust or the
full-length fig.became customary decoration on
a ship's prow.'p.28
 '...the ship carver.is.truly one of our best
sources of American folk art.'p.32

LC VM308.P5 1969

AP
1
N547
NCFA
v.9

II.C.4 - WAX

Wall, Alexander James, 1884-
 Wax portraiture

In:N.Y.Hist.Soc.Q.Bull.
9:3-26 Apr.,'25 illus.

 FOR COMPLETE ENTRY
 SEE MAIN CARD

705
A56
NCFA
v.100

II.C.4 - WOOD

Smith, Robert C.
 Finial busts on 18th century Philadelphia
furniture

In:Antiques
100:900-905 Dec.,'71 illus.

Repro.incl.:B.Franklin;John Locke;John Milton;
Washington
 '...study of all this furniture...could well
reveal ..resemblances linking it with the shop
of Benjamin Randolph. Saunders.Am.colonial portr
 N7593.1.S28,p.74,note 152

AP1
A64
v.68
NCFA

II.C.4 - WAX

Warner, Oliver
 Wax portraits & reliefs

In:Apollo
68:116-17 illus. Oct.,1958

 Examples fr.1527-1808,Italian,German,English

 Encyclop.of World Art
 Portrs.bibl. N31E56 Ref.

II.C.5. SPECIAL FORMS & SUBJECTS, A-Z

 For list of SPECIAL FORMS &
 SUBJECTS see "Guide to Classified
 Arrangement"

NPG

II.C.4 - WAX

Weil, Elma Allee
 Wax portraiture

In:Antiquarian
10:49-52 Mar.,'28 illus.

 FOR COMPLETE ENTRY
 SEE MAIN CARD

II.C.5 BUSTS CAMEOS & INTAGLIOS CARICATURE COINS &
MEDALS EQUESTRIAN FIGUREHEADS FUNERARY(Sculp-
ture) HEADS MASKS MINIATURES PROFESSIONS
(Sculpture) RELIEF SELF-PORTRAITS STANDING
FIGURES

AP
1
A64
NCFA
v.24

II.C.4 - WAX

Williamson, George Charles, 1858-1942
 Portrait work in wax

In:Apollo
24:27-33 July,'36 illus.

 FOR COMPLETE ENTRY
 SEE MAIN CARD

705
B97
NCFA
v.91

II.C.5 - BUSTS

Esdaile, Katherine.
 The busts & statues of Charles I

In:Burl.Mag.
91:9-14 Jan.1949 illus.

 Busts by LeSueur,Besnier(attr.),Roubiliac
(terra-cotta & marble),Adey after Bernini, sta-
tues by LeSueur,Bushnell

 Rep.,1948-49=1130

731
.N19 II.C.5 - BUSTS

New York. Metropolitan museum of art
...A special exhibition of heads in sculpture
from the museum collection.N.Y.,Jan.16 through
March 3,1940....1940.
.54.p. illus.(chiefly)
Illus.arr.in pairs for comparison:similari-
ties in different cultures.
Review by J.Goldsmith Phillips In:Met Mus B
35:2-4 Jan.,'40 illus.

Review initialed J.W.L. In:Art N
38,no.16:16,17

LC NB1300.N1 Portr.bust.NB1300.P6x NPG
 Bibl.

705
A7875
NCFA II.C.5 - BUSTS - RENAISSANCE

Lavin, Irving
 On the sources and meaning of the Renaissance
portrait bust

In:Art Q
33:207-26 Autumn,1970 illus.

 Equestrian sculpt.:over life-size,made by pub-
lic decree; busts:life-size,privately commis-
sioned & displayed; medals:small for selected
audience. Relation of Renais.bust to ancient &
medieval

N
7624
R26
NPG
2 cops. II.C.5 - BUSTS

Raydon Gallery, New York
 Masters in portraiture.Cat.of exh. Spring,
1971
 24 p. illus.

 Mainly ptgs.,some busts

NB
1309
P6x
NPG II.C.5 - BUSTS - 14-18th c.

The Portrait bust; Renaissance to Enlightenment.
.Providence?1969?.
.64.p. illus.

 Cat.of an exhib.prepared by students in the
Dept.of Art,Brown Univ.,and held at the Mus.of
Art,Rhode Island School of Design,Mar.5-30,1969

 Biographical references

LC NB1309.P6

708.2
V62 II.C.5 - BUSTS

Victoria and Albert museum,South Kensington
 ...a picture book of portrait busts.London,
Publ.under the authority of the Board of Edu-
cation.1927.
 .4.p. 20 pl. (Its Picture book,no.23)

II.C.5 - BUSTS - 15-18th c.

.Victoria and Albert Museum, South Kensington..
 Portraits in sculpture: a V.and A. exhibi-
tion

In:Illustr. London News
207: 1945 no.5555 illus.

 Incl.:Busts of Charles II by Pelle(1684),
Charles I by LeSueur(1631),Henry VII by Torri-
giani(c.1504),etc.

LC AP4 I3 Rep.,1945-47*1029

cont.
& exs.
of il-
lustr's
in VF
Portrs.,
Roman II.C.5 - BUSTS - ANTIQUITY

Jucker, Hans
 Das bildnis im blätterkelch. Olten,Urs Graf
Verlag. Geschichte und bedeutung einer römi-
schen porträtform. 1961
 2 v. illus.
 (Bibliotheca Helvetica Romana,3)

NIC MH NJP CU I.Lavin in Art Q.,v.33
 autumn,1970,p.217

II.C.5 - BUSTS - 18th c.

Galeries Georges Petit, Paris
 Exposition de cent pastels du 18e siècle...
et de bustes....Paris,Gal.Georges Petit.1908.

FOGG
6.48
P48

 FOR COMPLETE ENTRY
 SEE MAIN CARD

II.C.5 - BUSTS - ANTIQUITY- ROME

Roman portraits in New York

In:Archaeology
1:104-14 1948 illus.

 Busts in Metrop.Mus.of Art

LC GN700.A725 Rep.,1948-47*5036

NB
1309
I 94
NPG II.C.5 - BUSTS - 18th c.

Iveagh Bequest, Hampstead, Eng.
 Eighteenth century portrait busts..Exhi-
bition at the Iveagh Bequest,Kenwood..June to
September, 1959
 31 p. illus.

 Portr.bust.Renaiss.to En-
 lightenment.NB1309.P6x NPG
 Bibl.

AP
1
A64
NCFA
v.102

II.C.5 - BUSTS - 19th c.

Avery, Charles
 Neo-classical portraits by Pistrucci and
Rauch

In:Apollo
102:36-43 July,'75 illus.

FOR COMPLETE ENTRY
SEE MAIN CARD

rfm
124n
NCFA

II.C.5 - BUSTS - FRANCE - 18th c.

George, Waldemar, 1893-
 Man in Excelsis:French 18th century busts

In:Apollo
17:248-54, June,'33 illus.

 Pertains to exh.at André Seligmann,Paris,
1933
 Repro.:Lemoyne, Gois, Pigalle, Caffieri,
Houdon
 "...intense expressionism & stylization.is
characteristic of French busts...French portr
of the Rococo pe riod differs from
Source:NB1309.P6x NPG
Bibl.

II.C.5 - BUSTS - AUSTRIA - 18th c.

Kris, Ernst, 1900-
 A psychotic sculptor of the 18th century

In.his.Psychoanalytic explorations in art.New
York,Schocken Books.1964,1952.

 pp.128-50 illus. Based on a paper read
to the Vienna Psychoanalytic Soc.,Nov,'32,publ.
in Imago,XIX,1933.Span.transl.in Revista de Psi-
coanalisis,III,1945/46

 Repro.:Busts by Messerschmidt

LC N70.K84 1964

735
H98P23
NCFA

II.C.5 - BUSTS - FRANCE - 18th c.

Paris. Galeries Buvelot
 Exposition du centenaire de Houdon,organi-
sée au bénéfice des ligues française et espag-
nole contre le cancer;préface de A.Caroin...
5 juin au...5 juillet,1928..Paris,1928.
 107 p. illus.

 see also:Réau,L..Les expos.du centenaire...
in:Gaz.Beaux-Arts,v.17:339-56,June,'28 illus.

705
.C75
NCFA
v.121

II.C.5 - BUSTS - FRANCE

Réau, Louis, 1881-
 A great French sculptor of the 18th century:
Jean-Antoine Houdon

In:Connoisseur
121:74-7 Jun,1948 illus.

 Repro:Marble busts of Franklin,Mme Victoire,
etc. Houdon in Italy, France, Germany, U.S. &
England

Rep.,1948-49=8006

II.C.5 - BUSTS - FRANCE - 18th c.

Rostrup, Haavard, 1907-
 Franske portraetbuster fra det 18 aarhun-
drede.Avec un résumé en français.Copenhagen,
Levin & Funksgaard,1932
 137 p. illus.

 Review in:Burl.Mag. 62:299 1933

 French portr.busts of the 17th to early 19
century

Cty Portr.bust.Renaiss.to En-
 lightenment.NB1309.P6x NP
 Bibl.

705
A7832
NCFA
v.34

II.C.5 - BUSTS - FRANCE

Seymour, Charles, 1912-
 A group of royal portrait-busts from the
reign of Louis XIV.in the National gallery,Kress
collection.

In:Art Bull.
34:285-96 Dec,1952 illus.

 Systematic evaluation of stylistic diversity
of official sculpture in France,ca.1700
 Repro:Coysevox,Prou,Girardon,etc.

Enc.of World Art,v.11
N31E56 Ref.,col.513
bibl.on portr.

II.C.5 - BUSTS - FRANCE - 18th c.

Tschaegle, Robert
 Actualism in portrait sculpture:a problem
of style based on examination of the naturol-
ism of French 18th c.portrait busts with emphe-
sis on the style of Houdon

 Master's Th.-Chicago,Ill.,1937

Lindsay,K.C.,Harvur Ind.of
master's theses in art...
Z5931.L74 1955 NCFA Ref.
p.33,no.591

705
A786
NCFA

II.C.5 - BUSTS - FRANCE - 18th c.

Frankfurter, Alfred M.
 Unique view of French sculpture,18th cen-
tury masterpieces:The David-Weill collection

In:Art N
38,no.29:6-8 Apr.20,'40 illus.

 Pertains to exh.at Wildenstein & co.,inc.,
New York,Apr.16-May 4,1940

 Repro:Portr.-busts by Peru,Coysevox,Houdon,
Lemoyne,Pajou,de Montigny.
 Portr.bust.Renaiss.to En-
 lightenment.NB1309.P6x NPG
 Bibl.

II.C.5 - BUSTS - FRANCE - 18th c.

Versailles. Bibliothèque municipale
 Centenaire de J.-A.Houdon,né à Versailles.
Préface de m.Paul Vitry.Avril-mai,1928..Ver-
sailles,1928.
 55 p. illus.

 Bibliography p.52-55

 see also:Réau,L.Les expos.du centenaire...
in:Gaz.Beaux-Arts,v.17:339-56,June,'28 illus.

NJP

II.C.5 - BUSTS - FRANCE - 18th c.

Vitry, Paul, 1872-
 Les accroissements des musées.(Musée du
Louvre).Quelques bustes du 18e siècle récem-
ment entrés au Musée

In:Les Arts
10,no.117:1-6 Sept.,'11 illus.

 Repro.:[No#]-Nicolas Coypel by J.-B.Lemoyne.
Antoine Coypel by Coysevox. Mme.Favart by De-
fernex

LC N2.A85 Portr.bust.Ren.to Enlighten-
 ment.NB1309P6x NPG

NK
928
C75
1968
NCFA

II.C.5 - BUSTS - GREAT BRITAIN - (early)18th c.

Honour, Hugh
 Painting and sculpture

In:The Connoisseur's Complete Period Guides
p.593-605 illus.

 Incl.chapters on portraits,conversation
pieces,busts(sculpture)during early Georgian per.

 Repro.:Reynolds,Ramsay,Gainsborough,Roubil-
lac,Rysbrack,Scheemakers,Kneller,Van Loo,Jervas,
Richardson,Hudson,Knapton,Hogarth,Highmore,Devis

705
G28
v.10
NCFA

II.C.5 - BUSTS - FRANCE - 18-19th c.

Réau, Louis, 1881-1961
 Houdon sous la révolution et l'Empire

In:Gaz Beaux-Arts
10(5ième ser):59-86 Jul,Aug.,1924 illus.

Repro.incl.:Busts of Lafayette,Necker,Mirabeau,
Barnave,Dumouriez,Napoleon,Lalande,Collin d'Har-
leville,Sabine Houdon

705
A5
NCFA
v.8

II.C.5 - BUSTS - GREAT BRITAIN - 18-19th c.

Hopkins, Walde
 English portraiture in ceramics

In:Am Coll.
8:8-9,20 Sept.'39 illus.

 Repro.incl:2 busts of Washington & 2 stand-
ing figs.of Franklin

 Winterthur Mus.Libr. fZ881
 W78 NCFA v.6,p.220

N
40.1
D24P2
NCFA

II.C.5 - BUSTS - FRANCE - 19th c.

Paris. Musée de la monnaie
 David d'Angers,1788-1856.Hôtel de la mon-
naie,Paris,juin-sept.,1966.Cat.par François
Bergot.Préfaces par Pierre Dehaye et Pierre
Pradel,Paris,Hôtel de la monnaie,1966
 151 p. illus.

 Bibliography
 Repro.incl.:Ptgs.miniatures,daguerreotype,
caricatures,drags.,prints by D.'s contempora-
ries.Bronze statuettes,busts,medallions by
David d'Angers of poets,military,clergy,states-
men,artists
 List of sitters

AP
1
A64
NMAA
v.127

II.C.5 - BUSTS - GREAT BRITAIN - 19th c.

Bilbey, David C.
 Nineteenth-century English portrait sculp-
ture.Marble busts in the Nat'l Gall.of Canada.

In:Apollo
127:334-8 May,'88 illus.

 Repro.incl.:Nollekens,Chantrey

II.C.5 - BUSTS - GREAT BRITAIN

London. Royal College of Surgeons of England
 Catalogue of portraits and busts in the
Royal College of Surgeons of England,with short
biographical notes.Revised to January,1930.
London,Printed by Taylor and Francis,1930.
 95 p. illus.

 Prepared by Fred.C.Hallett

 Bibliography

MN CU-M MiDW-M DNLM
PP CtY Yale ctr.f.Brit.art Ref.
 N1165.R6A55

NK
928
C75
1968
NCFA

II.C.5 - BUSTS - GREAT BRITAIN - 19th c.

Woodward, John
 Painting and sculpture

In:The Connoisseur's Complete Period Guides
p.1333-44, 1377-9 illus.

 Incl.portraiture during early Victorian per.

 Repro.:Wilkie,Hayter,Partridge,Eastlake,Etty,
Rossetti(drg.),Landseer,Watts,Winterhalter;
Carew,Behnes,Woolner,Gibson

N
7598
W59
NPG

II.C.5 - BUSTS - GREAT BRITAIN - 17-19th c.

Colnaghi, P.& D.& co.,ltd.,London
 English ancestors,a survey of British por-
traiture 1650-1850.Cat..of exh.22 Feb.to 31
March 1983.ed.by Clovis Whitfield,assisted by
Ursula Lane.1983.
 109 p. illus(part col.)

 Arranged by artists in alphabetical order
 Foreword by John Harris

 Incl.:Groups,children & portr.busts

705
C75
NCFA

II.C.5 - BUSTS - ITALY - 15th c.

Comstock, Helen
 Quattrocento portrait sculpture in the
National Gallery,Washington

In:Conn.
122:45-9 Sept.,'48 illus.

 Busts by Mino da Fiesole, Verrocchio, Deside-
rio da Settignano, Laurana, Ant.Pollaiuolo;
Busts by lombard School

 Portr.bust.Renaiss.to En-
 lightenment.NB1309.P6x NPG
 Bibl.

705
B97
NCFA
v.43

II.C.5 - BUSTS - ITALY - 15th c.

Dussler, Luitpold, 1895-
Unpublished terra-cottas of the quattrocento

In:Burl.Mag.
43:129-30 Sept.,'23 illus.

Busts in the coll.of Michel van Gelder,
Château Zeebrugge(near Brussels)

II.C.5 - BUSTS - ITALY - FLORENCE - 15th c.

Schuyler, Jane
Studies of Florentine Quattrocento portrait
busts.₌n.p.₌1972₌c.1975₌
318 p. illus.

Ph.D.Dissertation,Columbia U.,1972

Bibliography

Photocopy of typescript,Ann Arbor,Mich.,
Uni.Microfilms,1975

Diss.Abstr.Z5055.U49D57NPG
v.35no.10,Apr.75p.6603A
no.75-9359

MWiCA

II.C.5 - BUSTS - ITALY(16th c.)

Grisebach, August
Römische porträtbüsten der gegenreformation.
Leipzig,H.Keller,1936
176 p. illus. ₌*₎
16th c.busts on tombs in Rome.
Biographical outlines,art-historical notes

Review by Middeldorf In:Art Bull
20:111-17 1938 illus.
*) (Römische Forschungen der Bibliotheca Hertziana)
v.XIII

LC N7606.G7 Rep.,1936#332

q N
40.1
T487S2
NPG

II.C.5 - BUSTS - SCANDINAVIA

Sass, Else Kai, 1912-
Thorvaldsens portraetbuster. Copenhagen,
G.E.C.,Gads Forlag,1963-65

3 vol. illus.

Review in Art Bul by Fred Light
52:334-6 Sep.,1970
"Most important work on Th."
Two short essays & chronological cat.raisonné
in English

NB723.T5S26

705
A7832
NCFA

II.C.5 - BUSTS - ITALY(16th c.)

Middeldorf, Ulrich
Römische porträtbüsten der gegenreformation;
August Grisebach,ed.

In:Art Bull
20:111-17 May,1938 illus.

16th c.busts on tombs in Rome

NB
25
N53
1962
NPG
2 c.

II.C.5 - BUSTS - U.S.

New York University. Hall of Fame
The Hall of Fame for Great Americans at New
York University....₌N.Y.,N.Y.Uni.Press,1962

FOR COMPLETE ENTRY
SEE MAIN CARD

705
B97
NCFA
v.112

II.C.5 - BUSTS - ITALY - 17th c.

Pershad, David L.
A series of papal busts by Domenico Guidi

In:Burl Mag
112:805-9 Dec.,'70 illus.

Spike.Baroque portraiture
in Italy.N7606.S75NPG
Bibl.p.154

705
A56
NCFA
v.100

II.C.5 - BUSTS - U.S. - 18th c.

Smith, Robert C.
Finial busts on 18th century Philadelphia
furniture

In:Antiques
100:900-905 Dec.,'71 illus.

Repro.incl.₌B.Franklin;John Locke;John Milton;
Washington
'...study of all this furniture...could well
reveal ..resemblances linking it with the shop
of Benjamin Randolph.₌Saunders.Am.colonial portr
N7593.1.S28,p.74,note 152

705
B97
NCFA
v.97

II.C.5 - BUSTS - ITALY(works in Great Britain)-
₌18th c.

Webb, M.I.
Giovanni Battista Guelfi:an Italian sculp-
tor working in England

In:Burl Mag
97:139-45 May,'55 illus.
Aug.'55

Whinney.Sculpt.in Britain.
NB464.157 NCFA ₌Bibl.p.204₌

N
40.1
B878B4
NCFA

II.C.5 - BUSTS - U.S. - 19th c.

Bennett, James O'Donnell, 1870-
The mask of fame;the heritage of historical
life masks made by John Browere,1825 to 1833
₌by....and Everett L.Millard. ₌Highland Park,Ill.
The Elm press₌c.1938₌
29 p. illus.

Bibliography

LC NB237.B7B4

7 M
AR07
N8
237
B7 Fox
N PG

II.C.5 - BUSTS - U.S. - 19th c.

Browere, John Henri Isaac, 1792-18.4
Life masks of noted Americans of 1825...
exhib.,Feb.12-24,1940 under the sponsorship of
the New York state historical association,Coo-
perstown,New York.N.Y.,M.Knoedler and cy.,1940,
6 p. illus.

Foreword signed:Dixon Ryan Fox

LC NB237.B7F6

Kimball.Life portrs.of Je
ferson.N7628.J45K4,p.532
NPG NCFA

705
A784
NCFA
v.38

II.C.5 - BUSTS - U.S. - 19th c.

Millard, Everett Lee
The Browere life masks

In:Art in Am.
38:69,71,74,76,78,80 Apr.,'50 illus.

Busts in N.Y.State hist.assoc'n's "Hall of
Life Masks"in Fenimore hse.,Cooperstown,N.Y.

This article is drawn fr.Millard's ms of a
life of J.H.I.Browere

Arts in America q25961.U5
A77X NCFA Ref. I72

709
A56
NCFA
v.110

II.C.5 - BUSTS - U.S. - 19th c.

Demer, John H.
The portrait busts of John H.I.Browere

In:Antiques
110:111-7 July,'76 illus.

"B.spent more than $12000.-attempt'g.with-
out success to establish a Nat'lGall.of Busts
and Statues."-Demer

Incl.H.Clay;Ths.Jefferson;Js.Madison;Dolley
Madison;J.Adams;Lafayette;M.van Buren;J.Q.Adams.
Checklist of B.'s sculptures

AP
1
W78
v.7
NCFA

II.C.5 - BUSTS - U.S. - 19th c.

Mitchell, James
Ott & Brewer:Etruria in America

In:Winterthur Portfolio
7:217-28 illus.

Etruria Pottery,Trenton,N.J.,1863-1893,
established by Bloor,Ott & Booth.later C.S.
Burroughs & John Hart Brewer became partners

Repr.incl.:Busts of U.S.Grant,Lincoln,all
Parian porcelain.Washington,bisque metallic
green porcelain. Pitcher with head of Wa-
shington.Ivory porcelain. All in N.J.State m

II.C.5 - BUSTS - U.S. - 19th c.

Frazee, John
The autobiography of John Frazee(1790-1852),
first American sculptor in marble

In:Am.Coll.
16:12-4 Nov.,'46 illus.

'...portr.-busts which brought nat'l fame
to...his work.'
Most of the portr.-busts in Boston, Athe-
naeum

LC NK1125.A15

AP
1
J8643
NYAA
v.4

II.C.5 - BUSTS - U.S. - 19th c.

Rauschenberg, Bradford L.
William John Coffee,sculptor-painter:His Sou-
thern experience

In:J.Early So.dec.arts
4,no.2:26-48 Nov.,'78 illus.

NB
1310
H32
NPG

II.C.5 - BUSTS - U.S. - 19th c.

Hart, Charles Henry, 1847-1918
Browere's life masks of great Americans, ...
New York,Printed at the De Vinne press for
Doubleday and McClure company,1899
123 p. illus.

LC NB1310.H3

N
40.1
B8537
85
NPG

II.C.5 - BUSTS - U.S. - 20th c.

Brilliant, Fredda
Biographies in bronze...1st ed. N.Y.,Shapels-
ky,c.1986
159 p. illus.

Originally published by Vikas,1986

VF
Frazee

II.C.5 - BUSTS - U.S. - 19th c.

Maxfield, David M.
Historian traces obscure path of once-cel
brated portrait sculptor

In:Research Reports
no.45:2,8 Spring,'85 illus.

Re-evaluation of John Frazee,the 1st Ameri
can to fashion a portr.in marble.
'Frazee's work was good,better than anyon
ever realized.'-Fred Voss

AP
1
I261
NPG
v.78

II.C.5 - BUSTS - U.S. - ILLINOIS - CHICAGO -
19-20th c.

Garvey, Timothy J.
Conferring status:Lorado Taft's portraits
of an artistic community

In:Ill.Hist.J.
78:162-78 Aut.,'85 illus.

II.C.5 - CAMEOS & INTAGLIOS
incl. glass cameos

II.C.5 - CAMEOS & INTAGLIOS - ANTIQUITY - ROME

Heintze, Helga von
Römische glyptik und münsprägekunst

N
5760
K92
NCFA

In:Kraus,Theodor.Das römische weltreich.Propyl-
läen Kunstgeschichte II.Berlin,...1967
p.281-6 illus(part col.)

LC N5760.K7

708.1 II.C.5 - CAMEOS & INTAGLIOS
N38

Isaac Delgado Museum of Art, New Orleans
Cameos and corals.Cat.of exh.from local co
lections,Feb.,1938

In:Is.Delg.Mus.of Art leaflet
3:1-10 July,'38 illus.

Arranged by the Delgado Art Mus.Project,
Women's & Professional Projects Division,Work
Progress Administration,Louisiana

II.C.5 - CAMEOS & INTAGLIOS - ANTIQUITY - ROME

Vessberg, Olof, 1909-
Studien zur kunstgeschichte der römischen
republik.Lund,C.W.K.Gleerup,1941
304 p. illus. (Svenska institutet i Rom.
Skrifter 8)

MET
617
V63

Bibliography
Based on.Diss.-Uppsala.1941.

LC DG12.S8 v.8,etc. Gasda.Etrusc.infl.in fune-
rary reliefs...In:Temporini
Aufstieg u.niedergang...
LC DG209.T36.Bd.1.T.h p.855

II.C.5 - COINS & MEDALS

ND
621
F52
NCFA

Firenze e l'Inghilterra.Rapporti artistici e
culturali dal 16 al 20 secolo.Firenze,Pa-
lazzo Pitti,luglio-settembre 1971.Firenze,
Centro Di,1971
77,1. illus(col.cover) (Cataloghi,23)

Cat.ed.by M.Webster

see also article by Ormond in Connoisseur
v.177:166-74

LC ND621.F7F57

II.C.5 - CAMEOS & INTAGLIOS - ANTIQUITY - ROME

Vollenweider, Marie Louise
Die porträtgemmen der römischen Republik;
Katalog & tafeln.Mainz,P.von Zabern,c.1972.
110 p. 168 p.of illus.

LC NK5566.V64 Verzeichnis lieferbarer Bü-
cher 1973/74 NPG v.1,
p.2020

II.C.5 - CAMEOS & INTAGLIOS - ANTIQUITY

Furtwängler, Adolf, 1853-1907
Die antiken gemmen.Geschichte der stein-
schneidekunst im klassischen altertum.Leipzig,
Berlin,Giesecke & Devrient,1900
3 v. illus.

LC NK5565.F8 Hiesinger.Portr.in the Rom.
Rep.Bibl.In:Temporini.Auf-
stieg u.niederg....LC DG209
T36,Bd.I,T.4,p.821

II.C.5 - CAMEOS & INTAGLIOS - ANTIQUITY - ROME

Vollenweider, Marie Louise
Les portraits romains sur les intailles et
et camées de la collection Fol.Genève,1960
137,-152 p. illus.

Reprinted from Genava,n.s.,v.8

InU

II.C.5 - CAMEOS & INTAGLIOS - ANTIQUITY

Richter, Gisela Marie Augusta, 1882-
The engraved gems of the Greeks,Etruscans
and Romans.London,Phaidon,1968-1971.
2 v. illus(part col.)

Bibliography

LC NK5557.R5 Hiesinger.Portr.in the Ror
Rep.Bibl.In:Temporini.Auf-
stieg u.niederg....LC DG2
T36,Bd.I,T.h,p.821

II.C.5 - CAMEOS & INTAGLIOS - ANTIQUITY - ROME

Vollenweider, Marie Louise
Verwendung und bedeutung der porträtgemmen
für das politische leben der römischen republik

In:Museum Helveticum
12?:96-111 1955

LC PA3.M73 Hiesinger.Portr.in the Ro-
man Republ.LC DG209.T36
Bd.1,T4,Bibl.p.821

NPG | II.C.5 - CAMEOS & INTAGLIOS - 19th c.

Christie,Manson & Woods,ltd.
Fine miniatures,gold boxes and Russian
works of art to be sold at Christie's...London
...1980

Incl.:some cameos...

FOR COMPLETE ENTRY
SEE MAIN CARD

705
375
v.67
NCFA | II.C.5 - CAMEOS & INTAGLIOS - GREAT BRITAIN -
.19th c.

Way, Herbert W.L.
Apsley Pellatt's glass cameos in the col-
lection of Mrs.Applewhaite-Abbott

In:Connoisseur
67:3-10 Sept.,1923 illus.

Repro.incl.:cameo portrs.of Nelson,Welling-
ton,George IV,Rbt.Burns,Shakespeare,George III,
Queen Charlotte,etc.
Apsley Pellatt,1791-1863,Brit.glass manufac-
turer.His process:Crystallo ceramie

q QE
126
S86
1984
NPG | II.C.5 - CAMEOS & INTAGLIOS - FRANCE - 17th c.

The Sun King,Louis XIV and the New World;an
exh.,organized by the Louisiana State Mu-
seum...New Orleans,Louisiana State Museum,
c.1984
343 p. illus(part col.) (Studies in
Louisiana culture,v.3)
Incl.Index
Steven G.Reinhardt,ed.
Exh.dates:Louisiana State Mus.,New Or-
leans,La.,Apr.29-Nov.18,1984.The Corcoran
Gall.of Art,Washington,D.C.,Dec.15,1984-
Apr.7,1985
Incl.Ptg., sculpture,cameos

705
C75
NCFA
v.137 | II.C.5 - CAMEOS & INTAGLIOS - PORTUGAL - 19th c.

Pinto, Augusto Cardoso
Portuguese glass cameos

In:Connoisseur
137:32-4 Mar,1956 illus.

19th c.moulded cut glass with incrustations.
Also pressed glass plates with incrusted medals.
José F.Pinto Basto,1774-1839,founder of factory:
Fábrica Vista Alegre in 1824

705
C75
NCFA
v.112 | II.C.5 - CAMEOS & INTAGLIOS - GREAT BRITAIN -
.16-17th c.

Jones, E.Alfred
Some notes on Nicholas Hilliard,Miniaturist
and Goldsmith,c.1547-1617

In:Connoisseur
112:3-6 Sept.'43 illus(part col.)

Repro.incl.:Queen Elizabeth,the'Pelican por-
trait'.Second Great Seal of England.Miniatures:
Self portr.Queen Elizabeth.A gentleman.Alice
Brandon,wife of N.H. The Armada jewel

736.2
.C42 | II.C.5 - CAMEOS & INTAGLIOS - U.S.

Chapin, Howard Millar, 1887-
Cameo portraiture in America,...Providence,
Printed by the Plimpton press for Preston &
Rounds co.,1918
46 p. illus.

.Incl.history of cameos.

LC NK5720.C5

705
A6
NCFA
v.57 | II.C.5 - CAMEOS & INTAGLIOS - GREAT BRITAIN -
.19th c.

Hughes, George Bernard, 1896-
Crystallo Ceramie.Illustrated examples at
Buckingham Palace

In:Apollo
57:183-5 June,'53 illus.

Repro.incl.:Cameos of Queen Victoria.King
Geo.III,by Apsley Pellatt.Princess Charlotte.
King Geo.IV,by Apsley Pellatt.Fred.,Duke of
York,King Geo.IV by Apsley Pellatt.

Technique of Sulphide cameos embedded
in glass

N
40.1
S13D7
NPG | II.C.5 - CAMEOS & INTAGLIOS - U.S.

Dryfhout, John, 1940-
Augustus Saint-Gaudens:the portrait reliefs,
the National Portrait Gallery,the Smithsonian
Institution.New York,Grossman Publishers,1969.
unpaged illus.

Intro.by Marvin S.Sadik
Cat.by John Dryfhout & Beverly Cox
Bibliography
Exh.Nov.13,1969-Jan.30,1970

LC NB237.S2D7

705
C75
NCFA
v.62 | II.C.5 - CAMEOS & INTAGLIOS - GREAT BRITAIN -
.19th

Way, Herbert W.L.
Apsley Pellatt's glass cameos

In:Connoisseur
62:78-82 Feb,1922 illus.

Portraits:George IV,Louis XVIII,Prince Leopold
Princess Charlotte,Fred.William III,Shakespeare
Apsley Pellatt,1791-1863,Brit.glass manufac-
turer.His process:Crystallo ceramie

705
A56
NCFA
v.33 | II.C.5 - CAMEOS & INTAGLIOS - U.S. - 19th c.

Fresh reflections on American glass
IV.Cup plates with cameo incrustations

In:Antiques
33:82-3 Feb.,'38 illus.

Repro.incl.:Napoleon;Lafayette

AP
1
A51A64
Palmer, Arlene M.
NCFA American heroes in glass:The Bakewell sul-
v.11 phide portraits

II.C.5 - CAMEOS & INTAGLIOS - U.S. - 19th c.

In:Am.Art J.
11:4-26 Jan.,'79 illus.

Cameo-portraits embedded in glass

FOR COMPLETE ENTRY
SEE MAIN CARD

II.C.5 - COINS & MEDALS

Alvares Ossorio, Francisco
 Medallas de Benvenuto Cellini, Leon y Pompeyo,
Leoni y Jácome Trezzo, conservadas en el Museo
arqueologico nacional

In:Arch.esp.Arte
22:61-78 1949

 Incl:Alexander de Medicis,Francis I,Margaret
of Austria by Cellini,Charles V,Maximilian of Aus-
tria,Philip II,Titian,Michelangelo,Granvelle by
Leoni
LC N7.A68 Rep.,1948-49*7627

N
40.1
S13D7
NPG
Dryfhout, John, 1940-
 Augustus Saint-Gaudens:the portrait reliefs,
the National Portrait Gallery,the Smithsonian
Institution.New York,Grossman Publishers,1969.
unpaged illus.

II.C.5 - CARICATURE - U.S.

 Intro.by Marvin S.Sadik
Cat.by John Dryfhout & Beverly Cox
Bibliography
Exh.Nov.13,1969-Jan.30,1970

LC NB237.S2D7

II.C.5 - COINS & MEDALS

Babelon, Jean, 1889-
 Les monnaies racontent l'histoire..Paris,
Fayard.1963.
 211 p. illus. (Résurrection du passé)

LC CJ75.B3 Richter,O. Portrs.of the
 Greeks N7586R53,v.3,p.293

II.C.5 - CHILDREN

George, Waldemar
 L'enfant dans la sculpture et le mythe de
l'innocence

In:Formes et couleurs
8:83-90 no.4-5 1946 illus.

 Egyptian,classical, medieval,renaissance and
20th c.approach

 Incl.:Houdon,Ligier-Richier,Donatello,Deside-
derio,Despiau,etc.
LC N2F65 Rep.,1945-47*868

II.C.5 - COINS & MEDALS

Babelon, Jean, 1889-
 Portraits en médaille:introduction de Jean
Babelon,photos de Jean Roubier.Paris, Alpina,1946
.4.p. 40 plates (Encyclopédie Alpina.13.

IU Winterthur Mus.Libr.fZ881
 W78 NCFA v.6,p.219

AP
1
N277
NCFA
v.15
Weinman, Robert A.
 Children in sculpture

II.C.5 - CHILDREN - U.S. - 20th c.

In:Nat Sculp R
15:18-21 Spring,'66 illus.

II.C.5 - COINS & MEDALS

Blank, M.
 Der medailleur Leonard Posch und seine
Goethebildnisse

In:Blätter f.Münzfreunde & -forschung,Lübeck
:213-7 1941

 Rep.,1945-47*8299

II.C.5 - COINS & MEDALS
 incl. Seals

II.C.5 - COINS & MEDALS

Burchardus,provost of Ursperg, d.1230
 Chronicum Abbatis Vrspergensis...Strassburg,
.Crafft.Mylivm,1537
 506 p. illus.

 Woodcuts after medals

NN NJP CBmH NIC Rave.Jb.d.Berl.Mus.I 1959
 LC N3.J16 fol. p.130
 Paolo Giovio & d.bildnisvitenbücher...

II.C.5 - COINS & MEDALS

Evelyn, John, 1620-1706
Numismata. A discourse of medals ancient and modern. Together with some account of heads and effigies of illustrious and famous persons, in sculps, and taillodouce of whom we have no medals extant; and of the use to be derived from them. To which is added a digression concerning physiognomy... London, B. Tooke, 1697
342 p. illus.

LC CJ5536.E8 Winterthur Mus. Libr.
 fZ881.W78 NCFA v.9, p.779

II.C.5 - COINS & MEDALS

Johns Hopkins University. John Work Garrett
 Library
Medals relating to medicine... in the numismatic coll. of the Johns Hopkins Univ., a cat. by Sarah Elizabeth Freeman. Baltimore, Evergreen House Foundation, 1964
430 p. illus. (Evergreen House Foundation. Publication no.?)

Bibliography

LC CJ5793.M4J6 Wolstenholme. The Royal College of Physicians of London
 1977 N4b1 p.XII

II.C.5 - COINS & MEDALS

Forrer, Leonard
Biographical dictionary of medallists; coin, gem, and seal engravers... 500B.C.-1900. London, Spink & son, 1902-30
8 v. illus.

Bibliography, v.1

LC CJ5535.F7 Lederer. Portrs. in wax
 In: Conn. 705/C75, v.94, p.105

II.C.5 - COINS & MEDALS

Lange, Kurt
Charakterköpfe der weltgeschichte. Münzbildnisse aus 2 jahrtausenden. München, Piper, 1949.

52 p. illus.

LC N7580.L28 Rep., 1948-49*1010
Harvard univ. libr.

II.C.5 - COINS & MEDALS

Goltzius, Hubert, 1526-1583
Les images presqve de tovs les emperevrs, depvis C.Ivlivs Caesar ivsqves à Charles V et Ferdinavs son frère, povrtraites av vif, prinses des medailles anciennes... par Hvbert Gholts... 1557. Livre I
350 p. illus.
149 portrs. by Joos Gietleughen after drags. by Goltzius (see over)
Italian edition: LC fJ 036.351: early ex. of chiaroscuro pr
Latin edition: LC N7627.C6

NG CLU-C PPPM PU-Mu Amsterdam, Rijksmus. cat.
 Z5939A52, deel 1, p.134

II.C.5 - COINS & MEDALS

Panvinio, Onofrio, 1529-1568
Fasti et triumphi Romanorum a Romulo rege usque Carolum V. Caes. Venetiis, Jac. Strada, 1557

Woodcuts after medals

V & A

 Rave. Jb. d-Berl. Mus. I 1959
 LC N3.J16 fol. p.132
 Paolo Giovio & d. Bildnisvi-
 tenbücher...

705
C75
NCFA
v.99

II.C.5 - COINS & MEDALS

Grant, M.H.
Medals of queer men

In: Connoisseur
99:142-4 1937 illus.

Medallions of 18th & 19th c.

 Rep., 1937*362

II.C.5 - COINS & MEDALS

Paris. Bibliothèque Nationale
Expo. "Effigies & portraits". 25 siècles d'art monétaire. Bibl. Nat'l 24 mai-30 juin 1957 & Expo. internationale des médailleurs contemporains, Musée monétaire, 23 mai-30 sept. 1957
Paris, Imprimerie nationale, 1957.
83 p. illus.

FOOO
Arc
1675.75

 Bousek, Antický portrét.
 NB1296.B78 NPO Bibl. p.59

II.C.5 - COINS & MEDALS

Huttich, Johann, 1480?-1544
Imperatorum et Caesarum vitae.... Argentorati Vuolphgangus Caephalaeus excussit. 1534
2pts. in 1 v. illus.

(Argentoratum-Strassbourg, Caephalius-Koepfel 1st ed. 1525)
Woodcuts after medals, most of them by Hans Weiditz II
Contains portrs. of the Roman, Byz. & German emperors to Charles V & archd. Ferdinand, etc.

LC DG203.H8 1534 Rave. Jb. d. Berl. Mus. I 1959
 LC N3.J16 fol. p.128/9
 Paolo Giovio & d. Bildnisvitenbücher...

CJ
161
K54M66X
NPO

II.C.5 - COINS & MEDALS

Paris. Musée de la monnaie
La monnaie Miroir des Rois. Exh. 31 jan.-29 avr., 1978. Paris. L'imprimerie nationale, 1978
622 p. illus.

L'effigie des souverains dans les monnaies, les médailles et les sceaux
Preface by André Chastagnol. Intro. by Hélène Nicolet
Bibliographies
Coins & medals from Antiquity to 20th c., grouped in : Portrs.; Symbols; Events; (contains

II.C.5 - COINS & MEDALS

Roubier, Jean, 1896-
Dauernder als erz;das menschenbild auf
münsen und medaillen von der antike bis sur
renaissance...Text von Jean Babelon.Wien,
A.Schroll.1958.
38 p. illus.

FOGG
Arc
1348.60

Fogg,v.11,p.325

II.C.5 - COINS & MEDALS - ANTIQUITY

Balmuth, Miriam S.
Portraits and coins

In:Connoisseur
143:58-61 March,'59 illus.

A general look on the antique monetary por-
traits fr. the 4th c.B.C. to the reign of Justi-
nian I(551 A.D.)

II.C.5 - COINS & MEDALS

Roubier, Jean, 1896-
Great coins & medals. 167 photos. Text by
Jean Babelon...New York,Viking Press.1959.
37 p. illus.

LC NK6306.R598

Encyclopedia of world art
N31E56 REF.v.11,p.510
Portraiture,bibliography

NB
1296
B78
NPG

II.C.5 - COINS & MEDALS - ANTIQUITY

Bousek, Jan
Antický portrét.Katalog vystavy.Národ-
niho muzea v Prze,25.5-3.9,1972,vPraze,c.1972.
64 p. illus.

Bibliography

Greek & Roman portraits in Czechoslova-
kian collections.Sculpture & Coins & medals.

Summary in English,p.61-4

II.C.5 - COINS & MEDALS

Rouillé, Guillaume, 1518?-1589
...La première.-la seconde.partie du promptv-
aire des medalles des plus renommé en personnes
qui ont esté depuis le commencement du monde...
end with king Henry II.Lyon,G.Roville,1553
2v.in 1 illus.

Title:Promptvaire des medalles
For revision see Keller,Diethelm
Dedication v.2...signed:Charles Fontaine

Over 600 illus.by Georges Reverdy
LC CJ5569.R74
LC has also Italian ed.CJ556 .R7

II.C.5 - COINS & MEDALS - ANTIQUITY

Franck, Sebastian, 1499-1542
Germaniae Chronicon.Von des gantsen Teutsch-
lands.Frankfurt:Egenolff.1539

Woodcut portrs.after antique medals

LC DD87.F82
LC has also Augspurg ed., 1538 and others

N
7628
W31T8

II.C.5 - COINS & MEDALS

Tuckerman, Henry Theodore, 1813-1871
The character and portraits of Washington..
N.Y.,G.P.Putnam,1859
104 p. illus.

Cont.-Publisher's note.-The character of
Washington.-The portraits of Washington.-Appen-
dix:1.Trumbull's list.-2.Greenough's statue by
A.H.Everett.-3.The Washington coins.-4.Personal
appearance of Washington

LC E312.4T89

Weddell.A mem'l vol.of Va.
hist.portraiture.757.9.W3c
NCFA Bibl. p.439

II.C.5 - COINS & MEDALS - ANTIQUITY

Fulvio, Andrea, fl.1510-1543
Illvstrivm imagines...Romae,Jacopo Mazochio,
1517
illus.

202 portrs.Woodcuts by Ugo da Carpi or work-
shop after antique medals of Mazochio's coll.
"One of the oldest publications...with portrs
-Prinz
"this work became the example for numerous
portr.works".-Rath Prinz.Slg.d.selbstbildn.in d.
Uffisien N7618/P95 Bd.1,p.146
C N7585.F8 ote 43.Rave.In:Jb.d.Berl.m.
lso in: 1959 LC N3.J16 fol.p.128
ath.Portr.werke in Lex.d.ges.Buchwesens,III,p.39 NPGxerox

II.C.5 - COINS & MEDALS - ANTIQUITY

Babelon, Jean, 1889-
Le portrait dans l'antiquité d'après les mon-
naies, avec 308 reproductions de monnaies. Paris,
Payot,1950

202 p. illus.

LC N7580 B12
Rep.,1942-44.+683

II.C.5 - COINS & MEDALS - ANTIQUITY

Keller, Diethelm
Kunstliche und aigendtliche bildtnussen der
Römischen Keysern,ihrer Weybern und Kindern
auch anderer berümpten personen wie die auff
alten Pfennigen erfunden sind...auss dem Latin
jetz neüwlich vertheütst...Zürych,A.A.Gessner,
1558
703 p. illus.

717 woodcut portrs.
Revision of Rouillé.Promptvaire & Strada.
Epitome
Rave.Jb.d.Berl.Mus.I 1959
LC N3.J16 fol. p.132
LC CJ985.K29
Paolo Giovio & d.Bildnisvitenbü-
cher

II.C.5 - COINS & MEDALS - ANTIQUITY

Lange, Kurt
 Herrscherköpfe des altertums im münsbild
ihrer zeit. Berlin, Zürich, Atlantis-verlag. c.1938.
 161 p. illus.

 Bibliography

LC N7580.L3 Fogg, v.11, p.323

II.C.5 - COINS & MEDALS - ANTIQUITY - GREECE

Newell, Edward Theodore, 1886-1941
 Royal Greek portrait coins,...being
trated treatise on the portrait coins i
rious kingdoms, and containing historice
ces to their coinages, mints, and rulers.
W. Raymond, inc., 1937
 99 p. illus.

LC CJ351.M4 Balmuth. Portrs.&
NMAH 737.0938N54 In: Conn.143:61 M:

II.C.5 - COINS & MEDALS - ANTIQUITY

Regling, Kurt ‹Ludwig›, 1876-
 Die antike münze als kunstwerk...1.aufl.
Berlin, 1924 (Kunst und Kultur, v.5)

 148 p. illus.

 Bibliography

LC CJ265.R4 Pfuhl, E. Die anfänge der
 griech. bildniskunst

II.C.5 - COINS & MEDALES - ANTIQUITY - GREECE

Seltman, Charles Theodore, 1886-1957
 Greek coins; a history of metallic currency
and coinage down to the fall of the Hellenistic
kingdoms.. 2nd ed., London, Methuen. 1955.
 311 p. illus. (Methuen's handbooks of
archaeology)

 Bibliography, p.15-26

LC CJ335.S4 1955
NMAH 737.0938.S46 1954 Balmuth. Portrs.& coins
 In: Conn.143:61 Mar, '59

II.C.5 - COINS & MEDALS - ANTIQUITY

Strada, Jacobus de, à Rosberg, d.1588
 Epitome dv thresor des antiquites, c'est à
dire, pourtraits des vrayes medailles des empp.
tant d'Orient que d'Occident...Tr. par Iean Lou-
veau d'Orleans. Lyon, Par I.de Strada, et T. Cverin,
1553
 394 p. illus.
 For revision see Keller, Diethelm
 485 portr. woodcuts by B. Salomon after Strada
drags., made from antique medals in Strada's coll.
 Emperors fr. Caesar to Charles V

LC CJ4975.S8 Rave. Jb. d. Berl. Mus. I 1959
 LC N3.J16 fol. p.131 Paolo
Giovio & d.Bildnisvitenbücher...
Rath. Porträtwerke, p.39

II.C.5 - COINS & MEDALS - ANTIQUITY - ROME

Babelon, Ernest Charles François, 1854-1924
 Description historique et chronologique de
monnaies de la république romaine...Paris,
Rollin & Feuardent, 1885-86
 2 v. illus.

 Reprinted Bologna, 1963

LC CJ909.B2 Bieber. Developm't of por
 n Rom. Republ. coins. In: Tem
 porini. Aufstieg u. niederg
 p.871 LC DG209.T36, Bd.1, T.4, p.87

II.C.5 - COINS & MEDALS - ANTIQUITY

Vico, Enea, 1523-1567
 Augustarum Imagines...Venetiis. Paul Manuce?,
1558
 192 p. illus.

 55 engravings of Roman empresses after medal

 1st ed.1557

LC DC276.5.V5 Rave. Jb. d. Berl. Bus. I 1959
 LC N3.J16 fol. p.145
Paolo Giovio & d. Bildnisvitenbücher

II.C.5 - COINS & MEDALS - ANTIQUITY - ROME

Bieber, Margarete, 1879-
 The development of portraiture on Roman
Republican coins

VF In: Temporini, Hildegard. Aufstieg und niedergang
Portrs., der römischen welt.. Berlin, N.Y., Walter de Gruy-
Roman ter, 1973. Pt. I: Von den anfängen Roms bis sum aus-
 gang der republik, v.4 (in 2 parts, text & plates)
 p.871-896 (text), & p.207-215 (plates)

 Bibl. footnotes

LC DG209.T36 Temporini. Aufstieg und nie-
Bd.., T.4 dergang...LC DG209.T36

II.C.5 - COINS & MEDALS - ANTIQUITY

Zantani, Antonio
 Le Imagini e le vite de gli imperatori tratt
dalle medaglie e dalle historie de gli antichi.
Florence, Enea Vico, 1548

 From Caesar to Domitian, engravings after
medals

Oxford
Uni. Bod- Vico, the publisher was an engraver
leian
libr. has latin ed.

 Rave. Jb. d. Berl. Mus. I 1959
 LC N3.J16 fol. p.141-2
Paolo Giovio & d. Bildnisvitenbücher.

II.C.5 - COINS & MEDALS - ANTIQUITY (ROME)

Brilliant, Richard
 Gestures & rank in Roman art. The use of
gestures to denote status in Roman sculpture &
coinage. New Haven, The Academy, 1963
 238 p. illus. (Memoirs of the Conn. Acad. of
Arts & Sciences, v.14)

 Bibliography

LC NB115.B7

II.C.5 - COINS & MEDALS - ANTIQUITY - ROME

British Museum. Dept.of Coins and Medals
Coins of the Roman Empire in the British
Museum.London,Printed by order of the Trustees,
1923-
 v. illus.

 v.1 by Harold Mattingly

 Bibliography

LC CJ969.A4

II.C.5 - COINS & MEDALS - ANTIQUITY - ROME

Giacosa, Giorgio
 Women of the Caesars;their lives and por-
traits on coins.Milan,Edizioni arte e moneta,
c1977?
 164 p. illus(part col.)

Incl.descriptive index,incl.photographs at na-
tural size of each coin,obverse and reverse

 These coins are an achievement of an high
point in the history of portraiture.

MdBLN DAU CtY etc.

II.C.5 - COINS & MEDALS - ANTIQUITY - ROME

British Museum. Dept.of Coins and Medals
Coins of the Roman republic in the British
Museum,by H.A.Grueber...London,Printed by order
of the Trustees,1910
 3 v. illus.

LC CJ909.B7

Hiesinger.Portr. in the Rom.
Rep.Bibl.In:Temporini.Auf-
stieg u.niederg....LC DG209
T36,Bd.1,T.4,p.821

II.C.5 - COINS & MEDALS - ANTIQUITY - ROME

Heintze, Helga von
 Römische glyptik und münzprägekunst

In:Kraus,Theodor.Das römische weltreich.Propy-
läen Kunstgeschichte II.Berlin,...1967
 p.281-6 illus(part col.)

N
5760
K92
NCFA

LC N5760.K7

II.C.5 - COINS & MEDALS - ANTIQUITY - ROME

Cohen, Henry, 1808-1880
 Description historique des monnaies frap-
pées sous l'Empire romain.Paris,Rollin & Feu-
ardent,2nd ed.,1880-92
 8 v. illus.

 vols.3-8 cont.par Feuardent

LC CJ1987.C72

Bieber.Developm't of portr.
on Rom.Republ.coins.In:Tem-
porini.Aufstieg u.niederg...
LC DG209 T36 Bd.1,T.4,p.821

II.C.5 - COINS & MEDALS - ANTIQUITY - ROME

Hulsius, Levinus, d.1606
 XII Primorvm Caesarvm et LXIIII ipsorvm
vxorvm...ex antiquis numismatibus...collectae.
Sumptibus Pauli Brachfeldij,Francoforti ad Moe-
num,1597
 198 p. illus.

 Engr.after Vico by Theodor de Bry

 Vico's Le imagini of 1548 & 1557 combined

NN ICN CtY Lenox coll.

Rath,in:Lex.d.ges.buchwe-
sens,Bd.III,p.39
LC Z118.L67(NPG xerox copy

II.C.5 - COINS & MEDALS _ ANTIQUITY(ROME)

Delbrück, Richard, 1875-
 Die Münzbildnisse von Maximinus bis Carinus.
Berlin,Gebr.Mann,1940

 240 p. illus.

 (Das römische Herrscherbild,III,Abt.Bd.2)

LC CJ1005.D4

II.C.5 - COINS & MEDALS - ANTIQUITY - ROME

CJ
161
P65J46L
NPG

Jentoft-Nilsen, Marit, 1938-
 Ancient portraiture:the sculptor's art in
coins and marble.[loan exh.on display at the
Virginia Museum,Apr.29 to July 20,1980...
Richmond,Virginia Museum,c.1980
 64 p. illus.

 Most items from the coll.of Jeffrey H.
Miller and the Getty Museum
 Excellent introd.to the numismatic portrai-
ture in relation to work in marble.
Discussion of the development of portrs.by the
Romans
 Worldwide Art cat.B. v.17
 D.W527 UMAA p.60

II.C.5 - COINS & MEDALS - ANTIQUITY (ROME)

Franke, Peter Robert, 1926-
 Römische kaiserporträts im münzbild...
München,Hirmer.1961.
 55 p. illus(part col.)

FCOG Bibliography
1480.66

NN MoSW

Enc.of World Art v.11,p.511
Portraiture,bibl. N31E56Ref.

II.C.5 - COINS & MEDALS - ANTIQUITY - ROME

Sydenham, Edward Allen, 1873-1948
 The coinage of the Roman republic.Revised
with indexes by G.C.Haines...London,L.Spink,
1952
 343 p. illus.

FCOG
Arc1480
.19.10

Bieber.Developm't of port
on Rom.Republ.coins.In:Tem-
porini.Aufstieg u.niederg.
LC DG209.T36,Bd.1,T4, p.871

NR
1296.3
T69
1978 bX
NPG

II.C.5 - COINS & MEDALS - ANTIQUITY - ROME

Toynbee, Jocelyn M.C.
Roman historical portraits. London, Thames &
Hudson ltd.; Ithaca, Cornell Uni.Press, 1978
208 p. illus. (Aspects of Greek and
Roman life. General editor H.H.Scullard)

Bibliographical sources

II.C.5 - COINS & MEDALS - 16th c.

Arnold, Paul, fl.1967-
Medaillenbildnisse der Reformationszeit.
Berlin, Evang.Verl.Anst.(1967)
119 p. illus.

LC CJ5777.A7 Rep.1967 #1125

II.C.5 - COINS & MEDALS - ANTIQUITY - ROME

Vessberg, Olof, 1909-
Studien zur kunstgeschichte der römischen
republik. Lund, C.W.K.Gleerup, 1941
304 p. illus. (Svenska institutet i Rom.
Skrifter 8)

MET
617
V63

Bibliography
Based on.Diss.-Uppsala.1941.

LC DG12.S8 v.8,etc. Gasda.Etrusc.infl.in fune-
rary reliefs....In:Temporini
Aufstieg u.niedergang...
LC DG209.T36.Bd.1.T.4. p.855

II.C.5 - COINS & MEDALS - AUSTRIA

Domanig, Karl, 1851-1913 ed.
Porträtmedaillen des erzhauses Österreich
von Kaiser Friedrich III. bis Kaiser Franz II., aus
der medaillensammlung des allerhöchsten kaiser-
hauses. Wien, Gilhofer & Ranschburg, 1896
MET 40 p. illus. (Kunsthistorische sammlungen
140.92 des allerhöchsten kaiserhauses)
D71
Q

MH NBuG CaOTP TU MdBJ Amsterdam,Rijksmus.,cat.
Z5939A52,deel 2,p.683

II.C.5 - COINS & MEDALS - ANTIQUITY - ROME

Zehnacker, Hubert
Premier portraits réalistes sur les monnaies
de la république romaine

In:Rev.Numism.
6e ser.3:33-49 1961 illus.

Étude d'un groupe de portrs.monétaires qui se
place entre 62 et 46 av.J.-C.

LC CJ3.R6 Kiesinger.Portr.in the Ro-
man Rep. LC DG209.T36 Bd.1,
T 4, Bibl.,p.821
also Rep.1961 #4263

CJ
6092
J667
1979
MKAA

II.C.5 - COINS & MEDALS - EUROPE

Jones, Mark
The art of the medal.exh.May 17-Sept.9,
1979 held at.British museum.Text by.Mark
Jones.Brit.Mus.Publications,c.1979
192 p. illus(part col.)

CJ6092
J66X
1979
NMAH

Bibliography
Index
Repro.incl.:single portrs.;groups
Origin & develop'nt of the art of the me-
dal;a survey of European medals fr.13th-20th c
They are usually dedicated to the achievem'ts
of individuals Worldwide Art Cat.B. 705
#927,v.17,no.2,1981,p.22

9CJ
6201
G62
NPG

II.C.5 - COINS & MEDALS - RENAISSANCE

Goldscheider, Ludwig, 1896-
Unknown renaissance portraits. Medals of
famous men & women of the 15 & 16th c.
London, Phaidon, 1952
14 p. illus.

Bibliography

LC NK6305.G6

II.C.5 - COINS & MEDALS - FRANCE

Bie, Jacob de, 1581-
Les vrais portraits des rois de France,
...sceaux,médailles...(Down to Louis XIII).
Paris,chez Jean Camvsat,1636

MET
115.01 This is the 2nd ed.of the 2nd vol.of "La
B471 France métallique,etc."
Q

Brit.mus.
185.d10
LC N7604.B47=1st ed.1634
NN NN MH=2nd ed.1636 FOR COMPLETE ENTRY
SEE MAIN CARD

II.C.5 - COINS & MEDALS - RENAISSANCE

Hill, George Francis, 1867-
Medals of the Renaissance. Oxford, The Claren-
don Press, 1920

204 p. illus.

Bibliography

LC CJ5767.H5 Irving Lavin in Art Q,v.33
autumn 1970,footnote 1

II.C.5 - COINS & MEDALS - FRANCE

Gauthier, Maximilian
Le renouveau de la médaille française

In:Art et Industrie
:21-4 no.15,1949 illus.

Repro.:Henry IV by Briot,Louis XIII by Varin,
Louis XIV by Roussel,Louis XV by Duvivier,Napo-
leon by Andrieu & works by Rodin,etc.

LC NK2.A498 Rep.,1948-49#712

II.C.5 - COINS & MEDALS - FRANCE - 19th c.

David d'Angers, Pierre Jean, 1788-1856
 Les médaillons de David d'Angers, réunis et
publiés par son fils. Paris, Lahure, 1867
 11 p. illus.

 Preface signed Edmond About

 Incl. :portrait of Houdon

ICN KU
 v.9:170
 Réau. L'iconogr. de Houdon
 Gaz Beaux Arts ser.6 1933

II.C.5 - COINS & MEDALS - GERMANY - 16th c.

Habich, Georg, 1868-1932 ed.
 Die deutschen schaumünsen des 16.jahrhunderts
Teil I.Bd.1-2.München, F.Bruckmann A.-G., 1929-
34.
 2 v. in 4 illus.

7000
Arc
1508 H11
 "herausgeg.mit unterstützung der Bayr.akade-
mie der wissenschaften und der notgemeinschaft
der Deutschen wissenschaft im auftrag des Deut-
schen vereins für kunstwissenschaft."

FOR COMPLETE ENTRY
SEE MAIN CARD

N
40.1
D24P2
NCFA

II.C.5 - COINS & MEDALS - FRANCE - 19th c.

Paris. Musée de la monnaie
 David d'Angers,1788-1856.Hôtel de la mon-
naie,Paris,juin-sept.,1966.Cat.par François
Bergot.Préfaces par Pierre Dehaye et Pierre
Pradel.Paris,Hôtel de la monnaie,1966
 151 p. illus.

 Bibliography
 Repro.incl.:Ptgs.miniatures,daguerreotype,
caricatures,drags.,prints by D.'s contempora-
ries.Bronze statuettes,busts,medallions by
David d'Angers of poets,military,clergy,states-
men,artists
 List of sitters

NK
4335
R36w
NPG
2 ccps.

II.C.5 - COINS & MEDALS - GREAT BRITAIN

Reilly, ~~David~~ Robin
 Wedgwood portrait medallions. A catalogue.
London,Barrie & Jenkins,1973?.
 .48.p. illus(part col.)

 Review by H.L.Blackmore In:Connoisseur
185:314-6 Apr,'74

 Cat. of ca.100 medallions in Exhib.at
London,NPG, ~~ca.1973~~ Oct.3,1973-Jan.5,1974

LC NK4210.W4B42

N
40.1
D24S3
NPG

II.C.5 - COINS & MEDALS - FRANCE - 19th c.

Schazmann, Paul-Émile, 1902-
 David d'Angers,profils de l'Europe.Genève,
Ed.de Bonvent,c1973.
 136 p. illus.

 Bibliography

II.C.5 - COINS & MEDALS - GREAT BRITAIN

Reilly, ~~David~~ Robin and George Savage
 Wedgwood.The Portrait medallions.London,
Barrie & Jenkins,1973?.
 379 p. illus(part col.)

 Review by H.L.Blackmore In:Connoisseur
185:314-6 Apr,'74 illus.

 "Catalogue covering the whole subject of
Wedgwood relief portraiture,ancient & modern.."
 Refers to Josiah Wedgwood's cat.of 1773
which incl."Heads of Illustrious Moderns"
LC NK4210.W4R43

II.C.5 - COINS & MEDALS _ GERMANY

Bernhart, Max, 1883-
 Selbstbildnisse deutscher medailleure. Halle,
Riechmann,1938.
 .31 p. illus.

Rep.,1938#579

II.C.5 - COINS & MEDALS - GREAT BRITAIN - 15-16
 .th c.

Farquhar. Helen
 Portraiture of our Tudor monarchs on their
coins and medals.London,1908
 66 p. illus.

v.1.1

 Reprint from the Brit.Numismatic Journal IV

Brit.Num.Js..
LC CJ2470.B7

II.C.5 - COINS & MEDALS - GERMANY - 16th c.

Grotemeyer, Paul
 Da ich het die Gestalt;deutsche Bildnisme-
daillen des 16.Jahrhunderts. München,Prestel
c1957.
 56 p. illus. (Bibliothek des Germanischen
National Museums,Nürnberg,zur deutschen Kunst-
& Kulturgeschichte,Bd.7)
 Bilder aus deutscher Vergangenheit

LC NK6350.G7
 Enc.of World Art v.11
 N31E56Ref.col.514
 bibl.on portr.

II.C.5 - COINS & MEDALS - GREAT BRITAIN - 16-17
 .th c.

Farquhar, Helen
 Nicholas Hilliard,"embosser of medals of
gold"..London,1908
 33 p. illus.

 Reprinted from the Numismatic Chronicle,
4th ser.,vol.8

Numism.Chron.
LC CJ2.N6
PP

705
C75
NCFA
v.112

II.C.5 - COINS & MEDALS - GREAT BRITAIN - 16-17c

Jones, E.Alfred
Some notes on Nicholas Hilliard,Miniaturist
and goldsmith,c.1547-1617

In:Connoisseur
112:3-6 Sept.'43 illus(part col.)

Repro.incl.:Queen Elizabeth,the'Pelican por-
trait'.Second Great Seal of England.Miniatures:
Self portr.Queen Elizabeth.A gentleman.Alice
Brandon,wife of N.H. The Armada jewel

II.C.5 - COINS & MEDALS - GREAT BRITAIN - 18th c

Farquhar, Helen
Some portrait-medals struck between 1745
and 1752 for Prince Charles Edward...London,
Harrison and sons,ltd.,1927
55 p. illus.

Reprinted from the Brit.numismatic Journal,
v.17,1923-24

(LC 2n65.?50)
CtY

AP
1
W225
NCFA
v.4

II.C.5 - COINS & MEDALS - GREAT BRITAIN - 17th c

Piper, David
The contemporary portraits of Oliver Crom-
well

In:Walpole Soc.
34:27-41 1952-1954 illus.

Repro.incl.:Rbt.Walker,van Dyck,Sam.Cooper,
Lely; the Great Seal by Ths.Simon,the Dunbar
medal by Ths.Simon,several medals by Ths.Simon,
death mask;engravings;funeral effigy.

705
C75
NCFA
v.61

II.C.5 - COINS & MEDALS - GREAT BRITAIN - 18th c.

Hodgson, Mrs.Willoughby
Old Wedgwood portrait medallions in the
coll.of Mr.David Davis,J.P.,L.C.C.

In:Connoisseur
61:201-9 Dec.,'21 illus.

Repr.incl.:Washington,Franklin,George I,
George III,George IV

705
C75
v.110
A

II.C.5 - COINS & MEDALS - GREAT BRITAIN - 17th c.

Rhode, Winslow
England's greatest medallists Abraham and
Thomas Simon

In:Connoisseur
110:34-8 Oct.,'42 illus.

N
40.1
T2107
1974
NPG

II.C.5 - COINS & MEDALS - GREAT BRITAIN - 18-
19th c

Gray, John Miller, 1850-1894
James and William Tassie...with a cat.of
their portrait medallions of modern personages.
London,The Holland Press,1974

Incl.:Index of other modellers of portrs...

FOR COMPLETE ENTRY
SEE MAIN CARD

II.C.5 - COINS & MEDALS - GREAT BRITAIN - 17th c.

Vertue, George, 1684-1756
Medals and other works of Thomas Simon;
engraved and described by George Vertue
1753 (and 1780)

South Kensington 1780
Brit.mus. 1753, 1st ed. Universal cat. of books

N
40.1
H514M2
NPG

II.C.5 - COINS & MEDALS - GREAT BRITAIN - SCOT-
LAND - 19th c.

Henning, John, 1771-1851
John Henning,1771-1851:"...a very ingenious
modeller.."text John Malden;photography Alexan-
der Wilson..Paisley,Renfrew District Council
Museum and Art Galleries Dept.,1977
139.p. illus(1 col.)

LC NK9582.H46A4 1977

II.C.5 - COINS & MEDALS - GREAT BRITAIN - 17-18
th c.

Farquhar, Helen
Portraiture of our Stuart monarchs on their
coins and medals.London,1917
8 pts.in 1 v. illus.

V & A Bibliography

Reprint from Brit.Numismatic Journal V-XI,
1909-15

Brit.Numis.J.
LC CJ2470.B7 Reynolds. Walpole Soc.
 34:18. Piper. " "
 34:38 Bibl.

II.C.5 - COINS & MEDALS - ITALY - RENAISSANCE

Armand, Alfred, 1805-1888
Les médailleurs italiens des quinzième et
seizième siècles...2.éd.,rev.,cor.et considé-
rablement augm...Paris,E.Plon et cie.,1883-87
3 v.

"Liste des ouvrages mentionnés à la suite
des descriptions des médailles comme contenant
des reproductions figurées de ces pièces":v.1
XVII-XVIII. Addition à la liste...v.3,1p.
Supplément...

LC CJ6201.A7 1883

II.C.5 - COINS & MEDALS - ITALY - RENAISSANCE

Bernareggi, Ernesto
 Monete d'oro con ritratto del Rinascimento
italiano,1450-1515. Milano,M.Ratto,1954
 200 p. illus.

FOGG Bibliography
Arc
1490.65F

LC Zn38 O9 Enc.of Worl Art,v.11
 N31E56 Ref.col.513
 biblon portr.

II.C.5 - COINS & MEDALS - ITALY - RENAISSANCE

Hill, George Francis, 1867-
 A corpus of Italian medals of the Renaissance
before Cellini. London,British museum...,1930

 2 v. illus.(202 pl.)

 Bibliography

LC NK6352.H45 Lipman.The Florentine pro-
 file portr...

II.C.5 - COINS & MEDALS - ITALY - RENAISSANCE

Friedländer, Julius, 1813-1884
 Die italienischen schaumünsen des 15.jahrh.
(1430-1530)...Berlin,Weidmann,1882
 223 p. illus.(42pl.)

LC CJ6201.F8 Hill.Burl.Mag.13:274 note 1

705
B97
NCFA II.C.5 - COINS & MEDALS - ITALY - RENAISSANCE

 Hill, George Francis, 1867-1948
 Notes on Italian medals

 In:Burl Mag
 9:408-12 Sept.,'06 illus.
 10:384,387 March,'07 "
 12:141-50 Dec.,'07 "
 13:274-86 Aug.,'08 "
 14:210,215-7 Jan.,'09 "
 15:31-2,35 Apr.,'09 "
 94,97-8 May,'09 " Wax models
 16:24-6,31 Oct.,'09 " Frauds of 16-17th c.

II.C.5 - COINS & MEDALS - ITALY - RENAISSANCE

Habich, Georg, 1868-1932
 Die medaillen der italienischen renaissance.
Stuttgart & Berlin,Deutsche Verlags-Anstalt
,1924,
 100 pl & other illus.

FOGG
Arc
1670.57 F

 Middeldorf.portrs.by Fr.da
 Sangallo.In:Art Q 1:136
 note 4

737
H64 II.C.5 - COINS & MEDALS- ITALY - RENAISSANCE

 Hill, George Francis, 1867-
 Portrait medals of Italian artists of the
 renaissance...London,P.L.Warner.,.,1912
 92 p. illus (part col.)

LC NK6352.H5

II.C.5 - COINS & MEDALS - RENAISSANCE

Heiss, Aloÿss, 1820-
 Les médailleurs de la renaissance.Paris,J.
Rothschild,1881-1892
 9 v. illus.

LC CJ2921.H5 Middeldorf.Portrs.by Fr.da
MdBWA MH MM MJP MB Sangallo.In:Art Q 1:136
 note 6

II.C.5 - COINS & MEDALS - ITALY - RENAISSANCE-18th c.

Panvini Rosati, Franco
 Medaglie e placchette italiane dal Rinasci-
mento al 18 secolo. Roma,DeLuca,1968

 72 p. illus.

 Bibliography

LC CJ6201.P36 1968

705
B97
NCFA II.C.5 - COINS & MEDALS - ITALY - RENAISSANCE
v.18
 Hill, George Francis, 1867-1948
 Classical influence on the Italian medal

 In:Burl.Mag.
 18:259-68 Feb.,'10 illus.

 Moller.Physiognomical the-
 ory...N2161 1961 p.53
 footnote

CJ
5805
F16 II.C.5 - COINS & MEDALS - U.S.
NPG
 Failor, Kenneth M.
 Medals of the United States;by K.M.Failor
 and Eleonora Hayden.Washington;For sale by the
 Supt.of Docs.,U.S.Govt.Print Off.,1969.
 274 p. illus.

 First printed Aug.,1969,revised 1972
 Incl.History of the U.S.presidential medals
 series,by Francis Paul Prucha,S.J.,p.285-8,
 The medallic sketches of Augustin Dupré in
 American collections,by Carl Zigrosser,p.289-
 304.
LC CJ5805.F3

N
7628
W31B16
1565
NPG

II.C.5 - COINS & MEDALS- U.S.

Baker, William Spohn, 1824-1897
Medallic portraits of Washington,with...a
descriptive catalogue of the coins,medals,tokens,
and cards.Philadelphia,R.M.Lindsay,1885
252 p. illus.

Reprint,Iola,Wisc.Krause Publ.,1965

FOR COMPLETE ENTRY
SEE MAIN CARD

Whitehill.The Arts in ear-
ly Amer.Hist.:Z5935.W59 NPG
LC E312.43H164 Bibl.,p.99

AP
1
A5152
NCFA

II.C.5 - COINS & MEDALS -U.S.

Viola, Herman J.
Portraits,presents,and peace medals:Thomas
L.McKenney and the Indian visitors to Washing-
ton

In:Am.Scene
11,no.2 June,1970 illus(part col.)

Incl.documentation of portrs.by Chs.Bird
King in the Ths.Gilcrease Inst.of Am.Hist.& Art
Tulsa,Okla.

Viola.Ind.legacy...N40.1
K52V7 Bibl.

NPG
Ref.
coll.

II.C.5 - COINS & MEDALS - U.S.

National Portrait Gallery, Washington, D.C.
The president's medal,1789-1977,by Neil
MacNeil. N.Y.,Clarkson N.Potter,Inc. In asso-
ciation with the NPG,Smithsonian Inst.,1977
160 p. illus.

Intro.by Marvin S.Sadik

Exh.Jan.15-Sept.5,1977

LC CJ5802.2.W37M3 1977

AP
1
S66
NPG
v.3

II.C.5 - COINS & MEDALS - U.S.

Viola, Herman J.
Washington's first museum:The Indian off.
collection of Ths.L.McKenney

In:Smiths.Jl.of Hist.
3,no.3:1-18 Fall 1968 illus.

p.10-14:The gallery of 130 portrs.of In-
dian dignitaries by Athanasius Ford and Chs.
B.King, some after sketches by J.O.Lewis

Viola.The Ind.legacy...P
N40.1K52V7 NPG

CJ
5807
N53
NPG

II.C.5 - COINS & MEDALS - U.S.

New York University. Hall of Fame
America's most distinguished series of medals
honoring our nation's immortals..New York,1966.
1 v. illus.

N
7628
F8J08
NPG

II.C.5 - COINS & MEDALS - U.S. - 18th c.

Grolier club, New York
Cat.of an exh.commemorating the 200th anni-
versary of the birth of Benjamin Franklin...
January,1906.N.Y.,De Vinne press,1906.
100 p.

458 numbers:1-291 portrs.;292-303 medals;..
375-421 ceramic portrs.;422-443 paintings,etc..

LC Z8313.G85 Levis.Descr.bibl.Z5947.3
L66 1974 NCFA p.385

CJ
5805
P47
1587
NPG

II.C.5 - COINS & MEDALS - U.S.

Pessolano-Filos, Francis, 1900-
Medals of the presidents,secretaries of the
treasury and directors of the U.S.mint,1789-1981.
Edited by Armando de Trevera.1st ed. N.Y.,Eros
Publ.Cy.,1587
1 v. illus.

Incl.all presidents till Ford.

Bibliography

CJ
5805
L89
1967
NPG

II.C.5 - COINS & MEDALS - U.S. - 18th-19th c.

Loubat, Joseph Florimond, duc de, 1831-1927
The medallic history of the U.S.of America,
1776-1876...New Milford,Conn.,N.Flayderman,1967.

FOR COMPLETE ENTRY
SEE MAIN CARD

CJ
5807
P97
NPG

II.C.5 - COINS & MEDALS - U.S.

Prucha, Francis Paul
Indian peace medals in American history.
Madison,State Historical Society of Wisconsin,
1971
186 p. illus.

Bibliography:p.165-72
Repro.incl.:Geo.III;Chs.IV;'Presidential
series';Ptgs.by Catlin & by Samuel F.Brookes &
draws.by St.-Mémin & photographs of Indians
wearing the medals.

N
7628
W31R2
NPG

II.C.5 - COINS & MEDALS - U.S. - 18-19th c.

Raymond, Wayte, 1886-1956 comp.
...The early medals of Washington...N.Y.,
c.1941.
16 p. illus. (The coin collector series
no.4)
On cover:1776-1834

Bibliography

LC E312.43.R3

II.C.5 - COINS & MEDALS - U.S. - 19th c.

Douglas, Susan Harvey
George Washington medals of 1889

In:Numismatist
62:274-83,344-50,395-409 May,July,1949

LC CJ1.N8 FOR COMPLETE ENTRY
 SEE MAIN CARD

CJ
5813
J84x II.C.5 - COINS & MEDALS - U.S. - 19th c.
NPG
 Julian, R.W.
 Medals of the U.S.Mint.The first century,
 1792-1892.The Token & Medal Soc.,Inc.,1977
 424 p. illus.

 'Index of Medals'contains list of individ-
 al sitters

II.C.5 - EQUESTRIAN ·

Friis, Hjalmar
 Rijterstatuens historie i Europa fra old-
tiden indtil Thorwaldsen. København, 1933

 556 p. illus.

Review by Thorlacius-Ussing,V., In:Tilskueren
:361-84 1933(pt.1) illus.

LC NB1293.F7
Tilskueren in LC AP42.T5 Rep.,1933#156

II.C.5 - EQUESTRIAN

Grossmann, Otto
 Das reiterbild in malerei und plastik.Berlin
Lankwits,Würfel Verlag,1931
 136 p. illus.

 Bibliography

AET
115.7
C91

IaU CSt CU ICU Eller,Povl.Kongel.port.ma-
 lere,p.511

II.C.5 - EQUESTRIAN - GREAT BRITAIN

Gleichen, Lord Edward, 1863-1937
 London's open-air statuary.London,N.Y.,.etc.
Longmans,Green and Co.,ltd.,1928
 258 p. illus.

 Bibliography

 IndexI:Statues & monuments;II:Sculptors,ar-
chitects,designers,writers,donors,etc.

 Repro.incl.portr.statuary 17-20th c.(see
next card)

LC NB470.05

NK
4087
B19 II.C.5 - EQUESTRIAN - GREAT BRITAIN - 19th c.
1960
NPG Ralston, Thomas
 Staffordshire portrait figures of the Vic-
 torian age.Newton,Mass,C.T.Branford,.1960,
 c.1958.
 93 p. illus(part col.)

 The cat.is divided in chapters:Royal family;
 Statesmen;Naval & military;Religious;Authors;
 Stage;Sport;Crime;Miscellaneous

LC NK4087.S6B3 (London,Faber Winterthur Mus.Libr.fZ881
& Faber,.1958.) .W78 NCFA v.6,p.220

705.
S94 II.C.5 - FIGUREHEADS
NCFA
 Gould, Mr.& Mrs. G.Glen
 The Nadelman ship figureheads

 In:Studio
 94:51-3 Sept.,'29 illus.

 N.Y.,MOMA 709.73.N5 NCFA
 bibl.p.51

II.C.5 - FIGUREHEADS

Major, Alan P.
 Maritime antiques.An illustrated dictionary.
N.Y.& San Diego,The Tantivy Press,ltd.,1981

 Incl.Figurehead,p.83-89
 p.83..Pharaoh.was.used on the stemhead of an-
cient Egyptian vessels.p.86:Cromwell.had.a ship,
The Naseby,whose figurehead was a graven image
of.himself..The ship.Hancock of 1776,named after
John Hancock,President of Congress had a fig.of
that gentleman...The Prince Consort of 1862 had
a medallion portr.—' Albert.as figurehead.
LC V745.M34

N
40.1
P55M3 II.C.5 - FIGUREHEADS
NCFA
NPG Marceau, Henri, 1896-
 William Rush,1756-1833;the first native
 American sculptor...Cat.of an exh.held at the ,
 Pennsylvania Museum of Art,Philadelphia,1937
 85 p. illus.

 Complete list of R.'s works

LC NB237.R8M3 Morris.Art of healing

NK
806
L52 II.C.5 - FIGUREHEADS - U.S. - 18-19th c.
1974 t
NCFA Lipman,Mrs.Jean Herzberg, 1909-
 The flowering of American folk art,1776-
 1876.by.J.Lipman and Alice Winchester,N.Y.,
 Viking Press,.1974.
 288 p. illus(part col.) (a studio book)
 Bibliography p.284-7

 Portraits p.15-49,sculpture p.119-28,
 figureheads p.129-36

 Flint Inst.of Arts.Am.naive
 ptgs.ND210.5.P745 1981 (
 FIAAA bibl.p.92

II.C.5 - FIGUREHEADS - U.S. - 18-19th c.

Pinckney, Pauline A.
American figureheads and their carvers.
Port Washington,N.Y.,Kennikat Press,Inc. 1969
223 p. illus.

Bibliography

'...actual portrs.,either the bust or the
full-length fig.became customary decoration on
a ship's prow.'p.28
'...the ship carver.is.truly one of our best
sources of American folk art.'p.32

LC VM308.P5 1969

II.C.5 - FUNERARY - ANTIQUITY - ROME

Gazda, Elaine Kathryn
Style and technique in the funerary reliefs
of late Republican Rome..n.p.,1971
167 l. illus.

Doctoral Diss.Harvard,1971

MH

Gazda.Etrusc.infl.in the fu-
nerary reliefs...In:Tempori
ni.Aufstieg u.niedergang...
LC DG209.T36,Bd.1,T.4,p.&c

II.C.5 - FUNERARY

Lichtenberg, Reinhold von, 1865-
Das porträt an grabdenkmalen,seine entstehung
und entwicklung vom alterthum bis zur italieni-
schen renaissance. Strassburg,J.H.E.Heitz,1902
151 p. illus. (zur kunstgeschichte des
auslandes.Heft 11) (Intro.& 3 chapters:Habili-
tationsschrift,Karlsruhe,1900.)

Bibliogr.footnotes

LC NB1800.L55 Amsterdam,Rijksmus.Cat.
 Z5939A52,deel 1,NCFA,p.125

II.C.5 - FUNERARY - ANTIQUITY - ROME

Kleiner, Diane E.E.
Roman group portraiture,the funerary reliefs

LC NB1296.3.K55 1977 FOR COMPLETE ENTRY
 SEE MAIN CARD

II.C.5 - FUNERARY

Panofsky, Erwin, 1892-1968
Tomb sculpture, four lectures on its changing
aspects from ancient Egypt to Bernini. New York,
H.N.Abrams,1964.
319 p. illus.

Edited by H.W.Janson

Bibliography

LC NB1800.P3 Breckenridge.Likeness...
 N7580.B82 NPG bibl.notes

705.1
N52
NS 3 II.C.5 - FUNERARY - 14th c.
Jul'44
Jun'45 Forsyth, William H.
 A head from a royal effigy

 In:B.Metropolitan Mus.Art
 3:214-19 May,1945 Illus.

 Tomb effigies of Marie de France by Jean de
 Liége, Jeanne de France, Marie d'Espagne, Blanche
 de France, Jeanne d'Evreux

 Rep.,1945-7#5864

II.C.5 - FUNERARY - ANTIQUITY(GREECE)

Collignon, Maxime, 1849-1917
Les statues funéraires dans l'art grec...
Paris,E.Leroux,1911

404 p. illus.

LC NB94.C6 Schefold,Karl.D.bildnisse
 d.ant.dichter,redner und
 denker

N
5070
B5N59 II.C.5 - FUNERARY - EUROPE
NMAA
 Bilder von menschen in der kunst des Abend-
 landes.Jubiläumsausstellung der Preuss.
 Museen Berlin 1830-1980.Berlin,Mann,c.1980
 400 p. illus(part col.)

 Cat.of the exh.held May 7 to Sept.28,
 1980 in the Nationalgal.Berlin Staatl.Mus.
 (West Berlin)

 Part.contents:L.Giuliani.Individual & ideal.
 Antiquity.-H.-G.Severin.Portrs.betw.Antiquity
 & Middle Ages.-P.Bloch.Portrs.in the Middle
 Ages.Rulers'por' Sepulchral portrs.Donors.
 H.Bock.,R.Cross s.The portr.The autonomous
 (

II.C.5 - FUNERARY - ANTIQUITY - ROME

Gazda, Elaine K.
Etruscan influence in the funerary reliefs
of late Republican Rome:A study of Roman verna-
cular portraiture

VF In:Temporini,Hildegard.Aufstieg und niedergang
Portrs., der römischen welt...Berlin,N.Y.,Walter de Gruy
Roman ter,1973.Pt.I:Von den anfängen Roms bis zum aus
 gang der republik,v.4(in 2 parts,text & plates)
 p.189-205(plates),& p.855-870(text)

 Bibl.footnotes
LC DG209.T36 Temporini.Aufstieg und nie
Bd.1,T.4 dergang...LC DG209.T36

705
G28
?per II.C.5 - FUNERARY - FRANCE
v.36
NCFA Müntz, Eugène
 Les tombeaux des papes en France

 In:Gaz.Beaux Arts
 36:275-85 1887(pt.2) illus.
 :367-87 illus.

 Popes of the 11th - 14th c.

II.C.5 - FUNERARY - GREAT BRITAIN

Cotman, John Sell, 1782-1842
Engravings of sepulchral brasses in Norfolk
and Suffolk, tending to illustrate the ecclesias-
tical, military & civil costume ...with an intro-
ductory essay by Dawson Turner...2d ed....
London, H.G.Bohn, 1839
2 v. illus.in color

LC NB1842.C7 Amsterdam, Rijksmus., cat.
 Z5939A52, deel 1, p.152

705
A7832
NCFA

II.C.5 - FUNERARY - ITALY(16th c.)

Middeldorf, Ulrich
Römische porträtbüsten der gegenreformation;
August Grisebach, ed.

In:Art Bull
20:111-17 May,1938 illus.

16th c.busts on tombs in Rome

NK
928
C75
1968
NCFA

II.C.5 - FUNERARY - GREAT BRITAIN - 16-17th c.

Mercer, Eric
Sculpture

In:The Connoisseur's Complete Period Guides
p.101-3 illus.

Incl.chapters on portraiture on tombs during
Tudor period and begin.17th c.

AP
1
N277
NCFA
v.15

II.C.5 - HEADS - 20th c.

Bell, Enid, 1904-
Portrait heads in sculpture

In:Nat Sculp R
15:6,16-21 Fall,'66 illus.

FOR COMPLETE ENTRY
SEE MAIN CARD

AP
1
W225
NCFA
v.34

II.C.5 - FUNERARY - GREAT BRITAIN - 17th c.

Piper, David
The contemporary portraits of Oliver Crom-
well

In:Walpole Soc.
34:27-41 1952-1954 illus.

Repro.incl.:Rbt.Walker,van Dyck,Sam.Cooper,
Lely; the Great Seal by Ths.Simon, the Dunbar
medal by Ths.Simon,several medals by Ths.Simon,
death mask;engravings;funeral effigy.

731.75
.B46

II.C.5 - MASKS

Benkard, Ernst, 1883-
... Undying faces; a collection of death masks, with a note
by Georg Kolbe, translated from the German by Margaret
M. Green. New York, W. W. Norton & company, inc. [1929,
Lond., Leonard and Virginia Woolf at the Hogarth
... ... 43 p. illus. 24 cm. Press, 1929.
Printed in Great Britain.
"This book is a translation from the German second edition of Das
ewige antlitz."

1. Masks (Sculpture) i. Green, Margaret, Miana, 1899- tr.
ii. Title.
 30—6841
Library of Congress NB1310.B43 1929
 [48e]

NK
928
C75
1968
NCFA

II.C.5 - FUNERARY - GREAT BRITAIN - 17th c.

Whinney, Margaret Dickens
Sculpture

In:The Connoisseur's Complete Period Guides
p.353-7 illus.
Pertains to Stuart period
Repro.:Cure,Stone,Le Sueur,Bushnell,Marshall
Colt,Pierce,Gibbons,Cibber

NB
1310
H98
NPG

II.C.5 - MASKS

Hutton, Laurence,1843-1904
Portraits in plaster,from the collection of
Laurence Hutton. New York,Harper & brothers,1894
271 p. illus.

Masks;portraits

LC NB1310.H9

II.C.5 - FUNERARY - ITALY(16th c.)

Grisebach, August
Römische porträtbüsten der gegenreformation.
Leipzig,H.Keller,1936
176 p. illus. *)
16th c.busts on tombs in Rome.
Biographical outlines,art-historical notes

Review by Middeldorf In:Art Bull
20:111-17 1938 illus.

*) (Römische Forschungen der Bibliotheca Hertziana)
 v.XIII

LC N7606.G7 Rep.,1936#332

NK
650
43S713
NPG

II.C.5 - MASKS

Sorell, Walter, 1905-
The other face;the mask in the arts.Indi-
anapolis,Bobbs-Merrill,1973.
240 p. illus(part col.)

Bibliography

NB
1310
T68
NPG

II.C.5 - MASKS

Toronto. Royal Ontario Museum. Art and Archae-
ology Division
Masks,the many faces of man.An exh...,Feb.17
to April 5,1959.Toronto.1959.
79 p. illus.

LC NB1310.T6

II.C.5 - MASKS - POLAND

Berlewi, Henryk
Portraits et masques. Anvers,De Sikkel,.1937.
illus.

Preface de Jules Destrée

Rep.,1938,#570

AP
1
W225
NCFA
v.34

II.C.5 - MASKS - GREAT BRITAIN - 17th c.

Piper, David
The contemporary portraits of Oliver Crom-
well

In:Walpole Soc.
34:27-41 1952-1954 illus.

Repro.incl.:Rbt.Walker,van Dyck,Sam.Cooper,
Lely; the Great Seal by Ths.Simon,the "unbar
medal by Ths.Simon,several medals by Ths.Simon,
death mask;engravings;funeral effigy.

N
40.1
B878B4
NCFA

II.C.5 - MASKS - U.S. - 19th c.

Bennett, James O'Donnell, 1870-
The mask of fame;the heritage of historical
life masks made by John Browere,1825 to 1833
.by...and Everett L.Millard. .Highland Park,Ill..
The Elm press.c.1938.
29 p. illus.

LC NB237.B7B4

II.C.5 - MASKS - ITALY - RENAISSANCE

Pohl, Joseph, 1914-
...Die verwendung des naturabgusses in der
italienischen porträtplastik der renaissance.
Würzburg,Triltsch,1938
68 p.
Bibliogr.footnotes

FOGG
FA5098.11

Inaug.-Dissertation - Bonn

Portr.bust.Renaiss.to En-
lightenment.NB1309.P6x NP
Bibl.

73N
A887
N B
287
B7F6x
NPG

II.C.5 - MASKS - U.S. - 19th c.

Browere, John Henri Isaac, 1792-1834
Life masks of noted Americans of 1825...
exhib.,Feb.12-24,1940 under the sponsorship of
the New York state historical association,Coo-
perstown,New York.N.Y.,M.Knoedler and cy..1940.
6 p. illus.

Foreword signed:Dixon Ryan Fox

LC NP237.B7F6

Kimball.Life portrs.of Jef-
ferson.N7628.J45X4,p.53?
NPG NCFA

P
1239.3
M4M4BX
NPG

II.C.5 - MASKS - MEXICO

Mexican masks..Essay by Donal Cordry.Fort Worth
Amon Carter Museum of Western Art,c.1973,
32 p. illus.

Cat.of an exh.from the collection of Mr.
and Mrs.Donald Cordry,presented at Witte Memo-
rial Museum,San Antonio,Jan.6-Mar.3,1974,and
other museums.

705
A56
NCFA
v.110

II.C.5 - MASKS - U.S. - 19th c.

Demer, John H.
The portrait busts of John H.I.Browere

In:Antiques
110:111-7 July,'76 illus.

"B.spent more than $12000.-attempt'g.with-
out success to establish a Nat'l Gall.of Busts
and Statues."-Demer

Incl.H.Clay;Ths.Jefferson,Js.Madison;Dolley
Madison;J.Adams;Lafayette;M.van Buren;J.Q.Adams.
Checklist of B.'s sculptures

II.C.5 - MASKS - NEW GUINEA

Strathern, Andrew
Man as art.New Guinea.Photographs by Mal-
colm Kirk.N.Y.,The Viking Press,1981
144 p. illus(part col.) A Studio Book

Portrs.of warriors,ceremonial masks& carved
masks

LC GN671.N5K57 1981

NB
1310
H32
NPG

II.C.5 - MASKS - U.S. - 19th c,

Hart, Charles Henry, 1847-1918
Browere's life masks of great Americans, ...
.New York.Printed at the De Vinne press for
Doubleday and McClure company,1899
123 p. illus.

LC NB1310.H3

705
A784
NCFA
v.38

II.C.5 - MASKS - U.S. - 19th c.

Millard, Everett Lee
The Browere life masks

In:Art in Am.
38:69,71,74,76,78,80 Apr.,'50 illus.

Busts in N.Y.State hist.assoc'n's "Hall of
Life Masks"in Fanimore hse.,Cooperstown,N.Y.

This article is drawn fr.Millard's ms of a
life of J.H.I.Browere
Arts in America q25961.U5
A77X NCFA Ref. I72

VF
Galt

II.C.5 - PROFESSIONS - JURISTS - U.S.

O'Neal, William P.ainter.
Chiselled lyrics(Alexander Galt,jr.,sculp-
tor)

In:Arts in Va.
7,no.1:4-19 Fall,1966 illus.

Winterthur Mus.Libr.
Z881.W78 NCFA v.6,p.224

E98
M3K53
NPG

II.C.5 - MASKS - U.S. - N.W.COAST

King, Jonathan C.H.
Portrait masks from the Northwest coast of
America.N.Y.,Thames & Hudson,1979

FOR COMPLETE ENTRY
SEE MAIN CARD

NK
3712
S93E83a
NPG

II.C.5 - PROFESSIONS - MARINE - U.S.

American heroes portrayed in ceramics;from the
17th throuth the 20th century.Everson Mus.
of Art of Syracuse and Onondaga County,
Syracuse,N.Y.,9 April - 6 June 1976,cat.,
s.l.,Visual Artis Publication,c1976,
24 p. chiefly illus.

Organized by M.Jessica Howe with assis-
tance of Jan Tropea

Bibliography

708.1
N52
NCFA
v.35-36

II.C.5 - MINIATURES

Remington, Preston
Miniature portraits in wax:a recent gift

In:Bull.of Met mus.
35:54-6 Mar,1940 illus.

Incl:Samuel Percy, Joachim Smith(?)

NK
3712
S93E83a
NPG

II.C.5 - PROFESSIONS - MILITARY - U.S.

American heroes portrayed in ceramics;from the
17th throuth the 20th century.Everson Mus.
of Art of Syracuse and Onondaga County,
Syracuse,N.Y.,9 April - 6 June 1976,cat.,
s.l.,Visual Artis Publication,c1976,
24 p. chiefly illus.

Organized by M.Jessica Howe with assis-
tance of Jan Tropea

Bibliography

NK
4087
B19
1960
NPG

II.C.5 - PROFESSIONS

Balston, Thomas
Staffordshire portrait figures of the Vic-
torian age.Newton,Mass,C.T.Branford,c1960,
c.1958,
93 p. illus(part col.)

The cat.is divided in chapters:Royal family;
Statesmen;Naval & military;Religious;Authors;
Stage;Sport;Crime;Miscellaneous

LC NK4087.S6B3 (London,Faber Winterthur Mus.Libr.fZ881
& Faber,c1958.) .W78 NCFA v.6,p.220

NK
3712
S93E83a
NPG

II.C.5 - PROFESSIONS - STATESMEN - PRESIDENTS - U.S.

American heroes portrayed in ceramics;from the
17th throuth the 20th century.Everson Mus.
of Art of Syracuse and Onondaga County,
Syracuse,N.Y.,9 April - 6 June 1976,cat.,
s.l.,Visual Artis Publication,c1976,
24 p. chiefly illus.

Organized by M.Jessica Howe with assis-
tance of Jan Tropea

Bibliography

NB
25
N53
1962
NPG
2 c.

II.C.5 - PROFESSIONS

New York University. Hall of Fame
The Hall of Fame of Great Americans...
N.Y.,N.Y.Uni.Press,1962

Arranged in 14 categories by profession

FOR COMPLETE ENTRY
SEE MAIN CARD

VF
Galt

II.C.5 - PROFESSIONS - STATESMEN - U.S.

O'Neal, William P.ainter.
Chiselled lyrics(Alexander Galt,jr.,sculp-
tor)

In:Arts in Va.
7,no.1:4-19 Fall,1966 illus.

Winterthur Mus.Libr.
Z881.W78 NCFA v.6,p.224

II.C.5 - PROFESSIONS
see also
I.E - PROFESSIONS

II.C.5 - RELIEF - ANTIQUITY - ROME

Kleiner, Diane E.E.
Roman group portraiture,the funerary reliefs

LC NB1296.3.K55 1977

**FOR COMPLETE ENTRY
SEE MAIN CARD**

705
C75
NCFA
v.23

II.C.5 - RELIEF

Farrer, Edmund, 1848-1935
Lady de Gex's collection of reliefs in co-
loured wax

In:Connoisseur
23:225-32 Apr.,'09 illus.

FOR COMPLETE ENTRY
SEE MAIN CARD

N
40.1
S13D7
NPG

II.C.5 - RELIEF - U.S.

Dryfhout, John, 1940-
Augustus Saint-Gaudens:the portrait reliefs,
the National Portrait Gallery,the Smithsonian
Institution.New York,Grossman Publishers,1969.
unpaged illus.

Intro.by Marvin S.Sadik
Cat.by John Dryfhout & Beverly Cox
Bibliography
Exh.Nov.13,1969-Jan.30,1970

LC NB237.S2D7

II.C.5 - RELIEF - ANTIQUITY - ROME

Bonanno, Anthony
Portraits and other heads on Roman histori-
cal relief up to the age of Septimius Severus.
Oxford,Brit.Archaeological Reports,1976
227 p. illus. (BAR suppl.series;6)

Bibliography p.215-27

LC NB1296.B66 Art Books 1950-79 Z5937
 775 NCFA Ref. p.896

II.C.5 - SELF-PORTRAITS

Bernhart, Max, 1883-
Selbstbildnisse deutscher medailleurs. Halle,
Riechmann,1938
31 p. illus.

Rep.,1938#579

II.C.5 - RELIEF - ANTIQUITY - ROME

Gazda, Elaine K.
Etruscan influence in the funerary reliefs
of late Republican Rome:A study of Roman verna-
cular portraiture

VF
Pertrs.
Roman

In:Temporini,Hildegard.Aufstieg und niedergang
der römischen welt...Berlin,N.Y.,Walter de Gruy-
ter,1973.Pt.I:Von den anfängen Roms bis zum aus
gang der republik,v.4(in 2 parts,text & plates)
p.109-205(plates),& p.855-870(text)

Bibl.footnotes

LC DG209.T36 Temporini.Aufstieg und nie
Ed.1,T.4 dergang...LC IG209.T36

II.C.5 - STANDING FIGURES - GREAT BRITAIN

Gleichen, Lord Edward, 1863-1937
London's open-air statuary.London,N.Y.,.etc.
Longmans,Green and Co.,ltd.,1928
258 p. illus.

Bibliography

IndexI:Statues & monuments;II:Sculptors,ar-
chitects,designers,writers,donors,etc.

Repro.incl.portr.statuary 17-20th c.(see
next card)

NB470.05
C

II.C.5 - RELIEF - ANTIQUITY - ROME

Gazda, Elaine Kathryn
Style and technique in the funerary relief
of late Republican Rome..n.p.:1971.
167 l. illus.

Doctoral Diss.Harvard,1971

MH

Gazda.Etrusc.infl.in the f
funerary reliefs...In:Tempo
rini.Aufstieg u.niedergang.
p.55 LC DG209.T36 Pt.1 T.4

705
A5
NCFA
v.8

II.C.5 - STANDING FIGURES - GREAT BRITAIN -
 .17-19th c.

Hopkins, Walde
English portraiture in ceramics

In:Am.Coll.
8:8-9,20 Sept.'39 illus.

Repro.incl:2 busts of Washington & 2 stand-
ing figs.of Franklin

Winterthur Mus.Libr. fZ881
W78 NCFA v.6,p.220

NK
4087
B19
1960
NPG

II.C.5 - STANDING FIGURES - GREAT BRITAIN - 19th

Balston, Thomas
 Staffordshire portrait figures of the Vic-
torian age.Newton,Mass,C.T.Branford,.1960,
c.1958.
 93 p. illus(part col.)

 The cat.is divided in chapters:Royal family;
Statesmen;Naval & military;Religious;Authors;
Stage;Sport;Crime;Miscellaneous

LC NK4087.S6B3 (London,Faber Winterthur Mus.Libr.f2881
& Faber,1958.) .W78 NCFA v.6,p.220

AP
1
A51A64
NCFA
v.6

II.C.5 - STANDING FIGURES - U.S. - 19th c.

Crawford, John Stephens •
 The classical orator in 19th century Ameri
can sculpture

In:Am.Art J.
6:56-72 Nov.,'74 illus.

 Pt.3 examines the specific statues of the
rican orators & their relationship to antique
prototypes,p.61-72

 Am.Art J.,May'77,p.19

NK
3712
S93E83a
NPG

II.C.5 - TOBY JUGS

American heroes portrayed in ceramics;from the
 17th through the 20th century.Everson Mus.
 of Art of Syracuse and Onondaga County,
 Syracuse,N.Y.,9 April - 6 June 1976,cat.,
 ,s.l.,Visual Artis Publication,,1976,
 24 p. chiefly illus.

 Organized by M.Jessica Mowe with assis-
tance of Jan Tropea

 Bibliography

MET
143.02
An24

II.C.5 - TOBY JUGS

Andrade, Cyril
 Old English pottery,Astbury,Whieldon,Ralph
Wood;Cyril Andrade collection..London,n.d.
 .11.p. illus.(32 phot.on 29 pl.)

705
C75
NCFA
v.8

II.C.5 - TOBY JUGS

Calthrop, Dion Clayton
 The Toby jug;an 18th century grotesque

In:Connoisseur
8:140-4 March,'04 illus.

II.C.5 - TOBY JUGS

Doulton and company,ltd.,Lambeth(Eng.)
 Character jugs and Toby jugs.Manchester,
195-?,
 20 p. illus. (Its Collectors book,3)

MET
143.02
D74

II.C.5 - TOBY JUGS

Eyles, Desmond
 "Good Sir Toby";the story of Toby jugs and
character jugs through the ages.London,Doulton,
1955
 108 p. illus(part col.)

 Bibliography

LC NK4087.S6E9

705
I 61
NCFA
v.75

II.C.5 - TOBY JUGS

Northend, Mary Harrod
 The jolly old toby

In:Studio
75:154-6 Apr.,'22 illus.

 'These queer little figs.often bore likenes-
ses of famous military & naval heroes...Staf-
fordshire potters also made likenesses of some
of the kings of England as of Geo.II & Geo.IV...
Collectors now prefer the portr.tobies.'

II.C.5 - TOBY JUGS

Price, Robert Kenrick
 Astbury,Whieldon,and Ralph Wood figures,
and Toby jugs,coll.by Captain R.K.Price...with
an intro.by Frank Falkner...London,John Lane,
1922
 140 p. illus(part col.)

 'Largest coll.of tobies in the world.'-North-
end in:The joly old toby

LC NK4087.S6P7

II.C.5 - TOBY JUGS

II.D. DECORATIVE ARTS, A-Z

 For list of DECORATIVE ARTS see
 "Guide to Classified Arrangement"

<table>
<tr><td>

705
A6
NCFA
v.47

II.D - CERAMICS

Tipping, Conrad H.
 A pottery memorial bowl

In:Apollo
47:41-3 Feb 1948 illus.

 Bowl with portrs. of Washington, Lafayette,
Franklin after Cochin; probably Liverpool of
c.1825. Washington after Peale (1795)

 Black-printed under glaze

 Rep.,1948-49*9750

</td><td>

II.D - CERAMICS - GREAT BRITAIN - 17th c.

 Little, Wilfred
 Royalty in English ceramics

 In:Connoisseur.Antique dealers' no.:76-9
 June,'53 illus.

 Repro.incl.:Dish with portr.of Chs.I.,
 Chs.II,William III.Busts of Js.II by John
 Dwight of Fulham and Georges II.

In:Conn.Souvenir of the Antique
dealers'fair & other exhibition Rep.1953 *1204
LC NK1125.A357

</td></tr>

<tr><td>

NK
3712
S93E83a
NPG

II.D. CERAMICS - 17-20th c.

American heroes portrayed in ceramics:from the
17th through the 20th century.Everson Mus.
of Art of Syracuse and Onondaga County,
Syracuse,N.Y.,9 April - 6 June 1976.cat..
.s.l.:Visual Artis Publication,.1976.
24 p. chiefly illus.

 Organized by M.Jessica Howe with assis-
tance of Jan Tropea

 Bibliography

</td><td>

705
A6
NCFA
v.57

II.D - CERAMICS - GREAT BRITAIN - 17th c.

 Tilley, Frank
 Some royal portraits on English pottery
 and porcelain

 In:Apollo
 57:192-7 June,'53 illus.

 Widely used since the 16th c. & especial-
 ly under William III.

 Repro.incl.:English Delft royal charger:
 Chs.I & 3 of his children,1653.Ths.Toft slip
 ware dish:Chs.?

 Rep.1953 *1205

</td></tr>

<tr><td>

705
A56
NCFA
v.26

II.D - CERAMICS - 18-19th c.

Jackson, Mrs.F.Nevill, 1861-
 Profiles on porcelain

In:Antiques
26:217-9 Dec.,'34 illus.

 Silhouettes on porcelain,most items in Mrs.
Jackson's collection

</td><td>

705
A56
NCFA
v.24

II.D - CERAMICS - GREAT BRITAIN - 18th c.

Donnell, Edna.Bowden, 1891-
 Portraits of eminent Americans after draw-
ings by Du Simitière

In:Antiques
24:17-21 July,1933 illus.

 Repro.incl:Washington on ceramics;enamel
cloak hooks;printed cotton with portr.medal-
lions derived fr. engravings after Du Simitière
 Incl.list of Prévost's,Reading's & B.B.
Ellis' engravings.

</td></tr>

<tr><td>

705
A63
NCFA
v.46

II.D - CERAMICS - GREAT BRITAIN

Dunsmuir, Richard
 Memorable mugs:commemorative subjects from
Charles II up to the Common Market

In:Antique collector
46:37-41 Aug.,'75 illus.

</td><td>

705
C75
NCFA
v.47

II.D - CERAMICS - GREAT BRITAIN - 18th c.

Hodgson, Mrs. Willoughby
 Shakespeare in pottery and porcelain

In:Connoisseur
47:3-7 Jan,'17 illus.

 Repro.incl.:Terra-cotta model of Roubiliac's
statue,1757;Statuette,earthenware,Staffordshire,
1800;Portr.in black transfer on Worcester mug,
c.1760;Medallion,Wedgwood Jasper,1780;Bust,
black basaltes;Bust col.earthenware,Stafford-
shire,by Enoch Wood:-Js.Quin as Falstaff,

</td></tr>

<tr><td>

705
A56
NCFA
v.20

II.D - CERAMICS - GREAT BRITAIN

Lee, Albert, 1868-1946
 Possibilities in ceramic portraiture

In:Antiques
20:274-9 Nov.,'31 illus.

</td><td>

F
24
A34
1987X
NMAA

II.D - CERAMICS, GREAT BRITAIN - 19th c.

Agreable situations:society,commerce and art
 in southern Maine,1780-1830;ed.by Laura
 Fecych Sprague;essays by Joyce Butler...
 .et al..Kennebunk,Me.Brick Store Mus.
 Boston:Distributed by Northeastern Univ.
 Press,1987
 289 p. illus(part col.)
 Incl.Brewster,jr.,deaf artist,p.88,122,254
 Cat.of selected objects from the Brick
 Store Mus.et al
 Index
 Bibliography

</td></tr>
</table>

II.D - CERAMICS - GREAT BRITAIN - 19th c.

M
7628.J4
C86X
NPG
2 c.

Cunningham, Noble E., 1926-
The image of Thomas Jefferson in the public
eye:portraits for the people,1800-1809....Char-
lottesville,Univ.Press of Va.,1981
185 p. illus.

Incl.index
Incl.:Engravings,medallions,Liverpool potter;
caricatures,silhouettes.One portr.on glass,en-
graved in gold(fg.59)
Appendix:Sources of the People's image:Bust,
ptgs.,drag.

705
C75
NCFA
v.61

II.D - CERAMICS - WEDGWOOD WARE

Hodgson, Mrs.Willoughby
Old Wedgwood portrait medallions in the
coll.of Mr.David Davis,J.P.,L.C.C.

In:Connoisseur
61:201-9 Dec.,'21 illus.

Repro.incl.:Washington,Franklin,George I,
George III,George IV

II.D - CERAMICS - U.S. - 18th c.

Grolier club, New York
Cat.of an exh.commemorating the 200th anni-
versary of the birth of Benjamin Franklin...
January,1906.N.Y.,De Vinne press,1906.
100 p.

458 numbers:1-291 portrs.;292-303 medals;..
375-421 ceramic portrs.;422-443 paintings,etc..

LC Z8313.085

Levis.Descr.bibl.Z5947.3
L66 1974 NCFA p.385

NK
4210
W4N38
1976X
NPG

II.D - CERAMICS - WEDGWOOD WARE

National Portrait Gallery, Washington, D.C.
Wedgwood portraits and the American Revolu-
tion...Washington.:National Portrait Gallery,
Smithsonian Institution,1976
134 p. illus.
Cat.of an exhibition,July 13-Oct.31,1976

Foreword by Marvin Sadik

Intro.by Bruce Tattersall

Bibliography

LC NK4210.W4N38 1976

AP
1
W78
v.7
NCFA

II.D - CERAMICS - U.S. - 19th c.

Mitchell, James
Ott & Brewer:Etruria in America

In:Winterthur Portfolio
7:217-28 illus.

Etruria Pottery,Trenton,N.J.,1863-1893,
established by Bloor,Ott & Booth.Later C.S.
Burroughs & John Hart Brewer became partners

Repr.incl.:Busts of U.S.Grant,Lincoln,all
Parian porcelain:Washington,bisque metallic
green porcelai; Pitcher with head of Wa-
shington.Ivory porcelain. All in N.J.State m

NK
4335
R36w
NPG
2 cops.

II.D - CERAMICS - WEDGWOOD WARE

Reilly, David Robin
Wedgwood portrait medallions. A catalogue.
London,Barrie & Jenkins.1973?.
.48.p. illus(part col.)

Review by H.L.Blackmore In:Connoisseur
185:314-6 Apr,'74

Cat. of ca.100 medallions in Exhib.at
London,NPG, ea.1973 Oct.3,1973-Jan.5,1974

LC NK4210.W4B42

NK
4335
B93
NPG

II.D - CERAMICS - WEDGWOOD WARE

Buten, David and Patricia Pelehach
Wedgwood and America.Wedgwood bas-relief
ware.Merion,Pa.,The Buten Mus.of Wedgwood,1977

II.D - CERAMICS - WEDGWOOD WARE

Reilly, David Robin and George Savage
Wedgwood.The Portrait medallions.London,
Barrie & Jenkins.1973?.
379 p. illus(part col.)

Review by H.L.Blackmore In:Connoisseur
185:314-6 Apr,'74 illus.

"Catalogue covering the whole subject of
Wedgwood relief portraiture,ancient & modern.."

LC NK4210.W4R43

705
A784
NCFA
v.4

II.D - CERAMICS - WEDGWOOD WARE

Halsey, Richard,T.ownley,H.aines, 1865-1942.
Ceramic Americana of the 18th century

In:Art in Am
4,Pt.1:85-98 Feb.,1916 illus.
Pt.2:224-32 June,1916 illus.
Pt.3:276-88 Aug.,1916 illus.
5,Pt.4:41-56 Dec.,1916 illus.
Repro.incl.:Chelsea porcelain statuettes:Wm.Pitt,
John Wilkes,Catharine Macaulay. Wedgwood medal-
lions of Franklin,Washington,Marie Antoinette,
etc.etc.

705
A56
NCFA
v.100

II.D - CERAMICS - WEDGWOOD WARE

Smith, Robert C.
Finial busts on 18th century Philadelphia
furniture

In:Antiques
100:900-905 Dec.,'71 illus.

Repro.incl.:B.Franklin;John Locke;John Milton;
Washington
'...study of all this furniture...could well
reveal ..resemblances linking it with the shop
of Benjamin Randolph.Saunders.Am.colonial portrs
N7593.1.S28,p.74,note 152

II.D - CERAMICS - WEDGWOOD WARE

705
C75
NCFA
v.98

Thomas, John
Wedgwood ceramic portraits

In:Connoisseur
98:29-35 July,'36 illus(part col.)

Repro.incl.:Jos.Wedgwood by Hackwood;Wm.Hershel by John Flaxman;Queen Charlotte by Flaxman;
Adam Smith by Js.Tassie;Lord Nelson by Devaere;
Linnaeus by Flaxman;Josh.Reynolds by Flaxman;
Is.Newton by Flaxman

II.D - FABRICS

705
A5
NCFA
v.16

Secon, Carolyn
A fine collection of historical textiles

In:Am Coll
16:12-15 Sept.,'47 illus.

Repro.incl.:Kerchief printed with equestrian
fig.of Wm.Henry Harrison,c.1840;Lincoln kerchief,
c.1864;silk kerchief broadside with portr.of Washington,Jefferson & Adams,French,c.1820;printed
yard-goods fabric with G.Stuart's portr.of Washington,early Federal period

II.D - FABRICS

Borland,Mrs.Belle(McCullough)
Philippe de Lasalle,his contribution to
the textile industry of Lyons...Chicago,Ill.,
The univ.of Chicago press.1936.
49 p. illus.

This essay is a rearrangement of the author's
thesis
Repro.incl.:woven portrs.of Philippe de
Lasalle,Catherine the Great
Re:Portrs.woven in silk see p.41-42,46

LC NK8949.B6 1936

II.D - NEEDLEWORK - GREAT BRITAIN - 17th c.

705
C75
NCFA
v.188

Mayorcas, J.D.
English stumpwork

In:Connoisseur
188:254-9 Apr.,'75 illus.

Bibl.footnotes
Repro.incl.:Charles I as a martyr,1649,a copy of the frontispiece of Eikon Basilike...the
Pourtraicture of his Sacred Majestie fr.an engr
by William Marshall
See also:Nevinson,Walpole Soc.28,Pl.VII

II.D.- FABRICS

705
A56
NCFA
v.24

Donnell, Edna Bowden, 1891-
Portraits of eminent Americans after drawings by Du Simitière

In:Antiques
24:17-21 July,1933 illus.

Repro.incl:Washington on ceramics;enamel
cloak hooks;printed cotton with portr.medallions derived fr.engravings after Du Simitière
Incl.list of Prévost's,Reading's & B.B.
Ellis' engravings.

II.D - NEEDLEWORK - GREAT BRITAIN - 17th c.

705
A786
NCFA
v.36

Property from estates

In:Art N
36:23 Sept.17,'38 1 illus.

Repro.:Stumpwork picture of James I & Anne
of Denmark

II.D - FABRICS

705
M18
NCFA
v.7

Early American engraved portraits.An exh.at
the N.Y.Public Library

In:Mag Art
7:452-7 Sept.,'16 illus.

Exh.May-Oct.15,1916.First public exh.of
early Amer.engr.portrs.in N.Y. Incl.the first
engr.published in the U.S.:Ths.Emmes' Increase
Mather,1701;Washington as central fg.in a Toile
de Jouy(Printed fabric)which also shows medallion portrs. of distinguished Americans

II.D - NEEDLEWORK - GREAT BRITAIN - 17th c.

705
C75
NCFA
v.17

Rae, Olive Milne
Needlework pictures

In:Connoisseur
17:199-203 March,'07 illus.

Repro.incl.:Charles I & Henrietta Maria,
stumpwork,17th c.;Charles II,stumpwork,17th c.

II.D - FABRICS

N
7592
F35X
NPG

Paris. Musée des arts décoratifs
La famille des portraits....Paris,1979

Ch.3.Le portrait-tissé,p.242-7

FOR COMPLETE ENTRY
SEE MAIN CARD

II.D - NEEDLEWORK - GREAT BRITAIN - 17th c.

708.1
R176
NCFA
v.16

Two needlework pictures in the museum,by M.A.B.

In:R I Sch Des Bull
16:16-8 Apr.,'28 illus.

Repro.incl.:Charles I & Henrietta Maria.
Stumpwork,17th c.

Description of stumpwork,p.15-6

705
C75
NCFA
v.75

II.D - NEEDLEWORK - GREAT BRITAIN - 17th c.

Ward, Frank
A fine group of needlework portraits

In:Connoisseur
75:39-40,43 May,'26 illus.

King Charles II,Queen Catherine of Braganza,
Duke of Buckingham,Earl of Rochester

II.E. PHOTOGRAPHY

705
A56
NCFA
v.119

II.D - NEEDLEWORK - U.S. - 19th c.

Deutsch, Davida Tenenbaum & Betty King
Homage to Washington in needlework and
prints

In:Antiques
119:402-17 Feb.,'81 illus(part col.)

Needlework after engravings:Washington Fami-
ly,W.'s resignation,W.crossing the Delaware...

Wick.Geo.Washington...
N7628.W3W5 NPG Bibl.p.173

II.E.1. GENERAL COLLECTIONS

746
A18
NCFA

II.D - TAPESTRY

Ackerman, Phyllis, 1893-
Tapestry,the mirror of civilization...N.Y.
...etc.:Oxford univ.press,1933
451 p. illus.

Bibliography

For development of woven portrs.fr.Egyptian
4-7th c.to 18th c.gobelins see p.19,21,214,215,
214,215,223,224,402. Pls.3,33,35
'In the 18th c.the Gobelins brought this

LC NK3000.A25

orland.Phil.de Lasalle

II.F.1

Allen, Mary
Portrait photography;how and why.London,
Focal press,1973.
290 p. illus.

LC TR575.A46

Cumulative book index 1974
The World list by author...
NPG p.1637

II.D. - TAPESTRY

Kauffmann, Hans
Ein selbstporträt Rogers van der Weyden
auf den Berner Trajansteppichen

In:Rep.Kunstwiss.
39:15-30 illus. 1916

MET
100.53
R29
P v.39

LC N3R4

Panofsky.Facies illae Ro-
geri..:"finest contribu-
tion to our literature"

II.F.1

Apropos;a series of art books,no.3,Portrait
painting.London,Pilot Press,ltd.;Lund
Humphries;Transatlantic Arts,Co..1945?.
illus.

Contents:Portr.paintg.and portr.photography,
by E.H.Gombrich.-Picasso's treatment of the
head,by Rbt.Melville.-To start a ball rolling,
by Peter Ustinov.-The portr.in the past & pre-
sent,by Osk.Kokoschka.-Intro.to the exh.of por-
traits at the Arcade gall.London,March 1945.-
Catalogue

LC N7445.A7

MOMA, v.11,p.431

Xerox copy II.D - TAPESTRY

NPG
in VF
Por-
trai-
ture

Panofsky, Erwin, 1892-
Facies illa Rogeri maximi pictoris

In:Late classical & medieval studies in honor of
A.M.Friend,jr.Edited by Kurt Weitzmann...Prince-
ton,N.J...1955 pp.392-400 illus.

One of the figs.in "Miracle of the Tongue"in
R.v.d.Weydon's tapestries "Examples of Justice"in
Bern considered to be self-portr.(Testimony of
Cardinal Nic.Cusanus)

LC N5975.W4

Encyclop.of World Art
bibl.Portrs. N31L56 Ref.

II.F.1

Arts Council of Great Britain
"From today painting is dead."The begin-
nings of photography.London.The Council.1972
60 p. illus.

MOMA
Photo
dept.
72 K66

Cat.of exh.16 March-14 May,1972,shown at
the V.& A.Mus.,London
Bibliography
Incl.Essay:Aspects of portr.photography,by
Tristram Powell,p.9-11;Chapter on Collecting
celebrities,p.41-6
Repr.incl.:Queen Victoria & Family see over

Pfister.Facing the light
TR680.P47X NPG Bibl.p.361
(Buckland,Gail)

II.E.1

Benjamin, Walter, 1892-1940
Kleine geschichte der fotografie

In his.:Das kunstwerk im zeitalter seiner tech..
nischen reprodusierbarkeit,drei studien zur
kunstsoziologie.Frankfurt am Main,Suhrkamp ver-
lag.1963. 160 p. (Edition Suhrkamp,28)
p.67-9%.

LC N72.86B4 1963 Die 20er jahre im portr.
 S868.5.E9Z97 NPG p.22

705
A784
NCFA
v.49

II.E.1

Coke, Van Deren, 1921-
 Camera and canvas

In:Art in Am.
49,no.3:68-73 1961 illus.
 Development of the influence of photogra-
phy on art as a profession.Quoted are the por-
traitists Ch.Harding, Rembrandt Peale,Ths.Sully,
Wm.Page,O.P./.Healy and Whistler
 Repros.show ptgs.& the photographs used for
them
 Rudisill.Mirror image
 RJ65.R916 NCFA,p.24?

II.E.1

Bomback, Edward S.
 Portrait manual,by E.S.Bomback & Arnold J.
Coppel.2nd ed. London,Fountain P.,1967
 238 p. illus.

 Photography

LC TR575.B58 1967

qN
72
P5C68
NCFA

II.E.1

Coke, Van Deren, 1921-
 The painter and the photograph from Dela-
croix to Warhol.2nd rev. & enl.ed..Albuquerque,
Uni.of New Mexico Press.1972.
 324 p. illus.

 Bibl.references

 "...a history,pictorial & verbal,of various
ways in which artists of many countries have
used photographs...in their works since the per-
fection of photography in 1837."
LC N72.P5C6 1972 MOM*.p.431, v.11

II.E.1

Bomback, Edward S.
 Portraits in colour.London,Fountain Press
.1962.
 94 p. illus(part col.) (Fountain photo-
book series)

LC TR575.B6 Books in print.Subject
 guide.Z1215.P92 v.2 NPG
 p.2960

II.E.1

Cornwall, James E.
 Die Frühzeit der photografie in Deutsch-
land,1839-1869,die männer der ersten stunden
und ihr verfahren.Herrsching/Ammersee,Verlag
für Wirtschaft u.Industrie,c.1979
 159 p. illus.

 Index
 Bibliography,p.148-153

 McCauley.Likenesses...
 qTR575.M12 NPG note 138

II.E.1

Bossert, Helmuth Theodor,1889- and Heinrich
 Guttmann
 Aus der frühzeit der photographie,1840-
1870;ein bildband nach 200 originalen.Frank,
furt a.M.,societäts-verlag,1930
 .15.p. illus.

 Bibliography

LC TR15.B6 Benjamin.Kleine geschich-
 te der fotographie,p.94

II.E.1

The Great themes.compiled.by the editors of
 Time-Life Books.(Series editor Rbt.G.
 Mason).N.Y.,.c.1970.
 246 p. chiefly illus(part col.) (Lif.
library of photography)

 Arranged in groups:...Portraits

 Bibliography

LC TR650.G73
 Arts in America qZ5961.U
 5A77X NCFA Ref. N69

TR
642
C33
1901X
NCFA

II.E.1

Caffin, Charles Henry, 1854-1918
 Photography as a fine art.N.Y.Amphoto
.1972,c.1901.
 191 p. illus. (An Amphoto facsimile bk.

 Ch.III:Mrs.Käsebier & the artistic-commer-
cial portrait

II.E.1

Croy, Otto R., 1902-
 ...Das farbige porträt...Harzburg,Heering ver-
lag,1942
 110 p. illus(col.)

 Photography

LC TR575.C69

II.E.1

Croy, Otto R., 1902-
 The photographic portrait...Philadelphia,
Chilton book co.,1968,
 245 p. illus(part col.)

German ed.1957

Incl.contributions of other portrait photo
graphers, p.241-2

Index of contributors

LC TR575.C713 Verzeichnis lieferbarer B
 cher 1973/74. NPG v.1,p.
 335

II.F.1

Freund, Gisèle
 La photographie en France au 19ième siècle
étude de sociologie et d'esthétique...Paris,
Le maison des amis des livres,A.Monnier,1936
 154 p. illus.

Thèse-Univ.de Paris

Bibliography

Disc.incl.the use of photography by portr.
ptrs. Scharf,A.Art & photography,
LC TR71.F7 1936 N72.P5S31 NCFA p.260(14)

II.E.1

Dührkoop, Rudolf
 Das kamera-bildnis und seine kulturelle
bedeutung.Berlin,1907
 24 p. illus.

..: NMC

TR
15
G25
NPG

II.E.1

Gassan, Arnold
 A chronology of photography;a critical sur-
vey of the history of photography as a medium
of art.Athens,Ohio,Handbook Co.,...1972,
 373 p. illus.

Incl.ch.on portrait,p.42-69.Chronology,p.
296-369
 From the beginning of photography through
1972
 Bibliography
LC TR15.G33

QN
40.1
E368A1
NPG

II.E.1

Eisenstaedt, Alfred, 1898-
 People.N.Y.Viking Press,1973,
 259 p. illus. (A studio book)

LC TR680.E33 1973 Cumulative book index
 Z1219.C97 NPG p.757

II.E.1

Gaudin,Marc Antoine, 1804-1880,
 Portraits instantanés avec grandissement

In:La Lumière
 March 30, 1862

NMAH DP NN McCauley.Likenesses qTR
 575.M12 NPG p.23 notes
 no.76

II.E.1

Essen. Museum Folkwang
 Menschen von gestern und heute.Photogra-
phische portraits...,Essen,1973,

FOGG
FA 10389
.465

MWiCA FOR COMPLETE ENTRY
 SEE MAIN CARD

II.F.1

Gaudin,Marc Antoine, 1804-1880,
 Sur le perfectionnement des portraits
photographiques

In:La Lumière
 Apr.,15,1863

NMAH DP NN McCauley.Likenesses qTR
 575.M12 NPG p.23 notes
 no.77

ND
210
F62
NCFA

II.E.1

Flexner, James Thomas, 1908-
 The decline of the portrait.In,his,That
wilder image:The painting of America's native
school fr.Ths.Cole to Winslow Homer,1st ed.,
Boston,Little,Brown,1962, Ch.11,p.205-20

 FOR COMPLETE ENTRY
 SEE MAIN CARD

TR
650
G37
1962
NCFA

II.F.1

Gernsheim, Helmut, 1913-
 Creative photography:Aesthetic trends,
1839-1960,1st American ed.,Boston,Boston Book &
Art Shop,1962,
 258 p. illus.

Ch.V:Immortal portrs.,p.60-8

Incl.:Short biographies of photographers

TR
15
G37
NPG
Ref.
II.E.1

Gernsheim, Helmut, 1913-
 The history of photography from the ear-
liest use of the camera obscura in the 11th
century up to 1914...London,N.Y.,Oxford Uni-
versity Press,1955
 395 p. illus.

 Bibliography. Bibliographical footnotes.

 Ch.10:The daguerreotype in Great Britain,
p.85-114

LC TR15.G37

II.E.1

Harrison, James
 On the artistic element in French photo-
graphic portraiture compared with English

In:Brit.J.of photography
 May 3, 1867

LC TR1.B8 McCauley.Likenesses qTR
 575.M12 NPG notes p.23
 no.89

II.E.1

Gombrich, Ernst Hans Josef, 1909-
 Portrait painting and portrait photography
 28 p.

In:Paul Wengraf,ed.Apropos portrait ptg.London,
1945 (Apropos;a series of art
books)

LC N7445.A7 CC1MA Gombrich.Mask & face.In Art
 percept'n & reality
 N71/G64X NCFA p.2 footnote

TR
575
H33
NCFA
II.E.1

Hartmann, Sadakichi, 1867-1944
 Composition in portraiture...N.Y.,Edw.L.
 Wilson,1909

II.E.1

Les grands peintres;a series.Geneva,R.Kister,
 1956-
 v. illus.

 Some publ.in English with series title
'Great painters'

 Each booklet on individual artist,e.g.
 Villon,Atlan,Segonzac,Picasso,Rouault,Léger;
 text by Bernard Dorival,André Verdet,Michel
NPG has Ragon.Photogr.of artist by Roger Hauert,Rbt.
Villon Doisneau,Gilles Ehrmann
N40.1.V75D6
LC see ed.1953-7,1958-62 MOMA, v.11,p.436
 Dorival,Ragon,Ver

II.E.1

Henkels, firm,auctioneers, Philadelphia
 Cat.of rare & choice engravings;incl.an ex-
traordinary coll.of portraits of Washington &
other notable Americans & of European celebri-
ties,a coll.of Napoleoniana & misc.engravings
to be sold Nov.24 & 25,1896 at the rooms of
Thos.Birch's Sons,Phila.,Pa....1896
 52 p. illus.

 940 engravings,18 photographs (no.768)
 (For more locations of this cat,see:Lugt
Rép.des cat.de ventes,1861-1900;01?
MH MdBP OC1 NIC MiU ⌢ p.615,no.54768)

II.E.1

Gruber, L.Fritz ed.
 Fame;famous portraits of famous people by
famous photographers.London,N.Y.,Focal press
 1960
 159 p. illus.

 See:Gruber,L.F. Famous portraits.N.Y.,Ziff-
Davis Pub.Co.,1960, qTR 680.G75X NPG

LC TR680.G74 MOMA,v.11,p.437

II.E.1

Hough, E.K.
 Expressing character in photographic pic-
tures

In:Am.J.of Photo.& the Allied Arts
1,no.11:171-5 Nov.1,1858
 no.12:183-7 Nov.15,1858
 no.14:211-6 Dec.15,1858

LC TR1.A56 Pfister.Facing the light
 TR680.P47X NPG p.361

qTR
680
G75X
NPG
II.E.1

Gruber, L.Fritz ed.
 Famous portraits.N.Y.,Ziff-Davis Pub.Co.
 1960
 159 p. illus.

II.E.1

Kalett, Jim
 People and crowds;a photographic album
for artists and designers.N.Y.,Dover publi-
cations,1978
 91 p. chiefly illus.

LC TR680.K24 1978 Cumulative book index
 Z1219.C97 NPG 1979 p.136

705
A784
NMAA
v.75

II.E.1

Kosloff, Max
 Opaque disclosures.An examination of the for-
mal and informal modes of portrait photography
reveals some of the contradictions of the genre

In:Art in Am
75:144-53,197 Oct.'87 illus.

 Repro.incl.:Sander:Raoul Hausmann;Cartier-
Bresson:Gandhi,Irène & Frédéric Joliot-Curie,
Jos.W.& Stewart Alsop,Edith Piaf;Brandt:Dylan
Thomas,Alec Guinness;Morath:Carter-Bresson. etc.

II.E.1

Maywald, Wilhelm, 1907-
 Portrait+atelier;photos.Brattleboro,Vt.,
Greene,c.1958,
 1 v.(unpaged) illus.

 English,German and French

 Bibliography

 Contents:Chagall,Léger,Rouault,Matisse,
Laurens,Picasso, Le Corbusier,Utrillo,Villon,
Arp,Braque,Miró

LC N6852.M3 1958

II.E.1

Lécuyer, Raymond
 Histoire de la photographie.Paris,Baschet,
1945
 451 p. illus(part col.)

 Bibl.notes

 "The most lavishly illustrated history ever
published.It extends to 1939."-Gernsheim

LC TR15.14 Gernsheim TR15.037 Ref.
 Bibl.,p.375

II.E.1

Mortensen, William
 Outdoor portraiture;problems of face and
figure in natural environment.San Francisco,
Camera Craft,c.1940,1943,
 142 p. illus.

LC TR575.M6

qTR
680
M17
NPG

II.E.1

Maddow, Ben, 1909-
 Faces;a narrative history of the portrait
in photography...Boston,Publ.for N.Y.Graphic
Soc. by Little,Brown,1977

 FOR COMPLETE ENTRY
 SEE MAIN CARD

TR
15
N54
1964
NPG
NCFA

II.E.1

Newhall, Beaumont, 1908-
 The history of photography from 1839 to
the present day. Rev.and enl.ed. N.Y.,MOMA...
,1964,
 215 p. illus.

 Bibliography
Ch.4:Portrs.for the million,p.47-58.-Portrs
incl.throughout.
 "Deals almost exclusively with the evolu-
tion of photography as a means of expression."-
Gernsheim.
 Index gives dates of photographers
LC TR15.N47 Gernsheim.TR15.037 Ref.
 Bibl.p.375

II.E.1

Manning, Jack
 The fine 35mm portrait.Garden City,N.Y.,
Amphoto,c.1978
 200 p. illus(part col.)

 Incl.:Index

LC TR575.M35 Cumulative book index
 Z1219.C97 NPG 1979p.1580

II.E.1

Noren, Catherine
 The camera of my family.1st ed. N.Y.,Knopf,
1976
 240 p. chiefly illus.

 Based on exh.cat.Jewish museum,N.Y.,1973
,12,p.

LC TR680.N68 1976

II.F.1

Mathews, Oliver
 The album of carte-de-visite and cabinet
portrait photographs,1854-1914.London,Reedmin-
ster Publications,1974

 Incl.:Historical summary of the discovery
of photography.Description of different tech-
niques...

LC TR680.M37 FOR COMPLETE ENTRY
 SEE MAIN CARD

II.E.1

OVO Magazine
 Portraits

In:OVO Mag.
13,no.50:1-48 1983 illus.

Md.U.Art Libr.
TR640.C71 Folio

II.E.1

Pauer, Hans
 Das Bildarchiv der Österreichischen Natio-
nalbibliothek,ein institut zur öffentlichen
pflege der dokumentarphotographie.Geschichte
und programm.Wien,Gallus-Verlag.c.1947.
 130 p. illus.

 Repro.incl.:Photo of Leon Gambetta;Johann
Strauss with Johannes Brahms
 Appendix p.117 lists :Reproduktionsplatten
aus abteilungen der Österr.Nat'lbibl.500001-
600000 Porträtsammlung(Graphik und foto)

LC Z794.V66P3

II.E.1

Salmon, Percy R., 1872-
 Home portraiture for amateur photographers.
By Richard Penlake(Percy R.Salmon,F.R.P.S.)...
London,L.Upcott Gill,1899
 140 p. illus.

LC TR680.517 Brit.Mus.Cat.of printed
 books Z921.B861 1881a Suppl.
 NPG v.9,S-Stephanus,p.39

705
C91
NCFA
v.4

II.E.1

Peale, Rembrandt, 1778-1860
 Portraiture

In:The Crayon
4:44-5 1857

 'Observations on the quality of photographic
portraiture compared with ptgs. Also reflects
attitudes on visual art relative to photogra-
phy:-Rudisill,Mirror image,p.251

LC N1.C9 Sobieszek.Spirit of fact
 qN40.1.S71S86 NPG p.162

N
72
P5S31
1969
NCFA

II.E.1

Scharf, Aaron, 1922-
 Art and photography.Baltimore,Allen Lane,
The Penguin Press,1969.c.1968.
 314 p. illus.

 Bibl.references
 Based on thesis for Ph.D.,Courtauld Inst.
of art,Univ.of London

 The problems of style caused by exchange
betw.the different media.Chapter on Portrai-
ture,p.18-51.Use of daguerreotype by ptrs.in

LC N72.P5S3 Coke.Ptr.& photograph qN72
 P5C68 NCFA Preface

II.E.1

Porträts und Situationen.Fotografiert von David
Octavius Hill,Rbt.Adamson,August Sander,
Jean Philippe Charbonnier,Tony Ray-Jones,
Gabriele und Helmut Nothhelfer,Roland La-
boye...Berlin,Haus am Waldsee,c.1976

LC TR646.G42B46

 FOR COMPLETE ENTRY
 SEE MAIN CARD

705
M19
NCFA
v.42

II.E.1

Schwarz, Heinrich, 1894-
 Art and photography:Forerunners and influ-
ences

In:Mag.Art
42:252-7 Nov.,'49 illus.

 From Schmalcalder's profile machine of 1806
to the 2nd half of 19th c.,when portraiture was
taken over by photography to Cézanne,when pho-
tography was dethroned.

 Coke.Ptr.& photograph...
 qN72-P5C68 NCFA Preface

II.E.1

The portrait in painting..Motion picture....
 Lawrence,Kan.,Centron Films,1978

LC.ND1300.

 FOR COMPLETE ENTRY
 SEE MAIN CARD

II.E.1

Spitzing, Günter
 The photoguide to portraits.Garden City,
N.Y.,Amphoto,1974.
 179 p. illus(part col.)

 Transl.of"Porträtfotos-gewusst wie"

LC TR575.S6613 Verzeichnis lieferbarer Bü-
 cher NPG v.1, p.1828

TR
15
R67X
NMAA
2 c.

II.E.1

Rosenblum, Naomi
 A World history of photography.N.Y.,Abbe-
ville Press,1984
 671 p. illus(part col.)
 Incl.:Index

 Ch.2:A plenitud of portraits,1839-1890,
p.38-93
 Portrs.up to 1980 discussed in many chap-
ters

II.E.1

Spörl, Hans, 1867-
 Die porträtkunst in der photographie;ein
lehrbuch über neuzeitliche porträtdarstellung
auf photographischem wege für fachleute und
liebhaber..I-.II.teil.Leipzig,E.Liesegangs
Verlag,M.Eger,1909
 2 v.in 1 illus.

 Contents--I.Teil,Aesthetik,124 p.,74 illus.
II.Teil,Praxis,125 p.,78 illus.

ICJ TxU Sander,August qTR647.S214
 K2 E1986 NPG,Bibl.p.62

II.E.1

Stenger, Erich, 1878–
 Die photographie in kultur and technik;
ihre geschichte während 100 jahren...Leipzig,
E.A.Seemann,1938.
 286 p. illus(1 col.)

LC TR15.S75

II.E.1

Vigneau, André, 1892–
 Une brève histoire de l'art de Niepce à
nos jours.Préf.de Jean Cassou.Paris,R.Laffont
‹1963›.
 190 p. illus(part col.)

 Various ways photography has interacted
with art

LC NC450.V45 Coke.Ptr.& photograph...
 1N72.P5C68 Preface

II.E.1

Stevens, C
 <u>Public faces</u>

In:Print
29,pt.5:54-68 Sept.-Oct.,'75 illus.

 Five photographers of celebrities:...

LC Z119.P8985 **FOR COMPLETE ENTRY
 SEE MAIN CARD**

COLLECTIONS
(Author of book/article is disregarded)

II.E.1

Strasser, Alex
 Immortal portraits,being a gallery of fa-
mous photographs by David Octavius Hill,Julia
Margaret Cameron...& others.Selection & commen-
tary by Alex Strasser.London & N.Y.:The Focal
press,1941.
 141 p. illus.

LC TR 680.S92 Gernsheim T15.G37 Ref.
 Bibl.p.376

II.E.1.a. PUBLIC, A-Z, by institution

II.E.1

Taylor, Joshua Charles, 1917–
 La fotografia e la macchia;in.his.Vedere
prima di credere;saggi sull'arte del primo otto-
cento...Parma,Università di Parma,Istituto di
storia dell'arte.1970.
 pp.73-94 illus. (Quaderni di storia
dell'arte 7)

WU

II.E.1.a – LONDON. CARLTON HOUSE TERRACE
 see
II.E.1.a – LONDON. NATIONAL PORTRAIT GALLERY

II.E.1

<u>Unvergängliches Antlitz.Versuch e.dichter.s.</u>
Deutung u.Bild-Dokumentation...Steinfeld
(Eifel),Salvator-Verlag.1974.

LC TR681.F3U57 **FOR COMPLETE ENTRY
 SEE MAIN CARD**

AP
1
C175
NCFA
v.58

II.E.1.a – LONDON. NATIONAL PORTRAIT GALLERY

Ford, Colin John, 1934–
 People in Camera,1839-1914

In:Camera
58:3-50 June,'79 illus(part col.)

 Publ.for an exh.at NPG exh.rooms 15 Carlton
Terrace,London SW1,1 June-12 Aug.,'79 by C.J.
Bucher ltd.& Camera,Switzerland
 List of photographs
 Alphabetical list of photographers
 Most photographs from the NPG coll.

II.E.1.b. PRIVATE, A-Z, by name of
collector

II.E.2. CHRONOLOGICAL

TR
680
H88
1977X
NPG

II.E.1.b - GRUBER, L.FRITZ

Museum Ludwig
Fotografische künstlerbildnisse..Cat.of exh..
Museum Ludwig,Köln,16.Des.1977-19.Febr.1978
.hrsg.vom Generaldirektor der Museen der Stadt
Köln,Gerhard Bott;Kat.Jeane von Oppenheim.Köln,
Mus.der Stadt Köln,1977
20 p. illus.

Bibliography
International photographers from the coll.
L.Frits Gruber.60 years portrait-photography,
1904-1965

Holsten.N7618..H75 NPG Bibl.
p.119

qN
40.1
H6393 B8
NCFA

II.E.2 - 19th c.

Bruce, David, 1939- comp.
Sun pictures;the Hill-Adamson calotypes.
.London.Studio Vista.c.1973.
247 p. illus.

Bibliography

Repros.incl.:Portrs.of Hill and of Adamson.
The"Disruption Painting"for which calotype
"sketches" had been used to achieve the like-
ness of ca. 500 people in the painting;etc.

VF
Houston
Mus.Fine
Arts

II.E.1.b - MARVINS, KAYE & FAMILY

Houston, Tex. Museum of fine arts
The Sonia and Kaye Marvins portrait coll.
.Cat.of exh.Apr.10-June 22,1986..Houston,Mus.
of fine arts,1986
24 p. illus.

Coll.of famous subjects & famous photogra-
phers given to the mus.by the Marvins family.
Incl.:Duke & Duchess of Windsor by Avedon;
Casals by Yousuf Karsh;Victor Hugo by Bertall;
Horst's self-portr.with Gertr.Stein;Albert
Schweitzer by Smith,etc.
Incl.:Article by A.W.Tucker.Checklist
by M.Olvey

qN
40.1
C18PE
1973
NPG

II.E.2 - 19th c.

Cameron, Julia Margaret(Pattle),1815-1879
Victorian photographs of famous men & fair
women.With intro.by Virginia Woolf & Roger Fry.
Preface by Tristram Powell.Boston,D.R.Godine
.1973.
32 p. illus.

In preface:Description of Mrs.C.'s methods;
explanation of wet collcdion process,invented
by Fred.Scott-Archer,1851
Sitters incl.Carlyle,Longfellow,Rbt.Browning,
Darwin,Tennyson,Jos.Joachim,etc.-Pre-Raphaelite
ideal evoked in "tableaux"

Books in print.Subj.guide
Z1215.P52 1975 v.2,p.2955

qN
40.1
B81K9
NPG

II.E.1.b - MESERVE, FREDERICK HILL, 1865-1962

Kunhardt, Dorothy Meserve, 1901-
Mathew Brady and his world;...from pic-
tures in the Meserve coll....Morristown,N.J....
Silver Burdett Co.,c.1977

FOR COMPLETE ENTRY
SEE MAIN CARD

N
40.1
H6393E2
NPG

II.E.2 - 19th c.

Hill, David Octavius, 1802-1870
An early Victorian album;the Hill/Adamson
collection.Edited and with an intro.by Colin
Ford and a commentary by Roy Strong.London,
J.Cape.1974.
350 p. illus.

Call no. refers to 1st American ed.,N.Y.,
Knopf,1976

LC TR651.H53 1974

II.E.1.c. DEALERS, A-Z, CATALOGUES &
COLLECTIONS

II.E.2 - 19th c.

In unnachahmlicher treue:Photographie im
19..Jhrh.,ihre geschichte in den deutsch-
sprachigen ländern;eine ausst.der Josef-
Haubrich-Kunsthalle Köln in zusammenarbeit
mit dem Foto-Historama Agfa-Gevaert Lever-
kusen vom 8.Sept.bis 21.Okt.1979.Kat..
Heinz Langholz,Ferdinand von den Ecker,
Christoph Müller.Köln,Mus.der Stadt Köln,
1979
370 p. illus(part col.)
Bibl.references
Index

LC TR6.03G644

705
A63
NMAA
v.58

II.E.2 - 19th c.

Lee, David
Royal cartes de visite.Popular Victorian
portrait photography.

In:Ant collector
58:84-91 March,'87 illus.

History of the portr.photography in Bri-
tain.
Exh.:"Crown and camera,the Royal family
and photography 1842-1910"at Queen's Gall.,
13 march- ,'87
Repro.incl.

VF
Houston
Mus.Fine
Arts

II.E.2 - 19-20th c.

Houston, Tex. Museum of fine arts
The Sonia and Kaye Marvins portrait coll.
.Cat.of exh.Apr.10-June 22,1986..Houston,Mus.
of fine arts,1986
24 p. illus.

Coll.of famous subjects & famous photogra-
phers given to the mus.by the Marvins family.
Incl.:Duke & Duchess of Windsor by Avedon;
Casals by Yousuf Karsh;Victor Hugo by Bertall;
Horst's self-portr.with Gertr.Stein;Albert
Schweitzer by Smith,etc.
Incl.:Article by A.W.Tucker.Checklist
by M.Olvey

CT275
L73A1 al
NPG

II.E.2 - 19th c.

Lincoln, Abraham,Pres.U.S., 1809-1865
An album of Lincoln.Photographs and words
(Eakins pocket album 3)

Incl.7 portrs.of Lincoln from 1858-1865

Photographs by A.M.Byers,T.P.Pearson,Lloyd
Ostendorf,C.S.German,M.B.Brady,A.Gardner,
A.Berger

TR
680
L69
1982
NPG

II.E.2 - 19-20th c.

Lichtbildnisse:Das porträt in der fotografie;
hrsg.von Klaus Honnef in zusammenarbeit
mit Jan Thorn Prikker.Köln,Rheinland-
Verlag,1982
744 p. illus. (Kunst und Altertum
am Rhein,no.110)
illus(part col.)

Bibl.references
Index
Encompasses the work of the most notable Ameri
can,British & European photographers of the
19th & 20th c. Worldwide Art cat.Bul.
705.W927 NMAA v.19,no.2
p.11

TR
680
F68X
NPG

II.E.2 - 19th-20th c.

Fotoportret..Voorbereiding:C.H.Broos e.a.
Hague,1970.
92 p. illus.

"Uitgegeven bij de tentoonstelling Foto-
portret,Haags gemeente mus. 6feb-3 mei,1970"

Bibliography

130 jaar foto-portret,p.2-65.-Relatie met
de andere technieken van de beeldende kunst;p.66
-76.-Sociale funktie,p.76-91

LC TR680.F68

N
7592
F35X
NPG

II.E.2 - 19-20th c.

Paris. Musée des arts décoratifs
La famille des portraits.Cat.of exh....
Paris,1979

FOR COMPLETE ENTRY
SEE MAIN CARD

P
C175
NCFA
v.58

II.E.2 - 19-20th c.

Ford, Colin John, 1934-
People in camera,1839-1914

In:Camera
58:3-50 June,'79 illus(part col.)

Publ.for an exh.at NPG exh.rooms 15 Carlton
Terrace,London SW1,1 June-12 aug.,'79 by C.J.
Bucher ltd.& Camera,Switzerland
List of photographs
Alphabetical list of photographers
Most photographs from the NPG coll.

N
7592.6
C72
NPG

II.F.2 - 20th c.

Columbia University. Dept.of Art History and
Archaeology
Modern portraits.The self and others....
1976

Exhibition...at Wildenstein,N.Y.,Oct.20-
Nov.28,1976

II.E.2 - 19-20th c.

Harvard University William Hayes Fogg art mus.
Exhibitions
The portrait in photography:1848-1966.Exh.
Apr.10-May 15,1967.Fogg art mus.Harvard Univ.
Organized by Carl Chiarenza.and.Davis Pratt.
Cambridge,Mass..1967.
7 l.

F000
6715
H33

Xerox copy of checklist of the exhibition

Fogg v.7,p.11

705
A786
NMAA
v.86

II.E.2 - 20th c.

Hoy, Anne .Hoene., 1942-
Art circles:Portrait photographs from
Art News,1905-1986

In:Art N
86:93-100 Feb.,'87 illus.

Pertains to an exh.at the Internat'l Ctr.
of Photography,N.Y.,Feb.27-Apr.19,1987
Repro.incl.:Marcel Duchamp by Marvin Laza-
rus;Pollock by Hans Namuth;Hopper by Bernice
Abbott;Calder by Agnès Varda;Pat Steir by Ro-
berta Neiman,etc

BH
56
PL6118
1987X
NMAA

II.E.2 - 20th c.

Hunter, Jefferson, 1947-
Varieties of portraiture .in his."Image and word".Cambridge,Mass.,Harvard Univ.Press,1987
p.115-60 illus.

Incl.:Vortographic portraiture;Serial portraiture;Photographic simplicity;Endurance of the primitive;Vignette and frame
Repr.incl.:F.Weston,R.Frank,A.Newman,A.L.Coburn A.Stieglitz,A.Sander,D.Lange,R.Lee,P.Strand, A.Rothstein,J.Liebling,L.Hine,B.Brandt

II.F.2 - 20th c.

Pecsi, Josef
Zur porträtphotographie unserer tage

In:Dt.Kst.u.Dek.
49:221 ff. 1921-22

LC N3.D4

Die 20er jahre im portr.
N6868.5.E9297 NPG, p.143

TR
681
F3M87
1978X
NPG

II.F.2 - 20th c.

Muray, Nickolas, 1892-1965
Muray's celebrity portraits of the twenties and thirties.135 photographs by Nickolas Muray;introd.by Marianne Fulton Margolis.N.Y., Dover Publications,1978
.140.p. chiefly illus.

Cumulative book index
Z1219.C97 NPG 1979 p.1733

II.E.2 - 20th c.

Perret, Patti, 1955-
The faces of science fiction;photographs... N.Y.,N.Y.,Bluejay Books,c.1984
unpaged

Introd.by Gene Wolfe

LC PS374.S35P38 1984

qTR
680
M97
NPG

II.E.2 - 20th c.

Muray, Nickolas, 1892-1965
The revealing eye;personalities of the 1920's,in photographs by Nickolas Muray and words by Paul Gallico..1st ed..New York,Atheneum,1967
307 p. illus.

LC TR680.M87

II.E.? - 20th c.

Reiser, Walter
Begegnung;maler und bildhauer der gegenwart.Encounters;contemporary artists and sculptors.Einführung von Dietrich Mahlow.Stuttgart. Belser Verlag.ca.1970.
1 v.(unpaged) mostly illus(part col.)

Photographic portrs.of 135 artists and their works
Chronologies
Text in German

LC N40.R4

MOMA, v.11,p.439

TR
680
M88
1977X
NPG

II.E.2 - 20th c.

Museum Ludwig
Fotografische künstlerbildnisse..Cat.of exh.. Museum Ludwig,Köln,16.Des.1977-19.Febr.1978 .hrsg.vom Generaldirektor der Museen der Stadt Köln,Gerhard Bott;Kat.Jeane von Oppenheim.Köln, Mus.der Stadt Köln,1977
20 p. illus.

Bibliography
International photographers from the coll.
L.Frits Gruber.60 years portrait-photography,
1904-1965
Holsten.N7618.H75 NPG Bibl.
p.119

II.F.2 - 20th c.

Salomon, Erich
Berühmte zeitgenossen in unbewachten augenblicken...mit 112 bildern.Stuttgart,J.Engelhorns nachf..ca.1931.
46 p. illus.

Descriptive letterpress in German,English, French and Italian...

LC TR680.S175

Die 20er jahre im portr.
N6868.5.E9297 NPG,p.143

II.E.2 - 20th c.

Namuth, Hans, 1915-
Fifty-two artists.Photographs by Hans Namuth.Scarsdale,N.Y..Committee for the visual arts .c.1973.
.46 p. illus.

N61
713
N15
c

II.E.2 - 20th c.

Schwartz, Bern
Contemporaries;portraits by Bern Schwartz; text by Benny Schwartz.London,Collins,1978
150 p. chiefly col.portrs.

LC TR681.F3S38

Cumulative book index
Z1219.C97 NPG 1979 p.2216

II.E.3. BY COUNTRY, A-Z, subdivided -
chronological & regional

II.E.3 - GERMANY - 19-20th c.

Menschen der zeit.Hundort und ein lichtbild-
nis wesentlicher männer und frauen aus
deutscher gegenwart und jüngster vergan-
genheit.Königstein im Taunus,Karl Robert
Langewiesche,1931
112 p. incl.101 photos (Die blauen
Bücher)

Photographic portrs.of German personali-
ties by various artists

LC R757qM53 MOMA,v.11,p.438
 MOMA photo dept.76.3/H36

qTR
575.M12
NPG
3 c.

II.E.3 - EUROPE.- 19th c.

McCauley, Elizabeth Anne
Likenesses:Portrait photography in Europe
1850-1870.Albuquerque,N.M.,Art Mus.Univ.of New
Mexico,c.1980
85 p. illus.

.Exh..Nov.14,1980-Jan.11,1981

Bibl.references

Rosenblum.A World hist.o
photography.TR15..67X NMAA
Bibl.p.836

II.E.3 - GERMANY - 20th c.

Keller, Ulrich
Die deutsche portraitfotografie von 1918
bis 1933,p.37-66

In:Beiträge zur geschichte und aesthetik der
fotografie.Contributions to the history and
aesthetics of photography.Giessen,Anabas,1977
96 p. illus.

LC TR185.K39 Rila IV/1 1978 #77

II.E.3 - GERMANY

Stein, Fred
Deutsche portraits.von.Fred Stein.und.
Will Grohmann.Stuttgart,E.Battenberg.1961.
1 v.(unpaged) illus.

Text and captions in German,French & English

Portrs.by Stein & biographies on opposite p.

Incl.photos of artists

LC DD243.S8 MOMA, v.11,p.437

II.E.3 - GERMANY - 20th c.

Sander, August, 1876-1964
Antlitz der zeit;60 aufnahmen deutscher
menschen des 20.jahrhunderts...mit einer ein-
leitung von Alfred Döblin.München,Transmare
verlag.etc.,c.1929.
177 p. 60 pl.

LC TR680.S2

II.E.3 - GERMANY - 19th c.

Cornwall, James E.
Die Frühzeit der photografie in Deutsch-
land,1839-1869,die männer der ersten stunden
und ihr verfahren.Herrsching/Ammersee,Verlag
für Wirtschaft u.Industrie,c.1979
159 p. illus.

Index
Bibliography,p.148-153

McCauley.Likenesses...
qTR575.M12 NPG note 138

II.E.3 - GERMANY - 20th c.

Sander, August, 1876-1964
Men without masks;faces of Germany,1910-
1938.With an introd.by Gunther Sander and fore-
word by Golo Mann...Greenwich,Conn.,N.Y.Graphic
Society.1973.
313 p. illus.

Translation of Menschen ohne Maske.
London ed.publ.under title:August Sander:
photographer extraordinary.

LC TR680.S2313 1973b

TR
647
H23D5
NMAA

II.E.3 - GERMANY - 19th c.

Hanfstaengl, Franz, 1804-1877
Album der zeitgenossen.Hrsg.von Christian
Diener und Graham Fulton-Smith.München,W.Heyn
.1975.
.96.p. chiefly illus.
Fotos 1853-1863

Incl.:essay on Hanfstaengl by Helmut
Gernsheim

LC TR680.H26 1975 Keller.Deutsche portrait
 tografie...LC TR185.K39
 p.64

II.E.3 - GERMANY - BAVARIA - 19-20th c.

Gebhardt, Heinz, 1947-
Königlich Bayerische photographie 1838-
1918.Munich,Laterna Magica.1978
383 p. illus(part col.)

Bibliographical references & indexes

LC TR73.3.G4 McCauley.Likenesses
 qTR575.M12 NPG notes no.

N
40.1
C18L8
NPG

II.E.3 - GREAT BRITAIN - 19th c.

Cameron, Julia Margaret(Pattle), 1815-1879
The Herschel album;an album of photograph,
presented to Sir John Herschel...London,Natio-
nal Portrait Gallery,c.1975
«30»p. chiefly illus.

LC TR681.P3C355

N
40.1
B258L7
NPG

II.E.3 - GREAT BRITAIN - 19th c.

Lloyd, Valerie
The camera and Dr.Barnardo.s.l. s.n.,1974?
40.p. illus.

Catalogue of an exhibition held at the
National Portrait Gallery,London.

Mainly photos of abandoned children on ad-
mission to Dr.B.'s "Homes"

LC HV887.G5B34 1974

N
40.1
S868F6
NPG

II.E.3 - GREAT BRITAIN - 19th c.

Ford, Colin John, 1934-
Sir Benjamin Stone,1838-1914 & the Nation-
al Photographic Record Assoc.,1897-1910.cat.to
accompany an exh.at.the National Portrait Galle-
ry,London,c.1974
32 p. illus.

Creative Camera.AP 1.C916
NCFA,May,'74,p.150,foot-
note

TR
575
P93
1985a
NPG

II.E.3 - GREAT BRITAIN - 19th c.

Prescott, Gertrude May, 1955-
Fame and photography:Portrait publica-
tions in Great Britain,1856-1900
409 p. illus.

Incl.lists of portr.publications in the
engraved,lithographic & photographic media.

Ph.D.diss.-Univ.of Texas at Austin,1985
Bibliography:p.263-81

mf
Diss.Abstr.v.47no.03,Sept.
1986,p.691/92A

705
C69
NCFA
v.29

II.E.3 - GREAT BRITAIN - 19th c.

Fuller, John
An un-Victorian photograph of the 1860's

In:Art Journal
29,no.3:303-8,400 Spring,1970 illus.

Bibliography
Edw.Draper's photograph'Boy with parrot're-
veals something of childhood.It shares common
ground with 20th c. portraiture rather than with
British portr.tradition of portraying a child
to transfer moral messages,sweet sentiment
status symbols. Loma 1970,p.369 «70P511.»

II.E.3 - GREAT BRITAIN - 19th c.

Stone, John Benjamin, 1838-1914
Sir Benjamin Stone's pictures;records of
national life and history.repro.fr.the coll.
of photographs made by Sir Benj.Stone.with des-
criptive notes by M.F.OgDonagh.London,Paris,N.Y.
& Melbourne,Cassell & co.,ltd.,1906
2 v. illus.

V & A

«I.Parliamentary scenes & portrs.
«II.Festivals,ceremonies & customs

LC(no call no.) Creative Camera.AP 1.C916
NCFA,May,'74,p.150,footn.

TR
57
H49X
NPG

II.F.3 - GREAT BRITAIN - 19th c.

Heyert, Elizabeth
The glasshouse years;;;Montclair,N.J.,1978

FOR COMPLETE ENTRY
SEE MAIN CARD

qN
40.1
C18 0 9
NPG

II.E.3 - GREAT BRITAIN - 19th c.

A Victorian album:Julia Margaret Cameron and her
circle...N.Y.,Da Capo Press,1975

Incl.photos by Lewis Carroll,W.Jeffrey,Oscar
Rejlander,Lord Somers

LC TR681.P3V52 1975b FOR COMPLETE ENTRY
SEE MAIN CARD

TR
681
F3H65
NPG

II.E.3 - GREAT BRITAIN - 19th c.

Hillier, Bevis, 1940-
Victorian studio photographs;from the col-
lections of Studio Bassano and Elliott & Fry,
London,by B.Hillier;with contributions by Brian
Coe,Russell Ash and Helen Varley.Boston,David R.
Godine,1976, c.1975
144 p. illus.

Incl.Index

ND
1314.4
1983
1985
v.1-2
NPG Ref.

II.E.3 - GREAT BRITAIN - 18th c.

Walker, Richard
Regency portraits.London,NPG,1985
2 vols. illus. v.1:Text;v.2:Plates

Edited by Judith Sheppard
Indexes
Incl.:Sculpture,Medals,Engravings,Photo-
graphs

Groups p.597 f.

TR
646
O8L84
NPG

II.E.3 - GREAT BRITAIN - 19-20th c.

Arts Council of Great Britain
The real thing;an anthology of British pho-
tographs,1840-1950.London,1975.
124 p. chiefly illus.

Selection & intro.by Ian Jeffrey;essay by
David Mellor

Cat.of an exh.held at the Hayward Gall.,Lon-
don,19 March-4 May,1975 & 4 other museums.
In 'Notes':2.Art photographers & portrai-
tists,p.118;-11.Portraiture,p.123
Rila II/2 1976 #5694

II.E.3 - U.S. - 19th c.

Brady, Mathew B., 1823-1896
Brady and Handy's album of the 50th Con-
gress of the U.S....designed and published
by M.B.Brady and Levin C.Handy.Washington,1888
.84.p.of mounted photos
illus.

LC.JK1059 50th .B8.MnHi

TR
647
C78P4
NPG

II.E.3 - GREAT BRITAIN - 20th c.

Pepper, Terence
Howard Coster's celebrity portraits.101
photographs of personalities in literature
and the arts.London,NPG,c.1985
113 p. illus.

Publ.in connection with the exh.'Howard
Coster:Camera portraits of the twenties and
thirties,held at the NPG fr.28 june to 8 sept.
1985
Biographical references
Index
LC TR681.P3P47 1985

N
7628
173H2
NPG

II.E.3 - U.S. - 19th c.

Hamilton, Charles, 1913-
Lincoln in photographs;an album of every
known pose,by Charles Hamilton and LloydOsten-
dorf..1st ed..Norman,University of Oklahoma
Press.c.1963.
409 p. illus.

Bibliography of Lincoln photograph books

Photographs by Brady and his employees &
associates

LC E457.6.H23

II.E.3 - GREAT BRITAIN - SCOTLAND - GLASGOW

Scottish Arts Council Gallery
Glasgow portraits by J.Craig Annan(1864-
1946)photographer.Cat.of exh..Glasgow,Scottish
Arts Council Gallery,Dec.2,1967-Jan.27,1968.
Scottish Arts Council,1967
41 p. illus.

Traveled to Aberdeen, Dundee,Perth

Intro.by Geo.A.Oliver(p.9-12)

LC TR680.S36

N
40.1
B81H8
NPG

II.E.3 - U.S. - 19th c.

Horan, James David, 1914-
Mathew Brady,historian with a camera....
N.Y.,Crown Publishers.1955.
244 p. illus.

"A picture album"p.c91.-c228.
"A pictorial bibl.of Brady pictures":p.235-38
Incl.bibliographies.

LC TR140.B7H6

II.E.3 - ITALY

Parma. Università. Istituto di storia dell'arte
Ugo Mulas.Immagini e testi.Con una nota
critica di Arturo Carlo Quintavalle.Parma:The
Institute,1973.
157 p. illus.

Catalogue of exhibition 1973

MOMA, v.11,p.438
MOMA Photo dp..77.M85xP2

II.E.3 - U.S. - 19th c.

Jareckie, Stephen B
American photography 1840-1900;exh..2 June-
25 July 1976.Worcester,Mass.,Worcester Art Mus.,
c.1976
60. p. illus.

108 works shown

Portrait photography,daguerreotypes

OASU Rila III/1 1977 #2193

TR
23
T12
NPG

II.E.3 - U.S.

Taft, Robert, 1894-1955
Photography and the American scene;a social
history,1839-1889.N.Y.,Dover Publs..1964,c.1938.
546 p. illus.

Bibliography

"The best source book on the 1st half-cen-
tury of American photography".-Gernsheim

Ch.2:First portraits and first galleries,
p.22-45(incl.first portr.photographers:Samuel
F.B.Morse
LC TR23.T3 1964 Gernsheim,TR15.G37 Ref.Bibl.
p.375

CT
219
K43
NPG

II.E.3 - U.S. - 19th c.

Ketchum, Richard M., 1922-
Faces from the past.N.Y.,American Heritage
Press.1970.
172 p. illus.

Kelly.Moses Billings
N40.1.B5575K2 NPG note 72

QCT
275
L8378l
1968
NPG

II.E.3 - U.S. - 19th c.

Lorant, Stefan, 1904-
Lincoln;a picture story of his life.Rev.
& enl.ed.N.Y., Norton & Co.,Inc.,1969,
336 p. illus.

Repro.ptgs.,life masks,photographs
Contents & Bibliography. Index

Appendix...B:The photographer of Lincoln...
C:All of Lincoln's photographs in chronological
order

LC F457.6.L78 1969

705
A786
NCFA
v.46

II.E.3 - U.S. - 19th c.

Newhall, Beaumont, 1908-
First American masters of the camera

In:Art N
46:91-8, Nov.,'47 illus.
168-72
'The birth of photography in the U.S.:Faces
of the colorful & great of pre-Civil War days
seen through the lens of Southworth & Hawes,
the...ston daguerreotypists'
Repro.incl:Daniel Webster,John Quincy Adams
Lemuel Shaw,Lola Montez,Horace Mann,Harriet B.
Stowe,H.W.Longfellow

N
40.1
B81M5
NPG

II.E.3 - U.S. - 19th c.

Meredith, Roy, 1908-
Mr.Lincoln's camera man,Mathew B.Brady...
N.Y.,C.Scribner's sons,1946
368 p. illus.

Bibliography

LC
TR140.B7M4

TR
139
W55
1985X
NPAA

II.E.3 - U.S. - 19-20th c.

Willis-Thomas, Deborah, 1948-
Black photographers,1840-1940:an illus-
trated bio-bibliography...N.Y.,Garland,1985
141 p. illus. (Garland ref.libr.of the
humanities;v.401)

Bibliography

Incl.:Indexes
List of photographers,in chronological
groups

N
40.1
B81M5m
NPG

II.E.3 - U.S. - 19th c.

Meredith, Roy, 1908-
Mr.Lincoln's contemporaries;an album of
portraits by Mathew B.Brady.N.Y.,Scribner,1951
233 p. illus.

LC F415.8.M4

II.E.3 - U.S. - 20th c.

Avedon, Richard, 1923-
Observations.Photographs by Richard Avedon,
comments by Truman Capote..N.Y.,Simon & Schus-
ter,1959.
151 p. illus.

Incl.:Individuals associated with fine arts
& films. For names see over

LC TR680.09 MOMA, p.436, v.11

R
.L7 M5

II.E.3 - U.S. - 19th c.

Meserve, Frederick Hill, 1865-
The photographs of Abraham Lincoln,by Fre-
derick Hill Meserve and Carl Sandburg.N.Y.,Har-
court,Brace and company,1944. 1st ed.
30p. illus.

Contents.-The face of Lincoln,by Carl Sand-
burg.-Frederick Hill Meserve,by Carl Sandburg.-
The photographs of Abraham Lincoln,by F.H.
Meserve

LC F457.6.M569

AP
1
D81
NCFA
v.35

II.E.3 - U.S. - 20th c.

Kayser, Alex
Zehn amerikanische photographen

In:Du
35:66-75 Sept.,'75 illus.

Photographs by A.Kayser of Imogen Cunningham
Ansel Adams,Wynn Bullock,André Kértesz,Minor
White,Harry Callahan,Nathan Lyons,Elliot Erwitt,
Bruce Davidson,Duane Michals.Biographical info.

Rila II/2 1976 #5765

II.E.3 - U.S. - 19th c.

Meserve, Frederick Hill, 1865-1962
Portraits of the Civil War period,photo-
graphs for the most part from life negatives
by M.B.Brady,now in the possession of F.H.
Meserve..N.Y.,Corlies,Macy & Co.,incorp...1903?,
36 p. illus.

LC N7624.M4

II.E.3 - U.S. - 20th c.

Ray, Man, 1890-
Portraits.Hrsg.und eingeleitet von L.Fritz
Gruber..Gütersloh,S.Mohn,1963.
15 p. illus.,73.

Man Ray's commentary accompanies each portr
Incl.Cocteau,Maar,Dali,Tanguy,Eisenstein,Le Cor
busier,Loos,Pascin,Tanning,Derain,Braque,Léger,
Giacometti,Brancusi,Matisse,Picasso,etc.

LC TR680.R36 MOMA,v.11,p.437

qN
40.1
S81A1
NPG

II.E.3 - U.S. - 20th c.

Steichen, Edward, 1879-
A life in photography.Publ.in collaboration with the Mus.of Modern Art.Garden City,N.Y., Doubleday;1963
1 v.(unpaged) illus(part col.)

Ch.10:On portraits & portraiture.3 p.,44 portrait photographs of celebrities of the 20th c.

LC TR140.S68A25

705
A63
NMAA
v.58

II.E.4 - CARTES DE VISITE

Lee, David
Royal cartes de visite.Popular Victorian portrait photography.

In:Ant collector
58:84-91 March,'87 illus.

History of the portr.photography in Britain.
Exh.:"Crown and camera,the Royal family and photography 1842-1910"at Queen's Gall., 13 march- ,'87
Repro.incl.

qN
6520
.P63
1983X

II.E.3 - U.S. - LOUISIANA - NEW ORLEANS - 19th c.

Poesch, Jessie J.
The Art of the Old South,painting,sculpture,architecture,and the products of craftsmen,1560-1860...1st ed.N.Y.,Knopf,1983
384 p. illus(part col.)

Incl.index
Bibliography,p.361-366

Repro.incl.:Eye miniature by Malbone,p.162; Portrs.of Amer.Indians by Curtis,p.272;by Römer & by Catlin,p.273.Portrs.within portrs., p.265.Groups by Earl,p.171;by Johnson, p.159

N
40.1
D505
M12
NPG

II.E.4 - CARTES DE VISITE

McCauley, Elizabeth Anne
A.A.E.Disderi and the carte de visite portrait photograph...1980
3 v.in 2(356,206 p.) illus.

Thesis(Ph.D)Yale Univ.,1980
Photocopy of typescript.Ann Arbor,Mich.: Univ.microfilms international,1981
Contents:v.1.Text.v.2.Plates
Bibliography:p.327-56
TR647.D611M2 1985:Book with same title
Discussion incl.:The importance of the carte de visite in breaking down the division betw.portr aiture and genre

II.E.4. SPECIAL FORMS & SUBJECTS - Divided like I.E.
(used only for works exclusively (or primarily) of photographic interest)
(Otherwise see I.E.)
Divided like I.E. A-Z (Inserted: CARTES DE VISITE)

II.E.4 - CARTES DE VISITE

Mathews, Oliver
The album of carte-de-visite and cabinet portrait photographs,1854-1914.London,Reedminster Publications,1974

LC TR680.M37

FOR COMPLETE ENTRY
SEE MAIN CARD

N
40.1
T63A4
NPG

II.E.4 - CARTES DE VISITE

Olland, Alexander
Heinrich Tönnies,cartes-de-visite photographer extraordinaire.N.Y.,Camera/Graphic press ltd.,1978
unpaged illus.

English & Danish

II.E.4 - CARTES DE VISITE

Paris. Musée Carnavalet
Étienne Carjat,1828-1906,photographe,:cat. of exh.:Nov.25,1982-Jan.23,1983.:Paris.Musées de la ville de Paris.1982.
107 p. illus. (Dans le cadre du Mois de la Photo organisé par l'Association Paris Audovisuel)
Bibliography
Intro.by Sylviane Heftler,p.7-32;incl.article by Philippe Néagu.
Cat.grouped by Self-portrs.,artists,authors politicians,medicine,musicians,actors,etc.

NGA

MdU-BC, NmU,a.o.

II.E.4 - CARTES DE VISITE

Real, S.B.
Carte-de-visite portraits of the Royal family,eminent and celebrated persons.London, 1866

V & A

Heyert.Glasshouse years.
TR57.H5.9X NPG Publ.

TR
681
F3K96
NPG

II.E.4-CHILDREN

Kupferberg, Tuli
As they were.by.T.Kupferberg and Sylvia Topp.N.Y.,Links,c.1973.
unpaged chiefly illus.
.155.p.

Photos of famous people when they were children;in alphabetical order

LC CT107.K86

N
40.1
R258L7
NPG

II.E.4 - CHILDREN - GREAT BRITAIN

Lloyd, Valerie
 The camera and Dr.Bernardo.s.l. s.n.,1974?
 40.p. illus.

 Catalogue of an exhibition held at the
National Portrait Gallery.London.

 Mainly photos of abandoned children on ad-
mission to Dr.B.'s "Homes"

LC HV887.05B34 1974

II.E.4 - ETHNIC GROUPS - NEW GUINEA

Strathern, Andrew
 Man as art.New Guinea.Photographs by Mal-
colm Kirk.N.Y.,The Viking Press,1981
 144 p. illus(part col.) A Studio Book

 Portrs.of warriors,ceremonial figs.& carved
masks

LC GN671.N5K57 1981

II.E.4 - CHILDREN - U.S. - 17-18th c.

Earle, Alice (Morse), 1851(or 1853)-1911
 Child life in colonial days...with many
illus.from photographs...N.Y.,The Macmillan
comp.;London,Macmillan & co.,ltd.,1899
 418 p. illus.

LC E162.E13

 Colonial Williamsburg,inc.
 American Folk Art N6507
 C72 NCFA Bibl.p.49

705
C69
NPAA
v.46

II.E.4 - FAMILY

Halle, David
 The Family photograph

In:Art J.
46,no.3:217-25 Fall,1987 illus.

 Content, use & mode of display of family
photos.Their meaning & the reason why they have
replaced portrait paintings:

II.E.4 - DEATH

Hujar, Peter, 1934-
 Portraits in life and death.Introd.by Susan
Sontag.N.Y.,Da Capo Press,1976
 ‹91›p. chiefly illus.

LC TR680.H77

 Rila III/2 1977 #5592

II.E.4 - FAMILY

Images of information;still photography in so-
cial sciences;Jon Wagner,editor;pref.by
Howard S.Becker.Beverly Hills,Sage Publi-
cations,c.1979
 311 p. illus.

 Incl.:Christopher Musello.Family photo-
graphy. 'Ethnographic discussion.'-Halle

LC H62.I536

 Halle.In Art J. v.46
 v.46:224,note 2

TR
647
P5C44
NPG

II.E.4 - ETHNIC GROUPS - NEGRO

Bial, Raymond
 In all my years.Portraits of older Blacks
in Champaign-Urbana....Exh.at.Champaign County
Historical Museum,Champaign,Ill.,1983
 unpaged illus(52 photos)

TR
681
F28H57X
NPG

II.E.4 - FAMILY

Hirsch, Julia
 Family photographs.Content,meaning,and
effect.N.Y.,Oxford,Oxford Uni.Press,1981
 139 p. illus.

 Family portrs.ranging from Renaissance pain-
ings to photographs
 Bibliography

TR
139
W55
16R5X
NPAA

II.E.4 - ETHNIC GROUPS - NEGRO

Willis-Thomas, Deborah, 1948-
 Black photographers,1840-1940;an illus-
trated bio-bibliography...N.Y.,Garland,1985
 141 p. illus. (Garland ref.libr.of the
humanities;v.401)

 Bibliography

 Incl.:Indexes
 List of photographers,in chronological
groups

II.E.4 - INDIVIDUAL SITTERS - CONSTANTIN
 FERDINAND JOSEPH DESIRE

 see

II.E.4 - INDIVIDUAL SITTERS - FERNANDEL, 1903-
 .1971

AP
1
I261
NPG
v.67

II.F.4 - INDIVIDUAL SITTERS - DOUGLAS, STEPHEN, (ARNOLD), 1813-1861

Ostendorf, Lloyd & Duncan, Bruce R.,
 The photographic portraits of Stephen A.
Douglas

In:Ill.State Hist.Soc.J.
67:6-69 Feb.,1974 illus.

LC F536.I18 Pfister.Facing the light
 TR680.P47X NPG p-366

CT
275
L74 O 8
1969
NPG

II.E.4 - INDIVIDUAL SITTERS - LINCOLN, MARY
 1818-1882

Ostendorf, Lloyd
 The photographs of Mary Todd Lincoln.
Springfield,Ill.State Hist.Soc.,1969.
 64 p. illus.

 Reprinted fr.the journal of the Ill.State
Hist.Soc.,v.61,no.3,autumn 1968

 Bibl.footnotes

LC E457.25.0 8 1969 Pfister.Facing the light
 TR680.P47X NPG p.370

II.E.4 - INDIVIDUAL SITTERS - FERNANDEL, 1903-
 1971

Halsman, Philippe, 1906-1979
 The Frenchman:A photographic interview.N.Y.
Simon & Shuster,1949.
 unpaged 24 portrs.

 24 portrs.in which by facial expression,
the model replies to questions asked in the
caption.The model is Fernandel

LC PN2638.C73H3 Arts in America qZ5961.U
 5A77X NCFA Ref. N600

II.F.4 - INDIVIDUAL SITTERS - TENNYSON,1st baron
 1809-1892
Ritchie, Anne Isabella(Thackeray)lady, 1837-1919
 Alfred,lord Tennyson and his friends...
London,T.F.Unwin,1893

Stanford Univ.Libr.for LC FOR COMPLETE ENTRY
MH CtY NN etc. SEE MAIN CARD

fN
7628
L73m5
NPG

II.E.4 - INDIVIDUAL SITTERS - LINCOLN

The face of Lincoln.Comp.and edited by James
Mellon.N.Y.,A Studio book.The Viking press,
1979
 201 p. illus.

 Photographs & selection of L.'s writings
and description of L.by people who knew him

LC E457.6.F33

VF
NPG

II.F.4 - INDIVIDUAL SITTERS - TREADWELL, NICHOL.

Portrayal or Betrayal;an exh.of portraits of
Nicholas Treadwell,oct.23-Nov.17,1973 at
Nicholas Treadwell gallery,London
 4 p. folder illus.
 26 artists portrayed N.Treadwell."The re-
sult is an interesting comparison of reality
through the eyes of each artist...Pop,New Fi-
guration,Realism combined with use of photogr
phy have brought about a new style of portrai-
ture,appropriate to society now & valid as art.
-Treadwell.

N
762B
173N2
NPG

II.E.4 - INDIVIDUAL SITTERS - LINCOLN

Hamilton, Charles, 1913-
 Lincoln in photographs;an album of every
known pose,by Charles Hamilton and LloydOsten-
dorf.1st ed.Norman,University of Oklahoma
Press,1963.
 409 p. illus.

 Bibliography of Lincoln photograph books

 Photographs by Brady and his employees &
associates

LC E457.6.H23

II.F.4 - INDIVIDUAL SITTERS - WALLACH FAMILY

Noren, Catherine
 The camera of my family.1st ed.N.Y.,Knopf.
1976
 240 p. chiefly illus.

 Based on exh.cat.Jewish museum,N.Y.,1973
12 p.

LC TR680.N68 1976

B
.L73M5

II.E.4 - INDIVIDUAL SITTERS - LINCOLN

Meserve, Frederick Hill, 1865-
 The photographs of Abraham Lincoln,by Fre-
derick Hill Meserve and Carl Sandburg.N.Y.,Har-
court,Brace and company,1944. 1st ed.
 30p. illus.

 Contents.-The face of Lincoln,by Carl Sand-
burg.-Frederick Hill Meserve,by Carl Sandburg.-
The photographs of Abraham Lincoln,by F.H.
Meserve

LC E457.6.M569

II.E.4 - INDIVIDUAL SITTERS - WASHINGTON

New York. Metropolitan museum of art
 Portrait in history.Filmstrip.Chicago,Rand
McNally,c.1970

 Presents artists' impressions of Geo.Washing-
ton over a period of 2 centuries....

LC.N7628. FOR COMPLETE ENTRY
 SEE MAIN CARD

705
A786
NMAA
v.82

II.E.4 - INDIVIDUAL SITTERS - WHITMAN, WALT,
c.1819-1892

Homer, William Innes
Who took Eakins' photographs?

In:Art N
82:112-9 May,'83 illus.

Refers mainly to photographs of Walt
Whitman

705
A784
NMAA
v.75

II.E.4 - PROFESSIONS

Kozloff, Max
Opaque disclosures.An examination of the for-
mal and informal modes of portrait photography
reveals some of the contradictions of the genre

In:Art in Am
75:144-53,157 Oct.'87 illus.

Repro.incl.:Sander;Raoul Hausmann;Cartier-
Bresson;Gandhi,Irène & Frédéric Joliot-Curie,
Jos.V.& Stewart Alsop,Edith Piaf;Prandt;Dylan
Thomas,Alec Guinness;Korath;Carter-Preston. etc.

TR
647
B5C44
NPG

II.E.4 - OLD AGE

Bial, Raymond
In all my years.Portraits of older Blacks
in Champaign-Urbana....Exh.at,Champaign County
Historical Museum,Champaign,Ill.,1983
unpaged illus(52 photos)

II.E.4 - PROFESSIONS

Tournachon, Félix, 1820-1910
Nadar;préface de Jean-François Bory;intro...
par Philippe Néagu...et Jean-Jacques Poulet-
Allamagny.Paris,A.Hubschmid,c.1979
2 v.(1298 p.) illus.

Contents:t.1.Photographie(grouped by prof-
fessions:artists,authors,actors,musicians,etc.)
t.2:Dessins et écrits(incl.:Le panthéon Nadar
with preparatory drawings)

Incl.indexes

LC TR681.F3T685 1979

qN
40.1
C97A6
NPG

II.E.4 - OLD AGE

Cunningham, Imogen, 1883-1976
After ninety.Introd.by Margaretta Mitchell
Seattle,Univ.of Washington Press,c.1977
111 p. illus.

Bibliography

LC TR654.C86

Cumulative book index
Z1219.C97 NPG 1979 p.614

TR
647
H196A16
1986
NMAA

II.E.4 - PROFESSIONS - U.S.

Halsman, Philippe, 1906-1979
Philippe Halsman's jump book;introduced by
Mike Wallace.N.Y.,Abrams,1986,c.1959
96 p. illus.

Originally publ.N.Y.,Simone & Schuster,1959

II.E.4 - OLD AGE

Retslaff, Erich
Das Antlits des alters,photographische
bildnisse von Erich Retslaff,einleitung von
Jakob Kneip.Düsseldorf,Pädagogischer verlag,
1930
21 p. illus.

LC TR680.R43

Sander, August.qTR647.
S214K2 E1986 NPG
Bibl.p.61

TR
6
N57
NPG
2 c.

II.E.4 - PROFESSIONS - ADMINISTRATION

Photography in the Fine Arts
Museum directors' selections for the 1965
N.Y.World's Fair exh..N.Y.,c.1965.
[47] p. illus.

Incl.:Portra.of 11 museum directors by
Yousuf Karsh

Winterthur Mus.Libr. fZ881
.W78 NCFA v.6,p.221

TR
139
W55
1985X
NMAA

II.E.4 - PHOTOGRAPHERS - AFRO-AMERICAN

Willis-Thomas, Deborah, 1948-
Black photographers,1840-1940:an illus-
trated bio-bibliography...N.Y.,Garland,1985
141 p. illus. (Garland ref.libr.of the
humanities;v.401)

Bibliography

Incl.:Indexes
List of photographers,in chronological
groups

II.E.4 - PROFESSIONS - ARTISTS

Heilbrun, Françoise
Portraits d'artistes,cat.établi et rédigé
par Françoise Heilbrun et Philippe Néagu.Paris,
Ministère de la culture et de la communication,
Éditions de la Réunion des musées nationaux,
c.1986
95 p. illus. (Dossiers du Musée d'Orsay,
v.7)
Cat.of an exh.held at the Musée d'Orsay,
Dec.9,1986 to March 1, 1987
Bibliography

Iu NN OO etc. Wasmuth Cat.no.154 April,
1988,no.1790

705
A786
NMAA
v.86

II.E.4 - PROFESSIONS - ARTISTS

Hoy, Anne «Hoene», 1942-
Art circles:Portrait photographs from
Art News,1905-1986

In:Art N
86:93-100 Feb.,'87 illus.

Pertains to an exh.at the Internat'l Ctr.
of Photography,N.Y.,Feb.27-Apr.19,1987
Repro.incl.:Marcel Duchamp by Marvin Laza-
rus;Pollock by Hans Namuth;Hopper by Bernice
Abbott;Calder by Agnès Varda;Pat Steir by Ro-
berta Neiman,etc

II.F.4 - PROFESSIONS - GREAT BRITAIN - 19th c.

Maull and Polyblank
Photographic portraits of living celebri-
ties...London,Maull & Polyblank and W.Kent,1859

MOMA
Photo
Dpt.
coll.

FOR COMPLETE ENTRY
SEE MAIN CARD

TR
681
A85835
1987X
NPG

II.E.4 - PROFESSIONS - AUTHORS - 19-20th c.

Sciascia, Leonardo
Ignoto a me stesso:ritratti di scrittori da
Edgar Allan Poe a Jorge Luis Borges;a cura di
Daniela Palazzoli.Milano,Bompiani,c.1987
222 p. illus(part col.) (La fotografia
vista da...)

«Cat. of exh.at Turin,Mole Antonelliana
Apr.9-June 28,1987»

Index
Bibliography

TR
647
N217R9
NMAA

II.E.4 - PROFESSIONS - ACTORS - RUSSIA - 20th c.

Nappelbaum,Moisei Solomonovich,1869-1958
«Moyh vek:foto»grafii/«cised Nappelbaum;
sostavitel» I»ia Rudiak,«Our age,photographs
«of» Nappelbaum;ed.by Ilya Rudiak.Ann Arbor,
Ardis,c.1984
145 p. chiefly portraits

In English and Russian
Incl.:Index

LC TR681.F3N36 1984

II.E.4 - PROFESSIONS - AUTHORS - 20th c.

Hambourg,Maria Morris
Photographers and authors.A coll.of por-
traits of 20th c.writers;from the Carleton
College collection.Northfield,Minn.,Carleton
College,c.1984
15 p. 43 plates

LC TR681.F3H35

N
40.1
S245B3
NPG

II.E.4 - PROFESSIONS - ACTORS - U.S. - 19th c.

Bassham, Ben L.loyd, 1942-
The theatrical photographs of Napoleon
Sarony...Kent,Ohio,Kent State University Press,
c.1978
122 p. illus.

Bibliography

LC TR140.S37B36

II.E.4 - PROFESSIONS - DANCERS

Bachardy, Don, 1934-
Ballet portraits..Santa Monica,Calif.,
c.1966.
30 illus.(portfol.)

Photographic portrs.of members,past and
present,of the N.Y.City Ballet

Arts in America qZ5961.U5
A77X NCFA Ref. Q144

TR
681
A7B912
NPG

II.F.4 - PROFESSIONS - ARTISTS

Brussels. Musée royaux des beaux-arts de Bel-
gique. Musée moderne
Portraits et perspectives;le monde de l'ar-
tiste...«1969?»

FOR COMPLETE ENTRY
SEE MAIN CARD

II.E.4 - PROFESSIONS - GREAT BRITAIN

Reeve, Lovell «Augustus», 1814-1865, ed.
Portraits of men of eminence in literature,
science and art,with biographical memoirs.The
photographs from life by Ernest Edwards.London,
Reeve & Co.,1863
6 vols. illus(144 photographic portraits)

LC DA531.1.R3

Heyert.Glasshouse yrs.TR57
H49X NPG Bibl.Illustr.books

705
A784
NCFA
v.63

II.E.4 - PROFESSIONS - ARTISTS

Cohen, Ronny H.
Avedon's portraits:the big picture

In:Art in Am
63:94-5 Nov.-Dec.,'75 illus.

...His subjects incl.artists...

FOR COMPLETE ENTRY
SEE MAIN CARD

II.E.4 - PROFESSIONS - ARTISTS

Nadar photographe:portraits d'artistes...exposition...Paris,Direction des musées de France?,1975,

LC TR681.A7N32

FOR COMPLETE ENTRY
SEE MAIN CARD

II.E.4 - PROFESSIONS - AUTHORS - RUSSIA - 20th c.

TR
647
N217no
NPO
Mappel'baum,Moisei Solomonovich.1869-1958
,Nash vek:fotografii/Moisei Nappel'baum;
sostavitel' I'ia Rudiak.,Our age,photographs
Moses Nappelbaum;ed.by Ilya Rudiak.Ann Arbor,
Ardis,c.1984
145 p. chiefly portraits

In English and Russian
Incl.:Index

LC TR681.F3N36 1984

qN
40.1
T72506
1976
NPG
II.E.4 - PROFESSIONS - ARTISTS

Tournachon, Félix, 1820-1910
Nadar.by.Nigel Gosling.1st American ed.
N.Y.,Knopf...,1976
298 p. illus.

Portrs.of celebrities:artists,writers,musicians,theatre personalities

II.E.4 - PROFESSIONS - AUTHORS - U.S. - 20th c.

Perret, Patti, 1955-
The faces of science fiction;photographs..
N.Y.,N.Y.,Bluejay Books,c.1984
unpaged

Introd.by Gene Wolfe

LC PS374.S35P38 1984

TR
647
N217no
NPAA
II.E.4 - PROFESSIONS - ARTISTS - RUSSIA - 20th c.

Mappel'baum,Moisei Solomonovich.1869-1958
,Nash vek:fotografii/Moisei Nappel'baum;
sostavitel' I'ia Rudiak.,Our age,photographs
Moses Nappelbaum;ed.by Ilya Rudiak.Ann Arbor,
Ardis,c.1984
145 p. chiefly portraits

In English and Russian
Incl.:Index

LC TR681.F3N36 1984

PN
1998
A2H614X
NPG
II.E.4 - PROFESSIONS - MOTION PICTURES - U.S.

Hollywood glamor portraits:145 photos of stars,
1926-1949;ed.by John Kobal.N.Y.,Dover Publications,1976
144 p. chiefly illus.

II.E.4 - PROFESSIONS - AUTHORS

Nadar photographe:portraits d'artistes et de
critiques;,exposition,,..Paris,Direction
des musées de France?,1975,

LC TR681.A7N32

FOR COMPLETE ENTRY
SEE MAIN CARD

TR
678
K6
1980X
NPG
II.E.4 - PROFESSIONS - MOTION PICTURES - U.S.
Kobal, John
The art of the great Hollywood portrait
photographers,1925-1940.N.Y.,Alfred A.Knopf,
1980
291p. illus.

Incl.index

The camera brought aclose up to the face

II.E.4 - PROFESSIONS - AUTHORS - GB.BR. - 19th c.

Ritchie, Anne Isabella(Thackeray)lady,1837-1919
Alfred,lord Tennyson and his friends...
London,T.F.Unvin,1893

Stanford Univ.Libr.for LC
MH CtY NN etc.

FOR COMPLETE ENTRY
SEE MAIN CARD

PN
2285
M65X
NPG
II.E.4 - PROFESSIONS - MOTION PICTURES - U.S.

Movie-star portraits of the forties:163 glamor
photos...N.Y.,Dover Publications,1977

FOR COMPLETE ENTRY
SEE MAIN CARD

TR
6.7
N217H9
NMAA

II.E.4—PROFESSIONS - MUSICIANS - RUSSIA - 20th c.

Nappelbaum,Moisei Solomonovich,1869-1958
..Moh vek;foto;parss/Arised Nappelbaum;
sostavitel; I"ia Rudiak..Our ago,photographs
Moise Nappelbaumjed.by Ilya Rudiak.Ann Arbor,
Ardis,c.1984
145 p. chiefly portraits

In English and Russian
Incl.;Index

LC TR681.F3N36 1984

TR
6.7
N217H9
NMAA

II.E.4 - PROFESSIONS - STATESMEN - RUSSIA - 20th c.

Nappelbaum,Moisei Solomonovich,1869-1958
..Moh vek;foto;parss/Arised Nappelbaum;
sostavitel; I"ia Rudiak..Our ago,photographs
Moise Nappelbaumjed.by Ilya Rudiak.Ann Arbor,
Ardis,c.1984
145 p. chiefly portraits

In English and Russian
Incl.;Index

LC TR681.F3N36 1984

fAP
1
W3175
NMAA

II.E.4 - PROFESSIONS - PHOTOGRAPHERS - U.S. -
.20th c.

Photographers and their subjects.10 photogra-
phers/17 artists

In:Wash Rev
12,no.2:3-25 Aug/Sept.,'86 illus.

II.F.4 - PROFESSIONS - STATESMEN - ROYALTY -
.GR.BR.

Real, S.P.
Carte-de-visite portraits of the Royal fa-
mily...London,1866

V & A

FOR COMPLETE ENTRY
SEE MAIN CARD

II.E.4 - PROFESSIONS - SCHOLARS - FRANCE

Paris. Musée des arts décoratifs
Victor Regnault,1810-1878,oeuvre photogra-
phique..Exh.at.Mus.des arts décoratifs,Paris,
Apr.25-July 1,1979
unpaged mainly illus.

MET
107.4
P1392
.57.

Incl.;article Victor Regnault by Roméo
Martinez
'Les portraits de savants...aux alentours de
l'année 1851 dénotent une volonté documentaire
et objective où l'objet devient une part signi-
fiante du portrait.'

DA
28.1
C69X
NPG

II.E.4 - PROFESSIONS - STATESMEN - ROYALTY -
.GR.BR.

Ormond, Richard
The face of monarchy;...Oxford,Phaidon,1977

FOR COMPLETE ENTRY
SEE MAIN CARD

TR
15
O53X
NCFA
p.110-4

II.E.4 - PROFESSIONS - SCIENTISTS

Michaelson, Katherine
The first photographic record of a scienti-
fic conference

In:One hundred years of photographic history...
p.110-4

FOR COMPLETE ENTRY
SEE MAIN CARD

II.E.4 - PROFESSIONS
see also
I.E - PROFESSIONS

705
A784
NCFA
v.63

II.E.4 - PROFESSIONS - STATESMEN

Cohen, Ronny H.
Avedon's portraits:the big picture

In:Art in Am
63:94-5 Nov.-Dec.'75 illus

...His subjects incl...politicians...

FOR COMPLETE ENTRY
SEE MAIN CARD

II.E.4 - SELF-PORTRAITS

Innsbruck. Galerie im Taxispalais
Selbstportrait als selbstdarstellung..Aus-
stellung.Galerie im Taxispalais,14.10-5.11.1975
.verantwortlich Peter Weiermair.Innsbruck,Galerie
im Taxispalais,1975
.68.p. chiefly illus.

LC TR680.I54 1975

Selbstportrait...N7618
S45 NPG p.26,note 3

II.E.4 - SELF-PORTRAITS - 20th c.

Autoportraits photographiques 1898-1981,brève
rencontre par Denis Roche.exh.at.Centre
Georges Pompidou..Paris.Herscher,c.1981
84 p. chiefly illus.

Publié à l'occasion de l'exposition Autopor-
traits au Musée national d'art moderne,
Centre Georges Pompidou,8 juillet-14 sep-
tembre 1981

Bibl.references

LC TR680.A88 1981 Billeter.Selbstportraits
 d7618.895 NPG p.26,note 3

II.E.4 - SELF-PORTRAITS - U.S.

Alinder, James ed.
 Self-portrayal, the photographer's image.
101 contemporary self-portraits with essays
by Peter Hunt Thompson,Dana Asbury,R.Duncan
Wallace.Carmel,Calif.,Friends of photography,
c.1978
 116 p. chiefly illus.

CoU ICD-L NjPoR TxU-Da Lingwood.TR680.S822 1986X
WMUW NPG Bibl.p.127

TR
680
S822
1986X
NPG

II.E.4 - SELF-PORTRAITS

Lingwood, James
 Staging the self:self-portrait photogra-
phy 1840s-1980s..a NPG and Plymouth Arts Centre
exh.ed.by Js.Lingwood.London,The Gallery.Ply-
mouth,The Centre.1986.
 128 p. illus. Worldwide books no.20738

 Cat.for an exh.held at NPG,Oct.3,'86-Jan.11
'87 & at other English locations 1980-1987
 Bibliography p.127
 Articles by Jean-François Chevrier,Susan
Butler,David Mellor

II.E.4 - WOMEN - 20th c.

Unsere zeit in frauenbildnissen..Leipzig.
 Niels Kampmann.19-?.
 unpaged illus.

MN

7618
845
1985
NPG

II.E.4 - SELF-PORTRAITS - 20th c.

L'Autoportrait à l'âge de la photographie,
 peintres et photographes en dialogue avec
 leur propre image,publié par Erika Bil-
 leter.Cat.of an exh.presented at the Musée
 cantonal des beaux-arts Lausanne,Jan.18-
 Mar.24,1985 and at the Württembergischer
 Kunstverein,Apr.19-June 9,1985.Lausanne
 Musée cantonal des beaux-arts,c.1985
 512 p. illus(part col.)

 Préface de Michel Tournier.Contribu-
tions de Erika Billeter....et al.
CU MiEM French and German
MoSW Bibliography p.77-9

II.E.4 - WOMEN - U.S. - WASHINGTON(STATE)
Gallacher, Dorothy
 Hannah's daughters:Six generations of an
American family,1876-1976.N.Y.,Ths.Y.Crowell,
c.1976
 343 p. illus.

LC HQ1412.G34 1976 Hirsch.Family photographs.
 TR681.F28H57X NPG Bibl.
 p.139

II.E.4 - SELF-PORTRAITS - GERMANY - 20th c.

Steinert, Otto, 1915- ed.
 Selbstporträts.....Gütersloh.S.Mohn.1961.

Purdue Univ.Library
NN etc.
 FOR COMPLETE ENTRY
 SEE MAIN CARD

II.E.5. SPECIFIC TECHNIQUES, A-Z

 For list of SPECIFIC TECHNIQUES
 see "Guide to Classified
 Arrangement"

II.E.4 - SELF-PORTRAITS - RUSSIA

Attie, David
 Russian self-portraits.N.Y.,Harper & Row,
c.1977
 .96.p. chiefly illus.

 An Irwin Glusker book

LC TR680.A87 Cumulative book index
 Z1219.C97 NPG 1979 p.149

II.E.5 - CALOTYPE

qN
40.1
H6393 B8 Bruce, David, 1939- comp.
NCFA Sun pictures;the Hill-Adamson calotypes.
 .London.Studio Vista.c.1973.
 247 p. illus.

 Bibliography

 Repros.incl.:Portrs.of Hill and of Adamson
 The"Disruption Painting"for which calotype
 "sketches" had been used to achieve the like-
 ness of ca. 500 people in the painting;etc.

N
40.1
H6393E2
NPG

II.E.5 - CALOTYPE

Hill, David Octavius, 1802-1870
· An early Victorian album;the Hill/Adamson
collection.Edited and with an intro.by Colin
Ford and a commentary by Roy Strong.London,
J.Cape.1974.
350 p. illus.

Call no. refers to 18t American ed.,N.Y.,
Knopf,1976

LC TR651.H53 1974

II.E.5 - COLLODION PROCESS

Paris. Musée Carnavalet
Étienne Carjat,1828-1906,photographe,:cat.
of exh..Nov.25,1982-Jan.23,1983..Paris.Musées
de la ville de Paris.1982.
107 p. illus. (Dans le cadre du Mois
de la Photo organisé par l'Association Paris
Audiovisuel)
Bibliography
Intro.by Sylviane Heftler,p.7-32;incl.ar-
ticle by Philippe Néagu.
Cat.grouped by Self-portrs.,artists,authors
politicians,medicine,musicians,actors,etc.

NGA

MdU-BC, NmU,a.o.

TR
15
053X
NCFA
p.110-4

II.E.5 - CALOTYPE

Michaelson, Katherine
The first photographic record of a scienti-
fic conference

In:One hundred years of photographic history...

Calotypes taken by D.O.Hill & R.Adamson in 1844

**FOR COMPLETE ENTRY
SEE MAIN CARD**

II.E.5 - COLLODION PROCESS

Tournachon, Félix, 1820-1910
Nadar;préface de Jean-François Bory;intro...
par Philippe Néagu...et Jean-Jacques Poulet-
Allamagny.Paris,A.Hubschmid,c.1979
2 v.(1258 p.) illus.

Contents:t.1.Photographie(grouped by prof-
fessions:artists,authors,actors,musicians,etc.)
t.2:Dessins et écrits(incl.:Le panthéon Nadar
with preparatory drawings)

Incl.indexes

LC TR681.F3T685 1979

fN
40.1
H6393
P2
NPG

II.E.5 - CALOTYPE

The painter as photographer;David Octavius Hill,
Auguste Salzmann,Charles Nègre...Vancouver,
B.C.,Vancouver Art Gallery.1978?.

**FOR COMPLETE ENTRY
SEE MAIN CARD**

II.E.5 - DAGUERREOTYPE

Bogardus, Abraham
The lost art of the daguerreotype

In:The Century Mag.
68,no.1:83-91 May,1904

Comments on portraiture & the public,noting
some of the practical operating tricks of the
trade for making people appear better

LC AP2.C4

Rudisill.Mirror image
TR365.R916 NCFA p.240

II.E.5 - CALOTYPE

Paris. Musée des arts décoratifs
Victor Regnault,1810-1878,oeuvre photogra-
phique..Exh.at.Mus.des arts décoratifs,Paris,
Apr.25-July 1,1979
unpaged mainly illus.

MET
107.4
P1392
c57.

Incl.:article Victor Regnault by Remée
Matines
'Les portraits de savants...aux alentours de
l'année 1851 dénotent une volonté documentaire
et objective où l'objet devient une part signi-
fiante du portrait.'

N
40.1
D128G3
1968
NPG

II.E.5 - DAGUERREOTYPE

Gernsheim, Helmut, 1913-
L.J.M.Daguerre;the history of the diorama
and the daguerreotype...N.Y.,Dover Publications
c1968.
226 p. illus.

Bibliographical references

LC TR140.D3G47 1968

qN
40.1
C18P8
1973
NPG

II.E.5 - COLLODION PROCESS

Cameron, Julia Margaret(Pattle),1815-1879
Victorian photographs of famous men & fair
women.With intro.by Virginia Woolf & Roger Fry.
Preface by Tristram Powell.Boston,D.R.Godine
c1973.
32 p. illus.

In preface:Description of Mrs.C.'s methods;
explanation of wet collodion process,invented
by Fred.Scott-Archer,1851
Sitters incl.Carlyle,Longfellow,Rbt.Browning
Darwin,Tennyson,Jos.Joachim,etc.-Pre-Raphaelit
ideal evoked in "tableaux"

Books in print.Subj.guide

II.E.5 - DAGUERREOTYPE

Gouraud, François
Description of the daguerreotype process,
or a summary of M.Gouraud's public lectures,
according to the principles of M.Daguerre.With
a description of a provisory method for taking
human portraits.Boston,Dutton & Wenworth's
print.1840
16 p.

"First photographic manual published in
the U.S.".-Taft

MH MB
LC FC8.G7424 840d(A)

Taft,R.TR23.T12,p.45:Repr.
of title page

N
40.1
F97M6
NCFA

II.E 5 - DAGUERREOTYPE

Millet, Josiah B., ed.
George Fuller:His life and works.Boston,
Houghton Mifflin & co.,1886
93 p. illus.

Incl.'Notes.on.very early employment of the
daguerreotype by an itinerant portr.ptr. & dis-
cusses economic motivations.'-Rudisill

LC ND237.F846

Rudisill.Mirror image
TR365.R916 NCFA p.250

TR
15
G37
NPG
Ref.

II.E.5 - DAGUERREOTYPE- GREAT BRITAIN

Gernsheim, Helmut, 1913-
The history of photography from the ear-
liest use of the camera obscura in the 11th
century up to 1914...London,N.Y.,Oxford Uni-
versity Press,1955
395 p. illus.

Bibliography. Bibliographical footnotes.

Ch.10:The daguerreotype in Great Britain,
p.85-114

LC TR15.G37

705
M19
NCFA
v.42

II.E.5 - DAGUERREOTYPE

Newhall, Beaumont, 1908-
The Daguerreotype and the painter

In:Mag.Art
42:249-51 Nov.,'49 illus.

Discusses the uses & problems of daguerreo-
types for ptrs.of portrs. 1843 a "Nat'l Daguer-
reotype miniature Gall"was founded in N.Y. &
M.B.Brady's "Valhalla of America"on Broadway,fr.
which F.d'Avignon made 12 lithographs for Bra-
dy's book,"Gall.of Illustrious Americans"(ed.by
Lester)
Rudisill.TR365.R916 NCFA
p.250

II.F.5 - DAGUERREOTYPE - SWITZERLAND

Stenger, Erich, 1878-
Der daguerreotypist J.B.Isenring;seine ver-
dienste um einführung und ausgestaltung der da-
guerreotypie 1839-1842.Berlin,Selbstverlag des
verfassers,1931
16 p. illus.

N.Y.P.L.

Kunstausstellung enthaltend eine sammlung
von lichtbildern meistens porträts nach dem le-
ben gefertigt im Mai,Juni,Juli 1840 von J.B.
Isenring,maler aus St.Gallen...
Bibliography

N
72
P5S31
1969
NCFA

II.E.5 - DAGUERREOTYPE

Scharf, Aaron, 1922-
Art and photography.Baltimore,Allen Lane,
The Penguin Press,1969,c.1968,
314 p. illus.

Bibl.references
Based on thesis for Ph.D.,Courtauld Inst.
of art,Univ.of London

The problems of style caused by exchange betw.
the different media.Chapter on Portraiture,p.18-
51.Use of daguerreotype by ptrs.in execution of
portrs.& in recording their ptgs.Invent'n of pho-
tographs on canvas Coke.Ptr.& photograph qN72
P5C68 NCFA Preface
LC N72.P5S31

4593
A75
NPG

II.E.5 - DAGUERREOTYPE - U.S.

American Jewish Historical Society
Paintings,daguerreotypes,artifacts;comp.
and ed.by Carlo M.Lamagna & Judith E.Endel-
man.Waltham,Mass.,Amer.Jew.Soc.,1974
48 p. illus.

TR
23
T12
NPG

II.E.5 - DAGUERREOTYPE

Taft, Robert, 1894-1955
Photography and the American scene;a social
history,1839-1889.N.Y.,Dover Publs..1964,c.1938.
546 p. illus.

Bibliography

"The best source book on the 1st half-cen-
tury of American photography".-Gernsheim

Ch.2:First portraits and first galleries,
p.22-45(incl.first portr.photographers:Samuel
F.B.Morse
LC TR23.T3 1964
Gernsheim.TR15.G37 Ref.Bibl.
p.375

II.E.5 - DAGUERREOTYPE - U.S.

Jareckie, Stephen B
American photography 1840-1900;.exh..2 June-
25 July 1976.Worcester,Mass.,Worcester Art Mus.,
c.1976
60 p. illus.

108 works shown

Portrait photography,daguerreotypes

GASU

Rila III/1 1977 #2193

II.E.5 - DAGUERREOTYPE - GERMANY

Lichtwark, Alfred, 1852-1914
Das bildnis in Hamburg. Leipzig,kunstgesch.
verlag K.W.Hiersemann
2 v. illus.

MET
115.01
L61

Social,political & artistic function of the
portr.Appendix with short cahpters on miniatures
silhouettes,prints & daguerreotype. (Advert.in
A.Lehmann,Das bildnis bei d.altdeutschen mei-
stern)

Waetzold ND1300.W12

N
40.1
B575K2
NPG

II.E.5 - DAGUERREOTYPE, U.S.

Kelly, Elizabeth K
Moses Billings:19th century portrait paint-
er...1979
69 p. illus.

Reproduction of typescript.
Incl.Cat.of artist's works
Thesis Georgetown Univ.,Nov.5,1979
Bibliography

II.E.5 - DAGUERREOTYPE - U.S.

Moore, Charles LeRoy
 Two partners in Boston:the careers and da-
guerreian artistry of Albert Southworth and
Josiah Hawes.University of Michigan,1975
 2 v. (652 p.)

 Portraying according to Romantic ideals.The
daguerreotypist's most important task was to be
the interpreter of virtuous character...to guide
the nation,which in turn,by virtue of its super-
ior technology,was destined to lead the world.

mfm no. Ph.D.diss.Uni.of Mich.
76-11,676 Diss.Abstr. Sobieszek.The spirit of
Z5055U49D57 NPG fact.qN40.1S716S6 NPG.p.16:
v.36 no.11 Bibl.

qN
40.1
S716S6 II.E.5 - DAGUERREOTYPE - U.S.
NPG
 Sobieszek, Robert A., 1943-
 The spirit of fact:the daguerreotypes of
Southworth & Hawes,1843-1862.Robert A.Sobies-
zek and Odette M.Appel;with research assis-
tance by Charles R.Moore.Boston,D.R.Godine,
c.1976
 163 p. illus.
 Cat.of an exh.held at the Intern'l Mus.of
Photography at the Geo.Eastman House,Rochester,
Feb.,June 1976;at the NPG,Washington,July-Dec.
1976;and at the MFA,Boston,Jan.-Feb.1977

 Bibliography

LC TR365.S6

TR
365
N54 II.E.5 - DAGUERREOTYPE - U.S.
1968
NPG Newhall, Beaumont, 1908-
 The daguerreotype in America..Rev.ed. N.Y.,
N.Y.Graphic Society:c.1961,1968.
 176 p. illus.

 Bibliography

 Incl.Biographies of photographers
 Pl.1:Sitter holds a daguerreotyped portr.

II.E.5 - DAGUERREOTYPE - U.S.

U.S. 41st Cong.3d sess.House of Representatives
 Report no.46,Mar3,1871
 Brady's coll.of historical portraits

FOR COMPLETE ENTRY
SEE MAIN CARD

705
A7 6
NCFA II.E.5 - DAGUERREOTYPE - U.S.
v.46
 Newhall, Beaumont, 1908-
 First American masters of the camera

In:Art N
46:91-8, Nov.,'47 illus.
168-72
 'The birth of photography in the U.S.:Faces
of the colorful & great of pre-Civil War days
seen through the lens of Southworth & Hawes,
the...Boston daguerreotypists'
 Repro.incl:Daniel Webster,John Quincy Adams
Lemuel Shaw,Lola Montez,Horace Mann,Harriet B.
Stowe,H.W.Longfellow

N
40.1
D12803 II.E.5 - DIORAMA
1968
NPG Gernsheim, Helmut, 1913-
 L.J.M.Daguerre;the history of the diorama
and the daguerreotype...N.Y.,Dover Publications
.1968.
 226 p. illus.

 Bibliographical references

LC TR140.D3047 1968

TR
680
P47X II.E.5 - DAGUERREOTYPE - U.S.
NPG
 Pfister, Harold Francis
 Facing the light;historic American portrait
daguerreotypes;an exh.at the National Portrait
Gallery,Sept.22,1978-Jan.15,1979....Smithsonian
Inst.Press,City of Washington,1978
 178 p. illus.

 Foreword by Marvin Sadik
 Curatorial preface by Wm.F.Stapp
 Bibliography

II.E.5 - HELIOGRAVURE

Tripier Le Franc J.
 Histoire de la vie et de la mort du baron
Gros,le grand peintre...illustrée...de six de
ses portraits retracés par l'héliogravure
d'Amand Durand...Paris,J.Martin.etc..1880
 706 p. illus(part col.)

LC ND553.G85T7 Aubert.In:Gas.Beaux-Arts
 jul./aug.'86,v.108,p.29
 note 2

705
A56
NCFA II.E.5 - DAGUERREOTYPE - U.S.
v.21
 Snow, Julia D.Sophronia
 King versus Ellsworth

In:Antiques
21:118-21 Mar.,'32 illus.

 Repro.:incl.Daguerreotypes
 Snow identifies miniatures,f'ly given to
James Sanford Ellsworth as Josiah Brown King's
work.She presents evidence in support of her at-
tributions.
 Sherman,F.F.,J.S.Ellsworth
 In:Lipman,Prim.ptrs.in Amer
 ND236.L76,p.71

II.E.5 - PHOTOCERAMICS

Lafon de Camarsac, A.
 Portraits photographiques sur émail,vitri-
fiés et inaltérables comme les peintures de
Sèvres...Paris,l'Auteur,1868.
 28 p.

N.Y.P.L.

705
G28
NCFA
v.80

II.E.5 - PHOTOMONTAGE

Adhémar, Jean
Étienne Carjat

In:Gaz Beaux-Arts
80:71-81 Aug.'72 illus.

'...il ne représente pas ses modèles en
pied,mais jusqu'au genou...'.-Adhémar

Repre.incl.:photomontage:Courbet conversing
with himself,ca.1862
Paris.Mus.Carnavalet.E.
Carjat,p.3

AP
1
C59
NMAA

II.E.6

Black, Mary.C.
Phrenological associations.Footnotes to
the biography of two folk artists.J.Wh.Stock &
A.Ames.
In:Clarion
1982-84:44-52 Fall,'84 illus.

'The photograph became..a guide,providing ar-
tists.with inspiration for portraits.'

TR
23
T12
NPG

II.E.5 - TINTYPE

Taft, Robert, 1894-1955
Photography and the American scene;a social
history,1839-1889.N.Y.,Dover Bubls..1964,c.1938.
546 p. illus.

Bibliography

"The best source book on the 1st half-cen-
tury of American photography".-Gernsheim

Ch.2:First portraits and first galleries,
p.22-45(incl.first portr.photographers:Samuel
F.B.Morse
LC TR23.T3 1964 Gernsheim,TR15.G87 Ref.Bibl.
p.375

ND
1300
C5X
NPG

II.E.6

Chittock, Derek, 1922-
Portrait painting...London,Batsford,1979
120 p. illus(part col.)
Incl.indexes
Bibliography

'...covers almost every aspect of portr.
ptg.'-D.C.in introduction

Incl.:History of portr.ptg.;Intention of
sitter & artist;Use of photography

Review in Am.Artist,v.44:24-5,Oct.'80

II.E.6. USES OF PHOTOGRAPHY IN PORTRAITURE.
RELATION OF PHOTOGRAPHY TO OTHER
PORTRAIT MEDIA

N
40.1
C628
W18
NCFA

II.E.6

Close, Chuck, 1940-
Close portraits.Walker Art Center,Minnea-
polis,exh.,edited,by Lisa Lyons and Martin
Friedman.Minneapolis,The Center,c.1980.
90 p. illus(part col.)

Checklist inserted
Bibliography

LC N6537.C54A4 Worldwide Art Cat.Bul.
705.W527 NMAA v.17no.2 1981
p.53

II.E.6 USES OF PHOTOGRAPHY IN PORTRAITURE;RELATION OF
PHOTOGRAPHY TO OTHER MEDIA

705
A784
NCFA
v.32

II.E.6

Dods, Agnes M.
A check list of portraits and paintings by
Erastus Salisbury Field

In:Art in Am
32:32-40 Jan.,'44 illus.

'Used daguerreotypes as an aid in producing
good likenesses on canvas.'-Robinson

II.E.6

Anargyros, Spero Dresos, 1915-
Electronic portrait sculpture

In:Southwest Art
5,pt.7:70-1 Jan.,'76 illus.

Describes the 'Pechman'system...the use of
multiple cameras which programme a computer.This
then instructs implements which will produce an
exact replica of the subject.This provides a
sculptor with accurate material for making portr.
busts
LC N6525.858 Artbibl.modern,v.7,no.2
1976 qZ5935.L105 NCFA *6504

AP
1
N547
NCFA
v.36

II.E.6

Flexner, James Thomas, 1908-
Benjamin West's American Neo-Classicism,
with documents of Benjamin West and William
Williams

In:N.Y.Hist.Soc.Q.
36:5-41 Jan.,'52 illus.

Mentions use of camera,p.11,12(15),for ptg.
in general

Alberts.Benj.West N40.1
.W49A3 NPG Bibl.p.488

ND
210
F62
NCFA

II.E.6

Flexner, James Thomas, 1908-
The decline of the portrait.In.his.That
wilder image...p.250-20

FOR COMPLETE ENTRY
SEE MAIN CARD

N
8217
I5H63
1987
NMAA

II.E.6

Hight, Kathryn Sweeney
The frontier Indian in White art,1820-1876.
The develpment of a myth.Ann Arbor,Mich.Univ.
Microfilms International,1989
421 leaves illus.

Bibliography:leaves 387-421
Incl.:Discussion of the art work concerning
Indian subjects by Samuel Seymour,Js.Otto Lewis,
John Neagle,Chs.Bird King,P.Rindisbacher,Geo.Cat-
lin,Karl Bodmer,John Mix Stanley,Seth Eastman.
Some works wer~roduced from daguerreotypes.
Ph.D.Disserta- tion.UCLA,1987

TR
680
F68X
NPG

II.E.6

Fotoportret..Voorbereiding:C.H.Broos e.a.
Hague,1970.
92 p. illus.

"Uitgegeven bij de tentoonstelling Foto-
portret,Haags gemeente mus. 6feb-3 mei,1970"

Bibliography

130 jaar foto-portret,p.2-65,-Relatie met
de andere technieken van de beeldende kunst;p.66
-76.-Sociale funktie,p.76-91

LC TR680.F68

N
6512.5
R45L5
1976a
NMAA

II.E.6

Lemon, Robert S.,Jr.
The figurative pretext:A comparative ex-
plication of the fiction of Alain Robbe-
Grillet and the photo realists. 1976
145 p. illus.

Bibliography p.127-37
Photocopy of typescript
Thesis Ph.D.-Ohio Univ.,1976

fig.2:Self-portrait of Close

AP
1
C76
NPG
v.28

II.E.6

French, Reginald F.
Erastus Salibury Field,1805-1900

In:Conn.Hist.Soc.B.
28:97-130 Oct.,'63 illus.

'Field often worked from daguerreotypes.'-
French,p.101

FOR COMPLETE ENTRY
SEE MAIN CARD

N
40.1
F97M6
NCFA

II.E.6

Millet, Josiah B., ed.
George Fuller:His life and works.Boston,
Houghton Mifflin & co.,1886
93 p. illus.

Incl.'Notes on.very early employment of the
daguerreotype by an itinerant portr.ptr. & dis-
cusses economic motivations.'-Rudisill

LC ND237.F8M6 Rudisill.Mirror image
 TR365.R916 NCFA p.250

II.E.6

Freund, Gisèle
La photographie en France au 19ième siècle
étude de sociologie et d'esthétique...Paris,
La maison des amis des livres,A.Monnier,1936
154 p. illus.

Thèse-Univ.de Paris

Bibliography

Disc.incl.the use of photography by portr.
ptrs.
LC TR71.F7 1936 Scharf,A.Art & photography
 N72.P5S31 NCFA p.260(14)

ND
1311.8
I PN27
NPG

II.E.6

National Society of the Colonial Dames of America.
Iowa
Portraits in Iowa;portraits of Americans,
made before 1900 and now located in Iowa.Limited
ed..s.l.:National Soc.of the Col.Dames of Ameri-
ca in the State of Iowa,1975
171 p. illus.

Incl.:Index by artist. Washington by
Gilbert Stuart;by Jane Stuart;reversed ptg.on
glass by unknown artist. All forms of original.
one-of-a-kind portraiture. Portrs.drawn or ptd.
over photographs.

II.E.6.

Hartmann, Wolfgang
..."Face farces" von Arnulf Rainer

In:Rainer, Arnulf, 1929-
Der grosse bogen.Cat.of the exh.Apr.30-June 15
1977 in Bern,Kunsthalle
p.17-27 illus.

..rry of the history of physiognomy,
Psychology of the expressionism.Influences of
psychical realism & Vienna actionists on Rainer,
R.seen as one of the most influential artists o
the present.Pho- \tography used by painters.

ND
1311.8
I PN27
Suppl.
NPG

II.E.6

National Society of the Colonial Dames of Ame-
rica. Iowa
Portraits in Iowa;portraits of Americans,
made before 1900 and now located in Iowa:a
supplement to the 1975 edition.Des Moines?,
1982
21 p. illus.

Incl.:Index by artists

LC N7593.N25 suppl.

705
M19
NCFA
v.42

II.E.6

Newhall, Beaumont, 1908-
The Daguerreotype and the painter

In:Mag.Art
42:249-51 Nov.,'49 illus.

Discusses the uses & problems of daguerreo-
types for ptrs.of portrs. 1843 a "Nat'l Daguer-
reotype miniatures Gall'was founded in N.Y. &
M.B.Brady's "Valhalla of America"on Broadway,fr.
which F.d'Avignon made 12 lithographs for Bra-
dy's book, "Gall.of Illustrious Americans"(ed.by
Lester) Rudisill.TR365.R916 NCFA
 p.250

N
72
P5S31
1969
NCFA

II.F.6

Scharf, Aaron, 1922-
Art and photography.Baltimore,Allen Lane,
The Penguin Press,1969.c.1968.
314 p. illus.

Bibl.references
Based on thesis for Ph.D.,Courtauld Inst.
of art,Univ.of London

The problems of style caused by exchange
betw.the different media.Chapter on Portrai-
ture,p.18-51.Use of daguerreotype by ptrs.in

LC N72.P58J

Coke.Ptr.& photograph qN72
P5C68 NCFA Preface

DA
28.1
069X
NPG

II.E.6

Ormond, Richard
The face of monarchy;British royalty por-
trayed...Oxford,Phaidon,1977
207 p. illus(part col.)

Bibl.references

Index

LC DA28.1.069

705
M19
NCFA
v.42

II.E.6

Schwarz, Heinrich, 1894-
Art and photography:Forerunners and influ-
ences

In:Mag.Art
42:252-7 Nov.,'49 illus.

From Schmalcalder's profile machine of 1806
to the 2nd half of 19th c.,when portraiture was
taken over by photography to Cézanne,when pho-
tography was dethroned.
 Coke.Ptr.& photograph...
 qN72-P5C68 NCFA Preface

N
40.1
H6393
P2
NPG

II.E.6

The painter as photographer;David Octavius Hill,
Auguste Salzmann,Charles Nègre...Vancouver
B.C.,Vancouver Art Gallery.1978?.

FOR COMPLETE ENTRY
SEE MAIN CARD

II.E.6

Stelzer, Otto
Kunst und photographie.Kontakte,einflüsse,
wirkungen.München,Piper(1966)
192 p. illus.

Bibliography

Photography fostered international art
styles by publishing ptgs. in magazines around
the world

LC N72.P58B

Coke.Ptr.& photograph...
 qN72.P5C68 Preface

VP
NPG

II.E.6

Portrayal or Betrayal;an exh.of portraits of
Nicholas Treadwell,oct.23-Nov.17,1973 at
Nicholas Treadwell gallery,London
4 p. folder illus.
26 artists portrayed N.Treadwell."The re-
sult is an interesting comparison of reality
through the eyes of each artist...Pop,New Fi-
guration,Realism combined with use of photogra-
phy have brought about a new style of portrai-
ture,appropriate to society now & valid as art.
-Treadwell.

II.E.6

Strelow, Liselotte, 1908-1981
Das manipulierte menschenbildnis,oder Die
kunst fotogen zu sein..1.Aufl.,Düsseldorf,
Econ-Verlag,.1961.
320 p. illus.p.:136.-.232.

NN InLP +B

Lichtbildnisse TR680.L69
1982 NPG p.734

II.E.6

Reaves, Wendy Wick, 1950-
Heroes,martyrs and villains;printed por-
traits of the Civil War

In:Print Council of America.Newsletter 1983
:8-12 Spring 1983,no.5

Pertains to exh.in the NPG,Sept.10,'82-
Apr.3,'83
Printed portrs.,sometimes based on photo-
graphs,were published as propaganda & as news.
Sometimes different heads were substituted on
the same body.

TR
185
P487X
NMAA

II.F.6

Townsend, George Alfred
Brady,the grand old man of American photo-
graphy.An interview.1891
5 p. illus.

In:Newhall,B.Photography:Essays & images,p.45-
49.Reprinted from The World,N.Y.,Apr.12,1891,
p.26

Repro.incl.:Lincoln.-Steel engravings fro.
B.'s daguerreotypes of Henry Clay & F.Cooper
Chs.Elliott ptd.the portr.of Fenimore
Cooper fr.B.'s photograph.

II.E.7. (Number not used presently)

qN
40.1
H6393 B8 Bruce, David, 1939- comp.
NCFA Sun pictures;the Hill-Adamson calotypes.
 ₍London₎Studio Vista₍c.1973₎
 247 p. illus.

 Bibliography

 Repros.incl.:Portrs.of Hill and of Adamson
 The"Disruption Painting"for which calotype
 "sketches" had been used to achieve the like-
 ness of ca. 500 people in the painting;etc.

II.E.8 - ADAMSON, ROBERT, 1821-1848

II.E.8. INDIVIDUAL PHOTOGRAPHERS, A-Z (for
 individual portrait artists in other
 media, see I.B.2.)

N
40.1
H6393F2 Hill, David Octavius, 1802-1870
NPG An early Victorian album;the Hill/Adamson
 collection.Edited and with an intro.by Colin
 Ford and a commentary by Roy Strong₍London₎
 J.Cape₍1974₎
 350 p. illus.

 Call no. refers to 1st American ed.,N.Y.,
 Knopf,1976

 LC TR651.H53 1974

II.E.8 - ADAMSON, ROBERT, 1821-1848

II.E.8 - INDIVIDUAL PHOTOGRAPHERS
 For individual portrait artist in other media see
I.B.2 -

When appropriate use both:
II.E.8 and I.B.2

TR
15
O53X Michaelson, Katherine
NCFA The first photographic record of a scienti-
p.110-4 fic conference

 In:One hundred years of photographic history...
 p.110-4

 Calotypes taken by ... R.Adamson in 1844

 FOR COMPLETE ENTRY
 SEE MAIN CARD

II.E.8 - ADAMSON, ROBERT, 1821-1848

TR
647
A13N2 Abbott, Berenice, 1898-
NMAA Berenice Abbott,the 20's and the 30's.
 Washington,D.C.,Publ.by the Smithsonian Inst.
 Press for the NPAA,1982
 unpaged illus.

 Intro.by Barbara Mosanov

 Incl.:8 portrs.

II.E.8 - ABBOTT, BERNICE, 1898-

fN
40.1
H6393 The painter as photographer;David Octavius Hill,
P2 Auguste Salzmann,Charles Nègre...Vancouver,
NPG B.C.,Vancouver Art Gallery₍1978?₎

 Hill/Adamson studio became the setting for
 hundreds of portraits of Edinburgh society

 FOR COMPLETE ENTRY
 SEE MAIN CARD

II.E.8 - ADAMSON, ROBERT, 1821-1848

TR
647
A13 O O'Neal, Hank
58- Berenice Abbott,American photographer.N.Y.,
NPAA McGraw-Hill,ca.1982
 256 p. illus. (An Artpress book)

 Incl.Ch.:Paris portraits

 LC TN654.0724 1982

II.E.8 - ABBOTT, BERENICE, 1898-

Scottish Arts Council Gallery
 Glasgow portraits by J.Craig Annan(1864-
1946)photographer.Cat.of exh.,Glasgow,Scottish
Arts Council Gallery,Dec.2,1967-Jan.27,1968.
Scottish Arts Council,1967
 41 p. illus.

 Traveled to Aberdeen, Dundee,Perth

 Intro.by Geo.A.Oliver(p.9-12)

LC TR680.836

II.E.8 - ANNAN, JAMES CRAIG, 1864-1946

II.E.8 - AVEDON, RICHARD, 1923-

Avedon, Richard, 1923-
Observations.Photographs by Richard Avedon,
comments by Truman Capote..N.Y.,Simon & Schus-
ter,1959.
151 p. illus.

Incl.:Individuals associated with fine arts
& films. For names see main card

LC TR680.A9

MOMA, p.436, v.11

TR
681
F3H65
NPG

II.E.8 - BASSANO(STUDIO)

Hillier, Bevis, 1940-
Victorian studio photographs;from the col-
lections of Studio Bassano and Elliott & Fry,
London,by B.Hillier;with contributions by Brian
Coe,Russell Ash and Helen Varley.Boston,David R.
Godine,1976, c.1975
144 p. illus.

Incl.Index

QN
40.1
A94R8
NCFA

II.E.8 - AVEDON, RICHARD, 1923-

Avedon, Richard, 1923-
· Portraits/Richard Avedon;essay,Harold
Rosenberg.1st ed.N.Y.,Farrar,Straus & Giroux,
1976
.141.p. illus.

Rosenberg's essay:"A Meditation on like-
ness".p.1-19.

LC TR68.1F3A93

N
40.1
B375C2
NPG

II.E.8 - BEATON, CECIL WALTER HARDY, 1904-

Beaton, Cecil Walter Hardy, 1904-
The best of Beaton...(1st Amer.ed.)N.Y.,
Macmillan,1968,

LC TR650.B38 1968

705
A784
NCFA
v.63

II.E.8 - AVEDON, RICHARD, 1923-

Cohen, Ronny H.
Avedon's portraits:the big picture

In:Art in Am
63:94-5 Nov.-Dec.,'75 illus.

FOR COMPLETE ENTRY
SEE MAIN CARD

II.E.8 - BEATON, CECIL WALTER HARDY, 1904-

Beaton, Cecil Walter Hardy, 1904-
The book of beauty.London,Duckworth,1930
67 p. illus.

NN MnU

Arts Council of Gr.Br.
The real thing TR646.G8L84
NPG,p.123

TR
647
A948M6
NPG

II.E.8 - AVEDON, RICHARD, 1923-

Minneapolis, Institute of Arts
Avedon.Minneapolis,1970
1 portfolio,consisting of a pamphlet.11.p.
illus.

Cat.of exh.July 2-Aug.30,1970

240 miniature repros.of portr.photographs
Bibliography

Arts in America q25961
U5A77X NCFA Ref. N421

II.E.8 - BELLOCQ, E.J.,1873-1949

New York. Museum of modern art
E.J.Bellocq:Storyville portraits.Photo-
graphs from the New Orleans red-light dis-
trict,ca.1912.Reproduced from prints made by
Lee Friedlander,pref.by Lee Friedlander,ed.
by John Szarkowski.N.Y.,The Mus.of mod.art,
1970
MOMA
945 18 p. 34 pl.
&
Photo dpt. Publ.in conjunction with an exh,Nov.19,
77.B35 1970-Jan.10,1971

MET Arts in America q25961.U5
213R41148 A77X NCFA Ref. N425

II.E.8 - BACHARDY, DON, 1934-

Bachardy, Don, 1934-
Ballet portraits..Santa Monica,Calif.,
c.1966.
30 illus.(portfol.)

Photographic portrs.of members,past and
present,of the N.Y.City Ballet

NN Arts in America q25961.U5
A77X NCFA Ref. Q144

TR
647
B5C44
NPG

II.E.8 - BIAL, RAYMOND

Bial, Raymond
In all my years.Portraits of older Blacks
in Champaign-Urbana....Exh.at,Champaign County
Historical Museum,Champaign,Ill.,1983
unpaged illus(52 photos)

N
40.1
P9575X2
NPG

II.E.8 - BILLINGS, MOSES, 1809-1879

Kelly, Elizabeth K
 Moses Billings:19th century portrait paint-
er...1979
 69 p. illus.

 Reproduction of typescript.
 Incl.Cat.of artist's works
 Thesis Georgetown Univ.,Nov.5,1979
Bibliography

qN
40.1
B81K9
NPG

II.E.8 - BRADY, MATHEW B., 1823-1896

Kunhardt, Dorothy Meserve, 1901-
 Mathew Brady and his world...Morristown,N.J.
...Silver Burdett Co.,c.1977

FOR COMPLETE ENTRY
SEE MAIN CARD

II.E.8 - BLANDFORD, fl.2nd half 19th c.

Edwards, Amelia Blandford
 Photographic historical portrait gallery,...
Photographed by ...Blandford & Co. London,P.
and A.Colnaghi,Scott & Co.,1864...

Brit.Mus.
1752.b &
1055

FOR COMPLETE ENTRY
SEE MAIN CARD

II.E.8 - BRADY, Mathew B., 1823-1896

Lester, Charles Edwards, 1815-1890, ed.
 The gallery of illustrious Americans,con-
taining the portraits...of 24 of the most emi-
nent citizens of the American republic,since
the death of Washington.From daguerreotypes by
Brady...by d'Avignon.N.Y.,M.B.Brady,F.d'Avig-
non,C.E.Lester,1850
 3 p. illus.

 Only 12 lithographs were completed.NPG Print
 Dpt. Brady,M.B.The Gallery of illustrious Ameri-
NPG cans,12 biographies.
Print Dpt.
LC E302.5.L47 Rare book

II.E.8 - BRADY, MATHEW B., 1823-1896

Brady, Mathew B., 1823-1896
 Brady and Handy's album of the 50th Con-
gress of the U.S....designed and published
by M.B.Brady and Levin C.Handy.Washington,1888
 84 p.of mounted photos
 illus.

LC.JK1059 50th .B8.MnHi

qCT
275
L73L8f
1969
NPG

II.E.8 - BRADY, MATHEW B., 1823-1896

Lorant, Stefan, 1904-
 Lincoln;a picture story of his life.Rev.
& enl.ed.N.Y.,Norton & Co.,Inc.,1969.
 336 p. illus.

 Repro.ptgs.,life masks,photographs
 Contents & Bibliography. Index

 Appendix...B:The photographer of Lincoln...
 C:All of Lincoln's photographs in chronological
 order

LC F457.6.L78 1969

N
7628
L73H2
NPG

II.E.8 - BRADY, MATHEW B., c.1823-1896

Hamilton, Charles, 1913-
 Lincoln in photographs;an album of every
known pose,by Charles Hamilton and Lloyd Osten-
dorf..1st ed.,Norgan,University of Oklahoma
Press,c.1963,
 409 p. illus.

 Bibliography of Lincoln photograph books

 Photographs by Brady and his employees &
associates

LC E457.6.H23

N
40.1
B61M5
NPG

II.E.8 - BRADY, MATHEW B., ca.1823-1896

Meredith, Roy, 1908-
 Mr.Lincoln's camera man,Mathew B.Brady...
N.Y.,C.Scribner's sons,1946
 368 p. illus.

 Bibliography

 LC
TR140.F7M4

N
40.1
B81H8
NPG

II.E.8 - BRADY, MATHEW B., ca.1823-1896

Horan, James David, 1914-
 Mathew Brady,historian with a camera....
N.Y.,Crown Publishers,1955.
 244 p. illus.

 "A picture album"p.91.-228.
 "A pictorial bibl.of Brady pictures":p.235-38
 Incl.bibliographies.

LC TR140.F7H6

N
40.1
B81M5m
NPG

II.E.8 - BRADY, MATHEW B., ca.1823-1896

Meredith, Roy, 1908-
 Mr.Lincoln's contemporaries;an album of
portraits by Mathew B.Brady.N.Y.,Scribner,1951
 233 p. illus.

LC F415.8.M4

II.E.8 - BRADY, MATHEW B., 1823-1896

Meserve, Frederick Hill, 1865-1962
Portraits of the Civil War period, photographs for the most part from life negatives by M.B.Brady, now in the possession of F.H. Meserve..N.Y.Corlies,Macy & Co.,incorp...1903?.
36 p. illus.

LC N7624.M4

II.E.8 - BRANDT, BILL, 1904-1983

Brandt, Bill
Portraits,photographs by Bill Brandt.Intro. by Alan Ross.London,Gordon Fraser,1982
chiefly illus. (Gordon Fraser photographic monographs,v.11)

Intro.in English,French and German

LC TR681.F3B73 1982b Phil.M.of A.Bill Brandt
TR647.B821P5 NMAA Bibl.p.98

II.E.8 - BRADY, MATHEW B., ca.1823-1896

TR 185 P487X NMAA

Townsend, George Alfred
Brady,the grand old man of American photography.An interview.1891
5 p. illus.

In:Newhall,B.Photography:Essays & images,p.45-49.Reprinted from The World,N.Y.,Apr.12,1891, p.26

Repro.incl.:Lincoln.-Steel engravings from B.'s daguerreotypes of Henry Clay & F.Cooper Chs.Elliott ptd.the portr.of Fenimore Cooper fr.B.'s photograph.

II.E.8 - CALDESI, LEONIDA, fl.2nd half 19th c.

Edwards, Amelia Blandford
Photographic historical portrait gallery,... Photographed by L.Caldesi...London,P.and A. Colnaghi,Scott & Co.,1864...

Brit.Mus. 1752.b & 1055

FOR COMPLETE ENTRY
SEE MAIN CARD

II.E.8 - BRADY, MATHEW B., 1823-1896

U.S. 41st Cong.3d sess.House of Representatives
Report no.46,Mar3,1871
Brady's coll.of historical portraits

FOR COMPLETE ENTRY
SEE MAIN CARD

II.F.8 - CAMERON, JULIA MARGARET(PATTLE), 1815-1879

N 40.1 C18L8 NPG

Cameron, Julia Margaret(Pattle),1815-1879
The Herschel album;an album of photographs presented to Sir John Herschel...London,National Portrait Gallery,c.1975
32 p. chiefly illus.

LC TR681.P3C355

TR 647 B821P5 NMAA

II.E.8 - BRANDT, BILL, 1904-1983

Philadelphia Museum of Art
Bill Brandt:Behind the camera,photographs 1928-1983,presented by the Alfred Stieglitz Center,Phila.Mus.of Art.Published to accompany the retrospective exh.June 8 to Sept.21,1985.
Phila.Mus.of Art,Aperture,1985
99 p. illus.
Ch.on Portraits,p.40-51
Introductions by Mark Haworth-Booth
Essay by David Mellor
Bibliography

René Magritte,1966,p.47(holding his 'La grande guerre')

II.F.8 - CAMERON, JULIA MARGARET(PATTLE), 1815-1879

Cameron, Julia Margaret(Pattle), 1815-1879
Julia Margaret Cameron;an album.Washington, Lunn Gallery...c.1975
57 p. all illus.

LC TR680.C28

II.E.8 - BRANDT, BILL, 1904-1983

Brandt, Bill, 1904-1983
Bill Brandt;photographs,cat of an exh.by, the Arts Council of Great Britain,Hayward Gall London,30 Apr.-31 May,1970;organised by the Museum of Modern Art, N.Y. London,Arts Council
c1970,
16 p.of illus.

LC TR647.B7A2 1970
Cha NMAH

II.E.8 - CAMERON, JULIA MARGARET (PATTLE), c1815-1879

TR 647 C18W3 NPG

Cameron, Julia Margaret (Pattle), 1815-1879
Julia Margaret Cameron,1815-1879,by,Mike Weaver.1st M.S.ed.Boston,Little,Brown,1984
160 p. illus. (A N.Y.Graphic Soc.book)

NMAH TR680 C18 1984

This book is based on the cat.for the exh. of J.M.Cameron's work,organ.by the John Hansard Gall.,the Univ.,Southampton

Bibliography

Worldwide Books.Mus.& Gall publicat's.European Art 19th c. no.1804

qN
40.1
C18P8
1973
NPG

II.E.8 - CAMERON, JULIA MARGARET(PATTLE), 1815-
1879

Cameron, Julia Margaret(Pattle),1815-1879
Victorian photographs....1973.
32 p. illus.

705
.28
MCFA
v.80

II.E.8 - CARJAT, ÉTIENNE, 1828-1906

Adhémar, Jean
Étienne Carjat

In:Gas Beaux-Arts
80:71-81 Aug.'72 illus.

'...il ne représente pas ses modèles en
pied,mais jusqu'au genou...'.-Adhémar

Repro.incl.:photomontage:Courbet conversing
with himself,ca.1862
Paris.Mus.Carnavalet.É.
Carjat,p.3

II.E.8 - CAMERON, JULIA MARGARET(PATTLE), 1815-
1879

Gernsheim, Helmut, 1913-
Julia Margaret Cameron;her life and photo-
graphic work....2nd ed.,Millerton,N.Y.,Aperture
,1975
260 p. illus.

Bibliography

Incl.index

LC TR140.C27G47 1975

II.E.8 - CARJAT, ÉTIENNE, 1828-1906

Paris. Musée Carnavalet
Étienne Carjat,1828-1906,photographe,.cat.
of exh.,Nov.25,1982-Jan.23,1983.,Paris,Musées
de la ville de Paris.1982.
107 p. illus. (Dans le cadre du Mois
de la Photo organisé par l'Association Paris
Audiovisuel)
Bibliography
Intro.by Sylviane Heftler,p.7-32;incl.ar-
ticle by Philippe Néagu.
Cat.grouped by Self-portrs.,artists,author
politicians,medicine,musicians,actors,etc.

NOA

MdU-PC, NmU,a.o.

II.E.8 - CAMERON, JULIA MARGARET(PATTLE), 1815-
1879

Ritchie, Anne Isabella(Thackeray)lady,1837-1919
Alfred,lord Tennyson and his friends...from
the negatives of Mrs.Julia Margaret Cameron...
London,T.F.Unwin,1893

Stanford Univ.Libr.for LC
MH CtY NN etc.
FOR COMPLETE ENTRY
SEE MAIN CARD

N
40.1
L636L8
NPG

II.E.8 - CARROLL, LEWIS(CHARLES DODGSON),1832-
1898

London. National Portrait Gallery
Lewis Carroll at Christ Church;edited by Co-
lin Ford;introduction by Morton N.Cohen.
,London,...1974
32 p. ,chiefly,illus.

Photographic album:28 portrs.by Lewis
Carroll together with 'Hiawatha's photograph-
ing';a parody of Longfellow's 'The Song of
Hiawatha',

LC PR4612.L8 1974

II.E.8 - CAMERON, JULIA MARGARET, 1815-1879

Strasser, Alex
Immortal portraits,being a gallery of fa-
mous photographs by David Octavius Hill,Julia
Margaret Cameron...& others.Selection & commen-
tary by Alex Strasser.London & N.Y.,The Focal
press,1941.
141 p. illus.

LC TR 680.S92
Gernsheim T15.037 Ref.
Bibl.p.376

TR
647
C327V2
E 1985
NPG

II.E.8 - CARTIER-BRESSON, HENRI, 1908-

Cartier-Bresson, Henri, 1908-
Henri Cartier-Bresson photoportraits.Preface
by André Picyre de Mandiargues...N.Y.,Thames &
Hudson,1985
283 p. chiefly illus.

Kozloff.In:Art in Am
75:197 Oct.'87

qN
40.1
C18 0 9
NPG

II.E.8 - CAMERON, JULIA MARGARET(PATTLE), 1815-
1879

A Victorian album:Julia Margaret Cameron...N.Y.,
Da Capo Press,1975

LC TR681.F3V52 1975b
FOR COMPLETE ENTRY
SEE MAIN CARD

TR
647
C78P4
NPG

II.E.8 - COSTER, HOWARD, 1885-1959

Pepper, Terence
Howard Coster's celebrity portraits.101
photographs of personalities in literature
and the arts.London,NPG,c.1985
113 p. illus.

Publ.in connection with the exh.'Howard
Coster:Camera portraits of the twenties and
thirties,held at the NPG fr.28 june to 8 sept.
1985
Biographical references
Index

LC TR681.F3P47 1985

VF
Costume

II.F.8 - COUPON, WILLIAM

Dutch portraits.A photographer's art
Photographs by William Coupon

Int'l/A Ambassador
76-81 Oct.,1985 illus.

qN
40.1
D368B8
NPG

II.F.8 - DE MEYER, ADOLF, 1868-1949

De Meyer, Adolf, 1868-1949
DeMeyer...N.Y.,Knopf;...1976

FOR COMPLETE ENTRY
SEE MAIN CARD

N
40.1
C94.2A7
NPG

II.E.8 - CRONISE, THOMAS JEFFERSON, 1853-1927

The Art perfected.Portraiture from the Cronise
studio."introduced by Susan K.Seyl.Oregon
Historical Soc.,1980
147 p. illus.

Photographs from 1880-1927

II.E.8 - DISDERI, ANDRÉ ADOLPHE EUGÈNE, 1819-
1890

Disderi,A.A.E.,1819-1890,
L'Art de la photographie,avec une intro-
duction par Lafon de Camarsac.Paris,l'Auteur,
1862
367 p. illus.

D.elaborates on the psychological atmos-
phere that must be created for a successful
portrait.

NWC MdBJ CU McCauley.LikenessesqTR575
.M12 NPG notes p.22 no.17

II.E.8 - CROY, OTTO R., 1902-

Croy, Otto R., 1902-
The photographic portrait...Philadelphia,
Chilton book co.,1968.
245 p. illus(part col.)

German ed.1957

Incl.contributions of other portrait photo
graphers, p.241-2

Index of contributors

LC TR575.C713 Verzeichnis lieferbarer B
cher 1973/74 NPG v.1,p.
335

N
40.1
D595
M12
NPG

II.E.8 - DISDERI, ANDRÉ ADOLPHE EUGÈNE, 1819-
1890

McCauley, Elizabeth Anne
A.A.F.Disderi and the carte de visite por-
trait photograph...1980
3 v.in 2(356,206 p.) illus.

Thesis(Ph.D)Yale Univ.,1980
Photocopy of typescript.Ann Arbor,Mich.:
Univ.microfilms international,1981
Contents:v.1.Text.v.2.Plates
Bibliography:p.327-56
TR647.D611M2 1985:Book with same title
Discussion incl.:The importance of the
carte de visite in breaking down the divi-
sion betw.portr aiture and genre

qN
40.1
C97M6
NPG

II.F.8 - CUNNINGHAM, IMOGEN, 1883-1976

Cunningham, Imogen, 1883-1976
After ninety.Introd.by Margaretta Mitchell
Seattle,Univ.of Washington Press,c.1977
111 p. illus.

Bibliography

LC TR654.C86 Cumulative book index
Z1219.C97 NPG 1979 p.614

II.F.8 - DODGSON, CHARLES
see
II.F.8 - CARROLL, LEWIS(CHARLES DODGSON), 1832-
1898

N
40.1
D128G3
1968
NPG

II.E.8 = DAGUERRE, LOUIS JACQUES MANDÉ, 1787-1851

Gernsheim, Helmut, 1913-
L.J.M.Daguerre;the history of the diorama
and the daguerreotype...N.Y.,Dover Publications
c.1968.
226 p. illus.

Bibliographical references

LC TR140.D3G47 1968

II.E.8 - DOISNEAU, ROBERT, 1912-

Les grands peintres;a series.Geneva,R.Kister,
1956-
v. illus.

Some publ.in English with series title
'Great painters'

Each booklet on individual artist,e.g.
Villon,Atlan,Segonsac,Picasso,Rouault,Léger;
text by Bernard Dorival,André Verdet,Michel
Ragon.Photogr.of artist by Roger Hauert,Rbt.
NPG has Doisneau,Gilles Ehrmann
Villon
N40.1.V75D6
LC see ed.1953-7,1958-62:
Dorival,Ragon,Verde. MOMA, v.11,p.436

II.E.8 - DOUGLAS, FRED

Douglas, Fred
 Durations;Fred Douglas.Vancouver,B.C.,Inter-
media,1975.
,46,p. illus.

 Photographic portraits

LC TR680.D68

II.E.8 - EDWARDS, ERNEST, 1837-1903

Reeve, Lovell ,Augustus., 1814-1865, ed.
 Portraits of men of eminence...The photo-
graphs from life by Ernest Edwards.London,Reeve
& Co.,1863

LC DA531.1.R3

FOR COMPLETE ENTRY
SEE MAIN CARD

705
C69
NCFA
v.29

II.E.8 - DRAPER, EDWARD, fl.1860

Fuller, John
 An un-Victorian photograph of the 1860's

Int Art Journal
29,no.3:303-8,400 Spring,1970 illus.

 Bibliography
 Edw.Draper's photograph'Boy with parrot're-
veals something of childhood.It shares common
ground with 20th c. portraiture rather than with
British portr.tradition of portraying a child
to transfer moral messages,sweet sentiment &
status symbols. Loma 1970,p.168 e70.P53L8

II.E.8 - EHRMANN, GILLES

Les grands peintres;a series.Geneva,R.Kister,
1956-
 v. illus.

 Some publ.in English with series title
'Great painters'

 Each booklet on individual artist,e.g.
 Villon,Atlan,Segonsac,Picasso,Rouault,Léger;
 text by Bernard Dorival,André Verdet,Michel
NPG has Ragon.Photogr.of artist by Roger Hauert,Rbt.
Villon Doisneau,Gilles Ehrmann
N40.1.V75D6
LC see ed.1953-7,1958-62; MOMA, v.11,p.436
 Dorival,Ragon,Verdet

II.E.8 - DUEHRKOOP, RUDOPH, 1848-1918

Dührkoop, Rudolf
 Das kamera-bildnis und seine kulturelle
bedeutung.Berlin,1907
 24 p. illus.

..: NBG

QN
40.1
E368A1
NPG

II.E.8 - EISENSTAEDT, ALFRED, 1898-

Eisenstaedt, Alfred, 1898-
 People.N.Y.Viking Press,1973.
 259 p. illus. (A studio book)

LC TR680.E33 1973

Cumulative book index
Z1219.C97 NPG p.757

705
A786
NMAA
v.82

II.E.8 - EAKINS, THOMAS, 1844-1916

Homer, William Innes
 Who took Eakins' photographs?

Int Art N
82:112-9 May,'83 illus.

 Refers mainly to photographs of Walt
Whitman

TR
681
F3H65
NPG

II.E.8 - ELLIOTT

Hillier, Bevis, 1940-
 Victorian studio photographs;from the col-
lections of Studio Bassano and Elliott & Fry,
London,by B.Hillier;with contributions by Brian
Coe,Russell Ash and Helen Varley.Boston,David R.
Godine,1976, c.1975
 144 p. illus.

 Incl.Index

R
315
C65
1984X
NMAA

II.E.8 - ECHELMEYER, RICK

College of physicians of Philadelphia
 The College of physicians of Philadelphia
portrait catalogue,by,Julie S.Berkowitz;with
photographs by Rick Echelmeyer.Philadelphia,The
College,1984
 244 p. illus.

 Incl.:Indexes

II.E.8 -

Erfurth, Hugo, 1874-1948
 Bildnisse.Hrsg.von Otto Steinert,eingelei-
tet von J.A.Schmoll,gen.Eisenwerth,Gütersloh,
S.Mohn,1961.
 31 p. illus.

 ...aus der fotografischen sammlung der Folk-
wangschule für Gestaltung...Essen

 Bibliography

LC TR680.E7 MOMA,v.11,p.436

qTR
647
F895L7
NPG

II.E.8 - FRIEDLANDER, LEE, 1934-

Friedlander, Lee, 1934-
 Lee Friedlander portraits.Foreword by
R.B.Kitaj,p.9-15.Boston,Little,Brown & Co.,
c.1985
 Chiefly illus. (a N.Y.Graphic Soc.book)

 Index

LC TR680.F738 1985

II.E.8 - GAUDIN, MARC ANTOINE, 1804-1880

Gaudin,Marc Antoine, 1804-1880.
 Sur le perfectionnement des portraits
photographiques

 In:La Lumière
 Apr.,15,1863

NMAH DP NN McCauley.Likenesses qTR
575.M12 NPG p.23 notes
no.77

TR
681
F3H65
NPG

II.E.8 - FRY

Hillier, Bevis, 1940-
 Victorian studio photographs;from the col-
lections of Studio Bassano and Elliott & Fry,
London,by B.Hillier;with contributions by Brian
Coe,Russell Ash and Helen Varley.Boston,David R.
Godine,1976, c.1975
 144 p. illus.

 Incl.Index

II.E.8 - GIRAUDON, A.

Le Recueil d'Arras,conservé à la bibliothèque
 de l'Abbaye de Saint-Vaast.Paris,A.Giraudon.
 1906
 20 p.

A'dam Photographies,par A.Giraudon,de 280 portrs.
Kunst-h. représentant des personnages ayant vécu aux
Bibl. cours de Flandre et de Bourgogne pendant les
 14e,15e et 16e s.:From Arras Codex.
V & A 'The Arras Codex is now preserved in the Bibl.
(under Municipale d'Arras,Recueil de portrs.MS266'.-
Giraudon) W.Gibson Cat.der Kunsthist.Bibl.in
 het Rijksmus.te A'dam Z5939
 .52 NCFA deel 1,p.132
 (cont'd on next card)

II.E.8 - GALLATIN, ALBERT EUGENE, 1881-1912

New York university. Gallery of living art
 Gallery of living art,A.E.Gallatin col-
lection,N.Y.University....N.Y.G.Grady press,
1936.
 .39.p. illus.

 Portrs.of Braque,Léger,Matisse,Picasso,
Mondrian,Miró;photographs by A.E.Gallatin

LC N620.M4A3 MOMA,v.11,p.138

II.E.8 - HALSMAN, PHILIPPE, 1906-1979

Halsman, Philippe, 1906-1979
 The Frenchman:A photographic interview.N.Y.
Simon & Shuster,.1949.
 unpaged 24 portrs.

 24 portrs.in which by facial expression,
the model replies to questions asked in the
caption.The model is Fernandel

LC PN2638.C73H3 Arts in America qZ5961.U
5A77X NCFA Ref. N600

II.E.8 - GALELLA, RON

Galella, Ron
 Offguard...N.Y.,McGraw-Hill,c.1976

LC TR681.F3G34 **FOR COMPLETE ENTRY
SEE MAIN CARD**

qN
40.1
H83A1
NPG

II.E.8 - HALSMAN, PHILIPPE, 1906-

Halsman, Philippe, 1906-
 Halsman sight and insight...Garden City,N.Y.
Doubleday,1972
 186 p. illus.

LC TR681.F3H35

II.E.8 - GAUDIN, MARC ANTOINE, 1804-1880

Gaudin,Marc Antoine, 1804-1880.
 Portraits instantanés avec grandissement

 In:La Lumière
 March 30, 1862

NMAH DP NN McCauley.Likenesses qTR
575.M12 NPG p.23 notes
no.76

TR
647
H196A16
1986
NMAA

II.E.8 - HALSMAN, PHILIPPE, 1906-1979

Halsman, Philippe, 1906-1979
 Philippe Halsman's jump book;introduced by
Mike Wallace.N.Y.,Abrams,1986,c.1959
 96 p. illus.

 Originally publ.N.Y.,Simon & Schuster,1959

902

qN40.1
H183
H19
NPG

II.E.8 - HALSMAN, PHILIPPE, 1906-1979

Halsman, Philippe, 1906-1979
Portraits/Halsman;selected and edited by
Yvonne Halsman;with Irene Halsman Rosenberg
and Jane Halsman Bello.N.Y.,McGraw-Hill,
ca.1983
119 p. illus.

LC TR681.P3H355

705
A786
NCFA
v.46

II.E.8 - HAWES, JOSIAH JOHNSON, 1808-1901

Newhall, Beaumont, 1908-
First American masters of the camera

In:Art N
46:91-8, Nov.,'47 illus.
168-72
'The birth of photography in the U.S.:Faces
of the colorful & great of pre-Civil War days
seen through the lens of Southworth & Hawes,
the ...ston daguerreotypists'
Repro.incl:Daniel Webster,John Quincy Adams,
Lemuel Shaw,Lola Montez,Horace Mann,Harriet B.
Stowe,H.W.Longfel low

TR
647
H23D5
NMAA

II.E.8 - HANFSTAENGL, FRANZ, 1804-1877

Hanfstaengl, Franz, 1804-1877
Album der zeitgenossen.Hrsg.von Christian
Diener und Graham Fulton-Smith.München,W.Heyn
,1975.
,96,p. chiefly illus.
Fotos 1853-1863

Incl.:Essay on Hanfstaengl by Helmut
Gernsheim

LC TR680.H26 1975 Keller.Deutsche portraitf
tografie...LC TR185.K39
p.64

qN
40.1
S71636
NPG

II.E.8 - HAWES, JOSIAH JOHNSON, 1808-1901

Sobieszek, Robert A., 1943-
The spirit of fact:the daguerreotypes of
Southworth & Hawes,1843-1862.Robert A.Sobies-
zek and Odette M.Appel;with research assis-
tance by Charles R.Moore.Boston,D.R.Godine,
c.1976
163 p. illus.
Cat.of an exh.held at the Intern'l Mus.of
Photography at the Geo.Eastman House,Rochester,
Feb.,June 1976;at the NPG,Washington,July-Dec.
1976;and at the MFA,Boston,Jan.-Feb.1977

Bibliography
LC TR365.S6

II.E.8 - HAUERT, ROGER

Les grands peintres;a series.Geneva,R.Kister,
1956-
v. illus.

Some publ.in English with series title
'Great painters'

Each booklet on individual artist,e.g.
Villon,Atlan,Segonzac,Picasso,Rouault,Léger;
text by Bernard Dorival,André Verdet,Michel
Ragon.Photogr.of artist by Roger Hauert,Rbt.
NPG has Doisneau,Gilles Ehrmann
Villon
N40.1.V75D6
LC see ed.1953-7,1956-62: MOMA, v.11,p.436
Dorival,Ragon,Verde

qN
40.1
H6393 B8
NCFA

II.E.8 - HILL, DAVID OCTAVIUS, 1802-1870

Bruce, David, 1939- comp.
Sun pictures;the Hill-Adamson calotypes.
,London,Studio Vista,c.1973,
247 p. illus.

Bibliography

Repros.incl.:Portrs.of Hill and of Adamson.
The"Disruption Painting"for which calotype
"sketches" had been used to achieve the like-
ness of ca. 500 people in the painting;etc.

II.E.8 - HAWARDEN, CLEMENTINA,Viscountess, 1822-
,1865
Hawarden, Clementina, Viscountess, 1822-1865
Clementina,Lady Hawarden;...N.Y.,St.Martin's
Press,1974
112 p. of illus.

LC TR680.H354 1974 **FOR COMPLETE ENTRY
SEE MAIN CARD**

N
40.1
H6393E2
NPG

II.E.8 - HILL, DAVID OCTAVIUS, 1802-1870

Hill, David Octavius, 1802-1870
An early Victorian album;the Hill/Adamson
collection.Edited and with an intro.by Colin F
Ford and a commentary by Roy Strong.London,
J.Cape,1974.
350 p. illus.

Call no. refers to 1st American ed.,N.Y.,
Knopf,1976

LC TR651.H53 1974

II.E.8 - HAWES, JOSIAH JOHNSON, 1808-1901

Moore, Charles LeRoy
Two partners in Boston:the careers and da-
guerreian artistry of Albert Southworth and
Josiah Hawes.University of Michigan,1975
2 v. (652 p.)

Portraying according to Romantic ideals.The
daguerreotypist's most important task was to be
the interpreter of virtuous character...to guide
the nation,which in turn,by virtue of its super-
ior technology,was destined to lead the world.

mfm no. Ph.D.diss.Uni.of Mich.
76-11,676 Diss.Abstr. Sobieszek.The spirit of
Z5055U49D57 NPG fact.qN40.1S71636 NPG.p.162
v.36 no.11 Bibl.

TR
15
053X
NCFA
p.110-4

II.E.8 - HILL, DAVID OCTAVIUS, 1802-1870

Michaelson, Katherine
The first photographic record of a scienti-
fic conference

In:One hundred years of photographic history...
p.110-4

Calotypes taken by D.O.Hill... in 1844

**FOR COMPLETE ENTRY
SEE MAIN CARD**

II.E.8 - HILL, DAVID OCTAVIUS, 1802-1870

Mickel, Heinrich L.
· David Octavius Hill;wurzeln und wirkungen
seiner lichtbildkunst.Halle,Fotokinoverlag
Halle.1960.
93 p. illus. (Meister der Kamera)

Bibliography

MH DLC InLP

II.E.8 - HUGO, VICTOR MARIE, 1802-1885

Gruyer, Paul, 1868-1930
Victor Hugo photographe.Paris,C.Mendel,1905
38 p. illus.

(LC #TR16.2.H8709) CLU Galerie Octant.Souvenirs
de Jersey.Bibl.

fN
40.1
H6393 II.E.8 - HILL, DAVID OCTAVIUS, 1802-1870
P2
NPG The painter as photographer;David Octavius Hill,
 Auguste Salzmann,Charles Nègre...Vancouver,
 B.C.,Vancouver Art Gallery,1978?.

 FOR COMPLETE ENTRY
 SEE MAIN CARD

II.E.8 - HUJAR PETFR, 1934-

Hujar, Petor, 1934-
Portraits in life and death.Introd.by Susan
Sontag.N.Y.,Da Capo Press,1976
91.p. chiefly illus.

LC TR680.H77 Rila III/2 1977 #5592

II.E.8 - HILL, DAVID OCTAVIUS, 1802-1870

Schwarz, Heinrich, 1894-
David Octavius Hill,master of photography.
N.Y.,The Viking press,1931
47 p. illus.

Bibliography

LC TR680.S32

II.E.8 - ISENRING, JOHANN BAPTIST, 1796-1860

Stenger, Erich, 1878-
Der daguerreotypist J.B.Isenring;seine ver-
dienste um einführung und ausgestaltung der da-
guerreotypie 1839-1842.Berlin,Selbstverlag des
verfassers,1931
16 p. illus.

N.Y.P.L.
Kunstausstellung enthaltend eine sammlung
von lichtbildern moistens porträts nach dem le-
ben gefertigt im Mai,Juni,Juli 1840 von J.B.
Isenring,maler aus St.Gallen...
Bibliography

II.E.8 - HILL, DAVID OCTAVIUS, 1802-1870

Strasser, Alex
Immortal portraits,being a gallery of fa-
mous photographs by David Octavius Hill,Julia
Margaret Cameron...& others.Selection & commen-
tary by Alex Strasser.London & N.Y.,The Focal
press,1941.
141 p. illus.

LC TR 680.S92 Gernsheim T15.G37 Ref.
 bibl.p.376

qN
40.1 II.E.8 - JACOBI, LOTTE, 1896-
J165W8 (JACOBI REISS, JOHANNA ALEXANDRA)
NPG Jacobi, Lotte, 1896-
 Lotte Jacobi;ed.by Kelly Wise.Danbury,N.H.,
 Addison House,c.1978

 FOR COMPLETE ENTRY
 SEE MAIN CARD

TR
647 II.E.8 - HORST, 1906- (Bohrmann,Horst Paul
H79W3 Albert)
NMAA Watters, James
 Return engagement:Faces to remember-then
 and now...with new photographs by Horst.1st
 ed.N.Y.,C.N.Potter,inc.;distributes by Crown,
 inc.Publishers,1984
 168 p. illus.

 Index

 Books in print.subject
 guide,1985-86,p.4865

AP
1 II.E.8 - KÄSEBIER, GERTRUDE, 1852-1934
A79
NCFA Bunnell, Peter C.
v.16 Gertrude Käsebier

 In:Arts in Virg.
 16:2.4 Fall,'75 illus.

 FOR COMPLETE ENTRY
 SEE MAIN CARD

TR
642
C33
1901K
NCFA

II.E.8 - KÄSEBIER, GERTRUDE, 1852-1934

Caffin, Charles Henry, 1854-1918
Photography as a fine art.N.Y.Amphoto
.1972,c.1901.
191 p. illus. (An Amphoto facsimile bk.)

Ch.III:Mrs.Käsebier & the artistic-commercial portrait

TR
6
N57
NPG
2 c.

II.E.8 - KARSH, YOUSUF, 1908-

Photography in the Fine Arts
Museum directors' selections for the 1965
N.Y.World's Fair exh..N.Y.,c.1965.
.47, p. illus.

Incl.:Portrs.of 11 museum directors by
Yousuf Karsh

Winterthur Mus.Libr. fZ881
W78 NCFA v.6,p.221

II.E.8 - KAR, IDA

Gernsheim, Helmut, 1913-
The photographs of Ida Kar

In:Motif
9:90-95 Sept.,'62 illus.

Photos of Gino Severini,Ivon Hitchens,Marc
Chagall, Geo.Braque,Ossip Zadkine

LC N1.M88

MOMA, v.11, p.436

AP
1
D81
NCFA
v.35

II.E.8 - KAYSER, ALEX

Kayser, Alex
Zehn amerikanische photographen

In:Du
35:66-75 Sept.,'75 illus.

Rila II/2 1976 #5765

II.E.8 - KARSH, YOUSUF, 1908-

Karsh, Yousuf, 1908-
Faces of destiny;portraits by Karsh.Chicago,
N.Y.,Ziff-Davis publ.co. London,Geo.G.Harrap co.
ltd..1946,
158 p. illus.

LC TR675.K3

Art Books 1876-1949. A5937
775 NCrA Ref. p.496

II.E.8 - KIRK, MALCOLM

Strathern, Andrew
Man as art.New Guinea.Photographs by Malcolm Kirk.N.Y.,The Viking Press,1981
144 p. illus(part col.) A Studio Book

Portrs.of warriors,ceremonial figs.& carved
masks

LC GN671.N5K57 1981

II.E.8 - KARSH, YOUSUF, 1908-

Karsh, Yousuf, 1908-
Karsh Canadians.Toronto;Buffalo:Univ.of
Toronto,c.1978
203 p. illus.

LC TR681.T3K375

Cumulative book index
Z1219.C97 NPG 1979 p.1360

II.E.8 - LENDVAI-DIRCKSEN, ERNA, 1883-

Lendvai-Dircksen, Erna, 1883-
Das deutsche volksgesicht.Mecklenburg
und Pommern.2nd ed.Bayreuth,Gauverlag.1st ed.
1940.
unpaged 70 photos

CtU

II.E.8 - KARSH, YOUSUF, 1908-

Karsh, Yousuf, 1908-
Portraits of greatness..London,New York.
T.Nelson.1959.
207 p. illus.

Photographer's anecdotes.
The ambiguity & interpretability of the
arrested face

LC TR680.K3

Gombrich.Mask & face.In:
Art,percept'n & reality
N71/G64X NCFA p.20

II.E.8 - LENDVAI-DIRCKSEN, ERNA, 1883-

Lendvai-Dircksen, Erna, 1883-
Ein deutsches menschenbild.Antlitz des
volkes.In 148 Bildern dargestellt von Erna
Lendvai-Dircksen.Frankfurt/M.,Umschau Verlag
.1961.
156 p. illus.

LC DD76.L47 NN

II.E.8 - LERSKI, HELMAR

Lerski, Helmar
 Köpfe des alltags.Unbekannte menschen ge-
sehen von H.Lerski...Einl.Curt Glaser.Berlin,
Verlag H.Reckendorf,1931
 1 p. 80 pl.

LC TR680.14
 Die 20er jahre im portr.
 N6868.5.E9Z97 NPG,p.143

qTR
647
Y258
N2
NMAA

II.E.8 - MAPPLETHORPE, ROBERT, 1947-1989

Mapplethorpe, Robert
 Mapplethorpe portraits,introductory essay.
twelve facets of Mapplethorpe by Peter Conrad.
London,NPG,1988
 96 p. illus.

 Published to accompany an exh.at the NPG,
London,24 March-19 June,1988

 Index
 Bibliography
 Exh.organizers:Robin Gibson & Alexandra
Knaust

N
6850
L69
1968
NCFA

II.E.8 - LIBERMAN, ALEXANDER, 1912-

Liberman, Alexander, 1912-
 The artist in his studio;text and photos
by Alexander Liberman,with a foreword by James
Thrall Soby.N.Y.,Viking Press,1968,
 284 p. illus(part col.) (A Studio book)

 "A.L.records & interprets with a camera
the personalities & ambiance of some of the
leading European artists.of our time."-Soby

 MOMA,v.11,p.437

MOMA
Photo
Dpt.
coll.

II.F.8 - MAULL & POLYBLANK(STUDIO,fl.1850's)

Maull and Polyblank
 Photographic portraits of living celebri-
ties...London,Maull & Polyblank and W.Kent,1859

 FOR COMPLETE ENTRY
 SEE MAIN CARD

II.E.8 - LOTZ, HERBERT A., 1944-

Long Beach, Calif. Museum of Art
 Photographs:Herbert A Lotz;exh.11 Jan.-
29 Feb.,1976
 36 p. illus.

 32 works shown

Portrait photography,1970-75

 Rila III/1 1977 #2868

II.E.8 -

Maywald, Wilhelm, 1907- ed.
 Artistes chez eux,vus par Maywald...
 Boulogne(Seine),Architecture d'aujourd'hui,
1949.
 23 l. illus.
 Leaves 1-21 are illus.

 In special issue of L'Architecture d'au-
jourd'hui:"2e numéro hors-série...consacré
aux arts plastiques."

LC L
709.09.A78,a

N.Y.P.L. MAN
 + MOMA,v.11,p.436

II.E.8 - MAN, FELIX H., 1893-

London. National Portrait Gallery
 Felix H.Man:reportage portraits 1929-76.
Exh.1 Oct.,1976-2 Jan.,1977.Cat.text by Felix
H.Man
 17 p. illus.

 Bibliography

74 works shown
 'Photographs taken with the aim of portray-
ing the sitters spontaneously...Artists,writers
musicians,politicians...'-Rila

LC TR681.F3M36 Rila III/1 1977 # 2888

II.E.8 -

Maywald, Wilhelm, 1907-
 Portrait+atelier;photos.Brattleboro,Vt.,
Greene,c.1958.
 1 v.(unpaged) illus.

 English,German and French

 Bibliography

 Contents:Chagall,Léger,Rouault,Matisse,
Laurens,Picasso, Le Corbusier,Utrillo,Villon,
Arp,Braque,Miró

LC N6852.M3 1958

II.E.8 -

Man, Felix H., 1893- ed.
 Eight European artists photographed and
edited by Felix H.Man...Intro.by Graham Greene
and Jean Cassou...London,Heinemann,1954.
 241 p.incl.plates(part col.)

 English,French,German

 Incl.:Braque,Chagall,Léger,Le Corbusier,
Moore,Picasso,Sutherland

LC N6758.M35 MOMA,v.11,p.437

q1h
647
M827M6
NPG

II.E.8 - MORATH, INGE, 1923-

Morath, Inge
 Portraits,photographs and afterword...
N.Y.,Aperture,c.1986

 Introd.by Arthur Miller

II.E.8 - MULAS, UGO

Parma. Università. Istituto di storia dell'arte.
Ugo Mulas.Immagini e testi.Con una nota
critica di Arturo Carlo Quintavalle.Parma,The
Institute,1973.
157 p. illus.

Catalogue of exhibition 1973

MOMA, v.11,p.438
MOMA Photo dpt.77.M85xP2

TR
647
N217ito
NMAA

II.E.8 - MAPPEL'BAUM, MOISEI SOLOMONOVICH,
1865-1958

Mappel'baum,Moisei Solomonovich,1865-1958
,Nash vek;fotografii/Moisei Mappel'baum;
sostavitel' Il'ia Rudiak,slur ago,photographs
Moses Nappelbaum;ed.by Ilya Rudiak.Ann Arbor,
Ardis,c.1984.
145 p. chiefly portraits

In English and Russian
Incl.:Index

LC TR681.F3N36 1984

TR
681
F3M87
1978X
NPG

II.E.8 - MURAY, NICKOLAS, 1892-1965

Muray, Nickolas, 1892-1965
Muray's celebrity portraits of the twen-
ties and thirties.135 photographs by Nickolas
Muray;introd.by Marianne Fulton Margolis.N.Y.,
Dover Publications,1978
,140,p. chiefly illus.

Cumulative book index
Z1219.C97 NPG 1979 p.1733

fN
40.1
H6393
P2
NPG

II.E.8 - NÈGRE, CHARLES, 1820-1880

The painter as photographer;David Octavius Hill,
Auguste Salzmann,Charles Nègre...Vancouver
B.C.,Vancouver Art Gallery,1978?,

FOR COMPLETE ENTRY
SEE MAIN CARD

qTR
680
M97
NPG

II.E.8 - MURAY, NICKOLAS, 1892-1965

Muray, Nickolas, 1892-1965
The revealing eye;personalities of the
1920's,in photographs by Nickolas Muray and
words by Paul Gallico.,1st ed.,New York,Athe-
neum,1967
307 p. illus.

LC TR680.M87

qN
40.1
N547A1
NCFA

II.E.8 - NEWMAN, ARNOLD ABNER, 1918-

Newman, Arnold, 1918-
One mind's eye:the portraits and other pho-
tographs of Arnold Newman,foreword by Beaumont
Newhall;intro.by Rbt.Sobieszek.Boston,D.R.
Godine,c.1974
192 p. chiefly illus.

Bibliography

Incl.:Index

LC TR680.N48

II.E.8 - NADAR(pseud.)
see
II.E.8 - TOURNACHON, FÉLIX, 1820-1910,called Nadar

II.E.8 - NIBBELINK, DON D

Nibbelink, Don D
Picturing people...Garden City,Amphoto,
c.1976

LC TR575.N5 FOR COMPLETE ENTRY
SEE MAIN CARD

II.E.8 -

Namuth, Hans, 1915-
Fifty-two artists.Photographs by Hans
Namuth.Scarsdale,N.Y.,Committee for the visual
art ,c.1973,
,4, p. illus.

MET
213
N15
Q

N
40.1
P242N2
NPG

II.E.8 - PARKINSON, NORMAN, 1913-

Parkinson, Norman, 1913-
Photographs by Norman Parkinson;50 years
of portraits and fashion.London,NPG,1981
112 p. chiefly illus(part col.)

Published in connection with the exh.held
at the National Portrait Gallery from 7 Aug.
to 25 Oct.1981
Bibliography
Incl.:Index of sitters
Intro.by Terence Pepper
Essay by Menda Parkinson
Worldwide art cat.bull.
705.W927 NMAA v.18,no.2,
1982 p.23

II.E.8 - PECSI, JOSEF

Pecsi, Josef
. Zur porträtphotographie unserer tage

In:Dt.Kst.u.Dek.
49:221 ff. 1921-22

LC N3.D4

Die 20er jahre im portr.
N6868.5.E9Z97 NPG, p.143

II.E.8 - REGNAULT, VICTOR, 1810-1878

Paris. Musée des arts décoratifs
Victor Regnault,1810-1878,oeuvre photogra-
phique..Exh.at.Mus.des arts décoratifs,Paris,
Apr.25-July 1,1979
unpaged mainly illus.

MET
107.4
P1392
.57.

Incl.:article Victor Regnault by Romée
Matines
'Les portraits de savants...aux alentours de
l'année 1851 dénotent une volonté documentaire
et objective où l'objet devient une part signi-
fiante du portrait.'

qTR
647
P41289 Penn, Irving,1917-
NPG Irving Penn.by.John Szarkowski..Exh.at.Mus.
of modern art,N.Y.N.Y.,The Museum,c.1584
216 p. chiefly illus(part col.)

Bibliographical references

Incl.:Portrs.of artists,writers,theater
people

II.E.8 - PENN, IRVING, 1917-

N
40.1
R37J7 Jones, Edgar Yoxall
NGFA Father of art photography:O.G.Rejlander,
1813-1875.Greenwich,Conn.,N.Y.Graphic Soc.
.1973.
112 p. illus.

Bibl.references

Darwin commissioned Rejlander to illustrate
his 'Expression of the emotions in man & animals

LC TR140.R43J66

Stevenson.V.Dyck in check
trousers,NK4743.S848NPG
p.116

II.E.8 - REJLANDER, OSCAR GUSTAV, 1813-1875

q TR
647
P810 Ponsold, Renate
A8 Eye to eye.The camera remembers:portrait
NPG photographs by Renate Ponsold....

II.E.8 - PONSOLD, RENATE MOTHERWELL, 1935-

FOR COMPLETE ENTRY
SEE MAIN CARD

II.E.8 - RETZLAFF, ERICH

Retzlaff, Erich
Das Antlitz des alters,photographische
bildnisse von Erich Retzlaff,einleitung von
Jakob Kneip.Düsseldorf,Pädagogischer verlag,
1930
21 p. illus.

LC TR680.R43

Sander, August.qTR647.
S214K2 E1986 NPG
Bibl.p.61

II.E.8 - RAY, MAN, 1890-1976

Ray, Man, 1890-1976
Man Ray,photographs,1920-1934...N.Y.,East
River Press,1975

LC TR653.R39 1975

FOR COMPLETE ENTRY
SEE MAIN CARD

II.E.8 - RIEBESEHL, HEINRICH

Photographierte Erinnerung---.Kat.Konzeption und
realisation,Heinrich Riebesehl..Hannover,
Kunstverein.1975.

LC TR680.P49

FOR COMPLETE ENTRY
SEE MAIN CARD

II.E.8 -

Ray, Man, 1890-
Portraits.Hrsg.und eingeleitet von L.Fritz
Gruber..Gütersloh.S.Mohn.1963.
15 p. illus..73.

Man Ray's commentary accompanies each portr
Incl.Cocteau,Maar,Dali,Tanguy,Eisenstein,Le Cor
busier,Loos,Pascin,Tanning,Derain,Braque,Léger,
Giacometti,Brancusi,Matisse,Picasso,etc.

LC TR680.R36

MOMA,v.11,p.437

qTR
647
R844R8 Roth, Sanford, 1906-1962
NPG Portraits of the fifties,photographs by San-
ford Roth;text by Beulah Roth;with an intro.by
Aldous Huxley.San Francisco,Mercury House,1987
107 p. illus.

List of sitters

II.E.8 - ROTH, SANFORD, 1906-1962

II.E.8 - RYDER, JAMES FITZALLAN, 1826-

Ryder, James Fitzallan, 1826-
Voigtländer and I in pursuit of shadow
catching;a story of 52 years' companionship
with a camera.Cleveland,Cleve.Printing & Publi-
shing co.,190?
251 p. illus.

Incl.early portrs:daguerreotypes & photo-
graphs

LC TR149.R99 Sobieszek.Spirit of fact
 qN40.1.S716S6,Bibl.

II.E.8 - SARONY, NAPOLEON, 1821-1896

40.1
S245B3 Bassham, Ben L.loyd, 1942-
NPG The theatrical photographs of Napoleon
 Sarony...Kent,Ohio,Kent State University Press,
 c.1978
 122 p. illus.

 Bibliography

 LC TR140.S37B36

II.E.8 - SALOMON, ERICH

Salomon, Erich .
 Berühmte zeitgenossen in unbewachten augen-
blicken...mit 112 bildern.Stuttgart,J.Engel-
horns nachf.:ca.1931.
 46 p. illus.

Descriptive letterpress in German,English,
French and Italian...

LC TR680.S175 Die 20er jahre im portr.
 16868.5.E9297 NPG,p.143

II.E.8 - SCHOMMER, ALBERTO, 1928-

Schommer, Alberto, 1928-
 Las fotos psicológicas...Madrid,Nueva Lente
;1975?;

 LC TR680.S313 FOR COMPLETE ENTRY
 SEE MAIN CARD

II.E.8 - SANDER, AUGUST, 1876-1964

Sander, August, 1876-1964
 Antlitz der zeit;60 aufnahmen deutscher
menschen des 20.jahrhunderts...mit einer ein-
leitung von Alfred Döblin.München,Transmare
verlag;etc.,c.1929.
 17? p. 60 pl.

L
C TR680.S2

II.E.8 - SCHWARTZ, BERN

Schwartz, Bern
 Contemporaries:portraits by Bern Schwartz;
text by Ronny Schwartz.London,Collins,1978
 150 p. chiefly col.portrs.

 LC TR681.P3S38 Cumulative book index
 Z1219.C97 NPG 1979 p.221c

qTR
647
S214K2 Sander, August
E1986 August Sander:Citizens of the 20th cen-
NPG tury;portrait photographs,1892-1552...ed.by
 Gunther Sander;text by Ulrich Keller...Cam-
 bridge,Mass.,MIT Press,c.1986
 431 p. illus.

 Bibliography,p.59-62

 LC TR680.S22613 1986

II.E.8 - SANDER, AUGUST, 1876-1964

II.E.8 - SKREBNESKI, VICTOR, 1929-

qN
40.1
S6285 Skrebneski, Victor
D7 Skrebneski portraits...Garden City,N.Y.,
NPG Doubleday & Co.,Inc.,1978

 FOR COMPLETE ENTRY
 SEE MAIN CARD

NPG
book
card
1973 II.E.8 - SANDER, AUGUST, 1876-1964

 Sander, August, 1876-1964
 Men without masks;faces of Germany,1910-
 1938.With an introd.by Gunther Sander and fore-
 word by Golo Mann...Greenwich,Conn.,N.Y.Graphic
 Society.1973.
 313 p. illus.

 Translation of Menschen ohne Maske.
 London ed.publ.under title:August Sander:
 photographer extraordinary.

 LC TR680.S2313 1973b

II.E.8 - SOUTHWORTH, ALBERT SANDS, 1811-1894

Moore, Charles LeRoy
 Two partners in Boston:the careers and da-
guerreian artistry of Albert Southworth and
Josiah Hawes.University of Michigan,1975
 2 v. (652 p.)

 Portraying according to Romantic ideals.The
daguerreotypist's most important task was to be
the interpreter of virtuous character...to guide
the nation,which in turn,by virtue of its super-
ior technology,was destined to lead the world.

mfm no. Ph.D.diss.Uni.of Mich.
76-11,676 Diss.Abstr. Sobieszek.The spirit of
 Z5055U49D57 NPG fact.qN40.1S716S6 NPG.p.16:
 v.36 no.11 Bibl.

705
A796
NCFA
Y.46

II.E.8 - SOUTHWORTH, ALBERT SANDS, 1811-1894

Newhall, Beaumont, 1908-
First American masters of the camera

In:Art N
46:91-9, Nov.,'47 illus.
168-72
'The birth of photography in the U.S.:Faces
of the colorful & great of pre-Civil War days
seen through the lens of Southworth & Hawes,
the...Boston daguerreotypists'
Repro.incl:Daniel Webster,John Quincy Adams,
Lemuel Shaw,Lola Montez,Horace Mann,Harriet B.
Stowe,H.W.Longfellow

II.E.8 - STEINERT, OTTO, 1915-

Steinert, Otto, 1915- ed.
Selbstporträts....Gütersloh,S.Mohn,1961.

Purdue Univ.Library
NN etc.

FOR COMPLETE ENTRY
SEE MAIN CARD

QN
40.1
S71656
NPG

II.E.8 - SOUTHWORTH, ALBERT SANDS, 1811-1894

Sobieszek, Robert A., 1943-
The spirit of fact:the daguerreotypes of
Southworth & Hawes,1843-1862.Robert A.Sobies-
zek and Odette M.Appel;with research assis-
tance by Charles R.Moore.Boston,D.R.Godine,
c.1976
163 p. illus.
Cat.of an exh.held at the Intern'l Mus.of
Photography at the Geo.Eastman House,Rochester,
Feb.,June 1976;at the NPG,Washington,July-Dec.
1976;and at the MFA,Boston,Jan.-Feb.1977

Bibliography
LC TR365.86

TR
646
U6N484X
NPG

II.E.8 - STIEGLITZ, ALFRED, 1864-1946

New York. Metropolitan museum of art
The collection of Alfred Stieglitz...N.Y.,
Viking Press,1978,

FOR COMPLETE ENTRY
SEE MAIN CARD

QN
40.1
S81A1
NPG

II.E.8 - STEICHEN, EDWARD, 1879-

Steichen, Edward, 1879-
A life in photography.Publ.in collaboration
with the Mus.of Modern Art.Garden City,N.Y.,
Doubleday,1963
1 v.(unpaged) illus(part col..)

Ch.10:On portraits & portraiture.3 p.,44
portrait photographs of celebrities of the
20th c.

LC TR140.868A25

NF
508
268
NCFA

II.E.8 - STIEGLITZ, ALFRED, 1864-1946

Zigrosser, Carl
The artist in America.24 close-ups of con-
temporary printmakers.N.Y.,A.A.Knopf,1942
207 p. illus.

Incl.Photographer Alfred Stieglitz
Illus.:3 works and 1 portr.of each artist,
with the exception of Jasper Plum

MOMA,v.11,p.439

TR
647
S812Pt
NPG

II.E.8 - STEICHEN, EDWARD, 1879-1973

Peterson, Chistian A.
Edward Steichen,the portraits;an exh.
organised by the Minneapolis Inst.of Arts...
circulated by the Art Mus.Assoc'n of America...
San Franciso,Calif.,The Association,c.1984
44 p. illus.

Cat.of an exh.held at the Art Gallery,
California State College,San Bernardino,Calif.
Oct.1-30,1984 and other locations

TR680.P464
LC [illegible] 1984

Additional short-listed
titles of Worldwide art
cat.Bul.

N
40.1
S868F6
NPG

II.E.8 - STONE, JOHN BENJAMIN, 1838-1914

Ford, Colin John, 1934-
Sir Benjamin Stone,1838-1914 & the Nation-
al Photographic Record Assoc.,1897-1910.cat.to
accompany an exh.at the National Portrait Galle-
ry,London,c.1974
32 p. illus.

Creative Camera.AP 1.C916
NCFA,May,'74,p.150,foot-
note

II.E.8 - STEINERT, OTTO, 1915-

Essen. Museum Folkwang
Menschen von gestern und heute.Photogra-
phische portraits....Essen,1973.

Eine Ausstellung von Otto Steinert

FO00
FA 10389
.465

MWiCA

FOR COMPLETE ENTRY
SEE MAIN CARD

V ^ ^

II.E.8 - STONE, JOHN BENJAMIN, 1838-1914

Stone, John Benjamin, 1838-1914
Sir Benjamin Stone's pictures;records of
national life and history.repro.fr.the coll.
of photographs made by Sir Benj.Stone,with des-
criptive notes by M.J.QaDonagh.London,Paris,N.Y.
& Melbourne,Cassell & co.,ltd.,1906
2 v. illus.

I.Parliamentary scenes & portrs.
II.Festivals,ceremonies & customs

LC(no call no.)

Creative Camera.AP 1.C916
NCFA,May,'74,p.150,footn.

II.E.8 - STRAND, PAUL, 1890-1976

London. National Portrait Gallery
 Paul Strand,ᵉcat.of.ᵃa retrospective exh.
of his photographs,1915-68ᵉorganized by theᵉ
NPG in association with the Arts Council of
Great Britain.London,the Gallery,1976
 16 p. illus.

 Exh.arranged by the Philadelphia Museum of
Art and on view at the NPG annex 30 Jan-4 Apr.,
1976

LC TR647.S85L66 1976

TR
185
P487X
NMAA

II.F.8 - TOURNACHON, FÉLIX, 1820-1910, called
 ₑNadar
Burty, Philippe, 1830-1890
 Nadar's portraits at the exh.of the French
Soc.of photography.1859
 1 p. 4 illus.
In:Newhall,B.Photography:Essays & images,p.109-
111.Reprinted from Gaz Beaux-Arts,2:215-6,May15,
1859.Translated by Beaumont Newhall

 Repro.:Daumier,Delacroix,Gautier,Baudelaire

 Rosenblum.World hist.of
 photographs TR15.R67 1984X
 NMAA notes p.617no.23

II.F.8 - STRELOW, LISELOTTE, 1908-1981

Strelow, Liselotte, 1908-1981
 Liselotte Strelow:Portraits 1933-1972
ₑRheinisches Landesmuseum Bonn,Ausst.h.8-
6.9,1977.Red.Klaus Honnef...et al.Köln,Rhein-
land-Verlag;Bonn,Habelt.in Komm.1977
 197 p. chiefly illus. (Kunst und Al-
tertum am Rhein,Nr.78)

 Bibliography of L.Strelow's works,p.189-9

LC N2255.R5A5 Nr.78 Lichtbildnisse TR680.L69
 1982 NPG p.256,no.6a

II.F.8 - TOURNACHON, FÉLIX, 1820-1910, called
 ₑNADAR
Nadar photographe:portraits...Paris,Direction
des musées de France?ₑ1975ₑ

LC TR681.A7N32 FOR ᴄᴏ ᴀʏ
 SEE MAIN CARD

II.E.8 - STRELOW, LISELOTTE, 1908-1981

Strelow, Liselotte, 1908-1981
 Das manipulierte menschenbildnis,oder Die
kunst fotogen zu sein.ₑ1.Aufl.Düsseldorf,
Econ-Verlag,ₑ1961ₑ
 320 p. illus.p.ₑ136ₑ-ₑ232ₑ

NN InLP MB Lichtbildnisse TR680.L69
 1982 NPG p.734

N
40.1
T725P2
NPG

II.E.8 - TOURNACHON, FÉLIX, 1820-1910, called
 ₑNADAR
Paris. Bibliothèque Nationale
 Nadar.exposition.Paris,1965
 1 v.(unpaged) illus.
 Préface par M.Étienne Dennery
 Contents.I.Nadar et sa famille.Portrs.et ca-
ricatures(Photos & drags.)II.N.et le journalisme
III.N.écrivain.IV.Le Panthéon Nadar(celebrities,
e.g.Dumas,Victor Hugo,Rossini,Balzac,Baudelaire,
Daumier,Edm.de Goncourt.V.N.photographe(Portrs,ᵉ
Berlioz,Sarah Bernhardt,Delacroix,George Sand...ₑ
VI.N.et l'aéronautique

LC TR620.T6P3 Stelzer.Kunst & photogr.
 LC N72.P5S8 p.176

N
40.1
T6314
NPG

II.E.8 - TÖNNIES, HEINRICH, 1825-1903

Alland, Alexander
 Heinrich Tönnies,cartes-de-visite photogra-
pher extraordinaire.N.Y.,Camera/Graphic press
ltd.,1978
 unpaged illus.

 English & Danish

qN
40.1
T72506
1976
NPG

II.E.8 - TOURNACHON, FÉLIX, 1820-1910,called NA-
 ₑDAR
Tournachon, Félix, 1820-1910
 Nadar.by.Nigel Gosling.1st American ed.
N.Y.;Knopf...,1976
 298 p. illus.

 Portrs.of celebrities:artists,writers,musi-
cians,theatre personalities

II.E.8 - TOURNACHON, FÉLIX, 1820-1910, called
 ₑNadar
Barret, André
 Nadar:50 photographies de ses illustres con-
temporains...Paris,A.Barret,ᴰiffusion inter Fo-
rum,c.1975

LC TR140.T6B37 FOR COMPᴸᴇ ᴵᴺʏ
 SEE MAIN CARD

II.E.8 - TOURNACHON, FÉLIX, 1820-1910,called
 Nadar
Tournachon, Félix, 1820-1910
 Nadar:Karikaturist,fotograf,aeronaut.Organi-
sation der ausstellung Katharina Schmidt und
Max Vilette.ₑDüsseldorf,Institute française und
Kunsthalle,1976
 29 p. illus.

MET Cat.of exh.Nov.5-Dec.5,1976 at Städtische
107.3 Kunsthalle,Düsseldorf
D9444
ₑ10ₑ

NNMM

II.E.8 - TOURNACHON, FÉLIX, 1820-1910, called
=NADAR

Tournachon, Félix, 1820-1910
 Nadar:photographe,caricaturiste,journaliste;
photographies,textes et dessins rassemblés par
Catherine et Bertrand Meyer.Paris,Encre,c.1979
 75 p. illus. (Les Arcanes du Temps)

LC TR681.F3T69 1979

QN
40.1
V274M4
NPG

II.F.8 - VAN VECHTEN, CARL, 1880-1964

Van Vechten, Carl, 1880-1964
 Portraits,the photography of Carl Van Vech-
ten,compiled by Saul Mauriber.Indianapolis,
Bobbs-Merrill,1978,
 172 p., illus.

II.E.8 - TOURNACHON, FÉLIX, 1820-1910, called
=NADAR

Tournachon, Félix, 1820-1910
 Nadar;préface de Jean-François Bory;intro...
par Philippe Néagu...et Jean-Jacques Poulet-
Allemagny.Paris,A.Hubschmid,c.1979
 2 v.(1298 p.) illus.

 Contents:t.1.Photographie(grouped by prof-
fessions:artists,authors,actors,musicians,etc.)
t.2:Dessins et écrits(incl.:Le panthéon Nadar
with preparatory drawings)

 Incl.indexes

LC TR681.F3T685 1979

AA
185
P487X
NMAA

II.F.8 - WILSON, EDWARD L., 1838-1903

Wilson, Edward L., 1838-1903
 To my patrons.1871
 5 p. illus.

In:Newhall,B.Photography:Essays & images,p.129-
133
 'The booklet gives a vivid insight into
the enormous popularity of photographic por-
traiture in the 1870s.'-Newhall

II.E.8 - TOURNACHON, GASPARD FÉLIX
 see
II.E.8 - TOURNACHON, FÉLIX, 1820-1810,called Nadar

II.F.8 - WOLFF, BERNARD PIERRE, 1930-

Wolff, Bernard Pierre, 1930-
 Friends and friends of friends;with an in-
troduction by John Leonard.1st ed.N.Y.,E.P.
Dutton,c.1978
 121 p. chiefly illus.

LC TR680.W64 1978

Cumulative book index
Z1219.C97 NPC 1979 p.2712

II.E.8.- TOURNACHON, PAUL, 1856-1939, called
 son of Félix
 =NADAR

Tournachon, Félix, 1820-1910
 Nadar;préface de Jean-François Bory;intro...
par Philippe Néagu...et Jean-Jacques Poulet-
Allemagny.Paris,A.Hubschmid,c.1979
 2 v.(1298 p.) illus.

 Contents:t.1.Photographie(grouped by prof-
fessions:artists,authors,actors,musicians,etc.)
t.2:Dessins et écrits(incl.:Le panthéon Nadar
with preparatory drawings)

 Incl.indexes

LC TR681.F3T685 1979

II.E.8 - VANDERCAM, SERGE, 1924-

Témoignages pour l'art abstrait 1952,introd.de
 Léon Degand...Photographies-portraits par
 Serge Vandercam.Boulogne(Seine)Éditions
 "Art d'aujourd'hui.1952,
 295 p. illus(part col.)

MOMA,v.11,p.439

LC N6490.T45

Index to Topics

Bibliography on Portraiture—Index to Topics

x indicates a "see" reference from an unused term to a
used one, e.g. CAMECS & INTAGLICS x GEMS

sa refers from a broader term to a narrower term, e.g.
CERAMICS(SCULPTURE) sa II.C.5 - TOBY JUGS

xx precedes the broader term from which the narrower
term is derived, e.g. TOBY JUGS xxCERAMICS(SCULP-
TURE)

AFRO-AMERICAN ARTISTS

see

I.B.2 - JOHNSON, JOSHUA(Johnston,Joshua)
I.B.2 - REISS, WINOLD

ACRYLIC

see

II.A.5 - ACRYLIC

xx SPECIFIC MEDIA, A-Z (Painting)

ALLEGORY & RELIGION

see

I.E - ALLEGORY & RELIGION

x MYTHOLOGY
x RELIGION
x SYMBOLISM
x PORTRAIT HISTORIÉ

xx SPECIAL SUBJECTS, A-Z

ACTORS

see

I.E - PROFESSIONS - ACTORS

xx PROFESSIONS

ALTERED PLATES

see

I.G.3 - MUTILATION

ADMINISTRATION

see

I.E - PROFESSIONS - ADMINISTRATION

xx PROFESSIONS
sa GOVERNMENT - STATE AND LOCAL

ANATOMY

see

I.E - ANATOMY

x EAR
x EYE

xx SPECIAL SUBJECTS, A-Z

AESTHETICS

see

I.H.2 - AESTHETICS

ANCESTRAL

see

I.E - ANCESTRAL (only used when especially discussed)

x IMAGO CLIPEATA

xx SPECIAL SUBJECTS, A-Z

ARCHITECTS

see

I.E - PROFESSIONS - ARCHITECTS

xx PROFESSIONS

AUCTION-CATALOGS

see

I.B.1.d - AUCTION-CATALOGS,A-Z (by name of auction house)

ART

see

I.E - PROFESSIONS - ART

xx PROFESSIONS

AUTHORS

see

I.E - PROFESSIONS - AUTHORS

xx PROFESSIONS
x JOURNALISTS
x POETS
x WRITERS

ARTISTS

see

I.E - PROFESSIONS - ARTISTS

sa I.B.2 - INDIVIDUAL ARTISTS
sa I.E - ARTISTS, PHYSICALLY HANDICAPPED
xx PROFESSIONS

x PAINTERS
x SCULPTORS

BILDNISVITENBÜCHER

see

II.B.3.f - BILDNISVITENBÜCHER

x BLOCKBOOKS
x CHRONICLES
x MÜNZBILDBÜCHER

ARTISTS, PHYSICALLY HANDICAPPED

see

I.E - ARTISTS, PHYSICALLY HANDICAPPED

xx SPECIAL SUBJECTS, A-Z

BISCUIT

see

II.C.4 - CERAMICS (Sculpture)

ASSISTENZIA (ASSISTENTIA)

see

I.H.5 - "DISGUISED" PORTRAITS (ASSISTENZIA)

BISHOPS

see

I.E - PROFESSIONS - CLERGY - BISHOPS

BLACKS

see

I.E - ETHNIC GROUPS, A-Z

BLOCKBOOKS (Portraits)

see

II.B.3.f - BILDNISVITENBÜCHER

BRONZE

see

II.C.4 - METAL - BRONZE

BUSINESSMEN

see

I.E - PROFESSIONS - BUSINESSMEN

xx PROFESSIONS

BUSTS

see

I.F.5.a - BUSTS

sa II.C.5 - BUSTS (Sculpture)

xx LENGTH

BUSTS (Sculpture)

see

II.C.5 - BUSTS(Sculpture)

x FURNITURE

xx SPECIAL FORMS & SUBJECTS, A-Z (Sculpture)

BYZANTINE (Sculpture)

see

II.C.2 - BYZANTINE (Sculpture)

xx SPECIAL PERIODS & STYLES - CHRONOLOGICAL

CALOTYPE

see

II.E.5 - CALOTYPE

xx SPECIFIC TECHNIQUES, A-Z (Photography)

CAMEO INCRUSTATIONS

see

II.C.5 - CAMEOS & INTAGLIOS

CAMEOS & INTAGLIOS

see

II.C.5 - CAMEOS & INTAGLIOS (incl.glass cameos)

x GEMS

x INTAGLIOS

x CAMEO INCRUSTATIONS

x CRYSTALLO CERAMICS

x SULPHIDES

xx SPECIAL FORMS & SUBJECTS, A-Z (Sculpture)

CARICATURE

see

II.B.4 (Prints & drawings)

sa CARICATURE (Painting or when several media are discussed)

sa CARICATURE (Sculpture)

xx PHYSIOGNOMY

CARICATURE (Painting or when several media are discussed)

see

I.E - CARICATURE

sa II.C.5 - CARICATURE (Sculpture)

xx SPECIAL SUBJECTS, A-Z

CARICATURE (Sculpture)

see

II.C.5 - CARICATURE

xx SPECIAL FORMS & SUBJECTS, A-Z (Sculpture)

CARTES DE VISITE

see

II.F.4 - CARTES DE VISITE

xx SPECIAL FORMS & SUBJECTS (Photography)

CERAMICS (Decorative arts)

see

II.D - CERAMICS (Decorative arts for portraits on ceramics)

x EARTHENWARE
x PORCELAIN
x POTTERY
x STAFFORDSHIRE WARE
x TERRA-COTTA
sa WEDGWOOD WARE

CERAMICS (Sculpture)

see

II.C.4 - CERAMICS (Sculpture)

sa II.C.5 - TOBY JUGS
sa II.D - CERAMICS (Decorative arts for portraits on ceramics)

x BISCUIT
x EARTHENWARE
x PORCELAIN
x POTTERY
x STAFFORDSHIRE WARE
x TERRA-COTTA
x DERBY PORCELAIN
xx SPECIFIC MATERIAL (Sculpture)

CHALCOGRAPHY

see

II.B.3.e - ENGRAVING

CHARACTERIZATION

SEE

I.H.4.a - PHYSIOGNOMY

CHARCOAL

see

II.B.2.e - CHARCOAL

xx SPECIFIC MEDIA (Drawings)

CHILDREN

see

I.E - CHILDREN

sa II.F.4 - CHILDREN (Photography)
sa CHILDREN (SPECIAL MEDIA)

xx SPECIAL SUBJECTS, A-Z

CHILDREN (Photography)

see

II.E.4 - CHILDREN

xx SPECIAL FORMS & SUBJECTS (Photography)

CLERGY - BISHOPS

see

I.E - PROFESSIONS - CLERGY - BISHOPS

xx CLERGY
x BISHOPS

CHILDREN (SPECIAL MEDIA)

see

(Medium)-Children (e.g.II.C.5 - CHILDREN) (Sculpture)

CLERGY - POPES

see

I.E - PROFESSIONS - CLERGY - POPES

xx CLERGY
x POPES

CHRONICLES (illustrated)

see

II.B.3.f - BILDNISVITENBÜCHER

CLERGY - RECTORS

see

I.E - PROFESSIONS - CLERGY - RECTORS

xx CLERGY
x RECTORS

CIVIC GUARD

see

I.E - PROFESSIONS - GOVERNMENT (STATE & LOCAL)

CLERGY - REFORMERS

see

I.E - PROFESSIONS - CLERGY - REFORMERS

xx CLERGY
x REFORMERS

CLERGY

see

I.E - PROFESSIONS - CLERGY

sa CLERGY - BISHOPS
sa CLERGY - POPES
sa CLERGY - RECTORS
sa CLERGY - REFORMERS

xx PROFESSIONS

COINS & MEDALS

see

II.C.5 - COINS & MEDALS

x MEDALS
x NUMISMATICS
x SEALS
x PORTRAIT MEDALLIONS

xx SPECIAL FORMS & SUBJECTS A-Z (Sculpture)

COLLAGE

see

II.A.1 - COLLAGE

COMPUTER ART

see

I.C.7 - 20th c.

COLLECTIONS

see

I.B.1.a - PUBLIC, A-Z (by name of institution)
I.B.1.b - PRIVATE, A-Z (by name of collector)
I.B.1.c - DEALERS' CATALOGS, A-Z (by name of dealer or gallery
I.B.1.d - AUCTION CATALOGS, A-Z (by name of auction house)

CONNOISSEURSHIP

see

I.C.1 - CONNOISSEURSHIP

COLLODION PROCESS

see

II.E.5 - COLLODION PROCESS

xx SPECIFIC TECHNIQUES, A-Z (Photography)

CONSERVATION

see

I.C.4 - CONSERVATION

COMPARISONS

see

I.C.9 - COMPARISONS

CONVERSATION PIECES

see

I.F - GROUPS

COMPOSERS

see

I.E - PROFESSIONS - MUSICIANS

COPTIC

see

I.C.2 (Early Christian, Coptic, Byzantine)

COSMETICS

see

I.E - COSMETICS

x MAKE-UP

CRYSTALLO CERAMICS

see

II.C.5 - CAMEOS & INTAGLIOS

COSTUME

see

I.E - COSTUME

xx SPECIAL SUBJECTS, A-Z

CURIOSITIES

see

I.E - CURIOSITIES

xx SPECIAL SUBJECTS, A-Z

COUNTRIES

see

I.D - SPECIAL COUNTRIES

DAGUERREOTYPE

see

II.E.5 - DAGUERREOTYPE

xx SPECIFIC TECHNIQUES, A-Z (Photography)

COUNTRIES, INDIVIDUAL (SPECIAL MEDIA)

see

(Medium)- BY COUNTRY (e.g.II.A.3 - AUSTRIA)(Painting)
 (e.g.II.C.3 - FRANCE)(Sculpture)

DANCERS

see

I.E - PROFESSIONS - DANCERS
II.E.4 - PROFESSIONS - DANCERS

xx PROFESSIONS

CRAYON

see

II.B.2.e - CRAYON

xx SPECIFIC MEDIA (Drawings)

DEALERS

see

I.B.1.e - DEALERS

DEATH

see

I.E - DEATH

sa II.E.4 - DEATH (Photography)

xx SPECIAL SUBJECTS, A-Z

"DISGUISED" PORTRAITS (ASSISTENZIA)

see

I.H.5 - "DISGUISED" PORTRAITS (ASSISTENZIA)

x ASSISTENZIA (ASSISTENTIA)

DEATH (Photography)

see

II.E.4 - DEATH

xx SPECIAL FORMS & SUBJECTS (Photography)

DISSERTATIONS

see

I.J - THESES & DISSERTATIONS

DERBY PORCELAIN

see

II.C.4 - CERAMICS (Sculpture)

DONOR PORTRAITS

see

I.E - DONOR PORTRAITS

xx SPECIAL SUBJECTS, A-Z

DIGITIZED COMPUTER PORTRAIT

see

I.C.7 - 20th c.

DOUBLE PORTRAIT

see

I.E - GROUPS

DIORAMA

see

II.A.5 - DIORAMA

xx SPECIFIC TECHNIQUES, A-Z (Photography)

DRAWINGS

see

II.B.2 - DRAWINGS

EAR

see

I.E - ANATOMY (EAR)

ENCAUSTIC

see

II.A.5 - ENCAUSTIC

xx SPECIFIC MEDIA, A-Z (Painting)

EARLY CHRISTIAN

see

I.C.2 (Early Christian, Coptic, Byzantine)

xx SPECIAL PERIODS & STYLES - CHRONOLOGICAL

ENGRAVING

see

II.F.3.e - ENGRAVING

x CHALCOGRAPHY
x LINE ENGRAVING
x STEEL-ENGRAVING

xx SPECIFIC MEDIA (prints)

EARTHENWARE

see

CERAMICS II.C.4 (Sculpture)
II.D (Decorative arts)

EQUESTRIAN

see

I.E - EQUESTRIAN

sa II.C.5 - EQUESTRIAN (Sculpture)

xx SPECIAL SUBJECTS, A-Z

EMPERORS

see

I.E - PROFESSIONS - STATESMEN - ROYALTY

EQUESTRIAN (Sculpture)

see

II.C.5 - EQUESTRIAN

xx SPECIAL FORMS & SUBJECTS, A-Z (Sculpture)

ENAMEL

see

II.A.5 - ENAMEL

xx SPECIFIC MEDIA, A-Z (Painting)

ESSAYS

see

I.B.3.a (Festschriften, Essays)

x FESTSCHRIFTEN

ETCHING

see

II.B.3.e - ETCHING

xx GRAPHIC MEDIA (Prints)

EYEGLASSES

see

I.E - EYEGLASSES IN ART

x SPECTACLES

xx SPECIAL SUBJECTS, A-Z

ETHNIC GROUPS

see

I.E - ETHNIC GROUPS, A-Z

sa II.E.4 - ETHNIC GROUPS (Photography)

x BLACKS
x INDIANS
x JEWS

xx SPECIAL SUBJECTS, A-Z

FABRICS

see

II.D - FABRICS

x WOVEN
x TOILE DE JOUY

ETHNIC GROUPS (Photography)

see

II.E.4 - ETHNIC GROUPS

xx SPECIAL FORMS & SUBJECTS (Photography)

FAKES

see

I.C.2 - FORGERIES

EXPLORERS

see

I.E - PROFESSIONS - EXPLORERS

xx PROFESSIONS

FAMILY

see

I.E - FAMILY (used when collection or essay emphasizes
 family relationship,e.g.artist paints his
 wife; family groups in art, etc.)

sa II.E.4 - FAMILY (photography)

xx SPECIAL SUBJECTS, A-Z

EYE

see

I.E - ANATOMY (EYE)

FAMILY (Photography)

see

II.E.4 - FAMILY

xx SPECIAL FORMS & SUBJECTS (Photography)

FESTSCHRIFTEN

see

I.B.3.a (Festschriften, Essays)

FORMS (Painting)

see

II.A.6 - SPECIAL FORMS, A-Z (Painting)

FIGUREHEADS

see

II.C.5 - FIGUREHEADS

xx SPECIAL FORMS & SUBJECTS, A-Z (Sculpture)

FORMS (Photography)

see

II.E.4 - SPECIAL FORMS & SUBJECTS (Photography)

FOLK ART

see

I.E - FOLK ART

sa II.A.4 - PRIMITIVE (Painting)

xx SPECIAL SUBJECTS, A-Z

FORMS (Sculpture)

see

II.C.5 - SPECIAL FORMS & SUBJECTS, A-Z (Sculpture)

FORGERIES

see

I.G.2 - FORGERIES

x FAKES

FREEMASONS

see

I.E - MASONS

FORMAL VS. INFORMAL PORTRAITS

see

I.H.4.e - FORMAL VS. INFORMAL PORTRAITS

xx INTENTION (of sitter and/or artist)

x INFORMAL
x REPRESENTATIONAL

FRESCO

see

II.A.6 - MURALS

FRONTAL

see

I.F.2 (Frontal)

xx SPECIAL POSE OR LENGTH

FUNERARY (Sculpture)

see

II.C.5 - FUNERARY

xx SPECIAL FORMS & SUBJECTS, A-Z (Sculpture)

FULL SEATED

see

I.F.5.e - FULL SEATED

xx LENGTH

FURNITURE

see

II.C.4 - WOOD
II.C.5 - BUSTS(sculpture)
II.D - CERAMICS - WEDGWOOD WARE

FULL STANDING

see

I.F.5.d - FULL STANDING

xx LENGTH

GEMS

see

II.C.5 - CAMEOS & INTAGLIOS

FULL STANDING (Sculpture)

see

II.C.5 - STANDING FIGURES

xx SPECIAL FORMS & SUBJECTS, A-Z (Sculpture)

GENERAL TREATISES

see

I.B (General treatises, incl History)

sa I.D - SPECIAL COUNTRIES
sa II.A - PAINTING
sa II.C - SCULPTURE

x HISTORY
x THEORY

FUNERARY MEMORIALS

see

I.E - FUNERARY MEMORIALS (other than sculpture)

sa II.C.5 - FUNERARY (Sculpture)

x TOMBS

xx SPECIAL SUBJECTS, A-Z

GLASS

see

II.A.6 - GLASS (e.g.Hinterglasmalerei)

sa II.B.3.f - GLASS (engraved)
sa II.C.5 - CAMEOS & INTAGLIOS (incl.glass cameos)
x VERRE ÉGLOMISÉ
x HINTERGLASMALEREI

xx SPECIAL FORMS, A-Z (Painting)

Bibliography on Portraiture—Index to Topics

GLASS (engraved)

see

II.B.3.f - GLASS (engraved)

GROUPS

see

I.E - GROUPS

x CONVERSATION PIECES
x MOTHER AND CHILD
x DOUBLE PORTRAITS

xx SPECIAL SUBJECTS, A-Z

GOUACHE

see

II.A.5 - GOUACHE

xx SPECIFIC MEDIA, A-Z (Painting)

HAIR

see

II.A.5 - HAIR

xx SPECIFIC MEDIA, A-Z (Painting)

GOVERNMENT (State and local)

see

I.E - PROFESSIONS - GOVERNMENT - STATE AND LOCAL

sa PROFESSIONS - ADMINISTRATION

x GOVERNORS
x MAYORS

xx PROFESSIONS

HAIRDRESSING

see

I.E - HAIRDRESSING

GOVERNORS

see

I.E - PROFESSIONS - GOVERNMENT - STATE AND LOCAL

HALF LENGTH

see

I.F.5.b - WAIST, HALF LENGTH

x KIT CAT SIZE

xx LENGTH

GRAPHITE

see

II.B.2.e - GRAPHITE

x PLUMBAGO

xx SPECIFIC MEDIA (Drawings)

HEADS

see

II.C.5 - HEADS (Sculpture)

xx SPECIAL FORMS & SUBJECTS, A-Z (Sculpture)

HELIOGRAVURE

see

II.E.5 - HELIOGRAVURE

xx SPECIFIC TECHNIQUES, A-Z (Photography)

INDIANS

see

I.E - ETHNIC GROUPS, A-Z

HINTEROLASMALEREI

see

II.A.6 - GLASS (e.g.Hinterglasmalerei)

INDIVIDUAL ARTISTS

see

I.B.2 - (Name)

x MONOGRAPHS
x PAINTERS
x SCULPTORS

HISTORY

see

I.B (General treatises incl.History)

INDIVIDUAL SITTERS

see

I.E - INDIVIDUAL SITTERS, A-Z

sa INDIVIDUAL SITTERS (Photography)

x SITTERS

xx SPECIAL SUBJECTS, A-Z

HUDSON VALLEY PATROON PAINTERS

see

AUTHORS SECTION - Hudson Valley Patroon Painters

x PATROON PAINTERS

INDIVIDUAL SITTERS (Photography)

see

II.E.4 - INDIVIDUAL SITTERS, A-Z

xx SPECIAL FORMS & SUBJECTS (Photography)

IMAGO CLIPEATA

see

I.E - ANCESTRAL

INFLUENCES

see

I.C.9 - INFLUENCES

INFORMAL

see

I.H.4.e - FORMAL VS. INFORMAL PORTRAITS

JEWS

see

I.E - ETHNIC GROUPS, A-Z

INTAGLIOS

see

II.C.5 - CAMEOS & INTAGLIOS

JOURNALISTS

see

I.E - PROFESSIONS - AUTHORS

INTENTION (of sitter and/or artist)

see

I.H.4.b - INTENTION (of sitter and/or artist)

xx PSYCHOLOGY

JOURNALS

see

I.B.3 - JOURNALS

IRON

see

II.C.4 - METAL - IRON

JOUY PRINTS

see

II.D - FABRICS

ITINERANT PORTRAITISTS

see

II.A.3 - U.S.

JURISTS

see

I.E - PROFESSIONS - JURISTS

x Lawyers

xx PROFESSIONS

JUVENILE WORKS

see

I.B.5 - JUVENILE WORKS

LEAD

see

II.C.4 - METAL - LEAD

KINGS

see

I.E - PROFESSIONS - STATESMEN - ROYALTY

LENGTH

see

I.F.5 - LENGTH

sa BUSTS
sa HALF LENGTH
sa THREE QUARTER LENGTH
sa FULL STANDING
sa FULL SEATED
sa WAIST
sa KIT CAT SIZE
xx SPECIAL POSE OR LENGTH

KIT CAT SIZE

see

I.F.5.b - WAIST, HALF LENGTH

xx LENGTH

LIGHTING IN PORTRAITURE

see

I.F - LIGHTING IN PORTRAITURE

xx SPECIAL SUBJECTS, A-Z

LABORERS

see

I.E - PROFESSIONS - LABORERS

xx PROFESSIONS

LIMNERS
see

I.B.2 - AETATIS SUE LIMNER
I.B.2 - BEARDSLEY LIMNER
I.B.2 - BLUNT, JOHN S., the BORDEN LIMNER
I.B.2 - BLYTH, BENJAMIN, 1737(?)-1803(?)
I.B.2 - BORDEN LIMNER
I.B.2 - BORDER LIMNER
I.B.2 - CROSS, PETER
I.B.2 - DE PEYSTER LIMNER
I.B.2 - FREAKE LIMNER

(continued on next card)

LAWYERS

see

I.E - PROFESSIONS - JURISTS

LIMNERS (card 2)
see
I.B.2 - FRYMIRE, JACOB
I.B.2 - GANSEVOORT LIMNER
I.B.2 - GREENLEAF, BENJAMIN
I.B.2 - HEATEN, JOHN, the WENDELL LIMNER
I.B.2 - HESSELIUS, JOHN
I.B.2 - KENT LIMNER
I.B.2 - PATRIDGE, NEHEMIAH, the AETATIS SUE LIMNER
I.B.2 - PAYNE LIMNER
I.B.2 - PERKINS, SARAH
I.B.2 - PHILLIPS, AMMI

(continued on next card)

LIMNERS (card 3)

see

I.B.2 - PIERPONT LIMNER
I.B.2 - POLK,CHARLES PEALE
I.B.2 - POLLARD LIMNER
I.B.2 - SCHUYLER LIMNER
I.B.2 - TARRYTOWN LIMNER
I.B.2 - VAN EPPS LIMNER
I.B.2 - VANDERLYN, PIETER, the GANSEVOORT LIMNER
I.B.2 - VAN RENSSELAER LIMNER
I.B.2 - VEEDER LIMNER
I.B.2 - WATSON, JOHN
I.B.2 - WENDELL LIMNER

MACHINE PORTRAITS

see

I.E - OBJECT PORTRAITS

LIMNERS

see also

Fisher, Leonard Everett. The limners;America's earliest
 portrait painters...N.Y.,F.Watts,1969

 Fisher discusses the motivations,materials
and techniques of the first "Artists"in Colo-
nial America. The sign painters and how their
works contribute to a better understanding of
early American history

LC ND1311.F5

MAKE-UP

see

I.E - COSMETICS

ND LIMNERS
207.W78
1971 see also
NPG
Black, Mary C. Pieter Vanderlyn and other limners of the
 Upper Hudson

MANUSCRIPTS

see

II.A.6 - MANUSCRIPTS

xx SPECIAL FORMS, A-Z (Painting)

LINE ENGRAVING

see

II.B.3.e - ENGRAVING

MARINE

see

I.E - PROFESSIONS - MARINE

x NAVAL

xx PROFESSIONS

LITHOGRAPHY

see

II.B.3.e - LITHOGRAPHY

xx SPECIFIC MEDIA (Prints)

MASKS

see

II.C.5 - MASKS

xx SPECIAL FORMS & SUBJECTS, A-Z (Sculpture)

MASONS

see

I.E - MASONS

x FREEMASONS

xx SPECIAL SUBJECTS, A-Z

MEDICINE

see

I.E - PROFESSIONS - MEDICINE

x PHYSICIANS

xx PROFESSIONS

MATERIAL (Sculpture)

see

II.C.4 - SPECIFIC MATERIAL (Sculpture)

MEDIA (Drawings)

see

II.B.2.e - SPECIFIC MEDIA (Drawings)

MAYORS

see

I.E - PROFESSIONS - GOVERNMENT - STATE AND LOCAL

MEDIA (Painting)

see

II.A.5 - SPECIFIC MEDIA, A-Z- (Painting)

MEDALLIONS

see

II.C.5 - COINS & MEDALS

MEDIA (Prints)

see

II.B.3.e - SPECIFIC MEDIA (Prints)

MEDALS

see

II.C.5 - COINS & MEDALS

x MEDALLIONS

MEN

see

I.E - MEN

xx SPECIAL SUBJECTS, A-Z

METAL

see

II.C.4 - METAL

x BRONZE
x IRON
x LEAD

xx SPECIFIC MATERIAL (Sculpture)

MINIATURES (Painting)

see

II.A.6 - MINIATURES

xx SPECIAL FORMS, A-Z (Painting)

MEZZOTINT

see

II.B.3.e - MEZZOTINT

xx SPECIFIC MEDIA (Prints)

MINIATURES (Sculpture)

see

II.C.5 - MINIATURES

xx SPECIAL FORMS & SUBJECTS, A-Z (Sculpture)

MIDDLE AGES

see

I.C.3 - c.5th c.-14th c.

sa II.C.2 - MEDIEVAL (Sculpture)

xx SPECIAL PERIODS & STYLES - CHRONOLOGICAL

MONOGRAPHS

see

I.M.2 - (Name)

MIDDLE AGES (Sculpture)

see

II.C.2 - MEDIEVAL

MOSAICS

see

II.A.6 - MOSAICS

xx SPECIAL FORMS, A-Z (Painting)

MILITARY

see

I.E - PROFESSIONS - MILITARY

xx PROFESSIONS

Mother and Child

see

I.E - GROUPS

933

MOTION PICTURES

see

I.E. - PROFESSIONS - MOTION PICTURES

xx PROFESSIONS

MUTILATION

see

I.G.3 - MUTILATION

x ALTERED PLATES

MÜNZBILDBÜCHER

see

II.B.3.f - BILDNISVITENBÜCHER

MYTHOLOGY

see

I.F - ALLEGORY & RELIGION

MUMMIES

see

I.E - MUMMIES

xx SPECIAL SUBJECTS, A-Z

NAVAL

see

I.E - PROFESSIONS - MARINE

MURALS

see

II.A.6 - MURALS

x FRESCO

NEEDLEWORK

see

II.D - NEEDLEWORK

x STUMP WORK

MUSICIANS

see

I.E - PROFESSIONS - MUSICIANS

X COMPOSERS

xx PROFESSIONS

NOBILITY

see

I.E - PROFESSIONS - NOBILITY

xx PROFESSIONS

NUMISMATICS

see

II.C.5 - COINS & MEDALS

ORIGAMI

see

I.E - ORIGAMI

xx SPECIAL SUBJECTS, A-Z

OBJECT PORTRAITS

see

I.E - OBJECT PORTRAITS

x MACHINE PORTRAITS

xx SPECIAL SUBJECTS, A-Z

OUTLAWS

see

I.E - PROFESSIONS - OUTLAWS

XX PROFESSIONS

OLD AGE

see

I.E - OLD AGE

sa II.E.4 - OLD AGE (Photographs)

xx SPECIAL SUBJECTS, A-Z

PAINTERS

see

I.F.2 - (Name)

sa I.E - PROFESSIONS - ARTISTS

OLD AGE (Photographs)

see

II.E.4 - OLD AGE

xx SPECIAL FORMS & SUBJECTS (Photography)

PAINTING

see

II.A - PAINTING

ORATORS

see

I.F - PROFESSIONS - ORATORS

PASTEL

see

II.A.5 - PASTEL

xx SPECIFIC MEDIA, A-Z (Painting)

PATHOLOGY

see

I.H.4.a

PHILOSOPHY

see

I.H.3 - PHILOSOPHY

PATROON PAINTERS

see

HUDSON VALLEY PATROON PAINTERS

PHOTOCERAMICS

see

II.E.5 - PHOTOCERAMICS

xx SPECIFIC TECHNIQUES, A-Z (Photography)

PERIODS

see

I.C - SPECIAL PERIODS & STYLES - CHRONOLOGICAL

PHOTOGRAPHERS

see

II.F.8 - (Name)

sa II.E.4 - PROFESSIONS - PHOTOGRAPHERS
sa II.E.4 - PHOTOGRAPHERS - AFRO-AMERICAN

xx SPECIAL FORMS & SUBJECTS (Photography)

PLASTER

see

II.C.4 - PLASTER

xx SPECIFIC MATERIAL (Sculpture)

PHOTOGRAPHERS - AFRO-AMERICAN

see

II.F.4 - PHOTOGRAPHERS - AFRO-AMERICAN

xx SPECIAL FORMS & SUBJECTS (Photography)

PHILOSOPHERS

see

I.E - PROFESSIONS - PHILOSOPHERS

xx PROFESSIONS

PHOTOGRAPHY

see

II.E - PHOTOGRAPHY

PHOTOMONTAGE

see

II.E.5 - PHOTOMONTAGE

xx SPECIFIC TECHNIQUES, A-Z (Photography)

PLAYING CARDS

see

II.B.3.f - PLAYING CARDS

PHRENOLOGY

see

I.H.4.a - PHYSIOGNOMY

PLUMBAGO

see

II.B.2.e - GRAPHITE

PHYSICIANS

see

I.E - PROFESSIONS - MEDICINE

POETS

see

I.E.- PROFESSIONS - AUTHORS

PHYSIOGNOMY

see

I.H.4.a - PHYSIOGNOMY

sa CARICATURE

x CHARACTERIZATION
x PHRENOLOGY

xx PSYCHOLOGY

POPES

see

I.E - PROFESSIONS - CLERGY - POPES

PHYSIONOTRACE

see

II.B.1.e - PHYSIONOTRACE

PORCELAIN

see

CERAMICS II.C.4 (Sculpture)
 II.D (Decorative arts)

PORTRAIT HISTORIE

see

I.E - ALLEGORY & RELIGION

POSTAGE-STAMPS

see

I.E - POSTAGE-STAMPS

x STAMPS

xx SPECIAL SUBJECTS, A-Z

PORTRAIT-MAKING AS AN OCCUPATION

see

I.B.4 - PORTRAIT-MAKING AS AN OCCUPATION

POSTERS

see

II.B.3.f - POSTERS

PORTRAIT MEDALLIONS

see

II.C.5 - COINS & MEDALS

POTTERY

see

CERAMICS II.C.4 (Sculpture)
II.D (Decorative arts)

PORTRAITS WITHIN PORTRAITS

see

I.H.6 - PORTRAITS WITHIN PORTRAITS

PRESIDENTS

see

I.E - PROFESSIONS - STATESMEN - PRESIDENTS

POSE OR LENGTH

see

I.F - SPECIAL POSE OR LENGTH

PRIMITIVE (Painting)

see

II.A.4 - PRIMITIVE

PRINTED FABRICS

see

II.D - FABRICS

PROFILE

see

I.F.4.a - PROFILE(GENERAL)

sa II.C.5 - COINS & MEDALS
sa I.F.4.b - PROFILE SILHOUETTE

xx SPECIAL POSE OR LENGTH

PRINTERS

see

I.E - PROFESSIONS - PRINTERS

xx PROFESSIONS

PROFILE SILHOUETTE

see

I.F.4.b - PROFILE SILHOUETTE

x SILHOUETTE

xx PROFILE

PRINTS

see

II.B.3 - PRINTS

PSYCHOLOGY

see

I.H.4.a PSYCHOLOGY

sa I.H.4.b - INTENTION
sa I.H.4.a - PHYSIOGNOMY
sa I.H.4.c - FORMAL VS. INFORMAL PORTRAITS
x PATHOLOGY

PROFESSIONS

see

I.E - PROFESSIONS, A-Z

sa SPECIAL SUBJECTS (SPECIAL MEDIA)

xx SPECIAL SUBJECTS, A-Z

QUEENS

see

I.E - PROFESSIONS - STATESMEN - ROYALTY

PROFESSIONS - PHOTOGRAPHERS

see

II.E.4 - PROFESSIONS - PHOTOGRAPHERS

xx SPECIAL FORMS & SUBJECTS (Photography)

RECTORS

see

I.E - PROFESSIONS - CLERGY - RECTORS

REFORMERS

see

I.E - PROFESSIONS - CLERGY - REFORMERS

ROYALTY

see

I.E - PROFESSIONS - STATESMEN - ROYALTY

RELIEF

see

II.C.5 - RELIEF

xx SPECIAL FORMS & SUBJECTS, A-Z (Sculpture)

SCHOLARS

see

I.E - PROFESSIONS - SCHOLARS

xx PROFESSIONS

RELIGION

see

I.E - ALLEGORY & RELIGION

SCIENTISTS

see

I.E - PROFESSIONS - SCIENTISTS

xx PROFESSIONS

RENAISSANCE

see

I.C.4 - 14th c.-17th c.

sa SPECIAL PERIODS & STYLES (SPECIAL MEDIA)
sa I.D - SPECIAL COUNTRIES, A-Z

xx SPECIAL PERIODS & STYLES - CHRONOLOGICAL

SCULPTORS

see

I.b.2 - (Name)

sa I.E - PROFESSIONS - ARTISTS

REPRESENTATIONAL

see

I.H.4.c - FORMAL VS. INFORMAL PORTRAITS

SCULPTURE

see

II.C:- SCULPTURE

SEALS

see

II.C.5 - COINS & MEDALS

SERVANTS

see

I.E - PROFESSIONS - SERVANTS

xx PROFESSIONS

SELF-PORTRAITS (Painting.Also:General works or more than one medium)

see

I.E - SELF-PORTRAITS

sa SPECIAL SUBJECTS(SPECIAL MEDIA)
sa SPECIAL FORMS & SUBJECTS, A-Z (Sculpture)
sa SELF-PORTRAITS (Photography)
xx SPECIAL SUBJECTS, A-Z

SILHOUETTE

see

I.F.4.b - PROFILE SILHOUETTE

SELF-PORTRAITS (Photography)

see

II.E.4 - SELF-PORTRAITS

xx SPECIAL FORMS & SUBJECTS (Photography)

SITTERS, INDIVIDUAL

see

I.E - INDIVIDUAL SITTERS, A-Z

SELF-PORTRAITS (Sculpture)

see

II.C.5 - SELF-PORTRAITS

xx SPECIAL FORMS & SUBJECTS, A-Z (Sculpture)

SKULLS

see

I.E - SKULLS

xx SPECIAL SUBJECTS, A-Z

SERJEANT PAINTERS

see

AUTHORS SECTION - Serjeant painters

Serjeant painter is a title of the particular office or function at the court of an English monarch in the 16th and 17th centuries

SPECIAL COUNTRIES, A-Z

see

I.D - SPECIAL COUNTRIES, A-Z (Special countries,if medium is not known or if more than one medium or the specific country's approach to portraiture is discussed)

x COUNTRIES

SPECIAL COUNTRIES, INDIVIDUAL (SPECIAL MEDIA)

see

(Medium) - BY COUNTRY (e.g.II.A.3 - AUSTRIA)(Painting)
 (e.g.II.C.3 - FRANCE)(Sculpture)

x COUNTRIES, INDIVIDUAL

SPECIAL PERIODS & STYLES (SPECIAL MEDIA)

see

(Medium) - CHRONOLOGICAL (e.g.II.A.2 - CHRONOLOGICAL)
 (Painting)

SPECIAL FORMS, A-Z (Painting)

see

II.A.6 (Glass,Manuscripts,Miniatures,Mosaics)

x FORMS (Painting)
sa GLASS
sa MANUSCRIPTS
sa MINIATURES
sa MOSAICS

SPECIAL POSE OR LENGTH

see

I.F - SPECIAL POSE OR LENGTH

sa FRONTAL
sa PROFILE
sa PROFILE SILHOUETTE
sa LENGTH

x POSE OR LENGTH

SPECIAL FORMS & SUBJECTS (Photography)

see

II.E.4 - SPECIAL FROMS & SUBJECTS (Photography)

sa CARTES DE VISITES,CHILDREN,DEATH,ETHNIC GROUPS,FAMILY,
 INDIVIDUAL SITTERS,OLD AGE,PHOTOGRAPHERS-AFRO-AMERICAN,
 PROFESSIONS,SELF-PORTRAITS,WOMEN

x FORMS(Photography)
x SUBJECTS(Photography)

SPECIAL SUBJECTS, A-Z

see

I.E - SPECIAL SUBJECTS, A-Z
sa SPECIAL SUBJECTS (SPECIAL MEDIA)
sa ALLEGORY & RELIGION,ANATOMY,ANCESTRAL,ARTISTS,PHYSICAL-
 LY HANDICAPPED,CARICATURE,CHILDREN,COSTUME,CURIOSITIES,
 DEATH,DONOR PORTRAITS,EQUESTRIAN,ETHNIC GROUPS,A-Z,
 EYEGLASSES IN ART,FAMILY,FOLK ART,FUNERARY MEMORIALS,
 GROUPS,INDIVIDUAL SITTERS,LIGHTING IN PORTRAITURE,MA-
 SONS,MEN,MUMMIES,OBJECT PORTRAITS,OLD AGE,ORIGAMI,POS-
 TAGE STAMPS,PROFESSIONS,SELF-PORTRAITS,SKULLS,YOUTH

x SUBJECT, SPECIAL

SPECIAL FORMS & SUBJECTS, A-Z (Sculpture)

see

II.C.5 - SPECIAL FORMS & SUBJECTS, A-Z (Sculpture)

sa BUSTS,CAMEOS & INTAGLIOS,CARICATURE,COINS & MEDALS,
 EQUESTRIANS,FIGUREHEADS,FUNERARY,HEADS,MASKS,MINIA-
 TURES,PROFESSIONS,RELIEF,SELF-PORTRAITS,STANDING FI-
 GURES

x FORMS (Sculpture)

SPECIAL SUBJECTS (SPECIAL MEDIA)

see

(MEDIUM)- SPECIAL SUBJECTS (e.g.II.B.3.d - PROFESSIONS)
 (Prints)

SPECIAL PERIODS & STYLES - CHRONOLOGICAL

see

I.C - SPECIAL PERIODS & STYLES - CHRONOLOGICAL

sa SPECIAL PERIODS & STYLES (SPECIAL MEDIA)
sa I.D SPECIAL COUNTRIES
sa EARLY CHRISTIAN
sa MIDDLE AGES
sa RENAISSANCE

x PERIODS
x STYLES

SPECIFIC MATERIAL (Sculpture)

see

II.C.4 - SPECIFIC MATERIAL (Sculpture)

x MATERIAL (Sculpture)

SPECIFIC MEDIA (Drawings)

see

II.B.2.# - SPECIFIC MEDIA (Drawings)

x MEDIA (Drawings)

STAFFORDSHIRE WARE

see

CERAMICS II.C.4 (Sculpture)
II.D (Decorative arts)

SPECIFIC MEDIA, A-Z (Painting)

see

II.A.5 - SPECIFIC MEDIA, A-Z (Painting)

x MEDIA(Painting)

STAMPS

see

I.E - POSTAGE-STAMPS

SPECIFIC MEDIA (Prints)

see

II.B.3.e - SPECIFIC MEDIA (Prints)

x MDIA (Prints)

STANDING FIGURES

see

II.C.5 - STANDING FIGURES

x FULL STANDING (Sculpture)

xx SPECIAL FORMS & SUBJECTS, A-Z (Sculpture)

SPECIFIC TECHNIQUES, A-Z (Photography)

see

II.E.5 - SPECIFIC TECHNIQUES, A-Z (Photography)

sa CALOTYPE, COLLODION PROCESS, DAGUERREOTYPE, DIORAMA, HELIOGRAVURE, PHOTOCERAMICS, PHOTOMONTAGE, TINTYPE

x .TECHNIQUES (Photography)

STATESMEN

see

I.E - PROFESSIONS - STATESMEN

sa INDIVIDUAL SITTERS
sa STATESMEN - PRESIDENTS
sa STATESMEN - ROYALTY

xx PROFESSIONS

SPECTACLES

see

I.E - EYEGLASSES IN ART

STATESMEN - PRESIDENTS

see

I.E - PROFESSIONS - STATESMEN - PRESIDENTS

xx STATESMEN

x PRESIDENTS

STATESMEN - ROYALTY

see

I.E - PROFESSIONS - STATESMEN - ROYALTY

xx STATESMEN

x ROYALTY
x EMPERORS
x QUEENS

STYLES

see

I.C - SPECIAL PERIODS & STYLES - CHRONOLOGICAL

STEEL-ENGRAVING

see

II.B.3.e - ENGRAVING

SUBJECTS (Photography)

see

II.B.4 - SPECIAL FORMS & SUBJECTS (Photography)

STIPPLE

see

II.B.2.e - STIPPLE

xx SPECIFIC MEDIA (Drawings)

SUBJECTS, SPECIAL

see

I.E - SPECIAL SUBJECTS, A-Z

STONE

see

II.C.4 - STONE

xx SPECIFIC MATERIAL (Sculpture)

SULPHIDES

see

II.C.5 - CAMEOS & INTAGLIOS

STUMP WORK

see

II.D - NEEDLEWORK

SYMBOLISM

see

I.E - ALLEGORY & RELIGION

TAPESTRY

see

II.D - TAPESTRY

THESES AND DISSERTATIONS

see

I.J - THESES & DISSERTATIONS

x DISSERTATIONS

TECHNIQUE

see

II.A.1 - PAINTING, GENERAL (incl.some items on technique)

THREE QUARTER LENGTH

see

I.F.5.c - THREE QUARTER LENGTH

xx LENGTH

TECHNIQUES (Photography)

see

II.E.5 - SPECIFIC TECHNIQUES,A-Z (Photography)

TINTYPE

see

II.E.5 - TINTYPE

xx SPECIFIC TECHNIQUES, A-Z (Photography)

TERRA-COTTA

see

CERAMICS II.C.4 (Sculpture)
II.D (Decorative arts)

TOBY JUGS

see

II.C.5 - TOBY JUGS

xx CERAMICS (Sculpture)

THEORY

see

I.B (General treatises incl.History)

TOILE DE JOUY

see

II.D - FABRICS

TOMBS

see

II.C.5 - FUNERARY

WATER-COLOR

see

II.A.5 - WATER-COLOR

xx SPECIFIC MEDIA, A-Z (Painting)

USES OF PHOTOGRAPHY IN PORTRAITURE

see

II.F.6 - USES OF PHOTOGRAPHY IN PORTRAITURE

WAX

see

II.C.4 - WAX

xx SPECIFIC MATERIAL (Sculpture)

USES OF PORTRAITS

see

I.H.1 - INTELLECTUAL CONCEPTS - GENERAL

WEDGWOOD WARE

see

II.D - CERAMICS - WEDGWOOD WARE

x FURNITURE
 xx CERAMICS (Decorative arts)

VERRE ÉGLOMISÉ

see

II.A.6 - GLASS (e.g.Hinterglasmalerei)

WOMEN

see

I.E - WOMEN

sa II.E.4 - WOMEN (Photography)
sa WOMEN(SPECIAL MEDIA)

xx SPECIAL SUBJECTS, A-Z

WAIST

see

I.F.5.b - WAIST

xx LENGTH

WOMEN (Photography)

see

II.E.4 - WOMEN

xx SPECIAL FORMS & SUBJECTS (Photography)

WOMEN (SPECIAL MEDIA)

see

(Medium) - WOMEN (e.g.II.B.2.d - WOMEN)(Drawings)

WOVEN

see

II.D - FABRICS

WOMEN ARTISTS

see

I.E - PROFESSIONS - WOMEN ARTISTS

xx PROFESSIONS

WRITERS

see

I.E - PROFESSIONS - AUTHORS

WOOD

see

II.C.4 - WOOD

xx SPECIFIC MATERIAL (Sculpture)

x FURNITURE

YOUTH

see

I.E - YOUTH

xx SPECIAL SUBJECTS, A-Z

WOOD ENGRAVING

see

II.B.3.e - WOOD ENGRAVING

xx SPECIFIC MEDIA (Prints)

WOODCUT

see

II.B.3.e - WOODCUT

xxSPECIFIC MEDIA (Prints)